The New York Times
Theater Reviews

𝕿imes BOOKS / Ⓖ𝖯

Times Books & Garland Publishing, Inc. / New York 1994

Published by TIMES BOOKS,
The New York Times Book Co., Inc.
130 Fifth Avenue, New York, N.Y. 10011
and by
GARLAND PUBLISHING, INC.
New York & London

ISBN 0-8153-0643-1

Printed on acid-free, 250-year-life paper

Manufactured in the United States of America

Contents

Foreword

All theater reviews published in The New York Times between 1870–1990 have been assembled and reproduced in book form under the title THE NEW YORK TIMES THEATER REVIEWS.

This collection is accompanied by computer-generated indexes which cover the periods 1870–1919, 1920–1970, 1971–1972, 1973–1974, 1975–1976, 1977–1978, 1979–1980, 1981–1982, 1983–1984, 1985–1986, 1987–1988, and 1989–1990. Each index is divided into three sections: Titles, Personal Names, and Corporate Names.

The present volume updates the collection by reproducing all of the Times theater reviews published in 1991–1992. It also includes articles about the shows that won Pulitzer Prizes, New York Drama Critics Circle Awards, Antoinette Perry (Tony) Awards, and other awards. The volume is completed by a three-part index, prepared along the same lines as the earlier indexes.

New compilations will be published periodically to keep the collection constantly updated.

The New York Times
Theater Reviews
1991

Playwrights Rate Life a Love Game In an Era of Sagging Morale

By DAVID RICHARDS

I DON'T KNOW IF YOU REMEMBER the ending of the second act of "The Last of the Red Hot Lovers," Neil Simon's 1971 triptych about the futile attempts of the proprietor of a seafood restaurant — married, middle-aged and thickening at the waist — to catch up with the sexual revolution. I found myself thinking of it the other night, while leaving a play that had nothing to do with seafood restaurants, the sexual revolution (whatever that is, these days) or middle-aged discontent. There it was, nonetheless, as clear in my mind as what I *had* just seen, and I believe I know why.

■

Mr. Simon's red-hot lover, if you'll permit me the flashback, had already had one go at an extramarital assignation and failed miserably, but was trying again — this time with an aspiring actress, who seemed to think her career was being derailed by wide-ranging conspiracies. She was also given to smoking pot and had convinced her would-be Lothario, who had never done so before, to take a drag or two.

As the act ended, she had succumbed to the particular despair of knowing that she was never going to get a big break. He was not only losing all sensation in his limbs, but had the growing impression that his very life was disintegrating. The two lost souls slumped to the base of the sleep sofa that was to have served other purposes, leaned back and launched into a stoned, but no less heartfelt rendition of "What the world needs now, is love, sweet love . . ."

Of late, we've been hearing that song a lot in the theater. Not literally, of course.

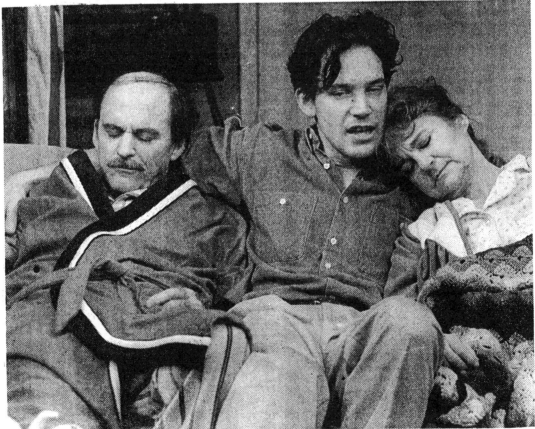

Gerry Goodstein/Circle Repertory Company

Edward Seamon, Barry Sherman and Lynn Cohen in Harry Kondoleon's "Love Diatribe"—What you're left with is Mr. Kondoleon's conviction that the times desperately demand some wise words.

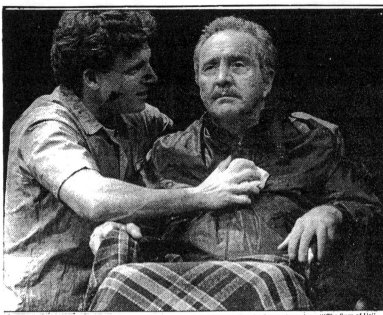

Carol Rosegg-Martha Swope Associates/"The Sum of Us"

Tony Goldwyn and Richard Venture in "The Sum of Us"—love's constancy versus the inability to alter destiny's course

Actors aren't trading in their curtain speeches for a pop tune. But it's been the leitmotif of at least a half dozen new plays — from "The Sum of Us," which has turned into a robust Off Broadway hit (and deservedly so), to Harry Kondoleon's all

In a time of despair, the proliferation of dramas about caring may be, in fact, a call for caring — an S O S of sorts.

too aptly titled "Love Diatribe." Sometimes, the characters march right down to the footlights and draw the moral for us, loud and clear, the way traveling players once begged an audience's indulgence. That's what happened in John Patrick Shanley's short-lived absurdist comedy, "The Big Funk." Sometimes, the message is tucked away in the wreckage of lives that haven't seen enough love, sweet love, as it is in Richard Greenberg's affecting drama, "The American Plan."

If you factor in, among others, "Shadowlands," the account of C. S. Lewis's passionate, late-in-life marriage to the poet Joy Davidman, and the redemptive ending of the Broadway musical "Once on This Island," it would be easy to assume that a wave of romanticism is upon us. It is, however, equally conceivable that this sudden invocation of love's healing powers is telling us something else about the times,

something far more troublesome. Our playwrights may be looking to love because there's no other panacea in sight. The proliferation of plays about caring may, in fact, be a call for caring — a not-so-thinly-disguised S O S.

"You get to the point," says the mother in "Love Diatribe," after a taxing day at the hospital, "where people screaming for help is just an

annoying noise." The homeless roam the streets. Despite massive efforts to curb it, drug addiction is rampant. Our apathy and fears have come together to produce what Mr. Shanley perceived as a kind of spiritual paralysis — that big funk — and his hero was determined to buck up our sagging morale.

"I know. You can explain why I'm wrong," he said, heading off any ob-

jections from the audience at the Public Theater with his affable manner. "Why the streets have to be dirty and the politicians have to be corrupt ... and why there's cruelty right there in your face and you can't do anything about it. But you're wrong! Listen to me! I'm not wrong! We could make things better than they are.... Cause it's just cowardice to say, Oh, that's the way things are. You can't do nothing about that. I'm telling you, Brothers and Sisters, we could be heroes!"

You can argue that such sermonizing belongs in a pulpit, not a theater. But the pulpits must not be working. Similar exhortations are coming at us from too many plays right now to chalk it up to coincidence. It's been two decades since we were urged so baldly to make love (not war). Then, of course, the cry implied a throwing off of convention's shackles. The Establishment was the enemy and our

You don't urge people to cherish one another if cherishing's the norm.

inhibitions made us its patsies. Love was the route to freedom, a political act that could effect a new world.

The tone is totally different today. There's no implication of a new world aborning. Love, apparently, will be hard pressed just to keep this one from going under. Notice is being served. You don't urge people to cherish one another if cherishing's the norm.

The chief character in "Love Diatribe" (at the Circle Repertory Company) even comes armed with a miraculous potion, brewed from mountain wildflowers, which is supposed to promote trust and understanding. Frieda is her name and she claims to be a foreign exchange student when she drops in on one of Mr. Kondoleon's characteristically neurotic suburban families. And none too soon.

■

Bickering was always the family pastime and now that the middle-aged children have come home to roost — Sandy from a failed marriage and Orin from a dead-end job at the library — the bickering's on again. What's more, sweet Mrs. Anderson, the next-door neighbor, barges in every other moment, and while she generally shows up with leftovers, she also has her ax to grind. (Sweetly, of course.) Her older son was an early victim of AIDS and Mrs. Anderson isn't certain that Orin's disparaging remarks at the time didn't hasten his demise. "When you are nice to people," she says, "they can live for a very long time. They do not die."

Frieda's potion to the rescue. You don't drink it yourself, she informs Orin, "you serve it to your family or the people around you who you need to love more." After they fall into a deep sleep, it seems, Orin will then

revive them by making amends for the past and telling them how much he loves them. O.K., I wasn't quite sure of the mechanics either, but let that ride for the sake of Mr. Kondoleon's fantasy. Part of this current absorption with love seems to be a childlike obsession with love's magical side — the charms, incantations and liquors that produce instant results. Reason has proved wanting. Bring on the amulets.

Indeed, if Orin will follow instructions, "then all this fire comes up and eats your timidity, eats your spoiled sense of never being good enough, of being left outside. It changes the molecular structure of everything. One well-placed kiss ... can cause a turnaround just when you thought there was no god, no spirit, no use in continuing." The prognosis pretty much proves true in "Love Diatribe," which concludes with the characters, roused from their slumber by loving words, falling into one another's arms. No irony intended, either, as far as I could detect.

Is it churlish of me to point out that the milk, no, the *cream* of human kindness has not resulted in one of Mr. Kondoleon's sharper plays? Next to the raging neurotics in his earlier works ("Christmas on Mars," "The Vampires"), these folk are penny-ante whiners. Nor can I say he has produced a particularly inventive fable either. Frieda is barely a step removed from the standard-issue fairy godmother with the sparkly wand — there to make a few transforming passes for the plot's sake and utter wise words. What you're left with is Mr. Kondoleon's earnest conviction, one he obviously shares with Mr. Shanley, that the times desperately demand some wise words.

The playwright Richard Greenberg also employs the imagery of fairy tales — castle keeps, moats, heraldic crests and the like — in "The American Plan" (at the Manhattan Theater Club). But he does so wistfully, mockingly. The play, his first since "Eastern Standard," is the sort of romance that Jean Anouilh might have produced, were he to have traded, say, a country park in Normandy for an enchanted glade by a lake in the Catskills, circa 1960. There's an elegant tone of bitter-sweetness to the writing that persists even after youth has been squandered, disenchantment has set in and all that remains of a summer's idyll are ashen memories.

On the far shore of that lake looms a large resort, where the raucous guests sport mink coats by the pool, play Simon Says and gorge themselves on food. "The lower life forms," sniffs Eva, a wealthy Jewish refugee, as she sips tea from bone china in her leafy sanctuary and casts disparaging looks in the direction of the distant vacationers. Change her accent and she could be one of Anouilh's ferocious dowagers, fretting over the decline of standards. No less possessive — and certainly no less vain — Eva is determined, when the occasional young swain makes his way across the lake, not to lose her highly strung daughter, Lili, to a fortune hunter.

This particular summer, it is Nick Lockridge, a sleek WASP straight out of the Arrow Shirt ads, who stumbles on their preserve. Immediately, Lili casts him as the Prince Charming who will break her mother's spell and carry her away on a piebald steed. What ensues is warfare, although it is not immediately apparent, because this war is conducted with decorum, wit and an appreciation for the potential of words to captivate, as well as to destroy.

"You wish for so many things ... isn't that so?" muses Eva. "And you really don't get any of them, do you? ... Because the world has a wish of its own for you ... and it's never good ... You try to shelter those you love from this wish, you become something you never dreamed. But no ... All you may do, really, is stand by in a kind of horror, until the world has finished and you can collect whatever remains."

∎

The considerable fascination of the play is that things are never quite as they appear. Or rather, they are *more* than they appear. Mr. Greenberg's characters operate out of overlapping and often contradictory motives that are, in the end, inimical to conformist America's notion of love. Didacticism is not his style. But given the tenor of the current season, his play can easily be viewed as a cautionary tale about people's failure to forge the connections they most desire. It doesn't take much — a little duplicity, a little recklessness, a little egotism — before you're picking up the pieces. Happiness may exist, but as Lili says, "it's for other people."

Love very nearly slipped by C. S. Lewis, too, if we're to believe William Nicholson's "Shadowlands" (at the Brooks Atkinson Theater), and since it is splendidly performed, there is no reason we shouldn't. The British writer and Christian apologist was en-

sconced in tweedy bachelorhood, until the American poet Joy Davidman entered his life — first as a correspondent, then as a friend and finally as a soulmate, before dying of cancer in 1960.

No one's laughing now, much less singing.

Those who view the play as a theatrical echo of television's weekly wallow in terminal disease are minimizing its most significant aspect: the love and concomitant pain that make Lewis a whole human being. When his bliss with Ms. Davidman is most intense, he can't help looking ahead to the inevitable end. "That pain then is part of this happiness now. That's part of the deal," is her forthright response. Forget the literary trappings. "Shadowlands" is about a man who abandons the protective armor of intellect and the comfort of his habits and takes the deal. Mr. Nicholson makes a wrenching case that Lewis was far richer for it. And death, as a result, is momentarily tamed.

We've always been reluctant to accept its arbitrariness. And now, with death seemingly everywhere, the necessity to believe that it can have an enobling legacy is greater than ever. For her selflessness in love, the gods in "Once on This Island" (at the Booth Theater) transform a forsaken peasant girl into a tree, whose abundant foliage will shelter generations of presumably happier lovers to come.

Merely eluding death for another difficult day is considered a triumph in "Marvin's Room." Scott McPher-

son's play, which is making the rounds of the regional theaters, is an apparent contradiction — a *feeling* black comedy. The heroine, a spindly, middle-aged spinster, has spent her life attending to her dotty aunt and her bedridden father, little more than a vegetable with hair. In rapid order the playwright hits her with leukemia, denies her the bone-marrow transplant that could save her, then sits back to watch what happens. She carries on, caring. The import of this strangely uplifting play is that caring is everything. Doesn't sweet Mrs. Anderson say as much in "Love Diatribe"?

The constancy of love also accounts, I think, for the popularity of "The Sum of Us" (at the Cherry Lane Theater), David Stevens's play about a working-class father who not only accepts his gay son, but encourages his pursuit of happiness. When the father is struck dumb by a stroke, the son assumes the role of the supportive parent, ministering to needs and fears that can no longer be articulated.

It is not difficult to see the specter of AIDS in all this, although "Marvin's Room" makes no mention of the scourge and if the father in "The Sum of Us" weren't so solicitous of his child's welfare, it probably wouldn't crop up there, either. Terrible as the reality is, AIDS has also emerged as a brutal metaphor for our inability to

alter destiny's course. Against the terror of helplessness, compassion and understanding seem to be the only weapons at our disposal.

In an extraordinary program note for the Hartford Stage Company's production of "Marvin's Room," Mr. McPherson traced the genesis of his play to his widowed mother, who hurled herself into overwhelming family responsibilities with a determination that refused to acknowledge their magnitude. "Now I am 31," the note continued, "and my lover has AIDS. Our friends have AIDS. And we all take care of each other, the less sick caring for the more sick. At times, an unbelievably harsh fate is transcended by a simple act of love, by caring for another."

Are we getting the message?

I suspect that we have grown numb, instead. The feeling's gone out of our fingers, our vision is fuzzy and we've slumped to the base of the sleep sofa. We can't pinpoint any conspiracies, but news of their existence wouldn't surprise us. No big breaks are headed our way. Something out there seems terribly wrong. Curious that not so long ago this was the stuff of broad comedy. No one's laughing now, much less singing.

Is it, I wonder, because we're mute that our playwrights have taken up the song for us? □

1991 Ja 6, II:1:2

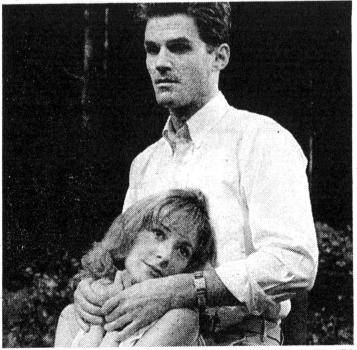

Gerry Goodstein/The Manhattan Theater Club

Wendy Makkena and D. W. Moffett in Richard Greenberg's "American Plan"—Happiness may exist, but it's for other people.

STAGE VIEW/Benedict Nightingale

Families That Play Together, Stage Together

LONDON

IS IT AN UPSCALE MARKETING GIMmick or could it be a useful shortcut to the kind of ensemble acting all performers aspire to achieve? After no less than three family reunions in the London theater recently, the evidence is still irritatingly inconclusive. No, casting sisters as sisters, or parent and child as parent and child, does not mean that the instinctive rapport of the playpen is magically re-established. Yes, it can amount to more than a high-cultural counterpart of those ads that bring together John Doe and his shiny brood in order to sell domestic togetherness and breakfast cereal.

When Sinead, Niamh and Sorcha Cusack came center stage and huddled together in Adrian Noble's fine production of "The Three Sisters" last summer, you certainly felt that Chekhov's Prozorov girls had shared scores of childhood games and adolescent secrets. It was not just their remarkable family resemblance. There was authentic intimacy in their sibling joys and griefs.

But that is not so obviously the case either at the Queens Theater, where members of the Redgrave dynasty both eminent and obscure have recently opened in the same play,

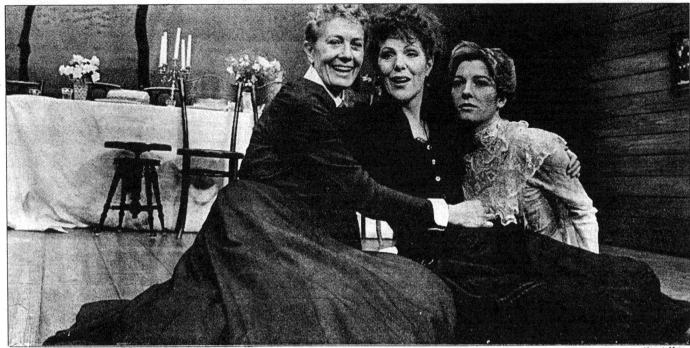

Alastair Muir

"The Three Sisters"—From left, Vanessa and Lynn Redgrave appear with their niece, Jemma Redgrave, in Robert Sturua's production at the Queens Theater.

or at the Old Vic, where Laurence Olivier's widow and children are appearing in J. B. Priestley's "Time and the Conways." Joan Plowright plays a small-town matriarch; her real-life daughters, Julie-Kate and Tamsin Olivier, are her fictional ones, too; her son Richard directs; but there is little feeling that they have ever giggled and squabbled over their early-morning cornflakes. That will not, however, prevent the family taking the play to the Royal Alexandra Theater in Toronto in late February.

No such trans-Atlantic trip is currently planned for the "Three Sisters," which is a pity, because Michael Redgrave's descendants are mostly more accomplished as well as more experienced. If Jemma Redgrave, who plays Irena Prozorov, has yet to acquire the technique to plausibly rage through her laughter or laugh through her rage, her celebrated aunts fully justify their casting as her sisters, Olga and Masha. Robert Sturua's production has its eccentricities, but at least it allows Vanessa to remind London of her power and Lynn to demonstrate unlooked-for range.

Such gatherings of the clan are not exactly new. Members of the great theatrical houses have sometimes appeared on stage together in the past, though not usually as kith and kin. John Philip Kemble's genteel Macbeth was upstaged by his sister, Sarah Siddons's powerful Lady Macbeth. The most memorable of the Barrymores' few joint performances were in plays where they were cast as enemies. In Edward Sheldon's "Jest," Lionel was a 16th-century bully who spent the evening terrorizing an effete young painter played by John. In George du Maurier's "Peter Ibbetson," Lionel was the vicious guardian of a woman loved by John, and actually ended up murdered by him. In each case the brothers gave bravura displays of acting. But sibling rivalry doesn't appear noticeably to have shaped their performances — any more than sibling affection could save "Claire de Lune," an overblown history play in which Ethel Barrymore played a scornful queen and John a maimed mountebank.

Family rapport is not the special strength of the Redgrave "Three Sisters" either. That may partly be because a generation separates 53-year-old Vanessa and 47-year-old Lynn from their 25-year-old niece, while they themselves look as different as a giraffe and a bear. But it is more because the emphasis of Mr. Sturua's production is not on the nuances of relationships. It has its subtleties, but they are more outer and physical than inner and psychological. At times the audience may even feel that the play it is watching had its origins, not in Stanislavsky's Moscow Arts Theater, but in the Moscow State Circus.

The main characters go in for a lot of pushing and pulling, and even for some pummeling of bodies and slapping of faces. Jeremy Northam's Andrei is justified in looking as nervous as he does when Jemma's Irena is around because she expresses sisterly irritation by kicking at him or swatting his head with her shawl. And when Lynn's Masha seems more than usually moody, both Irena and Vanessa's Olga seize her by a leg and drag her across the floor, prodding her, tickling her, and ending up in an undignified heap, a pile of laughing Prozorovs.

Robert Sturua is the director of the Rustaveli Theater Company in Soviet Georgia, a troupe known for bravura acting; and he

Gatherings of the clan in London: The Redgraves star in 'The Three Sisters,' the Oliviers in 'Time and the Conways.'

sometimes leaves his all-British cast looking a bit strenuously Slavic. For instance, there seems no good reason for Adrian Rawlins's interestingly young, insecure Solyoni, finding himself alone on the stage, to flip onto his hands and walk upside down across it. Thanks largely to such acrobatic ado, some of the transitions of behavior, for instance the schoolmaster Kulygin's switch from petty

despot to caring husband, seem sudden, extreme and insufficiently motivated. Yet the feverishness has point and purpose, too.

■

In the case of the Redgraves, it expresses that blend of restlessness and impotence, yearning and frustration, which is the sisters' collective character flaw. Their machinery whirrs and screams, but is not organized enough to accomplish what Irena, in particular, so badly wants, and carry the family out of the provinces to the sophistication of Moscow. At first, their turbulence is expressed mainly in horseplay, indicating that there is something unrealistic and immature about their dreams. As the evening progresses, desperation and anger set in. The children have been deprived of the long-promised prize, and it hurts, hurts a lot. The Redgraves' pain can be comic, but it is pain all the same.

■

If the approach is unconventional, so is the casting that principally embodies it. Vanessa would seem born to play the romantic Masha, and Lynn well suited to the more homely Olga. But the reversal of roles works astonishingly well, and not just because Vanessa gives a marvelously unselfish performance of a warm, outgoing woman who suppresses her natural playfulness for the sake of obligation, duty, and sisters to whom she has become a surrogate mother. Lynn scores a substantial success by defy-

At its best, casting siblings in the same production brings to life childhood games and secrets.

ing both tradition and expectation, and concocting a Masha who is not obviously romantic at all.

She slumps on a chair or trudges across the stage, a whey-faced, sul-

len, rancorous woman with two particular problems: a weakness for vodka and, in Michael Carter's Kulygin, a husband who brutally snatches the glass out of her hand and the cigarettes from her mouth when she displays just a little independence. A commanding Kulygin is unusual, and hard to reconcile with the text. An opportunist, callous Vershinin for Masha to love and lose, though also unorthodox, works better. In Stuart Wilson's performance, his Chekhovian philosophizing is partly a come-on to a promising mistress, partly a way of boring and distracting others while he passes her surreptitious notes. There is no charm in their relationship and little in Lynn's Masha herself: a bold, unsentimental piece of acting, this, a good example of Redgrave derring-do.

■

Mr. Sturua opens his production with Vanessa's Olga pushing back the hands of the grandfather clock he has portentously put at the front of the stage. This is presumably her vain attempt to defeat time the enemy. The hostility of the calendar is also the theme of Priestley's play.

Indeed, "Time and the Conways" plays tricks with chronology, rather in the manner of Harold Pinter's much later "Betrayal," in order to make somewhat somber points about hope, disillusion and the pains and comforts of memory. Now the family and its friends are carousing merrily away; then it is 20 years later, and those who are not dead have become disappointed spinsters or unhappy spouses; and then we are whisked back to a party it is difficult to see quite so straightforwardly.

The play, written in 1937, shows its own age in some ways, but can prove touchingly elegiac in performance. That it does not do so at the Old Vic seems mainly due to a production with an aversion to pause, silence, nuance and subtext.

As for the Oliviers on view, Joan Plowright plays the domineering Mrs. Conway with majestic complacency, as if Lady Bracknell had been transplanted to the suburbs; Tamsin brings a certain authority to the role of an aspiring novelist who ends up dolefully writing pop journalism; but Julie-Kate, charged with playing the family life-force, tends to flicker rather than blaze. We may know they are related about as closely as people can be. But anyone unfamiliar with theatrical family trees would have little chance of guessing it. □

1991 Ja 6, II:5:1

―――――

A Bright Room Called Day

By Tony Kushner; directed by Michael Greif; set design by John Arnone; costumes, Walker Hicklin; lighting, Frances Aronson; sound score by John Gromada; projections by Jan Hartley; associate producer, Jason Steven Cohen. Presented by Joseph Papp. At the Public Theater/LuEsther Hall, 425 Lafayette Street.

Zillah Katz	Reno
Agnes Eggling	Frances Conroy
Annabella Gotchling	Joan MacIntosh
Paulinka Erdnuss	Ellen McLaughlin
Vealtninc Husz	Olek Krupa
Gregor Bazwald	Henry Stram
Die Alte	Marian Seldes
Roland and Emil Traum	Kenneth L. Marks
Rosa Malek	Angie Phillips
Gottfried Swetts	Frank Raiter

By FRANK RICH

Perhaps if the world were not actually on the brink of war, "A Bright Room Called Day," a fatuous new drama about a world on the brink of war, would not be an early front-runner for the most infuriating play of 1991. But then again, is the time ever right for a political work in which the National Socialism of the Third Reich is trivialized by being

equated with the "national senility" of the Reagan era? Or in which George Bush's ultimatum to Iraq, the Iran-contra scandal and Mr. Reagan's AIDS policy are all frivolously lumped together as historical progeny of the Reichstag fire and Dachau? "History repeats itself, first as tragedy, then as farce," goes one of the evening's many aphorisms. "A Bright Room Called Day" would be a sitcom if only it were any fun.

Written by Tony Kushner, the play is of note because it marks the return of the gifted young director Michael Greif to the Public Theater after his success with "Machinal." What's more, the production boasts a stellar cast that includes Frances Conroy, Joan MacIntosh, Marian Seldes and the performance artist Reno. The actors are unfailingly professional in trying circumstances — poor Ms. Seldes must don rags to play a cronish symbolic ghost known as Die Alte, if you please. Yet no one can escape a script that starts off with a Berliner's leadenly ironic declaration that Berlin is a "relatively safe" place to be in 1932 and gets less subtle from there.

Mr. Kushner is playwright in residence at the Juilliard School of Drama, and "A Bright Room Called Day" is nothing if not a product of a reading list. Its principal characters, a handful of middle-class German artists and film-industry workers caught in the collapse of the Weimar Republic, often seem like studied stand-ins for Sally Bowles and the rest of the indolent, omnisexual drifters in Christopher Isherwood's "Berlin Stories." When Mr. Kushner is not paraphrasing Isherwood ("I am *not* a camera," says Reno), he rehashes Marx and Freud, and at the end of Act I, the company re-enacts "Faust" by way of "Mephisto." (Frank Raiter plays the modern-dress devil in a devil-may-care manner appropriate to a less pretentious adaptation of Goethe, "Damn Yankees.") For the audience's further edification, the speechifying is accompanied by slide projections relaying the red-letter events of the period and the author's analysis of those events in textbookese.

The most forceful interruptions to Mr. Kushner's nominal narrative, however, are those periodic monologues gamely delivered by Reno, who plays Zillah Katz, a contemporary Jew from Great Neck, L.I., who

Alastair Muir

Acting Like a Family

Are there, for an audience, tangible artistic gains from seeing blood relations performing in family plays?

The Oliviers are cautious on the subject. Joan Plowright (in photograph) notes that her daughters play only two of six children in what is essentially a company play. And Richard Olivier, her son, says there is nothing extraordinary about it: families have been acting together since the days of strolling players.

However, "there is something," says Lynn Redgrave, "about the touch of skin on skin and the look in the eye that gives you not an invented history of sisterhood but a real one. It is in the terrible flare-ups and misunderstandings that the real sister shorthand is most useful. If you like someone and you're playing sisters, you can do the warm, tactile side. What is difficult is knowing how far you can go with the kind of explosions that happen in families."

But to what extent is acting talent inherited?

Richard Olivier says he never felt comfortable as an actor and took a director's course at the University of California to discover his niche in the theater. The Redgrave daughters slid naturally into acting — Vanessa made her debut at 19 opposite her father, Michael, in the West End, and Lynn began in Laurence Olivier's

National Theater company. But they differ on the genetic factor.

Vanessa concedes there may be a Redgrave look, but regards it as inessential. "I tend to disagree," says Lynn. "I think there is some tiny proscenium arch racing through our genes. Our father was much less consistent than some of his peers, but there was about him a naked emotional transparency. Maybe a little bit of that has been passed on."

— *Michael Billington*

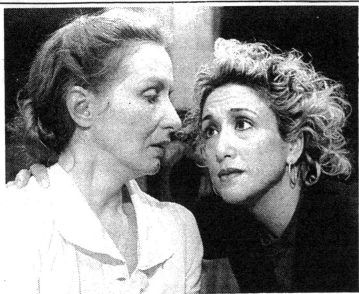

Frances Conroy, left, and Reno in "A Bright Room Called Day."

has for some metaphysical reason visited Berlin in 1990. Through some clumsily executed theatrical cross-cutting, the playwright can draw his false analogies between 1932 and the present, as well as make wisecracks about Patrick Buchanan, Leonard Bernstein, Jesse Helms and No Doz. (No Doz is definitely the most germane of these references.)

•

Amid these ramblings, one intriguing question is raised: If Hitler is this century's standard for "absolute evil," is it an "unusable standard" that prevents anything else from being called evil? But the argument is immediately vitiated by Mr. Kushner's insistence on indiscriminately dumping all present-day ills into Zillah's diatribes until all moral distinctions are blurred and history is rendered meaningless. One hardly has to be a Reagan or Bush partisan to be offended by the author's juvenile line of attack; if anything, the play inflicts a greater slander on the antiwar movement of this fateful moment by making its spokeswoman as mindless as Zillah.

It says everything about the interchangeability of Mr. Kushner's political equations — and his opportunism — that when this play was produced in London two years ago, Zillah's monologues likened Thatcherite England to the Third Reich. The same lack of specificity can be found in the playwright's indistinguishable characterizations: Aside from a mascara-fixated homosexual (Henry Stram), everyone on stage has the same windy diction, from a hot-headed Hungarian refugee (Olek Krupa) to an opium-addicted starlet (Ellen McLaughlin) to Zillah and Die Alte. While Mr. Kushner's political position is clear — he is angry at selfish liberal dilettantes, then and now, who equivocate rather than act — he is unable to animate the people who reveal it. Even as Ms. Conroy cries her way through the second act, her character's internal conflict, that of a well-meaning movie actress who cannot bring herself to join either the underground or her friends in exile, remains externalized and remote.

•

For Mr. Greif, "A Bright Room Called Day" is an odd choice with which to follow up his revival of "Machinal," and not just because of its

quality. Mr. Kushner's play is set in virtually the same period as that 1928 Sophie Treadwell drama of pre-Depression New York and, more crucially, is written in the same mock-

Nazi Germany heading for war is held up to reflect today.

Expressionist style. Inevitably Mr. Greif must repeat himself here, and just as inevitably, the repetitions (the nightmarish noise effects, the Brechtian blackouts) will seem stale to those who saw the earlier show. As in "Machinal," Mr. Greif again seems at his weakest in directing actors, but, as was not the case last time, he also loses command of the production's look. Frances Aronson's lighting must overcompensate for the menace missing from John Arnone's uncharacteristically flavorless parlor set, which lies in an awkward gully dividing the audience.

Curiously enough, "Machinal" tapped into more of the anxiety associated with a prewar civilization than this effort does; at its best, in fact, Mr. Greif's treatment of "Machinal" was reminiscent of Harold Prince's landmark staging of the Isherwood-inspired "Cabaret," which bridged the ominous moods of Weimar Germany and the Vietnam-War-divided America of its time. "A Bright Room Called Day," by contrast, seems to take place in the same distant, ethereal nowhere land as its artsy, unilluminating title. Mr. Greif, talented as he may be, must return to earth if he is serious about enlisting in the theater's efforts to bring the new war home.

1991 Ja 8, C11:1

My Civilization

Researched, written, designed and performed by Paul Zaloom; directed and with additional writing by Donny Osman; lighting design, William Shipley Schaffner. Presented by Dance Theater Workshop, at the Bessie Schönberg Theater, 219 West 19th Street.

By MEL GUSSOW

To create his theater, all that Paul Zaloom needs is a stage, himself as actor — and enough trash to fill a month's quota at a recycling center. In Mr. Zaloom's dextrous hands, the detritus of consumerism is converted into artful subjects for satire. One can imagine him wheeling a cart through a supermarket, shopping for visual puns and metaphors. The result, as demonstrated in his new show, "My Civilization" (at Dance Theater Workshop), is puppetry of a high political priority.

The title piece, the first of three monologues, is nothing less than a solipsistic history of the world, from protoplasm through the Garden of Eden and on to the life of Mr. Zaloom, all in 30 minutes. Using an overhead slide projector and an assortment of liquids and solids, both syrupy and spidery, which he sloshes and manipulates on transparent surfaces, he takes us on a jaunty tour back to the beginning of time.

As these various items are orchestrated into mysterious and comic patterns on screen, he delivers a demented, nonstop play-by-play description of civilization and his insecure place in it. The Zaloom of "My Civilization" is besieged by forces beyond his, or our, ken. Wherever he turns, something is testing his mettle, whether it is a self-corruptive society or unpredictable natural occurrences (a fork suddenly jumps on screen to simulate a bolt of lightning).

The monologue is a kind of satiric acid rain, insidious and damaging to the accepted order of things. His attitude as author and director is one of abashment, as in his suggestion that either he is going through an early midlife crisis or, as usual, he is indulging in cheap special effects. These effects may be cheap in price, but they are very special. I know of no other performance artist who is working in this idiosyncratic mode.

•

In his second sketch, "Phood," he attacks foolishness and faddishness in food, a favorite target of this consumer advocate who is ever ready to warn us not to eat before analyzing content. Employing photographs and other promotional material, he hangs the food industry by its own labels while he pretends to lecture a conference of like-minded individuals who care less about nutrition than about profits.

At the top of his indictment is the use of artificial ingredients — the reconstituted made to look like the real thing; additives that preserve a

Paul Zaloom

product to perpetuity, unless they happen to explode. There is no short shelf life in this world. Everything lasts forever, or at least until it kills us.

Having disarmed his audience with laughter, Mr. Zaloom then unveils his finale, a sketch entitled "Meanwhile," a shorter version of which was seen earlier this season in the Dangerous Ideas marathon. Somehow he mixes foreign policy with the savings and loan scandal and the controversy over public support of the arts. Dashing from cluttered table to table like a crazed table tennis player, he animates a tag sale of objects and becomes a quick-change puppetmaster.

Naturally, some of the remarks are too off the cuff, just as some of the assault moves from wryness to a lesser plane of whimsy, but enough of the humor is derisively on target. Mr. Zaloom's mind and funnybone are synchronized, especially when he is dealing with questions of endangerment to the arts.

•

Here comes the National Endowment for the Arts, as represented by a football with a pipe in its mouth, equivocating about awarding grants to performance artists (the grants are frugally distributed from a family-size tin of peanuts — and are then reclaimed). Private patronage is a tall, thin brand name cigarette and the Internal Revenue Service by two giant screws, marching alongside a large can of squiggly worms. That Senator from North Carolina is personified by a big prop foot and the artists themselves are small tomatoes, easily squashable.

In Mr. Zaloom's performance, there is a quality of child's play, but it is most inventive gamesmanship. In the years since he began performing, he has grown as a clown and as a social commentator. He has become an ecological antidote to the poisons and pollutants in everyday life.

1991 Ja 10, C21:1

The Country Girl

By Clifford Odets; directed by Kenneth Frankel; sets by Hugh Landwehr; costumes by David Murin; lighting by Stephen Strawbridge; sound by Philip Campanella; production stage manager, Roy W. Backes; general manager, Ellen Richard. Presented by the Roundabout Theater Company, Todd Haimes, producing director; Gene Feist, founding director. At 100 East 17th Street.

Bernie Dodd	Paul McCrane
Larry	Stephen Mendillo
Phil Cook	George Morfogen
Paul Unger	Jim Abele
Nancy Stoddard	Geraldine Leer
Frank Elgin	David Rasche
Georgie Elgin	Karen Allen
Ralph	Henry LeBlanc

By MEL GUSSOW

Although "The Country Girl" proved to be one of Clifford Odets's most popular works, he considered it a superficial play. In this instance, it is the author who should have the last word, or so it would seem from Kenneth Frankel's production at the Roundabout Theater Company.

This backstage drama about an aging actor's decline into alcoholism and his reclamation through the efforts of his wife and an ambitious young director thrived on Broadway and in its Hollywood adaptation. It further demonstrated a resilience in the 1972 Broadway revival.

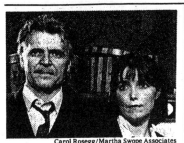
Carol Rosegg/Martha Swope Associates
David Rasche and Karen Allen in "The Country Girl," at the Roundabout Theater.

Forty years after the first production, "The Country Girl" is mired in middle age. In quest of rejuvenation, it needs a superbly balanced trio of performances. This is not the case with the three leads at the Roundabout: David Rasche, Karen Allen and Paul McCrane. The most promising effort comes from Ms. Allen, but despite the play's title, the central role is not that of the wife but of the actor (Mr. Rasche).

•

For "The Country Girl" to work, there should be, at least in the beginning, an ambiguity about the motivations of the characters. In the current revival, the actor's lies — about his wife's instability and her suicidal tendencies — are transparent. The wife's loyalty is self-evident and the director's gullibility in believing the husband's story is incredible, especially for someone so eager to pull his production together.

All this is aggravated by the direction, which is surprisingly languourous considering Mr. Frankel's previous successes with other naturalistic plays. At the root of the problem is the author's portrait of a theater life that seems to derive more from fiction than from reality. We are asked to believe that the director would stake his incipient career on this apparent wreck of an actor because of a childhood memory of a performance in which the man equaled the artistry of Laurette Taylor. In the first of several manipulated turning points, the actor improvises a scene and reveals his genius. Another character proclaims, "Where was that seedy guy hiding all that power and majesty?" In Mr. Rasche's performance, the greatness remains hidden.

•

The stage is strewn with similar pronouncements, some rhapsodic, some portentous. It is the director (Mr. McCrane) who makes the most platitudinous observations, all spoken without a tinge of irony. The wife demonstrates her latent erudition by reading Jane Austen and by saying things like her parting comment to the director: "Stay unregenerate. Life socks the sauciness out of us soon enough."

Hearing such lines, one might think they are impossible messages to deliver, but in earlier incarnations of the play, there was, to use Odets's words, a sauciness beneath the sentimentality and occasional hints of self-mockery. In this rather stolid production, everything is played straight, at face value.

•

Even as Harold Clurman observed in his otherwise admiring analysis of the original production, "Creation in 'The Country Girl' is left to the actors." Mr. Rasche, who has been amusing in comedy, captures the glad-handedness of his role as a man who wants to be liked. But the trage-dy of the actor's self-delusion eludes him, as does the sudden spark that is supposed to be ignited when he finds himself back onstage.

Mr. McCrane faces the obstacle of a less interesting though catalytic role, partly surmountable were he to have stressed the steeliness of the director rather than simply the willfulness and naïveté.

In common with Grace Kelly in the film, Ms. Allen successfully conceals her beauty behind a facade of plainness and drab clothes. The wife has been beaten down by her husband's failure — a failure that is not adequately explored in the text — but is also something of a pretender. In Ms. Allen's performance, she is a woman who finds solace in self-effacing martyrdom. Missing are the harmful side effects of the wife's sheltering attitude. By protecting her husband from danger, she has also been instrumental in assuring his defeat.

Both Ms. Allen and Mr. McCrane rise in their pivotal dramatic encounter, a moment of truth telling. Then in an intrusive maneuver by Odets, the characters are asked to express an unbelievable romantic interest in each other. Such formulaic plotting and the thunderstruck quality of the dialogue undercut the characters and the play's familiar, though still valid thesis: the restorative effect of self-esteem in the perilous world of the theater.

1991 Ja 12, 16:3

Full-Moon Killer

Written and directed by Stephan Balint; music written and arranged by Roy Nathanson; sound, Connie Kieltyka; set design, Eva Buchmuller and Jan Gontarczyk; lighting, Michael Chybowski. Presented by Squat Theater, 512 West 19th Street.

WITH: Eszter Balint, Michael Thomas, Augustin Rodriguez; Kelvin Garvanne, Michael Strumm, David Lee, Nelson Nazario, Delroy Simpson, Masashi Ohtsu and Richard Jones.

By MEL GUSSOW

In the plays of Squat Theater, the urban center cannot hold. Everything flies askew: the police as well as codes of criminal behavior. And there is a literalness about the expression "man in the street." The streets are filled with nightmarish events.

Several seasons ago in "Dreamland Burns," Squat's resident playwright, Stephan Balint, consolidated his anger into a hallucinatory piece about our troubled cities. His subsequent play, "L Train to Eldorado," was a reversion to the group's more anarchic ways, and his new work, "Full-Moon Killer," is similarly a trackless chain of sporadically evocative vignettes.

During its running time of less than an hour, "Full-Moon Killer" (at the Kitchen, 512 West 19th Street, Manhattan) demonstrates a split-screen personality. One half of the play deals with a serial killer stalking his seemingly random victims, the other with a convoluted tale of another felon's brush with the law.

The murderer has a half-moon mask for a face (which should make him a half-moon killer), one of the play's few touches of surrealism. After killing a boxing champion and several other people, he himself is shot by a would-be private investigator named Spice Lee. In this section of the play, there is an attempt at sar-donic humor, at least in its portrait of the investigator, who wears a television set around his body like a kind of puppet stage. Perhaps Mr. Balint,

> ## Sardonic humor, a Spike Lee clone, and a television set worn as a belt.

who is both the director and the author, is suggesting that the character's real-life model is entrapped by the media.

•

Such questions are avoided in the other half of the show, in which a criminal in confinement (a jail house that could also serve as a crack house) tells a rambling story about his flight from the police through the streets of the East Village. In other Squat plays, the ensuing car chase might have been visualized on screen. The company has made its signature by artfully weaving film and theater, but in this case the cinematic effects are minimal.

The group's set designer, Eva Buchmuller, has not overly exerted her imagination. A scenic collaborator, Jan Gontarczyk, is responsible for what is described as an "electric tree," pretty enough to serve in a holiday department-store display. Although the actors are limited by the material, there are enlivening moments with Eszter Balint (who starred in the film "Stranger Than Paradise") and Michael Thomas.

"Full-Moon Killer" is the third and final part of a projected trilogy entitled "Killing Time," but it is the first section to be performed as a self-sufficient work. The play is incomplete and in need of progress.

1991 Ja 13, 43:5

SUNDAY VIEW/David Richards

A Tale of One City Set in Two Times

TONY KUSHNER'S "BRIGHT Room Called Day" (at the Public Theater's LuEsther Hall) is an ambitious, disturbing mess of a play, and while I can't deny that it exercises a certain dank fascination in places, I suspect my discontent would have been less if the pieces had fit together better.

Oh, I'm not talking about a jigsaw puzzle fit. Mr. Kushner is writing about evil, oozing its way from Germany in the 1930's to the present day, and there's nothing tidy about that. The Devil even puts in a brief appearance, surrounded by geysers spewing forth billows of sulfurish smoke. A seemingly respectable gentleman right down to the walking stick (on second thought, his teeth *did* look rather sharp and his silver hair a bit spikey), he admits he's lost his fantastical color over the centuries and that his new form for the 20th century is "no form at all." Nebulous, diffuse, taking to the air "like powdered gas," he can, he boasts, spread himself around more effectively these days.

The smoke, I guess, is for old times' sake. But a point is made. Evil is insidious, pervasive, so much a part of the contemporary climate that contagion is inevitable. A lot of the Devil's nebulousness, in fact, seems to have spilled over into the play itself.

■

One half of "A Bright Room Called Day," which is set in an apartment in Berlin, shows us a handful of artists trying ineffectually to oppose the gathering forces of Nazism and, when the fight has become hopeless, scattering their separate ways — a few taking the high road, but most the low. The focus is primarily on one Agnes Eggling (Frances Conroy), a bit player in the movies, who, it turns out, won't have much more of a role in the political upheavals around her. While slides, flashing on overhead screens, chronicle the rise of Hitler and the National Socialist Party

("The Nazis Win 37 Percent of the Popular Vote," "A Mysterious Fire," "The Flag of the Weimar Republic Is Abolished"), Agnes and her circle of friends — an actress, a cameraman, a graphic artist, a homosexual — argue tactics, question motives, smoke opium and temporarily fool themselves that they are making a difference.

No serious dramatic problems there. If we've seen variations of their plight before, the characters are nonetheless quirky enough to merit our attention. When he puts his mind to it, Mr. Kushner can write nervous, scratchy dialogue streaked with the dark phosphorescence of poetry.

The play also takes place concurrently in 1990 in that very same apartment, where a middle-class American graduate student, Zillah Katz, fleeing the somnolence of the Reagan years, has come seeking some of the grit and viscera of the past. "The last decade was too hard for a history junkie like myself — the Decade of the Great Communicator," she explains to the German she's just picked up in a bar. "Your Great Communicator spoke and created a whole false history; ours spoke and history basically came down with arteriosclerosis; from the Triumph of the Will to the Triumph of the Brain Dead, from National Socialism to National Senility."

■

Zillah Katz is played by Reno, the performance artist, and everything about her — her manic personality, her frazzled eyes, the harum-scarum hairdo — suggests that, just before going on stage, she has stuck her finger in an electric light socket. The presence is amusing, alert. No particular problems there, either.

Still, you don't put then and now under the same roof, just so you can hopscotch back and forth for a couple of hours. Sooner or later, there's got to be contact, a coming togeth-

er, a bleeding of the past through to the present. In "A Bright Room Called Day," however, the connection is never made.

At one point, Zillah and her German boyfriend have a seance to raise the ghosts hovering in the apartment. A restless Agnes materializes — tormented, perhaps, by her conscience and the principles she compromised in order to survive the war. You can't say for certain, though. Zillah only senses her presence dimly, and the sensing is the closest the play ever comes to joining its two halves.

Before long, Agnes resumes her timorous place in the past. And not too long after that, Zillah is taking the stage to announce with crisp determination, "Home. Now. An end to the exile." Mr. Kushner pretty much leaves us speculating on what has brought her quest to its sudden conclusion, or what the quest was to begin with. Has Zillah felt the invisible wind of corruption blowing across a half century of history? Is she afraid of succumbing to Agnes's moral lassitude? Or is it the prospect of a united Germany, putting its horrible past behind it, that sends her scurrying. Yours to decide.

■

Mr. Kushner is willing to settle for the ironic juxtaposition of two worlds on the assumption that sparks will automatically leap back and forth. They don't. Side by side is not a dramatic stance; face to face is. It's not enough to have Zillah draw parallels between reactionary Germany then and reactionary America now. If the play is to be theatrically valid, we should see the idea dawning and un-

derstand what's brought it about. (I suspect that Zillah's ideas were formed well before she ever reached Berlin.) Somehow, a critical confrontation in "A Bright Room Called Day" never got written.

The director, Michael Greif, whose staging of "Machinal" earlier this season at the Public, proved triumphantly vivid, has been unable to coax similar vitality from the script. Ms. Conroy, who in repose projects the homely timidity of an Iowa spinster, tends in moments of anguish to rely upon a bovine bellow of startling resonance. As an ominous scavenger in rags, Marian Seldes could be one of the orphans from "Annie 2," grown up but still scarfing down the odd crust of bread and acting abominably. And Olek Krupa's Polish accent is so thick that fully a quarter of what he says, as the one-eyed Hungarian cameraman who is Agnes's lover, was indecipherable to my ears.

Some of the other performances are better — Ellen McLaughlin's, as a self-centered actress, for instance; and Angie Phillips's and Kenneth L. Marks's, as a pair of hot-headed Communists, constantly squabbling over

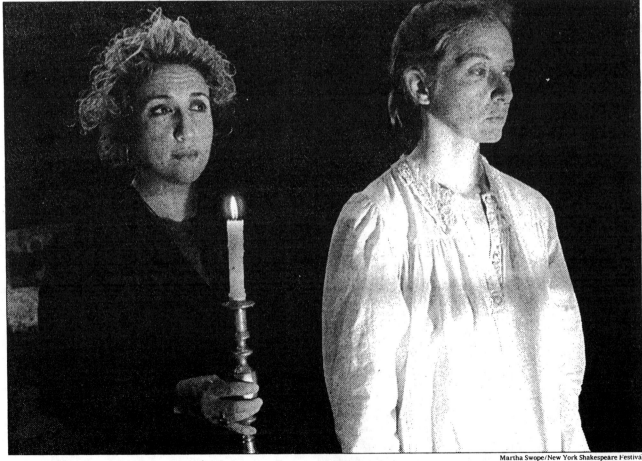

Martha Swope/New York Shakespeare Festival

Reno, at left, and Frances Conroy in "A Bright Room Called Day" by Tony Kushner—quirky enough to merit our attention

'Bright Room Called Day' depicts Berlin in the 30's and today; why 'The Country Girl' couldn't leave.

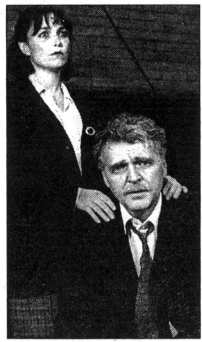

Carol Rosegg/Roundabout Theater Company

Karen Allen and David Rasche in Clifford Odets's "Country Girl"

party doctrine. But this is an erratic cast at best.

The poster for "A Bright Room Called Day" reads, "Germany in the 30's. America into the 90's. The only people sleeping soundly are the guys who are giving the rest of us bad dreams." That's one way of putting it — tantalizingly succinct. It is not, unfortunately, Mr. Kushner's way.

'The Country Girl'

The years haven't been all that kind to the plays of Clifford Odets, but they've done a terrible number on "The Country Girl" (at the Roundabout Theater), the playwright's 1950 hit about an alcoholic actor and how he is rehabilitated in time to score a major artistic success on Broadway. I don't know which has changed more in four decades — the mechanics of doing business on Broadway or our understanding of alcoholism and its poisonous effect on others. Odets's depiction of the former now seems touchingly quaint, his rendering of the latter distressingly naïve.

To see Georgie Elgin, the actor's downtrodden wife, shoring up his morale, suffering his abuse and justifying his pathetic lies is to understand what co-dependency is all about. But no, this is perceived as supportive behavior and Georgie is presumably something of a saint for sticking by the lout, whose egotism is excused on the grounds that he possesses a talent

Side by side is not a stance that produces the sparks of drama; face to face is.

as magnificent as Laurette Taylor's. Well, there's another problem right there. Find me an actor who can project that kind of genius and maybe I'll start believing in "The Country Girl." I can only tell you it isn't David Rasche, who comes across as a big crybaby in the Roundabout's thumpingly dull revival.

As Georgie, Karen Allen has been outfitted as unflatteringly as possible in an array of frumpy bathrobes and shapeless sweaters. When she's not propping up her husband, she stands around, hands dangling at her sides, looking either grieved or catatonic. You begin to get the unsettling impression that she's stayed on all these years because packing a suitcase required more energy.

Paul McCrane plays the whiz-kid director who battles Georgie for the artistic soul of her husband, at least until the rapturous notices are in. If you want a reason to catch this production, his bright, feisty perform-

ance is as legitimate as any. While the play moves with the lumber of a circus pachyderm, he bobs and weaves like a flyweight boxer who knows that the championship is his. Mr. McCrane is on his toes all evening long. Even when he's sitting down. □

1991 Ja 13, II:5:1

Let Me Live

By Oyamo; directed by Bill Mitchelson; music composed and directed by Olu Dara; fight director, David S. Leong; artistic director, Mr. Mitchelson; assistant director, Mark Plesent; lighting, Don Holder; assistant director, Mark Plesent; general manager, Celina Davis; production and stage manager, James Marr; set and costumes, Anne C. Patterson; sound, Serge Ossurguine. Presented by the Working Theater. At the Harold Clurman Theater, 420 West 42d Street.

Kennedy	Randy Frazier
Dupree	Leland Gantt
Allen	Earl Hagan
Bracey	Rande Harris
Jenkins	Lawrence James
Shonuff	Robert Jason
Smiley	Mitchell Marchand
Davis and Jenkins	Jasper McGruder
Clancy	Eugene Nesmith
Angelo	Monte Russell

By MEL GUSSOW

In 1932 a black union leader, Angelo P. Herndon, was wrongfully imprisoned for his efforts at organizing workers in Georgia. The story of Herndon's incarceration and his eventual release is the inspiration for Oyamo's impassioned new play, "Let Me Live."

Instead of writing a documentary drama about the court case, the playwright has used it as a starting point for an indictment of racism and the penal system in the South during this period. The focus of the play (a Working Theater production at the Harold Clurman Theater) is as much on the other inmates as it is on the young labor leader. Most of them have been given long sentences on exaggerated charges, but they are without Herndon's apparent erudition and his access to outside legal assistance. The motley group includes moonshiners as well as layabouts.

In jail, Herndon (Monte Russell in a self-effacing performance) is subjected to a kangaroo court, in which he is forced to understand the hopelessness of the shared imprisonment and the living death they will endure if they are placed on a chain gang.

By its nature, "Let Me Live" is hortatory. It embraces overstatement, especially when it deals with Herndon's commitment to Communism and his proselytizing for his cause. This is not a well-made play, and it would benefit from judicious editing. But it has an energy and an immediacy (even though it takes place in the 1930's), factors that are equally attributable to the author and to the cast assembled under the direction of Bill Mitchelson.

•

Working together, they offer a pungent feeling of what it would mean to be confined in the Fulton Tower Prison in Atlanta. Repeatedly the play threatens to spill over into the audience. Even as the convicts suffer deprivation through neglect, they hold on to their life in their prison within the prison. In this hermetic environment, they create their own code, in which they mock the society from which they are outcasts.

At the head of the hierarchy is a convicted murderer known as Shonuff. As played by Robert Jason, he is a swaggerer with a visceral sense of self-importance as well as a diabolical humor. Both the character and the actor dominate the play. Led by Shonuff, the self-elected warden of this interior prison, the inmates banter, rap and sing their way through their daily routine. The music, composed by Olu Dara and most of it played on the guitar by Rande Harris as one of the inmates (and sung by the actors), is one of the play's strongest elements.

"Let Me Live" has a flavorful sense of period — if the inmates should be released, they would step back into the Depression — but is more concerned with antagonistic crosscurrents within the prison environment. For that reason, the play reminds one somewhat of an early Oyamo work, "The Breakout," about convicts in a contemporary prison in a northern city. The characters in "Let Me Live" are on the brink of an emotional breakout, as their resentment flares against one another and against the repressive system.

•

If anything, Herndon is less dramatically interesting than some of his fellow inmates, because of the air of ingenuousness he retains about his party politics, in contrast to the hardbitten pragmatism expressed by the others. Presiding over this court of lost resort is Mr. Jason as Shonuff. His guileful role-playing and pleasure in his own power make him seem like a character out of Genet. Surrounding him are Mitchell Marchand, Randy Frazier, LeLand Gantt and others as convicts fighting for survival in a prison world in which survival means the continuation of despair.

1991 Ja 17, C21:1

Taking Stock

By Richard Schotter; directed by Marilyn Chris; sets, Ray Recht; costumes, Gail Cooper-Hecht; lights, Najla Hanson; composer, Ronnie Breines; production stage manager, Nina Heller. Presented by the Jewish Repertory Theater, Ran Avni, artistic director; Edward M. Cohen, associate director. At 344 East 14th Street.

Alvi	Lee Wallace
Sam	George Guidall
Howie	Stephen Singer

By STEPHEN HOLDEN

Set in a fading sporting goods store on the Upper West Side of Manhattan, Richard Schotter's slender comedy, "Taking Stock," at the Jewish Repertory Theater, is so consumed with the problems of maintaining a small business that audiences should come prepared to do some mental calculating.

The play's less-than-burning central question is a financial problem. Should Alvi (Lee Wallace) and Sam (George Guidall), who have been partners in the store for 40 years, allow their yuppie landlord to buy them out for $50,000 apiece? Or should they sign a new lease that would raise the store's rent 300 percent to $4,800 a month? Were the partners to keep their store, they would have to renovate it for $40,000, which would severely deplete their retirement savings.

Psychologically complicating the situation is the fact that their land-

lord, Howie (Stephen Singer), grew up in the neighborhood and regards them as surrogate uncles. Far from trying to gouge them, his 300 percent raise is fair, given the inflated value of the area's real estate.

●

At its perkiest, the 90-minute play, directed by Marilyn Chris, suggests a male counterpart of the television series "The Golden Girls," but set in New York City, with the hysteria considerably muted. There are few real jokes in a play whose tepid humor comes mostly from homey bittersweet observation and from Mr. Wallace's and Mr. Guidall's skillful low-key performances.

Alvi, once a sharp-dressing mambo virtuoso, is an intransigent nostalgist who wants to preserve every scuff and coffee stain on the store's well-worn counter. Puttering about in a dream world of 50's baseball memories, he is terrified of retirement. A recent trip to Florida with his wife left him with a nightmarish vision of men "shuffling three feet behind their wives like zombies." "I will not die in a mall!" he proclaims.

●

Sam, a forward-looking widower who is dating a much younger woman, has to contend with his own failing virility. "Sometimes the mustard gets cut, sometimes it doesn't and sometimes you can't even open the jar," he says ruefully. Even the go-getting Howie is bathed in wistfulness. Unsatisfied as a successful developer, he dreams of a career in stand-up comedy.

Although the director has squeezed about all the juice possible from this drab little comedy, it still seems like a one-act play padded into a full evening's entertainment.

1991 Ja 17, C21:1

Frisky People and Bears

By MEL GUSSOW

At the Moscow Circus, the Cranes soar high above the stage. With split-second synchronization, these aerialists twist, turn, do multiple somersaults and fall headlong in space before being caught by the outstretched arms of their partners. Repeatedly, the Cranes defy gravity. At one point, a Crane leaps upward as if jet propelled, moving from a trapeze to the utmost heights of Radio City Music Hall, where a catcher is waiting.

This 10-member troupe provides the final, breathtaking moment of the Moscow Circus's show, which began a two-week engagement on Wednesday evening. There are other acts of daredevilry and acrobatic artistry, all of which certify the performance expertise of the company, which has been gathered from circuses around the Soviet Union.

It is almost as if everything is staged in double time. The show clocks in at barely over two hours. This is just short enough to hold the fascination of small children as well as adults in the audience. The speed of the events overrides the few less-than-exciting performers, the jugglers and clowns who seem interchangeable with others in lesser traveling circuses. Fortunately, the cavorting of the clowns is held to a minimum. Amusement is provided by the performing bears, as trained by the husband-and-wife team of Vladislav Zolkin and Svetlana Mikityuk. These bears are so much like people as to make one wonder if each is not concealing a person under a bear suit. At the same time, the performers are so attuned to their animal colleagues as to seem bearlike themselves. The bears are also hams, mirthfully hogging the spotlight at curtain call.

Animal versatility is also exemplified by the Dyusembayev horses, charging around the ring and sending a breeze rippling toward the audience. The horses seem to gallop sideways, as their riders pass over and under their mounts and at one point give the impression of running alongside them. Like the Big Apple Circus, the Moscow Circus plays in a single ring, but because of the expansiveness of the hall, the show lacks the intimacy of its smaller, American cousin. The grander the act, the more visible the talent. This is true not only of the Cranes, but also of the Chernyevskys. In this teeter-totter balancing routine, a bearded Soviet gymnast who looks suspiciously like a fugitive Flying Karamazov Brother does high-flying back flips from the stage into a barrel seat.

Spectacle is also provided by the Abakarovs. Like human spiders, they seem wedded to wire. They perform handstands and headstands on the highest of wires. One walker harnesses his feet to a precarious line and spins himself like a one-man whirligig. There are occasional missteps and mistakes. Everyone is human, even the bears and the Cranes. The Cranes are dancers and aerialists. To the music of the "Ride of the Valkyries," they perform a celestial ballet commemorating Soviet soldiers who died in World War II. The Cranes work at so high an altitude that theatergoers have to crane their necks to watch them. Because the fliers move so fast, it is difficult to determine whether an individual has done a triple or quadruple somersault in midair. But whatever the Cranes do, they are phenomenal.

1991 Ja 18, C5:3

Lyndon

By James Prideaux; based on "Lyndon: An Oral Biography" by Merle Miller; directed by Richard Zavaglia; makeup designed by Kevin Haney. Presented by Eric Krebs, in association with Don Buford. At the John Houseman Theater, 450 West 42d Street.

Lyndon Johnson Laurence Luckinbill

By MEL GUSSOW

Laurence Luckinbill's impersonation of Lyndon B. Johnson in James Prideaux's monodrama, "Lyndon," is a life-size portrait of a larger-than-life character. The Johnson visage — from the jug ears to the jowls — fits Mr. Luckinbill, and so does the role, so, considering the actor's previous accomplishments. With his even features and usually urbane manner, Mr. Luckinbill would not seem a natural to play Johnson.

Through his acting and his talent for mimicry (and with the help of Kevin Haney's makeup), he assumes the Johnson persona. He becomes a gangly, good old Texas boy, balancing a bucolic charm against a fierce willfulness. This Johnson knows far more than one might think; he certainly knows his enemies and his long memory is a spur to fulfilling his great ambition.

The secret of power, he says, is timing, which, one might add, is one of the secrets of Mr. Luckinbill's performance (at the John Houseman Theater). In tune are his gestures, rough-as-sandpaper voice and guileful expressions. He punches the air as if it were an opponent, smiles with his eyes as he twists someone's arm and becomes abashed when he is momentarily deterred from his goal. As directed by Richard Zavaglia, Mr. Luckinbill humanizes our 36th President. But anyone expecting a revealing perspective on Johnson's career should look elsewhere, beginning with Robert A. Caro's critical biography in progress.

In contrast, Mr. Prideaux's play, drawing on Merle Miller's "Lyndon: An Oral Biography," is more oral than history. It is a selected — and laundered — version of Johnson's life in the public eye. There is no mention, for example, of the charge that Johnson had his aides stuff the ballot box in order to win his initial election to the United States Senate. In fact, there is not a single reference to his competitor in that race, Coke Stevenson, the Texas Governor treated to adulation in the second volume of Mr. Caro's biography. All that Mr. Prideaux offers in regard to that pivotal campaign is an amusing picture of Johnson barnstorming by helicopter and shouting down from the sky at prospective voters.

●

The play takes place in the Oval Office in 1968 just after Johnson has announced he will not run for a second Presidential term. Addressing the audience as loyal supporters, he rambles back to his boyhood and onward through his early years. The first part of the show is folksy and anecdotal, filled with ribald Johnsonian humor. At one point, Mr. Luckinbill imitates Johnson imitating President Roosevelt, with the Texan stopping to shine his shoes, country-style, on the back of his trousers before paying a call on the man who became one of his mentors. Such details add authenticity to the performance.

Once Johnson becomes Vice President, the play becomes more schematic. In quick vignettes, he tells us about the assassination of President John F. Kennedy and about his own assumption of the office. While Johnson reminisces, antiwar protesters

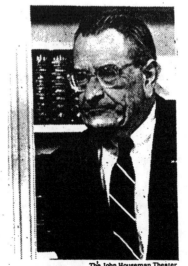

The John Houseman Theater

Laurence Luckinbill in the title role of "Lyndon."

are demonstrating outside his White House. It is here that Mr. Prideaux strikes dramatic shallows, as the play glosses over Johnson's role in the Vietnam War.

The defense of the play would be that the story is told from Johnson's point of view; we only hear what he wants to tell us. But because of the importance of the subject, the playwright has a greater obligation, at least to have a sharper focus on what he chooses to dramatize. This was the case, for example, with "Secret Honor," Donald Freed's monodrama about Richard M. Nixon.

When Johnson is not discussing Vietnam or other thorny issues, the play is on more secure ground, especially when it is dealing with his quirks of character, including the dismissive attitude he takes to anyone he feels he can manipulate.

●

The chief asset is Mr. Luckinbill, who manages to capture the man both on a general and a specific level. There is more than a measure of J. R. from "Dallas" in his performance; he approaches Johnson as a man one hates to hate (because he is so colorful). Mr. Luckinbill conveys the roguishness as well as the relish that Johnson feels for his own performance on a major world stage.

As played by Mr. Luckinbill, Johnson is such a theatrical figure that he does not need questions to stimulate a response. Watching him hunker down in the Oval Office, one is entertained by his exuberant performance in a play that does not measure up to the complexity of the character.

1991 Ja 19, 19:4

Philemon

Words by Tom Jones; music by Harvey Schmidt; directed by Fran Soeder; scenic design, James Leonard Joy; costumes, Mariann Verheyen; lighting, Natasha Katz; production stage manager, Michael J. Chudinski; technical director, Matt Goldin; musical direction, Norman Weiss. Presented by the York Theater Company, Janet Hayes Walker, producing director; Molly Pickering Grose, managing director. At the Church of the Heavenly Rest, 2 East 90th Street.

Cockian	Michael Tucci
Marcus	Kenneth Kantor
Servillus	Tony Floyd
Andos	Joel Malina
Kiki	Jean Tafler
Marsyas	Kim Crosby
Woman	Kathryn McAteer

By STEPHEN HOLDEN

"Philemon," a chamber musical by Tom Jones and Harvey Schmidt, who created "The Fantasticks," is an ambitious oddity of a show. It was the most warmly received of four experimental musicals that evolved out of the Portfolio Studio, a music-theater workshop that the team established with profits from "The Fantasticks" and had a brief commercial run in 1975. Sixteen years later, it has been revived by the York Theater Company in a production supervised by Fran Soeder, who directed the York's memorable revival of "Pacific Overtures."

A folk musical on the theme of martyrdom with a score that at its loftiest suggests an unlikely hybrid of Brecht-Weill, Ernest Bloch and Stephen Schwartz, "Philemon" tries to carry the Christian folk-rock musical exemplified by "Jesus Christ Superstar" and "Godspell" to higher artistic ground. The show, based on events from the third century and set in

Antioch, tells the story of a lewd street clown named Cockian who is pressed to become a spy for the Roman military by impersonating the spiritual leader of an outlawed Christian sect whose members are in prison. Revered as a saint by his fellow inmates, Cockian becomes so moved by their selflessness that he is transformed into the man he is impersonating and is eventually martyred.

A street clown becomes what he impersonates.

The York Theater production repeats the staging ideas of the original, in which the costumes double as scenery. Actors, wearing reversible capes that are drab on the outside and lined with bright colors inside, indicate scene changes by removing their capes and hanging them on hooks at the rear center of the stage.

If "Philemon" has more than its share of allegorical pretensions for a small-scale show, at its heart it is a passion play that demands performances of a high-voltage emotional intensity. While Mr. Soeder's staging gives the show the sense of formal control that he brought to "Pacific Overtures," the production is fatally chilly at the core.

Because "Philemon" compacts a great deal of plot into a series of semi-abstract, ritualistic tableaux, everything depends on finding actors who seize the moment and give the songs an urgency that transcends the show's artier conceits. In the role of Cockian, Michael Tucci fails to convey either the character's comic or his tragic dimensions. As a bawdy street actor singing "Gimme a Good Digestion," a double-entendre-laced tribute to the versatility of sausage, Mr. Tucci exhibits no comic zest. The performance is so passionless that Cockian's ultimate martrydom has no heroic pathos. With supporting performances as muted in their expressiveness as Mr. Tucci's, "Philemon" emerges as a sterile exercise in music-theater myth-making.

1991 Ja 20, 46:3

SUNDAY VIEW/David Richards

Is It Ibsen? Or Is It Stephen King?

Mark Lamos attends to the spookiness of 'The Master Builder' at Hartford Stage; 'When We Dead Awaken' emphasizes the symbolic.

"**T**HEY SHOULDA ROLLED THE head on stage," said the burly high school student in the letter jacket, who had just seen the Hartford Stage Company's production of "The Master Builder" and was making his way up the aisle and out into the street, where a yellow bus waited to collect him and his companions.

The girl walking beside him screwed up her face and said, "Gross."

He was insistent, however. "Yeah, that's what I would do. I would make up this head to look all bloodylike, and then after the crash, I'd roll that sucker right out on stage."

"Weird," she said.

I do not have to point out that this is not how Ibsen's 1892 drama traditionally ends.

Usually, Solness, the aging architect, leaves the stage in a state of exaltation. Inspired by Hilda, a young enchantress from the mountains, he has resolved to climb to the top of his new house and place a wreath triumphantly on its highest point. We don't see the ascent, but Solness's unsteady progress up the building's facade is reflected in the eyes of the characters who are watching and clearly fearing the worst. Suddenly, they all let out a shocked gasp and we hear that crash. Solness, we instantly understand, has lost his footing and plummeted to his death.

Reared, no doubt, on action movies and horror films, the student naturally expected to see some of the carnage. And since he didn't, it occurred to him that rolling Solness's head on stage would be a logical, not to say slam-bang, way to bring the drama to a close.

■

The more I've thought about it, the more I've decided he wasn't that far off the mark. "The Master Builder" *is* a horror story. The characters are decidedly strange. What unites them approaches the perverse. There isn't a touch of Ibsen in "Misery," the Stephen King thriller about a writer imprisoned by his "No. 1 fan" that's currently raising goose bumps in the nation's movie houses. But there may be more than a touch of "Misery" in "The Master Builder."

I know that we're not supposed to think of the play in those terms. Scholars like to tell us that Ibsen is writing about the artist's attempt to recapture the vigor and inspiration of youth, that he is tallying up the costs of a life (most likely his own) devoted to the rigors of creativity. Decline and regeneration are themes we're to look for. They love to pick apart the play's symbolism — and not just the obvious phallic implications of a man mounting steeples and towers and crowning them with wreaths.

Solness, they note soberly, starts out constructing churches (which represent Ibsen's early romantic and historical plays), then turns to homes for people (which correspond to the realistic social dramas of the playwright's middle years), and winds up promising Hilda "castles in air" with turrets rising higher than any church steeple. Doesn't that promise suggest the spiritual dramas, "The Master Builder" among them, that Ibsen himself produced in his final years?

■

Even the press release sent out by the Hartford Stage Company falls right in step, pointing out that the play is examining "the conflicting demands of morality and art." Well, morality and art can conflict all they want. It seems to me that "The Master Builder" is, first of all, a very spooky play. If you're going to get audiences interested — get them to a point where art and morality are even considerations — you'd better attend to the eeriness, which is precisely what the director Mark Lamos has done.

Indeed, over the residence of Solness, as the set designer Marjorie Bradley Kellogg has imagined it, hangs a gnarl of dead branches, tormented by the wind. Although it is not apparent until the branches part later in the evening, an eagle with a ferocious beak has been carved out of the upper stories of the house.

At first glance, the characters are respectable Victorians, living in Victorian comfort, but you soon sense that such appearances are deceptive. Solness (Sam Waterston) is too quick to anger; his wife, Aline (Veronica Cartwright), too disposed to self-abnegation; his employees, either too sullen or too cowed. And when Hilda (Cynthia Nixon) skips into their midst — a straw hat on her golden head

11

and a girlish giggle on her lips — something about her forthright manner goes beyond mere exuberance to suggest a terrifying potential for tyranny.

A heavy past weighs on this household and, in the best tradition of haunted house stories, it emerges in dribs and drabs, each new revelation helping to fill in the picture, perhaps, but also distorting it, nudging it closer to nightmare. A mysterious fire, dead babies, sudden success, suffocating guilt, insanity, paranoia — it's all there. And it may be there because Solness himself willed it.

"Don't you agree with me, Hilda," he asks feverishly, "that there are a few select individuals — chosen people — who have been given the ability, the talent, the power to wish for something, to desire something, to want something — so insistently and so — devotedly — that in the end they have to get their way? Don't you believe that? . . . The helpers, the servants, they have to participate, too. Oh, yes, if anything is to come of it. But they never appear on their own, you see. One has to call them very insistently from the inside. . . . It's the troll in you, that's it, who calls for the forces from the outside — and then you have to give in, whether you like it or not."

Not unlike Anthony Perkins, Mr. Waterston has always projected an ambivalent boyishness — affable but jittery, as if he were about to crack under some intense inner strain. When fury seizes him, it pounds in his temples, pinches his vocal chords and sends tremors through his body. But the disturbance lifts as suddenly as it strikes, and the uneasy calm resumes. I don't know if you'll necessarily think of Mr. Waterston as a prosperous Norwegian builder — actually, he looks more like a New England parson with a pocketful of brimstone — but his emotional lurches are unsettling in their unpredictability. This is a dark, dense performance of a man who has ceded all power to the troll within.

Ms. Cartwright, on the other hand, sneaks up on madness. We are given to understand that grief has possessed her, ever since that unexplained fire reduced her family home to rubble. Traumatized, she was unable to nurse her twin sons properly and they died shortly after. Now, she is little more than a hush with downcast eyes. A reproving glance from Solness suffices to keep her from expressing the anguish that has soured her heart.

Only when she finds a more sympathetic listener in Hilda, do we learn that it's not the death of her sons that continues to bother her, but the incineration of so many irreplaceable family possessions — the silk outfits, her grandmother's lacework, the jewelry and "nine exquisite dolls." How she loved them, those dolls! How often she'd play with them whenever Solness's back was turned! Then in a tone that admits nothing out of the ordinary, she adds, "I carried them under my heart, just like a child before it was born." Ms. Cartwright's voice seems to have been lightly scratched by brambles, but that's as far as the histrionics go. And the confession has you sitting bolt upright.

∎

It may be Ms. Nixon, however, who is the most troubling presence of all, because on the surface, she appears a bright, impetuous peasant girl, still young enough to like to turn awkward circles in the sunshine. Her eyes are cornflower blue; her round face, open and innocent. "Rapturous" is her favorite word, and the sheer prospect of living rapturously gives her visible shivers of ecstasy.

Ten years ago, while erecting a church in her village, Solness promised her, as he might any pretty child, that she could be his princess one day and that he would build her a palace. Now, by Hilda's reckoning, the day has come and she is there to claim her kingdom — giddily, at first, then with a deepening determination that carries hints of savagery. Ms. Nixon's performance is similar to those trick illusions in children's play books. Depending on which way you look at it, she is the free spirit or the implacable fury, a songbird or a bird of prey. Mr. Lamos and Ms. Nixon are perfectly happy to let the enigma stand.

The myriad abstractions that can be read into the play — and usually are — have been put aside for the time being. The emphasis is on the mystery and the production is palpably suspenseful. Instead of asking ourselves what it all means, we're far more concerned with how it will all turn out. And that's just as it should be.

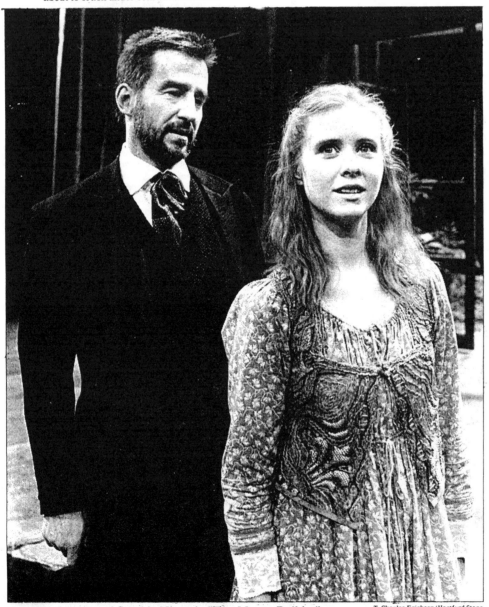

Sam Waterston and Cynthia Nixon in "The Master Builder"—
Hook viewers with eeriness, then hit them with morality.

T. Charles Erickson/Hartford Stage

'When We Dead Awaken'

By way of contrast, you have only to consider the production of Ibsen's

"When We Dead Awaken," which is part of the rotating bill this season at the Jean Cocteau Repertory Off Off Broadway, and which, short as it is, will have you scratching your head in no time. Ibsen's last play (he called it a dramatic epilogue), it echoes many of the preoccupations in "The Master Builder." The hero is an aging sculptor, whose one masterpiece, "Resurrection," lies well behind him. While on a holiday at a mountain spa, he encounters the model who served as his inspiration and whom he ruthlessly cast aside once the work was completed. Although apparently deranged, she convinces him to climb — up through a gathering storm — to the dizzying peak of the mountain. Before they get there, they are en-

Instead of asking ourselves what it all means, we're far more concerned with how it will all turn out.

gulfed by an avalanche and dashed to their death.

Admittedly, the acting is grim, when it is not inept. Wrapped as she is in bolts of fabric and sporting a veritable waterfall of platinum white curls, Angela Vitale looks less like the ghostly artist's model than she does the ghost of Cher, while Craig Smith plays the role of the sculptor through gritted teeth, as if the whole affair were almost too distasteful to bear. But there's a deeper failing, and that's the director Eve Adamson's proclivity for favoring the play's symbols over any flesh-and-blood reality.

The set is a surrealistic collection of attic clutter — a grandfather clock, a mirror, a bird cage — to which has been added a truncated Greek column or two. When the action moves into the great outdoors, the various objects are draped with white sheets, which are subsequently drawn together in a swirl to make the giant cocoon that passes for an avalanche. Now and then, an ominous nun appears — sometimes in the shadows, sometimes dimly in that mirror — to let us know that destiny's keeping a sharp eye on things. Any resemblance between her exaggerated headdress and a raven's wings is purely intentional.

The undertaking is pregnant with meanings, large and small, although what they are I'd be hard pressed to specify. Instead of making a nebulous play more concrete, the production makes it even more abstract. Abstractions can't hold the stage for very long, however, before our attention wanders, then shuts down altogether. That's precisely what happens at the Jean Cocteau Repertory.

It is well and good for the Hartford Stage Company to alert us that art

and morality will be going at one another tooth and nail in "The Master Builder." We can spout that to our friends afterwards and sound intelligent. But that's not the battle we're there to witness, and Mr. Lamos knows it.

What we really want to see is people going at one another.

And maybe a head rolling on stage at the end. □

1991 Ja 20, II:5:1

The Glass Menagerie

By Tennessee Williams; directed by Emily Mann; set design, Ming Cho Lee; costume design, Jennifer von Mayrhauser; lighting design, Robert Wierzel; original music by Mel Marvin; props design, Sandy Struth; production stage manager, Susie Cordon. Presented by the McCarter Theater, Princeton, N.J.

The Mother	Shirley Knight
Her son	Dylan McDermott
Her daughter	Judy Kuhn
The Gentleman Caller	Jeff Weatherford

By MEL GUSSOW

Special to The New York Times

PRINCETON, N.J., Jan. 18 — Emily Mann opened her first season tonight as the artistic director of the McCarter Theater with a production of "The Glass Menagerie" that demonstrates the director's fidelity to Tennessee Williams and the play's eloquence, undiminished after 46 years. "The Glass Menagerie" remains Williams's most deeply personal work, a play that expresses both his rite of passage and a coming to terms with family ghosts.

Williams's memories in "The Glass Menagerie" were burnished by regrets about the limits of love, especially as represented by Amanda Wingfield, a transposed portrait of the playwright's mother. Defeated in her dreams, she strives for a kind of romantic fulfillment through the image of her crippled daughter.

Having called his public self "that artifice of mirrors," Williams looked for reality in "The Glass Menagerie" and found a searing truth. In the play he tells us how his surrogate, the prodigal son, Tom, could only seek his own vision only by abandoning his mother and sister, leaving his sister adrift in an illusory world. The guilt for that action was something the playwright was to confront throughout his life and work.

•

In Ms. Mann's production, Shirley Knight is a radiant Amanda. She is a grand Southern belle who one afternoon in her youth received 17 gentlemen callers and is also a self-martyring matriarch desperately trying to hold on to the remains of her hopes. As called for by the role, Ms. Knight is demanding to the point of being overbearing, but always with a grasp of Amanda's gracefulness.

Within this story there are deceptions, a word that is heard almost as frequently in "The Glass Menagerie" as the word mendacity is heard in "Cat on a Hot Tin Roof." Amanda is fearful of facing facts. From her perspective, her long absent husband, a telephone man "who fell in love with long distance," is simply traveling on the road and her daughter, Laura, is not crippled.

In lesser hands than those of Ms. Knight, Amanda can seem like a ter-

magant. But she should never be less than charming, or, on her own terms, well-intentioned. This is a woman "bewildered by life," but still "obsessed with jonquils," those remembrances of her girlhood. Ms. Knight has had a long affinity with the works of Williams, as exemplified by her soulful Blanche in "A Streetcar Named Desire" at the McCarter, and her subsequent appearance in "A Lovely Sunday for Creve Coeur." She fills the role of Amanda with compassion.

•

This is especially evident when she prepares herself for the visit from Laura's gentleman caller, a friend of Tom's at the shoe factory. Dressed in her cotillion gown, Amanda is girlish but not foolish. When the caller expresses his admiration, it is with believable sincerity. Even at her most anxious, Ms. Knight carries with her intimations of a faded glamour.

As Laura, Judy Kuhn exudes fragility, in direct contrast with Amanda's vivacity. Timid to the point of being tremulous, she seems to wilt when anyone looks in her direction. Ms. Kuhn conveys Laura's longing as a woman unable to free herself from the private dimensions of her menagerie of glass objects.

The scene in which Laura meets her caller (Jeff Weatherford) and is led to reawaken her schoolgirl crush on him is played gently and with freshness. Mr. Weatherford's caller is, as the playwright described him, "a nice, ordinary young man." He is a high school star who has never measured up to the potential that others saw in him. Mr. Weatherford finds the lost boy behind the bravado. He is kindly even as he momentarily deceives Laura as to his intentions.

•

With an assurance that partly derives from the fact she has staged the play before (at the Guthrie Theater in Minneapolis), Ms. Mann lets "The Glass Menagerie" unfold with a quiet resonance. A playwright and a director, she shares with Williams a concern for people trapped by their lives.

There is a single problem in this production and that is in aspects of Dylan McDermott's performance as Tom. Irritated by his mother's solicitous manner, he overdoes Tom's an-

ger, and he blurs several soliloquies. But he and Ms. Kuhn delineate the intimacy that exists between siblings. He also underlines Tom's insularity, as in his confession to Amanda, "There is so much in my heart that I can't describe to you." That line is made even more meaningful by the fact that Williams himself was eventually able to communicate his inmost feelings to strangers in a theater.

The staging is enhanced by Ming Cho Lee's impressionistic setting, which removes the walls from the Wingfield home, and in so doing adds a fluidity. The action remains interior; unlike other productions of "The Glass Menagerie" there is no representation of the bright, tempting lights of the Paradise Dance Hall across the alley. The Wingfields are seen in a world by themselves, shimmering with the beauty of a fond but rueful look back at an artist's formative experience.

1991 Ja 21, C11:1

T. Charles Erickson/McCarter Theater
Dylan McDermott and Judy Kuhn in "The Glass Menagerie."

Ice Capades
On Top of the World

Produced and directed by Willy Bietak and Tom Scallen; choreography by Sarah Kawahara; production designed by Robert W. Rang; costumes designed by Jef Billings; lighting designed by Marcia Madeira; musical direction and arrangements by Euromusica Design Group. Presented by Mr. Scallen. At Madison Square Garden.

WITH: Simone Grigorescu, Tracey Solomons and Ian Jenkins, Julie Brault, the Beattys, Kelly Johnson and Jonathan Thomas, David Nickel, Bobby Beauchamp, Don Otto, Tricia Klocke, Scott O'Neill, Shannon Sowers, Richard Swenning, Kelby Riley, Steve Taylor and Chris and Andy Beatty.

By RICHARD F. SHEPARD

It's been a week of sitting home and watching the world skate on thin ice and a pause may be in order, without for a moment forgetting the awesome imbalances of global politics, to go out and relax by seeing some great skaters demonstrate equilibrium on the real stuff.

That is to say that the Ice Capades, that perennial escape into a fantasy of glissade, is back in Madison Square

Garden with its 51st edition. It's an all-new show, they say, but don't be disheartened if you are a regular customer who may be leery of change.

This installment still has the same spirit and general look of the others, the mixture of grace and daring that has always attracted aficionados with an eye for what constitutes the extraordinary on something as uncertain as two steel blades beneath the feet.

There is certainly talent enough under foot. Simone Grigorescu, a former World Professional Ladies' Gold Medalist, solos with beauty and passion. Tracy Solomons and Ian Jenkins are a fusion of brinksmanship and esthetics; when he whirls about with her spinning horizontally atop his head, one realizes that effortlessness on ice results from hairbreadth planning and, of course, effort.

There is skating for every mood. Bobby Beauchamp almost sears the frozen surface as he speeds over it, even trailing a finger on the ice as he tears on. Steve Taylor's boldness is of a different sort: he's an incorrigible leaper, first over a barrier, then through a rotating flaming hoop and finally over a station wagon.

The pace changes as Kelly Johnson and Jonathan Thomas circle the arena in an interlude of pure dancing. And then we have the Beattys, a couple who mock the pretensions of ballroom dancing in a number that is not as witty as it is brazenly funny, with pratfalls and falling pants. The small fry particularly relished Don Otto's act, with high-dive pratfalls, and that of the Scarecrows, a trio that commits comic mayhem on one another and spills over into the audience.

•

But the most familiar faces for the young audience and those they most appreciated were of the Simpson family, fresh from animated television, with Bart and the others popping up around the seats and finally on the ice. There was also a scramble to jump into the iceboats to be pushed around Madison Square Garden by sturdy ice dancers.

While the skill that is skating itself may be enough for the aficionado, the Ice Capades has always seemed to realize that technique alone is not enough to keep audiences, particularly younger ones, in their seats for two and a half hours.

The show has always emphasized production values, and this edition is no different. The settings, with dramatic high-rise backdrop techniques as well as lighting and music, keep the eye involved, whether in a sequence set in a stylized city tableau, a torrid segment in an unfrigid tropical background, a lively session with a ghostly motif or, finally, for jitterbugging and big-band themes that look back to the days that used to be.

This new Ice Capades, subtitled "On Top of the World," is reassuringly friendly evidence that while the world changes, certain tastes do not.

1991 Ja 22, C16:4

Grown Ups

By Jules Feiffer; directed by Lonny Price; sets, John Falabella; costumes, Gail Brassard; lighting, David Holcomb; production stage manager, Eric Eligator; technical director, Aaron Shershow; assistant director, Marcyanne Goldman; scenic artist, Mary Blanchard. Presented by American Jewish Theater, Stanley Brechner, artistic director. At the Susan Bloch Theater, 307 West 26th Street.

Helen	Rosemary Prinz
Jack	Len Stanger
Marilyn	Barbara Niles
Jake	Barry Craig Friedman
Louise	Lisa Emery
Edie	Lauren Gaffney

By STEPHEN HOLDEN

One of the happy surprises of the American Jewish Theater's scorching revival of Jules Feiffer's "GrownUps" is how well this nasty Freudian comedy has aged since it opened on Broadway nearly 10 years ago.

Mr. Feiffer's finest play dissects the crippling psychological warfare among members of an American Jewish family of a type made familiar in novels by Philip Roth and Joseph Heller. The central character, Jake, is a man who on the surface seems to have it all. A successful journalist and about-to-be-published author of a book on "the moral and ethical disintegration of the American dream," he lives comfortably on the Upper West Side of Manhattan with his wife, Louise, and their precocious 9-year-old daughter, Edie.

But underneath, Jake is a caldron of rage. His domineering, censorious mother, Helen, and nebbishy, inarticulate father, Jack, still demand the kind of unlimited access to their son (and now their granddaughter) that they enjoyed when he was growing up in their house. At the tense family gatherings portrayed in the first and third acts, the forced bonhomie between generations quickly disintegrates into brutal recrimination. The most agonized moments in a play that sustains the emotional tone of a half-stifled scream occur in the second act when Jake directs his bottled-up fury toward his wife in an after-dinner argument that escalates into threats of divorce and suicide.

•

Like Mr. Feiffer's other plays, "Grown Ups" is not a grandly designed drama, but rather a series of connected sketches that omit much important information about the characters, their history and background. What holds it together is its relentless accumulation of small, incisive observations — the way a seemingly trivial phrase, repeated over and over, can convey repressed, potentially explosive feelings, or the illogical directions a domestic argument takes.

The revival, directed by Lonny Price at the tiny Susan Bloch Theater, is significantly different in atmosphere from the Broadway production, which originated at the American Repertory Theater in Cambridge, Mass. With the audience seated only inches from the actors in a cramped cellar space, the play seems far more intimate and its emotional crosscurrents more volatile. Although "Grown Ups" is still billed as a comedy, the few laughs it generates are mostly nervous ones. For much of the rest of the time, the theater is so charged with tension and rage that one has the uncomfortable feeling of attending a party at which friends or relatives suddenly turn on one another.

As he demonstrated in his masterly direction of the American Jewish Theater's revival of the Bock-Harnick musical "The Rothschilds," Mr. Price knows how to create a sense of family dynamics that is so strong the bonds seem physically palpable. The ensemble acting is so finely tuned that the six characters seem genuinely related by blood and by marriage. The performances have such a concentration of detail that one follows the actors' eyes in an attempt to read inner emotions the characters might be trying to repress.

•

Both the casting and the tone of the dialogue emphasize the play's Jewishness more pointedly than did the Broadway production. Where Frances Sternhagen made the Broadway Helen a rather grand ogress, Rosemary Prinz portrays her as more of a stereotypical Jewish mother — a caricature who partially masks an iron-willed selfishness under a stream of chirpy vaudevillian shtick.

But the revival's most significant change in its approach to a character is its view of Jake. In contrast to the sour, nagging husband of Bob Dishy's Broadway portrayal, Barry Craig Friedman plays him as a tormented, fiery-eyed journalist attempting to keep a calm exterior while trying desperately but futilely to flee from the injurious psychological forces that shaped him. When his irrational rage boils up, his inability to transcend the wounds and humiliations of childhood assumes nearly tragic dimensions. In spite of everything, he is sympathetic.

Barbara Niles, as Jake's self-effacing sister Marilyn, gives the play's most warm-hearted portrayal, while Lisa Emery imbues Louise with a grating neurotic edge that is a perfect trigger for her husband's anger. As Jack, Len Stanger succeeds in infusing a simple jocular question, "So what's new?" with chilling overtones of parental resentment and evasion.

"Grown Ups" is a situation comedy turned inside out. It wears its black heart on its sleeve.

1991 Ja 24, C18:5

Better Days

By Richard Dresser; directed by John Pynchon Holms. Presented by Primary Stages Company, Casey Childs, artistic director; Janet Reed, associate artistic director. At 354 West 45th Street.

Ray	Daniel Ahearn
Arnie	Kevin McClarnon
Faye	Susan Greenhill
Phil	James Gleason
Crystal	Ann Talman
Bill	Larry Pine

By MEL GUSSOW

Richard Dresser's "Better Days" could be regarded as a black comic postscript to Jerry Sterner's "Other People's Money." In the New England town that is the setting of Mr. Dresser's play, the mill is permanently closed and almost everyone is out of work and out of money — and many are already out on the street. People are thrown back on what is left of their wits. Scrounging and stealing have become favorite occupations.

Those who are not yet homeless are heatless. They huddle in their overcoats and burn furniture. A disbarred lawyer is living in his car with his girlfriend; when someone asks him his address, he gives him the number of his license plate. Supermarket bandits will soon be succeeded by arsonists, torching cars and homes for the insurance. One of the many unanswered questions in this play (at Primary Stages) is how insurance companies are able to pay all the claims.

"Better Days," which supposedly takes place in the present, has a far-out sense of humor and the timeliest of subjects. But it is a cluttered, overlong comedy without a clear train of thought. Gags march in (and some fall flat) and plots collide. The least intriguing plot is the central one. Having had a vision on the roof of his house, a former factory worker (Daniel Ahearn) has decided to found the True Value Church.

In this case, revivalism is less funny than arson, the latter represented by Larry Pine as the con-artist chairman of the booming firebug business. With a flick of his thick roll of money, he can turn friend against friend. Another go-getter is that former lawyer, who now sells hardware door to door in the middle of the night, a useless campaign when houses are falling.

•

Somewhere offstage there may be a movie in all this. One could imagine a cameraman roaming the streets of this ghost town, capturing cataclysmic events that we receive as hearsay. The action in the play is confined to Mr. Ahearn's home, where he and his wife (who dresses for her role as a waitress at the Happy Pilgrim) occasionally meet to share food she has plundered from her restaurant.

More often, Mr. Ahearn and his mates are comparing notes on their destitution and holding prayer meetings with pizza as sacrament. Outsiders are warned not to touch that pizza. The play goes on and on in its circuitous fashion, as if daring the audience to lose interest. Then there will be a momentary comic alert that will remind one that the world is in a state of emergency.

Although John Pynchon Holms's rough-edged production is unable to instill a sense of order on the play's disarray, there are amusing performances by, among others, Mr. Ahearn, Mr. Pine (especially when he loses his temper) and Susan Greenhill as the Happy Pilgrim, who somehow manages to keep her equilibrium in a sunken economy.

As in his other social comedies (like "The Downside," about the wages of careerism), Mr. Dresser can be a caustic critic of self-wounding capitalists and consumers. But he continues to have difficulty in marshaling his ideas into a coherent play.

1991 Ja 24, C20:1

Tom Wopat, above, and Michael Rupert in "City of Angels"

The Musical Returns To America

By FRANK RICH

WHEN the 1980's departed, it was not only the Trump yacht and Drexel Burnham Lambert that sailed into the sunset. Somewhat less conspicuously, the theater's own symbol of a money-crazed decade — the over-produced English musical — began its inexorable retreat to the wings. Built on opulent stage effects, London's theatrical spectaculars were as symptomatic of the money-mad 80's as a Malcolm Forbes birthday bash, and in the 1990's, their party, too, seems to be over.

In the nearly two years since "Aspects of Love" opened in the West End, no new Andrew Lloyd Webber project has gone much past the press-release stage in New York, London or Hollywood. The only smash hit "English" musical still in the pipeline to New York, "Miss Saigon," is in fact the work of French and American authors. And whatever that production's merits prove to be in its New York incarnation, doesn't it already feel like old news?

All of which brings hope to those diehard chauvinists who dream of the resurgence of the American musical. That dream has been fueled of late not just by the pricking of the English-musical bubble, but by the steady rise in American musical-theater output. "Assassins," Stephen Sondheim's new show, opens at Playwrights Horizons on Sunday night, the third prominent musical, following "Falsettoland" and "Once on This Island," to originate at that company since last spring. Despite a recession that has otherwise flattened Broadway production, at least two major new American musicals are promised to follow "Miss Saigon" onto Broadway this spring: "The Secret Garden" and "Will Rogers at the Follies."

Until then, the front line for the American musical remains the two current flagship American musicals on Broadway, "City of Angels" and "Grand Hotel." Both recently entered the second year of their runs, and that in itself represents a comeback for the form. Not since the 1983-84 Broadway season produced both "La Cage aux Folles" and "Sunday in the Park With George" have two new American musicals opening in the same season had such staying power on Broadway.

"City of Angels" and "Grand Hotel" deserve their longevity, without

Martha Swope/City of Angels

15

Martha Swope/Grand Hotel

Chip Zien, left, and Lynnette Perry in "Grand Hotel."

question. But revisiting the two shows this month to see how they were faring after substantial cast turnovers, I was struck by how transitional they both look. These musicals seem to be taking place on two different planets, esthetically at least, and each seems incomplete, as if it were lacking what the other had. If the American musical is now poised to rally for another era of international glory, it can make good on that promise only by transcending the sum of both these shows' better theatrical parts.

Those parts are still in splendid working order. "Grand Hotel" never depended on the quality of its cast — which was largely mediocre when the show opened — and it still doesn't. It's hard to believe that the director Tommy Tune could find an actress as inappropriately cast as a fading ballerina (the old Garbo role) as that tough French cabaret chanteuse Liliane Montevecchi. But in Rene Ceballos, a gawky exemplar of Broadway brashness, he has found an equally far-fetched replacement. As the ballerina's lesbian aide-de-camp, the not untalented Caitlin Brown tailors her voice, makeup and hair so exactly to the image of her distinctive predecessor, Karen Akers, that it's hard to know whether her performance is meant to flatter Ms. Akers or give her the creeps. At least the one major cast holdover, David Carroll as the Baron, acts with more elegant command now than he did before, but what really matters at "Grand Hotel" is Mr. Tune's staging. It remains pristine, and thrilling.

At "City of Angels," Tom Wopat's rumpled, battered masculinity proves ideal for Stone, the fictional hard-boiled 1940's private eye first played by James Naughton. As Stine, the jaundiced novelist turned screenwriter who created Stone, Michael Rupert is more plausibly cast than his boyish predecessor, Gregg Edelman, but is taking the character's Hollywood humiliations so much to heart that Stine threatens to become as glum as Willy Loman. The gifted Mr. Rupert needs to move a bit further away from the anguish of his last musical role (in "Falsettoland") to retrieve the buoyant charm he brought to his last role in a Cy Coleman musical (opposite Debbie Allen in "Sweet Charity").

"City of Angels" and "Grand Hotel" have lost the respective supporting players, Randy Graff and Michael

Jeter, who won Tony Awards for late-evening show stoppers, and in both cases the replacements (Chip Zien as the dying bookkeeper in "Grand Hotel," Susan Terry as the long-suffering secretary in "City of Angels") rekindle the spirit if not the spark of their predecessors. Even so, the experience of seeing either of these musicals is not markedly different today than it was at the end of 1989. But a repeat visitor may find, as I did, that seeing a second cast does bring the strengths and failings of the musicals themselves into sharper relief.

Given its reviews, its Tony Award for best musical and its consistently higher attendance, "City of Angels" has been judged by most audiences to be the superior of the two shows, and I concur with that sentiment. The mirror-image double narrative of Larry Gelbart's script is a farcical

Signs of revival in an American art form.

wonder, as one would expect from the co-author of "A Funny Thing Happened on the Way to the Forum," and his Hollywood-phobic dialogue is a volley of detonating punch lines worthy of the man who also co-wrote "Tootsie" and the television series "M*A*S*H." Mr. Coleman's exuberant mock-period jazz score, which has been rousingly arranged in the Billy May-Nelson Riddle tradition by Billy Byers, can be faulted only because it imitates the past (sometimes Mr. Coleman's own past) rather than attempting something fresh.

•

Vastly entertaining as this musical is, however, there are times when I wish it might check into Mr. Tune's "Grand Hotel." To be sure, the "City of Angels" director, Michael Blakemore, and his designer, Robin Wagner, have done an ingenious job of piggy-backing the show's on-screen and off-screen Hollywood tales by depicting them, respectively, in black-and-white and color. At its best, the ricocheting between the show's two realities is as hilarious as was Mr. Blakemore's similar juggling of on- and offstage shenanigans in his classic production of Michael Frayn's backstage farce, "Noises Off." But "City of Angels" has virtually no musical staging, despite the listing of someone charged with that responsibility (Walter Painter) in the Playbill.

By musical staging, I do not mean dancing per se — though "City of Angels" has none of that, either — so much as a sense of show-biz authority in the presentation of musical numbers. Too many songs are statically set forth, dead center stage, and most of them trail off rather than come to a punctuated, exhilarating finish. For all the sophistication of its content, "City of Angels" is, in theatrical terms, a throwback to George Abbott musicals of the 1950's and early 60's, minus the contributions of Jerome Robbins and Bob Fosse: Nearly every scene is a separate blackout sketch, bordered by a set change (often occurring behind a drop).

•

"Grand Hotel," though also short of dancing, is a celebration of the mod-

ern musical-theater stagecraft that "City of Angels" avoids. Often several stories are told simultaneously during Mr. Tune's intricately designed two hours of swirling, nonstop movement, and nothing that happens is hidden from the audience behind drops or within blackouts. Mr. Tune needs only an evocative, two-level skeletal set (by Tony Walton), movable stiff-backed chairs, a portable revolving door and waltzing bodies to evoke every dark cranny of a seething, doom-laden Berlin hotel of 1928. When a curtain finally does fall late in "Grand Hotel" — the only curtain to fall all evening — the effect is shocking. Mr. Tune uses the curtain's slow descent in the most showy way imaginable: to demonstrate that only the lowering of a figurative wall could possibly still the churning panorama of life that he has unfurled onstage before.

This director is some kind of genius, with an impeccable theatrical eye and an ability to take subconscious charge of an audience's vision. As the change in performers accentuates, the real reason why the dying bookkeeper's number ("We'll Take a Glass Together") stops the show has less to do with character, plot or performance than with a visual twist in the staging: Mr. Tune heightens the celebratory excitement of the oppressed bookkeeper's belated leap to freedom by making him the only character in the evening who literally leaps out of the grid-like frame that encases the show.

The blot on "Grand Hotel," aside from its occasional rehashes of directorial ideas from Harold Prince's "Cabaret" and from Mr. Prince and Michael Bennett's "Follies," is that the whole show is fairly meaningless except as a predictable mood piece about Weimar Germany. "Forbidden Broadway" rightly parodied this musical as "Grim Hotel," for its grimness is ludicrously unearned, despite the periodic attempts to drag in class conflict by having scullery servants harangue the audience with the lyrics "Some have/Some have not." Does anyone really believe that Mr. Tune gives a hoot about Marxism? Worse, the director seems to invest little passion in the pulpy aspects of "Grand Hotel" as well. The show never delivers the romance, sexiness and tear-jerking soap operatics of the M-G-M movie that shares its title.

In part this shortfall is due to the casting and the score, both of which are far too lackluster to convey grand emotions. ("Grand Hotel" may be the first Broadway musical since World War II to run more than a year without anyone lifting a finger to record it.) But surely Mr. Tune has the power to recruit better performers and to insist upon stronger material; is it possible he does not want any other strong creative personality to upstage him? This has been and continues to be the principal impediment to his career. Unlike Mr. Bennett, Mr. Prince, Mr. Robbins, Gower Champion and Agnes de Mille, Mr. Tune has never worked on a musical in which the other principal collaborators, off- and onstage, were all of his artistic stature. Would those directors be considered giants today if their reputations rested on musicals of the caliber of "Nine" and "Grand Hotel"?

A triumph of showmanship over substance, "Grand Hotel" has the sensual kick and clammy aftertaste of high camp. A triumph of witty literary intellect over musicality, "City of Angels" is the funniest musical in years but hardly among the

most theatrical. Neither show whips up one genuine emotion — both are far more at home with the put-on — and neither has a song that will make it to Broadway's all-time hit parade. Yet both have unmistakable, idiosyncratic personalities that linger in the imagination long after the assembly-line English spectaculars have blurred together, and they remain essential viewing for anyone who really cares about where the American musical goes from here.

1991 Ja 25, C1:1

When Lightning Strikes Twice

By H. M. Koutoukas; directed by Eureka; scenery by Tom Moore; costumes by Daniel Boike; lighting by Richard Currie; props by Vicky Raab; jewelry by Wendy Gell; production stage manager, James Eckerle; music and sound, Mark Bennett. Presented by the Ridiculous Theatrical Company, Everett Quinton, artistic director; Steve Asher, managing director. At the Charles Ludlam Theater, 1 Sheridan Square.

AWFUL PEOPLE ARE COMING OVER SO WE MUST BE PRETENDING TO BE HARD AT WORK AND HOPE THEY WILL GO AWAY

Clickety Clack........................Everett Quinton
Mrs. Trompe l'Oeil ClackEureka

ONLY A COUNTESS MAY DANCE WHEN SHE'S CRAZY

The Countess Olie Samovitch Everett Quinton

By MEL GUSSOW

"When Lightning Strikes Twice" inspires Everett Quinton into a double feat of acting acrobatics. In these two short plays by H. M. Koutoukas, he leaps with boundless abandon from hapless husband to unaccountable countess. The two Koutoukas plays are performed in repertory with Mr. Quinton's impersonation of "Camille" at the Charles Ludlam Theater.

In the first and more substantial comedy, the excessively titled "Awful People Are Coming Over So We Must Be Pretending to Be Hard at Work and Hope They Will Go Away," the actor ruminates about the weight of the world and other grave matters. In particular, he is worried about Dutch elm disease, which is infecting his favorite tree.

Emerging into his backyard from a doghouse-size cottage (a neat toy design by Tom Moore) and speaking a New Yorkese that would not be out of place in the film "Goodfellas," Mr. Quinton tells us about the sufferings of his life, including his wife. She is played by Eureka, seen in silhouette through a window of the house. Eureka is both the director of the show and the prodder of her querulous spouse.

Mr. Koutoukas, a camp classicist as playwright, has written a breezy, nonstop near-monologue. The play is strewn with philosophical asides, which assume more meaning in Mr. Quinton's ebullient performance. As he says about his fatalistic character, he hasn't been the same "since they shot Bambi's mother." This means that disillusionment is deep. Facing old age, he says with conviction, "Grim, grim is the reaper." Funny, grim is the performance.

Supposedly the play takes place during the time of Franklin D. Roosevelt, but it is really undated. There are only a few period signposts. Mr. Quinton's character is presented as the most familiar of paterfamilias, with a twist. His heaviest burden is that Dutch elm disease, which he

Everett Quinton in "When Lightning Strikes Twice."

Henny Garfunkel/Ridiculous Theatrical Company

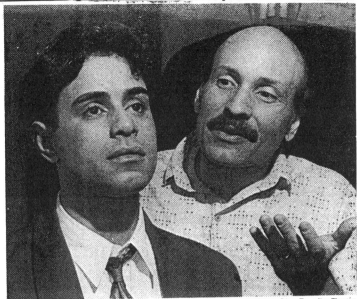

Orlando George, left, and Emilio del Pozo in a scene from Raúl de Cárdenas's "In Miami as It Is in Heaven."

Peter Krupenye/Puerto Rican Traveling Theater

abbreviates as D.E.D., as in "as a doornail." Mark Bennett has also written a song by that name (a catchy malady). In the course of the comedy, Mr. Quinton saws branches, is accosted by a bald eagle and, finally, is surprised by lightning.

Until that last clash, he keeps his precarious balance even on the roof of his house, despite the fact that he takes frequent nips from whisky bottles he has stashed in hiding spots on- and off-stage. Though undoubtedly the play is more amusing in performance than on paper, one should not overlook the limberness of the writing.

•

During an intermission as long as each play, the stage is completely reset as a Gothic chamber for "Only a Countess May Dance When She's Crazy." This time, Mr. Quinton is a lady who "has lost everything but her money." Standing in a cubicle behind a cardboard mock-up of a woman in a voluminous evening gown, he looks like a target for beanbags.

As the executive assistant to an unseen, mysterious scientist, the countess is desperately desirous of working in the mad doctor's laboratory, a word that Mr. Quinton trills with seven R's. Later he takes the word terror and gargles with it. This cartoon is partly an excuse to demonstrate Mr. Quinton's vocal dexterity and his ability to look glamorous in an array of gowns. Every time he comes out of that cubicle, he is differently attired: a quick-change couturier collection.

Behind the scenery, Eureka and her helpers busily assist the star in his transformations. The set is equipped with gimmicks and gimcracks, including a stairway to nowhere. Both plays have the added asset of quirky tunes by Mr. Bennett. In "Only a Countess," Mr. Quinton sings, "You be the father fork, I'll be the mother fork and together we'll spoon," and also does a diabolical danse macabre.

The play is Mr. Koutoukas's defense of what the countess calls "the ancient laws of glitter." But in contrast to the first one-act, the writing is marginalia. It is Mr. Quinton's lamé-brained performance that turns the character into such a mad scamp creature.

1991 Ja 25, C6:3

In Miami as It Is in Heaven

By Raúl de Cárdenas; English translation by Asa Zatz; directed by Alba Oms; sets by Michael Sharp; lighting, Rachel Budin; costumes, Mary Marsicano; production stage manager, Lisa Ledwich; producer, Miriam Colón Valle. Presented by the Puerto Rican Traveling Theater. At 304 West 47th Street.

Primitivo	Emilio del Pozo
Lola	Suzanne Costallos
Maruja	Cari Gorostiza
Vivian	Eileen Galindo
Mario	Orlando George

By STEPHEN HOLDEN

Raúl de Cárdenas's play "In Miami as It Is in Heaven" examines the generational conflicts among Cuban refugees living in Miami, and finds a spiritual void amid prosperity and cultural assimilation. The opening production of the Puerto Rican Traveling Theater's 24th season, the drama is set in 1985 and follows one tempestuous day in the life of a family that fled Cuba 20 years earlier.

Primitivo (Emilio del Pozo), the head of the household, is a hard-nosed used-car dealer from working-class roots who has built up a successful business in southern Florida. He and his wife, Lola (Suzanne Costallos), are divided souls despite their comfort. On the one hand, they are conservative bourgeois, upwardly mobile and concerned with appearances. On the other, they are nostalgic for their poorer former life, which in retrospect had a vitality and romance that are missing from the present. Primitivo is proud and fiery tempered and places great store in being a man's man. Both parents worship the memory of Ernesto, their oldest child, who died in Vietnam and whose room is kept as a shrine.

•

Their two surviving children are comparative disappointments. A daughter, Vivian (Eileen Galindo), does well selling real estate. Mario, their youngest child (Orlando George), is an aspiring pianist. As the play unfolds, he confronts his father with his homosexuality and then with the news that he has AIDS. Also living with the family is a relative (Cari Gorostiza) who left Cuba five years earlier during the Mariel exodus.

"In Miami as It Is in Heaven" holds many seeds that might make for high drama, yet it is a curiously flat and unmoving play. The characters' histories and conflicts are revealed in expository speeches that have none of the spontaneity of actual conversation. The playwright coyly withholds information, like the circumstances of Ernesto's death and the details of Mario's personal life, to generate a suspense that is far too contrived to have a dramatic pull.

The problems of the writing are underscored by Alba Oms's leisurely direction, which keeps a mute on the play's explosive emotions. Time and again, the characters complain about how tired they are of living in a house where everyone is arguing all the time. Yet the tone of performances rarely rises above one of heated conversation, and the performances are so physically inhibited that at moments the production has the static quality of a drawing-room comedy.

The only signs of animal ferocity in Mr. del Pozo's Primitivo are his flashing eyes, and Mr. George delivers Mario's anguished confessions in a somnolent singsong. Although Ms. Costallos conveys some of Lola's gallantry, the character's conflicts remain mostly beneath the surface.

A serious and well-meaning play, "In Miami as It Is in Heaven" deserves a rewrite as well as a more spirited production. It has performances in English on Wednesday, Thursday and Friday and in Spanish on Saturdays and Sundays. The performance reviewed was in English.

1991 Ja 27, 44:4

SUNDAY VIEW/David Richards

A Text on Loneliness And a One-Man Solo

"THE GLASS MENAGERIE," WE are told at the outset, is a memory play. At the McCarter Theater in Princeton, N.J., where the telling is currently unfolding, memory sure is one big place.

On a stage that could easily accommodate spectacles by Ziegfeld, Tennessee Williams's drama looks a bit like a waif in a municipal train station. Being surprisingly scrappy for a play with such a delicate title, it tries not to be intimidated by the forbidding scale. It carries on, bravely ignoring the echoes and pretending that nothing's out of the ordinary, before finally giving in to the troubling truth: it is lost.

Close quarters are not the chief reason for discord among the Wingfields, the St. Louis family that Williams loosely based on his own, but they certainly don't help. Nobody's living on top of anybody else at the McCarter, though. Nobody's living anywhere *near* anybody else. You could invite in all the customers at the Paradise Dance Hall across the alley and not begin to populate the wide-open spaces. Quiet confessions don't stand much

chance of being heard under the circumstances. Only thunderclaps and revelation need apply.

In every respect, save the housing, the production — the maiden effort of Emily Mann in her capacity as the McCarter's recently appointed artistic director — can be regarded as resolutely traditional. If Ms. Mann, herself a playwright of some adventurousness, has bold designs for her theater, she must be holding them in reserve for later endeavors. No liberties are being taken with Williams's

> # There is indestructible magic in a scene from 'Glass Menagerie'; 'Mambo Mouth' is fierce and funny braggadocio.

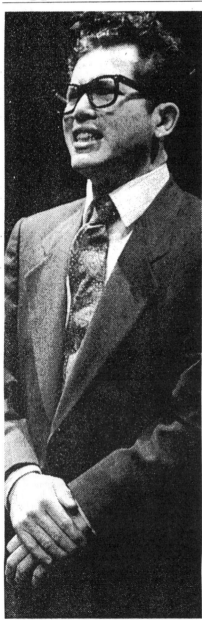

Jack Manning/The New York Times

John Leguizamo—a sit-up-and-take-notice talent in "Mambo Mouth," seven sketches on the down and out

play, one of the few sacred texts of the American theater. The casting hews pretty much to type. Predictably, Mel Marvin's original score relies on the tinkle of wind chimes and the sweet regrets of a violin to establish its wistful moods.

■

The set designer Ming Cho Lee has even tried to do something about reducing the McCarter stage to manageable proportions. A thrust has been built out into the audience, and panels of gauze, bearing the faded traces of cabbage roses, suggest ceilings and walls, hovering in the vastness. Still, when Amanda Wingfield, all aflutter at the sudden prospect of a gentleman caller for her daughter, runs her eyes over the apartment, makes a checklist of things to be done and then adds nervously, "Of course, I'd hoped to have these walls repapered," the line gets a particularly robust laugh.

The distances can't help lending a surrealistic aspect to the production. The various pieces of furniture stand out in stark isolation, as if de Chirico had been consulted on their selection and placement. And when the lighting designer Robert Wierzel bathes them in gray, wavering light (memory's filter, I guess), you get the disquieting sensation that you're looking at the ocean floor. Could the whole affair really be taking place under water?

I suppose you can defend such impressions on the grounds that this is a play about loneliness and drowning and people slipping away from one another. At least one moment in the production indicates that the distortions of dreams can be fruitfully brought to bear on the proceedings without necessarily pulling the text asunder. Sick with anxiety, Laura has bolted into the kitchen rather than face her gentleman caller. But everyone's now seated at the dinner table, and Amanda, tolerating her daughter's absence no longer, commands her sternly to appear. As she clumps across the stage — dread, as much as her deformed foot, slowing her step — time and space seem to expand, and the trip proves agonizingly long. For a few protracted seconds that could be an eternity, we're seeing life from her painfully self-conscious perspective.

Ms. Mann isn't able to find too many other ways to put the huge stage to such revelatory uses, though. Mostly, she maneuvers her actors down front as best she can and leaves it

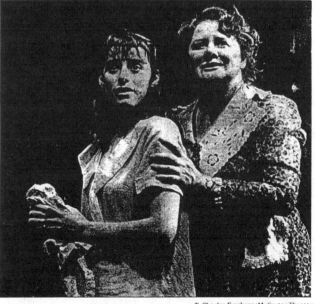

T. Charles Erickson/McCarter Theater

Judy Kuhn and Shirley Knight in Tennessee Williams's "Glass Menagerie" at the McCarter Theater in Princeton, N.J.

at that. The performances still have the length of the hall to travel, so I suppose a certain broadness can be expected, if not excused.

■

The greatest offender is Dylan McDermott. As Tom, the son with an itch to write and a greater urge to roam, he is fairly disagreeable. As the play's narrator, he is supercilious. When anger grips him, he simply goes out of control — stripping his vocal cords and the paint off the walls. Charm, requiring a subtler tack, eludes him.

Shirley Knight brings a lot of red-cheeked vigor to the role of Amanda, but she frequently courts garishness, and more of tne character's light-headedness comes through than her terrible desperation. Squeezed into the dress she wore years ago as the belle of the cotillion, clutching an armful of jonquils, flirting with breathless abandon, Ms. Knight seems at one point to have inadvertently wandered off into a Restoration comedy.

Judy Kuhn mostly hangs around the edges of the production, trying to look invisible as Laura, until Jeff Weatherford's gentleman caller gets her talking about her glass collection, lectures her gently on the need for self-esteem, and then recklessly raises her fragile hopes by kissing her.

It is one of the most exquisite scenes Williams ever wrote — so perfectly set in motion, so honestly developed, so unavoidably heartbreaking in its outcome that it almost seems to play itself. (Put it this way, I've never seen a production, however misguided elsewhere, in which it didn't work.) For a moment, the world is no bigger than the golden glow cast by a candelabrum on the floor and we are intimately drawn to the two lost souls in the flickering light. The indestructible magic happens all over again here, too.

But how many scenes, I wonder, can stand up to the McCarter like that and defy its dimensions? Whatever other problems Ms. Mann encounters as the theater's artistic director, fitting plays to playhouse is going to be a major challenge. Most works these days tend to come in snack packs, while I believe you could describe the facility as the super-jumbo family size.

'Mambo Mouth'

On the modest platform that calls itself the Sub-Plot Theater (in the bowels of the American Place Theater Off Broadway), you couldn't overlook John Leguizamo if you wanted to. He's definitely a sit-up-and-take-notice talent, and his one-man outing, "Mambo Mouth," seven monologues illustrating the different faces of Latino braggadocio, is fierce and funny.

His characters are drawn from the bottom of the social scale and don't have much to show for their lives. But when they talk, they come on as strong as any three-card monte dealer out to fleece the first rube who'll stop, look and listen. The greater the underlying hopelessness, the greater the verbal razzle-dazzle. Even in handcuffs, they claim to have the world on a string.

After he's tried unsuccessfully to raise bail from his wife, his girlfriend and his mother, a young drug dealer shrugs off impending incarceration by boasting, "I never needed nobody. I got more guts than a slaughterhouse." A sleazy talk show host, dispensing virulently sexist advice on public-access TV, takes a minute "to say hello to all the women I've loved around the world." An illegal immigrant facing deportation bellows from behind bars, "Who's going to pick your chef salads for you?"

Losers all, they are distinguished by thick accents, foul mouths and the aggressive confidence that comes from having nothing to begin with, consequently nothing to lose. The 26-year-old Mr. Leguizamo — born in Colombia, raised in Queens — plays them with the edgy, finger-snapping urgency that you might imagine, but also with flashes of pathos that are apt to catch you totally off-guard. Although the writing sometimes succumbs to the obvious, the performing never does.

As a brazen transvestite hooker, he is riveting when he could be patently ridiculous. Outfitted in a purple mini-dress and a fall that allows him to toss his head back with maximum effect, he seems to be punching invisible holes in the floor with his spike

John Leguizamo offers glimpses of tenderness in a performance that is never obvious.

heels. The manner is all hiss and vinegar, so that the sibilance in a line like "I'm so malicious and delicious" leaves slash marks in the air. Sentiment doesn't get within an arm's reach of the characterization, and yet between solicitations, Mr. Leguizamo allows you glimpses of a heart still capable of tenderness.

In his final sketch, he plays a once flamboyant Latino who has successfully made himself into the very model of Japanese propriety and is now conducting a "crossover" seminar to help others tone down for success. Do you have a "henna dependency," he asks. Are your clothes "cutting off your circulation"? How many of the "dreaded tortilla chins" can you count? Before and after slides help make his point: you'll never get any money in this world if you don't give the appearance of having it. And who gives that appearance better than the Japanese? The sketch hurls one stereotype at another and leaves both in pieces.

Mr. Leguizamo has elicited favorable comparisons to Eric Bogosian, Lily Tomlin, Spalding Gray and Eddie Murphy, which says something. That he is already his own man probably says a great deal more. □

1991 Ja 27, II:5:1

Assassins

Music and lyrics by Stephen Sondheim; book by John Weidman; directed by Jerry Zaks; choreography by D. J. Giagni; set by Loren Sherman; costumes, William Ivey Long; lighting, Paul Gallo; sound, Scott Lehrer; musical director, Paul Gemignani; hair, Angela Gari; production stage manager, Clifford Schwartz; production supervisor, Paul E. King; musical theater program director, Ira Weitzman. Presented by Playwrights Horizons, Andre Bishop, artistic director; Paul S. Daniels, executive director. At 416 West 42d Street.

Leon Czolgosz	Terrence Mann
John Hinckley	Greg Germann
Charles Guiteau	Jonathan Hadary
Giuseppe Zangara	Eddie Korbich
Samuel Byck	Lee Wilkof
Lynette (Squeaky) Fromme	Annie Golden
Sara Jane Moore	Debra Monk
John Wilkes Booth	Victor Garber
Balladeer	Patrick Cassidy
Emma Goldman and Bystander	Lyn Greene
Lee Harvey Oswald	Jace Alexander

With: Joy Franz, John Jellison, Marcus Olson, William Parry and Michael Shulman

By FRANK RICH

No one in the American musical theater but Stephen Sondheim could have created the chorus line that greets — or should one say affronts? — the audience at the beginning and end of "Assassins," the new revue at Playwrights Horizons.

Dressed in motley garb ranging from Victorian finery (John Wilkes Booth) to worker's rags (Leon Czolgosz) to shopping-mall leisure wear (John Hinckley), this chorus line is entirely populated by that not-so-exclusive club of men and women who have tried, with and without success, to kill the President of the United States. While their song may echo the sentiments in dozens of other Broadway musicals — "Everybody's got the right to their dreams" goes a lyric — the singers' expressions are variously glassy-eyed and vacant, demented and smiling, angry and psychopathic. Everyone strutting in this procession packs, and eventually points, a gun.

•

The effect of this recurrent chorus line, a striking image in a diffuse evening, is totally disorienting, as if someone had removed a huge boulder from the picturesque landscape of American history to expose to light all the mutant creatures that had been hiding in the dankness underneath. In "Assassins," a daring work even by his lights, Mr. Sondheim and his collaborator, the writer John Weidman, say the unthinkable, though they sometimes do so in a deceptively peppy musical-comedy tone. Without exactly asking that the audience sympathize with some of the nation's most notorious criminals, this show insists on reclaiming them as products, however defective, of the same values and traditions as the men they tried to murder.

To Mr. Sondheim, the dreams of Presidential assassins seem not so much different from those empty all-American dreams of stardom he enshrined in "Gypsy": these killers want to grab headlines, get the girl, or see their names in lights. In keeping with his past musicals animating the passions of the certifiably insane ("Anyone Can Whistle") and mass murderers ("Sweeney Todd"), this songwriter gives genuine, not mocking, voice to the hopes, fears and rages of two centuries' worth of American losers, misfits, nuts, zombies and freaks. These are the people who have "Another National Anthem" because they are too far back in line to get into the ball park where the official one is sung. These are the lost and underprivileged souls who, having been denied every American's dream of growing up to be President, try to achieve a warped, nightmarish inversion of that dream instead.

•

One need not agree with Mr. Sondheim's cynical view of history and humanity to feel that "Assassins" has the potential to be an extraordinarily original piece of theater. In its Off Broadway premiere, unfortunately, that potential is unfulfilled. For a show that takes on so much, mixing and matching historical periods and characters with E. L. Doctorow's abandon, this work often seems slender and sketchy, and not just because it runs only 90 minutes and has only 8 songs.

The gap that separates Mr. Sondheim's most acute contributions from Mr. Weidman's jokey book and Jerry Zaks's strangely confused production is often glaringly apparent. While "Assassins" can be applauded for intellectual ambitions unknown to most American musicals, such high intentions, intermittently realized, hardly seem like achievement enough. Given the subject and the talent at hand, shouldn't the artistic yardstick for the content of "Assassins" be Don DeLillo's novel "Libra" or Martin Scorsese's film "Taxi Driver" rather than, say, "42d Street"?

Mr. Sondheim's better numbers in "Assassins" do aspire to the highest standard and not infrequently meet it. As the show as a whole attempts to rewrite American history, so the composer audaciously attempts to rewrite the history of American music. This is an anti-musical about antiheroes. Every song upends a traditional native form: folk music, spirituals and John Philip Sousa are all rethought along with Broadway idioms and the official national musical oratory of Irving Berlin and Francis Scott Key.

•

Some of the music is pretty in a manner that recalls the revisionist theatrical folk music of Frederick Loewe (in "Paint Your Wagon") and Kurt Weill ("Johnny Johnson"). As in "Sweeney Todd," the sweetest sounds are often heard when the singers' thoughts are most homicidal. In "Gun Song," Booth (Victor Garber), the Garfield assassin Charles Guiteau (Jonathan Hadary) and the McKinley assassin Czolgosz (Terrence Mann) achieve an eerie yet lovely harmony while singing "All you have to do is move your little finger, and you can change the world." In "Unworthy of Your Love,"

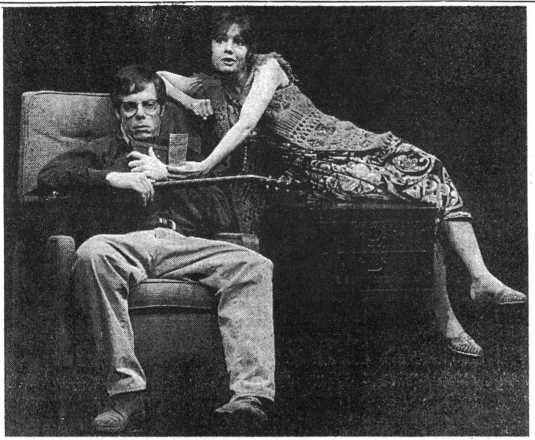

Ruby Washington/The New York Times

Greg Germann and Annie Golden in "Assassins," a new musical by Stephen Sondheim.

Hinckley (Greg Germann) and Lynette (Squeaky) Fromme (Annie Golden) sing of their warped devotion to Jodie Foster and Charles Manson in a sumptuous ballad that both parodies and exploits the soft-rock hits of their American generation. Guiteau and the would-be killer of Franklin Roosevelt, Giuseppe Zangara (Eddie Korbich), each belt out long end notes as they reach their spastic literal ends in, respectively, a hangman's noose and an electric chair.

A premise: The Presidents and the killers were both made in America.

Brilliant as these songs can be individually, they never cohere into a fully realized score that builds in cumulative effect the way most of the later Sondheim scores do. Perhaps that shortfall can be blamed on the show's revue format, or on the three-piece band necessitated by the small playhouse. (Though the three musicians are the august musical-theater hands Paul Ford, Paul Gemignani and Michael Starobin, the synthesizer-laden arrangements sound tinny.) Harder to explain away is a prosaic "Ballad of Booth" that repeats a lame gag about the assassin's bad reviews as an actor three times, or a comic ditty ("How I Saved Roosevelt") that flatly burlesques the eyewitness-to-history theme of "Someone in a Tree," the wisest song in the previous Sondheim-Weidman historical musical, "Pacific Overtures."

The flaws of the "Assassins" score — its stop-and-go gait and sometimes collegiate humor — become major failings when magnified in the show's book and staging. To his credit, Mr. Weidman does have some clever ideas for scenes: he brings together the two very different American women who took shots at Gerald Ford, Fromme and the junk-food-addicted housewife Sara Jane Moore (Debra Monk), and he lavishes attention on the fascinating Samuel Byck (Lee Wilkof), an articulate lunatic in a Santa Claus suit who was obsessed with Leonard Bernstein and wanted to crash a hijacked jet into the Nixon White House. But the sketches are neither funny enough nor serious enough, despite allusions to Thoreau, Shakespeare and Arthur Miller. Too often Mr. Weidman regurgitates history without dramatizing it or, worse, settles for tired gags, whether about Mr. Ford's clumsiness or Mr. Sondheim's lyrics for "West Side Story." The show's putative payoff, a Rod Serlingesque encounter between Booth and Lee Harvey Oswald (Jace Alexander) in the Texas School Book Depository, never delivers the promised chills.

Mr. Zaks, a masterly director of warm, funny plays ("Six Degrees of Separation" most recently), seems to have lost control of this nasty musical rather than to have found a style for it. The show looks handsome, but it has been far too busily designed by the gifted Loren Sherman, as if Mr. Zaks were throwing scenery at the evening's internal esthetic conflicts rather than trying to resolve them. "Assassins" does not flow like a musical, but seems to start anew with each scene, and the scenes sit like clumps in isolation from the songs. The order of the numbers often seems arbitrary, and the attempts to impose unity, whether with a fair-

ground motif or a strolling folk balladeer (Patrick Cassidy), are at best haphazard.

●

As is to be expected with Mr. Zaks, the acting is generally excellent. (A grating exception is the strained camp of Ms. Monk's Sara Jane Moore.) If Mr. Korbich's burning Zangara, a Sweeney Todd-like avenger of the proletariat, and Ms. Golden's fanatical Manson acolyte are the most touching figures, that may be because, as realized in the writing, their characters most demonically demonstrate Mr. Sondheim's conviction that there is a shadow America, a poisoned, have-not America, that must be recognized by the prosperous majority if the violence in our history is to be understood and overcome.

This is not a message that audiences necessarily want to hear at any time, and during the relatively jingoistic time of war in which this production happens to find itself, some may regard such sentiments as incendiary. But Mr. Sondheim has real guts. He isn't ashamed to identify with his assassins to the extreme point where he will wave a gun in a crowded theater, artistically speaking, if that's what is needed to hit the target of American complacency. While that target is a valuable one, especially at this historical moment, "Assassins" will have to fire with sharper aim and fewer blanks if it is to shoot to kill.

1991 Ja 28, C19:3

Romeo and Juliet

By Shakespeare; directed by Bill Alexander; sets and costumes, Fotini Dimou; lighting, Frances Aronson; fight direction, David S. Leong; choreography, Dona Lee Kelly; voice and text consultant, Robert Neff Williams; production stage manager, Allison Sommers; music composed by Matthias Gohl. Presented by Theater for a New Audience, Jeffrey Horowitz, artistic/producing director. At the Victory Theater, 207 West 42d Street.

WITH: Irwin Appel, Renée Bucciarelli, Omar Carter, Jamie Cheatham, David Deblinger, Mark Dold, Drew Ebersole, Lynnda Ferguson, Richard Ferrone, Ken Forman, Miriam Healy-Louie, Max Jacobs, Patrick Kerr, Daniel Dae Kim, John Lathen, Paul Lima, Jacie Loren, Mark Niebuhr, Peggy Pope, Mary Ed Porter and Timothy D. Stickney.

By MEL GUSSOW

When the Victory Theater on West 42d Street reopened as a legitimate theater for a brief time last year, the play was Mac Wellman's "Crowbar," and the audience sat on the stage as the action and the nostalgia unfolded all around them. For the Victory's new tenant, "Romeo and Juliet," theatergoers are in their traditional seats and the actors are on stage and rushing up the center aisle. The Victory, for too many years a low-grade movie house, is still in need of repairs, but watching "Romeo and Juliet," one can feel emanations of the building's former respectability and its possibilities as a home for classics.

"Romeo and Juliet," as directed by Bill Alexander, is a production of Theater for a New Audience, a nomadic troupe that extends its quest for newness to its acting company. The stage is filled with fresh young faces, some of them as talented as they are eager, especially so in the case of Mark Niebuhr and Miriam Healy-Louie in the title roles.

Mr. Niebuhr has the impetuousness and the clarity of speech for Romeo and Ms. Healy-Louie has the tender-

Shakespeare with fresh young faces in an old (but now legitimate) theater.

ness for Juliet. In both instances, one feels the impulsiveness that drives the ill-starred couple toward tragedy, as well as the mutual passion that binds them together.

●

The vitality of the two leading players and of several of their colleagues (including Omar Carter and Irwin Appel in supporting roles) energizes the evening and Fotini Dimou's set

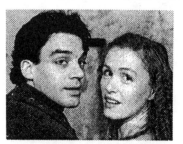

Carol Rosegg/Martha Swope Associates

Mark Neibhur and Miriam Healy-Louie in "Romeo and Juliet.".

design offers them a most conducive Shakespearean environment. The stage, tiled to resemble a piazza, thrusts into the orchestra of the theater. This means the balcony scene can be played, most suggestively, in a former theater box. The staging brings the action closer to the audience, as the actors (costumed by Ms. Dimou) swagger through the streets of Verona like Italianate Sharks and Jets.

Mr. Alexander, a British director admired for his work with the Royal Shakespeare Company (Antony Sher's "Richard III" is among his notable productions) has marshaled the youthful actors into a semblance of an ensemble. But he has been far less agile with the older members of the company. Role for role, they overact.

Max Jacobs is a raving Capulet, Lynnda Ferguson and Mary Ed Porter are twin banshees in a hair-pulling match as the ladies Capulet and Montague, and Peggy Pope, as a facemaking Nurse, seems to be trying out for a role as Mrs. Lovett in "Sweeney Todd." These histrionics prove to be infectious. When Mark Dold's blonded Tybalt duels with Timothy D. Stickney as Mercutio, each saws the air as if conducting a battle of hams. Mr. Stickney is more reasonable when delivering dialogue.

•

The production begins on an odd note, with a workman retiling a piece of the piazza and warning that there is a curse on both houses. There is no need for such foreshadowing. When the plague arrives, hot tempers flare, as the Montagues arm themselves against the Capulets. At times, there seems to be an improvisatory tone to the conflict. Fighting Tybalt, Romeo drops his sword and is handed a pistol, which he uses to shoot his rival.

Though the first act is lively, the second act wanes, partly because of the actors playing the older characters, partly because of unwise excisions in the text. Paris no longer makes his appearance in Juliet's tomb, a fact that reduces and damages Romeo's final scene. It is as if the director were eager to wrap the play up before he loses the attention of the audience. The audience seems willing; the staging is unsupportive.

Even in such an unsettled state, "Romeo and Juliet" is a welcome visitor to West 42d Street. It was here, many years ago, that John Barrymore played Hamlet and Lionel Barrymore did Macbeth. The idea of Shakespeare at the Victory is enticing.

1991 Ja 31, C21:1

Dance of Death

By August Strindberg; translated by Harry G. Carlson; directed by Shepard Sobel; set design, Robert Joel Schwartz; lighting, Stephen Petrilli; costumes, Shelley Saltzman; sound, Arthur C. Mortensen; choreography, Alice Teirstein. Presented by the Pearl Theater Company, 125 West 22d Street.

Edgar	Richard Fancy
Alice	Joanne Camp
Jenny and Old Woman	Janet Kingsley
Kurt	Paul O'Brien

By WILBORN HAMPTON

If Chekhov, Ibsen and Strindberg are to be believed, one of the overriding facets of life at the end of the 19th century was a pervasive sense of discontent. In "Dance of Death,"

Strindberg's vicious portrait of marriage, which is being revived by the Pearl Theater Company, Edgar and Alice have escalated 25 years of dissatisfaction and ennui from daily sniping attacks into a mortal war of wills.

Approaching their silver wedding anniversary, Edgar and Alice are living in a house that was once a prison on a remote island garrison, isolated and ostracized by the rest of the community, comfortable in their mutual scorn.

The opening pas de deux in "Dance of Death" is a study in boredom. Sitting alone and listening to music waft from a neighbor's party to which they have not been invited, Edgar and Alice engage in a nightly ritual of bickering. "Do you want the doors open?" "Why aren't you smoking?" "Isn't it time for your whisky?" "Did the butcher's bill come?" "Can you pay it?" "Do you want to play cards?"

•

With the arrival of Kurt, Alice's cousin and Edgar's old friend, on his way to the party next door, the battle is joined in earnest to claim the visitor's allegiance. It is a duel they have often fought, whether over the love of their children or anyone else who comes within their range. Deceit and sexual seduction are only fair means to obtain Kurt's sympathy. Truth has long lost any meaning for either of them. Edgar and Alice, in fact, could be literary forebears to Edward Albee's George and Martha in "Who's Afraid of Virginia Woolf?"

To make such amoral manipulation credible as drama, Edgar and Alice must be imbued with a profound sense of love or hatred — either will do, but it must shake their very soul. Unfortunately, the Pearl cast never comes close to such depths, and the production never rises much above the level of a domestic melodrama with comic overtones.

Edgar is variously described in Harry G. Carlson's translation as a tyrant and a monster with a heart of stone. Yet there is little that is angry, let alone cold and menacing, in Richard Fancy's reading of the role. Mr. Fancy delivers a wide-eyed eccentric whose behavior may be decidedly odd but hardly threatening. And Joanne Camp, while occasionally catching a shrewish note, is never quite believable as a tormentor prepared to gleefully watch her husband die and dance on his grave. Paul O'Brien's Kurt, who is supposed to represent the hope of salvation through acceptance of God's will, looks like he's sorry he ever stopped by. Shepard Sobel directed.

1991 Ja 31, C21:3

Dead Mother; Or Shirley Not All in Vain

Written and directed by David Greenspan; set design, William Kennon; costumes, Elsa Ward; lighting, David Bergstein; associate producer, Jason Steven Cohen. Presented by Joseph Papp. At the Public/Susan Stein Shiva Theater, 425 Lafayette Street.

Harold/Eris	David Greenspan
Daniel/Peleus/Paris	Ben Bode
Sylvia/Thetis	Terra Vandergaw
Maxine/Aphrodite/Athena/Hera	Mary Shultz
Uncle Saul/Prometheus	Ron Bagden
Melvin/Zeus	Steve Mellor

By FRANK RICH

Scratch nearly any ordinary male American playwright, and he'll bleed

out an angry play about a hateful mother. But David Greenspan apparently aspires to be the Richard Wagner of the genre. Mr. Greenspan not only wrote and directed "Dead Mother," the matricidal comedy at the Public Theater, but he is also the evening's star, playing both a terribly sensitive son and the castrating Jewish mother who, metaphysically at least, returns from the dead to humiliate and torture him.

"Dead Mother; or Shirley Not All in Vain," as the evening's full title goes, rises from its own shallow grave only when Mr. Greenspan inhabits the title role. Wearing a string of pearls, clawing the air with agitated hands and sometimes stuffing his

Dante, Virgil, Alice B. Toklas and others have something to say.

mouth with chocolate cake, the playwright disappears into the mother's persona with psychotic, or perhaps one should say "Psycho"-like, fervor. As Shirley lashes out at her son, shrieking a stream of abuse and accusing him of being "a disgraceful faggot," Mr. Greenspan's rage gets such exercise that the throbbing veins in his forehead threaten to burst.

•

The rest of the time, the author seems almost embarrassed by the narrow, red-hot personal agenda at his work's core, and he tries to cover it up. It wouldn't do, after all, for a serious young playwright, especially one of the apparently boundless pretension and self-indulgence of Mr. Greenspan, to write anything as banal as another get-mother play set in an upper-middle-class Jewish household. For the sake of camouflage, the crucial 15 or so minutes of familial blow-out in "Dead Mother" are surrounded by more than two hours' worth of ostensibly weightier digressions, in a showy variety of theatrical styles.

Every character in the play has been assigned a number and a role in Greek mythology as well as a regular name, thus allowing the author to swing as the mood strikes him between modernist Pirandellian games and smirky (but by no means brief) re-enactments of favored classical anecdotes. In one interminable interval, the men in the company sit on stools to read a self-contained chamber play in which Alice B. Toklas (Ron Bagden) anachronistically attacks the dubious theories of M. Scott Peck and William Shockley while lecturing on the "illuminating similarities and differences between the history of Jews and the history of gays." By the end, Dante, Virgil, the New Testament and Melville have also been heard from, the last represented by a chatty, ubiquitous sperm whale who is rolled from scene to scene.

•

Mr. Greenspan's ego knows no limits, as befits a playwright whose fondest idea of a sight gag involves the size of Paris's proudly displayed phallus. At one particularly embarrassing point, an astute observer can spot the author in the shadows admir-

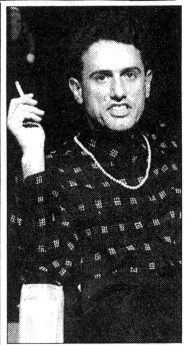

Martha Swope/Public Theater
David Greenspan in "Dead Mother; or Shirley Not All in Vain," at the Public Theater.

ingly mouthing his own words in sync with the actor who is delivering a lengthy monologue center stage. Lest any theatergoers be so unsophisticated as to criticize "Dead Mother" for its "incessant stream of words," its "unstructured story" or its catch-all content, Mr. Greenspan beats them to the punch by having his dimmer characters express these exact same criticisms about a play they attend in Los Angeles.

This defensive technique actually begins before "Dead Mother" does. As the house lights go down, the audience hears an amplified woman's voice complaining about an unnamed subscription theater that has made her feel "left out" by producing too many plays about gay people. The woman sounds like a numbskull, and the implications of her gratuitous prologue are clear: Anyone who complains about "Dead Mother" is either a Philistine or homophobe as she is. But one hopes that no visitor to the Public Theater will be swayed by such intimidation tactics. If you feel left out at Mr. Greenspan's play, that does not necessarily mean you are a moron or a bigot — but only, perhaps, that you have a healthy aversion to being bored.

1991 F 1, C3:1

Betrayal

By Harold Pinter; directed by John Tillinger; sets by John Lee Beatty; costumes by Jane Greenwood; lighting by Richard Nelson; production stage manager, Janet Friedman. Presented by the Long Wharf Theater, Arvin Brown, artistic director; M. Edgar Rosenblum, executive director. At New Haven.

Emma	Maureen Anderman
Jerry	Michael Goodwin
Robert	Edmond Genest
Waiter	Bernard Jaffe
Bartender	James O'Neill

By MEL GUSSOW

Special to The New York Times

NEW HAVEN, Jan. 29 — Harold Pinter's "Betrayal" is a malicious

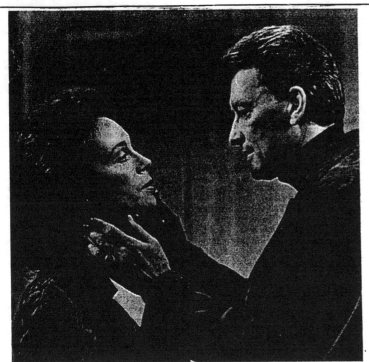

T. Charles Erickson/Long Wharf Theater

Maureen Anderman and Edmond Genest in a scene from "Betrayal."

comedy of manners about mutual deceit. In this 1978 play, the web is taut and the words are weighted with portent and humor. The playwright tells his story in nine pithy scenes, all he needs to capture the hermetic world of his three conspirators. The essence of this devious work is delineated with precision in John Tillinger's revival at the Long Wharf Theater. Having previously mastered the farcical art of Joe Orton, Mr. Tillinger proves to be equally secure with the understated intrigue of Mr. Pinter.

In "Betrayal," time moves backward, a method of storytelling that deepens the narrative. Answers are followed by questions, apparent contradictions by clues to behavior. Characters are revealed through a warp of memory, as time tricks the unwary.

The first scene takes place in a pub after an affair has ended between a woman and her husband's best friend, the best man at their wedding. Then, step by step, the play returns to the start of the romance, the flame that has been extinguished at the beginning of the play.

•

The primary question is not what drove the adulterous couple together, or, later in their lives, what separated them, but who knew what and when, and what anyone did about it. Did the husband, Robert, know of the affair before or after he and his wife, Emma, took a trip to Venice — and what did Robert do on his own solitary journey to Torcello? Is Jerry, the lover, the only one who thinks the years of afternoon trysts occurred in a vacuum?

There is less of a mystery here than the characters would like to believe. Surreptitiousness, it seems, is only in the eye of the secretive. In fact, in "Betrayal," there are apparently no secrets, only closely guarded trains of thought and artificial walls of forgetfulness.

Betrayal, Mr. Pinter explains, need not be an act of infidelity. It can be the simplest of deceits or words not spoken — for example, Emma's not telling Jerry that her husband knows about their affair. The play is most

intricately plotted and subplotted as other, unseen characters pass through the orbit and affect the people we see on stage.

Most of the characters, seen and unseen, are involved with literature. Robert is an editor with a distaste for books, and Jerry is an author's agent with his own ambiguous allegiances to his clients. Neither of these two should be confused with the seemingly related publishing figures who populate plays by Simon Gray (to whom "Betrayal" is dedicated). The professional life of Robert and Jerry is untapped territory. It is the play and counterplay of their friendship and rivalry — at home, about Emma and even on the squash court — that fascinates the playwright and the audience.

•

"Betrayal" was beautifully orchestrated in Peter Hall's original London production and in the subsequent film, less so in the Broadway version, in which an American cast obscured the work's Englishness. Although the American actors in Mr. Tillinger's production — Maureen Anderman as Emma; Michael Goodwin and Edmund Genest as the men in her life — assume only the slightest of English accents, they artfully communicate the Pinter landscape and language. The turntable setting by John Lee Beatty has its own pristine self-assurance.

As intended, each actor conceals facets of a character's personality. Ms. Anderman's Emma is more a willing accomplice than a temptress. She seems awakened by the idea of dalliance but is not transported by the actual romance. The actress retains an air of graceful reserve. As portrayed by Mr. Goodwin, Jerry emanates self-control and an odd sense of propriety even as his anxiety surfaces. With him, there is a sense of self-entrapment. Mr. Genest's Robert remains the coolest of the three. More than the others, he seems aware of what is going on, but he is manipulative about what he cares to reveal.

Under Mr. Tillinger's guidance, the actors are finely tuned to the indirect

actions of their characters and to the dramatic currents beneath the terse dialogue. The many guises of betrayal are explored with eloquent dispassion in this tantalizing play.

1991 F 3, 55:4

They Shoot Presidents, Don't They?

By DAVID RICHARDS

EVER SINCE HE HUNKERED down in the Texas School Book Depository in Dallas and fired the bullets that slew President Kennedy, the question has refused to go away. Did Lee Harvey Oswald act alone or was he merely the front man, carrying out the orders of others?

Not only does "Assassins," the audacious new musical by Stephen Sondheim and John Weidman at Playwrights Horizons, unequivocally endorse the conspir-

No musical in the last decade has dared as much as 'Assassins,' Stephen Sondheim's dark morality tale.

acy theory, it actually names the co-conspirators — eight in all. If I tell you that John Wilkes Booth is one, Lynette (Squeaky) Fromme another and John Hinckley a third, then you may get an idea of what I mean by audacious. History lesson, carny show and bad dream all swirled into one, "Assassins" is a spangled celebration of America, a land where anybody can grow up to kill a President.

■

Mr. Sondheim has long since accustomed audiences to expect the unexpected. His musicals have brought the characters in a famous pointillist painting to life, ''''' merrily backward in time and taken the Brothers Grimm one step beyond happy ever after. He has imagined beguiling songs for Japanese warlords, over-the-hill Follies girls and a barber with a hyperactive razor. Nothing, however, quite prepares you for the disturbing brilliance of "Assassins," unless it is the irony that has always been the constant in Mr. Sondheim's work. And even that has been raised to teeth-chattering levels.

Those who claim that his music requires repeated hearings before revealing its beauties will have no cause to complain here. The score is instantly appealing — an all-American compendium of show tunes and Sousa marches, broad-shouldered

hymns and wind-swept folk songs. But melody and message are purposefully, *defiantly*, at odds. Watching "Assassins" is rather like receiving a death notice in the form of a singing telegram.

You have only to consider "Unworthy of Your Love," a brokenhearted lament that would appear tailor-made for popular success. First, however, it will have to disengage itself completely from the show. In "Assassins," you see, it is sung by a disconsolate John Hinckley (Greg Germann), and while it is possible to appreciate the quiet poetry of the opening lines — "I am nothing / You are wind and water and sky" — by the time he's moved on to, "Tell me, Jodie, how I / Can earn your love," your hair is beginning to curl.

■

Soon, an equally despondent Squeaky Fromme (Annie Golden) joins in — pledging *her* unworthy affections to a certain "Charlie," whom I probably needn't tell you is Charles Manson. No one's forcing the issue — certainly not the two performers, who seem to be shot up with Novocain. Yet when they're through, a simple, seemingly unassuming number has taken on diabolical overtones. Indeed, with no further ado, Hinckley draws a gun, turns upstage and fires repeatedly at a billboard-sized photograph of a beaming Ronald Reagan, while Squeaky goads him on with her mockery.

■

The full contingent of assassins — actually, the full contingent minus one, but more about that in a second — is lured on stage in the opening number by the try-your-luck spiel coming from the congenial proprietor of a shooting gallery. "Hit the Prez and Win a Prize," proclaims the sign over his head. "Some guys/ Think they can't be winners," he coos, all slick and encouraging, "First prize/ Often goes to rank beginners." One by one, they let themselves be convinced and plunk down their money, before adding their insolent voices to the sweet refrain: "Everybody's/ Got the right/ To their dreams."

Thereafter, Mr. Weidman's book — a scrapbook, really — plays fast and loose with time and place. It thinks nothing of having Charles Guiteau (the assassin of President Garfield), for example, put the make on Sara Jane Moore (who bungled her attempt on the life of President Ford). Samuel Byck, a lunatic in a Santa suit who plans to divebomb President Nixon's White House, frequents the same saloon as Giuseppe Zangara, who moans that nothing will cure the sharp ache in his stomach, until a dapper Booth steps forward and suggests, with all due respect, "Have you considered shooting Franklin Roosevelt?"

For its first hour or so, "Assassins" seems little more than a revue, content to present its characters and their heinous deeds in songs, sketches and monologues — some of which are sardonically funny. Sara Jane Moore (Debra Monk) is a true flibbertigibbet, as likely to pull a banana from her capacious handbag as she is a

A chilling vision of evil—Bystanders react as Leon Czolgosz, played by Terrence Mann, in foreground, shoots President McKinley in "Assassins." Martha Swope Playwrights Horizons

pistol. When she finally does lay her hands on the pistol, nothing says she won't turn it on her dog or a bucket of Colonel Sanders' fried chicken. While a sullen Zangara (Eddie Korbich), strapped to an electric chair, waits for the switch to be thrown, a clutch of Florida vacationers reaps all his publicity by boasting, in a lively patter song, "How I Saved Roosevelt."

The musical delivers a rebuke to George M. Cohan on his very own turf.

Byck (Lee Wilkof) almost qualifies as a stand-up comic, as he dictates a message to Leonard Bernstein into his tape recorder, urging him to save the world with his God-given talent and write more love songs. Then, barely taking time to shift gears, he decides that Bernstein, with his hotshot life style, probably doesn't give a hoot. Nobody gives a hoot! And he's off to get himself a President.

As for the preening Booth (Victor Garber), well, isn't he an actor already? The other assassins call him "our pioneer," but he seems to see himself more as an impresario of the damned.

∎

If you find yourself thinking that matters are a bit scattered, I suspect that you're reacting just as the

show's creators intend. Early on, a balladeer (Patrick Cassidy), who serves as the unofficial narrator, points out that, "Lots of madmen/ Have had their say /But only for a day." We are being encouraged to look upon the various assassins as flukes of history. Their craziness passes. The country mends. Who even remembers Leon Czolgosz (Terrence Mann), the unemployed bottle maker who took up his place in the receiving line waiting to greet President McKinley at the Pan American Exposition in Buffalo, and instead of pumping his hand, pumped lead into him? There may be madness in their acts, but surely no method, no pattern, no connection.

Then, the turntable at Playwrights Horizons revolves 180 degrees to reveal the Texas School Book Depository and Lee Harvey Oswald (Jace Alexander). We'd almost forgotten him in the preceding hullabaloo. No matter. He doesn't look much like an assassin, anyway. He's entirely too preoccupied with his own collapsing life to hear the news on the radio that President Kennedy's plane is landing at nearby Love Field. What concerns him is the note he's busy scribbling, after which he intends to train the pistol in his lunch box on himself.

Booth won't hear of it. Suicide is such a wasteful gesture. Appearing from behind a stack of cardboard boxes, he tries to stay Oswald's hand and redirect it to a more consequential target. Called in as reinforcements, the other assassins add their supplications to Booth's: If Oswald comes over to their side, they will no

longer be freaks and misfits. They will be a force, a dark necessity, a permanent shadow on the national anthem.

"Bring us together," pleads Byck. "We're your family," intones Moore. "You are the future," asserts Zangara.

∎

It is a stunningly theatrical ploy, even though the outcome is a foregone conclusion. Suddenly, the fragments of "Assassins" have coalesced in a chilling vision of evil reaching out to evil, and dark acts begetting dark acts. There is no coherent sociological explanation for the behavior of assassins, nor does the show pretend to offer one. They simply *are* — the lurking side of human nature. They come with history. Mr. Sondheim and Mr. Weidman have produced a morality play about the forces of good and bad, and then boldly exiled goodness to the wings.

No musical in the last decade has dared this much.

If the form is thought to be quintessentially American, it is because for years musicals fostered optimism and endorsed enterprise. Their brash spirits, we liked to believe, were the country's. "Assassins" has no shortage of energy in the grand Fourth of July staging by Jerry Zaks, but it turns the musical's traditional values inside out and delivers a rebuke to George M. Cohan on his very own turf.

Loren Sherman's set design, which relies on tabloid photographs and period etchings for backdrops, artfully evokes the twilight zone where journalism meets history. And one look at Squeaky Fromme's red dress and kerchief (sort of latter-day French Revolution) is enough to convince you that William Ivey Long has the costumes just right. Ms. Golden's drugfueled fervor is manifestly the kind that wants to burn down the world — the only question in her eyes, black as a badger's, is where to begin.

∎

If some of the performances are more vivid than others, some assassins, frankly, have been more colorful than others. Ms. Monk makes Moore's shrill discombobulations wildly amusing, while Mr. Garber goes about Booth's dirty work with arrogant majesty. Jonathan Hadary's religious zeal, as Guiteau, extends to his bristling coiffure, which is also striving to meet the Lord. This puts him at the opposite end of the spectrum from Mr. Germann, whose Hinckley is nothingness itself, hiding behind glasses and woebegone bangs. Splendidly cursed, all of them.

In "Gypsy," Mr. Sondheim had three tired strippers coach an inexperienced Gypsy Rose Lee on the secret of success. "You gotta have a gimmick," they told her. But, of course, you don't. "Assassins" lets us know that a gun will do just fine.

And you, too, can be a shooting star. □

1991 F 3, II:1:2

Ruby Washington/The New York Times

Jonathan Hadary as Charles Guiteau, who assassinated President Garfield, and Marcus Olson as the Hangman—goodness exiled

Earth and Sky

By Douglas Post; directed by André Ernotte; set design, William Barclay; lighting, Phil Monat; costumes, Deborah Shaw; sound, Bruce Ellman; hair, Antonio Soddu; production stage manager, Crystal Huntington; stage manager, J. Courtney Pollard. Presented by Second Stage Theater, Robyn Goodman and Carole Rothman, artistic directors. At 2162 Broadway, at 76th Street.

Sara McKeon	Jennifer Van Dyck
David Ames	Ted Marcoux
Sgt. Al Kersnowski	Ron Nakahara
Detective H. E. Weber	Justin Deas
Joyce Lazio	Lisa Arrindell
Billy Hart	Michael Genet
Carl Eisenstadt	Evan Thompson
Marie Defaria	Lisa Beth Miller
Julius Gatz	Paul Kandel

By MEL GUSSOW

Douglas Post's "Earth and Sky" is a case of film noir on stage. Hardbitten but with a tinge of sentiment, the play (at Second Stage) follows the mysterious travails of a Chicago poet and librarian (Jennifer Van Dyck) whose lover has suddenly and inexplicably been murdered.

Dismayed by the recalcitrance of the police in offering her information about the killing, she undertakes a private investigation of the crime. With a kind of forceful naïveté, she is led deeper and deeper into a world of criminality and violence. Wisely, the playwright and his director, André Ernotte, do not offer the audience time for contemplation, moving briskly, without intermission, from twist to twist and from murder to solution. The devious U-turns in the plot continue past the ending of this taut new thriller.

Mr. Post, a Chicago playwright in his New York debut, evidently knows his milieu, a seedy strip of the urban underworld where there is an indistinct demarcation between law enforcement and law infringement, and where one clue is immediately contradicted by another.

In outline, "Earth and Sky" seems suspiciously like a television movie stripped down for stage action. The playwright intermittently embraces clichés of language and character, as in the title, which is a phrase from the heroine's tribute to her murdered friend. But behind that stance is a healthy measure of skepticism and humor.

●

At one point, Ms. Van Dyck goes to a disreputable bar. Searching for evidence, she encounters a bartender (Michael Genet) who has all the right manners and moves of his profession as well as a roguish disregard for tourists who invade his lair. Asked what she does for a living, she replies, "I'm a poet." Deadpan, the bartender responds, "All right, so don't tell me." Later when she loftily quotes Dylan Thomas, to her astonishment he quickly counters with the next line from the poem.

Along her path to justice, Ms. Van Dyck meets a shooting gallery of undercover characters, most of whom face possible termination. Simultaneously, the playwright shifts the romance into reverse, working backward to the first meeting between Ms. Van Dyck and Ted Marcoux, as the man who becomes the center of her life.

Their initial meeting strains credibility, as do several other moments in the narrative. Such questions of motivation are cosmetized by the play's momentum. But William Barclay's set is a distinct detriment, an attempt at an abstraction of a city landscape that looks like a faux Lou-

24

ise Nevelson assemblage of doors and spindles. The coldness of the design undercuts moments of intimacy, as in the romantic interludes in the heroine's apartment.

●

Led by Ms. Van Dyck, the cast compensates for the rudimentary quality of the setting, and in her case, for the rhapsodic flights of dialogue. The actress carries with her a febrile intensity that makes her convincingly a hopeful poet and avenging angel. Once embarked on her mission, she never lets up. Ms. Van Dyck's performance encourages the audience to accept the fact that the character would repeatedly jeopardize her life to justify her fidelity to a man who seems increasingly like a complete stranger.

Mr. Marcoux is appropriately shifty as the murdered man seen in flashbacks; Justin Deas and Ron Nakahara convey the well-worn cynicism of police veterans and Lisa Beth Miller has an eye-catching cameo as a two-faced bimbo. In his few scenes, the swaggering Mr. Genet comes close to stealing the show, and in fashioning the bartender's dialogue, Mr. Post offers a glimpse of his originality as a dramatist. With "Earth and Sky," he seems content to hold fast to his chosen genre, which he does with suaveness and a sense of pace.

1991 F 5, C13:1

Walt Disney's World On Ice
Mickey Mouse Diamond Jubilee

Produced by Kenneth Feld; theatrical director and writer, Jerry Bilik; skating director and choreographer, Bob Paul; music directors, Mr. Bilik and Alan Oldfield; scenic designer, Reid Carlson; costume designer, Keith Anderson; lighting designer, Marilyn Lowey; assistant choreographer, Jill Shipstad Thomas. At Radio City Music Hall.

PRINCIPAL SKATERS: Sean Abram, Doug Barnhart, Miranda Hamstra, Joseph Mero, Atsushi Oshima, Sylvia Ponce, Victor Ponce, Tricia Puccio, Barbara Steele and Eddi Vallon.

By STEPHEN HOLDEN

Mickey Mouse's diamond jubilee is the theme of the newest edition of "Walt Disney's World on Ice," the family extravaganza that brought 60 performers with 3.5 million sequins between them to Radio City Music Hall on Friday afternoon.

The show, which runs through Sunday, celebrates the 10th anniversary of the traveling ice event, which is produced by Kenneth Feld and written and directed by Jerry Bilik. While this edition offers plenty of glitter, it has far too many dull moments and no feats to set one's adrenaline racing.

"Mickey Mouse Diamond Jubilee" stitches together staged sequences from Mickey Mouse cartoons with stunts and balletic acrobatics. A tribute to the Jazz Age in which other Disney characters bounce about on skates introduces a scene from "Steamboat Willie," the 1928 cartoon in which Mickey made his movie debut. Other scenes commemorate Mickey's appearances in "The Sorceror's Apprentice," from "Fantasia" (1940), his courtship with Minnie as depicted in "Puppy Love" (1933), and "Mickey and the Beanstalk" (1947).

The show's one moment of genuine visual magic is its re-creation of "The Sorceror's Apprentice," in which Mickey is surrounded by dancing brooms. The broom handles that cover the skaters' faces are made of soft sculptured fluorescent orange and the eeriness is augmented by black lighting effects.

One reason the scene works so well is that it has no words. In the talking and singing sequences, the skaters impersonating characters awkwardly synchronize dialogue blared from offstage with flailing gestures. It is often impossible to tell which character onstage is talking. The show's most coherent storytelling involves a game of cat and mouse between Mickey and the the malevolent Madame Mim, a Disney character from "The Sword and the Stone."

For daredevil thrills, there is nothing in this show like Randy Nelson, a stunt cyclist who stopped the show seven years ago at Donald Duck's 50th birthday party at Madison Square Garden. This edition's most exciting skater, the 21-year-old Doug Barnhart, executed an impressive jump over a flaming oven from which sharp objects scissored threateningly.

1991 F 5, C18:1

Camp Logan

By Celeste Bedford Walker; directed by A. YuJuan Carriere'-Anderson; production stage manager, Avan. Presented by Brooklyn's Professional Resident Black Theater Company, Marjorie Moon, producer, in association with Mountaintop Productions. At the Billie Holiday Theater, 1368 Fulton Street, Bedford-Stuyevesant section, Brooklyn.

Captain Zuelke	Chaz McCormack
Franciscus	Kelly Lamarr
Bugaloosa	Darrell Hughes
Moses	LeVerne Summers
Hardin	Kevin Richardson
Gweely	Alvin Walker
Sergeant McKinney	Zaria Griffin

By WILBORN HAMPTON

In June 1917 the United States entered the Great War, and the American Expeditionary Forces, commanded by Gen. John J. Pershing, fought its first action. At about the same time, units of the 24th Infantry Regiment, one of only four black regiments in the United States Army, arrived in Houston and began to build a new camp on the outskirts of town.

"Camp Logan," a forceful new play by Celeste Bedford Walker at the Billie Holiday Theater in Brooklyn, chronicles events leading to the mutiny of the regiment's Company I and an armed confrontation between the soldiers and a group of townsmen that turned into one of the most violent racial conflicts in United States military history.

The 24th Infantry had served under Pershing both in the Philippines against the Spanish and in New Mexico against Pancho Villa, and the men were eager to go to France and join the fighting. The black soldiers saw World War I as an opportunity to finally prove their mettle alongside the white soldiers in the trenches.

But the men of the 24th would first have to combat the prejudice of the local population, and Ms. Walker's play is a story of the daily battles the black soldiers had to fight in defense of their personal dignity.

"There are signs telling colored where to eat, where to sleep, where to get on the pot and where to get off," one of the soldiers from Company I complains to his black NCO, Sergeant McKinney. But the sergeant is not impressed. "Those are the rules. You follow 'em," he orders. "This is the South. It ain't like some other places we've been. This town ain't gonna make us forget our duty."

But the bigotry is relentless. One soldier brings back a sign he took from a local store warning, "No Negroes or Dogs Allowed." The local white construction workers at the camp keep emptying the "colored" water barrel. A streetcar driver refuses to let black soldiers sit in the front seats of his tram even if there are no whites to occupy them, and finally will not even stop for the black G.I.'s.

"How do you expect to deal with living in a trench in France, if you can't deal with a cracker streetcar driver," Sergeant McKinney admonishes.

●

The white commanding officers, personified by Company I's Captain Zuelke, abet these injustices in an attempt to appease the local population. Black M.P.'s, for example, are not allowed to carry sidearms because of the fears of the townspeople, and the local police are permitted to arrest black soldiers and take them to the city jail. "There ain't nothin' worse to these white folks than a loud, drunk, cussin' nigger," the sergeant explains to his men. In one of the coarsest indignities, the white officers order the black soldiers to put on a minstrel show for the townsfolk and insist that they wear blackface.

"Camp Logan" focuses on five soldiers of Company I, their sergeant and their company commander. Ms. Walker has a wonderful ear for dialogue, and the barracks banter of the men swapping war stories and talk-

ing of women is both natural and funny. The characters, with one exception, are fully drawn, and by the end the audience knows them well. "Camp Logan" at times almost takes the tone of a documentary or a history lesson, but it is a well-crafted play that is dramatically told and one that could not be more timely.

●

There are elements of genuine tragedy in some of the characters, especially in the figure of Sergeant McKinney, a 22-year veteran who can remember "when a colored soldier had to sleep outside the barracks and eat with his hands instead of a knife and fork." But Ms. Walker never fully explores why he or his veteran soldiers, all of whom have suffered racial injustices in the past, would risk their careers, even their lives, now. The final spark, which lights the fuse of their mutiny, comes when the sergeant and his men learn that the regiment will not be sent to to France.

The cast brings a lot of energy and vitality to the play. Alvin Walker gives an excellent performance as Gweely, and LeVerne Summers is quite good as Moses; both are company veterans who come slowly to rebellion. Kevin Richardson, Kelly Lamarr and Darrell Hughes all deliver solid readings as other soldiers. Zaria Griffin brings insight and understanding to Sergeant McKinney, even if he never quite captures the depth of anguish that leads him to insubordination. The one disappointment, both in the text and the playing, is a stereotypical caricature of the white company commander. A. YuJuan Carriere'-Anderson directed with a good eye for ensemble acting and a brisk pace that glides over some repetitious passages.

1991 F 7, C23:1

Tragedy Is Rewriting Avant-Garde's Agenda

By JOHN ROCKWELL

The opening event of the annual benefit series presented by Performance Space 122 last week was like a crash course in the performance art of the 1980's. But the very forces that have rendered much of those 80's antics almost offensively irrelevant may also be toughening the avant-garde for the 90's, lending it a resonance and a seriousness it has so grievously lacked. In short, tragedy may make for better art than rampant greed and trivial hedonism.

Some background on the benefit: P.S. 122 is one of five avant-garde

A 90's program becomes a requiem for the 80's.

institutions housed in the former Public School 122 on First Avenue at Ninth Street. Like Franklin Furnace, it has become one of the premier forums for the performance art that proliferated in the East Village in Manhattan over the last decade. Much of that art tested normal boundaries of propriety, and as a result became a prime target for the religious right in its fulminations against the National Endowment for the Arts.

P.S. 122 still lists the endowment as a supporter, but it deliberately — heroically, even — courts confrontation with the agency's new "decency" guidelines. Last week's benefit opener offered Annie Sprinkle as host. Ms. Sprinkle is the porn actress turned performance artist whose past appearances have included inviting the audience to examine her vagina through a gynecological instrument.

But there was a good deal more than just Ms. Sprinkle and her privates. There was Diamanda Galas, stripped to the waist and covered with a convincing likeness of blood, howling and screaming in agony, as is her wont. Bebe Miller and three of her fine dancers contributed an athletic excerpt from a larger work in progress. John Kelly did a fey falsetto

25

Dona Ann McAdams

Annie Sprinkle at the Performance Space 122 benefit last week.

imitation of Byronic poetic lassitude, too lightly flavored with camp, in an aria from Bellini's "Sonnambula." Pat Oleszko cavorted in one of her remarkably elaborate costumes. Eric Bogosian told stories, and Julee Cruise repeated her kewpie-doll chanteuse act, singing or lip-synching to her album, which is mostly soundtrack music from "Twin Peaks" with words by David Lynch and music by Angelo Badalamenti, both uncredited.

•

For one who never fully accepted the East Village bar-scene, fun-and-games performance-art esthetic, in which young people tarted themselves up in unattractive ways and acted out sexually provocative charades, the P.S. 122 benefit was like a farewell to a not-very-appealing era. If the 80's were defined by manic acquisitiveness and self-gratification uptown, the decade's downtown mirror was this performance art scene, formalized at publicly supported spaces like P.S. 122. Its denizens may have thought they were making trenchant comment upon Donald Trump and Michael R. Milken, but in a disturbing way they were acting out those same vulgar, exhibitionistic fantasies on an underground level.

As the 80's advanced, however, AIDS turned the party into a nightmare. AIDS is a tragedy that transcends America and its artists. But in the East Village Bohemia of the 80's, where sexual experimentation and heroin both played a larger role than in most sectors of society, the disease hit with a terrifying vengeance. Now the Persian Gulf war has come along, with an as yet undetermined effect on our traditionally left-leaning artistic vanguard. So far, that effect has been fragmented, with the left confused by contradictory impulses. But artists voice concerns before the rest of society, and horror at war and death already looms large among those who took part in the P.S. 122 benefit.

All of this cast the evening into a rather different light than one might have expected from what was, after all, a celebratory gala. One need not subscribe to the implied conspiracy theories of Mr. Bogosian — "What does the gulf war have in common with AIDS? Everything" — to sense the impassioned concern that has transformed the East Village community.

•

The shift in vanguard sensibilities could be observed most clearly in the case of Ms. Sprinkle.

Not that she has been fully tamed, or turned into some politically prim and proper propagandist. While she didn't invite us to peer at her genitalia, she did allude to all manner of questionably attractive people doing mildly gross things, and she did perform her "bosom ballet," in which she jiggles and manipulates her breasts in time to bouncy ballet music.

But this time, at least, there was more to Ms. Sprinkle than a rather ordinary, overweight woman flaunting her wares. It was her principal monologue that defined the new agenda facing artists today. After a parade of slides of her lovers, in all shapes and races and sizes and sexual inclinations, the mood darkened. Lover after lover, it turned out, had died of AIDS; descriptions of their attributes and endowments shifted to the past tense. What had been happily hedonistic became a funeral procession of martyrs to the cause, the cause being a community's search, through sexual liberation and artistic license, for anarchic bliss.

One could argue that her success, her ability to move her audience and make it feel her pain, was inadvertent, provided not by her art but by the somber foil of our time. But wittingly or unwittingly, her transformation of sexual celebration into a litany of death provided a focus for what could have been an otherwise disparate benefit evening, a focus that

turned all the artists involved into voices for their generation.

1991 F 9, 13:1

Unchanging Love

Written by Romulus Linney, from "In the Ravine," a story by Anton Chekov; directed by John Dillon; music direction by Edward Morgan; lighting design, Nancy Collings; set design, Steven Perry; costume design, Amanda J. Klein; stage manager, Jerry Grant; technical direction, Paul Israel. Presented by the Triangle Theater Company. At the Church of the Holy Trinity, 316 East 88th Street.

Elmer Musgrove....................Gordon G. Jones
Annie Musgrove........Elisabeth Lewis Corley
Judy Musgrove.................Jennifer Parsons
Benjamin Pitman.................Tom McDermott
Barbara Pitman.................Jacqueline Knapp
Avery Pitman.....................Mark Doerr
Leena Pitman.......................T. Cat Ford
Shelby Pitman.....................Scott Sowers
Crutch Holston.......................Fred Burrell
Oats Pyatt............................Cap Pryor

By MEL GUSSOW

Anton Chekhov's short story "In the Ravine" is a sorrowful tale of small-town greed and cruelty partly offset by a figure of enduring innocence. Artfully transplanting the narrative from late-19th-century Russia to the foothills of Appalachia in the 1920's, Romulus Linney demonstrates his own creativity as a playwright and the universality of Chekhov. In this adaptation, Mr. Linney continues to be a poet of America's heartland.

His play, "Unchanging Love," by the Triangle Theater Company, is doubly fascinating: for what Mr. Linney has chosen to retain of the original story and for what he has chosen to reinterpret to make it a regional American experience.

Characters have been excised, combined or strengthened and at several points there is a dramatizing of what is only hinted at in Chekhov. The dialogue is new. But the basic storyline and thematic content remain the same. Chekhov speaks through Mr. Linney, with a North Carolina twang.

The prosperous Russian storekeeper becomes Benjamin Pitman, an unbenevolent patriarch in a dirt-poor Southern mill town. In tandem with his grasping daughter-in-law, Leena, he runs his store and rules the community. Under the guise of respectability, he sells customers rancid food and charges exorbitant prices. At the same time, he retains a Lear-like domination over the fortunes of his family.

As is true in Chekhov, the catalyst is the storekeeper's prodigal son, whose big-city machinations have given him a dubious character. Returning home, he decides to marry the daughter of an impoverished farmer. She is the innocent who will prove to be the anomaly in this amoral community.

•

The play begins disarmingly with a background of hymns and folk ballads, liltingly sung by the bride-to-be (Jennifer Parsons) and her parents. Their singing is a continuing uplift in the evening, evoking atmosphere and a tradition — submerged in this town — of country harmony.

In direct contrast to this trio are the Pitmans, who in Mr. Linney's version move a step toward the world of Lillian Hellman. The rapacious daughter-in-law (T. Cat Ford) could turn into Regina Giddens herself. In fact, one begins to wonder if in writing "The Little Foxes," Miss Hellman — an admirer of Chekhov — might have been influenced by "In the Ravine."

Taking a cue from Chekhov, Mr. Linney depicts a community polluting and poisoning itself while remaining in thrall of the wealthy Pitmans. An environmental disaster is in the wind and corruption will prove to be endemic.

•

In the original story, the storekeeper's wife was quietly dutiful; one trusted in her decency. Mr. Linney has given her a more active role, and she speaks some of the sentiments reserved in the short story for pass-

Tom Brazil

Elisabeth Lewis Corley, left, and Jacqueline Knapp of the Triangle Theater Company in Romulus Linney's "Unchanging Love."

ing travelers who represent the spirit of Mother Russia.

One might say that the wife (Jacqueline Knapp) becomes the voice of Mother Appalachia, pleading for humanity and horrified by the realization that in their town "everybody cheats on everybody else." Her pragmatic husband replies, "Men can't do business without cheating," and he adds the qualifying word, "some," to excuse his own chicanery.

In several instances, Mr. Linney simply transposes Chekhov, but he adds colorful local touches, often dealing with religion and sex. The withdrawn Ms. Parsons is repeatedly introduced by her father as someone who was, as a child, "carnally deceived by a preacher," and at the wedding reception the men of the valley gather for a rambunctious display of their feelings of male superiority.

•

A few questions remain unresolved, and to compensate for the absence of Chekhov's wide time frame, Mr. Linney has to foreshadow the final indigence of Ben Pitman,

cast out of his own home. Steven Perry's scenic design is overly spare. But these are minor issues in a play with a Chekhovian breadth of character.

John Dillon, who staged the first production of the play at the Milwaukee Repertory Theater, has cast it with lesser-known actors who blend with the work's regionalisms as well as with its sensibility. The most moving performances are given by Ms. Ford, who almost makes the wily Leena seem reasonable; Ms. Knapp, as the storekeeper's wife, and Ms. Parsons as the waiflike bride. Scott Sowers has the necessary cockiness for the miscreant son.

V. S. Pritchett has called the short story one of Chekhov's "surpassing masterpieces," in which the author "deepens his portrait of people" by letting them "speak in their voices as they live out their passions." In "Unchanging Love," the setting and the dialogue are different, but the voices remain unalterable.

1991 F 10, 64:1

claustrophobic terror the theater can handle with no problem at all. It's quite another to give the characters free rein of Chicago, as Mr. Post does, and expect us to go along with the chase. "Earth and Sky" really wants to deal with images, and time and again it is forced to fall back on words — words that are expected to do the job of close-ups and tracking shots. The plot is not necessarily a bad one, as these plots go, but it cries out for the brooding atmosphere that the camera alone can provide. Words are not enough.

Mr. Post has already broken his script down into dozens of brief scenes, which would greatly facilitate a switch to film. Mostly, they chart Sara's deepening entanglement with the cops who are handling the case — but not assiduously enough for her satisfaction — and with a predictable sampling of lowlife. Along the circuitous way, flashbacks show us how Sara's relationship with the dead man came about. On both fronts, Mr. Post reveals his gift for the clichés of the game. Hard-bitten investigator to Sara: "Justice, when it happens, is an accident." Lover to Sara: "There are *many* things you don't know about me."

Apparently nonplussed by such banality, the director André Ernotte plows ahead with a staging that proves as dull as the mostly black-and-gray color scheme. Someone frail

SUNDAY VIEW/David Richards

A Voyage From Chicago to Chelm

WOULD YOU SETTLE THIS morning for a TV movie, a resurrected theater and a vaguely philosophical question?

You can't catch the TV movie, Douglas Post's "Earth and Sky," on television right now. It's in play form and it's being performed Off Broadway at the Second Stage. But I don't know when I last encountered a play so unhappy to be a play. If the proper mogul came along, "Earth and Sky" would give up the stage in a flash. For the sound stage, of course.

Can you blame it? Mr. Post's story concerns a part-time librarian and poet, Sara McKeon (Jennifer Van Dyck), who decides to do a little detective work after her lover of two and a half months (Ted Marcoux) is found dead in a Dumpster. But the action is locked away in a set that looks like one of Louise Nevelson's boxes, with odd pieces of windows, doors and furniture all glued top to bottom and end to end.

How, under the circumstances, can you show police cars barreling through the slick city streets, sirens wailing? What are you supposed to do about the friendly bartender who gets pushed in front of an onrushing train? Or the shadowy figures who stalk the heroine as she makes her way through seedy neighborhoods?

And frankly, how much risk is she running by returning home alone late at night, when home is the darkened stage and the only indication of danger is the deep breathing coming over the sound system? As soon as the lights are turned on, we're right back in that Nevelson box, and whoever was doing the deep breathing has vanished.

■

It's one thing to close up a bunch of characters and one killer in an isolated manse and let them play cat and mouse. That kind of

Carol Rosegg-Swope Assoc./"Romeo and Juliet"

Mark Niebuhr and Miriam Healy-Louie are the lovers in "Romeo and Juliet" at the Victory Theater—Time is everywhere of the essence.

An urban murder mystery, 'Romeo and Juliet' and a nostalgic English-Yiddish revue provoke a few questions.

and vulnerable — the young Audrey Hepburn — would do O.K. as Sara, but Ms. Van Dyck is a bit of a scold in the part and vulnerable as carpet tacks. I liked Mr. Marcoux, however, who has a way of alternately raising and dousing your suspicions. As the lover, he's either one swell guy or a deadbeat.

The title comes from the heroine's profession that her lover is everything to her — her earth and sky. I should imagine it would be the very first thing to be changed, if Mr. Post's play finds life beyond Second Stage. Otherwise, people could think they were tuning in to a documentary about the Australian outback. Or potters with ambition.

'Romeo and Juliet'

The theater I mentioned, the Victory, is the oldest surviving playhouse on 42d Street. Like so many of its neighbors, hard luck and porn flicks had long since become its destiny when, last February, legitimate theatergoers were invited back in for the first time in 60 years. The occasion was the En Garde Arts' production of "Crowbar," a sound-and-light show of sorts that evoked some of the ghosts of the venerable premises and required the spectators to sit on the stage and gaze out into the auditorium.

The text was on the murky side, but there were compensations, as the actors materialized in the boxes, darted across the balconies and scooted up and down the aisles. You could contemplate some of the architectural details that age and the latter-day film clientele hadn't destroyed and muse on the history of a theater that, in its heyday, housed "Abie's Irish Rose" and boasted a roof garden with a real watermill.

Now, marking a further step in the theater's rehabilitation, spectators are actually getting an opportunity to sit in the auditorium and face the stage — as they did in 1900. The occasion, this time, is a production of "Romeo and Juliet," mounted by the British director Bill Alexander and performed by the Theater for a New Audience. Much as I welcome the Victory back to the ranks of functioning playhouses, looking out into the auditorium really was the more interesting experience.

That's not to say the facility won't work just fine with more accomplished actors on the job. It's already surprisingly cozy, and Fotini Dimou's dramatic set design only underscores the feeling of immediacy. From the public fountains along the rear stage wall, Verona's town square sweeps past the Victory's ornate proscenium arch, out over the orchestra pit and down into the audience. (The spectators in the front rows could set up fruit and vegetable stands and not be out of order.) The purpose is clear:

Shakespeare's play is to be spilled in our laps.

■

It's equally revelatory that several of the characters have watches pinned to their costumes and that a town clock presides over the square. There's a headlong rush to events, and not just the rough-and-tumble street fights. Aren't Romeo and Juliet head over heels in love? Servants, masters, friar and prince all seem shot out of a cannon. Time is everywhere of the essence. Only a few seconds here and there, after all, keep the play from ending happily.

Unfortunately, if we're being afforded a perfect chance to observe the tragedy close up, the cast can't withstand the scrutiny. No point belaboring matters, but Miriam Healy-Louie is far from the worst offender, and I've seen earnest high school actresses do as much with the role of Juliet. Mark Niebuhr communicates Romeo's impulsiveness, although little of his poetic wonder, while Peggy Pope's nurse suggests what might happen if ever Edith Bunker were given a whack at the part.

Two inspirations bear noting. In the last act, Ms. Dimou lowers dozens of bright white skulls into the darkness over Juliet's tomb. Where stars once shone, death now grins mockingly. Beautifully eerie, that. Mr. Alexander also does something I've never seen before: he rouses Juliet from her trance *before* Romeo succumbs to poison. The youth is still waiting for its lethal effects to take hold, when suddenly he notices Juliet's hand stirring. His eyes open wide with uncomprehending horror, then he dies. Wonderfully theatrical, that.

However, the evening's chief pleasure comes from sitting in the Victory

and knowing it's once again being put to the use for which it was intended. It's no jewel yet. But the skid has been arrested. Nothing's wrong with the place that some paint and good acting can't remedy.

'Those Were the Days'

As for that vaguely philosophical question, it popped into my mind during a recent performance of "Those Were the Days," the English-Yiddish (but mostly Yiddish) musical revue that's been winning hearts for several months now at the Edison Theater. The first half of this cheerful, if modest, enterprise is given over to largely sentimental songs about the

Nostalgia, if you think about it, involves a simplification and falsification of the past.

shtetl; the second half devotes its attention to the slightly wrier entertainments of the music hall. Not only was the audience clapping along to familiar rhythms and nodding appreciatively at the first strains of familiar tunes, it was supplying punch lines to jokes that must have already been told a thousand times.

■

The show amounts to a benign display of nostalgia, although nostalgia, if you think about it, involves a simplification and a falsification of the past. History is getting a face lift. The revue I'd much rather see is "These *Are* the Days," but nobody appears to be leaping to the task. Maybe too little about today merits the unalloyed enthusiasm that's visibly propelling the five performers at the Edison. Maybe it takes an accumulation of rosy memories to soften an age's crueler and uglier contours. Or is it that we simply don't know we're having a good time until we've had it?

Just asking. ⬚

1991 F 10, II:5:1

La Bête

By David Hirson; directed by Richard Jones; scenery and costumes by Richard Hudson; lighting, Jennifer Tipton; sound, Peter Fitzgerald; technical supervisor, Jeremiah J. Harris; production stage manager, Bob Borod. Presented by Stuart Ostrow and Andrew Lloyd Webber. At the Eugene O'Neill Theater, 230 West 49th Street.

Elomire	Michael Cumpsty
Bejart	James Greene
Valere	Tom McGowan
Dorine	Johann Carlo
Prince Conti	Dylan Baker
Madeleine Bejart	Patricia Kilgarriff
De Brie	John Michael Higgins
Catherine De Brie	Holly Felton
Rene Du Parc	William Mesnik
Marquise Therese Du Parc	Suzie Plakson

With: Cheryl Gaysunas, Ellen Kohrman, Michael McCormick and Eric Swanson

By FRANK RICH

"La Bête," the new play by David Hirson at the Eugene O'Neill Theater, begins with a bang that can make even a jaded New York audience abruptly spring to attention. The lights come up on a chorus of babbling 17th-century French swells who are figuratively guillotined by a progression of elegant, falling front curtains, each more disfigured than the last by blotted, calligraphic graffiti. Not long after that, the same curtains rise on a new shock for the eye: a towering period anteroom in nearly unrelieved white, as seen from a skewed, fisheye-lens perspective. And then comes the pièce de résistance: A corpulent buffoon — the beast of the title, known as Valere and played by Tom McGowan — delivers a marathon soliloquy that runs some 400 lines and, like the entire play, has been composed in rhymed verse!

●

No, one won't soon forget the first half-hour or so of "La Bête," which takes the brave chances so rare in new American plays. The flip side of such daring, however, is the high expectations it raises. Mr. Hirson promises nothing less than a mock-Molière comedy of manners and ideas as refracted through (or deconstructed by) a post-modern sensibility. His theme is equally expansive: the decline and fall of culture in a West where "mediocrity is bound to thrive/while excellence must struggle to survive." Yet the followthrough is almost nonexistent. By the time "La Bête" dwindles down to a coda as embarrassingly mawkish as its prologue was startling, one is still waiting for the promised laughter, ideas and dramatic conflict to possess center stage.

The evening's premise certainly is capable of shouldering high ambitions. Mr. Hirson has amusingly imagined that Elomire (Michael Cumpsty), an austere theatrical genius whose name is an anagram of Molière, is forced by his royal patron, Prince Conti (Dylan Baker), to add Valere, a common street clown, to his company of actors. Valere is the bull in the china shop of art: a vulgar, self-infatuated, facilely talented self-promoter who will pander to any audience, whether a prince or the masses, to win applause. Elomire is his sworn enemy, an esthete holding out for the highest standards in a civilization where the lowest common denominator is increasingly prized.

●

Of course the world of "La Bête" is a double for our own. The Prince who tries to affect a shotgun artistic marriage between the disparate Valere and Elomire might as well be a cynical Broadway producer attempting to shoehorn this year's Hollywood sensation into a revival of "Peer Gynt." Fair enough, but do we need to go to the theater to be instructed that the heathens are at the gates of high culture? After laying out his unexceptional moral, Mr. Hirson misses opportunity after opportunity to make something entertaining or challenging out of it. "La Bête" has no dramatic surprises, and the author never offers any intellectual corollaries or counter-arguments to his initial, unassailable ideological position. The play instead runs in place, repeating itself over and over, louder and louder each time.

Valere's big soliloquy in Act I, for instance, merely illustrates with countless, interchangeable examples

what a self-congratulatory fraud the clown is. Much of the rest of that act and the beginning of the second is devoted to regurgitating Elomire's well-worn objections to the proposed partnership, with the end of Act II trailing off into another lengthy monologue in which Elomire reiterates the playwright's message several more times. The one actual theatrical event in "La Bête" — the Act II play-within-the-play in which Valere parades his emptiness — is a fizzle, both as a satirical example of the beast's fake art and as a farcical collision between the two antagonists. For that matter, Mr. Hirson never provides a fiery, Peter Shaffer-esque duel of words between the genius Elomire and the mediocrity Valere; this is a play in which everyone talks at rather than to one another.

•

The dramatic inertia, often accentuated by the declamatory staging provided by the English opera director Richard Jones, might not matter so much if the couplets and star performance were consistently funny. Though Mr. Hirson's sustained versifying is impressive as a technical achievement and though his rhymes can be cute ("caterwaul" with "warts and all"), he never comes remotely near the standard of wit for simulated French couplets in English set by Richard Wilbur in his Molière translations and in his lyrics for the Leonard Bernstein "Candide." Mr. Hirson provokes smiles when he needs howls.

So it goes as well with Mr. McGowan, a burly young actor who was a good incidental clown in the James Lapine "Winter's Tale" at the Public Theater two seasons ago. The steep demands of "La Bête," which require that Valere make vulgarity both funny and chillingly evil, exceed his skills. While Mr. McGowan flounces through his lengthy Act I monologue with every syllable and low-comic gesture professionally intact, he offers the letter of burlesque clowning without the instinctual spirit that might make such antics hilarious and unsettling. The dangerous comic bravura of a Zero Mostel, Charles Ludlam, John Belushi — or, to descend to mere mortals, a Tim Curry or John Candy — is desperately needed to create a tour de force out of a role too laboriously written to soar on an industrious actor's energy alone.

•

Revealingly Mr. McGowan reaches his one outrageous peak not when he is speaking Mr. Hirson's lines but when he defaces the set with a marker, one of several striking visual gags in a production that has been brilliantly designed by Richard Hudson (sets and costumes) and Jennifer Tipton (lighting). In a supporting cast that includes underused talents (James Greene) and overstretched ones (Johann Carlo), the outstanding comic turn comes from Mr. Baker, who is almost unrecognizable under the wig, lengthy train and pancake makeup of the campy, Cyril Ritchard-like Prince. ("I'm hardly king," he says, sounding every bit like a man who would be queen.) Mr. Cumpsty's impassioned Elomire is also very fine, given the limits of a bombastic role that is less a character than a one-note authorial stand-in.

That note is grating. Elomire eventually sounds less like Molière, or one of that playwright's Puritanically rigid comic targets, than like a neoconservative scold. In his final, crowd-pleasing tirade, he rages at a culture that values form over content,

highfalutin words over ideas, pretension over truth, and he attacks charlatans like Valere for appropriating the vocabulary of real art to justify their transgressions. But isn't "La Bête" pandering just as much as its villain? There is not a single idea or debate in this play aside from its cost-free endorsement of excellence over trash, and even that one conviction is conveyed not through theatrical excellence but by a sermon that implicitly flatters the audience for its own elevated taste and for its cultural superiority to the riff-raff presumably watching those Broadway shows written in lowly prose.

•

Thus does an exceptionally promising work intended to shake up a complacent audience deteriorate into an almost insufferably smug example of the exact middlebrow fluff it wants to attack. Offering verse without poetry and the gilded rhetoric of culture as if it were the content, "La Bête" is not so much a play on Molière's "Bourgeois Gentilhomme" as a play for today's bourgeois gentilhomme, or for anyone who confuses high-mindedness with high art.

1991 F 11, C11:3

Festival of One-Act Comedies
Evening A

Artistic associate, Jonathon Mintz; sets by Vaughn Patterson; lighting by Pat Dignan; costumes by Sharon Lynch; sound by Aural Fixation. Presented by Manhattan Punch Line Theater, Steve Kaplan, artistic director. At the Judith Anderson Theater, 422 West 42d Street.

VARIATIONS ON THE DEATH OF TROTSKY, by David Ives; directed by Jason McConnell Buzas.

GORGO'S MOTHER, by Laurence Klavan; directed by Steve Kaplan.

GANGSTER APPAREL, by Richard Vetere; directed by Matthew Penn.

STAY CARL STAY, by Peter Tolan; directed by Charles Karchmer.

WITH: Michael Aschner, Ronnie Farer, David Goldman, Daniel Hagen, Cheryl Hulteen, Chris Lutkin, Nora Mae Lyng, Michael Raynor, Elaine Rinehart, Steven Rodriguez, Kathrin King Segal, Ben Siegler, Joseph Siravo and Christine Toy.

By MEL GUSSOW

Trapped in a stale marriage, a woman (Christine Toy) seeks help from a psychiatrist and is advised to get a dog for company. She names her new pet Carl. In Peter Tolan's "Stay Carl Stay," the title character is given a waggish performance by Daniel Hagen. This shaggy dog story is the riotously funny finale to four amusing plays in Evening A of the Manhattan Punch Line festival of one-act comedies.

Carl turns out to be a talking dog. One minute his new owner is teaching him how to change a woof into a word, and the next minute Carl is watching "The MacNeil/Lehrer Newshour." Blink, and the dog is seated at the dinner table with his mistress, something the bored husband refused to do. In contrast to the husband, Carl conducts a stimulating conversation about worldly affairs. But because he is a pawed creature of habit, he has his head deep in his doggie dish.

The play is filled with circuitous flights of fancy, including Bingo (David Goldman), a gay dog that is in-

stantly smitten with Carl. The wife also pays a return visit to the psychiatrist (Kathryn King Segal), who is startled to learn that the talking dog is not a figment of her patient's imagination.

Starring Carl the news hound and Trotsky the perennial victim.

Mr. Hagen, who has the physique and shambling manner of John Goodman, is the thinking dog's dog. Even without wearing a hair suit, he matches the performance of professional stage animals like the ones who played Sandy in "Annie," combining a dogly demeanor with a distinctly human touch. Under Charles Karchmer's low-key direction, all of the actors are precise, but it is Mr. Hagen's cannily canine impersonation that lifts the comedy into delirium.

•

The evening (at the Judith Anderson Theater) opens with Mr. Hagen in a very different role. With equal verisimilitude, he plays Leon Trotsky in David Ives's quick-triggered curtain-raiser, "Variations on the Death of Trotsky." Living up to its title, the play uses Mr. Ives's signature device. This is a "bell play," in which one scene is played and replayed, each time with different results.

When first seen, Trotsky has a mountain climber's ax stuck in his head, but he does not yet realize he is dead. After he falls, a bell rings, and Trotsky returns to life — and Mr. Ives offers the next in a series of deadly comic scenarios.

Did the Spanish gardener do it? Or was Trotsky the victim of a more domestic dastardly deed? The playwright keeps guessing, and Mr. Hagen keeps dying, never losing his dazed expression or the ax in his head. With the help of Nora Mae Lyng as Mrs. Trotsky and the nimble direction of Jason McConnell Buzas, the comedy escalates to the final bell.

•

Laurence Klavan's "Gorgo's Mother" (directed by Steve Kaplan) is attenuated but entertaining — and it also has dramatic potential. This is a Schnitzler-like "La Ronde" about four sub-yuppies who repeatedly meet in Central Park. Joanne loves Kenny, who loves Terry, who loves Brian, and so on. The catalyst is Kenny (Ben Seigler), a casual drug-dealer who amiably takes advantage of everyone while defeating his own best interest.

The actor Joseph Siravo is the swaggering center of Richard Vetere's "Gangster Apparel," a madcap spoof of all those gangster movies that are crowding neighborhood screens. As a hired gun preparing to shoot a rival mob boss, he poses before an unseen mirror and inhales to disguise the beginnings of a paunch. He fancies himself a fashion plate. In his eyes, clothes make the gangster, even as he mismatches his own ties and shirts.

When his shabbily attired partner (Michael Raynor) arrives and questions the necessity of style, Mr. Siravo stares balefully at his sartorial opposite. As he knows, the most important

thing for a gangster is to be "in control of his wardrobe." Although the final twist is a reach, Mr. Vetere's sketch has a shifty sense of mockery. As directed by Matthew Penn, the two actors adeptly convey the banter and the bravado of this pair of goodfellas. Mr. Siravo is especially mirthful as a man who is dressed to kill — or be killed.

1991 F 12, C14:3

Absent Friends

By Alan Ayckbourn; directed by Lynne Meadow; sets by John Lee Beatty; costumes by Jane Greenwood; lighting by Ken Billington; production stage manager, Pamela Singer. Presented by the Manhattan Theater Club, Ms. Meadow, artistic director; Barry Grove, managing director. At City Center Stage 1, 131 West 55th Street.

Evelyn	Gillian Anderson
Diana	Brenda Blethyn
Marge	Ellen Parker
Paul	David Purdham
John	John Curless
Colin	Peter Frechette

By FRANK RICH

Alan Ayckbourn has written more plays than William Shakespeare and perhaps as many good plays, of all shapes and sizes, as any other English dramatist of his generation. But if you wanted to define the Ayckbourn sensibility with a single incident in a single play, you could do it by turning to a passage in Act II of "Absent Friends," the early comedy (1974) that is receiving its belated New York premiere in an exquisitely orchestrated production directed by Lynne Meadow at the Manhattan Theater Club.

The incident involves a perfectly conventional suburban English housewife, Diana, who is sitting on her living room couch presiding over a Saturday afternoon tea party. Diana — played by the sublime English actress Brenda Blethyn, in her New York debut — is a cheery sort, with button eyes, rosy cheeks and a jolly word for nearly anyone who will look benignly in her direction. But things have not gone well at her tea party, and suddenly Diana cracks at the realization that she long ago took a wrong turn in life and has ever since been stuck "doing all the wrong things." Her arms folded and her posture still erect, Ms. Blethyn starts crying and shrieking uncontrollably, inconsolably, plunging from chattery contentment to rage and nervous collapse.

It's an upsetting spectacle, and it will not quit. Diana just keeps sobbing from her perch on the couch. But what makes the scene quintessential Ayckbourn is what happens next: The poor woman's friends must restore order by somehow maneuvering her to her bedroom, where she can be put to rest. The trouble is that Diana won't go easily or quietly, and she is too heavy to be carried to the second floor. As her neighbors clumsily and at first ineffectually try to push her up the stairs, a tragic spectacle becomes a farcical one without relinquishing any of the gravity of Diana's despair. Mr. Ayckbourn, abetted by Ms. Blethyn's admixture of fragility and luminosity, really has carried off the trick of making an audience laugh and cry at the same time.

•

"Absent Friends" does not always reach this level of achievement, but it is a gem that succeeds at everything

it wants to do in two brisk hours. Mr. Ayckbourn has described the play as being "about death and the death of love" and has decreed from hard experience (after its West End failure) that it is best performed in "a small intimate theater where one can hear the actors breathing and the silences ticking away." Ms. Meadow, who did such a good job with Mr. Ayckbourn's "Woman in Mind" a few seasons ago, is completely in sync with these intentions, as are her cast (all American except for Ms. Blethyn) and her set designer, John Lee Beatty.

Diana's living room, ostensibly a model of affluent interior decoration as decreed by glossy magazines, is just antiseptic enough to suggest a mausoleum. The death that briefly visits it is that of a woman who was engaged to be married to Colin (Peter Frechette), an amiable young man who moved to another town three years earlier. "Absent Friends" is a minute-by-minute account of the casual reunion Diana holds for the long-absent Colin when he returns to his old neighborhood for a visit. In truth, the hostess, her husband and their guests didn't know and don't remember Colin that well — and never met his fiancée, who died in a drowning accident — but they feel obliged to make a show of sharing his grief.

Mr. Frechette, last seen at the Manhattan Theater Club as the trendy artist in "Eastern Standard," is equally incisive here as a provincial Ayckbourn nerd, all kindly smiles and sentimental homilies. He isn't bitter about the loss of his beloved — he still has dozens, if not hundreds, of snapshots of her, which he pushes on anyone in sight — and he tells his old companions that he is not envious of their freedom from his nightmare. Yet Colin's good cheer has an inverse effect on everyone else. The more he natters away, complimenting his

friends on their marriages, children and careers and recounting idyllic shared memories that they but dimly recall, the more his hosts are forced to confront the gap that separates Colin's fantasy of their contentment from the suffering and disappointment that are their actual lot.

•

Though the obtuse Colin cannot recognize the truth, his friends are all either parasites or losers, from a philandering, selfish businessman (Diana's husband, played by David Purdham), to a sad-sack salesman (John Curless) with a boundless repertory of irritating nervous tics, to an unconvincingly perky wife (Ellen Parker) martyred to a frequently

In an early work, the essential sensibility is already full grown

bedridden, grotesquely overweight spouse. It is the way of the world in Mr. Ayckbourn's suburbia that the men tend to be either malevolent or helpless infants while the women are their lonely, unappreciated and often abused nannies.

The only exception to this general rule is the youngest woman on stage, and the only one who is mothering an actual baby: Evelyn, a sullen malcontent with what one antagonist calls a "really mean little face" and a penchant for speaking solely in contemptuous words of one syllable (usually "no"). Gillian Anderson, the Chicago actress cast in the part, turns Evelyn into a dark void, a glowering presence as devoid of humanity as Mr. Frechette's Colin is overflowing with

it. She is a hilarious, if frightening, representative of abject evil, yet it is Mr. Ayckbourn's grimmest joke that Colin's fatuous good will proves just as destructive as Evelyn's undisguised cynicism and malice.

As always, this playwright makes the mundane middle class theatrical by tucking the casual cruelty, deep sorrow and occasional bravery of his characters into the humble, often funny calamities of diurnal domesticity — the ill-fated shopping expedition, the inopportune phone call, the baby carriage left out in the rain. If Mr. Ayckbourn were American, the underside of his plays' antics might be likened to the suburban tales of John Cheever: Terror always lurks just beneath the surface of ostentatiously comfortable homes where real comfort is nowhere to be found. By the final curtain, as the first shadows of evening fall across Diana's living room, nearly everyone in "Absent Friends" is more or less sedated. Though Colin calls sleep "the great healer," the fugue of deep breathing filling the twilight air is heavy with defeat and regret.

A couple of the pathetic revelers — those played by Mr. Curless and Ms. Parker — could be profitably explored for more depth. Some of the writing lacks depth, too. In later plays — and there have been more than two dozen since "Absent Friends," most unseen in New York — Mr. Ayckbourn has camouflaged the machinery of his dramaturgy more expertly than he sometimes does here, and he has expanded his canvas beyond the living room to spread his darkness over an entire town ("A Chorus of Disapproval"), an entire nation ("A Small Family Business") and an entire era (the epic "Revengers' Comedies"). But if "Absent Friends" is a chamber piece by the current Ayckbourn standard, it still takes the audience to the fractured heart of a comic

universe where only the pratfalls don't hurt.

1991 F 13, C13:3

Timid Angel Visits Sad Woman

By JACK ANDERSON

Many mimes are trying to change their image. They seek to demonstrate that their art involves more than the antics of gently comic and sweetly sad clowns in white-face makeup. These days, some mimes even talk. Despite their efforts, skeptics still charge that mime shows are too often nothing but collections of self-consciously clever wigglings and grimacings.

There were outbursts of French and English in "La Croisade" ("The Crusade"), the mime play created and performed by Steven Wasson and Corinne Soum that was presented Saturday night at Gould Hall by Le Théâtre de l'Ange Fou, a Paris-based organization. Neither Miss Soum, a French mime, nor Mr. Wasson, an American, wore clown makeup. Nevertheless "La Croisade" was nothing but an hour of self-consciously clever wigglings and grimacings.

The work concerned a bumbling and timid angel's visit to an unhappy young woman. Miss Soum and Mr. Wasson tried to make its incidents varied, and they included everything from a comic drunk scene to a somber visit to a battlefield. Yet the piece soon grew intolerably coy because of the performers' habit of offering scores of gestures where only one or two well-chosen ones would have sufficed.

•

Miss Soum was dithery as the heroine. But all her flutters and fidgets did no more than make her look tiresomely fey. Mr. Wasson kept equally busy as the angel. His incessant gesticulations turned him into such a fussbudget that his angel resembled the caricatures of department-store floorwalkers that used to turn up in old Hollywood movies. Neither character was consistently amusing or touching.

Doris Humphrey, one of the pioneers of modern dance, used to tell novice choreographers fond of compositional overelaboration, "Don't just do something; stand there!" Watching "La Croisade," one knew what she meant.

1991 F 14, C14:6

Mule Bone

By Langston Hughes and Zora Neale Hurston; prologue and epilogue by George Houston Bass; music by Taj Mahal; directed by Michael Schultz; sets by Edward Burbridge; costumes by Lewis Brown; lighting by Allen Lee Hughes; sound by Serge Ossorguine; musical supervisor, Mr. Mahal; fights staged by Ron Van Clief; production manager, Jeff Hamlin; dances staged by Dianne McIntyre. Presented by Lincoln Center Theater, Gregory Mosher, director; Bernard Gersten, executive producer. At the Ethel Barrymore Theater, 243 West 47th Street.

Gerry Goodstein/Manhattan Theater Club

Peter Frechette, left, Brenda Blethyn and David Purdham in Alan Ayckbourn's "Absent Friends."

Lincoln Center Theater

Eric Ware

WITH: Akosua Busia, Marilyn Coleman, Paul S. Eckstein, Clebert Ford, Frances Foster, Arthur French, Sonny Jim Gaines, Fanni Green, Donald Griffin, Leonard Jackson, Ebony J0-Ann, Robert Earl Jones, T. J. Jones, Joy Lee, Edwina Lewis, Pee Wee Love, Theresa Merritt, Pauline Meyer, Reggie Montgomery, Mansoor Najeeullah, Kenny Neal, Peggy Pettitt, Shareen Powlett, Myra Taylor, Eric Ware, Vanessa Williams, Allie Woods Jr., Bron Wright and Samuel E. Wright.

By FRANK RICH

IF ever there was a promising idea for a play, it is the enigmatic story of what went on when two giants of the Harlem Renaissance briefly collided in 1930 to collaborate on "a comedy of Negro life" they titled "Mule Bone."

The writers were the poet Langston Hughes and the anthropologist, folklorist and novelist Zora Neale Hurston. Both were in their late 20's, and both had the same dream of a new truly African-American theater. Their goal was Broadway, which they hoped to liberate from the stereotypical minstrel musicals (the many progeny of "Shuffle Along") and sentimental problem dramas ("Green Pastures," "Porgy") that then distorted the black experience on the mainstream stage. Yet "Mule Bone" was never finished and never produced because, as Hughes put it, "the authors fell out."

What went wrong? No one knows for sure, despite the fascinating and painstaking efforts of both writers' authoritative biographers, Arnold Rampersad (Hughes) and Robert E. Hemenway (Hurston), to piece the events together. Everyone agrees, as Henry Louis Gates Jr. has written, that the fight was "an extremely ugly affair" that at the very least involved a battle over authorial credit and the neurotic machinations of a wealthy white patron. Hurston's present-day publisher, Harper Perennial, has just brought out a first edition of the uncompleted text of "Mule Bone" in which all the relevant biographical accounts and documentary evidence have been assembled, and the volume leaves no doubt that whatever the provocation, the Hughes-Hurston conflict was the stuff of high drama. The same, sad to say, cannot be said of "Mule Bone" itself, at least

as mounted by Lincoln Center Theater at the Barrymore Theater on Broadway, six full decades after Hurston and Hughes set their sights on the Great White Way. This is an evening that can most kindly be described as innocuous — not an adjective usually attached to either of its authors — and it is not even a scrupulously authentic representation of what Hughes and Hurston wrote, fragmented and problematic as their aborted collaboration was. Indeed, there's something disturbingly disingenuous about the entire production. This "Mule Bone" is at once watered down and bloated by various emendations that one can never be entirely sure if Lincoln Center Theater is conscientiously trying to complete and resuscitate a lost, unfinished work or is merely picking its carcass to confer a classy literary pedigree on a broad, often bland quasi-musical seemingly pitched to a contemporary Broadway audience.

On occasion — rare occasion — this rendition does make clear what Hurston and Hughes had in mind, which was to bring to the stage, unfiltered by white sensibilities, the genuine language, culture and lives of black people who had been shaped by both a rich African heritage and the oppression of American racism. The play was adapted from an unpublished Hurston story recounting one of the many folk tales she had collected during her anthropological exploration of Eatonville, Fla., the black town where she was born. In the story, two male friends come to blows over a turkey, with one knocking out the other with a mule bone and ending up in a trial that turns on an issue of biblical interpretation. In the play, the object of dispute is a woman named Daisy, not a turkey — the change is believed to have been Hughes's — but the anecdote remains in any case an excuse for an explosion of vernacular speech, blues poetry and extravagantly ritualized storytelling.

•

Perhaps if the writers had had the chance to finish "Mule Bone" and to see it with an audience, they would have tightened or rethought what was a work in progress. Perhaps even if they had completed their mission, "Mule Bone" would still seem as dated today as other ambitious American plays of its exact vintage, such as Eugene O'Neill's "Mourning Becomes Electra." We'll never know. As the text stands, it often feels like a rough draft in which two competing voices were trying to reach a compromise. Among the more arresting sections are a boisterous trial scene featuring dueling Baptist and Methodist congregations and a late-evening confrontation in which the antagonists compete for their woman's hand with hyperbolic metaphors. When the men try to court Daisy by bragging about how long a chain-gang sentence they would serve to win her over, "Mule Bone" surely succeeds in creating startling, linguistically lush folk com-

edy that nonetheless reflects the tragic legacy of slavery.

Those scattered passages, as well as sporadic well-turned lines, make the Barrymore vibrate, but they are surrounded by slack sequences and contemporary interpolations. "Mule Bone" opens with an embarrassing prologue by George Houston Bass, the literary executor of the Hughes estate until his death last year, in which Hurston herself awkwardly appears as a character on stage and gives the audience a primer on her career. At other isolated junctures five Hughes poems have been set to music by Taj Mahal, and sweet as the music and words are, the songs are not particularly well sung and always bring a flaccidly constructed show to a self-defeating halt. Dianne McIntyre's rudimentary, thigh-and-knee-slapping choreography lends only perfunctory animation.

•

As staged by Michael Schultz, who is certainly capable of tougher work, the whole enterprise has a candied Disneyesque tone, more folksy than folk. "Mule Bone" entirely lacks the striking visual style and gut-deep acting with which George C. Wolfe and his collaborators so precisely distilled the tough-minded voice of Hurston and the passions of her characters in "Spunk" last year. ("Spunk" also dramatized three Hurston stories in less time than "Mule Bone" takes to dramatize one.) Here the production design is mostly hokey, the performances often aspire to be cute, and even the fisticuffs are not played for keeps. While the authors intended "Mule Bone" to be funny, this production confuses corny affability with folk humor.

No wonder, then, that a number of precocious children roam the stage. The company is also profusely stocked with distinguished actors who have a lot of time on their hands while waiting for an occasional cue: Reggie Montgomery, Frances Foster, Robert Earl Jones, Arthur French. Though the three principal performers — Eric Ware, Kenny Neal, Akosua Busia — are at best likably amateurish, their efforts are balanced by the assured center-stage turns of such old pros as Leonard Jackson, as a fuming man of the cloth, and Theresa Merritt, who gets to shimmy to a traditional blues recalling her Broadway performance as August Wilson's Ma Rainey. But it is all too typical of the evening that Ms. Merritt's song, the sole rousing musical interlude, is abruptly truncated before it can reach a soaring conclusion. It's almost as if this maiden production were determined to make "Mule Bone" prove on stage what it has always been in literary legend — a false start that remains one of the American theater's more tantalizing might-have-beens.

1991 F 15, C1:4

When We Dead Awaken

By Henrik Ibsen; English version by Robert Brustein; adapted and directed by Robert Wilson; set design by Mr. Wilson and John Conklin; costume design by Mr. Conklin; lighting design by Stephen Strawbridge and Mr. Wilson; sound environment by Hans Peter Kuhn; songs by Charles (Honi) Coles; assistant director, Ann Christin Rommen. Presented by the American Repertory Theater, in collaboration with the Alley Theater in Houston and A.T.&T.: Onstage. At Cambridge, Mass.

Rubek Alvin Epstein
Maya Stephanie Roth
Spa Manager Charles (Honi) Coles
Maid Margaret Hall
Lars Steven Skybell
Manservant Michael Starr
Ulfheim Mario Arrambide
Irene . Elzbieta Czyzewska and Sheryl Sutton

By MEL GUSSOW

Special to The New York Times

CAMBRIDGE, Mass., Feb. 13 .— Ibsen's final play, "When We Dead Awaken," is one of his most adventurous and intensely personal works. As the author intended, it is a "dramatic epilogue" to his naturalism and a return to the poetic symbolism of earlier plays like "Peer Gynt" and "Brand." In it, an artist, a surrogate for Ibsen, suffers "remorse for a forfeited life."

Because of its allusiveness and its epic canvas, the play leaves ample room for directorial imagination. This is strikingly true in the case of Robert Wilson, in his first attempt at Ibsen (at the American Repertory Theater here). As a conceptualist, Mr. Wilson might find himself confined by the domesticity of "A Doll's House." But "When We Dead Awaken" acts as inspiration to his brand of theatrical magic realism.

The words are Ibsen's (in translation); the images and the interludes belong to Mr. Wilson. This is an interpretation, not a deconstruction of a text. The director's perambulations do not obscure Ibsen's unrelenting exploration of the agony of an aged, depleted artist. Though the production has a few rough edges, especially of a technical variety, it represents a creative collaboration between the director and the playwright, and between the director and his partner in design, John Conklin.

•

The protagonist of the play is a sculptor named Rubek, who has channeled all his passion into his sculpture and in the process has compromised his own genius. Late in life, cynical about his worldly success, he torments himself with what he has lost — in particular, the woman who was the model and muse of his youthful endeavors.

At a coastal spa, Rubek and his young wife, Maya, exude the boredom of a sterile marriage. They are Ibsen characters embarking on a Strindberg marital dance of death. Suddenly the model appears, aged and burdened by disillusionment. While hewing to Ibsen's play, Mr. Wilson approaches the characters as figures on a shifting metaphorical landscape. The play expands in length as well as in imagery: the Wilson version adds more than 30 minutes.

In keeping with the barrenness of the central couple, the resort of the first act is a cracked-earth wasteland; in the background we hear crashing waves, the first evidence of Hans Peter Kuhn's vivid score of sounds. The characters then move to a forboding mountaintop, heightened by two towering cliffs.

Rubek sits in a huge spidery chair that looks like a throne designed by Giacometti. From there he looks down on his wife standing before a bright blue ribbon of light representing a stream. Maya places a shoe in the stream and it magically floats away. The stage picture is mesmerizing; each time the curtain rises, there is a scenic transformation.

•

The spirit that most affects the landscape is that of Ingmar Bergman, in his own epic phase, as in "The Seventh Seal," not least of all because

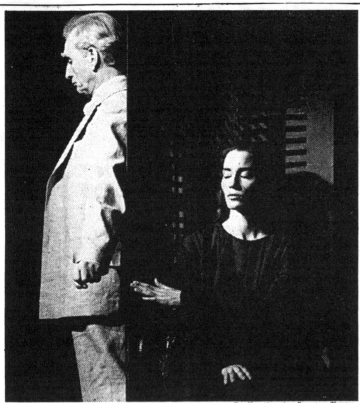

Dan Nutu/American Repertory Theater

Alvin Epstein and Stephanie Roth in a Robert Wilson production of Henrik Ibsen's "When We Dead Awaken" in Cambridge, Mass.

Death is a lingering presence. A Bergman "When We Dead Awaken" might approximate aspects of the Wilson version. There are no trees in sight, only stone, earth and ice, signifying the harsh, jagged view of people enthralled by their fate.

Alvin Epstein is a brooding Rubek, haughtily dismissive of his wife. As played by Stephanie Roth, the wife has the mercurial unpredictability of Hedda Gabler (who was also trapped in an impossible marriage of her own choosing). The model is an enigmatic force, doubly so in Mr. Wilson's conception. She is symbolically portrayed by two actresses, old and young, Elzbieta Czyzewska and Sheryl Sutton. Her shadow (and protector) is now her alter ego.

As one has come to expect from Mr. Wilson, the acting is highly stylized, voice and gesture burnished with a tinge of Kabuki. What at first is disconcerting becomes ritualistic as the director tries to choreograph the characters' inner emotions. Maya's willfulness, for example, comes out in sudden, almost violent mood swings.

•

For all the seriousness of effort, the production repeatedly uncovers a troll-like comedy within Ibsen, as in the conception of the bear hunter who seduces Maya. He is intended as a crude, natural man, almost a beast. As played with diabolical humor by Mario Arrambide, he becomes a satyr, down to his cloven hoof. His roguish abandon is the opposite of the sculptor's rigid repressiveness.

In the third act, as the characters head toward a threatening glacier, Mr. Wilson's invention momentarily flags, and there is a brief dramatic letdown. Flames spark unconvincingly before the final coup de théâtre, as the earth is struck by the rumble of an avalanche.

In characteristic fashion, Mr. Wilson has devised three short "Knee Plays" or entr'actes, which are presented in front of the curtain while the scenery is being changed. The legendary tap-dancer Charles (Honi) Coles sings sweet and sad blues of his own composition, often in harmony with the other actors. Mr. Coles appears fleetingly in the play itself as a hotel manager. Though the Knee Plays have nothing to do directly with Ibsen, they are a kind of contemporary evocation of the love the characters have denied themselves. These interludes could be excised, but we would miss Mr. Coles's engaging essence.

In the play, Mr. Kuhn's score, the lighting, scenery and performance all unite in a daring attempt to scale a craggy, neglected masterwork.

Simultaneously with the play's production, there is a retrospective exhibition, "Robert Wilson's Vision," at Boston's Museum of Fine Arts. In a series of walk-in installations, one can examine more closely the designs, sculptural objects, masks and puppets from the director's onstage dream world. Both the Ibsen play and the exhibition will travel to Houston; the play, May 22 to 26; the exhibition, June 15 to Aug. 18.

The exhibition echoes with memories of Wilson plays and operas, including an electronic panel from "Einstein on the Beach," a simulation of a spaceship that seems about to take flight. Visiting the museum and the American Repertory Theater, one experiences the double-edged nature of Mr. Wilson's work: the theatricality of his art and the visual splendor of his theater.

1991 F 16, 17:1

Light Shining in Buckinghamshire

By Caryl Churchill; directed by Lisa Peterson; sets by Bill Clarke; costumes , Michael Krass; lighting, Brian MacDevitt; dialect coach, Elizabeth Smith; original music and sound, Mark Bennett; production manager, George Xenos; production stage manager, Liz Small. Presented by New York Theater Workshop, James C. Nicola, artistic director, Nancy Kassak Diekmann, managing director. At Perry Street Theater, 31 Perry Street.

WITH: Bill Camp, Philip Goodwin, Steve Hofvendahl, Cherry Jones, Shona Tucker and Gregory Wallace.

By MEL GUSSOW

"Light Shining in Buckinghamshire" is a challenging play on the subject of revolution — the English civil war of the 17th century. Written in 1976, this was Caryl Churchill's first collaboration with the Joint Stock Theater Group, with playwright, actors and director immersing themselves in a historical canvas and creating a dramatic collage of a turbulent time.

Theatergoers seeing the play in its United States premiere at the Perry Street Theater may find themselves disoriented by the swirl of events and even by the style of storytelling. In this New York Theater Workshop production, four actors and two actresses repeatedly switch roles while playing dozens of characters. Identification is often blurred.

All this is as purposeful as it is demanding. The playwright seeks to give a comprehensive picture of the passions — and paradoxes — at the root of a rebellion that proved to be so consequential in English history.

•

The play is interesting for itself and for its renewed relevance in periods of world crisis. It is also significant in terms of Ms. Churchill's career. In subsequent plays like "Fen" (about farm workers in England) and "Mad Forest" (about the recent Romanian revolution), she has refined her theatrical techniques and her uses of the collage form. Rough and occasionally repetitive, "Light Shining in Buckinghamshire" is definably an earlier work, but in it she was powered by her conviction and by her desire to illuminate the most complex of issues.

England's 17th-century civil war is used as a canvas.

As Ms Churchill says in a prefatory note to the play, the belief in the millennium led to a war to establish heaven on earth. What was established instead was "an authoritarian parliament, the massacre of the Irish, the development of capitalism." In other words, the effects of the war can still be measured today. In the panoply of this densely populated play, we see children abandoned and men and women abused by those in power. One feels especially the plight of women at home and men recruited to be killed in battle without ever knowing what they are fighting for. Injustice replaces the law of the land.

The playwright seems most concerned with recurrent themes and a collective consciousness. But in performance, individuals emerge: a woman who is beaten and driven from parish to parish for the simple

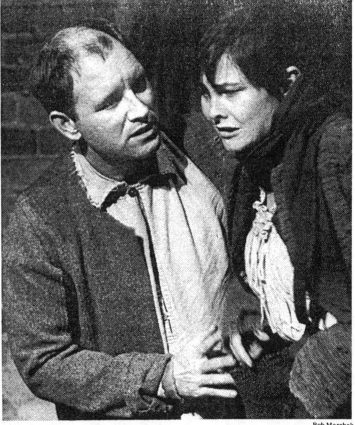

Bob Marshak

Steve Hofvendahl, left, and Cherry Jones in Caryl Churchill's "Light Shining in Buckinghamshire," at the Perry Street Theater.

fact that she is poor; the visionary (based on a real person) who looks behind the reign of terror and sees "a tiny spark of transcendent, unspeakable glory." Many scenes are glimpses on the run, others are extended confrontations and colloquies, as the play provides an object lesson as well as a group portrait of a country in extremis.

•

In evident emulation of Max Stafford-Clark's original English production, Lisa Peterson, the director, has kept the play stripped to its Brechtian core. The actors perform with the sparsest scenery and props. Bill Clarke's design has a Shaker-like simplicity: a table that when upended serves as a pulpit; chairs that are hung on pegs. Occasional songs are heard, and bells are rung as a call to arms and to meetings.

Under Ms. Peterson's impressive leadership, the cast is deft in its handling of the English atmosphere and material, with committed work from Philip Goodwin, Bill Camp, Shona Tucker, Gregory Wallace, Steve Hofvendahl and, especially, Cherry Jones. The austerity of the design is reflected in the performances.

The play asks for the audience's concentration and for a certain basic familiarity with the civil war. In that sense, "Light Shining in Buckinghamshire" is a very English play; one can readily understand why it has taken so long to arrive here. But it is a play that commands one's attention and that can lead to enlightenment.

1991 F 17, 71:1

**SUNDAY VIEW**/David Richards

'La Bête' (Rhymes With Set) Arrives

David Hirson's comedy in couplets explores artistic integrity; at Arena Stage, two new plays uncover buried secrets.

ECCENTRICITY IS FOREVER getting mixed up with originality. The woman who paints her fingernails black and her lips puce is thought to be original, as is the man who shares his one-room apartment with an iguana, three chickadees and a Dandie Dinmont terrier. Whenever people are expected to deliver words of appreciation — and those words just aren't forthcoming, "How original!" is the catch phrase that's usually rushed into the breach. It is said of artworks fashioned out of old galoshes and orange rinds, papyrus beach wear and new Brazilian dances.

■

I have no doubt it will also be said of "La Bête" (at the Eugene O'Neill Theater). Here, after all, is a mock 17th-century comedy written by David Hirson entirely in rhymed couplets and played in an elegant all-white French salon that appears to have had one drink too many and lost its equilibrium. Indeed, the walls rise to a vertiginous peak, while a massive gold chandelier hangs from the ceiling at a 45-degree angle, so that the audience actually has the sensation of sitting *under* it.

Once he manages to get a foot through the trapezoidal door, the lead character, a fatuous actor-playwright named Valere, embarks upon a 25-minute panegyric, celebrating his own limitless virtues, modesty included. Nothing — cockeyed set, other actors or the simple physiological limitations of the human lung — curbs the logorrhea. In that respect, Valere is the antithesis of Dorine, the maid, who expresses herself only in monosyllables that rhyme with "do" and otherwise resorts to pantomime to make her point. (With her bee-stung lips, red corkscrew curls and a black pannier that makes her appear wider than she is tall, Dorine looks rather like Little Bo Beep, as dressed by Pierre Cardin.)

Not only are Molière's comedies the obvious model here — "The Affected Young Ladies" and "The Impromptu of Versailles" immediately come to mind — Mr. Hirson has also made the master one of his characters in the person of Elomire (the anagram Molière's detractors used when taking him to task, usually for his popularity with the common folk). After years of touring the French countryside, Elomire has finally managed to establish himself and his troupe at court under the protection of the Prince of Conti. Now the Prince, eager to inject a little novelty into Elomire's repertory, has proposed that Valere be made part of the company.

You might as well ask Paul Bocuse to welcome Frank Perdue into his kitchen, but plots have to turn on something. For two hours, Elomire suffers personal affronts, digests artistic insults and even appears in "The Parable of Two Boys From Cadiz" (pronounced "Ca-DITH"), the idiotic play within the play that is Valere's masterpiece, before he finally asserts his artistic integrity and rejects the proposed alliance. To say this is not the usual fare on Broadway is self-evident. This is not the usual fare anywhere.

■

I wish I could go one step further and hail it for its originality. But that suggests a breakthrough, a new way of dramatic thinking, difference with a consequence, and "La Bête" merely seems born of collegiate bravado. It is the literary equivalent of packing as many bodies as you can into a telephone booth. A dare made good.

Mr. Hirson is undeniably adept at churning out couplets that are nimble, witty and sometimes even graceful. The trouble is, he can't stop churning them out. "La Bête" is intent on proving that more is more, not less, and that the boorishness of the title character is endlessly diverting. While the cast numbers 10 characters, plus servants, Valere hogs the place of 9. He's Buddy Hackett on the chateau circuit.

Tom McGowan makes a game effort at playing him — darting about the premises on tippy-toes, when he is not plastering himself against the walls in heroic poses. Let him forget the "bon mot" he's just coined, and he's down on his hands and knees looking for it as if it were a lost cuff link. He pouts, coos, rails. He makes faces and rude noises.

Criticism bounces off him like BB's off rhino hide. "To summarize in 30 words or less," says a deeply angered Elomire, when he's finally able to slip a couplet in edgewise, "I'd say you have the power to depress/ With every single syllable you speak,/ With every monologue that takes a week/ And every self-adoring witticism!" Mr. McGowan earns a big laugh by furrowing his brow and inquiring, "When you say 'depress,'/ Do you mean *bad* 'depress' or *good* 'depress'?"

Fifteen minutes of him are funnier than 30, however, and 30 are easier to take than 45. Mr. McGowan is operating under the law of diminishing returns, and it's not his fault. Valere, existing as he does in a self-contained universe of one, is allowed precious few chances to interact with others. The actor must play off himself, set up his own punch lines, find his comic

Joan Marcus/"La Bête"

Cast members of "La Bête" encourage the maid, Dorine (Johann Carlo), to talk in more than monosyllables—That this is not usual Broadway fare is self-evident.

inspiration in what he himself has just done. Zero Mostel could have pulled it off, I imagine, but for now, Mr. McGowan is not that resourceful.

■

Michael Cumpsty's Elomire is everything we would like to think Molière himself was — virile, intelligent and principled — although the scant historical evidence indicates a troubled side, too. (For that, Mr. Cumpsty's dark good looks will have to do.) As the Prince, Dylan Baker is depravity in a haughty state — the upward tilt of his sharp nose presumably compensating for his rotting teeth. He's harmless enough until crossed. Then, his voice drops an octave, his eyes narrow to disapproving pinholes, and his face, already pasty-white, acquires a distinctly grayish pallor.

If looks were all, "La Bête" could consider the battle won. Long after I had heard enough, I was still willing to watch. Those who applaud the audacity of Mr. Hirson's script are, I venture, really cheering for the production that houses it. Richard Hudson is responsible for the set and costumes, Jennifer Tipton for the lighting, and Richard Jones for the

staging, and you could rightfully say they've all gone and thrown classical theater into a tizzy.

Unlike Molière's comedies, in which a last-minute turnaround usually saves the day, "La Bête" ends

A pair of plays at Arena Stage in Washington show skeletons in the family closet: AIDS and the Nazi legacy.

with the Beast triumphant and the true artist obliged to flee into the wings. Mr. Hirson believes that ours is an age of debased ideals, tarnished humanity and empty words. (You didn't think "La Bête" was really about the 17th century, did you?) The man of conscience must be vigilant, "for nature gives advantage to a fool."

Such ideas are not unworthy. But in light of the evidence that precedes them here, don't they run the risk of being considered vaguely self-incriminating?

'Before It Hits Home'

Wherever you look these days at Arena Stage in Washington — and you have your choice of two new plays in repertory — skeletons are tumbling out of closets and demanding to be acknowledged. In Cheryl West's "Before It Hits Home," a bisexual black musician reveals that he has AIDS to his middle-class parents, who are not prepared to deal with the fact. Meanwhile, in Ari Roth's "Born Guilty," a Jewish journalist attempts to determine the psychological legacy of the Nazis by interviewing some of their children, now grown up and leading lives of varying desperation.

I can understand why Arena Stage would want to put the two works back to back. The assumption in each case is that a buried truth is really a lie, and that knowing, whatever pain it entails, is better than not knowing. There's no denying the timeliness of the bill, either. The reunification of Germany has once again thrown the

spotlight on that country's militaristic past, while the AIDS epidemic has proven to be no respecter of demographics. By showing us the impact of controversial issues on the family, the unit most of us understand best, both plays are performing a useful social function.

■

Ms. West is at the beginning of her career, and you can sense her straining for significance. However, embedded in an often didactic play, like explosions of quartz in an outcropping of rock, are some scenes of stunning fury. Neither the director Tazewell Thompson nor a cast dominated by Trazana Beverley and Sandra Reaves-Phillips backs off for an instant.

"Before It Hits Home" follows Wendal Bailey (Michael Jayce), a jazz saxophonist, from his first telltale cough in the blue haze of a nightclub to his last incoherent gasp on a hospital bed. Like the earliest AIDS dramas, it wants to sound the alarm and overturn some dangerous myths. Wendal's doctor tells him about support groups and public assistance programs and says things like, "I know it's difficult, but you have a

34

Joan Marcus/Arena Stage

Jurian Hughes, Mercedes Herrero and Michael Jayce appear in "Before It Hits Home" at Arena Stage—overturning some myths

responsibility to inform your partners." When Wendal can no longer fend for himself and returns home, he has the ignorance of his family to combat — which affords Ms. West further opportunity to correct misconceptions.

"Read the paper, Daddy! Ain't no joke," Wendal argues, after his father dismisses the epidemic as just another ploy by the white establishment to keep blacks in their place. "Black folks is sleeping and AIDS is steadily creeping. It's wearing a black face, Daddy. Not just a white face . . . How many people got to lay down and die before ya'll believe it." At moments like this, Ms. West's characters aren't talking to one another so much as addressing an audience for whom the whole subject of AIDS remains touchy, if not taboo.

Just when you're tempted to dismiss it all as film writing for the stage, Ms. West hurls two blistering scenes at you, and you know a playwright is at work. In the first, Ms. Beverley, who has given every indication of being a loving mother, discovers that her love doesn't extend to a son with AIDS. If the epidemic is to take up residence in her house, she'll leave. The mix of anger, helplessness and fanaticism trying to contain itself is galvanizing. Wrapping herself in numbness, Ms. Beverley heads for

the door — each hollow step disinheriting the child who has always been her favorite.

◼

Ms. Reaves-Phillips, who plays Wendal's good-time aunt, gets the other big scene, when she is called upon to embrace her nephew, by now wasted and half-crazed. Her raucous good nature dissolves at the prospect, and she turns into a savage, wailing raw tears of terror and shame.

Elsewhere, the play dwells in the less heady precincts of journalism. Once the AIDS crisis has passed, its reason for being will also disappear. For now, its novelty lies in the middle-class black setting — a tidy world of starched tablecloths and handmade afghans — where everything has a place and there's no room for the messiness of a scourge. A closed environment, Ms. West has rightly sensed, is an open invitation to drama.

'Born Guilty'

"Born Guilty" also wants to venture into prohibited territory. It is taken from a 1987 book of interviews by the journalist Peter Sichrovsky, who turns up as a character in the

stage adaptation, as well, interrogating a cross section of Germans — many of whose fathers belonged to the SS and participated in the extermination of the Jews. Some, it turns out, are coping with their poisonous heritage. Others have turned their backs on it. Still others have devised elaborate rationalizations for the confusion and pain they feel.

While they are all more complicated than the nicknames Sichrovsky (Henry Strozier) gives them — "the decent one," "the stuck one," "the intelligent one" — an effort is under way to categorize their behavior and fit it into a larger picture of collective guilt. The individual stories can be absorbing, but it struck me that the only valid conclusion is the obvious one: different people react differently to trauma. The case histories are spelled with comic vignettes in which Sichrovsky attempts to rent a car or purchase an apple in a supermarket and quickly runs afoul of procedures and regulations. The unavoidable implication is that Germans continue to follow orders.

◼

Zelda Fichandler's staging imposes a certain fluidity on this meandering quest, and among the actors who play multiple roles, Helen Carey is always crisp and to the point. In the end, though, I came away from "Born Guilty" feeling as if I'd been watching a sober-minded documentary on public television. There's no play there that I can spot. □

1991 F 17, II:5:1

Maybe It's Cold Outside

Direction and choreography by John Kelly; set design by Huck Snyder; film by Anthony Chase; costume design by Katherine Maurer; lighting design by Stan Pressner; music by Bach, Bellini, Elgar, Arvo Part and Stravinsky; produced by Liz Dunn. Presented by the Kitchen and John Kelly and Company. At the Kitchen, 512 West 19th Street.

WITH: Vivian Trimble, Byron Suber, Marleen Menard, Kyle deCamp and Mr. Kelly.

By MEL GUSSOW

With its gigantic watch faces and other oversized objects, Huck Snyder's evocative scenery for "Maybe It's Cold Outside" looks like a companion landscape to that in Maurice Sendak's storybook "In the Night Kitchen." The stage setting for this show (written, directed and choreographed by John Kelly, in collaboration with his company) soon becomes a field for the play of Mr. Kelly's imagination, as the audience is transported into a world of shadowy mood and memory. At the heart of the talismanic performance piece (at the Kitchen) are Mr. Kelly's reflections about growing up, about the pleasures and problems — and the brevity — of childhood.

The scene opens in an elementary schoolroom where the actors, dressed in uniforms, squirm in their seats. With a clownish agility, they compete for attention and positions of priority. They also pursue their feelings of sexuality. Then the students hopscotch to a higher grade to study

French. What follows is a mischievous dance for dunces, a fantasia in which the director demonstrates his quirky sense of comedy.

In the middle of the show, the performers (a harmonious cast of five headed by Mr. Kelly himself) are glimpsed in outline behind individual screens preparing themselves for a night's slumber. Soon they are swept into a dream within the dream play, culminated by Mr. Kelly's emergence to sing an aria from "La Sonnambula" by Bellini. His rapturous falsetto lifts the music into the already etherized atmosphere.

Sleepwalking is endemic to Mr. Kelly's directorial vision. One of his earlier pieces was "Diary of a Somnambulist." There is something trancelike — and entrancing — about Mr. Kelly's theater, in which he asks the audience to embark with him on an elliptical journey to an unsettling destination. As is his style, he melds various performance arts into a media mélange. In this case, there is a short film by Anthony Chase as well as an accompanying chamber concert of music played on the cello by Tomas Ulrich.

"Maybe It's Cold Outside" is an open-ended anthology, in contrast to other fully structured Kelly pieces, like "Pass the Blutwurst, Bitte" (his musings on the life of Egon Schiele) and "Find Your Way Home" (in which he used novel forms to retell the Orpheus myth). The new show's episodic, improvisatory nature will allow the director to expand or to distill it further.

Beneath the offbeat comedy there is an underlying seriousness, formally asserted toward the close of the show. Hooded stagehands who have been silently moving the scenery are suddenly caught up in the action. They fall to the ground like projectiles. At the same time on the screen are seen iconographic indications of numerous fatalities. Death has entered Mr. Kelly's dominion, as the beguiling innocence of youth is replaced by an adult melancholy. At its end, the play begins to explore the coldness beyond the door of the play room.

1991 F 19, C14:3

An Unfinished Song

Book, music and lyrics by James J. Mellon; directed by Simon Levy; scenery by Scott Bradley; costumes by Jeffrey Ullman; lighting by Robert M. Wierzel; sound by Raymond D. Schilke; musical supervision and arrangements by Lawrence Yurman; musical director, Marc Irwin; production stage manager, Karen Moore. Presented by Cheryl L. Fluehr and Starbuck Productions Ltd. At Provincetown Playhouse, 133 Macdougal Street.

Worth	Aloysius Gigl
Debbie	Joanna Glushak
Brad	Robert Lambert
Mort	Ken Land
Beth	Beth Leavel

By STEPHEN HOLDEN

If the measure of a new musical was its gawky sincerity, "An Unfinished Song," which has music, lyrics and book by James J. Mellon, would earn high marks. The show, at the Provincetown Playhouse, is an examination of grief that has the feel of a personal cry from the heart. But like so many works that try to exorcise personal pain, it hasn't the foggiest idea when to stop.

"An Unfinished Song" tells the story of a free-spirited young songwriter named Mort (Ken Land), who dies of bone cancer after concealing the news of his impending death from his estranged but still-adoring lover, Worth (Aloysius Gigl). Their happy eight-year union ended when Worth, a closeted gay lawyer, left Mort in New York to accept a law partnership in Chicago.

The blighted love story, which begins just after Mort's funeral and ends with the scattering of his ashes in the ocean, is told in flashbacks that involve the couple's three closest friends. Beth (Beth Leavel) is Mort's wisecracking, career-hopping ex-girlfriend. Brad (Robert Lambert) and Debbie (Joanna Glushak) are show-business aspirants who start out in New York and end up in Malibu.

The show is essentially a talky soap opera in which everything important is expressed at least three times. Mr. Mellon's soft-rock score aspires to the lyrical acuity of Stephen Sondheim and William Finn but misses by a mile, partly because his songs have so many more words than notes. With their hackneyed tunes and clichéd generalities, the big ballads sound like unedited rough drafts of Barry Manilow songs. It doesn't help that all five principals have unappealing voices and that the director Simon Levy has instructed the cast to declaim many of the numbers directly at the audience from center stage.

The show's one moment of levity is a number called "The Frying Pan." The song, which describes a crisis of indecision in Macy's basement, is unrelated to anything significant in the story.

1991 F 19, C14:5

Taking Steps

By Alan Ayckbourn; directed by Alan Strachan; set by James Morgan; costumes by Gail Brassard; lighting by Mary Jo Dondlinger; production stage manager, William Hare. Presented by Circle in the Square, Theodore Mann, artistic director; Robert A. Buckley, managing director; Paul Libin, consulting producer; Broadway at 50th Street.

Elizabeth Jane Summerhays
Mark .. Jonathan Hogan
Tristram Spike McClure
Roland Christopher Benjamin
Leslie Bainbridge Bill Buell
Kitty .. Pippa Pearthree

By FRANK RICH

A true man of the theater always makes a virtue of necessity, and that's what Alan Ayckbourn did when he wrote "Taking Steps" in 1979. In this work, the dramatist and director wanted to concoct a low farce of the door-slamming school — the play is an homage to Ben Travers, the between-the-wars master of British farce — but as always, Mr. Ayckbourn needed to tailor his grand plan to fit his home company in Scarborough, England, the Stephen Joseph Theater in the Round. How do you send actors popping in and out of rapidly slamming doors when they are always in full view of the spectators ringing an arena stage?

Mr. Ayckbourn's ingenious solution was to substitute floors for doors. In "Taking Steps," the sitting room, master bedroom and attic of a creaky English mansion are all placed side by side at ground level, with the "steps" between each of the three

Martha Swope/Circle in the Square Theater

Pippa Pearthree and, on floor from left, Christopher Benjamin, Bill Buell and Spike McClure in Alan Ayckbourn's "Taking Steps."

floors represented by flat carpeted paths on which the frantic characters mime their mad dashes up and down stairs. At the Circle in the Square, where the Broadway revival of "Taking Steps" opened last night, Mr. Ayckbourn's Scarborough-inspired scheme proves a trans-Atlantic godsend as well. For once, a problematic New York playhouse can house a script expressly conceived for its unorthodox topography.

To assure the authenticity of the staging, Circle in the Square has hired Alan Strachan, a longtime Ayckbourn associate, to direct the production. Though the results prove far less consistently uproarious than the premise and author promise, "Taking Steps" delivers enough spurts of frivolous pleasure to serve as an amusing, if plainly lesser, companion piece to "Absent Friends," the 1974 Ayckbourn comedy that is coincidentally in residence at the Manhattan Theater Club.

If anything, these two plays from the 1970's illustrate the opposite poles of the Ayckbourn esthetic personality that would merge seamlessly a decade later in culminating works like "A Small Family Business" and "The Revengers' Comedies." As "Absent Friends" is a dark piece exploring disappointed suburban lives, so "Taking Steps" is sheer froth, more intent on exploring the mechanics of theater than the workings of the heart. The two plays do share a middle-class milieu and some incidents — both send a sobbing, betrayed spouse farcically up a staircase, for instance — but "Taking Steps" never delves into its characters' psychological mishaps; instead, it exploits them for plot twists and

gags. Farce is too ruthless a form to allow for the leisure of introspection.

Mr. Ayckbourn's farce is prompted not only by its clever theatrical gimmick, which sometimes pays off by allowing three concurrent scenes to crisscross the stage at once, but also by the second, thematic meaning of its title: The evening begins when Elizabeth (Jane Summerhays), a former go-go dancer in television commercials, takes a step toward freedom by running away from her suffocating husband of three and a half months, a bucket magnate named Roland (Christopher Benjamin). And Elizabeth is not the only character taking steps to break out of her constricted existence. Her brother Mark (Jonathan Hogan) is trying both to get Roland to finance a fishing shop that is his life's dream and to reclaim the fiancée (Pippa Pearthree) who ran away on their wedding day with a waiter from the local Boar's Head pub.

To multiply the exits and entrances exponentially, Mr. Ayckbourn has also thrown in a ghost — Elizabeth and Roland's home is a supposedly haunted former brothel — and such non-paranormal phenomena as a scheming local builder in black motorcycle gear (Bill Buell), a nerdy young lawyer overdue for romantic adventure (Spike McClure), a strategically placed bottle of sleeping pills, a clamorous thunderstorm and a couple of unsigned letters that may or may not be suicide notes. In the fewer than 24 hours in which the action unfolds, the characters unwittingly ricochet between death and life almost as often as they bounce from bed to bed and floor to floor.

Once Mr. Ayckbourn cranks up all his machinery — which takes roughly

half of a nearly 90-minute first act — "Taking Steps" reaches a mirthful plateau, where it remains until the middle of Act II, at which point the laughter is cooled by the laborious tying up of the many loose ends. Perhaps some of the evening's strained and contrived passages would be more entertaining with a cast that sharpened the eccentricities that define the characters. In London, Mr. Strachan has often been responsible for directing the replacement casts in Mr. Ayckbourn's long-running hits, and, curiously, much of his New York company for "Taking Steps" has a second-team feel to it. This show could use a Nathan Lane or two.

No one is incompetent, but virtually every performance could be more polished and, in the later reconciliation scenes, less sentimental. Mr. Buell and Mr. McClure rely much too heavily on cartoon voices that are lazy substitutes for full-throttle comic invention. Ms. Summerhays never finds the daffy physical burlesque in Elizabeth's recidivist bursts of go-go dancing, and Ms. Pearthree's rebellious fiancée is rarely either as outrageous or pathetically lost as her punk costume and makeup suggest. The agreeable Mr. Hogan, a good actor not known as a farceur, hasn't quite located the forlorn comic spirit of an archetypal Ayckbourn loser, a man so dull that he need only begin talking about his deepest feelings to send his nearest and dearest nodding off.

The one exception to the workmanlike performance level — and a big one, happily — is Mr. Benjamin, an imported English actor whom New York audiences may recall from his Royal Shakespeare Company visits as Crummles in the original "Nicholas Nickleby" and as Dogberry in the Derek Jacobi-Sinead Cusack "Much Ado About Nothing." His bucket tycoon is a riotous throwback to the inflated, middle-aged, middle-class twits played by Terry-Thomas and company in the old Ealing film comedies of the 1950's. Pompous and impeccably clubby in the suburban manner, Mr. Benjamin's Roland gradually escalates his red-faced drunken boorishness until finally even his nose seems to have thickened along with his voice. He's a self-satisfied fool riding for a fall — and he takes it, in a performance that is the evening's most sustained vindication of Mr. Ayckbourn's vision of hysteria in the round.

1991 F 21, C13:1

Custer vs. the Indians, as the Indians See It

By BERNARD HOLLAND

The grace of "Winter Man" at the Dance Theater Workshop on Saturday night came as a surprise, and it was interesting in retrospect to figure out why one approached Andy Teirstein's musical-theater piece about the winning and losing of the West apprehensively and then came away with different feelings.

"Winter Man," first of all, preached to a largely young, hip audience long since converted to its cre-

ator's political intentions. Even those who did not feel deep guilt over America's abuse of the American Indian are plugged into the correctness of such a stance.

Unsurprisingly, Mr. Teirstein's sequence of 35 numbers — a mixture of singing, dialogue, dance and mime — sees the clash of the Cheyenne, the white settlers and their army under Custer largely from the Indian point of view, adding as a sort of Greek chorus the observations of a trader, Dutch. He is the solitary Wandering Jew of Eastern European tradition here transposed to frontier Colorado.

One braced for strident self-righteousness, but unnecessarily. Victoria Bussert's direction and Russ Borski's simple production design are models of succinctness and restraint. There are no dead spots, no opportunities for sentiment to creep in and hog the conversation.

Mr. Teirstein's book is not without humor or irony. The powwows between Black Kettle (J. Reuben Silverbird) and Custer (Eric Hanson) are negotiated through a devastatingly aphoristic army interpreter (Simon Brooking). The white man's disturbing justifications for violence and the Indians's pride-ridden militance in response are dutifully balanced; their relevance to our current warlike mentality makes itself clear without an added push from the stage.

The music is in a pleasant through-composed, pop-ballad style. It is always fluent and takes on real character in set pieces like "A Prisoner in Your Dream," sung ardently here by Marin Mazzie. Ms. Mazzie and Mr. Hanson are the noticeably professional voices, yet the quieter, occasionally faltering amateurism in other parts of the cast has a genuineness that adds rather than subtracts.

Dianne Adams at the piano is the leading instrumentalist. She is surrounded by Kevin Tarrant and Jorge Alfano playing a collection of Indian drums and flutes old and new. This is an ensemble work with 13 active singers and actors. There are blown lines, but everyone seems to know why they are where they are on stage.

It all works, reminding us that political heat placed beneath art can sometimes burn it to a crisp. "Winter Man" employs the cool hand of technique. Audience members leave the theater moved and troubled precisely because they have been made to see clearly.

Neal Ben-Ari is appropriately low-keyed and nicely musical as Dutch. Other cast members included Michelle St. John, Richard Ortiz, Robert Zolli, Machiste, James Apaumut Fall, Steve Ortiz, Maria Antoinette Rogers and Jody Kruskal.

1991 F 21, C20:1

Lost in Yonkers

By Neil Simon; directed by Gene Saks; scenery and costumes by Santo Loquasto; lighting by Tharon Musser; sound by Tom Morse; production supervisor, Peter Lawrence. Presented by Emanuel Azenberg. At the Richard Rodgers Theater, 226 West 46th Street.

Jay.................................Jamie Marsh
Arty................................Danny Gerard
Eddie...............................Mark Blum
Bella..............................Mercedes Ruehl
Grandma Kurnitz.............Irene Worth
Louie..............................Kevin Spacey
Gert................................Lauren Klein

By FRANK RICH

OF all the odd couples created by Neil Simon in his 30-year career in the theater, none has been less funny or more passionately acted than the battling mother and daughter indelibly embodied by Irene Worth and Mercedes Ruehl in "Lost in Yonkers," the writer's new memory piece at the Richard Rodgers Theater.

Ms. Worth, her usual elegance obliterated by a silver bun of steel-wool hair, rimless spectacles and a limping stride, is an elderly widow known only as Grandma Kurnitz. A childhood immigrant from Germany to the United States, she has devoted her adulthood to the Yonkers candy store over which she makes her home. Bella, played by Ms. Ruehl, is the 35-year-old child who never moved out and has paid with her life. A gawky woman with an eager smile and a confused, bubbly manner, Bella is, as one line has it, "closed for repairs." Her mind isn't quite right, her existence is bounded by the soda counter, and her development is arrested in early adolescence.

There's some humor in this, but, as one character remarks of Ms. Worth's Grandma, "I never said she was a lot of laughs." One doesn't have to be of German Jewish descent to recognize this ice-cold woman who yanks her face away from anyone who tries to plant a kiss on it and who belittles any relative who attempts to puncture her scowling reserve. She is terrifying, and not primarily because she wields a mean cane. As acted with matchless precision by Ms. Worth, Grandma is a nearly silent killer whose steely monstrousness can be found in the emotions she withholds rather than in whatever faint feelings she might grudgingly express.

As nature dictates, Bella is her opposite, and Ms. Ruehl imbues her with a vulnerability as electric in its way as the comic ferocity she so memorably brought to the role of a hellbent Mafia wife in Jonathan Demme's film "Married to the Mob." All elbows and knees, Ms. Ruehl seems to jitterbug constantly about the parlor, thirsting for any experience or human contact, however small and humdrum, that might come her way before her mother snuffs it out.

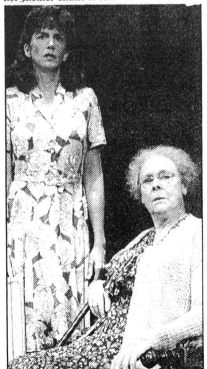

Martha Swope

Mercedes Ruehl, left, and Irene Worth in Neil Simon's "Lost in Yonkers."

Grandma and Bella are on a collision course, and when the blowout arrives, it not only brings "Lost in Yonkers" to a wrenching catharsis, but it also wipes out much of the nostalgically sentimental family portrait that Mr. Simon presented to Broadway audiences in his autobiographical trilogy of the 1980's. Whatever the virtues of the author's Brighton Beach plays, they always seemed a little too roseate to be true. The relatives on stage were guilty of peccadilloes and frailties, never major crimes. That's not the case here, where the only lines referring to the family as a safe haven are bitterly ironic. Grandma has a crushed foot — from her Berlin childhood — and she is out to get revenge on the world by crushing anyone or anything in her path. While Mr. Simon's autobiographical cycle officially ended with "Broadway Bound," it is in "Lost in Yonkers" that he seems at last to be baring the most fundamental scar of all, that of a child rejected by a parent.

I don't see how anyone can fail to be moved by the sight of Ms. Ruehl, the lonely repository of this grief, when she stands center stage in Act II of "Lost in Yonkers," crying and begging for the intimacy, physical and otherwise, she has always been so cruelly denied. If this play kept its focus on Bella and Grandma throughout, one might even be able to mention it in the same paragraph, if not necessarily the same breath, as "The Glass Menagerie," "The Effect of Gamma Rays on Man-in-the-Moon Marigolds" and "Gypsy," among other American classics about lethal mothers and oppressed daughters. But Mr. Simon, whether by sloppiness or design, falls considerably short of this hallowed territory. If he is no longer camouflaging human brutality, he is still packaging it within a lot of fluff, and not always his best fluff at that. While the gripping Grandma-Bella drama is never quite lost in "Lost in Yonkers," it is too frequently crowded out by domestic comedy of a most ordinary sort.

•

As it happens, the dramatic axis of this play is not usually Bella but Grandma's teen-age grandchildren, a pair of Hollywood-wise boys who share virtually all traits except their names with the brothers in the Brighton Beach plays. They are reluctantly dumped at Grandma's for a period of months by their father, Bella's widowed and broken brother (a vivid Mark Blum), who must take to the road as a salesman to pay off his late wife's hospital bills.

The boys are well enough played by youngsters (Jamie Marsh and Danny Gerard) whose only sin is that they are not Matthew Broderick, but their characters often are as secondary as the Pigeon sisters in "The Odd Couple": the brothers usually seem like wisecracking observers of the play rather than fully realized, fully engaged participants in it. For all their stage time, and all the talk about how much they may or may not be damaged by their own extended exposure to Grandma, their actual conflicts with her are bite-sized sitcom anecdotes, unsullied by the complexities of puberty or much visible fallout from the loss of their mother.

The other characters who pass through the Kurnitz apartment are two more of Grandma's damaged adult children, a daughter (Lauren Klein) who is reduced to a single scene and a single running gag and a mysterious gangster son who, as act-

ed with a commanding mixture of malevolence and avuncularity by Kevin Spacey, presides over some of the play's fresher comic interludes. (Mr. Spacey also makes high drama out of a dazzling curtain line revealing the identity of his true partner in crime.) Like the boys, these supporting players seem to come and go arbitrarily, as if Mr. Simon wanted everyone to hang around to entertain the troops as a way of forestalling the main, troublesome events involving his principal antagonists.

Given this dramatist's recent command of his craft — let's forget "Rumors" — the flaccid structure and automatic-pilot jokeyness of "Lost in Yonkers" are unexpected. Among the clumsier lapses are an opening scene of exposition that repeats itself incessantly for no reason other than the hokey, artificial delay of the formidable Grandma's star entrance, and two subsequent scenes that amount to little more than blackout sketches with thudding payoffs. Nearly every joke, theme or plot turn in "Lost in Yonkers" is laboriously telegraphed, to the point where even a playful conversation about a Bette Davis movie is drenched in pregnant meaning and virtually every character's guilty secret is transparent well before anyone onstage wises 'up. The only real narrative surprise all evening is an abrupt, supposedly shocking Act II sexual confession that seems pulled, unedited, from a Psych 101 textbook.

•

The passages that surround the confrontations between Ms. Worth and Ms. Ruehl are nothing if not painless, and they have been staged by the estimable Gene Saks with a bravura that sometimes is impressive (a family dinner in Act II) and sometimes overcompensates for the weaker writing and for the expansive confines of the Rodgers, not the coziest of Broadway theaters for nonmusical plays.

Ms. Worth excepted, everyone in "Lost in Yonkers" is "on" in the show-biz sense most of the time, which may explain why at the press preview I attended a mood-shattering ovation could break out in the middle of Ms. Ruehl's big soliloquy, as if the actress were belting a medley of show-stopping songs. The whole production could use more of the delicacy to be found in Santo Loquasto's set, which, as affectionately lighted by Tharon Musser, recalls the designer's sepia Coney Island interiors of the same period for Woody Allen's "Radio Days" and, in a richly textured front curtain, the New York chiaroscuro of Reginald Marsh.

If such lightness of touch is otherwise rare, its absence is balanced by the presence of something new in the playwright's canon: a raw anguish that not even the usual (and forced) upbeat final curtain can wish away. "Lost in Yonkers" is hardly Mr. Simon's most accomplished work, but when the riveting Ms. Worth and Ms. Ruehl take center stage to tear at each other and the audience, the wounds run so deep that one feels it just may be his most honest.

1991 F 22, C1:4

Ancient Boys

By Jean-Claude van Itallie; directed by Gregory Keller; design concept by Jun Maeda; music by Tony Scheitinger; movement by John Goodwin; lights by Michael Smith; costumes by Mary Brecht; stage manager, Marybeth Ward; assistant director, Kate McCamy. Presented by LaMama E. T. C. At 74A East Fourth Street.

Luke	Tom Bozell
Danny	Preston Dyar
Chris	Wayne Maugans
Ruben	Michael Ornstein
Sherry	Rosemary Quinn

By MEL GUSSOW

A gigantic sculpture of an animal dominates the stage in Jean-Claude van Itallie's "Ancient Boys" (at La Mama Annex). Towering like an icon, this is a Trojan horse-like assemblage designed by Jun Maeda from twigs and branches. Would that Mr. van Itallie's play had lived up to Mr. Maeda's design. "Ancient Boys" is itself like a Trojan horse, promising one thing (a probing study of the effects of AIDS) and delivering another (a sentimentalized dramatization of a death in a family).

Although the play may derive from deep personal feelings, the central character, a scenic designer and sculptor named Ruben, is seen at a distance through a purple haze of idealization. Frequently the audience is informed that Ruben is greatly admired, that he is in fact a genius. Neither the playwright's conception nor Michael Ornstein's performance approximates that genius.

The mercurial artist seems self-indulgent and confused about his loyalties — in friends as well as in art. On the most immediate level, the play is simply too brief to give an adequate impression of the reasons why Ruben is the center of his universe. In what has become a formula approach, he is introduced after his death, by his friends who have gathered in his studio to pay homage. Ruben has kept each of these people in a separate compartment, sealing off various aspects of his life. Through memories, the play flashes back.

Mr. van Itallie is somewhat more effective in depicting the people in Ruben's orbit than he is with the central character. But even here he has strayed into stereotype. Each of the friends is too easily tagged by a profession — psychiatrist, chorus boy, hustler, actress. The actress

Jonathan Slaff
Michael Ornstein in "Ancient Boys," by Jean-Claude van Itallie.

(Rosemary Quinn) seems to have the clearest understanding of the contradictory elements in Ruben's personality; more so, it would seem, than the psychiatrist. At public events, she is often asked to play the fictitious role of girlfriend, which she does with an alacrity that proves her kinship.

Watching "Ancient Boys," one thinks of other, more moving attempts to deal with related crises, including William Hoffman's "As Is" and Terrence McNally's "André's Mother." Theatergoers familiar with Mr. van Itallie's previous work would be justified in expecting a play of greater resonance.

In addition to Mr. Maeda's design, Gregory Keller's production benefits from its score, composed and played on stage by Tony Scheitinger on a variety of wind and percussive instruments. The music underscores the play with a mysticism not otherwise expressed in the text.

1991 F 24, 59:5

Juba

Music by Russel Walden; book and lyrics by Wendy Lamb; choreography by Mercedes Ellington; lighting by Susan White; set design by James Leonard Joy; costumes by Daniel Lawson; musical director, Ted Kociolek; production stage manager, Bruce Greenwood; production manager, Christophe Pierre. Presented by the AMAS Musical Theater, Rosetta LeNoire, founder and artistic director; Jeffrey Solis, producing director. At the Dimson Theater, 108 East 15th Street.

Juba	Kevin Ramsey
Diamond	James Brennan
Polly	Katharine Buffaloe
Hayden	Lawrence Clayton
Uncle Jim	Ken Prymus
Bella	Terri White
Fogarty	Mark Hardy
Spruce	Steve Boles

By STEPHEN HOLDEN

It isn't every day, or even every year, that a new musical comes along with the epic ambitions and solid craft of "Juba," which the AMAS Musical Theater is presenting in a skeletal production at the Dimson Theater.

With music by Russel Walden and a book and lyrics by Wendy Lamb, both musical-theater unknowns, the show is based on the biography of William Henry Laine, a young black street dancer (nicknamed Juba) who fell in love with Polly Spracket, a white British actress, in the 1840's. Set mostly in a poor New York neighborhood where disenfranchised blacks and impoverished Irish immigrants vied for the lowest rungs on the economic ladder, the show also details the cutthroat competition between Juba and his neighborhood rival, John Diamond, a hotshot Irish stepdancer. And its dialogue is unstinting in portraying the racial abuse heaped upon blacks, even those northerners like Juba who were born free during the pre-Civil War era.

The parallel stories of star-crossed lovers and a fight for esteem give "Juba" all the makings of terrific musical theater. Very roughly, and without borrowing too heavily, the show compacts the dramatic worlds of "Show Boat" and "West Side Story." With sub-themes of the exploitation of Juba in minstrel shows and the hiding of runaway slaves, the work has more narrative threads than it can comfortably accommodate.

That "Juba" can sort out the many strands so efficiently is owing largely to a score that carries much of the show's narrative weight while blending echoes of Irish traditional music and Negro spirituals into a conservative romantic format. The music reaches a height of eloquence early in the second act, with an extended pop spiritual, "My Yellow Sun," in which Juba's friends and neighbors voice their dreams for the future.

Sheldon Epps, the director, is best known for having conceived and directed the revue "Blues in the Night," which has had engagements on and Off Broadway. As with "Blues

Carol Rosegg/Martha Swope Associates
Kevin Ramsey and James Brennan as competing dancers in "Juba."

in the Night,'' he has taken material with incendiary passions and muted it into a pleasant, mild-mannered entertainment of historical interest.

The show's handling of the interracial love affair is at once timid and far too sketchy. Although Kevin Ramsey, in the title role, conveys his character's flaming defiance, Katharine Buffaloe's Polly is too much an ingenue and not enough of a free spirit for their attraction to make sense.

•

Of the three leading actors, James Brennan is the most comfortable, in his role of John Diamond. Although the story calls for Juba to rout him in an exuberant dance contest that ends the first act, Mr. Brennan is a more accomplished and agile stepdancer than Mr. Ramsey, so the outcome

isn't credible. Mercedes Ellington's demanding choreography calls for the two performers to execute rapid changes of style and pace while parodying each other as they compete. The fussiness of the choreography and the limitations of the actors make the contest less than riveting.

Given the meager resources of a company like the AMAS Theater, however, the production's many shortcomings are understandable. What is so heartening is that the show still holds together under such trying circumstances. Although the production isn't billed as a workshop, it might well be one for a show that has genuine Broadway potential.

1991 F 24, 60:1

Brenda Blethyn and Peter Frechette in "Absent Friends"—more sugar?

Gerry Goodstein/Manhattan Theater Club

SUNDAY VIEW/David Richards

An English Tea And a Folk Tale

In Ayckbourn's 'Absent Friends,' passing remarks are telling; in 'Mule Bone' tall tales grow taller by the second.

THERE'S NO SHORTAGE OF REAsons to catch "Absent Friends," the 1974 Alan Ayckbourn comedy that has been impeccably revived by the Manhattan Theater Club. But let's start with the breakdown that the British actress Brenda Blethyn undergoes midway through the second act.

In her American debut, Miss Blethyn is playing a housewife named Diana who doesn't have a lot to show for her life, if you discount a philandering husband and a rather too perfectly appointed house, which she does. Still, she's not going to let her discontent surface — not after she's gone to all the trouble of organizing an afternoon tea for long-lost Colin (Peter Frechette).

Colin's fiancée drowned in the ocean a few months earlier and Diana wants him to know that his old friends are standing by in his time of distress. Putting aside her own concerns and the fact that her husband's latest conquest may be one of the guests, she has been carrying on like a wren in charge of ushering in springtime. (She looks a bit like a wren, too, come to think of it, with her darting eyes and the nervous little side-to-side movements of her head.)

Whenever conversation has flagged, she's been there to start it up again. She's kept the sandwiches circulating and the tea flowing. She's listened to Colin's insipid memories, as if he were recounting miraculous exploits, and led the chorus of "oohs" and "ahhs," when he trotted out his photo album. In short, she's done all a hostess can humanly do, and finally she has to admit that the tea party is a bust.

Worse, her own life is a bust. Collapsing in a daze on the divan, she finds herself reminiscing about the red coat she always wanted as a child, although it turned out to be a disappointment when she got it. Because it wasn't a red coat, *per se*, she wanted. She wanted to join the Royal Canadian Mounted Police. Only everyone told her that young girls don't join the Canadian Mounties. They marry and have children, instead. So she followed their advice. And look what it's got her.

Suddenly, she can no longer contain the sobs, and she is wailing hysterically. Then in a tone that would galvanize a Greek theater, she screams, "I want to join the Mounted Police. *Please!*" It is an utterly absurd desire, of course, but it is also a shattering expression of a lifetime of frustrations. In the space of a few minutes, Miss Blethyn has gone from propriety to collapse — a breath-catching feat made even more so by the effortless brilliance with which the actress accomplishes it.

You would think such an outburst would be like a pail of cold water on "Absent Friends." It certainly brings the tea party to a screeching halt. But no. The grimmer matters get, the funnier they are. There may be no contemporary playwright more adept than Mr. Ayckbourn when it comes to marshalling comic evidence in support of Thoreau's proposition that "the mass of men lead lives of quiet desperation."

When it was first produced, "Absent Friends" represented a significant darkening of the playwright's canvas, although the third act of his 1972 comedy, "Absurd Person Singular," was clearly pointing in this direction. The evolution has only accelerated since then and his more recent works, yet to arrive here from London, seem to be actively courting misanthropy.

On our shores, however, his reputation rests largely on the technical virtuosity of such early works as "The Norman Conquests" (a trilogy that recounts the events of a weekend from the perspective of three different rooms in a country house) or "How the

Other Half Loves'' (a veritable jigsaw of a farce that superimposes one couple's drawing room upon another couple's living room and then lets the action in each locale unfold simultaneously).

■

By such yardsticks, "Absent Friends" is gimmick-free, which is not to say it isn't clever. Mr. Ayckbourn has assembled a houseful of bored, unhappy people and asked them to function as spiritual cheerleaders. Colin's spirits, it transpires, are in great shape. (One look at Mr. Frechette's beaming, ear-to-ear smile would tell you that.) But his penchant for dredging up inappropriate memories or indulging in instant character analysis throws his friends into a collective tailspin. The turnabout is as old as comedy itself and as fresh as last night's social debacle.

Few of Mr. Ayckbourn's lines are funny on their own. In the suffocatingly middle-class context, however, even passing remarks are instantly telling. Often, it is the blandest observation, offered up in distraction or duty, that proves the most hilarious. Indeed, at times the small talk in "Absent Friends" is so infinitesimal that it slips down between the sofa cushions, leaving everyone to munch the sandwiches in deafening silence.

In the course of this benighted reunion, less than two hours long, Mr. Ayckbourn also shrewdly evokes all the empty years that have gone before. The director Lynne Meadow, wonderfully alert to the discomfort of the present, is no less aware of the past humiliations. Her staging is accurate to a squirm. John Lee Beatty's set could have been lifted from House Beautiful, but under the circumstances it might as well be laid with mines.

■

Diana and Paul (David Purdham) parted ways long ago, even if they continue to live under the same roof. He skips out for squash and the occasional fling, while she stays home and practices the deadly art of being chipper. Terminally bored Evelyn (Gillian Anderson, and she's a find) buries her nose in women's magazines and if she even bothers to answer the outside world, it is in the curtest of monosyllables. Meanwhile, her oafish husband (John Curless) is either dancing around the room like a punch-drunk boxer or nervously jangling the change in his pocket. "The good thing about Evelyn," he volunteers, although no one has asked, "is that she has absolutely no sense of humor. Which is very useful since it means you never have to waste your time trying to cheer her up." The two also have a baby, whom they leave out in the rain a lot.

Good old Marge (Ellen Parker) also has a baby. It just happens to be her 302-pound husband, who doesn't show up for the tea party because he is at home in bed, spilling cough medicine on the mattress, exploding his hot water bottle and pleading, via telephone, for his wife to come home and nurse him. As party picker-uppers, they are an ill-chosen lot. But as a cast they make splendid companions in wretchedness. This is clearly the company that misery loves.

Mr. Frechette bobs in their midst like a cork on oily waters — impervious to the dark currents swirling around the furniture, up the stairs and out into the kitchen. He's what passes for happiness in Mr. Ayckbourn's universe, and that's only because he's unapologetically dense. His so-called friends are absent in spirit by the party's end, but so, in his own grinning, everything's-for-the-best fashion, is he.

'Mule Bone'

"Mule Bone," the folk comedy by Langston Hughes and Zora Neale Hurston, checks in at more than two hours, when 30 minutes would do just fine. Would its authors have realized that, if they'd had the opportunity to see their work up on its feet? Would they have strengthened the plot, pruned away the repetitions and imposed a firmer shape on the amiable sprawl that is currently on view at the Ethel Barrymore Theater?

Hypothetical questions. The play was still in its formative draft when the two writers, both prominent in the Harlem Renaissance, had an acrimonious falling out in 1930. The collaboration ceased abruptly, plans for an African American theater were shelved, and "Mule Bone" went into a 60-year seclusion, from which it is only now emerging in this Lincoln Center Theater production. Although it has been outfitted with a new prologue and epilogue by George Houston Bass and music by Taj Mahal and given an energetic staging by Michael Schultz, it remains very much a dramatic artifact — more viable today as sociology than as entertainment.

It is set in Hurston's hometown of Eatonville, Fla. (population 300, not counting snakes, rabbits and an obstreperous mule or two), where the main activity is gathering on the front porch of Joe Clark's general store and shooting the breeze. The language is flavorful, the put-downs good-natured and the tales tall and growing taller by the second. (Typical boast: "I seen [a woman] once so big she went to whip her little boy and he run up under her belly and hid six months 'fore she could fin' him.")

Because of the unabashed country dialect and the broad characterizations, "Mule Bone" has long been viewed in some quarters as perpetuating noxious stereotypes. In many ways, it's the black equivalent of Dogpatch. As if to defuse such charges, Hurston herself (Joy Lee) appears in the prologue to let us know that the town is being observed through the "spyglass of anthropology." The play is folklore, not fact. So be it.

Unfortunately, it's just not a very good play. The plot — when "Mule Bone" gets around to it — has to do with Dave (Eric Ware) and Jim (Kenny Neal), best friends who sing and dance for a living, and winsome Daisy (Akosua Basia), who comes between them for a while. In a fit of jealousy, Jim whacks Dave over the head with the "hock-bone of Brazzle's old yaller mule," is brought to trial in the Macedonia Baptist Church and exiled from Eatonville. When Daisy reveals a demanding side, however, the two men throw her over, renew their friendship and return home for the final hoedown.

Simple as it is, the plot is left unattended for great stretches at a time, while the townsfolk devote

Brigitte Lacombe/Lincoln Center Theater

Eric Ware, foreground, Akosua Busia and Kenny Neal in "Mule Bone" by Langston Hughes and Zora Neale Hurston.

themselves to gossip and neighborly insult. Any 15 minutes of this rural slice of life tells you as much as the whole. Fussing and feuding is, after all, fussing and feuding: The charac-

'Mule Bone' is set in Hurston's hometown (population 300, not counting an obstreperous mule or two)

ters — henpecked husband, domineering spouse, sanctimonious preacher, dim-witted sheriff — are overly familiar types by now. The large, likable cast can do only so much before "Mule Bone," a sketch at heart, simply runs out of sass. □

1991 F 24, II:5:1

Candida

By George Bernard Shaw; directed by Gus Kaikkonen; set by Bob Barnett; costumes, Steven F. Graver; lighting, Stephen J. Backo; music by Ellen Mandel; production stage manager, Matthew G. Marholin. Presented by Riverside Shakespeare Company. At Playhouse 91, 316 East 91st Street.

Miss Proserpine Garnett................Alice White
The Rev. James Mavor Morell........Guy Paul
The Rev. Alexander Mill..Christopher Mixon
Mr. Burgess...................Victor Raider-Wexler
Candida Morell........................Laurie Kennedy
Eugene Marchbanks........................Don Reilly

By STEPHEN HOLDEN

If the gist of George Bernard Shaw's play "Candida" were reduced to a single slogan, it might read, "All men are little boys." In Shaw's serious comedy, which the Riverside Shakespeare Company is presenting at Playhouse 91, the title character, Candida Morell, is an all-knowing sexual diplomat who mediates between the two men who vie for her like a mother pacifying bratty siblings.

Nearly a century after the play was first presented, the contestants for Candida's love remain an amusing and cleverly balanced pair of adversaries. Pious, suave and seemingly self-possessed, Candida's Christian Socialist husband, James, is a theatrical prototype for a modern-day narcissist beneath whose smug middleaged exterior terrible insecurities churn. His rival, the whining, compulsively candid 18-year-old poet Eugene Marchbanks, is no less self-absorbed. But naïve and romantically obsessed as Marchbanks may be, he is also, Candida perceives, the more resilient of the two.

In Candida, Shaw created a character who, by her strength and ability to cope calmly with male sexual turmoil, is a forerunner of modern feminists. In other ways, however, she is a merely progressive variant of a Victorian archetype of female benignity. The pedestal on which the playwright places her sits at an uncomfortably airless altitude.

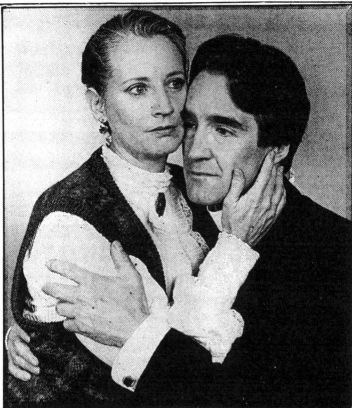

Carol Rosegg/Martha Swope Associates
Laurie Kennedy and Guy Paul in George Bernard Shaw's "Candida."

Not the least of the virtues of the Riverside Shakespeare Company's competent production is its clarity. As staged by Gus Kaikkonen, the two suitors' competing claims have the balance of a mathematical equation. Laurie Kennedy, the veteran Shavian actress who won praise for her Broadway debut as Violet in Shaw's "Man and Superman," is an engaging, slightly matronly Candida. In a low-keyed performance completely lacking in frills, she effortlessly embodies both men's fantasies of her as an angel of romantic mercy and a serenely compliant wife.

In the role of James, Guy Paul maintains a delicate balance between the character's charm and smugness that makes him seem at once likable and overdue for a comeuppance. As Marchbanks Don Reilly has some amusing moments flailing about the Morells' drawing room, but he plays the character as too much of a fool and not enough of a poet.

The most glaring absence from the production is a feeling of revelry in Shaw's aperçus. "Candida" is a play of ideas that much of the time has the tone of an arch drawing-room comedy. Any production of the play that mutes the ring of its epigrams undermines its wit.

1991 F 25, C13:1

The Mermaid Wakes

Based on the book by Lora Berg, Margaret Deutsch and Canute Caliste. Directed by Elizabeth Swados; based on the original workshop production by Ms. Swados; dramaturge, Dianne Houston; additional material by Lora Berg; music by Judy Bennett, Barrington Antonio Burke-Green, Natalie Carter, Percy Pitzu, Silindile Sokutu and Ms. Swados. Choreography by Mr. Burke-Green, Leslie Boyce, Thuli Dumakude, Dennison George and Ms. Sokutu; sets, Beau Kennedy and Jane Sablow; lighting, Brian Aldous; costumes, Mary Myers; masks, Mr. Kennedy. Presented by Under One Roof, in association with the Triplex. Wickham Boyle, producing director. At 199 Chambers Street.

WITH: Judy Bennett, Barrington Antonio Burke-Green, Leslie Arlette Boyce, Natalie Carter, Jerriese Daniel Johnson, Jesse Moore, Percy Pitzu, Silindile Sokutu and Felicia Wilson.

By STEPHEN HOLDEN

Jubilant calypso music washes through "The Mermaid Wakes," a fable-like family musical that celebrates the daily life and mythology of a Caribbean village. The facades of the village and its pathways have been constructed in a storybook set at the Triplex Theater, along with a painted shoreline and a dark-blue ocean that extends almost to the feet of the front-row spectators.

Collectively created by its cast of 10 actors and 4 musicians (many of them born in the West Indies) along with the director and composer Elizabeth Swados and the choreographer Thuli Dumakude, "The Mermaid Wakes" is the opposite in shape from a show like "Once on This Island," which has a similar location. Instead of translating one culture into the vernacular of another while keeping only some ethnic flavorings, it lifts the culture of its African-Caribbean setting intact and plunks it down whole.

Where "Once on This Island" concentrates on a single folk tale, Ms. Swados's exuberant pageant of singing, folk dancing and storytelling interweaves many vignettes into a tapestry of village life that has no conventional narrative thrust.

The song lyrics and poems maintain the evocative and not always comprehensible island patois. "When we get done/we go home/we cook/we lick de finger," goes a typical lyric. Although the work's 37 songs and poems take various shapes, many are simply fragments connected to one another without interruption so as to suggest a collective stream-of-consciousness.

"The Mermaid Wakes," was inspired by the work of Canute Caliste, a painter and seaman from the Grenadines island of Carriacou who has recorded the lives of his family and friends for the last six decades. Mr. Caliste is portrayed in the show as the visionary, fiddle-playing Grandpa, an eccentric communal patriarch. The show also incorporates the poetry of Lora Berg, who wrote much of it while living in Barbados.

The world of "The Mermaid Wakes" is one in which everyday activities, dreams and supernatural intuitions are so thoroughly interwoven as to be inseparable. In the song called "Kylee's Kite," for instance, a young girl flies a kite that soars over a coral reef and into a house where her grandfather is sleeping, and it becomes a part of his dream. This world also has different notions of time and death. The souls of the dead, declares one song, sit on the shore watching the living. "You can't see the old parents," it continues, "but they see you."

Ms. Swados, who has had extensive experience developing collective music-theater rituals, has woven all the material into a seamless show that runs under 90 minutes without an intermission. This kind of work stands or falls on the caliber of the performers, and "The Mermaid Wakes" has a wonderful cast. Jesse Moore, Felicia Wilson, Barrington Antonio Burke-Green and Silindile Sokutu are among those who combine vibrant voices with vivid personalities.

If its exotic language and swift pace make "The Mermaid Wakes" at times mystifying, together the performers succeed in creating a microcosm of an appealing folk culture.

1991 F 25, C14:3

Henry IV, Parts 1 and 2

By Shakespeare; directed by JoAnne Akalaitis; set designed by George Tsypin; costumes designed by Gabriel Berry; lighting designed by Jennifer Tipton; original music by Philip Glass; musical director, Alan Johnson; sound designed by John Gromada; hair and makeup by Bobby Miller; projections designer, John Boesche; fight director, David S. Leong; vocal coach, Catherine Fitzmaurice; associate producer, Jason Steven Cohen. Presented by Joseph Papp. At the Public/Newman Theater, 425 Lafayette Street.

King Henry IV......................Larry Bryggman
Henry, Prince of Wales.........Thomas Gibson
The Lord Chief Justice
 Richard Russell Ramos
Henry Percy and Bullcalf.........Miguel Perez
Henry Percy (Hotspur), Pistol and Feeble..............................Jared Harris
Lady Percy......................Lisa Gay Hamilton
Thomas Percy and Lord Bardolph
 Daniel Oreskes
Sir Edmund Mortimer.............Mark Deakins
Lady Mortimer......................Moon Hi Hanson
Sir John Falstaff............................Louis Zorich
Ned Poins......................................René Rivera
Mistress Quickly.....................Ruth Maleczech
Francis...............................Roger Bart
Rumor...........................Caris Corfman
Page.......................................Jason S. Woliner
Doll Tearsheet...........................Susan Wands
Shallow...................................William Duell
Silence..................................Richard Spore
Davy...................................Peter Schmitz
Mouldy...................................Tim Perez
Shadow......................................Tom Nelis
Wart......................................Arnold Molina

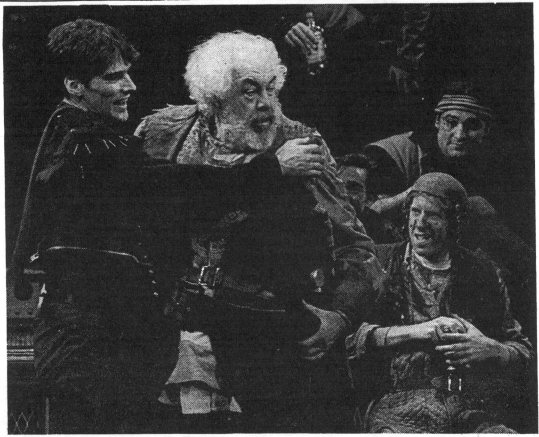

Martha Swope/New York Shakespeare Festival

From left, Thomas Gibson, Louis Zorich, David Manis, seated, and Tim Perez in "Henry IV."

By FRANK RICH

Kenneth Tynan famously described the two parts of "Henry IV" as "the twin summits of Shakespeare's achievement." The first good news about JoAnne Akalaitis's New York Shakespeare Festival production of both plays is that she hasn't turned them into "Twin Peaks."

Surprisingly, Ms. Akalaitis, whose narcissistic, post-modern "Cymbeline" sank on the same Public Theater stage (the Newman) in 1989, serves not just herself this time but herself and Shakespeare — and not always in that order. To be sure, one can spot the director's sensibility throughout her "Henry IV": the strikingly cinematic, fog-swept battle scenes boast traces of her mixed-media burlesque of the nuclear age, "Dead End Kids" (a Mabou Mines piece of 1980), and the Eastcheap tavern sometimes resembles the doomsday brothel from her staging of Genet's "Balcony" (at the American Repertory Theater in 1986). But one never feels that Ms. Akalaitis's own artistic signature is defacing Shakespeare's vision. The director is earnestly searching for, and often finding, common ground with a classic.

The other good news about this "Henry IV" is that Ms. Akalaitis has retained such imaginative "Cymbeline" collaborators as the set designer George Tsypin, the lighting designer Jennifer Tipton and the composer Philip Glass, but has not invited back that show's largely amateurish cast. "Henry IV" is solidly, if not brilliantly, acted throughout, by a mixture of familiar faces and engaging newcomers, and every line of a very tight text (each part weighs in at just under three hours) hits its mark. While this troupe lacks the unforgettable Falstaff or Hal or Hotspur that can make

an audience's blood rush, its deep professionalism extends to such secondary roles as Poins (René Rivera) and Lady Percy (Lisa Gay Hamilton).

•

Anyone who elects to visit "Henry IV" should see both parts — best accomplished on a single day, matinee and evening — because Ms. Akalaitis correctly sees them as an indivisible, sweeping canvas. Though the plays are ostensibly a freewheeling historical account of the waning, revolt-plagued reign of its title character and the concurrent rise of his successor, Henry V, they thicken into an epic that reaches from medieval times to the Renaissance, from city to country and from throne room to taproom while simultaneously examining the eternal conflicts between war and peace, rulers and ruled, parents and children, mind and heart, order and chaos. As much as the two parts of "Henry IV" are summits of their author's achievement, they are also at times a summation of Western civilization. One scales the plays' heights much as one sinks into the overstuffed Victorian novels that are among their literary descendants.

Few directors could realize the whole sprawling work, and perhaps any director's strengths and weaknesses will be exposed by Shakespeare's many theatrical challenges. The strong spine of Ms. Akalaitis's production is Prince Hal's rise to power. Thomas Gibson, a fine-featured young actor with high cheekbones and an aristocratic vocal mellifluousness, at first plays the heir apparent as a puckish country-club idler who goes slumming with Falstaff much as a present-day Prince of Wales might drop in at a Mayfair disco. The contrast is conventionally but dynamically drawn between this carousing dilettante and Jared Harris's headstrong Hotspur, a splenetic

rebel whose single-mindedness is conveyed through an excitable, stuttering vocal attack and an outlaw's take-no-prisoners scowl.

•

Once Hal has delivered his pledge to reform, Mr. Gibson steadily gains gravity and a Hamlet-like studiousness until finally he convincingly assumes the weight of a warrior who can vanquish Hotspur in arm-to-arm combat at Shrewsbury. (The gifted Mr. Harris doesn't disappear with Hotspur's demise but re-emerges in Part 2 as another kind of braggart soldier, a smoking and rubber-lipped Pistol.) Thanks to Larry Bryggman's wan, guilt-ridden Henry IV, the plays' tortured father-son relationship quickly fills the dramatic vacuum left by the resolution of the Hal-Hotspur rivalry. By the time the crown is to be handed down late in Part 2, the hollow-eyed Mr. Bryggman is as haunted as Macbeth by his Machiavellian past and Mr. Gibson's incipient Henry-V is a sterling leader, ready for the Agincourt heroics of "Henry V." The final reconciliation between Henry and Hal, played far downstage in a nocturnal hush at the king's deathbed, is a tender emotional reckoning.

The bond between Hal and his unofficial second father, Falstaff, proves less compelling. With his huge belly and silver beard, Louis Zorich looks picture-book perfect as the plump knight, and he captures the shrewd, world-weary intelligence of the role's set pieces, notably the catechism on honor. But the larger-than-life personality and sack-fueled wit that make the character a Rabelaisian fount of humanity in all its earthy excess is replaced by a more modest avuncularity; he hardly seems like an irresistible force of nature. Only when the newly crowned Hal callously banishes his mentor late in the evening does one feel the connection the two men once had. Trying to

retain his pride in the face of humiliation, Mr. Zorich's deflated Falstaff achieves the depth his puffed-up one never musters.

That the comedy of Falstaff often eludes this "Henry IV" is in keeping with Ms. Akalaitis's most obvious failing as a director, her scant sense of humor. The production's longest sags are its extended comic interludes, from the Gad's Hill robbery of Part 1 to the Gloucestershire diversions with Justices Shallow and Silence in Part 2. The slapstick clowning is noisy, broad and Teutonically choreographed, and the braying of Ruth Maleczech's Mistress Quickly brings low camp rather than low comedy to Eastcheap.

More unexpectedly, Ms. Akalaitis is also flummoxed by the plays' sober official sequences: the political conferences of the royals and the rebels. The actors are able — especially Daniel Oreskes, Mark Deakins, Rodney Scott Hudson, Arnold Molina and Richard Russell Ramos — but their stiff, front-and-center declaiming be-

Prince Hal, Falstaff and, of course, History.

longs to the old-fashioned school of historical drama in which august personages become human statues incapable of such mortal activities as, say, going to the bathroom.

It is in the larger movements of history that Ms. Akalaitis finds her most powerful theatrical effects. At times recalling Frank Galati's stunning "Winter's Tale" last season at the Goodman Theater in Chicago — Ms. Akalaitis directed the production that followed it there — this "Henry IV" is elegantly set at once in its actual period and in all of history. At its worst, this free-floating chronology leads to small-beer gags (Alka-Seltzer and Budweiser cans, among other contemporary kitsch, turn up as props) but at its best, it allows for inventive spectacle: In Part 2, Ms. Akalaitis uses subtle design adjustments, whiteface makeup and a hedonistic dumb show to remake the Bruegelesque, relatively bucolic Boar's Head tavern of Part 1 into a metaphor for an old civilization splintering into modern decadence and the savagery of the charnel house.

•

Mr. Tsypin's fluid sets are always inspired, seamlessly merging black-and-white slide projections and evocative silent film clips with classical design elements dominated by a decaying Gothic cathedral. One is reminded of bloodied landscapes as varied as Mathew Brady's Civil War and the fascist-infested forest of Bernardo Bertolucci's "Conformist." No less exceptional are Gabriel Berry's detailed, multi-period costumes and Ms. Tipton's lighting, which achieves an autumnal, medieval glow for the end of Part 1 and a wintry, snowy, at times fluorescent barrenness for the more contemporary terrors of Part 2. A few Nintendo-sounding battle riffs aside, Mr. Glass's score carries its own dramatic weight, adding a background of gusty, militaristic sound reminiscent of his "Mishima" in Part 1 before subsiding into melancholy chimes of midnight for Part 2.

Yet it is in the foreground that the grief and intimacy that dominate this reading of "Henry IV" are usually most vivid. It is typical of the director's meticulous approach that an arresting final image of Part 1 — a faceless soldier's slow exit across a smoldering battlefield with a corpse thrown over his shoulder — is echoed hours later by the sight of Hal carrying off his dying father into the enveloping darkness. Ms. Akalaitis has hardly embraced the whole universe of "Henry IV," but she finds her own world within that universe and, in a day and a night, takes the audience full circle on its orbit.

1991 F 28, C15:1

The Speed of Darkness

By Steve Tesich; directed by Robert Falls; set design, Thomas Lynch; costumes, Merrily Murray-Walsh; lighting, Michael S. Philippi; music and sound, Rob Milburn; production stage manager, William Dodds; associate producers, Howard Platt, Sheila Henaghan, Michael Cullen and Constance Towers. Presented by Robert Whitehead and Roger L. Stevens with Robert L. Sachter and American National Theater and Academy. At the Belasco Theater, 111 West 44th Street.

Joe	Len Cariou
Anne	Lisa Eichhorn
Mary	Kathryn Erbe
Lou	Stephen Lang
Eddie	Robert Sean Leonard

By FRANK RICH

"**T**HE SPEED OF DARKNESS," Steve Tesich's new play, is only a few minutes old when a character announces that blood will eventually be spilled on the living-room carpet of the all-American home where it takes place. By the time the final curtain falls more than two hours later, blood has indeed been spilled, and so have guts, shameful secrets and a heap of dirt that stands for the stain on a family and a nation. That's the kind of play Mr. Tesich has written: one that tells you what it is going to do and then does it, messily perhaps, but with a vengeance and, once it finally gets going, with an inexorable grip.

It is also the kind of defiantly old-fashioned drama, big-boned, unsubtle and aflame with passion, that few writers as high-minded as Mr. Tesich, best known as the author of the film "Breaking Away," would be caught dead writing anymore. There could be no more perfect setting for it than the Belasco Theater, a glorious old Broadway house that has known its own darkness more often than not in recent decades. David Belasco, the impresario and dramatist who built the place in 1907, believed in thunderous emotions, and his theater, an almost ecclesiastical cavern glinting with mosaics of colored glass, seems designed to showcase them. In "The Speed of Darkness," Mr. Tesich's best scenes mesh with some thrilling acting to turn back the Belasco's clock.

The evening's cast is headed by Len Cariou and Stephen Lang, as Vietnam soul mates whose paths cross again 20 years after they left the service. Mr. Cariou is Joe — war hero Joe, self-made Joe, Middle American Joe, the archetypal father who runs a construction business and presides over the Naugahyde-upholstered South Dakota household at hand. Mr. Lang is Lou, the buddy he long ago rescued, and these days a homeless man with moth-eaten cloth-

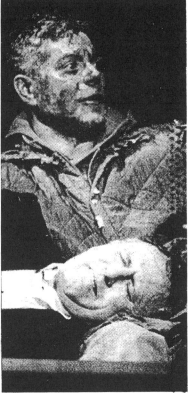

Martha Swope/"Speed of Darkness"

Buddies
Stephen Lang, top, and Len Cariou star in "The Speed of Darkness," about a reunion of two Vietnam veterans in a South Dakota town some 20 years after the war.

ing, lice-infested hair and a gift for street-corner philosophizing. Lou devotes his energies to following a copy of the Vietnam Veterans Memorial — a traveling "son of wall" — that has found its way to Sioux Falls as part of a cross-country tour. He soon settles in with Joe, Joe's wife (Lisa Eichhorn) and their high-school senior daughter (Kathryn Erbe) as an uninvited if not entirely unwelcome guest.

To say more about the story of "The Speed of Darkness" would be to spoil one of its prime assets, for Mr. Tesich unabashedly believes in narrative. He also has faith in other familiar verities of traditional American dramaturgy. The fifth member of the cast, that sensitive young actor Robert Sean Leonard, plays a neighborhood boy who doubles as an unofficial Greek chorus, promising the audience a tragedy and sometimes

An extreme stain is portrayed in an extreme style.

sounding like the lawyer who portentously narrates Arthur Miller's "View From the Bridge." Mr. Tesich also gives "The Speed of Darkness" a buried crime out of Mr. Miller's "All My Sons" and a symbolic, imaginary baby out of Edward Albee's "Who's Afraid of Virginia Woolf?" or more recently Sam Shepard's "Buried Child." Joe's family sometimes behaves like the Vietnam-era brood of David Rabe's "Sticks and Bones,"

and is it my imagination that Mr. Cariou is starting to look like Lee J. Cobb?

•

Sure, there's a paint-by-numbers quality to some of this, and no, Mr. Tesich does not deliver a Great American Tragedy by the final scene — just a very chewy climactic soliloquy for Mr. Cariou that substitutes an excess of melodramatic revelations for the one deep truth that might raise characters and audience alike to higher ground. But speaking as someone who has found Mr. Tesich's more recent plays ("Division Street," "Square One") and screenplays ("The World According to Garp," "Four Friends") either precious or pretentious, I was almost always captivated by his heartfelt writing here, despite his sometimes open manipulation of his character's strings and the slow-motion exposition that cripples the first half or so of the first act.

Many of the best lines belong to Mr. Lang, a fascinating actor who specializes in psychos ("A Few Good Men," the coming film "The Hard Way") but here keeps us guessing whether Lou is the craziest or wisest person on stage, or both. With his military stature, feral eyes and weathered face, he is, as always, a mesmerizing figure, and his diction, as classically polished as his body and clothes are filthy, adds to his unsettling presence. He could not have a better opportunity to show off his range than "The Speed of Darkness." Mr. Lang is brilliant in his delivery of Mr. Tesich's funniest speech — a Robin Williams-esque spiel about the relative merits of pre- and post-modern public statuary to the urban homeless — and he gives a searing account of the play's most moving monologue, in which Lou recounts his arrest for trying to scratch his name with a can opener into the Washington wall of the dead.

•

Lou's point is that the survivors of the Vietnam War deserve a memorial, too, because many of them, like him, survived in name only and are still what he calls M.I.A., or Missing in America. ("We weren't saved. We were rescued," is how Joe puts his own emergence alive from battle.) Mr. Tesich's larger theme is that the entire country must break through the wall it has erected around an unhappy chapter in its history if it is to be free of its guilt. Along with the wall, the evening's other principal metaphor is garbage, for it is in garbage removal that Joe got his postwar start in civilian life, taking his neighbors' "trash and filth and waste" and burying it "somewhere, anywhere, out of sight." In the playwright's view, that waste, however ugly and poisonous, must be brought from the darkness into the light if it is at last to be understood and overcome.

Mr. Tesich has not so successfully worked out his play at the marital level, and Joe's wife, well played by Ms. Eichhorn in apparent emulation of Dianne Wiest, never adds up. Though it still lacks a wholly satisfying ending, "The Speed of Darkness" has otherwise been profitably shorn of much, if not all, of its overwriting since its premiere almost two years ago at the Goodman Theater in Chicago. Then as now the firm director is the Goodman's artistic leader, Robert Falls, and if he shares responsibility for the evening's early leaden gait (and the unfortunate "Twilight Zone"

music accompanying it), he also presumably deserves credit for the inspired recasting. (Only Mr. Lang is a holdover from the Chicago company.) In Ms. Erbe, a beautiful and poised young actress who makes Joe's daughter an intelligent girl-woman with a rapidly evolving, transparently exposed psyche, he may have made a major discovery.

For Mr. Cariou, "The Speed of Darkness" may be the most challenging assignment since "Sweeney Todd," and he acts his heart out in a role that variously calls for Chamber of Commerce boorishness, belligerent drunkenness, paternal tenderness and finally the promised self-exorcism in which he spews out Joe's own garbage of a lifetime. By then, the V-shaped back wall of Thomas Lynch's domestic set seems to have blackened into another, hellish image of the war memorial, a jolting go-for-broke gesture that typifies a drama intent on retrieving the theater's past no less than the trauma of Vietnam.

1991 Mr 1, C1:1

Critic's Choice

Adapted from Chekhov's short story "In the Ravine," Romulus Linney's "Unchanging Love" is a plangent play about a conflict between small-town greed and untainted innocence. In it, Mr. Linney has linked his art with that of Chekhov, transplanting the narrative from Russia to the foothills of Appalachia. The characters and themes belong to Chekhov; the dialogue is Mr. Linney's.

In his version (at the Triangle Theater Company), country music and Carolina accents set the bucolic tone. At the center is a wealthy storekeeper, who, along with his grasping daughter-in-law, is unencumbered by questions of morality. Both characters are uncaring about the environmental disaster that is about to strike the community.

Tom Brazil

T. Cat Ford in "Unchanging Love," at the Triangle Theater Company.

As directed by John Dillon, who staged an earlier production at the Milwaukee Repertory Theater, "Unchanging Love" features a cast of lesser-known actors who are closely attuned to the work's regionalisms and to the subtleties of Mr. Linney's characterizations. There are especially evocative performances by three actresses, Jennifer Parsons, Jacqueline Knapp and T. Cat Ford (as that daughter-in-law, who is overcome by her ambition). Playwright, director and actors create a portrait that exudes vitality and local color.

Mr. Linney's plays are done with great frequency at America's regional theaters. Unfortunately, they do not always reach New York, and when one is presented here, it is usually for a brief run at a small theater. This is the case with "Unchanging Love," which is scheduled to give its final performances tonight and tomorrow at 8 and Sunday at 3 P.M. at the Triangle Theater, 316 East 88th Street. Tickets are $12. Information: (212) 860-7244.

MEL GUSSOW

1991 Mr 1, C22:5

The Almond Seller

By Oana-Maria Hock; directed by Tina Landau; lighting design, Peter West; music and sound, Jeff Halpern; set design, Clay Snider; costume design, Nephelie Andonyadis. Co-produced by House Frau Inc. and Via Theater. Presented at BACA Downtown, Bonnie Metzgar, director. At 111 Willoughby Street, in downtown Brooklyn.

Ion Nebunu	Paul Zimet
Baba Iana and Fate	Maria Porter
Anika and Fate	Nina Mankin
Lina and Fate	Theresa McCarthy
The Widow's Daughter	Nancy Hume
Alexa	Thomas Nahrwold
Toma	Kirk Jackson

By MEL GUSSOW

The recent Romanian revolution did not end with the execution of Nicolae Ceausescu and his wife but continued through the subsequent election of his successor. Those turbulent times were chronicled with perspicacity by Caryl Churchill in "Mad Forest," seen last year in London. "The Almond Seller" by Oana-Maria Hock is both a parallel work to that of Miss Churchill and an extension of it, moving ahead into the aftermath and also looking back into a kind of mythical pre-history.

Ms. Hock's play (at BACA Downtown, 111 Willoughby Street in downtown Brooklyn) lacks the clarity and dark humor of "Mad Forest." Audiences at the Brooklyn theater may find it as confusing as the revolution itself, and it is certainly overwritten. At the same time, the work is heightened by scenes that testify to the playwright's conjuring talent. Ms. Hock, a Romanian who emigrated to the United States and revisited Romania last June, also speaks with the authenticity of someone who has been steeped in her native culture.

The first idea that could be safely jettisoned from the play is the framework of three Fates, who introduce the evening with linguistic toil and trouble. With the entrance of Paul Zimet in the title role, the play gains its footing. Mr. Zimet is both gravedigger and almond seller. Rooting for relics in a mass grave, he finds wooden spoons and wild radishes along with old bones, layer upon layer, all buried together in what is described as "a holy mess."

At the center of the narrative are three young Romanians, two men who once were as close as brothers and a woman who fled from her country to America. The woman (Nancy Hume) returns to her home with the most naïve of journalistic purposes, "to do a photographic essay of free Romania." As she soon realizes, freedom is a mirage. Eventually she re-encounters the two friends from her youth, now battling on opposing sides, as well as three women of the town (Fates in modern guises) who embody the permanency of sorrow.

The photojournalist does not know which way to turn. Her recollections are rebuffed as intrusions and her attempts at amelioration are hopeless. In her relatively brief absence from Romania, she has become an outsider and is made to feel guilty for abandoning her friends and family. Even as the heroine is caught up by the siege of events, it is clear that she has returned too late. As the playwright indicates, to know a revolution one must live through it — or die in it.

Under Tina Landau's forthright direction, "The Almond Seller" sprawls over Clay Snider's large, dusty set. The atmosphere is filled with gritty imagery. Many of the scenes take place in the town square, as represented by a small platform at the front of the stage. This is a crossroads where Government-supported miners are mobilized to fight rebellious students, who are variously disdained as intellectuals and as tramps.

Without a map, it is difficult to differentiate locations and antagonists. But the play is helped by its sense of history (and by Jeff Halpern's score, which is threaded with sounds of Romanian music). Beneath the encrusted earth is, we are told, the oldest village in the world. In time, detritus of this latest rebellion will join the sediment.

Though there are forceful performances by Ms. Hume, Kirk Jackson and Thomas Nahrwold as the three friends, it is Mr. Zimet's acting and the spirit of his symbolic character that give the play density. He is portraying a man who has suffered through and survived wave upon wave of revolutionary combat.

1991 Mr 2, 15:1

Underground

By Joshua Sobol; English adaptation by Ron Jenkins; directed by Adrian Hall; set design by Andrew W. Boughton; costume design by Azan Kung; lighting design by Glen Fasman; music composed, arranged and directed by Barbara Damashek. Presented by Yale Repertory, Lloyd Richards, artistic director; Benjamin Mordecai, managing director. At New Haven.

WITH: Rob Campbell, Thomas Derrah, William J. Devany, Kristin Flanders, Ruth Jaffe, Paul Kielar, Richard Kneeland, Howard London, Derek Meader, Marty New, Barbara Orson, Ford Rainey, Martin Rayner, Liev Schreiber, Priscilla Shanks, Bennet Stephens, John Watson, Jack Willis and Zoey Zimmerman

By MEL GUSSOW

Special to The New York Times

NEW HAVEN — "Underground" is the third play in Joshua Sobol's trilogy about life in the Vilna ghetto during World War II, a trilogy that began with "Ghetto," produced two seasons ago on Broadway. Unfortunately, the new play (in its world

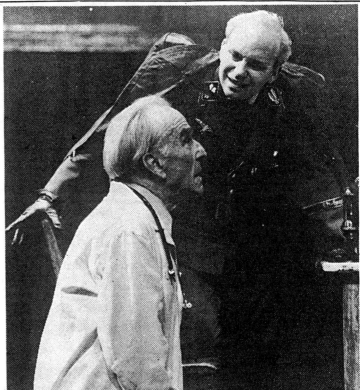

Gerry Goodstein/Yale Repertory Theater

Ford Rainey, left, and Thomas Derrah in "Underground," a tale of the Vilna, Lithuania, ghetto, at the Yale Repertory Theater.

premiere at the Yale Repertory Theater) suffers from some of the same problems that troubled the earlier work. Beneath the evident sincerity, there is an artistic manipulation, exacerbated by the awkwardness of Mr. Sobol's writing. Once again, the playwright's ambition exceeds his grasp.

The subject is, of course, heavy with portent. Vilna, called Vilnius today, was considered the "Jerusalem of Lithuania," and in spite of the German occupation, the ghetto managed to continue as a center of Jewish culture. The play "Ghetto," deals with the theatrical group that performed inside the walls of the city within the city. "Underground," using several of the same characters, focuses on medical aspects of the confinement, specifically a new ward in the ghetto's hospital set up in order to conceal cases of typhus from the Nazis.

In search of a modern relevance for the work, the narrative begins in Jerusalem today during an Iraqi bombing of that city. If handled provocatively, this prelude might have given the work texture. Instead it seems superimposed. The play is not about the war in the Persian Gulf.

Intrepidly, the author brings an "anonymous man" to an Israeli hospital for observation. A nurse's convenient discovery of the patient's journal sends the play spinning on a backward path to Vilna, where the man had been a patient in the typhoid ward. In the past, the ghetto doctor (Martin Rayner) reluctantly opens the ward and becomes a heroic figure, challenging the Germans while pursuing his own altruistic goals. In a subplot, he has an affair with his medical assistant (Priscilla Shanks). That romance is the weakest element in the play.

In the background is Jacob Gens (also a character in "Ghetto"), the head of Jewish police within the ghetto. Depending on one's point of view,

Gens is either a pragmatic rescuer of people doomed to destruction or an amoral traitor willing — perhaps eager — to act as God, giving up certain lives in order to save others.

As in "Ghetto," the playwright raises ethical questions in the person of Gens, but does not adequately confront the contradictions. In the end, Gens is a subsidiary character, in contrast to the two doctors. The first act is a long and superficial buildup to the opening of the new ward. That delay would be less important were the writing of a higher caliber, but the dialogue never rises to the demands of the material.

•

Finally, with the typhoid ward, the play momentarily comes to life, as the patients, in collusion with their doctors, create bogus symptoms in order to outwit the Gestapo. If the Nazis knew the true nature of the illnesses, they would take drastic action. Of the Nazi officers depicted on stage, only one (Thomas Derrah) is more than an empty uniform, and he is that stereotypical Nazi character who mixes high esthetic tastes with a sadistic craving for power. In "Ghetto," that role was played by Stephen McHattie.

Under Adrian Hall's direction, the play moves with relative swiftness from present to past; Mr. Hall is a proven expert at deploying masses of people. Mr. Rayner and Ms. Shanks are steadfast as the Vilna doctors and lovers, Jack Willis emphasizes Gens's dominant personality and Mr. Derrah has the requisite oiliness for the head Nazi. But many of the characters disappear into the background or simply become mouthpieces for the author. The play's structural flaws remain undisguised. "Underground" is an instance of too little artistic imagination brought to bear on a subject of great moral complexity.

1991 Mr 3, 64:1

Blue Heat

Written, designed and directed by John Jesurun. Lighting design, Jeffrey Nash; production manager, Dayton Taylor; choreographer, Richard Eric Winberg. Presented by INTAR Hispanic American Arts Center, Max Ferrá, artistic director; Eva Bruné, managing director. At 508 West 53d Street.

WITH: Oscare de la Fé Colón, Divina Cook, Larry Tighe, Michael Tighe, Sanghi Wagner and Eileen Vega.

By MEL GUSSOW

With "Blue Heat," John Jesurun continues his idiosyncratic experimentations in the uses of sound, light and video to create a multiplex environment. This time, his setting (at Intar Two) is a scooped-out space that in a shimmering light looks like the inside of a plushly lined coffin.

Once the lights come up and the play begins, the set is used as a nightclub stage and, later, as a swimming pool without water. As usual with a Jesurun piece (from "Deep Sleep" through last year's "Everything That Rises Must Converge"), tricks are played on a theatergoer's eyes and ears. This time, however, there is little to stimulate one's mind, or rather, what there is seems like intentional illogicality.

In characteristic Jesurun fashion, the play is about noncommunication or methods of avoiding connection. The chaotic narrative concerns a touring troupe of Hispanic dancers and singers performing in a tacky club somewhere in Ohio. They are pursued by the immigration authorities. Plot complications include a horde of mice and an elephant that has fallen into the swimming pool (all creatures are of course unseen by the audience). There is a passing reference to "The Wizard of Oz," as if all this might be a dream, Dorothy. Additional attempts at exegesis will only lead to a crowded cul de sac. As one character says, "This is a tough nut to crack" — and so it is.

•

The sanest course is to concentrate on the visual canvas and Mr. Jesurun's inventive use of special effects. The actors on stage exchange dialogue with colleagues backstage whose images appear on a bank of television monitors. In one dressing room, a television screen pictures a third actor who makes this a three-way conversation, the Jesurun equivalent of Chinese boxes.

Mr. Jesurun, author, director and designer, also plays with language as sound, shifting from English to Spanish and a dialect halfway between. Interspersed are pop songs with a Hispanic beat. Two lithe dancers (Sanghi Wagner and Eileen Vega) share the stage with Larry Tighe in drag. Others include Michael Tighe, who transmogrifies from a doll with a dubbed voice to a live person subjected to various indignities.

Dialogue and narrative are not Mr. Jesurun's métier, but this time the textual climate is cloudier than normal. Fortunately, "Blue Heat" is brief, offering the theatergoer ample opportunity to experience the counterplay of technical dexterity and scant time for reflective thought.

1991 Mr 3, 64:5

Neil Simon Finds a Tragic Character at Last

By DAVID RICHARDS

NO ONE WILL HAVE ANY TROUBLE RECOGnizing "Lost in Yonkers" as a product of Neil Simon's seemingly inexhaustible imagination. For 30 years now, he has been wringing comedy out of domestic discord with a regularity that may safely be termed obsessive. In this, his 27th work for the theater, he's up to his old tricks again, but with one significant difference. He begins "Lost in Yonkers" where most of his other plays leave off.

It has long been his custom to take characters in a state of apparent normalcy and self-control and then, over the course of the evening, drive them to distraction. Or more accurately, let them drive one another to distraction. (Mr. Simon rarely goes for the jugular, you may have noticed. Nerve endings are his preferred target.) Such is the operating premise of "Barefoot in the Park," "The Odd Couple," "Prisoner of Second Avenue" and "Rumors," to cite but a few. The comedy lies in the progressive breakdown of functioning people.

In "Lost in Yonkers," however, he is asking himself, What would happen if the characters were dysfunctional at the outset? What if the nerves were already shot, the damage wreaked, the psychic toll taken? What becomes of your comedy then?

The results, on view at the Richard Rodgers Theater, are closer to pure surrealism than anything Mr. Simon has hitherto produced and take him several bold steps beyond the autobiographical traumas he recorded in "Brighton Beach Memoirs" and "Broadway Bound." No longer content to dramatize divisive arguments around the family table, he has pulled the family itself out of shape and turned it into a grotesque version of itself. These characters are not oddballs, they're deeply disturbed creatures. Were it not for his ready wit and his appreciation for life's incongruities, "Lost in Yonkers" could pass for a nightmare.

He pulls the family out of shape and turns it into a grotesque version of itself.

The time is 1942. The place is a decidedly dour apartment, one flight above a soda fountain and candy shop in Yonkers. At the curtain's rise, Eddie, a widowed father up to his neck in debt, is entrusting his two young sons to the care and feeding of their grandmother, while he goes south in search of work. The grandmother is a tyrant, who doesn't like anyone making noise in her presence or soiling the lace antimacassars on the living-room sofa. To enforce her will, she wields a quick cane. Young boys, however, make noise, and greased cowlicks soil antimacassars.

Surely you can see this one coming a mile away. But you can't, really. Of Mr. Simon's seven characters, only the two youths — 13½-year-old Arty (Danny Gerard) and 15½-year-old Jay (Jamie Marsh) — can be considered reasonably well adjusted, given their already topsy-turvy lives. The rest are victims of Grandma Kurnitz (Irene Worth), an old-world Jew who herself was victimized in prewar Germany and has since encased her feelings in steel. (Arty, something of a wiseacre, is pretty certain you could cut off her braids and sell them for barbed wire.) Two of the old lady's progeny died young, which merely strengthened her conviction that in a cruel world only the hardened survive. She beat that unmerciful lesson into her four remaining children. None reached adulthood unmaimed.

Mr. Simon has always had an ambivalent attitude toward togetherness. On the one hand, he celebrates it. On the other, he sees it as an endless

Mr. Simon is capable of playing the game for keeps.

source of chafe and strain. In "Lost in Yonkers," he is flirting daringly with its tragic potential. At the same time, he doesn't want to let go of the comedy completely. It makes for a precarious balancing act.

Eddie (Mark Blum) is forever mopping his face, either because he's perspiring with fear or because he's just burst into tears. Gert (Lauren

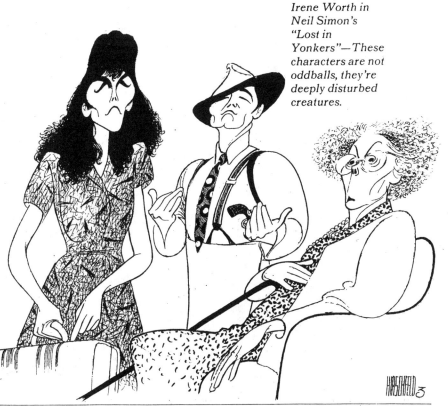

Mercedes Ruehl, Kevin Spacey and Irene Worth in Neil Simon's "Lost in Yonkers"—These characters are not oddballs, they're deeply disturbed creatures.

Klein) has developed a unique speech defect. She delivers the first half of her sentences on an outward rush of air, then bug-eyed and breathless and seemingly drowning, inhales desperately all the while she is finishing the second half. "I once saw her try to blow out a candle," notes Jay (no slouch at one-liners). "Halfway there she sucked it back on."

Louie (Kevin Spacey) turned out as tough as Grandma could have hoped, then spoiled it all by taking up with mobsters. He sports the mandatory suspenders and the spit-shined shoes, and he can make $5 bills materialize in his nephews' pajama pockets. But under the flash, he's small potatoes, no less a flop than his sorry siblings.

The sorriest of all, though, is Bella (Mercedes Ruehl) — a 35-year-old spinster, still living under Grandma's iron fist and doing her curt bidding at home and in the candy store. Bella's limited intelligence seems to be the consequence of a childhood illness, although getting knocked repeatedly on the side of the head while growing up can't have helped. But if "she's a little — you know — closed for repairs" (that's Jay again), her heart makes up for it by working overtime. And she has no shortage of enthusiasm for the movies she forgets as soon as she sees them, or for the four-scoop ice-cream sodas she whips up in the candy shop and then gives away at bargain prices that would curl Grandma's lips, if they weren't set in granite.

The two children are our sole connection to a world of conventional relationships and values. As played by Mr. Gerard, who resembles a cheerful bulldog with bangs, and by Mr. Marsh, who tends to bring a scared scarecrow to mind, they are enormously likable. Have no doubt about it, though — Mr. Simon certainly doesn't — they're not just lost in Yonkers, they've been deposited, wide-eyed and slack-jawed, in a loony bin. Daffiness may be there to extend a knock-kneed welcome in the person

of Bella. But menace and unpredictability are as much a part of the surroundings as the dreary oversized furniture that the designer Santo Loquasto has placed strategically about the apartment. (It's the kind of set, perfect in its fashion, that gives you an ache in the lower back just from looking at it.)

During the eight months Jay and Arty spend with their relatives, Bella takes it into her addled head that she's going to leave home, marry the usher at the local movie house, open a restaurant and have babies — more or less in that order. Louie, on the lam, uses the apartment as a hideout and practices his big-time swagger. ("It's like having a James Cagney movie in your own house," marvels Arty.) On a drop-in visit, Gert is swept up in the turmoil and soon is gasping like a beached goldfish. Meanwhile, Grandma tries to keep them all in order with a stern demeanor and the ominous tapping of her right foot that suggests she is marking time to a particularly fierce dirge, audible to her alone.

Either the boys know what is going on and are scampering to stay out of harm's way. Or else they're in the dark, wondering where harm will strike next. Both prospects are far more terrifying than Mr. Simon seems to want to let on. To maintain the anguish at a comfortable level, he has reverted to an old habit: he uses jokes as a safety valve. The jokes don't fall flat — Neil Simon's rarely do — but they're clearly disruptive. The material is intrinsically too powerful for them.

■

As it is, the playwright allows simple-minded Bella to get so carried away with her visions of marriage and babies that she is desolation itself when Grandma refuses to entertain such foolishness, refuses even to waste a word by way of disapproval. The scene, flawlessly staged by Gene Saks, is devastating — Ms. Ruehl,

pleading against all hope for permission to marry, then pleading with no hope whatsoever, because she just can't quiet this awful need for warmth and love; Ms. Worth, listening with barely a quiver of the jowls or a pursening of her apple-doll mouth, but communicating by immobility her mountainous displeasure and then clinching it by rising silently and hobbling out of the room. The writing is unflinching, further demonstration, if demonstrations are required at this late date, that Mr. Simon is capable of playing the game for keeps, not just for laughs.

Having edged out on the high diving board, however, and jumped up and down to test its spring, he ends up backing down the ladder. The promised plunge isn't taken after all. Tamer comic traditions are meant to prevail. Grandma relents. Bella wins her freedom. Eddie returns home — debts liquidated, eyes dry — to reclaim his offspring who, for their part, have presumably matured in the interim. The dysfunctional family is conveniently restored to working order, which tends to give the lie to all that's gone before. We can't help but wonder why Grandma's tyranny, so detrimental to her own children, would have a beneficial effect on her grandchildren.

In the play's opening moments, Eddie lays out the bleak prospects ahead to his sons, then seeing a look of panic in their eyes, adds comfortingly, "I wouldn't tell you all this if there wasn't a happy ending." That's the playwright talking to his audience, too. The conclusion of "Lost in Yonkers" will satisfy all traditional expectations. But I can't help thinking that Mr. Simon's reluctance to follow the very forces he himself has set in motion to their logical extremes deprives us of something dark and insightful and quite possibly magnificent.

Who better to show us what lies beyond laughter, than someone who knows laughter's parameters so

well? Granted, some of his characters — going back more than 20 years to the forsaken wife in the first act of "Plaza Suite" — have ventured into that forbidden territory. But he himself continues to stop at the frontier. It's as if he finds something threatening about desperation, something that must eventually be defanged and domesticated.

"Lost in Yonkers" is equipped with such a terrific cast that one can only regret Mr. Simon's last-minute loss of nerve. Ms. Worth, a shoo-in for a Tony nomination, is a one-woman Mount Rushmore — craggy and imposing. I'm not sure which is more astonishing — her control or the range of emotions she has buried behind the obdurate facade. With his slicked-back hair and that sly moonbeam of a sideways smile, Mr. Spacey looks not unlike Jack Benny, which couldn't be more appropriate, since the tinhorn gangster is also a self-styled comic.

The artful performance makes everything about the character gloriously shallow, except for the abiding mediocrity, and that's bottomless. As for Ms. Ruehl, she comes on with a crazy lurch, a voice just this side of a buzz saw and a smile that could melt all the boysenberry ice cream in the freezer downstairs. Hers may be the most delicate assignment of all — playing a child who is also a woman and a dunce who is wise — and she acquits herself of it with reckless beauty.

For all the play's unsettling promise and that one big burst of power, there is ultimately more reassurance than revelation in "Lost in Yonkers." Maybe that's how Mr. Simon's audiences want it. Maybe that's how *he* wants it. Sooner or later, though, I suspect he's going to get it the other way around. And I want to be there when he does. ☐

1991 Mr 3, II:1:1

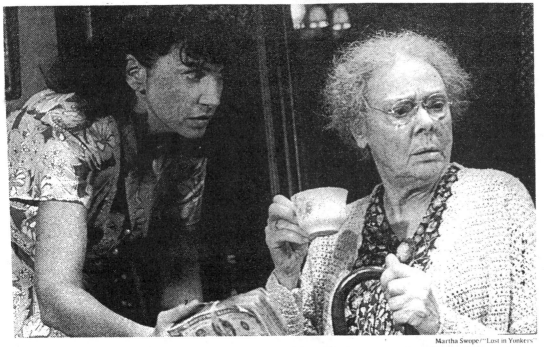

Martha Swope/"Lost in Yonkers"

Mercedes Ruehl and Irene Worth in "Lost in Yonkers"—ambivalence toward togetherness

The Big Love

Written by Brooke Allen and Jay Presson Allen, based on the book by Florence Aadland and Tedd Thomey; directed by Mrs. Allen. Scenery and projections by David Mitchell; costumes by Jane Greenwood; lighting by Ken Billington; sound by Otts Munderloh; original music by Stephen Lawrence; makeup by Kevin Haney; production stage manager, Dianne Trulock. Presented by Lewis Allen Productions, Robert Fox Ltd., Witzend Productions and the Landmark Entertainment Group, in association with Home Box Office Inc. At the Plymouth Theater, 236 West 45th Street.

Florence Aadland Tracey Ullman

By FRANK RICH

"For the first time in my life, I was absolutely speechless," says Florence Aadland, the Hollywood mother played by Tracey Ullman in "The Big Love," as she recalls her 15-year-old daughter's fateful night of violent sex with Errol Flynn in 1957. If "The Big Love" is any indication, the first time Florence Aadland was speechless was also the last. In this one-woman play that has washed ashore on Broadway at the Plymouth Theater, Ms. Ullmann natters on for two hours, a not inconsiderable proportion of which is devoted to joking descrip-

Martha Swope/"The Big Love"

Tracey Ullman in "The Big Love," a one-woman play.

tions of rape. She refers to the penis by two different affectionate nicknames in the first half-hour alone. '

"The Big Love" was directed and co-written (with Brooke Allen) by Jay Presson Allen, the creator of "Tru." Apparently its mission is to do for Ms. Ullman and Florence Aadland what "Tru" did for Robert Morse and Truman Capote. Like Mr. Morse, Ms. Ullman needs a career break but no introduction, at least to those who have admired this young English comic actress on television, in films ("I Love You to Death") and in last summer's "Taming of the Shrew" in Central Park. But who, you ask, is Florence Aadland?

Not necessarily someone you would invite to breakfast at Tiffany's. She was a sometime cocktail waitress and fulltime Hollywood stage mother whose jailbait daughter, Bev, carried on with a washed-up Flynn in the final two years of the movie star's life. After Flynn's death, Florence exploited her child's vicarious brush with tabloid celebrity in the 1961 book that gives this show its title, a tell-all memoir that achieved cult status with the help of a rave review by William Styron in Esquire. But that was 30 years ago, and neither the scandalous Aadlands nor, arguably, Flynn himself have had the longevity of, say, Fatty Arbuckle. Even their 15 minutes of fame came up 10 minutes short.

Yet Florence Aadland is given the same elaborate stage treatment as Capote. Like "Tru," "The Big Love" greets the audience with a kitschy front curtain — in this case a period map of movie stars' homes — and ends with its down-but-not-out protagonist's gallant exit to face a new day. In between, the heavily made-up Ms. Ullman sips drinks, slews campy gossip and attempts to justify a pathetic, loveless existence higher on self-destruction than achievement. For occasional dramatic incident, the phone rings or the record player plays or the lights dim for an often blurry slideshow of scrapbook photographs. For sight gags, Ms. Ullman tries to tie up some Venetian blinds with a pair of nylons in Act I and to cut some packing tape with a corkscrew in Act II.

As it soon becomes apparent, the "Tru" formula could not be more ludicrously misapplied. Unlike Capote, Flo Aadland did nothing of interest, pimping for her own daughter excepted. In a script as conspicuously padded as Ms. Ullman's costume, the anecdotes about waitressing prove trance-inducing and the closest thing to a witty punch line (at the end of a sexual anecdote) is "Let those puppies loose!" Under these circumstances, a theatergoer cannot be blamed for flipping through the Playbill to find out who in his right mind would produce such a script, and in this case, the list includes Home Box Office, which presumably has the inside track on any future television adaptation. If no one else is getting a big laugh out of "The Big Love," perhaps Showtime is.

•

Television can improve the play, at least, simply by reducing its physical scale. The realistic set that confronts the audience at the Plymouth is not the East Side penthouse, with glittering river view, of "Tru" but a soiled, rock-bottom Hollywood bungalow that is magnified by Broadway demands to VistaVision proportions, all painted an institutional, Necco-wafer shade of green. In order to accommodate the slide exhibition, this eyesore is dominated by its rear wall, a green monster to rival Fenway Park's, and after two hours of staring at it, you may feel as if you're being held in high-school detention.

So may Ms. Ullman. The people who coaxed her into "The Big Love," especially at this length and in this large a house, are not her friends. Hideously outfitted with a platinum perm, a synthetic wardrobe and turquoise earrings that match her eye shadow, the actress looks like Tammy Faye Bakker and sounds like Lucille Ball taking a wild stab at impersonating Dolly Parton. Five minutes of such clowning might be tolerable, but what audience wants someone like this in its face all night?

•

Ms. Ullman's complete failure to create a richer character or, failing that, to hold the stage by sheer personality becomes, by default, the biggest drama in "The Big Love." Not only is the comedy strained but so are the loud, mawkish tears meant to make Flo a sympathetic sort of Nathanael West lonely heart, innocently victimized by the false Hollywood gods of glamour and fame. All but winking at the audience to acknowledge her and our superiority to this white-trash drunk, Ms. Ullman condescends to Aadland instead of inhabiting her and sometimes puckers her lips in lame imitation of Dana Carvey's Church Lady on "Saturday Night Live" at those moments when Flo's most vulgar gestures or stupid lines are meant to cue patronizing guffaws. "It must mean *something*, right?," she announces to the audience just before her final exit. Wrong.

1991 Mr 4, C11:1

Athleticism Leavened With Artistry

By ANNA KISSELGOFF

Brian Boitano, so pure of style that his technical perfection becomes expressive in itself, and Katarina Witt, whose power is put at the service of a a natural glamour, stand to be the big pop stars of international skating.

The ice revue the two Olympic gold medalists have put together for the second consecutive year, "Skating II," certainly points in that direction. As singles skaters, they are not entirely well matched when paired. But each communicates directly to an audience through the high-level bravura that makes ice skating so exciting at its core.

The sight of Mr. Boitano shooting upward in his celebrated triple turns in the air and then reaching an even more astounding height as if suddenly propelled by an invisible rocket booster is enough to make the spirit soar as well.

This is great skating and it symbolizes the accent on athletic virtuosity in "Skating II." Artistic substance is nonetheless not absent in the production, which was presented at Madison Square Garden on Friday night. Someone has been smart enough to include Gary Beacom, a Canadian who is one of the most creative talents on ice. His exploration of movement is thoroughly avant-garde and the wit of his characterizations runs deep: the gamut is from pain to laughter.

A few years ago he seemed a Jack Nicholson on skates. Now sporting a beard, black granny glasses and red suspenders, Mr. Beacom has shed his nihilistic cool for a new persona. His old codger is all philosopher — jogging, jiggling, hobbling on the ice, a figure who collapses with rag doll legs but always springs back to life with elastic resilience. There are also virtuosic images: Mr. Beacom executing a sit spin with a collapsing leg behind him rather than extended in front.

These brilliant ways of inventing new locomotion transform Mr. Beacom later in the show into a hooded black catlike figure who mimics Miss Witt and also stands on his head, a symbol of life's absurdity. Spiderman? Rather a human blob, related to similar shapes in Paul Taylor's "Three Epitaphs."

Subtlety and nuance, however, are not prevalent throughout this show. Its focus is on set moves or "elements," as they are called in skating. Mr. Boitano and Miss Witt apparently see such athletic feats as their strength, and this unshaded virtuosity is taken into account by Sandra Bezic, who has choreographed the show with Michael Seibert. The drawback is the conventional look of most of the numbers.

Like rock stars, Mr. Boitano, who comes from San Francisco, and Miss Witt, who was on the East German team at the 1984 and 1988 Olympics, get by on pure personality and technique. They could do more, as Mr. Boitano shows in the rhythmic complexity of his successful macho solo, "Big Man on Mulberry Street."

G. Paul Burnett/The New York Times

Ice Skaters Combine Artistry and Athleticism

Brian Boitano and Katarina Witt, the Olympic gold medalists, performing in "Skating II" at Madison Square Garden.

His natural romantic ardor is best seen in a solo, "The Carousel Waltz," rather than as a Don José to Miss Witt's Carmen, where she, on the contrary, exudes a passion missing elsewhere.

Her wholesome bad-girl image, complete with low-cut costume and a a Prince recording, "The Question of U," is the source of her appeal. Yet it is a cardboard image, in need of dramatic direction.

●

"Skating II" is essentially a variety show and it has a generosity toward individual talent. In addition to the North Americans, there are a number of Soviet skaters.

Aleksandr Fadeyev has the originality to work against familiar musical associations; he builds up dynamically rather than expires in "The Dying Swan." Vladimir Kotin, skating to Duke Ellington's music, has an intriguing improvisational air. Yelena Valova and Oleg Vassiliev are polished but less complicated than Barbara Underhill and Paul Martini, the popular Canadian pair who act out troubled relationships between tosses and lifts. Both pairs teamed up successfully in an ironic Russian folk number set to the bitter lyrics of the late Soviet balladeer Vladimir Visotsky.

Judy Blumberg and Mr. Seibert bring their usual refinement to a revolving duet set to Samuel Barber's Adagio for Strings. Caryn Kadavy, Yvonne Gomez and the new Soviet-American pair Renee Roca and Gorsha Sur complete the international cast that glides out in hand-holding circles at the end. It is a warm, viewer-friendly show.

1991 Mr 4, C12:3

To Kill a Mockingbird

Based on the novel by Harper Lee; adapted by Christopher Sergel; directed by Robert Johanson; scenic design, Michael Anania; costume design, Gregg Barnes; lighting design, Mark Stanley; sound design, David R. Paterson; hair design, Paul Germano; costume coordinator, José M. Rivera; music written and arranged by Phil Hall; assistant to the director, Larry Grey; production stage manager, Peggy Imbrie. Presented by the Paper Mill Playhouse, Angelo Del Rossi, executive producer; Mr. Johanson, artistic director. At Paper Mill Playouse, Millburn, N. J.

WITH: George Grizzard, Paul Albe, Alexander Barton, Jesse Bernstein, Jack Bittner, Doris Brent, James Cronin, Dale Dickey, Harriett D. Foy, Katharine Houghton, Edward James Hyland, Marjorie Johnson, Page Johnson, Tiffany Kriessler, Elizabeth Owens, Daniel Reifsnyder and Michael White.

By STEPHEN HOLDEN

Special to The New York Times

MILLBURN, N.J., Feb. 23 — With its stalwart lawyer-hero Atticus Finch, who prods the conscience of a Depression-era town in Alabama, Harper Lee's 1960 novel, "To Kill a Mockingbird," still stands as a reassuring, stately expression of American idealism in the early days of the civil rights movement.

The novel, which was adapted into a memorable film starring Gregory Peck, tells the story of a Southern lawyer and father of two who stands against his fellow townspeople by defending an innocent young black man accused of raping a white woman. Even though he loses the case, his actions begin to soften the town's hard-shell racial bigotry. As a candidate for theatrical adaptation, the novel presents challenges because it involves narrative complications (the events are remembered by Atticus's daughter, Scout) and a very large cast.

The challenge of bringing the book to the stage has been solved quite successfully by Christopher Sergel, a playwright whose previous theatrical adaptations include "Up the Down Staircase" and "Cheaper by the Dozen." His stage version of "To Kill a Mockingbird," which is having its American premiere at the Paper Mill Playhouse here, is a sprawling, somewhat old-fashioned family entertainment that floods the stage with actors and scenery.

●

In Mr. Sergel's adaptation, the story unfolds in scenes introduced by Miss Maudie (Katharine Houghton), a woman of the village who serves as guide and narrator. Her terse, twangy reminiscences, accompanied by quiet piano music, do a skillful job of effecting transitions. They also impart a storybook quality to the production that is mirrored in Michael Anania's lush scenic design in which the simple clapboard houses of Maycomb, Ala., are practically smothered in flowers and moss dripping from trees.

The backbone of the production is George Grizzard's powerful, understated performance as Atticus. Cast in a role that would tempt almost any actor to call attention to the character's nobility through oratorical tricks, Mr. Grizzard plays him as a man who is as plain as the red dirt on the streets of Maycomb. Not someone given to sentiment, his Atticus is a profoundly decent soul who heeds his conscience. Gruff but not folksy, intense but in no way flamboyant, Mr. Grizzard's portrayal conveys the character's full moral stature.

The surrounding performances in the production, which was directed by Robert Johanson, are comparatively uneven, with several tending toward the self-consciously folksy. The strongest belong to Dale Dickey as the sullen, self-proclaimed rape victim and to Paul Albe as her brutal tobacco-spitting father. Tiffany Kriessler and Jesse Bernstein, as Atticus's two children, acquit themselves creditably in demanding roles.

●

The lavishness of the production cannot camouflage deficiencies that smack of a lack of courage in presenting the story's darker aspects. A potentially horrifying scene in which Atticus and the children defuse a lynch mob is so low-key that the would-be killers seem scarcely more dangerous than a group of men lounging around at a barn dance. In the extended trial scenes, the audience is treated as the jury, with the lawyers required to direct their arguments with their backs turned to the courtroom. The device seems not only awkward, but a corny, grandstanding bid for audience involvement.

Such tactics may make the drama more palatable for family audiences, but they undermine its integrity by softening it into a kind of theater that feels too warm and cozy to make a deep impression. What keeps things from becoming too flaccid is Mr. Grizzard's performance. His tough, thorny Atticus is someone who would not go along with such compromises. His words leave their mark.

1991 Mr 4, C13:4

A Room of One's Own

From the book by Virginia Woolf; adapted and directed by Patrick Garland; scenic design by Bruce Goodrich; lighting by Lloyd Sobel; production manager, Mitchell Erickson; company manager, Laura Heller. Presented by Arthur Cantor. At the Lamb's Theater, 130 West 44th Street.

Virginia Woolf.............................Eileen Atkins

By MEL GUSSOW

In "A Room of One's Own," Virginia Woolf used her discerning wit and intellectual acumen to assail the bastion of male prejudice against women as artists. Her two historic lectures and the book that grew out of them are a cornerstone of feminist doctrine and freethinking criticism. Although the essay was written to be delivered in public (at Cambridge University in 1928), it was not regarded as a dramatic piece — until Eileen Atkins gave it life on stage.

In her performance at the Lamb's Theater, Miss Atkins offers a virtuosic feat of acting and a luminous portrait of the artist. She brings to the role a great assurance, humor and resonance.

The reinvention of Virginia Woolf is in spite of the fact that Miss Atkins does not really look like her, though her hair style and tailored clothes are in the Woolfian mode. Emotionally, she has plunged into the heart of her character, as a wise and demanding woman of feverish intensity who was unequivocal in matters of art and ethics. Though the brilliance of the performance might seem to contradict the public image of this private artist, it is clearly a reflection of how the writer must have seemed to those who were close to her.

●

Miss Atkins instills the performance with a conversational flow, the feeling that the words are being spoken for the first time, that theatergoers are, in fact, in the audience at Cambridge with the young women whose artistic hopes are destined to be dashed by the realities of a patriarchal society.

In performance, Miss Atkins becomes the woman whose self-knowledge allowed her to admit to her own "remorseless severity." Behind that severity is a scathing humor, which

Alistair Muir "A Room of One's Own"
Eileen Atkins as Virginia Woolf in "A Room of One's Own."

she directs against all those who believed that women were capable only of child-bearing and husband-pleasing. With controlled fury, she lashes out at the diffidence felt toward women by the ruling class of men, the economic, political and artistic repression practiced through history.

Picking up a copy of Trevelyan's "History of England," a contemporary book, she reads, "Wifebeating was a recognized right of man," and continues that a woman who rejected her parents' choice of a husband was "liable to be locked up, beaten and flung about the room." That last phrase, "flung about the room," is repeated with increased mockery. It is unthinkable that anyone would ever have the nerve to try to fling Woolf or Miss Atkins about the room, and the very idea provokes laughter from the audience.

There is a steeliness but never a stridency in this characterization, which burnishes word, inflection and gesture. Disallowing herself acting mannerisms (a pitfall in any such one-woman performance), Miss Atkins delights in the nuances of the author's graceful language.

●

Though her anger is self-evident, she does not become exasperated, but maintains a gentility that makes her indictment more devastating. Striking the paradox at the core of her argument, she indicates that at the same time that women were treated as chattel in real life, their heroic and romantic qualities were celebrated in fiction and drama. Miss Atkins describes Shakespeare's women with artfully understated irony.

High in her pantheon are Jane Austen, Emily Brontë, Aphra Behn — and Judith Shakespeare. The last is, of course, a Woolf invention, Shakespeare's imaginary, gifted sister, who, forbidden to be creative, was driven to suicide. Her tragedy and that of those who came after her could be avoided, she says, if a woman had an annual income of £500 and a room of one's own.

The challenge echoes to today, down to the fiery conclusion that the spirit of Judith Shakespeare lives on in the potential of all her sister artists. Were Miss Atkins to have delivered the original lectures, the audience of women might have marched on Parliament, or at least on Cambridge.

A shorter version of the performance was recently presented on "Masterpiece Theater" on television. The play benefits from being seen in its longer form and from the responsiveness between audience and actress.

In his adaptation, Patrick Garland (who is also the director) has somewhat compressed the original text and interwoven it with commentary from the author, heard on tape. The taped segments allow Miss Atkins breathing space in a demanding evening, but they are questionable additions, and also threaten the performance with the quirks of electronics. That choice aside, this an event of theatrical magnitude.

With her Virginia Woolf, Miss Atkins joins Hal Holbrook (for "Mark Twain Tonight!") and Alec McCowen (for "St. Mark's Gospel") at the pinnacle of the monodramatic art. Each is a perfect meeting of actor and subject.

1991 Mr 5, C11:2

Botánica

By Dolores Prida; directed by Manuel Martín Jr.; assistant to the director, Beatriz Córdoba; sets and costumes by Randy Barceló; lighting by Robert Weber Federico; technical director, Rigoberto Obando; production assistant, Manuel Herrera. Presented by Repertorio Español, Gilberto Zaldívar, producer; René Buch, artistic director. At the Gramercy Arts Theater, 138 East 27th Street.

Doña Geno Ofelia González
Anamú Ana Margarita Martínez-Casado
Milagros Castillo Iliana Guibert
Rubén .. Rolando Gómez
Pepe El Indio Juan Villarreal
Luisa ... Irma Bello
Carmen .. Marielva Sieg

By D. J. R. BRUCKNER

Book learning doesn't stand a chance against worldly wisdom in Dolores Prida's new play, "Botánica," which, under the direction of Manuel Martín Jr., has been added to the current roster of works being presented by Repertorio Español at the Gramercy Arts Theater. But Ms. Prida seems to have a bottomless fund of humor that keeps the contest alive even when the outcome is clear.

Ms. Prida, who has written about a dozen works in the last 15 years, most of them musicals, knows no fear of familiar plots and theatrical tricks. Like many old Hollywood comic writers, she uses them deliberately and counts on her verbal facility to get a laugh out of every line. Given her success, who will fault her for that?

•

"Botánica" ("Knowledge of Plants," of course, but a fair rendition for this play might be "wild") explores cultural conflicts in East Harlem among an old Puerto Rican woman, her daughter and her granddaughter, who has just graduated from an Ivy League university.

The old woman, Doña Geno, runs a business dealing in herbs, spells and spiritual powers. She and her daughter, Anamú, expect Anamú's daughter, Milagros Castillo, to take over the shop, La Ceiba. (It's the round tree seen everywhere in the Carribean, with seed pods harvested for kapok; here it may help to know that many people in the tropics hint at certain powers it has when they call it the God tree).

Obviously, Milagros — who began calling herself Millie at college, since, as she says, Miracles Castle isn't a great name in English — plans to take up a career in a big bank downtown and forget about the barrio. But she has things to learn that the Ivy League doesn't teach, and Doña Geno is just the professor she needs. The old woman, who knows nothing of computers and banks, and who may not even know much about herbs and what Millie calls spiritual mumbo jumbo, is astute about life in the way only a great survivor can be. Besides, she has the help of a couple of popular flashy saints whose crafty connivances would astonish theologians.

•

All of the action is predictable. Indeed, a few of the characters seem to be thrown in only to be the butt of jokes. And some of the incidents are merely distracting, including one emotionally powerful moment between Millie and her grandmother. Dramatic logic is not Ms. Prida's strength.

The language of laughter, and of the streets, is, and she makes the most of it. After more than 20 seasons of increasingly impressive performance, the Repertorio Español has installed an infrared simultaneous translation system to reach a wider audience. But "Botánica" is not one of this year's works for which translation is provided. Maybe it would be impossible, or of limited use. Even an audience of people who speak Spanish tends to break into time-lag outbursts as it catches late the meaning of some of Ms. Prida's dialogue. The language is Spanish, with some English phrases mixed in, but the idiom is New York barrio, and a lot of that can be lost in translation.

As one has come to expect of this company, the ensemble performance is admirable. But the play provides especially fine comic opportunities for Ofelia González as Doña Geno and Iliana Guibert as Milagros. Ms. González is a gifted veteran of the troupe and a formidable presence, but Ms. Guibert, a relative newcomer, has an assurance and a feel for comedy that make the contest between the two spirited, and great fun.

1991 Mr 5, C16:1

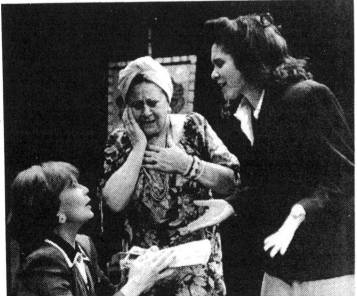
Gerry Goodstein/"Botánica"

Ana Margarita Martínez-Casado, left, Ofelia González and Iliana Guibert, right, in a scene from Dolores Prida's new play, "Botanica."

Festival of One-Act Comedies, Evening B

Artistic associate, Jonathon Mintz; set design by Vaughn Patterson; lighting design by Pat Dignan; costume design by Kitty Leech; sound design by Aural Fixation. Presented by Manhattan Punch Line Theater, Steve Kaplan, artistic director. At the Judith Anderson Theater, 422 West 42d Street.

THE EXPERTS, by Bill Bozzone; directed by Chris Ashley.

FOREPLAY, or, the Art of the Fugue, by David Ives; directed by Jason McConnell Buzas.

THE STAGED READING, by Michael Panes; directed by David Konig.

MAILMAN, by Matthew Carnahan; directed by Jonathon Mintz.

THE CHRISTMAS RULES, by Craig Wright; directed by Louis Scheeder.

WITH: Nelson Avidon, Peter Basch, Esther Brandice, Tony Carlin, Veanne Cox, Laura Dean, Jay Devlin, Brian Howe, Elizabeth Karr, Scott Klavan, Donald Lowe, Alison Martin, Ken Martin, Dan Moran, Anne O'Sullivan, Elaine Rinehart, Robert Stanton, Mark Tymchyshyn and Daisy White.

By MEL GUSSOW

Remember when Woody Allen's hapless bank robber in "Take the Money and Run" passed a note across the counter to inform the teller that he was armed and carrying "a gub"? A similar spirit of inane ineptitude in the criminal class enlivens "The Experts" by Bill Bozzone. This travesty of sidewalk thievery is not only the high point of Evening B of the Manhattan Punch Line's festival of one-act comedies, it is also the only point.

Mr. Bozzone's stick-up man (Mark Tymchyshyn) is a yuppie fallen on hard times and forced to make his living by demanding your money or your life. He is so lacking in felon finesse that he does not even know how to load his gub. Luckily for him, his intended victim (Jay Devlin) is a good-natured soul with an instructive streak. He is soon teaching the thief the tricks of the profession. What ensues onstage at the Judith Anderson Theater is a cautionary comedy about facing gunpoint.

As he has shown in numerous other comedies (at the Ensemble Studio Theater as well as the Punch Line), Mr. Bozzone has a devious wit and an expertise when writing in the short theatrical form. Chris Ashley, as director, and the actors are his helpful accomplices in his comic assault.

Were it not for Mr. Bozzone, Evening B would be barren. Even the reliable David Ives is operating at less than peak. His "Foreplay, or, the Art of the Fugue," fuguelike variations on love and miniature golf, is sandtrapped. At least Mr. Ives has an idea for a play, if not the follow-through. The three other playwrights, all of them less experienced, are running on empty.

•

Matthew Carnahan's "Mailman" is a simplistic cartoon about a postman with a perfect record for delivery and an imperfect marriage. The title character's plunge into misanthropy is entirely too fast and too farfetched. "The Staged Reading" by Michael Panes is a self-conscious backstage comedy that manages to include a mutant (non-Ninja) in its cast. There is a possible situation in "The Christmas Rules" by Craig Wright, about the surprises awaiting a soldier returning home after World War II. But Mr. Wright's cupboard is crowded with clichés, well-worn on television and in the movies.

Faced with the possibility of seeing Evening B at the Punch Line, theatergoers would be better advised to choose Evening A. With its comic batting average of four for four, this selection of one-acts features Mr. Ives's "Variations on the Death of Trotsky" and "Stay Carl Stay," Peter Tolan's priceless comedy about a talking, thinking dog.

1991 Mr 5, C16:3

Life During Wartime

By Keith Reddin; directed by Les Waters; scenery by James Noone; costumes by David C. Woolard; lighting by Michael R. Moody; original music and sound by John Kilgore; production stage manager, Tom Aberger; casting, Donna Isaacson; artistic associate, Michael Bush; general manager, Victoria Bailey. Presented by Manhattan Theater Club, Lynne Meadow, artistic director; Barry Grove, managing director. At City Center Stage 2, 131 West 55th Street.

Heinrich .. W. H. Macy
Sally and Megan Welker White
Tommy .. Bruce Norris
John Calvin, Fielding, Lieutenant Waters and DeVries .. James Rebhorn
Gale ... Leslie Lyles
Howard, Waiter, Richie and Delivery Boy ... Matt McGrath

By FRANK RICH

In the roughly five years since Keith Reddin began spending more time writing than acting, he has produced a steady stream of black comedies about the underground of corruption, political and moral, that lurks just beneath the slick sitcom surface of American life. His plays, notably "Life and Limb" and "Rum and Coke," are unfailingly intelligent and are generally produced by the finest resident theaters in and outside New York. Yet Mr. Reddin has not so far caused a serious stir within the nonprofit theater, let alone with a larger public. He is perpetually on the verge.

Why? The answer can be found at the Manhattan Theater Club Stage 2, where Mr. Reddin's "Life During Wartime" has opened in a nimble, well-acted production swiftly staged by Les Waters, the English director who specializes in the canons of both Mr. Reddin and Caryl Churchill. "Life During Wartime" is an archetypal sample of its author's work. Its hero is a boyish naif, Tommy (Bruce Norris), who stumbles into Kafkaesque conspiracies beyond his wildest nightmares while working as a door-to-door salesman for a company that sells home-security systems. In the suburban households he visits, Tommy finds terror and violence; back at the office, his white-collar colleagues prove to be the perpetrators of a lethal shell game that has more to do with the practice of crime than its prevention.

"Let's be realistic," says Tommy's sinister boss, named Heinrich no less, at the very start of the play. "It's a dangerous world. Everyone has a weapon." Heinrich is played by W. H. Macy, an actor long associated with David Mamet, and it is in that opening speech that Mr. Reddin's problems begin. Heinrich's three sentences are Mamet lines if ever there were any, an echo heightened by the bristling Mr. Macy's delivery of them. They also sound like dialogue that might have been written by Howard Korder, whose "Search and De-

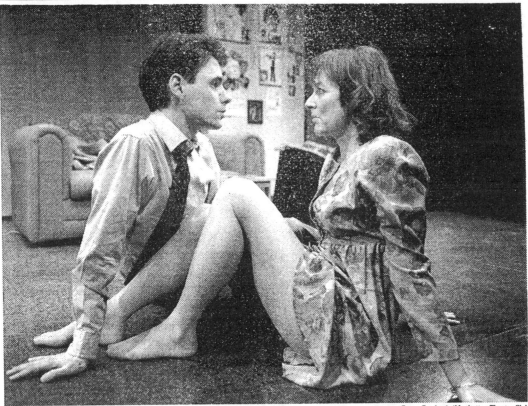

Gerry Goodstein/Manhattan Theater Club

Bruce Norris and Leslie Lyles in a scene from "Life During Wartime," at the Manhattan Theater Club.

stroy," seen at the Yale Repertory Theater this season, had an actress (the spacey Welker White), themes and even the military coinage of its title in common with "Life During Wartime."

•

Can Mr. Reddin beat these masters at the game of dramatizing dog-eat-dog American men in staccato, paranoia-tinged comic vignettes? Of course not. And he surely goes out of his way to court comparisons here by giving his salesmen a scene in a Chinese restaurant, the site of similar and more pungent sales conferences in Mr. Mamet's "Glengarry Glen Ross."

A door-to-door salesman for whom paranoia is realism .

But an even bigger failure in "Life During Wartime" rises out of Mr. Reddin's major departure from the Mamet pattern — his use of an innocent hero. Every Reddin play I've seen has had such a center-stage figure: a wide-eyed do-gooder who is shocked to the quick once he discovers that the business world or the government is duplicitous and rotten. The playwright's fatal error is his assumption that everyone except himself is just as unsophisticated as his protagonists. As a result, the audience is almost always a few impatient steps ahead of his heroes, waiting for that long-delayed moment when the light bulb will go on and they

will at last wise up to blatant corruption all around them.

In "Life During Wartime," the bright side of Mr. Reddin's talent — the originality that keeps one rooting for his eventual artistic breakthrough — is also apparent. Throughout the evening, a Bible-thumping John Calvin, dressed in full 16th-century regalia and played with an amusingly incongruous ear-to-ear grin by James Rebhorn, keeps dropping in to give his views on "Leave It to Beaver" and the acting talents of Mickey Rourke as well as to reopen for debate the doctrine of original sin. The gifted young actor Matt McGrath, playing several roles, gets to deliver a couple of hysterically pitched, vividly written monologues that have an Eric Bogosian-like take on the hallucinatory fevers of the underclass. It is also representative of Mr. Reddin's imagination at its most free-wheeling that a dead character in his play refuses to stay dead and that dismemberment becomes a source of surreal comedy.

•

As Tommy, Mr. Norris is both highly likable and convincingly puppyish: He's a slight, handsome young man, as such a specimen might be drawn by Charles Schulz. No less appealing is his unexpected romantic partner, Leslie Lyles, an older woman Tommy meets on a sales call.

While the couple's love affair leads Mr. Reddin to an uncharacteristically sentimental (and implausible) denouement, it also allows Ms. Lyles to perform a rapturous reading of E. E. Cummings's "Anyone Lived in a Pretty How Town." What does that pretty poem have to say about life during wartime? Beats me, but surely it should say something to Mr. Reddin that Cummings's light verse is more heart-stopping than anything else in his smart, ambitious yet curiously inconsequential play.

1991 Mr 6, C13:1

A Teacher of Russian

Written by Aleksandr Buravsky; directed by Yevgeny Kamenkovich; translated into English by Alexander Gelman; set, designed by Aleksandr Borovsky; music compiled by Viktor Apukhtin; lighting designed by Yefim Udler; stage manager, Lyudmila Ulanova. The Oleg Tabakov Moscow Theater-Studio presented by the Acting Company. At the Triplex Theater, 199 Chambers Street, Manhattan.

Tolya	Aleksandr Marin
Kozitskaya	Mariya Mironova
Dr. Popov	Vladimir Mashkov
Nina	Irina Petrova

By RICHARD F. SHEPARD

There is a certain pleasure in being able to savor a play, or any work for that matter, without considering its political impact because it was banned in Moscow or Boston or anywhere else. The pleasure in this instance is compounded by the creative acting and staging of "A Teacher of Russian" by the Moscow Theater-Studio in its New York presentation at the Triplex Theater on Chambers Street.

Oleg Tabakov's company, which is in the United States as part of a cultural exchange with the Acting Company, is now an established one in its homeland. And Aleksandr Buravsky's "Teacher of Russian" is sharp and witty in its commentary on Soviet life.

The play, presented in Russian with excellent headset simultaneous translation by Alexander Gelman, is mostly a comedy, with solemn, declamatory Russian overtones. It is set — shades of Chekhov, reminders of Solzhenitsyn — in a hospital in a resort area, where the doctor's racket is to rent rooms to tourists who are passed off, for the record, as patients. Not coincidentally, the play parallels life, where even the oppressors are oppressed by the system. Suffice it to say it is about the doctor, a nurse and two "patients": an elderly woman, who won't go along with an attempt to

deceive official investigators; and a young man, who will, to his ultimate regret.

Although there is much to see and hear, including love making in the hospital bathtub and scenes of the surf beating on the shore, the meat is all in the dialogue, in the tart observations that reflect the perceptions of Soviet life by those who live it.

"A Russian will always find a thousand ways to show he doesn't need freedom," the elderly woman says in one of the many pointed lines in the script.

The director, Yevgeny Kamenkovich, adroitly moves the four cast members. Vladimir Mashkov, as the doctor, is the very essence of an apparatchik out to line his own pockets. Irina Petrova portrays the sexy nurse who wears a skimpy bikini beneath her smock. Aleksandr Marin, as the young victim, has a mime's clarity with his impression of a man imprisoned in a plaster cast. But the real star is Mariya Mironova, who projects an earthiness, a humorous levelheadedness, as the elderly woman.

"A Teacher of Russian" is to have the last of its three performances tonight. The company is to stage Aleksandr Galich's "My Big Land," directed by Mr. Tabakov, tomorrow through Sunday.

1991 Mr 7, C16:6

Road to Nirvana

By Arthur Kopit; directed by Jim Simpson; sets by Andrew Jackness; costumes by Ann Roth; lighting by Scott Zielinski; sound by Stewart Werner and Chuck London; production stage manager, Fred Reinglas; production manager, Jody Boese. Presented by Circle Repertory Company, Tanya Berezin, artistic director; Terrence Dwyer, managing director. At 99 Seventh Avenue South, at West Fourth Street.

Al	Jon Polito
Lou	Saundra Santiago
Jerry	Peter Riegert
Ramon	James Puig
Nirvana	Amy Aquino

By FRANK RICH

IT has long been a Hollywood axiom that a producer will sign away his blood or perhaps even a testicle or two if that's what it takes to make a deal. The principal joke — very gruesome, not very funny — in Arthur Kopit's new play is that "the biggest rock star in the world" would literally demand these human sacrifices and more from producers begging to film her life story. The star's name is Nirvana, and Mr. Kopit's play is titled "Road to Nirvana." It is not paved with clear intentions, let alone good ones.

Much of this elaborate production, which can be found at the Circle Repertory Company, seems like little more than an attenuated buildup to a masochistic castration fantasy, replete with excruciating offstage screams. Much of that buildup takes the form of an imitation — whether slavish, envious or merely nasty — of David Mamet's Hollywood comedy, "Speed-the-Plow." After Keith Reddin's "Life During Wartime," this is the second new play of the week to be strongly influenced by Mr. Mamet, but in this case, the influence is so all-pervasive that Mr. Kopit seems a man clinically obsessed.

Self-destructive as it sounds, he initially courted comparisons by nam-

ing this work "Bone-the-Fish" when it was produced at the Actors Theater of Louisville last year, and the switch to a title that seeks to bask in reflected glory from Athol Fugard's "Road to Mecca" hardly disguises the obvious: Its first act is devoted to a combative dialogue between two sometimes fraternal, sometimes fratricidal Hollywood hustlers (played by Jon Polito and Peter Riegert) that is only vaguely distinguishable in style and content from Act I of the Mamet prototype. Act II repeats the "Speed-the-Plow" pattern as well: A spiritually minded Madonna, which is to say Nirvana (Amy Aquino), takes command of the men.

The parallels between the two plays are so naked that one keeps feeling that Mr. Kopit, a writer whose long career includes such distinguished works as "Indians" and "Wings," must be making some larger, more subtle point, or failing that, constructing the Mamet parody to end all Mamet parodies. But the payoff never comes. "Road to Nirvana" is really interested only in expressing conventional contempt for women and for Hollywood, and it is far too juvenile to pass as satire.

•

Mr. Kopit does come by his Hollywood animus honestly. His funny early comedy, "Oh Dad, Poor Dad, Mama's Hung You in the Closet and I'm Feeling So Sad," was many years ago turned into a barely released Rosalind Russell vehicle that is surely among the worst screen desecrations of a hit play ever filmed. In "Nirvana," a few of Mr. Kopit's movie industry gags strike fresh sparks. The playwright imagines that his pretentious rock star would outrageously pass off "Moby-Dick" as her autobi-

ography, with her name substituted for Ahab's. In the play's funniest speech, a producer explains how educational films promoting safe sex to high-school students might be lasciviously reshot to maximize their commercial prospects. Mr. Kopit also has some laughs at the expense of reincarnation, the ultimate crypto-religious rationalization of Hollywood narcissism. As Nirvana explains, why should she worry about destroying her body with drugs if she is going to be reborn anyway?

Even the better lines do not add depth to the characters or reveal any subterranean struggles that might give their relationships the raw heat of drama. For all the scatological punctuation of the ferocious exchanges between the vulgar producers in Act I, Mr. Kopit never creates any tense psychological warfare between them, only the loud noise of two caricatures barking. (If his intention was to prove that anyone can write explosive Mamet dialogue, he instead demonstrates exactly the opposite.) A similar failing hobbles the more intriguing Act II, in which Nirvana is portrayed as a master manipulator outfoxing the men who want something from her. Mr. Kopit keeps the power plays at the surface, with the result that the rock star emerges as a run-of-the-mill megalomaniac rather than as the feminine force who might lend the play a mysterious theatricality.

•

Ms. Aquino, a good, dry comic actress who is completely miscast in age, looks and temperament for a ruthless superstar like Nirvana, cannot come to the author's rescue, but then little in Jim Simpson's sledgehammer production does, Andrew Jackness's poolside sets excepted. The evening's least strained performance comes from the wry, disciplined

Gerry Goodstein/Circle Repertory Company

Saundra Santiago

Mr. Riegert, but his character, who undergoes two crucial yet arbitrary changes of heart in the play, never adds up, and he is battered at every turn by the sweaty, spectacularly unfunny ranting of his partner, Mr. Polito. As Mr. Polito's bimbo-ish companion, Saundra Santiago performs with a refreshing minimum of clichés, not to mention a minimum of clothes.

Given Ms. Santiago's bare breasts and an Act I gag that requires Mr. Riegert to contemplate a meal of feces, "Road to Nirvana" will no doubt be faulted by some for bad taste. The real problem, though, is lazy writing. But the evening is too weird to be boring, and surely somewhere David Mamet, at least, is smiling. Wasn't he last sighted in Hollywood?

1991 Mr 8, C1:1

The Learned Ladies

By Molière; translated and adapted by Freyda Thomas; additional adaptive material by Richard Seyd and Ms. Thomas; directed by Mr. Seyd; scenic design, Richard Hoover; costume design, Beaver Bauer; lighting design, Mary Louise Geiger; composer, Gina Leishman; production stage manager, Carol Dawes. Presented by CSC Repertory, Carey Perloff, artistic director; Patricia Taylor, managing director. At 136 East 13th Street.

Philamente	Jean Stapleton
Bélise	Georgine Hall
Henriette	Julia Gibson
Trissotin	Nestor Serrano
Clitandre	Peter Francis James
Ariste	Frank Raiter
Chrysale	Merwin Goldsmith
Armande	Alice Haining
Ariste's Assistant	Martin B. Nathan
Bélise's Suitors	Michael Reilly
Martine	Amy Brenneman
Lépine	Michael R. Wilson
Vadius/Judge	Peter Bartlett

By MEL GUSSOW

In "The Learned Ladies" ("Les Femmes Savantes"), as in "Tartuffe," a scoundrel inveigles his way into a household and turns it upside down. In this case, the rogue is Trissotin, a bogus artist, and his chief acolyte is a woman with intellectual pretensions. With Trissotin as mentor, she gathers female relatives into a salon of precious poetasters, while

her timid husband sits on the sidelines thinking about dinner.

The play, Molière's penultimate work, is a sharply satiric commentary on literary pretension and wounded vanities. As directed by Richard Seyd at the CSC Theater, the comedy accrues laughter while it rushes to its salutary conclusion, the showing up of the insidious guest.

Led by Jean Stapleton and Julia Gibson as the self-proclaimed head of the family and her lovestruck younger daughter, the production is light-hearted fare acted with sprightliness. But there is a problem, and it is one that cannot be ignored.

Instead of using Richard Wilbur's eloquent verse translation, Mr. Seyd has chosen to work with an adaptation by Freyda Thomas, with his own and Ms. Thomas's "additional adaptive material." This version colloquializes dialogue and, at various points, diverges from the substance of the text. Intermittently, it Trissotinizes Molière.

The intention was evidently not to revamp the play or to wrench it out of its period, but simply to cajole it into a more modern mainstream. But as with other Molière, the wit is undated and always relevant. By inference, theatergoers can easily equate the snobbishly chic salon of Philamente (Ms. Stapleton) with contemporary attempts at social climbing and intellectual ascension. There is no need for an adapter to underline the parallels.

Heedless of that fact, Ms. Thomas intrudes expressions like "spinach quiche" and "make our vows legit" and, about Trissotin, "he's a creep." On occasion, the lines are forced into rhyme or simply flattened out, as in a young suitor's statement, "I'm condemned, and why? I'm just an ordinary guy," which makes Molière sound like a 17th-century version of Oscar Hammerstein 2d. As a result, Trissotin and others lose some of their loftiest, self-mocking dialogue.

In almost all other respects, the production is sure-footed. The two-level setting by Richard Hoover (the production designer of "Twin Peaks") is an elaborate environmental installation offering a staircase of comic possibilities to the intrepid actors. Costumes are generally in period and Gina Leishman's musical background is scored for harpsichord.

Most importantly, the actors seem fully capable of playing the real Molière instead of the mock. In Ms. Stapleton's performance, Philamente has the determination of a corporate C.E.O. and is blind to any criticism. But the actress also stresses the fact that Philamente is self-deluding so that her inevitable awakening does not catch the character totally by surprise. Nestor Serrano offers a novel non-foppish interpretation of Trissotin. In his red cape and with the look of a roué, he seems to swagger even when he is lying on a couch. In a world populated by fools, one of the most foolish — and one of the funniest — is Georgine Hall as a maidenly aunt who mistakenly thinks every swain has fallen for her charms.

The appealing Ms. Gibson wisely refrains from sentimentalizing the daughter. Of all the characters, this is one of the most sensible. She is in love, but is well aware that steps must be taken if she is to escape from her mother's control. Peter Francis James as her suitor is too bumptious at first but later settles into a state of

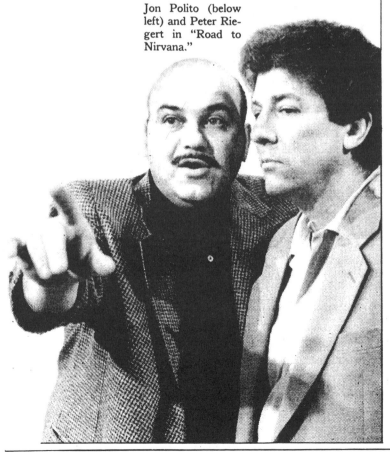

Jon Polito (below left) and Peter Riegert in "Road to Nirvana."

Paula Court

Jean Stapleton and Georgine Hall in a scene from "Learned Ladies."

helpless ardor. There are also amusing contributions from Frank Raiter, Merwin Goldsmith and Alice Haining.

•

In this high comedy of domestic discord, Molière is not above a sight gag (a furniture-tripping servant), but principally he is concerned with literate plays on words and with ridiculing the pseudo-savantes who are proudly protective of their own ignorance.

In the introduction to his translation, Mr. Wilbur warned against forced attempts to remove the author from his historical perspective. If Mr. Seyd had been less linguistically incautious, his version of "The Learned Ladies" would have been more pleasurable.

1991 Mr 10, 58:1

Sparky and the Fitz

By Craig Volk; directed by Stephen Rothman; set by Deborah Jasien; costumes by Barbara Forbes; lighting by Donald Holder; production stage manager, Michael Suenkel. Presented by the George Street Playhouse, Gregory S. Hurst, producing director. At the New Brunswick Cultural Center, 9 Livingston Avenue, New Brunswick, N.J.

Sparky..Eli Wallach
Fitz...Anne Jackson
Rudy..Ben Hammer

By STEPHEN HOLDEN

Special to The New York Times

NEW BRUNSWICK, N.J. — Sparky and Fitz, the cutely nicknamed husband and wife who jabber away in Craig Volk's "Sparky and the Fitz," are one of the quirkier couples to be found in a contemporary comedy.

A retired ambulance driver, Sparky (Eli Wallach) keeps a telescope near the front door of his suburban house to observe the neighbors, and he tipples from a bottle he keeps hidden inside an empty oatmeal can. His chattery, health-obsessed wife, Fitz (Anne Jackson), frets about her loss of youth between phone calls from an aged mother complaining of constipation.

Cooped up together in their suburban house, the couple are, as Fitz puts it, "biding time." Instead of completing their unfinished jigsaw puzzle of Venice, they spend most of their hours bickering and picking over the past. The play spans a Halloween afternoon and evening and the day after, during which old grievances are aired, masks are donned, and Fitz nearly runs off with a bewigged lug who drives a delivery truck.

"Sparky and the Fitz," which is having its world premiere engagement at the George Street Playhouse in New Brunswick, N.J., seems an unlikely project for a playwright who graduated three years ago from the Yale School of Drama, where he won two writing awards. With its stream of unfunny jokes about aging, diet and sex, the play has the stale, dessicated feel of a cast-off script for "The Golden Girls" dressed up with a few absurdist touches and padded out for two dreary hours. The text has no structure, no momentum and no discernible points to make.

When out of the blue it is revealed that the couple blame each other for being childless, one expects the sudden interjection of pathos to make things gel. But the matter is simply dropped. Even by the loose standards of situation comedy, the romance of Fitz and her truck driver, Rudy (Ben Hammer) eludes credibility.

What could have attracted actors of the caliber of Mr. Wallach and Miss Jackson to such an amorphous stew? Perhaps they thought they could mold coherent characters out of the play's deluge of banter. Mr. Wallach at least makes Sparky a likable old goat, who even when attempting to terrorize Rudy in the second act, couldn't hurt a flea. But Fitz is so thoroughly unpleasant — hypochondriacal, jealous, two-faced and whining — that not even Miss Jackson's gamely upbeat performance can make her worth caring about.

1991 Mr 10, 59:1

When We Dead Awaken

By Henrik Ibsen; translated by Rolf Fjelde; directed by Eve Adamson; music by Edvard Grieg; set by Sara Waterbury; costumes, Jonathan Bixby; lighting, Ms. Adamson. Presented by Jean Cocteau Repertory, Robert Hupp, artistic director; David Fishelson, managing director. At the Bouwerie Lane Theater, 330 Bowery.

Prof. Arnold Rubek.......................Craig Smith
Maja..Elise Stone
The Manager...........................Mark Waterman
Ulfhejm...Joseph Menino
Irina...Angela Vitale
The Nun...Grant Neale

By WILBORN HAMPTON

It is always something of a surprise to encounter the very early or the very late plays of Ibsen, in which the master of naturalism took flight to realms of symbolism and romantic fancy. In these works Ibsen indulged the poet he always insisted he was and turned his attention away from the problems of the individual as a member of society to focus on the inner struggles of the soul, always a difficult task for actors to portray.

The main conflict, for example, in "When We Dead Awaken," Ibsen's final play, which is being revived at the Cocteau Repertory Company, takes place within the mind of Arnold Rubek, a famous sculptor who has returned to his native Norway to rediscover the source of his earlier inspiration. The secondary plot concerns a similar battle within Maja,

Miguel Pagliere

Eli Wallach and Anne Jackson in a scene from "Sparky and the Fitz."

Jonathan Slaff

Craig Smith

his wife, who is suffocating from ennui after four years of marriage.

Under the directorial hand of Eve Adamson, who never hesitates to undertake difficult plays, Craig Smith as Rubek and Elise Stone as Maja make a game effort to bring some credibility and meaning to Ibsen's last autobiographical mutterings.

The opening scene, in which Rubek and Maya portray their mutual boredom while reading a newspaper on the terrace at a spa, is promising. Ms. Adamson allows Mr. Smith and Ms. Stone to take their time over a scene that establishes the artist's quiet arrogance and bitterness and his wife's disillusion. Mark Waterman contributes an amusing turn as the spa manager. Then Ibsen starts introducing the characters who serve as symbols and the play moves into allegory.

Joseph Menino is stalwart as Ulfhejm, the bear hunter who hates sickness and weakness and whose closest friends are his dogs, and Angela Vitale is ethereal as Irina, the model for Rubek's masterpiece who is now quietly shadowed by a black-habited nun.

Written on the eve of the 20th century, "When We Dead Awaken" is almost embarrassing nearly 100 years later in its unabashed romanticizing of the aging artist questioning his life. For Rubek, Irina was the "soul of my inspiration," the model he "could never touch because it would defile my artistic vision of her." But Irina has always carried with her the key to the treasure chest of Rubek's mind, and he now seeks her out to unlock it and again free his creativity and desire.

It is very difficult to find serious meaning in all the melodramatic dialogue that refers to statues as dead children and museums as cemeteries. Mr. Smith captures the contradictions, the abounding capacity for self-forgiveness and even the flashes of humor in Rubek. And Ms. Stone gives a thoughtful reading to Maja. But in the end the actors and director find themselves struggling to make believable drama out of what is basically a self-indulgent treatise on the burdens and sacrifices of artistic genius.

1991 Mr 10, 59:1

SUNDAY VIEW/David Richards

At the Public, This Bud's for You, Bard

Pop detritus winks through 'Henry IV'; Tracey Ullman paints a Hollywood tale in Gothic style; Steve Tesich registers the Vietnam aftershock.

A LOT WILL NO DOUBT BE MADE of the anachronisms that the director JoAnne Akalaitis has sprinkled liberally throughout her staging of "Henry IV, Parts I and II," the 16th and 17th productions in the Public Theater's continuing Shakespeare marathon.

The epic is barely under way when Poins, that nimble-fingered rogue no less nimble on his feet, bounds on stage — a drumstick in his mouth, a bagel in his pocket and a television set, presumably pilfered, under his arm. From there on in, there is hardly a scene that doesn't bear the trace or the detritus of the 20th century. Sometimes it is as blatant as an automobile tire, hung around the neck of an abject army conscript, or the clutter of empty Budweiser cans at the foot of a tavern bed. Other times, it's no more intrusive than a chain of safety pins dangling from the shoulder of a denim jacket or a paper parasol decorating a drink.

■

You could almost make an evening of it (actually about six hours, if you catch the two plays in tandem), tracking down violations in the basic medieval landscape. Here, I am tempted to say, is the stage's answer to the Waldo books, in which that mischievous little chap, about a quarter-inch high, is hidden away in elaborate illustrations of other places and other ages. And yet, you'd be surprised at how easy it is to accept a world of broadswords and Tommy guns, princely robes and sunglasses.

There is only one condition, really. You've got to believe the actors.

It doesn't matter all that much whether Falstaff collapses into a wooden chair or, as he does here, into an old automobile seat and then finds the force of so much descending weight carrying him and the chair over backward, so that all we see for a second are the soles of his immense boots. If the man's girth and gourmandise are real to us, the ungainly somersault will be, too, whatever the chair that's proved wanting.

Nor does it necessarily hurt that Prince Hal's wardrobe consists more or less of the sort of leisure wear you could spot on any campus quad these days. Until he undergoes a conversion to higher purposes, Prince Hal is his era's equivalent of the fraternity hellraiser. If we accept the rebelliousness in his soul, we'll accept the clothes on his back. And there, as the man said, is the rub.

The vision that Ms. Akalaitis has put on the stage of the Newman Theater — a synthesis of High Gothic elegance, the brown and wintry squalor of Bruegel and the pasty-white institutional madness codified by Peter Brook in "Marat/Sade" — is often astonishing to behold. But it is almost totally unsupported by the acting and therefore likely to strike many as maddeningly arbitrary. (Why an automobile tire? Why not a steering wheel?) The natural reaction is to condemn the director for tinkering — it can't, after all, be the lines that are letting us down — and to dismiss these "Henrys" as one more misguided attempt to catch Shakespeare up with our times.

In fact, it seems to me that the deficiencies lie primarily with the casting. Put these very same actors in a more conventional production — one in which the character of Rumor, say, is *not* a little bleached chippy in a black plastic raincoat decorated with wagging tongues — and I suspect the experience would be even less gratifying. This may not be designer Shakespeare, but the designers are doing all the interesting work.

Within a crumbling brick cathedral, dusted with dead leaves and, later, the sad downward drift of snow, the set designer George Tsypin evokes brawling inns, drafty palace rooms and scorched battlefields. Jennifer Tipton's lighting ranges boldly from the golden flicker of real on-stage fires to the flat, accusatory glare of neon tubes, while you could say that Gabriel Berry's costumes are right off the wrack — torn as they are between the old world and the new.

The Boar's Head Tavern — as they imagine it and Ms. Akalaitis populates it — is a ghastly charnel house, with gutted piglets hanging from the rafters and syphilitic customers entwined lewdly on the floor. Once the bacchanal has subsided, the bodies, still writhing in tortured slumber, are blanketed in half-light, while Henry IV appears above them to deliver his paean to the "gentle sleep" cradling his poor subjects. The speech, culminating with the observation that "uneasy lies the head that wears a crown," is rendered bitterly ironic under the circumstances. A whole society lies uneasy.

This kind of texturing is characteristic of the productions as a whole. Ms. Akalaitis thinks nothing of superimposing filmed images on slide projections on live action and then, for good measure, adding a further layer of smoke. While aspects of these "Henrys" are undeniably ugly and brutal, the panoramic impression, curiously enough, is often one of autumnal beauty. Very nearly all the enticements are visual, though. Ms. Akalaitis puts together one extraordinary picture after another, but the scenes themselves have no momentum. They chronicle flurries of activity, not forward motion. Were it not for Philip Glass's lovely original score, suggesting time itself rushing and tumbling toward the uncertain future, we would have little sense of events building to a climax.

■

Narrow the focus to the individual performers and the productions lose their interest completely. Louis Zorich is a Falstaff as tradition pictures him — the head of Father Christmas on the body of a giant squash — but the lusty emotions are perfunctorily rendered, and you can't say his friendship with

George E. Joseph/New York Shakespeare Festival

Caris Corfman as Rumor in "Henry IV, Part II"—The panoramic impression, curiously enough, is often of autumnal beauty.

Prince Hal runs deep. As Hal, Thomas Gibson brings to the part great cheekbones and not much else — he's a small, naturalistic actor lost in the vastness of Shakespeare. In that, he is not alone. Ruth Maleczech's squawking Mistress Quickly would be more at home haggling in a bargain basement. With the exception of Larry Bryggman, a forceful enough Henry IV, even in death's clutches, and Rodney Scott Hudson, a coolly devious Archbishop of York, no one seems comfortable speaking Elizabethan English.

In Jared Harris's case, the discomfort is intentional. Mr. Harris's Hotspur has a speech defect that stops him dead in his feverish tracks. Whenever he hits a word beginning with "b" — like "buh . . . buh . . . buh . . . Bolingbroke" — his eyes bug out and he threatens to explode from the buildup of internal pressure. Mr. Harris returns later, tripped-out and reeling, as Pistol, a man with a Vespa, if not a mission.

Few in the large cast are without tics of some kind or another. (Even fewer are without lice.) Character, in Ms. Akalaitis's view, tends to boil down to idiosyncrasy, and language is simply disturbance made audible.

It would be foolhardy, as a result, to go to these troubled "Henrys" to listen. Your ears are sure to wander. Go to look. Your eyes will tell you all there is to know.

'The Big Love'

I won't pretend that "The Big Love" (at the Plymouth Theater), the one-woman show by Brooke Allen and Jay Presson Allen about the very marginal life of Florence Aadland, is anything more than it is — a curious slice of Hollywood Gothic. But it is being performed under the best possible conditions: Tracey Ullman is starring in it.

Without going overboard, let's just say that Ms. Ullman is terrific, playing a not very bright woman whose notions of glamour, success and morality have been entirely shaped by the movies. Florence Aadland's only claim to fame was that she was the mother of Beverly Aadland, a starlet whose only claim to fame was that at 15, she became the mistress of Errol Flynn. For the two years prior to his death in 1959, Beverly led a semblance of the Hollywood high life and so, vicariously at least, did Florence.

Since Beverly was a minor, Flynn was a legendary swordsman and the Eisenhowers still stood as symbolic guardians of the public virtue, the affair earned a measure of notoriety in the press, while Florence was branded by the less gentlemanly supermarket tabloids as "the Mother Procuress." Beverly subsequently went on to a brief nightclub career and obscurity. For her sins as an unfit parent, Florence was sentenced to two months in jail and later wrote "The Big Love," her rapturous ac-count of days and nights with Beverly and Errol, on which this script is based. Set in a tawdry L.A. bungalow in the hours before Florence is to go into the slammer, it finds her packing her meager possessions, sipping red wine and chatting up a confidential storm, as if the theater itself were one big beauty shop.

∎

Obviously, we're talking footnotes here. Ten years later, the Aadlands' escapades probably would have passed unnoticed. But the Allens (mother and daughter) have been right to sense that the tale, weird and pathetic as it is, is also touched with surrealistic comedy. Ms. Ullman, looking like Tammy Faye Bakker trying to look like Ginger Rogers, is brilliant at capturing all that is cheap, vulgar and off-center about the woman without once condescending to her. But there's a feisty gallantry to the portrait, too. "We're not exactly Beverly Hills here," she says, casting a disparaging look about the surroundings. "Wanna hear my new motto? *'So what!'* " Apologies are not part of her style, which runs to lacquered blond hair, harlequin glasses and naughty tales, even if they are being told out of school.

Fate dealt her two miscarriages and she lost a foot in an automobile accident, but the way she sees it — mist momentarily clouding her eyes, heavy with mascara — Beverly is "my gift from the universe." No mother ever tended a daughter's shrine more assiduously. She has the snapshots to back up the glittery memories, Beverly's "Heidi" dress, and the menu from that fabulous night at the Copacabana, signed by everyone who was present — Beverly, Errol, Frankie Laine and the head-waiter.

Eager to communicate the full measure of her daughter's talent, she puts "Let a Smile Be Your Umbrella" on the phonograph and sings and dances the number, just as Beverly does in her sensational nightclub act. She's a bush-league Mama Rose and the overwrought routine is hilarious. Ms. Ullman doesn't stop there, though. Florence swells with all the breathless pride of a job well done. The evidence is, to her mind, incontrovertible, however pitiful we may find it.

But then, she doesn't want our pity, merely our acknowledgment that a daughter like Beverly would make any mother's existence worthwhile. In that respect, the character is not unlike the washed-up Truman Capote, who spent the week before Christmas in Jay Presson Allen's "Tru" repeatedly evoking his genius to excuse the wreckage of his life. "Tru," of course, had the advantage of showing us the underside of a celebrity. Florence Aadland was a nobody to begin with and a nobody in the end. And you can't say she did much with the years in between. It is Ms. Ullman's huge talent and brilliant intuitions that make her, against considerable odds, a somebody.

Martha Swope/"The Speed of Darkness"
Mr. Lang as Lou in "The Speed of Darkness"—scary as blazes

'The Speed of Darkness'

As part of a high-school assignment designed to discourage teen-age pregnancy, the young daughter in "The Speed of Darkness" (at the Belasco Theater) carries with her at all times an 11-pound bag of dirt, her "baby." She is getting off easy. The adult characters in Steve Tesich's drama about the legacy of the Vietnam conflict are lugging around two-ton sacks of guilt.

This is what is generally called a "serious" play, which means that it addresses issues of consequence with a gravity that can be easily taken for importance. It certainly deserves no one's disrespect. But its ponderousness cannot be denied, either. From the start, Mr. Tesich holds out the promise of a shocking revelation at the play's end. When the long-awaited moment comes, revelation proves a massive letdown. It's rather like having the covers whipped off a sludge pile. The contours were more tantalizing under wraps.

Mr. Tesich is not the first to point out that the Vietnam veteran took a psychological and physical battering on the battlefield, and that when he returned home — often to indifference or, worse, scorn — he brought the war with him. David Rabe's "Sticks and Bones," Tom Cole's "Medal of Honor Rag," the Vietnam Veterans Ensemble Theater Company's "Tracers" have all spun variations of the story. However, the spareness and formality of Mr. Tesich's dialogue suggest that he is trying to move the tale beyond naturalism and

Tracey Ullman chats up a storm; Stephen Lang is an M.I.A. – 'Missing in America.'

at least nudge it in the direction of Greek tragedy.

His pivotal character, a middle-aged veteran named Joe (Len Cariou), has presumably got on with his life in South Dakota. He has a caring wife, a bright daughter, a successful construction business and a home with a picture window that affords him a spectacular view of the mesa in the distance. As the play begins, he's about to be named South Dakota's "Man of the Year." But every aspect of his life — wife, daughter, business, award — involves a lie and I probably don't have to tell you that even the mesa hides a secret. When Lou (Stephen Lang), his old battlefield buddy, shows up, the unravelling begins.

■

Mr. Lang, who played such a vivid martinet in "A Few Good Men," has a crazed sweetness as a homeless veteran who once tried to scratch his name into the Vietnam Memorial with a can opener and whose chief occupation these days is following the touring version of the memorial ("son of wall," he calls it) around the country. He's one of the M.I.A.'s — "Missing in America" — and no one's bothering to look for him. At times, the performer is eerily reminiscent of Art Carney in "The Honeymooners" — almost goofily good-natured. Then, his mind goes out of focus and he's scary as blazes. Simply having him around adds a welcome level of ambiguity to "The Speed of Darkness," and when he produces a gun from under his ragged fatigues, he jolts the play momentarily to life.

Mr. Cariou is hard put to top him. His portliness argues for a life of comfortable self-indulgence, not gathering torment, and he attacks the final monologue with the gluttony of a good burgher chomping into a roast leg of lamb. The performance never transcends an inherent weightiness: Mr. Cariou gives us all of the anguish of confession and little of the enlightenment.

The title refers, I would guess, to the rapidity with which lives can fall apart, when they are rooted in falsehood. But the solemnity of Robert Falls's direction lends it an unintended irony. Destruction comes slowly, although hardly inexorably, to the empty heartland of Mr. Tesich's America. The supporting cast — Lisa Eichhorn, Kathryn Erbe and Robert Sean Leonard — seems trapped between a vague foreboding and a growing numbness.

"The Speed of Darkness" is the first production to be offered under the Broadway Alliance, which aims to encourage the presentation of new plays in certain under-used Broadway theaters by trimming costs across the board. In theory, the top ticket price, $24, will be instrumental in luring audiences back to Broadway. In reality, the plan's success rides entirely on the merits of the plays in question. But hasn't that always been the case?

Cut-rate prices for cut-rate goods are no bargain, after all. They're just another come-on. □

1991 Mr 10, II:5:1

I Can Get It for You Wholesale

Book by Jerome Weidman, based on his novel; music and lyrics by Harold Rome; directed and choreographed by Richard Sabellico; musical direction, Jonny Bowden; set design, David Sumner; costume design, Gail Baldoni; light design, Tom Sturge. Presented by the American Jewish Theater. At the Susan Bloch Theater, 307 West 26th Street.

WITH: Jim Bracchitta, Deborah Carlson, Carolee Carmello, Patti Karr, Alix Korey, Richard Levine, Vicki Lewis, Evan Pappas, Sam Brent Riegel and Joel Rooks.

By MEL GUSSOW

Harold Rome's 1962 musical "I Can Get It for You Wholesale" is remembered as the show that introduced Barbra Streisand to Broadway and catapulted her to stardom. Richard Sabellico's well-balanced revival at the American Jewish Theater puts the show in perspective but it remains a middling example of its genre.

The protagonist is Harry Bogen, a Seventh Avenue variation of Hollywood's Sammy Glick. He is a former shipping clerk who, in quick time, runs roughshod over everyone in his rise to the top, and then steps on the same people on his way down. Despite its hard-boiled aspirations, "Wholesale" is not on a satiric plane with "Pal Joey" or "How to Succeed in Business Without Really Trying."

One problem is that there have been so many Sammys and Joeys on and off the musical stage. Harry is himself a cliché, as are some of the people around him, especially the timid partner he so easily cheats and the showgirl who demands diamonds

Martha Swope/"The Big Love"
Ms. Ullman as Florence Aadland in "The Big Love"—I'm somebody. Who are you?

before she gives him the key to her apartment.

•

Fortunately, Evan Pappas brings a slick charm to the role created on Broadway by Elliot Gould. One can understand why others let him take advantage of them. Come along with him, he urges, and share in his success (and ignore the fact that he is unscrupulous). Mr. Pappas keeps Harry firmly on his single track, as a man with no world beyond his ambition. When someone changes the subject, the actor's eyes gaze into the distance; he has tuned out and is plotting his next maneuver. The performance helps to replenish the familiar character.

With its small, naturalistic dimensions, the show was not comfortable as a big Broadway musical, and is more efficient in this stripped-down version. Mr. Sabellico focuses on Harry and plays down the frenetic background, except the first-act finale, "Ballad of the Garment Trade." It should be added that the Susan Bloch Theater, with its narrow stage and bad sightlines, is not a conducive environment for musicals. The director and his cast combine their energies and partly overcome the restrictive setting. Emotionally and musically, the show is kept in scale, even during the few obligatory moments of sentiment, the salutes to a mother's love (and a mother's blintzes).

Mr. Rome's score is always serviceable and in harness to Jerome Weidman's book (based on his novel of the same name). Together, they express the essential grittiness of the story, emphasized by a newly revised downbeat ending.

•

"Too Soon" is a double-edged lament in which Harry's mother warns her prospective daughter-in-law about her son's guile and "Who Knows" is a nostalgic salute to New York's innocent past. The most abrasive songs are "The Sound of Money" and "The Way Things Are," in which Harry unashamedly boasts of his own greed. Recalling Mr. Rome's signature number from his show, "Pins and Needles," these two could be called songs of antisocial significance.

Patti Karr locates the latent cynicism of the mother, a woman who readily accepts Harry's gifts while maintaining a dispassionate attitude toward his corruption. Carolee Carmello, as the nice girl Harry jilts, keeps her character sugar-free, and her rendition of "On the Way to Love" becomes an angry indictment of his selfishness.

This leaves Miss Marmelstein. As this harried secretary, Ms. Streisand (at the age of 19) was a clown in perpetual motion; deservedly she was a show stopper. Vicki Lewis's caricatured approach to the role does not make one forget her predecessor, but she is amusing and likely to seem funnier to anyone who did not see the original.

•

Though a minor character, Miss Marmelstein is actually the most interesting person onstage. She is a compulsive loyalist who sees right through Harry, knows all his failings and goes along for the heady ride. For her, Harry promises excitement, even as he plummets to misfortune.

If "Wholesale" is not, in the parlance of its setting, cut velvet, it is at least well-fitting ready-to-wear, and very much in the spirit of its time.

1991 Mr 11, C14:3

Belle Reprieve

Devised and performed by Lois Weaver, Peggy Shaw, Bette Bourne and Precious Pearl. Inspired by "A Streetcar Named Desire." Directed by Ms. Weaver; musical collaboration, Laka Daisical and Phil Booth; set design and painting, Nancy Bardawil and Matthew Owens; lighting design, Howard S. Thies; costume design, Susan Young; stage manager, Karen Horton. Presented by La Mama E.T.C. and Drill Hall Arts Center (London). At One Dream, 232 West Broadway, near White Street, in TriBeCa.

By WILBORN HAMPTON

There comes a moment in the campy drag show "Belle Reprieve," and it comes quite early, when one is forced to ask, just what is the point of any of the goings-on onstage?

The answer, of course, is that there is no point. "Belle Reprieve," which has moved from La Mama to One Dream in TriBeCa for an extended run, is billed as a "musical sendup" of Tennessee Williams's "Streetcar Named Desire." It is, in fact, a simple cabaret vehicle for Split Britches, the New York lesbian company, and Bloolips, a London gay troupe, to sing a few kitschy and faintly bawdy songs and romp about in several pun-filled scenes that use Williams's play only as a point of departure.

Th musical part of the show consists of parodies of songs ranging from Muddy Waters and the Gershwins to British music-hall ditties, and includes a mildly ribald rendition of the hokeypokey. The dialogue is laced with tired double-entendres about genitalia, male and female, and the humor tends to find its own level. One routine asks the age-old question whether squirting someone with a bottle of seltzer or hitting someone in the face with a pie is funnier, and another concerns extricating foreign matter from someone's nose.

The two main roles are in drag. Blanche is played by Bette Bourne, a founder of Bloolips, while the part of Stanley is taken by Peggy Shaw of Split Britches. In only slightly straighter casting, Lois Weaver, who also directed, is Stella and Precious Pearl plays Mitch.

•

The most successful parts of the show are some of the musical numbers. A takeoff on Muddy Waters's "I'm a Man" is quite funny, and an original song by Paul Shaw (the nom de chanson, as it were, of Precious Pearl) captures the spirit of a music-hall ballad. Another number in which three paper lanterns do a tap dance is lively.

But apart from the fact that the "Belle Reprieve" characters are named for characters in "Streetcar," and that the names of Marlon Brando and Vivien Leigh, the stars of the movie version of the play, are taken in vain several times, there is little to connect the two works, even as a takeoff. A couple of skits are set up by scenes from the play (Stanley goes through Blanche's trunk; Blanche takes a bath) and some famous lines are given a twist ("I've always trusted in the strangeness of strangers"), but on the whole there is little originality in the show.

All four actors bring a lot of energy to their joint creation, and fans of the two companies will doubtless have some fun. But even as a spoof, the level of "Belle Reprieve" is more sophomoric than sophisticated.

1991 Mr 11, C14:5

The Haunted Host

Written by Robert Patrick; directed by Eric Concklin; production design, David Adams; production stage manager, Joe McGuire. Presented by La Mama E.T.C. At 74A East Fourth Street.

Jay Astor..................................Harvey Fierstein
Frank..Jason Workman

By STEPHEN HOLDEN

Harvey Fierstein has never been an actor one could call demure. The creator and star of "Torch Song Trilogy" is a bellowing clown and operatic ham who suggests a fire-breathing combination of Lucille Ball, Elmer Fudd and a dancing bear. In the revival of Robert Patrick's 1964 play, "The Haunted Host," at La Mama, Mr. Fierstein almost literally chews the scenery playing Jay Astor, a gay Greenwich Village writer mourning the suicide of his roommate and unrequited lover, Ed.

In his sweaty over-the-top performance, Mr. Fierstein tramps across the furniture, mugs, camps, goes in and out of a Southern accent, imitates Bette Davis and twice gets himself up in amusingly outlandish drag. It is all for the benefit of Frank (Jason Workman), a 19-year-old aspiring writer from Iowa a friend has sent over for professional advice and whose uncanny resemblance to the late Ed sends his host into a tizzy.

With its three scenes, set within a 24-hour period, the one-act drama depicts a marathon power struggle between the host and his guest that is complicated by Ed's unseen ghost, who still haunts the apartment and engages Jay in noisy one-sided conversations. It is a battle in which the smitten Jay defends himself with challenges, insults and epigrams against a guest who alternately flirts, condescends and begs for advice.

"The Haunted Host" has a special place in the annals of New York theater. In its original production at the Cafe Cino in Greenwich Village, Mr. Patrick portrayed Jay, and William Hoffman, who years later wrote "As Is," played Frank. Written in the days before gay liberation, the play is now quite dated. Yet it stands as one of the first American plays to present an openly gay character from a perspective that was at least partly affirmative.

As staged by Eric Concklin, the La Mama revival shrewdly spins the production around Mr. Fierstein's oversize stage personality. The set is a garish clutter of mirrors, photos, colored lights and music boxes. The look of the play, which is set in 1964, has some glaring anachronisms. If the sound track is appropriately early Barbra Streisand, the production design, with its tie-dyed bed sheets and peace symbols is more late Woodstock.

In the role of Frank, Mr. Workman, a soap opera actor who also played the boy next door in the Broadway production of "Meet Me in St. Louis," gives a bold, flashy performance. Playing down the character's ingenuousness, he makes Frank a shameless narcissist and teasing flirt. In high-pitched conversation that seesaws wildly between friendliness and reproach, Mr. Workman holds his own, even though Mr. Fierstein is given most of the best lines.

"The Haunted Host" is not a deep play, nor even a particularly relevant one. But it has plenty of thrashing energy, and two performers who revel delightedly in the tussle.

1991 Mr 12, C15:1

The Farewell Supper
Countess Mitzi

Two plays by Arthur Schnitzler; set design, Robert Joel Schwartz; costume design, Barbara A. Bell; lighting design, Stephen Petrilli; sound design, Arthur C. Mortensen; stage manager, Norma Dunkelberger; technical director, Richard A. Kendrick; assistant stage manager, Corey Stieb. Presented by the Pearl Theater Company, 125 West 22d Street.

THE FAREWELL SUPPER Directed by Frank Geraci
Max...Stuart Lerch
Anatol..Arnie Burton
Annie......................................Robin Leslie Brown
Waiter..Hank Wagner

COUNTESS MITZI Directed by Tom Bloom
Valet...Arnie Burton
Count Arpad Pazmandy.............Richard Seff
Countess Mitzi............................Joanne Camp
Gardener and Wasner...............Frank Geraci
Prince Egon Ravenstein.........Richard Bourg
Philip...Hank Wagner
Lolo Langhuber...................Robin Leslie Brown
Professor Windhofer...................Stuart Lerch

By STEPHEN HOLDEN

Few theatrical worlds are more inviting than upper-class Vienna at the end of the 19th century as portrayed in the plays of Arthur Schnitzler. At once opulent and refined, Victorian and bohemian, it is one setting whose denizens come awfully close to having their cake and eating it, too. Schnitzler was psychologically shrewd enough to create characters with depth, and enough of an entertainer to invest even his more hapless creations with a patina of glamour.

"Countess Mitzi," the more substantial of the two one-act Schnitzler plays being presented by the Pearl Theater Company at its West 22d Street headquarters, affectionately examines an aristocratic milieu whose sexual arrangements are completely at odds with appearances. The propriety-obsessed Count Arpad (Richard Seff) is loath to present his longtime mistress, Lolo Langhuber (Robin Leslie Brown), to his spinster daughter Mitzi (Joanne Camp), who unknown to him, had a child by his best friend, Prince Ravenstein (Richard Bourg) many years ago. The play shows what happens when Lolo and the prince's grown-up son pop up simultaneously in the count's home.

The biggest problem of the Pearl Theater production, directed by Tom Bloom, is the cast's unease at playing aristocrats. Dialogue that should glint with innuendo while flowing like champagne is delivered in stilted cadences. Joanne Camp in the title role suggests her character's double life by wearing a twinkly, enigmatic smile much of the time. It's not enough to make Mitzi come alive. Mr. Seff's Count and Mr. Bourg's Prince, though somewhat more confident, don't convey a sense of being to the manor born. And Hank Wagner's eyeball-popping, grinning performance of the son, Philip, is a goofy travesty.

Set in the same milieu, the evening's opening play, "The Farewell Supper," explores the breakup during a fancy meal of an aristocrat and a dancer who have both found new lovers. Although a very minor work, it is incisive in its analysis of sexual jealousy, competition and cruelty between two spoiled people who had sworn to be "civilized" if their relationship should end. Robin Leslie Brown, who also plays Lolo in "Countess Mitzi," gives the role of the dancer, Annie, a dark, edgy hauteur that is quite interesting. Arnie Burton, as her faithless lover, Anatol, lacks the grace and solidity to give the role any weight.

1991 Mr 13, C12:4

Humor in Unlikely Subjects

By JENNIFER DUNNING

"Feet Brushes and Breath," a three-part series of collaborations by dancers, painters and performance artists, got off to an eloquent and very funny start with "Painted Tooth" on Thursday at the Mulberry Street Theater (70 Mulberry Street). Virtually a solo, the hourlong piece gave Laurie Carlos a chance to let out all the stops as a performance artist and writer. And Ms. Carlos can create or decimate whole worlds with a widening of her eyes or slight drop or rise in her voice.

Here she is, a plump, disheveled but beautiful woman trying to force herself to go to a party in spite of the fact that she feels ugly and doesn't feel like talking about movies. There are telling allusions to everything from the Persian Gulf war to being a woman, the latter occurring as Ms.

Carlos makes herself up and performs a wicked rendition of "I Enjoy Being a Girl."

A sprawling work that is held together by the integrity of Ms. Carlos's words and presence, "Painted Tooth" is also about being black, not being rich and about male-female relationships. Ms. Carlos finds new things to say, in new ways, in a magically iridescent and translucent boudoir and bedroom designed by Helen Oji, who changes places with Ms. Carlos at the last moment.

Annette Elderkin designed the sensitive lighting.

The series, presented by Stackmotion Productions, will continue with work by Anita Gonzalez and Kimberly Bush on Thursday, Friday and Saturday and with work by Marlies Yearby and Dindga McCannon for three days beginning March 21.

1991 Mr 13, C14:3

A Fierce Attachment

Based on the book "Fierce Attachments," by Vivian Gornick; adapted and directed by Edward M. Cohen; sets, Ray Recht; costumes, Carrie Robbins; lights, Brian Nason; stage manager, Geraldine Teagarden. Presented by the Jewish Repertory Theater, Ran Avni, artistic director; Mr. Cohen, associate director. At 344 East 14th Street.

WITH: Tovah Feldshuh

By MEL GUSSOW

After a father's early death, a woman and her teen-age daughter continue to live together, and to grow apart. That is the first premise of Vivian Gornick's 1987 memoir, "Fierce Attachments" (adapted to the stage by Edward M. Cohen, at the Jewish Repertory Theater). From there, Ms. Gornick tells the story of a self-centered woman who spends her life mourning her loss of a husband, and of a self-contained daughter who tries to discover herself as a woman and a writer away from the domination of her mother.

In the present, as the two become conversational antagonists and incessant walkers in the city, Ms. Gornick looks back to the tenement of her childhood in the Bronx. This claustrophobic environment is filled with unhappy women, most of them trapped in a "sexual rage." Mother and daughter have common ground but not common memory; they see the same people and events from entirely different perspectives.

The book's mood is more that of anger than of wistfulness. The

The struggle to slip the suffocating grip of a self-centered widow.

"fierce" in the title is an adjective that is well earned. Mr. Cohen's adaptation, using the singular form, "A Fierce Attachment," is a definite

miss as a work of theater, in tone as well as content. The only rewards that come from this monodrama are that it offers Tovah Feldshuh an opportunity to demonstrate a range of emotions, accents and acting skills, and that it might encourage audiences to read Ms. Gornick's memoir.

Mr. Cohen, who is the director as well as the adapter, has scissored the book for anecdotes and observations and pasted them together with awkward transitions. Through his selections, he has managed to conceal the individuality of the characters. Onstage, this seems too close to just another reminiscence of a strong-willed Jewish mother and her rebellious daughter, as exemplified by the mother's Henny Youngman-like introduction, "I'd like you to meet my daughter — she hates me."

The narrative is surrounded by a clichéd theatrical device: the character as author trying to write. We meet Ms. Feldshuh (as Ms. Gornick) sitting at her typewriter and crumpling false starts. By the end of the play, she is tapping away confidently on her word processor, presumably writing the book that leads to this performance. The act of writing is not the point of the memoir; it is the daughter's impressionistic interior life and her complex relationship with her mother.

With the help of Ms. Feldshuh, there are glimpses of this intense family bond. We see a mother who is always at center stage and a daughter who is relegated to the role of supporting player, a daughter who finds herself unappreciated no matter what her accomplishments are. There is one disturbing confrontation, which ends with the daughter's thought that one of them is "going to die of this attachment." But most of the time the play is at a distance from the real story. Just as the adapter has been capricious in what he has chosen to use from the book and what he has chosen to omit, he has not clearly defined the dramatic voice.

The burden of definition falls on Ms. Feldshuh, and she does as much as she can to compensate for the failings of the play. She is adept at changing from the daughter's articu-

late speech to the mother's Bronx-accented colloquialisms, occasionally mimicking other characters (neighbors, men on the street). The actress becomes an intelligent, empathetic surrogate for Ms. Gornick and, to a certain degree, she also brings the mother to life. Her performance conceals some of the abrupt shifts in the text. But the play's episodic nature and its lack of a narrative drive prove to be formidable obstacles.

At moments during a preview performance, Ms. Feldshuh reacted directly to the audience's laughter of recognition. Though that response seemed outside the context of Ms. Gornick's confessional, it was clearly an attempt on the part of the actress to find a connection that eluded the adapter. He has not given the author or the actress the necessary dramatic support. The most advisable course might have been for Ms. Gornick to have the memoir expanded onstage (at least for a cast of two) or on film rather than allowing Mr. Cohen to try to compress it into a monodrama.

1991 Mr 14, C18:1

SUNDAY VIEW/David Richards

A Ragtime Reverie; A California Detour

'Heliotrope Bouquet' is rap music for the turn of the century; 'Road to Nirvana' ends in Hollywood.

ERIC OVERMYER IS NOT A PLAYwright who does things simply, so it's probably not enough to say that his latest theatrical conceit, "The Heliotrope Bouquet by Scott Joplin and Louis Chauvin" (at Center Stage in Baltimore), is a dream play. It's really *three* dreams — wrapping themselves around one another like languid tendrils of opium smoke stirred by a ceiling fan.

The first dreamer is Scott Joplin, widely heralded as the king of the ragtime composers, although when we initially meet him, slumped over a piano by the dim light of a Harlem morning, fame and inspiration are behind him, and his tortured mind is obsessed with sultry images of the "poxy girls" in the House of Blue Light, a New Orleans sporting house he frequented as a youth.

The second, more impertinent, dreamer is Louis Chauvin — Joplin's match, if not his better, in the art of syncopation — who had the misfortune (or the contrariness) to leave nothing behind him when he died of multiple sclerosis at 26. The only concrete evidence of his genius is "Heliotrope Bouquet," the slow drag two-step he wrote with Joplin, who saw to it that the sheet music got published. The third dreamer is Mr. Overmyer himself, who has seized upon this fleeting collaboration and its few tangible details as the pretext for some graceful musings about the ephemeral nature of art and reputation.

If I have this right then — and I'm not claiming 100 percent accuracy — "The Heliotrope Bouquet" is a playwright's reverie about a famous composer, who is dreaming about his past and a forgotten partner, who is dreaming about *his* past. Chinese boxes, you might say. In fact, when the two men actually meet face to face in a Chicago opium den — Joplin determined to rescue Chauvin and his talent for posterity's sake; Chauvin not all that certain posterity is anything worth reforming a life for — they immediately fall to arguing.

Mr. Overmyer has long been an artistic associate at Center Stage, and his play marks a critical point in the institution's fortunes. On the one hand, it is the inaugural production in the Head Theater, the company's newest performing space, a $5.9 million facility that can be reconfigured at will. On the other hand, it is the last production to be directed by Center Stage's artistic director, Stan Wojewodski Jr., who was recently named dean of the Yale School of Drama and artistic director of the Yale Repertory Theater. No one wants the Head Theater to come off looking poorly. (It doesn't. It looks spectacular.) And if the opulence of his valedictory effort is any indication, Mr. Wojewodski has obviously chosen not to sneak out of town.

The audience is seated in a horseshoe around a large acting area, painted blue-green and polished to a high shine by the set designer, Christopher Barreca. An upright piano sits in the center, just asking to be put into action. Behind it, a wrought-iron staircase rises in graceful swirls, like a giant corkscrew, until it finally disappears from view. The four large windows that are a permanent part of the theater's outside wall have been covered with wooden louvers, as if to keep out a stifling heat.

Inside, it's mostly a nocturnal world, drenched by Richard Pilbrow in the gold of candlelight and the silvery white of moonbeams. But when the script calls for it, he has found an ingenious way to make day break. In an attic room above the theater, he set up a dozen aircraft landing lights and trained them on a plexiglass mirror suspended from an office building on the opposite side of the street. The mirror, in turn, has been angled so that the beams striking it bounce right

Essene R, left, and Monti Sharp in "The Heliotrope Bouquet"—lavish fancies

Richard Anderson/Center Stage

"It's my dream, not yours. My fever dream, my very own," says Chauvin, impudent as a kid staking out his claim to a sandlot. "You're not even here."

"I'm dreaming you dreaming," immediately counters Joplin.

"Are you sure?" questions Chauvin, mischief compounding the impudence. "Maybe I'm dreaming you dreaming me dreaming."

You are right to think that from a dramatic standpoint, this is dangerously nebulous operating procedure. But if you sense a certain elusive theatricality in the shifting planes and fuzzy contours, you're right, too. In "The Heliotrope Bouquet," places have a way of turning into other places. Time, just when you think you've pinned it down, slips between your fingers. Even some of the characters are subject to change, depending on which dream is predominant at the moment. There's a teasing seductiveness to it. Playwriting as a form of dalliance.

Gerry Goodstein/Circle Rep

Amy Aquino, Saundra Santiago, Jon Polito and Peter Riegert, standing, in "Road to Nirvana"—the stakes increase

back and stream through the louvers. No doubt the sun could do as convincing a job, but it is less reliable.

While Mr. Overmyer's characters are riff-raff, riffraff dressed well back then, and Catherine Zuber's costumes — dapper suits in browns and tans for the men; fancy nightdresses in off-white for the women — take elegant note of the fact. "The Heliotrope Bouquet" is never so lush and haunting as when the performers are drifting down the spiral staircase or sashaying desultorily across the gleaming floor, leaving little ripples of laughter behind them. But that very evanescence is also the play's shortcoming.

Joplin's second wife, Lottie, puts her finger on the problem, even though she's really addressing another issue entirely. Joplin is constantly mistaking her for his first wife, Belle, and sometimes when he focuses his cloudy eyes on Spice, the serving girl, he thinks his dead daughter has come back to life. Lottie knows his mind is unsettled by syphilis and he's seeing ghosts. But her patience is tested each time, and she can't keep the irony out of her voice when she finally observes, "Ghosts come and go. That's the advantage of being a ghost. You can do as you damn well please."

That's the advantage of writing about them, too. Characters in a

dream play can do pretty much as they damn well please — all the more so if drink and debauchery have poisoned the dreamers' heads. There is no apparent dramatic necessity to "The Heliotrope Bouquet." No dominant psychology is molding the vision before us. Its lavish fancies seem supremely arbitrary.

In a characteristically poetic passage, Chauvin describes music as "bits of colored glass and sounds of rings falling. Like water. Something dropping. Something hitting something else. . . . Dropping like rain. Water on stone." But he might as well be referring to Mr. Overmyer's fascination with words. As he has demonstrated in such works as "On the Verge" and "In a Pig's Valise," the playwright likes their antic nature and the little puffs of magic they release under the proper conditions. Above all, he seems to relish the lovely sounds they make, dropping, rebounding, hitting up against one another. At times in "The Heliotrope Bouquet," the gap between words and music is tantalizingly small.

Indeed, instead of playing the piano for the ragtime competition at the Rosebud Cafe, the various contes-

tants brush the ivories to set them in motion and then talk their compositions — matching verbal images to the sweet and tangy moods pouring out of the box. If the turn of the century had known rap music, it would have sounded like this. But you've probably sensed the problem here, too. Words, not characters, are reacting to one another. The tensions are all literary. The behavior of language is as much the evening's preoccupation as the conduct of people.

And yet it is a stylish cast that Center Stage has assembled for the occasion. As Chauvin, Victor Mack brings a sprightliness to wanton self-destruction, just as Monti Sharp suggests that Joplin's earnestness was his torment, even if it salvaged his reputation for future ages. Essene R is forceful as Joplin's two wives, while Wil Love craftily extends promises of money and immortality as Joplin's white music publisher. The supporting players, no less good, take to the brothels and dives as if they were going to Delmonico's.

"The Heliotrope Bouquet" is filled with enchantments, but very little serves to anchor them in place. Now you see it. Whoosh! Now you don't. The magic does not come without frustrations.

In 'Road to Nirvana,' Arthur Kopit has taken the crude vernacular of Hollywood literally.

'Road to Nirvana'

I can recommend Arthur Kopit's new comedy, "Road to Nirvana" (at the Circle Rep), to two groups only: those whose taste in humor runs to the scatological and those who like to see playwrights of some achievement fall flat on their faces. Others may abstain with no compunctions whatsoever. There is more pleasure in washing the dog.

Mr. Kopit seems to have two targets in mind — the craven mentality of Hollywood deal makers and David Mamet's play, "Speed-the-Plow," which, you may recall, concerned itself with Hollywood deal makers. So maybe it's just a target and a half. At any rate, the attack is broad, overwrought and wholly ineffective. Not unlike a child who has just come into possession of his first dirty word and persists in using it repeatedly, Mr. Kopit is willfully out of control. He has stretched what is at best a one-act sketch to two acts, during which he insists on hitting us over the head time and again with the same lame joke.

I'll make this brief. Would he had! Al (Jon Polito), a crass producer, and his coke-sniffing partner, Lou (Saundra Santiago), stand to make millions: they have the film rights to the life story of Nirvana, the world's hottest rock star. They are willing to bring Jerry (Peter Riegert) in on the project, but first he must prove his loyalty, his hunger, his complete and selfless devotion to the cause. Will he slash his wrists to have a part of the action? Eat excrement? Give up his testicles?

All that Mr. Kopit has done is take the crude vernacular of Hollywood literally. Al harangues and bullies a reluctant Jerry, until he submits to the first demand, whereupon they move on to the next. As the stakes increase, the play gets shriller and shriller, not funnier and funnier.

Nirvana (Amy Aquino), it turns out, has so fried her brains on drugs that she hasn't written an autobiography at all. She has simply copied Melville's "Moby-Dick" and substituted her name for Captain Ahab's. She, too, takes things literally, so that when it comes time to discuss the prospective movie, she envisions scenes of a great white penis rising out of the sea. The penis swallows her. "Somehow, I get out. And regroup," she says.

Heaven knows, Hollywood deserves every clubbing it receives. But what did the theater do to merit junk like this? Mr. Kopit can't even write a credible parody of a Mamet line. He just unleashes a blizzard of profanity and thinks the task done. That the performances are dreadful is probably unavoidable and no fault of the actors themselves. Since Mr. Kopit has brought up the subject of humiliations, I can think of few greater than having to appear in his abject play. □

1991 Mr 17, II:5:1

The Substance of Fire

By Jon Robin Baitz; directed by Daniel Sullivan; set by John Lee Beatty; costumes, Jess Goldstein; lighting, Arden Fingerhut; sound, Scott Lehrer; production stage manager, Roy Harris. Presented by Playwrights Horizons, Andre Bishop, artistic director; Paul S. Daniels, executive director. At 416 West 42d Street.

Sarah Geldhart.............Sarah Jessica Parker
Martin Geldhart......................Patrick Breen
Isaac Geldhart.................................Ron Rifkin
Aaron Geldhart................................Jon Tenney
Marge HackettMaria Tucci

By FRANK RICH

One need not be a jaded constituent of New York's literati to recognize Isaac Geldhart, the esteemed publisher and embattled Jewish father who stands at the center of "The Substance of Fire," the new play by Jon Robin Baitz at Playwrights Horizons. A childhood refugee from the "wrecked world" of the Holocaust, Isaac came to New York an orphan, reinvented himself as a bon vivant, married well and found a measure of fame and fortune as a rigorously independent champion of literary books that wouldn't be caught dead on a best-seller list. By the late 1980's, when Mr. Baitz's play unfolds, Isaac has long since been a brand name in the culture industry. He is one of those survivors, of post-war American intellectual firestorms no less than Old Europe's bloodbaths, who run Manhattan with an iron tongue.

Isaac is such a familiar type that one could draft an extensive list of actual literary power brokers — no names will be named here — who share some or most of his childhood background, professional résumé, neo-conservative politics and cosmopolitan accent. But to recognize a Manhattan archetype is not the same thing as knowing one, and it is the searing achievement of "The Substance of Fire" that it keeps chipping

and chipping away at its well-worn, well-defended protagonist until finally he and the century that shaped him and then reshaped him are exposed to the tragic quick. As written with both scrupulous investigative zeal and bottomless sympathy by Mr. Baitz and as acted in a career-transforming performance by Ron Rifkin, Isaac Geldhart is one of the most memorable and troubling characters to appear onstage this season.

●

He is also the harbinger of what is likely to be a major playwriting career for a dramatist who is only 29 years old. Mr. Baitz, who has previously been represented in New York by the highly promising "Film Society," is going to write better plays than "The Substance of Fire," but line by line, insight by insight, scene by scene, his writing is already so articulate, witty and true that it's only a matter of time before his theatrical know-how, some of which must come with experience, catches up with his talent. Mr. Baitz seems to understand so much — about people, language, society — and to be so eager to say what he knows that the naturalistic conventions of a work like "The Substance of Fire" simply cannot contain him.

Though this play wanders all over the place during its two enthralling hours, as if the young author were trying out different dramatic strategies for size, nearly every place it visits is of interest, not in the least because Mr. Rifkin's congenitally combative Isaac is always center stage. In Act I, the publisher is placed in a typical family-business conflict: to save his increasingly insolvent firm from Japanese takeover sharks, he must browbeat his three adult children, all principal stockholders, into philosophical and financial submission. In Act II, set a few years later, what seemed to be a potentially high-charged boardroom drama is all but forgotten (as are some of its players) while Mr. Baitz forces Isaac to confront the demons that would destroy him from within.

●

All of Isaac's struggles, of course, date back to the war in which his parents and grandparents died in the camps while he escaped incarceration. If Isaac has his share of survivor's guilt, compounded by the death of his wife six years before the play opens, he also has a survivor's arrogant omnipotence. With his natty, custom-made, double-breasted suits, verbal elegance and chilling charm, Mr. Rifkin presents the publisher as a figure of dazzling intellectual authority who long ago realized that he was the smartest person in any book-lined New York room. He never hesitates to remind all listeners that in an America where so many people dispose of their history and convictions for expediency's sake, he has kept the "fire" ignited by his youth, the spirit that keeps him sticking up for the highest standards in morality and literature alike.

Even his attractive and accomplished children do not escape his bullying condescension. Isaac refers to his Wharton-educated son (Jon Tenney), a partner in the publishing business, as an accountant and to his other son (Patrick Breen), a Rhodes scholar who teaches landscape architecture at Vassar, as an "assistant gardener." He dismisses his sensitive daughter (Sarah Jessica Parker), an actress in children's television, as "a hired clown." When all three suggest that a commercial novel of the brat pack school might bail out his bottom

line, Isaac sticks to his plan of publishing a six-volume scholarly work on Nazi medical experiments and delivers a hilarious discourse on "slicko hipster" fiction that surpasses any diatribe yet published about "American Psycho."

For all his nastiness, it is hard to dislike Isaac, even as one is grateful that he is not one's own father or cocktail-party acquaintance. He is just too smart and funny and, on occasion, too right to be dismissed. Once Mr. Baitz ruthlessly challenges the premises by which Isaac has lived — examining the real meaning of his survival, the substance of his "fire" — the audience is caught up in the sad reckoning facing him in late middle age. Is Isaac's proud insistence on holding onto his past the choice that allowed him to survive, or is it a burden that robbed him of any hope for happiness?

"I thought that if I published Hazlitt and Svevo, I'd be spared," says a frayed and clinically depressed Isaac in Act II. But he has not been spared: if the Nazis destroyed his family in Europe, he has "trashed" his own family, effectively if not as definitively, in New York. Not for nothing does he pore over some illustrated letters among his prized possessions — "gestures of love" by other witnesses to the "bloodthirsty century" like Osip Mandelstam and George Grosz — with a teary intimacy he cannot achieve with his own children. Just as pointedly does Mr. Baitz indicate that the "most crucial part" of Isaac's collection of ephemera is a watercolor postcard painted by the young Hitler in Vienna at a time when he

"fancied himself a serious artist." Does Hitler's painting make a mockery of all humane connections between life and art? If so, is it possible that the life of literature that Isaac has invented in New York is an escape from life rather than life itself, just as the love of books is a flight from love?

To yank Isaac into these conundrums — and the audience into the timeless drama of how any adult succeeds or fails in replaying a traumatic childhood — Mr. Baitz must bring on a psychiatric social worker (a hard-working Maria Tucci) who has a few too many crosses of her own (and New York City's) for the evening to bear. To dramatize the harm Isaac has inflicted on his children, the playwright schematically gives each of them a casebook infirmity, psychological or physical, to serve as a literal parental scar. The denouement of "The Substance of Fire" is also too pat, though it is so beautifully understated in Daniel Sullivan's staging that it is touching anyway.

Then again, Mr. Sullivan's entire production is flawless, from the snowy Gramercy Park light that the designer Arden Fingerhut visits on John Lee Beatty's elegant set to the perfect-pitch orchestration of dialogue that ranges from bitchy, sophisticated publishing-industry gossip to painful excavations of horrors civilization can never shake. Every performance is finely shaded in texture. Ms. Parker, an actress whose development has been a joy to watch since her childhood appearance in "Annie," is both impassioned and comic

as a weightier counterpart to the Los Angeles woman-child she plays just as winningly in the Steve Martin film "L.A. Story." Mr. Breen and Mr. Tenney portray both the outward, hard-won maturity and buried, infantile hurts of Isaac's sons with equal conviction.

It says much about all three actors playing the Geldhart children that they can, when need be, stand up to Mr. Rifkin, whose caustic humor and infernal anger seem to be forces of nature. It says much about "The Substance of Fire" that when it is Isaac's turn to be flattened by life's blows, Mr. Baitz does not provide the satisfaction of a bully getting his comeuppance, just the ineffable melancholy of a flame flickering out. This is a deeply compassionate play, as imperfect as it is youthful, by a writer who with one play or another is bound to be embraced by the wrecked world.

1991 Mr 18, C11:1

The Little Tommy Parker Celebrated Colored Minstrel Show

By Carlyle Brown; directed by Douglas Turner Ward; set design, Michael Green; costume design, Gregory Glenn; lighting design, William H. Grant 3d; sound design, Selina Dixon; production stage manager, Femi. Presented by the Negro Ensemble Company, Mr. Ward, artistic director/president; Susan Watson Turner, general manager. At the Master Theater, 310 Riverside Drive.

Henry	Douglas Turner Ward
Doc	Helmar Augustus Cooper
Tambo	O. L. Duke
Soloman	Ed Wheeler
Archie	Kevin Smith
Percy	Charles Weldon

By MEL GUSSOW

Humor in the face of adversity was exemplified by those black minstrels who toured the United States in the years after the Civil War. Blackening

their faces with burnt cork, they sang, danced, clowned and played the fool for white audiences while knowing that an evening's popularity would be followed by the pain of exclusion and prejudice.

This double-edged world is explored with understanding and suppressed anger by Carlyle Brown in "The Little Tommy Parker Celebrated Colored Minstrel Show." Presented by the Negro Ensemble Company, the play opened last night at the Master Theater (the former home of Equity Library Theater).

A troupe of minstrels is temporarily quartered in a seedy railway parlor car in Hannibal, Mo. While readying themselves for that evening's show, they exchange tales of life on a treadmill. Their world is a study in false faces. In order to survive, they must mock themselves and their traditions, but there is a vitality in the air and in their act, portions of which are seen in the course of the performance.

Despite their kowtowing to the demands of the audience, these are professionals who could aptly be compared with those athletes who were confined to segregated baseball leagues. They too are barnstormers; they give a single performance and get out of town as fast as they can.

Families have been abandoned in distant cities as the minstrels pursue a futile dream of breaking through in show business. The favorite reading is a newspaper column entitled "Minstrelsy and Variety," which brings news of competitive performers and sends the characters off on tangents wondering at the prowess of the talking horses and two-legged pigs that share equal billing.

Under the direction of Douglas Turner Ward, who also appears as an older, outspoken member of the company, the play builds to a challenge dance match at the end of the first act. Two minstrels (O. L. Duke and Kevin Smith) do a high-stepping cakewalk, accompanied by banjo, tambourine and spoons. They prance zestfully through this stereotypical dance, which is reclaimed by being

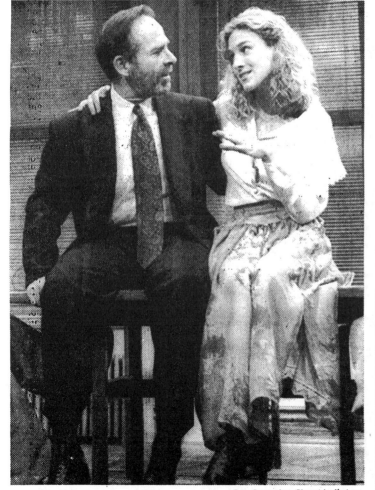
Peter Cunningham/Playwrights Horizons
Ron Rifkin and Sarah Jessica Parker in "The Substance of Fire."

Bert Andrews
O. L. Duke, left, and Charles Weldon in "The Little Tommy Parker Celebrated Colored Minstrel Show."

performed by black men not wearing minstrel makeup.

Along the way, there are gaps in the storytelling. Not enough is told about the whereabouts of the company manager, who is frequently discussed but never seen. Mr. Brown also has difficulty in deciding when and how to end his play. The present epilogue simply seems appended. Furthermore, there are rough patches in the staging, including a trunk that obstructs the audience's line of vision.

Both the script and the direction could be tightened, but the actors are persuasively a team performing in a specific period. There is especially strong work by Helmar Augustus Cooper as the most erudite of the group and by Mr. Smith and Mr. Duke, who, more than the others, demonstrate a vaudeville bent. Ed Wheeler plays a minstrel with a fall-back position as Pullman porter. The play is strewn with vivid vignettes dealing with the hard times of these showmen. Even as they polish material, they know that their work will be co-opted and copied by the white majority. The catalyst for the drama is a songwriter and actor (Charles Weldon), potentially the most versatile member of the troupe, but a man whose career is repeatedly blocked by his compulsiveness to speak his mind.

The playwright is most effective in dealing with the close-quartered interaction of these characters, the playful but often bitter banter that is passed around the railway car along with Mr. Ward's bottle of moonshine. Camaraderie co-exists with rivalry. Abundant talent — derailed and forgotten in its time — is recalled with ruefulness in Mr. Brown's observant new play.

1991 Mr 18, C16:4

And the World Goes 'Round
The Songs of Kander and Ebb

Music by John Kander; lyrics by Fred Ebb; conceived by Scott Ellis, Susan Stroman and David Thompson. Directed by Mr. Ellis; choreography by Ms. Stroman; scenery, Bill Hoffman; costumes, Lindsay W. Davis; lighting, Phil Monat; sound, Gary Stocker; musical direction, vocal and dance arrangements, David Loud; orchestrations, David Krane; production stage manager, Michael A. Clarke. Presented by R. Tyler Gatchell Jr., Peter Neufeld, Patrick J. Patek, Gene R. Korf, in association with the McCarter Theater. At the Westside Theater, 407 West 42d Street.

WITH: Bob Cuccioli, Karen Mason, Brenda Pressley, Jim Walton and Karen Ziemba.

By FRANK RICH

John Kander and Fred Ebb have reliably been turning out catchy, jazzy Broadway songs for more than 25 years now, but anyone who is not a musical-theater fanatic would have to think twice to recall the titles of their shows. With the single, whopping exception of "Cabaret" — their second Broadway effort, in 1967 — the Kander-Ebb musicals have been also-rans like "The Happy Time," "Zorba," "Chicago," "The Act," "Woman of the Year." Not flops, for the most part, and never embarrassments, just average entertainments and star vehicles that linger for a season or two before being forgotten by everyone but the buffs.

Sing Out Karen Ziemba and Bob Cuccioli perform in "And the World Goes 'Round — The Songs of Kander and Ebb" by Scott Ellis, Susan Stroman and David Thompson.

"And the World Goes 'Round: The Songs of Kander and Ebb," the new revue at the commodiously renovated Westside Theater, may be its authors' long overdue smash. The evening is an unexpected delight: a handsome, tasteful, snazzily staged outpouring of song and dance that celebrates all the virtues of the Kander-Ebb catalogue while scrupulously avoiding most of the cloying clichés of and-then-I-wrote anthologies. The revue is sophisticated enough to satisfy aficionados like myself, who recently spent a week's allowance to replace a worn copy of the out-of-print cast album of "The Happy Time," and welcoming enough to convert new audiences to the Kander-Ebb fold. The five fresh performers, mostly familiar but unheralded Broadway hands, are the best team of its sort to hit town since the quintet in "Ain't Misbehavin'."

Rather like "Cabaret," "And the World Goes 'Round" takes off like a shot in the very first number and rarely descends to earth thereafter. That number is the revue's title song, a Liza Minnelli specialty from the Martin Scorsese film "New York, New York," and it is sung very simply and powerfully by Brenda Pressley, in a voice that rises from Mabel Mercer supper-club elegance to a Broadway belt even as the accompaniment builds from a tinkling, insinuating piano to a rousing, brassy blare. In both its presentation and delivery, the song establishes the parameters of the entire production. Ms. Pressley never tries to echo the star who first established the song, and there is no explanatory dialogue or glitzy appliqué to weigh down or oversell the performance.

The song itself also typifies the Kander-Ebb esthetic. These are not songwriters whom one turns to for deep feeling, or intellectual provocation. They trade in splashy show-biz emotions, as emblemized by the kinds of hyperbolic anthems of survival that Stephen Sondheim parodied in "I'm Still Here." When a Kander-Ebb heroine cries out "Sometimes you're happy and sometimes you're sad, but

Joan Marcus/"And the World Goes 'Round: The Songs of Kander and Ebb"

Karen Mason, left, and Brenda Pressley in a scene from "And the World Goes 'Round: The Songs of Kander and Ebb."

the world goes 'round," she really means it, just as she means that life is a cabaret, old chum, or that maybe this time she'll win. No wonder that Mr. Kander (who writes the music) and Mr. Ebb (the lyricist) are for Ms. Minnelli what Harold Arlen and Johnny Mercer were for Ms. Minnelli's mother. If songs like "Quiet Thing," "Colored Lights" and "My Coloring Book" cannot prompt the soulful tears of an Arlen classic, they do at least deliver the goose bumps of Broadway at its most extravagantly self-dramatizing.

While a recording of "And the World Goes 'Round" will surely be a must, the show is theater, not a concert or cabaret recital. The imaginative director is Scott Ellis, who was responsible for the loving revival of the first Kander-Ebb musical, "Flora, the Red Menace," seen Off Broadway a couple of seasons ago as well as for the City Opera "Little Night Music." Following Richard Sabellico, who staged the moving new revival of "I Can Get It for You Wholesale" at the American Jewish Theater, he is the second musical-theater director of unusual promise to make a splash Off Broadway in the last two weeks.

•

In collaboration with a busy choreographer, Susan Stroman, Mr. Ellis has made one smart decision after another, starting, as he must, with casting and ending with ingenious encores that shake the cobwebs from the two most overplayed songs in the canon ("Cabaret" and "New York, New York"). Karen Mason and Karen Ziemba, the other two women in the company, are no less beguiling than Ms. Pressley, and all three convey the slightly jaded urbanity required by songwriters who are nostalgically in love with a glossy New York, New York, that vanished just before they arrived on Broadway. If Ms. Mason's voice is as thrilling as Ms. Pressley's, her personality is a bit more battered and less direct, allowing her to find an affecting, ironic undertone in "How Lucky Can You Get" (from the film "Funny Lady"). Ms. Ziemba is another good singer but an even better dancer, and she manages to tread wittily on the turf once owned by Gwen Verdon and Chita Rivera without losing her own, somewhat daffier profile.

Ms. Ziemba's partner in the dance routines is Jim Walton, a durable Broadway juvenile who has been waiting a decade for an opportunity like this. Mr. Walton's pleasing tenor is no secret (it was last heard in the

role of the sailor in the revival of "Sweeney Todd") and his tap skills were in evidence during his long tenure as a replacement in "42d Street." But who knew that he was a hot ragtime pianist and a graceful actor? His Scott Joplin-esque keyboard contribution to "All That Jazz" is rousing, and his forlorn delineation of the loser spotlighted in a rare Kander-Ebb character song, "Mr. Cellophane," is ineffably sad. Bob Cuccioli, the other man in the cast, has less splashy assignments but his chesty baritone makes the strongest case yet for songs from "The Rink" and "Kiss of the Spider Woman."

It's impossible to be faithful to the Kander-Ebb spirit without having slick Broadway production values

Music that glories in the values of Broadway.

and musical arrangements, and so "And the World Goes 'Round" offers a riot of bright costumes by Lindsay W. Davis and a swinging second-story band that through David Loud's conducting and David Krane's orchestrations evokes the signature Ralph Burns and Don Walker arrangements without imitating them. (Fond fragments of old orchestrations and songs left unsung turn up in Mr. Loud's dance arrangements.) While some of the special-material numbers culled from nightclub acts and television specials are strained, the sassy humor in Broadway show stoppers like "Class" and "The Grass Is Always Greener" seems freshly minted, despite the absence of the stars for whom they were originally designed. Thanks to Ms. Stroman's unpretentious homages to choreographic styles ranging from Bob Fosse's to M-G-M's, "And the World Goes 'Round" even has its full-fledged production numbers, one of which rides aloft on banjos and another of which whirls by on roller skates.

The attractive, simple set designed by Bill Hoffman for "And the World Goes 'Round" at first seems an odd choice: its walls and floor are stenciled with dictionary definitions for terms like ballad, collaboration and vamp. But by evening's end, when it is graced with a Hirschfeld portrait of the songwriters, the set seems pre-

cisely to the point. John Kander and Fred Ebb are first and foremost professionals who have done their job, and done it with infectious enthusiasm, season after season, even as the by-the-book Broadway crafts and traditions they follow have steadily eroded. Surely they know as well as anyone that the world goes round. Isn't it kind of wonderful that they have finally triumphed by staying put?

1991 Mr 19, C11:2

Ringling Brothers and Barnum & Bailey Circus

Produced by Kenneth Feld. Director and stager, Walter Painter; costume designer, Arthur Boccia; associate producer, Tim Holst; production designer, Keith Anderson; choreographer, Carl Jablonski; music director, Keith Greene; lighting designer, Rick Belzer. At Madison Square Garden, Seventh Avenue and 33d Street.

By JENNIFER DUNNING

The Ringling Brothers and Barnum &. Bailey Circus has gotten a little more sophisticated in its 121st year. But it is also sweet and silly, with a more intimate atmosphere, fewer showgirl numbers and some adorable animals and exciting daredevilry.

The stars of this year's show, which plays through April 28 at Madison Square Garden (Seventh Avenue at

Ringling Brothers and Barnum & Bailey Circus

A dancer rests her feet astride an elephant during a performance of the new Ringling Brothers and Barnum & Bailey Circus.

33d Street), are indisputably the Incredible Españas of Mexico. They double as the Flying Españas for a soaring trapeze number in which they are matched in midair, turn for turn and flip for flip, by the Flying Vargas family, also of Mexico. But there's nothing quite as exciting as their Globe of Death act. Preceded by a line of motorcycle mamas dressed to look like Darth Vader astride their motorized steers, Ivan and Noe España and their cousin Carlos Leal circle full-speed inside a steel-mesh globe. Upside down or sideways, they career through wild loops that would seem to guarantee collisions.

•

The Wheel of Death is as exciting, with Marco and Philip Peters counterbalancing each other in huge treadmills at the ends of a revolving girder, with two Bengal tigers joining them for the opening spins. After they've ditched the tigers, the brothers get serious about defying death, with Marco racing between two lines of fire and Philip diving 40 feet from the top of the wheel.

David Larible, the headline clown, opens the show with a winning bit of stage magic, seeming to sweep on the full panoply of performers in dazzling light by the deft manipulation of his cloth cap. Mr. Larible is funniest and most imaginative as Mario the Magnificent, a bumbling knife-thrower, and as a reluctant human cannonball, though both acts eventually turn a little sour. There is also some witty flirtation with the gracious aerialist Vivien Larible, his sister. But this

was generally a show for those who love good clowning.

The genial Acrobats from the People's Republic of China engage in several mad routines, riding bicycles in pyramids of 11 men and women and climbing, hanging and throwing themselves between high twin towers. The Fabulous Dessi and Gery spin body hoops as they dangle from ropes. And the Astounding Gregory Popovich might well be called the Baryshnikov of jugglers.

But the animals nearly steal the show — particularly four amiably phlegmatic pigs in Lisa Dufresne's Barnyard Bustle. There were three endearing showoffs among the Radiant and Royal Lippizaners, directed by Mark Oliver Gebel and Tina Gebel, offspring of the circus star Gunther Gebel-Williams. Standouts in the Crescendo of Cats act were a yawnstifling tiger, a lion who waved slyly to the audience and another tiger who squinted nearsightedly as Marco Peters cracked his whip.

The circus roster also included impressive teeterboard feats by the Hernandez, Kehaiovi and Franco Troupes, aerialist acts by Lorelei and by the Navahrr and Alejandro Duos, and appearances by camels, goats and two fuzzy llamas. Nineteen patient elephants formed a pyramiding chain across the three circus rings. And Philip Peters and Jon Weiss were shot out of a cannon in a truly spectacular finale that was marred by an all-out eruption of the shameless jingoism that had lurked throughout the show.

1991 Mr 24, 63:1

Leonce and Lena Woyzeck

Two plays by Georg Büchner; English versions by Eric Bentley; directed by Robert Hupp; set design by George Xenos; costume design by Jonathan Bixby; lighting design by Brian Aldous; additional songs by Arnold Black; musical direction by Ellen Mandel; choreography by Margaret Garrett. Presented by Jean Cocteau Repertory, Mr. Hupp, artistic director; David Fisheison, managing director. At 330 Bowery, at Second Avenue.

WITH: Harris Berlinsky, Betty Burdick, David Cheaney, Francis Henry, Joseph Menino, William Charles Mitchell, Grant Neale, Craig Smith, Elise Stone, Billy Swindler, Angela Vitale and Mark Waterman

By WILBORN HAMPTON

Few if any playwrights have had as far-reaching and profound an influence on modern drama with such a small body of work as Georg Büchner, the early 19th-century German dramatist who became a forerunner for most schools of 20th-century theater from Brecht to Beckett.

At the time of his death from typhoid fever in 1837, at the age of 23, Büchner left two completed plays and several unfinished drafts of a third. So far ahead of his time was he that none of the plays were performed for decades after his death. With the possible exception of "Danton's Death," Büchner's first play, his work is too rarely seen. The Jean Cocteau Repertory is to be commended for pairing the other two — "Leonce and Lena," Büchner's one comedy, and "Woyzeck," the uncompleted work — in a worthwhile production.

There has been scholarly debate over the various drafts of "Woyzeck." Alban Berg used the text of a 1914

production in Vienna, mistitled "Wozzeck," for the libretto of his opera. Eric Bentley, whose new translation is admirable, says he was guided by a 1984 edition published in Leipzig and edited by Henri Poschmann.

•

Academic disputes apart, "Woyzeck" is a disturbing work that dramatizes society's indifference to the sufferings of the downtrodden. If the scenes do not quite add up to a cohesive whole, they are taut and gripping and presage much that we have come to call modern drama.

Woyzeck is a simple soldier ("I loved life, so I joined the army") who falls in love with a woman of easy virtue and fathers her child. His greatest happiness would be to do his duty and receive the love of a faithful wife in return. But the society of the more learned and privileged conspires against him.

As he runs to and fro, trying to hold on to his dreams and his sanity, Woyzeck becomes the butt of his captain's jokes and a guinea pig for the town's doctor. Chastising him for urinating on the side of a building, the Doctor tells Woyzeck he must practice better muscle constriction: "The bladder should be subject to your will."

•

Craig Smith is a portrait of haunted terror in the title role. As he lurches through Woyzeck's daily chores, pounding his head at his ignorance, suffering the abasement of his superiors until he succumbs to madness and violence, Mr. Smith never abandons his character's quiet dignity. Elise Stone as Woyzeck's wife, Marie, Harris Berlinsky as the Doctor, Joseph Menino as the Captain and Mark Waterman as the Drum Major stand out among the able cast.

Robert Hupp, the director, evokes a battlefield bleakness by putting the actors in a sort of trench at the back of the stage from which they emerge for their individual scenes. Arnold Black composed some music to fit old German folk songs found by Mr. Bentley, and Billy Swindler plays them on an accordion.

Büchner was reputedly a great admirer of Shakespeare, and the opening piece at the Cocteau, "Leonce and Lena," in a witty translation also by Mr. Bentley, might be a study of a lovesick Hamlet if he had hung out with Lear's Fool instead of Horatio and never seen his father's ghost.

•

Prince Leonce, played with fine deadpan by Mr. Waterman, is finding it difficult to fall in love. "Will you love me forever?" one hopeful asks. "That's a long word," the Prince observes, and suggests a compromise of 5,000 years or so.

Leonce's father, King Peter, is eager for his son to marry a Princess he has never seen. But the Prince is not in such a rush. "If my bride awaits me," he reasons, "I will defer to her wishes and let her wait."

The Prince's savior comes in the form of Valerio, a wonderfully drawn Fool — deftly played by Mr. Menino — whose main object in life is to escape boredom. In a fast-moving and convoluted plot, Büchner manages to satirize most of what was held holy by the Romantics.

The pacing of the comedy is not always as smooth as it should be and some of the performances are uneven. But it makes a diverting hour.

1991 Mr 24, 63:5

SUNDAY VIEW/David Richards

3 for the Show: Sounds of Music, Sounds of Battle

Kander and Ebb's world goes 'round, while Harold Rome goes 'Wholesale' (again); Jon Robin Baitz writes of a family at war.

THE SONGWRITERS JOHN Kander and Fred Ebb are probably the Broadway musical's foremost advocates of the art of positive singing. Sally Bowles's credo has always been theirs, too. What good *is* sitting around on your duff? Jump right in. Reach for the brass ring. Say yes.

Inside every fat person, it has been noted, is a thin person struggling to get out. Inside every introvert, Kander and Ebb believe, is an extrovert eager to parade his stuff. Razzmatazz is not just a style with them; it is philosophical stance. Take a song like "Maybe This Time." Mr. Ebb's lyrics, in essence, are telling us that if first you don't succeed, try, try again. But that urgency is also built into the lift of Mr. Kander's music, which starts out sad and blue and aching, progressively rallies its spirits, and finishes in a blaze of confidence.

■

The revue "And the World Goes 'Round" gathers 30 of their songs under the same roof — the roof being that of the newly refurbished Westside Theater — and short of a sudden spring day, I can't imagine a better pick-me-up. Most of the numbers come from the team's Broadway shows — "70, Girls, 70," "The Rink," "Chicago," "Woman of the Year," "The Happy Time" and "Cabaret" — and the movies "New York, New York," "Funny Lady" and "Cabaret." (Anyone who cannot sing the title number of "Cabaret" by now will go stand in the corner, please.)

If there's a problem, it's that a fair share of the songs come with strong associations.

"My Coloring Book" continues to bear Barbra Streisand's imprint. To the extent that "All That Jazz" instantly conjures up images of performers in derbies and fishnet hose, throwing their pelvises and elbows every which way, it's Bob Fosse's number. And let's not encourage a tug of war here, but "New York, New York" belongs to Frank Sinatra, unless, of course, Liza Minnelli is belting it out. Even a comic ditty like "The Grass Is Always Greener" seems to demand Lauren Bacall's heavy-lidded hauteur (it sure wasn't her singing that put the number over in "Woman of the Year"), bouncing off Marilyn Cooper's deadpan delivery.

None of the five performers at the Westside Theater delivers that kind of wallop, but they're energetic and attractive. As much as their talent, which is not inconsiderable, their collective good nature and game spirits will win you over. Indeed, "And the World Goes 'Round" is never quite so ingratiating as when the performers are doing a soft-shoe on roller skates (encouraged by the hurdy-gurdy abandon of "The Rink"). Or when, having lulled you with the sweet strains of "Me and My Baby" (from "Chicago"), they reach tenderly into the bassinets at their feet for the infants inside. Only "baby" turns out to be a banjo and the number is off and running in an altogether different, but no less joyful, direction.

■

Without resorting to hopeless gimmickry, the director, Scott Ellis, and the choreographer, Susan Stroman, have managed to present the overly familiar songs in an unfamiliar light. "Money, Money" (from the movie "Cabaret") has the cast slouching about the stage like so many Victorian rent collectors on the first day of the month. And I dare say, "New York, New York" takes on a new dimension when it is sung in the various languages of the world. Swedish, for instance. But the show's creators also sense when there's no need to meddle and let such songs as "I Don't Remember You," "Quiet Thing" and "Sometimes a Day Goes By" stand on their own beguiling merits.

Brenda Pressley gets the title number, which she ushers from a velvet hush to lustrous roar. Karen Mason is the show's brass section, so she's responsible for "Ring Them Bells." (Among the cardinal virtues, Kander and Ebb include sheer nerve, and Ms. Mason is appealingly pushy.) Bob Cuccioli, a sleek baritone, mines the title number from "Kiss of the Spider Woman" for its lurid power, while Karen Ziemba and Jim Walton, penny-bright, both of them, dance their way through the stages of courtship in "When It All Comes True."

Proper and demure at the outset, they're carrying on like a house afire by the time it's over. But isn't that the characteristic trajectory of a Kander and Ebb song?

The pair will never be accused of holding back, underselling the goods, sinning by omission. Even when they write about a nobody, a sad sack so invisible to others that "Mr. Cello-

Bob Cuccioli, Karen Ziemba, Jim Walton, Karen Mason and Brenda Pressley in "And the World Goes 'Round."

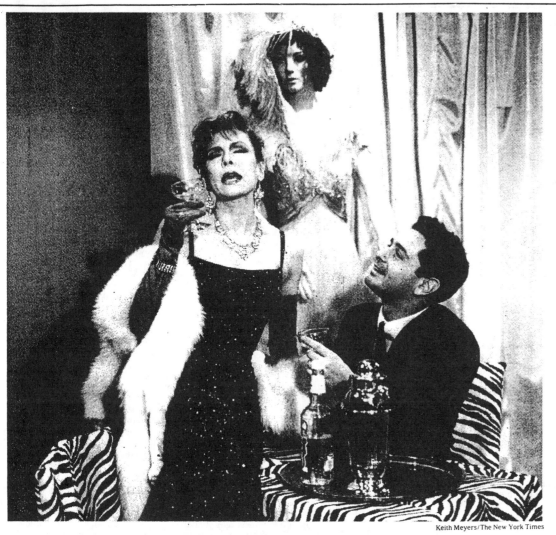

Deborah Carlson and Evan Pappas in "I Can Get It for You Wholesale"—surprises on the good side

Keith Meyers/The New York Times

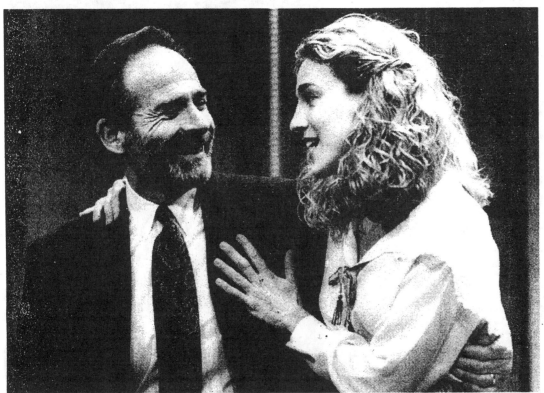

Ron Rifkin and Sarah Jessica Parker in "The Substance of Fire"—the cross fire is lively

Peter Cunningham/Playwrights Horizons

phane'' should be his name, the number builds boldly with each refrain, until the self-effacing soul has surprised even himself with his assertiveness and begs off with an apology.

Kander and Ebb can't help themselves, I guess. They just have to go and turn everything into a drama. Bless 'em.

'The Substance of Fire'

In the first act of Jon Robin Baitz's drama ''The Substance of Fire'' (at Playwrights Horizons), Kreeger/Geldhart Publishers, a family-run enterprise specializing in high-minded, money-losing titles, is teetering on the edge of bankruptcy. The various shareholders — a father and his three grown children — have come together in an emergency session to determine how to stave off ruin. Actually, the father, Isaac Geldhart (Ron Rifkin), an old-world autocrat who prides himself on his impeccable standards, has every intention of carrying on business as usual, which means more esoteric tomes about Hiroshima and the Holocaust for the remaindered tables.

It is his offspring — Martin, a professor of landscape architecture at Vassar; Sarah, an actress on a public TV children's show; and especially Aaron, the publishing firm's business manager — who are trying to effect a turnaround. Couldn't Kreeger/Geldhart lower its lofty sights long enough to bring out a juicy pulp novel that might help replenish the coffers? The father won't hear of the plan. More to the point, as the arguments rage over the conference table, it is evident that he holds his own children in open contempt.

The cross fire is lively; the insults, quick and cutting. (Recalling the last meal he had with his father, Martin observes, ''It was like dinner with Duvalier. Both of them.'') Long-smoldering resentments break through the thin veneer of civility, and since Mr. Baitz's characters come from an honorable literary line, they tend to be articulately expressed. By the end of the act, Isaac may have lost the battle, but his stiff, unyielding back, as he stalks out the door, gives every sign that the war will continue.

In Act II, however, Mr. Baitz chooses to leap ahead three and a half years. Isaac has been reduced to a slovenly existence in his once-grand Gramercy Park apartment. Not only has he lost control of the firm, he may also have lost his senses. One thing's sure: the play has lost whatever steam it built up earlier.

The children have all but dropped out of sight, although at their instigation, a social worker (Maria Tucci) has come by to ascertain Isaac's mental state. The encounter allows Isaac to rant further about the decline of values, wallow in childhood memories of the Holocaust and trot out his prized possession — a watercolor postcard painted by a youthful Hitler, which, apparently, speaks deeply to him of a time just before the world went to hell.

Isaac is persuasively acted by Mr. Rifkin, which means, I am sorry to report, that he is a shrill, bad-tempered egotist. The social worker succeeds momentarily in rousing him from his self-preoccupation, when she

reveals her own woes as the widow of a corrupt New York City borough president. And by the final fadeout, there are hints that maybe, just maybe, Isaac will be more accommodating in the future. He's going out in the snow for his first walk in months. But his redemption — if redemption it be — is so begrudging and comes so late in the game, I'm not sure it matters much.

In "The Film Society," an earlier play about a crumbling English boys' school in South Africa, Mr. Baitz made you feel for his authoritarian characters, even though some of

'Wholesale' is 30 and largely wrinkle-free.

them were struggling to perpetuate an outmoded class system and could be insufferably priggish. Isaac is no less an elitist, but it's hard to work up any emotion for him, beyond a growing impatience with his truculence.

The character is most stageworthy when he's attacking his children in the board room as if they were so many philistines swarming over the walls. A hapless social worker, fumbling through official forms, however, seems a contrived, not to say unworthy, target for his fulminations. In the moldering apartment, his wrath loses its urgency and his diatribes begin to sound suspiciously like whines. On the other hand, his custom-made bookshelves, courtesy of the set designer John Lee Beatty, are definitely something to envy.

'I Can Get It For You Wholesale'

If the 1962 Broadway musical "I Can Get It for You Wholesale" is remembered these days, it's for catapulting a 19-year-old Barbra Streisand to fame. As a harried secretary in the garment district, complaining that everyone always addresses her as "Miss Marmelstein" (not "cootchie coo" or "passion pie"), she was a sensation. Otherwise, the show had a mixed reception and, despite a 300-performance run, failed to turn a profit.

Vicki Lewis, who looks a bit like Minnie Mouse's plain cousin — slump-shouldered, nearsighted and twitchy around the nose — does splendidly by the number in the revival put together by the American Jewish Theater. That much you're expecting, though, if you're expecting anything. The surprise, in this case, is how good the rest of the musical is. No standards came out of Harold Rome's score (the measure, a few decades ago, of a score's worth), but what a succession of pleasing and pointed songs he devised for this tale of Harry Bogen (Evan Pappas), a $12-a-week delivery clerk who connives his way to success as a dress manufacturer, and then lets the money go to his head and his showgirl mistress.

■

Jerome Weidman's book, based on his novel of the same name, is tough

and snappy, but there are just enough tender moments so that it can't be accused of rank cynicism, just a healthy respect for "The Way Things Are." As that opening number puts it, setting the tone, "You're either the diner or the dinner." The time is the late 1930's, and the show's proletarian sympathies run high. But if you change a few of the figures (somehow a $72,000 bankruptcy no longer looms as ruin on a grand scale), the material has hardly dated.

At the last minute, the 1962 version capitulated to convention and exacted a change of heart from its calculating hero. The American Jewish Theater, in keeping with Mr. Weidman's original intentions, lets him be a scoundrel to the finish. As a result, Bogen belongs right up there with Sammy Glick and J. Pierre-pont Finch, those other musical proponents of how to claw your way to the top without revealing your nails. Mr. Pappas varnishes the heel with boyish charm and it's no hindrance — especially when he's trying to weasel his way out of a bind — that he bears a passing resemblance to Regis Philbin, the terminally loquacious morning TV talk-show host.

The cast, as a whole, is strong, partly because the roles are well defined to begin with and, in an egalitarian spirit rare to musicals these days, everyone gets a crack at the goodies. Of course, a piano is no substitute for an orchestra, and the minimal sets, while serviceable, leave a bit too much to the imagination. Still, the director-choreographer Richard Sabellico works nimbly on a dime, and you can sense his admiration for a show that is 30 years old and largely wrinkle-free.

I know the arguments against a repertory theater devoted to Broadway musicals. The costs would confound a rajah. The logistics would defeat a computer. And nobody in possession of a rational mind would ever staff it. Still, if you want an argument in its favor, this fortuitous revival will serve just fine. Better "I Can Get It for You Wholesale" on a shoestring than not at all. Seeing it at the Susan Bloch Theater, however, can only whet your appetite for catching it again on a grander scale. □

1991 Mr 24, II:5:1

The Balm Yard

By Don Kinch; directed by Shauneille Perry; set design, Robert Joel Schwartz; costume design, Judy Dearing; light design, Sandra Ross; sound design, Pepsi Robinson; production stage manager, Jacqui Casto; choreographer, Thomas Pinnock; musical director, Julius Williams. Presented by the New Federal Theater, Woodie King Jr. At Theater of Riverside Church, 91 Claremont Avenue, at 120th Street.

Spirit	Ras Tesfa
Celia	Nichole Thompson
Batuola	Nick Smith
Hilda	Roxie Roker
Samson	Gary Dourdan
Edna	Kim Weston Moran
Daisy	Donna Manno
Prime Minister	Trevor Thomas
Spirits	Carla Williams, Irene Datcher and Mac Arthur
Musician	Larry McDonald

Bert Andrews

Donna Manno, left, Roxie Roker and Kim Weston Moran, right, in a scene from "The Balm Yard," at the Theater at Riverside Church.

By STEPHEN HOLDEN

Don Minch's play with music, "The Balm Yard," depicts life in a West Indian town where the animistic spiritual beliefs and daily lives of the inhabitants are virtually indivisible. Those who are tainted by the materialism of the outside world become alien voices in a society united by reverence for what one character calls "the ground that made me."

In the opening scene of the show, which the New Federal Theater is presenting at the Theater at Riverside Church, the town's spiritual leader Batuola (Nick Smith) delivers an incantation that declares the secrets of the universe to be found "down in the gulley." The island's political leader has just died. And Batuola and the town's other spiritual leaders have chosen as the next Prime Minister an ordinary man (Trevor Thomas) who accepts the responsibility only reluctantly.

All too quickly, the new leader becomes corrupted and alienated from his people. He sells land to outside developers who plan to build gambling casinos on the island. And although he insists that the business will be good for the economy, Batuola and the other islanders realize that they will only be exploited. The new Prime Minister, who, unlike the rest of the cast members, wears an executive business suit, also rejects the young woman who has been carefully groomed to be his wife, and instead has an affair with a rebellious malcontent (Kim Weston Moran).

●

In portraying the Prime Minister's rise and fall and his eventual replacement by Samson (Gary Dourdan), a young man whose spiritual ties to the land are stronger than his predecessor's, the show argues passionately against Western intrusions on Afro-Caribbean culture.

"The Balm Yard" also shares some of the same themes as "The Mermaid Wakes," the recent Elizabeth Swados show. But where that was a family musical, in which many of the songs looked at Caribbean culture through children's eyes, "The Balm Yard" is a grown-up political and spiritual fable. Its technique of freely interweaving music and dialogue into an extended, informal ritual also recalls "The Mermaid Wakes." But instead of calypso, the music is a blend of reggae and spirituals. The range of musical styles demonstrates the process of musical cross-pollination in the West Indies and its relation to the fusion of Christianity and Caribbean animism.

Although Mr. Kinch's story deals with political corruption and betrayal, the play is still essentially a jubilant celebration of cultural roots. The director Shauneille Perry has staged it as a kind of Caribbean gospel musical in which the lines between the dialogue and singing and dancing are deliberately blurred. The musical numbers range from familiar spirituals like "Balm in Gilead" to several reggae songs by Ras Tesfa, who plays the show's narrator and commentator. Donna Manno, a cast member, and Julius Williams, the show's musical director, also contributed songs to the score, which the cast performs with a winning exuberance and good humor.

1991 Mr 25, C15:1

A Walk on Lake Erie

Written by Heather McCutchen; directed by Randy Rollison; production design by H. G. Arrott; lighting design by Timothy Hunter; art direction by Barbara Busachino; sound design by Chuck Montgomery and Mr. Rollison; production stage manager, Kay Foster. Presented by Home for Contemporary Theater and Art. At 44 Walker Street in TriBeCa..

Ann Noski	Melissa Hurst
Arthur Noski	Sal Barone
Stuart Cutler	Gary Kimble
Louise Haberzettle	Lillian Jenkins
Eddie Haberzettle	Daniel A. Harrison
Chris	Louis Falk
Sue	Karen DiConcetto
Dennis	John Augustine
Becker/Chuck Montgomery	
McFaul	George Vlachos

By MEL GUSSOW

Buried deep within "A Walk on Lake Erie," there may be signs of a serious attempt to come to terms with child murder and environmental suicide, but one would scarcely know it from Randy Rollison's production at the Home for Contemporary Theater and Art. The direction and acting compound the failings of Heather McCutchen's play.

The work is based on an actual case in Cleveland, in which a child was savagely murdered by his mother's lover. As written and acted, the killer, a doctor in a local hospital, is transparent in his villainy. Even before his crime, his behavior is so sadistic as to make the mother's toleration of him seem aberrant. How could she place her son in such obvious jeopardy, and why would the hospital continue to employ him in a position of responsibility?

Stripping the play of its reality, Mr. Rollison has staged it in a heightened style that moves it dangerously close to a horror story. The principal events occur in and near a landfill. This sprawling trash heap (designed by H. G. Arrott) is loaded with foul debris but is used as a playground by neighborhood children. When the children dig in a festering pit as if it were a sandbox, theatergoers may well expect a mutant to emerge. The only monster, as it turns out, is that mad doctor.

For the most part, the acting is amateurish, with the exception of Melissa Hurst as the mother. She brings enough pathos to her role to make the audience wish she would take an active step against the doctor instead of remaining his passive victim.

There is only one other point of interest in this otherwise dismissable venture — the fictionalized portrait of Dennis Kucinich, who in 1977 was elected mayor of Cleveland at the age of 31. In the play, the mayor (called Dennis) becomes involved in the manhunt, using it for overt political reasons. As portrayed by John Augustine (who was half of "Dawne" in Christopher Durang's cabaret show, "Chris Durang and Dawne"), he has a guileful innocence and instills some needed humor into the ghoulish play. Inexplicably, "A Walk on Lake Erie" was a winner of a grant from the Fund for New American Plays.

1991 Mr 25, C15:1

Rules of Civility and Decent Behavior in Company and Conversation

By George Washington; adapted and directed by Hanon Reznikov; music by Patrick Grant; musical direction, Michael Shenker; lighting by Michael Smith; set by Ilion Troya; assistant director, David Callaghan; stage manager, Judi Rimerman; technical director, Alexander Van Dam; production manager, Gary Brackett; produced by Judith Malina. Presented by the Living Theater. At 272 East Third Street.

Washington the Man	Michael Strong
Washington the Boy	Lauren Wissot

WITH: Amber, Johnson Anthony, Laurence Frommer, Gene, Felipe Hernandez, Robert Hieger, Dean Jackson, Marlene Lortev, Andrea Malloy, Chris Mareska, Bradford Martin, Antonio Negrão, Emily Nussdorfer, Cynthia Poirier and Parvaneh Torkamani.

By STEPHEN HOLDEN

"Labour to keep alive in your Breast that Little Spark of Celestial fire Called Conscience," goes the 110th and final dictum in George Washington's "Rules of Civility and Decent Behavior in Company and in Conversation."

America's first President is thought to have been a teen-ager when he wrote down his guidelines for etiquette in a manuscript that is preserved in the Library of Congress. The text, which the Living Theater has adapted into a one-hour ensemble performance piece, deals with everything from personal hygiene and table manners to broader conduct in social and business situations. Many of the rules are as applicable today as they were in the 18th century.

If Washington's rules suggest how better manners could improve society, that improvement would entail restrictions on emotional spontaneity and self-expression. And the Living Theater has created a piece in which a distorted interpretation of Washington's rules is made emblematic of an oppressive social and political hierarchy.

Dressed in military combat garb, the 15-member ensemble shouts out the rules while going through robotic training exercises. As staged by Hanon Reznikov, the rules are illustrated as quasi-military tableaux some of which evoke heroic paintings of the Revolutionary War. The demonstrations are accompanied by a minimalist, martial-sounding score by Patrick Grant.

One ritual involves the sectioning of a pineapple. In another, the ensemble forms a human pyramid. In others, the actors are deployed into the aisles to make eye contact with audience members and to confide information in whispers. The evening ends with the actors leading the audience out of the theater for a candlelit peace vigil on the four corners of Avenue C and Third Street.

"Rules of Civility" has an interesting premise, but its execution lacks the passion of 1960's Living Theater works like "Paradise Now." The line readings and occasional songs sung by the ensemble members are amateurish in quality. The dramatizations of Washington's rules are not tied closely enough to his actual words to make any but the broadest ironic commentary. Although the concept offers much potential for humor, the piece remains as solemn as can be.

1991 Mr 25, C15:1

Pygmalion

By George Bernard Shaw; directed by Paul Weidner; set design by John Conklin; costumes by Martin Pakledinaz; lighting by Natasha Katz; sound by Philip Campanella; production stage manager, Kathy J. Faul. Presented by the Roundabout, Todd Haimes, producing director; Gene Feist, founding director. At 100 East 17th Street.

Clara Eynsford-Hill	Pamala Tyson
Mrs. Eynsford-Hill	Annie Murray
Freddy Eynsford-Hill	Willis Sparks
Eliza Doolittle	Madeleine Potter
Colonel Pickering	Earle Hyman
Henry Higgins	Anthony Heald
Mrs. Pearce	Joyce Worsley
Alfred Doolittle	Charles Keating
Mrs. Higgins	Anne Pitoniak

WITH: Lester Chit-Man Chan, Page Clements, Edwin J. McDonough, Daniel Tedlie, Henry Traeger, Angela Schreiber and Michael Schwendemann.

By MEL GUSSOW

With Paul Weidner's production of "Pygmalion," the Roundabout Theater Company steps forthrightly into nontraditional theatrical waters. The revival, which opened yesterday, is novel in casting, design and directorial concept. The approach is refreshing without diminishing the flavor of the popular Shavian classic.

For a prospective director, "Pygmalion" poses double jeopardy. The play is familiar in itself and through "My Fair Lady." It is impossible to watch it without silently humming a coda to so many of Shaw's lines. The musical lyricism of Alan Jay Lerner and Frederick Loewe is inescapably wedded to the original play.

Mr. Weidner and his designer, John Conklin, have begun by sweeping the stage of memories and of any lingering fustiness. In the wrong hands, "Pygmalion" can seem like an exercise in English affectation. In this case, one set serves all — bare straight chairs and a few tables aligned in front of symbolic representations of various locales. This eliminates all delay in scenic changes, distilling the play to two tight acts as the action moves briskly from Henry Higgins's study to his mother's drawing room.

As it should, atmosphere comes through the acting, and Mr. Weidner has boldly confronted preconceptions and typecasting. In almost all respects, his actors imaginatively meet the challenge of playing roles that might previously have been considered outside their range. The result is harmonious rather than motley.

Charles Keating, who has achieved his reputation principally through an expression of his dry wit (in comedies by Joe Orton and others), turns out to be an inspired Alfred P. Doolittle. He is dashing in both of Doolittle's incarnations, as the earthy dustman and as the wealthy lecturer on the evils of middle-class morality. Similarly, Earle Hyman, a distinguished actor of Shakespeare and Ibsen, unveils a disarming humor and affection as kindly Colonel Pickering.

•

Can the woman who played the definably American title character in "'Night, Mother" be transformed into Henry Higgins's mother? Absolutely. The stylish performance by Anne Pitoniak should open new doors for this fine actress, who could effortlessly move on to Molière and Shakespeare. As Higgins's housekeeper, Joyce Worsley is much more of a known quantity — she has appeared frequently in "My Fair Lady" — but

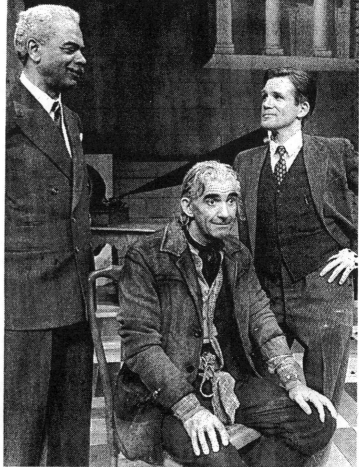

Martha Swope/Pygmalion

Earle Hyman, left, Charles Keating and Anthony Heald, right, in the Roundabout Theater Company's production of "Pygmalion."

that does not detract from the enjoyment of watching her put her employer squarely in his place.

Madeleine Potter offers a generous Liza Doolittle, especially after the ball when she must endure the self-congratulatory fatuousness of her mentors (as Ms. Potter listens silently, a single tear appears on her cheek).

Among the leading players, only Anthony Heald as Higgins is problematic, and that fact is partly attributable to the director. Clearly Mr. Weidner has decided to make Higgins more of a boorish male chauvinist and, in so doing, to push Shaw further into feminism. The point is palatable for today and we cheer Higgins's comeuppance even more than usual,

An austere staging leaves a play in the hands of the actors.

but a price is paid. Mr. Heald's professor is severely lacking in charm; he is too much of a bully and a bumbler in society.

The stripped down design can also be a hindrance, as in the opening sequence in which Covent Garden is, colorless and without a drop of rain. But once past that prologue, the scenery is rarely a stumbling block, except for Mr. Heald (a bicycle of indeterminate ownership forces him to take an unwelcome pratfall).

In other respects, Mr. Weidner's interpretation is invigorating. Focusing on the words and characters, the director reaffirms "Pygmalion" as one of Shaw's most literate comedies of class and a Cinderella story of unfailing enchantment.

The actors bring so much buoyancy to their performances as to make one wish they followed the play with a production of "My Fair Lady." Were he to sing Henry Higgins — as he could — Mr. Heald might lighten up and reveal more of the self-mocking humor in this most demanding of men.

1991 Mr 25, C15:4

Easter Show

Production conceived and created by Patricia M. Morinelli and William Michael Maher; directed and choreographed by Erté; scenery, sets and costumes designed by Erté; scenery designed by Eduardo Sicangco; lighting designed by Ken Billington and Jason Kantrowitz; co-costume designers, Mr. Sicangco and Jose Lengson; orchestrators, Michael Gibson, Dick Lieb, Glenn Osser and Jim Tyler; musical director and vocal arranger, Don Pippin; dance music arrangers, Gordon Lowry Harrell, Mark Hummel and Marvin Laird; special musical material by Larry Grossman; special material by Hal Hackady; additional material by Stuart Ross; production stage manager, Howard Kolins; assistant director and assistant choreographer, Linda Haberman; directorial assistant, Dennis Callahan. "Glory of Easter" lighting design by Billy B. Walker, restaging by Linda Lemac and vocal solo recording by Marilyn Horne. Presented by Radio City Music Hall productions, executive producer, David J. Nash; sponsored by Tropicana Pure Premium. At 50th Street and Avenue of the Americas.
WITH: The Rockettes, the Radio City Music Hall Orchestra and Wayne Cilento.

By STEPHEN HOLDEN

Last year, after an 11-year hiatus, the Radio City Music Hall revived the annual Easter extravaganza that had been a Music Hall tradition from 1933 to 1979. This season it is back, more finely tuned and more engaging than ever.

The Easter Show, which runs through April 4, is a streamlined 90-minute entertainment that hurtles forward without an intermission while presenting a lighthearted kaleidoscopic compilation of Easter-related iconography. One reason it works so well is that its solemn moments come at the beginning. "The Glory of Easter" prologue, developed in the early 1930's by the producer Leon Leonidoff, presents a ceremonial procession in a spectacular Gothic cathedral setting. Sixty years later it still matches one's most extravagant fantasies of Vatican pomp and ceremony while remaining vague about the religious meaning of it all.

From there, the show immediately turns into a giddy salute to spring, led by a chipper floppy-eared Easter Bunny (Wayne Cilento) who emerges from a laser-beamed rabbit hole to sing, dance, conduct and hop around. The show is so well put together that its 10 scenes melt into one another with a minimum of transitional clunk, and none of the tableaux last a minute too long. Just at the moment when a shot of energy is needed, the Rockettes troop onto the stage in eye-catching headgear that becomes more flamboyant each time they reappear.

The scenes are divided between frolicsome high jinks aimed at children, including a staged version of the hare and tortoise fable that involves the Big Bad Wolf from "Little Red Ridinghood" and two acrobatic segments featuring the tumbling troupe Antigravity and lavish nostalgic tableaux aimed at everybody.

One of the best is "Yesteryear," whose settings evoke New York in the 1890's, with the scene shifting from lower Manhattan where strolling Gibson girls, bicyclists and a barbershop quartet mingle blissfully, to a strutting holiday promenade in front of St. Patrick's Cathedral. The equally impressive "Dancing in the Dark" sequence features ballroom dancers swooping and gliding against a laser starscape.

Two of the show's more sumptuous scenes, "With Gershwin" and "Rainbow Follies," were designed by the noted Art Deco designer Erté, who died last year. "With Gershwin" opens in a plush ocean-liner setting and culminates in a burst of martial pageantry. In "Rainbow Follies," a salute to Ziegfeld that prominently features tunes by Sondheim and Berlin, the entire cast troops down a multi-colored staircase in glittering finery. As befits the Music Hall's tradition of family extravaganzas, Easter and show-business history merge and become one.

1991 Mr 25, C18:4

The War in Heaven
By Sam Shepard and Joseph Chaikin.

Struck Dumb
By Jean-Claude van Itallie and Joseph Chaikin.

Directed by Nancy Gabor; scenic design, Woods Mackintosh; lighting, Beverly Emmons; costume, Mary Brecht; composer and musician, Edwina Lee Tyler; production manager, Andrew Meyer; production adviser and dramaturge, Bill Coco; production stage manager, Lloyd Davis Jr. Presented by American Place Theater, Wynn Handman, director; Dara Hershman, general manager. At 111 West 46th Street.
WITH: Joseph Chaikin

By MEL GUSSOW

In 1984, in the process of collaborating with Sam Shepard on a one-man play entitled "The War in Heaven," Joseph Chaikin had a stroke. As a result, he was left in a state of aphasia, which put the continuation of his career as an actor and director in jeopardy. Despite that fact, he returned to performing, currently in a double bill of monologues — the completed version of "The War in Heaven" and "Struck Dumb," written with Jean-Claude van Itallie.

The plays (at the American Place Theater) share a sensibility and a feeling of life imperiled. Each is a mysterious journey of discovery and an eloquent emanation from a character who seems to be lost in time and space and is fearful that he may be unable to communicate. Both are fictional narratives resonating with parallels to Mr. Chaikin's own ordeal.

Because of the effects of his illness, he delivers the words haltingly, but his acting artistry is intact, surviving all shocks to his system. The performance is filled with a childlike wonderment. If "Tongues," an earlier piece Mr. Chaikin wrote with Mr. Shepard, is a collage of echoes from

A stroke does not keep an actor from performing his monologues.

the dead, the new plays are final reverberations from the land of the living.

"The War in Heaven" deals with a fallen angel, an alien from another sphere. In the course of this dense, elegiac dream, the angel moves from birth toward death, evoking a memory of Samuel Beckett's reflection that man is "born astride the grave."

●

As the angel, Mr. Chaikin has an appropriately seraphic look, seeming like a man who has parachuted to earth. Immobilized, he becomes a battleground of ideas, a searcher who has not achieved his goal but feels it is time to be turned loose — to freefall back to his origins, whatever they may be.

That wishfulness is recapitulated in "Struck Dumb," in which the actor asks, "What is endless?" His hushed response is, "No answer." With a greater specificity than in the opening play, "Struck Dumb" charts the life in America of a Lebanese immigrant.

Wandering in California, he listens to voices and tries to locate a path out of chaos. There are currents of eccentric humor as the startled speaker tries to comprehend the foreignness that impinges upon him. For this piece, Nancy Gabor, Mr. Chaikin's closely attuned director, moves the actor around the stage from table to podium, adding visual elements to the monodrama. In the background there is a throbbing score of music and sounds by Edwina Lee Tyler.

The plays are individualized but allied as attempts to find a philosophy to justify a life in perpetual imbalance. At the end of "Struck Dumb," the character can only accept the act of continuation. Life goes "on and on and on," with the last word followed by an ellipsis.

After the two plays, Mr. Chaikin reads "What Is the Word," a brief text by Beckett that his publisher calls the author's "final literary utterance." It is both an epilogue to and an extension of the previous monologues. In it, Beckett — with Mr. Chaikin as his surrogate — continues to grasp for language as life preserver. The reader has a "need to seem to glimpse," but knows the folly of that desire. The piece closes with a reiteration of the title, stated as a fact not as a question. In his courageous return to the stage, Mr. Chaikin movingly expresses his endless search for the unknowable.

1991 Mr 26, C15:1

An 'Oresteia' Embracing Techniques From India, Japan and the Mideast

By JOHN ROCKWELL

Special to The New York Times

PARIS, March 25 — Ariane Mnouchkine remains one of the world's extraordinary theater directors, and her absence from the United States, New York in particular, remains one of the saddest indictments of America's inability to import major performing artistry from abroad.

Miss Mnouchkine's latest project at her Théâtre du Soleil in Paris, seen Saturday and Sunday afternoons, is a four-play cycle of Aeschylus' "Oresteia" trilogy with Euripides' "Iphigenia in Aulis" as the first installment. Introduced in pieces starting last November and now three-quarters complete — Aeschylus' "Eumenides" is scheduled to go into rehearsal this fall — the cycle may be the most astonishing tour de force in a career filled with them.

Miss Mnouchkine's stage work is best known in the United States, insofar as it is known at all, for her Shakespeare productions, some of which were seen at the 1984 Olympic Arts Festival in Los Angeles. Those productions, and indeed all her work

over the last couple of decades, has drawn upon the varied resources of world theater. Kathakali, the elaborately costumed dance drama of the South Indian state of Kerala, is central. But Japanese, Arabian and even Western theater play roles as well.

What is interesting about this mélange is how quickly one accepts it as a viable medium for the Western plays she addresses. The stylistic blend is artfully accomplished, with traditions merging, not clashing. They provide their own theatrical reality, conventions one accepts and believes in. They legitimize an unusual admixture of dance and music (the sometimes telling, too often new age-noodling of Jean-Jacques Lemêtre).

•

For all the riveting beauty, there is no specious spectacle. In her connected chain of large and airy warehouses in an old munitions depot in the Bois de Vincennes, Miss Mnouchkine has installed a large, deep stage that she surrounds with simple set pieces. The actors rush in from the rear and obtain the brilliance of their effects through movement and athleticism.

Above all, none of this intensely personal style, achieved through months of rehearsal of a sort simply impossible in commercial theater, gets in the way of powerful individual performances — performances that would achieve their impact in any style, but can reach a rare level of rhetorical intensity through the very use of distancing non-Western traditions.

The Aeschylus trilogy, about the implacable working out of destiny through successive murderous generations of the House of Atreus, has been cleverly prefaced with the Euripides. This allows us to see Agamemnon's cruelty in sacrificing his daughter Iphigenia to enable his fleet to sail for Troy. This makes Clytemnestra's subsequent slaughter of her husband Agamemnon more understandable, deepening and softening her character. And it adds yet another level of horror to Orestes' murder of his mother, Clytemnestra.

It also make possible a feminist reading of Miss Mnouchkine's intentions. The strong characters in these productions are the women — Clytemnestra above all, but also Iphigenia, Cassandra and Electra. The men are mostly vain and dithering, reaching a comic height in Achilles' posturing silliness in "Iphigenia." Arguably, all this lies in the texts, but the juxtaposition of the Euripides with the Aeschylus and Miss Mnouchkine's direction underscores it.

•

The Kathakali techniques make something very special of the chorus, so prominent in all these plays and in the Aeschylus trilogy especially. Played by both men and women, their sexes masked by makeup and costumes, the chorus is mostly benign women in "Iphigenia," fierce male warriors in "Agamemnon" and black-clad, vulturelike Furies in "The Libation Bearers."

It is a sign of the shared purpose in the Théâtre du Soleil troupe that its

most prominent actors, when they aren't onstage as principals, participate in the chorus (Miss Mnouchkine happily clearing dirty dishes during the intermission). But Catherine Schaub, unrelenting as the chorus leader in the first and third plays, deserves special mention.

Ultimately, though, it is those principal actors who invest these productions with a life their brilliant trappings could not otherwise provide. All except Juliana Carneiro da Cunha, overwhelming in her dignity and malevolence as Clytemnèstra, play multiple roles. Nirupama Nityanandan portrays Iphigenia, a wizened male chorus leader, Cassandra and Electra with enormous intensity, although the subtle femininity of her Iphigenia, graced by beguiling Kathakali dance skills, is especially touching. (Unlike Peter Brook's international ensemble, also based in Paris, Miss Mnouchkine's actors all seem to speak perfect French.) Georges Bigot is almost as striking in a range of second-level roles.

But the star of this cycle is Simon Abkarian. Mr. Abkarian takes on Agamemnon, Achilles, a chorus leader, a Messenger, Orestes and, as an almost giddy bonus, Orestes' aged Nurse. These are parts with a huge range, and Mr. Abkarian was master of them all.

•

But the climax of "The Libation Bearers" — Orestes crazed with madness as the Furies crow in vengeful triumph, trying to taunt the corpses of his mother and her lover back to life so he can kill them again, drenched in blood and reeling with madness — found Mr. Abkarian almost unbearably intense. The end of the play left the audience stunned, then cheering, and it made one wonder how Miss Mnouchkine can possibly stage the Furies of "The Eumenides" with any greater ferocity.

1991 Mr 27, C13:3

Martine Franck/Magnum
Members of the Théâtre du Soleil troupe in "Agamemnon."

A Funny Thing Happened on the Way to the Forum

Book by Burt Shevelove and Larry Gelbart; music and lyrics by Stephen Sondheim; directed and choreographed by Pamela Hunt; scenery design, James Morgan; costume design, Beba Shamash; lighting design, Mary Jo Dondlinger; production stage manager, Mary Ellen Allison; musical director, Lynn Crigler. Presented by the York Theater Company, Janet Hayes Walker, producing director; Molly Pickering Grose, managing director, in association with One World Arts Foundation. At the Church of the Heavenly Rest, 2 East 90th Street

Prologus and Pseudolus	Jack Cirillo
Senex	John Remme
Domina	Chris Callen
Hero	Jeffrey Herbst
Hysterium	Jason Graae
Erronius	Jim Harder
Miles Gloriosus	Ken Parks
Lycus	Tony Aylward
Tintinabula	Hope Harris
The Geminae	Denise Ledonne and Isabel Rose
Vibrata	Valerie Macklin
Gymnasia	Sloan Wilding
Philia	Deborah Graham
The Proteans	John Dietrich, Mark DiNoia and Barry Finkel

By MEL GUSSOW

"A Funny Thing Happened on the Way to the Forum," the first musical for which Stephen Sondheim wrote both the music and lyrics, is as effervescent today as it was three decades ago. Surviving countless revivals, the

1962 musical remains a surefire combination of low comedy and high jinks, Plautus revamped to serve modern vaudeville purposes.

Pamela Hunt's nimble production at the York Theater Company reminds us that the words musical and comedy were once interlocked and that Mr. Sondheim can have the lightest and most limber of musical touches. For this show, his comic collaborators were Burt Shevelove and Larry Gelbart. All three are maestros of the musical comedy form.

The witty lyrics are a verbally inventive match for the melodies, which, in the best sense, pay homage to such stylists as Cole Porter and Lorenz Hart. They could have envied the playful parallelisms of those dialogues in song, "Everybody Ought to Have a Maid" and "Impossible." As intended, the opening number, "Comedy Tonight," sets a tone that is unabated throughout the evening.

The book by Mr. Shevelove and Mr. Gelbart is a breezy model of free handed pastiche. It somehow manages to revolve a complicated plot on the head of a pin or rather, a ring, on which is etched a gaggle of geese. Tongue-twisting lines and lyrics vie with buffoonery in a farce that compounds laughter as it accelerates.

In its original Broadway version, "A Funny Thing Happened" may have often seemed like a one-man show — Zero Mostel hilariously leading a legion of fellow clowns. In Ms. Hunt's production, the comedy is more evenly distributed. The musical easily sustains that approach as character after character commands the spotlight for a self-defining song.

The dim-witted ingénue (Deborah Graham) widens her eyes to confide that she is "Lovely." A hysterical slave steels himself to withstand assault by proclaiming "I'm Calm" (he is quivering). And a muscle-bound warrior proudly boasts, "I am a parade."

At the center is Pseudolus, that machinating malcontent who will sell his soul to win his freedom. Of course, Mr. Mostel is missed, especially for his masterly mime of the erotic poses on a Roman pot and the way he could act out a threat like "evisceration!" Jack Cirillo's Pseudolus is a more earthly figure, a common-sense clown with quick reflexes and a mobile body. He seems to have an elastic neck, useful for doubletakes. Often he seems to be looking backward while racing out of the line of fire.

In the evening's funniest performance, John Remme is deadpan-droll as the old relic jolted out of creeping senility into a state of youthful ardor. As the nervous Hysterium, Jason Graae finds humor in hyperventilation and in posing as a momentarily dead courtesan. The mock-sinister procurer Lycus is played by Tony Aylward with a borderline daffiness, and laughter is also earned by Chris Callen, Jim Harder and the amazingly Amazonian Sloan Wilding.

Not all the actors are as precise as they could be, but no one intrudes on the merriment. As choreographed by Ms. Hunt, there is more dancing than is customarily found in shows by the composer. The musical director, Lynn Crigler, leads a five-piece band that seems twice its size. A fauxmosaic setting has been designed by James Morgan, offering a colorful mock-Roman background for the farcical shenanigans.

This is the seventh Sondheim musical presented at the York, a series that has previously given a second

life to "Pacific Overtures" and "Sweeney Todd." "A Funny Thing Happened" is an irresistible addition to that roster of revivals.

1991 Mr 28, C16:4

The Kingfish

By Larry L. King and Ben Z. Grant; directed by Perry Martin; production design, R. S. E. Limited; lighting design, F. Mitchell Dana; sound design, Tom Gould. Presented by Claudet and Christen Productions Inc., Michel Claudet and Darryl K. Christen. At the John Houseman Theater, 450 West 42d Street.

Huey P. Long John McConnell

By MEL GUSSOW

Although Huey Long was only 42 years old when he was assassinated, he packed more excitement and controversy into his relatively brief career than other politicians have in a lifetime of office holding. As T. Harry Williams wrote in his authoritative biography of the Louisiana senator, he aroused every feeling: "amazement and admiration, disbelief and disrespect, love and hatred, and, with many individuals, cold apprehension." Once, when reporters were trying to define him, Long responded with full-throttled arrogance, "Say I'm sui generis and let it go at that."

This outrageous character is, of course, large enough for fiction (as Willie Stark in Robert Penn Warren's Long-inspired novel, "All the King's Men") and documentary film (Ken Burns's 1985 "Huey Long"). From "The Kingfish" (at the John House-

man Theater), it is evident that he is too complex and contradictory a figure to be compressed into a one-man show with less than two hours of stage time.

As written by Larry L. King and Ben Z. Grant and as performed with suspender-snapping verisimilitude by John McConnell, the play is a quick character sketch with anecdotes and asides, rather than the full-length portrait the subject deserves. Something similar was true of "Lyndon," James Prideaux's one-man show about Lyndon Johnson that was on the same stage earlier this year.

Garnishing the facts of Long's career with invented dialogue, the authors have tried to give a kaleidoscopic picture of this handmade populist, from his traveling-salesman days in rural Louisiana through his death in 1935. In an unwise addition, the play begins by bringing Long back from the grave to have him reflect on his career and also on events that came long after his death (including the assassination of John F. Kennedy).

When Mr. King and Mr. Grant restrain their intrusive impulses and hold to the life itself, they are moderately successful in conjuring their character. Though the view seems somewhat softened from the public perception, we do receive an image of Long's manipulative brand of politics.

He is shown in confrontation with unseen people ranging from his brother, Earl Long, to Franklin D. Roosevelt, who became his nemesis. In one of the show's more engrossing sections, Long tells us how he managed the seemingly impossible trick of getting Hattie Caraway, an ob-

scure Arkansas politician, re-elected to the United States Senate.

Although Mr. McConnell seems taller and less rumpled than his character, he bears a resemblance to Long's white-suited, country-boy persona. The performance offers a sampling of Long's vulgarity, intelligence and cracker-barrel humor, as well as his on-the-stump power of persuasion, as he explains his radical Share Our Wealth program. In Mr. McConnell's

favor, he is a native Louisianian, with the flavor of his state in his speech.

The show was presented at the Republican National Convention in New Orleans in 1988 and might serve as an after-dinner entertainment on the rubber-chicken circuit. But it is not entirely comfortable as a monodrama on an Off Broadway stage.

1991 Mr 31, 39:1

SUNDAY VIEW/David Richards

Tennessee Williams Without the Neuroses

The playwright's early collaboration, 'You Touched Me!,' bears strong hints of the plays and characters to come.

CLEVELAND

NEW PLAYS, WE KNOW, HAVE A tough time making their way in the world. But I wonder if old plays don't have an even tougher time of it.

Someone, it seems, is always coming forward with one program or another designed to unearth the new plays, coddle and nurture them, so that when they venture out into the cold marketplace, their spirits won't buckle. Old plays are pretty much dependent on the vagaries of fate and fond memories for their continued life. I'm not talking about the masterpieces — a "Death of a Salesman" or an "Our Town" — which can usually be counted upon to fend for themselves. I'm talking about the others, the also-rans, that didn't make much of a splash on the first go round. No one's out to save them. There are no societies for the rehabilitation and perpetuation of old plays. The whales have a larger constituency.

■

This thought occurs to me regularly, but what got me thinking it again was the announcement that the Cleveland Playhouse would be staging "You Touched Me!," the 1943 romantic comedy that Tennessee Williams wrote with Donald Windham. I dare say we haven't seen a lot of "You Touched Me!" over the years. It didn't get seen a lot in its day. And if the Cleveland Playhouse weren't celebrating its 75th-anniversary season and, consequently, interested in drawing attention to its rich history, we probably wouldn't be seeing it now, either.

Fame and Williams were still strangers when the playhouse produced the world premiere of "You Touched Me!," the only collaboration of his career. Williams was then laboring (or not laboring, if you believe his correspondence) in the back lot at M-G-M. Reaction to the play was encouraging enough, however, so that the young authors could allow themselves to entertain dreams of a Broadway production. And indeed, in

Carol Rosegg/Martha Swope Associates

John McConnell as Gov. Huey P. Long, in "The Kingfish.

September 1945, "You Touched Me!" pulled into the Booth Theater with a cast that included the young Montgomery Clift and the old but lovably irascible Edmund Gwenn.

Maybe it would have had an indifferent reception, whatever the circumstances. But its fortunes were not aided by the fact that six months earlier "The Glass Menagerie" had beaten it to Broadway and established Williams as a major playwright. There's never any competing with a masterpiece. Despite some amiable virtues, "You Touched Me!" suffered from the comparison. "Quite a step down," sniffed the reviewer for The Times, while The New Yorker judged it "an elaborate and intensely literary version of 'Snow White.'" After 109 performances, "You Touched Me!" called it quits. And a play — not without its prophetic implications — became a footnote.

More than just historical curiosity, it turns out, is satisfied by the playhouse's revival, although satisfying curiosity is not an unworthy achievement in itself. Faded photographs and yellowing newsprint can only say so much about the theater's past. If you really want to know a play, you have to see it on its feet, stepping lively or stubbing its toes.

In many ways, watching "You Touched Me!" here in the wood-paneled Drury Theater, where it first took form, proves a ghostly experience. The ghosts, however, are young and friendly and filled with youth's certainty that the years ahead contain heady delights and headier triumphs. Even a world war was no discouragement. Williams's stamp is all over the play, but none of his neuroticism. Did the partnership hold it in check?

"Our shared laughter was perhaps the strongest bond between us," Mr. Windham notes in an article written for the playhouse program. "To the often-asked question, 'How did you and Tennessee collaborate?' I can best answer that we did it by departing as little as possible from our nonworking pleasure in each other's company, in each other's sense of humor, improvising dialogue, viva voce, in that small room, laughing at our inventions, taking turns typing on my portable typewriter, and going down to the pool to swim."

■

A short story of the same name by D. H. Lawrence was their starting point. In particular, the budding playwrights seem to have been attracted to Lawrence's notion of the transforming power of a simple, inadvertent touch between people. They moved the action forward to World War II, but kept as the setting the Pottery House — a tidy, claustrophobic English country residence, protected from the tumult of the outside world by a thick privet hedge and a double row of petunias. Ruling over its lifeless rooms is Emmie Rockley (Jennifer Harmon), a middle-aged spinster with such a fierce sense of propriety that "it's surprising [she] will even put a teaspoon in a cup." (Why do I think Williams must have been responsible for that line?)

Once a lusty sea captain, Emmie's brother Cornelius (John LaGioia) has become a flush-faced old drunk who nips rum from a flask, pinches the serving girl and indulges his memories of singing porpoises in a bedroom furnished like a ship's cabin. But the Pottery House is no welcomer of lustiness. His daughter, Matilda (Calista Flockhart), a shy slip of a thing, has grown progressively shyer under her aunt's dominion, and spinsterhood looks to be her eventual lot, too.

■

Years ago, hoping to counter the smothering spirit of the place, the captain brought home a young found-

ling, Hadrian (Roger Howarth), and raised him as his son. But one day, with nary a goodbye, the sly, enigmatic youth up and disappeared. Not long after the curtain rises on "You Touched Me!" the front door of the country house swings open, and there he is, fully grown, sporting the dashing uniform of the Royal Canadian Air Force, and shrouded, romantically, in the lingering smoke of the train that's just brought him back to town.

The play pits the determined foundling against the equally determined aunt for the hesitant soul of Matilda. The aunt claims to have decency on

her side, not to mention the moral support of a bronchial pastor (John Curry), who drops by for tea and comic relief. But Hadrian has the vigor of life and the connivance of the captain going for him. If there's ever any doubt over the outcome — and of course there isn't — the first magical touch between handsome airman and trembling maiden dispells it.

Matilda thinks she's checking up on her father when she sneaks into the cabin bedroom and caresses the forehead of the slumbering body in the bunk. But it's Hadrian who sits bolt upright — as surprised, bewildered and ultimately transported as she. The director, Josephine Abady, fills the awkward silence that follows with the throbbing strains of violins. The moment is as schmaltzy as any Hollywood put on celluloid in the 1940's. But it's curiously beguiling, too. Innocence is waking up to the world and liking what it sees.

The playhouse production can't mask all the play's deficiencies. With three acts and six scenes at its disposal, the script is prone to dawdling. Furthermore, the battle lines are too easily drawn and maintained. And the "Englishness" of the enterprise is something of an affectation. (The play would really be better off if it were unfolding in the American South — Gulfport, maybe, or Savannah.) The acting is uneven — persuasively strapping in Mr. Howarth's case; unduly tentative in Mr. Curry's, to cite the extremes; and Ms. Flockhart, while sweet-tempered, looks too much like a Kewpie doll to make Matilda's vulnerability entirely convincing.

What Ms. Abady has captured, however, is the sheer sunniness of the piece, its uncomplicated heart and its good nature. The worst the captain does, when he's been tippling, is toss the serving girl's butterfly garter out the upstairs window into the garden, where it lands in the astonished reverend's lap. I suppose Emmie qualifies as the play's heavy, and she's really more fussy than mean.

■

If that were the extent of it, "You Touched Me!" would be charmingly inconsequential. All the while, though, you can't help seeing in it the plays and characters to come. The virile stranger who surges into town and inflames or infuriates the womenfolk with his sexuality would become a quintessential Williams creature (Val in "Orpheus Descending," for example, or Chance Wayne in "Sweet Bird of Youth"). The raw sex just didn't make it into "You Touched Me!" Matilda — so delicate that she deserves "to be barely touched, hardly breathed upon" — is a precursor of Laura in "The Glass Menagerie"; while Emmie, turning up her nose at the corporeal pleasures, is kin to Alma Winemiller, the hysterical spinster in "Summer and Smoke." The flesh and the spirit are reconciled in "You Touched Me!" but forever after in Williams's plays they would be at war.

In the final days of rehearsals, that autumn of 1943, the playhouse artistic director, Frederic McConnell, took it upon himself to make serious alterations in the script. From California, Williams lodged a protest. "I have

written plays that were potential TNT," he wrote. "But this isn't one of them. It won't take the roof off your theater one way or the other. All it requires is a workmanlike performance to be at least — shall we say — clean entertainment."

He was right. The TNT came later. From today's perspective, however, there's something both vivifying and sad about "You Touched Me!" — rather like finding yourself at the beginning of a wonderful voyage and knowing, at the same time, that the voyage will end badly. Nothing about "You Touched Me!" is heartbreaking except, perhaps, the optimism of its authors, so eager to get on with their careers and make their mark in the theater.

The flesh and the spirit are reconciled in 'You Touched Me!' but forever after they would be at war.

Hard as it is to be a playwright these days, being yesterday's playwright is harder. (Mr. Windham would end up, in fact, writing novels and short stories.) A country that worships the newest in automotive styling and the cutting edge in video technology is naturally going to want to see the latest play, if it's remotely interested in seeing plays. Even "last year's hit" has a faintly disparaging ring about it. And heaven protect a play like "You Touched Me!" — which wasn't a hit to begin with. Very little stands between it and oblivion.

Our theater relishes nothing so much as the surprise of the new. And yet I sometimes think the surprise of the old is greater. The new by its very nature catches us off-guard. But the old was there all along and we just didn't know it.

Onward and upward is the country's unofficial motto — our theater's, too, I guess — which is fine by me, as long as a few happy stragglers promise to glance over their shoulders now and then. □

1991 Mr 31, II:5:1

The Baby Dance

By Jane Anderson; directed by Jenny Sullivan; set design by Marjorie Bradley Kellogg; costume design by David Murin; lighting design by Kirk Bookman; production stage manager, Tammy Taylor. Presented by Long Wharf Theater, Arvin Brown, artistic director; M. Edgar Rosenblum, executive director. At New Haven.

Wanda	Linda Purl
Al	Richard Lineback
Rachel	Stephanie Zimbalist
Richard	Joel Polis
Ron	John Bennett Perry

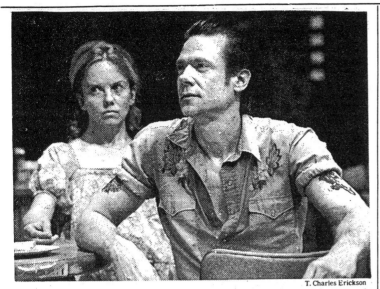

T. Charles Erickson

Linda Purl and Richard Lineback in a scene from the Long Wharf Theater's production of "The Baby Dance," by Jane Anderson.

By MEL GUSSOW

Special to The New York Times

NEW HAVEN — The usefulness of theater as a forum for contemporary issues is confirmed by "The Baby Dance," Jane Anderson's play about problems of adoption. The fact that the work (at Long Wharf Theater) is flawed does not decrease one's interest in the arguments raised. It is a play that audiences will take home with them; it might provoke disagreement, as do the issues themselves.

This is not a Baby M case, torn from the headlines, but a more frequent occurrence, in which an adoption is privately arranged for a childless couple, with a lawyer acting as baby broker. What seems a simple legal arrangement turns out to be plagued by formidable complications, as second and third thoughts bombard both couples, and as social differences divide them even further.

The difficulty with the play is not in its lack of answers, but that the tone wavers between comedy and drama while always trying to retain the audience's empathy. Reversing the usual order, "The Baby Dance" is less effective in the beginning than in the ending. The author is apparently so eager to picture the differences between the two women, the city wife (Stephanie Zimbalist) and the country mother (Linda Purl) that she underlines them as opposites.

Visiting Ms. Purl in her trailer home, Ms. Zimbalist is immediately patronizing about her standard of living and her health habits. This attitude may be an effort to demonstrate her discomfort at being in an unfamiliar situation. But, as written and as performed by Ms. Zimbalist, the scene is closer to a situation comedy than to a real-life dilemma. Ms. Anderson is led to trivialize her own work, and Ms. Zimbalist does not convey enough of the character's suppressed feelings.

The arrival of Ms. Purl's husband (Richard Lineback) puts the play on its dramatic track, as he exudes his resentment at his predicament. He and his wife have put their unborn baby up for adoption because they cannot afford to raise another child. When Ms. Zimbalist expresses her irritation at Mr. Lineback's casual prejudices, he counterattacks by

wondering why she, as a liberal, specifically advertised for a white baby. One of the play's strengths is in such sidelong perceptions, as it asks a diversity of questions about the adoption process.

Later, there is an incisive scene between Ms. Zimbalist's husband (Joel Polis) and their lawyer (John Bennett Perry), who in a flash of phone calls keeps computerized control of his nationwide adoption process. This time the playwright uses humor to her advantage, though even here she cannot resist the temptation for an easy laugh. From there, the play moves to a poignant conclusion in which all parties are forced to make decisions about their priorities and their ethical commitments.

Though the play focuses on the two women, it is the men who prove to have the more interesting roles, especially so in the case of Mr. Lineback and Mr. Perry, with both actors revealing their characters through small but significant details. Ms. Zimbalist and Mr. Polis have difficulty persuading us of their bond, in contrast to the other husband and wife who seemed immured in the fecundity of their marriage.

Despite a previous production in California, the play (as directed by Jenny Sullivan) still seems to be in flux. But theatergoers should be stimulated by the subject, by the crosscurrents that cloud deeply personal choices with contractual obligations and by the emotional stress of people desperate for parenthood.

1991 Ap 1, C14:1

The Encanto File and Other Short Plays

Scenic design by Mark Fitzgibbons; lighting by Franklin Meissner Jr.; costumes by Barbara Beecio; sound by Bruce Ellman; production stage manager, Jill Cordle; assistant stage manager, Jennifer Plate. Presented by the Women's Project and Productions, Julia Miles, artistic director. At the Judith Anderson Theater, 422 West 42d Street.

THAT MIDNIGHT RODEO By Mary Sue Price; directed by Melanie Joseph.

BUT THERE ARE FIRES By Caridad Svich; directed by Susana Tubert.

RELATIVITY By Marlane Meyer; directed by Ms. Joseph.

PAGAN DAY By Sally Nemeth; directed by Ms. Joseph.

THE ENCANTO FILE By Rosa Lowinger; directed by Melia Bensussen.

WITH: Dana Bate, Divina Cook, Dorrie Joiner, Thomas Kopache, Wendy Lawless, Patrick McNellis, Faye M. Price and Cliff Weissman.

By MEL GUSSOW

Rules and rigidities of marital and business relationships are at the core of an evening of five one-acts presented by the Women's Project. Four of the plays are as literal as they are commonplace. Only one, Marlane Meyer's "Relativity," has even a spark of mystery to it, and that is not enough to save it from the mediocrity of the evening.

Ms. Meyer focuses on the secret scientific musings of an incapacitated older man. While he idly watches erotic programs on television, he speaks — or dreams that he speaks — into a tape recorder, expounding his ideas about relativity. The title also extends to the family unit, which includes two women who have their own ambiguous relationship. It would be easy to under-read the events in this stultifying household. At no point does the play approach Ms. Meyer's more substantial work like "Etta Jenks."

But in comparison, the other one-acts (at the Judith Anderson Theater) are marginalia. Mary Sue Price's "That Midnight Rodeo" is slighter than a vignette (about a pregnant rodeo rider). Caridad Svich's "But There Are Fires" is a bleak look at a blue-collar love triangle, a playlet that pays odd homage to E. M. Forster with the suggestion that, in this marriage, "there's no center anymore." In this company, Sally Nemeth's "Pagan Day," a blunt neo-militaristic cartoon, at least has the asset of brevity.

•

Rose Lowinger's contribution gives the anthology its title, "The Encanto File and Other Short Plays," perhaps for the simple reason that it is the longest of the efforts — an attenuated story of blackmail among Cuban émigrés in Miami. Hidden in this picture is a mildly amusing dialogue between two office workers on the fringe of corruption.

In an evening without dramatic recompense, there are several performances worth noting — by Divina Cook as a Hispanic office worker, Wendy Lawless as the rodeo rider and Patrick McNellis as a man who casually cuckolds his best friend. With a world of possible plays to choose from, the Women's Project has been self-defeating in its selection of one-acts for production.

1991 Ap 2, C14:5

Penn and Teller
The Refrigerator Tour

By Penn Jillette and Teller; music by Yma Sumac; set by John Lee Beatty; lighting by Dennis Parichy; sound by T. Richard Fitzgerald and Craig Van Tassel; production stage manager, Cathy B. Blaser; associate producer, Marc Routh. Presented by Richard Frankel, Thomas Viertel and Steven Baruch. At the Eugene O'Neill Theater, 230 West 49th Street.

WITH: Penn Jillette, Teller, Carol Perkins and Gary Stockdale.

By MEL GUSSOW

A chandelier drops to the stage in "Phantom of the Opera." A helicopter lands in "Miss Saigon." And in "Penn and Teller: The Refrigerator Tour," a refrigerator crashes down on the show's two stars. Where the Broadway competition delays a big theatrical moment in order to increase anticipation, Penn and Teller brazenly use it to begin their show. Should something go awry, it would of course end the show. Fearful theatergoers need not worry about the squashing of Penn and Teller. They survive the refrigerator, laugh at the audience's gasp and move into two hours of iconoclastic assault on the temple of magic.

Searching for a category in which to pigeonhole the partners, one might come up with new-wave magicians or comic illusionists. They are also — to use their own word — charlatans. As debunkers, they seek to remove the mystique from magic, to demonstrate the digitation behind the presti. In that sense, they are cogent critics of their own profession. Practicing the art of show and tell, first they do it, then they explain how they did it, while still leaving ample subterfuge in the air.

Because they are evidently so pleased with the title trick, they perform a variation of it later in the show, with an anvil substituting for the refrigerator and a duck standing in for Penn and Teller. In other words, one duck equals two quacks.

•

To those who may have missed their previous New York performances, their television appearances, or their movie, "Penn and Teller Get Killed" (everyone missed their movie), it should be said that Penn Jillette is big and burly and has long hair, though he has combed away the Daliesque curl on his forehead. Teller (who goes by no other name) is short and seemingly timid, but leonine in his daring, especially when he is on a stage yawning with animal traps.

In their return to New York, in a show that opened last night at the

Card tricks, disappearances and self-mockery share the bill.

Eugene O'Neill Theater, Penn and Teller have added a number of new routines to twists and variations on ones from past performances. Card tricks still share the stage with large-scale, Houdini-style disappearing acts. As usual, not everything is intended to amuse, although almost everything is intended to confound.

Even if they were available for hire, they would not be magicians of choice for a child's birthday party. In at least one routine, the show leaps over the edge into grotesquerie, as Penn and a female assistant, Carol Perkins, engage in a mock-sexual challenge match of prandial pyromania — or fire-eating. Though the show may not be to everyone's taste, one cannot deny the originality of the performance.

•

In a switch on sawing a woman in half, Penn does a trick in which he

Anthony Loew/"Penn and Teller: The Refrigerator Tour"

Penn Jillette, left, and Teller, in "The Refrigerator Tour."

appears to shuffle Teller's disembodied head and limbs in a variety of boxes. Then he repeats the moves with transparent boxes and we see Teller slither from place to place, poking his head, waving an arm and flexing a foot. For all the candidness about magic trickery, they reveal only as much as they want to. We never do find out how they manage to float a volunteer in the air while her head rests on the back of a chair.

Watching the show, I was reminded of Alfred Hitchcock (not just in the malicious humor). With Penn and Teller, magic gains a MacGuffin: a hook, sometimes farfetched, on which to hang invention. Some of the tricks are so complicated as to make one lose sight of the original purpose. The fun is in the playing out of the exercise. It becomes shaggier and more labyrinthine, as in an audience-involving game show entitled "Mofo, the Psychic Gorilla."

In this routine, Teller speaks, though he pretends not to. For most of the show he is mum. This is certainly not the case with Penn, who is unable to stop talking. Like a sideshow barker, he gabs his way through a rodomontade spiel in which he needles his fellow magicians, fools the audience and foils his partner. Teller is no easy mark. Even wordless he may be the wittier half. Together, Penn and Teller are a matchless team of self-mocking sorcerers.

1991 Ap 4, C15:5

Lucifer's Child

By William Luce, based on the writings of Isak Dinesen; directed by Tony Abatemarco; music by Charles Gross; scenery by Marjorie Bradley Kellogg; costumes by Noel Taylor; lighting by Pat Collins; sound by T. Richard Fitzgerald; production stage manager, Patrick Horrigan. Presented by Ronald S. Lee. At the Music Box Theater, 239 West 45th Street.

Isak Dinesen, Baroness Karen Blixen
 Julie Harris

By FRANK RICH

THE Playbill for "Lucifer's Child," Julie Harris's solo performance on Broadway as the writer Isak Dinesen, says that the play takes place in its heroine's study in Rungstedlund, Denmark. But the curtain is up as the audience files into the Music Box, and the room in view seems to belong to another cultural realm entirely. With a jutting ceiling that resembles a proscenium arch, some sticker-plastered steamer trunks and an array of proudly displayed costume gowns, the setting for "Lucifer's Child" looks not so much like a lionized Danish writer's den as a star actress's dressing room on the road. Though it's hard to picture the author of "Out of Africa" at work here, who would doubt that Miss Harris is completely at home?

And a good thing, too, for her reassuring presence, however little it may have to do with Isak Dinesen, can at times justify an evening as otherwise slight as "Lucifer's Child." Here is a performer who has been on stage for most of any present-day audience's lifetime, and it is pure pleasure for a theater enthusiast to watch the focused energy, twinkling humor and sheer expertise with which she executes her own rarefied art.

Miss Harris's first entrance in "Lucifer's Child," in which she emerges in a Pierrot costume from behind a hanging sheet, is a small masterpiece of star cunning, as is her curtain call, in which a troubadour's modesty is crowned by the regal smile with which she silences the peaking applause to bid one and all goodnight. As a special treat at the press preview I attended, Miss Harris had to cope with a large oil painting that tumbled to the floor in mid-soliloquy. The actress never missed a beat as she ad-libbed to cover the accident, resumed her speech, picked up the fallen prop and then, chattering all the while, waited for exactly the right textual pause that would allow her to replace the canvas without further blemishing the mood of the play.

No, not even Africa can boast a species as endangered as the kind of true-blue theatrical trouper epitomized by Julie Harris, and "Lucifer's Child" is best enjoyed as a genteel display of this magical actress at work. As a drama about the Baroness Karen Blixen (1885-1962), it fails to wring much new excitement, information or understanding from either her pseudonymous memoirs and tales or her troubled private life, with its broken marriage and aborted love affair. There is little if anything here that cannot be found in fuller detail in Judith Thurman's authoritative biography of Dinesen, and there is more overlap in content with the soppy film adaptation of "Out of Africa" than one might assume, Meryl Streep's thick Danish accent always excepted (Miss Harris barely attempts it).

William Luce, the playwright who also collaborated with Miss Harris on her Emily Dickinson show, "The Belle of Amherst," has at least done a professional job of skimming the high points of a fascinating life, and he is more scrupulous about the facts than were the Hollywood creators of "Out of Africa." He sets "Lucifer's Child" in the late 1950's, when the septuagenarian Dinesen was more than two decades out of Kenya and declining into the final stages of the syphilis she contracted from her philandering husband, Baron Bror von Blixen-Finecke, during their first year of marriage. Not unlike Florence Aadland in another one-woman play across 45th Street, "The Big Love," Dinesen is found singing along with old songs, boozing it up, packing her bags — in this case for her first lecture tour of the United States — and reminiscing. Her psychological touchstones, unsurprisingly, include the deaths of her mother, her father (by suicide) and her big love, the great white game hunter Denys Finch Hatton, as well as the publication of her books and her fond memories of Farah, Kumante and other servants of her legendary coffee farm.

As written by Mr. Luce and directed by Tony Abatemarco, "Lucifer's Child" is not so slapdash as "The Big Love" or so statically presented as Eileen Atkins's delivery of Virginia Woolf's "Room of One's Own." Mr. Luce knows when to push the pedals for comedy and pathos, and he can be confident that Miss Harris will always keep up with him. Her expert comic timing is given a mild workout by gags about the names Dinesen assigns to her clothes (typically, a pair of gloves is known as Tristan and Isolde). Young actors could learn much from the technique with which Miss Harris falls to the floor in a sudden paroxysm of spinal pain, or turns unexpectedly in mid-exit to remark, almost as an afterthought, "I did see God."

•

The slick surface of "Lucifer's Child" cannot, however, camouflage the lack of depth. While Dinesen's achievements, sorrows, erotic drive and more vexing traits are given lip service — and while the play's title provides a theme about art as redemption for inner wounds — such raw psychological material never coheres into a portrait. The men and relatives in the heroine's life remain ciphers and her profound feelings about them, about her illness and about her other traumatic experiences are elusive. This Dinesen is less a character than a commonplace eccentric with a literary pedigree, and the audience is presumably expected to fill in the blanks from other sources, starting with Dinesen's letters and major works.

What is moving about "Lucifer's Child" is Miss Harris, not its sketchy glimpse of its famous subject. She is an actress in the grand manner, but refreshingly, she is never grand. She does not mind looking her age — with her silver wig and occasionally nervous hands, she's an incipient Mary Tyrone — and yet when she tilts her head back and her eyes catch the light, we see that famous, much photographed pose she struck as Joan of Arc in "The Lark" more than a generation ago. Perhaps she reveals some of her Sally Bowles, too, during those interludes when Dinesen is found wielding a champagne flute and a long cigarette holder. What is always visible in any case is a rare exemplar of American theatrical tradition single-handedly holding down the fort. The idea of Julie Harris sweeping from dressing room to dressing room across the country barnstorming in the role of a pioneer like Isak Dinesen can be cherished well after one has forgotten "Lucifer's Child" itself.

1991 Ap 5, C1:1

SUNDAY VIEW/David Richards

The Lord of the Rings Meets Penn and Teller In Malice Aforethought

I DON'T WANT TO BE THOUGHT PER-
verse, especially considering the lengths
to which the Ringling Brothers and Bar-
num & Bailey Circus is going to wrap up
its 121st edition in an orgy of patriotism.
I mean, all the performers — dozens of them
— are waving starry banderoles, showers of

white confetti are raining down from on high,
while strains of "America, the Beautiful"
are filling up Madison Square Garden to the
brim. Even the sequins seem to be blaring
out a deeply held belief in the country's good-
ness.

So I'll try to be tactful about this. I know
the circus is family fare, true blue and all-
American. Having daredevils shot out of can-

At the circus, exquisite torture is the stuff of entertainment. Just ask Penn and Teller. They understand all too well.

nons is part of the noble tradition, like the
clowns whacking each other over the noggin.
No symbolism is intended. The ropes and the
whips and the harnesses are just the tools of
the trade.

But tell me, am I the only one who is struck
by the rampant eroticism of it all?

Maybe a bikini is the most efficient outfit
for a performer like Vivien Larible, who
stands on her head on a trapeze while she's
juggling a ball with her feet and twirling
rings with her outstretched hands. There is
not a whole lot of fabric to get in the way or
snag, accidentally, on the wires. So yes, may-
be a bikini *is* a safety precaution. But I doubt
it.

The circus celebrates the arrogance of the
flesh. Everywhere you look are bulging bi-
ceps, bare midriffs, well-turned thighs, proud
breasts and defiant pecs. It's the Folies-Ber-
gère with sawdust on the floor. There may be
no staircases to descend, but the dancers still
wear high heels. The men have lightning
stripes on their tights and sport gladiatorial
collars, studded with rhinestones.

Anthony Loew/Penn and Teller

Fred R. Conrad/The New York Times

*Dessi Kehaiova with hula hoops during a performance of Ringling Brothers and Barnum & Bailey Circus at Madison
Square Garden—an elegant, undulating fish out of water. Penn Jillette, far left, and Teller, accompanied by props animal
and mineral, have brought their "Refrigerator Tour" to the Eugene O'Neill Theater—a healthy amount of pure spite*

I'm sure I didn't view things this way as a child. (Mostly, as I recall, I was afraid the lions would get loose.) And although from New England, I am not one of those who sees prurience in a petunia. But whenever I behold statuesque showgirls triumphantly astride great exotic beasts, or sinewy aerialists being plucked out of space by their ankles, then flung right back, something tells me that the Marquis de Sade really should be the ringmaster.

To my knowledge, the only other place you'll find wild animals and humans in various states of undress mingling so freely — and the laws of gravity suspended, seemingly, for the duration of the encounter — is in the sort of dreams usually described as forbidden. But here it's all real — the two elephants, for example, standing head to head, like bookends pushed together, and the spangled showgirl who has a foot planted triumphantly on each elephant's head. Under the promptings of Mark Oliver Gebel (Gunther Gebel-Williams's son), the elephants slowly back off — which, if you've followed me, results in the brave woman being lowered into an obligatory split.

■

In my eyes, this constitutes a strange agony, not far removed from drawing and quartering. When played out under a big top, however, exquisite torture is the stuff of entertainment. Lorelei, a stunningly muscled aerialist, hangs by her heels from a trapeze. Dessi and Gery, a sister act devoted to the artistry of the hula hoop, would appear tame enough, until Dessi, grabbing a ring with her right hand, is hoisted above the crowd. Suspended in midair, she manages to keep a half dozen or so hoops spinning with her undulating torso, which brings to mind an elegant fish out of water. The Alejandro Duo works from a device called the cradle, and while I

couldn't get a clear bead on their sky-high contortions from where I was sitting, I have the distinct impression that at one point he was holding her up with his teeth. (People surrender state secrets for less, but they usually get to wear more clothes.)

Imagine, for the sake of my argument, the wheel inside a hamster cage. Next, imagine the hamster scurrying on the *outside* of the wheel. Put that wheel with its scurrying hamster, and another just like it, at either end of a 50-foot stainless-steel beam, and set the beam rotating in space like a drum majorette's baton. Now, replace the hamsters with the Peters Brothers — Marco and Philip. That should give you a general idea of the Wheel of Death. You'll have an even better idea if you put a black hood over Marco's head and set fire to one of the wheels.

Who's the technical adviser for this act? Edgar Allan Poe?

The Wheel of Death is not to be confused with the Globe of Death, which is a metal sphere suitable for the entrance to any world's fair, except that inside it, the Amazing Españas, three of them, are doing loop-the-loops on motorcycles. For a climax, "a fearless femme" (in the terminology of the souvenir program) climbs into the globe, and the cyclists do their loop-the-loops around *her*. Somehow, the notion of bikers and a skimpily clad woman locked inside this infernal contraption seems flagrantly adult to me, but then I'm a flagrant adult. The kids, I guess, make of it what they will. Most 7-year-olds I know are 16 anyway.

Keeping to a theme, you might say, this year's most startling production number features the showgirls, each outfitted in black mini shorts and crowned with a centurion's plumage, va-va-vooming around the ring on gleaming motorcycles like so many Mad Maxines. Once they formed kick lines. Now they're out, evidently, to reclaim small towns from the forces of thugdom.

Suzanne DeChillo for The New York Times

Marco Peters and a friend at Madison Square Garden— when Muscle Beach gets married to Minsky's

These days, it's the pachyderms that make up the kick line, 19 beasts long, and the stallions that walk on their hind legs, pawing the air more or less in unison. The buffaloes, for their part, go down on bended knee, as if to ask forgiveness for the lewd conduct around them. That of the pigs, no doubt. A couple of rings away, the pigs waddle about luxuriously for a while before letting themselves be coaxed into defying death in their fashion by inching down a slide.

Clearly, this is no place to evoke the higher values. And that, I think, is why the acrobats from the People's Republic of China register as such a novelty. They are polite. Their costumes are prim and on the loose-fitting side. Some are decorated with cloth roses. They spin plates on the ends of poles with sweet humility, and when they twirl ropes, their delight seems to lie in the pretty patterns they're tracing in the air. No Ropes of Death for them.

■

They don't do bicycle tricks. They do a "bicycle ballet." One by one, then two by two, they climb on a bicycle circling the center ring, until the passenger count is 14. Never did a human pyramid appear so light, so delicate, almost like those exotic paper flowers that spring from clam shells, when you drop them in a glass of water. It's a lovely interlude, but it's definitely at odds with the rest of the show, which emphasizes the effort, not the ease, the dazzle, not the decorum.

The Ringling Brothers and Barnum & Bailey Circus has never been quiet about its appeal. It's as blatant as a trombone and as pushy as a dance hall hostess. It's hootchy-kootchy on a colossal scale, daredeviltry in a G-string, Muscle Beach married to Minsky's. Profane to the core.

The clowns, I have come to believe, are just camouflage.

'Penn and Teller: The Refrigerator Tour'

Since we are talking about sadomasochism (and we are, you know), it is probably an auspicious moment to mention Penn and Teller, who have taken up temporary residence at the Eugene O'Neill Theater. The engagement is part of their cross-country "Refrigerator Tour," so named because the macabre but ever-entertaining show begins with a 450-pound refrigerator being dropped on the duo. Some two hours later, Teller is swinging upside down from a trapeze over a bear trap in an attempt to pluck a sandwich from its lethal jaws, while Penn radiates the kind of melting pleasure the rest of us reserve for a litter of newborn kittens.

A healthy amount of pure spite has always separated Penn and Teller from their peers in magic and illusion. As Penn, the bullying one, explains, most of the evening is rehearsed, but "there are moments within the script when I am allowed to be malicious." Much of the malice is directed at Teller, who looks like a slightly bilious choirboy and suffers the abuse patiently. The audience,

however, comes in for its share of badgering and seems to adore it.

Teller, as is well known by now, is the mute half of the team, although at one point he provides the voice of Mofo, a carnival hand-me-down billed as the Psychic Gorilla. This he accomplishes by holding his hand over his mouth and pretending not to talk, thereby preserving, if barely, the appearance of mutism. Like much of what Penn and Teller do, the fraud is intentional and very funny.

∎

Self-confessed charlatans, they are eager to debunk the ploys of the "tuxedo-clad rabbit tuggers." To that end, Teller climbs inside a sentry box,

The audience at the 'Refrigerator Tour' comes in for its share of badgering and seems to adore it.

which Penn dismantles in sections, each section seemingly containing a different part of Teller's anatomy — a hand here, legs there. Then the trick is repeated, with a clear plastic sentry box, which, of course, lets the cat — or Teller — right out of the bag. Later, Penn drops an anvil on a quacking duck inside a shopping bag. But just so we don't all besiege the A.S.P.C.A., Penn goes through that bit of viciousness a second time, too, pinpointing the crucial switcheroo that keeps the duck from becoming pâté.

Some mysteries, on the other hand, are never revealed. Teller swallows a pincushion's worth of needles and then a yard of thread, only to cough up the thread, seconds later, with the needles neatly hanging from it. Don't ask me how. The only explanation for the fire-eating routine that Penn performs with Carol Perkins — the two lolling about seductively on a sofa and not so much exchanging kisses as bursts of flame — is that they're both out of their heads.

If my memory of their prior tours serves me well, about a third of Penn and Teller's current show is new. The rest is tried, true and dependably weird. Houdini may be their avowed master, but Charles Addams has to be their patron saint. ☐

1991 Ap 7, II:5:1

Jeffrey Essman's Artificial Reality

Written and performed by Jeffrey Essmann; directed by David Warren; music by Michael John LaChiusa; set design by George Xenos; lighting design by Pat Dignan; costume design by David C. Woolard; sound design by Mark Bennett; production stage manager, Liz Small. Presented by New York Theater Workshop, James C. Nicola, artistic director; Nancy Kassak Diekmann, managing director. At the Perry Street Theater, 31 Perry Street.

By STEPHEN HOLDEN

In "Sister Bernice," the final sketch of his dazzlingly funny evening of character comedy, Jeffrey Essmann, wearing a nun's habit, impersonates an ancient parochial-school teacher grimly introducing herself to a fourth-grade class on the first day of school. Shaking her finger, she announces that her very name embodies a terrible warning. Those who are not "nice," she says, hissing, will "burn" in Hell.

Trouble soon erupts during a sing-along in which the class (the audience) is invited to join voices for "He's Got the Whole World in His Hands," reading the words printed on flipped pages attached to a blackboard. Unknown to Sister Bernice, on page 3, a mischievous student has carefully crossed out "world" and written "wiener." So much for niceness.

In one way or another, all eight of the sketches in "Jeffrey Essmann's Artificial Reality," a compilation of his twisted characters at the Perry Street Theater through April 28, un-

Jeffrey Essmann

covers "wieners" in situations that promised more wholesome worlds. Some of his characters, like Sister Bernice, he has been performing for years. Others are more recent creations.

Among his newest characters is Scott Thornton, a utopia-minded men's movement guru who holds workshops in which the participants (the men in the audience) are exhorted to sing upbeat slogans describing the beauty of their genitals before being sent outdoors with spears to go on a hunt.

Another is Stan M., a lonely shoe salesman and "recovering recovery addict" who has been through Alcoholics Anonymous, Narcotics Anonymous and every other anonymous

Barbie splashes herself with vodka; Sister Bernice scares a class.

organization, winning attention and sympathy with his bogus stories of addiction. He just can't give up the recovery game.

Then there is "The Barbie Nightclub," in which Mr. Essmann, wearing a ludicrous blond wig and standing on tiptoe as though condemned to walk on high heels for eternity even when shoeless, delivers the unhappy true confessions of a Barbie doll while splashing himself with vodka to the tune of "Valley of the Dolls."

In these sketches, Mr. Essmann is not out to savage the Roman Catholic Church, alumni of the Betty Ford Center, Mattel toys or followers of Robert Bly per se as much as to puncture the mystiques surrounding them through ridicule.

Mr. Essmann reserves a special disdain for pretentious theatrical airs. His skit "The Passion of Patsy" is a subtle, devastating takeoff of the kind of one-person show in which a character remembers living through momentous historical times and also re-enacts crucial personal turning points. In this case, it is the life story of a prolific Croatian poet of no discernible talent whose husband fired the shots that triggered World War I.

Hunched under a shawl, eyes twinkling wickedly, the character remembers such things as singing to goats, eating cabbage pudding and party snacks that included "turnips carved to look like little roses."

Even funnier is "The Sturm and Drang Songbook," a mock revue of songs written by the fictional duo of Harold Sturm and Arnie Drang, a sort of Richard Maltby Jr. and David Shire-manqué. The legendary team met in the early 1970's and is so prolific that by 1986 they had written 46 shows, Mr. Essmann tells us. If you're a New York actor and don't have a Sturm and Drang revue on your résumé, he asserts, "you're probably lying."

He then proceeds to perform two songs by the mythical team that hilariously distill a generic style of revue song that purports to have a subject but is really a rhymed list set to a desperately cheerful, completely forgettable melody.

The talented composer Michael John LaChiusa, who wrote both tunes and who supplies live piano accompaniments for the other skits, is Mr. Essmann's invaluable sidekick

throughout the show. For "The Barbie Nightclub," he even dons a Raggedy Ann red mop wig. Mr. LaChiusa's musical wit consistently matches Mr. Essmann's literary humor and lends an extra richness to a show whose rarefied sense of humor sits somewhere between Lily Tomlin and Ruth Draper in elevation, but for good measure adds a dash of Jonathan Winters silliness.

1991 Ap 8, C11:1

I Hate Hamlet

By Paul Rudnick; directed by Michael Engler; setting by Tony Straiges; costumes by Jane Greenwood; lighting by Paul Gallo; sound by Scott Lehrer; music by Kim Sherman; fight direction by B. H. Barry; associate producers, 126 Second Avenue Corporation and William P. Wingate. Presented by Jujamcyn Theaters, James B. Freydberg, Robert G. Perkins and Margo Lion. At the Walter Kerr Theater, 219 West 48th Street.

Felicia Dantine	Caroline Aaron
Andrew Rally	Evan Handler
Deirdre McDavey	Jane Adams
Lillian Troy	Celeste Holm
John Barrymore	Nicol Williamson
Gary Peter Lefkowitz	Adam Arkin

By FRANK RICH

"I love this apartment because it's like a stage set, it's like the theater," says Andy Rally, a young bicoastal actor who has taken up new digs in Greenwich Village after the cancellation of his television series "L.A. Medical." And no wonder. Andy's new flat is the extravagantly Gothic apartment long ago occupied by John Barrymore, and even in 1991 it remains a suitably regal throne room for any show-business prince, past, present or still aspiring. Since Andy (Evan Handler) is about to assume Barrymore's most celebrated Shakespearean role in a Joseph Papp production in Central Park, what is to stand in the way of his complete artistic fulfillment? Only one thing. Much as Andy loves his apartment, loves the theater and loves stardom, he hates Hamlet.

●

"I Hate Hamlet," the new comedy by Paul Rudnick at the Walter Kerr Theater, is the unapologetically silly and at times hilarious tale of how Andy rises above his fear and loathing of the role people ritualistically refer to as "the greatest in the English-speaking world." To do so, he must seek the help of Barrymore himself, who comes back from the grave to give his young would-be successor instructions in Shakespearean acting, not to mention life and love. Don't ask how and why Barrymore rises from the dead — Mr. Rudnick's séance takes far too long as it is — but do be cheered by the news that the ghost is played by Nicol Williamson. A first-class Hamlet in his own right once upon a time, and on occasion as flamboyant an offstage figure as Barrymore was, Mr. Williamson is a riotous incarnation of a legendary actor, lecher and lush (not necessarily in that order) whom even death has failed to slow down.

Mr. Williamson gets the audience laughing from the moment he enters in full Hamlet regalia and makes a beeline, as if yanked by a magnet, to the nearest uncorked Champagne bottle. Mr. Rudnick, a wisecrack artist whose other works include the play "Poor Little Lambs" and the novel "Social Disease," quickly gives

his star some high-flying bouts of drunken hamming worthy of Sid Caesar on "Your Show of Shows," or Peter O'Toole in "My Favorite Year." When Barrymore instructs his young protégé on the art of the curtain call, Mr. Williamson demonstrates how to milk the crowd with a cynical yet rousing bravura that might have impressed the real-life Barrymore clan. His woozy swoons, bombastic braggadocio and swashbuckling sexual antics are so eerily reminiscent of John Barrymore himself in his self-parodistic decline that Mr. Williamson creates the illusion of bearing much more of a physical resemblance to his celebrated prototype than he actually does.

Charmingly enough, Mr. Rudnick's play tries, albeit with scarce success, to recall the screwy comic style of Barrymore's Hollywood and Broadway day: the spirit of "Here Comes Mr. Jordan," "Topper" and "Blithe Spirit" can be found in the supernatural pranks of "I Hate Hamlet," and the director, Michael Engler, has added to that nostalgic mood with a fabulously glossy set by Tony Straiges, silver-screen moonlight by Paul Gallo and hokey old-time background music by Kim Sherman. For a further whiff of period flavor, Celeste Holm, an actress whose own career dates back to the tail end of the Barrymore period, appears in "I Hate Hamlet" as a one-time Barrymore flame, and her reunion with her deceased paramour in Mr. Rudnick's play gives the evening an all-too-brief injection of rueful Lubitsch romantic fantasy.

That scene excepted, the tone of "I Hate Hamlet" tends to be more contemporary and collegiate, and the writing is highly variable, taking a noticeable plunge every time Mr. Williamson fades into the set's acres of Gothic woodwork. Mr. Rudnick is witty on such subjects as Method acting ("We must never confuse truth with asthma"), the resistance of modern audiences to Shakespeare ("It's algebra on stage!") and Hollywood's patronizing attitude toward the New

York theater. The humor becomes mechanical, however, when the playwright tosses in one-liners on such well-worn topics as television programming, real-estate brokers and trendy courses of study at the New School.

The duller volleys of dialogue would not be so noticeable if the playwright had devised an air-tight comic structure to keep the play moving forward no matter what. But "I Hate Hamlet" is too often content to be an extended two-hour sketch and never musters the theatrical ambitions of Michael Frayn's "Noises Off" and Terrence McNally's "It's Only a Play," the better made backstage comedies it occasionally echoes. Mr. Rudnick's oddest lapses are his inability to make consistently riotous farcical hay out of Barrymore's spells of ghostly invisibility and his decision to keep his play's promised climax, Andy's opening night, offstage. The most elaborate subplot in "I Hate Hamlet" — Andy's attempts to bed his virginal, Ophelia-esque girlfriend — piles up far more stage time than laughs.

In his direction, Mr. Engler seems less secure here than he did in "Eastern Standard" and "Mastergate." Snappily choreographed scenes intermingle with those in which Mr. Williamson seems to be lolling idly about like standby equipment. The production's biggest failure is the performance of Mr. Handler, who was so good this season as the enraged doctor's son in "Six Degrees of Separation." As Andy Rally, he lacks what Mr. Rudnick calls the "right twinkle" required of a television star, and his comic range rarely extends much beyond that memorable note of hysteria he brought to his temper tantrum in "Six Degrees." Jane Adams and Caroline Aaron, as Andy's pretentious love interest and pushy broker, are also adequate rather than inspired, though Adam Arkin is remarkably fresh as a Hollywood huckster who explains that television is

artistically superior to theater, not in the least because the audience need not pay any attention to it.

•

Throughout the evening's running debate about the merits of the stage and the small screen, there is never any doubt which side Mr. Rudnick is on. It is even possible that the playwright does not hate "Hamlet," all the jokes at its voluminously gloomy expense notwithstanding, for he permits Mr. Williamson to act Hamlet's advice to the players and act it movingly, after which the actor delivers

an equally fervent soliloquy in which Barrymore regrets how he squandered his art and soul in Hollywood following his Shakespearean stage triumph in New York. That Act II speech seems to touch something deep, almost tragic, in Mr. Williamson, and so it does in us. But mostly "I Hate Hamlet" is light and ramshackle, affectionately amusing about the theater when at its sharpest, and, one must say, still a little funnier than "Hamlet" when not.

1991 Ap 9, C13:3

A Catharsis for Forgotten Women Of Vietnam at Louisville Festival

By MEL GUSSOW

Special to The New York Times

LOUISVILLE, Ky., April 7 — As the lights came up on a reproduction of the Vietnam Veterans Memorial in Washington, women who served in that war placed mementoes of their experience as if they were flowers on a grave. The reaction of the audience at the Actors Theater of Louisville was palpable. Sobs filled the house in a crescendo that became a group lamentation. This final scene in Shirley Lauro's new play, "A Piece of My Heart," is a catharsis as well as a coup de théâtre. The women in the play are the most forgotten among all those who had been forgotten in Vietnam.

The play itself was the climax of the 15th annual Humana Festival of New American Plays, seen this weekend in a marathon of seven full-length works and two one-acts. In previous

years, the festival (under the artistic direction of Jon Jory) has reached individual heights (with plays from Beth Henley's "Crimes of the Heart" to last season's "2" by Romulus Linney) and collective depths in a period in which Mr. Jory commissioned plays from celebrities.

This year was an on-season for Actors Theater, as the company resoundingly expressed its valuable purpose, to encourage playwrights to challenge themselves and the hundreds of theatergoers who converge on Louisville for the annual spring festival. Gone was the pretentious

Shirley Lauro play is climax of this year's Humana Festival.

symbolism of plays in which metaphorical hounds of hell seemed to bark at the door of every drama. Instead there were tangible and meaningful plays by three theater artists. Along with Ms. Lauro, the Actors Theater offered a striking study of revolutionary Cuba by Eduardo Machado and, as an audience rouser, a dark comedy about a troupe of female wrestlers, written by Jane Martin, the first full-length play with interacting characters by this pseudonymous Louisvillian.

Through these plays and others of varying interest ran the festival's primary theme: the violence, psychological and physical, suffered by women, and their valiant attempts at self-assertion. These views ranged from the journey into madness of a lonely shopkeeper (in Shem Bitterman's evocative but attenuated interior monologue, "Night-Side") to the serial killer who regards the murder of women as an extension of seduction (Lee Blessing's disappointing "Down the Road").

In Ms. Lauro's "Piece of My Heart" (based on Keith Walker's oral history of the same title), six women, most of them nurses, fly to Vietnam on a wave of innocence and idealism — almost immediately replaced by

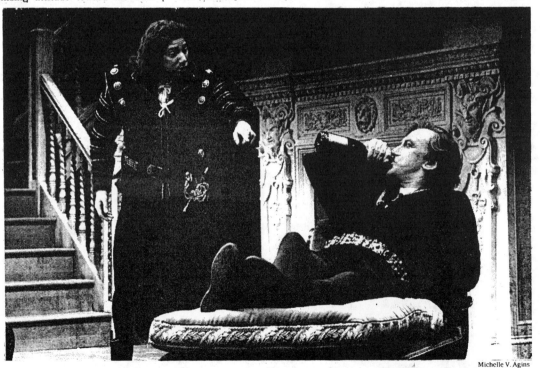

Michelle V. Agins

Evan Handler, left, as a young actor and Nicol Williamson as the ghost of John Barrymore in the Paul Rudnick comedy "I Hate Hamlet."

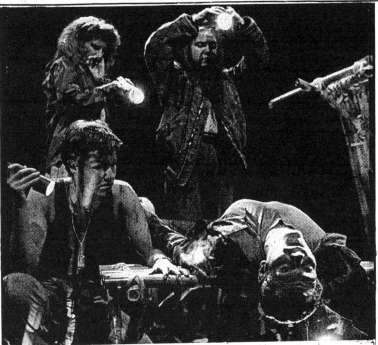

Richard C. Trigg/Actors Theater of Louisville

A scene from Shirley Lauro's new play, "A Piece of My Heart" at the Actors Theater of Louisville.

panic. They are insufficiently trained and totally unprepared for the maimed bodies, the river of blood that flows through the hospital after it is bombed and the illogic of the war itself. In the second act, back home, we see the full nightmare of the war and its aftermath.

There have been a number of plays dealing with Vietnam (most recently Steve Tesich's "Speed of Darkness") but none with the direct emotional impact of Ms. Lauro's work. It is, on one level, a model of the art of the dramatic collage. The playwright has taken true stories and crossthreaded them so that the monologous nature is completely concealed. In collaboration with the director, Allen R. Belknap, and a symbiotic company of actresses (one actor plays all the male roles), Ms. Lauro has turned firsthand impressions into a disturbing drama that evokes empathy for survivors as victims, especially the women in the war zone, whose only weapons are their hearts.

With equal perceptiveness, three of the talented actresses in Ms. Lauro's play have totally disparate roles in Ms. Martin's "Cementville," directed by Mr. Jory. The title (pronounced "seementville") is a fictional Tennessee town with a sports arena that once housed greats like Jake LaMotta but has now fallen on seedy times. Mock wrestling matches are staged for the rabble, sports descended to the depths of show business.

In a fiercely funny first act, a border state reversal of David Storey's "Changing Room," female wrestlers are in a dingy locker room preparing for the evening's show. As she did in "Talking With," Ms. Martin creates a panoply of individualized characters, but, in contrast to that earlier anthology of monologues, these people become an interwoven ensemble.

In the second act, the play spins into an outbreak of locker bashing violence, which unwisely makes explicit things more effectively encountered as offstage emanations. But the ending itself knits the play together in a moment of ruefulness. "Cementville" offers additional confirmation

of Ms. Martin's gift for dialogue, as she captures the local colorfulness of obsessive characters. There is also a knowing sense of our times, as in one character's prediction that fantasy entertainment is the growth industry of the 90's.

●

For Mr. Machado, "In the Eye of the Hurricane" is a long awaited realization of the playwright's early promise. The success is shared equally with the director, Anne Bogart, whose visually arresting production offers a tangoesque view of a Cuban family and Cuba itself (in 1960) in the throes of radical change. Emotions seethe and flare, as the playwright and the director orchestrate a symphony of contradictions.

The stage echoes with love-hate, along with outlandish humor akin to that of Mario Vargas Llosa. When the family's bus line is about to be nationalized by Castro, relatives agree to lie down in front of the buses in order to safeguard the vehicles. The confident head of the household takes his prone position in front of a giant tire, awaiting vindication or death, and then, as the bus pulls away, realizes that he has forgotten the alternative of reverse gear.

"We are what they want to throw away," he says in reference to the new regime. This is a disposable nouveaux riche society and to a great extent the characters have brought about their own downfall with their chicanery and guile. Feminism emerges in the portrait of the matriarch, still demanding in her old age (a feisty Lynn Cohen) but a woman submerged in a male heirarchy. The most stylish performance is given by Christopher McCann as the serpentine son, for whom compromise becomes a condition of survival.

The other plays included "A Passenger Train of 61 Coaches" by Paul Walker, a Story Theater style exercise about Anthony Comstock's crusade about censorship. The work is surprisingly enervating considering the renewed timeliness of the subject. "The Death of Zukasky" by Richard Strand brings the repression of

women into the board room, with a funny cartoon about corporate politics and backstabbing behind the infrastructure. In it, a woman executive becomes the unwitting foil of the company's con artist. In sitcom fashion, "Zukasky" provides laughs, but it is the memory of plays by Ms. Lauro, Mr. Machado and Ms. Martin that theatergoers will take home from Louisville this year.

1991 Ap 10, C13:3

Theater in Review

■ Looking for an exit from the world ■ Just like you and me, but homeless ■ Among various sexual inclinations ■ Two chamber musicals.

Eddie Goes to Poetry City: Part 2

La Mama, Annex Theater
74A East Fourth Street
Through April 28

Written, directed and designed by Richard Foreman; lighting designer, Heather Carson; costume designer, Donna Zakowska. An Ontological-Hysteric Theater production presented by La Mama E.T.C. With: Kyle deCamp, Brian Delate, Rebecca Ellens, Colin Hodgson and Henry Stram.

In the art of Richard Foreman, two dozen plays in the past 20 years, there is an absolute precision of language and imagery that transcends traditional questions of exegesis. The audience may never learn the play's destination, but Mr. Foreman — as author, director and designer — confidently communicates his own understanding, as we accompany him on a parabola-like journey.

With his new play, "Eddie Goes to Poetry City: Part 2," Mr. Foreman is once again in his patented territory. On a set crammed with clocks and other clutter, the author's hero embarks on a free-floating search for an escape route from his present confinement. Even as he looks for an exit, Eddie is advised by the offstage voice of Mr. Foreman that such a passage does not exist in this world.

Eddie (played by Henry Stram) keeps striving. In common with the character of Rhoda, the heroine of a number of earlier Foreman pieces, Eddie is manipulated by others.

Just as Mr. Foreman's recorded voice has an acoustical crispness, the moves of the characters are sharply synchronized; they almost stride into choreography. Throughout the play, visual and aural images are repeated. Eddie and his manipulators spin a single bicycle wheel as if it were a wheel of fortune or the lock on a secret safe. Repeatedly, a small hand-held curtain is placed like a movie clapboard in front of an actor's face, then parted, to reveal the beginning of another play.

"Eddie Goes to Poetry City" retains its sense of theatricality as the hero is buffeted by forces far beyond his ken. Suddenly he stares into space and asks, "Why is everybody looking at me?" The sepulchral voice of Mr. Foreman explains with irascible humor, "You're in a play, Eddie."

At another point, the author raises a banner of self-criticism. What we are seeing, he suggests, is "richness without content." The content, the intellectual ballast, is sub rosa. The play is brief and pithy, definably the creation of this theatrical experimentalist.

MEL GUSSOW

Jonathan Slaff

Henry Stram as Eddie with Kyle deCamp, center, and Rebecca Ellens in Richard Foreman's latest play, "Eddie Goes to Poetry City."

Blues in Rags

Harry De Jur Playhouse
466 Grand Street

Written and directed by Marketa Kimbrell; lyrics by Ms. Kimbrell; score composed and played by Nick Cosco; lighting by Zdenik Kriz; choreography by Marcia Donalds. Presented by the New York Street Theater Caravan. With: Marcia Donalds, Jennifer Johnson and Ariel Joseph.

Homeless people are the same as everybody else except that hard luck has left them without a roof over their heads. That is the message of the New York Street Theater Caravan's play "Blues in Rags."

In the nearly two-hour work with music, Marcia Donalds, Jennifer Johnson and Ariel Joseph dramatize in pantomime, song and short skits the plight of three homeless women they met when the troupe performed at the Women's Homeless Shelter at First Avenue and 52d Street.

Ms. Donalds plays the most fully realized character, a teen-age girl from El Salvador who ends up sleeping beneath Grand Central Terminal. Ms. Johnson portrays a pregnant young woman from upstate New York who comes to the city for an abortion but cannot raise the necessary $200. The characters sing their stories to a simple blues melodies.

The performers, especially Ms. Donalds, bring an upbeat energy to their roles, yet the play doesn't offer any sentimental palliatives or fake happy endings.

STEPHEN HOLDEN

Advice From a Caterpillar

Lucille Lortel Theater
121 Christopher Street

By Douglas Carter Beane; directed by Edgar Lansbury; scenery by Rick Dennis; costumes by Jonathan Bixby; lighting by Brian Nason; original music by David Abir. Presented by John Nassivera and Don Schneider, by special arrangement with Lucille Lortel. With: Dennis Christopher, David Lansbury, Ally Sheedy and Harley Venton.

Douglas Carter Beane, the author of "Advice From a Caterpillar," has an irresistible urge to drop brand names and buzz words. Advice to the playwright: resist that urge. His play is so burdened with supposedly trendy references that there is scarcely room left for plot or meaningful dialogue.

Mr. Beane tells the story of a postmodern artist (Ally Sheedy) moving among friends and lovers of various sexual inclinations. As a brief skit, this might have some small validity, but at full length, the material is stretched past the point of pliability.

Ms. Sheedy's bisexual lover is named Brat, though there is nothing bratty about him. In fact, as played by David Lansbury, he is the only appealing figure on stage. Mr. Lansbury has an amiable, offhand manner that overcomes Brat's doltishness. The other actors do about as well as can be expected in the dire circumstances.

The playwright's second most annoying habit is his frequent use of the words "like" and "very." An attachment is "like love" and a comment is "very suburbia." As it stands, "Advice from a Caterpillar" is like very sit-com. *MEL GUSSOW*

Love in Two Countries

St. Peter's
54th Street and Lexington Avenue
Through April 13

Two one-act operas directed by Michael Montel; libretto by Sheldon Harnick; music by Thomas Z. Shepard; sets by Marie Anne Chiment; lighting by Betsy Adams; costumes by Amanda J. Klein; choreography by Karen Azenberg; musical director, Albert Ahronheim. Presented by Musical Theater Works.
THAT PIG OF A MOLETTE
With: Bill Carmichael, Scott Robertson and Elizabeth Walsh.

A QUESTION OF FAITH
With: Michael Brian, SuEllen Estey and Lannyl Stephens.

The two new one-act chamber musicals by Thomas Z. Shepard and Sheldon Harnick, grouped under the title "Love in Two Countries," are intended to be a double flight of passion, depicting romance in France and Russia during the 19th century.

But in them, love often seems to be taking second place to food and other matters, as in Mr. Harnick's lyric: "To me you are my blinchiki. No, better yet, my caviar." The lyric goes on to enumerate all the accouterments served with caviar, including, climactically, onion.

The musical featuring that menu-style song is called "A Question of Faith." It is based on a story by Nikolai Leskov, and plays like self-parody. In the double bill, talent goes unimaginably far astray — and very far from the mark set by Mr. Harnick and his previous collaborator, Jerry Bock.

"That Pig of a Molette," based on a story by Guy de Maupassant, is the more unfortunate of the two ventures, filled with awkward clumps of recitative, as the show traces the porcine flirtations of a boorishly bourgeois shopkeeper. The self-congratulatory tone of the writing is reflected in the artificiality of the performances.

In the Russian half of the show, in at least one case, the show sinks to doggerel. "Eena Meena Peena Weena" is a number that will have no future except perhaps to count fingers and toes in the nursery.

MEL GUSSOW

1991 Ap 10, C15:1

Making History

By Brian Friel; directed by Charlotte Moore; set design, David Raphel; costume design, Natalie Walker; sound and lighting design, Richard Clausen; production stage manager, Mary E. Lawson. The Irish Repertory Theater, producing director, Ciaran O'Reilly; artistic director, Ms. Moore, presented by The Irish Repertory Theater Co., Inc. and One World Arts Foundation, Inc. At Samuel Beckett Theater, 410 West 42d Street.

Harry Hoveden	Ray Fitzgerald
Hugh O'Neill	Robert Murch
Hugh O'Donnell	Ciaran O'Reilly
Peter Lombard	W. B. Brydon
Mabel	Miriam Foley
Mary	Angela Cooper Scowen

By MEL GUSSOW

The title of Brian Friel's "Making History" could be "Remaking History," for in it the playwright shows us how facts and opinions can be altered to suit the needs of their times. The subject is Hugh O'Neill, commonly regarded as Ireland's greatest hero, and a man who is known for his victories not for his defeats or for his personal failings.

Mr. Friel peers behind the legend to discern the man in his cloak of contradictions, and he does so with thoughtful introspection. Though the play deals with the conflict between Ireland and England, the battle is studiously kept offstage. "Making History" (presented by the Irish Repertory Theater) is more concerned with O'Neill's private doubts and with his view of what history will make of him.

The play takes place 400 years ago, but, in common with the author's contemporary work (Mr. Friel's "Dancing at Lughnasa" recently received an Olivier Award as best new play of the current London season), it deals with themes of loyalty, betrayal and exile. Emphasizing the continuing relevance of "Making History," the author has refused to make the dialogue sound archaic.

•

In the beginning, as O'Neill and his secretary conduct official business, the play bogs down in detail, but it is soon invigorated by the conflict between O'Neill and his closest supporters and between him and his English wife. Among his countrymen, O'Neill seems to be the single pragmatist, a man who is able to bring about progress through compromise. He is successful in these efforts, until the historic defeat at Kinsale when the Spanish momentarily joined the Irish against the English.

Charlotte Moore's resourceful production at the Samuel Beckett Theater keeps everything in scale — emotions as well as atmosphere. Robert Murch is stalwart in the central role, though he misses the tragedy of O'Neill's exile in Rome. Ciaran O'Reilly adds zest as a fellow fighter for Irish freedom and W. B. Brydon captures the fullness of an Irish archbishop, whom, Mr. Friel says, was "by no means diminished by his profession."

O'Neill in exile wants to be remembered as "the schemer, the leader, the liar, the statesman, the lecher, the patriot." It is the archbishop as his biographer who explains the reasons why it is more important to offer the Irish a national hero. In his exploratory play, Mr. Friel demythologizes and humanizes that popular image.

1991 Ap 11, C24:1

Miss Saigon

Music by Claude-Michel Schönberg; lyrics by Richard Maltby Jr. and Alain Boublil; adapted from original French lyrics by Mr. Boublil; additional material by Mr. Maltby; directed by Nicholas Hytner; orchestrations by William D. Brohn; musical supervision, David Caddick and Robert Billig; sets by John Napier; lighting by David Hersey; costumes by Andreane Neofitou and Suzy Benzinger; sound by Andrew Bruce; musical staging by Bob Avian. Presented by Cameron Mackintosh. At the Broadway Theater, 53d Street and Broadway.

The Engineer	Jonathan Pryce
Kim	Lea Salonga
Gigi	Marina Chapa
Chris	Willy Falk
John	Hinton Battle
Thuy	Barry K. Bernal
Ellen	Liz Callaway
Tam	Brian R. Baldomero

WITH: Zar Acayan, Alan Ariano, Tony C. Avanti, Raquel C. Brown, Annette Calud, Eric Chan, Mirla Criste, Francis J. Cruz, Imelda de los Reyes, Paul Dobie, Michael Gruber, JoAnn M. Hunter, Sala Iwamatsu, Leonard Joseph, Darren Lee, Jason Ma, Paul Matsumoto, Sean McDermott, Thomas James O'Leary, Gordon Owens, Christopher Pecaro, Matthew Pedersen, Kris Phillips, W. Ellis Porter, Ray Santos, Jade Kaiwalani Stice, Melanie Mariko Tojio, Alton F. White, Nephi Jay Wimmer and Bruce Winant.

By FRANK RICH

THERE may never have been a musical that made more people angry before its Broadway debut than "Miss Saigon."

Here is a show with something for everyone to resent — in principle, at least. Its imported stars, the English actor Jonathan Pryce and the Filipino actress Lea Salonga, are playing roles that neglected Asian-American performers feel are rightfully theirs. Its top ticket price of $100 is a new Broadway high, sprung by an English producer, if you please, on a recession-straitened American public. More incendiary still is the musical's content. A loose adaptation of "Madama Butterfly" transplanted to the Vietnam War by French authors, the "Les Misérables" team of Alain Boublil and Claude-Michel Schönberg, "Miss Saigon" insists on revisiting the most calamitous and morally dubious military adventure in American history and, through an unfortunate accident of timing, arrives in New York even as the jingoistic celebrations of a successful American war are going full blast.

So take your rage with you to the Broadway Theater, where "Miss Saigon" opened last night, and hold on tight. Then see just how long you can cling to the anger when confronted by the work itself. For all that seems galling about "Miss Saigon" — and for all that is indeed simplistic, derivative and, at odd instances, laughable about it — this musical is a gripping entertainment of the old school (specifically, the Rodgers and Hammerstein East-meets-West school of "South Pacific" and "The King and I"). Among other pleasures, it offers lush melodies, spectacular performances by Mr. Pryce, Miss Salonga and the American actor Hinton Battle, and a good cry. Nor are its achievements divorced from its traumatic subject, as cynics might suspect. Without imparting one fresh or daring thought about the Vietnam War, the show still manages to plunge the

audience back into the quagmire of a generation ago, stirring up feelings of anguish and rage that run even deeper than the controversies that attended "Miss Saigon" before its curtain went up.

Challenged perhaps by the ill will that greeted their every move, the evening's creators, led by the director Nicholas Hytner, have given New York a far sharper version of "Miss Saigon" than the one originally staged in London. The much publicized (and inane) helicopter effect notwithstanding, this is the least spectacular and most intimate of the West End musicals. The most stirring interludes feature two or three characters on an empty stage or in a bar girl's dingy hovel, and for once the production has been made leaner rather than fattened up for American consumption. (Though the Broadway Theater is among the largest Broadway houses, it seems cozy next to the cavernous Drury Lane, where the show plays in London.) If "Miss Saigon" is the most exciting of the so-called English musicals — and I feel it is, easily — that may be because it is the most American. It freely echoes Broadway classics, and some of its crucial personnel are Broadway hands: the co-lyricist Richard Maltby Jr., the choreographer Bob Avian, the orchestrator William D. Brohn.

Without two legendary American theatrical impresarios, David Belasco and Harold Prince, there would in fact be no "Miss Saigon." It was Belasco's turn-of-the-century dramatization of the Madame Butterfly story that inspired Puccini's opera, and

it was Mr. Prince who, inspired by Brecht and the actor Joel Grey 25 years ago, created the demonic, symbolic Emcee of "Cabaret," a character that is unofficially recycled on this occasion in a role called the Engineer and played by Mr. Pryce. These two influences are brilliantly fused here. Altered substantially but not beyond recognition, the basic "Butterfly" premise of an Asian woman who is seduced and abandoned by an American military man is affectingly rekindled in "Miss Saigon" by Mr. Schönberg's score and Miss Salonga's clarion, emotionally naked delivery of it. Whenever that tale flirts with bathos, along comes the leering, creepy Mr. Pryce to jolt the evening back into the hellish, last-night-of-the-world atmosphere that is as fitting for the fall of Saigon as it was for the Weimar Berlin of "Cabaret."

•

The theatrical poles of "Miss Saigon" represented by its two stars are equally powerful. Miss Salonga, whose performance has grown enormously since crossing the Atlantic, has the audience all but worshiping her from her first appearance as Kim, an open-faced 17-year-old waif from the blasted Vietnamese countryside who is reduced to working as a prostitute in Saigon. As her romance with an American marine, Chris (Willy Falk), blossoms "South Pacific"-style in a progression of

Joan Marcus/Miss Saigon
Willy Falk, left, and Hinton Battle

haunting saxophone-flecked ballads in Act I, the actress keeps sentimentality at bay by slowly revealing the steely determination beneath the gorgeous voice, radiant girlish features and virginal white gown. Once Chris and his fellow Americans have fled her and her country, the determination transmutes into courage, and the passages in which Kim sacrifices herself for the welfare of her tiny child, no matter how hokey, are irresistibly moving because Miss Salonga's purity of expression, backed up by the most elemental music and lyrics, simply won't let them be otherwise.

Mr. Pryce, a great character actor whose nasty streak has been apparent since his memorable Broadway debut in Trevor Griffiths's "Comedians" 15 years ago, makes disingenuousness as electrifying as Miss Salonga's ingenuousness. The Engineer is a fixer, profiteer and survivor who can outlast Uncle Sam and Uncle Ho: a pimp, a sewer rat, a hustler of no fixed morality, sexuality, race, nationality or language. Wearing wide-lapelled jackets and bell bottoms of garish color, he is the epitome of sleaze, forever swiveling his hips, flashing a sloppy tongue and fluttering his grasping fingers in the direction of someone's dollar bills or sex organs. With his high-domed forehead and ghoulish eyes, Mr. Pryce is also a specter of doom, and he manages to turn a knee-jerk number indicting the greedy "American Dream" into a show-stopper with the sheer force of his own witty malice.

•

As choreographed by Mr. Avian in demented parody of an old-fashioned Broadway song-and-dance turn, "The American Dream" looks like the Fellini-esque "Loveland" sequence in the 1971 Stephen Sondheim musical "Follies," and no wonder, given the song's imitation Sondheim lyrics and the fact that Mr. Avian was Michael Bennett's associate choreographer on "Follies." Among the other old favorites in "Miss Saigon" are a balcony scene out of "West Side Story," a departing refugees scene out of "Fiddler on the Roof," an Act II song for Mr. Pryce that recalls Fagin's equivalent solo in "Oliver!" and some dancing North Vietnamese who seem a cross between the Peronists in "Evita" and the ritualistic Japanese dancers of "Pacific Overtures." It is only when "Miss Saigon" imitates West End musicals of the 1980's,

however, that it goes seriously astray. The helicopter stunt, which will most impress devotees of sub-Disney theme parks, is presented out of historical sequence in an Act II flashback, for no good reason other than to throw Andrew Lloyd Webber fans a pseudo-chandelier or levitating tire. A neon-drenched Bangkok night-life spectacle in the same act is a grim reminder of the ill-fated "Chess."

Of all the failings of modern British musicals, the most severe has been their creators' utter bewilderment about what happens between men and women emotionally, psychologically and sexually. "Miss Saigon" is not immune to this syndrome, either, and it shows up most embarrassingly in the lyrics characterizing Chris's stateside wife, who, despite a game portrayal by Liz Callaway, induces audience snickers and giggles in her big Act II solo. Chris himself is nearly as faceless, and Mr. Falk, a performer with a strong pop voice and a Ken doll's personality, does nothing to turn up the hero's heat.

•

If anything, "Miss Saigon" would be stronger if Mr. Battle, who plays Chris's best friend, had been cast instead as Kim's lover. Mr. Battle's grit and passion are far more redolent of the marines who fought in Vietnam than Mr. Falk's blandness, and his one brief encounter with Miss Salonga has more bite than any of her scenes with her paramour. Mr. Battle, who has heretofore been better known as a dancer than a singer, also rescues the sanctimonious opening anthem of Act II — a canned plea for homeless Amerasian children — with a gospel delivery so blistering and committed that he overpowers an onslaught of clichéd lyrics, film clips and a large backup choir.

With the aid of his designers, especially the lighting designer David Hersey, who uses John Napier's fabric-dominated sets as a floating can-

A British production is made leaner.

vas, Mr. Hytner usually keeps the staging simple. An opening "Apocalypse Now" sunrise that bleeds into a hazy panorama of a Saigon morning is as delicate as an Oriental print, and the Act I climax, in which boat people set off for points unknown, is stunning because it relies on such primal elements as an outstretched helping hand and the slow exit by the characters to the rear of a deep, darkened stage stripped of most scenery.

To be sure, the hallucinatory view of Vietnam familiar from the films of Oliver Stone, the journalism of Michael Herr and the fiction of Robert Stone, among many others, is beyond Mr. Hytner's mission, if not his considerable abilities, just as any thoughtful analysis of the war is beyond the libretto. The text of "Miss Saigon," second in naïveté only to "Nixon in China," says merely that the North Vietnamese were villains and that the Americans were misguided, bungling do-gooders. Facts and haircuts are fudged, the corrupt South Vietnamese regime is invisible and any references to war atrocities are generalized into meaninglessness.

Jonathan Pryce and Lea Salonga in the musical "Miss Saigon," at the Broadway Theater.

Photographs by Michael LePoer Trench (Pryce) and Joan Marcus (Salonga)/Miss Saigon

Yet the text is not the sum of a theatrical experience, and however sanitizing the words and corny the drama of "Miss Saigon," the real impact of the musical goes well beyond any literal reading. America's abandonment of its own ideals and finally of Vietnam itself is there to be found in the wrenching story of a marine's desertion of a Vietnamese woman and her son. The evening's far-from-happy closing tableau — of spilled Vietnamese blood and an American soldier who bears at least some responsibility for the carnage — hardly whitewashes the United States involvement in Southeast Asia. "Miss Saigon" is escapist entertainment in style and in the sense that finally it even makes one forget about all the hype and protests that greeted its arrival. But this musical is more than that, too, because the one thing it will not allow an American audience to escape is the lost war that, like its tragic heroine, even now defiantly refuses to be left behind.

1991 Ap 12, C1:2

Betsey Brown

Book by Ntozake Shange and Emily Mann; music by Baikida Carroll; lyrics by Ms. Shange, Ms. Mann and Mr. Carroll; based on an original idea by Ms. Shange; directed by Ms. Mann; musical staging and choreography, George Faison; scenery and projections, David Mitchell; costume design, Jennifer von Mayrhauser; lighting design, Pat Collins; sound design, Fox and Perla Ltd.; properties design, Sandy Struth; production stage manager, Susie Cordon; musical director, vocal arranger and conductor, Daryl Waters. Presented by the McCarter Theater. At Princeton, N.J.

Carrie Kecia Lewis-Evans
Vida Ann Duquesnay
Betsey Brown Raquel Herring
WITH: Tichina Arnold, Eugene Fleming, Phillip Gilmore, Tommy Hollis, Pamela Isaacs, Angel Jemmott, Marc Joseph, Ted L. Levy, Mesha Millington, Harold Perrineau Jr., Melodee Savage and Amir Jamal Williams.

By MEL GUSSOW

Special to The New York Times

PRINCETON, N.J., April 11 — Growing up in the late 1950's in St. Louis, Betsey Brown is a deeply sensitive child of a black middle class committed to affirming its cultural roots. Ntozake Shange's searcher — who is, one assumes, the author's surrogate — has had a long history, from a 1974 story through an eponymous novel and on to the musical "Betsey Brown," now playing at the McCarter Theater. After several workshops and an earlier regional production, the show is still evolving, but the ingredients are there to make it a musical with something relevant to say about the durability of traditional values. The story is far closer in spirit to "The Member of the Wedding" than it is to Ms. Shange's own outspoken "For Colored Girls."

At present there is a wandering focus, which is not the case with Ms. Shange's novel. In the book, we see Betsey and her family through the girl's eyes, which are opening to her own possibilities as well as to societal changes as a result of the Supreme Court decision on school desegregation (so movingly dramatized in television's "Separate but Equal").

In the musical by Ms. Shange, Emily Mann and Baikida Carroll, and directed by Ms. Mann, Betsey Brown has difficulty distinguishing between what is important and what could be left as background. We learn very

T. Charles Erickson/McCarter Theater

Tommy Hollis and Raquel Herring in "Betsey Brown."

little about Betsey's school days and the effects of that court decision. On the other hand, we hear far too much about Betsey's snobbish grandmother, who in the writing and the performance becomes too easily an antagonist. Betsey's father and mother are one-dimensional. More could be said about the girl's insouciance; when given the opportunity, Raquel Herring, the appealing actress playing the title role, is amusing when mimicking her elders.

●

The lyrical quality in Betsey's dialogue is matched with the gentle ebullience of Mr. Carroll's music. A jazzman as well as composer, Mr. Carroll has skillfully imitated songs of the period — rhythm-and-blues, with a touch of gospel (although a few of the 24 numbers could be trimmed). An equal partner is David Mitchell's impressionistic set design, which makes an asset of dappled scrims and, more than anything else, depicts the juxtaposition of affluence and poverty in St. Louis at the time.

Gradually — too slowly — the central story asserts itself. It concerns Betsey's relationship with the family's new housekeeper, Carrie, who assumes her duties when Betsey's mother abruptly leaves home. It is this character, in Kecia Lewis-Evans's vibrant, highly musical performance, who carries the show, and indicates its potential, as in her song admonishing Betsey and other children, "Contemplate Your High Points." That might itself be a suggestion to the authors.

With her firm sense of morality combined with her hearty embrace of life's pleasures, this self-styled troublemaker becomes a rich theatrical character. It is from her that Betsey learns tolerance and self-confidence. Carrie's eventual departure from the household is, as intended, a rite of passage for her as well as the child. Their bond becomes so strong that by the end of the evening one can accept Carrie's observation, "Girl, you got a poetry about you," which could be regarded as a prophecy about Ms. Shange, herself. It is up to the creative collaborators to unify the

show's inherent poetry and decency with the demands of the musical theater.

1991 Ap 13, 14:5

Sabina and Lucrecia

By Alberto Adellach, English translation by Jack Agüeros; directed by Alba Oms; set designer, Edward Gianfrancesco; lighting, Rick Butler; costumes, Mary Marsicano; production stage manager, Lisa Ledwich; producer, Miriam Colon Valle. Presented by the Puerto Rican Traveling Theater. At 304 West 47th Street.

Lucrecia Cordelia Gonzalez
Sabina Nancy Walsh

By D. J. R. BRUCKNER

As a test of actors' ability to sustain a menacing mood of madness, Alberto Adellach's "Sabina and Lucrecia" is a good piece of work, however deficient it may be as an instrument of entertainment, enlightenment or emotional stimulation.

In the production at the Puerto Rican Traveling Theater, under the direction of Alba Oms, Cordelia Gonzalez as Lucrecia and Nancy Walsh as Sabina pass the test with high marks. (On weekends, when the play is performed in Spanish, Tatiana Vecino takes the role of Sabina.)

Mr. Adellach's story is simple; all of its elements are familiar to moviegoers and television audiences. Two women escape from what one of them calls a "nut house" and hide out in an abandoned slum building that was the home of one of them before she was committed to the institution. Through a couple of days and nights, they discover that in freedom they become one another's jailers, inquisitors, even torturers.

But the threatening games they play have very different purposes. The younger one, Sabina, toys with Lucrecia's perceptions and emotions to distract her so that Sabina can break free. The prospect of Sabina's freedom, however, becomes intolerable to Lucrecia, and only great violence can put her anxiety to rest.

Once the situation is set up, the action in a story like this is inevitable; the effect of the play depends entirely on the direction and the acting. Ms. Oms gives the whole piece a that of tone of quiet understatement, like a ghost story told in the dark of night. And Ms. Gonzalez and Ms. Walsh resist all the obvious temptations to histrionic exaggeration.

The result is a chilling, disturbing experience. Even as the innocence conferred on these characters by their mental condition becomes more evident, and appealing, it also becomes the means of their destruction. At the end one can imagine it is evil that steps forward first to take a bow.

1991 Ap 14, 52:1

The Mayor of Zalamea

By Pedro Calderón de la Barca; English translation by Adrian Mitchell; director, René Buch; production designer, Robert Weber Federico; assistant director, Beatriz Córdoba; music, Pablo Zinger; technical director, Rigoberto Obando; production assistant, Manuel Herrera. Presented by Repertorio Español, Gilberto Zaldívar, producer; Mr. Buch, artistic director. At the Gramercy Arts Theater, 138 East 27th Street.

WITH: María José Alvarez, Martín Balmaceda, Ricardo Barber, Irma Bello, José Luis Ferrer, Rolando Gómez, José Cheo Oliveras, Carlos Osorio, Adriana Sananes, René Sánchez, Diego Taborda, Braulio Villar and Juan Villarreal.

By D. J. R. BRUCKNER

For directors as well as actors, performing a play by the great 17th-century Spanish writer Calderón must seem about as easy as dancing on a high wire, and none of Calderón's plays requires a surer sense of balance than "The Mayor of Zalamea" ("El Alcalde de Zalamea"). But difficulty never seems to intimidate the Repertorio Español, and its presentation of this classic is a fascinating, if occasionally wobbly, effort.

A generation before Calderón, Lope de Vega had written a play of the same name in which two daughters of a wily farmer in the village of Zalamea eloped. When they were apprehended, their father, who had become Mayor, hanged their suitors and sent the women to a convent, and the King himself honored him for his heroic sense of justice.

While Calderón took his characters — and many lines — from Lope de Vega, he turned the relatively innocent story much darker. Here the Mayor, Juan Crespo, has but one daughter, Isabel, who is abducted and raped by an army captain passing through the village with King Philip II's army on its way to invade Portugal.

A few years before he wrote the play, Calderón had been in battle as an officer in a knightly order; his revulsion at the lawless conduct of the army suffuses his play. His attack on military morality thrusts at the values of the whole society.

Thus, before he takes his revenge for the rape of his daughter, Crespo kneels before the rapist and begs him to marry her, to save the family's honor; the captain's refusal is his death warrant. Calderón doesn't need to use even a hint of irony to score points off a society with such values. From that point Crespo's language rises to a tone of assured authority. When a nobleman demands release of the captain, since men in the King's service are not subject to civil law, Crespo asserts the superiority of simple justice to any other authority and turns over the captain only after he has been strangled. Philip II himself confirms Crespo's judgment and makes him Mayor for life.

For all its serious purposes, this play is not a tragedy; indeed, it is peppered with comic incidents. The play of ideas underlying the action is almost exhausting; the shifts of tone and emotion are very rapid, and the range of vocabulary and rhetorical devices is vast.

The Repertorio Español's production under René Buch's direction — in Spanish, with simultaneous translation through an infrared system — is characteristically energetic. Understandably, the text has been pruned, in some places radically. The cutting, and the line of direction, give this

production a general tone that one might well quarrel with. Some of the comedy is lost.

And in one place, some genuine horror is lost. In the text, in one of the more repulsive revelations of what the old order held sacred, Crespo's son wants to kill not only the rapist but also Isabel, since her "honor," and the family's, has been ruined.

When the son's rage is tempered in the performance and his design on his sister muted, one of the important themes goes unheard.

Nonetheless, this is a performance that gets a good tribute from its audience: people seem to want to stay around arguing afterward.

1991 Ap 14, 52:1

One-Person Plays Meet the Age of Blabbitry

By DAVID RICHARDS

I ALWAYS ASSUMED THE ONE-person play was the theater's way of dealing with the shrinking dollar. You really can't get more basic — a performer, a platform, a text. Take away anything else and what do you have? A loon emoting in the street or a mime show.

Lately, though, I've been wondering if the form, which usually brings a historical figure back from the grave to chat with us — presumably in his or her own words — isn't curiously attuned to our times in a deeper way. We have never been so besotted with celebrities. We have even come to believe that celebrityhood carries with it one duty above all others: an obligation to spill the beans.

It's still too early to pin a label on the current season. But if you're looking for distinguishing characteristics — beyond the hullabaloo caused by the coming to town of "Miss Saigon" — there's no avoiding the rash of solo endeavors. Julie Harris, assuming the strange, silvery persona and exotic wardrobe of the Danish writer Isak Dinesen in "Lucifer's Child," is only the latest example. She has been preceded by reincarnations of Virginia Woolf ("A Room of One's Own"), Huey Long ("The Kingfish"), Lyndon Baines Johnson ("Lyndon") and Florence Aadland ("The Big Love"), among others.

Characters open up fastest in one-person plays. What choice do they have?

Economics, of course, is not to be discounted in any of these cases. The new penury is upon us. The city is cutting back on services, department stores on their inventories, restaurants on the $50 entrees. It follows that the theater would scale back, too, although when a show like "The Big Love" ends up costing $800,000, "scaling back" is a relative term.

There is, however, another explanation for this vogue of one-person plays. We're very close to it when, for example, Miss Harris first mentions the lifelong syphilis, "the flowering of Nemesis ... inside me," that ravaged Isak Dinesen's health. "There are two things a woman can do in such a situation," she explains forthrightly, "accept it or shoot the man." Then, fixing the audience at the Music Box Theater with a look that is both elegant and defiant and perhaps a little mischievous, too, she explains what she did instead. "I gave my soul to Lucifer. In return, he promised to transmute my sorrow into tales the whole world would read. So, you see, I am Lucifer's child."

The British actress Eileen Atkins, who is the sly, piercingly intelligent and altogether bracing Virginia Woolf in "A Room of One's Own" at the Lamb's Theater, is ostensibly talking about women and literature when she asserts that "it is fatal for anyone to be a man or a woman pure and simple. One must be woman-manly, or man-womanly." The act of fruitful artistic creation, she argues, depends on "some collaboration ... in the mind between the woman and the man." For a

Ruby Washington/The New York Times
Eileen Atkins as Virginia Woolf in "A Room of One's Own"—We sense Woolf's essence as keenly as if she were reading excerpts from her diary.

second, her fierce intensity goes beyond the confines of literature and seems to dare us, presumably so sure of our definitions, to define gender. A revolutionary's zeal is clearly stirring in this concentrated creature.

In both instances, the characters are approaching confession, and confession, these days, has become something of a national obsession. Rare is the sin that cannot be absolved by being publicly aired. Keeping secrets, once a component of good manners, is suspect. And in the theater, the quickest way to get characters to reveal themselves is to put them in one-person plays.

What other choice do they have? They're there to reminisce, settle scores, set a record or two straight and generally sum themselves up. Occasionally, they will answer the telephone or call out to an invisible maid. But those are just diversionary maneuvers. We're the ones they're really addressing — owning up to, you could say. Conventional plays expect us to be no more than onlookers. But the one-person play casts us as confidants.

CBS

Hal Holbrook as the 70-year-old Mark Twain in his one-man show "Mark Twain Tonight"— a purpose and a dramatic necessity

Paula Court

Spalding Gray in his solo performance "Monster in a Box"—the right man at the right time in the right society

There was some critical disagreement over the value of what Florence Aadland had to tell the world in the recently departed "Big Love." As the mother of Beverly Aadland, onetime 1950's starlet and underage mistress of Errol Flynn, she witnessed Hollywood lowlife from the sidelines and fooled herself into thinking she was at the center of big-time glamour. But Tracey Ullman's extraordinary performance gave no hint whatsoever that the woman was holding anything back. For better or worse, sympathy or ridicule, there she was — a flashy, foolish nobody, pouring out her tinseled heart to us and, since her candor was stronger than her vanity, admitting to an artificial foot, as well.

Likewise, Miss Harris's magical presence is the glory and redemption of "Lucifer's Child," a more ambitious play, but not necessarily a more successful one. The script is by William Luce, who has already stitched the retiring existence of Emily Dickinson into the luminous "Belle of Amherst" for Miss Harris and fashioned the travails of Lillian Hellman into the feisty "Lillian" for Zoe Caldwell. This time, however, his work seems particularly piecemeal and unfocused. The setting is Denmark just before and just after a lecture trip that Dinesen, then in her mid-70's, made to America in 1959 — hardly a pivotal event in her life. Why, it may well be asked, are we tuning in here?

The movie "Out of Africa" painted Dinesen as a romantic heroine struggling to make a go of a coffee plantation in Kenya and

T. Charles Erickson

Julie Harris as the Danish writer Isak Dinesen in "Lucifer's Child"—Her powdery-white face remains triumphantly mutable.

braving man, beast and elements. "Lucifer's Child" seems to view her as a cross between a crumbling grande dame of letters and a disease-ridden Auntie Mame who calls her fur piece "Beowulf" and gathers mushrooms by the light of an electric torch. It is only Miss Harris's confidential performance that makes a whole of this patchwork of memories, yearnings and regrets. Her voice has always sounded like heartbreak feels. And her powdery-white face remains triumphantly mutable. Depending on the light, you can see in it the child, the flirt, the crusader or the crone. That helps.

The one-person play, after all, has a lot of places to go and people to see, even if it's only the mind's eye that's doing the visiting. Or, more to the point, the re-visiting — which brings us to a fundamental drawback of the form: it is backward-looking. The emotions being experienced are recollected emotions. The time for doing is long over. (The folksy demagogue John McConnell portrays in "The Kingfish" at the John Houseman Theater is already dead at the play's start and coming to us, apparently, from the other side.) What's left is the recounting, which is why the one-person play tends to be nostalgic in thrust. It prefers the question "Who was I?" to the more nettlesome "Who am I?"

A way exists out of this trap, although it is not open to everyone. Some one-person plays, instead of recreating a life, recreate a public moment in the life. That usually means repairing to the lecture hall or the legitimate theater itself, where the individual might once have appeared. Such was the tactic taken by Hal Holbrook in "Mark Twain Tonight," which is probably responsible, as much as anything, for the flowering of the one-person show in our times. Preceded by a puff of cigar smoke, Mr. Holbrook ambled on stage, as Twain himself had done at the end of his career, to tell a few tall tales, talk about piloting a steamboat down the Mississippi, and then read a selection from "Tom Sawyer" or "Huckleberry Finn."

The advantages of this approach are obvious. The stage is treated as a stage, not a confessional, and the audience can be addressed, with no violation of logic, as an audience. More importantly, the subject is still active and operating in the present tense. Packing and unpacking are all that Isak Dinesen can find to do in the here and now, before an old dress or a faded photograph activates her memories. Her dramatic motivation is the memorabilia all around her. But Mr. Holbrook's Twain had a lecture to give — which is to say a purpose and a dramatic necessity.

So does Miss Atkins, as she makes her way through the audience and up onto the wood-paneled stage, removes her cloche hat and wraparound coat and prepares to share an opinion "upon one minor point" with the young ladies of Girton College. "A woman," she says, "must have money and a room of her own if she is to write fiction." The elaboration of that deceptively simple thesis leads her to consider the status of women throughout history, ponder the implications of men and wealth, and recount the tragic destiny of one Judith Shakespeare, imaginary sister of Will and every bit as inspired, who tried to follow in his footsteps and came to a sorry end.

The script has been adapted by Patrick Garland from Woolf's book, "A Room of One's Own," which is an expansion of two papers the writer herself delivered in Cambridge in 1928. Miss Atkins, crafty as the fox she resembles with her sharp eyes and long nose, makes an exhilarating adventure out of it — leading us surely along the path of Woolf's thought, pausing here and there to let us drink in the magnificent vistas, before

pushing onward, past boulder and precipice, to the dizzying summit. Knowing that the audience expects "a peroration," Miss Atkins obliges in the final dazzling moments by expanding a shrewd feminist manifesto into a thrilling call for freedom that includes everyone in the hall.

"A Room of One's Own" is the least anecdotal of one-person shows, resorting to autobiography only when it's necessary to reinforce an intellectual point. While sentiment is discouraged, wit and irony are plentifully indulged. ("There are people whose charity embraces even the prune," she notes at one point, with a faint curl of distaste that indicts the charity as much as the prune.) In the workings of her quick mind, however, we sense Woolf's essence as keenly as if she were reading excerpts from her diary.

In conventional dramas we are onlookers. The solo show casts us as confidants.

Today's performance artists are probably reluctant to acknowledge a debt to the one-person play. But really how different was, say, Wallace Shawn's extended mea culpa, "The Fever"? We never did learn the identity of the speaker, marooned in a revolution-torn country in the third world and feeling profoundly guilty about his privileged life. It is safe to assume, though, that a large part of the character, well born and cultivated, was Mr. Shawn himself. On the other hand, there was never any question that Spalding Gray was the subject of "Monster in a Box" — Mr. Gray being the subject of all his monologues. In fact, there isn't anything he *won't* tell you about himself, which certainly makes him the right man at the right time in the right society.

Not too long ago, when someone said, "That's a personal matter," "personal" meant "none of your business." No more. Biographers don't consider their work well done unless they have painted "an intimate portrait." Supermarket tabloids thrive on blabbing — and sometimes inventing — the embarrassments of the rich and the notorious. But most of all, television, I think, has sanctioned this urge to pry. The mighty willingly submit to the indignities of the so-called in-depth interview, while common citizens think nothing of going on talk shows to divulge the troubles they are having with the law, their sexual partners or their kidneys. Even humiliating home videos are now the stuff of highly rated TV specials. What are we to conclude? We are peeping Toms without even leaving our living rooms.

The one-person play merely represents the high end of what has become a ravenous appetite for the low down. □

1991 Ap 14, II:1:2

Theater in Review

■ The broadcast speech of a renegade at SoHo Rep

■ A no-ring circus of the new ■ One man's

comments on the truth as he sees it.

Jonathan Slaff/SoHo Rep

Kario Salem, foreground, Deborah Mansy and J. Reuben Silverbird in a scene from Eric Overmyer's "Native Speech," at SoHo Rep.

Native Speech

SoHo Rep
46 Walker Street
Through May 5

By Eric Overmyer; directed by John Pynchon Holms; set by Kyle Chepulis; costumes, Patricia Sarnataro; lighting, Steve Shelley. Presented by SoHo Rep. With Kario Salem, Sámi Chester, James Encinas, Fracaswell Hyman, Deborah Mansy.

Hunkered in his acoustically controlled basement bunker, Hungry Mother is the self-crowned king of the nighthawks, turning dead air into delirium. From his one-man studio, he broadcasts to an audience of insomniacs. Spinning disks and offering advice to "the rubble," he imparts doom and gloom in a nonstop sociocultural effusion. Hungry Mother is the demonic center of Eric Overmyer's "Native Speech," a vertiginous black comedy that, with Hungry Mother's radio station, operates on its own renegade frequency.

After several regional productions, "Native Speech" is running its sizzling course at SoHo Rep, newly installed in a theater in TriBeCa. The play is early Overmyer, written before his "On the Verge" and before Eric Bogosian's "Talk Radio," and sharing with that latter work a nerve-twitching intensity. Alone at his console, the talk showman bedevils his midnight callers and is besieged by invaders in the dark, some of whom he waylays into speaking unknowingly over a wide-open microphone.

Kario Salem, who has played Hungry Mother in previous productions, has stamped the role with his wit and ferocity. With his glaring eyes and corona of curly hair, he looks a bit like Mr. Bogosian, but with his own idiosyncratic rhythm and command of verbal and physical comedy. In his bravura performance, he rappels his way down the linguistic peaks of the dialogue. As usual, Mr. Overmyer is omnivorous in his appetite for onomatopoeia — and unable to eschew eschatology.

The play is overlong and it ends in a predictable, studio-leveling apocalypse, but it is a live-wire experience. Tune in and hold on tight for a manic riff of language, metaphor and zounds of the Zeitgeist.

The evening is additionally enlivened by the outcasts who cruise through Hungry Mother's orbit. They include endangering species like an American Indian trio of "patho-rockers." The hero's nemesis is a pimp named the Mook, who also happens to be the icy impresario of the twilight station. Sámi Chester plays this role with guile and bite; his scenes with Mr. Salem are menacingly mano a mano. As a battlefront report on urban guerrilla warfare, "Native Speech" is, to borrow a word from the playwright's lexicon, radioactive.
MEL GUSSOW

Cirque du Soleil

Battery Park City
Battery Place and West Street
Through May 5

Franco Dragone, artistic director; Gilles Ste-Croix, creative director; Michel Crete, set designer; Dominique Lemieux, costume designer, Rene Dupere, original score and musical director; Luc Lafortune, lighting designer; Debra Brown, choreographer. With: Brian Dewhurst, Vladimir Kekhaial, France La Bonte, Anne Lepage and David Shiner.

When it comes to circuses, the no-ring Cirque du Soleil, which arrived in New York with stunning éclat over the weekend, is to the three-ring Ringling Brothers and Barnum & Bailey extravaganza playing Madison Square Garden what Le Cirque is to Mama Leone's in dining circles.

Cirque du Soleil, akin perhaps to elegant nouvelle cuisine (this new production is, in fact, called "Nouvelle Expérience"), serves smaller portions than the big Ringlings spread, but each of the nearly score of courses on its menu must appeal to the most demanding gourmet.

Cirque fills the tent it has pitched at Battery Place and West Street with creative choreography and compelling music that is at once urgent, extremely tuneful and often eerie. There is neither ring nor formal stage. There are no animal acts, either, but as one winces admiringly at the pretzel bends of the seemingly boneless contortionists, gawks at the fellow who perches and balances atop a precarious tower of piled-up chairs, and gasps at the devil-may-care wire walkers and high flyers, the wildlife is not really missed.

The star of this assortment of talent is a clown, a marvelous and extraordinarily intelligible mime named David Shiner. He is the binding for the show, the figure of a hayseed tourist wandering through extraterrestrial realms. Mr. Shiner sports no red nose or whiteface, but he is brilliantly funny, whether diving into the audience to drum-beat a bald head or staging a make-believe shooting of a silent film. His silent eloquence is expressed in a body that communicates like a semaphore.

While Ringling has always said it was a circus for "children of all ages," Cirque may be a little more selective; one might say it is a circus for sophisticated children of all ages. Call it what you will, Cirque is a wonderful show, high art and all — with popcorn, if you like.
RICHARD F. SHEPARD

Only the Truth Is Funny

Westside Arts Theater, Downstairs
407 West 43d Street

One-man comedy with Rick Reynolds; written and directed by Mr. Reynolds. Lighting, Wendall S. Hinkle; executive producers, Jack Rollins, Charles Joffe, Scott Sanders and Ed Micone. Presented by Rollins & Joffe and Radio City Music Hall Productions, in association with Showtime Networks.

From the raw material of his life, Rick Reynolds has fashioned a monologue that is both acerbic and self-analytical. As the title of his show, "Only the Truth Is Funny," indicates, this is an exercise in the reality of comedy. In contrast to Woody Allen and others, there is no exaggeration for comic effect, but simply the facts as seen through Mr. Reynolds's eyes.

His targets are wide ranging, from his adolescent insecurities ("As my acne started to go away, so did my hair") to miracles in the Bible. He seasons his show with a salutary dash of cynicism, as in his remarks about couples who seek quickie divorces. As a traditionalist in marriage (and other matters), he would like to institute elaborate divorce ceremonies, paid for by the husband's parents.

In Mr. Reynolds's first New York theatrical appearance (at the Westside Arts Theater), the shift from stand-up comedian to performance artist is not yet complete, as in his confessions about personal family traumas. Dealing with related material, Spalding Gray, for one, is as fascinating as he is introspective. Mr. Reynolds seems more like a man on the next bar stool compulsively spilling autobiography.

At the same time, he need not be so insistent about asking for the audience's trust. Without such urging, he is likable and neighborly in his demeanor. In delivery as well as appearance, he is unprepossessing. He is neither a clown nor a mimic but an artful storyteller who knows the uses of the deadpan, as in his observation that every issue has two sides. Take abortion. On one side there are women who want to have control over their bodies and on the other side, he adds, without cracking a smile, there are "brain-dead zealots."

With his memoirlike monologue, he grows from childhood to adulthood, from a man who regards children as "little stupid people who don't pay rent" to an adoring father. Savoring the mirthfulness of the moment, Mr. Reynolds very nearly proves the truth of the title of his show.
MEL GUSSOW

1991 Ap 17, C15:1

Three Sisters

By Anton Chekhov; adapted by David Mamet from a translation by Vlada Chernomordik; directed by W.H. Macy; scenery, James Wolk; costumes, Laura Cunningham; lighting, Howard Werner; music, Robin Spielberg. Presented by Atlantic Theater Company, 336 West 20th Street.

Olga Sergeyevna Melissa Bruder
Irina Sergeyevna Mary McCann
Masha Sergeyevna Elizabeth McGovern
Chebutykin Herbert DuVal
Tuzenbach Todd Weeks
Vershinin ... Jordan Lage

By MEL GUSSOW

David Mamet has demonstrated his affinity for Chekhov in his own work and in his adaptations of "The Cherry Orchard," "Uncle Vanya" (recently presented on WNET) and "Three Sisters," which opened last night at the Atlantic Theater. While each playwright is certainly localized within his time and environment, they share a common concern with indirect action in plays that, in Mr. Mamet's words about Chekhov, speak to our subconscious.

Barring an occasional Mamet-like repetition of words and a few anachronisms, the new version of "Three Sisters" is respectful of the text and is not so distant from other translations. Unfortunately, the production, under the direction of W.H. Macy, denatures the original.

Many of the actors appeared to their advantage as young urban Americans in Howard Korder's "Boys' Life," at Lincoln Center, where, as led by Mr. Macy, they seemed precisely in character and in period. They have also performed notably in works by Mr. Mamet, but most of them seem self-consciously contemporary when playing Chekhov. They have neither the quiet dignity nor the desperation of these provincial Russian characters. It is not a question of the youthfulness of the actors so much as their obvious inexperience with the material.

Melissa Bruder's Olga is officious but without the extra measure of stoicism that keeps this schoolteacher fitfully stabilized within her lonely life, and Mary McCann lacks the vul-

Carol Rosegg/Martha Swope Associates/"Three Sisters"
Elizabeth McGovern and Jordan Lage in "Three Sisters."

nerability that inspires Irina to constant thoughts of flight and that makes her the subject of admiration. Others are many versts away from Chekhov territory.

•

The primary exception in this disappointing production is Elizabeth McGovern, a guest artist with the Atlantic company. Cast in the pivotal role of Masha, she tellingly communicates her character's suppressed desire. Reclining on a couch, trying to avoid the trivia that surrounds her, she exudes discontent with her position as the single vital force in this otherwise stultified community. In an interesting Mamet variation, Olga calls her the clownish sister rather than the silly one, and Ms. McGovern apparently takes that as a clue to an interpretation. Her Masha is more amusing than usual, without losing a sense of the mercurial.

Though Jordan Lage seems too young for the role of the world-weary Vershinin, he does capture the colonel's talent for self-dramatization. Together, he and Ms. McGovern charge the play with needed passion. Todd Weeks has a more modest success as the inept Baron Tuzenbach.

In addition to the adaptation, there are other outward manifestations of fidelity, beginning with James Wolk's simple but evocative scenic design and a background score by Robin Spielberg that finds plangency in the sounds of the accordion. But it is evident that most of the Atlantic cast is unequal to the challenging task, and the director provides insufficient assistance, leading the actors into distracting moments of stage busyness.

1991 Ap 18, C14:3

Critic's Choice

A One-Man Multiplicity

Among the plethora of solo performers who have created multiple characters on the stage recently, Jeffrey Essmann is exceptional for the literary refinement of his language and for his esoteric choice of subjects. Who else would think of portraying a Serbo-Croatian poet whose husband fired the shots that triggered World War I? Or an English aristocrat from an E. M. Forster novel who is so repressed he cannot recognize his own homosexual urges?

These eccentrics are the main characters in two of the eight dazzlingly funny sketches that make up "Jeffrey Essmann's Artificial Reality," at the Perry

Roy Blakely/New York Theater Workshop
Jeffrey Essmann

Street Theater. Others include Sister Bernice, an iron-fisted nun addressing her fourth-grade class on the first day of school, and a harried cabaret singer performing a salute to the mythical and insanely productive songwriting team of Harold Sturm and Arnie Drang in "The Sturm and Drang Revue." For the revue, Mr. Essmann's talented sidekick, Michael John LaChiusa, has written dead-on musical parodies of inane revue songs.

In the course of the show, the audience is also taken to a men's-rights gathering at which participants are invited to chant slogans exalting the beauty of their genitalia, and to a meeting for "recovering recovery addicts," run by a character who is trying to wean himself from addiction to anonymous organizations.

Mr. Essmann's show has performances tomorrow at 7 and 10 P.M. at the Perry Street Theater (31 Perry Street in Manhattan). Tickets are $18, and are available through Ticket Central: (212) 279-4200.
STEPHEN HOLDEN

1991 Ap 19, C3:1

The Good Times Are Killing Me

By Lynda Barry; directed by Mark Brokaw; set design, Rusty Smith; lighting, Don Holder; costumes, Ellen McCartney; sound, Janet Kalas; musical director, Steve Sandberg; choreographer, Don Philpott; production stage manaer, James Fitzsimmons. Presented by Second Stage Theater, Robyn Goodman and Carole Rothman, artistic directors. At 2162 Broadway, at 76th Street.

Edna Arkins Angela Goethals
Lucy Arkins Lauren Gaffney
Mom and Mrs. Doucette Holly Felton
Aunt Martha and Bonita Ellia English
Mr. Willis Wendell Pierce
Mrs. Willis Kim Staunton
Aunt Margaret Ruth Williamson
Earl Stelly, Preacher and Marcus
... John Lathan
Cousin Ellen, Mrs. Hosey and Mrs.
Mercer Jennie Moreau
Sharon and Theresa Doucette
... Kathleen Dennehy
Uncle Jim Ray DeMattis
Dad and Cousin Steve Peter Appel
Bonna Willis Chandra Wilson
Elvin Willis Brandon Mayo

By FRANK RICH

The wonderful thing about children is that they believe everything is possible. What makes Lynda Barry's first play a happy occasion is that she captures the innocent abandon of childhood with the wit of a mature writer but without letting go of the uninhibited child still lurking deep within herself.

Ms. Barry's uneven but highly promising comedy at the Second Stage, "The Good Times Are Killing Me," is about Edna Arkins, a pre-adolescent girl of the mid-1960's who believes, for the duration of elementary school anyway, that miracles like movie stardom and racial harmony are to be had for the asking, no matter what obstacles parents might place in the way. Ms. Barry, a syndicated cartoonist whose strip, "Ernie Pook's Comeek," appears in The Village Voice in New York, is just as free-spirited as her heroine in her first effort at writing for the stage. Like Edna, Ms. Barry at her best would rather hop, skip and jump than walk a straight dramatic line be-

tween any two points. She does not feel obliged to honor any dreary adult rules of the theater until her second act, at which time the play and Edna alike begin to settle into a conventional, lackluster maturity.

Until then, the evening has the rambunctious style if not the campiness of John Waters movies like "Hairspray" and "Cry-Baby" in which the rituals of growing up, the increased racial segregation of rock music and the accelerating civil rights movement all converge on the streets of a changing blue-collar urban neighborhood. Edna sets the tone right away by telling the audience that her once all-white block is in a state of traumatic demographic transition and that music is the center of her life. As her story progresses, sociological sea changes and intimate familial episodes are both defined by pop songs, whether the singers be Johnny Mathis, Paul Anka, James Brown, Elvis Presley or in one loopy interlude Julie Andrews in "The Sound of Music."

•

Mark Brokaw, the production's impressive young director, is in perfect tune with the playwright's jukebox approach to the traditional memory play. As Edna remarks that a song can make "the past rise up and stick in your brain," so old songs (and at times old "American Bandstand" or "Soul Train" dances) rise up in fragrant patches to accompany the script's remembered anecdotes about variously beloved and thorny relatives and neighbors. The writing and staging are both so fluid that "Good Times" sometimes seems to be touring the early chapters of its heroine's biography with the same ease with which one might pass in and out of distant radio stations while turning a dial. Upbeat episodes like Edna's budding friendship with a black girl next door, Bonna (Chandra Wilson), are as gracefully and economically revisited as such heartbreaks as a father's desertion or a child's accidental death. Life, by turns romantic and bitter, just keeps popping in and out of the doors that line the set's row-house facade.

As acted by Angela Goethals with a fetching precocity that never turns bratty, Edna is a winning guide to her wonder years. Her observations about teen-agers and adults are funny, especially when they are fleshed out by such pungent actors as Ruth Williamson (as a perpetually put-upon aunt given to making "tiny little faces"), Jennie Moreau (as both a patronizing older cousin and a ruler-banging music teacher) and John Lathan (as the hippest black male on the block). Ms. Goethals is moving, too, when she and her sad-faced kid sister (Lauren Gaffney, another fine child actor) turn their house's basement into a "Record Player Nightclub" that, though conceived as a joyous imaginary refuge from their parents' marital travails, becomes a mausoleum for lost love.

While not as fully written, the story of the black family next door is just as well acted, particularly by Ms. Wilson, whose Bonna eventually becomes a feisty co-narrator of the play, and by Kim Staunton, whose portrayal of Bonna's mother grows from a buoyant young woman singing "I Could Write a Book" while doing household chores to a wizened specter of middle-aged disappointment. Even when the writing lacks fine detail, one still feels Ms. Barry's kinship with black characters whose deferred dreams are touched by but not really redeemed by such revolutionary phenomena as "A Raisin in the

Susan Cook/Second Stage

From the left, Lauren Gaffney, Angela Goethals and Chandra Wilson in "The Good Times Are Killing Me."

Sun," "To Kill a Mockingbird" and the Black Panthers.

"Good Times" begins to dwindle when the author takes the issue of race relations head on rather than elliptically. Act II devolves into a diagrammatic tale of the gradual parting of Edna and Bonna during the seventh grade, and the girls' story all too heavily symbolizes the larger tale of racial separatism on the eve of the riots of the late 60's. Suddenly a previously free-form play leans on a contrived plot twist — an exclusionary teen-age party — and takes to making points didactically: Edna's uneasy participation in a black family ritual (a gospel church service) is laboriously contrasted with Bonna's participation in a quintessential white counterpart (a camping trip). It's almost as if the playwright, like the girls on stage, had abruptly decided she had to grow up and trim her wings. By the final half hour, her writing has become as formulaic and glib as the television specials on racial tolerance that the play has previously mocked.

Young audiences — and this is a play sure to earn the respect and laughter of young audiences — will not mind the faults of Act II too much, for the author never patronizes her young characters even when her storytelling becomes a bit numbing to those of parental age. While the failings of "The Good Times Are Killing Me" (its awkward title included) are real, they are those of breadth, not depth. Lynda Barry's engaging debut as a playwright is anything but cartoonish.

1991 Ap 19, C3:1

Grand Finale

By Copi; translated by Michael Feingold; directed by André Ernotte; set by William Barclay; lighting by Phil Monat; costumes by Carol Ann Pelletier; production stage manager, Elise-Ann Konstantin. Presented by Ubu Repertory Theater Inc., Françoise Kourilsky, artistic director. At 15 West 28th Street.

Cyril..Keith McDermott
Nurse....................................Margo Skinner
Hubert.......................................David Pursley
Reporter..................................Jack Koenig
Regina Morti.....................Delphi Harrington
Dr. Backsleider..............Robertson Carricart

By WILBORN HAMPTON

It was Swinburne who advised "Take hand and part with laughter" (later vulgarized by George Michael Cohan into "Always leave them laughing"), and the French playwright Copi took them at their word in "Grand Finale," a comedy of the very blackest sort about an actor dying of AIDS.

Copi, an Argentine-born designer, cartoonist and actor as well as the author of 15 plays, wrote the work as his own grand finale before dying of the disease in 1987. Knowing all too well that AIDS is no laughing matter, Copi aimed at an Ortonesque farce that parades a cavalcade of lunacy through the hospital room of Cyril, a notoriously gay actor of some renown, on the last day of his life. In Michael Feingold's fine translation, at Ubu Repertory Theater, he comes close to the mark.

Cyril (Keith McDermott) is going in sumptuous style: the actor's hospital room, in William Barclay's set, could rate a star in the Michelin Guide. Apart from the chaise longue, figurine lamp and Oriental rug, there is a hookah and cache of opium to help Cyril over the rough spots. When Hubert (David Pursley), Cyril's devoted admirer and lifelong friend (but not lover), arrives with the pâté de foie gras, wine and raspberry sorbet, the room begins to get crowded.

First, there is a young man introduced as a reporter (Jack Koenig), who reminds Cyril of a Botticelli in Verona ("third down from the Virgin on the left"). The nurse (Margo Skinner) warns against the visit but is interrupted by Regina Morti (Delphi Harrington), an opera singer to whom Cyril may or may not have written a billet-doux one night at La Scala. Regina and Hubert argue over where Cyril should be buried. The diva wants him in Genoa, but Hubert has already commissioned a mausoleum at Père Lachaise ("just across from Wilde and around the corner from Gide").

But it is with the arrival of Dr. Backsleider (Robertson Carricart) that the mayhem begins in earnest. The doctor specializes in treating AIDS patients and in performing lobotomies. When Cyril laments that he doesn't want to die without playing Richard III, the doctor offers to let him put on plays at the hospital "like the Marquis de Sade — I can loan you some patients from the mental ward."

Copi did not believe in long goodbyes, and at just 70 minutes, "Grand Finale" ends before the material wears thin. In trying to build a farce around AIDS, the director, André Ernotte, understandably lets all the actors run over the top, but some performances are unfocused. Mr. Carricart's mad doctor is especially good, and Mr. McDermott and Mr. Pursley add able readings as Cyril and Hubert, particularly in the final scene.

1991 Ap 21, 60:1

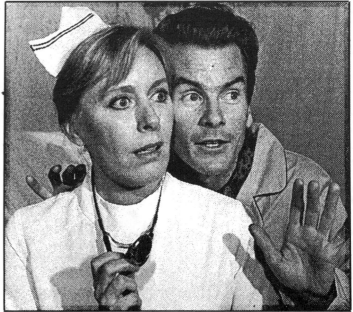

Carol Rosegg/Martha Swope Asociates

Margo Skinner and Keith McDermott in scene from "Grand Finale."

SUNDAY VIEW/David Richards

The 'Saigon' Picture Is Worth 1,000 Words

Among the epic stage effects of the late-20th-century musical, we now must count the embassy evacuation.

PUT ASIDE FOR A MINUTE THE considerable talent of the British actor Jonathan Pryce and the galvanizing mixture of ferocity and subservience that he brings to "Miss Saigón." Disregard the loud sport shirts and slinky bell-bottom trousers that he wears. Forget, if you can, his bony fingers, always on the move, like those of a cheap magician about to produce a bouquet of paper flowers from an unsuspecting lady's décolletage.

There is another reason he stands out these nights on the stage of the Broadway Theater like a snarl of India ink on a piece of parchment: in a musical without dialogue, he gets the best lyrics.

To the other performers in Alain Boublil and Claude-Michel Schönberg's tumultuous saga about a G.I. in Vietnam and the bar girl he leaves behind, fall the soaring melodies, the breast-rending passions and the noble sentiments. Mr. Pryce's character — a two-bit hustler called the Engineer, trafficking in phony Rolex watches and soiled virgins, just before the fall of Saigon — represents the low end of humanity.

No conflict troubles his dingy soul. Like the cockroach, he operates purely out of an instinct for self-preservation. His single ambition is to make his way to America, and then only because he thinks he can practice his hustles on a larger scale there. He is without ambiguity and, theoretically, at least, unambiguous characters tend to use up their welcome rapidly. Mr. Pryce has a significant trump card, however. The words that have been put in his mouth by Mr. Boublil and Richard Maltby Jr., the show's lyricists, are the rare words that do not seem to have come from a faltering greeting-card factory.

■

In a dazzlingly sardonic second-act production number, staged by Bob Avian, Mr. Pryce articulates "The American Dream" that has helped his character not only survive one of Ho Chi Minh's re-education camps, but endure the even greater humiliation of having to rope customers into a Bangkok fleshpot for 10 cents an hour. Although softer here than in the original London production, the number remains triumphantly sleazy — a worm's-eye view of a land where "bald people think they'll grow hair," "call girls are lining Times Square," and life is "as sweet as a suite in Bel Air."

Mr. Pryce is soon joined by a line of chorus girls emitting waves of peroxide, and grinning chorus boys in the sort of powder-blue tuxedos once favored by Wayne Newton. Then, out of the billowing clouds emerges the vision: a pristine Cadillac convertible, carrying a piece of cheesecake pretending to be the Statue of Liberty. Eyes gleaming like silver dollars, tongue flickering lasciviously, Mr. Pryce throws himself on the hood as if it were a voluptuous hooker.

All the stops are clearly being let out. But the real electricity in the air isn't generated by the perverse spectacle. It comes from Mr. Pryce, an anorexic Al Jolson, biting into lyrics that can actually lay claim to some bite of their own. The word has briefly emerged from the background and is being allowed to paint images as vivid as those that the director Nicholas Hytner and the designer John Napier have been putting on the stage all evening long.

Most of the time in "Miss Saigon," it's the other way around. The story is abundantly illustrated for us, but the lyrics function as little more than captions or subtitles. While "Guys and Dolls" in German, say, would probably prove a fairly baffling experience for anyone not conversant in that language, I suspect that "Miss Saigon" in French or Finish would still yield up most of its secrets to us.

What Mr. Boublil and Mr. Schönberg are striving to reproduce, as they did in "Les Misérables," is the grandeur of opera in popular garb. Puccini's "Madama Butterfly" has been widely cited as the show's precursor, but don't let that intimidate you. The doomed love between Kim (Lea Salonga), the innocent Vietnamese bar girl, and Chris (Willy Falk), the burned-out G.I. who finds regeneration in her arms before losing her in the chaos of the American withdrawal, is played out on an epic scale. "Miss Saigon" puts the lovers into Cinemascope décors, wraps them in Mr. Schönberg's lush music, and then, when their passion is white hot, throws a chain-link fence between them and exiles them to opposite ends of the globe.

As big as the emotions want to be, however, they are constantly whittled down to size by

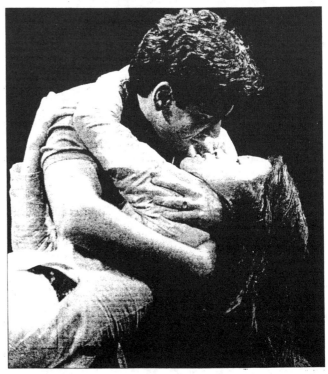

Joan Marcus/"Miss Saigon"

Willy Falk and Lea Salonga in "Miss Saigon"—They look good in each other's arms the way movie stars looked good.

lyrics that border on the simple-minded. "I feel walls in my heart/ Closing in/ I can't breath/ I can't win" hardly takes full measure of the agony in Kim's soul when she learns, three hard years after their liaison, that Chris has married an American. The reaction of the American wife (Liz Callaway) to her Vietnamese counterpart is even feebler. "There are days/ There are days when your life clouds over," kvetches Miss Callaway, with the sour demeanor of one who has got up on the wrong side of the bed.

■

This great divide between words and feelings runs the entire length of the show. While "Miss Saigon" is surely going to amaze a lot of people for years to come, the greatest of its amazements, to my mind, are the ways Mr. Hytner and company have managed to bridge the gap.

Sometimes it is the passionate commitment of the performers that creates the impression of wholeness and keeps ludicrousness at bay. The purity of Miss Salonga's features and the tenacity of the devotion she lavishes first on her lover, then on the child who is born after his departure, contribute significantly to her character's stature. She is touching at first sight — a shy, shrinking peasant girl amid the carnivores in a raucous Saigon dive. Even though her perilous destiny at times rivals that of Mother Courage, she never entirely loses her dewy freshness.

We certainly take as many cues from Mr. Falk's earnestly American, nice-guy aura, and the vigor of his voice, as we do from what he is singing. When he and Miss Salonga come together, the basic laws of biology supplant those of the drama. They *look* good in each other's arms, the way movie stars looked good when the studios were masterminding their careers.

For all its rumored anti-Americanism, the show's politics seem rooted primarily in esthetics. The war was bad because it was untidy. ("All I made was a mess," laments Chris, "just like everyone else.") It despoiled a misty landscape and upset pretty customs. But its most reprehensible sin seems to be that it split up a handsome couple, leaving an adorable poster child fatherless.

In that respect, it was surely inspired casting to put Hinton Battle in the role of John, Chris's Vietnam buddy, who, years later, heads a campaign to rescue the bui-doi, those hapless "half-breeds" sired by American

servicemen and abandoned to a society that treats them as "the dust of life." In the guise of a lecture, Mr. Battle sings about their plight before a large screen on which film clips of their woebegone faces are projected. The number is so flagrantly moralistic as to recall "You've Got to Be Carefully Taught," that Sunday school lesson from "South Pacific." Mr. Battle's soulful voice, however, curls itself around the preachy lyrics, lifts them up and infuses them with a dignity they do not possess on their own.

Sometimes, it is the romantic excess of Mr. Hytner's staging that fills in the blanks in the libretto. At the end of "The Last Night of the World" — the ecstatic duet between Kim and Chris that occurs early in the show — the two lovers embrace fervently. While a saxophone wails and the sky turns red, the balcony on which they are standing slowly carries them off into the night. For one rapturous moment they are detached from the squalor, the war, the world.

Among the astounding stage effects of the late-20th-century musical

(Grizabella's ascent to heaven in "Cats" or Inspector Javert's suicidal plunge into the waters of the Seine in "Les Misérables"), we now must count the evacuation of the American Embassy in "Miss Saigon." Preceded by the roar of whirling blades, a helicopter lowers itself onto the embassy roof while searchlights sweep the auditorium. Meanwhile, crowds of frenzied Vietnamese, clutching their worthless papers, hurl themselves against the embassy's gates. The

When the two lovers come together, the basic laws of biology supplant those of drama.

scene is nightmarish in its desperation.

Then, as the helicopter takes off without them, the crowds slowly turn to follow its flight, until they are facing us — dejected and hopeless in the falling light. Nightmare has been suddenly bled of its fury. What's left is still and sour and scary. This is potent imagery, especially when it is underscored by an orchestra operating at full tilt.

■

Mr. Hytner knows the intrinsic power of the material he is dealing with. But more significantly, given the lyric shortfall, he knows its iconography. A mother leading a tiny child by the hand or a file of weary refugees plodding toward the unknown can't help unleashing in us an instinctive emotional response. I think that may be why "Miss Saigon", which can often seem overwhelming in performance, fades so quickly afterward. It takes canny advantage of all the theater's resources, except the most basic — the word, which would give the multimillion-dollar swirl some of poetry's sticking power. The eye is surfeited. The mind's eye starves. □

1991 Ap 21, II:5:1

Black Eagles

By Leslie Lee; conceived and directed by Ricardo Khan; sets by Charles McClennahan; costumes by Beth A. Ribblett; lighting by Natasha Katz; choreography by Hope Clarke; fight direction by Rick Sordelet; sound by Rob Gorton; music coordination by Robert La Pierre; "Julius' Theme" by Damien Leake; ventriloquy consulting by Robert Aberdeen; production stage manager, Casandra Scott; artistic associate, Michael Bush; general manager, Victoria Bailey. Presented by Manhattan Theater Club, Lynne Meadow, artistic director; Barry Grove, managing director; in association with Crossroads Theater Company. At City Center Stage 1, 131 West 55th Street.

Elder Clarkie	Lawrence James
Elder Nolan	Robinson Frank Adu
Elder Leon	Graham Brown
General Lucas	Michael Barry Greer
Clarkie	Raymond Anthony Thomas
Roscoe	Damien Leake
Nolan	Scott Whitehurst
Buddy	Reggie Montgomery
Leon	David Rainey
Othel	Brian Evaret Chandler
Pia	Illeana Douglas
Dave Whitson	Larry Green
Roy Truman	Milton Elliott

By FRANK RICH

At the curtain call of a press performance of "Black Eagles," the new play about black World War II pilots at the Manhattan Theater Club, the company silenced the applause to introduce some real-life characters in the audience. Two distinguished-looking men, identified as actual members of the squadron known as the Tuskegee Airmen, stood up in the auditorium and received the warmest hand of the night. No wonder. Not only were the men bona-fide war heroes, but they also looked as authentic as the bowing actors dressed in spotless, wrinkle-free khaki looked fake.

It might have salvaged the evening if the two veterans had lingered to reminisce for a while, for "Black Eagles," which was written by Leslie Lee, has almost nothing to say about its fascinating subject beyond the documentary facts. The play un-

earths a neglected chapter in American history only to present it onstage as a talking mural suitable for study in a dogmatic high-school civics class.

●

The historical chapter is that of the Army Air Forces' 99th Fighter Squadron, a brave and invaluable participant in the war effort that was given the same back-of-the-bus treatment in Italy as its men received in the segregated America back home. To their severe frustration, the black pilots were restricted for much of the war to the subservient task of escorting white bomber crews in the air, and they were excluded from white recreational facilities on the ground. "Maybe we're fighting on the wrong damn side," says one of the men in anger. "We're on the right side, but the right side's got itself a hell of a lot of problems," comes the reassuring answer from one of his buddies. Most of "Black Eagles" merely reiterates the same basic facts and the same bare-bones political debate in numbing, if increasingly sentimental, variations.

More is promised at first. Mr. Lee's play opens at a 1989 reunion of the pilots, who now appear (from their well-tailored business suits, not the unrevealing dialogue) to be successful Establishment types, and then leaps back in time to 1944. One assumes that the author will dramatize the transforming journey both the men and their nation took during the intervening 45 years, but the flashback structure turns out to be a gimmick for beginning and ending each act, not a tool for the investigation of either character or history. Sometimes it is even difficult to match up the trio of 1989 characters with their 1944 antecedents, who are in turn distinguished only by superficial traits from their wartime peers.

Mr. Lee, whose other plays include "The First Breeze of Summer" and "Colored People's Time," a historical pageant that shares some of this work's impersonal tone, wrote "Black Eagles" on commission from its director, Ricardo Khan. Perhaps that's why the writing has the stiffness of an assignment dutifully executed instead of the passion of a burning mission. Mr. Lee's script is full of boilerplate in which the characters talk about "changing things for the better back home" and "helping to pave the way" in the battle against racism, but it is short of intimate exchanges that might turn the men from symbols into people. The one elaborate attempt to give a pilot an interior life — in the form of an affair with an Italian sculptor (Illeana Douglas) — is mired in cliché. The white characters, who include three servicemen in addition to the Italian woman, are not vilified as much as their patronizing treatment of blacks might justify, but neither are they individualized enough to seem like anything other than mannequins.

As directed by Mr. Khan, the cast of 13 does little to compensate for the scantly differentiated roles; Graham Brown, David Rainey and Reggie Montgomery are the sole actors to rise above the anonymous norm. Along with the choreographer Hope Clarke, who presumably staged the amusing "Jitterbug Drill" for the men, the production's other distinctive participant is Charles McClennahan, whose set, as intricately lighted by Natasha Katz, serves as barracks and cockpit alike. Only when the de-

Theater in Review

■ Hollywood blacklisting as comedy ■ A musical about adolescence, based on autobiography ■ Dario Fo's humor on both sides of any dialectic.

Gerry Goodstein/"Black Eagles"

Reggie Montgomery in the play "Black Eagles."

signers rev up their simulated bombing missions does "Black Eagles" seem powered by a theatrical imagination more forceful than one locked into automatic pilot.

1991 Ap 22, C13:1

Ivy Rowe

Adapted by Mark Hunter and Barbara Bates Smith; based on the novel "Fair and Tender Ladies" by Lee Smith; directed by Mr. Hunter; scenic design, James Morgan; costumes, Vicki S. Holden; lighting, Ken Kaczynski; production stage manager, Suzanne V. Beerman. Presented by the Ivy Company. At Provincetown Playhouse, 133 Macdougal Street.

Ivy Rowe.........................Barbara Bates Smith

By MEL GUSSOW

Although "Ivy Rowe," the monodrama by Mark Hunter and Barbara Bates Smith that opened yesterday at the Provincetown Playhouse, treads the same narrative path as that of Lee Smith's epistolary novel "Fair and Tender Ladies," it lacks the resonance of the book. It is an episodic selection from a folio of letters rather than a complete dramatic characterization.

In the novel, in a cornucopia of letters written to relatives and friends, Ivy Rowe tells the story of her life as a Virginia mountain woman born at the beginning of the century. This is more a life of the heart than of the mind, as Ivy follows her own impetuous will without a care about convention. She is defined by her spunk, to use one of her favorite words. As she reveals herself through her letters, she also evokes the world of her unseen correspondents.

On stage, all we see and hear is Ivy, portrayed by Barbara Bates Smith, talking endlessly to herself. A truly virtuosic performance would go a long way in conjuring the other characters and in compensating for the limitations of the adaptation. But Ms. Smith (the actress not the novelist)

seems to be a performer of modest range. Although she has the accent and intonations of her rustic character, she is straightforward rather than probing, and Mr. Hunter's staging is rudimentary.

Growing from a preadolescent pen pal to a septuagenarian reaching out for understanding, the actress barely alters the sound of her voice, though as Ivy late in life she affects a stoop. There is little sense of maturation or an inner life beneath the words, such as Brenda Currin conveyed several years ago in her one-woman evening drawn from the work of Eudora Welty.

At the same time, "Ivy Rowe" needs the intervening hand of a dramatist to transform oral history into theater. When, at the end of the show, Ivy tells her daughter (who has become a novelist like Lee Smith, who is not related to the actress) that her latest book lacks plot, the charge acts as self-criticism against the wordy play.

Intermittently, the monodrama becomes evocative — when Ivy is swept away by a story, as in her recounting of an extramarital frolic with a wandering beekeeper. As a set piece, this tale has a flavorful country air (as does the background music). It acts as a justification for Ivy's feeling that though you make your own bed, you do not have to sleep in it forever. But the free spirit that is Ivy Rowe remains intangible on stage.

1991 Ap 22, C15:5

Red Scare on Sunset

WPA Theater
519 West 23d Street

By Charles Busch; directed by Kenneth Elliott; setting by B. T. Whitehill; lighting by Vivien Leone; costumes by Debra Tennenbaum. Presented by WPA Theater, Kyle Renick, artistic director; Donna Lieberman, managing director.
WITH: Mr. Busch, Andy Halliday, Julie Halston and Arnie Kolodner.

As a playwright and star, Charles Busch has proved himself to be a master of the Hollywood pastiche, cross-stitching nostalgia with his own brand of camp comedy. Recently he has been dabbling in politics. In "The Lady in Question" the issue was the rise of Nazism, and in his new play, "Red Scare on Sunset," it is Hollywood blacklisting. "Red Scare" is, to say the least, political commentary of a most peculiar sort.

Mr. Busch and his director, Kenneth Elliott, have concocted an impish imitation of a Hollywood movie, a backlot spectacle about Lady Godiva (impersonated, naturally, by Mr. Busch). Unfortunately that story is only the subplot of a B movie melodrama about a projected Communist takeover of the film industry. It is in the treatment of the blacklist and censorship that questions about Mr. Busch's purpose arise.

The play could be regarded as an attempted an attempt to justify the blacklist, which would be perverse in the extreme. On the other hand, it could be argued that the author intends the play to be an imaginary reflection of Hollywood in the 1950's — if Senator McCarthy had been right about the infiltration of the movies. In either case, confusion results.

Mr. Busch is over his head and fuzzy-minded as a political theorist, but the play's brambled path is strewn with quirky comedy. Hollywood becomes a 'toon town in which heroine and villains are generic caricatures, the heroine represented by the author in a typically glamorous star turn. Even posing pseudo-nude as Godiva on a horse, he is as ladylike and as seemingly imperturbable as Deborah Kerr.

His evil opposite is Julie Halston, amusing as an imperious Hedda Hopper-like radio vixen who sets out to eradicate all leftists from the movies but becomes a rabid turncoat when threatened with Red blackmail. Guilty secrets abound, enough to sink several studios, as in the notion that Communists were plotting "to destroy the Freed unit," the M-G-M production outfit that gave America so many upbeat musicals. That thought is ridiculous enough to make one reconsider "The Wizard of Oz" from a Red-eyed propagandistic perspective, with Dorothy and Toto, a running dog of capitalism, marching on the yellow brick road to an imperialistic society. *MEL GUSSOW*

O Solo Mio Festival

Perry Street Theater
31 Perry Street
Through Saturday

Two one-act plays by Dario Fo; translated by Ron Jenkins; directed by Christopher Ashley; set designer, George Xenos; costumes, David C. Woolard; lighting, Pat Dignan. Presented by New York Theater Workshop, James C. Nicola, artistic director; Nancy Kassak Diekmann, managing director.
EVE'S DIARY
WITH: Jane Kaczmarek
THE STORY OF THE TIGER
WITH: Rocco Sisto.

Dario Fo is a radical, antiestablishment revolutionary writer who never lets his politics get in the way of his sense of humor. As part of its O Solo Mio Festival, the New York Theater Workshop is offering two of Mr. Fo's monologues, "Eve's Diary" and "The Story of the Tiger," that demonstrate the author's ability to expose the nonsense on both sides of any dialectic, whether it treat on Marxism, fundamentalism or feminism.

The second and more engaging piece of this diverting 70-minute evening is a sort of shaggy tiger story that recounts the experiences of one young soldier on Mao Zedong's Long March. Wounded by Chiang Kaishek's forces and left to his fate by his comrades, the young man is suckled back to health by a mother tiger with whom he shares refuge in a cave from a flood. At once humorous and discerning, the fable carries a political moral that could be a caution for the people of just about any society on the map, whatever political system they struggle under.

Rocco Sisto turns "The Story of a Tiger" into a small tour de force. Roaring, purring and burping tiger's milk, Mr. Sisto is a captivating storyteller and makes a difficult performance look easy.

The opening monologue, which is loosely adapted from half of Mark Twain's short story "The Diary of Adam and Eve," is Eve's account of what really happened during those first weeks in the Garden of Eden. In this somewhat revisionist version, we learn that Adam was a little slow on the uptake. His first reaction upon encountering Eve, for example, was to climb a tree. And it was Eve who had to name all the animals, since Adam never quite got the hang of it. As a case in point, the one animal he did name was the yak.

Among the other bits of information Eve imparts is that it was Adam who sent her to pick the apples. And she tells an amusing anecdote about how she discovered the difference between her and Adam. But her recollections about the first seduction still leaves open the question of who actually seduced whom. In Jane Kaczmarek's whimsical and animated recital, it all sounds plausible.

Under Christopher Ashley's direction, both Mr. Sisto and Ms. Kaczmarek work a lot harder than they

T. J. Boston/WPA Theater

Charles Busch as Lady Godiva in "Red Scare on Sunset."

Bob Marshack/New York Theater Workshop

Rocco Sisto in a scene from "The Story of the Tiger."

have to, constantly moving about the stage and gesticulating over every line, as though no one quite trusted the audience to grasp the material. It is to the credit of Mr. Fo's wit, adroitly captured in Ron Jenkins's translation from the Italian, that the excessive gesturing was not more of a distraction.

WILBORN HAMPTON

Custody

Westbeth Theater Center
151 Bank Street
Through Sunday

Based on a portion of the novel "Walking Papers" by Sandra Hochman; book and lyrics by Ms. Hochman; music by Marsha Singer; directed by Mina Yakim; choreography by Darryl Quinton; music director, Jim Mironchik; set design, Pat Sutton. Presented by Ms. Hochman, Ms. Singer and Sybil Wong, in association with the Risk Company. WITH: Martin Austin, Robin Boudreau, Lenny Mandel, Barbara J. Mills and Tara Sands.

Teen-age life, with its messy emotions and peer-pressure tyranny, has not often been depicted on the stage as truthfully as it is the new musical "Custody." Set in an artsy Connecticut boarding school, many of whose students come from broken homes, the show traces the growing pains of Diana Balooka, a precocious 13-year-old who is dumped there while her divorced parents engage in a brutal custody battle. Diana writes poetry, joins a boy-crazy clique known as the Gang of Six, and falls in love with a boy whom her rich, boorish father arranges to have removed from the school.

The show has music by Marsha Singer and a book and lyrics by the poet Sandra Hochman, who adapted the story from her autobiographical novel, "Walking Papers." The central character is played by two actresses. The adult Diana (Robin Boudreau) narrates a series of flashbacks in which the young Diana (Tara Sands) enters early adolescence convinced that neither of her parents cares about her. As portrayed by Lenny Mandel and Barbara J. Mills, the Balookas are indeed selfish, screaming monsters.

"Custody" has been staged by Mina Yakim as a sort of school assembly pageant in which the cast members, seated around the stage on chairs and boxes, ritualistically rise to re-enact Diana's memories of

events at school and in the court in choreographed set pieces. If the reminiscences of the grown-up Diana are too archly poeticized, the vignettes of boarding school life have an unpretentious immediacy that is underscored by engaging performances from a largely teen-age cast.

Ms. Hochman and her collaborator have managed the tricky balancing act of writing songs for characters in their early teens that are ingenuous but not patronizing. Some of the show's best moments portray Diana's chaste but passionate romance with Patrick (Martin Austin), a sensitive Irish-American boy who shares her poetic inclinations. Mr. Austin and Miss Sands imbue songs like "Watercolor Girl" and "Stargazers" with exactly the right mixture of trembling sincerity and adolescent gawkiness.

Enhancing the show's dramatic edge is a sense of simmering anger that rises to the surface in songs like "Throwaway Kid," "It Hurts Like a Razor Strap" and a rap song in which the cast gleefully lets loose a litany of obscenities.

STEPHEN HOLDEN

1991 Ap 24, C10:5

The Secret Garden

Book and lyrics by Marsha Norman; music by Lucy Simon; based on the novel by Frances Hodgson Burnett; directed by Susan H. Schulman; scenery by Heidi Landesman; costumes by Theoni V. Aldredge; lighting by Tharon Musser; orchestrations by William D. Brohn; musical direction and vocal arrangements, Michael Kosarin; dance arrangements, Jeanine Levenson; sound by Otts Munderloh; choreography by Michael Lichtefeld. Senior associate producer, Greg C. Mosher. Presented by Heidi Landesman, Rick Steiner, Frederic H. Mayerson, Elizabeth Williams, Jujamcyn Theaters/TV Asahi and Dodger Productions. At the St. James Theater, 246 West 44th Street.

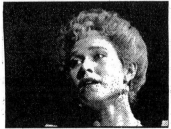

Bob Marshak/The Secret Garden

Rebecca Luker.

Lily	Rebecca Luker
Mary Lennox	Daisy Eagan
Fakir	Peter Marinos
Ayah	Patricia Phillips
Rose	Kay Walbye
Capt. Albert Lennox	Michael De Vries
Lieut. Peter Wright	Drew Taylor
Lieut. Ian Shaw	Paul Jackel
Major Holmes	Peter Samuel
Claire	Rebecca Judd
Alice	Nancy Johnston
Archibald Craven	Mandy Patinkin
Dr. Neville Craven	Robert Westenberg
Mrs. Medlock	Barbara Rosenblat
Martha	Alison Fraser
Dickon	John Cameron Mitchell
Ben	Tom Toner
Colin	John Babcock
Jane	Teresa De Zarn
William	Frank DiPasquale
Betsy	Betsy Friday
Timothy	Alec Timerman
Mrs. Winthrop	Nancy Johnston

By FRANK RICH

IN "The Secret Garden," the new musical at the St. James, a devoted team of theater artists applies a heap of talent and intelligence to the task of bringing Frances Hodgson Burnett's beloved children's novel of 1911 to the stage. They have accomplished that basic mission, all right, but whether "The Secret Garden" is a compelling dramatic adaptation of its source or merely a beautiful, stately shrine to it is certain to be a subject of intense audience debate. I, for one, often had trouble locating the show's pulse.

The musical's principal creators — the playwright Marsha Norman, the composer Lucy Simon, the director Susan H. Schulman, the designer Heidi Landesman — are nothing if not thorough. With flashbacks, dream sequences and a strolling chorus of ghosts, they explore the meaning of the novel's every metaphor, the Freudian underpinning of every character and event, the spiritual hagiography of its Victorian milieu. From the rococo set, a pop-up period toy-theater that greets the audience upon arrival, to the Act II introspective soliloquies given even to characters who receive only scattered mentions in the novel, this musical leaves no stone unturned in "The Secret Garden." Yet where, to use Burnett's own language, are the Magic and the Mystery that have made the work endure?

At its heart, after all, "The Secret Garden" tells a simple story that is endemic not only to children's literature, but also to such Broadway staples as "The Sound of Music" and "Annie." A 10-year-old orphan, Mary Lennox (Daisy Eagan), must win the love of her distant, widowed guardian, her uncle Archibald Craven (Mandy Patinkin), even as she must find her own soul and self-worth by communing with nature in the locked garden of the uncle's vast Yorkshire estate. In the musical version, this tale's primal pull is often severed at its roots. Burnett had the cunning to keep the uncle a remote, mysterious figure for a third of the book, but since he is played by a star, the show must bring him on (and deflate the suspense) by the second scene. Worse, Burnett's exciting recounting of the obstacles Mary must overcome to enter the locked garden is short-changed in Ms. Norman's script, and so, eventually, is the garden itself. The actual stage time devoted to this show's equivalent of Oz is brief, and the climactic, moving song about the garden's transforming powers — the equivalent to the "garden" songs of Leonard Bernstein's "Candide" and "Trouble in Tahiti," for instance — never arrives.

Where Burnett practiced the instincts of a born storyteller, the creators of the musical prefer to intellectualize. Mary's dead parents and Uncle Archie's dead wife haunt almost every scene, lest anyone forget that death and rebirth are themes of "The Secret Garden," and because these ghosts' appearances necessitate echo-chamber sound, supernatural lighting cues and a totemic replay (sometimes in song and dance) of the past, the musical seems to take two clumsy steps backward for each one

forward. Only once does this scheme advance the show instead of halting it: in a lovely, early trio, "I Heard Someone Crying," Mary, her uncle and her dead aunt (Rebecca Luker) sleepwalk through the haunted mansion, projecting their own deepest familial longings on the sound of a child's crying deep within the night.

●

Otherwise, the musical's emphasis on subtext overwhelms the text. Much more so than "Into the Woods," which was as much about Bruno Bettelheim's interpretation of Grimm tales as the tales themselves, "The Secret Garden" favors theme over story, as if it were a learned essay about the book instead of a new version that might speak for itself. That would not be a problem if the characters were as clearly seen in the foreground of the musical as they are during the symbolic pageantry. But the leading players often seem upstaged by loud-mouthed secondary figures — a chambermaid (Alison Fraser), an old gardener (Tom Toner) — who pop up at arbitrary intervals to sing cheery, on occasion inspirational musical-comedy ditties of the "Mary Poppins" variety and then disappear until another jolt of enforced ear-to-ear grinning is required.

Though performed with spirit by the young Miss Eagan, Mary never really gets a chance to blossom as a girl in tandem with the garden that stimulates her emotional growth, and her sickly young cousin, Colin (John Babcock), never amounts to more than just another smiling Broadway tyke. Mr. Patinkin, by contrast, is given every opportunity to display the tortured psyche of the lonely, hunchbacked uncle, but by using the same contorted posture (loping walk, dangled left hand) he displayed in his excruciating Broadway concert recital of last season and by excusing himself from the rest of the company's efforts to maintain British accents, he turns "The Secret Garden" into a show about his own contemporary, New York show-biz persona whenever he is at center stage. I'm saddened to report that his trademark gestures — the squinting of the eyes, the cranking of the voice up an octave in mid-song — are calcifying into shtick, and they seem to dramatize Mandy Patinkin's notions of ambivalence, not Archibald Craven's guilt and grief. The finale, in which he reunites with the ghost of his lost love in the garden, is as synthetic here as it was heartfelt when Mr. Patinkin performed virtually the same reconciliation with a dead woman in the greenery of "Sunday in the Park With George."

•

The star's voice is as lilting as ever, at least, and there is other powerful singing by Ms. Luker (who seems too talented to be filtered through sonic effects), the redoubtable Ms. Fraser and that fine actor Robert Westenberg, whose incidental role of a doctor is ludicrously inflated into a quasi-villain to vamp for time during Mr. Patinkin's long absence in Act II. Ms. Simon's music, accompanied by the solid lyrics Ms. Norman often draws from Burnett's own dialogue, is fetching when limning the deep feelings locked within the story's family constellations. But when Ms. Simon descends to a conventional musical-comedy mode, the score falls apart, most notably in some songs for Dickon, the elfish boy who is Mary's unofficial guide to the garden. As sung by the charming, if opaquely accented, John Cameron Mitchell — unrecognizable after his turn as a wormy student con man in "Six Degrees of Separation" — the boy's dialect-laden odes to nature sound like Neil Diamond ballads as they might be delivered by Ringo Starr and orchestrated for "Brigadoon."

The cluttered, scattershot approach of "The Secret Garden" to its drama and musical numbers extends to its every element, from the book's insistence on talky clumps of redundant exposition to Ms. Schulman's staging, which regurgitates the nightmare party sequence but not the dramatic urgency of her superb revival last year of "Sweeney Todd." The gifted Ms. Landesman's collage-like scenic design, which embraces sources as varied as Victorian line drawings, Joseph Cornell boxes and the spooky imagery of the director Robert Wilson, is fabulous to look at but not hospitable to actors, who have to fight to be in focus despite the exceptionally busy efforts of the brilliant lighting designer Tharon Musser. Since the choreography (by Michael Lichtefeld) is scant and amateurish, "The Secret Garden" has no theatrical means for achieving that graceful, seemingly effortless falling into place that levitates fairy-tale musicals (among others) into en-

chantment. In this show, the hard work is always apparent; one is con-

Flashbacks, dreams, ghosts: no metaphor left unturned.

stantly aware that the authors are thinking hard — too hard.

Fanatical devotees of the Burnett novel, young and old, are likely to enjoy the evening anyway, while those who have never heard of "The Secret Garden" or those who don't quite hold it in the same high regard as, say, the "Iliad" or "Charlotte's Web," may be either baffled or bored by it. At its best, this show may not be a transporting entertainment like the M-G-M "Wizard of Oz" or Broadway "Peter Pan," but it can certainly be considered a musical-theater equivalent to a profusely illustrated, and perhaps even more profusely annotated, edition of a children's classic.

Is it too churlish to wish that they turned the pages a little faster?

1991 Ap 26, C1:1

An Evening of Short Plays by Joyce Carol Oates

Directed by Gordon Edelstein; set design by Hugh Landwehr; costume design by David Murin; lighting design by Arden Fingerhut; original music and sound design by John Gromada. Presented by the Long Wharf Theater, Arvin Brown, artistic director; M. Edgar Rosenblum, executive director. At New Haven.

The Anatomy Lesson
WITH: Elisabeth Fay and Ann McDonough
How Do You Like Your Meat?
WITH: Ms. Fay, Lou Ferguson, Julia Gibson, Robert Kerbeck, Rob Kramer, Christopher Scott Mazur, Gary McCleery and Ms. McDonough.
Friday Night
WITH: Ms. Gibson, Mr. Kerbeck, Ms. Knight, Mr. Kramer and Mr. McCleery
Darling I'm Telling You
WITH: Ms. Knight and Mr. McCleery

By MEL GUSSOW

Special to The New York Times

NEW HAVEN, April 24 — In a quartet of short plays at Long Wharf Theater, Joyce Carol Oates expresses herself in diverse dramatic modes. Each becomes a determined experiment in extending the range of this widely accomplished novelist and short story writer. But as with Ms. Oates's other writing for the theater, the plays are shadowed by the artistry of her prose.

Thematically, they share common ground. As in her fiction, including her recent novel, "Because It Is Bitter and Because It Is My Heart," three of the plays deal with women who are magnetically attracted to perilous, uncontrollable situations. These are women on the abyss.

In "How Do You Like Your Meat?," which gives the title to the anthology, a self-described professional woman returns east from a business trip and rashly accepts a ride from an apparently unlicensed

car service. On the road home, overcome by fears about the driver's motives, she bolts from the vehicle and seeks sanctuary with a suburban family. That family turns out to be a frightening example of lovelessness and incipient racism.

As a short story, this would undoubtedly envelop the reader in the woman's anxiety, as she is crushed by self-doubt and inertia. But on stage, without the vividness of the Oates narrative, the audience remains somewhat at a distance. The realistic dialogue is not sufficient to account for the apparent dementia. This is despite an intense performance by Ann McDonough and a painterly view (by Ms. Oates and her director, Gordon Edelstein) of a backyard barbecue. In their hands, this looks like an Eric Fischl painting — apparent calm on the surface but with aberrant undercurrents in various corners of the canvas.

•

"Friday Night" is a more intriguing piece, focusing on the loneliness of a young single woman in a small Midwestern town. The woman, played by Lily Knight, has centered her adult life on an extension of her high school experience and still worships the class athletic hero. To outsiders, he can only seem cloddish.

In a gathering at a favorite bar, old friends reveal the strayed ends of their limited lives — and Ms. Knight sees her mystical premonitions fulfilled. Though this scenariolike play would benefit from the expansiveness of film or television, it does delineate a measure of the young woman's obsession, with the help of Ms. Knight's introspective performance.

These two long one-acts are bracketed by vignettes, "The Anatomy Lesson" and "Darling I'm Telling You." The latter monologue, seen earlier this season in an Oates anthology at the American Place Theater, is a small painful memory from beyond the grave from a murdered go-go dancer (acted, in this production, by Ms. Knight).

"The Anatomy Lesson" is a mother-daughter dialogue about the facts of birth. It opens the evening on an impertinently amusing note. The conversation is filled with a child's confusion and a mother's difficulty in communicating what she believes to be common sense. As deftly acted by Ms. McDonough (as a mother trying to be forthcoming about sex) and Elisabeth Fay (as a 5-year-old given to deductive reasoning), this brief sketch completely achieves its objec-

tive. In contrast with the other Oates pieces, it also seems perfectly at home on the stage.

1991 Ap 27, 14:5

A Diverse Cast, All Played By Tina Smith

By STEPHEN HOLDEN

Among the half-dozen intriguing characters portrayed by Tina Smith in "Don't Get Me Started," her one-woman show of monologues at Theater Arielle (432 West 42d Street), are a country-and-western singer whose fictionalized biography is about to be made into a movie, a poet-cum-performance artist from Brooklyn who is grotesquely ill-equipped for a literary career, and a woman who bills herself as "the only holistic new-age exotic dancer in Las Vegas."

Each of these women is facing a moment of truth in her life. The singer, who realizes that her confessions will probably end her career, comes clean about a suburban middle-class background that is wholly at odds with her official myth as someone from a dirt-poor background.

The poet, who has a Cyndi Lauper accent, is about to give a reading in an East Village library. One of the ghastly poems she declaims comes from her so-called nature series and is called "Bird Do." The exotic dancer has developed a new form of entertainment called "chance," which she describes as a combination of chat and dance.

The show was directed by Kathy Najimy of the comic duo Kathy and Mo, and Ms. Smith's work shares their feminist sensibility and sociological precision. Ms. Smith has a very good ear for regional dialect and captures the body language of characters who range from Manhattan yuppies to rural southern housewives.

But the monologues also ramble far too much, and most lack a coherent structure. Ms. Smith's portraits are filled with telling details, but she repeatedly fails to give her characters revelatory comic moments, and it is not for lack of trying. Her show is just not funny enough.

1991 Ap 27, 14:6

SUNDAY VIEW/David Richards

Barrymore Lives, and So Does Light Comedy

The frisson of 'I Hate Hamlet'; the 60's pulse of 'The Good Times Are Killing Me'; Saturday night blithe with Jeffrey Essmann.

ERE'S MY THEORY ON WHY the British actor Nicol Williamson is so vivid in "I Hate Hamlet," the perfectly amiable comedy at the Walter Kerr Theater, in which he plays the ghost of John Barrymore brought back from the hereafter against his will. The black velvet tunic and tights that he's wearing have been wired for electricity. And every now and then someone in the wings is throwing the switch.

The jolt is nothing that would do a body harm, but it is enough to rouse Mr. Williamson from a state of woozy dreaminess, cause his head to snap to attention and a shock of blond hair to go flying off his forehead, and put tiny lightning bolts in his eyes. The actor doesn't just sit down on a chaise longue, you'll notice. He flings himself backward into it, and then does this exaggerated scissors kick with his legs, before subsiding into a pose of elegant languor. That's got to be the electricity again.

And how else do you explain his delivery? "Am I dead?" he asks, shortly after turning up on earth, "or just *incredibly* drunk?" The great, shivery emphasis makes the line far funnier than you'd imagine. If my theory is correct, the offstage electrician, in what must be counted as a stunning display of scientific precision, has managed to concentrate the juice on the adverb alone.

On the other hand, I suppose it is possible that Mr. Williamson is doing this with no assistance at all — letting himself drift off like a great lovesick calf only to come abruptly to his histrionic senses and remember his obligations to the world as a great profile. "I do not overact," he bristles at one point with the indignation of one whose masculinity has been impugned. "I simply possess the emotional resources of 10 men. I am not a ham; I am a crowd."

Well, I never saw Barrymore in the flesh, but in Mr. Williamson's case, I am willing to take him at his word. However you want to account for it, the performance is as entertaining as any you're likely to find on Broadway right now.

■

As for "I Hate Hamlet," while it will go down in nobody's book as a classic, it deserves nobody's opprobrium. A few decades ago, the playwright Paul Rudnick would have been warmly welcomed for turning out a light comedy, generous with the laugh lines, respectful of the theater's past, and savvy enough to show off its star to astute advantage. Frankly, I don't see why he shouldn't get the same welcome today.

I know the general thinking holds that no one writes light comedies any longer, not even Neil Simon, and that the form, having been appropriated by television, has ceased to have a place on Broadway. This certainly flies in the face of my experience. Television, as I see it, hasn't taken over the light comedy so much as it has cornered the market on the stupid comedy. And if the theater wants to deal in diversions and delights, why shouldn't it?

Not so coincidentally, Mr. Rudnick's lead character, one Andrew Rally (Evan Handler), is a television actor whose series, "L.A. Medical," has just been canceled, although his commercial for Trailburst Nuggets continues to keep his face before the country's cereal lovers. In a career lull, he's returned to New York, where he's weighing an offer to appear as Hamlet in Central Park. He and his 29-year-old girlfriend, Deirdre (Jane Adams), have been looking at apartments, but the fact that she continues to cling obstinately to her virginity is doing nothing for his self-confidence.

At any rate, at the curtain's rise, the apartment they are looking at is an ornate, two-story, High Gothic affair that once belonged to Barrymore himself. Surely, Deirdre says, trembling like one of those silent film heroines who were always being tied to the tracks, the great actor's spirit must haunt

Roy Blakey/The New York Times

Jeffrey Essmann as the tyrannical Sister Bernice—There's nothing like a quavering voice to remove the sting from the threat of eternal damnation.

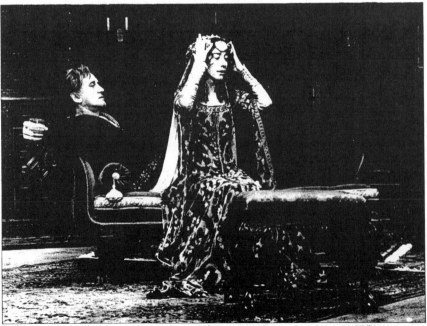

Michelle V. Agins/The New York Times

Nicol Williamson, as the ghost of John Barrymore, and Jane Adams in "I Hate Hamlet"—If the theater wants to deal in diversions and delights, why shouldn't it?

the place. Since the real estate agent has psychic abilities, a séance is hastily improvised. (O.K., into every comedy, a little contrivance must fall.) And indeed, who should appear, although not to everyone's eyes, but the rakish idol himself.

"John Barrymore," he thunders by way of introduction. "Actor. Legend. Seducer. Corpse."

For the rest of the play, when he is not getting stewed on champagne and hazy memories, he will take it upon himself to teach Andrew the art of acting Shakespeare and the slightly more complicated art of seducing a maiden fair. At the same time, Andrew is being urged by the director of his old series, a cheerful Hollywood vulgarian (Adam Arkin), to take the safe way out and sign up for another dimwitted TV pilot that could net him millions. So there's a tug of war. Of sorts.

Andrew's indecision is not quite Hamlet's. As philosophical quandaries go, there is really not a whole lot of doubt as to whether 'tis nobler in the mind to do a series about an earnest ghetto schoolteacher who can fly after sundown, or commit to "the great plays — Ibsen, O'Neill, nothing under four hours." Still, Mr. Rudnick gets considerable mileage out of pitting New York against Los Angeles, art against commerce, drama schools against Method gurus, East Coast pretension against West Coast pretension.

It's obvious where his sympathies lie, but he reserves enough barbs for the live theater to avoid the charges of arrant partisanship. A legitimate actor is defined as "just some English guy who can't get a series," while Shakespeare in the Park comes in for a grand working over as "algebra on stage." Since all you can purchase at intermission, argues Mr. Arkin, not without logic, are whole wheat brownies, little bags of nuts and raisins and a Mostly Mozart tote bag to put them in, "it's not even dinner theater ... it's snack theater. Shakespeare for squirrels."

The burly Mr. Arkin, it should be noted, holds his own nicely in the company of the formidable Mr. Williamson, and Ms. Adams has a loopy presence that grows on you, rather like ivy entwining a wrought-iron

grille. The script shortchanges Celeste Holm, who nonetheless manages, as Andrew's nicotine-addicted agent, to emit a silvery grace between hacking coughs. The weakest performer — although not so weak as to bring down Mr. Rudnick's house of cards — is Mr. Handler, whose kinship with the no-talent he's playing is occasionally too close for comfort.

As his opening night approaches, Andrew, clearly marked for disaster, appeals to Barrymore for some last-minute tips. Mr. Williamson obliges with Hamlet's advice to the players, honestly and beautifully spoken. For the duration of the speech, the bravado is put on hold, the flashing eyes turn reflective and the heaving breast is still.

The speech is thrilling, but it also serves to remind us that Mr. Rud-

nick's piece of fluff is about something after all. It's about truth and integrity and not selling out — and how to appear so incredibly humble at the curtain call that even the customers in the second balcony have no choice but to leap to their feet.

The Good Times Are Killing Me

Lynda Barry's "Good Times Are Killing Me," which started out life as a novel, has now turned up Off Broadway at the Second Stage Theater with a bunch of performers in tow, so I guess it may be technically classified as a play. But an awful lot of the novel is still showing.

Set in the 1960's in what was politely called a neighborhood in transition, it focuses on the growing up of Edna Arkins, a gawky, curious white girl, and her friendship with Bonna Willis, the slightly hipper black girl who lives next door. They play records in the basement of Edna's house, attend Girl Scout meetings, share secrets, get in dutch with their parents, go camping, squabble, make up and generally do all those impossibly exciting, totally inconsequential things that kids do en route to the seventh grade. Then seventh grade begins, and the best friends learn that the rest of the world is not as colorblind as they are. A gulf opens up between them, and innocence disappears into it.

Ms. Barry, primarily a cartoonist by trade, has an eye for passing details that are right on target, if my own memories of the 1960's don't betray me. Although you wouldn't call the work a musical, somebody always seems to be playing or singing one of the pop hits of the day. Unfortunately, "The Good Times" can't boast of anything so protracted as a scene. Edna narrates fully two-thirds of the script, and while the young Angela Goethals is a trouper, that may be expecting a bit too much of her. The other characters, decidedly underwritten and underemployed, toss in a line here and there.

Mark Brokaw has staged the offering story-theater style in a set made up of screen doors and blue siding. For all the bustle, I kept thinking we'd be just as far along if Miss Goethals had simply stepped up to a podium, opened a leather-bound manuscript and read the whole thing. There may be 14 actors in the cast, but "The Good Times" is really a one-woman show. Make that a one-little girl show.

Jeffrey Essmann's Artificial Reality

At the outset of "Jeffrey Essmann's Artificial Reality" at the Off Broadway Perry Street Theater, Mr. Essmann, the evening's chief performer, explains that his compulsion to portray different characters probably stems from a narcissistic personality disorder. Somehow as a baby, he failed to establish himself as a separate being with his own distinct identity. Instead, he developed this ability to reflect the unconscious needs and desires of the people around him.

"Like a mirror," he says. "Or a hooker."

He's not complaining. Far from it. Matters are barely under way, and he's already wriggled out of any responsibility for what ensues. If his actions are a reflection of our needs — and the eight sketches he is about to act go poorly — well ... you get it. Happily, the night I caught his show, the audience's collective unconscious must have been truly fraught with want, because Mr. Essmann was hilarious.

Although he can be biting, he stops far short of Eric Bogosian's savagery. And while he delights in puncturing fads and faddishness, he tends to eschew the social earnestness of a Lily Tomlin. Silliness is part of it, but I suppose you'd best describe him as a congenial screwball with insights. He keeps you on your toes, but you're never uncomfortable in his presence. After all, Sister Bernice, his version of the tyrannical nun, is so old that merely writing her name in chalk on the blackboard leaves her momentarily out of breath. There's nothing like a quavering voice to remove the sting from the threat of eternal damnation.

The character called Scott Thornton, a divorced husband who is leading a men's self-love workshop, believes that a frank and open celebration of one's genitalia is the first step on the road to wholeness. But when the men in the audience fail to repeat vigorously after him, "My penis is just fine, and so am I," he doesn't insist. As he explains, "We became so obsessed with finding our sensitive side, the part that wanted to help raise the kids, that we lost touch with the aggressive side, the part that wanted to eat them."

The vogue for recovery groups is gently skewered by Stan M., a nebbish in search of a social life, who discovered that a lurid confession, however fictional, could make him a hit at Alcoholics Anonymous. Having since run through Overeaters Anonymous, Narcotics Anonymous and a half-dozen others, he now wants to mend his ways. But he's still on shaky ground when he stands up and admits, "My name's Stan, and I'm a recovering recovery addict."

Three of Mr. Essmann's sketches have to do with the folly of show business, always fertile territory. "The Passion of Patsy" is a deliriously accurate parody of one-woman shows — Patsy being the great Croatian poet and lover of blood sausage, Nadia Mulvyena Porochnjik. Later, in a blond wig and spandex dress, Mr. Essmann turns up as a Barbie doll (out of the valley of the dolls), falling apart in the middle of her nightclub act. Finally, "The Sturm and Drang Song Book" allows him to pay tribute to the prolific Broadway career — 46 shows in 13 years — of the legendary songwriters Harold Sturm and Arnie Drang.

Piano accompaniment for "Artificial Reality" is adroitly provided by the composer Michael John LaChiusa. Inasmuch as he willingly dons wigs and costumes and plays the tremulous background music for "The Passion of Patsy" shrouded in what appears to be an old lace curtain, I judge him to be every inch the blithe spirit Mr. Essmann is. □

1991 Ap 28, II:5:1

Susan Cook/Second Stage

Angela Goethals in "The Good Times Are Killing Me"—growing up and out of a friendship in a world not as colorblind as you are

Our Country's Good

By Timberlake Wertenbaker; based on the novel "The Playmaker" by Thomas Keneally; directed by Mark Lamos; scenery by Christopher Barreca; costumes by Candice Donnelly; lighting by Mimi Jordan Sherin; sound by David Budries; the Hartford Stage Company production presented by Frank and Woji Gero, Karl Sydow, Raymond L. Gaspard, Frederick Zollo and Diana Bliss. At the Nederlander Theater, 208 West 41st Street.

WITH: Neville Aurelius, Amelia Campbell, Tracey Ellis, Peter Frechette, John Hickok, Cherry Jones, Adam LeFevre, Ron McLarty, Richard Poe, J. Smith-Cameron, Sam Tsoutsouvas and Gregory Wallace.

By FRANK RICH

This is the final week of a parched Broadway season, so the timing could not be better for "Our Country's Good," a play that says, yes, the theater is important, inspiring, a boon to civilization. Actually, when you consider "La Bête" and "I Hate Hamlet," it could be argued that roughly half the new plays on Broadway this season delivered the very same gung-ho message about the theater, as if New York's producers were in a desperate conspiracy to reassure audiences (and themselves) that it is not a sign of certifiable insanity either to attend or to present drama in a commercial playhouse.

"Our Country's Good" — an English play by an American writer set in Australia — sometimes proves them right. It champions the theater with eloquence and, at its best, does so by example rather than by preaching. The author, Timberlake Wertenbaker, has adapted the work from a historical novel ("The Playmaker") by Thomas Keneally about the first play produced in Australia in its earliest days as a penal colony. The play was George Farquhar's "Recruiting Officer," a Restoration comedy of 1706, and the actors who performed it were the hungry and mostly illiterate criminals, outcasts and misfits that Georgian England had banished Down Under in 1788. Their director was a young lieutenant in the Royal Marines named Ralph Clark, who undertook the task as a noble experiment to free his charges at least temporarily from their eternal pattern of "crime and punishment."

It's a touching tale that almost seems too incredible to be true. The first sound one hears in "Our Country's Good" is the beating of a passenger on the ship bound for Sydney Cove. That cry of suffering is never forgotten, yet what follows is the fascinating spectacle of chained and brutalized prisoners, one of whom awaits hanging, giving their all to stage roles several class and cultural stations above their own feral existence. With the homeliest prop — a piece of wood substituting for an aristocratic fan — one scowling convict (Cherry Jones) with matted hair and rotting teeth gradually warms to the role of a rich lady. Another prisoner (Richard Poe), inebriated by the new possibilities of words, is inspired by "The Recruiting Officer" to attempt stage writing of his own, and still another (Tracey Ellis) acquires the dignity of Farquhar's heroine, Silvia, until finally she wins the offstage love of the director (Peter Frechette).

Such transcendent metamorphoses lovingly uphold the redemptive power of theatrical make-believe, both for those who practice it and those who watch it, and Ms. Wertenbaker is usually not pious about imparting that message. There is welcome backstage humor in "Our Country's Good" once its amateur actors, just like the most hardened professionals, start bickering about the size of their parts, their motivations and the sanctity of the playwright's text. However exotic and savage the surrounding environment, the "Recruiting Officer" rehearsals are not far removed in tone from the antic play-within-the-play rehearsals in such other recent English comedies as Michael Frayn's "Noises Off" and Alan Ayckbourn's "Chorus of Disapproval."

The convicts of early Australia give their all on stage.

The only trouble with the theatrical sequences in "Our Country's Good" is their brevity and, especially in Act I, their infrequency. Ms. Wertenbaker's play had its premiere at the Royal Court Theater in London, and at her least inspired, she insists on carrying that company's distinctive ideological baggage even when it clearly impedes the compelling story she has to tell.

●

By far the most positive Royal Court influence on Ms. Wertenbaker is that of Caryl Churchill, whose imprint can be seen when the actresses playing convicts in "Our Country's Good" double in the roles of English officers. The cross-sexual casting not only echoes a Churchill comedy about colonialism ("Cloud 9") and, for added dividends, the farcical plot of "The Recruiting Officer" itself, but it also honors Ms. Wertenbaker's point about the subversive power of theater to liberate an audience from all shackles of reality, including divisions of sex and class. But the playwright's other Royal Court tics are dead weight. Australia's aborigines are represented by a token everyman, and a particularly guilt-ridden enlisted man is tormented in a mechanical subplot. In other lazy scenes, bearing Brechtian titles like "The Authorities Discuss the Merits of the Theater," the officers debate Ms. Wertenbaker's themes in instructional, anachronistic terms suitable for a British television chat show.

While the production's director, Mark Lamos of the Hartford Stage Company, does not always take full command of the expansive Nederlander Theater, the awkwardly staged incidental vignettes and the weaker performances are outweighed by his and his company's bolder theatrical strokes. Christopher Barreca, an imaginative young designer, makes an invaluable contribution with his set, which in abstract terms suggests both the historical and backstage realms of the play. Though Mr. Barreca's design is symbolically dominated by the skeletal hull of the ship that transported the convicts — an apocalyptic Old Testament ark — it also exposes the Nederlander's stage machinery and boasts an elegant yet soiled 18th-century front curtain emblemizing both the pride and primitivism of Sydney's first theatrical endeavor.

Perhaps because their roles are better written, the women dominate Mr. Lamos's acting company, with the remarkably versatile Ms. Jones and the stealthily intense Ms. Ellis both bridging their abrupt Act II transformations with an unsentimental subtlety missing from the script. No less impressive is Mr. Poe, who doubles vibrantly as the colony's liberal Governor and the one intellectual convict. In smaller roles, Adam LeFevre, Amelia Campbell and Sam Tsoutsouvas are most vivid.

For fans of Mr. Frechette, most recently seen in "Absent Friends" at the Manhattan Theater Club and "Thirtysomething" on television, "Our Country's Good" will be a disappointment. His performance as the earnest director is above reproach, but he alone in Mr. Lamos's cast has a single role and, despite some homesick soliloquies, a pale role at that. Easily Mr. Frechette's finest moment comes in the evening's denouement, when the curtain at last rises on "The Recruiting Officer" and its motley amateur company is seen in the wings, basking at last in the glow of its first footlights and first audience. While not all of "Our Country's Good" is so stirring, its inconsistencies, like its flashes of power, make it wholly representative of the season of Broadway drama it brings to a close.

1991 Ap 30, C13:4

Martha Swope/"Our Country's Good"

Peter Frechette and Tracey Ellis in "Our Country's Good."

Theater in Review

■ Life, art and 'Modigliani ■ Village Light Opera revives 'Carousel' ■ Beating the clock and other scenes from the mating front.

Modigliani

Jewish Repertory Theater
344 East 14th Street

By Dennis McIntyre; directed by Bryna Wortman; sets, Scott Bradley; costumes, Barbara A. Bell; lights, Brian Nason; sound, Aural Fixation; production stage manager, D. C. Rosenberg. Presented by Jewish Repertory Theater, Ran Avni, artistic director; Edward M. Cohen, associate director. WITH: David Beach, Ronald Guttman, Daniel James, Dane Knell, Martin Rudy, Will Scheffer and Karen Sillas.

It is difficult to watch the revival of Dennis McIntyre's "Modigliani" at the Jewish Repertory Theater without thinking about the life of the playwright. Amedeo Modigliani was a classic case of a great artist unappreciated in his time, and although the specifics of his story are distant from Mr. McIntyre, there is a correlation between the two men. The playwright died last year before achieving the recognition his talent deserves.

To carry the comparison one step further, Modigliani's art is perma-

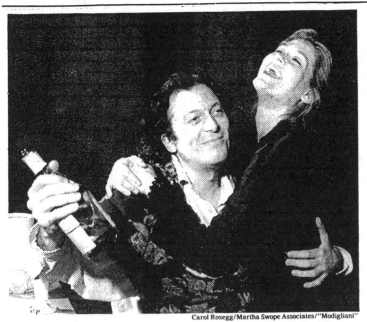

Carol Rosegg/Martha Swope Associates/"Modigliani"

Ronald Guttman and Karen Sillas in a scene from "Modigliani."

nent, but as a playwright Mr. McIntyre is subject to the variables of performance. Except for Ronald Guttman's portrayal of the title character, Bryna Wortman's production is inferior to the play's two New York productions in the late 1970's.

As we see Modigliani and his comrades in art, Maurice Utrillo and Chaim Soutine, they are facing a stone wall of disregard. In desperation, they steal food and even canvas. Modigliani, the center of this Montparnasse circle, is plunging headlong toward self-destruction. In one horrifying offstage episode, he burns a stack of his paintings outside the Louvre.

Although Mr. Guttman conveys the painter's mercurial nature as he moves from fitful elation to depression, there is an overheated quality to the staging and to most of the other performances. It is not simply a question of the accents, which, other than Mr. Guttman's, are an ocean away from Paris. The prelude depicting the artists' rambunctious night life edges into farce, and subsequent scenes are melodramatic. The most self-defeating performance is given by Karen Sillas as Modigliani's mistress and model, the English poet Beatrice Hastings. Assuming a distinctly American manner, Ms. Sillas seems to act under the delusion that the play is about her.

Only one member of the cast begins to approach Mr. Guttman's league: Martin Rudy as an art dealer who, in the play's most telling scene, is haughtily dismissive of the artist's prospects. It is he who informs Modigliani of a wounding truth: that Picasso, faced by a need for a fresh canvas, has cavalierly scraped paint from a Modigliani and painted a Picasso over it. Except for that scene and a few others, newcomers to the play will have to look past the production to find the evocative essence of "Modigliani." *MEL GUSSOW*

Carousel

Village Light Opera Group
Fashion Institute of Technology
227 West 27th Street
Through May 5

Music by Richard Rodgers; book and lyrics by Oscar Hammerstein 2d; direction and musical staging, Margaret Rose; music director and conductor, Ronald W. Noll; choreography, Bill Waldinger; scenic design, Kevin Sullivan; costumes, Jamie Weeden; lighting, Jeff Zeidman; production stage manager, Dan Rubenstein; technical director, Rick Stanley; producer, Fredda Kaufman.
WITH: Rodne Brown, Teresa Lane Hoover, James Lightstone, Kim Stengel and Mira Stunkel.

For a nonprofessional music theater organization, the Village Light Opera Group has built a considerable reputation for its lively revivals of classic musicals. The company's spirited 1988 production of "Oklahoma!," with Jamie Lightstone as Curly, showed what could done by enthusiastic nonprofessionals using minimal resources. But its revival of "Carousel," starring Mr. Lightstone as Billy Bigelow, is, sadly, not in the same class.

The story of a ne'er-do-well carnival barker in a New England mill town in the 19th century has been staged by Margaret Rose (who also directed "Oklahoma!") more as a pageant than as a musical play. The songs are rendered perfunctorily by singers who have good voices but pump little drama into Rodgers and Hammerstein's majestic score.

Most of the players in the large cast barely go though the motions of acting. The only two who bring any conviction to their roles are Mr. Lightstone, who projects Billy's anguished self-doubt reasonably well and delivers the famous "Soliloquy" with some feeling, and Mira Stunkel as his daughter, Louise, who also brings some emotion into an otherwise poorly executed dream ballet. The rest of the performances, in a production that hardly seems to have been directed at all, are at best half-finished, at worst opaque.
STEPHEN HOLDEN

Love Lemmings

The Village Gate, Upstairs
160 Bleecker Street

By Joe DiPietro; directed by Melia Bensussen; music by Eric Thoroman; lyrics by Mr. DiPietro and Mr. Thoroman. Presented by Fireball Entertainment, in association with Mark May.
WITH: Steve Ahern, Becky Borczon, John Daggett and Helen Greenberg.

Near the end of "Love Lemmings," a comedy revue that satirizes contemporary dating and mating rituals, a man and a woman meet on a particularly nasty game show called "Beat the Biological Clock." The woman is a 38-year-old professional who is desperate to find a man and have a child. The man, who still lives with his mother and earns $5,000 a year, is the quintessential creepy milquetoast.

While an emcee fires personal questions at the woman, the man controls the position of a baby doll suspended just out of her reach. As she scrambles to think up the most self-abasing possible answers to questions about her expectations of love and marriage, the man lowers the doll to within inches of her grasp. If she can catch the doll, she gets the man.

"Beat the Biological Clock" is among 20 viciously funny sketches in the revue, which has wended its way from the West Bank Cafe to Steve McGraw's Supper Club to the Village Gate, where it has arrived in an expanded and more polished form. In the show, written by Joe DiPietro and directed by Melia Bensussen, four actors portray an assortment of singles, mostly yuppie types, playing games of entrapment and evasion.

"Basic Dating" portrays a military-style training camp for unmarried people who are instilled with the slogan "Dating is hell!" and who chant to the strains of "Sound Off": "I want to own a great big house/I want to marry the perfect spouse." The goal, the drill instructor announces, is to turn the recruits into "lying, deceitful single people."

In a sketch called "Men Who Don't Call and the Women Who Wait for Them," a young man and woman who have just met are advised by friends to adopt elaborate, defensive telephone stratagems that virtually guarantee they won't reconnect. "Jacoby & Meyers" imagines a world in which lawyers are posted in a couple's bedroom threatening lawsuits if each doesn't satisfy the other's sexual needs.

The acuteness of the humor rarely flags, and the performances imbue Mr. DiPietro's dialogue with just the feeling of cartoon caricature. Helen Greenberg, who recalls Gilda Radner, is particularly impressive. Wearing an expression of someone who has just had a lemon twisted in her face, she oozes a sense of sweet-and-sour merriment.
STEPHEN HOLDEN

1991 My 1, C15:1

The Will Rogers Follies
A Life in Revue

Book by Peter Stone; music composed and arranged by Cy Coleman; lyrics by Betty Comden and Adolph Green; directed and choreographed by Tommy Tune; inspired by the words of Will and Betty Rogers; sets, Tony Walton; costumes, Willa Kim; lighting, Jules Fisher; sound, Peter Fitzgerald; projections, Wendall K. Harrington; orchestrations, Billy Byers; musical direction, Eric Stern; production stage manager, Peter von Mayrhauser; Presented by Pierre Cossette, Martin Richards, Sam Crothers, James M. Nederlander, Stewart F. Lane, Max Weitzenhoffer, in association with Japan Satellite Broadcasting Inc. At the Palace Theater, 1564 Broadway, at 47th Street.

Ziegfeld's Favorite	Cady Huffman
Will Rogers	Keith Carradine
Unicyclist	Vince Bruce
Wiley Post	Paul Ukena Jr.
Clem Rogers	Dick Latessa
Wills's Sisters and Betty's Sisters	Roxane Barlow, Maria Calabrese, Colleen Dunn, Dana Moore, Wendy Waring and Leigh Zimmerman
Betty Blake	Dee Hoty
The Wild West Show	Bonnie Brackney and Tom Brackney
Will Rogers Jr.	Rick Faugno
Mary Rogers	Tammy Minoff
James Rogers	Lance Robinson
Freddy Rogers	Gregory Scott Carter
The Roper	Vince Bruce
The Will Rogers Wranglers	John Ganun, Troy Britton Johnson, Jerry Mitchell and Jason Opsahl
The New Ziegfeld Girls	Roxane Barlow, Maria Calabrese, Ganine Derleth, Rebecca Downing, Colleen Dunn, Sally Mae Dunn, Toni Georgiana, Eileen Grace, Luba Gregus, Tonia Lynn, Dana Moore, Amiee Turner, Jillana Urbina, Wendy Waring, Christina Youngman and Leigh Zimmerman
The Voice of Mr. Ziegfeld	Gregory Peck

By FRANK RICH

Will Rogers never met a man he didn't like. Tommy Tune never met a costume he didn't like. Just how these two great but antithetical American archetypes — the humble cowboy philosopher, the top-hatted impresario of glitz — came to be roped together in a multi-million-dollar Broadway extravaganza is the real drama of "The Will Rogers Follies," the most disjointed musical of this or any other season.

When Will Rogers — in the utterly beguiling form of Keith Carradine — is at center stage in the huge mock-Ziegfeld pageant at the Palace, "The Will Rogers Follies" is a drippingly pious testimonial to a somewhat remote American legend, written in a style known to anyone who does not doze during the presentation of the Jean Hersholt Humanitarian Award on Oscar night. But when Mr. Tune gets his chance to grab the production's reins, school is out! Suddenly Will is shunted aside so the high-flying director and choreographer, who has a theatrical eye second to none, can bring on the girls, the boys, the dog tricks and a Technicolor parade of Willa Kim costumes and Tony Walton sets that not only exceed these designers' remarkable past achievements but in all likelihood top the living tableaux that Joseph Urban once concocted for Florenz Ziegfeld himself.

What the inspirational Rogers story and the blissfully campy Tune numbers are doing on the same stage is hard to explain and harder to justify, for they fight each other all evening, until finally the book wins and "The Will Rogers Follies" crashlands with a whopping thud a good half act or so before Rogers has his fatal airplane crash in Alaska. Apparently, the show's authors — the playwright Peter Stone, the composer Cy Coleman and the lyricists Betty Comden and Adolph Green — were overimpressed by the fact that Rogers was a headline performer in the "Ziegfeld Follies" of the 1920's, twirling his rope and taking humorous potshots at Congress while sharing the stage with chorines, Eddie Cantor, Fanny Brice and Ed Wynn. This slender happenstance has led them to shoehorn the Rogers biography into their synthetic "Follies" show — a revue written in the style that dazzled audiences in the days before the modern musical and "The Ed Sullivan Show" were invented.

•

The concept, which is repeatedly explained in fussy, almost deconstructivist interruptions by an invisible Ziegfeld (a taped Gregory Peck), must have sounded better at a story conference than it plays in the thea-

Angel Franco/The New York Times

Keith Carradine in the title role of "The Will Rogers Follies." On the backdrop was a portrait of the cowboy philosopher.

ter. Rogers had many talents — joke-making, newspaper writing, political punditry, public speaking, rope twirling — but he was not a musical comedy song-and-dance man. It is impossible to build a show-biz musical around a character who isn't a singer (Mr. Carradine can sing, but not in the "Follies" style) or dancer — which is presumably why the real Rogers usually shared top billing with equally celebrated singers, dancers and clowns in the Ziegfeld shows. It is also difficult to build a musical around a famous character whose private life was a bore, or seems so in Mr. Stone's retelling. For no discernible reason other than to follow the "Follies" format — which required an Act I wedding finale and torch songs — this show endlessly chronicles the courtship, marriage and mild spats between Will and his wife, Betty (Dee Hoty), whose only character trait is a whiny insistence that her husband spend less time at work and more time back at the ranch.

When dealing with the substance of Rogers's career, Mr. Stone's book is longer on exposition than humor. Hardly has Mr. Carradine arrived than he is gratuitously explaining that Will Rogers was more than a name given to the hospital that perennially passes the hat at the nation's movie theaters. Yet the ensuing attempts to rekindle Rogers's topical wisecracks are toothless, and despite a promise that Will will draw gags from today's newspaper, the evening's most persistent comic target is the fateful pilot Wiley Post. More confusingly, "The Will Rogers Follies" never decides for sure what period it wants to make jokes about. Though the Playbill says the musical is set in "the present" and though there is much tedious explanation that Rogers has risen from the dead for our amusement, the evening's only dramatic event occurs when, abruptly in mid-Act II, the legend "1931" is emblazoned on the stage, the scenery lifts away and a platoon of stagehands marches on to repossess the colorful costumes of the showgirls.

●

Is this the Twilight Zone, or what? Though the stagehands wear contem-porary jeans and T-shirts, a grim-faced Mr. Carradine enters to deliver a long radio sermon championing the poor and homeless of the Great Depression. Yet as he does so, the theater's house lights come on, as if to embarrass the present-day audience into examining its own conscience in preparation for confronting the pan-handlers lying in wait on Broadway after the final curtain.

Whatever decade we're in, the holier-than-thou tone of this lavishly expensive production's pitch for the downtrodden seems every bit as hypocritical as the similarly shameless Act II plea for Amerasian orphans in "Miss Saigon," and it goes on even longer. One fully expects ushers to pass through the aisles soliciting for the Will Rogers Hospital. And those collection bottles are not all that is conspicuously missing: This show, which so strenuously wraps itself in Will Rogers's democratic values, does not have a single black performer. The W.P.A.-style "We the People" finale that follows — in which a heavenly choir recites Rogers's famous achievements from behind slide projections of the great unwashed American masses — seems more than a little hollow in context.

●

It is a tribute to Mr. Carradine — his air of unpretentious conviction, humility, warmth and good humor — that he keeps "The Will Rogers Follies" from riding off the rails into

The musical's chorus just keeps coming at the audience.

ridiculousness in its pompous waning scenes. He doesn't really resemble Rogers, and he's at best a passable lariat twirler, but he surely captures the man's engaging spirit even when the show is making every effort to embalm it.

The evening's second bananas — Ms. Hoty, Dick Latessa (as Rogers's

dad), Cady Huffman (a leggy Zieg-feld emcee) — are all able, but their material is routine. Mr. Coleman's music, orchestrated to a brassy fare-thee-well by Billy Byers, recalls but never equals the period show-biz songs the composer wrote for "City of Angels," "Little Me" and "Barnum" (the Coleman show this one most resembles). The Comden-Green lyrics, faithful to the musical's misguided conception, are professional regurgitations of Ziegfeld-era specialties. The exceptions include a Woody Guthrie-style ecological lament sung by a guitar-strumming Mr. Carradine in Act II, and the inevitable "Never Met a Man I Didn't Like," in which Will seems to be going through the Yellow Pages to list every single such man, from politician to mortician, from Napa Valley to Shubert Alley.

There would have been more fun if the songwriters had come up with the hilarious or sardonic numbers of such other Ziegfeld-inspired latter-day musicals as "Funny Girl" and "Follies." Mr. Tune must lean for wit instead on the production's visual riches, immaculately lighted by Jules Fisher. The scenic design is extraordinary because of its cleverness, not its budget: Mr. Walton daringly builds his set around a material as humble if pertinent as rope. The props alone — rope phones, suitcases, doors — are more worthy of museum exhibition than the actual Rogers artifacts exhibited in the Palace's lobby, but even more spectacular is the vast proscenium arch that extends the Western motif into the upper reaches of the vast old two-a-day house. The bygone whimsy of a vaudeville past missing elsewhere in these "Follies" can always be found in Mr. Walton's fantasies, among them backdrops that render the totems of Rogers's career (sagebrush, Hollywood greenbacks) in iconography true to both Ziegfeld overkill and the abstract tenets of modern theatrical art.

●

Ms. Kim's costumes, which are more cognizant of Busby Berkeley and Vargas than the higher sexual consciousness of "the present," are just as breathtaking, with such minor details as the lining of a 10-gallon hat and the intricately stitched pattern of a pair of suspenders capturing the designer's full imaginative attention. In the show's first and best number ("Will-a-Mania"), the musical's chorus just keeps coming and coming at the audience over the horizon of the movable Follies staircase that dominates the set, each time with new chaps, new colors, new headdresses. Even though the heavily amplified lyrics are indecipherable, the text is anything but the point.

Not all of Mr. Tune's numbers are so thrilling, and some of them recycle his own routines from "The Best Little Whorehouse in Texas" and "A Day in Hollywood," not to mention bits of Gower Champion (a ramp procession from "Hello, Dolly!") and Bob Fosse (an ultraviolet gimmick from "Dancin' "). But this director is always a master of his particular art, which makes it all the more frustrating that, after exercising total control over every inch of "Nine" and "Grand Hotel," he seems to be hogtied for so much of this show. If "The Will Rogers Follies" could only be whittled down to the Tommy Tune Follies, grateful audiences would find a musical twice as buoyant and less than half as long.

1991 My 2, C17:1

Fata Morgana

Written and directed by Paul Zimet; music by Ellen Maddow and Harry Mann; set design, Debbie Lee Cohen; lighting, Carol Mullins; costumes, E. G. Widulski; production stage manager, Billy Love. The Talking Band presented by Theater for the New City, George Bartenieff, executive director; Crystal Field, executive artistic director. At 155 First Avenue, at 10th Street.

WITH: William Badgett, George Bartenieff, Christen Clifford, Anne Coyne, Rebecca Gomez, Brenna Humphreys, Ellen Maddow, Ian Magilton, David Mann, Harry Mann, David McIntire, Clayton Nemrow, Rosemary Quinn, Sonja Rzepski-Vanatta, Tina Shepard, Jill Tompkins and Andrew Weems.

By MEL GUSSOW

In Arthurian legend, Morgan le Fay practiced the art of mirage, placing her enemies in situations that resembled reality but were actually fantasies of her invention. In his new play, "Fata Morgana" (the Italian name for Morgan le Fay), Paul Zimet keeps the witch at bay, but her spirit haunts all that happens in this mystical voyage at sea.

"Fata Morgana" (in a newly renovated space at Theater for the New City) is itself a chimera, merging various symbolic sources — the lost isle of Atlantis as well as the novel "Ship of Fools" — as a cruise ship embarks on what is to become a final journey. Despite moments of mystery, the play does not take adequate advantage of its ominous emanations.

The work is most enticing when it focuses on the central couple, a medical scientist (George Bartenieff) and his wife (Tina Shepard), a former singer suffering from an incurable disease. Formally dressed, the two are an elegant pair trying to disregard the doom that is impinging on their holiday. In their cabin, the doctor overhears voices on an unknown frequency. His wife is given to reclining on the deck of the ship at night and gazing at the sky. In response to her dreams, a giant puppet albatross drifts over the ship and lands on the railing.

●

Unfortunately, the other characters are less interesting, and several verge on stereotype. Mr. Zimet might reconsider his passenger list and, as director, re-evaluate some of the performances. Most of the actors do not rise to the level established by Mr. Bartenieff and Ms. Shepard.

It is in the surrealistic effects that the play demonstrates possibilities — the bell that seems to ring continually for meals (breakfast is immediately followed by another breakfast); the appearance of one tourist with and without an eye patch; the nonappearance of the captain and crew, which makes one wonder who is steering the ship.

●

The show is also enhanced by brief shipboard entertainments — an inversion of a song from "South Pacific" and a scene from "Terminal," the Open Theater's play about death. Booking passage on a ship in which "Terminal" was performed, a passenger might well switch cruises in midstream. But these helpless travelers blithely continue their ill-fated expedition. It is in the final moment of this Talking Band production, as simulated waves ripple over the broad stage, that Mr. Zimet and his set designer, Debbie Lee Cohen, allow their imaginations to expand into uncharted waters.

1991 My 3, C20:4

SUNDAY VIEW/David Richards

Only the Wind Should Sigh in This 'Garden'

Ghosts do all the teaching in 'The Secret Garden.' At Radio City, Kander and Ebb bring out the brass and wide-eyed pluck in Liza Minnelli.

ALL DURING "THE SECRET GARden," the new musical at the St. James Theater, I kept trying to account for my mounting sense of claustrophobia. But it wasn't until midway through the second act that an explanation occurred to me. No one was paying the slightest attention to the weather.

If ever children's book celebrated the restorative virtues of fresh air, it is Frances Hodgson Burnett's classic of the same name, upon which this mysteriously beautiful, if almost unbearably morose enterprise is based. But where were the vivifying winds, blowing in off the moors, stirring dormant plants to life and putting a blush of color in sickly children's cheeks?

There are, I'll grant you, three thunderstorms in the course of the show, which is, frankly, two too many if you have an eye for variety. Thunderstorms, however, can be equated with the emotional turbulence in troubled souls, and the stage is certainly full of *that*. But there's no rain, for rain's nurturing sake. No warming sunshine. No crisp morning dew. When you come right down to it, the only climate this "Secret Garden" is really interested in is moral.

■

I'd even be willing to argue that the playwright Marsha Norman, who is responsible for the book and lyrics, has gone and turned Burnett's novel on its head. The original tale, if you need a quick refresher, concerns a spoiled young girl, Mary Lennox, who loses her parents to a cholera epidemic in India and is shipped back to England to be raised by a cold uncle, Archibald Craven. Initially, life at Misselthwaite Manor, his 100-room domain on the edge of the Yorkshire moors, is somber. Ever since Archibald's wife, Lily, died in childbirth, her favorite garden has run wild, the locked gate discouraging any intruders. Shut away in a wing of his own, Archibald's puny son, Colin, languishes on his "wick," as Dickon's Yorkshire dialect puts it. Nature is clearly setting an example. A rose is a rose is a teacher.

Ms. Norman, as odd a choice as one could imagine for this project, envisions it far differently. In the musical she has fashioned with the composer Lucy Simon, the director Susan H. Schulman and the set designer Heidi Landesman, nature has an incidental role. Ghosts are doing the instructing.

The show begins in India in 1906 with the cholera epidemic, although it may take you a while to figure that out since the plague is depicted symbolically. Women in ball gowns

and men in crisp military uniforms are playing drop-the-hanky. The hanky, red as blood, is death, apparently. The losers gather in the center of the circle. A mosquito net falls over them. Then a doll house — a colonial mansion in miniature — bursts into flame. Only Mary gets out of this muddle alive. But for the rest of the show, she will be dogged by phantoms.

Adding apparition to specter, Misselthwaite also turns out to be haunted. Although his wife has been dead for 10 years, Archibald (Mandy Patinkin) hasn't forgotten her. There she is, perched above the stage in an ornate picture frame, rather as if she were a Gibson girl in a swing. From then on, she drifts in and out of the premises — tracing lovely, lavender circles in the mustiness, looking in protectively on her bedridden son and singing love duets with her grieving husband.

What seems to concern Ms. Norman more than the children's bond with nature is their relationship to the grown-ups, some living and remote, others dead and benevolent. In her harrowing drama, " 'Night, Mother," she showed us a mother unable to prevent her daughter from committing suicide. This time, among other acts of supernaturalism, she wants to show us a deceased mother urging her ailing son to embrace life. A mystical spin has been put on matters, and for anyone not familiar with Burnett's narrative, I suspect the intermingling of here and hereafter may prove confusing. Ms. Norman's is not a joyful temperament, and she ends up convoluting a simple story, without necessarily improving upon it.

A large part of the book's lasting appeal is that it recognizes a child's desire for a sanctuary, safe from the prying eyes of adults. Not the musical. It takes Mary all of Act I to find the door to the garden and crack it open, letting in a flood of celestial light. At the beginning of Act II, she dreams of holding a party in its confines, attended by everyone she knows or once knew. The all-white vision — "Sunday in the Park With George" minus the colored dots — is eerily elegant, but still nothing you'd call a garden.

Bob Marshak/"The Secret Garden"

Nature's children—from left, Peter Marinos, Daisy Eagan, Alison Fraser, John Babcock, John Cameron Mitchell and, rear, Rebecca Luker in "The Secret Garden".

Mary and Dickon don't get down to the hard, redemptive work of pruning and

mulching until the second act is half over. And even then the chores are symbolically undertaken in "Come Spirit, Come Charm," a druidic-like incantation accompanied by sinuous Indian dance movements. This isn't cultivation, it's conjuration.

Ms. Simon's score, when it forsakes the echoes of Ancient India, devotes itself to the sounds of Olde England — madrigals, jigs, rounds, folk songs and the like. None of this is jarring to the ear, but it is not particularly beguiling. Its cool temperature, however, is right in keeping with the show as a whole. For fear of succumbing to mawkishness, the creators have made "The Secret Garden" nearly emotion-free.

■

Mr. Patinkin is the most fervid of performers — that tenor voice can quiver like a grove of aspens — but it is his fate in "The Secret Garden" to flee all human contact. As Lily, Rebecca Luker extends comforting arms and beckons enticingly, but she's a ghost, after all, and it's her misfortune to keep melting away. Robert Westenberg, as the in-house doctor, delivers dire ultimatums sternly. While the servants could be expected to add a more playful note, only Alison Fraser, as a spunky chambermaid, evinces much earthiness.

With Daisy Eagan, the show has just the right Mary — cute, but not button-cute; knowing, but not calculating. Sitting Sunday-school straight, her mouth drawn in a tight line, she really does seem to be a willful little girl with a mind of her own and not just a Broadway trouper following a stage mother's directives. In a musical largely concerned with the secrets children keep, though, there are precious few scenes for the children themselves. The heroine's critical relationship with Dickon (the oddly elfin John Cameron Mitchell) is brushed over lightly. Mary manages at one point to put hysterical Colin (John Babcock) in his place, but that friendship is given no chance to evolve either and is simply presented as a fait accompli. I should imagine theatergoers under 12 would feel particularly shortchanged.

The topsy-turviness is endemic. Whatever's dark and repressed in the fable is invariably favored over all that is bright and open. Ms. Landesman's designs, extraordinary as they are, also contribute to the feeling of dislocation. The stage of the St. James has been remade to resemble that of an ornate 19th-century toy theater, while the surrealistic sets themselves often bring to mind those boxes in which the artist Joseph Cornell tucked away butterfly wings, postage stamps, cigar bands and old photographs. A baby's face, big as a billboard, sometimes gazes down on the action, as if it were no more than a bubble in a naptime dream.

■

For most of the evening, the garden is represented by four huge interlocking pieces of topiary — a dove, a peacock, a swan and an owl — that could be ice sculptures for a giant's

punch bowl. The sight of trees and flowers in their full summer finery is reserved for the finale, when curtain upon curtain of lacy pastel blossoms is dropped into place. The image is as pretty as a Victorian valentine and as airless as a Portobello antiques shop. (You'd catch your breath, were there any breath around to be caught.)

As a result, "The Secret Garden" is unlikely to instill in anyone a heightened awareness of the great salutary outdoors. But I wouldn't be surprised if you came away from it, as I did, with a compelling need to throw open a few windows — which is not at all the same thing.

'Liza: Stepping Out At Radio City'

I learned one lesson at "Liza: Stepping Out at Radio City," the concert-cum-stage show that Liza Minnelli is performing at Radio City Music Hall. If you're looking for a song to fill up that cavernous auditorium, one by Fred Ebb and John Kander is probably your best bet. Since Kander and Ebb are also doing quite well filling up the small Westside Theater, Off Broadway, with the retrospective revue "And the World Goes 'Round," it is possible they are a songwriting team for all halls.

But back to Ms. Minnelli, who certainly appears out of her element warbling the black-and-blue chansons of Charles Aznavour or pumping up Stephen Sondheim's ballad "Losing

My Mind" into a piston-driven dance number. She's on much surer ground ripping ferociously through "Some People" from "Gypsy." (The next revival really should be hers, guys.) Kander and Ebb, however, bring out the best in her — the brass and the wide-eyed pluck. "New York, New York" needs no endorsement at this stage of the game, but even "Sara Lee," that silly tribute to the queen of calories, lends itself nicely to Ms. Minnelli's brand of strutting. Since "Stepping Out," the title number of her forthcoming film, falls squarely in the tradition of Kander and Ebb songs exhorting stay-at-homes to paint the town, it also has her name stamped all over it.

"Stepping Out" actually receives two hearings — as a first-act solo, then as a second-act production number, in which the star is joined by what she calls her "demon divas," a dozen women of assorted sizes,

> ### 'I got my drive from my mother, but I got my dreams from my father.'

shapes and ages. The chorus line made up of disparate types can be

Jack Vartoogian for The New York Times

Ms. Minnelli—exhorting stay-at-homes to paint the town

good fun for a while, but the "demon divas" are wildly overused. They're fine in the medley of songs about men ("Stouthearted Men," "Some Day My Prince Will Come," "Hit the Road, Jack," etc.) that they share with Ms. Minnelli. But they don't have the bodies to do angular justice to the show's tribute to Bob Fosse — a marriage of "Pack Up Your Troubles" and "It's a Long Way to Tipperary." And having them pound out jungle rhythms on oversize toy drums is high-precision drill work in its most rudimentary form.

In a quieter vein, Ms. Minnelli recounts some memories of her father, Vincente Minnelli, who in the early 1930's was the Music Hall's art director, before going to Hollywood. "I got my drive from my mother, but I got my dreams from my father," she says. Judging from the photographs projected on the large screen behind her, she also got his expressive hands. The trip through the family album is touching. Too much of the time, however, "Liza: Stepping Out at Radio City" doesn't seem to know what direction to take and leaves its eager star, covered with bright lights, stabbing bravely in the dark. □

1991 My 5, II:5:1

The Old Boy

By A. R. Gurney; directed by John Rubinstein; set design by Nancy Winters; costume design by Jane Greenwood; lighting design by Nancy Schertler; sound design by Bruce Ellman; production stage manager, Michael Pule. Presented by Playwrights Horizons, André Bishop, artistic director; Paul S. Daniels, executive director. At 416 West 42d Street.

Dexter .. Richard Woods
Bud ... Clark Gregg
Sam ... Stephen Collins
Harriet .. Nan Martin
Perry .. Matt McGrath
Alison ... Lizbeth Mackay

By FRANK RICH

The title of A. R. Gurney's entertaining new play at the Playwrights Horizons Studio Theater, "The Old Boy," could also serve as the title of such past Gurney comedies as "The Dining Room," "The Cocktail Hour" and "Love Letters." In this prolific writer's accounts of the upper-middle-class precincts of Northeastern WASP-dom, the men are almost always boys who have not grown up and do not really have to. Fortified by privilege and gin, they sail through life via the old-boy network that assures them entry to the right schools, the right clubs, the right firms.

Like Philip Barry and John Cheever before him, Mr. Gurney knows that his old boys pay a price for their eternal juvenility. A typical Gurney protagonist reaches middle age to discover that he has alienated his children, married the wrong woman and followed a pointless career. Sam (Stephen Collins), the sometime Congressman and ambassador at the center of "The Old Boy," is no exception. When this distinguished alumnus returns to his old prep school to give a fund-raising speech, he finds himself feeling "a little hollow." Sam may be on his way to the governorship of "a very important state," but his second marriage is faltering and his political profile amounts to nothing more than the résumé of Wash-

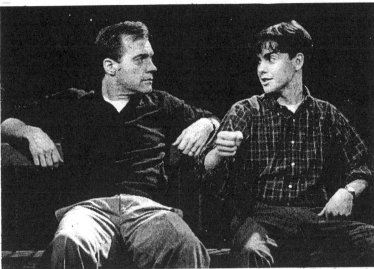

Stephen Collins, left, and Matt McGrath in "The Old Boy."

Joan Marcus/"The Old Boy"

ington jobs he has accumulated "mostly by luck and pull."

Were "The Old Boy" simply the story of its title character's mid-life crisis, it would be hard to take. Sam is every bit as hollow as he says he is — a mechanical womanizer, a lockjawed glad-hander, an empty Brooks Brothers suit. But Mr. Gurney has expanded his canvas, if not his social milieu, in this play. He asks the audience to care less about aging old boys and more about those less privileged souls who are denied admission to the fraternity. While Sam is the evening's largest role and dramatic fulcrum, the most compelling scenes belong to Perry (Matt McGrath), a homosexual who had been a schoolmate of Sam's, and Alison (Lizbeth Mackay), a woman who had loved Sam back then but had been manipulated by him into marrying the closeted, desperate-to-conform Perry.

Perry has died in mysterious circumstances when Mr. Gurney's play opens, and his student friendship with Sam in the early 1960's is revisited in flashbacks that sometimes recall "Tea and Sympathy." These scenes are unabashedly written from the perspective of a guilt-ridden heterosexual: Perry stands for all that is selfless, sensitive and artistic in civilization — he acts Viola in a school production of "Twelfth Night" and listens constantly to "La Forza del Destino" — while Sam is a selfish, vaguely bigoted jock incapable of love.

But if the distinctions Mr. Gurney draws between his hetero- and homosexual post-adolescents are mainly well-meaning clichés, his portrayal of homophobia is fresh and savage. The climactic battle between the boys is as powerful as anything this playwright has written — an explosion of truthful confession, violent rage and repressed erotic longings that brings Sam and Perry to the brink of a new understanding before they must retreat sadly back into the oppressive status quo.

It is in the present that Sam must confront the widowed Alison, who, along with Perry's aged mother (Nan Martin), is also visiting the school during the weekend of his speech. In another affecting scene, acted with bristling conviction by Ms. Mackay, Alison describes not only her love-hate relationship with her gay husband but also her far more bitter resentment of Sam and his heterosex-

ual ruling elite, whom she indicts for pushing her and Perry into unhappiness and, for thematic good measure, for forcing America into Vietnam. Mr. Gurney, a writer who has often emulated his psychologically blocked characters by minimizing front-and-center confrontations in his plays, makes a welcome breakthrough in the big blowouts of "The Old Boy." After "Love Letters," a play designed to keep its crucial emotional encounters discreetly off stage, one was beginning to fear that he was becoming an insufferably genteel old boy himself.

Even so, "The Old Boy" is not as deeply moving as it should be, because there are other glib writing habits Mr. Gurney has not broken. Unwilling to make an audience work even a little, he insists on having his characters announce every present or future change of heart directly at all times. (Not once but twice is it said that the truth shall set Sam free.) The mysteries of human nature that give life its real drama are missing here, replaced instead by breathlessly presented yet unbelievable plot twists involving the political ruin Sam supposedly risks by speaking at a moneyed private school in the post-crash 1990's and by publicly championing the rights of gay AIDS victims. From the opening scenes in which characters exchange information they already know to spoon-feed it to the audience to a denouement that brings Sam's and Alison's lives full circle, "The Old Boy" has the artificial shape of a boulevard play.

Much as one wishes that Mr. Gurney took more chances, there is no denying the sharpness of his wit (which reaches its peak here in a theological discourse on the difference between tennis and golf) and his increasing mastery of his craft. The alternation between past and present in "The Old Boy" is graceful, and that fluidity is matched by John Rubinstein's impeccable staging. With the assistance of Jane Greenwood's precise costumes and Nancy Schertler's leafy, memory-shaded lighting, the director keeps two distinct eras of prep school history in constant dialogue.

Mr. Rubinstein has also elicited fine performances from his cast, including Clark Gregg, as Sam's ambitious young aide de camp, and Richard Woods, as an obsequious, conspicuously unmarried school elder who

exemplifies the old order even as he seems to have been a victim of its prejudices. Ms. Mackay and Mr. McGrath scrupulously refuse to sentimentalize the ill-fated Alison and Perry while Mr. Collins is just as rigorous in capturing Sam's cold, thoughtless personality as both boy and adult. As Perry's domineering, fabulously wealthy mother, a sort of Nancy Reagan with a pedigree, the superb Miss Martin is at once a ruthless enforcer of what she calls "traditional values" and a pathetic, helpless victim of their erosion. The sole old woman and the least predictable character in "The Old Boy," she surely merits a chapter of her own in Mr. Gurney's continuing saga of the WASP's decline and fall.

1991 My 6, C11:4

Theater in Review

■ 'When the Bough Breaks,' parents of drug addicts ■ 'Pageant,' big-boned contestants ■ 'Moe Green,' gangsters and 'The Godfather.'

When the Bough Breaks

La Mama E.T.C.
74A East Fourth Street

Conceived and directed by Lawrence Sacharow; text by Darrah Cloud; music by Carman Moore; setting by John Brown; lighting by Howard Thies. Presented by La MaMa E.T.C., in association with Daytop Family Association, Etan Merrick and River Arts.
WITH: Arlene Chadnow, Judy DiMenna, Peter Fontes, Roseann Lattarulo, Lurline Martineau, Florence Rader, Elizabeth Waslin and Anita Weinstein.

In "The Concept," recovering drug addicts from Daytop Village revealed their harrowing personal stories. In "When the Bough Breaks," parents of addicts search for causes as well as possible solutions to the problems of their offspring. As with the earlier piece, the roles in the sequel are played by people who lived through the original or related experiences.

Because of the personalization, it is impossible not to be touched by these memories as the characters lead us through the often contradictory impulses in broken family lives. They explore steps not taken in a disregard of urgent warning signals. With justification, both Daytop plays draw an empathetic response from the audience, particularly from people who may have faced similar difficulties. "When the Bough Breaks" (at La Mama) has value as a concerned act of community service, but a distinction must be made between the two plays.

"The Concept," evolving in the late 1960's during a time of encounter groups, was unsettling in its time. Because of its dramatic cogency, it proved to be no less valid in 1986 when the play was revised and revived. "When the Bough Breaks" is less fully realized as a work of theater, both in the writing and in the performances.

As adapted by Darrah Cloud from true stories, the play is a patchwork of alternating and interrupted monologues. It lacks a give and take between characters and between the actors and the audience. An opening sequence in which parents talk about their own earlier lives is overly familiar. Although Lawrence Sacharow, who conceived and directed both plays, smooths over the transitions (with the help of Carman Moore's music and changes in lighting), he is

unable to conceal the performance inexperience of the cast.

"When the Bough Breaks" gains a relevance when it is approached in context with "The Concept." Having learned about the desperation of the addicts, we now watch their parents trying to open lines of communication to their children and to their own feelings. Guilt fills the air along with a continuing hopefulness. As one parent says, "Nothing bad lasts forever." Onstage, they face uncertainty together. *MEL GUSSOW*

Pageant

Blue Angel
323 West 44th

Books and lyrics by Bill Russell and Frank Kelly; music by Albert Evans; conceived, directed and choreographed by Robert Longbottom; set design, Daniel Ettinger; costume design, Gregg Barnes; lighting design, Timothy Hunter; hair design, Lazaro Arencibia; orchestrations, musical arrangements and musical supervision by James Raitt; musical direction, Mr. Raitt; co-choreographer, Tony Parise. Presented by Jonathan Scharer.
WITH: Randl Ash, J. T. Cromwell, David Drake, Russell Garrett, Joe Joyce, John Salvatore and Dick Scanlan.

There has never been a beauty contest quite like the Miss Glamouresse competition, a fake television special being held nightly at the Blue Angel under the title "Pageant." At each performance, a panel of judges selected from the audience chooses between the same six finalists who compete in the traditional categories and hawk such Glamouresse beauty products as Smooth-as-Marble Facial Spackle and a nutritious lipstick called Lip Snack that comes in 27 shades and flavors.

When Frankie Cavalier (J. T. Cromwell), the ceremony's leathery-faced answer to Bert Parks, introduces the contestants, he lauds them for being "each and every one a natural-born female." They are not, of course. Amusingly costumed as parodies of regional stereotypes, Miss Texas (Russell Garrett), Miss Great Plains (Dick Scanlan), Miss Deep South (David Drake), Miss Industrial Northeast (Joe Joyce), Miss West Coast (John Salvatore) and Miss Bible Belt (Randl Ash) are drag performers who gleefully caricature the smiles, swivels and teary-eyed nonsense of it all.

Scott Humbert/Pageant

At each performance of "Pageant," a panel of judges from the audience chooses the winner of the Miss Glamouresse competition. From left, Randal Ash, Russell Garret, and Dick Scanlan in a scene from the musical, which is playing nightly at the Blue Angel.

For her talent segment, Miss Texas, whose name is Kitty-Bob Ames, delivers a screamingly funny dramatic recitation called "I Am the Land," which begins portentously with the lines, "I am a handful of dirt," and goes downhill from there. Karma Quinn, the new-age-fixated Miss California, lurches through an interpretive dance called "The Seven Ages of Me."

Ruth Anne Ruth, Miss Bible Belt, sings a money-obsessed country-gospel song, "Banking on Jesus," which declares, "My wealth earns interest that's eternal." Miss Industrial Northeast, Consuela Manuela Raffela Lopez, clomps around on roller skates while playing "The Beer Barrel Polka" on accordion.

"Pageant," which was conceived, directed and choreographed by Robert Longbottom and written by Bill Russell and Frank Kelly, belongs to the same camp genre as the popular musical revue "Forever Plaid," a tongue-in-cheek tribute to squeaky-clean male pop groups of the 1950's. Although its style is broader than "Forever Plaid," "Pageant" also celebrates and ridicules kitsch American culture with the same sense of enjoyment.

It is also one drag show that is not at all misogynistic. The contestants are portrayed as a lovable bunch of big-boned gals. It is the ritual itself, which forces the contestants to behave like obsequious wind-up toys, that is under hilarious attack. Indeed, the roles could have been played by women. Having them played by men, however, carries the whole charade to another level of zaniness.

STEPHEN HOLDEN

Moe Green Gets It in the Eye

*RAPP Arts Center
220 East Fourth Street.
Through May 26*

Written by Anthony DiMurro; directed by R. Jeffrey Cohen; production design by Alexis Siroc; lighting design by Jim Kellough. Presented by the RAPP Performance Institute/RAPP Theater Company.
WITH: John Bakos, Mr. DiMurro, Vinnie Edghill, Darian Sartain and Howard Wesson.

Toward the end of Francis Ford Coppola's film "The Godfather," Michael Corleone settles some old scores. While Michael is standing as godfather at the baptism of his infant nephew, his gunmen are busy eliminating several rival Mafia chieftains and just about anybody else who may have crossed the Corleone family in recent years. One of these victims is a Las Vegas hood named Moe Green, who is shot through the right eye while on a massage table.

All of that is by way of explaining the title and an opening vignette in "Moe Green Gets It in the Eye," a new play by Anthony DiMurro being presented by the RAPP Theater Company. Nothing else in this extremely slight play has to do with Moe Green, Michael Corleone or "The Godfather," Parts I, II or III, although the playwright seems almost obsessed with Mario Puzo's novel and Mr. Coppola's three films based on it. Mr. DiMurro's characters discuss "The Godfather" at the start and one of the movie's most famous lines (having to do with refusing unattractive business offers) is repeated in both acts.

What little action there is in the play centers on the head of a small-time numbers racket and his two nephews, one of whom reads Screw magazine and the other Sophocles. Not much happens. Since the play is about a criminal family, one assumes that somebody is going to get killed, and the only suspense comes in wondering who will be rubbed out. For comic relief, there is a running recitation of gangsters' humorous nicknames.

The playwright is clearly fascinated by the mob, and despite a program note condemning society's romanticization of mafiosi, his play romanticizes them, depicting a two-bit neighborhood don as a sensitive and sentimental old man filled with remorse for the awful things he must do. If there is a moral, it is that hit men should not look in the wallets of their victims.

"Moe Green" is Mr. DiMurro's first play, and he is not without talent as a writer. He should be advised for future work, however, that long anecdotal reminiscences do not in themselves constitute a plot or even create a character, and that boring arguments about whether to eat a sandwich or ask a girl for a date do not generate conflict or even pass for dialogue.

Darian Sartain as the elder nephew is the best of a pedestrian cast, delivering a credible angry young thug on the way up. Howard Wesson is passable as the local capo. R. Jeffrey Cohen directed.

WILBORN HAMPTON

1991 My 8, C12:3

The Resistible Rise of Arturo Ui

By Bertolt Brecht; directed by Carey Perloff; translated by Ralph Manheim; scenic design, Douglas Stein; costume design, Donna Zakowska; lighting design, Stephen Strawbridge; composer, David Lang; sound design, Daniel Moses Schreier; production stage manager, Richard Hester; music director, Catherine Reid; fight director, Jason Kuschner. Presented by CSC Repertory, Ms. Perloff, artistic director; Patricia Taylor, managing director. At 136 East 13th Street.

Flake and Defense Counsel	Larry Joshua
Butler, Judge and Pastor's Voice	
	Michael McCormick
Mulberry, O'Casey and Hook	Miguel Perez
Caruther, Greenwool and Goodwill	
	Keith R. Smith
Clark, Actor and Fish	Richard Ziman
Sheet, Gaffles, Prosecutor and Dullfeet	
	Ron Faber
Dogsborough	Sam Gray
Young Dogsborough,	Ted Ragg and
Inna	Nicholas Turturro
Bowl	Michael Reilly
Arturo Ui	John Turturro
Ernesto Roma	Olek Krupa
Dockdaisy, Wounded Woman and Betty	
Dullfeet	Katherine Borowitz
Emanuele Giri	Zach Grenier
Butler	Michael R. Wilson
Giuseppe Givola	David Patrick Kelly
Court Physician	Tom Delling

By MEL GUSSOW

Carey Perloff's production of "The Resistible Rise of Arturo Ui" is an opportunity to encounter Bertolt Brecht in his most virulent, polemical mood and to see the actor John Turturro venture away from the contemporary tales of urban violence with which he has won his reputation. In several respects, "Arturo Ui" is a challenge. The fact that it is less than a success is attributable to the play as well as to the revival at the CSC Repertory Theater.

Of all Brecht's works, this is one of the most problematic. Dramatically, it is outclassed by plays like "The Caucasian Chalk Circle" and "Mother Courage," which, for good reason, are performed with greater frequency. Written in 1940 after the author had fled from Berlin to Finland, "Arturo Ui" was conceived in rage as a mordant parable about the still-rising Hitler. The play was not performed until 1958, after Brecht's death. The last previous New York presentation was on Broadway in 1963, in a production starring Christopher Plummer. The CSC is offering the New York premiere of Ralph Manheim's translation.

•

Following Brecht's guidelines, Ms. Perloff has approached the play not as a parody, but as a three-dimensional work with cartoon implications. In contrast to Mr. Plummer's flamboyant version, Mr. Turturro and his colleagues do not attempt direct impersonations of Hitler and his henchmen, or even recognizable gangster prototypes.

The result is an intelligent, low-key production of a savage comedy, one that unintentionally illuminates the play's flaws. In "Arturo Ui," Brecht seems obsessively concerned with the details of his parable — to the diminution of the horrors of Nazism. For example, Hitler's anti-Semitism is not confronted. Comic at moments, but also portentous, the play adheres to the story of a gangland uprising among members of the so-called Cauliflower Trust in Chicago. At the CSC, everything is staged on a floor filled with sawdust, which gives the play the aura of a barroom rather than that of a music hall.

Mr. Turturro, who is known for his emotional and physical intensity in movies as well as on stage, plays Arturo with surprising restraint, an approach that acts as a double-edged sword. He makes him a Wozzeck-like figure, an ordinary man who is manipulated by his followers and caught up in the craze of his time. Though the choice to play down Arturo's mania is supportable in the text, it vitiates the chance for clowning, as in Chaplin's film "The Great Dictator."

The realistic manner helps Mr. Turturro in his delivery of the prologue and in his transition from dupe to dictator. He is amusing in the scene in which an actor is hired to teach Arturo stage presence and projection. Marching across the stage in imitation of the actor's histrionics, he transforms himself as we watch him. Eventually, he is goosestepping. More scenes like this would have enlivened the play.

•

Several in the supporting cast offer their own incisive portraits, most notably David Patrick Kelly as the character who stands in for Goebbels and Zach Grenier as a version of Göring. In Mr. Kelly's case, the actor is also adept at delivering David Lang's Weill-tinged songs, which appear intermittently. On the other hand, Olek Krupa muffles the menace of the character patterned after Ernst Roehm.

"Arturo Ui" is a long play, which may be one reason Brecht asked that it be performed "at top speed." Disregarding that suggestion, the revival is slow, especially in the second half when the performance falls into a holding pattern before gathering itself for the climax. Despite serious reservations, the CSC is to be acknowledged for allowing audiences to see what Brecht had in mind when he mocked his country's evil.

1991 My 9, C15:1

The Stick Wife

By Darrah Cloud; directed by David Warren; scenery by James Youmans; costumes by David C. Woolard; lighting by Donald Holder; sound by John Kilgore; fight director, J. Allen Suddeth; production stage manager, Christine Michael. Presented by Manhattan Theater Club, Lynne Meadow, artistic director; Barry Grove, managing director. At City Center Stage 2, 131 West 55th Street.

Jessie Bliss	Lindsay Crouse
Ed Bliss	Murphy Guyer
Marguerite Pullet	Julie White
Big Albert Connor	Lanny Flaherty
Betty Connor	Margo Martindale
Tom Pullet	Michael Countryman

By FRANK RICH

Although it surely was not her intention, Darrah Cloud has brought off the bizarre feat of writing a politically correct play about the 1963 bomb-

Gerry Goodstein/Manhattan Theater Club

Lindsay Crouse

ing of a black church in Birmingham, Ala., that all but ignores the bombing's victims. The play is titled "The Stick Wife," and rather than concern itself with the casualties of racism, it pleads what the author seems to feel is the now more timely cause of the Ku Klux Klan's oppressed wives. They, too, have a cross to bear.

"The Stick Wife" arrives at the Manhattan Theater Club Stage II after previous productions at several other nonprofit theater companies, none of them anywhere near the South. The setting is the hard-scrabble backyard of a poor white trash household, designed (by James Youmans) to uphold a sophisticated New York audience's prejudices about how the other, unwashed half lives in Dixie. In this tacky arena, Ms. Cloud delineates the pathetic life of Jessie Bliss (Lindsay Crouse), who ekes out a drab, terrified existence in the shadow of a bullying husband who destroys her self-esteem by day and spends most nights away from home dressed up in a sheet.

The playwright's point — that racist men are also sexist — is as indisputable as it is obvious. But where is the drama? The Klansmen in "The Stick Wife" are the standard snarling cretins, while their fundamentally decent, if low-rent, wives are stereotypes of a more sentimental (and recent) sort. There is a single funny speech — in which one of Jessie's friends, played by Julie White, joyously imagines her display of grief when the day comes for her despised husband's funeral — but otherwise there are none of the novel insights or even reportorial observations with which writers like Beth Henley and

Horton Foote, among many others, revitalize and humanize the usual Southern suspects.

Worse, by retroactively and rigidly imposing an anachronistic feminist agenda on one of the tragic racial cataclysms of the 1960's, Ms. Cloud ends up trivializing two political movements in one play. The punishment the Klan wives suffer at their husbands' hands — verbal and physical abuse, domestic drudgery bordering on servitude — is so didactically presented that it seems like theoretical boilerplate. The graver injuries that the same male villains inflict on their black victims — murder, for instance — are given second-class dramatic treatment to the point where they become remote abstractions. Right as Ms. Cloud no doubt is about the martyrdom of Klan wives, she does her cause no service by failing to see these women's suffering in any kind of psychological depth or historical perspective.

•

The heavy-handed director, David Warren, has not done the playwright any favors, either, by staging "The Stick Wife" in a naturalistic manner that seems more appropriate to "Tobacco Road" or perhaps "Steel Magnolias." For better or worse, Ms. Cloud has written a stylized work that includes fantasized soliloquies about Hollywood fame for its heroine and that is pockmarked, if only to jolt an audience awake, by such apocalyptic visions as the inexplicable slammings of doors and windows and the mysterious profusion of symbolic blood-red dresses on a clothesline. In Mr. Warren's staging, "The Stick Wife" veers ludicrously between travesties of the styles of Carson McCullers and Stephen King.

Ms. Crouse, a good actress back on the New York stage after a long absence, is asked to sob her way through her role, which she does admirably, reaching her grandest outpouring when Ms. Cloud throws in the bulletin of John F. Kennedy's assassination to bolster the final curtain. With the exception of Ms. White's performance, the rest of the acting is predictable, but no more so than the writing. Like "Black Eagles," the becalmed drama about black World War II pilots on the Manhattan Theater Club's main stage, "The Stick Wife" suggests that this otherwise rigorous theatrical company feels that the somber history of American racial conflict can somehow dignify the inferior plays it is dumping on the audience at the end of the season.

1991 My 10, C4:3

SUNDAY VIEW/David Richards

The Tall Truths of a Yarn Spinner

AFTER ALL THE BAD BLOOD stirred up on Broadway by "Miss Saigon," along comes "The Will Rogers Follies" to make things better again. More than better. A-O.K. Jim dandy. Preceded by no weekly updates on the advance ticket sales, no protests over its

Angel Franco/The New York Times

Mr. Carradine in "The Will Rogers Follies"—
This is the musical audiences were really waiting for.

casting, no now-it's-off-now-it's-on-again bulletins, it opened recently at the newly minted Palace Theater with next to no fanfare, unless you regard the 35-foot cowgirls above the marquee to be fanfare. But you can bet a lot of people are going to be talking about it from here on in. This, I suspect, is the musical audiences were really waiting for, all the time the paid drumbeaters told them they were waiting for "Miss Saigon."

It boasts sumptuous production numbers, exquisite chorus girls, phosphorescent rope tricks in black light, a dog act, songs you actually want to hum, a stairway to paradise (or somewhere thereabouts), close harmony, shapely legs in kaleidoscopic patterns, and a thoroughly engaging star performance by Keith Carradine, as the laconic cowboy-philosopher from Oklahoma.

You do not come away from so much abundance, however, feeling satiated. Astutely built into the extravaganza by its incessantly inventive director-choreographer, Tommy Tune, is a heartfelt acknowledgment of the hard times the country happens to be currently experiencing. Without being maudlin, "The Will Rogers Follies" says we'll get through. Without being jingoistic, it says Americans usually do.

Probably the most widely known advocate of common sense since Tom Paine, Rogers was a vaudeville performer, radio personality, newspaper columnist and motion picture star before his untimely death

in an airplane crash in 1935. During the 1920's, he was also one of the regular headliners in the Follies, Florenz Ziegfeld's yearly endorsement of conspicuous consumption and the female anatomy. Hence the basic idea behind the show. Why not make Rogers's own story the stuff of a

In 'Will Rogers,' Keith Carradine plays America's conscience with the sparkle of Tommy Tune's stardust.

Ziegfeld production? Rogers could offer running commentary about himself and the passing scene, as he did in his day. The lavish numbers, presumably, could be used to illustrate some of the life's highlights. By subtitling the whole affair "A Life in Revue" — as indeed the show's creators have done — you could even underline the connection beforehand and get a pun out of it.

All right, the premise is not foolproof. It is even seriously flawed. Whose existence naturally lends itself to the mindless glitter Ziegfeld splashed across the stage? Before his death, Liberace was already his own Ziegfeld revue, and Zsa Zsa Gabor, alas, seriously jeopardized her prospects by slapping the police. The fit is just not going to be all that exact, whoever the subject may be. That is probably why the book writer Peter Stone has the voice of

Ziegfeld (played by the voice of Gregory Peck) intervene periodically to make sure that his time-honored theatrical tenets are being enforced, and to hell with what really happened.

When the moment comes for Rogers to meet his future wife, Betty (Dee Hoty, all fresh, warm and wonderful), Ziegfeld rejects the Oklahoma setting where the meeting actually took place and insists, instead, that it unfold "on the moon." Accordingly, the set designer Tony Walton provides a silvery vision of the planets in a sky of midnight blue, and the costumer Willa Kim drapes Ms. Hoty in moonbeam white. (Erté surely would have turned green.) Still, the transposition is forced — beyond silly. "You're so down to . . . moon," stammers Betty, struggling to make the necessary adjustment, while she's gazing adoringly into the eyes of her ingenuous beau. Not very clever, that.

And let's face it, an animal act is an animal act. The six canines billed as Brackney's Madcap Mutts (five daredevils, one showoff) are incontestably the best thing I've ever seen on 24 legs. The show manages to work them in under the banner of the St. Louis World's Fair of 1904, at which Rogers proposes to his future wife. But we're still facing the same problem — one man's biography butting up against another man's format.

If Mr. Tune were not the extraordinary showman he is, and Mr. Carradine were a less affable presence, "The Will Rogers Follies" would probably crack right up the middle. But the union holds. In the second act, it flourishes.

Consider, by way of proof, "Favorite Son," the production number that serves to commemorate Rogers's entrance into Presidential politics in 1928 — on the not altogether serious "anti-bunk" ticket. To a razzle-dazzle campaign ditty by the composer Cy Coleman,

Angel Franco/The New York Times

Keith Carradine and the Ziegfeld girls—shapely legs in kaleidoscopic patterns, rope tricks, a dog act, songs you actually want to hum and even a stairway to paradise.

Mr. Tune has devised an ingenious routine for 16 seated chorus girls, who clap their hands, pat their thighs, cross and uncross their legs in crisp patterns that suggest the child's game of pat-a-cake raised to the power of about 20 or so.

The precision is enough to boggle anyone who ever had trouble rubbing his stomach and patting his head at the same time. There, however, dead center in the red-white-and-blue line, grinning like the cat that ate the cream and wouldn't mind seconds, is Mr. Carradine. He's clapping, patting, crossing and uncrossing with the best of them, but there's no sign on his blissful face that any of this is costing him the slightest effort. The more complicated Mr. Tune makes the routine, the easier it seems to be for Mr. Carradine to follow along. The rivalry is certainly good-natured, if you can even call it rivalry. But it's also clearly responsible for the spring in the number.

■

Whatever its claims, "The Will Rogers Follies" does not find its drama in the events of Rogers's life, although the one-eyed aviator Wiley Post, seated in a box, is on hand to call out periodically, "Let's go flying, Will," and remind us of the inevitable ending. Rogers's private existence has been largely boiled down to two running misunderstandings — one with his father (Dick Latessa), who disapproves of his son's choice of show business as a career; the other with his wife, who has no quibbles with show business, but wishes her husband devoted less time to it.

The show's real drama has far more to do with the pairing of two diametrically opposed temperaments — Mr. Tune, exuberant, excitable, always on the lookout for a way to top himself; Mr. Carradine, sly, unflappable, looking just as keenly for a way to undercut himself. Mr. Tune takes the show up. Mr. Carradine takes it down. The one's incipient giddiness is chastened by the other's tongue-in-cheek wryness, just as the wryness is sharpened, vitalized, by the enveloping high spirits. The relationship is not only mutually beneficial, but it lends a continuing dynamic to what otherwise might be just a sequence of numbers hitched to the passing years.

The evening's most opulent indulgence, "Presents for Mrs. Rogers," is, in fact, abruptly stopped in its spangled tracks to make place for Rogers's plainest speaking. In a tribute to rare jewels, the Ziegfeld girls, each spectacularly costumed to represent a

different gem, have been parading majestically down the staircase. And the staircase, not to be thought disobliging, has been regularly changing its color — red, when rubies are being saluted; blue for the onslaught of sapphires; green for the wave of emeralds. Then, the Depression strikes.

Without being maudlin, 'The Will Rogers Follies' says Americans will get through hard times, they usually do.

The lighting designer Jules Fisher pulls the plug on the bright lights, stagehands dismantle the set, and wardrobe mistresses rush on to reclaim the elegant costumes, forcing the stunned chorus girls to wrap themselves in gray sheets. Cady Huffman, Ziegfeld's favorite, gazes out into the hall, hoping for a reassuring word from her protector. But the panache has gone out of her strut, and Ziegfeld is noticeably silent.

The company's sagging spirits are the country's, too, and for once, Rogers isn't sure he can rally them. Head bowed by the gravity of the assignment, Mr. Carradine steps up to a microphone and admits he's as baffled as the next man by the homeless everywhere, the hunger, the inequity. "We hold the distinction of being the only nation in the history of the world that ever went to the poorhouse in an automobile," he says. The words are Rogers's own and were delivered over the radio in 1931 at the invitation of President Herbert Hoover, who had just addressed the nation on the mounting unemployment. They've not gone out of date. Only the easygoing delivery — content to let an irony rise or fall on its proper merits — signals a different era. And when he asks, "Where are all the big men? Lord, we could sure use one now," even irony is temporarily set aside.

No Broadway musical in its right mind would leave things at that. And "The Will Rogers Follies" doesn't. Slowly, steadily, it builds from there to its uplifting finale. The only difference is that the build is undertaken by Mr. Carradine and Mr. Tune working in tandem, coming at matters from the same angle. The occasion is "Never Met a Man I Didn't Like," a catchy country-western-flavored melody with appropriately homespun lyrics by Betty Comden and Adolph Green. Mr. Carradine — standing center stage, an overcoat thrown over his arm, hat in his hand — is not about to change his basic manner. The mocking twinkle has been extinguished, however. That's his part of the bargain.

■

With each refrain, Mr. Tune enlarges the number surrounding him. But he does so without setting off fireworks at the star's feet. That's *his* concession. Faintly, at first, then with increasing distinctness, the homely faces of common Americans come into focus on the scrim behind Mr. Carradine. And just as faintly, too, the voices of the chorus join in. Before long, the sea of faces stretches off into infinity, and Mr. Carradine's voice is riding the crest of a full choir. But no one's stirring. Mr. Carradine is still center stage — coat on arm, hat in hand — standing firmly by his humble credo. Theatrically speaking, however, a reconciliation has been effected. One man's modesty and another man's flair have been triumphantly joined.

All that remains is for Rogers to take up Wiley Post's offer, climb the stairs into the billowing white clouds and go flying. The show, by this point, has long since been airborne. □

1991 My 12, II:1:2

Walking the Dead

Written by Keith Curran; directed by Mark Ramont; sets by Tom Kamm; costumes by Toni-Leslie James; lighting by Kenneth Posner; sound by Scott Lehrer; fight director, Rick Sordelet; hair design by Bobby H. Grayson; production stage manager, Denise Yaney; production manager, Jody Boese. Presented by Circle Repertory Company, Tanya Berezin, artistic director; Terrence Dwyer, managing director. At 99 Seventh Avenue South, at West Fourth Street.

Veronica Tass	Ashley Gardner
Dottie Tass	Scotty Bloch
Maya Deboats	Myra Taylor
Chess Wysynysky	Christopher Shaw
Bobby Brax	Cotter Smith
Dr. Drum	Tyrone Wilson
Stan	Joe Mantello

By MEL GUSSOW

In a variation on the opening lines of "Anna Karenina," a character in Keith Curran's "Walking the Dead" announces that "all cultural stereotypes are equally infuriating." The play, a dark cul-de-sac of a comedy, bears witness to that mock Tolstoyan statement, but not without falling victim to fallacies of Mr. Curran's own creation, including a melodramatic ending. "Walking the Dead," which opened last night at the Circle Repertory Company, is a flawed work that manages to shed humor — if not a clear light — on some of the more bizarre recesses of the human psyche.

At the outset, the playwright warns theatergoers to be prepared for an outrageous ride, a loop-the-loop about transsexualism and other less radical forms of emotional surgery. The play begins with all the characters facing the audience and jabbering simultaneously about a person who has recently died. She is, we soon find out, a lesbian who becomes a transsexual and suffers the gravest of consequences.

By having the operation, she imperils her seemingly happy relationship with her lesbian lover (an artist who is a black feminist version of Judy Chicago). Unbelievably, the artist does not question the surgery. Repeatedly, Mr. Curran courts implausibility, which is not reduced by his open admission of that fact. Eventually the play is trapped in a thicket of diverse sexuality.

All this is mitigated by the acting and by the supporting characters. These are people in "desperate flux," trying to cover up their anxieties with self-wounding comedy. Though Mark Ramont, as director, has not suppressed the playwright's moments of self-indulgence, he has elicited fine performances from his cast, starting with Ashley Gardner's portrayal in the demanding central role.

The others include Scotty Bloch as the heroine's mother who is burdened with her own guilt-edged conscience; Cotter Smith as a cynical bisexual; Myra Taylor as the lesbian lover whose gruff exterior and confrontational art conceal a loving spirit, and Christopher Shaw in the role of Ms. Gardner's gay friend and soul mate. Of all the characters, he is the most vulnerable, a compulsive volunteer who always identifies with victims. Working on a suicide hot line, he

Gerry Goodstein/"Walking the Dead"

Ashley Gardner in Keith Curran's "Walking the Dead."

helplessly agrees that if things are really that bad the caller should end his life.

This mismatched quartet of friends and relatives is keenly observed by the playwright, and acted with sensitivity even in the play's blacker periods. The dialogue veers from the wry to the self-consciously clever. There is a pseudoprofundity in the air, as in the suggestion: "Be careful how you live your life. You may end up having to live your life that way."

That line eventually rebounds on the playwright. Having decided to present "Walking the Dead" as a play within a documentary film (with acerbic remarks about a careering movie maker), he endlessly calls attention to the play's artifice. In so doing, Mr. Curran undercuts the emotional effectiveness of his drama.

●

The playwright is unable to come to terms with the demons he has summoned, especially in regard to the heroine. Despite Ms. Gardner's multifaceted performance, her character lacks dimension, even as she alters her sexuality and changes her name from Veronica to Ronnie to Ronald and, finally, for unconvincingly Odyssean reasons, Homer.

One is encouraged to believe that through her operation she is "fixing a bad mistake" of nature, but there is still the question — raised but not answered by the playwright — that the act is one of willful self-mutilation. In the end, the play does a curious turnabout. The heroine's plight is less moving than that of those in her orbit, especially the gay friend who ministrates to all misfits while remaining one himself and the wisecracking mother, for whom a daughter will always be a disappointment, even in death.

1991 My 13, C12:1

Theater in Review

- Colette, musically, in two parts
- 'Julius Caesar' in futuristic costumes
- Achieving salvation while disintegrating.

Colette Collage
Two Musicals About Colette

Theater at St. Peter's Church
Citicorp Center
54th Street at Lexington Avenue
Through Sunday

Book and lyrics by Tom Jones; music by Harvey Schmidt; directed by Mr. Jones and Mr. Schmidt; scenery and costumes by Ed Wittstein; lighting by Mary Jo Dondlinger; musical director, Norman Weiss; production stage manager, Ira Mont; production manager, Hilliard Cohen; production supervisor and associate director, Dan Shaheen; choreography and musical staging by Janet Watson and Scott Harris. Presented by Musical Theater Works, Anthony Stimac, artistic director; Mike Teele, managing director. WITH: Joanne Beretta, Paul Blankenship, Betsy Joslyn, James J. Mellon and Craig Wells.

For 20 years, Tom Jones and Harvey Schmidt have been writing a musical about the life of Colette, a project that threatens to be as long-running as the team's Off Broadway annuity, "The Fantasticks." The newest version of their "Colette Collage," two related one-act musicals dealing with the French author, is now playing at St. Peter's Church, under the auspices of the Musical Theater Works. Although a number of the songs are tuneful in characteristic Jones-Schmidt fashion, the book just skims the surface of its fascinating subject. After all these years, the show is still a work in progress.

The idea is to focus on two crucial romantic relationships in Colette's life — her marriage to Henri Gauthier-Villars (or Willy, as in his pen name), the man who discovered her and then claimed authorship for her early novels, and her late-in-life affair with a younger man, Maurice Goudeket. The first half of the show is vivified by the egotistical personality of Willy — he was someone for Colette to fight against — just as the second half is vitiated by the dreariness of Gaudeket. "Colette Collage" eventually becomes Colette cliché.

The first half is also the stronger musically. With the song "Come to Life," the roguish Willy entreats the adolescent Colette to surrender her innocence, quickly followed by "Do It for Willy," a cynical ode to the art of plagiarism. The catchier numbers in the second act are generically French ("Riviera Nights") and transposable to other musicals.

The show is sprinkled with Coletticisms, as in her explanation of her corona of curly hair: "A feminine face needs leafage." But by limiting themselves to the two specific periods, the composers brush past the heady middle years when Colette was at the height of her creative powers.

This would matter less if the production, co-directed by Mr. Jones and Mr. Schmidt, had more flavor of Colette and her times. But the atmosphere is evanescent and the staging is rudimentary. Betsy Joslyn plays Colette with a peppy American show business air. Kenneth Kantor, Joanne Beretta and, especially, Ralston Hill (as Colette's lifelong confidant) are closer to the Gallic mark. But despite an occasional ooh-la-la (the title of a Jones-Schmidt song), the Paris of "Colette Collage" is far west of the Left Bank.

MEL GUSSOW

Julius Caesar

Bouwerie Lane Theater
330 Bowery

By William Shakespeare; directed by Eve Adamson; music by Joseph Blunt; set by Robert Joel Schwartz; costumes by Martha Bromelmeier; lighting by Ms. Adamson; music performed by Haze Greenfield; sound design by Christopher Martin. Presented by the Jean Cocteau Repertory, Robert Hupp, artistic director; David Fishelson, managing director. With: Harris Berlinsky, Joseph Menino, Craig Smith, Elise Stone, Angela Vitale and Mark Waterman.

"Julius Caesar" marked something of a change for Shakespeare as a playwright. Through most of his earlier work, he was more interested in the intricacies of plot. But with this tragedy surrounding perhaps history's most famous conspiracy and assassination, Shakespeare concerned himself more with the minds and motives of the characters than with the events themselves. "Caesar" is a play about Brutus and Cassius more than it is about Mark Antony, let alone the title character.

For the play to achieve any measure of the vibrancy of which it is capable, there must be a clear and sharp delineation between the three main protagonists. And that is the main problem with an acceptable yet rather dull revival at the Jean Cocteau Repertory. Although Harris Berlinsky, Craig Smith and Joseph Menino deliver able and intelligent readings as Brutus, Cassius and Antony, one has the feeling they could all trade places in any given scene and no one would notice. Among the rest of a weak supporting cast, Grant Neale's Casca is credible.

One excellent performance in the Cocteau's "Caesar" comes from Mark Waterman, who has been consistently good with the company this season, in the title role. Oddly cast as a Caesar younger than the conspirators or even Antony, Mr. Waterman nonetheless captures all the haughty arrogance and shrewd cunning of the vain, slightly deaf, epileptic Roman general.

When the conspirators arrive to fetch Caesar to the Senate, Mr. Waterman's eyes dart back and forth as he silently weighs the political dangers of heeding the auguries and staying at home against the possible other dangers of which his wife has dreamed. Later, doubling as Octavius, Mr. Waterman catches a more youthful and calculating imperiousness in the character that would become Augustus.

Borrowing a page from the English director Deborah Warner, Eve Adamson has put several ladders to good use in her staging, especially in some effective battle scenes. Even when the play is cut to just over two hours, there are still political lessons to be learned from "Julius Caesar," not the least of which is the importance of having a good speech writer. Lust for power is still the basis for any political system, and it is doubtful that will change in the next century. Although notes for the Cocteau revival suggest an analogy to the present, the futuristic costumes — black jump suits with capes and enormous gold and silver cuffs — look more like an episode from "Star Trek."

WILBORN HAMPTON

The True Story of a Woman Born in Iran and Raised to Heaven in Manhattan

One Dream Theater
232 West Broadway,
at North Moore Street Through May 25

Written and directed by Assurbanipal Babilla; assistant director, Donal Egan; set design, Sonia Balassanian; light design, Kristabelle Munson. Presented by Purgatorio Ink and One Dream. WITH: Mr. Babilla; Leyla Ebtehadj, Donna Linderman, Jessie Marquez and Tom Pearl.

In a singular Persian version of the struggle for sainthood depicted in "The True Story of a Woman Born in Iran and Raised to Heaven in Manhattan," by Assurbanipal Babilla, achieving salvation seems no more difficult than coming apart at the seams. And the play, which Mr. Babilla calls "an autobiographical comedy," may leave viewers with an oddly exhilarating feeling of disintegration.

In about an hour and a half this wild work sweeps over Iran, the Soviet Union, the Gobi Desert, the Bermuda Triangle, Vietnam, the Vatican and two oceans before its heroine is raised to glory not, as the title says, in Manhattan, but in Brooklyn, "the land of separations." And its five actors seem to float in a kind of graceful dance through a story that encompasses a vast web of intrigues, a murder, a cult of golden idol worshipers, helicopter assaults, orchestral concerts and global prostitution rings.

At the center of all this is Mr. Babilla, who says he had to flee his native Iran in 1979 because the new Government in Teheran would have found his theatrical work offensive. He is the founder of Purgatorio Ink, the company producing "True Story" at the One Dream theater in TriBeCa; he wrote the piece; he directs it; he stars in it, and his recorded voice intones the chaotic saga while he and the supporting cast perform a series of comic scenes that once in a while illustrate his story.

Narrative cohesion is not his strength, and may not be his aim. If he has a theme, it derives from a remark by Kierkegaard quoted in the program, that theater and religion do the same thing but theater does it more honestly. Mr. Babilla, who says he once studied theology at a Methodist institute in Beirut, Lebanon, takes aim not at Methodism or at the ayatollahs now ruling his homeland, but at Roman Catholicism.

Old church, old jokes. Fortunately, there are not many. Mr. Babilla turns to other targets at every turn, from militarism to macho conduct to scholarly fads to whatever strikes him. But these are all minor distractions. When he sticks with the adventures of his hapless heroine, he has a surprisingly engaging tale, absurd and touching.

In fact, "True Story" would be memorable if there were no story. For Mr. Babilla and the members of this cast have strong theatrical imaginations. On a minimal set without stage machinery or elaborate lighting they create tableaux that linger in the mind like glittering animated paintings full of humor, pity and wonder and that make this otherwise neo-Dada work emotionally seductive.

D. J. R. BRUCKNER

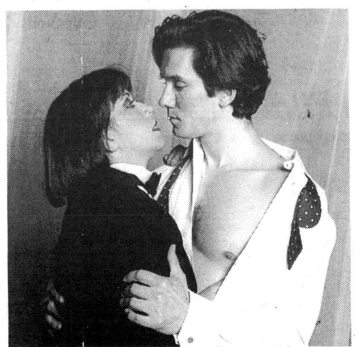

Carol Rosegg/Martha Swope Associates/"Colette Collage"
Betsy Joslyn and James J. Mellon in "Colette Collage."

1991 My 15, C12:3

Letters to a Student Revolutionary

By Elizabeth Wong; directed by Ernest Abuba; sets, Kyung Won Chang; historical consultant, David Jiang; slides, Corky Lee; costumes, Maggie Raywood; sound, Ty Sanders; lighting, Anne Somogye; stage manager, Sue Jane Stoker. Presented by Pan Asian Repertory Theater, Tisa Chang, artistic and producing director. At Playhouse 46, St. Clement's Church, 423 West 46th Street.

Bibi...............................Caryn Ann Chow
Karen...........................Karen Tsen Lee
Charlie, Jonathan, Brother and Chorus 1.............................Andrew Ingkavet
Cat, Lu Yan, Father and Chorus 2Keenan Shimizu
Boss, Immigration Officer, Soldier and Chorus 3...........................Christen Villamor
Sweeper, Mexican Lady, Mother and Chorus 4..Mary Lum

By MEL GUSSOW

While visiting Beijing as a tourist, a young Chinese-American accidently encounters a Chinese woman of her own age. Their fleeting conversation leads to an epistolary friendship that extends over a period of 10 years, until the student uprising in Tiananmen Square.

Elizabeth Wong's "Letters to a Student Revolutionary" (at the Pan Asian Repertory Theater) draws on the playwright's own cross-cultural experiences as a traveler and letter writer. In the play, she dramatizes that long-distance relationship and its transforming effect on both characters. The story is told with a modesty and an ingenuousness such as one might find in teen-age fiction, but there are hints here and there of a nascent theatrical ability.

Instead of having the two women simply read letters to each other, Miss Wong neatly shortcuts the postal system so that there can be an onstage dialogue. A question is followed by an immediate response from across the ocean. Background is filled in by four actors doubling in roles in both countries. The result is a collage of two disparate but intersecting lives.

Rosegg/Swope Associates/Pan Asian Repertory

Postal Exchange Members of the Pan Asian Repertory Theater perform in "Letters to a Student Revolutionary," Elizabeth Wong's drama about the decade-long correspondence between two women from different cultures.

At first, the American (Caryn Ann Chow) is hesitant about revealing herself in letters to a stranger (Karen Tsen Lee). She assumes that her Chinese counterpart is trying to take advantage of her by asking for help in obtaining a visa. Eventually each sees the starker truth behind the preconception.

Miss Lee captures the forthright sincerity of the Chinese correspondent, while Miss Chow concentrates on her character's ebullience and her desire to be an average American. As director, Ernest Abuba has smoothly bridged the geographic division, allowing each character to enter the other's environment.

The playwright has an assurance in depicting life in California, where the American has a disregard for anything political or intellectual until she opens herself to the needs of someone who is only beginning to taste the possibilities of freedom. But when dealing with China, Miss Wong does not amply call upon her imagination to convey the events of the uprising and the horrific aftermath. In this brief play, she settles for a personalized, anecdotal approach, followed by that swift, sad closedown. The massacre in Tiananmen Square ends the play and also the correspondence. In a poignant note in the program, the playwright says she has not heard from own epistolary friend since last spring.

1991 My 16, C18:1

States of Shock

By Sam Shepard; directed by Bill Hart; sets by Bill Stabile; costumes, Gabriel Berry; lighting, Pat Dignan and Anne Militello; composer, J. A. Deane; production stage manager, Lloyd Davis Jr. Presented by American Place Theater, Wynn Handman, director; Dara Hershman, general manager. At 111 West 46th Street.

Colonel........................John Malkovich
Glory Bee........................Erica Gimpel
White Woman........................Isa Thomas
White Man........................Steve Nelson
Stubbs........................Michael Wincott
Percussionists
 Richard Dworkin and Joseph Sabella

By FRANK RICH

SAM SHEPARD has been away from the New York theater for only six years — since the epic "Lie of the Mind" — but "States of Shock," his new play at the American Place, could lead you to believe he has been hibernating since his East Village emergence in the Vietnam era. "States of Shock" is in its own elliptical way an antiwar play, written with the earnest — one might even say quaint — conviction that the stage is still an effective platform for political dissent and mobilizing public opinion. Whether or not one agrees with Mr. Shepard's contrary views about recent history, his ingenuous faith in the theater is uplifting. "States of Shock" is less so.

The evening begins with a literal bang, a hallucinatory sound, shadow and light display that vaguely evokes torture sequences in Costa Gavras films or perhaps CNN's fuzzier nocturnal Persian Gulf war coverage. Just when the audience might expect a helicopter to land, an even greater whirligig arrives — a demented John Malkovich, cast in a role known only as Colonel and hilariously costumed (by Gabriel Berry) in military rags drawn from several centuries and at least as many nationalities. But the setting is an American coffee shop — "a family restaurant," it is repeatedly said — of the present day. Mr. Malkovich's companion, a Christ-like young man called Stubbs (Michael Wincott) in a flag-bedecked wheelchair, was severely wounded by artillery fire while trying unsuccessfully to save the life of Colonel's son in a victorious battle against a barbarous, unidentified enemy.

When the indispensable Mr. Malkovich horses around in the early going, "States of Shock" is much funnier than its ideological concern suggests. The actor came to prominence, after all, in the 1982 Steppenwolf revival of "True West," and he is a born Shepard outlaw: sardonic, seedy, stoned in demeanor, a Belushian slob when juggling food jokes. In "States of Shock," he has such straight foils as a timid waitress (Erica Gimpel) and a couple of middle-aged, middle-American vulgarians (Steve Nelson and Isa Thomas) who are waiting with growing impatience at a neighboring table for a long-delayed order of clam chowder. Wielding props that include a retractable military-briefing pointer, a ferocious saber and a particularly runny banana split, Mr. Malkovich disrupts a coffee shop with more malicious glee than anyone since Jack Nicholson in "Five Easy Pieces."

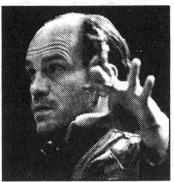

Martha Holmes/States of Shock

John Malkovich in Sam Shepard's new play, "States of Shock."

Yet the explosive humor soon gives way to narrow preaching. While Mr. Shepard is much too poetic (and cagey) a writer to lecture, he does pile on repetitive incantations and images that define the play's territory with didactic rigidity. Colonel, a cheerleader for aggression, is forever expressing gratitude to the enemy whose evil united a country in revenge. For counterpoint, Stubbs is forever displaying his grapefruit-size chest wound, which may have resulted from friendly fire and which in any event belies his constant self-description as "the lucky one."

•

"How can we be so victorious and still suffer this terrible loss?" is the question that hangs over "States of Shock." With manifest sincerity and some courage, Mr. Shepard wishes to examine the casualties, corporal and spiritual alike, of even a fast, victorious, morally right-minded war, and he also wishes to question the values of a society that leaps so readily into the fray. For all Colonel's encomiums for America's legendary achievements (from the Great Northern Railway to Little Richard), common sense and pioneer stock, there may be something tragically amiss in the familial nation that has devolved into the play's family restaurant.

Fair enough, but the issues under debate are far too complex to be illuminated by the plain dramatic elements of this 75-minute work. "States of Shock" does not really go anywhere intellectually or theatrically once it has established its basic thematic attack. Instead it mechanically imposes its ideas on some typical Shepard conceits: The play's fratricidal men trade aspects of their identities, mythos-laden American songs (notably "Goodnight Irene") swamp the action, a buried child will not rest in peace. Gradually Mr. Malkovich resorts to ranting and raving in his "Burn This" manner to counteract the inertia. At the same time, the special effects, punctuated by off-stage percussionists, reach the apocalyptic proportions of Mr. Shepard's collaboration with Michelangelo Antonioni on "Zabriskie Point." Something of a nadir is reached when the sight of a male diner masturbating is accompanied by images of familial and battlefield brutality. Surely Mae West made the analogy between machismo and weaponry with rather more wit.

•

Bill Hart's energetic, tightly focused production is blameless for the lulls. Bill Stabile's austere set (in the

style of the diner artist John Baeder), the busy lighting of Pat Dignan and Anne Militello and the acting of the entire cast are in perfect sync with the author's intentions. As the play's two martyrs, the wounded Mr. Wincott and the subservient Ms. Gimpel (a black woman all too pointedly left to clean up the mess of white men), bring off the considerable feat of carrying their heavy symbolic burdens lightly. Indeed, it may be because of their poignant simplicity that some of Mr. Shepard's message lodges in the mind despite the blustery dialogue.

"Ideas emerge from plays, not the other way around," the playwright once wrote in an essay, and he was right. In his haste to rush back to the theater before the shelf life expires on his particular polemical mission, Mr. Shepard seems to have shifted his customary creative process into reverse.

1991 My 17, C1:3

The Hunchback of Notre Dame

Written and directed by Everett Quinton; freely adapted from the novel by Victor Hugo; music by Mark Bennett; lyrics by Mr. Quinton and Mr. Bennett; scenery by Tom Moore; costumes by Mr. Quinton; lighting by Richard Currie; props by Jeffrey Rebelo; production stage manager, Karen Ott. Presented by the Ridiculous Theatrical Company, Mr. Quinton, artistic director; Steve Asher, managing director. At the Charles Ludlam Theater, 1 Sheridan Square.

Quasimodo	Hapi Phace
Archdeacon	Everett Quinton
Gracie St. Paul	Stephen Pell
Esmeralda	Cheryl Reeves
Jehan Frollo	Gary Mink
Pierre Gringoire	Sophie Maletsky
Old Man and Master Florian Poussypain	Bobby Reed
Passerby, Sister Gudule and Dame Aloise	Eureka

By MEL GUSSOW

In Everett Quinton's highhanded adaptation, "The Hunchback of Notre

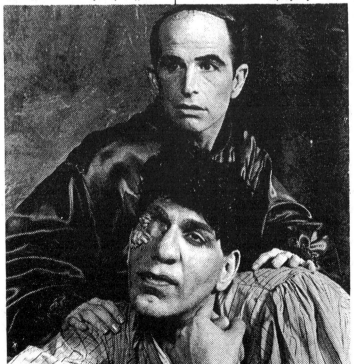

Anita Shevett/Hunchback of Notre Dame
Everett Quinton, rear, and Hapi Phace in the Ridiculous Theatrical Company's production of "The Hunchback of Notre Dame."

Dame" becomes a free-for-all in a camp Quasimodo mode. Though not a bell ringer like Charles Ludlam's vintage travesties, the show is far more lighthearted (and less misérable) than that uptown Victor Hugo frolic. In its own chaotic, Ridiculous Theatrical fashion, Mr. Quinton's "Hunchback" is even quasi-faithful to the plot of the original novel.

At first, it seems totally faithless, as the small stage at the Charles Ludlam Theater is filled with preening queens and peeping tomfoolery. A street show, a rarefied raree, is in progress on the steps of the cathedral. It is a musical version of "Hei-

Everything is askew. And then it's not. Sort of.

di," in which the Alpine mountain girl leads a zinging foot-slapping chorus of "Heterosexual Heidi." What, you may ask, is Heidi to Hugo, or he to Heidi?

The answer, of course, is nothing, and that storybook interpolation is followed by a descent to a Parisian netherworld where everyone seems to have put on clothes more customarily suited to the opposite sex. Finally, after too long a pause, the play segues into "The Hunchback." Quasimodo appears in the huge, hulking form of the actor Hapi Phace, who is so stooped that it looks as if his nose will nudge the ground.

Arrested in the city square, the monstrously disaffected Quasimodo cries out for a drink of water. The gypsy Esmeralda obliges, thereby winning a lifelong safety warranty from this beastly protector. Whenever she is in trouble, which is most of the time, Quasi clumps to her rescue. The plot is additionally thickened by a vile archdeacon (a juicy role Mr.

Quinton wisely reserves for himself), who has his own not-so-secret passion for the gypsy. Around them swarm assorted nuts and dolts, not all of whom are native to Notre Dame.

As a playwright, Mr. Quinton cannot resist an opportunity for a double-entendre, and the script sprawls indecently. But the play is stuffed with funny business, linguistic as well as physical, including such playful punning as Esmeralda's aside to her pet goat, "It's just you and me, kid," and Quasimodo's quizzical thought, "I have a hunch."

•

What keeps the show in forward gear is the music, and for lunacy's sake it could have been even more of a musical. Mark Bennett as composer and Mr. Quinton, who collaborated with him on the lyrics, have concocted an effusive and often melodic pastiche of songs, blending gypsy airs

with hummable hymns and a few honky-tonk sentiments like "It was God who made you a drag queen." Mr. Bennett is a flamboyant presence at the keyboard.

Besides Mr. Quinton and Mr. Phace, the diverse and quixotically talented cast includes Cheryl Reeves as Esmeralda, Sophie Maletsky as a mustached troubadour and Stephen Pell as a red-hot mama. Hiding under a bridge like a trawling troll is Eureka, accosting those who pass by, while also acting as assistant director.

For his scenic design, Tom Moore has turned the stage into a children's playground, suitable for a game of hide and seek in the "kingdom of cutpurses and parasites." The garish costumes were designed by Mr. Quinton, who skulks around Paris in a sinister black outfit that makes him look like a phantom from the nearby opera.

1991 My 17, C3:1

In the Language of Lockjaw, Subtext Is All

A. R. Gurney tries to find the new WASP man in his 'Old Boy.'

Art meets real-life Broadway in 'Our Country's Good.'

EARLY ON IN HIS CAREER, THE playwright A. R. Gurney once observed, he found his subject — the upper-class WASP's who inhabit the Northeastern corner of the United States and who, for the first half of the 20th century at least, not only ran the country, but also most of the country clubs. For better or worse, he joked, it was a little like writing about the 1957 Chevy. Great car for its time, even if the times had moved on.

Now, it would appear, Mr. Gurney wants to move on, too. What his well-bred characters have always suspected — that theirs is a vanishing world — is openly and emotionally acknowledged at the end of "The Old Boy," his latest work (at Playwrights Horizons). In addition, they are facing up to homosexuality, AIDS, minority rights and "the ghettoization of America" — subjects that not so long ago would have been banished from the standard Gurney dining room faster than a bum in bare feet.

■

Paradoxically, however, the playwright's attempts to catch his characters up with the 1990's have not resulted in an up-to-date play. "The Old Boy" seems decidedly more old-fashioned than "The Cocktail Hour," "The Golden Age" or "The Middle Ages" — works that have earned Mr. Gurney the double-

edged reputation of being a latter-day Philip Barry. By calling for an end to the privileged enclaves that have long been his characters' stomping ground, he may be doing the right thing, the fair thing, the *democratic* thing. But from a dramatic point of view, keeping the ivied walls in place has its value.

At first glance, Mr. Gurney has not changed his stripes in "The Old Boy." The setting is an exclusive New England prep school, to which middle-aged Sam (Stephen Collins) has returned to deliver a commencement address and announce a new tennis facility to be built in the memory of a recently deceased classmate named Perry. In the time-encrusted tradition of the school, Sam served as Perry's "old boy," which is to say his first-year mentor and friend.

Sam has since been dabbling in the shallows of politics, mostly in appointed posts, but he's got a golden aura and is so untouched by controversy that he is widely viewed as gubernatorial, if not Presidential, timber. Because of that, Bud, his eager aide (Clark Gregg, in the second-best performance of the evening), views the impending speech as pure trouble. "No one likes WASP's anymore," he points out. Even George Bush was tainted by "the preppy thing." But Perry's wealthy mother, Harriet (the commanding Nan Martin, in the best performance), expects Sam to honor her son, and she is more than accustomed to getting her way.

This is the point at which the old Gurney leaves off and the new Gurney takes over. "The preppy thing" proves the least of Sam's worries, after a quick security check on Perry reveals the grim circumstances of his death. In mid-life, he came out of the closet, ran wild, contracted AIDS and committed suicide. Surely, Bud reasons, this is cause enough for Sam to pull out of the speech.

In his prior plays, Mr. Gurney's sociology has been flawless. He knows this world of manicured hedges and good connections inside and out. He understands its deeply ingrained beliefs in privacy, Latin as a cornerstone of a sound education and self-control as the proper response to an indulgent world. The lockjawed accents, far from being an affectation, are often an attempt to keep unseemly emotions in check.

What gives his plays their fascination is the underlying tension that manners mask but can't defuse. Unpleasantness is rarely met head-on.

Anything that is not deemed civilized, fit for decent ears, is conveyed indirectly — by a tone, a euphemism, an eyebrow arched disapprovingly. Even affection, lest it be thought sloppy, is implied. Mr. Gurney's characters feel more than they allow themselves to verbalize — feel more, occasionally, than they know they feel.

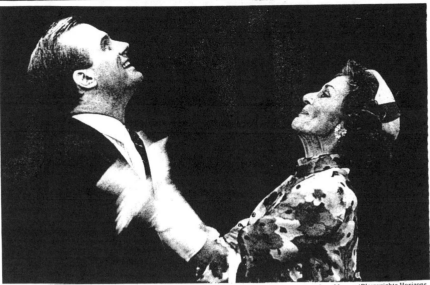

Joan Marcus/Playwrights Horizons

Stephen Collins and Nan Martin in "The Old Boy"—What gives Mr. Gurney's plays their fascination is the underlying tension that manners mask but can't defuse.

Since their facades are so securely buttoned-down, they rely largely on subtext to express themselves.

Curiously, though, the subtext is the most serious failing of "The Old Boy." While Sam is wrestling with his political conscience, the play flashes back to show the influence he exercised over Perry — encouraging him to play varsity tennis, for example, instead of Viola in "Twelfth Night." When Perry admits that he enjoys the company of men more than women, Sam ridicules the notion and bullies him into taking up with Alison, one of his throwaway girlfriends (Lizbeth Mackay).

"So," Sam concludes, having argued the merits of the straight life to his apparent satisfaction, "we are no longer doomed to hang around bars with creeps in New York and go to operas. We're rejoining the human race. Is it a deal?"

■

Granted, all this appears to be taking place in the late 1950's, when sexual liberation was still a decade away, those men who weren't jocks were suspect, and an interest in classical music very nearly qualified as deviancy itself. Still, the flashbacks are the play's least convincing scenes — not just quaint, but squirmingly naïve. We see Sam and Perry, more or less hewing to the prevailing code of conformity, but nothing of what conformity hides. Any homosexual yearnings on Perry's part are presented as awkward fumblings — more confusion than compulsion. Whatever his protestations of friendship, Sam seems to be operating primarily out of a need to be idolized, when he's not guzzling beer and chasing women.

The unarticulated relationship between the two men, the *felt* relationship, isn't there. Just where a strong subtext would count most, Mr. Gurney has gone dry, and the director, John Rubinstein, is unable to fill the void. It helps not at all that in addition to playing the mature politician, Mr. Collins also portrays the young Sam,

Martha Swope/"Our Country's Good"

Cast members in "Our Country's Good"—The sight of the players primping nervously is bound to lift the heart of any devoted theatergoer.

while the role of Perry falls to Matt McGrath, a versatile actor, but one who looks to be barely in his 20's. Side by side, these two come across as father and son, not as buddies.

Consequently, when the play reverts to the present and Sam takes to the podium to eulogize his "good friend … a gay friend" and claim that "I loved him as much as I've ever loved anyone else in this world," you wonder whom he's talking about. Sam's speech is a virtual wallow in guilt — guilt over the old-boy network that has refused to embrace "the wonderful variety which constitutes American life"; guilt over the drug epidemic; guilt that homosexuals have been forced "to make their own isolated ghettos, where they may destroy themselves in the frantic attempt to construct an emotional life denied to them by the world outside."

I'm not sure such a speech wouldn't be hooted down these days as being about 20 years too late — and patronizing, to boot. But allow the character his slow-to-bloom social conscience. As Alison notes in a blistering attack on the old boys, the thick shells they have built up "all these years no, wrong, all these *generations*" are not easily cracked. Mr. Gurney nonetheless continues to face a serious theatrical problem: the flashbacks simply don't support the intensity of Sam's mea culpa.

In the past, the playwright's characters tended to keep their prejudices neatly tucked away — not that we were ever fooled. All it took was a little chip in their veneer of good breeding to reveal the neuroses underneath, the unfairness in their hallowed principles of fair play. But their proclivity for playing emotional hide-and-seek made them tantalizingly real. In "The Old Boy," Mr. Gurney has created a character who throws off the old shackles and lets it all hang out. And he doesn't seem real in the least.

A little hypocrisy, I'd say, can sometimes be a very useful thing. Dramatically speaking, of course.

'Our Country's Good'

Coming, as it has, at the end of a season that's given us precious little to celebrate, Timberlake Wertenbaker's "Our Country's Good" is either a shining beacon of hope or a fool of a play, whistling in the dark.

Set in Sydney, Australia, in 1789, when Sydney was no more than a brutal penal colony, it recounts the efforts of an ambitious British officer, Second Lieut. Ralph Clark, to stage the first theatrical production ever down under — "The Recruiting Officer" by George Farquhar. Since the prospective cast will necessarily be made up of thieves, rogues and prostitutes, shipped out of England for their sins, there is heated debate among Clark's fellow officers as to whether the enterprise will have a civilizing effect or further degrade the already shockingly low level of morals.

"Put the play on, don't put it on," huffs one officer, impatiently, "it won't change the shape of the universe."

No, counters Clark, "but it could change the nature of our little society."

Which view Ms. Wertenbaker endorses is never in doubt. But for a while it's touch and go for Clark (Peter Frechette), an idealist who is not so idealistic that he doesn't know that a successful theater production will stand him in good stead with his superiors. Only two copies of Farquhar's script exist in this benighted realm, few of the would-be performers can read, and not long after rehearsals begin, one of the leading ladies (an unscrubbed Cherry Jones, and stubborn as a stump) is accused of theft and threatened with hanging. As for the hangman, he'd like nothing better than to have a role in the play, but every time he shows up, he is greeted with salvos of spit.

Imagine "The Torch-Bearers,"

The season closes with 'Our Country's Good,' a fan letter to the stage.

George Kelly's perennial tribute to amateur theatrics, as it might have been written by Bertolt Brecht, and you've got the general drift of "Our Country's Good." The evocative set is the rotting hull of a sailing ship, beached, as it were, on the desolate stage of the Nederlander Theater. The cast members, most of whom were originally recruited for an earlier production by the Hartford Stage Company, double as the scurvy convicts and their ruthless keepers — which neatly underscores the notion that man is his own worst enemy.

■

Under Mark Lamos's direction, the play is less confusing than it sounds and often proves to be good, significant fun, with an emphasis on the significance. Little by little, the snaggle-toothed troupe acquires a semblance of dignity and self-respect, and imagination asserts its power to remold harsh reality. The sight of the players in whiteface and makeshift costumes, primping nervously as they prepare to brave their opening-night audience, is bound to lift the heart of any devoted theatergoer.

Inasmuch as "Our Country's Good" is the second play to be staged this season under the Broadway Alliance, the production may well have as much to do with New York in 1991 as it does with Sydney in 1789. By slashing costs across the boards, the alliance aims to revive the commercial fortunes of serious drama and thereby improve the nature of a Broadway that has all but surrendered its identity (some would say its integrity) to musicals. While the Nederlander Theater isn't as forbidding as colonial Australia, it is certainly in an analogous state of shabbiness.

What remains to be seen, I guess, is whether or not Ms. Wertenbaker's triumphant ending applies to our scabrous little society, as well. □

1991 My 19, II:5:1

Breaking Legs

By Tom Dulack; directed by John Tillinger; scenery by James Noone; costumes by David C. Woolard; lighting by Ken Billington. Presented by Elliot Martin, Bud Yorkin and James and Maureen O'Sullivan Cushing. At the Promenade Theater, 2162 Broadway, at 76th Street.

Lou Graziano	Vincent Gardenia
Angie	Sue Giosa
Terence O'Keefe	Nicolas Surovy
Mike Fransisco	Philip Bosco
Tino De Felice	Victor Argo
Frankie Salvucci	Larry Storch

By FRANK RICH

"Breaking Legs," the play that has brought Philip Bosco and Vincent Gardenia to the Promenade Theater, is set in an Italian restaurant, and during much of it, people discuss, order or devour hearty Italian food, from antipasto to veal and peppers. Surely it must say something about this show that it leaves you starving for Chinese.

The author is Tom Dulack, who was represented on Broadway a decade ago by "Solomon's Child," a melodrama about cults and deprogramming. Here he turns his hand, or perhaps one should say his fist, to comedy. Despite the efforts of the evening's two reigning farceurs — and of the director John Tillinger, an expert at the works of Joe Orton, A. R. Gurney and Terrence McNally — "Breaking Legs" boasts very few laughs, and they are as widely spaced over its two hours as a half-dozen meatballs stirred into an industrial vat of spaghetti sauce.

There's no story to sustain "Breaking Legs," just a premise. A professor and fledgling dramatist (Nicolas Surovy) from a New England state university is so desperate to get New

York backing for his play that he solicits money from gangsters he meets through a former student (Sue Giosa) of Italian-American stock. Mr. Bosco, in pin-stripes and shades, is the main Mafioso, and Mr. Gardenia is the former student's nagging father, a restaurateur who is not above pimping for his daughter if that's what it takes to marry her off.

●

The only dramatic event in "Breaking Legs" is the offstage murder of an otherwise insignificant character, a deadbeat played by Larry Storch, who appears in a single scene in Act I but whose wake unaccountably consumes most of the players' energies in Act II. Mr. Bosco gets the evening's funniest line — "If you ask me, our next President will be Alfonse D'Amato" — though a more representative joke is Mr. Surovy's pronouncement, "Some things ought to be sacred, and religion is certainly one of them." The one consistently funny performance comes from the stone-faced Victor Argo, who plays Mr. Bosco's grumpy aide-de-camp with a funereal deadpan that gives each of his disappointingly few lines a ridiculous twist.

As directed by a seemingly inattentive Mr. Tillinger, the rest of the cast misses the gag, such as it is. Comedies about naïve schnooks caught up with the mob can be funny only if the gangsters are acted with some real menace, as George Raft did in "Some Like It Hot," Dean Stockwell did in "Married to the Mob," Marlon Brando did in "The Freshman" and Mr. Argo does here. Mr. Bosco broadly and benignly lampoons a tough guy instead of impersonating one, so Mr. Surovy, whose ludicrously nerdy professor also lacks credibility, is never placed in the serious jeopardy that might ignite the farce.

●

One waits in vain for Mr. Gardenia to have the sort of apoplectic fit he is justly celebrated for (most recently in "Moonstruck") or to get into at least one big shouting match with Mr. Bosco. The other deficiencies of "Breaking Legs" include a running gag about Connie Chung, the curiously ill-chosen Nino Rota music (from Fellini's "Amarcord," not "The God-

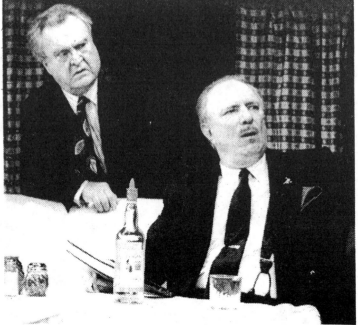

Peter Cunningham/"Breaking Legs"
Vincent Gardenia, left, and Philip Bosco in "Breaking Legs."

father") during scene changes, and the exceptionally hideous set and costumes. As designed by James Noone, the restaurant filling the Promenade's thrust stage is a gloomy sea of aggressive mustard-and-blue floor tiles studded with plastic ferns and red Leatherette furniture and backed by brick-framed windows that, with an excess of symmetrical zeal, look out on a brick wall.

Historians of the New York theater may also note that "Breaking Legs" is the second play within a week, following Sam Shepard's "States of Shock," to feature a lengthy simulation of masturbation by diners in a restaurant. Takeout, anyone?

1991 My 20, C11:1

F. M. and The Love Suicide at Schofield Barracks

Two one-act plays written and directed by Romulus Linney. Production stage manager, Ellen Melaver; lighting design, Jeffrey S. Koger; set design, E. David Cosier; costume design, Teresa Snider-Stein; original music composition, Paul Earls. Presented by the Signature Theater Company. At the Kampo Cultural Center, 31 Bond Street, between Lafayette and Bowery.

F. M.
WITH: Elisabeth Lewis Corley, Ann Sheehy, Scott Sowers and Adrienne Thompson.
THE LOVE SUICIDE AT SCHOFIELD BARRACKS
WITH: Kernan Bell, Constance Boardman, Fred Burrell, S. J. Floyd, Gordon G. Jones, Garrison Phillips, James Seymour, Mary Jane Wells and John Woodson.

By MEL GUSSOW

Unless the playwright's name happens to be Shakespeare or Shaw, a theatergoer rarely has the opportunity to see an author's plays in context with one another, to weigh individual merits and identify recurrent themes and motifs. The new Signature Theater Company is meeting an artistic need by devoting an entire season to a single writer and by having him in residence. The company begins auspiciously with Romulus Linney, who has a rich and varied body of work, one that should certainly benefit from such scrutiny.

The opening production is a pairing of "F.M.," a one-act comedy from the 1980's, and an abbreviated version of the 1972 Broadway play, "The Love Suicide at Schofield Barracks." As directed by Mr. Linney, both are running at the Kampo Cultural Center through June 2.

In revival, "The Love Suicide" remains one of the author's more troublesome efforts, but it has been improved through distillation. In full-length form this story of a United States Army general and his wife, who commit ritual suicide to protest the war in Vietnam, had a certain idealistic pretension. The couple, not seen on stage, seemed unbelievably selfless.

•

Though problems of credibility remain, the 70-minute version focuses more tightly on those who have been influenced by the life and death of the couple. In a special court of inquiry, called at the request of the general himself, a series of witnesses offer testimony as well as their own surmises about the reason for the suicide. They include aides who are resentful of the general's humanistic

approach to military affairs and a hard-bitten poet with an underlying understanding of the couple's tragic self-awareness.

As the double portrait emerges, one feels crosscurrents of sympathy and horror. For symbolic purposes the suicide was supposed to have involved the death of an innocent victim. The playwright does not attempt to excuse the general's mania but to help us see the extremes to which the guilt-ridden can be driven. To a certain degree, the play is a precursor of Mr. Linney's "2," about the Nuremberg trials, a work that deals more perceptively with questions of conscience.

"The Love Suicide" benefits from being presented on a small open stage and from Mr. Linney's understated direction. As a result, theatergoers are brought closer to the tribunal. Mary Jane Wells, Gordon G. Jones and Fred Burrell, among others, manage to uncover bitter humor beneath the drama.

•

In his long career, Mr. Linney has alternated ambitious morality and history plays with light comedies, often dealing with provincial American life. One of his most amusing one-acts is "F.M.," first seen in a trilogy entitled "Laughing Stock." This is a satiric study of an adult class in creative writing, in which a struggling novelist (Ann Sheehy) tries to educate a pair of small-town dilettantes; a man-hating divorcée (Adrienne Thompson) and a shrinking violet (Elisabeth Lewis Corley) from the Olivia de Havilland school.

Into this hothouse strides a rough, bourbon-soused renegade (Scott Sowers) with a bulky manuscript and a Faulknerian imagination. The plot twists may be predictable, but the journey is signposted with laughter, as Mr. Linney spoofs artistic attitudinizing while leaving room for a heartening conclusion.

The Linney festival is scheduled to continue in the fall with "The Sorrows of Frederick," to be followed by new plays as well as revivals by this virtuosic dramatist. After exploring the theater of Mr. Linney, the company could turn to plays by contemporaries like John Guare, Sam Shepard and Lanford Wilson, to name a few with substantial bodies of work.

1991 My 20, C13:5

The Way of the World

By William Congreve; directed by David Greenspan; sets by William Kennon; costumes by Elsa Ward; lighting by David Bergstein; choreography by James Cunningham; associate producer, Jason Steven Cohen. Presented by Joseph Papp. At the Public/Susan Stein Shiva Theater, 425 Lafayette Street, Manhattan.

Fainall	René Rivera
Mirabell	André Braugher
Witwoud	Joe Urla
Petulant	Burke Moses
Sir Wilfull Witwoud	Joseph Costa
Waitwell	James Lally
Servant, Messenger, Coachman and Footman	John Elsen
Lady Wishfort	Ruth Maleczech
Mrs. Millamant	Jayne Atkinson
Mrs. Marwood	Caris Corfman
Mrs. Fainall	Mary Shultz
Foible	Angie Phillips
Mincing	Terra Vandergaw
Betty, Peg and Mrs. Hodgson	Ami Brabson

By MEL GUSSOW

As David Greenspan's production of "The Way of the World" unfolds, almost everyone lights up a cigarette

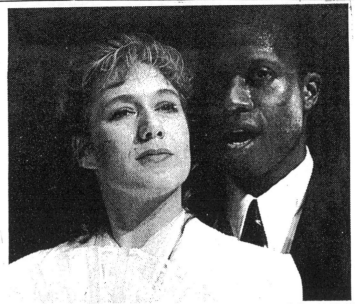

Rebecca Lesher/Martha Swope Associates/"The Way of the World"
Jayne Atkinson and André Braugher in "The Way of the World."

and puffs hard until the air is cloudy. (The artistic weather is already inclement.) Perhaps this is the director's way of indicating atmosphere or the harmful effects of tobacco, but, like so much else onstage, the smoking seems gratuitous.

At the Public Theater, Mr. Greenspan has his way with "The Way of the World," taking an aberrant approach to the wittiest of Restoration comedies, one of the great adornments of the English-speaking theater. After manhandling Chikamatsu Monzaemon's "Gonza the Lancer" earlier this season, he has now taken a lance to William Congreve.

Certainly it is possible, though not desirable, to relocate and reinterpret "The Way of the World." Some years ago, at the Brooklyn Academy of Music, an English company headed by Edward Petherbridge moved the play to Edwardian times, accenting the parallels between Congreve and Oscar Wilde. But Mr. Greenspan's version simply unmoors the play in a vaguely contemporary, underfurnished environment.

•

The play has been stripped of its elegance, then overlaid with modernist touches. The stage is as bare as a rehearsal room, and the costumes are a patchwork of such items as one might find in a resale shop or, in the case of the women, as rejects from Madonna's wardrobe. The lighting scrutinizes the features of the actors with white-hot harshness. Out the window go the charm and the specificity of Congreve's world, where cuckoldry is endemic and love becomes a game of intrigue.

Behind the attitudinizing, some of the actors seem quite capable of performing a real "Way of the World," should that have been the choice. One has the strange impression that the production would seem more authentic and far more tolerable if it were heard but not seen. Should we wait for the cast recording?

Jayne Atkinson has the panache necessary to play Mrs. Millamant, the queen bee and the most glamorous member of her set, although in her case she is severely hampered by having to wear one of the production's most unflattering costumes. Behind the smoke screen and the sunglasses, André Braugher is a re-

spectable Mirabell, able to banter with Ms. Atkinson, to play Benedick to her Beatrice.

•

In supporting roles, Joe Urla gives a puckish turn to Witwoud's foppery, and Mary Shultz has a gentle ease as Lady Wishfort's manipulative daughter. The performance problems begin with Lady Wishfort herself, a titanic flirt and self-deluder. In the absence of evidence, she believes that every swain has fallen in love with her, despite the fact that her character is, we are told, "the antidote to desire." Coquettishness is not Ruth Maleczech's strong suit, and neither is high comedy.

Several other actors are either miscast or simply out of their element in Congreve. There is one truly deplorable performance: by Burke Moses, whose portrayal of Petulant is all smirks and simperings.

At odd moments, the actors bow with flourishes or dance a courtly dance, in sudden memory of the characters' Restoration origins. Although the text is shortened, it is otherwise intact. Bits and pieces of the play may stir a responsive chord, especially in that matchless romantic scene between Mirabell and Mrs. Millamant, a prefeminist colloquy that remains as relevant today as it was in the author's time. The performances improve in the second act, but nothing could certify the validity of the directorial intrusions. Productions of Congreve's masterwork are too few in this country to encourage such casual philistinism.

1991 My 22, C11:1

Drama in Review

■ Playing, though not too well, the hand one is dealt ■ Awash in drabness and fantasies ■ Love, hate and so much misunderstanding.

Fridays

*Riverside Shakespeare
Company at Playhouse 91
316 East 91st Street
Manhattan
Through June 23*

Written by Andrew Johns; directed by Gus Kaikkonen; set by Bob Barnett; costumes by Steven F. Graver; lighting by Stephen J. Backo; production stage manager, Matthew G. Marholin. Presented by Riverside Shakespeare Company.
WITH: Kent Adams, Henderson Forsythe, David Edward Jones, Stephanie Madden, John Peakes and Alice White.

"Fridays" is a sort of buddy play for the elderly set around a nickel-dime poker game that has taken place in George Herrick's basement game room every Friday night for donkey's years. At the time of what passes for action in Andrew Johns's play, which is being presented by the Riverside Shakespeare Company, the number of regulars has dwindled to three. The game badly needs some new blood, just as long as it doesn't belong to a woman.

Most of the first act is given to George (Henderson Forsythe) calling around town trying to find a couple more players to fill the table, while Holly Crawford (John Peakes), who is George's old crony, and Chuck Hart (Kent Adams), a young man who should have better things to do, swap what is very likely meant to be witty banter. It's all about as scintillating as, well, going through an address book trying to get up a card game late on a Friday night. There's more suspense in a game of solitaire.

The focus of "Fridays" is Holly, a lifelong bachelor who seems to live for the weekly poker session. In dialogue, Holly is presented as an irascible bully with whom few of George's friends are willing to play. In truth, enlightened by Mr. Peakes's fine performance, he's a rather endearing old codger who would be welcome at any poker game I've known.

The point of the play seems to be how Holly copes with George's death. There is also a stereotypical son who wishes he had known his father better and a daughter-in-law who bakes cookies. (There is also another son and a wife, neither of whom appear onstage, absences the playwright is continually explaining: the son "is working on his car"; the mother "is upstairs in the kitchen.")

Death, of course, is always sad for someone, especially loving sons and old friends. But it is not in itself a reason to write a play, even if it does lead to women at the poker table. With the exception of Mr. Peakes, the cast pretty much reflects the lack of inspiration of the play. Gus Kaikkonen directed.

WILBORN HAMPTON

East
An Elegy for
the East End

*La Mama E.T.C.
74A East Fourth Street
Manhattan
Through June 2*

Written by Steven Berkoff; directed by Paul Hellyer; technical director, Chris Brophy; lighting and set design, Jeff Rowlings. Presented by La Mama E.T.C.
WITH: Paul Finnocchiaro, Stephanie Hunt, Delia MacDougall, Dennis Matthews and Joel Mullennix.

Susanna Frazer and Brett Rickaby in "Yokohama Duty."
Jonathan Slaff/"Yokohama Duty"

No modern dramatist wallows in the voluptuousness of the English language with the savage delight of the playwright Steven Berkoff. Speaking in a sonorous Elizabethan diction, his characters disgorge their inner lives in verse that though awash in scatology and modern street argot, drives that language toward Shakespearean heights.

The playwright's 1975 drama "East," which opened a three-week engagement at La Mama's First Floor Theater on Friday evening, is a characteristically gamy and excessive work and is not for the squeamish. The five-character play, which is subtitled "An Elegy for the East End," mixes monologues, songs and dramatic set pieces to evoke the working-class East End of London where the playwright grew up in the 1950's

"East" examines the same drab working-class milieu portrayed in the angry young men school of English plays and films three decades ago but gives that world's denizens a ferocious articulateness. Mum (Stephanie Hunt) and Dad (Paul Finnocchiaro) live an automatonlike existence, she in front of the television set, he stewing in beery memories of the good old days of World War II.

Mike (Dennis Matthews), Sylv (Delia MacDougall) and Les (Joel Mullennix) represent the younger generation who find their only release from the enveloping drabness through sex and fighting. Each of the younger characters voices an extended sexual fantasy in which the scatological imagery and Anglo-Saxon epithets assume a rhapsodic intensity.

The production, which originated in San Francisco, was directed by Paul Hellyer and it couldn't be stronger. The principal prop is a battered chain-link fence, which the characters use as a perch and through which they scuttle like noisy rodents.

Unusually convincing when assuming English accents, all five cast members deliver the caterwauling dialect with the fluency and ease of born Londoners. Mr. Matthews and Mr. Mullennix give an electric physicality to their meaty roles along with a fierce, mocking sense of challenge.

STEPHEN HOLDEN

Yokohama Duty

*SoHo Rep
46 Walker Street,
between Church and Broadway
Through June 9*

Written by Quincy Long; directed by Julian Webber; set design, Stephan Olson; costumes, Patricia Sarnataro; lighting, Donald Holder; stage manager, Monty Hicks. Presented by SoHo Rep, Marlene Swartz and Julian Webber, artistic directors.
WITH: Nesbitt Blaisdell, Michael Cullen, Susanna Frazer, Bruce Katzman, Cheri Nakamura, Brett Rickaby, Preston Keith Smith and Peter Yoshida.

It is fitting that Quincy Long's "Yokohama Duty" was produced by the SoHo Rep. The company has migrated into a theater not in SoHo, but in TriBeCa. And Mr. Long's characters — variously self-defeating Americans and a buoyant Japanese brother and sister in Yokohama just after World War II — all seem to be alien to the whole world. They speak as though they are not sure they are heard, but certain they are misunderstood.

They are right. In all of Mr. Long's plays, the law of nature is irony. Here an old Anglican missionary (Nesbitt Blaisdell), more sorely tried by his own self-knowledge than by hell's wiles, lasts out the war in enemy territory by gambling with the church's funds, only to become besieged by a young simpleton of a priest (Bruce Katzman) sent from America to examine the mission's books.

The missionary takes refuge in prayer: "Kill him, God, just kill him." And the answer to that plea is the elevation of the young cleric to an unimaginably high place in the American pantheon.

As the young man follows his path to glory, a marine with a steel hide and a soft heart (Michael Cullen) finds compassion for enemies; a military policeman who knows the hard ways of life (Preston Keith Smith) falls in love with a Japanese orphan who knows the wise ways (Cheri Nakamura); a soldier who foresees his death (Brett Rickaby) learns how to outwit the whole Pentagon; a nurse too smart to be fooled by love (Susanna Frazer) finds that she is a hopeless romantic, and a crazed, wounded Japanese man vanquishes fear and his conquerors (Peter Yoshida).

Mr. Long has a gift for odd characters and bizarre dialogue, and Julian Webber's taut direction makes the most of them. But even he cannot bring order to this plot.

D. J. R. BRUCKNER

1991 My 22, C15:1

Night Sky

By Susan Yankowitz; directed by Joseph Chaikin; set design by George Xenos; lighting by Beverly Emmons; costumes by Mary Brecht; sound by Mark Bennett; production stage manager, Ruth Kreshka. Presented by the Women's Project and Productions, Julia Miles, artistic director. At the Judith Anderson Theater, 422 West 42d Street.

Daniel..............................Edward Baran
Bill..................................Tom Cayler
Anna.............................Joan MacIntosh
WITH: Aleta Mitchell, Paul Zimet and Lizabeth Zindel

By MEL GUSSOW

Aphasia is the subject and astronomy the metaphor in Susan Yankowitz's "Night Sky," a play that was generated by Joseph Chaikin's own battle with the communication disorder. That Mr. Chaikin has directed the play (for the Women's Project) adds a personal immediacy, as he and the playwright collaboratively embark on a journey into the mysteries of this affliction.

"Night Sky" is evocative as well as informative, but it is almost too ambitious for its scale, operating with fluctuating success on several simultaneous philosophical planes. Ms. Yankowitz tries to deal not only with aphasia but also with questions of the cosmos as projected through the distorted consciousness of an astronomer who is a victim of the disorder. Among other problems under scrutiny is the unrest in the protagonist's home life. The play lacks the cohesiveness of such disparate but related works as Arthur Kopit's "Wings" and "The War in Heaven," the Sam Shepard-Joseph Chaikin monodrama that Mr. Chaikin performed earlier this year.

●

What binds the diffuse elements is the performance of Joan MacIntosh. With unwavering concentration, she offers a harrowing portrait of a wom-

an suffering an eclipse of the brain. Even after the debilitating accident, her mind remains in a state of agitated awareness. Stumbling over words as she struggles to speak, she says that she feels as if she has "elephants on tongue." The recovery is painfully documented by the actress. Her eyes fight for understanding and her hands become semaphores as her words contradict themselves, regroup and gradually achieve coherence. As we watch, she is reborn.

The picture is further complicated by the fact that the character is obsessively devoted to herself and to her career — to the neglect of the two people closest to her, her teen-age daughter (Lizabeth Zindel) and her mate (Edward Baran), an aspiring opera singer. Both Ms. Zindel and Mr. Baran are acutely in tune with their roles. Before and after the accident, the astronomer demands to be the sun in her domestic solar system. As a result, others are forced to make sacrifices.

•

Dramatic difficulties arise when the playwright ventures into other spheres, beginning with the protagonist's academic colleague (Tom Cayler), whose lectures on the universe are intended to counterpoint Ms. MacIntosh's attempt to reactivate herself. Delivering these fanciful speeches, Mr. Cayler never seems convincingly a scientist. At the same time, Aleta Mitchell, who doubles in roles as a speech therapist and newspaper reporter, is unable to conceal the fact that her dialogue is simply functional.

When "Night Sky" holds to Ms. MacIntosh, it is revealing about a horrifying but apparently reversible condition. As the astronomer pushes herself in a feverish desire to read a paper at a scientific conference, she also punishes herself. With the help of the playwright and the director, the actress illuminates the aphasiac's personal black hole.

1991 My 23, C24:5

Song of Singapore

Book by Allan Katz, Erik Frandsen, Robert Hipkens, Michael Garin and Paula Lockheart. Music and lyrics by Mr. Frandsen, Mr. Hipkens, Mr. Garin and Ms. Lockheart. Directed by A. J. Antoon. Set design by John Lee Beatty; costume design, Frank Krenz; lighting design, Peter Kaczorowski; sound design, Stuart J. Allyn; musical supervision, Art Baron; orchestrations, John Carlini; vocal arrangements, Yaron Gershovsky; jazzaturg, Ms. Lockheart; production stage manager, Ron Nash; production manager, Miriam Schapiro; associate producer, Marc Routh. Presented by Steven Baruch, Richard Frankel, Thomas Viertel, in association with Allen Spivak and Larry Magid. At Song of Singapore Theater, 17 Irving Place, off East 15th Street.

WITH: Cathy Foy, Erik Frandsen, Michael Garin, Robert Hipkens, Francis Kane, Art Baron, Jon Gordon, Oliver Jackson Jr. and Earl C. May.

By MEL GUSSOW

One might expect Indiana Jones to swagger into the nightclub, be served an explosive cocktail and bash a few foes before embarking on his journey to the Temple of Doom. Indy never arrives, but there is a floor show, "Song of Singapore," that sends out an entertainment S O S to all fans of 1940's B-movie melodrama. The show, which opened last night in a lavishly redecorated club hall on Irv-

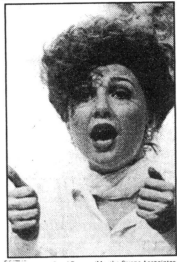
Carol Rosegg/Martha Swope Associates
Donna Murphy

ing Place, is an amiably madcap musical sendup.

Imagine an East Asian cross between "Oil City Symphony" and "Tamara" performed by a swing band that might have played at Rick's in Casablanca and that features a torch singer known as Rose of Rangoon, and you might begin to have an inkling of the eclecticism of the evening. This is the sort of saloon in which someone will rush in and say, "Do you know there's a dead man at the bar?" and a member of the band will answer: "Sure. B flat," and then segue into a tune. Count on the gag being repeated.

The book does not have the sheer lunacy of "Help!" or "Duck Soup" and could be arrested for trafficking in silliness. Running two hours, the show might be tightened without loss. But to its credit, "Song of Singapore" is not insistent, and is always ready to stop for a song or to reach for a laugh.

•

At the center of the coherent confusion is Donna Murphy as Rose, a "lowdown cheap saloon singer" who lost her identity (but not her voice) on a road to or from Mandalay. She is, we eventually learn, an amnesiac with an aviatrix up her sleeve.

Ms. Murphy is a terrific singer who can sing blues as well as barrelhouse and can move from an animated chorus of "You Gotta Do What You Gotta Do" to a silky rendition of "Sunrise." As an actress, she is funnier than Rita Hayworth, Dorothy Lamour and other stars who ventured into movie Malaysia. She also plays a deft trumpet and kazoo.

Anything goes onstage (and on the dance floor), starting with vaudeville jokes and including a conga line that snakes through the audience. But everything is tongue in cheek, especially the villainy, as represented by a duplicitous policeman in a pith helmet.

•

The plot, a collaborative endeavor like the music and lyrics, is as thick as chutney and twice as sticky, dealing with stolen jewels in the shape of a fish. (This leaves room for red herrings.) The show refuses to take itself seriously, deferring to the mockery and the music. The band is replete with musicians with an instinct for comedy and an ability to

play a variety of instruments (the usual, plus ukulele, tambourine and washboard). One horn player yodels in Dutch.

The score merrily plunders and parodies songs of the period (by Da Sylva, Brown, Henderson, et al.) while pursuing its own tuneful course. There are numbers that sound like ones hummed before, but with a twist, as in "Harbor of Love," a neo-Porter spoof about the sex life of sea life ("Even crustaceans have infatuations").

The musical talent begins with Ms. Murphy and extends to the supporting players in and out of the band. Cathy Foy is suitably slinky as a slit-skirted Dragon Lady; Michael Garin plays a blind pianist like a wry Ringo Starr and there is support from Erik Frandsen and Robert Hipkens. The last two and Mr. Garin are among the co-authors.

A. J. Antoon has directed the show in and around the audience, which is invited to come early and dance to music that seems left over from a 1940's high school prom. As designer, John Lee Beatty has seemingly sacked warehouses of chinoiserie, filling the large ballroom with lanterns, bird cages and other Pan-Asian paraphernalia. This is most assuredly a fictive Singapore, but one that can be welcomed by anyone with a fond memory of all those Shanghai gestures and rainy days in Ranchipur and by those eager to join in an audience-involving frolic.

1991 My 24, C26:2

Marathon 1991
New One-Act Plays
Series A

Producer, Kate Boggott; associate producer, Margaret Mancinelli. Set design, Ann Waugh; lighting, Greg MacPherson; sound, One Dream; costumes, Deborah Rooney; production supervisor, Paul E. King; production stage manager, Carol Avery. Presented by Ensemble Studio Theater, Curt Dempster, artistic director; Dominick Balletta, managing director. At 549 West 52d Street.

WITH: Sherry Anderson, John Augustine, Garrett M. Brown, Steven Goldstein, Deborah Hedwall, Ilene Kristen, Paul McIsaac, Melinda Mullins, David Rasche, Lynn Ritchie, Victor Slezak and William Wise.
WHERE WERE YOU WHEN IT WENT DOWN? By David Mamet; directed by Billy Hopkins.
NAOMI IN THE LIVING ROOM
Written and directed by Christopher Durang.
INTIMACY
From a short story by Raymond Carver; adapted and directed by Harris Yulin.
YOU CAN'T TRUST THE MALE
By Randy Noojin; directed by Melodie Somers.
A WAY WITH WORDS
By Frank D. Gilroy; directed by Christopher A. Smith.

By MEL GUSSOW

Whenever he comes to New York, a writer (David Rasche) has lunch with his best friend from high school (William Wise). During one of these annual meetings, Mr. Wise suddenly announces that his wife left him 13 years earlier. The writer is astounded, while the friend is abashed at having kept up the charade for so many years.

What follows in Frank D. Gilroy's one-act comedy "A Way With Words" is a mirthful contemplation of the limits of friendship and the obsessiveness of a spurned spouse. Mr. Wise is

thinking of getting married again, but he wants to be sure there is no chance of reconciliation with his former wife (Melinda Mullins). Mr. Rasche is enlisted as reluctant go-between.

In less than 30 minutes, the playwright offers a complete comic picture of the three intertwined characters, as each helplessly misinterprets the others' signals. Under the direction of Christopher A. Smith, the cast paints with the blithest of brush strokes.

•

Mr. Gilroy's wry roundelay ends Series A of the Ensemble Studio Theater's three-part marathon of one-acts. Unfortunately, it is the only one of the evening's five plays with substance as well as flair. The quintet begins with negligible contributions from two of the company's most celebrated playwrights, Christopher Durang and David Mamet.

Mr. Durang's "Naomi in the Living Room" is a cartoon about a dragon-like woman, her son and his wife. There is only half a joke here, as the matriarch defines each room of her house by its name: one lives in the living room and collects kitsch in the kitchen. Mother and son are played by Sherry Anderson and John Augustine, who were billed as Dawne in the playwright's nightclub act, "Chris Durang and Dawne." "Naomi" is a mere footnote to such other Durang family comedies as "The Marriage of Bette and Boo."

If anything, Mr. Mamet's "Where Were You When It Went Down?" is even slighter, a five-minute dialogue about a supermarket robbery that may or may not have taken place. Just as the conversation gets rolling and one starts to have a focus on the two characters, the play ends. This is clearly a case of Mamet minutiae.

•

The short stories of Raymond Carver would seem to provide the most natural dramatic material.

A Frank Gilroy comedy winds up a one-act marathon.

Harris Yulin's adaptation of "Intimacy" indicates otherwise. In this story a writer pays an unannounced visit to his divorced wife and she ventilates her pent-up resentment at his betrayal. Despite Deborah Hedwall's relentless performance and the use of dialogue from Mr. Carver's story, the adaptation misses the verbal rhythm and oppressive mood of the original.

The second half of the evening opens with a glimmer: a brief sketch, "You Can't Trust the Male," by a newcomer, Randy Noojin. A nosy mailman (Garrett M. Brown) makes a play for an attractive woman (Lynn Ritchie) on his route. There are awkward, repetitive patches in the script and Mr. Brown has assumed a wandering immigrant accent, but there are minor compensations. The actors are amusing as the oddly matched pair, and the author offers off-the-wall observations about the quirks of mail delivery. A theatergoer arriving after the intermission may share a few smiles with Mr. Noojin before settling down in the confident company of Mr. Gilroy.

1991 My 26, 57:5

SUNDAY VIEW/David Richards

American Nightmare in a Family Restaurant

Sam Shepard plays the symbols in 'States of Shock.'

The Mafia trio in 'Breaking Legs' wins name that goon.

ARMAGEDDON COMES TO A FAMily restaurant in Sam Shepard's first drama in six years, "States of Shock" (at the American Place Theater).

But even though there's a red vinyl booth to one side of the stage, and a middle-aged couple waiting to be served their clam chowder at a table on the other side of the stage, you probably won't be fooled. You won't be fooled when the waitress calls the establishment Danny's and recalls the days it was known for the convivial clinking of coffee cups and the pretty pictures on the menu.

The family restaurant is really post-Vietnam America — a place of violent moods, blood lust and lousy service. The rampant militarism that has always fueled our manifest destiny is merely on hold, waiting out "the stupid boredom of peacetime" for the chance to swing into action once again. Whatever was good about the nation is going, going, gone. By the end of this 75-minute, intermissionless drama, the customers have begun to curl up in fetal position on the floor, while a wounded veteran, with a hole in his chest the size of a pie plate, prepares to take his vengeance on a bully known only as the Colonel.

■

We are in that special province of the drama that used to be called the morality play, until the distinctions between good and evil grew fuzzy and the very notion that a man's soul might be something worth fighting over was deemed theatrically archaic. Still, Mr. Shepard's play doesn't make a whole lot of sense on any other grounds. You could call it a nightmare, I suppose, which is one way of acknowledging, if not forgiving, its meandering, murky ways. But if you look at it as chronicling the battle for a nation's soul, there seems to be some vague method to the playwright's madness.

This much is certain about "States of Shock." The Colonel (John Malkovich) has brought Stubbs, the veteran of a recent but unspecified conflict, to the family restaurant. Stubbs (Michael Wincott) is confined to a wheelchair bedecked with tiny American flags. Sometimes he blows a shrill blast on the police whistle around his neck, raises his shirt and exposes his wound, which was caused by a missile tearing through his body. Standing behind him at the time was the Colonel's son, who was killed outright by the projectile. To mark the anniversary of that death, the Colonel wants to treat Stubbs to a fancy dessert. Maybe a hot fudge sundae.

Meanwhile, the middle-aged couple, dressed all in white, complains about wasting time (45 minutes and counting, at the play's start) waiting for their clam chowder when they could be out "buying things." The waitress, for her part, has trouble carrying dishes on a tray and walks very slowly.

The Colonel urges Stubbs to reconstruct the moment just before his son was killed — using toy soldiers in his knapsack and implements on the restaurant table. "A catastrophe has to be examined from every possible angle," he explains. Stubbs is reluctant. The Colonel insists. An ugly showdown would appear to be in the offing.

Beyond such apparent facts, however, anything more I could tell you would be pure speculation. Are we witnessing an episode in the eternal rebellion of sons against their fathers? Or is a victim calling his aggressor to account? Are these the two faces of American manhood — the maimed and the maniacal? And for that matter, will someone tell me why the Colonel can balance a coffee cup on his head and the waitress can't?

Mr. Shepard's plays have always sprung deep from the subconscious. They chronicle raw intincts and primitive urges, a sadness for what used to be and a rage to despoil what remains. To expect hard and fast meanings from them is to betray their elemental force. In his most stageworthy works ("Buried Child," say, or "Fool for Love"), the tensions suffice, binding the characters so dynamically to one another that the need for explanations is temporarily defused.

It's a little like coming on a fight in the street. You do not have to know who the combatants are or what's brought them to blows to be transfixed by the row. *Something* is clearly at stake. Only when the fury abates and the tensions slacken do you feel the need to start asking questions and bring order to the altercation. At "States of Shock" you'll have questions from the beginning. The director Bill Hart can't get the theatrical voltage up high enough to still the demands of the rational mind.

Mr. Malkovich — his head closeshaven, his face sporting a stubble of whiskers — gives a curiously flaccid performance as the Colonel. Few actors are better at portraying a certain kind of blurry, thick-tongued madness. His eyes wander the walls oddly, his voice takes on an insistent nasal whine and you can't help wondering what asylum he's inhabiting. But there's nothing sharp or steely about his presence. This is the madness of the slovenly or the depraved, and in this case it's too soft to drive "States of Shock." Think, by way of contrast, how Stephen Lang's metallic craziness galvanized "The Speed of Darkness," Steve Tesich's recently departed play, which also dealt, albeit more directly, with the legacy of Vietnam.

Mr. Wincott doesn't have a steady bead on Stubbs and tends to get lost in the role's ambiguities. The middle-aged couple (they could be Mommy and Daddy from "The American Dream" by Edward Albee) are meant to be caricatures of vacuous Middle America, I suspect. At any rate, they're played as such by Isa Thomas and Steve Nelson, while Erica Gimpel, as the waitress, picks her way gingerly across the floor as if it were also a minefield, which it is.

■

Periodically, two offstage percussionists beat out the sounds of thunder and bombs, and the family restaurant is illuminated by flashes of atomic lightning. But all the explo-

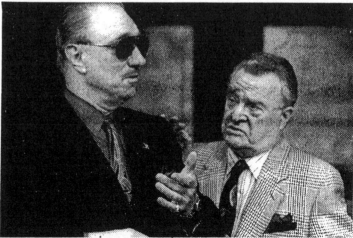

Philip Bosco and Vincent Gardenia in Tom Dulack's comedy "Breaking Legs"—godfathers who show some respect for theater

sions, you can't help noticing, are taking place in the wings. On stage, Stubbs is claiming to be the victim of friendly fire, while the Colonel is screaming for rivers of blood. The middle-aged woman, served her chowder at long last, salts it endlessly, while the middle-aged man masturbates under a napkin. The waitress is soon pining for better days — as who wouldn't under the circumstances. And then they're all singing "Goodnight, Irene," the cowboy's lament for the woman he'll see in his dreams, if he doesn't throw himself in the river and drown first.

There is, it seems to me, entirely too much of the Rorschach test in this for a drama's good. All too easily, Mr. Shepard has settled for shapes, not states, of shock.

'Breaking Legs'

"Breaking Legs," a featherbrained comedy by Tom Dulack (Off Broadway at the Promenade Theater), has three things going for it — the magnificent mugs of Vincent Gardenia, Philip Bosco and Victor Argo.

Mr. Gardenia's face — two pin-dots for eyes, a hooked nose and a disapproving mouth wrapped in folds of flesh — seems to be reacting to the omnipresent stench of skunk. Mr. Bosco's — with its great sloping forehead and its deferential chin — bears the imprint of the mole, blinking dumbly in the sunlight after a long winter's slumber, while Mr. Argo's frozen deadpan suggests that he has just come from the dentist and the Novocain hasn't had a chance to wear off.

The actors have been cast as Mafia kingpins who have decided to expand operations beyond their New England town and invest in a Broadway play. The play is, apparently, an arty affair, written by a local university professor, who at first welcomes the investment, then, when he realizes the company he's keeping, starts sweating profusely. For most of the evening, the comedy has to struggle simply to keep up with your average TV sitcom. Buffalo, Italian food and "Cats" come in for a predictable ribbing, as do the Medicis — Carlo and Jimmy of Worcester, Mass. On the other hand, the first-act curtain consists of the university professor inducing an orgasm in the daughter of one of the thugs by massaging her feet. So all's not TV.

■

The best of "Breaking Legs" has to do with the Mafiosi pronouncing themselves on Broadway. Wisely, they recognize the necessity for a great title (like "Pajama Games" or "Gypsies") and a forceful producer (like Daniel Merrick). But they also respect the theater for the great institution it is. Just look at the reverential glow given off by Mr. Bosco, as he recalls the time he saw "Ettle Merman ... a very great actress ... in 'The Desert Song.'" O.K., the line isn't that funny. But the awe-struck face sure is.

Even Larry Storch, in a cameo appearance as a rat in the hot seat, contributes some memorable features — a nose sharp enough to serve as a letter opener, and a pair of eyes

that, when he squints, disappear completely, leaving only wrinkles behind.

Pusses like these deserve a Mount Rushmore of their own. □

1991 My 26, II:5:1

Casanova

By Constance Congdon; directed by Michael Greif; set design by John Arnone; costumes by Gabriel Berry; lighting by Frances Aronson; music and sound by John Gromada; musical direction by James Cunningham; choreography by James Cunningham; associate producer, Jason Steven Cohen. Presented by Joseph Papp. At the Public/ Martinson Hall, 425 Lafayette Street.

WITH: Erika Alexander, Marylouise Burke, Margaret Gibson, Ethan Hawke, Kaiulani Lee, James Noah, Liana Pai, Latanya Richardson, John Seitz, Robert Stanton, Jack Stehlin, Martha Thompson and Jeff Weiss.

By FRANK RICH

Having opened his debut season at the New York Shakespeare Festival with a revival of Sophie Treadwell's "Machinal," a feminist play of 1928, the director Michael Greif now closes it with Constance Congdon's "Casanova," a feminist play of the present day. Mr. Greif's talent remains a constant in both productions, and so, in general terms, do the authors' views of how cruelly the world works.

But where nearly everything about "Machinal," starting with its title, twisted the familiar into the unsettling and disturbing, "Casanova" seems like an open-and-shut case from start to finish. Do we really need to spend three hours in a theater to learn that Casanova is not the passionate free thinker he would have posterity believe but is instead, to paraphrase his daughter's final judgment, nothing more than a sack of spermatozoa?

●

Ms. Congdon is not without theatrical imagination, and she is nothing if not relentless in her efforts to trick up both her predictable message and the frequently dramatized Casanova saga with the devices of epic theater. As the audience takes its seats, it finds the backstage area in full view and watches the company trying on costumes, wigs and makeup. Once the play actually begins, the author deconstructs its protagonist's celebrated memoirs by refracting their events, told in flashback, through

Martha Swope/"Casanova"

John Seitz as elderly Casanova.

three conflicting storytellers: the elderly Casanova (John Seitz), the young Casanova (Ethan Hawke) and Casanova's abandoned wife, Therese (Margaret Gibson). The play's language veers between 18th- and 20th-century diction — the phrase "politically incorrect" makes an early appearance — while the colorblind casting adds a subtext of liberation to the text's heavy-handed sermonizing about sexual subjugation.

Collaborating with three bold designers — John Arnone (sets), Gabriel Berry (costumes) and Frances Aronson (lighting) — Mr. Greif seizes every opportunity for visual amusement he can find. While "Machinal" was done in the Expressionist style in vogue in Treadwell's day, the extravagant, transparent role-playing in "Casanova" recalls the later modernism of Jean Genet. A smidgen of a much earlier form of masked theater, commedia dell'arte, is also thrown in — Casanova's parents are seen as actors with Goldoni's troupe — and so are some calligraphy-decorated curtains, an echo of the recent "La Bête." By the time Mozart and Lorenzo da Ponte make cameo appearances to illustrate Casanova's shadowy connection to the composition of "Don Giovanni," one even sees echoes in technique, if not content, between "Casanova" and the Peter Hall stage version of "Amadeus."

●

Most of Mr. Greif's staging reveals his sharp eye, good ear (John Gromada's fetching music bridges several eras) and a spirit of intellectual playfulness. And occasionally the director and playwright connect to deliver the substance of "Casanova" in dramatic rather than pedagogical terms. The evening's high points include those scenes in which the two pathetic Casanovas survey each other's lives, and especially a ballroom finale in which Mr. Seitz's decrepit and rouged elder Casanova has an ironic final waltz with a transvestite whose proud self-realization makes a mockery of the dying rake's old masculine order.

Jeff Weiss gives the production's most commanding performance as that transvestite, but it is typical of the play that he must spend most of the evening lecturing from the sidelines in tandem with Casanova's heartsick daughter (Kaiulani Lee), a woman who must be disabused of her male dependency at a laborious pace before everyone can go home. "Oh,

skip this part!" cries out Mr. Weiss to halt one dull post-coital scene, and one only wishes that he had been allowed to edit his own speeches as well as all the other boilerplate speeches and scenes that are not skipped. When romance is described as a drug to keep women "dazed and compliant" or the young Casanova asks, "Am I a real man now?" after losing his virginity or the old Casanova is accused of loving women without ever knowing them, "Casanova" speaks in an official, not a human, voice. The same is true of those obligatory scenes decrying the penis and sentimentalizing sexual acts that don't require its participation.

Given the prevalence of such familiar polemics, it is understandable that the actors rarely can create characters who might make striking impressions. (Then again, none of this season's three Greif productions, which also include "A Bright Room Called Day," have been distinguished by their acting.) Aside from Mr. Weiss, the strongest work here comes from Mr. Seitz, whose crumbling Casanova amusingly recycles the dissolute Don Juan he once played for Richard Foreman, and, in a variety of roles, two young actresses, Erika Alexander and Martha Thompson.

●

Yet "Casanova" is so distant — and not the Brechtian distance presumably intended — that finally not even good acting can make a crucial rape sequence in Act II deliver the terror it should. Though Ms. Congdon is a more sophisticated and literary writer than Sophie Treadwell, it is hard to sit through their respective plays in the same theater in the same season and not be struck by how much more urgent and tough-minded the 1928 "Machinal" seems in its depiction of women being chewed up and spit out by a masculine hiearchy. Is the discrepancy in impact between Treadwell's play and Ms. Congdon's a matter of talent, or merely a function of the fact that Treadwell, writing in a less enlightened time, had to speak more strenuously to make herself heard? Whatever the explanation, "Machinal" still lingers as an authentic cry of rage while "Casanova" evaporates even as one watches it into a smug exercise in preaching to the converted.

1991 My 29, C11:5

Drama in Review

■ Eight plays, short and ambiguous ■ That nasty business of war and declining values ■ A merry widow and her many credit cards.

Momentary Lapses

Avalon Repertory Theater
2744 Broadway,
at 105th Street
Through Sunday

Eight short plays presented by the Zena Group Theater. Producers, Jeremy Gold, Josh Liveright and Bruce Marshall Romans; production stage manager, Kate Splaine; sets by the Company; costume design, Hollis Jenkins Evans.

VALENTINE'S DAY, by Kathleen Chopin; directed by Kate Cummings.

WHAT SHE FOUND THERE, by John Glore; directed by Libba Harmon.

OUT THE WINDOW, by Neal Bell; directed by Tracy Brigden.

MIXED EMOTIONS, by Bob Krakower; directed by Rod McLachlan.

REALLY BIZARRE RITUALS, by Reid Davis; directed by Jameel Khaja; music composed by Max Risenhoover.

AFTER YOU, by Steven Dietz; directed by Alex Aron.

THE PROBLEM SOLVER, by Michael Bigelow Dixon and Valerie Smith; directed by Ms. Cummings.

Glen M. Santiago, left, and Damian Young in Peter Mattei's "Amerikamachine," at the Cucaracha Theater.

THE LAST SUPPER, by Mr. Davis; directed by Ms. Harmon.
WITH: Diane Casey, Kara Flannery, Mr. Gold, Arthur Halpern, Margaret Howard, Marta Johnson, Matt Kozlowski, Mr. Liveright, Belinda Morgan, Mr. Romans and Ms. Splaine.

In "Valentine's Day," the first of eight short one-act plays that have been produced together under the title "Momentary Lapses," three young men and a barmaid while away the late-night hours on a February evening, letting the songs on the jukebox express their loneliness. One man calculates that in a town of 80,000 the number of eligible women could not exceed 250. He belatedly realizes that the very eligible barmaid might be in love with him, and in a series of inadvertent gaffes, he blows any possibility of a relationship.

"Valentine's Day" is typical of the eight plays presented by the Zena Group Theater, a collective formed last year by 12 members of the Actors Theater of Louisville Apprentice Program in Kentucky. Written by Kathleen Chopin, it has no particular truth to tell. And like the evening's seven other plays, it is more interested in creating ambiguity than in revealing character.

Although the styles of the other plays run from the surreal to the farcical, all pull their punches in ways that seem coy and defensive. In "The Last Supper," Reid Davis, the flashiest of the seven playwrights and the only one to contribute two offerings, a couple and their best friend share a drunken picnic during which it is revealed that the three have taken lethal doses of pills and are waiting to die. Although nuclear fallout is mentioned, it isn't really clear what inspired this triple suicide, and the play seems empty and sensationalistic. His other play, "Really Bizarre Details," is an inscrutable farce involving sunglasses and video cameras.

In John Glore's cutesy vignette, "What She Found There," a young woman who stepped out of a mirror explains to her truck driver lover how everything happens backward in her world, including making love first

and being introduced afterward. Bob Krakower's "Mixed Emotions," which is about a peripatetic rock star and his friends and lovers, is too short and has too many characters for any to be developed.

In Neal Bell's surreal "Out the Window," a man in a wheelchair finds himself perched improbably on a table, his sexual potency miraculously restored, the morning after a wild party. Valerie Smith's sliver of a comedy, "The Problem Solver," revolves around the assembly of some patio furniture by vacationers who detest one another. In Steven Dietz's "After You," a couple who are about to be divorced enjoy a rapprochement while he shaves her legs.

While several of these playwrights have acquired regional reputations, the 10-minute-play format has proved too constricting for solid work to emerge. The acting, though not embarrassing, is far too self-conscious. Kate Splaine, the most talented performer, can be seen in the plays "Valentine's Day" and "The Problem Solver." STEPHEN HOLDEN

Amerikamachine

Cucaracha Theater
81 East Second Street
Through June 8

Text, direction and design by Peter Mattei; lighting designer, Brian Aldous; costume designer, Mary Myers; sound designer, Jeffrey Taylor; stage manager, Pam Thompson. Presented by the Cucaracha Theater. With: Garrick Ambrose, Les Baum, Joey L. Golden, Damon Grant, Lauren Hamilton, Kirk Jackson, Christie MacFadyen, Freja Mitchell, Brennan Murphy, Glen M. Santiago, David Simonds, Elizabeth Woodruff and Damian Young.

The stark opening image that echoes through Peter Mattei's cyberpunk theatrical thriller, "Amerikamachine," is an illuminated pile of sand, studded with toy soldiers and miniature tanks. Over the course of the 80-minute play presented by the Cucaracha Theater, the sand, an emblem of the Persian Gulf war, also comes to symbolize the earth itself, which in the play's futuristic setting

has become a desert known as the planet Amerika. Government activity has devolved into militaristic Nintendo games supervised by the monstrous General Blackhead, who runs down children in his limousine, assuming they are terrorists.

The play's characters include a trillion-megaton human replicant doomsday machine who calls himself Hamlet Prinz von Denmark Rotten, an Ophelia who becomes a go-go dancer for the troops, the demented ghost of Robert Oppenheimer and a Central Intelligence Agency chief who near the end of the play delivers a hilarious gibberishy deconstruction of Hamlet's "to be or not to be" soliloquy. Hamlet, who first appears as a sort of laboratory specimen seen from the neck up in a fish tank, is an out-of-control invention who turns into a muscle-flexing parody of Arnold Schwarzenegger in "The Terminator."

The play, which is divided into more than 20 short numbered scenes performed out of order, is really a collection of grimly funny theatrical and linguistic jokes that evoke the decline of language, literacy and human values into what Saul Bellow has called "the moronic inferno." Beneath the smart literary humor seethes a palpable rage and disgust.

If the density of the play's allusions, which jam together Shakespeare, Georg Büchner, Heiner Müller, Allen Ginsberg and others, is intimidating, the production has been directed by Mr. Mattei and performed in Cucaracha's drab East Second Street headquarters with an electrifying energy.

The scenes are punctuated with the tapping of computer keyboards and divided by sharp musical explosions. Christie MacFadyen's solo violin underscores the production's more serious moments with biting lyricism. The sculptural lighting gives the vignettes an appropriately monumental look, and visual puns abound, from "The Terminator" to "Dr. Strangelove" to Michelangelo's "Creation of Adam."

In a consistently strong cast, Elizabeth Woodruff and Lauren Hamilton are respectively outstanding as the cool, snooty C.I.A. chief who flaunts

her Yale pedigree and a radical-feminist go-go dancing Ophelia.
STEPHEN HOLDEN

Charge It, Please

Puerto Rican Traveling Theater
304 West 47th Street
Through June 23

Book, music and lyrics by Carlos Gorbea; directed by William Martin; co-director and associate producer, Alba Oms; producer, Miriam Colon Valle; Spanish translation by Walter Krochmal. Presented by the Puerto Rican Traveling Theater. With: Fred Barrows, Mel Gorham, Alberto Guzman, Joan Jaffe, Iraida Polanco and Jeanette Toro.

When a young Puerto Rican widow in East Harlem discovers the power of countless credit cards in "Charge It, Please," banks totter but business booms. Its author, composer and lyricist, Carlos Gorbea, calls it a "comedy with music." But it sounds like a good old-fashioned Broadway musical, complete with a couple of downright wicked dance routines.

There are no first-class singing voices in the cast of the production, but Mr. Gorbea's sassy lyrics hardly call for bel canto. And if the story unravels a bit at the end, after two hours of laughter one hardly notices.

In the spirit of the piece, the director, William Martin, goes for snap, speed and surprise. And the actors deliver: five of them in more than two dozen roles including addled clerks and waiters, a drunken ghost, a mad process server, a brainless Dallas socialite and a crooning mermaid.

Mel Gorham as the sexy widow (Wednesday through Friday in the English performances; Jeanette Toro takes the role on weekends in Spanish) and Iraida Polanco as her plain sister are comic competitors trying to steal the show. Alberto Guzman, as a shopkeeper in love with the widow, is a perfect straight man for both. But perhaps the most enviable parts belong to Joan Jaffe and Fred Barrows, who shine in all of their 20 roles, switching accents, wigs and costumes with the teasing ease of magicians.

Against a spectacular backdrop of giant murals by Marc Lida, Rick Butler's classy set has all kinds of panels and doors that let characters pop out of walls, vanish and then reappear as someone else two feet away, and even land on a roof by helicopter. Obviously, everyone with a hand in this production has worked hard, and it shows; "Charge It, Please" is great fun.
D. J. R. BRUCKNER

1991 My 29, C14:3

The Most Happy Fella

Based on Sidney Howard's "They Knew What They Wanted." Book, music and lyrics by Frank Loesser; directed by Gerald Gutierrez; scenery, John Lee Beatty; costumes, Jess Goldstein; lighting, Craig Miller; artistic associate, Jo Sullivan; musical direction, Tim Stella; choreography, Liza Gennaro. Produced by Michael P. Price. Presented by Goodspeed Opera House, East Haddam, Conn.

Cashier, Postman and Doctor	Tad Ingram
Cleo	Liz Larsen
Rosabella	Sophie Hayden
Tony	Spiro Malas
Herman	Guy Stroman
Clem	Bob Freschi
Jake	John Soroka
Al	Ed Romanoff
Marie	Claudia Catania
Max and Priest	Bill Badolato
Joe	Charles Pistone
Pasquale	Mark Lotito
Ciccio	Buddy Crutchfield
Giuseppe	Bill Nabel

Diane Sobolewski/Goodspeed Opera House

Spiro Malas and Sophie Hayden in "The Most Happy Fella."

By FRANK RICH

Special to The New York Times

EAST HADDAM, Conn., May 27 — Though "The Most Happy Fella," the haunting and spectacularly ambitious show Frank Loesser wrote after "Guys and Dolls," is receiving two major stagings this year — one at the Goodspeed Opera House here through July 12, the other to open at the New York City Opera in September — it has always been the most unlucky musical.

The original production, while well received, had the misfortune to be overshadowed by "My Fair Lady," which beat it to Broadway by two months in 1956. Since then, this musical about the May-September union between an aging immigrant grape grower and his young mail-order bride in the Napa Valley of the 1920's has proved too problematic for frequent revival. With more than 40 musical numbers — some in a mock-Puccini idiom and others, like "Standing on the Corner" and "Big D," in the Tin Pan Alley style of the author's "Once in Love With Amy" and "Luck Be a Lady" — "The Most Happy Fella" requires operatic and musical-comedy voices without landing firmly in either camp. The one previous major resuscitation — on Broadway in 1979 by people who had triumphed a few seasons earlier with "Porgy and Bess" — was a fine, loving effort but it revealed the seams in the piece and proved short-lived. The show went back to being a cult cause, kept alive mainly by the complete original cast recording (three LP's worth) that Goddard Lieberson produced for Columbia Records.

The Goodspeed production may change all that, for it justifies the minority view that Loesser created some sort of cracked American classic with this show, which took him four years to write and whose like he would not attempt again before his death in 1969. A serious rethinking of the musical rather than a museum restoration of it, this revival is an achievement of rare beauty. The audience arrives at the intimate, antique Goodspeed expecting the house's signature evening of nostalgia, laughter and tap dancing and is soon swept away instead by an unfamiliar show whose calling cards are gorgeous music and unadulterated romance.

The director is Gerald Gutierrez, who has worked at Goodspeed before, but is best known to New York audiences for his highly polished stagings of bright contemporary comedies by playwrights like Wendy Wasserstein and Jonathan Reynolds. For "The Most Happy Fella," Mr. Gutierrez has made a number of smart, gutsy decisions. His biggest gamble — really unthinkable to any "Fella" purist — is to remove the orchestra, and with it, the grand orchestrations by Don Walker, who arranged this score with the same feeling he brought to such stylistically related musicals as "Carousel" and "She Loves Me." The Goodspeed pit is occupied by two pianos instead — playing a Loesser-approved arrangement by Robert Page — and much as one may miss the Walker underscoring and act preludes, the ear soon adjusts and the compensating pleasures soon outweigh the losses. By jettisoning the orchestra, Mr. Gutierrez liberates the show from both its operatic pretensions and its show-biz slickness — and frees the audience from its parallel expectations — with the result that the characters and their drama, pushed forward on a thrust stage, take over.

●

To further sharpen the focus, there has been some very subtle editing of the text, particularly the book but occasionally the score, with an eye toward eliminating digression and melodrama. (Nothing major is missing, and one musical passage cut during the original production's pre-Broadway tryout is restored.) Most important, Mr. Gutierrez has cast singers who can really act in every role, including such relatively minor ones as the three neighborhood chefs, who, as played by Mark Lotito, Buddy Crutchfield and Bill Nabel and as delightfully choreographed by Liza Gennaro, prove that it is possible to sing an Italianate operatic trio (in Italian, yet) while juggling like the Flying Karamazov Brothers.

The lead performers offer perfect-pitch emotions to go with their voluptuous singing. The title character of Tony Esposito is completely stripped of buffoonish cliché by Spiro Malas, who, like his more illustrious predecessors in the part (Robert Weede in 1956, Giorgio Tozzi in 1979), is primarily an opera performer. Tony, the audience is told, is not good looking, not young and not smart, which is why he dishonestly sends a photograph of his handsome young foreman Joe (a robust-voiced Charles Pistone) rather than one of himself to Rosabella, the San Francisco waitress he woos by mail. The scrupulously truthful Mr. Malas, indeed neither good looking nor young, makes Tony enormously appealing without short-changing the character's obtuseness during the courtship or his severe depression after his young wife betrays him. Mr. Malas surely fulfills

Tony pays the price for not being all that he seemed.

Loesser's highest intentions when, in his final aria, he seems to be thinking in song while sorting out what remains of his life. The intimacy with which the audience can view his passage from despair to reconciliation makes the show's happy finale inexorable and cathartic rather than glibly sentimental.

●

As his beloved, Sophie Hayden is no less wonderful. Attractive but a bit lumpy, and with a Barbara Cook-like emotional tremor lurking just beneath her clarion soprano, her Rosabella is desperate and battered enough to bet her life on an epistolary romance and reckless and angry enough to resort to infidelity when she discovers Tony's ruse. Ms. Hayden arouses compassion from her very first solo, "Somebody Somewhere," in which she comes far forward, wearing the institutional plaid cotton uniform, ratty cloth coat and heavy-duty shoes of her dreary labors, to sing hungrily, not cloyingly, of how she "wants to be wanted, needs to be needed." When she and the crippled Tony fall in love for keeps much, much later — in the duet "My Heart Is So Full of You" — her world-weary cynicism and Mr. Malas's pathetic lack of self-esteem both melt away in what feels like a thunderclap of warmth, desire and regeneration.

The song is big enough to contain its singers' highly charged feelings. In the years since Loesser wrote "The Most Happy Fella," Pucciniisms and pop near-opera have become commonplace on the Broadway stage, but this songwriter's music and lyrics, unlike those of his successors, speak from an open heart and a witty, articulate mind. In this production, even Rosabella's wisecracking best friend, Cleo, proves to have a savage emotional undertow in Liz Larsen's bracing, belting performance, and the trio ("Happy to Make Your Acquaintance") she shares with the two leads, a song of newfound intimacy disguised as a farcical English lesson for Tony, has never been so funny and so touching all at once.

●

Mr. Gutierrez's faith in simple dramatic conviction is shared by the production designers — John Lee Beatty (scenery), Jess Goldstein (costumes) and Craig Miller (lighting) — who do not shy away from the autumnal moods and cold, threatening skies that sometimes darken the bucolic Northern California vineyards and barns where the love story unfolds. When Tony and Rosabella sing the tender "How Beautiful the Days," the golden glow of sunset becomes a bittersweet counterpoint to their contentment, as if to foretell the sorrow that will soon derail their happiness. That sorrow must come, of course, and when it does, it hurts. But this is one of those extraordinary nights when an audience cannot separate its tears for the characters from its own tears of sheer musical-theater joy.

1991 My 30, C13:1

Caged

Written and created by Michael Kennard and John Turner; directed by Karen Hines; lighting designer, Michel Charbonneau; art director, John Dawson; music and sound, David Hines; general manager, Laura Heller. Presented by Arthur Cantor and Hollywood Canada Productions. At the Astor Place Theater, 434 Lafayette Street.

Mump	Michael Kennard
Smoot	John Turner
Wog	Debbie Tidy

By MEL GUSSOW

Mump and Smoot are an aggressively grotesque pair of Canadian clowns who specialize in comedy of violence. Their show, "Caged" (at the Astor Place Theater), is a petit Guignol with diminishing comic returns.

Though the clowns share a country of origin with the Cirque du Soleil, they are definitely not to be confused with that French-Canadian troupe. The Cirque has a transporting sense of theatrical magic. For all their supposed mystery, Mump and Smoot offer a heavy-handed chamber of horrors in which masochism is matched by sadism.

Smoot (John Turner), who has two tiny goatlike horns on his head, begins the play confined inside a cage with widely spaced bars. Trying to extricate his friend, Mump (Michael Kennard, with one horn) succeeds only in trapping himself in the cage. Though there are easy exits, the two make everything seem difficult. This incapacity is at the root of their supposed humor.

Whenever there is a hint of progress, their nemesis, a woman named Wog (Debbie Tidy), appears in a puff of smoke. Dressed in Vampira black, this witch takes pleasure in abusing her prisoners, pulling their arms beyond the point of elasticity in the mistaken impression that they are animated cartoon characters. While trying to outwit Wog, Mump and Smoot occasionally find themselves at cross-purposes.

At odd interludes, they reveal an aptitude for mime and clowning, especially when involved in such mechanical activities as using an improvised fishing rod to hook an object far across the stage.

Eventually, they extract their revenge on their persecutor. In an interminable scene of strobe light slow motion, they capture Wog, put her behind bars and subject her to acts of torture, an attack that could easily be mistaken for misogyny.

Arthur Cantor Inc./"Caged"

John Turner, left, as Smoot, and Michael Kennard as Mump.

Throughout the play, Wog remains silent while Mump and Smoot speak gibberish (one clown's "Moodo, moodo, moodo" is another's "Moolo, moolo, moolo"). It would be safe to say that "Caged" stages better than it would read.

1991 My 31, C3:1

Food and Shelter

By Jane Anderson; directed by André Ernotte; scenic design by Ann Sheffield; lighting, Donald Holder; costumes, Muriel Stockdale; sound and music, Aural Fixation; production stage manager, Crystal Huntington; production manager, Mark Lorenzen. Presented by the Vineyard Theater, Douglas Aibel, artistic director-theater; Barbara Zinn Krieger, executive director; Jon Nakagawa, managing director. At 108 East 15th Street.

Earl......,................Philip Seymour Hoffman
Lois..Kelly Coffield
Chrissie...T-F Walker
Policeman and Clerk...........John Speredakos
Lamar.....................................Isiah Whitlock Jr.
A Librarian...................................Virginia Wing

By MEL GUSSOW

After winning $100 in a lottery, a homeless young California family splurges on a day at Disneyland. While there, the father (Philip Seymour Hoffman) decides to prolong the experience by staying on in the theme park after closing time. He and his wife and their daughter camp on Tom Sawyer's Island, and the couple have a romantic interlude in the Swiss Family Robinson treehouse. As might be expected, the reckless idyll ends disastrously. But within months the family has become fabled among other homeless people as the ones who lived at Disneyland.

This is the fanciful but grim beginning of Jane Anderson's "Food and Shelter," at the Vineyard Theater. At the outset Ms. Anderson sets her polarities: the magical though manufactured kingdom against the dreariness of those whose only residence is a car and whose life is otherwise circumscribed by food stamps and soup kitchens. If the playwright had been able to sustain the initial feelings aroused by her work, this might

have been a disturbing portrait of what it means to be down and falling out in recession-struck America.

●

For all its flashes of quirky humor and its realistic depiction of everyday frustration and anguish, "Food and Shelter" wanders over the landscape. The play shifts in and out of Disneyland and loses its best intention on the road to social commentary.

With the family split after the overnight adventure, the mother and daughter embark on a desperate struggle for borderline survival — and to overcome the red tape and recalcitrance of those who are supposed to be offering them help. Unable to work because she has no place to leave the child, the mother waits impatiently for word from her prodigal husband.

Despite one's natural sympathy for the mother's predicament, she soon becomes irritating as she moves helplessly from one unwelcome place to another. Although some of the encounters make their point, scenes are repetitive. A curious reversal takes place. We feel an annoyance with the woman even as she faces obstacles. Kelly Coffield's single-edged performance as the mother does not enhance the situation, although admittedly the playwright has not given her an interesting character with which to work. As the daughter, T-F Walker seems overly quarrelsome.

In an evident attempt to inject imagination into the script, Ms. Anderson creates a fantasy friend for the girl, who is suddenly enabled to read and to see through mailboxes. The flirtation with magical powers leads to a few comical moments, but it is ultimately as fleeting as the family life itself. While Ann Sheffield's design is elaborate — a mock Matterhorn towers over the first act — it also means unwieldy changing of scenery. André Ernotte's staging is unable to conceal the episodic nature of the narrative.

●

Not until the father returns after months of abandonment does the play regain its dramatic stride. With the enthusiasm of someone who has been reborn on the road, Mr. Hoffman tells shaggy tales about riding the rails and discovering untarnished beaches.

At one point he describes two Beverly Hills professional men who once a year pretend to be homeless, traveling with hoboes while keeping their credit cards sewn in their clothing for a quick return to prosperity.

These and other stories — and Mr. Hoffman's vibrant performance —

make one think that the playwright may have concentrated attention on the less rewarding half of the family, or at least that she should have been more equitable in her split-focus vision of people "living on the outside of regular life."

1991 Je 2, 65:1

A 'Happy Fella' With Less Offers More

Loesser's musical

fits the cozy

Goodspeed.

'Song of Singapore'

draws a line

at the conga.

WITH SO MANY BIG, EXPANsive musicals all around us today, we sometimes forget how satisfying an intimate one can be.

Like "The Most Happy Fella" by Frank Loesser.

Oh, I know, "The Most Happy Fella" wasn't an intimate musical when it had its premiere on Broadway in 1956. Although Mr. Loesser insisted he had written "a musical comedy — with a lot of music," most of the critics viewed it as a vastly more ambitious undertaking — not quite opera, but heading there. The show was almost totally sung, with only snippets of dialogue breaking up wave upon wave of cascading melodies. In three acts, not the usual two of musical comedy, it elevated the dusty story of an aging Italian immigrant farmer in the Napa Valley and his mail-order bride to that epic plane where love becomes Love, and Forgiveness battles Jealousy for a man's Happiness.

The pit orchestra alone was made up of 35 musicians.

However, at the tiny Goodspeed Opera House (in East Haddam, Conn.), which is launching the summer season in splendid fashion with "The Most Happy Fella," the orchestra is down to two pianists, and the set designer, John Lee Beatty, has seen fit to cover over the unoccupied part of the pit with planking. Those performers courageous enough to venture to the edge, do so knowing the whites of their eyes will be visible from the back row.

That used to be firing range. What it means in this instance is that the Goodspeed is free to remove all the capital letters from musical. The cast members are singing their hearts out — no question of that — but they are also singing what's in their hearts with the delicate shadings and quiet misgivings that would be lost in a larger hall. The subtleties more than compensate for the reduction

in scale. In fact, a paradoxical law of the theater kicks in. A small production, fully realized, can actually seem bigger than an extravaganza with nothing much on its mind.

Our recent musicals, from "Shogun" to "Miss Saigon," have pushed the limits of physical space — the one proving that yes, you can sink a Dutch galleon on stage if you're willing to sink a few million bucks into the machinery; the other convincingly demonstrating the use of the stage as a heliport. But inevitably, for all of the technological advances, there's the back wall of the theater to contend with. Inner space, on the other hand, is limitless. It extends as far as the performers are able to take us.

■

"The Most Happy Fella" produced its share of popular hits — "Standing on the Corner," "Joey, Joey, Joey" and "Big 'D,' " that foot-stomping celebration of Dallas. Elsewhere in the show, however, Mr. Loesser also gave expression to a full-throated lyricism that was far less common in the Broadway musical of the day. "Somebody Somewhere," "Mamma, Mamma," "Please Let Me Tell You," and that soaring duet for the show's unlikely lovers, "My Heart Is So Full of You," plunge unhesitatingly into the tumult of souls ravaged by the confusion and bliss of loving.

The mixture of Broadway pizazz and semi-operatic arias was once taken as evidence of the show's split personality. In the light of today's pop operas ("Les Misérables," "The Phantom of the Opera," "Miss Saigon"), Mr. Loesser seems to have been boldly ahead of his time.

The pop opera, however, has a tendency to divide its characters into two groups, the good and the bad (with a subdivision for the ugly), while Mr. Loesser's characters — waitresses, farmhands, small-town folk — occupy the fertile in-between ground. Tony (Spiro Malas), the prosperous Italian farmer, is probably as good as they come, a man

not only wise enough to forgive his bride for the one-night fling that has left her pregnant, but generous enough to accept the child as his own. In Mr. Malas's glorious performance, so open as to be childlike, we also see that Tony is lonely, embarrassed about his age, his faltering English, his girth and, most of all, terribly frightened that a woman won't be able to sense the warmth inside him.

As Rosabella, the San Francisco waitress he courts with sweet-talking letters and a fraudulent photograph, Sophie Hayden turns up in Napa, "wanting to be wanted, needing to be needed." But there's just as much hesi-

Diane Sobolewski/"The Most Happy Fella"

Sophie Hayden and Spiro Malas in the Frank Loesser musical "The Most Happy Fella" at the Goodspeed Opera House.

Michele V. Agins/The New York Times

Donna Murphy in "Song of Singapore"—The good times are pitched at you as if fun could only be delivered by the shovelful.

Drama in Review

tation in her, and she's quick to persuade herself that she's landed in a fix. The actress starts out weary, a little puffy, not quite pretty, then blooms ever so warily. She is no more a traditional romantic lead than Mr. Malas, but quite the nicest aspect of "The Most Happy Fella" is that by the time the two do fall into each other's arms, the pairing looks and feels absolutely right. The spirit has totally remade the flesh, which, when you think of it, is usually how love operates.

The secondary love interest hews to a more traditional Broadway formula that calls for the girl to be brash, wisecracking and full of pep; and the boy to be good-natured, a bit nitwitted and full of pep. Still, playing Rosabella's best friend and a goofy farmhand, Liz Larsen and Guy Stroman bring dollops of freshness to their roles. The choreographer, Liza Gennaro, hasn't given them a whole lot of original things to do with their feet, but since they can't keep their hands off each other, the failing is not critical.

Charles Pistone, for his part, barely has to lift a finger as the foreman who seduces Rosabella. His sultry voice does it all and the way he handles the dip in the first measures of "Don't Cry" very nearly qualifies as a caress in itself. But then the singing everywhere is first-rate, if never so spirited as when Mark Lotito, Buddy Crutchfield and Bill Nabel are celebrating "Abbondanza." There's a delirious nuttiness about their manner that encompasses the arrogance of the headwaiter, the panache of the four-star chef and the zeal of the Sicilian street vendor.

With all due respect to Mr. Loesser, Gerald Gutierrez has directed "The Most Happy Fella" as if it were a *play* with a lot of music. He's on the lookout for the first sparks of awareness and the second doubts — all those early stirrings that precede a big change of heart and make it inevitable. Directors of musicals generally rely on broader strokes. Of course, this kind of detail work is possible only in a theater like the Goodspeed, where a twinkle does the work of a twinkle and a sigh can be a sigh. No magnification required, none desired.

"The Most Happy Fella" doesn't have to come to us. We don't have to go to it. We're all in it together. Cozy. Warm. Rewarding.

'Song of Singapore'

For "Song of Singapore," Mr. Beatty (busy man these days) has taken the club hall of the Polish Army Veterans of America, District No. 2, and turned it into Freddy's Song of Singapore Cafe, a No. 1 dive. Located on Irving Place at 15th Street in Manhattan, it's very much a Terry and the Pirates kind of hangout, with lots of red lacquer and paper lanterns. Fantastical dragons snake along the walls and curl around the columns, while a real dragon lady (Cathy Foy), her imperious eye peeled for trouble, drifts among the tables, trailing cigarette smoke and such aphorisms as "Danger is in the round eye of the beholder."

On the bandstand, the blind Cockney bandleader Freddy S. Lyme (Michael Garin) is putting the Malayan Melody Makers and its lead vocalist, Rose, through their paces. The time is

1941 and, according to the periodic radio announcements, the Japanese are advancing down the Malay peninsula at a furious clip. This may be the last night for Freddy's Song of Singapore Cafe, but for the next few hours, at least, it's music, intrigue and dis-

Maybe you could call 'Singapore' an 'environment in two acts.'

gusting-looking hors d'oeuvres, as usual.

"Song of Singapore" isn't exactly a musical, although it has an original score by Mr. Garin, Erik Frandsen, Robert Hipkens and Paula Lockheart. It's more than just a cabaret entertainment, since it can also claim a dopey book by all of the above, plus Allan Katz. Maybe you could call it an "environment in two acts." More than once, I had the sinking sensation that I'd stumbled into the Singapore Pavilion at Disney World, except that the Disney folks would probably do it better and shorter.

Under the direction of A. J. Antoon, the show makes a concerted effort to involve the spectators, if not directly in the action at least tangentially, by inviting them to join a conga line or unleashing a reeling "Hindu hootch hound" in their midst. You're frisked at the door and bar girls, their satin dresses slit up the side, do a hefty traffic in come-hither looks. Some people may find the participatory pretenses amusing. I guess you've got to be in the right mood. Or drunk. To that end, the establishment offers a mixed drink called the Frank Sumatra for $6.50.

Periodically, the musicians — especially, the percussionist, Oliver Jackson Jr. — whip up some flurries of excitement. But the good times are pitched at you as if fun could only be delivered by the shovelful. Chief among the pitchers is Donna Murphy, who as Rose, the amnesiac songstress, is introduced at one point as "a girl who will steal your heart and then forget where she put it." Ms. Murphy's desperation is not so much that of one trying to get out of Singapore as it is that of one trying to break into show business.

The light touch is not greatly in evidence and no one connected with "Song of Singapore" will ever stand accused of holding back. That's the hitch. Like the Goodspeed's "Most Happy Fella," "Song of Singapore" creates a cozy atmosphere. But only so the performers can subsequently blow it to smithereens. □

1991 Je 2, II:7:1

■ Trying to cut through man's indifference and venality ■ The life of Francis of Assisi, with music ■ A Finnish eulogy, with spite.

Humanity

The Living Theater
272 East Third Street
Through June 23

By Walter Hasenclever; directed by Elena Jandova and Martin Reckhaus; produced by Hanon Resnikov and Judith Malina; composers and musicians, Patrick Grant and Philip Brehse; lighting, Tony Angel and Gary Brackett.
WITH: Alan Arenius, Philip Brehse, Joanie Fritz, Laura Kolb, Chris Maresca and Pat Russell.

Summarizing the plot of an Expressionist play is futile, but here goes: In "Humanity" ("Die Menschen"), a 1918 German work by Walter Hasenclever, a murdered man, roused from his grave, spends a spectral day trying to bring compassion into a world ruled by money lust and indifferent to injustice, before he finds peace in his grave again when his murderer discovers his own humanity.

Other viewers of the production at the Living Theater will give other accounts, no doubt. Most will find it weirdly exciting. And it is quick; the directors, Elena Jandova and Martin Reckhaus, whip 19 actors in 31 roles through 24 scenes in just over an hour. But Hasenclever wrote the play as a string of almost speechless blackouts, and here it is given spectacular staging. Some scenes — such as the murdered man's discovery that a head he carries around in a sack is his own — fade in bright light.

The program says the set designer, Tom Bynum, is a yacht designer. I believe it. Only a man required to contemplate shipwreck could dream up the metallic, jagged and broken city in 20 pieces, which the characters constantly dismantle and reconstruct. Admittedly, haunting music by Patrick Grant and Philip Brehse makes it all seem a ballet, but one fears limbs may be lost.

This is the kind of play the members of this company are good at — very good. It would be hard to forget the scenes of tycoons gambling billions and pyramiding paper empires while around them people assault one another for pennies and see their babies starve, or a dynamite dialogue of only 14 words revealing that Hasenclever's view of socialist solutions was also bitterly realistic.

To convey so many subtle ideas so dramatically and economically is a considerable achievement. This performance is a gift that makes one want to see the scores of other plays Hasenclever wrote.

D. J. R. BRUCKNER

Troubadour

Ubu Repertory Theater
15 West 28th Street
Through August 3

Directed by D. J. Maloney; music by Bert Draesel; lyrics, John Martin; book by Mr. Martin and Mr. Draesel; set, Tom Cariello; lighting, Curt Ostermann; costumes, Daniele Hollywood; production stage manager, Barry Ravitch. Presented by Beech Knight Productions, in association with the Ubu Repertory Theater.
WITH: Sarah Downs, Steve Gilden, Christopher Howatt and William R. Park.

"Troubadour," a show based on the life of Francis of Assisi, belongs to a genre of musical comedy that might be called ecclesiastical. Bert Draesel, who composed the music and co-wrote the book with the show's lyricist, John Martin, is the rector of the Church of the Holy Trinity on the Upper East Side of Manhattan. The production that he, Mr. Martin and the director D. J. Maloney have concocted at the Ubu Repertory Theater is a two-and-one-half-hour Sunday school pageant with Broadway pretensions.

Stylistically, the music in "Troubadour" music offers a fairly sophisticated pastiche of Rodgers and Hammerstein by way of Andrew Lloyd Webber. But the score is also terribly long-winded, with too many of the songs given over to redundant spiritual debate. The central conflict pits the unworldly, anti-materialistic Francesco (Christopher Howatt) against Elias (Michael McLernon), a scheming Franciscan friar who envisages a brotherhood of celebrated scholars. The show offers a crude, chronological account of the life of Francesco (including scenes of the Crusades) that assumes too much knowledge of his life. The book and lyrics are larded with cloying ecclesiastical witticisms.

Because three-quarters of the show is sung, casting it necessitated finding decent singers. Although the young cast delivers the demanding score with aplomb, the acting is no better than what one might expect to find in a suburban Sunday school play. Mr. Howatt has a strong voice but emotes with his arms extended, his eyes glazed, and his face frozen in an expression of blissed-out sanctimony.

The uniformly stiff and self-conscious performances are underscored by choreography that has the Franciscan brotherhood playing synchronized catch with papier-mâché rocks in one number and clomping about in ring-around-the-rosy style in two others. At moments like these — and there are many — all the robust singing in the world can't keep "Troubadour" from seeming simply ridiculous.

STEPHEN HOLDEN

Five Women in a Chapel

St. Peter's Church
Lexington Avenue and 54th Street

By Arto Seppala; directed by Oeyvind Froeyland; translated by Philip Binham; adapted by Kevin Kane; set design, Edith Stylo; lighting, Paul Palazzo; costumes, Deborah Rooney; choreography, Amy Berkman; musician, Falkner Evans; production stage manager, Mary-Susan Gregson; company manager, James Boglino. Presented by Northern Lights Theater, Inc.

Mike Frey/The Living Theater

Pat Russell, left, and Chris Maresca in a scene from "Humanity."

WITH: Betty Aberlin, Shami Chaikin, Diane Kagan, Geraldine Singer and Reenie Upchurch.

Northern Lights Theater is a relatively new venture, dedicated, its press material says, to bringing "contemporary Scandinavian plays to American audiences." Judging by its latest offering, "Five Women in a Chapel" by Finland's Arto Seppala, the company needs to search harder for plays.

The title characters of "Five Women in a Chapel" are the mother, two wives, mistress and a confidante-confessor of Kalervo Rasanen, a recent suicide, and the first act is given to stream-of-consciousness monologues by the women during a memorial service for him. Although each woman remembers him differently, he was by all accounts a spoiled, self-absorbed alcoholic and something of a bore as well — the sort of man to avoid at parties. As theater, it is about as interesting as attending a memorial service for someone you didn't know and, after listening to the eulogies, are glad you didn't.

Just when the final "amen" is said and you think the ordeal is over, everyone is invited back to the widow's house for coffee, and a second act gives the five women the chance to bring their backbiting out in the open. After hearing two hours of these spiteful women carp at one another and pick over the man's dull life, one begins to understand why a gunshot in the brain may have been an attractive option for him.

The program notes say that "Five Women in a Chapel" had its premiere in Tampere, Finland, in 1979 and ran for six years before touring Finnish regional theaters. Perhaps something has been lost in Philip Binham's translation or in Kevin Kane's "adaptation," but one is at a loss to explain its native popularity. The winter nights, of course, are very long in Finland.

Oeyvind Froeyland's direction can't seem to decide whether to play for comedy or slice-of-life realism. The indecision is reflected in the performances, which shed little light on either the women or the deceased. Betty Aberlin, as the second wife, is the best, and she plays it straight for laughs. WILBORN HAMPTON

1991 Je 5, C22:3

The Subject Was Roses

By Frank D. Gilroy; directed by Jack Hofsiss; set design by David Jenkins; costumes by Michael Krass; lighting by Beverly Emmons; sound by Philip Campanella; production stage manager, Kathy J. Faul. Presented by the Roundabout Theater Company, Todd Haimes, producing director; Gene Feist, founding director. At 100 East 17th Street.

John ClearyJohn Mahoney
Nettie Cleary.......................................Dana Ivey
Timmy ClearyPatrick Dempsey

By FRANK RICH

Though the date was 1964, it seems a lifetime ago that "The Subject Was Roses" was Broadway's little play that could: a three-character drama that opened at season's end with no stars, a tiny budget and a tinier advance sale ($165) but that miraculously built an audience that led to an 832-performance run and the Pulitzer Prize.

In the theater, perhaps, "Roses" really was a lifetime ago. Such fairy tales don't happen on Broadway anymore — unless they are manufactured with an infusion of capital and hype. And people don't really write plays like this one anymore, either, in which a plain-spoken Mom, Dad and Son settle every score once and for all, neatly, directly, in two acts that leave no psychological threads untied.

The latent unfashionability of Frank D. Gilroy's play may help explain why 27 years had to go by for it to receive its first major New York revival. That revival, under the workmanlike direction of Jack Hofsiss, opened at the Roundabout last night with John Mahoney, Dana Ivey and Patrick Dempsey in the roles originated by Jack Albertson, Irene Dailey and Martin Sheen.

Unless my memory is playing tricks, Mr. Hofsiss's staging varies at most one or two iotas from Ulu Grosbard's original, right up to the half-mast "Welcome Home" sign in the living room. The sign is to greet Timmy Cleary (Mr. Dempsey), an aspiring writer who has returned to his parents' apartment in the Bronx after three years of service in World War II.

While Timmy is just bursting into manhood, he is soon catapulted back to his childhood, finding himself

A family settles every score directly, with no loose ends.

caught in crossfire more lethal than any he found overseas. His father barks, his mother bursts into tears,

and the son burns with confusion and guilt. "When I left this house three years ago, I blamed him for everything that was wrong here," Timmy tells his mother an hour and a half and several confrontations into the play. "When I came home, I blamed you. Now I suspect that no one's to blame. Not even me."

That is the sum of "The Subject Was Roses," and at its flattest, with its whisky-fueled 2 A.M. confessions and recriminations, the familial geometry is so simple and so mechanically set forth that the play could be a generic American Domestic Drama belonging more to the Inge 1950's than the Albee 60's in which it was written.

John Cleary, the father, is a blustery Irishman with traits from both O'Neill's James Tyrone (a self-made man's tight-fistedness) and Miller's Willy Loman (a salesman's taste for "hotel-lobby whores"). Both John and his wife, Nettie, have revelatory monologues in which they effortlessly pinpoint for the audience the exact long-ago turning point (a lost military opportunity, a lost job) at which their lives took a wrong turn into disappointment and regret. As for the roses of the title, they are a portentous, fragile symbol of soon-to-be-smashed illusions akin to Laura Wingfield's glass menagerie. The audience waits for the vase to drop as if it were the other shoe, and inevitably it does.

•

But Mr. Gilroy is capable of more, and here and there, in the father and son's shared memory of the vaudevillian Pat Rooney or in the mother's faint reminiscence of courtship, "Roses" has frisky or melancholy poetry to embroider its direct statements of grim truth and its spare, unsurprising dramatic structure. Whether these subtleties are given full weight by Mr. Hofsiss and his cast is another question. I don't think the shortfall of this revival can be blamed entirely on the erosion that time has inflicted on Mr. Gilroy's play.

G. Paul Burnett/The New York Times

John Mahoney and Dana Ivey in the revival of "The Subject Was Roses" at the Roundabout Theater.

The evening's most robust performance comes from Mr. Mahoney, a fine actor who captures the father's rage and pigheadedness but nonetheless seems miscast. The poignance of John Cleary, it would seem, is his decline from the cocky, good-looking young Irishman of his wife's frayed memories to the boozy malcontent he is now. That sad sense of waste and decay is largely absent from Mr. Mahoney, who is dapper, handsome and, his silver hair notwithstanding, rather youthful in appearance. Far from being exhausted, this John Cleary still seems to have some of his best years ahead of him.

As the mother, Dana Ivey, a comic actress with a Maggie Smith brittleness, seems out of her depth. Though she captures the frigid, controlling nature of Nettie, she never conveys the heartbreak of a desperate woman trapped in a miserable marriage. She doesn't so much suffer as mope. When Ms. Ivey returns in defeat from a short-lived effort to run away from home, her declaration that "the past 12 hours are the only real freedom I've ever known" comes across as an

actress's grand pronouncement rather than Nettie's cry of pain. Mr. Dempsey, who brings ingenuous charm to Timmy's more comic and sarcastic turns, seems to stand outside his juicier introspective speeches much as Ms. Ivey does, as if he was observing and relishing his own performance.

"The Subject Was Roses" affected me deeply in its original production, not only because the acting was better then but also, no doubt, because I was nearly Timmy's age at the time, and the play is unabashedly written from the alienated son's point of view. I can't go home again, of course, and neither can Mr. Gilroy. His most recent play, a delightful one-act comedy titled "A Way With Words," which was presented last month as part of the Ensemble Studio Theater marathon, is as wry and elliptical as this youthful hit is prosaic. Maybe "Roses," too, can still speak to some audiences in 1991, but that is a matter that a more sensitive production and the new generation of Timmys who see it will have to decide.

1991 Je 6, C13:2

Sandy Underwood
Tessie Hogan playing Helena Blavatsky in "The Mesmerist," which runs through the end of June at the Cincinnati Playhouse in the Park.

In a Cincinnati Park, Plays About Dynamic Women

By MEL GUSSOW

CINCINNATI, June 5 — Nestled on top of a hill overlooking the city, the Cincinnati Playhouse in the Park has one of the most picturesque settings of any major American regional theater, equaled perhaps only by the Denver Theater Center, which faces the Rocky Mountains.

The playhouse is in Eden Park, which is also the home of the Cincinnati Art Museum. Because of the theater's name, newcomers may think of it as an outdoor summer amphitheater. In fact, it is a year-round company, performing a 10-play repertory of new works and classics on two stages. The ample public spaces are glass-enclosed, giving the appearance of a greenhouse, and theatergoers can dine there before performances. For each play there is an individual menu, which could be interpreted as a metaphor for the vari-

A pairing of Blavatsky and Earhart.

ety of theater served at the Playhouse.

Under the direction of Worth Gardner, the 31-year-old company offers a more stimulating diet than one might find in theaters with a greater national reputation. Currently, there is a provocative pairing of new plays dealing with the lives of dynamic women — "The Mesmerist" by Ara Watson, about Helena Blavatsky, a spiritualist during the Victorian age and the co-founder of the International Theosophical Society; and "Lost Electra," Bruce E. Rodgers's exploration of the legend of Amelia Earhart,

While both plays deal interestingly with their subjects, "The Mesmerist" (on the company's main stage) is by far the more substantial drama. For Ms. Watson, who has until now specialized in small-scale stage plays and naturalistic films for television, this is a challenging step into a world that is both philosophical and mysterious.

Depending on one's point of view, Blavatsky was either a saint or a charlatan — or something elusive in between. Famed in her lifetime (1831-91) for her teachings as well as her supposed acts of precognition and astral projection, she toured the world as a Sarah Bernhardt of the spiritualist circuit. As a Theosophist, she preached brotherhood while continuing the search for divine wisdom. She was a forerunner of contemporary seers, psychics and revivalists, with a range of appeal that cut across several schools of thought and religious sectarianism.

Her life was one of high drama and illusionist alchemy, much of which has been conjured in Ms. Watson's probing play. Though the subject could seem esoteric, she has made it theatrical, even to incorporating acts of magic on stage. That the author still has to resolve certain questions of motivation and to find ways to dramatize episodes now introduced through narration does not markedly detract from the ingenuity or the ambition of the effort.

For one thing, she has avoided a dry documentary overview in favor of focusing on a crucial period in India when Blavatsky's integrity was called into doubt. As characterized by the author, she is a primal force of nature, chain-smoking ideas along with cigarettes. A blunt, self-indulgent woman, she nevertheless exudes a spirituality and a considerable charm. She is, in other words, a figure of striking contradictions.

Some, but not all, of this is captured in Tessie Hogan's performance. Ms.

Hogan, who joined the cast several days before last night's opening, after the sudden indisposition of the original actress, is clearly too young for the role. Blavatsky was 53 at the time of the play. Given those facts, Ms. Hogan has craftily assumed her colorful plumage and should certainly grow in the course of the run of the play. This is a role that a Meryl Streep could sink her talent and accent into (the multilingual character emigrated from Russia to the United States).

The investigation of Blavatsky is conducted by a representative of England's Society for Psychical Research. In the play he acts as both commentator and catalyst. Charges of fraud are raised, followed by counterattack. While the idol is damaged, overstatement (the claim, for example, that she was acting as an agent of the Czar) clouds the case against her. Though the accusations drive her into a crisis of faith in herself, the play concludes with an enigmatic note and the suggestion that even if she used bogus methods, "the flaws of the teacher do not destroy the value of the teachings."

Effectively supporting Ms. Hogan are Steven Crossley, Betty Miller and A. D. Cover (as the Civil War colonel who co-founded the Theosophical Society). Harsh Nayyar is poignant in a pivotal role as a faithful acolyte. Although the cast is small, Mr. Gardner's production has a grandness of design, beginning with Marjorie Bradley Kellogg's palatial representation of the group's headquarters in India. David Smith's raga-toned sound score throbs in the background.

While Ms. Watson concentrates on the persona of Blavatsky, Mr. Rodgers's "Lost Electra" (on the company's smaller, experimental stage) is concerned with the aura of Amelia Earhart. Though the title of his play is a reference to Earhart's aircraft, the play deals principally with a family in the 1960's. The head of that household is a former World War II pilot (Frank Muller) who becomes obsessed by his idol, Earhart, and in

fantasy sequences has conversations with her.

•

The play (winner of the annual Rosenthal New Play Prize of Cincinnati) begins as a sitcom of the 1960's about a preoccupied father, a dizzy mother and a 12-year-old "Leave It to Beaver" son. At times the play is as dysfunctional as the family. The two halves mix but do not meld.

Under Margaret Booker's direction, "Lost Electra" shifts between cartoon and melodrama, then overreaches for tragedy. It is a problem-strewn work that is burdened with a dour, unappealing hero and is fueled by the conception of Earhart herself. She is as self-possessed as she is single-minded. Both of these aspects are tellingly conveyed by Kathleen Marsh, who acts as if she could climb into the cockpit and soar away to Atlantis.

With all its flaws, the play leads quite naturally to the conclusion that everyone has the responsibility of making choices. It is the playwright's feeling that Earhart knew and accepted all the dangers of her last flight. Similarly, the characters in the domestic drama must accept blame for their often damaging actions. This philosophy is not so distant from the Theosophical definition of karma: man weaves his own destiny.

While "The Mesmerist" will continue to the end of June, "Lost Electra" concludes its run on Sunday. It will be followed by the final production of the season, Charles Ludlam's "Mystery of Irma Vep," the Playhouse in the Park's venturesome idea of summer fare. Theatergoers seeking dinner and theater can choose between two special menus, the spicy salsa of "Irma Vep" and the couscous of "The Mesmerist."

1991 Je 8, 11:1

Marathon 1991
New One-Act Plays
Series B

Producer, Kate Baggott; associate producer, Margaret Mancinelli; sets, David K. Gallo; lighting, Greg MacPherson; sound, One Dream; costumes, David E. Sawaryn; production supervisor, Paul E. King; production stage manager, Carol Avery. Presented by Ensemble Studio Theater, Curt Dempster, artistic director; Dominick Balletta, managing director. At 549 West 52d Street.

PRACTICE, by Leslie Ayvazian; directed by Elinor Renfield.

FACE DIVIDED, by Edward Allan Baker; directed by Risa Bramon Garcia.

RAPID EYE MOVEMENT, by Susan Kim; directed by Margaret Mancinelli.

OVER TEXAS, by Michael John LaChiusa; directed by Kirsten Sanderson; musical direction by David Loud.

CAN CAN, by Romulus Linney; directed by David Shookhoff.

WITH: Leslie Ayvazian, Trazana Beverley, Gloria Bogin, Hope Davis, T. Cat Ford, Heather Lupton, Cass Morgan, Anne O'Sullivan, Kellie Overbey, Mary Beth Peil, Ethan Phillips, Karen Rizzo, Sam Rockwell, Anthony Sandkamp, Scott Sowers, Debra Stricklin, Michael Wells and Julie White.

By MEL GUSSOW

There are five diverse one-act plays in Series B of the Ensemble Studio Theater's Marathon 1991. The works include an earthy slice of urban life, a fantasy about a wife's very nervous breakdown, and an operatic musical that takes place on Air Force One over Dallas on Nov. 22, 1963.

By a narrow margin, Edward Allan Baker's "Face Divided" is the most interesting of one-acts. It is another street-smart study by this chronicler of the stresses in working-class relationships. Through neglect or by accident, a young girl has been injured — or perhaps the cause was parental abuse.

Late at night in a hospital, the parents (Sam Rockwell and Kellie Overbey) act out what must be their ritualistic conflict, battling even as they are victimized by helplessness and self-entrapment. A knowing nurse (Trazana Beverley) manages to restrain herself from undue interference. Mr. Baker's observations are sharp, as are the three performers under the taut direction of Risa Bramon Garcia.

In Susan Kim's fanciful comedy "Rapid Eye Movement," Anne O'Sullivan is overcome by her delusions. She thinks night creatures are inhabiting the body of her easygoing but preoccupied husband (Ethan Phillips). Adding to her disorientation is a demanding sister (Heather Lupton), who seems as liberated as her sibling is repressed. The sisterly rivalry has a wacky humor, and the two ac-

tresses strike amusing responses from each other. But the nightmare side of the escapade moves the comedy on to a more self-conscious plane of whimsy.

Michael John LaChiusa's "Over Texas" has a heightened hothouse style reminiscent of that in Leonard Bernstein's "Trouble in Tahiti," with everyone singing intensely about seemingly mundane matters. Though the next step in the political story is, of course, national tragedy, the prelude is chiefly concerned with day-to-day trivialities of two personal secretaries, one working for President Kennedy, the other for the First Lady.

In less than 30 minutes, the composer reveals his musical versatility as well as a questioning sense of what it means to work closely with those in the public spotlight. While Mary Beth Peil has a total dedication to the President, Debra Stricklin has a more tenuous feeling of obligation to the First Lady. The appearance of Mrs. Kennedy (Julie White) and Lady Bird Johnson (Gloria Bogin) in a dream sequence adds an intrusive note, and it is not helped by the fact that Ms. Stricklin looks more like the First Lady than Ms. White does.

Because of the subsequent events in Dallas, "Over Texas" seems like a prelude to Stephen Sondheim's "Assassins." According to the program, it is part of a larger work about First Ladies, a LaChiusa musical that one looks forward to. The apt direction is by Kirsten Sanderson.

"Practice" is the slightest of the evening's efforts, a near monologue by a hopeful award-winner long before she has even been nominated. Even at less than 15 minutes, this sketch seems padded, but Leslie Ayvazian, as author and actress, wins smiles for her variations on the acceptance theme, as in her opener, "I want to thank all women and some men."

Closing the evening is Romulus Linney's "Can Can," a split-screen story about two romances — between a former G.I. and a French woman and between a young Southern woman and a scruffy waitress. The heterosexual half of the story has an engaging wistfulness, while the other half simply seems implausible. A 1986 production of the play in an evening of six Linney one-acts made the relationships seem less disparate and more believable.

Along with Frank D. Gilroy's "Way With Words" in Evening A of the Marathon, the plays demonstrate the breadth of writing and acting talent drawn into this annual festival.

Series B ends today; Series C begins on Wednesday.

1991 Je 9, 60:5

SUNDAY VIEW/David Richards

In Gentler Times, 'The Subject Was Roses'

For Gilroy's family
drama, two decades
seem a great divide.

'Casanova' lifted voyeurism to a cosmic plane.

YOU CAN'T BLAME THE PLAYwright Frank Gilroy for the fact that the American family has come apart at the seams since he wrote "The Subject Was Roses." It's hardly his fault that children stand up to their parents, parents abuse their children, and the life span of the average marriage has dwindled to about six months. But neither can you deny that his drama, the winner of the 1965 Pulitzer Prize, now seems to dwell on the far side of a great divide.

It was always a modest play, this account of three days in the life of the Cleary family of the Bronx. The son has just returned from World War II, no longer the sickly mama's boy he was when he left. Once the initial euphoria of homecoming has worn off, he and his parents must come to new terms with one another. That means dismantling a few fictions, settling a few lingering accounts and uttering a few truths, including "I love you," that have gone too long unspoken. The work was as homely as the kitchen table, around which much of the action takes place, but, perhaps because Mr. Gilroy was drawing on his own life, it had the ring of authenticity for the mid-1960's. If no great dramatic heights were scaled, understandings were nonetheless struck and decency prevailed in the end.

The decency is still very much evident in the revival of the play that Jack Hofsiss has directed for the Roundabout Theater Company. And Mr. Gilroy's characters are certainly no less honest. If anything, we are apt to find them too articulate about their plight. Listen to Timmy, the son (Patrick Dempsey), who's beginning to see the family in a more forgiving light. "When I left this house three years ago," he tells his mother, "I blamed *him* for everything that was wrong here . . . when I came home, I blamed *you*. . . . Now I suspect that no one's to blame. . . . Not even me."

That's just too pat. We know there are no guilty parties here. They can all claim extenuating circumstances — the doting mother for her martyred airs; the dictatorial father for his quick temper; the overly sensitive son for his habit of playing one parent off the other. The playwright is drawing a conclusion that we're perfectly capable of drawing on our own, if we've been keeping our eyes and ears open. There are no buried motivations in "The Subject Was Roses" that do not eventually surface. No secrets go unrevealed. Mr. Gilroy operates on the solid, if currently unfashionable, dramaturgical assumption that human behavior can be fathomed, that causes have effects and that an apple core can change a destiny.

It's Nettie, the mother (Dana Ivey), who finds herself entertaining that last fanciful notion. Another squall has just blown through the apartment, stirring up resentments that may be 20 years old, but continue to smart each time they're raised. Unable to sleep, she has taken refuge on the lumpy green living room sofa and, when her son discovers her, is struggling to make sense of the past. As she tells it — in the play's most compelling remembrance — she was young and eager, due to start her first job in a law firm, when a bashful boyfriend, trying to get her attention, threw an apple core at her. It hit her in the eye. The morning of her first day of work, she awoke with a shiner that so embarrassed her, she called in sick. The employer hired someone else.

G. Paul Burnett / The New York Times

Dana Ivey and Patrick Dempsey in "The Subject Was Roses"—
Why do the quarrels and confrontations seem so tiny?

"The next job I found," she says, fingering her worn bathrobe to give her hands something to do, "was the one that brought your father and I together." The irony is not lost on her.

Prodded by Timmy, she goes on to recall the air of wildness that her future husband gave off, the energy that marked him, in her eyes at least, as a millionaire in the making, the Irish conviviality that converted perfect strangers into instant friends. Ms. Ivey plays the scene beautifully — her chiseled features taking on a girlish flush, the tightly drawn mouth softening into a suggestion of a smile. As she reminisces, Mr. Dempsey is inexorably drawn to her. He's seeing something he's never seen before — his mother, as a young woman whose hopes haven't curdled and whose heart has yet to be broken. The golden light, cast by a dowdy lamp, seems to expand and embrace them both with its warmth.

■

Mr. Dempsey is an appealing actor, and his performance neatly acknowledges the residual kid in the emerging man. He's old enough to have his own ideas, but still young enough to be a little sheepish about them. As the father, John Mahoney is the hail fellow well met that Ms. Ivey says he is. The Depression, however, dashed his ambitions of being a millionaire, and he's become a little cheap — not just with the odd $5 bill, but with his affections. Bluster is mostly what keeps his self-respect intact now.

Given a cast as adept as this one, the question naturally arises, why doesn't "The Subject Was Roses" pack more power? Why do the quarrels and confrontations seem so tiny? There's just not a whole lot of punch in a son informing his father that he's stopped being a Catholic, then, when the father bristles at such heresy, adding hastily that he still believes in "something bigger than myself." By today's standards, a mother, bolting from the house for 12 hours of "the only real freedom I've ever known," is not making a large statement. (Twelve *days*, maybe.)

Not unlike the 1946 Chevrolet Fleetmaster that the set designer David Jenkins has painted on the billboard behind the Clearys' home, the play is as picturesque as it is obsolete. It assumes on the part of the audience a belief in the tightly knit family, dutiful progeny and togetherness as the American way. The slightest deviation from that norm is automatically construed as dramatic. But we don't bring that perspective to the theater nowadays, or if we do, it is only as a nostalgic yearning. Our notion of the family is far more brutal. More's the pity for us. More's the pity for "The Subject Was Roses."

Masterpieces create their own contexts, which is one reason they are able to move confidently through the ages. But lesser plays, like Mr. Gilroy's, draw their power from the temper of the times. There's nothing wrong with that, of course, until the times go and change on them.

'Casanova'

In "Casanova," which opened and closed in a flash at the Public Theater's Martinson Hall, the playwright Constance Congdon made a boring muddle of the life of the Italian lover, and while I'm sure she didn't mean for it to be dull, I wonder if the muddle was supposed to be revelatory. The very last word of the play was "Lost!" It could have served as the epitaph for the title character, who was played by two actors — one (Ethan Hawke) for the youthful, more innocent days; the other (John Seitz) for the more depraved and increasingly disease-ridden years. That didn't prevent their paths from crossing — time and place being putty in Ms. Congdon's hands.

After the older Casanova had casually deflowered a 13-year-old girl, the younger Casanova shouted indignantly at him, "Who *are* you?" There was some evidence that the older incarnation considered himself "an elder statesman of the world." But Sophie (Kaiulani Lee), one of the daughters he had sired and left by the wayside, concluded bitterly that he was no more than "spermatozoa." In the courtly Parisian ball that ended the play, a tottering Casanova, his face clown white, was seen dancing with a transvestite in full 18th-century regalia, and he seemed, above all, a ludicrous relic.

Ms. Congdon told her story from so many different points of view, however, that her drama failed to congeal, and a coherent portrait of the rogue never came into focus. About a third of the play was devoted to the middle-aged Sophie, who had a history of hapless love affairs, and to Bobo (Jeff Weiss), that flamboyant transvestite, who served as her surrogate father. While they were hashing over their memories of Casanova, the decrepit rake was making his way by carriage to Paris and attempting, en route, to reconstruct his autobiography. Furthermore, one of his conquests, Therese Imer (Margaret Gibson), although dead, presided over the play as a mistress of ceremonies, setting scenes, opening and shutting curtains and throwing in her two lire.

The flashbacks fell all over one another (just as the characters were forever going down for a tumble). Casanova was not the only one to be represented by a younger self and therefore able to eavesdrop upon himself. Ms. Congdon appeared intent on elevating voyeurism to a cosmic plane, whereby a body didn't necessarily need an armoire to hide in, but could just as easily take cover in a different year. To make certain we didn't confuse her approach with slapdash playwriting, the production was strewn with intentional anachronisms — blue jeans and sneakers for the young Casanova, references to "gender jealousy" and "politically correct" opinions, and a touch or two of vaudeville.

Had "Casanova" been more successful, I suppose the swirl of powdered grotesques, libidinous clergy, castrati and ravenous old crones eager to change their sex would have merited the adjective "Fellini-esque." The director Michael Greif managed to impose bursts of momentum on the disjointed tale, and by using curtains and makeup tables as the recurring elements in his set, the designer John Arnone underscored the role-playing that is a large part of seduction. But the play was a hodgepodge from the start, and a hodgepodge it remained.

■

I can't pretend that Casanova got much of a break from Mr. Hawke or Mr. Seitz. The former gave us a bland youth, who could claim neither impetuousness nor innocence as defining traits. While the latter made a splendidly vile ruin, nowhere were there left-over traces of the charm that women apparently found irresistible. The most compelling performance was that of Mr. Weiss, a Zaza for the ancien régime, progressively transforming himself over the course of the evening into the ghastly porcelain figurine who wound up dancing decorously with Casanova at the ball. His facade was brittle, but there were understanding and compassion in his heart, and ironically, he just may have been the one true man in this tale.

Casanova was marked for extinction, the last of his species, the dying swain. Unfortunately, while serving him his death notice, Ms. Congdon succeeded only in turning out a deadly play. And the Public Theater, which has been adrift all season long, washed a little closer to the rocks. □

1991 Je 9, II:5:1

Mr. Gogol and Mr. Preen

By Elaine May; directed by Gregory Mosher; sets by John Lee Beatty; costumes by Jane Greenwood; lighting by Kevin Rigdon; sound by Serge Ossorguine. Presented by Lincoln Center Theater, Mr. Mosher, director; Bernard Gersten, executive producer. At the Mitzi E. Newhouse Theater, Lincoln Center, Broadway and 65th Street.

Mr. Gogol...............................Mike Nussbaum
Mr. Preen.............................William H. Macy
The WomanZohra Lampert

By MEL GUSSOW

Elaine May is one of the most original and unpredictable of writers and directors and she is to be welcomed back to the New York theater after a long absence even though the result, "Mr. Gogol and Mr. Preen," is a disappointment. In her new play, which opened last night at the Mitzi E. Newhouse Theater in Lincoln Center, there are glimmers of her special talent, but not enough to justify the fuzziness of the effort.

The subject is friendship and its opposite, loneliness, as represented by two New Yorkers of decidedly

In an apartment's unwashed chaos, enter the vacuum cleaner.

different background and temperament. Mr. Gogol (Mike Nussbaum), an intellectual European refugee of no apparent profession, is living reclusively in a derelict New York apartment. He is surrounded by books, dirty dishes and other detritus of a household that exists without the benefit of housekeeping. Through his spectacularly cluttered set design, John Lee Beatty makes his own commentary about a city dweller's ability to exist in chaos. Amusing sight gags subsequently derive from the set.

Enter a dapper vacuum cleaner salesman (William H. Macy) who gets his Swiftilux in the door and begins his prepared sales pitch. The show starts on a promising note, as Mr. Nussbaum finds an alibi for every egg stain on his carpet and Mr. Macy soft-soaps his hard sell. The two engage in vaudeville-style banter, moving Gogol and Preen into competition with Gallagher and Sheen. But once the customer reluctantly buys the unwanted appliance, the play stalls.

•

Ms. May goes on. She backs up, moves into reverse, pauses and then heads in a different direction. The basic story line, through all these delaying mechanisms, is that Mr. Macy is being held in the apartment against his will. This is not a novel idea. Nor is it a story by John Fowles or a play by Harold Pinter. For one thing, it lacks any sense of menace. Despite all the author's instincts and the contribution of the actors and Gregory Mosher as director, this is a one-act play stretched beyond its limits.

The quick turns and reversals are of course indicative of an inward dramatic purpose. Mr. Nussbaum is so incredibly lonely that he will do anything, even commit an act of betrayal, in order to keep the stranger in the apartment, and the salesman remains because he secretly craves human contact. There is a statement here about urban isolation, how one can be invisible in a crowd.

•

Having established her premise, the author runs out of ways to illustrate it, padding the play and seemingly allowing the actors to fill in the blanks. Both of them are highly skilled character actors, particularly adept at performing plays by David Mamet (Mr. Macy most recently in "Oh, Hell" on this same stage), and they do their best in the confining circumstances.

At least, Mr. Nussbaum has been given some eccentric aphorisms and political observations ("The man who tells the lie must continue it; that's why the incumbent is always

re-elected"). He delivers them with the zest of a natural conversationalist suddenly emerging from a long silence. He is also funny cheating at chess and trying to stop a flood of water flowing under the bathroom door. The sight of the befuddled Mr. Nussbaum in his underwear rushing around the room and frantically mopping and sopping is laughable.

As a self-styled anarchist and "remarkist" (he makes remarks), Mr. Nussbaum opinions his guest to the floor. Any normal person would bolt for the door, but Mr. Macy, forced by the exigencies of the plot, remains tongue-tied on the premises. All the actor can do in this bland role is to become agitated, at which point he always feels sick and has to lie down. He spends much of the show on a couch, where he squints (his eyes are bad and his host has taken his glasses) and says things like, "I don't understand what you're talking about," a sentiment that may be shared by theatergoers.

When the dialogue runs dry, a neighbor (Zohra Lampert) knocks on the door. She is Mr. Nussbaum's former friend who has been rejected in favor of the salesman. Except for the door-knocking interludes, Ms. Lampert has nothing to do. Perhaps in response to the emptiness of her role, she has devised an indeterminate accent that calls for her to tell Mr. Nussbaum that by rejecting her, "You blook my art."

It is only at the very end of the play that Ms. May clearly articulates a more serious goal. In a role reversal, Mr. Macy takes care of Mr. Nussbaum, imitating his solicitousness with a concern that borders on desperation. In an instant, the abject loneliness of the now intertwined lives disappears and we can see the redemptive power of communication. But the touching moment seems appended to what is an attenuated exercise in woolgathering.

1991 Je 10, C13:1

Miss Julie

By August Strindberg; directed by Ingmar Bergman; scenery and costumes by Gunilla Palmstierna-Weiss. The Royal Dramatic Theater of Sweden, Lars Lofgren, artistic director, presented by the Brooklyn Academy of Music, Harvey Lichtenstein, president and executive producer, in association with the New York International Festival of the Arts. At the Majestic Theater of the Brooklyn Academy of Music, 651 Fulton Street, Fort Greene section.

Miss Julie...................................Lena Olin
Jean......................................Peter Stormare
Kristin.....................................Gerthi Kulle
WITH: Marie Richardson, Kicki Bramberg, Ingrid Bostrom, Per Mattsson, Bjorn Granath and Jakob Eklund

By MEL GUSSOW

It is midsummer night and the light through the windows of the kitchen has an unnatural glow. In the course of Ingmar Bergman's staging of Strindberg's "Miss Julie," that light will go through many subtle changes, counterpointing the emotional turbulence of the characters onstage. Their duel is a class war as well as a fierce battle of the sexes.

Despite all the portent, the play never loses its personal dimension, its sense of wounds mutually inflicted. Strindberg called "Miss Julie" a naturalistic tragedy, a fact that has never been so evident as in Mr. Bergman's stunning production. This is the opening play of the Royal Dramatic Theater of Sweden's all too brief season at the Brooklyn Academy of Music.

As the production flawlessly unfolds on stage at the Majestic Theater, one necessarily thinks of Bergman films like "Persona," in which the director confines disparate characters in domestic disharmony. Though the play remains firmly fixed within that kitchen, there is a feeling of life outside the room. "Miss Julie" is commonly regarded as a small-scale intimate drama. The director enlarges its dramatic vision so that the audience more clearly understands the psychological and societal forces that drive the title character to her destructive acts.

•

Initially, we see only the inhabitants of the kitchen: Jean, the valet, and Kristin, the cook. Jean (Peter Stormare) exudes fastidiousness. Pouring himself a glass of wine, he pretends to be both servant and master, and, after a sip, he offers himself an approving glance. Except for the accident of his birth, he could be an aristocrat. Later we will see that Miss Julie (Lena Olin) has a vulgarity that would be unacceptable in the servant class. Kristin (Gerthi Kulle) is quietly submissive in the background, demeaning herself to Jean's wishes.

Gunilla Palmstierna-Weiss's pale gray setting is perfect — everything neatly arranged in a pristine, painterly environment. There is as much significant and unobtrusive atmospheric detail in this room as in Mr. Bergman's "Fanny and Alexander."

Suddenly Miss Julie enters, her red dress and her forthright manner a brusque intrusion on the placidity of the room. Miss Olin brings with her a swirl of sensuality and immediately embarks on the seduction of Jean. But which one is the predator? Both could answer the call, as each is, to use the title of a related Strindberg drama, "playing with fire."

•

Miss Olin is a glamorous figure and she and Mr. Stormare are mutually attracted — with good reason. They

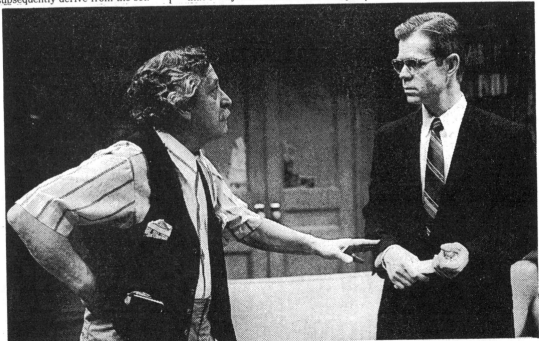

Brigitte Lacombe/"Mr. Gogol and Mr. Preen"

Mike Nussbaum, left, and William H. Macy in "Mr. Gogol and Mr. Preen," a play by Elaine May.

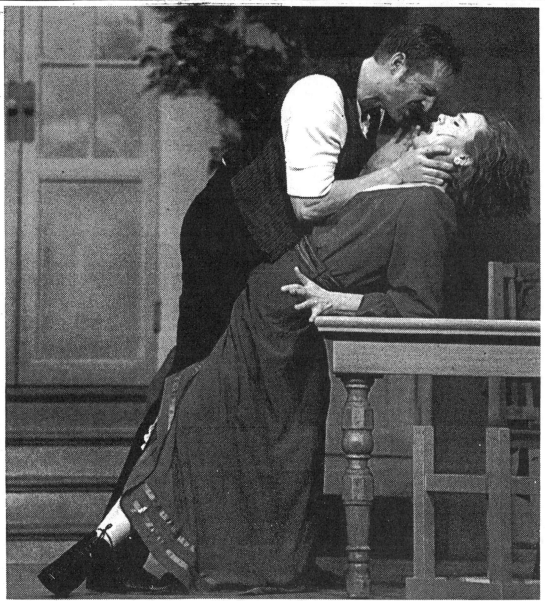

Bengt Wanselius/Brooklyn Academy of Music

Lena Olin and Peter Stormare in the Royal Dramatic Theater of Sweden's production of "Miss Julie."

Theater in Review

■ Fighting sexism in Zimbabwe ■ A young woman alone ■ 'Little Red Ridinghood' all grown-up ■ With food and folly.

Stitsha

Amakhosi Theater, Zimbabwe
Performance Space
150 First Avenue, at Ninth Street
June 19 to 23

Written and directed by Cont Mhlanga; music by the performers.
WITH: Princess Dlamini, Doubt Dube, Sithembiso Gumpo, Patriciah Mhete, Alois Moyo, Andrew Moyo, Joyce Mpofu, Taurai Dumisani Muswere, Nomusa Ncube, Herebert Phiri, Pedzisai Sithole and Priscilla Sithole.

The Amakhosi Theater, a youthful 12-member ensemble from Bulawayo, Zimbabwe, is among 150 semiprofessional theater companies in a country that has a tradition of agitprop theater. During the country's protracted struggle for independence, exhortatory no-frills plays were often performed in township halls to dramatize and spur the struggle against British colonialism.

That tradition has continued to flourish since the country achieved independence in 1980. And under the auspices of the New York International Festival of the Arts, Performance Space 122 and the New Faces/New Voices/New Visions series of Davis Hall at City College, the company has undertaken a two-week tour of performing spaces around New York City.

"Stitsha," which had its American premiere at Davis Hall on Monday evening and which will continue its shows at Performance Space on June 19, is one of two works being presented by the company during its visit. Written and directed by Cont Mhlanga, the 90-minute play with music and dance tells the story of Thuli, a young performer who, against the wishes of her father, insists on pursuing a theatrical career. Thuli prefers slacks to the more demure traditional garb, refuses to act like a servant to the men in her family and feistily rebuffs a local businessman who offers her a secretarial job in hopes of winning her love. Her liberated attitudes make her the victim of a male conspiracy.

The play, which is performed in Ndenglish, a patois that blends English and the Ndebele language of Zimbabwe, is an exuberant comedy that takes a sudden tragic twist in the middle of Thuli's birthday party, then ends abruptly, leaving the fate of several characters up in the air. Facing the audience, the cast announces that what happens next is up to them.

About two-thirds of "Stitsha" consists of dialogue and one-third of songs and dances connecting the scenes. The Amakhosi Theater began as a karate club, and the choreographed dances with their graceful

are so evenly matched that a newcomer to the play might not be aware which character is the stronger. Although Miss Julie grasps control of her fate, it is Jean who will survive the "spell of this magical night."

Theatergoers can hear the dialogue in English on headsets, although without the translation, one is still aware of the themes — of submission, dishonor and revenge, of the urge but not the will toward flight. Even in moments of silence, the production never loses its highly charged intensity.

Just as the play alternates currents, Miss Olin is mercurial as Miss Julie. She is demanding in her approach to Jean, yet at odd times seems almost unsure of herself, summoning demons she is unable to control. The actress offers a beautifully seductive, virtuosic performance, one that translates in any language.

Mr. Stormare, who played the title role in Mr. Bergman's version of "Hamlet" several seasons ago at the Brooklyn Academy, also reveals the breadth of his artistry. His Jean is cool in his arrogance and childlike about receiving his due, whether it is the admiration of Kristin or a fulfillment of a youthful dream of paradise on earth.

Jean can seem stiff and fussy. Mr. Stormare keeps him aggressively masculine and also locates the self-mocking humor, as in his response to Miss Julie's suggestion that death may be his solution. "Die?" he says, dismissing the notion. "That's stupid. I'd rather start a hotel."

In a role that is often neglected, Miss Kulle offers a proud and watchful portrait of Kristin. She endures indignities, while shrinking from all of Miss Olin's patronizing overtures. Because the actress is herself attractive, she poses more of an alternative to Miss Julie than in many productions.

•

The director devises an evocative variation on the servants who dance onstage in a mime show. Instead of having them represent a joy of life, they are all self-indulgently drunk, falling over themselves like figures in a Breughel canvas.

The production runs almost two hours rather than the author's suggested 90 minutes. Mr. Bergman has slightly expanded the text by inserting a passage cut by Strindberg. But the primary reason for the length is that the director, with his cinematic eye, takes time for subtext, using the kitchen as an active presence and

dramatizing mood along with character. This is an eloquent performance of a masterwork, in every sense a transcendent evening of theater.

"Miss Julie" will give its final performance tonight and will be followed by "Long Day's Journey Into Night" and "A Doll's House." Each play runs for a scant three performances. The Royal Dramatic Theater engagement is part of the New York International Festival of the Arts.

1991 Je 12, C13:1

ritualized kicking, stamping and thrusting movements have their origins in martial-arts training. Both the dancing and passionately exuberant chants infuse the play with a spiritual energy that extends to the acting, which is broad but not cartoonish.
STEPHEN HOLDEN

The Have-Little

Intar
420 West 42d Street
Through June 30

By Migdalia Cruz; directed by Nilo Cruz; scenic design by Donald Eastman; costumes by Gabriel Berry; lighting by Kenneth Posner; sound design, Fox and Perla Ltd. Presented by Intar Hispanic American Arts Center, Max Ferrá, artistic director; Eva Bruné, managing director.
WITH: Divina Cook, Gabriella Díaz Farrar, Marisol Massey and David Roya.

At one point in their travels, Don Quixote and Sancho Panza happen upon a sumptuous wedding party and Sancho makes the observation, in Motteux's translation, "There are but two families in the world, the have-much and the have-little." The characters in Migdalia Cruz's play "The Have-Little" definitely belong to the second category. Cervantes even figures in the plot.

Lila Rivera (Marisol Massey) is a pubescent girl living in the South Bronx with her mother, Carmen (Divina Cook), in the mid-1970's. Lila's life is one of abandonment — by her father José (David Roya), to drink; by her best friend, Michi (Gabriella Díaz Farrar), to a better life, and by her mother, to death. Although she is discouraged by all of them in her mediocre efforts at school, Lila plods along with her homework. "I like to try," she explains apologetically to her indifferent mother. Finally, eager for kind words from any quarter, she gives herself to the first boy who says he loves her, and is then abandoned by him as well, to an overdose of heroin, leaving her pregnant at 15.

It is a familiar story, and although there is little new in Ms. Cruz's account of the terrible waste of life in the modern ghettos of poverty, she conveys the sadness and frustration of their inhabitants. If she offers no solutions for breaking the cycle that devours so many of the nation's youth, she at least brings understanding and sympathy to their plight.

Ms. Cruz has talent as a writer and some of the brief vignettes that make up the 90 minutes of "The Have-Little" are amusing, warm and human. In other scenes, the imagery needs considerable work. There may be a certain poignancy in the childhood memory of having one's ears cleaned by one's father, but it would take more adroit handling than as written here to convey it. Elsewhere, themes are raised but not pursued. The subject of blood comes up frequently, for example, but it is never woven into the context of the play.

Good performances in the roles of the three women lift the characters above stereotype. Ms. Massey evokes pity as the naïve and vulnerable Lila. Ms. Díaz Farrar is hip and savvy as her friend Michi. And Ms. Cook is thoroughly believable as the mother, delivering the most touching moment in the play when she reads to her daughter in Spanish from the family's one prized possession, an old edition of "Don Quixote." Nilo Cruz directed.
WILBORN HAMPTON

Nova Velha Estoria (New Old Story)

Repertorio Español
Gramercy Arts Theater
138 East 27th Street
Through June 23

Conceived and directed By José Alves Antunes Filho; scenery and costumes by J. C. Serroni; lighting by Davi De Brito; sound by Raul Teixeira. Grupo de Teatro Macunaima presented by Repertorio Español, Gilberto Zaldivar, producer, Rene Buch, artistic director, in association with The New York International Festival of the Arts.
WITH: Ondina Castilho, Helio Cicero, Geraldo Mário, Luis Melo, Samantha Monteiro and Yara Nico.

Theater is not often as enchanting as José Alves Antunes Filho's "Nova Velha Estoria" ("New Old Story"), a sly, wise, adult version of "Little Red Ridinghood" performed by Mr. Filho's Brazilian company, Grupo de Teatro Macunaima, at the Repertorio Español's Gramercy Arts Theater as part of the New York International Festival of the Arts.

Nor is an audience often asked to bring its own dialogue. For the voluble characters here speak a tongue dreamed up, no language at all, but one soon imagines it is comprehensible, subtle. And around this gifted babble swirls a score that without distracting from the story at all, sends up Schubert songs, several operas, "The Sound of Music" and the sound track of the film "2001: A Space Odyssey."

The Macunaima is an enormously intelligent troupe: every move, dance and pause is vividly imaginative; nothing, and everything, is innocent. Here Red Ridinghood's adventure is a passage to womanhood and the wolf is the eternal tempter who arrives with the new moon (glowing huge above the auditorium) to seduce, not devour. The grandmother meets her end dancing ecstatically with him, and his conquest of Red Ridinghood — all growls, yelps and flailing feet — leaves him broken, howling. When he is caught, Red Ridinghood saves him from the hunter's gun and he floats off inside the moon, to return another year.

In this superbly disciplined cast, Samantha Monteiro grows in a single hour from a giggling red-capped teenager to a woman who turns back fate; as the wolf, Luis Melo is by turns cunning, defiant and vulnerable; Helio Cicero makes a mother of great bulge and bustle and then a grandmother who is frailty itself, but with a dancer's grace, and Geraldo Mário is twice spectacular, as a lumpy gnome with an alluring treasure and as the hunter, an apparition of brilliant sapphire: blue skin, blue clothes and hat, even blue blunderbuss.

"Nova Velha" is perfect fantasy perfectly realized.
D. J. R. BRUCKNER

The Bay of Naples

La Mama E. T. C.
74A East Fourth Street.
Through Sunday

Written and directed by Joël Dragutin; administrator, Martine Potencier; production coordinator, Anna Kouyate; stage manager, Pascal Levesque; production assistants, Betty Sanchez and Anne-Marie Puppo.
WITH: Jean-Claude Bonnifait, Bernard Charnace, Mr. Dragutin, Françoise D'Inca and Elisabeth Tual.

It's much more amusing to visit the people in Joël Dragutin's "Bay of Naples" ("Baie de Naples") than it would be to dine with them, for in the course of the evening they utter almost every cliché one has ever heard at a dinner table.

The one-act comedy, which is performed in French (with no translation) by Théâtre 95, a company from Cergy-Pontoise, France, is the work of a playwright and actor with a finely tuned ear or an efficient tape recorder. He has caught perfectly the rapid-fire utterings of people hoping to find a semblance of interconnection in group meal-takings.

The two women and three men in the cast start the first course — real food is used, and eaten — with separate identities, but assume different names, relationships and even sex during the several meals and seasons depicted. They speak words that are not really their own, skipping from topic to topic, embarking on one thought after another without ever setting sail. And eventually even the simulated conviviality can't hide the fear and disappointment lurking beneath the ritual politesse.

The sheer volume of words merits praise for the cast, which seems never to stumble — although how could one tell at that velocity? Mr. Dragutin also acts admirably, but he should don his directorial hat to stop himself from waving a knife around so vulgarly. Elisabeth Tual's vulnerability is particularly touching.
G. S. BOURDAIN

1991 Je 12, C14:3

Critic's Choice

A Mambo Mouth With Salsa Feet

Fresh off the "arroz con pollo circuit," Agamemnon is a coolly confident talk show host with a hyperactive libido. He is one of seven pungent personalities that populate "Mambo Mouth," John Leguizamo's wry passage through the aspirations and frustrations of Hispanic America. In his one-man show, he quickchanges from druggie to dealer, from a transvestite prostitute to a homeless wanderer on the streets of Nueva Jork.

•

After playing at the American Place Theater, "Mambo Mouth" reopened this week at the Orpheum Theater. This is a route also followed by Eric Bogosian and Mr. Leguizamo begins his show by joking that his predecessor is still in his dressing room. Mr. Leguizamo needs no prompting, though he might benefit from guidance in structuring his mono-

Emidio Luisi/Fotograma Brazil
José Alves Antunes Filho performing in a scene from his "Nova Velha Estoria" ("New Old Story").

David Hughes/"Mambo Mouth"

John Leguizamo in "Mambo Mouth" at the Orpheum Theater.

logues to greater comic effect. The material runs thin in the middle of his 90-minute show. But as an actor, he remains high in attitude and satiric humor.

A mischievous mimic with an ear for self-parody and an eye for pretention, he spoofs himself as well as fellow homeboys, especially those eager to rise through assimilation. One of his characters confides that he is not really Mexican but Swedish — or Irish or Israeli or whatever ethnicity happens to be popular. Mr. Leguizamo mixes his accents into a diabolical mosaic. The funniest sketch is reserved for the finale, in which he plays an Hispanic who outwits the system by becoming Japanese. As the newly Orientalized "Crossover King," he flashes slides to illustrate the ease with which a Tito can turn into a Toshido. But whenever music starts playing, the neo-Nipponese suffers a Latino relapse. In other words, "Mambo Mouth" has salsa feet. The Orpheum Theater is at 126 Second Avenue, at St. Marks Place, Manhattan. Shows this weekend are at 8 P.M. today, at 7 and 10 P.M. tomorrow and at 3 P.M. on Sunday. Tickets are $25. Information: (212) 477-2477.

MEL GUSSOW

1991 Je 14, C3:1

The Dead Class

Created by Tadeusz Kantor; sound, Marek Adamczyk. Cricot 2 Theater presented by La Mama E.T.C., in association with the New York International Festival of the Arts. At 74A East Fourth Street.

WITH: Zbigniew Bednarczyk, Tomasz Dobrowolski, Zbigniew Gostomski, Ewa Janicka, Leslaw Janicki, Waclaw Janicki, Maria Stangret Kantor, Maria Krasicaka, Jan Ksiazek, Bogdan Renczynski, Mira Rychlicka, Roman Siwulak, Lech Stangret, Teresa Welminska and Andrzej Welminski.

By MEL GUSSOW

In the theater of Tadeusz Kantor, the dead return to life in order to evoke a tragic vision of the past. It is a theater dense with symbolism, shadowing the audience with dreams that emerged from the director's psyche. These are autobiographical and historical memories about the lifeline that brought him through the 20th century.

Kantor's early opus, "The Dead Class," returned this week to La Mama to reintroduce theatergoers to the work of this icon of experimentalist drama. The director died in December and his company, Cricot 2, is carrying on his work. In the company's previous visits to the United States, all of them at La Mama, Kantor was himself integral to the performance. A brooding totemic figure, he appeared onstage with his actors, serving as conductor, stagehand and silent watchman. His presence added an immeasurable dimension to the theatrical experience. It was almost as if we were looking at "Guernica" while Picasso was painting it.

Though the plays were scripted and rehearsed, they seemed to be happening only in the immediate present and, as our conduit, Kantor refined the structure as the play was in progress. That structure was somewhat amiss at the opening of "The Dead Class" on Wednesday. The performance moved at a slower, more deliberate pace than one remembered. Had the director been alive, undoubtedly he would have prodded his actors to be less reverential and more spontaneous.

Nevertheless, the spirit remains. "The Dead Class" continues to invade the audience's subconscious with its ritualistic images of war and death. The play (performed in Polish with a smattering of English and Latin) begins as a flashback to pre-World War I Poland. In a strong, unchanging light, a cadre of ghosts returns to a classroom. The specters take their place amid mannequins representing themselves in childhood. As is customary in the work of Kantor, the play freely mixes actors and effigies, with one often standing in for the other. Puppets are lifelike while actors can seem like sculptural objects. At the same time, tableaux alternate with highly kinetic imagery.

A guide in the program offers a step-by-step map of the journey, but there are ellipses and divergencies. For one thing, though camels are indicated in the outline, they never appear in performance. One signpost admits that "important events are lost within the dream in progress." Surprises await, even in scenes that are repeated. The effect is hypnotic as we watch the disturbing stage pictures — a mountain of battered books as refuse, the washing of corpses, a mass grave of doll-like children.

Though the tone is calamitous, it can also be blackly comic, as represented by two identical men, sitting in the back of the schoolroom. They are themselves a motif in other Kantor plays. As one of the twins is forcibly evicted from his desk — the actor moving as limply as a ragdoll — his deadpan doppelgänger pops up in his place. That sequence is repeated as in a silent movie comedy. At other times, as the actors march in a grand parade to the tune of plangent music, the play becomes a Polish variation on a Fellini film.

•

Throughout the show, there are spiritual emanations of man triumphing over degradation. This is also evident in Kantor's other plays, including the last one he directed in New York, the prophetically entitled "I Shall Never Return." In common, they are dramatizations of the author's dedication to art. It was theater that sustained him, that offered him an outlet through which he could come to terms with his nightmares. As hauntingly depicted by "The Dead Class," the Kantor legacy survives.

The play runs through Sunday, to be followed next week by Kantor's final work, "Today Is My Birthday." Both are part of the New York International Festival of the Arts.

1991 Je 14, C15:1

The Complete Works of William Shakespeare (Abridged)

Written by Jess Borgeson, Adam Long and Daniel Singer, with additional material by Reed Martin. Costume design, Sa Thomson; set design, Kent Elofson. The Reduced Shakespeare Company presented by Maly Productions Inc./Ken Marsolais. At the Marymount Manhattan Theater, 221 East 71st Street.

With: Reed Martin, Jess Borgeson and Adam Long.

By MEL GUSSOW

Thrift, thrift, Horatio! could be the motto of the R.S.C. That's R.S.C., as in the Reduced Shakespeare Company, which should not be confused with that august English company with the same initials. This iconoclastic American troupe does more with less. Or is it less with more? The title of the show (at Marymount Manhattan Theater, 221 East 71st Street, through June 23) says it all: "The Complete Works of William Shakespeare (Abridged)." In other words, this is clearly a case of reductio ad absurdum.

In less than the announced two hours, the R.S.C. condenses all of Shakespeare's plays, the authenticated as well as the disputed, and throws in a postage stamp summary of the sonnets for good measure for measure. Blink and you might miss the "interpretive dance, performance art version" of "Troilus and Cressida," or all the history plays compacted into a crown-passing football game ("The quarterback gives it to the hunchback"), which snubs Lear as a substitute because he is fictional. That noise we hear is not Shakespeare's bones rattling, but the soup bone used in the Julia Child-style cooking class introduction to "Titus Androgynous."

Though everything is good-natured, the approach might be called one of Will-ful destruction, as the three R.S.C. clowns locate and then undermine the essence of each play. The pithier-than-Python parodies defolio Shakespeare.

These zanies could be cousins to the Flying Karamazov Brothers. In fact, one of the actors, Jess Borgeson, looks like a renegade from that company. He and his teammates, Reed Martin and Adam Long (they are also the co-authors of the show along with the unseen Daniel Singer), juggle Shakespeare's plays as if they were hot coals. Hold on to one too long and it might singe a fardel.

•

In the Reduced "Romeo and Juliet," Juliet (Mr. Long) falls off the balcony (Mr. Borgeson), followed by Tybalt rushing on stage and proclaiming, "Oh, I am slain." Within minutes comes the Tom Stoppard-like announcement, "Romeo and Juliet are dead." As erstwhile academicians, the actors conclude that Shakespeare was a formula writer and that all the comedies (including the romances) share the same plot. Soon six sisters posing as men are matched with six shipwrecked sailors in a "Tempest"-tossed Shakespearean salad.

The cast handles the overpopulation with swift changes of character and costume (though all characters wear sneakers). Dummies play dead bodies and a stringy wig doubles as a beard, once at the same time when Mr. Long is both Claudius and Gertrude. Mr. Long specializes in Shakespeare's women, all of whom look alike and suffer from indigestion.

By the end of an hour, the actors have zoomed through 36 plays (some only mentioned in passing). That leaves "Hamlet." They will do anything to avoid Elsinore, even eat fire and toast marshmallows. Finally, Mr. Martin decides to cross that abridgement when he comes to it — and declares an intermission.

The irresistible pièce de résistance comes in four sizes, a 30-minute Thirtysomething episode; a fast-frozen variety that features a mad scene in which Ophelia says, "I'm out of my tiny little mind"; and a breakneck tongue-tripper. Then, as an encore, the R.S.C. offers its equivalent of a triple somersault in midair, a three-second backward reversion, the "ydegarT fo telmaH," with dialogue that sounds like the original Danish. The show, part of the New York International Festival of the Arts, is almost as high in hilarity as it is in contumely.

1991 Je 15, 17:1

126

Long Day's Journey Into Night

By Eugene O'Neill; Swedish translation by Sven Barthel; directed by Ingmar Bergman; scenery and costumes by Gunilla Palmstierna-Weiss. The Royal Dramatic Theater of Sweden, artistic director, Lars Lofgren, presented by Brooklyn Academy of Music, Harvey Lichtenstein, president and executive producer, in association with the New York International Festival of the Arts. At the Majestic Theater of the Brooklyn Academy of Music, 651 Fulton Street, Fort Greene section.

James Tyrone.............................Jarl Kulle
Mary Cavan TyroneBibi Andersson
Jamie Tyrone.....................Thommy Berggren
Edmund TyronePeter Stormare
Cathleen...................................Kicki Bramberg

Uncle Vanya

By Anton Chekhov; directed by Eimuntas Nekrosius; sets and costumes, Nadiezda Gultiajeva; lighting, Romualdas Treinys and Gintautas Urba; English adaptation, simultaneous translation, Arunas Ciuberkis; music, Faustas Latenas; lighting adaptation, Michael Blanco; production stage manager, Birute-Ona Jaruseviciene; artistic director, Ruta Wiman. The State Theater of Lithuania presented by the Joyce Theater Foundation and Lincoln Center Theater, in association with the New York International Festival of the Arts. At 175 Eighth Avenue, at 19th Street.

Alexandr Vladimirovitch Serebryakov
 Vladas Bagdonas
Yelena Andreyevna.......................Dalia Storyk
Soyfa Alexandrovna.................Dalia Overaite
Marya Vassilyevna.....Elvyra Zebertaviciute
Ivan Petrovich Voynitsky. Vidas Petkevicius
Mihail Lvovitch Astrov.....Kostas Smoriginas
Ilya Ilyitch Telyegin...................Juozas Pocius
MarinaIrena Tamosiunaite
Servants...Rimgaudas Karvelis, Jurate Aniulyte and Vytautas Taukinaitis

By MEL GUSSOW

Ingmar Bergman's version of "Long Day's Journey Into Night" is an evening of anguished cries and fearful whispers, in which the troubled Tyrones haunt one another with specters from the past. In this Swedish-language production (presented on the weekend at the Brooklyn Academy of Music's Majestic Theater), the director has made minor alterations in the text, but has kept the powerful core of O'Neill's masterpiece intact.

In contrast, Eimuntas Nekrosius's Lithuanian-language production of "Uncle Vanya" (through June 30 at the Joyce Theater) is an eccentric adaptation, like no other version of the play one has seen — or that Chekhov could have imagined. This State Theater of Lithuania production is earnest in its eagerness to be unconventional and unerring in its ability to be digressionary.

Both plays are part of the New York International Festival of the Arts.

Coming after the Royal Dramatic Theater of Sweden presentation of "Miss Julie" last week, "Long Day's Journey" proves that Mr. Bergman is as attuned to O'Neill's ruefulness as he is to Strindberg's mordancy. While retaining the Irish-American sensibility of the original, the director has added a few unobtrusive Swedish touches (in setting and costumes). Stripping the play of excess trappings, he and his designer, Gunilla Palmstierna-Weiss, have unmoored it on a platform, a simulated island representing a sparsely furnished Tyrone parlor. At significant moments, striking cinematic images are projected in the background: the exterior of the home, a Mark Rothko-like window and the fog itself. Without losing its naturalism, the play gains in symbolic resonance.

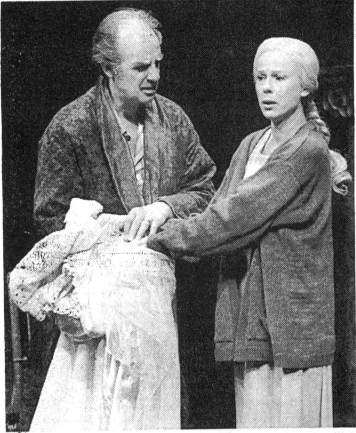

Bengt Wanselius/Brooklyn Academy of Music

Jarl Kulle and Bibi Andersson in Ingmar Bergman's version of Eugene O'Neill's "Long Day's Journey Into Night."

Under Mr. Bergman's brilliant direction, the actors become a close-knit chamber quartet, led by Bibi Andersson, who uncovers a great emotional range in the role of Mary Tyrone. She brings with her a fragile beauty as well as a profoundly poetic sense of the mother's loneliness.

Even when she is offstage, as in most of the final scene, one is aware of her luminous presence and of the meaningfulness of her character to the other members of the family. When she is onstage, the others cannot stop watching her, looking futilely for a ray of hope in a sky fogged with despair.

Though Jarl Kulle begins too effusively as James Tyrone, he soon fills the role with an actorial authority, striking profiles and launching into speeches in the manner of a man who has spent his life onstage and is compulsively theatrical even in life.

Peter Stormare, who played the valet in "Miss Julie" and the title role in Mr. Bergman's "Hamlet," continues to demonstrate his virtuosity, with a lyrical and very natural approach to Edmund. He makes a sometimes subordinated role seem more consequential. It is impossible to watch any performance of Jamie Tyrone without thinking of Jason Robards, who created the role and left his signature on it. Thommy Berggren moves in a disparate direction, emphasizing the character's flashiness as a helpless habitue of seedy bars and bordellos. Their late-night battle is, as it should be, a revelation for both brothers.

The production stresses the emotional turmoil and the bonds within this divisive family, as each character longs to be loved and respected by the others. Frequently, they embrace as if reaching for a cohesiveness that can never exist because, as Mary Tyrone observes: "The past is the present. It's the future, too."

Although the production runs nearly four hours, the intensity of the performance is unabating. The opposite is true of Mr. Nekrosius's three-and-a-half-hour "Uncle Vanya." It seems endless.

•

The Lithuanian "Vanya" takes place in an indeterminate environment that could be an anteroom to "Grand Hotel." It begins not, as in the original, with the old nurse serving tea from a samovar but with her reclining on a chair and Astrov singeing her with flames in an apparent attempt to cure some unnamed malady. Then the doctor rolls up one sleeve and a leg of his trousers, as if he is about to give himself a double dose of drugs. Next, he lifts a doorstop-size weight above his shoulders.

All these early morning activities do nothing except delay the play. Subsequent divergencies are for undefined dramatic and political purposes, as the director apparently tries to equate the Professor's domination of the household with the Soviet repression of the Baltic states.

When Astrov tells Yelena about his environmentalist concerns, he shows her minuscule maps, holding them up with tweezers, in the manner of a dentist displaying X-rays of teeth. It is possible that this is meant as a symbolic commentary on a country's shrinking resources. More likely it is a commentary on a director's overreaching imagination and his disregard of Chekhovian context. Despite all the directorial proclamations and critical attempts at exegesis during the play's international tour, the political statements seem superimposed rather than organic.

Stanislovos Kairys/Lincoln Center Theater

Vidas Petkevicius in the State Theater of Lithuania's production of Chekhov's "Uncle Vanya."

In what would have been news to the author, the play is presented as a black comedy. It is not clear what is intended to be comic and what is unintentionally amusing. Sonya, for example, is weighted by two thick ugly braids of hair that hang down almost to her toes. When Yelena says politely that she has beautiful hair, the line becomes laughable. The servants have been transformed into clowns, skating onstage in slippery shoes and pummeling their masters in their own private revolution.

Because of the directorial concept, experienced actors are led into prodigal paths, where it is difficult to measure performance. The Professor is smug to the point of being supercilious. Still there is no justification for having the actor walk at a perpetual tilt or to have him tied up at the end of the play, like a carpet awaiting shipment.

When he is not lifting weights, Kostas Smoriginas can be found shooting Vanya's pistol and crawling around the stage under the cover of an animal skin, all of which may add to Astrov's world weariness. Two performances are as pointed as they are authentic. Juozas Pocius is amusing as homely old Waffles, and in the title role Vidas Petkevicius demonstrates an empathetic understanding of Vanya's desperation. Around them is an ersatz experimentalist environment.

With his expansive vision, Mr. Bergman illuminates O'Neill's universality while Mr. Nekrosius takes a deconstructionist and reductive approach to Chekhov.

1991 Je 17, C11:3

Selling Off

By Harris W. Freedman; directed by Gene Feist; set design by James Youmans; costumes by David C. Woolard; lighting by Donald Holder; sound by Scott Lehrer; production stage manager, David Hyslop. Presented by Takka Productions Ltd. At the John Houseman Theater, 450 West 42d Street.

Leon Berkowitz	Andrew Bloch
Sydney O'Leary	Deborah Cresswell
Maurice Hughes	John Braden
Ethel Berkowitz	Dody Goodman
Sally Lowell	Janet Zarish
Harvey Schnorr	Robert Stattel
Arnold Handler	John C. Vennema
Muriel Berkowitz	Sofia Landon
Bernie Weiner	Larry Block

By WILBORN HAMPTON

Sooner or later, no matter what trade or profession one is in, the urge strikes to cash in one's chips and try a different game. Plumbers want to become musicians; lawyers yearn to go to sea; accountants decide to write plays.

"Selling Off," a new comedy by Harris W. Freedman at the John Houseman Theater, is about an accountant who decides to quit solving other people's problems and "find himself." By odd coincidence, Mr. Freedman is a former accountant himself. One hopes he kept his C.P.A. certificate. "Selling Off" has about as much humor as a tax audit.

•

The structure of the play is simple to the point of being simple-minded. Leon Berkowitz is determined to sell his Fifth Avenue accounting firm. Everybody else — his mother, his partner, his former wife, his lawyer, his lover and a couple of clients — is adamantly opposed to this idea. As Leon sees it, this unified opposition to his constitutional right to pursue his own happiness is motivated by one thing only, individual selfish greed. They are all living off the sweat of Leon's brow, or at least the ink of his ledgers, and he has had enough. Leon admits, under frequent questioning, that he has no idea exactly what it is he wants to do instead of accountancy. But he argues repetitively that the life of a bookkeeper is consuming him.

In a succession of scenes, each of the foes of Leon's plan parade on and off stage to present, either in person or more often over the telephone, his or her case against it. Each is also meant to be something of a character, whose eccentricities will wittily carry the show. But a recitation of cliental idiosyncrasies, amusing though they may be to someone in the same profession, is not enough to build a play on. And the roles of the fussing mother, nagging former wife and difficult girlfriend are so stereotypically drawn that they soon become tiresome. Even Leon, whom one is presumably supposed to regard as a free spirit, grows boring before the end of the first act.

Mr. Freedman employs several Creative Writing Class tricks in a vain attempt to develop a sense of madcap farce. Among other forced plot devices, a variety of permutations of the multiple conversation gimmick are used. (A character simultaneously talks to one person on the phone and another in the room. A character talks on two phones at the same time. A character talks to one person in the room and another on an intercom. The wrong character answers a phone and doesn't know who is on the other end of the line.) A lot of the play's action, in fact, takes place over telephones. Home telephones, office telephones, beauty parlor telephones, cellular telephones, public pay telephones and, of course, an answering machine.

•

A game cast of nine tries to put flesh and blood into what are little more than caricatures. Larry Block comes closest with a good performance as the shark of a lawyer who starts a stopwatch the moment he picks up a phone. Dody Goodman has a modest success doing her usual ditsy turn as the mother. Andrew Bloch never quite finds a sympathetic chord in the role of Leon. The director, Gene Feist, tries to keep things moving briskly, but there are still too many pauses both during and between all those phone calls.

No one can fault the production. James Youmans's set design, which includes assorted apartments, a law office, a hair salon and a phone booth that whirl out of the wings, is a delight. And the Art Deco office he has given Leon, with its spectacular view of Manhattan from a backstage window, is the classiest thing about the show.

1991 Je 17, C13:4

The Tragedy of Macbeth

By William Shakespeare; directed by Stephen Rayne; production designer, Gerry Lidstone; costumes, Emma Ryott; lighting, Christopher Gorzelnik; stage manager, Melanie Adam. Cindy Kaplan and Voza Rivers for the Haworth Shakespeare Festival and Committed Artists, in association with the New York International Festival of the Arts present leading British actors from the Royal Shakespeare Company and the Royal National Theater. At St. Bartholomew's Church, 109 East 50th Street.

WITH: Bhasker, Burt Caesar, David Case, Trevor Gordon, Mona Hammond, Caroline Lee-Johnson, John Matshikiza, Desmond McNamara, Patrick Miller, Clara Onyemere, Indra Ove, Solomon, Alex Tetteh-Lartey.

By WILBORN HAMPTON

Ambition, greed, lust for power and ultimately paranoia — in short, all the things that make politics so exciting — are not the exclusive properties of history. In a vibrant production put together by a group of black actors from Britain, Shakespeare's "Tragedy of Macbeth" has been transported from 11th-century Scotland to 20th-century Africa.

Adroitly directed by Stephen Rayne and well acted by the cast of 13, this staging at St. Bartholomew's Church (which runs through Sunday as part of the New York International Festival of the Arts) transforms what is too often regarded as a jinxed period piece that many actors refuse even to call by name into a modern political play. This "Macbeth" is as timely as today's headlines.

A stark series of gripping, rapid-fire tableaux immediately rivet the audience's attention. A fierce tattoo of drums pounds from the darkness. The lights come up on soldiers in jungle camouflage fatigues and red berets firing semiautomatic weapons as they rout a ragtag band of rebels and sack a village. Throats are slit; women are raped. There are more drums, then Duncan and his entourage, in colorful silk African robes draped over Western-style suits, enter to hear the reports of victory

Tony Nandi/Jeffrey Richards Associates

John Matshikiza and Caroline Lee-Johnson in "Tragedy of Macbeth" at St. Bartholomew's Church.

and Macbeth's battlefield heroics. Suddenly medieval Scottish clans are not so far removed from present-day African tribes. We could be watching the evening news on television.

•

Hearing the familiar praise of Macbeth as brave, valiant and worthy thus creates a new context for the play. Rather than perfunctory opening scenes that must be got through before the perfidy and real bloodletting begin, one reflects on any number of names on the contemporary political stage, and not just in Africa, who have been welcomed at once as saviors only to be later damned as tyrants. Program notes take pains to disavow specific parallels to modern countries. Apart from the obvious recent news from Ethiopia, names like Lumumba, Kasavubu, Tshombe, Amin and Bokassa crowd the mind. Once Lady Macbeth enters, one cannot help but wonder if she also collects shoes. And the vision of a popular commander returning from war and being urged to consider politics is even closer to home.

Mr. Rayne has taken no liberties with the text to reinforce the point. None are needed. He has allowed the actors the time to develop each scene, and as a result the characters become more alive. Still, the action moves smartly along.

The performances are strong if occasionally studied. John Matshikiza's reading of the title role is thoughtful and solid, although it tends toward the ruminative. Mr. Matshikiza has a full understanding of the tragic dimensions of Macbeth, a facet of the character that is too often lost by those who would portray simply his villainy. The actor is less secure moving in and out of Macbeth's madness,

and in these passages he tends to rely on a textbook rendering by gesturing with his right arm and addressing the lines to some distant point, in this case the rear of the church. But his is a thoroughly human portrayal and never less than credible.

The strongest performance is Caroline Lee-Johnson's excellent Lady Macbeth. Stunningly beautiful, Ms. Lee-Johnson erases all preconceived notions of Lady Macbeth from the moment she first enters to welcome her husband home and Duncan to his death. This is no hardened and scheming noblewoman who will have her way by sheer force of will. Clad in a shimmering silk pajama suit and exuding sexual power, she leaves no doubt about who is in control at Dunsinane. In the sleepwalking scene, Ms. Lee-Johnson paints a fully believable portrait of madness, pitifully trying to gnaw her hand clean of the blood that all the perfumes of Arabia will ne'er wash away.

Trevor Gordon is admirable as Banquo. An electric figure on the stage, Mr. Gordon is one of those actors to whom one's eyes almost immediately turn and who is always totally involved in a scene. Desmond McNamara plays Seyton as a modern white mercenary and delivers an amusing turn as the Porter. Patrick Miller is good as Malcolm in the final scenes. Burt Caesar's Macduff too easily falls into a stentorian declamatory style with the result that his grief over the slaughter of all his pretty chickens and their dam in one fell swoop becomes hollow and unconvincing.

1991 Je 18, C13:4

Theater in Review

■ Four new plays, one act each ■ A Dixieland-
flavored 'Twelfth Night' ■ Jewish Rep takes a
musical look back

New One-Act Plays Marathon 1991 Series C

Ensemble Studio Theater
549 West 52d Street.
Through June 23

Producer, Kate Baggott; associate producer, Margaret Mancinelli; set design, Ann Waugh; light design, Greg MacPherson; sound design, One Dream; costume design, Patricia Sarnutaro; production stage supervisor, Craig T. Raisner; production stage manager, Carol Avery. Presented by the Ensemble Studio Theater, Curt Dempster, artistic director; Dominick Balletta, managing director.
THE WORLD AT ABSOLUTE ZERO, by Sherry Kramer; directed by Jason McConnell Buzas.
SALAAM, HUEY NEWTON, SALAAM, by Ed Bullins; directed by Woodie King Jr.
THE LAST YANKEE, by Arthur Miller; directed by Gordon Edelstein.
BIG AL, by Bryan Goluboff; directed by Peter Maloney.
WITH: Debra Cole, Michael Countryman, Evan Handler, John Heard, Biff McGuire, Ramon Melindez Moses, Mansoor Najeeulla, Gus Rogerson and Charles Welton.

Without fanfare, an unpretentious and quietly observant new play by Arthur Miller opened this week at the Ensemble Studio Theater. "The Last Yankee" is about 20 minutes long and apparently has no illusions about enlarging its dimensions. As neatly directed by Gordon Edelstein, "The Last Yankee" is one of four plays in Series C in the company's marathon of one-act plays.

In it, two men meet at a state hospital, where their wives are patients. Both women are manic depressives. The two husbands, a retired businessman (Biff McGuire) and a carpenter (John Heard), look for possible causes for the illness. Gradually, and with humor, it becomes clear that the cases are completely dissimilar. The play notches no new dramatic ground for the author, but it is tersely written and performed.

"The Last Yankee" is followed by "Big Al," an offbeat comedy by Bryan Goluboff. The subject is the obsession of a fan (Evan Handler) with Al Pacino. As the world's expert on the actor, Mr. Handler has amusingly memorized his moves as well as his movies. It is his dream to write a screenplay for the actor. He enlists his writing partner (Gus Rogerson) in the assignment, and they brainstorm a movie they call "Maniac Priest."

Brightly bantering Hollywood lore, Mr. Handler suggests that it would not officially be a movie without a role for Charles Durning, Ned Beatty or Brian Dennehy. The play is filled with affectionate humor, but the ending needs a rewrite, as Mr. Goluboff reaches for the bizarre instead of settling for mirthful commentary.

Under Peter Maloney's assured direction, the two actors are an engaging team, especially as they chorus Michael Corleone's crucial line in "Godfather III": "But they pulled me back in!"

"The World at Absolute Zero" by Sherry Kramer, is an empty dialogue delivered by a tiresome couple on their first date. At 30 minutes, the play is a half-hour too long.

Ed Bullins's "Salaam, Huey Newton, Salaam" is a provocative idea for a play, but it needs shaping. The aftermath of the black revolution is represented by a down-and-out Huey P. Newton. Mansoor Najeeullah's opening monologue goes on far too long. But once Newton (Charles Weldon) is on stage, the one-act bristles with street knowledge and authenticity.
MEL GUSSOW

Twelfth Night or What You Will

Playhouse 125
125 West 22d Street
Manhattan
Through June 23

By William Shakespeare; directed by Peter Royston; musical direction and composition by Peter Nissen; costumes, Elizabeth Royston; lighting, David Kramer; choreography, Kathleen Dempsey. Presented by the Royston Company.
WITH: Joanne Comerford, James Corbett, Charls Hall, Michele Remsen and John Steber.

Twelfth Night is to winter what Midsummer Night is to its season, and there are few jollier merriments around for this summer's solstice than the Royston Company's production of Shakespeare's "Twelfth Night."

With a seven-piece Dixieland band and a mostly able cast of 17, the director Peter Royston has turned Shakespeare's most musical play into a foot-tapping romp that transports Illyria to New Orleans.

A clarinet and keyboard rendition of "Basin Street Blues" sets the tone even before the lights dim. Then, once the exposition scenes are out of the way, Mr. Royston gives full rein to the comedy while letting the romance lope along at its own pace.

All four of the main comic characters contribute to the energetic lunacy. At the center and acting as a sort of ringmaster for all the carryings-on is the Clown, and Paul Barry, got up in a red rubber nose and red sneakers, turns the role into a one-man minstrel. Mr. Barry's deft foolery, like the sun, shines everywhere, and he even plays the clarinet and sings.

His major foils are equally happily filled. Charls Hall's Sir Toby Belch is a revel. Never without a bottle in his hand, Mr. Hall reels from misadventure to misadventure, but manages to keep his wit intact. James Corbett, a bearded and seersucker-clad Sir Andrew Aguecheek, is his comical straight man. They are good together, especially in a funny garden scene in which an inebriated Sir Toby precariously carries a comatose Sir Andrew piggy-back around the stage while the band plays "When the Saints Go Marchin' In." Ted Rooney's Malvolio cuts an amusingly ridiculous figure, limping along cross-gartered in his

Carol Rosegg/Martha Swope Associates
Stuart Zagnit in "Encore" at the Jewish Repertory Theater.

yellow stockings, and gets the most from the letter-reading scene. Lisa Langford adds a fine performance as Maria.

On the romantic side, John Steber, as Orsino, and James Bianchi, as Sebastian, give fine performances and both are very likely natural Shakespeareans. Joanne Comerford is an ardent Viola and Michele Remsen gives Olivia an appealing come-hither reading. Kevin Alfred Brown is a credible Antonio.

Peter Nissen composed some Dixieland music for the Elizabethan songs in the text and leads the band from the banjo's chair.

The production is by no means flawless, and there is some slow going in spots. But if the music that be the food of love is Dixieland, then let the horn blow, the banjo strum, the tuba oomph and the trombone slide. After all, the subtitle is "What You Will."
WILBORN HAMPTON

Encore

Jewish Repertory Theater
344 East 14th Street

A revue of songs and scenes from Jewish Repertory Theater musicals. Conceived by Ran Avni and Raphael Crystal; directed by Mr. Avni; sets, Jeffrey Schneider; costumes, Gail Cooper-Hecht; lights, Brian Nason; musical director, Andrew Howard; production stage manager, D. C. Rosenberg; musical supervision, Mr. Crystal; musical staging and choreography, Helen Butleroff. Presented by Jewish Repertory Theater, 344 East 14th Street, Manhattan, Mr. Avni, artistic director; Edward M. Cohen, associate director. WITH: Adam Heller, Michele Ragusa, Susan Friedman Schrott, Steve Sterner and Stuart Zagnit.

In every way, the opening of "Encore" — the season finale for the Jewish Repertory Theater — was music to the ears, tuned to the past and to the future.

First of all, Ran Avni, the director and founder of this 17-year-old English-language company, announced that contrary to earlier fears, the company would play for another year in its house in the Emanu-El Midtown Y.M.-Y.W.H.A., where plans for sale and eventual demolition of the building had been reported. Having given assurance of a year to come, the program went ahead with what turned out to be a sparkling reprise of the music from eight shows the Jewish Rep has staged since 1983.

Avoiding the pitfalls of boring déjà vu that often accompany "and then we did . . .," the pair whose conception it is, Mr. Avni, the director, and Raphael Crystal, musical superviser, have woven almost 30 songs from unrelated shows into a surprising unity.

Adam Heller, Michele Ragusa, Susan Friedman Schrott, Steve Sterner and Stuart Zagnit constitute the cast and it says much that they can turn on a dime when it comes to being farcical, boisterously merry, pensive, romantic and blue, not to mention the dexterity of footwork and expression that ranges from buck-and-wing to pathetic totter. Their enthusiasm, by the way, was matched, perhaps inspired by, the piano accompaniment of Mr. Crystal and Andrew Howard.

The skillfully blended excerpts come from some of the company's best productions: "Kuni-Leml," "The Special," "Chu Chem," "The Grand Tour," "Sophie," "Up From Paradise," shows that range in theme from Jews in China to a portrait of Sophie Tucker.

"Encore" is more than your average retrospective; it is an outstanding example of how talent can take something old and convert it into something tunefully new.
RICHARD F. SHEPARD

1991 Je 19, C12:3

A Doll's House

By Henrik Ibsen; Swedish translation by Klas Ostergren; directed by Ingmar Bergman; scenery and costumes by Gunilla Palmstierna-Weiss. The Royal Dramatic Theater of Sweden, Lars Lofgren, artistic director, presented by the Brooklyn Academy of Music, Harvey Lichtenstein, president and executive producer, in association with the New York International Festival of the Arts. At the Majestic Theater of the Brooklyn Academy of Music, 651 Fulton Street, Fort Greene section.

Torvald Helmer	Per Mattsson
Nora	Pernilla Ostergren
Dr. Rank	Erland Josephson
Mrs. Linde	Marie Richardson
Krogstad	Bjorn Granath
Hilde	Erika Harrysson

By MEL GUSSOW

Nora in Ingmar Bergman's astonishing production of "A Doll's House" is charmingly seductive, intelligent and beautiful. In the director's interpretation and in Pernilla Ostergren's masterly portrayal, she is not a frivolous child-wife, but a willful woman with a mine of emotional resources. This seemingly revisionist approach to Ibsen's classic does not negate any of Nora's acknowledged traits, but it probes deeply into her psyche.

In every sense, Mr. Bergman's version, which concludes its three-performance run tonight at the Brooklyn Academy of Music's Majestic Theater, makes the play even more relevant to contemporary society. Traditional revivals emphasize Nora's ingenuousness and her husband Torvald's small-minded vindictiveness.

Pernilla Ostergren as Nora in "A Doll's House."

Bengt Wanselius/"A Doll's House'

capturing the cross-currents of conflict that permeate this household.

Miss Ostergren, who was Ophelia in Mr. Bergman's "Hamlet," is a radiantly expressive actress, combining intimacy with boldness, as in her tarantella. Lifting her skirts high above her knees, she dances with ferocity on top of a table, threatening to be swept away in a dance of death. Mr. Mattsson, dazzled by his wife, is a handsome, elegant Torvald, but with an insidiousness that would make him an uncomfortable companion and employer.

Erland Josephson is equally fine as Dr. Rank. In his characterization, the doctor has an air of vulnerability as well as authority, as he succumbs to Nora's sly charms. Their flirtation is made more flagrant and gives a clearer picture of why the doctor has become a ubiquitous guest in this house.

Mr. Bergman's most radical stroke is reserved for last. He splits the final act in two, so that the showdown between Nora and Torvald takes place in their bedroom, where a now rebellious and triumphant wife assails her husband, who has been aroused from his bed. He is amazed at the violence of her reaction. When he declares, "No one sacrifices his honor for love," Miss Ostergren exudes confidence as she says, simply, "Thousands of women have."

As Miss Ostergren's Nora abandons her marriage, it is impossible to believe there is the slightest hope for "a miracle" of reconciliation. That door slam reverberates more conclusively than in any other production of the play one has seen.

With "A Doll's House" following "Miss Julie" and "Long Day's Journey," it is evident that the visit of Mr. Bergman and the Royal Dramatic Theater of Sweden is the most memorable theatrical event of the New York International Festival of the Arts — and of the theater season.

1991 Je 20, C13:3

Today Is My Birthday

Created by Tadeusz Kantor; Cricot 2 Theater presented by La Mama E. T. C., in association with the New York International Festival of the Arts. At 74A East Fourth Street.

WITH: Loriano della Rocca, Leslaw Janicki, Waclaw Janicki, Ludmila Ryba, Marie Vayssière and Andrzej Welminski.

By STEPHEN HOLDEN

When Tadeusz Kantor died in December at the age of 75, his last work was in its final stages of rehearsal by his theater company, Cricot 2. As in many of his works, Kantor was to have been a participant in the autobiographical play "Today Is My Birthday," which is being presenting at La Mama in a five-night engagement that began on Tuesday as part of the New York International Festival of the Arts.

Like the director's earlier works, including his 1975 play "Dead Class," which was revived at La Mama this month, "Today Is My Birthday" presents a surrealistic evocation of his country's war-torn history that unfolds as a succession of hallucinatory tableaux, all done in somber shades of ash. But "Today Is My Birthday" was also to have been a more literal self-portrait in which the director, sitting at a table and gazing at a framed photo of his family, conjured up personal visions of the past.

Instead, there is only an empty chair and the pre-recorded voice of the director announcing his presence.

•

Kantor, who was a noted experimental painter before turning his energies to the theater, treated the stage as a kind of three-dimensional canvas into which his visions erupted, spilling toward the audience and overlapping, and then retreating. In this final work, the director's artistic background is underscored by the presence on the stage of three large empty picture frames, behind which much of the action unfolds. This simple but powerful concept of pictures within pictures becomes the work's central metaphor for the imagination.

The tiny figures in the family photograph — a mother, a father, a violin-playing uncle and a priest — periodically materialize like living, breathing tintypes, white-faced from the grave, to pose and strut behind the largest frame at the rear of the stage. The frames on either side contain an actor in a contemplative pose, who represents the author's self-portrait, and a young woman with an enigmatic smile, who represents Velázquez's portrait of the Infanta Margarita and who mischievously hikes her skirt up over the metal extension that push it out from her body. A kind of Dadaist joke at the heart of the production, she also remains detached from the action and never loses her composure.

Scattered around the stage are emballages, body bags containing many of the characters who stir and awaken at the director's summoning. During the action, a cleaning lady — who's also called the Critic — putters about the dingy, junk cluttered stage which Kantor designated "the poor room of imagination."

•

The 90-minute intermissionless play is divided into six short acts that dissolve into one another in a way that creates a feeling of accelerated time. Besides the director's family, the imaginary visitors include

Tom Brazil

Andrzej Welminski in a scene from "Today Is My Birthday."

In this production, both characters are more complex and unpredictable. The Torvald of Per Mattsson is certainly an egotist, but he is also very much a banker on the rise and someone who is fiercely protective of his image.

•

One of the director's many contributions is to locate and dramatize the passion in the Nora-Torvald relationship. This Nora is far more than a coquette. She is a highly sensual woman with a sense of vanity and a determination to achieve her goals.

Miss Ostergren's performance, along with those of Lena Olin in "Miss Julie" and Bibi Andersson in "Long Day's Journey Into Night," the previous Bergman productions at the Brooklyn Academy, remind one of the director's cinematic success with roles for actresses. In the case of each play, a woman becomes by far the dominant figure.

The production of "A Doll's House" is searingly intense and filled with Bergmanesque images and directorial surprises. Using a Swedish translation by Klas Ostergren (translated into English over headsets), Mr. Bergman has reordered the text and in some areas applied a scalpel, while remaining faithful to Ibsenism. In his adaptation, the director has removed the minor household characters and replaced the three Helmer children

with one, a girl, who is used for symbolic as well as narrative purposes.

"A Doll's House" takes place, as does Mr. Bergman's version of "Long Day's Journey," on an island-like platform, which is sparsely and imaginatively furnished by Gunilla Palmstierna-Weiss. Instead of the one set of the original play, there is a succession of three rooms — parlor, dining room and bedroom, for a climactic scene that as much as anything on stage testifies to Mr. Bergman's inspiration.

•

There are moments that cause the audience to gasp, as when Krogstad, furious at Nora's resistant manner, strikes her on the shoulder, physicalizing his fury at her and at the injustice he thinks has been inflicted on him. Repeatedly and with great effectiveness, there are visceral representations of inward emotions.

Moving a step away from naturalism, the production is as stylized as a Bergman film. That platform set is backed by a large photograph of the interior of the Helmer home, a picture that itself resonates with significant detail. When the actors are not participating in a scene, they sit on either side of the platform, as silent witnesses to what is occurring at center stage. When they enter a scene, it is without introduction. There are no transitions, just quick cinematic cuts,

friends, fellow artists, historical figures and allegorical characters.

The life it evokes is virtually inseparable from the unhappy modern history of Poland. The family tranquillity is quickly shattered, first by World War I, then by the Nazis and finally by Soviet domination. It ends in a scene of complete chaos that is cut off in a dramatic freeze-frame pose held by the 31-member group.

The play's most devastating moments evoke the horror and chaos of war with a panoramic bravura underscored with Polish and Russian folk music. Chalky-faced soldiers wheeling cannons, bearing rifles and strutting in mock-heroic grandeur storm onto the stage and pantomime rape, torture and execution. In these moments, the stage becomes a turbulent living painting that hits the spectator with devastating force.

Even more troubling than the controlled, almost statuesque chaos being served up is the sense of how these images roiled the director's memory. It portrays his mind both as a graveyard sprung to life and as a primal battlefield from which all wars emanate, its inhabitants shouting, marching, competing and suffering endlessly and futilely.

•

Had the director lived to participate in this production, he would have probably "conducted" the performances, as was his way, adjusting the actors and acting as the proud, whimsical maestro of his own private world brought to life. Without Kantor's physical presence and his striking, Buster Keaton-like face, "Today Is My Birthday" lacks some of the dark humor of his earlier pieces, but it is a still a searing work of the highest theatrical art.

1991 Je 20, C16:1

Forbidden Broadway 1991½

Created, written and directed by Gerard Alessandrini; costumes, Erika Dyson; wigs, Teresa Vuoso; production consultant, Pete Blue; musical director, Brad Ellis; assistant director, Phillip George; production stage manager, Jerry James. Presented by Jonathan Scharer. At Theater East, 211 East 60th Street.

WITH: Mary Denise Bentley, Susanne Blakeslee, Brad Ellis, Herndon Lackey and Jeff Lyons.

By MEL GUSSOW

As long as there is a Broadway, that sharpshooting parodist Gerard Alessandrini will be serving hemlock on the rocks to sacred cows, fat "Cats" and bullionaire Brits. And speaking of the last category, where would "Forbidden Broadway" be without Cameron Mackintosh?

The producer of hits from "Phantom of the Opera" to "Miss Saigon" has his signature on marquees (and on checks) all over town. In his new rush-to-criticism revue, "Forbidden Broadway 1991½," Mr. Alessandrini puts Mr. Mackintosh at center stage (in the person of the impish Jeff Lyons). Remove him from the scene and the show would be substantially shorter and, one might add, so would the Broadway season.

In this reverse celebration at Theater East, Mr. Alessandrini, as author and director, takes an acerbic look back at a decidedly nonvintage year. But dire or not, there is always some-

Carol Rosegg

Susanne Blakeslee in "Forbidden Broadway 1991½."

thing to satirize, forgotten failures as well as the few hits.

•

The most entertaining number is a sendup of "Miss Saigon," which begins with Herndon Lackey's priceless imitation of Jonathan Pryce singing "I'm an Asian Too." In this polyglot world, we are told, "everyone is cast wrong." To prove the point, Mr. Lyons bounds on stage in a red dress as Lea Salonga. Later, Mr. Lackey destroys "The American Dream."

If all the parodies were on the level of this one, the show would be a showstopper. But in common with the theater it mocks, the evening has its highs and its lulls, this time a few more lulls, beginning with the opening jibe at small Off Broadway musicals. Among the misfires is a rap song version of John Guare's "Six Degrees of Separation"; nearly as dispiriting is the takeoff on "The Will Rogers Follies." One problem there, of course, is that the show is close to self-parody.

In several instances the idea is funny but the writing lacks invention. This is the case with a spoof of Stephen Sondheim's "Assassins," which borrows from Irving Berlin for "You Can't Get a Hit with a Gun." The number is far outclassed by Mr. Alessandrini's previous Sondheim salutes "Into the Words" and "Teeny Todd."

Two other sketches promise more than is delivered: "I Hit Hamlet," with Nicol Williamson striking his costar with the help of songs from "Kiss Me Kate"; and a duel between Broadway's biggest stars, the chandelier in "Phantom" and the helicopter in "Miss Saigon." Not only is there room here for a commentary on today's mechanistic musicals, there could be more reflection on stars of the past (Susanne Blakeslee's heli-

copter outshouts Mary Denise Bentley's chandelier in the manner of Ethel Merman).

•

On the positive and malicious side is "The Secret Deodorant Garden," which assails Marsha Norman by confusing " 'Night Mother" with her ghostly musical, ridicules Mandy Patinkin's histrionics (again, Mr. Lyons) and also spoofs the score as a replay of the Tara theme in "Gone With the Wind."

In the cast of four (plus a pianist), the two men take comic precedence. While the actresses seem to be making faces, the actors are deft mimics and clowns, with Mr. Lackey doubling as a very slow-singing Topol and a gladhanding Will Rogers, and Mr. Lyons switching from a fast-quipping Jackie Mason to Andrew Lloyd Webber, the phantom of the musical.

There are a number of reprises from last year's show, including the devastating "Forbidden Grand Hotel," in which "people come, people go, people move chairs." The chameleonesque Mr. Lyons clangs silverware and plays Death and Kringelein. Then he suddenly becomes Joel Grey who wilkommens himself to Grim Hotel because it looked "like a quasi-Nazi musical." As usual, long-running shows raise the comic quotient of the annual "Forbidden Broadway."

1991 Je 21, C3:1

The Square

Written and directed by Eimuntas Nekrosius; set and costumes, Adomas Jacovskis; lighting, Gintautas Urba; lighting adaptation, Michael Blanco; English adaptation, Arunas Ciuberkis; artistic director, Ruta Wiman. Presented by the Joyce Theater Foundation Inc. and Lincoln Center, in association with the New York International Festival of the Arts. At 175 Eight Avenue, at 19th Street.

He .. Kostas Smoriginas
She .. Dalia Overaite
Doctor, announcer and prison guard
 Remigijus Vilkaitis
Prisoner Gerardas Zalenas

By WILBORN HAMPTON

While the theme of political oppression has quite understandably dominated nearly all the dramatic literature from east of the Oder River or the Bohemian Forest for the last several decades, it has not been a topic of primary concern to the English-speaking stage. By and large, the territory of the Gulag, or even the threat of the Gulag, is unknown to Western writers.

If Western theatergoers have dutifully attended productions of East European playwrights, like those of Vaclav Havel at the Public Theater and elsewhere, for example, and found them slightly dull, it is probably because we don't really recognize the terrain. We do not live in constant fear of a midnight or even a noontime knock on the door. If writers in the West have any real fear of prison, the cause is more likely to be income-tax evasion than their last play.

In an alternately gripping and humorous production that is also a post-Communist cautionary tale, the State Theater of Lithuania is presenting Eimuntas Nekrosius's play "The Square" through this weekend and July 2-7 at the Joyce Theater as part of the New York International Festival of the Arts. Although "The Square" is performed in Lithuanian with simultaneous translation, only passing attention need be given to the headset since one of the main strengths of this show is the excellent performances of its fine cast, especially that of Kostas Smoriginas as the unnamed prisoner, which make the words almost unnecessary.

•

The landscape of "The Square" is one of searchlights in the courtyard, of disembodied voices coming over hidden public address systems and broadcast by speakers in the corner of the cell, of watchtowers and alarm bells that go off when you put your foot in the wrong place. It is a nether world of doors without doorknobs and the muffled clickety-clack of rolling stock going by in the night. Instructions come from men in greatcoats speaking through bullhorns.

Mr. Nekrosius's story is about a prisoner, identified only as He, and a woman, identified as She. The play opens in a doctor's office after the man has been freed, then goes back to where he first saw the woman, began corresponding and received a visit from her. At the doctor's he is so used to doing only what he has been told that the doctor has to order him to resume breathing once the man has been X-rayed.

In "The Square," Mr. Nekrosius adds a few extra strokes to the usual grim portrait of life under political oppression, and they spell a warning to those who would think that freedom can somehow be legislated into existence. As He leaves the prison camp after more than 10 years there ("Freedom!" He says, stepping

through the door. "Already?"), He finds that alarm bells still go off when he makes a misstep. And the sharp commands of the doctor trying to help him ("Breathe! Do as you're told!") have the opposite effect.

The final success of "The Square" is largely due to a cast that makes all the characters believable through small human touches. When Mr. Smoriginas talks to the trees around the camp, it seems only natural. When he shivers from the cold, one wishes for a sweater. And when he tries to put a crease in his tattered prison trousers and slick back his matted hair before meeting the woman, it is a gesture both funny and heart-rending. As he tries to win her confidence with sugar cubes, he is touching. Dalia Overaite (who alternates with Janina Matekonyte as She) is no less credible in the role of the woman who befriends the prisoner. And Remigijus Vilkaitis is splendid in three roles as the doctor, a train announcer and especially the prison guard. Gintautas Urba's lighting, adapted here by Michael Blanco, adds immeasurably to the sense of distance that separates the world of He and She from that of their audience.

1991 Je 21, C3:5

Dionysus

Based on "The Bacchae" by Euripides; directed and designed by Tadashi Suzuki; stage manager, Keiji Osakabe; lighting, Leon Ingulsrud and Makiko Kume; sound, Shuichi Tomobe; costume, Takako Okamoto. Suzuki Company of Toga presented by the Japan Society Inc., in association with the New York International Festival of the Arts. At the Juilliard Theater, Lincoln Center, 155 West 65th Street.

Cadmus.............................. Kosuke Tsutamori
Pentheus............................Takahisa Nishikibe
Agave ... Mari Natsuki
Priests of Dionysus
Uichiro Fueda, Akihide Nakajima, Yoichi Takemori, Toshihiro Sakato, Michitomo Shiohara and Haruo Takayama

Maenads
Michiko Ishida, Akiko Aizawa, Satomi Fujii, Yuko Yanase and Tomoko Onodera
Reverend Mother................. Kazuko Yoshiyuki
Attendant...............................Hiroko Tasahashi
Believers

Kazuhiko Goda, Minoru Togawa and Masaharu Kato

By RICHARD F. SHEPARD

The New York International Festival of the Arts more than lives up to its aspiration as a crossroads of culture with the Japan Society's presentation at the Juilliard Theater of "Dionysus," a Japanese adaptation of a Greek classic with an injection of Shakespeare along the way.

This short (less than an hour and a half, with no intermission) but dramatically staged interpretation of Euripides's "Bacchae" is the handiwork of Tadashi Suzuki, founder and director of the Suzuki Company of Toga, whose previous American visits have won critical acclaim with productions of classics by Shakespeare, Chekhov and others.

According to the indispensable program notes by Mr. Suzuki, "the aim here is not to stage Euripides's play, but to use Euripides's play to stage my world view." This, he explains, is that the conflict between the god Dionysus and Pentheus, the King of Thebes, is actually one between a religious sect and political authority.

Jack Vartoogian

A scene from the Japan Society's presentation of "Dionysus."

As the play opens, Pentheus criticizes his grandfather Cadmus, who is a disciple of Dionysus. Pentheus is killed when he goes to watch the revels in the hills; it turns out that his mother, a frenzied cultist, is one of the guilty.

Although the presentation is brilliantly theatrical, its impact is not so much visceral as it is visual. The highly stylized actions are often like those of a stop-motion camera, each view quite effective but somehow separate from another. The appearance of three characters in wheelchairs, members of a "Farewell Cult" representing those who want to divest themselves of the weight of history, is an almost comic intrusion; the three sing nursery songs and repeat Macbeth's "Tomorrow, and tomorrow, and tomorrow. ..."

The tragedy is played on a bare, black-painted stage, lighted by glaring white beams that illuminate the characters who are speaking. The actors perform with melodramatic emotion and are stunningly made up and costumed. The company's method, with music to match, reflects what appears to be traditional Japanese theater style with Western embellishments reminiscent of theater exercises that blossomed here about 20 years ago.

"Dionysus" has its final performance this afternoon at Juilliard. However one may react to this curious blend of philosophy and stagecraft, it is a performance that may be one of the most international in the International Festival of the Arts.

1991 Je 23, 43:1

El Esplendor

A theatrical collaboration by Grupo Zero and El Taller. Written by Lalo Cervantes and Anita Mattos; directed by José Guadalupe Saucedo; producer, Joe Lambert; assistant director, Nilda Reillo Hernández; set design, Lauren Elder; costume design, Callie Floor; lighting design, Wendy W. Gilmore. Presented by Teatro Pregones, Dance Theater Workshop, the National Performance Network and Life on the Water's Latino Theater Project, in association with the New York International Festival of the Arts. At Pregones Theater, 295 St. Ann's Avenue, at 140th Street, the Bronx.

WITH: Miguel Angel de la Cueva, Roberta Delgado, Raquel Haro, Eduardo López Martínez, Berta Alicia Macías Lara, Miguel Nájera, Rashad Vanessa Pérez, Arturo Torres Romero, David Termenal and Velza Trussell.

By D. J. R. BRUCKNER

"What words have I to give you?" a retired vaudeville actress in "El Esplendor" asks a young woman who has been writing about her and searching for her since she was a little girl. "It is my life. But it is your story."

The ancient theatrical puzzle of finding what is reality and what is illusion is given some new twists in this work performed in English and Spanish at the Pregones Theater in the Bronx by members of Grupo Zero, a Mexican company dedicated to traditional Mexican carpas, or vaudeville, and El Taller, an experimental Chicano-Latino theater laboratory in San Francisco. The production is part of the New York International Festival of the Arts.

All the characters in the main story — which is about traveling vaudevillians who entertained all Mexico for generations until movies triumphed — also take roles in half a dozen skits that erupt into the play and reflect its themes in comic, subversive ways. The effect is like watching life through a kaleidoscope that shatters and reassembles one's understanding.

•

While the acrobatic vaudeville skits are uproarious, the central story is a poignant tale of a little Mexican girl who is lost in a crowd and comforted by a glamorous vaudeville actress and who, when she has become a successful Hollywood writer, pursues her memories to a rundown Baja California hotel (its name is the play's title) where she finds not only the actress but herself as well.

This is a work-in-progress to which members of the cast are still contributing, and seams show. Far too much thematic material — about the loss of cultural identity and the difficulty of breathing life into it even if it can be rediscovered — is not transformed into drama but is presented in dialogue. The whole work needs a firm directorial hand, and a firmer one guiding the writing, and cutting. But it is well worth the labor; its ideas are powerful and its story touching.

The actors, with a couple of exceptions, are perfect for their roles — imaginative, reflective, ironic and with a gift for comedy. If there is an imbalance in the cast, it is caused by Arturo Torres Romero as a vaudevillian crippled in a tightrope accident who has come to live at the old hotel among other former carperos. The role itself gives him advantages, but Mr. Torres Romero uses every gesture and glance, every silence, so effectively that when he trundles onstage in his wheelchair everyone else tends to fade from sight.

1991 Je 23, 43:1

SUNDAY VIEW/David Richards

Of Salesmen, Servants And Other Deceivers

Elaine May's
'Gogol and Preen':
friends in need.

There it is,
a 'Pageant' parody.

Bergman creates a
hallucinatory 'Julie.'

I'VE ALWAYS THOUGHT I COULD lose my head for Elaine May. Back in the 1960's, when she and Mike Nichols were perpetrating acts of improvisational madness, I almost never watched him. Oh, I knew he was critical to their functioning as a comedy team. But I couldn't help myself. She was the loose cannon, the wild card, the knuckle ball headed for home plate. You were never certain what she was going to do next. Whatever it was, I didn't want to miss it. I even liked it when all she was doing was tossing back her hair.

Consequently, it pains me to note that, with one possible exception, the liveliest aspect of "Mr. Gogol and Mr. Preen," Ms. May's new comedy at the Mitzi E. Newhouse Theater at Lincoln Center, is the cover illustration on the Playbill. Two men appear to be doing battle with an octopus, except that it's not an octopus that has wrapped itself around their waists, bound up their legs and reared a nasty-looking head. It's a vacuum cleaner and, to the victims' astonishment, the vacuum cleaner hose is what's tying them together.

Ms. May's work — an "Odd Couple" with absurdist overtones — depicts the relationship between a slick door-to-door vacuum cleaner salesman and the Russian-born anarchist who signs on the dotted line — not because he needs the appliance, but because he craves companionship. So the illustration (it's by Edward Sorel) is right to the point; the evening is all about entanglements. More than that, though, the squiggly-lined drawing has a feeling of freshness and spontaneity almost totally missing from the flesh-and-blood play.

Mr. Preen (William H. Macy) is the salesman, neat as a pin-stripe suit and aggressively polite, who touts the virtues of the Swiftie Lux, as if it represented salvation itself, not just a higher electric bill. The customer, Mr. Gogol (Mike Nussbaum), claims to be "a remarkist," who, following in the footsteps of Pascal, is writing a book of his thoughts. Life, he thunders, "is a wild argument with evil," and he loves to argue. If not an outright fraud, however, Mr. Gogol is a tricky little devil, who twists logic to his own ends and sees nothing wrong in brazen lying.

■

He is also a sloven of the first rank, and his apartment, masterfully designed by the ubiquitous John Lee Beatty, is a grand ruin, strewn with the stuff of a dozen garage sales.

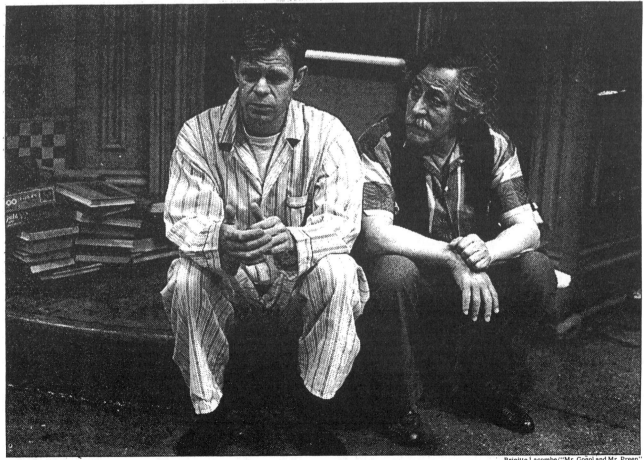

William H. Macy and Mike Nussbaum in "Mr. Gogol and Mr. Preen"—an "Odd Couple" with absurdist overtones

(In those places where your ordinary slob drops his socks, Mr. Gogol deposits moldering pies and half-eaten pizzas.) When Mr. Preen experiences a temporary malaise and has to lie down on the couch, Mr. Gogol takes it upon himself to nurse the salesman back to health. Or keep him prisoner. Anything, after all, for a friend.

What follows may be described as a battle of wits, although as battles go, it's fairly listless, and as wits go, they're less than nimble. I kept hearing faint echoes of Samuel Beckett — the Samuel Beckett who relished the antics of music hall clowns. Or maybe I'm just being misled by a title that sounds as if it could be vaudeville billing. Still, Mr. Gogol and Mr. Preen are one of those couples, like Didi and Gogo, who get on each other's nerves, constantly threaten to head their own ways and prove inseparable in the end.

Periodically, a teary old woman (Zohra Lampert), with whom Mr. Gogol seems to have had an affair, shows up on the landing outside his door and pleads to be let in so she can be forgiven for transgressions unspecified. Mr. Gogol denies knowing her until the final moments of the play, when he claims to have betrayed her. Are there metaphysical implications in this I'm not grasping?

Mr. Macy, all business at the start, is a wreck in no time — his glasses broken, his digestion shot, his nerves frazzled. Mr. Nussbaum, looking a bit like the plaster elf on a garden wall, is the revolutionary primarily as mischief maker. He talks loudly but carries a little stick. While Gregory Mosher's direction helps make a good case for why these two irritate each other, the underlying friendship is never convincingly developed. You get the idea that if Mr. Preen hadn't come calling, Mr. Clean or Mr. Sheen would have worked out just fine.

Beside the Playbill cover, the other exception to the general torpor is provided by an overflowing toilet, which sends a veritable cataract of water rushing out from under Mr. Gogol's bathroom door and spilling down the stairs into the living room. Although a similar calamity has probably befallen all of us, only Ms. May, I want to believe, would ever think of putting it on the stage. The faulty plumbing definitely injects a note of urgency into the proceedings. Mr. Gogol has to scramble to contain the flood, and while he does, "Mr. Gogol and Mr. Preen" reflects at least some of its author's deliciously perverse unpredictability.

'Pageant'

How do you parody a parody?

I raise the question because early in the game it must have occurred to the creators of "Pageant," the mad and merry musical entertainment at the Blue Angel. The task that the writers Bill Russell and Frank Kelly, the composer Albert Evans and the director-choreographer Robert Longbottom have set for themselves — between, I assume, deep inhalations of nitrous oxide — is to skewer the great American beauty contest.

However, as anyone knows — anyone, that is, who ever watched a Miss Kansas twirl a baton to a Rachmaninoff concerto or a Miss Tennessee explain how she plans to further world peace through a career in show business — these enterprises are already self-

satirizing. The reason Bert Parks imitations aren't funny is because long ago Bert Parks himself beat the caricaturists to the punch. How can you take the beauty pageant one step further without succumbing to total vacuousness?

"Pageant's" solution is as simple in theory as it is delirious in execu-

Scott Humbert/"Pageant"

Russell Garrett in "Pageant" at the Blue Angel—delirious in execution

tion: You have the contestants played by men in drag, and you make certain they do nothing they wouldn't do in the Miss America contest. It's all here — the tears, the nerves, the frozen smiles, the platitudes, the bad taste and, of course, the raging ambition just under the lacquered surface that gives beauty pageants their fascinating subtext. The only thing hilariously wrong with the picture is the gender of the participants.

To win the coveted title of Miss Glamouresse, the show's six contestants must not only compete in the usual evening gown, bathing suit and talent categories. There is also the "spokesmodel" face-off, which requires them to tout the merits of such dubious Glamouresse beauty products as Lip Snack ("color *and* calories in one attractive cylinder") and Smooth-as-Marble Facial Spackle. Members of the audience are selected beforehand to serve as judges, but among Miss Texas, Miss Great Plains, Miss Deep South, Miss West Coast, Miss Industrial Northeast and Miss Bible Belt, you're bound to come up with your own favorite.

■

Mine was Miss Industrial Northeast, who, as incarnated by Joe Joyce of the darting Latin eyes and bashful smile, gives the impression that he expects lightning to zap him between the shoulder blades at any moment.

But I can't deny what the terminally genteel David Drake, as Miss Deep South, does for the art of ventriloquy. (Sort of what Sherman did for Georgia.) Meanwhile, every utterance that J. T. Cromwell makes turns instantly to fatuousness, which makes him the perfect emcee for this romp.

Once the voting is over and the crown has been bestowed on the rightful head, he's the one who points the new Miss Glamouresse toward the runway, indicates her waiting subjects, and barks, "Take a walk!"

'Miss Julie'

If you'll allow me a transition from the ridiculous to the sublime, the *dress that Lena Olin wore as the title character in Ingmar Bergman's* production of "Miss Julie" was bright red, and the provocative way she flounced in it, her proud head held high, made you think it could have been a matador's cape. August Strindberg's play, which pits a capricious aristocrat, uncomfortable in her skin, against an opportunistic va-

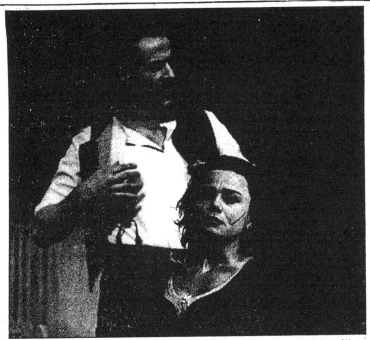

Bengt Wanselius/Brooklyn Academy of Music

Lena Olin and Peter Stormare in "Miss Julie"—pushed to the edge

let, who views seduction as a means of social advancement, is one of the fiercest accounts ever written of the war between the sexes. And Mr. Bergman and the Royal Dramatic Theater of Sweden, appearing all too briefly at BAM's Majestic Theater as part of the New York International Festival of the Arts, pushed it to the edge.

■

Even with an imposing scar on her left cheek, Ms. Olin is a ferociously beautiful woman, and her remarkable performance had no trouble reconciling Miss Julie's whimpering weaknesses with her commanding will. The haughty flirtatiousness quickly acquired the glints of a dangerous madness, and the violence of the mood swings took your breath away. Peter Stormare, as her seducer, had the less flashy role, but there was a similar vacillation in him between the coward and the bully, the desperate vulgarian and the aspiring esthete. Once the battle was joined, you could only fear for the emotional wreckage and hope no bones got broken.

The set, the kitchen of an obviously prosperous country estate, was rendered entirely in shades of gray and white, while Kristin (Gerthi Kulle), the cook who kept it spotless, loomed sternly in black. Even the lesser servants, caught up in the celebration of Midsummer's Eve, had the sickly pallor of drunkenness about them. Ms. Olin's red dress turned out to be the solitary touch of color. With its subliminal suggestions of blood and sin, it was troublingly apt.

Strindberg maintained that "Miss Julie" was Sweden's "first naturalistic tragedy." But this production was too hallucinatory, its terrors too hypnotic, for that. By the end of the evening, you no longer felt you were in the bowels of a Swedish manor. Somehow, you'd been led inside a deep wound. □

1991 Je 23, II:5:1

Lips Together, Teeth Apart

By Terrence McNally; directed by John Tillinger; sets by John Lee Beatty; costumes by Jane Greenwood; lighting by Ken Billington; sound by Stewart Werner; production stage manager, Pamela Singer; fight staging by Jerry Mitchell; artistic associate, Michael Bush; general manager, Victoria Bailey. Presented by Manhattan Theater Club, Lynne Meadow, artistic director; Barry Grove, managing director. At City Center, 131 West 55th Street.

Chloe Haddock	Christine Baranski
Sam Truman	Nathan Lane
John Haddock	Anthony Heald
Sally Truman	Swoosie Kurtz

By FRANK RICH

"I think these are terrible times to be a parent in," says Christine Baranski, as one of the two wives trying to enjoy a Fourth of July Fire Island weekend with their husbands in Terrence McNally's fine new play, "Lips Together, Teeth Apart." Her sister-in-law, Swoosie Kurtz, counters: "I think these are terrible times to be *anything* in."

The times, of course, are our own, but on the surface they don't seem so terrible. In "Lips Together," a comedy that hurts, two affluent couples laze about a newly inherited beachhouse that they liken to paradise — and whose market value they estimate at $800,000. As designed by John Lee Beatty at the Manhattan Theater Club, the house floats on a breeze-swept landscape of dunes and is equipped with a glorious expanse of blond-wood deck, a kitchen bespeaking the tyranny of shelter magazines and, reaching toward the audience's lap, a swimming pool whose crystalline blue is pure Hockney. "I can see right to the bottom," says Nathan Lane, as Ms. Kurtz's husband, a New Jersey building contractor, when he first goes near the water.

But the wives are right. There is terror in paradise. No one ever goes swimming in that pool — out of an unspoken if irrational fear that its previous owner, Ms. Kurtz's deceased brother, might have tainted it with AIDS. One of Mr. McNally's four 40-ish characters is battling an invisi-

ble but terminal biological "malevolence" of a more traditional kind, while another is struck with random psychological dreads that reduce him to forgetting how to knot his tie and shoelaces. One couple is tormented by repeated miscarriages, and both are blighted by a love triangle that eventually sends the two brothers-in-law — Mr. Lane and Anthony Heald, a prep-school admissions officer — into a violent altercation at poolside. Terrible times for Mr. McNally's characters in "Lips Together" are the same as they were for those in "Frankie and Johnny in the Clair de Lune," his previous play about a couple skirmishing into the moonlit hours. Life is "cheap and short," and there are "a million reasons" for men and women not to love each other.

The playwright has no solution to this quandary beyond the prescription that gives his play its title — a bedtime litany that will allow one to fall asleep without grinding one's teeth. But because Mr. McNally can see right to the bottom of both his world and the people who inhabit it, most of his recent works, "The Lisbon Traviata" and "André's Mother," as well as "Frankie and Johnny," offer unsentimental hope about the possibilities for intimacy at a time when fear and death rule even beachfront land. "Lips Together" is his most ambitious survey of this territory yet, and though not flawless, his most accomplished. The bright wit that has always marked Mr. McNally's writing and the wrenching sorrow that has lately invaded it are blended deftly throughout three concurrently funny and melancholy acts. The evening's moods are as far-ranging as its allusions to "A Star Is Born" and Virginia Woolf and as changeable as its incidental score, which runs from the show-biz cacophony of "Gypsy" to the serenity of "Così Fan Tutte."

Mr. McNally's premise for "Lips Together" reaches back to "The Ritz," his early bathhouse farce, for its fundamental fish-out-of-water gag is to inject heterosexual characters into a gay milieu. But how times have changed in two decades! The heterosexuals of "Lips Together" are enlightened — in varying degrees, up to a point — about homosexuality, and

they co-exist at a cordial distance with the occupants of the houses on either side of their own. Mr. McNally's perspective has changed, too. "Lips Together" is as much about what the hetero- and homosexual communities — or at least those of the white middle class — have in common in an infected, diminished civilization as it is about what sets them apart. The play's great generosity can be found in its insistence on letting the audience see each camp through the eyes of the other without distorting either point of view, and, as it happens, without bringing a gay character on stage.

Nowhere is the author's depth of understanding more visible than in the role of Sam Truman, the contractor played by Mr. Lane. Sam is the play's least sophisticated, most homophobic figure, an unpretentious suburban Joe. But both as written by Mr. McNally and as beautifully acted by the incomparable Mr. Lane, Sam is not unsympathetic. The "least defended" of the weekenders, he is a sloppy fount of humanity whose emotions cannot be predicted or typed. Sam may dismiss the gay neighbors as "the boys from Ipanema" — "What do these people have against Tony Bennett?" he howls after one musical selection too many from across the dunes — but by Act III and without pretending to reform his prejudices, he has found some vague, sustaining epiphany in the lovemaking of two men he spies in nearby bushes. For all his babyishness, Sam is desperate to connect to his straying wife, and Mr. Lane, that rare comic actor who is not afraid to expose himself completely (a riotously sudsy onstage shower included), makes the audience share that aching hunger.

●

Under the exquisitely modulated direction of John Tillinger, all the actors in "Lips Together" are first-rate, but, like Mr. Lane, Ms. Baranski is a little more equal than the rest. Her role of Chloe is an indelible and finally touching comic turn — a self-described "walking nerve end" and "overbearing" suburban matron who is constantly jabbering about inanities (sometimes in French) while serving hamburgers and Bloody

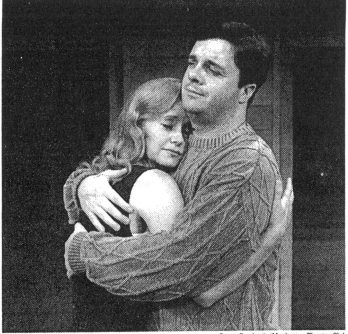

Gerry Goodstein/Manhattan Theater Club

Swoosie Kurtz and Nathan Lane in "Lips Together, Teeth Apart."

Marys and bursting into songs (especially Miss Adelaide's from "Guys and Dolls") that she performs in community-theater musicals back home. Ms. Baranski has played similar neurotics before (including Mr. McNally's), but in keeping with her brother Sam, Chloe has another dimension and a firmer, more valiant grip on her troubled life than her comic ditsiness might at first suggest. By the time she baldly concedes to her patronizing sister-in-law that "just about everyone is superior to me," the audience has stopped feeling superior to her — and is being touched by lines that earlier provoked laughs.

It's not the actors' fault that the spouses of these star siblings are less compelling. It's to the credit of the author that Chloe's preppy, selfish husband is not ennobled by illness — "With or without cancer, I'm still the same person," as he puts it — and Mr. Heald plays him with that pinched, insidious malice he first revealed in "The Lisbon Traviata" and perfected as the bureaucratic villain in "The Silence of the Lambs." Ms. Kurtz brings her transparent honesty to the only dishonest writing in the play: Her most brooding speeches strain for the poetic — as does a symbolic, phantom swimmer she sees on the horizon — and Mr. McNally never makes it clear how her character, a painter of fragile sensibilities, became the wife of the plebeian Sam.

Otherwise, this is an evening in which people forever assail truth as unattainable and "too formless to grasp" — in life and art alike — yet inexorably zero in on it. The playwright's candor includes a willingness to let the play flow and ebb naturally rather than crest in false theatrical climaxes; no secrets are artificially withheld from the audience, and both the medical and marital crises of the plot are delivered in asides to the audience in the opening minutes. For the characters, truthfulness takes the form of an acute self-awareness that allows them to see their own limitations and those of their spouses and fight for love anyway, in a valiant effort to believe that they are not as alone and unprotected and doomed as the nattering insects whose electrocution by a nearby bug lamp punctuates the night.

"I wanted to see what death looks like and not be afraid of it," says Ms. Kurtz, as the character whose brother died of AIDS before the play begins. "Lips Together, Teeth Apart," a work with real teeth and equally penetrating compassion, cannot take away that fear of death. But it does something that the theater must do now more than ever, by leaving an audience exiled from paradise feeling considerably less alone.

1991 Je 26, C11:1

Theater in Review

■ Teen-age Brooklyn in the 40's, with a New York debut ■ 14 years after the curse of initial success ■ Three one-acts at Theater Row.

Club Soda

WPA Theater
519 West 23d Street

By Leah Kornfeld Friedman; directed by Pamela Berlin; setting by Edward T. Gianfrancesco; lighting by Craig Evans; costumes by Deborah Shaw; sound by Aural Fixation; choreography by John Carrafa; musical direction by Edward Strauss.
WITH: Dan Futterman, Aaron Harnick, Katherine Hiler, Patricia Mauceri, Alanna Ubach, Lenny Venito and Danny Zorn.

The time is 1947. The place is Brooklyn. The Mills Brothers' "Paper Doll" is the hit of the day, and the Lindy is still a favorite dance. Jackie Robinson, a black second baseman, is about to make baseball history in Flatbush. Lillie, a nice Jewish girl from the Brownsville section, is about to lose her virginity.

"Club Soda," a new play by Leah Kornfeld Friedman at the WPA Theater, is one of those comedies best described as nostalgia vérité, a pleasant and amusing stroll down memory lane that comfortably reassures us nothing much has changed in the last few decades, even if the family doctor can now counsel about abortion in-

stead of recommending mustard baths for teen-age girls who think they may be pregnant.

The play follows Lillie's senior year in high school. Lillie, a clever and inquisitive young woman who wants to read every writer from Austen to Zola before she dies, would like to go to college. But her mother, whose taste in reading matter runs to movie magazines, wants her to get a job after graduation. Lillie also has a crush on Binnie. She's smarter than he is; but she likes the way he leans against a lamppost.

The boys in the neighborhood, tired of harmonizing on the street corner, chip in and organize a private club, the Club Soda of the title. Girls are allowed in only at certain times (and for certain purposes). By prom time, Binnie asks Lillie to marry him.

At the level of fond and humorous reminiscing, "Club Soda" is a charming if familiar exercise. As a serious play on adolescence from the feminine point of view, a sort of "Diner" or "Radio Days" for girls, it is rather mundane, lacking either depth of characterization or specificity to give it substance. The absence of Lillie's father, for example, although explained in a couple of lines, is a major omission.

A major credit for any success of "Club Soda" at the WPA belongs to Alanna Ubach, who brings such buoyance and vivacity to Lillie that it's no wonder all the boys try to kiss her in the library. Although the program says she is from California, every bouncy move and saucy intonation Ms. Ubach makes bespeaks Rockaway Avenue. This is Ms. Ubach's New York debut, and she is an actress to keep your eye on. The rest of the cast is able and Pamela Berlin's direction keeps the action moving smartly.
WILBORN HAMPTON

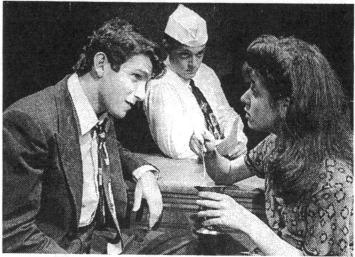

Martha Swope/"Club Soda"

Dan Futterman, left, Lenny Venito and Alanna Ubach in a scene from "Club Soda," a coming-of-age comedy set in 1947 Brooklyn.

Currents Turned Awry

Nat Horne Theater
440 West 42d Street
Through Sunday

By D. L. Coburn; directed by Philip Galbraith; assistant director, Sharon Fallon; lighting, Richard Kent Green. Presented by Love Creek Productions and Isy Productions.
MEET DOYLE MACINTYRE
WITH: Michael Cannis, Larry Collis and Robert Lindley Sutton.
DINNING OUT ALONE
WITH: Nick Stannard.

One of the worst things that can happen to a beginning playwright is to have his very first effort picked up by a major producer, plunked down smack on Broadway, cast with two of the theater's most stellar luminaries and, to complete the dream, be given the Pulitzer Prize. This is not to suggest that D. L. Coburn did not deserve all the success he achieved for "The Gin Game," his funny and poignant 1977 play directed by Mike Nichols and starring Jessica Tandy and Hume Cronyn. But for the last 14 years Mr. Coburn has been trying to overcome it.

The playwright is now back in town with two new one-acts, jointly billed under the title "Currents Turned Awry," at the Nat Horne Theater. The title, of course, comes from the end of Hamlet's great soliloquy when he observes that too much brooding makes one hesitate, and that life-and-death matters thus become like "currents turned awry and lose the name of action." In each of Mr. Coburn's one-acts, the issue of "great pitch and moment" concerns suicide.

The first and far more absorbing play, "Meet Doyle MacIntyre," brings a 60-year-old executive into a sleazy bar during the day. He has been forced out of his job and wants to talk. The only other customer is an unshaven barfly who will be happy to hear the life story of anybody who's buying.

As the two men compare career notes, the playwright deftly mines the inherent humor of a businessman discussing the vagaries of corporate America with a deadbeat alcoholic. But when the businessman begins to talk of "believing in signs," takes a pistol out of his briefcase and suggests a game of Russian roulette, the dramatic stakes rise.

Robert Lindley Sutton is excellent as the barfly, his voice husky from booze and his attention never wavering long from the bottle on the table. Larry Collis, who took over the executive's role on short notice, commands a full understanding of the character and no doubt has all his lines off by now.

The second play, "Dining Out Alone," although it boasts a cast of 14, is no more than an extended skit, and a lowbrow one at that. A feature writer for a newspaper in a Southern college town is alone on Thanksgiving eve at Jorge's Gourmet Mexican. The journalist, who fantasizes about being a famous novelist when he is not lusting after the waitress, pours forth sneering stream-of-consciousness criticism of the Yahoo provincialism of the other diners, who include an extended family, a couple in leisure suits and a pair of local celebrities.

Nick Stannard is faintly amusing as the smug journalist in a stand-up comic sort of way. But neither his impulsive decision to kill himself with a sword from the restaurant wall nor his abrupt change of heart about his fellow diners is believable. Philip Galbraith directed both plays.
WILBORN HAMPTON

Working One-Acts '91

Theater Row Theater
424 West 42d Street
Through Sunday

Presented by the Working Theater, Bill Mitchelson, artistic director; Mark Plesent, general manager.
NEW HOPE FOR THE DEAD, by John Sayles; directed by Earl Hagan
BETTING ON THE DUST COMMANDER, by Suzan-Lori Parks; directed by Liz Diamond
ABANDONED IN QUEENS, by Laura Maria Censabella; directed by Mr. Mitchelson
WITH: Kevin Davis, Linda Marie Larson, Dean Nichols, Joseph Palmas, Roger Serbagi, Pamala Tyson.

In Suzan-Lori Parks's one-act play "Betting on the Dust Commander," Kevin Davis and Pamala Tyson give beautifully detailed portrayals of a married couple in Kentucky in the 1950's sinking into an abyss of habit and stale recollection.

The best of three plays presented by the Working Theater in its "Working One-Acts '91" program, Ms. Parks's drama takes an extended swatch of small talk in which a husband and wife happily recall meeting and marrying, then repeats the same dialogue word for word, but in a weary mood that suggests the passage of many soul-deadening years.

Images of dust and of plastic permeate the play. Their meeting involved a racehorse called the Dust Commander. For their wedding ceremony, they used plastic flowers. As they reminisce, the wife removes a plastic slipcover from an armchair and pats clouds of dust from the cushion into the air. By the end of the play, the images of dust and plastic, which are reinforced with props suspended from the ceiling, become almost suffocating metaphors for unfulfilled lives.

The lightest of the program's offerings is John Sayles's surreal two-character comedy "New Hope for the Dead." Set in the basement of a sports arena, it depicts an encounter between a self-proclaimed idiot savant named Pharaoh (Joseph Palmas), who boxes popcorn and has an eerie knowledge of ancient Egypt, with Candace (Linda Marie Larson), a failed actress who has been used and abused by scores of men and wants only to be famous. The play consists essentially of two interlocking monologues on immortality that reach an amusingly surreal synthesis. The witty encounter is infused with the same generosity of spirit that runs through Mr. Sayles's screenplays.

The third play, Laura Maria Censabella's "Abandoned in Queens," is an overly long realistic drama in which a boorish furniture salesman (Roger Serbagi) and his sensitive son (Dean Nichols), clash in very predictable ways after the salesman's neurotic, long-suffering wife has walked out on him. Although the playwright lavishes abundant compassion on her characters, and the roles are well-acted, they never quite transcend kitchen-sink stereotypes.

STEPHEN HOLDEN

1991 Je 26, C12:3

Getting Married

By G. B. Shaw; directed by Stephen Porter; scenic designer, James Morgan; costume designer, Holly Hynes; lighting designer, Mary Jo Dondlinger; production stage manager, William Hare. Presented by Circle in the Square Theater, Theodore Mann, artistic director; Robert Buckley, managing director, Paul Libin, consulting producer. At 1633 Broadway, at 50th Street.

Mrs. Bridgenorth......................Elizabeth Franz
Collins.......................................Patrick Tull
General.....................................Nicolas Coster
Lesbia......................................Victoria Tennant
Reginald...................................Simon Jones
Leo...Madeleine Potter
Bishop......................................Lee Richardson
Hotchkiss.................................Scott Wentworth
Cecil...J. D. Cullum
Edith..Jane Fleiss
Soames.....................................Walter Bobbie
Beadle......................................Guy Paul
Mrs. GeorgeLinda Thorson

By WILBORN HAMPTON

To wed or not to wed, that is the question facing most of the Bridgenorth family in "Getting Married," Shaw's still timely if loquacious disquisition on the institution, not to mention the superstition, of marriage.

In a new production at Circle in the Square, the first major New York revival of the play in 40 years, the director Stephen Porter and his mostly able cast humorously expound a litany of farcical heresies concerning matrimony in the first half of the evening before becoming bogged down in what Shaw himself admitted was "nothing but talk, talk, talk, talk, talk."

But the talk is all Shaw talk, or as the playwright described it, "a row of Shaws, all arguing with one another." There are a bishop, a general, a gentleman, a snob, a greengrocer, a bridegroom and the women in each of their lives. Every one of them has a different view on the subject of marriage, especially the women.

All of these people come together in the kitchen of the Bishop of Chelsea's residence on the morning of his youngest daughter Edith's wedding. General Bridgenorth, the bishop's brother, is to give the bride away. But weddings always remind him of his unrequited love for Lesbia, the headstrong sister of the Bishop's wife. The room is soon filled with guests, both invited and uninvited. Among the latter is Reginald, another Bridgenorth brother, reputed to be a scoundrel who knocked his wife, Leo, to the ground in front of the gardener and then ran away with a streetwalker to Brighton. As it turns out, Reggie was only doing the gentlemanly thing by providing Leo with grounds for divorce so she could marry young St. John Hotchkiss, a snob with "a face like a mushroom."

•

Never one to dawdle when he's building plot, Shaw immediately ushers in St. John, followed by Cecil himself, who has some disquieting news. Both Edith and Cecil have received pamphlets titled "Do You Know What You Are Doing by One Who Has Done It," setting out the liabilities each faced under Edwardian England's marriage laws. Being sensible people, each has separately decided the holy bonds of matrimony consist of little more than indentured servitude. The prospect of taking someone for better or worse, when there's no way of knowing just how bad the worse might be, provides Shaw his soap box, and the rest of the play takes on the aspect of a debate on Speaker's Corner.

Through one character after another, Shaw puts forward arguments for polygamy, for polyandry and for abolishing marriage altogether. Just when everyone decides the only reasonable course is to draw up a contract that would set down all the conditions for a marriage, no one can agree on any of the terms. As Donald and Ivana could have told them, prenuptial agreements just tend to make work for lawyers.

Stylistically, Shaw made several departures in writing "Getting Married." The play is not divided into acts or scenes and takes place on one set without any lapses in time (although there is an intermission taken in the middle at Circle in the Square). The plot moves by conversation rather than action, and the play changes in form as it goes along. What begins as a quite funny farce becomes an amusing sociological comedy and finally shifts into the torpid realm of mysticism. As the bishop says at one point, "It's hard to know the right place to laugh."

By the end, Shaw is not so sure it is a laughing matter. In the last third of the play he introduces a new character, Mrs. George, who is the coal merchant's wife, the Mayoress, the greengrocer's sister-in-law and the author of a series of anonymous love letters to the bishop. She is also a clairvoyant who represents Woman personified, and Shaw gives her a couple of tedious sermons that deflate the levity and move the audience to steal glances at their watches.

•

Up until that time, with a couple of brief exceptions when the production

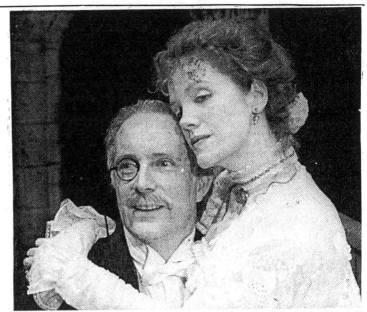

Martha Swope/"Getting Married"

Simon Jones and Madeleine Potter in a scene from Shaw's "Getting Married," at the Circle in the Square Theater.

moves slowly, Mr. Porter mines Shaw's wit with the help of some fine performances. The most successful of the ménages is the tangled affairs of Reggie, Leo and St. John. Simon Jones is splendid as Reggie, the plain, honest, dull husband who would thump his wife in the garden if that would make her happy. Monocled and positively exuding a stiff upper lip, Mr. Jones is a born Shavian. Madeleine Potter is outrageously saucy as his wife, Leo, who insists on her right to change men as often as the spirit moves her. And Scott Wentworth's St. John is the model of a bounder who holds as dogma that "the whole strength of England lies in the fact that the enormous majority of its people are snobs."

There are other strong readings. Lee Richardson is shockingly sensible as the bishop, who insists on giving the Devil fair play. Elizabeth Franz, who was hilarious as a nun (Sister Mary Ignatius) a few seasons back, is no less credible as the Bishop's wife, whose main concern is the propagation of the race. And Walter Bobbie delivers an excellent deadpan turn as Soames, the solicitor turned chaplain who considers all marriage an abomination and whose advice to one and all is to "take Christian vows

of celibacy and poverty." Jane Fleiss is a feisty Edith and J. D. Cullum is the jittery bridegroom Cecil. Patrick Tull's greengrocer would never be mistaken for a duke, and Nicholas Coster has all the bluster for a general, though it becomes a one-note exercise.

There are a couple of problem roles, however, that can't be simply blamed on the weaknesses of the last half of the play. Linda Thorson's Mrs. George is so misconceived as to be an affront. The character is supposed to represent Womanhood: wife, companion, lover, mother all rolled into one. In Ms. Thorson's hands, Mrs. George more resembles a trollop, flighty and flirtatious to the point of being a flibbertigibbet. When she goes into a trance to deliver what Shaw rather ambitiously described as "the entire female sex crying to the ages," Ms. Thorson leaps onto the dining table like a sideshow fortune teller. And Victoria Tennant, in the role of Lesbia, who wants children but not badly enough to take a husband to get them, is more of a whiny old maid than a model of incipient feminism.

1991 Je 27, C14:3

Othello

By William Shakespeare; directed by Joe Dowling.

Roderigo...................................Jake Weber
Iago..Christopher Walken
Brabantio.................................George Morfogen
Othello.....................................Raul Julia
Cassio.......................................Michel R. Gill
Desdemona...............................Kathryn Meisle
Emilia.......................................Mary Beth Hurt

By FRANK RICH

 HEN a New York Shakespeare Festival presentation is clicking in Central Park, the sun knows just when to set and even the leaves rustle on cue.

Such was the case at the Delacorte Theater during the press opening of "Othello." The sun plopped down just as Christopher Walken, the inexhaustibly snide Iago of the evening, announced his dark intention to lead Othello by the nose into self-destruction. The trees made their contribution somewhat later, swaying malevolently at the precise moment Iago comes upon the

Raul Julia, bottom, and Christopher Walken
in a scene from "Othello" in Central Park.

Martha Swope/New York Shakespeare Festival

handkerchief that seals his Machiavellian plot. Only in the final scene, at Desdemona's death bed, did nature fail to oblige the director, Joe Dowling, and his able cast, for the "huge eclipse of sun and moon" that Othello (Raul Julia) expects to greet his murder of his wife did not materialize. But even this late-hour lapse was, at least, in sync with the production, whose own most severe failing is an inability to sound the deepest tragic notes.

Until that shortfall becomes conspicuous, and even after, there is much to enjoy here. Granted, enjoyment is not what one most expects from a play in which many of the principal characters die, and for no just reason. But this "Othello," like so many before it, is dominated by its villain — who has the longest, wittiest and most active role to play — and Mr. Walken's nastily comic performance sets the wicked tone for a staging that offers surefooted storytelling and tense domestic drama rather than grand passions and interpretive brilliance.

As always, Mr. Walken's idiosyncrasies require some indulgence. Appearing with patently dyed hair and in a black-leather jacket (designed by

Jane Greenwood in a style that might be called punk Renaissance), the actor makes no more concessions to Shakespearean convention as Iago than he did as Coriolanus. But his raspy Brandoish inflections and perpetual sneer cannot obscure the fact that he is at home in the verse; better still, his concentration is too fierce to permit many detours into outrageousness. Though occasionally he is so flamboyantly two-faced it strains credulity to believe he could bamboozle his prey, much of the laughter Mr. Walken earns is legitimate. His Iago assumes he is the smartest person in any scene, and he spins his web of deceit with the slightly bored condescension of an intellectual snob who does not suffer fools gladly.

What is missing from the interpretation is the pitch-black nihilism, the motiveless malignancy, that fuels a great, terrifying Iago like the one Christopher Plummer played opposite James Earl Jones on Broadway in 1982. Mr. Walken's (and his director's) reading of the play is much simpler, for the motive for Iago's revenge against Othello seems unambiguously his resentment at losing a military promotion to Michel R. Gill's more presentable, more politic but less brainy Cassio. While Mr. Walken can seem reptilian in the icy spotlight that isolates him during asides and

soliloquies, he is in the relatively benign summertime tradition of sexy villains whom alfresco audiences love to hate.

That it is hard to care as much about his prime victim is the fault of Mr. Julia, whose tragic hero is fine in most ways except the one that matters most: the revelation of a steadily disintegrating psyche. This was also the shortcoming of his Macbeth, 18 months back in a previous installment of Joseph Papp's Shakespeare Marathon, though his Othello is otherwise far, far superior to that outing. Always ready with a sunny yet official smile, Mr. Julia has the physical and vocal authority of a military leader so commanding he literally bestrides the map of war in an early scene. But once his mind is poisoned by distrust, he tends to bray and bark at a steady, impersonal pitch that conveys Othello's raw fury but little of his jealousy. A few poignant waning reflections aside, Mr. Julia's characterization seems a display of his admirable theatrical technique instead of an unstinting exploration of a man's divided and finally shattered soul.

Whether by intention or accident, the actor also makes little of the Moor's sympathetic predicament as an outsider in Venetian society. Indeed, Mr. Dowling, an Irish director who did the memorable Gate Theater

Dublin "Juno and the Paycock" imported to New York a few summers ago, goes against the American grain by refusing to see "Othello" as a piece in part about racism. The dominant image in Frank Conway's handsome, scrupulously classical set is a slab of female statuary that is toppled once the hero's ideals about Desdemona are upended. Honor and evil are the warring forces at work here, not whites and blacks, and certainly this is a legitimate view of a 17th-century play that was not necessarily envisioned by its author as the ur-text of "Jungle Fever." But Mr. Julia's portrayal is deficient anyway, not because he is not black but because he rarely conveys the pathos of the prideful Othello's insecure status among those who often view him patronizingly as a heathen.

With the exception of one silly interlude — a show of native Cyprus revelry that might be mistaken for limbo night at Club Med — everything else about this "Othello" is above reproach. Not only has Mr. Dowling found a refreshingly adult Desdemona in Kathryn Meisle, who is intelligent and self-possessed as well as pretty, but his casting consistently perks up the minor roles, from Miriam Healy-Louie's Bianca, a vulnera-

ble as well as a racy courtesan, to George Morfogen's forlorn Brabantio to Jake Weber's Roderigo, a foolish suitor so pathetically unaware of Iago's manipulations that he for once earns pity along with derision. In a class apart is Mary Beth Hurt as Emilia, Iago's long-suffering wife and Desdemona's most devoted friend. Her chilling realism about men and women — "They are all but stomachs, and we all but food" — and her harrowing awakening to her husband's crimes give this "Othello" a somewhat compensating emotional punch during its underwhelming death throes.

Using a fairly full text (sans clown), Mr. Dowling keeps most of the performances front and center and most of the action swift, as befits the play's uncommonly intimate focus and tight construction. However lacking in tragic dimension, this entertaining "Othello" is sufficiently above the recent Shakespeare in the Park norm that an audience can count it at least a minor tragedy when and if a performance is curtailed by rain.

1991 Je 28, C1:1

SUNDAY VIEW/David Richards

Scene Stealers At Stratford Fete

**'Hamlet' makes a
virtue of profligacy.**

**'Much Ado' raises
picturesque to an art.**

**And a stark 'Timon of
Athens' counters the
opulence.**

STRATFORD, Ontario

THE STRATFORD FESTIVAL IS, arguably, North America's finest repertory theater. But it is also a major tourist attraction, and like its competition — the Rockies, Old Faithful, Niagara Falls — it knows the value of grandeur. Even in these times of penury, it continues to produce Shakespeare on such a lavish scale that, were the impulse not roundly discouraged, half the spectators would probably be grabbing for their Instamatics.

Consider the transition from the first to the second scene of "Hamlet," one of the principal offerings of this, the festival's 39th season. Chased away by the cock's crow, the gray ghost of Hamlet's father has disappeared into the inky blackness, trailing a cloak that seems to be fashioned of cobwebs.

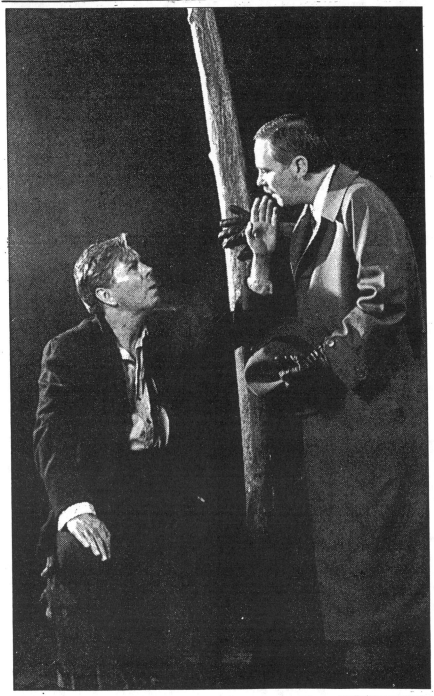

Tom Skudra/Stratford Festival

Brian Bedford, left, as Timon, and Miles Potter as his servant Flavius—standout

foaming soups, a roasted boar's head borne triumphantly high and a multi-tiered cake that is already listing dangerously in the direction of the guests. Meanwhile, another army of servants is setting out the flickering candelabra and draping garlands along a stately balcony. The preparations alone suggest it will be the party of the year, which, in this staging, happens to be 1790.

■

Whatever else it may be at Stratford, Shakespeare is beautiful to behold — as beautiful, in fact, at the end of "Hamlet," when the bodies are collapsing in poisoned agony, as it is at the end of "Much Ado," when dancing prevails. The picturesque is raised to a mighty art here. The approach definitely brings in the crowds — and more power to it. But it also underlines the festival's kinship with the practice of interior decoration. You know an indecent pile of money is involved, but the good taste with which it has been spent makes a virtue of profligacy.

Under the circumstances, it is no surprise that the current festival standout should be "Timon of Athens," if only by stark contrast with the luxuriousness elsewhere. With its intentionally drab look and its spartan scenery, it is the decidedly poor cousin of the family. The play, widely thought to be an unfinished draft, was probably never acted during Shakespeare's time. At Stratford, it has been assigned to the least elegant of the festival's three performing spaces — the Tom Patterson Theater, which, from the outside, at least, could pass for a vintage airport hangar.

As directed by Michael Langham, however, the work proves rivetingly contemporary. If the action is as simple as a child's fable, the tone is mordant, the humor cutting and the misanthropy all-embracing. With his reckless generosity, Timon, a wealthy Athenian (Brian Bedford), has attracted about him a circle of leeches and sycophants whom he truly believes to be friends. But when his fortune runs out and he appeals to them for help, all he encounters are lame excuses, weak apologies and deaf ears. Incensed at man's ingratitude, Timon retreats to the wild and becomes a hermit.

■

There, while digging for sustenance, he uncovers buried treasure, and soon the flatterers are back with open hands. Instead, Timon gives the money to Alcibiades, a rebellious Athenian army captain, and to a clutch of bandits and whores, so that they will wreak devastation and pestilence on the city. The loyalty of his faithful servant Flavius (Miles Potter) is not enough to temper Timon's bile. He dies, a believer in nothingness.

In "The Misanthrope," Molière put an equally acerbic character on the stage in the person of Alceste and had him turn a defiant back on humanity in the end, too. But the French playwright also allowed more temperate points of view to be expressed. (Célimène, the flirt whose complaisance so enrages Alceste, is actually a creature of considerable charm.) There are no opposing voices in "Timon of Athens," no one to qualify Timon's fulminations. From the outset, Apemantus (John Franklyn-Robbins), the churlish philosopher who comments on events from the sidelines, believes what Timon will come to believe — that "the strain of man's bred out into baboon and monkey." The acrimony goes uncontested.

Mr. Langham's production is set in Europe in the early 1930's, about the time the Depression began to show it had real sticking power. A large Braque painting hangs in Timon's house, and its colors — olive, black, brown — predominate in the costumes of Ann Hould-Ward. This is the same society that crops up

The members of the watch, still blinking uncertainly at what they've seen, dash off to apprise Hamlet of the indistinct apparition. Then, with barely a pause, the lights come up blazing on the court of Elsinore and a breathcatching vision of 19th-century opulence — fire-engine-red military uniforms dripping with braid, and white satin ball gowns edged with pearls.

Everything — the bold sashes, the jewels, the gold tassels, even the glossy black boots — seems to capture the brightness, refract it and throw the splinters back up into the celebratory air. It's like being propelled from the peephole of a kaleidoscope to the tumbling magnificence at the other end.

Or let someone call for a great supper, as Leonato does in "Much Ado About Nothing," also a big festival drawing card this summer. An army of obedient servants instantly materializes to speed the feast on its way. We're in for a veritable parade of steaming pies,

in the canvases of Otto Dix and Ernst Ludwig Kirchner — corrupt businessmen in homburgs; thin, jaded women in flapper dresses, and military officers with eyes cold as medals.

When Timon entertains, an exotic dancer very much like Josephine Baker, wearing a G-string of bananas, is the after-dinner titillation. Duke Ellington wrote an insinuating jazz score for "Timon" when Mr. Langham initially staged it at Stratford in 1963. The composer Stanley Silverman has reconstituted the music for this production, and its sexy and sad moods permeate the proceedings like sweet cigar smoke, as if to say how enticing are the ways of dissipation, how elusive the bonds of men.

After Timon retreats to the wilderness, the set designer Douglas Stein transforms the stage into a desiccated terrain, all rock and dirt, with but a single tormented tree offering any sign of life. Samuel Beckett's "Waiting for Godot" would be right at home here. Indeed, munching on a root and cursing his blasted destiny, Timon could well be a Beckett tramp, except that he has given up waiting for anything or anyone. His unflinching despair goes beyond a mere city of hypocrites to embrace a whole universe constructed on the principle of thievery. The sun, after all, robs the seas of their waters; the moon "her pale fire snatches from the sun,"

while the earth feeds ravenously on decomposing bodies and "gen'ral excrement."

■

The apocalypse can come none too soon for Timon. When it does, it is announced by a faint whine in the air, so faint you think you're hearing a hornet or maybe a horsefly. Then it dawns on you that the buzzing is really a warplane passing high overhead and that mass destruction is in the offing. The realization is chilling. Once the bombing and strafing are over, though, Mr. Langham finds an even more chilling sound on which to end "Timon of Athens" — the hollow whistling of the wind as it blows over an empty land.

Mr. Bedford's Timon is not the foolish spendthrift he's sometimes taken for. Instead, the actor plays him as a fervent soul who believes devoutly in the fellowship of men and thinks he's advancing it with his prodigality. His awakening is rude and sour, and the actor manages to extinguish all traces of that flush-faced, crinkly-eyed pomposity which sometimes gives him the appearance of a smug

pumpkin. (For that side of Mr. Bedford, catch his performance as Dogberry in "Much Ado.")

Among the fawners and parasites there are vivid portrayals by Nicholas Pennell, Louis Negin and Tom Wood — oily and deferential, when Timon's largesse is coming their way; indignant and superior when it isn't. I never once thought of them as Elizabethan characters or "Timon of Athens" as a play four centuries old. This remarkable production seems to be giving direct voice to the greed and sanctimoniousness of the 1980's and the bitterness and impoverishment that have followed.

■

Neither "Hamlet" nor "Much Ado," both of which are presented in Stratford's flagship auditorium, the Festival Theater, can lay claim to that urgency. While you don't want to call them museum productions, you do get the impression periodically that you're looking at sumptuous illustrations of the plays, not the plays themselves. Colm Feore is not a particularly compelling Hamlet (with his high forehead, sharp nose and round eyes, he could have been drawn by Edward Gorey), and Sidonie Boll's Ophelia is close to dreadful. In fact, only Edward Atienza's Polonius, delighted to be at the heart of so much intrigue, struck me as rising above

the general level of well-polished competency.

Mr. Feore fares much better as the bantering Benedick in "Much Ado," trading quips with Goldie Semple, whose Beatrice synthesizes Goldie Hawn's daffiness and Susan Sarandon's smarts and the bright looks of both — if you can imagine that. Richard Monette's direction is deliciously spirited, until the play gets entangled in the Hero/Claudio subplot, which is where most productions bog down, as this one does. So you focus on the lovely Renaissance church setting and the wedding finery that the designer, Robin Fraser Paye, has contributed to the occasion.

■

The eye is certainly courted at every turn, and, in the final count, that may help explain why Shakespeare at Stratford seems to be unfolding at a remove, as if under glass. Things are too perfect, too cared for, too immaculate. Nothing is allowed to be ragged and unkempt, not even raggedness itself. Dogberry's cohorts are picture-postcard bumblers. Granted, the director David William sets one scene of "Hamlet" in a torture chamber, but it has no more reality than the painted whip marks on the backs of the tortured. The prevailing esthetic forbids messiness. Grace clearly outranks grit. As the sign on the hotel door says, "Do Not Disturb."

In the gardens outside the Festival Theater, every begonia knows its place, and the lawn, trim as a dandy's beard, rolls down to the banks of the Avon River, where swans trace gentle ripples in the water. When Shakespeare is not just a playwright, but a vacation stop, as well, the obvious temptation is to keep everything as tidy as possible. The traveler in me appreciates that, relishes it even. But the theatergoer gravitates to "Timon's" troubling landscape. □

1991 Je 30, II:5:1

Elisabeth Feryn/Stratford Festival

Colm Feore as Hamlet and Patricia Collins as Gertrude—a sumptuous illustration of a play

The Balcony Scene

By Wil Calhoun; directed by Michael Warren Powell; sets by Kevin Joseph Roach; costumes by Thomas L. Keller; lighting by Dennis Parichy; sound by Chuck London and Stewart Werner; fight director, Rick Sordelet; production stage manager, Fred Reinglas; production manager, Jody Boese. Presented by Circle Repertory Company, Tanya Berezin, artistic director; Terrence Dwyer, managing director. At 99 Seventh Avenue South, at Fourth Street, Manhattan.

Paul.....................................William Fichtner
Karen..Cynthia Nixon
Alvin ...Jonathan Hogan

By FRANK RICH

When a play's dramatic climax involves one man's brave efforts to defy the elements by renting a videotape during a virulent Chicago thunderstorm, you had better believe that it is nap time. "The Balcony Scene," a new play by Wil Calhoun, is 80 minutes of nearly uninterrupted slumber that wastes the energies of two fine actors, Cynthia Nixon and Jonathan Hogan, and leaves an audience questioning the judgment of the Circle Repertory Company, a home for such

Gerry Goodstein/"The Balcony Scene"

Jonathan Hogan and Cynthia Nixon in the Circle Repertory Company's "Balcony Scene."

distinguished writers as Craig Lucas and Lanford Wilson. What was this theater thinking of? It's one thing for a nonprofit company to aim high and fail, but "The Balcony Scene" aspires to be "Same Time, Next Year" and crash lands at roughly the esthetic altitude of "Three's Company."

•

The story of two new neighbors who meet cute on adjacent balconies in a high-rise apartment building and inexorably end up in each other's arms, "The Balcony Scene" is "Two for the Seesaw" without the seesaw, or, arguably, the microwavable version of the Circle Rep's "Burn This." Its romantic partners are Karen (Ms. Nixon), a perky young airhead in advertising sales who is getting over a bad-news beau (a briefly seen William Fichter), and Alvin (Mr. Hogan), a freelance writer and rabid Chicago Cubs fan who has not left his apartment in seven months, even for Wrigley Field.

Alvin is prone to soliloquies about the decline and fall of civility in supermarkets and other chaotic outposts of the urban jungle — he's a gentile stand-in for the kvetchers in Herb Gardner plays like "I'm Not Rappaport" and "Thieves" — and it is Karen's duty to teach him that life is worth living if you "roll with it" and learn how to "defend yourself." This she does, and not a moment too soon. By the time Alvin at last does screw up his courage to go outside and rent that videotape, the audience is grateful mainly because it will soon be able to do the same and perhaps yet salvage an evening otherwise bereft of entertainment.

•

Mr. Calhoun fails to provide his chosen genre's rock-bottom necessities: eroticism and laughs. Instead he offers predictable vignettes larded with unmotivated confessional monologues and other implausibilities. To believe various developments in this play, one has to buy the notions that Karen would invite a strange man into her home and that she would not lock her apartment door (apparently unprotected by a doorman downstairs) even as she receives threaten-

ing phone calls. One also has to find it credible that a nonfiction writer like Alvin can not only pursue a career without leaving his desk but also that he can "pay the bills" with a series of articles on Reconstruction in the post-Civil War South! (Presumably this series is being published by either Cosmopolitan or Playboy, for it pays so well that Alvin changes into a new shirt roughly every 10 minutes.) Even Mr. Calhoun's smallest character details don't add up: Karen, a self-described Woody Allen fanatic, has never seen "Annie Hall."

Scant conviction is added by the director, Michael Warren Powell, who drowns the script in wistful new-age music instead of striking so much as a spark of spontaneity. His production is distinguished only by Dennis Parichy's lighting and by the whimsically deployed skyline that redeems Kevin Joseph Roach's busy realistic set. There is no sexual charge between the two leads, and Ms. Nixon smiles and babbles so insistently to shore up a male playwright's sentimental idea of a dizzy girl-woman

that she gives the first irritating performance of her exemplary career. Mr. Hogan's old-shoe charm is sturdy enough, though he often looks studied, whether asked to show off Alvin's sports fanaticism by wearing a baseball cap indoors or his intellectual bent by reading "The Old Man and the Sea" on his terrace.

•

At all times the point of this exercise remains a mystery. Perhaps agoraphobes are to be encouraged by Alvin's miraculous ability to overcome his malady without leaving home or consulting a therapist. Perhaps singles are to find new hope in the ease with which Mr. Calhoun's yuppies find true love right next door. Whatever the intention, "The Balcony Scene" brings a lesser Circle Rep season to a dead end and, for those of us who care, looks like another bad omen in what is shaping up to be an even more disastrous year for the Cubs.

1991 Jl 1, C9:1

The Weeks Before the 1959 Senior Prom, Set to Music

By STEPHEN HOLDEN

Popular culture has so severely strip-mined 1950's teen-age life that replays of "Grease" and "Happy Days" can no longer be counted on to yield nostalgic nuggets at the first drop of a "daddy-o." "Prom Queens Unchained," the amusing new 50's musical that opened on Sunday downstairs at the Village Gate, deals with this depletion of resources by evoking the period as a shrill, campy cartoon whose nonstop comic silliness stampedes any thoughts of nostalgia.

The show, which has music by Keith Herrmann, lyrics by Larry Goodsight and a book by Stephen Witkin, is set largely in the corridors and classrooms of Robert Underwood High School in the weeks before the 1959 senior prom. As patrons enter the theater, a smiling Mom, dressed like a cafeteria worker, distributes bagged lunches along with advice not to open until instructed. After the students troop in, everyone is asked to rise and pledge allegiance to the flag.

Despite its moments of audience participation and some scattered

prom decorations, the show is not really an environmental theater piece. The story revolves around the competition among four girls for the title of prom queen. Sherry Van Heusen (Connie Ogden), the smiling honey-haired captain of the cheerleaders, has a bag of lethal tricks up her sleeve to insure victory even though she is the front runner. Cindy Mackelroy (Dana Ertischek), who is described as "good natured, punctual and with good hygiene" is a reluctant rival.

Louise Blaine (Sandra Purpuro), the class tramp who is still on probation after two years in prison, feels she has nothing to lose. Carla Zlotz (Susan Levine), a bongo-beating beatnik, is too busy mourning the demise of her boyfriend, Minka Lasky (Mark Edgar Stephens) to pay much attention to the contest. Minka, who composed an acne-ridden ballad called "Squeeze Me in the Rain," accidentally tripped and fell while leaving a woodshop class.

Among the other teen-agers on the scene are Switch Dorsey (David Phillips), a lanky greaser, and Venulia, a mysterious exchange student whom Switch believes to be a Communist spy until she gives him his first lessons in kissing. Finally, there is Richie Pomerantz (Mark Traxler) the class nerd and science wizard who conceives of "transmoleculization" — a process that, if care isn't taken, can transform an arm into a giant-sized hamburger. Underwood High's entire faculty is portrayed by Ron Kurowski, with a slipping and sliding freneticism that recalls Terry Sweeney at his most uninhibited .

•

"Prom Queens Unchained" was directed and choreographed by Karen Azenberg in a free-for-all, semi-slapstick style that matches the frantic tone of the dialogue. The show grows steadily loopier until it becomes permanently and deliriously unhinged when an effort to bring Minka back from the dead instead produces Mario Lanza.

Mr. Witkin's book is little more than a succession of pun-filled jokes whose tone is carried over to Mr. Goodsight's lyrics. Although Mr. Herrmann's music has a 50's rock-and-roll flavor, his songs don't even try to capture period musical styles in any detail. The wittiest numbers are Cindy's mother's saccharine ode to a corsage that she has stored in the refrigerator for the last 20 years, and a lunchtime anthem that turns the "day-o" of "The Banana Boat Song" into "mayo."

Mayo, however, is not an ingredient in Mom's lunch bag. Expect instead to find a golden oldie of budget-minded 50's culinary audacity: a soggy peanut butter and banana sandwich.

1991 Jl 5, C3:2

SUNDAY VIEW

For 'Othello,' the Fault Lies in the Stars

By DAVID RICHARDS

NOT ALL OF "OTHELLO" (AT THE DELA-corte Theater in Central Park) is dreadful. But, unfortunately, the worst of it can be traced to the pairing of its two stars, which means that most of the time the dreadfulness is front and center. Raul Julia is the title character and Christopher Walken, his nemesis, Iago. And sometime before July 14, when the run ends, someone really ought to introduce them to each other.

With this production, Joseph Papp's Shakespeare marathon is now 18 plays old, but it still has not come of age. Has nothing been learned from prior efforts? Does it really have to be hit or miss each time out? And why, frankly, is the New York Shakespeare Festival seemingly incapable of developing a discernible style? I'm not even talking about a style that would necessarily connect one production to the next — not when A. J. Antoon gives us a slapstick "Taming of the Shrew," plopped down in the American Wild West, while JoAnne Akalaitis treats "Henry IV, Parts I and 2" as a collage fashioned from the detritus of the last five centuries. I mean consistency *within* a given production.

"Othello's" director, Joe Dowling, has shown a deep, invigorating understanding of the works of Brian Friel and Sean O'Casey. (His staging, a few seasons back, of "Juno and the Paycock," for example, wrenched that drama free from a long-entrenched tradition in the Irish theater that held poverty to be picturesque and reeling drunkenness quaint. What Mr. Dowling, an Irishman, perceived instead was degradation and squalor.) His imprint on this production is much less decisive, and he seems to have been unable to exercise any influence whatsoever over Mr. Julia and Mr. Walken, who are going their separate ways with a vengeance.

Two more disparate, ill-accorded performances are hard to conceive. Mr. Julia, taking his second crack at

Othello for the festival (the first was in 1979), plays the brooding Moor as if he were one of the gods in "Once on This Island." Mr. Walken looks to have stepped out of a sleazy motorcycle film set in the indeterminate future when law and order (and diction) have disappeared from the planet. They enjoy no rapport, create no sparks, stir no currents in the night air. You don't even get the impression, as you do with some actors, that they enjoy working with each other.

Let's start with Mr. Walken, since Iago is the linchpin, and if his performance doesn't hold up, the rest of the play will crumble about his shoulders. Iago is, obviously, an unrepentant villain — vicious, conniving, manipulative. He hatches the plot that will bring Othello low, keeps it moving when it threatens to flag and redirects it when unexpected obstacles crop up. He has a whole arsenal of lies and half-truths at his disposal. But he also knows the value of *not* speaking. By pretending to avoid a question lest the answer incriminate his fellow man, he gets it both ways. His honor remains intact, and incrimination's work is done anyway. Pure guile, he hoodwinks every major character in the play.

Iago's villainy, however, is the last thing you want to underline. He can save his true nature for us, when no one else is around. But when he's with others, the mask had better go up fast. What we want to see, above all, is the charm that deceives so many, men and women, and the air of noble impartiality even as he's nimbly stacking the deck. There must be a reason the surrounding characters trust Iago, call him a good and honest man and put their fate into his safekeeping. Something about him has to be seductive enough to cloud judgment. Otherwise, they come off as nitwits.

■

Yet Mr. Walken's Iago announces himself on first sight. His skin is a bloodless white, pulled tight over a face that resembles a death mask. His wears his hair in a brush cut, dyed punk maroon. His sensuous lips appear swollen, and the slump of his body suggests a street-corner sullenness, until anger stirs it erratically to action. Physically, the actor emits nothing but danger signals, and his vocal delivery — mumbled, offhand, cool — doesn't alter the impression. Even Iago's wit

Martha Swope/"Othello"

Christopher Walken with a toppled head of Aphrodite in "Othello" at Shakespeare in the Park

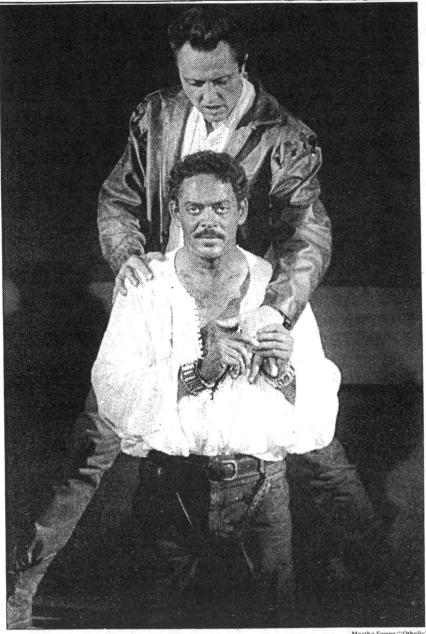

Martha Swope/"Othello"

Raul Julia and Christopher Walken, rear—With "Othello," the Shakespeare marathon's 18th production, another title can be dutifully stricken from the list.

Mr. Julia seems to envision Othello as a simple giant, of slow and deliberate manner. His speech is lilting, far more evocative of a gentle Caribbean island than fierce Mauritania. Although Othello's tales of his pitiable upbringing and exotic adventures are what first beguile Desdemona, it is Mr. Julia's openness, his affability and his childlike wonder that capture our attention.

His inability, however, to catch on to Mr. Walken's ploys, when those ploys are so transparent to us, end up turning a simple man into a simpleton. The trust begins to loom as recklessness, the rising emotions sound increasingly hollow and the terrible heartbreak that crowns the play somehow registers as Othello's just deserts. Because Mr. Walken fails to keep pace — appears, in fact, willfully ensconced in some private world of his own — Mr. Julia has to elevate the stakes single-handedly and lead himself ever deeper into deception. By the end, he is not just tearing passion to tatters, but tearing the tatters to tatters.

Mr. Dowling has greater success with the actresses in his cast. Kathryn Meisle is a strong, self-possessed Desdemona, clinging to the only reasonable interpretation of events — that Othello's madness is a temporary aberration. Far and away the production's best performance, though, is given by Mary Beth Hurt as Emilia, Iago's wife. She speaks sense forthrightly, views the inequity of women's lot with a wryness that never degenerates into jaundice, and by the delicacy of her restraint shows the depth of her compassion. Although "Othello" is one of Shakespeare's grandest tragedies, it is also one of the most intimate. And you're never so aware of the intimacy as when these two actresses steal a moment, just before Desdemona retires to her bed, to share confidences with each other.

This being outdoor Shakespeare, a certain

Caribbean deity (Raul Julia) and motorcycle hoodlum (Christopher Walken) have a not-so-close encounter in the park.

grandeur is mandatory, if only to offset nature's own effects, which included a spectacular full moon the other night. Venice and Cyprus, as the set designer Frank Conroy has conceived them, are monumental locales. A great granite arch of triumph marks Venice's might, while the huge head of Aphrodite rules over Cyprus, until rowdy Venetian soldiers send it toppling to the ground — a bold foreshadowing of the downfalls to come. Jane Greenwood's costumes have a similarly forceful elegance. But we're still a long way from a satisfying production.

The Shakespeare Festival, of course, can now put one more notch in its belt, and another play title can be dutifully stricken from the list. Granted, I missed the earliest productions. But if there is an overriding esthetic to the marathon — beyond getting the next play on — I can't define it for you. From what I've seen, a body of work is not being artfully amassed. Individual productions are simply being plucked from the grab bag, with the random results and rude disappointments that chance inevitably begets. □

1991 Jl 7, II:1:1

is reduced to something uncomfortably close in rhythm and emphasis to Jackie Mason shtick.

Since there is so little difference between the public and the private man, Mr. Dowling throws a white searchlight on Mr. Walken whenever Iago is expressing his inner thoughts. The tactic is helpful, I suppose, the way traffic signals are helpful, although it further bleaches out the actor's face and makes him look like a stunned animal, frozen in an automobile's headlights, just before it becomes road kill. The performance is so flagrantly spooky as to compound, not solve, the play's thorniest problem.

■

The problem is this: Othello has always been quick to swallow the bait. He doesn't want to believe Desdemona unfaithful, but once the idea is planted in his mind, he can think of nothing else. His towering jealousy borders on capriciousness. Without the full force of Iago's persuasion behind it, the evidence that takes him in (hearsay and a handkerchief) can strike us as ridiculously flimsy. Iago has to make the case, or there's no case.

Body and Soul

Written and directed by John Glines; scenery by David Jensen; lighting by Tracy Dedrickson; costumes by Ina Raye. Presented by the Glines, John Glines, director. At the Courtyard Playhouse, 39 Grove Street.

Sky....................................David Boldt
Lou...................................Martin Outzen
Max..................................Eddie Cobb
Denny.............................Randall Denman
Todd................................Douglas Gibson

By D. J. R. BRUCKNER

Sex isn't what is unsafe in "Body and Soul" by John Glines; friendship can be, and love definitely is. But most of the characters in what is billed as a romantic comedy at the Courtyard Playhouse crave all three. The one who doesn't supplies the mysterious soulfulness every romance needs, and he has enough for several sequels.

Mr. Glines borrows plot and situation from the timeless-romance handbook: Sky Eliot (David Boldt), who teaches religion and art at a university, had a brief affair years ago with a young photographer, Denny (Randall Denman), but walked away from it when it became too intense.

•

Now an older Sky and his young nephew, Lou (Martin Outzen), are staying at the summer home of Sky's friend Max (Eddie Cobb), on a lake in New Jersey. Lou develops a crush on a handsome photographer who is making pictures for a splashy magazine of a nearby estate where Lou works as a gardener. When this heartthrob turns up at Max's house to see Lou, he turns out to be ... who else? There is a lot of memory, re-crimination, confession, hope, hesitation, pride, humiliation and a great reconciliation of the old lovers as the sun rises. This is just the way they used to write them.

Mr. Glines is dedicated to plays for general audiences, but on gay themes. So he tosses in some politically correct observations about gay life and its critics, and even brings in the obligatory character whose lover has just died (Todd, played by Douglas Gibson). Literary references hang in festoons all over the dialogue, and so do the old jokes for which this playwright is noted — some would say notorious. He wisely assigns most of them to Mr. Cobb, who has very good timing and knows how to make camp a little menacing.

For all its polished surfaces, the play seems like a work in progress. Mr. Glines loves repartee, but as both writer and director he has a terrible time with some basics, such as transitions and simply getting people on and off the stage. The creak and clatter of the dramatic machinery can get distracting.

•

More annoying is the playwright's failure to develop adequately some powerful material at the heart of this piece, in two direct confrontations between Sky and Denny. During the years since their affair ended, Denny has followed Sky's old dreams, pursuing medieval mysticism, Jungian psychology, even metaphysics through a couple of continents — while Sky has retreated inside himself, away from those passions, until, he says, he is like a high-flying acrobat who has let go of one trapeze and has not yet grabbed the next. In Denny, Sky not only faces his past, but his past self, embodied not just in another character who is a foil, but in someone whose power over him almost terrifies him.

Jonathan Slaff/"Body and Soul"
Eddie Cobb in "Body and Soul."

At that point the play rises to a classic dramatic battle of wills. An audience is moved by its recognition of its own vulnerability. Mr. Glines has not thought through the implications of this situation very well, and at times the two characters involved in the struggle are not quite believable. But they do succeed in making all the sparkling and mannered chatter around them appear brittle and a little sad. For a few moments, at least, the audience sees that gay life is simply human life, filled with familiar absurdities and perils. It is enough of a glimpse into real drama to make anyone wish there were more.

1991 Jl 10, C18:3

Duchamp Thinking About Life

By STEPHEN HOLDEN

What is art and what is not art? When you hold a picture frame in front of a chair does that instantly make it art? Is drawing a mustache on the "Mona Lisa" an act of desecration or a creative masterstroke? And what does it matter anyway?

Such questions preoccupied Marcel Duchamp, the French Dadaist whose theories helped inspire contemporary performance. And in "The Mysteries and What's So Funny?," David Gordon's play with music and movement, they are carried from the realm of esthetics into the day-to-day world of personal relationships and family history. The 90-minute work, which had the first of three performances at Alice Tully Hall as part of Lincoln Center's Serious Fun festival on Thursday evening, is a gently humorous, quietly profound meditation on life's uncertainties. The final performance is tonight.

Within a Red Grooms cartoon environment that features a mustachioed "Mona Lisa," the elderly Duchamp, played with luminous clarity by Valda Setterfield, muses eloquently on his life and times. His apercus are intended to ruffle the certitude of anyone who believes that history, whether of art or of a family, is fixed and monumental.

"I think a picture dies after a few years," Duchamp reflects. "The history of art is what remains of a time in a museum. But it's not necessarily the best of that time."

•

Interwoven with the artist's reflections are other vignettes offered by characters who wander on and off the stage in circular connecting patterns and who ultimately form a kind of extended family chorus. Directed by Mr. Gordon, their movements are accompanied by a fluid, Minimalist score for solo piano composed by Philip Glass and played by Alan Johnson. The actors often carry witty, painted cutouts by Mr. Grooms that evoke Duchamp's life and times. Among the items are a chess table and a miniature staircase (an allusion to his famous painting "Nude Descending a Staircase"), which is plunked down on the stage for Duchamp to descend.

"The Mysteries" parallels an informal biography of Duchamp, a great artist, with the more mundane story of Rose (Lola Pashalinksi) and Sam (Ralph Williams), an elderly couple from Brooklyn who have been married for more than 50 years and whose health is failing.

Also present are Rose's angry, complaining mother, Fanny (Jane Hoffman), who rails against her treatment in a hospital; the young Rose and Sam (Karen Graham and Benjamin Bodé), who re-enact scenes from their courtship, and the couple's only child (Norma Fire), also known as the Detective. When querying her parents about the family's history, she is given an official-sounding account whose facts don't add up. The wonderfully versatile Alice Playten plays 21 characters, ranging from a baby to a grandfather.

Two other couples put in appearances. Mr. and Mrs. Him (Jonathan Walker and Gayle Tufts) argue furiously about what to eat for breakfast and about Mr. Him's habit of calling his wife Hon. In one of the play's lighter moments, Mrs. Him, who is obsessed with finding the right pair of shoes, laces up a gigantic pair of foot-high rectangular clodhoppers designed by Mr. Grooms and clomps off the stage.

The Hims are goaded into frustration by a demonic pair of practical jokers known as Anger I and Anger II (Scott Cunningham and Karen Evans-Kandel), who, unseen by the couple, manipulate them for their own

G. Paul Burnett/The New York Times
Alice Playten is framed on stage in David Gordon's "Mysteries and What's So Funny?," inspired by the life of Marcel Duchamp and part of Lincoln Center's Serious Fun festival.

casual amusement. In the show's wackiest bit of dialogue, Mr. Him and Duchamp discuss Madonna's preference for wearing her underwear on the outside and surmise that had Adlai Stevenson worn his jockey shorts outside his Brooks Brothers suit he might have been elected President.

Such jokes lend a Dadaist air to a work that at heart is a poignant meditation on the human life cycle and how much of life seems random, disconnected and unknowable. The end of the play is tinged with a Beckettian bleakness as the aged Sam remembers that he loves his wife and compares that realization to taking to a nasal decongestant.

Queried about death, even the normally unflappable Duchamp is a bit cowed. "Despite yourself you're impressed," he admits, "by the undeniable fact that you're going to disappear completely."

1991 Jl 13, 11:1

I Can't Get Started

By Declan Hughes; directed by Lynne Parker; designed by Barbara Bradshaw; music composed and arranged by John Dunne; lighting design by Conleth White; costumes by Marie Tierney; production manager, Padraig O'Neill. Presented by Rough Magic Theater Company, Mr. Hughes and Ms. Parker, artistic directors; Siobhan Bourke, general manager. At the Staller Center for the Arts, State University of New York at Stony Brook.

Lillian Hellman Anne Byrne
Dashiell Hammett Arthur Riordan
Daniel Webster Stanley Townsend
Sylvia Bryant Helen Montague
Ethan Bryant and Bob............ Miche Doherty
Betty Friedrich and Nell Kilcoyne
Carol Scanlon
Albert Friedrich, Curtis Bryant and Bill
Jonathan White

By STEPHEN HOLDEN

Special to The New York Times

STONY BROOK, L.I., July 10 — Declan Hughes's play "I Can't Get Started" takes a ponderously serious approach to an idea that has been executed far more adroitly on Broadway in the musical "City of Angels." A writer of detective fiction and one of his characters engage in an imaginative dialogue at a critical moment in the writer's life.

"I Can't Get Started," which the Rough Magic Theater Company from Dublin is giving its North American debut through Sunday at the International Theater Festival in Stony

Brook, is complicated by the fact that the writer was the real-life Dashiell Hammett. His alter ego, Daniel Webster, is a gumshoe who is desperate to be given literary life at a moment in the early 1950's when the author, who has stopped writing, has been summoned before the House Committee on Un-American Activities in its investigation of Communism in Hollywood. Hammett, who refused to name names, was blacklisted, spent six months in prison, and emerged with his health seriously deteriorated. He died in 1961.

Scenes from the story Hammett imagines but never writes are interspersed with documentary-style scenes from the author's life, many of them focusing on his combative relationship with Lillian Hellman. The detective novel he concocts in his head is seamy even by the standards of hard-boiled fiction and involves an evil right-wing senator, father-son incest, multiple murder and mutilation. In its gory way it mirrors the paranoia of the era of the Communist witch hunts.

•

Mr. Hughes's concept, though hugely ambitious, is only fitfully brought to life in a play that cannot decide whether to be a romantic drama or a serious comedy and that assumes far too much knowledge of Hammett's life on the part of the audience. After starting out as a straightforward evocation of the Hammett-Hellman relationship, the play starts to wobble with the appearance of the fictional detective, and never regains its balance.

The playwright's seeming infatuation with the mythology of the relationship has prompted tiresome scenes of verbal sparring between the couple that sound as though they are adapted from biographical accounts; they are fatally lacking in verbal snap. Although Arthur Riordan, who plays Hammett, offers a sharp, unsentimental portrait of the author as a self-destructive, emotionally blocked alcoholic, Anne Byrne's shrill girlish Hellman completely lacks the aura of theatrical grandiosity that was one of the playwright's outstanding traits.

It is to the credit of the director, Lynne Parker, that the Irish cast flawlessly captures the idiom of hard-boiled Americanese. But except for one eerie scene in which a fictional demagogue rails fascistic platitudes in front of a slide projection of the American flag, the production fails to sustain any tension between fictional and biographical worlds that are supposed to reflect on one another.

1991 Jl 13, 12:5

'Forbidden Broadway' affronts impartially.

THE SUN IS BRIGHT, THE SKY IS crystalline, and a breeze is wafting in off the ocean. It promises to be the perfect Fourth of July. Standing on the deck of a sleek Fire Island beach house, drinking in the sea air, Chloe is contemplating the day ahead.

"No agenda," she announces idly. But she can't help herself. She still has to tick off the possibilities. "Swim, take a walk, read, volleyball, paint, barbecue, nap, doze, eat, drink, laze, nothing."

Chloe is one of those flibbertigibbets for whom no thought, however passing, deserves to go unexpressed. Her credo could be, "I speak, therefore I am." But besides establishing her hyperactive personality, her dithering on this particular sun-drenched morning also puts "Lips Together, Teeth Apart" in immediate perspective.

On the surface, Terrence McNally's fascinating and ultimately quite touching new play (at the Manhattan Theater Club) seems to be built from Chekhovian blueprints. Two couples, uncomfortable with themselves and shaky in their marriages, have come together for a weekend. Closeness makes their hearts grow bitter. They busy themselves with distractions. Time passes. And eventually some secrets get spilled, some fears are acknowledged, and a few truths are uttered. The play is a slice of life, made up of lives that are troubled, adrift, hurting.

But the casualness of "Lips Together, Teeth Apart" is deceptive. It masks, I think, something bolder, more virulent, something as poisonous as the snake slithering under the deck of the beach house that John Lee Beatty has designed with scrupulous allegiance to the best architectural digests. Mr. McNally's characters are willfully out of sync with one another. Their conversation is disjointed, and their little enthusiasms are purposefully exclusionary.

Left to their own devices, they retreat — into the New York Times crossword puzzle, a half-finished oil painting of the sea, or the aimless tasks of the handyman. They utter their most corrosive fears in monologues intended for our ears alone, which is to say they keep the private side of themselves from one another. Chloe's description of an agenda-less day is really a prescription for continuing chaos.

The rampant self-absorption makes for an extraordinary imbalance. If someone is suffering shudders of mortality, you can be pretty sure someone else will be buried in a Life magazine article about jellyfish and won't notice. A splinter lodged in one man's foot causes more yelps of pain than the slow-growing cancer in another man's throat. While the sight of a swimmer, headed straight out into the ocean, bothers three of the characters not in the least, it stirs uncontrollable dread in the fourth.

Mr. McNally shows considerable dexterity as he moves his two couples back and forth from the trivial to the life-threatening. Even

SUNDAY VIEW/David Richards

Two Shapes of Comedy — Tragic and Spoof

Terrence McNally's dark 'Lips Together, Teeth Apart' confronts mortality.

Gerry Goodstein/"Lips Together, Teeth Apart"

Nathan Lane, Swoosie Kurtz, Christine Baranski and Anthony Heald in "Lips Together, Teeth Apart"—a Fourth of July setting where everything is suspect.

handedly prevents this tiny society from disintegrating.

The part is funny, flashy and oddly gallant. Ms. Baranski — who looks not unlike a child's stick-figure drawing of Mom — gives herself over to flightiness with hilarious results. The actress has long since demonstrated a facility for playing neurotic bubbleheads ("Rumors," "Elliot Loves"). But here she also burrows deep. Under the blitheness is the desperation of one who knows she is not being attended to. The gregariousness is loneliness in loud togs. (While other Off Broadway performances this season were as vivid as Ms. Baranski's, none to my mind was better.)

Mr. Heald anchors the role of John in an equally fruitful contradiction: he resorts to superior airs, not because he considers himself superior, but because he suspects that he is unlikable. The chilliness prevents the world from finding him out. On the other hand, Mr. Lane takes no pains to hide the overgrown crybaby in proletarian Sam. Like Jackie Gleason's Ralph Kramden (to whom he bears a surprising resemblance), he is a welter of insecurities that advertise themselves as hollow bluster and whiny prejudice. In both cases, the fit of actor to role is snug.

more revelatory is the way he has charted their respective attention spans — which rise, fall and sometimes crisscross, but rarely converge for long.

If, as Linda says in "Death of a Salesman," attention must be paid, "Lips Together, Teeth Apart" recognizes how badly we pay it. We wake up to tragedy when it's too late to make a difference, or we come to it too early, tire and then wander off. We're either too interested or not interested enough. The proportions of our concern are almost never right.

Mr. McNally's characters are already uneasy enough and he's gone and complicated matters by putting them into a setting where everything is suspect. Sally (Swoosie Kurtz), a New Jersey housewife, has inherited the $800,000 beach house from her brother, a homosexual who died of AIDS. Her blue-collar husband, Sam (Nathan Lane), doesn't like the ocean, but they figure they ought to try out the house before disposing of it. To keep them company, they've brought along Sam's sister, Chloe (Christine Baranski), and her upper-crust husband, John (Anthony Heald).

The day has barely begun, however, and they're all beginning to feel vaguely out of place. Sally can't shake her grief for her dead sibling or the terrible thought that he got what he deserved. Oafish Sam eyes the next-door neighbors, "the boys from Ipanema," with suspicion. But he's taken a greater aversion to John, so haughty and well groomed, whom he suspects of having slept with his wife. If indeed John is secretly consumed by his love for Sally, he is also being slowly eaten away by inoperable cancer of the esophagus.

Meanwhile, hot as the weather gets, the characters stick to the edge of the swimming pool. Reason tells them the water could hardly be contaminated by the AIDS virus. But in an age of infections, who thinks reasonably?

The only cohesiveness, ironically, is provided by Chloe, in her self-appointed roles as chef, social director and general newscaster. Prattling incessantly — sometimes in intrepid flights of bad French — she insists on keeping everyone abreast of the latest blip in her mind. When her mind goes blank, she takes it upon herself to read someone else's. Either way, she is a major irritant. But, if only by forcing her presence on others, she single-

Only Ms. Kurtz seems out of kilter with the character she is playing. For one thing, the part isn't as good as the others. But Ms. Kurtz naturally gravitates toward eccentrics, and Sally — with her contemplative nature — is the least flamboyant of creatures. Brooding, however, so knits Ms. Kurtz's brow and sorrow sends her mouth into such a bold downward swoop that she occasionally seems to be courting comedy in spite of herself.

If you stop to consider all that's going on — confessions, crises, deceptions, fights, revelations, fireworks and a side-splitting game of charades — "Lips Together, Teeth Apart" is jam-packed with action. Credit the director John Tillinger with folding the tumult into the lackadaisical rhythms of a day by the ocean. Mr. McNally counts on the friction engendered by close quarters to ignite the drama; Mr. Tillinger underlines the yawning distances between characters standing side by side.

In the end, the predominant light on stage is an eerie blue glow emitted by a bug catcher. Periodically, the device buzzes efficiently — indicating that it has fried an unwary insect. But so darkly evocative is Mr. McNally's play by this point, that the crackle carries sinister metaphysical overtones.

With each zap, the gods themselves seem to be stunning another hapless mortal, as is their mischievous wont, just for the fun and the sorrow of it.

'Forbidden Broadway 1991½'

"Forbidden Broadway," Gerard Alessandrini's continuing spoof of Broadway's shows and the good people who perform them for you, prides itself on staying current. The newest edition to open at the Theater East carries the dateline "1991½" and brings us up to last month's Tony Awards, an event distinguished in Mr. Alessandrini's eagle eye by Julie Andrews's vocal shortcomings and Anthony Quinn's reading difficulties.

Duly mocked are not just the season's high and low points, but very nearly *all* its points. (It was, remember, a paltry season.) Mr. Alessandrini and his four-member cast zero in on Nicol Williamson's bellicose ways in "I Hate Hamlet," the "Miss Saigon" casting flap, the bellying up

The naked egos running wild in 'Forbidden Broadway' are as common to board rooms as to dressing rooms.

of "Assassins," the helicopter in "Miss Saigon," sexism in "The Will Rogers Follies," Topol's scenery chewing in "Fiddler on the Roof," "Once on This Island's" chewed-up scenery, the helicopter in "Miss Saigon," Marsha Norman's ghoulish approach to "The Secret Garden," Mandy Patinkin's ghoulish approach to "The Secret Garden," Tyne Daly's tiny singing voice, and the self-congratulatory liberalism of "Six Degrees of Separation." Oh, yes, and the helicopter in "Miss Saigon."

It is "Forbidden Broadway's" long-standing practice to borrow songs from the very shows under attack and outfit them with self-incriminating lyrics. "If I Were a Rich Man," Topol's big solo from "Fiddler," for example, becomes "If I Sing It Slower," an even bigger solo. The altered lyrics from "Sun and Moon," the love duet from "Miss Saigon," now proclaim exultantly, "You sing Hallmark and I sing postcard." ("Forbidden Broadway" has a low tolerance

for sap.) Furthermore, in keeping with the tenets of nontraditional casting, Susanne Blakeslee plays Chris, the American G.I., while Jeff Lyons, padded to the gills, is Kim, the decidedly plump Vietnamese bar girl. I'd be spoiling the fun for you if I revealed too many more specifics, but perhaps a few general observations are not out of line.

● Wigs (not clothes) make the man or woman. If you're trying to look like someone famous, you don't necessarily have to go for the most prominent facial feature — the cauliflower ears, say, or the dimpled chin. "Forbidden Broadway" proves that if you master the hair, the rest of the impersonation tends to fall right into place. Mr. Lyons no more resembles Jackie Mason than a raccoon does a chipmunk. But clamp the right champagne-colored wig on him and he's two-thirds there. To clinch it, Mr. Lyons puffs up his cheeks, bugs out his eyes and chops at the air with hands like the wooden soldier's.

La Chanze, Colleen Dewhurst and Tyne Daly have so little in common you wouldn't exactly expect Mary Denise Bentley to shine as all three. But she does, and again, the hairstyles give her the critical head start. Teresa Vuoso is the woman behind "Forbidden Broadway's" coiffures, and if there's such a crime as character assassination by wig, I hereby pronounce her guilty on all counts.

● A big mouth is not necessarily funny, but if you're funny, having a big mouth is an asset. Consider Ms. Blakeslee, who possesses an incorrigible instinct for caricature and a mouth as expressive as any caricaturist's pen. Its upward, downward and sideways mobility is amazing, especially when it is striking out in all directions at once. (When it is fully open, Ms. Blakeslee seems to be holding a bullhorn before her face.) As Marsha Morbid, explaining decomposition, cholera and suicide to all the little boys and girls at what has been dubbed "The Secret Deodorant Garden," she is moroseness on a Homeric scale. A big mouth has the further advantage of being seen as easily by those at the back of the house as by those in the front, although it probably helps in Ms. Blakeslee's case that she also has eyes like silver dollars.

● The dictum that there are no people like show people is untrue. Lots of people are like show people — politicians, highway patrolmen, P.T.A. presidents, dictators, anyone, in short, with temperament, a lust for power or a podium. If "Forbidden Broadway" were only about the theater, it would be no more than an industry in-joke. What's ultimately being satirized are naked egos running wild, a phenomenon as common to board rooms as it is to dressing rooms.

■

That said, I should probably point out that "Forbidden Broadway 1991½" leaves some of its comic premises in the lurch and that a lot of the big laughs turn up at the beginning of the numbers. (A big laugh is always welcome, of course, but when it dwarfs those that follow, you sort of wish it could postpone its arrival a

while.) Still, the mayhem at Theater East is on the whole bright and lethal. So this edition doesn't get away with murder. It gets away with assault and battery. ⊡

1991 Jl 14, II:5:1

Eagle in the Bubble

By Byron Ayanoglu and Jiri Schubert; directed by Mr. Schubert. Musical director, Christopher Cherney; lyricist, Jim Camicia; movement coordinator, Marcy Arleen-Aboumajd; lighting design, Zdenek Kriz; set design, Marcia Altieri. Presented by Schubert/Schaller. At the Henry Street Settlement, Harry De Jur Playhouse, 466 Grand Street.

WITH: Marek Vasut, Ron Jones, Ruby Lynn Reyner, Brenda Perryman, Michael Murauckas, Susan Huffaker, Ken Gray and Sveva Camurati.

By STEPHEN HOLDEN

A confused mixture of Eastern European cabaret and environmental theater, Byron Ayanoglu and Jiri Schubert's musical play "The Eagle in the Bubble" focuses on three social misfits, two of whom live in an abandoned Broadway theater. Nostro (Ron Jones), an androgynous seer, and Rosie (Ruby Lynn Reyner), a self-proclaimed Communist who fled to New York City from upstate, are lovers of sorts. Periodically, they are visited by Pavlov (Marek Vusut), a loud-mouthed Eastern European punk who brings them sausages and drugs.

When it is announced that a Scud missile has deposited chemical weapons on the neighborhood, their stronghold is invaded by frightened zombie-faced workers who claw at plastic shower curtains separating them from the trio. Rosie, Nostro and Pavlov reflect at excruciating length about their wasted lives and imminent deaths. Their shrill, whining monologues are interspersed with renditions of songs that range from Alice Cooper's hit, "Only Women Bleed" (sung by Ms. Reyner as a parody of Marlene Dietrich), to a Czechoslovak folk song called "Amerika."

●

Every so often the cast interacts with the audience, which is seated on the stage of the Harry De Jur Playhouse. The only person in the theater's orchestra section is a slumped-over dummy in an aisle seat. As pretentious as it is incoherent, "The Eagle in the Bubble" takes a potent subject — the decay of New York — and beats it to death.

1991 Jl 16, C15:1

All the Members Of This Wedding Sound Like Shaw

He may call it 'Getting Married,' but that's more easily said than done.

Getting out is what's tough in 'The Balcony Scene.'

IF YOU THINK YOU'D LIKE TO MAKE acquaintance with George Bernard Shaw's "Getting Married," I recommend that you trot off to the library, check out Volume IV of the collected plays and prefaces, and settle into a comfortable armchair for a couple of hours.

You could also drop by the Circle in the Square, where this talkative 1908 work — its author called it a "conversation" — is being performed. But I don't know that you'd be much further ahead of the game. While I am not one of those who feel that Shaw is usually better read than said, this fitful production is awfully tedious in the long run. And it's tedious because the characters never seem to be speaking their own minds. They're all speaking Shaw's.

In this case, the topic on which the grand man wished to hold forth was (obviously) marriage, an institution he found seriously wanting, as he did most institutions. But since he couldn't help playing devil's advocate, he also found it necessary, ridiculous, desirous, iniquitous, outdated and enduring. That's where "Getting Married's" 13 characters come in. Whatever their sex, age and station in life, their primary function is to allow Shaw to argue with himself. They show up in the kitchen of Archbishop and Mrs. Bridgenorth (Lee Richardson and Elizabeth Franz), when he needs their point of view to stoke the continuing debate. When he doesn't, they're rather summarily dismissed.

Shaw's ideas can be bracingly modern. Here he is, for example, proposing the notion of prenuptial contracts some seven decades before the Trumps, and claiming, well in advance of the women's movement, that keeping a house is legitimate work, worthy of remuneration, and not just a wifely duty. But a modern idea here and there does not justify the play's prolixity. (Am I alone in thinking discussions of what makes a proper English gentleman no more fascinating than inquiries into what constitutes a good Yorkshire pudding?) This much is sure: your tolerance for "Getting Married" will depend largely on the resilience of your Anglophilia.

The play takes place on the morning the Archbishop's sixth daughter, Edith, is to be

wed to a pleasant little worrywart named Cecil. The guests are already ensconced in the church and the organist is running dangerously low on music, when the bride and groom announce their intention to call the whole thing off. He is leery of her outspokenness, because British law will hold him financially responsible for her libelous tongue. She has just been reading a dire pamphlet, "Do You Know What You Are Going to Do? By a Woman Who Has Done It," and consequently can imagine only matrimony's perils. Shaw must have felt that reconciling them to their fate was too simple a task, though, for it is by far a lesser concern of the play.

■

The rest of his characters pose greater challenges and allow him to ponder more complex marital arrangements. Lesbia, the liberated woman (Victoria Tennant), has no use for a husband, let alone the general (Nicolas Coster) who has just proposed to her for the 10th time in 20 years. She can, however, envision a scenario whereby he might sire her child, if he'd clear out promptly after the birth.

For giddy Leo (Madeleine Potter), who can see good points about both men in her life, some form of polyandry would appear to be the only solution. The greengrocer (Patrick Tull) favors muddling through marriage as it is, while the archbishop's chaplain (Walter Bobbie) proselytizes vigorously for celibacy, which is either taking the high road or avoiding the issue entirely. Shaw even elevates the play momentarily into the realm of the mystical by having the mayoress (Linda Thorson) go into a trance and speak the reproachful verities of Womankind.

All this begets, under the arid direction of Stephen Porter, great streams of nattering and a single stage-worthy scene, in which the principals sit down at the long kitchen table and attempt to draw up "the first English partnership deed," only to discover that they cannot agree on the slightest provision. Otherwise, there is an excessive amount of shouting and the kind of stiff-backed posturing that is meant to pass for high style.

For a play about the sundry ways men and women try to legitimize what is presumably biology's call, "Getting Married" is surprisingly sexless. No one seems to be remotely under the thrall of carnal desire — not even Hotchkiss (Scott Wentworth), gentleman and snob, who claims to be devoured by an uncontrollable passion for the mayoress and therefore not responsible for his actions. But there's little chance he'll be carried away by ardor — not as long as he has something to *say* about it first. Which is the problem in a nutshell. The characters are talking heads, dead from the neck down.

The trick in playing Shaw, it seems to me, is getting the body back into it. You could say, to borrow a phrase from the Bible, that the word has to be made flesh, or at least it has to galvanize the flesh. The British actress Eileen Atkins understood the necessity perfectly when she appeared earlier this year as Virginia Woolf in "A Room of One's Own." The one-person play, fashioned from two lectures on the subject of women and literature that Woolf herself delivered in Cambridge in 1928, illustrated the range and alertness of the author's mind. Ms. Atkins, however, brought to it a concentrated intensity and a passionate commitment that stemmed from the gut. As a result, intellectual issues became living issues.

Although some of the performances in "Getting Married" are not quite as bloodless as others, none carries the mark of the

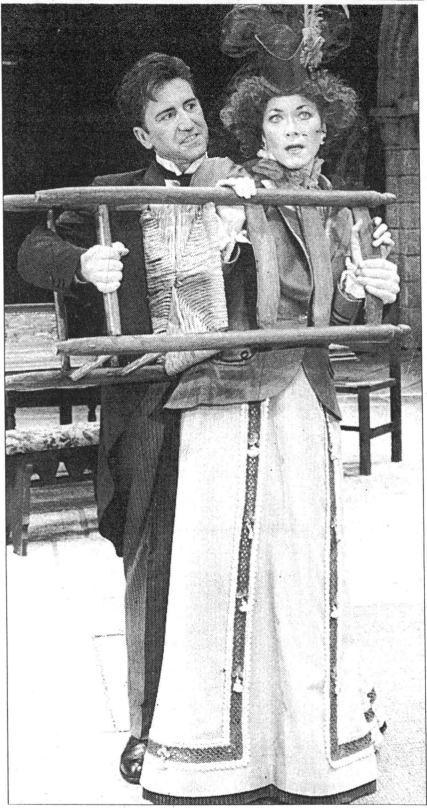

Martha Swope/"Getting Married"

Scott Wentworth and Linda Thorson in "Getting Married"—word vs. flesh

pounding heart or the feverish brow. No hands are tingling. No heads are spinning. Any shortness of breath is caused primarily by the difficulty of delivering Shaw's compound sentences. Ms. Tennant and Mr. Coster are particularly bland, while Ms. Thorson, an able actress, has simply been put in the wrong role (wouldn't she be better as Lesbia?) and costumed as deplorably as an organ grinder's monkey, to boot. Mr. Bobbie, Mr. Richardson and Simon Jones, as an amiable cuckold, are closer to the mark. But

there are precious few signs of life here, independent of the playwright's.

Did Shaw know to what extent he dominated his characters? I suspect he did. When Hotchkiss is upbraided for making himself the subject of conversation yet again, he offers an apology that is also a sly defense. "I'm so sorry," he says. "I get so interested in myself that I thrust myself into the front of every discussion in the most insufferable way."

The implication, of course, is that no one else is half so interesting and that he's not being insufferable at all. If that's not Shaw talking, I don't know who else it could be.

'The Balcony Scene'

If "Getting Married" is top-heavy with ideas, "The Balcony Scene," the offbeat romantic comedy at the Circle Repertory Company, is bereft of them. The playwright Wil Calhoun has taken the material for a half-hour TV pilot and inflated it to 80 minutes or so, which pretty much guarantees you lots of time between laughs to catch your breath, if for some unknown reason you should lose it.

The setting is two adjoining balconies of a Chicago high-rise. One belongs to Karen (Cynthia Nixon), who works in advertising, loves Woody

One character hasn't gone out in seven months: overcrowding and car horns just got to him one day.

Allen films and is dizzy. The other is Alvin's. Alvin (Jonathan Hogan) writes articles about history, prefers Jerry Lewis films, and is neurotic. In fact, he hasn't been out of his apartment in seven months. The overcrowded supermarkets and honking car horns, apparently, just got to him one day.

■

"The Balcony Scene" is the saga of how they fall in love. First, however, she has to coax him off his balcony and over to her place for dinner (that alone takes about 50 minutes). Next, they have to deal with Paul, Karen's jealous ex-lover (William Fichtner), who shows up unexpectedly. Finally, Alvin must be persuaded that he's capable of going to the video store on hi own. In the end, however, everything turns out fine. Nobody jumps or is pushed off either balcony.

Given the predictability of the plot and the mediocrity of the dialogue, an undue burden is placed on Ms. Nixon and Mr. Hogan to be appealingly kooky. You can't fault them for their efforts. Her natural sunniness is a nice counterpoint to his anxious reserve. I doubt you'll warm to their nutty courtship, though.

Insubstantiality is not necessarily a fatal dramatic flaw. Many a flimsy play has been redeemed by charm. It's just that Mr. Calhoun's isn't. ☐
1991 Jl 21, II:5:1

Home and Away

Written and performed by Kevin Kling; directed by David Esbjornson; set design, Mr. Esbjornson; lighting design, Frances Aronson; sound design, Mark Bennett; hair design, Antonio Soddu; production stage manager, Crystal Huntington. Presented by Second Stage Theater, Robyn Goodman and Carole Rothman, artistic directors. At Broadway and 76th Street.

By STEPHEN HOLDEN

In the second act of his gripping autobiographical monologue, "Home and Away," Kevin Kling tells of journeying to the Australian heartland where he experiences a spiritual awakening that is connected to aboriginal tribal beliefs in sacred ground and family ties.

"The aborigines' family tree," he remembers an Australian friend explaining, "is like vines running horizontally around the earth." When a pregnant woman feels the first kick of her unborn child, the spot on which she felt the kick is believed to be a point on a trail that extends latitudinally around the world. After the child is born, everyone else who kicked on that trail is considered a relative.

Another broader way of interpreting that teaching might be to say that all roads lead home. That is certainly the unstated theme of "Home and Away," the funny, finely honed solo theater piece that Mr. Kling is performing at the Second Stage. The play, which is directed by David Esbjornson, describes a series of surreally tinged true adventures that begin with Mr. Kling's childhood experiences in rural Minnesota and ripple in ever-widening circles as he travels to Spain, Czechoslovakia, Australia and Brazil.

●

The central image of the play, one that also reverberates outward as the narrator accumulates political insights and small spiritual jolts, is of being hit by lightning and surviving. Mr. Kling remembers being struck by lightning as a child, while helping his father build an airplane during a thunderstorm. Years later, after his father dies of cancer, he discovers that his uncles, grandfather and brother had all been hit by lightning and lived to tell of it. They are a family club.

On the surface, the experiences that Mr. Kling describes — of Halloween trick-or-treating, playing games with his brother in church and learning how to stuff animals — might seem to evoke a cozy Norman Rockwell-style vision of Americana. Yet many of those experiences have a life-or-death immediacy. The eccentric neighbor who gives trick-or-treaters sour Halloween pickles commits suicide. A fraternal breath-holding contest during a church service leaves him unconscious. A fellow Boy Scout's over-zealous efforts in taxidermy involve the trapping and asphyxiation of small animals.

The adult travel experiences Mr. Kling describes in the second act hark back to the childhood memories of Act I. During a trip to Czechoslovakia, he discovers that it is not the Czechoslovak Government but the American Government that has forbidden performances of his play. The realization resonates with his earlier

description of a childhood operation and a doctor's lies. His father's mild objections to his artistic career find a sharper echo in Spain, where he meets a blind, homosexual dancer whose father had buried him in effigy, not for being gay but for being an artist.

●

If Mr. Kling's surrealistic linkage of events has something in common with Spalding Gray's view of the world (especially in "Swimming to Cambodia"), his style and point of view are very different. Mr. Kling's lean, terse storytelling has a faintly folksy ring. His vignettes have plenty of dark corners, but they don't aspire like Mr. Gray's to capture the millennial anxieties of our time. The world is not imminently coming apart.

The personality that Mr. Kling presents is ingenuous without seeming in any way naïve. Where other monologuists display sophisticated, multi-faceted personalities, Mr. Kling projects an intense boyish enthusiasm. But as emotional as his tone becomes, he never claws at the edges of desperation as Mr. Gray, David Cale and John O'Keefe (who have also done solo shows at the Second Stage) sometimes do.

"Home and Away" ultimately rejoices in the strange interconnectedness of bizarre phenomena. Many years after learning to stuff animals, Mr. Kling, in Brazil, finds himself driving through a village whose residents set up card tables on the side of the road and attempt to sell him stuffed, mounted animals with large blue-glass eyes. It is one of many moments, he suggests, in which being away is really the same thing as being home. Only the geography changes.

1991 Jl 24, C16:3

A Rendezvous With God

Written by Miriam Hoffman; English translation by Ms. Hoffman and Rena Berkowicz Borow; directed by Sue Lawless; musical director, Ben Schaechter; production designer, Don Coleman; production stage manager, Karen Federing. Presented by Eric Krebs. At the John Houseman Studio Theater. 450 West 42d Street.

WITH: Avi Hoffman

By STEPHEN HOLDEN

Itzik Manger, who died in 1969, was a major Yiddish poet, but his significance is not easy to grasp in Miriam Hoffman's rushed, confusing play, "A Rendezvous With God," at the John Houseman Studio Theater.

The 65-minute appreciation, which stars Avi Hoffman as Manger, is a mélange of songs, poems and unfunny comic shtick that has a homey atmosphere but is too scattered to cast much light on Manger's writing or on his life. In the play's opening moments, Manger wanders onto the stage with a bottle of pink wine, plunks himself down at a table and embarks on a one-sided conversation with God, announcing to his maker that he's going to tell "what it's like to be a Yiddish poet on this side of paradise." By the end of the show, Manger who describes himself as "a loser and a boozer" has drained the bottle and seems mildly tipsy.

Manger's story begins literally in his mother's womb, which he recalls being very reluctant to leave, then

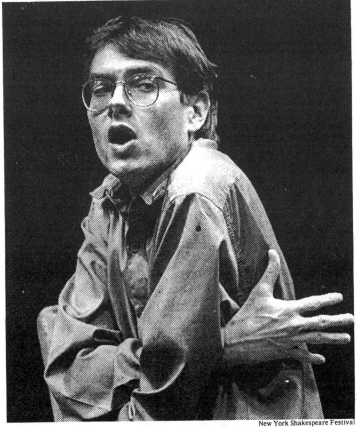

New York Shakespeare Festival

Kevin Kling in "Home and Away" at the Second Stage.

lurches forward to his days as a hairdresser's apprentice. He describes romantic misadventures, including his passion for a woman whose golden curls he didn't know were artificial until she removed them in the bedroom.

The heart of the story finds Manger in Warsaw in the years before the Holocaust. It is there that he had a vision in which he saw the people around him as Old Testament characters. And as he recalls a baker and his wife who suggested modern-day equivalents of Abraham and Sarah, a literary portrait begins to emerge. Then the narrative leaps forward again, and the essence of an author whose novel "The Book of Paradise" portrayed a small-town heaven, in which God and the angels were Eastern European Jews, recedes. The Holocaust and its aftermath remain an unspoken tragedy whose horrors are referred to only very indirectly.

Interpersing the reminiscences are songs with lyrics by Manger translated into English by the playwright and sung by Mr. Hoffman, who is accompanied on the piano by Ben Schaechter. One of the most famous is "Yiddle With His Fiddle," which was sung by Molly Picon in 1935 in an early Yiddish film musical.

Talking to God, occasionally breaking into song.

Mr. Hoffman brings a Bacchic exuberance to the shtick and considerable fervor to the songs, but he is unable to piece together the fragments of a play that seems like a crude sketch for a much larger work.

1991 JI 25, C14:5

Performance Art
Holding Hu-person-ity Up to Ridicule

By STEPHEN HOLDEN

"I'm in a rotten mood and I bet you are too," announced Rachel Rosenthal in the opening moments of her performance piece "Pangaean Dreams," which had its East Coast premiere at Alice Tully Hall on Tuesday evening as part of Lincoln Center's Serious Fun festival.

The 64-year-old Los Angeles-based performance artist, who arrived on the stage in a wheelchair, angrily

Beatriz Schiller
Rachel Rosenthal

lamented the destruction of wildlife by a recent pesticide spill in the Sacramento River. Then she pulled herself up, peeled off assorted casts and bandages and began comparing her history of bone fractures and other physical problems with the breakup of Pangaea, the mythical supercontinent that may have existed 250 million years ago. For Ms. Rosenthal, that supercontinent serves an all-purpose metaphor for a mystical unity of mind, body and spirit on the earth that has been shattered by human evolution.

"Pangaean Dreams" is accurately subtitled "A Shamanic Journey." During its 90 minutes, Ms. Rosenthal, a burly woman with a shaved head and many voices, slipped back and forth among the roles of priestess, prophet, poet, feminist commentator, geologist, archeologist and wisecracking comedian. She was accompanied by a fluid percussive score performed by Leslie Lashinksy and a striking video environment designed by Dain Olsen.

The gist of her message is that humanity's separation from the rest of nature has put the species on the path to extinction. Among the scores of metaphors she offered, the most resonant was drawn from archeology. Periodically she rummaged through a pile of dirt on the stage, pulling out bones and finally a death-mask, which at the end of the evening were pieced together into a human relic and strung up over the stage.

Ms. Rosenthal can be growlingly ominous, especially when impersonating the beastly half of the angel-dinosaur dichotomy she sees as the essence of human nature. But she can also be very funny. In an amusing scatological tangent, she speculated on the effect on the planet of all the methane gas expelled from the human body. A poetic descent into the center of the earth, in which everything is portrayed as devouring everything else, was lightened with the comic image of a screaming tomato. During a speech on sexuality, she speculated that she was "a gay man trapped in a woman's body." Senator Jesse Helms was labeled "the quicker picker upper" because of his desire for the world to be morally "pristine like a vinyl tablecloth."

Besides Ms. Rosenthal's commanding stage presence, what made "Pangaean Dreams" exciting was the sheer deluge of its images, ideas and perspectives, many of them contradictory. But Ms. Rosenthal cheerfully observed: "Chaos is our natural state. We try to create the illusion of order, but things insist on flying apart."

1991 JI 25, C15:1

As You Like It

By William Shakespeare; directed by Declan Donnellan; designer, Nick Ormerod; composer and musical director, Paddy Cunneen; lighting designer, Judith Greenwood. Cheek by Jowl Company, England, Mr. Donnellan and Mr. Ormerod, artistic directors, presented by the Staller Center for the Arts, State University at Stony Brook, L.I.

Corin/Le Beau	Mike Afford
Oliver	Mark Bannister
Silvius	Mark Benton
Audrey	Richard Cant
Jacques/Charles	Joe Dixon
Phebe/Adam	Sam Graham
Jacques du Boys/1st Lord	Richard Henders
The Dukes	David Hobbs
Denilis	Anthony Hunt
Rosalind	Adrian Lester
Touchstone	Peter Needham
Amiens/Hymen	Conrad Nelson
Orlando	Patrick Toomey
Celia	Tom Hollander

By MEL GUSSOW

Special to The New York Times

STONY BROOK, L.I., July 24 — The Cheek by Jowl Company, which has made its international reputation through unconventional productions of classics, offers an answer to skeptics who still believe the old canard that the English are stuffy about their Shakespeare.

In its United States debut in the Sixth Annual International Theater Festival at the State University here, this traveling troupe addresses the varieties and mysteries of one of Shakespeare's most popular comedies, "As You Like It." The actors enter the Forest of Arden with a spontaneity that never overlooks or undervalues the verse. The production is staged by Declan Donnellan, who, along with Deborah Warner and Nicholas Mendes, is one of a number of new young innovative English directors.

Mr. Donnellan's nontraditional approach to "As You Like It" can be traced back to the earliest Shakespearean tradition. All the roles are played by men (as they also were in Clifford Williams's National Theater version). Although there is ultimately a question of how much the approach adds to our knowledge of the play, it provides a congenial atmosphere in which Shakespeare can take flight, and in which a youthful cast can demonstrate its vibrancy and versatility.

Mr. Donnellan and the designer Nick Ormerod (they are the co-founders and artistic directors of Cheek by Jowl) immediately establish the principle that, like the players in "Hamlet," the actors have arrived to engage in performance. A prelude of "All the world's a stage," later fully expounded in its proper place in the text, sets the highly theatrical, deliberately modest tone.

The actors begin the play dressed identically in black suits and white shirts. Two move stage left, indicating that they will soon undertake the principal female roles of Rosalind and Celia, which they do, in costume, without camp flourishes and flounces. Adrian Lester is a tall, reserved Rosalind, Tom Hollander a more effusive and girlish Celia.

Within minutes, Patrick Toomey's Orlando, a figure of manly virtue, is enmeshed in battle with Charles the wrestler, with Joe Dixon's Charles looking as if he had stepped out of an English sporting print. The scene is imaginatively staged as a kind of men's-club smoker, with the other actors circling the contestants, cheering them in combat.

After Charles is vanquished, Mr. Dixon reappears as Jaques, signaling a note of mordancy beneath the melancholia. He and his fellow exiles in Arden wear long coats and somber expressions. They seem like highwaymen on the run, capturing the desperation of this band as well as their sense of dislocation from society. David Hobbs artfully plays both Dukes, the banished and the banisher.

There are occasional lapses along the way, including a shepherd whose slowness of speech is intended to be humorous but which becomes tiresome. In the scene in which Orlando posts love notes to Rosalind on trees, Mr. Toomey and Mr. Lester are unable to evoke the necessary romantic passion for one another. But to their advantage, they remain unself-conscious in their role playing, and there is the added amusement of seeing the talented Mr. Lester pretend to be a woman pretending to be a man. In more overtly comic roles, Richard Cant and Sam Graham offer amusing portraits of Audrey and Phebe, with Mr. Graham doubling as the old servant Adam.

As the evening progresses, Mr. Ormerod gradually asserts his own artistic presence, with the collaboration of Judith Greenwood as lighting designer. In both of these cases, less speaks for more, with minimal props and subtle changes of lighting adding fluidity to the production as it moves effortlessly from court to forest, from day to night. Though the performance runs more than three hours, time is not wasted. The emphasis is on the words, which are articulated with a clarity that honors Cheek by Jowl's training, discipline and understanding of Shakespeare.

1991 JI 26, C18:4

Correction

Because of an editing error, a theater review yesterday about a production of "As You Like It" by the Cheek by Jowl Company at the State University at Stony Brook, L.I., misidentified a director who was cited among "young, innovative English directors." He is Sam Mendes, not Nicholas Mendes.

1991 JI 27, 3:2

SUNDAY VIEW/David Richards

That Sometime Actor, Big City, Is a Star

'Book of the Night,' in Chicago, traces the pulsing lives beneath the stony heart of a metropolis.

CHICAGO

"**B**OOK OF THE NIGHT," THE ambitious musical-theater piece having its world premiere at the Goodman Theater, wants to show us life, as it unfolds in an American city from the time the sun goes down on a hot and bothered Saturday night until it comes up on the forgiving Sunday morning that banishes the demons.

"The dark has secrets/ Daylight never knows," sing the 13 cast members in the opening number, which gives us our first glimpse of the agitated souls who'll presumably be revealing a few of those secrets in the ensuing 100 minutes. They're all part of a feverish mass, surging back and forth across the stage like a restless tide. Behind them,

fueling their excitement and anxiety over what's to come, is the changeable city itself, revealed in a series of rear-screen color projections.

Many caring hands have clearly gone into the making of "Book of the Night," and the physical production is exhilaratingly beautiful. As soon as the musical starts singling out individuals, however, all the concentrated promise in that introductory assault rapidly evaporates. The co-authors, Thom Bishop and Louis Rosen, who previously collaborated on "Bagtime," the adventures of a bag boy in a Chicago supermarket, have both contributed music and lyrics to the show. (In keeping with the current mania for sung-through musicals, there is no spoken dialogue.) But neither seems to have much of a mind for specifics.

■

You need only run your eyes down the cast of characters to sense the trap into which they have fallen. Just three of these restless night owls rate names, and they're limited to first names at that. The others are known variously as The Gypsy, The Cop, The Desk Clerk, The Dealer, The Young Widow, Jill's Husband and Jack's Wife. (Jack is nowhere on the premises, although Jill, glued to a TV set, changes channels throughout the evening with a ferocity that suggests she really wants to change her life.) No one can claim an identity that is exclusively his own. They are all card-carrying types, abstracts of human behavior.

If I tell you that The Woman From Room 220 rents her room in a fleabag called the Empty Arms Hotel, I suspect you'll be able to construct her sad biography with no further

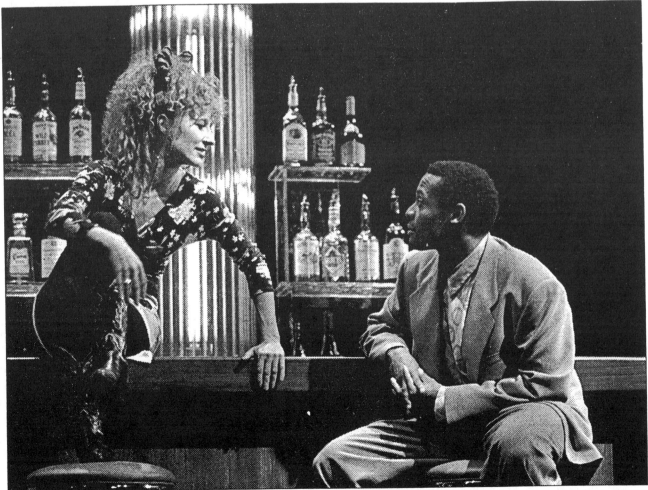

Eric Y. Exit/"Book of the Night"

Vicki Lewis and Keith Byron-Kirk in "Book of the Night" at the Goodman Theater in Chicago—anonymity and angst

assistance from me or Jessica Molaskey, who plays her. The Wishing Woman — actually, she appears to be a waitress by trade — is wishing for someone to love at the start of the show. The Wishing Man is, too. Knowing that, you know their paths will cross. The only unanswered question is when.

The city that Mr. Bishop and Mr. Rosen are evoking, you see, is the generic Big City, a locale not unknown to Hollywood and television in other days. The home of angst, anonymity and lonely hearts, it could be anywhere the sidewalks aren't rolled up by 9 and at least one bar stays open round the clock. The omnipresent danger is that anywhere easily ends up being nowhere. By generalizing people and their sad affairs, the creators of "Book of the Night" may have hoped to impart a universality to their endeavors. But at this stage in the long, downward spiral of urban America, generalities run the real risk of being perceived as hollow clichés.

The role of the street singer (Ora Jones) is a good illustration, not that any of the characters wouldn't make the point equally well. "I can't get no work,/ I can't get no credit," she wails when the spotlight falls on her. "I went to the bank/ And they said, 'Forget it.' " Not only is this doggerel, it is doggerel about the misfortune of millions of Americans. There's no revelation here, no surprise that can't be deduced from the woman's rags or the imploring look on her face, no quirkiness that merits a second glance. The best you can say is that she *represents* homelessness. The condition is expected to speak for itself.

"Book of the Night" draws its multiracial characters from various locations throughout the city, proceeds to that seedy hotel for some shady dealings, wanders over to the Midnight Bar and Grill for livelier encounters, and winds up in assorted bedrooms, where those who are sleeping are having nightmares, and those who aren't are thrashing wildly on the sheets. Wherever we're taken, though, we encounter states of being — insolence, despair, recklessness — not human beings. (Unfortunately, once insolence has shown us its brazen face, not a great deal remains for it to do. So the musical moves on.)

The 25 numbers are conceived in a variety of styles — blues, country-western, gospel and swing. More than a passing nod is made to the Stephen Sondheim who wrote "Company," probably the first and best musical about urban anomie. But the music, never more than pleasant, fails to provide the show with the strong definition it needs.

"Just Say Yes," the credo of the drug-pushing Dealer, comes closest to qualifying as a show-stopper. And Jim Corti, dressed in a spangled jumpsuit and throwing himself into the splits as aggressively as he barks out his lyrics, treats it as such. He's backed up by three female soul singers — outfitted, respectively, in red, white and blue from the tips of their bouffant wigs to the toes of their high-heeled pumps. When they've built the song to a final, frenzied exhortation, flashing lights on the women's costumes spell out an electric Y-E-S.

Yet for all the energy and dazzle, the number is decidedly derivative. It's a pint-sized version of "The American Dream," that scathing indictment of capitalistic greed in "Miss Saigon." While there's some bravado in the Dealer's vow that "I'll build my very own wing at the Betty Ford," there's no glory in rhyming the line with "Once I get what I've been working toward."

∎

The performers who fare best in "Book of the Night" are the lucky few who are permitted to counter the prevailing anguish — Vicki Lewis, as The Wishing Woman, asserting her perky confidence in a voice that could do the job of a couple of foghorns; John Herrera, as the philosophical Desk Clerk who has seen everything and has long since resigned himself to it; and David Studwell, as a 33-year-old husband, who gazes up at the stars and wonders quietly what happened to his 17-year-old self. But the most beguiling performance is Keith Byron-Kirk's. As The Wishing Man, he's charming, relaxed, ironic, and just secretive enough so that the audience comes to him.

The director Robert Falls has woven their divergent odysseys together with fluid grace (the two treadmills are a big help) and Marcia Milgrom Dodge has provided some nervous choreography. To look at the production is to conclude that a whole lot is going on. But the movement is deceptive. Psychologically, matters are static, and the characters largely checkmated. All you can say in the end, really, is that a long, empty night has been got through. But another will present itself in 12 hours. Any one revolution in the continuing cycle, you gather, would be as representative as the next.

Michael S. Philippi (who has designed the sets) and John Boesche (who is responsible for the projections) are the evening's saviors. That may not be Chicago they've put up there on the stage, but the nameless city has been fashioned from skyscrapers and cornices, rooftops and glistening streets that are distinctly Chicago's. As a result, the musical seems anchored in a gloriously real, one-of-a-kind place.

Occasionally, the designers resort to abstract backgrounds — great washes of color that could pass for Georgia O'Keeffe canvases. But it's never long before they connect the musical back up with the nitty-gritty of stoplights and blinking signs and frumpy hotel rooms that let by the hour. They alone seem to recognize our constant craving for details.

Whatever greater meanings we take home from the theater, when we're in a playhouse, watching, we want things to be concrete, idiosyncratic, particular. The singular destiny interests us, not the life that echoes a thousand others. If we must be told about the rule, we want to be shown the exception that proves it. Business reports may be lauded for their comprehensiveness, for the perspective they bring to bear on complicated situations, for the accuracy of their demographic profiles. Musicals never are.

"Book of the Night" goes for the overview, but it doesn't have much interest in the underpinnings. The authors simply have it backward. □

1991 Jl 28, II:5:1

A Feast Of Revenge, Menace And Guilt

By MEL GUSSOW

Special to The New York Times

LONDON — Tyranny, torture and vengeance were the subjects of plays here this summer as England's continuing concern for political theater assumed as a global perspective. On various London stages there were outspoken plays from Chile, the Soviet Union and Trinidad, among other countries. England itself was represented by a brief sketch by Harold Pinter entitled "The New World Order," inspired by the war in the Persian Gulf. The intentionally ironic title of that piece resonated in a number of other works that questioned the results of sweeping geopolitical changes as well as revisionist history.

By far the most powerful of the plays was Ariel Dorfman's "Death and the Maiden," in the upstairs studio space at the Royal Court Theater. Through the years, the Royal Court has itself been a frequent setting for plays that address challenging issues by playwrights from John Osborne through Caryl Churchill and Timberlake Wertenbaker.

The new drama by Mr. Dorfman, an exiled Chilean novelist and playwright who lives in the United States, was the centerpiece of a monthlong political mini-festival within the annual London International Festival of Theater. Through the cooperative efforts of the Royal Court and the Royal National Theaters, "Death and the Maiden" was paired with a series of curtain-raisers. I saw it with "The New World Order."

It was Mr. Pinter who was instrumental in bringing the Dorfman play to the attention of the Royal Court. His own sketch, offering a variation on themes of oppression evoked in his "One for the Road" and "Mountain Language," set the ominous tone for the main play.

As tautly directed by Lindsay Posner and acted by a cast of three headed by Juliet Stevenson, "Death and the Maiden" proved to be a play of ideas in the guise of a political thriller. In it, Mr. Dorfman illuminates both the psychopathological results of torture on an individual and the corruptive effects of years of tyranny on a country's psyche.

"People can die from an excess of truth," warns a cautious liberal lawyer (Bill Paterson). He has just been appointed to a presidential commission investigating violations of human rights in a country like Chile. But as the lawyer's wife (Miss Stevenson) responds, the only way to salvage their communal soul is to face the truth of the past, regardless of the consequences. She speaks from her own excruciating experience as a victim of torture during the country's days of repression.

She has carried the psychological devastation of her ordeal with her for more than 15 years, even as the country has changed leadership. Democ-

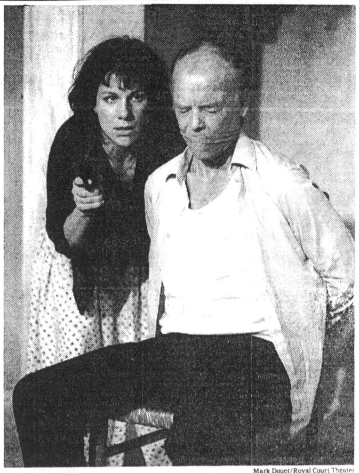

Mark Douet/Royal Court Theater

Juliet Stevenson and Michael Byrne in "Death and the Maiden."

racy promises a new order, but having endured tyranny, she knows how easily it can return. Suddenly, the doctor who was her primary assailant re-enters her life, or so she thinks. She had been blindfolded during the interrogation and can only identify him through his voice and his mannerisms. Confronting him in the present, she plots a savage course of revenge.

Once past the contrived beginning — the doctor is introduced in an act of peacetime good samaritanism — the play moves through twists and turns, riveting the audience for an unrelenting 90 minutes. The suspenseful, cat-and-mouse drama is deepened by the political arguments, as conscience collides with temporal justice, as a desire for retribution conflicts with moral responsibility.

Though the play deals with a South American situation, it achieves a universality that extends beyond the political into an area that is movingly personal. Watching Miss Stevenson take the law into her own hands, one thinks of the anguish felt by victims of rape and other crimes who are unable to prove their case in court.

One of many paradoxes of the play is that the husband's human rights commission will limit itself to people who have died, implying that only death can certify true victimization. As the wife wonders, in any new world order what will happen to the walking wounded and the permanently impaired, like herself? Wisely, Mr. Dorfman leaves conclusions open, in a play that audiences will carry out of the theater and into life.

On this small stage, all three actors deliver knife-edge performances. Mr. Paterson as the temporizing husband, Michael Byrne as the captor

turned terrified captive and, most important, Miss Stevenson as the avenging angel, a woman whose sanity is at stake along with a country's future. Coming after her deeply moving performances in recent London seasons as Hedda Gabler at the National Theater and opposite John Malkovich in "Burn This," "Death and the Maiden" consolidates her position as one of the most extraordinary of young English actresses.

'The New World Order'

In his confession (which may or may not be true), the doctor admits to being seduced by his sinister work. In the Pinter sketch, two watchmen (Mr. Paterson and Mr. Byrne) stand guard over a blindfolded prisoner and insidiously threaten him. With Mr. Pinter, words wound along with deeds. Then Mr. Byrne reveals that his position of authority has given him a feeling of purity, of being able to keep "the world safe for democracy." In this fiendish cameo of menace, the author concludes that fascism does not have exclusivity in matters of injustice.

In an essay celebrating Mr. Pinter's 60th birthday, printed in the 1990 edition of The Pinter Review, Carlos Fuentes links himself to the playwright in having "failed dreams," and praises Mr. Pinter for opening "a terrifying chasm between memory and remembrance, reality and imagination, past and present." Those words also apply, in varying degrees, to other political plays on the London stage.

'Brothers and Sisters'

Coincident with the series at the Royal Court, the London festival pre-

sented the Maly Drama Theater of Leningrad, with a production of "Brothers and Sisters," a six-hour, two-part epic adapted by the director Lev Dodin from a trilogy of novels. This is the play that canceled its New York engagement in 1988 because of a lack of financing.

"Brothers and Sisters" is a monumental chronicle about World War II and its aftermath. Simultaneously, it is bitter in its indictment of the Stalinist regime and revealing in its intimate portrait of a community at war with itself. Mr. Dodin's staging of this rich narrative tapestry is a model of economy and innovation.

'The Coup'

Next to the intensity of "Death and the Maiden" and the breadth of "Brothers and Sisters," Mustapha Matura's new play, "The Coup," at the National, seems small in scale. It is a satiric comedy about the limits of revolution.

Mr. Matura can be a very comic writer, as he demonstrated in plays like "Meetings," and, to his credit, he kicks sacred cows. In the post-revolutionary environment of "The Coup," everyone is tainted, not only the strong-armed but also the high-minded, and the newly elected, newly imprisoned president (Norman Beaton). He is a smooth rascal who wins the audience's allegiance even though he is a master of extortion and more serious crimes against the state. With sharpening (in writing as well as performance), "The Coup" would cut deeper.

'White Chameleon'

In contrast, Christopher Hampton's "White Chameleon," at the National, is not overtly a political play. But it is more socially conscious and more personal than other works by the playwright, who is best known for adaptations like "Les Liaisons Dangereuses." The new play is an autobiographical reflection on the failed dreams of the author's boyhood in Egypt, where his father was employed as an engineer during the Suez Canal crisis.

The core of the play, not fully developed, deals with the young Hampton's father-son relationship with an Egyptian servant (a probing performance by Saeed Jaffrey) who remains an Anglophile even to his own jeopardy. Beneath the family story and the tale of a writer's beginnings is commentary on Britain's colonialist past, as represented by the rude remark that "wogs begin at Calais." In other words, everyone beyond the boundaries of the British Isles is considered a member of a third (and lesser) world.

Mr. Hampton's wry response is that the mean-mindedness of his countrymen made them victims of their own insularity and doomed the empire.

1991 Jl 31, C11:4

Short Shots

Directed by Bill Blechingberg; musical director, Steve Alper; lighting design, Gary Harris; lighting technician, Susan Tenney; stage manager, Ute Hansen. Prologue, music and lyrics by Lynn Portas. Presented by the Improvisation, 358 West 44th Street.

NORMAN, book and lyrics, Frank Jump; music, Mr. Jump and Ms. Portas. With: Lisa Asher and Mr. Jump.

OUT OF FOCUS, book and lyrics, Benita Green; music, David Tenney. With: Bryan Johnson, Larry Klein, Lorraine Serabian and Denise Whelan.
POOPSIE, book and lyrics, Dan Clancy; music, Ms. Portas. With: Ms. Asher and Mr. Klein.
ROOM 1203, book and lyrics, Mr. Clancy; music, Ms. Portas. With: Lawrence Faljean and Ms. Serabian.
A JOININ' OF THE COLORS, by Reena Heenan. With: Christopher Brown, Mr. Faljean, Mr. Johnson, Anne Healy, Milo Heenan and James Saxenmeyer.

By STEPHEN HOLDEN

The nurturing of aspiring musical theater talent is a laudable goal, but it requires a lot more care than has been brought to "Short Shots," an execrable program of five one-act musicals at the Improvisation.

The authors and composers of the five shows are all members of the B.M.I. Musical Theater division. The offerings range from Reena Heenan's clunkingly didactic antiwar musical, "Joinin' of the Colors," about the violence in Northern Ireland, to "Norman," a witless musical comedy sketch by Frank Jump and Lynn Portas built around the punch line, "I'm a lesbian trapped in a man's body."

In "Poopsie" the owners of two dead canines that refused to mate engage in whining recriminations. "Out of Focus" portrays the reunion of a plastic surgery patient with her blind high school sweetheart three decades later. "Room 1203" offers a preposterous dialogue between a spinster schoolteacher and a male prostitute she has engaged.

Although some of the cast members have Off Broadway and regional

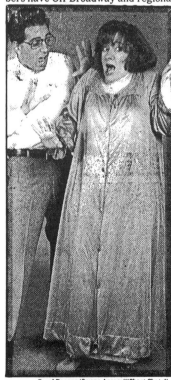

Carol Rosegg/Swope Assoc./"Short Shots"

Sounds of Music

Larry Klein and Lisa Asher perform in "Short Shots," a show of new original musical-theater pieces by David Tenney, Benita Green, Reena Heenan, Frank Jump, Lynn Portas and Dan Clancy.

theater credits, the acting is uniformly amateurish, the singing fair to poor.

The shows have been crudely shoved by the director Bill Blechingberg into two separate nooks of the Improvisation, a cramped comedy cellar on West 44th Street that is ill-suited to be a theatrical showcase.

1991 Ag 1, C14:4

Sonho de Uma Noite de Verão (A Midsummer Night's Dream)

By William Shakespeare; directed, translated and adapted by Cacá Rosset; scenery and costumes by José De Anchieta Costa; lighting by Peter Kaczorowski; assistant director, Maria Alice Vergueiro; choreography by Val Folly; musical direction by Duca Franca; circus coach, José Wilson Leite; gymnastic coach, Regina Oliveira; fencing coaches, Peter Gidali and Erwin Leibl; skating coach, Luciano Marcelo Coutinho; Festival Latino directors, Oscar Ciccone and Cecilia Vega; associate producer, Jason Steven Cohen. Teatro do Ornitorrinco presented by the New York Shakespeare Festival, Joseph Papp, producer, in association with New York Telephone. At the Delacorte Theater, enter at 81st Street and Central Park West or 79th Street and Fifth Avenue.

Theseus and Oberon José Rubens Chachá
Hippolyta and Titania Christiane Tricerri
Hermia .. Elaine Garcia
Lysander Rubens Caribé
Demetrius Richard Homuth
Helena Carolina N. Riberiro
Nick Bottom and Pyramus Cacá Rosset
Francis Flute and Thisby Ary França
Puck .. Augusto Pompeo

By MEL GUSSOW

With its spells and incantations, "A Midsummer Night's Dream" freely lends itself to directorial invention, as is amply demonstrated in the Brazilian production of the play that opened last night at the Delacorte Theater in Central Park. As adapted and staged by Cacá Rosset, this is a lithe and fanciful "Dream." Through graceful use of nudity, the production underlines the natural primitivism of the story.

The members of Mr. Rosset's Teatro do Ornitorrinco perform in Portuguese and there is no simultaneous translation. For an English-speaking audience, the Shakespearean language certainly is missed, but the action is easy to follow and there is something to be said for hearing familiar words spoken in a lilting, unfamiliar language. Fortunately, the dialogue is communicated through actors who are vocally and physically expressive.

There have been more magical, metaphorical productions (beginning with Peter Brook's version). Mr. Rosset takes a lighter, less ambitious approach. Clearly he is interested in the comedy as a springboard for entertainment and performance art with a distinct Brazilian tang. The actors are acrobats, jugglers, mimes and even fire-eaters. This robust troupe of variety performers might be equally at home in a circus, but they have a forthright feeling for Shakespeare and for the imagery evoked by the director.

A dance of half-naked nymphs looks like an animated Cézanne. Performed in soft moonlight, the scene casts a glow across the Delacorte.

Martha Swope

The elves in a scene from the Brazilian production of "A Midsummer Night's Dream" at the Delacorte Theater in Central Park.

The open-air New York Shakespeare Festival theater has seldom seemed more ethereal than at this moment. There are revels and parades with colorful streamers, music (by Villa-Lobos and Mendelssohn and a Brazilian rap song for Puck), played by an onstage band. Late in the evening there is a scene of aerialist daring as elves swing precariously from perch to perch.

It is certainly an unusual "Dream" when the outstanding performances are given by the fairies (female) and elves (male), and in which cameo roles are added for a strongman and a belly dancer. With its expanded population, the forest kingdom is in fact the dominant element in the production.

•

The evening is less secure in court, though some of this reaction may be a result of hearing scenes with extended exposition in a foreign language. José Rubens Chachá and Christiane Tricerri, doubling in the regal roles, are more persuasive as Oberon and Titania than as Theseus and Hippolyta. Augusto Pompeo is a particularly saucy Puck.

The clowns are led by Tácito Rocha's amusingly instructive Peter Quince. Mr. Rosset himself appears as Bottom, a role he plays with the buffoonery of an American vaudevillian. In an act of modesty, Bottom's love scene with Titania seems to have been shortened, one of a number of reductions in the text. Later there is an episode that can be taken as self-criticism. When the clowns offer to present an epilogue to their mildly funny version of "Pyramus and Thisby," the members of the court rise in unison and shout a loud no.

The passion of the actors helps to transcend language barriers and to speed the performance to its conclusion. Hermia (Elaine Garcia) is treated as a rag doll to be hurled across the stage and Lysander and

Demetrius spar in a dashing duel, with each slicing the air under his opponent's feet.

•

While the spirit of the show is never less than playful, there is a covert, unexplored social message. Perhaps taking a clue from the fact that Titania is the queen of the Amazons, the play is staged in an Amazonian rain forest, but one that has been defoliated by an unspecified calamity. Trees have been reduced to stumps. The scenery is spare and there is only a small pool at the center of the stage to indicate an aspect of an oasis.

Except for the setting, the darker elements of the play do not fall under the director's scrutiny. He is content to present a frolicsome Brazilian carnival, what could be called a Bottom's "Dream," and it is most welcome in its outdoor environment.

1991 Ag 2, C3:1

Estrella!
Who Can You Trust In a City of Lies?

Written and directed by Daniel Keene; lighting design, Joni Wong; set design, Christina Weppner; music by Evan Lurie from his album "Selling Water by the River"; additional music by Joan Lurie. Presented by Interart Theater, Margot Lewitin, artistic director. At 549 West 52d Street.

WITH: Rhonda Wilson

By D. J. R. BRUCKNER

Daniel Keene's "Estrella!" — being presented at the Interart Theater through Aug. 11 — leaves one with the impression of having listened to a two-hour unaccompanied aria. And the urge to cheer the actress Rhonda

Wilson for having got through this one-character performance without collapsing is irresistible.

The suggestion of opera is hardly accidental. Mr. Keene, an Australian, has not only written for opera, but also has packed houses in his homeland with his dramatic adaptation of "Madama Butterfly." And the plot of "Estrella!" has more than a hint of "Tosca" in it.

Here, however, the heroine has lived her life not for art but for politics, the politics of revenge in an unnamed Latin American country where, under the rule of a junta, people have simply disappeared for many years, including members of her own family.

She is a survivor; for all we know, the only one. Alone in her family's empty house (she has burned all the furniture as a kind of expurgation of the past) she remembers all the horror: the murder of her father and slow suicide of her mother, the disappearance of her siblings, the killing of her son. She also recalls being recruited by an underground opposition group known as "the invisibles," becoming the mistress of the junta's minister of death, and eventually ridding her bloodied country of him.

Miss Wilson, an Australian actress who starred in several other Keene plays produced here in the past five years, can hold an audience enthralled for a long time, but not for the entire length of this piece. For "Estrella!" she has adopted a Spanish accent that is not distracting, but is probably not necessary. She uses her powerful voice almost prodigally. Its range is tremendous; she can project a whisper so far it seems to come from behind the audience, but she never assaults the ear.

She is at her best describing encounters — erotic, affectionate, violent, hesitant — with other people; she can almost make them appear on the stage, especially the savage general she hates and makes love to, and her 5-year-old son who walks innocently into a hail of gunfire. But there are too few opportunities for that kind of dramatic illusion in this vastly overwritten play. The story is diffuse, contorted and exhaustingly circumstantial (after all, the core of this tale has been around since before the biblical Judith enchanted Holofernes and took his head home in an ancient version of a shopping bag, and the value of such stories to a dramatist is that they can arouse great emotion when they are only referred to in passing).

The result is that, at the end of a long evening, we may know with some dismay that even the winners lose something important in a battle against evil, but we never really understand this woman. That would be less exasperating if she were less interesting.

1991 Ag 2, C24:4

Waste
(A Street Spectacle)

Directed by Judith Malina; adaptation by Hanon Reznikov; composer and musical director, Michael Shenker; production manager, Gary Brackett; technical director, Tony Angel; stage manager, Dena Kazmin; set, Ilion Troya; lighting, Mr. Brackett; costumes, Michael Steger. Presented by the Living Theater. Performed at various locations; for information call 979-0601. Free.

WITH: Alan Arenius, Bob Paton, Gary Brackett, Gene, Jerry Goralnick, Kristin Armstrong, Laura Kolb, Nomena Strusz and Robert Hieger.

By D. J. R. BRUCKNER

The Living Theater has finally tossed in the kitchen sink. Through several decades, some of the company's vast productions have aroused suspicions it was trying to encompass the universe in one show. But one could always dream up some little thing it missed.

Not this time. "Waste," an environmental epic concocted by Hanon Reznikov and presented at various outdoor locations through Aug. 25, shamelessly (Mr. Reznikov's word) plunders plays and operas from 2,500 years and 3 continents to convey more than anyone could possibly comprehend about water and air pollution, vegetarianism, feminism, war, imprisonment, homelessness, wage slavery, nuclear contamination, the disappearance of species, garbage and the politics of all these things.

•

This turbulent spectacle is not only cosmic but — a most welcome departure for the company — often very funny. Eteocles from Aeschylus' "Seven Against Thebes" turns up as the Mayor of New York City battling for the soul of the mob against his fraternal foe Polyneikes, a Bush Administration mouthpiece. Mario Cavaradossi from Puccini's "Tosca" sings, to the melody of his famous opening aria, peculiar lyrics about galactic survival while he paints not saints but a big transparent globe of Earth.

The peasants and rogues of a famous 17th-century commedia dell-'arte piece about marriage teach a hilarious lesson on the evils of eating meat (the final roundup of the herds is a riot) and characters from David

Mamet's "American Buffalo" merrily butcher capitalism. Brecht's Mother Courage not only saves the lives of

A treatise on the environment parodies 2,500 years of theater.

armies, but replaces shells in the soldiers' muskets with peace pamphlets aimed at the audience. In an update of the medieval "Harrowing of Hell," Jesus routs the Devil from real estate and rescues the homeless and imprisoned.

The point being made by the characters from a 15th-century No play about dreams inspired by a Chinese pillow seems to have been lost. And messages from Queen Victoria and Albert Einstein (about salvation through a new "special theory of esthetic relativity") are at best baffling, if no more baffling than the Philip Glass opera "Einstein on the Beach," which this bit mimics.

But Hamlet is totally transparent as a state senator from Queens imported by a huge green Ghost of the Hudson Watershed and a termagant of a lobbyist called Ophelia to close down the Indian Point Nuclear Power Station ("A full life, or a half-life, that is the question") and turn his back forever on those wicked profiteers Claudius and Gertrude.

More goes on than mere storytelling in any Living Theater production.

Gianfranco Mantegna

Members of the Living Theater in "Waste."

Blazing pageants sweep over the landscape, choruses roar and lament, dancers leap and tumble, music soars. All that and twisted bits from 10 plays in 2 hours. And members of the audience can even join the cast in some scenes, as slime molds, dinosaurs, soldiers, whatever.

Does it catch the audience? Well, the night I saw it, when the crowd on cue sang the anthem of the Industrial Workers of the World, "Solidarity Forever," it would have brought tears to the eyes of any old Wobbly. Does the audience learn anything? Sometimes. When a soulful wretch in the cast, perhaps envious of Mayor David N. Dinkins's citizens consultations this week, cried out for ideas to end human misery, some people muttered "abolish landlords" or "no-rent housing." But one husky voice yelled, "steal!"

It is that kind of evening.

1991 Ag 7, C13:1

Growing Up With Faith That Miracles Happen

"The Good Times Are Killing Me," initially produced by Second Stage, has reopened at the Minetta Lane Theater, 18 Minetta Lane, Manhattan. Following are excerpts from Frank Rich's review, which appeared in The New York Times on April 19.

The wonderful thing about children is that they believe everything is possible. What makes Lynda Barry's first play a happy occasion is that she captures the innocent abandon of childhood with the wit of a mature writer, but without letting go of the uninhibited child still lurking deep within herself.

Ms. Barry's uneven but highly promising comedy, "The Good Times Are Killing Me," is about Edna Arkins, a pre-adolescent girl of the mid-1960's who believes, for the duration of elementary school anyway, that miracles like movie stardom and racial harmony are to be had for the asking, no matter what obstacles parents might place in the way. Ms. Barry, a syndicated cartoonist ("Ernie Pook's Comeek"), is just as free-spirited as her heroine in her first effort at writing for the stage. Like Edna, Ms. Barry at her best would rather hop, skip and jump than walk a straight dramatic line between any two points.

The evening has the rambunctious style if not the campiness of a John Waters movie like "Hairspray" in which the rituals of growing up, the increa ed racial segregation of rock musi and the accelerating civil rights movement all converge on the streets of a changing blue-collar urban neighborhood. Sociological sea changes and intimate familial episodes are both defined by pop songs, whether the singers be Johnny Mathis, Paul Anka, James Brown, Elvis Presley or, in one loopy interlude, Julie Andrews in "The Sound of Music."

•

Mark Brokaw, the production's impressive young director, is in perfect tune with the playwright's jukebox approach to the traditional memory play. As Edna remarks that a song can make "the past rise up and stick in your brain," so old songs (and old "American Bandstand" or "Soul Train" dances) rise up in fragrant patches to accompany the script's remembered anecdotes about variously beloved and thorny relatives and neighbors. "Good Times" sometimes seems to be touring the early chapters of its heroine's biography with the same ease with which one might pass in and out of distant radio

stations while turning a dial. Upbeat episodes like Edna's budding friendship with a black girl next door, Bonna (Chandra Wilson), are as gracefully and economically revisited as such heartbreaks as a father's desertion. Life, by turns romantic and bitter, just keeps popping in and out of the doors that line the set's rowhouse facade.

As acted by Angela Goethals with a fetching precocity that never turns bratty, Edna is a winning guide to her wonder years. Ms. Goethals is moving, too, when she and her sad-faced kid sister (Lauren Gaffney, another fine child actor) turn their house's basement into a "Record Player Nightclub" that, though conceived as a joyous imaginary refuge from their parents' marital travails, becomes a mausoleum for lost love.

While not as fully written, the story of the black family next door is just as well acted, particularly by Ms. Wilson and Kim Staunton. Even when the writing lacks fine detail, one still feels Ms. Barry's kinship with black characters whose deferred dreams are touched by, but not really redeemed by, such revolutionary phenomena as "A Raisin in the Sun," "To Kill a Mockingbird" and the Black Panthers.

•

"Good Times" begins to dwindle when the author takes the issue of race relations head on rather than elliptically. Act II devolves into a diagrammatic tale of the gradual parting of Edna and Bonna during the seventh grade, and the girls' story all too heavily symbolizes the larger tale of racial separatism on the eve of the riots of the late 60's. Suddenly a previously free-form play leans on a contrived plot twist — an exclusionary teen-age party — and takes to making points didactically. By the final half-hour, the writing has become as formulaic and glib as the television specials on racial tolerance that the play has previously mocked.

Young audiences — and this is a play sure to earn the respect and laughter of young audiences — will not mind the faults too much, for the author never patronizes her young characters even when her storytelling becomes a bit numbing to those of parental age. While the failings of "The Good Times Are Killing Me" are real, they are those of breadth, not depth. Lynda Barry's engaging debut as a playwright is anything but cartoonish.

1991 Ag 9, C3:5

My Son the Doctor

By Marc J. Bielski; directed by Jeffrey B Marx; costume coordinator, Blair Hammond; lighting designer, Thomas Simitzes; set designer, Bill M. Effrey; stage manager, Dennis Higgins; production coordinator, Harold Bell. Presented by Gerald White. At the Irish Arts Center, 553 West 51st Street.

David	Matthew Boston
Doctor and Steve	Colin Gray
Leonard	Dan Gershwin
Dorothy	Joyce Renee Korbin
Phyllis and Nurse	Bunny Levine
Sondra	Sheila Sawney

By WILBORN HAMPTON

There seems to be a growing epidemic among professional men who are suffering from delusions that the idiosyncrasies of their vocations are just the stuff for hilarious comedies. In less than a year, Off Broadway has been subjected to the theatrical aspirations of a stockbroker ("Money Talks") and an accountant ("Selling Off"). Now Marc J. Bielski, a doctor, has brought the medical profession into it with "My Son the Doctor," a singularly silly new play at the Irish Arts Center.

The vanity of such literary ambitions aside, perhaps a more alarming aspect of these efforts is that they take the most vapid television sitcoms as a model of attainment. One can almost envision the would-be playwrights, watching a couple of episodes of their favorite shows on the tube and deciding, "Hey, I can do that" before starting a draft of a pilot on the back of their TV Guide.

Unfortunately, the one piece of advice they all seem to have heard is the freshman creative-writing class maxim, "Write about what you know," and then they promptly misconstrued it. Dr. Bielski's play, for example, is not really about doctors, despite all the medical lingo sprinkled through the dialogue. It is about

a young man named David who wants to break into show business. He just happens to be a doctor who drops out of his residency program in pediatrics to pursue his ill-conceived plan.

•

Most of the play consists of David's scratching a variety of creative itches to the attendant consternation of his parents, with whom he has moved back in. He first tries to write, but develops a block after three sentences. He then takes a stab at songwriting and stand-up comedy, and even toys with becoming an Olympic luge champion. There is also a girlfriend from the hospital whom David keeps at arm's length, a hypochondriac aunt and a ne'er-do-well cousin whose get-rich-quick schemes leave David briefly in trouble with the mob. It all tends to aim for zany. None of it is funny.

These situations and confrontations, which become repetitive very quickly, are neatly constructed in 8-to-10-minute segments separated by blackouts (presumably where commercials would go). There are occasional pauses (presumably where a laugh track would go). But the silence of a live audience quickly turns the atmosphere in the theater into that of a hospital waiting room.

The acting never rises much above the level of a junior high school play. Matthew Boston's David aims at a cross between Doogie Howser, M.D. and Tom Hanks in "Big" and ends as a spoiled adolescent who should have been disciplined as a child. Mr. Boston at least displays a lot of energy bouncing around the stage, apparently trying to inject a sense of hoopla into the proceedings through exaggeration. Jeffrey B. Marx's direction mostly confines the action to a space that could easily be framed by a 19-inch television screen.

1991 Ag 10, 12:6

Life's Underside Often Gives You the Woollies

A flaky Washington troupe matches wits with the bizarre in 'Fat Men in Skirts.'

WASHINGTON

IT WAS PURE COINCIDENCE THAT the Woolly Mammoth Theater Company was already well into the run of "Fat Men in Skirts" when the grim details of the Jeffrey Dahmer serial killings in Milwaukee hit the press. The play by Nicky Silver is a dark comedy about, among other topics, dismemberment and cannibalism, as practiced by a mother and son who also happen to be lovers. But in the light of sordid events, what was distinguished by its unadul-

terated outrageousness, when it opened last June, has now acquired a ghoulish reality.

You can't plan for this, of course. Nor would you want to. Yet the ironic overlapping of absurdities — those of life and those of literature — is something that audiences have come to expect of the Woolly Mammoth, or the Woollies, as its members are affectionately called. (The unorthodox name, signifying nothing in particular, was chosen only for its attention-grabbing properties.)

In this, the least bohemian of American cities, the company, now winding up its 11th season, has forged a reputation for being unconventional, bizarre, loony to the point of flakiness, troubling, unpredictable and somehow uniquely plugged in to the mad temper of the times. Because it is small (its quarters at 1401 Church Street, N.W., seat only 132), it can afford to offend, as the grandiose Kennedy Center cannot. Because it is relatively young, it allows itself acts of silliness and derring-do that the more mature Arena Stage would think twice about committing.

The plays of Harry Kondoleon ("Christmas on Mars," "Zero Positive" and "The Vampires"), Don DeLillo ("The Day Room") and Wallace Shawn ("Marie and Bruce" and "Aunt Dan and Lemon") have all had enthusiastic receptions here. One of the company's earliest succès de scandale, "The Choir" by the Australian playwright Errol Bray, dealt with the castration of young boys — as a metaphor, it was said, for the ways society cripples its young. More recently, the Woollies had the town howling over Nick Darke's "Dead Monkey," the lurid love story of an aging California surfer with a monkey on his back (a real one), his slatternly wife, and what happens to their marriage when the monkey up and croaks.

Outlandish as it is, "Fat Men in Skirts" falls right in line. It opens on a deserted tropical isle, where Phyllis Hogan, a stylish matron with a shoe fetish slightly less acute than Imelda Marcos's, and Bishop, her 11-year-old son, have just walked away from a plane crash that has left all the other passengers dead. Shaking off the sand and addressing the audience in a tone somewhere between exasperation and incredulity, Phyllis explains that there were eight on the aircraft, including the pilot, but one died of a heart attack during the in-flight movie, which featured Tatum O'Neal.

They were all en route to Italy, where she and Bishop were to have joined her husband, Howard, a film maker who specializes in movies about lovable extraterrestrials. "He was a director in the 70's, now he's a film maker," she points out, the disparagement suggesting she doesn't have much regard for their marriage, either. Then, with no warning, down went the aircraft. And look at her now! A perfectly good pair of shoes ruined. Only two packs of cigarettes in her purse to last who knows how long. And a stuttering son who, when he is not driving her crazy with his encyclopedic knowledge of Katharine Hepburn films, is clamoring for something to eat.

"What's to eat?" very quickly turns into "Who's to eat?" But it will be five years before Phyllis gets a fresh pack of cigarettes. In the interim, Bishop loses his stutter, acquires a ferocious sex drive and develops proprietary instincts toward his mother, who goes batty.

■

Back in the civilized world, Mr. Silver is showing us Howard's growing involvement with an amphetamine-popping porn film actress who claims, among her many credits, "A Room With a View." "You were in 'A Room With a View?' " he asks, impressed. "No," she answers, "I just said that. I don't

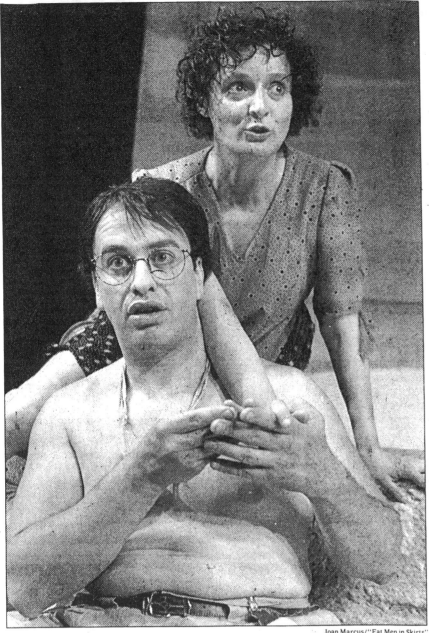

Joan Marcus/"Fat Men in Skirts"

Nancy Robinette and Rob Leo Roy in Nicky Silver's "Fat Men in Skirts"

know why." Just saying things, it seems, is a habit with her.

She's pregnant by the time Phyllis and Bishop are rescued and this nuclear family, such as it is, is reconstituted. But not for long. A play that starts out as a macabre version of Robinson Crusoe ends up behaving rather like "Psycho" wedded to "The Texas Chain Saw Massacre." Although it can be argued that Mr. Silver, a 30-year-old Off Off Broadway playwright, breaks no ground not already broken by the Greeks, the Jacobeans or "The Silence of the Lambs," he flouts taboos brashly and never loses his sense of humor. "Fat Men" cuts too close to the bone — figuratively and literally — not to make it touch and go much of the while. Still, what seems notable is not the nastiness of the dramatic situations but their improbable exuberance.

There are, you may have surmised, no fat men on stage. They turn up in Phyllis's recurring dream of a childhood visit to the zoo. Each time she gets to the monkey house, the monkeys have vanished. In their place are dozens of overweight men in skirts with matching jewelry sets, swinging from limb to limb, laughing. And all of them bear Bishop's face. Exactly what we're to make of this little bit of surrealism, I couldn't say. Monkey imagery runs throughout the play (the beast in us all, I guess). Mr. Silver is not prodigal with insights, and when he serves up a truth it is apt to be along the speculative lines of Phyllis's observation that "300-pound transvestites are pretty much on their own in the world, I should think."

Sociology is the least of the play's concerns. Mostly, I suspect, "Fat Men" just wants to put us in an awkward position. Our urge to laugh is constantly battling the notion that we shouldn't be laughing. The gruesome is merely off-putting. But if you add in a certain matter-of-factness, as Mr. Silver does, you have an altogether different climate. A severed limb, passed from hand to hand, as if it were no more than a saltshaker, evokes a reaction both more complex and more nagging than simple disgust.

To a large degree, it is the Woolly Mammoth production that makes the material — dare I say it? — palatable. Under the artistic directorship of Howard Shalwitz, the company, a loose assemblage of eight actors, has long since developed a distinctive style. The inner psychology is often fierce, but the outside tends to be deadpan. (It's the same comic equation you find in the cartoon strip "The Far Side.") Understatement is the general rule, although when a Woolly Mammoth actor goes over the top, the reckless idiocy of it all brings to mind a daredevil going over Niagara Falls in a bathtub.

■

Nancy Robinette, an actress who can raise dither to epic heights and still convince you she's underplaying, is hilarious as Phyllis. Morality's restraints are falling all about her — and her son has begun to treat her the way Tarzan treated Jane — but she could be presiding over a bad dinner party. Then, without changing the mannerisms of the frazzled socialite, but simply heightening the panic inside, she proceeds to turn Phyllis into a blasted, hollow-eyed wreck.

Rob Leo Roy's transformation from a preteen pudge-ball, exulting in Katharine Hepburn trivia, to Stone Age chest-thumper, salivating over leg of vixen, is equally impressive. With his hair combed over his forehead and his eyes rolled back into his head, he's the Fourth Stooge — the one the other three couldn't trust not to run amok and kill the cameraman.

Grover Gardner doubles expertly as the film maker husband and a white-coated doctor in the asylum where Bishop confesses his terrible deeds. And Desiree Marie adds two succinct characterizations — first, as the ambitious porn actress; then as Popo Martin, one of Bishop's asylum mates. Boundlessly energetic and irrepressibly cheerful (she's already up to her 38th sunburst-yellow potholder), Popo yearns to wallow in a hopeless depression once in her life. "But it just goes against my grain," she notes, with a dazzling smile. "So I tried to kill myself."

That's typical of the cockamamie explanations in "Fat Men in Skirts." When Bishop informs the doctor that he slew his father because "I was hungry and there were no spareribs in the kitchen," we're probably as close to an answer as we'll get. Mr. Silver is dealing with the unexplainable, after all.

The Bishop Hogans and the Jeffrey Dahmers are said to be disturbing because of what they tell us about human malevolence. But that's not it, really. We've always known as much. No, the upsetting part is what they *don't* tell us.

And what they don't tell us — can't ever, perhaps — is why. □

1991 Ag 11, II:5:1

Light, Outdoor Fare Based on a Novel

By MEL GUSSOW

Special to The New York Times

WILLIAMSTOWN, Mass., Aug. 12 — Just before dusk, three mysterious hooded strangers rush through the audience uttering incantations and a rider on horseback races across a field. The Williamstown Theater Festival's free outdoor version of "The Moonstone" begins with a swirl of suspense, as befits an adaptation of a novel by Wilkie Collins.

"The Moonstone" and other Collins works like "The Woman in White" were forerunners of modern detective fiction, and, as such, are naturals for light summer theatrical fare. This was the case several years ago when the New York Shakespeare Festival presented its open air version of Charles Dickens's "Mystery of Edwin Drood."

Collins and Dickens, close friends and occasional collaborators, shared an interest in what were called Novels of Sensation, in which guilty secrets were kept covert through cliffhanging chapters until a final climactic disentanglement. In this instance, the secret concerns the theft of the mystical moonstone, first from a shrine in India and many years later from a young woman's boudoir in England.

Steve Lawson's adaptation of this long and detailed novel necessarily cuts to the case, simplifying the text and reducing the sense of character. This is not "Nicholas Nickleby" by a long shot, or even the musical "Drood," and much of the acting in the cast of nearly 30 is decidedly amateurish. But for families who like

their entertainment al fresco and with the added inducement of a picnic hamper, "The Moonstone" has something to offer. The event takes place from 6 to 8 P.M., nightly through this Saturday, on a small stage in Buxton field, just up the road from the Clark Art Institute.

Painted curtains by Barbara Cohig cleverly picture everything from household interiors to a cliff overlooking a threatening pit of quicksand that will soon claim one of the principal characters. Frank Lindquist's music sets an eerie electronic background and Therese Bruck's costumes add period atmosphere. Somewhat arbitrarily, but without great harm, Mr. Lawson has shifted the story to New England and updated it to the turn of the century.

The original narrative is ingeniously told from diverse points of view. The adaptation is straightforward and holds to the family steward, Gabriel Betteredge, as narrator. This is a wise choice, considering the fact that the role is played by Tom Poston. He lends authority to a shaky dramatic endeavor. Stepping in and out of the play, he addresses the audience, at one point asking if anyone has any idea who the jewel thief might be. "The butler," shouted one theatergoer at Sunday night's performance, a suggestion that brought a smile to Mr. Poston's face.

Mr. Poston keeps his aplomb even as less experienced actors move into caricature. Betteredge remains close to Collins's concept, freely quoting his favorite book, "Robinson Crusoe," to suit all exigencies. Mr. Poston receives able support from Michael Johnston in the romantic lead and from several others, including Jessi-

ca Hendra and Christina Rouner (even as she makes a deformed maid a more appealing figure than the author intended).

Adapting a 19th-century mystery writer for modern-day picnickers.

Neel Keller's staging is as roughhewn as the adaptation. Both would benefit from revision, but the attempt has a proprietary regard for the source. There are many far less enjoyable ways to spend a summer evening at the theater.

A New 'Speed-the-Plow'

Take, for example, Williamstown's current main stage production, John Badham's version of David Mamet's "Speed-the-Plow," a challenging choice in a Williamstown season dominated by more traditional slices of Americana ("1776" and "Inherit the Wind"). Mr. Badham's production completely deMametizes this scathing satire of Hollywood.

Problems begin and end with the performances — by Wayne Rogers and Treat Williams as the twinned movie sharpshooters and Justine Bateman as the office temp who momentarily divides them. In roles that call for attack dogs, the men are the tamest of tabbies, most damagingly in the case of Mr. Rogers.

The viciousness of Ron Silver's hilarious Broadway performance has been replaced by the vapidity of Mr. Rogers's rendition. In his portrayal, one can too readily see why he was beaten out for the job of studio chief by his friend and rival. Mr. Williams (in the Joe Mantegna role) is marginally better than Mr. Rogers, but the relationship between them has neither bark nor bite.

In this vitiated version of a diabolical original, nothing is at stake, certainly not the lives of a pair of cutthroat careerists. As played at Williamstown, they are as mild as cronies discussing what neighborhood movie to see. In their hands, the rapierlike, ritualistic dialogue is slowed to a hesitation waltz. Slurring her speech, Ms. Bateman offers dim wattage as the catalyst (the role created by Madonna). It is unfathomable that Mr. Williams would be seduced by her screenplay sales pitch for a novel about radiation by "an Eastern sissy writer."

In contrast to the stylized Broadway production, Mr. Badham and his designer, Robert Darling, aim for a more detailed scenic approach, filling the studio chief's lair with fooraraw, including a hoop and ladder. Unfortunately, the result looks less like Century City than porch and patio.

Because Mr. Badham, as a film director, is a Hollywood insider, one might have expected insights into the mania conjured by Mr. Mamet. This is definitely not the case. When Mr. Rogers speaks one of the playwright's most pointed lines, "It's only words, unless they're true," the sentence echoes with unintentional irony.

1991 Ag 15, C16:4

Damon Runyon's Tales of Broadway

Starring John Martello; production design, Lutz Gock; costume design, Thom Heyer; production stage manager, Joe Caruso. Presented by Double Image Theater, at 15 Vandam Street.

By MEL GUSSOW

On Damon Runyon's Broadway, the toughest guys are the softest touches, especially when it comes to pretty dolls. The role models for these mugs may have been real gangsters like Frank Costello, but when the stories were filtered through the author's imagination, they turned into myth.

Although Runyon's world has been memorialized in countless films and shows, there is something novel about encountering his people in their original prose context, as is the case in John Martello's "Damon Runyon's Tales of Broadway." This one-man show at the Double Image Theater can be approached as an easygoing curtain-raiser to "Guys and Dolls," due for revival on Broadway this season. Sit long enough eating borscht in Mindy's restaurant and Nathan Detroit or Nicely Nicely Johnson may walk in the door.

As adapter and performer, Mr. Martello is trying to rescue Runyon for a new generation, which thinks of Broadway as something far different from what it was in the author's heyday, when one could stay up all night drinking in speakeasies — and not be mugged on the way home.

•

After a slow beginning, in which Mr. Martello underlines the differences between himself and other monologists, he moves to the diverting middle of his entertainment, three short stories redolent with Runyonese.

In the first, Waldo Winchester, a stand-in for Runyon's crony Walter Winchell, becomes involved in a romantic liaison that goes wildly out of control. Then the scene shifts from Bookie Bob's to New Haven, where Sam the Gonoph and his crew are "hustling ducats" for the Harvard-Yale football game and acting as father protectors to a society doll in deep trouble.

The final and most fully developed tale follows the peregrinations of another protector, Little Pinks, who has a crush on a stuck-up beauty called Your Highness. When she is forced to face hard times, he rescues her and their relationship grows into something approximating a romance.

Mr. Martello, a short actor with well-rounded edges, plays all the characters. Though he is not a natural mimic, he has an affectionate feeling for his material and for the colorful, self-defining slang. In this amiable 90-minute revisit to New York's past, Mr. Martello does nicely nicely.

1991 Ag 16, C3:4

Richard Feldman/"The Moonstone"

Christina Rouner and Michael Johnston in the Williamstown Theater Festival's free outdoor version of "The Moonstone."

SUNDAY VIEW/David Richards

Madcap Arthur Meets the 90's

'Arthur: The Musical' says less about alcohol than it does about the new punctiliousness.

EAST HADDAM, Conn.

PUBLIC ATTITUDES TOWARD drinking have changed a lot over the last decade, but it would be a pity if we started holding Arthur Bach accountable for his actions. You remember Arthur. He's the millionaire playboy who weaved through New York high life, tweaking the snooty, making terrible jokes and generally carrying on like a 12-year-old in the 1981 movie "Arthur." Most of the time, he was thoroughly soused. But, as Dudley Moore played him, he was the quintessence of the lovable drunk, so harmless in his inebriation that you didn't blame the liquor for his errant ways. You blamed the stuffpots and the workaholics around him, who wanted him to mend his behavior and marry a dreary socialite with perfect manners and impeccable hair or lose his $750 million inheritance.

Now Arthur has resurfaced at the Goodspeed Opera House, in a new musical that its creators are calling, with scrupulous logic, "Arthur: The Musical." He has cut back seriously on his imbibing, and, it turns out, he's almost no fun at all. Neither is the show. I don't want to say it's a simple matter of cause and effect and that giving Arthur a few more stiff martinis is the answer. But it would be a step in the right direction.

I can imagine the thinking that must have gone on behind the scenes to produce such a sobering state of affairs. Alcoholism is a serious social problem these days, not to be made light of. Falling-down drunks are *not* cute, even if Dudley Moore is. Anything or anyone who suggests otherwise is not acting responsibly. If you're not careful, you'll have MADD or the Women's Christian Temperance Union on your back.

■

So, yes, you make it clear that Arthur tipples. You allow him a few slurred rejoinders (the best are lifted directly from Steve Gordon's screenplay). At the end of Act I you can even let him lead the company in a paean to "Champagne." After all, he's just had to tell the kooky waitress from Queens that he can't marry her, much as he'd like to, and if a man can't resort to drink in times of heartbreak, when can he? But you bring the curtain down before he's too wobbly to keep up with the kick line.

To have Arthur roar giddily, gloriously, hilariously out of control and, what's more, enjoy himself enormously — as perhaps only a man with a benevolent butler, a faithful chauffeur and a wealthy and indulgent grandmother can enjoy himself — is a prospect the musical prefers not to entertain. The

Dian Sobolewski/"Arthur: The Musical"

Gregg Edelman as Arthur at Goodspeed—bringing down the curtain before he's too wobbly to keep up with the kick line

book by David Crane and Marta Kauffman hews pretty much to the events in the movie, but it so plays down Arthur's *joie de boire* that it's no longer a very original story. Rich playboy meets poor girl, leaves poor girl for rich girl, learns (from his dying butler) that "you can do anything with your life that you want to" and throws over rich girl for poor girl. Since in America that in itself does not constitute a happy ending, he also manages to keep the $750 million.

I want to believe that Gregg Edelman, who created the role of the beleaguered screenwriter in "City of Angels," can draw upon more impish charm than he does here. He's a strong singer, but he proves fairly bland as an actor, and as a cracker of ridiculous quips he's positively limp-witted. Mr. Edelman also communicates the self-defeating impression that he knows what he's doing every second he's on the stage, even though Arthur's enduring challenge is getting a grip on himself.

The movie's other asset, besides the grinning Mr. Moore in a top hat, is Sir John Gielgud, who gave Hobson, the butler, a magnificent hauteur that didn't preclude a stubbornly unsentimental love for his naughty charge. At the Goodspeed, Michael Allinson's loftinesss doesn't rise half so high, and his caring doesn't run nearly as deep. Although his death finally makes a man of Arthur, their stage leave-taking is perfunctory and without emotional impact.

The one movie performance that might easily have been improved on is Liza Minnelli's, as the waitress, Linda Marolla by name, who relies on attitude to mask her vulnerables. Carolee Carmello's injured pout won't fool you, though. Under the tough exterior lies a tougher cookie. The musical gives her several numbers in which she reveals what it's like to be dumped for someone else. Ms. Carmello lets us know in no uncertain terms that it's no damn good.

■

I don't mean to imply that the performers are chiefly responsible for this dud. They're right out there on the front lines, however, and it wouldn't hurt if you liked them or liked looking at them or, at least, felt that *they* liked one another. But you'll find more chemistry going on at a fourth-grade science fair.

Nothing else about the show, unfortunately, is apt to win you over. The score by Michael Skloff is second-rate Marvin Hamlisch — and not the Marvin Hamlisch who wrote "A Chorus Line" either, which might be tolerable, but the Marvin Hamlisch who gave us the forgettable "They're Playing Our Song." When Mr. Crane and Ms. Kauffman's lyrics deal with matters of the heart, they tend to be mawkish; when they go for humor, they tend to be moronic.

Act II opens with a production number, "Can I Live Without the Man," which pays tribute to the magnetic personality of Attila the Hun. (Linda is an aspiring actress, you see, and she's rehearsing an Off Off Broadway musical about the marauder. But you don't need to know this.) "When all is said and done, there'll never be another one, like my Attila," sings the chorus. "My Attiiiiiiilllllla, he's my hon." While Arthur's wealthy fiancée (Jan Neuberger) waits for him to show up at the altar, she tries to impress every magical detail on her mind, so she'll never forget "the sound of the zipper, the smell of the hair spray ... the taste of the Tic-Tacs."

Or the glow of the exit sign, maybe.

The director Joseph Billone has made his mark staging industrial shows and, apparently, sees no need to change his selling tactics at this point in his career. The whole production is beamed straight out front, rather like a spiel for discount mattresses. The best of Tony Stevens's choreography takes place at Coney Island. Arthur and Linda are on their first madcap date and the dancing simulates the various rides. Otherwise, it's routine stuff. Arthur's la-di-da engagement party in Southampton is worse: it's laughably trite. This may be a brand-new musical, but it already looks 30 years old.

The only sign of the times is the show's chariness of Demon Rum. You may have noticed that a new punctiliousness is upon the land. We have to watch what we do and what we say, lest someone take offense and lodge a suit, or at least a vociferous complaint. You can no longer use certain words that were acceptable as recently as six months ago. Sex is becoming taboo all over again. Smoking is out. And drinking is sanctioned only in moderation and under proper supervision.

Well, maybe that's making for a better world. I wouldn't claim to know. I do know this, though. An Arthur who can't tie one on is no Arthur at all. □

1991 Ag 18, II:5:1

Irish Theater Imbued With New Life and Works

By MEL GUSSOW

Special to The New York Times

DUBLIN — The boldness that Deborah Warner brought to Shakespeare in her productions at the Swan Theater in Stratford-on-Avon was reasserted this summer with Ibsen at the Abbey Theater. As directed by Miss Warner and as compellingly portrayed by Fiona Shaw, "Hedda Gabler" becomes an even more impassioned, psychologically prescient study of a woman totally out of step with her time and her society.

The fact that this striking production opened in Dublin rather than at Stratford or in London says something about the convocation of talent that is energizing the Irish theater. The revitalization comes not only from new Irish plays but also from a linkage with a world theatrical tradition. Clearly this is one reason Dublin was named the European City of Culture for 1991.

In the performing arts, theater has always been the city's primary strength, although Dublin has far fewer theaters than London. The audience is small but committed. The works themselves draw from a relatively limited pool of actors, directors and playwrights. This season, for example, that fine actor Donal McCann starred in revivals of both "The Faith Healer" by Brian Friel and "A Life" by Hugh Leonard.

●

In the case of "Hedda Gabler," most of the talent happens to be female: Miss Warner, who is English; Miss Shaw, an Irish actress who has made her reputation in London, in her Irish theatrical debut, and Garry Hynes, who recently moved from the artistic direction of the experimental Druid Theater in Galway to the august Abbey, the Irish National Theater. In her choice of co-workers (like Miss Warner and Sebastian Barry, a young playwright who is on the theater's board), Miss Hynes seems determined to be forward-looking and to shatter stereotypes of what constitutes theater in Ireland.

Simultaneous with the Abbey's "Hedda Gabler," the Gate Theater, under the leadership of Michael Colgan, expressed its venturesomeness with a raffish new version of "Threepenny Opera" as adapted by Frank McGuinness, himself one of a wave of talented young Irish playwrights. The Dublinized adaptation ("Thrupenny Opera," in local parlance) is the Irish premiere of the 1928 Brecht-Weill musical.

To keep everything in balance, Dublin, in common with London and New York, presents a broad spectrum of theater, commercial entertainments as well as plays by Mr. Friel, Mr. Leonard and lesser-known writers. One of the most commercial shows of the summer has been "Moll," a broad farce by John B. Keane, starring Barry McGovern, known for his performance in works by Samuel Beckett. There is also a revival of "Carousel," with the added audience incentive of seeing Cyril Cusack as a non-singing archangel.

●

"Hedda Gabler" has been an undisputed success, with Miss Shaw filling the role with urgency. From the moment she appears on stage in a silent prelude devised by Miss Warner, she is an explosive force. Before dawn she is prowling her household. Trapped in the cage of a meaningless

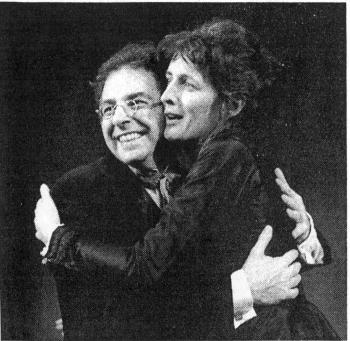

Abbey Theater
Fiona Shaw and Garrett Keogh in a scene from "Hedda Gabler."

life and obsessed by her pregnancy, she is on the brink of madness. This is a woman who can do damage to others as well as to herself. She is helplessly in thrall to her anger and frustrations.

Her home is as underfurnished as her life. In Hildegard Bechtler's monochromatic design, there is cold comfort, only a bare dining table, wooden chairs and a small couch. Hedda's meddling aunt, a meaner figure in this production than is generally the case, keeps shifting the furniture, and Hedda compulsively rearranges it, as if in so doing she can instill her own idea of order on her life. Nervous, restless, she remains in incessant motion.

When the Lovborg manuscript is left in her care, Miss Shaw hides it in plain sight, putting it under the couch rather than in a drawer. We are always aware of the manuscript, even as Lovborg remains oblivious of its presence. After he leaves, Hedda takes the book and burns it. But instead of placing it a few pages at a time in the fireplace, as indicated in the text, she flings it whole into the flames. It is a shocking moment — as if she has tossed a child onto a funeral pyre — and it is one that encapsulates the entire production.

In less artistic hands, the largeness of the gesture in this scene and others might lead to self-indulgence; not with Miss Shaw. With the help of her director, she keeps herself contained within the role. As a result, Hedda's suicide achieves the inevitability it deserves. When Judge Brock says, "People don't do that kind of thing," the unstated response is, not unless the name is Hedda Gabler.

Except for the few jarring Anglicisms in Una Ellis-Fermor's translation and the fact that Tesman is played in a familiar wimpish manner, the production exudes authority. Miss Shaw is evenly matched by Hugh Ross's patrician Judge Brock and Robert O'Mahoney's Byronic approach to Lovborg. The actress locates the embittered laughter without diminishing the brooding Hedda flailing against the encroaching night.

•

In contrast to Miss Warner's highly detailed "Hedda," Patrick Mason's production of "Threepenny Opera" seems at first to be a concert version. A seedy band of instrumentalists and all the actors are assembled on stage. Eventually the musical has all the earthy atmosphere it needs. Mr. McGuinness has transported the events to London in 1953 at the time of the coronation of Queen Elizabeth II and has populated Brecht's underworld with characters who seem recently arrived from Ireland.

It is the adapter's announced intention to approach Brecht from the point of view of Sean O'Casey, to make the musical a hybrid of these "two wild spirits" of the 1920's. In pursuit of this goal, he has given an Irish tinge to the lyrics while retaining the Germanic abrasiveness. The

In numbers small but strong: audiences, actors, and playwrights.

adaptation and the production are more Brechtian than many.

Paul Raynor's Mack the Knife is the opposite of the one that Sting played on Broadway. He is not a young renegade but a world-weary confidence man approaching his middle years and trying to hold on to a more youthful image. Some of the actors are not up to the musical demands of the show, with the definite exception of Marianne Faithfull, who in a note of inspired casting plays Pirate Jenny. Intuitively she has exactly the right combination of cynicism and sadness, and a voice that is splendidly suited to Weill. The Gate has given Irish life to a world classic.

One oddity of theater in Dublin is the drabness of the buildings that house its major companies. The Gate looks like a small fortress and inside has the appearance of a school auditorium only recently converted into a theater. The Abbey (rebuilt in 1966) has a faceless monolithic design and has the additional debit of seats so drastically tilted backward that they might be more at home in a dentist's office. None of this detracts from the vitality of the work onstage or the enthusiasm of the audience.

•

One significant indication of the Irish theater's self-renewal is the posthumous recognition accorded its self-exiled son Samuel Beckett. Dublin is presenting a festival of his work in October, under the joint sponsorship of the Gate, Trinity College Dublin (Beckett's alma mater) and Radio Telefis Eireann. During a period of three weeks, all of Beckett's stage plays (19 by count of the festival) will be staged, along with colloquies and broadcasts of his radio and television work. Among the actors will be Barry McGovern, Billie Whitelaw and others closely identified with his art. It is a rare opportunity for theatergoers to experience a body of work in its entirety.

1991 Ag 20, C11:1

The Matchmaker

By Thornton Wilder; directed by Lonny Price; set design by Russell Metheny; costumes, Gail Brassard; lighting, Stuart Duke; sound, Philip Campanella; music, Claibe Richardson; production stage manager, Roy W. Backes. Presented by Roundabout Theatre Company, Todd Haimes, producing director; Gene Feist, founding director. At 100 East 17th Street.

Mrs. Dolly Levi	Dorothy Loudon
Horace Vandergelder	Joseph Bova
Cornelius Hackl	Jim Fyfe
Barnaby Tucker	Rob Kramer
Irene Molloy	Lisa Emery
Minnie Fay	Lisa Dove
Ermengarde	Wendy Lawless
Malachi Stack	Jarlath Conroy
Ambrose Kemper	Michael Hayden
Joe Scanlon/Cabman	Theodore Sorel
Rudolph	Jack Cirillo
August	Michael Hayden
Miss Flora Van Huysen	Eileen Letchworth
Gertrude/Cook	Mary Diveny

By MEL GUSSOW

Though the source of "The Matchmaker" is a 19th-century Viennese comedy, Thornton Wilder made his version archetypally American by creating the character of Dolly Gallagher Levi. That flamboyant woman has entered our mythology through the musical adaptation, "Hello, Dolly!," as well as the Wilder play. She is the busiest of busybodies, poking into everyone else's affairs while arranging a marriage for herself with that miserly old merchant of Yonkers, Horace Vandergelder.

To present a full-bodied "Matchmaker," a theater needs a Dolly with charm as well as determination and a supporting cast that draws inspiration from her effervescence. Despite that dominant force at the center, "The Matchmaker" is far from a one-woman vehicle. Unfortunately, Lonny Price's revival, which opened last night at the Roundabout Theater Company, is lackluster in almost every department. Apart from the lead, the play is undercast, and it is sloppily staged, even making experienced actors seem ineffectual.

•

With her expressive features and clownish manners, Dorothy Loudon would seem to be a natural to play Dolly in either the Jerry Herman musical or the play. But along with her colleagues she ambles through the performance as if her mind were on other matters. Her initial entrance into Horace's house is applauded by the audience, probably in fond recollection of her terrible-tempered Miss Hannigan in "Annie," but there is little about the performance to stir enthusiasm or to remind one of her talent.

Admittedly, Joseph Bova's Horace offers her no comic or romantic encouragement. He is a stolid crank, all bluster and no blarney. His meanness seems just that, unmitigated by humor or self-parody. It is he, not Dolly Levi, who is exasperating. Just as Ms. Loudon is overshadowed by Dollys who have preceded her, Mr. Bova is haunted by Horaces, beginning with Walter Matthau in the movie of "Hello, Dolly!" There is a certain mock-Matthau attitude afoot in Mr. Bova's grumpy performance.

The fault is not so much with individual actors as it is with Mr. Price's staging, which suffers from late-summer lassitude. There is no purpose in the air, except to fill out the Round-

Thornton Wilder's character in her pre-musical life.

about's final Off Broadway season (in the fall the company moves to the Criterion Center on Broadway).

Though Jim Fyfe is affable as Horace's older clerk, Cornelius Hackl, he lacks the dash that drives this character into acts of temporary madness. Rob Kramer plays his sidekick Barnaby Tucker not as a young innocent but as a goofy caricature. In neither case can one imagine a glint of romance with the ladies from the millinery shop (played by Lisa Emery and Lisa Dove). Considering the frailty of the performance by other supporting players, these two actresses seem to be the most comfortable in their roles.

Seeing the revival, audiences may wonder if there is any life left in the play, if it hasn't been superseded by the musical. But when Sada Thompson assumed the role at the Hartford Stage Company a dozen years ago, Dolly was lovable as well as droll, and the play stood on its own as a period farce.

Mr. Wilder once wrote that "the pleasures of farce, like those of the detective story, are those of development, pattern and logic." In addition, there should be crisp clockwork timing, especially in those seemingly surefire comic scenes in the millinery shop and the Harmonia Gardens Restaurant. In spite of the efficiency of Russell Metheny's turntable set at the Roundabout, the farce fizzles.

1991 Ag 28, C12:4

Los Jíbaros Progresistas

Original version by Ramón Méndez Quiñones; directed by David Crommett; musical director, Mr. Crommett; sets, Daniel Ettinger; costumes, Amparo Fuertes; sound, Gary Harris; stage manager, Hector Marin. Produced by Miriam Colón Valle. Presented by the Puerto Rican Traveling Theater. Performed outdoors at various locations. For information and reservations: 354-1293. Starting Sept. 11, at the Puerto Rican Traveling Theater, 304 West 47th Street, Manhattan.

Juaniya	Bersaida Vega
Chepa	Miriam Cruz
Cleto	George Bass
Anton	Adriano González
Bruno	Anibal Lleras
Don Pico	Rafael Picorelli

By D. J. R. BRUCKNER

As far as the outdoor audience is concerned, the stars of "Los Jíbaros Progresistas" are the musicians, Anibal Lleras and Rafael Picorelli. The play by Ramón Méndez Quiñones arouses great laughter, but it is the hands of Mr. Lleras on the guitar and Mr. Picorelli on the sweet little superguitar called a cuatro that make the audience's feet and hands thump on the ground and finally bring people to their feet, bouncing.

The play, first performed by the Puerto Rican Traveling Theater 10 years ago, is being presented in Spanish by the company in outdoor locations throughout the city's boroughs and in New Jersey through Sept. 8. Then it moves into the company's theater on West 47th Street for a two-week run starting Sept. 11.

A jíbaro is simply a country bumpkin, progress is probably regarded with skepticism by people speaking all languages, and the title really suggests "savoir-faire in the sticks." The play is a wonderfully serviceable comedy that can be pulled and twisted into various shapes (a year ago it ran at Repertorio Español as fullfledged comic opera).

•

The story is about a family out in the Puerto Rico countryside trying to decide whether to attend a festival in what they think of as the enormously sophisticated city of Ponce. The daughter and her boyfriend desperately want to go, and the father connives with them. But the mother is deeply suspicious of what the two young people really might end up doing in the city, and she has to be won over by hilarious arguments all delivered in a kind of rattling verse and by a lot of ruses familiar to theater audiences for centuries.

Such a play virtually begs a director and actors to indulge in high jinks, and that is an invitation obviously welcome here to David Crommett, the director, and the cast: George Bass as the bumbling father; Miriam Cruz as a mother who seems to prolong her resistance only for the love of being cajoled; Bersaida Vega as a daughter in whom mischief is blooming alongside sex, and Adriano González as a suitor whose dashing appearance masks his occasional wit-

lessness. And the two musicians do extra duty as neighbors.

The words are almost superfluous but the lively music is not.

It would probably help to know a lot of Spanish, perhaps even the kind that is special to the Caribbean, since the playwright likes dialect. But what is going on is no mystery, and many people watching in Central Park on Sunday obviously had no Spanish and just as obviously understood enough to have a very good time. The songs are delightful, and the guitar and cuatro music is a language of its own, at times so eloquent it makes one oblivious to all but its own sound.

1991 Ag 29, C18:3

La Tempestad (The Tempest)

By William Shakespeare; directed by Carlos Giménez; adapted by Ugo Ulive; set by Marcelo Pont-Verges and Augusto González; costumes, Hugo Márquez, Mr. Pont-Verges and Mr. González; lighting, Trevor Brown and Mr. Giménez; original music, Juan Carlos Núñez; sound, Eduardo Bolivar; artistic production, Jorge Borges, Andrés Vázquez and Gabriel Flores; technical director, Freddy Belisario; Festival Latino Directors, Oscar Ciccone and Cecilia Vega. Executive producer, William López; associate producer, Jason Steven Cohen. Presented by Joseph Papp, in association with New York Telephone and with the cooperation of the City of New York. At the Delacorte Theater, Central Park, enter at 81st Street and Central Park West or 79th Street and Fifth Avenue.

Ariel .. Erich Wildpret
Prospero José Tejera
Miranda Nathalia Martínez
Caliban Daniel López
Fernando Jesús Araujo
Captain/Old Spirit Rodolfo Villafranca
Boatswain/Spirit Norman Santana
Alonso German Mendieta
Antonio Francisco Alfaro
Gonzalo Hugo Márquez
Sebastian Aitor Gaviria
Adrian Ramon Goliz
Black Spirit William Cuao
Trinculo Cosme Cortazar
Estefano Anibal Grunn
Old Spirits/Sailors
 Ricardo Martínez and Hector Becerra

Young Spirits/Sailors
 Ismael Monagas and Gregorio Milano
Godesses/Nymphs Ivezku Celis
Sailor Alejandro Faillace

By MEL GUSSOW

In Carlos Giménez's Spanish-language version of "The Tempest," Prospero's island is a white sandy beach in the Caribbean. It is a land detached from specific time, but linked to a mythic past. The most impressive aspect of the set in the Rajatabla theater's production at the Delacorte Theater in Central Park is a huge carved head toppled in the sand. Looking like an ancient god, it splits apart to reveal Prospero's laboratory in its interior: a brain within a brain. At moments, spirits moving across the beach simulate the stance of pre-Columbian sculptural figures.

In contrast, there is a multi-level assemblage of platforms in the background, a modern construction site or launching pad, lined with workmen shooting sparks into the air. This double-edge "isla" is full of noises: a roaring storm, animal cries and a score by Juan Carlos Núñez that free-ly interprets Shakespeare's suggestion of "solemn and strange music." The scenic, sound and lighting design merge to give an imaginative grounding to what is otherwise an elusive "Tempest."

•

Neither "The Tempest" nor the Brazilian version of "A Midsummer Night's Dream," recently performed in Portuguese at the Delacorte, has simultaneous translation, for technical reasons having to do with this outdoor theater. Both productions are part of the Festival Latino of the New York Shakespeare Festival. The fanciful "Dream" transcended the language barrier by being more freely allusive in its imagery. "The Tempest," in this adaptation by the Venezuelan company, presents greater obstacles, beginning with the dense, textual nature of the play.

With his low, rumbling voice and sorcerer's manner, José Tejera would seem to be a persuasive Prospero (though he is somewhat young for the role). But without his soliloquies, Prospero is unrealized. Watching Mr. Tejera but not understanding most of his words, one vividly recalls other actors in the role, including John Wood who recently delivered a magisterial Prospero for the Royal Shakespeare Company. In the circumstances, it is a relief to hear Ferdinand address Miranda for the first time. Unsure what the language of this strange creature might be, he speaks with such slowness and deliberation as to be comprehended by a theatergoer with basic Spanish at his command.

Nathalia Martínez's Miranda and Jesús Araujo's Ferdinand are among the evening's dramatic assets, particularly in the case of Miss Martínez, whose bright-eyed ingenuousness seems ideally suited to her role and to the vastness of the Delacorte.

The drunken sailors, with their scenes of low comic horseplay, neces-sarily take precedence. Cosme Cortazar's amusing Trinculo wears a chef's hat and a deadpan Stan Laurel look, while Anibal Grunn's Stephano (Estefano in the Spanish version) is a boisterous clown, regaling in the momentary glory bestowed upon him by Caliban (given a rather subdued performance).

In collaboration with Ugo Ulive as adapter, Mr. Giménez has pared the text to less than two hours, beginning with the exclusion of the shipwreck. Instead of a crew devastated by a tempest, Ariel simply picks up an ivory model ship in his arms and flies up to the sky with the help of a mechanical rigging. Ariel's flights add a needed airiness to the production.

•

A synopsis of the adaptation inserted in the program gives the audience a clearer indication of the director's concept. His "Tempest" is conceived as a play within a play. When Prospero puts down his book, it is not intended to be a book of magical spells, but the text of the play itself. In other words, Prospero is actually Shakespeare, an interesting interpretation that is not evidenced in the events seen on stage. There are intriguing moments in the Rajatabla's "Tempest," but when a character asks, "¿Que pasa?," a theatergoer may want to echo the question.

1991 Ag 30, C3:3

Earthly Possessions

From the novel by Anne Tyler; adapted and directed by Frank Galati; scenery, Kevin Rigdon; costumes, Erin Quigley; lighting, Robert Christen; sound and music, Rob Milburn; projections, John Boesche; production stage manager, Robyn Karen Taylor; assistant stage manager, Alden Vazquez. Presented by Steppenwolf Theater Company; artistic director, Randall Arney; managing director, Stephen Eich. At The Steppenwolf Theater, Chicago.

Charlotte........................... Molly Regan
Mrs. Emory Joan Allen
The Beautiful Child, Selinda
 Kimberly Dal Santo
Jake Kevin Anderson
Mr. Ames, Julian, Bank Customer
 Alan Wilder
Bank Customer Ellen Beckerman
Mrs. Ames Rondi Reed
Woman at the fair, Miss Feather
 Peggy Roeder
Man at the fair, Linus, Oliver..... Rick Snyder
Saul Mr. Arney
Mindy Sally Murphy

By FRANK RICH

Special to The New York Times

CHICAGO — If the sheer emotional weight of family, with all its burdens of love and pain and responsibility and memory, could somehow be represented by a single stage set, it could certainly look like Kevin Rigdon's design for "Earthly Possessions," the new play Frank Galati has adapted from Anne Tyler's novel for the Steppenwolf Theater Company.

Mr. Rigdon has taken the possessions of the title — the household furnishings of Ms. Tyler's heroine, Charlotte Emory of Clarion, Md. — and piled them high on either side of the stage. The furnishings are clunky lamps, overstuffed chairs, tables, console radios and cabinets of the most comforting sort, the ubiquitous garage-sale totems of every American neighborhood, but Mr. Rigdon has subverted their familiarity by painting them a disconcerting coal-black. And rising above the stage,

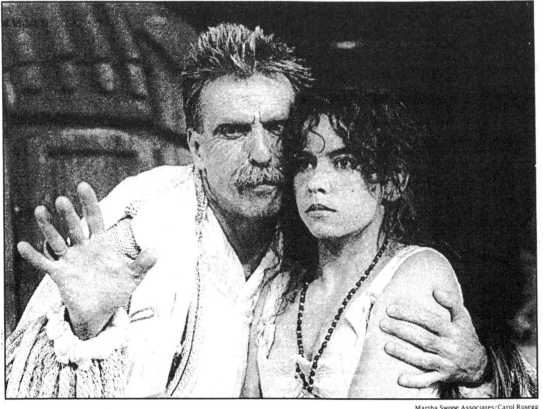

Martha Swope Associates/Carol Rosegg

José Tejera, as Prospero, and Nathalia Martínez, as Miranda, in "The Tempest."

Michael Brosilow/Steppenwolf Theater Company
Kevin Anderson and Joan Allen in the Steppenwolf Theater Company production of "Earthly Possessions."

towering clear to heaven, is a wall of equally homey front doors and back doors and screens and shutters, all just as black, all just as ambivalent in effect. Is the American family a warm place to come home to, Mr. Rigdon's monumental collage seems to ask, or is it a dark tomb that must at all costs be escaped?

●

That question hangs over much of Ms. Tyler's fiction, and "Earthly Possessions," written in 1977, is no exception. The novel tells of how Charlotte, a passive housewife with fantasies of running away from her dreary preacher husband, is abruptly forced

Charlotte dreams of leaving home. A bank robber gives her no choice.

to put her plan into action when she is taken hostage by a bank robber, Jake, and involuntarily joins him on the lam. As robbers go, Jake is not a bad guy, and Charlotte's flight from the encumbrances of family often seems as liberating as she had wished. But don't look to Ms. Tyler for "Thelma and Louise." The familial constellation Charlotte left behind, however barren, still exerts its pull, and even the impulsive renegade Jake finds he cannot entirely resist the tendrils of soft domesticity he purports to defy.

"Earthly Possessions" is the first new American play to be produced by Steppenwolf in the handsome, rough-hewn new proscenium theater it opened this year. The production is a first-team affair, directed as well as written by Mr. Galati, who won a Tony Award for his Steppenwolf adaptation of a much different kind of American road novel, "The Grapes of Wrath," and who was also nominated for an Oscar for co-writing the Hollywood version of a later Tyler work,

"The Accidental Tourist." The evening's stars, Joan Allen (Charlotte Emory) and Kevin Anderson (Jake), are among the most familiar of Steppenwolf company members, most recently to Broadway audiences in "The Heidi Chronicles" and "Orpheus Descending."

●

The qualities that Mr. Galati brought to "The Grapes of Wrath" are all apparent in "Earthly Possessions": the keen visual sense, the scrupulous respect for the language and intentions of his literary source, the conviction that even the most intimate drama can have a cinematic sweep on stage. As the Joads' truck dominated the last Galati production, Jake's getaway car is usually at the center of "Earthly Possessions," with the homesick restaurants and lonely Edward Hopper vistas on its route filled in by animated, black-and-white slide projections (by John Boesche) in a funky Jim Jarmusch style.

Much as one savors the intelligence and integrity of the effort, however, "Earthly Possessions" still seems more like an elaborate staged reading of the Tyler novel than a dramatization of it. Mr. Galati simply has not been able to crack the technical problems presented by translating this particular book to the stage even as he and Mr. Rigdon have so evocatively illustrated its themes and locales. Not every novel, after all, can be made into a play, and the problems built into the textual fabric of "Earthly Possessions" may be insurmountable.

Having no other workable option, Mr. Galati has retained Ms. Tyler's fractured narrative structure, in which scenes of Jake and Charlotte's present-tense misadventures alternate with the flashback history of Charlotte's childhood and marriage. But what is a routine device for a novel proves a momentum killer in the theater; the play always seems to be taking two steps backward for each road stop it advances. The diffuse focus of the stage version of "Earthly Possessions" is aggravated further by the slide show, which inevitably dwarfs the actors beneath it,

and by Mr. Galati's decision to have a second actress, Molly Regan, play Charlotte alongside Ms. Allen, seemingly to fill in more of the novel's first-person narrative.

Other playwrights — like Brian Friel in "Philadelphia, Here I Come!" and Peter Nichols in "Passion" — have brought off the device of splitting the public and private selves of one character between two actors. Mr. Galati fails, mainly because Charlotte is so inward a personality that her two selves are indistinguishable, no matter how her thoughts, lines and actions are divvied up, no matter how many distinctions the actresses try to draw. Miss Allen, whose little smiles and big-eyed acknowledgements of life's shocks sometimes recall her performance as Wendy Wasserstein's Heidi, is at a terrible disadvantage here, having to share even Charlotte's meatiest scenes with an alter ego. Ms. Regan, an able actress, is too often asked to stand around expressionless as if she were another piece of furniture cluttering the set, albeit one not allowed to fade into the black woodwork.

●

There is always too much to distract one from the main event, Charlotte's gradual reconciliation with the idea of family, in "Earthly Possessions," but some of the distractions are pleasant. Mr. Anderson's leather-jacketed robber is a charming, if less than intense, variation on the drifter he played opposite Vanessa Redgrave in "Orpheus," and Sally Murphy (Rose of Sharon in "Grapes of Wrath") injects a bright, Lolita-like mixture of overripe sexuality and childish ingenuousness into the role of Mr. Anderson's pregnant teen-age girlfriend. In a good cast, the only serious wrong note — and Mr. Galati bears responsibility — is Rondi Reed's campy turn as Charlotte's obese mother, who devolves from the forlorn, pathetic woman she was in the novel to a ridiculous freak in clownish makeup.

This lapse is particularly hard to fathom given that the mother's death remains the fulcrum of Mr. Galati's

play as it was of Ms. Tyler's book. The death scene captures the book's vision of family anyway, not because it is possible to mourn the matriarch but because even at the end her survivors remain confused, at once suffocated and sustained by that pile of earthly possessions they call home.

1991 S 4, C13:2

The Jersey Girls

By Larry Manogue; directed by Ken Lang; scenic design, Janice L. Klotz; lighting, Karl Carrigan; stage manager, Laurena Allan. Presented by Florence Olsen and Harry Walters, in association with Comrade Productions. At the Actors' Playhouse, 100 Seventh Avenue South, at Fourth Street, Manhattan.

Glen Connors	William White
Mim Connors	Kipling Berger
Lisa Howard	Kimberly Auslander
Derba	Suzanne Scott

By WILBORN HAMPTON

At the end of the tedious first act of "The Jersey Girls," a dreadful play by Larry Manogue at the Actors' Playhouse, Glen and Lisa begin teasing their old chum Mim about the time she lost her bra on a date in high school. Angered by the indelicacy of such revelations, the prudish Mim huffily declares, "Some things just aren't funny." Unfortunately, "The Jersey Girls" is one of them.

●

Billed as a new comedy, "The Jersey Girls" is neither. It takes the most banal of television sitcoms as a starting point and then trivializes it even further. Glen, Lisa and Mim are living together as a sort of New Jersey version of "Three's Company." Returning from a week's vacation in San Francisco, Lisa and Mim decide to move to California, in hopes of meeting some eligible men. They do. Move to California, that is. They find jobs and an apartment in San Jose with a new roommate. They write letters home to Glen. He writes back. He comes to visit on his vacation, also hoping to meet some eligible men. Another exchange of letters. Glen returns at Thanksgiving. More correspondence. The girls go back to Jersey for Christmas. The end. Not exactly a laugh riot.

Other things happen, of course. Lisa starts dating a married man; Mim becomes engaged; Glen decides to come out of the closet during a faculty meeting at the school where he teaches, and even musters the courage to get an AIDS test. All of these things, however, happen offstage. We hear about them only in passing, either in late-night chitchats (when all three arrive home from their dates within seconds of one another) or in the letters that intersperse the play's 10 scenes. We never meet any of the men in either the girls' or Glen's lives. Most of the actual dialogue is of the "who told what to whom and when" variety, or soap opera moralizing. Weak stabs at establishing a certain worldly sophistication in this ménage include a contest to see who can fit a condom on a peeled banana first. As you might guess, there is a lot of dead time onstage.

●

There appears to have been no direction in the production beyond the blocking, and that is awkward at best. For the most part, the acting is never above the level of a cold line-reading.

Suzanne Scott is the only one who comes close to giving a credible performance and she plays a blonde California bimbo.

1991 S 4, C16:1

Critic's Choice

World of Kander and Ebb Goes 'Round in a Show

The songs of John Kander and Fred Ebb, which form the heart of "And the World Goes 'Round," at the Westside Theater, belong to a brassy, bustling tradition of Broadway tunefulness that is an increasingly endangered species of popular music nowadays. But if that tradition is down, it is certainly far from out, as is evidenced by the enthusiastic performances of the Off Broadway show's five youngish performers, Joel Blum, Terry Burrell, Bob Cuccioli, Karen Mason and Karen Ziémba.

The show's success has as much to do with staging as with the songs themselves. Scott Ellis and Susan Stroman, the directorial and choreographic team who co-conceived the evening with David Thompson, have turned 30 Kander and Ebb songs into a buoyant sequence of whimsical set pieces acrobatically performed on a witty set stenciled with dictionary definitions of things having to do with songwriting.

The material covers the breadth of Mr. Kander and Mr. Ebb's 26-year collaboration, from the 1965 show "Flora, the Red Menace" ("A Quiet Thing") to the recent "Kiss of the Spider Woman" (the title song). Most of the team's best-known showstoppers are represented. Besides "Quiet Thing" (sung by Ms. Ziémba), they include "Maybe This Time" and the revue's title song,

both sung by Ms. Burrell; an exuberant ensemble version of "Cabaret," and a finale of "New York, New York," which adds some clever new twists.

The Westside Theater is at 407 West 43d Street. Performances this weekend are at 8 tonight, 2 and 8 P.M. tomorrow and 3 P.M. Sunday. Tickets are $37.50. Information: (212) 307-4100.

STEPHEN HOLDEN

1991 S 6, C3:1

The Skin of Our Teeth

By Thornton Wilder; directed by Robert Hupp; set and lighting, Giles Hogya; costumes, Jonathan Bixby; music and sound, Ellen Mandel; production stage manager, Julie Bleha; technical director, Patrick Heydenburg; production assistants, Harold A. Mulanix and Macha Ross. Presented by Jean Cocteau Repertory; artistic director, Mr. Hupp; executive director, David Fishelson. At the Bouwerie Lane Theater, 330 Bowery Street, Manhattan.

Announcer, Stage Manager
 Harris Berlinsky
Mr. Antrobus...................Craig Smith
Mrs. Antrobus.................Elise Stone
Sabina..........................Jeanne Demers
Dinosaur, Fortune Teller, Hester
 Betty Burdick
Mammoth, Broadcast Official Robert Ierardi
Telegraph Boy, Fred Bailey........Grant Neale

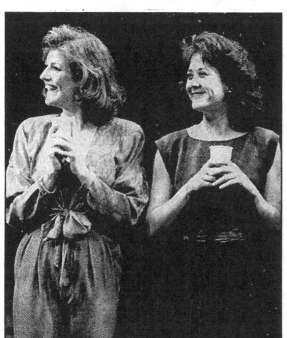
Joan Marcus

Karen Mason, left, and Karen Ziémba in a scene from "And the World Goes 'Round."

Henry..............................Joe Menino
Gladys.............................Angela Vitale
Homer, Bingo Caller, Mr. Tremayne
 Mark Waterman
MosesWm. Charles Mitchell

By WILBORN HAMPTON

The summer of 1940 was one of the bleakest of the century. The Germans entered Paris in June and less than a month later the Luftwaffe launched the bombing blitz that Winston Churchill called the Battle of Britain. Londoners defied the Nazi terror by flocking to hear Shakespeare in the Strand. In the United States, Thornton Wilder began writing a play that, when it opened on Broadway two years later, was called "The Skin of Our Teeth."

To begin its third decade, the Jean Cocteau Repertory has mounted a solid revival of Wilder's comedy on catastrophe that still finds relevance in today's headlines. In a preface written for a 1958 edition of his "Three Plays," Wilder acknowledged that the play "mostly comes alive under conditions of crisis." If the geography of the current world crisis suggests the Moscow Art Theater might be a more suitable venue for a new production of "The Skin of Our Teeth," the Cocteau's staging is a reminder that what happens anywhere on the planet affects us all, whether it is ecological disaster or political upheaval.

Although he vigorously denied it, Wilder was, along with Brecht and Beckett, one of the great innovators of 20th-century theater. His ploy in "The Skin of Our Teeth" was to take three global calamities — the Ice Age, the Flood and Armageddon — and let a modern man and his family deal with them.

Wilder's candidate to rebuild the world from each of these disasters is one George Antrobus, who resides at 216 Cedar Street, Excelsior, N.J. He has a wife, Maggie, two children, Henry and Gladys, and a maid, Sabina. As he did with the Stage Manager in "Our Town," Wilder also uses a play within a play format that allows Sabina and another Stage Manager to address the audience from time to time.

Antrobus is an Everyman. He is an inventor (he has done the lever and the wheel and is working on the alphabet and multiplication tables), a politician (president of the Mammal Society), and a general ("Who won the war?"). When a sudden August snowstorm presages the Ice Age, the Antrobuses face the moral dilemma of whether to let the neighbors share their fire and what remains of their food. Written at a time when there were strong objections to the United States opening its shores to thousands of D.P.'s fleeing the Nazis, this treatise on the plight of refugees can still inspire and instruct today.

Later, when a rain turns into a deluge at a rowdy Mammal convention in Atlantic City, Antrobus abandons his philandering with a beauty queen to organize a world-saving evacuation while a bingo game proceeds in the background and a boardwalk gypsy tells fortunes. But when he returns home from seven years of war, Antrobus finds he has finally lost "the most important thing in the world: the desire to begin again."

But Wilder is nothing if not hopeful. And if the prevailing mood now tends more toward cynicism, a healthy measure of hope is still essential for anyone undertaking to rebuild the world, or even a part of it. Taking heart from his books (Spinoza, Aris-

totle, Plato, the Bible, "voices to guide us"), Antrobus once again begins the task. And it is left to Sabina to remind the audience that "the end of this play isn't written yet."

The director, Robert Hupp, has taken a straightforward approach and produced a revival thoroughly faithful to the original text. If half a century has dulled the edge of some of the jokes, the intrinsic humor of Wilder's imaginative vision still shines through.

The principal roles are ably filled. Craig Smith is excellent as Antrobus, creating a thoroughly human savior who has his dark side as well as his heroic. No less outstanding is Jeanne Demers's performance as Sabina. Her characters — from the Antrobuses' maid to the Atlantic City beauty queen to the "actress" playing both — are all distinct and well-defined. Elise Stone's Mrs. Antrobus and Harris Berlinsky's Stage Manager also stand out. Mark Waterman, as a blind Homer and a bingo caller, and Grant Neale, as an usher called on to read Spinoza, deliver especially fine cameo turns. A couple of the minor roles are not all one might hope, but that is a quibble. The Cocteau is off to a running start for its next 20 years.

1991 S 7, 14:3

Sarrasine

By Neil Bartlett, based on a story by Honoré de Balzac; music, Nicolas Bloomfield; design, Mr. Bartlett; set and lighting, Mr. Bartlett and David Kavanagh; costume design, Mr. Bartlett, Juliet Hamilton and Julie Sissons; photography, Mike Laye, Sean Hudson and Sheila Burnett; graphics, Roy Trevelion; set painting, Alison Inkpen. Presented by Gloria; producer, Simon Mellor. At Dance Theater Workshop, 219 West 19th Street.

Mme. de RochefideSheila Ballantine
La Zambinella
Bette Bourne, Francois Testory and Beverley Klein

By STEPHEN HOLDEN

The notion that sexuality and gender, and not just beauty, are theatrical illusions projected in the eye of the beholder has animated a lot of recent popular theater, from "La Cage aux Folles" to "M. Butterfly." But it has rarely been explored with the richness and depth of feeling that can be found in "Sarrasine," a two-and-a-half-hour musical theater work that is being performed at Dance Theater Workshop through Sunday.

Based on a Balzac story that tells of the obsessional passion of Jean Ernest Sarrasine, a Frenchman, for La Zambinella, a young castrato singer, "Sarrasine" is the work of an English production company called Gloria. The Balzac story was also the focus of a well-known essay by Roland Barthes, of which the creators of "Sarrasine" seem to be aware. For in adapting it for the stage, the show's librettist, designer and director, Neil Bartlett, and its composer, Nicolas Bloomfield, have created a sprawling, post-structuralist music-theater elaboration that is part chamber opera, part music-hall revue.

•

"Sarrasine" is a frequently funny, sometimes anguished reverie on desire and illusion that links castrati, drag performers and the divas they imitate with modern gay culture in a continuum that extends over 250 years. The role of Zambinella is played by three actors. Bette Bourne, the English drag performer, who is

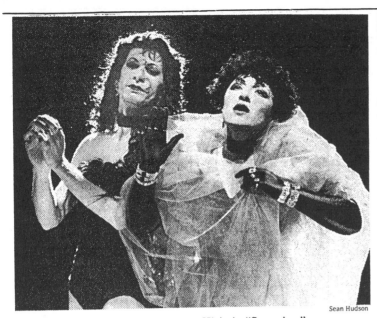

Sean Hudson

François Testory, left, and Beverley Klein in "Sarrasine."

celebrated for his performances with the vaudevillian troupe Bloolips, plays Zambinella as an ancient, broken-down diva.

Beverley Klein, an actress who has portrayed Édith Piaf, gives the middle-aged Zambinella a softened Piafian pathos. François Testory, a French dancer, singer and mime, embodies Zambinella as a youth, when his androgynous beauty and vocal powers were at their peak. Sheila Ballantine plays Mme. de Rochefide, who in the Balzac version is told the tale of Zambinella by a young male suitor and is left so disturbed that she vows to live a celibate life. The character becomes as obsessed with Zambinella as did Sarrasine himself.

•

The drama unfolds as a series of interwoven monologues, songs, and ensemble bits in which the three Zambinellas tell their stories and reflect on their lives. When the audience enters the theater it is filled with smoke, which clears away to reveal a setting that suggests a decrepit opera house cum music hall. Everything the three Zambinellas do is executed with show-business flourish that varies in tone from the high flown to the crudely campy.

Mr. Bloomfield's extensive score is as chameleonlike as the central character. The music parodies operatic styles from Monteverdi to Bellini to Puccini, interweaving them with more contemporary English and French music-hall numbers in which the performers express themselves more directly. Mr. Bloomfield, who plays piano and harpsichord, leads an ensemble that includes oboe, viola and double bass. The score is demanding, and the quartet's ragged, sometimes out-of-tune playing is the show's biggest weakness.

But the performances are so commanding that the musical deficiences seem minor. As the 250-year-old Zambinella, Mr. Bourne is a phantasmal apotheosis of a renegade erotic spirit, at once a ruined (though regal) grand dame and a sad clown. His bravura performance is nearly matched by Mr. Testory's portrayal of the youthful Zambinella as a star who while showered in Champagne, jewels and adoration, stands trapped within the illusion he projects. Wearing a tawdry stripper's outfit and singing in both a baritone and in a clear falsetto, he connects the operatic world of the

castrati with the music-hall world of the drag performer, revealing them as essentially the same, at least through the eyes of the isolated performer who creates the magic. As the master illusionist of desire, his Zambinella is as scornful of his suitor as he is protective of his power to project an illusion that is finally shattered with the confession that he is not a woman.

•

The reverberations of "Sarrasine" extend beyond obvious sexual politics having to do with role-playing and sexual diversity, to art and especially to performance and the notion of glamor. Why are we attracted to it? And what do we want from it? And isn't any attraction to a performer really a dream of love?

"Sarrasine" ends with a question, intoned as a music-hall torch song by Mr. Bourne in a husky, world-weary voice. "If your dreams aren't dreams of love," he sings, "how will you live when you're awake?"

1991 S 9, C16:4

Another Person Is a Foreign Country

By Charles L. Mee Jr.; directed by Anne Bogart; music by Daniel Schreier; sets by Kyle Chepulis; costumes by Claudia Brown; lights by Carol Mullins; sound designer, Eric Liljestrand; music director, John M. Buchanan; production stage manager, Paul J. Smith. Presented by En Garde Arts; producer, Anne Hamburger; associate producer, Portia Kamons. At the Towers, 455 Central Park West, Manhattan.

Jimmy	Robert Beatty Jr.
Opera Singer (Linus)	Victoria Boomsma
Manuel, the boy	Rashid Brown
Twin 1 (Milicent)	Christine Campbell
Isabella	Maria Clarke
Ajax	Bruce Hlibok
Fergie	Marie Kalish
Ethyl	Terence Mintorn
Poet	Tom Nelis
Jennifer	Jennifer Rohn
Mike	David Steinberg
Twin 2 (Melody)	Kelly Taffe

With: Adam Auslander, Paul Carter, Irene Fitzpatrick, Erika Greene, Emily Knowles, Monica Koskey, David McIntyre, Mary McBride, Barry Rowell, Roy Scott, Richard Sheinmel, Natalie Trapnehis, Halina Ujda and Lora Zuckerman.

By STEPHEN HOLDEN

One would be hard put to find a more dramatic outdoor setting for a play than the courtyard of the Towers, a decrepit fortress at 106th Street off Central Park West that is the location for the En Garde Arts production of "Another Person Is a Foreign Country."

It was built in the late 19th century by the architect Charles Coolidge

Haight and served as the first American hospital devoted entirely to cancer care. In the 1950's, it was converted into a nursing home by Bernard Bergman, whose syndicate of nursing homes became the focus of a series of state investigations in the 1970's that revealed widespread patient abuse.

Condemned and left vacant for 15 years, the the Towers has fallen into spectacular disrepair. And in some of the most indelible moments of "Another Person Is a Foreign Country," it becomes a Gothic house of horrors in which members of the cast writhe like terrorized prisoners, illuminated

A surrealistic panorama of a world that is cold and cruel to most.

by candlelight in the building's decaying rooms.

One of the goals of En Garde Arts, a production organization run by Anne Hamburger that specializes in site-specific performances at New York architectural landmarks, is to relate each piece to the history of its setting. Last year, for instance, En Garde turned several streets in the meat-packing district into the setting of a surreal family banquet for a production called "Father Was a Peculiar Man," based loosely on "The Brothers Karamazov." These tableaus have a similarly startling visual impact.

•

"Another Person Is a Foreign Country," which opened a four-week engagement at the Towers on Sunday

William Rivelli/"Another Person Is a Foreign Country"

A scene from the En Garde Arts production of "Another Person Is a Foreign Country."

evening, is a sprawling 90-minute pageant written by Charles L. Mee Jr., and directed by Anne Bogart. It features an ensemble of 35 actors, many of whom are people considered marginal to mainstream society because of physical disabilities that include blindness and deafness or because of race, sexual orientation or old age. Some of the cast members were recruited through agencies serving the disabled.

Working closely with the actors, who tell stories that often deal with the problems of being an outsider, Ms. Bogart and Mr. Mee have created a messy, many-layered surrealistic show whose focus is a large banquet table in the center of the courtyard. In an extended prologue to the piece, the table is gradually set by actors dressed as angels for a dinner that never arrives, while the players, who include a choir of blind and visually impaired singers, intone the words "May we serve you."

Finally, the actors emerge from the building, some carried in the arms of others, and arrange themselves around the table. Among the characters to take turns speaking at a testimonial banquet, which might have been imagined by Luis Buñuel, are a poet who has visionary fits (Tom Nelis); a transvestite named Ethyl (Terence Mintern); Milicent and Melody (Christine Campbell and Kelly Taffe), black women who are twins; Ajax (Bruce Hlibok), who is deaf, and Fergie (Marie Kalish), an elderly woman.

Some of the stories are wrenching. The most powerful is Ajax's description of an insensitive piano teacher's sadistic attempts to force him to "hear" music. On a somewhat lighter side, a midget (David Steinberg), tells of his encounters with Jean Genet in Tangier and recalls the time he visited a nightclub and was literally picked up by a strange woman who took him to the dance floor for a whirl.

●

Interwoven with the stories taken from the performers' own lives are Mr. Mee's incantatory meditations on the cruelties of the world, many of which are recited by Robert Beatty Jr. One passage enumerates the ways of killing a rat, another matter of factly lists methods of human torture. Periodically, the verbiage is suspended and the entire company erupts in a spasm of ritualized chaos, tumbling on the dirt, dancing and wailing from the windows and surrounding scaffolds, while a band plays loud music.

If the individual speeches are dramatically uneven (and diminished by the tinny outdoor miking), "Another Person Is a Foreign Country" still makes a strong theatrical impact. In relating the horrors of the world to the morally blighted history of the site, it paints the seedy castle and its inhabitants as a microcosm of the world.

The biggest risk facing En Garde Arts was in inadvertently presenting a sophisticated freak show. Very quickly, however, one's awareness of the actors' differentness shifts into a deeper recognition of human diversity. The work also avoids the opposite pitfall of conjuring an atmosphere of smug, cozy togetherness.

"Another Person" surges with vitality, but it doesn't shrink from its vision of the world as a chamber of horrors where only a lucky few get to sit at the banquet table and happily gorge to their hearts' content.

1991 S 10, C11:1

Sublime Lives

By Paul Firestone; directed by William E. Hunt; sets, Don Jensen; costumes, Traci di Gesu; lighting, David Neville; production stage manager, Otis White. Presented by Merry Enterprises Theater Inc.; artistic director, Lily Turner. At Theater Row Theater, 424 West 42d Street, Manhattan.

Richard Mansfield	William Verderber
William Winter	Jordan Charney
Fred	Ron Keith
Henry Salomon	Lenny Singer
Beatrice Cameron	Pamela Cecil
Clyde Fitch	Hans Freidrichs
Constance Neville	Susan Farwell

By WILBORN HAMPTON

It might seem gratifying to some critics to think that actors would sell their souls for a good review. It might seem even more satisfying for anyone on the other side of the footlights — actors, directors, producers, even budding playwrights — to believe that critics would sell their good opinion for a few dollars stuffed in an envelope. Paul Firestone assumes both points of view in "Sublime Lives," his slight first play at the Theater Row Theater, in which the author has taken a cast of characters from the American theater of a century ago and tried to fabricate a morality tale around them.

Mr. Firestone is clearly smitten by the theater, especially the fin de siècle era of actor-managers whose fame often rested as much on their egos as on their talent. At the center of "Sublime Lives" is Richard Mansfield, who is about to commission the play "Beau Brummell" from an aspiring young playwright named Clyde Fitch. In Mr. Firestone's version, this rouses the jealousy not only of William Winter, the drama critic for The New York Tribune, who wants to write the play himself, but also of Beatrice Cameron, Mansfield's leading lady and future wife, who is afraid Fitch will seduce him.

●

It is always a risky business to take real figures from history and force a fiction on them to teach a lesson. The moral tends to be obscured in direct proportion to the number of liberties taken. Mansfield, for example, was a genuine stage star for whom "Beau Brummell" was a huge success; Fitch was a sort of Neil Simon of his day, a popular and prolific playwright known mostly for social comedies and melodramas, and Winter was a well-known critic who had the bad luck to have poor taste and is remembered mostly for his savage attacks on new writers like Ibsen and Shaw (two playwrights, by the way, whom Mansfield later championed).

●

In his eagerness to drop names from that most important decade of the dawn of the modern theater, Mr. Firestone tends to get a little careless. It is one thing to have Fitch claim a friendship, even a liaison, with Oscar Wilde and another to have him read "Dorian Gray" a year before it was published in Lippincott's magazine. Or to have Mansfield receive a copy of one of Shaw's plays before he started writing them. Or to have Beatrice Cameron return from a trip to England, where she saw "Lady Windemere's Fan" a year before it opened, and have supper with "Wilde and Bosie" before the author had even met Lord Alfred Douglas.

But there are more serious problems of structure and characterization with "Sublime Lives." Mr. Fire-

stone undermines the moral dilemma he tries to build for Mansfield by compromising his hero's integrity in the opening scenes. By the end of the first act, Mansfield has staged a bogus phone call from President Benjamin Harrison to get a bank loan, passed on bribe money to Winter for his good reviews, and lied to everyone around him. One doubts the Mansfield of Mr. Firestone's play would have any qualms about anything short of a felony except in how it might reflect on himself.

Mr. Firestone also makes a mistake common to beginning playwrights by having most of the interesting parts of his story take place offstage. In the case of "Sublime Lives" most of the drama seems to happen during intermission. The first act ends with several questions hanging. Coming back for the second act, the audience is informed in recitative fashion about all that's gone on while they were away.

A couple of good performances under William E. Hunt's direction manage to keep one's interest from wandering too far. William Verderber is thoroughly credible as Mansfield, capturing the posturing of a matinee idol without going overboard and keeping his unflagging self-interest within the normal bounds of any superstar. Jordan Charney's Winter is a portrait of well-bred corruption and snobbish villainy. Hans Freidrichs is somewhat affected as Fitch, although he makes the most of one genuinely funny scene. In it, Fitch flirts with Mansfield by telling about a previous incarnation in which Fitch was one Willie Hughes, an actor and "intimate friend" of Shakespeare who created the role of Juliet ("Shakespeare wrote the part for me") and who was the "Mr. W. H." to whom the sonnets were dedicated.

1991 S 16, C14:4

Tartuffe

By Molière; translated by Donald M. Frame; directed by Shepard Sobel; set design, Robert Joel Schwartz; costume design, Barbara A. Bell; lighting design, Richard A. Kendrick; sound design, Donna Riley; stage manager, David Waggett. Presented by the Pearl Theater Company, 125 West 22d Street.

Mme. Pernelle	Anna Minot
Flipote	Janine Lindsay
Damis	Hank Wagner
Mariane	Kathryn Lee
Dorine	Julia Glander
Cleante	Dugg Smith
Elmire	Joanne Camp
Orgon	Frank Geraci
Valere	Arnie Burton
Tartuffe	Martin LaPlatney
M. Loyal	Earle Edgerton
A Gentleman	Alex Leydenfrost

By D. J. R. BRUCKNER

By the end of the Pearl Theater Company's production of Molière's "Tartuffe" one is a little suprised that any of the actors has breath left for a last laugh.

There is something to be said for fast pacing in a venerable old comedy like this. But the director, Shepard Sobel, rushes the cast through the play so quickly that meaning and emotion are lost in key scenes.

●

The problem is most acute in the famous sting scene, where Elmire, the wife of the gullible Orgon, who has been duped by the pious fraud Tartuffe, seduces the hyprocrite into seducing her on top of a table while the

appalled Orgon listens and watches from underneath it.

As it is written, this passage is miraculously economical. But, without the right pauses, without mute hesitations and speaking glances and internal struggles, it becomes unbelievable — slapstick at best. After all, no matter how lust-crazed Tartuffe has become, his ability to con Orgon out of house, fortune and family indicates a lot of wary caution in the man, and Molière has him express some of that at the beginning of the scene. In this production Elmire gets him out of his pants so quickly he looks like a simple fool, and a lot of the playwright's humor, as well as his subtlety, is missed.

To be sure, every character in "Tartuffe" is foolish, but in any Molière play folly is no simple fault; it has depths and it grows. An audience ought to be able to savor the slow revelation of how empty-headed Orgon's son and daughter, and the daughter's lover, are. Here they are all transparent from the beginning. They exist only when they speak. That's too bad. Some of the most essential developments in this play happen in silence.

Finally, what one misses most here is the sheer audacity of Molière — not as a social satirist but as a dramatist. His characters, deluded or not, are affronted, injured, cheated. Anger, pain and despair lurk just out of sight, so that one ought to be astonished, even bewildered, by his own laughter. To play "Tartuffe" only for the laughter is to diminish the playwright.

●

What is welcome here is the new translation by Donald M. Frame, best known for his English rendition of Montaigne. It is fresh and racy but not without a certain appropriate formality. Now, if someone could convince most members of this cast that the rhymes in Mr. Frame's couplets will be heard clearly without any effort by the speaker to produce a monotonous clangor ... but that might be demanding too much.

1991 S 16, C14:4

Esperando la Carroza

By Jacobo Langsner; directed by Braulio Villar; sets, lighting and costumes, Robert Weber Federico; technical director, Rigoberto Obando. Presented by Repertorio Español; producer, Gilberto Zaldívar; artistic director, Rene Buch. At 138 East 27th Street, Manhattan.

Jorge	René Sánchez
Mamá Cora	Ofelia González
Susana	Vivian Deangelo
Sergio	Ricardo Barber
Elvira	Virginia Rambal
Matilde	Irma Bello
Nora	Adriana Sananes
Antonio	Carlos Osorio
Emilia	Ana Margarita Martínez-Casado
Jovencito	Cheo Oliveras
Doña Gertrudis	Chela Herrero
Doña Elisa	Lilia Veiga
Señora	Katerina Lladó

By D. J. R. BRUCKNER

As a personal achievement in private life, scandal is no longer attainable in this country; the word is still used about some aberrations in public life, but even there the meaning has worn so thin most people cannot perceive it.

Too bad. The sense of scandal was a wonderful vehicle for comedy, as "Esperando la Carroza" ("Waiting

Gerry Goodstein/"Esperando la Carroza"

Adriana Sananes in "Esperando la Carroza," by Jacobo Langsner.

for. the Hearse'') by the Uruguayan playwright Jacobo Langsner reminds one. Mr. Langsner's farcical romp, playing at the Repertorio Español's Gramercy Park Theater, traps all of its conniving characters in one form of personal scandal or other to expose their greed, hypocrisy, mendacity, lust and mere sloth. What makes the pretensions of these people so funny is the firm conviction of every character that even a whisper about the slightest lapse from rigid morality will create a scandal in a family, then among neighbors and finally in the whole world.

Mr. Langsner seems to find absolutely everything about the human condition laughable, including the audience; he tickles all right, but sometimes with a knife point. Here the plot is definitely secondary; what matters is the crackle, wit and effrontery of the dialogue. Under the vigorous direction of Braulio Villar, the members of this company make the lines sound like the fire of automatic weapons.

•

The story, set in an unnamed Latin American city, is about an aged woman, Mama Cora, whose increasing and energetic waywardness makes her a difficult problem for her middle-aged daughter and three sons and something of a demon to the sons' three wives. Mr. Langsner makes no attempt to be delicate about all this, especially after the police report that an old woman has flung herself under a train and conclude it must have been Mama Cora since the victim was wearing Mama Cora's shoes. This is an excuse for an orgy of mourning and disastrous self-revelation, especially by Mama Cora's three daughters-in-law.

In those roles Virginia Rambal, Adriana Sananes and Vivian Deangelo have to carry the play, and they fly with it. Given Mr. Langsner's conviction that rot rises with class, one of the women is poor, one middle-class and one rich. But his contempt is quite democratic. While Ms. Sananes as the rich one is the most comic of the three, and Ms. Rambal as the figure of middle-class envy is the most intelligent and biting, it turns out at the last moment that Ms. Deangelo's poor overworked housewife is the most cunning of all.

The material here is all old-fashioned stuff. It is up to the director and actors to make something of it. So it is a perfect piece for this company,

whose members, in slight and unintrusive ways, always let the audience in on the interplay of rivalries among actors. Mr. Villar, the director, has done things for the play the author did not bother to do. He has trimmed out a couple of characters who added nothing but more confusion to the already chaotic second act. And his judicious cutting of lines in that act gives the play much more speed than the original, making one pay attention to how funny, not how improbable, the last few minutes are.

For reasons no one bothered to note in the program, simultaneous English translation of the Spanish dialogue, on the theater's infrared sound system, will not be available until Feb. 22, when the play will be back in the repertory. But for people who want a good laugh, it is worth waiting for.

1991 S 18, C15:1

Unidentified Human Remains and the True Nature of Love

By Brad Fraser; directed by Derek Goldby; scenery and costumes, Peter Hartwell; lighting, Kevin Rigdon; original music and sound, Richard Woodbury. Presented by Michael Frazier, Richard Norton and Ted Snowdon. At the Orpheum Theater, 126 Second Avenue, at Eighth Street.

Benita	Kimberley Pistone
David	Scott Renderer
Candy	Lenore Zann
Bernie	Clark Gregg
Kane	Michael Connor
Jerri	Michelle Kronin
Robert	Sam Rockwell

By MEL GUSSOW

In the eyes of the playwright Brad Fraser, Edmonton, Alberta, is the bleakest of cities, filled with dropouts and dead-enders who have no aim except to pass a 10-month winter with casual sex, alcohol and hard drugs. For some, life is meaningful only when one is flirting with death. This is, Mr. Fraser suggests, an ideal breeding ground for a serial killer.

The view in his play, "Unidentified Human Remains and the True Nature of Love" (at the Orpheum Theater), is cynical in the extreme — a pitch black vision of people falling off the edge. With its pungent dialogue and highly graphic sexuality, the play repeatedly arrests the audience's attention, but the cynicism wears thin and the plot is porous. This study of sex and violence is not, as intended, a thriller. Instead of being mysterious, it telegraphs its twists, and at moments it approaches sentimentality.

•

After a first act in which the characters simulate diverse forms of sexual congress — you name it, they do it — one wonders what could be left for the second act. The answer is, not much, except for the unmasking of the killer, whose identity has been hinted at from early in the evening.

Only at moments does "Human Remains" evoke an eerie atmosphere, and that largely derives from a minor character, a psychic prostitute (Kimberley Pistone) who interrupts the action to tell hair-raising comic tales of murder and dismemberment.

Miss Pistone operates on the fringe of the play, where she is visited by the protagonist (Scott Renderer), a television actor who has become a waiter because he finds it "more artistically

satisfying." As directed by Derek Goldby, the actors add immeasurably to the endeavor, especially Mr. Renderer and Lenore Zann as his roommate (in formulaic fashion, he is gay; she is straight; they are soulmates).

Mr. Renderer keeps his character cool but with a certain charm. He is quite amusing in one sitcom scene in which Miss Zann is confronted simultaneously with her male and female suitors. In this domestic quarrel, Mr. Renderer is a gadfly on the wall.

As called for, Miss Zann acts impetuously, then becomes immediately disoriented, whether she is in bed or indulging in a junk food pigout. There is also a sweet-tempered performance by Michael Connor as a rich, highly impressionable teen-ager and there is an insidious performance by Clark Gregg as the one person with a sense of employment.

As a motif, the characters improvise their activities, with Mr. Renderer leaving himself open "for whatever." But in this environment "whatever" leads neither to fun nor reward, and certainly not to love.

For a play that is so concerned with the omnipresence of its setting, it is curious that there is not a single mention of hockey, to outsiders the essence of Edmonton. Perhaps if these self-defeated thirtysomethings had gone to an Oiler game, they would have found at least momentary distraction if not exultation.

1991 S 20, C26:4

Accident: A Day's News

By Christa Wolf, adapted from her novel by Ninth Street Theater with script assistance by Eileen Myles; directed by Joanne Schultz; music composed and performed by Ralph Denzer; lights, Mark Sussman; paintings, Donna Evans; puppet, Stephen Kaplin. Presented by Bartenieff/Field. Performed by Ninth Street Theater. At Theater for the New City, 155 First Avenue, at 10th Street.

The Writer	Jody Moore
The Brother/Scientist	Stephen Kaplin
The Other	Joanne Schultz
Taped Voices (Heinrich Plaack, a Radio Preacher)	Jack Sheedy
Taped Voices (Experts on the Radio)	John Bell and Stephen Kaplin

By STEPHEN HOLDEN

Now that the cold war has eased, collective fears of nuclear catastrophe may have abated. But as accidents like the ones at Chernobyl and Three Mile Island have shown, war isn't the only avenue to nuclear nightmare. And "Accident: A Day's News," a play based on a short novel by the German author Christa Wolf, offers a reminder that the unthinkable disasters still loom.

The one-hour performance piece, which plays at the Theater for the New City through Sunday, is a meditation on the meltdown at Chernobyl that blends diary excerpts, puppetry, music and scientific lore into a kind of personalized science fiction. Performed on a set of movable panels depicting the inside of a nuclear reactor, the piece intersperses the reflections of a character called the Writer (Jody Moore) with depictions of a nuclear scientist undergoing brain surgery. The scientist is represented by a Bunraku-style puppet manipulated by Stephen Kaplin. An atmospheric cool-jazz-flavored score composed and performed by Ralph

Martin Lucas/"Accident: A Day's News"

Jody Moore with a puppet representing a nuclear scientist undergoing brain surgery in "Accident: A Day's News."

Denzer, who plays a synthesizer and muted trumpet, accompanies the action.

•

An intriguing notion proposed by the play is that nuclear fission, in the deepest metaphorical sense, is an extension of the human brain. Why, the author asks, do scientists who know they have discovered forces as destructive as nuclear power feel compelled to follow through and develop what the author calls "absolute experiments"? On a mythic level, the nuclear specter is compared to a children's fairy tale about the drinking of forbidden water that turns people into wild beasts.

These musings punctuate the writer's day-by-day record of events, feelings and emerging scientific data in the immediate aftermath of the Chernobyl disaster. The reflections culminate with a personal nightmare of putrescence and death.

If "Accident" has metaphorical resonance, its theatrical elements are not well integrated in Joanne Schultz's gawky, threadbare production. The writer's interactions with another character known as the Other, who is played by the director, are mystifying, and Ms. Moore's and Ms. Schultz's line-readings are monotonously flat. The puppetry and dialogue are so crudely integrated that a show conceived as a theatrical collage has the feel and texture of no more than an illustrated reading.

1991 S 23, C14:3

Bon Appétit!
Two Musical Monologues

Music by Lee Hoiby; words by Ruth Draper and Julia Child; directed by Carey Perloff; sets, Donald Eastman; costumes for "The Italian Lesson," Rita Riggs; costumes for "Bon Appétit!," Jean Putch; lighting, Mary Louise Geiger; musical direction, Todd Sisley; adaptations, Mark Shulgasser; production stage manager, Crystal Huntington. Presented by CSC Repertory; artistic director, Carey Perloff; managing director, Patricia Taylor. At CSC Theatre, 136 East 13th Street.

Mrs. Clancy Jean Stapleton
Julia Child................................ Jean Stapleton

By MEL GUSSOW

Anyone who has seen Julia Child on television knows that she is the most theatrical of French chefs, tossing off bons mots with the same panache that she flings eggshells over her shoulder. Capitalizing on Miss Child's effervescent personality, Lee Hoiby has had the novel notion of taking one of her popular television cooking classes and setting it to music.

The result puts Jean Stapleton in a mock-up of a kitchen onstage at the CSC Repertory, where she sings the recipe. "Bon Appétit!," the second of two one-woman mini-musicals linked under that title, is airy, as intended in Miss Child's creation of gâteau au chocolat, l'éminence brune, the subject of the evening's lesson.

But while watching Miss Stapleton talk in Miss Child's shoes, one may well wonder where's the boeuf à la mode? As an appetizer, there is only an unnecessary musical adaptation of the Ruth Draper monologue, "The Italian Lesson." The slight double musical (directed by Carey Perloff) is lacking in a main course.

In Miss Draper's sketch, a Park Avenue club lady does everything to avoid concentrating on studying Dante. She makes phone calls, talks to her children and plans menus (without benefit of a Julia Child). The monologue, celebrated in its time and for Miss Draper's performance, shows its age more than its mettle. Mr. Hoiby's score merely adds a musical background and makes the piece seem twice its natural length.

The Julia Child musical arrives none too soon — for the actress as well as the audience. It offers Miss Stapleton, last seen extending her range at the CSC in plays by Pinter and Molière, an opportunity to put on her mad cap, which she does with nonchalance. She mimics Miss Childs's distinctive voice as she rolls up her sleeves and dives into her "battle plan" (or is it "batter plan"?). A general of the kitchen, she mimes the marshaling of her pots, pans and cornstarch and suggests that anyone following her instructions should have "a self-cleaning kitchen like mine."

With an abandon that is characteristically Julia Child, she stages a race between a hand beater and a mixing machine and is caught up in the exercise. As the actress sings and pretends to cook, Todd Sisley accompanies her on the piano, underlining the words with food music. Mr. Hoiby, as composer, reaches his pinnacle when Miss Stapleton beats her imaginary egg whites into stiff shining peaks. At this point, the music ripples.

While snacking on this modest little kitchen-stove musical, one must acknowledge that it offers no ironic commentary on Miss Child, who might be a suitable subject for satire. Furthermore, it would be more amusing if this were an actual kitchen, with a real flurry of flour. As the

opening item on this season's menu at the CSC, "Bon Appétit!" encourages one's appetite for more nourishing theatrical provender.

1991 S 26, C18:3

Macbeth

By William Shakespeare; directed by Gus Kaikkonen; set design, Bob Barnett; costume design, Pamela Scofield; lighting design, Stephen J. Backo; music, Ellen Mandel; fight direction, Ian Rose; production stage manager, Matthew G. Marholin. Presented by Riverside Shakespeare Company. At Playhouse 91, 316 East 91st Street.

Duncan/Porter Victor Raider-Wexler
Malcolm.................................... Don Reilly
Sergeant/Caithness.................... Alex Spencer
Donalbain................................ Aaron Goodwin
Ross Dan Daily
1st witch Olivia Charles
2nd witch Jeannie Dobie
3rd witch/Lady Macduff Kathleen Christal
Macbeth................................ Stephen McHattie
Banquo.................................... Gilbert Cruz
Lady Macbeth.................... Jennifer Harmon
Seyton.................................... Brian Mulligan
Fleance Joseph Acosta
Macduff.......................... Richard McWilliams
Lennox/Lady Ross Diane Ciesla
Young Ross Martin Hynes
1st murderer Robert Ruffin
2nd murderer Steven Satta
Boy Macduff Richard Bereck
Boy Macduff (Alt).......Edwin Hansen-Nelson
DoctorAbe Novick

By MEL GUSSOW

Foul is fair in Gus Kaikkonen's vaguely updated version of "Macbeth" for the Riverside Shakespeare Company. The three witches have been transformed into attractive, nun-like Army nurses who begin the play by ministrating to the needs of wounded soldiers in a World War I field hospital. This is a confusing overlapping of the first and second scenes of the play.

Later the unweird sisters appear in Macbeth's nightmare, hovering around his bed along with a ubiquitous doctor to give him a shot of an unknown substance. In other words, in this quasi-interpretation, drugs may be the cause or the aftermath of Macbeth's mania. There is no cauldron in sight, no witches' brew, thunder or mystery. There is not much of a "Macbeth" on this stage, despite Stephen McHattie's performance in the title role.

In this troublesome approach, Lady Macbeth (Jennifer Harmon) is not a malevolent presence. Her sleepwalking scene is so mild, in fact, that it would not wake the neighbors. Almost everything is played out under bright lights, which vitiates the feeling of menace. Some of the doubling in roles is distracting. One witch, for example, also plays Lady Macduff, and King Duncan is also the Porter.

One distinct problem is the choice of military hardware. Some of the soldiers carry rifles, others have swords. Several, obviously low in rank, march into battle with small shovels. They look like garden tools, suitable for potted plants. A spade is a spade for all that, and theatergoers should have no doubt which characters will be the losers.

Though warned about the walking woods, Macbeth is surprised by a small band of soldiers carrying tiny twigs, what might be considered the bonsai version of Birnam. There are bigger boughs at any nearby sidewalk florist than there are onstage at Playhouse 91. The purpose may be thrift, but the result is overly spartan.

Behind all this cavalier conceptualization, there are a few defensible aspects to the Riverside "Macbeth," including Bob Barnett's useful, Japanese-style set. Mr. McHattie is a forthright Macbeth and is clearly capable of performing the role in a more faithful production. He is evenly matched by Richard McWilliams as Macduff. Their duel is the sharpest moment in the evening.

Earlier, Mr. McWilliams is victimized by one of Mr. Kaikkonen's more ill-conceived notions. When Macduff seeks out Malcolm to convince him to

return to Scotland, he finds him lolling on a blanket with a lady friend. The couple look and sound like figures from an Oscar Wilde comedy. The lady, who does not exist as a character in Shakespeare, suddenly becomes Malcolm's protector and draws a pistol on Macduff, demanding that he lay off Malcolm. At this and other points, a theatergoer might be justified in borrowing Macbeth's final words: "Hold, enough!"

1991 S 27, C15:1

SUNDAY VIEW/David Richards

What Would Sally and Geraldo Say?

In 'Unidentified Human Remains,' the nudity and obscenity volumes are on high.

In 'Tartuffe,' impulsiveness is on low.

I AM NOT ONE TO TUNE IN THE DAYtime talk shows on television, so it was pure happenstance that I recently caught Geraldo Rivera interviewing a man who had been lured into and escaped from the apartment of the self-confessed serial killer Jeffrey Dahmer. The following morning, as the luck of the dial had it, I stumbled upon Sally Jessy Raphael commiserating with a mother who had accidentally run over her daughter with a lawn mower.

In both cases, I watched until these two understandably distraught souls burst into tears, which wasn't all that long. (Sobbing is as ubiquitous on daytime TV as the laugh track is on prime time.) What little I saw, however, made me queasy enough to switch off the set.

I'm not an ostrich — I know people and lawn mowers do terrible things — and I wasn't just reacting to the macabre subject matter. It was Geraldo and Sally who were responsible for my uneasiness — he, suggesting with his furrowed brow and locked jaw an Old Testament gravity; she, all but drowning her guest with melting looks of compassion. What, I couldn't help asking myself, were they really up to? And what did they want from me? Was I supposed to be horrified or forgiving? Count my lucky stars? Curse the fates? Or maybe just keep watching?

I wouldn't bring this up if I hadn't experienced a similar reaction the other night at "Unidentified Human Remains and the True Nature of Love," the drama by the Canadian playwright Brad Fraser that has taken up residence Off Broadway at the Orpheum Theater. With a dauntlessness that Sally and Geraldo would recognize, it purports to show

Carol Rosegg/Martha Swope Associates/"Unidentified Human Remains and the True Nature of Love"

Kimberley Pistone as Benita in "Unidentified Human Remains and the True Nature of Love"—users and abusers

us the mating games of seven young people in Edmonton, Alberta — a locale, if we are to believe the hometown playwright, rarely given to carefree days and even less to joyous nights.

Besides laying claim to the world's largest shopping mall, the city apparently boasts one of Canada's highest violent crime rates per capita. Accordingly, while Mr. Fraser's seven characters — barely a step or two above riffraff — go about searching for love in all the wrong places, a mass murderer stalks the shadows for his next victim. Suspense is the last thing on the playwright's mind, though. The unmasking of the killer comes as no surprise when it finally occurs. He's simply the ultimate extension of neuroses that, to lesser degrees, are shared by all the characters. Everyone in this relentlessly grim chronicle of feverish sexual mores uses and abuses his partner of the moment, before moving on to the next unfulfilling conquest.

"I've never met anyone born after 1960 who wasn't incomplete somehow," laments David (Scott Renderer), a onetime TV performer now scraping by as a waiter and gay hustler. "Microwaves," he adds, by way of explanation. That's as good as any given by Mr. Fraser, who seems to define these people primarily by what they do in bed. Bernie claims to be straight but entertains more than comradely feelings for David, who lives platonically with Candy, but pines for Kane, a teen-age busboy. Candy, for her part, is being besieged by Robert, a married bartender, and by Jerri, a lesbian in her aerobics class. Benita, a hooker and Louise Brooks lookalike, sleeps with pretty much anybody.

If Mr. Fraser had a surer sense of structure, I suppose you could credit him with a latter-day version of "La Ronde." But his play proceeds in staccato bursts of dialogue. Like atoms, the characters come together, break apart and recombine — careering, in the process, from one pool of light to another. A scene may be considered protracted if it lasts more than a minute. A whole society's on the prowl, and what few connections are forged in desperation are fleeting and squalid. This gives "Unidentified Human Remains" a jagged restlessness. Once you've got that much, however, I'm afraid you've got it all.

Mr. Fraser seems to hold the times accountable for the behavior of his characters. (If only the times were nicer, they would be, too.) "Everyone lies" is a recurring complaint. The admonishment to "Be yourself" elicits the retort "Which one?" Male and female alike carry the onerous burden of their "stuff." The telephone-answering machine is the emblem of their solitude. ("Call me!") They have sex all the time, but "I love you" is uttered only in cases of extreme duress.

The British director Derek Goldby, greatly aided by Richard Woodbury's ominous music and Kevin Rigdon's brooding lighting, manages to evoke a spooky climate on the boxy Orpheum stage. But climate is not drama, merely one of drama's aspects. The actors are hard pressed to rescue these sorry creatures from the province of cliché. When they do, it is usually to tumble into the morass of self-pity — Mr. Renderer more than most. Clark Gregg is the sole exception, as Bernie, a minor government worker with an addiction to late-night life. Watching his but-

toned-down Ivy Leaguish presence come un-buttoned is not without its fascinations.

■

Otherwise, I'm not entirely sure what we are to make of "Unidentified Human Remains." It is not an enigmatic work, but its motives strike me as questionable. It tries to be shocking, although like most enterprises with that ambition, it underestimates our sophistication. The sexual encounters are graphically enough staged to indicate that titillation is a considerable part of the game plan. Nudity is prevalent. Obscenities abound. Mr. Fraser wouldn't be looking to the box office, would he?

A playwright can always claim, of course, that he's not responsible for what's under the rocks he lifts up, and that enlightenment is his objective, however unsavory his topic. Something about the pandering tone of "Unidentified Human Remains" prevents me from believing the argument this time. I no more believe it when Sally and Geraldo blanket their guests with understanding and ask them, as the camera zooms in close, to share their innermost feelings with the viewing public. The tactics are too exploitative, the inevitable revelations too tawdry to justify the prying. The only cause that is being served, it seems to me, is that of voyeurism. Only no one's saying so.

If the creators of "Unidentified Human Remains" were honest about matters, they'd erect a big keyhole between the audience and the stage. At least there would be no question about where we stood.

'Tartuffe'

The usual view of Molière's "Tartuffe" is that it is a play about the devious ways of a religious hypocrite. Not so. It's a play about a family of hotheads dealing with the religious hypocrite in their midst. Tartuffe is the eye of this particular storm, cold and calculating. He loses his self-control only in the presence of his benefactor's wife, whom he finds sexually irresistible. And even then, he's leery about giving in too readily to her charms and has to be coaxed.

The other characters, however, are popping off left and right, venting their anger, voicing categorical opinions with a vehemence that refuses to recognize they'll be contradicting themselves in short order. The impulsiveness bridges three generations — from Madame Pernelle, the outspoken grandmother, to her headstrong son, Orgon, right on down to Orgon's temperamental offspring, Damis. It's no surprise that Molière, who usually reserved the richest assignments in his plays for himself, passed over the part of Tartuffe for that of Orgon. Tartuffe puts all his energy into hewing the straight and narrow — or appearing to. Orgon gets to go to the comic extremes.

However, in the inert production of the play staged by Shepard Sobel for the Pearl Theater Company Off Broadway, there's no sense of the family's endemic recklessness, scant evidence that its members invariably act first, then think second, if they think at all. Looking like mildly vexed porcelain figurines, the actors labor to make the rhymed couplets in Donald Frame's translation sound conversational. In doing so, they succeed merely in making the verse crushingly monotonous. They also pose a lot, holding their hands delicately away from their bodies — which doesn't so much suggest the elegance of 17th-century France as it does a shortage of paper towels in the washroom.

It's no surprise that Molière, who usually took the richest roles, passed over the part of Tartuffe.

Arnie Burton puts some dash into the proceedings as the suitor of Orgon's daughter. And Martin LePlatney's stringy-haired Tartuffe is properly repugnant, when he appears. But by waiting for him to stir up the pot, this modest production errs seriously. After all, Tartuffe doesn't make his entrance until nearly the halfway mark, whereas the distraught household is reeling from the start. Not that you'd know it here. This overreaching troupe has trouble just working up a tizzy. □

1991 S 29, II:5:1

The Time of Your Life

By William Saroyan; directed and designed by Liviu Ciulei; costumes, Marjorie Slaiman; lighting, Nancy Schertler; choreography, Joey McKneely; sound, Susan R. White; dramaturg, Laurence Maslon; technical director, James Glendinning; stage manager, Maxine Krasowski Bertone. Presented by Arena Stage, Douglas C. Wager, artistic director; Stephen Richard, executive director; Guy Bergquist, general manager. At Washington.

Joe	Casey Biggs
Nick	Jeffery V. Thompson
Willie	Sean Baldwin
Tom	Kevin James Kelly
Kitty Duval	Pamela Nyberg
Harry	Joey McKneely
Dudley	John Leonard Thompson
Wesley	Teagle F. Bougere
Blick	Henry Strozier
Mary L.	Tana Hicken
Krupp	David Marks
McCarthy	Michael Gaston
Kit Carson	Richard Bauer
Anna	Ricardee Pearson
A Society Lady	Halo Wines
A Society Gentleman	Ralph Cosham

By FRANK RICH

Special to The New York Times

WASHINGTON, Sept. 30 — In these rough economic times, one might expect Arena Stage, the premiere resident theater in the nation's capital, to use its art to prod politicians into action. But Arena is instead opening its new season with William Saroyan's San Francisco barroom reverie of 1939, "The Time of Your Life," surely the most comforting American play to emerge from the Depression, and will soon follow it with a musical adaptation of Frank Capra's "It's a Wonderful Life," another work that champions the power of fundamentally decent Americans to vanquish any misfortune single-handedly. Far from challenging Washington's conventional wisdom, Arena's 41st season — the first under the artistic direction of Douglas C. Wager, Zelda Fichandler's successor — seems eager to chime in with its own program for a thousand points of light.

●

The wattage will have to be a lot higher than it is in Liviu Ciulei's staging of "The Time of Your Life" if Arena is to convince anyone that the country is full of good Samaritans as its chosen scripts would have audiences believe. Mr. Ciulei, a Romanian-born director and designer capable of startling visions of classics, would seem to have a special fondness for Saroyan's play; though he has now been working in the United States for nearly two decades, it is the first American play he has chosen to direct here.

Yet, with the exception of one major performance, by Casey Biggs as Joe, and a few minor ones, this production is sloppily acted as well as flaccidly paced, running three hours despite textual trims. Mr. Ciulei's approach to the work is pure stock — even his saloon set looks as pre-fab as a Pizzeria Uno franchise — and his only bold directorial gesture is to change the play's favored jukebox tune from "The Missouri Waltz" to "You Go to My Head."

It would be easy, but wrong, to blame the evening's failings on Saroyan. The standard line on this writer, who died a decade ago, has long been that he is a sentimentalist whose literary string ran out when World War II rendered his sunny world view obsolete. But he has never lacked for critical defenders — Edmund Wilson, Mary McCarthy and Harold Clurman have been among them — and in truth "The Time of Your Life" seems less dated than many other touchstone American plays of the same period.

●

Unburdened by ideology, the work has none of the antiquated preachiness of Odets; bereft of structure, it is free of the creaking plot mechanics of Kaufman and Hart. Yes, the play's characters, from the philosophical longshoreman to the lovable cop to the whore with a heart of gold, are too good to be true, but they have their own poetic reality. Saroyan's off-center vignettes about his ethnic cross-section of drifters and his shaggy,

unforced sense of humor make his play, initially titled "The Light Fantastic," as brightly colored and animated as the pinball machine at center stage.

For the show to fly, each character's turn has to be supercharged with theatrical personality, not naturalistic acting, like succeeding comic acts in a vaudeville bill or a circus. Though "The Time of Your Life" was written in the same year that O'Neill wrote "The Iceman Cometh," the denizens of its bar dream attainable dreams, not pipe dreams, and the play upholds magical illusions rather than spreading disillusionment.

In an Arena cast exceeding two dozen, the light fantastic is tripped only by Joey McKneely, who brings a Dead End Kid's tattered innocence and a hoofer's grace to the role of an erstwhile "natural born dancer and comedian" originally played on Broadway by Gene Kelly, and, to a more incidental degree, by Jeffery V. Thompson as the bartender, Nick, and Teagle F. Bougere as an itinerant honky-tonk pianist.

●

Among the more central and damaging performances are those of Pamela Nyberg, who acts Kitty, the sweet and distraught prostitute, as if she were a cross young suburban matron, and Kevin James Kelly, who goofily and sexlessly caricatures the young man smitten by her. In a class apart is Richard Bauer, outfitted in long whiskers and full Buffalo Bill regalia as a mock frontiersman who calls himself Kit Carson. A mountain of mannerisms — odd crouches, vocal twangs, stomach pattings, whisky-eyed winks — he pays attention to the other actors only if they threaten to upstage him. During his longest soliloquy, the cast surrounds him in worshipful, open-mouthed poses (a prostrate posture of adulation mimicked by a minority of the audience) while Mr. Ciulei spins the revolving stage to show off his prize specimen of ham from every angle.

As Joe, the mysteriously wealthy, Champagne-sipping philanthropist who functions as the play's unofficial stage manager, Mr. Biggs is a most elegant antidote to such shenanigans. This is a very, very fine performance in an impossible role: the wry, distanced Joe could seem bland next to the barflies around him, and he often seems to be Saroyan's stand-in for God. An urbane figure in a gray suit, Mr. Biggs wears his halo lightly. He is serene without being unctuous, a martini-dry rather than syrupy-sweet humanitarian. He sounds the dark notes in the play — the European drums of war, most notably — without being portentous, gently nudging the audience to recognize that Saroyan had more on his mind than the wonderfulness of little people. In the compassionate, troubled undertow of Mr. Biggs's Joe, which recalls the world-weary tone of the wartime Hollywood performances of Claude Rains, one feels the brunt of the play's principal refrain, recited by an unnamed Arab: "No foundation all the way down the line."

●

One does not want to make too much of Saroyan's seriousness even so. "In the time of your life, live" is the play's main, and lightweight, message, and it is as a fantasy, an entertainment, that the play must live, not as any kind of exercise in social realism. From its first production, there have been arguments over how best to realize the piece — Saroyan drove away the original, fabulist-

inclined director, Robert Lewis, and designer, Boris Aronson, during the New Haven tryout — and one can see why. If "The Time of Your Life" never had much to add to political debates, it remains a fertile ground for esthetic debate and experimentation in the theater. But the play's dream world of 1939 is no more present at Arena Stage than the real world of 1991. Milking Saroyan merely for his hokiest jokes and cheap nostalgia, Mr. Ciulei has reduced an artist's genuine feat of escapism to a truly irrelevant, and synthetic, heap of corn.

1991 O 2, C17:1

Theater in Review | Mel Gussow

■ Recollections of grandma and grandpa's unhappy marriage ■ Reliving early television sitcom days ■ An individual view of black history.

Brooklyn Academy of Music

Alan Bern, left, and Eric Bass using puppets in a scene from Mr. Bass's "Invitations to Heaven (Questions of a Jewish Child)."

Invitations to Heaven (Questions of a Jewish Child)

Lepercq Space
Brooklyn Academy of Music
30 Lafayette Avenue (at Ashland Place), Fort Greene, Brooklyn
Through Oct. 5

Conceived and created by Eric Bass; directed by Richard Edelman; music adapted and composed by Alan Bern; written by Mr. Bass, with the collaboration of Mr. Edelman and Mr. Bern; design and puppets by Mr. Bass, with the assistance of Bart Roccoberton, Mary Sinclair, Ines Zeller Bass, Marylynn Hancock, Carol Fugelstad, Wendy Sawyer, Iver Johnson, Ezra Caldwell and Andy Voda; consultant for Yiddish language, culture and dance, Michael Alpert. Eric Bass/Sandglass Theater, presented by the Next Wave Festival of the Brooklyn Academy of Music.

Grandson/Angel Elijah...... Eric Bass
Angel Omeyn (Amen)........Alan Bern

In "Invitations to Heaven (Questions of a Jewish Child)," Eric Bass looks back on the long, unhappy marriage of his grandparents. From their arranged wedding in Poland to a struggle to remain together through difficult years in New York, the two are a capsulization of an aspect of the Jewish immigration experience. What makes Mr. Bass's play unusual is his ingenious use of puppets to tell the story.

As artfully manipulated by Mr. Bass and by Alan Bern, the show's composer, the lifelike puppets illuminate the mythic texture of the material. Puppets stand in for the grandparents, Gershon and Rivka, and also for their alter egos, or, as the author would suggest, their souls.

In one of the play's more mysterious events, Rivka suspects her husband of committing adultery in their home. Whisking back the sheets, she uncovers the astonished Gershon in bed with the wife's double image. Is the husband's infidelity a fact or fantasy? We never learn, but a clear picture emerges of a driven and somehow unlucky man and his increasingly resentful wife. Something besides tradition binds them.

As a framework for this intimate family album, Mr. Bass sets the story in heaven, where two angels (played by the author and the composer) banter vaudeville-style. This prelude delays the story and adds an unwarranted note of whimsicality. It is not until Mr. Bass begins to move his puppets that the play achieves its hard edge.

Underscoring the performance is music, written, adapted and played (on the accordion) by Mr. Bern, with Mr. Bass joining in on the banjo. The Yiddish-accented songs add transition to the narrative and serve as a flavorful background, especially in those moments when the grandparents, devoted ballroom dancers, dance together.

Mr. Bass's puppets have a touching reality, as in the scene in which the grandfather is forced to recognize his indebtedness to his wife. In this moment there is an echo of one of the play's earlier statements, "No choice is also a choice." By remaining married rather than taking the active step of separating, Mr. Bass's grandparents laid out the geography of their shared lives and a road map for their grandson's rueful family remembrance.

The Real Live Brady Bunch and the Real Live Game Show

Village Gate
160 Bleecker Street
(at Thompson Street)
Through Dec. 8

THE REAL LIVE BRADY BUNCH
Episodes of "The Brady Bunch" television series created by Sherwood Schwartz; stage direction, Jill and Faith Soloway; music, Faith Soloway; technical director, Jim Jatho; stage manager, Madeline Long; costumes, Ms. Long; set design, Dan Kipp and Mr. Jatho. Ron Delsner presents a Soloway Sisters/Eric W. Waddell Production, in association with Metraform's Annoyance Theater. WITH: Andy Richter, Jane Lynch, Pat Towne, Becky Thyre, Benjamin Zook, Melanie Hutsell, Tom Booker, Susan Messing and Mari Weis.

THE REAL LIVE GAME SHOW
Musical director, Faith Soloway; floor director, Pat Towne; technical director, Dan Kipp; set design, Mr. Kipp and Terry Ayers. With: Wayne Waddell, Dana Cunningham, John Copeland and Andy Richter.

With "The Real Live Brady Bunch," the flirtation between theater and television becomes an embrace. Onstage at the Village Gate, actors from the Annoyance Theater of Chicago re-enact original episodes from "The Brady Bunch," that popular sentimental sitcom of the early 1970's. The episodes, which will change weekly, are performed as written, without comment from the actors or the director. They offer "Brady Bunch" fans a gloss of nostalgia. For the rest of the world, the show should serve as self-parody.

While a live "Brady Bunch" may be defensible as cultural trivia preservation, the opening act has no such claim. Before arriving at the Brady home, the audience is expected to sit through "The Real Live Game Show," in which volunteers are brought up on stage to challenge one another in a mind-numbing party game that moves theater further back into television archeology.

To ensure that the terrain is recognized, there are television monitors and an applause sign, and the game show is interrupted for unfunny commercials for other Off Broadway shows. "The Real Live Game Show" is several steps below seeing "Wheel of Fortune" in a television studio. "Brady Bunch" enthusiasts might consider arriving after the intermission.

From the opening bar of the theme song, the pseudo-sitcom comforts the audience with remembered kitsch. While all the actors try to mimic their television models, it is only Mari Weis as the maid who provokes smiles. As in the original show, she has the most waspish wisecracks. Canned laughter is a natural accompaniment to the tinniness of the undertaking.

After the episode, there is a 30-second sendup in which the actors quickly simulate the erotic entanglements and pot smoking that might have gone on behind the scenes if the Bradys had been real instead of make-believe. This coda is not enough to justify the theatricalization, when re-reruns can be seen in perpetuity (weekday afternoons on WTBS). Should "The Real Live Brady Bunch" find a following in New York as it did in Chicago, will the real live Partridges, Nelsons and Cleavers be far behind?

Folks Remembers a Missing Page (The Rise and Fall of Harlem)

*By J.E. Gaines; directed by André Mtumi; set, Terry Chandler; light-*ing, Sandra Ross; music, Bob La Pierre; visual design, Eve Burris; sound, Bill Milbrodt; technical director, Erik Stephenson; stage manager, Lynn Franklin. Presented by B&G Associates; William E. Lathan, associate producer. At the Nat Horne Theater, 440 West 42d Street.

Folks..................Sonny Jim Gaines
Ming................................Itself

"Folks Remembers a Missing Page (The Rise and Fall of Harlem)" would seem to provide a most conducive environment for J. E. Gaines's brand of thoughtful reflection, demonstrated in previous plays like "What If It Had Turned Up Heads?" Unfortunately, this time Mr. Gaines's intention is not matched by his accomplishment.

The play is overly inclusive, a meandering chronicle that blurs its sense of history as it moves back and forth across the decades. Not content with a view of Harlem, the author reaches out to cover blacks all over the United States in the 20th century. There is enough raw material here for dozens of works, but not enough focus for a single two-hour play.

Mr. Gaines, a k a Sonny Jim Gaines, is introduced as a member of the urban homeless surrounded by the detritus of a life lived on the street. He gives us facts of that dispossessed life but does not fully establish a character for himself. Instead he is more of a spokesman, framing his play as a conversation with his unseen cat, which he alternately addresses and ignores. A real cat would be out the door of the theater and down the street.

Along the way, Mr. Gaines speaks about Marcus Garvey, the Harlem Renaissance, Joe Louis and Malcolm X, and he briefly tells how white men like Fred Astaire co-opted black dance. But it is not until the second act and his consideration of crime

that the play begins to have more than a thread of a sustained narrative.

As directed by André Mtumi, the production is rudimentary: a few projections as a visual aid, and an occasional song. Although Mr. Gaines remains an engaging actor, the play leads one to the conclusion that the rich subject of Harlem's history has been more interestingly served in books, documentary films and photographic exhibitions.

1991 O 2, C18:3

The 1991 Young Playwrights Festival

Four plays by writers under the age of 19. Sets by Allen Moyer; costumes by Elsa Ward; lighting by Pat Dignan; sound by Janet Kalas; production manager, David A. Milligan; production stage managers, Roy Harris and Liz Small; production director, Nancy Quinn; managing director, Sheri M. Goldhirsch. Presented by the Foundation of the Dramatists Guild. At Playwrights Horizons, 416 West 42d Street.

SECRETS TO SQUARE DANCING, by Denise Maher; directed by Gloria Muzio.

I'M NOT STUPID, by David E. Rodriguez; directed by Seret Scott.

DONUT WORLD, by Matthew Peterson; directed by Michael Mayer.

MAN AT HIS BEST, by Carlota Zimmerman; directed by Mark Brokaw; fights by Rick Sordelet.

WITH: Paul Bates, Louis Falk, Seth Gilliam, Steve Hofvendahl, Peter Francis James, Anne Lange, James G. Macdonald, Curtis McClarin, Olga Merediz, S. Epatha Merkerson, Ethan Phillips and Mary Testa.

By MEL GUSSOW

The four plays in the 1991 Young Playwrights Festival have a diversity of styles and purposes but they are unified by the theme of denial and by a high caliber of performance. In each work, people refuse to accept an image of themselves that is either earned or imposed on them by outsiders. In several cases, the reaction is vociferous.

Denial is most dramatically encountered in David E. Rodriguez's "I'm Not Stupid," in which a recently widowed mother is unable to cope with her son's mental disability. Though the play has its contrivances, the playwright has created three sharply focused characters: a vengeful mother (S. Epatha Merkerson); her childlike son (Curtis McClarin), and a psychiatrist (Peter Francis James) whose concern is limited by his self-containment.

The psychiatrist is repeatedly faced with the question of how far he is willing to go to protect the apparently endangered youngster. Tellingly, the author applies the title of his play to each of the characters until it becomes a binding motif. Under the assured direction of Seret Scott, the actors offer a trio of taut performances.

Sponsored annually by the Foundation of the Dramatists Guild, the festival gives center stage at Playwrights Horizons to writers under the age of 19. The quality of the acting and directing is a hallmark of the series, now in its 10th season. This certainly is the case with the evening's other ostensibly serious work, Carlota Zimmerman's "Man at His Best," this year's entry from Nancy Fales Garrett's prolific playwriting class at St. Ann's School in Brooklyn Heights.

Overly influenced by the movie of "The Kiss of the Spider Woman," the playwright has written about a collision between two toughened inmates, a murderer and a hustler, locked together in a cell where they play mutually threatening games.

The dialogue is spicy and the play is performed at full throttle by James G. MacDonald and Seth Gilliam. Credit is also shared by the director Mark Brokaw, the designer Allen Moyer and the fight director Rick Sordelet. Were Ms. Zimmerman herself an inmate instead of a high school student, one might give more credence to her choice of material and to her story. But there is no denying her ability to conjure conflict in tight quarters.

The other two plays are slight cartoons, one about an adult-like child, the other about a child-like adult. In the first, Denise Maher's "Secrets to Square Dancing," a mother and a son are besieged by a barrage of brain testers. The son (Louis Falk) has not lived up to academic expectations on S.A.T.-style exams, and Federal agents have come to correct his mistake.

Surrounded by an alphabet soup of testing services and agencies and the charge that she may be "unfit for intelligent parenting," the mother (Anne Lange) rejects all criticism. The son takes his own more enterprising approach. The idea of the

The characters won't accept the images imposed on them by others.

comedy is more amusing than the results, despite the carefully synchronized acting as directed by Gloria Muzio.

In Matthew Peterson's "Donut World," Paul Bates plays a grown-up addicted to his model railroad empire, which covers his kitchen. In this world, a wife (Olga Merediz) is treated as a lackey, and a man's real work is relegated to an avocation. When a casual reference is made to his hobby as "toy trains," Mr. Bates rises in the highest dudgeon, and speechifies about the adult challenge of his Lilliputian engineering.

The play is childish but the author and his director, Michael Mayer, have concocted a few offbeat sight and sound gags, including a hungry offstage dog (barking supplied by Ethan Phillips) and a box of doughnuts that, when opened, glows like a long-buried treasure chest. As for Mr. Bates, he is a younger, portly version of Charles Dutton.

1991 O 3, C20:3

SUNDAY VIEW/David Richards

Saroyan, Through a Glass Darkly

A Romanian skeptic creates a rueful 'Time of Your Life.'

Coriolanus may be a man only a mother could love.

WASHINGTON

AS LIVIU CIULEI HAS DIRECTED it at Arena Stage, you could almost conclude that "The Time of Your Life" was written by Eugene O'Neill.

It wasn't, needless to say. It was written by William Saroyan in 1939, ran for 185 performances on Broadway and won its author the Pulitzer Prize (which, for his art's sake, he refused). The oddballs and misfits who've found a home in Nick's Pacific Street Saloon on the San Francisco waterfront were, in Saroyan's mind, representative of the country's glorious diversity, and he considered their willingness to live and let live the very lifeblood of democracy.

I won't say that the Romanian-born Mr. Ciulei is a doubting Thomas. He has, however, a European's skepticism and the wariness of one who was obliged to flee the Ceausescu dictatorship and spend much of his artistic career in exile. By nature and circumstance, he is discreet, observant, shrewd. The loud, brash guffaw of the extrovert is not his. He is far more likely to bestow an ironic smile on the world's absurdities and, being a chain smoker, follow it up with a curl of blue smoke.

It is not surprising, then, that he would look at "The Time of Your Life" and see reflections of O'Neill's "Iceman Cometh." Both plays are set in dives run by softhearted bartenders. Both deal with the delusions that keep us going from day to day. And in both cases, among the habitués, there is one character who would patch up the sorry lives around him. Hickey, the traveling salesman in O'Neill's drama, gives rowdy pep talks, calls his mates on their pipe dreams and sends them scurrying into the hard light of the streets, presumably for their own good. In Saroyan's case, it's Joe (Casey Biggs), a mysterious millionaire who, between endless glasses of $6 champagne, bucks up those spirits that need bucking up with his whimsical acts of philanthropy. But each, in his way, is playing God in a godless world.

"The Iceman Cometh" is an infinitely darker play, of course. Saroyan had a strong sentimental streak and just so long as human beings weren't mean or hurtful, he thought they were pretty wonderful creatures, every last one of them. What Mr. Ciulei has done, however, is surround "The Time of Your Life" with darkness. Literally. Instead of

Marty Katz for The New York Times

Nick's bar is a refuge in "The Time of Your Life" at the Arena Stage, with, from left, Sean Baldwin, Pamela Nyberg, Kevin James Kelly, Casey Biggs and Jeffery V. Thompson—a tiny planet in space.

locking up the play in a box set behind a proscenium, he has opted to stage it in the four-sided Arena. Serving as his own designer, he has put Nick's place — the leather booths, the fancy horseshoe bar and an obstreperous pinball machine — on a large turntable. Then, as a bluesy version of "You Go to My Head" blares from the jukebox, the customers stumble in and the play sets out on its woozy, wobbly course, the stage itself begins to revolve slowly.

The movement is not continuous. But whenever emotions are high — or especially tender — you'll notice that the turntable is usually contributing to the mood. In one sense, Mr. Ciulei is simply being pragmatic. Actors performing in the round are always going to have their backs to part of the audience. Lest some spectators feel unduly shunned, a director has to multiply the reasons and pretexts to move the cast about. Here, the actors can sit down at a table, nurse a drink and give in to their peculiar flights of philosophy — confident that they'll be seen by all. The turntable does the moving for them.

More important, it lends a note of precariousness to the production. You get the feeling after a while that Nick's bar is drifting through the vastness of the night, as if it were a tiny planet way out there in space. Nancy Schertler's lighting — more shadow than light, actually — certainly enhances the impression. Resilient as Saroyan's characters are, it is their vulnerabilities and the sweet futility of their ambitions that seem most to engage Mr. Ciulei.

There have certainly been more antic productions of "The Time of Your Life." (Instead of looking at the play through the prism of O'Neill, you can just as easily view it as boozy Kaufman and Hart — "You Can't Take It With You" in a honkytonk.) I don't think I've seen a more rueful interpretation, though.

Under the benevolent if drunken eye of Joe, characters float in from the gloom — some stopping just long enough for a shot; others putting down roots. Nothing much happens and everything does. Romance flowers between Kitty Duval (Pamela Nyberg), a streetwalker who likes to pretend she was in burlesque once, and Tom (Kevin James Kelly), Joe's jug-eared errand boy, who aspires to be a long-distance truck driver someday with Kitty perched beside him in the cabin.

Harry (Joey McKneely) proclaims himself "a natural born dancer and comedian," then launches into eccentric routines that leave no one laughing, even if a burly longshoreman admits encouragingly that he's laughing like crazy, "although not *out loud.*" With a lilting rendition of "When Irish Eyes Are Smiling," a newsboy (Michael Rodgers) proves to be a great lyric tenor in the making, and so what if he's a Greek from Salonika. Among his other adventures, a grizzled cowpoke (Richard Bauer), who goes by the name of Kit Carson, reminisces lustily about the times he fell in love with a 39-pound midget, "that Amazonian of small proportions," and herded cattle on a bicycle in Toledo in 1918.

Periodically, an Arab at the bar (Victor Strengaru) mutters "No foundation, all down the line," with barely a shrug of his great sloping shoulders. He's right. Hitler is on the rise, World War II is imminent and everywhere the walls are about to come crumbling down. For the time being at Nick's, however, it doesn't

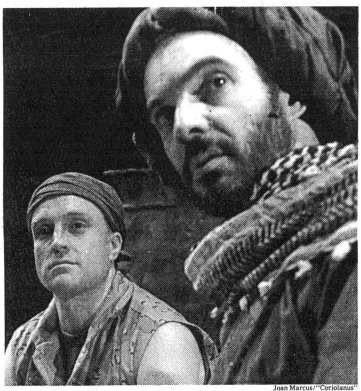

Joan Marcus/"Coriolanus"

Bradley Whitford and Edward Gero in "Coriolanus" at the Shakespeare Theater at the Folger in Washington—sweet revenge

matter. Nick (Jeffery V. Thompson) may cock a dubious eyebrow at each new arrival, but he invariably ends up extending the benefit of the doubt to one and all, and a plate of food to those who haven't eaten in a few days. If it were not for a sadistic vice cop, a kind of lovely, cockamamie harmony would prevail. But then, there's always a thug or a Hitler to mess up our peaceable kingdom.

With nearly 30 characters, "The Time of Your Life" has pretty much become the province of the not-for-profit theaters, which alone can marshal the resources these days to put it on. (The curtain call qualifies as a virtual parade.) Not everyone in the Arena cast is ideal, but the acting is strong where it most needs to be. Mr. Biggs, who has always projected the flinty all-American decency of a young Jimmy Stewart, continues to do so here, but adds complicating layers of disenchantment and guilt. Ms. Nyberg's attempts to hold up her chin and assert her dignity as Kitty are particularly touching because her conception of dignity is so pathetically limited. Mr. Bauer, Arena's pre-eminent character actor, has a high ole time with Kit Carson's tall tales.

It is not the acting, however, that distinguishes this produciton so much as it is the cosmic spin that Mr. Ciulei has put on the work. He first staged "The Time of Your Life" (and played the role of Joe) in 1966 at the Bulandra Theater in his native Bucharest. The Ceausescu regime confiscated the theater in the early 70's, dismissed him as its artistic director and forced him into exile. Mr. Ciulei recently returned to a triumphant welcome in Romania, but the in-between years have left their mark.

You can read it at Arena in the loneliness and despair that keep trying to push their way through the swinging doors to Nick's — a haven, perhaps, but an extremely fragile one.

'Coriolanus'

At a time when our political candidates go out of their way to kiss mewling babies, President Bush has himself photographed on the rim of the Grand Canyon and Gen. H. Norman Schwarzkopf peddles the world rights to his autobiography for a sum estimated to be in excess of $5 million, a man like Coriolanus is hard to fathom.

Fearless in battle and mighty in reputation, he won't do the one thing that would make him a hero to the people, which is pander to the people. In "Coriolanus," the final tragedy in the Shakespearean canon, the consulship of Rome is his, if only he'll appear before the rabble, show off his wounds and beg for indulgence. (Even Lyndon Johnson, a man of some arrogance, willingly displayed his scars, while Jimmy Carter had no qualms about fessing up to the lust in his heart.)

■

The public formalities are too much for Coriolanus, however, and he is spurned by the fickle mob as a result. Incensed, he promptly goes over to the enemy and proceeds to make war on his ungrateful country-

men. Somewhere along the line, he thunders the Elizabethan equivalent of "That'll show 'em."

At the Shakespeare Theater at the

If nothing else, Shakespeare's 'Coriolanus' is a chronicle of mob psychology.

Folger, Bradley Whitford is playing the proud warrior in a production staged by the British director William Gaskill. Mr. Whitford is a more than able actor, but he doesn't cast much illumination on the part. Outfitted in G.I. camouflage fatigues — yes, it's one of those productions — the actor looks and sounds a lot like the late Aldo Ray in a World War II film. The character's fanatical concern with his honor and his shuddering distaste for the crowd border on neuroticism, as does his fierce attachment to Volumnia, his mother. But while a deeply neurotic Coriolanus might take very nicely to the stage these days, that doesn't seem to be what anyone has in mind.

Mr. Gaskill's staging is, in fact, unaccountably pedestrian. If nothing else, "Coriolanus" is a vigorous chronicle of mob psychology. But here the "the beast with many heads" stands about dutifully, speaks in unison and only occasionally brandishes a hoe or a baseball bat to suggest its latent unruliness. Didn't Mr. Gaskill catch any of the television news footage out of Eastern Europe earlier this year?

Jane White does her part, as Volumnia, to bring some gutsiness to the production, while Emery Battis, as the nattering patrician Menenius, contributes considerable humor. But the standout performance is Edward Gero's. He is Aufidius, the general of the conquered Volscians, who has no sooner vowed revenge on Coriolanus than Coriolanus himself comes knocking at the door, proposing a joint military offensive against Rome.

Welcoming his arch-rival in the evening's best scene, the intense Mr. Gero is as eager as he is wary, as seductive as he is calculating. Trustworthiness and treachery are rarely fused so seamlessly. □

1991 O 6, II:5:1

The Radiant City

Written, designed and directed by Theodora Skipitares; musical score, Christopher Thall; lyricist, Andrea Balis; lighting, F. Mitchell Dana; sound, David Wonsey; kinetics, Raymond Kurshals; technical design, Nir Lilach; dramaturg, Cynthia Jenner; production stage manager, Lloyd Davis Jr. Presented by American Place Theater, Wynn Handman, director; Dara Hershman, general manager, in association with Skysaver Productions Inc. At 111 West 46th Street, Manhattan.

WITH: William Badgett, Charles W. Croft, Edward Greenberg, Cora Hook, John Jowett, Lisa Kirchner, Michael Preston, Jane Catherine Shaw and Christopher Thall.

By MEL GUSSOW

Was Robert Moses a visionary or the destructive genius characterized in Robert A. Caro's biography "The Power Broker"? Theodora Skipitares, the creator of "The Radiant City," comes down firmly on the Caro side of the fence. Her provocative new puppet play at the American Place Theater is an unswerving act of social criticism.

In expressing her point of view as author and director, Ms. Skipitares calls Moses as self-incriminating witness with such statements as, "Nothing I have ever done has been tinged with legality," and "If the end doesn't justify the means, what does?" His desired end, as described in the play, was to turn New York into a World's Fair-like Futurama, monopolized by skyscrapers and superhighways leading to superparks.

●

For this grand scheme, the car is ennobled while mass public transportation is ignored. As the author deplores the proliferation of cars and roads to accommodate them (or was it vice versa?), her commentary becomes scathing. Moses, she says, tried to improve our lives by destroying neighborhoods and by tying the city together in a "concrete knot." In one of her more challenging observations, she suggests that Moses kept buses out of Jones Beach in order to discourage lower-class blacks from using the park.

In previous shows, Ms. Skipitares and her team of puppeteers tripped through Darwinism, nutrition and the age of invention. With Moses, her canvas is larger and more elaborate — a band and two singers are on one side of the stage — but the position is no less committed. She has not altered her manner or her insightful regard for the effect of individuals on history. The methodology is the same, a cross between Bunraku and Brecht.

●

The evening begins like an illustrated lecture, with words and pictures projected on a screen and the author unseen but raising a figurative pointer to instruct the audience as visitors to her animated museum installation. Soon, puppets and scenery become sculpture in motion, dancing in rhythm to raplike songs by Christopher Thall and Andrea Balis.

A frieze of street people as might appear on the facade of a bank moves into action and a map of the metropolitan area lights up and pulsates with highways so that it looks like an inside view of the human brain. Moses' own image is ubiquitous and diverse. He appears as a hologram, a dozen disembodied heads on a spinning Ferris wheel (representing his various New York posts) and a huge bust that puts him a step away from Mount Rushmore. Overlooking the landscape are mockup representations of New York landmarks — the Chrysler, Empire State, Pan Am and the Flatiron Buildings and Rockefeller Center — silent sentinels watching the dismemberment of the surrounding city.

As the network grows, it is interesting to ponder a time when there was no Triborough Bridge or Belt Parkway, a time, in other words, before Moses. While crediting him with freeing transportation traveling to and from the city, Ms. Skipitares condemns his role in creating gridlock within the city and mocks his more eccentric ideas. According to the play, one radical plan called for an elevated crosstown expressway to be

driven through the second or third floors of buildings.

●

One of the author's surmises moves beyond rationality into fantasy, her linking of Moses with four other puppet "master builders": Julius Caesar, Hannibal, Genghis Khan and Adolf Hitler, who do a cartoon dance together. Hitler may have prided himself on the German highway system, but other comparisons between him and Moses are odious. A subsequent song and dance by Nelson and David Rockefeller, twinned as Moses's nemeses, is much more to the satiric point.

The problems in the show are endemic to the material. Ms. Skipitares

The thesis: Robert Moses built a city more suited to cars than people.

specializes in awesome subjects, but Moses is too sizable a figure to condense into 90 minutes. As a result, the author is led into overstatement and oversimplification. Some historical notations seem like footnotes, as in the Ice Age prologue. Transitions are often lacking between the myriad scenes, spaces that are unevenly filled with songs. The score is less sharp than those in previous Skipitares ventures, like "Defenders of the Code."

All this is offset by Ms. Skipitares's imagination and by her resolve to explore the roots of our city and try to understand what turned promise into chaos. In "The Radiant City," this politically concerned experimentalist traces New York's urban ills directly back to its primary planner, that self-designated, unelected Medici of parks, highways and bridges.

1991 O 7, C15:4

Babylon Gardens

By Timothy Mason; directed by Joe Mantello; sets by Loy Arcenas; costumes by Toni-Leslie James; lighting by Dennis Parichy and Michael J. Baldassari; sound by Scott Lehrer; production stage manager, Denise Yaney; production manager, Jody Boese. Presented by Circle Repertory Company, Tanya Berezin, artistic director; Terrence Dwyer, managing director. At 99 Seventh Avenue South, at West Fourth Street, Manhattan.

Bill	Timothy Hutton
Molly	Bobo Lewis
Jean	Mary-Louise Parker
Opal	Cynthia Martells
Andrew	Steve Bassett
Jessica	Lea Floden
Larry	Bruce McCarty
Robin	Cordelia Richards
Philippe	Robert Jiménez
Hector	Hector M. Estrada

By FRANK RICH

Loy Arcenas, the designer known for the childlike innocence and fairytale hues he brought to "Once on This Island" and "Prelude to a Kiss," has left his palette, though not his talent, at home for "Babylon Gardens," the new play by Timothy Mason at the Circle Repertory Company. The Playbill lists Mr. Arcenas's assignment as "New York City, the present

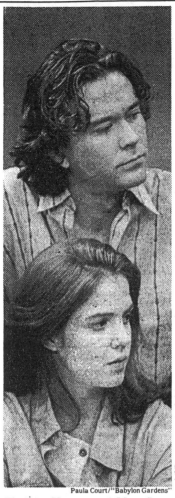

Paula Court/"Babylon Gardens"

Timothy Hutton and Mary-Louise Parker in "Babylon Gardens."

day," and surely it's a sorry sign of the times that the only color the designer can muster is gray.

The monochromatic pall extends from the twisted beams and rotting steel girders that crown the set to the cinder blocks that fill in most of its tenement windows to the slab of concrete floor on which sits the forlorn living room occupied by Bill and Jean, an East Village couple played by Timothy Hutton and Mary-Louise Parker. And "Babylon Gardens," it must be said, courts exactly such gloom. Mr. Mason has drawn an unrelentingly open-eyed survey of an environment blighted by poverty, crime, drugs and cynicism, a city where apartment dwellers live behind bars and where anyone with means moves to Santa Fe or Seattle and feels "terribly self-righteous about it."

While the play falls well short of the searing, cautionary horror tale its author envisions, it offers some vivid writing and good acting while avoiding any self-righteousness of its own. Mr. Mason, whose career has been nurtured by the Circle Rep for almost a decade, has humor to go with his poetic despair, and, like the company's signature playwright, Lanford Wilson, he empathizes with a demographical cross section embracing several generations and ethnicities.

•

The characters of "Babylon Gardens" do have one common trait, however: they are all casualties of the urban war zone. Bill, a drug-abusing nurse, is frequently as wasted as the emergency-room patients to whom he administers anesthesia; Jean, a painter, relives the recent

death of her newborn child in her grotesque canvases. Their friends, bedraggled, marginal yuppies of the 90's rather than the slick, flush ones of the boom decade, have lousy marriages and unrewarding careers. Their neighbors include a black homeless woman named Opal (Cynthia Martells), whom the guilt-ridden Bill daily supplies with dollar bills, and Hector (Hector M. Estrada), a 12-year-old Hispanic youth whose artistic inclinations Jean attempts to encourage with a starter box of pastels.

It is all too in keeping with present-day New York that no such good deeds go unpunished in "Babylon Gardens." Bill and Jean's stabs at charity among the Tompkins Square destitute are as misguided, if never as farcical, as the East Hamptonites' attempt to adopt an Upper East Side bag lady in Richard Greenberg's "Eastern Standard." Yet Mr. Mason refuses to assign blame or preach glib sociological remedies for the city's tragic schisms. Opal, who may be a Nyquil junkie or a prophet or both, is neither deified as a welfare casualty nor vilified in the manner of the underclass manipulators of "Bonfire of the Vanities." She is just a feral fact of the street, sometimes terrifying, sometimes pitiful and sometimes irritating in Ms. Martells's flashy performance.

Mr. Mason is equally circumspect in drawing some of the middle-class white characters who fear the city's Opals, thereby offering juicy opportunities to such intelligent supporting players as Bobo Lewis (as a Jewish grandmother), Steve Bassett (as a jaded doctor) and Cordelia Richards (as an unhappily pregnant wife). Under the supple direction of Joe Mantello, the lead performances are also excellent. Mr. Hutton's depressive intelligence suits the drugged Bill far more than it did the effervescent hero of "Prelude to a Kiss," and the off-center, emotionally transparent Miss Parker manages to modulate her aggressive comic style just enough to capture Jean's mental unraveling without losing a few unexpected laughs along the way.

•

Even so, their roles are the obstacles that "Babylon Gardens" never overcomes. For all the grit in the play's backdrop, the leading players at center stage remain out of focus. Mr. Mason never tells the audience enough about them to explain their mechanically alternating bouts of pharmacological and psychological collapse or make them credible. Their seemingly arbitrary mood swings are like a crude rehash of the soap operatics of "The Days of Wine and Roses," and their randomly reckless behavior strains credibility, as if the playwright were pulling their strings manicly for no loftier purpose than belatedly working up a sensational plot.

Mr. Mason's tendency to stack the deck also turns up in some of his more literary atmospherics, starting with the scriptural images of apocalypse that underlie his title. There is too much talk correlating the death of America to the death of babies — Edward Albee and Sam Shepard have been there first in any case — and must the characters' favored film be "Night of the Living Dead"? When a patient checks into a hospital in "Babylon Gardens," you can be sure the case is terminal; when someone turns on the television, you can bet that game-show contestants will be playing "Final Jeopardy."

The melodramatic overkill finally makes one feel more defeated than moved or aroused by the bleak urban terrain of the play. "Babylon Gardens" is a cul-de-sac that leaves its characters and audience alike immobilized by depression, and its final verbal image, a sentimental wish for a vanished, romantic Manhattan, is too false and too late to lift the funk. In truth, one gets Mr. Mason's entire message at the outset, from Mr. Arcenas's set: All hope abandon, ye who enter here! But if that's the case, and we cannot all move to Santa Fe, doesn't a playwright have an obligation to transport us somewhere, anywhere, by at least trying to imagine the New York drama that begins when hope is dead?

1991 O 9, C17:1

Theater in Review

■ A priest in the land of the living dead ■ From the ridiculous to the absurd as freedom reigns ■ Blowing the whistle on an age of insincerity.

Damien

Irish Arts Center
553 West 51st Street
Manhattan
Through Sunday

By Aldyth Morris; production stage manager, Kurt Wagemann, dialect coach, Joann Dolan. Presented by Double W Productions, in association with The Irish Arts Center. WITH: William Walsh

Joseph Damien De Veuster, the protagonist of Aldyth Morris's one-character play "Damien," was a Belgian missionary who for 18 years ministered to the lepers who had been forcibly exiled to the Hawaiian island of Molokai. From 1871 until 1889, when he himself died of leprosy, Father Damien lived in a place he describes as a "charnel house" and "a community of the living dead." It was a place whose population, lacking medicine, adequate food or housing, died more from ailments related to extreme poverty than from leprosy itself.

Determined not to stand apart from his congregation, Father Damien became a full member of the community who fought successfully with the local Board of Health for more humane treatment of lepers. Eventually he became a heroic symbol of Christian charity and self-sacrifice who was celebrated enough to be able to raise substantial funds for the colony. Set in 1936, when his body was disinterred from a Hawaiian grave and sent to Belgium for formal burial, the play is a series of ghostly flashbacks.

"Damien," which is being presented by the Irish Arts Center, was briefly seen in New York 10 years ago in a production at the Theater for the Open Eye, and has also been produced for public television. Its recollections begin with Father Damien's first impressions of Hawaii and end with memories of his Belgian youth. In describing Molokai's horrors — its stench and the sight of people with rotting flesh hanging on their limbs — the play doesn't mince words, but neither does it sensationalize. Overall, it is a deft, unsentimental character study of a spiritual renegade whom the church hierarchy considered too passionate to make a good priest.

The Irish Arts Center revival of "Damien," is unfortunately flawed by a fatal miscalculation. In the pursuit of verisimilitude, a dialect coach was brought in to instruct William Walsh, who plays Father Damien, in a Flemish accent. The result is a strangely sing-songy performance that leaves the emotional inflections of the language completely flattened. At moments, the dialect is so disconcerting as to obscure the narrative. Mr. Walsh's performance, though honorably intended, reduces an absorbing tale into a finicky 75-minute speech exercise.

STEPHEN HOLDEN

The Boxing Day Parade

Intar 2
508 West 53d Street
Manhattan
Through Sunday

By Clifford Mason; directed by Jennifer Vermont-Davis; set and lighting, Donald L. Brooks; costumes, Myrna Colla-Le and Ali Turns; choreography by Jeffrey Dobbs. Presented by Vere Johns.
WITH: Jeffrey Dobbs, Arthur French, Pam Hyatt, Carol London, Clifford Mason, Norman Matlock, Morgan, Monica Parks and John Steber

As one has come to expect of Clifford Mason, the central idea in his new play, "The Boxing Day Parade," is sharp and salutary: in an age when almost everyone claims to be a victim of someone else, here is a timely reminder that oppression is not always imposed from the outside.

"Boxing Day" is also filled with the kind of biting, humorous dialogue with pointed literary allusions that Mr. Mason has been writing for some years, and with his wicked insights into how ridiculous most people are most of the time. But he has not made coherent theater of all this.

In this play he returns to the day 29 years ago when Jamaica won its independence from Britain (here it is declared abruptly in a telephone call from a wealthy Jamaican to Queen Elizabeth II), which was also the theme of his "Time Out of Time" in 1986.

A group of the island's upper-class blacks — with a little help from an English dowager bent on some final mischief before she follows the rest of the old colonial establishment back to England — move into the places of power left vacant by their old masters. They immediately assume not

Ray Carlson/Double W Productions
William Walsh in "Damien."

only the arrogant behavior but all the demeaning attitudes of the departed whites.

Through the first four scenes, the pretensions of these people are very funny. But then, suddenly, a conspiracy is hatched, the Governor General is murdered — the shift in mood is signaled by the roar of a smoking pistol — and most of the characters begin spouting heavy reflections on history and bitter recriminations against one another. If the audience were to flee when the assassin pulls out the weapon, it would go home in a better mood.

Mr. Mason tends to attract good casts. He always creates odd characters and loves challenges that tempt actors, like terrible singing (in this case bits of "The Mikado") and impossible steps (these flabby nabobs try their best to perform fiery Jamaican dances). But an enthusiastic cast and the earnest direction of Jennifer Vermont-Davis cannot rescue "The Boxing Day Parade" from its inherent confusion.

D. J. R. BRUCKNER

The Misanthrope

York Theater Company
2 East 90th Street
Manhattan
Through Oct. 20

By Molière; translated into English verse by Richard Wilbur; directed by Alex Dmitriev; scenic design, James Morgan; costumes, Barbara Beccio; lighting, Jerold R. Forsyth; technical director, John Miller; production stage manager, Mary Ellen Allison. Presented by the York Theater Company, Janet Hayes Walker, producing director, and Molly Pickering Grose, managing director.

WITH: Patrick Stretch, Andrew Borba, Lee Chew, Oliver Clark, Michael Hammond, Gillian Hemstead, Gordana Rashovich, Shari Simpson and Ian Trigger.

Alceste in "The Misanthrope" is either a piercing truth teller or a moral snob, or perhaps both at the same time. He is, of course, the fervid title character of Molière's dark comedy, a classic that validates itself for every age. Watching the play in Alex Dmitriev's production for the York Theater Company, one can transpose the character's criticism to any climate in which hypocrisy rides high.

In his woefully insincere Parisian society, Alceste is a whistle blower

who, in Wyndham Lewis's apt description, "is a perfectionist of almost lunar fantasy." While wounding others with his blunt honesty, he victimizes himself through his choice of a woman to love, the duplicitous Célimène.

The actors give the play a clear-spoken, conversational reading that falls far short of eloquence. Fortunately, the most adept performance is given by Patrick Stretch, a late replacement in the title role. A young actor from the American Conservatory Theater in San Francisco making his Off Broadway debut, Mr. Stretch shows a promising grasp of his character's dilemma.

Alceste prides himself on "speaking plain" while acidulously assailing the liars and gossips around him. Verbally fencing with a poetizing rival, Mr. Stretch is a keen marksman. But in his scenes of romantic endeavor, he overdoes the obsessiveness and seems to simulate Tartuffe, an approach that proves to be diversionary.

At least the actor adds zest to a production that otherwise idles on a level of competence, and he is a partial antidote to Shari Simpson's overly mannered and uncoquettish Célimène. Gordana Rashovich is more in keeping with her role as Célimène's inimical friend, and Ian Trigger adds sauciness as a foppish courtier. James Morgan's scenic design and Barbara Beccio's costumes are suitably fashionable. The York Theater "Misanthrope" uses Richard Wilbur's verse translation, which is always gratifying to hear, even in this less than satisfying production.

MEL GUSSOW

1991 O 9, C18:3

On Borrowed Time

By Paul Osborn; based on the novel by L. E. Watkin; directed by George C. Scott; set, Marjorie Bradley Kellogg; costumes, Holly Hynes; lighting, Mary Jo Dondlinger; production stage manager, William Hare. Presented by Circle in the Square Theater, Theodore Mann, artistic director; Robert A. Buckley, managing director; Paul Libin, consulting producer. At 1633 Broadway, at 50th Street.

Pud	Matthew Porac
Gramps	George C. Scott
Granny	Teresa Wright
Mr. Brink	Nathan Lane
Marcia Giles	Alice Haining
Demetria Riffle	Bette Henritze
Boy in Tree	Matt White
Workmen	Arnie Mazer and James Noah
Dr. Evans	Conrad Bain
Mr. Grimes	George DiCenzo
Mr. Philbeam	Allen Williams
Sheriff	Joseph Jamrog

By FRANK RICH

George C. Scott, an actor whose calling card has long been gruff irascibility, wants to be lovable in "On Borrowed Time," the 1938 Paul Osborn comedy that brought him back to the Circle in the Square on Broadway last night.

The portly, bearded star looks more like an avuncular Papa Hemingway than ever, albeit one with a cracker-barrel accent. His costume is the sort of pristine, neatly pressed denim overalls given to actors playing twinkly-eyed heartland bumpkins in television commercials for synthetic old-fashioned lemonade. As if this were not enough, the character he has chosen to play is known as Gramps, and the closest Gramps ever gets to being a grump is his

Martha Swope/"On Borrowed Time"
George C. Scott in a scene from "On Borrowed Time."

occasional indulgence in cuss words, like "hell," that are suitable for publication in a family newspaper.

●

It's a stretch, but with his timing and command of the stage both firmly intact, Mr. Scott pulls off the trick with ease, infusing everything he does with a burly warmth and kindly authority. He is the main reason for even considering a visit to "On Borrowed Time," a play that can at most be recommended as a light diversion for those theatergoers who have more time, borrowed or not, than they know what to do with. In the seasons since the 1980 Broadway revival of Osborn's 1939 failure, "Morning's at Seven," proved a surprise and deserved hit, this effort marks the third attempt by a major New York theater company to find another hidden treasure in the Osborn canon. But as with "Oliver Oliver" (staged by the Manhattan Theater Club in 1985) and "Tomorrow's Monday" (at the Circle Repertory Company the same year), the best to be said about "On Borrowed Time" is that it goes down pleasantly and, with this production's cuts, quickly.

Given that the play's subject is death, it might seem odd to call the evening pleasant, but defanging mortality was Osborn's mission. Set in an idyllic Anytown, U.S.A., "On Borrowed Time" is about how Gramps forestalls Death, in the form of a man called Mr. Brink and played by Nathan Lane, by keeping him barricaded in an apple tree. Gramps wants to linger long enough to rescue his orphaned grandson, Pud (Matthew Porac), from the clutches of an evil aunt (Bette Henritze). Yet even Gramps understands that death is part of the natural order of things and a necessary sacrifice on an overcrowded earth where youth must have its day. Osborn, who was the son of a Baptist minister, sugarcoats that grim reality by having Mr. Brink usher his victims painlessly into a hereafter in which happily reunited families can pick up where they left off.

●

Is it coincidence that Mr. Brink found favor with American audiences when the country was on the brink of war? "On Borrowed Time," which was made into a movie in 1939, proved among the first of a number of Hollywood wartime fantasies ("Heaven Can Wait," "Here Comes Mr. Jordan," "A Guy Named Joe") that patriotically promised an afterlife to an audience increasingly primed to sustain heavy casualties

overseas. This same psychic panacea was also offered by "Our Town," which, as it happened, opened on Broadway the night after "On Borrowed Time" and became an even bigger hit.

In pop culture, as in religion, there will always be a mass market for a great beyond — witness "Ghost" — but "On Borrowed Time" is too corny and soft-headed to satisfy, even by the mushy standards of the genre. When a husband and wife are killed in an automobile crash early in this play, the pain of grief is dispensed with entirely and the couple's immediate family is found in a jocular mood in the very next scene, set a week later. In Osborn's hands, death not only loses its sting but also seems considerably less discomforting than a bad cold.

What juice remains in the script can be found after intermission, when the author reaps the farcical payoffs of a plot that temporarily rescues even insects from their final rewards. The unbeatable Mr. Lane, dressed in devilish variations on period formal wear (spats and starched collars included), has a high time up that tree, presenting Mr. Brink as an easily perturbed fussbudget; the role taps the James Coco side of Mr. Lane's comic personality that has also been exploited by his more demanding assignments in Terrence McNally comedies. When given the chance, he and Mr. Scott match each other clownish take for take, as they did on the same stage in the 1983 "Present Laughter" that first gave a boost to Mr. Lane's career.

●

Then, as now, Mr. Scott serves ably as his own director. He knows his way around the Circle in the Square's awkward arena, and so does the designer Marjorie Bradley Kellogg, whose graceful indoors-outdoors set features a cozy, Stickley-furnished parlor and a fabulist Thomas Hart Benton tree. Though there is one glaring casting gaffe — Ms. Henritze's battle-ax aunt is a coarse Margaret Hamilton impersonation — Mr. Scott has otherwise recruited such solid supporting players as Conrad Bain (as a fussy doctor), Alice Haining (a kindly neighbor) and, especially, Teresa Wright as a beautiful, no-nonsense Granny. If there has to be a cute tyke named Pud onstage, then I suppose young Mr. Porac is as inoffensively adorable as any child actor one could hope to find.

But little Pud is no match for the cuddly, beaming, expansive star who turns even his trademark hot-under-the-collar outbursts into geniality incarnate. George C. Scott as Gramps! Who would have imagined it? These days, I guess, even a Patton must bend to fashion and become a Schwarzkopf.

1991 O 10, C19:1

Beau Jest

By James Sherman; directed by Dennis Zacek; production designed by Bruce Goodrich; costumes, Dorothy Jones; lighting, Edward R. F. Matthews; production stage manager, Jana Llynn. Presented by Arthur Cantor, Carol Ostrow and Libby Adler Mages. At the Lamb's Theater, 130 West 44th Street, Manhattan.

Sarah Goldman	Laura Patinkin
Chris	John Michael Higgins
Bob	Tom Hewitt
Joel	Larry Fleischman
Miriam	Roslyn Alexander
Abe	Bernie Landis

Martha Swope

Laura Patinkin

By MEL GUSSOW

In "Beau Jest," James Sherman's breezy but formulaic new comedy at the Lamb's Theater, a young unmarried Jewish woman (Laura Patinkin) hires an unemployed actor to play her parent's idea of an ideal mate. He pretends to be — what else? — a Jewish doctor. As a former member of Chicago's Second City, the actor (Tom Hewitt) has learned to improvise under pressure, and in a series of skitlike scenes, he proves to be completely convincing as the daughter's suitor.

Though he himself is a WASP, the actor has learned a bit about Jewish customs and traditions from playing in "Fiddler on the Roof." As he confides to Ms. Patinkin, "Topol thought I was Jewish." At a family dinner, he is called upon to say the prayer over wine, and to the daughter's amazement, his Hebrew turns out to be word perfect, and it is immediately followed by a remembered chorus of the song "L'Chaim."

When the play comments on the actor's artfulness (what he knows about medicine, he has picked up from "St. Elsewhere"), there is a freewheeling spontaneity. At these moments, Mr. Sherman seems like an American cousin of Alan Ayckbourn, but he proves to be far less inventive in terms of plot and character.

•

"Beau Jest" is a staged sitcom (or rather, skit-com), repeating situations with lessening effect and stretching a very thin joke to three acts while coaxing the audience to laugh at stereotypical behavior. The mother and father are slices of the same kugel, the mother's favorite food. The events are predictable right down to the contrived conclusion, which suggests that all is blissful in what to the outsider might seem like a highly disputatious family.

The play could have been written decades ago, for all that it avoids saying about parental possessiveness and women's rights. In fact, except for touches of contemporaneity in the dialogue, Mr. Sherman's Goldmans are not so far removed from the television world of "The Goldbergs."

What enlivens the comedy, besides the character of the actor, is the cast, under the low-pressure direction of Dennis Zacek. Mr. Zacek first presented the play at Chicago's Victory Theater. The performers neither overact nor patronize the material.

As the daughter, Ms. Patinkin has a gentle ease and affability, even though her character would be a figure of ridicule at any feminist gathering. She earns a certain degree of sympathy for a woman foolishly entrapping herself in a thicket of lies.

• •

As the eager-to-please actor hired from the Heaven Sent Escort Agency, Mr. Hewitt has the delivery of a young Dick Van Dyke. Guilelessly he throws himself into his role of playing doctor. With an attitude of "I can do that," he is never at a loss for a comic touch, just as his character is never at a loss for words.

Watch him, for example, when the family questions him about his mythical medical career. "What kind of surgery do you do?" he is asked. "Whatever comes up," he responds casually. "Hearts, brains." The two young people are such an obvious love match that one becomes impatient waiting for them to find each other behind the charade.

Larry Fleischman and Roslyn Alexander are calmly in command as the blustering father and overbearing mother, both of whom resolutely conform to cliché. The mother tries to mind her daughter's kitchen as well as her romantic life. The father specializes in leading a shortcut seder, which emphasizes wine and food at the expense of religious ritual ("We were slaves, then we were free, let's eat"). For an audience accustomed to television and to rites of family, "Beau Jest" should have a soothing familiarity.

1991 O 11, C16:6

Correction

A theater review on Friday about the comedy "Beau Jest" at the Lamb's Theater misidentified the actor who plays the father. He is Bernie Landis; Larry Fleischman plays Joel.

1991 O 15, A3:1

SUNDAY VIEW/David Richards

New York Is Cast as Villain and Victim

Deep in 'Babylon Gardens' an urban jungle thrives.

I N THE SECOND ACT OF "BABYLON Gardens," things would appear temporarily to be looking up for Opal, a homeless black woman and Jesus freak who's been surviving as best she can in the streets and alleys on the Lower East Side of New York. Bill, a perpetually stoned anesthetist, has taken her to a flophouse, paid for two nights' lodging, rented her a TV set and even given her $12 in mad money.

Opal is not appeased, though. Fixing her benefactor with a fierce stare, she thunders — as Daniel did to the King of Babylon — "Your kingdom is finished. You have been weighed in the balance and found wanting."

"You get no argument from me there," replies Bill, too exhausted by this time to be his usual flip self.

The trouble is you'll get no argument from the playwright Timothy Mason, either, which may explain why "Babylon Gardens" is so dramatically fallow. Ostensibly, the play, which recently opened the season at Circle Rep, examines some troubled young professionals coping with life in New York City in the troubled 1990's. But don't fool yourself. It's really about America the Not So Beautiful — home of the drugged, the crazed and the dispossessed.

How Mr. Mason's characters got so messed up — or, for that matter, how the country did — is not the issue. They just are. It just is. Mr. Mason's mind is made up from the start. The land and its people have been weighed in the balance, and the balance has had its say. Nothing that happens on stage is going to alter that judgment. The play, for all practical purposes, is over before it begins.

Bill (Timothy Hutton), a transplant from Little Falls, Minn., starts out stoned, stays stoned at home and in the operating room, and, except for a brief and unsatisfying flirtation with sobriety, winds up stoned. Since he has the faintly imbecilic sensibility of a latter-day flower child, maybe it's a deep nostalgia for the 1960's that accounts for his drug habit. But who can say? I suspect we're simply supposed to accept his addiction as evidence of how rotten things are around him.

■

When he proclaims, "I am an anesthetist because I desire to spread peace in the world," he means to be funny. But Mr. Mason is reading a certain amount of symbolism into the profession. The 1990's are too much with us. We need numbing.

Bill's wife, Jean (Mary-Louise Parker), has already found her escape hatch — periodic flights of madness that can be traced to the birth of her anacephalic baby. Although the deformed fetus was immediately whisked away, she sees the child everywhere, talks about its education, worries over its welfare. She also lives in terror of the rays emitted by the television set and sees "shapes" in the window that opens onto mean streets getting meaner by the second.

"I'm not always weird," she admits in what may be the truest analysis of her character. "I am just sometimes weird."

I don't believe that Mr. Mason has made these characters up out of whole cloth. The play gives off too strong a scent of autobiography for that. But he has left so many blank spaces and glossed over so many motivations that the actors and their director, Joe Mantello, should probably be credited as co-au-

thors merely for finding their way through the piece.

With his stringy hair, his eyes narrowed to slits and a complexion the color of old sheets, Mr. Hutton has the "air of wastedness" the other characters attribute to him. But even he, a likable actor, is bereft of charm in the role. Ms. Parker's tactic is to position herself on the near side of madness. No plunges off the deep end, no wild and sudden seizures. Quietly, sweetly, she slips into her fantasies — the look of candor on her face giving no indication that anything's amiss. The drifting back and forth is artfully done, although just what provokes it each time is matter for conjecture.

Dramatically fuzzy as they are, the drugged-up hubby and his wigged-out wife are still the best delineated of Mr. Mason's characters. Opal (Cynthia Martells) — who once stripped on bar tops for dollars, now quotes scripture for free and favors a nip or two of Nyquil before curling up on the sidewalk — seems like a reject from Whoopi Goldberg's one-woman stage show. Molly (Bobo Lewis), a double mastectomy patient, is there only to let us know that in olden days — and they were *better* days — the authorities flooded the now notorious Tompkins Square in winter, turning it into a free skating rink.

As for the Puerto Rican youth (Hector M. Estrada), whom Jean, in her sentimental folly, befriends by the East River, he's not the innocent he appears, as any tourist from Wichita could tell you. Well, altruism is tricky business. Nobody in this city is who he pretends to be. And if you consider the state of the country — make that the state of the world — we're all homeless.

Sam Shepard plunged us into similarly murky metaphorical waters last season with "States of Shock," in which a family restaurant stood for America, a rampaging general embodied our blood lust and a crippled Vietnam veteran represented the maiming of Manhood Itself. By the conclusion, bombs were exploding offstage and the customers had begun to curl up in fetal position on the floor.

Mr. Mason doesn't envision such a violent end in "Babylon Gardens," just continuing deterioration. But there's no question that he, too, considers greatness behind us. "Anybody remember when America died?," Bill asks some of his married friends who've dropped by for the evening. "Where Were You When America Died? Think of it as a party game."

O.K. If we must. You go first.

'The Radiant City'

"Babylon Gardens" may be unable to elucidate our urban angst, but there's no shortage of explanations for why New York City, at least, turned out as it has in "The Radiant City," the new multimedia presentation written, designed and directed by Theodora Skipitares at the American Place Theater. Here, in an enchanted nutshell, is a history of the town and its environs, beginning with the Ice Age and continuing on down to the World's Fair of 1964-65, with particular emphasis on the life and schemes of the city planner and demagogue Robert Moses. If that sounds dry and academic, let me add hastily that Ms. Skipitares is the most fanciful of professors and frolicsome of theorists.

While she has her points to make, she makes them with such invention that it may be more helpful to look upon "The Radiant City" as one of those eccentric sideshow exhibits that come magically alive when you insert a nickel in the slot. In her limitless imagination, which she seemingly has no difficulty translating to the stage, skyscrapers dance, highways unfurl like banners and beach umbrellas perform a bright Busby Berkeley routine, all the while puppets act out Moses's rise to prominence, his stranglehold on city development in the 1940's and 50's and his eventual fall from grace — with a shove or two from the Brothers Rockefeller.

In 'Radiant City,' skyscrapers dance and highways unfurl like banners.

I realize that if you mention puppets, most of the country's adult population automatically starts running in the other direction. Know, then, that it is the loosest of terms for the captivating variety of constructions that Ms. Skipitares employs in her 90-minute show. There are puppets on rods and puppets on strings and little whitewashed figures attached to movable platforms (the ordinary people uprooted by Moses's vast redevelopment plans) that could have been designed by George Segal.

There are heavy marble friezes of the sort that were once carved over post office doors — except that here they depict poor folk in Depression bread lines, who actually shrug their shoulders and bow their heads in despair. Moses's political cronies in Albany are life-size papier-mâché sculptures, similarly articulated, so that one can puff on a cigar, a second toss back a shot of whisky and a third roll his eyes craftily from side to side, just to make sure no one catches him in a shady deal.

■

Moses comes in all sizes and shapes, depending on the state of his fortunes. At birth, he's a featureless wooden doll, stirring in the dust inside an empty aquarium. At his political apogee, he's represented by a massive stone bust (petty dictator model) that is just asking to be toppled by the people. After the inevitable toppling, he's reduced to a pathetic Giacometti-like figure, shaking a wispy head in bewilderment or senility.

They are all splendidly manipulated by a team of performers dressed in black. But the puppets (sorry!) are only part of a beguiling mixture that includes film footage, vintage slides, model roadsters, juggling, Hannibal on an elephant, light-up maps, a Ferris wheel of fortune and a three-piece band, playing a dissonant, although often witty, musical score by Christopher Thall. Lisa Kirchner and William Badgett supply the narration, speak for the characters and sing the quasi-Brechtian commentary.

■

No 90-minute show, of course, can pretend to give a comprehensive picture of Moses's long and controversial career. (For that, we have Robert Caro's masterful biography, "The Power Broker.") What seems fascinating to me about "The Radiant City" is that Ms. Skipitares's assertive social consciousness in no manner precludes an extravagant sense of play. While "The Radiant City" gives you lots to ponder — the arrogance of developers, the efficiency of glaciers and the inevitability of traffic jams — she illustrates her ideas so originally that you don't really think of them as abstractions so much as pop-up surprises in some fun house of the mind.

If ever the Disney corporation decides to build a theme park for intellectuals, Ms. Skipitares is the obvious choice to preside over the planning committee. □

1991 O 13, II:5:1

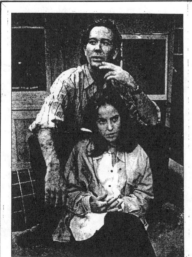

Paula Court/"Babylon Gardens"

M. Draper/"The Radiant City"

Timothy Hutton and Mary-Louise Parker in Timothy Mason's "Babylon Gardens" at the Circle Rep, and a sculpture of Robert Moses from "The Radiant City" by Theodora Skipitares at the American Place Theater—varieties of urban experience.

Return to the Forbidden Planet

Written and directed by Bob Carlton; musical director, Kate Edgar; scenic design, Rodney Ford; costume design, Sally J. Lesser; lighting design, Richard Nelson; sound design, Bobby Aitken for Autograph; special film effects design, Gerry Anderson; Ariel costume design, Adrian Rees. Presented by Andre Ptaszynski and Don Taffner. At the Variety Arts Theater, 110-12 Third Avenue, at 14th Street, Manhattan.

WITH: Gabriel Barre, Allison Briner, Julee Cruise, Mary Ehlinger, Erin Hill, David LaDuca, Robert McCormick, Michael Rotondi, Steve Steiner, Chuck Tempo, Louis Tucci and James H. Wiggins Jr.

By MEL GUSSOW

Eons ago, before "Star Trek" and "Star Wars," there was "Forbidden Planet," an ingeniously high-tech science-fiction movie that drew its basic story line from "The Tempest." "Return to the Forbidden Planet," Bob Carlton's musical version, which incorporates rock and rhythm-and-blues of the 1950's and 1960's, is a case of Shakespeare rattled and rolled.

The show won an Olivier award as best musical in London, in a backlash beating out "Miss Saigon." The American production, directed by Mr. Carlton, opened Off Broadway last night at the newly refurbished Variety Arts Theater. It is a febrile, hectic attempt at blending diverse modes. On stage the worlds of Shakespeare, science fiction and classic rock collide.

Where the movie kept parallels to "The Tempest" subtle, the musical is overt, plundering Shakespeare for dialogue, which it twists to suit its purpose, often as a lead-in to a musical number. At the same time, it borrows songs from singers as disparate as the Beach Boys and James Brown. Roy Orbison, Elvis Presley and, perhaps most noticeably, Jerry Lee Lewis are all represented in the pastiche score, with "Great Balls of Fires" becoming close to a theme song. For a while it looks as if there are going to

be references to every rock hit of the period and to every Shakespearean play with the exception of the disputed "Two Noble Kinsmen."

As an added inducement to American audiences, the Off Broadway version is introduced and fleetingly narrated by Scotty from "Star Trek." In his cinematic appearances on a screen, the actor James Doohan looks more Falstaffian than Prosperous. Actually, he delivers his lines with a capable grasp of Shakespearean language.

For purposes of the theatrical expedition, the Variety Arts has been rigged out as a spaceship with tinnily mechanized equipment on the stage and on platforms in the audience. A rock band-acts as mission control. Later when the ship lands there is interplanetary paraphernalia, including long tentacles descending from the ceiling. The actors pretend to be ensnared. For all its effects, Rodney Ford's stage design looks like a Times Square electronic games parlor.

To underline the Shakespearean background, the leader of the trek is named Captain Tempest, the mad scientist is called Dr. Prospero and Robby the Robot from the movie is now formally identified as Ariel. Actually, Ariel (Gabriel Barre) looks like the Tin Man from "The Wizard of Oz," with Michelin tires wrapped around his legs. The fact that Mr. Barre is wearing roller skates also makes him seem like a fugitive caboose from "Starlight Express."

The actors are adept at singing and playing a variety of instruments, although no undue strain is placed on their acting ability. Erin Hill (as Miranda) and Louis Tucci have good voices, and Mr. Barre has a robotic wryness, but only Julee Cruise invigorates the show with musical personality. Well remembered for her singing on "Twin Peaks," she is spunky as well as amusing although the script unwisely keeps her offstage for most of the first act. She is playing Prospero's lost wife, Julia, in the movie,

renamed Gloria so that she can sing the Van Morrison song of that name.

As intended, the musical is loud and raucous — and so overmiked as to endanger the eardrums of the ushers. In an attenuated preshow warm-up

Captain Tempest, Dr. Prospero, and Robby the Robot becomes Ariel.

and at other moments, theatergoers are asked to become involved in the performance, raising their arms in a space-age variation on the Tinker Bell effect. In terms of its comic inventiveness, the show is a galaxy away from Monty Python.

Coming after "Buddy" and before "Five Guys Named Moe," scheduled to open on Broadway later this season, "Return to the Forbidden Planet" is part of an English ripple of reverse Americana, rock transported over the ocean and then returned to sender. The musical is good-natured, but in common with the wild-haired Dr. Prospero, it seems marooned in space.

After seeing the show, I put a laser disk of the original film on television, and watched a boyish Leslie Nielsen lead the voyage to the "Forbidden Planet," where he discovered Walter Pidgeon as a debonair though demented philologist. Thirty-five years later, the movie still has an innocent charm. In the musical, the charm is o'erthrown.

1991 O 14, C13:1

March of the Falsettos and Falsettoland

Book, lyrics and music for "March of the Falsettos" by William Finn. "Falsettoland" by Mr. Finn and James Lapine, with music and lyrics by Mr. Finn. Directed by Graciela Daniele; orchestrations and musical supervision by Michael Starobin; musical director, Henry Aronson; set, Ed Wittstein; costumes, Judy Dearing; lighting, David F. Segal; sound, David Budries; production stage manager, Barbara Reo. Presented by Hartford Stage, Mark Lamos, artistic director; David Hawkanson, managing director. At 50 Church Street, Hartford.

WITH: Roger Bart, Joanne Baum, Andrea Frierson, Adam Heller, Etan and Josh Ofrane, Evan Pappas and Barbara Walsh.

By FRANK RICH

Special to The New York Times

HARTFORD, Oct. 11 — It is not news that the history of American musicals in the 1980's begins and ends Off Broadway at Playwrights Horizons, with a pair of startling one-act musicals by William Finn that bracketed the decade, "March of the Falsettos" (1981) and "Falsettoland" (1990). But it was a secret, until now, that the two "Falsetto" shows, fused together on a single bill, form a whole that is not only larger than the sum of its parts but is also more powerful than any other American musical of its day.

For this discovery, audiences owe a huge thanks to the Hartford Stage. Under the artistic direction of Mark Lamos, it has the guts to produce these thorny musicals together at a time when few nonprofit theaters are willing to risk aggravating dwindling recession audiences by offering works that put homosexual passions (among many other passions in the "Falsetto" musicals' case) at center stage.

Just as important, Mr. Lamos had the intuition to entrust the production to Graciela Daniele, a director and choreographer (most recently of "Once on This Island") who would not be the most obvious choice to direct a show about Marvin, a nice young neurotic Jewish man who leaves his wife, Trina, and bar-mitzvah-age son, Jason, for a male lover. "I was born in Argentina," Ms. Daniele writes in a program note. "I'm not Jewish, I'm not a gay man, I've never even been to a bar mitzvah!" Yet she has brought off an inspired, beautifully cast double bill that is true to its gay and Jewish characters — and to the spirit of the original James Lapine productions — even as it presents the evening's densely interwoven familial and romantic relationships through perspectives that perhaps only a woman and a choreographer could provide.

•

Seen through Ms. Daniele's eyes, and seen together so they can achieve both cumulative and symbiotic effect, the "Falsetto" shows seem even richer than before. Though "March of the Falsettos" and "Falsettoland" are set only a year apart — in 1980 and 1981, respectively — the nine years separating their creation makes them a de facto map of the giddy rise and tragic fall of a decade within one slice of middle-class New York life.

The first of the two, bright and fizzy in the style of a wisecracking revue, seems pulled from a time capsule now. Written without benefit of historical hindsight, it exuberantly bottles the joy of men (both hetero- and homosexual) who begin the 1980's gorging on the promise of sexual and

Michelle V. Agins/The New York Times

Steve Steiner, left, and Gabriel Barre in a rehearsal for "Return to the Forbidden Planet."

A scene from William Finn's "March of the Falsettos" and "Falsettoland" at the Hartford Stage in Hartford.

T. Charles Erickson/Hartford Stage

emotional liberation, all achieved with the benediction of Marvin's friendly shrink, Mendel, who himself takes up with the abandoned Trina.

In "Falsettoland," however, Mr. Finn's music has a wintry chill and his once buoyantly articulate lyrics are clouded by a literally nameless dread. "Something bad is happening," sings an internist puzzled by the "sick and frightened bachelors" passing "unenlightened" through her hospital. By the final curtain, no word has yet been found to name the virus in question, but the evening's clutch of friends and family has been reduced to "a teeny tiny band" huddling together in love and terror on a vast, darkened stage.

That vast stage, a feature of the Hartford playhouse, was not available in the theaters where the Finn shows played in New York. For her finale, Ms. Daniele exploits the spatial dimensions at her disposal with an overwhelming coup de théâtre (not to be divulged here) that first reduces an audience to sobs and then raises it to its feet. Until that point, her staging is as lithe and uncluttered as the Lapine originals — movable cubes substitute for rolling chairs — without replicating them. Ms. Daniele uses the Hartford thrust stage's nearly basketball-court-size floor space to work out the constantly changing configuration of Marvin's family in bouncy, lightly drawn geometric dance terms. Nowhere is this more apparent than in the director's pointed exclusion of Trina (Barbara Walsh) from songs like "Four Jews in a Room" in which the swaggering male characters hold sway.

Ms. Daniele's most pronounced departure from the original productions overall is her treatment of Trina, who is no longer a resilient comedian with a belter's voice but, in Ms. Walsh's modestly sung but hugely affecting performance, a rueful figure who is allowed genuine as well as comic anger at all "the happy men who rule the world." Fittingly, in the evening's sole alteration of the original shows' text, Trina is given an additional song, adapted from "In Trousers," an earlier Finn musical about Marvin's travails.

As the wife gains gravity through Ms. Walsh's acting, so the son, Jason, is enhanced simply by the linking of the two shows. The evening's dramatic thread becomes the boy's efforts to become a man even as his parents split up, his mother remarries and his father moves in with his friend, Whizzer. Jason's journey from his hilarious, innocently homophobic solo, "My Father's a Homo," early in Act I to his heroic Act II decision to celebrate his manhood by having his bar mitzvah in the dying Whizzer's hospital room gives the show its most inspiring burst of hope.

Not that the troubled love affair between Marvin and Whizzer is in any way shortchanged. Evan Pappas, who was so fine as another brand of selfish New Yorker in last season's Off Broadway revival of "I Can Get It for You Wholesale," is equally striking here, bringing a savage edge (along with his strong voice) to Marvin's self-indulgence and emotional greed ("I want it all!") no matter who is hurt along the way. Roger Bart's Whizzer is as narcissistic a "pretty boy" as the lyrics claim, yet so ingenuously boyish that it is easy to see why he eventually earns the loyalty of his lover's son and why his example finally inspires a latently generous Marvin to embrace selfless love at last in the evening's final, searing duet, "What Would I Do?"

It is a tribute to both Mr. Finn's lyrics and his music, here played by Henry Aronson's sprightly band in the original Michael Starobin arrangements, that they can carry the depth of these characterizations and those by Adam Heller (as Mendel), Josh Ofrane and Etan Ofrane (identical twins who share Jason's role an act apiece) and Andrea Frierson and Joanne Baum (as the "spiky lesbians" who arrive after intermission). The eclectic musical-comedy melodies of Act I and the torrential lyricism of Act II still seem freshly minted, as do the many comic turns of phrase about matters as various as the methodology of psychotherapy and the plight of doting parents who must watch "Jewish boys who cannot play baseball play baseball."

The audience must experience grief along with the music and laughter, of course, for something bad is happening in Falsettoland, now no less than in the distant year of 1982 when the show's story ends. But surely there is solace to be had when the theater strikes back at something bad in life with a show that is this exhilaratingly good.

1991 O 15, C13:1

Theater in Review

■ A Shakespeare adaptation with a political point
■ A crime farce set in Brooklyn ■ A mother and
daughter lost in America's heartland.

A Tempest

Ubu Theater
15 West 28th Street
Through Oct. 27

By Aimé Césaire; translated by Richard Miller; directed by Robbie McCauley; set by Jane Sablow; lights by Zebedee Collins; costumes by Carol Ann Pelletier; musical director, Tiyé Giraud; movement director, Marlies Yearby. Presented by Ubu Repertory Theater, Françoise Kourilsky, artistic director.

WITH: Rafael Baez, Ron Brice, Leon Addison Brown, Leo V. Finnie 3d, Clebert Ford, Arthur French, Bryan Hicks, Lawrence James, Jasper McGruder, Sharon McGruder, Patrick Rameau, Robert G. Siverls, Kim Sullivan and Marlies Yearby.

Caliban's the main man in "A Tempest," a bright political comedy by Aimé Césaire, and Ariel is his brother, one who longs in magnificent lyrics for freedom, not only for them but for their oppressor, Prospero. For Prospero, the white magician of Shakespeare's "Tempest," may remain white here, but his magic is black. He, and the band of shipwrecked noblemen washed ashore on Caliban's island, are colonial exploiters.

Mr. Césaire, one of the founders of the French literary movement called négritude and the most widely honored poet now writing in French, has been the mayor of Fort-de-France in Martinique and the Martinican member of the National Assembly in Paris for four decades; his every word has a political point. But he is also an inspired playwright who knows how to persuade by laughter.

The Ubu Repertory Company's production of his 1969 play, in a translation by Richard Miller — the first of three works in a festival of West Indian plays this autumn — is a sprightly and song-filled enchantment with a first-rate cast under the direction of Robbie McCauley. The luminous intelligence of Mr. Césaire's meditation on the absurdities of colonialism shines through the antics of the bewildered characters.

Good humor is the key to the play's meaning, and Ms. McCauley brings it all out. Mr. Césaire is a gentle mocker of self-delusion — in the drunken plans of the peasants Stefanio and Trinculo to capture Caliban and make him a sideshow star, in the nobleman Gonzalo's dream of building an agricultural empire out of guano, in Prospero's belief that magic can preserve his power. Even Caliban and Ariel, the embodiments of hope, fall prey to illusions now and then. In the end, the playwright seems to be saying, freedom depends on grasping the truth about our common humanity more than on holding political power.

Jane Sablow's clever set, with its changing perspectives, and Tiyé Giraud's musical arrangements, with their ever changing moods, help sustain from beginning to end the happy illusion that is the play itself.

D. J. R. BRUCKNER

Our Lady of Perpetual Danger

Judith Anderson Theater
422 West 42d Street

By Adam Kraar; directed by Joel Bishoff; produced by Roy Gabay; production stage manager, Roger Lee; set design, Steve Carter; lighting, Matthew Frey; costumes, Amy Lenzcewski. Sea Crest Associates presents a Quaigh Theater production.
WITH: Robert Arcaro, Arija Bareikis, Kevin Cristaldi, Nancy Kawalek and Mary Tahmin.

"I want you to taste my blood. I want you to hold my heart in your hands and drink!" pleads Will (Kevin Cristaldi), an ambitious young investigative reporter to his wife, Concetta (Nancy Kawalek), near the end of Adam Kraar's comedy "Our Lady of Perpetual Danger."

Such declarations define the tone of Mr. Kraar's hectic farce, set in present-day Brooklyn. The idiotic Will expects to become a famous journalist by exposing a petty toy-smuggling racket involving Concetta's ex-boyfriend Valducci (Robert Arcaro). When not sleuthing, he tries to coax the squeamish Concetta, who runs a small accounting business, to do "dangerous" things like take the afternoon off and make love on the kitchen table.

For a journalist so concerned with integrity, Will is a study in deception. Though Jewish, he faked an Italian background to get his apartment and win Concetta, who hates lies and responds to them with judo chops to the groin. He has also covered up a wild bachelor past that his old pal Sally (Arija Bareikis) divulges after sneaking into his apartment through a back window.

"Our Lady of Perpetual Danger" has none of the lightness of a good farce, and its plot goes haywire. The acting is mediocre, and under the direction of Joel Bishoff a comedy that is already far too shrill for its own good is delivered at a screaming pitch. *STEPHEN HOLDEN*

Ready for the River

Home for Contemporary
Theater and Art
44 Walker Street
Through Oct. 27

By Neal Bell; directed by Joshua Astrachan; set design, Derek McLane; lighting, Greg MacPherson; costumes, Melina Root; sound, Tom Gould; stage manager, Kate Broderick; associate set designer, Elizabeth Hope Clancy; guitar, David Lott; special makeup, Jennifer Aspinall; production associate, Andie Coller. Presented by Home.
WITH: Randy Danson, David Eigenberg, Kathleen O'Neill, Dylan Price and James Riordan.

"How far away is far enough?" The question, which is repeated several times in Neal Bell's "Ready for the River," resonates like an anxious incantation through a surrealistic comedy about a mother and her adolescent daughter trying to flee their hometown and getting lost in a decaying American heartland.

The landscape through which they journey by night in a car that eventually breaks down, is a ghostly wasteland of abandoned farms on whose walls a teen-age gang has spray-painted apocalyptic warnings about AIDS. The mother, Doris (Randy Danson), and her bratty daughter, Lorna (Kathleen O'Neill), have taken to the road after witnessing Lorna's brutal husband shoot a local banker who was about to foreclose on their farm.

Pursuing them are the dead man's ghost, who pops up in the back seat in gory makeup; his gay son, who wants to escape with them, and a man in a ski mask who may or may not be the ghost of the killer.

The play, which Joshua Astrachan has directed at the Home for Contemporary Theater and Art, is filled with ominous images that his taut, bare production effectively underscores. "What's the difference between a dead baby lying in the middle of the road and a flattened skunk?" Lorna asks, then answers deadpan, "There are skid marks around the skunk." The sick joke is one of the play's many allusions to eviscerated animals.

Such remarks reveal an ear well tuned to a sarcastic American vernacular that carries a rock-and-roll punch and suggests a heightened, self-conscious echo of Sam Shepard. But although the play is promising, it is too long, and by the end the repetitions have begun to sound pretentious.

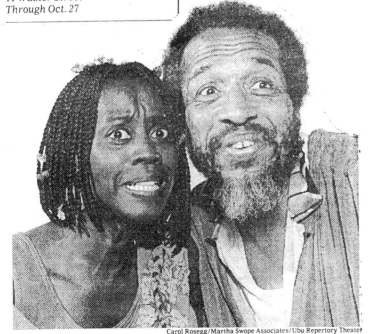

Carol Rosegg/Martha Swope Associates/Ubu Repertory Theater
Sharon McGruder and Arthur French in a scene from "A Tempest."

The play is superbly acted. Ms. Danson and Ms. O'Neill add a twangy Middle American authenticity to the playwright's rough language. They compellingly evoke a mother-daughter relationship that seesaws between harrowing conflict and a tenacious affection. *STEPHEN HOLDEN*

1991 O 16, C18:3

Maturando

By Marcos Caetano Ribas; conceived, created and directed by Mr. Ribas; sets and props by Rachel Ribas; puppets by Rachael and Marcos Ribas; lighting design by Mr. Ribas; musical direction by Hector Gonzales and Graziela De Leonardis; technical direction by Paulo Roberto Brandão; body preparation by Fernanda Amaral. Grupo Contadores de Estorias presented by the Brooklyn Academy of Music, Harvey Lichtenstein, president and executive producer. At Lepercq Space, 30 Lafayette Avenue, at Ashland Place, Fort Greene, Brooklyn.
WITH: Marcos Caetano Ribas, Fernanda Amaral, Rachel Ribas and Alza Helena Alves.

By STEPHEN HOLDEN

"In a gray sky, the full moon is like a pearl," reads one of the haiku that the Brazilian puppet-theater company Grupo Contadores de Estorias illustrates in its lyrical 90-minute dream play, "Maturando."

The work, which was performed at the Brooklyn Academy of Music last week, Wednesday through Sunday, as part of the Next Wave Festival, is a luminous, moonlight-drenched evocation of a woman's life cycle, in which the two characters, a woman and her lover, are alternately portrayed by hand puppets and by the actors who manipulate them in the style of Bunraku puppetry. By the end of the wordless piece, one is left with the eerie sense that the miniature figures are more "real" than the humans who slip in and out of the same roles.

"Maturando," which was created by Rachel and Marcos Caetano Ribas and features a cast of four, including themselves, is a play in six scenes, broken by two visualizations of haiku poetry in which the moon is literally hung up over the stage. It begins with a scene of a female puppet in labor and ends with a miraculous transformation in which the same woman, grown old, exchanges her wizened head for a new young one.

In between are scenes in which actors step into the puppet roles. In one, a man who has just made love with a woman who has vanished sorts through their scattered clothes, slowly dresses himself, and experiences a moment of voluptuous happiness as he contemplates her lingerie. In another, a woman, dressing in front of her mirror, streaks her hair with gray, then faces the audience with an angry mocking smile.

The puppet and the human dimensions of a work that is as meticulously symmetrical as it is romantic come together in a scene in which the puppet woman's dreams of youth and love are visualized in dreamy erotic tableaux portrayed by the puppeteers and behind a spotlighted scrim.

"Maturando" is accompanied by an eclectic, prerecorded sound track that embraces everything from South American folk to European classical music. The mood of sensual longing reaches a peak of intensity with Arvo Pärt's ravishing "Cantus in Memory of Benjamin Britten."

1991 O 17, C19:1

Distant Fires

By Kevin Heelan; directed by Clark Gregg; scenic design, Kevin Rigdon; lighting, Howard Werner; costumes, Sarah Edwards; stage manager, Matthew Silver. Presented by Atlantic Theater Company, by special arrangement with Evangeline Morphos Brinkley and Nancy Richards. At 336 West 20th Street.

WITH: Giancarlo Esposito, Jordan Lage, Ray Anthony Thomas, Jack Wallace, Todd Weeks and David Wolos-Fonteno.

By MEL GUSSOW

Tempers are flaring on a construction site in Kevin Heelan's "Distant Fires," as five laborers pour cement and react diversely to the limits of their lives. This perceptive group portrait of men at work is the combined contribution of the playwright, his director, Clark Gregg, and an ensemble cast.

"Distant Fires" is at the Atlantic Theater, a company initiated by David Mamet and W. H. Macy. Both the play and the production owe at least an unconscious debt to Mr. Mamet, as was also true of Howard Korder's "Boy's Life," an equally fine example of the Atlantic style of theater. In the Mamet tradition, the dialogue is pithy and profane and filled with a sidewalk spontaneity. The play moves effortlessly from amusing working-class conversation to an atmosphere that is highly charged with conflicting points of view.

While taking part in the specifics of the shared activity, the characters exchange comments on their hard-hat world and reveal their emotional bruises, some of them self-inflicted. Three of the men are black, with their opportunities rigidly circumscribed by insidious acts of discrimination in the building industry.

The one laborer (Ray Anthony Thomas) who has the capability and ambition to move up in the ranks and become a member of the local bricklayers union clearly will be thwarted by his own willingness to compromise. The narrative of the play follows Mr. Thomas's growing realization of the causes of his frustration, culminating in a silent scene in which the actor movingly expresses his pent-up resentment. The story line is slim but sufficient to contain the indirect drama.

Carol Rosegg/Martha Swope Associates/"Distant Fires"
Giancarlo Esposito in a scene from "Distant Fires."

181

Quietly, "Distant Fires" raises sobering questions about racism in the workplace and about the roots of urban violence. The play neither overstates its case nor overstays its welcome; it remains brief and to the point. The playwright's avoidance of melodrama testifies to his confident command of background and character. Having created characters, he allows them to speak for themselves. With the help of the actors and their details of dress and behavior, each becomes a vivid personality.

Mr. Thomas, hopeful of progress, is the only member of the crew who has respect for the work ethic. Around him are slackers and talkers. The latter position is appealingly typified by David Wolos-Fonteno as an affable hedonist who works only to be able to play after hours. Idling alongside him is Giancarlo Esposito as a man simmering with rage and unfocused energy. He is easily drawn into the riots that are engulfing a nearby neighborhood (the "distant fires" of the title), which repeatedly impinge on the play.

•

The outsiders on the crew — insiders in life — are a handsome Maryland equivalent of a hillbilly (Jordan Lage), who, because he is white, will advance in his job despite his occupational deficiencies, and a guileless teen-ager (Todd Weeks) who may be the author's spokesman. On the periphery is the man in charge of the project (Jack Wallace), a figure with power but absolutely no conviction.

Though some of these characters may seem familiar, each one is highly individualized in the writing and in performance. The actors are inseparable from the hard-hat roles they are playing. Under the skillful guidance of Mr. Gregg, functioning as unseen foreman of the work crew as well as director, they achieve a veracity within the play and beyond the stage space they occupy (an evocative set design by Kevin Rigdon). One could imagine them finishing their day's work and dropping in at a local bar for beer and banter, and then returning the following morning to the construction site.

1991 O 17, C22:1

The Sorrows of Frederick

Written and directed by Romulus Linney; artistic director, James Houghton; assistant director, Francesca Mantani Arkus; stage manager, James Marr; set design, E. David Cosier; lighting design, Jeffrey S. Koger; costume design, Teresa Snider-Stein. Presented by the Signature Theater Company. At Kampo Cultural Center, 31 Bond Street, Manhattan.

WITH: Kernan Bell, Bryant Bradshaw, Fred Burrell, James Coyle, Katina Commings, Claude D. File, Elliot Fox, Austin Pendleton, Garrison Phillips, Mitchell Riggs, T. Ryder Smith, Richard Thomsen and John Woodson.

By MEL GUSSOW

By devoting a full year to the plays of Romulus Linney, the Signature Theater Company is performing a distinct service for theatergoers as well as for the playwright. The wide-angle perspective should lead to a greater awareness of the depth and diversity of Mr. Linney's work. Late last season, audiences were offered a sampler — revivals of two one-acts. Currently the company is revisiting the author's first play, "The Sorrows

of Frederick," with Austin Pendleton returning to a role he has played several times in the past.

Though it was written in the mid-1960's and presented in England, the play did not have its New York premiere until 1976. Today, as in that earlier rudimentary production, this is an introspective look at a most contradictory monarch, Frederick the Great of Prussia, the warlike philosopher-king.

In revival, the play retains its complexity and its flaws. As an ambitious attempt to reveal the humanity shrouded by history, it offers a psychological portrait of a totally obsessive personality. In that sense and others, it can be compared to Marlowe's "Edward II." In both cases, a king is driven by his mania to become his own victim.

As the play sprawls through Frederick's disordered mind and Prussia in the 18th century, it encounters obstacles, including a slow flashback through the character's early life. Some of the structural problems might be overcome if the play had the fully realized production it demands. Once again, an epic play is approached as a chamber drama, in this case under the direction of the playwright. The spareness of the staging adds to the audience's quandary, as it tries to find an equilibrium in a highly volatile world.

•

Mr. Pendleton is most persuasive in conveying the comic side of the King's madness; he has more difficulty with the tragic dimensions. In this production, Mr. Linney seems to move the work further into black comedy, as the King savagely imposes his anarchic will while acting out a self-assigned role as tyrannical humanist.

Bullied by his father, the artistically inclined Frederick sets out to prove himself, suffering from delusions as he strives toward unattainable greatness. Mr. Pendleton reaches his apogee when he defies his dead father from the pinnacle of his newly acquired power. With insolence, he asks, "What do you think of the little fop that plays the flute?"

As before, the people who surround him are less individual than prototypical, with the definite exception of Voltaire (Garrison Phillips), a favored visitor in the Prussian court. Voltaire would seem to be the one man unafraid to stand up to the King. Their dialogue is one of the strongest elements in the play.

In this revised version of the text, a brief epilogue wrenches the play forward into the 20th century, offering a glimpse of the rise of Nazism and the suggestion that it was an outgrowth of Frederick's reign. This observation might have been better left to the audience's imagination.

What that coda does indicate is the growth of the playwright's writing talent, from "The Sorrows of Frederick" to "2," his most recent drama, presented at the Actors Theater of Louisville (Ky.) and still unproduced in New York. The new play is an excoriating study of Hermann Göring and the Nuremberg war-crime trials. In his second dramatic exploration of the history of Germany, the playwright has honed his theatrical and political skills to the sharpest cutting edge

1991 O 17, C22:1

The Baby Dance

By Jane Anderson; directed by Jenny Sullivan; scenery by Hugh Landwehr; costumes, David Murin; lighting, Kirk Bookman; sound, Brent Evans; production stage manager, Tammy Taylor. Presented by John A. McQuiggan, Lucille Lortel and Daryl Roth, in association with Susan Dietz. At the Lucille Lortel Theater, 121 Christopher Street, Manhattan.

Wanda	Linda Purl
Al	Richard Lineback
Rachel	Stephanie Zimbalist
Richard	Joel Polis
Ron	John Bennett Perry

By FRANK RICH

Any chronic theatergoer is sooner or later asked, "What is the worst play you've ever seen?" There is no answer, of course, but if pressed to the wall, I might be tempted to start such a discussion with "The Wayward Stork," a short-lived farce of 25 years ago in which the late, great comedian Bob Cummings, his hair all but aflame with red dye, played a husband caught up in a botched effort at artificial insemination. There were, if memory serves, many jokes about chicken basters. Loved that Bob.

•

"The Baby Dance," the new play at the Lucille Lortel Theater, is nothing if not a "Wayward Stork" for the 1990's. Though the quality of the writing is a couple of rungs above rock bottom and though the tone is lugubrious rather than antic, it takes the same sad situation, that of an infertile couple eager to have children, and exploits and trivializes it to equally numbing effect. Reflecting its own time, "The Baby Dance" is much more pretentious than "The Wayward Stork," and, instead of being cooked up by a Broadway schlockmeister, it has been nurtured by three nonprofit theater companies that list themselves in a wayward honor roll in the Playbill: the Pasadena Playhouse, the Long Wharf Theater and the Williamstown Theater Festival.

No doubt reflecting this parentage, the play's plot, about an affluent Los Angeles couple buying the impending baby of a poor Louisiana couple, touches on such matters as class conflict, racism, abortion, birth control and the ethics of surrogate parenthood, among other aspects of the present-day baby market, legal and not. But the author, Jane Anderson, has nothing to say about these issues; she just milks them for cheap melodrama in the apparent hope that she'll bring forth a commercial entertainment, an "Other People's Baby."

•

Ms. Anderson condescends to all her characters except the unborn. The baby-makers, a redneck couple living in a rural Louisiana trailer court, wear tattoos, eat both Cool Whip and Miracle Whip, own a Princess phone and use a Crisco can as a

T. Charles Erickson

Linda Purl

flower vase. Yet they have primitive parental instincts and animal sexual passions beyond the ken of sterile rich folk. The California couple — damningly employed at the lowest end of the film-industry food chain (he's in business affairs, she's in development) — are defined by such brand names as Honda, Evian and Williams-Sonoma. The husband in this couple, a Jewish man who will only buy a baby commensurate with his own economic and intellectual status, is presented so mean-spiritedly that the characterization comes across as anti-Semitic. For added measure, a stereotyped baby-bartering lawyer wanders in for Act II; he may be one of those two-bit slick operators that Senator Orrin Hatch warned the nation about during the Judiciary Committee hearings last weekend.

•

Under these circumstances, the actors deserve sympathy, especially in Act I, when, in keeping with the Louisiana weather noted in the Playbill ("Highs are in the 90's and the humidity is 100 percent"), they are all drenched in sweat. It is also in that act that Linda Purl is asked to end a scene with the center-stage declaration, "I got to get my tubes tied!"

At least she and Richard Lineback bring some fierce passion to the white-trash couple, who might otherwise seem to have stepped out of "The Beverly Hillbillies." As the wealthy husband and wife, Stephanie Zimbalist and Joel Polis are to the mannered born. In keeping with the soapy text, Jenny Sullivan's direction is stagy in the extreme, with far more pregnant pauses than even this play's subject demands.

1991 O 18, C5:1

1991
(A Performance Chronicle of the Rediscovery of America by the Warrior for Gringostroika)

Written, directed and performed by Guillermo Gómez-Peña; light design, Tony Giovannetti; maps and mirrors designed by Luis Brindis. Presented by the Brooklyn Academy of Music, Harvey Lichtenstein, president and executive producer. At the Lepercq Space of the academy, 30 Lafayette Avenue, at Ashland Place, Fort Greene.

By MEL GUSSOW

As a writer and performance artist, Guillermo Gómez-Peña seeks to identify and correct injustices committed against Hispanic people since the time of Christopher Columbus. In his play "1991 (A Performance Chronicle of the Rediscovery of America by the Warrior for Gringostroika)," he says that Columbus "arrived in America without papers" and should have been deported. This is one of the sharper comments in his show, part of the Next Wave Festival at the Brooklyn Academy of Music.

In keeping with his self-characterization, Mr. Gómez-Peña takes a militant stance on a variety of ethnocentric issues. He is filled with attitude but proves to be a wavering communicator of his own grievances. Even on its own kaleidoscopic terms, his play is fragmentary. It is a series of broad impersonations, played against an eclectic background of recorded Spanish music. As a performer of his own work, he seems to have a limited

range, in contrast to such monologuists as Eric Bogosian and John Leguizamo, who can populate an entire stage with their chameleonesque personalities.

•

The show makes flamboyant use of motley costumes. Mr. Gómez-Peña begins in wrestling regalia, which is in keeping with his description of himself as a "social wrestler." As the actor destroys stereotypes, Coco Fusco portrays an inexpressive Queen Isabella with a model ship sitting on top of her head.

Mr. Gómez-Peña frequently states an iconoclastic opinion and then leaves it dangling in air, like the plucked chickens that hang down over the stage. In one scene, he puts on boxing gloves and completely shrouds himself in what could be considered a cloak of mourning. Then he spars with one of the chickens, which according to a program note symbolize migrant workers who were hanged in Texas in the 1930's. That fact additionally confuses the one-sided boxing match.

Acting as a shaman, he takes objects from a crowded table and manipulates them in performance: lighted candles, a rubber snake, a Big Mac. Often the humor begins and ends with a reference to a brand name or a star. The language fluctuates between English and Spanish, sometimes settling for Spanglish.

At a seemingly predetermined point in the first act, he stops the show to announce, "This is not working; we need more performers," and one readily agrees. He begins again, and after a brief period declares an intermission. The second, shorter act seems an afterthought and the show ends without a climax. While recognizing the value of Mr. Gómez-Peña's assault, one must also register disappointment with his performance chronicle, especially from someone recently honored with a MacArthur Award.

1991 O 18, C14:5

SUNDAY VIEW/David Richards

Death Takes A Holiday, In an Apple Tree

Martha Swope/"On Borrowed Time"

Matthew Porac and George C. Scott have time on their side once death (Nathan Lane) is treed in "On Borrowed Time."

George C. Scott is rocking-chair easy in the sentimental 'On Borrowed Time.'

The audience is abuzz at 'Beau Jest,' and for good reason.

GEORGE C. SCOTT HAS JUST turned up at Circle in the Square in "On Borrowed Time," unless it is Santa Claus on a late-summer sabbatical. The raspy voice that sounds rather like pebbles in a Cuisinart leads me to believe that it is Mr. Scott. But the thatch of hair and the whiskers — the color of snow and sunshine — argue for Santa.

That would also explain the potbelly, although it's not so much a potbelly, really, as a barrel chest that has settled with time and contentment. And the blue eyes, bluer than the worn work overalls he's wearing, blue as cornflowers by a country roadside, have to be considered as corroborating evidence.

But then Santa, if Santa it is, will go and open those eyes wide on you, and for a minute you can see fear and a kind of glossy craziness in them. Or else his impatience with human foolishness will momentarily get the best of him and he'll brand someone a "pismire" or a "bird-stuffer." And while those

terms wouldn't amount to much in anyone else's mouth, here they're epithets to be reckoned with. So I guess it is Mr. Scott up there after all. But I've certainly never seen him so charmingly homespun, so rocking-chair easy, so at peace with a role.

In Paul Osborn's gooey 1938 fantasy, he's playing 70-year-old Julian Northrup, affectionately known as Gramps to the little bundle of curiosity and cuteness who is his grandson and who, I fear, is affectionately known as Pud. Since Pud's parents have recently perished in a car crash, the duty of raising the child seems to have fallen to Gramps, who sees it as no duty at all but as an opportunity to start collecting frogs again.

Gramps's wife (Teresa Wright), a fretting sort, wonders if he isn't poisoning the boy's mind, however, with all his swearin' and drinkin' and pipe smokin'. Aunt Demetria Riffle (Bette Henritze), deeply convinced of it, is ready to adopt the youth herself and enroll him in a Baptist boarding school for girls that, as luck would have it, has begun accepting boys. But the biggest threat to Gramps's authority is posed by the dapper gentleman in the gray suit and gloves (Nathan Lane), who shows up, as discreetly as a mortician at a banker's funeral, and indicates, shortly after the family battle lines have been drawn, that it's the old man's time to go "where the woodbine twineth."

If you have not yet gathered that the mysterious caller — Mr. Brink — is death and that it's not Hawaii he's referring to with his talk of twining woodbine, or even New Jersey, then perhaps "On Borrowed Time" still has enough power to enchant you. On the other hand, the sap runneth pretty thick — and not just in the branches of the gnarled apple tree that the designer Marjorie Bradley Kellogg has planted at the far end of the horseshoe-shaped stage. For all-American

goodness and kindly eccentricity, Osborn's world is on a par with Norman Rockwell's.

Mr. Brink is smart, but not so clever that he can't be coaxed into climbing up that apple tree. Once there, according to the particular laws of this fantasy, he can no longer harm so much as a fly and is reduced to fuming impotently (a very amusing fumer, Mr. Lane) until Gramps agrees to let him down. This does not usher in a new age of bliss, though. As long as death is on hold, suffering and sorrow just accumulate on earth — like trash. You need a Mr. Brink to put people out of their misery, clear away the pain, tidy up the landscape.

■

That idea — the only one in "On Borrowed Time" — goes straight to the heart of the right-to-die movement, I dare say, and raises all sorts of thorny moral issues that Osborn would have been horrified to contemplate. In its time, with World War II just around the bend, the play was perceived as warm and comforting. Why fear Mr. Brink — or any of his appointed henchmen — when giving in to him, apparently, is quite a pleasant sensation that makes you feel 2 years old again and light as a feather?

Our images of death tend to be far more graphic these days and, Shirley MacLaine notwithstanding, we're not so sure that when the moment comes, it comes all that easily. Osborn's reassuring sentimentalism and the play's moseying ways tend to make "On Borrowed Time" look every one of its 50-odd years. ("Morning's at Seven," Osborn's gentle comedy of sisterly rivalries, produced the following year and revived successfully on Broadway in 1980, seems positively Dostoyevskian, by comparison.) To the extent that "On Borrowed Time" survives, it is as an unabashed period piece that allows a handful of character actors to put on small-town togs and folksy airs.

Mr. Scott, who is also the evening's director, makes no bigger claims for the production, and fortunately the cast is happy to abide by his rules. It includes Conrad Bain, as the sagacious local doctor; George DiCenzo, as a frazzled emissary from the state asylum, and a mutt named Marilyn, as a mutt named Betty. In the role of Pud, you also get a child actor, Matthew Porac, who is a child first and an actor second — which helps a lot when he has to say things like "heap of tape" for "adhesive tape."

But let's not kid ourselves. Mr. Scott is carrying this old chestnut on his burly shoulders — and complaining about it no more than any law-abiding citizen has a right to complain. At the end, when he ventures into the eternal night, there's an unmistakable twinkle in his eye and he's even begun to give off a golden glow. Granted, the lighting designer Mary Jo Dondlinger is responsible for the glow. But Mr. Scott, old Billy Goat Gruff himself, has put the twinkle there.

'Beau Jest'

I'm hardly the first to point out that spectators talk more in the theater now than they did 20 years ago, or that they've cultivated the habit while watching television. When you find them talking a lot in the theater, however, it's usually because the play unfolding on stage is television.

I mean, nobody talks during a play by Brecht, although more than a few doze quietly. Silence, which is to say a sort of respect, prevails at dramas by Tennessee Williams or Eugene O'Neill. And I've still to hear anyone pipe up from the back of the house, "O, that I had been writ down an ass," before Dogberry does. But let the play start behaving like television and before they know it — almost without knowing it — audiences

are off and running at the mouth. (Pavlov, I think, may have something to say about this.)

James Sherman's "Beau Jest," to cite the latest example, certainly had everyone at the Lamb's Theater jabbering the other night. Most of the time, the actors kept the upper hand — being elevated and brightly lighted. But what the audience lost by having to sit in the darkness it made up for in numbers. As much as anything else I might tell you, that may serve to position Mr. Sherman's comedy on the dramatic spectrum. It invites all the idle chatter it is getting.

In three bubble-headed acts, "Beau Jest" shows what happens when Sarah Goldman (Laura Patinkin), a Jewish kindergarten teacher, hires Bob (Tom Hewitt), an out-of-work actor, to impersonate her boyfriend. She already has a boyfriend, but he's a gentile, and her parents won't hear of the match. A Jewish doctor would be more to their liking. So Bob, who is also a gentile, but an actor don't forget, pretends to be a Jewish doctor. I am sure you can fill in the ensuing complications with no help from me. But if you do get lost, someone in the audience will be happy to answer any further questions.

Nothing the six cast members do lends much originality or charm to the script, although Mr. Hewitt invests considerable energy in his two-faced role and could never be accused of being a spoilsport. Ms. Patinkin seems to be searching for the dramatic truth in her part, which is rather like panning for gold in the Hudson. Roslyn Alexander and Bernie Landis are Jewish parents, as stereotype would have them.

Sometime during "Beau Jest," as the buzz in the auditorium reached a noticeable high, the thought struck me that maybe we've been coming at the problem of noisy audiences from the wrong angle. Telling people to mind their manners seems to be leading us nowhere. Maybe banning TV from the theater will do the trick. ☐

1991 O 20, II:5:1

André Heller's Wonderhouse

Created, designed and directed by André Heller. Assistant director, Ivana De Vert; lighting by Pluesch; costumes, Susanne Schmoegner; sound, T. Richard Fitzgerald; curtain, Erté; English-language adaptation by Mel Howard; incidental music arranged and orchestrated by Andrew Powell. Presented by Mr. Howard, in association with Jean D. Weill. At the Broadhurst Theater, 235 West 44th Street, Manhattan.

Igor ... Billy Barty
Olga ... Patty Maloney
The Stagehand Gunilla Wingquist
WITH: Ezio Bedin, Marion and Robert Konyot, Baroness Jeanette Lips von Lipstrill, Macao, Milo and Roger, Carlo Olds, Omar Pasha and Rao.

By MEL GUSSOW

There is New Vaudeville and there is the old vaudeville, and then there's "André Heller's Wonderhouse," a variety show featuring some of the most ancient clichés and tired theatrics in show business. A clown plays a tune by ringing dozens of tiny bells; the

"king of paper sculpture" turns out to be a man who makes paper dolls and trees, and a Wagnerian-sized woman purses her lips and whistles Offenbach. All that is missing from Mr. Heller's penny-ante arcade at the Broadhurst Theater is for someone to hold his hand in front of a spotlight and project a bunny rabbit shadow puppet on a screen. Just wait.

Almost any one of these eight acts might have been suitable as a warm-up routine for the Ed Sullivan show or as an entertainment for a 7-year-old's birthday party (probably the 7-year-olds would prefer Penn and Teller). All of the performers have a certain facility at their crafts, albeit of a very limited kind, but, taken together, they cancel one another out.

●

The show is supposed to be a surprise party for a 70-year-old vaudevillian (Patty Maloney). The surprise, arranged by her husband (Billy Barty), is a visit from her favorite entertainers from the past. With the statuesque Gunilla Wingquist acting as stagehand and with a small band playing, the performers give a reprise of the olden days of vaudeville.

Here come Ezio Bedin, who imitates the sounds of a traffic jam and of a cowboy movie, and Marion and Robert Konyot, an aging team of knockabout dancers, who reach for laughter by falling all over each other on stage. Then there is Baroness Jeanette Lips Von Lipstrill. She is the whistler, and "Glow Little Glowworm" glowers in her repertory. A restless member of the audience might well shout, "No encore!" But the whistling baroness will carry on regardless.

The troupe has an earnestness, but seeing "André Heller's Wonderhouse" after Le Cirque du Soleil, the Big Apple Circus and America's many virtuosic New Vaudevillians, it should cause disbelief. It is as if we have entered a time warp, trapped in variety past.

●

The fact that the shadow puppeteer, Rao, is agile with his hands and can form not only a bunny rabbit, but also dogs, an elephant and an army of undignified dignitaries, does not earn him his spot on a big Broadway stage. The cast also includes Omar Pasha, who makes things suddenly appear in black light, and an illusionist team that must have been doing its routine since the early days of burlesque. Those illusionists, Milo and Roger, at least have the nerve to let themselves be upstaged by a duck that disappears on cue.

Watching the show brought to mind "Broadway Danny Rose," in which Woody Allen played a hapless agent who books the oddest talent, the kind of act no one wants, like penguins, parrots and a woman who plays music on water glasses. Danny Rose might identify with "André Heller's Wonderhouse." For others, the only wonder is that the show managed to get to Broadway.

1991 O 21, C15:1

The Brief, Dark Flower Of Weimar Culture

By MEL GUSSOW

Special to The New York Times

LOUISVILLE, Ky., Oct. 20 — The culture of the Weimar Republic, that brief flowering of artistic expression between two totalitarian German regimes, was analyzed and celebrated this weekend at the Actors Theater of Louisville. As the culmination of a two-month, citywide Classics in Context festival, several hundred academics and theater professionals delved into the origins of Weimar, the depth of the creativity and the aftereffects that are still being felt today in many countries, including a reunified Germany that is still troubled by divisiveness.

Though the festival covered a spectrum from "The Blue Angel" to the Bauhaus and included a Schoenberg concert and an exhibition of drawings by Josef Albers, the focus this weekend was on theater. In particular, the subject was Bertolt Brecht and Odon von Horvath, the two major playwrights of the era.

A revue of Brecht songs, performed by members of the Berliner Ensemble, and an Actors Theater production of Horvath's masterwork, "Tales From the Vienna Woods," were by far the highlights of an enlightening weekend.

John Willett, an author and a Brecht scholar, set the tone with his lecture, "Weimar and Germany: The 20's and Today," in which he vividly characterized the nature of the time and the diversity of the art, which, he said, was marked by "stress and passion." This was exemplified by George Grosz's statement, "I felt the ground shaking beneath my feet, and the shaking was visible in my work."

From 1918 to 1933, between the fall of the Kaiser and the rise of Hitler, there was a renaissance of art in Weimar, the city of Goethe and Schiller, and it spread to Berlin and other places. Just a sampling would include Kandinsky, Gropius, Breuer, "The Cabinet of Dr. Caligari," the theater of Erwin Piscator and, of course, Brecht and Kurt Weill. Much of Weimar culture was later labeled degenerate by the Nazis. As Peter Gay points out in his book "Weimar Culture," "the brilliance of refugees from Hitler" was a measure of the success of Weimar. Among those refugees was Brecht. After World War II, his plays became the legacy of the Berliner Ensemble, the company he founded and headed.

In "Love and Revolution: A Brecht Cabaret," two actors from the Berliner Ensemble, Carmen-Maja Antoni and Hans-Peter Reinecke, recaptured the searing cynicism of songs that put civilization on trial, symbolically represented by the title of "Song of the Insufficiency of Human Endeavor" from "The Threepenny Opera." With a refreshing lack of didacticism, the performers let Brecht's lyrics — and the music by Weill and others — speak for themselves. The two sang songs of love denied and hope abandoned in a world in which self-interest had a primal authority.

Mr. Reineke approached his selections with an informality that was in admirable contrast to other Brechtian interpreters who accent the stridency of the message. The feisty Miss Antoni provided occasional English explanations as in her statement that Brecht was "singing in dark times about dark times." Accompanied by Karl-Heinz Nehring on the piano, they swept through more than 30 songs before arriving at the inevitable finale, "The Ballad of Mack the Knife." They honed a new edge on that knife, underlining the embitterment while retaining the lilting melody.

It was clear from the cabaret and from the more vigorous discussions that for all its aspirations, Weimar was very far from an ideal, artistically as well as politically. Even as artists searched for an earthly paradise, they were misunderstood, ignored or contradicted and, in some cases, corrupted, staying on in Germany and collaborating with the Nazis.

The survival of the democratic Weimar instinct is represented by Horvath, a Hungarian who found his artistic roots in Germany. In one of the most bizarre cultural juxtapositions, just after seeing Walt Disney's "Snow White and the Seven Dwarfs" he was struck dead by a falling tree during a storm in Paris. In his brief career he wrote 17 plays. It has been his fate to be rediscovered again and again. As Christopher Hampton pointed out in one colloquium, "Tales From the Vienna Woods" "makes it absolutely clear where the country is going" — toward self-destruction.

Mr. Hampton's translation of "Vienna Woods" was first produced more than a dozen years ago in London at the National Theater with Kate Nelligan in the leading role of the defeated shopgirl Marianne. While not equalling that epic English version, Mladen Kisilov's intimate approach in Louisville also reached the core of the work, the paradox of a most unromantic story being played against a background of Viennese waltzes. The cast, led by Claire Beckman, V. Craig Heidenreich and Mary Beth Peil, conveyed the helplessness of people in a centerless society.

Mr. Kiselov added a haunting directorial touch as a silent coda to the play. With her life devastated and her baby carelessly left to die, Marianne (Ms. Beckman) faces the futility of her future and, by inference, that of her country. Slowly an overturned, empty baby carriage spins by on a

Odon von Horvath

turntable, signifying the suffering of children victimized by adults who should have been their watchful guardians. The image of the carriage becomes a Horvathian equivalent of the canteen wagon dragged back into action by Brecht's Mother Courage.

Even more than Brecht, Horvath was a harbinger of theater today. With his portrait of the meanness of everyday life, he anticipated the work of Franz Xaver Kroetz, Rainer Werner Fassbinder and Peter Handke, who in a much quoted essay indicated his preference for Horvath, as being more responsive than Brecht to contemporary tides.

Linking Weimar theater with experimental German films, the Actors Theater screened Walter Ruttman's 1927 documentary, "Berlin: Symphony of a Great City," a mosaic of one day of urban life, cross-cutting factory workers, soldiers and shopkeepers with scenes of mechanization, all of it presented with irony and imagination. The film paralleled the photographs of August Sander exhibited at the J. B. Speed Museum. In the brochure for the exhibition, the photographer is praised for "seeing the familiar in an unfamiliar way," something that would also apply to Ruttman, Horvath and many other artists of the period.

Throughout the weekend there was a sense of a continuum, a living time line of the art and also of the prob-

The times were grim and mean. So were the arts.

lems that continue to divide a newly reunified people. In one panel, the Berliner Ensemble actors painted a bleak picture of the future of their company, besieged by pressing economic concerns and faced by a new five-man directorate.

Responding to Miss Antoni's curiously specific statistic that Brecht's plays are 74 percent of the Berliner repertory, one member of the audience wanted to know why more plays by other writers were not being done. While avoiding the obvious answer, that Brecht was a cornerstone of the German theater, the actress seemed to argue against the union of West

Bertolt Brecht, whose work was examined in a celebration of the culture of the Weimar Republic.

and East Germany. But, she insisted: "We don't want to turn the wheel back. We want to advance it."

Weimar culture would seem to have been a less popular choice for a Classics in Context festival than those at the last two annual gatherings (dealing with the Moscow Art

Theater and commedia dell'arte). But the performances and discussions confronted a responsive audience with a provocative sense of theater's role in contemporary history and history's role in contemporary theater.

1991 O 23, C17:4

Theater in Review

■ Interracial romance, Steppenwolfishly rendered

■ Jane Austen, meet Mr. Right ■ A 60's sex parable amid 90's angst ■ When Hitler could be laughed at.

Servy-n-Bernice 4Ever

Provincetown Playhouse
133 Macdougal Street

By Seth Zvi Rosenfeld; directed by Terry Kinney; scenery by Edward T. Gianfrancesco; costumes by Judy Dearing; lighting by Kenneth Posner; sound by Jeffrey Taylor; associate producer, Eugene Musso; production stage manager, M. A. Howard. Presented by Al Corley, Bart Rosenblatt and Marcy Drogin.
WITH: Ron Eldard, Lisa Gay Hamilton, Erik King and Cynthia Nixon.

Two disparate shows share the stage at the Provincetown Playhouse, Seth Zvi Rosenfeld's quite ordinary new play, "Servy-n-Bernice 4Ever," and Terry Kinney's high-powered, hyperkinetic production.

Mr. Kinney, an actor and director known for his work with the Steppenwolf Theater, does his utmost to disguise, and to divert us from, the deficiencies of the drama. In this task, he is aided by the cast, in particular by two actors, Ron Eldard and Erik King. Unfortunately, the play offers the most stubborn resistance.

The narrative centers on an interracial romance between two people from the urban underclass, Bernice (Lisa Gay Hamilton), a black model, and Servy (Mr. Eldard), a petty thief who, given a choice, might prefer to be black. While Bernice fantasizes about her family background to make it more appealing to her upper-class best friend (Cynthia Nixon), Servy is earthy and unembarrassed about his past.

The first problem is Bernice, the play's tiresome leading character, a woman given to unconvincing mood swings (distraught, she throws her clothes out the window). In contrast to the other actors, Ms. Hamilton is unable to enhance her role. Her friend, though stereotypical, is more interesting, largely because Ms. Nixon plays her at a feverish pitch, with her body and mind always in motion. She is well matched by Mr. King as Servy's black friend, a stylish swaggerer who seemingly can con his way into any woman's bedroom although not necessarily into her bed.

As for Servy, fresh out of prison, he is a punk on the hoof. We wonder why the presumably more sensitive Bernice remains so enamored of him and can put up with his shabby ways. But Servy is zestfully personified by Mr. Eldard. Under Mr. Kinney's direction, Mr. Eldard plays him as a brute with a heart. In pursuit of his love, he does everything except cry, "Ber-

nice!" at the foot of the stairs. As an actor, Mr. Eldard would fit right into any work that would call for John Malkovich to have a younger brother.

In at least one respect, Servy and Bernice behave out of character. That is in scenes in which they pretend to be romantic figures in movies, role playing that Mr. Eldard does with amusingly shifting guises and a clever Cagney imitation. The performances and Mr. Kinney's Steppenwolfish direction are deserving of a more substantial play.

MEL GUSSOW

The Novelist

Theater Row Theater
424 West 42d Street

By Howard Fast; directed by Sam Schacht; set design, Jane Clark; costume design, Kitty Leech; light design, Victor En Yu Tan; music arrangement, Joseph Bloch; graphic design, Denny Tillman; production stage manager, Sara Gormley Plass. Presented by J. B. Matthews, in association with the Ensemble Studio Theater, produced by Kate Baggott.
WITH: Gretchen Walther and Will Lyman.

What if Jane Austen had found true love in the last three months of her life? It is a proposition that intrigued the veteran novelist, screenwriter and playwright Howard Fast enough to write a two-character play that imagines the wooing and winning of the 41-year-old author (Gretchen Walther) by a dashing 45-year-old Mr. Right.

Her lover, Thomas Crighton (Will Lyman) is a figure straight out of a historical romance. Tall, handsome, witty, gallant, moneyed, he is a retired British naval captain and widower who lives in a country house just a mile from hers. Within moments of his first visit, he announces that even before meeting the author he had fallen in love with her from reading her novels.

Intially offended by his forwardness, Austen, who is completing her last novel, "Persuasion," steadily warms to his blandishments. After some initial skirmishes, the only serious difference they have is over his bluntly negative response to the completed "Persuasion." Their idyll is cut short when Napoleon returns to France in triumph from exile in Elba and Thomas is briefly pressed back into naval service. When he returns three months later, she is dying.

"The Novelist," which is directed by Sam Schacht, is a well-written if sentimental portrait of Austen by a playwright who is unabashedly enamored of his subject. The play's first

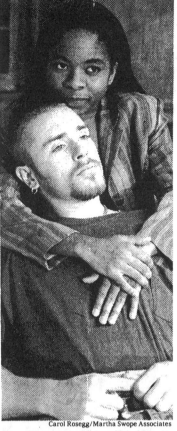

Carol Rosegg/Martha Swope Associates
Ron Eldard and Lisa Gay Hamilton in Seth Zvi Rosenfeld's new play, "Servy-n-Bernice 4Ever."

act, in which he pursues and she parries, has the kind of controlled emotional flow and intelligent dialogue that one finds in Austen novels. Without being obtrusive about it, the playwright inserts pertinent facts and details about the author, who wrote her first novel, "Pride and Prejudice" at the age of 21 and who, throughout her writing career, appeared to be all but oblivious to world events.

The performances are solid, if less than galvanizing. Mr. Lyman confidently conveys Thomas's winning mixture of charm and solidity, though his English accent wanders a bit. Jane Austen is the more difficult role, because the character has to melt from the soul of decorum into a smitten woman in a very short time. Ms. Walther skillfully negotiates the changes by suggesting a lifelong inner struggle between propriety and a passionate temperament that has been methodically suppressed.

STEPHEN HOLDEN

Futz

La Mama
74 East Fourth Street
Through Nov. 3

By Rochelle Owens; direction, music and set design, Tom O'Horgan; lighting design, Howard Thies; costume design, Ellen Stewart; set construction, Jun Maeda and David Adams; stage manager, Marybeth Ward. Presented by La Mama E. T. C.
WITH: Penny Arcade, John Bakos, Paul Beauvais, Peter Craig, Sheila Dabney, Kimberly Flynn, Tom Keith, John Moran, Doug von Nessen, Jonathan Slaff and Marilyn Roberts.

As much as any experimental play of the 1960's, Rochelle Owens's

"Futz" symbolizes that era's gleeful embrace of rude Dionysian revelry to tweak establishment sensibilities.

A primal yawp of barnyard poetry and song, Ms. Owens's comic satire tells the story of Cyrus Futz, an eccentric farmer who is jailed and killed by the local villagers after he is seen having sex with his adored sow Amanda. The characters include the town tramp Majorie, whom Cyrus rejects in favor of Amanda, and a mother-fixated murderer who claims he was driven to rape and to kill after observing Futz's porcine union.

"Futz" created a sensation when it was performed in 1967 at La Mama in a production directed by Tom O'Horgan, who also composed its crude, folkish score. And as part of La Mama's 30th-anniversary celebration, that production has been revived, with Mr. O'Horgan once again directing and several members of the original ensemble stepping back into their roles.

Seen nearly 25 years later, Ms. Owens's parable of sexual repression still has a compressed, blasting comic energy, although given the reactionary, AIDS-anxious sexual climate of the 90's, its message isn't as direct. The play's fanciful rural dialect, which suggests a bawdy expressionist answer to "Li'l Abner" cartoons, has lost none of its salt. And the 11 members of the cast, including John Bakos, who played Futz in the original production, portray the villagers with a grunting, snorting, snout-wiggling exuberance.

For the revival, Mr. O'Horgan hasn't modified his ritualistic total-theater style of direction in which the dialogue, song and choreography blend to create an orgiastic communal energy. The play begins as a demented rustic chorale in which the villagers sing and play instruments that include a washboard and homemade single-string bass and culminates in a familiar O'Horgan-style tableau of the martyred Futz and villagers reaching up to him.

As the meek, pig-smitten farmer, Mr. Bakos projects a sly humor along with an understated poignancy. But the strongest performance is Penny Arcade's slatternly Majorie. The stage has rarely held a lustier town tramp. *STEPHEN HOLDEN*

Geneva

Jean Cocteau Repertory
Bouwerie Lane Theater
330 Bowery
In repertory through Dec. 6

By George Bernard Shaw; directed by Casey Kizziah; set design by Robert Joel Schwartz; costume design by Jonathan Bixby; lighting design by Brian Aldous; music and sound design by Ellen Mandel; production manager, Patrick Heydenburg. Presented by the Jean Cocteau Repertory, Robert Hupp, artistic director; David Fishelson, executive director.
WITH: Harris Berlinsky, Jeanne Demers, Robert Ierardi, Joseph Menino, William Charles Mitchell, Grant Neale, Craig Smith, Dan Snow, James Sterling, Elise Stone, Angela Vitale and Mark Waterman.

There are still a few laughs in George Bernard Shaw's "Geneva," but only a few. Even in the energetic performance given by members of the Jean Cocteau Repertory Theater under Casey Kizziah's direction, this 1938 political tract, which lampoons dictatorship and other political follies, creaks and falters through its long progress.

Shaw delighted in exposing the absurd megalomania of Hitler, Mussolini and Franco (called Battler, Bom-

bardone and Flanco de Fortinbras in the play), but he also lashed out at the evil of their regimes, especially against Nazi anti-Semitism. In one stirring bit of dialogue he anticipated the arguments later used for putting the leaders and generals, not the soldiers fighting under them, on trial for war crimes. And he eloquently cut through the moral posturing of political thugs who claimed they only followed orders.

There is not a word against Stalin here, of course; to the end Shaw remained his defender. The only reference to Communism comes when an Anglican bishop obsessed by fears of a red revolution is done in by the mere sight of a Soviet commissar. Religion in general is roundly satirized, along with aristocracy, nationalism, patriarchal society and scientific fads.

But there is also a lot of serious political preaching. That, and the weakest plot Shaw ever stumbled into, make "Geneva" a terrible challenge. Mr. Kizziah and his cast concentrate their efforts on the nearly lunatic behavior of the dictators, the bishop and a woman driven mad by religious fervor — and they produce moments of great hilarity.

They cannot rewrite history, however, and 1938 was the last year in which Hitler and Mussolini could still appear ridiculous. No theatrical troupe can restore to us the innocent laughter "Geneva" may have aroused during its first production.

D. J. R. BRUCKNER

1991 O 23, C19:1

Beggars in the House of Plenty

Written and directed by John Patrick Shanley; scenery by Santo Loquasto; costumes by Lindsay W. Davis; lighting by Natasha Katz; sound by Bruce Ellman; production stage manager, Renée Lutz; associate artistic director, Michael Bush; general manager, Victoria Bailey. Presented by Manhattan Theater Club, Lynne Meadow, artistic director; Barry Grove, managing director. At City Center, 131 West 55th Street, Manhattan.

Johnny.................................Loren Dean
Ma.......................................Dana Ivey
Pop............................Daniel von Bargen
Sheila..............................Laura Linney
Joey..................................Jon Tenney
Sister Mary Kate...............Jayne Haynes

By FRANK RICH

If you can get past the forbidding title, "Beggars in the House of Plenty," and the patches of overwrought writing that occasionally echo it, you will find that the new play at the Manhattan Theater Club Stage 2 crackles with the energy of artists who are going places. The artists in question are the playwright, John Patrick Shanley, and his principal actor, Loren Dean. Their fleeting convergence in an intimate Off Broadway playhouse is a theatrical event not likely to recur anytime soon.

For the young Mr. Dean, the destination may be stardom. Though little known, he has revealed an impressive range in supporting roles on stage (as a teen-age hustler in Paul Zindel's "Amulets Against the Dragon Forces") and screen (an affluent high-school kid in "Say Anything"). Now, as show-biz fate would have it, he is coming to prominence by playing variations on the same leading role — a Bronx boy confronting man-

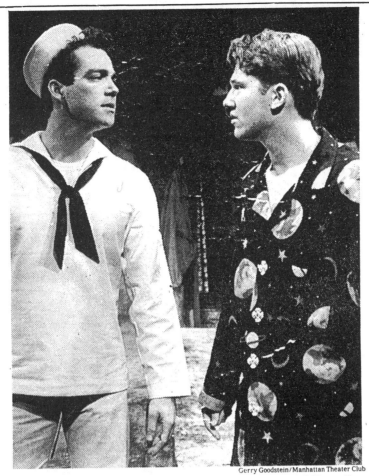

Gerry Goodstein/Manhattan Theater Club

Jon Tenney and Loren Dean in "Beggars in the House of Plenty."

hood — not only in Mr. Shanley's play but also in the movie version of "Billy Bathgate," which opens next week. While these assignments temporarily restrict Mr. Dean to a single persona, that of a sensitive, gap-toothed man-child buffeted by violent adults, they do allow him to charm audiences in a big way.

Mr. Shanley, of course, is a star already; he won an Oscar for his screenplay for "Moonstruck." But in some of his more recent projects (the film "Joe Versus the Volcano" and the play "The Big Funk"), he has been adrift, and "Beggars in the House of Plenty" seems to be his belated and savage effort to break through the creative bottleneck. Until now, the typical Shanley hero, whether Nicolas Cage's maimed baker in "Moonstruck" or the losers played by John Turturro on stage in "Danny and the Deep Blue Sea" and "Italian-American Reconciliation," has been a romantic young man whose fearful relationship to women traces back to an amorphous horror in his familial past. But in "Beggars," the Shanley hero's romantic misadventures are for once left offstage so that the old hurts can at last be cathartically exhumed.

•

The author's vulnerability in this play is so transparent that one admires the gutsy self-exposure even when the artistry becomes frayed. Johnny, the narrating protagonist played by Mr. Dean, enters in moon-motif pajamas and pointedly shares the author's background and literary ambitions as well as his first name; his story is too angry and painful not to be true. Even so, Mr. Shanley rarely stoops to offering the audience raw childhood wounds or mawkish self-pity and instead whips his autobiog-

raphy into surreal domestic comedy reminiscent of the blue-collar Roman Catholic family plays of John Guare and Christopher Durang. There's even a boisterous, rosary-toting Sister Mary Kate (Jayne Haynes), who, in a typical display of her limited tolerance, reassures Johnny's family that marrying outside its tight Irish community is "not wrong" but "just unnatural."

An autobiography is whipped into a surreal domestic comedy.

Still, it is inevitably Ma (Dana Ivey) and Pop (Daniel von Bargen), not the church, who are at the crux of the author's complaints. Lest there be any ambiguity about who has crippled Johnny or any of Mr. Shanley's other male protagonists, Pop turns out to be a butcher who works in a slaughterhouse, barks like a Marine sergeant and is usually armed with either a cleaver or a shotgun. As domineering Irish-American patriarchs go, this one makes even Eugene O'Neill's James Tyrone seem benign. Until he is old enough to discover words, Johnny's chosen weapon of revolt is pyromania, as if his pent-up anger were a manifestation of the raging fires of his first Bronx neighborhood's mean streets.

•

"Beggars" glosses over the predictability of its parental indictments with its intensely compressed time

scheme and almost lunatic tone of voice. The three acts unfold without a break on a fabulous set by Santo Loquasto that is partly a shrine to charred Bronx memories and kitsch and partly a cartoonish Charles Addams horror house. The design is so literally double-edged that the strings of colored holiday lights are intertwined with barbed wire. And so goes Mr. Shanley's own hellzapoppin style here, both as a writer and as an increasingly accomplished director. In a breathless 90 minutes, 40 topsy-turvy years of family history flood across the stage in a cacophonous rush as dense as the bric-a-brac in Mr. Loquasto's set. Glimpses of Christmases and wedding days intermingle with wars, deaths and vanished television programs dating back to "Davy Crockett."

Whatever Johnny's reminiscences, his questions remain the eternal ones: Why do parents withhold love and approval? Why does one sibling become "the lucky one," surviving a childhood's knockout punches, while another never rises from the floor? Why does anyone have to beg, "like dogs at a butcher shop window," for love in a family in the land of plenty? It is only in the last act, in which Johnny burrows into the most subterranean and hellish stratum of memory to confront his family demons in mythological terms, that the author's invention deflates into the pretentions of "The Big Funk." At that point Mr. Shanley starts to address his questions preachily, shoving his undigested (and unexceptional) views about life on the audience instead of transforming them into theater.

Even then, the ingenuous Mr. Dean draws us close to Johnny's hurt, and he is supported at every turn by a fine cast, which also includes Laura Linney and Jon Tenney as the sister and brother who have their own different crosses to bear. As their principal persecutor, the wild-eyed Mr. von Bargen is hilarious as well as forbidding, braying in such exaggerated stentorian tones that minor struggles with tooth decay and hemorrhoids become earthshaking traumas for his nearest and dearest.

For Ms. Ivey, Johnny's chilly, selfish mother is a grotesque caricature of the similar but more naturalistically drawn Bronx Irish mother she played only last spring in Frank Gilroy's "Subject Was Roses." Her performance is very funny, too, but it becomes deeper in the evening's final moments, when she and Mr. Shanley reveal the sweeter young woman who long ago withdrew into the tough carapace of the middle-aged Ma. That coda, reconciliatory and generous, suggests that the playwright may yet write a fuller family play than this fuming comedy despite Johnny's declarations that he has his family "pegged" and is "through with this subject." No one is ever through with this subject. More honest and less moonstruck than ever, Mr. Shanley is poised to enter a whole new phase.

1991 O 24, C17:4

Dancing at Lughnasa

By Brian Friel; directed by Patrick Mason; set design by Joe Vanek; lighting by Trevor Dawson; sound by T. Richard Fitzgerald; production supervisor, Jeremiah J. Harris; choreography by Terry John Bates. The Abbey Theater Production presented by Noel Pearson, in association with Bill Kenwright

and Joseph Harris. At the Plymouth Theater, 236 West 45th Street.

Michael	Gerard McSorley
Chris	Catherine Byrne
Maggie	Dearbhla Molloy
Agnes	Brid Brennan
Rose	Brid Ni Neachtain
Kate	Rosaleen Linehan
Gerry	Robert Gwilym
Jack	Donal Donnelly

By FRANK RICH

WHENEVER an Irish dramatist writes a great play, or even a not-so-great one, habit demands that non-Irish audiences fall all over themselves praising the writer's poetic command of the English language. Those audiences may be in for a shock at "Dancing at Lughnasa," Brian Friel's new play at the Plymouth Theater, for its overwhelming power has almost nothing to do with beautiful words.

Just as living is not a literary experience, neither is theater at its fullest — theater that is at one with the buried yearnings and grave disappointments that are the inescapable drama of every life. In "Dancing at Lughnasa," Mr. Friel and an extraordinary company of actors, most of whom originated their roles at the Abbey Theater in Dublin, uncover that eternal drama in stolen glances, in bursts of unexpected laughter, in an idle fox trot to a big-band tune on the radio. That is the poetry of this play — its "dream music," in the narrator's phrase — and like the most fragrant music, it strikes deep chords that words cannot begin to touch.

Words are hardly scanted in "Dancing at Lughnasa," but as Mr. Friel gradually reveals, they serve a different, less ethereal, more troubling function. Many of them are spoken by that narrator, a middle-aged autobiographical stand-in for the author named Michael (Gerard McSorley), who sets out to tell the audience about the "different kinds of memories" he has of three weeks in August 1936, when he was 7 years old.

As Michael says at the outset, nothing of remarkable note happened over those weeks at the rural, financially straitened County Donegal house where

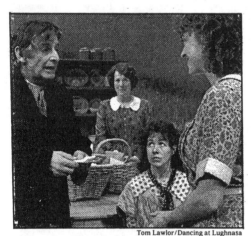

Tom Lawlor/Dancing at Lughnasa

From left, Donal Donnelly, Rosaleen Linehan, Brid Ni Neachtain and Catherine Byrne.

he lived with five unmarried women, his mother, Chris (Catherine Byrne), and her four sisters. His little-seen father, a charming Welsh drifter named Gerry (Robert Gwilym), unexpectedly pops up for two brief visits. An old uncle, Jack (Donal Donnelly), returns to his sisters' home for keeps after 25 years in exile as a missionary priest at a Ugandan leper colony.

The only other red-letter event in the Mundy household is the arrival of its first wireless set, a clunky wooden box emblazoned with its brand name, Marconi. But the far-off music summoned by the radio, like the alluded to in Mr. Friel's title, exerts a tidal pull on the characters far stronger than any domestic occurrence. As the sisters go about their

offstage village festival chores in Act I, bickering and gossiping and joking in the kitchen, they are titillated by intermittent reports of the Lughnasa celebration, in which

their neighbors honor the pagan god of the harvest, Lugh, with dancing and fires and other back-hills rituals well beyond the bounds of their own strictly enforced Christian propriety. Though the women's participation in the fun remains unlikely, an explosion of Celtic music on the new radio possesses them all, even the schoolmarmish Kate (Rosaleen Linehan), and leads them into a spontaneous, short-lived dance in which uninhibited leaps and cries of pure animalistic hunger momentarily throw off the monotony of a drab, impoverished existence for an incandescent explosion of joy.

What does the dancing mean? It is not our business to know, exactly, for as Michael later says, dancing is a language "to whisper private and sacred things" — the expression of a search for an "otherness," a passion that might be spiritual or romantic or uncategorizable but that in any case is an antidote to the harsh facts of an earthbound existence. It is typical of the production's delicacy that in the first, tumultuous dance, each sister's gestures, steps and whoops have been precisely choreographed to raise the curtain, however briefly and enigmatically, on the individual passions of five contrasting private souls. It is typical of the play's own pagan force that that scene seems to yank the audience into communion with its own most private and sacred things, at a pre-intellectual gut level that leaves us full of personal feelings to which words can not be readily assigned.

●

Many of the other profoundly moving interludes in "Dancing at Lughnasa" grab the audience in the same way, by expressing the verbally inexpressible in gesture and music. The frustrated sexual affection between the young mother Chris and the ne'er-do-well Gerry is dramatized not in the dialogue of their tongue-tied reunion so much as in their Fred-and-Ginger spin to the radio's outpouring of "Dancing in the Dark," a song whose lyrics pointedly elude them. The unacknowledged longings of Uncle Jack, who seems to have left his heart back in Africa and has trouble retrieving his English vocabulary after 25 years of Swahili, can be articulated only when he walks toward the wheatfields beyond the Mundy garden and taps two sticks together in time with some Dionysian tribal rhythm banging about in his head. Almost as poignant are the faces of those characters who cannot hear the music or join in a dance: When the four other sisters watch Chris and Gerry two-step from afar, each of their expressions becomes a distinctive, haunting portrait in complex suppressed emotions.

As directed by Patrick Mason, "Dancing at Lughnasa" gets the bril-

liant acting it demands; no between-the-lines nuance is lost by the ensemble of eight performers. Among the more indelible images are those provided by Brid Brennan as the angriest and most secretive of the sisters and by Mr. Donnelly, whose aging, distracted, shuffling Uncle Jack adds a poignant perspective to a career that has been linked with Mr. Friel's since he starred as the sassy young protagonist in the playwright's first Broadway success, "Philadelphia, Here I Come!," 25 years ago.

Such is Mr. Friel's generosity of spirit that every acting assignment in this play makes the actors stretch, starting with Mr. McSorley, who must act not only his present age but also fill in the voice of Michael as a wide-eyed and often lost child. Even seemingly unsympathetic characters like the irresponsible Gerry and the stern Kate are aware of their own limitations, and in the performances of Mr. Gwilym and Ms. Linehan, they concede their faults with a defenseless candor that makes one want to embrace them no less than the boisterous, good-humored Maggie (Dearbhla Molloy) and the simple, fragile Rose (Brid Ni Neachtain).

●

For all Mr. Friel's compassion toward the characters in "Dancing at Lughnasa," he is not remotely sentimental. In a chilling device that recurs in his canon, he periodically has Michael step out of the past and jump-cut the narration to tell the audience what will happen to the characters long after the play's circumscribed action is over. It is giving away nothing to say that the denouements are cruel, for Mr. Friel's people, no less than anyone else, are headed toward death, some by paths more circuitous and tragic than others.

Yet the play keeps going well after Michael has told the audience all the bad news its characters will some day learn. This is a memory play, after all, and as Michael says, in memory "atmosphere is more real than incident" and nothing is owed to fact. Even knowing what he knows and what everyone knows about life's inevitable end, he clings to his vision of his childhood, a golden end-of-summer landscape in this production's gorgeous design, for what other antidote than illusions is there to that inescapable final sadness? "Dancing at Lughnasa" does not dilute that sadness — the mean, cold facts of reality, finally, are what its words are for. But first this play does exactly what theater was born to do, carrying both its characters and audience aloft on those waves of distant music and ecstatic release that, in defiance of all language and logic, let us dance and dream just before night must fall.

1991 O 25, C1:4

SUNDAY VIEW/David Richards

Magicians of a Thousand and One Nights

WHETHER OR NOT YOU should drop by the Broadhurst Theater for "André Heller's Wonderhouse" can be determined fairly easily by your answers to the following questions:

1) Do you continue to miss "The Ed Sullivan Show" and believe that Sunday night has never been the same since it went off the air?

2) Do you have no notion whatsoever of retiring and applaud those who intend to carry on merrily to the end — auditing tax forms, building brick walls, reviewing plays?

Those answering in the negative may make other plans immediately. Mr. Heller's Wonderhouse is no place for them. It will strike them as a useless and fatiguing endeavor, rather like jai alai for octogenarians. Fine. They have their opinions.

I won't pretend that under its faintly surrealistic trappings Mr. Heller's two-hour show is anything that Ed Sullivan couldn't have given us if he'd concentrated on the older talent pool. Here are eight variety acts that have been holding forth, collectively, for 400 years or so. The Baroness Jeanette Lips Von Lipstrill, for example, has been whistling numbers by Offenbach for half a century with a Tyrolean vigor that gives no signs of abating, while Macao, a portly Swiss gentleman who looks not unlike the kindly king in a children's book, has devoted as many decades to producing elaborate versions of the paper snowflakes we all used to cut in grade school.

It is very easy to feel superior to all this. I, for one, however, happen to think that when the time comes for our earthly labors to be weighed in the pearly scales, a lifetime of making paper sculptures will be worth at least a lifetime in the Senate.

Most of these acts have fallen out of fashion, but they haven't fallen into disrepair.

The future is a sworn enemy of the idiosyncratic 'Wonderhouse.'

They still work. If you can accept the fact that Carlo Olds, the sweet white-faced clown who opens the show, is playing a miniature concertina that fits snugly in the palm of one hand, then you have to admit that he's playing it amazingly well.

The pretext for this parade of venerable talent is the surprise 70th-birthday party of Olga (Patty Maloney), thrown by her husband, Igor (Billy Barty). Little people and retired performers themselves, they make their way down the aisle of the Broadhurst and up on to the darkened stage, where the guests — rouged, powdered and primped — are preparing to "take us back to a time different from all others." The small on-stage orchestra plays a brief overture, "Chopsticks" — a large bird with an orange beak is in charge of the bass — and the celebration is on. Igor makes the introductions, while a languorous woman with marcelled hair and pink eyeshadow, wearing a bridal gown for much of the evening, serves as the stagehand, whenever a stagehand is required. Mr. Heller's heart appears to belong to dada.

The guests are an eclectic bunch, united only by the pride they take in their curious specialties and the radiant pleasure performing obviously continues to give them. Ezio Bedin is, for want of a more exact term, a human noisemaker. He imitates cars, trains, traffic and the various instruments in a mambo band playing "Cherry Pink and Apple Blossom White." Rao, a gentle giant from India, casts shadows on a screen with his hands. Not just rabbits and dogs and funny-looking people, either, but great soaring birds, flapping their wings majestically and actually coming closer and closer as they do so.

Omar Pasha, who works inside a black box, produces Day-Glo objects (and people) at will and then simply erases them, as if they were no more than chalk drawings on a kindergarten blackboard.

But it is Marion and Robert Konyot who threaten to bring down the musty foundations of the Wonderhouse with 10 of the funniest minutes in any Broadway theater right now. Mr. Konyot, a slightly arthritic dandy in a tuxedo and bad wig, and his plump but gracious wife in chiffon and marabou, have every intention of doing a Fred Astaire and Ginger Rogers imitation. But if the spirit is willing, the bones aren't, and forget about their timing. A routine that is marred at first by what he confesses in his lingering Hungarian accent to be "little mistake" quickly turns into a succession of rather big mistakes.

■

Mr. Konyot, however, seems to believe that if you keep a smile on your face, no one will notice that you've just dropped your partner or that she's accidentally kicked you in the nose or, worse, that your wig is suddenly listing three degrees to the left. His unalterably sunny equanimity is what you'd get if you were to turn Buster Keaton's deadpan inside out. For a climax, Ms. Konyot stands on the shoulders of Mr. Konyot. Or attempts to. "We've been practicing this trick for 40 years," he announces, still smiling. "And now we're too old to do it."

You've certainly gathered that this is not a show for those who like their entertainment on the cutting edge. The future, I suspect, is the sworn enemy of idiosyncratic acts like these — honed over thousands of nights in a thousand different halls. Nobody on either side of the footlights has the time or the patience anymore. That may explain the sadness that settles now and again over the festivities, like dusk over an autumn day.

Once, late in her career and early in mine, I saw Sally Rand perform her celebrated fan dance. No one was doing fan dances by then, and Ms. Rand had probably done hers better.

No matter. What the act had lost in elegance it made up for in a kind of gallantry that refused to bow to the passing years. The memory came back to me during "André Heller's Wonderhouse." I thought I'd forgotten her.

'The Baby Dance'

Jane Anderson, the author of "The Baby Dance," owes us at least one more scene, if she doesn't expect us to leave the Lucille Lortel Theater, Off Broadway, feeling completely shortchanged. I don't want to say this fervid play about the perils of adoption lacks an ending, since that implies a tying up of things, a settling of accounts, a neatness that is just not in the cards. But I do think we deserve to see some of the consequences of the drama that's been brewing for two acts — first in a sweltering trailer in northern Louisiana, then in an antiseptic hospital room nearby.

Where is the final do-si-do in 'The Baby Dance'?

There are plenty of reasons to abandon Ms. Anderson's play along the way — not the least being the air of sweaty importance it exudes. If we keep watching, however, it's because we sense a moral dilemma shaping up. Sooner or later (much later, as it turns out), her characters are clearly going to find themselves in deep trouble and we'd like to be there when they do. How will they cope with the pain and the confusion, when the arrangement that was to simplify their lives suddenly backfires?

■

Wanda and Al (Linda Purl and Richard Lineback), the dirt-poor inhabitants of that grimy trailer, already have four children straining their meager resources, so when Wanda gets pregnant a fifth time, adoption would seem to be the happy

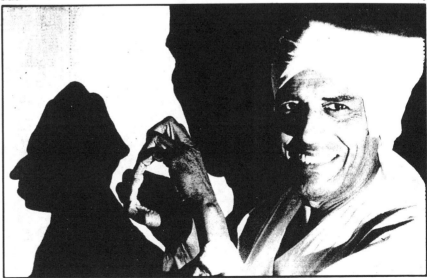

Daniel Cande/"André Heller's Wonderhouse"

Prasanna Rao, an Indian shadow player, in "André Heller's Wonderhouse" at the Broadhurst Theater—a kind of gallantry that refuses to bow to the passing years

answer to their problems. Rachel and Richard (Stephanie Zimbalist and Joel Polis), upwardly mobile film executives from L.A., have everything it takes to raise a child there — a backyard, a swimming pool, money. To everyone's apparent satisfaction, a deal is struck: Richard and Rachel will pay for all the expenses of pregnancy and childbirth in exchange for the baby.

If Al siphons off some of the cash for car repairs and Wanda has periodic spells of regret, if Rachel proves oversolicitous of the mother's health and Richard can't help wondering if he isn't being financially exploited, well, those are hitches to be expected. Then the child is born under abnormal conditions, the doctors can't vouch for its health, and the bargain is off. Richard and Rachel will return to L.A. childless, leaving Al and Wanda to figure out their next move.

I scarcely need report that they're all highly distraught by this point. Nothing has gone according to plan. One couple's dreams have been shattered, while another couple has been plunged deeper into grinding poverty. Why, then, is Ms. Anderson choosing this moment to bring down the curtain? The two acts we've been sitting through are just so much preparation, dramatically speaking, but having weathered them, we have a right to know what comes next. What goes on in hearts that have been robbed of hope and in souls stripped of dignity? How do well-meaning people convince themselves they can reject a child, merely because that child may be less than perfect?

"The Baby Dance" ends where it does, I venture, because Ms. Anderson has no answers to those nettlesome questions. She doesn't really understand these characters intuitively, which is the way playwrights must understand their characters if they're to command a stage. She knows them the way sociologists know their subjects — factually. Al and Wanda are defined by the red raspberry Jell-O they eat; Rachel and Richard by the bottled water they drink. What Wanda calls "keeds," Rachel refers to as "children." Al has tattoos and smokes. Richard carries a briefcase and fumes. This do-si-do is being danced by rednecks raised in Dogpatch and yuppies raised on Doonesbury.

That the roles are acted with grueling conviction merely underlines the drama's deficiencies. It's as if a symphony orchestra were called upon to play "Row, Row, Row Your Boat" — the tune doesn't bear up under the assault. Ms. Purl — in short shorts and a maternity top, wisps of hair falling about her perspiring face — may give the evening's most credible performance, as a woman more fertile than bright.

But is this the proper place for it? Wouldn't she really feel more at home, say, in "Tobacco Road"? □

1991 O 27, II:5:1

The Homecoming

By Harold Pinter; directed by Gordon Edelstein; set by John Arnone; costumes by William Ivey Long; lighting by Peter Kaczorowski; sound by Philip Campanella; production stage manager, Kathy J. Faul; general manager, Ellen Richard. Presented by Roundabout Theater Company, Todd Haimes, producing director; Gene Feist, founding director. At the Criterion Center Stage Right, 1530 Broadway, at 45th Street.

Max	Roy Dotrice
Lenny	Daniel Gerroll
Sam	John Horton
Joey	Reed Diamond
Teddy	Jonathan Hogan
Ruth	Lindsay Crouse

By FRANK RICH

When Harold Pinter's cryptic family play "The Homecoming" reached Broadway in early 1967, American audiences had fun poring over every line, arguing about what, if anything, its terse lines, elliptical pauses and curious, possibly amoral, sexual gestures could possibly mean.

Such orgiastic textual debate was the fashion of the day, especially in regard to cultural imports with a British accent. "Blow Up," the Italian director Michelangelo Antonioni's enigmatic film reverie about mod London, had caused similar arguments in the months before the Pinter play arrived, and the Beatles' "Sgt. Pepper's Lonely Hearts Club Band" would follow a few months later, sending young and old alike into brooding contemplation of how many holes it takes to fill the Albert Hall.

The current Broadway revival of "The Homecoming," the Roundabout Theater Company's first attraction at its new home in the Criterion Center, is only a block from the Music Box, the site of the original production in 1967. But it might as well be playing on another planet, so changed is the cultural context. The Pinter revolution against theatrical literal-mindedness has long since been fought and won. In a world where David Lynch can work in prime-time television and David Mamet can write Hollywood movies, what audiences are going to be baffled by the meaning of "The Homecoming"?

•

Now everyone knows that what you see is what you get with any work that aspires to be Pinteresque, whether written by Mr. Pinter or not. In the case of "The Homecoming," an expatriate philosophy professor, Teddy, returns from America with his wife, Ruth, to the gloomy, all-male North London household shared by his 70-year-old father, his uncle and his two younger brothers. A series of malevolent games of conquer-and-destroy ensue, in which the men battle one another and Ruth for supremacy. At stake are not only the territorial domains within a family, but also the eternal balance of power between the sexes. The mysterious Ruth, at once madonna and whore, rekindles her hosts' conflicted memories of their dead matriarch even as she arouses their entrepreneurial instincts in the field of prostitution.

Gordon Edelstein's able staging of the piece for the Roundabout is very faithful to the Peter Hall original, down to the famous Act II opening in which the lighting of cigars becomes a parodistic tribal ritual. Yet "The Homecoming" plays differently now that the aura of mystery and shock that once surrounded it is gone. The nastiness and humor come through, but not the terror.

Perhaps this is a shortcoming that time has exposed in Mr. Pinter's play, but it may also be a function of a couple of crucial casting lapses in Mr. Edelstein's otherwise solid production. As the sole female character, Lindsay Crouse tries to suggest a damaged soul beneath her cool demeanor, but neither her diligent acting nor her tartish poses and makeup can make her Ruth ruthless — a mesmerizing, manipulative queen bee capable of bringing brutal men to their knees. Jonathan Hogan, as her husband, is further off-key, a petulant rather than fierce antagonist to the siblings and the father who would destroy him. Since Ruth and Teddy amount to one of the two major camps in the play's internal warfare, the default of these performances inevitably deflates the evening's tension.

•

But the gallows humor that remains is sometimes reward enough, starting with that to be found in John Arnone's bleak house of a set: The windows look out on nothing (except the lighting designer Peter Kaczorowski's heavy winter dusk), and the dark walls, floor and furniture are in a state of advanced decay. Roy Dotrice's fine turn as the father, Max, is the perfect centerpiece for this hellish household. Grizzly in appearance, with a gangster's lethal cackle to match, the actor spews malice. His paternal smiles are so sinister that his teeth all seem to be incisors.

Mr. Dotrice's facetious way with his lines accentuates just how much the playwright's insult humor recalls old-time cockney vaudeville. Max's every expression of family feeling takes on a twisted meaning, whether he is asking for "a cuddle and kiss" or speaking with supposed nostalgia of his late wife. ("She wasn't such a bad woman. Even though it made me sick just to look at her rotten stinking face.") As Lenny, the predatory pimp among his sons, Daniel Gerroll becomes the straight man in a grotesque comedy team, matching each of Mr. Dotrice's insults with a well-timed sneer. It is also Mr. Gerroll's duty to deliver Lenny's ostensibly funny monologues, extended anecdotes of deranged misogyny that the actor fields with just the right note of appalling, deadpan detachment.

While the production markedly sags whenever these two actors are not at center stage, there is also first-rate work in smaller roles, from John Horton as Uncle Sam, a ludicrously class-conscious chauffeur whose onstage collapse is farcically ignored by his relatives, and Reed Diamond as the hollow-eyed Joey, the brother with pugilistic ambitions unlikely to be realized in the professional boxing ring. For this family, violence begins at home, where animalistic brawls over power are fought to the death and not even the fittest can necessarily survive. Although time has ren-

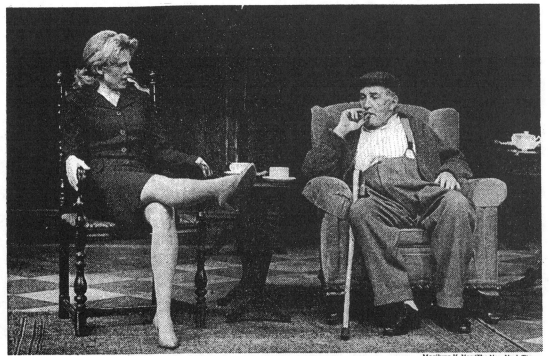

Marilynn K. Yee/The New York Times

Lindsay Crouse and Roy Dotrice in Harold Pinter's play "The Homecoming," at the Criterion Center.

dered Mr. Pinter's message considerably less obscure and startling than it once was, his writing still seems so mean that, even after all these years, a sentimental "Homecoming" is out of the question.

1991 O 28, C13:1

Cabaret Verboten

An evening created by Jeremy Lawrence; directed and staged by Carey Perloff and Charles Randolph-Wright; from the works of William Bendow, Bertolt Brecht, Hanns Eisler, Werner Finck, Fritz Grünbaum, Friederich Hollaender, Walter Mehring, Edmund Meisel, Rudolf Nelson, Marcellus Schiffer, Mischa Spoliansky, Konrad Tom, Kurt Tucholsky and Karl Valentin. Adaptation, additional material of selected English lyrics by Mr. Lawrence; musical arrangement by Marjorie Poe; translations by Kathleen L. Komar, Laurence Senelick and John Willett; creative consultant, Peter Jelavich; scenery, Donald Eastman; costumes, Gabriel Berry; lighting, Mary Louise Geiger; musical direction, Ms. Poe; assistant director, Nick Mangano. Presented by CSC Repertory, Ms. Perloff, artistic director; Patricia Taylor, managing director, in association with Center Theater Group/Mark Taper Forum. At 136 East 13th Street, Manhattan.

WITH: Betsy Joslyn, Mark Nelson, John Rubinstein and Carole Shelley.
Musicians: Marjorie Poe and Bill Ruyle.

By MEL GUSSOW

During the years of the Weimar Republic, cabaret in Germany offered Bertolt Brecht and his compatriots a place where they could express their deepest fears about the Nazi threat. Accenting the radicalism of Weimar comedy, Jeremy Lawrence has entitled his musical revue, "Cabaret Verboten."

As presented at the CSC Theater (in repertory with Jean Stapleton in "Bon Appétit!"), the show is an uneven anthology of songs and sketches ridiculing fascism and racism. It gives a feeling but not the full flavor of a desperate time when theater played the role of political provoca-

teur. In Mr. Lawrence's adaptations of writings of the 1920's and 30's, the sketches survive less well than the songs.

The revue is most incisive when it is straightforward, as in the mock accusatory song "The Jews Are All to Blame' (which is set to music from "Carmen"), and in John Rubinstein's delivery of the fervently cynical "O Fallada." This tragicomic number by Brecht and Hanns Eisler tells about a cart horse that collapses and is torn apart by a once friendly, starving populace. The parable echoes with anger.

Mr. Rubinstein opens the show somewhat in the manner of Joel Grey wilkomming theatergoers to the musical "Cabaret," an unnecessary comparison. But in his derby and with an insinuating manner, he is soon able to establish a distinctive, suavely seedy personality. Along with Carole Shelley, he is equally adept at the vaudeville and the dramatic demands of the musical. The other members of the cast, Betsy Joslyn and Mark Nelson, are less effective with the underlying bitterness. Marjorie Poe and Bill Ruyle add a helpful musical accompaniment.

In content and performance, "Cabaret Verboten" suffers in comparison with a Brechtian cabaret recently presented by the Berliner Ensemble at the Actors Theater of Louisville in Kentucky. The Berliner actors allowed the songs to speak for themselves, which is not always the case at the CSC. As directed by Carey Perloff and Charles Randolph-Wright, the show reaches for a brashness that seems at odds with the severity of the material.

While it is interesting to hear lesser-known songs and sketches (by Kurt Tucholsky, Walter Mehring and others), the durability of the selections varies widely. Brecht, with two songs, remains the most caustic commentator. Kurt Weill is marked by his absence. Karl Valentin, that daring clown who directly challenged

Hitler (he would come onstage, raise an arm in a Nazi salute, say, "Heil," then add, "I forgot his name"), is represented only by a vignette from his play "Fingeltangel."

"Cabaret Verboten" was originally staged at the Mark Taper Forum in Los Angeles, where its run coincided

with an exhibition of art that Hitler designated as degenerate, a word he would have also applied to such a cabaret. The forbidden games of political satire are relevant in every age in which freedom is imperiled.

1991 O 29, C16:1

Theater in Review

■ Laughing at the goody-goody, with death in the background ■ How a nation in love with nuclear power is funny ■ In poetry, a black woman's life.

No Cure for Cancer

Actors' Playhouse
100 Seventh Avenue South, near
Bleecker Street
Manhattan
Through Nov. 17

Written and performed by Denis Leary; directed by Chris Phillips; scenic lighting by Larry Lieberman; music by Mr. Leary, Mr. Phillips and Adam Roth; sound by Peter Klusman; executive producer, Full Circle Management. Presented by Jason M. Solomon, Pamela Ross and Comedy Central.

"If Jesus had lived to be 40, he would have ended up just like Elvis," suggests Denis Leary midway in his one-man show, "No Cure for Cancer." The 33-year-old comedian from Boston goes on to imagine Christ's final days with his "12-man entourage" so vividly that he frightens himself with the possibility of going to hell for his fantasies.

Christians are not the only people likely to be offended by Mr. Leary's risky, high-octane comedy. His show takes merciless aim at vegetarians, environmentalists, Barry Manilow

fans and Kitty Dukakis, and reserves special venom for John Denver, Sting, Dan Fogelberg and other musicians who have earnest goody-goody images.

Mr. Leary is all for everyone's going outside and raising their aerosol cans defiantly to the heavens and spraying them into the ozone layer. Why, he wonders, do we want to try to save the dolphins caught in tuna fishermen's nets while not also trying to save the tuna? It's because we "eat" the tuna fish, he answers with a vengeful, lip-smacking glee. An orgiastic paean to red meat segues into a meditation on cannibalism and the recommendation that when traveling by air one find a corpulent seat mate in case the plane goes down in a wilderness with no food supply.

The comedian, who looks like an impish cross between Willem Dafoe and Christian Slater, is of course being largely ironic. But the lusty rock-and-roll energy with which he plays the devil's advocate makes his irony anything but smug. He becomes downright likable when recalling his Irish-Catholic upbringing in Boston

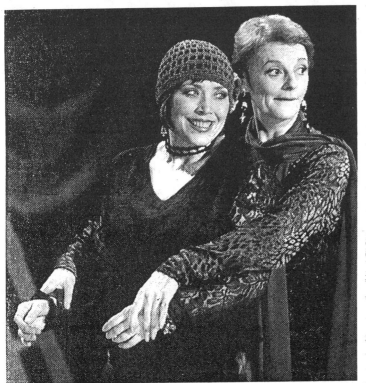

Gerry Goodstein/"Cabaret Verboten"
Betsy Joslyn, left, and Carole Shelley in "Cabaret Verboten."

"No Cure for Cancer"
Denis Leary in a scene from "No Cure for Cancer."

and the mixed psychological legacy of an ultra-macho father.

Such personal recollections help to humanize a show that deals, above all, with the fear of mortality. Symbolized by the cigarettes he chain-smokes, whose poisons he acknowledges with suicidal glee, Mr. Leary returns like an undaunted prizefighter to the specter of death, not only Elvis's but his own, ours and the planet's, and makes it seem terribly, angrily funny.

STEPHEN HOLDEN

Atomic Opera

Ohio Theater
66 Wooster Street
Manhattan
Through Sunday

Created by Kevin Malony, Michele Elliman and John O'Malley; score and sound, Douglas J. Cuomo; production design, Alexander Brebner; costumes, Anne Patterson; lighting, Richard Schaefer; choreography, Mr. O'Malley and Ms. Elliman; concept, text and direction, Mr. Maloney. Presented by T.W.E.E.D., in association with the Neo Labos Dancetheater.
WITH: Torrin Cummings, Michele Elliman, Audrey Fort, Lisa Gillette, Peggy Gould, Renate Graziadei, Mia Kim, David McGrath, John O'Malley, Colleen O'Neill and Craig Victor.

Anyone who grew up in the cold-war era and was weaned on blood-chilling terms like "anticipatory retaliation" is likely to find grim fun in "Atomic Opera," a 70-minute dance-theater work that satirizes America's love affair with atomic energy in the late 1940's and 50's.

A collaboration between T.W.E.E.D., a talented young theater company, and the Neo Labos Dance-theater, the piece is a collage of music, dance and pageantry that cartoons 40-year-old styles of American culture with a terrific visual flair. In one scene, while pompous radio voices describe the testing of a hydrogen bomb, a corps of bathing beauties dons sunglasses and slithers through a dance that suggests an Esther Williams water ballet for the landbound. In another, Craig Victor, swathed in glittery Statue of Liberty drag, is towed onstage on a patriotic float to mouth "God Bless America" as sung by Kate Smith.

Other characters include the doll-like Populux Penny (Lisa Gillette), a quintessential 1950's housewife with a desperately cheerful expression, who talks exclusively in uplifting clichés. As the play goes along, the messages become garbled. Or as Penny chirps in one of her many mixups, "A stitch in time has a silver lining."

"Atomic Opera," which was conceived, written and directed by Kevin Malony, begins with the discovery of radium and ends sometime after America's giddy love affair with technology began to go sour. Like "Dead End Kids," the Mabou Mines imaginative history of atomic energy, it finds all sorts of theatrical metaphors and cultural corollaries for the splitting of the atom, although "Atomic Opera" is campier and not as verbal.

Not the least of its strengths is a musical score by Douglas J. Cuomo that blends electronically treated classical fragments and vintage kitsch into an eerie sound track that suggests the breaking down and reconstitution of matter into something ominous and uncontrollable. Mr. Cuomo's score also includes an elegiac art song for piano and voice that is sung by Mia Kim. Her performance stands out because it is one of the few

moments in the play in which the cast is not lip-synching to prerecorded dialogue or talking along with it.

For all its visual flair, "Atomic Opera" still seems unfinished. While it succeeds beautifully in capturing the headier aspects of an oppressive, scary time, it ends abruptly with no concerted effort to tie up its thematic threads.
STEPHEN HOLDEN

Caught Between the Devil and the Deep Blue Sea

Performance Space 122
150 First Avenue, at Ninth Street
Manhattan
Through Sunday

Written and performed by Peggy Pettitt; directed by Remy Tissier; visual and set design by Mr. Tissier; lighting by Jan Bell-Newman; costume consultant, Pascaline Tissier. Presented by Performance Space 122.

The text of Peggy Pettitt's "Caught Between the Devil and the Deep Blue Sea" is subtle and surprisingly affecting poetry, and her performance of this hourlong play at Performance Space 122 is bewitching.

The lines are not verses. But this tale of an ordinary black woman's life weaves together popular songs, children's rhymes and a series of metaphors that grow out of the story and echo one another so that the viewer comes to understand much more than the storyteller has told or the actor portrayed. It achieves what a good poem does.

With few words and spare gestures Ms. Pettitt creates a whole family: Helen, who from youth to death has wonderful strength and self-possession; her eldest daughter, who becomes an anthropologist; a younger daughter petulant with envy of her elder sibling; a ne'er-do-well son whom Helen locks out of her house; a baby grandson whose father is in prison; Henry, who, after seven children are born, thinks he ought to marry Helen and who is killed in the crossfire of gang warfare. Ms. Pettitt even creates a very credible angry dog.

Objects pulled out of nooks in Remy Tissier's ingenious set of an old house almost become characters themselves in Helen's hands: her one good dress, an infant's bathtub, children's shoes, soap bubbles blown to soothe a child, a Walkman whispering Mozart, an old woman's cane, a plain mask eloquent of peace in death. They seem to be wonderful things fallen to earth from the dreamed worlds of Helen's songs.

Ms. Pettitt's judgments of her characters are clear-eyed and sharp, and so is her judgment of life. "Between the Devil and the Deep Blue Sea" is full of sadness and disappointment, but also of wisdom and wicked humor. No one in the play ever has to say it: it is clear in the end that Helen's harsh, simple life was a grand adventure.
D. J. R. BRUCKNER

1991 O 30, C14:1

The White Rose

By Lillian Garrett-Groag; directed by Christopher Ashley; set by Edward T. Gianfrancesco; lighting, Debra Dumas; costumes, Michael Krass; sound, Aural Fixation. Presented by the WPA Theater, Kyle Renick, artistic director; Donna Lieberman, managing director. At 519 West 23d Street, Manhattan.

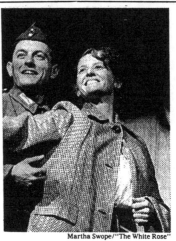
Martha Swope/"The White Rose"
J. D. Cullum and Melissa Leo in "The White Rose."

Schmidt and Christoph Probst	Roger Howarth
Hans Scholl	J. D. Cullum
Sophie Scholl	Melissa Leo
Mahler	Victor Slezak
Robert Mohr	Larry Bryggman
Bauer	Brad Greenquist
Alexander Schmorell	Michael Louden
Willi Graf	Billy Morrissette

By FRANK RICH

A couple of years ago the WPA Theater inaugurated a late-night Silly Series with "The Lady in Question," Charles Busch's extravagantly hilarious send-up of 1940's Hollywood movies about little people who get caught up in the anti-Nazi German underground. Last night the WPA opened its new season, its 15th, with "The White Rose," a terminally solemn example of the exact sort of clodhopping melodrama that Mr. Busch demolished with mockery. Is there some inside joke kicking around at the WPA that the audience is not being let in on?

"The White Rose," which was written by Lillian Garrett-Groag and comes to New York by way of the Old Globe Theater in San Diego, is one of those plays in which the characters and events are historically accurate and yet every scene and line seems utterly bogus. The dialogue sounds like the captions in those instructional film strips that were the bane of every elementary school in the days before the invention of the videocassette. For interludes of comic relief, wholesome Munich university students can be found sipping wine and sharing their enthusiasm for Frank Sinatra records with a Teutonic spontaneity that recalls the flirtation between the aspiring SS thug Kurt and the 16-going-on-17 Liesl Von Trapp in "The Sound of Music."

Not that the students in "The White Rose" are thugs. They're good Germans who, as they remind us more than once, believe in the Germany of Goethe, Schiller and Beethoven, not the one of Der Führer. They risk their lives by circulating leaflets, titled "The White Rose," urging Hitler's overthrow. But as the leaflets are anonymous, so, in Ms. Garrett-Groag's hands, are the courageous real-life characters who wrote them. The four male students in her play, though given ample stage time, are often distinguishable only by their tastes in sweaters and eyeglass frames. The one young woman who joins their cause, Sophie Scholl (Me-

lissa Leo), has the longest speeches but is equally lacking in any personality beyond her anti-Nazi views.

The character who interests the playwright most is Robert Mohr (Larry Bryggman), the police investigator who spends the evening cross-examining Sophie and her pals, trying to get them to confess to their treasonous activities. Herr Mohr is a relatively benign civil servant who scoffs at his office's gung-ho Nazi bureaucrat (Victor Slezak) and even disdains "Heil Hitler!" as a telephone greeting. He cares only about "getting by" and is variously described as a "common man" and a "simple man," lest anyone miss the point that he is one of those common, simple Germans who believed that willful ignorance of the Third Reich's crimes cleared them of moral culpability.

Eventually "The White Rose" narrows down to a yelling match in which Sophie tries to convince Mohr otherwise, demanding that he open his eyes to the Nazi atrocities around him and take a stand against them. She fails. The rest is history.

●

Mr. Bryggman, his brow forever furrowed, and Ms. Leo, her eyes feverish with idealism, are fine actors who shout so ardently that one is almost (but not quite) tempted to believe that their debate has more intellectual substance than an open-and-shut case. As directed by Christopher Ashley, "The White Rose" offers such other distractions as a convoluted two-level set by Edward T. Gianfrancesco (flashbacks are on the second floor) and an Expressionist sound-and-light scheme that portentously accentuates the shrieking of police sirens, the clanging shut of jail-cell doors and the violent crumpling of Nazi interoffice memos. Charles Busch couldn't have done it any campier.

1991 O 30, C15:1

Booth Is Back

By Austin Pendleton; directed by Arvin Brown; set, John Lee Beatty; costumes, Jess Goldstein; lighting, by Dennis Parichy; production stage manager, Anne Keefe. Presented by Long Wharf, Arvin Brown, artistic director; M. Edgar Rosenblum, executive director. At New Haven.

Junius Brutus Booth	Frank Langella
Edwin Booth	Raphael Sbarge
Mary Ann	Maureen Anderman
Asia Booth	Isabel Rose
Johnny Booth	Alexander P. Enberg
Mrs. Hill	Joyce Ebert
Page	Ralph Williams
Baxter	Bob Morrisey
Adelaide	Beth Dixon

By MEL GUSSOW

Special to The New York Times

NEW HAVEN, Oct. 29 — When Edwin Booth was 13 years old, he left school and joined his famous father, Junius Brutus Booth, barnstorming in theaters across America. It was Edwin's role to be a watchful guardian, to keep his father sober enough to play King Lear and Richard III, whichever he should happen to choose minutes before going onstage. Gradually the son moved from dresser to walk-ons to more important parts, eventually displacing his father in the public's esteem.

The tumultuous relationship between father and son is at the core of

Austin Pendleton's "Booth Is Back," directed by Arvin Brown at the Long Wharf Theater. At its sharpest, the play is a revealing two-character study of that family rivalry and of the itinerant, emerging American theater of the mid-19th century.

This is very much an actor's play, written by an actor for actors, in this production Frank Langella and Raphael Sbarge. The two, especially Mr. Langella as Junius Booth, breathe theatrical life into the subject, and in his initial attempt at writing a play Mr. Pendleton proves to be an astute observer of the history and the demands of the acting profession.

But in pursuit of a sustaining narrative to stitch together what is essentially a double portrait, the author invents incidents and wanders into less secure dramatic terrain. The play, too long at three acts and almost three hours, falters both at the beginning and at the end, and misses the opportunity to divide the focus equitably and foreshadow the full extent of the son's growth.

The catalyst for all that occurs is the titanic figure of Junius Booth, as personified by Mr. Langella as an actor of the oldest school, a man uninterested in anything else onstage but his own virtuosic display of language and temperament. Derelict in his personal habits and embracing rant in performance, he nevertheless stirs audiences to heights of passion. Booth is understandable in this bold, often histrionic performance.

His eyes gleaming with arrogance, Mr. Langella creates a most vivid impression of a demonic personality who constantly puts himself in jeopardy but has no doubts about his powers, which are seen in glimpses of the actor playing Shakespeare. As we watch, Mr. Sbarge's Edwin moves from awe to independence, which he expresses in his more emotionally truthful approach to his art. To the father, there is no room for divergence from the tradition he has established, and there is no such thing as innovation in acting.

When the play reaches beyond the intense father-and-son bond, it relaxes its dramatic grasp. Scenes with Junius Booth's mistress (Maureen Anderman), his abandoned wife and his other children are dampened by clichés. The picture of John Wilkes Booth as a young man is particularly unconvincing and gives no indication of any seeds of his adult mania.

Among the supporting characters, the only one of serious interest is a promising actor whom Booth has systematically reduced to a journeyman. As played by Ralph Williams, this character adds a note of poignancy and humor to a work that aspires to tragedy.

Shifting from family farm to theater, John Lee Beatty's set is a model of adaptability, and Mr. Brown's assured staging has its own period authenticity. The flaws in the play could be remedied. With "Booth Is Back," the center stage can hold as father and son, each a quintessential, bitterly competitive actor, vie for domination in theater and in life.

1991 O 31, C18:1

Greetings From Coney Island

Conceived and directed by Paul Binder; music director, Rik Albani; original music by Linda Hudes; clown coordinator, Michael Christensen; scenery by James Leonard Joy; costumes by Donna Zakowska; lighting by Jan Kroeze; choreography by Lisa Giobbi; associate director, Dominique Jando; performance directors, Bryan Fox and Guy Manetti; ring crew chief, Tom Larson. Presented by the Big Apple Circus, Mr. Binder, founder and artistic director; James C. McIntyre, executive director. At Damrosch Park at Lincoln Center.

WITH: Marie Pierre Benac, Jeff Gordon, Dana Kaseeva, John Lepiarz, Barry Lubin, Olivier Merlier, Melinda Merlier, Yelena Panova, the Rios Brothers, Katja Schumann, Taso Stavrakis, Les Frères Taquin, Vanessa Thomas, the Flying Vazquez and William Woodcock.

By MEL GUSSOW

Grace in motion is the key to the Big Apple Circus, whether the performers are the Flying Vazquez, six riderless Schumann horses prancing around the ring or a pair of elegant, intelligent elephants. New York's hometown circus is back for a seasonal visit, in residence in a tent at Lincoln Center through Jan. 5.

This year, the title of Paul Binder's small-top extravaganza is "Greetings From Coney Island," a resort that the founder and master of ceremonies remembers fondly from his youth. Coney Island was a place, he tells us, with three entire amusement parks as well as beach, boardwalk and arcades.

In contrast to past shows, the theme is not fully integrated into the performance, but conveyed passingly in the scenic background, postcard poses and hurdy-gurdy music. This is a Sunday in Luna Park with Paul Binder and friends, including three bathing beauties who stand on large beach balls and roll them upward on a roller coaster-style runway, a lighthearted Coney Island version of Sisyphus at his labors.

The Big Apple remains a congenial circus, one that can be enjoyed by grownups as well as children. There is nothing frightening afoot though daredevils are flying. Adults asked to participate as volunteers may be shy, but youngsters rise to the spotlight, as was the case Wednesday when a golden-haired little girl was so self-possessed in performance that one could imagine her riding a Schumann horse in a subsequent circus.

It is one measure of the intimacy of the Big Apple that even when the timing of an act is momentarily off, the audience is eager to offer a second chance. This was the case with the Rios Brothers, experts at Risley, the art of foot juggling. After a falter, they outdid themselves, with one Rios brother spinning the other in 30 high speed circles so that he looked like the blade of a fast-moving helicopter. Similarly, when Miguel Vazquez performed a quadruple somersault in mid-air but accidently eluded the grasp of his catcher, he arose from the net with panache and joined his family for the next feat of derring-do.

Sitting so close to the ring, one can enjoy the subtleties of performers like Yelena Panova, a balletic Russian aerialist who twists and turns herself on a single trapeze, and the agile team of Olivier and Melinda. The muscular Olivier balances Melinda in the palm of his hand, and she, along with other performers, never loses her smile.

Between the acts, the Big Apple Circus clowns cavort like Keystone Kops while sawdust is raked and carpets put in place for the next flight of fancy. The clowns are funny, especially the one known as Gordoon, but the drollest performers are William Woodcock's elephants. As always, they are pachydermic showstoppers. In the Big Apple tradition, they make the difficult look easy, the easy seem breezy. With split-second synchronization, the elephants bow and lift their hind hooves high in the air, equaling the Vazquez with their effortless equilibrium.

1991 N 1, C19:1

SUNDAY VIEW/David Richards

Embracing the Past

'Dancing at Lughnasa' is set in the mythical realm between truth and memory.

FEW PLAYWRIGHTS ARE SO ENtranced by the siren call of the past — and so wary of it — as Brian Friel.

In "Dancing at Lughnasa," his newest play (at the Plymouth Theater), he's remembering the summer of 1936 — which was the last summer the five unmarried Mundy sisters spent together in the village of Ballybeg before whim and hardship sent them their separate ways. And yet even as he's bringing them and their squabbles to rollicking life, part of him is wondering if memory isn't getting the better of him.

Ballybeg is the mythical Irish village in Donegal in which Mr. Friel has set a number of his plays, but the Mundy sisters are modeled after the playwright's own mother and the four aunts who raised him, fussed over him and sometimes made good-natured sport of him. And the temptation is to paint them more colorful than they were, to infer heartbreak where there was perhaps only slow-gathering disappointment, to view their humble hearth as a battleground between the liberating power of paganism and the stern Irish Catholicism that would suppress it. ∎

Art and memory have this in common: they sometimes run away with themselves, rearranging details, restructuring events and putting words in the mouths of people who never said them or never said them quite so succinctly. Mr. Friel's play is a lovely, lyrical evocation of another time, when he was young and just beginning to sense "a widening breach between what seemed to be and what was." But it is also a play about the seductive nature of remembrance, and the playwright intends to remain on his guard, lest he celebrate what never was.

You'd sense his resistance, I suspect, even if he hadn't gone and put himself on the stage in the form of Michael, born out of wedlock to Chris, the prettiest of the Mundys, and Gerry, a cavalier Welshman who didn't stick around much afterward. The grown-up Michael (Gerard McSorley) narrates the drama and plays his 7-year-old self, when his younger self is not off hiding somewhere or so absorbed in the making of kites that he might as well be hiding. He embodies the contradiction that has gripped Mr. Friel throughout his career — the desperate compulsion, on the one hand, to embrace his past, and the equally strong urge, on the other, to hold it at bay. (While embraces can be comforting, they can also suffocate.)

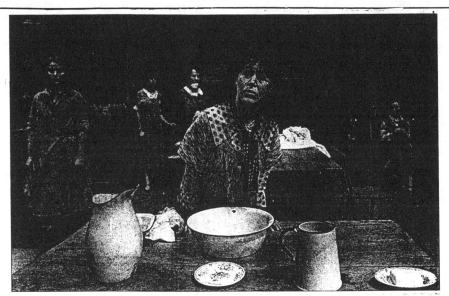

Tom Lawlor/"Dancing at Lughnasa"

From left, Dearbhla Molloy, Catherine Byrne, Rosaleen Linehan, Brid Ni Neachtain and Brid Brennan in "Dancing at Lughnasa"—frenzied passions of lives not led.

Mr. Friel takes several seemingly unrelated incidents — none critical in itself — and attempts to show how they conspire to pull the sisters apart. Gerry (Robert Gwilym), that errant father, pays a couple of drop-in visits, and while he's no more than a gadabout, light on his feet and easy with promises, his charm can be destructive. With puzzlement bordering on horror the sisters come to realize that Uncle Jack has lost every vestige of his Catholic faith and that a heathen dwells in their midst. Or perhaps it's no more than the acquisition, extravagant under the circumstances, of a Marconi wireless that undermines order in the house. Like a temperamental deity, it spews forth the head-turning popular tunes of the day, then, when both it and the sisters are overheated, dissolves into mocking static.

■

If the play has a deficiency, it is that Mr. Friel has chosen to concentrate on "the hair cracks" that suddenly appear in this little world, indicating to Kate that "control is slipping away" and that "the whole thing … can't be held together much longer." We never see the hair cracks widen into chasms, and we can't help wanting to.

This was the very tug of war going on in the playwright's first American success in 1966, "Philadelphia, Here I Come!" About to depart for America, its young hero found that pulling up his roots was more agonizing than he anticipated. But he also recognized the trap he was falling into. "Just the memory of it — that's all you have now — just the memory," he told himself, thinking back on all the inconsequential, adolescent tomfoolery he was leaving behind. "And even now, even so soon, it is being distilled of all its coarseness; and what's left is going to be precious, precious gold."

Mr. Friel is older and wiser, but in "Dancing at Lughnasa" he continues to distill gold from homely lives. Or maybe just a fool's gold. He's not entirely sure. A sentimentalist, he is also an ironist. You could call "Dancing at Lughnasa" — with a nod to Chekhov, of course — "The Five Sisters."

In the course of the play, the women will perform everything from a furious jig on the kitchen table to a wide-screen Hollywood waltz in the garden. Uncle Jack (Donal Donnelly), a touch of malaria still befuddling his mind, will stomp out the tribal rhythms he learned from the lepers as a Roman Catholic priest in Uganda. But Mr. Friel is dancing, too. Sometimes he reels his characters in, so he's swaying with them lovingly, cheek-to-cheek. Sometimes he twirls them away from his side, as if to send them spinning out into the world. At the last minute, however, he invariably catches them by the hand and gracefully pulls them back — partners in memory.

The title refers to the annual Irish harvest festival that can be traced back to the pre-Roman era, and which is still being celebrated in the back country at the time the play takes place. An occasion for bonfires and drunken abandon, it serves to underscore the repression that has long gripped the Mundy household, although now and again Maggie (Dearbhla Molloy) allows herself a salty remark and a Wild Woodbine cigarette. What little money comes in is provided mostly by Kate (Rosaleen Linehan), a schoolteacher not above lecturing her younger sisters about their behavior, and emitting huffs of displeasure or shock when it fails to meet her rigid standards. Poverty has always threatened the family, even as the threat has served as a kind of glue. Until this particular summer, that is.

For sheer theatricality, the play's most arresting scene, in fact, occurs midway through the first act. Shy and retiring Agnes (Brid Brennan) has just suggested, ever so tentatively, that it might be fun to attend the harvest dance before they're all too old to lift a foot. One by one, her sisters have taken up the idea, imagining what they might wear and how the country folk would react. But Kate has said no. The notion itself is just too unseemly, and there's an end to the discussion.

They're all back at their humble chores when Chris switches on the Marconi. What comes out — the thumping raucous sounds of traditional Irish dance music — makes the argument no one could marshal earlier. The sisters can resist no longer. Yelping and shrieking, they throw themselves into a bacchanal — pounding the kitchen floorboards with their work boots, spinning like dervishes and filling up the house with all the frenzied passions of the lives they *haven't* led. It's an explosive moment that has us hungering for more.

There's no equivalent scene later on, however, when the collapse Kate desperately fears actually comes about, when ache converts to pain, and it's clear that the family's fate is irreversibly sealed. While I felt as deeply for the Mundy sisters at the end of Act II as I did at the end of Act I, I didn't feel *more* deeply. Mr. Friel's drama, I think, wants a kind of progression.

And yet it is flawlessly acted in this production directed by Patrick Mason and featuring most of the Abbey Theater cast who helped make it a London hit last season. One performance inevitably enriches the next. Miss Molloy's easygoing ribaldry as Maggie is heightened by Miss Linehan's pinched air of authority as Kate. Similarly, Miss Linehan's sober strength is brought into focus by the dreaminess of Miss Byrne, whose Chris is ready, at the drop of a sweet

word, to believe in a hopeless romance all over again.

The wildness that Brid Ni Neachtain brings to Rose, the simple-minded sister, is what's churning *inside* Miss Brennan, who knits gloves quietly and listens dutifully as Agnes, but can't always prevent the flush on her cheeks from betraying the inner

The playwright Brian Friel is dancing, too.

turbulence. They are never less than individuals, and yet they are very much part of a larger sorority — the Mundy girls, grown older and bound together by the years of drudgery and frustration.

Although men are not banned from their presence, they're a bit like tourists on foreign soil. Gerry is just too irresponsible to notice, as Mr. Gwilym suggests with the reckless charm of the penny ante swashbuckler. After his long African exile, Uncle Jack is more comfortable speaking Swahili than English and can't always match the right name to the right sister. Mr. Donnelly plays the confusion so apologetically that his fragility is doubly moving. That leaves the earnest Mr. McSorley, who, as Michael, is both living the play and observing it. And he's stranded, too, somewhere between truth and fiction, between the way things were and the way they keep coming back to him.

But then, hasn't the need to see clearly what time and sentiment would distort always been part of Mr. Friel's struggle? In "Dancing at Lughnasa" the glorious language only seems effortless. Its eloquence is hard fought. □

1991 N 3, II:5:1

A Piece of My Heart

By Shirley Lauro, suggested by the book by Keith Walker; directed by Allen R. Belknap; sets by James Fenhagen; costumes by Mimi Maxmen; lighting by Richard Winkler; sound by John Kilgore; production stage manager, Richard Hester; guitar and vocal arrangements, Cynthia Carle. Presented by the Manhattan Theater Club, Lynne Meadow, artistic director; Barry Grove, managing director; by special arrangement with Roger L. Stevens. Michael Bush, associate artistic director; Victoria Bailey, general manager. At Union Square Theater, 100 East 17th Street, Manhattan.

Martha	Annette Helde
Maryjo	Cynthia Carle
Sissy	Corliss Preston
Whitney	Sharon Schlarth
Leeann	Kim Miyori
Steele	Novella Nelson
All the American men	Tom Stechschulte

By FRANK RICH

At the end of "A Piece of My Heart," Shirley Lauro's new play about the unsung American women who served in Vietnam, the characters appear before a replica of the Vietnam Veterans Memorial in Washington and place homely mementos of the war at its base. It is a powerful tableau — like every other glimpse of that long, dark wall — and it allows Ms. Lauro at last to stir up the feelings of grief and anger that she has been chasing all night.

Yet, for me at least, the feelings evaporated the moment I was back on the street, at which point I resented having my buttons pushed so cheaply. Right until its coda, "A Piece of My Heart," a Manhattan Theater Club presentation by way of the Actors Theater of Louisville, is embarrassingly clichéd in its efforts to bring home the stories of forgotten survivors of the Vietnam nightmare. Are we to applaud a playwright who uses the wall to prop up what is otherwise an incompetent piece of work?

"A Piece of My Heart" can be called incompetent because it coarsens and wastes valuable documentary material. Ms. Lauro's source is a 1986 oral history by Keith Walker in which 26 of the estimated 1,500 American women who went to Southeast Asia recounted their experiences, whether as nurses, civilian dogooders or entertainers. These women had their own distinctive and courageous war to fight: with their consciences, with the Vietnamese, with the American military command, with primitive medical facilities and, most pointedly, with men.

Though the playwright draws on the words of her actual subjects, her play seems synthetic, like an old-fashioned news-magazine round-up story with archetypal, if not composite, characters speaking in souped-up quotes. Bizarrely enough, most of Ms. Lauro's major characters are so generic that they could have stepped out of the stereotyped male ranks of bygone service comedies like "Mister Roberts" or "No Time for Sergeants": the tough-talking but big-hearted military lifer (Novella Nelson), the rich college kid (Sharon Schlarth), the religious small-town naif (Corliss Preston) and even the immortal Andy Griffith role, that of the thick-accented yet shrewd country bumpkin (Cynthia Carle) who strums a mean guitar.

"A Piece of My Heart" never makes the audience feel close to these or its other characters because Ms. Lauro manipulates them from without rather than observing them from within. Once the women have shipped off to Vietnam, the action of the play is not driven by their specific narratives, intimate thoughts or feelings; instead the players become faceless, symbolic figures in a mural.

Whether appearing individually in didactic vignettes or banding together for lengthy rounds of group recitation, the women react mechanically to the expected checklist of red-letter experiences, from their first encounter with the brutality of combat through their initiations into drugs and booze, sexual harassment and official duplicity (during the Tet Offensive). When the women return home to face a series of new indignities in Act II (unemployment, discrimination, Agent Orange mutations), they go their separate ways but just as predictably. The alcoholic finds salvation in Alcoholics Anonymous; the idealist joins Vietnam Veterans Against the War; the true believer becomes a born-again Christian.

Everything in this play is overgeneralized to the point of blandness. Even the potentially theatrical idea of assigning all the male roles to a single actor (Tom Stechschulte) — a conceit reminiscent of Amlin Gray's harrowing Vietnam play, "How I Got That Story" — comes to nothing because virtually all the male roles turn out to be variations on the same blue-collar white Everyman. The ideological point of this all-purpose man is clear and unexceptional enough — "Men wanted that war, men made that war," says one of the women in Act II — but the device has the odd and falsifying side effect of completely eliminating black men from the Vietnam story.

Such lapses are surprising coming from Ms. Lauro. In "Open Admissions," her searing play about a confrontation between a black male student and a white female teacher in an urban university, she met head-on the sorts of complex ideological and racial conflicts that are either oversimplified or sidestepped here. "A Piece of My Heart" has far more in common with another Manhattan Theater Club production this year about a neglected patch of American military history, "Black Eagles," in which the tale of black World War II fighter pilots was reduced to a lulling pageant of unassailable worthiness and infinitesimal drama.

Ms. Lauro's play must struggle under the additional handicap of being presented at the expansive Union Square Theater (until recently the home of the Roundabout Theater Company) while "Lips Together, Teeth Apart" continues its extended run at the Manhattan Theater Club's snugger auditorium at City Center. Under the direction of Allen R. Belknap, the performers often seem to be inflating their soliloquies, whether perky or sorrowful, to fill the big house, with the consequence that both their wartime experiences and sobbing postwar nervous breakdowns sometimes come across like audition monologues from "A Chorus Line." Mr. Belknap's staging also boasts an arsenal of cheesy sound-and-light effects that, like the rest of the evening's sloppy histrionics, say nothing about the tragedy of Vietnam that can remotely match the eloquence of the wall's mute, unadorned listing of the names of the dead.

1991 N 4, C15:1

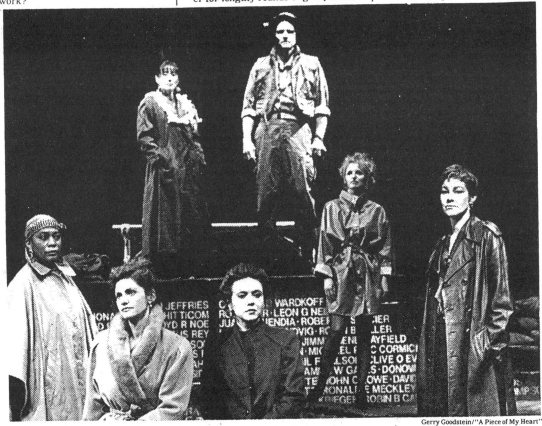

Gerry Goodstein/"A Piece of My Heart"

A scene from "A Piece of My Heart," Shirley Lauro's new play at the Union Square Theater.

In the Jungle of Cities

By Bertolt Brecht; directed by Anne Bogart; set design, Donald Eastman; costumes, Gabriel Berry; lighting, Heather Carson; sound, Jacob Burckhardt and L. B. Dallas; music, Judson Wright; production stage manager, Buzz Cohen; in association with Via Theater. Presented by Mabou Mines and the New York Shakespeare Festival; JoAnne Akalaitis, artistic director; Jason Steven Cohen, managing director. At the Public Theater, Martinson Hall, 425 Lafayette Street, Manhattan.

WITH: Raul Aranas, Mario Arrambide, Karen Evans-Kandel, Fanni Green, Brian Jucha, Ruth Maleczech, David McIntyre, Greg Mehrten, Frederick Neumann, Terry O'Reilly, René Rivera and Royston Scott.

By FRANK RICH

Black-and-purple banners of mourning hang from the facade of the Public Theater these nights. Do not expect "In the Jungle of Cities," the first presentation of the New York Shakespeare Festival's post-Joseph Papp regime, to lighten the mood. In this bleak 1923 play, the 25-year-old Bertolt Brecht let loose with a young man's nihilistic howl of rage. Two men in a mythical Chicago — a mysterious Malayan entrepreneur named Shlink and an idealistic young library worker named Garga — conduct a "war of annihilation" that levels philosophies and people alike. For these bitter antagonists, even death leaves something to be desired.

The revival at the Public — only the third major staging the play has received in New York — is a co-production with Mabou Mines, the troupe that introduced Papp to his successor, JoAnne Akalaitis. As directed by Anne Bogart in a cerebral, fussy and static style, this tame "Jungle" seems less like the dawning of a new era than a throwback to the quaint bohemianism attending New York's Brecht craze of the late 1950's.

Written in jumpy, hallucinatory vignettes that freely mix fragments from pulp gangster fiction with quotations from Rimbaud, this play could have been a feast for an adventurous director of 1991. Brecht's text is not a rigid blueprint but a liberating springboard for theatrical images of destruction and chaos, of urban cru-

elty and horror. As Shlink and Garga carry out their figurative wrestling match, a family is destroyed, women are degraded, capitalism runs amok and a white lynch mob hunts for prey — but always in abstract, poetic terms that allow ample room for experimentation.

Ms. Bogart, working with a lean, occasionally sanitized translation by Gerhard Nellhaus, musters but a few striking ideas. Starting with a prologue in which Ruth Maleczech, as an unofficial street singer, faintly warbles Brecht's introductory author's note, the director tries to inject Weimaresque cabaret turns into the action and finally achieves one of true melancholy, delivered by Karen Evans-Kandel near the end. Donald Eastman's all-purpose set, an industrial warehouse reminiscent of a spooky George Tooker painting, is evocative until its monochromaticism becomes wearying, and it opens up into a deep black expanse that, as lighted by Heather Carson, suggests a chilling Lake Michigan. Gabriel Berry's costumes draw on both George Grosz caricatures and Hollywood camp to offer cartoonish commentary on old-time gangster fashions.

But only Frederick Neumann's performance as the unscrupulous Shlink fully inhabits the physical production. Looking like a beefy Carl Sandburg and sounding like Orson Welles at his most insidious, the silver-haired actor creates an aura of weirdness and danger. It's too bad that Mario Arrambide's mild, smirking Garga is no match for him; without two equal opponents the Darwin-

ian, sadomasochistic and arguably homoerotic heat of the men's struggle for supremacy dissipates. Since most of the large supporting cast is as smart-alecky in voice and gesture as Mr. Arrambide, the jungle of Ms. Bogart's Chicago is less a savage industrial wasteland out of Upton Sinclair than a benign absurdist cartoon, a rather sexless retread of R. Crumb.

Ms. Bogart does not dream big. She is so cautious that she minimizes the seedy Chinatown fantasized by Brecht, perhaps out of fear that a contemporary audience might be offended by the author's tongue-in-cheek use of old Charlie Chan ethnic stereotypes. (Even Shlink's Malayan identity is all but obliterated.) As bold esthetic sensuousness is missing from this "Jungle," so is most of Brecht's raw pain at discovering man's "infinite isolation." Far more care is devoted to the busy deployment of two moving men whose endless shifting of a few sticks of furniture typifies the evening's pedantic illustration of Brechtian stagecraft.

Running 100 intermissionless and fairly monotonous minutes, the whole exercise is so dry and academic that the director almost seems to be discoursing on the play for a graduate-school seminar rather than staging it afresh for new audiences. The production's particular retro brand of collegiate hipness is matched by the newly opened coffeehouse in the Public's lobby, where the lights are low and the atmosphere can only be described as really cool.

1991 N 6, C19:2

Theater in Review

■ Of brothers and mental disorders ■ Romance and the power of letters ■ Can a marriage without a contract be kosher? ■ Actress, actress on the wall.

The Dropper

One Dream Theater
234 West Broadway, at North
Moore Street
Manhattan

Written and directed by Ron McLarty; set by Stephan Olsen; lighting by Michael Stiller; costumes by Traci di Gesu; music by Wayne Jones; production stage manager, Scott Peg. Presented by Prima Artists New York.
WITH: John Dawson Beard, Nick Giangiulio, Bob Horen, Richard Long and Wendy Scharfman.

When a young plumber decides to emigrate from rural England to the United States in the early part of this century, he is filled with trepidation, principally because it means leaving his mentally handicapped brother, who is his closest friend and ward. The loving fraternal bond is at the emotional center of "The Dropper," a fragile but evocative new play by Ron McLarty at the One Dream Theater.

That relationship occupies one half of the play, which is crosscut with scenes in the present as the plumber, now aged and long retired, is about to be moved into a nursing home. Osten-

sibly, the work is less concerned with the specifics of this character than with problems of the handicapped over a period of generations.

In the counterpointed scenes in the present, we see the old man's married granddaughter faced with the agonizing decision of whether to prolong the life of her severely incapacitated baby. The title refers to nurses who in an earlier time intentionally dropped damaged infants and allowed them to die.

As the granddaughter and her husband waver between their idealism and fear (for themselves and for the effect the baby would have on their relationship with their healthy older son), the play begins to resemble a television problem drama. There is nothing in the narrative to move this situation to a deeper dramatic level.

On the other hand, when Mr. McLarty holds to the plumber's story, the play is emboldened by a feeling of familial loyalty as well as a man's lifelong guilt at abandoning his brother. The two actors playing the leading character at different ages, Bob Horen as the patriarchal figure and Richard Long as his hopeful younger self, add vigor to their roles

as well as a sense of mutual identification. One can readily envision the one growing up and becoming the other.

Under Mr. McLarty's direction, the play is presented in quick vignettes viewed through the haze of memory, as the old man remembers his rambunctious days in England. In possible emulation of David Threlfall's Smike in "Nicholas Nickleby," John Dawson Beard (as the younger brother) becomes too emphatic in his acting especially for such a small space, but the kinship between siblings always seems in evidence. Caught up in that part of the story, theatergoers may want to see a wider-focus picture of the youthful life.

In the present, Wendy Scharfman and Nick Giangiulio keep themselves carefully contained within the boundaries of a couple making a difficult parental decision. Mr. Horen, with sudden bursts of clarity and intuition, anchors both the play and the production.

The One Dream Theater is an unassuming storefront company near Canal Street in TriBeCa. On the basis of "The Dropper," the theater's dream has promise.

MEL GUSSOW

Shmulnik's Waltz

Jewish Repertory Theater
344 East 14th Street
Manhattan

By Allan Knee; directed by Gordon Hunt; music by David Shire; sets by Ray Recht; costumes by David Loveless; lighting by Betsy Finston; musical director and adaptor, William Schimmel; production stage manager, D. C. Rosenberg; managing director, Nina Heller.
WITH: Rob Gomes, Wendy Kaplan, Robert Katims, Ilana Levine, Marilyn Pasekoff, Steve Routman and Stephen Singer.

If the central story of Allan Knee's new play, "Shmulnik's Waltz," seems wholly familiar, it is not less enjoyable for that; one version or another turns up in folklore and fairy tales from many cultures.

Shmulnik is an absurdly romantic peddler on the Lower East Side at the turn of the century who falls in love with a beautiful young woman, Rachel. He pursues her in word and song and tries to enlist the support of her plain sister, Feyla, a school teacher.

Rachel is also sought by a handsome, successful businessman, who is a bit stupid and illiterate and who hires Shmulnik to write letters to Rachel for him. Her replies reveal that the passion and honesty of the letters have won her heart. But then it turns out that her replies were really written by Feyla and ... well, you see where this will probably end and why variations on this story have enchanted so many people for centuries.

In the production of the play at the Jewish Repertory Theater, an attractive cast under Gordon Hunt's direction has a lot of fun with Mr. Knee's sprightly dialogue. And an accordion and violin add their own comic voices.

Of course, this little love story does not take much time to tell, so Mr. Knee pads it. His play opens in a Russian village from which all these people later migrate to New York. This makes for a slow and episodic beginning, but, if something has to go

slow, it is better at the beginning than at the end. One other bit of filler — a visit by the innocent Shmulnik to a good-natured prostitute — might seem out of place in so gentle a tale, but it is so funny it could find a place in almost any comedy. It fits fine here.

Steve Routman makes a winning Shmulnik and his wordless songs sound wonderful; Marilyn Pasekoff, a gifted comedian, steals a whole chunk of the show as the lady of pleasure; and Ilana Levine as the plain sister provides the best surprise in a play that turns on surprises: the revelation at the end of the woman's true character is touching, satisfying and convincing.

D. J. R. BRUCKNER

The Marriage Contract

The Folksbiene Playhouse
123 East 55th Street
Manhattan

By Ephraim Kishon; directed by Howard Rossen; translated into English by Israel Becker; set by Harry Lines; costumes by Susan Sigrist; lighting by Alan Baron; music by Ed Linderman; arrangements by Barry Levitt; translator, Simcha Kruger; stage manager, Judith Scher. Presented by the Folksbiene Playhouse of the Workmen's Circle, Ben Schechter, managing director; Morris Adler, Chairman.
WITH: Zypora Spaisman, David Rogow, Diane Cypkin, Sandy Levitt, Richard Carlow and Shira Flam.

In the Tel Aviv home of the Borozovsky family, peace is as illusory as it is in the Middle East. There is a tacit truce. The Napoleonic husband, Elimelech, supports a clockwork

Alex Rupert/"The Dropper"
Wendy Scharfman and Bob Horen in "The Dropper."

196

household with his work as a plumber, insisting upon such rights as a bottle of soda water with his supper. His long-suffering wife, Shifra, respectfully obliges, but maintains her dignity with an occasional sarcastic spritz at him.

The pleasure of Ephraim Kishon's periodically performed Yiddish comedy, "The Marriage Contract," which opened last weekend, comes from watching the assumptions of this truce break down when the Borozovskys have to confront the marriage of their own daughter.

The groom's mother, wanting to make sure the pedigree of her future daughter-in-law is kosher, asks to see the Borozovskys' own marriage contract. But they were kibbutz dwellers when they fell in love 25 years before and formalities weren't always followed.

"The last time I saw a rabbi was at my circumcision," Elimelech says.

Without a visible contract, does their marriage still have a rationale?

"Twenty-five years ago you didn't drink seltzer," his hesitant wife tells him.

David Rogow and Zypora Spaisman, two deft professionals who cut their dramatic teeth in prewar Europe, milk these fast-fading Jewish archetypes for all they're worth. Their delightful portrayals should be captured in a museum. Richard Carlow plays the groom as a stuffed shirt and mama's boy and earns his laughs. The other actors are fine.

For those who do not know Yiddish, there is a simultaneous English translation through infrared headsets. But it helps to keep one's ear open for such incomparable idioms as "Vos dreystu mir a kop!" "What are you nagging me about," simply does not capture its wounded frustration.
JOSEPH BERGER

The Dressing Room

*Pan Asian Repertory Theater
Playhouse 46 at St. Clement's
Church
423 West 46th Street
Manhattan
Through Nov. 30*

By Kunio Shimizu; directed by Kati Kuroda; original translation by John K. Gillespie; adapted and with dramaturgy by Chiori Miyagawa; lighting by Tina Charney; composer, Bert Moon; set by Atsushi Moriyasu; sound by Ty Sanders; costumes by Eiko Yamaguchi; stage manager, Sue Jane Stoker; set execution, Red Dot Scenic. Presented by Pan Asian Repertory, Tisa Chang, artistic/producing director.
WITH: Constance Boardman, Carol A. Honda, Shizuko Hoshi and Mary Lee.

"The Dressing Room," a rarefied backstage play by Kunio Shimizu, opens the 15th-anniversary season at the Pan Asian Repertory Theater. Mr. Shimizu, a prolific contemporary Japanese writer, is also the author of "Tango at the End of Winter," which was recently presented on the West End in London in a production directed by the playwright's frequent collaborator, Yukio Ninagawa.

In contrast to Mr. Shimizu's new play, "The Dressing Room" ("Gakuya") is a long one-act that dates back to 1977 and deals with the interior life and illusions of four actresses. Each of the women seems to have a greater affinity for Western theater than for Oriental art. In particular, they are drawn to Chekhov and Shakespeare. "The Seagull" shadows "The Dressing Room," as the actresses invoke their own conception

of how to play their favorite role, Nina. Gradually it becomes clear that two of the women are figures from the past, occupying a dreamlike niche behind the mirrors of this room.

The play has an intriguing premise but little momentum, standing still for monologues and dialogues while not advancing either character or action. It exists largely as a vehicle for actresses playing actresses and overcoming doubts about performing in the theater.

Shizuko Hoshi and Carol A. Honda have the more rewarding roles as the women behind the glass, who exchange banter while the two others enter their dressing-room sanctuary. The mirror images are actually more sanguine than their real-life counterparts, a star and her prompter.

As enacted under the direction of Kati Kuroda, the play has moments of poetry as well as of artificiality. The characters seem like hothouse flowers able to exist only in a protected environment. Atsushi Moriyasu's backstage set has an anticipatory air that is not fulfilled by the play itself, a small, hermetic chamber work.
MEL GUSSOW

1991 N 6, C21:1

Approximating Mother

By Kathleen Tolan; directed by Gloria Muzio; set by David Jenkins; costumes by Elsa Ward; lighting by Jackie Manassee; sound by Mark Bennett; production stage manager, Robert L. Young. Presented by the Women's Project, Julia Miles, artistic director. At the Judith Anderson Theater, 422 West 42d Street, Manhattan.

Molly	Mia Dillon
Brena	Shawana Kemp
Fran	Deirdre O'Connell
Ellie, Sylvia and Grace	Tonya Pinkins
Jack and Eugene	Richard Poe
Mac	Steven Ryan
Jen	Ali Thomas

By MEL GUSSOW

Watching Kathleen Tolan's "Approximating Mother," a man may feel he is eavesdropping on an intimate conversation among women. That effect is somewhat akin to what might be a female response to plays by David Mamet. In Ms. Tolan's play (presented by the Women's Project at the Judith Anderson Theater), women talk about their most vital concerns: motherhood, marriage, love and self-fulfillment. The dialogue is pungent and not flattering to the men in the play. They are bystanders, either passive or uncaring, and they deserve the implied criticism.

The play begins as an engaging luncheon discussion between best friends, Mia Dillon as a pregnant wife and Deirdre O'Connell as a woman who is single, 38 and desperate to have a child of her own. The biological clock is only one of several ticking urgencies. In the case of both women, a world of hopes is passing by, and fortysomething is approaching. Each would like to stop the clock and each, particularly Ms. O'Connell, is thrown back on memories of romantic roads taken and not taken.

Although "Approximating Mother" is less a fully realized drama than an impressionistic series of scenes in overlapping lives, it has considerable humor and understanding. In all respects, the play is a decided improve-

ment over Ms. Tolan's last work, the solipsistic "Kate's Diary." This time, the playwright looks into relationships between men and women and parents and children and never forgets that parents were once children. She presents diverse sides of what turns out to be a problem play about childbearing and adoption.

The author is so intent on airing points of view that there are moments when the work begins to resemble a round-table discussion, with every speaker having a chance to state a case. This fair-mindedness eventually leads to a nonexistent conclusion. The problems in the problem play remained unsolved. But throughout the evening, Ms. Tolan demonstrates her intuitive reflectiveness and a willingness to be truthful to the emotions of her people.

In keeping with that spirit, Gloria Muzio's production has an understated ease, especially in the scenes between Ms. Dillon and Ms. O'Connell. The former is irrepressible in her enthusiasm even as one detects an inner discontent. The latter seems unsettled, but is more closely in touch with her own desires. The two speak like real people rather than fictional characters, breaking up their sentences with distinctive turns of phrase and surprising themselves with their own incautious observations. In the background there are doctors, social workers, lawyers and relatives, a motley group of the barely helpful and the harmful.

Beneath the spontaneous flow of dialogue is an undertow of consequence, as Ms. O'Connell pursues the path of adoption and wavers when she realizes the obstacles that confront her. In light of actual legal difficulties, the adoption in the play seems too easily arranged; it calls for a suspension of disbelief. But once Ms. O'Connell has embarked on her course of action, the details of the case draw us in.

•

A Midwestern teen-ager, newly pregnant, finds herself with severely limited options. Without parental approval, she cannot have a legal abortion and there is never a thought given (except by the teen-ager herself) to the possibility that she might bring up the baby. Ali Thomas, the actress playing the expectant mother, is effusively adolescent, as she tells a friend about her predicament and, later, as she becomes fully aware of her entrapment.

In contrast to "The Baby Dance," Jane Anderson's formulaic treatment of the same subject, "Approximating Mother" unfolds so naturally that one might suggest the play takes a Lamaze approach to its theme. Ms. Tolan's play is revealing in its exploration of a woman's quest for maternity.

1991 N 7, C21:1

Moscow Circus-Cirk Valentin

Music by Bobby Previte; choreography by Pavel Briun; book and staging by Bob Bejan; artistic director, Valentin Gneushev; production design by Stephen Bickford; costumes by Audrey Carter; lighting by Mr. Bickford; sound engineers, Scott Rogers and Aleksei Volkov; makeup/hair styles, Lev Novikov; wardrobe, Larisa Kotelnikova; Soviet technical director, Andrei Streltsov; technical interpreter, Arsen Arsenyan; press interpreters, Alla Savranskaya and Michael Yevstafyev; company manager, Brian Cooper; production

supervisor, Robert Socha; stage manager, Jon Wismer; executive producer, Bill Franzblau; general manager, Marvin Krauss. Presented by Steven E. Leber and Soyuzgoscirk. At the Gershwin Theater, 222 West 51st Street, Manhattan.

WITH: Yuli Babich, Igor Boitsov, Yuri Borzykin, Pavel Boyarinov, Gennadi Chizhov, Yelena Fedotova, Aleksandr "Sasha" Frish, Natalya Ioshina, Aleksei Ivanov, Sergei Kuznetsov, Yelena Larkina, Serogya Loskutov Jr., Sergei Loskutov Sr., Slava Lunin, Yuri Mayorov, Irina Mironova, Yelena Mironova, Yuri Odintsov, Andrei Ridetsky, Sergei Rudenko, Sergei Shipunov, Vladimir Sizov, Aleksandr "Sasha" Streltsov, Anatoly Stykan, Valery Sychev, Nikolai Zemskov, Nina Zemskova and Vladimir Zhih.

By MEL GUSSOW

Russian gymnasts and equilibrists seem to leap higher, fly faster and defy gravity with greater daring than their counterparts in other countries, all of which was in evidence in the Flying Cranes sequence in the Moscow Circus's last visit to Radio City Music Hall. Only one act in the new Moscow Circus-Cirk Valentin approaches the Flying Cranes, and that is the Chimes, a troupe of daredevils who simulate the hands and pendulum of an enormous clock high above ground.

The remainder of the show at the Gershwin Theater has its ups and downs. Many of the acts should entertain the dedicated circusgoer, but there is not enough imagination to justify the ballyhoo that made this company sound like a wonder of the new-age circus world. Cirk Valentin, under the artistic guidance of Valentin Gneushev, the impresario responsible for the Flying Cranes, is not a conceptual invention like the Cirque du Soleil or Le Cirque Imaginaire but a random anthology of acrobatic and clown routines.

The most novel aspect of the Cirk Valentin is that it has no rings and takes place at center stage in a Broadway theater. The least appealing element is the overemphatic sound and light show and blaring musical score that accompany the performance.

The relatively brief cavalcade begins in an antic humor. A clown brings out what appears to be a tiny stuffed elephant. He pretends to wind it up with a large key, then places the toy on the floor. The elephant suddenly picks itself up and runs around the stage. Those who suspect that there is a trained dog inside an elephant suit will have to wait until the end of the evening for verification. This skit offers a promissory note about clowning to come. But except for Serogya Loskutov Jr., a 10-year-old who imitates Chaplin, comedy is not the company's strong suit.

•

The high point, in several senses, is the Chimes. In this aerial ballet, divers and catchers spin from a towering catwalk and move so quickly that our vision of them blurs. The synchronized precision of men and trapezes makes the Chimes seem like a Constructivist mechanism come to life. Then there are the jumpers, who, led by twin sisters, bounce from bar to bar as if they have springs in their shoes, and an act called Polarity in which men turn themselves into tops gyrating around long perpendicular rods.

Yuri Borzykin is a juggler who circulates five balls in the air while balancing atop a rolling globe. He is surefooted, although, in common with several other acts, he bobbled a bit on opening night. Perhaps it was a ques-

Moscow Circus

Pavel Boyarinov, a clown with the Moscow Circus-Cirk Valentin.

Joan Marcus/"Park Your Car in Harvard Yard"

Jason Robards as a retired high school teacher.

tion of being in the spotlight on this large stage, not the ideal setting for a circus. Among the less interesting performers is a woman who twirls so many Hula Hoops around her body that she resembles a human Slinky. A similar act appears currently at the Big Apple Circus.

Without question, the weirdest routine in Cirk Valentin is the one entitled Rattango, in which a long-haired Daliesque mime performs a pas de deux with a white rat as partner. The rat scurries all over Gennadi Chizhov's limber body, from finger to toe and under his shirt, while the mime maintains his poise in the most ticklish situation. One could give this act high marks for ratiocination and rodent control. But for this viewer, a rat is a rat even if it happens to be a white Russian that is fast on its feet.

1991 N 8, C3:1

Park Your Car in Harvard Yard

By Israel Horovitz; directed by Zoe Caldwell; set by Ben Edwards; costumes by Jane Greenwood; lighting by Thomas R. Skelton; sound by John Gromada. Presented by Robert Whitehead, Roger L. Stevens, Kathy Levin and American National Theater and Academy. At the Music Box Theater, 239 West 45th Street, Manhattan.

Jacob Brackish.............................. Jason Robards
Kathleen Hogan................................... Judith Ivey

By FRANK RICH

HE is "the oldest living man in Gloucester, Mass.," a crotchety retired high-school teacher who never married. She is the warm-hearted young widow, also childless, who answers his ad for a live-in housekeeper. He is Jewish. She is Catholic. He is a chilly intellectual. She is a sentimental slob. He likes Mozart. She likes Phoebe Snow. He has a hearing aid. She has a big mouth.

So it goes, and goes and goes and goes, in "Park Your Car in Harvard Yard," the Israel Horovitz comedy that has parked Jason Robards and Judith Ivey at the Music Box Theater on Broadway, one of New York's most merciless tow-away zones. The play is one of those one-set, two-actor, odd-couple contraptions that periodically seduce producers in search of low budgets and high returns along the lines of "Same Time, Next Year" or "Educating Rita." This particular example is only five minutes old before the audience is sure that the playwright can only be heading in one of two directions: either one of his characters will die in bed, or both of them will have sex there. In the evening's sole burst of ingenuity, Mr. Horovitz nearly pulls off both these denouements, though the advanced age of Mr. Robards's teacher requires that the carnal climax be achieved by proxy.

As for the inevitable onstage death that follows, even it cannot accurately be said to bring this brazenly padded, intermissionless, almost two-hour anecdote to its final curtain. The character who survives keeps chattering away at the corpse of the deceased for another scene or so, wrapping up loose ends, offering a few sentimental tears and in general assuring the portion of the audience not lost in its own slumber that death can be a happy ending, or had better be, given Broadway ticket prices.

What precedes this coda is so jerrybuilt that it is hard to believe that "Park Your Car in Harvard Yard" was written by one of this country's most prolific professional dramatists, the author of such plays as "The Indian Wants the Bronx," "The Primary English Class" and "North Shore Fish." The evening's only stab at drama is a series of completely unconvincing revelations, all of them involving previously hidden associations between the two characters, that are meted out at the rate of roughly one every five minutes. Most of these surprises are sprung by Ms. Ivey, who turns out to be not the total stranger Mr. Robards takes her for in the opening scene but a former student in his music appreciation class and one whose entire family seems to have known the old teacher in varying degrees of intimacy, ranging from casual to lurid.

In between these bombshells come the jokes, starting with the inevitable insult humor. (She: "Saying you're a hard man to please is kind of like saying a rattlesnake is a hard animal to hug.") Much is made of how much Ms. Ivey's boots leak when she first arrives, and the puddle motif is meticulously upheld a little later when she copes at farcical length with a leaky iron. Mr. Robards's hearing aid is also a source of much buffoonery, especially when Ms. Ivey switches the radio dial from classical to pop when its batteries run out. That radio and its ubiquitous disk jockey prompt a running gag about public-radio pledge drives — always a rip-roaring source of comedy — and, when all else fails, Mr. Horovitz allows his otherwise prim characters a smattering of naughty words, not neglecting the new national favorite, "pubic hair." There will always be a hardcore audience for the spectacle of old people and practicing Catholics talking dirty.

"Park Your Car in Harvard Yard" has been staged on a grim Ben Edwards set that overzealously fulfills the script's description of the teacher's home as a "pathetic hovel." The director, Zoe Caldwell, has impressively timed the two most heart-tugging, theme-mongering monologues in the play — one for him, one for her — so that they each precisely fill out the length of the syrupy musical selection, the Pachelbel Canon, that just happens to be piping forth from the radio during both of them.

The acting is variable. Ms. Ivey, who can be a gutsy comedienne, seems entirely phony here, from her thick accent to her blubbering efforts to express grief over the rather suspicious number of past family deaths with which Mr. Horovitz hopes to elicit sympathy for her long-suffering character. The actress also is asked to perform an act of self-flagellation such as Broadway has not seen since Ms. Ivey herself engaged in an act of literal breast-beating in the shortlived "Precious Sons."

•

Sentenced to do much of his acting by variously knitting, wiggling and raising his eyebrows, Mr. Robards does nothing in this play either to augment or to contradict his standing as one of our best actors. Here, as in such other recent Broadway vehicles as "You Can't Take It With You" and "A Month of Sundays," he offers a light version of the tragic old codger he has played in O'Neill and, one hopes, might yet play in "King Lear." As befits his character, Mr. Robards also delivers a few lectures on musical appreciation, including one on a Bach piece in which "the same few notes are repeated in different variations over and over, nothing changed, sometimes slower, sometimes faster." In this sense, I guess, "Park Your Car in Harvard Yard" is just like Bach, or would be if only those faster interludes ever arrived.

1991 N 8, C1:4

From the Mississippi Delta

By Dr. Endesha Ida Mae Holland; directed by Jonathan Wilson; set and costumes by Eduardo Sicangco; lighting by Allen Lee Hughes; sound by Rob Milburn and David Budries; associate producers, Ric Cherwin, Adrianne Cohen, Harlene Freezer and Bernard Friedman; traditional music arranged and performed by Michael Bodeen and Mr. Milburn. Presented by Susan Quint Gallin, Calvin Skaggs, Susan Wexler, Judith Resnick and Oprah Winfrey. At the Circle in the Square (Downtown), 159 Bleecker Street, Manhattan.

Woman One Sybil Walker
Woman Two Jacqueline Williams
Woman Three Cheryl Lynn Bruce

By FRANK RICH

Dr. Endesha Ida Mae Holland is 47 years old and has already lived enough fascinating lives to fuel a half-dozen autobiographical plays. But was it a good idea to write all of them at once? "From the Mississippi Delta," Dr. Holland's staged memoir at the downtown Circle in the Square, lurches between vivid anecdote and confusing shorthand as its author tries to pack in the many chapters of her own remarkable up-from-poverty story and the several decades of violent American racial history that serve as its tumultuous backdrop.

"From the Mississippi Delta" arrives as a finished Off Broadway production after an odyssey through the nation's resident theaters that began four years ago at New York's own New Federal Theater and that has included stops at the Goodman Theater in Chicago, Arena Stage in Washington and the Hartford Stage. One wonders if the play has been fattened up rather than refined by this artistic journey.

Among the dramas fighting for both the author's and the audience's attention during the evening are Dr. Holland's reminiscences of an oppressed dirt-poor childhood as a black girl in racially polarized rural Mississippi; her liberation by the accelerating civil rights movement in the early 1960's; her stints in prostitution and in the penal workhouse; her migration to the urban North; her successful pursuit, against high odds, of a doctoral degree from the University of Minnesota, and, finally, her emergence as a professor and writer eager to further the literary traditions exemplified by Zora Neale Hurston and Alice Walker. All of this in a running time of two hours, intermission included.

•

For efficiency's and perhaps feminism's sake, "From the Mississippi Delta" is performed by three actresses — Cheryl Lynn Bruce, Sybil Walker and Jacqueline Williams — who in relay fashion share the many cameo parts (regardless of age, sex or race), the narration and even the role of the heroine. At the evening's liveliest, these spirited performers combine with Dr. Holland's most sustained extravagances of storytelling, her ear for Delta vernacular and her sharpest observations of character to create self-contained playlets that distill the essence of a hermetic, idiosyncratic and often terrifying world.

Ms. Williams, her face distorted by fear and humiliation, is harrowing as a pre-adolescent girl who is raped by her white employer and transformed into an "old woman" by the experience. In a lighter scene that could be right out of "Gypsy," Ms. Walker is endearingly precocious as a stage-

T. Charles Erickson/"From the Mississippi Delta"

Appearing in Dr. Endesha Ida Mae Holland's "From the Mississippi Delta" at the downtown Circle in the Square are, from the left, Cheryl Lynn Bruce, Sybil Walker and Jacqueline Williams.

struck teen-ager whose sexuality and dreams of escape are catalyzed by

A Delta woman's story, from the blues to she *shall* overcome.

benign encounters with the erotic dancers of an old-time traveling fair. Ms. Bruce is a figure of serene strength and wry humor in the inspiring role of Dr. Holland's unmarried mother, a midwife of native medical genius (as dramatized in a gripping re-enactment of a troubled childbirth) who eventually becomes a tragic victim of a suspicious Mississippi burning.

It is typical of Dr. Holland's reach as a writer — when she allows herself some repose — that the funeral that follows the mother's death is a mixture of heartfelt drama and anthropological observation. For all the sorrow of the occasion, Dr. Holland happily does not neglect the farcical mis-

adventures of a drunken mourner. But the play's fully realized episodes are outnumbered by others in which the actresses seem to be reciting undramatized monologues or short stories rather than inhabiting them. The abundant use of the blues, impressively sung spirituals and unmodulated choral readings, at least as routinely deployed by the director, Jonathan Wilson, does not in itself transform Dr. Holland's vignettes into full-blown theater to match George C. Wolfe's crackling adaptation of Hurston's folkloric fables in "Spunk."

•

After intermission, when "From the Mississippi Delta" moves from its rambling reminiscences of the title's setting to relatively linear autobiography, the play gains narrative momentum yet frustrates the audience by raising more questions than it answers. The civil rights battles and organization (the Student Nonviolent Coordinating Committee) that shaped the heroine are not dramatized with specifics so much as generically saluted (with a few catch phrases and a rendition of "We Shall Overcome"). Dr. Holland's experiences in prostitution, her encounters with Northern whites and blacks, her means of ascent to Minnesota, and her intellectual development are

each glossed over in a few vague sentences. (Typical of the play's extreme compression is Dr. Holland's attribution of her entire awakening to Afro-American history to one book, by John Hope Franklin.) By the time the heroine receives her diploma, "From the Mississippi Delta" has taken on the superficial, self-congratulatory tone of a "This Is Your Life" testimonial, complete with a lengthy thank-you speech longer on proper names and egoism than on insights into the life being examined and celebrated.

But even the evening's chaotic waning passages are redeemed slightly by patches of eloquence, notably when Dr. Holland changes the subject from herself to the "fire of the 20th century" that "came roaring down Main Street." In this week of the Louisiana gubernatorial election, that blaze of racial conflagration continues unabated. "From the Mississippi Delta" is all over the map, but within it one can hear a strong voice that might harness the fire next time.

1991 N 12, C13:1

Theater in Review

■ Souvenirs of life on the way to death ■ Working their way toward 'Saturday Night Live' ■ A pared-down version of 'The Trojan Women.'

"As a Dream That Vanishes"

Albert Radcliffe in the play "As a Dream That Vanishes."

As a Dream That Vanishes (A Meditation on the Harvest of a Lifetime)

575 Broadway (entrance, 142 Mercer Street, at Prince Street), Manhattan
Through Nov. 24

Created by Merry Conway and Noni Pratt. Constructor of museum, Gregor Paslawsky; lighting, Mike Taylor; performance coordinator and sound engineer, Ron Botting. Presented by Creative Time, in association with the Guggenheim Museum and Conway and Pratt,
WITH: Ms. Conway, Ms. Pratt and Albert Ratcliffe.

"As a Dream That Vanishes: A Meditation on the Harvest of a Lifetime" is part walk-through museum installation and part performance piece, the combined creation of Merry Conway and Noni Pratt, who are actresses as well as visual artists. Paradoxically, it is the environmental exhibition that is the more animated half of the show.

As the title indicates, this is a contemplation of life leading to death. Entering the large, unnamed basement space, the future home of the Guggenheim Museum SoHo, a theatergoer passes under a representation of Charon (played by an actor) rowing across the River Styx. This macabre initial image is replaced by encyclopedic introspection.

In curio cabinets and on shelves are objects that could fill the attic of a gabled mansion. There are old photographs, antique hats, cracked pottery and other bric-a-brac, an accumulation of things one cannot bear to throw away. Most of the objects have no particular value, but taken together they are proof of possession and artifacts of existence. They once were and still could be meaningful.

The installation is reminiscent of exhibitions at the Victoria and Albert Museum in London, for example, one that was dedicated to the art of the English garden and included in its mementos Gertrude Jekyll's gardening tools and shoes. The Conway-Pratt exhibition, which has its share of spades and trowels, is similarly microcosmic.

Visitors to this Creative Time project are encouraged to wander, to sift through chatty letters from someone's Aunt Verna and to read literary signposts from Wallace Stevens and Vladimir Nabokov. Next to the Closet of Decay (the decay is everyday) is the Closet of Epitaphs, where, if so inclined, one can add an epitaph to those inscribed.

This is not a random tag sale, but an artistically arranged exhibition of memories and memorabilia, organized by Gregor Paslawsky with a sense of self-parody. A theatergoer may wonder why such trivia is saved, and even cherished, and then remember similar objects undisposed at home. The eccentricity of the collections is like an "Alice in Wonderland" inversion of reality.

After 30 minutes of individual viewing, the audience is directed to an array of mismatched chairs to watch the performance as played out on various planes, both live and on film. The nonlinear narrative centers on a dying man (Albert Ratcliffe) living alone and wearing a clown nose. His passage from life to death is in counterpoint to images of fire and water. On film there are scenes in a cemetery as the play moves into the protagonist's subconscious.

In the background are heard snippets of dialogue and popular songs announcing that life is make-believe and just a bowl of cherries. Ms. Conway and Ms. Pratt dart in and out of archways, surprising each other as if in a children's game. In contrast to the first half of the evening, the performance is short on literary and artistic content, replacing it with an artiness. The visual and cinematic elements of the performance suffer in comparison to those in related efforts by Ping Chong and Meredith Monk.

As the old man slowly succumbs to his illness, the play becomes a long day's dying and a dispiriting coda to what has preceded it. Waiting for the close, a theatergoer may wish to return to the exhibition, to browse again in the albums and vitrines of Victoriana, and to learn more about the souvenirs of other people's lives.

MEL GUSSOW

Absolutely Rude

Comedy Cellar
117 Macdougal Street
Manhattan

Music and lyrics by Rick Crom; direction and vocal arrangements by John McMahon. Lighting, Sean Haines; board operators, David Hopkins and Tom Fudel. Presented by the Comedy Cellar Theater and Rick Crom.
WITH: Mr. Crom, Frankie Maio, Mark-Alan, Virginia McMath and Amy Ryder.

In the funniest sketch in "Absolutely Rude," an 80-minute musical comedy revue, Amy Ryder cheerfully introduces herself as Sally Struthers, "TV's most annoying spokesperson." After declaring, "I grovel for the causes I believe in; I've whined and whined and whined," the character goes on to plead for yet another cause, "the acting lessons I so desperately need," and encourages viewers to contribute just 50 cents a day toward that training.

Ms. Ryder's bit is one of the very few moments in the show that are sharp enough to be worthy of "Saturday Night Live," which does this sort of needling topical comedy better than anyone else. The only comparably funny moment finds Pee-wee Herman, smirkingly impersonated by Mark-Alan, as the host of a smutty late-night cable television show.

The rest of the show's humor is too pat and too safe to live up to its claim of being rude. Rick Crom, who wrote most of the songs, impersonates John Cardinal O'Connor wishing he were the Pope, to the tune of "If I Only Had a Brain." Mr. Crom also created the show's most ambitious number, a capsule version of "Oklahoma!" as Stephen Sondheim might have written it in his "Sunday in the Park With George" mode. The parody falls apart for lack of conceptual focus. An even weaker attempt at a musical comedy spoof, "Cole Porter's 'Star Trek,'" finds the television characters chirping about their adventures in a generic Broadway style.

The show's five performers exude an appropriately frothy sense of merriment, but the fun is too scattershot and the music too pallid for "Absolutely Rude" to amount to more than a mildly diverting entertainment.

STEPHEN HOLDEN

The Trojan Women

Pearl Theater
125 West 22d Street
Manhattan
Through Dec. 7

By Euripides; translated by Richmond Lattimore; directed by Shepard Sobel; set, Robert Joel Schwartz; stage manager, Mary-Susan Gregson; costumes, Barbara A. Bell; lighting, Paul Armstrong; sound, Donna Riley. Presented by the Pearl Theater Company.
WITH: Carlo Alban, Robin Leslie Brown, Arnie Burton, Joanne Camp, Belynda Hardin, Bella Jarrett, Alex Leydenfrost, Stuart Lerch, Diane Paulus, Laura Rathgeb, Hank Wagner and Donnah Welby.

"The Trojan Women" remains the most gut-wrenching antiwar play of all, able after 2,400 years to arouse pity and terror, and plenty of both.

For his version at the Pearl Theater, Shepherd Sobel makes some deep cuts — principally in the chants of the chorus — and emphasizes the relentless grinding-down of the widowed and enslaved Trojan women. His production lasts 90 minutes and leaves one feeling hammered. People who know the original will miss some of the sweeping choral odes; their meaning is often murky, but they give the play a slow, majestic rhythm that heightens the terror.

There are problems with Mr. Sobel's direction. His vision of Cassandra (played by Laura Rathgeb) is really annoying. She acts like a kind of prancing Ophelia gone nuts, when in fact her dances and ravings should reveal possession by a dreadful god. And a few other actors have not been instructed that their characters are supremely dignified and that their composed demeanor should make their fate more terrible.

The key roles are the old queen, Hecuba; Hector's widow, Andromache, and Helen of Troy. Bella Jarrett is a terrific Hecuba, a dangerous fury filled with contempt and sorrow, who knows how to make words caress, or lash and tear. Donnah Welby's Andromache embodies despair itself when the triumphant Greeks murder her young son to finish off the Trojan royal family. And Robin Leslie Brown as Helen has the right mixture of sensuality, fear and defiance to be a believable cause of war.

Finally, a word should be said about Astyanax, the killed child. Ancient Greek commentaries give no clue about how this silent role was handled. In this case Carlo Alban is admirable, most admirable in death. It has many years since I have seen an actor of any age play dead so convincingly for so long. It is a great relief to see him galvanized again during curtain calls.

D. J. R. BRUCKNER

1991 N 13, C21:1

The Rivers and Ravines

By Heather McDonald; directed by Henry Fonte; set, Allen D. Hahn; costumes, Marjorie Fennan; lights, Douglas O'Flaherty; sound, Richard L. Sirois and Eric Annis. Arena Stage. Presented by the Village Theater Company. At 133 West 22d Street, Manhattan.

WITH: Barbara Bercue, Michelle Berke, Matthew Caldwell, Michael Curran, Susan Farwell, Marjorie Feenan, Christie Harrington, J. C. Hoyt, Randy Kelly, Terrence Martin, David McConnell, Julia McLaughlin, Patricia Randell, Patrick Turner, Howard Thoresen and Zeke Zaccaro.

By MEL GUSSOW

The crisis leading to rural unemployment and loss of farm property is

given a diligent examination in "The Rivers and Ravines," by Heather McDonald. Originally produced at the Arena Stage in Washington, this sprawling play is having its New York premiere at the Village Theater. Both the play and the production are marked by earnestness and ambition. It is to the credit of the Village Theater that it has attempted the work.

Ms. McDonald, the author of "Faulkner's Bicycle," crosscuts stories of farmers and ranchers in Colorado in the late 1970's and early 1980's. Seduced by the suggestion that "perpetual debt is the wave of the future," they borrow in order to expand and quickly find themselves facing foreclosure. The suicide of one distraught wife sends the other characters spinning on a path of self-doubt.

•

To help one another through the ordeal, neighbors form a rural hotline, enabling the previously silent to air their grievances, which they do in several of the play's more moving scenes. On the fringe are those farmers who have joined forces with banks and Government agencies in removing people from the land. The playwright studiously avoids polemics while making the case that the farmers are helpless, driven to destroy crops rather than sell them below market value.

For all the work's conviction, there is a familiarity both in the theme and in the kaleidoscopic approach. The play opens with the most predictable of framing devices: a television team tries to report on the crisis and distorts the truth for dramatic purposes. Then the scene shifts briefly but more interestingly to an Indian woman who becomes a shamanistic conscience of the community. This character, as tellingly portrayed by Susan Farwell, could have played a larger role in the story.

•

Instead, the play moves back and forth among families, not all of whom achieve definition. At one point, it is suggested that after television reporters, political campaigners and the Jessica Lange film "Country" have all left town, the people and the problems still remain. That movie was more personalized than anything that happens in this play, which was certainly true of that earlier, related work, "The Grapes of Wrath."

Under the utilitarian direction of Henry Fonte, 16 actors, many of them doubling in roles, crowd the small stage, which, in Allen D. Hahn's set design, is made to resemble a leaf-covered field lined with haystacks. It seems to be eternal autumn in this community, even though the emotional climate becomes wintry. Despite the play's flaws, Ms. McDonald's message echoes with clarity, an emergency signal about hard times and more difficult days to come.

1991 N 14, C28:6

Bluebeard

By Charles Ludlum; directed by Everett Quinton; scenery, T. Greenfield; costumes, Toni Nanette Thompson; lighting, Richard Currie; music and sound, Jim Badrak; props, Tom Moore; production stage manager, Karen Ott. Presented by the Ridiculous Theatrical Company, Mr. Quinton, artistic director; Steve Asher, managing director. At the Charles Ludlam Theater, 1 Sheridan Square, Manhattan.

Bluebeard	Everett Quinton
Sheemish	Kevin Scullin
Miss Cubbidge	Eureka
Mrs. Maggot	Stephen Pell
Leopard Woman	Brian Neil Belovitch
Good Angel/Bad Angel	Shawn Nacol
Sybil	Lisa Herbold
Rodney Parker	Bill Graber
Hecate	H. M. Koutoukas

By MEL GUSSOW

Charles Ludlam's "Bluebeard" has returned and the comedy is as bizarre and crack-brained as ever, even without the author in the title role. Everett Quinton, Ludlam's successor as artistic director and star of the Ridiculous Theatrical Company, has placed his sinister signature on the character. Mr. Quinton's revival opened last night at the Charles Ludlam Theater.

Enter the Baron Khanazar von Bluebeard, the tyrannical landlord of the legendary lost island. In Mr. Quinton's impersonation, the baron has closely cropped blue bristle on his face, a wild gleam in his eyes and a turban that makes him look like a swami. Introducing himself, he adds five k's to Khanazar, strangles his vocal cords and finally exclaims his name so melodramatically that it sounds like a strike of thunder.

This Bluebeard is a vivisectionist (and also a vegetarian) bent on a path to create a third sex. The next victim on the operating table will be his nubile niece, Sybil, and his cohorts in the experiment include Sheemish, a sheepishly sniveling servant.

•

Before writing "Bluebeard," which was his first major Ridiculous success, Ludlam evidently watched and cross-indexed every mad-doctor and monster movie ever made, beginning with the Charles Laughton thriller

A skewed, slightly lewd comedy about a mad vivisectionist.

"Island of Lost Souls." To this collage, he added linguistic tomfoolery and ludicrous lubricity.

There is, of course, no way to equal the experience of discovering Ludlam's first hysteric production in 1970. Two of the original cast members are definitely missed: Black-Eyed Susan, who was a perfectly ingenuous Sybil even as she appeared surgically enhanced, and John Brockmeyer, whose Sheemish was a cringer of the old Karloffian school.

But Mr. Quinton is not to be deterred by his or our memories. There is a calm rationality in his character's insanity. This is a Jekyll only halfway to Hyde. He is a neater Bluebeard who takes his dapperness to bed with him. His seduction scene with Sybil's Malapropish guardian (portrayed by a trimmed-down Eureka) is maniacally funny, with both performers harvesting the laughter.

As he strips to his turban and garters, Mr. Quinton neatly folds each item of clothing before placing it carefully on the mantel for safekeeping. This act of fastidiousness proceeds at a crawl, increasing in humor while the lustful Eureka waits, with

Everett Quinton as the title character in "Bluebeard."

Martha Swope

growing impatience. The erotic romp itself rushes to fast forward as the actors dive onto and then into a chaise longue with a conveniently false bottom. It is impossible to watch this farcical scene with a straight face, even as the artistic director abandons every inhibition.

Amusingly on the sidelines is Stephen Pell as Mrs. Maggot, Bluebeard's busybody housekeeper who is held in check with threats of torture in the House of Pain. "Not the House of Pain!," she cries in alarm, one of several running jokes that do not suffer from being repeated.

As director, Mr. Quinton pursues every corkscrew turn of the comedy, starting with the mock-horror opening: mechanical rats clattering across the stage, followed by Sheemish's broom. In T. Greenfield's garish set design, doors slam without a human touch and the mysterious Leopard Woman darts in and out of a convenient fireplace. Ghoulish things are happening in this madman's lair, especially in the mysterious laborrrr-ratory. "Bluebeard" was never a family entertainment, unless that family happened to be named Addams.

1991 N 15, C3:1

SUNDAY VIEW/David Richards

Curmudgeons by a Whisker

'The Homecoming,' 'Park Your Car in Harvard Yard' and 'On Borrowed Time' may set a trend: waspish graybeards.

IT IS, APPARENTLY, THE SEASON TO be curmudgeonly.

At Circle in the Square, George C. Scott is playing a flinty old coot who chases death up a tree and keeps him there in "On Borrowed Time." At the Roundabout Theater Company, which has just moved into the Criterion Center, Roy Dotrice is an utterly disreputable paterfamilias in

"The Homecoming." Meanwhile, Jason Robards is carrying on as the holy terror of Gloucester, Mass., in "Park Your Car in Harvard Yard" over at the Music Box.

Since little else is happening on Broadway right now — other than "Nick and Nora's" protracted birthing pains — I hereby declare a trend: The New Cantankerousness. Those who are chewing up the scenery these days are doing so by chewing out their fellow performers. Civility has ceded the stage to obstreperousness.

Listen to Mr. Dotrice, who, as Max, a retired butcher in the north of London, is recalling his dearly departed wife. "She wasn't such a bad woman," he says sweetly. "Even though it made me sick just to look at her rotten stinking face."

Mr. Scott — he's playing one Julian Northrup, otherwise known as Gramps — is just as unequivocal on the subject of his sister-in-law Demmie. "Adam saw a dog and it looked like a dog and he called it a dog," he explains. "I saw Demmie, she looked like a bird-stuffer and I called her a bird-stuffer, so she *is* a bird-stuffer." (Come on, the play is 53 years old.)

Mr. Robards has turned up as Jacob Brackish, a retired high school English and music appreciation teacher who spent 40 years flunking one student after the next. Not only did his middle-aged housekeeper fall before his impossible standards, but so did her deceased husband and both her parents. When she points out that nobody in the whole town was ever good enough for him, he retorts with righteous glee, "I did not, young lady, flunk the 'whole town of Gloucester.' I did nothing of the kind! You *failed*! Your family *failed*!"

A curmudgeon speaks his mind, all right. He also lets the hair on his face run riot. Mr. Dotrice, you'll notice, is sporting a scruffy set of white whiskers. So is Mr. Scott. So is Mr. Robards. (And you thought I was whipping up a trend out of thin air.)

∎

If Mr. Dotrice easily proves the most fascinating of the three, it may be because he has Harold Pinter's play on his side. When it was first produced on Broadway in 1967, "The Homecoming" raised a firestorm of controversy. Whatever did it mean — this oblique saga of a college professor who brings his wife, Ruth, home to meet the family: his father, Max; a bachelor uncle; and two seedy brothers, one a pimp, the other an aspiring pugilist? Ruth is barely over the doorstep before the men take possession of her, unless, of course, she's bending them to her unarticulated will.

By the end of the play, she has, at any rate, cheerfully decided to stay on as their cook and concubine, and, when schedule permits, turn a few tricks on the side for her room and board. Her husband offers no protests, and our parting image of the perverse household is that of Max, groveling at his daughter-in-law's feet and begging toothlessly for her sexual favors.

Time has not clarified matters, although time has taught us that it's foolhardy to try to hold Mr. Pinter to tidy meanings. What's obvious is that all sorts of power plays are going on, that what is said bears little relationship to what is meant, and that speech is either a diversionary tactic or a veiled threat. You can, however, experience — even savor — the tensions among people, without necessarily knowing what has brought them about. *Not* knowing, in fact, is what makes Mr. Pinter's plays comic, as well as menacing. The rare explanations his characters do give for their actions are either so tangential or so irrelevant as to be unexpectedly funny.

Marilynn K. Yee/The New York Times

Roy Dotrice in "The Homecoming"—Chewing up the scenery these days means chewing out fellow performers.

In the Roundabout's altogether praiseworthy production, Mr. Dotrice leads the comic charge — uttering platitudes as if he had just brought them down from the mount, and indulging in ridiculous flights of sentimentality that invariably dissolve into sputters of pure spite. He is pomp without circumstances, a suburban Lear in a dirty pea-green armchair. "I worked as a butcher all my life," he boasts, "using the chopper and the slab, the slab, you know what I mean, the chopper and the slab!" Then, with nary a nod to the squalid thrift-shop surroundings, he adds triumphantly, "To keep my family in luxury."

There isn't a shred of niceness in the man, although, for conviviality's sake, he's not beyond plastering a cozy grin on his face and batting his eyes like a flapper on gin. It's never long, though, before he reverts to his true, irascible nature. Full of excuses for himself, he is bereft of charity for others. (That contradiction, too, is oddly comic.) Loutish and bullying — yes, he admits to the shortcomings, and more. "But at the same time," proclaims Mr. Dotrice in an inflated tone that suggests he's talking to the ages and not just to a son who's buried his nose in a newspaper, "I always had a kind heart. Always."

The performance couldn't be nastier ... or better.

In "On Borrowed Time," Paul Osborn's warm and reassuring fable, Mr. Scott is giving us the other side of the coin, the endearing curmudgeon whose worst vices, as his homespun wife chides him repeatedly, are "swearin' and smokin' that smelly pipe." His language probably needs mindin', too, if he's not to make a "smutty mouth" out of his grandson, Pud.

But this geezer is scratchy on the surface only. Under the porcupine quills, he could be the Saturday Evening Post's grandfather of the year, assuming the year were 1910. The people he tells off are the prigs and the fussbudgets who want to take his grandson away and put him in a Baptist boarding school, for Pete's sake, and therefore deserve every last tongue-lashing they get. In the battle for Pud's soul, Gramps is even willing to go up against death himself — a dapper gent in homburg and spats.

In this instance, Mr. Scott can't begin to match Mr. Dotrice for bile and vituperation. His accomplishment — and don't underestimate it — is keeping his cranky head above the goo. The performance is as unpretentious as the faded overalls he's sporting and as effortless as a lazy afternoon of front-porch rocking. Yet something about the actor (is it his grizzly-bear voice, his intimidating size or simply his reputation?) is acerbic enough to keep all the sweetness in Mr. Osborn's play from curdling. Mr. Scott isn't going against the grain, but he's not exactly going with it, either. He's charting his own way through the proceedings, thank you, and the feistiness is what allows him to twinkle to his heart's content. If Mr. Scott chooses to be lovable, after all, who in his right mind is going to stop him?

Joan Marcus/"Park Your Car in Harvard Yard"

Mr. Robards in "Park Your Car in Harvard Yard"—geezer fever?

Compromise, on the one hand, seems to have done in "Park Your Car in Harvard Yard," a mournful two-character affair by Israel Horovitz that can't have required all that much to scuttle it in the first place. Compared to the events transpiring inside Jacob Brackish's gray, dusty and thoroughly depressing Gloucester house, the periodic blast of an offstage foghorn registers as jubilance. Among the play's many plodding faults, only one is pertinent here, though: Mr. Horovitz can't decide whether Jacob ("Backlash" to his enemies, which is to say everybody) is a true scoundrel or just an apparent one.

I suspect the play may have started out much darker and then lost some of its misanthropic fury on the way to Broadway. What has opened at the Music Box, in any case, is an uneasy mixture of astringent drama and foolish situation comedy. The forbidding character of Jacob has been tempered with cute idiosyncrasies, presumably intended to make him more palatable to audiences.

Still, envy has obviously poisoned his life and pedantry soured his vast storehouse of knowledge. Complaining is his abiding joy, and the litany runs from drafts and tourists to old age and unclear grammatical antecedents. Even more maddening, the batteries in his hearing aid keep going dead. When they do, a shudder of exasperation seizes Mr. Robards, his voice rises several decibels and his pronunciation turns so stingingly precise he could be dressing down a foreigner or an idiot.

This, however, is no more than a ploy on Jacob's part to find out what people say about him when they think he can't hear them. The housekeeper (Judith Ivey) seizes one such opportunity to let loose with a justifiable barrage of scatological insults. Jacob doesn't so much as flinch.

But he does change his heart. The very rigor, which we are given to understand has destroyed so many lives, is redirected to the task of educating the wretched woman and restoring her self-respect. There was a softy in this Scrooge all along, although by withholding the revelation until the last possible moment, Mr. Horovitz seems to be dragging it in from left field. If Mr. Robards — eyes blazing under droopy lids — starts

Roy Dotrice, Jason Robards and George C. Scott speak their minds, all right.

out the evening reminding you of James Tyrone in "Long Day's Journey Into Night," he somehow ends up evoking Grandpa Vanderhof in "You Can't Take It With You." It isn't his fault the character never comes alive.

The actor is one of our best. But in "Park Your Car in Harvard Yard" he finds himself betwixt and between, which is no place for a curmudgeon to be somebody. ☐

1991 N 17, II:5:1

Free Speech in America

Written and performed by Roger Rosenblatt; directed by Wynn Handman; lighting, Todd Bearden; production stage manager, Matthew Farrell. Presented by the American Place Theater, Mr. Handman, director; Dara Hershman, general manager. At 111 West 46th Street.

By MEL GUSSOW

Have you ever wondered why Lüchow's went out of business? It was all because of Roger Rosenblatt and his brother, whose telephone number was one digit away from that of the famous restaurant. When people phoned the Rosenblatt home by mistake, the two young men played an increasingly elaborate practical joke. They would book tables in what they called the Himmler Room and, in the dead of winter, they would ask diners if they wanted to be seated on Lüchow's roof. If someone tried to cancel a reservation, they were adamant in their refusal.

Mr. Rosenblatt confesses this caper in his one-man show at the American Place Theater, using it to illustrate the capacious title of his monologue, "Free Speech in America." Where most humorists would like to be taken more seriously, it would seem that this commentator would like to be taken more humorously. In his professional theatrical debut, he proves to be as adept at lectern comedy as he is at writing articles and books. He appears on the "MacNeil/Lehrer Newshour" and his essays are published in Life magazine.

Tongue in cheek, bodkin bared, he assails the bumblers, wherever they may be, especially in high places. His mission is to protect our language from abuse. As a wordsmith he takes pleasure in linguistic precision.

●

Politicians are his best bête noire. A favorite Rosenblatt ploy is to have a famous figure hoist himself by his own self-regard. Repeatedly, he catches a politician with his foot in his mouth, as in President Ronald Reagan's comment to the Lebanese foreign minister that his nose "looks just like Danny Thomas's" and President Bush's election year remark that the undecided voters "could go one way or another." It is, Mr. Rosenblatt says, "a lot easier to defend free speech if no one hears it."

Although he vows to avoid easy targets, he cannot resist Vice President Dan Quayle, whose words, he thinks, were handed down from Groucho Marx, one of Mr. Rosenblatt's role models. He says John H. Sununu, the White House chief of staff, is "known as the brains of the outfit," and adds, as Groucho said of Harpo, "That gives you an idea of the outfit." An inveterate watcher of television news colloquies, he has a harsh view of those who are eternally employed as armchair experts, like a certain former security adviser who "makes wildly inaccurate predictions." He

Gerry Goodstein

Roger Rosenblatt in the monologue "Free Speech in America."

proposes a movie based on that man's life: Tom Hanks starring in "Zbig."

●

The show is high in political protein, but Mr. Rosenblatt is also an avid cultural consumer who can quote Madonna to his purpose ("Free speech is as good as sex"), and he dismisses advertising as something that "fills the gap between greed and death."

Though he wanders from his theme (free speech allows that freedom), he has a columnist's ability to smooth transitions. As directed by Wynn Handman and helped by an occasional use of visual aids, he employs the simplest of dramatic maneuvers. On the theater's cabaret-style stage, the show remains conversational, punctuated by passing attempts at mimicry: he can be Nixonian.

The fact that he once taught at Harvard gives him a certain ease at presenting his case in public, but it

Roger Rosenblatt wants to be taken humorously. Please.

also leads him into instructional paths, as in his brief dissertation on 19th-century American literature. This mini-lecture concludes with a reading from "Huckleberry Finn," crediting Mark Twain with the clearest example of free expression.

From Twain to Calvin Trillin, writers have directly encountered their readers, perhaps fulfilling a natural desire for feedback as well as a way to augment income. Mr. Rosenblatt has poise but his timing is not yet on a par with that of Mr. Trillin, who preceded him in this American Humorists' series. At this stage of Mr. Rosenblatt's new career, it is the material more than the manner that draws the laughs.

●

The commentary is seasoned with personal asides, especially about his father, who apparently did his utmost to discourage free speech in the Rosenblatt household, a goal with which the owners of Lüchow's would undoubtedly have concurred.

In his 90-minute monologue, Mr. Rosenblatt allows himself a few moments of wishful thinking: a sailing holiday with the model Ashley Montana and, in common with other celebrities, a profit-making perfume of his own, which he would label Roger Rosenblatt's Depression. More accurately, one could call his essence eau de wit.

1991 N 18, C11:1

Theater in Review

■ Performance art, with the audience as artwork

■ Live sex shows in 17th-century England (and the resulting furor) ■ Prison for bad poets.

Tubes

Astor Place Theater
434 Lafayette Street
Manhattan

Artistic coordinator, Caryl Glaab; directed by Marlene Swartz; set, Kevin Joseph Roach; lighting, Brian Aldous; costumes, Lydia Tanji and Patricia Murphy; sound, Raymond Schilke; computer graphic design, Kurisu-Chan; associate lighting design, Stan Pressner; associate producers, Akie Kimura and Broadway Line Company. Blue Man Group Band, Brian Dewan, Larry Heinemann and Ian Pai. Blue Man Group presented by Mark Dunn and Makoto Deguchi. WITH: Matt Goldman, Phil Stanton and Chris Wink.

The three bald blue bullet-headed comedians known as Blue Man Group give a barbaric yawp of childlike pleasure as they attack the art and appetites of a computerized society force-fed junk food. The blue men in "Tubes" look and act like robots from outer space trying to acclimate themselves to a brain-dead Planet Earth.

In their hands (and spewing from their mouths), you art what you eat. A syncopated chorus of Cap'n Crunch munching makes that breakfast cereal sound like a platoon of pile drivers excavating a New York City street. Lining up at kettle drums, the threesome spill bright paint as they play in tympanic tune and hold up canvases to catch the spatter, Jackson Pollock style.

Matt Goldman, Phil Stanton and Chris Wink, the actors and artists masquerading in blue, are aggressive but good-natured, preferring to coax laughter from theatergoers as they explore the furthest reaches of action comedy. That comedy is intentionally confused with fractal geometry and cyberpunk, played to a burbling musical background.

Beneath the assault there is an intelligent awareness of the dangers of mind control. The deadpan actors speak no dialogue, though occasional words are heard on a sound track and messages are transmitted on electronic display units that read like a Jenny Holzer artwork run amok. Clearly the group knows what it wants to spoof: performance art and art that pretends to perform. In other words, the objects of disaffection are anything regarded as "fake faux."

This sense of double negative turns into deconstructivism, as the performers mock a dead fish to prove that in matters of artiness, all emperors have no clothes. As critics, they weigh in against the traditional as well as the experimental, at one point removing Christina from "Christina's World," zooping the painted figure out of the pictorial background and into a suction tube.

Industrial tubes are the primary motif of the show. They dangle like stalactites, they infiltrate our seats (listen and one can hear voices) and they twist their way into the performance. Kevin Joseph Roach's set design looks like an explosion in a boiler factory. How Marlene Swartz managed to direct these lunatics is a matter of conjecture. Perhaps she just shouted suggestions while ducking for cover.

A warning to prospective theatergoers: if you sit in the front rows, be sure to don the plastic garbage bags that are provided with your programs — and do not volunteer. Blue Man carries the A.P.Q. (audience-participation quotient) to the extreme. One volunteer is hung by his feet, swabbed with paint and lobbed against a canvas like a large human paintbrush. Later, the company wraps the audience. For the intrepid theatergoer, the show can be a performance-art pigout.

MEL GUSSOW

The Guise

Triplex Theater
Borough of Manhattan Community
College
199 Chambers Street
Manhattan
Through Sunday

By David Mowat; directed by Brian Astbury; assisted by Yvonne Bryceland; set and costumes, Katrina Lindsay; music, William Hetherington; stage manager, Tony Kerr. Presented by Arts Threshold. WITH: Tania-Jane Bowers, Karen Bowlas, Timothy Chipping, Karl Collins, Michael Hodgson, Carine Sinclair and Andrew Weale.

The liveliest scenes in "The Guise," David Mowat's dramatic satire on censorship past and present, imagine a 17th-century English king who, to the horror of his family and the court, commissions plays that are little more than live sex shows. A bawdy excerpt from one, acted in pantomime by members of the Arts Threshold Company, shows milkmaids lustfully competing for the favors of a country bumpkin. Timothy Chipping, portraying a monarch who is a composite of Charles I and Charles II, offers a ribald Falstaffian caricature of a royal sex maniac running amok.

Very quickly, reaction sets in and England is ruled by a Puritanical Oliver Cromwell-like barrister named William Prynne (Michael Hodgson), who decrees that all plays, before being performed, must be submitted to his office for approval. When no plays are approved, the London theater all but dies. Leading the movement for a free theater is a young playwright and actor, Richard Daborne (Andrew Weale), who lives in poverty with his wife, Janine (Tania-Jane Bowers). Left at home in the slums with their children while her husband fights for the survival of his profession, Janine must cope with continuing threats of violence, including rape.

The two-and-a-half-hour play, which offers explicit parallels between its 17th-century world and present-day England, is a complex Brechtian work that is not easy to follow. Playing members of the Free

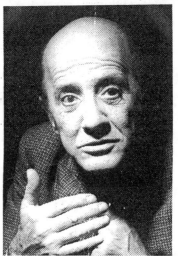
Carol Rosegg/Martha Swope Studios/"Iron Bars"

Garry Goodrow as Emmanuel in "Iron Bars."

Theater Company of 1654, the cast of seven young actors from the Arts Threshold Company re-enacts the events of 1642 when London's theaters were closed down. Under the direction of Brian Astbury, the performances, particularly those of Mr. Chipping as the randy king and Mr. Hodgson as the cold-eyed Prynne, are strong.

But the transitions within this play within a play are as jarringly abrupt as its changes in tone (from farce to political dialogue to horror show) and its shifts in vernacular from a post-Shakespearean to contemporary dialect.

The play builds to a confrontation between Daborne and Prynne, in which the imperious censor describes his agenda. Replying to Daborne's charges that he is "destroying the theater," Prynne maintains with an icy hauteur that he is merely protecting "the interests of the majority." Coming in the wake of the debates about the National Endowment for the Arts grants, such arguments for censorship have a chilling contemporary ring.

STEPHEN HOLDEN

Iron Bars

Riverside Shakespeare Company
Playhouse 91
316 East 91st Street
Manhattan

Written by Arpad Goncz; translated by Katharina M. and Christopher C. Wilson; directed by Andre de Szekely and Laszlo Vamos; set by Bob Barnett; costumes by Pamela Scofield; lighting by Stephen J. Backo; music composed and arranged by Tommy Vig; production stage manager, Matthew G. Marholin. WITH: Lisbeth Bartlett, Bruce Edward Barton, Mikel Borden, Peter Brown, Maureen Clarke, Dan Daily, Garry Goodrow, Brian Keane, David Lipman, Christopher Mixon, James Ryan, Richard Thomsen, Alice White and Mark Young.

Prison is the proper place for a poet of indifferent talents, Arpad Goncz seems to be saying in "Iron Bars." And he makes his point in a series of scenes filled with wry humor and irony.

This is a remarkable conclusion for a man who wrote this play in the 1960's after he himself had spent six years in prison for his role in the 1956 Hungarian uprising. But Mr. Goncz, who is now the President of Hungary, has said he based his protagonist, a second-rate poet named Emmanuel, on a poet he met in prison.

At the outset, two buffoonish prosecutors plead with Emmanuel (Garry Goodrow) in prison to agree to pretend that the country's President collaborated with Emmanuel in writing the national anthem. If he will, they will free him. The more they talk about freedom, the more obdurate Emmanuel gets.

Little good it does him. The President has ordered him released after 10 years in captivity, and the second act finds him at home: a new apartment the President has given Emmanuel's family.

Emmanuel is miserable at home, made more miserable by the attentions of his foolish wife, Dolores (Alice White), and a politically doctrinaire friend, Beata (Lisbeth Bartlett), who has evidently been his lover in the past. The women have to lock him in to prevent him from returning to prison.

His salvation comes at the hands of a shrewd doctor (Maureen Clarke) in an asylum, who decides he means it when he says he longs for his old cell, and accommodates him, but not before he has to sit through a hilarious visit from the pompous President (Richard Thomsen), who has serious difficulty recognizing any distinction between himself and the whole universe.

Under guidance from two Hungarian directors, Andre de Szekely and Laszlo Vamos, the 14 members of this cast, taking about three times that many roles, give loving attention to the insinuating, tickling humor of "Iron Bars." But there are limits to what they can do. This is a writer's, more than an actor's, play, with much of the laughter reserved for reflection after one has left the performance.

D. J. R. BRUCKNER

1991 N 20, C23:1

Women in Beckett

All of Samuel Beckett's short plays for women. Directed by Moises Kaufman; produced by Rohana Kenin; stage manager, Laura Teusink; set by Marsha Ginsberg; lighting, Jack Jacobs; costumes by David Zinn; video design by Greg Allen. At the Theater for the New City, 155 First Avenue, at 10th Street.

WITH: Rosemary Brady, Pat Kier Edwards, Mimi Feiner, Janet Gibson, Megan Hunt, Lilian Johnson, Anne C. Putnam and Nellie Zastawna.

By MEL GUSSOW

Moises Kaufman as director has had the notion of presenting an evening of four of Samuel Beckett's short plays about women, in the hope that they would form a quartet of contemplations about the loneliness of old age. He borrows the title of his production, "Women in Beckett," from Linda Ben-Zvi's valuable anthology of essays and interviews on that subject. To emphasize Mr. Kaufman's point, most of the eight actresses in his cast at Theater of the New City are over the age of 65. Drably costumed, they look like inhabitants of a Beckettian environment. The plays are eloquent emanations, but in each case the directorial approach studiously undermines the author's intention.

Mr. Kaufman makes characters visible when Beckett wanted to remain unseen. Mood is sacrificed, along with intensity. By increasing the size of the cast, the director takes

the focus away from the central figure. In "Footfalls," May paces her nine steps back and forth on a narrow path, while her mother, who should exist only in her daughter's memory, stands onstage and watches. As a result, one is distracted from the ritual of the pacing, so important to May's painful interior journey.

The director similarly distorts the perspective in "Not I," in which our attention should be transfixed by a character's mouth, delivering an obsessive monologue. In this version, the Auditor, a spectral, totemic presence, becomes a woman standing in a bright light and staring at a television screen showing a picture of the Mouth (Janet Gibson, who also plays May in "Footfalls"). Behind a wall, the other actresses take turns speaking the Mouth's breathless words. The play becomes a generic collage instead of a heightened and particularized revelation of a woman's psyche.

All the actresses appear onstage in the one-character "Rockaby." This results in a chorus of old women rocking, instead of one woman rocking her way out of life. Again the approach is damaging to the text, but in this case there is an intriguing peripheral note. The orchestrated rockers look like the aged residents of a nursing home or hospital ward; they become a replicated character embarking on a collective pilgrimage.

The brief production closes with "Come and Go," a vignette or "dramaticule," in which three women meet like the witches in "Macbeth" and comment on their shared schoolgirl past. Where Beckett wrote it as a ghostly piece for colorless voices, Mr. Kaufman plays it cheerfully, with each woman smiling her way through the crosscurrents of conversation. As performed, "Come and Go" provokes a smile, but at a dramatic price.

The actresses speak clearly but not always with the voice shadings required by the text. Watching them, one recalls Billie Whitelaw, who is so closely identified with the works of Beckett. In her individual performances in these plays (and in "Happy Days") she consistently illuminates the connections among Beckett's agonizing women.

1991 N 22, C17:1

SUNDAY VIEW/David Richards

Things That Go Splat and Squish in the Night

In 'Tubes,'

Blue Man Group

paints a mustache on

the face of Art.

A storyteller's voice

infuses 'From the

Mississippi Delta.'

I SUPPOSE THE GENERIC TERM FOR the odd doings of the trio called Blue Man Group in "Tubes" is performance art. But as soon as you say "performance art," you're obliged to deliver learned commentary about its meaning, its antecedents and its general place in the esthetic cosmos, and frankly I'm not up to it this morning. And even if I were, I'm not sure I wouldn't be leading you down the wrong path.

Whatever the intellectuals may make of "Tubes," a lot of it strikes me as a wild extension of timeless frat house behavior — food fights, hazing rituals and "T.P.ing," which is, of course, "toilet-papering" or the practice of filling up an unsuspecting victim's room with roll upon roll of bathroom tissue.

Now, I've gone and made the evening sound sophomoric, and that's as bad as making it sound relevant. Still, if you sit in the front rows of the Astor Place Theater, Off Broadway, you'd be advised to wear the clear plastic Baggie provided by the management. And no matter where you sit, expect to be buried — yes, *buried* — in a deluge of paper at the end.

You've got to appreciate things that go splat and squish in the night, and it helps to like the thunder of drums, kettle and bass. If you do, you're apt to find "Tubes" as exhilarating as it is intrepid. I enjoyed it as much as I did finger painting as a child, which is a great deal. In fact, much of the time, Blue Man Group made me feel like a goggle-eyed kid again, which is why I say the intellectual view of things is sort of missing the boat, or at least the show's sheer, visceral fun.

The group is made up of Matt Goldman, Phil Stanton and Chris Wink, although they're virtually indistinguishable since their heads and faces are painted a shiny cobalt blue and they're wearing identical work uniforms. I thought they bore a decided resemblance to the monster in "The Creature From the Black Lagoon," but my companion said they reminded her more of grown-up Smurfs. I guess that merely shows there is a fierce side to their playfulness or a playful side to their ferocity. They say nothing in the course of the evening, so their actions pretty much have to speak for themselves.

Here's how they make paintings. One Blue Man tosses what seem to be balls from a bubble-gum machine to second Blue Man, who catches them in his mouth, chews them, then spits them out, in vivid color, onto a blank canvas. Or else they pour paint onto the head of a drum, then beat the drum madly, which produces something akin to Mount Vesuvius erupting. Then it's merely a question of catching the falling aqua and orange spray on another blank canvas.

Phil Stanton, Chris Wink and Matt Goldman as Blue Man Group—aliens from inner space

More complicated still — but whoever said art was easy? — they pluck someone out of the audience, dress him in a white jump suit and helmet and lead him into the bowels of the theater. There, after the brave soul is strung up by his feet, a coat of blue paint is applied to his jump suit with a roller. (This part of the show comes to us via the magic of videocam.) Finally, he is repeatedly swung up against yet another canvas, the collisions resulting in some interesting blobs and splotches. Penn and Teller meet Abstract Expressionism, you could say, although the sadism of the undertaking is tempered by having the hapless volunteer eventually emerge, smiling triumphantly and none the worse for the shellacking, from a rather large mold of orange Jell-O.

■

On the other hand, Blue Man Group couldn't have been more solicitous of the young woman whom they invited on stage for Twinkies the other night. They'd all nodded happily to the music from a boom box for a while, admired the splendors of a clap-on, clap-off desk lamp, and were just getting into the serious business of feasting on the Twinkies when one Blue Man began emitting a violent stream of chrome-yellow goo from what I'd judge to be his clavicle. He couldn't help himself, apparently. But even as the indignity mounted, he kept glancing over at the young woman to make sure *she* was all right. Gross-out humor usually isn't so considerate.

Besides making a colossal mess, Blue Man Group makes music. I've mentioned the drums and the seismic zeal with which they're played throughout the evening. Using the soles of their shoes, the guys also pound out numbers on a marimbalike instrument fashioned out of upright paper-towel tubes. I'm told the tubes are really made from polyvinyl chloride — hence Blue Man Group's name for the device, "the PVC instrument." Its hypnotic sound is similar to that of a jug band at full tilt, and in black light the tubes turn pale lime, baby pink and daffodil yellow. The men's tongues, which are hanging out by now — either from so much effort or just for bald effect — are Day-Glo green and sunset orange. It's all quite lovely, really.

In fact, my best advice to you is to sit back and drink in the sights, and try to keep away from the lofty arguments that would justify your pleasure. Blue Man Group doesn't have a whole lot of truck with critical analysis, as it is. Midway through the show, a canvas with a dead fish glued to it is lowered into view. As each Blue Man contemplates it, his thoughts flash, rather like the headlines on the tower in Times Square, across a mini-electronic billboard. "It seems to be making a statement about censorship," opines

The author carried with her the inspiration of the strong, unsung women who populated her youth.

one, which prompts robust expletives from the other two.

O.K., Blue Man Group is sending up our need to make art and then pick it to pieces. By unveiling three sets of oversized flip cards at the same time and then flipping them so fast you barely have the chance to read one, let alone three, they're saying something about our subjective vision. (One card mockingly notes that, while the people next to you were reading the really meaningful stuff, "once again, you have chosen the wrong poster.") And, of course, the Blue Man who manages to pack a few dozen marshmallows in his cheeks, then regurgitate them in the form of abstract sculpture, is not simply playing games with his food. (Almost, though.)

The satirical impulse isn't exactly what you'd term finely honed. The show's appeal is its extravagant nuttiness. "Tubes" may be no more than an elaborate practical joke, but hasn't that always been the measure of a practical joke? The more elaborate, the less *practical*, the better? The finale certainly throws any last vestige of restraint to the wings. The music is pulsating, and the strobe lights are strobing, while clusters of vinyl tubes are twirling right over the spectators' heads. As the frenzy builds, Blue Man Group — this crew of aliens from inner space — strides out into the auditorium and begins to festoon it with streams of paper that become rivers of paper that turn into torrents. Before you know it, you're completely blanketed, gift-wrapped, mummified.

The youthful crowd went crazy the night I was there. Gleefully, I reported this to a friend in Los Angeles shortly thereafter, thinking that if anyone would understand, he, a devotee of Southern California eccentricity, would. "You've lost it," he told me. I figured that was the point.

'From the Mississippi Delta'

Dr. Endesha Ida Mae Holland calls herself a playwright, although on the evidence of "From the Mississippi Delta," storyteller would really be a more accurate designation. An account of her rise out of poverty and prostitution to academic glory, this rambling, sometimes high-spirited affair can be seen at the Circle in the Square (Downtown). But I can't help wondering what the stage adds to the material. Wouldn't it be equally effective if it were being presented over a kitchen table, around a campfire, in the pages of a book? Its strengths are essentially narrative, not dramatic.

Dr. Holland has had a remarkable and tumultuous life. The daughter of a rural midwife (father uncertain, if not unknown), she was raped on her 11th birthday, turned to prostitution as an alternative to working the fields, enjoyed a giddy one-night stand as a carny dancer and got involved more or less by chance in the civil rights struggle when members of the Student Nonviolent Coordinating Committee came to town to register black voters.

That struggle opened her eyes to a larger world and she went on to earn a Ph.D. at the University of Minnesota, carrying with her the inspiration of the strong, unsung women who populated her youth. Foremost was her self-tutored mother, Aint Baby, whom the townsfolk viewed as "the second doctor lady," and who was to perish at the height of the racial antagonisms in the 1960's in a fire of suspicious origin. (When the author is awarded her degree at the play's end, she refers to herself proudly as "the third doctor lady.")

■

This is the kind of confessional saga that can hold you rapt when it's coming from a stranger sitting next to you on the train. Were Dr. Holland

Jacqueline Williams, Sybil Walker and Cheryl Lynn Bruce in "From the Mississippi Delta"—devout believers

herself to tell it, I suspect we'd be more than happy to do away with the weathered planking and the neat pots of petunias that constitute Eduardo Sicangco's setting, and forgo Allen Lee Hughes's lighting, which evokes the pristine delta dawn as successfully as the troubled night that brings out the cross-burners. They tend to be so much podium dressing, anyway.

While the script has nominally been broken down into 11 scenes, only one voice is talking in "From the Mississippi Delta" and it's Dr. Holland's. Three actresses alternately relate and enact portions of the text. Each also gets to play the author at flash points in her life — an arrangement that, theoretically, emphasizes various sides of her personality. However the text is apportioned though, you still end up with a single perspective, and drama, at its bare minimum, is what occurs when *two* perspectives intersect.

Dr. Holland's best writing has the zeal of church testimony, when it's supported by an enthusiastic congregation. Cheryl Lynn Bruce, Jacqueline Williams and Sybil Walker, versatile actresses all, are certainly devout believers. They deliver the rolling words with faith, hope and a welcome touch of ribaldry, and throw themselves into this story of adversity overcome almost as if it were theirs.

As Dr. Holland's mother reminds her, any obstacle can be dealt with if "you keep your footses turned toward the top of the ladder." She was stubborn enough to follow the advice, and she made it up the rungs. If you don't go looking for a play, you may conclude that "From the Mississippi Delta" does enough by illustrating the arduous climb. □

1991 N 24, II:5:1

Pericles, Prince of Tyre

By William Shakespeare; directed by Michael Greif; sets by John Arnone; costumes by Gabriel Berry; lighting by Frances Aronson; original music and music direction by Jill Jaffe; sound by Mark Bennett; choreography by Kenneth Tosh; hair and makeup by Bobby Miller. Presented by the New York Shakespeare Festival, JoAnne Akalaitis, artistic director; Jason Steven Cohen, managing director; Rosemarie Tichler, associate artistic director. At the Public/Newman Theater, 425 Lafayette Street, Manhattan.

WITH: Robert Beatty Jr., Larry Block, Paul Butler, MacIntyre Dixon, Cordelia Gonzalez, Joseph Haj, Byron Jennings, Bobo Lewis, Saundra McClain, Don R. McManus, Steve Mellor, Arnold Molina, Dan Moran, Martha Plimpton and Campbell Scott.

By FRANK RICH

People may not hold their noses at the mere mention of the title "Pericles, Prince of Tyre," but at the very least they shrug their shoulders. It is the only one of Shakespeare's 37 plays that failed to be collected in the First Folio of 1623, and it is welcomed no more warmly on the contemporary stage, where productions of it are few and far between. The first two acts are no longer even attributed to Shakespeare but are thought instead to be the mundane cobbling of one or several hacks who were the

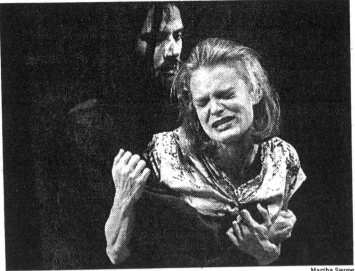

Martha Swope

Campbell Scott and Martha Plimpton performing in a scene from Shakespeare's "Pericles," at the Public Theater.

Jacobean equivalent to the staff writers of, say, "Columbo."

Yet there is a case to be made for "Pericles," both as myth-laden spectacle and as a touching gateway into the great romances that follow it in Shakespeare's final period. The play has everything, really, except coherence: a valiant prince whose windswept odyssey bats him from one colorful Mediterranean location to another, a couple of onstage tempests at sea, hired assassins, a kidnapping by pirates, a god-sent miracle or two, a gritty whorehouse sequence and, finally, a father-mother-daughter reunion that anticipates the spellbinding denouement of "The Winter's Tale" even as it recapitulates the powerful finale of "King Lear."

Very little of this hurly-burly is brought to exciting life, however, at the Public Theater, where "Pericles" has been assigned to Michael Greif, a politically minded director who distinguished himself last season with a revival of Sophie Treadwell's "Machinal." Perhaps Mr. Greif is too young to embrace this autumnal Shakespearean work, which is consumed with the sorrows of aging and death, or perhaps he is too intellectual for it. The transcendent theme of "Pericles" — its belief in renewal and rebirth, as dramatized by characters who almost literally rise from the dead — could not be more timely at the New York Shakespeare Festival. But that deep spiritual yearning is untapped and unfelt in Mr. Greif's production, which makes do instead with some small, show-offy jokes and handsome theatrical set pieces.

•

The director's line of attack is a double waste, really, because he has cast "Pericles" fairly well. Campbell Scott, in the title role, has all the makings of a late Shakespearean hero: brooding good looks, a poetic vocal instrument, an open heart and, for that matter, an impressive body that is gratuitously, if dimly, revealed in the first storm sequence. As Marina, the daughter who is born at sea and then cast adrift for 14 years, the pretty, fiercely concentrated Martha Plimpton reveals less flesh but a goodly share of classical promise that includes a sometimes luminous facility with verse.

Yet it's a measure of the production's shortfall that the scene that matters most for both of these actors

(and the audience), the Pericles-Marina recognition scene, is unmoving here. The jokey tone of the sequences preceding this reunion make it impossible for the actors to raise the production's emotional temperature abruptly at that late juncture, no matter how hard they work. It does not help, either, that Mr. Scott's performance is almost the same at the end as it had been at the beginning. From his first entrance, his Pericles is a teary, Hamletesque figure, and, despite the addition of a wig and a beard for the final act, Mr. Scott does not seem to have taken a hard-won inner journey, let alone aged, during his long exile at sea.

Mr. Greif is somewhat more forceful at depicting the hero's external adventures than his psychic ones. With a crack design team — John Arnone (sets), Gabriel Berry (costumes), Frances Aronson (lighting) — he has turned a knights' tournament at Pentapolis, at which Pericles gallantly wins his bride, Thaisa (Cordelia Gonzalez), into a piece of pop-up-book, fairy-tale fun. Hokey silent film is deployed, albeit a bit skimpily, to burlesque some of the plot's more far-fetched extravagances, and the big storm sequence is presented almost abstractly as a composition of canvas, wind and rain. As befits a fantastic text that encourages a contemporary director to engage in time as well as geographic travel, Mr. Greif sets down his brothel in what appears to be Miami Beach and allows Shakespeare's practitioners of sexual harassment to tune in the Clarence Thomas hearings.

The acting, too, is all over the map, but with far less pleasing results. Genuinely villainous figures, like the incestuous king, Antiochus (Byron Jennings), and Marina's evil stepmother, Dionyza (Saundra McClain), are played as camp clowns, and the buffoonery is too amateurish to supply laughter where there might at least have been a few melodramatic chills. Only one performer in the entire company — Larry Block, who doubles as a sleazy modern procurer in gold chains and as the mystical, Prospero-like doctor who revives the seemingly drowned Thaisa — jumps among periods and theatrical styles with grace and ease.

•

Since "Pericles" is a hodgepodge, there's nothing wrong in principle

with Mr. Greif's own leapfrogging, or, if you will, post-modern approach. But the plodding pace and constant about-faces in tone tell the audience early on that there is no blazing passion underlying the director's conceits, no personal vision that might weave the many loose threads into a magical, dreamy tapestry. Whether Mr. Greif is quoting his own past work (by giving Gower, the chorus, a radio microphone out of "Machinal") or evoking the epic stagecraft of Peter Brook (by setting much of the action in a sandbox), his production seems to be reflecting upon the theater in general rather than upon "Pericles" in particular. Not only is Shakespeare's healing faith in resurrection lost in the process, but so, for New York audiences, is the possibility that any other company will attempt to resurrect this unjustly neglected, lovably imperfect runt of the canon anytime too soon.

1991 N 25, C13:1

All's Well That Ends Well

By William Shakespeare; directed by Mark Lamos; set by Loy Arcenas; costumes, Catherine Zuber; lighting, Christopher Akerlind; sound, David Budries; dramaturg, Greg Leaming; production stage manager, Barbara Reo; assistant stage manager, Deborah Vandergrift. Presented by Hartford Stage, Mr. Lamos, artistic director; David Hawkanson, managing director. At Hartford.

WITH: Susan Appel, Lisa C. Arrindell, Robin Chadwick, Steven Dennis, Stephen Di Rosa, Frank Geraci, John Hickok, Curt Hostetter, Peggy Johnson, Delphi Lawrence, John McDonough, Frank Raiter, Kate Reid, Don Reilly, John Straub and Max Trace.

By MEL GUSSOW

Special to The New York Times

HARTFORD, Nov. 21 — "All's Well That Ends Well" is one of the more problematic of Shakespeare's problem plays. The virginal heroine Helena is helplessly in love with a count who radiates callowness and inattention. To secure his love, she must resort to a deceit that stretches credibility to the breaking point. Nevertheless, the play has a mature wit, and Shakespeare has made Helena into one of his noblest creations, a feminist far before her time.

At the Hartford Stage, Mark Lamos has wisely looked beneath the play's surface and located a fairy tale, in which a sleeping prince, or in this case a count, is led to discover a woman's inner beauty. The director takes a surrealistic approach to an historical romance.

With the collaboration of Loy Arcenas as designer, he has set the play on a wavelike platform, an island in space. The setting is part playroom and part boudoir, an environment that might have been conceived by Magritte. On the sideline is a silvery model of a horse, later ridden into battle. At one point, the militia men (crisply attired by Catherine Zuber, the costume designer) march like toy soldiers. It is up to Helena to break out of this child's world, run by men for men, and assert her independence.

•

Through various changes of landscape, a canopied bed remains at the center of the stage. Here the King of France lies dying and Helena works her magical cure of his illness. The lush look of the production enriches the romantic hue and carries the au-

dience through the convolutions of the plot.

At the same time, the setting becomes the imaginative background for the playing out of the director's premise that "All's Well" deals subtextually with feminist principles. In the play, a woman takes history and romance into her own hands. Helena has both a sense of self-determination and a stalwart innocence that is untarnished by the hostility of Bertram, the Count of Rossillion.

The chief shortcoming of this challenging production is that Mr. Lamos has not found an actress versatile enough to convey the full dynamism of the heroine, as Harriet Walter did in the celebrated Royal Shakespeare Company version in the early 1980's. Susan Appel is articulate in the role, but she misses that intangible charm that makes the character such a presence in whatever company she keeps, with the exception, of course, of Bertram.

•

Fortunately, there is a panoply of deft performances surrounding her: Don Reilly's self-righteous count, who sees no impropriety in his rudely dismissive behavior; Robin Chadwick offering a clownish portrayal as the flamboyant cynic Parolles; John Straub and Frank Raiter as leaders at court, and Lisa C. Arrindell as Diana, the maid who allows herself to be part of a ruse to help Helena.

Kate Reid does not impart the queenliness that Peggy Ashcroft brought to the Countess of Rossillion in the original cast of the Royal Shakespeare production, but she does capture the character's compassionate sense of fair play, her readiness to help her ward Helena counterattack the injustice done to her by the son of the countess.

On one level, this is a play about the strongest of women who refused to be repressed by the conventions of a male-dominated society. The countess and her free-thinking peers (who include the maid Diana as well as Helena) conspire and conquer, as "All's Well" earns its title and its earlier Shakespearean designation as "Love's Labour's Won."

1991 N 25, C14:3

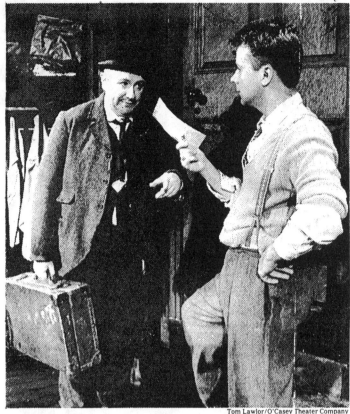

Tom Lawlor/O'Casey Theater Company

Niall Buggy, left, and Ian Fitzgibbon in "The Shadow of a Gunman."

Theater in Review

■ A 1920's play from Ireland ■ A volatile mix of homosexual subjects ■ The arrogance of Sir Arthur in trying to kill Sherlock Holmes.

The Shadow of a Gunman

Symphony Space
2537 Broadway, at 95th Street
Manhattan
Through Dec. 8

By Seán O'Casey; directed by Shivaun O'Casey; set design by Brien Vahey; set decoration, Josie MacAvin; costumes, Jan Bee Brown; lighting design, Rory Dempster; sound, Paul Bull; production stage manager, Bryan Young; music, Tommy Sands; produced by Sally de Sousa. Presented by the O'Casey Theater Company of Newry County Down, Northern Ireland.
WITH: Niall Buggy, Risteard Cooper, Michelle Fairley, Ian Fitzgibbon, Pauline Flanagan, Stephen Gabis, Richard Holmes, Doreen Keogh, Sean McCarthy, Shauna Rooney and George Vogel.

Although it is nearly 70 years old, "The Shadow of a Gunman" retains its harsh immediacy within and also beyond its depressed Dublin environment. It is a tightly focused, unsentimental play about heroism both false and real and about how people respond to the challenge of an emergency. Shivaun O'Casey's production, brought to Symphony Space by the new O'Casey Theater Company, is more successful at capturing the raffish comedy than it is at suggesting the darker recesses of the drama.

The play's protagonist, Donal Davoren, allows his neighbors to regard him as a rebel on the run. "On the Run" was Sean O'Casey's original title, with a double meaning intended.

Donal, a would-be poet, is not in flight from the authorities but from himself. Holed up in his tenement room with the peddler Seumas Shields, he is forced to confront his conscience and his responsibility to lovely, young Minnie Powell, whose head is filled with idealism and love of poets. In Miss O'Casey's production of her father's play, the colorful characters are carefully in place. But there is a curious turnabout in our perspective.

Because of Niall Buggy's resonant portrayal of Seumas, that character achieves a greater importance in the narrative. This is the most significant contribution of the revival. The regret is that the rest of the production is not equal to Mr. Buggy's performance. There is a concurrent loss, as Donal, given a rather stolid rendition by Ian Fitzgibbon, begins to fade into the background.

Sharing that background are the other tenement dwellers. Some of them offer standard comic turns, but a few like Pauline Flanagan, as the nosiest of busybodies, bring the play closer to its tragicomic dimensions. The outcome, the martyrdom of Minnie (Michelle Fairley), should send a chill through the thin tenement walls, which has been the case in a number of other productions.

One problem at Symphony Space is Brien Vahey's confined setting, which forces actors to enter and exit through a central door and to step forward to deliver set pieces. In several instances, actors remain partly hidden behind that door. The staging conveys little sense of a threatening exterior world.

What intensity accrues comes largely from the text and from Mr. Buggy's performance. In this interpretation, Seumas is as crafty as he is craven. He is determined to preserve his safety, but he seems to have a self-awareness about the reasons for his inaction. Because of his intelligence, we begin to wonder why he is a peddler rather than a philosopher or poet. Seumas makes the most cynical observations about his compatriots, but when Mr. Buggy speaks those

lines, they echo with a renewed relevance and the character's cantankerousness approaches despair.
MEL GUSSOW

Seven Pillars of Wicca-Dick: A Triumph

Duality Playhouse
119 West 23d Street, Manhattan
Through Dec. 8

Written and performed by Mark Ameen; directed by Rich Rubin; lighting, Susan Hamburger; set design, Angelo Underhill. Presented by P.I.A. Productions.

In "Monologue of a Dying Beast," the long, impassioned poem with which he concludes his one-man performance piece, "Seven Pillars of Wicca-Dick: A Triumph," the actor and poet Mark Ameen addresses the AIDS epidemic, homophobia and his childhood sexual attraction to his father, among other volatile subjects.

Reflecting on AIDS, he wonders: "Shall I embrace my disease and claim it as 'the gift of love' like gonorrhea? Or consider it earthly penance for the sins of sleaze?" Musing on society's attitudes toward homosexuality, he declares, "We are condemned as self-involved and feared as self-sufficient, dismissed as self-indulgent and embraced as self-defeating."

The tone of this twisting, effusive broadside zigzags from defensiveness to sarcasm, accusation, self-laceration and self-affirmation. Much like the novelist John Rechy, this 33-year-old poet and performer takes a narcissistic pride in being what Mr. Rechy has called a sexual outlaw. In political terms, he sees himself as someone who is a virtuoso of ecstasy as opposed to the mainstream of American society, which is concerned with power.

The 90-minute show is divided into two acts, for the first of which, "Monologues of an Anonymogamist," Mr. Ameen wears a tank top, jeans, and running shoes and augments his recitations with choreography while portraying a range of gay stereotypes from a street tough to a campy queen. At one point, he dons an elbow-length black satin glove, adopts a swiveling Mae West pose and insinuatingly invites the audience to "read my hips." His sarcastic tone often undercuts the raw emotions of his verses by making them seem ironic.

But the biggest problem that Mr. Ameen faces and only partly solves is in making his dense poetry comprehensible in a theatrical context. Although the choreography and Mr. Ameen's angry charisma help elucidate the language, "Seven Pillars" is finally less of an integrated theater piece than a theatricalized poetry reading. *STEPHEN HOLDEN*

The Death and Life of Sherlock Holmes

The Open Eye: New Stagings
270 West 89th Street, Manhattan
Through Dec. 15

By Suzan L. Zeder; based on the stories of Sir Arthur Conan Doyle; directed by Russell Treyz; costumes, Marianne Powell-Parker; scenery, Adrienne J. Brockway; lights, Spencer Moss; stage manager, James Marr. Presented by Amie Brockway, artistic director.
WITH: Elton Beckett, Kermit Brown, George Cavey, Mitchell Greenberg, Amanda Gronich, Jim Helsinger, Tara Mallen and Arleigh Richards.

Moriarity was deluded. There was no way, even with the help of the hellish Reichenbach Falls, he could take Sherlock Holmes to his death. Everyone knows how Holmes's passionate public let Sir Arthur Conan Doyle know that neither he nor Moriarity could pull such a stunt. Holmes

lives, no matter what his creator or his enemy might think. After all, who were Moriarity and Doyle, anyway?

Answering that question is what Suzan L. Zeder challenges the audience to do in "The Death and Life of Sherlock Holmes," being presented at the Open Eye: New Stagings on the Upper West Side.

Drawing on a handful of the most familiar Holmes stories, Ms. Zeder creates a labyrinthine plot with some nifty surprises in its final twists and turns and merry confusion along the way. Ms. Zeder is best known for her children's plays. This one is not precisely for children but certainly for the young at heart. It is also good holiday fare; the only real violence is worked on Cockney and provincial English accents.

The director, Russell Treyz, and the actors all know the more famous performances of the Holmes stories and have fun sending them up.

George Cavey's Dr. Watson is delightfully confident, and wrong. And Mitchell Greenberg's Holmes, the familiar brainy whiz at the outset, is utterly baffled at the end. Indeed, the astonishment registered by Holmes and Watson at their final fate is a delicious comic close.

Throughout, this frisky cast gets a lot of help from Adrienne J. Brockway's set, which carries us from Holmes's study to London streets and country gardens with a mere flick of a curtain. Her fog machine is a marvel; its vapor may come on cat feet but not little ones; it hisses, spits and grumbles. And her Reichenbach Falls — a shimmering backdrop curtain rippling in eerie mist — is most ridiculously satisfying; one would like to take it home.

D. J. R. BRUCKNER

1991 N 27, C17:1

SUNDAY VIEW/David Richards

The Perils of Pericles, a Serial Adventure

At the Public, Campbell Scott plays the stalwart sufferer at the mercy of a plot with the hairpin turns of a roller coaster.

PERICLES HOLDS TO A TRUE course all through the storm-tossed romance that Shakespeare named after him. But so does Campbell Scott, who happens to be playing the young prince of Tyre right now at the Public Theater. Given the impetuous nature of the production that surrounds him — and would probably swallow him up if it could — Mr. Scott's achievement may just be the more noteworthy.

After all, it's one thing to cling to virtue in a capricious universe, as Pericles does. But to maintain your credibility as an actor — and even project an unassuming dignity — when the tone of the production changes so radically from scene to scene you can hear gears being stripped, well that's something else entirely. It assumes a presence that naturally rises above circumstances without appearing haughty or superior. Nothing distinguishes Mr. Scott's performance quite so much as his ability to keep his artistic head high, when all about him — not least the director Michael Greif — are losing theirs.

∎

Both the character and the actor get a rude buffeting in "Pericles," the 19th installment in the Public Theater's continuing Shakespeare marathon. The play is as episodic as any Shakespeare wrote — or didn't write, there being some belief among scholars that the uneven work is a collaboration and only partly Shakespeare's doing. It subjects Pericles to the whims of villainous rulers and

fury of the natural elements, and pretty much bats him all around the Mediterranean basin.

He is pursued by antiquity's equivalent of a hit man, betrayed by potentates who've profited from his generosity, whiplashed by tempests and, at one point, shipwrecked and tossed up on the shore for dead. Thaisa, the princess he wins in a jousting contest (Cordelia Gonzalez), dies in childbirth — again during a violent storm — just as he's taking her by boat back to Tyre. As a sop to the raging elements, she is tossed overboard in a casket. Their daughter, Marina (Martha Plimpton), survives the traumatic birth. But Pericles entrusts her to jealous guardians, who, years later, are about to have her murdered when she's kidnapped by pirates and sold off to white slavers. Not knowing her fate and thinking her dead, Pericles sinks into despondency and lets his hair grow to lengths Rasputin would have envied.

Unlike Job, he never gets boils, but he endures his terrible misfortunes with the fortitude of that biblical patriarch. Pericles is the least remonstrant of Shakespearean heroes, a stalwart sufferer who is not about to challenge the injustice of the gods, as does a Lear or a Timon of Athens. Perhaps as a reward for his constancy — or more likely, because Elizabethan audiences relished reconciliation scenes — he lives to see wife, daughter and kingdom restored to him.

Mr. Scott bears up worthily under everything Shakespeare pitches his way. His dark looks and burning eyes give him the romantic air of a troubled matinee idol, so he doesn't ever have to insist upon the suffering. He has a pleasant voice, not without authority, when authority is called for. Whatever his delivery may lack in poetic sonority it makes up in virile intelligence. Pericles is pushed around, but Mr. Scott is never a pushover.

Unfortunately, the actor is not simply dealing with the sudden dips and hairpin turns of a plot that could teach a roller coaster a lesson or two. He is also faced with the directorial interventions of Mr. Greif, who is bent on leaving his fingerprints on every square inch of this production. Last season at the Public, Mr. Greif did some stunning, stylistically coherent work ("Machinal"), and some stylistically splintered and consequently less stunning work ("Casanova"). "Pericles" belongs in the latter category.

It begins looking very much like a knockoff of Peter Brook's "Mahabharata." The brick of the back wall of the Newman Theater is exposed. In the center of the bare stage, the set designer John Arnone has planted a large sandbox, which serves as the principal acting area. A buried gas jet sends a ball of fire leaping ferociously into the air. Overhead, several dummies dangle from nooses, while another turns slowly on a rack. For the time being, at least, the costumer Gabriel Berry has limited herself to blacks, whites, grays and the occasional khaki. John Gower (Don R. McManus), the medieval English poet who serves as the play's chorus, has the sickly pallor of old cobwebs.

∎

Here in Antioch, the first of the evening's way stations, a primitive austerity prevails, although I suppose the appearance of a stagehand, setting up a vintage radio microphone, is a tip-off that it won't prevail for long. Indeed, if you'll allow me to jump forward several scenes, Mr. Greif is soon busy turning the land of Pentapolis into a high camp version of Arthurian England. The stage is populated with knights who could have been clipped from a picture book, steeds fashioned from plywood and maidens fair, trailing extravagant silks from the tips of their conical hats. An obliging stagehand helps swell the

ranks by sticking his head through the hole in one of those painted backdrops employed by boardwalk photographers.

This is the realm of good King Simonides, a gay blade in purple robes who seems to equate good government with gracious hostessing. The part is played by Byron Jennings, but it could be Paul Lynde in a giddy mood. The giddiness is contagious. Having won the hand of Thaisa, Pericles and his newly betrothed dance a tango.

Allow me one more jump forward, and I think you'll see my point. Pericles has by now been soaked by an on-stage downpour; Thaisa, presumably dispatched to her watery grave; and Marina delivered into bondage. We're off the Aegean coast, in Mytilene, which bears a strong resemblance to a Bangkok fleshpot, as "Miss Saigon" might conceive it. Painted beauties sit behind a window carrying the warning that customers without condoms will be turned away. A muffled reference to "Long Dong Silver" comes over the TV set.

The proprietors of this dubious establishment (Bobo Lewis and Larry Block) wouldn't be out of place in the seedier districts of Miami Beach. Mr. Block wears a loud sports shirt, while Ms. Lewis, in red socks and sandals and a baggy sweater, seems to be anticipating a cold snap. They kvetch a lot because Marina refuses to service the clientele. Their Latino servant (Arnold Molina) undertakes to deflower her himself, dropping his pants to reveal skinny legs and flashy briefs.

You've gathered what's happening. Every time the play changes locale, Mr. Greif changes the tone and tenor of the production. No single vision is going to be allowed to dominate. The evening's style is *many* styles, each undercut by the next. I would like to believe that this has all been carefully calculated, and that Mr. Greif's antic unpredictability is meant, in some fashion, to echo the changeable fates. But it doesn't work that way in practice. In practice, it's a hash.

Rather than enlivening an odd play, in fact, the staging tends to betray what virtues "Pericles" does possess — a wondrous innocence, despite so much skulduggery; and the magical charm you find in some illuminated manuscripts of the Middle Ages. That the final reconciliation scene should provoke laughs, as it did the other night at the Public, suggests that Mr. Greif's approach is entirely too clever for the tale's good.

Keeping matters simple is sometimes the wisest, if hardest, tack to take with Shakespeare. In what is easily the production's most captivating scene, Thaisa is discovered in her casket by an industrious lord (Mr. Block again, but far surer of himself), who rubs her down with unguents and massages her limp body. The sad strains of a cello underscore the action, but otherwise there's no directorial commentary to distract us from the lord and his servant, who are thoroughly concentrated on their life-giving mission. Thaisa's awakening, as a result, seems truly miraculous. Mr. Greif can't maintain the hands-off stance for long, however.

The actors double and triple in the numerous roles, thereby doubling and tripling the impression that, for the most part, Shakespeare lies beyond their grasp. Ms. Lewis, drooping like a hammock, is ridiculous as the whining Jewish brothelkeeper. But is she any more ridiculous than Steve Mellor, who plays the governor of Tarsus as an exalted officer of the Shriners?

Or Saundra McClain, who portrays his evil wife as a Southern diva with attitude, defiantly rhyming "good" with "bud," then throwing a "take *that*" glare at the audience before she flounces offstage? As Marina, Ms. Plimpton is a frightful scold, for a creature whose shining purity is supposed to speak for itself. You can say this, though: in keeping with Pericles's peregrinations, the acting is all over the place.

Without Mr. Scott's solid and reliable performance, the production would be doomed by its determination to go off in a dozen directions. There's an irony here. The actor is playing an unfortunate prince who is driven from pillar to post and back, and he ends up being the evening's one fixed point. □

1991 D 1, II:5:1

Theater in Review | Mel Gussow

■ The Iran-contra hearings dramatized ■ One man's recollection of growing up in the 70's ■ The immigrant experience in America set to music.

Deposing the White House

Ensemble Studio Theater
549 West 52d Street
Manhattan
Through Dec. 10

By Dan Isaac; directed by Christopher A. Smith; stage manager, Randal Fippinger; assistant director, Anders Wright; dramaturg, Michael Winks. Presented by the Ensemble Studio Theater.
WITH: Jay Barnhill, Stephanie Cannon, Chris Ceraso, Jude Ciccolella, Eric Conger, Sam Gray, David Konig, Pirie MacDonald, J. B. Martin, T. L. Reilly, Jaime Sanchez and Anders Wright.

The purpose of the Ensemble Studio Theater's yearlong festival "In Pursuit of America" is to present "a collage of thinking about our national character." That aim is provocatively explored in "Deposing the White House," Dan Isaac's gathering of testimony from the Congressional investigation of the Iran-contra affair.

Although no smoking gun is uncovered, the play raises questions about the role of the Vice President. His response to charges that he knew about the channeling of arms for cash for aid to the contras is that he was "outside the loop." In the testimony heard on stage, theatergoers receive a condensed accounting of what was going on inside that loop: the deniability and the selective memories that seem endemic to those who were involved.

At the center of the reproduced hearings is Donald Gregg, the Presidential security adviser who was the single holdover from the Carter Administration, and by his side is Felix Rodriguez, a "counter insurgency expert." Mr. Rodriguez's cloak-and-dagger operation may deserve a play of its own, something that could also be said about Oliver North, who is discussed but is not represented on stage. Because it stresses the role of someone as enigmatic as Mr. Gregg, the play has its elusive side.

Mr. Isaac is not eager to fictionalize or even to dramatize the case. The play is a fact-finding mission and, by inference, a moral quest. It is up to the audience to reach a conclusion. One unavoidable conclusion is that the material would be more authentically encountered as a television documentary rather than as a staged re-creation with actors pretending to be the real witnesses. But a re-enactment of the hearings gives them renewed immediacy. For many theatergoers the testimony itself will seem fresh, especially the contradictions and trivialities that pepper the proceedings. There is the notion, for example, that Mr. Rodriguez spent time showing the Vice President his photo album of helicopters.

On opening night, Christopher A. Smith's production lacked the necessary sharpness. Though Chris Ceraso and Pirie MacDonald are worthy adversaries as the chief questioner and Mr. Gregg, others in the cast were ill prepared. The most troublesome performance was that of Sam Gray as an lawyer whom Mr. Isaac uses as our guide. Mr. Gray went so far as to refer to "Vice President Bird" before correcting himself. For a moment it sounded as if Iran-contra was being confused with "MacBird," the 1968 play that used parody to poke fun at political duplicity. In his documentary drama, Mr. Isaac allows witnesses to incriminate themselves and to put their own probity in jeopardy.

Big Frame Shakin'

Ensemble Studio Theater
549 West 52d Street
Manhattan
Through Dec. 15

Written and performed by James G. Macdonald; directed by Shirley Kaplan; stage manager, Dathan Manning. Presented by Ensemble Studio Theater.

"Big Frame Shakin' " is James G. Macdonald's kaleidoscopic chronicle of growing up in America in the 1970's. The apparently autobiographical character in this monologue survives a multitude of familial dysfunctions. His father has gone away and his mother has gone awry. A bisexual druggie with a severe mental disorder, the mother tows her two small sons around the country, racing from the Midwest to California. Finally she heads to the Pacific, searching for a vision of Christ ("Our Father Who art in Hawaii").

Mr. Macdonald's surrogate, a boy named Jim, reacts by mixing reality and fantasy, outrageously teasing his gullible younger brother by making him think he is a stranger in their house. Jim dreams of an escape by riding his magic carpet of a skateboard.

Performed as part of the Ensemble Studio Theater's festival In Pursuit of America, the monologue does not reach the dramatic and comic depths plumbed by Eric Bogosian and Spalding Gray, but it still taps its own touching threnody. It is a text to be performed, and Mr. Macdonald, a supple and expressive actor, becomes our conduit to his experience, leading us quietly into his helter-skelter world. As directed by Shirley Kaplan, the performance has a spontaneity that makes the work seem more conversational than confessional.

The audience may well wonder how Mr. Macdonald managed to live through such a bizarre childhood and to emerge seemingly intact and aware enough to write and act this piece. Though it has rough edges and a certain amount of repetition, "Big Frame Shakin' " is clearly an act of personal reflection and an attempt to come to terms with the cruelties of the past.

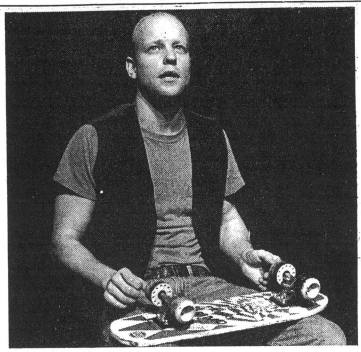

Valerie Brea Ross/Ensemble Studio Theater

James G. Macdonald performing in his "Big Frame Shakin'."

Rags

American Jewish Theater
307 West 26th Street
Manhattan

Book by Joseph Stein; music by Charles Strouse; lyrics by Stephen Schwartz; directed and choreographed by Richard Sabellico; set design, Jeff Modereger; lighting, Tom Sturge; costumes, Gail Baldoni; sound, Randy Hanson; stage manager, Kim Vernace. Presented by American Jewish Theater, Stanley Brechner, artistic director; Lonny Price, associate artistic director.

WITH: Rachel Black, Ann Crumb, Philip Hoffman, Jonathan Kaplan, Crista Moore, Jan Neuberger, David Pevsner, Robert Tate and Alec Timerman.

For its last two musical revivals, "The Rothschilds" and "I Can Get It for You Wholesale," the American Jewish Theater reached into Broadway's past for shows that had respectable original runs. For its current revival, the company turns back just a few theatrical pages to "Rags," which lasted for only four performances on Broadway in 1986. As it turns out, "Rags" is by far the most old-fashioned and least original of the three shows. Even with revisions — and despite the substantial accomplishments of the musical's creative team — it reduces the American immigrant experience to simplistic dramatic terms.

What "Rags" does have in its favor is Charles Strouse's music, as sung by a talented cast headed by Ann Crumb and Crista Moore. Mr. Strouse has written a rousing collection of diverse but thematically related songs: ballads, a Sousa-fied anthem, a tune in ragtime and the uplifting "Children of the Wind," which speaks about the indomitability of nomadic travelers. In that song, which gives the show a new subtitle, and in a few others, Mr. Strouse's music is matched by Stephen Schwartz's lyrics. At other times, the lyrics settle for predictable rhymes.

On Broadway, Ms. Crumb's character, a young immigrant mother escaping from a Russian pogrom, was portrayed by Teresa Stratas, who dominated the stage with her operatic presence. In the revised version, the woman's best friend (played by Ms. Moore) is of almost equal importance, as their lives in New York in the early part of this century are paralleled.

Although this gives the show a greater balance, the plot continues to follow an overly familiar course, **through domestic squabbles and stereotypical encounters. Ms. Moore** falls victim to a sweatshop fire, apparently an obligatory scene in shows dealing with immigrants. Attempts at social commentary — about prejudice and politics — are cursory. The banalities in Joseph Stein's book are in stark contrast to the libretto he wrote for "Fiddler on the Roof," which could be regarded as a prelude to "Rags."

The other significant alteration in "Rags" is that the show's rambling story is now told through the eyes of the heroine's young son. This narration is obtrusively inserted and it is awkwardly delivered by Jonathan Kaplan.

The two leading actresses offer compensations. Ms. Crumb has a strong singing voice and seems much more at home here than she did in "Aspects of Love." Ms. Moore, who played the title role in the recent production of "Gypsy," has an insouciant humor as well as musicality. Their duet "If We Never Meet Again," written for the revival, is a melodic high point of the show.

In the expensive Broadway version of "Rags," there was considerable attention to atmosphere, with teeming choreographic scenes on the city's streets. In this miniaturized version, there are two pushcarts on stage and the characters look out of imaginary windows and describe the exterior activity to the audience.

The Broadway cast of more than 30 has been replaced by 9 very busy actors, most of them rushing in and out of roles and changing beards, mustaches and wigs. David Pevsner plays the two men in Ms. Crumb's life, and Philip Hoffman doubles as a long-bearded Jewish patriarch and a flamboyant Irish politician. Mr. Hoffman also plays Hamlet in an amusing interpolated scene from an "improved" Yiddish adaptation of Shakespeare. As resourcefully directed by Richard Sabellico, the production proceeds without a glitch, but except for the music, the show seems secondhand.

1991 D 4, C22:3

Mad Forest

By Caryl Churchill; directed by Mark Wing-Davey; set and costumes by Marina Draghici; lighting by Christopher Akerlind; sound by Mark Bennett; fight director, David Leong; dialect coach, Deborah Hecht; production stage manager, Thom Widmann; production manager, George Xenos. Presented by New York Theater Workshop. At the Perry Street Theater, 31 Perry Street, Manhattan.

WITH: Rob Campbell, Randy Danson, Garret Dillahunt, Lanny Flaherty, Calista Flockhart, Mary Mara, Christopher McCann, Tim Nelson, Mary Shultz, Joseph Siravo and Jake Weber.

By FRANK RICH

Three months after the 1989 fall of the Ceausescus, a theatrical brigade including the British playwright Caryl Churchill, a director named Mark Wing-Davey and 10 of Mr. Wing-Davey's acting students went to Romania on what promised to be a preposterous mission. Their aim was to become instant experts on a nation in post-revolutionary turmoil and to make a play about what they had seen. Their visit was scarcely longer than a week.

Can you picture the results already? The acting students, being by definition romantics, would create a let-a-thousand-flowers bloom pageant. Miss Churchill, being an archetypal Royal Court Theater ideologue of her day, would insist on equating Ilena Ceausescu with Margaret Thatcher.

Or so one might reasonably imagine. But real artists — not to be confused with the cultural camp followers who have turned Prague into a chic tourist spot — are unpredictable. There is nothing kneejerk about "Mad Forest," as Miss Churchill named her play, and it turns out to be just as surprising, inventive and disturbing as the author's "Top Girls" and "Fen." In its American premiere under the aegis of the New York Theater Workshop, a full 18 months after the London opening, the piece has not dated in the way that newspaper accounts of the same history already have. If anything, this "play from Romania," as it is subtitled, seems to seep beyond its specific events and setting to illuminate a broader nightmare of social collapse, especially in the insinuating production Mr. Wing-Davey has fashioned at the Perry Street Theater with a crack American cast.

"Mad Forest" can penetrate beneath the surface of its well-chronicled story precisely because it is not journalism. Only in the second (and least successful) of the three acts, a Living Newspaper in which the company temporarily simulates Romanian accents to recite an anecdotal oral history of the tumultuous week after the massacre of demonstrators at Timosoara, does the play purport to traffic in documentary reality. The rest of "Mad Forest" forgets about the facts, which remain murky anyway in Romania, and exerts a theatrical imagination to capture the truth about people who remain in place no matter what regimes come and go.

Miss Churchill achieves this by devoting her first and third acts to an examination of two Bucharest families, one of laborers and one of intellectuals, before and after the revolution. But if the two families give the evening a focus and a story of sorts — the households are to be linked by marriage — the technique of "Mad Forest" is elliptical and atmospheric, often in the manner of Eastern European fiction of the Kundera and Havel era. In Act I, the double lives of people trapped in a totalitarian state are dramatized by gesture and image — the mute, dour figures waiting hopelessly in a meat queue, for instance — rather than by the dialogue, which is often oblique or insincere, lest the dread secret police, the Securitate, be eavesdropping. In Act III, the liberated Romanians do little but talk, but they often talk over each other, screaming and arguing in paroxysms of xenophobia and paranoia that sometimes seem even more frightening than the sullen episodes of repression that precede them.

As is the playwright's style, some vignettes are meanly funny. A young woman (Calista Flockhart) seeking

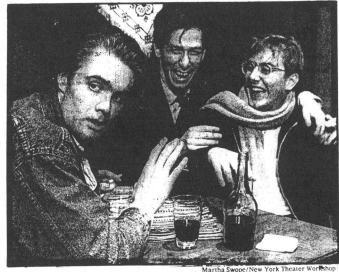

Martha Swope/New York Theater Workshop

Garret Dillahunt, left, Tim Nelson, center, and Jake Weber in Caryl Churchill's "Mad Forest."

an abortion in Act I is told by a doctor (Joseph Siravo) that "there is no abortion in Romania" even as he pockets the bribe that will secure his illicit services. A teacher (Mary Shultz) who lauds the Ceausescus in her classroom at the play's outset is wondering by Act III what strings can be pulled to keep her job in a new, upended Romania where "we don't know who we know." A rebellious art student (Jake Weber) turns on his parents for collaborating with the discredited dictatorship even as he finds the sloganeering of the new, Iliescu Government chillingly interchangeable with that of the old.

But such conventional political satire is eventually overwhelmed by a more surreal form of theater. A nasty madman (Rob Campbell) roams through a hospital, challenging the official version of the December events by incanting such unanswered questions as, "Did we have a revolution or a putsch?" and, "Were the Securitate disguised in army uniforms?" Mythological figures enter the action, among them an archangel who seemingly collaborated with the genocidal Iron Guard of the 1930's and an elegant Transylvanian vampire drawn by the smell of blood. As the phantasmagoric sequences thicken and grow more grotesque, Miss Churchill gives poetic voice to the new crisis of a society in which the old totalitarian order has splintered into a no less malignant disorder. Abruptly the new democrats look suspiciously like the old fascists and a hunt for class and racial enemies becomes the pathological preoccupation of people who remain hungry and enraged.

By using a small cast to populate this large canvas, Miss Churchill once again provides exceptional opportunities for actors to play multiple roles. What Mr. Wing-Davey achieves with his familiar but often unsung New York ensemble evokes memories of Tommy Tune's achievement with the American cast of Miss Churchill's "Cloud 9" a decade ago. Everyone in "Mad Forest" is excellent, starting with Ms. Flockhart and Mr. Weber, though the showiest role-switching stunts belong to Lanny Flaherty (who plays both a proletarian lout and a tweedy translator), Randy Danson (representing several classes of Romanian womanhood), Mr. Siravo (as a variety of bloodsuckers) and Christopher McCann (doubling as an effete architect and a mangy street dog).

As designed by Marina Draghici (sets) and Christopher Akerlind (lighting), who turn a small stage into an ever-changing Chinese box of oppressively angled walls and shadowy, Kafkaesque cul-de-sacs, the evening's physical production also plays a major role. The staging often conjures up tableaux as evocative as the play's title, which refers to the dense forest that once stood where Bucharest is now and was, as a program note says, "impenetrable for the foreigner who did not know the paths." Miss Churchill does not pretend to know those paths, either — each scene is pointedly introduced by a banal sentence read from a tourist's Romanian phrasebook — but she does see the forest for the trees. Nowhere is this clearer than in the play's wedding finale, where every element of the production whirls together in an explosively choreographed panorama of drunken revelry and sadistic, retributive violence. Few lines can be heard over the ensuing pandemonium — "This country needs a strong man" is one —

and the chaos that engulfs the small theater is terrifying. Surely I was not the only American in the audience who found the climax of "Mad Forest," with its vision of an economically and racially inflamed populace on a rampage for scapegoats, a little too close to home.

1991 D 5, C15:3

Zion

By Beverly Trader; directed by Thomas W. Jones 2d; set design and lighting, Richard Harmon; costumes, Gregory Glenn; sound, Carmen Griffin; musical consultant, Oral Moses; production stage manager, Lisa L. Waton; musical director/arranger, Uzee Brown. Presented by New Federal Theater Inc., Woodie King Jr., producing director. At Theater of Riverside Church, 91 Claremont Avenue, at 120th Street, Manhattan.

WITH: David Edwards, John D. Fitzgibbon, Lee James Ganzer, Roberta Illg, Maurice Langley, Kathleen J. Masterson, Ronald E. Richardson, Phyllis Y. Stickney and Michele-Denise Woods.

By STEPHEN HOLDEN

"Zion," Beverly Trader's epic play with music by the New Federal Theater, depicts the 30-year struggle of parishioners in Marietta, Ga., to establish one of the earliest black churches in the United States. The play, a sprawling hybrid of historical drama and gospel pageantry, begins in 1836 and spans the Civil War. Although it embraces a lot more material than it can comfortably assimilate, it still conveys a pungent sense of history's wheels grinding painfully forward.

Unwieldy and weakened by an abrupt ending, "Zion" still churns up a lot of pertinent thoughts about race relations and religion. And the interpolation of nearly a dozen traditional spirituals, sung either a cappella or with minimal accompaniment, goes a long way toward binding up the show's loose ends. The superb cast of singing actors is led by Ronald E. Richardson, who gives what may be his strongest performance since the Broadway musical "Big River." Portraying Ephraim B. Rucker, a preacher who leads his black followers to separate from the white Baptist church, he acts and sings with a majestic oratorical fervor.

Other outstanding performances in a strong supporting cast belong to Michele-Denise Woods, as an angry servant for the white family that owns Ephraim, and Phyllis Y. Stickney as Ephraim's sometime sweetheart Hetty, a woman whose leanings toward a polytheistic African-oriented religious pantheon cause conflict with the others.

The playwright's blunt dialogue hammers out the essential issues of slavery, biblical teaching and race. Although its white Confederate characters are monstrous, they are also sharply drawn individuals, including a reptilian arch-racist (David Edwards), a smug white minister with little tolerance (Lee James Ganzer) and a late-blooming abolitionist (Kathleen J. Masterson).

The director, Thomas W. Jones 2d, employs some striking theatrical devices, including dramatic silhouettes and ritualized slow-motion movement to portray violence and resistance. And Richard Harmon's spare set of crosslike trees evokes Christian iconography and a war-scarred Southern landscape, as well as ominously foreshadowing lynchings and other atrocities.

1991 D 5, C22:4

Marvin's Room

By Scott McPherson; directed by David Petrarca; set design by Linda Buchanan; costumes by Claudia Boddy; lighting by Robert Christen; music and sound by Rob Milburn; production stage manager, Roy Harris; production manager, David A. Milligan. Presented by Playwrights Horizons, André Bishop, artistic director; Paul S. Daniels, executive director. At 416 West 42d Street, Manhattan.

Bessie	Laura Esterman
Dr. Wally	Tim Monsion
Ruth	Alice Drummond
Bob	Tom Aulino
Lee	Lisa Emery
Dr. Charlotte and Retirement Home Director	Shona Tucker
Hank	Mark Rosenthal
Charlie	Karl Maschek
Marvin	Adam Chapnick

By FRANK RICH

THE title character of "Marvin's Room," who is seen only as a blurred shape behind the glass-brick wall of his sickroom, has been dying for 20 years. Eaten up by cancer and crippled by strokes, he turns for entertainment to the simple pleasure of watching his lamp's light bounce around the walls and ceiling when it is reflected at bedside from a compact mirror.

The heroine of "Marvin's Room" is the woman who takes care of Marvin, his 40-year-old daughter Bessie (Laura Esterman). She is dying of leukemia. The play's other characters include Marvin's aged sister and Florida housemate, Aunt Ruth (Alice Drummond), who has electrodes in her brain to stop the pain of three collapsed vertebrae, and Bessie's sister, Lee (Lisa Emery), a cosmetician who is in good health but has two severely troubled teen-age sons, the older of whom has been confined to a mental institution since burning down his own house and much of his neighborhood.

Is there any chance you will believe me when I tell you that "Marvin's Room," which was written by Scott McPherson and opened at Playwrights Horizons last night, is one of the funniest plays of this year as well as one of the wisest and most moving? Maybe not. And that's how it should be. When the American theater gains a new voice this original,

this unexpected, you really must hear it for yourself.

In bald outline, I know that "Marvin's Room" sounds like other things, from disease-of-the-week television movies to their more pretentious theatrical cousins, right-to-live and right-to-die plays like "The Shadow Box" and "Whose Life Is It, Anyway?" While its characters in fact watch soap operas to fill up their own afternoons, "Marvin's Room" is most decidedly not a soap itself. Nor is it a pitch-black gallows farce in the British mode of Joe Orton or Peter Nichols, though Mr. McPherson's ability to find laughter in such matters as bone marrow transplants, a doctor's fumbling attempts to draw blood, the strapping down of mental patients and the disappearance of Monopoly hotels into a respirator are at least minor miracles of absurdist comedy. "Marvin's Room," which was previously seen at the Goodman Theater in Chicago and the Hartford Stage, is just too American to subscribe to European cynicism. It sees life as it is and how it could be, and it somewhat optimistically imagines how one might bridge that distance.

What separates "Marvin's Room" from so many synthetic American plays that cover its rough territory, however, is that even at its occasional sunniest, it never lies or sentimentalizes the truth. Mr. McPherson does not pretend that God has a divine plan for everyone. (As the dotty Aunt Ruth merrily puts it, the pain she has had since birth may be God's way of teaching her forbearance but may also be a less profound lesson in "how to dress without standing up.") Mr. McPherson does not pretend that people always die with dignity, either, or that everyone isn't dying. Instead he asks, What good can we do with the time, however much or little it is, that we have left before our inevitable harsh fate arrives?

For Bessie, the answer is never in doubt. She has taken care of her father and her aunt for her whole adult life, and she will continue to do so until they drop or she does. Both as written and as acted by Ms. Esterman, Bessie is the heart of "Marvin's Room" because she serves as a caretaker cheerfully, without complaint or self-pity or desire for thanks, without ever questioning or regretting a

G. Paul Burnett/The New York Times

Playing ordinary people — Alice Drummond, left, and Laura Esterman.

Vic DeLucia/The New York Times

Lisa Emery

moment of it, even as her own terminal disease worsens.

"I can't imagine a better way to have spent my life," she says, and not only does Bessie mean it, but she also has trouble imagining how anyone might question her conviction that giving to others is its own reward, an end in itself. That she is a credible, ordinary person rather than a gooey fictive saint is a tribute to Ms. Esterman's extraordinary performance as well as to the writing. The actress has a gamin's features, a shade clownish with a touch of sadness tugging at her big, brimming eyes, and the airy, tickling comic voice of an Elaine May or Barbara Harris. She has a tough spine, which is revealed when facing down her selfish sister, and while she never married, she has a sexuality, which was once tapped by a carny worker who came to his own miserable end. Ms. Esterman always convinces us that Bessie's generosity is for real, not for show, a healthy choice rather than a neurotic need. We even laugh with her, not at her, when she can't stop herself from leaving coins in place of the candy her sister empties into her purse from the bowl in a nursing-home waiting room.

•

While Bessie's goodness cannot cure her physical ailments or those of her father and aunt, her impact on the psychological states of her selfish sister and her two antisocial nephews is the underlying story of "Marvin's Room." In Ms. Emery's hilarious but never cheap portrayal, Lee is a white-trash vulgarian, a promiscuous and self-involved single mother of a sort who all too understandably could drive a child to pyromania. When she travels to Bessie's Gulf Coast household from her town in Ohio in the play's opening scenes, it is the first time she has bothered to see her sister, father or aunt in years. She wouldn't mind making a fast escape after writing a guilt-easing check.

But Lee and the boys, wonderfully played by Mark Rosenthal and Karl Maschek, must hang around, and "Marvin's Room" finds its most powerful scenes as all three are inexorably transformed by the uncritical, guileless affection Bessie showers on them no less than on her dying elders. In one unforgettable scene, Lee finally musters some love for her sister in the only way she can — by offering her services as a budding beautician — and prompts Bessie to remove the wig used to hide the rav-

ages of chemotherapy so that it might be styled into a "sophisticated, on-the-town evening" look. This intimate gesture of reconciliation, at once tender, funny and mournful, is about as gripping as family drama gets. And it is matched by other moments, including one in which the dwindling Ms. Esterman, her thin wrists beating the air to express her incongruous joy, tells Ms. Emery how lucky she has been to have so much love in her life: not the love she has received but the love she has given to others.

•

Bessie's high spirits are bottled by the director, David Petrarca, whose seamless production is punctuated by buoyant, Claude Bollingesque jazz (by Rob Milburn), bright sets (by Linda Buchanan) and the bubbly comic turns contributed by Ms. Drummond's wired Aunt Ruth and Tim Monsion as a doctor with a bedside manner of burlesque-sketch vintage. "Marvin's Room" is so sure of its own, idiosyncratic tone that some of its most rending interludes unfold quite naturally during a visit to the cartoon-populated landscape of Disney World.

Even so, the evening's joy — that contained in the play and that prompted by the revelation of an exciting new playwright — is inevitably tempered by one's knowledge, hinted at in the author's Playbill note and expanded upon in an interview in this newspaper, that Mr. McPherson, who is 32 years old, has AIDS. "Marvin's Room" was written before Mr. McPherson became ill and in any case asks for sympathy no more than Bessie does. But like some other recent comedies that have nothing specifically to do with AIDS and everything to do with the force of selfless love in a world where life is short — plays like Craig Lucas's "Prelude to a Kiss" and Terrence McNally's "Frankie and Johnny in the Clair de Lune" — "Marvin's Room" wasn't conceived in a vacuum. It is a product of its time.

Like its peers, "Marvin's Room" reaches beyond its time. That isn't to say that Mr. McPherson's play is for everyone. Lee's tart-tongued sons concede in one youthful bedtime conversation that they never "think about actually dying," and one imagines that even the most worldly teenagers would not know what to make of this evening either. Nor, perhaps, would those adults fortunate enough never to have stood in a room and watched a loved one die.

But I can't speak for that audience. I can only speak for myself. My first impulse after seeing Mr. McPherson's play was to gather those I care about close to me and take them into "Marvin's Room," so that they, too, could bask in its bouncing, healing light.

1991 D 6, C1:5

Catskills on Broadway

Conceived by Freddie Roman; entire production supervised by Larry Arrick; sets by Lawrence Miller; lighting by Peggy Eisenhauer; sound by Peter Fitzgerald; musical director, Barry Levitt; opening musical sequence arranged by Donald Pippin; projection design by Wendall Harrington; associate producer, Sandra Greenblatt; creative consultant, Richard Vos; technical supervisor, Roy Sears. Presented by Kenneth D. Greenblatt, Stephen D. Fish and 44 Productions. At the Lunt-Fontanne Theater, 205 West 46th Street, Manhattan.

WITH: Mr. Roman, Marilyn Michaels, Mal Z. Lawrence and Dick Capri.

By MEL GUSSOW

The title of the show "Catskills on Broadway" deserves a truth-in-advertising award. With these four stand-up comics at the Lunt-Fontanne Theater, you pay your money and you get the jokes, unless you happen to miss the punch lines because of the laughter.

Appropriately, the show begins with a quick, clever montage of photographs of celebrities and guests enjoying themselves at diverse hotels. The song "Comedy Tonight" is heard in the background. For receptive theatergoers, "Catskills on Broadway" offers something familiar, and something entertaining. Is Broadway ready for the Catskills? Do Catskill hotels serve too much food?

One-liners and ethnic wisecracks speed by as these jokesmiths offer their shtick in trade, just as they would if they were performing their routines in a nightclub. Despite the presence of a director, Larry Arrick, there is no special adaptation to the Broadway stage. Expect no newness here, although there are updated variations on old themes. The comics, three men and a woman, deliver a spritz of recognition.

Freddie Roman, who conceived the show and is the opening act, reflects on his boyhood in Queens. After knocking today's cinderblock cineplexes, where if you leave a theater to go to the bathroom "you forget which movie you're seeing," he remembers the grandeur of Loew's Valencia. The mere mention of that palace evokes an audible sigh from theatergoers. Responding to nostalgic references, the audience becomes an integral part of the show, so much so that Mr. Roman is forced to interrupt and comment, "Who's working here?"

His effervescence becomes infectious as he shifts targets from the Catskills to Florida. He pinpoints the problem of retirees living in perpetual sunshine until their grandchildren arrive for their annual holiday visit, when it rains every day. By his own description, Mr. Roman is a semi-chubby man in the midst of a midlife crisis, and he is as personal as his medical report. "I took a cholesterol test," he says. "My number came back 911."

Finishing his finely honed routine, he introduces Dick Capri, followed by Marilyn Michaels and Mal Z. Lawrence. Mr. Capri, who adds an Italian-American note to a mostly Jewish field of humor, is the most predictable of the four comedians. But he serves at least one useful purpose: He lets the audience catch its breath between laughs.

Then Ms. Michaels appears, backed by a band, to deliver deft and often daft imitations. Of the comics, she has the most individualized talent. The objects of her mimicry are so instantly identifiable that there is no need for her to introduce them by name.

Her booming version of Ethel Merman imperils the chandelier, and her Elizabeth Taylor assumes a tremolo. After raining on Barbra Streisand's parade, she tosses off a passing impression of Jackie Mason, who, of course, is the role model for the current entertainment. Ms. Michael's chef d'oeuvre is a three-minute version of "The Wizard of Oz," in which she imitates Judy Garland, Bert Lahr, Toto, the witches and the munchkins, one of whom sounds suspiciously like Dr. Ruth.

Mr. Lawrence, who has a ponytail and the manner of a Borscht Belt hipster, winds up the show with a rapid-fire monologue that races from the mountains to the shore, in this case Atlantic City, which he says is not a city but a bus terminal. Proving his point, he takes the audience aboard a bus dense with geriatric gamblers.

"Catskills on Broadway" manages to reproduce the ambiance of the Catskills. The basic difference is that on Broadway there is not a nosh in sight. But there is a groaning board of jokes about eaters and stuffers. As Mr. Lawrence observes, everyone in the Catskills wears warm-up suits. Warming up for what, he asks, sumo wrestling?

After every comic has had a 30-minute spot, the show ends with a chorus of one-liners as each tries to top the others. They could keep going for hours. Catskill resorts may be fighting the recession, but Catskill comedy has not lost its flair.

1991 D 6, C28:4

Basement

Conception, text, space, costume, sound track, direction and performance by Denise Stoklos; lighting, Ms. Stoklos and Isla Jay; executive producer, Gilda Almeida; lights, Jann Bell Newman; light and sound operation, Micahel Kang, stage manager, Howard Patlis. Presented by La Mama E.T.C. At 74A East Fourth Street, Manhattan.

By STEPHEN HOLDEN

"I eat, I eat, I eat, I eat, I eat, and I never put on weight," announces Denise Stoklos in her exuberantly amusing new performance piece, "Basement."

A sequel to her ensemble work "Casa," which played at La Mama last season, this solo performance offers a more acute portrait of contemporary humanity bumbling through a sterile technologized environment with a Chaplinesque determination and vigor.

Like a primitive creature who has been propelled forward in a time machine, Ms. Stoklos gawks at the contents of an open refrigerator. She sticks her head in the oven, and reaches into a toilet to pull out a clock. She plays an accordion with a wild ecstatic frenzy, rolling around on the floor. Later in the one-hour show she drags a television set from a corner of the stage and sits and stares at it, then turns it around to reveal that its screen is a mirror. She animatedly addresses the audience while making popcorn that she ends up tossing into the air like confetti.

Throughout the piece Ms. Stoklos, who calls her style of theater essentialist, embodies a life-affirming everyperson with stylized, exaggerated body language and emphatic heavily accented speech that suggest a weird dichotomy between the physical and the mental. Her provocative dialogue takes many tangents but pointedly returns to the theme of human evolution. One of the most evocative passages imagines human beings developing over millions of years while being watched in wonder by monkeys who have not evolved in the same way.

The comparison between people and monkeys is underscored by Ms. Stoklos's style of movement, which is

flamboyantly theatrical but also quite simian. In the end, her caricature of human nature, in which bestial, intellectual and spiritual impulses are forever bubbling up and colliding with one other, is both touching and funny.

1991 D 8, 83:5

SUNDAY VIEW/David Richards

Is There Life Beyond Broadway? Yes and No.

The Arena Stage revamps 'It's a Wonderful Life.'

The Long Wharf picks up where Dylan Thomas left off.

WE HAVE TWO DISTINCT problems on our hands this morning, and one common ambition.

The problems are "A Wonderful Life" at Arena Stage in Washington and "Adventures in the Skin Trade" at the Long Wharf Theater in New Haven. The ambition is to build a better mousetrap, which, in the theater, has come to mean concocting the next big Broadway musical.

Of course, no one likes to say as much — especially in our not-for-profit institutions. To admit that Broadway is your goal these days is seen as either an act of recklessness (given the hopeless odds), an expression of hubris (given the hopeless odds) or an unseemly capitulation to greed (given "Miss Saigon's" grosses).

And yet I never met a musical, however humble its chorus line, that didn't somewhere in the back of its spangled mind entertain the improbable hope. There's a growing

Joan Marcus/"A Wonderful Life:

From left, Jeffery V. Thompson, Casey Biggs and Ralph Cosham in "A Wonderful Life" at the Arena—With so well known a property, you've got to tread delicately.

traffic in personnel between the regional theaters and what remains of the commercial musical theater establishment. Broadway professionals no longer look upon the out-of-town work experience as a comedown, although they do persist in viewing it as another kind of tryout. The regional theaters, for their part, have become less prickly about having their artistic integrity tinkered with. A modus vivendi seems to have been struck.

So I'm sorry to have to report that the mice are safe, for the time being. Arena's musical has been adapted from Frank Capra's widely beloved 1946 movie, "It's a Wonderful Life." (One of my acquaintances has seen it so often the opening credits are enough to activate his tear ducts.) Long Wharf's "Adventures in the Skin Trade" takes the unfinished novel by the Welsh poet Dylan Thomas and, among other matters, tries to find an ending for it. But in each instance, the results are soporific. Music adds little to either tale, other than playing time.

'A Wonderful Life'

Obviously, with so well known a property as "It's a Wonderful Life," you've got to tread delicately, lest you be accused of wanton destruction. The book writer and lyricist Sheldon Harnick has pruned Capra's screenplay of its lesser incidents, but leaves intact the basic story of benevolent George Bailey — the would-be globe-trotter, who is invariably called back to his job at the Building and Loan office every time he tries to put the town of Bedford Falls, N.Y., behind him. Mr. Harnick's chief invention is to expand events on the celestial front, where Clarence, an angel in waiting, hopes to earn his wings — and the roller skates that come with them, apparently — by doing a good earthly deed.

The movie was happy to leave Clarence unseen, until he materialized on a bridge and prevented George, by then in despair over what he assumed to be a wasted life, from jumping off. In the musical, Clarence and his boss, Joseph, are on hand from the start, narrating the story, providing transitions from one scene to the next and carrying on, all things considered, rather like cute Christmas cards. The score was composed by Joe Raposo — he of "Sesame Street," "The Great Muppet Caper" and other picker-uppers. But it never gets beyond chipper, when it wants to be joyful, and its dramatic ambitions qualify as sentimental, at best.

The film may be schmaltzy, but like the wide-eyed waif who won't take no for an answer, it eventually forces you to capitulate. The musical is no less schmaltzy, but its impact is diluted by too many songs that either state the obvious or regurgitate what we already know about these decent folk. At nearly three hours, it ends up being the one thing the film wasn't: bland.

As is Arena's wont, the show has been given a sleek, glossy production in the round. The set designer Thomas Lynch has painted the stage floor to resemble the earth, as it might appear from a satellite or St. Peter's gate, and dusted it with clouds and snowdrifts. As the landmarks of Bedford Falls — the Baileys' dining room, the school gymnasium, an Art Deco bank lobby — glide silently on and off, the cosmic and the homely are artfully blended. The staging by Douglas C. Wager aims for a similar marriage, but the material is ultimately too soft and mushy for him. He has a grand gift for orchestrating bedlam (the revivals of the Marx Brothers' musicals "The Cocoanuts" and "Animal Crackers," for instance) that goes begging here, and he s far more comfortable deflating the kind of gooey emotions that "A Wonderful Life" wants to inflate.

Does that help explain Casey Biggs's downbeat performance as George Bailey? The actor certainly seems tired and discouraged from the outset. There's little of the natural buoyancy that would keep the character from reaching the end of his rope before his time. Brigid Brady, as his understanding wife, Mary, suffers from his mopiness, especially when she's having to reassure him, "I Couldn't Be With Anyone but You."

Roly-poly, I believe, is the adjective of choice for Jeffery V. Thompson, who plays Clarence with the joviality of a chain-store Santa, until he is awarded his roller skates and starts behaving as if God were going to break his kneecaps. Although the competition is not keen, the show's liveliest performance is Richard Bauer's, as Mr. Potter, the town Croesus. Mr. Bauer has taken his look from Lionel Barrymore, who played the role in the film, his nastiness from Scrooge and his gleeful little giggle from the troll under the bridge. His foulness is, in this cloying musical, very close to a breath of fresh air.

'Adventures in the Skin Trade'

The Long Wharf Theater doesn't have to worry about desecrating a masterpiece. Dylan Thomas wrote only 50-odd pages of "Adventures in the Skin Trade" before abandoning it and leaving young Samuel Bennet, an aspiring poet, dangling in the surrealistic company of some eccentric Londoners. Theoretically, the novel, which begins with Samuel trashing the family home in Swansea so he'll never be able to return, was to have traced his progressive loss of faith as he made his way through a topsy-turvy world. But as the fragment stands, the worst of his adventures is getting drunk on a tumbler of cologne and passing out in a bathtub of cold water. That, and frequenting a bohemian dive, where one man can actually be spotted dancing with another.

In order to fashion a full-length musical out of this, John Tillinger and James Hammerstein have opted to back up, as a first step. The initial act of their adaptation is given over to describing provincial life in Swansea and having young Sam (Daniel Jenkins) repeatedly voice his determination to escape its clutches so he can "pave the streets of London with all my boiling verse." The authors and the composer, Tom Fay, are clearly trying to endow Swansea with the nostalgic charm that might momentarily stay a green youth eager for the bright lights and loose women of the city. But the musical is just marking time until the final minutes of the first act, when Sam breaks his mother's china, stuffs his sister's crocheting up the chimney and generally wreaks a tame version of the havoc that opens Thomas's tale.

The second act takes him to London, where he meets Mr. Allingham (Thomas Hill), whose flat is packed to the ceiling with old furniture; pretty Polly (Lily Knight), who likes to "depict" the great emotions; lavender-scented George Ring (Albert Macklin), otherwise known as "the passing cloud," and stern Mrs. Dacey (Victoria Boothby), who, in Thomas's inimitable description, "held her head primly as though it might spill." What seems to interest them most about Sam is not his budding genius, but the fact that his finger is stuck in a bottle of ale. Although they're promisingly bizarre characters, their collective escapades have only begun when the novel gives out. All the creators can imagine, by way of conclusion, is to have Sam lose his virginity and proclaim "Fern Hill," Thomas's poem about childhood's bursting glories.

The show's eccentricities are wholely superficial. At heart, "Adventures in the Skin Trade" is a conventional coming-of-age musical that tames the novel's drunken flights of prose and trivializes its wonderfully cockeyed imagery. You could argue that Thomas's own words have more music in them than any of the pleasant but perfectly innocuous songs that Mr. Fay has provided for the occasion. Why bother, if it means coming up with less?

The first-rate design team — John Lee Beatty (sets), Jane Greenwood (costumes) and Tharon Musser (lighting) — has turned out a production that mostly looks second-rate, while the performances, under Mr. Tillinger's direction, are never more than benignly quaint.

a workable musical can't be coaxed out of Thomas's fable. But it would take a far more radical exercise of the imagination than is currently in evidence at the Long Wharf. There's no adventure in these "Adventures." There's barely the shadow of a plot.

I suppose my discouragement would be greater right now if I hadn't picked up a recent newsletter of the National Alliance of Musical Theater Producers, which indicates the voracious appetite for musicals across the country. And not just for the old favorites, either, which have rarely languished on the shelf for long.

Consider this, though: The Lincolnshire Marriott Theater, just outside Chicago, is about to mount "Annie Warbucks," which began life as "Annie II," flopped at the Kennedy Center early in 1990 during its pre-Broadway tryout, then repaired to the Goodspeed Opera House in East Haddam, Conn., several months later for a major overhaul. Now it's ready to try again. The Goodspeed, on the other hand, has just closed "Conrack," a musical about an idealistic schoolteacher on an island off the South Carolina coast. That show is headed for Ford's Theater in Washington. Yes, the same Ford's Theater that, three years ago, gave birth to the musical version of "Elmer Gantry" currently undergoing further refinements at the La Jolla Playhouse in California.

If this keeps up — and there's no reason to think it won't — we're going to have to cease referring to the Broadway musical. For accuracy's sake, the operative term will be the *American* musical. Broadway will simply be a stopping-off place. □

1991 D 8, II:5:1

Nick and Nora

Book by Arthur Laurents; music by Charles Strouse; lyrics by Richard Maltby Jr.; directed by Mr. Laurents; choreography by Tina Paul; scenery by Douglas W. Schmidt; costumes by Theoni V. Aldredge; lighting by Jules Fisher; orchestrations by Jonathan Tunick; musical and vocal direction by Jack Lee; dance and incidental music by Mr. Strouse; dance and incidental music arranged by Gordon Lowry Harrell; sound by Peter Fitzgerald. Presented by Terry Allen Kramer, Charlene and James M. Nederlander, Daryl Roth and Elizabeth Ireland McCann. At the Marquis Theater, 1535 Broadway, at 45th Street.

Nora Charles............................Joanna Gleason
Nick Charles Barry Bostwick
Tracey Gardner Christine Baranski
Yukido...Thom Sesma
Max Bernheim..........................Remak Ramsay
Victor Moisa.............................Chris Sarandon
Spider Malloy.................................. Jeff Brooks
Lorraine Bixby Faith Prince
Edward J. Connors Kip Niven
Lieutenant Wolfe.................. Michael Lombard
Maria Valdez Yvette Lawrence
Lily Connors..............................Debra Monk
WITH: Tim Connell, John Jellison, Kathy Morath, Kris Phillips, Hall Robinson, Kristen Wilson and Riley.

By FRANK RICH

Leaving the Marquis Theater after "Nick and Nora," I kept hearing the same jaded comment from other members of the audience beside me on the escalator: "Well, it's not nearly as bad as they said it would be."

True, this comment is hard to evaluate if you have no way of knowing which "they" these people are refer-

ring to. After all, nearly 100,000 customers paid full price to see "Nick and Nora" during its nine weeks of previews before its official "opening" last night, and that's a lot of suspects, each, no doubt, bad-mouthing the show to a different degree. Even so, I bet the theatergoers I overheard on the Marquis escalator are right. "Nick and Nora," in its finished form, is *not* as bad as they said, whoever the "they" might be.

Which is not to say that it is good.

●

Like the less-than-gifted celebrity who is famous for being famous, this musical will no doubt always be remembered, and not without fondness, for its troubled preview period, its much-postponed opening, its hassles with snooping journalists and its conflict with the city's Consumer Affairs Commissioner. Indeed, the story of "Nick and Nora" in previews, should it ever be fully known, might in itself make for a riotous, 1930's-style screwball-comedy musical. But the plodding show that has emerged from all this tumult is, a few bright spots notwithstanding, an almost instantly forgettable mediocrity. As no one will confuse it with the hit musicals its authors have worked on in happier times — "Gypsy," "West Side Story," "Bye Bye Birdie," "Annie" and "Miss Saigon," among many others — neither is "Nick and Nora" remotely in the calamitous league of such recent, excessively previewed fiascos as, say, "Carrie" and "Legs Diamond."

The distinguished authors — Arthur Laurents (book), Charles Strouse (music), Richard Maltby Jr. (lyrics) — began with a highly promising idea, a musical murder mystery prompted by the glamorous husband-and-wife detective team created by Dashiell Hammett in the Depression and immortalized on screen by William Powell, Myrna Loy and Asta, their canine sidekick. The setting is Hollywoodland, the atmosphere is meant to be that of a glittering black-and-white Art Deco movie musical, and the whodunit plot aspires to be adult and ingenious. Yet one need not indulge in invidious comparisons with the old "Thin Man" movies (which were not all that wonderful to begin with) or legitimate comparisons with Broadway's current, similar and far superior "City of Angels" to see that "Nick and Nora" was probably doomed before it played its first preview.

●

For starters, this production might have spent a little less time searching for the perfect Asta and a lot more time trying to find the right Nick and

A big musical finally opens after a long run in preview.

Nora. Barry Bostwick is a handsome leading man with an agreeable manner and sturdy voice, and Joanna Gleason, better still, is an astringent comic actress with impeccable timing and her own strong voice. But if either of these talents, together or separately, has the larger-than-life personality or all-around musical-comedy pizzazz it takes to ignite a

star-centric Broadway musical, that incandescence is kept under a shroud in "Nick and Nora." The heart sinks from their opening number, a low-key, charmingly written piece titled "Is There Anything Better Than Dancing?" Instead of setting the tone implied by its title, the song, as performed, reveals that Mr. Bostwick and Ms. Gleason have limited warmth and cannot really dance, and that their would-be Astaire-and-Rogers routines, wanly choreographed by Tina Paul, will have to be fudged all night. (As in fact they are, right through a finale that, if better executed, might have echoed "Rosie," the beguiling equivalent duet at the end of Mr. Strouse's "Bye Bye Birdie.")

The other fatal drawback for a musical aspiring to the style of "Nick and Nora" is tipped off in the second number, in which the evening's second banana, Christine Baranski in the role of an egomaniacal movie queen, sings of how "Everybody Wants to Do a Musical." The song is set in a film studio and is redolent of the Busby Berkeley era, yet the campy fantasy of its lyric is never illustrated with chorus performers or even scenery. To put it another way, the sparsely appointed and underpopulated "Nick and Nora" looks from the start as if it were produced on the cheap — or as if its budget, however large, was not smartly spent — and that impression never dissipates. The final production number of Act II, typically, is a Carmen Miranda send-up in which the singer (Yvette Lawrence) is backed up by two — count 'em, two — dancers.

•

All the other failures in "Nick and Nora" are secondary to its inability to deliver the glamorous stars and atmosphere promised by its title. (Such scenery as there is, by Douglas W. Schmidt, is bland and Theoni V. Aldredge, in a rare lapse, has costumed all the women unbecomingly.) As director, Mr. Laurents must shoulder some of the blame for those central shortfalls, as well as for the sluggish, stop-and-go gait of the entire, nearly three-hour evening. His talky book is also not his sharpest, offering a murder puzzle that is ambitious and convoluted without being pleasurable and Hollywood repartee that for all its knowing allusions to Max Ophuls, Joseph Kennedy and Louella Parsons

is not especially funny. A subplot about Nick and Nora's marital travails seems to have been shredded into confusion during revision, so much so that the other man who briefly sours the couple's relationship (Chris Sarandon) is never coherently identified.

Though Mr. Strouse has written some rousing scores for frail shows ("It's Superman," "All American," "Rags"), that of "Nick and Nora" is not one of them. Yet there are some pretty tunes along the way, and one is always struck by how enthusiastically and professionally he and Mr. Maltby embrace and sometimes conquer the tough technical challenges of musical-theater writing. At their cleverest here, in one song in each act, they use witty music and lyrics to bring together all the suspects and motives in Nick and Nora's murder case so that the detectives and audience alike might weigh every conceivable scenario. At their worst, they give two of the most gifted comic actresses in town — Ms. Baranski and Debra Monk — flat would-be showstoppers that make the performers seem both unfunny and vocally uncomfortable.

•

A third supporting actress, Faith Prince, fares far better in the role of the evening's ubiquitous murder victim, Lorraine, a platinum-wigged film-industry bookkeeper who, among other attacks on her dubious character, is accused of trying to "play Barbara Stanwyck with Jean Harlow hair." Though Lorraine is already dead when the show begins, she keeps popping up again and again as her murder is re-enacted in repeated flashbacks to the scene and night of the crime. The dizzy Ms. Prince not only takes a mean pratfall each time the gunshots ring out but also brings a brash, belting delivery to "Men," a musical diatribe that almost does to its satirical target what Miss Hannigan did to "Little Girls" in Mr. Strouse's "Annie."

We can look forward to hearing a lot more from Ms. Prince. In the meantime, there is no escaping the unfortunate fact that the liveliest thing in "Nick and Nora" is a corpse.

1991 D 9, C11:3

The Crucible

By Arthur Miller; directed by Yossi Yzraely; settings by David Jenkins; costumes by Patricia Zipprodt; lighting by Richard Nelson; musical direction by John Kander; production supervisor, Thomas A. Kelly; incidental music supervision, David Loud; sound by T. Richard Fitzgerald; executive producer, Manny Kladitis. Presented by the National Actors Theater. At the Belasco Theater, 111 West 44th Street, Manhattan.

WITH: Jane Adams, Nell Balaban, John Beal, Danielle Ferland, John Fiedler, Andrew Hubatsek, Bruce Katzman, George N. Martin, Peter McRobbie, Genia Sewell Michaela, Maryann Plunkett, Madeleine Potter, Brian Reddy, Molly Regan, Martha Scott, Martin Sheen, Priscilla Smith, Patrick Tull, Fritz Weaver, Carol Woods and Michael York.

By FRANK RICH

A National Actors Theater performing classics at reasonable ticket prices in the beautiful Belasco Theater: is Tony Randall's new company a theatrical fantasy come true or a television star's ego trip? This is a question that audiences, not interfering board members or drama critics or Broadway's harsh economics, will answer, for Mr. Randall has attracted full houses of subscribers to his inaugural season of three plays. If they like what they see, they'll be back for season No. 2.

•

One assumes that their patience will extend beyond the company's stately opening production, "The Crucible." Like the National Actors Theater itself at this early point, this evening must be applauded in principle. It brings together nearly two dozen actors, some of them first-rate, for the worthy cause of performing Arthur Miller's evergreen drama, written during the Joseph McCarthy witch hunts of the 1950's, about the Salem witch hunts of 1692. The cast includes welcome old favorites of the New York stage (Martha Scott, John Beal), popular character actors of more recent seasons (Maryann Plunkett, Madeleine Potter, George N. Martin, Jane Adams) and a trio of stars (Martin Sheen, Michael York, Fritz Weaver).

But even actors of this quality need direction, and that help is not forthcoming from Yossi Yzraely, a former artistic director of the Habimah National Theater in Israel. Mr. Yzraely

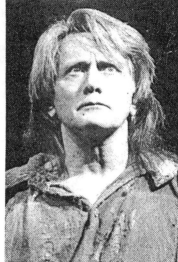

Joan Marcus/The National Actors Theater

Martin Sheen in "The Crucible."

has staged a stiff high-school edition of Mr. Miller's play. "The Crucible" is doled out as something that is good for you, sour medicine that must be swallowed slowly.

The actors tend to saw the air with their hands, thump their chests and declaim to the Belasco's two balconies. Worse, those cast members who are not speaking often surround the orators in semicircular formations, making an exaggerated show of listening with varying degrees of head-cocking approval or open-mouthed disbelief. Mr. Yzraely seems to have directed the play as if it were written in 1692 instead of set then. What emerges is a bogus Puritan pageant

A new company with top actors stages a modern classic.

more redolent of Old Sturbridge Village than of Mr. Miller's divided community of frightened, often sexually fevered souls succumbing to whispering campaigns, mass psychosis and the tyranny of the mob.

•

I won't bore you by repeating the familiar, and undying, moral lessons of Mr. Miller's piece and lecturing on how relevant they are today. It is not the playwright's preachments that make "The Crucible" his most produced play, in any case, but his ability to animate his moral debate through characters who may talk in clotted Puritanese (the work's one conspicuous flaw) but who are manifestly human. This is especially the case with John Proctor, the guilt-ridden, Hawthorne-esque protagonist who is no saint until that climactic moment when justice must rise up against evil. Mr. Sheen, looking more like Daniel Boone than a New England farmer, loses that complexity in a vocally constricted performance of sloppy emotions and knee-jerk righteous indignation. He also seems in less than full command of his lines, despite the fact that "The Crucible" put off its press opening nearly as long as did "Nick and Nora."

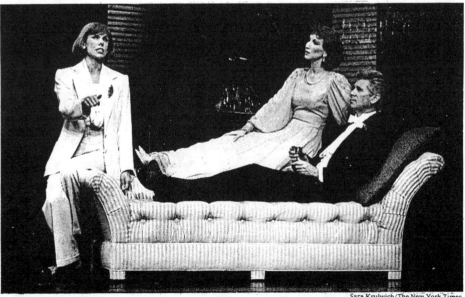

Sara Krulwich/The New York Times

Joanna Gleason, Barry Bostwick and Christine Baranski, left, in "Nick and Nora," which opened after nine weeks of previews.

John Hale, the fascinating clergy-man who undergoes the most radical change of heart in the play, is also allotted but a single (and weepy) note in the reading of Mr. York, who looks here as if he stepped off a Dutch Masters cigar box. No less monochro-matic are the drama's villainous conspiracy theorists and name namers, who, with the exception of Mr. Weaver's majestically malevolent Deputy-Governor Danforth, are routinely presented as snarling, physically unattractive screamers. By far the most compelling performance comes from Ms. Plunkett, who conveys the torn loyalties and deep conscience of Elizabeth Proctor with a neurotic intelligence that keeps sanctimoniousness at bay. It is no surprise to learn that this fine actress's connection with her role predates this production; she played Elizabeth under the direction of Arvin Brown at the Long Wharf Theater in New Haven two years ago.

Also, admirable is David Jenkins's all-purpose set, a clearing in the wilderness, dominated by tall, barren trees and a pitch-black sky. But the terror implicit in this environment and in Mr. Miller's vision of a poisoned America on trial rarely spills past the footlights. In 1991, surely, it is not asking too much that the theater bring forth a "Crucible" that is at least as dramatic as the televised cross-examinations of Clarence Thomas and William Kennedy Smith.

1991 D 11, C17:1

Theater in Review

■ Looking for self-help in the sunshine ■ Brecht's 'Galileo,' on the struggle of recantation ■ On Christmas Eve, family revelations.

Reality Ranch

American Place Theater
111 West 46th Street
Manhattan

Written and performed by Jane Gennaro; directed by Peter Askin; scenery and costumes by John Esposito; lighting by Natasha Katz; sound by Daniel Schreier; composer, Mr. Schreier; production stage manager, Michael Robin. Presented by the American Place Theater, Wynn Handman, director; Dara Hershman, general manager.

Zoe Henry, the protagonist of Jane Gennaro's loopy monologue, "Reality Ranch," longs to write fiction but is sentenced to paraphrase "infotainment" for a slick, trendy magazine. On assignment, she flies to the ranch that gives the show its title. At this "last resort," she encounters a crowd of post-Club Med vacationers seeking self-help in the sunshine.

A clever mimic as well as comedy writer, Ms. Gennaro lampoons generic personalities rather than specific celebrities in her new show at the American Place Theater. Zoe's editor for life, Cassandra Page Billings Dagmar, borrows like Helen Gurley Mirabella Tina Brown. The doyenne of Dagmar, the magazine, the editor is a compulsive trend spotter and setter eager to toe the cutting edge no matter how sharp it may prove to be.

As a fearless freelance, Zoe takes a gimlet-eyed view of people who spoof themselves, especially those who visit the "I'm O.K., You're O.K. Corral" ranch. She is the most acute person on the premises as she intercuts her journalistic research with remembered travail of her Catholic girlhood, in which she was punished for her poetry. Acting as her adviser is Aunt Francis, a friendly family ghost who sounds like Bette Davis with an Irish accent.

As conceived and performed by Ms. Gennaro, "Reality Ranch" is amusing, although the excursion has a tendency to drift. In this move from radio comedy to the stage, a follow-up to "The Boob Story" of several seasons ago, Ms. Gennaro has not turned her talk into a free-flowing stream of experience. More help could be provided by her director, Peter Askin, who also staged John Leguizamo's one-man show at the American Place last year. At Reality Ranch, one wants to move along to the next activity before it is announced.

In her favor, the gaminesque Ms. Gennaro has diverse voices at her command and an ability to differentiate between characters. She uses her disarmingly affable personality to make satiric stabs at quick-fading fads that tend to make one feel a step behind the times. *MEL GUSSOW*

Galileo

Jean Cocteau Repertory
Bouwerie Lane Theater
Manhattan
Through Feb. 14

By Bertolt Brecht; English version by Charles Laughton; direction and lighting by Eve Adamson; set by John Brown; costumes by Jonathan Bixby; music by Hanns Eisler; production manager, Patrick Heydenburg. Presented by the Jean Cocteau Repertory Theater, Robert Hupp, artistic director. WITH: Harris Berlinsky, Jeanne Demers, Ian Duckett, Robert Ierardi, Corinne Julie Kendall, Joseph Menino, William Charles Mitchell, Grant Neale, Kate Sherry, Craig Smith, Elise Stone, Tony Stone, Angela Vitale and Mark Waterman.

Throughout history, every major advance in mankind's halting march toward knowledge has been accompanied by a crisis of faith. But with the possible exception of Darwin's voyage on the Beagle, none were more critical than at the dawn of the Age of Reason when Galileo cobbled together a telescope, trained it on the heavens and expanded our universe.

Brecht's witty and incisive play on the life of Galileo is timeless, even if it is politicians rather than scientists who are now moving the world into uncharted territory (and it is the Marxists who are facing a crisis of faith). Eve Adamson has mounted a first-rate revival of "Galileo" for the Jean Cocteau Repertory, a staging that focuses on the real drama: Galileo's own struggle with his recantation.

Brecht first wrote "Galileo" in the dark days of Nazi Germany just before World War II. After Hiroshima, which Brecht said "placed the conflict of Galileo in a new light," he rewrote it in collaboration with Charles Laughton as a vehicle for the actor, and continued to tinker with it the rest of his life. Ms. Adamson has used the Laughton version for the Cocteau, adding some of the later emendations. It is the most human portrait of a man "who cannot say no to an old wine or a new thought" and who knows that "truth is the daughter of time, not authority."

The play begins with Galileo's discovery of four of Jupiter's satellites, observations that raise the first disturbing questions. As his friend Sagredo fearfully asks him, "Where is God?" To which Galileo answers, "Within ourselves." It was the sort of response for which Giordano Bruno was burned at the stake.

By the time Galileo offers his proof that the earth circles the sun, and not the other way round, the Holy Office is hot on his case. "He cannot be tortured," the Pope admonishes the Inquisitor. "At most you can show him the instruments." But as the Inquisitor observes: "That's all it will take. Galileo understands machines."

Ms. Adamson moves her fine cast at a steady narrative pace that takes the time to develop the conflict yet never dawdles. Harris Berlinsky delivers a wry and convincing Galileo. Whether conniving to get a few extra scudi from the Venetian nobles or relishing a gift goose, Mr. Berlinsky's

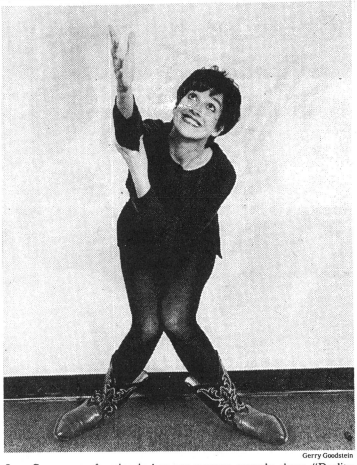

Gerry Goodstein

Jane Gennaro performing in her one-woman comedy show, "Reality Ranch," at the American Place Theater in Manhattan.

Galileo is jubilant drawing universes in chalk on the floor and distraught over his recantation.

Most of the rest of the cast members double in various roles. Mark Waterman is especially good in the difficult task of switching his zeal between the roles of Galileo's prize pupil, Andrea Sarti, and the Inquisitor. Craig Smith is credible as both Sagredo and Pope Urban VIII and William Charles Mitchell is noteworthy as Galileo's assistant, Federzoni, and as Cardinal Bellarmin. Jonathan Bixby's excellent costumes deserve special mention, switching fashions between the courts of Venice and Florence.

WILBORN HAMPTON

Greetings

One Dream
232 West Broadway, entrance on
North Moore Street
Manhattan
Through Dec. 22

By Tom Dudzick; directed by Seth Barrish; set by Markas Henry; costumes by Nina Canter; lighting by Eileen H. Dougherty; sound by David Schnirman; stage manager, Marjorie S. Goodsell; production supervisor, Nancy Kramer; fight director, Rick Sordelet; technical director, Timothy Noble. Presented by the Barrow Group.

WITH: Marcia DeBonis, Tom Riis Farrell, Aaron Goodwin, Vince O'Brien and Natalie Ross.

Tom Dudzick's "Greetings" mixes crabby humor and holiday sentiment so deftly that one can almost forgive it for shamelessly manipulating a well-worn formula.

In this cozy coming-home-for-Christmas vignette, Andy Gorski

(Tom Farrell), a thirtyish advertising copywriter from New York, brings his fiancée, Randi (Marcia DeBonis), to his parents' house in Pittsburgh for the holidays. Andy's mother, Emily (Natalie Ross), is introduced as "Pittsburgh's answer to June Cleaver." His father, Phil (Vince O'Brien), a former minor-league ballplayer and devout Roman Catholic, is an Archie Bunker type who mutters darkly about people who don't put up their Christmas lights being atheists. Living in the house is the couple's other son, Mickey (Aaron Goodwin), who is retarded.

Trouble erupts the moment Phil learns that Randi is Jewish. It escalates into a family feud when she recalls a tragic accident that left her an atheist. Just as things are about to explode, the spastic, inarticulate Mickey interrupts to begin talking in a strange, elegant diction. The person speaking through Mickey calls himself Lucius and wears a chilly, slightly demonic smile as he dispenses elliptical advice on spiritual growth and emotional healing. Is it a miracle or a devilish trick?

As pat as it is, the material has given been the best production imaginable by the Barrow Group at One Dream, a small, cramped theater in SoHo. Directed by Seth Barrish, the cast of five brings such conviction and precise detail to their portrayals that the play comes to life in spite of its triteness. Every gawky, emotionally loaded maneuver inside the Gorskis' tense family dynamic is made to ring true. The best of the five impeccable performances is Mr. Goodwin's Mickey. He metamorphoses back and forth from a drooling, spasmodic manchild to a spooky angel without missing a fraction of a beat.
STEPHEN HOLDEN

1991 D 11, C23:1

Two Gentlemen of Verona

By William Shakespeare; adaptation and direction by Mark Milbauer and David Becker; sound, Mr. Becker; costumes, Melina Root; set designer, Sarah Lambert; lighting, Scott Zielinski. Presented by Cucaracha Theater, Richard Caliban, artistic director. At SoHo Repertory, 46 Walker Street, TriBeCa, Manhattan.

WITH: Les Baum, Lia Chang, Mark Dillahunt, Joseph Fuqua, Joey L. Golden, Vivian Lanko, Julie Moses, Hugh Palmer and Damian Young.

By STEPHEN HOLDEN

Largely because of its ending, "Two Gentlemen of Verona" has always been one of Shakespeare's more problematic comedies. How can one make psychological sense of the story of two friends, Proteus and Valentine, whose relationship is betrayed when Proteus pursues and sexually assaults his best friend's true love, Sylvia, and is then instantly forgiven?

Finding an answer to that question is a major goal of the Cucaracha Theater's gripping deconstruction of "Two Gentlemen of Verona" at SoHo Rep. In Mark Milbauer and David Becker's adaptation, the play has been shortened and streamlined into a brutal satire of sexism in society, and directed by the adapters in what might be described as a hip-hop style.

Parts of the text have been redistributed among the characters, and scenes have been broken up and others reordered. The production begins with Proteus's molestation of Sylvia,

an ugly Draculian assault on a massage table that is prefaced by two actors who enter with posters announcing, "First the climax." The scene is repeated toward the end of the production.

References to contemporary America and to Italy 400 years ago reverberate energetically throughout the production. The robes and conspicuous gold chains worn by the aristocrats suggest both ancient times and a shady newly moneyed society with Mafia overtones. Sylvia is portrayed by Vivian Lanko as a sullen Mafia princess. The farcical scenes featuring Launce and Speed are staged as brutal dirty-minded stand-up comedy routines delivered with the crude glee of an Andrew Dice Clay monologue. Stitching everything together is a semi-hip-hop score composed and performed live by Mr. Becker that is full of digital drum beats and cheesy sound effects. The agitated electronic punctuation infuses the production with a mood that is nervously hard-edged and sleazy.

All the performances are good, with Ms. Lanko's brooding Sylvia and Joey L. Golden's reptilian Proteus outstanding. If this interpretation of "Two Gentlemen of Verona" sacrifices much of Shakespeare's humor, it solves the play by placing it in a world where every cry of date rape is met with a conspiratorial closing of the male ranks.

1991 D 12, C21:3

Forbidden Broadway/ Forbidden Christmas

Created, written and directed by Gerard Alessandrini; costumes by Erika Dyson; wigs by Teresa Vuoso; production consultant, Pete Blue; musical director, Brad Ellis; assistant director, Phillip George; production stage manager, Jerry James. Presented by Jonathan Scharer. At Theater East, 211 East 60th Street, Manhattan.

WITH: Susanne Blakeslee, Brad Ellis, Leah Hocking, Herndon Lackey and Michael McGrath.

By MEL GUSSOW

Broadway ticket prices are up and many theaters are dark, but "Forbidden Broadway" is wishing everyone a merry Christmas, or rather "Merry Bah, Humbug." For a seasonal offering, Gerard Alessandrini, the author and impresario behind this long-running revue, has gift-wrapped a "Forbidden Christmas."

The new show at Theater East starts jauntily with two of the actors pretending to be boorish latecomers arriving with big brown shopping bags and shoving their way into occupied seats. In other words, "Forbidden Christmas" begins on a note of stark reality.

Soon the company moves into the never-never land of wish fulfillment as Luciano Pavarotti (Michael McGrath, wearing a white shirt as big as a bedsheet) sings "O Holy Note" and tries to hold it forever, and Elvis Presley (a richly lacquered Herndon Lackey) swaggers onto a Las Vegas stage to sing "I'll be home for Christmas/Because I'm still alive."

By focusing on the holiday season, Mr. Alessandrini has broadened his barrage and is able to include ubiquitous entertainers from television and nightclubs as well as familiar "Forbidden Broadway" faces. Most of the

material is new or revised for Christmas.

•

Topol, as impersonated by Mr. Lackey, wonders what it would be like to be a Gentile man, and Andrew Lloyd Webber is the spirit behind a Nativity scene that features Madonna (Susanne Blakeslee) as the Madonna. In this intricate parody, Mr. Alessandrini cleverly weaves in references to almost every one of Mr. Lloyd Webber's musicals.

Those newcomers Nick and Snora appear in a skit that will last longer than their musical. (It closes on Sunday.) Unfortunately, the parody itself needs amplification to be more than a one-jape comedy. It is one of several lapses in "Forbidden Christmas," but there is more than enough humor in the revue to offset the doldrums encountered in other aspects of theater. Call it a tonic for the holidays.

The cast of four (plus a pianist) is fine-tuned to the "Forbidden" method. All of them are talented singers and mimics. Mr. Lackey specializes in such dramatic performers as Mandy Patinkin, Topol's Tevya, everyone's Jean Valjean and Jonathan Pryce, insisting that he is an Asian, too. The equally chameleonesque Leah Hocking does a mock sinuous turn as Kathleen Turner and then segues into a role as "Natalie King Cole," who is shadowed by a cardboard figure and the mellow voice of her father.

"Miss Saigon" already gives signs of occupying a regular spot in "Forbidden Broadway," along with "Grim Hotel" and "More Miserable." To remind us of last season's conflict with Actors' Equity, a picket parades onstage proclaiming such equal-opportunity sentiments as "Cast 'Cats' With Cats." But Cameron Mackintosh himself is less in evidence. In previous revues, he was so busy selling tickets and souvenirs that the evening could have been entitled

"Forbidden Mackintosh." Perhaps Mr. Alessandrini is simply biding his satiric time until the producer's new musical, "Five Guys Named Moe,"

Poking fun at 'Nick and Nora' and Topol, too.

arrives on Broadway later this season.

For now, he spoofs a theater critic named John Simon Scrooge, who is the cranky center of "A Broadway Christmas Carol." In this mini-musical, cameo appearances are made by Ethel Merman as the Ghost of Christmas Past and Stephen Sondheim as the Ghost of Christmas Present. Both score comic points, but when it looks to the Ghost of Christmas Future, the show momentarily miscues with the Phantom of the Opera. Perhaps a more appropriate choice would be Mr. Lloyd Webber's next show, "Sunset Boulevard," or another character in "A Broadway Christmas Carol," Tiny Annie, a fabulous invalid who keeps hoping and crying that she too will come back tomorrow. The sketch closes the mischievous revue with Dickensian delirium.

1991 D 13, C3:4

Martha Swope Associates/Carol Rosegg

From left, Susanne Blakeslee, Herndon Lackey and Michael McGrath in a scene from "Forbidden Christmas."

SUNDAY VIEW

'Nick and Nora' by Way of 'Rashomon'

By DAVID RICHARDS

AFTER SHE DECIDES TO INVESTIGATE THE murder that is the centerpiece of the new musical "Nick and Nora," Nora Charles carries a tiny notebook and gold pen with her at all times so she can jot down the incriminating facts and the telltale details. You would be well advised to do as much if you choose to catch what, as it happens, will be the final performance today. I realize that the scratching of a thousand pens on a thousand pieces of paper may create a distraction in the auditorium of the Marquis Theater. But I don't see how you are going to stay abreast of matters otherwise.

It's 1937 in Hollywood, and Lorraine Bixby, the platinum-blond accountant who's been keeping the ledgers on Tracy Gardner's new motion picture, has just been "aced" in her bungalow. That's clear as can be. However, as the various suspects recount their version of events leading up to the fatal shot (or was it shots?), the

Despite a score and lyrics that could be engaging, the musical's plot thickened — and that was the problem.

musical gives us one contradictory flashback after another.

Recording your own observations, along with Joanna Gleason's strangely giddy Nora, will also give you something constructive to do during those protracted patches when "Nick and Nora," the Broadway show (forget about the mystery), is trying fitfully to lock gears and manufacture a little entertainment. The only original musical scheduled for the Broadway season, it may be closing prematurely, but it's hardly the unmitigated disaster rumormongers had been predicting during the extended preview period. Call it a *mitigated* disaster.

Each flop flops for a precise and individual set of reasons, never to occur again. So there's no lesson to be learned here, no theorem that would prevent future

Sara Krulwich/The New York Times
Asta, as played by Riley—not a suspect

mishaps. Science builds on knowledge acquired in the past. Art doesn't. Every time actors, directors and designers gather in a rehearsal hall, it's back to square one. Something tells me "Nick and Nora" didn't necessarily have to turn out this way, though.

The title characters come from "The Thin Man," Dashiell Hammett's lippy detective novel and the legendary films it inspired. But the particular crime, unfolding over and over on the stage of the Marquis, has been cooked up by Arthur Laurents, who seems to want to teach "Rashomon" a thing or two. As I was going up the aisle, I heard a man ask his wife, "Did you figure out who did it?" "Did I figure out who did *what?*" she replied testily, if understandably. The evening is decidedly more addling than mystifying.

For every spark it throws off, there are the smoldering ashes of an idea gone wrong or the faded outline of an inspiration left unaccountably to languish. It's never quite one step forward, two steps back, which would result in motion, albeit in an unintended direction. "Nick and Nora" consistently takes one step forward and *one* step back — the bad canceling out the good, the boorish defusing the charming, the spiteful negating the witty. Whatever ferment may have been part of its making, the show seems, above all, the product of creative paralysis.

I'm not sure whether the director should have taken the writer more firmly in hand and insisted on an overhaul, or whether the writer should have called the director on his megalomania. But since they are both Mr. Laurents, he would appear to be the culprit here. As the author and/or director of such smash musicals as "Gypsy," "West Side Story" and "La Cage aux Folles," he has a wealth of experience — which only takes him so far. Then it's uncharted territory for him as it would be for anyone else.

Not content to hatch the show's convoluted plot, he has also rethought Nick and Nora's relationship, which, until now, has been based largely on a shared taste for smooth martinis and smart quips. Mr. Laurents wants to put their marriage to the test and make Nora a woman for the 1990's. Consequently, she's eager to take on the case that Nick (Barry Bostwick) would just as soon sit out, jealous of her turf when he eventually tries to help, and bold enough to allow herself a serious flirtation with Victor (Chris Sarandon), the union boss with a white carnation in the lapel of his pin-stripe suit.

If the marital rift were of greater consequence, I suppose it could have served to carry us through the confusions elsewhere and even provided a lift at the end, when Nick and Nora fall into each other's arms and waltz off dreamily into the starry night. But Ms. Gleason seems more flighty than independent — she's allowed a curious quiver to creep into her speaking voice — and Mr. Bostwick's silver-haired charm has a tendency to run to the bland. They are not a natural couple — certainly not one to put a dent in anyone's memories of Myrna Loy and William Powell.

■

Their temporary falling out registers as penny-ante spatting in a show in which everyone has daggers out for everyone else and the kick line in the big production number, "A Busy Night at Lorraine's," takes its duties literally. Two by two, the suspects approach Lorraine's inert body and, without missing an exuberant beat or disturbing the rakish angle of their homburgs, kick the corpse right down to the footlights. Mr. Laurents has no love for Hollywood or the corruption it breeds, but, unlike "City of Angels," this is retaliation on a low level.

If it could just free itself from the nasty goings-on, I have an inkling that the score by Charles Strouse might actually prove rather engaging. The lyrics by Richard Maltby Jr.

aren't half bad either. "Is There Anything Better Than Dancing?," the opening number, is silky and insinuating. Lorraine's jazzy diatribe against "Men" has a lot of fizz, especially as belted out by Faith Prince in a voice that sounds like Minnie Mouse doing an imitation of Ethel Merman. (Ms. Prince, who looks like Jean Harlow doing an imitation of a popular uprising, is wonderful, by the way.) In the show's cursory attempt to acknowledge women's liberation, the man is awarded the torch song, an after-hours lament entitled "Look Who's Alone Now" that rolls with a nice wryness off Mr. Bostwick's tongue.

But the score is forever getting short shrift in "Nick and Nora." The opening number is interrupted by a knock at the door and the arrival of tony Tracy Gardner (a grievously miscast Christine Baranski), bearing more exposition than is healthy for a living character.

Of course, we have to know that Tracy and Nora were chums at the Farmington School for Girls, that Tracy is in a swivet because her career is sagging and that the German director who will re-establish her stardom has been arrested for murder. But do we have to know it all, just as the music is building and Mr. Bostwick and Ms. Gleason are preparing to glide about the premises, like the blissful couple in the poster for ballroom dance lessons?

I'm afraid that's entirely too typical of the show. So much information has to be processed — alibis, charges, countercharges, speculations — that there isn't a whole lot of time for singing and dancing. It's as if musical numbers were a luxury, not to be overindulged in. As it is, they are staged with a minimum of flair by Mr. Laurents and the choreographer Tina Paul. After a while, you can feel a collective strain in the cast members, raring to show what they can do, if only someone would provide them with elbow room and an unconditional opportunity to shake a leg.

■

There are nine viable suspects, if you include the sadistic police lieutenant with a shoe fetish (Michael Lombard), and I saw no reason not to. Each is equipped with a past and a motive. Edward J. Connors (Kip Niven) — the East Coast bootlegger turned banker who's financing his first motion picture (any resemblance to Joseph P. Kennedy Sr. is strictly intentional) — thinks Hollywood is taking him for a ride. Lorraine, his mistress, is cheating on him with one Maria Valdez (Yvette Lawrence), a Latin spitfire angling to become the next Carmen Miranda.

Max Bernheim (Remak Ramsay), the authoritarian director, has been dipping into Connors's books, and getting caught would mean deportation. For her part, Connors's pigeon-breasted wife, Lily (Debra Monk), is determined to protect the family honor, and if rosary beads won't work, maybe bullets will. Oh, the tangled web Mr. Laurents weaves. One of the characters slouching about is even called Spider Malloy.

It would be far easier to dismiss "Nick and Nora," however, if you believed it was wrongheaded from the start. Some musicals — "Carrie," "Shogun" — never should have bothered; they were doomed at their inception. "Nick and Nora" isn't one of them, though. There was considerable potential here — a pair of sophisticated sleuths who have long since laid claim to our affections; a stylish Los Angeles setting at a time when the smog had yet to settle in permanently and the sunsets lived up to the lurid colors in the picture postcards; a murder story, presumably told with a light, bantering touch. Plus Asta, a performing dog.

Well, the set designer Douglas W. Schmidt got the sunsets right, the costumer Theoni V. Aldredge delivered some handsome outfits, and the lighting designer Jules Fisher managed the shimmer in the night sky. But little else seems to have come together, as promised, and the light touch turned out to be leaden. Your heart is bound to sink at the Marquis. What could have been so good is so mediocre. I am unable to vouch for the producers, but I do know Broadway can't afford the waste.

As Lorraine puts it, indignation sharpening the squeak in her vocal cords, "Don't that just kiss ya!"

It do, Lorraine. It do. □

1991 D 15, II:1:1

Joy Solution

Written by Stuart Duckworth; directed by Seth Gordon; set design, Bob Phillips; lighting, Allen D. Hahn; costumes, Martha Bromelmeier; sound, Gayle Jeffery; general manager, Jerry Goehring; production stage manager, Joe McGuire. Presented by Primary Stages Company, Casey Childs, artistic director; Janet Reed, associate artistic director. At the Primary Stage Company, 354 West 45th Street, Manhattan. Through Sunday.
WITH: Daniel Ahearn, Justin Cozier, Leigh Dillon, Anne Newhall and Shareen Powlett.

By D. J. R. BRUCKNER

Whoever billed Stuart Duckworth's new play, "Joy Solution," being presented by Primary Stages, as a comedy has some sense of humor. The title refers to an abortogenic agent given by an abortionist in a motel to one character, who then shudders through cramps, bleeding and vomiting throughout the play. "Joy Solution" is, in the words the character uses about her situation, "a sitcom gone haywire."

The time is the day in 1970 when Ohio National Guardsmen killed student demonstrators at Kent State University. But the place is Detroit. Kent State, a metaphor that remains hidden, is distant news. Steve, a failed actor and drama coach, is invaded at home by his two sisters: Esther, an abused housewife, and Judith, an actress who, after many years away, has returned to Detroit for an abortion.

Judith writhes through the day at Steve's apartment while Esther, whose husband has blackened her eye, goes to a wedding in a downpour. Steve, on acid, hallucinates about many things, including his mother's death. The general hysteria is punctuated by all-too-brief visits from a precocious young black man, Richard, a student of Steve's, and his little sister, Valerie.

Except for Richard and Valerie, there are no comic roles, and there are few funny lines. How could there be? Virtually all the dialogue concerns abortion, closet homosexuality, assisted suicide, battered women and total disillusion.

The cast struggles energetically, and Seth Gordon, the director, tries to keep things moving. But since the action has no clear direction, the effort shows, except in the cases of Daniel Ahearn, who demonstrates real comic gifts as Richard, and 9-year-old Shareen Powlett, who, as Valerie shows that she knows a thing or two about how important timing is to getting a laugh. One ends up wondering how they fell in with such grim company.

1991 D 16, C14:5

The Rose Quartet

By Thomas Cumella; directed by Tee Scatuorchio; sets by Loren Sherman; costumes by Thomas L. Keller; lighting by Dennis Parichy; sound by Stewart Werner and Chuck London; production stage manager, Lori M. Doyle. Presented by Circle Repertory Company, Tanya Berezin, artistic director; Terrence Dwyer, managing director. At 99 Seventh Avenue South, at West Fourth Street, Manhattan.

Rose Brill.....................................Joan Copeland
Helen BrauerRuby Holbrook
Jack Singer..Larry Keith
Lou Gold...................................... Mason Adams

By FRANK RICH

In another era, no Broadway season was complete without one play or musical whose characters worked in the shmata business. Producers knew where some of their most reliable clientele was: on Seventh Avenue, bearing expense accounts. So they perennially served these steady customers such fare as "The Fifth Season," "Seidman and Son" and "I Can Get It for You Wholesale." But that was another theater and another garment industry. Why is the Circle Repertory Company, the Off Broadway home of such playwrights as Lanford Wilson and Craig Lucas, reviving the genre at its most trivial on the eve of 1992?

●

Don't look for answers here. "The Rose Quartet," as the Circle Rep's offering is called, makes no more sense as either commerce or art than did this company's other boulevard play of the year, "The Balcony Scene," which, like this one, told of the mating dance of urban apartment dwellers. This time we watch the heartwarming story of two widows, one a lifetime worker in ladies' hats, who become Upper West Side roommates and try to snare two single male neighbors who are partners in a long-running ribbon business. Were it not for the late-in-the-evening revelation that the two elderly gentlemen are discreetly gay — an off-the-rack effort to be with it — there is nothing in the play that might not have appeared in a bygone vehicle for Menasha Skulnik, Sam Levene or Gertrude Berg. But those stars would have demanded funnier material, even if they had to pay retail.

●

Thomas Cumella, the author of "The Rose Quartet," provides the expected odd-couple disagreements between his two golden girls, the selfish and pursed-lipped Helen (Ruby Holbrook) and the outgoing and giggly Rose (Joan Copeland), as well as the obligatory gags about dentures, a forced comic scene involving a movie

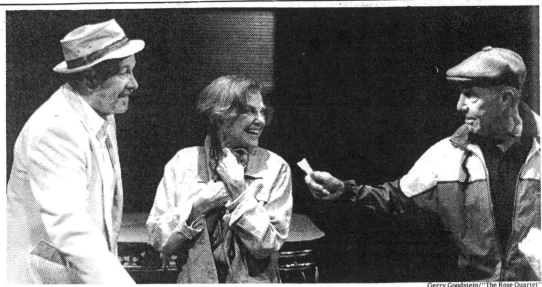

Larry Keith, left, Joan Copeland and Mason Adams in the Circle Repertory Company's "Rose Quartet."

Gerry Goodstein/"The Rose Quartet"

titled "I Dismember Mama" and a joke about colostomies that is so worn that members of the audience were reciting it in sync with the script. There are nostalgic soliloquies about old ethnic New York — Rose tossed matzoh balls out the window on V-J Day — and in Act II, increasing intimations of mortality, precisely timed to match the dimming of Dennis Parichy's lighting on Loren Sherman's setting of an apartment house roof.

The only moment in "The Rose Quartet" that does not seem phony is a brief indirect exchange of verbal intimacy between the two men (Mason Adams and Larry Keith) just before their final exit. This is also the

only moment in the play when the interaction between the characters is dramatized rather than just announced (usually in long monologues). Under the trying circumstances, it would be silly to fault the director, Tee Scatuorchio, or the very hard-working cast. Mr. Adams and Ms. Copeland in particular lavish unflagging energy and good humor on their thankless assignments. For them and the audiences trapped with them at "The Rose Quartet" for the duration of the holiday season, Christmas is going to be a little late this year.

1991 D 18, C23:1

Dance" an appropriately dreamy look, the program has little theatrical cohesion. A perfunctory script by Mr. Ross and Michael Sommers intersperses the songs with dry biographical data and clichéd hyperbole, and the ordering of the songs, especially in Act I, seems haphazard. In the second act, two slide shows illustrate thematic segments recalling Astaire's leading ladies and his inappropriate film appearances as a beer-drinking Middle European.

"I Won't Dance" is the first offering of the first season of the American Cabaret Theater at the Theater at St. Peter's, a series that has the laudable aim of showcasing cabaret performers in a theatrical setting. If the series is to succeed, the music will

need more embellishment than the mixture of slides and polite patter offered by "I Won't Dance."
STEPHEN HOLDEN

Big Noise of '92
Diversions From
the New Depression

Cherry Lane Theater
38 Commerce Street
Manhattan

Set, Ann Davis; costumes, Gregg Barnes; lighting, Douglas O'Flaherty; sound, Serge Ossorguine; wigs, Elizabeth Katherine Carr; choreography, Tony Musco; musical arrangements, Mario Sprouse; assistant producer, Gregg Wilcynski. Presented by Neilan Tyree.
WITH: Mr. Tyree, Mink Stole, Tim Michaels and Tom Kosis. Kit McClure and Her All-Girl Orchestra and Joel Forrester, piano.

For the opening second-act number of "Big Noise of '92," a two-hour variety show subtitled "Diversions From the New Depression," its costars Neilan Tyree and Mink Stole lurch woozily through Noël Coward's "Why Must the Show Go On?" then fret about their weak second act. Never mind the second act; Coward's musical question should have been asked 10 minutes into this vanity showcase for Mr. Tyree, who produced it.

With a big wink, "Big Noise of '92" aspires to be the tackiest variety show ever produced. Assuming that cartoonish ineptitude must be funny, the show loosely stitches together heavily sequined production numbers that lampoon everything from Astaire-Rogers musicals to Carmen Miranda with a hyperkinetic klutziness.

Mr. Tyree bears a passing resemblance to Tommy Tune if Mr. Tune turned into a campy, mugging self-parody. When he isn't baring his teeth, rolling his eyes and flailing his

Theater in Review

■ Seeking to be suave, à la Astaire ■ Trying to be tacky, à la John Waters ■ Going for giggles, à la Yiddish vaudeville, with Fyvush Finkel presiding.

I Won't Dance

American Cabaret Theater
Theater at St. Peter's
619 Lexington Avenue (at 54th Street)
Manhattan

Text by Steve Ross and Michael Sommers; musical arrangements by Walter Harper; additional arrangements by Mr. Ross and Bruno David Casolari; set design by Jean Valente; lighting by Matt Berman; sound by Cynthia Daniels; production supervisor, Mr. Sommers. Presented by American Cabaret Theater, Peter Ligeti, producing director.
WITH: Mr. Ross, Mr. Casolari and Brian Cassier.

Among contemporary cabaret performers who have been inspired by Fred Astaire, none have cultivated the style of Hollywood's greatest song-and-dance man more assiduously than the singer and pianist Steve Ross. And in "I Won't Dance," his evening-length tribute to the star, Mr. Ross, in white tie and tuxedo, looks every inch the debonair society blade

as he and his keyboard partner, Bruno David Casolari, whisk through dual-piano arrangements of some 40 songs associated with Astaire.

Many of those songs, among them "Dancing in the Dark," "Begin the Beguine," "Cheek to Cheek" and "Let's the Face the Music and Dance," are classics. But even those that are not, including several obscurities that illustrate Astaire's limited songwriting talents, are of historical interest.

Where most Astaire acolytes like to emulate his easygoing romanticism, Mr. Ross's take on the star emphasizes high-styled elegance. The arrangements for two pianos have a starchy period formality matched by Mr. Ross's precise elocution. Like Astaire, Mr. Ross has a technically limited voice. What Mr. Ross lacks is the compensatory warmth and rhythmic fluidity that elevated Astaire's conversational singing into the transcendent vocal equivalent of his dancing.

Although Jean Valente's handsome Art Deco set design gives "I Won't

William Gibson/Martha Swope Associates/"Finkel's Follies"

Fyvush Finkel, center, with Laura Turnbull, left, Avi Ber Hoffman and Mary Ellen Ashley in a scene from "Finkel's Follies."

arms, he talks and sings in a seasick monotone that occasionally echoes Tallulah Bankhead. Ms. Stole, who is a veteran of several John Waters films, is not much better.

The "special guest stars" include a mediocre belly dancer, a passable magician and two ambulatory black-and-white striped barber poles (or are they buoys?) that lumber onto the stage, bow clumsily and exit. Musical accompaniment is provided by the saxophonist Kit McClure and her All-Woman Orchestra.
STEPHEN HOLDEN

Finkel's Follies

John Houseman Theater
450 West 42d Street
Manhattan

Conceived by Fyvush Finkel; adapted and directed by Robert H. Livingston; music by Elliot Finkel; lyrics by Phillip Namanworth; scenery and costumes, Mimi Maxmen; lighting, Bob Bessoir; musical director, Mike Huffman; production stage manager, Robert Lemieux; Presented by Eric Krebs. WITH: Mr. Finkel, Mary Ellen Ashley, Laura Turnbull and Avi Ber Hoffman.

Fyvush Finkel has a face that could launch a thousand shticks.

His cheeks are two stout doormen flanking the long sloping awning of his nose. His darting eyes can illuminate or annihilate. With a quick change of hats, he can be a quackish doctor or a peacockish cantor or a Jewish Count Dracula. "Boy, has she got the wrong vampire," he says, when a woman tries to fend him off with a cross.

All of which makes him indispensable for "Finkel's Follies," a merry valentine to Yiddish vaudeville acted in English peppered with Yiddish.

Between the 1920's and the 1950's, there were two Yiddish vaudeville houses on the Lower East Side, and many of their timeless, schmaltzy routines are here. Like the doctor who tells a woman complaining that her arm hurts in two places, "Don't go to those places." Or the waiter who scolds a customer griping about a filthy napkin: "Eleven people used that napkin. You're the only one who complained!" Knowing the jokes beforehand enlarges the pleasure of watching Mr. Finkel pull them off.

The comic sketches work far better than the cast's efforts at recapturing the more rueful sentiments of immigrant life. "The Shawl," an attempt to copy Molly Picon's evocation of a woman's struggles, just didn't squeeze the requisite tear. The Yiddish standards like "Joseph, Joseph" are best sung unadorned. But, overall, the spritely cast, topped by Avi Ber Hoffman, and a lively band allow Mr. Finkel to deftly operate on the audience's funny bones.

When the jokes are bad, Mr. Finkel knows, and his exasperated expressions make even those funny. And when he reprised Menasha Skulnick's classic "Not on the Top," Mr. Finkel had the whole audience singing along.
JOSEPH BERGER

1991 D 18, C25:1

A Christmas Carol

By Charles Dickens; adapted by Patrick Stewart; lighting by Fred Allen. Presented by Timothy Childs. At the Eugene O'Neill Theater, 230 West 49th Street, Manhattan.
WITH: Mr. Stewart.

By MEL GUSSOW

"A Christmas Carol" has been so musicalized and cinematized that it may be difficult to remember the beautiful simplicity of the original Dickens story, an ode to Christmas past, present and future and a moral fable of heartwarming intensity. Patrick Stewart's one-man dramatic version at the Eugene O'Neill Theater is restorative, revealing the work's full narrative splendor, its humor as well as its humanity.

Because of Mr. Stewart's virtuosity, the show could be considered a coda to the Royal Shakespeare Company's "Life and Adventures of Nicholas Nickleby." The actor offers his solo equivalent of that expansive ensemble act of the imagination, making an audience believe it has entered a magical world dense with character, atmosphere and action.

For those who think of Mr. Stewart principally as Jean-Luc Picard on television's "Star Trek: The Next Generation," it must be said that before he captained the starship Enterprise he was a stellar member of the Royal Shakespeare Company. He was brilliant in roles as varied as Enobarbus in Peter Brook's production of "Antony and Cleopatra" and Shylock at Stratford-on-Avon.

His supple look and voice enable him to portray the widest range of Dickens characters without altering his costume or makeup. Classically trained, he has the verbal dexterity of Ian McKellen. All this is combined with his own delectation in performance. In this show, that performance is both Dickensian and Shakespearean, savoring each role as well as the lush descriptive language and, whenever possible, re-creating dramatic encounters.

•

The large stage is bare except for several pieces of utilitarian furniture. Informally dressed, Mr. Stewart makes a casual entrance and holds a book — presumably the text of his performance — over his head like a

Alone on a stage, an actor re-creates the entire world of a Dickens classic.

beacon. Then he runs with "A Christmas Carol," in his own careful two-hour distillation of the story. Although the reading would be even more congenial in a smaller theater, he easily fills a Broadway stage.

All of the essentials are in place, with the accent on the juxtaposition of despair and joyfulness. At the center, of course, is that "squeezing, wrenching, grasping, scraping, clutching, covetous old sinner," Ebenezer Scrooge. Mr. Stewart allows for no softening around the edges, in either the character or the story, yet he does not make Scrooge into a caricatured villain.

From his initial appearance in the frigid offices of Scrooge & Marley, there is a feeling that his self-containment is also an evasion, that he has buried a side of his personality. Acting as narrator, Mr. Stewart says,

"Darkness is cheap — and Scrooge liked it," and he shows us how the man's emotional life was as dim as the embers in his hearth.

As Scrooge is returned to his past and then recalled to life, Mr. Stewart plays all the roles (including a merry crowd of dancing Fezziwigs) as well as imitating sounds like chiming clocks and bells. He mimes the props and the scenic effects, simulating the wind on the streets and the echoes in Scrooge's solitary chamber. As called for, he is cheerful, sepulchral, childlike and feminine, as well as stout-hearted when it comes to Bob Cratchit.

The Cratchit Christmas dinner, in which the actor portrays the entire family, Scrooge and the Ghost of Christmas Present, and is also on the verge of impersonating the goose on the table and the Christmas pudding with holly stuck into the top, is a tour de force. It reminds us not only of what an inventive actor he is, but also of Dickens's own great theatricality.

Seeing the actor in this show is the closest we can come to Dickens in his public performances, in which he also dominated a bare stage with his talent and his zest for his subject. At the end of Mr. Stewart's eloquent "Christmas Carol," one wishes he would move on to "The Cricket on the Hearth" and other Dickensian treasures.

1991 D 20, C3:1

Critic's Choice

A Neapolitan Expression Of Bethlehem

A Neapolitan Christmas, as we think the 17th century expe-

rienced it, is being rethought at a Manhattan theater called Home three times this weekend: at 8 tonight and tomorrow nights and at 3 P.M. on Sunday.

The result is an update of an old tradition and constitutes what we today would call a mixed-media event: music, dance, masks and puppets. Together they blend the fears and ecstasies of the Christian experience with the comic gestures of commedia dell'arte. The show itself is done in Italian, but with the help of English narrations and printed programs, everyone should understand.

Called "La Cantata dei Pastori," the presentation derives from the 17th-century writer Andrea Perrucci and has been performed annually in Naples for centuries. In New York, the group called I Giullari di Piazza (Jesters of the Square) has been maintaining the tradition since 1983.

The setting is the journey of Mary and Joseph to Bethlehem. The Devil has dispatched demons to prevent the birth of Jesus. Hell in all its medieval fury is revealed, also the encounter between the Archangel Gabriel and Satan in the form of a dragon.

Home is at 44 Walker Street, near Broadway and Church Street. Tickets are $14; $7 for students and the elderly. Information: (212) 431-7434.
BERNARD HOLLAND

1991 D 20, C29:1

Into the Woods, Where Passions Lurk

The large cast in 'The Crucible' holds out a promise.

'Mad Forest' invokes tyranny's collar alongside freedom's chaos.

I CAN EASILY TELL YOU WHAT thrilled me most about "The Crucible," the inaugural production of the National Actors Theater: seeing 21 actors lined up in a semicircle on the stage of the Belasco Theater for the curtain call.

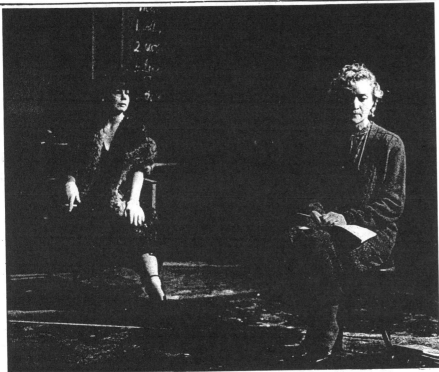

Martha Swope/"Mad Forest"

Randy Danson, left, and Mary Shultz in Caryl Churchill's "Mad Forest"— a defiantly theatrical experience, much of it wildly surrealistic without even trying.

That's what it takes to put on Arthur Miller's play, 21 actors of varying ages, shapes and dispositions. Of course, we never get them all at once in the course of the evening. They come and go, as the drama dictates, driven by the winds of hysteria blowing through Salem, Mass., in 1692.

The only time they do come together is after the hysteria has taken its toll. The young girls, who have been spotting witches in the floorboards and the treetops, have finally been discredited, although not before Mr. Miller's hero, John Proctor, has chosen death on the gallows and his good name over life and a politically expedient confession. Then, there they are, side by side, 21 actors holding hands, bowing and smiling with the particular blend of pride and sheepishness that you often find in people when they're being publicly congratulated.

■

A cast that size is all but unheard of on Broadway these days, unless you're dealing with a musical. The chorus line of "The Will Rogers Follies" may go on and on and on. (Actually, there are 16 New Ziegfeld Girls on tap. I just checked.) And at times, it looks as if "Les Misérables" has chosen to put to work all the able-bodied inhabitants of a Parisian arrondissement. But plays are another matter. They're subject to stricter and stricter population control. Consider some recent Broadway entries: "Shadowlands" had a cast of 10; "I Hate Hamlet," 6; "The Speed of Darkness," 5. "Lost in Yonkers" carries on with 7, although when she was still starring in it, Irene Worth was forceful enough to count for 2.

If the small-cast play has become more or less the rule on Broadway, it is very much the exception in the history of the theater. So there's a reason for the bodies on the stage of the Belasco that goes beyond the immediate demands of Mr. Miller's play. You can't have a repertory company devoted to the classics without lots of actors. The National Actors Theater, which hopes to be that company, is not starting out big. It is starting out realistic.

It is also, regrettably, starting out dull. Only Fritz Weaver manages to rise above the deadly earnestness that the Israeli director Yossi Yzraely has brought to the production. As Deputy-Governor Danforth, Mr. Weaver is in charge of the witch hunt, and if fanaticism makes him dangerous, egotism makes him formidable. Draped in billowing burgundy robes, the hollows of his face set off by a powder-white beard, he could be an Old Testament prophet announcing glad tidings. But his nose, large and sharp, suggests the beak of a rapacious bird, and his eyes burn with a feverish righteousness.

When he speaks, it is with a deceptive resonance that enfolds the accused in understanding. Reason will prevail, it seems to promise, in these difficult times. Then his patience snaps, a blazing fury grips him, adding to his already imposing stature, and the resonance that was so reassuring is suddenly like an ominous roll of thunder. With each striding entrance, Mr. Weaver rouses the production to life, and each time he exits, it tumbles back into a leaden gravity.

"The Crucible" was written partly as a rebuke of the House Un-American Activities Committee, which in the early 1950's had the nation momentarily believing in a Red menace by flushing Communists out of nooks and crannies, where, more often than not, there were none. For all the rightness of its moral stance, though, the play emits an air of sanctimony which, if not checked, can lead to the bloat of self-importance. Mr. Yzraely, checking nothing, goes for momentousness. It is a fatal miscalculation.

No sooner has the curtain gone up on David Jenkins's set — a clearing in the woods — than the ending is a foregone conclusion There's no foliage anywhere, just huge tree trunks, rising up like so many gnarled prison bars and filtering out any light that might dispel the hobgoblins. This isn't Salem, it's some kingdom of gloom. The death sentence has already been signed and sealed and remains only to be delivered. Pleading will be for naught; protests futile.

From a theatrical standpoint, that's going at it backward. The way you make "The Crucible" work, it seems to me, is to insist first on its homeliness. The zealotry can fend for itself with no encouragement. But if we have no sense of ordinary lives to begin with, the horror of ordinary lives destroyed is greatly minimized. At the center of this production, where John Proctor usually stands — strong,

Joan Marcus/"The Crucible"

"Crucible" cast members include, from left, Michael York, Maryann Plunkett, Fritz Weaver, Martha Scott, Martin Sheen and Patrick Tull—21 and counting.

decent, plain speaking — there's a void. As Martin Sheen plays him — or doesn't play him — the character emerges as a pasty-white, vaguely porcine nobody, with a whiny voice that is forever giving out mid-sentence. Hardly the salt of the Puritan earth.

Maryann Plunkett is properly cold and sullen as his wife, but shouldn't we feel the stubborn tug of a buried love there? Michael York, on the other hand, seems to have stepped out of a Three Musketeers film. He's all flourish and grandiloquence as the Rev. John Hale, who starts out clamoring for hangings but comes to see the folly of his demands. Mr. York's idea of repentance is to indulge in a round of good old-fashioned breast-beating. As for Madeleine Potter, briefly Proctor's mistress, she is not so much a young girl scorned as a Greek Fury unchained. Far too many performances are out of sync for me not to think that Mr. Yzraely is at fault. He obviously intends for this production to make a Big Statement; but he ignores the minutiae, out of which big statements are necessarily built.

One production, of course, does not a repertory company make (or break). It generally takes a while for actors to develop the trust in one another that is a condition of their creativity; for directors to learn which casting combinations are explosive and which ones aren't; for collective strengths to make themselves felt and individual weaknesses to be remedied. Undeniably, a huge amount of work lies ahead. The National Actors Theater may have a manifesto, but, as yet, it has no personality. It has a founder and artistic director, the actor Tony Randall, but time alone will tell if he's a visionary.

What I find encouraging are those 21 bodies. On the stage, as elsewhere, there may be no safety in numbers. But there are theatrical possibilities. We probably ought to see a few more of them before we decide whether the fledgling company is entertaining legitimate ambitions or just dreaming pie-in-the-sky dreams.

'Mad Forest'

If you want to see an impressive acting ensemble right now — not two months or two productions from now — then you should hasten to the New York Theater Workshop at the Perry Street Theater Off Broadway, where 11 persuasive young performers are making "Mad Forest" an intensely vivid experience. Caryl Churchill's play is a triptych about life in Romania before, during and after the demonstrations of December 1989 that toppled the ruthless dictator Nicolae Ceausescu and his no less ruthless wife, Elena. Yes, the evening is often as grim as it sounds. And no, that's not a reason to stay away. What a defiantly theatrical experience you'd be missing if you did.

Early in 1990, Ms. Churchill, one of Britain's more politically minded dramatists, the British director Mark Wing-Davey and a handful of students from the London Central School of Speech and Drama visited Romania to talk with their counterparts and perhaps uncover the raw materials of a play. What they seem to have found is that post-revolutionary life there is no better than the pre-revolutionary variety. A different kind of insanity prevails, that's all. Ms. Churchill distilled the findings into

the several dozen brief scenes — some almost wordless — that constitute the first and third acts of the play. The middle act is derived from the first-person testimony of actual Romanians, who recount what they were doing on the fateful days of Dec. 20-23 — thereby providing us with the common man's view of revolution.

Acts I and III loosely follow the interrelated fortunes of two families — the proletarian Vladus and the white-collar Antonescus. While Ceausescu is still in power, they have to deal with terrible food shortages and queues everywhere, and no one doubts that Big Brother is listening round the clock. The characters have learned to cope, however, even if it means turning up the radio so loud that conversation is impossible to overhear. Sometimes, nothing is said, a knowing look or the surreptitious exchange of bank notes supplanting speech. Other times, what is said is the exact opposite of what is meant. But you quickly gather that the beleaguered citizens have evolved ways to outwit repression.

In Act III, the Ceausescus are gone — and their benevolently smiling portraits with them. If their tyranny was despicable, though, it was dependable. Take it away and a terrible chaos ensues. The characters in "Mad Forest" exult in the crumbling of the dictatorship, only to fall into a morass of confusion and uncertainty that has them, at one point, wondering if the revolution itself wasn't just another diabolical scheme of the powers that be. Under Ceausescu, you could at least pull strings, grease a few paws. Not so in the disorder of the

'Mad Forest' is a defiantly theatrical experience in which what is said can mean its very opposite.

new government. As one schoolteacher, about to lose her job, complains desperately, "We don't know who we know."

The official history, which celebrated Ceausescu as "founder of the country ... more, founder of man," was pure poppycock. But the characters' understanding of events that happened under their very noses is so muddled, so speculative, that they end up having no history. Before, they dared to say little. After, they can't argue enough. The play concludes with a wedding, presumably uniting the two families, but the celebration turns into such a melee that the services of a fight director (David Leong) have been enlisted to keep the actors from going through the walls.

■

Much of this is wildly surrealistic without even trying. But Ms. Churchill, who also has a macabre sense of fantasy, introduces elegant vampire, medieval angel and starving dog into the mix, and Mr. Wing-Davey, who combines the instincts of the painter with those of the photojournalist, has staged it with a sharp-edged clarity. By relying on a few well-chosen details to represent the whole picture, Mr. Wing-Davey, along with the set and costume designer Marina Draghici and the lighting designer Christopher Akerlind, turns the tiny Perry Street Theater into a desolate apartment one minute, a menacing street the next and a forlorn hospital ward not long after that.

The actors, playing multiple roles, are similarly selective — invariably evoking a complete person with a gesture or an intonation. Sometimes, it's simply how they smoke (and everyone smokes) that's the giveaway. To cite Randy Danson over Jake Weber, or single out Calista Flockhart and not Lanny Flaherty, or praise Mary Mara more than Mary Shultz is to indulge in meaningless favoritism. Individually and collectively all 11 are superb.

It isn't entirely coincidental that Ms. Churchill views Romania today as a mad forest, and that the National Actors Theater actually chose a forest as the setting for Mr. Miller's drama. Both plays are about societies made crazy by power and persecution. Dark woods naturally come to mind. The difference is this: in the grandiose production at the Belasco, you can't see the trees for the forest, but at the Perry Street Theater, even the tiniest bramble catches your eye. □

1991 D 22, II:5:1

Raft of the Medusa

By Joe Pintauro; directed by Sal Trapani; scenery by Phillip Baldwin; costumes by Laura Crow; lighting by Dennis Parichy and Mal Sturchio; sound by Chuck London; production stage manager, Marjorie Horne. Presented by Peggy Hill Rosenkranz. At Minetta Lane Theater, 18 Minetta Lane.

WITH: Robert Alexander, Annie Corley, Brenda Denmark, William Fichtner, Dan Futterman, Robert Jimenez, Steven Keats, David Louden, Bruce McCarty, Reggie Montgomery, Patrick Quinn, Abigael Sanders and Cliff Weissman.

By MEL GUSSOW

In Théodore Géricault's painting "The Raft of the Medusa" survivors of a shipwreck cling to a raft that is crowded with those who are dead or dying. The painting is an apt metaphor for those who have been struck by AIDS. The difference, as expressed in Joe Pintauro's play "Raft of the Medusa," is that the survivors will also succumb.

The play, which opened last night at the Minetta Lane Theater, is a comprehensive examination of the effects of AIDS on a cross section of the urban population and how the less sick become the caretakers of those who are in more imminent jeopardy.

Because of the author's slice-of-life approach and his shorthand techniques of characterization, "Raft of the Medusa" has its manipulative aspects. It does not have the direct emotional impact of works like "The

Survivors, a playwright contends, will also succumb.

Normal Heart" and "As Is." In trying to do too much in too little time, it veers into sermonizing. But the play is informative and has its primary value as an instrument of social awareness about AIDS issues.

●

In the opening scene, one victim dies and in an evocation of the Géricault painting, the patient's hospital bed is carried off the stage as if it were a boat capsized in a storm. In the succeeding 90 minutes, we encounter a dozen people in a P.W.A., or People With AIDS, group-therapy session led by a psychiatrist (Steven Keats). The members of the group contracted AIDS in a diversity of ways; they include heterosexuals who are outraged that they have been infected with what they consider to be exclusively a gay disease.

Under the direction of Sal Trapani, the session is heated. Charges are followed by countercharges, as people bare their bitterness and their fright, if not their souls, as announced in the play. Not all the characters are able to clarify themselves, but with the help of the actors many of them achieve an immediacy on stage.

This is the case with Robert Alexander as a sweet-tempered model whose brain has been assaulted by illness; Annie Corley as a heterosexual fired with resentment at what she thinks of as her entrapment; Reggie Montgomery, who more than most is able to relate to the problems of others, and Brenda Denmark as a deaf drug addict whose family has been decimated. Ms. Denmark's character speaks to the psychiatrist through sign language. The play is at its most effective with characters like these, when Mr. Pintauro allows them to unveil themselves through their actions.

●

At one point, a wealthy newcomer to the group reluctantly admits to his illness and then announces that he plans to go to Amsterdam to seek euthanasia. The mention of foreign flight sets the others off into wistful dreams and songs, of travels remembered and others never to be taken. As one song overlaps another, the music becomes louder and more cacophonous, rising like waves against a sinking ship.

Marooned Patrick Quinn appears in "Raft of the Medusa," a drama by Joe Pintauro, about a group of young people struggling to survive in the age of AIDS.

Tom McGovern/"Raft of the Medusa"

The desperation in that singing, the need to confront the fact that each of the people in the play will have a-drastically curtailed life momentari-ly lifts the work to a more resonant plane. "Raft of the Medusa" becomes a microcosmic crisis clinic, airing aspects of a tragedy and entreating the audience into an act of empathy.

1991 D 23, C15:1

The Don Juan and the Non Don Juan

Book by James Milton; based on the writings of Marvin Cohen; lyrics by Mr. Milton and David Goldstein; music by Neil Radisch; directed by Evan Yionoulis; scenic design by William Barclay; lighting design by A.C. Hickox; costume design by Teresa Snider-Stein; production stage manager, Renee Lutz; musical supervisor, Jan Rosenberg; musical director, Dale Rieling. Presented by Vineyard Theater, Douglas Aibel, artistic director; Barbara Zinn Krieger, executive director; Jon Nakagawa, managing director. At the Vineyard Theater, 309 East 26th Street.

WITH: Joseph Adams, Monica Carr, Vicki Lewis, Karen Mason and Polly Pen.

By MEL GUSSOW

Updating and Americanizing the Don Juan story, three collaborators have created a prosaic chamber musical. The title of the show at the Vineyard Theater is "The Don Juan and the Non Don Juan," and for all the forced effusiveness in evidence on this minuscule stage, the musical is about as animated as that Stone Guest who dines with the Don Juan of legend.

The notion behind James Milton's book is that the activity in an exceedingly insular New York social scene centers around two single men with opposite temperaments: Tom Gervasi, who is the idol of all womanhood, and Al Lehman, the essence of ineptitude in all attempted liaisons.

The twist is that both characters are played by the same actor, Joseph Adams. For unpersuasive reasons, Tom as well as Al seeks the other's advice on how to change his romantic tune. Though Mr. Adams has a pleasant singing voice, the doubling is far from a transformation. His Al is Tom, slouching. In neither role does he have that extra edge of charm or zaniness that would provoke the women to have such strong feelings about him.

Around Mr. Adams are clustered four actresses, Vicki Lewis, Polly Pen, Monica Carr and Karen Mason, playing the many women in his orbit. Each is a strong singer, but only Ms. Lewis has a chance for acting diversi-

fication, and that is by also playing a baby boy. The staging by Evan Yionoulis is of the playroom, jack-in-the-box variety, with people frequently shifting modular blocks and popping in and out of convenient doors. There is one inexplicable element in the setting: newspapers are printed on yellow paper.

•

All of the women are equally aggressive and dressed in black. In this age of female assertiveness, they seem out of step with their time, allied in their eagerness to submit themselves to male domination. Abandonment leads one of them to kill herself by taking rat poison, a box of which plays a crucial role in the resolution. In spite of such macabre touches, the musical is intended to be lighthearted and even whimsical.

Mr. Milton's cluttered book is tied to lyrics (written by him and David

> Four aggressive women, dressed in black and eager to be dominated.

Goldstein) that are so insistently rhymed as to become doggerel ("Al, pal, banal"). Neil Radisch's music is the sturdiest part of the show. There is a single clever song, which deals with the seemingly peripheral question of divorce. Some of the others reprise familiar motifs. "Sweeney Todd" is evoked when a character sings about a "big empty hole in the middle of my soul," in context a very pretentious sentiment.

The show's banalities are in stark contrast to so many other adaptations of the story, from Molière to Mozart and including "The Last Days of Don Juan," the imaginative Tirsa de Molina variation recently presented at the Royal Shakespeare Company. In a final self-defeating note, the Vineyard version closes by referring to the doomed lover as Tom Giovanni and Don Gervasi, "one more Don Juan who's gone to Hell." That is, one might say, a moment of musical truth.

1991 D 23, C16:1

Cinderella

By Norman Robbins; directed by Laura Fine; music composed and arranged by Dan Levy; lyrics by Amy Powers and Mr. Levy; set design by Harry Feiner; costume design by Gail Baldoni; lighting design by Stephen Petrilli; production stage manager, Paula Gray. Presented by Riverside Shakespeare Company, Gus Kaikkonen, artistic director; Stephen Vetrano, managing director. At Playhouse 91, 316 East 91st Street.

WITH: John Keene Bolton, Diane Ciesla, Lora Lee Cliff, Jim Fitzpatrick, Pat Flick, Mark Honan, Robert Mooney, Anthony Stanton, Fredi Walker, Melanie Wingert and Jay Brian Winnick.

By D. J. R. BRUCKNER

Genial rowdiness presides over the Riverside Shakespeare Company's production of "Cinderella" at Playhouse 91, and a very cheerful spirit it is. This version of the tale, written by Norman Robbins and directed by Laura Fine, is modeled on the British music hall pantomimes, and while it does not collapse into mayhem as often as those rude riots do it does leave one with the satisfying feeling of having ridden a very fast merry-go-round wobbling out of control.

The names indicate the attitude: the heroine is called Cinders, her bad stepmother is Baroness Hardupp (first name, Medusa), the lumpish stepsisters are Asphyxia and Euthanasia, a couple of town louts are Ammer and Tongs and Prince Charming's equerry is Dandini.

Amy Powers and Dan Levy have written snappy, if not always inspired, lyrics and Mr. Levy's score is most pleasant when he is committing outrages on old masters, notably Bizet and Handel. The opening number of Act II, "Waitin' on the Women," *is* inspired: a nifty vocal sextet that merrily ridicules old-time sexism and ends with the singers mimicking their way through a little coda of strings and a muted cornet.

•

Cinders (Melanie Wingert) captivates not only the prince, but a likable yokel named Buttons (Mark Honan). It's a nice touch, but her resolution of this conflict may not be convincing. Also, since Anthony Stanton's Prince Charming is a kind of beautiful lame-brain, the romance might be even funnier if Ms. Wingert put a little more bite into her virtuous character.

Diane Ciesla as the stepmother holds the plot together every time it threatens to unravel. The audience loves to hiss her, and she loves to be hissed (her over-the-shoulder glances in response to this steamy disapproval are positively lascivious). Robert Mooney, all round and raspy, and John Keene Bolton, towering and bony, are more raucous than campy as Asphyxia and Euthanasia, and always very funny. Mr. Bolton's tap dance at the prince's ball puts one in mind of a redwood in a frenzy.

Lora Lee Cliff's Fairy Godmother is a perpetually surprised Southern belle who puts down discord with magic and laughter that is all molasses, and Fredi Walker as Dandini has so much exuberant energy she makes one think she keeps this whole dizzy carousel spinning by the touch of her fingertip.

With occasional encouragement from Mr. Honan's Buttons, the audience expands its role from hissing to bird calls, singing and even a little back talk and ends up applauding itself along with the paid performers.

1991 D 23, C16:4

Dearly Departed

By David Bottrell and Jessie Jones; directed by Gloria Muzio; sets by Allen Moyer; lighting by Don Holder; costumes by Ellen McCartney; sound by Mark Bennett; hair by Antonio Soddu; production manager, Carol Fishman; production stage manager, Stacey Fleischer; stage manager, Robert L. Young. Presented by Second Stage Theater, Robyn Goodman and Carole Rothman, artistic directors. At Second Stage, 2162 Broadway, at 76th Street.

Bud and Ray-BudLeo Burmester
Raynelle.................................Mary Fogarty
Marguerite..............................Sloane Shelton
Royce....................................Greg Germann
LucilleJessie Jones
JuniorDylan Baker
Suzanne..................................Linda Cook
Reverend Hooker, Norval and Clyde
....................................J. R. Horne
Delightful and Nadine............Wendy Lawless
The Joy of Life Singers
Ms. Fogarty, Jill Larson and Ms. Shelton
Veda and Juanita............................Ms. Larson

By MEL GUSSOW

"Dearly Departed," a comedy about a death in a Southern family, leaves one with a double dose of déjà vu. Theatergoers have been down this trail before in plays by Beth Henley and others. The play by David Bottrell and Jessie Jones earns a few smiles, but it is simply not funny enough to justify its two-hour running time or its place at Second Stage.

In the first scene, Uncle Bud suddenly keels over dead. What ensues in his wake is a raucous, backbiting gathering of his many relatives to play their last disrespects to the old codger. The minister practices his flowery eulogy, then asks the widow (Mary Fogarty) what kind of man her husband was. With calm self-assurance deriving from decades of marital misery, she says, "Mean and surly." Those are the words she wants engraved on Bud's tombstone, although her son opts for an ameliorative "Rest in peace."

Hardly anyone else in the Turpin family is willing to forgive the past. Marriages are threatened, fraternal envies arise, and the play goes on and on. After seemingly running out of fuel (and funereal jokes), it momentarily sputters to life with some outlandish digressions, including a minor, very fecund character who gives her offspring names like Zsa Zsa, Oprah and Geraldo because in her eyes each is a star. Other gags are run into the ground; for reasons not worth explaining, the deceased is buried wearing ballet slippers.

The show is kept breathing by its cast, hard at work under the direction of Gloria Muzio. Allied in the effort are several experts in the good ol' boy school of comedy, beginning with Leo Burmester, who has perfected his bumptious blowhard character in shows like "Lone Star" and "Big River." In "Dearly Departed," he plays both the departed, Bud, and his son, Ray-Bud. Even without the lines to sustain him, Mr. Burmester is a man worn to a comic frazzle.

Ray-Bud's no-account younger brother, who has invented a machine to clean parking lots, is dryly played by Dylan Baker, and there is comic support from Ms. Fogarty, Sloane Shelton, Greg Germann, J. R. Horne and the co-author, Ms. Jones, who appears as one of the bereaved daughters-in-law.

In the course of the play, an over-weight young woman named Delightful stuffs her mouth with Ruffles, everyone eats a corn dog and the plot turns on a fond memory of drinking

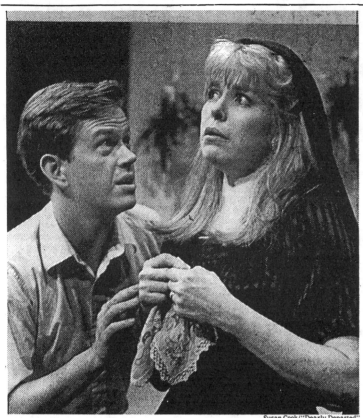

Susan Cook/"Dearly Departed"

Dylan Baker, left, and Linda Cook in "Dearly Departed."

If anyone is slightly shortchanged here it is Cyndi B. Galloway-O'Connor as the wife and mother who saves the family from itself. She's impressive and wise, but in a house full of nuts she seems just a little remote. But Mr. Roquemore ties this bundle of laughs together with rap, some of it very funny, and Ms. Galloway-O'Connor gets her moment when the mother puts her youngest son down with a delicious takeoff on one of his rap songs.

1991 D 26, C13:1

Theater/1991

BY FRANK RICH

Throw Away Those Scripts. Some of the Greatest Moments Were Wordless.

Great Theater Without Words I In Brian Friel's "Dancing at Lughnasa," five unmarried sisters in the County Donegal, Ireland, of August 1936 momentarily escape poverty, drudgery and despair with a spontaneous dance to the pagan music blaring forth from their new Marconi wireless.

Great Theater Without Words II In Jon Robin Baitz's "Substance of Fire," Ron Rifkin plays a modern King Lear of Gramercy Park — an elitist New York book publisher and embittered Jewish father — who tries to eradicate a lifetime of crippling rage by setting fire to a postcard painted by Adolf Hitler.

Great Theater Without Words III Nathan Lane, Christine Baranski, Anthony Heald and Swoosie Kurtz test the waters of a Fire Island swimming pool whose owner died of AIDS in Terrence McNally's "Lips Together, Teeth Apart."

Great Theater Without Words IV A compact mirror bounces a shower of healing light against the glass wall of a sickroom in Scott McPherson's "Marvin's Room."

Too Many Words The imaginatively staged "La Bête," a comedy attacking the cynicism of craven popular entertainers and the stupidity of their audiences, was written entirely in rhymed couplets, lest anyone confuse its author (David Hirson) with hoi polloi.

Immortal Words After the Clarence Thomas hearings, a reference to "pubic hair" turned up in "Park Your Car in Harvard Yard," while excerpts from the hearings were played in the New York Shakespeare Festival production of Shakespeare's "Pericles."

Wordless Drama Critic Nicol Williamson, who strolled offstage during the scenes that bored him in Paul Rudnick's high-spirited comedy about the over-the-top ghost of John Barrymore, "I Hate Hamlet."

Never Met a White Man I Didn't Like "The Will Rogers Follies," a musical whose democratic hero champions the poor and downtrodden in an Act II sermon, opened without a single black performer in its large cast.

grape slush. But there is barely enough junk food, to say nothing of protein, to nourish a half-hour sitcom.

Cut to the funnybone, "Dearly Departed" might suffice as an idea for an episode of "Evening Shade," but it would need a firmer sense of pace. As it is, the play wobbles and weaves, telegraphs twists and wanders shamelessly to its shaggy destination.

1991 D 24, C11:1

Lotto
Experience the Dream

Written and directed by Cliff Roquemore; sets and costumes by Felix E. Cochren; lighting, William H. Grant; production stage manager, Avan. Presented by the Billie Holiday Theater, Marjorie Moon, producer. At Billie Holiday Theater, 1368 Fulton Avenue, Bedford-Stuyvesant, Brooklyn.

WITH: Steve Baumer, John L. Bennett, Karl Calhoun, Elise C. Chance, Earl Fields Jr., Maurice Fontane, Bridget Kelso, Frederick Kiah Jr., Cyndi B. Galloway-O'Connor, Bryan Roquemore, Jessica Smith and Otis Young Smith.

By D. J. R. BRUCKNER

Every situation in Cliff Roquemore's "Lotto: Experience the Dream," at the Billie Holiday Theater in Bedford-Stuyvesant, Brooklyn, is familiar, and virtually every line could be picked out of the air from any week's television fare. But surprisingly, it all works quite well; laughter builds until, at the end of two hours, the audience is shouting.

Mr. Roquemore, who is directing his own work, is an old hand at movies, television and theater, and very smooth. He creates the impression that he simply got together a first-rate scenic designer, Felix E. Cochren, with an exuberant group of actors, told them to clown around and

then wrote around them. That illusion draws in the audience and makes it much more receptive to all the old comic tricks that make up the play.

The title tells the story. A middle-aged water department worker in Los Angeles wins $10 million in the lottery with numbers that came to his sister in a dream. The money not only changes him and his friends, but also his sister, his sons and daughter and their friends, everyone but his wife, who in the end saves all the others from their own folly.

What happens scarcely matters in this piece; the characters are everything. Earl Fields Jr., as the lucky water worker, suffers wonderful frustrations as he tries to assert authority over grown children who have never heard of control. Maurice Fontane as his friend Lester would be a stock comic relief character except that Mr. Fontane has a way with repartee that always makes any character he plays seem like a disguised spirit dropped on earth by a benign divinity to make people laugh at their own misfortunes.

Bryan Roquemore as the oldest son is a lazy dreamer constantly tripping over his own schemes as he keeps his gaze fixed on pie in the sky. Karl Calhoun as his teen-age brother is a fine bundle of rap, raunch, resentment and ridicule who is baffled by the world, his family and his own feelings. Elise Chance as their sister seems far too sane to belong to the same brood, until her own sense of superiority makes her ridiculous.

By far the most uproarious member of this disaster-prone clan is Aunt Mildred, played by Jessica Smith. Ms. Smith has a voice that outwails fire engine sirens, dance steps that give one a whole new insight into, and respect for, cantilever construction and a comic gift that lets her turn her character's physical disabilities into hilarious burdens on those around her.

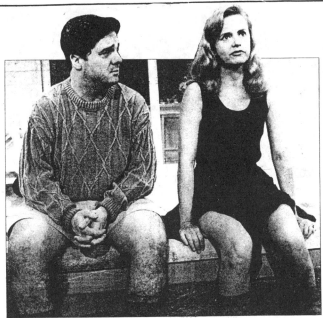

Gerry Goodstein/"Lips Together, Teeth Apart"

Nathan Lane and Swoosie Kurtz in "Lips Together, Teeth Apart".

Sara Krulwich/The New York Times

Rusty, en pointe, in the Broadway musical "The Will Rogers Follies"

Never Met a Madman They Didn't Like

"Everyone's got the right to their dreams," sang John Wilkes Booth, Charles Guiteau, John Hinckley and the other title characters of the Stephen Sondheim-John Weidman musical, "Assassins."

Never Met an Award It Didn't Win

Neil Simon's "Lost in Yonkers" won almost every theater prize in June but lost its powerhouse prize-winning stars (Irene Worth, Mercedes Ruehl, Kevin Spacey) and capacity audiences in the fall.

The American Dream

Jonathan Pryce, whose claim on the role of a Eurasian pimp brought the New York theater community to the brink of civil war in 1990, received a Tony Award from his former antagonists for his electrifying star turn in "Miss Saigon."

The Hit That Got Away

The best Broadway musical score of 1991 was that written by Alan Menken and Howard Ashman for the Disney animated movie "Beauty and the Beast." Mr. Ashman, who died of AIDS this year, and Mr. Menken were frequent collaborators Off Broadway but had never worked as a team on a Broadway musical.

BY DAVID RICHARDS

A Dog at the End of Its Rope (No, Not That One)

Best Performance by an Animal

Rusty — part spitz, pure daredevil — stands on his hind paws on a rope in "The Will Rogers Follies."

Anticlimax of the Year

Three years after it was first announced for Broadway, 61 days after it began previews, "Nick and Nora," having canceled its out-of-town tryout and delayed its opening night twice, finally opened and then closed after nine performances.

Mark My Words

"Even if my play is successful, I will never win the Pulitzer," declared Neil Simon, whose "Lost in Yonkers" proved a huge success and won him the 1991 Pulitzer Prize for drama.

Major Misfires

"The Road to Nirvana," Arthur Kopit's satire of Hollywood mores, which took scatology to a new low; "La Bête," faux Molière by David Hirson, written entirely in rhymed couplets; "States of Shock," Sam Shepard in a nonelectric mode.

Most Ecstatic Dance in a Broadway Show (Not Choreographed by Tommy Tune)

The frenzied jig that suddenly seizes five Irish spinsters and sends them reeling about the kitchen in "Dancing at Lughnasa," Brian Friel's lovely memory play.

Most Enthralling Performance

Eileen Atkins, as Virginia Woolf, subtly expounding upon a woman's need to have "A Room of One's Own," if she ever hopes to be a writer.

Worst Off-Broadway Pun

"Beware the ids that march," from "Return to the Forbidden Planet." (Runner-up: "Two beeps or not two beeps. That is the question," also from "Return to the Forbidden Planet.")

A Love Song Like No Other

In "Assassins," Stephen Sondheim's most daring musical yet, John Hinckley and Lynette (Squeaky) Fromme sang "Unworthy of Your Love," directing their unrequited affections to Jodie Foster and Charles Manson.

Mea Culpa, Mea Culpa

"Miss Saigon" offered an opportunity to repent the Vietnam War at $100 a seat.

The Year's Most Affecting Plays, Although You'd Never Know It From the Titles

Terrence McNally's "Lips Together, Teeth Apart" and Scott McPherson's "Marvin's Room."

Emptiest Shoes

Joseph Papp's.

Hollowest Promise

Despite reassurances that it would never come to that, the Nederlander Organization sold

the Mark Hellinger Theater to the Times Square Church, which conducts Pentecostal services from the stage where Rex Harrison once taught Julie Andrews proper diction in "My Fair Lady."

Martha Swope/"Our Country's Good"

Members of the cast in "Our Country's Good," Timberlake Wertenbaker's play about the founding of Australia.

BY MEL GUSSOW

Very Special Deliveries From Sweden and Ireland

There Is No Such Thing as a Language Barrier Ingmar Bergman's productions in Swedish of Ibsen, Strindberg and O'Neill at the Brooklyn Academy of Music.

Art in Harmony Brian Friel's "Dancing at Lughnasa," which has the finest writing, acting and dancing in any drama this season.

Help! Stop Me Before I Become a Trend The "Real Live Brady Bunch," in which installments of an old television sitcom are re-enacted on stage.

Most Provocative Response to Senator Jesse Helms and Other Self-Appointed Censors Paul Zaloom's solo environmental satire "My Civilization."

Symbiotic Meeting of Actress and Character Eileen Atkins as Virginia Woolf in "A Room of One's Own."

Clearest Articulation of the Ameliorative Effects of Theater Timberlake Wertenbaker's "Our Country's Good," which demonstrated how the stage helped transform a slave colony into the country of Australia.

Strongest Encouragement to Stage-Struck Journalists "Free Speech in America," in which Roger Rosenblatt left the printed page to become a performance-art humorist.

Bookless Can Be Beautiful "And the World Goes 'Round," an imaginative collage of show tunes by John Kander and Fred Ebb.

Distinguished Actors Taking It Easy as Curmudgeons on Broadway George C. Scott in "On Borrowed Time" and Jason Robards in "Park Your Card in Harvard Yard."

Most Promising New Ventures Tony Randall's National Actors Theater, which is presenting classics on Broadway, and the Signature Theater Company, which is devoting an entire season to the work of a single playwright, Romulus Linney.

Audience Abused and Amused In a year when theatergoers have been forcibly involved in performance, Blue Man Group's "Tubes" steps over the cutting edge by trussing up a volunteer and using him as a human paintbrush.

1991 D 29, II:5:1

Theater in Review
Stephen Holden

■ A New York City type of love, scheming and angst that seem so sweet in retrospect ■ Reno returns, this time taking on the Republicans.

What About Luv?
York Theater
2 East 90th Street
Manhattan

Based on the comedy by Murray Schisgal; book by Jeffrey Sweet; music by Howard Marren; lyrics by Susan Birkenhead; directed by Patricia Birch; musical director, Tom Helm; scenery, James Morgan; costumes, Barbara Beccio; lighting, Mary Jo Dondlinger; technical director, John Miller; production stage manager, William J. Buckley. Presented by the York Theater Company, in association with One World Arts Foundation, Janet Hayes Walker, producing director; Molly Pickering Grose, managing director. WITH: David Green, Judy Kaye and Austin Pendleton.

With a running time of under two hours, a steady barrage of tepid witticisms (sample: "I'm being held cap-

Joan Marcus/"La Bête"

Tom McGowan in David Hirson's comedy "La Bête," written in rhymed couplets.

tive in my own life") and a peppy score whose style filters Petula Clark hits through generic 50's show tunes, the York Theater's production of "What About Luv?" might be described as the diet shake of current musicals. A revised version of the 1984 Off Broadway show "Love," which itself was adapted from Murray Shisgal's 1964 hit play "Luv," the three-character show evokes a neurotic New York City ambiance that in light of today's urban pressures seems almost utopian.

One night on the Brooklyn Bridge, a suicidal scholar named Harry (Austin Pendleton) is saved from leaping by the coincidental appearance of Milt Manville (David Green), his best friend from college. An unhappily married stockbroker, Milt comes up with the notion of dumping his brainy wife, Ellen (Judy Kaye), on the loveless Harry.

The plan succeeds, and the so-called Dostoyevsky of Polyarts U. and Ellen fall in love. In the play's funniest scene, they test their devotion by being cruel and then daring each other to remain goo-goo-eyed with love. For a time, Harry even stops wearing a bag over his head to protect himself from bird droppings. But when all three meet a year later in the same spot, things have not worked out nearly so well as they had hoped.

"What About Luv?," which has a book by Jeffrey Sweet, music by Howard Marren and lyrics by Susan Birkenhead, is a smoothly concocted entertainment that has the mood of a 1960's cartoon by Jules Feiffer padded with songs, dances and pratfalls and seasoned with a dash of theater of the absurd. As directed by Patricia Birch and expertly performed by its three-member cast, it moves like clockwork. But it has no edge. The nasty Freudian undertones are smoothed over and the characters' neuroses played for sitcom farce.

Reno Once Removed

The Public
Anspacher Theater
425 Lafayette Street
Manhattan

Conceived, written and performed by Reno; directed by Evan Yionoulis; original music by Mike Yionoulis; lighting by Dan Kotlowitz. Presented by I.P.A. Presents and the New York Shakespeare Festival, JoAnne Akalaitis, artistic director; Jason Steven Cohen, producing director; Rosemarie Tichler, associate artistic director.

Among performance artists who have emerged from the East Village in the last decade, Reno may be the most physically uninhibited. Her arms flailing, her jaw thrust out, her eyes darting with mischief, she spins around the stage in her new show like a perpetual motion machine. Squirming around the floor while trying to find shade from an imaginary bonsai tree or demonstrating how she wrings out and saves her paper towels to protect the environment, Reno triumphantly joins a classic slapstick tradition.

"Reno Once Removed," her one-woman show, had its premiere in the summer at Alice Tully Hall, where it was one of the hits of Lincoln Center's Serious Fun festival. Spruced up with some new material, its timing sharpened by the director Evan Yionoulis, it is tighter and funnier in its return engagement at the Anspacher.

Early in the 90-minute intermissionless show, Reno, who suggests a more compact, kinetic Bette Midler, accurately describes herself as "an entertainer passing as an artist." Several things, however, set her above and apart from mainstream stand-up comedy. One is her rough-and-tumble physicality. Another is her outspoken antiestablishment political stance. She lets the Republicans have it with both barrels smoking.

Reno is wonderful discussing the abuse of the word "denial," which she calls "the upper-class version of lying." In a funny spiel about the economy, she imagines America as a "pyramid scheme" that she traces back to Columbus's discovery of America. "Of course, there were 850,000 people here," she observes. "This country was born in denial."

And there is much more that is just as blunt in its polemics and scarily funny in its evocation of an overall moral bankruptcy.

1991 D 30, C14:1

The New York Times
Theater Reviews
1992

1992

As You Like It

By William Shakespeare; directed by Anthony Cornish; set design by Robert Joel Schwartz; fight director, Rick Sordelet; costumes, Barbara A. Bell; lighting, Paul Armstrong; songs by Guy Wolfenden; sound, Donna Riley; music director, Gene Bender. Presented by the Pearl Theater Company, Shepard Sobel, artistic director, 125 West 22d Street, Manhattan. Through Jan. 25.
WITH: Craig Bockhorn, Robin Leslie Brown, Arnie Burton, Joanne Camp, Dan Daily, David Gottlieb, Wynn Harmon, David Edward Jones, Stuart Lerch, Alex Leydenfrost, Frank Lowe, Laura Rathgeb, Hank Wagner and Donnah Welby.

By MEL GUSSOW

Commenting on "As You Like It," George Bernard Shaw said that "Rosalind is to the actress what Hamlet is to the actor." By that he meant that, given a performer's "reasonable presentability," failure is "hardly possible." In both instances, Shaw was probably being intentionally ingenuous. Neither character is foolproof and each poses a formidable challenge. Rosalind demands an actress with charm as well as insouciant humor, which is what the role receives from Joanne Camp in the production at the Pearl Theater Company.

Ms. Camp is a lithesome Rosalind, someone who easily moves from courtly propriety to bucolic mischief, shifting modes of behavior while remaining winsome with Shakespearean wit. She is a graceful hoyden, on the edge between expressing her womanly passion and savoring her own impersonation of a man.

For the purposes of pretending to be Ganymede, she switches to trousers but lets her long hair flow. The changeover is subtle, a matter of voice shading and stance. She asks for a suspension of disbelief on the part of Orlando and of the audience, and we play along with her play-acting.

•

In her career, Ms. Camp has alternated between contemporary roles (some of them on Broadway, like "The Heidi Chronicles") and classics at the Pearl. With her light comic touch, she is the sprightly center of Anthony Cornish's production of "As You Like It." This is an unassuming, small-scale version, without affectations and without an overlay of interpretation. There is little scenery on this tiny stage. Robert Joel Schwartz has designed a wispy rather than lush forest of Arden, and it is underpopulated. The pastoral beauty is in Shakespeare's words.

Next to Ms. Camp, the most notable performance is that of Craig Bockhorn as Touchstone, who is impish without being frivolous. The other actors are uneven, but there is sturdy support from Arnie Burton and David Gottlieb as the warring de Boys brothers; Dan Daily as both dukes, the usurped and the usurper, and Stuart Lerch as Jaques. Mr. Lerch has the plummy voice and manner for his character, placing him on the younger side of middle age. As lovers are bound to each other and as Hymen sings a song of wedlock, Mr. Lerch sits dolefully on the sidelines, detached and contemplating new ways to don his cloak of melancholy.

There is something almost novel about seeing unadorned Shakespeare during a time of directorial conceptualization and textual deconstruction. For that reason and for Ms. Camp's performance, the Pearl's "As You Like It" has validity.

1992 Ja 1, 23:1

Carol Rosegg/Martha Swope Associates
Joanne Camp as Rosalind in "As You Like It."

The Theater of AIDS: Attention Must Be Paid

By DAVID RICHARDS

I N A COUNTRY BESET WITH SO MANY PROBlems that it is hard to know where to direct a helping hand, the theater seems to have paid greatest attention to AIDS. The concern is understandable. The ravages of the epidemic have been particularly acute in the theater, which has suffered horrible losses across the board — playwrights, performers, designers, as well as all those who labor behind the scenes.

This is not to deny the awful facts of homelessness or the deterioration of the environment or society's increasingly callous disregard for the welfare of its children. But you fight the scourge on your doorstep first. And in the theater that's been AIDS.

Tom McGovern/"Raft of the Medusa"
Steven Keats, left, and Dan Futterman in "Raft of the Medusa"— The underlying anger and the desperation are real.

233

When the subject was still very much taboo, the theater sent out the earliest warnings ("As Is," "The Normal Heart"). And, as AIDS has become an incontrovertible part of our times, not to go away soon, the theater continues to try to put it into some kind of perspective ("Prelude to a Kiss," "Marvin's Room"). Disease, on its own, signifies nothing, of course, beyond the absurd precariousness of our condition. If there are meanings to be found in AIDS, they'll be drawn from the hearts and minds of those who are living with it. In that respect, the theater has not had to look far afield for examples.

But there is, I think, another reason for this preoccupation. Few subjects are so fraught with emotion, so quick to penetrate our myths of self-sufficiency and invincibility. AIDS has caused uncalculable suffering, so I certainly don't mean to be flip when I say that it is the most theatrical of illnesses. Nothing less than our mortality is on the line. There are no outs. Even if a play is make-believe and not much of a play at all, the death sentence is palpably real.

That's certainly the case with "Raft of the Medusa," the new drama by Joe Pintauro that got me thinking these thoughts. I didn't believe it much of the time. The writing seemed manipulative; the characters overheated. And yet I never doubted the play's underlying anger or its desperation. "Raft of the Medusa" may do little more than refer us to a reality beyond the playhouse door, but that reality still has a primal power to disturb.

Ninety minutes in length, Mr. Pintauro's play shows us the weekly meeting of a support group for PWA's (Persons With AIDS), conducted by a shrink named Jerry (Steven Keats) and attended, this particular week, by 11 PWA's from various social classes. Some are straight, some homosexual; some have adjusted to their plight, others seethe with anger. One, Nairobi (Brenda Denmark), a black drug addict, fulminates in sign language.

They sit on folding chairs in a semicircle facing the audience at the Minetta Lane Theater. Except for a few quick flashbacks — and a dreamlike coda — the turbulent meeting is the play. Mostly, the characters vent their emotions on one another and shoot down one another's lies. A famous actor (William Fichtner), new to the group, claims he's just there to do research for a role, but he's not allowed to maintain the fiction for long. Suspicions lie heavily on a journalist (Bruce McCarty), who may simply be pre-

tending to have AIDS in order to tape-record the meeting and sell the revelations to the tabloids. Nairobi, armed with the syringes of her addiction, has her ways of ascertaining the truth.

■

I suspect that the author and the director Sal Trapani are trying to forge the theatrical equivalent of cinéma verité. We're supposed to believe that these characters are going about their business as usual, picking up their problems where they left them the week before, responding to antagonisms born of the moment. But the conceit allows Mr. Pintauro pretty much carte blanche. He needs no other pretext to have his characters divulge their pasts, spill their secrets, blow their stacks. That's why they're there. And if any encouragement is required, well, the doctor can always pose a leading question (How do you feel about this? Why don't you tell us about that?).

In practice, however, the dramaturgy is too facile to be persuasive. Anybody can attend the meeting, and anybody does. While that allows Mr. Pintauro to expand his canvas — one of the PWA's is an angry Roman Catholic housewife (Annie Corley) in tailored clothes and pearls — the group seems preposterously diverse. The performers have been encouraged to go with their strongest feelings, when the more convincing tack might have been for them to resist a little.

The play's title has been taken from the 19th-century painting by Théodore Géricault, which depicts the living hell experienced by some of the survivors of the shipwrecked frigate Medusa, who were deposited on a flimsy and overcrowded raft and left to fend for themselves. The analogy is obvious. It also suggests the storm-tossed urgency that has been injected into every corner of the production. But then, when time is of the essence, as it is with this epidemic, the natural tendency is to shout loud and throw so many punches that attention has to be paid.

If you are looking for enduring art, most AIDS plays don't qualify, which doesn't mean they don't serve a purpose. They tell us what the temperature is right now and capture the current state of our fears and prejudices. That's useful information to have. As sociological documents, filed from the edge, they

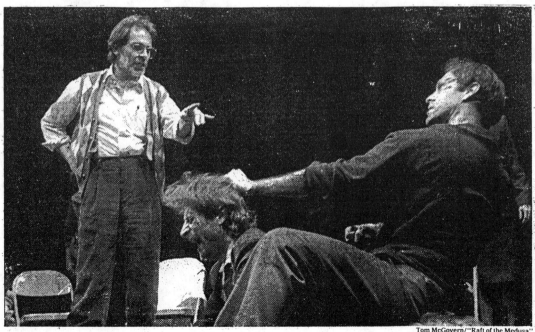

Tom McGovern/"Raft of the Medusa"

Featured in Joe Pintauro's new drama "Raft of the Medusa" are, from left, Steven Keats, Bruce McCarty (on floor) and Cliff Weissman—Nothing less than mortality is on the line.

can still hit hard. When science comes to the rescue and finally produces a cure, a play like "Raft of the Medusa" will probably seem helplessly distraught.

For the time being, however, the helplessness is revelatory. And the objections of drama criticism, even as I'm raising them, somehow strike me as vaguely irrelevant.

'What About Luv?'

I didn't see "What About Luv?," the musical based on Murray Schisgal's comedy "Luv," when it was first produced Off Broadway in 1984 (under the title "Love"). So what the show's creators — the writer Jeffrey Sweet, the composer Howard Marren and the lyricist Susan Birkenhead — have wrought in the way of improvements for the revival by the York Theater Company I can't tell. The most conspicuous shortcoming has to have been there from the start, though: the book and the score belong to entirely different worlds.

Like Mr. Schisgal's play, "What About Luv?" takes three desperate New Yorkers, puts them on a bridge and then encourages them either to throw themselves into the waters below or hurl themselves into one another's arms. High anxiety is their normal state, unless it is paralyzing depression. Their childhoods were rotten. Adulthood isn't proving much better and their sex lives are thudding disappointments.

What we have here is an extended comic kvetch, delivered by Harry Berlin, middle-aged sad sack; his long-lost college chum, Milt Manville, a miserable stockbroker; and Milt's wife, Ellen, a martyr in mink. In the name of luv, Milt foists Ellen off on Harry for a while, but it doesn't take. For one thing, Harry likes to sit around with a paper bag on his head. So Ellen returns to Milt, although not before he's plunged into the drink a couple of times. Mr. Sweet's adaptation preserves the guilt-edged neuroticism of Mr. Schisgal's play, if not its furious pace. But you get the drift.

You do, that is, until someone starts to sing. The score that Mr. Marren has hatched for the occasion couldn't be more pleasant. Lovely little tinkling songs with echoes of hurdy-gurdies in them. Gentle ditties to pick up sagging spirits and set heads gently bobbing. A hint — but no more than a hint — of the softest of soft-rock beats. Even when Ms. Birkenhead's lyrics are trying for some bite, the melodies are as well-mannered as a church tea.

Talk about incompatibility. The book and the score are engaged in an active tug of war, and the director Patricia Birch is unable to reconcile them. It appeared to me that the performers — Austin Pendleton, David Green and Judy Kaye — were holding back. But then maybe it's the musical's split personality that's holding *them* back. Either way, matters come to a standstill pretty quickly at the York Theater.

'Reno Once Removed'

Reno, on the other hand, keeps the pot boiling all through "Reno Once Removed," which ends tonight in the Anspacher Theater at the New York Shakespeare Festival. The solo show — presented briefly this summer as part of Lincoln Center's Serious Fun festival, and since honed by the comedian and actress and her director, Evan Yionoulis — is fidgeting on an epic scale.

Agitated is entirely too puny an adjective to describe Reno's comic manner, although it may serve for her hairdo. Frazzled isn't strong enough either. Let me put it this way: Reno doesn't appear so much shot out of a cannon as propelled out of a hot seat. Every fiber of her being screams "Yikes!"

"I always wanted everything to be black and white, and nothing else," she says, offering a more coherent explanation for her behavior. "But it turns out to be houndstooth." The mere contemplation of a Jesse Helms sends her reeling, as do the policies of the Bush Administration, the N.E.A. and big bankers. But Reno can get just as incensed over the indifferent teller in the bank, the humiliation of mammograms, or the unsettled state of the English language, so besieged by feminists and politically correct theorists that a woman no longer knows what to call herself. After all, woman, she points out, is, wo-*man*. Wo-person is still tainted with *son*. And wo-per-*daughter* is a mouthful.

Anger may fuel her diatribes, but it is astutely balanced by the frank discombobulation that makes her one of us. Every now and then, in a rare moment of stillness, she'll allow a wisp of pathos to creep into the material. (Even more wouldn't hurt.) There's a touch of Joan Rivers in her, before Ms. Rivers turned glamourpuss and cozied up to the celebrities she once mocked. There are echoes, too, of the brassy Bette Midler, yet to become a Hollywood star. The sheer energy she puts into a rampage prompts comparisons with the T.V.A.

But mostly, Reno is her own wo-, er, wo-per-daughter. I hereby declare myself a fan. □

1992 Ja 5, II:1:1

Theater in Review
Mel Gussow

■ A revue dares to spoof even 'Chorus Line' ■ The art of the pickup in one of five single-act comedies.

Varieties

Rainbow and Stars
30 Rockefeller Plaza
Manhattan
Through January

Conceived and produced by Steve Paul and Gregory Dawson; staged by Fred Greene; lights and sound by Shawn Moninger; production manager, Scott Perrin. Presented by Rainbow and Stars.
WITH: Douglas Bernstein, Jason Graae, Marilyn Pasekoff, Sharon Douglas and Fred Wells; special guest appearances by Chris Durang and Dawne, Anne Francine, Tony Roberts and Brian O'Connor.

Do you remember Mr. Karpf, the fictional acting teacher at the High School of Performing Arts who made life unbearable for the character of Morales in "A Chorus Line"? In an inspired inversion in "Varieties," a comedy revue at Rainbow and Stars, Douglas Bernstein gives us Karpf's side of the story, how he was frazzled by an inept student actress who went on to tell her story to Michael Bennett. Now Morales gets monthly checks from "A Chorus Line," bemoans Karpf, "and I get nothing."

Mr. Bernstein is the co-author (with Denis Markell) of four of the brightest numbers in a revue that prides itself on its spontaneity and does not disguise its randomness. Presented on Sunday evenings through January, "Varieties" informally welcomes guest entertainers as additions to its regular company (Mr. Bernstein, Jason Graae, Marilyn Pasekoff and Sharon Douglas).

Besides playing Karpf, Mr. Bernstein is Rabbi Dave, the glad-handed religious leader and emcee of the Temple for the Performing Arts in Los Angeles, a man who urges his congregation "to use our 800 number and atone by phone." Later the actor sings a plangent and very funny paean to his favorite newscaster, Michelle Marsh, and then joins his colleagues in "Don't You Hate It?," a timely Bernstein-Markell assault on shows that command audiences to participate.

Enough of the material is familiar from other shows to make "Varieties" seem like a reprise. There are two numbers from "Forbidden Broadway," and last Sunday there was a short-form version of the act entitled "Chris Durang and Dawne." That routine includes Mr. Durang's attack on "Man of La Mancha," which makes Aldonza's dire tale laughable.

Mr. Graae, who was somewhat subdued in the recent "Rodgers and Hart Revue" at Rainbow and Stars, demonstrates an impish humor, threatening to sing every Jacques Brel song ever written and melodramatically ending a romance before it begins, in "The Moment Has Passed" (by Al Carmines). Ms. Pasekoff reruns her diabolical spoof of Julie Andrews and Ms. Douglas, in a parody of "The Sound of Music," enumerates her least favorite things, becoming angrier as the list progresses.

Outstanding among the guest artists were Anne Francine and Tony Roberts. Wearing a jacket that made her look like a Frank Stella painting,

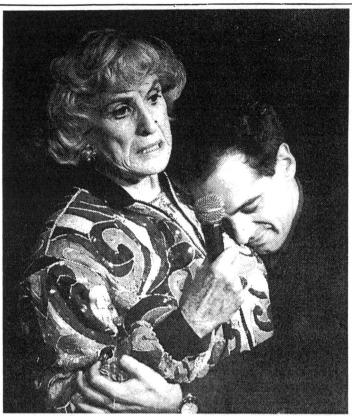

Marc Bryan-Brown/"Varieties"

Anne Francine and Jason Graae in "Varieties" at Rainbow and Stars.

Ms. Francine revealed her impassioned, richly accented adoration of Julio Iglesias. Mr. Roberts played a worldly boulevardier, singing about the impossibility of finding a fresh way to sing about the pleasures of Paris.

As befitting such an open-ended endeavor, the revue seesaws, but the down spots are brief, and with the help of Fred Greene's direction and Fred Wells's piano playing, the performance speeds along to its finale.

Five Very Live

The Atlantic Theater
336 West 20th Street
Manhattan
Through Jan. 18

Five one act plays by contemporary American playwrights: David Ives, Patrick Breen, Howard Korder, David Van Matre and Peter Hedges; scenery by James Wolk; lighting by Howard Werner; production stage manager, Matthew Silver. Presented by the Atlantic Theater Company.
WITH: Robert Bella, Ron Butler, Sarah Eckhardt, Steven Goldstein, Kristen Johnson, Mary McCann, Neil Pepe, David Pittu, Robin Spielberg and Damian Young.

In "Five Very Live," an anthology of unequal one-act comedies dealing with sociocultural matters, a troupe of eager young actors from the Atlantic Theater Company has ample elbow room to display its comic resourcefulness.

Mary McCann and Robert Bella are the entire cast of David Ives's "Sure Thing," the first and by far the funniest of the comedies, a sharp-sighted take on contemporary mating habits. In this curtain-raiser, which was previously produced at the Manhattan Punch Line, a man approaches a cafe table and begins a round robin of small talk with a woman who is reading "The Sound and the Fury."

His first maneuver fizzles, and, after the sound of a buzzer, he tries again. The buzzer keeps sounding and interrupting and the dialogue keeps changing, until the play becomes a virtuosic series of variations on a single theme. Moving from Faulkner to Woody Allen, Mr. Ives shifts degrees of aggressiveness and self-defensiveness, in 10 nimble minutes offering a thesaurus of the modes and mannerisms of the pick-up. Under Scott Zigler's direction, Ms. McCann and Mr. Bella are the deftest of reactors and counter-reactors.

Later, Ms. McCann appears with Kristen Johnston, a hopeful hostess in Howard Korder's "Wonderful Party," another repeat from the Manhattan Punch Line. This is a raucous, one-note cartoon about hangers-on and gate-crashers, which finds some fun in the specifics of party giving (Ms. Johnston offers tropical drinks "with or without an umbrella"). The sketch reaches a climax when 20 uninvited guests crowd the apartment with a Babel of forced bonhomie.

Mr. Bella's showiest role is in the play that gives the anthology its title, David Van Matre's sophomoric send-up of tabloid television journalism. The actor plays a baseball star hounded from the game on unproven moral charges. Mr. Bella is amusing as the abashed athlete and Ms. McCann and Ron Butler radiate smugness as the anchors in charge of allegations and rumors.

David Pittu holds the stage alone in Patrick Breen's whimsical "Call of the Wily." He plays Wily, the mischief-making coyote in cartoons. As interpreted by Mr. Pittu and as disguised in a seedy coyote costume by Kia Heath, Wily is a highly cultured sort. Standing at a bar, he soliloquizes like a Dudley Moore film character. The unanswered question of the moment is why does the coyote never capture the Road Runner?

"The Age of Pie" by Peter Hedges closes the evening with farce turning into slapstick. This is a flat-handed attempt to write a play to end all plays about encounter groups. In this case, the therapy session leads to squabbles and, in the absence of a resolution, culminates with custard pies. Despite the slippery demands of the play, the actors perform with panache. Once again, humor derives less from the words of a playwright than from the exuberance of a community of actors.

1992 Ja 8, C17:1

The Mind King

Written, directed and designed by Richard Foreman; assistant director, David Herskovits; technical director, Colin Hodgson; sound operator, John Collins. Presented by the Ontological-Hysteric Theater at St. Mark's Theater, Mr. Foreman, artistic director. At St. Mark's Church, 131 East 10th Street.
WITH: David Patrick Kelly, Henry Stram and Colleen Werthmann.

By MEL GUSSOW

While other theatrical experimentalists have allowed themselves to be subjected to the vagaries of change and fashion, Richard Foreman has remained dedicated to first Foreman principles for more than 20 years. His plays continue to be personal to the point of being idiosyncratic. They are documentations in words, deeds and images of his own innermost thought processes and obsessions with time, communication and the irrationality of presumed reality.

Because of their abstraction, his works are not entirely intelligible to the audience, which is asked to accept meaning at least partly on faith. The reward, as in his new play, "The Mind King," is a voyage that is simultaneously mysterious and enticing. Come with me, invites Mr. Foreman as playwright, director and designer, into a world of dream pictures.

Arriving early at St. Mark's Theater, audiences have time to acclimate themselves to the symbol-filled surroundings. Some of the trappings and the entrapments are recognizable from previous visits to Foreman country. The compact stage is artfully rigged with odd hanging objects, string (this time over theatergoers' seats), unshaded bulbs soon blinding with bright light, and cardboard cutouts that might have been discarded by a circus sideshow.

In this instance, there are also long tables set for a celebration (which will not take place), a glass cabinet of curios and, as scenic subtext, Hebrew letters. The letters ring the set, and one is implanted on the forehead of Henry Stram, who also wears a prayer shawl. Playing one half of the split-screen title character, Mr. Stram could be considered the thoughtful, Talmudic side of the Mind King, a Philosopher King, while David Patrick Kelly, who shares the role, represents a king of action. Eventually, they switch costumes and identities, further confusing the issue.

•

Just as we keep trying to decipher the characters and track the narrative as it darts up one cul-de-sac after another, Mr. Foreman seems to be going through his own ratiocination as the play is in progress. Occasionally his voice is heard intoning in the background. He is not above making fun of himself, of spoofing the pretension that seems endemic to such a mind field.

On one level, Mr. Foreman is confronting his critics and himself as his own critic. "My belief system is under attack," Mr. Stram says calmly,

Paula Court/The Mind King

David Patrick Kelly, top, and Henry Stram in a scene from Richard Foreman's "Mind King," at St. Mark's Theater.

adding, "My taste is questioned," and then names other crimes against the stage. Urged to tell a story, he says, "Once upon a time," but, before he can proceed, Mr. Kelly cuts him off: "Are you blocked? That's understandable."

What follows, an escapade about a woman named Marie who holds a clock in front of her face, never really gets started. Dialogue is interrupted, the storyteller suffers real blockage and each actor, in the author's words, trips over connectives. At times, the actors are called upon to interact with the scenery. There is a vaudeville side to the portent, with humor arising from body English, as Mr.

Kelly and Mr. Stram, expert Foreman interpreters, try to out-tilt each other.

Finally, Mr. Foreman offers a hint of an explanation if not an exegesis. Thinking too hard, he suggests, can spoil the pleasure of the moment. In other words, one should go with the ebb as well as the flow of experience, including the novel experience of watching a Foreman play unfold. It is his hope that viewers will be "released into a true world of impulse." "The Mind King" is impulsive, in 70 devious minutes delivering a series of sharp shocks to the body theatric.

1992 Ja 11, 9:1

SUNDAY VIEW/David Richards

A Cast Changes And, Suddenly, A Play Is Reborn

In 'Lips Together,' all four actors can hyperventilate now.

The steel has become slightly pliable in 'Lost in Yonkers.'

Grand Hotel still upstages its guests.

SINCE THE PUSH IS ON FOR ACcuracy in labeling these days, it occurs to me that theater criticism ought to come with a cautionary warning. Somewhere in the notices — rapturous or otherwise — shouldn't it be recorded, "Perishable contents" or "Invalid after June 1"?

We like to think — we who produce it, especially — that criticism is timeless. But its shelf life is probably not significantly longer than that, say, of a carton of yogurt. The reason is plain. Critics bear witness to a singular event, destined by the conditions of its making never to be the same again. The theatergoer rarely sees what the critics see, and by that I don't mean what the critics *perceive*. (That's another, thornier, issue.) I mean what they actually, physically, see.

If, on the advice of the movie reviewers, you decide to take in "Bugsy," "Bugsy" is what you'll get. Same frames, same tracking shots, same line readings. However, if you opt for Terrence McNally's "Lips Together, Teeth Apart," which wound up its run at the Manhattan Theater Club and moved to the Lucille Lortel Theater Off Broadway last week, you will most assuredly not be encountering the same play that critics cheered 220 performances ago.

Can we pretend that "Grand Hotel," which has just acquired a new star, Cyd Charisse, is the "Grand Hotel" that opened in November 1989 with Liliane Montevecchi as the aging prima ballerina rejuvenated by love? Or that the departure of Irene Worth from the cast of "Lost in Yonkers" hasn't shifted the balance of power in Neil Simon's comedy about tyrannical Grandma Kurnitz and the dysfunctional family that she raised to tremble at her approach? (You might as well pretend that the removal of General Noriega left Panama unaltered.)

Casts invariably change. The blazing revelations of opening night can lose their luster with time, while buried insights can, over the same period, work their way to the surface. Stage relationships wax and wane, and the play or musical that contains them necessarily assumes a different shape to accommodate the altered dynamics.

'Lips Together, Teeth Apart'

Consider the case of "Lips Together, Teeth Apart," Mr. McNally's drama about two married couples — Sally and Sam, and Chloe and John — who are spending the Fourth of July weekend in a beach house on Fire Island and feeling a little uneasy about it. The sleek house belonged to Sally's brother, who recently died of AIDS, and it sits smack in the middle of a largely gay summer colony. In that respect, Mr. McNally's characters are strangers in a strange land. But they are no more comfortable with one another. While they go through all the lazy, distracted motions of a summer holiday — kite-flying, barbecuing, suntanning, practical-joking, daydreaming — the gulfs between them widen and deepen. Loneliness has them by the throat.

Although the four roles are equal parts of the restless whole, it was hard, when the play

Martha Swope/"Lost in Yonkers"

Jane Kaczmarek as Bella in Neil Simon's "Lost in Yonkers." Mutability is the theater's survival mechanism.

opened last June, not to think that Chloe's part was perhaps just a little *more* equal. It was played then by Christine Baranski, sporting an array of beach wear that not only attested to the woman's passion for amateur theatricals, but also seemed to reflect a psychological aversion to peace and quiet. If the beach house had been a cruise ship, Chloe would have been its social director. Making chitchat (sometimes in bad French), serving endless snacks, drawing sourpusses out of their shells (or their naps) and generally setting an example of cheeriness in a gloomy world, Ms. Baranski was rabidly gregarious. Even when she was off in a corner of the sun deck all by herself, rehearsing her songs and gestures as Miss Adelaide in "Guys and Dolls," she dominated the proceedings. In her company, the rest of the characters were slower to come into focus and capture their fair share of our attention.

Chloe is now being played by Hillary Bailey Smith, a somewhat cuter actress whose prattling doesn't carry the neurotic edge of Ms. Baranski's. The performance is decidedly less flashy, but in its favor it allows the other actors hyperventilating room of their own. The chief beneficiary is Roxanne Hart, who has taken over for Swoosie Kurtz in the role of Sally, a character I judged the first time around to be the least interesting of Mr. McNally's foursome.

Now I'm not so sure. Sally is withdrawn, yes, still experiencing a vague metaphysical dread as she stares out to sea, still under the thrall of her recently deceased brother. Ms. Kurtz, however, wrapped herself in moroseness. Ms. Hart is fighting to throw it off, to reconcile the love she had for her sibling with the distaste she felt for his sexual proclivities and to come to terms with the numbing sorrow he bequeathed her, along with an $800,000 vacation property. The portrayal is alive with struggle, and when, in the second act, Ms. Hart lets her grief well up, shattering any pretense of self-control, the moment is devastating.

As her proletarian husband, Jonathan Hadary is a worthy successor to Nathan Lane, while Anthony Heald, the one holdover from the original cast, continues to play John, Chloe's snobbish husband, with the cool air of one who knows, deep down, that he is not particularly likable and wants the judgmental world to stay its distance. Because Chloe is not all over him now — coddling, cuddling, reassuring — his solitude is more acute than ever. In its new configuration, I certainly laughed less at "Lips Together, Teeth Apart." But I was considerably more aware of its aching humanity.

'Lost in Yonkers'

At first sight, Jane Kaczmarek appears to be giving a carbon copy of Mercedes Ruehl's performance as Bella in "Lost in Yonkers," so it may sound curious to say that I liked her better in the role. I did, though, and I think I know why.

Bella, you may remember, is a middle-aged spinster, a bit slow upstairs, but full of energy and enthusiasm despite a life that consists of

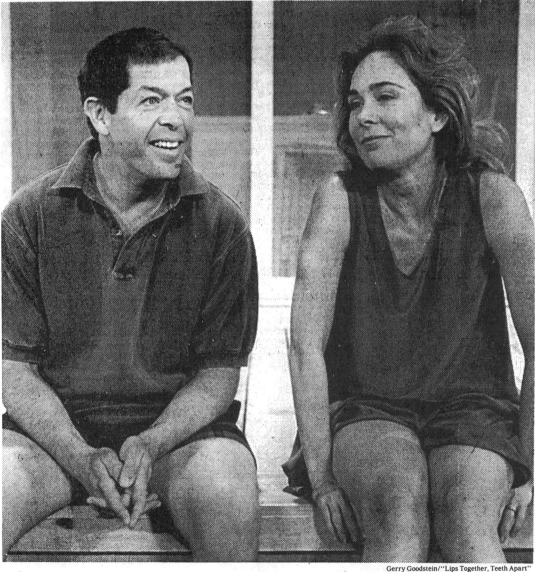

Gerry Goodstein/"Lips Together, Teeth Apart"

Jonathan Hadary and Roxanne Hart in "Lips Together, Teeth Apart"—strangers in a strange land

little more than tending the family candy store, massaging the back of her tyrannical mother, Grandma Kurnitz, and running off now and again to an afternoon feature at the neighborhood picture palace. Part of Mr. Simon's play (at the Richard Rodgers Theater) recounts what happens when Grandma Kurnitz's two young grandchildren come to live with her for 10 rigorous months that could be described as a kind of boot camp for kids. But the more affecting part has to do with Bella's desires to marry an usher she's met at the movies, wriggle out from under Grandma's iron will and start a family of her own.

The notion is preposterous. Bella may sense within her the instincts of a woman, but she's saddled with the mind of a 12-year-old girl, as Grandma Kurnitz constantly reminds her, using scorn or icy silence to reinforce the point. What the autocratic mother refuses to acknowledge is her daughter's heart — so full of love to give that it's about to explode.

Knees knocking, arms flapping, Ms. Kaczmarek lurches about the stage like an adolescent who's shot up 12 inches in six months and hasn't fully regained her balance. Her smile is the equivalent of a four-scoop sundae, while her voice could be the chopped nuts. When she's excited and her eyes start rolling in their sockets, it's almost as if she's been hit with a skillet, not just an idea. She is so open and without defenses that it takes audiences, I'd guess, an average of a minute and a half to fall head over heels for her. Ms. Ruehl had a similar effect, however, so what's the difference here?

The difference is Grandma Kurnitz. Rosemary Harris has stepped into the woman's forbidding corset and her black orthopedic shoes, and while she's no pushover, she's not the unflinching monster Ms. Worth was. Is it the actress's round cheeks, as rosy as any nipped by a winter frost? Or the rippling voice which, no matter how forcefully Ms. Harris raises it, retains a definite musicality? Ms. Worth's performance was steel through and through. But Ms. Harris hasn't totally masked her own graciousness — may not want to, I suspect — and the residual civility at least opens up the chance of a last-minute conversion.

As a result, when Bella comes to Grandma Kurnitz, begging for permission to marry and have the babies she'll cherish more than anyone ever cherished a child, she is no longer flinging herself up against a brick wall. There is just enough give in Ms. Harris's performance to keep Bella's wild hopes — and ours — alive. Ms. Kaczmarek can let herself get carried away, knowing she won't appear completely crazed. In her desperate plea for love, the love and the desperation have been put on an equal footing.

The relationship between Ms. Ruehl and Ms. Worth may have thrown off more sparks of pure theatricality (both actresses won Tony Awards last year). But the rapport between Ms. Kaczmarek and Ms. Harris seems more faithful to day-to-

Carmen Schiavone/"Grand Hotel"

Cyd Charisse in "Grand Hotel"—carried right along with the flow

day realities. In a play that comes close to surrealism on occasion, the humbler truth is, I think, welcome ballast.

■

The other cast replacements are having less of an effect on the overall evening. As Uncle Louie, petty gangster, Kevin Spacey reminded me of a second-rate nightclub comic who thinks he's telling first-rate jokes. Alan Rosenberg, his successor, resembles a second-rate ventriloquist, except when he grins maniacally. Then, he looks like the ventriloquist's dummy. Either way, the character still evokes the lower realms of show

From the first day of rehearsals until the final performance, evolution is unavoidable.

business, even as he goes about his shady dealings. Benny Grant is now Arty, Grandma Kurnitz's youngest grandson, to whom fall some of Mr. Simon's funniest quips. I'm pleased to report that the young Master Grant, a butterball in knickers, doesn't let a single one go to waste.

'Grand Hotel'

In that Tommy Tune's staging is the real star of "Grand Hotel" (at the Martin Beck Theater), the addition of a bona fide Hollywood star, Cyd Charisse, to the cast is probably not the momentous occasion it would be if the musical in question were "Mame" or "Hello, Dolly!" For this, her Broad-

way debut, Ms. Charisse is playing the fabled ballerina, Elizaveta Grushinskaya, who at the age of "49 years and 49 months" is discovering that the devoted fans aren't showing up any longer.

Hers is merely one of a half dozen or so stories that are transpiring in 1928 in Berlin's most expensive hotel — home to the corrupt, the opportunistic and the merely ambitious. The silken way Mr. Tune moves from one story to the next — advancing each in its turn, then folding it back into the continuing swirl — has always been more entrancing than the stories themselves. Ms. Charisse offers no resistance; she, too, is carried right along with the flow.

Swathed in velvet and fur, she is a handsome woman. Although "Grand Hotel" doesn't ask much dancing of her, the legendary legs are up to the challenge. As an actress, let's just say she has an elegant presence. And as a singer, well, let's not say anything at all. Her sudden romance with the dashing but penniless Baron Felix Von Gaigern (Greg Zerkle) doesn't work. But frankly, I'm not sure it has ever worked.

Nothing says love can't bloom between an aging, insecure woman and a young rake who claims to find her wrinkles touching evidence of the rich life she's led. I've seen three different sets of performers in the roles, though, and each time the pairing has failed to match up to the tumultuous music that underscores it. Something patronizing about him and something grasping about her make the relationship disconcerting, and it will remain so until the casting department comes up with a couple who combust spontaneously. (And then, I imagine, basic biology will have more to do with it than any laws of show business.)

The nice thing about the theater, of course, is that second and third tries are permissible. Several days before opening night, a director customarily "freezes" the show. No more fiddling is allowed. A form, if not *the* form, has been found and must be set. In fact, nothing is ever really frozen.

From the first day of rehearsals until the final performance of a long run, evolution of some sort is unavoidable. Desirable even. After all, if a play could be duplicated precisely every night, it wouldn't be a play, it would be a machine. Mutability is the theater's survival mechanism.

If a film is out of sync with the times, its only recourse is to wait for a more receptive age. A play can change *with* the times. With the weather. Overnight. For better. For worse. It even changes imperceptibly because *you* — and not another — are watching it.

How can a drama critic hope to keep up? ☐

1992 Ja 12, II:5:1

Theater in Review

☑ Amid songs and slapstick, a Chaplinesque Job

finds life is a circus, and suffering a subway

■ Of Chernobyl and other technotraumas.

Job
A Circus
One Dream Theater
232 West Broadway
Manhattan
Through Feb. 2

Conceived and directed by Elizabeth Swados; producing director, Wickham Boyle; clown routines created by Gabriel Barre, Mary Dino, Michael Gunst, Jeff Hess, Alan Mintz and Stephen Ringold; music by Ms. Swados; vocal arrangements by Ann Marie Milazzo, Cathy Porter and Michael Sottile; production stage manager, Tori Evans; set and costumes designed by Nephelie Andonyadis; lighting by Kristabelle Munson. Presented by Under One Roof.
WITH: Ms. Dino, Ms. Evans, Mr. Gunst, Mr. Hess, Ms. Milazzo, Mr. Mintz, Mr. Neiden, Paul O'Keefe, Mr. Ringold and Mr. Sottile.

Stories from the Old Testament have provided Elizabeth Swados with a mosaic of musical material, as in her "Haggadah" and "Jerusalem." For her new chamber musical, she has turned to the Book of Job, but instead of writing a dramatic oratorio she has created an informal

Michael Gunst, left, and Stephen Ringold in "Job: A Circus."

clown show, with moments of audience participation. The result, "Job: A Circus," is a freewheeling cavalcade of songs and sight gags.

The idea is to approach Job as a Chaplinesque soul who endures a diversity of woes and never knows where the next slapstick or custard pie will come from. As the show stands, and as Job pratfalls, this is an up and down, fragmented affair. But it is light enough in spirit to justify its role as a family show, a brief entertainment with a moral but not too heavy a message.

As director, Ms. Swados has deemphasized scenic design and given her company of energetic young actors free rein to improvise routines and to mime, juggle and tumble. Along with the music, the clowning is the most enjoyable aspect of the show.

With a ringlet of hair sprouting from his head, the show's Job, Stephen Ringold, looks like a tall Tintin. He is downcast, deadpan and undiscouraged. Wherever he turns, someone takes advantage of him, but, in keeping with his biblical origins, he remains a righteous man.

As the engaging ringmaster, Jeff Hess is a quick-thinking skirmisher who is unabashed about the more awkward episodes in the show. Alan Mintz is wry as a mock-sinister Satan who in this pompadoured version looks and sings like the ghost of Elvis. In keeping with the circus setting, God is the unseen Great Magician and the world is an improvisational vaudeville. In characteristic Swados fashion, the music is an eclectic blending of calypso, ballads, country and rap. Occasional liturgical strains are sung in Hebrew, with lively accompaniment on piano and guitar.

To expand the repertory of afflictions, Mr. Hess asks for the audience's assistance in bedeviling the put-upon protagonist. At Sunday's matinee, volunteers shunned the thought of fire and flood and suggested that Job be hit with a recession and be made to ride the New York subway. Both punishments were meted out by the actors with a fierceness that can only come from experience on the urban firing line.

MEL GUSSOW

Explosions

La Mama E.T.C.
74 East Fourth Street
Manhattan
Through Sunday

Created by Virlana Tkacz and Wanda Phipps; directed by Ms. Tkacz; music by Roman Hurko; set and lights by Watoku Ueno; movement by June Anderson; costumes by Yuko Yamamura. Presented by La Mama E.T.C. and Yara Arts Group.
WITH: Richard Abrams, Jessica Hecht, Ralph B. Pena, Jeffrey Ricketts, Sean Runnette, Dawn Saito, Olga Shuhan and Jeff Sugarman.

Not the least of the problems facing theater artists who want to evoke the horrific scope of a technological catastrophe like the 1986 nuclear accident at Chernobyl is finding a stage vocabulary that is as resonant as the nightmare visions an audience brings to such a project. In the Yara Arts Group's theatrical collage "Explosions," which is playing at La Mama through Sunday, the impact of that accident on people's lives is explored through a mixture of poetry, music and eyewitness accounts strung together with excerpts from Georg Kaiser's 1919 German Expressionist drama, "Gas 1." The blend is dramatically inadequate to the subject, and the pieces never cohere.

The Kaiser play, which is about the aftereffects of an explosion in a power plant that has produced a gas that is the world's primary source of energy, doesn't synchronize with the Chernobyl story. Tiresome arguments over whether the engineer who devised the formula for the gas should be dismissed are reiterated by actors who accompany their dialogue with sign language.

The production, directed by Virlana Tkacz, is also undermined by mediocre acting. Whether dramatizing the Kaiser play, delivering poetry by writers like Allen Ginsberg and Anne Waldman, or simply relaying journalistic accounts, the Yara Arts Group's young cast maintains a stiff, declamatory tone that makes the events and emotions seem remote. The music, composed by Roman Hurko and played by him and two guitarists behind a scrim, is a scruffy, nondescript art-rock pastiche with one short blast of heavy metal.

The show's most disturbing elements are the grim statistics flashed on a wall that say, among other things, that 576,000 people have been officially registered as contaminated by radiation from the Chernobyl disaster. *STEPHEN HOLDEN*

1992 Ja 15, C17:1

The 'Near Future' of 1970 Arrives in a Revival

By MEL GUSSOW

Special to The New York Times

NEW HAVEN, Jan. 14 — In "The Philanthropist," Christopher Hampton turned "The Misanthrope" inside out by creating a title character who likes everyone and apologizes for everything, even when it is someone else's fault. Because of the accuracy of the playwright's perceptions, the play is far more than a case of reverse Molière. It is a highly literate comedy of manners, with sobering undertones. The subjects are academic insularity and artistic arrogance, the assumption that words are more relevant than actions or emotions. Although the play was first presented in 1970, it seems not to have aged at all, as demonstrated in Gordon Edelstein's vibrant new production at the Long Wharf Theater.

This bourgeois comedy was originally set in the "near future." That future is now, and also tomorrow, whenever and wherever people forcibly detach themselves from the problems of the world around them and seclude themselves in a hothouse. In this university environment, the characters suffer from severe myopia. They are unmoved by suicide and even mass murder, as long as it happens to other people.

Mr. Hampton's passive hero is a philologist, a man with no critical faculties, who confesses, in one of the play's most quoted lines, that he does not "even have the courage of my lack of convictions." He is so amenable that he will go to bed with a woman he does not like simply because he is afraid of hurting her feelings. Philip, the philologist, is a champion at linguistics. He is always able to analyze a friend's speech patterns and to anagramatize any polysyllables that pass his way. But in all social situations, he is a fumbler.

•

His moral opposite is a pandering novelist who seems to despise everyone, including his own egotistical self. When he learns that terrorists have decided to kill 25 of the most eminent English writers, and he is not on the list, he does not know whether to be "relieved or insulted."

With Mr. Hampton's deft intervention, these two and others having dinner in Philip's flat are individualized by their words and by their incompatible attitudes toward one another. Led by Tim Choate as the philologist, the characters achieve definition.

Mr. Choate, performing somewhat in the mode of Alec McCowen, who created the role in the original English production, enhances his performance with rich physical detail that illustrates the character's awesome ineptitude. He is all arms and elbows as he tries to embrace a woman, and he is unable to walk across a room without encountering an unseen impediment. Compulsively he mimes the actions of others; someone leaves the room and he automatically flips his hands as if shutting a miniature door.

Occasionally the actor's cleverness hints at caricature, but the performance is as inventive as the play itself. The danger, avoided in this instance, is to accentuate Philip's blandness. Mr. Choate gives him a carefree otherworldly quality. He also meets the melancholic demands of a character who believes he has led "a full life and an empty one."

•

In a small but crucial role, Ronald Guttman plays the novelist with a natural hauteur, placing himself first and insulting those he categorizes in a subordinate position. The actor infuses his malicious character with a scandalous charm. Another choice performance is offered by Sam Tsoutsouvas as Philip's best friend, a don who is dryly disparaging of the educational process and his own pointless role in it. He is the most stylish and also the most superficial man in this ménage.

The male characters are more shrewdly observed than the female characters, two of whom remain one-dimensional. The third, Philip's fiancée, is given an amusing plausibility by Gillian Anderson, introduced to New Yorkers last season in "Absent Friends." Along with her Long Wharf colleagues, she smoothly captures an English patina.

After writing "The Philanthropist" at the age of 24, Mr. Hampton has gone on to a notable career as a playwright and adapter. In revival, this youthful effort retains its zestful wit and its theatrical self-assurance.

1992 Ja 16, C17:1

Two Shakespearean Actors

By Richard Nelson; directed by Jack O'Brien; sets, David Jenkins; costumes, Jane Greenwood; lighting, Jules Fisher; sound, Jeff Ladman; poster art, James McMullan; original score, Bob James; fight director, Steve Rankin. Presented by Lincoln Center Theater, Gregory Mosher, director; Bernard Gersten, executive producer. At the Cort Theater, 138 West 48th Street.

WITH: Tom Aldredge, Brian Bedford, Ben Bodé, Alan Brasington, Michael Butler, Jeffrey Allan Chandler, Richard Clarke, Frances Conroy, Hope Davis, La Clanché du Rand, Mitchell Edmonds, Katie Finneran, Victor Garber, Laura Innes, Zeljko Ivanek, Judy Kuhn, Tom Lacy, David Andrew Macdonald, Tim MacDonald, Katie MacNichol, Bill Moor, James Murtaugh, Susan Pelligrino, Thomas Schall, Eric Stoltz, Jennifer Van Dyck, Graham Winton and John Wojda.

By FRANK RICH

HAM actors may be a horror, but fine actors playing ham actors are almost always a joy. Brian Bedford, cast as the 19th-century British tragedian William Charles Macready in Richard Nelson's new play, "Two Shakespearean Actors," is no exception. Very grand, often pickled and prone to forgetting the end of any sentence well before he has made it to the verb, Mr. Bedford's puffed-up Macready would be right at home in the hapless theatrical companies of "Nicholas Nickleby," "The Dresser" and "Noises Off." Even his version of the actor's nightmare is egomaniacal: when Macready dreams this dream, he does not forget his lines but instead plays all the parts at once.

Mr. Bedford, a British actor who has been a mainstay of Broadway and Stratford, Ontario, over a 30-odd-year stage career, pours a lifetime of both classical and boulevard-comedy experience into this role. In Mr. Nelson's play, Macready is a tired, fading figure who arrives to perform "Macbeth" in the New York City of 1849 only to find his supremacy challenged by a younger local upstart, the first great American Shakespearean, Edwin Forrest (Victor Garber), who is performing his own "Macbeth" elsewhere in town. It's an ugly situation. A symbolic target for enraged nationalistic forces beyond his comprehension, Macready suffers the indignity of less-than-full houses, a pelting with stones and, finally, a full-scale Anglophobic riot that leaves more than a score dead outside the Astor Place Opera House.

Yet in Mr. Nelson's fictionalized retelling of this actual history, and in Mr. Bedford's meticulous performance, Macready never ceases to be human and never becomes the butt of the piece. Though he is always patronizing to his New York hosts (his idea of a compliment is to call Americans "intelligent in an instinctive sort of way"), Mr. Bedford cloaks the snobbery in a rheumy laugh, merry eyes and a glinting smile. For all the outrageousness of Macready's Macbeth — performed in a kilt with a Lady Macbeth firmly consigned to the upstage shadows — this babbling ham actor is, finally and all too fleetingly, a tragic figure. When the mob boos and stones him, Mr. Bedford gives a stunned reading of the simple line "They have interrupted my performance!" that conveys the abject terror of another actor's nightmare, an audience's rejection. When the riots break out later, the spent, frightened Macready drifts into a passage from "King Lear" that Mr. Bedford plays for keeps, a

fallen giant baring himself to an empty house as "a poor, infirm, weak and despised old man."

People who love the theater will dote on Mr. Bedford, and they will be nearly as fond of Mr. Garber, who is just as good in a much less juicy role. But even if one does cherish the backstage lore and actors' shoptalk that are the currency of "Two Shakespearean Actors," it's hard to shake the feeling that this evening, often diverting and sometimes more than that when Mr. Bedford is center stage, never lives up to its promise. And a lot is promised. The star turns, the fascinating premise, the huge cast that greets the audience in the play's opening moments and the elegant staging by Jack O'Brien all imply that this production, a Lincoln Center Theater presentation at the Cort Theater on Broadway, will have epic ambitions akin to "M. Butterfly" or "Amadeus," or, perhaps more aptly, to the revisionist cultural-historical fictions of E. L. Doctorow. But Mr. Nelson's writing, as epitomized by the prosaic title, rises only sporadically to the scale of everything else.

This disappointment is unexpected, because "Two Shakespearean Actors" is poised to pick up where the author's savage previous comedy, "Some Americans Abroad," left off. As in that play about American Anglophiles agog in present-day England, this one trades in Jamesian themes: the cultural clash between the Old World and the New, the declaration of an independent American artistic identity that is at once brave and vulgar, dynamic and insecure. Unfortunately, Mr. Nelson does not expand upon these points this time so much as reduce them to a simplistic, frequently reiterated duel of acting styles. Macready, representing England, stands for textual fidelity and outward sophistication while the rising American, anachronistically portrayed as an incipient Method Actor, stands for raw energy and the obsessive, inward study of subtext.

•

Even if this formulation were an accurate picture of the contrast between English and American actors of 1849 — which it is not — it still would not be a big enough conflict, or, if you will, metaphor, to explain the bloody Astor Place riots. But no other explanation, real or imagined, is forthcoming in "Two Shakespearean Actors," which consistently whets the audience's curiosity about its subject only to leave it unsatisfied. The political, economic and xenophobic forces that lead to the evening's anticolonial conflagration — sentiments that have resurfaced, less violently, as recently as the Jonathan Pryce-"Miss Saigon" contretemps — remain hinted at but unexamined. Eventually the riots are all but forgotten, except as explosive noises off, while Mr. Nelson brings Macready and Forrest together for a sentimental, historically dubious display of noble theatrical fraternity that seems to belong to another play.

Since the personal stories of the title characters, notably Forrest's sad offstage juggling of a wife (Frances Conroy) and mistress (Jennifer Van Dyck), are also sketchily told, "Two Shakespearean Actors" often lacks emotional as well as intellectual bite. Anecdotal in structure, it is almost always at its best when it is dealing simply, parochially and sometimes uproariously with the theater of missed cues, onstage mishaps and offstage egos. The one conspicuous exception is a wildly overlong Act I sequence in which the

rehearsals of the Forrest and Macready productions of "Macbeth" are supposedly contrasted but, accents and costumes aside, prove to be more alike than not.

There and elsewhere, Mr. Garber offers evidence that he can act Shakespeare at the same high level at which he acts everything else. (Having done a mock Otello in "Lend Me a Tenor" and a mock Macbeth here, maybe it's time for him to try the real thing.) His Forrest, a creature of the stage tortured by private demons Mr. Nelson never illuminates, is a commanding matinee idol who can make even self-pity and arrogance charming. In a company full of outstanding actors in cameo roles that never quite pay off, the better assignments, all executed superbly, belong to Zeljko Ivanek as a perennial understudy torn between two companies and countries, Eric Stoltz in a lecherous and opportunistic portrait of the Irish playwright Dion Boucicault and Tom Lacy as a cynical supporting player nearing the farcical end of an unsung career.

•

Like Mr. Nelson's play, Mr. O'Brien's production evinces an overwhelming affection for the theater. As bathed in silken simulated gaslight by Jules Fisher, the simple, wood-beamed set by David Jenkins allows the action to swing gracefully from auditorium to backstage to dressing room to tavern; the sense of being taken into a hermetically sealed theatrical world of the Victorian age is completed by the Cort Theater itself, a gilded relic closer in origin and spirit to 1849 than 1992. Though Mr. Nelson is an American writer, "Two Shakespearean Actors" was first produced two years ago with a different cast and director by the Royal Shakespeare Company at Stratford-on-Avon. Rather than risk another riot, I will assume that the English production was far inferior to our own.

1992 Ja 17, C1:1

Brigitte Lacombe

Dueling Macbeths — Victor Garber, left, and Brian Bedford.

Down the Flats

By Tony Kavanagh; directed by Nye Heron; produced by Marianne Delaney; music written by John Doyle; music performed by the Chanting House: Susan McKeown and John Doyle with Jimmy Daley; set by David Raphel; costumes by Carla Gant; lighting by Jonathan Sprouse; stage manager, Freda Grealy. Presented by the Irish Arts Center, 553 West 51st Street.

Henry	Donald Creedon
Fran	Donal J. Sheehan
Mother	Caroline Winterson
May	Carmel O'Brien
Father	Chris O'Neill
Bridie	Marian Quinn
Margaret	Susan McKeown
Paul	Jim Smallhorne

By MEL GUSSOW

Faced with two choices, going on the dole or being a petty thief, the protagonist of Tony Kavanagh's "Down the Flats" decides the second is the more remunerative and even the more self-respecting option. "P.C.'s, professional criminals, that's our trade," this ex-convict says with pride to his street crony. There is, of course, a third possibility, to leave Dublin and emigrate to the United States, a course eventually taken by the playwright.

The substance of "Down the Flats" (at the Irish Arts Center) has been frequently encountered in theater

and in life. Mr. Kavanagh's distinction, like that of Miguel Piñero, is that he himself exchanged a career in crime for one as a playwright, and in his first play seems to have a natural affinity for the theater and an instinct for writing dialogue.

Although the play takes place entirely within the confines of a single room in a threadbare family flat, it exudes authenticity and a feeling of a city outside its walls, a Dublin where endurance depends on desensitizing oneself to reality.

The father of the family is a mean-spirited street sweeper who keeps taking the pledge to give up drinking, and breaking it by nightfall. His forlorn wife is quietly acquiescent to the family's collapse, and their two adult offspring are defeated by the lack of opportunity and the decay that surrounds them like a dense cloud.

In outline, the characters may seem as dreary as their environment, but Mr. Kavanagh communicates their earthy humor. Call it bleak comedy, as in the son's tale of how he and his friend robbed an undertaker's parlor or the father's casual statement that he always had time to admire "a man who escapes from jail."

For all its atmosphere, "Down the Flats" is clearly an apprentice effort. The playwright has problems shaping his plot and is arbitrary in how he ends both the first and second acts. This is scarcely more than an extended slice of life. But Mr. Kavanagh has promise, and Nye Heron has given the play a solid, rough-hewn production.

The actors, many of them former Dubliners, clearly know the territory, the talk, the brogue and even the slouch that comes from years of being beaten down. None of them plead for our empathy, but most of them earn it. There are evocative performances by Chris O'Neill and Caroline Winterson as the parents; Marian Quinn as the young daughter already past her prime, and Jim Smallhorne as the daughter's druggy boyfriend who says everything about his character simply through his woefully shabby appearance.

Donal J. Sheehan is the sturdy center of the play as the son and surrogate of the playwright. There is hardly a glimmer of Irish poetry in this character, but there are signs of a growing self-knowledge that offer hope for the son on his road away from Dublin and for the playwright himself in his newly acquired profession.

1992 Ja 17, C5:1

When Little Things Mean a Lot, It's Chekhov

Emily Mann's 'Three Sisters' is all about imbalance.

In 'Job: A Circus,' Elizabeth Swados paints a clown.

ANTON CHEKHOV'S "THREE SISters" is a profoundly ridiculous play, and I mean that as a compliment.

His characters are bumblers and daydreamers, mired in a dull, provincial town that might as well be built on quicksand. Their lives are foolish and aimless and amount to nothing. If their emotions ran less deep, you could almost mistake them for those mismatched creatures in a Feydeau farce who are always slamming into closed doors or embarking on illicit affairs that end up under the bed, not on it.

But they do feel — these sisters in exile and the idle military officers who make up their society for a time. They feel the contradictions of their plight as acutely as they do the howling winter or the still, airless summer. For all their dreams of Moscow in the spring, they know instinctively that they're headed nowhere. They may pretend that their suffering is preparing humanity for a golden age, 200 or 300 years down the line, but that's only so they won't have to face a harsher truth — that their suffering is meaningless. They look to hard work for salvation, and then collapse on the divan, having barely lifted a finger. Because they can easily see themselves as puppets, however, they are more than puppets.

Their self-delusion accounts for everything that is ridiculous in the play, their self-awareness for all that is profound. And if you don't strike the right balance between the two, you really don't get Chekhov. You've made him too giddy or too moody, too lachrymose or too pretentious.

■

Take the current production at the McCarter Theater in Princeton, N.J. To the extent that her intentions are decipherable, the director Emily Mann has emphasized the hesitant buffoonery in the play. It's hard to tell, though. Some of the performers are richer in film credits than theatrical experience, so the floundering may be completely inadvertent.

Still, casting the diminutive Linda Hunt as Olga, the most authoritarian of the sisters, has to be purposefully ironic. If nothing else, everyone will be obliged to stoop low just to kiss the actress's cheek or shake her hand. The incongruity is further underlined by entrusting Masha to the tall, smoldering Frances McDormand, whose raw voice could silence a regiment if the fury in her flashing eyes didn't first. Round out the trio, as Ms. Mann has done, with Mary Stuart Masterston, reedlike and silvery in the part of Irina, the youngest sister, and it becomes obvious that the production is not concerned with bloodlines. Ms. Mann seems instead to want to illustrate the disproportion, the imbalance, plaguing the family.

That's a legitimate notion, but it's a comic one. These actresses look so peculiar together that we're primed to laugh at their misfortunes and their peccadilloes. If they're going to move us, too, they've got to work doubly hard. The spiritual links among them, however, are never compelling enough to offset the physical impression. You wind up, I fear, with a kind of Slavic three stooges.

The McCarter is using a felicitous translation by Lanford Wilson, commissioned by the Hartford Stage Company in 1984. But the text is almost always subtler than the performances. It may say something that at one moment I caught myself thinking that the three sisters could be distant kin to Winnie, the heroine of Samuel Beckett's "Happy Days," who natters on desperately about the glories of her existence and the great gifts of God, as she slowly sinks into a huge mound of earth. The more the sisters talk about escaping their dreary outpost and returning to Moscow, the greater the paralysis that grips them, rooting them, too, to the spot. Then again, it may say something that I found myself with more than enough time to think during the McCarter production. I certainly wasn't getting pulled in emotionally.

Provocative as the casting is on paper, much of it proves baffling in practice. If, as Olga claims, Baron Tuzenbach is so homely that she burst into tears when she first saw him, is Mark Nelson really the right actor to portray him? Mr. Nelson is as bright-eyed and alert as a puppy out to please, and Olga would be more likely to pat him on the head. Although the sisters lament that their brother, Andrei, has grown fat and slothful, Paul McCrane, who plays him, remains tense and wiry until late in the game, when the costumer Jennifer von Mayrhauser finally straps a little potbelly on him. Laura San Giacomo's vulgarity, on the other hand, would seem right for Natasha, Andrei's self-centered wife, who takes control of the sisters' house

room by room. Unfortunately, Ms. San Giacomo has precious little acting skill to accompany her native sullenness.

But then, even the experienced Josef Sommer earns some disconcerting laughs as Chebutykin, the old drunken army doctor, when he confesses in an abject late-night monologue that he killed a woman the week before on the operating table. It's probably the spectacle of Mr. Sommer in long johns and black riding boots, weaving unsteadily, that's triggering the laughter. Nonetheless, the upshot is the same: the doctor's anguish is effectively neutralized.

Only two performers — John Christopher Jones and Edward Herrmann — manage the trick of making their characters seem inconsequential and significant at the same time, which is exactly what's required.

Mr. Jones plays Kulygin, pedantic schoolteacher and devoted husband to Masha, who will cuckold him before his eyes, knowing that he'll overlook the humiliation. Mr. Jones's face is the equivalent of a Russian happy button, and his determination to keep smiling, as indignities mount, is touching. But it is Mr. Herrmann, as Vershinin, the army

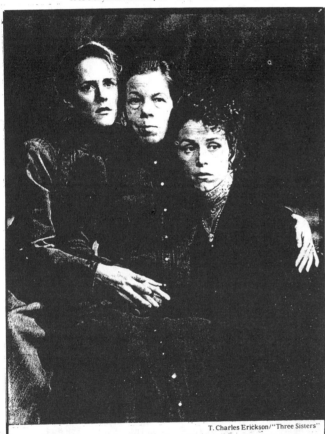

T. Charles Erickson/"Three Sisters"

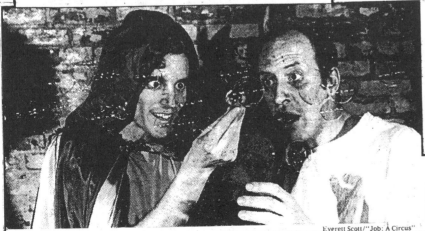

Everett Scott/"Job: A Circus"

officer doing the cuckolding, who best embodies the Chekhovian duality.

The actor doesn't cut a particularly dashing figure. In fact, he reminds you of a stock company Cyrano, with his pointed goatee, his prominent nose and his hair slicked back to reveal a high forehead. All the while Mr. Herrmann is behaving impulsively, he's telling himself that impulsive actions ill befit a man in his middle years. It's well and good that Masha loves him helplessly. He's afraid of appearing silly in his own eyes, and that self-consciousness introduces lovely notes of awkwardness and discretion into the performance. By not wanting to make a scene, Mr. Herrmann redeems every scene he's in.

Otherwise, the evening is unrewarding. When so many actors appear this inept, you don't have to search too far for the guilty party. Either Ms. Mann has been unable to implement her vision of the play, or she has a flawed vision to start with. Whatever the explanation, you're left with a depressing sense of ennui. And, regrettably, Chekhov has very little to do with it.

'Job: A Circus'

"Job: A Circus," a musical by Elizabeth Swados, produced Off Off Broadway by the Under One Roof Theater Company at One Dream Theater, is more bad news. Its hero is the biblical patriarch, who has been turned into the sad sack in the center ring and whose unending tribulations are depicted as a series of clown routines, most of which are humiliating, few funny.

Job (Stephen Ringold) is visited with balloons and packing tape, standing in for boils and rashes. An intrepid doctor, who seems to mistake him for an automobile, subjects him to a 5,000-mile checkup, while a mad scientist tosses him into an electronic device that reduces him to so many free-floating body parts. Ms. Swados, apparently, sees this as a way to make Job a pertinent figure for the 1990's. But her tiny Big Top romp is a throwback to the early 1970's and "Godspell," which used playground fun and games to recount the life of Jesus.

At least "Godspell" had novelty and an infectious song, "Day by Day," going for it. Ms. Swados, who also serves as director, and her youthful company of 10 performers are tilling an exhausted field, and the eclectic score contains no melodies or lyrics that lingered in my mind. Such works as "Nightclub Cantata" and "Runaways" brought the composer a modicum of popularity more than a decade ago. The charms of "Job: A Circus" are unlikely to do much for her reputation, limited as they are to giant soap bubbles and wafted silks, disappearing fire, colored streamers and a ballerina on stilts.

There is some attempt to enlist the audience as participants in the slapstick action. Ideas for improvisational interludes are periodically requested, although the night I was there, everyone was understandably puzzled when asked for "suggestions of ways we punish ourselves for the bad sins we've committed." One gentleman was more than happy, however, to volunteer for the pie-throwing segment and hit Job in the puss with a plateful of what was probably shaving cream.

The point of the falderal — for there is always gravity under an intellectual's shenani-

From left, above, Mary Stuart Masterson, Linda Hunt and Frances McDormand in "Three Sisters"; Michael Gunst, far left, and Stephen Ringold in "Job: A Circus"

gans — is that we will "never know what comes next or why," so we'd best live each moment fully and, as one number had it, "make a joyful noise." The advice was considerably easier to follow, I discovered, once I'd left the theater. □

1992 Ja 19, II:5:1

Bella, Belle of Byelorussia

By Jeffrey Essmann; directed by Christopher Ashley; music by Michael John La Chiusa; set by James Youmans; lighting by Debra Dumas; costumes by Anne C. Patterson; sound by Aural Fixation; musical staging by John Carrafa; production stage manager, Karen Moore. Presented by WPA Theater, Kyle Renick, artistic director; Donna Lieberman, managing director. At 519 West 23d Street.

Bella...................................Claire Beckman
Ludmilla and Waitress...........Harriet Harris
Sally......................................Becca Lish
Oglokov..................................Joe Grifasi
Giorgi.................................Willis Sparks
Mamushka..........................Ann Mantel
Sergei and Vladivostok Jimmy
 Jefferson Mays
Musicians
Susan Fisher, accordion, flute and keyboards; Michael John La Chiusa, keyboards; Paul Wegmann, strings, guitar, banjo and balalaika.

By MEL GUSSOW

"Bella, Belle of Byelorussia" at the WPA Theater, a delirious new comedy with music about neogeopolitics, might have been conceived by the Marx Brothers (Groucho, Harpo, Chico and Karl). The play was written by Jeffrey Essmann, the music by Michael John La Chiusa. Although the show is brief, it is packed with shaggy

commentary about everything from gulags to glasnost.

The title character is a young woman out of step with her time. She is as wide-eyed as Judy Garland in an M-G-M backstage musical. The year is 1989 and the Soviet Union is on the verge of collapse, but the backward-looking Bella, a tractor-factory worker in Minsk, wants nothing more than to be enrolled as a member of the Communist Party. In contrast, her pragmatic family and friends are scrambling aboard the leaky ship of capitalism.

The humor that aerates the book and music also extends to Christopher Ashley's production, which never drops its deadpan approach. Led by Claire Beckman, who is a winning Bella, the cast remains dry even as the vodka flows and the jokes spin into the land of the ridiculous.

•

Ms. Beckman's Bella is one of three women on a mini-assembly line. They are united nonworkers idling in a factory left over from a Stalinist propaganda film. At Bella's side are Harriet Harris, who confides that she is a princess from prerevolutionary days (she has czars in her eyes), and Becca Lish, who is so peppy that she might have been a cheerleader in her homeland of Uzbekistan.

Carol Rosegg/Martha Swope Associates
Claire Beckman in "Bella, Belle of Byelorussia."

The characters are soon caught in an intricate web of blackmail and black-market icons. Some of these shenanigans could stand clarification, but to their credit Mr. Essmann and his collaborators maintain their uninsistent attitude, throwing away the more disposable jokes.

In the playwright's conception, Minsk might be mistaken for a city in any country fighting a recession. The accents are intentionally American, with occasional infusions of da and nyet and a final burst of Uzbek to remind one of the territory. Despite their school courses in subjects like the decline of Western civilization, these young people have an affection for all things American, beginning with Hollywood movies.

Representing the old line of politics is Joe Grifasi, as an apparatchik with a top-heavy chest of medals and the gray-faced look of a Leonid Brezhnev. Even this grave image has an antic side; he breaks into a song and dance. Love interest is provided by Willis Sparks, whose double agentry is as broad as his smile.

Everyone sings, beginning with Ann Mantel as Bella's mother, who opens the show with a mock Brecht-Weill salute to misery. In the words of another song, "We'll keep on building tomorrow if we can just get through today." Comedy derives from such futile stoicism. The score is a clever pastiche, including Red anthems, a rap song and a Mongol lullaby, with some of the music played on a balalaika. The composer is one of the show's musicians. A few more tunes would turn "Bella" into the full musical it deserves to be.

The scenic designer, James Youmans, makes his own amusing contribution. Tilted at crazy angles, the factory set looks like a caricature of Constructivism. The costumes by Anne C. Patterson add a note of impertinence, as in Ms. Lish's party dress, a wedding cake of tiers and and frills.

As brisk as it is subversive, "Bella, Belle of Byelorussia" takes a Gogolian glee in its spoof of Soviet disunion. In its originality, the show compensates for recent WPA musical missteps (like "20 Fingers, 20 Toes") and reminds one that this is the company that first gave a stage to "Little Shop of Horrors."

1992 Ja 20, C18:1

Sight Unseen

By Donald Margulies; directed by Michael Bloom; sets by James Youmans; costumes by Jess Goldstein; lights by Donald Holder; music and sound by Michael Roth; production stage manager, Harold Goldfaden; associate artistic director, Michael Bush; general manager, Victoria Bailey. Presented by the Manhattan Theater Club, Lynne Meadow, artistic director; Barry Grove, managing director. At the Manhattan Theater Club Stage 2, City Center, 131 West 55th Street.

Jonathan Waxman............Dennis Boutsikaris
Nick................................Jon De Vries
Patricia...........................Deborah Hedwall
Grete...............................Laura Linney

By FRANK RICH

In a theatrical space as intimate as the Manhattan Theater Club Stage 2, you can tell when a play has gripped its audience, for no one seems to breathe, let alone shift in his seat. The phenomenon can be observed first-hand these nights at "Sight Unseen," a smart and sad new comedy by Donald Margulies that has all sorts of

unpleasant things to say about the 1980's art scene, the loss of love and the price of assimilation, both ethnic and intellectual, in an America where authenticity often has little to do with an artist's — or anyone else's — rise to the top.

The scene that reduces the house to a dead hush is an Act II encounter set in a sleek London art gallery where a provocative American painter named Jonathan Waxman (Dennis Boutsikaris) is being honored with a retrospective. Jonathan, an intense, fashionably dressed young man who wears a pony tail and may or may not resemble Eric Fischl or Julian Schnabel, has been the subject of adulatory profiles in Vanity Fair and The New York Times. He has a long waiting list of patrons who have commissioned his future pictures, sight unseen, at outrageous prices. But to maintain his marketability, he must suffer through tedious interviews, like the one he is now giving to Grete (Laura Linney), a leggy blonde German woman who is a ferocious student of his work and tends to ask long, multi-clause questions in impeccable, if strongly accented, English.

For all her flirtatious obsequiousness, Grete is a hostile interviewer. She demands that Jonathan reconcile his material success with his bleak paintings about the "emptiness and spiritual deadness of middle-class life." She asks why he employs a press agent. She traps him into spewing contempt for his own audience and for what she calls "the very system that made you what you are today." Worse, she attacks the content of his paintings from the politically correct left, reading sexual brutality and racism into a notorious canvas Jonathan regards as a celebration of physical love and a statement against bigotry.

•

Unsurprisingly, Jonathan squirms and grows defensive. But what holds the audience rapt is the double-edged drama Mr. Margulies has written into Grete's cross-examination. The more she closes in on Jonathan, the more Jonathan begins (and not without reason) to suspect her of anti-Semitism. But is she in fact anti-Semitic? Or is Jonathan, who has strayed far from his Brooklyn Jewish roots, just exploiting the charge of anti-Semitism to deflect this German journalist's legitimate attacks on his work and integrity? The brilliance of the scene, aside from its stiletto language, is that Mr. Margulies answers yes to both questions, refusing to let anyone, least of all the audience, off the hook. Both Jonathan and Grete are right even as they are wrong, and the rest of us, left with no one to root for, must confront Mr. Margulies's own vision of a spiritual deadness he finds in middle-class intellectual life of the present day.

Not all of "Sight Unseen" is as bracing as this one confrontation, but the evening is almost always absorbing, especially as superbly acted by its cast of four in Michael Bloom's flawless production. As Mr. Margulies's daring last play, "The Loman Family Picnic," toyed a bit with "Death of a Salesman," so this one takes a leaf from "After the Fall," its fractured time structure included. The narrative thread of "Sight Unseen," told simultaneously in the present and in flashbacks, is the tale of Jonathan's mid-life crisis: spurred by his empty pre-eminence, his father's recent death and the impending birth of his first child, the artist takes a journey into his past to find

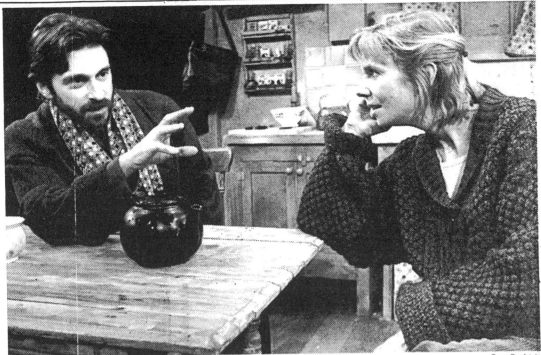

Gerry Goodstein

Dennis Boutsikaris and Deborah Hedwall in "Sight Unseen" at the Manhattan Theater Club Stage 2.

out how he lost his way. The quest leads him both to his bohemian student days and to a reunion with his first muse and lover, a self-described "sacrificial shiksa" named Patricia (Deborah Hedwall) who expatriated herself and married a British archeologist, Nick (Jon De Vries), after Jonathan abandoned her 15 years earlier.

While the overall arc of Jonathan's path to self-discovery is predictable, Mr. Margulies makes the individual scenes crackle with biting dialogue, fully observed characterizations and unexpected psychological complexities. In "Sight Unseen," the metaphor of the title extends beyond a hollow painter's distant relationship to his art to a collection of long intertwined and emotionally dishonest personal relationships. The scenes in which Jonathan invites himself to Patricia and Nick's cottage in the English countryside have the lethal undercurrents of Harold Pinter's love-triangle plays, for the archeologist, a fount of malicious facetiousness in Mr. De Vries's unsettling performance, becomes almost unhinged in his esthetic and personal loathing for his unwelcome house guest. As the two men battle over the history of art (and obliquely over Patricia), the question is not who will be the victor but who is the unhappier man, the bigger self-deceiver and moral sham.

•

The play is less effective, even glib, when it jumps back to the Brooklyn home and art-school studio of Jonathan's youth to show when the painter

was at his most authentic, as a painter and as a Jew. Jonathan's scantly described offstage parents carry more thematic weight than they can bear, and the whole juxtaposition between the jaded now and the idealistic then seems pat. That these scenes more or less work anyway is a tribute to Mr. Bloom's production: the short cuts that eventually crop up in the script are camouflaged by the designer James Youmans's evocation of a Brooklyn boy's bedroom, Michael Roth's shimmering incidental music and, most especially, the acting of the two principal players.

Mr. Boutsikaris, looking uncannily like Ron Silver, succeeds in keeping Jonathan from becoming unbearable in the present-day scenes without soft-pedaling his arrogance, then manages to find the frisky, likable artist as a young man in the flashbacks. As the woman he cannot forget, Ms. Hedwall is simply thrilling, and not just because of her technical mastery of abrupt time-leaping transitions that force her to jump from glassy-eyed middle-aged disappointment to youthful dewiness. In a play in which everyone, the older Patricia included, has made bad bargains with life and art, she is asked to embody the pure, direct human connection, the unclouded vision, that has been lost since the characters were young. This Ms. Hedwall achieves with a nakedness of spirit so incandescent that she adds a ray of hope to the otherwise angry brush strokes that dominate the canvas of "Sight Unseen."

1992 Ja 21, C13:3

Iron Lung

La Mama E.T.C.
74A East Fourth Street
Manhattan
Through Sunday

Written, directed and designed by John Jesurun; lighting, Jeff Nash; stage manager, Mathew Buckingham; technical director, Jim Coleman. Presented by La Mama E.T.C. and the Shatterhand Company.
WITH: Oscar De La Fe Colon, Rebecca Moore, Larry Tighe, Michael Tighe and Sanghi Wagner.

The plays of John Jesurun promise the unexpected. The actors on stage may interact with their own images on movie screens, or the scenery itself may whirl around like a giant propeller, offering glimpses of various vignettes in a nonsequential narrative. For this inventive theater artist, "Iron Lung" is an uncharacteristic venture. In this new work, there are five live actors playing characters on a single, stationary set. In other words, "Iron Lung" (at La Mama Annex) is almost a real play.

Despite the seemingly realistic surroundings, mystery curls behind closed doors and filters through the theater like unseen fog. As is customary with Mr. Jesurun, style supersedes substance. Ostensibly, this is a play about a songwriter (Larry Tighe) who is barren of musical ideas and hires two young people to write songs for him. To the composer's annoyance, every number they write turns out to be familiar, leading to his conclusion that all the good songs may already have been written.

The characters are residents in a vast basement room in a palatial hotel that has no other guests. As designed by Mr. Jesurun, this could be a waiting place in purgatory or an annex to the hotel in "Barton Fink." Any minute the walls may begin to peel. As the atmosphere becomes more ominous, questions arise. Why is water seeping down from an Olympic-size pool on the floor above? Is the composer's nickname, Papa Du, intended to be a reference to the dictator Duvalier?

Instead of addressing these and other issues, Mr. Jesurun pursues the

story of the composer and his unoriginal writers. Although the central narrative has amusing moments, it cannot sustain itself. The dialogue eventually runs dry (the water keeps dripping). Portent comes from the setting, the hotel manager (who is heard on an intercom) and the character of a maid (Sanghi Wagner), who seems to know far more than she admits. By the end of "Iron Lung," the maid is on the verge of assuming control of the hotel and of the play itself. She is a spark of a dramatic life in what is otherwise a closed circuit environment.

"Iron Lung" is most effectively viewed not in isolation but in context, as a sidestep in Mr. Jesurun's exploratory career. For an earlier view of this conceptualist in his multimedia action phase, the new play will be followed next week by a return visit from "Shatterhand Massacree," the playwright's investigation of the myth of the wild child.

MEL GUSSOW

Invention for Fathers and Sons

American Jewish Theater
307 West 26th Street
Manhattan

By Alan Brody; directed by Jay E. Raphael; set design, Bill Clarke; costumes, Elizabeth Covey; lighting, Kirk Bookman; sound, David Smith; production stage manager, Gail Eve Malatesta. Presented by American Jewish Theater, Stanley Brechner, artistic director; Lonny Price, associate artistic director; Richard Sabellico, resident director.
WITH: Glynis Bell, Monica Bell, Elaine Grollman, Ben Hammer, Gordon MacDonald, Len Stanger and William Verderber.

In Alan Brody's "Invention for Fathers and Sons," William Verderber portrays an ophthalmologist named Joel who, while waiting for a traffic light, has a mystical encounter with his dead father, Max (Len Stanger). In spite of his worldly success, Joel is filled with a rage that is destroying his marriage to a devoted wife (Monica Bell) and that has turned his adolescent son (Gordon MacDonald) into a cowering rebel with a learning disability.

He attributes his lifelong anger to his affable but nebbishy father, who died of brain cancer when Joel was 15 years old and his father was 48, the age Joel has reached. An encounter that begins as a friendly question-and-answer session opens up into a series of increasingly strife-ridden flashbacks that encompass Max's own childhood, when he was intimidated by his immigrant father, Elihu. Elihu was a practitioner of the "old country" school of child-rearing in which the children were expected to serve their parents.

"Invention for Fathers and Sons," which was directed by Jay E. Raphael, interweaves two motifs, a man's midlife crisis and a Jewish family tale, that have been explored so frequently in novels and plays over the last 40 years that the characters and situations seem almost stereotypically familiar. Although credible, the psychological family pattern that is revealed — bullying patriarch emasculates son, who is in turn too wishy-washy to discipline his own son — also seems a bit pat.

But as familiar as it is, the play still strikes many dramatic sparks. Mr. Brody's dialogue, especially in the family flashbacks, crackles with pas-

Theater in Review

■ Jesurun makes the expected unexpected ■ A mystical encounter with a dead father at a traffic light ■ The Ice Capades keeps up with the times.

Sanghi Wagner and Ocsar De La Fe Colon in "Iron Lung."

Jonathan Slaff/"Iron Lung"

sion. The scenes depicting the awkward communication between three generations of fathers and sons capture the fears and uncertainties of encounters that are loaded with volatile, unexpressed emotional baggage. And in a confrontation between the compulsively philandering Joel and his fed-up wife, soap-opera histrionics have been pared, leaving only words that are lean and deadly.

The performances are uniformly detailed and truthful, with Mr. Stanger's Max the most interesting. The role is almost a case study of a nice guy whose reluctance to express anger or to exert power wreaks psychological havoc.

"Invention for Fathers and Sons" offers no magic solutions. Once all the shouting and recrimination have subsided, the traffic light changes and Joel's life goes on, perhaps with a few new useful insights.
STEPHEN HOLDEN

Tom Scallen's Ice Capades

Madison Square Garden
Seventh Avenue and 33th Street
Manhattan
Through Sunday

Produced and directed by Willy Bietak and Mr. Scallen; choreography by Sarah Kawahara; production design, Robert W. Rang; Firebird costumes, Pete Menefee; other costumes, Jef Billings; lighting, John McLain; musical direction and arrangements, Euromusica Design Group. Presented by L'eggs Sheer Energy Panty Hose.
WITH: Yelena and Vladimir Bogolyubov, Rick Boudreau, Angelo D'Agostino, Dave and Joey, Tom Dickson, Angelique Gandy-Doud, Brad Doud, the Foy Flying Ballet, Kitty Kelly, Catarina Lindgren, Kristan Lowery, Chip Rossbach and Steve Wheeler.

Although the Ice Capades at Madison Square Garden could be criticized for many things, being behind the

times is not one of them. The perennial ice extravaganza, which opened at the Garden on Friday, has a recorded sound track with music by Hammer, Mariah Carey, C&C Music Factory, Paula Abdul and the European studio group Enigma, among others. It features a timely Cole Porter salute whose most spectacular number finds iridescently lighted skaters whirling and somersaulting in midair to the sounds of U2 singing "Night and Day." In "The World of Hanna-Barbera" cartoon sequence, skaters portraying the Flintstones audition for the show and are rejected until they start bouncing around to the sounds of Hammer.

The two-act show, produced and directed by Willy Bietak and Tom Scallen, is a shrewdly blended combination of children's fun and folliesstyle glamour, all laced with some blatant commercial pitches. The show is best when sticking to the realm of circusy pop entertainment, as when Dave and Joey, a clown duo, horse around acrobatically, and Brad Doud, portraying "the perfect gentleman," embarrasses his female partners and turns graceful leaps into pratfalls.

The show's most heavy-handed moments are those in which glitter and pomp substitute for grace and playfulness. Steve Wheeler, an illusionist, oversees several unthrilling feats of disappearance and escape. "Firebird" is a kitschy pop parody of the famous ballet.

Among the show's athletically impressive stars, Catarina Lindgren, from Sweden, displays the most grace; Angelo D'Agostino, from the United States, the most acrobatic prowess; Kitty Kelly, from Canada, the most personality, and the Russian

duo of Yelena and Vladimir Bogolyubov the most team virtuosity.
STEPHEN HOLDEN

1992 Ja 22, C17:1

When Lithuania Ruled the World, Part 3

Written and directed by Kestutis Nakas; producer and assistant director, Bonnie Sue Stein; production stage manager, Stephen Kinny; costumes, Linda Hartinian; set, Jan Gero; music, Dan Davis; choreography, Ellen Fisher; lighting, David Crocker. Presented by Goh Productions. At the Courthouse Theater, Anthology Film Archives, 32 Second Avenue, at Second Street, Manhattan. Through Sunday.

WITH: Jason Bauer, Holly Bush, Sylvia Castro, Karen Crumley, Rob Donaldson, Ellen Fisher, Jan Gero, John Hagan, Britton Herring, Vit Horejs, Keith Jones, Beata Kapelinski, Ken Kensei, Christa Kirby, Roberta Levine, Sidney Maryska, Edgar Oliver, Nicky Paraiso, Uzi Parnes, Paul Plunkett, Gary Ray, Duncan Raymond, Lenny Sansanowicz, David Maurice Sharp, Kimberly Velez, Oliver Wadsworth, David Wilkins and Wendy Yondorf.

By D. J. R. BRUCKNER

People who know nothing about the Baltic nations and Central Europe in the Middle Ages should not try to find out anything before seeing "When Lithuania Ruled the World, Part 3" by Kestutis Nakas at the Courthouse Theater of the Anthology Film Archives. It is enough to know that the history of that region is saturated with myth, romance and continuing ferocious controversy. Besides, Mr. Nakas is a very clever subverter of all versions of history; mere knowledge won't keep anyone a step ahead of him.

The medieval world Mr. Nakas goes on creating (Parts 1 and 2 of this weird epic appeared in the 1980's; Part 4 is soon to be a film) is populated by good Lithuanian kings and rotten princes, Byzantine and Russian patriarchs, porcine and idiotic Teutonic knights, a saintly but stupid Good King Wenceslaus, a Russian czar with yeti feet, a splendidly barbaric Mongolian warlord, an underground god with horns and tail, wolves, wraiths and a monster with a bull's head wearing a cowbell.

•

This swirling menagerie of exotically garbed creatures who occasionally burst into ridiculous song — 26 actors in at least 50 roles — is sort of guided through a plot full of heroism, conspiracy, betrayal and redemption by a grand wizard intoning verse oracles in a voice that falls somewhere between Joan Greenwood and a cello.

Experiencing this dizzying spectacle is certainly different and quite exhilarating, perhaps like seeing all the operas of Wagner and Mussorgsky jammed together and staged in Grand Central Terminal at rush hour.

1992 Ja 23, C14:4

Who's Afraid of Virginia Woolf?

By Edward Albee; directed by Paul Weidner; set design, John Conklin; costume design, Jess Goldstein; lighting design, Natasha Katz; stage manager, Deborah Vandergrift; assistant stage manager, Barbara Reo. Presented by the Hartford Stage, Mark Lamos, artistic director; David Hawkanson, managing director. At Hartford.

Martha	Marlo Thomas
George	Robert Foxworth
Honey	Heather Ehlers
Nick	Burke Moses

By MEL GUSSOW

Special to The New York Times

HARTFORD, Jan. 21 — The Broadway opening of "Who's Afraid of Virginia Woolf?" sent a seismic shock through the American theater. In common with "Look Back in Anger" in England, the Edward Albee play was something new and bracing in an art that was trapped by tradition. With surgical precision, "Virginia Woolf" revealed the psychological truths within a disastrous, festering marriage.

The play awakened a dormant theater at the same time it offended the Pulitzer Prize committee, which rejected its justified nomination as the finest drama of its season. Still, 1962 was very much Mr. Albee's year. Coming after his Off Broadway one-acts, the play confirmed his artistry and its success opened doors for writers like Sam Shepard, Lanford Wilson and David Mamet who followed him in replenishing the theater. Thirty years later, "Virginia Woolf," in revival at the Hartford Stage Company, retains its natural ferocity and brilliance. This is in spite of a production that is crucially marred in one of its two principal roles.

Although Robert Foxworth has all the self-harmful bitterness for George, Marlo Thomas is an unsuitable Martha. She takes a straightforward approach and misses the primal terror that is so essential to the character. As described by the author, Martha is "a large, boisterous woman." Ms. Thomas is petite and neatly groomed. At the very least, she should have decosmetized her looks, as Elizabeth Taylor did in the film version of the play. The character is blowzy, the better to exude blatant sensuality.

From Ms. Thomas's entrance on John Conklin's surprisingly unimaginative set and her utterance of the line, "What a dump," it is evident that the actress is not equal to the challenge. She does not bray and she has no bite, as demanded by the role. One keeps wondering what she is doing in Martha's house (she is certainly not in Martha's shoes). By playing the role as she does, she diminishes the intensity of her relationship with George. Anyone seeing the play for the first time might think of them as a bickering couple and not as mutually destructive people, in George's words, who have suffered so much "blood under the bridge."

She only begins to rise to the emotional demands of the role at the end of the play, the aftermath of exorcism. After a disheartening delivery of the frantic monologue that opens the third act, she conveys a glimmer of the defeat that surrounds her. As a woman who has endured a marriage of lies, she moves past the point of accommodation and gropes for life support.

The final tearful scene between the married couple reminds one that Ms. Thomas has residual resources, as

demonstrated in the television movie "Nobody's Child." But in this performance she does not encompass Martha, and Paul Weidner, as director, is unable to help her. His staging has an efficiency but not the assurance that he brought to previous Albee productions at Hartford Stage, including a "Tiny Alice" that was superior to the Broadway original.

Mr. Foxworth is in every way a contrast to his co-star. He assumes his role like a hair shirt made to his measure. Arriving home as an absent-minded academic, he soon delineates the despair of a man who has willed himself into failure. All he has left is his self-appointed role as eternal sparring partner. The actor is easily in a class with his predecessors in the role, Arthur Hill and Richard Burton (in the film).

Delivered with Mr. Foxworth's expert timing, the playwright's lines zing with accuracy. They are as fresh as when they were written, the elaborate tales from a professor's past as well as the acerbic give and take. In the actor's performance, George knows exactly how far he has fallen and how much guilt he carries.

With Burke Moses as the opportunistic young teacher, Nick, Mr. Foxworth finds a worthy antagonist for his game of "get the guest." Mr. Moses is so slick and sure of himself that he can casually unveil his own family secrets. He stresses the technocratic side of Nick, earning George's approbation as one of the "wave of future boys." The confrontations between Mr. Foxworth and Mr. Moses are the most forceful moments on stage. As Nick's mousy wife, Heather Ehlers conveys the limited demands of her character.

"Virginia Woolf" still has explosive power, but for renewed realization it must have an actress who can assume the full wounding dimensions of Mr. Albee's Martha.

1992 Ja 23, C19:4

The Visit

By Friedrich Dürrenmatt; adapted by Maurice Valency; directed by Edwin Sherin; sets by Thomas Lynch; costumes by Frank Krenz; lighting by Roger Morgan; music and sound by Douglas J. Cuomo; masks by Michael Curry; production stage manager, Matthew T. Mundinger. Presented by the Roundabout Theater Company, Todd Haimes, producing director; Gene Feist, founding director. At the Criterion Center Stage Right, 1530 Broadway, at 45th Street.

Claire Zachanassian Jane Alexander
Anton Schill Harris Yulin
WITH: Jarlath Conroy, John Jason, Paul Kandel, Ellen Lancaster, Richard Levine, Timothy Britten Parker, Doug Stender, Tom Tammi, Kelly Walters, Gordon Joseph Weiss and Garry D. Williams.

By FRANK RICH

NO one need go to the theater to learn that people will do anything for money. So why does "The Visit," Friedrich Dürrenmatt's drama about a town that sells its soul for a fortune, still exert a chilling grip nearly 35 years after it shook up genteel Eisenhower-era audiences who had been drawn to it by the star power of Alfred Lunt and Lynn Fontanne?

The answers are there to be found in the Roundabout Theater Company's revival at the Criterion Center. As directed by Edwin Sherin without

benefit of star power but with lots of intelligence and a fiercely conceived lead performance by Jane Alexander, "The Visit" stands revealed as a small masterpiece of misanthropy, a play whose cynicism is so thickly layered that the greed driving the plot at its surface seems almost the least of its characters' sins. For Dürrenmatt, people, not money, are the root of all evil.

Better still, the playwright's sense of theater is as nasty as his view of humanity. "The Visit" is not a soul-searching morality play in the earnest manner of a contemporaneous American work like "The Crucible," but a grotesque fable whose icy laughter and bizarre fantastical sideshows (a pair of blind, guitar-strumming eunuchs, for instance) reflect its Swiss author's proximity to both the Holocaust and the accompanying absurdist revolution in theater. People don't sit around and debate the issues in "The Visit." Like the pet black panther that mysteriously stalks the play's progress, its characters lie in wait, then move in for the kill.

The most spectacular killer, of course, is the one played by Ms. Alexander: Claire Zachanassian, a woman who is on her eighth husband and now owns half the world but has returned to her backwater hometown, Güllen, in Central Europe, to avenge her cruel, impoverished childhood. Claire offers her desperate, starving former neighbors a billion marks in exchange for the life of the grocer Anton Schill (Harris Yulin), who seduced and abandoned her 38 years earlier. Although the good people of Güllen are insulted by the notion that they would even consider doing in their most popular and re-

Martha Swope

Harris Yulin

spected citizen for money, there's never any doubt that they will do exactly that. The ghoulish fun in "The Visit" comes from watching Dürrenmatt, his own cynical voice often inseparable from that of his heroine, as he sadistically tightens the vise on the town, forcing its hypocrites to reveal their ugly true colors in ever more vicious ways.

Mr. Sherin is keenly aware of Dürrenmatt's black humor and utter lack of sentimental illusions. Everyone in Güllen — starting with the mayor, the schoolmaster and the priest — is morally corrupt, and, accordingly, Mr. Sherin puts every actor except the two leads in fiendish Expressionist masks. (As designed with a Weimar flourish by Michael Curry, they also help mask the blandness of a supporting cast spread thin as it doubles and triples in roles.) The conceit quite properly jolts "The Visit" out of naturalism, but not so much so that attention is distracted from the dialogue, which, in Maurice Valency's English adaptation, offers savage counterpoint to the action. The characters are always standing up for "simple human decency" and bragging about Güllen's "ancient democratic institutions," its abolition of capital punishment and its status as a "cradle of culture" once visited by Brahms and Goethe. Meanwhile, they spend Claire's blood money prematurely, steadily acquiring new shoes, gold teeth and other emblems of the good life on credit.

Thomas Lynch's set and Roger Morgan's lighting, though sometimes heavy-handed in their Brechtian effects, augment Mr. Sherin's imaginative scheme. With its tattered banners, hellishly colored interiors and strings of carnival lights, this "Visit" looks like a doomsday circus, an incipient charnel house. It is a shame that the director cannot always fill in the arresting broad canvas with telling details. The famous train-station scene in which Schill tries and fails to flee Güllen brings on intermission with a thud in Mr. Sherin's perfunctory staging of it, and it is further compromised by Mr. Yulin's minimalist performance. Neither Schill's terror nor, in the final act, his growing inner serenity is delineated in a lazy characterization that clings throughout to a single, sluggish note of shabby middle-aged defeat.

●

Mr. Yulin's failings put a big burden on Ms. Alexander, and she often carries it. Claire Zachanassian is a great role for any actress, but a particular feast for this one, whose innate coldness is far better suited to the bloodcurdling than the heart-warming. (Witness "Shadowlands.") With rouged cheeks, a pile of red hair, a garish crimson gown and a prosthetic leg that she delights in dragging noisily across the floor, Ms. Al-

Martha Swope

Cutting a demonic figure — Jane Alexander.

exander is virtually unrecognizable in "The Visit." She cuts a demonic image as she surveys the action from her sedan chair (held aloft by two muscle men), smokes cigars, orders her retinue about and mocks the self-righteous platitudes of the Güllen officials. This fascinating performance would be a great one were it not subject to Ms. Alexander's own limitations in executing it. The commanding size of a true avenging fury — a matter of presence, not physical stature — is missing from this Claire, most obviously when her venomous declarations ("The world made me a whore. I make the world a brothel!") emerge as raspy wisecracks (augmented by a loud hand rattle) rather than as a panther's jungle roars.

Given the production's inconsistencies, it cannot honestly be called essential viewing for those who have vivid memories of great previous stagings of "The Visit" — whether the legendary Peter Brook version with the Lunts, about which I have only heard tell, or the haunting Harold Prince production with Rachel Roberts and John McMartin that the New Phoenix Repertory Company brought to Broadway in 1973. But Dürrenmatt's play itself is essential viewing, and the Roundabout rendering is good enough to put across its horror to newcomers. That horror remains fresh because the citizens of "The Visit" are not remote abstractions, abject money-grubbers or Nazi thugs, but articulate champions of justice who congratulate themselves on their civic virtues even as they take a vote to rationalize murder. A nightmare about democracy, Dürrenmatt's play will always be pertinent; and when more so than in an election year?

1992 Ja 24, C1:2

Hamlet

By William Shakespeare; translation to the Hebrew by Avraham Shlonski; adapted and directed by Rina Yerushalmi; stage design by Moshe Sternfeld; costume design by Ofra Zadik; musical direction by Shosh Reisman; lighting by Judy Kupferman. The Itim Ensemble, the Cameri Theater of Tel Aviv, Matan presented by the Brooklyn Academy of Music, Harvey Lichtenstein, president and executive producer, in conjunction with the Consulate General of Israel in New York, Consul for Cultural Affairs, Noam Semel, in association with U.J.A.-Federation of New York's Operation Exodus, Peter W. May, chairman. At Brooklyn Academy of Music, Lepercq Space, 30 Lafayette Avenue, at Ashland Place, Fort Greene.

Guildenstern Noam Ben Azar
Rosencrantz Chanan Ben Shabat
Ophelia ... Dina Blei
Gertrude .. Pnina Bradt
Ghost and Player Amnon Douieb
Claudius .. Efron Etkin
Player .. Orna Katz
Horatio .. Moshe Malka
Player ... Elisha Nurieli
Laertes ... Amihai Pardo
Osrick and Player Yossi Pershitz
Hamlet ... Shuli Rand
Polonius and Gravedigger Shlomo Sadan

By MEL GUSSOW

To kill or not to kill, that is the question in Rina Yerushalmi's provocative adaptation of "Hamlet" at the Brooklyn Academy of Music. In reassessing Shakespeare's text from her contemporary Israeli point of view, the director offers a Hamlet as a man of moral conviction. From her perspective, no killing is justified even if the motive is revenge for fratricide or, for that matter, crimes

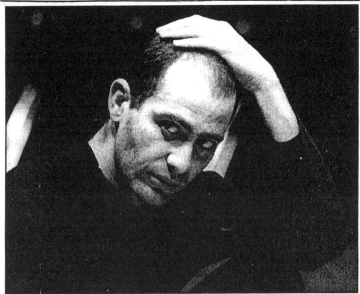

Shuli Rand in the role of Hamlet.

William Gibson/Martha Swope Associates

A Play That Improves The More It Travels

By MEL GUSSOW

Caryl Churchill's "Mad Forest" is a rare case of a play that has been strengthened in its travels from theater to theater. Despite that fact and the enthusiasm of the audience, which has filled the Perry Street Theater ever since the work opened in December, "Mad Forest" is scheduled to end its brief run next weekend. Producers have apparently been unable to arrange for a move to another, equally hospitable theater. But the premature closing should not detract from the process that brought the play to this highly creative point. .

With a quick response to a volatile political situation, Miss Churchill used her playwright's art to clarify the chaos of the Romanian uprising. Several months after the dictator Nicolae Ceausescu was executed for crimes against the state, Miss Churchill, the director Mark Wing-Davey and a group of students from the Central School of Speech and Drama in London went on a fact-finding mission to Romania. On location, they explored the roots and the effects of the revolution that toppled the Ceausescu Government from power. By the summer of 1990, Miss Churchill had completed "Mad Forest," and the students performed it in London for a limited run.

In that initial engagement, "Mad Forest" had rough edges, but it was riveting political theater, with a first-hand sense that the events were still happening as the audience watched. We became witnesses to social upheaval and to the tremors that continued to shake Romania. With intelligent equanimity, the playwright probed a crisis that seemed as impenetrable as the forest outside Bucharest that gave the play its title.

One of several theatrical steps might have followed. Miss Churchill could have labored on the play so much that it would have lost its harsh immediacy, or it could have been recast and redirected to make it more commercially viable. Instead, the work was allowed to gestate, and the playwright and the director gave the most careful consideration to the next stage of development during the play's subsequent run at the Royal Court Theater in London. In its New York Theater Workshop production at the Perry Street Theater, "Mad Forest" proves to be even more compelling than it was in its first incarnation.

This is in contrast to so many other plays. Theatrical history is filled with works that have lost something, either concrete or ephemeral, between London or regional theater and New York, or between Off Broadway and Broadway. Plays as strong as Harold Pinter's "Betrayal" and David Hare's "Secret Rapture" suffered in their New York premieres because of imprecision in casting or direction.

Earlier this season, there was the case of "A Piece of My Heart," by Shirley Lauro, in which the change of theater — of physical space — proved to be crucial. In a proscenium house Off Broadway, this play about women who served in Vietnam severed the bond of intimacy that had been established between the audience and the actors when the drama was performed on an open stage at the Actors Theater of Louisville. Miss Churchill herself was a victim when "Serious Money" was recast for its move from Off Broadway to Broadway in 1988. The new actors were unable to capture the production's original improvisational air. With "Mad Forest," all such pitfalls have been averted.

Although there are no major textual alterations, there has been a general tightening of the script, and the removal of one of the two intermissions has given the work a tauter structure. The actors in the American cast are two steps removed from the Romanian revolution, but they have a visceral awareness that they are performing fact before it marches into myth.

The students in London were a young and evolving ensemble. In the present company, the actors vary in age and have greater professional experience. Eleven actors are called upon to play dozens of characters, young, old and imaginary, and the American actors prove to be more malleable in shifting from role to role, including Randy Danson as both a worried mother and the ghost of a grandmother, and Joseph Siravo as a doctor, a priest and a bloodthirsty vampire. From the intensity of the performances (and even of the cigarette smoke that clouds the stage), one can almost feel that the actors have lived the events in the play. In the Caryl Churchill tradition, they have in effect relived them, under the astute supervision of Mr. Wing-Davey.

In its first production, the play was staged in a theater that resembled a school gymnasium. Scenery and lighting effects were kept to a minimum. Theatergoers sat on cinder blocks; actors and audience seemed to share discomfort. While there was justification for the approach, it also added an element of clinical distance.

At Perry Street, in a confined space, the audience is closer, psychologically and physically, to the characters. We are caught up in the confusion and deprivation of the people depicted on stage.

Marina Draghici's new scenic design is an important enhancement. Sliding and shifting panels quickly move the play from home to hospital, from street to church, where the audience can catch glimpses of religious frescoes in the background. The matchbox design has an Expressionistic tinge, as if ominous events are unfolding just out of sight.

The play's resilience is, of course, directly traceable to the author's method of work. When she undertakes a project, whether it deals with the English civil war in the 17th century ("Light Shining in Buckinghamshire," which also had its local premiere last year at the New York Theater Workshop) or the plight of modern farm workers ("Fen"), she begins as the theatrical equivalent of an investigative journalist. She amasses evidence and collates interviews and opinions. Then she takes a further step into interpretation. Eventually, her process moves far beyond the documentary and repre-

against the state. The Cameri Theater production performed in Hebrew (retranslated into English over headsets) is running through Sunday as part of a festival entitled Israel: the Next Generation.

Miss Yerushalmi's theorizing permeates her staging, but for theatergoers the primary reason for sitting through this long and demanding "Hamlet" is the director's stylistic approach, which accents the physical over the oral.

Clearly influenced by Peter Brook and other experimentalists, she has stripped her production to essentials. Instead of a Brook carpet, there is a

The question now becomes: To kill or not to kill.

circle of light, and that becomes the central playing area. Thirteen actors in contemporary dress begin the tragedy in a conversational mode. Soliloquies are confided to the audience, which sits on three sides of the stage. There is an absolute minimum of scenery and lighting changes.

•

The accent is on the physical interaction of the performers. While following the general sequence of the text, with occasional cuts and shifts for emphasis, the director concentrates on dialogues. Each dialogue becomes the equivalent of a pas de deux, with the characters acting out their visceral response to each other.

Hamlet and the Ghost, a most corporeal figure, do not pass on the battlements. They meet in the center of the stage, embrace and seem on the verge of engaging in a wrestling match. Each may be trying to expunge the other from his conscience. The struggle is graphically externalized.

This approach can lead the director into ridiculous paths. Claudius and Laertes compete in a childish game of bumping heads, like barflies trying to best one another. The Hamlet-Ophelia relationship, in which Hamlet twists and turns her around his body,

is further undercut by the fact that the actress playing Ophelia is made to look so androgynous. On the other hand, there is an urgency in the encounter between Hamlet and Gertrude. Hamlet begins by sitting at his mother's dressing table, a rare bit of scenery. When she appears, the scene is struck with passion, and there is no Ghost to interrupt Hamlet's tirade.

•

The actors are so adept at the physical demands of their roles that one could watch the play without headsets and know exactly what was going on. Shuli Rand as Hamlet has the intensity of a Jonathan Pryce, whether he is seated on a chair moodily watching his mother and Claudius or dashing into combat. Because Mr. Rand is omnipresent, one could regard the production as "Hamlet" restaged by its title character. The director makes many of her thematic points through Hamlet's choices. He does not plan to kill Claudius, but kills him in an act of rage. After Laertes has stabbed him, Hamlet drinks from the cup of poison, willing himself more quickly to his death.

As Polonius, Shlomo Sadan is an ambassador with briefcase and raincoat, someone who might be about to make a speech at an international congress. Later the actor doffs his hat to become a genial gravedigger. Rosencrantz and Guildenstern are twinned as vaudevillians. Along with Horatio, they are no longer sidelong figures, but play a more active role in the drama.

For the players scene, the audience is led into an adjoining space to watch the actors on a platform. That scene, which ends the first act, adds a touch of theatricality to what is otherwise an austere production. The pace slackens in the second act. The Israeli "Hamlet" is not a striking, radical interpretation of the play, as was Ingmar Bergman's version, but it is heightened by the director's seriousness of purpose and the fine-tuned athleticism of the company.

1992 Ja 24, C3:1

sents a bold leap of the imagination into a world that can approach magic realism.

In the course of her distillation process, she lets her mind roam freely. One of the most haunting aspects of "Mad Forest" is the paralleling of two fantastical conversations, one between a priest and an angel who has chosen to walk on earth, the other between a Transylvanian vampire and a flea-bitten dog (played by Christopher McCann). The dog, a stand-in for the oppressed common man, desperately wants to be adopted, even if it means eternal servitude to a vampire.

These scenes are examples of Miss Churchill's search for context. This

was true in "Serious Money," her satiric broadside about London's financial market and Wall Street. The author found a precursor in "The Volunteers, or, the Stockjobbers," a 1692 comedy by Thomas Shadwell, and began with a borrowed scene from that play. Similarly, in writing about problems of women in the workplace in "Top Girls," she cast her imagination back to heroines through the centuries. By relating present to past and by focusing on individuals caught up in revolutionary change, she has become a dramatizing historian of her time.

1992 Ja 25, 13:3

Life in the Theater (and What a Life)

'Two Shakespearean Actors' upstages the outside world.

'Sight Unseen' is a jigsaw puzzle about art and its cost.

"**T**WO SHAKESPEAREAN AC-tors" may be Richard Nelson's love letter to the theatrical profession, but he has written it with a poison pen and sealed it with a Judas kiss.

What starts out apparently as an affectionate celebration of 19th-century troupers ends up, two and a half hours later, as a rather stinging critique of their irresponsibility. I'm reminded of those ersatz Victorian valentines that look properly warm and sentimental until you open them and get hit with an insult. Mr. Nelson's tactics aren't quite so abrupt. In fact, his episodic play dawdles terribly in the second act before it comes to the point. But you can't pretend that the playwright's affections are pure. There's bile in this tribute, which Lincoln Center Theater has lavishly produced at the Cort Theater on Broadway.

■

Mr. Nelson has built "Two Shakespearean Actors" around the Astor Place riot, which broke out in New York City on May 10, 1849, and left more than 20 dead and 100 injured by the time the police and the militia had reestablished order. On the stage of the Astor Place Opera House at the time, the bombastic British actor William Charles Macready was holding forth in "Macbeth." The rebellious crowds were thought by some to be expressing their loyalties to Macready's chief American rival, Edwin Forrest, who was appearing nearby at the Broadway Theater and whose repertory also included a "Macbeth."

In fact, poverty, class antagonisms and a lingering hostility toward the British in general seem to have had more to do with the

riot than any artistic allegiances. But I'm not sure that matters here, because neither Macready nor Forrest, as Mr. Nelson conceives them, has any understanding of what is going on. And besides, neither cares a whole lot.

The play begins a week earlier and then — jumping from rehearsal hall to banquet room, hotel to tavern — makes its leisurely way to the fateful night in question, when Macready (Brian Bedford) is forced to seek refuge in the theater of his supposed enemy. Although the sharp crack of rifles in the distance can't help but remind them that the riot continues to run its deadly course, the two actors find themselves drawn into a late-night discussion of their craft.

Dismissing the gunfire as no more than a pesky intrusion, not unlike an unruly spectator in the second balcony, Forrest (Victor Garber) invites his unexpected guest out onto the empty stage for a look around. Before long, they're performing Shakespeare for the phantoms in the hall — Forrest trying on his Othello for size; Macready, his Lear. When another round of shooting disrupts their declamations, Forrest's patience snaps and he screams in the general direction of the disturbance, "I told you before, to *just leave us alone!*"

That defiant outburst, I think, goes to the heart of Mr. Nelson's drama. For his two celebrated actors, the imagined world is more important than the real world. The roles they play on stage eclipse any they might play in life. When functioning at their peak, they proudly claim to "lose" themselves in a part, although it would be equally accurate, judging from their often disreputable behavior offstage, to say that they lose *track* of themselves.

■

At a drunken dinner party, thrown by the Irish playwright Dion Boucicault, Forrest

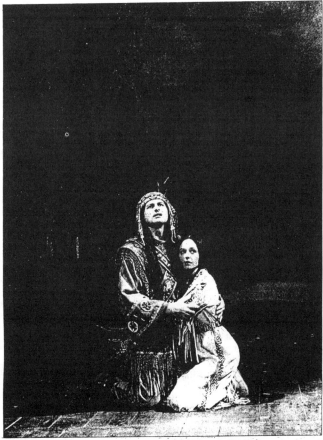

Brigitte Lacombe/"Two Shakespearean Actors"

Victor Garber and Hope Davies perform in "Metamora," a play within Richard Nelson's "Two Shakespearean Actors".

ticks off a day's worth of troubles. "And then you play Hamlet," he concludes, barely able to hold his head erect. "To do this you must learn to forget. Sometimes I think this is my favorite part of being an actor."

Forrest and Macready — not to mention the dozen or so journeymen who make up their respective companies — are running away from the very realities that they presumably illuminate with their art. That paradox makes Mr. Nelson squirm. He appreciates the eternal child in the actor but can't help wishing an adult dwelled there, too. You see why, as love letters go, this one strikes me as highly ambiguous.

"Two Shakespearean Actors," which has handsome costumes by Jane Greenwood and a series of rugged sets by David Jenkins, provides a broad panorama of a curiously unchanging breed at work, at play and at gossip. Drop by any theater hangout or any dressing room these days; the types are the same. So are their jealousies, their preoccupations and the expectant look that says, with as much pride as anxiety, "You *are* going to tell me I'm good, aren't you?"

Well, as it happens, Mr. Bedford is good, very good. His Macready is a gloriously puffed-up characterization, filled with great malice (toward others) and greater delight (in himself). His flushed face seems to have been inflated with a tire pump, and two large curls bracket his swollen forehead like parentheses. Pomposity comes effortlessly to him, even if the pompous words don't. He is constantly throwing himself into a grand pronouncement, only to produce a half-finished thought or a dusty platitude. No matter. What's a missing word or two, as long as the stance is right and he's upstaging everyone else?

■

Mr. Garber's Forrest, being leaner and meaner, is less wonderful, although still eminently stageworthy. (Having already played John Wilkes Booth in "Assassins," the actor has no trouble with the arrogant tilt of the chin or the maniacal glint in the eyes. Cut him and he'd probably bleed blue.) A carouser, Forrest finds nothing wrong in parading his mistress before the ashen face of his wife, and Mr. Garber shows us why: the man views himself as a doomed romantic hero, a blood brother to the noble savage he portrays in "Metamora." That 19th-century war horse is the linchpin of Forrest's repertory and Mr. Nelson makes a place at the top of Act II for a representative excerpt, Metamora's death

scene. It allows Mr. Garber to fail pathetically, sink to the floor, and then, just when you think he's a goner, rouse himself for another round of agonizing — which is more or less how Forrest carries on outside the theater, as well.

About two-thirds of the evening is spent illustrating the respective temperaments of the two thespians. But unless you dote on theatrical lore, that's not enough to put it over the finish line. In the end, "Two Shakespearean Actors" succumbs to the very tunnel vision it is lamenting. The play would be more interesting if it opened out onto the world that the characters insist on fleeing, if pretense and reality were more dynamically related. (Most forms of nontheatrical life have simply been relegated to the wings.)

As a result, you're apt to appreciate the work more for its pungent bits and pieces than for its meandering whole. There's a hilarious rehearsal sequence, staged with bravura by the director Jack O'Brien, that pits Macready's production of "Macbeth" against Forrest's. (Mr. Bedford, in a plaid kilt and ridiculous tam-o'-shanter, careers about the stage like a balloon with the air rushing out.) Tom Lacy, as Tilton, an actor in Forrest's troupe, works himself into a spectacular state of discombobulation when his lines stop coming to him and he finds the part of the drunken porter turning into a ghastly knock-knock joke. And Tom Aldredge certainly makes the most of his cameo as Washington Irving, who has been drafted by the leading citizens of New York to reassure Macready and his troupe that they will be safe in the metropolis. ("I told them — you probably had never even heard of me," he laughs, and from the way his features sag in the awkward pause that follows, it's clear they haven't.)

■

Quite the nicest of Mr. Nelson's characters, however, is the greatest exception to the rule. He's John Ryder, Macready's traveling companion and an actor of mod-

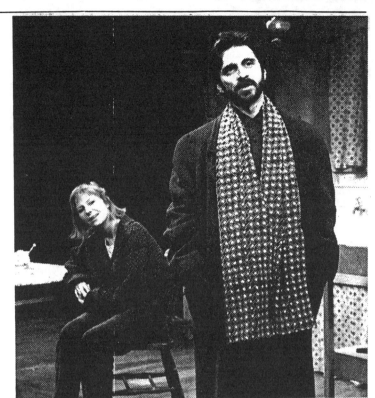
Gerry Goodstein/"Sight Unseen"

Deborah Hedwall and Dennis Boutsikaris in "Sight Unseen"

est ego, who's thrilled just to be able to ply his trade in the company of greats. Zeljko Ivanek plays him with a lovely scratch in his voice and a sweetly awed expression on his face. Then it occurs to you that the servility may just be *his* way of manipulating others, in which case, Ryder is merely the subtlest of the gesticulating monsters.

Actresses get decidedly shorter shrift or no shrift at all. A pinched Frances Conroy does what she can to suggest years of quiet suffering as Forrest's neglected wife, while Jennifer Van Dyck imparts a measure of independence to Forrest's mistress — both roles are minuscule. There are witches to be played in "Macbeth," of course. But while the rake in Forrest makes sure their bloomers show, the prig in Macready casts men as the harpies and covers them up with rags. Women are so much scenery here, when they are not expected to blend into it.

The theatrical world in "Two Shakespearean Actors" is as smug as any men's club that ever evoked its prerogatives and rituals to blackball the bothersome riffraff beyond the door. And yet, Mr. Nelson acknowledges that these petty, self-involved creatures have a rare power to touch our souls. Another paradox for you. But then it's paradoxes, more than historical events, I suspect, that are the real stuff of this play.

Despite their professional differences, Forrest and Macready have too much in common to let a little thing like a riot come between them.

'Sight Unseen'

Art, what it is, how it's made, what it's worth and furthermore, who says so, are also concerns of "Sight Unseen," an intelligent, vaguely Pinteresque drama by Donald Margulies

at the Manhattan Theater Club Stage II. Its hero, Jonathan Waxman (Dennis Boutsikaris), is a contemporary painter whose large, brooding canvases have begun to fetch astronomical prices in the marketplace. As the play begins, he's about to have his first major retrospective in London and he has come to England to help ready the exhibition.

Since his inspiration is seriously blocked, he also intends to look up Patricia (Deborah Hedwall), an expatriate American who served as his model and mistress in earlier, more fecund years. Maybe she has the key that will unlock his creativity. Patricia has since married Nick (Jon De Vries), a British archeologist, although she doesn't much love him, and now spends cold, dreary days in the countryside mucking around in a medieval garbage dump, digging up bones and artifacts.

"Sight Unseen" unfolds on three fronts. There are the scenes in a country farmhouse that show Jonathan trying to come to terms with Patricia and Nick, although Patricia's bitterness and Nick's loutish jealousy don't favor reconciliation. There are the scenes in the London gallery, where Jonathan is interviewed by an aggressive German journalist (Laura Linney), who persists, somewhat threateningly to Jonathan's mind, in perceiving his work as a reflection of the guilt in middle-class Jewish life. And finally, there are the scenes that take place in New York in the distant past and afford us a look at Jonathan and Patricia when they were fresh and unspoiled and art loomed as a magnificent adventure.

Mr. Margulies cuts back and forth, which makes his play a bit of a jigsaw puzzle. But his dialogue is articulate and his characters are thoughtful, so "Sight Unseen" is always worth lis-

tening to. If it doesn't deliver much of an emotional payoff, that may not be entirely the playwright's fault. A lot is going on under the surface, and the director Michael Bloom seems to want to keep it there. While the tactic enhances the play's mystery, it lessens the visceral impact. Still, the cast members are convincing. Ms. Hedwall not only has a chip on her shoulder, but her delivery is so mesmerizingly distinctive I want to say she has a chip on her voice. I stopped believing only when she was required to shed 17 years and project the directness and simplicity of youth. Complication and disenchantment would appear to be more her style.

1992 Ja 26, II:5:1

A Little Hotel On the Side

Translated by John Mortimer from "L'Hôtel du Libre Échange" by Georges Feydeau and Maurice Desvallières; directed by Tom Moore; settings by David Jenkins; costumes by Patricia Zipprodt; lighting by Richard Nelson; sound by T. Richard Fitzgerald; original music composed by Larry Delinger; production supervisor, Glen Gardali;, executive producer, Manny Kladitis. Presented by the National Actors Theater, Tony Randall, founder and artistic director. At the Belasco Theater, 111 West 44th Street,Manhattan.

WITH: Doug Adair, Nell Balaban, John Beal, Danny Burstein, Danielle Ferland, Richard Ferrone, John Fiedler, Kia Graves, Andrew Hubatsek, Bruce Katzman, Zane Lasky, Rob Lowe, Alec Mapa, George N. Martin, Maryann Plunkett, Madeleine Potter, Tony Randall, Brian Reddy, Lynn Redgrave, Patrick Tull, Siobhan Tull, Paxton Whitehead and Carol Woods.

By FRANK RICH

For a farce to succeed onstage, it need not offer the audience redeeming social value, literary merit, great acting, esthetic perfection or brilliant wit. A farce need be only one thing: funny.

By that simple criterion, the National Actors Theater staging of "A Little Hotel on the Side" can be called a complete flop, and it doesn't fare better by any other criteria, either.

Laughter does emanate from pockets of the Belasco Theater, but it is at most tangentially related to the ingenious roundelay of disastrously ill-fated trysts that Georges Feydeau wrote with Maurice Desvallières in 1894 (and which is performed here in a mangled version of John Mortimer's delightful 1984 translation). Much of the audience's giggling is a response to the shameless mugging of Tony Randall, who, in the role of Pinglet, a Parisian building contractor, revives the eye-bulging hysteria and hyperventilating tantrums of Felix Unger, beloved hero of a thousand late-night television reruns.

"The Odd Couple" is a classic in its own right — and the frenetic Mr. Randall, thickly painted with ruddy makeup, does seem almost cryogenically frozen in time since its inception — but why insert little pieces of Felix into "A Little Hotel"? Neil Simon gets as raw a deal as Feydeau does, and Mr. Randall, by ungenerously refusing to sacrifice so much as one dropped jaw from his television persona for the greater good of the show at hand, makes a mockery of his own company's selfless goal of becoming "a classical repertory theater."

The fear that the National Actors Theater would rather be winter's answer to celebrity-laden summer stock is further heightened by Rob Lowe's appearance in the role of Maxime, a bespectacled student who, like most of Feydeau's other characters, is caught with his knickers down in the dubious hotel of the play's title. Was Mr. Lowe cast to fulfill the company's stated mission of presenting "the world's greatest actors in civilization's greatest plays" or because the circumstances of his role dovetail with the Atlanta hotel-room scandal that brought him a brush with the law and tabloid headlines a few years ago? You be the judge. Suffice it to say here that Mr. Lowe goes about his assignment with all the effervescence of a miscreant fulfilling a court-ordered sentence of community service.

As with "The Crucible," this company's previous offering, one's heart goes out in "A Little Hotel on the Side" to the unfamous actors who work hard to legitimize the floundering, undisciplined stars at center stage but find themselves miscast, misdirected or both. Maryann Plunkett, whose fine Elizabeth Proctor was the saving grace of the Arthur Miller play, cannot find the right exaggerated tone for the role of a reluctantly philandering wife, and, like Madeleine Potter, who sinks just as fast in the part of the randy maid pursuing Mr. Lowe, she emits not an iota of erotic heat. (The only sexual gag conveyed passionately in this production has nothing to do with men and women, but is a bit in which Mr. Randall's posterior is penetrated by an errant corkscrew.) Cameos that should be polished comic gems — a voyeuristic hotel manager (Patrick Tull), a libidinous hotel porter (Alec Mapa), a police inspector (John Fiedler), a wayward schoolteacher (Zane Lasky) — are so lame that one wonders if the actors have been told that the Belasco's bill has switched from Puritan Salem.

Faring marginally better are Lynn Redgrave, as Mr. Randall's battle-ax of a wife, and Paxton Whitehead, as a country gentleman visiting Paris with four daughters who, as winningly costumed by Patricia Zipprodt, seem to have stepped out of Ludwig Bemelmans's "Madeline." Another Zipprodt design abets Miss Redgrave, who turns up in Act III with crushed millinery plumage, a soiled and torn black-and-mustard gown, and a black eye that leave her looking like Marie Dressler exhumed from a watery grave. The perpetually befuddled Mr. Whitehead, an experienced hand from such farces as "Run for Your Wife" and "Noises Off," makes the most of a typically nasty running Feydeau gag, a painful stutter that proves to be a crucial cog in the plot.

•

The play's director, Tom Moore, is also experienced at farce — indeed, he has directed this play before — but you would never know it from his work here. No unity of acting style is attempted that might set up the proper bourgeois French milieu that must be firmly in place if the characters' pratfalls from propriety into lecherous disrepute are to seem comic later on. When the plot's mistaken identities and inopportune coincidences, not to mention a platoon of Keystone gendarmes, all kick in during Act II, Mr. Moore's clumsy, confusingly lighted slamming-door choreography is more furious than funny, and the attempts to juice it up with canned music suitable for a television sitcom are embarrassing. With staging and

Joan Marcus/"A Little Hotel on the Side"

Maryann Plunkett and Tony Randall in "A Little Hotel on the Side."

acting this mechanical, why not go all the way and throw in a laugh track as well?

Of course, farce is itself a machine, heartless and relentless, and that is precisely why it becomes an instrument for torture instead of laughter, like an unattended merry-go-round, when left to run amok. It figures that nothing, not even Mr. Randall, receives as big a hand in "A Little Hotel on the Side" as the two turntables that move the prefab belle époque scenery. At this National Actors Theater production, the audience learns all too quickly that only the gears beneath the actors can be trusted to give Feydeau's clockwork antics a precise spin.

1992 Ja 27, C17:1

Crazy He Calls Me

By Abraham Tetenbaum; directed by John Ferraro; scenery by Loren Sherman; costumes by Jennifer von Mayrhauser; lighting by Dennis Parichy; sound by Raymond D. Schilke. Presented by Weissman Productions and Roger Alan Gindi. At the Walter Kerr Theater, 219 West 48th Street, Manhattan.

Benny .. Barry Miller
Yvette... Polly Draper

By FRANK RICH

At first "Crazy He Calls Me," a new two-character play by Abraham Tetenbaum at the Walter Kerr Theater, seems like just another boy-meets-girl, girl-helps-boy-masturbate romantic comedy.

The time is 1948, the place Brooklyn. Benny (Barry Miller), a young lawyer who still lives with his mother and sister, has fallen for Yvette (Polly Draper), a Polish émigré, née Yetta, who has a burning mission to raise money for a Hebrew home for the aged. But no sooner has Benny stopped off for the first time at Yvette's apartment for a nightcap than the audience begins to suspect darker doings. Not only does Yvette insist on helping her date achieve orgasm while he remains fully dressed in his pin-striped suit but she proudly displays an impressive collection of lipstick-stained napkins kept in a bureau drawer and yells at a possibly imaginary uncle through her parlor floor.

•

Crazy you call her? Some of Yvette's other habits include a propensity for picking fights with waitresses and construction workers, a tendency to speak in guttural inner voices that sound like Fanny Brice

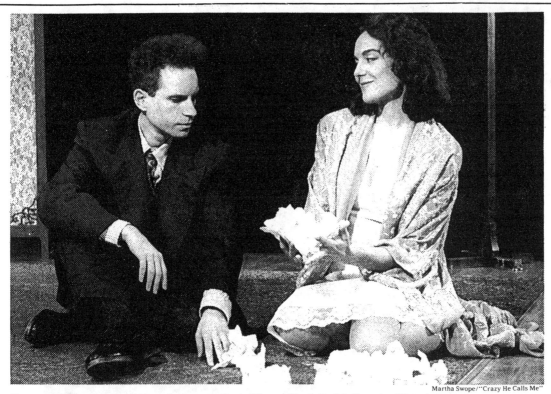

Barry Miller and Polly Draper in a scene from "Crazy He Calls Me," at the Walter Kerr Theater.

Martha Swope/"Crazy He Calls Me"

impersonating Linda Blair, and an insistence on canceling her own recitals as a classical pianist just as the audience takes its seats. Her sense of humor is nothing if not single-minded. When Benny, in the course of a bucolic picnic lunch, gently suggests that Yvette consider submitting to a medical examination, she angrily hands him a thermos and insists that he fill it to the brim with a urine specimen.

Yet Benny's ardor remains unshakable. As he recounts his courtship and marriage to Yvette in flashback, he constantly reassures the audience that he had "no indication we'd be anything but an ideal couple" and rhetorically asks, "How could anyone have known I was being deliberately misled?" That he was a fool to fall for Yvette is apparent to anyone but him, however, from Scene 1. Besides the circumstantial evidence of the heroine's lunatic behavior, there is the fact that Benny delivers his narration from beneath a courthouse portico and refers to Yvette as "the defendant." Only the nature of the crime, and implicitly the true identity of the mysterious heroine, remains elusive throughout. Has Yvette ended up on trial as a clandestine ax murderer, a sex offender, a saboteur of Schubert, a member of an anti-fascist underground, a terrorist in league with the homeless Hebrew aged?

●

Since the playwright, unlike his characters, does not believe in immediate gratification, the answer to that question is withheld until the final minutes. And when the revelation arrives — it will not be divulged here — it proves even more anti-climactic than Benny's indelible Act I curtain line, "The plaintiff moves that we adjourn for a short recess." After two hours of repetitive, windy exposition including that 20-minute recess and enlivened only by a scene in which Mr. Miller silences Ms. Draper by stuffing a knish into her mouth, "Crazy He Calls Me" has no real payoff

except a vague, sentimental message. The experience of seeing this play is like watching a whodunit in which the butler is revealed as the murderer in the opening scene and promptly arrested, but the characters spend two hours more rehashing the same two or three clues.

Given that "Crazy He Calls Me" is on Broadway, another eternal and clichéd mystery inexorably presents itself. How did such a tiny piece of nonsense attract producers and grow into a huge and costly web that would ultimately ensnare a smart director (John Ferraro), a first-rate design team (Loren Sherman, Jennifer Von Mayrhauser, Dennis Parichy), and a pair of actors as talented as Ms. Draper and Mr. Miller? One never knows. Maybe the producers' script reader is their butler.

●

The artists who lend their skills to "Crazy He Calls Me" are guilty of nothing except wasting their own time and other people's mad money. The vibrant Ms. Draper, returning to the New York stage from her Hollywood sojourn in "Thirtysomething," gets to wear a lot of lingerie and, intentionally or not, parody Meryl Streep's performance in "Sophie's Choice." Mr. Miller, playing a young man so naïve it seems a miracle that he can tie his shoelaces by himself, spends an undue amount of time on his knees. If he isn't praying, he should be.

1992 Ja 28, C11:1

Theater in Review

■ Four scenes from David Greenspan's life

■ Kafka and papa

■ Considering Racine's 'Phèdre' and all its consequences.

The Home Show Pieces

Public/Martinson Theater
425 Lafayette Street
Manhattan
Through Feb. 16

Written and directed by David Greenspan; set by William Kennon; costumes by Elsa Ward; lighting by David Bergstein. Presented by the New York Shakespeare Festival, Joseph Papp, founder; JoAnne Akalaitis, artistic director; Jason Steven Cohen, producing director; Rosemarie Tichler, associate artistic director.
WITH: Ron Bagden, Tracey Ellis and David Greenspan.

Before he became a director at the New York Shakespeare Festival and began staging his own maladroit deconstructions of classics ("The Way of the World"), David Greenspan was the author of plays like "2 Samuel II, Etc.," a provocative and highly personalized re-evaluation of the story of David and Bathsheba. In "The Home Show Pieces," a revival of four one-act plays presented several years ago at the Home for Contemporary Theater and Art, Mr. Greenspan is once again in his autobiographical mode,

but with diminished dramatic returns.

As written and directed by Mr. Greenspan, each of the plays wears a label of self-indulgence. How else could one characterize "Portrait of the Artist," in which the author sits on a toilet and expounds about the life of the playwright and the wages of success? As it turns out, this play is the only one of the four that clearly communicates its intention to the audience. It is also the only one that almost justifies its length. Each of the others is excruciatingly attenuated, which is not mitigated by the fact that characters acknowledge that the work is too long.

As unlikely as it might sound, there is some amusement to be found in Mr. Greenspan's bathroom monologue. The scene is an absurd variation on that moment in "All About Eve" when Eve Harrington walks on stage and pretends to take a bow before an appreciative audience. Posing as a newly acclaimed star playwright, Mr. Greenspan tries on the cloak of celebrity. "Being famous was never that important to me," he explains to an unseen interviewer, and then almost immediately takes it back to bask in his own narcissism. There is a sadness in this comic fantasy. Underlying the words in all four plays is a note of abject loneliness.

This is certainly the case with the opening effort, "Doing the Beast," an enervating slice of life in which the playwright is home alone in bed and has his erotic dreams interrupted by extended telephone calls from friends and relatives. One of the callers, a favorite aunt, is apparently hard of hearing, forcing her nephew to repeat his words ad infinitum infinitum.

The repetitive language is what passes for style in this case without momentum, as the plays stifle the audience in an intricate overlapping of scenes and lives. Characters reappear in the same or a different guise in different plays. For example, the role of gay Jewish artist played by Mr. Greenspan is also assumed by an actress, Tracey Ellis.

Illustrating the "home" in the title, the plays shift between rooms and porch and patio where we find Ms. Ellis and Ron Bagden acting out scenes from an unhappy marriage. Except for an occasional pithy line and for Ms. Ellis's appealing presence, the plays offer little illumination. They are a showcase for Mr. Greenspan's solipsism. For all but his most devoted admirers, this is a hermetically sealed environment.

MEL GUSSOW

Kafka: Father and Son

La Mama E.T.C.
74A East Fourth Street
Manhattan
Through Feb. 9

By Mark Rozovsky; adapted from Franz Kafka's "Letter to His Father" and "Judgment" translated by Elena Prischepenko. Directed and designed by Leonardo Shapiro. Design associate, set construction and technical director, Michael Casselli; design associate, costumes and props, Liz Widulski; lights by Blu; music by Marilyn Zalkan; sound by Kyle Chepulis; production stage manager, Paul J. Smith. Presented by La Mama E.T.C. and the Shaliko Company.
WITH: George Bartenieff and Michael Preston.

In "Kafka: Father and Son," Mark Rozovsky, a Russian writer and director, has taken Kafka's "Letter to His Father" and "Judgment," an earlier story about an obedient son who throws himself in the river when his

father condemns him to death by drowning, and tried to cobble a play from them.

In fact, Mr. Rozovsky has not written a play so much as stitched together a patchwork of simulated dramatizations based on Kafka's epistolary and fictional indictment of his father. For some reason, both Mr. Rozovsky and his director, Leonardo Shapiro, felt it necessary to embroider on the original.

In the "Letter," for example, Kafka recalls a childhood episode in which he whined for a glass of water after being put to bed. His father, failing to quiet him with usual threats, grabbed little Franz from his bed and locked him out on the balcony. In Mr. Rozovsky's version, the father proceeds to fetch a glass of water and pour it over his son's head. And the opening vignette, in which father and son argue over the son's plans to marry (the "Letter" was written following Hermann Kafka's opposition to Franz's engagement to Julie Wohryzek), is played out while the father is urinating.

Apart from such expansions on the author's reminiscences, Mr. Rozovsky cannot resist the compulsion to pad out Kafka's words with dialogue of his own. The result is a pair of characters who often sound more like refugees from a Beckett play than a Kafka story.

These conceits aside, a major interpretive problem with "Kafka" is its narrow view that the "Letter" is little more than a monochromatic portrait of child abuse and that there is a political subtext beneath Kafka's celebrated conflict with his father. Kafka himself dismissed the former, and while one might read Kafka's epistle as a "Letter to God," it should never be mistaken for a "Letter to the Commissar."

Michael Preston as Kafka and George Bartenieff as his father strive to turn all this into drama. At a recent performance, they also had to contend with a host of technical problems that, among other things, brought the house lights up at odd moments in several scenes. Mr. Preston's Kafka is an intense young man who uses

bulging eyes and shaking hands to signify his rage, fear and guilt. Mr. Bartenieff's father is garrulous, bullying and manipulative. It is a credible character, but bears faint resemblance to the father Kafka describes in his letter.

WILBORN HAMPTON

We Should . . . (a Lie)

Living Theater
272 East Third Street
Manhattan
Through Feb. 16

By Kenneth Bernard; directed by Robert Press; lighting by Craig Kennedy; costumes by Daniel Cole; original music by Roberto Pace; assistant director and stage manager, Dena Kazmin; producer, Judith Malina; French text translation, Richard Wilbur; French dialect coach, Joan Templeton. Presented by the Living Theater New Directors Series.
WITH: Joanie Fritz, Gene, Lois Kagan, Kevin D. Mayes, Victoria Murphy, Joe Pichette and Michael St. Clair.

One has to suspect that Kenneth Bernard's "We Should . . . (a Lie)" is more comprehensible when it is read than when it is seen and heard. Still, it is so intelligent, quick and ironic that it ignites a viewer's imagination.

In this play, as in his increasingly appreciated short stories, Mr. Bernard can change one's perceptions and shatter emotions from phrase to phrase, and he has an unerring instinct for the dramatic possibilities in philosophical questions that have troubled people for thousands of years.

Here a group of actors rehearses Racine's "Phèdre," itself a meditation on Euripides' terrifying "Hippolytus." The attraction of such a situation for someone of Mr. Bernard's wit is obvious. As the rehearsing actors remind themselves, "this is a play about monsters," and as they try to flesh out the Racine characters — or force them into more humane dimensions — all are slowly overwhelmed by the disaster that destroyed the house of Theseus when that mythical king's wife Phaedra falsely claimed

she had been ravished by her stepson, Hippolytus.

The different actors' varying perceptions of the Racine play, its characters and its moral issues are all sparks for Mr. Bernard's verbal explosions, and great intellectual fun. And the members of this cast — especially Michael St. Clair as Phaedra and Kevin D. Mayes as Hippolytus — deserve the outburst of applause they get; to a remarkable degree they keep the audience aware of the intricate mental gymnastics the playwright is performing.

They are not always helped by Robert Press's direction. Occasionally he has inspired notions of how to illuminate the plot by simply letting the audience see the implications of what characters are saying. But on the whole he flattens the play's layered ironies with exaggerated and even crude depictions of its violent and sexual elements, exercises that call attention to his intrusions and distract it from the play itself.

D. J. R. BRUCKNER

1992 Ja 29, C17:1

Boesman and Lena

Written and directed by Athol Fugard; sets and costumes by Susan Hilferty; lighting by Dennis Parichy; associate director, Ms. Hilferty; production stage manager, Sandra Lea Williams; associate artistic director, Michael Bush; general manager, Victoria Bailey. Presented by Manhattan Theater Club, Lynne Meadow, artistic director; Barry Grove, managing director. At City Center, 131 West 55th Street, Manhattan.

Boesman	Keith David
Lena	Lynne Thigpen
Outa	Tsepo Mokone

By FRANK RICH

Whether or not you get to the Manhattan Theater Club's revival of "Boesman and Lena," you can always see another, informal version of its drama day or night on a Manhattan sidewalk or subway platform or vacant lot. Athol Fugard's image of an itinerant homeless couple sheltered within their scrap-heap possessions and awaiting the next official eviction is now as common in New York City, among other places, as it was in the South Africa where he set and wrote his play in the late 1960's. Even at the time of its premiere, "Boesman and Lena" was recognized as a universal work that might speak to audiences long after apartheid had collapsed. But who would have imagined that the universality would soon prove so uncomfortably literal?

•

The troublesome thing about the Manhattan Theater Club production, which Mr. Fugard himself has directed with Keith David and Lynne Thigpen in the title roles, is that it is less searing than the version playing outside the theater. The problem is not that real life has rendered "Boesman and Lena" redundant, for, as written, Mr. Fugard's play can never be outstripped by events. Boesman and Lena, a "colored" couple adrift from both blacks and whites in their own society, are more than a journalistic paradigm of homelessness or of South African racist oppression. Their shared life, alternately a refuge and a brutal prison, is above all a marriage, observed by the author at a microscopic range Strindberg might have admired and as elemental and timeless as the primitive

campsite where the play's single evening of action takes place.

What really makes this "Boesman and Lena" tame is a mundane matter, that of the production. As a director of his own canon, Mr. Fugard has ranged from supple (" 'Master Harold' . . . and the Boys") to stagy ("My Children! My Africa!"), and he has not always shown a sophisticated ear for the tonal nuances of American acting. "Boesman and Lena" brings out his weaknesses. While the play is hardly realistic — if anything, it unfolds in a self-consciously Beckett-like void — its metaphors are still rooted in intimately observed human behavior. Yet starting with Susan Hilferty's gorgeous but almost too elegantly composed design of the Swartkops River mud flats setting, this "Boesman and Lena" tends to announce itself as a larger-than-life classic. The highly theatrical solo turns Mr. Fugard has elicited from his two gifted leading players often fail to connect with each other, and in tandem they often jolt us out of the play's hermetic realm.

Lena is the more crucial role, for "Boesman and Lena" is to a large extent her digressionary monologue. Ms. Thigpen, an emphatic performer with a rich mezzo voice, cuts such a big-boned figure both vocally and physically that all the rags at a costume designer's disposal cannot make her seem like someone who day and night must scrape out the most marginal, impoverished of existences in a wilderness. Ms. Thigpen's Lena is not merely the strong survivor she must be — "There's still daylights left in me!" she cries — but an often exhausting paragon of take-charge leadership, with nearly all her mood swings, from joyousness to rage to grief, coming at the audience at the same high pitch. It is hard to reconcile this performance with a heroine who is so disoriented — geographically, emotionally, socially, ontologically — that she is reduced, in one spectacular passage of writing, to retrieving the landscape of her existence by mapping it out with household utensils on top of a wash basin.

Mr. David captures the smoldering violence of Boesman, a man who expresses his own feelings of worthlessness by treating his partner as cruelly as the white world has treated him. The speech in which he identifies himself as "white man's rubbish" remains harrowing, but it is harder to locate the character's grace notes, what Boesman calls "the secrets in my heart," within Mr. David's full-throttle boisterousness. The blood knot that connects him and Lena, binding them together even now and often in hatred, does not seem rotted so much as completely severed in a production in which each mate tends to pull out all the stops at center stage.

•

Easily the most effective scenes in this "Boesman and Lena" are those in which the couple's diurnal dynamic is roiled by the arrival of a third character, Outa, an old black man whose Afrikaans language they cannot understand. Ms. Thigpen's desperate efforts to elicit a connection with this stranger, if only in the form of his rote repetition of her name, are rending, and Mr. David's drunkenly vague jealousy of the innocent intruder has an enigmatic complexity his major arias do not. What is more, Tsepo Mokone, the actor playing Outa, boasts a commanding presence that he establishes through the simplest means: his still posture as he

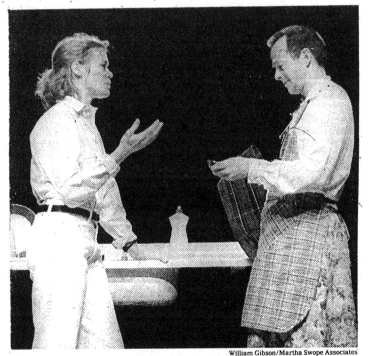

William Gibson/Martha Swope Associates

Tracey Ellis and Ron Bagden in "The Home Show Pieces."

huddles beneath a blanket before Lena's fire, the slight sparkle in his peaceful eyes, the calm and mellifluous cadences of his indecipherable words. In Mr. Mokone's performance, one rediscovers the drama that can make "Boesman and Lena" such powerful, even hopeful theater, that of a man finding the home within himself that a heartless universe will not provide.

1992 Ja 30, C15:1

Rosencrantz and Guildenstern Are Dead

By Tom Stoppard; translated by Joseph Brodsky; directed by Yevgeny Arye; scenery by D. Krimov; costumes by Galina Lioly; lighting by Alan Bochinsky and Michael Cherniavsky; music by R. Berchenko, A. Nedsvetdky and N. Artamonov. Gesher Theater Company, Mr. Arye, artistic director; presented by the Brooklyn Academy of Music with the Consulate General of Israel in New York and U.J.A.-Federation of New York's Operation Exodus. At Lepercq Space, 30 Lafayette Avenue, at Ashland Place, Fort Greene.

WITH: Boris Achanov, Michael Asinovsky, Alexander Demidov, Yevgenya Dodina, Shaul Elias, Yevgeny Gamburg, Vladimir Halemsky, Rolland Heilovsky, Mark Ivanir, Yevgeny Terletsky, Igor Voytulevitch and Natalya Voytulevitch.

By MEL GUSSOW

"Rosencrantz and Guildenstern Are Dead," Tom Stoppard's virtuosic play on "Hamlet," vaults a time and language barrier in the Gesher Theater Company production, performed in Russian, through Sunday at the Brooklyn Academy of Music. While retaining its essence as an existential comedy about a pair of classic outsiders caught up in the confusion at Elsinore, the play gains new relevance in this production and in the light of recent political turmoil in the former Soviet Union.

This refreshing, swift-paced version of Mr. Stoppard's youthful travesty is directed by Yevgeny Arye, leading an Israeli company of émigré Russian actors. Simultaneous translation back into English is provided over headsets, adding a further Stoppardian twist to the multi-cultural experience.

The production, using an adaptation by Joseph Brodsky that abbreviates the text, retains the author's linguistic limberness at the same time that it adds sprightly physical comedy. The Gesher actors are adept as clowns and mimes. The result is considerably livelier than the recent film version directed by the playwright.

Mr. Arye places the characters on a narrow runway, a precarious strip of stage between sections of the audience. While Rosencrantz and Guildenstern struggle for their equilibrium in the mysterious story that engulfs them, there are glimpses of that other play in progress. Hamlet chases Ophelia, or is she chasing him? Uprooted from their source, the words fly up. Hamlet's "to be" is not to be. Claudius and a particularly lusty Gertrude are rough and tumble in their randiness. Carrying a diplomatic pouch, Polonius looks as imperious as a sommelier brandishing a wine list. Without clarification by Shakespeare, the rest is chaos, and it is an antic antidote to the intense chamber "Hamlet" presented on this stage last week by the Cameri Theater of Tel Aviv.

Jim Estrin/The New York Times

Mark Ivanir, left, and Yevgeny Terletsky

Even as Rosencrantz and Guildenstern lose their footing, they retain their sense of foolishness. Mark Ivanir's impish Rosencrantz has the wider mood swings while Yevgeny Terletsky's Guildenstern is the more eupeptic and philosophical. The two move a step closer to Estragon and Vladimir, their models in this game of waiting. At the same time, one is more keenly aware of their roles as hired henchmen of the king, dupes enlisted in the Danish equivalent of the K.G.B. Over everyone's shoulders is the specter of contemporary politics.

Along with the title characters, the leading player (here called the Actor) is at the center of the charade. He brings his motley troupe into the castle's pandemonium. With his natural hauteur, Boris Achanov could offer histrionic instruction to Macready and Forrest in "Two Shakespearean Actors." His underlings, jumping in and out of roles and costumes, are a gymnastically inclined ensemble. This is especially so in the case of Alexander Demidov as Alfred, the actor who specializes in female roles and is prepared to play the one-woman version of "The Rape of the Sabine Women."

The play within the play becomes a quick flurry of blackouts and tableaux: at one point a pitcher of poison is poured into the ear of the player king. There is a brief let up in the third act, but not enough to becalm the comedy. Repeatedly, the director stresses the overheard nature of the story. Things are witnessed at odd angles and, on the run, through doors at either end of the platform. In the scene aboard ship, the stage itself suddenly rocks as if struck by a tempest.

In the background is heard the hurdy-gurdy of Felliniesque music, emphasizing the carnival aspect of the show. Galina Lioly's modern-dress costumes provide their own amusing commentary in an invigorating reinterpretation of the original Stoppard. The production is inventive without obscuring the author's ideas. Man is at the mercy of history. In life as in the play, it is impossible to know exactly what is happening, even if one is at the vortex of the event.

1992 Ja 31, C15:1

A Woman Without a Name

By Romulus Linney; directed by Thomas Allan Bullard; set design, E. David Cosier; costumes, Teresa Snider-Stein; assistant costume designer, Jonathan Green; lighting, Jeffrey S. Koger; stage manager, Dean Gray. Presented by the Signature Theater Company, James Houghton, artistic director. At the Kampo Cultural Center, 31 Bond Street, Manhattan.

The Woman Barbara Andres
William Craig Fred Burrell

Susan Johann

Barbara Andres.

Fanny Knapp Elisabeth Lewis Corley
Calistra Susan Ericksen
Susie Balis Marin Hinkle
Arthur Moore Jim Ligon
David Bernie McInerney
Ed .. Peter G. Morse
Charlie .. Mark Niebuhr

By MEL GUSSOW

Although she is barely literate, the title character in Romulus Linney's "Woman Without a Name" begins to keep a journal. At first, she simply records her day-to-day household activities, as if in an almanac. But beneath the small-town banalities of life in the United States at the turn of the century, we can hear the beat of a different, very dark story, one of frustration, rage and violent death. Eventually, the journal and the play itself become a journey of discovery.

As wife and mother, the Woman (Barbara Andres) has been a contradictory combination of overbearing maternal concern and terrible parental neglect. As her children die, one after another, and as her marriage stagnates, she is forced to confront the fearful fact of her own culpability.

The narrative amasses around the Woman's shoulders and insinuates itself into the minds of theatergoers. "A Woman Without a Name" (at the Signature Theater Company) is a psychological drama with insightful undertones about how people can damage one another. The play is a strange, gnarled work that courts the mundanity it is recounting while moving step by step into an area that approaches Southern Gothic.

Although it maintains an outward austerity, the play — based on Mr. Linney's novel "Slowly by Thy Hand Unfurled" — gives a detailed picture of a family that is completely dysfunctional. At the same time, the mother emerges into self-knowledge. Her growth is political as well as personal, as she begins to take a more active part in the local temperance movement and in aspects of women's rights.

Were it not for Mr. Linney's insistence on understatement, the family tragedies might be too heavy a burden for two hours of theater. As it is, the play is not alleviated by the author's customary indigenous humor, as in his "Holy Ghosts." In common with other Linney plays, like "Heathen Valley," it has a flinty, unvarnished surface.

•

The characters in "A Woman Without a Name" remain distant from one another. They may touch, but they are hesitant to embrace. The Woman's husband (Bernie McInerney) finishes a long day at his general store by fishing far into the evening instead of coming home and facing his own responsibilities. His collapse into inertia is as inevitable as the morbidity that invades a son's attempts at art.

Beneath all this is a feeling of the community, small-minded people who are as quick to condemn one another's failings as they are reluctant to offer forgiveness. The hypocrisy of the town is represented by an unseen matriarch who grasps piety as a path to power. As in other works by Mr. Linney, the church is both a beacon and a hiding place in which to conceal one's complicity in deeds of questionable ethical nature.

In keeping with the spirit of the play, Thomas Allan Bullard's production has the spareness of a meeting in a church basement. The actors sit on hard chairs, with Ms. Andres at the center. Each enters the action, then returns to silence. A surprising amount of theatricality is evoked in the severe surroundings, through the playwright's laconic dialogue and the actors' studious containment within their characters.

In the demanding central role, Ms. Andres never veers from the Woman's innate simplicity while conveying her deep reserve of conflicting emotions. With the help of the actress, a woman without a name becomes an individual of very human dimensions.

1992 F 2, 54:5

SUNDAY VIEW/David Richards

When Little Girls Grow Into Dragon Ladies

Set in the land of dreams, 'The Visit' with Jane Alexander is grisly fun.

'Crazy He Calls Me' puts romance in a straitjacket.

JANE ALEXANDER IS GIVING AN astonishing performance in the Roundabout Theater Company's production of "The Visit" at the Criterion Center on Broadway. So don't misunderstand me when I say that nothing about her seems real.

She is playing Claire Zachanassian, the world's richest woman, in Friedrich Dürrenmatt's mordant drama, and all that money can buy she snapped up long ago — oil wells, banks, airlines, Japan's biggest chain of bordellos. No sooner has she stepped onto the railway platform of Güllen, her impoverished hometown somewhere in Central Europe, than it's clear she has also spent lavishly in a futile attempt to outwit the ravages of time.

The massive stack of red curls, which sits on her head like congealed cherry topping on a sundae, is obviously a wig. Her frozen features attest to one face lift too many. Thick blue eye shadow weighs down her weary lids, while a bold slash of lipstick does violence to her mouth. When she talks, there's a gumminess that suggests her teeth are false and ill-anchored. And when she walks, she has to swing her left leg away from her body in an ungainly semicircle, because from the knee down it is made of wood.

∎

It's as if all the best doctors and plastic surgeons in the world had labored long and hard to make her look like Arlene Dahl and had failed. Ms. Alexander's laugh — a dull bark, cured with the smoke of a million cigarettes — lets you know she can live with that. She's survived a humiliating youth, seven husbands and a plane crash that pulverized most of the bones in her body. No one has ever been able to take her vulgarity away from her, though. And that gives a person inner strength.

The actress's startling presence is only one of the changes that have been wrought on "The Visit," which brought the legendary careers of Alfred Lunt and Lynn Fontanne to a triumphant end in 1958. The play chronicles what happens when Madame Zachanassian, as she's respectfully addressed, offers the good folk of Güllen one billion marks — half to go to the municipality, half to be divided equally among the citizens themselves. The sole condition: they must kill the grocer Anton Schill, who wronged her in her youth.

The Lunts and their director, Peter Brook, persisted in viewing the drama as a deliciously perverse love story carried to the extreme. At the Criterion, love has long since burned itself out, and what remains is both funnier and more grotesque. Maybe the best way to underline the difference between the two productions is to point out that when Fontanne returned to the scene of her shame, the arch of her swanlike neck and the upward tilt of the chin bespoke an impossible grandeur. Ms. Alexander holds her head high, too, but that's because arthritis seems to have welded her neck to her shoulder blades. Fontanne, turning noblesse oblige upside down, was only doing what she had to do. Ms. Alexander is the ultimate pragmatist, seeing to it that the job gets done with a minimum of bother.

Well, romance has long since drained out of our age, money is no longer glamorous and millions of desperate people are out of work. Edwin Sherin's staging of the play for the Roundabout is telling us nothing the 1980's haven't already driven home. Still, he's concocted a wonderfully garish spectacle that looks a lot like a meltdown in a Hummel figurine factory.

All the actors — with the exception of Ms. Alexander and Harris Yulin, who plays Schill — wear masks, wittily designed by Michael Curry to emphasize everything that is bul-

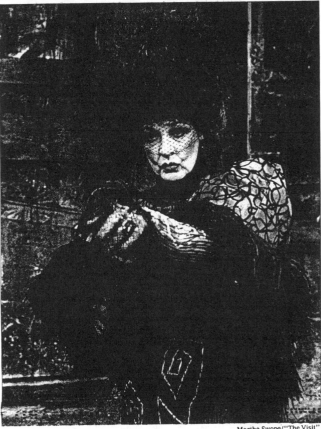

Martha Swope/"The Visit"

Jane Alexander, as the richest woman in the world, in "The Visit"—Revenge is more than enough to keep her alive.

bous and protuberant about the human face. (Eight of the cast members are actually performing some 27 roles, although you'd never know it if the curtain call didn't reveal the subterfuge.) Frank Krenz has provided costumes that could have been pilfered from a comic operetta troupe fallen on dismal times. Güllen, as the set designer Tom Lynch imagines it, is a toy village, or would be, if the lighting designer Roger Morgan didn't keep hitting it with poisonous splotches of phosphorescent green and ruby red.

This is the land of dreams, where every little girl can grow up to be a dragon lady and pay back every little boy who ever welshed on a promise made in the heat of a haystack.

At first, the citizens of Güllen indignantly reject Madame Zachanassian's proposition. They may be poor, but they have their principles and intend to stand by them. Little by little, however, the righteous huffing and puffing diminishes and cold-blooded rationalizing takes over. Then someone turns up with a pair of bright yellow shoes. There's no connection, of course, except that the shoes were purchased on credit and the only money Güllen will conceivably ever see happens to lie in Madame Zachanassian's vaults. By the end, the whole town is sporting bright yellow footwear and, not so coincidentally, clamoring for Schill's murder. By now, though, they're calling it justice, long overdue and richly merited.

Turnabout is not fair play, but it gives "The Visit" the satisfying simplicity of a perverse children's fable. Maurice Valency's aptation has always been darkly droll. Mr. Sherin's production goes one step further makes it grisly fun. This is certainly not th chilling high drama the Lunts acted in, but horror show populated by so many Chuck dolls run amok.

There is just one problem — a serious or too — with Mr. Sherin's conception of the

play. I'm not sure he's figured out what to with Anton Schill. On one hand, you can't r duce him to a caricature the way you can t mayor or the stationmaster or the reporte who are no more than types to begin with. the other hand, if you play him realisticall you're going to tear a stylistic hole in the p duction. I remember Lunt, stopped in mid flight by the townsfolk, becoming so overcome with fear that he collapsed on the ground and vomited. Plainly, that wouldn' do here.

Mr. Sherin and Mr. Yulin seem to have opted for a compromise: Anton Schill will be played realistically, but he'll be a realistic *nobody* — faceless, even though we see the actor's face. A voice of protest, perhaps, but entirely too ineffectual to curb the production's caricatural zest. I'm afraid the finesse doesn't work. Schill ends up being colorless, a sacrificial lamb in lamb's clothing.

If I were you, I'd still want to catch Ms. Alexander, seated in a gilded sedan chair and flanked by the two musclemen who carry her and the two milky-eyed eunuchs who serve as her jesters. From the lofty perch, she surveys the groveling world with a look of supreme indifference that could be scorn, if it's not the effect of massive shots of Novocain. The muscles of her face no longer work. As for her heart, it atrophied long ago. Little matter. Revenge is more than enough to keep her alive and put rouge on her cheeks.

The world made her a whore and now she's returning the favor by making the world into a brothel. Logic demands nothing less of her. Logic and good manners. Logic, good manners and a whim of steel.

'Crazy He Calls Me'

Abraham Tetenbaum's "Crazy He Calls Me" (at the Walter Kerr Theater) is a two-character play about Benny, a mousy Brooklyn lawyer, and Yvette, the flamboyant accountant who draws him out of his shell, weds him and then so irritates him with her, well; capriciousness, I guess, that he goes to court to annul the marriage. She has a breakdown and eventually he has a change of heart, making "Crazy He Calls Me" perhaps the first romantic comedy in Broadway history to end up in a mental institution with the heroine confined in a straitjacket.

When I say romantic comedy, I use the term guardedly. It was never particularly evident to me how I was supposed to respond to Mr. Tetenbaum's play, which is neither funny nor captivating nor touching nor insightful, but does end happily, despite that straitjacket. So let's stick with romantic comedy on the grounds that the ways of love are often indecipherable anyway. The action unfolds in and around Brooklyn over a two-year span beginning in 1938. Mr. Tetenbaum has so little feel for the period, however, and the sets by Loren Sherman are so dreary, that nostalgia never enters into the equation.

■

At one point it occurred to me that maybe the playwright was dramatizing a page out of his own family's history. But I can't vouch for that either. Yvette and Benny aren't exactly the kind of relatives you'd parade in public, unless, of course, you're trying to settle old accounts. Do what they may, the show's stars, Barry Miller and Polly Draper, are unable to animate these characters and only risk alienating the following they have built up on television (he, in the series "Equal Justice"; she, in "Thirtysomething").

With his jug ears, George S. Kaufman pompadour and stick-figure torso, Mr. Miller's Benny has nebbish stamped all over him. Ms. Draper's Yvette is a runaway locomotive with curves. A buried strain of madness may prevent her from being a truly liberated woman, but she's not about to let social proprieties, sexual restraints or even a thick Russian accent stand between her and her goals. As I understand it, she succeeds in rousing the "Bengal tiger" in him, while he learns to accept her, loony tunes and all. None of this is very persuasively laid out by Mr. Tetenbaum or the director, John Ferraro.

If I tell you that Ms. Draper looks sensational in a slip, I should also point out that she's taller than her co-star and has a bigger chest. In life, who'd care? But when a leading lady doesn't seem to be kissing her leading man so much as gobbling him up, can we legitimately talk of on-stage chemistry?

For the record, "Crazy He Calls Me" is the third play to be produced under the Broadway Alliance, which aims to cut costs and lower ticket prices. For the record, too, it looks to be the third flop.

1992 F 2, II:5:1

Theater in Review

■ In and out of the mainstream, with comic insights ■ An American abroad, perpetually perplexed ■ 'Chess,' ever game, tries again.

Julie Halston's Lifetime of Comedy

Actors' Playhouse
100 Seventh Avenue South, at
Bleecker Street
Manhattan

Written and performed by Julie Halston; directed by Kenneth Elliott; scenery by B. T. Whitehill; lighting by Vivien Leone; production stage manager, Allison Sommers; associate producers, Dea Lawrence and Carmel Gunther; company manager, Alan D. Perry.

As anyone who has seen a Charles Busch comedy knows, Julie Halston is the essence of equipoise, droll in her delivery even in moments of high camp. It turns out that she is also a writer and monologist with the clearest sense of who she is and what she thinks about everything. She is, she tells us in "Julie Halston's Lifetime of Comedy" at the Actors' Playhouse, "divorced, over 30 and hormonely unbalanced." That self-description only begins to tell the story of this shrewdly observant actress. Her one-woman show is less about her life in the theater than it is about her life and the theater she sees around her every day.

The monologue is autobiographical with detours. It follows a zigzag from Commack, L.I., to Hofstra University to a long-running job on Wall Street. Against all odds and against her mother's judgment, she left the security of the stock market for the insecurity of the performing arts, and quickly became a star of "Vampire Lesbians of Sodom." Several leaps later she was the reactionary radio gossipist in Mr. Busch's "Red Scare on Sunset."

With the deftness but not the malice of Joan Rivers and the show business sassiness of Bette Midler, she welcomes theatergoers to a mockup of her home and confides some of her favorite habits. A compulsive quoter of wedding announcements in The New York Times, she takes pleasure in anything approaching the prototypical: the super preppy who is the daughter of a yachtsman and a watercolorist; the bride whose nuptials appear under the headline, "A Clown Marries." She offers a groan of sympathy for the parents of a daughter who wants to be so identified, though were Ms. Halston to wed, her headline could read, "A Clown Remarries."

Whatever is preying on her mind works its way into the act, her first marriage, her parents and her fondness for realistic English movies of the angry generation (her role model is Julie Christie). She even offers a mirthful account of a worrisome visit to the doctor. A special spot is reserved for her movie non-debut. She played one of the victims of Hannibal the Cannibal in "The Silence of the Lambs," but to her disappointment her body parts ended up on the cutting room floor.

In such a fashion she swims in and out of the mainstream, offering wickedly amusing insights on a wide diversity of subjects. As she rambles on with abandon (but not indelicacy), one could easily envision her moving along into a sitcom. To a certain extent, her show is already a sitcom of her life. Enjoy it now, with its very original cast of one.

MEL GUSSOW

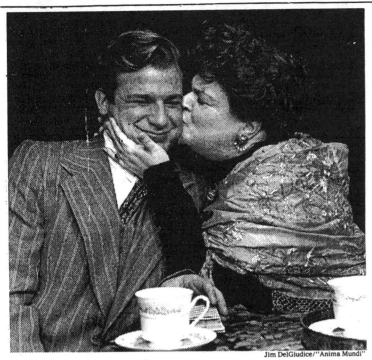

Michael Curran and Julia McLaughlin in Don Nigro's "Anima Mundi."

Anima Mundi

Village Theater Company
133 West 22d Street
Manhattan
Through Feb. 23

By Don Nigro; directed by Henry Fonte; assistant director, Gigi Rivkin; set by Mr. Fonte; sound by Jim Harrington; stage manager, Lisa Jean Lewis; technical director, Zeke Zaccaro; lighting by Craig Little; costumes by Marjorie Fennan. Presented by the Village Theater Company.
WITH: Michelle Berke, Michael Curran, Susan Farwell, Marjorie Feenan, Christie Harrington, Randy Kelly, Terrence Martin, Julia McLaughlin, David McConnell, Howard Thoresen, Patrick Turner, Patrick White and Zeke Zaccaro.

Oscar Wilde, William Butler Yeats, Ezra Pound, Aleister Crowley and Madame Blavatsky are among the historical figures who parade through Don Nigro's panoramic comedy-drama, "Anima Mundi." The two-and-a-half-hour play at the tiny Village Theater follows the adventures of David Armitage (Michael Curran), a quintessentially innocent American abroad at the turn of the century.

When first encountered, David, an apple-cheeked farmboy and would-be poet from Ohio is visiting the London salon of Madame Blavatsky. Portrayed by Julia McLaughlin as a bossy, motor-mouthed meddler and probable con artist, the legendary fortune teller presides over a séance involving tarot cards that reveal David's future. In a series of flash-forwards that show David interacting with assorted literary lions, Parisian prostitutes and battle-crazed soldiers in the fields of World War I, David goes through the experiences that will inform his life's work, an epic poem called "Anima Mundi."

The continuing thorn in David's side is his unconsummated passion for Elizabeth Carrolton (Michelle Berke), an expatriate American dancer whom he meets at Madame Blavatsky's home. Arrogant, self-deluded and pathologically contrary, Elizabeth is a thorough pill who eventually becomes captive to Crowley's satanic cult. But David loves her in spite of everything.

Mr. Nigro's play, which has more than 20 characters and spans half a century, teems with energy and incident. Yeats philosophizes, Wilde quips, Pound raves and Crowley hisses with evil schemes. And David, a self-professed pacifist, goes to war and kills. But beneath all the excitement, none of the famous characters emerge as more than reconstructed cartoon figures. And David, after 50 years of tooting about Europe and America, seems essentially the same decent, perplexed observer that he was at the beginning.

Although the play is much too large for its cramped performance space, the problem of sets has been efficiently dealt with by having the actors perform in front of thematically evocative slides of paintings by van Gogh and Bosch. The vigorous acting and direction (by Henry Fonte) are of semi-professional caliber.

STEPHEN HOLDEN

Chess

Masters Theater
310 Riverside Drive, at 103d Street
Manhattan
Through Feb. 23

Music by Benny Andersson and Björn Ulvaeus; book and lyrics by Tim Rice; directed by David Taylor; scenery by Tony Castrigno; lighting by John Hastings; costumes by Deborah Rooney; new arrangements and orchestrations by Phil Reno; sound by Creative Audio Design; production stage manager, Doug Fogel; assistant director and choreographer, Madeline Paul. Presented by the Artists' Perspective, in association with Chess Players Ltd.
WITH: Bob Frisch, Jan Horvath, Patrick Jude, Kathleen Rowe McAllen, J. Mark McVey and Ray Walker.

"Chess," the board-game musical, is working its way back to a record album. After previous elaborate incarnations in London and on Broadway, the show reopened Off Broadway in what is supposed to be the new, improved, definitive version. It is shorter, which is the most complimentary thing that can be said about this continually misfiring musical.

This is, as you may remember, a show by Tim Rice without Andrew Lloyd Webber, with music written by Benny Andersson and Bjorn Ulvaeus. When "Chess" was first done in London in 1986 it had a certain novelty, but it was already dated in its treatment of global politics. Today, after the breakup of the Soviet Union, it is a lukewarm leftover of the cold war.

Unless one has seen an earlier, more detailed production, it might be difficult to know what all the singing-shouting is about. Mr. Rice has jettisoned Richard Nelson's Broadway book and its top-heavy subplot in favor of a show that has more singing and less speaking. The simplification highlights the score, which is a pop pastiche that veers between the pleasant and the argumentative while evoking familiar strains. But because of the shorthand style of storytelling, the politics seems even more confusing.

While trying to be economical, David Taylor's production becomes reductive. In London, the set was an enormous hydraulic chessboard, which was raised and lowered to symbolize the tilt in the power struggle (obvious but eyecatching). On Broadway, the characters played hide and seek around monolithic towers. Now the stage is dominated by a bleacherlike staircase, which might be used for a touring company of "The Will Rogers Follies" but is pointless as a background for "Chess."

Ray Walker and J. Mark McVey, who play the two chessmen, are stronger at singing than at acting. Kathleen Rowe McAllen, as the woman involved with both men, gives the evening's sharpest performance. "I Know Him So Well," the duet she sings with Jan Horvath, is, as before, the most memorable number in the score.

Surrounding the musical is a mountain of portentousness. Anthems are sung about chess as if it were the French Revolution, which is more dramatic weight than the show can support. After repeated attempts, it should be time for Mr. Rice and his collaborators to resign from this match and move on to more rewarding musical territory.

MEL GUSSOW

1992 F 5, C19:3

Correction

A brief theater review yesterday about "Julie Halston's Lifetime of Comedy" at the Actors' Playhouse omitted the name of the show's producer. He is Drew Dennett.

1992 F 6, A3:2

Creditors

By August Strindberg; translated by Paul Walsh; directed by Carey Perloff; sets, Donald Eastman; costumes, Candice Donnelly; lighting, Frances Aronson; assistant director, Nick Mangano; dramaturg, Allen Kennedy; production stage manager, Richard Hester. Presented by CSC Repertory, Ms. Perloff, artistic director; Patricia Taylor, managing director. At 136 East 13th Street.

Adolf	Nestor Serrano
Gustav	Zach Grenier
Tekla	Caroline Lagerfelt
Women	Elizabeth Beirne and Elena McGhee
Porter	Denis Sweeney

By MEL GUSSOW

Jealousy and mistrust surround the seaside resort that is the setting for Strindberg's "Creditors," as the play's characters damage one another with a diabolical fury. As Carey Perloff's taut production at the CSC Theater reminds one, the play is a tragi-comedy. Written in 1888, the same year as "Miss Julie," "Creditors" derives from the author's early naturalistic phase. But beneath the tangible surface are symbolic undercurrents about diseased marriage and the distortions of various creative acts.

Two of the three characters are artists: a painter turned sculptor and his wife, who is a writer. The third, mysterious figure is an artist with words, which he uses to intrude into the couple's relationship. When the wife is away, this stranger (Zach Grenier) insinuates himself and becomes the husband's first friend outside of his marriage. Then he tortures him into self-doubt about his role as artist and husband.

As is soon revealed, Mr. Grenier's character is actually the wife's former husband, and his course is as demonic as it is determined. Vengeful about losing his wife, he wants to poison his new friend's mind and wreck his marriage. In other words, a creditor has knocked on the door to collect for past-due bills of injustice.

Having set this premise, Strindberg is masterly at tracking its permutations and pitting one character against the other. Each pair dances a deadly pas de deux. In truth, each character is a creditor, but it is the pathetic husband who is most vulnerable to the malice of others.

Using a smooth new translation by Paul Walsh and staging the play on a simple, white box set (designed by Donald Eastman), Ms. Perloff has kept it firmly in its period. The cast is evenly balanced, but it is Mr. Grenier in the pivotal role who leads the company into the darker recesses of the play.

The character, who is based on the former husband of Strindberg's wife, Siri von Essen, is a fiendish figure. At first Mr. Grenier makes him seem sincere in his concern for the husband's welfare, but his light banter soon becomes threatening. Remaining suave even as he pushes the husband into a state of nervous collapse, Mr. Grenier embodies a sinister serenity at the core of the play. The husband (Nester Serrano) is at least partly his own victim, expecting and demanding too much from relationships. Showing off his nude sculpture of his wife, he exudes pride of creativity, shattered under fire from his antagonist.

When the wife (Caroline Lagerfelt) arrives, it is clear that she has her own agenda. She has used each man to her advantage. Strindberg who based the character on his wife, regarded her as a vampire; as he said, "in a phrase, woman as I see her." Ms. Lagerfelt stresses the character's strength of mind and her eagerness to use her sensuality to win a point. She believes she is in control, but as the play rushes to its conclusion, it is evident that no one is in control. To a great extent, "Creditors" foreshadows modern comedies of menace, as the characters are led to mutually destructive ends.

1992 F 7, C3:1

La Cándida Eréndira

Based on a novella by Gabriel García Márquez; adapted by Jorge Alí Triana and Carlos José Reyes; directed by Mr. Triana; English translation by René Buch and Felipe Gorostiza; original music by Germán Arrieta; scene design, Liliana Villegas; costume design, Rosario Lozano; lighting design, Robert Weber Federico; production manager/assistant director, Virginia Rambal. Presented by Repertorio Español, Gilberto Zaldívar, producer; Mr. Buch, artistic director. At the Gramercy Arts Theater, 138 East 27th Street, Manhattan.

WITH: Anthony Alvarez, Martín Balmaceda, Ricardo Barber, Irma Bello, Josie Chávez, Rolando Gómez, Ofelia González, Carlos Linares, Florencia Lozano, Jimmy Navarro, José Cheo Oliveras, Carlos Osorio, René Sánchez, Bersaida Vega, Lizandra Vega and Braulio Villar.

By D. J. R. BRUCKNER

Gabriel García Márquez's fiction is notoriously difficult to dramatize in any form, including film, but the Colombian director Jorge Alí Triana has transformed a novella by Mr. García Márquez into sumptuous magic realism on the stage.

His production of "La Cándida Eréndira" ("Innocent Eréndira and her Heartless Grandmother") at the Repertorio Español tends — as the best Latin American theater often does — toward opera, combining drama, a memorable original score by Germán Arrieta and spectacular scenic and lighting design by Liliana Villegas and Robert Weber Federico. Virtually everything about this production, including the simultaneous translation from Spanish, is pristine.

At times the elegant Gramercy Arts Theater seems about to burst from the sweeping grandeur and ex-citing energy of this play; its successful compression into such a small space is testimony to the skills of everyone involved, especially the 16 members of the Repertorio Español who make all of the gritty, sometimes spectral, characters in this hallucinatory tale vivid, harsh and strangely beautiful.

García Márquez's sardonic study of life and truth.

Mr. Triana, the founder of Teatro Popular in Bogotá, has worked with Mr. García Márquez in the past, mostly on films. Here, without consulting the writer, he has molded the famous story of a young woman forced into prostitution by her grandmother into a black comedy that reveals possibilities in the original novella we may never have imagined. Not a line of that story goes untransformed in this swift, shocking and intelligent play, and very few of our ordinary moral assumptions about life and truth escape its mocking examination.

On the stage a great gray angel hovers over and swoops past the filthy soldiers, politicians, mountebanks, smugglers and lovers who spin around the nightmare landscape of a notorious Colombian desert region. And when the play ends, a viewer might well feel that the beating wings of a spirit fallen from heaven will awaken him in the night for many years and return him to this bleak, shining place of wonder.

1992 F 9, 65:1

The Comedy of Errors

By William Shakespeare; directed by William Gaskill; music composed by Deniz Ulben; set by Power Boothe; costumes by Gabriel Berry; lighting, Frances Aronson; masks by Karin Weston and Mr. Berry; fight director, J. Allen Suddeth; production stage manager, Carol Dawes. Presented by Theater for a New Audience, Jeffrey Horowitz, artistic and producing director. At Theater at St. Clement's Church, 423 West 46th Street.

WITH: Al Carmines, Donavon Dietz, Wally Dunn, Karen Foster, Jeffrey Guyton, Robert Hock, Polly Humphreys, Benjamin Lloyd, Linda Maurel, Scott Rabinowitz, Ramon Ramos, Elizabeth Meadows Rouse, Peter Schmitz and Richard Spore.

By MEL GUSSOW

One aim of Jeffrey Horowitz's Theater for a New Audience is to connect classics with young urban theatergoers, as exemplified last year by a production of "Romeo and Juliet" that was performed with youthful vitality. The company's current version of "The Comedy of Errors" at St. Clement's Church is easygoing and broadly eclectic. A motley group of professionals and near professionals has been gathered under the leadership of William Gaskill, the distinguished British director. Only a few of the actors seem to have a feeling for Shakespeare beyond the immediate horseplay.

The company specializes in nontraditional casting and in so doing approximates on stage the broad ethnicity of the people in the audience. In principle, this serves a very useful purpose, but as practiced in "Comedy of Errors" it leads to unnecessary confusion. The two actors twinned as Antipholus do not look or sound anything like each other, contradicting a crucial point in this comedy of mistaken identity.

•

On the other hand, their two servants wear identical masks. Although one Dromio is much taller than the other, at least the masks give them a certain uniformity. As it turns out, Peter Schmitz and Jeffrey Guyton, the actors playing the Dromios, are the primary sources of amusement on stage, along with Elizabeth Meadows Rouse as the woman who is married to an Antipholus. In several instances, actors are used as sight gags, as in the turnabout that has a man playing the role of the abbess. Power Boothe's house-of-cards setting and Gabriel Berry's colorful costumes add brightness to the background.

The play can inspire directorial ingenuity, as in the recent Royal Shakespeare Company clown version in which one actor doubled in Dromios and another played both faces of Antipholus. This meant fast moves and frenetic footwork. In contrast, Mr. Gaskill's production is footloose.

1992 F 9, 65:2

Gerry Goodstein/"Innocent Eréndira and Her Heartless Grandmother"
Josie Chávez, left, and Ofelia González, in "La Candida Eréndira."

SUNDAY VIEW/David Richards

Farce Demands a Canoe That Has No Paddle

In 'A Little Hotel on the Side,' sex is a passing itch, while reputation is forever.

The times define Athol Fugard's 'Boesman and Lena.'

DEADLY BUSINESS, THIS FORM called farce. Not for those of us sitting out front, of course. For us, it can be giddy, liberating fun. I'm thinking of those unwitting characters, farce's sacrificial victims, who have no idea when the curtain rises of the torments and terrors that lie ahead. For them, the experience is sheer hell — rather like discovering that the current has picked up, the

paddle has slipped away and the canoe is headed straight for the falls.

As the roar grows louder, they panic, clutch their hearts and mop their brows. Their lives flash before them. The world grows fuzzy. Like tragic heroes, they curse their stars, although in the end it's usually a lucky star that saves them. In addition to the telltale smudge of lipstick, these helpless souls have the mark of doom upon them. Any production that doesn't take their flailings seriously is a production in trouble.

"A Little Hotel on the Side," for example.

The classic turn-of-the-century French farce, written by Georges Feydeau and Maurice Desvallières and translated by John Mortimer, has popped up as the second attraction of the National Actors Theater (at the Belasco Theater). It clearly signals a change of pace from the inaugural offering, "The Crucible," which was earnest to a fault. This time, matters are meant to be frisky, saucy, stylish. Having beaten its collective breast, the company is now out to show that it can kick up its collective heels. That's one of the appeals of repertory theater — seeing actors pass from night to day, somber to silly. But I can't help believing that some of the earlier earnestness would go a long way toward solving the problems of "A Little Hotel on the Side."

■

Like all of Feydeau's farces, this one pretends to chronicle the tangled affairs of the adulterous heart. A henpecked Parisian building contractor (Tony Randall) lusts after his neighbor's succulent wife (Maryann Plunkett). Since her husband is a "lump of cold halibut," she agrees to an evening of infidelity. Having plotted their alibis and disguised their tracks, they repair to the notorious Hotel Good Night. No sooner have they settled in, than they promptly cross paths with everyone they want to elude — friends, relatives, maid, constables, even the cold halibut himself. Instead of trying to climb into the sack with each other, wriggling out of a compromising situation becomes their overriding concern.

Consummation, however devoutly wished, is never really part of Feydeau's plan. He is much more interested in illustrating the ridiculous lengths to which these good, respectable citizens of the Third Republic are driven to maintain the appearance of propriety. Sex gets the plot rolling, but it's only a passing itch. A reputation is forever, and keeping it intact is the life-and-death issue. Lower the ante, and you sabotage the game.

Mr. Randall has his comic weapons — an exaggerated sense of meticulousness that certainly served him well as the prissy half of TV's "Odd Couple"; a face that is looking more and more like a basset hound's; a pair of hazel eyes that surprise or candor can open big as saucers. In "A Little Hotel on the Side," though, he is apt to remind you more of a happy lepidopterist on a field trip than a libidinous philanderer on the prowl. The little leaps, the bounding steps, the gamboling spirit all communicate the buoyancy of springtime. Lighter than air, the performance tends to rise above the play and float over it like a bobbing balloon.

The actor doesn't suffer any hard consequences. If he's occasionally in trouble, he's never once in danger. A shrug, a pirouette, a hasty double take, and he's on his unfettered way. But that very blitheness minimizes the dramatic stakes and makes mockery of a situation that, for the characters at least, is a galloping nightmare.

Mr. Randall is, I suspect, "playing farce." Most of the actors are. If, however, they simply went about their business with that single-minded determination that blinds Fey-

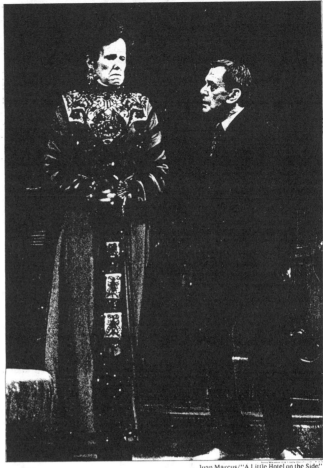

Lynn Redgrave and Tony Randall in "A Little Hotel on the Side"—Farce is a pure form, akin to a laboratory experiment.

deau's characters, the farce would take care of itself. In that respect, Ms. Plunkett probably gives the evening's best performance, as the erring spouse whose pulse beats far faster at the prospect of discovery than it ever did over the possibility of hanky-panky.

■

Lynn Redgrave, who plays Mr. Randall's wife, proves a spectacular battle-ax, no small thanks to the costumer Patricia Zipprodt, who has wrapped her in layers of orange and black, hung bugle beads everywhere and crowned her with a headdress of crows' feathers. (Ms. Redgrave ends up resembling a stormy Halloween night.) And there's an amusing turn by Paxton Whitehead, as a pesky house guest from the provinces with four little daughters all in a row. The character also speaks with a hopeless stutter, although only when it rains. (Feydeau was always saddling his characters with exotic speech defects.) What's funny here is the concentrated intensity, the herculean effort, Mr. Whitehead brings to the task of overcoming the handicap.

Elsewhere, you get the motions of farce with little of the underlying conviction that fuels it. As Mr. Randall's virginal nephew, Rob Lowe wears knickers, wire-rimmed glasses and a blank expression that turns to mild contentment after the maid, the overconfident Madeleine Potter, seduces him. Patrick Tull, who presides over the Hotel Good Night with cockney swagger, could have stepped out of a Dickens novel. I have no idea where Alec Mapa, the prying hotel porter, is coming from. An old Philip Morris advertisement maybe. The acting is decidedly of the mix-and-match variety, which doesn't help.

The director Tom Moore, normally no slouch at this sort of thing, has been unable to impose a consistent style on the production. And that's bothersome, too. Farce is a pure form, akin to a controlled laboratory experiment. If bits and pieces of foreign matter are allowed to creep into the test tube, the results will invariably be falsified.

The set designer David Jenkins has provided a properly opulent belle époque salon for Mr. Randall to call home, but it seems to me he's got the Hotel Good Night all wrong. He's concocted a two-story rabbit warren with lots of discreet cubicles for a clientele that prefers to slip in, unnoticed, and slip out. The floor plan works in favor of sinners, not against them. Shouldn't the establishment be laid out so that embarrassing late-night encounters are unavoidable and quick escapes an impossibility?

The Hotel Good Night is not just another fleabag, you see. It's a trap, wherein to catch the conscience of some cowardly libertines.

'Boesman and Lena'

"Boesman and Lena" is Athol Fugard's "Waiting for Godot."

In it, two of humanity's castoffs wander the bleak mud flats near Port Elizabeth, South Africa, looking for someone or something to lend their lives meaning. Boesman is cruel, abusive, given to sullen silences. Lena, his wife, jabbers incessantly about everything and nothing. They set up a temporary lean-to by the trunk of a fallen tree and are preparing for another empty night when Lena spots Outa, an old tribesman, in the distant shadows.

With the scorn of one pariah for another, Boesman turns his back on the intruder. But Lena brings him in from the cold and gives him a cup of tea. Since he doesn't even speak their language, he is a poor partner in commiseration. But at least, she reasons, someone will have seen her, acknowledged her presence during her passage on earth. Then Outa dies, having acknowledged precious little. Boesman and Lena are left to resume their wanderings in the void.

How far are we from Vladimir and Estragon, Samuel Beckett's tramps, who spend their desolate days by a withered tree — chatting, complaining, raging, all the while they're vainly awaiting the arrival of one Godot, who will presumably validate their existence? Not very. The parallels between the two works are especially evident at the Manhattan Theater Club, where "Boesman and Lena," directed by its author, is being given a sober, reflective revival. In fact, Mr. Fugard's direction seems to underscore the kinship.

When it was first produced in this country Off Broadway in 1970, "Boesman and Lena" had a stunning impact. Not only was it a powerful denunciation of apartheid but, as acted by Ruby Dee, James Earl Jones and Zakes Mokae, it was a wrenching chronicle of how forsaken people can turn their despair against one another. The Beckettian correspondences were always there, but you needed to back off to see them, and instead you found yourself smack up against the play.

The production at the Manhattan Theater Club doesn't have such gut-churning immediacy. It is cooler, observed, as it were, from a distance. The Cinemascope set by Susan Hilferty — a seemingly endless stretch of wasteland backed by a bruised and bleeding sky — purposefully dwarfs Boesman and Lena. And Dennis Parichy's lighting, by dispelling only so much of the darkness, suggests the frightening infinity of space into which they will eventually disappear, like motes of dust. But there's also a vaguely literary tone to Mr. Fugard's direction. Words are never sacrificed to feelings. The sharpest howl of pain is still an articulated howl.

Although no author likes to see his lines overwhelmed by raw emotion, a certain rawness is definitely missing here. And yet the cast appears fully capable of delivering it. Even in repose, Keith David's Boesman is a creature of brute strength and lethal restlessness. When he turns on his wife, his eyes really do flash daggers. Lynne Thigpen's Lena is an exasperating chatterbox, until you realize that chattering is how she holds the fear and loneliness at bay. Underneath, she's screaming for help.

The little tenderness that hasn't been beaten out of her, she lavishes on a dying old man, dredged out of the gloom. The scene is the only counterpoint to the misery, and Tsepo Mokone, who portrays the derelict, is transcendent. Muttering scraps of Xhosa, his weathered face nearly impassive, he nonetheless manages to project a serenity that comes close to holiness.

Unlike "Waiting for Godot," Mr. Fugard's play has real social and political underpinnings. The plight of Boesman and Lena is the direct result of government policies that have long classified people by the shade of their skin. Now that those policies have finally begun to crack, the thrust of the play is bound to change, *has* to, if the drama is to survive as more than a painful sociological document. I think that process is already under way at the Manhattan Theater Club.

Mr. Fugard seems to want us to take the long view now, which is to say, the metaphysical perspective. What's emerging in "Boesman and Lena" is the metaphor. □

1992 F 9, II:5:1

George Washington Dances

By David Margulies; directed by Jack Gelber; stage manager, Beth Sonne; production manager, Andrew Kaplan; lighting designer, Greg MacPherson; set designer, Sarah Lambert; sound designer, Michael Sargent; costume designer, David Sawaryn. In Pursuit of America Series 2 presented by the Ensemble Studio Theater, Curt Dempster, artistic director; Christopher A. Smith, asso-

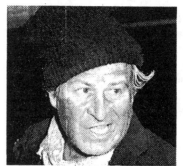
Valerie Brea Ross/"George Washington Dances"

David Margulies

ciate artistic director; Dominick Balletta, managing director. At 549 West 52d Street, Manhattan.

Howell..David Margulies
Harry...Jahn Margulies

By MEL GUSSOW

With rags wrapped around his feet and dirt encrusting his face and clothing, the derelict would provoke any passer-by to cross to the other side of the street. But when this disreputable-looking man begins to speak, we immediately take notice. He says he has been in this city since 1861. As the dates and names begin to tumble, it is soon clear that he is from another era, or at least that is what he believes. He is, he confides, the nephew of George Washington. In some strange time trip he has become one of New York's present-day homeless.

What follows in "George Washington Dances," written and performed by David Margulies, is a rodomontade journey through America's past, as recounted by a very vocal oral historian. The play is at the Ensemble Studio Theater, as part of that company's continuing series In Pursuit of America.

•

At first, the tale is disarming. Behind his scrofulous appearance, the character hides an encyclopedia of facts and fictions. He casually describes meetings out of context ("I ran into Dred Scott") and offers a litany of lore about everything from his uncle's teeth to Gilbert Stuart's private annoyance at painting the President's portrait. The play's shagginess is additionally spiced by Mr. Margulies's timeless intrusions, as in his admonition to other homeless people to "stay off the books." Anonymity, it would seem, is the secret of survival through the ages.

As the one-way conversation proceeds, it retraces its steps and reiterates references. What might have been a pungent half-hour character sketch starts to sound like a filibuster. At the same time, the recollections dip deeply into whimsy, with cozy mentions of his uncle's friend "Tommy Jeff" and others of equal historic weight.

•

Washington himself, when he is quoted, sounds as wooden as those teeth ("I reprehend with severity"). The cleverness of the initial idea is increasingly diminished. A theatergoer may try to practice Washington's preaching of patience, impossible when Mr. Margulies pads his comedy by turning names of contemporary actors into Spoonerisms. Occasionally he addresses another, virtually silent homeless person sleeping under a pile of refuse, but this is very close to a one-man show.

Because Mr. Margulies is so creative a character actor, it is not surprising that he would try to take a step into playwriting. But he has set a difficult task for himself as a performer: to keep the audience interested even when the lines are nonsupportive. His expressiveness in look and voice goes a long way to lend variety to the circuitous monologue. Aided by Jack Gelber as director, he decosmetizes his character with earthy details. In this familial reminiscence about the world of George Washington, the acting is far more inventive than the writing.

1992 F 11, C16:1

The Baltimore Waltz

By Paula Vogel; directed by Anne Bogart; sets by Loy Arcenas; costumes by Walker Hicklin; lighting by Dennis Parichy; sound and score by John Gromada; production stage manager, Denise Yaney. Presented by the Circle Repertory Company, Tanya Berezin, artistic director; Terrence Dwyer, managing director, in association with A.T.&T.: Onstage and Alley Theater. At 99 Seventh Avenue South, at West Fourth Street, Manhattan.

Anna..Cherry Jones
Carl...Richard Thompson
Third Man..Joe Mantello

By FRANK RICH

"To the memory of Carl — because I cannot sew," reads the Playbill dedication of Paula Vogel's new play, "The Baltimore Waltz," at the Circle Repertory Company. Who Carl is we can only imagine, but can there be much doubt about what kind of memorial Ms. Vogel would like to sew for him? Her play is about an elementary-school teacher named Anna (Cherry Jones) who learns that her brother, a young San Francisco librarian named Carl (Richard Thompson), is terminally ill. Anna's response is to sweep her brother and herself into a fantasy world — a crazy-quilt patchwork of hyperventilating language, erotic jokes, movie kitsch and medical nightmare — that spins before the audience in Viennese waltz time, replete with a dying fall.

The result is a dizzying evening at several levels, and the fact that "The Baltimore Waltz" is performed without an intermission did not prevent several Circle Rep subscribers from walking out at a critics' preview. This is not only a rare AIDS play written by a woman but also a rare AIDS play that rides completely off the rails of documentary reality, trying to rise above and even remake the world in which the disease exists.

Though ostensibly set in a Baltimore hospital, the actual landscape of Ms. Vogel's play is Anna's mind, which knows few imaginative bounds. Anna's powers of empathy are such that it is she, not her brother, who becomes the dying swan in her elaborate fantasies; she sees herself as the victim of a deadly malady that counts single teachers among its high-risk groups. Anna's dreams take her and Carl on a whirlwind tour through Europe that culminates in a macabre replay of the Carol Reed-Graham Greene thriller "The Third Man," with its zither music, Ferris wheel and a mad doctor (Joe Mantello) who usurps Orson Welles in the role of the mysterious Harry Lime.

•

"In art as in life, some things need no translation," says Carl. Some of

"The Baltimore Waltz" too flagrantly defies translation, lacking the internal logic that can make some dream plays, including the pre-eminent Circle Rep dream play of recent vintage, Craig Lucas's "Reckless," add up on their own idiosyncratic terms. Yet I respect what Ms. Vogel is up to and was steadily fascinated by it, even when her play seems too clever by half or less funny than it wants to be.

The fever pitch of "The Baltimore Waltz," almost an oxygen rush at times, is always enlivened by the playwright's antic literacy and always justified by the tragedy at hand. "It's the language that terrifies me," says Anna when she first encounters the medical world, and it's language with which Ms. Vogel creates her heroine's strange wonderland. As the dialogue rifles several Berlitz phrase books or veers off into linguistic riffs (an extended declension of the sentence "There is nothing I can do," for instance), the play's words seem to splinter and finally metastasize in sync with the young bodies racked by an incurable epidemic.

The audience's irresistible human guide through the heady wordplay of Ms. Vogel's text is Ms. Jones, that wonderful actress last seen as a sullen 18th-century convict in "Our Country's Good." A tall, big-boned woman with an incongruously pixieish face, she is credible as a devoted first-grade teacher, as an adoring sister and most important as an improvisational artist desperately ransacking her soul to create something transporting, even beautiful out of the sadness life has dealt her. Ms. Jones makes Anna's generosity of spirit a matter of intellectual and emotional bravery rather than of sentimental outward show. Along the way, she provides a bravura display of seamless acting technique, most spectacularly when she demonstrates each of Elizabeth Kubler-Ross's stages of terminal illness in a rapid-fire series of vignettes that sandwiches rage and heartbreak within the laughter of sketch comedy.

•

Ms. Jones's quicksilver changes of tone are matched by the supple production, which finds the director Anne Bogart treating a new script with a becoming delicacy and polish she does not always lavish upon the classics. "The Baltimore Waltz" is to be produced at several daring institutional theaters around the country this season, and one can only hope, for this brittle play's sake, that it is handled as sensitively elsewhere as it is here. With the help of Dennis Parichy's lighting, John Gromada's score and Walker Hicklin's costumes, Loy Arcenas's sterile hospital set becomes a magical arena for Anna's tour around the world in 90 minutes. Ms. Bogart also makes the most of the work's satirical interludes, with her principal accomplice being Mr. Mantello, who winningly performs a potpourri of burlesque turns in cameo roles of several nationalities and sexual dispositions.

While Mr. Thompson is likable in the role of Carl, it is one of the intriguing aspects of "The Baltimore Waltz" that he is not an active character in his own drama: the play really is intended as a living memorial to him, a sister's loving, uninhibitedly sensuous, even lusty valentine to a brother whose private life away from her is represented only by a vague symbol, a child's stuffed toy rabbit, that floats benignly through the reveries. That Ms. Vogel has succeeded in creating that memorial is most apparent when she finally must burst the balloon,

turning her enchanted accidental tourist back into a grieving schoolteacher, the rabbit back into a dying man's bedside totem, the mysteries of Vienna back into the cold, clammy realities of a hospital ward in Baltimore. Having turned up the volume and body heat of life so high with her dreamy theatrics, the author makes us feel the loss all the more deeply when another young corpse is carted off the stage.

1992 F 12, C15:3

Theater in Review

■ 2 friends part, enter a mental institution and meet again ■ 2 friends dance, marry others and meet again ■ Peter Pan meets ice. Flies.

Appointment With a High-Wire Lady

Alice's Fourth Floor
432 West 42d Street
Manhattan
Through Sunday

Written by Russell Davis; directed by Michael Mantell; set and lights by Michael Francis Moody; costumes by David Sawaryn; music composed and performed by Jane Ira Bloom and Jayne Atkinson; producer, Patricia Cornell; executive producer, Kate Baggott; production stage manager, Sally Plass. Presented by Alice's Fourth Floor, Susann Brinkley, artistic director. WITH: Ms. Atkinson, Suzanne Shepherd and Victor Slezak.

Having flirted with death, a young man has crash landed into a state mental hospital, where he sits silently in the dayroom. He has lost his sense of touch and his ability to focus his eyes and his attention. In Russell Davis's "Appointment With a High-Wire Lady," the patient (Victor Slezak) is gradually drawn back into life by a friend from his past (Jayne Atkinson). There are lapses in the play, including a second psychiatric patient who carries more metaphorical weight than her character can justify. But Mr. Davis is subtle and unsentimental in telling a story about two people trying to find a connection that has previously eluded them.

The play is a puzzle in which the author continues to hide some pieces. We find out little about the characters outside the environs of the hospital, but there are clues to their interior lives, partly through carefully planted recollections of epiphany. These are moments that have to do with reflections on death.

Like a character in an Oliver Sacks case history, Mr. Slezak awakens and makes the most tentative moves into a world of reality. The effectiveness of the characterization is inseparable from Mr. Slezak's moving perform-

ance. Led by Michael Mantell, as director, he is like a newborn, feeling his way into an alien environment. Mr. Slezak never overplays the character's cards of identity, as they are tentatively recalled.

Ms. Atkinson is equally assured as the woman who is reluctantly drawn again into his orbit. Clearly there was a turbulence in their original relationship, including a conflict between the young man and the woman's father. There are also affectionate memories and, between moments of anxiety, she becomes his life preserver.

In contrast to this couple, the other patient (Suzanne Shepherd), a fugitive from political oppression, seems like an intrusion from a different play. In her brief scenes, she becomes unnecessary comic relief.

Before arriving here in this austere production, "Appointment With a High-Wire Lady" went through a series of workshops at the Ensemble Studio and Long Wharf theaters, among other places. The play needs further distillation, but it has a sensitive awareness of the renewable vitality within an interrupted relationship. In extremis, says the playwright, can come understanding.
MEL GUSSOW

After the Dancing in Jericho

York Theater Company
2 East 90th Street
Manhattan
Through Feb. 23

Written and directed by P. J. Barry; sets by Daniel Ettinger; costumes by Barbara Beccio; lighting by Mary Jo Dondlinger; technical director, John Miller; production stage manager, Alan Fox; choreography, Dennis Dennehy. Presented by the York Theater Company, Janet Hayes Walker, producing

director; Molly Pickering Grose, managing director, in association with One-World Arts Foundation.
WITH: Pamela Burrell, James Congdon, Jack Davidson, John Kozeluh, Michelle O'Steen and Ginger Prince.

When Kate Driscoll and Jim Conroy, the central characters in P. J. Barry's "After the Dancing in Jericho" first appear, they are chirpy high school dancing partners polishing their jitterbug in a studio in a fictional town called Jericho, R.I. It is the late 1940's, and the pair, played by Michelle O'Steen and John Kozeluh, epitomize the innocence of suburban teen-age life during the Truman-Eisenhower era.

Moments later, they are joined by the adult Kate (Ginger Prince) and Jim (Jack Davidson). It is 1984. Both have been married (though Jim has divorced), and each union has produced two children. Jim, who lives in New York, has been eking out a living in show business and is still friendly with his former wife, Gloria (Pamela Burrell), a psychoanalyst. Kate's marriage to a former test pilot (James Congdon) has gone a bit stale. It was Jim's appearance in a television commercial that prompted Kate to look him up.

"After the Dancing in Jericho," which the playwright has also directed, unfolds as a gently comic dance to the music of time with scenes of the youthful Kate and Jim interwoven with the progress of pair's breathlessly happy reunion 35 years later. Until the play takes a sudden left turn in the second act, it seems to be a comfy, nostalgic sitcom that hangs on the question of whether the grown-up Kate and Jim will become romantically involved, something they just missed being as teen-agers. Although it would be unfair to give away the crucial plot twist, it should suffice to say that Johnny, the unseen focus of

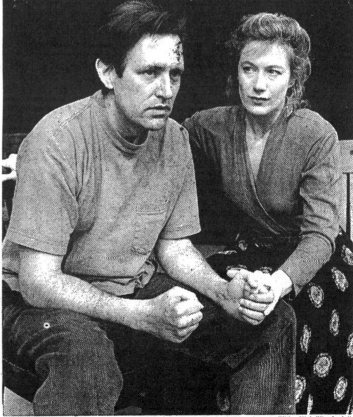

T. Charles Erickson/"Appointment With a High-Wire Lady"

Victor Slezak and Jayne Atkinson in a scene from Russell Davis's "Appointment With a High-Wire Lady," at Alice's Fourth Floor.

their reminiscences, who was Kate's wild teen-age boyfriend and Jim's best buddy, becomes the catalyst for some surprising personal revelations.

The playwright knows his characters inside and out, and not a line or nuance rings false. The action has been deftly staged, with the young Kate and Jim shown upstage, elevated above their older selves in blazing light. The interplay between then and now proceeds so seamlessly that as the story deepens, the teen-age and grown-up characters begin to merge. The finely tuned performances suggest the ways in which youthful tics and mannerisms are integrated into adult speech and body language. And Dennis Dennehy's choreography finds exactly the right balance between teen-age gawkiness and terpsichorean flash.

Mr. Barry, whose play "The Octette Bridge Club" was produced on Broadway in 1985, is a sure-handed craftsman of the sort of stage entertainment that used to be seen regularly on Broadway until it became movie-of-the-week television fodder. And "After the Dancing in Jericho," notwithstanding an overly contrived dramatic structure, is a superior example of such a play.

STEPHEN HOLDEN

Disney's World on Ice Starring Peter Pan

Radio City Music Hall
Manhattan
Through Sunday

Theatrical director and writer, Jerry Bilik; skating director and choreographer, Bob Paul; music director, Mr. Bilik; costumes by Arthur Boccia; production design by Keith Anderson; lighting by Marilyn Lowey; Disney characterization direction by Larry Billman and Roy Luthringer. A Kenneth Feld Production presented by Radio City Music Hall Productions.
WITH: Bobby Davis, Michael B. Dolan, Jaimee Eggleton, Carla Ericson, Dawn-Ann Oliphant, Dawn Porter and Christopher Shrimpling.

The latest edition of "Walt Disney's World on Ice," this one starring Peter Pan, is a gentle romp, for toddlers, with some dazzling scenic effects for adults. The whole Disney crew — including Mickey and Minnie Mouse, Donald and Daisy Duck and the singing Chipmunks — is reassuringly on hand at the start of the show to lead the audience through Merrie London with an English bobby and a generic nanny type as guides. A golden statue center rink proves to be a depiction of J. M. Barrie's "Peter Pan," which eases the audience nicely into this year's theme.

The ice show sticks fairly closely to the traditional story, adding only a giant second crocodile that gulps down the pirate Captain Hook and then slides heavily off the rink. Mr. and Mrs. Darling go out for a night on the town, leaving their children, Wendy, John and Michael, alone with Nana, a large, woolly four-skated creature, on the fateful night the story opens. Peter arrives, searching for the shadow he left behind on his last visit to the Darling household.

Learning that this is to be the children's last night together in the nursery before Wendy gets a room of her own, Peter flies them off to Never Land and encounters with Lost Boys, Indians, pirates and a crocodile. Then it's back to London for the Darling children and the Lost Boys, with Peter looking out over the audience and urging everyone not to lose the child

in them. No midlife crises here, as there were in the Steven Spielberg movie.

"Walt Disney's World on Ice Starring Peter Pan" is a judicious mix of cartoon-style capers and exciting skating. Performers race across the ice at breakneck speed in large airy circles. There are daredevil acrobatic jumps and catches and skimming, twirling duets. There are several chances for the audience to join in, clapping, singing and yelling, one time to save the dying Tinkerbell. The music, some of it familiar, is pretty. And even Mickey gets a chance to fly. But best of all are the magical night flights across the rooftops of London, stars spinning out over the darkened Music Hall.

Jaimee Eggleton is an amiable, hard-skating Peter who manages to look both elegant and rambunctious on ice. Carla Ericson gets off some impressive pyrotechnics on skates as Tiger Lily. Dawn Porter is a hyperactive, ditzy Wendy until she starts dancing on ice, with lyrical expertise. There is exciting acrobatic duet-dancing by Penny Booth and Michael Nemec as a variety of characters. Michael B. Dolan and Christopher Shrimpling are enjoyable as Captain Hook and his pratfalling cohort, Mr. Smee. The lead cast is completed by Dawn-Ann Oliphant and Bobby Davis as Michael and John Darling.

JENNIFER DUNNING

Making Book

Primary Stages Company
354 West 45th Street
Manhattan
Through March 1

Written by Janet Reed; directed by Susan Einhorn; scenery and costumes by Bruce Goodrich; lighting by Spencer Mosse; sound by One Dream; production manager, Jerry Goehring; production stage manager, Christine Catti. Presented by Primary Stages Company, Casey Childs, artistic director.
WITH: Daniel Ahearn, Catherine Curtin, Claudia Fielding, Percy Granger and Allison Janney.

Political correctness is only one of the pitfalls of modern life, but for anyone trying to create a new fifth-grade social-studies textbook that will sell to the California Board of Education, it is clearly the one most fraught with danger. That, at any rate, seems to be the premise for "Making Book," a new comedy by Janet Reed.

Ellen Winston (Claudia Fielding) is a schoolteacher who, complaining about the homogenized pap in the textbook she teaches, is hired by a publishing house to help create a new one. Nomenclature of ethnic minorities is the least of her problems, albeit a recurring one inasmuch as it keeps changing from week to week. Ellen's attempts to introduce the topic of slave ships, insert a quote from "Black Elk Speaks" or use photographs of immigrants less than overjoyed about being among the huddled masses at Ellis Island are greeted with horror and derision.

The inherent weakness with "Making Book" is that once Ms. Reed goes through the list of inequities in the fifth-grade canon, she has run out of things to say. To pad out her play, and try to inject some conflict in it, the playwright detours through some mundane office politics and sex.

There is probably a good one-act play hidden somewhere in "Making Book," and some of the writing is lively, as in one scene in the second act set around an editorial meeting on

the great melting pot. But in trying to flesh out the plot and, presumably, give her characters depth, Ms. Reed lets the play become repetitious, preachy and predictable.

In fact, much of "Making Book" plays like a series of scenes hastily stitched together for a final reading. When Ms. Reed needs to get a character offstage, for example, she has him abruptly announce he has to make a phone call and exit.

The cast brings a lot of energy to roles that in the final analysis are little more than stereotypes. Catherine Curtin is a delight as an intern straight from college ("Barnard 4.0") who not only has her eye on the main chance, but knows how to catch the main chance's eye as well. Daniel

Ahearn is so oily as a sexist snake of an editor it's hard not to hiss him when he comes onstage. Allison Janney is credible as his chic and savvy yet hardened assistant. Ms. Fielding seems as confused as the naïve teacher-cum-textbook creator she portrays, which only underlines the contradictions in the character.

Bruce Goodrich's sets and costumes are smart and attractive. Susan Einhorn, the director, keeps things moving briskly, although judging by a weekend performance the show could use another technical rehearsal or two.

WILBORN HAMPTON

1992 F 12, C17:1

The Most Happy Fella

Book, music and lyrics by Frank Loesser; based on Sidney Howard's "They Knew What They Wanted." Entire production directed by Gerald Gutierrez; choreography by Liza Gennaro; sets, John Lee Beatty; costumes, Jess Goldstein; lighting, Craig Miller; musical direction, Tim Stella; duo piano arrangements, Robert Page, under the supervision of Frank Loesser; artistic associate, Jo Sullivan; production manager, Jeff Hamlin. Presented by the Goodspeed Opera House, Center Theater Group/Ahmanson Theater, Lincoln Center Theater, the Shubert Organization and Japan Satellite Broadcasting/Stagevision. At the Booth Theater, 222 West 45th Street, Manhattan.

Cashier, Postman and Doctor	Tad Ingram
Cleo	Liz Larsen
Rosabella	Sophie Hayden
Tony	Spiro Malas
Herman	Scott Waara
Clem	Bob Freschi
Jake	John Soroka
Al	Ed Romanoff
Marie	Claudia Catania
Max	Bill Badolato
Joe	Charles Pistone
Pasquale	Mark Lotito
Ciccio	Buddy Crutchfield
Giuseppe	Bill Nabel
Priest	Bill Badolato

WITH: John Aller, Anne Allgood, Molly Brown, Kyle Craig, Mary Helen Fisher, Ramon Galindo, T. Doyle Leverett, Ken Nagy, Gail Pennington, Jane Smulyan, Laura Streets, Thomas Titone and Melanie Vaughan.

By FRANK RICH

NOSTALGIA alone does not explain why Americans still adore Broadway musicals of the 1940's and 50's. The appeal of these shows is much plainer than that. Men and women step forward and express their most primal desires in simple poetry and unforgettable melodies: I want this. I must go there. I love you.

These feelings, which are no less profound for being universal, will never go out of fashion, and neither will the musicals containing them if they are as powerfully acted, sung and staged as the revival of Frank Loesser's

1956 musical, "The Most Happy Fella," which opened at the Booth Theater last night. As directed by Gerald Gutierrez and performed by a cast led by Spiro Malas and Sophie Hayden, this work can hold its own with "Carousel" and "The Music Man" on the hit parade of Broadway romantic classics of the golden Rodgers and Hammerstein era. It is so stirring that even as your head tells you that you cannot possibly be moved by its preposterously simple love story of a middle-aged immigrant Napa Valley grape

farmer of the 1920's and his young mail-order bride, the rest of you is tugged right in.

"The Most Happy Fella" has not always exerted such a tidal pull. From its successful original production, which was upstaged by the arrival of "My Fair Lady" two months earlier, through the last New York revival at the City Opera this season, the show has usually been staged as a majestic quasi-opera, reflecting the length of its score (more than 30 numbers) and the Puccini-isms of some of its lusher pas-

sages. This time Mr. Gutierrez strips away the theatrical grandiosity and corn by making a few textual trims, by replacing the original 35-piece orchestra with a simple, two-piano accompaniment Loesser commissioned but never used, and more important, by insisting on the sort of adult, honest acting and singing that one almost never finds in Broadway musical revivals (let alone at the opera). In other words, the director bets that the material itself — the integrity of its emotions and the voluminous musical beauty with which those emotions are expressed — will carry the evening without embellishment. Thanks to the intimacy of the Booth, even the deadening filter of electronic amplification is

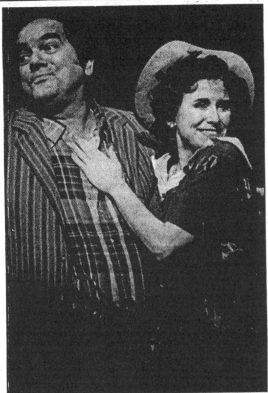

Martha Swope

A simple love story — Spiro Malas and Sophie Hayden in Frank Loesser's musical, at the Booth.

virtually eliminated as Mr. Gutierrez pitches his cast forward on a thrust stage.

The bet pays off with a nonstop surge of passion, much of which flows from the sterling and unorthodox lead performances. Mr. Malas could not be a less likely romantic hero. As the title role of Tony demands, he is not young, not good looking, not smart, not fluent in English and for much of the show not ambulatory. (A road accident lands him in a wheelchair.) But Mr. Malas, an opera baritone whose thick body and large

peasant features suggest a lifetime of both hard knocks and gargantuan appetites, immediately wins us over, not with a fat man's musical-comedy jolliness but with the plaintive hunger and deep humility in his sweet, timid hopes for happiness with Rosabella, the San Francisco waitress whom he courts by letter. When he later must overcome some formidable obstacles to win his bride's love, Mr. Malas uses his voice as a caress, playing down its power in favor of its tenderness, until finally the audience, too, is seduced by this unexpected Romeo.

Ms. Hayden, whose warm soprano has an affecting undercurrent of sadness, is his ideal match. She is not the standard, girlish ingénue usually cast in roles like Rosabella but a woman who actually looks like the less-than-virginal, greasy-spoon waitress she is when Tony meets her. She's attractive but not daintily so, and in the opening scene she sings with a cigarette dangling from her mouth. Like Mr. Malas, she is also transformed inexorably by affection, in her case

from a broke and abandoned pickup to an unselfish lover. The songs in which Tony and Rosabella exchange lessons in English and Italian ("Happy to Make Your Acquaintance" and "How Beautiful the Days") become gripping dramatizations of two lost souls breaking a psychological rather than merely a language barrier. When the floodgates finally open on a duet that is Loesser's answer to "Bess, You Is My Woman Now" (its crippled hero included), the entire house seems to embrace the two leads as ecstatically as they at last enfold each other.

"My heart is so full of you, there is no room for anything more," sings Ms. Hayden at that point. It is the measure of this production's success that one is thrilled rather than embarrassed by songs in which lovers sing nakedly of being "warm all over" and "wanting to be wanted, needing to be needed," and that Loesser's childlike vulnerability seems no less authentic than the Tin Pan Alley urbanity of his "Guys and

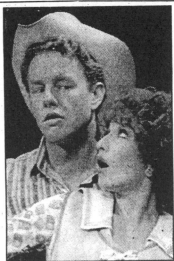

Jay Thompson

Scott Waara and Liz Larsen

Dolls." Even so, this staging does not shortchange the score's conventional show-biz turns, starting with the pop harmonizing and incipient soft-shoe of "Standin' on the Corner," The dazzling Liz Larsen and Scott Waara, as the show's archetypal comic couple (indeed, undisguised retreads of Ado Annie and Will Parker), are as unhackneyed as Mr. Malas and Ms. Hayden, so sexy and funny and real they obscure their roles' vaudeville roots. They and the rousing chorus of singers and dancers ambush the second act with the human stampede Liza Gennaro has choreographed for "Big D."

Much of the Broadway showmanship of Mr. Gutierrez's "Fella" has been brought to a higher gloss since this production was first seen at the Goodspeed Opera House in Connecticut last summer. (The only glaring exception is Claudia Catania's wrong-note performance as Tony's meddling sister, Marie.) The trio of juggling and harmonizing chefs (Buddy Crutchfield, Bill Nabel and Mark Lotito) remains a delight, as, in a different key, does the robust voice of Charles Pistone as Joe, the dark Lothario of the piece. John Lee Beatty's sets, Jess Goldstein's costumes and Craig Miller's lighting offer a lovely blend of Tuscan-hued vineyard landscapes and 20's working-class fashions. For a show that places its first

A show starts inside its characters but is also visual.

priority on the interior of its characters, this "Fella" never neglects the visual, moving delicately from the bleak winter of its lovers' first encounter to a radiant summer of harvest and regeneration.

Sure, one does miss the musical colors of the haunting Don Walker orchestrations at first; the twin pianos that usurp them sound more out of place in a Broadway house than they did at Goodspeed. But I must confess that when I went home after the performance and put on the exemplary 1956 cast album, a boon companion for most of my theatergo-

ing life, it seemed for the first time a little heavy, a little hollow. Or is it just that the new "Most Happy Fella" leaves one's heart so full that there is no room for anything more?

1992 F 14, C1:4

Antigone

By Sophocles; directed by Jim Niesen; choreographer, Annie-B Parson; musical director and pianist, Steven Osgood; composer, Walter Thompson; clown advisor, Lenard Petit; scenic designer, Kennon Rothchild; lighting designer, Hilarie Blumenthal; costume designer, Elena Pellicciaro. Presented by the Irondale Ensemble Project. At the House of Candles, 99 Stanton Street, Manhattan.

By STEPHEN HOLDEN

What could possibly connect Sophocles' "Antigone" with the art of clowning? That question is explored in considerable depth by the Irondale Ensemble Project in its iconoclastic production of the Greek tragedy, which plays through Saturday. It is also elaborated in program notes that quote from Bertolt Brecht and Joseph Campbell. Brecht praises a show he saw in which a clown banged his head, sawed off the swollen bump and ate it, as wittier than anything in the entire contemporary theater. Campbell, musing on the appeal of clowns, suggests that children see in them reflections of a primal innocence.

These ideas are rather hazily integrated into the Irondale Project's interpretation of the play, in which Creon is a circus ringmaster and Antigone a stubborn woman-child in clown whiteface. In the company's tiny performing space on the Lower East Side, several of the performers enter by descending from ropes. The seven-member Walter Thompson Orchestra plays a dissonant score that juxtaposes skewed circusy marches with a galumphing arrangement of "The Man on the Flying Trapeze."

The production varies in tone between a clown show with slangy interpolations and a fairly straightforward reading of pieces of the play. Terry Greiss's Creon veers between a twinkly, avuncular ringmaster and a megalomaniacal despot. As these metamorphoses take place, "Antigone" suggests, among other things, an allegory of public life in an age when politics have become show business. The charming, faintly seedy ringmaster who welcomes the audience is the public face of power, while the vengeful monarch who against reason and decency demands the death of a disobedient subject is the behind-the-scenes reality. The Greek chorus, which does song-and-dance routines, seems as fickle and susceptible to manipulation as the American populace in its responses to George Bush.

An attempted coup de théâtre near the end of the play turns tragedy into farce. Creon chases Antigone around the stage brandishing a knife that turns out to be a rubber stage prop. After attacking her with other fake weapons, he settles for landing a custard pie in her face.

But if that's the end of the show, it's not the end of the story. Thebes becomes a plague-ridden hell piled with corpses.

The production's basic clown metaphor seems forced. But once it has been asserted, the other parallels between ancient and contemporary times fall into place.

1992 F 16, 70:5

SUNDAY VIEW/David Richards

'Baltimore Waltz' Is Part Wish Fulfillment

The Frank Loesser musical plays its heart on its sleeve.

'Baltimore Waltz' is part dream, part wish fulfillment.

WE REALLY OUGHT TO BE tossing something in the air this morning. Our hats. Confetti. The bambino. In a world where things usually go wrong, "The Most Happy Fella" has come through splendidly.

Success has *not* given it a swelled head. Nobody has thought to gild the sets or pad the orchestra, which consists exactly of two tuxedoed pianists. Frank Loesser's musical is every bit as warm and endearing at the Booth Theater as it was last summer, when it proved to be a gargantuan hit for the tiny Goodspeed Opera House in East Haddam, Conn.

"The Most Happy Fella" has always been the most deliriously musical of musicals — packed with snappy Broadway show tunes, exquisite love songs, passionate arias, exuberant trios and "Big D," the hoedown that put Dallas on the map. That much we've known since 1956, when at least one reviewer complained that the work, about an aging Italian patriarch in the Napa Valley and his mail-order bride, contained music enough for at least two shows. What the Goodspeed set out to discover was whether or not you could hear the pitter-pat of the human heart in the prodigious outpouring of melody.

It wasn't just a question of scaling an expansive Broadway musical down to size. Any production at the Goodspeed — 398 seats nestled in a Victorian candy box — is necessarily going to be an intimate production. It was a matter of emphasis. What if you treated "The Most Happy Fella" as a drama about the hesitation, the generosity, the self-doubts and the sudden shivers of joy that overtake people when they're falling under each other's spell? The director Gerald Gutierrez meant no disrespect to Loesser's score, but with only those two pianists in the orchestra pit the priorities were clear: he was putting the characters' emotional lives first. The set designer John Lee Beatty even covered up the unused portion of the pit, which allowed the performers to edge even closer to the audience, further enhancing the coziness.

What happened, of course, was that Loesser's score not only sounded better than ever, it also seemed more of a piece — its operatic urges no longer at odds with its happy-go-lucky outbursts. The cast, headed by Spiro Malas and Sophie Hayden, bloomed all down the line. A transfer to Broadway was inevitable. The only potential snag in the felicitous scenario was this: Would the producers leave intact what was wonderful in its discretion

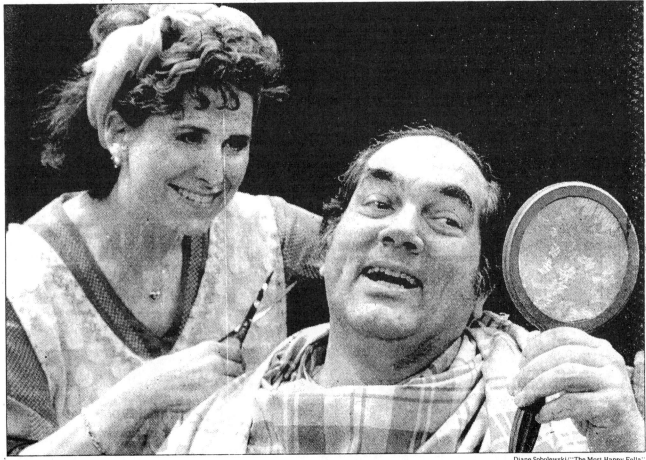

Diane Sobolewski/"The Most Happy Fella"

Sophie Hayden and Spiro Malas in "The Most Happy Fella"— What if you treated the musical as a drama about the hesitation, generosity, self-doubts and shivers of joy that overtake people when they're falling under each other's spell?

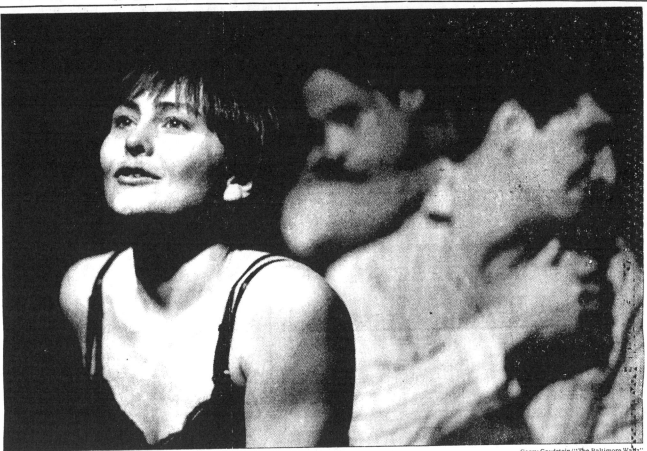

Gerry Goodstein/"The Baltimore Waltz"

Cherry Jones, Joe Mantello and Richard Thompson in "The Baltimore Waltz"— Reluctant to write yet another AIDS play Paula Vogel has brought a bizarre sense of fantasy to bear on a situation that, unfortunately, has become all too common.

and its subtlety? Or, Broadway being Broadway, blow it up. In more ways than one.

Well, there's been some polishing here, some tightening there. Mr. Beatty's scenery looks to be fresh as rain. And Scott Waara has taken over the role of Herman, the goofy farmhand who can't help liking everybody he meets, especially Liz Larsen, who plays a wry, wisecracking waitress as if the species had never been seen before. (That simply means that the secondary love interest is in better shape than ever.) Otherwise, the production's gloriously confidential moods remain unchanged. The Booth, one of Broadway's smallest theaters, couldn't be more hospitable. There, as at the Goodspeed, a wink does the work of a wink and an inadvertent trembling of the jaw is sufficient to suggest that the heroine is less brave than she's pretending.

■

Set against the lush Nothern California vineyards and the friendly main street of Napa in the 1920's, "The Most Happy Fella" takes an unlikely match and makes it seem inevitable. On the inside, Tony (Mr. Malas) is as decent a man as they come — understanding enough to forgive his bride for the one-night stand that has left her pregnant; wise enough to claim the child as his own. On the outside, however, he's an old, balding immigrant who speaks broken English and looks suspiciously like a Dead End Kid grown up.

Rosabella, his intended (Ms. Hayden), is a tired San Francisco waitress whose puffy face testifies to years of disappointment and dashed dreams. It doesn't help that Tony, no one's idea of Prince Charming, lures her to his Napa farm with guileless letters and a photograph of his dashing young foreman. As soon as she spots the ruse, her defenses go

right back up, hiding the needy soul and the heart that's aching to give itself to someone.

If "The Most Happy Fella" is a joyful experience, it's not because love triumphs in the end. Love triumphs all the time in B movies and vapid sitcoms. It's because in the extraordinarily delicate performances of Mr. Malas and Ms. Hayden, the characters' inner qualities gradually work their way to the surface, remaking external reality. The two not only come to see each other with different eyes, but we do, too. By the time they sing their exultant duet, "My Heart Is So Full of You," the spirit has transformed the flesh. A June-November pairing that flouts every traditional romantic expectation ends up seeming totally natural. Desirable even.

That's why it was so critical to keep the production intimate and every spectator close at hand. "The Most Happy Fella" chronicles a huge change of heart, but it does so by tiny increments. Play it grandly, sweepingly, for the upper gallery, as the New York City Opera did recently, and the tale turns to bombast and melodrama. Play it with homely truth, and the evening acquires the lovely glow of fireflies at dusk.

The show's moods are not exclusively sentimental, although while I'm on the topic, I should mention "Joey, Joey, Joey," surely as seductive an expression of wanderlust as any in the Broadway canon. (Charles Pistone sings it with a beautiful wistfulness.) "Standing on the Corner" is the kind of brazenly chipper four-part harmony that's been getting its own tribute these days Off Broadway in "Forever Plaid." And for sheer brio, how can you beat "Abbondanza," an

exhilaratingly nutty celebration of nature's bounty. Mark Lotito, Bill Nabel and Buddy Crutchfield tackle the number with the reckless panache of provincial acrobats sipping vino on the high wire.

I'm tempted to say that the old saw about good things coming in small packages applies here, if it's ever applied anywhere. Except that "The Most Happy Fella," belying its actual dimensions, never seems contained. So much enchantment pours off the stage of the Booth that one is left with an impression of profligacy. Nothing is smaller than a big show that's empty. Or bigger, for that matter, than a little show that's so full to the brim it's bursting.

'The Baltimore Waltz'

In "The Baltimore Waltz," a discombobulating new play at the Circle Repertory Company, a brother and sister take a grand tour of Europe,

while the playwright Paula Vogel goes on a guilt trip.

A few hard facts may be helpful here. In 1986, Ms. Vogel's brother Carl, then HIV-positive, proposed that she visit Europe with him. Unaware of his condition and caught up in other projects, she declined the offer. Early in 1988, Carl died of AIDS in Maryland. The trip never got taken.

Written a year and a half later, Ms. Vogel's play is the journey they might have experienced — part dream, part movie pastiche, part wish fulfillment.

Paula Vogel's play describes a journey that might have taken place.

Carl is still Carl, a San Francisco librarian, fired for wearing a pink triangle on the job. Anna, an elementary-school teacher, is the stand-in for the playwright. An additional character, billed only as Third Man, crops up as everybody along the way, including Harry Lime, the black marketeer, whom Orson Welles played in the movie classic "The Third Man."

The playwright's greatest deviation from reality, however, is to make Anna the sick one, not Carl. Early in the play, the doctor informs her she has ATD, "Acquired Toilet Disease," a terminal illness contracted by sitting on public toilet seats. Single schoolteachers between the ages of 24 and 40 seem to be the chief victims. Medical science is baffled. Safe toilet practices offer the only protection. "Do squat, don't sit," advises the Department of Health and Human Services.

While the European voyage will be in the nature of a last goodbye for the siblings, they entertain the tiniest of hopes that Dr. Todesrocheln, an 80-year-old Viennese urologist, will be able to save Anna. Off they go — Anna, dressed in a trench coat and black slip, and determined to have one last fling in each country they visit; Carl, wearing a suit coat over his striped pajamas and clutching a stuffed rabbit, ready to explore higher, more cultural pursuits. The Third Man, for his part (or parts), is kept busy playing clichéd versions of the amorous Frenchman, the stalwart Dutchman who put his finger in the dike, the abusive Berliner in black leather and Dr. Todesrocheln, a Dr. Strangelove knockoff in a fright wig and blood-spattered laboratory coat.

Reluctant to write yet another AIDS play, Ms. Vogel has brought a bizarre sense of fantasy to bear on a situation that, unfortunately, has become all too common. But even as she's letting her imagination run riot, a terrible remorse seems to have her in its grip. One impulse wars against the other. "The Baltimore Waltz" is too tortured to be whimsical, too wigged-out to be moving and just hermetic enough so that you may not care.

The action takes place in a sterile hospital room that could also be an airport waiting lounge. (The lush travelogue music tells you when it is Paris or Vienna.) The director Anne Bogart — never one to clear up a mystery — has chosen to accent the play's eccentricities at the expense of any internal logic. The symbolism of Carl's stuffed rabbit alone is enough to keep you in a state of befuddlement. Depending on the scene, it would seem to represent contraband, a phallus, a badge of initiation, the innocence of childhood or a stuffed rabbit.

At one point, Carl enthusiastically suggests showing the audience slides of the Rhineland. The lights are dimmed and the pictures turn out to be depressing views of Baltimore. No problem there. When shots of Disneyland creep into the mix, though, Carl is furious.

As who wouldn't be?

Anna is played by Cherry Jones, who projects some of the waifish vulnerability of the young Shirley MacLaine; Carl, by the bland Richard Thompson; and all the others by Joe Mantello, whose energy is more astounding than his versatility. They all appear to be deeply committed to Ms. Vogel's work. But then, "The Baltimore Waltz" would be most meaningful to those most directly involved. Isn't therapy? □

1992 F 16, II:5:1

Grandchild of Kings

Adapted and directed by Harold Prince; from the autobiographies of Sean O'Casey; set by Eugene Lee; lighting by Peter Kaczorowski; costumes by Judith Anne Dolan; sound by James M. Bay; musical director, Martha Hitch; conductor, Rusty Magee; choreographer, Barry McNabb; production stage manager, Kathe Mull. Presented by the Irish Repertory Theater Company Inc., artistic directors, Ciaran O'Reilly and Charlotte Moore, and One World Arts Foundation Inc. At Theater for the New City, 155 First Avenue, at Ninth Street, Manhattan.

WITH: Nesbitt Blaisdell, Chris Carrick, Maeve Cawley, Paddy Croft, Terry Donnelly, Louise Favier, Rosemary Fine, Patrick Fitzgerald, Pauline Flanagan, Michael Judd, Chris A. Kelly, Dermot McNamara, Padraic Moyles, Brian F. O'Byrne, Chris O'Neill, Denis O'Neill, Ciaran O'Reilly, Ciaran Sheehan and Georgia Southcotte. Musicians: Mary Courtney, Carmel Johnston and Margie Mulvihill.

By FRANK RICH

When "Nicholas Nickleby" opened on Broadway a decade ago, the New York theater world was so consumed by Anglophilia that hardly anyone noticed that the Royal Shakespeare Company epic owed a debt to one of Broadway's own innovators, the director Harold Prince. The environmental staging, the use of a roving ensemble to conjure up the atmosphere of Victorian England and the relish in exposed stage machinery all echoed Mr. Prince's landmark productions of the 1970's: the arena-format revival of "Candide" and the original, proscenium-framed "Sweeney Todd."

So if Mr. Prince's new Off Broadway project, an evocation of the playwright Sean O'Casey's Dublin youth titled "Grandchild of Kings," rekindles a few memories of "Nicholas Nickleby," from a mimed coach ride to a farcical play-within-the-play, the director is well within his rights. And however short he may fall of realizing his full intentions, he is certainly on top of his talent as a master of stage pictures. Though the Playbill indicates that Mr. Prince's time has lately been devoted to at least 11 productions of Andrew Lloyd Webber's "Phantom of the Opera" around the world, his continued replication of a single production has in no way dulled his instinct for orchestrating performers, movement, sights and sounds into a vibrant theatrical landscape far removed from the opulence of West End and Broadway musical spectaculars.

•

Using the actors of New York's Irish Repertory Theater Company and the new, Cafe LaMama-like performance space of the Theater for the New City, Mr. Prince thrusts the audience into a miniature turn-of-the-century Dublin in "Grandchild of Kings." A crucial collaborator once again is the designer Eugene Lee, who here, as in "Candide," has scattered isolated stage areas and clusters of spectators' seats in countless crannies on several levels of the gymnasium-size room. Depending on your location, you may find yourself cheek-by-jowl with the young John Casey (as Sean O'Casey was originally named) as he receives crude hospital treatments for his ailing eyes or, more pleasantly, you may be an involuntary Peeping Tom at one of the grown hero's fumbling romantic flings. Even in repose, Mr. Lee's set, lighted in Joycean shades of dusk by Peter Kaczorowski, is a visual treat, with such evocative way stations as a two-story-high pub, a frayed old Abbey Street theater (complete with grandiose curtain and marquee) and, hanging throughout the theater, a constellation of antique lamp shades that in themselves summon up a city's warm parlors and lonely bed-sitting rooms.

Throw in some wandering musicians, singers and jig dancers, not to mention a cast of 20 playing more than 80 roles, and it's easy to imagine how teeming a background Mr. Prince has created for his play. The trouble with "Grandchild of Kings" is its foreground, which is pallid by comparison, and that failing is one of writing, not staging: The director has done his own adaptation of "I Knock at the Door" and "Pictures in the Hallway," the first two installments of O'Casey's six-volume autobiography, and he simply has not succeeded in transforming those books' prose into drama. Perhaps a more experienced dramatist was needed to help make these self-mythologizing (and sometimes fictionalized) memoirs into scenes that might have the stageworthiness, not to mention the power, of those in O'Casey's own dramas of the Dublin slums.

•

Mr. Prince's script is a diligent and intelligent exercise in excerptation, but nearly all the chapters of the playwright's formative years are self-contained anecdotes given roughly equal weight: the death of his father, his conversion from a Protestant to a Gaelic identity, his discovery of sex, his embrace of the theater, his enlistment into the cause of Irish nationalism. O'Casey's emotional, po-

Carol Rosegg/Martha Swope Associates/"Grandchild of Kings"

Pauline Flanagan and Padraic Moyles in "Grandchild of Kings."

litical and artistic coming of age is always seen from the outside, not within, and the device of using three omnipresent actors to represent the protagonist at different ages only adds to the remoteness and fractionalization of his character. "Grandchild of Kings" most flavorfully evokes its hero's presence when it is simply regurgitating his own literary narration as stage narration. The scenes of O'Casey in public activity — chafing at school or laboring as a clerk or acting in Boucicault's "Shaughraun," for instance — are almost always more effective than the more important episodes intended to reveal the tension of his relationships with family, friends and his embryonic ideals.

While the Irish Rep has proved itself a credible acting troupe in the past, it seems stymied by the blurriness of its assignments in this piece. The performers are often more compelling as extras in the larger canvas than at close range as specific people; one does not feel here, as at such recent productions as "Mad Forest" and "Dancing at Lughnasa," that the acting ensemble has created an exotic foreign community and folded the audience into it. A few individual turns rise above the general blandness: Patrick Fitzgerald, who provides a brooding portrait of O'Casey as a young man; Louise Favier, as an early and earthy lover, and Pauline Flanagan, who was seen in New York only a few months ago in Shivaun O'Casey's traveling production of "Shadow of a Gunman" and who on this occasion portrays the playwright's doting mother as a prototype for the matriarch of "Juno and the Paycock."

The affection for O'Casey in Ms. Flanagan's performance is matched by that of Mr. Prince, who explains in a program note that he created this work in honor of his wife, Judy, whose longtime infatuation with O'Casey's writings inspired his own. But in this production, the director's identification with his hero is, if anything, too complete. Like the young, vigorous and still artistically unformed O'Casey, he seems to be knocking loudly at a door that he has yet to walk through.

1992 F 17, C13:1

Theater in Review

■ Of G.I.'s in Korea

during the Vietnam war

■ Ex- and interior

monologues, with bows

to Wilde and Woolf ■ In

'Ghosts,' Ibsen whole.

Korea

Ensemble Studio Theater
549 West 52d Street
Manhattan
In repertory through March 4

By Bill Bozzone; directed by Kate Baggott; stage manager, Elizabeth Brady Davis; lighting by Greg MacPherson; set by Sarah Lambert; sound by Michael Sargent; costumes by David Sawaryn. In Pursuit of America, Series 2, presented by the Ensemble Studio Theater, Curt Dempster, artistic director; Christopher A. Smith, associate artistic director; Dominick Balletta, managing director; Kevin Confoy, producer.
WITH: Pete Benson, Bill Cwikowski, Zach Grenier, Josh Hamilton, Bai Ling, Kevin O'Keefe and Kevin Thigpen.

It is 1968 and the war is raging in Vietnam, but the G.I.'s in Bill Bozzone's "Korea" could be slackers in the peacetime Air Force. They have been called up and sent to Korea, where they idle away their nights and days in soldierly pastimes like wisecracking and womanizing. This new play by the talented Mr. Bozzone has a gentle, wistful tone that wraps its characters — some of its characters — in a nostalgic hue, especially so in the case of the protagonist played by Josh Hamilton.

In this play at the Ensemble Studio Theater, Mr. Hamilton and his high school buddy (Pete Benson) are the self-styled Two Musketeers of Scranton, Pa. They are neither pro nor antiwar, but they are very much in favor of expanding their experiences. They want tales to tell when they go home, and their barracks-room banter is filled with amusing put-downs and verbal sleight of hand, even as it becomes clear that Mr. Hamilton has been Dear John-ed by his fiancée and has very little waiting for him back home.

Shadowing the lives of the G.I.'s is the threat of being sent to Vietnam. Even more ominous are the reports that come into their outpost via radio, news of race riots and other outbreaks of violence in the United States, which culminate in the assassination of the Rev. Dr. Martin Luther King Jr. One of the telling points of the play is that the characters are insulated and isolated, or, in the case of the third man in the barracks room, a redneck from New Hampshire, bigoted. Only gradually does Mr. Hamilton realize that he has an obligation to himself and to society, even if his best friend is ready to compromise every principle.

The dialogue and the acting, under Kate Baggott's direction, are so sharp that they almost make one overlook the familiarity of the plot. Naturally, the hero will fall in love with a prostitute (Bai Ling), and he and the bigot (Kevin O'Keefe) will come to blows. But Mr. Bozzone always has a few twists left in his typewriter, as in Mr. Hamilton's attempts to assimilate. He tries to learn Korean, which he does with comic ineptitude, accidently wishing Miss Ling "potatoes" instead of "good luck."

"Korea" is not a play like David Rabe's "Streamers," which moves into darker dramatic waters. Despite its increasing seriousness, it remains a service comedy, small in scale but with deft observations to make about the nonmilitant military life and a young man's desire to come of age.
MEL GUSSOW

Lady Bracknell's Confinement and The Party

Vineyard Theater
108 East 15th Street
Manhattan

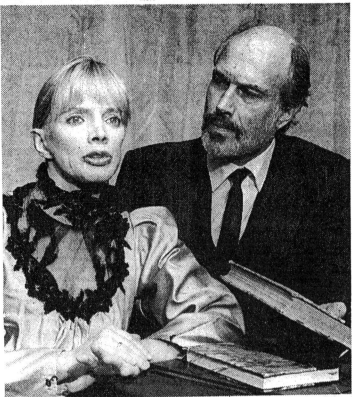

Carol Rosegg/Martha Swiope Associates/"Ghosts"

April Shawan and Michael Levin in the Pearl Theater's "Ghosts."

Lady Bracknell's Confinement
By Paul Doust; directed by Maria Aitken; set by G. W. Mercier; lighting by Phil Monat; sound by Bruce Ellman; costumes by Muriel Stockdale; wig and makeup by Michael Costain; production stage manager, Crystal Huntington. Presented by the Vineyard Theater, Douglas Aibel, artistic director; Barbara Zinn Krieger, executive director; Jon Nakagawa, managing director.
With: Edward Hibbert

The Party
From three stories by Virginia Woolf; adapted by Ellen McLaughlin; directed by David Esbjornson.
With: Kathleen Chalfant

Tepid epigrams inflated with words like "pulchritude" and "perpendicularity" tumble from the stage of the Vineyard Theater "Lady Bracknell's Confinement," by Paul Doust, the first play of two one-acts that seem aimed at Anglophilic audiences.

A one-joke monologue, directed by Maria Aitken and starring the English actor Edward Hibbert, "Lady Bracknell's Confinement" asks the question: What if Augusta Bracknell, Oscar Wilde's pillar of Victorian propriety from "The Importance of Being Earnest," had really been a man? Mr. Hibbert, who struts around looking a lot like the author and personality Quentin Crisp at his most imperious, has fun with the part. Dressed in a starched purple gown, waist-length pearls and a veil, and expressing himself with exaggeratedly rolled r's and raised eyebrows, he presents an engaging caricature of disdainful hauteur.

Unfortunately, the convoluted confession of how a working-class youth transformed himself into a Victorian matriarch and the father of Gwendolen Fairfax is so elaborate it leaves little room for satire. Although the tone of Mr. Doust's neo-Wildeian language elicits chuckles, the play has no scintillating bon mots that come close to matching Wilde's.

There is more to savor, literarily, in "The Party," Ellen McLaughlin's skillful adaptation of three Virginia Woolf stories: "The New Dress," "Together and Apart" and "A Summing Up." For "The Party," Ms. McLaughlin interweaves the interior monologues of three women and one man who are attending the same social function. All are played by Kathleen Chalfant.

Because the actress doesn't try to impersonate individual characters, the play, which was directed by David Esbjornsen, is more a dramatic recitation than a full-blooded theater work. As Ms. Chalfant changes character, the shifts of persona are indicated only by changes in lighting.

But because Woolf's sensibility is so acutely attuned to the characters' moment-by-moment changes of feeling, there is real drama in the play's depiction of sensitive souls navigating through social terrain that is as treacherous as it is familiar. And Ms. Chalfant succeeds in the tricky feat of conveying their emotional turmoil while maintaining a semi-objective narrative voice.
STEPHEN HOLDEN

Ghosts

Pearl Theater Company
125 West 22d Street
Manhattan
Through March 14

By Henrik Ibsen; translated by William Archer; adapted by Robert Brink; set by Robert Joel Schwartz; stage manager, Sue Jane Stoker; costumes by Barbara A. Bell; lighting by Vicki Neal; assistant stage managers, Colleen David and Emily Garrick; sound by Donna Riley; technical director, Richard A. Kendrick; properties, Lynn Bogarde. Presented by the Pearl Theater Company.
WITH: Robin Leslie Brown, Arnie Burton, Michael Levin, Edward Seamon and April Shawhan

In "Ghosts," Henrik Ibsen went for efficiency. His entire vision is there:

the destruction of humanity by social convention, the despair that comes of understanding, the poisoning of happiness by personal restraint and much more. And it is all laid out plainly: he chose congenital syphilis as a symbol of society's condition and the action of the play suggests the course of the disease.

But as the Pearl Theater Company's production shows, it has power. And unlike some other late Ibsen works, it is not of the "hang yourself before it is too late" variety. In fact, the transparency of its dramatic machinery is interesting; the Ibsen method is laid bare.

Robert Brink, the director, does not try to disguise it; this is "Ghosts" much as it was written, and it can make the audience smile — especially at the end, when an avalanche of moral and physical catastrophes buries the whole cast — and yet the two women break into ecstatic praise of "the joy of life," meaning sex without guilt and creativity in general.

Ibsen created no dull characters. Here Michael Levin brings the right touch to Pastor Manders; he seems astonished to find he is the abject victim of his own sham piety. Edward Seamon has a gift for making the sinister palpable and his Engstrand the carpenter a loathesome package of flattery, greed and deceit; when he touches someone, a viewer's flesh crawls. And April Shawhan manages to grow into the character of the widow Alving until, by the third act, one feels real compassion for her.

Arnie Burton makes the doomed Alving son Oswald pathetic, but not the powerful embodiment of destruction he might be. And Robin Leslie Brown's Regina, a woman cheated of happiness by her real father, and by the man who claims to be her father, is a bit too aggressive to arouse much sympathy.　　　*D. J. R. BRUCKNER*

1992 F 19, C16:3

Crazy for You

Music by George Gershwin; lyrics by Ira Gershwin; book by Ken Ludwig; co-conceived by Mr. Ludwig and Mike Ockrent; directed by Mr. Ockrent; choreographed by Susan Stroman; inspired by material by Guy Bolton and John McGowan; scenery by Robin Wagner; costumes by William Ivey Long; lighting by Paul Gallo; dance and incidental music arranged by Peter Howard; musical consultant, Tommy Krasker; sound by Otts Munderloh; fight staging by B. H. Barry. Presented by Roger Horchow and Elizabeth Williams. At the Shubert Theater, 225 West 44th Street, Manhattan.

Tess	Beth Leavel
Patsy	Stacey Logan
Bobby Child	Harry Groener
Bela Zangler	Bruce Adler
Irene Roth	Michele Pawk
Mother	Jane Connell
Moose, Mingo and Sam	
	The Manhattan Rhythm Kings
Polly Baker	Jodi Benson
Everett Baker	Ronn Carroll
Lank Hawkins	John Hillner
Eugene	Stephen Temperley
Patricia	Amelia White

By FRANK RICH

When future historians try to find the exact moment at which Broadway finally rose up to grab the musical back from the British, they just may conclude that the revolution began last night. The shot was fired at the Shubert Theater, where a riotously entertaining show called "Crazy for You" uncorked the American musical's classic blend of music, laughter, dancing, sentiment and show-

Joan Marcus/"Crazy for You"

Harry Groener in a scene from the new musical comedy "Crazy for You," at the Shubert Theater.

manship with a freshness and confidence rarely seen during the "Cats" decade.

Arriving within days of the enchanting production of "The Most Happy Fella," its next-door neighbor in Shubert Alley, and a few weeks before three other eagerly anticipated American musicals promised for this season ("Guys and Dolls," "Jelly's Last Jam" and "Falsettos"), "Crazy for You" could not be a more celebratory expression of a long-awaited shift in Broadway's fortunes. And what more appropriate house could it play in than the Shubert, a theater too cozy to contain London's musical spectaculars, a theater that has been the sad symbol of the hole in Broadway's heart since "A Chorus Line" closed there two years ago?

●

"Crazy for You" calls itself a "new Gershwin musical comedy," and

that's what it is: a musical comedy with songs by George and Ira Gershwin that makes everything old seem young again, the audience included. It is not a revival of "Girl Crazy," the 1930 Gershwin hit with which it shares 5 of its 18 numbers and a smidgen of plot, and it is not to be remotely confused with recent Broadway exercises in camp and nostalgia like "42d Street," "My One and Only" and "Oh, Kay!" The miracle that has been worked here — most ingeniously, though not exclusively, by an extraordinary choreographer named Susan Stroman and the playwright Ken Ludwig — is to take some of the greatest songs ever written for Broadway and Hollywood and reawaken the impulse that first inspired them. "Crazy for You" scrapes away decades of cabaret and jazz and variety-show interpretations to reclaim the Gershwins' standards, in all their glorious youth, for the dynamism of the stage.

As soon as the overture begins, you know that the creators of this show have new and thrilling ideas, and are determined to make us hear familiar songs as if for the first time. William D. Brohn's orchestration acknowledges the standard treatment of "I Got Rhythm" but then reworks it, holding its full contour in smoldering check until finally it must erupt like a forest fire through the conductor Paul Gemignani's rollicking pit band. When the curtain rises, it is to the elevating opening bars of "Stairway to Paradise," a song that is never sung in "Crazy for You" but, in a typical example of the evening's cunning, is used more than once as an incidental motif to pump up the audience's pulse rate before springing the next theatrical surprise.

Those surprises are often the creations of Ms. Stroman, who, given a full corps of crack dancers, expands exponentially on the winning style she

revealed in the revue "And the World Goes 'Round." In "Crazy for You," she works her magic with the plainest of stories. Mr. Ludwig's book is about nothing more than a wealthy Manhattan ne'er-do-well of the Depression, the stage-stuck Bobby Child (Harry Groener), who ends up in a broke Nevada mining town, where he rescues a bankrupt theater and wins the local girl, Polly Baker (Jodi Benson). Yet the choreographer reminds us that the well-worn imperatives of archetypal Astaire-and-Rogers, Mickey-and-Judy scenarios — boy meets girl, let's put on a show — can evoke untold joy when harnessed to movement, melodies and words that spell them out with utter conviction in musical-comedy skywriting.

•

Ms. Stroman's dances do not comment on such apparent influences as Fred Astaire, Hermes Pan and Busby Berkeley so much as reinvent them. Rather than piling on exhausting tap routines to steamroll the audience into enjoying itself, the choreographer uses the old forms in human proportion, to bring out specific feelings in the music and lyrics. When Mr. Groener leaps sideways on a thrice-repeated phrase in "Nice Work if You Can Get It" — to take just a throwaway bit — his legs are both punching out the notes in George Gershwin's tune and illustrating the sexual yearning in Ira Gershwin's verse. Ms. Stroman is not afraid of repose, either. In "Embraceable You," the embrace counts more than the steps, and the number reaches its consummation with a kiss that leaves the dance as dizzyingly unresolved as the newly acquainted couple's relationship.

Yet it is the big numbers in "Crazy for You" that people will be talking about, and in these, Ms. Stroman's signature is her use of homespun props, rather than an avalanche of spectacle, to turn her dances into theater. In "I Got Rhythm," the Act I finale, the regenerated hicks and drunks of Deadrock, Nev., whip up a torrent of music and merriment with washboards, corrugated tin roofing and mining picks. "Slap That Bass" creates a visual jamboree out of pieces of rope, while "Stiff Upper Lip" finds the exhilarated populace erecting a house of chairs that figuratively parallels the accelerating spirits of their song and dance.

Short of George Balanchine's "Who Cares?" at the New York City Ballet, I have not seen a more imaginative choreographic response to the Gershwins onstage. That Ms. Stroman's numbers are theater dances that advance the show rather than bring it to repeated halts is also a tribute to Mr. Ludwig. His book has no intellectual content, and wants none, but is a model of old-school musical-comedy construction in its insistence on establishing a context, whether narrative, comic or emotional, for every song. Mr. Ludwig also knows how to write jokes in the 1930's style, the funniest of which are reserved for such fine, acerbic clowns as Bruce Adler (a Florenz Ziegfeld stand-in), Jane Connell (the hero's meddling mother), and John Hillner and Michele Pawk as a pair of villains who fuse in a sadomasochistic dance (to the obscure "Naughty Baby") that is the funniest of the several Stroman duets that turn seduction into an intricate, combative entanglement of limbs.

Mr. Ludwig is not above recycling mistaken-identity gags from his previous 1930's show-biz farce, "Lend Me a Tenor" — which had twin Otel-

los to match this script's twin Ziegfelds — but, as directed with a deep appreciation of slapstick by Mike

Singing, dancing and showmanship, with no intellectual content to spoil it.

Ockrent, the burlesque humor rarely flags. Mr. Ockrent, it must be said, is English, but, unsurprisingly, his hit West End musical of the 1980's was "Me and My Girl," a knockoff of Broadway musicals of the Gershwin 30's.

Those looking to quibble with Mr. Ockrent's lithe production, which marches to a contemporary rhythm rather than that of a period piece, may question his choice of a leading lady. Ms. Benson's big voice (best known from the title role of the Disney film "The Little Mermaid") and brash Mermanesque manner are fun, but she does not find the tenderness in "Someone to Watch Over Me." As for the exuberant Mr. Groener, a Jimmy Stewart who can hoof and sing, he typifies the kind of Broadway performer who has had too little work in our day; he has spent more time on television than onstage since his smash debut as Will Parker in the 1979 "Oklahoma!" Here he not only commands his numbers but also sets the cool tone required to make a complex theatrical undertaking look carefree.

•

Among the sophisticated complexities of "Crazy for You" is Robin Wagner's scenery, which, as backed by the starry Hollywood sound-stage skies of the lighting designer, Paul Gallo, transport the company from a glittery old Times Square to a picture-book comic frontier reminiscent of "Destry Rides Again." Since Mr. Ludwig's book largely unfolds in and around theaters, Mr. Wagner gets to recreate Joseph Urban's facade for the original Ziegfeld Theater in New York as well as the gilded Victorian interiors of a mythical, reborn Gaiety Theater in Deadrock.

The most startling of Mr. Wagner's theatrical settings, though, is the first, an angular vision of a Broadway theater's wings that specifically echoes the opening set of "Dreamgirls," the last of this designer's collaborations with Michael Bennett. "Crazy for You" is not innovative, as the Bennett shows were, and it lacks the brand-new songs that must be the musical theater's lifeblood. But the evening is bursting with original talent that takes off on its own cocky path, pointedly mocking recent British musicals even as it sassily rethinks the American musical tradition stretching from the Gershwins to Bennett.

"In 2,000 years, there has been one resurrection, and it wasn't a theater," goes one of the evening's many show-biz one-liners. But in the secular land of Broadway, starved musical-theater audiences can't be blamed for at least dreaming that "Crazy for You" heralds a second coming.

1992 F 20, C15:3

Private Lives

By Noël Coward; directed by Arvin Brown; set design, Loren Sherman; costumes, William Ivey Long; lighting, Richard Nelson; sound, Tom Morse; choreography, Michael Smuin; fight direction, Ellen Saland. Presented by Charles H. Duggan, by arrangement with Michael Codron. At the Broadhurst Theater, 235 West 44th Street.

Sybil Chase	Jill Tasker
Elyot Chase	Simon Jones
Victor Prynne	Edward Duke
Amanda Prynne	Joan Collins
Louise	Margie Rynn

By FRANK RICH

FOR those of us who never warmed to her latter-day incarnation in "Dynasty," Joan Collins will always be the very sexy young actress who took the trashy parts Elizabeth Taylor rejected in the Technicolor B movies of the 1950's. So there's a certain rough justice in the fact that the revival of Noël Coward's "Private Lives" that has brought Miss Collins to the Broadhurst towers over the production that Miss Taylor and Richard Burton visited upon Broadway in 1983.

Is it rude to point out that nearly every other play seen on Broadway in the last decade or so, with the possible exception of "Moose Murders," also towered over the Taylor-Burton "Private Lives"?

Well, let's leave those bitter memories behind and focus instead on the spectacle at hand, which, while not remotely a satisfying production of Coward's classic 1930 comedy, may well titillate Miss Collins's most ardent admirers. The truth is that the star, if only by default, is the most spontaneous thing in Arvin Brown's production. After the nervous opening scene, in which she hyperventilates as if she had been shot out of a cannon, she relaxes into her task like a practiced hostess eager to please. An ideal Amanda Prynne she is not, but she may be the best possible Joan Collins.

The actress and the play are more or less the same age, and if the play seems younger, that's a tribute to Coward, not a comment on Miss Collins's considerable talent for self-preservation. "Private Lives" may have little plot and, its oft-quoted zingers notwithstanding, a lot of inconsequential dialogue. Yet beneath that famously brittle surface lies a burning plea for the right to lead an uninhibited, even hedonistic private life. When Amanda and her former husband, Elyot Chase, meet up by chance while on their respective second honeymoons and run away together — only to come to fisticuffs soon thereafter — Coward creates an exquisite tension between the unruly dictates of sexual passion and the absurdly arbitrary rituals of middle-class propriety, marriage and divorce included.

Mr. Brown's production, which seems not so much directed as stage-managed, is content with mining the work's superficial details. The pace is brisk, the timing of the lines is appropriately clipped and the total effect is monotonous. The director's reading is less a violation of Coward's intent than a mechanization of it, designed to net the sure-fire laughs on the wisecracks and to give an Anglophilic American audience some broad approximation of a vanished Continental elegance.

Sex seems the last thing this "Private Lives" has on its mind. Simon Jones, the good comic actor cast as Elyot, gives a totally neutered farcical performance, completely robbing his leading lady of an erotic partner with whom she might alternately spark and spar. The only spine in Mr. Jones's Elyot is to be found in his enunciation of lines like "Don't quibble, Sybil." Neither his lust nor his violent rage for Amanda is paid any more than lip service, and it's stiff-upper-lip service at that.

•

The supporting performances contributed by Edward Duke and Jill Tasker as the discarded new spouses and Margie Rynn as the briefly seen French maid all rely on trick comic voices, with Miss Tasker's whine being insufferable far beyond the dreary Sybil's call of duty. When these actors are at full tizzy, it is calming to study Loren Sherman's scenery, which is suitably glossy to frame the star and is, in the case of a wood-paneled Art Deco Parisian flat, novel as well as attractive.

As for that star, maybe she would rise higher if one of the other performances made some claim on her attention, sexual or otherwise. Then again, maybe not. Her vocal range is quite narrow, and one senses that her histrionic range boasts fewer colors than her many costumes. She seems to have chosen "Private Lives" out of the belief that it will stay within the boundaries of her celebrity personality rather than make any demands on her as an actress.

Amanda does require more, and those deeper qualities, among them an anarchic spirit and a touch of heartache, are not to be found in Miss Collins's alternately good-natured and mildly bitchy portrayal. One enjoys both her relish with a double-entendre and her big, glowing eyes,

which besides living up to lovely memories, often suggest that she is as surprised to find herself on stage as we are to see her there.

1992 F 21, C1:1

The Bells

Adapted and performed by Everett Quinton; directed by Eureka; music composed and performed by Mark Bennett; scenery by Richard Cordtz; lighting by Richard Currie; costume by Toni Nanette Thompson; props by Therese McIntyre; production stage manager, Karen Ott. Presented by the Ridiculous Theatrical Company, Mr. Quinton, artistic director; Steve Asher, managing director. At the Charles Ludlam Theater, 1 Sheridan Square, Manhattan.

By MEL GUSSOW

"The Bells" was one of Henry Irving's greatest theatrical successes, a melodrama that the Victorian actor seemed doomed to perform forever. He played Mathias, a rich Alsatian innkeeper tormented by a guilty secret. In the Everett Quinton version of "The Bells," Mr. Quinton outlaughs Irving by playing all the characters — male, female, heroic and villainous — as well as sight and sound effects. His ringing adaptation of this vintage thriller sweeps the stage at the Charles Ludlam Theater.

The Ridiculous Theatrical approach is akin to that of Mr. Ludlam and Mr. Quinton in the two-man tour de force "The Mystery of Irma Vep." In that Gothic horror comedy, the actors darted in and out of a lonely cottage, each time emerging in a strange new guise. With "The Bells," Mr. Quinton never leaves the stage or changes his costume. He simply swings with heightening flair from one role to another.

He is headstrong as the handsome young quartermaster engaged to Mathias's beautiful daughter. As the quartermaster eyes his fiancée, Mr. Quinton turns the other profile and smiles engagingly at her lover. Quick switch and he is a barfly, a barmaid, a barrister and a mysterious mesmerist with a hypnotic stare. The stage is soon crowded with Quintons. A watchful theatergoer should have no difficulty distinguishing them, though one may lose count of the number.

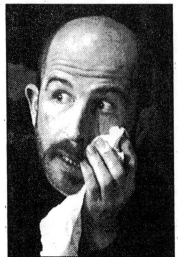

Richard Currie

Everett Quinton

In a flashback, we see "the Polish Jew" (as in the title of the Emile Erckmann-Alexandre Chatrian novel that inspired the original play). Many years ago, this wanderer entered the town and never made it past an ominous bridge, where he was murdered by Mathias for his money. Now, as the mayor and the father of the bride to be, Mathias is swelling with pride but haunted by his dastardly deed. He is also haunted by the sound of bellllls, bellllls, bellllls, gonging through his mind (and our ears). Every time he hears them, he becomes more and more crazed, ending up the hapless victim of his tortured conscience.

Accompanying the actor's gestures with silent-movie background music is Mark Bennett at the piano. Eureka is the director, but Mr. Quinton is the show's centrifugal force. "The Bells" is not as devious or as complex as "Irma Vep." Lasting 50 minutes, it is a curtain-raiser without a follower. But it is a deadly, diabolical showcase for the chameleonesque Mr. Quinton.

1992 F 21, C20:1

Saint Joan

By George Bernard Shaw; directed by Peter Royston; original music by William Catanzaro; stage design by Rhys Williams; lighting, Jeffrey Whitsett; costumes, Elizabeth Royston and Rebecca Schroyer. Presented by the Royston Theater Company. At Playhouse 224, 224 Waverly Place, between West 11th Street and Seventh Avenue South, Manhattan.

WITH: Isaiah Bard, James R. Bianchi, Kevin Brown, Joanne Comerford, James Corbett, Philip Cuomo, Donald Grody, John Haggerty, Charls Hall, Ted Hewlett, Jerry Koenig, William D. Michie, Con Roche, Ira Rubin, Gregory St. John and John Steber.

By WILBORN HAMPTON

Joan of Arc, like every other visionary to come along in the last few centuries, has been an enigma to theologians, composers and playwrights alike. It took the Church of Rome nearly 500 years to decide whether she was a heretic or a saint. And it was more than 20 years after George Bernard Shaw described her as a "half-witted genius" that he changed his mind and wrote a play about her.

"St. Joan," which is being given a commendable revival by the Royston Theater Company, is more of a staged biography with dramatized footnotes than the usual Shavian dialectic on social and human foibles. In fact, if one is familiar with the story of the Maid of Orleans, "St. Joan" is basically a sermon on the nature of faith and a caution to prophets of any age against overstaying their welcome. But sermons can be amusing as well as enlightening, especially when it's Shaw in the pulpit, and "St. Joan" contains not only some of the playwright's most acerbic writing but also his most poetic.

Peter Royston, whose young company has been staging imaginative and literate revivals of classics the last few seasons, has directed with a solid understanding of Shaw's vision of Joan and her place in history. For Shaw, Joan of Arc was the forerunner not only of Protestantism and Nationalism but of individual conscience as well. Here was a simple farm girl who did not need a noble to tell her duty nor a bishop to interpret God but who heard His voice in church bells and in the song of larks and saw His face in the flowers of the fields.

The Royston production is, once past a plodding opening scene, lively and engaging, with the major roles ably filled. Shaw's Joan, as Walter Kerr once pointed out (and contrary to popular opinion), is not a star turn. Far from any complexity of character, Joan gushes sentimentality and melodrama. She is a naïve and idealistic teen-ager with a great deal of the tomboy in her. That is not to say it is an easy role, and Joanne Comerford is a thoroughly believable Joan, exuberant in her passion for both soldiering and religion.

In a standout performance worthy of a Broadway or West End stage, James R. Bianchi is so smoothly cunning as Richard de Beauchamp that one wonders if Machiavelli had that English Earl in mind when he wrote "The Prince" nearly a century later. John Steber is excellent as Peter Cauchon, the Bishop of Beauvais, who tried to find Joan a loophole in the Inquisition, and James Corbett's English Chaplain is a wide-eyed lesson on fanaticism. There are other good performances, especially from Charls Hall as the Dauphin, Ira Rubin as La Trémoille (and as the modern English gentleman in the epilogue), Gregory St. John as the Archbishop of Rheims and Kevin Brown as Dunois.

1992 F 23, 51:5

SUNDAY VIEW/David Richards

The Wedded Hiss of Albee Turns Verbal

In 'Marriage Play' at the McCarter, it's chess now, more than King of the Hill.

'Grandchild of Kings' evokes pictures at an exhibition.

IN EDWARD ALBEE'S "MARRIAGE Play," a two-character drama filled with questions, the question that crops up most frequently is, "What do you mean?"

It is, understandably, the first utterance out of the mouth of Gillian, a middle-aged wife, when her husband, Jack, returns home early one afternoon and announces point-blank, "I'm leaving you."

The marriage is 30 years old and prosperous, if you can judge from the couple's sleek living room. The three children have been successfully raised; old infidelities long since laid to rest. No wonder Gillian would glance up from her reading, a bit surprised, and ask laughingly, "What do you mean?"

The question gets asked far too frequently after that, however, for me not to think that it's the key to Mr. Albee's play, which was first performed in Vienna in 1987 and is now receiving its American premiere at the McCarter Theater in Princeton, N.J. Jack and Gillian, like most of Mr. Albee's characters these days, are acutely aware of the language they use. On one level, "What do you mean?" is simply an attempt to avoid semantic confusions, clear away any grammatical deadwood and get to the nub of what's being said.

While Jack claims to be undergoing the "profoundest change" of his life, Gillian can't help interrupting him to point out that "most profound, not profoundest" sounds better to

T. Charles Erickson/"Marriage Play"

*Shirley Knight and Tom Klunis in Edward Albee's "Marriage Play"—
Husband and wife are forced to contemplate far scarier prospects than separation.*

her ears. And even he has the presence of mind, after asserting that the matter is "not to be dealt lightly with," to catch the dangling preposition and add, "with *lightly*; dealt with lightly."

But the linguistic skirmishes are only part of it. Mr. Albee also intends that the question be taken metaphysically. Jack's 30-year itch upsets a comfortable status quo. In the 90 minutes that follow, husband and wife are forced to contemplate far scarier prospects than separation. How do they figure in the bewildering scheme of things? What does a marriage count for, if on the other side of the floor-to-ceiling windows and the blindingly white walls there is nothing but nothingness? What do they mean as human beings?

Those who would like to see the playwright return to the raw power of "Who's Afraid of Virginia Woolf?" and hurl some thunderbolts about the stage are not going to rally to "Marriage Play." They're probably engaged in a futile waiting game anyway. In a note in the McCarter program, Mr. Albee even takes pains to distance Jack and Gillian from George and Martha, lest one assume that since both plays involve sparring spouses and tottering marriages they are bed mates.

"Marriage Play," which is acted by Shirley Knight and Tom Klunis, certainly doesn't have the heat of Mr. Albee's earliest endeavors. It is a work more pondered, I suspect, than felt. Even though Jack and Gillian engage in a cat-and-dog fight that has them rolling indecorously on the carpet at one point, the sparring is mostly intellectual. Words are going up against words, as much as one person against another. Frankly, I'm not sure you'd be missing all that much if you were only to hear the play over the radio.

Like it or not — and most critics don't — Mr. Albee has grown increasingly introspective over the years. The psychological games his characters play — remember Get the Guest? — are ever more rarefied: chess, say, as opposed to King of the Hill. In "Marriage Play," Jack and Gillian are grappling exclusively with past experience, some of it half forgotten, which may help account for the elegiac tone of the evening. Gillian has even

kept a "Book of Days," in which she has entered the time and date of every sexual encounter they've had together — some 3,000 in all — along with descriptive comments. ("Twelve hundred and six," he calls out. She looks it up, then reads, "Nothing much; O.K., but nothing much.")

Otherwise, specifics are few. The characters' biographies are practically nonexistent. (The program note told me Jack and Gillian have three children.) The play seems to matter most to the playwright as a formal composition, similar to the elegant abstract painting on the upstage wall. In one of the most revelatory lines, Gillian observes: "Passion in a marriage never dies; it changes. When the passion of passion wanes, there are all the others waiting to rush in — the passion of loss, of hatred, the passion of indifference; the ultimate, the finally satisfying passion of nothing." Lovely speech, lovely literary cadences. Still, most of us would probably expect a fiftyish housewife who's had her marriage pulled out from under her to put it somewhat differently.

Mr. Albee's ruminative ways are clearly not about to change, but we shouldn't necessarily abandon him for that. His insights are too provocative, however obliquely they're being expressed right now. What could change — indeed, what could give "Marriage Play" some of the dramatic urgency it's so conspicuously lacking — is the staging. It has become Mr. Albee's wont to direct his own works, which he does with a stateliness, a gravity even, that never loses sight of the author's interests for an instant. The characters come in a distant second.

■

The McCarter production, co-sponsored by the Alley Theater in Houston, is studied, self-conscious and, at its worst, overtly declamatory. A far more visceral approach is called for — one that minimizes the sense of artifice and brings some real fury and panic to bear on the proceedings. Granted, Mr. Albee's characters sometimes "perform" for one another, but when Ms. Knight and Mr. Klunis appear to be performing all the time, who can tell what's playacting and what's not?

The author's disclaimer notwithstanding, Gillian is close enough to Martha so that she, too, talks baby talk, tosses back the booze and taunts her husband for being too insubstantial to produce "a vacancy" by leaving her. Ms. Knight, who is beginning to look dangerously like Shelley Winters, just seems loopy in the role. Mr. Klunis's best moments come when he tries to describe what it's like to have reality alter drastically before your eyes for no explicable reason, but that's because he's dealing with a private vision. Let him go face to face with Ms. Knight, and the play's affectations become all too apparent again.

If "Marriage Play" does not do a whole lot for Mr. Albee's reputation, it's partly because Mr. Albee doesn't do a whole lot for "Marriage Play." Plays, like children, have to make their own path in the world eventually. Reluctant to let go, the playwright proves to be a stifling parent. The apron strings, I fear, are tripping everybody up.

'Grandchild of Kings'

It would be unfair to say that the director Harold Prince is up to old tricks again in "Grandchild of Kings." But he's up to *one* old trick — the playful environmental staging that served him and the musical "Candide" so well in 1974.

"Candide," if I can back up a moment, had a history of unsuccessful productions until Mr. Prince hit upon the idea of letting it unfold on a series of stages connected by cat-

walks and bridges, all plopped down in the middle of the Broadway Theater. The set designer Eugene Lee put the fun house together in such a way that the audience ended up sitting pretty much everywhere — some on bleachers, some on stools, some looking down on the action, others looking out at it from odd little alcoves. Since "Candide" was a musical about an innocent batted the world over by natural calamity and human perversity, fragmenting the acting area and strewing the pieces in all directions was an inspired notion.

Now Mr. Prince has applied it to "Grandchild of Kings," his own adaptation of the first two volumes of Sean O'Casey's six-volume autobiography, which the Irish Repertory Theater Company is performing Off Broadway at Theater for the New City. The script is a leisurely chronicle of the Irish playwright's birth, childhood and coming of age in turn-of-the-century Dublin, ending with his realization that "he was staying too

long in the hallway looking at the pictures. All done by others. Very beautiful and strong, but all done by others. He'd have to start now doing things for himself." In short, another portrait of the artist as a young man, though not an unappealing one.

Once again, Mr. Lee has built a kaleidoscopic environment — borrowing bits of Dublin's storefronts, tenements and squares for the job. Staircases and sidewalks lead that way and this, and there's a conventional stage lurking at one end of the hall that is pressed into use whenever

What O'Casey did with words, Hal Prince wants to do with props, ladders, coffins and curtains.

a conventional stage is needed (O'Casey tried his hand at acting) or the production wants to give its hero a glimpse of the higher echelons of Irish society. Rows of wooden chairs for the audience are an integral part of the maze, so chances are good that the ophthalmologist examining the young Sean's ulcerated eyes will be doing so under your nose, if the periodic street brawls aren't erupting at your feet.

Charming and flavorsome as the evening can sometimes be, there's a serious hitch in Mr. Prince's environmental strategy this time. It's not a question of a novelty wearing out its welcome either. O'Casey's youthful years, as the director has dramatized them, aren't half so rough and tumble as the staging suggests. Coddled by a protective mother, inhibited by his poor eyesight, introspective by nature, the young playwright, in fact, seems the antithesis of the picaresque hero who is obliged to scurry about the hall as if caught up in a whirlwind.

The production actually gives us three O'Caseys — the boy (Padraic Moyles), the young man (Patrick Fitzgerald), and the frail old writer (Chris O'Neill), wrapped in a cocoon of woolen garments and ensconced in

a massive armchair, who serves as narrator for much of the evening. The narration is in O'Casey's own prose — taken from "I Knock at the Door" and "Pictures in the Hallway" — and glorious prose it is, imparting poetry and magic to the humdrum.

■

Inevitably, however, narration gives way to dramatized events, at which point "Grandchild of Kings" becomes a fairly hackneyed account of a sickly youth growing up poor and Protestant, running errands, discovering literature, awakening to girls, getting his first kiss, landing a lowly clerk's job, losing his virginity and acquiring the beginnings of a political conscience. The originality is all in O'Casey's description. Recognizing this, Mr. Prince, I think, has tried to come up with equally evocative stage pictures.

What O'Casey did with words, he wants to do with performers, props, ladders, rolling beds, coffins and curtains, and step-units that lock together to form a horse-drawn cab. The cast of 19, playing most of Dublin, is constantly scampering up, down, over and around — often to the sprightly music of the three lasses who call themselves Morning Star. The tumult is not implicit in O'Casey's early life, however, which appears to have been considerably less hyperactive. It's directorially induced. And there's the hitch.

Still, a number of actors get the opportunity to shine — chief among them Mr. Fitzgerald, who has the long face and touseled mane of a poet-in-the-making and who finds in the young O'Casey an engaging mixture of eagerness and reticence. As Mr. Prince propels them all about the sundered stage, you can see the stubble on their chins and the smudge on their boots. And, occasionally, the glints of a fine madness in their smiling Irish eyes. □

1992 F 23, II:5:1

Carol Rosegg/Martha Swope Associates/"Grandchild of Kings"

Patrick Fitzgerald portrays the playwright Sean O'Casey as a young man in "Grandchild of Kings"—A mix of eagerness and reticence.

Akin

Conceived, choreographed and directed by John Kelly; music by Richard Peaslee; lyrics by Mark Campbell; music director, Roberto Pace; set by Huck Snyder; costumes by Donna Zakowska; lighting by Howell Binkley; film by Anthony Chase; sound by Tim Schellenbaum; production stage manager, Lisa Buxbaum. Presented by La Mama E.T.C., Music-Theater Group and John Kelly and Company. At 74A East Fourth Street, Manhattan.

WITH: Peter Becker, Kyle de Camp, John Kelly, Larry Malvern, Marleen Menard and Vivian Trimble.

By MEL GUSSOW

In his haunting new musical play, "Akin" (at La Mama Annex), John Kelly brings to life the world of the medieval troubadour, then, through a split-frame narrative, moves his story centuries ahead into our present. In characteristic Kelly fashion, he unifies mime, modern dance, music and music-hall variety into a living tableau of images.

Mr. Kelly is one of the most intensely personal of performance artists even as his subjects range widely in classical history and mythology. Through his alchemic art, he manages to identify himself with figures as disparate as Egon Schiele (in "Pass the Blutwurst, Bitte"), Orpheus and the Mona Lisa. Each becomes an extension of the tragic poet personality he projects on stage.

In his new collaborative venture, he has surrounded himself with familiar co-workers, including actors from his company, Huck Snyder as scenic designer and Anthony Chase as film maker, while also drawing upon the combined creativity of Richard Peas-

lee as composer and Mark Campbell as lyricist. This musical team underlines "Akin" with a score that moves between periods as easily as the author does. The music is alternately rhapsodic and mournful; the lyrics have a poetic inventiveness. A few more songs would add further fluidity to the show.

The episodic nature of the work allows for the insertion and the occasional intrusion of diverse scenes and songs. Although the show itself could be more cohesive, individual moments are lustrous. A co-production with Lyn Austin's Music-Theater Group, "Akin" is scheduled to run at La Mama through March 8.

●

The troubadour (Peter Becker) begins by contemplating his muse, naked behind a scrim on Mr. Snyder's dreamlike stage within a stage. When Mr. Becker reaches out toward the woman, the scrim becomes opaque. In such a manner, the play moves back and forth between the tangible and the unattainable.

Soon the play is filled with buoyant humor as the troubadour's children enter, dancing on their knees. They are Mr. Kelly's vaudeville equivalent of Bunraku puppets and puppeteers, cleverly disguised in double-image costumes. When the child played by Mr. Kelly grows up, he rises to his feet and shares center stage with his domineering theatrical father. While the father sings of his exuberant days as a trouper, his son is concerned with loss and self-denial.

As with most of the author's shows, "Akin" is at least partly a collage, consolidating images from afar. The furthest in this case is Joan of Arc. Marleen Menard appears bound at

the stake to sing a comic lament in the style of Edith Piaf. Strange though it may sound, the song encourages the thought that the single scene could be expanded into its own chamber musical.

The show leads to the sorrowful moment when Mr. Kelly, as a gaunt modern-day troubadour, comments on AIDS without ever mentioning the subject. "Eleven years and counting," he sings in his delicate countertenor voice. In common with Ms. Menard's St. Joan, he refuses to despair. In its coda, "Akin" becomes an elegiac musical affirmation of life and of love.

1992 F 25, C14:5

Theater in Review

■ Mass murder, necrophilia and other modern phenomena ■ A sympathetic look at Mary Stuart in a new translation of Schiller.

The Law of Remains

Diplomat Hotel
116 West 43d Street
Manhattan
Through March 14

Created and directed by Reza Abdoh; produced by Diane White; sets by Sonia Balassanian; lights by Rand Ryan; sound by Raul Vincent Enriquez; costumes by Liz Widulski; special props by Marion Appel; video by Adam Soch; African dance by M'Bewe Escobar; ballroom dance by Stormy; assistant director, Jennifer Loeb; production stage manager, Mike Taylor. Presented by Dar A Luz.
WITH: Sabrina Artel, Brenden Doyle, Anita Durst, Giuliana Francis, Stephan Francis, Ariel Herrera, Priscilla Holbrook, Peter Jacobs, Kwasi Boateng, Sardar Singh Khalsa, Veronica Pawlowska, Raphael Pimental, Tom Pearl, Tony Torn and Kathryn Walsh. Drummer, Carlos Rodriguez.

The young Los Angeles director Reza Abdoh is notorious for theater pieces that have the decibel level of rock shows and apocalyptic imagery involving graphic sexual parody and violence. And in "The Law of Remains," a multi-media extravaganza staged in the abandoned ballroom of the Hotel Diplomat, he has created one of the angriest pieces of theater ever to be hurled at a New York audience.

A year and a half ago, Mr. Abdoh made his New York debut with "Father Was a Peculiar Man," a spectacular theatrical deconstruction of "The Brothers Karamazov" presented by the En Garde Arts company on the streets of Manhattan's meatpacking district. One of the work's central images was a surrealistic family banquet that took up nearly a whole city block.

In "The Law of Remains," that feast has turned into a blood-soaked pageant of contemporary Grand Guignol depicting mass murder, sexual mutilation, necrophilia and cannibalism simulated by actors portraying the serial killer Jeffrey Dahmer (named Jeffrey Snarling in the script) and Andy Warhol and his entourage. The work is divided into seven scenes, scattered over two floors of the hotel, that are intended to trace the soul's journey as described in the Egyptian Book of the Dead.

The script incorporates lengthy excerpts from Milwaukee police reports of the Jeffrey Dahmer case. Focusing on Mr. Dahmer's beating and later murder of a teen-age Laotian boy and the casual response of the police who were called to the scene of the assault, it hammers home the point that because the victim was gay and could not speak English, the crime wasn't taken seriously and the boy was left with Mr. Dahmer. The event becomes a metaphor for governmental indifference to the AIDS crisis.

There is much to admire in the work, which is a skillful compendium of avant-garde styles. The director's deployment of a 14-member cast suggests the grand ensemble choreography of Pina Bausch. His herding of the audience around the ballroom to witness a series of grotesque tableaux recalls Squat Theater. And the way the youthful cast is pushed to the limits of its physical endurance echoes the Flemish director Jan Fabre's "Power of Theatrical Madness."

But "The Law of Remains" also continually undermines its own political ambitions. The sheer density of the noise and tumult make it hard to follow. And the notion of having Mr. Dahmer's grisly crimes re-enacted as a parody of a movie being made by Warhol and his fame-obsessed minions clouds the issue by seeming to attack the Warhol ethos for its kinkiness when the intended target is the mass media's sensationalistic exploitation of serial killers.

Never allowed to stay put for long, the audience is rudely prodded to move from place to place around the ballroom. This unceremonious treatment is only one aspect of a production that seems to want to punish as much as to enlighten. "The Law of Remains" is a disturbing work that runs amok in its own gory imagination. *STEPHEN HOLDEN*

Mary Stuart

Jean Cocteau Repertory
Bouwerie Lane Theater
330 Bowery (at Second Avenue)
Manhattan
Through April 3

By Friedrich Schiller; translated by Robert David MacDonald; directed by Casey Kizziah; set design by George Xenos; costume design by Gregory Gale; lighting design by Brian Aldous; production manager, Patrick Heydenburg. Presented by the Jean Cocteau Repertory, Robert Hupp, artistic director; David Fishelson, executive director.
WITH: Harris Berlinsky, Robert Ierardi, Joseph Menino, Grant Neale, Craig Smith, Elise Stone, Angela Vitale and Mark Waterman.

History provides few tales that can match the passion, the palace intrigue and the perfidy of the struggle between Queen Elizabeth I and Mary, Queen of Scots for the throne of England. And few writers can match the romance, suspense and melodrama of Friedrich Schiller's telling of that bloody story in "Mary Stuart," which is being given a compelling revival by the Jean Cocteau Repertory.

It is with "Mary Stuart," written some 200 years after that glorious age of English history, that Schiller most closely emulates Shakespeare, his main influence, and finally breaks from the Sturm und Drang with which he is usually identified.

For its production, the Cocteau is using a new translation by Robert David MacDonald, a Scot who, possibly inspired by the playwright's clear sympathy with the title character, has produced a modern text that maintains the rich romance of Schiller's rhetoric yet gives the play an immediacy that keeps the audience riveted for its three hours. If one did not know the story, it would be easy to imagine this "Mary Stuart" as a modern political play in fancy dress. And the dress in the Cocteau production is certainly fancy, all starched ruffs and brocaded gowns and doublets. Gregory Gale's stunning Elizabethan costumes are worthy of the Metropolitan Opera stage should that company ever revive the Donizetti opera based on Schiller's play.

Although Schiller takes the side of Mary against her kinswoman (and plays a bit fast and loose with both history and geography in building his drama), any successful production must have strong performances in both roles. After all, both were strong women. Each had known power and each had known prison, and both knew that only one would survive.

The Cocteau ably fills both parts. Elise Stone portrays Mary, that "loveliest of women and the saddest," with a regality and full-blooded passion tempered by warmth and softness. She is a woman who knows how to use her beauty with subtlety to achieve her ends, and in Ms. Stone's performance it is easy to remember that nearly half the English population supported her. Angela Vitale's Elizabeth is more angular and harsh, yet also more shrewd and cunning. She is a strong-willed and imperious monarch who would not believe she was truly Queen until Mary was dead, until "the moment England can no longer choose between us." No talk at this court about "the weaker sex."

Another standout in a generally strong cast is Grant Neale as Mortimer, the duplicitous nephew of Mary's jailer. Mr. Neale is so convincing on both sides of his double-dealing, one can never be quite sure until the final scene whom he really supports. Other notable turns include Craig Smith's Burleigh, Harris Berlinsky's Paulet, Mark Waterman's Leicester and Joseph Menino's Shrewsbury. Mr. Kizziah wisely takes a straighforward approach, mindful that nothing less was at stake than the destiny of England.

1992 F 26, C19:1

Search and Destroy

By Howard Korder; directed by David Chambers; scenic design by Chris Barreca; costumes by Candice Donnelly; lighting by Chris Parry; sound design, David Budries; production stage management, William Hare. Presented by Circle in the Square Theater, Theodore Mann, artistic director; Robert A. Buckley, managing director; Paul Libin, consulting producer. At 1633 Broadway, at 50th Street, Manhattan.

Martin Mirkheim	Griffin Dunne
Accountant	James Noah
Lauren, Jackie and Radio Announcer	
	Jane Fleiss
Robert	T. G. Waites
Kim	Keith Szarabajka
Marie and Terry	Welker White
Roger	Gregory Simmons
Hotel Clerk and Carling	Michael Hammond
Security Guard and Núñez	Jerry Grayson
Dr. Waxling	Stephen McHattie
Bus Driver and State Trooper	Mike Hodge
Ron	Paul Guilfoyle
Pamfilo	Arnold Molina
Lee	Thom Sesma

By MEL GUSSOW

Facing bankruptcy and far over his head in back taxes, Martin Mirkheim has only one marketable asset: a natural ability to lie. Obviously, he will try to enter the movie business. In Howard Korder's malevolent comedy, "Search and Destroy," Mirkheim cheats and schemes his way to the top. This is a play about the American dream, or, if you will, the death of the American dream.

In the new work, as in "Boys' Life," Mr. Korder demonstrates a sharp wit and an insider's grasp of contemporary jargon. There is often a David Mamet beat to his language, with half-sentences repeated and inverted, as in "Top of the food chain, you're not," offered as a key comment on the shallow protagonist of "Search and Destroy."

The problem with the play is not so much that it speeds its plow over familiar terrain but that the sum is less than some of its parts. The play spins along, idles as if waiting to be refueled, then reaches for a black comic conclusion. Watching it at Circle in the Square, where it arrived last night after two previous regional productions with different casts, one is reminded of the fact that Mr. Korder has, up to now, been most successful at the short form.

•

The funniest scenes in "Search and Destroy" are like comedy sketches or brief one-act plays. Included in that category is the prologue in which Mirkheim (Griffin Dunne) chatters away about his hapless life as if he is talking to his psychiatrist. The truth is he is in conference with his accountant, who is trying to straighten out his chaotic business affairs.

Several quick cuts later, a demure receptionist is telling him the gory plot of her unfilmed script. This is Mr. Korder's apt commentary on our movie madness, the fact that everyone has a script or a film idea to peddle. The woman's scenario is ripe with maimings and mutilations, enough to make Elm Street nightmares look like the mildest of daydreams. The scene is a sardonic set piece, one of several in this open-gaited play. But it is Mirkheim, not the receptionist, who is supposed to be the driving force behind the narrative, and he is as bumbling as he is obsessive. Although his ineptitude is itself a commentary on corporate vacuity, it wears thin as a comic device and vitiates the audience's interest.

This is in spite of the intensity of Mr. Dunne's performance. As played by the actor, the character is so tightly wound that with one tap on his head his feverish brain might explode. A mass of worry lines, he finds himself emotionally straitjacketed in a series of predicaments that would send any ordinary man back to his original profession, booking circus and wrestling acts. When he finally confronts the one man he is desperate to meet, Mr. Dunne happens to be handcuffed to a chair, which does not stop him from fawning (physically a neat feat for the actor).

Mr. Dunne's first objective is to obtain the movie rights to a doctor's mystical self-help novel, but the author is unapproachable. This leads the hero to travel the country looking

for the doctor, touching down in cities that are indistinguishable from one another. At least one stop could easily be excised. Despite a mountain of discouragement, Mr. Dunne remains persistent.

In his Broadway debut, the actor exhibits a flair for comedy of self-parody. We smile as his character repeatedly makes a fool of himself, a sure sign that he will fail upward. Is this way the world will end, not with a bang but with a wimp? Looking for motivation within, one might say that this would-be movie producer has a fear of fear. He wants to soar, but in terms of self-esteem and self-promotional ability, he is grounded.

As another character predicts, the 90's will be "the fear decade." Fear is endemic to the play, as it moves through drug dealing and acts of violence. The antidote to terror, Mr. Korder would have us believe, is nerve. Nerviness and a compulsion to take chances eventually carry the hero to a position of power; he even changes his last name to Power to elude the feds on the track of his taxes. Still, in the end it is unclear what moral or lack of it Mirkheim is intended to represent.

Keith Szarabajka is suave as Mirkheim's smartly suited chief adviser, and there are malicious cameo performances by Paul Guilfoyle as a nervous drug dealer, Stephen McHattie as the greedy author — he snarls like George C. Scott — and Welker White as the not-so-innocent screenwriter who probably has the brightest future in Hollywood.

Accenting the play's own geographic sprawl, the open stage is marked like an airport landing strip or highway, with sparse furniture standing in for more elaborate settings. Under David Chambers's brisk direction, the play is buoyed by its cynicism at the same time that it is hobbled by its choice of hero and an inability to gather momentum. In Mr. Korder's dire view of the fear decade, the producer and his peers are waiting for opportunism to knock.

1992 F 27, C18:5

A Losing Flight From The Demons Of the Past

"The Substance of Fire," originally produced by Playwrights Horizons, has reopened at the Mitzi E. Newhouse Theater at Lincoln Center. Following are excerpts from Frank Rich's review, which appeared in The New York Times on March 18, 1991.

One need not be a jaded constituent of New York's literati to recognize Isaac Geldhart, the esteemed publisher and embattled Jewish father who stands at the center of "The Substance of Fire," the new play by Jon Robin Baitz. A childhood refugee from the "wrecked world" of the Holocaust, Isaac came to New York an orphan, reinvented himself as a bon vivant, and found fame and fortune as

a rigorously independent champion of literary books that wouldn't be caught dead on a best-seller list. By the late 1980's, when Mr. Baitz's play unfolds, Isaac has long since been a brand name in the culture industry. He is one of those survivors, of postwar American intellectual firestorms no less than Old Europe's bloodbaths, who run Manhattan with an iron tongue.

It is the searing achievement of "The Substance of Fire" that it keeps chipping and chipping away at its protagonist until finally he and the century that shaped him and then reshaped him are exposed to the tragic quick. As written with both scrupulous investigative zeal and bottomless sympathy by Mr. Baitz and as acted in a career-transforming performance by Ron Rifkin, Isaac Geldhart is one of the most memorable and troubling characters to appear onstage this season.

He is also the harbinger of what is likely to be a major playwriting career. Mr. Baitz is going to write better plays than "The Substance of Fire," but his writing is already so articulate, witty and true that it's only a matter of time before his theatrical know-how, some of which must come with experience, catches up with his talent.

•

Though this play wanders all over the place during its two enthralling hours, nearly every place it visits is of interest. In Act I, Mr. Rifkin's congenitally combative Isaac is placed in a typical family-business conflict: to save his increasingly insolvent firm from Japanese takeover sharks, he must browbeat his three adult children into philosophical and financial submission. In Act II, set a few years later, what seemed to be a potentially high-charged boardroom drama is all but forgotten while Mr. Baitz forces Isaac to confront the demons that would destroy him from within.

All of Isaac's struggles date back to the war in which his parents died in the camps while he escaped incarceration. If Isaac has survivor's guilt, he also has a survivor's arrogant omnipotence. Mr. Rifkin presents the publisher as a figure of dazzling intellectual authority who never hesitates to remind all listeners that in an America where so many people dispose of their history and convictions for expediency's sake, he has kept the "fire" ignited by his youth, the spirit that keeps him sticking up for the

highest standards in morality and literature alike. Even his attractive and accomplished children do not escape his bullying condescension.

Arrogance and intelligence can conquer all but memory.

Yet for all Isaac's nastiness, it is hard to dislike him. He is just too smart and funny and, on occasion, too right to be dismissed. Once Mr. Baitz ruthlessly challenges the premises of Isaac's life — examining the real meaning of his survival, the substance of his "fire" — the audience is caught up in the sad reckoning facing him in late middle age. Is Isaac's proud insistence on holding on to his past the choice that allowed him to survive, or is it a burden that robbed him of any hope for happiness?

•

"I thought that if I published Hazlitt and Svevo, I'd be spared," says Isaac in Act II. But he has not been spared: if the Nazis destroyed his family in Europe, he has "trashed" his own family, effectively if not as definitively, in New York. Not for nothing does he pore over some prized illustrated letters — "gestures of love" by other witnesses to the "bloodthirsty century" like Osip Mandelstam and George Grosz — with a teary intimacy he cannot achieve with his own children. Just as pointedly does the "most crucial part" of Isaac's collection of ephemera prove to be a watercolor postcard painted by the young Hitler in Vienna at a time when he "fancied himself a serious artist." Does Hitler's painting make a mockery of all humane connections between life and art? If so, is it possible that the life of literature that Isaac has invented in New York is an escape from life rather than life itself, just as the love of books is a flight from love?

In Daniel Sullivan's flawless production, every performance is finely shaded. It says much about all three actors playing the Geldhart children

— Sarah Jessica Parker, Patrick Breen, Jon Tenney — that they can stand up to Mr. Rifkin, whose caustic humor and infernal anger seem to be forces of nature. It says much about "The Substance of Fire" that when it is Isaac's turn to be flattened by life's blows, Mr. Baitz does not provide the satisfaction of a bully getting his comeuppance, just the ineffable melancholy of a flame flickering out. This is a deeply compassionate play, as imperfect as it is youthful, by a writer who with one play or another is bound to be embraced by the wrecked world.

1992 F 28, C3:1

A Life in the Theater

By David Mamet; directed by Kevin Dowling; sets, Rob Odorisio; costumes, Therese Bruck; lights, Brian Nason; sound, Jim van Bergen; production stage manager, Nina Heller. Presented by the Jewish Repertory Theater, Ran Avni, artistic director; Edward M. Cohen, associate director; Ms. Heller, managing director. At 344 East 14th Street, Manhattan.

Robert	F. Murray Abraham
John	Anthony Fusco
Stage Manager	Larry Klein

By WILBORN HAMPTON

Using the theater as a metaphor for life is hardly a literary innovation, but no contemporary playwright has applied it to the slings and arrows, not to mention absurdities, of modern existence with such penetrating humor as David Mamet in his gem of a play, "A Life in the Theater," which is being given a fond revival at the Jewish Repertory Theater.

Performed, as is life, without intermission, Mr. Mamet's play surveys the whole spectrum of human experience — its joys and sorrows, its pettifogging vanities and backbiting jealousies — from the backstage perspective of two actors as they trek from their shared dressing room to the stage and back again, night after night, acting out parodies of the entire history of the theater.

What is life, Mr. Mamet seems to ask, but a constant series of quick costume changes, rushing about to play out scenes of laughable melodrama, only to miss one's cues or forget one's lines, and just when the moment comes to cry out for truth, justice and liberty, having one's wig fall off?

First presented in 1977 at Chicago's Goodman Theater and then produced in New York later that same year, "A Life in the Theater" stands up extremely well. It is infused with the playwright's obvious affection for the theater and the people who populate it. And like Mr. Mamet's other works, the play has hidden depths of real poignancy. But it is first and foremost a comedy, and Kevin Dowling, the director of the Jewish Repertory production, has his cast go for the laugh every time, occasionally a bit too readily.

F. Murray Abraham and Anthony Fusco turn in fine performances as the two actors who share a dressing room that smells like a gym and exchange the parry and thrust of daily life while discussing the relative merits of makeup brushes.

Mr. Abraham is one of our more intelligent actors, and he gives a literate and carefully crafted portrayal of Robert, the veteran who busily and insistently bestows the benefits of his experience on John, the novice. Robert is one of those demanding men-

Playwrights Horizons

Ron Rifkin and Maria Tucci in "The Substance of Fire."

Carol Rosegg/Martha Swope Associates

Anthony Fusco, left, and F. Murray Abraham in "A Life in the Theater" at the Jewish Repertory Theater.

tors who, being praised by John on his performance one evening, wants to know in detail exactly what it was that John liked about it. Mr. Abraham's choices in the role also go strictly for the comedic. Whether weeping in the darkness of the wings while watching his protégé rehearse or trying to explain a bandaged, bloodied wrist, there is a sense that Mr. Abraham's Robert is doing it all only for sympathy. While this is a valid reading and in Mr. Abraham's hands is never less than amusing, it excludes the possibility that Robert's wounds are deeper than those inflicted by his vanity. There is a more profound quality to Robert that Mr. Abraham keeps at arm's length and allows the audience only to glimpse.

As John, Mr. Fusco presents an attractive straight man who, one feels certain, will soon find his way upstage of any number of Roberts. The one reservation on Mr. Fusco's performance is that there is little to distinguish between his portrayal of the wide-eyed John who hangs on Robert's every word at the beginning and the more confident John who quickly grows impatient with Robert's idiosyncrasies after he gets a call from a high-powered agent. One has the feeling that Mr. Fusco's John knows right from the start that he's going to get the better reviews and that the phone will ring with a movie offer.

Although Mr. Dowling keeps the pace steady, he allows it to wander at times, and while most of the scenes are well knit, some are a trifle ragged at the corners. For all the repetitions and monosyllabic rejoinders in his plays, Mr. Mamet is a poetic writer for whom not only every word but every syllable forms part of a cadence that is essential. Mr. Dowling and his cast catch that rhythm in many scenes but fall half a beat off in others.

Rob Odorisio's set and Therese Bruck's costumes are commendable, and Larry Klein is efficiently inefficient as the stage manager who cannot keep cigars in the stage humidor or make the phone ring when it's supposed to.

1992 F 29, 18:1

Time Flies When You're Alive

Written and performed by Paul Linke; directed by Mark W. Travis; flag design by Anders Holmquist; music by Francesca Draper Linke; lighting design by Pat Dignan; sound design by Mark Bennett; production stage manager, Liz Dreyer; production manager, George Xenos. The O Solo Mio Festival presented by New York Theater Workshop, James C. Nicola, artistic director; Nancy Kassak Diekmann, managing director. At the Perry Street Theater, 31 Perry Street, west of Seventh Avenue, Manhattan.

By STEPHEN HOLDEN

Early in his wrenching confessional monologue, "Time Flies When You're Alive," Paul Linke describes the moment nearly six years ago when his wife died of breast cancer. Recalling how a single tear formed in her left eye and fell down her cheek, he says, "I took that last tear and wiped it on my finger and put it in my mouth to savor her last gift to me."

The 90-minute performance, presented by the New York Theater Workshop at the Perry Street Theater, is dotted with such moments, in which Mr. Linke reveals the most sacred personal details of his 10-year marriage to Francesca Draper, a singer and organic gardener whom he loved deeply. That union produced three children, the last born when his wife was gravely ill. His recollections of her dying moments are balanced by equally detailed memories of the home birth of their first child, his cutting of the umbilical cord and his embrace of his newborn son.

As a writer and performer, Mr. Linke, who is known best for his six-year stint on the television series "Chips," is not an arch ironist like Spalding Gray nor a walking gallery of dramatic caricatures like Eric Bogosian. In relating the story of his wife's death, he adopts the tone of a long-absent friend who has reappeared for an intense catching-up session.

The actor's attitude of intimate folksiness is deceptively casual, since his story is a tightly structured monologue whose conversational tone is punctuated by short, poetic asides. It

is also timed so that the most agonized recollections are broken by little bursts of comic relief.

•

The bulk of the story deals with Francesca's ferocious losing battle

against cancer and her final months in home care. An ardent believer in holistic remedies, she rejected chemotherapy and chose a vitamin treatment in a Mexican clinic. She also consulted experts on healing and spirituality.

Mr. Linke's story is compelling because he describes not only the medical details but also the family's emotional changes with an unstinting honesty. And even though we know the outcome, the family's ups and downs are relived with a fervor that generates considerable suspense.

•

The script has its flaws. Too many of Mr. Linke's references come from show business. He talks of his "'Leave It to Beaver'-type house." A doctor is described as "a cross between Marcus Welby and Ichabod Crane." A wizened herbalist is likened to "a George Lucas character." And even his wife becomes "the Charles Bronson of organic gardening." Such shortcuts give the monologue a pop gloss that more probing descriptions might have avoided.

But despite its occasional glibness, "Time Flies When You're Alive" uplifts and inspires. Only the most hardhearted in the audience are likely to leave the theater not counting their blessings and feeling a renewed awareness of the preciousness of life and the power of love.

1992 F 29, 18:5

SUNDAY VIEW

'Crazy for You' Has More Splash Than Magic

By DAVID RICHARDS

"CRAZY FOR YOU" HAS EVerything a 1930's-style musical comedy could want, except a leading man and a leading lady.

It features more than a dozen songs by George and Ira Gershwin — some that are already etched in your memory; others, just out of the trunk, that in all likelihood you'll be hearing for the first time. The Technicolor sets, courtesy of Robin Wagner, recall the glory days of M-G-M, when M-G-M boasted the best sound stages in Hollywood for singing and dancing. Most impressive, it allows an abundantly gifted choreographer, Susan Stroman, opportunities galore to indulge her talents on a grand scale.

But where is the leading man in this — the combination song-and-dance man, comic and general charmer, who can not only keep up with a frisky musical but is also capable of pulling out in front of it, showing the way, *leading*, in essence?

The task has fallen to Harry Groener, who plays Bobby Child, a dapper New York playboy sent by his wealthy mother to foreclose on a theater in Deadrock, Nev. Instead, he tumbles for the prettiest girl in town, the only girl in town, actually, and decides to save the theater by putting on a show. Mr. Groener's industriousness cannot be faulted for a moment. If hard work alone made you a star,

The songs of the Gershwin brothers, Ira and George, at top, are part of the musical "Crazy for You" at the Shubert Theater, with a cast that includes, from left foreground, Jodi Benson, Harry Groener, Jane Connell and, upper right, the Manhattan Rhythm Kings— The choreography by Susan Stroman is not to be missed.

he'd have his rightful corner of the firmament. He does all that's required of him, ably, proficiently.

What he doesn't do, however, is charge the atmosphere in the Shubert Theater. To stoop to the show's level of wit, Astaire is called for and Mr. Groener . . . is a half-step. For all the sparkle thrown off by his blue eyes, he even looks a bit cadaverous in the role.

Does it matter that much? I think so. His blandness inspires nothing but more blandness in his leading lady, Jodi Benson, unless her range of expressions is naturally limited. Ms. Benson, who was the voice of Disney's "Little Mermaid," has a bouncy manner. But her hair is bouncier. The flirtation between these two is lackluster and their clinches are passionless. If you don't buy their romance — and I didn't — a gorgeous song like "Embraceable You" goes only so far. There comes a point when they might as well be singing "The Star-Spangled Banner" to each other.

The producers could have had a knockout on their hands, and instead they've simply managed a pleasant evening of escapism to help ease us through the recession. "Crazy for You" is "Me and My Girl" without Robert Lindsay, or "The Will Rogers Follies" on a night Keith Carradine is at home with the flu. Plenty of splashy entertainment everywhere but dead center, where boy meets girl, boy catches girl up in his arms and boy waltzes girl right off her feet.

■

The musical is pretty much a top-to-bottom remake of "Girl Crazy," the Gershwin brothers' whoop-de-do for 1930, in which Ethel Merman announced "I Got Rhythm" to the startled eardrums of Broadway. That number is one of five holdovers from the original score. From other Gershwin endeavors come "They Can't Take That Away From Me," "Nice Work If You Can Get It" and "Someone to Watch Over Me," although in William D. Brohn's orchestrations, they sound fresh from the mint. The playwright Ken Ludwig has rewritten the inane story and rejuvenated some arthritic jokes, or tried to. (Cowboy: "I ain't seen so much excitement around

here since my horse foaled." Dumb chorine: "Wow! It must be hard to fold a horse.") Being a great one for mistaken identity — remember the double Otellos in "Lend Me a Tenor"? — Mr. Ludwig obliges the hero to masquerade in Deadrock as Bela Zangler, a Florenz Ziegfeld clone. Then, of course, the real Zangler (Bruce Adler) comes crawling over the desert sands into town.

No one's going to be permitted to complain of too little. To that end, a reputed $7.5 million has been spent, re-creating the New York theater district by night; down-at-the-heels Deadrock by day; an 1884 opera house before and after a face lift; and an Art Deco dreamscape, by way of Busby Berkeley, that elevates Mr. Groener and Ms. Benson to the starry heavens. Despite the refurbishments, though, "Crazy for You" purposely clings to a 1930's outlook: it has no content, other than performers performing. Or, if you want to be precise about it, performers performing performers performing. Chinese boxes almost. At the least, theater inside theater.

In this context, the corniness of the jokes doesn't really matter, as long as someone engaging is cracking them. The story need not surprise us, merely allow the cast to charm us. Personality counts for everything here. It greases the wheels, lifts a familiar ballad to the realm of the unfamiliar, adds a particular human shine to the bright lighting. So why, oh why, has the director Mike Ockrent surrendered the choicest roles to the least charismatic of actors?

It is indicative that the best numbers in "Crazy for You," the real audience-rousers, are group numbers. Ms. Stroman would be welcome in any season, but at a time when the ranks of Broadway choreographers have dwindled tragically, her emergence on the scene is the equivalent of the cavalry arriving in the last reel. As she has already demonstrated in the Off Broadway revue "And the World Goes 'Round," she has an uncanny ability to reinvent the standards by introducing into them a few unexpected props and a slightly off-center attitude. In "Slap That Bass," she fashions bass fiddles out of strands of rope and perky chorus girls. For "I Got Rhythm," the first-act finale, she has the company sliding, rat-a-tat-tat, over panels of corrugated tin, tap-dancing on metal sieves normally used for panning gold, and swinging back and forth on pickaxes as if they were the pendulums of so many grandfather clocks.

Instead of the traditional stairway to paradise, the cast members construct a mountain

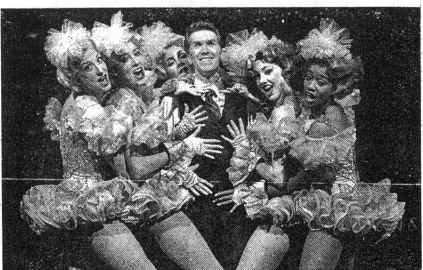

Joan Marcus/"Crazy for You"

Harry Groener is surrounded by, from left, Paula Leggett, Jean Marie, Ida Henry, Pamela Everett and Judine Hawkins Richard—Mining for Gershwin gold.

out of the gilded chairs in Deadrock's opera house, then scramble gleefully to the summit in "Stiff Upper Lip," a spirit-lifter that also takes a sly dig at the student revolutionaries mounting the barricade in "Les Misérables." The sheer athleticism of Ms. Stroman's choreography is a bracing reminder of Michael Kidd's. At the same time, she has the soul of a romantic who gets a big thrill out of a couple just swaying cheek to cheek under a pink-and-powder-blue sky.

The tighter the focus is on Ms. Benson and Mr. Groener, however, the more prosaic the show becomes, although I suppose "What Causes That?" must be considered at least a partial exception. The number pairs up Bela and Bobby, who, remember, is disguised as Bela, right down to the trim goatee and the silver streak in his skunk-black hair. Both men are heartsick, both hung over from the night before, both still befuddled enough to think, when they look at one another, that they're gazing in a mirror. The synchronized dance they do together couldn't be looser, the gentlemen being a bit unsteady on their feet. It's one thing to have the Rockettes behave with machinelike precision. What Ms. Stroman is synchronizing here is a lack of control, a queasiness that's capable of a few sudden, antic lurches. Brilliant notion, brilliantly executed by Mr. Groener and Mr. Adler, too.

Mr. Ockrent's staging is far less imaginative when it comes to giving the clichéd characters even an appearance of novelty. As Bobby's jealous fiancée, Michele Pawk is standard-issue vixen, whose most original gesture consists of lying back on a saloon table and kicking her leg so far over her head that she knocks the saloonkeeper, seated behind her, off his chair. Jane Connell harrumphs predictably as Bobby's mother, and the chorus girls are of the gum-cracking, smart-talking variety, recycled from dozens of musicals about Broadway.

What you haven't seen on stage before, I venture, is their striding entrance into Deadrock. Arm in arm, their colored dresses swishing about their calves, they surge out of the desert and advance gaily on main street. For a moment, you could be watching one of those 1950's movie musical previews that showed the line of smiling stars who would be in your neighborhood playhouse the next week, if they didn't push the camera aside and step off the screen right then and there.

That's Ms. Stroman's work for you — and not to be missed. As for "Crazy for You," it may be the first Broadway musical ever that left me eager to catch the replacement cast.

'Private Lives'

Some tiny part of me — the incurable optimist, I guess — held out hope that Joan Collins might put her television persona momentarily aside and act the character of Amanda Prynne in Noël Coward's "Private Lives." Or at least give it a stab, go through a few motions. But that hope evaporated five minutes after she made her first entrance on the stage of the Broadhurst Theater the other night. Miss Collins is immutably Miss Collins. A monument, of sorts. You might as well expect the Arch of Triumph to turn into the Great Pyramid of Giza. It just ain't gonna happen.

However, this does make the question of whether to attend "Private Lives" an elementary one. Here is an unparalleled opportunity to watch Miss Collins, in the living flesh, sit down, stand up and move around. Those who are going to seize it already know who they are and don't need me and my two cents. For a couple of hours they will get to study Miss Collins's makeup, as artful as that of any Kabuki performer, contemplate her glamorous gowns and reflect on the reddest fingernail polish I, for one, have ever beheld. If that were not enough, the woman "Dynasty" made world-famous also sings a little and does the splits.

That a play is unfolding at the same time does not distract from the evening's deeper purpose. Miss Collins blots out her fellow actors (Simon Jones, Edward Duke and Jill Tasker) with a self-absorption that is remarkable in its fashion. While her performance isn't extroverted enough to leave her open to charges of being a showoff, you can't deny that she has approached "Private Lives" purely as a pretext to show herself off.

And she does. Look, she's leaning on the grand piano. Ohmigosh, she's putting her feet up on the sofa. Isn't that a cigarette she's lighting now? The wonders never stop. □

1992 Mr 1, II:1:1

In London, a Writer Has a Three-Show Coup

By FRANK RICH

Special to The New York Times

LONDON, March 1 — While Broadway is flush with the promise of the spring's new plays and musicals, the West End seems trapped in a wintry past.

The hottest ticket is a revival of the earliest Andrew Lloyd Webber hit, the 1972 "Joseph and the Amazing Technicolor Dreamcoat," even as eight other brand-name musicals, some nearly as old and half of them also by Mr. Lloyd Webber, continue their immortal runs. These permanent fixtures are surrounded by no fewer than four other shows that anthologize American pop or rock-and-roll (from "A Swell Party" to "Good Rockin' Tonight") and three more that merchandise vintage Harlem jazz and dance (or the British idea of it) to almost exclusively white audiences. "The Mousetrap," anyone?

Only in one way does the current West End scene resemble Broadway: "Spare change?" is a ubiquitous line of dialogue. The recession, as much a factor in this British election year as it is in the American Presidential race, is visible on every block. Makeshift encampments for the homeless abound, as do the vacant storefronts and marquees that often serve as their backdrops. London's commercial producers, like their New York counterparts, are frequently discounting their high-priced tickets, often reserving star billing in their newspaper advertisements for the phrase "seats available."

Even so, don't cry for the London audience. If the West End is largely a theatrical vacuum, the big subsidized companies, the Royal National Theater and the Royal Shakespeare Company, easily compensate. Though the R.S.C.'s repertory of classics does not travel from Stratford-on-Avon to London's Barbican Center until later this month, the National is in full roar, fielding a remarkably diverse array of critical and popular hits by authors of several nationalities (the Americans Tennessee Williams and Tony Kushner included) on its three stages. There are turn-away crowds for virtually all of its productions, and it could be argued that at this moment Richard Eyre, who took over the company's artistic leadership from Peter Hall in 1988, is the most successful producer, not to mention the most versatile, in the English-speaking theater.

●

One of Mr. Eyre's most important artistic allies this season is the playwright, actor and sometime director Alan Bennett, who has two large-scale works in repertory at the National, a new play titled "The Madness of George III" and a long-running adaptation of the 1908 Kenneth Grahame children's classic, "The Wind in the Willows." In a coup of Lloyd Webber proportions, Mr. Bennett is also responsible for "Talking Heads," one of the very few serious dramas breaking up the musical monotony of the West End.

Actually, "Talking Heads" is an evening of monodramas, two performed by Patricia Routledge and one by Mr. Bennett himself, drawn in part from the television series of the same title, which has been seen on public television in the United States.

Alan Bennett offers 'George III,' 'Willows' and 'Talking Heads.'

Seeing the pieces on stage at the Comedy Theater is anything but a television experience, however. These riveting first-person accounts of lower-middle-class lives in Northern England are the dark side of monologues Mr. Bennett long ago performed in "Beyond the Fringe." In their caustic humor and aching loneliness, they set an American to thinking of the forlorn small-town Midwestern voices of Edgar Lee

Masters's "Spoon River Anthology" and Sherwood Anderson's "Winesburg, Ohio."

In the first and most devastating of the Bennett soliloquies, titled "A Woman of No Importance," Ms. Routledge sits in a chair, pocketbook firmly in hand, and gossips cheerily about the minutiae of her daily office machinations as a supposedly indispensable clerical worker in a large corporation. By the end of an hour, the chair has become a wheelchair, and the actress has seemingly melted from an animated busybody into a dying and solitary victim of an unidentified illness, her face distorted beyond recognition, her voice slurred, her body buried (in blankets) as if she were Samuel Beckett's Winnie in "Happy Days."

But Mr. Bennett's real concern is not illness so much as the isolation and self-deception of a woman who does not realize that her colleagues never cared for her and who is soon abandoned and dismissed with get-well cards as anonymous as the hospital identification band on her wrist. Ms. Routledge, a hilarious comic actress distantly recalled by some New York audiences for her musical-comedy appearances (she won a Tony Award for "Darling of the Day" a quarter-century ago), is a large pudding of a woman whose delineation of her character's unwitting disintegration, as directed by the author, is harrowing to behold. I have never heard a restive Wednesday matinee audience, or at least one typically packed with women of the same late middle age as Ms. Routledge, grow so hushed as the one at the Comedy did during the terminal stages of this tour de force.

In the actress's concluding turn in "Talking Heads," titled "A Lady of Letters," another unmarried woman, a dour moral scold, comes to a perverse happy ending: she finds in jail the warm community and emotional liberation she never knew in the semidetached isolation of her mean little

neighborhood. English life is also a prison in the middle monologue, "A Chip in the Sugar," in which Mr. Bennett insinuatingly embodies Graham, a repressed, psychologically impaired homosexual whose narrow existence is jeopardized when his 72-

'I am the King of England!' 'No, sir. You are the patient.'

year-old widowed mother threatens to evict him to make room for her new "fancy man." Like the two women of "Talking Heads," Graham and his unseen mother inhabit a fragmented and desolate human landscape in which an older generation is equally terrified of the T-shirt-wearing young, all racial minorities and any glimmer of social change.

•

It would seem a long leap from the bleak, present-day interior worlds of "Talking Heads" to Mr. Bennett's highly populated period pieces at the National, both of which have been given extravagant, epic stagings by Nicholas Hytner, the director of "Miss Saigon." Yet what most struck me about Mr. Bennett's version of "The Wind in the Willows" is that its hermetic vision of an eternal boyhood recalls Graham as much as Grahame.

Suffused with nostalgia for Edwardian England and its idyllic riverside vistas, this "Wind in the Willows" also cherishes the bygone boarding-school gentility and unarticulated gay crushes of Toad (Desmond Barrit), Rat (David Ross), Badger (Michael Bryant) and their new young protégé,

Mole (Adrian Scarborough). If anything, they are reminiscent of the gentlemanly traitors Anthony Blunt and Guy Burgess, as much Cambridge as Marxist, that Mr. Bennett dramatized in his previous National Theater work, "Single Spies." For children, if not this impatient adult, "The Wind in the Willows" offers lush spectacle (designed by Mark Thompson), Christmas-pantomime-style burlesque comedy and, in the "Cats" manner, the frequent deployment of a large and musical chorus of anthropomorphic rabbits, hedgehogs, squirrels and field mice.

•

"The Madness of George III" goes back to an even earlier Britain, that of 1788, when its title character, played by Nigel Hawthorne, was thought to have gone insane. Today George III is believed to have suffered from a metabolic rather than a psychological ailment, and much of Mr. Bennett's play is a nasty satire of the various quacks who torture the poor man with cruel and humiliating treatments in the name of advanced 18th-century medical science. The work's huge, gilt-framed canvas is filled out with lengthy recountings of Georgian political intrigues that add historical weight and plot to the evening without contributing much to either its dramatic force or intellectual passions.

It is when Mr. Hawthorne is at center stage that Mr. Bennett's play becomes highly charged, and not just because the actor is giving what may be the performance of his career as a quixotic monarch whose unpredictable behavior veers from clownish childishness to pathetic dementia to magisterial, Lear-like resignation, sometimes all in the same scene. "George III" is dominated by the image of its protagonist's illness, most horrifically realized at the Act I curtain, when he is strapped into a chair by his tormentors. As Handel's Coronation Anthem blares at top vol-

ume, the agonized, blistered Mr. Hawthorne howls defiantly, "I am the King of England!" only to be informed by his doctor: "No, sir. You are the patient."

•

As a suffering patient, this King is nothing if not a direct ancestor of the wheelchair-bound, middle-class woman of no importance played by Ms. Routledge in "Talking Heads." Alan Bennett's comedies may be crowd-pleasers, but they are subversive ones, depicting lost souls who seem to emblemize an unhappy England that cannot diagnose, let alone cure, its ills.

1992 Mr 3, C13:3

Correction

A picture caption on Tuesday with a review of plays by Alan Bennett in London misidentified the theater at which "Talking Heads" is playing. It is the Comedy Theater.

1992 Mr 7, 3:2

Photographs by Alastair Muir

Nigel Hawthorne, left, and Matthew Lloyd Davies in a scene from Alan Bennett's "Madness of George III" at the Royal National Theater in London. At right, Mr. Bennett appears in his play "Talking Heads," which is also playing at the Royal National Theater.

Theater in Review

Mel Gussow

■ Two rough views of modern urban life ■ Updated version of the 1930's Living Newspaper ■ An attempt to discover the real Nat Turner.

'Chain' and 'Late Bus to Mecca'

Judith Anderson Theater
420 West 42d Street
Manhattan
Through March 22

Two one-act plays by Pearl Cleage; directed by Imani; set design, George Xenos; lighting, Melody Beal; costumes, Ornyece; sound, Bill Toles; production stage manager, Jacqui Casto. Presented by the Women's Project and Productions, Julia Miles, artistic director, and the New Federal Theater, Woodie King Jr., producer.
WITH: Claire Dorsey, Karen Malina White and Kim Yancey.

In "Chain," Pearl Cleage has taken a shocking news story and tried to turn it into a play about the lengths to which some parents will go to protect their children against themselves and the dangers of urban violence. Last summer a Hispanic teen-ager was found chained to a metal pipe in her family apartment. When she was released by authorities, she defended her parents' drastic act of discipline.

Ms. Cleage, in her one-act play at the Women's Project, has focused on a black teen-ager in a similar, horrifying situation. The message is clear: no concerned parent could justify this destructive measure. But the monologue is self-defeating, meandering through seven days and marking time as the young woman drops cultural references (the "Cosby" kids as role models) while talking about her boyfriend and their life with hard drugs.

Karen Malina White feverishly tries to maintain an intensity in her performance, but the play is not there to support her. Long before she is unchained, theatergoers may feel that they too have suffered unwarranted punishment. The reporting of the real episode was far more moving than what is depicted on stage.

This seemingly endless play is followed by the shorter and pithier "Late Bus to Mecca," which moves back to 1970 to show us two different black women ground down by society. The one called Ava is a prostitute waiting in a Detroit bus station for a friend who never shows up. She chatters away to a stranger, who may be homeless or battered or both.

Despite her profession, Ava (Kim Yancey) would seem to be a woman of propriety or at least someone who obeys her own rules of behavior. She is well supplied with cosmetics and advice, both of which she offers freely. Whenever Ms. Yancey reaches out to her benchmate (Claire Dorsey), the other woman withdraws, but gradually she allows herself to be touched, physically and emotionally.

The play is not without its clichés, and Ms. Yancey's monologue, like that of the chained teen-ager in the earlier work, is repetitive. But the relationship has its tender side, and the two actresses are keenly attuned to their characters. Under Imani's intuitive direction, Ms. Yancey offers a hint of the sadness beneath the flamboyance and Ms. Dorsey, without speaking a word, communicates a range of feelings, all the way from impenetrable reserve to a tentative reawakening to life.

'New Living Newspaper'

Ensemble Studio Theater
549 West 52d Street
Manhattan
Through March 12

Editor in chief, Avery Hart; director, Jeff Schecter; original music by Ray Leslee; additional music by Andrew Howard and Shel Silverstein; lyrics by Peter Morris, Mr. Silverstein, Paul Mantell, Mr. Hart, Carl Sandburg, Robert Creeley and Mr. Leslee. Musical director, Andrew Howard; editorial consultant, Killian Ganly; choreographer, Janet Bogardus; head writers, Mr. Hart and Mr. Mantell. In Pursuit of America Series 2 presented by the Ensemble Studio Theater.
WITH: Polly Adams, Donald Berman, Stephanie Berry, Dominic Chianese, John-Martin Green, Baxter Harris, Gayle Humphrey, Mr. Mantell, Les J. N. Mau and Julia McLaughlin.

"Facts are high explosives," said Hallie Flanagan, the director of the Federal Theater Project, about her company's Living Newspaper of the 1930's. This was a provocative attempt to give a dramatic immediacy to the most pressing political, social and economic issues of the time. In keeping with the basic tenets of the Federal Theater concept, the Ensemble Studio Theater's updated version, "New Living Newspaper," is topical as well as hortatory.

What is lacking in the show, part of the theater's In Pursuit of America series, is an interpretive context. Too often headlines and news stories are allowed to speak for themselves; the criticism is by direct quotation. For all the social concern that is exhibited on stage, the cabaret-style show poses no satiric competition to Mark Russell and evokes a feeling of déjà revue, at least for those who keep up with current events.

The collaborative venture begins with President Bush's State of the Union message that the cold war is over and the "recession will not stand," follows that with statements from such diverse personalities as Lee Iacocca and Lee Atwater (his recantation of dirty tricks) and leads to a musicalized version of the Bill of Rights. The sketches are by a variety of contributors, the mildly sardonic songs by Ray Leslee.

Page by page, the actors move earnestly through the sections of a composite newspaper, from Metro to media. The approach is inclusive and humanistic but not overly productive. The show can be obvious, as in the assessment that more Americans are familiar with the jurisprudence of Judge Wapner than that of Chief Jus-

Bert Andrews/"Late Bus to Mecca"
Kim Yancey, top, and Claire Dorsey in "Late Bus to Mecca."

tice Rehnquist, or in the portrait of Vice President Dan Quayle wielding a golf club.

Occasionally an urgent matter is treated with a hard edge, as in a sequence in which four diverse women assail the President for his stand on abortion and in a mini-musical entitled "Financial Follies of 1992," which pays mock tribute to a red-caped song-and-dance team named the Amazing Salomon Brothers and features the "S-and-L Soft Shoe." It is in moments like this that "New Living Newspaper" demonstrates the renewability of the theatrical format and reminds one of the fierceness that motivated the first Federal Theater editions.

'Ascension Day'

Hudson Guild
441 West 26th Street
Manhattan
Through Sunday

By Michael Henry Brown; directed by L. Kenneth Richardson; musicians, Kwe Yao Agyapon and Atiba J. D. Wilson; set design, Tavia Ito; costumes, Lance Kenton; lighting, R. Stephen Hoyes; sound, Rob Gorton; fight direction, David Leong; choreographer, Donald Byrd; music composer and director, Olu Dara. Presented by the Working Theater, Bill Mitchelson, artistic director.
WITH: Michael Beach, Jesse Bernstein, Betty K. Bynum, Matthew C. Cowles, André De Shields, Arthur French, Jack Gwaltney, Novella Nelson, Colleen Quinn, Ving Rhames, Jeremy Stuart and Earl Whitted.

The insurrection led by Nat Turner in 1831, in which 55 slaveholders were slain by their slaves, echoes through American history. The controversy was deepened by William Styron's novel "The Confessions of Nat Turner." In "Ascension Day," Mi-

chael Henry Brown tries to uncover the real Nat Turner beneath the legend. Unfortunately, the play will only add to the confusion.

Mr. Brown proved himself to be a promising playwright with his "Generations of the Dead in the Abyss of Coney Island Madness" last season at the Long Wharf Theater in New Haven. With "Ascension Day" he submerges his drama in a morass of mysticism. Not content with probing the story of Nat Turner, he creates a woodland spirit, a griot, who repeatedly emerges from a tree to cast a spell. The self-conscious symbolism of the character is compounded by the overwrought performance by André De Shields. One wants to tell him to go back inside the tree and stay there.

There are other self-indulgent aspects that set the play off on a tiresome track and prolong it well past three hours. One difficulty is that the approach is too small in scale for such an epic subject. A few characters have to stand for many. The actual assault is ineffectively mimed by the actors, flailing axes and poles against the sky.

In Mr. Brown's concept, Nat Turner is the spiritual leader of his fellow slaves, and a man to whom they look for guidance. With the greatest reluctance he is drawn to violence, and then only when he discovers that his wife has been raped by a slaveholder, an apparent simplification of Turner's motivations.

In an uneven cast, there are two affecting performances, by Michael Beach as Nat Turner and Betty K. Bynum as his wife. Matthew C. Cowles, as a slave owner redeemed by Turner, adds a needed note of offbeat humor, though his later appearance as John Brown in a dime-store beard is unintentionally laughable. The play, which was awarded a major grant by the Fund for New American Plays, falls drastically short of its compelling subject.

1992 Mr 4, C19:1

The Reaganite Ethos, With Roy Cohn As a Dark Metaphor

By FRANK RICH

Special to The New York Times

LONDON, March 1 — At the end of Tony Kushner's "Angels in America," a new American play that has become a runaway sensation here, the theater rocks with deafening apocalyptic thunderclaps, a proscenium-size Old Glory explodes in a burst of lightning, and a beautiful angel descends from heaven to retrieve a young man who is dying of AIDS. "Very Stephen Spielberg," says the awed young man. "The Great Work begins," announces the Angel. "The Messenger has arrived."

It says a lot about Mr. Kushner's huge talent that this outrageous finale, far from seeming as over-the-top as it sounds, is an appropriate, cathartic and, yes, Spielbergian conclusion to the three-and-a-half hours of provocative, witty and deeply upsetting drama that have come before. Mr. Kushner, who is 35 years old and lives in Brooklyn, may well be creating a great work in "Angels in America," a two-part epic of which this multi-layered evening is only the first installment. Without question he is a messenger who demands to be heard.

Among many other things, this half of "Angels in America," subtitled "Part I: Millennium Approaches," is an idiosyncratically revisionist view of recent American political history in which Roy Cohn, the Joseph McCarthy henchman who lived on to become the most politically incorrect of closeted AIDS victims, emerges as the totemic figure. As a piece of writing, the play is a searching and radical rethinking of the whole esthetic of American political drama in which far-flung hallucinations, explicit sexual encounters and camp humor are given as much weight as erudite ideological argument.

The author labels his play "A Gay Fantasia on National Themes," and, pretentious as that may sound, he delivers on those ambitions, creating a modern answer to John Dos Passos' "U.S.A." from the uncompromising yet undoctrinaire perspective of a gay American man of the early 1990's. "Angels in America" is the most extravagant and moving demonstration imaginable that even as the AIDS body count continues to rise, this tragedy has pushed some creative minds, many of them in the theater, to new and daring heights of imaginative expression.

Mr. Kushner's script ended up at the Royal National Theater here — in the same intimate house, the Cottesloe, that was the site of the first production of David Mamet's groundbreaking "Glengarry Glen Ross" — by a circuitous route. The play was initially performed in a 1990 workshop at the Mark Taper Forum in Los Angeles, where Part II (subtitled "Perestroika") will have its premiere next season, but its first full-fledged production was at the Eureka Theater in San Francisco last year. It attracted the attention of the National's artistic director, Richard Eyre, who had the inspired idea of teaming Mr. Kushner with Declan Donnellan, a highly innovative director celebrated for the visual and sexual flamboyance he and his itinerant Cheek by Jowl company have brought to the classics.

Working with an ensemble cast that can be faulted only for the inevitable slippage of some of its American accents, Mr. Donnellan and his designer, Nick Ormerod, magically juggle overlapping scenes that whip among such diverse locales as a men's room in a Federal Court of Appeals, a middle-class home in Salt Lake City, the Ramble in Central Park and a Valium addict's mystical vision of an ozone-depleted Antarctica. But the many fantastic flights of "Angels in America" are always tied to the real world of the mid-1980's by Mr. Kushner's principal characters,

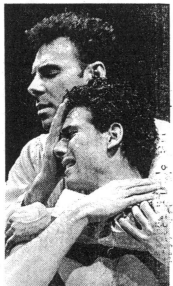

Alastair Muir/"Angels in America"
Sean Chapman, top, and Marcus D'Amico in "Angels in America."

who include two young couples, a pair of gay lovers, and a politically ambitious, rectitudinously Mormon lawyer and his wife. These couples are gradually brought into intersection by both their fantasy lives (sexual and otherwise) and their inadvertent proximity to the covert corridors of power ruled by Cohn in his latter-day incarnation as a Reagan-era Mr. Fixit.

Mr. Kushner, who likened the Reagan ethos to the Third Reich in a vapid previous agitprop drama ("A Bright Room Called Day"), certainly has some pointed things to say about the greed and selfishness of the Reagan decade. But "Angels in America" is more interested in looking ahead,

in taking the spiritual temperature of the nation as it approaches the millennium, than in rehashing the political disputes, even those about AIDS, of the recent past. "AIDS shows us the limits of tolerance," says Louis Ironson (Marcus D'Amico), a Jewish clerical worker who has discovered that his lover of nearly five years, Prior Walter (Sean Chapman), is scarred by the lesions of Kaposi's sarcoma. Among the limits tested are those of the Jewish and Mormon religions and, less abstractly, those of Louis himself, a sweet, smart man who nonetheless abandons his long-time companion with a callousness a more limited playwright might ascribe exclusively to heterosexuals.

In the ecumenically depressed America of this play, everyone is running away from whoever he or she is, whether through sex, drugs or betrayal, to dark destinations unknown. Yet for all his pessimism, Mr. Kushner sees many sides of every question. Nowhere is this more apparent than in his presentation of Cohn, who, in the demonic performance of Henry Goodman, is a dynamic American monster of Citizen Kane stature. True to fact, this Cohn, even at his most bullying and hypocritical, is neither stupid nor bereft of a sense of humor. In one typically arresting speech, he vehemently argues that he is not a homosexual but a heterosexual who has sex with men, for how could a man with his political influence be included among a constituency with "zero clout"? In Cohn's many fascinating self-contradictions, Mr. Kushner finds an ingenious vehicle for examining the twisted connections between power, sexuality, bigotry and corruption in an America that has lost its moral bearings.

Looking back and seeing a farrago of sex, power and corruption.

Such is the high-voltage theatricality achieved by both play and production that the English audience at "Angels in America" is totally gripped even as it must consult a program glossary to identify phenomena like Ethel Rosenberg (who materializes to call an ambulance for the stricken Cohn), Ed Meese, Shirley Booth and the Yiddish expression "Feh!" Even a graphic simulation of rough, anonymous sex — brilliantly accomplished by two fully dressed actors miming their actions at opposite sides of the stage — becomes a funny and affecting metaphor for Mr. Kushner's larger, painful canvas of a country splintering at every public and private level. There are scenes of "Angels in

America" that run on too long and thoughts that are not clear (though they may become so in Part II). But the excitement never flags. Mr. Kushner has created an original theatrical world of his own, poetic and churning, that, once entered by an open-minded viewer of any political or sexual persuasion, simply cannot be escaped.

To the British, the freshness of the writing in "Angels in America" may seem even more pronounced than it does to an American theatergoer for the simple reason that London sees very little contemporary American drama. Even London critics seem unaware of important current plays like "The Substance of Fire," "Marvin's Room," "Sight Unseen" and "Lips Together, Teeth Apart," though "Lost in Yonkers" and "Six Degrees of Separation" are scheduled for production here this summer. When a less prominent American play is given full-dress treatment in the West End, as Tina Howe's "Painting Churches" belatedly was in a recent and short-lived production, it is usually held up (and unfairly) as a symbol of touchy-feely American parochialism.

David Mamet, despite his inactivity as a playwright, and Arthur Miller, whose work is in perpetual London revival, remain the touchstones of American playwriting. Mr. Miller recently returned the compliment by having the premiere of his new play, "The Ride Down Mount Morgan," in the West End, arguing in interviews that the London commercial theater is not subject to the critical and economic pressures of Broadway. His play then received mixed reviews and, in the exact Broadway manner, closed prematurely after a run of four months at the Wyndham's Theater, where the new tenant is "Straight and Narrow," billed as "an adult comedy."

New York, of course, also misses out on a lot of English drama. Plans to bring over "Racing Demon," David Hare's powerful examination of a crisis of faith within an inner-city Anglican parish, fell through, as did the announced American tour of Alan Bennett's "Single Spies." Unlike "Racing Demon," "Murmuring Judges," Mr. Hare's new play on the National's Olivier stage, is not an obvious candidate for export. Its investigation of a deadlocked criminal justice system is rooted in local legalities and often seems a display of journalistic research shoehorned into a television police melodrama rather than an impassioned act of the imagination. Though Mr. Hare's and Mr. Kushner's plays share some political sympathies and are performing side by side, the declamatory "Murmuring Judges" is so old-fashioned that one can hardly believe that it and "Angels in America" were written in the same millennium.

1992 Mr 5, C15:5

'Marvin's Room': Life, As It Is and Could Be

"Marvin's Room," initially produced in New York by Playwrights Horizons, has reopened at the Minetta Lane Theater, 18 Minetta Lane, Manhattan. Following are excerpts from Frank Rich's review, which appeared in The New York Times on Dec. 6, 1991.

The title character of "Marvin's Room," who is seen only as a blurred shape behind the glass-brick wall of his sickroom, has been dying for 20 years. Eaten up by cancer and crippled by strokes, he turns for entertainment to the simple pleasure of watching his lamp's light bounce around the walls and ceiling when it is reflected at bedside from a compact mirror.

The heroine of "Marvin's Room" is the woman who takes care of Marvin, his 40-year-old daughter Bessie (Laura Esterman). She is dying of leukemia. The play's other characters include Marvin's aged sister and Florida housemate, Aunt Ruth (Alice Drummond), who has electrodes in her brain to stop the pain of three collapsed vertebrae, and Bessie's sister, Lee (Lisa Emery), a cosmetician who is in good health but has two severely troubled teen-age sons.

Is there any chance you will believe me when I tell you that "Marvin's Room," which was written by Scott McPherson, is one of the funniest plays of this year as well as one of the wisest and most moving? Maybe not. And that's how it should be. When the American theater gains a new voice this original, this unexpected, you really must hear it for yourself.

In bald outline, I know that "Marvin's Room" sounds like disease-of-the-week television movies and their more pretentious theatrical cousins. While its characters in fact watch soap operas to fill up their own afternoons, "Marvin's Room" is most decidedly not a soap itself. Nor is it a pitch-black gallows farce in the British mode of Joe Orton or Peter Nichols, though Mr. McPherson's ability to find laughter in such matters as bone marrow transplants are at least minor miracles of absurdist comedy.

The play is just too American to subscribe to European cynicism. It sees life as it is and how it could be, and it somewhat optimistically imagines how one might bridge that distance without ever sentimentalizing the truth. Mr. McPherson does not pretend that God has a divine plan for everyone or that people always die with dignity or that everyone isn't dying. Instead he asks, What good can we do with the time, however much or little it is, that we have left before our inevitable harsh fate arrives?

For Bessie, the answer is never in doubt. She has taken care of her father and her aunt for her whole adult life, and she will continue to do so until they drop or she does. Bessie is the heart of "Marvin's Room" because she serves as a caretaker cheerfully, without complaint or self-pity or desire for thanks, without ever questioning or regretting a moment of it, even as her own terminal disease worsens. That she is a credible, ordinary person rather than a gooey fictive saint is a tribute to Ms. Esterman's extraordinary performance as well as to the writing.

•

While Bessie's goodness cannot cure her physical ailments or those of her father and aunt, her impact on the psychological states of her selfish sister and her two antisocial nephews (Mark Rosenthal and Karl Maschek) is the underlying story of "Marvin's Room." The play finds its most powerful scenes as Lee and her sons are inexorably transformed by the uncritical, guileless affection Bessie showers on them no less than on her dying elders. In one unforgettable scene, Lee finally musters some love for her sister in the only way she can — by offering her services as a budding beautician — and prompts Bessie to remove the wig used to hide the ravages of chemotherapy so that it might be styled into a "sophisticated, on-the-town evening" look. And it is matched by other moments, including one in which the dwindling Ms. Esterman, her thin wrists beating the air to express her incongruous joy, tells Ms. Emery how lucky she has been to have so much love in her life: not the love she has received but the love she has given to others.

Bessie's high spirits are bottled by the director, David Petrarca. Even so, the evening's joy is inevitably tempered by one's knowledge that Mr. McPherson, 32, has AIDS. "Marvin's Room" was written before Mr. McPherson became ill and in any case asks for sympathy no more than Bessie does. But like some other recent comedies that have nothing specifically to do with AIDS and everything to do with the force of selfless love in a world where life is short, this play wasn't conceived in a vacuum. It is a product of its time.

That isn't to say that it is for everyone. Lee's sons concede in one youthful bedtime conversation that they never "think about actually dying," and even the most worldly teen-agers might not know what to make of this evening either. Nor, perhaps, would those adults fortunate enough never to have stood in a room and watched a loved one die.

But I can't speak for that audience. I can only speak for myself. My first impulse after seeing Mr. McPherson's play was to gather those I care about close to me and take them into "Marvin's Room," so that they, too, could bask in its bouncing, healing light.

1992 Mr 6, C3:1

Critic's Choice

A Husband's Memories

In his brave confessional monologue "Time Flies When You're Alive," the popular television actor Paul Linke ("Chips," "Parenthood") tells the true story of his first wife Francesca Draper's heroic losing battle against breast cancer. Adopting the folksy tone of a next-door neighbor, Mr. Linke confides the most intimate details of his life during the 10-year marriage, from his final LSD trip to the home birth of his first child to his tasting of his wife's final tear at the moment she died.

The bulk of the story is about her illness, her desperate pursuit of nontraditional treatments, and how Mr. Linke and the couple's two children (a third was born a year before she died) dealt with the crisis. Although the actor throws in too many show-business references, and the script's moments of comic relief ring a little too pat, the play, which has toured around the country and was shown on Home Box Office four years ago, is still very gripping. One leaves the theater surprisingly uplifted.

"Time Flies When You're Alive" has its final performances this weekend at the Perry Street Theater, at 31 Perry Street, Manhattan. Shows are tonight at 8, tomorrow at 7 and 10 P.M. and Sunday at 3 P.M. Tickets are $20. Box office: (212) 302-6989.

STEPHEN HOLDEN

1992 Mr 6, C3:1

The Other Side of Paradise

By John Kane; directed by Susie Fuller; music composed and produced by Fred Hellerman; costumes by Mary Peterson; lighting by Michael Chybowski; sound by Raymond D. Schilke; vocals by Michael Duffy; stage manager, Deborah Cressler; set decorator, Pearl Broms. Presented by Martin R. Kaufman. At the Kaufman Theater, 534 West 42d Street, Manhattan.

F. Scott Fitzgerald............................ Keir Dullea

By MEL GUSSOW

Although F. Scott Fitzgerald was an embittered man during the last days of his life, he was deeply involved in writing "The Last Tycoon." It was, of course, that unfinished novel and not his patchwork career as a screenwriter that became his Hollywood legacy. Fitzgerald's travail in the movies and how it eventually fed his artistry would seem to provide a rich subject for dramatization. Sadly, John Kane's monodrama, "The Other Side of Paradise," is misguided and superficial.

The play, which opened last night at the Kaufman Theater, reduces Fitzgerald to a burned-out egotist who has lost his adrenalin along with his wit. Loosely stitching together anecdotes from fact and legend, Mr. Kane puts everything into the mouth of the author, who alternately talks to himself and chats awkwardly with the audience. Occasionally there is an evocative story, but nothing the character says or does on stage persuades us that he could have written any of his books. The discredit for the show is shared by the playwright and the actor Keir Dullea, who has rashly decided to go it alone in this slapdash vehicle.

•

Mr. Dullea has an appearance that is approximate to that of the author, but in other respects he is not in tune with the role. As directed by Susie Fuller, he has a manner that is casual to the point of seeming absent-minded. Sloppy delivery and diction cannot be excused by the fact that for half of the play he is supposed to be an alcoholic.

The play is divided into two equally ineffective parts: Fitzgerald's first visit to Hollywood in 1927, when he was the celebrated young author of the recently published "Great Gatsby," and in 1940, as an unemployed screenwriter on the day before he died.

In the first act, not much is happening except for his work on a screenplay for an unfilmed silent movie called "Lipstick," so the character falls back on idle reminiscences. Lounging in his pajamas in a "bungalow next door to Jack Barrymore, the actor," he drops names and name tags while recycling familiar tales of Hollywood. The jazz-age antics of his wife, Zelda, figure prominently, beginning with a story about the couple throwing $100 worth of silver dollars out of a hotel window. When the novelist likes a particular phrase, he rushes to a desk to write it down for posterity.

By the second act, Fitzgerald is out of print, out of work and on the wagon. Alone in Sheilah Graham's apartment, he is writing the sixth chapter of his last book. He coughs like Camille and complains about Ernest Hemingway's description of him as "poor Scott Fitzgerald," a comment that may well arise in a theatergoer's mind while watching this show.

Marc Bryan-Brown/Minetta Lane Theater
Laura Esterman in a scene from "Marvin's Room."

"I am an alchemist with words," says Fitzgerald, and later repeats the claim in case we missed it the first time. One might suggest that in "The Other Side of Paradise," Mr. Kane and Mr. Dullea reverse the process: they turn gold into dross.

1992 Mr 6, C3:5

Visions of Hell, Urban and Garden Varieties

Gleefully sinister, 'Search and Destroy' shoots up the 90's.

In 'Hidden Laughter,' paradise found is then utterly lost.

'M NOT SURE IF THAT'S A SUPER-highway cutting across the stage of the Circle in the Square Theater these days, dividing it neatly in half. It could well be an airport runway. In either case, having "Search and Destroy" unfold on a sleek stretch of macadam couldn't be more appropriate. After all, Howard Korder's darkly compelling comedy is about getting somewhere in life and business, putting scruples behind you, taking off.

The set designer (and road builder) Chris Barreca has also provided just enough fragments of movable scenery — a hotel registration desk, a restaurant booth, the front seat of an automobile — to pin the play down to some real places. But you're always aware of that rolling highway underneath, leading inexorably onward, if not necessarily upward.

In "Search and Destroy," the national motto would no longer seem to be "In God we trust" but "Go for it." The American dream has been downgraded to a nebulous belief in "possibilities," what other ages probably would have called will-o'-the-wisps, and anything that impedes forward motion — the past, obligations, a highway patrolman — is to be disposed of as quickly as possible.

■

Mr. Korder's hero, a failed impresario named Martin Mirkheim, will even discover in his hairpin odyssey across the land that you can shed an identity, too, if it's cumbersome. Mirkheim wants desperately to become a big-time movie producer, although he's had a decidedly small-time career booking polka bands and ice-skating Smurfs in Florida. At the start of the play, the state is even hounding him for $47,956 in back taxes, exclusive of interest and penalties. What does it matter, he tells himself, if you've got an important project lined up, ready to roll. O.K., not lined up. And not ready to roll. It's *thinking* that makes these things so.

This loser is winningly played by a chipmunk named Griffin Dunne, who has trusting eyes, an air of muddled decency and an eagerness bordering on breathlessness. All of that is fated to change as he ricochets from an airport in Dallas to a bus stop in Provo, Utah, from a motel room in Ozone Park, Queens, to the foggy marshes off the Garden State Parkway. In the process, Mr. Korder's

increasingly desperate adventure tale acquires a fascinating tone. Bitterly funny and rather gleefully sinister, it is suspenseful enough in its final minutes to have you inching up to the edge of your seat.

Mr. Korder made an impressive showing a few seasons ago at Lincoln Center with "Boys' Life," the account of three would-be lotharios swashbuckling through a year in the 1980's as if they'd never heard of date rape. "Search and Destroy," which originated in California at the South Coast Repertory, then moved on to the Yale Repertory Theater before coming to Broadway, paints a broader canvas. And the rot runs far deeper. The author continues to write with such dazzling succinctness, however, that the X-acto knife, not the pen, would seem the proper emblem of his trade.

Mirkheim thinks he's structuring a deal when he sets out to track down Dr. Luther Waxling, a late-night television guru, and secure the motion-picture rights to "Daniel Strong," Waxling's novel about the virtues of unbridled striving. For financing, Mirkheim figures he can count on a chance cocktail-party acquaintance, a New York businessman who, from all well-tailored appearances, is in a position to help. Appearances are treacherous, though. Waxling — played by Stephen McHattie in a cool sneer and snake-skin cowboy boots — turns out to be an arrogant fraud. The businessman, in a brilliantly ambiguous performance by Keith Szarabajka, proves undefinable on any ethical or sexual grounds. He looks like a GQ cover boy, but his nicotine-coated voice is eerily reminiscent of the devil's in "The Exorcist." He obviously belongs to the Ivy League of good manners, unless the polished veneer is the expression of a chilling self-control. His eyes are either very dead or very wary. You guess. Mr. Szarabajka isn't telling.

All Mirkheim has to do is put the pieces and the players together and Hollywood will be his. Instead, the pieces crumble and the players sweep him into a nightmare of corruption, drug-dealing and double-dealing that more than justifies one character's observation that the 1990's are "going to be the fear decade." The least threatening of Mr.

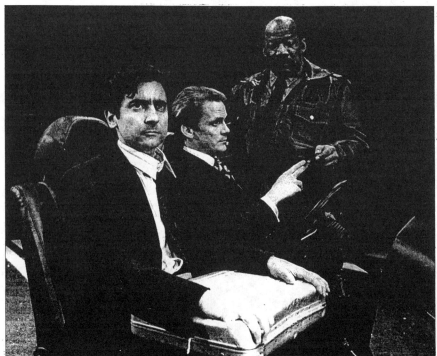

Martha Swope/"Search and Destroy"

Griffin Dunne, Keith Szarabajka and Mike Hodge, standing, in Howard Korder's "Search and Destroy"—Getting somewhere on possibilities and no scruples.

Korder's exploiters and opportunists is Waxling's receptionist (Welker White), but even she insists on describing in nauseating detail her screenplay for a blood-and-guts horror film. Over dinner.

Everyone else is engaged in acts of intimidation, flagrant or covert. They range from Waxling's right-hand man (Gregory Simmons), a Brooks Brothers robot, to Mirkheim's underworld connection (Paul Guilfoyle), a volatile mix of sleaze and violence wrapped in bluff, nonstop chatter. Mr. Korder's plot also manages to embrace the chief of media relations (Thom Sesma) for an aspiring Presidential candidate. In a particularly resonant scene for an election year, Mr. Sesma explains his manipulative campaign strategy with a cocky glibness that is fueled as much by cocaine as by a reckless desire to vault a mediocrity into office. Only the campaign slogan stymies him. "Believe . . . the . . . what," he mutters. "Believe the something. What's good to believe in?"

The director David Chambers knows just how far to let the performances go before they turn into nasty little caricatures of evil. The cast, respecting the boundaries, is uniformly excellent and the staging is a perfect example of climate control. What could be patently lurid remains tantalizing right up to the ironic flip ending. While the production has a lot of the slam-bang zest of a Saturday afternoon movie serial, it has none of the good guy/bad guy polarities. Mr. Korder isn't all that interested in right and wrong, anyway. It's the murky wasteland in between that intrigues him.

◼

The murkiness extends to Chris Parry's lighting, viscous and troubling. Whenever he can, Mr. Parry lights the actors from below, throwing the brightness up in their faces, like an accusation. No illumination is less flattering. Mr. Korder's characters are certainly not nice people. But in this world of blazing headlights, glaring neon and green-glowing dashboards, rarely are they allowed to be pretty people, either.

'Hidden Laughter'

I hope you won't think I'm resorting to a formula here. But the set also says a whole lot about Simon Gray's play "Hidden Laughter," which is currently receiving its American premiere at the Hartford Stage Company in Connecticut. As coincidence and talent would have it, the designer is the same Chris Barreca who's laid down the pavement at Circle in the Square. This time, he's produced an English garden in the full glory of a Devon summer. A natural amphitheater, it rises up to a raggedy hedge and, beyond, a tumble of cumulous clouds in a china-blue sky. On the dappled slopes, clumps of geraniums, phlox and zinnias run riot. Roses scent the air, and a sizable bird population appears to have taken up residence in the trees.

As soon as Harry Pertwee, a London literary agent, and his wife, Louise, an aspiring novelist, lay eyes on it, they sense instantly that they've found their Eden away from home. Eventually, they will baptize the cottage that looks out on the floral splendor Little Paradise. The garden is so idyllic, in fact, that almost before Mr. Gray's characters had caught their breath, I knew they were in for trouble. Paradise usually comes with a snake in the grass and its inhabitants tend to be marked for expulsion.

Simon Gray is ironic, yet not quite a misanthrope.

Indeed, "Hidden Laughter" follows the Pertwees' fortunes for a decade, during which Louise loses herself increasingly in her second-rate novels, Harry throws himself into the arms of a voracious secretary, and Harry's aged father succumbs to guilt and senility. The Pertwees' two young children manage to grow up — Nigel somewhat more conventionally than Natalie, whose rebelliousness leads her to single parenthood in a public housing flat. Mr. Gray describes the various erosions and estrangements with his characteristically ironic wit. He is not quite a misanthrope, but he's never shown much faith in our ability to forge happy, productive lives.

Family tribulations are only part of "Hidden Laughter," however. At the calm center of this observant and steadily absorbing play is Ronnie Chambers (James R. Winker), the village vicar and a man with the spine of a sapling. He's been taking care of the garden out of the goodness of his heart when the Pertwees first meet him. From then on, he'll be taking care of them, too — sharing their confidences, quieting their fears, smoothing over one rough edge after another. He flatters himself that he's part of the family, and even entertains a secret love for young Nigel, but he's more put-upon than trusted, more patsy than pastor.

Not that he admits it to himself, until the play's final moments. Alone in the garden, thrown back into his own sorry life, he's suddenly aware of a ripple of silvery laughter in the trees. It's an echo of the childish delight Nigel and Natalie once took at hide-and-seek — a sound so joyful that, when the doubting vicar first heard it, he was immediately convinced that ". . . there is a spirit. A human spirit, a divine spirit even . . ." that meet sometimes "by accident, if you're lucky. Or a touch dizzy. In an English garden." In light of all that has since transpired, though, the same silvery giggling rings out tauntingly, mocking his sad pretensions to heavenly grace.

If this sounds a bit familiar, it could be because Mr. Gray explored somewhat similar territory a decade ago in "Quartermaine's Terms." That comedy, you may recall, was about a "family" of teachers, instructing foreign students how to speak English. Their lives were falling apart, and they, too, had a habit of turning to a sweet nonentity, St. John Quartermaine, for advice, understanding and a baby sitter. But he really meant no more to them than Chambers does to the Pertwee clan, and when one of the teachers got fired, guess who it was.

At their core, both plays pose exactly the same theatrical problem. How do you find significance in an insignificant creature without making too much or too little of him? Too much, and you've betrayed the character's apparent wishy-washiness. Too little, and the audience is apt to wonder what's the point of watching. It makes for a delicate balancing act. At Hartford Stage, Mr. Winker often appears foolish and ineffectual, and his hair flies off in all directions, rather like a crew cut with no conviction. But he isn't as adept at suggesting the kernels of self-worth and

Judy Geeson and James R. Winker in Mr. Gray's "Hidden Laughter"—A delicate balancing act.

pride, way down deep, that help lend pathos to the character.

∎

Otherwise, the director Mark Lamos has orchestrated a persuasive production that's as attentive to the hairline cracks in a marriage as it is to gaping faults. Judy Geeson gives an unimpeachably honest performance as the wife for whom writing is a lark, then an adventure and finally an obsession allowing her to blot out the unpleasantness of others and her own conflicted emotions. I had no trouble believing Simon Templeman, as the roving husband, or Mark Hammer, who plays his father as a befuddled old walrus. David Alford and Penny Balfour, the children, know what

growing pains are all about. And Jack Stehlin, as a novelist in Pertwee's stable, gives a grand display of artistic temperament, just as Gloria Biegler, as the secretary, contains herself as long as possible, then explodes with startling sexual frenzy.

Unlike his colleague for "Search and Destroy," the lighting designer Stephen Strawbridge has bathed these miserable creatures in the kind of glorious sunshine that makes a body happy just to be alive. That's the final indignity, I suppose. If the weather were at all sympathetic, it would be pouring cats and dogs by the evening's end. ☐

1992 Mr 8, II:5:1

Boitano and Witt Bring Show to the Garden

By ANNA KISSELGOFF

"Brian! Brian!," teen-age girls and matrons scream. North America's newest matinee idol is not a movie actor but an ice skater.

Brian Boitano's technical excellence is beyond reproach. Tossing off perfect triple axels is still like falling off a log for the 1988 Olympic gold medalist. But no one really gets turned on by a revolution in the air. The fan-club squealing responds rather to Mr. Boitano's singular mix of refinement and athleticism; the elbow-swinging all-American jock who

stands revealed in his vulnerability. The romantic image is inescapable.

Mr. Boitano is a genuine star and one would hardly call Katarina Witt, the 1984 and 1988 women's Olympic skating champion, just a starlet. Potent box office, they joined forces for the third successive year, in their new revue, "Chrysler Skating '92," on Friday night at Madison Square Garden. Television has made the duo even more familiar thanks to their spots for commercials or commentaries during the recent Winter Olympics skating coverage.

As singles skaters turned professionals, they have never made a good

pair and their national tour, which ended with this appearance, has finally recognized the individuality of their talent. Images of manufactured romance, still prevalent in last year's show, "Skating II," have been toned down.

Miss Witt's love affair is very much with the audience. Anorexia is nowhere in sight when she turns up in a tight, sequined red bodysuit that accents every curve of her figure to the tune of Cole Porter's "Let's Do It." Her skating remains nonetheless on a highly conventional level. An attempt to take her in a different direction succeeds in a lyrical spiraling solo, "Echoes."

•

Sandra Bezic directed and choreographed the revue with Michael Seibert as associate choreographer. Again, the variety show format does not add up to much but specific numbers stand out, beginning with Mr. Boitano's elegance, polish and humor.

Gary Beacom choreographs his own amazing movement experiment with an outsider characterization. Robert Wagenhoffer, by contrast, pretends to be either redneck or biker. Caryn Kadavy's "Amazing Grace," choreographed by Marina Zoueva, made simple line and projection expressive.

•

Barbara Underhill and Paul Martini succeeded marvelously in "Why'd You Lie?" a sexy combative spoof. Judy Blumberg and Mr. Seibert's "Artistry in Rhythm" was just that in an intricate and elegant red-velvet duet.

Yvonne Gomez, Elena Valova and Oleg Vassiliev, Renée Roca and Gorsha Sur join the rest of the cast in a Cole Porter finale. Skating exhibition or artistic performance? The show never made up its mind.

1992 Mr 9, C11:1

G. Paul Burnett/The New York Times

Brian Boitano and Katarina Witt in "Chrysler Skating '92" at Madison Square Garden.

And

By Roger Rosenblatt; directed by Wynn Handman; set by Kert Lundell; lighting by Brian MacDevitt; production manager, Patrick Heydenburg; production stage manager, Lloyd Davis Jr. Presented by American Place Theater, Mr. Handman, director; Dara Hershman, general manager, at 111 West 46th Street, Manhattan.

WITH: Ron Silver

By MEL GUSSOW

In Roger Rosenblatt's "And," a journalist's fear that a magazine article might be rejected by unknowing editors is treated with the angst that might be reserved for the tragedy of an artist in extremis. The unnamed writer in this case is not a Kafka or a Dostoyevsky, but someone very much like Mr. Rosenblatt, a former essayist for Time magazine, a writer of think pieces and a relentless analyst of his work process and of any paradox that crosses his path.

The last time that Mr. Rosenblatt was in residence at the American Place Theater, he spoke his own lines in a witty stand-up monologue entitled "Free Speech in America." Now he has returned in the guise of a

Meanwhile, will the magazine article be accepted?

playwright, or monodramatist, with Ron Silver as his surrogate. Mr. Silver is a most dramatic and feverishly comic messenger. His virtuosity almost compensates for the work's flaws, but "And" is less a play than an ampersand. As an artistic entity, it is considerably less than "Free Speech in America."

The show begins promisingly with the writer alone in his book-lined study recalling an encounter with admirers who told him, "We love your work," then explained their adulation with words like synergy and self-actualization. Confronted with this response to his journalism, the writer questions its value and his contribution. While ridiculing the pretentiousness of his readers, he falls victim to a synergistic syndrome: he takes himself too seriously.

•

Does anyone care if that magazine article sells, or, if the writer should object to the editing, whether he will be man enough to try to withdraw it from publication? This is about as crucial a question as what kind of cereal to have for breakfast. From the highly ethical stance that Mr. Rosenblatt is striking in this first attempt at playwriting, one might imagine that he has given up the common ground of oat bran in favor of Moral Fiber.

Round and round the character goes, debating the merit of his article (about a prison inmate), excoriating his editors over the telephone and pitying the misunderstood journalist (himself). In a pique, he throws his other magazine articles to the floor, then picks them up and carefully puts them back on the shelf. Self-hate is replaced by wounded pride.

While nagging away at his freelanced wounds, the writer contemplates a stack of blank white paper;

ostensibly his passport to a flight from journalism to Real Writing. He desperately wants to be a novelist. But, like Jack Nicholson in the movie "The Shining," he is all show and no art. Those pages will remain blank reminders of writer's block.

During all this woolgathering, Mr. Silver invigorates the words with his expressive voice and animated body. With the slimmest of support from his playwright, but with encouragement from Wynn Handman as director, he creates a characterization and delivers freely from his actor's art. Changing to a sweatsuit, he returns to his study to do pushups and situps. He parses the lyrics of "Don't Fence Me In," switches to a rap song and follows that with a split, broadening the gymnastic elements of his performance. He savors the effusiveness of literary language and even the laundry list of authors he is called upon to quote (from T. S. to J. D.).

In a frenzy, he shouts to people from his window and blows up at his television set. In the manner of the Peter Finch character in "Network," he is mad as hell and is not going to take it anymore. Mr. Silver never stops talking, and some of the talk is amusing. But just as the character will do anything not to start that novel, the playwright will seemingly take any digression to avoid the hard work of structuring his thoughts into a play. He casts a line to reel in personal and political notes that would have been more appropriate in "Free Speech in America," while appending parentheses and footnotes.

At one juncture, he defines his title: "And," he says, "is the God of words, 'And' tells you there will be something else, an act to follow." Because Mr. Rosenblatt is such an articulate polymath, there should be no doubt that "And" itself is a beginning and that any critical "but" will not deter him from future ventures into the world of Real Writing.

1992 Mr 9, C12:5

Homo Sapien Shuffle

Written and directed by Richard Caliban; music composed and performed by John Hoge; sets, Kyle Chepulis; marionettes and costumes, Yvette Helin; lighting, Brian Aldous; sound, John Huntington; assistant director and production manager, Judy Minor; production stage manager, Paul J. Smith; associate producers, Alexander E. Racolin and Annette Moskowitz; producing director of Cucaracha Theater, Elizabeth J. Theobald. Presented by Cucaracha Theater and the New York Shakespeare Festival. At the Public Theater/Susan Stein Shiva Theater, 425 Lafayette Street, Manhattan.

Wheeler...Vivian Lanko
Moon..Erica Gimpel
Stage Manager.........................Diana Ridoutt
Stagehand..................................Mark Dillahunt
Craven.....................................Martin Donovan
Willa..Sharon Brady
Bernadette.............................Lauren Hamilton
Rocky...................................Glen M. Santiago
Cleo...Mollie O'Mara

By MEL GUSSOW

The intersection of life with chance seems to fascinate Richard Caliban as a playwright and director. In his plays and his productions of plays by other writers, accidents occur that throw widely disparate people into juxtaposition — accidents that prove to be fateful, even fatal. In "Homo Sapien Shuffle," at the Public Theater, a man is killed in full public view in Grand Central Terminal. But he is

not the intended victim. Why was he there, Mr. Caliban asks, and who was meant to die in his place?

Moving backward, he describes the paths that led the participants and onlookers to the homicide. These steps in time are intriguing, in characteristic Caliban fashion, but the play is too convoluted at the center to fulfill its role as a mystery. In it, the playwright is not as artful as he was in his earlier "Rodents and Radios," which more successfully covered the globe in search of character enlightenment.

As "Homo Sapien" (as the playwright spells it) shuffles among its episodes, only one couple consistently piques our curiosity, a professor (Martin Donovan) and an oceanographer (Mollie O'Mara). While he is instantly smitten with her, she remains obsessed with her scientific investigations. She looks at people as if they are marine life, and vice versa. Gradually she emerges from her emotional aquarium and responds to the professor's approaches. Other scenes, like those involving two mental patients, are more obfuscated.

•

What holds one's attention more than the interwoven stories is the manner of the storytelling. Adapting high-tech ideas from movies and television, Mr. Caliban as director creates rhythmic patterns of overlapping scenes. Sleekly sliding platforms glide by on tracks. The effect is like

that in a Hitchcock film, in which a passenger on one train may glimpse a strange event through the window of a passing car. The play is filled with overheard and barely seen vignettes, all of which should, but do not, connect in an interlocking puzzle.

The play is framed by a narrator (Vivian Lanko), who both sets the scenes and manipulates the action. Standing on a parapet over the stage, she becomes a director ex machina, supervising quick cuts and retaking encounters. Behind the drama is a sinister-sounding musical track, written and performed by John Hoge.

One moment seems totally gratuitous, even allowing for the role of happenstance. Toward the end of the play, a skeletal puppet figure suddenly appears, bearing the hologramlike video image of JoAnne Akalaitis. She introduces herself as the artistic director of the New York Shakespeare Festival and says, apropos of nothing, "Trust me." After this odd intrusion, Mr. Caliban turns to a countdown in which the conclusion duplicates the tableau-like murder at the beginning.

The playwright, the composer and the actors are frequent collaborators at the Cucaracha Theater, a downtown company given shelter space at the Public. Chance may have brought these artists together, but, like other actors in a Caliban collage, they share an enigmatic, evocative sensibility.

1992 Mr 10, C12:5

Theater in Review

■ In a group of one-acts, an exuberant depiction of a slumber party ■ Brecht among the tyrants of Hollywood ■ At a French school, a pallid paragon.

Manhattan Class One-Acts

Manhattan Class Company
120 West 28th Street
Manhattan
Through March 21

Presented by Manhattan Class Company, Robert LuPone and Bernard Telsey, executive directors; W. D. Cantler, associate director.
Group, A Therapeutic Moment, written and directed by Ethan Silverman.
WITH: Genie Francis, Karen Evans-Kandel, Sonja Lanzener, Matthew Lewis, Michael Louden and Jacquelyn Reingold.
Mixed Babies, by Oni Faida Lampley; directed by Jennifer Nelson.
WITH: Lisa C. Arrindell, Kathryn Hunter, Sonja Martin, Gwen McGee, Elise Neal and Afia Thomas.
A. M. L., by Ms. Reingold; directed by Brian Mertes.
WITH: Ashley Crow, Calista Flockhart, Michelle Hurd, Robin Morse and Erin Cressida Wilson.
St. Stanislaus Outside the House, by Patrick Breen; directed by Mr. Silverman.
WITH: Danielle DuClos, Seth Gilliam, Jamie Harrold, Portia Johnson and Curtis McClarin.

During the five years in which the Manhattan Class Company has been putting on its annual festival of one-act plays, the company has become known for the uncommonly high quality of its work. And this year it has a winner in Oni Faida Lampley's "Mixed Babies."

It is the early 1970's in Oklahoma City, and five black teen-age girls are frenetically horsing around at a slumber party. When not gyrating to Jackson Five records and arguing about which Jackson brother is the most desirable, they debate ethnic identity, skin color and personal goals in a raw, rough-and-tumble argot.

The five range from the smug, demure Andee (Elise Neal), who slavishly follows the white culture's standards of beauty, to Reva (Kathryn Hunter), who has become enthralled by a book about African life called "Nubian Journey." After much back-and-forth, Reva persuades two of the girls to join her outdoors in performing an elaborate coming-of-age ritual described in the book.

Enacted in the backyard at 4 in the morning, the ceremony becomes a sad little comedy in which bedsheets replace lavish robes and "holy water" is sloshed out of an empty bleach bottle. Yet for Reva the powers of imagination and sheer will triumph over the circumstances, and something magical happens.

Ms. Lampley's dialogue is remarkable for the way it maintains an exuberant comic tone while defining each character and giving her a social and political dimension. And Jennifer Nelson has directed a superb ensemble so that the tone of hysterical teen-age babble never sinks into a

dramatically self-conscious preachiness. Among the program's three other plays, Patrick Breen's "St. Stanislaus Outside the House" is the most theatrically ambitious. On the steps of an East Village church, five flamboyantly punkish misfits conduct a mock Academy Awards contest for best cartoon of all time. The winner by a landslide is "Dumbo." Although the play offers its cast of five some flashy acting opportunities, it is too sentimental by half. The characters may talk in obscenities, but beneath their nihilistic posing they have the hearts of hippie idealists. The most impressive performance is Danielle DuClos's ferocious portrayal of a self-described "homeless, paraplegic lesbian."

The two other plays — Jacquelyn Reingold's "A.M.L." and Ethan Silverman's "Group" — are small, skillfully executed ensemble pieces. Composed of poetically fractured fragments and divided among five actresses, Ms. Reingold's play is a young woman's agonized interior monologue about her relationship with a man who contracts leukemia. "Group" delivers a slice of a group therapy session awash in mean, petty bickering. STEPHEN HOLDEN

Bert Sees the Light

45th Street Theater
354 West 45th Street
Manhattan

Conceived and directed by R. A. White; set designer, Mr. White; lighting designer, Dave Feldman; costume designer, Virginia M. Johnson; general manager, Stephen W. Nebgen; production stage manager, Jill Cordle. Presented by Sito Productions and Mr. Feldman, in association with Gentlemen Productions.
WITH: Jack Black, Molly Bryant and Michael Rivkin.

On the day after the Reichstag fire, Bertolt Brecht fled Germany and spent the next eight years wandering around Europe, "changing countries more often than his shoes," as he once wrote about himself, until he finally landed in Hollywood in 1941. Brecht didn't have any better luck in tinseltown than any of the other literati who tried their hand there, but he stayed until 1947 when the House Committee on Un-American Activities started asking questions about his politics. He promptly caught the next boat back to Europe.

"Bert Sees the Light," a new play by R. A. White, attempts to find some humor in Brecht's exile among the back lots, studio board rooms and hot tubs of wartime Hollywood. (Personally, I'm skeptical there even were hot tubs in the 1940's, but Mr. White sets a scene in one.) The show is a chronology of vignettes that take Brecht from the clutches of Hitler to the grasp of movie moguls, with brief detours through his stormy marriage to the actress Helene Weigel and asides from acquaintances through interviews. The audience sees Brecht struggle, at the behest of a studio executive, to work references to dairy products into the script of "Hangmen Also Die," try to persuade Peter Lorre to act in his rewritten version of "Galileo" and attempt to collaborate on some songs with Abe Burrows (who was no Kurt Weill). The show is described as "kaleidoscopic," but jumble might be more apt since none of it falls together into a coherent pattern.

Mr. White, who has also directed the show, has tried to parody Brecht's own brand of theater, employing such

distancing effects as sung commentary, danced action, announcements to the audience and a sort of puppet stage at the rear to create a sense of disembodiment similar to that of the silver (or home) screen.

Some of this is mildly amusing, but too much of it tries to be more clever than it is. The songs are the best part. One number depicting Brecht's flight from Nazi Germany, in which he dances his way through half a dozen countries, is imaginative, as is another in which Brecht is driven around Hollywood in an open convertible, "a headless horseman in a horseless carriage," as the refrain goes. But the show is more madcap cabaret than serious satire, as though after researching Brecht's years in Hollywood, Mr. White decided it would make a great vehicle for the Marx Brothers.

Jack Black and Michael Rivkin take turns playing Brecht, with the other playing whatever second-banana role each vignette calls for. Molly Bryant plays all the women. The same trio created the roles in a Los Angeles production and their ensemble work is seamless as they energetically whiz from one scene to another and one character to another without a blink. *WILBORN HAMPTON*

The Best of Schools

Ubu Repertory Theater
15 West 28th Street
Manhattan
Through Sunday

By Jean-Marie Besset; translated by Mark O'Donnell; directed by Evan Yionoulis; set design by Karen TenEyck; lighting design, Greg MacPherson; costume design by Anky Frilles; production stage manager, David Waggett; presented by Ubu Repertory Theater, Françoise Kourilsky, artistic director. WITH: Gil Bellows, Jonathan Friedman, Fiona Gallagher, Mira Sorvino, Justin Scott Walker and Danny Zorn.

At the outset of "The Best of Schools," Jean-Marie Besset's bemused detachment from his characters makes one hope for a whole evening of ironic pleasure from the five conceited students at a Paris business school and one street hustler who inhabit this new play. But before long most of these people begin to talk alike — terribly seriously if not with much feeling — about careers, ecology, sex, class and loneliness. Exit irony.

Mr. Besset's play is the first of five recent works scheduled for a festival of French drama being presented by Ubu Repertory Theater, and the cast, under the direction of Evan Yionoulis, gives its best effort.

The action centers on one of three male roommates, Louis Arnault (Gil Bellows). Both female characters and one of his roommates, Paul (Jonathan Friedman), scheme to get in bed with him; and the hustler (Justin Scott Walker) stabs him, but only because he happens to be in the way.

But this paragon is so cold and taciturn that Mr. Bellows has little chance to let us know what makes him magnetic, and the others seem peculiarly inarticulate about this force that changes them. The only person not changed by it is a refreshing presence, the third roommate, Bernard, engagingly portrayed by Danny Zorn as a young man who comprehends the world and its business, but not its inhabitants.

If women are outnumbered two-to-one here, they get the best roles: Fiona Gallagher as a student who loves Paul, pursues Louis Arnault on

a bet, and knows how to vent her outrage at the indifference of both; and Mira Sorvino as a young woman confident that her upper-class breeding will draw Louis Arnault to her in the end no matter what happens, but who, with wonderfully malevolent eyes, battles her rivals for him at every turn. The tension between these two gives this play some life, proving that conflict remains much more dramatic than sex.

D. J. R. BRUCKNER

1992 Mr 11, C15:1

Correction

A brief theater review yesterday about a program of one-act plays at the Manhattan Class Company misidentified the actress who plays a lesbian in Patrick Breen's "St. Stanislaus Outside the House." She is Portia Johnson, not Danielle DuClos.

1992 Mr 12, A3:2

Before It Hits Home

By Cheryl L. West; directed by Tazewell Thompson; set, Loy Arcenas; lighting, Nancy Schertler; costumes, Paul Tazwell; sound, Susan White; production manager, Carol Fishman; production stage manager, James Fitzsimmons; stage manager, Cathleen Wolfe. Presented by Second Stage Theater in association with the New York Shakespeare Festival. At the Public Theater/LuEsther Hall, 425 Lafayette Street, Manhattan.

Wendal	James McDaniel
Simone and Miss Peterson	
	Sharon Washington
Douglas	Keith Randolph Smith
Reba	Yvette Hawkins
Maybelle	Marcella Lowery
Bailey	Frankie R. Faison
Dwayne	James Jason Lilley
Nurse	Carol Honda
Dr. Weinberg	Beth Dixon
Junior	Monti Sharp

By FRANK RICH

If you believe that all theater must succeed as art and art alone, don't even think about seeing "Before It Hits Home," Cheryl L. West's crudely written play about the impact of AIDS on a black Midwestern family.

Predictable in plot and populated by characters who often seem like archetypes instead of people, "Before It Hits Home" is a melodrama that owes its powerful passages, almost all of which occur after intermission, to the quality of its acting and the urgency of its explosive subject. Unlike the transcendent plays born of the epidemic — most recently Terrence McNally's "Lips Together, Teeth Apart," Scott McPherson's "Marvin's Room" and Tony Kushner's "Angels in America" — Ms. West's utilitarian piece is disposable eyewitness journalism, destined to be forgotten the moment AIDS has been eradicated.

But AIDS has not been eradicated, least of all in the inner city, where this play is set. For those who find it

'Before It Hits Home' examines the psychosis of denial.

impossible to shrug off the real world the moment they enter the theater, Act II of "Before It Hits Home" has validity and brute force despite its artlessness, as a raw report from a black war zone that is often invisible to white audiences. When a playwright is crying "Fire!" in a crowded theater with legitimate reason, should one criticize her pronunciation to the extent of disregarding her dire message?

It is only since Magic Johnson's announcement of his H.I.V. infection in November that many black elected officials have begun to speak out about the disease whose death toll is now rising fastest among minorities. In telling the tale of Wendal (James McDaniel), a bisexual jazz musician who returns to his parents' home to die, Ms. West explains this tardiness, deepening an outsider's understanding of the distinctive wall of silence that can surround black AIDS sufferers. "Before It Hits Home," a production of the Second Stage at the Public Theater, is not a play about victimization, predictably indicting either a virus or the white medical and political establishments for the spread of AIDS within the ghetto. It is instead an authentic, at times almost hysterical wake-up call to the black community, sounded from within.

What Ms. West reveals is an isolated, segregated world in which the deadly specter of AIDS, horrible as it is in itself, is compounded exponentially by a mass psychosis of denial. In the play's most tumultuous scenes, Wendal belatedly discloses what his illness is to his mother (Yvette Hawkins) and father (Frankie R. Faison), only to discover that these nominally loving parents respond with abject incredulity and rage. There is simply no place for AIDS in Mom's conservative gospel and Dad's rigid ethos of machismo. To them, the disease simply cannot exist — and therefore need not be fought.

Even Wendal's male lover (Keith Randolph Smith) is afraid to identify himself by name when making a hospital visit and can offer no more solace to his stricken friend than a gift of the book "When Bad Things Happen to Good People." For his part, Wendal is too embarrassed at first to inform his sexual partners about his disease. The evening's most adventurously written interlude finds him inhabiting two bedrooms at once, dissembling simultaneously to both his male and female lovers in a verbal fugue of rising anxiety and lethal irresponsibility.

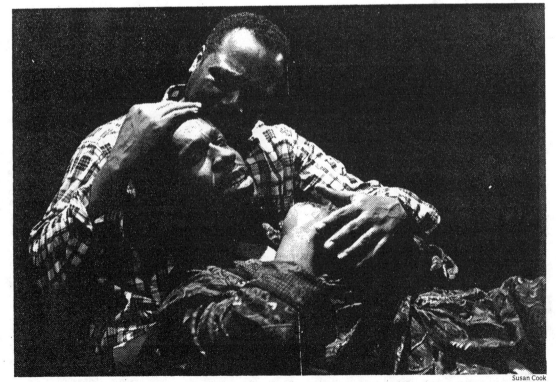

Susan Cook

James McDaniel, foreground, and Frankie R. Faison in Cheryl L. West's "Before It Hits Home."

The less felicitous dramaturgy of "Before It Hits Home" is so blatant, from the plodding exposition of Act I to the sentimental deathbed conversions of Act II, that it hardly need be catalogued here. The director, Tazewell Thompson, tries to dress up the more obvious moments by using Loy Arcenas's evocative black box of a set as a hallucinatory rather than realistic arena in which the yellow spotlight of a jazz club can also symbolize the gyrating blip on a hospital monitor.

It is the actors, though, who invest the roles with an anguish beyond Ms. West's words, particularly Mr. Faison, as a proud patriarch riding for a cruel fall, and Mr. McDaniel, last seen in "Six Degrees of Separation," as a saxophonist whose narcissistic arrogance dissolves inexorably into childlike helplessness as both his mind's and his body's defenses fail him. For some welcome comic relief, Marcella Lowery contributes a giddy turn as a neighbor whose loquacious affection for Wendal's family is tempered by her almost farcical fear of AIDS and her complete ignorance about how it might be spread.

"Before It Hits Home" has been performed in other versions at other theaters, including Arena Stage in Washington, in the last two years. Yet it may be more pressing now than when first conceived. By chance the play arrives at the Public at a time when a campaign commercial by Patrick J. Buchanan manipulates images of gay black men from the film "Tongues Untied" to spread misinformation and whip up bigotry among primary voters.

Given this context, one would like to believe that "Before It Hits Home" could be seen as well in its natural forum of television, where its running time would be compressed, its esthetic failings would be less apparent and, more important, its concerns would attract the widest possible audience. But in the political climate of 1992, is television or any other mass medium so eager to present the drama of AIDS and black America? For the moment, this particular slice of the AIDS story is one that the theater may be in a position to tell best, and that it may yet tell better.

1992 Mr 11, C17:2

Peacetime

By Elaine Berman; directed by Pamela Berlin; set by Edward T. Gianfrancesco; lighting by Craig Evans; costumes by Mimi Maxmen; sound by David Wiggall; choreography by Constance Valis Hill; production stage manager, Karen Moore. Presented by WPA Theater, Kyle Renick, artistic director, Donna Lieberman, managing director, and Capital Repertory Company, Albany, Bruce Bouchard, artistic director, Robert Holley, managing director. At 519 West 23d Street, Manhattan.

Morris Singer...........................Stephen Mailer
Jake Singer.................................Ken Garito
Hyman Singer............................Barry Snider
Frannie Singer.........................Jessica Queller
Adela Singer.........................Suzanne Costallos
Ben Singer..........................Gordon Greenberg
Miriam Greenblatt............................Kelly Wolf
Blossom Goldman.........................Sandra Laub

By MEL GUSSOW

Elaine Berman's "Peacetime" is so old-fashioned that it seems like an artifact of a different time and a vastly different style of theater, an era long before there was television and when Harold Lloyd was playing

in an "eastern western" at the neighborhood theater. Next to "Peacetime," television's "Brooklyn Bridge" might be seen as avant-garde.

In this play at the WPA Theater, a young veteran of World War I comes home to his immigrant family in Manhattan and finds that his future is fraught with obstacles. His lungs have been impaired by poison gas, money is tight and hopes are withering with every second of dialogue. In the background, "Dardanella" is playing on the phonograph. Amid the kitchen-sink clichés, there are unanswered questions.

Surrounded and smothered by his parents and siblings, who seem to crowd every room they are in, the veteran has a dream of starting a laundry (why a laundry?) and of going to the Bronx on weekends in search of romantic adventure (why the Bronx?). To build up her son's strength, his mother takes the doctor's advice and feeds him bacon (why bacon?). This leads to a very broad scene in which everyone in the family has a taste of the forbidden food, except the father. With a twinkle in his eye, he is tempted but prefers to keep kosher.

●

The sentiment is as pervasive as the cabbage cooking on the stove, so much so that after a while one no longer wonders why the veteran wants to go to the Bronx, but when he is going to get there. What gives this period soap opera its interest is Pamela Berlin's atmospheric production and the understated cast, in particular Stephen Mailer in the central role. Mr. Mailer finds the dash and ebullience in this sad, prematurely aged young man. During the war, he has grown so quickly from adolescence to adulthood that he becomes lost and is unable to find his place in a world that has stayed behind.

When we look at things through his eyes, we realize that family love can thwart freedom, his and that of his brothers and sister. As Mr. Mailer finally breaks away, the play moves forward from predictable familial conflicts and heads in a more rewarding dramatic direction, first in a scene with a young female neighbor (Kelly Wolf) who has adored him for years. Their date momentarily lifts the play to a more personalized level. Later, when the protagonist meets an available widow (Sandra Laub), the work takes another dramatic turn. Their relationship is impetuous to the point of being fanciful, but it adds a vivid note to what is otherwise a dreary domestic situation. This is also the case when Mr. Mailer's suave brother (Ken Garito) confesses his own dream of independence. He wants to get a job as a salesman at B. Altman's, one of many names from the distant nostalgic past. These are isolated episodes in a play that is like leafing through someone else's album of family photographs, recognizing the look, the lingering affection and the familiarity.

1992 Mr 12, C21:1

Death and the Maiden

By Ariel Dorfman; directed by Mike Nichols; set by Tony Walton; costumes by Ann Roth; lighting by Jules Fisher; sound by Tom Sorce; production stage manager, Anne Keefe; general manager, Leonard Soloway; associate producers, Hal Luftig, Ron Kastner, Peter Lawrence and Sue MacNair. Presented by Roger Berlind, Gladys Nederlander, Frederick Zollo, in association with Thom Mount and Bonnie Timmerman. At the Brooks Atkinson Theater, 256 West 47th Street, Manhattan.

Paulina Salas....................................Glenn Close
Gerardo Escobar.....................Richard Dreyfuss
Roberto Miranda.......................Gene Hackman

By FRANK RICH

In "Death and the Maiden," the new play at the Brooks Atkinson Theater, the Chilean writer Ariel Dorfman tells the story of a Latin American woman, Paulina Salas, who is thrown together by chance with a man, Dr. Miranda, whom she believes to be the police-state thug who repeatedly raped and tortured her 15 years earlier. Paulina ties up and gags Dr. Miranda in her living room, threatens him with a gun, then puts him on "trial" for his presumed crimes, not the least of which was pumping electric current through her body to the accompaniment of the Schubert quartet that gives Mr. Dorfman's play its double-barreled title.

Given this tale — one born of the author's own experiences as a witness to the horrors of the Pinochet dictatorship in Chile — it is no small feat that the director Mike Nichols has managed to transform "Death and the Maiden" into a fey domestic comedy. But what kind of feat, exactly? History should record that Mr. Nichols has given Broadway its first escapist entertainment about political torture! He has also allowed three terrific actors, welcome recruits to the stage, to practice artistic escapism of their own. Glenn Close (Paulina), Gene Hackman (Dr. Miranda) and Richard Dreyfuss (as Paulina's husband, Gerardo) all display their most charming star personae in lieu of acting, as if they were running for public office instead of animating characters locked in a harrowing struggle for survival.

●

So wide is the gap between the tense, life-and-death tenor of the play's text and the airy, bantering tone of the production that the packed house can only respond (and does) with absolute bewilderment. At the performance I attended, there was a severe coughing epidemic that might signal a public-health crisis were it not for the fact that the symptom was absent at the other plays I've seen this week. As for the laughter, it had a manic sound. The distinguished actors, not to mention the grave events in Mr. Dorfman's script, promise an audience that something of moment will happen onstage. When the drama never comes, theatergoers can hardly be blamed for overresponding to whatever stimulus they can find, even if that consolation amounts to small, bleak jokes incidental to the author's intentions.

Those intentions are not hard to decipher. "Death and the Maiden" is aimed at the jugular and devoid of the magical realism that has distinguished some of Mr. Dorfman's fiction. It's an unpretentious suspense melodrama, as slam-bang in its desired effects as "Wait Until Dark" or "Deathtrap" or even Ms. Close's most successful Hollywood vehicle, "Fatal Attraction." Set in an isolated beach house in a country that has just overthrown its dictator for a fledgling democratic government, the play is meant to keep the audience guessing until (and even past) its denouement. Is Dr. Miranda really the torturer who long ago harmed a blindfolded Paulina, or is Paulina simply indulging a paranoid fantasy symptomatic of the psychological damage caused

by her ordeal? Does Paulina's husband, a human-rights lawyer, try to stop his wife from taking vengeance because he reveres legal justice, as he says, or does he have some hidden agenda?

●

Except for the contrived setup that lands Dr. Miranda in Gerardo and Paulina's house in the first place, "Death and the Maiden" is as tautly constructed as a mousetrap. And it's a mousetrap designed to catch the conscience of an international audience at a historic moment when many more nations than Chile are moving from totalitarian terror to fragile freedom. Underneath the questions in Mr. Dorfman's plot are more urgent ones not unlike those raised by Caryl Churchill's recent drama of post-Ceausescu Romania, "Mad Forest." If the victims of police-state crimes take the law into their own hands, do they sink to the level of their former oppressors and endanger their nation's new prospects for democracy? Yet if they fail to take that revenge, do they invite the historical amnesia that might allow fascism to take root again someday?

Mr. Dorfman does not patly resolve these conundrums any more than he does his plot. What makes "Death and the Maiden" ingenious is his ability to raise such complex issues within a thriller that is full of action and nearly devoid of preaching. But the play cannot say anything whatsoever if the dramatic vehicle for its ideas — the grueling high-stakes war of wills between Paulina and her captive — remains inert.

In Mr. Nichols's production, nothing seems at stake and no character has an ambiguous second or third dimension. Though all three stars are well cast in principle, they all give similarly superficial performances, ingratiating to a fault. Paulina is such a great role that it is hard to understand how an actress as smart, talented and ambitious as Ms. Close could dribble it away. While her cheeks sometimes moisten with tears (in the immaculate Norma Shearer manner), and though she lowers her voice in rage and, more often, raises it to convey vaguely neurotic sarcasm, she is too genteel and controlled to suggest that Paulina might be teetering on the edge of madness or, more important, that she might be a true avenging fury, capable of actually using her gun.

●

Without those intense passions, she can neither move us with her remembrance of her unspeakable suffering nor, at the more primitive, "Jagged Edge" level, keep us guessing about what will happen next. Indeed, there's nothing in Ms. Close's performance here, a few gutteral impersonations of her torturer's obscenities aside, that wouldn't serve equally well the temporarily distraught newlywed of "Barefoot in the Park."

Mr. Hackman, an actor abundantly capable of conveying menace (and most anything else), is a gregarious, good-natured Dr. Miranda who never seems remotely guilty of having been a sadistic Dr. Mengele. In the least important role, Mr. Dreyfuss inherits the evening's laughs by default. When "Death and the Maiden" is stripped of its Costa-Gavras-style suspense, its secondary repartee about Gerardo's sexist treatment of his wife, the most wooden writing in the play, is thrust center stage. Mr. Dreyfuss soon finds himself performing a comic-book version of Torvald in "A Doll's House," driving Ms. Close at

one slapstick juncture to dropping a tray of dishes in a sink.

Although Mr. Nichols's choreography of the action is not dissimilar to that of Lindsay Posner's current and terrifying London production, he makes no effort to replicate its blood-curdling, locked-room atmosphere. This version, unlike that one, is played with an intermission (oddly inserted one scene into Act II) and in mostly bright lighting. Only in the play's coda, which is set before a proscenium-high mirror, does the staging achieve a chill, though the use of that mirror, both here and in London, owes a huge debt to Harold Prince's similar evocation of incipient totalitarianism in "Cabaret."

No doubt Mr. Nichols would argue that his bouncy "Death and the Maiden" is not an incorrect interpretation of the play, just an unorthodox one, in the way that, say, his film version of "Who's Afraid of Virginia Woolf?" offered a funnier though still valid alternative to the Broadway original. But what exactly is the point of his jokey take on a play whose use of the word death in its title is anything but ironic? In this tedious trivialization of Ariel Dorfman's work, even the glamorous beach-house set and heavenly Technicolor lighting seem designed, like everything else, for no purpose greater than gazing at stars.

1992 Mr 18, C15:4

Theater in Review

■ Attending a bar mitzvah where you pay at the
door ■ 'Supper' from Shelley Berman ■ A story
told by the diary of a rescued girl.

Bernie's Bar Mitzvah

24 Karat Club
327 West 44th Street
Manhattan

Written and directed by Howard Perloff; costume design, Dot Liadakis; production stage manager, Terry J. Moore. Presented by Mr. Perloff.
WITH: Ian Bonds, Carolyn Beauchamp, Benjamin Blum, Barney Cohen, Laura Covello, Tiffany Garfinkle, Bob Garman, S. Rachel Herts, Marjorie F. Orman, Louis Levy and Howard Segal.

People go to a bar mitzvah to toast the bar mitzvah boy, but also for the food, the drink and the dancing, all of which are on tap for a price at "Bernie's Bar Mitzvah." In theatrical terms, this simulated affair makes the most minimal contribution, far less, for example, than the long-running "Tony 'n' Tina's Wedding." Those who pay $75 ($85 on Saturdays) to watch Bernie's game of let's pretend may be less concerned with drama than with the question, where's the corned beef?

As written and directed, in a manner of speaking, by Howard Perloff, "Bernie's Bar Mitzvah" would not exist without audience participation. At the same time, it must be admitted that one can not always tell the theatergoers from the professional actors, although the actors are generally those in black tie or sequined dresses (with earrings like glittering bagels).

Bernie (Ian Bonds) is an elfin-looking young man with a ponytail who, like the others in the company, seems to have a familiarity with the customs of the ceremony. The rabbi sounds rabbinical, and the speeches, with one pair of parents trying to upstage the other, could be drawn from life. The attempted verisimilitude of "Bernie's Bar Mitzvah" is one of its troubles. There is no edge to the entertainment, and the moments of conflict, like the sudden introduction of platters of lobster, are contrived.

That leaves the music, a hybrid of Andrew Lloyd Webber and ethnic airs; the dancing (disco, hora and Cossack), and the food, which is a far cry from the menu at yesteryear's "Tamara." A hungry theatergoer is advised to stay with the hors d'oeuvres (smoked salmon and knishes) and forego the main course unless one has a taste for sweetened overcooked chicken. There is an open bar mitzvah bar as a needed inducement.

The only redeeming theatrical value concerns the cast. The event provides work for 29 actors (waiters and carvers as well as members of the families), some of whom trained for audience participation at the wedding of Tony and Tina. Many of them act as if they have real roles to perform, like Tiffany Garfinkle as Bernie's glum sister who, following the script, never smiles, and Linda Jones as the rambunctious housekeeper, who gets to sing "When the Saints Go Marching In." By trying hard, the actors seem to be having a good time, even though it means eating that soggy chicken eight performances a week. For that, they deserve free fitness training and a reduction in their dues from Actors' Equity. *MEL GUSSOW*

First Is Supper

American Jewish Theater
307 West 26th Street
Manhattan

By Shelley Berman; directed by Andre Ernotte; set by James Wolk; costumes by Muriel Stockdale; lighting by Howard Werner; sound by Bruce Ellman; production stage manager, David Horton Black; assistant lighting designer, Laura Manteuffel; associate artistic director, Lonny Price. Presented by the American Jewish Theater, Stanley Brechner, artistic director.
WITH: Barbara Andres, Blaze Autumn Berdahl, Donald Christopher, Louis Falk, Nile Lanning, Patricia Mauceri, Marilyn Salinger and Mark Zimmerman.

Shelley Berman opened his bottom desk drawer and out fell "First Is Supper." How else can one explain the presence onstage of this crudely written self-parody about Jewish family strife in 1919 Chicago? In an interview, Mr. Berman said he began writing the play in the 1960's. One wishes he had resisted the temptation

to complete it, or been more demanding of himself as a playwright.

In the play, life is hard and sentiment is cheap. A shoemaker and his wife live in a tenement with their three children, a retarded little girl, a pregnant elder daughter and a bratty son. The father storms around the apartment ignoring everyone except for his pampered younger daughter, to whom he says, "Come my dark eyes, ride the horsey," as she climbs on his back for a trot around the kitchen. "I know your supper is late, my breadwinner," his wife apologizes.

If all this sounds like a bad translation from another language, that is exactly what it is. Most of the dialogue is supposed to be transliterated Yiddish. When the characters are not banging a proverbial kettle, they are slurping tea loudly from saucers, shouting downstairs to neighbors or insulting a guest who comes to dinner.

Slurp, slurp, shout, shout, the play staggers from cliché to cliché. This is a play that Mr. Berman might have made fun of in his earlier incarnation as a stand-up social satirist. A melodramatic low is reached when the younger daughter leans over a tub of dirty laundry and then, after a blackout, is discovered to have died.

Andre Ernotte, a director of proven capability, allows, or encourages, a number of the actors to overplay their roles. The principal offender is Mark Zimmerman, whose mean-spirited shoemaker would make any sensible relative leave home. To indicate that the family lives in a high-floor walkup, the director has the actors who are entering or exiting retrace their steps in a narrow lane bordering the audience. This stretches the domestic dreariness by at least 20 minutes and puts a particular strain on the son, who spends most of his time walking up and down an imaginary staircase. *MEL GUSSOW*

Opal

Lamb's Theater
130 West 44th Street
Manhattan

By Robert Nassif Lindsey; directed by Scott Harris; musical staging by Janet Watson; set by Peter Harrison; costumes by Michael Bottari and Ron Case; lighting by Don Ehman; musical director, Joshua Rosenblum; assistant scenic designer, Steven E. Johnson; sound by Jim Van Bergen. Presented by Lamb's Theater Company, Carolyn Rossi Copeland, producing director.
WITH: Reed Armstrong, Mimi Bessette, Louisa Flaningam, Mark Goetzinger, Sarah Knapp, Alfred Lakeman, Judy Malloy, Marni Nixon, Tracy Spindler and Pippa Winslow.

In his new musical "Opal," at the Lamb's Theater, Robert Nassif Lindsey has captured the enchanting strangeness of a diary said to have been written by a shipwrecked 7-year-old girl rescued on the coast of Oregon in 1904 and brought up in a lumber camp. Mr. Lindsey's lovely music, and several memorable songs, combined with the odd, French-infused language of the famous diary of Opal Whiteley, draw one into a place of magical transformations.

Many of the book's improbable creatures are here, among them Rubens the pig, Mendelssohn the mouse and Michelangelo the fir tree, a towering tangle of three actors whose limbs the child climbs to reach a shining vision. And the humans with Opaline names as well: the lost Angel Parents, the surrogate Mamma (Louisa Flaningam), the Thought Girl (Pippa Winslow), the Man That Wears Gray Ties (Mark Goetzinger), the Girl That Has No Seeing (Mimi Bessette) and old Sadie the washerwoman (the indomitable Marni Nixon), whose age and wisdom barely disguise the little girl inside her.

The role of Opal is particularly demanding, requiring a child who can not only sing and act, but can use the diary's peculiar language confidently and clearly, as Tracy Spindler did in the performance I attended (Eliza Clark, originally cast as Opal, will return to the cast tomorrow).

This entire cast is strong, and, under Scott Harris's direction, the actors are admirably faithful to the spirit of the diary. They are real adults in a real world, but all seen through one child's eyes: some are witty, some gossipy, some wise, some romantic, all a bit strange; they know disappointment and tragedy, but curiosity, hope and the gift of expecting surprises makes them buoyant.

Carol Rosegg/Martha Swope Associates

Louis Falk and Nile Lanning in Shelley Berman's "First Is Supper," which opened on Sunday at the American Jewish Theater.

Opal Whiteley's diary was first published 72 years ago when its author was in her 20's, and it has had a following ever since. It has also been the center of great controversy, with many literary scholars holding that no child could possibly have written it. The author herself died recently at 95 in a London hospital to which she was committed as an incompetent 50 years ago. She had always insisted she was the daughter of a French prince.

This splendid little musical wisely ignores all that background and presents only the wonderful diary. It is a rare achievement: in some important ways it is better than the book itself. *D. J. R. BRUCKNER*

1992 Mr 18, C17:1

Four Baboons Adoring the Sun

By John Guare; music by Stephen Edwards; directed by Peter Hall; sets, Tony Walton; costumes, Willa Kim; lighting, Richard Pilbrow; sound, Paul Arditti; projections, Wendall K. Harrington; music director, Michael Barrett. Presented by Lincoln Center Theater, André Bishop, artistic director; Bernard Gersten, executive producer. At the Vivian Beaumont Theater, Lincoln Center, 150 West 65th Street, Manhattan.

Eros......................................Eugene Perry
Penny McKenzie................Stockard Channing
Philip McKenzie...................James Naughton
Wayne...................................Wil Horneff
Lyle...Michael Shulman
Sarah.............................Ellen Hamilton Latzen
Teddy..Alex Sobol
Halcy..................................Angela Goethals
Jane...Zoë Taleporos
Peter...John Ross
Robin.............................Kimberly Jean Brown
Roger......................Zachary Phillip Solomon

By FRANK RICH

John Guare's "Six Degrees of Separation" may be best remembered as a post-crash bonfire of the vanities, a savagely funny unmasking of all kinds of Manhattan impostors of the late 1980's. But what made the play moving to me and timeless was its story of one woman's heroic search for authenticity — for love and rebirth — amid all that fraudulence. At evening's end Mr. Guare left us not with satirical laughter but with the image of a sadder but resolute Stockard Channing, in the role of the society wife Ouisa Kittredge, as she yearned to revisit the Sistine Chapel and reach once more toward the hand of God, as she desperately hoped to hold on to the real passion she had briefly tasted in an encounter with a vanished con artist.

"Four Baboons Adoring the Sun," Mr. Guare's new play at the Vivian Beaumont and a fair bet to be the most controversial play of the season, puts the same great actress on the same stage in the same rending, do-or-die quest for some transcendent reason to go on living in a universe where there are too many degrees of separation between any two people. But everything else is wildly different, as if a beloved old folk tale had been set down in the middle of a mad dream. The least of the differences is Ms. Channing's new character, Penny McKenzie, a suburban housewife who has left her husband to marry an old collegiate flame, an archeologist named Philip (James Naughton). The other shifts in the landscape are so dramatic that even before the house lights dim the audience knows it is being shoved into an alien world.

Martha Swope

A scene from John Guare's "Four Baboons Adoring the Sun," with James Naughton, left, Eugene Perry and Stockard Channing.

What greets us upon arrival in Peter Hall's commanding and poetic production is a classical set designed by Tony Walton, a mosaic-flecked disk that oozes smoke from a center-stage opening and is surrounded by mysterious detritus redolent of the Bronze Age. When the play starts, the first character to arrive is Eros (Eugene Perry), an Ariel-like sprite who sings his dialogue to melancholy operatic fragments composed by Stephen Edwards. Though Ms. Channing's reassuringly familiar, contemporary presence emerges soon after in Gap fashions, Mr. Guare removes her from the recognizable social circumstances of Manhattan, strips away all but a few jokes, abandons logical narrative and piles on myths, dreams and hallucinations, not to mention a quasi-Greek chorus of nine tart-tongued American children.

For the audience, it's a take-it-or-leave-it proposition. One either accepts Mr. Guare's reverie on its own exotic terms from the start or is shut out entirely, with no clearly marked route back in. "Four Baboons" is certain to produce what might be called the "Sunday in the Park With George" effect on any row of spectators: some will be dozing at the end of its 80 minutes, others will be actively hostile, others will be sobbing.

I can understand all these points of view, but I can only speak from the perspective of someone who was deeply stirred by this play, not only esthetically by the bold risks of Mr. Guare's experiment but also at a cathartic level by the naked power of what he has to say about the risks of life itself. "Four Baboons" by its very definition demands a personal reaction, one way or another. It is not an intellectual work any more than any fable is. Those tempted to enter Mr. Guare's fantastical adventure need not bone up on mythology or opera or the meaning of antiquity. An open mind will help and so will an open heart. He demands that the audience, like his characters, leap from what the play calls Universe A, that of well-defended adulthood, to Universe B, the imaginative world of childhood to which one hungers to return.

"I'll die if I don't make a change and have love in my life," goes one of Penny's refrains in "Four Baboons." The play's premise is prompted by the making of such a change. Penny and Philip ran off with each other — and have now run to Sicily, where they are conducting an archeological dig at a burial site — because they were tired of being the "same old, same old" people, tired of being like everybody else who ever lived off Exit 4 of the Connecticut Turnpike (in Penny's case) or was trapped in the stultifying academic bureaucracy of a large state university (in Philip's). Turned on by each other and their new freedom, the newlyweds bring the offspring of their previous marriages together for the first time in Italy, hoping that their liberated example will save their children from the drugs and alienation that are the lot of American adolescents.

Of course nothing turns out as planned, and some of the events that happen in "Four Baboons" echo those in "Six Degrees." Brutally articulate children revolt against their parents. Philip and Penny are scandalized by an unorthodox sexual liaison in their household. A starry-eyed teen-age boy leaps through the sky in what may be an accident or a suicide attempt or a spiritual if misguided flight to heaven in emulation of Icarus. A teen-age girl is left inconsolable as she realizes that her idealistic dreams have been mutilated and she has been left a bitter, ordinary adult before her time.

There are more mystical and apocalyptic events, too — when the earth moves in this play, it really moves — but Mr. Guare's tale can only move in one inexorable direction. "Everything dies," sings Eros. "What's the big surprise?" As the mythological heroes whose tales Penny and Philip force on their children come to horrible endings, so in one way or another must the lives of the mere mortals who follow in their. paths. Like "Six Degrees," which had at least three deaths wrapped within its comic plot, "Four Baboons" embraces grief, then rises above it by offering the hope, however frail, of personal resurrection. Penny, like Ouisa, won't be deterred by tragedy from her conviction that her life might somehow be touched by grace, whether through the touch of a human hand or God.

What is technically impressive about "Four Baboons" is Mr. Guare's ability to work out his themes in spare, incantatory and sometimes witty dialogue and metaphorical images that all merge in musical harmony by the final moments. He actually does create a modern mythological realm in which Alitalia Airlines, the Stanhope Hotel and Bellini cocktails can play as large a role as the metamorphoses of ancient legend, in which the cynical realities of present-day divorce can co-exist with an innocent faith in primal magic. As a two-sided Kandinsky painting set the esthetic terms of "Six Degrees," so the titular artwork of this play, a favorite of Penny's and Philip's, dominates its imagery: a mysterious, 4,000-year-old granite sculpture in which four baboons stare into the sun, "their eyes running out of their heads with joy, their eyes burnt out because they've seen their God."

•

Mr. Hall's work in epic theater, both with classics of the stage and of opera, makes him an inspired choice for this piece, and he and his designers (of sounds and projections along with sets, costumes and lighting) have given it the spectacular treatment, part Etruscan, part Magritte, that it demands. Mr. Hall has also done an impressive job with the daunting pack of children, led by Angela Goethals, who has the most adult acting assignment, and Wil Horneff, a boy who is asked to be enchanting and actually is.

As the attractive though somewhat limited Philip, Mr. Naughton conveys the sturdy intelligence and charm one expects. But when his character is severely tested by the fates, the actor rises higher, turning the husband's inability to respond and grow ("I hate emotions!" he shouts) into a pathetic, if not tragic, flaw. As for Ms. Channing, she seems to have become Mr. Guare's muse, as inseparable from his art as the love and loss and grief and hope that are his subject. Only those who hate emotions could be

untouched by the sight of this woman rising from the ashes of unspeakable suffering to face a blinding new day's sun with eyes ablaze in joy.

1992 Mr 19, C15:3

The Master Builder

By Henrik Ibsen; translated by Johan Fillinger; directed by Tony Randall; settings by David Jenkins; costumes, Patricia Zipprodt; lighting by Richard Nelson; sound by T. Richard Fitzgerald; executive producer, Manny Kladitis. Presented by the National Actors Theater, Mr. Randall, founder and artistic director. At the Belasco Theater, 111 West 44th Street, Manhattan.

Kaja Fosli	Maryann Plunkett
Knut Brovik	John Beal
Ragnar Brovik	Pete McRobbie
Halvard Solness	Earle Hyman
Alvine Solness	Lynn Redgrave
Dr. Herdal	Patrick Tull
Hilde Wangel	Madeleine Potter

By FRANK RICH

Some theater companies take years to develop and refine a distinctive style, but the National Actors Theater has accomplished this feat in a single season. The latest example of its signature approach to the classics can be found in its production of "The Master Builder" at the Belasco Theater.

The style might be called the esthetic equivalent of the Heimlich maneuver. The director, whoever he may be, assumes that the classic play at his disposal is near death, or at least thought so by the audience, and must be resuscitated by being pounded out by the actors, with waving arms and often at top volume. If the actors stand in place while declaiming ("The Crucible" and "The Master Builder"), you're at a drama. If they are jumping up and down ("A Little Hotel on the Side"), it's comedy tonight.

•

Though "The Master Builder" is the first of the productions directed by Tony Randall, the company's founder and artistic director — the Playbill lists no previous directing credits for him of any kind in New York — he is already a master of this method. The only way you can distinguish his "Master Builder" from Yossi Yzraely's "Crucible" is by the smaller size of the cast.

Joan Marcus/National Actors Theater
Earle Hyman in Henrik Ibsen's "Master Builder."

Ibsen's plays are not that often given major stagings in New York, and though "The Master Builder" received a decent Roundabout Theater Company reading in 1983, the acclaimed and innovative productions of American directors like Robert Wilson and Mark Lamos and of British directors like Peter Hall and Adrian Noble remain only rumors here. The National Actors Theater "Master Builder," a passionless recital performed on dowdy realistic sets, could set the local Ibsen cause back a decade or two. In place of a psychologically tumultuous, at times mythic drama of an artist's self-inflicted decline and fall is one big slab of solid Norwegian wood.

Earle Hyman can be an interesting character actor, but his performance as Ibsen's autobiographical stand-in, Solness, is, like much of the production, beyond the purview of professional drama criticism. His voice, body and jowls all quivering, he doesn't act the role so much as sing it, often, unaccountably, in falsetto. As Hilde Wangel, the mysterious young woman from the mountains who tempts him to both ecstasy and disaster, the perky Madeleine Potter is miscast, unless one assumes that Solness's erotic tastes run in the direction of the Trapp Family Singers. Among the others, Maryann Plunkett can be applauded for applying her fierce concentration to the small role of the bookkeeper, and Lynn Redgrave can be praised for bringing some genuine feeling (and a hint of a Norwegian tone) to Mrs. Solness, despite being made up to look like Cloris Leachman in Mel Brooks's "Young Frankenstein."

In this "Master Builder," when Solness falls from a great height, it is such an anticlimax that he might as well be stumbling from a footstool. Ms. Potter marks Solness's demise by waving her white shawl not once but three times in a manic windmill gesture that, depending on your point of view, is either the apotheosis of the National Actors Theater style or a desperate plea of S O S.

1992 Mr 20, C3:1

Vinegar Tom

By Caryl Churchill; directed by Marjorie Ballentine; set design, William F. Moser; lighting design, Betsy Finston; stage manager, Ruth Hackett. Presented by Theater Labrador/New Georges. At Westbeth, 151 Bank Street, Manhattan.

Man, Doctor, Bell ringer and Sprenger	Erik Tieze
Alice	Susan Bernfield
Jack	James Rutigliano
Margery	Greer Goodman
Betty	Carolyn Baeumler
Joan	Charlotte Colavin
Susan	Colleen McQuade
Ellen	Deborah Kampmeier
Packer and Kramer	Patrick McCarthy
Goody	Sally Ramirez

By MEL GUSSOW

In "Vinegar Tom," Caryl Churchill set out to write a play about witches that did not have any witches in it, a play, she said, "not about evil, hysteria and possession by the devil, but about poverty, humiliation and prejudice." The result, though not as richly textured as Miss Churchill's most mature work, is fueled by the fierceness of its conviction. As staged by Marjorie Ballentine at Theater Labrador/New Georges, it is provocative theater as well as a conscience-baring feminist document.

The play was written in 1976, the same time that the author was working on "Light Shining in Buckinghamshire," her enlightening exploration of the English civil war of the 17th century. The two plays share a period and a sense of history trampling the individual spirit.

In "Vinegar Tom," that spirit is represented by a group of impover-

Caryl Churchill places feminism in a 17th-century context.

ished women who are victimized by the lowliness of their class and by men of various stations. As one man says early in the play, if a woman is not a wife, a widow or a virgin, then she must be a whore or, as it turns out, worse: a witch.

•

The playwright focuses on the deprivations of the provincial life, the entrapment of the characters and the malevolence of what passes for civil authority. There is never a question of right or wrong, and there is no investigation of the supposed witchery, simply a finger-pointing at the most vulnerable people, beginning with a character named Alice.

She wants to spring loose from her surroundings and find a more rewarding life, but she is forced to remain in the country, where she is repeatedly abused and debased. The play reflects tellingly not only on the witch hunt but also on a number of important women's issues.

Stylistically, this early Churchill play prefigures her later work, alternating realistic scenes in the 17th century with songs in a contemporary mode. The songs themselves are a call to arms.

The show is hortatory to a worthy purpose, to state an argument in dramatic terms in order to make the audience understand that injustice against women is not simply historical but perpetual. At all points the playwright avoids sentimentality and even heroism. These are people fighting for their lives without armaments or hope, not even that of a spiritual survival.

Although the cast is sometimes overemphatic, it echoes the conviction of the writing, compensating for a lack of experience with an intensity of identification. Because the performers are evidently not trained singers, they speak-sing some of the Churchill lyrics. Susan Bernfield's Alice is the stronghearted center of the production, but there are equally limber performances by Deborah Kampmeier and Colleen McQuade, among others.

Performed without an intermission in a rudimentary rustic setting, "Vinegar Tom" rushes to a conclusion in which two theologians haughtily discuss the wages of witchery and the weaknesses of women. In characteristic Churchill fashion, it is a scene deep in irony as these two hypocrites go about their business of filling "moral cavities" wherever they find them.

1992 Mr 21, 14:5

SUNDAY VIEW

'Death and the Maiden' Is a Thriller in Spite of Itself

By DAVID RICHARDS

IT'S BEEN SEVERAL DAYS NOW SINCE I CAUGHT Glenn Close in "Death and the Maiden," but one adjective keeps edging to the forefront of my mind to describe her remarkable performance: glistening.

I've been telling myself there must be other adjectives more appropriate. The actress is playing Paulina Salas, a deeply traumatized woman, who, 15 years after she was raped and tortured in a dictatorship not unlike that of the Chilean general Augusto Pinochet, still starts at the noise of an unfamiliar car chewing up the gravel in the driveway. She is all nerve endings just waiting to scream out. Compounding the old terror, which never went away, is a new terror that somehow, where and when she least expects it, she will lock eyes with her torturer.

Glistening can't be the word I want. And yet there's no denying the evidence on the stage of the Brooks Atkinson Theater. In a role that pushes her very nearly to the breaking point, the lady glistens. She glistens with madness, with sorrow, with righteous fury, and even with a miraculous purity that has survived acts of unspeakable filth and cruelty.

I certainly don't want to minimize the contributions of Richard Dreyfuss and Gene Hackman to this dark and anxious drama by the Chilean writer Ariel Dorfman. I'd hate to imagine it without them. Because the play is impeccably acted, you will be willing to overlook all the obvious carpentry work that has gone into its making.

But it is Ms. Close who will keep you riveted. Light becomes her. It plays off her translucent skin, caresses her soft blond curls and lends a diamond brightness to her

Impeccably acted, Ariel Dorfman's play is about the cost of repression and the tingle of suspense.

eyes the way a shaft of sun will sometimes ignite the far waters of a mountain pond. To look at her, she could be one of those resplendent mothers tenderly cradling a newborn child in a 1920's advertisement for bath soap. So when she stoops to the tactics of her tormentors and spews forth the very obscenities she once had to endure, you can feel the shock waves crashing over the auditorium.

In other days, when the theater eagerly embraced political and social issues, "Death and the Maiden" would probably have been called a thesis play. It is set in a seaside villa in a country — "probably Chile," notes the program — that is beginning to explore the ways of democracy after frightening years of tyranny. Gerardo Escobar (Mr. Dreyfuss), a lawyer, has just been named to a presidential commission to investigate human-rights abuses under the old regime, and while his mandate is severely limited, he views it as an opportunity to establish for the record, at least, the kind of atrocities people like his wife, Paulina, had to suffer.

While returning from the capital, it appears, he had a flat tire. An obliging Samaritan, Roberto Miranda (Mr. Hackman), rescued him from the side of the road and drove him home. Not long after the play begins, Miranda shows up again at the Escobars' door. He'd forgotten to drop off the flat tire earlier. But he has also learned about the lawyer's appointment over the radio and is full of hearty congratulations. Cowering in the shadows, Paulina recognizes him as the doctor who once tortured her to the elegant strains of Schubert's quartet "Death and the Maiden."

And not a whole lot longer after that, she has him bound and gagged in the middle of the living room, and is announcing to her incredulous husband that she is taking justice into her own hands. Only a trial, right there and then, will appease her demons and let her go on living. Two questions immediately arise. Is the doctor the villain she claims? (Since she was blindfolded as a prisoner, she is indicting him on the sound of his

Martha Swope/"Death and the Maiden"

Gene Hackman, Richard Dreyfuss and Glenn Close in "Death and the Maiden"—The most eloquent moments are those that lie beyond words, the heavily charged silences during which two people try to peer to the bottom of each other's soul.

voice and the scent of his skin.) Or is she, as the doctor asserts, "extremely ill, almost prototypically schizoid"? Caught in the middle, with a few dirty secrets of his own to hide, is the husband.

To divulge any more of the plot would be unfair. Mr. Dorfman has some lofty subjects on his mind — among them, the cost of repression, both political and psychological. What, he's wondering, do you have to do to stop violence from begetting retaliation from begetting even more violence? How does a society purge itself of its sins? How does an individual? I dare say similar questions are

being posed in a fair number of countries around the world right now.

Structurally, however, Mr. Dorfman has turned out an old-fashioned Broadway potboiler, not that far removed from such unapologetically devious thrillers as "Deathtrap" or "Sleuth" that manipulate circumstances to produce a surprise or a reversal every 10 minutes or so. The high-mindedness of the playwright's concerns cannot entirely mask the clumsiness of his dramaturgy. We play along, not because we're persuaded life unfolds in this fashion, but because if we accept the premise and overlook the coincidences, if we *agree* to be toyed with, we may be rewarded with the enjoyable tingle of suspense.

∎

No doubt Mr. Dorfman would like us to reflect upon the brutality of dictatorships. But I suspect what concerns us more is whether Ms. Close is going to pull the trigger of the revolver she's holding to Mr. Hackman's temple. "Death and the Maiden" is a throbbing melodrama hiding out in philosopher's robes. No one says "Zounds!" But Paulina does say to her husband, "Oh, my little man, you do fall for every trick in the book, don't you." And he says to her, "Paulina, Paulina. You want to destroy me? Is that what you want?" And the doctor thunders, when the gag is finally removed from his mouth, "This is inexcusable. I will never forgive you as long as I live."

In a less expert production, the breast-thumping rhetoric would be painfully evident. That Mike Nichols manages to grant Mr. Dorfman his soapbox, the actors their passion, the play its contrivances and come up with an often gripping production may be the season's deftest display of directorial tightrope-walking. Mr. Nichols meticulously cultivates each moment for its dramatic value. But he also enfolds the characters in the eeriness of a cold and heartless

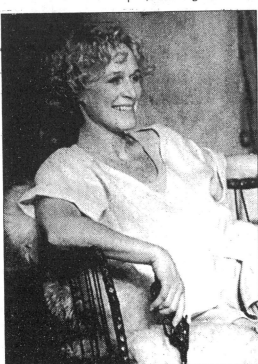
Martha Swope/"Death and the Maiden"

Glenn Close, as a victim, in "Death and the Maiden"—Will she pull the trigger?

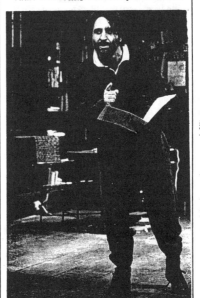
Martha Holmes/"And"

Ron Silver plays a journalist afflicted with writer's block in Roger Rosenblatt's one-man play "And"—A catalogue of symptoms.

dream. The ocean roars mournfully in the distance. Long gauzy drapes twist endlessly in the wind, like restless spirits. Day is milky white, and the night thick enough to repel the headlights of an errant automobile. The set designer Tony Walton has even replaced the stage curtain with a wall of shiny black plastic that, in the play's climactic scene, reflects the audience, making it an unwitting participant in conspiracies.

For two-thirds of the evening, Mr. Hackman is immobilized and able only to communicate with his eyes, which sometimes defiantly proclaim his innocence and other times smolder with the threat of retribution. When he is finally allowed to speak, the actor embraces a snarl as convincingly as a supplication. Even a hard confession, in which he admits to tactics, instruments and the sickening thrill of inflicting pain, may not be what it seems. Mr. Hackman is slippery, unsavory and thoroughly unsettling.

In this apparent battle of goodness and evil, Mr. Dreyfuss represents

Mike Nichols cultivates each moment for its dramatic value, while allowing for just enough ambiguity.

"the voice of civilization," which may mean that he is simply the spirit of compromise and conciliation. He has a case; at some point, the past has to be just that — over and done with. But his willingness to let specific bygones be bygones, as long as they're condemned on general principles, smacks of expedience. Mr. Dreyfuss puts the best possible face on it. He is affable, reasonable, passionately concerned. But his spinelessness may make him the biggest culprit of all.

■

You will come to your own conclusions. Mr. Nichols has allowed for just enough ambiguity so that "Death and the Maiden" is not the open-and-shut affair it could easily be. Indeed, the most eloquent moments are those that lie beyond words — the heavily charged silences during which two people try to peer to the bottom of each other's soul. What they see, perhaps even Mr. Dorfman doesn't know. Just such a moment — two heads turning, a look exchanged, heads turning back — provides the play with its resonant ending.

It seems to me that there is nothing wrong with Broadway that can't be remedied by a director and performers like these, whose box-office appeal is commensurate with their considerable talents. Nor is there anything so squalid and jerry-built in "Death and the Maiden" that Ms.

Close doesn't ultimately redeem it with her magnificent radiance.

'And'

Roger Rosenblatt, the journalist and essayist, has a lively mind, and it's no surprise that his first play, "And" (at the American Place Theater), percolates with lively ideas. However, the most dramatic *event* in this 90-minute monologue — and I don't mean this snidely — is the telephone ringing. Each time it does, your ears instantly prick up. Perhaps now the play will stop spinning its wheels, lock gears and start moving forward.

Mr. Rosenblatt's hero, played by Ron Silver, is not unlike Mr. Rosenblatt himself, apparently — a highly successful magazine journalist who has begun to feel that journalism is not enough and that he should be devoting himself to "the real writing." He's just polished off an essay about a black prisoner serving a life sentence, which he sees as his "bridge piece," leading him out of the drudge of the quotidian into the lofty realm of art. While he's awaiting word from his editor about the article's fate, he takes out a stack of blank paper, sharpens his pencils and prepares to put some enduring words to paper for a change.

They don't come easily. In fact, they don't come at all. "And" turns out to be a fairly exhaustive catalogue of all the things a writer does in order *not* to write — exercise, whine, sip coffee, philosophize, play "I Want to Be Happy" on the piano, reminisce about his youth, rationalize, pace the floor and shout abuse out the window. After about 15 minutes, it has been established beyond an unreasonable doubt: the writer is hopelessly blocked.

Dramatically speaking, that does not leave Mr. Rosenblatt with many options. The pressure can intensify, of course, and the blocked writer can eventually go mad. Accordingly, Mr. Silver throws a couple of fits, not to mention a stack of magazines about his apartment. But he's never so desperate that he can't appreciate the ironies of his situation and articulate them cleverly. He even has relevant quotations from T. S. Eliot and Nietzsche at his fingertips. (Sylvia Plath he can't quite recall.) These are not the actions of a self-destructive man.

If the play is not to cycle round and round all evening long, though, something's got to nudge the writer in one direction or another. That's why the ringing of the telephone assumes such importance. It extends a momentary promise that the equation is going to change, that Mr. Silver, who gives a persuasive although never particularly engaging performance, will have to grapple with more than his own festering malaise. Well, I won't deceive you by saying Ma Bell comes to the rescue. But to the degree that you can hope, she keeps hope alive.

Mr. Rosenblatt's title is taken from his hero's observation that "and" is "chief among words. God of words ... 'And' tells you there will be *something else*: an act to follow, a reprieve, a redemption, another day, another dollar, another love, an after-

glow, an afterlife, and on and on, and more, and more." You see what I mean about lively ideas.

I wish there had been someone as original on the other end of the line.□

1992 Mr 22, II:1:2

─────────

Jake's Women

By Neil Simon; directed by Gene Saks; scenery and costumes by Santo Loquasto; lighting by Tharon Musser; sound by Tom Morse; production supervisor, Peter Lawrence. Presented by Emanuel Azenberg. At the Neil Simon Theater, 250 West 52d Street, Manhattan.

Jake	Alan Alda
Maggie	Helen Shaver
Karen	Brenda Vaccaro
Molly (at 12)	Genia Michaela
Molly (at 21)	Tracy Pollan
Edith	Joyce Van Patten
Julie	Kate Burton
Sheila	Talia Balsam

By FRANK RICH

It is reassuring to know that Neil Simon, battle-scarred veteran of the sexual wars, is as confused as the rest of us: what he still does not know about men and women could probably fill half a dozen plays.

"Jake's Women" is one of them. In this new Simon comedy at the Neil Simon Theater, a successful novelist, played by Alan Alda, wrestles with intimacy, guilt, trust, control and several other buzzwords that have been known to saw through modern American marriages, upper-middle-class, upper-middle-age division. While the effort is painfully sincere and the jargon only slightly out-of-date (the characters seem untouched as yet by "Iron John" and "Backlash"), the insights prove as canned as those in any daytime talk show about men who hate women who love men who hate women. But since Mr. Simon does know more about playwriting and comedy than most mortals, and since a uniformly charming cast is on hand to carry out his theatrical schemes, "Jake's Women" is not without its ancillary amusements.

●

The play is essentially a rueful footnote to "Chapter Two," Mr. Simon's breezy piece of 15 years ago in which a young widower bounces back from mourning with remarkable agility once he meets a new dream girl. The 53-year-old hero of "Jake's Women" also lost his first wife at an early age, but we meet him a decade later as he learns that his second wife, Maggie (Helen Shaver), is halfway out the door after eight years of marriage. What's gone wrong? Both Jake and Maggie stand accused of brief extramarital flings, of workaholism (he writes compulsively, she climbs "the corporate ladder"), of spending too much time apart (three to four months a year). Jake has the added handicap, endemic to writers on stage and screen, of preferring "creative pleasure" at his word processor to real pleasure. "Reality is a bummer," he says.

To cure these ailments, Mr. Simon sends Maggie away on a dramatically convenient six-month separation so that Jake can roam through memories of women he has known, with the hope that he might make an emotional breakthrough and learn to live life instead of merely observe it. As written, however, the hero's confessional monologue often seems to be a series

of observations rather than a spontaneous experience, a manufactured stream of consciousness rather than an honest one. Jake is like the analysand who goes into a session with every revelation, even the most embarrassing anecdotes about Mom, carefully rehearsed and edited, lest any unexpected question or feeling actually emerge. For all his talk about pain and learning to "stand naked," he seems remote.

●

At least Mr. Simon does not misplace his sense of humor; some of the vignettes are quite funny. The boisterous Brenda Vaccaro, who barrels through as Jake's meddling and unattached sister, and Joyce Van Patten, as a therapist with dating woes of her own, are founts of wisecracks, all expertly delivered; one only wishes they had more to do. Mr. Alda also gets some delightful stand-up comedy riffs as Jake stage-manages the play's Pirandellian mixture of real, present-tense scenes, subjective flashbacks and wish-fulfilling fantasies.

The sadder incidents can also be effective self-contained playlets, reminiscent of the melancholy sketches Mr. Simon once shuffled into the comic decks of "Plaza Suite" and "California Suite." Ms. Shaver, a lovely actress with big, sad eyes and a forthright manner, has an affecting bit late in Act I in which she walks out a door a bubbly bride-to-be and re-enters moments later as a disillusioned wife eight years older. An imagined meeting between Jake's smart, college-age daughter and her long-dead mother is both sweet and feisty. Tracy Pollan's sharp intelligence keeps the daughter from lapsing into sentimentality, and Kate Burton, in what may be her long-awaited breakthrough performance, makes Jake's first wife, frozen in time at the age of 21, a magical incarnation of lost youth, the earthiest of ghosts.

Other episodes, whether comic or searching, do not come off so well, including a strained re-enactment of a name-dropping East Hampton cocktail party that opens the play very nervously, and a shrill altercation between Jake and a new fling (well acted by Talia Balsam) that is the major attempt to inject sustained laughter into a rudderless second act. The evening's supposedly cathartic denouement, which features the broadcast of recorded inner voices ("from some deep place I've never been before," says Jake) and the recitation of psychobabble to the accompaniment of easy-listening music, can only be described as bizarre. It's a new-age version of a Señor Wences comedy routine.

●

Those interludes most notably excepted, Gene Saks has directed "Jake's Women" in a refreshingly human key rather than with the hard-sell theatrics that begged for applause at the end of nearly every speech and scene of "Lost in Yonkers." The director has been less successful at commissioning an inviting set from Santo Loquasto. A brilliant designer of period Americana ("Lost in Yonkers" included), Mr. Loquasto gives Jake a SoHo apartment that resembles a duplex suite in a modern chain hotel and surrounds it with brick catacombs and staircases suggesting that the abstract recesses of Jake's psyche resemble an abandoned factory.

It is up to Mr. Alda to set the evening's tone and hold its focus, and he does both jobs most effectively. While there will be few surprises in

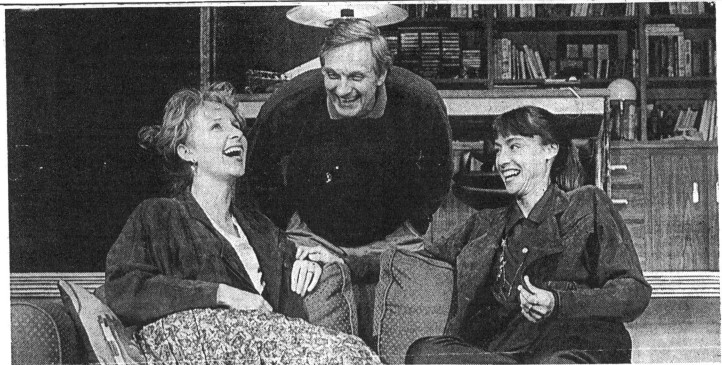

Martha Swope/"Jake's Women"

Kate Burton, left, Alan Alda and Tracy Pollan in the new Neil Simon play, "Jake's Women," directed by Gene Saks at the Neil Simon Theater.

his performance for devotees of "M*A*S*H," his stage skills have in no way atrophied since his Broadway heyday in the 1960's. Addressing the audience almost continuously, Jake could easily wear out a star's stamina and welcome, but Mr. Alda carries his duties lightly, practicing deft

Neil Simon posits a painless cure for what ails battling couples.

comic timing and displaying an old-shoe warmth and sensitivity that never become sanctimonious.

Mr. Simon is not sanctimonious, either, but he does come across as naïve. By the end of "Jake's Women," he has posited that battling married couples can cure what ails them by giving each other some space, cutting back on their workloads, getting in touch with their feelings and banishing their childhood demons by fiat. Is it all that easy, or is Mr. Simon merely desperate for a happy ending? Jake's simple, abrupt resolution of this play's deadlocked marital war recalls Senator George Aiken's memorable prescription for getting the United States out of Vietnam: declare victory and send everyone home.

1992 Mr 25, C17:3

Theater in Review

■ Lies, greed, sexism, murder: nasty things that propel a plot ■ In search of a video-perfect image of itself, a marriage falls apart. Abruptly.

Lovers

Alice's Fourth Floor
432 West 42d Street
Manhattan
Through April 5

By Mario Fratti; directed by Raymond Haigler; set by Edmund A. Lefevre Jr.; lighting by Scott Griffin; costumes by Rodney Munoz; set design associate, Allen Hahn; production stage manager, Janie Schwartz. Presented by the Miranda Theater Company, in association with the Italian Government Institution for Dramatists (E.N.A.P).
With: Susan Egbert, Alexandra Napier, Gwen Torry-Owens and Brian Poteat.

At the outset of "Lovers," a new play by Mario Fratti, a gullible millionaires meets the ex-wife (or third ex-wife, to be precise) of her new boyfriend, Albert, at a movie theater to get the lowdown on him. The ex-wife can't say enough bad about him. The man's failings, in and out of bed, know no bounds. Learning that Albert will get a $1 million a year allowance if he takes the heiress as wife No. 4, ex-wife No. 3 delivers the coup de grace by lying that Albert is a Communist, sending the capitalist fiancée fleeing. As it turns out, Albert is the best thing about the play. He doesn't appear in it at all.

In what is supposed to be a sex-driven murder mystery, "Lovers" tries to be titillating, scintillating and suspenseful and turns out boring, flat and predictable. Somehow in the process it manages to malign both lesbians and old-fashioned male chauvinist pigs alike.

After that opening scene in the movie theater, the action leaps forward a couple of years to find the millionairess, Marisa, married to Eugene, a serious sexist who knows something is amiss when his wife fails to bring him his cocktail and slippers upon his arrival home one evening. Marisa casually informs Eugene that she has a lover (who conveniently lives in the same building and arrives shortly) and that she wants a divorce. Eugene, who is a little slow on the uptake, is the last person in the theater to guess this new lover is a woman.

Eugene surprisingly takes all of this pretty well in stride and when the other woman, Tess, shows up he blithely suggests a ménage à trois as a sensible solution to this domestic dilemma. As it turns out, Tess is packing a pistol in her handbag and not everybody in the cast survives the first act.

There are more twists in the second act, including another murder. In fact, it is a major disappointment that more of the characters aren't killed off, and the only mystery involved is why the play was staged in the first place.

Apart from the incredulity of either the plot or the characters, the performances are never above the level of a beginners' scene-study class. Raymond Haigler directed.

WILBORN HAMPTON

The Wedding Portrait

Kampo Cultural Center
31 Bond Center
Manhattan
Through Sunday

By Gudmundur Steinsson; directed by Rebecca Kreinen; production stage manager, Kathy Shwiff; video by Doug Blum; lighting by Todd Bearden; set by Duane Domutz; costumes by Elly Van Horne; sound by Jim Van Bergen. Presented by Portrait Productions, in association with Franklin Furnace Archive.
With: Peter Galman, Rod C. Hayes 3d, Atli W. Kendall, Paul Kielar, Stacie Linardos, Tracey Osborne, Brenda Smiley, Martha Thompson and Anne B. Wyma.

There's the germ of an interesting theatrical concept in "The Wedding Portrait," a drama by the Icelandic playwright Gudmundur Steinsson that is unaccountably set in contemporary Pennsylvania. Sally and Rick Fenton (Brenda Smiley and Peter Galman), a couple celebrating their 19th wedding anniversary, have allowed a video director and sound technician into their home to tape an "American Family"-style documentary about their lives. Throughout most of the play, the director (Stacie Linardos) and technician (Tracey Osborne) creep silently around the stage shooting the drama, which is shown on six video monitors.

The play begins with a festive dinner party that includes the couple's punkish daughter Judy (Martha Thompson) and a pair of grandparents (Paul Kielar and Anne B. Wyma). The party leads to a surreal re-enactment of the couple's courtship and marriage ceremony for the camera. The next morning, the marriage comes apart in a spasm of mutual recrimination. Before the play ends, one character dies, prompting the observation: "Life's like that. One day we're here, then suddenly we're not!"

Although the stilted translation, which makes everything sound like a bad parody of Strindberg, is partly to blame, "The Wedding Portrait" is

jam-packed with such excruciating dialogue. And the play's insights into the relationship between video technology and people's personal lives suggest the perceptions of someone who just woke up from a 50-year sleep and discovered television.

Realizing that she has videotaped someone dying, the director gasps, "Oh, my God, I filmed death!"

"My films were going to make life better. But life is not a picture: life is a heart that beats!"

STEPHEN HOLDEN

1992 Mr 25, C19:3

The Virgin Molly

By Quincy Long; directed by Sarah Eckhardt; set by George Xenos; lighting by Howard Werner; sound by David Lawson; movement consultant, Rick Sordelet; production stage manager, Matthew Silver. Presented by the Atlantic Theater Company. At 336 West 20th Street, Manhattan.

Pvt. Molly Peterson Robert Bella
The Corporal William Mesnik
The Civilian Todd Weeks
Jones..Kevin Thigpen
The Captain ..Neil Pepe
Harmon...Don Reilly

By MEL GUSSOW

"The Virgin Molly," by Quincy Long, is a military-service comedy with a modern twist, dealing in a capricious manner with a charge of homosexuality in the peacetime United States Marines. At the center of the play is a sweet-tempered Kentuckian whose first name happens to be Molly. That name and aspects of his behavior cause him to become the object of barracks-room derision. As the play begins (at the Atlantic Theater Company), a military investigation is under way but not exactly in progress.

With a tip of his hat to "Catch-22," Mr. Long finds comedy in contradictions, beginning with a captain who is embarrassed at having to express any kind of command. Whatever it is that he is doing, he would prefer not to be doing it.

As the play somersaults from one setup situation to another, the author overtaxes his comic mileage. "The Virgin Molly" is relatively short, but still cannot sustain its premise. It soon descends to absurdity for absurdity's sake, including a running gag in which a new recruit leaps into the barracks followed by his flying suitcase. The flight is funny the first time it occurs, but like other aspects of the play, it suffers from repetition.

What invigorates the writing is the agile company of actors, half of

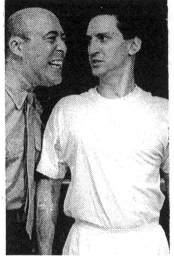
Carol Rosegg/Swope Assoc./"The Virgin Molly"

Privates on Parade William Mesnik and Robert Bella appear in Quincy Long's comedy "The Virgin Molly," about a Marine Corps investigation into a recruit's sexual preference.

whom are Atlantic regulars. Robert Bella finds a freshness in Molly's naïveté, even as he is forced to go through the manual of arms with a mattress substituting for a rifle. William Mesnik is all bark as the tough-talking corporal, and Don Reilly cleverly conceals a questionable character behind a leatherneck exterior.

The play is most amusing in its digressions, especially those concerning the captain (Neil Pepe), who keeps delaying his duties to tell longwinded tales that seem to circle around the subject of animal husbandry. Pigs are very much on his mind. He recalls a friend at law school who kept one as a close personal pet and then went on to become a judge in Sacramento. As the captain pities himself for his own lack of success and the fact that he is mired in the military, the corporal offers the obvious observation: he should have kept a pig.

Sarah Eckhardt has staged the play with a greater regard for the prankish comedy than for military authenticity. George Xenos's bootcamp barracks has the shape of a Quonset hut, and by the end of the play it has a life of its own, as it shakes and swells as if buffeted by an unseen tempest. As in his other comedies, the author almost raises quirkiness to an idiosyncratic art. What he needs is an idea sturdy enough to support his talent.

1992 Mr 27, C3:3

SUNDAY VIEW/David Richards

One Touch of Eros, and Worlds Divide

John Guare's 'Four Baboons Adoring the Sun' is a parable about blind desire.

'The Master Builder' deconstructs.

WE KNOW IT'S NOT NICE TO fool Mother Nature. But it's pretty difficult to upstage her, too.

Witness "Four Baboons Adoring the Sun," John Guare's new play about love and ecstasy in our age of multiple marriages and fractured families. It is set in Sicily, holiday playground of the ancient gods who, apparently, have not entirely abandoned the premises. Strange watery murmurings and clawlike scratchings continue to fill the air, alerting Mr. Guare's characters to the disasters that lie ahead, if they were only of a mind to heed such warnings.

Then, suddenly, murmuring turns to deep rumbling, and the stage of the Vivian Beaumont Theater parts to reveal, along a jagged fault line, the earth's red-hot embers. Clouds of sulfurous white smoke billow upward, while in the background, brimstone and fire rain down on the shaken island. It has taken a quartet of designers — Tony Walton (sets), Richard Pilbrow (lighting), Paul Arditti (sound) and Wendall K. Harrington (projections) — to engineer this eruption. But their work is spectacularly convincing.

Mr. Guare, needless to say, is not interested in special effects merely for their ability to get theatergoers sitting bolt upright in their seats and clutching the armrests. If he's written an earthquake or, for that matter, a boiling volcano into the script, it's because they are natural symbols for the rifts that destroy relationships and the seething passions that mock our rationality. In that respect, there's no denying their appropriateness.

■

But they may, in fact, be too appropriate. The trouble with "Four Baboons" is that its most commanding cataclysms are geological. The human drama, underwritten and sketchy, can't live up to the violence and magic of the locale. The landscape eclipses the creatures who are scrambling over it, drinking in its shimmering sights and absorbing its mysterious vibrations, until the plunge of events sends some of them home to a safe haven in America.

Mr. Guare is nothing if not an original dramatist and, beginning with the title — a reference to a cluster of 4,000-year-old statues — "Four Baboons" attests to his fertile and antic imagination. Although his plot flashes backward and forward in time, it concentrates mainly on three summer days during which Philip McKenzie, an archeologist, and his wife, Penny, set out to save their offspring from the 20th century. Philip (James Naughton) has four children from his first marriage, Penny (Stockard Channing) has five from hers.

Can they pool all nine together and forge a new family, she wonders, not long after the kids have arrived, hot and whining and obstreperous, at the airport in Palermo. At 13, Philip's oldest child, Wayne (Wil Horneff), already has a drinking problem in his past. Penny's oldest, Halcy (Angela Goethals), also 13, has been known to resort to pot to ease her passage through adolescence. Still, Penny and Philip are optimistic. "Children live in a mythic world," he tells himself. "No past. Everything free. Mythic. . . . All adults try to get back to that world."

There are plenty of reasons to question their optimism. For one, the god Eros (Eugene Perry) weaves invisibly in and out of the proceedings, trilling commentary in song, and the very first rhyme out of his gild-

ed mouth is, "The start of another perfect day/ Something will go wrong/ I do not control things/ I simply urge them along." For another, Penny decides, in one of her learning-can-be-fun moods, to give each child a classical name. Wayne is dubbed Icarus, which doesn't bode well. Then, too, none of the children is particularly happy to be on an island with an active volcano, even though Penny hastens to reassure them — with a touch of disturbing symbolism meant for us — that "lava comes from the word Lover."

Under the spell of Eros, the island and their own burgeoning hormones, Wayne and Halcy fall in love and announce to their disapproving parents that they intend to sleep together. The union is not fated to end happily, although the young lovers' flight up to the top of a cliff affords the production some more spectacular moments. I suppose you could describe the play as Mr. Guare's "Equus," in that it prizes the instinctual impulses of a pagan age, rues the cowardice and neuroticism of our own times, and asks how we go about recapturing a sense of wonder and wholeness again. On the other hand, I may be reading meanings into a script that is vague enough to invite a wide range of interpretations.

The playwright has always liked to tell odd stories and that's becoming a real problem. Not the oddness of the stories. But the fact that Mr. Guare is *telling* more and dramatizing less. The failing was already evident in "Six Degrees of Separation," in which a group of sophisticated New Yorkers spent as much time narrating their encounters with a con man who claimed to be Sidney Poitier's son as they did enacting them. In "Four Baboons," the imbalance seems even greater. Penny and Philip have a habit of planting their feet squarely in the sand, facing front and directly informing the audience what is happening, what has happened, what they think about it now and what they thought about it then.

∎

You end up with an abundance of testimony, but not a great deal of dramatic evidence, which is to say scenes. Mr. Guare seems to have adopted the ploys of Story Theater, popular in the late 1960's and early 70's, whereby performers both recounted fables and enacted bits and pieces of them, miming the props when necessary. A lot of ground can be covered that way; time and place present no obstacle that can't be overcome with a transitional phrase. But because the interactions between characters are usually short and swift, you don't get to know them very well. That's precisely what occurs in "Four Baboons." The action, crisply staged by Sir Peter Hall, roams all over the island, jumps back to New York, and takes us up in a jet and lets us peer down into the maw of Mount Etna.

Despite engaging performances by Ms. Channing and Mr. Naughton, however, Penny and Philip never seem more than vaguely well-meaning, vaguely befuddled newlyweds, daunted, as well they might be, by the prospect of having to keep nine children busy, fed and in their respective sleeping bags. Beyond a certain rebelliousness, Halcy and Wayne prove similarly ill defined. Consequently, the tragedy that strikes them is curiously without weight — another anecdote in an anecdotal evening. Eros's final summation is surely meant to be ironic, but he also puts matters firmly in perspective when he sings, "A boy dies/ A love dies/ A family dies/ But everything dies/ You know that/ They know that/ What's the big surprise?"

Well, the surprise in this case, I guess, is the evocative production that has been lavished on such a flimsy play. A circular stage, edged with bits of an old mosaic, serves as the chief acting area. Behind it hovers a huge spherical sculpture that floats in the dancing light like a planet in the cosmos. When Wayne scrambles up its face, followed breathlessly by Halcy, it becomes a relentless wheel of fortune that elevates mortals to the stars only to hurl them implacably into the abyss. Bathed in angry red light, it could be the eye of a malevolent deity.

Mr. Guare's play casts the faintest of spells. But the set could well be enchanted.

'The Master Builder'

If The National Actors Theater were a batter at the plate, it would be headed to the dugout right about now. The first two productions of Tony Randall's troupe — "The Crucible" and "A Little Hotel on the Side" — could be generously described as foul balls. With Henrik Ibsen's "Master Builder," the company fans the breeze. Doesn't even come close.

Just last season the director Mark Lamos put together a troubling and suspenseful production of the 1892

As the wife, Lynn Redgrave portrays a mouse caught between numbing guilt and a crippling sense of duty.

drama at the Hartford Stage Company, so you can't blame the Norwegian playwright for the current debacle, although a number of people seated near me at the Belasco Theater the other night seemed to want to. That's the upsetting legacy of Mr. Randall's high-aiming, low-achieving enterprise: it's beginning to give the classics a rotten name.

Earle Hyman's performance as the title character, an aging architect who fears his creative powers are waning, is full of quixotic line readings that simply defy explanation. The way the actor stretches out his words at times, they could be taffy. Then, for no apparent reason, he's rushing them together so violently as to suggest a pileup of bumper cars. Madeleine Potter is Hilde, the exalted young woman out of the mountains who urges him, as a way of recapturing his former glory, to climb to the top of a steeple and crown it with a wreath. Ms. Potter's voice, as shrill as any dentist's drill, is not made for such seductions, and her petulance is the sort that invites a good spanking.

The supporting cast offers few consolations beyond Lynn Redgrave's tight-lipped portrayal of the master builder's wife, a mouse caught between numbing guilt and a crippling sense of duty.

If Mr. Randall, who directs the production, has any personal insights into Ibsen, he's not sharing them with us. I will say this, though. By the end of the run, there will be no need to dismantle David Jenkins's scenery. It will already have been chewed to bits. □

1992 Mr 29, II:5:1

Conversations With My Father

By Herb Gardner; directed by Daniel Sullivan; set by Tony Walton; costumes by Robert Wojewodski; lighting by Pat Collins; sound by Michael Holten; production stage manager, Warren Crane. Presented by James Walsh. At the Royale Theater, 242 West 45th Street, Manhattan.

Charlie	Tony Shalhoub
Josh	Tony Gillan
Eddie	Judd Hirsch
Gusta	Gordana Rashovich
Zaretsky	David Margulies
Young Joey	Jason Biggs
Hannah Di Blindeh	Marilyn Sokol
Nick	William Biff McGuire
Finney the Book	Peter Gerety
Jimmy Scalso	John Procaccino
Blue	Richard E. Council
Young Charlie	David Krumholtz
Joey	Tony Gillan

By FRANK RICH

"I wish I could tell you that he won my heart in that final chapter, but he did not," a successful novelist named Charlie (Tony Shalhoub) says of his aged father in the waning moments of "Conversations With My Father." That line, at once brutally honest and clinically detached, seems to sum up just what is impressive and what is lacking in Herb Gardner's richly atmospheric new memory play at the Royale Theater.

In Eddie Ross, the immigrant Canal Street bartender played by Judd Hirsch, Mr. Gardner has created, without apologies, a most disagreeable Jewish patriarch. An angry, remote and abusive man who always lives "at the top of his voice and the edge of his nerves," Eddie is found yelling at a baby in his first scene and, a few joyous moments aside, rarely stops barking at all comers for two acts (and his 30 years of stage time) to follow. The sour realism of this portrait is not only uncompromising but is also a brave and unexpected feat from a writer whose "I'm Not Rappaport" offered the most adorable of cantankerous Jewish codgers, also played by Mr. Hirsch.

But if Eddie is too unlovable to win either his son's heart or an audience's by the final chapter, can he arouse any emotion deeper than irritation, whether pity or sorrow or rage? I wish I could tell you that he did, but "Conversations With My Father" may be honest to a fault. Mr. Gardner is so scrupulous about refusing to sentimentalize his title character that he hardly dramatizes him, leaving Eddie a distant figure changed by little but age from start to finish. No doubt that is how this stubborn father was in life, but after putting up with him all night, one hungers for some transcendent insight or conflict or catharsis that might strip him bare and deliver a knockout emotional punch. It says volumes about the evening's shortfall that Mr. Hirsch's two most wrenching moments find him with his back to the audience.

●

Mr. Gardner's play is far more satisfying in other departments, however incidental they sometimes seem to the father-son axis that is ostensibly its focus. Evocatively staged and superbly acted by a large cast, "Conversations With My Father" has some of its author's most flavorful writing. In telling the story of Eddie, Mr. Gardner also wishes to tell the saga of a first generation of American Jews who came of age in the Depression and assimilated at a high price during and after World War II. Although that history is dispiriting, the author's passionate affection for the Old World that Eddie wishes to disown gives the play a lot of warmth and more than a few piquant laughs.

Designed by Tony Walton with a poetic verve worthy of "The Iceman Cometh," Eddie's saloon is an airless den of dark wood whose only consistent source of light is a brightly colored Wurlitzer jukebox. The first music we hear is a holdover from the old country, and as the play is a struggle between father and son, so it also proves to be a struggle between two cultures, as typified by the clashing songs on the jukebox. Eddie is so eager to melt into the melting pot and make big bucks that he gives his bar an "early American" décor, legally changes his family's name and, when all else fails, periodically renames the bar, too, in feeble emulation of the sophisticated uptown clubs he reads about in Walter Winchell's column. Yet the haunting melody of his old identity is not so easily silenced.

That melody prevails in the actual music and prayers of the evening and in Mr. Gardner's re-creation of a vanished Yiddish universe. In a delightful early speech, delivered by Mr. Shalhoub with priceless inflections and timing, sterile American vernacular is compared to Yiddish and found terribly wanting. For further enlightenment, the playwright sends on a little-employed Second Avenue actor named Zaretsky, "a dying man with a dead language and no place to go," who boards with Eddie and his family. In the wry, bantam figure of David Margulies, Zaretsky is a magical repository of his artistic and ethnic heritage, especially in a transporting scene in which he performs excerpts from all his shows, from "Hamlet" to "The Dybbuk," while pulling props from a carpetbag. But he also lugs around a darker history. The old actor never stops reminding Eddie of the past pogroms and the gradually emerging Holocaust that the Americanized bartender would rather ignore.

●

Like the family relationships in this play, Eddie's battle with Zaretsky (and the themes it encapsulates) never comes to a resolution. A related

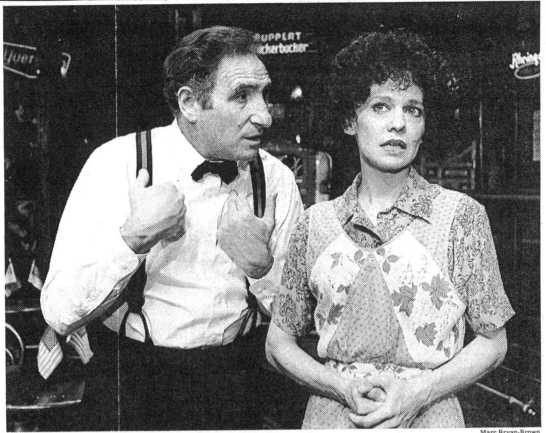
Marc Bryan-Brown

Judd Hirsch and Gordana Rashovich in "Conversations With My Father," at the Royale Theater.

and windy Act I subplot, in which Eddie and his older son, an aspiring pugilist named Joey, both must do battle against anti-Semitic toughs in their own neighborhood, also disappears abruptly. Depending on how you look at it, "Conversations" is either an impressionistic tapestry of flashbacks or an unfinished work that seems to have been hacked up and stitched together arbitrarily in a clumsy editing process. Too many major characters leave without saying goodbye. Too many supporting characters, starting with the various barflies, never amount to more than running gentile gags. Most grievously shortchanged is Eddie's blissfully unassimilated wife, Gusta, who is enlivened more by the actress Gordana Rashovich's radiant humor and frantic eyes than by anything in the text.

The play is directed by Daniel Sullivan with as much skill as he brought to New York's other current, if much different, play about an immigrant Jewish father at war with his heirs, "The Substance of Fire." This production boasts two exceptional performances by children: Jason Biggs, who as the smart older brother recalls the precocious boy played by Barry Gordon in Mr. Gardner's "Thousand Clowns," and David Krumholtz, as the childhood incarnation of Mr. Shalhoub's Charlie. What even a director as deft as Mr. Sullivan cannot disguise are the play's strange dramatic omissions. Although there is a big and effective showdown between Mr. Hirsch and young Mr. Krumholtz, the final confrontation between the father and the grown Charlie proves to be one of the several anticlimaxes that make "Conversations" seem to drift off rather than arrive at a final curtain.

●

Whether this is the playwright's intention or a failure to come fully to terms with his characters is a ques-

tion only he can answer. Either way, he has deprived Mr. Hirsch and Mr. Shalhoub of the payoff scene, that exorcism of personal dybbuks, that Arthur Miller or Neil Simon would have given them in their equivalent family dramas.

The play's many vignettes offer their own opportunities, all perfectly handled by the stars. Even in his few patches of benevolence, the fiercely energetic Mr. Hirsch acts with complete integrity here, never sugarcoating Eddie's bleak view of life as a constant boxing match in which each opponent, within or outside his family, is treated with derision. Mr. Shalhoub, who is onstage continuously,

either narrating or participating in every flashback, conveys wisdom, warmth and humor whether he is looking back with embarrassment at his awkward, horny adolescence or trying as an adult to have one conversation with his father that is not one-sided. It is hard to imagine how Mr. Gardner, or any other playwright, could be blessed with a better stand-in than this actor, who keeps you trusting, admiring and enjoying the storyteller even when you spot the holes in his tale.

1992 Mr 30, C11:3

Theater in Review

■ Man of a thousand (synchronized) voices ■ A

Hollywood spoof by Neil Simon ■ Swedish

mysticism ■ French romanticism.

Lypsinka! A Day in the Life

Perry Street Theater
31 Perry Street
Manhattan
Through April 19

Created and performed by John Epperson, with the Enrico Kuklafraninalli Puppets; directed and choreographed by Michael Leeds; set by James Schuette; costumes, Anthony Wong; lighting, Mark L. McCullough; sound, Mark Bennett and Jim Van Bergen; puppet maker, Randy Carfagno; production stage manager, Kate Broderick; production man-

ager, George Xenos. The Fourth Annual OSolo Mio Festival presented by the New York Theater Workshop, James C. Nicola, artistic director; Nancy Kassak Diekmann, managing director.

John Epperson is the master, or rather the mistress, of the marginal theatrical device of lip-synching. In other words, he can move his lips exactly in time with previously recorded songs and dialogue. This could be the beginning and the end of his new solo show, "Lypsinka! A Day in

the Life," were it not for the underlying commentary on roles imposed by men on women.

As the voices and dresses change in this collage of mimed impressions, the characterizations move barely a millimeter. Without a scorecard or a trivia-graphic memory, a theatergoer may find it difficult to tell one disembodied voice from another. As gathered by Mr. Epperson and as directed by Michael Leeds, the show has a purpose beyond simple simulation. Beneath the seedy glamorization, there is a pastiche of a life created out of cultural detritus.

The opening image is of Doris Day asking her audience never to underestimate a woman's touch. That touch, as demonstrated in this fast-moving one-hour anthology, repeatedly regards woman at a disadvantage, as servant or sex object. One does not want to belabor the point, but it is there and it gives the show some content in spite of its frivolous exterior.

This is especially true in a surrealistic scene in which Mr. Epperson rushes across the stage answering a barrage of imaginary telephones. Each time he picks up a phone a different voice is heard, sometimes simpering, sometimes insistent, from Marilyn Monroe to Bette Davis. Each is an image manufactured to suit public expectations.

The conduit for the message is slender, red-wigged and unflappable. He is also almost expressionless, except for the ability to twist a corner of his mouth in mockery. Though in costume he bears a fleeting resemblance to Lucille Ball, the effect is closer to that of a puppet, a feeling that is encouraged by the ventriloquist-like nature of his performance. Mr. Epperson is, in fact, more adept at being his own puppet than his unseen collaborators are in manipulating the blocklike puppets that appear in other sequences of the show.

James Schuette's picture-book setting and the sound design by Mark Bennett and Jim Van Bergen add atmosphere, especially in the case of the sound, which seems to situate Lypsinka in an echo chamber. The voices resonate as if coming from the screen in an old movie palace.

MEL GUSSOW

Little Me

The York Theater Company
2 East 90th Street
Manhattan
Through April 26

Book by Neil Simon; music by Cy Coleman; lyrics by Carolyn Leigh; based on the novel by Patrick Dennis; directed by Jeffrey B. Moss; sets by James E. Morgan; costumes, Michael Bottari and Ronald Case; lighting, Stuart Duke; technical director, John Miller; production stage manager, Alan Fox; musical director, Leo P. Carusone; choreographer, Barbara Siman. Presented by the York Theater Company, Janet Hayes Walker, producing director; Molly Pickering Grose, managing director, in association with One World Arts Foundation.
WITH: Jo Ann Cunningham, Stephen Joseph, Denise Le Donne, Amelia Prentice, Jonathan Beck Reed, Russ Thacker and Ray Wills.

When a musical has dialogue as funny as Neil Simon's laugh-a-minute book for the 1962 show "Little Me" and songs as catchy as the Cy Coleman-Carolyn Leigh score for that musical, some fun is virtually guar-

Martha Swope/"Lypsinka"

John Epperson performing one of the characterizations in the show "Lypsinka! A Day in the Life."

anteed, no matter how unfocused the production. And in the York Theater's miniaturized revival, Mr. Simon's raucous jokes and such good-natured Coleman-Leigh tunes as "I've Got Your Number" and "Real Live Girl" put over a production that is as spirited as it is raw and every which way.

Based on Patrick Dennis's spoof of a self-serving Hollywood memoir, and set around the time of World War I, "Little Me" chronicles the rise of Belle Poitrine (née Schlumpfert) from Drifter's Row in Twin Jugs, Ill., to movie stardom, riches and social glory. As she ascends, assorted lovers and husbands meet with sudden, untimely demises. The story is narrated by the mature Belle (Jo Ann Cunningham), with the events in her life reenacted by her younger self (Amelia Prentice).

"Little Me" was originally a vehicle for Sid Caesar, who played all of the significant men in Belle's life, from a bogus French music-hall performer to a colossally dumb prince. In the 1982 Broadway revival, those roles were divided between James Coco and Victor Garber. In the York Theater production, most are played by Jonathan Beck Reed.

In this drastically pared-down "Little Me," five actors — Mr. Reed, Stephen Joseph, Denise Le Donne, Russ Thacker and Ray Wills — play more than 50 parts. Mr. Wills's portrayals of a number of minor characters have the most comic subtlety, while Mr. Joseph's crude drag depictions of two female characters are more typical of the production's anything-goes attitude. The frantic donning and shucking of roles helps to give the production, which is directed by Jeffrey B. Moss, the feel of a slapstick revue, a lighthearted satire turned into a goofy musical cartoon in which loose-jointed vaudeville rou-

tines substitute for polished production numbers. The singing doesn't even try to be showstopping.

STEPHEN HOLDEN

Hour of the Lynx

Harold Clurman Theater
412 West 42d Street
Manhattan
Through April 12

By Per Olov Enquist; translated by Kjersti Board; directed by Oeyvind Froeyland; set by Campbell Baird; lighting, Paul Bartlett; costumes, Deborah Rooney; composer, Genji Ito; dramaturge, John Bergstrom; production stage manager, Lillian Ann Slugocki; managing director, James Boglino. Presented by Northern Lights Theater.
WITH: Rob Campbell, Heather Ehlers, Helen Harrelson and Jason Jacobs.

The search for God often leads the mind through dark and mystical territory. In "Hour of the Lynx," a new play by the Swedish writer Per Olov Enquist, a mentally unbalanced young man who murdered the couple who bought his deceased grandfather's farmhouse deifies a cat he was given to care for as an experiment in the asylum in which he is incarcerated.

More a case study than a play, "Hour of the Lynx" takes place during an interview the young man has in his cell with a Church of Sweden pastor and a university student, who is his supervisor in the behavior modification project, after he stabs another inmate and attempts suicide.

Mr. Enquist, who is best known as a co-author of the screenplay for "Pelle the Conqueror," has constructed a history for the young man that makes it almost impossible not to give him one's total sympathy and forget his crimes. Abandoned by his mother, the

boy was raised by an alcoholic grandfather who was an evangelical minister and to whom he used to read stories from back issues of Reader's Digest. After not speaking in the asylum for four years, the young man suddenly begins to talk to the cat he was given. It is not long, of course, before the cat, which he calls Valle after his grandfather, starts talking back.

A lot of undergraduate psychiatry is used to cover the young man's eventual transference of God onto the cat (the cat was never disappointed in him or made him feel guilty). "If nothing makes sense, you'll go mad," he explains at one point. But the play never deals with the question of what happens if the only thing that makes sense is itself madness.

"Hour of the Lynx" hints at incorporating the fantasy, symbolism and irrationality of Strindberg (minus the conventional drawing-room pleasantries) with the mysticism and romanticism of early Bergman films. If it fails as a play, it is an arresting study of a troubled mind.

That it holds the audience's attention is due largely to a strong performance by Rob Campbell as the boy. Mr. Campbell, who recently appeared in Caryl Churchill's "Mad Forest," has the makings of a major acting talent. He keeps a tight rein on the swirl of tortured emotions that are at conflict within the young man, unleashing them only once, with the result that the audience strains to follows his tortured logic, ignoring the fact that most of it is nonsense. By the end Mr. Campbell may convince you that a cat can talk. Neither Helen Harrelson as the pastor nor Heather Ehlers as the student seem to know what to do with themselves much of the time (though Ms. Harrelson at least pretends to listen to the boy); and Oeyvind Froeyland's direction does little to help them.

WILBORN HAMPTON

The White Bear

Ubu Repertory
15 West 28th Street
Manhattan
Through Sunday

By Daniel Besnehard; translated by Stephen J. Vogel; directed by Peter Muste; set by John Brown; lighting, Greg MacPherson; costumes, Carol Ann Pelletier; sound, Phil Lee and David Lawson; production stage manager, David Waggett. Presented by Ubu Repertory Theater, Françoise Kourilsky, artistic director.
WITH: Peter Bretz, Kathryn Rossetter and Nicolette Vajtay.

Love at sea, in more ways than one, is the theme of "The White Bear" by Daniel Besnehard, the second of five new French plays in translation being showcased in a spring festival at the Ubu Repertory Theater.

What is unexpected about this bitter romance is that it is such a traditional, even old-fashioned, story of a triangle. Around the turn of the last century, a widowed Polish countess sailing to New York abandons her topside stateroom to pursue her longing for her estate manager in his third-class cabin.

Dreaming vaguely of a new life in the New World, the two are awakened to several levels of reality at once: from steerage, where a thousand desperate immigrants are huddled; a young, pregnant Jewish woman from Bohemia whose husband has just died finds her way to the estate manager's cabin, ostensibly searching for a needle and thread.

The ensuing rivalry between the two women for a man who is reluctant to be tied to either of them has been told many times, but this version is given passages of intensity by Kathryn Rossetter as the countess and Nicolette Vajtay as the young woman. It is a contest between maturity, which can realize its whims or salve its hurts with money, and youth, which no matter how driven by passion, faces the urgent task of merely surviving. Peter Bretz as the man between is a perfect foil: brooding, defensive, weak, taking refuge in a selfishness that gives him the power of cruelty at key moments.

Peter Muste, the director, and John Brown, the set designer, have given this tale the look and feel of an old movie; people who like film romances of the 1930's will enjoy it. And Phil Lee and David Lawson, the sound designers, have provided at the very end a perfect, sad and amusing little note of punctuation.

D. J. R. BRUCKNER

1992 Ap 1, C16:3

Hamlet

By Shakespeare; directed by Paul Weidner; set by Christopher H. Barreca; costumes by Martin Pakledinaz; lighting by Natasha Katz; sound by Douglas J. Cuomo; fight director, David Leong; production stage manager, Kathy J. Faul. Presented by the Roundabout Theater Company, Todd Haimes, producing director; Gene Feist, founding director. At the Criterion Center Stage Right, 1530 Broadway, at 45th Street.

Bernardo and Fortinbras's Captain	
	James Colby
Franciso	Bruce Faulk
Horatio	Michael Genet
Marcellus	Thomas Schall
Claudius	Michael Cristofer
Laertes	Bill Campbell
Polonius	James Cromwell
Hamlet	Stephen Lang
Gertrude	Kathleen Widdoes
Ophelia	Elizabeth McGovern
Ghost of Hamlet's Father and Player	
King	Robert Hogan
Reynaldo and Priest	Torben Brooks
Rosencrantz	Michael Galardi
Guildenstern	Michaeljohn McGann
Player Queen and Fortinbras	
	David Comstock
Lucianus and Sailor	Bruce Faulk
Gravedigger	John Newton
Osric	Charles E. Gerber

By MEL GUSSOW

As one of our more accomplished and versatile actors, Stephen Lang may be ready for "Hamlet," but "Hamlet" may not be ready for him, at least until he is given more clear-sighted directorial guidance than he receives from Paul Weidner at the Roundabout Theater Company. Although Mr. Lang is always interesting to watch onstage, his restless energy cannot compensate for the imprecision that surrounds him.

The production that opened last night at the Criterion Center is without any sense of a cumulative vision, either in the play or the performances. Mr. Weidner has proven himself to be adept with small-scale contemporary plays, but he is uneasy in his assault on Elsinore. This is the first American "Hamlet" on Broadway in a number of seasons. Regrettably, it is not of a caliber with that of Kevin Kline at the Public Theater or Mark Lamos's version starring Richard Thomas at Hartford Stage, both of which offered compelling insights into the play.

Mr. Weidner's intention may have been to offer a more visceral or at least a more tactile "Hamlet," one

Martha Swope

Stephen Lang rehearsing a scene from "Hamlet" at the Roundabout.

that would capture the attention of an audience not ordinarily inclined to Shakespeare. The result is a production that is overemphatic (while blurring the undercurrents). Histrionics fly high in the mistaken notion that shouting is synonymous with acting. The staging, scenery and costumes are as motley as the company of actors, who, it would seem, are largely left to their individual devices and are overworked when it comes to doubling in roles.

•

The Roundabout "Hamlet" begins with a raucous re-enactment of the battlement scene, which finds Horatio (Michael Genet) barking his lines and sinking to his knees with a thud. Perhaps frightened away by Horatio, Robert Hogan's Ghost remains invisible. When he is finally seen, he is dressed in ragged night clothes and standing in bright light. Later he works his way through a bramble of branches masquerading as the castle garden. There is no sense of mystery in the portrayal of the Ghost or in the production itself.

With all the ranting from others, Mr. Lang's Hamlet at first seems like a calming influence, as he tells us sad tales about his too too sullied flesh. In his beard and mane of blond hair, he looks leonine and is in trim, princely form. But when he sees the Ghost, he topples over as if struck by lightning. There is no lightning here, only unorchestrated thunder.

Playing Hamlet in his mock insane mood, Mr. Lang is instantly transformed into a barefoot bohemian, a madman with twigs in his hair. Has he taken a premature step into the world of King Lear? Soon he is back in basic black and puzzling over how to say "to be or not to be" and not sound like other Hamlets. His solution to this and other soliloquies is to speak conversationally and to append occasional eccentric touches, an approach that shortchanges Shakespeare's poetry. At least Mr. Lang is articulate in his delivery, which is more than can be said for some of the other actors.

Michael Cristofer's Claudius is all bluster and no conviction, and the Players are a third-rate troupe. If they passed a hat after their performance, it would remain empty. Faced with an unresponsive rendition of the Murder of Gonzago, Claudius clutch-

es his stomach as if suffering indigestion. Or perhaps that reaction is intended as an act of theatrical criticism. Even as talented a Shakespearean actress as Kathleen Widdoes, who has played Gertrude before, is moved to raise her voice to be heard over the clamor.

James Cromwell's Polonius is pedestrian, which may be one reason (but no excuse) for Bill Campbell's weightless Laertes; this Laertes might have learned from his father's sanctimonious advice. Among the principals, Elizabeth McGovern is the closest to giving a fully recognizable performance. But she also has her quirks, including a mad scene in which her gown keeps threatening to fall down, and she is victimized by odd directorial choices. When Hamlet tries to hie her to a nunnery, she is crouching on her knees. He drags her by her hands, as if sliding a recalcitrant pet across the floor. Then he does it again.

•

The closet scene is bedless but with chairs, which look like remnants of Mr. Weidner's Roundabout revival of "Pygmalion." A moratorium should be declared on chairs as scenery. Slaying Polonius behind what looks to be a painter's dropcloth, Hamlet clutches his heart as if he might really have regret. But soon he is playing a gamboling game of hide and seek with Claudius, climbing to a perch atop a tall column, the sole reason for this piece of scenery being onstage.

Things improve in the duel between Hamlet and Laertes, with Mr. Campbell rising to Mr. Lang's challenge. Mr. Lang twirls his sword before he plunges skillfully into swordplay. But once the stage is littered with bodies, Fortinbras appears in the person of David Comstock, last seen as the Player Queen. As performed, the scene offers a tepid conclusion to a hugger-mugger production.

1992 Ap 3, C3:1

Steel Men, Dancing Dogs And a Tiger Bandleader

By JENNIFER DUNNING

The Mongolians have come, have been seen and have conquered. That much was obvious on Thursday afternoon when those snarling titans of New York City subway poster fame materialized in a triple-ring grand finale of the Ringling Brothers and Barnum & Bailey Circus at Madison Square Garden.

There were pretty, rubber-spined contortionists; hurtling tumblers for whom the human body was clearly just a handy projectile, and men-of-steel hefting and lobbing heavy steel balls and barbells without a grunt or hint of perspiration. Best of all was the closing equestrian number, in which exquisite, sleek horses raced into and out of the center ring, galloping full speed with riders upright, hanging upside down, clinging sideways and even dragged behind them. One of the riders was a young boy who leaped on and off the charging horses with all the skill of his beaming elders.

A white horse got loose, knocking over an attendant and driving riders from the ring as they attempted to subdue the animal. A gentle female equestrian with a golden silk bridal did the trick at last, with a little help from some soothing music. Has a

Tony Award for best actor ever been given to a horse?

It was the best kind of old-style circus performing. And in general this year's show is a good deal less glitzy than usual. A bow is made to

A Mongolian troupe with an array of other acts.

the teen-agers in the audience with NMotion, a trio of tousled, earringed lads who might have been assembled by a computer graphics expert. But there were a good many engaging animal acts.

•

Lloyd's Old English Sheep Dogs featured a battalion of barking canines and a kilted, shaggy-haired human foil named Juan Paul Rodrigues. Eric Adams put a crowd of clever performing poodles of all sizes through their paces, accompanied by a tiny, irrepressible dancing mutt. Ponies just slightly bigger cavorted

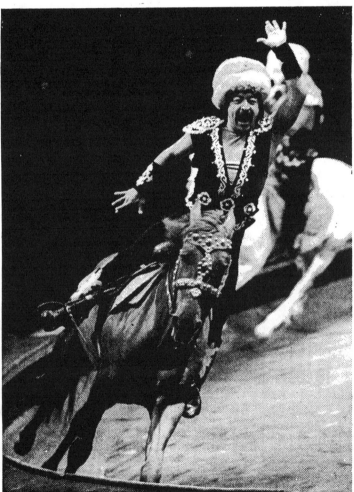

Ringling Brothers and Barnum & Bailey Circus

A Qorchin rider from Kazakhstan performing in the 122d edition of the Ringling Brothers and Barnum & Bailey Circus.

with their larger equine friends through a horse act overseen by Bernice Collins, a circus trainer who would look equally at home on a fashion show runway.

There were wise-eyed elephants, too, their backs providing a relatively secure base of operations for the acrobatics of the Gautier brothers, sixth-generation circus performers, and the Pivarals from Guatemala. The mighty King Tusk occupied center ring, sporting curling ivory tusks over six feet long. Wade Burck coaxed a large, sleepy tiger to climb on a slow-turning mirror ball to conduct the circus band, a task the animal could be glimpsed practicing with his large velvety paws throughout the act.

A high-wire act by the Mednikovs, from the Moscow State Circus, was almost too frightening to watch. There were slightly more reassuring aerial high jinks from the Mouratovs, the Panteleenkos and the Marinofs. The Nimble Nijinas of the Shanghai Wushu Group lived up to their name in a rapid-fire drill that would be a hit on the downtown performance art circuit. The Fausto Scorpions of the Philippines were genial good sports in an audience-volunteer sequence as well as deft and ingenious acrobats.

And last but never least, there were the famed — some might say notorious — Ringling Brothers and Barnum & Bailey prankster clowns in an "overtaxed taxi" act that was a sly send-up of life in a big city. A sloppy "rolling in dough" routine was a 4-year-old's delight, and there were sympathetic groans from a few women in the audience during a chase scene featuring a stork and a very pregnant mother pushing a carriage loaded with babies.

The Mongolian performers included the Boldbaatar, Beisembetov and Amarjargals acrobatic ensembles, the Qorchin riders, performers from the national School of Folk Dance and the contortionists Enkhtsetseg and Otgontsetseg; Indarma, who performed with white doves, and Indra.

Jim Ragona was the ringmaster. This 122d edition of the circus was staged by Walter Painter. It will run through May 3 at the Garden.

1992 Ap 4, 13:1

Red Diaper Baby

Written and performed by Josh Kornbluth; directed by Joshua Mostel; set, Randy Benjamin; lighting, Pat Dignan; costumes, Susan Lyall; sound, Aural Fixation. Presented by Second Stage Theater, Robyn Goodman and Carole Rothman, artistic directors. At the McGinn/Cazale Theater, 2161 Broadway, at 76th Street, Manhattan.

By MEL GUSSOW

Josh Kornbluth begins his one-man show "Red Diaper Baby" by announcing that his father was a Communist who believed in the overthrow of the United States Government and assumed that his son would lead the revolution. This means that the author was the reddest of the children of the leftist brigade. But seeing him onstage at Second Stage, one knows that he would be one of the last people to lead any march. Mild-mannered and self-effacing, he quickly learned how to duck for cover and avoid his father's wrath. Now, as an adult, he has become nostalgic about his fam-

ily's political past: about the fact, for example, that his father would awaken him in the morning by singing "Arise, ye prisoners of starvation" at the top of his voice.

What defines the storyteller is his upbringing amid soapbox orators and folk singers who vied for the floor at every party. The milieu is akin to that in Michael Weller's "Spoils of War." As the earthy father bullies everyone in sight, one realizes that there is material here for a play as well as a monodrama, about an impossible parent as seen by a forgiving son. From the first, Mr. Kornbluth seems to have an intuitive sense that his father and his friends cannot help themselves, whether they are liberating a Paul Robeson record from the public library or playing a Marxist dialectic version of Monopoly (in which everyone wants to go to jail).

As long as Mr. Kornbluth concentrates on Communism, his show retains its unusual perspective and offbeat humor, especially at this moment in history after the disintegration of the Soviet Union. As a performer of his own work, Mr. Kornbluth has an amiable personality, and the director, Joshua Mostel, gives "Red Diaper Baby" both movement and variety. But this loosely episodic

An American generation saw the Soviet Union as the promised land.

monologue wanders back and forth in the author's autobiography, often touching very familiar ground, beginning with his reflections on his first sexual experience.

The effect is similar to that of having a one-way conversation with a stranger who is unable to identify his best material and sometimes undercuts a story with flat imagery, as in his comment about a young woman he likes: "She looked like an ad for something nice." The show's meandering quality contrasts with the precision of a monologuist like Spalding Gray.

Eventually, the son takes a trip to "the promised land," which for the Kornbluths is the Soviet Union, in the days when some regarded it as the Evil Empire. Having learned Russian so that he can speak with the natives, he is disillusioned to find an apolitical aura extends from the Americans on his tour (socialites rather than socialists) to the Soviet students he encounters. The Soviet people are obsessed with all things American, blue jeans as well as John Denver records.

After excisable digressions, Mr. Kornbluth returns to the central issue, the radicalization of the family by his father. In a touching threnody, the son responds to his father's death by marching out of the funeral service singing a remembered song of protest.

1992 Ap 5, 53:5

Jake Writes to Survive, but Is That Enough?

It follows that in 'Jake's Women,' Neil Simon would now face up to the central dilemma of his adult life.

ERE'S WHAT I LIKED BEST about "Jake's Women," Neil Simon's new play: Jake's women. Jake, I had some problems with. No offense to Alan Alda, who portrays the 53-year-old writer in the grips of a midlife crisis.

But frankly, how can you resist Kate Burton, full cheeked and strawberry fresh, as Jake's first wife, Julie, bounding on stage as if she'd just been let loose in a summer pasture, her eyes every bit as bright as her voice? Although Julie has been dead for a decade and is only a remembrance in Jake's head, Ms. Burton is so flush with vitality, so primed for joyful encounters, as to explain the persistence of happy memories.

Or take Brenda Vaccaro, who plays Jake's divorced sister, Karen. Forthright as a jeep — sounding like one, too — Ms. Vaccaro is what they used to mean by a good-natured broad, before the noun was drummed from respectable vocabularies for being sexist. Her heart is big. So are her hips — the better to shoot from. If you don't want her opinion, you're going to get it anyway. Ms. Vaccaro is a one-woman stampede, and she has a great time barreling through Mr. Simon's play.

■

And let's not overlook Joyce Van Patten, crossing her legs neatly and vowing not to lose her professional cool, even though, as Jake's analyst, she's probably pointed out his hang-ups hundreds of times and will continue to do so at least a hundred times more. That she's clearly on Jake's side doesn't prevent her from being wry crisp. Jake may make her his straight woman, but you can tell from the smart tilt of her head and the firm set of her thin lips that she'll never be his patsy.

In all, Jake is surrounded by seven women of various shapes, temperaments and ages. Some are real, others figments of his imagination. From the evidence on the stage of the Neil Simon Theater, any man would be fortunate to know and love them. Jake, however, holds them at arm's length. Jake holds the world at arm's length. Jake is no damned good at intimacy. And therein lies the crux of the play, Mr. Simon's 28th for Broadway.

Mr. Alda, a warmly rumpled trouper, puts the best possible spin on a character who'd rather observe his life than live it. Events may be driving him round the bend and deep into a fantasy world, but he never relinquishes an easygoing decency. What would be rampaging ego in others seems merely an excess of sensitivity in him. Anger can't entirely mask his gentleness. If I were going to

bare my soul on a stage, which Mr. Simon has apparently chosen to do, I'd certainly want the actor for my stand-in.

But Jake may be too obsessive, too self-absorbed for even Mr. Alda to redeem completely. For long stretches, the writing is awash in unrelieved confession. Mr. Simon's way with a self-deflating quip appears to have deserted him this time. In what may be the evening's cruelest irony, the playwright's soul-searching alter ego is upstaged at every turn by the women who complicate his days and his daydreams.

At the play's start, Maggie (Helen Shaver), Jake's sleek, successful second wife, is preparing to pull the plug on their marriage and walk out the door. He continues to be preoccupied by Julie's death, guilt having supplanted grief long ago. And somewhere way back in the past lurks a scolding mother, who's still got her nails in him. Jake likes none of this and when he doesn't like things, his instinctive reflex is to step back and rewrite them.

About half of "Jake's Women" takes place in the SoHo apartment he calls home. The other half unfolds in the sanctuary of his mind, into which he has always retreated whenever the going gets rough. Now he's beginning to wonder if he hasn't just avoided existence. Has the typewriter been as much a curse as a salvation?

If "Jake's Women" is one of the most rigorously honest plays Mr. Simon has yet turned out, it is, paradoxically, one of the least engaging. I have no doubt that Broadway historians, 50 years hence, will consider it essential to an understanding of the playwright. Jake is telling us something insightful about Neil Simon when he says: "I don't observe because I choose to. I'm not alone because I prefer it. I'm not a writer because I'm good at it. I write to survive. It's the only thing that doesn't reject me. My characters are the only ones I know who love me unconditionally, because I give them life."

Theatergoers, less concerned with the inner workings of Mr. Simon's mind than with a night's entertainment, however, may find such revelations an unsatisfactory payoff for their time and attention. Having set up a premise that promises Pirandellian complications — or at least a few Walter Mittyesque confusions — the playwright largely fails to follow through. Jake's inner and outer worlds are distressingly similar.

Oh, Jake may claim he's going crazy, but the distortions of madness, fury or frustration are nowhere reflected in the scenes that transpire in his mind. What Jake imagines is stylistically no different from what he lives. The characters in his head are apt to say nicer, more flattering things to him, but they behave pretty much as do their real-life counterparts. The playwright has simply put two sitcoms up on the stage, side by side. The overlapping is minimal and what interaction there is is fairly predictable. In the second act, Jake has a spirited argument with Maggie, the imaginary version, while entertaining Sheila (Talia Balsam), a flesh-and-blood date, who thinks the nasty remarks are directed at her and eventually runs screaming from the room. Somehow, we expect more originality from Mr. Simon than pale shades of "Blithe Spirit."

Fortunately, we get it later in the second act, when the playwright totally divests himself of logic and lets his fancy soar. Julie has a favor to ask of Jake. She died in a car accident when their daughter, Molly, was a child, and she'd love to see her offspring grown up. Jake can do it for her, she pleads, with that girlish enthusiasm he never could resist. If only he'll think of them both, mother and daughter can have a reunion in his mind.

It makes for a touching scene of discovery, delicately played by Ms. Burton and Tracy Pollan under the benevolent gaze of Mr. Alda. That benevolence, in fact, infuses the encounter with a lovely sadness. Jake, after all, is looking at a happiness he never enjoyed, a family he never had, an emotional freedom he has yet to possess.

"Am I the only one who's ever done this?" he asks the audience, canvassing for allies. "I don't think so. There's not one of you who hasn't thought, at 3 o'clock in the morning staring up at a ceiling, of what it would be like to talk to your father who died 5 or 20 years ago. Would he look the same? Would you still be his little girl? ... You've played that scene out. We *all* do it ... My problem is I never *stop* doing it."

Mr. Simon wasn't writing that confidentially 20 years ago.

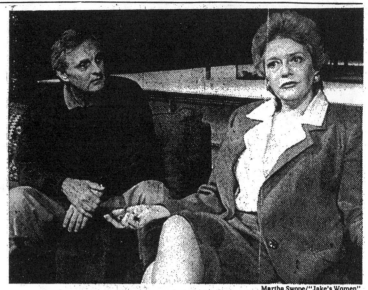

Martha Swope/"Jake's Women"

Alan Alda and Joyce Van Patten in "Jake's Women"—Jake may make her his straight woman, but she'll never be his patsy.

For the most part, though, "Jake's Women" is content to discuss the phenomenon of the writer/observer — whom the playwright once dubbed "this two-headed monster." It doesn't exploit the duality in theatrical terms. The shortcoming extends to Santo Loquasto's apartment set, tucked into a corner of what appears to be an empty warehouse but is

Alan Alda puts the best possible spin on a character who'd rather observe life than live it.

supposed to represent the inside of Jake's head. (Pretty desolate head.) The director Gene Saks draws so few distinctions between reality and imagination that going from one to the other is a bit like crossing from North to South Dakota. Tharon Musser's lighting, brightening visibly whenever Jake comes back to earth, offers the best clue as to what's going on. The play, substantially rewritten since an abortive tryout two years ago in San Diego, still isn't right. But this production doesn't make it any righter.

And yet, if you are willing to take the long view, "Jake's Women" does suggest an important evolution. From the outset of his career with "Come Blow Your Horn" in 1961, the playwright's inspiration has often been autobiographical, although by the time autobiography had been fully processed for the stage, only general outlines and odd details remained. Over the last decade or so in such plays as "Broadway Bound," "Biloxi Blues" and "Brighton Beach Memoirs," Mr. Simon has revealed more of what truly happened. More to the point, he has allowed his own feelings to color and shape his work. Quick, glib comedies have given way

to darker, more resonant comedy-dramas.

Even a play like last season's "Lost in Yonkers," which had very little factual truth in it, was emotionally autobiographical in its depiction of the traumas that come from growing up in a dysfunctional family.

It only follows that Mr. Simon would now face up to the central dilemma of his adult life. As a writer, he can make his characters do his bidding. He is in control. Secure. But as a human being, he is increasingly prey to chaos. People abandon him. Destiny goes its not-so-merry way. By making that realization — the anguish of that realization — his subject, Mr. Simon is venturing into fruitful new territory.

"I feel I'm trying to put together a jigsaw puzzle that has no picture on it," a bewildered Jake says at one point. That Mr. Simon, 64 and at the height of his success, is also trying to do as much attests to courage beyond the usual call of Broadway. ☐

1992 Ap 5, II:5:1

'Tis Pity She's a Whore

By John Ford; directed by JoAnne Akalaitis; scenery by John Conklin; costumes by Gabriel Berry; lighting by Mimi Jordan Sherin; original music by Jan A. P. Kaczmarek; sound by John Gromada; fight direction by David Leong; choreography by Timothy O'Slynne. Presented by the New York Shakespeare Festival, Joseph Papp, founder; Ms. Akalaitis, artistic director; Jason Steven Cohen, producing director; Rosemarie Tichler, associate artistic director. At the Public/ Newman Theater, 425 Lafayette Street, Manhattan.

Friar Bonaventure	Wendell Pierce
Florio	Frank Raiter
Giovanni	Val Kilmer
Annabella	Jeanne Tripplehorn
Putana	Deirdre O'Connell
Soranzo	Jared Harris
Vasques	Erick Avari
Donado	Helmar Augustus Cooper
Bergetto	Ross Lehman
Poggio	Mark Kenneth Smaltz
Lieutenant Grimaldi	Daniel Oreskes
Richardetto	Rocco Sisto
Philotis	Marlo Marron
Hippolita	Ellen McElduff
A Cardinal	Tom Nelis
Banditti	J. David Brimmer, Angel David and Larry Grant Malvern

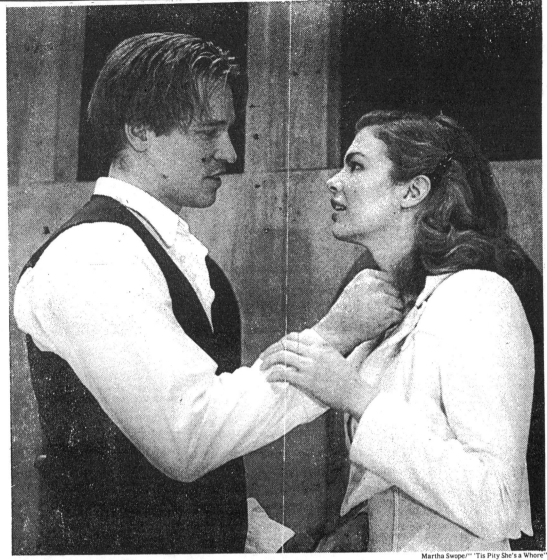

Martha Swope/" 'Tis Pity She's a Whore"

Val Kilmer and Jeanne Tripplehorn in " 'Tis Pity She's a Whore," at the Public Theater.

By FRANK RICH

If you were trying to assemble the most invigorating production of a classic to be seen in New York City this season, would you mix the following elements?

An infrequently produced Jacobean revenge tragedy that ends with its hero ripping out the heroine's heart and carrying it aloft on a skewer. ("Enter Giovanni with a heart upon his dagger," reads the Grand Guignol stage direction.) A pair of young lead actors better known for their Hollywood roles in lubricious movies like "The Doors" and "Basic Instinct" than for their experience in speaking verse. A severely intellectual director whose previous encounters with another 17th-century author, Shakespeare, have been her least successful projects. A set designer, most recently of the Metropolitan Opera's "Ghosts of Versailles," who regards a classical text as an occasion for practicing the modern arts of deconstruction and collage.

No, the pieces of this jigsaw puzzle do not remotely begin to connect. But one of the great things about the theater is that logic does not necessarily have anything to do with how artistic collaborations play out onstage. As directed by JoAnne Akalaitis, acted by Val Kilmer and Jeanne Tripplehorn and designed by John Conklin, " 'Tis Pity She's a Whore"

offers audiences at the Public Theater a fresh, contemporary encounter with a startling play written by John Ford in the 1630's. This is one of those evenings when you leave the theater convinced that the director must have rewritten the text, for how could a work with language so frank and nasty and sexual politics so sophisticated have been written almost four centuries ago? Yet Ms. Akalaitis has preserved Ford's words with an integrity one rarely finds at the New York Shakespeare Festival even as she weds those words to her own deeply personal vision of its author's themes.

●

For this director, " 'Tis Pity She's a Whore" begins with its famously incestuous love affair between Giovanni and his sister, Annabella — a hot couple indeed in the form of Mr. Kilmer and Ms. Tripplehorn — but hardly ends there. Retaining the original setting, Parma, while shifting the time frame to the 1930's of Mussolini, Ms. Akalaitis at first presents Ford's play as many do, as a celebration of an outlaw erotic obsession that seems almost pure and idealistic next to the decadent society and corrupt religious establishment that are scandalized by it. What this production does not forget, however, is that in the end it is Giovanni, not society, who butchers Annabella. In Mr. Kilmer's impressively measured performance, the hero stealthily grows from a colt-

ish Romeo into a Nietzschean megalomaniac, and he is not exempted from Ms. Akalaitis's withering indictment of a world in which most men treat most women as whores.

The director's slant on Giovanni is certainly supported by Ford, who shows the young man belittling Annabella's maidenhead as a "pretty toy" immediately after their first tryst. That this " 'Tis Pity" billows into dreamy theater rather than settling into earthbound polemic can be attributed to the imaginative depth of the staging. The transposition of Ford's Parma to the 1930's amounts to much more than merely the literal-minded deployment of Brown Shirts and the interjected salutes to Il Duce. The director instead situates " 'Tis Pity" in the hallucinatory 1930's of Surrealistic art, a state of mind as much as a Fascist state.

●

As stunningly visualized by Mr. Conklin and the lighting designer, Mimi Jordan Sherin, this Parma merges the eerily deserted piazzas of a Giorgio de Chirico canvas with the lunar dreamscapes of Yves Tanguy. As if to prefigure Annabella's eventual disembowelment, images of female body parts from Salvador Dali and Man Ray proliferate after intermission. The point is not to offer a discourse on art history, but to do what the Surrealists themselves did and bring a civilization's subconscious, forbidden emotions, including

its sadistic sexual impulses, to the surface. The scheme even extends to the high-style Italian furnishings, among them twine-covered chairs that seem to be in bondage, and to Gabriel Berry's spectacular costumes, which put the men in oppressive evening clothes and turn the women into Schiaparelli-era fashion victims.

Ms. Akalaitis then adds ominous music (by Jan A. P. Kaczmarek) and sound design (by John Gromoda) worthy of Bertolucci and Visconti films, and fills in the canvas's intimate details. In the secretly pregnant Annabella's wedding of convenience to the proper nobleman Soranzo, the director orchestrates the actors' movements and expressions into an involuntary revelation of their hidden, coarse hungers. These grotesque human tableaux of stylized spasms and malevolent whispering, suggestive of Richard Foreman's Ontological-Hysteric theater pieces, raise the play's temperature to a fever pitch even as they imitate Futurism, the aggressive school of art that actually formed a brief alliance with Mussolini's brutal school of Fascism. The dramatic payoff arrives soon after when Soranzo, played with a terrifying mixture of aristocratic gentility and uncontrollable rage by Jared Harris, punishes Ms. Tripplehorn for cuckolding him by repeatedly slamming her against a blood-red wall.

●

Ms. Akalaitis has been energized by " 'Tis Pity" in a way she was not by, say, the boys' universe of "Henry IV." That may be because this play's esthetics anticipate the Jean Genet works she has directed around the country and because its content overlaps the Franz Xaver Kroetz plays about dehumanized women ("Request Concert" and "Through the Leaves") that she staged so vividly in New York. This is not to say that her failings as a director have vanished. Once again Ms. Akalaitis, who has no

A reading informed by Surrealism as much as Fascism.

apparent sense of humor, tries to finesse a classic's comic interludes by giving the clowns leaden burlesque shtick that prompts winces, not laughs. Her tin ear for comedy has also led her astray in setting a tone for the catalytic role of the servant Vasques, an Iago-like villain, who is more flip than sinister in Erick Avari's performance.

Nor can Ms. Akalaitis resist hitting her ideological points with a sledgehammer near evening's end, at which point Man Ray is left behind for a jolting descent into the misogynistic pornography of snuff films. But these lapses cannot destroy the artistry of the feminist statement that has come before. One hallmark of this production is that the men, a few irredeemable creeps excepted, are at times allowed to be appealing and human while the abused women, including those played by Ellen McElduff (Hippolita) and Deirdre O'Connell (Putana), are too self-possessed to devolve into abject victims. Even when Annabella is driven to paroxysms of

sobbing by the horrors that befall her, Ms. Tripplehorn shows us a strong young woman with a fiery will rather than a trampled, helpless flower. True to its heroine, Ms. Akalaitis's " 'Tis Pity She's a Whore" insists on insinuating its way into our minds rather than emulating its hero by lunging at our hearts.

1992 Ap 6, C11:2

The End of the Day

By Jon Robin Baitz; directed by Mark Lamos; set by John Arnone; costumes by Jess Goldstein; lighting by Pat Collins; sound by David Budries; production stage manager, M. A. Howard. Presented by Playwrights Horizons, Paul S. Daniels, executive director; Don Scardino, artistic director. At 416 West 42d Street, Manhattan.

Graydon Massey............................ Roger Rees
Hilly Lasker/Swifty, Lord Kitterson
 Paul Sparer
Jonathon Toffler/Young Graydon
 John Benjamin Hickey
Jeremiah Marton/Tellman the Butler
 Philip Kerr
Rosamund Brackett/Jocelyn Massey
 Nancy Marchand
Helen Lasker-Massey/Lady Hammersmith
Urbaine Supton Stoat
 Jean Smart

By FRANK RICH

As befits a play whose opening night is an election night, Jon Robin Baitz's new comedy, "The End of the Day," begins with a man rehearsing the Pledge of Allegiance. As befits a play about the state of the nation, not to mention civilization, in the dispiriting year of 1992, the man mangles the pledge's words. Not that he cares. The man in question, an English-born psychiatrist named Graydon Massey, would rather stare narcissistically at himself in the mirror, puff on a cigar and try on different ties. Though he is expected to give a patriotic speech at the party celebrating his naturalization as an American citizen, he is in Malibu, after all. At the end of the day, what will really matter to his well-wishers: his choice of words or his choice of Armani?

Mr. Baitz's answer to that question is not remotely in doubt. "The End of the Day" offers a bleak yet hilarious portrait of a present-day world in which only money talks: in politics, business, medicine, culture and the privacy of one's own home. What is also not in doubt is Mr. Baitz's extraordinary talent. At the age of 30, this playwright now has two provocative, compulsively watchable plays running in New York City, and this one, like its predecessor, "The Substance of Fire," is marked both by the structural gropings of a fledgling craftsman and the aching articulation, scathing wit and deep convictions of a mature artist with a complete vision. "The End of the Day" also shares its predecessor's good fortune in receiving a wonderful production at Playwrights Horizons. Among other achievements, the director, Mark Lamos, has coaxed Roger Rees back to the New York stage for the first time since "Nicholas Nickleby" to give a performance that was worth the wait.

As Graydon Massey, Mr. Rees gets to play a dissipated cynic who seems to have stepped out of a Simon Gray comedy like "Butley" or "Otherwise Engaged" into a landscape that variously recalls the most jaundiced fictions of Evelyn Waugh, Nathanael West and Robert Stone. No sooner have we met Mr. Baitz's protagonist in the Malibu prologue (which is set in 1986) than the calendar advances six years and he flees his Beverly Hills psychiatry practice and adopted Jewish-American family to enlist as an oncologist at a rundown public clinic where Hispanic patients are dying around the clock, mostly of AIDS. In Act I, and in the "Butley" manner, the fatigued and despairing doctor is besieged by his former wife, his former father-in-law, his former medical school chum and his new and disapproving bureaucratic superior, played by Nancy Marchand. In a coup de théâtre almost matching that of Caryl Churchill's "Cloud Nine," the setting switches to Belgravia after intermission — a design triumph from John Arnone — and the cast, too, switches roles and nationalities with dizzying results.

In neither act is the doctor's story one of redemption or reform. As Massey says of himself with withering accuracy, his venture into public health is only that of "a fop doing penance, sloppy and unfelt." Mr. Baitz instead puts the increasingly benumbed Mr. Rees near the center of an ever-expanding web of corruption that ultimately entangles international shipping lines, a movie studio called Fiasco Films, a priceless George Stubbs canvas, a lucrative cocaine network and a foundation's beneficent donation of a new wing to a Los Angeles museum of fine arts. What Massey learns by the end of the evening is not how to do good but how to make it in a world where the winners reinvent themselves regularly and the fools are those unfortunates who not only have "some sort of value system" but then compound the mistake by sticking to it.

To Mr. Baitz's way of thinking, F. Scott Fitzgerald was wrong when he wrote that there were no second acts to American lives; the second acts belong to those like Richard Nixon who keep coming back for "second helpings." In the second act of "The End of the Day," the playwright further argues that Massey's discarded country is no better than his new one. The old-money London presented by Mr. Baitz is a fun-house mirror image of new-money Los Angeles, with "cads and bounders" substituting for hucksters and scam artists, Langham's Brasserie for Spago, a dying city for a dysfunctional medical clinic. In a play that often seems a hall of mirrors, Mr. Baitz eventually flips the action back to Los Angeles, where a terminal patient (John Benjamin Hickey) mimics his doctor's amorality. This may be the first play written in the shadow of AIDS in which even the dying lack decency, let alone compelling reasons to live.

So why is the evening so funny? As "The End of the Day" re-examines certain themes from "The Substance of Fire" — from father-son legacies to expatriation to the decline of the West in the century of the charnel house — so it is full of acerbic, highly quotable asides about such eclectic topics as John Major, "Annie," "Hamlet," the medical profession and the homophobic potboilers favored by today's Hollywood. But Mr. Baitz, writing in a far more flamboyant style than before, has also created some comic caricatures worthy of at least cameos in Waugh's "Loved One" and West's "Cool Million." As sharply written and acted, even the sleaziest characters are irresistible, most outrageously so in the case of Philip Kerr's craven gay Marxist British doctor turned greedy Hollywood bunco artist.

•

"The End of the Day" is a field day for actors all around, with Ms. Marchand giving what may be the funniest performance of the season in her two roles as Mr. Rees's sour boss in Los Angeles and as his terribly English and even more terribly castrating mum in London. One won't soon forget the experience of hearing this actress deliver scatological expletives in two different accents or her first Act II appearance (as abetted by the costume designer, Jess Goldstein) in a farcical aristocratic Eng-

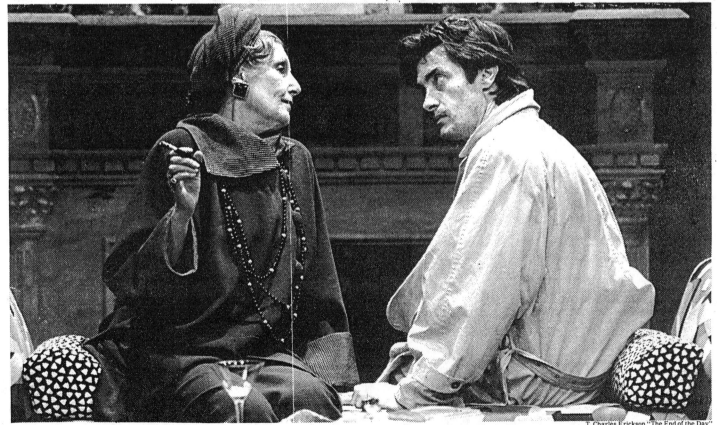

T. Charles Erickson "The End of the Day"
Nancy Marchand and Roger Rees in a scene from Jon Robin Baitz's new comedy, "The End of the Day," which is directed by Mark Lamos.

lish pose that might have given Beatrice Lillie pause. Paul Sparer also contributes a neat double turn as a pair of operators as different in cultural background as, say, Tommy Lasorda and Jeeves, while Jean Smart brings similar contrasts to a Rodeo Drive princess with "major self-worth problems" and an oppressive Englishwoman all too appropriately named Lady Hammersmith Urbaine Supton Stoat.

Except for one brief interlude in which he plays his own father, Mr. Rees is the one member of the cast who sticks with the same part from start to finish, a man of such selfishness, weakness and insensitivity that he makes those silly Hollywood Brits played by Dudley Moore in Blake Edwards movies look like saints. Rarely has a complete lack of integrity been played with so much integri-

ty, or so entertainingly. Mr. Rees is essential in setting the tone for Mr. Lamos's perfectly pitched staging, which must be as bright as the play is dark — and is.

•

Through no fault of his own, Mr. Lamos cannot solve Mr. Baitz's denouement, in which some of the theatrical balls juggled throughout the evening crash-land. One must also ask whether the relentless cynicism of "The End of the Day" is not a bit thick, a sign of glib youthful excess from a writer whose literary prowess otherwise belies his years. Then again, maybe it is simply impossible to subscribe to a play's utter hopelessness when its author offers so much hope for the American theater.

1992 Ap 8, C17:3

"Gunmetal Blues"

Marion Adler and Scott Wentworth star in "Gunmetal Blues."

Theater in Review

■ Playing Shakespeare for laughs ■ Mining Chekhov for his silly side (and there is one) ■ A private eye with a musical ear and a broken heart.

A Midsummer Night's Dream

John Jay Theater
899 10th Avenue (at 58th Street)
Manhattan
Through Saturday

By William Shakespeare; directed by Joe Dowling; set design by Douglas Stein; costumes by Catherine Zuber; lighting by Allen Lee Hughes; composer, George Fulginiti-Shakar; production stage manager, Elizabeth Stephens. Presented by the Acting Company, Zelda Fichandler, artistic director; Margot Harley, executive producer.
WITH: Jonathan Earl Peck, Trish Jenkins, Major West, Terra Vandergaw, Mark Stewart Guin, Rainn Wilson, Angie Phillips, Patrick Kerr, Andrew Weems, Duane Boutte, Derek Meader, Dan Berkey, Jed Diamond, Jeffrey Wright, Lisa Benavides and Kati Kuroda.

Every interpretation of "A Midsummer Night's Dream" must find its own special blend of ethereality and farce. Without shortchanging the play's magical elements, Joe Dowling, who directed the Acting Company's invigorating new production of Shakespeare's classic, tilts the balance toward rough-and-tumble comedy.

This is a production in which the four lovers, at the frenzied height of their misunderstandings, strip to their underwear and lunge at one another, with the women even trying out some martial arts moves. The forest through which they reel is no pastoral wood but a jungle teeming with eerie carnival sights and sounds. The spirits who continually buffet the lovers look like punks dressed up for Halloween, while Puck (Jeffrey Wright) is an earthbound homeboy glumly shadowboxing his way through the play. In the final scene, he comes out with a janitor's broom and begins sweeping the stage.

The performance that spins the production is Jonathan Earl Peck's commanding Oberon. The tall, lanky actor whose voice rings with a power that recalls James Earl Jones, personifies sophisticated regality. Trish

Jenkins's Titania matches his imperious sensuality. On being released from her love potion and spying the creature she adored, she lets out a bloodcurdling scream that quickly collapses into helpless belly laughs.

The mechanics aren't quite as loutish as they are often portrayed. But in their performance of Pyramus and Thisbe, every comic stop is pulled, including a Dolly Parton wig for Thisbe and a Marlon Brando motorcycle cap for Pyramus.

The production has many sly contemporary touches. The mechanics consult USA Today. Titania falls in love with Bottom as he bellows an out-of-tune "Strangers in the Night." The fairy lullaby is a doo-wop version of "Blue Moon."

Douglas Stein's set puts the action in an otherworldly jungle out of whose nooks the spirits steal like witches and goblins. Allen Lee Hughes's lighting design cloaks everything in an ambiguous light and shadow. Together with Catherine Zuber's witty fun-house costumes, the sets and lighting contribute mightily toward the realization of the play as an exuberant Halloween nightmare.

STEPHEN HOLDEN

Chekhov Very Funny

Pearl Theater
125 West 22d Street
Manhattan
Through May 2

Four one-act plays by Anton Chekhov; directed by Shepard Sobel; set design by Robert Joel Schwartz; costumes by Barbara A. Bell; lighting by A. C. Hickox; stage manager, Mary-Susan Gregson. Presented by the Pearl Theater Company.
CONCERNING THE INJURIOUSNESS OF TOBACCO
WITH: Dan Daily.
THE BEAR
WITH: Frank Geraci, Robin Leslie Brown and Dan Daily.

THE MARRIAGE PROPOSAL
WITH: Frank Geraci, Dan Daily and Robin Leslie Brown.
SWAN SONG
WITH: Frank Geraci and Dan Daily.

In the traditional homage to the genius of Chekhov, attention usually centers on the major masterpieces to the neglect of the wonderfully witty short pieces this great Russian writer called his "vaudevilles." The Pearl Theater Company has sought to correct that oversight by staging four one-acts in an evening titled "Chekhov Very Funny."

The best effort of the Pearl production is "The Bear," a delightful play on the war between the sexes that has kept audiences laughing since its first performance over 100 years ago. Smirnov, a lout of an artillery officer, intrudes on the mourning of a young widow, Elena Popova, to demand payment of 1,200 rubles owed him by her late husband.

As polite refusal turns to name-calling insults, this bear of an officer challenges the widow to a duel. "If women are to have equal rights, let them be equal," he growls. The widow hastens to fetch the pistols. Such instant enmity, of course, can only mean love.

Dan Daily is at his best as Smirnov, carefully avoiding any real menace in his humorous rage and deftly rationalizing his wrath into infatuation. Robin Leslie Brown is haughty in her fury and provides a fine romantic foil. Frank Geraci stumbles about amusingly as the widow's steward.

It is something of a puzzle, then, why the same cast turns "The Marriage Proposal," the other side of the same love token, into stale kvass. Lomov, a landowner, calls on his neighbor Chubukov to ask for the hand of his daughter, Natalya. Before Lomov can declare his love to Natalya, however, they fall into a terrible row over which family owns a certain meadow. Then, just when all seems put to rights, a slight disagreement over who owns the best hunting dog has them back at each other's throats.

Mr. Daily again proves credibly adept at the quick mood changes these Chekhov pieces demand. But in "The Marriage Proposal" Ms. Brown appears looking like a peasant girl who has just come in from feeding the chickens, her hair sticking out in all directions, and affecting an accent that sounds more like "Tobacco Road" than the Russian steppes. Everyone is soon jumping about like cartoon characters, mugging for laughs.

The other two pieces on the bill are "Concerning the Injuriousness of Tobacco," a monologue given a somewhat unfocused reading by Mr. Daily, and "Swan Song," a dramatization of an earlier short story about an aging actor, which Mr. Geraci plays rather monotonously. Earle Edgerton's translation is jarringly modern, occasionally to the point of distraction. Shepard Sobel directed.

WILBORN HAMPTON

Gunmetal Blues

Theater Off Park
224 Waverly Place
Manhattan
Through May 10

Book by Scott Wentworth; music and lyrics by Craig Bohmler and Marion Adler; directed by Davis Hall; scenery and costumes by Eduardo Sicangco; lighting by Scott Zielinski; production stage manager, Lisa Ledwich; musical direction, arrangements and orchestrations by Mr. Bohmler. Presented by AMAS Musical Theater, Rosetta LeNoire, founder and artistic director; William Michael Maher, producing director.
WITH: Daniel Marcus, Michael Knowles, Marion Adler and Scott Wentworth.

"She had hair the color of moonlight on topaz and a mouth that would have sent Shakespeare thumbing through a thesaurus," muses Sam Galahad (Scott Wentworth), a Sam Spade-like private eye, about a blonde who broke his heart. The central character in "Gunmetal Blues," a musical sendup of film noir presented by AMAS Musical Theater, Sam does a number of amusing things, including furiously slapping his trench coat in time to a lovelorn ballad.

The show is set in the Red-Eye Lounge, a dive billed as "one of those bars at one of those hotels out by the airport." Although the time is supposed to be "tonight, pretty late," and the roars of departing jets can be heard, the ambiance is more late-1940's than contemporary. Serving as house pianist, narrator and bit player is Buddy Toupee (Daniel Marcus), a musician who once had dreams of a major concert career. Marion Adler, an actress turned out in the slinkiest Lizabeth Scott-Veronica Lake tradition, portrays three characters known collectively as the Blondes.

As the musicals "City of Angels" and "In a Pig's Valise" have shown, film noir spoof is a fertile musical-comedy subject. And "Gunmetal Blues," which has a book by Mr. Wentworth and music and lyrics by Craig Bohmler and Marion Adler, offers its own genial take on the genre. Its satirical tone is much broader than either of the previous shows. Mr. Wentworth's book doesn't even attempt to tell a coherent story. And at the beginning of the second act, it lurches to a halt to allow Buddy to hawk cassettes of his music.

What the new show has in its favor is a score that is musically more sophisticated than either "Pig's Valise" or "City of Angels." Mr. Bohmler's torchy, swiveling melodies echo the moody grandeur of 40's film-noir soundtracks.

But it is Mr. Wentworth's portrayal of Sam as a pratfalling gumshoe caricature that defines the style of the production, which was directed by Davis Hall. Even when crossing the line from spoof into outright silliness, "Gunmetal Blues" remains diverting. STEPHEN HOLDEN

1992 Ap 8, C21:1

Five Guys Named Moe

By Clarke Peters; directed and choreographed by Charles Augins; vocal arrangements by Chapman Roberts; orchestrations by Neil McArthur; musical direction by Reginald Royal; set by Tim Goodchild; lighting by Andrew Bridge; costumes by Noel Howard; sound by Tony Meola; production stage manager, Marybeth Abel. Presented by Cameron Mackintosh. At the Eugene O'Neill Theater, 230 West 49th Street, Manhattan.

Nomax	Jerry Dixon
Big Moe	Doug Eskew
Four-Eyed Moe	Milton Craig Nealy
No Moe	Kevin Ramsey
Eat Moe	Jeffrey D. Sams
Little Moe	Glenn Turner

By FRANK RICH

Some Broadway musicals want to make you think. Some want to move you to tears. Some want to make you laugh. Some want to give you pure, mindless fun.

"Five Guys Named Moe," the London hit that opened at the Eugene O'Neill Theater last night, wants to sell you a drink.

●

This peculiar revue, ostensibly a celebration of songs made famous by the 1940's alto saxophone player and band leader Louis Jordan, has a specially designed restaurant called Moe's adjoining its auditorium, where you can eat, drink and be merry before, during or after the show — most notably during an extended intermission, when several extra bars are set up for your pleasure. If the management could only deliver alcohol intravenously, "Five Guys Named Moe" might actually con-

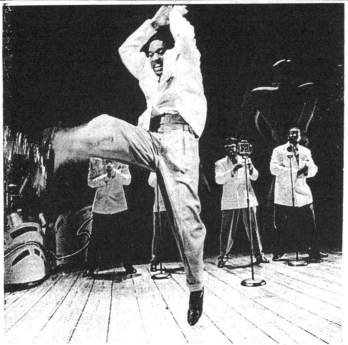

Jim Estrin/The New York Times

Kevin Ramsey performing in a scene from "Five Guys Named Moe," at the Eugene O'Neill Theater.

vince its patrons that the joint is jumping at those moments when there is no option other than to watch the entertainment onstage.

That entertainment is unlikely to be confused by many New York audiences with this production's obvious prototypes, "Ain't Misbehavin' " and "One Mo' Time," with which it shares its cast size, nostalgic musical ambitions and intended saloon ambiance. "Five Guys" is instead a British tourist's view of a patch of black American pop music history when Jordan (1908-1975) and his Tympany Five served as a crossover from post-World War II jump and boogie to mid-1950's rhythm-and-blues with hits like "Choo, Choo Ch'boogie," "Caldonia" and "Saturday Night Fish Fry." Given that the show's creators are both American-born black men — Clarke Peters (book) and Charles Augins (direction and choreography) — the evening's synthetic tone is most surprising.

Perhaps the problem is that Mr. Peters and Mr. Augins have spent too much time in London (most of their careers, according to the Playbill). Or perhaps they have inflated or mutilated innocent original intentions in recruiting a new cast and restaging this piece for Broadway. I cannot say, since I did not see the London edition, which began at a theater half the size of the O'Neill before moving to the West End. Whatever the explanation, something has gone seriously, discomfortingly wrong.

The six men in the Broadway cast have decent voices. But they are asked to smile incessantly, and their musical delivery is so monotonously cheery (except in ballads, where completely expressionless crooning reigns) that their stage personalities are distinguishable only by such character names as Big Moe, Little Moe and Four-Eyed Moe. This was hardly the case at a show like "Ain't Misbehavin'," where each voice was an instantly recognizable, idiosyncratic original. In "Five Guys," the goal seems to be a lowest-common-denominator, easy-listening, emotion-free version of the songs, and that

impression is heightened by an on-stage band that even Doc Severinsen might find lacking in funk.

"Five Guys" is closer to Shaftesbury Avenue than 52d Street in other ways as well. The set, by Tim Goodchild, is a candied affair that looks like a Claymation version of a Harlem street scene. The modest choreography rips off the broad gestures of a jazz style — raised arms, shaking shoulders, finger snapping — without delivering much actual dancing. The humor is deeply British, male division: if the men aren't sashaying about in drag, they are dressing up in chicken feathers for "Ain't Nobody Here but Us Chickens." Further sexist humor and racial stereotyping comes from the book, a shameless bit of padding about the travails of a present-day lovesick swain (Jerry Dixon, with his belt unbuckled) whose blues are chased away by the five Moes once they burst out of his radio in a puff of smoke.

Stage smoke is a mainstay of British musicals, and so is the evening's dependence on a Disneyland theatrical gimmick and party-or-die audience participation. Moe's restaurant, which looks more like a chain franchise in a mall than an urban jazz club Louis Jordan might recognize, serves the same purpose for "Five Guys" as the feline junkyard of "Cats" and the roller-skating rink of "Starlight Express." And as with "Cats" at intermission, the audience is invited onstage just before this show's intermission, in this case to participate in a mass conga line prompted by the incessant calypso "Push Ka Pi Shi Pie."

●

In fairness, I must report that many people, conspicuously including the former "Miss Saigon" star Jonathan Pryce, enthusiastically joined the conga line at the press performance I attended. I am sure, though I cannot prove it, that some participants in this spontaneous demonstration were not past or present employees of the "Five Guys Named Moe" producer, Cameron Mackintosh.

As the conga line heats up, one member of the cast yells out "Don't forget your pocketbooks!," surely the most heartfelt dialogue of the evening. That's the cue for the conga line to turn toward the bar, where those who empty their pocketbooks will be rewarded with the good news that they can take their drinks back to their seats.

Bottoms up!

1992 Ap 9, C17:2

The Best of Forbidden Broadway
10th-Anniversary Edition

Written and directed by Gerard Alessandrini; musical direction by Brad Ellis; choreography by Roxie Lucas and Michael McGrath; costumes by Erika Dyson; wigs by Teresa Vuoso; stage manager, Jerry James. Presented by Jonathan Scharer. At Theater East, 211 East 60th Street, Manhattan.

WITH: Brad Ellis, Leah Hocking, Alix Korey, Michael McGrath and Patrick Quinn.

By MEL GUSSOW

Isn't it 'Grim Hotel" and not "Grand Hotel" that moved from the Martin Beck to the Gershwin? People come, people go, people move chairs, and "Forbidden Broadway" may be eternal. This is the gleeful message of "The Best of Forbidden Broadway," a retrospective look at the last 10 years in the New York theater and at the first 10 years of Gerard Alessandrini's cabaret revue.

Pretension, pomposity and sheer star power are always ready for a comeuppance, as demonstrated by a vintage crop of spoofs in this anniversary anthology. Whenever possible, Mr. Alessandrini has added a veneer of timeliness to his recycled songs. There are also rude topical remarks, such as the suggestion that Tony Randall's repertory company is "proof that art should not be subsidized."

As usual, almost all the targets are musicals, and the key to the malice is in the stars, who define themselves through their roles and then live on in those who imitate them. The current cast of five is one of the revue's sharpest ensembles. Not only are the actors expert clowns and mimics, they could also play many of their roles straight in the original shows, at least if that were still possible after their devastating impersonations.

●

Although his characters have been performed by others in "Forbidden Broadway," Patrick Quinn seems inimitable. A tall leading man with a diabolical sense of humor, he is funniest at playing the big guys. A broad-shouldered Topol lumbers onto the tiny stage to milk applause by singing ... as ... slowly ... as ... he ... can. Jean Valjean wails in pain as he sings "This Song's Too High" in the show that is making him more miserable. Jonathan Pryce is still insisting against all ethnic evidence that he is an Asian too. In the revue's chef d'oeuvre, "Into the Words," Mr. Quinn becomes Stephen Sondheim mischievously entrapping unwary actors in a tongue-twisting thicket.

Patti LuPone spans the decade from "Don't Cry for Me, Barbra Streisand" (in that movie that still has not been made) to "Anything Goes" in which she seems to blot and blur every lyric. As Leah Hocking raises her arms in Evita's salute, there is a blackout, and she is replaced in exactly the same pose by

Alix Korey's Annie, that former tyke who sings: "I'm 30 years old, tomorrow. And I haven't worked since I did 'Annie.' " Actually "Annie" is only 15 years old, though she may seem like "Forever!"

Michael McGrath ranges from scenery eaters like Mandy Patinkin to scenery like Richard Harris. In that "quasi Nazi musical," Mr. McGrath seems to be playing all the parts, except for Ms. Hocking, who makes a leggy arrival as Cyd Charisse. It is left to the impish Ms. Korey to impersonate a Julie Andrews who has been too long away from her songbook.

•

Trying to be up to the second, Mr. Alessandrini gives us a whiff of future "Forbiddens." In his version of "Crazy for You," the co-stars share the dimmest wattage. Then there is Mr. Quinn striding on stage to announce "I am I, Raul Julia, the new Don Quixote." He may be the first Hispanic star of this show, but he is not the first singer to be crushed by the weight of singing an impossible song. At his side is Ms. Korey delivering a valley-girl impersonation of Sheena Easton's Aldonza.

Any "Forbidden Broadway" is allowed a misstep or two. In this case it's two: one old (a mindless Madonna mimicking Mamet) and one new (a wrongfooted sendup of "The Most Happy Fella"). Otherwise, the show is felicitous, without a single song about Cameron Mackintosh and with only passing reference to Andrew Lloyd Webber. "Cats" calls, but there is no "Phantom" in the shadows. Despite the doldrums of the decade, "Forbidden Broadway" manages to raise its satirical banner and continues to delight a theatergoing public.

1992 Ap 9, C19:3

A Terrible Beauty

Written and directed by Kevin Breslin; scenery by Tony Dunne; lighting by Gary Marder; costumes by Barbara Schulman Breslin; sound by Doug Kleeger; production stage manager, Paul D'Amato. Presented by Provincetown Playhouse, Arthur Cantor, executive director. At 133 Macdougal Street, Manhattan.

Pat McCann..............................William Hickey
Donna Murphy............................Tatum O'Neal
John Murphy............................Holt McCallany
Deirdre McCann.....................Fiona Hutchison
Damon O'Leary.....................Michael A. Healy

By MEL GUSSOW

From "The Iceman Cometh" to "Conversations With My Father," the bar has been a place where characters can bare their secrets and even their souls. On the other hand, a bar play can simply be an excuse to bring opposites together, as is the case with "A Terrible Beauty." Watching Kevin Breslin's play, one remembers Harry Hope's line in "The Iceman Cometh": there's "no life or kick" in the booze.

The intention is to be timely. "A Terrible Beauty," which opened last night at the Provincetown Playhouse, deals with this year's St. Patrick's Day parade and the conflict between die-hard Irish conservatives and gay and lesbian demonstrators. One would have learned far more about that battle from reading the newspapers.

Mr. Breslin's contrivance is a confrontation between a bigot and two gay-rights marchers. They meet in a run-down neighborhood bar before

"A Terrible Beauty"

Holt McCallany and Tatum O'Neal in a Kevin Breslin play.

and after the parade. The desultory chatter soon becomes inflammatory as the bigot (Holt McCallany) begins his diatribe and carries a sign that reads "God Hates Gays." The play never rises above the simplistic as it follows every predictable turn to a pat conclusion. Without ample justification, the author creates an ameliorative ending undermining the minimal drama that has preceded it.

•

For the entire first act of this very short play, one may wonder why the demonstrators are in the bar. The explanation is unconvincing, just as the continuing marriage between Mr. McCallany and his wife is unfathomable. Faced with a soap-operatic litany of injustices and injuries at the hands of her piggish husband, she makes only the most fainthearted protest. Trapped in the role of the wife is Tatum O'Neal, in her theatrical debut. An assessment about her talent for acting onstage will have to wait until she has a character to play rather than a human dart board. She is attractive and appealing, but the role is thankless.

The thinness of the play is made worse by the fact that it has been staged by the author, who, on the evidence here, would seem to know even less about directing than he does about playwriting. He moves his performers around Tony Dunne's scenery in the most inefficient manner. To cite one example, Ms. O'Neal hoists herself onto the bar, then jumps down and at intervals repeats the maneuver until it begins to seem like a physical fitness routine.

The actors avoid embarrassing themselves, but it is only William Hickey as the owner of the bar who momentarily alleviates the tedium. He is a peppery old rascal, forced to make geriatric jokes and to act like a stage Irishman. Occasionally he steps on one of his own lines, which is deserved. As a character says in another bar play, "No foundation all the way down the line."

1992 Ap 10, C18:1

Blood Knot

By Athol Fugard; directed by Tazewell Thompson; set design by Douglas Stein; costumes, Paul Tazewell; lighting, Allen Lee Hughes; sound, Susan R. White; stage combat choreography, Brad Alan Waller; production stage manager, Elizabeth Stephens. Presented by the Acting Company, Zelda Fichandler, artistic director; Margot Harley, executive producer. At the John Jay Theater, 899 Tenth Avenue, at 58th Street, Manhattan.

Morris ..Jed Diamond
Zachariah.........................Jonathan Earl Peck

By STEPHEN HOLDEN

"Blood Knot," the 1961 two-character drama that established the reputation of the playwright Athol Fugard, is not an easy play. A rambling, two-and-a-half-hour dialogue between Morris and Zachariah, two South African brothers of mixed racial background, it is as austere and claustrophobic as one of Samuel Beckett's metaphysical meditations. Rituals of daily life — the symbolic ringing of Morris's alarm clock; Zachariah's soaking of his tired feet in bath salts at the end of each workday — are repeated and drawn out with a solemnity that borders on tedium. Not until well into the second act of "Blood Knot" do its carefully set up emotional fireworks begin to detonate.

•

But the play, which the Acting Company, the long-running touring repertory group, has revived at the John Jay Theater in performances that continue through Wednesday, is also a classic. Slowly and methodically, it compiles a shattering vision of the horror of apartheid that erupts when the brothers playact the racial antagonisms that have tragically divided their country. Donning a business suit and twirling an umbrella that becomes a vicious weapon, Morris, who is light-skinned enough to "pass" as white, pretends to be a white boss humiliating his darker-skinned brother. The game is so emotionally loaded that the two players quickly become carried away.

The catalyst for the explosion is a pen-pal relationship that the illiterate Zachariah has struck up with an 18-year-old white girl at the suggestion of his literate brother, who conducts the correspondence. What seemed a harmless long-distance relationship turns threatening when the girl writes to Zachariah to say that she intends to pay him a visit.

•

The Acting Company's production, directed by Tazewell Thompson, features Jonathan Earl Peck as Zachariah and Jed Diamond as Morris. Both fine actors, they make an odd match, because they don't seem remotely related. Mr. Diamond, who has blond, thinning hair, resembles an effete Afrikaner. Mr. Peck, who made a dashingly aristocratic Oberon in the company's "Midsummer Night's Dream," brings the same charged dynamism to Zachariah. His physical authority contrasts dramatically with Mr. Diamond's portrayal of Morris as a prim, emasculated homebody bowed by an almost maternal guilt for his superior advantages in life.

Mr. Peck's heroic performance tips the play's sympathies too much toward Zachariah. It is not as easy as it should be to view the two characters as equally oppressed by a system that calls the white man "boss" and the black man "boy" and that finds them both living in a tin-roofed shack with few hopes for a better life.

1992 Ap 12, 65:3

/David Richards

A Last Call for Fathers, Sons and Barflies

Herb Gardner's 'Conversations With My Father' may be too full to talk.

' 'Tis Pity' at the Public is all visuals.

Lypsinka invades Eisenhowerland.

HAVE NO STATISTICS TO BACK THIS up. But it's my guess that the two most common manifestations of the American drama are the bar play and the father-son play.

The bar play — "The Time of Your Life," for example, or "The Iceman Cometh" —

Marc Bryan-Brown/"Conversations With My Father"

Judd Hirsch, right, with William Biff McGuire, far left, Marilyn Sokol and Peter Gerety in "Conversations With My Father"—Herb Gardner, who has written appealingly about the gentle loonies and unrepentant misfits on the fringes of society, is digging deeper than before and exposing wounds that lie close to his heart.

usually assembles a bunch of eccentrics in a corner dive and lets them indulge their eccentricities or dream their pipe dreams. In the father-son play ("Long Day's Journey Into Night" or "Death of a Salesman," to cite the best of the breed), the playwright generally sets out to record the emotional fallout of a relationship that was troublesome at best, crippling at worst.

Then there's "Conversations With My Father," the new drama by Herb Gardner that attempts to put the two forms together. Of course, it helps that Eddie Goldberg (Judd Hirsch), the father in this case, is also the proprietor of a bar on Canal Street in lower Manhattan. When he's not trying to shake his Russian-Jewish roots and figure out how to attract a fancy all-American clientele to the establishment, he's badgering his sons, Joey and Charlie, to make something of themselves. The play covers 40 years, beginning in 1936, during which the bar undergoes sundry face lifts, none particularly successful, and Charlie, a writer-to-be, struggles to come to terms, no more successfully, with the headstrong patriarch in suspenders and bow tie who "lives at the top of his voice and the edge of his nerves."

Mr. Gardner, who has written appealingly about the gentle loonies and unrepentant misfits on the fringes of society in such hits as "A Thousand Clowns" and "I'm Not Rappaport," hasn't exactly gone and changed his stripes on us. But he's obviously digging deeper than before and exposing wounds that lie close to his heart. "Conversations With My Father" may be his fullest play to date — so full that it's uncertain what shape it wants to take, which tales it intends to pursue and which sentiments it means to evoke. It makes for an uneven night at the Royale Theater that rewards and frustrates in about equal measure. The script is marked by lots of false starts, dead ends and unresolved scenes. Workaday life in Eddie Goldberg's Golden Door Tavern — later the Flamingo Lounge, later still the Twin-Fifties Cafe and, finally, in the 1960's, when ethnic is in, the Homeland Tavern — doesn't always feed into the family traumas that are being played out under the revolving ceiling fans and a benevolent portrait of F.D.R.

Two of the playwright's most colorful characters are really tangential to matters at hand, but they're so stageworthy you'd hate to see them banished to the wings. One, a white-haired police sergeant turned twinkling barfly in his retirement (William Biff McGuire), believes he's Santa Claus. ("Do you know who I am?" he asks the uninitiated. "I'll give you a hint: 'Ho, ho, ho.' ") The other, a baby-faced Italian hood (John Procaccino), tries to put the squeeze on Eddie for protection money and a percentage of the profits generated by the plump Wurlitzer jukebox that sits like a blazing sunset in the gloom. Although the resulting showdown illustrates what we already know — that Eddie is no one to push around with impunity — the scene is marked by plenty of feints and counter-feints and it will have you watching intently.

But is it really a pivotal scene? The one to ring down a first-act curtain? Momentarily, at least, the bar play would appear to have the upper hand. But when the curtain goes up on Act II, it's eight years later, Eddie's business is nowhere, and the father-son confrontation is gathering force.

First, however, there's Joey's tale to be told. Joey (Jason Biggs and, later, Tony Gillan) is the older son, Eddie's favorite and a scrapper, who will graduate from schoolyard fights to a minor boxing career before enlisting in the Navy and heading off to the Pacific for a fatal rendezvous with a kamikaze pilot. Then, and only then, does Charlie come to his father's attention, probably because there's no other target left. Eddie's wife (Gordana Rashovich), stubbornly attached to her Eastern European ways, has been bullied back into the kitchen, taking with her a sense of humor said (but not shown) to be legendary.

■

I don't mean to imply that the family history is confusing to follow. It isn't. But the play often seems to be operating without a compass, stretching this way to accommodate an irresistible character, meandering that way to include another story. Under the circumstances, you spend an undue amount of time wondering *what* the playwright is up to. There's never that transcendent moment when the drama coalesces, atmosphere and events join together and bar and family are somehow artistically one.

Mr. Gardner, I think, is banking on two factors — a recurring question and an omnipresent narrator — to do the unifying job that just isn't getting done. While Charlie is depicted at several stages in his life, the adult writer (Tony Shalhoub) is present from the start, as the play's tour guide, observing the blustering behavior of his father and presumably gathering evidence to support his contention that "it was steeplechase up there" in Eddie's head, a "goddamn roller coaster! None of it fit together."

Mr. Shalhoub is such a warm actor, however, and there's such forgiveness in his sad eyes, that he tends to argue the opposite case despite himself. Sure, Eddie was capricious, driven to foolish schemes, disdainful of his wife, who never shed her thick Yiddish accent. But as Mr. Shalhoub incarnates him, Charlie seems to have emerged from the hurly-burly with his sense of decency intact and no more scars, or so it struck me, than the rest of us. (He's also got material for a string of best-selling novels sentimentalizing the irascible old man.)

By the same yardstick, Mr. Hirsch, with his slightly punch-drunk face and his unflagging energy, is never totally unlikable, and actually gives a celebratory portrayal of a go-getter, eager to put the Old World behind him and forge a place for himself in the new. That may be viewed these days as spurning

your heritage, but once, when people still believed in a land of opportunities, it was the American Dream.

To assimilate or not to assimilate is the question that keeps cropping up, each time the family fortunes rise or fall a little. Eddie's views are set in concrete. He subscribes vociferously to the theory that you "gotta give 'em what they want, see. That's the Promised Land, pal — find out what they want and promise it to them." He'll even trade in the name Goldberg for Ross.

Countering him adamantly, is the upstairs boarder, Zaretsky (David Margulies), another of Mr. Gardner's wonderful larger-than-life originals. An aging actor who once graced the Second Avenue Yiddish Classic Art Players, he's now reduced to doing monologues in a sorry one-man show on the carpetbag circuit. His pride is undented, though, and Mr. Margulies plays him with cape-flourishing grandeur.

"You came to the melting pot, sir, and melted ... melted away," he says, staring down at Eddie (although he's probably staring up) and rebuking him as he would the villain in a turn-of-the century melodrama. Zaretsky can't forget the pogroms, and aren't the newspapers talking about a holocaust?

Still, I'm not sure this ongoing argument is ever conclusively tipped in one direction or the other. Eddie is doing what he has to, and so is Zaretsky, and if we're meant to choose sides, it's not clear which one "Conversations With My Father" endorses. More mixed signals, to my mind. While theoretically you can applaud Mr. Gardner for wanting to include as much as possible in his play, from a pragmatic standpoint, you wish he'd put in less.

■

The production, staged by Daniel Sullivan, doesn't stint on mood and the performances are, for the most part, richly layered. But I wasn't even of a fixed mind about Tony Walton's set — with its dark wood paneling, an ornate bar that might have propped up Anna Christie, and, perched above it, a stuffed moose head that, I swear, had an occasional grin on its chops. At times, the place struck me as down and out and dingy, a mockery of Eddie's ambitions. But then, Pat Collins's lighting would change and it would take on a burnished glow and a cockamamie warmth, and I caught myself thinking that if it existed, it would be in all the New York guidebooks.

Do you gather I seesawed all through "Conversations With My Father"?

' 'Tis Pity She's a Whore'

JoAnne Akalaitis's staging of " 'Tis Pity She's a Whore" (at the Newman Theater at the Public Theater) exhibits precisely the same strengths and deficiencies as her productions of "Henry IV, Parts I and II" last season. It is as alluring to look at as it is painful to hear. Ms. Akalaitis seems to elicit terrific work from her designers and technicians and terrible work from her actors. The spells engendered by the former are repeatedly ruptured by the latter, who insist on speaking their lines.

The director has chosen to advance John Ford's 1630 drama about incest

and evisceration to Fascist Italy in the early 1930's, where it has no trouble making a home for itself. The sets are by John Conklin, but they could be by de Chirico and Dali. Mimi Jordan Sherin's lighting, frequently flat and white, furthers the surrealistic effect, while the costumer Gabriel Berry has provided some elegant fashions for an indulgent aristocracy to preen in. (The stagehands, not to be left out, sport tuxes and bright red face masks.)

It's a chilly, hollow world, but on the surface only. Underneath, putrefaction has set in and forbidden emotions are festering. Now and again, we are afforded a glimpse into the rococo bedroom, behind the upstage scrim, where Giovanni (Val Kilmer) and his sister, Annabella (Jeanne Tripplehorn), are writhing on "lawless sheets." They are an undeniably handsome couple and catching them in the act makes you feel a bit like a peeping Tom. " 'Tis Pity," one of the grisliest plays ever written, is also one of the most voyeuristic.

Much of the action is underscored by original music, composed by Jan A. P. Kaczmarek, and it, too, contributes mightily to the impression of eerie foreboding. Everything, in fact, points to an overheated, sexually charged evening. Then the actors go and open their mouths, and the temperature plummets, the lasciviousness seems silly and Fascism looks as if it could be beaten back with a feather duster. Lurid passion, if it's not totally persuasive, registers as a big put-on.

The performances of Mr. Kilmer and Ms. Tripplehorn never seem compulsive or blood-driven, as they must. His delivery gravitates to the monotonously remote; hers, to the schoolgirlishly shallow. Biology doesn't have much to do with their coupling; perversity, even less. Jared Harris, as the evil nobleman Soranzo, hails from the Christopher Walken School of Villainy — pale face, dead lips, numb voice. Elsewhere, inept posturing predominates.

■

(Deirdre O'Connell is a fortunate exception, as the heroine's cheap, gossipy companion. And Ross Lehman caught me off guard with the poignance of his death scene, since up to that point he has been directed to portray Bergetto, a comic suitor, as an imbecilic vaudeville hoofer.)

Part of the considerable fascination of " 'Tis Pity" is the gusto with which it hurtles toward its gruesome climax. The performers at the Public are unable to keep pace, however. One by one, they tire and flag, and

'Conversations With My Father' doesn't stint on mood.

Ms. Akalaitis can't rally them. The divorce, considerable by the end, makes for a ridiculous state of affairs. Here is the play, bursting over the finish line, and way back there, panting in the dust, is the cast.

'Lypsinka! A Day in the Life'

Were the 1950's really that psychotic? So torn between visions of sweet domesticity and nightmares of impending destruction? So wigged out, self-deluded and double-faced? So frankly ... nuts?

They seemed pretty normal to me, growing up in Eisenhowerland. But the other night I left the New York Theater Workshop (at the Perry Street Theater), thinking that John Epperson has a point. Mr. Epperson, a recent Off Off Broadway phenomenette, practices the art of lip-synching, which is to say mouthing the words to other people's records. This talent — marginal, perhaps, but no less demanding for that — has given rise to Mr. Epperson's stage persona, Lypsinka, a flamboyant diva

The soundtrack — I guess that's what you'd call it — for Mr. Epperson's latest 80-minute extravaganza, "Lypsinka! A Day in the Life," is made up of novelty numbers, dopey songs, lines of movie dialogue and snippets of beauty advice, rescued with the care of an archivist from the midcentury's junk heap. Among the voices I recognized, or thought I did, were those of Abbe Lane, Doris Day, Bette Davis and Dolores Gray. Not that it matters. Before long, they all blend into a mad collage of Technicolor production numbers in which Lypsinka is sometimes supported, but never — I repeat, never — upstaged, by a chorus line of male cardboard cutouts.

■

Changing quietly garish gowns with a speed made possible only by double joints and Velcro, the star bounds from one incarnation of womanhood to the next. You'll recognize the types — saccharine, naughty, haughty, coy, dutiful, demanding, perverse, befuddled (by love, of course) — as they career by. All of them are highly stereotypical and, in that respect, indicative of the straitjacketed age that gave them birth. Lypsinka purposefully takes stereotype a couple of steps further down the road, at the end of which lurks madness. Or at least, a movie heroine, bathed in green light, shrieking her lungs out at the approaching monster.

I tended to find less hilarity in this candy-box spectacle than those around me. But I can't deny its hallucinatory quality. Mr. Epperson's gals and dolls once contributed gallantly to the pop culture of their age. Now what they seem to reveal is its crazed and scary underbelly. □

1992 Ap 12, II:5:1

Correction

A theater review on page 14 of the Arts and Leisure section today omits part of a paragraph in some copies. The passage, by David Richards about "Lypsinka! A Day in the Life," should read:

"They seemed pretty normal to me, growing up in Eisenhowerland. But the other night I left the New York Theater Workshop (at the Perry Street Theater), thinking that John Epperson has a point. Mr. Epperson, a recent Off Off Broadway phenomenette, practices the art of lip-synching, which is to say mouthing the words to other people's records. This talent — marginal, perhaps, but no less demanding for that — has given rise to Mr. Epperson's stage persona, Lypsinka, a flamboyant diva who resembles a cross between Lucille Ball and an angry flamingo."

1992 Ap 12, 3:2

A Streetcar Named Desire

By Tennessee Williams; directed by Gregory Mosher; set by Ben Edwards; costumes by Jane Greenwood; lighting by Kevin Rigdon; sound by Scott Lehrer; production stage manager, Michael F. Ritchie. Presented by Gregory Mosher, James Walsh, Capital Cities/ABC Inc., Suntory International Corporation and the Shubert Organization. At the Ethel Barrymore Theater, 243 West 47th Street, Manhattan.

Stanley Kowalski	Alec Baldwin
Stella Kowalski	Amy Madigan
Eunice Hubbell	Aida Turturro
Negro Woman	Edwina Lewis
Blanche DuBois	Jessica Lange
Steve Hubbell	James Gandolfini
Harold Mitchell	Timothy Carhart
Pablo Gonzales	Lazaro Perez
Young Collector	Matt McGrath
Mexican Woman	Sol Echeverria
A Man	William Cain
A Woman	Susan Aston

By FRANK RICH

Depending on your feelings about "Long Day's Journey Into Night," "A Streetcar Named Desire" is either the greatest or second-greatest play ever written by an American. But actors have to be half-mad to star in Tennessee Williams's drama on Broadway, where the glare is unforgiving and the ghosts of Elia Kazan's original 1947 production, as magnified by the director's classic 1951 film version, are fierce. Stacked against Marlon Brando, the first Stanley Kowalski, and Jessica Tandy and Vivien Leigh, the stage and screen originators of Blanche DuBois, who can win?

The exciting news from the Ethel Barrymore Theater, where Gregory Mosher's new Broadway staging of "Streetcar" arrived last night, is that Alec Baldwin has won. His Stanley is the first I've seen that doesn't leave

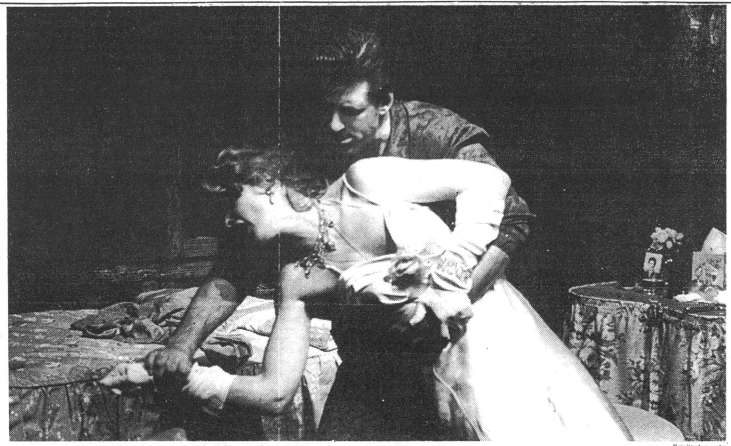

Brigitte Lacombe

Jessica Lange as Blanche DuBois and Alec Baldwin as Stanley Kowalski in "A Streetcar Named Desire," at the Ethel Barrymore Theater.

one longing for Mr. Brando, even as his performance inevitably overlaps his predecessor's. Mr. Baldwin is simply fresh, dynamic and true to his part as written and lets the echoes fall where they may. While his Stanley does not in the end ignite this play's explosive power, that limitation seems imposed not by his talent but by the production surrounding him and, especially, by his unequal partner in unhinged desire, Jessica Lange's Blanche DuBois.

•

Unsurprisingly, Mr. Baldwin imbues Stanley with an animalistic sexual energy that sends waves through the house every time he appears onstage. The audience responds with edgy delight from when he first removes his shirt and unself-consciously uses it to wipe the New Orleans sweat from his armpits and torso. Yet the actor's more important achievement is to bring a full palette to a man who is less than a hero but more than a brute. Cruel as Mr. Baldwin's Stanley is, and must be, he comes across as an ingenuous, almost-innocent working stiff until Blanche provokes him to move in for the kill. His Stanley is funny in a post-adolescent, bowling buddy way as late as the rape scene, when he fondly emulates a cousin who was a "human bottle-opener." Even the famous interlude in which he screams for his wife, Stella (Amy Madigan), becomes pitiful as well as harrowing when Mr. Baldwin, a fallen, baffled beast, deposits himself in a sobbing heap at the bottom of a tenement's towering stairs.

Not the least of the actor's achievements is to remind us why Williams's play is so much more than the sum of its story of Stanley's battle with the sister-in-law who invades his and Stella's shabby French Quarter flat. "I am 100 percent American, born and raised in the greatest country on

earth," Stanley rightly bellows at one point, after Blanche has taunted him one time too many for being a "Polack." He fills the play with the America of big-shouldered urban industrialism, of can-do pragmatism, of brute strength and vulgar humors: the swaggering America that believes, as Stanley paraphrases Huey Long, that "every man is a king." Mr. Baldwin makes it easy to see how Blanche and the ambivalent, self-destructive author for whom she is a surrogate could find this simian, menacing man mesmerizing even as he embodies the very forces on a "dark march" to destroy them and their romantic old America of decaying plantations, kind strangers and "tenderer feelings."

•

That destruction, which is the inexorable tragedy of "Streetcar," remains untapped here because Ms. Lange's Blanche leaves the play pretty much as she enters it: as a weepy, uncertain yet resourceful woman who has endured some hard knocks rather than suffered a complete meltdown into madness. A terrific film actress who deserves credit for courageously making her Broadway debut in the most demanding of roles, Ms. Lange can easily be faulted for her lack of stage technique, including a voice that is not always audible and never sounds like that of a lapsed Mississippi belle. But she works harder and more intelligently than all three movie stars put together across the street in "Death and the Maiden," and the real problem with her Blanche is less a matter of deficient stage experience than of emotional timidity.

"I don't want realism, I want magic!" goes one of Blanche's signature lines, but Ms. Lange insists on providing realism. She's not a moth facing disintegration as she flies into the flame but a spaced out, softer-spoken

Frances Farmer in her cups. The diaphanous web of artifice that surrounds this heroine, the gauzy lies and fantasies that cloak her as surely as her paper Chinese lantern disguises her room's naked light bulb, never materializes.

•

Without them, there are no layers of personality for Mr. Baldwin's Stanley to rip through and no chance for the audience to be shattered by the drama of a woman being stripped of illusion after illusion until there is nothing left but the faint, bruised memory of an existence torn between the poles of gentility and desire. In Ms. Lange's resilient characterization, which siphons off much of Blanche's fragility and sorrow into an omnipresent and much-twisted handkerchief, the heroine's wry English teacher's humor survives but the traumatic soliloquies, from the account of her husband's suicide to her late confession of promiscuity, seem thought out rather than felt.

Mr. Mosher, an unerring director of David Mamet's plays, does not seem to be at his best directing women, in "Streetcar" anyway. Ms. Madigan, whose stage work has generally been as accomplished as her screen appearances, captures Stella's Southern gregariousness but not the erotic exuberance and divided loyalties of a young, pregnant wife caught between her husband and her sister. As Mitch, the stolid suitor Blanche sees as a protector, Timothy Carhart still seems to be playing the coarse redneck of "Thelma and Louise." He is physically wrong for the role and anachronistic in tone and appearance.

What Mr. Mosher does achieve in his production is an impressive display of a director's stagecraft. Except for the placement of intermission, this "Streetcar" is meticulous in its efforts to conform to the well-

documented Kazan original, which played the same stage almost 45 years ago. Ben Edwards's brooding and decaying indoor-outdoor set, Kevin Rigdon's poetic lighting, the floating fragments of music and even the questionable dropping of the curtain at the end of each scene all respect tradition, to the cautious point of treating "Streetcar" as a museum piece.

While this approach does not permit many surprises, it does allow an audience to appreciate the baroque architecture and verdant language of a play that never ceases to fascinate, even in readings far inferior to this one. When the electric Mr. Baldwin is onstage, you can, for better and worse, imagine the bold new "Streetcar" that has been allowed to slip away.

1992 Ap 13, C11:3

Two Trains Running

By August Wilson; directed by Lloyd Richards; scene design by Tony Fanning; costumes by Chrisi Karvonides; lighting by Geoff Korf; production stage manager, Karen L. Carpenter. Presented by Yale Repertory Theater, Stan Wojewodski Jr., artistic director; Center Theater Group/Ahmanson Theater, Gordon Davidson, producing director, and Jujamcyn Theaters, Benjamin Mordecai, executive producer. At the Walter Kerr Theater, 219 West 48th Street, Manhattan.

Risa	Cynthia Martells
Wolf	Anthony Chisholm
Memphis	Al White
Holloway	Roscoe Lee Browne
Hambone	Sullivan Walker
Sterling	Larry Fishburne
West	Chuck Patterson

By FRANK RICH

In "Two Trains Running," the latest chapter in his decade-by-decade chronicle of black American life in

this century, August Wilson arrives at a destination that burns almost too brightly in memory to pass for history. "Two Trains Running" is Mr. Wilson's account of the 1960's, unfurling at that moment when racial conflict and the Vietnam War were bringing the nation to the brink of self-immolation.

Yet Mr. Wilson's play, which opened last night at the Walter Kerr Theater, never speaks of Watts or Vietnam or a march on Washington. The Rev. Dr. Martin Luther King Jr. is mentioned only once. The garrulous characters, the regulars at a Pittsburgh ghetto lunch counter in 1969, are witnesses to history too removed from the front lines to harbor more than the faintest fantasies of justice. They invest their hopes in playing the numbers, not in distant leaders sowing lofty dreams of change.

So determined is "Two Trains Running" to avoid red-letter events and larger-than-life heroes that it is easily Mr. Wilson's most adventurous and honest attempt to reveal the intimate heart of history. In place of a protagonist that a Charles Dutton or James Earl Jones might play is a gallery of ordinary people buffeted by larger forces that they can join or gingerly battle but cannot begin to promote or control. While such 60's props as a gun and cans of gasoline do appear in "Two Trains Running," the evening's most violent dramatic event causes no serious injury and takes place offstage. Even so, a larger, national tragedy is spreading underfoot.

●

As might be expected in a work that departs from every Wilson effort except "Joe Turner's Come and

Gone" in its experimental will to demolish the manufactured confrontations of well-made drama, "Two Trains Running" is not without blind alleys. And it is compromised by a somewhat bombastic production, staged by the author's longtime collaborator Lloyd Richards, that sometimes takes off running in a different direction from the writing. But the play rides high on the flavorsome talk that is a Wilson staple. The glorious storytelling serves not merely as picturesque, sometimes touching and often funny theater but as a penetrating revelation of a world hidden from view to those outside it.

●

Much of the talk is prompted by two deaths that filter into Memphis Lee's restaurant, itself doomed to be demolished. The sole waitress, Risa (Cynthia Martells), grieves for Prophet Samuel, an evangelist whose attainments included a cache of jewelry, a white Cadillac, a harem and a huge flock that is viewing his open casket down the street. The one stranger to visit Memphis Lee's, a newly released convict named Sterling (Larry Fishburne), is latently preoccupied with the 1965 assassination of Malcolm X, not out of any deep ideological convictions but because a rally in the fallen radical's name at the local Savoy Ballroom gives him a pretext to ask Risa for a date.

Though the issue is never articulated, Mr. Wilson's characters are starting to compare the prophets who offer balms for their poverty and disenfranchisement, and no two representative prophets could be more different than Malcolm X and Samuel. But the play's real question may be, as one line poses it, "How we gonna feel good about ourselves?" The liveliest

talkers in "Two Trains Running" are members of an older generation skeptical of all externally applied panaceas, secular and religious.

●

Memphis (Al White), who is negotiating a price for the city's demolition of his restaurant, is confident he can beat the white man at his own game as long as he knows the rules. To him, those who argue that "black is beautiful" sound like "they're trying to convince themselves." Holloway (Roscoe Lee Browne), a retired house painter turned cracker-barrel philosopher, is not only scathing about white men who exploit black labor but also about any effort by what he calls "niggers" to fight back. He sends anyone with a grievance to a mysterious, unseen prophet, the supposedly 322-year-old Aunt Ester, the neighborhood's subliminal repository of its buried African identity and a magical universe of faith and superstitions.

In some of the richest and most hilarious arias, the marvelously dyspeptic Mr. Browne encapsulates the whole economic history of the United States into an explosive formula and reminisces scathingly of a grandfather so enthralled by the plantation mentality he could not wait to die and pick heaven's cotton for a white God. Even nastier gallows humor is provided by West (Chuck Patterson), an undertaker whose practical view of death has made him perhaps the community's keenest social observer and certainly its wealthiest entrepreneur.

As conceived by Mr. Wilson, the monologues, musical in language and packed with thought and incident, are not digressions; they are the play's very fiber. Such plot as there is involves the fate of a symbolic mentally

unbalanced man named Hambone (Sullivan Walker) who pointedly

Political consciousness gets a lift from romantic ardor.

"ain't willing to accept whatever the white man throw at him" and the rising political consciousness and romantic ardor of Sterling, whose sincere efforts to cobble a post-penitentiary life and livelihood are constantly frustrated.

●

Along with the usual Wilson repetitions and the heavy metaphorical use of Hambone (who is a hammier version of the mentally disturbed Gabriel in "Fences"), the flaws of "Two Trains Running" include its inability to make more than a thematic conceit out of its lone woman, Risa, who enigmatically bears self-inflicted razor scars, and its failure to delve far below Sterling's surface, despite a searching performance by Mr. Fishburne. Mr. Wilson's reticence about his two youngest and most crucial characters turns up most glaringly in the pivotal but underwritten Act II scene that brings them together to the music of a previously dormant jukebox.

Mr. Fishburne, who greets each of Sterling's defeats with pride and heroic optimism, and Mr. Browne, an orator of Old Testament fire, are the jewels of the production. The rest of the cast is at most adequate, with Mr. White's ranting Memphis, whose longer soliloquies punctuate both acts, inflicting the greatest damage. The uneven casting is compounded by the harsh, bright lighting, the flatly realistic set and the slam-bang choreography of a text that needs to breathe rather than hyperventilate. Instead of looking like a production that has been polished during its long development process through the country's resident theaters, "Two Trains Running" sometimes seems the battered survivor of a conventionally grueling road tour.

The play fascinates anyway and makes its own chilling point. Just as this is the Wilson work in which the characters are the furthest removed from both Africa and the Old South (to which the untaken trains of the title lead), so it is also the Wilson play closest in time to our own. "You take something apart, you should know how to put it together," says Sterling early on, referring to a wristwatch he hesitates to dismantle. Rough in finish and unresolved at the final curtain, "Two Trains Running" captures a racially divided country as it came apart. That Mr. Wilson's history bleeds so seamlessly into the present is testimony to the fact that the bringing together of that America is a drama yet to unfold.

1992 Ap 14, C13:4

Jay Thompson/Jeffrey Richards Associates

Larry Fishburne, left, and Roscoe Lee Browne in August Wilson's new play, "Two Trains Running."

Guys and Dolls

Music and lyrics by Frank Loesser; book by Jo Swerling and Abe Burrows; based on a story and characters by Damon Runyon; directed by Jerry Zaks; settings by Tony Walton; costumes by William Ivey Long; lighting by Paul Gallo; musical supervision by Edward Strauss; dance music by Mark Hummel; sound by Tony Meola; orchestrations by George Bassman, Ted Royal and Michael Starobin; choreographed by Christopher Chadman; production stage manager, Steven Beckler. Presented by Dodger Productions, Roger Berlind, Jujamcyn Theaters/TV Asahi, Kardana Productions and the John F. Kennedy Center for the Performing Arts. At the Martin Beck Theater, 302 West 45th Street, Manhattan.

Nicely-Nicely Johnson............... Walter Bobbie
Benny Southstreet...................... J. K. Simmons
Rusty Charlie Timothy Shew
Sarah Brown Josie de Guzman
Arvide Abernathy................... John Carpenter
Agatha.................................. Eleanor Glockner
Calvin Leslie Feagan
Martha Victoria Clark
Harry the Horse......................... Ernie Sabella
Lieut. Brannigan Steve Ryan
Nathan Detroit Nathan Lane
Angie the Ox and Joey BiltmoreMichael Goz
Miss Adelaide Faith Prince
Sky Masterson........................Peter Gallagher
Hot Box MC.................................... Stan Page
Mimi .. Denise Faye
Gen. Matilda B. Cartwright
 Ruth Williamson
Big Jule................................... Herschel Sparber
Drunk Robert Michael Baker
Waiter Kenneth Kantor
WITH: Gary Chryst, R. F. Daley, Randy André Davis, Tina Marie DeLeone, David Elder, Cory English, Mark Esposito, Pascale Faye-Williams, Leslie Feagan, JoAnn M. Hunter, Carlos Lopez, Nancy Lemenager, John MacInnis, Greta Martin and Scott Wise.

By FRANK RICH

If you have ever searched Times Square to find that vanished Broadway of lovable gangsters, wisecracking dolls and neon-splashed dawns, you must not miss the "Guys and Dolls" that roared into the old neighborhood last night. As directed with a great eye and a big heart by Jerry Zaks and performed by a thrilling young company that even boasts, in Faith Prince, the rare sighting of a brand-new musical-comedy star, this is an enchanting rebirth of the show that defines Broadway dazzle.

It's hard to know which genius, and I do mean genius, to celebrate first while cheering the entertainment at the Martin Beck. Do we speak of Damon Runyon, who created the characters of "Guys and Dolls" in his stories and with them a whole new American language? Or of Frank Loesser, who in 1950 translated Runyon into songs with melodies by turns brash and melting and lyrics that are legend? This being the theater department, please forgive my tilt toward Loesser, whose musical setting of phrases like "I got the horse right here" and "a person could develop a cold" and "the oldest established permanent floating crap game in New York" are as much a part of our landscape as the Chrysler Building and Radio City Music Hall.

●

The thing to remember about Runyon is that he was born in Kansas and didn't reach Manhattan until he was 26. His love for his adopted town is the helplessly romantic ardor of a pilgrim who finally found his Mecca. That romance is built into the text of "Guys and Dolls," in which the hoods and chorus girls engage in no violence, never mention sex and speak in an exaggeratedly polite argot that is as courtly as dese-and-dose vernacular can be.

Runyon's idyllic spirit informs every gesture in this production. Mr. Zaks, the choreographer Christopher Chadman and an extraordinary de-sign team led by Tony Walton give the audience a fantasy Broadway that, if it ever existed, is now as defunct as such "Guys and Dolls" landmarks as Klein's, Rogers Peet and the Roxy. Yet it is the place we dream about whenever we think of Runyon and Loesser or anyone else who painted New York as a nocturnal paradise where ideas and emotions are spelled out sky-high on blinking signs and, to quote another lyric, "the street lamp light fills the gutter with gold."

Mr. Zaks, whose achievements include most relevantly the Lincoln Center revivals of "Anything Goes" and "The Front Page," stages the book of "Guys and Dolls" for both its comedy and its emotions. That book was written by Abe Burrows from an abandoned first draft by the screenwriter Jo Swerling, and its solid construction reflects the influence of the original production's director, George S. Kaufman. But funny and fast-paced as the dialogue is, the show seems about more than Nathan Detroit's farcical route to a crap game and the calculating efforts of Sky Masterson to win a bet by bamboozling the puritanical Sarah Brown, of the Save-a-Soul Mission, into a dinner date in Cuba. This company turns up the temperature just enough to induce goose bumps in the guy-and-doll encounters of "Guys and Dolls."

●

Peter Gallagher, who made an impression in one Broadway musical (the short-lived "A Doll's Life"), before moving on to heavier dramatic duties, is a heaven-sent Sky Masterson with brooding good looks, a voice that always remains both in mellow key and in gritty character, and a dark, commanding presence that is up to the high theatrical stakes of "Luck Be a Lady." Mr. Gallagher also has a shy smile that slowly breaks through his tough facade much as the Havana moon does through the clouds behind him. When he clasps the hands of his Sarah, Josie de Guzman, to his chest while she sings her half of "I've Never Been in Love Before," you feel the sweet infatuation typical of couples in Mr. Zaks's productions and you understand that the Loesser who wrote this ballad is indeed the same man who wrote "My Heart Is So Full of You" for "The Most Happy Fella." Ms. de Guzman, whose refreshing mission doll is bemusedly prim rather than a schoolmarm, makes a lovely partner to Mr. Gallagher, with a voice that peals joyously as well as tipsily in "If I Were a Bell."

The evening's biggest laughs, of course, belong to Ms. Prince's Miss Adelaide, the Hot Box dancer and perennial fiancée who stops the show with her sneeze-laden lament in Act I, then brings down the house in Act II with "Take Back Your Mink," surely the only strip-tease ever written as one long nasal kvetch. Ms. Prince, the only bright spot in the late "Nick and Nora," here crosses into another dimension as she punctuates "A Bushel and a Peck" with Marilyn Monroe squeaks, roars a lifetime of frustration into the phrase "then they get off at Saratoga, for the 14th time" and turns the word "subsequently" (as in "Marry the man today and train him subsequently") into a one-word playlet that makes happily ever after sound a bit like boot camp.

●

With her big features, piled blond hair and prematurely matronly sexuality, this wholly assured actress echoes Judy Holliday as much as she does her famous predecessor as Ade-

Peter Gallagher, far left, and Josie de Guzman in a scene from the revival of the 1950 hit musical "Guys and Dolls." Faith Prince and Nathan Lane, far right, also star at the Martin Beck Theater.

laide, Vivian Blaine. The combination, though, is a bracing original. As her eternal intended, that supremely gifted actor Nathan Lane does not remotely echo the first Nathan Detroit, Sam Levene, for whose New York Jewish cadences the role was written. Mr. Lane is more like a young Jackie Gleason and usually funny in his own right, though expressions like "all right, already" and "so nu?" do not fall trippingly from his tongue. But once he and Ms. Prince loudly lock vocal horns during "Sue Me," chances are you will forgive him anything.

In all his casting, Mr. Zaks seems to have followed the producer Cy Feuer's 1950 dictum of seeking "people with bumps." There are some classic gangster mugs on the mugs in this company, including those of J. K. Simmons (as Benny Southstreet), Ernie Sabella (Harry the Horse) and Herschel Sparber (the villain, Big Jule). Walter Bobbie nicely breaks the chubby mold established by Stubby Kaye in the part of Nicely-Nicely Johnson (the character is thin in Runyon) and leads an infectious "Sit Down, You're Rockin' the Boat" that is choreographed to a claustrophobic frenzy by Mr. Chadman, who has such spectacular dancers as Scott Wise and Gary Chryst stashed in his chorus.

●

Mr. Chadman's other dance routines, including the energizing "Crapshooters' Dance" led by Mr. Wise in the depths of a sewer, are in the spirit of Michael Kidd's wonderful originals (as re-created in the Sam Goldwyn film) but are not imprisoned by them. The same is true of the orchestrations, which preserve all the indelible passages of the Ted Royal-George Bassman originals but are helpfully amended by contributions from Michael Starobin and Michael Gibson.

The production's highly stylized design is in a class apart. William Ivey Long's boldly striped and extravagantly iridescent costumes pay an acknowledged debt to those first created by Alvin Colt and Irene Sharaff for Broadway and Hollywood, much as Mr. Walton's sets take a recogniz-

able bow to Jo Mielziner and Oliver Smith, who respectively designed the

A vanished Broadway era is evoked by a stage classic.

original settings for stage and screen. The brilliant lighting, which offers a rainbow of hues for all times of day, is by Paul Gallo, who both here and in "Crazy for You" is setting a high standard for his art that would have been unimaginable, and technologically unattainable, in the days of Loesser or the Gershwins.

●

But Mr. Walton's achievement here goes beyond his nostalgic evocation of 1950's musicals, with his pointed use of the painted drops that dominated Broadway design mechanics of that time. In his "Guys and Dolls," a black-and-white front curtain of an urban scene reminiscent of a Reginald Marsh drawing can pull up to reveal the same scene, now painted on a backdrop, that remakes New York in deeply saturated colors from the fantastic spectrums of Matisse and Dufy. A vintage pay phone can be splashed in sea green, as if rising up from an audience's buried collective fantasy of a distant past, and stacks of newspapers thrown on a Times Square pavement at daybreak can form a lonely composition worthy of Edward Hopper's New York.

Everything about Mr. Walton's design, like nearly everything about this production, demands that the audience look at "Guys and Dolls" again and see it fresh. The cherished Runyonland of memory is not altered, just felt and dreamt anew by intoxicated theater artists. No doubt another Broadway generation will one day find a different, equally exciting way to reimagine this classic. But in our lifetime? Don't bet on it.

1992 Ap 15, C15:3

Bunny (Joel Blum) who slides down a spectacular laser rabbit hole, sings, dances, jokes, conducts the Radio City Music Hall Orchestra and runs a race against a very dour tortoise.

It also has the Rockettes. In a show that is very much a celebration of the neighborhood, they are first seen trooping through revolving doors of a set depicting the Music Hall's entrance. Over the course of the 90-minute show they become Gibson girls, Ziegfeld girls and Fifth Avenue promenaders bedecked in humorously extravagant bonnets.

Much of the success of the Easter show, which is directed and choreographed by Scott Salmon, lies in its pacing. One tableau flows into another with no awkward breaks. Of all the extravaganzas that are presented at Radio City, the Easter show provides the best demonstration of the smoothness of its elaborate system of stage elevators and turntables.

STEPHEN HOLDEN

SoHo Rep Presents

SoHo Repertory Theater
46 Walker Street
TriBeCa
Through Sunday

A political satire by Mac Wellman; directed by Jim Simpson; set and lighting by Kyle Chepulis; costumes by Caryn Neman; sound by Mike Nolan; production stage manager, Catherine A. Heusel. Artistic directors, Marlene Swartz and Julian Webber. WITH: Valerie Charles, Kristen Harris, Melissa Smith, Reed Birney, Steve Mellor, John Seitz, John Augustine and Jon Tytler.

Senator Bob (no other name) believes in piety in the sky and censorship as a sentinel of democracy, but he also has a prurient mind. So what does he do when seven sexually explicit photographs are delivered to his chamber? First of all, he looks at them; he and his staff are goggle-eyed at the contortions in these unspeakable acts. Then he tries to sleuth the case, to determine if the photographs are intended as "smear or surveillance," or if he can use the pictures to make political hay at someone else's expense.

The new Mac Wellman comedy, the title of which is unprintable here, tracks the path of those incriminating photographs as they move up from secretary to senator, and as body parts are confused with Borzoi dogs and potted plants.

In previous works, like "Sincerity Forever," Mr. Wellman tellingly lampooned the philistines who inhabit bastions of American political life. In his current play (at SoHo Rep), he is up to his customary alarums and excursions, trying to alert the populace to the dangers of hypocrisy in high places. But the play does not have the linguistic dexterity of earlier Wellman. Operating on one note, it has too many scenes with characters looking at and commenting on those photographs. Even at its relatively brief length, the play seems stretched beyond its resilience.

At the same time, Mr. Wellman never loses his sense of outrage. For this playwright as iconoclast, the beleaguered United States Congress is a house of sitting lame ducks, easy targets for his scattershot. The objects of his derision are dissemblers in public life, the do-nothings and anti-civil libertarians who attack all endowments and would sell out a principle if it suited a pragmatic purpose.

Surrounding Senator Bob are a covey of yes men and women and a deacon of a television church, each of whom is fawning for his approval. It

is no surprise that the smartest of his flock is the ingénue who answers the telephone, "Hello. Nothing of value," and the least competent under fire is the aide who once worked for the Dartmouth Review. Mr. Wellman writes comedies that are also political position papers.

As director, Jim Simpson has enhanced the play with a piquant production. Kyle Chepulis's set and lighting are crisply coordinated, including even an ant farm, the Senator's pet plaything. The actors are an agile comic team: Valerie Charles, Melissa Smith and Reed Birney (as a legislative assistant who suffers a meltdown). Steve Mellor, as the television evangelist who cannot keep his mind on his morality, unravels a riff of dementia as he did in Mr. Wellman's "Terminal Hip."

As portrayed with calm arrogance by John Seitz, Senator Bob has the hide of a buffalo and the venom of a viper. Nothing will ever get him down, not a vote of censure and certainly not a crypto "maso-sado-momo-dodo" seeking a grant. Even in this lesser effort, Mr. Wellman strews the path with pith, as in the Senator's statement, "Ignorance of the law is nine-tenths of the law."

MEL GUSSOW

1992 Ap 15, C19:1

─────

Heartbreak House

By George Bernard Shaw; directed by Michael Langham; set by Douglas Stein; costumes by Ann Hould-Ward; lighting by Pat Collins; music by Stanley Silverman; sound by David Budries; dramaturge, Greg Leaming; production stage manager, Deborah Vandergrift. Presented by the Hartford Stage, Mark Lamos, artistic director; David Hawkanson, managing director. At Hartford.

Captain ShotoverJohn Franklyn-Robbins
Nurse GuinnessMary Diveny
Ellie DunnLisa Dove
Lady Ariadne Utterword.........Randy Danson
Hesione HushabyeHelen Carey
Mazzini Dunn..................Theodore Sorel
Hector HushabyeLarry Pine
Boss Mangan.............................Jerry Lanning
Randall Utterword.................Samuel Maupin
Billy Dunn...Ron Faber
An Indian boyAllan Dexter Lawson

By MEL GUSSOW

Special to The New York Times

HARTFORD, April 14 — The people who gather in "Heartbreak House" are intended to represent "cultured, leisured Europe" languishing before the outbreak of World War I. Complacently removed from anything remotely resembling political or social upheaval, they inhabit a stylish wasteland. They drink tea and exchange epigrammatic insights as the conflagration begins.

In his "fantasia in the Russian manner on English themes," Shaw freely paid his debt to Chekhov. "Heartbreak House" is a Shavian response to "The Cherry Orchard," a last estate before the end of an order. The play achieves its continuing vitality because of the eloquence of the dialogue and the pertinence of the themes in a world of renewable isolationism.

Although Captain Shotover, an ancient mariner turned landed gentry, is the officer in charge, the play demands a cast of equals, which is what it receives under Michael Langham's direction at Hartford Stage. This is, in all respects, a well-modulated production, carefully attuned to the nuances and giving each person an appropriate platform. Theatergoers can

Theater in Review

■ The Rockettes and others in Radio City's Easter celebration ■ Incriminating photographs and political haymaking in Mac Wellman satire.

The Radio City Easter Show

Radio City Music Hall
50th Street and Avenue
of the Americas
Through April 23

Production conceived by Patricia M. Morinelli and William Michael Maher; directed and choreographed by Scott Salmon; sets and costumes by Erté; lighting, Ken Billington and Jason Kantrowitz; costumes, Eduardo Sicangco and José Lengson; musical director, Don Pippin; production stage manager, Howard Kolins; soloist on "Glory of Easter" recording, Marilyn Horne. Presented by Radio City Music Hall Productions, J. Deet Jonker, executive producer; David J. Nash, producer.
WITH: The Rockettes, the Radio City Music Hall Orchestra, Joel Blum and Antigravity.

Now celebrating its third year at Radio City Music Hall after an 11-year hiatus, the "Radio City Easter Show" is an object lesson in how to stage a seasonal pageant that never flags and has something for almost everyone.

For the religious, it offers Vatican-style pomp and ceremony in its opening "Glory of Easter" sequence. For the athletic it features impressive gymnastic displays by the acrobatic dance troupe Antigravity. For the nostalgic, it has splashy tableaux recalling 1890's New York and the Ziegfeld Follies, and for the romantic its section "Dancing in the Dark" presents enraptured young couples gliding across an Art Deco field of stars. For children, it has an Easter

T. Charles Erickson/"Heartbreak House"

John Franklyn-Robbins in "Heartbreak House."

oe momentarily persuaded by an argument, until it is contradicted by an antithetical position. In this production, the characters retain their charm against all dramatic reason.

•

As promised, the house is "full of surprises," and the most surprising element is the Captain himself. He pretends to be in his dotage but is actually the closest to a rational force of nature. John Franklyn-Robbins's Shotover is clear-sighted rather than rheumy, a ditherer but not a dodderer. Looking like Shaw (often the case in the role), Mr. Franklyn-Robbins is a captain trying to overhaul a vessel while it is at sea. He is a codger with a residual sense of usefulness, perpetually seeking "a seventh degree of concentration."

As the captain's daughters, Helen Carey and Randy Danson are sterling opposites. Ms. Carey's Hesione is warmhearted and womanly as she stage-manages romances. Last seen at the Hartford Stage as a condemned prisoner in "Our Country's Good," Ms. Carey totally reverses herself and becomes the elegant hostess of "Heartbreak House."

In contrast, Lady Utterword is haughty and self-righteous but not without sympathy, as shown in Ms. Danson's amusing performance. She is someone who, in Harold Clurman's words, has a "desire to escape the prison of her class convention." To a great extent, the behavior of the sisters is a natural reaction to the obtuseness of the men who surround them with admiration. This could also be said about Ellie Dunn, the young woman who allows herself to be engaged to the boorish Boss Mangan. In the role, Lisa Dove is impetuous before she wills herself to self-determination.

•

If there is no true heartbreak in the play, no Shavian equivalent of the eradication of the orchard in Chekhov, there is more humanity than one customarily finds in works by the author, a fact that is enhanced in the performances by the actresses and by others in the company, including Larry Pine, Jerry Lanning and Samuel Maupin.

In his production, Mr. Langham has underscored the subtext by adding the nonspeaking role of an Indian servant to symbolize the loss of empire and by using an imaginative open-walled set by Douglas Stein. The set makes the house seem like a world unto itself. Within it there is a feeling of both personal habitation and geographic environment. In the background, Stanley Silverman's music adds a thread of colonial discontent.

Faced with such an intelligent version of a challenging play, one must note that no classic revival of similarly high quality revival can be seen in New York. Mr. Langham, an acknowledged master in matters Shakespearean, is equally dexterous when it comes to Shaw.

1992 Ap 16, C16:1

Metro

Book and lyrics by Agata Miklaszewska and Maryna Miklaszewska; music and musical direction by Janusz Stoklosa; English book by Mary Bracken Phillips and Janusz Jozefowicz; English lyrics by Ms. Phillips; directed and choreographed by Mr. Jozefowicz; scenery by Janusz Sosnowski; costumes by Juliet Polcsa and Marie Anne Chiment; lighting by Ken Billington; sound by Jaroslaw Regulski; laser effects by Mike Deissler; production stage manager, Beverley Randolph. Presented by Wiktor Kubiak. At the Minskoff Theater, 200 West 45th Street.

Anka	Katarzyna Groniec
Jan	Robert Janowski
Edyta	Edyta Gorniak
Max	Mariusz Czajka
Philip	Janusz Jozefowicz
Viola	Violetta Klimczewska
Iwona	Iwona Runowska

WITH: Krzysztof Adamski, Monika Ambroziak, Andrew Appolonow, Jacek Badurek, Alicja Borkowska, Michal Chamera, Pawel Cheda, Magdalena Depczyk, Jaroslaw Derybowski, Wojciech Dmochowski, Malgorzata Duda, Katarzyna Galica, Katarzyna Gawel, Denisa Geislerova, Lidia Groblewska, Piotr Hajduk, Joanna Jagla, Jaroslaw Janikowski, Adam Kamien, Grzegorz Kowalczyk, Andrzej Kubicki, Katarzyna Lewandowska, Barbara Melzer, Michal Milowicz, Radoslaw Natkanski, Polina Oziernych, Marek Palucki, Beata Pawlik, Katarzyna Skarpetowska, Igor Sorine, Ewa Szawlowska, Marc Thomas, Ilona Trybula, Beata Urbanska and Kamila Zapytowska.

By FRANK RICH

WHAT'S the Polish word for fiasco?

Whatever it is, I'm not sure even it is adequate to describe the unique experience that is "Metro," the hit Warsaw musical that arrived on Broadway last night.

Here is a show that wants nothing more than to imitate "A Chorus Line," and where is it playing? Not just in New York City, but at the cavernous Minskoff, right across Shubert Alley from the theater where the original "Chorus Line" ran for only about 15 years! It's one thing to carry coals to Newcastle, but a whole coal mine?

Purportedly costing $5 million, this show is "A Chorus Line" as it might have been produced by the Festrunk brothers, those wild and crazy Eastern European swingers that Dan Aykroyd and Steve Martin used to play on "Saturday Night Live." Gloomy and jerky, "Metro" often looks as if it is taking its cues from a faded 10th-generation bootleg videocassette of the film version of its Broadway prototype, with a reel of "Hair" thrown in by mistake. The score, by Janusz Stoklosa,

mixes fragments of ersatz Hamlisch with heavily miked Europop, though the music, too, sounds muted and distorted, as if in imitation of West European radio stations in the days when their signals still battled Soviet jamming on their way East. Should "Metro" be indicative of how our mass-cultural debris is filtering into the new Europe, America has a lot more to answer for than just Euro Disneyland.

The show's book, as translated into less-than-colloquial English, has to do with several dozen ragtag young street performers variously dressed in torn jeans and tutus who audition for an autocratic director assembling a new musical. When they fail to get jobs, they stage a rival show in the subway, and it proves so successful that capitalists start throwing money at them. "I think things were easier under the Communists," says one of the characters, who are torn between pure artistic principles and the Faustian prospect of selling out to show-biz commerce. Given "Metro" itself, the resolution of this moral drama is never in doubt.

•

The evening has a little bit of everything, including break-dancing, a love story, gymnastics, laser-light displays, a tap routine and for a socko finish, a suicide. The spare black set is dominated by a large post-Constructivist staircase that rotates on a turntable and by subway signs that spell out the alluring word Exit in a wide variety of languages. Periodically the cast pushes forward en masse and at the edge of the stage vehemently delivers a song that is the "Metro" answer to "Let the Sun Shine In." Though lyrics like "We are the children!" and "We are the people!" are repeatedly punctuated by loud cries of "Freedom!" the number does not significantly alter the audience's impression that it has landed in jail.

As Janis Joplin once sang, freedom's just another word for nothing left to lose. You have to feel sorry for the kids in "Metro," who work extremely hard, singing and dancing with unflagging energy in pursuit of starry-eyed dreams. If only New York City had a heart, someone might treat them to a steak dinner and maybe even tickets to a Broadway show.

1992 Ap 17, C1:3

One of the All-Time Greats

By Charles Grodin; directed by Tony Roberts; set design, Allen Moyer, lighting, Phil Monat; costumes, Muriel Stockdale; sound, Bruce Ellman; production stage manager, Maura J. Murphy. Presented by the Vineyard Theater, Barbara Zinn Krieger, executive director; Douglas Aibel, artistic director. At 108 East 15th Street.

Waiter	Kim Chan
Alvin	Larry Block
Lenore	Renée Taylor
Ric	Richard B. Shull
Norman	Lou Liberatore
Darlene	Helen Greenberg
Marty/Manny	Jack Hallett
Claudia	Francine Beers
Joe	Tom McGowan
Melanie Noelle	Kimberleigh Aarn

By MEL GUSSOW

In "One of the All-Time Greats," Charles Grodin chronicles the misfortunes of a Broadway disaster entitled "Thunder Road." Happily, Mr. Gro-

Martha Swope Associates/Carol Rosegg

Larry Block and Renée Taylor

din's new comedy is not one of those horrible examples. It is an airy, light-fingered commentary on the vagaries of theatrical production, an object lesson showing how experienced professionals can be carried away into a collective act of self-incrimination.

The play opened last night in the intimate surroundings of the Vineyard Theater, in a nimble production staged by Tony Roberts. Under the guidance of Mr. Grodin and Mr. Roberts (themselves expert comic actors), "One of the All-Time Greats" is an insider's report written with humor and affection.

While the play follows the formula for works of this genre, down to the second-act reading of opening-night reviews, Mr. Grodin has come up with diverse variations and maintains an engaging nonchalance in dealing with career obsessions. Although satiric points are made, no bodily harm is inflicted even on the most uncreative participant.

The playwright (Lou Liberatore) is a first-time venturer onto Broadway, the director (Larry Block) has been a frequent failure after a single success and the producer (Richard B. Shull) is like a campaign pollster addicted to taking the pulse of others. In this climate, everyone's opinion is equally valid, including the hospital workers who half-fill the theater before walking out at intermission.

Mr. Grodin has performed the neat trick of writing a backstage comedy that is not the theatrical equivalent of a roman à clef. No real names need apply. In contrast to Terrence McNally's "It's Only a Play," the mild-mannered but funny "All-Time Greats" gives a more generic view of Broadway strife.

The characters are shrewdly observed, beginning with the hapless director, who has become known as a trend ender. Habitually, he leaps aboard sinking ships, including plays that are the last of their kind. He desperately needs the work on "Thunder Road," which means that his direction is an exercise in self-denial. It is up to his wife (Renée Taylor, offering a leavening note of sanity in this den of delusion) to urge him to have either courage or convictions.

Meeting in a Chinese restaurant over a period of weeks from preview to opening, the mismatched collaborators try to thrash out their creative differences, if only they knew what they were. Much of the fun comes from the outsiders: the playwright's girlfriend who is unknowing but filled with suggestions; the Chinese waiter whose solution is to put Asians in the cast, and a trendy director called in as play doctor. In this cameo role, Tom McGowan merrily upstages everyone with his elephantine ego.

After restoring everything that has been cut from the play during previews, "Thunder Road" opens and everyone gathers to receive the death notices. One comes from the New

York Times critic, who, we have been warned, "has a personal prejudice against mediocrity." There is the inevitable euphoria about a single favorable notice, from the most obscure of the television reviewers. Cool heads will prevail when advertising dollars are on the line.

Mr. Grodin studiously avoids the specifics of parody and refrains from name dropping, except for a final apt joke about "M. Butterfly," which necessitates a formal apology to the Chinese waiter. Even when dealing with potentially inflammatory material, the author is genial rather than malicious. His play manages to have empathy for all the disparate parties, even for the critics and theatergoers who have had to sit through the play within the play.

1992 Ap 17, C3:1

More Fun Than Bowling

By Steven Dietz; directed by John Seibert; set by Bob Phillips; costumes, Amanda J. Klein; lighting, Nancy Collings; production stage manager, Cathy Diane Tomlin. Presented by the Triangle Theater Company, Michael Ramach, producing director. At Church of the Holy Trinity, 316 East 88th Street, Manhattan.

Jake .. Fred Burrell
Lois .. T. Cat Ford
Loretta .. Sue Kenny
Molly .. Kimberly Topper
Mr. Dyson Alexander Webb

By MEL GUSSOW

A fondness for bowling and a high threshold for whimsy are requirements for enjoying Steven Dietz's "More Fun Than Bowling." In this play, the author looks at the sport as a metaphor for life, death, love and

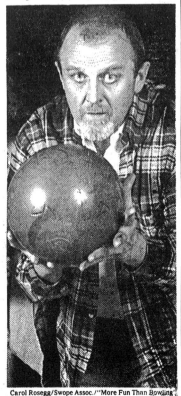

Carol Rosegg/Swope Assoc./"More Fun Than Bowling"

It's a Strike Fred Burrell is in "More Fun Than Bowling," a black comedy by Steven Dietz that compares the sport to life and death.

anything else that wanders into his lane of vision.

The centerpin of the heavily metaphorical landscape is the middle-aged proprietor of the Dust Bowl in the slow-moving town of Turtle Rapids. He has lost three wives — the first by divorce, the two others through sudden death — and he is dubious about his romantic prospects. As we are told in one of the play's surfeit of images about bowling: "Love is like being too drunk to go bowling. It doesn't happen very often." In all other respects, "More Fun Than Bowling" is terminally upbeat.

The protagonist (Fred Burrell) begins the play several feet underground, trying out a zip-top grave amid those occupied by his dead spouses. The cemetery is the plot of the play, as Mr. Dietz shifts self-consciously into a fanciful world where the dead return to life and never stop talking.

Everyone on stage is perky and sweet-tempered, except for a mock-sinister figure in black who lurks stealthily around the graveyard while targeting Mr. Burrell within his gunsights. This apparent villainy is far from the truth in a play in which each character is someone else's benefactor. For the work to be entertaining, it would have to have the offbeat humor of a William Saroyan. Mr. Dietz's comedy is of a baser mettle. It tries so hard to be ingratiating that it ends up being overinsistent about its ingenuousness.

Mr. Burrell seems rather glum to be a persuasive romantic hero, but the three actresses (Sue Kenny and T. Cat Ford as the wives, Kimberly Topper as Mr. Burrell's daughter) inject a certain lightness and amiability. For all the talk about strikes and spares, the play never leaves the cemetery, a patio-and-garden set by Bob Phillips, complete with tenpins substituting for floral arrangements. With justification, nonbowlers may feel that the play is simply not up their alley.

1992 Ap 19, 45:2

This One Thing I Do

By Claire Braz-Valentine in collaboration with Michael Griggs; directed by Gigi Rivkin; set design by Henry Fonte; costumes by Christie Harrington; lighting by Jason Livingston; sound by Jim Harrington; production stage manager, Lisa Jean Lewis. Presented by the Village Theater Company, 133 West 22d Street.

Susan B. Anthony Julia Flood
Elizabeth Cady Stanton Marjorie Feenan
WITH: Ellen Barry, Allyn Burrows, James Fleming, Belynda Hardin, Randy Kelly, David McConnell, Edward Tully and Tim Zay.

By D. J. R. BRUCKNER

"This One Thing I Do," a new play by Claire Braz-Valentine in collaboration with Michael Griggs, is nothing if not ambitious; it tries to evoke the turbulence and passion of the lives of Susan B. Anthony and Elizabeth Cady Stanton over 67 years and to celebrate their achievements.

The performance at the Village Theater, under the direction of Gigi Rivkin, is certainly celebratory and, in a few scenes depicting Anthony's confrontations with mobs and with the law, nearly riotous.

•

Julia Flood as Anthony and Marjorie Feenan as Stanton create a pair of

Jim DelGiudice/Specialized Photodesign

Marjorie Feenan in "This One Thing I Do," by Claire Braz-Valentine and Michael Griggs:

women toughened not only by opposition, but also by adversarial feelings

for each other. Ms. Flood captures the determination, anger and fury one finds in accounts of Anthony and in her writings. And Ms. Feenan, who brings out the legendary good humor of Stanton, also lets us feel her humiliation and indignation.

Any story about these women is bound to have some power, and a supporting cast of eight actors who take dozens of roles with great energy lets us glimpse the uproar of the suffragist campaign. But the play is chopped into moments of tumult and others of reflection, with few connections.

•

The problem appears sharply in an isolated late scene when an aging Stanton confesses to her supportive husband, Henry (Allyn Burrows), that she does not know what their lives might have been if, at the outset, she had had all the freedoms she was fighting for. There is a wonderful tension here that reminds one of how inherently dramatic were the lives of these women and how moving a play about them might be.

After all, if one of this play's theses is right, that they were founders not only of women's suffrage but of real modern democracy as well, what they did and thought are the stuff of great drama. One comes away from this play longing for that.

1992 Ap 19, 45:5

SUNDAY VIEW/David Richards

This 'Streetcar' Doesn't Travel Far Enough

The Williams revival qualifies as a miniature.

'Five Guys Named Moe' may lead the conga line too far.

IF YOU INTEND TO CATCH THE REvival of "A Streetcar Named Desire" starring Jessica Lange and Alec Baldwin at the Barrymore Theater, I have two pieces of counsel for you.

First, take a magnifying glass. Wherever you're seated — in the back of the balcony or fifth-row center — you're going to need it. If this production were twice as big and three times as loud, it would still qualify as a miniature. Rarely has Tennessee Williams's play, one of the sublime achievements of the American theater, seemed so small, so private, so bound up in itself.

Second, put out of your mind the steamy photograph of Mr. Baldwin and Ms. Lange that has been used to advertise the show. It gives rise to expectations, and you'll be better off without them. Rarely has a marquee promised so much and delivered so little.

I suspect that only someone involved in the proceedings from the start could account for what went wrong and who's to blame. But my hunch would be this: the production's root problem is its raison d'être — Ms. Lange, who is making her Broadway debut as Blanche DuBois. On the screen, Ms. Lange has given sensitive performances in such diverse films as "Tootsie," "Frances" and "Country." On the legitimate stage, however, she is adrift and very nearly helpless.

There is no point in belaboring her deficiencies, but the actress simply doesn't possess the vocal training, the acting technique or the physical stamina required to communicate a characterization to a live audience. Whatever she may be thinking and feeling as Blanche — and that may be a lot — isn't making it past the footlights. Once you have taken in her fine-boned beauty and the languor of her slender body, and heard the gentle rise and fall of her honey-coated voice, you have experienced pretty much all there is to experience.

While Ms. Lange is able to project certain generalized qualities — gentility, exhaustion, petulance — she appears incapable of combining them, so that we never see the ferocity, for example, in Blanche's flirtatiousness, or the willfulness in her displays of good breeding. The performance amounts to no more than a succession of vague moods, without visible dynamics. Invariably, it reduces Williams's heroine to a sacrificial victim, too spent to challenge the cruel world closing in on her, too passive to put up a last-ditch fight.

Ms. Lange is surrounded by actors more accustomed to the theater's demands than she, but they are necessarily obliged to downsize their performances, lest they appear, by contrast, to be shameless in their emoting.

∎

Mr. Baldwin is not a particularly compelling Stanley Kowalski, but he probably could be in other circumstances. He's got the build, the lung power and the sullen bad-boy looks for the part. (The broad New York accent could go.) The smallness of Ms. Lange's performance, I think, is what throws him off his stride here. She doesn't offer enough provocation to justify his brutishness, and her delusions are too evanescent to be threatening. Mr. Baldwin is being dealt pinpricks, but he is expected to roar like a lion.

The director Gregory Mosher has clearly had a terrible time trying to find a dramatic pitch that would accommodate both of his stars. Scene after scene is compromised, either because Ms. Lange can't rise to the challenge or because Mr. Baldwin is forced to rein in his efforts and drop back a level. I suppose most theatergoers will simply conclude

She, a movie actress, is playing hide-and-seek. Her performance requires that you go to it, search it out, as would a camera. He, theatrically trained, bristles with stored-up energy. His performance comes to you, demanding a reaction. A person could get dizzy just from watching the two of them together.

Regrettably, the supporting players are undistinguished, which makes you wonder what the show's three casting directors did with their time and lunches. Amy Madigan, as Stella, carries on like a Hatfield or a Mc-Coy, and when she and Blanche were dressing for their night on the town, I half expected her to don one of those straw hats that feature a bobbing daisy on the end of a long wire. Timothy Carhart looks like a Ralph Lauren

model, with his great tousle of blow-dried hair, his aquiline nose and his tall, rangy body — all of which makes for an admittedly glamorous Mitch..Glamour, of course, is the last thing you want of Mitch. But Ms. Lange comes up so short in that department that someone, I guess, has to provide it.

Eight other actors are lurking in the shadows and filling in the nooks of Ben Edwards's set, but they're not so much active participants in the production as they are merely part of the general atmosphere — broken-down people to go with the broken-down shutters in the Kowalskis' ramshackle New Orleans flat. Periodically, Mr. Mosher fills the night air with the lonely sounds of a saxophone or the yowl of a cat in heat. But he's just punctuating a void. The drama and the heartbreak aren't there.

And "Streetcar" may be the most heartbreaking drama Williams ever wrote.

'Five Guys Named Moe'

Like a rabid party-giver, "Five Guys Named Moe," the musical revue at the Eugene O'Neill Theater, clasps you to its heaving breast, plants a smooch on your cheek, bellows uproariously in your ear, pokes you conspiratorially in the ribs, winks and shimmies and shakes its fanny in your face, and *still* has enough nerve left over to ask if you're having a good time.

Heaven protect you if you don't roar back affirmatively. You may find yourself in a spotlight, having to explain your reticence. On the other hand, all the extroverted carryings-on do serve a purpose. They inflate what is at best a modest club entertainment to a two-act self-styled "musical."

Conceived in London by Clarke Peters, an expatriate American actor, "Five Guys Named Moe" sets out to pay tribute to the Arkansas-born Louis Jordan — singer, saxophonist, leader of the Tympany Five — who bridged the gap in the 1940's and 50's between swing and early rock-and-roll with such numbers as "Caldonia," "Is You Is or Is You Ain't My Baby?" and "Saturday Night Fish Fry." There are about two dozen songs in all, and if the on-stage band and the five zoot-suited singer-dancers, plus one, who make up the cast, just went ahead and performed them — no fuss, no patter, no stalling maneuvers — we'd all be back out on the sidewalk in 45 minutes.

That would be greatly preferable to the two hours you'll end up spending at the Eugene O'Neill and the connecting restaurant, Moe's, that pushes drinks during the extended intermission. But 45 minutes doesn't qualify as a Broadway musical, even in this age of greatly lowered sights. Accordingly, Mr. Peters has concocted a premise of sorts. A young man named Nomax (a scowling Jerry Dixon), who has just broken up with his girlfriend, sits disconsolately by his radio, when who should pop out of it to cheer him up and offer him advice? The five guys themselves — Big Moe (Doug Eskew), Four-Eyed Moe (Milton Craig Nealy), No Moe (Kevin Ramsey), Eat Moe (Jeffrey D. Sams) and Little Moe (Glenn Turner).

Exactly how songs like "Messy Bessy," "Ain't Nobody Here but Us Chickens" and "Dad Gum Your Hide Boy" are supposed to turn around the heartbroken youth is a question a keener mind than mine will have to answer. As staged and choreographed by Charles Augins, these ditties mainly allow the Moes to snap their fingers, roll their eyes and generally parade their collective stuff in period style. The show is less good about allowing them to assert an individual identity. Four-Eyed Moe's distinguishing characteristic is that he wears glasses, unlike Little Moe, who, you got it, is the fireplug of the bunch.

When they're not performing, the five guys are trying to badger the customers into performing. Since most of us are not prepared to jump right into the chorus of "Push Ka Pi Shi Pie," the hectoring fills up more time. Then, of course, the balcony is pitted against the orchestra, and the men against the women, and "all the beautiful, beautiful ladies" who "ever cheated on your husbands or your boyfriends" are instructed, less than hilariously, *not* to sing. Is it any wonder that everybody winds up barking like the studio audience for "The Arsenio Hall Show," which, at least, can be turned off? At the end of Act I, the footloose are offered an opportunity to hitch up to a conga line that wends an adventurous path across the stage, up the aisle and into the bar.

Maybe if you had stumbled on "Five Guys Named Moe" in the London cabaret where it originated, its charms would be more apparent. Blown up, spit shined and blazingly lit for the Broadway trade, it seems a phony piece of goods. The temptation is strong to bypass that conga line altogether and head for the nearest subway line instead. □

1992 Ap 19, II:5:1

Theater in Review

■ Portrait of a French family hoping for improvement ■ Portrait of a Puerto Rican family marching toward destruction.

Family Portrait

Ubu Repertory Theater
15 West 28th Street
Through Sunday

By Denise Bonal; translated by Timothy Johns; directed by Shirley Kaplan; set design by John Brown; lighting, Greg MacPherson; costumes, Carol Ann Pelletier; production stage manager, David Waggett.
WITH: Alice Alvarado, Paul Austin, Alison Bartlett, Robert Kerbeck, Joanna Merlin, Matthew Mutrie and Gareth Williams.

The family in "Family Portrait," a French import by Denise Bonal, consists of a mother who works as a cleaning woman and aspires to the petite bourgeoisie, a pregnant daughter whose live-in boyfriend is a French version of a couch potato, and two sons: one a small-time thief and biker (except his bike has been stolen); the other a misfit whose ineptitude extends to five failed suicides. There is also a neighbor whose wife went to buy salt one day and never returned, the biker son's Arab girlfriend, and a dog that occasionally barks from offstage.

The main problem with "Family Portrait" is that for all the absurdist pretentions Ms. Bonal tries to give her characters, they are, in the final analysis, a fairly conventional and hidebound lot — a bit bizarre, perhaps, and stereotypically racist, but essentially harmless and dull. Another drawback is that despite some brief discussion of a harebrained scheme by the men to kidnap the corpse of a wealthy local (thinking the family will ransom it in order to give it a decent burial), not much happens. This family is long on talk, but little of it is to any point or, worse for a comedy, very funny. And a bitterly angry ending comes out of left field to dispel what faint humor has been built up in two hours of hard

intermissionless work by a mostly fine cast.

Paul Austin, who plays the downstairs neighbor, captures more than anyone the tempo and tone necessary to turn the yawns in "Family Portrait" into laughs. Alice Alvarado stands out as the sharp and shrewd young Arab girl who is taking a big risk marrying into this dubious family while her father is on a hajj. Alison Bartlett gives a fine performance as the daughter. Gareth Williams as her boyfriend, Robert Kerbeck as the suicidal son and Matthew Mutrie as the biker son all contribute credible readings.

There is a crucial problem in the miscast Joanna Merlin as the mother. The veteran Ms. Merlin portrays the mother as a kindly if slightly ditsy woman holding onto some fanciful dreams about her family. As a result, the wrath the rest of the family directs against her is meaningless and she offers no foil for the others to play against. Timothy Johns's translation tends to be too literal (who could imagine the character of this mother using a word like "sinecure"?). Shirley Kaplan's direction moves things apace and somehow manages to keep the audience's interest from wavering too far afield.

WILBORN HAMPTON

The Oxcart (La Carreta)

Puerto Rican Traveling Theater
304 West 47th Street
Through Sunday

By René Marqués; translated by Dr. Charles Pilditch; directed by Alba Oms; set by H. G. Arrott; lighting, Brian Haynsworth; costumes, Mary Marsicano; production stage manager, Elizabeth Valsing; assistant stage manager, Luis Caballero; assistant director, Fernando Quiñones; producer, Miriam Colón Valle. Presented by the Puerto Rican Travel-

ing Theater, with the sponsorship of the Coors Brewing Company.
WITH: Eddie Andino, Miriam Cruz, Chris De Oni, Ebony Díaz, Jackeline Duprey, Norberto Kerner, Esther Mari, Iraida Polanco, Fernando Quiñones, Victor Sierra, Jeanette Toro and Walter Valentín.

A plot summary of "La Carreta" ("The Oxcart"), written in 1951 by the Puerto Rican novelist and playwright René Marqués, would suggest it could hardly succeed on stage: too mystical, too melodramatic, too argumentative.

But Marqués poured great emotional power into his tale of bewildered peasants who, thinking migration to San Juan and then to New York will bring them happiness, find only tragedy at the end of their road. They are such large figures that nothing they do could seem insignificant.

The Puerto Rican Traveling Theater, in its current production (in English today through Friday and in Spanish this weekend) under the taut direction of Alba Oms, gives eloquent voice to Marqués's passionate love of his island, and majestic movement to his doomed family's march toward destruction. And H. G. Arrott's set is so right it can almost be counted one of the characters, for Ms. Arrott subtly makes one realize that changes in the fortunes of the widowed Doña Gabriela and her children are signaled not only by alterations in their language, movements and silences, but also by slight transformations of the few sticks, rags and statues they own.

The company has gathered an unusually strong cast for "La Carreta," especially Norberto Kerner as a grandfather who embodies the values Marqués cherished most; Eddie Andino as the oldest son, whose illegitimacy is known by all but never admitted and who is a fine figure of the eternal outsider, and Esther Mari as Gabriela, a role in which she has to quietly dominate virtually every turbulent scene.

After 40 years many of Marqués's themes are very familiar: American imperialism disguised as beneficence, the virulence of racism in this country, the injustice of sexism. It is a mark of this production's vigor that it makes them seem fresh again, urgent. There is a lot of life in this old warhorse; one is surprised at the end to realize it ran almost three hours.

D. J. R. BRUCKNER

1992 Ap 22, C17:3

The High Rollers Social and Pleasure Club

Arrangements, musical direction and orchestrations by Allen Toussaint; conceived by Judy Gordon; directed and choreographed by Alan Weeks; scenery by David Mitchell; costumes by Theoni V. Aldredge; lighting by Beverly Emmons; sound by Peter Fitzgerald; music advisors, Jerry Wexler and Charles Neville; musical coordinator, John Miller; associate director, Bruce Heath; production supervisor, Mary Porter Hall; general management, Brent Peek Productions; associate producers, Nicholas Evans, Donald Tick, Mary Ellen Ashley and Irving Welzer. Presented by Ms. Gordon, Dennis Grimaldi, Allen M. Shore and Martin Markinson. At the Helen Hayes Theater, 240 West 44th Street, Manhattan.

Wonder Boy No. 1	Keith Robert Bennett
Queen	Deborah Burrell-Cleveland
King	Lawrence Clayton
Jester	Eugene Fleming
Sorcerer	Michael McElroy
Enchantress	Vivian Reed
Princess	Nikki Rene
Wonder Boy No. 2	Tarik Winston
Conductor	Allen Toussaint

By MEL GUSSOW

"The High Rollers Social and Pleasure Club" is a Broadway excursion into the mood and street sounds of the city of New Orleans. There is a Mardi Gras party going on here. Whether or not one feels like an invited guest will depend on how much one enjoys the music, a gumbo of diverse ingredients, and what demands one makes for art to go hand in hand with entertainment.

"High Rollers" is principally the creation of Allen Toussaint, who wrote a half-dozen of the more than 40 songs and is onstage as pianist, leading a tuneful combo. As the composer of songs like "Mother-in-Law" and as a successful record producer, Mr. Toussaint has made a considerable contribution to New Orleans rock and soul. But one can get the drift of a revue that opens with a garishly costumed jester standing atop a bar promising "a big powwow in the sky." He then introduces "the legendary Allen Toussaint," a description that may have been written by the aforesaid composer.

In other words, the show at the Helen Hayes Theater starts out on the wrong foot, achieving a kind of alienation effect on the audience. Later, it missteps, as vulgarity is confused with sexuality, and as some of the production accouterments like Theoni V. Aldredge's costumes cross the border into bad advice. On the positive side, the show has spirit and exuberance and a fervently talented cast, which sings and dances as if possessed by some musical genie. The performers, even more than the music, are the essence of the show.

●

The women are a striking trio: the willowy Vivian Reed, Deborah Burrell-Cleveland playing the role of "the queen" and the delicate Nikki Rene. Each has her own style, with Ms. Reed specializing in lowdown blues like "You Can Have My Husband" ("but don't mess with my man"). Singing together, as in Huey P. Smith's "Sea Cruise," they become a bouncing boogie-woogie black version of the Andrews Sisters.

Trapped by their obvious roles, and wearing black tights that would be more appropriate in a bicycle race, the men have a more difficult time asserting their individual identities. In his bowler hat, the muscular Michael McElroy seems to be reaching for the Geoffrey Holder crown, and Eugene Fleming preens beneath the glitter as the jester. But both of them and Lawrence Clayton have strong voices, especially so in the case of Mr. Clayton, who joins Ms. Burrell-Cleveland in the sinuous "Dance the Night."

They are followed by an equally passionate duet by Ms. Reed and Mr. McElroy. In a fillip to the first-act conviviality, the saxophonist Gary Keller (like the other instrumentalists, he looks out of place in a conventional suit) takes center stage for a mellow solo. After "the good times," as the first act is called, the second act's "more good times" are a bit of a letdown.

Spicing the menu are Tarik Winston and Keith Robert Bennett, paired as the Wonder Boys. They are like a couple of newsies tapping their way through "Feet, Don't Fail Me Now." Between their syncopated dancing and leaping splits, they further enliven an already lively show As for the other men, they seem to have taps on their tights.

Although the revue may or may not be typical of New Orleans, the songs try to make a virtue of eclecticism. There are nonsense ditties like "Tu Way Pocky Way," which could be a cousin to "Push Ka Pi Shi Pie" in "Five Guys Named Moe," a "Jelly Roll" and even a reach into the bayou for Hank Williams's "Jambalaya.".

All of the talk and especially the voodoo mumbo jumbo could be excised *without harm*, and there is too *much* hand waving in what passes for choreography. *Under* Alan Weeks's direction, the show speeds quickly by,

with the final three numbers merging into an obligatory chorus of "When the Saints Go Marchin' In," accompanied by a shower of confetti over the audience. Walking down 44th Street after the show, one can easily tell which theatergoers have just seen "High Rollers." This jamboree is as diffuse as it is frenetic, but in contrast to the casts of audience-participation shows at other theaters, these performers do all the work and earn their place in the musical spotlight.

1992 Ap 23, C15:2

Shimada

By Jill Shearer; directed by Simon Phillips; set by Tony Straiges; costumes by Judy Dearing; lighting by Richard Nelson; score by Ian McDonald; sound by Peter Fitzgerald; production stage manager, Martin Gold. Presented by Paul B. Berkowsky, Richard Seader, Furuyama International Inc., and Ellis and Mike Weatherly, in association with Sally Sears. At the Broadhurst Theater, 235 West 44th Street, Manhattan.

Shimada and Toshio Uchiyama	Mako
Eric Dawson	Ben Gazzara
Clive Beaumont and Mark Beaumont	Robert Joy
Commandant Matsumoto and Samurai	Ernest Abuba
Denny	Estelle Parsons
Jan Harding and Wisteria Lady	Tracy Sallows
Sharyn Beaumont	Ellen Burstyn
Billy	Jon Matthews

By FRANK RICH

"SHIMADA," a new Australian play at the Broadhurst Theater, opens with a secretary receiving a Federal Express envelope and ends with the secretary answering her phone.

("Beaumont Bicycle Company, can I help you?" is the evening's exact curtain line.) The most important plot twist in between is delivered by fax. Yet as drama "Shimada" moves at the pace of bulk mail, and its content is somewhat less scintillating than the typical missive from, say, Publishers Clearing House.

One had expected so much more! This is the play that New York radio listeners have been hearing about for weeks through advertisements that darkly promise a night of Japan-bashing to rival Michael Crichton's novel "Rising Sun." In these commercials, an announcer sounding rather less lighthearted than a prophet of doom implies that "Shimada" would rip open a world in which "we" sit around like lazy bums in front of our VCR's while "they" buy up Columbia Pictures, downtown Los Angeles and anything else "they" can get their dirty hands on. In reality, however, "Shimada" has a Japanese co-producer, and its xenophobia is not significantly greater than that to be found in other Broadway shows with Japanese co-producers, like "The Will Rogers Follies," "A Streetcar Named Desire" and "Guys and Dolls."

Worse, "Shimada" really is about a bicycle company.

As written by Jill Shearer, whom the Playbill describes as "Queensland's best-known and most frequently performed playwright," this work tells what happens when the Beaumont concern, a small-town Australian outfit with a shrinking market, receives a lucrative investment offer from a Japanese businessman named Uchiyama (Mako) who wants to retool the factory to manufacture motorized dirt bikes. The company's proprietor, the widowed Sharyn Beaumont (Ellen Burstyn), is inclined to sell out, but her hard-drinking sales manager, Eric Dawson (Ben Gazzara), strenuously objects.

"We're a pedal-bike factory! That's what we built our reputation on!" bellows the red-faced Mr. Gazzara in an apoplectic fury that elevates pedal-biking to a fundamental right of man, second only to freedom of speech. He also argues that Uchiyama may in fact be Shimada, the sadistic guard who tortured him and Sharyn Beaumont's late husband when they were held in a Japanese prisoner-of-war camp in the Burmese jungle in 1945.

Is Uchiyama actually Shimada, or is Eric merely a bigot who thinks that all Japanese look alike? This is one of several questions that Miss Shearer eventually fudges in a play that refuses to take a stand even on its own plot and has a kind word for everyone except the mysterious, teeth-baring Shimada, who re-enacts his tortures in flashbacks set in a foggy echo chamber. The dramatic and intellectual level of the debates leading up to the play's waffling denouement can

T. Charles Erickson

Now fighting a different war: Ben Gazzara, left, and Mako.

best be captured by citing some random samples of dialogue, spoken by a variety of interchangeable characters:

"It's an open market, and we can't compete anymore. We're overstocked and undercapitalized. Interest rates have skyrocketed!"

"If we refused to do business with any country we had a war with, where would we be?"

"Money makes the world go round!"

"It's a new ball game now!"

"We're a multi-cultural society whether you like it or not!"

"I thought we won the bloody war!"

"It's a different war now — a trade war!"

•

To deliver such pearls, the management of "Shimada" has rounded up an overqualified, and at times ludicrously overzealous, cast that includes such supporting players as Estelle Parsons (in work boots, overalls and goggles as a union leader, if you please), Robert Joy, Ernest Abuba, Tracy Sallows and Jon Matthews (as a drag chanteuse in the prison camp interludes). Most of the principals are rewarded with lengthy soliloquies in which they reminisce tearily about their departed spouses, and Mako, an actor capable of both delicacy and bite, delivers his the most persuasively. The others often pedal uphill in Australian accents that come and go more rapidly than the faxes.

The director, Simon Phillips, is from New Zealand, and the best that can be said about his staging is that it is more convincingly wooden than the furniture in Tony Straiges's substandard set. Judy Dearing has designed some colorful costumes for a

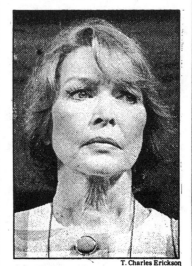

T. Charles Erickson

Ellen Burstyn

few cryptic Kabuki interludes and drab and unflattering outfits for the Australians, the incongruously chic Miss Burstyn excepted. Perhaps the most novel aspect of the production is its distinction, widely publicized, as the first Broadway show to offer a simultaneous Japanese translation. The headsets can be rented for $5, a bargain when you consider that by turning up the volume of the Japanese translation all the way, you can almost succeed in drowning out "Shimada" in English.

1992 Ap 24, C1:1

Candide

By Len Jenkin, adapted from the book by Voltaire; directed by David Esbjornson and Carey Perloff; scenic design, Hugh Landwehr; costumes, Teresa Snider-Stein; lighting, Brian MacDevitt; composer, David Lang; sound, John Kilgore 3d; production stage manager, Crystal Huntington; assistant director, David Hoffmann; movement director, Lesley Farlow. Presented by Ms. Perloff and Patricia Taylor. At CSC Theater, 136 East 13th Street, Manhattan.

Candide	Victor Mack
Pangloss/Pococurante	Edward Hibbert
Cunegonde/King of Eldorado	Julia Gibson
Martin	Kent Gash
Baron Sr./Cacambo	Dennis Reid
Baron Jr./Vanderdendur	Michael Gaston
Baroness/Old Woman	Rebecca Schull
Paquette/Clairon	Kimberley Pistone
18th-Century Gentleman/Don Fernando/ 18th-Century Gentleman/Jacques/Friar Giroflee/Ragotsky	William Keeler

By MEL GUSSOW

In "Candide," Voltaire defined optimism as a "mania for maintaining that all is well when things are going badly." In other words, the novel could be considered instructive advice for contemporary politicians campaigning for re-election and for theater companies embarking on a stage version of the 18th-century classic. "Candide" is an imperishable work of philosophy and satire, one that reached its theatrical peak in the Leonard Bernstein musical.

Ten years ago, the playwright Len Jenkin wrote a new adaptation, which was presented at the Guthrie Theater in Minneapolis. Now, for her parting production as artistic director of the CSC Theater, Carey Perloff is offering the New York premiere of the Jenkin version. The production is co-directed by Ms. Perloff and her CSC successor, David Esbjornson. While one must give the show points for ambition, it does not have the inventiveness that can make it seem anything more than high-minded.

•

The play starts on an intriguing note. A large puppet head of Voltaire, designed by Hugh Landwehr, dominates the open stage; emanating from it are voices in French deliver-

Gerry Goodstein

Rebecca Schull, left, Victor Mack and Julia Gibson

ing a babel of Voltaire. In the course of the play, the head is used for a variety of settings, but it eventually limits the movement of the actors, entrapping the play in the scenery.

At the same time, Mr. Jenkin's device of treating the novel in Story Theater style is self-depleting. A narrator explains what another character is about to do before he does it, or, in several instances, before he repeats the narration. During one of Candide's adventures, someone else comments enthusiastically that it is "a splendid sight." But we are shown nothing except for people staring at a brightening light. All this encourages the non-dramatic side of the narrative. After writing this less than imaginative adaptation, Mr. Jenkin went on to far more dramatic explorations in his original plays.

●

Except for occasional annoying anachronisms (knock-knock jokes, of all things), the text follows the general outline of the original Voltaire. The scene moves from Bulgaria to Eldorado and other far corners of a real and mythical world while never seeming to change its course. The principal alteration is one of speech, as the actors awkwardly affect different nationalities and accents.

The directors employ a cast of motley talents, none of them able to lift the material to Voltairean heights. In the title role, Victor Mack has the necessary ingenuousness but little comic flair. Edward Hibbert's fussily academic Pangloss is not chimerical in his changed appearances. Among the principals, only Julia Gibson as Cunegonde has a sprightly assertiveness. She, along with the others, is victimized by the lack of fluidity in the conception. The minor players, overworked in role doubling, often seem at sea off the coast of one of the countries visited by Candide.

Although it is always a pleasure to hear Voltaire's wit, albeit with a Jenkin twist, the play moves with painstaking slowness through the story, chapter by chapter, for nearly three hours. David Lang's sparse musical underscoring only makes one long for the Bernstein songs. A chorus of "Glitter and Be Gay" or "Auto da Fé" would considerably improve the voyage.

1992 Ap 24, C4:5

Man of La Mancha

By Dale Wasserman; music by Mitch Leigh; lyrics by Joe Darion; directed by Albert Marre; sets by Howard Bay; costumes by Mr. Bay and Patton Campbell; lighting by Gregory Allen Hirsch; sound by Jon Weston; musical director, Brian Salesky; dance arrangements, Neil Warner; casting, Richard Shulman; assistant to the director, Ted Forlow; production stage manager, Patrick Horrigan; executive producer, Manny Kladitis. Presented by the Mitch Leigh Company. At the Marquis Theater, 1535 Broadway, at 45th Street, Manhattan.

Cervantes/Don Quixote	Raul Julia
Aldonza/Dulcinea	Sheena Easton
Sancho	Tony Martinez
Governor/Pedro	Chev Rodgers
The Padre	David Wasson
Dr. Carrasco	Ian Sullivan
The Innkeeper	David Holliday
Antonia	Valerie De Pena
The Housekeeper	Marceline Decker
The Barber	Ted Forlow
Paco/The Mule	Hechter Ubarry
Juan/The Horse	Jean-Paul Richard
Manuel	Luis Perez
Tenorio	Gregory Mitchell
José	Bill Santora

Joan Marcus/"Man of La Mancha"

Tony Martinez, left, Raul Julia and Sheena Easton in the revival of the musical "Man of La Mancha" at the Marquis Theater.

Jorge/Guard	Chet D'Elia
María	Tanny McDonald
Fermina/Moorish Dancer	Joan Susswein Barber
Captain of the Inquisition	Jon Vanderthofen
Guitarists	Robin Polseno, David Serva
Guard	Darryl Ferrera

By MEL GUSSOW

When it comes to the revival of "Man of La Mancha" at the Marquis Theater, "Forbidden Broadway" was there first. In the latest version of that satiric revue, there is a malicious spoof in which the new Don Quixote strides boastfully on stage and sings, "I am I, Raul Julia," and declares himself as the first Hispanic actor to play the title role. He is followed by a Valley Girl impersonation of Sheena Easton as the lusty Aldonza. Overstatement is a comic essence of "Forbidden Broadway"; it is also no stranger to the sentiments of "Man of La Mancha."

In this production, the show proves to be what it always was: a quasi-inspirational musical about the Spanish Inquisition. It had, and still has, a novelty effect, as it tells a story remote in time and sensibility. A surprise success in 1965, it went on to become one of the longest running musicals and one that is frequently revived. It always seems to attract partisans, most of whom, one would suggest, have never so much as thumbed a copy of "Don Quixote."

The show has not become dated so much as eroded through exposure. It is not a musical that is crying for another revival, but here it is all the same (in several senses), and to deny its popularity would be like tilting with windmills.

●

At the core of "Man of La Mancha" are three or four hearty anthems (with music by Mitch Leigh and lyrics by Joe Darion) promoting a post-"Camelot" memory of idealism and uplift. While such noble feelings sound out of sync in cynical times, they still seem to touch responsive heartstrings. Between those songs, there is musical padding, ditties like "I'm Only Thinking of Him" and "A Little Gossip," which would not be out of place in a modern context. The book by Dale Wasserman, mixing "Don Quixote" with a story about the life of Cervantes, reduces the narrative to simplistic terms.

What "Man of La Mancha" had in its original version was Richard Kiley in the title role. His performance made the show seem like a dramatic oratorio and, more than anything, it conjured the spirit of Cervantes. Although Mr. Julia is well suited to the role by reason of his own dramatic and musical presence as well as his Hispanic background, his performance is not transcendent. He offers a lightly shaded variation, effective in the comic sequences, less so in dealing with the character's madness.

Part of the difficulty is in his singing voice, which seems more comfortable with the musical challenges of "Nine" and "The Threepenny Opera" than with the arialike demands of "Man of La Mancha."

Mr. Julia is, however, the stalwart center of the revival, which in other respects too often resembles a museum piece rather than anything freshly conceived. The director is Albert Marre, who staged the original production. He must know the show by rote, which is how he has staged it. Missing is an equivalent of Jack Cole's choreography as well as any sense of vibrancy in the musical direction, especially so in the fight scenes. They seem mechanical, as does the abduction of Aldonza.

This brings us to Ms. Easton, a pop singer making her theatrical debut. While she has a sweet voice and conveys a measure of the Dulcinea half of her character, she is not the tempestuous Aldonza, not by a long moonshot. Petite and pretty, she is far removed from anyone born on a dungheap. When she is flung about the stage by the muleteers, a theatergoer may wonder if she will suffer bodily harm. To accept her in this characterization, one would have to be as delusional as the Don himself.

Re-enlisting as Sancho Panza is Tony Martinez, who, the program informs us, has played his role in every major revival of the musical and recently celebrated his 2,000th performance. He is certainly familiar with the idiosyncracies of the character, including the childlike delivery of that song, "I Really Like Him," the number that may have inspired Sally Field's famous Oscar acceptance speech.

In stature and bearing, Mr. Julia and Mr. Martinez are a natural pairing: imposing and tiny, knightly and servile. The other actors are adequate to their roles, and in several instances they are something more. David Wasson, David Holliday and Ted Forlow are all experienced "Mancha" hands, with Mr. Forlow recreating the role of the Barber, which he played at one point in the original production.

At a critics' preview, the show was conducted by Mr. Leigh. Facing an unseen orchestra, the composer seemed to be reliving his impossible dream. Then he left the stage and Mr. Julia began "sallying forth," with one hand gloved (like an early-17th-century Michael Jackson?) and his corkscrew lance raised. As long as there are tickets to be sold, one assumes that the show itself will continue to sally forth.

1992 Ap 25, 13:4

SUNDAY VIEW/David Richards

A Bushel and a Peck for Adelaide

'Guys and Dolls'

has a dilly in

Faith Prince.

The Polish 'Metro' may have stalled between stations.

YOU ARE GOING TO LIKE FAITH Prince a great deal in "Guys and Dolls," partly because she is tremendously likable as Miss Adelaide, "the well-known fiancée," but also because there isn't a single performer in the revival that's scampering across the stage of the Martin Beck Theater these nights who comes up to her dimpled knees.

Ms. Prince is the evening's consistent salvation. Whenever she's on stage, you will be hard pressed to look at anyone else. And when she's off in the wings and the show's voltage has started to drop, you'll console yourself with the thought that she'll be back soon and full electrical service will be restored. Let's face it. A dismal musical like "Nick and Nora," in which Ms. Prince played a mousy Hollywood accountant earlier this season, couldn't do her in, so "Guys and Dolls," which is a Broadway classic, can only put her well on the road to stardom. It doesn't seem reckless speculation to think there would be a lot of heart-shaped candy boxes, gaudy floral bouquets and maybe even a Tony Award in her future.

If the other performers fit their roles half so snugly, this "Guys and Dolls" would qualify as a humdinger. But none of Ms. Prince's co-stars — Peter Gallagher, Nathan Lane and Josie de Guzman — manages to attain her giddily entertaining heights. The situation is not so grave as it is at "Crazy for You," which is a success *despite* its leads. But you wouldn't exactly say that "Guys and Dolls" is a triumph of casting, either. For the most part, this is a fair-to-good mounting of a show that, for all its 42 years, has always been great-to-sensational.

■

Frank Loesser's score is 17 numbers strong and there's not a dud among them. "I'll Know," "If I Were a Bell" and "I've Never Been in Love Before" chart the progressive stages of love with rushing melodies and still-pristine lyrics. Time has not diminished the novelty of "Take Back Your Mink" and "A Bushel and a Peck." And for picking up an audience by the scruff of its collective neck and giving it a brisk shaking, what has ever bettered "Sit Down, You're Rockin' the Boat"?

Walter Bobbie gives that last number his hallelujah best, pointing his round chin heavenward, throwing his hands above his shoulders and turning the inner act of contrition into an outward display of shameless razzle-dazzle. It's one of the few times, if we can put Ms. Prince's contributions aside for a moment, when these guys and dolls don't seem tamer than the material they're asked to deliver.

Consider Mr. Gallagher. He certainly looks every inch the rakish gambler Sky Masterson. Nature has provided him with a chiseled jaw, lustrous black hair and one of those mile-wide smiles that make women lose their equilibrium. And the costumer William Ivey Long has equipped him with padded shoulders out to here. From all appearances, the actor ought to be casting an irresistibly romantic spell. But Mr. Gallagher's singing is mediocre, and in this show, of all shows, that's a serious drawback.

The shortcoming is particularly evident in a number like "Luck Be a Lady." The thugs and confidence men who populate Jo Swerl-

Martha Swope/"Guys and Dolls"

Faith Prince as Miss Adelaide—Whenever she's on stage, the audience may be hard pressed to look at anyone else.

ing and Abe Burrows's vision of Broadway (a vision borrowed, of course, from Damon Runyon) have been shooting craps in a sewer somewhere under Times Square. The rolling of the dice has prompted some spectacular acrobatics on the part of the dancers — high-flying leaps, midair splits and, in the case of Scott Wise, a breathtaking front flip through the ozone that has him landing, easy as a tiddlywink, on his *knees*. "The Crapshooters' Dance," as this display of hurtling bodies is called, has threatened to throw the show into high gear for the second time. (Ms. Prince is responsible for the first acceleration, but I told you I'd be getting back to her.)

"Luck Be a Lady" is the very next number, and if ever a voice were required to boom over the footlights, lusty and vigorous, this is the occasion. But Mr. Gallagher's exhortation comes in way under the mark, robs him of his strapping appeal and leaves him, in the end, just another handsome face well served by a fedora.

■

It should be said, by way of exoneration, that Mr. Gallagher is laboring under a second, significant handicap — Ms. de Guzman. She plays the mission worker Sarah Brown, who converts Sky from a late-night adventurer into the faithful mate who'll stand by her side and beat the bass drum in the Save-a-Soul street band. The actress, a mid-preview replacement, sings pleasantly, moves clumsily and acts poorly. If she never convinces you she is unbending in the hot spots of Havana, it's because she is never particularly starchy to begin with. (In order to let your hair down, you've got to put it up first.) Between these two lovebirds, sparks do not drift, let alone fly.

Nathan Lane, on the other hand, is an adroit actor with sure comic instincts, so it's a bit dispiriting to see him lunging overboard as Nathan Detroit, Adelaide's husband-to-be for 14 years running and no wedding knot on the horizon. His chubby face and toothbrush mustache give him a certain resemblance to

a youthful Jackie Gleason, but what clinches it is the raucous bluster. Whenever Adelaide calls him on another broken promise, you'll also notice in his eyes the same look of apologetic fluster that Gleason used to mollify Audrey Meadows. It's an energetic, falling-about performance, but you keep thinking it should be funnier, and much of his effort seems directed at holding his own with Ms. Prince.

Well, she towers over this production on her impossibly high high heels. Rita Hayworth and Betty Grable would appear — from the flame color of her hair and the pinch of her waist — to be her idols. Minnie Mouse seems to be her vocal coach. While she brings to the world the fresh expectancy of one who won't give up on hope, she also projects the dark foreboding of one who has never got closer to Niagara Falls than the racetrack at Saratoga. The contradictory impulses make her performance vibrantly alive. It's as if she were embracing the philosophy of Norman Vincent Peale one minute, the counsel of Cassandra the next. Or rather, both at once.

Watch her mouth. It's a mouth that clearly expects a spoonful of honey from life and gets a shot of vinegar every time. Her top lip curls upward, her teeth lock and her smile undergoes a slow-motion curdle. Then, the sourness subsides. The upper lip resumes its rightful place. Deception is forgiven. And she's eagerly anticipating the next spoonful of honey.

∎

It has always seemed to me that the best comic number ever written for a Broadway musical was either "Adelaide's Lament" or "You Gotta Have a Gimmick" (from "Gypsy"). But when Ms. Prince sets out to enumerate, between wheezes and sniffles, the high price of finding yourself alone at the altar time after time, it's no contest. The lament wins hands down. The actress sings it

about halfway through the first act, thereby establishing a high-water point that this production never reaches again until the crap-shooting dancers seize the dice in the second act.

Not that the director Jerry Zaks and the choreographer Christopher Chadman aren't trying valiantly to punch up matters at every turn. No pastel colors — or sentiments — are allowed. Even Tony Walton's sets and Mr. Long's costumes have the frenzy — and the furious palette — of Fauve painting. The Hot Box, the strip joint where Miss Adelaide heads a line of decidedly anorexic chorus girls, resembles the inside of a pumpkin, as opposed to the sewer, which resembles the outside of an octopus.

Everywhere, purple is warring with tangerine, acidic yellow is taking on screaming chartreuse, while pink, lemon and red are tangling angrily down the street. The color scheme fosters a sense of urgency that you don't always get from the performers themselves. I've never thought of sets as so much hype, but that's the case here.

Only Ms. Prince seems able to stand before them and not be overwhelmed by the garishness — which says something about the strong colors she brings to a stage. The others tend to be eclipsed by the violence of their habitat.

'Metro'

The cast members of "Metro" — some 40 Polish and Russian youths, most barely out of their teens — reportedly spent a year not only training for their parts but learning English so they could perform the musical, a runaway hit in Warsaw, on Broadway.

They get A for effort. They get A for believing that if you pour your heart out on a stage you're home free. They get A for being bright-eyed and nimble and unspoiled and having a whole life ahead of them. For recognizing a losing cause, they get F.

Members of the cast in "Metro"—They get an A for believing that if you pour your heart out on a stage, you're home free.

Watching them give their all in this curious endeavor, which draws at least partially on their autobiographies, is one of the sadder experiences of the season. They do so want to please, but the musical, while arresting visually, isn't half so appealing as they are.

A mixture of "Hair" and "A Chorus Line" — augmented with laser beams and some phosphorescent gymnastics in black light — "Metro" (at the Minskoff Theater) takes place in a city somewhere in Eastern Europe that has recently thrown off the yoke of Communism. A group of street performers has come to audition for a show at what used to be the state-run theater. Summarily rejected, they gather in the subway. There, Jan, a disaffected musician (Robert Janowski), inspires them to put on their own show about the scourge of money, apparently, and the chaos that is the new freedom.

It's a big success and ends up transferring to the state theater, now a commercial enterprise under the directorship, ironically enough, of Jan's brother, Philip (Janusz Jozefowicz). Jan — who doesn't know what he wants but is pretty sure it isn't life "up there" — stays behind and throws himself in front of a train. Many years later, Anka (Katarzyna Groniec), the kooky gamin who has loved him in vain, returns to the subway in full-length chinchilla to assure us that "Dreams Don't Die."

I think.

The English translation by Mary Bracken Phillips and Mr. Jozefowicz, who is also the show's director, is not a model of clarity and seems to reduce the original book and lyrics by Agata and Maryna Miklaszewska to a string of flower-child aphorisms and political platitudes. Unless, of course, they were there from the start. Perhaps in Polish, a couplet like "Give me a cause that I can fight for/ Give me a wrong I can do right for" is pure poetry. Perhaps not. The cast operates on the assumption that it is, and sings the score by Janusz Stoklosa with a fervor that, in the West at least, is usually reserved for Andrew Lloyd Webber.

Back in the heady days of cultural exchanges, a musical like "Metro" would have been a nice trade for, say, "Shenandoah." Under a State Department grant, it could have played the big performing-arts centers across the country and given audiences a feel for the contemporary Polish sensibility. It's a little scary to see it up there, on the stage of the Minskoff, fending for itself. Even scarier is Philip's observation, "This is a free country now. We have to make money."

1992 Ap 26, II:5:1

Jelly's Last Jam

Written and directed by George C. Wolfe; music by Jelly Roll Morton; lyrics by Susan Birkenhead; musical adaptation and additional music composed by Luther Henderson; sets, Robin Wagner; costumes, Toni-Leslie James; lighting, Jules Fisher; musical supervision and orchestrations, Mr. Henderson; musical direction, Linda Twine; music coordinator, John Miller; sound, Otts Munderloh;

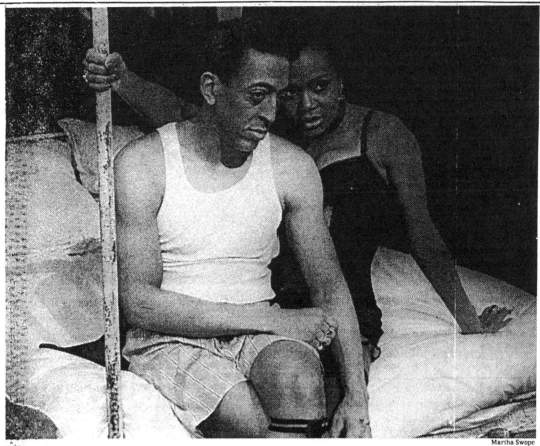

Martha Swope

Gregory Hines and Tonya Pinkins in George C. Wolfe's new Broadway musical, "Jelly's Last Jam."

mask and puppet design, Barbara Pollitt; production stage manager, Arturo E. Porazzi; hair, Jeffrey Frank; executive producer, David Strong Warner Inc.; technical supervisor, Francis A. Hauser; associate producers, Peggy Hill Rosenkranz, Marilyn Hall and Dentsu Inc., New York; tap choreography, Gregory Hines and Ted L. Levy; choreography, Hope Clark. Presented by Margo Lion and Pamela Koslow, in association with Polygram Diversified Entertainment, 126 Second Avenue Corporation/Hal Luftig, Rodger Hess, Jujamcyn Theaters/TV Asahi and Herb Alpert. At the Virginia Theater, 245 West 52d Street, Manhattan.

Chimney Man.....................Keith David
The HunniesMamie Duncan-Gibbs, Stephanie Pope and Allison M. Williams
Jelly Roll Morton.......................Gregory Hines
Young Jelly....................................Savion Glover
Miss Mamie.............................Mary Bond Davis
Buddy Bolden.............Ruben Santiago-Hudson
Gran Mimi.................................Ann Duquesnay
Jack the Bear..............Stanley Wayne Mathis
Anita..Tonya Pinkins
WITH: Ken Ard, Adrian Bailey, Steve Bargonetti, Sherry D. Boone, Brenda Braxton, Ben Brown, Ralph Deaton, Bill Easley, Brian Grice, Melissa Haizlip, Cee-Cee Harshaw, Don Johanson, Virgil Jones, Ted L. Levy, Victoria Gabrielle Platt, Gil Pritchett 3d, Michelle M. Robinson, Gordon Joseph Weiss and Britt Woodman.

By FRANK RICH

On the short list of people who have so much talent they hardly know what to do with it all, count Gregory Hines, the star, and George C. Wolfe, the author and director of the new Broadway musical "Jelly's Last Jam."

Mr. Hines's brilliance is no secret. Few, if any, tap dancers in this world can match him for elegance, speed, grace and musicianship, and, as if that weren't enough, he also happens to be a silken jazz crooner, supple in voice and plaintive in emotions. In the role of Jelly Roll Morton, Mr. Hines gets to display these gifts to the fullest, not to mention his relatively un-

sung prowess as an actor. Even when the band is taking a break, every note he hits rings true.

As for Mr. Wolfe, a visionary talent who is making his Broadway debut, he has given "Jelly's Last Jam" ambitions beyond the imagination of most Broadway musicals, many of the street's current hits included. The show at the Virginia Theater is not merely an impressionistic biography of the man who helped ignite the 20th-century jazz revolution, but it is also a sophisticated attempt to tell the story of the birth of jazz in general and, through that story, the edgy drama of being black in the tumultuous modern America that percolated to jazz's beat. And that's not all: "Jelly's Last Jam," a show in part about what it means to be African-American, is itself an attempt to remake the Broadway musical in a mythic, African-American image. Mr. Wolfe wants nothing less than to do for popular theater what Morton and his peers once did for pop music.

Is the effort a complete success? No. But after watching the sizzling first act of "Jelly's Last Jam," at once rollicking and excessive, roof-raising and overstuffed, you fly into intermission, high on the sensation that something new and exciting is happening, whatever the wrong turns along the way. The briefer Act II is another, deflating story, but one that should not be permitted to deface the memory of the adventurous Act I.

That adventure begins the moment Mr. Hines makes an unorthodox star entrance that is the first of the show's many breaches of Broadway tradition. Elevated into view on a platform at the edge of the darkened, empty stage, Mr. Hines arrives without fanfare. His back is to the audience, his posture crestfallen. When he finally turns to look at us, he is unsmiling, mute and shuddering. His baggy eyes

are wide with the fright of someone who has just seen a ghost.

As it happens, the ghost he has seen is his own. "Jelly's Last Jam" takes place on the eve of its title character's death. It is conceived as a Judgment Day inquisition into the meaning of a life that began in turn-of-the-century New Orleans, where Ferdinand Le Menthe Morton was born into light-skinned Creole gentility, and is about to end in the "colored wing" of the Los Angeles hospital where he died, destitute and forgotten, in 1941. The elastic setting for this trial is "a lowdown club somewhere's 'tween Heaven 'n' Hell," and its chief jurist is a mysterious, raffish agent of the supernatural, Chimney Man (a majestic Keith David), who accuses Jelly of denying the black heritage that gave his music its syncopation and its pain.

While this conceit sounds heavy, the execution is often liberating. Mr. Wolfe brings on a high-voltage company of singers and dancers and a series of musical numbers in which biographical flashbacks, daring theatrical stylization, boisterous entertainment and tragic inferences all mesh in repeated crescendos. The songs have been ingeniously crafted, mostly from Morton's own compositions, by the arranger and composer, Luther Henderson, and the lyricist, Susan Birkenhead, who have tailored this instrumental music to meet the demands of the theater and of singers without sacrificing its integrity.

•

In one remarkable sequence that seems to be Mr. Wolfe's pointed response to the vendors' scene in "Porgy and Bess," the young Jelly, played by that exuberant dancer Savion Glover, leaves behind his strait-laced Creole upbringing to assimilate the authentic indigenous music of a diverse army of New Orleans street

singers. This leads to a show-stopping tap challenge between Mr. Glover and Mr. Hines -- in which their heads, wrists and elbows are choreographed (by Mr. Hines and Ted L. Levy) as tightly as their feet — and then into a galvanic blues belted out in a Storyland brothel by Mary Bond Davis. As Jelly moves on toward fame and fortune in 1920's Chicago, he passes through a dance hall in which a whirlwind of a chorus picks up his steps, much as his tinkling piano is echoed by the blast of horns. "That's How You Jazz," as the number is called, makes the invention of jazz a miraculous, eruptive theatrical event.

The intimate moments in Jelly's story are handled just as innovatively, with the young Jelly's banishment by his disapproving grandmother and the older Jelly's romance with a tough, independent nightclub proprietor named Anita being dramatized through wildly different blues songs. Ann Duquesnay and Tonya Pinkins bring big voices to these roles, but Ms. Pinkins's powerhouse Anita also has spicy, outspoken dialogue redolent of the strong women in Mr. Wolfe's Zora Neale Hurston adaptation, "Spunk." Her first night in bed with Jelly, a war for dominance as funny as it is erotic, aims for a new adult standard in male-female encounters in Broadway musicals. It is soon followed by a bracing Act I finale, memorably choreographed by Hope Clarke and red-hot in rage, in which Jelly's racist denial of his own blackness spirals into a nightmarish explosion of the toadying minstrel mentality he cannot leave behind.

Mr. Wolfe's harsh view of Morton, touchingly leavened by Mr. Hines's sympathetic portrayal, will not surprise those who saw his "Colored Museum," in which Josephine Baker and Michael Jackson were skewered for denying their pasts. "Jelly's Last Jam" is also consistent with that previous work's satirical assault on "A Raisin in the Sun," for it regards white racism as an old-fashioned subject for drama. Except for one brief,

flat Tin Pan Alley sequence, Mr. Wolfe leaves whites offstage, choosing instead to examine schisms within black America from the inside. He is less concerned with whether Jelly can walk through doors labeled "whites only" than whether he will walk through a symbolic door, covered with tribal hieroglyphs, that leads to his African past. "Jelly's Last Jam" no more resembles old-time Broadway civil-rights musicals than it does those countless upbeat revues saluting Jelly Roll Morton's peers.

•

That this writer can paint his themes on a large, costly Broadway canvas without losing his own devilish voice and fabulist esthetics is doubly impressive. As director, Mr. Wolfe has also made an effortless leap, eliciting intense performances even from the ensemble and achieving a striking visual polish with the aid of such fine previous collaborators as the costume designer Toni-Leslie James and the mask and puppet designer Barbara Pollitt. The inventive sets are by Robin Wagner, whose sleek, abstract use of a black void and changing configurations of lights occasionally make a winking reference to the thematically related "Dreamgirls" that he designed for Michael Bennett.

When "Jelly's Last Jam" collapses in Act II, as it does despite Mr. Hines's heartfelt efforts, it is because Mr. Wolfe has not imaginatively recast the banal material of Jelly's decline and fall. Having nothing to add to his overall point about his hero's racial denial, he settles instead for the conventions of show-biz biography. The hit songs, money and women run out; a Freudian cliché is invoked to explain Jelly's lifelong inability to feel. And as the song-and-dance interludes dwindle, Chimney Man blows too much smoke by preachily repeating the evening's incantatory messages. The curtain finally falls on the show's one dishonest note, a Broadway happy button

slapped on to a denouement that is otherwise a downer.

The second act of Mr. Wolfe's career promises to be a lot more exciting than the second act of "Jelly's Last Jam." In the meantime, anyone who cares about the future of the American musical will want to see and welcome his first.

1992 Ap 27, C11:1

A Small Family Business

By Alan Ayckbourn; directed by Lynne Meadow; scenery by John Lee Beatty; costumes by Ann Roth; lighting by Peter Kaczorowski; sound by Tom Sorce; incidental music by Jake Holmes; fight coach, J. Allen Suddeth; production stage manager, James Harker; associate producer, Roger Alan Gindi; associate artistic director, Michael Bush; general manager, Victoria Baily; executive producer, Barry Grove. Presented by Weissman Productions Inc., Walt K. and Beth Weissman, and MTC Productions Inc., Ms. Meadow, artistic director; Mr. Grove, managing director. At the Music Box, 239 West 45th Street, Manhattan.

Jack McCracken	Brian Murray
Poppy	Jane Carr
Ken Ayres	Thomas Hill
Tina	Barbara Garrick
Roy Ruston	Robert Stanton
Samantha	Amelia Campbell
Cliff	Mark Arnott
Anita	Caroline Lagerfelt
Desmond	John Curless
Harriet	Patricia Conolly
Yvonne Doggett	Patricia Kilgarriff
Benedict Hough	Anthony Heald
Giorgio Rivetti, Orlando Rivetti, Vincenzo Rivetti, Lotario Rivetti and Umberto Rivetti	Jake Weber

By FRANK RICH

When Americans think about the greed of the 1980's, they think of that distant den of thieves on Wall Street. For the British, grand larceny begins at home. "A Small Family Business," the Alan Ayckbourn comedy that arrived at the Music Box Theater last night, is set entirely in the ordinary

households of England's cozy middle-class provinces, where shopping tends to be the major social activity and shoplifting the major misdemeanor. Yet by the time Mr. Ayckbourn brings down the curtain on his nattering suburbanites, they seem as culpable as any Ivan Boesky or Robert Maxwell for the criminal amorality of a decade. Illicit cash, drugs and blood all leave a trail across their immaculately carpeted floors.

Originally produced at the National Theater in London in 1987, just months before the stock market crash, "A Small Family Business" is Mr. Ayckbourn's own equivalent to Caryl Churchill's "Top Girls," David Hare's "Secret Rapture" and Mike Leigh's film "High Hopes": it's a bitter indictment of the Thatcher years as seen at the grass-roots level, at home and the office. But Mr. Ayckbourn, who is no political ideologue, goes after his prey in his own way. He opens with a hilarious gag involving a misbegotten family surprise party and continues to foment laughter well after members of that extended family have been exposed as thieves, adulterers, morons and thugs who are looting their shared ancestral business, a furniture manufacturer. Mr. Ayckbourn is no optimist, but he is a consummate man of the theater who would rather entertain than lecture while lowering the boom.

Some but not all of the play's humor and nastiness come through in this new American production. The director is Lynne Meadow, whose superb stagings of Mr. Ayckbourn's "Woman in Mind" and "Absent Friends" at the Manhattan Theater Club challenged the quality of the English originals and have helped restore the playwright's reputation in New York, where a few of his earlier comedies were manhandled on Broadway in the 1970's. "A Small Family Business" is the best of the dark Ayckbourn plays Ms. Meadow has yet directed — indeed one of this prolific writer's best plays, period —

Gerry Goodstein/"A Small Family Business"

John Lee Beatty's set for "A Small Family Business" at the Music Box Theater is a two-level house split into six visible rooms.

but the production, surprisingly, is something of a disappointment. The large supporting cast is so-so, and the tone is broadly comic rather than astringently so.

The evening's finest performance comes from Brian Murray, in the role of Jack McCracken created by Michael Gambon in London. The farcical complications of "A Small Family Business" spiral once the middle-aged Jack leaves his management job at a frozen-foods concern to take over Ayres & Graces, the company founded by his wife's now doddering father. Vowing to bring "basic trust" to an organization where "take, take, take" has been the prevailing ethos, Jack is such a good man he even frowns on the pilfering of office paper clips. Once his in-laws start to drag him down to their level of off-the-books scheming, however, he finds that even the strongest moral convictions cannot withstand the web of corruption that is the clandestine fabric of the society in which he lives.

"There's got to be a minimum level of decent human behavior beneath which none of us sink," says the innocent, woolly headed Mr. Murray just before his own descent begins. His eyes bulging larger and larger as he witnesses graver and graver iniquities, he is an appealing as well as funny straight man whose short-lived virtue is real, not drippy. The physical and esthetic architecture of the community surrounding him is also well conveyed here. John Lee Beatty's set, a two-level house split into six visible rooms, is a blond-wood monument to suburban soullessness. (All the furniture is from the family firm.) Ms. Meadow, following the rough blueprint of Mr. Ayckbourn's original staging, does an expert job of keeping the action bouncing from room to room as the actors and such props as a cash-stuffed briefcase ricochet between four different households that sometimes occupy the stage simultaneously.

But the many people inhabiting these rooms and slamming their doors too often seem as anonymous as their surroundings. That is not how it should be in a play in which each character, as written, offers a sharply etched Dickensian glimpse into venality, pathos or pure evil. Jane Carr, as Jack's well-meaning but easily compromised wife, offers a single shrill note while Barbara Garrick and Robert Stanton as the McCrackens' older daughter and son-in-law and Thomas Hill as the out-to-lunch family patriarch, make scant impression. The family's two principal illicit entrepreneurs, bored husbands respectively funneling money into consumer goods and a culinary obsession, are lackluster to a fault as played by Mark Arnott and John Curless.

The price paid for these faceless performances is flatness during the expository scenes of Act I, and a shortfall in comic hysteria during the chases, mix-ups and violent cataclysms of Act II. Did Ms. Meadow have to devote so much time to the play's complex choreography that the cast was short-changed? One wonders, especially when watching that good young actor Jake Weber lose the laughs in what should be a foolproof running gag or when the excellent (and ideally cast) Anthony Heald gives a studied, tic-ridden account of a twisted private detective whose monstrousness should flow seamlessly. Faring better are some of the female characters victimized by these men: Caroline Lagerfelt as a wife driven to compulsive acquisi-

tiveness and sadomasochistic promiscuity, and Patricia Conolly as another neglected wife so fixated on her mangy old pet mutt that her own demeanor is terminally hangdog.

Amelia Campbell is also striking as the evening's one member of the younger generation, Jack's teen-age daughter. The source of boisterous familial concern early on, she is completely forgotten by one and all at the final curtain. By everyone except Mr. Ayckbourn, that is, who will not let the laughing audience escape the hopeless image of this girl, the play's sole heir to the 1990's, as she cowers in her shiny bathroom, shivering, broken and alone.

1992 Ap 28, C13:3

Ambrosio

By Romulus Linney; co-directed by Mr. Linney and James Houghton; set design, E. David Cosier; costume design, Teresa Snider-Stein; assistant costume design, Jonathan Green; lighting design, Jeffrey S. Koger; production stage manager, Deborah Natoli; artistic director, Mr. Houghton. Presented by Signature Theater Company. At Kampo Cultural Center, 31 Bond Street, Manhattan.

Elvira	Jacqueline Bertrand
Rosario	Craig Duncan
Lucero	Mark Alan Gordon
Antonia	Marin Hinkle
Inquisitor	Garrison Phillips
Don Pedro	T. Ryder Smith
Ambrosio	Peter Ashton Wise

By MEL GUSSOW

In "Ambrosio," Romulus Linney probes deeply into the nature of heresy and the power of love, both spiritual and temporal. Always a rapt student of history, he uses a seismic event in the past, the Spanish Inquisition, as a sounding board for his provocative thoughts on what drives people to irrational acts and crimes of passion. At the same time, the playwright never ignores his role as storyteller.

"Ambrosio," the final production in the first season of the Signature Theater Company, validates the premise behind the formation of the troupe. In the course of a single year, this enterprising company has devoted itself entirely to plays by Mr. Linney: revivals, revisions, the New York premiere of "A Woman Without a Name" and now a new play that ranks with the author's most challenging dramatic works.

In a taut 90 minutes, Mr. Linney demonstrates the crushing weight of the Inquisition, as it destroys dissent and raises hypocrisy to lofty heights. Abhorrent actions are followed by the prayerful words "with God, with God." From the author's critical perspective, it is not God but the Devil that is the primary force in Spain in 1500, but the answers to questions of diabolism are wisely left to a theatergoer's imagination.

The play is written with the utmost economy. As with the author's earlier historical efforts, beginning with "The Sorrows of Frederick," the new work is the antithesis of self-important epics that subordinate meaning to panoply and melodrama. "Ambrosio" is a quietly intense chamber piece that keeps a sharp focus on its central subject at the same time that it widens its lens to include the background of a demoralizing society.

Throughout the play, there are alternating currents of rapture and retribution, as a charismatic priest, Father Ambrosio (Peter Ashton Wise),

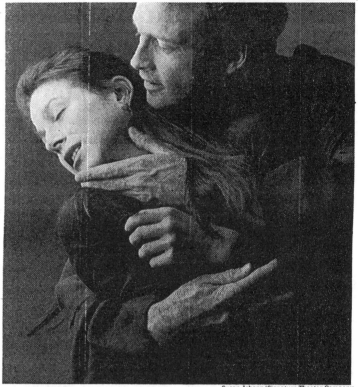

Susan Johann/Signature Theater Company

Marin Hinkle and Peter Ashton Wise in Romulus Linney's "Ambrosio," the Signature Theater Company's last show of the season.

is overcome by temptations. The sanctity of his cloistered life in an abbey is suddenly invaded by a longing for two people: a lovely young woman (Marin Hinkle), for whom he acts as confessor, and a mysterious monk (Craig Duncan).

The characters are clearly individualized and also represent divergent attitudes toward conflicts between church and state. The Inquisitor turns out to be a surprisingly judicious man, insisting on differentiating among sins, declaring that certain acts demonstrate "vanity, lunacy and lust, but not heresy."

An Inquisition-era priest whose life is suddenly invaded by longing.

To provide additional historical perspective, the author makes a passing reference to Martin Luther as a rising young man of the church. While remaining scrupulously within its period, "Ambrosio" also raises relevant arguments about other more modern times of non-enlightenment.

As directed by Mr. Linney and James Houghton, the actors evoke their characters in appearance as well as sensibility. Playing the seductive monk, Mr. Duncan has the look and the innocence of the boy in Picasso's portrait "Boy Leading a Horse." Similarly, T. Ryder Smith, through his invidious manner, underscores the diabolic nature of his character.

Moving from abject admiration for the priest to sudden moments of passion, Ms. Hinkle turns her confessional into a dream of lustful abandon. In

his New York debut, Mr. Wise takes an understated approach to his role. While not soliciting sympathy, he elicits curiosity, entreating the audience into his nightmare and the contradictions of a man enthralled.

The set design by E. David Cosier makes harmonious use of sparse scenery and slide projections, and Teresa Snider-Stein's costumes add authenticity.

With its intelligence and acuity about crises of faith, "Ambrosio" is a play that would honor any of our major theaters. That it happens to have its first production in the unpretentious surroundings of the Signature Company reinforces Mr. Linney's commitment to theater as an arena for the exploration of ideas.

1992 Ap 28, C15:1

Falsettos

Book by William Finn and James Lapine; music and lyrics by Mr. Finn; directed by Mr. Lapine; set design, Douglas Stein; costumes, Ann Hould-Ward; lighting, Frances Aronson; sound, Peter Fitzgerald; musical arrangements, Michael Starobin; musical direction, Scott Frankel; musical contractor, John Monaco; general manager, Barbara Darwall; production supervisor, Craig Jacobs. Presented by Barry and Fran Weissler. At the John Golden Theater, 252 West 45th Street, Manhattan.

Marvin	Michael Rupert
Whizzer	Stephen Bogardus
Mendel	Chip Zien
Jason	Jonathan Kaplan
Trina	Barbara Walsh
Charlotte	Heather Mac Rae
Cordelia	Carolee Carmello

By FRANK RICH

Last night's opening of William Finn's exhilarating and heartbreaking musical "Falsettos" at the John Golden Theater marked the official end of the Broadway season, and what more perfect end to this season

Carol Rosegg/Martha Swope Associates

In "Falsettos," from left: Chip Zien, Jonathan Kaplan, Barbara Walsh, Michael Rupert, Stephen Bogardus, Carolee Carmello, Heather Mac Rae.

could there be? In a theater year marked by signs of an American musical renaissance on Broadway and an explosion of American playwriting off Broadway, "Falsettos" is a show in which the boundary separating Off Broadway and Broadway is obliterated, a show in which the most stylish avatars of the new American musical embrace the same thorny urban landscape of embattled men and women to be found in so many new American plays.

The evening also brings this highly charged season to a close with the charged emotions of an eagerly awaited reunion. "Falsettos" is the seamless merging of two one-act musicals, "March of the Falsettos" and "Falsettoland," that were produced individually in 1981 and 1990. All three original leading men — Michael Rupert, Stephen Bogardus and Chip Zien — are back, as is the original director, James Lapine (who is also co-author of the book). A lot has happened to them since they and "Falsettos" first came together. A lot has happened to the audience. Like any reunion worth attending, this one tempers its feelings of joy with those of deep loss. The wave of euphoria "Falsettos" evokes is inseparable from the wave of tears that rises audibly through the house once Mr. Finn raises the ghosts of those Falsettoland loved ones no longer here to join the party.

●

Those who have never encountered this work in any form will have the enviable experience of meeting its achingly articulate characters and laughing for the first time at the idiosyncratic linguistic twists of songs about "Four Jews in a Room Bitching," the perils of psychotherapy and the familial predicament of watching "Jewish boys who cannot play baseball play baseball." Newcomers can also be confident that Mr. Lapine reassembles and refreshes his original intimate staging. Douglas Stein's spare and sparkling Pop Art production design remains intact, and so does the scale of the "teeny tiny band" playing the clever orchestrations of Michael Starobin. What old "Falsettos" hands will discover is that Mr. Finn has done some smart, delicate tinkering with "March of the

Falsettos" and that "Falsettoland" gains exponentially in power by being seen only 15 minutes, instead of 9 years, after the first installment.

Seen in this form, "Falsettos" also emerges as far more complex than its simple story might suggest. In telling the adventures of Marvin (Mr. Rupert), a man of 1979 who leaves his wife and son for a male lover, Whizzer (Mr. Bogardus), Mr. Finn is not merely writing about the humorous and sad dislocations produced by an age of liberated sexual choices and shifting social rules. When 1981 arrives in Act II — and with it, a virus "so bad that words have lost their meaning" — Mr. Finn is not merely charting the deadly progress of a plague. The unified "Falsettos" is as much about Marvin's abandoned

Joining two one-act plays makes a more complicated whole.

wife, Trina (Barbara Walsh), and young son, Jason (Jonathan Kaplan), as it is about Marvin, Whizzer and Mendel (Mr. Zien), the psychiatrist who goes from being Marvin's doctor to Trina's new husband. Most important, it is about all its people together, a warring modern family divided in sexuality but finally inseparable in love and death.

●

"I want a tight-knit family," sings a childish, self-absorbed Marvin early on as he tries to juggle lover, wife, son and shrink. Two acts later that ambition has been achieved and enriched as all the reconfigured couples are joined by still another couple, an endearing pair of "spiky lesbians" (Heather Mac Rae and Carolee Carmello), to celebrate Jason's bar mitzvah. But the battle to achieve that tight-knit extended family is not easy. It cannot be won until Mr. Finn's male characters answer the jokey question they ask rhetorically in song

in Act I: "Who is man enough to march to 'March of the Falsettos'?"

That question demands that these boys, whatever their age or sexuality, figure out what masculinity is. How they clumsily try to do so — in and out of bed, marriage and psychotherapy — is the source of the show's humor in Act I. The answer they discover is what gets them through the tragedy of Act II. As Mr. Finn sees it, the man who is man enough to march forward is the man who is man enough to love men, women and children unselfishly; standing face to face, no matter what. If Jason's bar mitzvah is one of the most moving you've ever seen, it is in part because it takes place in an AIDS patient's hospital room, in part because Marvin in tandem with his smart son has at last grown up to be a man.

●

This progress is beautifully delineated by Mr. Rupert, whose nearly 25 years of honorable service as a juvenile in Broadway musicals reaches its long deserved, highly affecting payoff in Marvin, a character whose leap past eternal boyishness into mature, consuming passion inspires the most full-throttle singing and acting of this performer's career. Marvin's story also gains some new gravity in "Falsettos" thanks to the recasting of his son and estranged wife. Jonathan Kaplan, a very young Woody Allen with a big singing voice, is a sublime Jason. Barbara Walsh, as Trina, repeats the strong performance she gave in Graciela Daniele's fine Hartford Stage Company production of "Falsettos" last fall. Because of Mr. Finn's revisions, she has a spine denied her distinguished, ditsier Off Broadway predecessors in the part, Alison Fraser and Faith Prince. In addition to her new show-stopper ("I'm Breaking Down," adapted from "In Trousers," an earlier Finn musical about Marvin and company), Ms. Walsh socks over a rewritten "Trina's Song" in which she indicts the "happy frightened silly men who rule the world" more fervently than before.

Mr. Zien, the most perpetually addled of therapists, and Mr. Bogardus, a pretty boy who ages fast, are both better than ever as respectively the wittiest and the most heroic of those

men. When Mr. Zien offers a citation from the Torah to support his contention that "Everyone Hates His Parents," he ignites one of Mr. Finn's most riotous verbal riffs, just as Mr. Bogardus's forceful, never entirely knowable Whizzer conversely extends the spectrum of "Falsettos" to defiance and political rage in the chilling, unsentimental "You Gotta Die Sometime."

●

At this late date, it may be superfluous to praise Mr. Finn's talent as a composer, but one of the virtues of "Falsettos" is that you take in his whole, wide range in one sitting and appreciate the dramatic uses to which he puts his music, not just the eclecticism of tunes that range from show-biz razzmatazz ("Love Is Blind") to lullabye ("Father to Son") to lush ballads ("Unlikely Lovers"). Neither an opera nor a conventional musical, Mr. Finn's score is full of fine details: a musical signature from Act I will turn up fractured in Act II just as a life cracks up; the notes underlying "spreading" in an internist's lyric about "something bad spreading, spreading, spreading round" themselves spread the terror of a still nameless virus that defies the meaning of words.

Mr. Finn's range is a decade's range, at least as seen from the admittedly limited perspective of mostly white, moderately young and affluent, often Jewish New York. When "March of the Falsettos" first charged confidently forward in the tiny upstairs studio theater of Playwrights Horizons 11 years ago, nothing so bad was happening, and the high spirits of that moment pump through Act I of "Falsettos" as if pouring out of a time capsule. Act II plays out in another key as lovers no longer "come and go" but "live and die fortissimo."

"Falsettos" may now be a Broadway musical, but it cannot and does not pretend for a second that the lovers have stopped dying. It is the heaven-sent gift of Mr. Finn and company that they make you believe that the love, no less fortissimo, somehow lingers on.

1992 Ap 30, C17:3

A Murder of Crows

By Mac Wellman; directed by Jim Simpson; scenery designer, Kyle Chepulis; costume designer, Bruce Goodrich; lighting by Brian Aldous; composer and sound designer, David Van Tieghem; choreography, Tina Dudek; production stage manager, Melanie White; production assistant, Amy Gaipa; associate artist director, Janet Reed. Presented by Casey Childs, artistic director, Primary Stages Company, in association with Douglas Durst. At Primary Stages, 354 West 45th Street, Manhattan.

Nella Anne O'Sullivan
Susannah Jan Leslie Harding
Howard William Mesnik
Georgia Lauren Hamilton
Raymond Steve Mellor
Andy............................. Reed Birney
Crow No. 1 Tina Dudek
Crow No. 2 Ray Xifo
Crow No. 3 David Van Tieghem

By MEL GUSSOW

In Mac Wellman's apocalyptic vision, civilization is facing a Love Canal of the mind and body. The view is as urgent as it is fearful. It is an ecological nightmare, as weather reports from past centuries become auguries of approaching climatic catastrophe. No matter where we are, "we are downwind of something peculiar." Mr. Wellman's scathing new comedy, "A Murder of Crows" (at Primary Stages), is a red alert, to be ignored at one's peril. Acid rain is coming, and the playwright is our caustic commentator and meteorologist.

The medium for his warning is a Middle-American mire. The people in this anonymous small town have moved past hard times to desperate days. As one character says, with full symbolism intended, "It's lucky the shallow end is near the beach." Otherwise everyone would drown in sludge.

In free-flowing Wellman fashion, there is a sense of surrealism afoot, which to cynics among us may seem scandalously close to reality. A prophet of misfortune, the author pinpoints the poisons in everyday life, describing how mankind is polluting the planet. He is also out to smash that other American dream, of getting something for nothing, and, with devilish glee, he mocks our hypocrisy about true and false heroics. A survivor of the war in the Persian Gulf comes home and literally turns into a public monument. He is gold-leafed and frozen on a pedestal.

Watching the grotesqueries unfold, one may ask why the play is so amusing. The answer is easy. Mr. Wellman has a gymnast's sense of equilibrium and a clownish sense of comedy. In virtuosic form in this new play, he never allows his danse macabre to become a dirge. There are hints of early Sam Shepard and of the socially conscious side of Franz Xaver Kroetz, but with the author's original voice.

Characters exorcise their anxieties, sometimes in direct address to the audience. Confessionals become riffs: from mother, daughter, crusty uncle Howard and his Klan-leaning wife (who could be a fugitive from Mr. Wellman's redneck romp, "Sincerity Forever"). Even the statu-esque war hero finally takes the opportunity to talk back. And a father who seemed to be dead magically returns to life, looking as encrusted as if he had been weekending in a Dumpster. In the background are three scavenger crows, mocking and baiting what is left of humanity.

"A Murder of Crows" is an exact meeting of play and production, as the director Jim Simpson animates a devious text into a dexterous performance. Many of the actors are experienced Wellman interpreters. The cast knows that in this comic territory overstatement would be damaging. The bizarre becomes matter-of-fact and the matter-of-fact seems bizarre.

•

Annie O'Sullivan and Jan Leslie Harding are distorted mirror images as embattled mother and daughter. William Mesnik is dryly bemused as Uncle Howard, even as his wife (Lauren Hamilton) waxes prejudiciously. That essential Wellman spokesman, Steve Mellor, expounds with a customary loop-the-loop circumlocution. In the hands of the actors, words fly fast.

Among the crows is David Van Tieghem, who is also responsible for the music and sound, a synchronized tapestry that ranges from sitcom strains to a pulsating beat that would be equally at home in Hitchcock. The designer, Kyle Chepulis, outdoes his previous Wellman efforts with an imaginative setting that poses its own danger.

The stage is seeping, as water drains ominously toward the front row of the audience. The dripping is incessant. This play needs a plumber! At one point, there is a sudden shower. Actors raise umbrellas but, like the characters they are playing, they are unable to duck for cover. In Mr. Wellman's ringing incitement, the world ends not with another big bang, but with a chorus of crows mischievously tapping and singing their way through the metaphorical landscape.

1992 My 1, C18:1

SUNDAY VIEW/David Richards

A People Face History's Mirror

August Wilson's 'Two Trains Running' upstages the 60's.

George C. Wolfe puts a soul on trial in 'Jelly's Last Jam.'

THERE'S NO PREDICTING THE course of a playwright's career. Even so, "Two Trains Running" at the Walter Kerr Theater is a play you wouldn't have expected August Wilson to write.

For some time, the gifted Mr. Wilson has been chronicling the lives and mores of black people in America — putting faces to those who might otherwise have been lost in the crowd, giving voice to their joy and their pain. The grand scheme calls for a play for each decade of the 20th century, although, obeying inspiration rather than chronology, he has jumped around a lot. He followed his first success, "Ma Rainey's Black Bottom," which was set in the Roaring Twenties, with "Fences," which took place in the moral twilight zone that was the 1950's. He then backed up to 1911 with "Joe Turner's Come and Gone," before moving forward to 1936 and "The Piano Lesson."

Varied as the works have been, in one fashion or another they've all examined the continuing struggle to survive in a system that has welshed on its promise of universal liberty and justice. White society has denied Mr. Wilson's characters a history, so they comb the past for signs and stories that tell them who they are and where they came from.

Now, in "Two Trains Running," the playwright is tackling the 1960's — the most racially disturbed decade of the century. Across the country, long-smoldering resentments were bursting into flame; inequities were being vigorously, even violently, contested, and the robust assertion of black pride was challenging the old submissiveness and remaking a people's vision of itself. Mr. Wilson's play would have to be incandescently angry, wouldn't it?

Well, no, it wouldn't, as it turns out. "Two Trains Running" is his most benevolent work to date. The funniest, too. Suffused with a forgiving warmth and a loving appreciation of human eccentricity, it is, if you will, Mr. Wilson in a near-Saroyanesque mode.

None of the regular customers of Memphis Lee's restaurant in the Hill district of Pittsburgh, the play's setting, is out to flail "whitey," although his deviousness in commerce is hilariously noted. No one's mounting a demonstration or raising a clenched fist. Instead of ultimatums, you have Holloway (Roscoe Lee Browne), retired house painter and chief, pretender to the window booth, opining that, "You got love and you got death. Death will find you . . . it's up to you to find love. That's where most people fall down at. Death got room for everybody. Love pick and choose."

■

The announcement of an impending rally and dance in memory of Malcolm X, downtown at the Savoy Ballroom, causes barely a ripple in the daily life of the restaurant. The characters are far more interested in following the progress of the burial rites of Prophet Samuel, who is laid out for viewing — rings on his fingers and hundred-dollar bills between them — in a nearby funeral parlor. For those who always felt the Prophet was a sham, Aunt Ester continues to dispense advice a block away to anyone who'll throw $20 in the Monongahela River. Her wisdom is generally thought sound, although her age, said to be 322, is open to discussion.

Twenty-five years ago, when much of the burgeoning black theater was virulently polemical, "Two Trains Running" would probably have been seen as an abnegation of politi-

cal responsibility. A battle had been enjoined, and playwrights like Amiri Baraka, Ed Bullins and Charles Gordone were serving white America a warning, if not a death notice. Mr. Wilson's play about the 1960's recognizes that there weren't militants everywhere and that two blocks away from the big protest march life tends to its homely course, anyway. In eight scenes — stretching from a Saturday morning to a Friday afternoon — it charts the comings and goings at Memphis Lee's, where nothing much happens and everything does.

When he's not running numbers, Wolf (Anthony Chisholm) tries to catch the eye of the pretty waitress, Risa (Cynthia Martells), whose eye is not for catching. At least not until Sterling (Larry Fishburne) arrives on the scene fresh out of the pen for bank robbery but determined this time to find an honest job and maybe a gun, for insurance. Risa once took a razor blade to her legs in the hope that the scars would make her unattractive and men would leave her in peace. But Sterling is not put off by her discouraging words — or the deliberate languor, verging on sullenness, with which she waits on customers. He persists amiably with his courtship, even if it has to be one way for a while, and eventually she gives ground.

West (Chuck Patterson), the prosperous funeral director, drops in regularly for a cup of coffee, his appearance generally provoking a round of gallows humor. Just as regularly, the retarded handyman they call Hambone (Sullivan Walker) tries to scrounge up a free bowl of beans. Nine and one-half years ago, he painted the fence of the neighborhood butcher in exchange for a ham. But the butcher presented him with a chicken instead and, ever since, Hambone has been parroting the same two sentences: "He gonna give me my ham!" and "I want my ham!"

Sterling teaches him a third sentence, "Black is beautiful," but it doesn't deflect Hambone from his appointed mission. The rallying cry of a generation is for him just a laborious speech exercise. Memphis Lee (Al White), meanwhile, is engaged in a standoff of his own. The city plans to demolish the restaurant and redevelop the neighborhood but is offering only $15,000 for the property, and Memphis Lee won't take a cent less than $25,000. So he's forever dashing off to City Hall to argue his case.

■

Almost all the significant events in "Two Trains Running" occur offstage. The restaurant seems to be primarily a place for reflecting on life, death and what's transpiring around the corner. A few dreams are indulged in, even if Holloway, ever the philosopher, feels obliged to point out that, "The more you sit around and talk about what you ain't got, the more you have to talk about."

If Mr. Wilson did not write such flavorful talk — and if this cast were not so accomplished at delivering it — the amorphousness of "Two Trains Running" would be even more apparent. As it is, the play doesn't really "go" anywhere, although I wonder if that doesn't also say something in retrospect about the 1960's. The Es-

tablishment never did come tumbling down and, by the 1980's, the plasterers were filling in a lot of the fissures that had opened up.

Mr. Wilson's characters are more than content to shoot the breeze and leave the big confrontations to a drama like "Fences." Much of their lives is matter for despair, but the play seems to want to celebrate the stubborn tenacity that holds despair at bay. The poetic vitality of the language is, in itself, a rebuttal of hopelessness.

■

Mr. Browne's Formica sage has seen it all, which may explain the heavy droop of his eyelids. If there's indignation in his soul, however, it comes second. Amazement comes first. Whatever his opinion, it is usually offered from the wry perspective of one who believes that human folly knows few bounds and certainly no racial bounds. The performance is wise and slyly life-affirming.

Mr. Fishburne puts an equally disarming spin on the character of Sterling, the ex-hood. Tilting his head down and then looking up at the world, he neatly marries the defensiveness of the adult to the shyness of the boy. Odds are that Sterling will end up in the slammer again, but you don't get that defeatist message from Mr. Fishburne, who has the buoyancy of a survivor.

Under Lloyd Richards's direction, the whole cast has settled into Tony Fanning's set as if it were a home away from home, which it is. Maybe it's the prevailing spirit of tolerance that accounts for the warmth of the play. Mr. Walker finds a rare sweetness in dementia, so even Hambone is viewed more as a nuisance than a disturbance. Only Risa strikes me as less than fully fleshed out. Mr. Wilson doesn't provide many clues to her strangely somnambulistic behavior. That wouldn't be fatal if you felt Ms. Martells had her own sense of the character's biography. But she just appears dazed and her traumas remain a mystery.

For the most part, Memphis Lee's is a haven in the storm. Not that there's much evidence of a storm. The inflammatory 1960's are happening elsewhere. In "Two Trains Running," the loudest explosions are produced by the restaurant door slamming shut every time someone comes in for company or heads out into the street and the distant fray.

'Jelly's Last Jam'

Don't mistake "Jelly's Last Jam" for one of those revues that pretend to relate the life of a famous musician but mostly string together a lot of

Jay Thompson/"Two Trains Running"

Anthony Chisholm, left, and Larry Fishburne in "Two Trains Running"—August Wilson in a near-Saroyanesque mode.

Martha Swope/"Jelly's Last Jam"

Keith David, left, and Gregory Hines in "Jelly's Last Jam"— The creators have set out to produce a latter-day morality play.

well-known songs and then dust them with a few biographical details and laudatory comments. The new musical at the Virginia Theater has a far bolder agenda: it is putting the legendary jazz pianist and composer Jelly Roll Morton on trial.

His sins? A New Orleans Creole, he was light-skinned enough to pass for white, or think he could. He turned a cold shoulder on his brothers and sisters. Worse, he refused to recognize that the source of his art was the black community of New Orleans and, by extension, tribal Africa itself. The blues were born to spread the story of a people's pain, explains the Chimney Man (Keith David), an ominous figure in top hat and tails, who is either death or death's very spiffy henchman, in the opening moments of the show.

But "it came to pass," he continues, "that a messenger was called,

who believed the message was him." Mr. David's voice is like rolling thunder and he moves with the sinuousness of a panther on the prowl. The Roll, as he's nicknamed, is in hot water, and were he not being played by Gregory Hines, as likable a performer as you could hope to put in the shoes of a cad, you'd fear even more for him.

It is the eve of Jelly's death and he is being given one last chance to look back over his life, justify his actions and maybe redeem himself. What the show's creators — the director and author of the book George C. Wolfe, the lyricist Susan Birkenhead and the composer Luther Henderson, filling in the gaps left by Morton's own songs — have set out to produce is nothing less than a latter-day morality play. A soul is in question. (So is soul.) The underlying themes of solidarity and collective pride may be

reminiscent of the very 1960's that "Two Trains Running" seems to by-pass. But there's enough stylistic bravado on other fronts for "Jelly's Last Jam" to qualify, some of the while, as a breakthrough musical.

Besides "Pal Joey," "What Makes Sammy Run?" and "I Can Get It for You Wholesale," I can't come up with too many white musicals that have had unvarnished heels for heroes. Offhand, I can't name a single black one. To Jelly may well go the laurels. After his mother died and his father bolted, as the musical tells it, he was raised by his grandmother (the powerful Ann Duquesnay), a pillar of genteel Creole society. Horrified to catch her grandson (Savion Glover) in the sporting houses, she summarily washes her hands of him. The distraught youth, we're given to understand, is emotionally scarred for life. He'll never let feelings get to him again. As he brazens his way North to fame and success in the early 1920's, his hide grows thicker, his smile harder and his ego bigger. Stirring up the crowds with his syncopated music (in Mr. Hines's case, it's his syncopated feet that do the stirring, but no matter), Jelly is soon boasting that "I invented jazz."

Historians will have to tell you how closely "Jelly's Last Jam" hews to actual biography. The musical, remember, is weighing his character. To illustrate the extent of his arrogance, it gives him a mistress, Anita, and a best friend, Jack the Bear, then has him betray them both. Anita is no one to push around, and Tonya Pinkins, who portrays her, is full of sexy aplomb. She can't help reeling, however, when Jelly tells her that he intends to continue playing the field, although, "as far as bitches go, you come the closest." At the opening of his Chicago club, he demotes Jack (Stanley Wayne Mathis) to the rank of doorman, tosses him a red porter's jacket and orders him to put it on, before greeting the guests. At moments like these, "Jelly's Last Jam" minces neither words nor actions.

∎

In the stinging first-act finale, a presumably triumphant Jelly grabs center stage to inform the world that "here comes Dr. Jazz" and that he's "got glory all around him, yes he has." But he doesn't. Out of the shadows, the choreographer Hope Clarke coaxes a mocking backup line — nine dancers, each dressed in the denigrating porter's outfit and sporting a messenger-boy hat. Their faces are garish with minstrel makeup. This is not the apotheosis Jelly expects. It's a nightmare. Our last image, before the intermission, is of Mr. Hines, hollow-eyed and slack-jawed, flailing in the shrinking spotlight as if it were a pool of quicksand.

Broadway, of course, likes its musicals upbeat, and "Jelly's Last Jam" sacrifices some of its stark originality to appease that taste. Early on, Mr. Hines and Mr. Glover engage in a lively challenge tap dance that is not so much a confrontation between the old, embittered Jelly and his younger, eager self as it is simply a lively challenge dance. There are some vigorous production numbers — people having a raucous time in the various

dives and clubs that marked Jelly's path to success. But they are what is least innovative about the show. "Legs Diamond," lest we forget, had those kinds of numbers, too. It's the darkness that gives "Jelly's Last Jam" its luster.

∎

Robin Wagner's sets, as lighted by Jules Fisher, are oases in the cosmic gloom. A forbidding front-door stoop is all that's provided — and all that's needed — for Jelly's banishment. A majestic four-poster, no bedroom, serves for the love scenes. The telling detail here is that it is rolled into place, then turned this way and that, by the Hunnies, three knowing, long-legged showgirls in black leather, who may be from heaven, but I doubt it. A series of revolving mirrors, bordered in pink neon, stands for New York, where Jelly discovered the vogue for swing was leaving him fast behind. Los Angeles, where he wound up, ill and forgotten in 1941, is a Cinemascope ribbon of blue, edged at the bottom by more neon. Simple and vivid, this.

Mr. Wolfe's staging is at its cutting best when pared down to the expressionistic basics that clearly recall his first success, "The Colored Museum." The larger the canvas, the less distinct the picture. Watching Mr. David step gingerly across the bare stage, for example, his teeth diamond bright, is every bit as compelling as seeing the full company cut loose on the dance floor in "The Chicago Stomp." Mr. Hines's performance is certainly never so arresting as when Jelly is behaving rottenly to his loved ones. We've long since known that he can heat up a show with his dancing, but who'd have thought he could project such chilly willfulness, such still, unyielding bitterness?

I'll leave it to you to discover whether Jelly mends the errors of the past and earns salvation. I will say this, though. The ending of "Jelly's Last Jam" is its least courageous gesture. Considering the ground that has been broken beforehand, you might even term it a capitulation. □

1992 My 3, II:5:1

Groundhog

Composed, written and directed by Elizabeth Swados; sets and costumes, G. W. Mercier; lighting, Natasha Katz; sound, Ed Fitzgerald; musical direction and arrangement, Ann Marie Milazzo and Michael Sottile; production stage manager, Richard Hester; associate artistic director, Michael Bush; general manager, Victoria Bailey. Presented by Manhattan Theater Club, City Center Stage II; artistic director, Lynne Meadow; managing director, Barry Grove. At Manhattan Theater Club, Stage 2, City Center, 131 West 55th Street.

Dr. R. T. EbneyStephen Lee Anderson
GilaAnne Bobby
Judge Alex T. WaldmanBill Buell
Zoe.................................Gilles Chiasson
Georgette BergenNora Cole
District Attorney RandallUla Hedwig
WeatherpersonAnn Marie Milazzo
Sandy....................................Lauren Mufson
Mayor of New YorkDaniel Neiden
Lauree.....................................Suzan Postel
GroundhogDavid Schechter
FezTony Scheitinger
Danilo ChelnikMichael Sottile
Musicans
Paul O'Keefe, Lewis Robinson, Mr. Sottile

By MEL GUSSOW

Family demons and the visceral realities of urban street life converge in Elizabeth Swados's venturesome new musical play, "Groundhog." Depending on one's point of view, the title character is either "a paranoiac schizophrenic" or "a primitive wild genius." For Ms. Swados, who knows him like a brother, he is both at the same time.

In this deeply personalized work (at Manhattan Theater Club's Stage II), Groundhog is partly based on Ms. Swados's own sibling, who died after years of living as a street person. For fictional purposes, he is combined with a character like Joyce Brown (also known as Billie Boggs), who became a subject of controversy in New York in the late 1980's. Acting as playwright, composer, and director, Ms. Swados is unflinching in her response to the madness of Groundhog (David Schechter), a figure to haunt anyone's nightmare. Watching the musical, one wonders how the author and her fictional surrogate (Anne Bobby) were able to endure the abuse.

The narrative deals with a court hearing to determine if Groundhog is sane enough to be released from confinement in Bellevue and return to his life as a street musician. As with Billie Boggs, he quickly becomes a political issue as the American Civil Liberties Union fights the District Attorney's office, and as the Mayor and the media compete for public attention. Naturally, all warring parties ignore Groundhog's best interests.

This ambitious attempt at writing a musical play of Brechtian proportions is not entirely successful. Searching for a resolution in the second act, Ms. Swados momentarily overlooks her musical needs and becomes tendentious. There are also steps along the way that should be abbreviated. But none of this substantially detracts from the seriousness and the immediacy of the effort.

In this show, as in her recently published family memoir, "The Four of Us" (Farrar, Straus & Giroux), Ms. Swados comes to terms with traumatizing events. Considering the pitfalls, the approach is remarkably free of self-pity and sentimentality. The role of Groundhog could have been conceived as a clownish eccentric. Instead, as written by Ms. Swados and as portrayed by Mr. Schechter, he has the hardest of edges, and around him is an aura of incipient malice. Mr. Schechter's tightly coiled performance would seem to be an authentic depiction of the extreme irrationality of the character in life.

The sister's role is that of anxious pawn. She keeps trying to do what she thinks is the right thing and is repeatedly blocked by her brother's delusionary behavior. Ms. Bobby tellingly conveys her character's mixed allegiances as, trying to embrace her brother, she is swept aside as if she is a fly that has landed on his face.

Ms. Swados widens her dramatic focus to explore the failings of social programs and of the court system. Especially in the courtroom, she reveals her flair for satirizing authority figures: the judge who hopes the case will become his movie of the week; the expert witnesses who have to consult their notes before contradicting one another. Groundhog stage-manages the trial while also playing the leading role. Interrupting the summations of the bitterly competi-

No Hiding Place David Schechter and Anne Bobby appear in "Groundhog," a play with music written and directed by Elizabeth Swados.

tive lawyers, he places his hands over their heads and announces, "It's 'College Bowl'!"

●

In characteristic fashion, the composer has created a highly eclectic score, with salsafied Swados alternating with rap and rock, with dialogue fading into recitative. The music is not as melodic as it was in "Runaways" and other Swados musicals, but it has a definite New York beat. Many of the strongest numbers are sung by Mr. Schechter and Ms. Bobby, separately and as duets.

With several exceptions, notably Nora Cole as Groundhog's lawyer and Daniel Neiden as a mayor with the vocal inflections of Edward I. Koch, the supporting cast lacks individuality. In part, that is due to the fact that the actors double in so many roles, moving from functioning citizens to homeless people huddling in blankets. In this austere production, the set designer, G. W. Mercier, has trimmed his own imagination, using interchangeable chairs and tables for courtroom, street and shelter.

Dominating the show is the figure of Groundhog, dancing on the edge of lunacy while mocking a closed society that is unable to deal with him and the other dispossessed. Unlike so many musicals, "Groundhog" has something relevant to say and speaks with a veracity that arises from experience.

1992 My 4, C14:1

Marathon '92

Produced by Kevin Confoy; production manager, Andrew Kaplan; lighting, Greg MacPherson; set design, Sarah Lambert; costumes, Sue Ellen Rohrer; sound, David Lawson; production stage manager, Dathan Manning; associate producer, Jeff Mousseau. Presented by the Ensemble Studio Theater; Curt Dempster, artistic director; Christopher A. Smith, associate artistic director; Dominick Balletta, managing director. At the Ensemble Studio Theater Mainstage, 549 West 52d Street, Manhattan.

THROWING YOUR VOICE, by Craig Lucas; directed by Kirsten Sanderson; stage manager, Liz Small; assistant to the director, Helena Webb.

Sarah.. Brooke Smith
Lucy.................................... Mary-Louise Parker
Richard...................................... James DuMont
Doug...Sam Robards

THE SHALLOW END, by Wendy MacLeod; directed by Susann Brinkley; stage manager, Simma Gershenson.

Becca.. Lauren Ambrose
Marjorie...Sara Rue
Theresa................................... Lizabeth Zindel
Addie...Kia Graves

WHAT IS THIS EVERYTHING?, by Patricia Scanlon; directed by William Carden; choreographer, Martha Bowers; stage manager, Randal Fippinger; assistant to the director, Richard Galgano.

Trash..Patricia Scanlon
Dirty....................................Brian Tarrintina
Father/Waiter Ed Satrakian

FASTING, by Bill Bozzone; directed by Kate Baggott; stage manager, Isaac Ho; assistant to the director, Justin Dorazio.

Emmett .. Joe Ponazecki
Frank...Baxter Harris
Mrs. McCann............................Carolyn Mignini
Leon ...Michael Wells

THE WILD GOOSE, written and directed by John Patrick Shanley; stage manager, Randy Lawson; assistant to the director, Terumi Matthews.

Jameson Robert Clohessy
Renaldo...............................Nicholas Turturro
Ramona Paula DeVicq

By MEL GUSSOW

For 15 years the Ensemble Studio Theater has celebrated spring with a festival of one-act plays, introducing new playwrights and encouraging more experienced ones to flex their talents. Naturally the quality of the writing varies, but the directing and acting invariably show a play in the best possible light or demonstrate how a play has fallen short of the performance.

In the opening series of Marathon '92, the most evocative work comes from an unexpected source. In her full-length "Apocalyptic Butterflies" and "The My House Play," Wendy MacLeod has often been overcome by whimsy. Her one-act play "The Shallow End" speaks with clarity and humor about young women embracing adolescence with all the mixed emotions of their age.

The story is overly familiar, but the writing is far more assured than in the playwright's longer efforts. "Life is filled with tough choices," says one of the play's four teen-agers. One of the most difficult of those choices has to do with friends, as a desire for acceptance can lead to compromising principles of decency.

Lounging by a swimming pool, Lizabeth Zindel manipulates her companions to her ill will, gradually revealing herself as a hostile force. Lauren Ambrose, as the prettiest of the group, goes along with her, even though it means taking advantage of others. But Kia Graves awakens to the possibility of her individualism. Off to one side is Sara Rue as an overweight outsider who, of course, is the girl with the most sense. As directed by Susann Brinkley, each actress delineates her character with an accuracy that seems to derive from a sense of identification.

•

Bill Bozzone's "Fasting" is a comedy about older age as two gay men share a holiday and cogitate on their long relationship. One, a former high school athlete, is facing his 40-year reunion and is trying to trim his weight for the meeting with his old classmates. As conflicts arise in the

present, one can see that the fasting is indicative of the character's denial of self.

The Ensemble Studio Theater opens its 15th festival.

The events are predictable, but as acted by Baxter Harris and Joe Ponazecki, the play has moments of amusement, and it is spiced by the character of a busybody housekeeper (Carolyn Mignini) who thumps a piano while quoting Scripture. Mr. Bozzone has a sure hand with such short insights.

The longest of the plays, "What Is This Everything?," is also the most unwieldy, and there is a self-consciousness about the dialogue that vitiates the quirkiness of the situation. Patricia Scanlon stars in her own play as a character named Trash who falls for a fellow named Dirty. Is there any more one needs to know? They meet in a greasy spoon, where Trash seems to be going through a coffee fit. Flashbacks to the woman's difficult past with her father undermine the immediacy of the couple's Frankie-and-Johnny relationship.

•

"The Wild Goose," written and directed by John Patrick Shanley, at least has the advantage of brevity. This is a forced attempt at creating a gangster vaudeville as two cronies spar for domination on a sun deck. Robert Clohessy and Nicholas Turturro swagger effectively as the tough guys, and Paula DeVicq is an attractive addition to the ménage.

In Craig Lucas's "Throwing Your Voice," two young couples exchange their trendy thoughts about current events. The point of the sketch is political correctness, how far one should go in expressing a social consciousness through consumerism. The conversation is weightless. The presence of such talented people as Brooke Smith and Mary-Louise Parker makes one wish there were a play to support them instead of a trifle with a trick conclusion.

Series A runs through Sunday. Two subsequent series will have plays by, among others, Percy Granger, Joyce Carol Oates, Oyamo and Frank D. Gilroy.

1992 My 5, C15:1

Theater in Review

■ Flashback from a murder ■ Stories of loss and forgiveness ■ A family drama set in Panama.

Empty Hearts

Circle Repertory Company
99 Seventh Avenue South, at West
Fourth Street
Manhattan

Written and directed by John Bishop; sets by John Lee Beatty; costumes by Ann Roth and Bridget Kelly; lighting by Dennis Parichy; music by Robert Waldman; production stage manager, Leslie Loeb; production manager, Jody Boese; sound by Stewart Werner and Chuck London; concert sequence staged by Marcia Milgram Dodge. Presented by the Circle Repertory Company, Tanya Berezin, artistic director; Terrence Dwyer, managing director.
WITH: Cotter Smith, Mel Harris, Edward Seamon, John Dossett, Joel Anderson, Susan Bruce and Claris Erickson.

What more can a play add to "Law and Order," "L.A. Law" and all the other legal cases crowding the small-screen docket? Obviously there is always room for a novel variation on a familiar theme, but if John Bishop's "Empty Hearts" were on television, one would change the channel.

In this play, a woman is murdered and her husband is accused of the crime. Searching for a solution, or rather for ways to cloud the solution, the playwright flashes back to the couple's courtship. Then he works his way forward and backward, sometimes breaking the time frame in the middle of a scene. Arbitrarily withholding information that would be on the table at the beginning of the trial, the playwright tries to inject a note of suspense but ends up simply teasing the audience as jury. Mr. Bishop was far more skillful in "The Musical Comedy Murders of 1940" and "Borderlines."

The accused (Cotter Smith) is a psychologist specializing in the problems of the elderly, and the victim (Mel Harris) is a volunteer in the hospital in which he works. They meet, they match and she leaves her husband, all in quick order. Before long, the new couple are arguing. Out of the blue, they are afflicted by financial problems. Faced with the disintegrating marriage, Mr. Smith never stops offering platitudinous advice and hectoring his mate on the question of unfulfilled lives. Not a word is said about unfulfilled plays.

Without the mystery to shroud it, the relationship would be of marginal concern. At the same time, Mr. Bishop has managed to extinguish the few dramatic sparks, such as Ms. Harris's reflexive use of the vernacular, which could have been indicative of an earthier way of life than is witnessed onstage.

Some interest is provided by minor characters: Mr. Smith's best friend (John Dossett), who leaps to the protagonist's defense whenever he is attacked, and an elderly patient (Claris Erickson) who once ran a boardinghouse for gangsters and sounds like a character in a William Kennedy novel. These two actors and others play a diversity of roles in and out of court.

In Mr. Bishop's production, there is a tendency to overplay cards of identity, as in the performance by Susan Bruce as the prosecutor. She stridently marches across the courtroom and badgers witnesses so much that it shatters what little credibility exists. Mr. Smith and Ms. Harris are accomplished actors who bring a sense of reality with them on stage. But Mr. Bishop has locked them into an unwinnable case. *MEL GUSSOW*

Like to Live/Tissue

One Dream Theater
2 North Moore Street,
at West Broadway
SoHo
Through Sunday

By Louise Page; directed by Edward Berkeley; sets and costumes by Miguel Lopez-Castillo; lighting by Jane Reisman; production stage manager, Julie Lancaster; stage manager, Roy Kokoyachuk. Presented by the Willow Cabin Theater Company and Alexander E. Racolin.
WITH: Laurence Gleason, Meg Wynn Owen and Maria Radman.

" 'Afterward,' they said, 'you'll feel an aching and a sense of loss,' " reflects Sally Bacon (Maria Radman), the central character in "Tissue," Louise Page's one-act play about a 29-year-old woman who has undergone a mastectomy.

That advice proves absurdly insufficient to describe the degree of emotional turbulence Sally experiences in the first of the two one-acts by Ms. Page that the Willow Cabin Theater Company is presenting in SoHo. Structured as an extended chamber piece in which Meg Wynn Owen and Laurence Gleason portray characters from Sally's childhood friends to her doctors and nurses, "Tissue" is an exhaustive psychological exploration of the personal implications of losing a breast.

In a play that skips wildly around in time, short scenes of cool official voices dispensing useful medical knowledge are interspersed with flashbacks of childhood games of doctor and with scenes of Sally dealing with family members, close friends and a lover before and after her operation.

Written in 1978, "Tissue" is an early work by Ms. Page, an English playwright and feminist who is best-known to American theatergoers for "Salonika," which the Public Theater presented in 1985. Although impressively researched and with impeccable acting and dialogue that avoids sudsy melodrama, "Tissue" feels like a skillful exercise in form and is a bit too long and repetitive to be entirely gripping.

Its companion piece, "Like to Live," is a more recent play, based on Shakespeare's "Winter's Tale," which imagines that 16 years that the queen Hermione spends under the care of her confidante and servant Paulina before reconciling with Leontes, the tyrannical husband who thought her dead. Shakespeare's transcendent fable of forgiveness demands a giant leap of faith from an audience, which is asked to believe that Hermione could harbor no ran-

Gerry Goodstein

Mel Harris and Cotter Smith in a scene from "Empty Hearts."

cor for monstrous cruelties brought on by an irrational fit of jealousy. And "Like to Live" doesn't attempt to offer elaborate explanations for her loyalty.

In its seven scenes, which move forward in time, the playwright tells Hermione's story in a language that has a stately Shakespearean air but is in no way archaic. Hermione (Ms. Owen) and Paulina (Ms. Radman) are depicted as women of near saintly patience and sweetness. Only near the end, when Hermione misreads the signs and imagines that Leontes is marrying another, does she succumb to a fit of despairing rage. Under the direction of Edward Berkeley, Ms. Owen delivers a persuasive, beautifully modulated portrayal of a passionate woman who survives on faith.
STEPHEN HOLDEN

Canal Zone

Downtown Art Company
64 East Fourth Street
Manhattan
Through Sunday

By Roger Arturo Durling; directed by Eduardo Machado; set by Donald Eastman; costumes by E. G. Widulski; lighting by Ken Posner. Presented by Downtown Art Company.
WITH: John Billeci, Vicente Castellanos, Elzbieta Czyzewska, Nancy Franklin, Ryan Gilliam, George McGrath, Troy Michael Rowland and Paul Alexander Slee.

Set in Panama during the final months of Gen. Manuel Antonio Noriega's dictatorship, Roger Arturo Durling's play "Canal Zone" portrays an upper-middle-class family whose duplicitous relationships symbolize the corruption of the country under General Noriega's rule.

Federico (George McGrath), the head of the household, once ran a slaughterhouse, until the government bribed him into letting it be turned into a drug depot and money-laundering center. A late-blooming member of the opposition, he has become smitten with a young Communist woman and now spends his time distributing anti-government literature. At the same time, his house has been stripped of furniture because his wife, Mariana (Elzbieta Czyzewska), has squandered the family fortune on a cocaine habit. Also on the premises are her gay son, Tomas (John Billeci), who is visiting from America; her alienated daughter, Laura (Ryan Gilliam), who has taken up with a hostile family servant (Vicente Castellanos), and Federico's mother, Nana (Nancy Franklin).

"Canal Zone," which Eduardo Machado directed for the Downtown Art Company, wants to be a sort of politicized, Panamanian answer to "Long Day's Journey Into Night." But the details of character and family history that might have made these individuals come to life have barely been sketched in. The dialogue is a series

of crudely prepared confrontations and railing, repetitive monologues. The acting varies from the flamboyantly campy (Miss Czyzewska's portrayal of Mariana as a fire-breathing gorgon) to the monotonously inept (Miss Franklin's wooden matriarch).
STEPHEN HOLDEN

Endgame

Jean Cocteau Repertory
Bouwerie Lane Theater
330 Bowery, at Bond Street
Manhattan
Through May 31

By Samuel Beckett; directed by Eve Adamson; set design by John Brown; costume design by Jonathan Bixby; lighting by Ms. Adamson; production manager, Patrick Heydenburg; production stage manager, Julie Bleha. Presented by the Jean Cocteau Repertory, Robert Hupp, artistic director; David Fishelson, executive director.
With: Harris Berlinsky, Joseph Menino, Angela Vitale and Mark Waterman.

Few plays in any language so rapidly quicken the mind as Samuel Beckett's "Endgame." When it is reasonably well produced and acted, as it is now at the Jean Cocteau Repertory Theater, it expands one's awareness of the puzzling fragility of time and human life and blows up storms of questions about personal identity and the mystery of friendship. And it arouses new questions and gives new pleasures every time it is seen.

Mark Waterman makes a fine Hamm in this production. Sitting in his wheelchair, he is spectral, so that his almost menacing manipulative power over the three other charac-

ters is startling and a bit unnerving; his face speaks when words fail. As Clov, Hamm's casually found, but inescapable, friend, Harris Berlinsky is by turns amusing, pitiable, exasperating and, in the end, baffling.

But as often happens, one comes away envying most the actors who get to play Hamm's parents, Nagg and Nell. In this version, Joseph Menino and Angela Vitale create exactly the right effect of incongruity as they convey the slightest impression of annoyance whenever Clov raises the lid of the garbage bin they slumber in, so that Hamm can ask them questions.

Eve Adamson's direction is dutiful, generally obedient to Beckett's instructions, although she has Clov taking a few too many steps and clowning just a little too much with the ladder he has to climb continually to glimpse the world outside his windows. And one wishes someone could coach the actors to speak as if timed by a metronome; the more precise the rhythms of the lines in this play, the deeper its lingering impression.

John Brown's set is wonderful. With wicked humor Beckett calls for a lace-curtain Irish mood, and Mr. Brown stretches walls of lace tautly from floor to ceiling, arranged like a Renaissance architectural illustration of how to achieve perspective when drawing a room. It leaves viewers feeling that they have been drawn, along with the cast, into an impossibly delicate web, as though the ideas framed by Beckett's spare words had become visible.
D. J. R. BRUCKNER

1992 My 6, C18:3

SUNDAY VIEW

'Falsettos,' an Ode to Joy on Broadway

By DAVID RICHARDS

I HAVE LITTLE DOUBT THAT YOU will cry tears of heartbreak at "Falsettos," the William Finn/James Lapine musical at the Golden Theater. But long before the story it tells — a story of friends, lovers and families in the age of AIDS — takes the turn that is so rending, you may find yourself crying for another reason — because artists are at work and their artistry is pure and beautiful.

Whatever the pleasures of "Guys and Dolls" and "Crazy for You," the reigning musicals of the current Broadway season, they are the pleasures of yesterday. Mr. Finn and a cast of seven gifted performers will tell

Heartbreak and hope entwine in William Finn's 'Falsettos.'

you about today. They will tell you what it's like to live in the flux, to grab for certainties

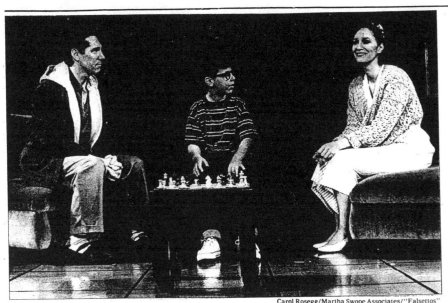

Carol Rosegg/Martha Swope Associates/"Falsettos"

Michael Rupert, left, Jonathan Kaplan and Barbara Walsh in "Falsettos"— Nothing seems superfluous or merely decorative; what is there is there because it counts.

and have them crumble, to turn to a relationship for comfort only to discover that it has altered and comfort is no longer there. They will also show you that it is possible to hold to the ground, "when the ground keeps shifting," to forge new alliances that take the place of the old and to experience joy in what often seems an era of inconsolable grief.

And they will do so with such honesty and directness — and, yes, even humor — that you cannot help but be exhilarated.

"Falsettos" combines two of Mr. Finn's one-act musicals ("March of the Falsettos" and "Falsettoland," which were first produced by Playwrights Horizons in 1981 and 1990, respectively) and proves that what he was really writing all along was one glorious full-length musical. "Falsettoland" doesn't just pick up where "March of the Falsettos" leaves off. The two parts so amplify and enrich each other that from now on the idea of producing them separately is inconceivable.

Ostensibly, Mr. Finn's central character is Marvin (Michael Rupert) — bright, Jewish and conflicted. In a prodigious tumble of melodies (the spoken dialogue is minimal), the musical recounts his search for "a tight-knit family." In the first act, which is set in 1979, he leaves his wife, Trina, and his precocious son, Jason, to take a male lover. But life proves as trying with Whizzer — handsome,

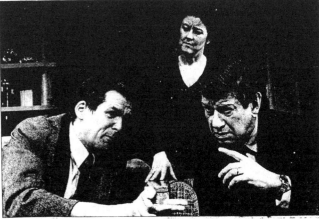

Gerry Goodstein/"A Small Family Business"

Anthony Heald, left, Jane Carr and Brian Murray in "A Small Family Business"— Funny and unflinching misanthropy.

half-Jewish and combative. By the end of the act, Whizzer has gone his own way, Trina has moved on to a new husband — Marvin's shrink, Mendel, no less. And Jason is struggling through an adolescence made no easier by the fact that "my father is a homo."

Having declared early on that "I want it all," Marvin winds up with next to nothing. But he has learned that being true to yourself is the beginning of manhood. In the touching father-son talk that closes the act, he passes along the advice to Jason. "Sing for yourself/ As you march along/ A man, kid, you'll be, kid/ Whatever your song."

When that act stood by and for itself, it was not difficult to view "March of the Falsettos" simply as a musical about coming out and to think that Marvin was scarcely less temperamental and self-absorbed out of the closet than in it. The second act, "Falsettoland," not only reveals the unsuspected strength and maturity in him, but also vastly enlarges the canvas, so that the evening revolves as much around Trina, balancing her roles as ex-wife, wife and mother; or Mendel, awakening with a sweet self-consciousness to the world of feeiings; or Whizzer, learning that youth is neither eternal nor invulnerable.

Only two years have passed since Act I. Marvin has resumed his relationship with Whizzer, and they are seemingly as passionate and passionately competitive as ever. Jason is edging up on his bar mitzvah, which keeps Trina, Mendel and Marvin in continuing contact, just close enough to be uncomfortable. The landscape, however, has undergone an irrevocable change. Charlotte, the

William Finn's death-defying musical sings about life in the flux that is today.

lesbian internist who lives next door to Marvin, is the first to note that "something bad is happening." Returning from the hospital puzzled and dispirited, she informs her lover, Cordelia, that "bachelors arrive, sick and frightened/ They leave, weeks later, unenlightened." We know what she's talking about, even if the others don't, and when Whizzer falters, shortly afterward, on the squash court, we also know that the mysterious virus has found one of its first victims.

None of the characters is remotely heroic. They are troubled and anxious. The grand gesture is beyond them. By the time Whizzer's illness has run its course, however, they will have come through with the best of themselves, which may be no more than a humble empathy. Against mortality we can only join hands and form a common front, and they do. I hasten to add that Mr. Finn doesn't sentimentalize or overdramatize his subject. All the same, by entwining Whizzer's illness and Jason's bar mitzvah in a way I will leave you to discover, he succeeds in making "Falsettos" wrenching and uplifting in almost equal measure.

You get the impression that, somewhere along the line, the sublimely talented Mr. Finn and his collaborators were overtaken by a truth, greater than any they had initially contemplated, and that *it* guided their efforts. Many of them go back to the original production of "March of the Falsettos" — and Chip

Zien, who plays Mendel, actually goes back to "In Trousers," the fairly inchoate work that first gave expression in 1979 to Marvin and his troubles. The longstanding association has allowed for a progressive deepening of the vision and a continual refinement of the presentation, rare in the theater. Indeed, "Falsettos" has been pruned to essentials. Nothing seems superfluous or merely decorative. What is there is there because it counts.

■

Marvin's life is whirling out of control. So is the society he inhabits. And that dizzying sense of spin is embodied in virtually every aspect of the musical — from the peck, peck, peck of eighth notes that Mr. Finn uses liberally to establish the edgy rhythms of nervous times, to the doors, tables and chairs that the set designer Douglas Stein has mounted on casters, so they can be pushed on stage — no, *propelled* on stage — and then propelled right back into the wings. I suspect that if Mr. Lapine, who is also the evening's director, could have put the performers on wheels, he would have. As it is, he maneuvers them through the show's 36 numbers with a smooth and gliding briskness that produces an inexhaustible series of kaleidoscopic images.

You are always watching people in motion — colliding, breaking up, recombining like atoms in a nuclear reactor. Stillness comes as a surprise. It is reserved for those moments when the characters shake free of their neuroses and disclose the courage in their souls. Since Mr. Lapine uses it sparingly, it carries a huge dramatic impact.

Mr. Rupert was exceptional as Marvin in 1981 and again in 1990. Nonetheless, you can't imagine a fuller performance than the one he is giving right now. It as if he and the character have grown together, suffered together, learned together. He doesn't soft-pedal what is reckless and maniacal about Marvin. But when, in the musical's final song, "What Would I Do," he stands tall and brave and proclaims that love is greater than the terrible pain of its ending, the actor's humanity is thrilling.

If I tell you that everyone has a standout moment, understand that it's the meshing of remarkable talents that is the evening's real triumph. Still, as Trina, Barbara Walsh loses her sanity and her balance with dazzle in "I'm Breaking Down" (Ms. Walsh has a lovely, crystalline clarity, and never so much, paradoxically, as when total confusion is knitting her brow and tripping up her feet). As Mendel, the chipper Mr. Zien delivers psychiatric insights as if they were the occasion for a wink and a soft-shoe, which, in this instance, they are. Pair him up with sage, young Jonathan Kaplan, who portrays Jason, and you have two very likable juveniles side by side. One just happens to be about 30 years older than the other.

Stephen Bogardus, inseparable from the role of Whizzer, brings a pounding fear and a heady intoxication to "You Gotta Die Sometime," a fierce acknowledgment in three-quarter time of the inevitable. However, the evening's most transcendent song, surely one that could serve as an anthem for a blighted generation, is "Unlikely Lovers." It is sung — in stillness — by Mr. Bogardus, Mr. Rupert, Heather Mac Rae (Charlotte) and Carolee Carmello (Cordelia), who vow with a reverence that can still admit a touch of black humor, to "buy the farm, arm in arm."

What Marvin was wishing for two hours earlier (or 11 years, if you take the long view) has been granted. He has his tightknit family. It isn't one he could have envisioned beforehand. But in an ever-changing universe, definitions have to change, too. We adapt or we perish. "Falsettos," I think, is one of those crucial works that help us redefine ourselves and our loved ones.

It's certainly the musical Broadway dearly needed this season, lest Broadway turn into a street of gaudy, escapist entertainments. More important, it is the musical we all need, if we are ever to look AIDS squarely in the face and not despair.

'A Small Family Business'

The conniving husbands and chiseling wives who make up the extended family in Alan Ayckbourn's "Small Family Business" appear to have taken a vow to have and to hold . . . and to acquire. In sickness and in health. For richer or for richer.

Not even death — or at least a murder that would have gladdened the heart of Alfred Hitchcock — can tear them apart. The family that swindles together, it would seem, stays together and drives a Porsche.

We all know what greed did to America in the 1980's. Mr. Ayckbourn's 1987 comedy affords a gleeful look at the British, as they go about stuffing their pockets and their closets. I need not point out that if Doris Day, violets and pastel sunsets are among your favorite things — if "My Favorite Things" is among your favorite things — you probably should steer clear of the Music Box. "A Small Family Business" is for those with a darker view of human nature.

For my money, though — reckless as it may be to talk money under the circumstances — this is the most bracing comedy on Broadway right now, probably because it feels no need to be likable. Unlike Neil Simon's "Jake's Women" or Herb Gardner's "Conversations With My Father," which palliate their hard truths, "A Small Family Business" is unflinching in its misanthropy. Mr. Ayckbourn's 17 characters are either morally bankrupt, self-centered, nasty-tempered or, in a few spectacular instances, all of the above.

■

Granted, the play would be difficult to take if these venal creatures *thought* of themselves as corrupt. They don't. They see themselves as perfectly normal suburbanites of their times, going after goodies that are only due them. They may bend a few rules in the process, but rules were made for bending, and even if they weren't, everyone bends them anyway. So what's the big deal? It's the very blitheness they bring to rotten deeds

The family that swindles together stays together in Alan Ayckbourn's satire on the 80's.

that proves so funny — just as trivial acts performed with great gravity can be funny.

For a while, there's a lone crusader in this ethical wasteland — Jack McCracken (Brian Murray), an upstanding businessman who, at the start of the play, is giving up a corporate career in fish sticks to run his aging father-in-law's furniture business. At the surprise party welcoming him into the ranks, he announces the theme of his impending regime: "basic trust." Instead of bleeding the firm dry, he urges the assembled family members to put something back in. "Let's start with the paper clips, shall we?" Although they

applaud him vigorously, he might as well be lecturing the plaster.

His problems begin almost immediately. His adolescent daughter is caught shoplifting eye liner and a bottle of shampoo. In order to get the private investigator, a Dickensian figure named Hough (Anthony Heald), to drop the case, McCracken offers him a job as a security officer in the family business. Hough noses around a little and soon uncovers evidence of massive fraud, implicating just about all of McCracken's relatives. The brains — not to mention the skimpily clad body — behind the operation is his sister-in-law, Anita (Caroline Lagerfelt), whose enthusiasm for things Italian extends to the five libidinous brothers (all played by Jake Weber) who are her lovers and hang on her like cheap costume jewelry. Designer furniture, it further turns out, is the company's second most important interest. The first is illicit drugs.

McCracken is repeatedly aghast — rather like an Eagle Scout who finds camp followers in the pup tent, then learns that the ladies are stoned and realizes after that that one of them is his kid sister. Mr. Murray has a round, rosy face, messed-up hair and innocent blue eyes — all of which make him perfect for a good shocking. If each revelation prompted only indignation in him, however, he'd be a bore. Mr. Murray seasons indignation with curiosity, amazement and a mounting respect for human cupidity, and he drives the production alternately with his pontificating zeal and his gasping horror.

∎

Of course, the harder he struggles to put the firm back on sound moral footing, the shakier his own equilibrium. Before long, he's sliding down the slippery slope with the rest of them. His unruly hair is slicked back, his face has become merely puffy and a reptilian glaze has replaced the idealistic sparkle in his eyes. By the end, he can truly call himself one of the family.

Well, it's widely known that you strike a bargain with the devil at the risk of your soul. And Mr. Heald — who has put a hunch in his back, shortened his neck by several inches and taken a rasp to his vocal cords — has clearly modeled the character of Hough on Old Scratch himself. Hough is pronounced "huff," incidentally, which is what the actor does a lot. He even shows up on the McCrackens' doorstep just as a bolt of lightning is rending the sky and a clap of thunder is breaking over the roof. I suppose certain comparisons with "Faust" would be in order, if "Faust" were just a teensy bit droller.

While there's no contesting the unforgiving fury of Mr. Ayckbourn's vision, there's also no denying its hilarity. The easiest way for me to illustrate this would be to quote some amusing one-liners, except that Mr. Ayckbourn, unlike Mr. Simon, doesn't write any. It's the characters' behavior in specific situations that triggers the merriment. To say that Jack's older daughter Tina (Barbara Garrick) earns the evening's loudest laugh by exclaiming, "Oh, my gawd, will you look at all this money!" tells you nothing, unless you're also told the circumstances prompting the utterance. And you won't get that out of me. Sometimes, however, a daughter has an obligation to stand by her mother's side, even if her mother is in the upstairs bathroom with a bounder.

The upstairs bathroom is just one of the locales where hanky-panky and subterfuge are taking place. The set designer John Lee Beatty has put a sleek two-story house on the stage of the Music Box (thereby going himself one story better than the handsome beach house he provided for "Lips Together, Teeth Apart"). That gives the director Lynne

Meadow at least six good-sized rooms, a flight of stairs, a pass-through from the kitchen to the dining room, plus countless doors to work with — in addition, of course, to the cast. It's an enormous undertaking and Ms. Meadow, who has staged two of Mr. Ayckbourn's smaller plays ("Woman in Mind" and "Absent Friends") for the Manhattan Theater Club, where she is artistic director — pulls it off with considerable flair.

∎

Something is always going on in one part of the house or another — as it does in an ant colony, although ants may have a higher sense of virtue and pick up after themselves. While I thought the entire cast just dandy in their odiousness, let me commend one more performer — Jane Carr, who plays McCracken's dutiful wife. Ms. Carr has a tight red bow for a mouth, a mousy little nose and eyes no bigger than pinholes. As she awakens to the corruption around her, however, her features get larger and her whole face, I swear, expands outward. The transformation is amazing. This may sound strange to you, but it made me think of the Big Bang. □

1992 My 10, II:1:2

Fairy Bones

By Laurence Yep; directed by Tina Chen; lighting, Deborah Constantine; sets, Atsushi Moriyasu; costumes, Juliet Ouyoung; stage manager, Sue Jane Stoker; sound, Jim Van Bergen; incidental music by Ms. Chen, performed by Steven Silverstein. Presented by Pan Asian Repertory Theater, Ms. Chang, artistic and producing director. At Playhouse 46, 423 West 46th Street, Manhattan.

Con Man and Peter......................Raul Aranas
Young Man...............................Keenan Shimizu
Young Woman......................................Lucy Liu
Spirit Woman.......................Christen Villamor

By MEL GUSSOW

The setting for Laurence Yep's two one-act plays at the Pan Asian Repertory Theater is the fictional California town of Fidele, named after the river steamer in Herman Melville's novel "The Confidence Man." As in the sign above the ship's barbershop in that book, there is "no trust" here. There are only people trying to outwit one another and to withstand oppressive white demons in what they call the "Land of the Golden Mountain."

The characters in Mr. Yep's "Pay the Chinaman" have no sense of loyalty to one another or to their Chinese-American heritage. They are crafty, even cutthroat gamblers. In this, the more rewarding of the one-acts, a con man is conned. Or is he?

The contest begins playfully, as the con man (Raul Aranas) wheedles a young barber (Keenan Shimizu) into games of chance, with increasingly higher stakes. Gradually, intensity accrues in the play and the performances as the younger man's wiliness is revealed. But the older man is never to be underestimated.

●

Behind them both is a sense of America in the 1890's and its exclusionary attitude toward Asian immigrants. "This place is all one big gamble," says the con man, and by that, of course, he means the entire country and the world at large. In this sense and others, the play is linked to David Henry Hwang's "Dance and the Railroad," which takes place about the same time.

The two characters in "Pay the Chinaman" have learned to conceal their true feelings, which is in itself a form of lying. It is also their method of survival. The playwright holds his cards close to his vest, encouraging theatergoers to determine the more artful of the two deceptions.

Although the play has its repetitive moments, it gathers itself for the conclusion, a dramatic payoff for both characters as confidence men. Under the direction of Tina Chen, the actors are agile at their theatrical gamesmanship, Mr. Aranas in his shiftiness, Mr. Shimizu in his apparent lack of guile.

●

The title play, "Fairy Bones," takes place behind closed doors in the same community, where a Spirit Woman, or shaman, offers advice and

Carol Rosegg/Martha Swope Associates/"Fairy Bones"

California Dreaming Raul Aranas is in "Fairy Bones," two one-act plays by Laurence Yep about Chinese settlers in 1890's California.

acts as a conduit for various spectral personalities. Played by Christen Villamor, she is a link to the past, in actuality as well as in myth. In the Chinese tradition, her feet have been bound, leading to a physical and, one might say, a psychological deformation. From her position of authority, she has turned her daughter-in-law (Lucy Liu) into her servant and protector.

In both the writing and the performance, this one-act is less resonant than "Pay the Chinaman." All those demons that are conjured eventually clutter the stage. At the same time, there is an imminent sense of dread as an angry mob gathers outside to protest the presence of Asian-Americans in the community. With the threat of violence, the play adds a historical context to the recent riots in Los Angeles.

It is evident from these atmospheric short plays that Mr. Yep, the author of a number of award-winning children's books (including "Dragonwings"), also has a natural affinity for theater.

1992 My 11, C11:1

Theater in Review

■ Politics and fairy tales by puppets ■ Campy musical farce on a child actress ■ Using Euripides' 'Iphigenia' as a starting point.

When the Wind Blows/ News Update

Dance Theater Workshop
Bessie Schönberg Theater
219 West 19th Street
Chelsea
Through Sunday

Two puppet theater pieces designed and directed by Janie Geiser. Presented by Dance Theater Workshop. WHEN THE WIND BLOWS, Conceived by Ms. Geiser; music composed by Chip Epsten; additional text from "The Ash King" by Daniel Zippi; lighting by Emily Stork. Puppeteers: Judith Anderson, Matthew Buckingham, Trudi Cohen, Ms. Geiser, Jenny Romaine and Mark Sussman. Musicians: Mr. Epsten, Konrad Kinard and Ms. Romaine. NEWS UPDATE, Audio by A. Leroy; developed in collaboration with the performers and Cathy Simmons. Puppeteers: Judith Anderson, Kyle de Camp and Ms. Geiser.

In the theater of Janie Geiser, there is a Lilliputian world of unpredictable occurrences. Watching "When the Wind Blows/News Update," a brief double-header of puppet plays at Dance Theater Workshop, the perspective of the audience is altered. On a small box set, a tiny puppet figure is suddenly chased by a tall pair of scissors threatening to shear her in half. When a door is opened on a doll-size house, the walls swing apart and the building collapses.

Weaving film with live action and using shadow, rod and hand puppets, this Atlanta-based director creates highly individualistic chamber plays. In its approach to puppetry, the work has the intentional primitivism of the Bread and Puppet Theater. Both are varieties of folk art.

"When the Wind Blows," the featured half of the current evening, offers variations on fairy tales strung together into a collage. For some, the stories may be too grim, as in the title of one scene, "How Some Children Played at Slaughtering." Within its carefully circumscribed dimensions, the narrative achieves an eerie reality. In this as in her other plays (like "Blue Night"), the imagery is as precise as the stories are elliptical.

For an aperitif before the main course, Ms. Geiser offers "News Update," a puppet comic-strip cousin to "Saturday Night Live's" Weekend Update. In it, Ms. Geiser reveals her impish sense of humor. First we see a Presidential puppet literally "riding the waves of gulf war popularity." He blithely sails the bounding main, then sinks and drowns. Later the President is revived and wanders through a woods under leaves ominously labeled Perot and Peru.

In such playful ways, Ms. Geiser tweaks politicians-as-usual. In a healthily bipartisan assault, the Democratic Presidential race is run by puppet horses, galloping at varying gaits. Broadening its scope to include the Clarence Thomas hearings as well as environmental issues, the cartoon is timely if not exactly up to the minute.

The show is executed by a collaborative team of designers and puppeteers, including Ms. Geiser herself. As composer, Chip Epsten provides an eclectic but cohesive underscoring, played by a small combo. Taken together, these are finely wrought performance pieces, two acts of theatrical conjuration.

MEL GUSSOW

Ruthless!

Players Theater
115 Macdougal Street
Manhattan

Book, lyrics and direction by Joel Paley; music and musical direction by Marvin Laird; scenery by James Noone; costumes by Gail Cooper-Hecht; lighting by Kenneth Posner; sound by Tom Sorce; production stage manager, Pamela Edington. The Musical Theater Works, Anthony J. Stimac, artistic director, presented by Kim Lang Lenny, Wolfgang Bocksch and Jim Lenny.

WITH: Joanne Baum, Laura Bundy, Donna English, Denise Lor, Susan Mansur and Joel Vig.

One of several running gags in "Ruthless," a campy musical farce that will do almost anything for a laugh, concerns the reason that Sylvia St. Croix, a woman who specializes in grooming talented children to become stars, has changed her name. "My real name is Sylvia St. Sydney; need I say more?" she huffs, referring to the veteran movie star Sylvia Sidney. Like most of the show's jokes, the humor is less in the words than in their ferocious delivery. As portrayed by Joel Vig, a stocky actor whose bright red dress matches his lipstick, Sylvia suggests an overweight Rosalind Russell playing a voracious talent agent.

Sylvia has descended on the suburban home of Judy Denmark (Donna English), a chirpy housewife, and her 8-year-old daughter, Tina (Laura Bundy), whom she is hellbent on turning into a child star. Tina, a cuddly little monster whose every move has the calculated cutesiness of a Shirley Temple routine, is only too eager for fame. The girl's ambition drives her to arrange the strangulation by jump rope of her victorious rival for the lead role in the school play, a moronic little musical called "Pippi in Tahiti."

"Ruthless," at the Players Theater, belongs to a theatrical genre exemplified by the comedies of Charles Busch, in which almost everything has a show-business reference. Shirley Temple movies, "Gypsy," "Mildred Pierce" and "All About Eve" are among the most obvious touchstones for a spoof that has enough absurd plot twists and multiple identities to fill several old movies.

Such shows stand or fall on their humor. And until it nearly runs amok late in the second act, "Ruthless," which has music by Marvin Laird and a book and lyrics by Joel Paley, who also directed, delivers a fairly steady quotient of laughs. The songs, which are mostly generic show-business anthems of the brassier sort, are uneven. The one attempt at a comic show stopper, "I Hate Musicals," falls apart on such too-obvious lines as "I hate musicals, but not as much as I hate the words to this song!"

Most of the fun comes from the sheer brazenness of the caricatures. They include Tina's loopy third-grade teacher (Susan Mansur), a pretentious drama critic named Lita Encore (Denise Lor), a monstrous Broadway prima donna (Ms. English) and her scheming, sycophantic assistant, Eave (Ms. Baum). The performance that holds things together is Ms. Bundy's Tina. Through her parody of a psychopathic latter-day Shirley Temple, the golden-locked young actress with a big piping voice projects an engaging sweetness.

The look of "Ruthless" matches its tone. James Noone's candy-striped sets and Gail Cooper-Hecht's fluorescent costumes create a stylized world in which all values have been reduced to the breathless childhood intoxication of show-business glory as experienced in a grade-school pageant.

STEPHEN HOLDEN

Iphigenia in Tauris

La Mama Annex
74A East Fourth Street
Greenwich Village
Through May 24

By Euripides; performance text compiled by Yannis Houvardas as adapted from the English translation by Richard Lattimore with excerpts from the original Greek text; directed by Mr. Houvardas; produced by Yanni Simonides; sets and costumes by Dionyssis Fotopoulos; music composed and performed by Genji Ito; lighting by Howard Thies; stage manager, Marybeth Ward. Presented by La Mama E.T.C., in association with the Greek Theater of New York and the Greek Society for International Communication Through the Arts.

WITH: Christina Alexanian, Paul Beauvais, Alyssa Bresnahan, Sandra Daley, Sarah Graham Hayes, Natalia Kapodistria, Akyllas Karazissis, Gregory Karr, Monica Koskey, George Kormanos, Anna Mascha, Randolph Curtis Rand, Laurie Galluccio and Ching Valdes-Aran.

The adaptation of Euripides' "Iphigenia in Tauris" directed by Yannis Houvardas at La Mama is so revisionary and idiosyncratic it makes Mr. Houvardas a coauthor, and a formidable one. Mr. Houvardas, a leading director in Athens, severely trims the ancient play and turns it inside out to dramatize his own intriguing ideas about cultural confrontation.

A brilliant white set suggests a mental-hospital ward where not one but eight Iphigenias (this device works surprisingly well; no chorus is needed since the heroine is one all by herself) try in dreams to recover their past, some of it terrifying, before the doors open and the fiery volcanic world crashes in on them. The Greek and American cast, accompanied by mesmerizing music composed and played by Genji Ito, speaks in a kind of chant (occasionally in Euripides' Greek if not often in his meters) that makes the performance, appropriately, a ritual.

The original play is the bloodiest and the most problematical in the Greek canon, its premise and conclusion equally unbelievable. But it has drama's first great letter scene, which is also a dramatic recognition scene, and a breathtaking escape sequence on a tempestuous sea.

Mr. Houvardas drains away much of the gore, but he keeps Euripides' Iphigenia mostly intact: having escaped death at her father's hands as a blood sacrifice, she rules over a blood-sacrifice temple in a Scythian kingdom where she is accidentally found by her brother, Orestes, whom she is duty-bound to kill but with whom she escapes. He also retains the notoriously awkward deus ex machina, Athena, who finally intervenes to resolve an impossible plot. Here she is simply spectacular, a wondrous if weird delight. But as he pursues his exploration of personal pain in cultural conflict, he loses some of the astonishment of the letter scene and most of the excitement of the great escape.

Nonetheless, for those who know the play — and it is a good idea to read it again beforehand since this director has chopped off chunks of contextual narrative — Mr. Houvardas and his cast have created a resonating piece of theater that is a moving and profound meditation not only on Euripides' play but also on drama itself.

D. J. R. BRUCKNER

1992 My 13, C14:3

Fires in the Mirror
Crown Heights, Brooklyn and Other Identities

Conceived, written and performed by Anna Deavere Smith; directed by Christopher Ashley; scenery by James Youmans; costumes by Candice Donnelly; lighting by Debra J. Kletter; projections by Wendall K. Harrington and Emmanuelle Krebs; music composed by Joseph Jarman; dramaturge, Thulani Davis; production stage manager, Karen Moore. Presented by the New York Shakespeare Festival, artistic director, JoAnne Akalaitis; producing director, Jason Steven Cohen. At the Joseph Papp Public Theater/the Susan Stein Shiva Theater, 425 Lafayette Street, Manhattan.

Roy Cohn/Jack Smith

"Roy Cohn" by Gary Indiana; "Jack Smith" by Mr. Smith, courtesy of the Jack Smith Archives; created by Gregory Mehrten, Clay Shirky, Ron Vawter and Marianne Weems; conceived and performed by Mr. Vawter; directed by Mr. Mehrten; lighting by Jennifer Tipton; costumes by Ellen McCartney. Presented by Garage Productions, a division of the Wooster Group. At the Performing Garage, 33 Wooster Street, Manhattan.

By FRANK RICH

SOME actors create their own one-person shows because their souls are on fire. Some do so because the world around them is in flames.

Anna Deavere Smith and Ron Vawter, two exceptional actors performing two very different solo shows on downtown stages right now, are so possessed by talent and a sense of mission that they fall into both camps. Ms. Smith, a Stanford University drama professor who is young and black, seems to pack all the inflammatory national passions rekindled by the Los Angeles riots into her piece at the Joseph Papp Public Theater, "Fires in the Mirror: Crown Heights, Brooklyn and Other Identities." Mr. Vawter, a longtime New York actor who now has AIDS, seeks to examine the very nature of homosexual identity in America in "Roy Cohn/Jack Smith," his Performance Garage show about two notable gay men who were both AIDS casualties of the 1980's.

Seen in tandem, these two evenings, both built from nonfiction texts, offer a brief but densely packed survey of the country's fissures at this moment. They also offer spectacular further proof, not that any more is needed this season, that the American theater is rising to illuminate these rancorous times with a vitality that may be equaled but is certainly not surpassed by any of our other native arts.

"Fires in the Mirror" is, quite simply, the most compelling and sophisticated view of urban racial and class conflict, up to date to this week, that one could hope to encounter in a swift 90 minutes. And it is ingenious in concept. An interwoven series of brief monologues by nearly 30 characters, ranging from the famous to the notorious to the nameless, the show consists entirely of verbatim excerpts from fresh interviews Ms. Smith conducted with her subjects. As an interviewer, she seems to have Studs Terkel's knack for gaining the confidence of a wide variety of people and inducing them to reveal themselves in haunting off-hand anecdotes and reminiscences.

As if that isn't enough, Ms. Smith also has the talent to impersonate all her interviewees herself: black, white, men, women, young, old. Without pause and with a minimum of props, this slender, elegantly featured performer in white shirt and black slacks whips among characters as varied as the playwright George C. Wolfe (of "Jelly's Last Jam") and the author Letty Cottin Pogrebin (of "Deborah, Golda and Me"), as the Rabbi Joseph Spielman and the rapper Monique (Big Mo) Matthews. Ms. Smith can capture the eruptive humors of the Rev. Al Sharpton even as she summons the good-natured but skeptical Jewish woman who wonders aloud of Mr. Sharpton, "I'd like to know *who* ordained *him*."

Ms. Smith's performance abilities are impressive and fun, but what makes "Fires in the Mirror" so moving and provocative, so remarkably free of cant and polemics, is its creator's ability to find the unexpected and unguarded in nearly each speaker and her objective grasp of the troubling big picture. Mr. Sharpton's guileless explanation of his hair style (as his personal tribute to the singer James Brown) is set next to an equally sincere and telling discourse by a Hasidic graphic artist named Rivkah Siegel about her ambivalent attitude toward wearing a ritualistic wig. Minister Conrad Muhammad, of the Nation of Islam, offers a searing short history of slavery that is then matched in brevity and power by a Pogrebin anecdote about how her family learned of the Holocaust in 1940.

•

As Ms. Smith shifts her focus from general snapshots of blacks and Jews to the actual narrative of the tragedy of Crown Heights, her journalistic balance remains perfectly pitched, her command of detail meticulous. Black outrage at the accidental death of a black 7-year-old, Gavin Cato, who was hit by a runaway car in the motorcade of the leader of the Lubavitch movement, Rabbi Menachem M. Schneerson, is given full, articulate vent and context even as the anti-Semitic homicidal rampage that led to the subsequent mob killing of Yankel Rosenbaum, a Hasidic scholar visiting Crown Heights from Australia, courses through the theater in all its terrifying ugliness.

Among so many other memorable people, we meet a feral youth who condones Rosenbaum's murder, a black Episcopal minister who mischievously questions why Rebbe Schneerson has "to be whisked" about like a President, and a wise Jewish matron, Roz Malamud, who amusingly explains how glad she was that her son was visiting the relatively safe Soviet Union during the Crown Heights riots, even though the Soviet coup also occurred on that same fateful day. In a brilliant example of Ms. Smith's technique at revealing character, Yankel Rosenbaum's brother, Norman, is presented first as a roaring public figure demanding justice at a rally in New York and then as a modest private man, a soft-spoken Melbourne lawyer incredulously recalling how his wife first told him the unbelievable news that his brother had been stabbed in a strange neighborhood 16 time zones away. Norman Rosenbaum is soon followed by the dignified, stricken figure of Gavin Cato's father, Carmel, whose grief is just as searing to witness and who knows as little about Rosenbaum's world as Rosenbaum does about his.

•

There are no villains in this piece, with the chilling exception of the CUNY professor Leonard Jeffries, who is found offering a megalomaniacal, name-dropping and anti-Semitic account of how he single-handedly tried to preserve the integrity of the television adaptation of "Roots." There are no answers to the questions raised by Ms. Smith's piece, either. Idiosyncratic thinkers as diverse as Angela Davis, now a University of California professor, and Robert Sherman, of the New York City Commission on Human Rights, question the very language (that of "healing" included) with which this country addresses issues of race and poverty. Richard Green, a resilient youth leader who founded a black and Lubavitch basketball team in Crown Heights, explains that most of the vigilantes yelling "Heil Hitler!" do not even know who Hitler was, so adrift is the ghetto underclass from any remaining outposts of school, family or social order of any kind. More than one observer in "Fires in the Mirror" promises a string of long, hot summers in which those powder kegs, our cities, are bound to explode. Though not offering any false hopes to the contrary, Ms. Smith herself represents some slender sort of hope. Her show is a self-contained example of what one person can accomplish, at the very least in disseminating accurate, unbiased inside reportage, simply by listening to all the warring occupants of the urban neighborhood. This puts Ms. Smith ahead of most politicians, and, indeed, she may be that rare actor who actually should be encouraged to run for public office.

•

In "Roy Cohn/Jack Smith," Mr. Vawter explores another strain of minority American political and cultural history. As he says in his show's introductory remarks, his two subjects, the Joseph McCarthy protégé Cohn and the 1960's avant-garde performer and film maker Smith, have nothing in common except their homosexuality and the virus that killed them. But the lives of both the closeted, self-denying Cohn and the gleefully uncloseted Smith, he implies, were inexorably shaped by a society that tried to suppress their sexuality.

In the first and less interesting half of his show, Mr. Vawter plays Cohn as he delivers a 1978 banquet speech championing family values and decrying homosexuals and Communists. The speech, a fictionalized mixture of jocular schmoozing and nasty barking devised by the writer Gary Indiana from a variety of documentary sources, sounds like Cohn, and so does Mr. Vawter. But Cohn's vicious brand of hypocrisy soon becomes tedious. One yearns for a more detailed portrait of this fascinating, self-contradictory, larger-than-life demon, like the one offered by Tony Kushner in his AIDS play, "Angels in America."

Jack Smith is another, richer story in Mr. Vawter's telling. Best known for "Flaming Creatures," a 1964 underground film that pointed the way to Andy Warhol's epic cinematic reveries, Smith reveled in his homosexuality. In the process and in his work, he helped forge an esthetic, hallucinatory in its use of time and imagery and uninhibited in its campy deployment of kitsch, that would in different ways be refined in the theatrical visions of Charles Ludlam, Robert Wilson and Richard Foreman, among others.

•

Working from memories and transcripts, Mr. Vawter offers a 40-minute condensation of a typical Smith performance piece from 1981. His eyes circled by colored glitter and his body wrapped in robes out of the "Sheik of Araby," Mr. Vawter's Smith reclines on a throne, supervises a surreal slide show featuring a toy penguin wandering through Amsterdam and speaks cryptic Dadaesque lines arbitrarily chosen from typed pages at his side.

The piece's text, which was titled "What's Underground About Marshmallows?," has to do with Smith's grievances with the film archivist Jonas Mekas, his deconstructed illustration of the value of onions in inducing stage tears and his mock veneration of the Hollywood goddess Maria Montez. But what makes Mr. Vawter's dramatization of Smith gripping is his presentation of Smith's own character. Forever fiddling with his props, lights and jewelry while speaking haltingly in a low, uninflected masculine voice, the performer seems at once to glory in his revolutionary artistic calling and to be strangely entombed within its languors. Mr. Vawter embraces Jack Smith's contradictions, born of both private liberation and public disenfranchisement, rather than attempting to reconcile or explain them. The result is a heroic act of minority cultural anthropology, at once mysterious and touching, by an eyewitness with a gift to make the rest of us begin to understand.

1992 My 15, C1:1

Paula Court

Ron Vawter, left, in "Roy Cohn/Jack Smith," and Anna Deavere Smith in "Fires in the Mirror."

Blood Wedding

By Federico García Lorca; translated by Langston Hughes; directed by Melia Bensussen; scenery by Derek McLane; costumes by Franne Lee; lighting by Peter Kaczorowski; composer/musical director, Michele Navazio; choreography by Donald Byrd. Presented by the New York Shakespeare Festival, founder, Joseph Papp; artistic director, JoAnne Akalaitis; producing director, Jason Steven Cohen; associate artistic director, Rosemarie Tichler. At the Joseph Papp Public Theater/the Martinson Hall, 425 Lafayette Street, Manhattan.

Mother	Gloria Foster
Groom	Al Rodrigo
Neighbor and the servant	Ivonne Coll
Wife of Leonardo	Cordelia Gonzalez
Mother-in-law	Phyllis Bash
Leonardo	Joaquim de Almeida
Child	Marchand Odette
Father	Mike Hodge
Bride	Elizabeth Peña

Bridesmaids/girls
 Gina Torres, Sara Erde and Ms. Odette
Youths/woodcutters
 Tim Perez, Michael Mandell and Omar Carter

Moon	Mr. Carter
Beggar Woman	Fanni Green

By MEL GUSSOW

The revolutionary legacy of Federico García Lorca endures in his poetry and in his three poetic tragedies. The first of the three plays, "Blood Wedding," surges with passion and earth wisdom, both of which are captured in Melia Bensussen's vivid production at the Joseph Papp Public Theater.

Using a lyrical translation by Langston Hughes, Ms. Bensussen explores the heart of this tale of barrenness and blood lust. Beneath the surface calm, all is turbulence, as fate and the masterly hand of the playwright drive the characters to their shared catastrophe. Inspired by a true story, García Lorca wrote of acts of violence that destroyed several families. As in Ibsen's "Peer Gynt," a man steals a bride on her wedding day, but with García Lorca the marriage thief pays the ultimate price.

From the opening scene, as a domineering mother (Gloria Foster) and her son (Al Rodrigo) discuss the son's wedding plans, thoughts of death are omnipresent (and, later, death appears in the figure of a beggar woman). The mother has not recovered from the loss of her husband and her other son. "Grief stings my eyes," she says, and that grief quickly becomes a lamentation.

Swirls of passion engulf the characters, even as they go through the ritual formalities of the wedding ceremony. Glowering on the sidelines is Leonardo, the bride's former suitor, who is discontented in his own marriage. Selfishly pursuing his own interests, he will soon eradicate everyone else's chance for romantic fulfillment.

In 90 unabated minutes, Ms. Bensussen and her company clarify the overweening love of the mother, the innocence of her son and the insidiousness of Leonardo: the warring elements that divide one character from the other and that activate this deadly dance.

As directed by Ms. Bensussen and as choreographed by Donald Byrd, the production merges both the naturalistic and metaphorical elements of the drama. Movement rises to flamenco, as characters stomp staccato messages. In the background we hear Spanish strains with a flavor of jazz. At one point, three young women become entwined in a cat's cradle of red string as they sing about winding a symbolic skein of wool.

The Langston Hughes translation, in its first professional performance, is relatively close to the traditional one by Richard L. O'Connell and James Graham-Lujan, but with greater smoothness and poetic intensity. The imagery remains visceral: tears "burn like blood" and eyes are "as sharp as thorns."

•

Evidently encouraged by the heightened language, Ms. Foster initially overdramatizes her dialogue, but soon holds herself to García Lorca's pitch. His plays are a natural subject for her talent (in the late 1960's, she played the title role in "Yerma" at Lincoln Center). Ultimately, her performance consolidates the mother's stoicism with her ferocity. She will stand for no questioning of her rights and motives, and when she is overcome she is devastated, and has no room for anyone else's remorse.

Mr. Rodrigo and Elizabeth Peña (as the bride) are evenly matched, in his resolute self-confidence and in her wishfulness, as she is seduced into a romance outside of marriage. Joaquim de Almeida is a brooding Leonardo, Ivonne Coll strikes musical sparks as a voice of caution and Mike Hodge offers a portrait of dignified restraint as the father of the bride.

Derek McLane's set design is an active participant in the performance, with stuccoed walls and cycloramic strips of sky simulating the Spanish landscape. The setting extends into the area just offstage in Martinson Hall, where we glimpse the edge of a Spanish garden. Late in the play, with the characters embarked on their tragedy, the backdrop turns into a Miró-like landscape. As events accumulate, the color of the environment shifts from blue to red and finally to black, for the play's horrific conclusion.

1992 My 15, C3:3

Eating Raoul

Book by Paul Bartel, based on the film "Eating Raoul"; directed by Toni Kotite; music by Jed Feuer; lyrics by Boyd Graham; choreography by Lynne Taylor-Corbett; set design by Loren Sherman; costumes by Franne Lee; lighting by Peggy Eisenhauer; sound by Peter J. Fitzgerald; production stage manager, Alan Hall; musical director, Albert Ahronheim; orchestrations, Joseph Gianono; vocal arrangements, Mr. Feuer and Mr. Ahronheim. Presented by Max Weitzenhoffer, Stewart F. Lane, Joan Cullman and Richard Norton. At the Union Square Theater, 100 East 17th Street, Manhattan.

Mary Bland	Courtenay Collins
Paul Bland	Eddie Korbich
Raoul	Adrian Zmed

WITH: Cindy Benson, Jonathan Brody, Lovette George, Allen Hidalgo, David Masenheimer, M. W. Reid and Susan Wood.

By MEL GUSSOW

Ever since "Little Shop of Horrors" proved to be a surprise success as a monster musical, people have been searching for a potential successor. One might suppose that research has been done in the creature feature section in video stores. "Eating Raoul," which opened Wednesday night at the Union Square Theater, is the latest losing candidate.

In spite of the seeming outrageousness of the material, this adaptation of Paul Bartel's 1982 cult movie is over its head in a vat of whimsy. The show tries so hard to be with it that it

Anita and Steve Shevett for The New York Times

Adrian Zmed with Lovette George, left, and Susan Wood in a scene from the musical "Eating Raoul," which opened on Wednesday night.

ends up being without it, that is, without anything except a shadow of what made the film funny in the first place.

The story, as you may remember, is a comedy of murder and cannibalism. Mary and Paul Bland, the squarest of married couples, become self-advertising "sexperts" to kill swingers for profit. Dispatching their victims by striking them on the head with a frying pan, they eventually find themselves trapped by their partner, Raoul, and are forced to take drastic action.

Where the movie was matter of fact as well as macabre, the musical takes a frying pan approach, hitting everything over the head. As adapted by Mr. Bartel and as directed by Toni Kotite, the show is more garish than grotesque.

•

The blandness of the central couple is matched by Jed Feuer's score, while Boyd Graham's lyrics are furrowed with banalities, as in "We'll give it a try/It's you and I/Do or die." Although "Eating Raoul" aims to spoof swingers, it deals with the subject in such an obvious way that sadomasochists might sue for defamation of character. The real core of the show is not sexuality but murder, as the Blands bop strangers with that long-armed cooking instrument. The final song, "One More Bop," comes none too soon.

As Mary, Courtenay Collins is peppy without the repressed sensuality that Mary Woronov projected in the role on screen. In Mr. Bartel's own role, Eddie Korbich is mired in the husband's wimpishness. He lacks the musical opportunity he had as the baker's apprentice in the Broadway revival of "Sweeney Todd," a show that makes mincemeat out of "Eating Raoul."

Adrian Zmed plays Raoul with an indeterminate polynational accent. At least he brings a certain flamboyance to his role, as does Cindy Benson as a public-access dominatrix who doubles as a caring mother. M. W. Reid plays a number of roles, including one flashy turn as a female impersonator, portraying Ginger Rogers waiting for a nonexistent Fred Astaire to enter her life.

"Eating Raoul," the musical, succeeds only in cannibalizing its source. Directed at the "Return to the Forbidden Planet" crowd, it offers the audience nothing special and no substitutions.

1992 My 16, 14:3

The Sunset Gang

Book and lyrics by Warren Adler; directed by Edward M. Cohen; music by L. Russell Brown; musical direction, arrangements and additional material, Andrew Howard; costumes, Edi Giguère; choreographer, Ricarda O'Conner; sets, Ray Recht; lighting, Spencer Mosse; production stage manager, Geraldine Teagarden; presented by the Jewish Repertory Theater, Ran Avni, artistic director; Edward M. Cohen, associate director; Nina Heller, managing director. At 344 East 14th Street, Manhattan.

Naftule and Male Yenta	Irving Burton
Yetta and Female Yenta	Shifra Lerer
Bill	Alfred Toigo
Mimi	Sheila Smith
Jenny	Chevi Colton
David	Gene Varrone

By STEPHEN HOLDEN

Until it suddenly shifts gear in the middle of Act I, "The Sunset Gang" has the feel of a cozy little revue about the pleasures and stresses of life in a Florida retirement community. No sooner have Bill (Alfred Toigo) and Jenny (Chevi Colton), who are each one-half of a different, recently retired couple, fallen in love, than the show becomes a bittersweet musical about aging and desire. Will Bill and Jenny, who are both in their 60's, abandon their longtime spouses to begin new lives together?

The show, with music by L. Russell Brown (who co-wrote "Tie a Yellow Ribbon Round the Old Oak Tree" with Irwin Levine) and a book and lyrics by Warren Adler (the screenwriter for "The War of the Roses"), is adapted from three short stories by

Mr. Adler that were produced as a trilogy for the PBS series "American Playhouse." The stage adaptation, directed by Edward M. Cohen for the Jewish Repertory Theater, veers between a singing-and-dancing answer to "The Golden Girls" and a deeper examination of love and loyalty among people over 60. The show doesn't have nearly enough time to develop its more serious theme with any emotional depth. And its score, though tuneful enough, has singsongy

Will Bill and Jenny abandon their longtime spouses?

lyrics that frequently state the obvious in unvarnished clichés.

As long as its tone remains light, "The Sunset Gang" has a diverting, if formulaic, charm. Most of the comedic moments are given to Naftule (Irving Burton) and Yetta (Shifra Lerer), a married pair of self-proclaimed yentas who are seasoned residents of the community. In the score's cleverest songs, they extol the pleasures of gossip and nostalgia. The show's high point, "The Shoichet Maid," is a burlesque of a Yiddish musical in which they play multiple characters.

But when "The Sunset Gang" becomes serious, it turns into a diluted soap opera. In the one song that the show gives to each of the betrayed spouses, their relatively mild reactions seem completely implausible, given their situations. Mr. Toigo and Ms. Colton also seem an unlikely and, as directed, a somewhat uncomfortable pair of mature lovebirds.

1992 My 16, 14:3

And Now, a Word From Off Broadway

'Fires in the Mirror' reflects on violence and what lies beyond.

'Ruthless!' hooks the shark in the cherub.

'Empty Hearts' is a courtroom whydunit.

'One of the All-Time Greats' isn't.

SO WHAT ABOUT OFF BROADway? For the last few months, there hasn't been much opportunity to get out of Times Square. Broadway, showing uncharacteristic signs of liveliness, has grabbed the lion's share of the attention. Two weeks from now, when the Tonys are awarded, there'll be even more grabbing. In the relative calm before that annual orgy of pride and humility, here's a quick look at what's going on in some theaters off the beaten macadam.

'Fires in the Mirror: Crown Heights, Brooklyn And Other Identities'

You could describe Anna Deavere Smith as a documentary film maker who has simply decided to dispense with the camera. Instead of capturing her subjects on film, she interviews them, then, using their own comments and a few of their mannerisms, portrays them on the stage. In "Fires in the Mirror: Crown Heights, Brooklyn and Other Identities" (at the Joseph Papp Public Theater), she assumes the personalities of nearly 30 people — male and female, young and old, famous and anonymous — caught up in racial unrest.

If the actress weren't vitally concerned with giving us the truth of each of her subjects, the 90-minute piece could easily come off as so much quick-change trickery. Instead, you are apt to leave the Public thinking that the old saw about every story having two sides vastly underestimates the matter. To every story, especially one as tangled and inflammatory as this, there are as many sides as there are participants. The fact that Ms. Smith takes all of them in turn strips the work of any partisanship. The prevailing tone is curiously cool and distanced, even when the actress is depicting behavior that isn't.

In "Fires in the Mirror," she is looking into the widely reported racial disturbances that rocked a Brooklyn neighborhood almost a year ago. The trouble began when an automobile, driven by a Hasidic man, leaped the curb and killed Gavin Cato, a 7-year-old black child. Several hours later, in what appeared to be an act of retaliation, a crowd of angry blacks stabbed Yankel Rosenbaum, a 29-year-old Hasidic rabbinical student visiting from Australia, who died shortly afterward in the hospital. Battle lines were rapidly drawn. Riots broke out. By the time they were over, the Jewish and the black communities were eyeing each other across a deep divide of bitterness and suspicion.

What's notable here is how little it takes to transform Ms. Smith. Dressed in black pants and white shirt, the barefoot actress occasionally relies on a prop or a piece of clothing to switch identities. She's not above modifying her voice or, more often, her vocal rhythms. But doing impersonations doesn't interest her as much as communicating essences. If you believe her as the Rev. Al Sharpton or the feminist rapper Monique (Big Mo) Matthews, as Gavin Cato's father or as Roz Malamud, an indignant Jewish homeowner, as an anonymous drugged-out bystander or Yankel Rosenbaum's outraged brother, it's because the actress commits herself fully to their passionate words. And the words actually remake her — hardening or softening her features, adding to her height or subtracting from it.

With the rioting in Los Angeles fresh in our minds, the obvious remark to make about "Fires in the Mirror" is that it couldn't be more timely. Yet the timelessness of the piece is what impressed me. Put the specifics aside and you have a view of people so at odds with one another that human nature itself seems to be to blame. We are stubborn creatures, claiming right for ourselves and wrong for the other guy, and that stubbornness repeatedly dooms us to violence. Nonetheless, we advance a thousand and one reasons, grand and pitiful, to explain why giving an inch just isn't possible.

Beyond the anger that separates the individuals in "Fires in the Mirror" is an unarticulated sadness that binds them together — if only they knew it.

'Ruthless!'

If Rhoda Penmark, that little darling better known as the bad seed, had craved a show-business career and killed for roles, instead of penmanship medals, she might have turned out rather like Tina Denmark, the pre-teen heroine of "Ruthless!" (at the Players Theater). Such, at any rate, is the operating assumption of the writer and director Joel Paley and the composer Marvin Laird, who have concocted this brash and campy musical spoof. As played by Laura Bundy, Tina is what you'd get were you to cross a cherub with a shark — a cloud of fluffy blond hair, smooth skin, sharp teeth and beady eyes that just dare you to move.

"I was born to entertain," she sings out, in the kind of voice that blows down electrical wires and topples church steeples. Soon after, she is tap

335

Carol Rosegg/Martha Swope Associates/"Ruthless!"

Donna English, left, and Laura Bundy in "Ruthless!"

Gerry Goodstein/"Empty Hearts"

Claris Erickson, at rear, and Cotter Smith in "Empty Hearts."

William Gibson/Martha Swope Associates/"Fires in the Mirror"

Anna Deavere Smith in "Fires in the Mirror."

dancing furiously on the living-room coffee table. When someone suggests that maybe she should postpone her ambitions and enjoy a normal childhood, she snaps back: "I've had a normal childhood. It's time to move on." She's a terror, all right.

■

In two acts and 14 songs, "Ruthless!" tries to get to the bottom of what is clearly a genetic predisposition toward celebrityhood. On the surface, Tina's mother (Donna English) seems to be a perfectly normal, if vacant, homemaker in polka dots, while her grandmother, the acid-tongued drama critic Lita Encore (Denise Lor), not only hates musicals, but can barely bring herself to sing her allotted number in this show. Before long, however, surprise twists are playing havoc with the family tree. Everybody is coming unglued and lunging desperately for the big time. That includes Sylvia St. Croix, an imperious, gravel-throated agent (played by Joel Vig in drag), and the frustrated actress turned third-grade teacher (Susan Mansur) who is directing the production of "Pippi in Tahiti, the Musical," which first stirs the blood lust in Tina.

The brash and campy musical spoof 'Ruthless!' has its moments of inanity.

While "Ruthless!" begins promisingly enough, by the end it has veered off into total inanity — which is not quite as good as total insanity. Even the cheerful score has become relentlessly cheerful. What you have here, I fear, is material for a solid half-hour

sketch. (Actually, Carol Burnett would have done it up brown in about 15 minutes.) Dragging it out only drags it down. The same joke — people will do anything to be in a show — is made time and again. Each time, it's a little less funny.

Still, I'd be lying if I didn't say the musical has its moments. Ms. Mansur, as the tyrannical teacher with envy lodged deep in her heart and curls like rusted bedsprings piled high on her head, is responsible for a lot of them.

'Empty Hearts'

Cotter Smith and Mel Harris are a sexy couple and they bring considerable heat to "Empty Hearts," a courtroom drama with flashbacks (at the Circle Repertory Company). He's a craggy/sensitive type, a Clint Eastwood who can quote Yeats. She comes on smart and tough — even her nose flips up defiantly — but underneath she's appealingly vulnerable and needy. As soon as they lock eyes, you sense something's going to combust.

They meet at a state hospital, where Mr. Smith plays Michael, a psychologist specializing in geriatric care. She portrays Carol, a volunteer with a young son and a lousy marriage. In no time, they're going to dinner. Then, they're going to a motel. And not too long after that, she's left her loutish husband, and she and Michael, draped with flowers, are headed for the altar.

Mr. Smith and Ms. Harris, who happen to be husband and wife off-stage, are thoroughly persuasive in their depiction of buried yearnings and runaway passions. What the playwright John Bishop gives them to say isn't particularly original. But the performers put so much oomph of their own into the relationship that you can get easily involved in their mating games.

Unfortunately, that's the flashback part of "Empty Hearts." Its immediate concern is Michael's trial for murder. (Accordingly, the set designer John Lee Beatty has made the inside of the theater into a courtroom.) You, the juror, will gather early on that Carol is the victim, which makes the play not so much a whodunit as a *why*dunit. The psychological motive, when it finally surfaces, will not exactly have you tumbling from your seat. Until then, Mr. Bishop, who is also the director, hopscotches back and forth between past and present — the present tending to extinguish whatever excitement is generated by the past.

The supporting players are required to enact two and three roles apiece — a task that John Dossett accomplishes very convincingly, and Edward Seamon and Susan Bruce accomplish not convincingly at all. Mr. Bishop's title is taken from the passing observation that now and again what seems like love is just "empty places desperate to be filled." I wish he'd looked further into the idea.

'One of the All-Time Greats'

In all the years that playwrights have been telling us what happens behind the scenes in the theater — producing comedies like Moss Hart's "Light Up the Sky," Edna Ferber and George S. Kaufman's "Royal Family," Terrence McNally's "It's Only a Play" — no one has ever accused show folk of being bland.

Self-centered, unreasonable, jealous, myopic, sentimental, magnificently temperamental, yes. Bland, no.

The actor and occasional playwright Charles Grodin may be breaking fresh ground. "One of the All-Time Greats" (at the Vineyard Theater), his comedy about the travails of putting on a Broadway show, is flat and colorless. The characters — the

director down on his luck; the blustering producer lacking in taste; the young playwright hungry for success; the hotshot director who may be hired as a replacement; plus assorted wives, girlfriends and hangers-on — are predictability incarnate. The drama that has brought them all together is an epic called "Thunder Road" and is described as a combination of "Barefoot in the Park" and Kafka.

"One of the All-Time Greats" takes place in the back room of a Chinese restaurant, where these ciphers gather during previews to thrash out personal and artistic differences; then again, after the opening night performance, to await the reviews, which are scalding. No surprise there. Momentarily closing ranks, they clap one another on the back in a brave expression of solidarity — which seems to be the fairly insignificant point of this endeavor. We may trust in God, but in times of theatrical calamity we embrace.

The actor Tony Roberts, making his directorial debut, stages the evening at such a glacial pace that the obvious becomes only more so. Renee Taylor, as the luckless director's wryly supportive wife, comes off best. In view of the evidence elsewhere, I suspect her wryness is a native, not Grodin-given, quality. It does serve effectively to shield her from professional harm, though. □

1992 My 17, II:5:1

336

Big Al and Angel of Death

Two one-act plays. Sets, James Wolk; costumes, Sarah Edwards; lighting, Howard Werner; sound, Bruce Ellman; production stage manager, Mark Cole; artistic consultant, Jack Temchin. Presented by the American Jewish Theater, Stanley Brechner, artistic director. At 307 West 26th Street, Manhattan.

BIG AL, by Brian Goluboff; directed by Peter Maloney.
Leo ..Evan Handler
Ricky ..Gus Rogerson

ANGEL OF DEATH, by Charlie Schulman; directed by Billy Hopkins.
Gunther LudwigDaniel von Bargen
RolfSteven Goldstein
Bill Century Keith Reddin
Betty Century Leslie Lyles
Woman and Melanie Baxter ..Anna Thomson

By MEL GUSSOW

The spotlight strikes, and the song-and-dance man smiles at the audience and stylishly steps into a chorus of "I like a Wagner tune. How about you?" The entertainer is none other than Josef Mengele, the so-called Angel of Death of Auschwitz, working his way up in show business under the alias Gunther Ludwig. At present he is in Paraguay, appearing nightly at the Club Führer in a cabaret act of his own creation.

Some theatergoers may find this idea offensive, but if Mel Brooks could concoct "Springtime for Hitler," then Charlie Schulman can write "Angel of Death," an outrageous comedy about the rise of Nazism and the fall of Hollywood. The one-act play is at the American Jewish Theater, in what is certainly a change of pace for the company. It shares a bill with Bryan Goluboff's "Big Al," which was presented last year in the Ensemble Studio Theater's Marathon of short plays.

The fiendishness of Mr. Schulman's humor is heightened by the performance of Daniel von Bargen in the title role. Last seen as the overbearing father in John Patrick Shanley's "Beggars in the House of Plenty," Mr. von Bargen hits just the right note of Aryan arrogance. For comic purposes, he is far more talented than Mengele could ever be. Along the way, he does imitations of Frank Sinatra ("My Way") and Elvis Presley ("In the Ghetto"). It is his heretical assumption that if the two singers had sided with Hitler, Germany would have won the war. He is also glad that the Berlin wall was torn down because "now we can return to normal."

As briskly staged by Billy Hopkins, the brief play is filled with acerbic asides at the expense of not-so-crypto-fascists and careerists of various moral persuasions. But unlike Mengele's nightclub routine, the show has a tendency to wander, especially after the Nazi fugitive is uncovered by a pair of would-be Hollywood players (Keith Reddin and Leslie Lyles). Skillfully mocking opportunistic producers, Mr. Reddin and Ms. Lyles hire Mengele to portray himself in a biographical movie.

Before the movie within the play has won Mengele an Oscar, the playwright clouds the issue by pushing his characters into a cinematic sequel. But the comedy regains its footing with Anna Thomson's malicious cameo as a dim-brained awards presenter and Mr. von Bargen's final bedazzlement about which role he is actually playing. As he realizes, he is being held captive in the story of his life.

Carol Rosegg/Martha Swope Associates
Daniel von Bargen as Josef Mengele in "Angel of Death."

Mr. Schulman is a witty writer, as he also demonstrated in his previous one-acts at the Young Playwrights Festival.

•

The curtain-raiser, "Big Al," is a shaggy tale of obsession, or is it possession? A movie fan (Evan Handler) hero-worships Al Pacino and is a walking encyclopedia of his roles. He can quote his dialogue ("But they pulled me back in") and will do anything, literally anything, to fulfill his dream of working with his idol. To reach that goal, he and his screen-writing sidekick (Gus Rogerson) brainstorm a Pacino vehicle called "Maniac Priest," a collaboration that becomes increasingly compulsive.

Mr. Goluboff has improved the ending of his play since its last production, and, as directed by Peter Maloney, the two actors re-create their agile performances as hungry writers. All they need for Hollywood success would be two powerhouse promoters like the characters portrayed by Mr. Reddin and Ms. Lyles in "Angel of Death." "Big Al" is amusing, but the main event belongs to Mr. Schulman. In his diabolic spoof, it is show time for Mengele.

1992 My 18, C15:1

Marathon '92/Series B

Produced by Kevin Confoy; production manager, Andrew Kaplan; scenic design, Peter Eastman; lighting design, Greg MacPherson; costume design, Anne Patterson; sound design, Jim Van Bergen; production stage manager, Dathan Manning. Presented by the Ensemble Studio Theater; Curt Dempster, artistic director; Christopher A. Smith, associate artistic director; Dominick Balletta, managing director. At the Ensemble Studio Theater Mainstage, 549 West 52d Street, Manhattan.

AWOKE ONE, by Jack Agueros; directed by Curt Dempster; music by Rob Tomoro; stage manager, Brooke Taylor.
WITH: Jay Barnhill, Peter Basch, Allyn Burrows, Chris Ceraso, Brad Greenquist, Peter Maloney, Alex Murphy, Timothy Britten Parker and Kurt Ziskie.

MY SIDE OF THE STORY, by Bryan Goluboff; directed by Marcia Jean Kurtz; stage manager, Jane Rothman.
WITH: David Eigenberg and Stephen Pearlman.

SCHEHERAZADE, by Percy Granger; directed by Matthew Penn; stage manager, Jessica Rhines.
WITH: Kristin Griffith, John Pankow, Lucille Patton and John Rothman.

GULF WAR, by Joyce Carol Oates; directed by Christopher A. Smith; stage manager, Catherine A. Heusel.
WITH: Scotty Bloch, Catherine Curtin, James G. Macdonald and Pirie MacDonald.

RIPPLES IN THE POND, by Jon Shirota; directed by Ron Nakahara; stage manager, Richard Lollo.
WITH: Helen Eigenberg, Glen Kubota and James Saito.

By MEL GUSSOW

In "Scheherazade," it is the playwright Percy Granger who is the tale spinner, with a lunatic comedy about life as soap opera and soap opera as it mirrors life. Pirandelloesque permutations brighten this journey in which the characters keep losing their place in the story line, and the audience shares the comic confusion. As airy as ether, "Scheherazade" is a high-flying one-act in Series B of the Ensemble Studio Theater's Marathon of short plays.

Tantrums flare as a television producer and his aide (she heatedly denies that job description) confront a new head writer for their show. He may be an imposter or even a spy. As played by John Pankow, the writer has the scruples of a housebreaker, which puts him in good company, as the other characters try to corner one another in a cul de sac. When the producer (John Rothman) says to the writer, "You think you can scare me with dialogue," full fright is intended.

The principal question here and in the unseen soap concerns a mysterious room. The last head writer arbitrarily anchored all scripts in that locale, and left the characters hanging when he departed from the show. Lost in the lurch, the remaining personnel grope for plot devices. For a moment, the doyenne of the soap (Lucille Patton) becomes Mr. Pankow's loyal supporter, but minds change freely in this vaporous environment.

Operating on several frequencies at once, "Scheherazade" crosscuts with a dizzying abandon while lampooning literary pretentiousness and plumbing various levels of artificial reality. In the background is the voice of doom, the piped-in sound of Standards and Practices, which occasionally breaks out of its robotic rigidity to ask for the punch line of jokes.

Mr. Pankow has all the limberness of a natural con man (though the character may be the real thing) and Mr. Rothman self-mockingly repeats trendy jargon. Ms. Patton and Kristin Griffith (as the aide) also add to the delirium. Under Matthew Penn's direction, invention never flags. When the writing is as clever as this, it makes the creation of one-act plays look easy.

Turning to Bryan Goluboff's "My Side of the Story," one can see all the pitfalls of the short form. This is a lugubrious story about a father and son estranged in the family business. When the story gets going, very slowly, it becomes boring, as the father vents his ire on his absent wife and the son threatens to assert himself. "Awoke One" by Jack Agueros tries to reinterpret paintings by Magritte as a biblical parable. The design, with all the actors dressed in bowlers and carrying umbrellas, is Magrittish. The play is pretentious.

But along with Mr. Granger's comedy, there are two plays of interest: Joyce Carol Oates's "Gulf War" and Jon Shirota's "Ripples in the Pond." The Oates is a comedy about new yuppies on the block and their collision with a couple of an older generation. The scene is a town ironically named Fairhaven.

Lost children figure prominently in this narrative, along with the disharmony within marriages. James G. MacDonald and Catherine Curtin as the younger couple could not be more disparate. Upwardly energized, he is completely dismissive of her interests, while she is a borderline depressive. Both actors are very amusing, as are Pirie MacDonald and Scotty Bloch as a more absent-minded pair. There is a tinge of Ionesco in the air in this "house without memory." "Gulf War" is an intriguing sidelight from a most prolific author.

•

"Ripples in the Pond" takes place in 1963 and the date is crucial in this story of a conflict between an assimilated Japanese-American and a Japanese businessman newly arrived in this country. This is a time between World War II and the Japanese economic ascension, when one character can wonder with all sincerity why any American would ever want to buy a Japanese car.

The first part of the play borders on farce as the businessman prepares for and then faces a tax audit, but as the narrative unfolds, friendly hands reach across the sea and the play achieves a poignancy. This is partly a result of the evocative performances by Glenn Kubota and James Saito. From the author of "Lucky Come Hawaii," this is a one-act with promise, both for its theatrical contribution and for what it says about the ameliorative possibilities between cultures.

1992 My 19, C18:3

The Extra Man

By Richard Greenberg; directed by Michael Engler; sets by Loy Arcenas; costumes by Jess Goldstein; lighting by Donald Holder; sound by Scott Lehrer; production stage manager, Robin Rumpf. Presented by Manhattan Theater Club, Lynne Meadow, artistic director; Barry Grove, managing director. At City Center, 131 West 55th Street. Manhattan.

Laura..Laila Robins
Keith...Boyd Gaines
Jess...Adam Arkin
Daniel...John Slattery

By FRANK RICH

The title of Richard Greenberg's new play about contemporary Manhattanites, "The Extra Man," has the ring of S. N. Behrman and Philip Barry. One pictures an elegant bachelor in a tuxedo, a Cary Grant updated to the Jay McInerney era, making mischief at dinner parties of the rich and famous. But Mr. Greenberg, whose other plays about New York's present-day upper middle class include "The Maderati" and "Eastern Standard," is not in so buoyant a mood. While his extra man is a bachelor, a congenital partygoer and a mischief-maker, this one leaves wrecked lives, not smashed champagne flutes, in his nocturnal wake.

Remarkably unpleasant and thoroughly misanthropic, "The Extra Man" is a daring effort not to be dismissed lightly. It's a play that wants to make the audience at the Manhattan Theater Club uncomfortable and does so, though not always in the way its author intends. At once underwritten and overdirected (by Mr. Greenberg's longtime collaborator, Michael Engler), "The Extra Man" lacks the surgical comic precision its dark mission requires. For every scene in which Mr. Greenberg levels his indictment against human-

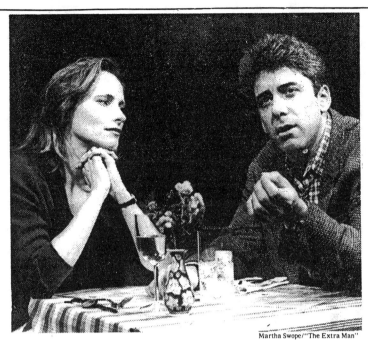

Martha Swope/"The Extra Man"

Laila Robins and Adam Arkin in a scene from "The Extra Man."

ity with his typically astringent wit, there is at least another one that coarsens his case or muddies it.

•

The script's biggest success and, paradoxically, the production's biggest failure is the title character, Keith, played by Boyd Gaines. An affluent, highly presentable writer who published one collection of stories some five or six years ago but who is pretentiously vague about current projects, Keith is an extra man who has stepped right out of whatever bar is in vogue this week. He knows everyone, lives in restaurants, has well-informed opinions about everything and is always available to be anyone's best friend, career adviser and purveyor of gossip.

Mr. Greenberg has captured him perfectly, from his clammy brand of asexual flirtation to his sly ability to camouflage his own intimate secrets even as he retails the intimacies of others. More amusingly still, the playwright makes Keith the fulcrum of his plot: with a mixture of suggestive half-truths and outright lies, Keith gradually pushes his dear friend Laura (Laila Robins), "one of the best young editors" in book publishing, into an extramarital affair with Jess (Adam Arkin), a desperately lonely film critic who is the author of "The Evil of Banality," a study of the abuse of Holocaust imagery in Hollywood movies.

Not unlike Iago, Keith practices his own banal form of evil on Jess and Laura for no logical reasons other than the malicious exercise of power and the esthetic kick of creating the dramas in life that he is too lazy to construct upon the page. The ease with which he spins his web says as much about his spineless victims as it does about him. "We don't have anything left to lose," concludes a joyless Laura once she finally decides to go to bed with Jess. In the moneyed, hectic New York of "The Extra Man," no character has anything left to lose, which is to say that no one has the values, morality or even secure sense of self that might combat an opportunistic parasite like Keith. Mr. Greenberg's characters are so bereft of interior lives that they are often found repeating the same witticisms,

not always original ones at that, in consecutive conversations.

Even so, the playwright is not saying that Keith's victims are stupid. Yet Jess and Laura would have to be very stupid indeed to be fooled by Keith as played by Mr. Gaines. Neither the actor nor Mr. Engler has found the subtle, insinuating tone this superficially charming character demands; Mr. Gaines's Keith is so creepy, so obviously mendacious and villainous from the start that his subsequent machinations seem predictable and his friends' inability to see through them seems incredible. Making matters more confusing is Ms. Robins's Laura. Is she an innocent patsy of Keith's schemes, an unwilling adulterer caught in a trap? Or is she a callous user in her own right? The script's point of view on her is hard to discern, and clarity is not provided by a performance that is often as falsely bright and gratingly phony as Mr. Gaines's.

•

The other two players are in much sharper focus. As Laura's husband, a noble lawyer too busy defending the powerless to attend to his own crumbling marriage, John Slattery is a sweet figure of baffled masculinity. His deft underplaying salvages a role that often seems a contrived symbol of goodness, mechanically programmed to espouse the correct sentiments about AIDS and other public matters. Mr. Arkin is simply wonderful as Jess. Not only does he deliver Mr. Greenberg's funnier lines with the wry nasality he brought to the Hollywood hustler in "I Hate Hamlet" last season but he also captures the aching loneliness of a man who is so desperate for "a little serious attention" that he is the last to know that he is being had.

In Mr. Arkin's moving performance, one can see how high "The Extra Man" aims. The destruction of the innocent Jess by a selfish, urbane society recalls not only the drift of Mr. Greenberg's "Life Under Water" and "American Plan" but also the fate of characters in the earlier modern New York fictions of Wharton and James and Dreiser and Fitzgerald. To achieve so lofty an ambition, Mr. Greenberg's writing cannot stoop, as it sometimes does here, to the same

generalized "standard-issue urban malaise" that he finds deplorable in his characters.

Mr. Engler greases the skids by indulging in some standard-issue Weltschmerz of his own. "The Extra Man" unfolds on faceless gray sets, designed by the gifted Loy Arcenas, that announce the characters' soullessness before the dialogue does and

that move on and off with excessive fussiness on lumbering treadmills. The effect could not be more counterproductive: Mr. Greenberg's bristling outcry against a hollow New York starts to seem itself like just another jaded product of the city's mannerist cultural assembly line.

1992 My 20, C15:4

Theater in Review

■ Trying to be the hippest person on earth

■ Insisting that a son is innocent ■ A lifetime of

abuse based on color ■ An impish 'Macbeth.'

Dancing on the White House Lawn

The Ballroom
253 West 28th Street
Manhattan
Through May 30

By Donna Blue Lachman; directed by David Petrarca. Presented by Tim Johnson.

WITH: Ms. Lachman.

Anyone who ever boasted of being a hippie is likely to relate to the true stories that Donna Blue Lachman, a 41-year-old Chicago-based playwright and actress, tells in her engaging autobiographical monologue, "Dancing on the White House Lawn."

The daughter of a furrier from Skokie, Ill., Ms. Lachman is a quintessential contemporary truth-seeker and self-described "wandering Jew" who has traipsed down many an offbeat path. Her adventures begin when she is a teen-age aspiring bohemian who pays $40 for a shopping bag full of marijuana that turns out to be spinach. From there she moves to LSD and then cocaine, from an ashram in northern California to a kibbutz in Israel, from Poland, where she auditions for the legendary director Jerzy Grotowski, to Haiti, where she explores voodoo. Eventually she finds herself freezing in Russia without a fur coat. Along the way, personalities ranging from the Zen Buddhist guru Alan Watts to the actors Jack Lemmon and John Belushi put in appearances.

"Dancing on the White House Lawn" is superficially quite similar in tone to one of Spalding Gray's monologues. Ms. Lachman's Chicago twang is as distinctively provincial as Mr. Gray's Rhode Island accent. Both adopt a tone of neighborly intimacy to recollect mind-shattering experiences.

The crucial and frustrating difference is that Ms. Lachman, in packing 20 years of experience into about 75 minutes, has only enough time to gloss over dozens of adventures, any of which would be worth an entire monologue in itself. In trying to encompass so much, she creates the impression that she spent two decades pursuing one phenomenon after another in a flighty drive to be the hippest person on the planet.

Many of the experiences she remembers have to do with seeking spiritual enlightenment. Yet Ms. Lachman imparts very little of what she discovered beyond offering some

amusing comparisons between the free-spirited late 60's and the rigidly conformist 80's and 90's. Beyond a reference to "a ménage à trois with two people old enough to be my grandparents," the monologue makes no reference to significant personal relationships.

The one nugget of enlightenment Ms. Lachman offers comes after a 1982 trip to the Southwest to participate in a ritual "ordeal" with Harvey Swiftdeer, an Indian shaman. His advice that it is selfish "not to sing your song," that to share it "is the spirit of the 'give away,' " comes as the sentimental punch line to an entertaining but rather shallow yarn.

STEPHEN HOLDEN

Tone Clusters

SoHo Rep
46 Walker Street
TriBeCa
Through June 7

By Joyce Carol Oates; directed by Julian Webber; set, Kyle Chepulis; costumes, Mary Myers; sound, David Schnirman; lighting, Don Holder; video, Mark Frankel; production stage manager, Kathryn Brannach. Presented by SoHo Rep, Marlene Swartz and Julian Webber, artistic directors.

WITH: Richard Adamson, Kathryn Langwell, John Nacco and Black-Eyed Susan.

No real-life television personality is as unctuously grandiose as the offstage voice (Richard Adamson) who harangues the parents of a convicted murderer in Joyce Carol Oates's disturbing one-act play "Tone Clusters." Sounding like Rod Serling as a supercilious philosophy student, the unnamed interviewer gushes, "We have here the heartbeat of parental love and faith. It's a beautiful thing."

When not spewing phony sincerity, he demands that his hapless guests theorize about determinism versus free will, the element of chaos in human identity and other lofty matters. As the interrogation continues, Frank and Emily Gulick (John Nacco and Black-Eyed Susan), both simple, working-class people, wilt into a state of dazed defensiveness.

The one-act drama, first performed in 1990 as part of the Humana Festival of New Plays at the Actors Theater of Louisville, is based on the real-life case of Robert Golub, a young man from Valley Stream, L.I., who was convicted two years ago of brutally murdering Kelly Ann Tinyes, a 13-year-old neighbor. The case tore apart the neighborhood and made the

Golubs pariahs. Without altering the basic facts, Ms. Oates has changed the names, shifted the scene to Lakepoint, N.J., and made a surreal interview with the murderer's parents a metaphor for the cold hypocrisy of the television age.

"Tone Clusters" uses several video monitors, including a giant 16-screen unit, to create a claustrophobic sense of people tyrannized by an omnivorous technology. As the Gulicks' home movies are played across the screen, they are augmented with garishly melodramatic music. Numbed by the tragedy and by medication, the couple talk in broken sentences, repeating the same banalities about their son ("He was such a shy boy"), who they insist is innocent, and issuing limp protests against the criminal justice system ("Is this America or Russia?") and their hostile neighbors ("You learn who is your friend and who is your enemy").

What emerges is a bitter satiric portrait of two people bullied by a medium that will do anything to maintain a sense of drama, even if that means unfairly casting them as villains. At the same time, it reveals them as people who think and speak in half-digested sound bites from overheard talk shows. Beautifully played by Mr. Nacco and Black-Eyed Susan, they are defeated figures pathetically clutching at the final shreds of their self-respect.
STEPHEN HOLDEN

Testimony

Henry Street Settlement's
Louis Abrons Arts Center
466 Grand Street
Lower Manhattan

By Safiya Henderson-Holmes; directed by Raina von Waldenburg; set, Nathan Jones; lighting, Marty Liquori. New Federal Theater, Woodie King Jr., producer, Shoestring Productions, Lynn K. Pannell, artistic director and producer.

WITH: Marty Liquori, Julie Bray-Morris, Mantee M. Murphy and Sonita Surratt.

There seems to be no bottom to the personal suffering caused by the racial animosity that Safiya Henderson-Holmes explores in her second play, "Testimony."

It is possible that the recent riots in Los Angeles give this play greater resonance. But one would guess this it would leave most people stunned and shocked even if the surface tranquilli-

ty of this troubled society had never been ripped apart. This young playwright is a poet who knows how to make words bite and gnaw.

The testimony of the title comes entirely from one young black woman, Jacintha (Sonita Surratt), being held in a New York City prison on a murder charge. A white psychiatrist (Julie Bray-Morris) is interviewing Jacintha. The session is audiotaped by a black technician (Mantee M. Murphy) while a white technician (Marty Liquori) makes a videotape that can be seen on two monitors, even though the interrogation frequently lunges beyond the gaze of the red eye.

Ms. Surratt meets a formidable acting challenge. Jacintha has several personalities, each with her own exquisitely devious program for concealing truth as a tale of appalling abuse and hopeless longing unfolds. The abuse comes from her mother, her employer, her neighbors — the whole world, it seems — and all of it is based on color. Ms. Surratt positively pulls the audience through this terrible labyrinth with her.

Ms. Henderson-Holmes still has things to learn about playwriting, mostly about economy. Her faults are those of generous youth: she tries to include everything imaginable about all her characters, and at times her story wanders beyond the attention of even the most alert audience. The director, Raina von Waldenburg, has a hard job trying to hold it all together. But Ms. Henderson-Holmes can surely write, passionately; her characters speak with absolute conviction, and often nobly, even when they mean to evade or deceive.
D. J. R. BRUCKNER

Macbeth

One Dream Theater
2 North Moore Street
TriBeCa
Through June 7

By William Shakespeare; directed by Edward Berkeley; set and costumes by Miguel Lopez-Castillo; lighting by Steven Rust; fight director, Bjorn Johnson. Presented by the Willow Cabin Theater Company.

WITH: John Billeci, John Bolger, Laurence Gleason, Cecil Hoffmann, Angela Nevard, Adam Oliensis, Dede Pochos, Linda Powell and Michael Rispoli.

An impish spirit of mirth keeps flitting through the Willow Cabin Theater Company's production of "Macbeth" at the One Dream Thea-

ter, upending what appears to be an attempt to present the tragedy seriously. Scottish accents wander from mouth to mouth and then fade altogether; Lady Macbeth's doctor is a startlingly campy apparition who adds no credibility at all to the sleepwalking scene, from which the doomed woman flees with a shriek to empty tombs; wounded Macduff and dead Macbeth scurry offstage on their knees after the last battle.

The imp really takes over at the banquet. Unaccountably, Banquo's murderers string him up by his heels in a corner, where he is still hanging upside down as the festivities begin. Then the three witches (who stay on stage throughout, doing menial chores when they are not conjuring) have to lower him to the floor and help him climb into Macbeth's chair so he can drive the guilty king raving mad — and raving is definitely Macbeth's reaction here.

Edward Berkeley, the director, obviously wanted to keep the play moving rapidly, but apparently he also let most of the actors adopt their own interpretations of their characters without much coordination. The result is breathless tumult.

There are some interesting insights here, as when intense rivalries surface among the young nobles plotting Macbeth's downfall; that kind of tension can heighten the anxiety of the final scenes. And John Bolger's energy in his portrayal of Macbeth is a refreshing reminder that this man is trapped by his ambition, not exhausted by it, as he is in so many productions.

But in the end, what one takes home from this version is the memory of the mischief that keeps popping up at the most inopportune moments.
D. J. R. BRUCKNER

1992 My 20, C18:1

One Neck

By Todd Alcott; directed by Randy Rollison; production design, H. G. Arrott; costume design, Carol Brys; lighting design, Mary Louise Geiger; action sequence coordinator and special effects, Rick Sordelet; original music and sound design, David Jackson; production stage manager, Kevin Cunningham. Presented by Michael Cohen and Lyle Saunders. The Home for Contemporary Theater and Art, 336 West 20th Street, Chelsea.

Wes	Frank Deal
Lucian	Todd Alcott
Guy	David Thornton
Patina	Melissa Hurst
Nyla	Allison Janney
Hack	Damian Young

By MEL GUSSOW

It is obvious that the characters in Todd Alcott's "One Neck" have not seen John Guare's "Six Degrees of Separation." If they had, they might have been less hospitable to the so-called friend of a friend who shows up, uninvited, for dinner. Instead of simply being a con man, he is a homicidal maniac. Before his identity is revealed, the play (at the Home for Contemporary Theater and Art) is a malevolent look at the emptiness of a cross-section of the thirtysomething generation. Afterward, it veers perilously close to a horror movie.

Sitting around the host's elegant Long Island beachhouse, the characters compare notes on the fearfulness of contemporary society. This is a world, they tell us, where one can be randomly mugged, raped or decapi-

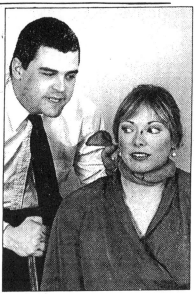
T. L. Boston/"One Neck"

Room for One More Todd Alcott and Melissa Hurst appear in "One Neck," a play about five friends who are visited by a nihilistic stranger at a dinner party.

tated by falling masonry. Standard liberal responses seem to have no effect. The uninvited guest fits right in with this company, except that he seems more skeptical and is less successful, professionally. He is, he says, an unlicensed psychologist, which, of course, might also be said about Hannibal Lecter.

One does not have to be a seer to guess that he is a serial killer. But even as he takes out a gun, the others seem oblivious to the danger in their midst. Mr. Alcott, who has written himself a choice role as the murderer, has overstated the complacency of the other characters, especially the host (Frank Deal), albeit for satiric purposes.

Still, the first act is well paced and plotted, and provokes a gasp at the curtain. The second act is a different story. Held captive, the characters are trapped as if in a slaughter house. Even as death knocks, they seem incapable of taking any action. This is especially true of the men. A female television producer who has suffered a nervous collapse at least has the presence to offer to put the murderer on camera so that he could tell his story to the nation.

Were this a realistic situation rather than a manufactured one, all the characters would be desperate, pleading for their lives rather than remembering other difficulties during a previous "bad week." When they finally fight back, the resistance is insufficient to the task. One keeps waiting for Jodie Foster to break down the door with a backup team from the F.B.I. Instead the villain simply goes on with his gruesome ritual.

The victims never become individually interesting, with the possible exception of an artist who bears some resemblance to Julian Schnabel. He finally appeals to the killer with talk about the proximity between creativity and destructiveness, but the argument is never developed.

When the violence erupts, it is ferocious and excessive. Graphically, the play goes over the edge. What is undeniable is the skillfulness of Ran-

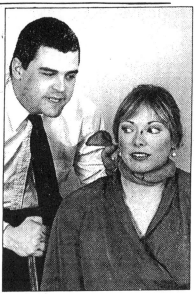
Lauren Santon/"Dancing on the White House Lawn"
Donna Blue Lachman in "Dancing on the White House Lawn."

dy Rollison's production, which is sharply delineated in its setting (by H. G. Arrott) and in its performances. Damian Young and Allison Janney are particularly colorful as an oddly allied couple. As the artist, he is a man who commits acts of violence on canvas. She is a lawyer who is highly wired on cocaine and wears a minidress so tight it makes her feel "im-

mortal," an unlikely word to use in the calamitous circumstances.

In the central role, Mr. Alcott is a portrait of calm before carnage. A choir-boy gentility masks his mania. Step by insidious step, the author as actor leads us into the killer's perverted view of reality. He likes to kill; he is chaos come to earth.

1992 My 22, C3:1

SUNDAY VIEW/David Richards

Melanie Klein? She Shrunk Her Kids

'Mrs. Klein' depicts a couch-potato analyst with attitude.

'Measure' computes the hypocrisy factor.

WASHINGTON

'M FAIRLY SURE THAT THE BRITISH playwright Nicholas Wright intends for us to be of several minds about Melanie Klein, the controversial Viennese psychoanalyst who is the central character of his 1988 drama, "Mrs. Klein."

A disciple of Freud, she was, it would appear, something of a tyrant who lay down her pioneering theories of child development as if they were law. But her combative temperament and her keen mind made her a fascinating tyrant, and she was not easy to ignore. For much of her adult life, which she spent in London beginning in 1926, she seems to have been at the center of one professional storm or another.

Currently receiving its East Coast premiere at Arena Stage, "Mrs. Klein" covers 24 hours in the spring of 1934, during which her family, such as it is, falls apart and her self-confidence is momentarily — very momentarily — shaken.

If you find yourself thinking there's more than a touch of Auntie Mame in her, well, that's perfectly understandable. After all, she does feel obliged to share every little hitch and tremor in her soul with the world at large, and not discreetly, either. "The ceiling's getting lower," she booms out at one point, crouching down and throwing a hand over her head, as though she were announcing an imminent air raid and not just the onset of one of her depressions. Hours later, the depression is lifting, the ceiling is moving upward and she's signaling the all-clear. The world can resume its business. She is a supreme egotist, but at least she's a *forthright* one.

■

And if you find yourself thinking that she's got a lot of Mommie Dearest in her, that's understandable, too. Melanie Klein began her career by psychoanalyzing her own children, and her investigations don't exactly appear to have set them free. At the start of Mr. Wright's play, in fact, Mrs. Klein has just learned that her son Hans, now a man of 27, has fallen to his death in a mountain-climbing accident. Mrs. Klein's daughter, Melitta, a psychoanalyst herself, is convinced it's a case of suicide and holds her interfering mother responsible. "Hans died because he

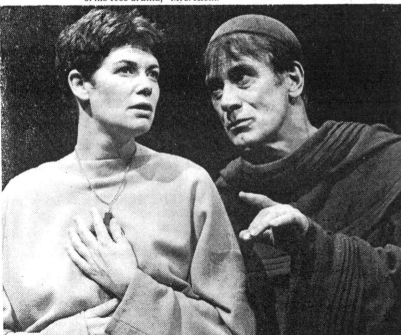

Joan Marcus/"Measure for Measure"

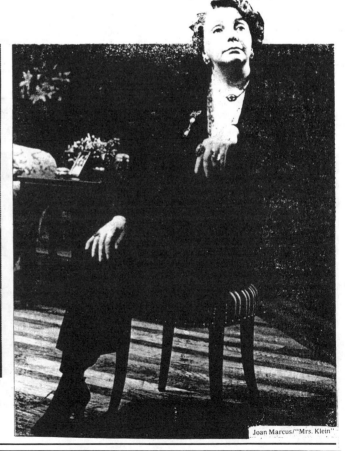

Joan Marcus/"Mrs. Klein"

Two productions from Washington are "Measure for Measure" at the Shakespeare Theater, with Kelly McGillis and Keith Baxter, above, and "Mrs. Klein" at the Arena Theater, with Halo Wines in the title role.

couldn't bring himself to hate you," rages the daughter, adding vindictively, "I can. I do." Mrs. Klein doesn't so much as bat an eye. Detachment is important to her. How else can she see her children for the flawed and miserable creatures they really are?

If, however, you find yourself musing that Mrs. Klein also has a good deal in common with Margaret Dumont, that imperious foil to the Marx Brothers, something is *not* all right. Something is seriously wrong. Granted, psychoanalysts have their blind spots and even a certain peremptoriness. But as played by the longtime Arena actress Halo Wines, Mrs. Klein is a rather silly, middle-aged dowager adorned in a splendid hauteur that allows her to suffer slings, arrows and Freudian insults with barely a ripple of her magnificent chins. No one — least of all the director Zelda Fichandler — seems to be aware that this production is perilously close to sending up the very woman it purports to be sounding out.

Melanie Klein's theories — at least as Mr. Wright has boiled them down for the stage — could easily be the stuff of a "Saturday Night Live" sketch. There's talk of the "good breast" and "the bad breast," "symbolic urine" and playing the violin as "a repressed masturbation fantasy." Automobiles, of course, are really penises and mountains are breasts, although whether good or bad is open for debate. When Ms. Wines draws herself up to her full tragic stature and trills about "the dawn of guilt" in the suckling infant that leads to a "fathomless depression" that will plague him all his adult life, the urge to guffaw is irresistible. While it would take an actress of particularly nimble intelligence to discourage laughter, Ms. Wines actually seems to welcome it.

Reviews of the original London production, however, assure me that Mr. Wright is chronicling a stormy night of a stormy soul. Mrs. Klein must come to terms not only with her son's death, but also with what for her is an intolerable thought — that she had nothing to do with it. Hans was not playing out childhood traumas or expressing latent hostilities when he went to his maker. He just slipped accidentally on a mountain path. Mrs. Klein doesn't like to admit to the possibility of accidents.

■

At the same time, she and Melitta, who *do* have years of personal animosities and professional differences between them, will arrive at a final, acrimonious parting of the ways. (The estrangement persisted right up to Melanie Klein's death in 1960.) The mother will waste no energy filling the void with Paula, the young protégée and eager patient who is the third character in Mr. Wright's drama. The irony here, I guess, is that a woman who has devoted her life to charting the "primitive jungle" that is childhood, ends up losing her own children.

It's not a huge irony, though, and seems a paltry reward for enduring two talky acts. Just as her ideas have been reduced to so much jargon, Mrs. Klein herself is no more than a variation on a cliché — the meddlesome Jewish mother run riot. It doesn't help that Ms. Fichandler, returning to Arena for the first time since she relinquished the artistic directorship two years ago, treats the script with unrelenting gravity. Such solemnity in the face of pretension only makes pretension progressively funnier.

Jurian Hughes is a credible Paula, in part because the character sticks to the sidelines, observing for much of the evening, and therefore isn't directly implicated by the torrent of psychobabble flooding the living room. Pamela Nyberg, however, turns the daughter into a nasty little ferret, shrill and complaining.

As Mrs. Klein — the sort of woman who accuses others of being "too dogmatic" dogmatically; who bristles whenever she feels "my little torch of knowledge" is "being crapped on yet again"; who encourages openness and honesty in others, then locks up the sherry — Ms. Wines offers an extravagant display of pigeon-breasted pomposity and nose-in-the-air affectation.

The actress has played Margaret Dumont types before, most notably in Arena's revival of the Marx Brothers' musical "The Cocoanuts." And I must say she was hilarious at it. I wasn't displeased to see the characterization one more time, even if it does effectively rob "Mrs. Klein" of what is already a very tenuous claim to seriousness.

'Measure for Measure'

"Measure for Measure," Shakespeare's dark comedy about law, order and hypocrisy, is tailor-made for this city, which has seen more than one Congressman, a few senators, a President or two and even a mayor trumpet virtue in public, only to succumb to vice once they'd stepped away from the microphone. When Vincentio, the Duke of Vienna, turning over the reins of government to his starchy and apparently high-minded deputy Angelo, wonders "if power change purpose," he's asking what in Washington has always been blindingly obvious. The discrepancy between public and private personas is what gives the place its fascination. The notion that an individual's pronouncements can fall into two categories — on the record and off the record — may not have originated here.

But it neatly symbolizes the often-pernicious duality of official behavior.

Michael Kahn's staging of the play for the Shakespeare Theater advances the action to the Roaring Twenties, the dark colors of Lewis Brown's costumes suggesting that a depression is not very far away. But Mr. Kahn doesn't force the comparisons with today. The production's biggest surprise is the revelation that under the peroxided wig and silken wrapper of Mistress Overdone, that fleshy bawd, lurks a large, defiant bald man in garters.

Keith Baxter plays the Duke, who no sooner leaves office than he's back, in the robes of a friendly friar, to see how his successor is doing. The performance is a little too folksy for my taste — it's always struck me that the Duke has taken lessons from Machiavelli and that a strain of sadism, not just cunning, informs his wise ways. While Philip Goodwin has got the icy prickliness of Angelo down pat — he could be a Nixon aide — he's less convincing when the virginal Isabella stirs the lasciviousness in his soul. Kelly McGillis suffers his advances bravely and, tears streaming down her contorted face, pleads an agonized case for chastity. But Isabella is basically a passive creature, and Ms. McGillis, I think, is more comfortable as those outgoing, plucky Shakespearean heroines — Portia, say, or Beatrice — who take their destiny firmly in hand and stride forth into the world, wit flying.

The only right-on-the-money portrayal, in fact, is Daniel Southern's. He's Lucio — fop, loudmouth, opportunist, survivor. Mr. Southern sports a wide-brimmed felt hat, which sets off his pale face, the two dark circumflex accents that are his eyebrows and the wide sneering mouth that makes him look not unlike the Joker in "Batman." He's doing what nearly everyone else in "Measure for Measure" is doing — working both sides of the street. He's just enjoying himself more than they are. That may be another reason why he stands out here. Hypocrisy is ingrained in the

system, but it's roundly and regularly condemned. No one admits for an instant that hypocrisy could ever be fun. ☐

1992 My 24, II:5:1

Dream of a Common Language

By Heather McDonald; directed by Liz Diamond; set design by Anita Stewart; costume design by Sally J. Lesser; lighting design by Michael Chybowski; composer and sound design by Daniel Moses Schreier; production stage manager, Jill Cordle. Presented by the Women's Project and Productions, Julia Miles, artistic director, in association with A.T. & T.: On Stage. At the Judith Anderson Theater, 422 West 42d Street, Manhattan.

Mylo	J. R. Nutt
Clovis	Mary Mara
Victor	Joseph Siravo
Marc	Rocco Sisto
Pola	Caris Corfman
Dolores	Mia Katigbak

By MEL GUSSOW

They were wives, models and mistresses and they were also artists, but the women who were among the early Impressionist painters were often slighted by their peers. In her new play, "Dream of a Common Language," Heather McDonald scrutinizes this disparity in French culture in the 1870's, when artists like Berthe Morisot and Mary Cassatt were allowed to exhibit their work but were not invited to take part in the decision-making process.

This is a fascinating idea for a play and Ms. McDonald arouses one's concern for the problems of her characters, fictionalized representations of real people. But Ms. McDonald never fully confronts the important subjects she raises, questions of art as well as feminism. Wendy Wasserstein, for one, was far more revealing dealing with related matters in passages of "The Heidi Chronicles."

Principally, it is the dialogue that lets Ms. McDonald down. The play (presented by the Women's Project and Productions at the Judith Anderson Theater) is more artificial than artful. Characters are given to making pronouncements about "inner voices" and about artists "giving away pieces" of themselves in their art. They become placards for divergent positions.

The leading male figure (Joseph Siravo), a successful artist and an organizer of the Impressionist salon, is a one-dimensional chauvinist, repressing his artist wife and certainly not convincing in terms of his own art. The women are more interestingly conceived, especially in the case of his wife.

•

As played by Mary Mara, she is soulful and poetic, but driven deep into depression by the exclusionary attitude of her society. Discouraged at all points, she has destroyed her paintings and given up her career, but remains her husband's model. In the course of the play, she reawakens to her own need for fulfillment outside of her marriage.

The plot focuses on a dinner meeting held to plan the first Impressionist exhibition. Ms. McDonald, who had once seen a painting of that event, wonders where the women are. She concludes that they are in the garden and, as men make demands on them, their activism rises. They decide to hold an alternative "soprano's dinner." That gathering, which begins

the second act, is the most telling section of the play, but it eventually dissolves into children's games and self-parody. As she did in "Faulkner's Bicycle," Ms. McDonald indicates her willingness to explore art and the politics of art, then steps back without accepting her own challenge.

Liz Diamond's production, the East Coast premiere of the play following a version at the Berkeley Repertory Theater, takes a painterly approach to its subject. Anita Stewart, as designer, has set the stage as a frame within a frame. The actors pose as if on a canvas, simulating the style if not the specifics of their role models. What leads up to it is absurd, but there is one final evocative image, of Manet's "Picnic in the Grass," with a novel reversal of male and female characters.

Through the efforts of the director and of Ms. Mara, one has a greater understanding of the author's aim: to show the plight of creative women in their time and its relevance to today.

1992 My 26, C12:5

The Richard Foreman Trilogy

Ontological at Saint Mark's Theater
Second Avenue and 10th Street
East Village
Through June 7

Three works created from previously unproduced, published writings by Richard Foreman; adapted by Spin Theater. Directed and designed by Paul Schiff Berman and Deborah Lewittes; lights, Brian C. Haynsworth; women's costumes, Zang Toi; sound, David Lawson. Presented by Spin Theater.
PART I: IN THE MIND
With: R. P. Brink.
PART II: MY FATHER WAS ALREADY LOST
With: R. P. Brink, Carol Blanco, Antonia Chiodo, Betty Anne Cohen, Sean Eden, Kay Gayner and Elisabeth S. Rodgers.
PART III: THE FIELD OF WHITE LIGHT
With: R. P. Brink and Kay Gayner.

By MEL GUSSOW

In his new book, "Unbalancing Acts," Richard Foreman defines his creative strategy as a desire to free the mind from the straitjacket of tradition. From this perspective, character, empathy and narrative limit impulse. And it is through acts of impulsiveness that Mr. Foreman puts himself and his audience in touch with primal instincts.

By serving as his own director and designer, he has added self-definition, so much so that his staging has always seemed to be inextricable from his text. "The Richard Foreman Trilogy" proves otherwise. In it, two of the author's associates, Paul Schiff Berman and Deborah Lewittes, demonstrate that divergent direction can be enlightening.

The material in these pieces (presented at Mr. Foreman's Ontological at St. Marks Theater) is drawn from his unproduced, published writings: philosophical musings on blindness, time and the nature of art. They in-

Tamara Loomis/"The Richard Foreman Trilogy"
R. P. Brink and Kay Gayner in "The Richard Foreman Trilogy."

clude references to characteristic symbols and to his muse, Rhoda, the central character in a number of his earlier plays. There is a structure, though no connective narrative, or at least none that is readily apparent. Structure is provided by R. P. Brink, the actor who inhabits all three pieces and creates a Foremanesque character, and by the use of a reproduction of the Édouard Manet painting "The Railway" as icon.

There are two figures in the painting, a woman facing the artist and a young girl, her back turned, contemplating the Gare St.-Lazare with all that it suggests about the venturesome possibilities of train travel. In the Foreman world, as influenced by Manet, "the promise would be as good as fulfillment" and the dream can become its own reality. As intended, each of the short plays is a case of "mental Impressionism." The visual imagery and the philosophical abstractions merge into nonlinear theater. Each of the three pieces becomes the equivalent of a one-act play.

As designed by Mr. Berman and Ms. Lewittes, each takes place in a strikingly disparate setting. Mr. Brink is first discovered alone on a carpet of sawdust studded with objects (lamps, a clock, toy soldiers), with which he interacts as he speaks. In the second and longest piece, the actor is in a tropical landscape to which he has wandered "under false premises." With other actors, he confronts the death of a father and related family matters. In the third, Mr. Brink and Kay Gayner take part in a courtship and ceremony in a white, curtained bower that is reminiscent of the Miranda-Ferdinand enclosure in "The Tempest."

The plays are as elliptical as they are enticing, but with several clear distinctions. The directorial austerity in presenting works of intellectual complexity is a hallmark of the author's own productions. These memoirlike explorations can be as intricate as "The Cabinet of Dr. Caligari," with sound and light often searing the ears and eyes of theatergoers while Mr. Foreman himself offers playful, sepulchral recorded commentary.

In the "Trilogy," all that has been replaced by a lushness. Clearing the stage of the monochromatic expressionism and the gewgaws (and string) associated with Mr. Foreman's staging, Mr. Berman and Ms. Lewittes show us how the text would look in an open, skyborne environment. One must remember that the romantic hue and the humor both arise from the original material. This innovative approach to Mr. Foreman's art offers its own ontological rewards.

1992 My 27, C15:1

Hauptmann

By John Logan; directed by Terry McCabe; set designer, James Dardenne; costumes, Claudia Boddy; lighting, Todd Hensley; sound, Galen G. Ramsey; production stage manager, Kristin Larsen; choreographer, Ann Hartdegen. The Victory Gardens Theater production presented by Dowling Entertainment, John Walker and Pamela Gay, Hal (Corky) Kessler and Gintare Sileika Everett, in association with Charles J. Scibetti. At the Cherry Lane Theater, 38 Commerce Street, Greenwich Village.

Lisa Ebright

Dev Kennedy, left, and Denis O'Hare in "Hauptmann."

Bruno Richard Hauptmann.......Denis O'Hare
Charles Lindbergh..................Gunnar Branson
Anne Morrow Lindbergh..........Donna Powers
Anna Hauptmann.....................Wendy Lueker
Prosecuting Attorney Wilentz.....Craig Spidle
Dr. CondonDev Kennedy
Judge TrenchardRod McLachlan

By MEL GUSSOW

The execution of Bruno Richard Hauptmann for the kidnapping and murder of the Lindbergh baby began a controversial chain of events that has continued for six decades. Since the trial there have been many books and documentaries dealing with the accused man's guilt or innocence. Hauptmann's widow, at the age of 93, is still pleading her husband's cause.

The playwright John Logan enters this legal maelstrom with his equanimity intact. His play, "Hauptmann," which opened last night at the Cherry Lane Theater, is fair-minded, marshaling facts as Mr. Logan has found them. He does not hazard

Only one verdict is clear: The judicial system was not served well.

guesses Oliver Stone-style, but encourages theatergoers to make up their own minds. Whether or not Hauptmann was guilty of the so-called crime of the century, one verdict is clear from the play: his trial was a disservice to the judicial system.

Within limits, Mr. Logan is informative, but his dramatic approach is stilted. The play and Terry McCabe's production, which originated at the Victory Gardens Theater in Chicago, seem mired in a storytelling sensibility that is reminiscent of the 1960's. Actors awkwardly mime their propless actions, such as searching a house for clues. Although Denis O'Hare is authoritative in the title role, the small supporting cast is strained by having to play dozens of characters. For all its surface modernism, "Hauptmann" compares unfavorably with overtly traditional courtroom dramas like "Inherit the Wind" and "Compulsion."

The play begins in prison just before the execution, then flashes back to the story of this German immigrant and his inexplicable involvement in the crime. It is not until the second act and the re-enactment of the trial that the play begins to have an independent dramatic life.

As we realize, Hauptmann was a victim of a faulty defense, a prosecution that apparently trampled on his rights and an aura of vengeance that turned the trial into a circus. At one point, celebrated journalists step forward with their reports: Alexander Woollcott covering the trial as if it were an opening night and H. L. Mencken proclaiming that the case was the "biggest story since the Resurrection."

While people testify against him, Hauptmann offers critical asides to the audience. In this, the most acute section of the play, the accused is revealed as arrogant and damaging to his own position. For no justifiable reason, the playwright undercuts this dramatic device and the case itself by not allowing Hauptmann's lawyer to have his turn in court. In what appears to be a quirky afterthought, Hauptmann pretends to stand in for the defense lawyer. Mr. Logan overplays his hand, as the witnesses for the prosecution are held up to ridicule, with one actor switching from caricature to caricature.

Charles and Anne Morrow Lindbergh are pictured simply as a golden couple posing for the camera, with no serious effort to explore their emotions. In a passing attempt at depicting the period, snatches of Fred Astaire songs are heard and the actors playing the Lindberghs step into a ballroom dance. With his sternness and his insistent expression of rectitude, Mr. O'Hare (in his New York stage debut) delivers an uncompromising portrait of Hauptmann. Unfortunately, that characterization is not equaled by the other aspects of the play or the production.

1992 My 29, C3:3

Marathon '92, Series C

Four one-act plays. Produced by Kevin Confoy; production manager, Andrew Kaplan; lighting by Matthew Frey; sets by H. Peet Foster; costumes by Sue Ellen Rohrer; sound by Jim van Bergen. Presented by the Ensemble Studio Theater; Curt Dempster, artistic director; Christopher A. Smith, associate artistic director; Dominick Balletta, managing director. At the Ensemble Studio Theater, 549 West 52d Street, Manhattan.

THE ONLIEST ONE WHO CAN'T GO NOWHERE. By J. E. Franklin; directed by Woodie King Jr.
WITH: Presley Edwards, Arthur French, Damon Harris and Lizan Mitchell.

BLUE STARS. By Stuart Spencer; directed by Jane Hoffman.
WITH: Eric Conger, Cecilia de Wolf and Kevin O'Keefe.

ANGELS IN THE MEN'S LOUNGE. By Oyamo; directed by Kevin Confoy.
WITH: Mark W. Conklin, Byron Utley and Gary Robert Dourdan.

JENNY KEEPS TALKING. By Lise Erlich; directed by Risa Bramon Garcia.
WITH: Leslie Ayvazian.

By MEL GUSSOW

In Lise Erlich's monodrama, "Jenny Keeps Talking," the title character is on the firing line. A tough-minded newspaper columnist, she is a victim of a change of management. In

common with Willy Russell's "Shirley Valentine," but without Shirley's congeniality, she is sitting in a room talking to a wall of silence. As articulately portrayed by Leslie Ayvazian, Jenny remains assertive even as she is fearful about her future.

Unlike the other three one-acts in Series C of the ensemble Studio Theater's Marathon, "Jenny" has insights as well as aspirations. The preceding plays, each by an experienced dramatist, follow an obvious course to a predictable conclusion.

The dialogue in Ms. Erlich's one-act is often literary, as if the character were writing rather than speaking her lines. Missing is a sense of immediacy, of someone compulsively filling an allotted space and meeting a recurrent deadline.

In spite of these factors, Jenny holds our attention with her willfulness. A self-proclaimed curmudgeon, she confesses that she lacks "full-length concentration." In three scenes, we see her before and after her dismissal from her job and when she finds sanctuary of a sort in an island hideaway. Life and love do not come easily for Jenny.

Through the combined efforts of the playwright, the actress (who keeps a harsh edge on the character) and Risa Bramon Garcia as the director, "Jenny Keeps Talking" rounds out a portrait of a character in grave emotional distress.

"The Onliest One Who Can't Go Nowhere" is a slight childhood reflection by J. E. Franklin, the author of the play "Black Girl." The sketch has the ingenuousness of teen-age fiction. In it, a youngster longs to go to a school prom but is strongly discouraged by her gruff father. Naturally, a feeling of family will prevail. Although Presley Edwards is appealing in the central role, the play is a minor sentimental effort.

Stuart Spencer's "Blue Star" aspires to wistfulness, but settles for whimsy as a repressed suburban housewife fantasizes about flight from her humdrum marriage. Mr.

Spencer has written several intriguing one-act comedies; this is not one of them.

Oyamo's "Angels in the Men's Lounge" reaches for the moon while remaining earthbound. An attendant in a lounge on a train is suddenly confronted by a man named Angel who has emerged from the Amazon jungle with Amazonian delusions.

Under Kevin Confoy's direction, the special affects and puppetry are awkwardly devised. Oyamo has been far more amusing with more rational comedic situations, as in his full-length plays "The Juice Problem" and "Fried Chicken and Invisibility."

Originally five one-acts were in this series at the Ensemble Studio. At the last minute, Frank D. Gilroy's "Give the Bishop My Faint Regards" was removed from the running after the actors withdrew from the cast.

At the performance I attended, Series C closed with a reading of the Gilroy play by the playwright and the director, Daniel Selznick, with Janet Zarish filling in as the third character. With characteristic Gilroy savvy, this is a cleverly plotted picture of a team of old Hollywood hands.

They are screenwriters like the Epstein brothers who wrote the script for "Casablanca," a film that figures tangentially in the narrative. The story focuses on the title "Give the Bishop My Faint Regards," the most famous line created by the writers, though neither of them is sure which one wrote it.

Mr. Gilroy and Mr. Selznick are not professional actors, but both are close enough to the play and to the Hollywood that inspired it to give a reading a certain veracity. Even without rehearsal, Ms. Zarish is on top of her catalytic role as a crafty interviewer.

In contrast to David Mamet's high-powered "Speed-the-Plow," Mr. Gilroy's play has an easygoing affability while making related satiric points. If it were appropriately cast and staged, "Give the Bishop" would be a pungent insider's report on peer and career pressures in the insanely competitive world of the movies.

1992 Je 2, C15:1

Theater in Review

- Call to nuclear arms.
- You take a trip. Who would expect murder? Or madness? And certainly not singing and dancing. ■ To hate.

Nebraska

Theater Row Theater
424 West 42d Street
Manhattan
Through June 28

By Keith Reddin; directed by Graf Mouen; set design by Christopher Barreca; lighting by Mimi Jordan Sherin; costumes by Connie

Singer; sound by Jeffrey Taylor; associate producer, Bob Goldberg; production stage manager, Randy Lawson. Presented by The New York Repertory Theater Company. With: Michael Griffiths, Michael Hayden, Paula Mann, Robert North, Cathy Reinheimer, Anne Torsiglieri and Jon Patrick Walker.

When Dean Swift (Michael Hayden), an ingenuous young American Air Force lieutenant, describes his work to his wife, Judy (Cathy Reinheimer), early in Keith Reddin's play "Nebraska," he solemnly declares that it is not just a job but a "duty."

Dean's assignment is to sit with a fellow officer named Henry Fielding (Michael Griffiths) in the subterranean control room of a silo outside Omaha and wait for orders to launch a nuclear missile. It being the post-cold-war era, the likelihood that the order will soon be given is extremely faint. Yet the ritual goes on, cloaked in secrecy and institutionalized paranoia. Should either Dean or Henry

shrink from turning the key when the order comes, each has been instructed to shoot the other, if necessary.

"Nebraska," which is structured as a series of short sardonically titled blackout sketches, offers a scathing satirically edged picture of a military way of life that has lost its sense of purpose since the fall of Communism in Eastern Europe. Nowhere are the boredom and despair more apparent than in the empty domestic lives of the families connected to the command base.

The play focuses on two couples, Dean and Julie, and Dean's superior officer, Jack Gurney (Robert North), and his wife, Carol (Paula Mann). In both instances, the husbands cling to their career security and their devotion to duty while their wives go stir-crazy. Julie is prone to hysteria, while Carol has affairs and drinks. The play's most chilling scenes are the domestic battles in which the husbands try to deflect the frustrated rage of wives who perceive their dead-end situations only too clearly.

Similar in its aims to Mr. Reddin's earlier plays, "Nebraska" explores the lives of everyday people swept up by history, in this case military careers made absurd almost overnight by the fall of Communism. Dean Swift is only the latest in a succession of young male protagonists in Mr. Reddin's plays who follow the rules only to suffer a rude awakening.

For the New York Repertory Theater Company production of the play, the director Graf Mouen has assembled a first-rate cast. Mr. Hayden's Dean is the epitome of a naïve yes-man whose smug sense of duty camouflages an underlying insecurity. Ms. Reinheimer and Ms. Mann chillingly distill different stages of marital bitterness. Mr. North, as Gurney, has the play's saddest role: a lifetime career officer with a milquetoast personality and a passion for opera that drives him to blast excerpts from "Tannhäuser" and "Don Giovanni" through his home.

Without bearing down too hard, Mr. Reddin makes these lives of quiet desperation a powerful and disturbing metaphor for a national identity crisis brought on by the collapse of the Iron Curtain.

STEPHEN HOLDEN

Carol Rosegg/Martha Swope Associates/"Nebraska"

Robert North in Keith Reddin's play "Nebraska," at the Theater Row Theater.

Nowhere

Ubu Repertory Theater
15 West 28th Street
Manhattan
Through Sunday

By Reine Bartève; translated by Bruno Kernz and Lorraine Alexander; directed by Françoise Kourilsky; set design by John Brown; lighting by Greg MacPherson; costumes by Carol Ann Pelletier; music by Genji Ito; production stage manager, Teresa Conway. Presented by Ubu Repertory Theater, Ms. Kourilsky, artistic director. With: Julie Boyd, William Carden, Du-Yee Chang and Stephen Mendillo.

At a deserted train station somewhere near the end of the line in France, an attractive Armenian woman named Marie disembarks late one night. In a strange yet haunting hour of murder and madness, interspersed with song and dance, Marie catalogues all the frustration and pent-up rage of generations of refugees.

Reine Bartève's "Nowhere," written and first performed in Paris in 1976, is as timely as today's headlines. With politicians calling in cartographers to redraw the maps yet again and whole populations finding themselves on the wrong side of the border, a century that has produced more refugees than any other is now multiplying their numbers at assembly-line speed.

After leaving the train, Marie separately encounters two men on the station platform. One is stereotypically xenophobic; the other wants to take her home with him. It soon becomes clear that Marie herself is more than a little unbalanced.

Miss Bartève occasionally employs a mix of cliché and rather obvious metaphor. The first man complains about all the foreigners being allowed in the country these days — "people who don't speak French" — who take all the jobs and who should be sent back where they came from. "The only way to get rid of the Armenian problem is to get rid of the Armenians," he advises as though he just thought it up on his own. He has similar solutions for "all the Jews and Arabs."

If parts of the dialogue sound commonplace, one need only read the latest party platform of France's National Front or accounts of recent attacks on foreigners in Germany. What might at first sound trite is actually the stuff of this year's political manifestoes and wall graffiti.

But there are other surprises in Miss Bartève's impressionistic play that salvage it from being a simple polemic and turn it into a troubling if somewhat obscure exercise. Not the least of them is an excellent performance by Julie Boyd as Marie. Ms. Boyd avoids turning the character into a wide-eyed naif and gives her a credibility that is sympathetic yet menacing. She is also a fine chanteuse. Stephen Mendillo and William Carden are both good as the two men who are her foils, and Du-Yee Chang plays the stationmaster.

Françoise Kourilsky, who staged the New York premiere of "Nowhere" at La Mama several years ago, has directed with a sure hand and sang-froid understatement that moves the action along and prevents the play from becoming a sermon. Genji Ito's evocative music wonderfully captures the mood of the piece.

WILBORN HAMPTON

God's Country

La Mama E.T.C.
74A East Fourth Street
East Village
Through June 14

By Steven Dietz; directed by Leonard Foglia; set design by Michael McGarty; costumes by Nina Canter; lighting by Russell H. Champa; sound by One Dream; fight choreographer, Rick Sordelet, stage manager, Christine Lemme; production supervisor, Nancy Kramer. The Barrow Group presented by La Mama E.T.C. With: Seth Barrish, Lee Brock, Marcia DeBonis, Tom Riis Farrell, Aaron Goodwin, Larry Green, Reade Kelly, Leigh Patellis, Wendee Pratt, Michael Elting Rogers and Stephen Singer.

The Barrow Group brings to Steven Dietz's "God's Country" at La Mama the kind of imaginative, tight ensemble discipline one has come to expect of this troupe. But even the great gifts of these performers, directed by Leonard Foglia, cannot always turn the author's earnest lessons into drama.

In a program note, Mr. Dietz says he has taken virtually all the lines from authentic statements of members of the Order of the Silent Brotherhood, an organization spawned a dozen years ago in the Pacific Northwest by several white supremacist groups espousing only slightly less violent racism than the Order. In 1983 and 1984, its members staged armed robberies netting more than $4 million, declared the establishment of a new all-white nation, and killed a Denver radio talk-show host, Alan Berg, in 1984 because he ridiculed them and because he was Jewish.

Eventually, most members of the Order landed in prison. Its founder, Robert J. Mathews, holed up with a huge arsenal on Whidbey Island near Seattle and was blown up when the Federal Bureau of Investigation torched his house from a helicopter.

The story is inherently dramatic, and occasionally, in this ingeniously designed and lighted production, it is spectacular. But somehow the often eloquent and terrifying statements of these lethal haters lose some of their force in Mr. Dietz's pastiche, which sometimes teeters on melodrama and falls headlong into it when he tries to alert us to the danger represented by raging skinheads. Lest we miss his point, he ends both acts with moral aphorisms, drawn from people like Voltaire and George Santayana and flashed on a backdrop.

But in between the sermons, when these actors are free to create, they become some haunting, troubling characters: a cold, flat-voiced "reformed" member of the Order who turned Government witness; a terrified F.B.I. mole in the outfit; a clear-cut couple teaching their young son to hate and kill; the taunting, sarcastic Berg and his former wife, who barely escaped being murdered with him, even two hilariously paranoid self-described "conspiratologists" on the fringe of this bloody madness. It's enough to make one wish the company had tossed away the script and improvised its own version of this fearful story.

D. J. R. BRUCKNER

1992 Je 3, C15:4

Punch Me in the Stomach

By Deb Filler and Alison Summers; directed by Ms. Summers; set design by George Xenos; lighting by Pat Dignan; sound by Mark Bennett; production stage manager, Thom Widmann. The New Directors Series presented by the New York Theater Workshop. At Theater Off Park, 224 Waverly Place, Greenwich Village.

WITH: Deb Filler.

By STEPHEN HOLDEN

Deb Filler, the robust, bushy-haired narrator of "Punch Me in the Stomach," aims for the impossible in her autobiographical monologue at Theater Off Park. Brought up in New Zealand, or "the land of no blintzes," as she calls it, she is the daughter of a Holocaust survivor. In her comic memoir, written with Alison Summers, who also directed, she interweaves her memories of growing up in New Zealand with the story of her father's imprisonment at Auschwitz.

The 90-minute monologue is an extended comic shtick in which Ms. Filler impersonates many members of her large Jewish family. She mimics accents well enough to be able to recreate a whole party of colorful relatives talking at once.

As comfortable as her childhood was, Ms. Filler says, she grew up in the shadow of her father's experience. She had an imaginary playmate with a shaved head and a number on her arm. Later, she was obsessed with "The Diary of Anne Frank." In New Zealand, her father became "a survivor celebrity," lecturing at Rotary clubs about his experiences. The monologue concludes with the story of how she and her father visited Auschwitz together and ended up collapsing in inexplicable laughter.

•

"Punch Me in the Stomach" aspires toward a grand gallows humor but never succeeds in finding the double-edged tone that might make such emotionally loaded material explode into an anguished hilarity. Although Ms. Filler has an engaging personality, the writing is too heavily larded with banal childhood and adolescent vignettes that don't have enough comic edge to be especially interesting or funny.

1992 Je 4, C12:1

Spike Heels

By Theresa Rebeck; directed by Michael Greif; set by James Youmans; lighting by Kenneth Posner; costumes by Candice Donnelly; sound by Mark Bennett; hair design by Antoni Soddu; production manager, Carol Fishman; production stage manager, Jess Lynn; stage manager, Allison Sommers. Presented by Second Stage Theater, Robyn Goodman and Carole Rothman, artistic directors. At 2162 Broadway, at 76th Street, Manhattan.

Andrew	Tony Goldwyn
Georgie	Saundra Santiago
Edward	Kevin Bacon
Lydia	Julie White

By FRANK RICH

There's still pleasure to be found in the glossy Hollywood romantic comedies of the unabashedly sexist 1950's, but it's a guilty pleasure. Entertaining as they may be, "Pillow Talk" and "The Seven-Year Itch" and even Billy Wilder's sublime "Apartment" relegate women to the

stereotypes of prig (Doris Day), bimbo (Marilyn Monroe) and victim (Shirley MacLaine). In "Spike Heels," a new comedy at the Second Stage, a young writer named Theresa Rebeck wonders if the beloved old gags of that era might be dusted off for retrograde fun even as the sexual roles are given a modern reversal. Her heroine is the smart cookie of the piece. It's the men's turn to be the virgins and tramps.

The idea is wicked and promising, but the execution is a letdown despite a sexy cast that features Saundra Santiago, Kevin Bacon and Tony Goldwyn as its principal triangle. The problem is not Ms. Rebeck's feminist agenda or her plot. As the working-class Georgie, the Boston secretary played by Ms. Santiago, bounces between her decent, bookish, chaste downstairs neighbor (Mr. Goldwyn, in the Tony Randall, Tom Ewell or Jack Lemmon role) and the slick lawyer who is her boss (Mr. Bacon, in the Rock Hudson or Fred MacMurray role), the complications are no less amusing for being familiar. And Georgie's highly developed sense of self-esteem is just the contemporary wild card to keep Ms. Rebeck's permutations on the vintage comic formulas from reaching predictable resolutions.

•

Yet "Spike Heels" is often arch and sometimes leaden. While the author has supplied some bright lines, she does not turn them out in the assembly-line volume with which George Axelrod and I. A. L. Diamond once kept such fluff afloat. The lines that are not funny frequently try to get by on scatological bombast: the proletarian Georgie pointedly swears with an uninhibited abandon that the yup-pie men cannot muster. When really stuck, the playwright takes to pounding in her points. There is too much talk about how men view women as property, or want to be in control of every situation, or try to pass themselves off as sensitive even as they are being manipulative. It's all true, no doubt, but if "Spike Heels" were really clicking as comedy, the audience would know without being lectured. Not once but at least four times are we told that the drop-dead shoes of the title are at once an emblem of Georgie's erotic appeal to men and symbolic shackles that keep her in subjugation and pain.

The play's director, Michael Greif, is best known for his Public Theater productions of dark works like "Machinal" and "Pericles," and there is little in his staging of "Spike Heels" to suggest that he might be hiding a light touch. Everyone yells too much here, especially the talented Ms. Santiago, whose Georgie looks like Gilda Radner, sounds like Mercedes Ruehl at full roar, and never strikes the springy balance between inner rage and outer eccentricity that might lend the evening a buoyant tone. To be sure, the complexity of this heroine makes larger demands than the simplistic stereotypes did, but Ms. Santiago's busy performance always seems to be shifting gears between Georgie's variously farcical and serious attributes rather than integrating them into a coherent character.

Mr. Goldwyn, whose ability to convey intelligence and tenderness onstage was amply demonstrated last season in "The Sum of Us," can do nothing with the most schematically written role in "Spike Heels," a bespectacled intellectual whose ear-

nest, ostensibly platonic concern for his unschooled neighbor is inevitably revealed to be a cover for snobbish condescension and sexual repression. In the much smaller part of his fiancée, a Beacon Hill blueblood who wears flats, Julie White makes a far more vivid impression. Rail-thin but with a broad face and features, this actress has an off-center style and piquant wit that make her a natural for high comedy of this or any other period.

•

"Spike Heels" gets its biggest lift, though, from Kevin Bacon, whose gift for wry wit has always been apparent in his stage work but has rarely surfaced on screen (Barry Levinson's "Diner" being an early and notable exception). Wearing Armani suits and a perpetual leer, his character is a scoundrel in seemingly every way. He defends drug dealers in court and, back at the office, regards sexual harassment as a silly legal nuisance rather than a serious crime. Still, both as charitably written by Ms. Rebeck at her least doctrinaire and as acted by Mr. Bacon with his tongue most insouciantly in cheek, this is one sleazy lawyer you love to hate. While he may project too much sophistication to be a Rock Hudson for our time, Mr. Bacon is at the very least our Gig Young.

1992 Je 5, C3:1

Any Place but Here

By Caridad Svich; directed by George Ferencz; set by Bill Stabile; costumes by Sally Lesser; lighting by Ernie Barbarash; sound by Alina Avila; stage manager, Jesse Wooden Jr.; production manager, Peter J. Davis. Presented by INTAR, Max Ferra, artistic director; Eva Brune, managing director. At 420 West 42d Street, West Side, Manhattan.

Lydia Jessica Hecht
Chucky Peter McCabe
Veronica Mimi Cichanowicz Quillin
Tommy.............................. Jim Abele

By MEL GUSSOW

The floor of the apartment is littered with leftovers; socks and underwear are drying on a lamp shade and Chucky is curled up as a couch potato watching pap on television. Caridad Svich's "Any Place but Here" (at INTAR Hispanic American Arts Center) wants to explore spiritual and emotional bankruptcy in contemporary society. But there is no exploration here, only a surface depiction of depressed working-class lives, with no present as well as no future.

What you see is what you see: two couples in a New Jersey town arguing vociferously while snacking on junk food. The play itself is like a bag of barbecue chips. It fills a gap but is lacking in nutrients. Intended as a black comedy, the work is bleak and unfunny.

Ms. Svich has a certain aptitude for describing people who are aimless as well as self-indulgent. This might suffice for a one-act sketch but it is unprofitable in a full-length play. Each character is mired in a rut: the childish Chucky, who does not care what he is watching as long as the television is turned on, and his wife and her best friend, who seem to live for the breaks during their workday at the factory. The friend's husband, who runs a bar that is failing, is the only one with a hint of gumption, and

he is the most mean-spirited of the lot.

Although the play is often concerned with sexual matters, the men are impotent or at least uninterested and each of the four is masturbatory. "Any Place but Here" is fueled by inertia. It could end at several junctures and come to the same nonconclusion: this dreary life continues.

In an attempt to produce adrenalin, George Ferencz has given the play an emphatic, cartoon-style production. In past seasons the director has staged several highly charged versions of early plays by Sam Shepard. But Ms. Svich lacks Mr. Shepard's inventiveness and his gift for language.

The style of performance diminishes the reality. Nothing is spoken that can be shouted. In the circumstances, the actresses have the less doleful assignments. While Peter McCabe (as Chucky) and Jim Abele are trapped by their single-edged roles, Jessica Hecht and especially Mimi Cichanowicz Quillin lighten their characters with a certain humor.

The aim may be verisimilitude, but the result verges on self-parody. Whenever anyone opens a door, a cold wind blows in, as in that W. C. Fields comedy in which it is not a fit night out for man nor beast. Indoors and outdoors, the weather is inclement in "Any Place but Here."

1992 Je 9, C13:1

The Price

By Arthur Miller; directed by John Tillinger; set by John Lee Beatty; costumes by Jane Greenwood; lighting by Dennis Parichy; sound by Douglas J. Cuomo; production stage manager, Matthew T. Mundinger. Presented by Roundabout Theater Company, Todd Haimes, producing director; Gene Feist, founding director. At Criterion Center Stage Right, 1530 Broadway at 45th Street, Manhattan.

Victor Franz.......................... Hector Elizondo
Esther Franz Debra Mooney
Gregory Solomon...................... Eli Wallach
Walter Franz........................... Joe Spano

By MEL GUSSOW

Old debts are paid in "The Price," the Arthur Miller play given a scrupulous revival by John Tillinger at the Roundabout Theater Company. In this perceptive study of possessiveness and rivalry within family relationships, an estate is settled, legacies are established and antipathetic brothers try to find a common ground. But behind everything is an aura of disunion. "The Price" is a play of recognizable human dimensions and a definite change of pace for the playwright. It is also an irresolute work, despite the series of revelations that come just before the conclusion.

In the play, the author created one of his most colorful and comic characters, Gregory Solomon, the octogenarian furniture dealer who is as judicious as his biblical name suggests, yet is wily to the core. He has come to buy the Franz family inheritance. That estate is jointly held by two brothers, one a policeman (Hector Elizondo), the other a surgeon (Joe Spano). With his crackling humor, Solomon (Eli Wallach in a flamboyant mode) runs away with the first act, then all but disappears, to be replaced by a fraternal colloquy about success and failure and family loyalty.

Mr. Wallach delights in the theatricality of Solomon, a role that can support histrionics. As he did in "Cafe Crown," he wears his stagecraft like a comfortable overcoat: the shrug, the quizzical pause and the rhetorical question that cuts to the quick. Despite his age, he is eager to return to business, especially if it means having an entire house of furniture. Mr. Wallach delivers a very physical portrait, often teetering at a humorous tilt, looking as if he might fall.

•

Led to an offstage bedroom to collect his thoughts and consider a price, Solomon is missing but not forgotten. The fact that he occasionally wanders back onstage merely stimulates our wish to have him figure more prominently in the central drama of the play.

"The Price" is bifurcated, a shrewd first act and a less satisfying follow-through. Mr. Tillinger has concealed the flaws by presenting a careful, measured production. With the help of his actors, he keeps each character as close to reality as possible, playing down the author's penchant for underlining philosophical points. Nothing is overdramatized. The director proves that he is as adept with Mr. Miller as he has been with such disparate playwrights as Joe Orton and A. R. Gurney Jr.

What gives the revival additional equilibrium is the performance of Mr. Elizondo as the policeman, the less fortunate of the brothers. He served as caretaker of his father after the older man became bankrupt during the Depression. Wandering among the family heirlooms and artifacts, the actor seems to startle himself with memories of his childhood and his abandonment of his own plans for a career in science.

The fact that Mr. Elizondo is playing a good cop only deepens the character's malaise. Approaching 50, he is frightened, with nothing to show for his life except his survivability. Mr. Elizondo uncovers the lingering dignity and the resilience that have carried the policeman through his disappointments.

•

A number of years ago the actor was memorable as the truck driver in "The Rose Tattoo" (at the Berkshire Theater Festival), as was Mr. Wallach when he created the same role in the Broadway production of Tennessee Williams's play, and there is something heartening about seeing two former Mangiacavallos parry in "The Price." It is an equal contest.

In contrast to Mr. Wallach, who remains a dreamer, Mr. Elizondo is the pragmatist, repeatedly wanting to conclude the deal and close the family album. As his wife, Debra Mooney is a constant spur. Although Mr. Miller has given Ms. Mooney platitudes to speak, she keeps the character from becoming abrasive and goes a distance in gaining the audience's sympathy.

Mr. Spano, who served many years on the police force in "Hill Street Blues," is effective as a member of the medical profession. As the surgeon, he is stalwart in his assertiveness, his ability to take charge of a situation, missing only the arrogance of a man who considers himself able to control the lives of others.

The set designer, John Lee Beatty, has filled the Roundabout stage with authentic duplications of furniture the Franz family would have collected, large, heavy pieces made to last a lifetime. As Mr. Wallach wryly ob-

serves, "With this kind of furniture the shopping is over." Given the opportunity, wise old Solomon might have been able to show the brothers the price of their self-limitations and of their mutual disaffection.

1992 Je 11, C13:1

Theater in Review

■ Surviving God's confusion ■ Quirks and other peculiarities ■ A tortured torturer.

Anna, the Gypsy Swede

Theater for the New City
155 First Avenue, between 9th and
10th Streets
East Village
Manhattan
Through June 28

By Viveca Lindfors; music by Patricia Lee Stotter; costumes by Franne Lee; lighting and set design by Vivien Leone. Presented by Theater for the New City, Bartenieff-Field.

WITH: Ms. Lindfors and Joseph C. Davies.

The title character of Viveca Lindfors's play, "Anna, the Gypsy Swede," is a kind of sentimentalized Swedish-American Mother Courage. Dressed in rustic garb and with her unkempt gray hair tied up in a black handkerchief, she clomps about the stage dragging a cart filled with possessions and tells the story of her life in a burst of emotion that lasts nearly two hours, including an intermission.

That story begins with a parable of two mice who fell into a pail of milk. One of them screamed for help and drowned, while the other began treading. In the morning the mouse that treaded "found she was on top of butter," recalls Anna, who naturally identifies with the survivor.

The play, which was inspired by a few pages from a Swedish immigrant's diary that the actress discovered and fleshed out by further research into Swedish immigration, carries Anna from Sweden to Minnesota in the mid-19th century. She survives a famine, the starvation of one of her children and a stormy Atlantic crossing during which 11 passengers perish.

The story, which lurches forward in fits and starts, is seasoned with folksy observations. "The same moon shines on every place, on everybody — it's reassuring," she observes. Or, as she puts it, when bad times come, it is usually because "God got confused."

Ms. Lindfors brings an impressive vitality and humor into a role that requires her to run an emotional gamut. She grieves, rejoices, spits, curses and tells jokes. She changes from an old woman who imagines herself young into an old woman looking squarely at death.

But her performance doesn't begin to camouflage the flaws of a rambling, episodic play that jumps forward confusedly, is unable to identify its supporting characters properly, and fails to shape its material into compelling vignettes. Far too much of the time, the play sounds like the monologue of a ravir ? eccentric who may possess an indomitable spirit but who has no idea of how to tell a good story. STEPHEN HOLDEN

A Fresh of Breath Air

Playhouse 125
125 West 22d Street
Chelsea
Manhattan
Through June 21

By Dale Stein; directed by Christopher Ashley; script and lyrics by Ms. Stein; music by Charles Goldbeck and Ms. Stein; set by Russell Metheny; lighting by Daniel MacLean Wagner; costumes by Sharon Lynch; production supervisor, Randy Norton. Presented by Randy Norton, in association with Eclipse Enterprise Productions.

WITH: Ms. Stein.

The main factor that separates a stand-up comic from a comic stage actor is one of material. In the end, the former is always telling a joke while the latter is telling a story.

Dale Stein, an energetic and able performer, wants to make the leap in her one-woman show, "A Fresh of Breath Air." She has created a disparate group of five characters and brought them together in an ill-defined cafe belonging to one, Fifi Mouloir. There is a loose narrative in which a silent and invisible writer interviews a faded actress while the others, including a street hustler and a spaced-out would-be singer, wander in and out of the cafe. But narrative in itself is not a story. And characters alone, as Pirandello pointed out, do not make a play.

Unlike Lily Tomlin (with the considerable help of Jane Wagner) or Eric Bogosian, two comedians who have transformed one-performer shows into full-blown theatrical experiences of searing and hilarious drama, there is nothing really at stake in Ms. Stein's piece and little that is engaging. The characters are faintly amusing in a quirky sort of way. Fifi, the restaurant owner who talks to her dog and the furniture, is slightly dotty; Nina, the actress with six ex-husbands and a penchant for martini olives, is slightly alcoholic; Lenny, the pill-popping, penny-ante street extortionist is slightly a nuisance, and Shane, the torch singer with a plastic brain, is slightly crazy. They are all, in short, slightly idiosyncratic.

But there's no real edge to any of these characters, no sense of danger or menace or longing or conflict or anything deeper than what one first encounters. There is nothing at risk. And despite some simulated sex in the alley and the brief loss of a diamond, nothing really happens in the course of the hour or so the audience spends with them.

This is unfortunate because Ms. Stein has a natural talent for mimicry, and she succeeds in making each of the characters distinct. If she does not move between them with the facility of Ms. Tomlin, it is not to say

The Zeisler Group/"Anna, the Gypsy Swede"

Viveca Lindfors performing in her one-woman show, "Anna, the Gypsy Swede."

that her piece is slow-moving. Apart from her own buoyancy, Christopher Ashley, her director, keeps the show from flagging. And Charles Goldbeck, her co-composer and onstage pianist, fills the gaps between wig changes with pleasant background music.
WILBORN HAMPTON

Bundy

Samuel Beckett Theater
412 West 42d Street
Clinton
Manhattan
Through June 21

By Dan Metelitz; directed by Seth Gordon; sound by Aural Fixation; lighting by Paul Palazzo; set by Allen Moyer; costumes by Yoko Metelitz; production manager, Paul King. Presented by MMM Inc.

WITH: Mr. Metelitz.

Most of the violence in Dan Metelitz's "Bundy" seems to drop from the ceiling onto the stage, or to pour out of big unseen loudspeakers. As for the real violence of Theodore Bundy's life — his serial killings of young

women and girls in various states, and his death in a Florida electric chair in 1989 — that is largely reduced to talk, reminiscence and a steady rhythm of broadcast shrieks and cries.

Mr. Metelitz, who stars in his one-character play under Seth Gordon's direction, wants to give the audience some insight into the tortured and confused soul of the serial killer in 75 minutes.

But apparently soul is not enough. A battery of gimmicks pounds at the senses throughout the play. Light and sound effects create thunderstorms, speeding cars, airports, planes in flight, whimpering dogs and babies, baseball crowds, crowds baying for Bundy's blood, and his mother's voice comforting him on death row (actually the voice of Mr. Metelitz's mother, the former actress Madaline Dalton).

The electric chair designed by Allen Moyer is a fine, lurid contraption on a steel platform. At the play's opening, it emits roiling clouds of smoke while ominous musical chords roar. And there is that fallout: a telephone drops 20 feet, smashing into a wall so Bundy can answer it; a television set crashes in pieces when Bundy tires of illusion and craves action; scores of great glass shards rain down on the stage when Bundy fears seeing himself in mirrors.

Mr. Metelitz's portrayal of Bundy fits right in: he runs, leaps, lunges, feints, mimes stabbings and garrotings, drives cars, swings at fast balls. His very few moments of silent brooding seem out of character.

None of this works. For, even with the best possible script — and this is not it — Mr. Metelitz would have tough competition: the memory of Ted Bundy, who only a few years ago was a mighty presence in print, radio and television. In him was a combination of allure, servility, distance and cold menace that might make cobras wary of getting too close. He did not have to say much to make one realize he was enormously complicated, quick and dangerous. Mr. Metelitz throughout his play is transparent, a likable man working hard to please; not harmless: he is large enough to knock people down with a punch, but no one watching him would believe he would throw one.
D. J. R. BRUCKNER

1992 Je 11, C16:3

Richard III

By William Shakespeare; directed by Richard Eyre; designer, Bob Crowley; lighting by Jean Kalman; music by Dominic Muldowney; movement by Jane Gibson; fight by John Waller; sound by Scott Myers. Presented by the Brooklyn Academy of Music, 30 Lafayette Avenue, at Ashland Avenue, Fort Greene, Brooklyn.

Richard III	Ian McKellen
Duchess of York	Rosalind Knight
Queen Margaret	Antonia Pemberton
Lady Anne	Anastasia Hille
Queen Elizabeth	Charlotte Cornwell
Lord Rivers	Alan Perrin
Lord Hastings	Richard Simpson
Duke of Buckingham	Terence Rigby
Lord Mayor of London	Sam Beazley

By FRANK RICH

WHEN Shakespeare's Richard III refuses to eat dinner until he is brought the head of the allegedly traitorous Lord Hastings, his henchmen hustle poor Hastings offstage to do the dirty deed. But in Richard Eyre's Royal National Theater production of "Richard III," transported to the 1930's and ignited by Ian McKellen's transcendent star performance, the audience's dinner is in jeopardy as well. Hastings's severed, silver-haired head, unceremoniously dumped into a red fire bucket, is soon set before Mr. McKellen, who idly pokes a worming finger into its bloody muck as if he were search-

ing its orifices for buried treasure or, worse, private pleasure.

What exactly Richard hopes to find in Hastings's head remains a mystery perhaps best left unsolved, but that strange, ghoulishly funny bit of business is typical of Mr. McKellen's uninhibited approach to the Shakespearean villain the 20th century has long since sadly recognized as its own. Without relinquishing any of the evil in the part, the actor finds some of the malicious humor in Richard that Brecht and Chaplin once found in Hitler. Neither a crookback nor sexually overheated, Mr. McKellen's king is a stunning antiheroic alternative to the archetypal Olivier image. He is something to see, and quickly, for "Richard III" is stopping at the Brooklyn Academy of Music for only two weeks before taking off on a cross-country tour.

The troupe surrounding the star, it must be said, is very much a road company. Except for some minor players, it is not the same supporting cast (then led by Brian Cox's Buckingham) that initiated this production in London two years ago, and its quality, often bland and sometimes poor, is far below the high National Theater standard visible right now at its home base in such productions as "Angels in America," "The Madness of George III" and Mr. Eyre's own staging of "The Night of the Iguana." Yet even at its worst, and even as it must battle royally with an acoustically inhospitable opera house, this cast can only dull, never obliterate, the rigorous intellectual and visual conceits that give this "Richard III" its distinct chill. Mr. McKellen's performance, meanwhile, seems to have gained in grotesque detail, only occasionally at the price of mannered excess, since its London debut.

Governing both the star and the staging is Mr. Eyre's typically inventive and very British vision of his updated setting. This is not another literal-minded "Richard III" set down in Nazi Germany or Il Duce's Italy. As sparely designed in black, white and blood-red by the superb Bob Crowley, the play unfolds in a paranoiac, inky, pre-World War II England atmospherically reminiscent of a contemporaneous Graham Greene novel like "The Ministry of Fear" or a Hitchcock movie like "The Lady Vanishes."

Interrogation lamps hang from above, faceless walls imprison the action, and fascism looms as an idea that the aristocracy is all too willing to entertain. Without being explicit, Mr. Eyre reminds the audience of how Edward VIII, Neville Chamberlain and Oswald Mosley might have pushed England into the fatal embrace of totalitarianism. As the weak, titled collaborators in Richard's criminal ascent to the throne meet at candle-lit formal dinner parties or dissemble in elegant Westminster cabinet rooms, they often share the stage with tableaux of plebeian thugs silencing those few citizens who bravely dissent.

•

It's in keeping with this scheme that Mr. McKellen is a regal English military man who is first seen marching rigidly toward the audience in uniform, braying about the winter of his discontent with the equine hauteur and dry pitch of a Colonel Blimp rather than in the addled tones of a madman. It is not until he takes off his cap or slithers in profile that we notice the deformities of his left side: a withered arm, a twisted spine and a mottled temple that recalls the gargoyle makeup of Michael Crawford's Phantom of the Opera or perhaps Jack Nicholson's Joker. Unlike most Richards, Mr. McKellen's does not truly match the physical traits others attribute to him — those of a "bottled spider," a "bunch-backed toad" — until that deep, unhinged point in the play when he is finally "so far in blood that sin will pluck on sin." It is also late in the evening when Mr.

The humor and terror in this Richard are inseparable. A cigarette dangles from Mr. McKellen's mouth at a sly Noël Cowardesque tilt even as he solicits the "happy" news of the murder of King Edward's two young sons. In the ominous Nuremberg-like rally that precedes intermission, Mr. McKellen wields a pocket Bible to adopt the public pretense of piety, then discards it with a contemptuous flick of a wrist so that he might lead the masses in a Black Shirt salute. While his Richard is, as he must be, a chameleon, faking emotions from grief to avuncularity, Mr. McKellen's highly sophisticated sense of theater and fun drives him to reveal the secrets of how he pulls his victims' strings whether he is addressing the audience in a soliloquy or not.

•

What the star cannot do in "Richard III" is show a New York audience how much his acting has grown in emotional depth in the dozen years since his last bravura performance here, as Salieri in the Broadway "Amadeus." Except for one brief (and beautifully done) mea culpa near evening's end ("My conscience hath a thousand several tongues"), Mr. McKellen is not allowed any introspection by this particular Shakespearean text, and the low, autumnal notes responsible for his triumph as Uncle Vanya at the National Theater this year remain unrevealed.

In a different way, this production offers only a small hint of the National's prowess under Mr. Eyre's extraordinary four-year tenure as its artistic leader. Not only is the stock supporting company (Miss Cornwell excepted) of this "Richard III" unrepresentative of the National, but so is "Richard III" itself only a tiny taste of the eclectic repertory fielded by the company on its three London stages. In our long winter of recession, both the National and the Royal Shakespeare Company have all but ceased to visit the United States. As Mr. McKellen's frighteningly insidious portrayal of a Machiavellian politician will make clear to a national audience in this election year, theater of this ferocious immediacy is one import this country should not do without.

1992 Je 12, C1:1

Theater in Review
Mel Gussow

■ Five aspects in search of an identity ■ Site-specific street theater in Harlem.

Balancing Act

Westside Theater
407 West 43d Street
Manhattan

By Dan Goggin; directed and staged by Tony Parise and Mr. Goggin; scenery by Barry Axtell; costumes by Mary Peterson; lighting by Paul Miller; sound by Craig Zaionz; musical direction, Michael Rice; orchestrations by Mr. Rice and David Nyberg; wig design by Carole Morales; production stage manager, Paul Botchis. Presented by the N.N.N. Company, in association with George Graham.

WITH: J. B. Adams, Nancy E. Carroll, Diane Fratantoni, Suzanne Hevner, Christine Toy and Craig Wells.

From the program for Dan Goggin's "Balancing Act," one might think this was a musical version of one of those multiple-personality stories like "The Three Faces of Eve." There are five sides or aspects to the Main Character, and each is played by a different actor or actress. One actress, Nancy E. Carroll, is cast as Everybody Else, meaning six characters, including one ominously named Dr. Sybil. Despite the apparent complexity of those credits, "Balancing Act" is simplistic and mired in familiarity.

The self-stated theme of the show at the Westside Theater is "one individual searching for identity," which in this case means an actor looking for work. The route to that goal traverses a time warp. The musical is as ingenuous as those Mickey Rooney-Judy Garland movies in which peppy youngsters created a musical in a barn.

I may be one of the few theatergoers who has not seen Mr. Goggin's "Nunsense." But I did see his 1972 musical success, "Hark!," which had charm, one of the many things lacking in his new show. "Hark!" also had

An actor finds the malicious humor that Chaplin found in Hitler.

gets what he wants by sheer gall and the relentless, shameless push of his sharp though warped intelligence. When his Richard woos Lady Anne (Anastasia Hille) over her own husband's corpse, he wears her down with sheer wily persistence and a battering-ram personality, not charm or eroticism. Indeed, Mr. McKellen seems the smartest person on stage in every scene, with only Charlotte Cornwell's Queen Elizabeth fleetingly proving an equal antagonist.

McKellen's voice at last roars at a dictator's pitch (in "I am not in the giving vein today") and his face devolves into a grinning, demonic death mask recalling the Weimar caricatures of George Grosz, not to mention latter-day photographs of Kurt Waldheim.

Since Mr. McKellen has few of a typical Richard's physical gimmicks to fall back on, and since this early Shakespeare melodrama (a tragedy in name only) does not give his part the psychological complexity of a Macbeth or Iago, he has lots of creative space in which to fashion an original characterization. Mr. McKellen fills it brilliantly by presenting a most contemporary tyrant, one who

collaborators. With "Balancing Act," Mr. Goggin is responsible for the book, music and lyrics and half the direction.

It all adds up to a double dose of déjà vu, as the hapless heroine moves from Hometown U.S.A. to New York City. In one of Mr. Goggin's old jokes, the question "Are you in show business?" is answered by "I was until I got to New York." Immediately rebuffed, the Main Character tries harder, makes it to the chorus, does an industrial show and finally has to choose between career and romance. In other words, she follows all the predictable steps while remaining locked into a barely changing platform set.

The confusion that results from splintering the character into five parts is intensified in the casting. It is one thing to suggest that the heroine has both male and female characteristics, quite another to have her played by such a diversity of actors, ranging from a petite Asian-American woman to an overweight man who looks a decade older than anyone else onstage. Presumably Mr. Goggin is saying that all theatrical experiences are similar if not identical. This overlooks racial and sexual individuality, a strange notion in a show that purports to deal with a search for identity.

Ms. Carroll's characters, defined by their wigs, are cartoons, beginning with a woman who pretends to be Angela Lansbury playing Mrs. Lovett in "Sweeney Todd." Christine Toy (as Optimistic) and Diane Fratantoni (as Sensitive) add a certain sprightliness, although it is not easy to differentiate the roles as they are written.

As for the score, it is a bland collage, as one might infer from the titles alone: "Home Sweet Home," "Play Away the Blues" and "A Tough Town." It does not help for Mr.

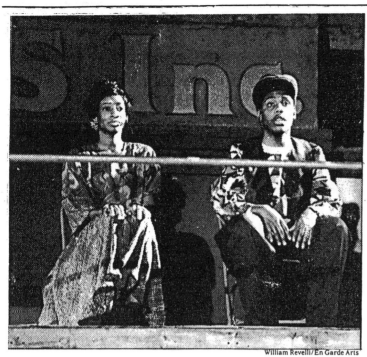

William Revelli/En Garde Arts

A scene from "Vanquished by Voodoo," at Dwyer Warehouses.

Goggin to call attention to the similarity of the songs to those in other shows, as in the opening number of the second act. Ms. Carroll sings "Welcome, Bienvenue" while telling us she is not Joel Grey.

When the Main Character arrives in Hollywood, there is a hint of humor. But it is not enough to make the trip worth the tedium. In its attempt at show-business satire, "Balancing Act" is far overshadowed by "Forbidden Broadway." Mr. Goggin shares the direction with Tony Parise, and their staging is as stolid as the show itself.

There is an additional note of interest in the program. One understudy, Merri Sugarman, is ready to play Sensitive, Optimistic and Humorous as well Ms. Carroll's six characters. All the show needs is someone to play Sneezy and Doc.

Vanquished by Voodoo

Dwyer Warehouses
West 123d Street and St. Nicholas Avenue
Manhattan
Through June 27

Written and directed by Laurie Carlos; music by Don Meissner; choreography by Marlies Yearby; set by Kyle Chepulis; costumes by Natalie Walker; lighting by Brian Aldous; sound by Tim Palmer; stage manager, Keith Jones; production manager, Michael Casselli. Presented by En Garde Arts.

WITH: Avis Brown, Dor Green, DeWarren Moses, Cynthia Oliver, Carl Hancock Rux and Viola Sheely.

For Laurie Carlos's "Vanquished by Voodoo," the latest En Garde Arts environmental exploration of New York, Anne Hamburger's intrepid troupe ventures into Harlem streets. This time the site specific is the Dwyer warehouse, a towering eight-story structure at 123d Street and St. Nicholas Avenue. With the facade ingeniously lighted by Brian Aldous, the abandoned building looks like a landmark. The play, performed outdoors, is characterized as a dance-music-theater piece, which in this case means fragments without mortar.

Once again, the En Garde Arts team of Mr. Aldous and Kyle Chepulis

(as set designer) has worked its architectural sleight of hand, making no cosmetic changes on an existing structure but reinvesting it with a theatrical immediacy. The building becomes a living sculpture. Stoves and refrigerators dangle from windows, seeming to float in space like objects on a trompe l'oeil landscape. Rhythmically, lights flash on and off in those windows.

In terms of at least momentary urban reclamation, the company did something similar with the Victory Theater on West 42d Street when "Crowbar" was in residence and with the Chelsea Hotel and the meatpacking district for other plays. This time, unfortunately, En Garde Arts does not have the dramatic material to match the site and the scenic and sound effects.

One of the original cast members of Ntozake Shange's "For Colored Girls," Ms. Carlos has also created pieces with Urban Bush Women. The current play never achieves the cohesiveness of collages by Ms. Shange and Suzan-Lori Parks. It is a random sampling: bits of dialogue, strands of music and an occasional dance, delivered by an energetic and exclamatory cast.

Ostensibly the piece deals with the sinking city and with the uses of language, or, as one character says, "making langwidge." The show analyzes the vernacular, with particular reference to varieties of food, while presenting its own langwidge problem. The fact is Ms. Carlos has little to say to her receptive audience.

That audience is very much a part of the performance, with some theatergoers arriving by special bus from Sheridan Square and others just stopping by to sit and watch or to move along to a spontaneous theatrical that may be taking place down the street. In the middle of one scene at a recent performance, a biker zipped by between the stage and the audience, as oblivious to the actors as if he were in the Tour de France.

At the same time, the real sounds of the street — sirens, car horns and boom boxes — converge with Tim Palmer's recorded sounds to create a cacophonous symphony. At stray mo-

ments, the actors interact with the audience, Viola Sheely stepping forward to ask: "Did you come by chartered bus? Is your fear intact?" The

show could use more such playful interchanges as well as connections with the evocative site itself.

1992 Je 17, C17:1

Theater in Review

■ Bobby Sands's fury and devotion to a cause
■ On the down side of a sexual obsession ■ A feisty grandmother's comic vulnerability.

Bobby Sands, M.P.

Irish Arts Center
553 West 51st Street
Manhattan

By Judy GeBauer; directed by Nye Heron; original theme composed by Brian O'Neill Mor; original music composed, arranged and produced by Mr. Mor and Nicholas Kean; set and lighting by Rick Butler; costumes by Carla Gant; production stage manager, Kurt Wagemann. Presented by the Irish Arts Center, Jim Sheridan, chairman; Mr. Heron, artistic director; Marianne Delaney, executive director; produced by Ms. Delaney and Donald Kelly.

WITH: Brenda Daly, Robin Howard, Brian Mallon, Fionna McCormac, Seamus McDonagh, Barry McEvoy, D. J. O'Neill, Donal J. Sheehan and Jimmy Smallhorne.

In 1981, after a 66-day hunger strike, Bobby Sands died in a Belfast prison. Convicted of illegal possession of arms, Sands had protested that he was treated as a criminal rather than as a political prisoner. The death of this member of the Irish Republican Army sent shock waves through Britain and elsewhere, and they are evoked again in Judy GeBauer's play, "Bobby Sands, M.P.," at the Irish Arts Center.

The play is serious-minded and polemical to the point of being one-sided. The difficulty is not so much with the politicization as with the insecure dramatization. Despite its aggrieved sense of assault on human dignity, Ms. GeBauer's work has neither the weight nor the individual characterization that would allow the play to have a life of its own. It draws its power largely from the public event and not from what occurs onstage, except for an occasional telling line (such as Sands's statement, "There is more to life than dying of old age") and for Jimmy Smallhorne's performance in the title role. The actor conveys both the character's fury and his devotion to a cause.

The play begins with Sands in prison. He is clothed only in a blanket, a result of his refusal to wear prison garb. The first act has several flashbacks to scenes of Sands and his family outside prison. The fact that the actor continues to wear the prison blanket is a damaging costume choice, weakening the effectiveness of the encounters. Back in prison in the second act, the play builds with a certain conviction, especially when Sands is faced with a last-minute plea from his mother.

Several years ago, the Irish Arts Center was host to the touring Trouble and Strife company with its collaborative play, "Now and at the Hour of Our Death," about a group of women in prison who staged a hunger

strike of their own a year before Sands's protest. In contrast to "Bobby Sands, M.P.," that play was harrowing in its intensity.

MEL GUSSOW

The Bitter Tears of Petra von Kant

85 East Fourth Street
East Village
Manhattan

By Rainer Werner Fassbinder; translated by Denis Calandra; directed by Brian Jucha; set design, Sarah Edkins; lighting design, Roma Flowers; music direction, Roberto Pace; costumes, Kasia Walicka-Maimone; Presented by Via Theater, Anne Bogart and Mr. Jucha, co-artistic directors.

WITH: Sheryl Dold, David Kellett, Tamar Kotoske, Anne McKenna, Tina Shepard, Karla Silverman, Megan Spooner, Reet Roos Varnik and Lisa Welti.

Before it was a film, Rainer Werner Fassbinder's "Bitter Tears of Petra von Kant" was a play, and to commemorate the 10th anniversary of the German film maker's death, Via Theater is reviving the stage version. The movie is better.

Written at the end of the 1960's when the sexual revolution was in full bloom and angst was all the fashion, the play is very much a piece of its time. To be sure, the pain of unrequited love is a perennial, but "Bitter Tears" is one of those I love you! I hate you! I love you! sagas that doubtless has more meaning for those who equate sexual obsession with love.

Petra von Kant is a fashion designer who, fresh from a failed marriage, starts a liaison with Karin, a young model who once might have been described as a "sex kitten." Inevitably, Karin soon decamps to pursue the rest of her life, leaving Petra to take a gin-fueled dive into the bitter tears of the title and spend the entire second act raging through a temper tantrum (except for one interlude when the action freezes and a tenor and soprano enter upstage and, apropos of nothing save to ponder the mystery of love, sing "Un di felice" from Act I of "La Traviata").

The Via staging is "site specific," which means the audience sits in a corner of Petra's apartment and watches the action with the detached proximity of, say, a plumber who finds himself in the middle of a domestic row while calling to fix a leaky faucet. There's a certain voyeuristic attraction when Petra and Karin frolic on a bed within arm's reach, but one needs to stay alert when Petra starts hurling glasses across the room.

As Petra, Tina Shepard gives an emotionally charged performance

with mixed results. Railing against all near and dear to her and slamming down the receiver on unwelcome telephone callers, she is a credible fury. But the abrupt transitions are sometimes blurred and she tends to anticipate lines. Tamar Kotoske, using nothing but facial expression and her hands, almost steals the show as Marlene, Petra's mute, adoring assistant-cum-vassal.

Lisa Welti is seductive as Karin, toying with the zipper that runs up the front of her skin-tight micro-mini and performing a slithery dance that might have been choreographed from the credit-roll of an old James Bond movie; Karla Silverman provides a fine foil as Petra's daughter, Gabi. In the duet David Kellett and Anne McKenna earn bravos, especially considering they are singing Verdi in a third-floor walk-up on East Fourth Street. Brian Jucha directed.
WILBORN HAMPTON

She Who Once Was the Helmet-Maker's Beautiful Wife

The Performing Garage
33 Wooster Street
SoHo
Manhattan

Written and directed by Peter Halasz and Seth Tillett, with "The Upper Road," "The Lower Road" and "The Clearing" by Peter Langer; music by Johann Strauss; producer, Laura Barnett; sound and lighting design, Ruud van der Akker. Presented by the Performing Garage.

Cora Fisher, Peter Halasz, Agnes Santha and Seth Tillett.

A life so grim it becomes hilarious and finally comforting unfolds in "She Who Once Was the Helmet-Maker's Beautiful Wife" by Peter Halasz and Seth Tillett. People familiar with the work of Mr. Halasz, the Hungarian-born director, actor and founder of Squat Theater and Love Theater, always expect bizarre, exquisitely imagined plays from him. But he has never more magically transformed his sometimes cruel vision into affectionate understanding than in this startling memoir of his Hungarian grandmother (played by himself).

This ancient woman, with one leg shorter than the other, is a petrified centenarian in a world intent on knocking her down, tripping her, collapsing on her and deluding her as she remembers her life in a grimy bedroom and calls out incessantly, cursing or pleading, to her grandson Peter.

It is he (played by Seth Tillett) who sits in front of the stage writing her life story, occasionally mocking her, ordering characters onstage to enact only his version of her history, and growing ever more amusingly annoyed as the story drifts away from him.

The grandmother's memories are spoken in often haunting words by an elegant young woman (Agnes Santha in the performance I saw) and her own version of her history is read intermittently by a little girl (Cora Fisher) who seems utterly unaware that it is a riotous catalogue of disasters marking the long decline of the grandmother's entire family, along with everyone else in the world.

Mr. Halasz is a comic vision of arthritic vulnerability and triumphant will power as he totters and

falls about the room, wrestles armchairs and lamps to the floor, gloats over a pile of plastic shopping bags hoarded for decades, and erects a trembling pyramid of wooden chairs on a table, groaning his way to the top of it so the grandmother can read her diary next to the dim ceiling light.

Only once do all the characters obey Peter, when at the end he orders them to tell the story again, only "with speed"; they dance a strange, awkward little ballet that, without a word, changes this tattered tale into a joyous parable about life itself. It prepares the audience for a slyly humorous kaddish Mr. Halasz sings as he tries with one gloved hand to smother the flames of a fistful of candles in the other hand; the stubborn survival of the last little light makes one want to cheer. Few people in theater now can manipulate simple images with so much wizardry, or make them so unforgettable.
D. J. R. BRUCKNER

1992 Je 18, C15:1

It's a Bird, It's a Plane, It's Superman

Book by David Newman and Robert Benton; music, Charles Strouse; lyrics, Lee Adams; directed by Stuart Ross; choreography, Michele Assaf; scenery, Neil Peter Jampolis; costumes, Lindsay W. Davis; lighting, Kirk Bookman; flying designs by Peter Foy; orchestrations, Keith Levenson; stage manager, Donna Cooper Hilton; produced for the Goodspeed Opera House by Michael P. Price; associate producer, Sue Frost; resident musical director, Tim Stella. Presented by the Goodspeed Opera House, East Haddam, Conn.

Superman/Clark Kent	Gary Jackson
Max Mencken	Jamie Ross
Lois Lane	Kay McClelland
Perry White	Michael E. Gold
Sydney	Jan Neuberger
Dr. Abner Sedgwick	Gabriel Barre
Jim Morgan	John Schiappa
The Suspects	Mark Santoro, Alexander Eriksson, Randy Charleville, Michael E. Gold and Bobby Miranda
Mustafa	Michael McCoy
The Fabulous Flying Fahzumis	Cadet Bastine, Michelle Chase, Alexander Eriksson and Mark Santoro
The Mayor	Carla Renata Williams

By STEPHEN HOLDEN

An amusing Freudian joke animates "It's a Bird, It's a Plane, It's Superman," the 1966 pop-art musical about a diabolical scheme to unman the Man of Steel. The show's archvillain, a mad scientist named Dr. Abner Sedgwick (Gabriel Barre), arranges for the city of Metropolis to be nearly destroyed while Superman attends the unveiling of a statue in his honor.

Overnight, the public hero becomes a public whipping boy, reviled in the newspapers as an egotist who would rather accept awards than do good deeds. Mortified, Superman drops out of sight. When next seen, he is a whimpering, impotent shell of his former self who believes all of his bad publicity.

It is easy to see why the show, which is playing through July 3 at the Goodspeed Opera House, in East Haddam, Conn., was chosen for a revival. Its satire of mass hero worship, media fickleness and dimwitted

Diane Sobolewski

hulks seems, if anything, more pertinent today than it did 26 years ago. The book, by David Newman and Robert Benton, gets off some good lines at Superman's expense. When asked how he got his name, he replies with a guileless cockiness, "It seemed to fit."

•

Along with some good zingers, "Superman" has a perky score by Charles Strouse and Lee Adams that brings light rock-and-roll echoes into a standard Broadway musical format.

But for all its cheer, the Goodspeed production is unfocused and overstuffed and lacks stylistic unity. The direction by Stuart Ross, who supervised the popular cabaret musical "Forever Plaid," attempts to conceal the inconsistencies of tone beneath a veneer of desperate campiness.

The most stable performances are Gary Jackson's Superman and Kay McClelland's Lois Lane. Mr. Jackson's Man of Steel is an opaque lug who wears a tight little half-smile and struts about in a padded suit with the self-consciousness of a model from a vintage Charles Atlas ad. His Clark Kent is an amusingly gangling, collapsible caricature of an oversized milquetoast. Unfortunately, Mr. Jackson doesn't have a voice to match his looks. Ms. McClelland's stage Lois is a lot like Margot Kidder's movie Lois, although not as tough.

•

If the central performances have a sly satiric edge, the supporting performances are flailingly farcical. Jamie Ross's hoofer-turned-columnist, Max Mencken, Veanne Cox's dumb-blond secretary, Sydney, and Mr. Barre's mad scientist are overplayed vaudevillian cartoons in a production that has been staged like a traveling circus.

That circus at least offers some diverting spectacle. Superman zooms onto the stage on a cable over the orchestra. And a core of actor-dancers who play the Fabulous Flying Fahzumis, an Arabian troupe of entertainers who work as strongmen for Dr. Sedgwick, do a frisky tumbling routine. But the choreography for the rest of the show is mediocre, and the stage, decorated in a drab collage of news clippings from The Daily Planet, is overcrowded.

In this incarnation, "It's a Bird, It's a Plane, It's Superman" has enough action to charm children but not enough wit to captivate grown-ups.

1992 Je 20, 16:4

Flaubert's Latest

By Peter Parnell; directed by David Saint; set by James Noone; costumes by Jane Greenwood; lighting by Kenneth Posner; original music and sound by John Gromada; dances choreographed by Paul Lester; fights by Rick Sordelet; production stage manager, William Joseph Barnes; production manager, David A. Milligan. Presented by Playwrights Horizons, Don Scardino, artistic director; Paul S. Daniels, executive director. At 416 West 42d Street, Manhattan.

Colin	Mitchell Anderson
Felix	Mark Nelson
Howard	Sam Stoneburner
Ursula	Mary Louise Wilson
Kuchuk Hanem	Leila Fazel
Gustave	John Bedford Lloyd
Louise	Jean DeBaer
Jace	Gil Bellows

By MEL GUSSOW

In Peter Parnell's first play, "Sorrows of Stephen," the hero was obsessed with Goethe and the idea of love. In Mr. Parnell's new play, "Flaubert's Latest," the hero is a Flaubertiste, the author's most ardent admirer. Where "Sorrows of Stephen" was an engaging romantic comedy with literary undertones, the new work is self-consciously literary. Although there is incidental amusement in the comedy at Playwrights Horizons, one has to sift it from the preciousness.

As a playwright, Mr. Parnell is known for his erudition; his "Romance Language" was crowded with famous authors and characters from American literature. He is knowledgeable about the arts, but he is relentless in calling attention to that knowledge.

In the opening minutes of "Flaubert's Latest," everyone from Jay McInerney to William Blake has his name invoked. Covering the cultural landscape, Mr. Parnell leaps from Mark Morris to Monet to Peter Mayle's books on Provence. Sometimes the reference is funny, as in the suggestion that J. D. Salinger has been secretly publishing novels under the pseudonym Joyce Carol Oates. But the list is as exhaustive as the boldface in a gossip column.

•

Ostensibly the play is about a young American novelist's attempt to finish writing Flaubert's unfinished novel, "Bouvard et Pécuchet." On cue, a medium, who is naturally acting as Mme. Arcati in a production of "Blithe Spirit," conjures Flaubert back to life. With a crash of thunder, the author arrives in a Connecticut garden in the company of his mistress, Louise Colet.

What results is a collision of temperaments, tastes and attitudes toward art and sex. The American novelist (Mark Nelson) is gay, and his lover (Mitchell Anderson) is a dancer and choreographer. The story is complicated by the fact that the lover is H.I.V.-positive, which is important to the characters but peripheral to the play.

Under the busy direction of David Saint, the play is a thicket of anachronisms and arguments, personal as well as artistic. Everything is enacted on James Noone's unsightly set, which looks like the world's largest and ugliest gathering of artificial flowers. Nothing wilts, and nothing is biodegradable. The air is so heady that there is no room for the characters to breathe. The playwright is a compulsive embroiderer, unable to

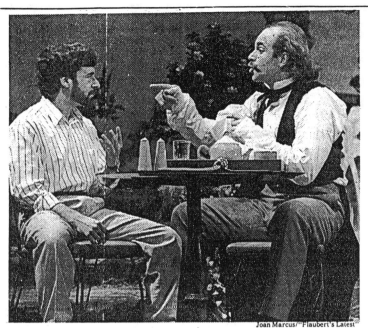
Joan Marcus/"Flaubert's Latest"

Mark Nelson, left, and John Bedford Lloyd appearing in a scene from "Flaubert's Latest," a new play by Peter Parnell.

resist topping a joke or making a topical reference.

As for Flaubert, he is so overbearing that the contemporary novelist is quick to regard him as an unwelcome guest, especially when he takes over the writing of his own incomplete book. John Bedford Lloyd plays Flaubert with a broad accent and a comic swagger. At times, he seems to be doing an imitation of Gérard Depardieu, who comes in for an obligatory mention.

The bumptiousness of Mr. Lloyd's Flaubert can be entertaining, as when he learns to love the word processor. It is, he says, "the greatest invention since the Cuisinart," a gadget he may have seen during a visit to a local mall. But some of the playwright's conceits are simply cute, as in the notion that Flaubert coined the phrase "a rose is a rose."

Mr. Parnell's cleverest invention is not Flaubert but his mistress. With the help of the actress Jean DeBaer, the often maligned Louise Colet becomes an appealing character. Though devoted to Flaubert, she is also depicted as a rising feminist and poet. With charming self-effacement, Ms. DeBaer makes her an amusing muse, someone who, given the opportunity, could inspire any of the artists onstage.

She and Mr. Lloyd share mirthful moments as they recreate their life together. But when they are absent, "Flaubert's Latest" goes precipitously downhill. With the other characters, Mr. Parnell takes a simplistic view of romance, suggesting that in any relationship one partner is a garden, the other a gardener. This symbolism provokes unintentional laughter when one is looking at the overgrown vegetation onstage.

•

The vividness of the performances by Ms. DeBaer and Mr. Lloyd is counterbalanced by the dullness of Mr. Nelson and Mr. Anderson as the modern lovers. Mr. Anderson's characterization is additionally hampered by his lumbering attempts to dance in that garden.

Watching the play, one recalls Tom Stoppard's "Travesties," which gave center stage to James Joyce, and Albert Innaurato's "Gus and Al," in which the playwright time-tripped back to the days of his idol, Gustav Mahler. In contrast to the imaginative humor in those works and in Julian Barnes's novel "Flaubert's Parrot," Mr. Parnell's attempt to humanize genius is frenzied and attenuated. Flaubert's parting words to the American are "Do not rewrite me, rewrite yourself," which is also good advice to the playwright.

1992 Je 22, C15:3

Weird Romance

THE GIRL WHO WAS PLUGGED IN, based on the story by James Tiptree Jr.

HER PILGRIM SOUL, based on the story by Mr. Brennert.

Book by Alan Brennert; music by Alan Menken; lyrics by David Spencer; directed by Barry Harman; choreography by John Carrafa; setting by Edward T. Gianfrancesco; lighting by Craig Evans; costumes by Michael Krass; sound by Aural Fixation; musical direction and vocal arrangements by Kathy Sommer; orchestrations and dance arrangements by Douglas Besterman; production stage manager, Joseph A. Onorato. Presented by WPA Theater, Kyle Renick; artistic director; Donna Lieberman, managing director. At 519 West 23d Street, Chelsea.

WITH: Danny Burstein, Ellen Greene, Jonathan Hadary, Marguerite MacIntyre, Jessica Molaskey, Valarie Pettiford, Eric Riley, Sal Viviano and William Youmans.

MUSICIANS: Kathy Sommer, conductor and keyboardist; Garth Roberts, associate conductor and keyboardist; Steve Mack, bassist; Ray Grappone, percussionist.

By MEL GUSSOW

With "Her Pilgrim Soul," the rewarding half of an evening of two short musicals grouped under the title "Weird Romance," the composer Alan Menken and his collaborators look back from the near future to the recent past. This reflective view solves a problem inherent in any attempt to musicalize science fiction.

There is no need to invent an artificially futuristic sound for the score.

The result is a melodious musical play about buried memory and reincarnation. Although Mr. Menken has written the show with new creative partners, David Spencer and Alan Brennert, it reminds one of his work with Howard Ashman. The score is closer in romantic spirit to their movie "Beauty and the Beast" than to "Little Shop of Horrors."

In contrast to "Her Pilgrim Soul," "The Girl Who Was Plugged In," the first part of the double bill at the WPA Theater, has a cruel narrative that leaves too little room for humanity.

•

"Her Pilgrim Soul," adapted by Mr. Brennert from his original short story, is concerned with a scientist (Jonathan Hadary) who is obsessed by his work to the exclusion of his wife. Suddenly one of the holograms in his laboratory comes to life and projects the scientist into a mystery that becomes a journey of self-discovery.

Drawing closer and closer, Mr. Hadary and Ellen Greene (as the holographic image) sing rapturous duets ("Pressing Onward," "Someone Else Is Waiting") leading to his discovery of the truth of their past together. During the show, Ms. Greene has to relive her life in cameo, and the actress ages from infancy to adulthood with grace and disarming humor. As the scientist opens himself to experience, Mr. Hadary warms along with his character. There is also an exuberant contribution from Danny Burstein as a loyal lab assistant.

As the hourlong show flows to its ameliorative ending, it takes a comedic sidestep into feminism as the scientist's lonely wife (Jessica Molaskey) joins a friend in an assertive declaration of freedom. Here and elsewhere, Mr. Menken's music is evenly matched by Mr. Spencer's jaunty lyrics.

The gentle certitude of "Her Pilgrim Soul" is offset by the shakiness of "The Girl Who Was Plugged In," which Mr. Brennert adapted from a Hugo Award-winning science-fiction story by James Tiptree Jr. (a pseudonym for Alice B. Sheldon). The grating tone of the show is set by the first song, "Weird Romance," sung by two characters who look like outcasts from a leather bar.

Once again, Mr. Hadary is playing a scientist, although in this case his misanthropy borders on madness. With a fiendishness, he has created a method of transmigrating souls into bodies that are empty vessels, an overly complicated plot that leads the composer, author and lyricist into a collective cul-de-sac.

Playing a homeless person in the year 2061 (some things never change), Ms. Greene has one affecting number, "Stop and See Me," which has the poignancy of "The Party's Over" as sung by Judy Holliday. But the script calls for her to spend most of the show as a waif encased in a barrel. Similar indignities are inflicted on Marguerite MacIntyre as her alter ego. William Youmans has a few funny moments as a go-between, but the other actors, especially Mr. Hadary, are trapped by their roles.

In both musicals, Barry Harman's direction is rudimentary, and Edward T. Gianfrancesco's set design

unnecessarily austere. Imaginative staging would enhance "Her Pilgrim Soul," allowing for a more effective simulation of holograms, which are so essential to the story. With that improvement and a few more songs, the musical might stand on its own.

1992 Je 23, C14:5

The Innocents' Crusade

By Keith Reddin; directed by Mark Brokaw; sets by Bill Clarke; costumes by Ellen McCartney; lighting by Michael R. Moody; sound by Janet Kalas; production stage manager, James Fitzsimmons. Presented by Manhattan Theater Club, Lynne Meadow, artistic director; Barry Grove, managing director. At City Center, Stage 2, 131 West 55th Street, Manhattan.

Bill	Stephen Mailer
Ms. Connell, Waitress, Ms. Cabot, Wendy and Helen	Harriet Harris
Karl	James Rebhorn
Mame	Debra Monk
Tommy, Mr. Clancy, Mr. Coover, Evan, Teller and Stephen	Tim Blake Nelson
Laura	Welker White

By MEL GUSSOW

As a playwright, Keith Reddin is fearless about undertaking challenging subjects — hot and cold wars, big-business corruption — always treating them in a comic fashion. Even when his plays spin off on a tangent, he retains his idiosyncratic sense of humor, a humor that is also very much in evidence when he puts on his other creative hat as an actor.

In his new play, "The Innocents' Crusade" (at Manhattan Theater Club's Stage 2), Mr. Reddin is writing in a characteristic vein, spoofing large issues, in this case youthful idealism in a time of cynicism. But this is a rambling road comedy that never reaches its intended destination. One is left with a feeling of talent expended, but not fulfilled.

There is fun along the road, provided by the playwright and his actors, under the direction of Mark Brokaw. Most notable is Stephen Mailer in the central role, a young man on a round of college interviews, following a circuitous route specified by his father. Father, mother and son are an odd team: the tradition-bound father, the mother lost in a cloud of wistfulness and the son a natural liar.

The play opens with Mr. Mailer in a college admissions office delivering a nonstop declaration of his self-designated role as polymath. He confesses that he can do everything in the arts, sciences and sports and, if called upon, he may consider holding public office. The monologue spirals toward the Shakespearean conclusion that some people are born great and others have greatness thrust upon them. In reality, the son is something quite different: a born loser. He is on his way to becoming a universal confidence man.

•

The play suddenly shifts gears when his mother (Debra Monk) casually mentions the Children's Crusade in the Middle Ages, and the impressionable young man finds his calling. He will strike out on a contemporary Crusade. On the road (still with his parents) he is joined by other would-be crusaders, beginning with a worldly and wise runaway (Welker White).

Through the highs and lows of the comedy, Mr. Mailer is a constant

source of amusement, overcoming all obstacles with a "Candide"-like confidence. Nothing seems to depress the character, not even rejection. Cheerfully he carries on. Where some actors might make the character seem annoying, Mr. Mailer is so genial about his mission and even about his egotism that he almost makes one see why others could believe him.

James Rebhorn's role as the father is one-dimensional, but both Ms. Monk and Ms. White have more to play with and each has her winning innings. Ms. Monk is sweet-tempered and Ms. White trusting without being ingenuous. Harriet Harris, as a series of impulsive characters, almost steals the show from Mr. Mailer. At one campus stop, she freely confesses her lurid past as a highly paid prostitute, a role that seems to have led most naturally to her present assignment interviewing prospective college freshmen. Later she plays a woman somehow converted to the new Crusade while watching "Alien 3" in a mall movie theater.

One keeps expecting more to come from the Crusade but all that is revealed is that it is a quest for idealism and total honesty. Otherwise it is as undefined as the stops on the road. In Bill Clarke's design, all colleges and way stations look alike as the extended family moves from motel to motel while having breakfast in identical Country Kitchens.

Another new Reddin play, "Nebraska," which ended its brief run last week, is a calculating look at the military men who control nuclear silos during a post-Soviet era. Although both plays offer sardonic commentary on contemporary society, "Nebraska" has the more sharply focused perspective.

1992 Je 24, C16:5

The Night Larry Kramer Kissed Me

Written and performed by David Drake; directed by Chuck Brown; set design, James Morgan; lighting, Tim Hunter; sound, Raymond Schilke; original music by Steven Sandberg; production stage manager, Ali Sherwin. Presented by Sean Strub, in association with Tom Viola. At Perry Street Theater, 31 Perry Street, Manhattan.

By D. J. R. BRUCKNER

Gay bars and gymnasiums are much funnier places in "The Night Larry Kramer Kissed Me" than they could ever be in reality, but the antics and attitudes of their inhabitants leave one with a distinct feeling of loss, if not sadness.

Two skits about those places, in the middle of David Drake's play, are the most memorable, enjoyable and troubling moments in what is otherwise a kind of celebratory and highly political set of sketches on gay life. In them Mr. Drake's writing is as good as his acting. Every line is spare, quick, complex; all the ideas seem self-reflective, skeptical and ambiguous.

And Mr. Drake's every movement and gesture give depth to an impressive number of characters he creates all in a few minutes. Even as he gently lampoons these gay stereotypes, his sly self-mockery invites the audience to laugh at itself, but with a bittersweet recognition that folly is

Michael Wakefield/Perry Street Theater

David Drake is the author and star of "The Night Larry Kramer Kissed Me," a series of vignettes about contemporary gay culture.

not the possession of a privileged minority and loneliness, known only to individuals, is the common lot.

The rest of this 90-minute one-man show at the Perry Street Theater has little of that dramatic density. Often it seems Mr. Drake the writer makes very heavy demands on the ingenuity of Mr. Drake the actor, especially in scenes recalling a precocious childhood in the 1960's. Many of the lines are funny, but they don't add up.

Nor does Mr. Drake seem entirely comfortable with a wholly serious subject in a scene ironically called "A Thousand Points of Light," about men he has known who died of AIDS. Formal rhetoric is not his great strength, and it can get quite intrusive here. Elsewhere in the play he makes it clear enough that to be gay now is to learn to smile in the face of death; that is a great deal more poignant than his tribute to the dead.

Running through all this is an angry, occasionally ferocious political statement about gay liberation in the age of AIDS. No one will doubt Mr. Drake's conviction and sincerity, and the sheer lashing intensity he brings to denunciations of anti-gay violence, public indifference to the pace of AIDS research and similar topics is exhausting.

Many of these themes have been made familiar in recent years by gay demonstrators, especially by Act Up, the coalition founded by the same Larry Kramer whose name gives this play its title. But Mr. Drake's formulation of them is unusually concise and comprehensive; one has to suspect that had he brought to these political statements the same kind of complex, reflective language he used in his bar and gym scenes, he would have had a much more telling effect. The kind of rage he summons up here can sometimes be effective in an Act

Up demonstration; on stage it sounds too histrionic.

1992 Je 25, C18:5

Salome
Chinese Coffee

Two plays in repertory: Sets and costumes by Zack Brown; lighting by Arden Fingerhut; production stage manager, William Hare. Presented by Circle in the Square Theater, Theodore Mann, artistic director; Robert A. Buckley, managing director; Paul Libin, consulting producer. At 1633 Broadway, at 50th Street, Manhattan.

SALOME, by Oscar Wilde; directed by Robert Allan Ackerman; choreography by Lar Lubovitch; sound by Fox and Perla.

Herod Antipas	Al Pacino
Salome	Sheryl Lee
Herodias	Suzanne Bertish
Jokanaan, the Prophet	Arnold Vosloo
Young Syrian	Esai Morales

WITH: Tom Brennan, Kermit Brown, Kevin Carrigan, Charles Cragin, Emilio Del Pozo, John Joseph Freeman, Tanya M. Gibson, Denise P. Huggins, Mark Kevin Lewis, Neil Maffin, Alan Nebelthau, Molly Price, Scott Rabinowitz, Frank Raiter, René Rivera, John Robinson, Keith Randolph Smith, John Straub and Mark Wilson.

CHINESE COFFEE, by Ira Lewis; directed by Arvin Brown.

| Jacob Manheim | Charles Cioffi |
| Henry Levine | Al Pacino |

By MEL GUSSOW

Bejeweled and spangled, Al Pacino swaggers onstage as King Herod in "Salome" and raises his voice almost to a falsetto. He does not edge into this role; he dives headlong. It is a daring performance that flirts dangerously with camp but stays strictly within the character, at least the character as Mr. Pacino envisions him.

The actor is performing the Oscar Wilde play in repertory with Ira Lewis's "Chinese Coffee" at Circle in the Square. "Salome" closes July 23, "Chinese Coffee" July 15.

In the end, his Herod is close to Caligula or Nero. He would have been right at home on television's "I, Claudius" as a maddened monarch who is so accustomed to having his way that he is stunned when someone, in this case, Salome, challenges him. He is playful in his manipulation of power; she is fiendish.

As a feat of acting, Mr. Pacino's performance may remind one of Marlon Brando's more eccentric characterizations, his foppish Fletcher Christian in the remake of "Mutiny on the Bounty," for example. But it is heightened by Mr. Pacino's own particular virtuosity and gift for black humor. It is a performance that obscures everything else on the stage. This is a good thing. Without him, the production of "Salome" would be sad news for Wilde as well as theatergoers.

Supposedly Wilde wrote the play (in French) with little thought about seeing it staged. It has survived in the Richard Strauss opera more than in the drama itself. When it is performed, it is sometimes mocked, as in the Lindsay Kemp all-male version, which came here from England some seasons ago. The play is a most questionable choice for revival, a fact that is made even more evident in Robert Allan Ackerman's production at Circle in the Square. The principal encouragements for presenting it today

would be an inspired directorial concept and a fine ensemble of actors. Neither is the case here.

•

With the exceptions of Mr. Pacino, Sheryl Lee as Salome and Suzanne Bertish as Herod's wife (and Salome's mother), the cast is a motley troupe, passable with a few of the supporting actors, insupportable with the soldiers, spear carriers and torchbearers. Mr. Ackerman's direction is effective in deploying the large band of troops and prisoners on the open stage. But there are far too many unintentional laughs, some of them provided by the ingenuous delivery of pretentious dialogue, others by the skimpy costumes.

Wilde's language ranges from the poetic to the bombastic, as when Jokanaan, the prophet (John the Baptist), fends off Salome's advances by saying repeatedly, "Back, daughter of Babylon." Undeterred, she catalogues what she loves about him (his eyes, his lips) while staring at other parts of his anatomy. All this ecstasy causes one of Salome's loyal aides to kill himself. It might propel a theatergoer to the exit were it not for the sudden arrival of Mr. Pacino. He immediately energizes the production. Ms. Lee is as lovely as she was as Laura Palmer on "Twin Peaks," although she lacks that David Lynch air of mystery, which would be helpful in this context. She is straightforward and extremely determined. Naturally, anticipation runs high as Salome's dance approaches. Unfortunately, Ms. Lee's modernistic dance, as choreographed by Lar Lubovitch, is not very sensuous, despite the fact that she removes all those veils.

Ms. Bertish stresses one note, Herodias as battle-ax, but does it persuasively. From her performance, it is very clear why Herod would like to drop her and take up with her daughter.

To Mr. Pacino's credit, he holds firmly to his conception of Herod. Considering the decadence that surrounds his court, he seems to be a man with common sense, and someone who does not want to endanger the status quo. He makes an offer to Salome that she cannot refuse. Dance for him and he will give her anything "even unto the half of my kingdom." He is astonished at her choice: the head of Jokanaan.

Anita and Steve Shevett

Al Pacino in "Salome."

Herod urges her to select another prize and lists the possibilities, from his great emerald to white peacocks to moonstones. Finally he arrives at chrysolites, chrysoprases and chalcedony. Mr. Pacino does not stumble over these tongue twisters. Nor does he allow Herod to lose his confidence even as he reaches a point of exasperation. Compelled to grant the request, he realizes, "She is her mother's child," a line the actor speaks with full irony intended. There is more to come from Mr. Pacino as he approaches his final vengeful command. He is the only reason to see this "Salome."

'Chinese Coffee'

"Chinese Coffee" is a small, naturalistic two-character play, scarcely more than a one-act sketch. Just as Mr. Pacino enlivens "Salome" with his presence, he is so intense in "Chinese Coffee" that he almost makes the work seem worthy of his talent. The actor has found a part but not a play.

In character, he looks as if he had not slept or washed in weeks. He wears layers of seedy clothing, warding off the winter cold in the manner of a homeless person. He is not homeless, simply angry: a struggling New York novelist who is tired of struggling. As the play begins, he is badgering his best friend (Charles Cioffi) for an unpaid debt and for praise for his latest manuscript. Neither will be forthcoming, but it takes time for the playwright to get to the point. As one readily surmises, the unpublished book is about the two friends and their not-so-carefree adventures.

The slim plot of Mr. Lewis's work deals with the artist's right to use material from his life and the lives of those who are close to him. The taunting interchanges become a verbal battle, but the characters do not seriously confront the central issue. They simply move from one argument to another.

"Chinese Coffee" is brewed according to formula. It does not have the two-character life of plays like Terrence McNally's "Frankie and Johnny in the Clair de Lune" (which Mr. Pacino did as a movie). Although it lasts only 90 minutes, it seems overextended. But it gives the actor impetus, and he embellishes his role with his savvy, humor and urban instincts. Fast on his feet and with his

Giving negligible plays the power of an actor's conviction.

mouth, and filled with unpredictable shifts of mood, he plays this part as if he is darting through traffic against the lights. One never knows where he will find his next opening.

Under the carefully paced direction of Arvin Brown, Mr. Pacino and Mr. Cioffi invest the show with acting panache. They become believable as duelists jabbing at each other's vulnerabilities and rising in dudgeon as the play demands. Mr. Cioffi is amusing in his bluster, but his character is hardly more than an irritant and sounding board. Mr. Pacino gives a more varied performance. He is an inventive actor even when he has so little with which to work.

1992 Je 26, C3:1

SUNDAY VIEW/David Richards

'The Price' by Miller And 'Flaubert's Latest'

In Arthur Miller's play, shopping triumphs over mercy.

'Flaubert's Latest': Garden-variety love.

WHEN ARTHUR MILLER'S "The Price" was originally produced in 1968, it flew resolutely against the temper of the day. The cry was for liberation. Sexual, political and social restraints were being vigorously contested, and here was Mr. Miller, lecturing, as is often his wont, about responsibility, morality and the price we pay for our actions.

Everywhere the past was being shed. Yet the playwright's characters, two long-estranged brothers, couldn't help dragging it up and hashing it over. One of them, Victor, a middle-aged policeman, had sacrificed a promising career and financial stability to take care of their father, a man so traumatized by the Great Depression that he ended his life sitting wanly in an armchair, staring into space. Without so much as a regret, the other brother, Walter, had stalked out the door and gone on to make a tidy fortune as a surgeon. On the pretext of disposing of their late father's furniture, Mr. Miller brought the siblings together in the attic of an old New York brownstone and let them hurl accusations and recriminations at each other.

In the age of Aquarius, the play's concerns seemed unduly stern and Mr. Miller something of a bore for raising them. His insistence on the lingering psychological and spiritual effects of the Depression was beginning to look like a fixation. Surely the rest of us were well beyond that catastrophe, even if the playwright wasn't.

Well, it's 1968 that now seems light years away. If you drop by the Criterion Center on Broadway, where "The Price" is enjoying a proficient revival by the Roundabout Theater Company, Mr. Miller's play seems more pertinent than it has ever been. Oh, its carpentry may be less than felicitous, and the tumble of revelations in the final half hour is still too neatly engineered. But the characters no longer seem swept up in some Great Moral Debate. In light of the current recession, they are dealing with worrisome specifics — the cold fear that losing a job can instill in a person, the terrifying threat of homelessness, the dashing of ambitions.

How, they wonder, do you accommodate yourself to a society that breeds such ills? What lies do you tell yourself, what fictions do you invent, to survive? And how much do you owe a helpless parent, when he may have a bankroll secretly stashed in the mattress? Those are no longer abstract issues for a lot of us. We have a real stake in the answers Mr. Miller's characters are groping for.

There was, in fact, a moment in the second act of the Roundabout production when I realized that the auditorium was eerily quiet and the audience listening raptly, even though the play's big explosions were minutes away. Hector Elizondo, who portrays Victor, was simply remembering the dismay he felt over the collapse of his father and the unfathomable laugh, which was all the bewildered patriarch had left to hurl in the face of adversity. "I didn't know what I was supposed to do," the actor was saying, in that sandpaper voice of his that sounds both weary and angry. "And I went out. I went over to Bryant Park behind the public library. The grass was covered with men. Like a battlefield; a big open-air flophouse. And not bums — some of them still had shined shoes and good hats, busted businessmen, lawyers, skilled mechanics. Which I'd seen a hundred times. But suddenly — you know? — I *saw* it. There was no mercy. Anywhere."

The pin-drop silence in the hall seemed to be acknowledging not just the truth of the actor's performance — it's a highly persuasive one, by the way — but the reality he was describing. That reality is with us again. Bryant Park may have since been refurbished. But equivalent scenes can be found all over the city. Garbage cans are rifled for food. Mercy is in dwindling supply. No wonder the hush.

Ironically, "The Price" also contains the most robust comic character in Mr. Miller's

canon — 89-year-old Gregory Solomon, who has been brought in to appraise the massive furnishings and whose despairing shrug immediately suggests that the figure will be disappointingly low. "What is the key word today?" he asks. "Disposable. The more you can throw it away the more it's beautiful. The car, the furniture, the wife, the children — everything has to be disposable. Because you see the main thing today is — shopping." Although Solomon's shrewd presence helped substantially to make the play a hit the first time around, the passing years have enhanced the accuracy of his observations, too. Eli Wallach, looking like a kindly Swiss watchmaker in a Disney cartoon, waxes philosophical with a wavering Russian-Jewish accent perhaps, but the relish he takes in the part is undiluted.

On other fronts, the casting is less noteworthy. Neither Debra Mooney, Victor's frustrated wife, nor Joe Spano, who plays Walter, meets the full emotional demands of those roles. There is, I think, more raw power in

"The Price" than is being unleashed at the Roundabout. But if the production never knocks you over, it never lies to you. The sobriety of John Tillinger's direction checks Mr. Miller's tendency to pontificate and lets you draw the inevitable parallels with today on your own.

"The Price" was not ahead of its time in 1968 — merely *between* its times. The legacy of the 1930's was remote for many, a bitter but fading memory, and the freewheeling 1980's had yet to wreak their havoc. After a decade of economic recklessness, though, we do seem to be disturbingly in sync with the play. And Mr. Miller makes this much clear: one way or another, the bills will be paid. The piper never gets stiffed.

'Flaubert's Latest'

If it weren't for Gustave Flaubert, Peter Parnell's latest play, which happens to be titled "Flaubert's Latest" (at Playwrights Horizons), would be just another sappy romantic comedy about an author who's having trouble completing a new novel and getting along with his male lover.

But Flaubert, the brooding French novelist, is very much a part of the proceedings. Materializing out of the 19th century with his mistress in tow, and plopping himself down in a flourishing garden in Litchfield County, Conn., he turns "Flaubert's Latest" into something more: a sappy, *pretentious* romantic comedy.

There are reasons for Flaubert's sudden, startlingly windblown appearance on the doorstep of Felix, Mr. Parnell's blocked author. Felix (Mark Nelson) is struggling to complete "Bouvard et Pécuchet," the very novel Flaubert sweated over for eight arduous years and then abandoned. Flaubert also had a long and tortured liaison with that mistress, Louise Colet, whom he dubbed his muse, although he treated her abusively and generally preferred the company of other women or, better still, his own characters. Felix, it appears, is so absorbed in his art that he, too, has been neglecting his companion, Colin (Mitchell Anderson), a modern dancer and choreographer. Flaubert is bound to be of assistance

in a couple of areas here, if he can bring himself to calm down for a minute.

■

I'll grant you that Mr. Parnell is aiming significantly higher than last season's amiable "I Hate Hamlet," the Paul Rudnick comedy in which the ghost of John Barrymore counseled an aspiring actor on the ways of courtship and Shakespearean acting. Having said that, though, I'm obliged to admit that "Flaubert's Latest" tumbles considerably lower. It wants to make all sorts of pronouncements on the demands of art and love; on a writer's unique relationship to his times, his work, his libido; on the repercussions of AIDS (although the epidemic is never overtly mentioned) and women's lib. The literary name-dropping alone is enough to qualify as littering. As a result, a fanciful conceit proves anything but fanciful in practice.

Reference is made, naturally, to Noël Coward's "Blithe Spirit." In fact, the medium (Mary Louise Wilson) who brings Flaubert and Louise into the 20th century has been cast as Madame Arcati in an amateur production of "Blithe Spirit" and is busy learning her lines when she's not going into her trances. Mr. Parnell, however, has written "Shrill Spirit." Once his characters have registered their surprise at finding themselves in one another's company, the garden echoes with the sounds of old squabbles renewed, injured feelings reinjured and the kind of nasty charges that lead to a slap in the face, if not a pistol shot in the arm.

Neither couple is having an easy go of it, and literature isn't the only thing that's complicating their lives. A handsome young gardener (Gil Bellows) has his eye out for Colin, while the Egyptian belly dancer Kuchuk Hanem (Leila Fazel), who has tagged along for the ride out of the 19th century, wouldn't mind wrapping her limbs around Flaubert again. So much jealousy. So much anguish. So much artistic temperament. So little wit.

When, after all the teapot tempests and an epileptic fit, Flaubert prepares to return to the 1850's — taking

When the French novelist goes shopping, he discovers joy at the mall.

the best of the 20th century, a computer and a Cuisinart, with him — his parting words are decidedly anticlimactic. "Write *your* own book," he instructs Felix. "And do not sacrifice your love. Never, never sacrifice that." And have a good day, while you're at it.

Mr. Parnell, although fully to blame for the script, is not wholly responsible for the debacle on the stage of Playwrights Horizons. The production has been inadequately cast and is charmlessly directed by David Saint. The bearded Mr. Nelson, not an unappealing actor, comes across here as a pint-sized version of Stephen Sondheim on a rotten day. Any belief you may invest in Mr. Anderson as a modern dancer is sorely tested each time he leaps into the air or twirls across the grass. Still, that's nothing compared to the assault that John Bedford Lloyd makes

on credibility as Flaubert. Since the part is written in French and English, an acute ear might be thought a prerequisite for the role. Mr. Lloyd, alas, has no detectable command of French, and when he speaks English, his Gallic accent proves unaccountably Nordic. Hair flying, chest barreling, he clunks about the stage — unintelligible for much of the evening.

Jean DeBaer is marginally more proficient in the language of Molière, but hers is a frivolous portrayal of Louise Colet, pitched too high to command much sympathy, and those bouncing sausage curls certainly don't do a lot for her sharp features. Literature breeds strange bedfellows, no doubt, but you can't help wondering why Louise keeps clinging to Flaubert, or why Colin, for that matter, doesn't throw over Felix. If it is Mr. Parnell's contention that writers can be difficult, he can't mean them to be such outright boors, can he?

In what may or may not be an act of solidarity, the play's excesses are perfectly embodied by James Noone's florid set choked with zinnias, roses and hydrangeas, all in riotous bloom. "Oh, look, it's 'The Secret Garden,'" proclaimed a wit seated behind me. "The Secret Garden" on steroids is more like it. ☐

1992 Je 28, II:5:1

Theater in Review

◼ A comedy double bill inspired by Chekhov and the Yiddish theater ■ A man who wins $10 million, the people who love him and how they all change.

The Last Laugh

Jewish Repertory Theater
344 East 14th Street
Manhattan

Two one-act comedies by Michael Hardstark; directed by Lou Jacob; sets by Rob Odorisio; costumes by Teresa Snider-Stein; lighting by Brian Nason; production stage manager, Nina Heller. Presented by Jewish Repertory Theater, Nina Heller, managing director; Ran Avni, artistic director.
IN THE CEMETERY, based on Anton Chekhov's story "In the Cemetery."
WITH: Adam Heller, Ron Faber and Larry Block.
THE CURE, based on Anton Chekhov's story "A Cure for Drinking."
WITH: Larry Block, Nick Plakias, Barbara Spiegel, Adam Heller and Ron Faber.

In this age of seemingly unslakeable thirst for backstage gossip, picture this: a big star from New York theater drunk backstage in Cleveland while the audience waits out front. He nuzzles the women's costumes; he passes out; he wakes to call for vodka, to play all the roles in some wacky drunkard's-digest version of a spavined romantic drama, and in his spare time, to grope for the buxom actress-wife of the theater company's harried actor-impresario.

That bedeviled ham, for his part, must contend not only with his sodden box-office draw but also the prospect that if the curtain doesn't go up on his imported star, it is going to come down on his company. And to compound the chaos, there is a young actor who is eager for better roles, has written a play he'd like the impresario to read and wants to tell a little story about teaching a czar's horse to talk.

Can a horse talk?

To provide the answer, there is "The Cure," the delightfully frenetic bonbon written by Michael Hardstark and directed with verve by Lou Jacob that is the second part of their twin bill of comedy titled "The Last Laugh," being presented by the Jewish Repertory Theater.

More than a few big names might accurately be attached to the bottled-in-bond star lampooned in "The Cure." But the action unfolds in 1908, and the talented drunk is the inventively named Yossel Terrifimenschsky, an import from New York's flourishing Yiddish theater. As played by Ron Faber, he is an engaging troublemaker who can sorely vex his colleagues while managing to have the audience rooting for him to shake off his stupor, cut short his binge and light up the stage.

As the young actor Simcha Gruber-nick, Adam Heller neatly carries off a multifaceted role that allows him to make his entrance bearded and in Orthodox Jewish costume, to reveal himself as the clean-shaven immigrant author of the realist drama "The Kesslers of Hester Street" and later to pass himself off as a dandyish charlatan from Warsaw. And Larry Block manages to make merry with the torment of the actor-impresario, Prof. Leo Broder, who must cope with the alcoholism of Yossel and the determination of Simcha as well as the distractions of his outspoken wife (Barbara Spiegel) and his ineffectual brother, Morris (Nick Plakias).

Mr. Heller, Mr. Faber and Mr. Block also turn up, acquitting themselves ably but with less panache, in "In the Cemetery," the occasion's comparatively subdued curtain-raiser. Like "The Cure," it evokes the Yiddish theater and has been adapted by Mr. Hardstark from a Chekhov story about coming to terms with life and death. And like "The Cure," it bears the stamp of the talents of Rob Odorisio, Teresa Snider-Stern and Brian Nason, who deftly provide, respectively, the production's sets, costumes and lighting.

LAWRENCE VAN GELDER

Lotto
Experience the Dream

"Lotto: Experience the Dream," originally produced by the Billie Holiday Theater in Brooklyn, has reopened at the Union Square Theater, 100 East 17th Street, in Manhattan. Following are excerpts from D. J. R. Bruckner's review, which appeared in The New York Times on Dec. 26, 1991.

Every situation in Cliff Roquemore's "Lotto: Experience the Dream" is familiar, and virtually every line could be picked out of the air from any week's television fare. But surprisingly, it all works quite well;

laughter builds until, at the end of two hours, the audience is shouting. Mr. Roquemore creates the impression he simply got together an exuberant group of actors, told them to clown around and then wrote around them. That illusion draws in the audience.

The title tells the story. A middle-aged water department worker in Los Angeles wins $10 million in the lottery with numbers that came to his sister in a dream. The money not only changes him and his friends, but also his sister, his sons and daughter and their friends.

What happens scarcely matters; the characters are everything. Earl Fields Jr., as the lucky water worker, suffers wonderful frustrations as he tries to assert authority over grown children who have never heard of control. Maurice Fontane as his friend Lester would be a stock comic-relief man except that Mr. Fontane has a way with repartee that always makes any character he plays seem like a disguised spirit dropped on earth by a benign divinity to make people laugh at their own misfortunes.

Bryan Roquemore as the oldest son is a lazy dreamer constantly tripping over his own schemes. Karl Calhoun as his teen-age brother is a fine bundle of rap, raunch, resentment and ridicule. Elise Chance as their sister seems far too sane to belong to the same brood, until her own sense of superiority makes her ridiculous.

By far the most uproarious member of this disaster-prone clan is Aunt Mildred, played by Jessica Smith. Ms. Smith has a voice that outwails fire sirens, dance steps that give one a whole new insight into, and respect for, cantilever construction and a comic gift that lets her turn her character's physical disabilities into hilarious burdens on those around her.

1992 Jl 2, C16:1

SUNDAY VIEW/David Richards

Pacino's Star Turn Reflects the Glories of Rep

'Salome' and 'Chinese Coffee' at Circle in the Square are a pretext for Al Pacino to dazzle and mesmerize.

I CERTAINLY RELISHED AL PAcino's performance in "Salome," just as I relished his performance in "Chinese Coffee." But what I found most satisfying was watching him in "Salome" *and* "Chinese Coffee."

Mr. Pacino is currently appearing in both plays at Circle in the Square on Broadway. One night, he wraps himself in gold jewelry and luxurious fabrics, as King Herod, a potentate of some renown. A few nights later, he's Harry Levine, a Greenwich Village novelist of no reputation whatsoever, and he's wearing a threadbare black raincoat and a shapeless Mexican sweater.

The double bill has been conceived as a fund-raiser for Circle in the Square, which, like most not-for-profit theater companies, has some bailing out to do at the end of the season. Although tickets are a flat $50, Mr. Pacino is proving a big draw. By the time the run is over on July 23, Circle in the Square estimates that an accumulated debt of $1.2 million will have been reduced by about $200,000.

So you can say the primary mission has been accomplished.

■

It strikes me, however, that the enterprise is helpful in another way — less immediately pragmatic, perhaps, but equally important in the long haul. It serves as a vivid reminder that there is no better measure of an actor's gifts than repertory theater. If you want to know just what a performer can do, let him play Hamlet on Tuesday and Biff Loman on Thursday. Or, in Mr. Pacino's case, a king, then a pauper. Back-to-back characterizations will expose any tricks and mannerisms in a flash. But they also reveal the stretch and breadth of an actor's talent in no equivocal terms. Theatergoers are given the increasingly uncommon opportunity to measure a performer against himself, not against fuzzy memories from prior seasons.

I won't pretend that either "Salome" or "Chinese Coffee" amounts to more than a pretext for Mr. Pacino to dazzle and mesmerize, although the former work is not without historical interest. Written originally in French, it is Oscar Wilde's ornate and overheated elaboration of the fairly straightforward biblical story. Rebuffed by the prophet Jokanaan (John the Baptist), Salome promises to dance her famous dance for Herod if afterward he will grant her whatever she wishes. He agrees. She sheds her veils, then demands — and receives — Jokanaan's head on a silver shield. Sarah Bernhardt was said to be impressed enough to think of putting on the play in London, which prompted Wilde to envision huge braziers of perfume on stage feeding heady scents into the auditorium in lieu of orchestral accompaniment. That should give you an idea. What Aubrey Beardsley is to the art of illustration, "Salome" is to the art of drama.

Ira Lewis's "Chinese Coffee," on the other hand, is a lean, contemporary two-character comedy, set in a dumpy photography studio belonging to one Jacob Manheim (Charles Cioffi). Manheim used to take pictures of soused nightclub patrons for a living and now shoots theatrical portraits. He's had exactly four customers in six months and business is slowing down. Looking like something the cat wouldn't drag in, Mr. Pacino shows up in the wee hours as the would-be writer Harry Levine. Ostensibly, he's come to claim the $473 Manheim owes him, but he really wants to hear what the photographer thinks of his new novel, a thinly veiled account of their friendship. Not a great deal, it turns out. By the night's end, the relationship has been irreparably damaged. Mr. Lewis's point would seem to be that failure, not success, goes to a person's head.

If you tried hard, I suppose you could make a case that the two roles are somehow related, that Mr. Pacino is showing us power and powerlessness in action. Or that a deep-seated neuroticism governs the conduct of both Herod and Harry Levine. But it wouldn't

be a very persuasive case. The actor himself is the only common denominator here. As directed, respectively, by Robert Allan Ackerman and Arvin Brown, his performances constitute a virtual about-face.

Early in the evening, Salome refers pointedly to Herod's "mole's eyes under his shaking eyelids," but it is Mr. Pacino's lips that are likely to draw your attention, when he drifts out of the banquet hall and onto the moonlit terrace where Wilde's play takes place. They're smeared with red, as if stained by gluttony or a drunken makeup man. Smacking his swollen chops and chewing constantly on his saliva, as old people sometimes do, Mr. Pacino suggests that years of self-indulgence have left a bad taste in his mouth and it won't go away.

He has untempered scorn for his servants and subjects — not unlike that of the interior decorator for cheap home furnishings. They offend his sensibility, even as they confirm his own sense of superiority. When told that someone calling himself the Son of Man has been raising the dead, he seems to object on grounds of taste alone. Changing water to wine is one thing. "But no man shall raise the dead," he insists, laying a spidery hand to his breast and turning up his nose in squeamishness. "It would be terrible if the dead came back."

The voice, although pitched sharp and high, is weary, as if it had barked entirely too many commands for one lifetime. The body, by contrast, is soft and effeminate. During the frenzied dance of Salome (Sheryl Lee), Mr. Pacino lets himself slump so far down on the throne that it could be a bed. The posture says he couldn't be more bored, but you'll notice his eyes don't leave her for a second. If petulance makes this king highly comic, it never makes him ineffectual. Under the run-

ning mascara and poses of dissipated grandeur lurks a despot who's biding his time before giving the order that brings the play to a chilling conclusion.

■

In "Chinese Coffee," Mr. Pacino is pretty much on edge all night long. If he's not running a nervous hand through his hair or grinding his teeth to chalk or trying to quiet the muscle spasm in his right leg, he's feeling the equivalent of red-hot nails in his intestines and persuading himself it's a heart attack. Let him sit at the beat-up kitchen table and bury his head disconsolately in his hands — his foot continues to dance a jittery little jig on its own.

Here is a man who can't fall asleep at night (Herod can't stay awake), whose thoughts are a muddle (Herod knows just what he thinks, even if he's not telling), who has accepted the indifference of others as his lot (Herod invites toadying). In short, a pasty-faced nobody, past his prime at 44, abandoned by his lover, with only the manuscript of a mediocre novel to pin his hopes on. And his best friend is telling him snidely, "Your idea of success seems to be to make it all the way up to the national poverty level."

By rights, Harry Levine should crumble there and then. But way down inside, where Herod's meanness slumbers, the writer has a nugget of self-respect. His novel may be lousy, but still he wrote it, got it off his chest, and that's more than the bitter photographer can boast. Just before he's thrown out of the studio for keeps, a crooked smile breaks over Mr. Pacino's face: he has suddenly realized that he's not shaking anymore. As dramatic revelations go, this is not a big one. "Chinese Coffee" doesn't ask a whole lot of its charac-

Photographs by Anita and Steve Shevett/"Salome" and "Chinese Coffee"

Mr. Pacino, as Herod, with Sheryl Lee in the title role in "Salome," and, right, the actor and Charles Cioffi in "Chinese Coffee"— From the paralysis of depression to table-pounding fury in under six seconds.

ters, other than that they get on each other's nerves.

■

Well, Mr. Pacino's tics are undeniably amusing, but the fascination of the performance lies elsewhere. While you're certain he's got a snapping point, you're never sure when or how he's going to erupt. The verbal uppercut causes no visible reaction, and he suffers the insulting right to the jaw without flinching. It's only later, in the middle of a seemingly innocuous reply, that the anger breaks through to the surface, dragging a lot of surprised words along with it. The actor can go from 0 to 60 mph — from the paralysis of depression to table-pounding fury — in under six seconds.

Did I say Mr. Pacino's two performances have nothing in common? I take it back. In both roles, the actor demonstrates an uncanny ability to communicate the gathering tension in characters who, to behold them, appear merely discombobulated or spent. (Even as Herod is sinking into a kind of heavy-lidded indolence, his patience is growing dangerously short.) The outburst of emotion — whatever it may be — comes as a *delayed* reaction, and catches you completely off guard. That's why it's so hard to take your eyes off the actor. He's a master of the sneak attack, and you don't want to be looking elsewhere when he strikes.

Maybe this would be just as obvious if he were performing in a single play, not two. But I doubt it. Plays and players really are better off in clusters. Put them side by side, they'll talk to one another. Interactions occur, connections get made. And everybody's vision is sharpened by the process.

As a rule, our theater doesn't make comparisons easy. If actors don't belong to an established company — and most don't — we see them all too infrequently in the flesh to indulge in fruitful discussions of their craft. When they become successful, they head to where the more lucrative work is — television or the movies. If they come back to the boards, it is usually for a limited engagement. They may not have lost their feel for the stage in the interim, but we tend to lose our feel for *them* on a stage. No sooner have we all begun to renew acquaintance than they're packing their bags.

I don't know when Gene Hackman, Richard Dreyfuss or Glenn Close will be back on Broadway again. While their performances in "Death and the Maiden" are still fresh in my mind, though, I'd be eager to see them assume other guises, undertake other confrontations. Jessica Lange was not critically well received in "A Streetcar Named Desire," but I hope that doesn't mean an end to her theatrical career. I, for one, still have questions. How much of her portrayal of Blanche Du Bois was instinctive behavior? How much the result of deliberate and conscious choices? There will be no hard answers until we are permitted another look at her in different theatrical surroundings.

To my mind, one of the most exciting performances last season was Jane Alexander's as Claire Zachanassian, the world's richest woman, in "The Visit." The actress was virtually unrecognizable in the part. I can say that confidently because Ms. Alexander has been better than most about showing her face regularly on the stage over the years.

The time, however, when Broadway had its stable of faithful stars, who returned each season in a new play, belongs to history. Continuity of any kind is rare these days. That's why Mr. Pacino's double-header at Circle in the Square is such a welcome reminder. One of the reasons we go to the theater, after all, is to watch actors act. The play doesn't always have to be the thing. If it did, the Lunts

wouldn't have had a whole lot to show for themselves and the decades of barnstorming.

■

Unfortunately, there is a serious hitch to repertory theater. It is enormously costly to keep whole casts and sets at the ready so they can be changed every few nights. While that is the practice at all the great theaters of the world — from the Comédie Française to the Royal National Theater of Britain — it is one we have never been able to implement for long in this country before the money runs out. Without healthy subsidies, it's no go, and we're all aware of the current state of governmental largesse.

The ultimate irony is that in order to relieve the economic pinch, Circle in the Square has resorted, however briefly, to repertory theater. You have to applaud the company for the gesture. Just because we can't afford a theatrical ideal, doesn't mean we should forget it altogether. □

1992 Jl 5, II:5:1

Dr. Faustus Lights the Lights

By Gertrude Stein; production conceived, designed and directed by Robert Wilson; assistant directors, Ann Christin Rommen, Claudia Bosse and Christoph Roos; music by Hans Peter Kuhn; lighting by Heinrich Brunke and Andreas Fuchs; dramaturge, Peter Krumme; choreography, Suzushi Hanayagi; costumes, Hans Thiemann, Andreas Auerbach, Anja Duklau, Marie Juliane Friedrich, Peter Pelzmann and Petra Peters. Presented by Lincoln Center for the Performing Arts in association with IPA/International Production Associates. At Alice Tully Hall.

Dr. Faustus
Thilo Mandel, Christian Ebert, Thomas Lehmann
Mephisto in Red Heiko Senst
Mephisto in Black Florian Fitz
Marguerite Ida and Helen Annabel
Katrin Heller, Wiebke Kayser, Gabriele Völsch
Little Boy Matthias Bundschuh
Dog .. Karla Trippel
Boy ... Christian Ebert
Girl .. Wiebke Kayser
Country woman Martin Vogel
Mr. Viper Moritz Sostmann
Man from over the seas Thomas Lehmann

By STEPHEN HOLDEN

When Gertrude Stein created "Dr. Faustus Lights the Lights," her whimsical play based on the Faust legend, she made the invention of the light bulb the brilliant central metaphor for the human assumption of godlike powers. And in the director Robert Wilson's staging of the 1938 play, which opened a three-night run at Alice Tully Hall on Tuesday as part of Lincoln Center's Serious Fun festival, the director has dug deeply into his bag of lighting tricks to illustrate the concept with some striking visual effects.

There are scenes in which the cast of English-speaking German actors from the Hebbel Theater in Berlin sit perched on bars of light that move slowly up and down and in seesaw motion through the air. Windows appear at the rear of the stage, change shape and color, then shrink and vanish. Banks of light bulbs float onto the stage and flare and dim with the

Johan Elbers

Karla Trippel as the dog in the play "Dr. Faustus Lights the Lights," at Alice Tully Hall on Tuesday.

changes in the language's emotional temperature. And when one character is bitten by a viper, a crimson crevice rips through the black rear curtain to the accompaniment of piercing electronic shrieks.

•

But if Mr. Wilson illustrates certain moments of the text in flashy ways, as is his wont, he doesn't attempt to impose a conventional interpretation on the work, which was conceived as a musical libretto but found no composer. His essential technique has always been to create a semi-abstract landscape for a piece, letting the text speak mostly for itself, while evoking mystery and surprise from the friction between the words and his broad theatrical concepts. And with Stein, whose open-ended exploratory sensibility and use of repetition foreshadowed modern-day Minimalism, he is playing against a sensibility that is closer than usual to his own. While the 90-minute work does not have the epic scope of "Einstein on the Beach," it is still solid, middle-level Wilson that will please his admirers and bore those looking for theater with more literary content.

Because the Stein play is a frolicsome, Cubist-inspired look at the Faust legend, Mr. Wilson has given the principal roles multiple interpreters. The title role is shared by three actors (Thilo Mandel, Christian Ebert and Thomas Lehmann). There are two Mephistos — one in red (Heiko Senst), the other in black (Florian Fitz) — and three Marguerites (Katrin Heller, Wiebke Kayser, and Gabriele Völsch).

The main characters are upstaged in this production by two subsidiary figures who provide light comic relief. Martin Vogel, wearing a frowzy red wig and a white gown and mechanically raised to eight feet tall, portrays a country woman who appears brandishing a sickle. He bears a marked resemblance to the performance artist Ethyl Eichelberger in one of his diva roles. Karla Trippel, a diminutive actress who wears a man's suit and has her hair in a short, floppy ponytail, plays an attention-seeking dog who midway in the show takes an old-fashioned vaudeville turn singing Stein's words.

•

The overall style of the acting, music and costuming suggests a modernist pastiche of German Expressionism. The actors, who resemble the slinky, chalk-faced urbanites in the paintings of Klimt and Schiele, drone their lines in a robotic, phonetically pronounced English. The director has assembled them into a series

Robert Wilson adds illumination, literally.

of slow-motion tableaux that are as visually striking as they are emotionally blank and stripped of social ramification. Where the mood of German Expressionist paintings of the 1920's and 30's suggests twisted secret lives festering underneath blithe hypersophisticated facades, the mood on the stage, as in so much of Mr. Wilson's work, is predominantly one of childlike wonder.

More than any other element, it is Hans Peter Kuhn's musical score that defines this mood. Using elec-

tronics and what often sound like toy instruments, the composer has created an aural environment that often suggests a Minimalist parody of Kurt Weill-style cabaret songs, written for children and interspersed with sound effects that range from animal noises to breaking glass. Mr. Kuhn's music, much of which has a light oom-pah-pah lilt, is a clever musical answer to Stein's language of insistence. Stein likened the repetitions of human speech to a frog croaking or a bird singing. And in "Dr. Faustus Lights the Lights," the composer's burping and squawking little ditties match her dry verbal wit.

1992 Jl 9, C15:3

As You Like It

By William Shakespeare; directed by Adrian Hall; scenery by Eugene Lee; costumes by Melina Root; lighting by Natasha Katz; music by Richard Cumming; dramaturge, Anne Cattaneo. Presented by the New York Shakespeare Festival, founder, Joseph Papp; artistic director, JoAnne Akalaitis; producing director, Jason Steven Cohen; associate artistic director, Rosemarie Tichler; with the cooperation of the City of New York, David N. Dinkins, Mayor; Luis R. Cancel, Commissioner of Cultural Affairs; Betsy Gotbaum, Commissioner of Parks and Recreation. At the Delacorte Theater, Central Park.

Duke Senior	George Morfogen
Duke Frederick	Larry Bryggman
Jaques	Richard Libertini
Orlando	Jake Weber
Touchstone	Donald Moffat
Corin	Brad Sullivan
Rosalind	Elizabeth McGovern
Celia	Kathryn Meisle
Phebe	Siobhan Fallon
Audrey	Kristine Nielsen

By LAWRENCE VAN GELDER

In the Forest of Arden, it is love that flowers above all else. But when the New York Shakespeare Festival opened its 30th-anniversary season on Wednesday night with "As You Like It" as the 20th presentation of its Shakespeare Marathon, love — like the trees and greenery of Central

Park that frame the Delacorte Theater — bloomed in the rain.

The steady downpour that began shortly before the intermission and continued through the evening could dampen neither the spirit of the comedy nor of a cast determined to give the work at hand and the huddled audience their due. This was an occasion when the decision was surely made: The play must go on.

So once again, the young nobles Orlando and Rosalind were mutually smitten, and, for their various and separate reasons, took to the forest inhabited by the banished Duke Senior and his retinue. And once again, Rosalind, disguised as a man and accompanied by Celia, daughter of the usurping Duke Frederick, set up as a sylvan Dear Abby to dispense counsel on love, especially to the unwitting Orlando. And around these principals swirled as lively a set of characters as one could hope to encounter on a summer's night, among them the clown Touchstone; the decrepit servant, Adam; the droll shepherd Corin, and Audrey, the forest's bimbo in waiting.

For them Shakespeare provides not only action that ranges from a potentially deadly wrestling match to a mass wedding but also lines cherished through the centuries from Elizabeth I to Elizabeth II: "Sweet are the uses of adversity ...," "All the world's a stage ..." and "Blow, blow, thou winter wind."

And how does a cast served so well by playwright serve playwright in return? Well, indeed; no more so than in the case of Elizabeth McGovern as Rosalind. Pivotal to the plot, she charged the action with energy and invested it with mischievous humor, all the while radiating a loveliness that made credible Orlando's unflagging ardor. As that swain, Jake Weber looked properly full of youthful vigor and raging passion, and once past the opening of the play, seemed equally at home with the language. Though hissable at first as Orlando's conniving elder brother, Oliver, Peter Jay Fernandez lent music to his

lines; and Kathryn Meisle made a saucy, beguiling Celia.

But this was a night when no one could be faulted now and then for saying: Bring on the clowns — the ever-welcome Donald Moffat as Touchstone, the fool who outwits one and all; John Scanlan as Adam, the old servant with the big heart, toothless mouth and failing flesh; Brad Sullivan as the dry-humored rustic Corin, and last but not least the red-haired Kristine Nielsen as the vexatious vamp Audrey, who steals laughs with every word, posture and change of expression.

Not to be overlooked, either, were the able contributions of Larry Bryggman as a daunting Duke Frederick, George Morfogen as the benign Duke Senior and Richard Libertini as Jaques.

If love is timeless and universal, then the staging by Adrian Hall seemed calculated to emphasize these qualities. In the court and forest created by Shakespeare, a car and tractor made appearances. The simple sets provided by Eugene Lee included antique furnishings (a desk and chair) at court and rural buildings (a shed, some wagons, a sheep pen with sheep) likely to be found on many farms in many lands. And, in most instances, the costumes by Melina Root evoked the past without appearing inappropriate to the present.

Bestriding past and present on opening night was the memory of Joseph Papp, who championed free Shakespeare in Central Park, who saw his vision realized and who died last year. Surely he would have wished for better weather for the opening night of "As You Like It." But just as surely he would have been happy to know that the play went on and that it provided delight and laughter.

1992 Jl 10, C3:1

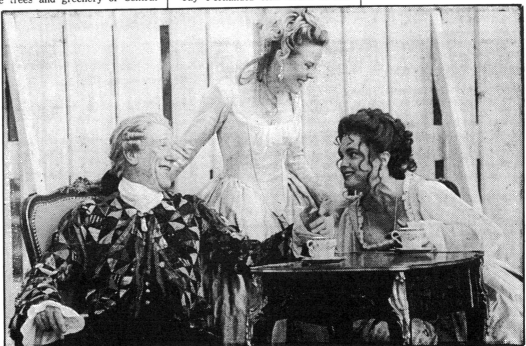

Suzanne DeChillo/The New York Times

Donald Moffat, left, Kathryn Meisle and Elizabeth McGovern in the New York Shakespeare Festival's production of "As You Like It," at the Delacorte Theater in Central Park.

Discovering Family Values at 'Falsettos'

By FRANK RICH

THE WEEK THAT THE VICE PRESIDENT began lecturing the country about family values, I decided to take my children — Nat, 12, and Simon, 8 — to a family musical on Broadway. Our options included:

● "The Secret Garden," a show about an orphaned girl who is raised by her widowed uncle.

● "Les Misérables," in which another orphan, the illegitimate daughter of a prostitute, is adopted by a bachelor who is never home.

● "Guys and Dolls," the story of a compulsive gambler and a nightclub dancer who have had sex without benefit of marriage for more than a decade.

● "Cats," which tells of a feline prostitute's aspirations to ascend to heaven.

All things considered, I decided that the most wholesome choice would be "Falsettos," the William Finn musical in which the hero, Marvin, sings in his first number of his overwhelming desire to be part of "a tightknit family, a group that harmonizes."

The Vice President might not agree. Though "Falsettos" offers such traditional family tableaux as a Little League baseball game and a bar mitzvah, it is set in an America where, as one song has it, "the rules keep changing" and "families aren't what they were." Marvin has left his wife, Trina, and his 12-year-old son, Jason, for a male lover, Whizzer. When Jason's bar mitzvah arrives at evening's end, it is held in a hospital room where Whizzer is dying of AIDS. Those in attendance include a lesbian caterer of "nouvelle bar mitzvah cuisine."

Before I got the tickets, I told my children about all of the above except the one concept certain to defy their understanding, nouvelle cuisine. Did they still want to see "Falsettos"? Yes, they said, though Simon added that AIDS made him "very sad because it is an awful disease." Not so sad, however, that he would forgo the show. The boys' curiosity was piqued not only by my sketchy description but also by their knowledge that a relative of ours, my cousin's son Isaac, was playing Jason in a Washington production of "Falset-

A father takes his young sons to a musical about another father (gay) and his son. They find that each boy must choose how to be a man.

toland," the second of the one-act musicals brought together in the Broadway "Falsettos." If you like "Falsettos" in New York, I told Nat and Simon, we'll check out Isaac's "Falsettoland" in Washington as well.

When we took our seats at the Golden Theater on a Friday night, the boys were amused to find that they were the subject of stares, given that they were the only children in the house. They weren't self-conscious, but I was. Waiting for the performance to start, I had second thoughts. Should I have taken the easy way out and joined most of the country's other families that weekend at "Lethal Weapon 3"?

Then again, I had chosen to take Nat and Simon to "Falsettos" in part as an antidote to the monolithic images of masculinity with which they are routinely assaulted by television and movies. I do not believe, as the Vice President does, that role models in pop culture determine what kind of adults children will become; if that were the case, my entire generation would resemble Lucy and Ricky Ricardo. Yet I wanted to take my children to an entertainment, a musical no less, that reinforces the notion that there are many ways to be masculine, from selfish to generous, from brutal to brave, and that it is up to each boy to make a choice. In this sense, "Falsettos" has more to say about becoming a man than some contemporary bar mitzvahs do.

I was also grateful to take my children to a show that depicts homosexuals neither as abject victims of prejudice or disease nor campy figures of fun but as sometimes likable, sometimes smarmy, sometimes witty, sometimes fallible, sometimes juvenile, sometimes noble people no more or less extraordinary than the rest of us. In other words, gay people are just part of the family in "Falsettos," and the values of Marvin's family are those of any other. Marvin and Whizzer and Trina and Jason fight and fight and fight — not for nothing is the first song titled "Four Jews in a Room Bitching" — only to unite when one of them is in desperate need.

It is an antidote to the monolithic images of masculinity with which children are routinely assaulted by TV and films.

Such domestic images of gay people, and of gay people lovingly connected to heterosexuals, almost never surface in Hollywood movies, or on network television, or in rock or rap music — the common cultural currencies of my children's (and most Americans') lives. They do exist frequently in the theater, but rarely in a piece so accessible to the young as "Falsettos." As co-written by James Lapine, whose other credits include the book of "Into the Woods," "Falsettos" hooks the audience on its unorthodox story as deftly as that Stephen Sondheim musical lured children into its subversive retelling of Grimm fairy tales.

Nat and Simon were riveted from the start, laughing in some if not all of the places adults did and taking in stride the show's PG-13 depictions of romantic homosexual intimacy in and out of bed. In Act II, they grew somber along with the characters, a change in key announced by the doctor's prognostic song, "Something Bad Is Happening." As kids tend to do, they bounced back from grief faster than the grown-ups around them, leaping to their feet at the curtain call.

What did my boys take away from "Falsettos"? They liked the acting, the story ("I could never make up a story like that," said Simon, a prolific tale spinner), the jokes and the music. But they also responded to the show's family values. "Marvin tried to be a good father, and I think he was the best

father he could be," said Nat, who added that he liked watching father and son work out their "adjustment" to a sudden change that was "hard to deal with at first."

Simon, who described the show as "very emotional," felt sorry for the "bummed-out" Trina but thought that Marvin had to leave her because, "if you're gay, you shouldn't be married." He liked the fact that Jason, who "thought it was kind of weird that his father was gay," ended up "liking his father better" at the final curtain. If Simon had been in Jason's place, would he have liked Marvin's gay lover? "If he was nice, like Whizzer." Was he surprised to discover that the gay characters in "Falsettos" were the same in most ways as heterosexuals? "They *are* the same, Dad."

Both Nat and Simon were disgruntled that "Falsettos" had lost the Tony Award for best musical to "Crazy for You," which they dismissed as "corny." " 'Falsettos' is really about something," said Nat.

A week later in Washington, we resumed our conversation about "Falsettos" with Isaac, who is 13. While "Falsettoland" is Isaac's first professional acting experience, rave reviews and several weeks of capacity audiences at the Studio Theater have given him the self-assurance of a hardened theatrical veteran. He particularly delights in telling the story of the night the house was bought out by a gay and lesbian square-dancing group, prompting the stage manager to warn the cast in advance to expect a more idiosyncratic audience response. "We told him we could relate to the gay and lesbian," said Isaac, "but not the square-dancing."

Inevitably, Isaac's 8-year-old sister, Lilly, had insisted on seeing the show her brother

Gay people are just part of the family, and the values of Marvin's family are those of any other.

had been rehearsing night and day. Her mother found a way to explain the show's characters, once Lilly noticed the similarity between a word she had recently learned in the second grade, homophone, and homosexuals, which is the first word sung in "Falsettoland." But "less than half" of Isaac's classmates had come to see him play Jason, and those who did were sometimes puzzled. One friend — "not my friend anymore" — told Isaac the next day in school that he had heard in the theater lobby that he was "a fag." Isaac chastised his friend for his language, then defiantly added, "I'm not a homosexual, but I work with numerous homosexuals!"

Isaac's own transformation into a knowing proselytizer for gay rights has been a fast one. Before "Falsettoland," he had never met anyone who was openly homosexual. In this he is no different from my sons, who do not know who, if anyone, among their acquaintances is gay. And Nat and Simon are no different from their father at their age, who, in another era not as distant as it seems, did not meet anyone until college who identified himself as gay and did not have an honest conversation with an uncloseted gay man until a couple of years after that.

Will a show like "Falsettos," or a dozen like it, sow tolerance, especially at a time

when an exclusionary definition of "family values" is being wielded like a club in a divisive political campaign? I have my doubts. My children do not. While Nat and Simon were not sure if their friends would enjoy "Falsettos" — "they're not into plays" — they were, to my amazement, utterly certain that every boy they knew would be accepting of homosexuals whether encountered in theater or in life. (They were less optimistic about the Vice President. Simon, who rated "Falsettos" 10 on a scale of 10, said he thought the Vice President, in light of the "Murphy Brown" episode, would give it "a 2.")

Surely not everyone they knew was so tolerant and free of the old sexual stereotypes, I insisted, but my children would have none of my adult pessimism. "*Kids* are stereotyped," said Nat, with an exasperated adolescent roll of the eyes meant to terminate the conversation. Since I believe in preserving tightknit families as strenuously as both Marvin and Dan Quayle do, I conceded to my son that he was right. □

1992 Jl 12, II:1:1

SUNDAY VIEW/David Richards

The Minefields In Monologues

David Drake's 'Night Larry Kramer Kissed Me': speak, memory, but not too much.

Josh Kornbluth's 'Red Diaper Baby': cribbing from fiction?

BLAME SPALDING GRAY. He certainly isn't the first person to get up on a stage and talk about himself. But he's been hugely successful with his theatrical monologues ("Swimming to Cambodia," "Sex and Death to the Age 14," "Monster in a Box"), recounting the odder and odder things that keep happening to him, despite his best efforts to lead a simple, hassle-free life.

You can see the danger he represents: all those people who consider their lives to be unusual (82 percent of the population, by my guess), and who also entertain ambitions of going into the theater (67 percent), will be sorely tempted to follow his example.

If he can dredge up his childhood, why can't they? He's not the only one to have wacky relatives. Others have been to Cambodia (O.K., Puerto Vallarta two summers ago), experienced depression, known stomach cramps. And, frankly, whose first sexual experience *wasn't* mortifying?

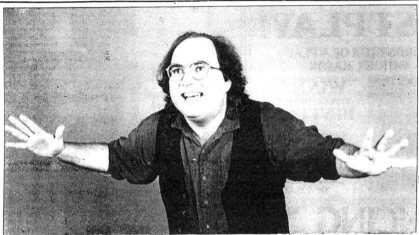

William Gibson/Martha Swope Associates/"Red Diaper Baby"

Josh Kornbluth, above, in "Red Diaper Baby" and David Drake in "The Night Larry Kramer Kissed Me"—How much can you theatricalize autobiography?

Autobiography, it would appear, is fast becoming the new drama. Since very few of us can claim a past without incident, performers who once might have looked elsewhere for material are looking to themselves and that memorable day in high school when they inadvertently blew up the chemistry lab.

Witness "The Night Larry Kramer Kissed Me" and "Red Diaper Baby," two one-man endeavors, currently Off Broadway, that seem to take their license from Mr. Gray.

"The Night Larry Kramer Kissed Me" (at the Perry Street Theater) is David Drake's account of growing up gay in Baltimore in the late 1960's and 70's, then moving to New York City for the action. "Red Diaper Baby" (at the Actors' Playhouse), which takes place at about the same time, is Josh Kornbluth's account of what it was like to grow up in New York City as the son of the last of the red-hot Communists. Both are frank, tell-all enterprises, dealing in the sort of unvarnished verities that also come up in psychiatrists' offices. They could be subtitled "How I Found Myself," or at least, "How I Got This Way."

In his show, Mr. Kornbluth graphically recreates the moment in his young life when he learned how to perform cunnilingus on the woman who was his crocheting teacher. For his part, Mr. Drake simulates the act of fellatio, as it is practiced in the back rooms of dingy bars he has frequented. It appears that Mr. Kornbluth's father, a large, beefy man who liked to walk around the apartment stark nude, bent over his son's cradle one day and branded him, albeit proudly, with a street epithet that stuck for life. As Mr. Drake tells it, *his* parents, learning that he was homosexual, contained themselves as long as they could before screaming, "You know, there's a place for people like you!" ("Yeah," retorted Mr. Drake, smartly. "New York.")

■

Mr. Drake is far and away the better performer, and on the whole he has turned out the more interesting, more inventive and ultimately more searching show. The title refers to the night in 1985 that he went to see Larry Kramer's landmark drama at the Public Theater, "The Normal Heart," and found himself jolted into an awareness of AIDS and society's indifference to it. Up to then, as a struggling performer and self-confessed musical-comedy freak, he had tended to lose himself in Broadway's escapist reveries. Thereafter, the activist in him would emerge.

"The Night Larry Kramer Kissed Me" is, in fact, part confession, part call to arms — both parts, I'd say, about equal. Mr. Drake

can envision a day — before the millennium, but after the revolution of 1994 — when a cure for AIDS will have been discovered and released (with only a year's delay), the Smithsonian Institution will be announcing plans for a Queer Cultures Wing, while "a whole lot of soap stars and TV anchor people that nobody really cared about anyway" will have been outed. The present is another matter — a minefield to be negotiated carefully.

Mr. Drake's feverishly hopped-up descriptions of the gym and nightclub scenes are hardly celebratory. In a segment entitled "Why I Go to the Gym," he makes it clear that he does so to see and be seen. Then the pace and tone of the segment pick up. His blue eyes turn steely gray and, like some manic drill sergeant, he barks out a darker possibility: "To get HARD, get COLD, get NUMB, and I won't have to feel the PUNCHES of the straight oppressors!" In a segment called "12-Inch Single," he takes a no less hallucinatory tour of the bars. A dark frenzy grips him, and before long he is howling, "Cruise me. Choose me. Abuse me. Lose me, boy." Like a wolf baying at the moon.

At the least, this world stands accused of fostering stupid role-playing. At the worst, it is riddled with cruelty and a kind of sweaty delirium that undermine the very notions of political solidarity that Mr. Drake is trying desperately to advance. He is on more humane ground when he talks about combing a starry night for the traces of all the friends and strangers who have died of AIDS. Mr. Drake tells their stories feelingly — they're partially his stories, too — lighting a candle

Michael Wakefield/
"The Night Larry Kramer Kissed Me"

for each as he goes about his pilgrimage. One for Gary, "the first, a neighbor, right next door." Another for Paul, "you singing, dancing, New-Age, 'Let-Go' gypsy, chorus-boy queen." And so on, until the stage fairly shimmers with sad candlelight.

Mr. Drake may now scorn the mindlessness of the musicals he used to prize as a youth, but he has not sworn off his love of theatricality. Although his writing often suggests an indulgent marriage of Dylan Thomas poetry and rap lyrics, his acting style, sharp and uncluttered, usually serves as a corrective. As a performer (Mr. Drake last played Miss Deep South in the Off Broadway spoof of beauty contests, "Pageant"), he is adept at quick impressions, about-faces, the look that's worth a thousand words. Chuck Brown's direction further edits down "The Night Larry Kramer Kissed Me" so that, at its best moments, it doesn't deliver its messages as much as it telegraphs them in vivid dots and dashes.

Mr. Kornbluth, an altogether more prolix individual, bounds on stage to inform us right off the bat that his parents, Paul and Bunny, believed devoutly that "there was going to be a violent revolution in this country . . . and I was going to lead it." Then, after a pause, he adds, "Just so you get an idea of the pressure." There you have both the unifying thread and the comic premise of "Red Diaper Baby." Mr. Kornbluth is not exactly assurance personified; whatever the magnitude of tasks facing him, as he grows up, he is never going to feel quite up to the mark. And since he resembles a friendly beach ball, to which have been appended stringy hair and flapping hands, these feelings of insufficiency are meant to be a continuing source of amusement.

His parents divorce. Mr. Kornbluth goes off to school. Or rather one school after another, since his habit of voicing his family's unorthodox political views in class, or organizing his fellow kindergarten students into cadres, invariably gets him thrown out the door. At the writers' workshop that his mother conducts in the apartment, he meets Marcie, the unhappily married housewife who initiates him into the wonders of sex and crocheting. Unwilling to stop lessons — and sex — he winds up crocheting a door for his bedroom.

There ensues a high school trip to the Soviet Union, a second love affair on the night train to Kiev and the coronary that puts his father in a coma for months before the old man's heart finally gives out. Well, believe it if you can. It strikes me that crocheting isn't

Both shows are tell-all enterprises, dealing in the sort of unvarnished verities that also come up in analysts' offices.

Mr. Kornbluth's downfall; *embroidery* is. What seems amusing and truthful in broad outlines becomes less so as the performer, directed by Joshua Mostel, fills in the details and adds color and shading. Mr. Kornbluth may not always be pulling your leg, but it sure feels like it. A largely untutored stage presence, he doesn't have the acting know-how that would allow him to exaggerate his experience and get away with it.

But then, that may be the big trap inherent in these enterprises. Just how much can you theatricalize them without betraying the autobiography that is, presumably, their reason for being? When Mr. Kornbluth talks about encouraging his fellow kindergarten students "to do Socialist Realism with finger paints," he is making a joke. I am willing to bet he did no such thing.

Mr. Drake probably sticks closer to the facts. But when he confesses that "I was completely swept up into that night / into the hurricane / of clarity / of organization / of grieving / of anger / equals action / equals life / equals people / equals meetings and dittos and treatment and data and posters and stickers and speeches and point of order . . .," he may be committing another kind of lie. The performer is describing his first demonstration before City Hall, but he's really giving himself over to a rush of words, words begetting more words, words getting carried away with themselves. The reality of the event is diminished by the self-consciousness of the verbiage that is supposed to bring it alive.

■

Well, Mr. Gray's words get rolling on occasion, too. And he is forever landing in situations that would make a stand-up comic's day. The business of talking about yourself in public is obviously trickier than it appears. Maybe this is the critical difference. The more outlandish his destiny, the more the look on Mr. Gray's gently furrowed brow says, "I can't believe this happened to me." If he has chosen to recount his life's story to an audience, it is seemingly because he is looking for someone to tell him he's not crazy. The fates *have* pitched a few knuckle balls his way, haven't they? It's not our laughter he's after, but our reassurance. The perpetual aura of doubt is what gives his monologues their authenticity.

To the extent that Mr. Kornbluth and Mr. Drake insist on the truth of their tales, they succeed, more often than not, simply in arousing our suspicions. I'm afraid oaths of honor aren't much help here. On the other hand, admissions of bewilderment are. ◻

1992 Jl 12, II:5:1

The Flash and Crash Days

Created and directed by Gerald Thomas; set and costumes by Daniela Thomas; lighting and soundtrack by Mr. Thomas; lighting supervisor, Wagner Pinto; technical director, Michael Blanco; stage manager, Domingos Varela. Presented by Lincoln Center for the Performing Arts, in association with I.P.A./International Production Associates. At Alice Tully Hall.

WITH: Fernanda Montenegro, Fernanda Torres, Luiz Damasceno and Ludoval Campos.

By STEPHEN HOLDEN

The one constant image in "The Flash and Crash Days," the Brazilian playwright and director Gerald Thomas's surreal evocation of a stormy mother-daughter relationship, is a miniature volcano at the center of the stage. During the 80-minute drama, which had performances on Tuesday and Wednesday evenings at Alice Tully Hall as part of Lincoln Center's Serious Fun festival, the volcano cone intermittently spews smoke and becomes a receptacle for one woman's severed head and the other's ripped-out heart.

The volcano is a typically blunt symbol of inexhaustible fury in a play that uses few words and offers many flashy and violent images of mother-daughter strife done in highly expressive pantomime. It is all underscored by a prerecorded soundtrack of thunderclaps, feverish string quartet music, Billie Holiday singing "Solitude" and, in the final scene, orchestral music from Wagner's "Ring" cycle.

The combatants in the primal emotional battle are Fernanda Montenegro, one of Brazil's most revered actresses, and her real-life daughter, Fernanda Torres. Their conflict is an endless duel in which both parties play vicious card games and act out fantasies of murder, mental torture and incest. Interacting with the women are a pair of archangels, who serve alternately as guards and referees.

●

Stylistically, Mr. Thomas's play suggests a Samuel Beckett clown show washed with Latin American surrealism. In one of the more spectacular entrances to be seen on a New York stage this year, Miss Torres,

who bears a marked resemblance to the young Giulietta Masina, appears with an arrow piercing her throat. That image is matched later in the performance when, after poisoning her mother, she plucks out her mother's heart and devours it while deliriously skipping around the stage.

For all the psychic violence on display, "The Flash and Crash Days"

has the raucous humor of a Punch and Judy show. Try as they might, the mother and daughter simply cannot do away with each other. By the end of the performance, when the two are mugging and furiously throwing playing cards at each other through a window, their connection seems almost loving.

1992 Jl 16, C15:1

Now Starring In 'As You Like It': Central Park

Down a country road to Shakespeare, by way of an Ozarks barnyard.

Mac Davis finds the twinkle Will Rogers left behind.

THE PRODUCTION OF "AS YOU Like It," currently at the Delacorte Theater in Central Park, boasts Elizabeth McGovern, as Rosalind; Jake Weber, as Orlando; Donald Moffat, as Touchstone, and Richard Libertini, as the melancholy Jaques. But the evening's most noteworthy performance is being given by Central Park, which is playing the Forest of Arden. And most fetchingly, at that.

In summers past, the park has always been an extra, hovering in the background, more sensed than seen. Now and again, a set designer might pierce the back wall of the Delacorte with great doors. But when they swung open, you got only a partial glimpse of what lay beyond. And then, invariably, they swung shut, bringing you right back to the no-

ble bodies about to die, or rustics gamboling, or whatever bit of Shakespearean business remained to be accomplished.

The director Adrian Hall and the designer Eugene Lee have adopted a more forthright tack in this, the 20th production of the New York Shakespeare Festival's continuing marathon. They've simply done away with the back wall entirely. Now, when you take your seat, you are able to look out on what is certainly one of the city's prettier landscapes: a flourishing canebrake in the foreground, then a lake, and, rising majestically from the far shore, a lush stand of trees. Off to the side, on a bold outcropping of rock, Belvedere Castle looms all too sternly and, consequently, a bit humorously. Birds swoop and dart among the reeds, hoping to catch a few insects, while the occasional flash of white in the distance indicates another jogger is determined to get in five miles before bedtime.

The view is even more magical after sundown. The lighting designer Natasha Katz has trained a battery of floodlights on this vista, and she has only to throw a switch for the leafy-green freshness to surge out of the dark. The effect is as vivifying as a sudden splash of sea spray. Mr. Hall, of course, concentrates his attentions on the stage, which has been covered with wood chips and features, to your right, a sheep cote (with real live sheep), to your left, a chicken house (with real live roosters) and in between, depending upon the moment, a vintage roadster, a gypsy's caravan or a blazing campfire.

Each time, however, the possibility arises to integrate his actors into that wider, greener world, Mr. Hall seizes upon it. No one enters from the wings here. They come up out of the canebrake, from over the hill, around a bend in the road. And after Duke Frederick repents the nasty fits of temper that have sent everyone fleeing into the Forest of Arden in the first place, you see him picking his way over the rocks in the company of a hooded monk, as he heads into self-imposed exile.

This is easily one of the most open and expansive productions of "As You Like It" you're likely to catch, until someone decides to perform the play on the rim of Grand Can-

Elizabeth McGovern, far left, and Richard Libertini in "As You Like It."
Suzanne DeChillo/The New York Times

yon. That said, I should also point out that it is one of the least poetical. Curious this should be, with nature's splendor all about. However, pastoral charms, as Mr. Hall envisions them, might be more accurately described as barnyard delights. The lovesick rustics, who are chasing after one another and falling over themselves in the process, are played as so many hayseeds and hillbillies. The Ozarks aren't far away, apparently. If the bib overalls, rubber boots and straw hats, rustled up by the costumer Melina Root, didn't tell you that, a variety of twanging accents surely would.

Mr. Hall's approach is purposefully, even crazily, anachronistic. Odd as some of the bits and pieces are, they're almost all evocative of rural America. While they're still at the court, Rosalind and her cousin Celia (Kathryn Meisle) favor 18th-century fashions and the manners that go with them. Touchstone, their servant, sports a powdered wig and a snooty attitude. Let them be banished to the woods, and it's another matter. Celia slips into a mud-stained tutu and boots, while Rosalind, wishing to pass herself off as a man, dons a pair of long pants that gather around her ankles and a jacket that's three sizes too big. The next thing you know, they're living out of that gypsy caravan, with geraniums in the window box and white smoke puffing out the chimney. Although a lazy windmill, towering nearby, doesn't seem to serve much purpose, an iron pump gushes water into a trough for anyone with gumption enough to work the handle.

You get a sense of place, all right. The drawback is that backwoods America is not particularly hospitable to the kind of badinage that makes up much of "As You Like It." Games of love and disguise don't belong here, not to mention poor Jaques — he of the pale demeanor and philosophical temperament. Mr. Libertini, who succeeds primarily in looking like Ichabod Crane, runs through the seven ages of man so perfunctorily, he could be ticking off a list of purchases at the general store. Does he sense that too much intelligence would make him suspect to the resident clodhoppers?

■

Shakespeare was generous enough when it came to populating the play with dolts. Mr. Hall has gone him one better and lowered I.Q.'s pretty much across the board. In the performance of Mr. Weber, Orlando is an overgrown boy with cheek of tan, a mop of straw-colored hair and big eyes that surprise is forever making bigger. Rosalind wraps him effortlessly around her little finger; then, in her guise as a man, continues to toy with him. Mr. Weber, affability itself, doesn't seem to mind in the least and goes right along. While that attitude makes for good group dynamics, it tends to be bad for drama.

Phebe (Siobhan Fallon), the shepherdess, appears to hail from a roadhouse down the pike, although the wisps of straw protruding from the flounces of her short red skirt suggest she has done time in a haystack. "Pity me not" comes out in her rushing, snorting and thoroughly bizarre delivery, "Piddeemenawtuh." Still, as wits go, she's steps ahead of such bumpkins as Silvius (Rob Campbell), Audrey (Kristine Nielsen), William (Michael Stuhlbarg) and Corin (Brad Sullivan), who barely qualify as lamebrains and merit a pat on the back for talking and walking at the same time.

Their falling-about antics are crowd-pleasing stuff, to the degree that the crowd comes primed for "Hee-Haw," not Shakespeare, and from the evidence the other night, more than a few had. Mr. Hall stages a lively production. The roadster, carrying the imperious Duke Frederick (Larry Brygg-

man) into the woods, belches and hiccups comically. There are even enough animals on stage to set up a petting zoo, once the silvery fireworks that bring the evening to a phosphorescent conclusion have melted into the night air.

Mr. Hall, however, glosses over the delicious sexual confusions, which really are the core of the play. It's not just that Rosalind assumes the appearance of a man, Ganymede, in the forest. In order to coach Orlando in the intricacies and delicacies of courtship, Ganymede promptly turns around and agrees to impersonate Rosalind. (If you've followed me, Ms. McGovern, therefore, is playing a woman, playing a man, playing a woman.) Orlando is helplessly in love, but he's never quite sure whom he's in love with. The gender-bending is enough to make a body — *everybody*, actually — a bit dizzy.

Well, your head will probably remain clear and your feet on the ground this time.

Ms. McGovern is sweet and gurgly as a woman, and gangly and a bit goofy as a man. As the misunderstandings escalate, she strives to keep order in one corner and promote harmony in another, and that has her bouncing pretty energetically about the stage. Her arms are flying and her head is bobbing, while her little legs threaten to buckle at any moment, if she doesn't trip on her trousers first. Ms. McGovern is not par-

Edward Patino/"The Will Rogers Follies"

Mac Davis as the title character in "The Will Rogers Follies."—Impish charm.

ticularly sexy, but she's good fun to watch —
a spunky baggy-pants clown who wandered
off the gentle path and ran into more than she
bargained for.

After Central Park, I liked her best.

'The Will Rogers Follies'

Mac Davis is the new Will Rogers in the
long-running "Will Rogers Follies" (at the
Palace Theater) and, although he's a little
deficient in rope-twirling skills, he meets all
the other requirements of the role handily.
What's most important, of course, is that he
appear to be doing as little as possible. Other
musicals may ask their stars to dance a wild
fandango or hit a high G or lay their guts on
the line. "The Will Rogers Follies" wants its
star to be perfectly unassuming. The splashi-
ness is in the show surrounding him. Will
Rogers is the calm, common-sensical eye at
the center of a storm of feathers and bugle
beads.

Mr. Davis certainly doesn't look like he's
capable of much when he first ambles on
stage for one of his periodic chats with the
audience on such befuddling topics as human
nature, politics and the Democrats. He's
short and compact, and with a cowboy hat
squashed down low on his head, there's not a
great deal of room left over for his face. His
rambling delivery isn't exactly flat, but it
seems to be headed there. First impressions
are deceiving, though. Mr. Davis has a lot of
impish charm. The longer you're around him,
the more susceptible you become.

Keith Carradine, who created the role of
the cowboy/philosopher as he might have ap-
peared in one of Florenz Ziegfeld's extrava-
ganzas, was the proud and artful possessor of
a dazzling ear-to-ear smile. He would crack a
joke and then, being in no particular hurry,
wait patiently for a reaction from the hall.
When it came, the smile breaking across his
face seemed to acknowledge that, yes, the
joke wasn't half bad. What really pleased
him, though, were all the nice folks out front
who caught it. He convinced you he liked au-
diences enormously, wanted them to have a
good time and was concerned that they get
home, safe and snug, after the singing and
dancing were done.

Mr. Davis is less immediately gregarious.
A kind of boyish modesty, if not self-con-
sciousness, holds *his* smile in check. But
you'll notice that his eyes have a tendency to
twinkle like crazy. He is trying not to let on
that humanity amazes and amuses him no
end. Still, those eyes, his most expressive fea-
ture, keep betraying him. The performance is
deceptive. It tends to sneak up on you. By the
end, when Mr. Davis delivers "Never Met a
Man I Didn't Like," I knew I was hooked,
even if I can't tell you exactly when or how he
got to me.

I suspect it has to do simply with an accu-
mulation of honest, unforced moments. The
performer's country-western roots serve
him well when it's time to pick up a guitar
and sing. He acts his scenes with the easy joc-
ularity of one who doesn't care if he's not
thought a great actor, perhaps, but would feel
badly if he were judged a bad sport. There's
no desperation here, no eagerness to please,
just the homely pleasure of finding oneself on
a stage in New York City of a summer's
evening.

"The Will Rogers Follies" constantly lets
out the stops, but Will Rogers himself never
does. The show is all about him and his life,
and he ends up persuading you he's merely
along for the ride. Quite a trick. Mr. Davis
has mastered it.

1992 Jl 19, II:5:1

Dog Show

Written and performed by Eric Bogosian;
directed by Jo Bonney. Serious Fun Festival
presented by Lincoln Center for the Perform-
ing Arts in association with IPA/Internation-
al Production Associates. At Alice Tully Hall.

By STEPHEN HOLDEN

In the funniest among several new
monologues that he performed at Al-
ice Tully Hall on Thursday and Fri-
day evening, Eric Bogosian parodies
the popular psychologist John Brad-
shaw as his philosophy might be mer-
chandized by a caricature of Werner
Erhard. Where Mr. Bradshaw's ear-
nest evangelical oratory exhorts peo-
ple to get in touch with the "inner
child" in themselves, Mr. Bogosian's
character is a sarcastic, aggressive
pitchman who urges people to indulge
their "inner babies." The quintessen-
tial inner baby experience he de-
scribes is the childish happiness of
successfully stealing a candy bar
while the storekeeper's back is
turned.

"Babies don't worry," he declares.
"They are connected to the center,
they are in the now." By making our
inner babies happy with feedings ev-
ery two hours, he promises, we can
make the world a better place.

This Swiftian sketch was one of
several new monologues in the pro-
gram titled "Dog Show," which Mr.
Bogosian created for Lincoln Cen-
ter's Serious Fun festival. The narra-
tor was one of several alter egos
through whom Mr. Bogosian pretend-
ed to come out in various shades
from behind the characters he cre-
ates. These possible versions of his
true self were sandwiched in between
several of the brilliantly realized
roustabout characters from his Off
Broadway shows "Drinking in Amer-
ica" and "Sex, Drugs, Rock & Roll."
They included a supercilious English
rock star touting a benefit concert for
the Amazonian Indians of Brazil and
an urban lout chortling to a friend
about the previous night's drug-
fueled violence.

The new work was an attempt by
Mr. Bogosian to shake up a mostly
white middle-class audience that has
absorbed the shock of his characters,
many of whom come from the lower
economic strata of American life. Mr.

Under civilized facades lurk selfishness and beastliness.

Bogosian's work has always trod the
line between incisive character com-
edy and something deeper and scari-
er. At the heart of his vision of hu-
manity is the idea that so-called civi-
lized behavior is just a middle-class
luxury. And in his newer material, he
suggested to his audience that under-
neath our civilized surfaces, we are
all selfish beasts. The inner-baby
monologue was a pointed jab at a
psychological climate that seems
mired in arrested development.

In the show's most prickly sketch,
Mr. Bogosian plays a middle-class
man reflecting with guilt and fear on
the meaning of his personal fulfill-
ment. "Starving Africans spoil every-
thing," he observes in a monologue
that becomes increasingly surreal as

he portrays the privileged life as one
in which people are interactive with
and dependent for security upon ma-
chines. Darkening this perspective is
his nightmarish vision of old age in
which he imagines himself a feeble
nursing home castaway whose only
pleasure in life is the occasional taste
of strained peaches out of a can.

As with so many of his other mono-
logues, this one ends with an ironic
punch line, as the man who has every-
thing except eternal youth and a clear
conscience sarcastically sings, "I'm
in with the in crowd."

1992 Jl 20, C13:1

49 Songs for a Jealous Vampire

Written and directed by Keith Antar Mason;
lighting and technical direction by Tom
Dennison; music by Steve Moshier; visual-
art installation and set design by Mark A.
Bradford; movement choreographed by Joel
Talbert. Serious Fun, a Hittite Empire pro-
duction, presented by Lincoln Center for the
Performing Arts in association with I.P.A./
International Production Associates. At Alice
Tully Hall.

WITH: Keith Antar Mason, Ellis Rice, Joel
Talbert, Nigel Gibbs, Wheaton James and
Michael Dyer.

By STEPHEN HOLDEN

The most insistent refrain that
rings through Keith Antar Mason's
play "49 Blues Songs for a Jealous
Vampire" is the phrase "Catch up
with me." During the work's pre-
miere at Alice Tully Hall on Saturday
evening, those words were shouted
again and again by Mr. Mason in
tones ranging from infuriated chal-
lenge to pleading desperation as he
addressed the plight of black men in
America. His refrain was counter-
pointed throughout the evening by
another recurrent phrase, "in the
boom box of L.A.," which worked as a
sort of bass figure in a polemic that
had the sprawling form of an extend-
ed jazz-blues suite.

The two-hour piece, which Mr. Ma-
son performed with five other mem-
bers of the Hittite Empire, a black
male theater collective in Santa Mon-
ica, Calif., was commissioned by Lin-
coln Center as part of its annual
Serious Fun festival. The work is an
interlocking series of incendiary riffs
on racial oppression, primarily di-
rected at young black men but includ-
ing many scalding asides aimed at
white liberals. The scores of topics it
addresses run from big events like
the Los Angeles riots to petty gripes
about the pop group Simply Red's
supposed boast that it invented the
Scottish blues to Mr. Mason's own
"sexual harassment" by a white fe-
male arts administrator.

For most of the play, this writer
and director, sitting in a rocking
chair, declaimed his anger, glaring at
the audience while tearing pages
from books and tossing them into a
pile on the floor. His point was that
Eurocentric history books are worth-
less, for having written black history
and mythology virtually out of exist-
ence. As he spoke, the other members
of the troupe pantomimed being the
victims of brutal police interroga-
tions under nooses hanging over the
stage. A prerecorded electronic
soundtrack faded in and out. The
other members of the troupe also
offered individual testimony of op-
pression. But whether they spoke for

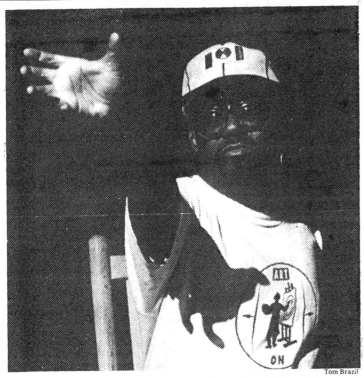

Keith Antar Mason in his play "49 Blues Songs for a Jealous Vampire," which had its premier on Saturday at Alice Tully Hall.

Tom Brazil

Mr. Mason or for themselves wasn't clear.

In a program note, Mr. Mason states, "If you can sing 49 blues songs, my grandfather used to say to me, straight through the night, the vampire can't get you." He adds: "Black male silence, I feel, is the No. 1 killer of black men in this country. Revealing our truths is my mission as a cultural worker." He describes himself as a "myth maker" who wants to create a form he calls "blue-saic," in which "the spoken word meets visual imagery and technology to transform human perception and emotions."

The Hittite Empire's theatrical style is in fact a mélange of influences whose literary antecedents are the Last Poets and the plays of Ntozake Shange. Mr. Mason and his troupe have raised the emotional temperature of this incantatory style to a full boil and fused it with the more ritualistic side of performance art.

What saved "49 Blues Songs" from degenerating into a one-note rant was the seam of sarcastic humor running through Mr. Mason's rhetoric. One sardonic fantasy imagined the future world left to black people, as whites leave the planet to conquer and plunder other galaxies. Another imagines the inauguration of the Democratic Representative Maxine Waters from South-Central Los Angeles as President, with the rap group N.W.A. performing at the inauguration ceremony.

•

At its most cutting, the humor evokes a depth of anguish that eclipses even the punchiest diatribes against white oppression.

How should a black man answer when a white policeman demands, "What were you doing there?" Mr. Mason asks.

Summing up his rage, he suggests that the appropriate reply be, "I was at the bottom of a slave ship."

1992 Jl 21, C11:2

The Tempest

By William Shakespeare; directed by Peter Royston; original music by William Catanzaro; lighting by David Kramer; set by Ron Meadows; stage crafts by Kate Ramirez; choreography by Kathleen Dempsey; costumes by Elizabeth Royston and Dora Ingthors. Presented by the Royston Theater Company. At Playhouse 125, 125 West 22d Street, Manhattan.

Master of a ship	Tom Byrne
Boatswain	Ted Hewlett
Mariner	Craig Mason
Alonso	Dimitri Christy
Antonio	James Corbett
Gonzalo	Warren Watson
Sebastian	Gordon T. Skinner
Ferdinand	Stephen De Rosa
Miranda	Julie Rapoport
Prospero	James R. Bianchi
Ariel	Rebecca Shroyer
Caliban	Gregory St. John
Stephano	Kevin Alfred Brown
Trinculo	John Haggerty
Iris	Catherine Walter
Ceres	Ylfa Edelstein
Juno	Soraya Butler

By WILBORN HAMPTON

An essential ingredient for any revival of "The Tempest" is a touch of magic. There is some magic here and there in the Royston Theater Company production, but it depends on which part of Prospero's island one visits.

Regarded by many as Shakespeare's valedictory, "The Tempest" has some of the playwright's most sublime poetry. It is also one of the most difficult plays to stage well, and some argue that it is better read than performed. And the same shoals on which productions have run aground for 380 years are not always successfully navigated by the director, Peter Royston, and his game cast.

One magical display that often eludes far more seasoned directors is Mr. Royston's opening shipwreck scene. Using one wildly swinging lantern, the crashing sound of waves from a synthesizer and pandemonium onstage, Mr. Royston creates a storm at sea that leaves the audience bracing for a drenching that mercifully never comes.

The exposition scene between Prospero and his daughter, Miranda, which follows the storm, always sets the interpretive mood for the rest of the play, and in the Royston revival there is both good and disappointing news. James R. Bianchi gives an intelligent and measured reading of Prospero. He avoids the extremes to which many actors struggling with the role resort, turning the exiled Duke of Milan into either an overbearing tyrant or a melancholic, absent-minded professor. The great soliloquies — "Our revels now are ended" and Prospero's farewell to his art — are moving if not inspired. But there is a uniformity in Mr. Bianchi's kindly portrayal that blunts the force of a complex character. Julie Rapoport, barefoot and clad in a silk ball gown, captures the wide-eyed innocence of Miranda and seems genuinely smitten by the brave new world that washes ashore on her island.

In other parts of the island, it's more hit or miss. Rebecca Shroyer's Ariel, fitted with silken gossamer wings, ably flits hither and yon like a petulant Tinker Bell doing aerobics. Gregory St. John is a chalk-white, half-mad Caliban, credibly writhing and hissing like some slimy refugee from a Tolkien tale. The clowns bring considerable energy to their scenes, but only Kevin Alfred Brown, a Stephano who could double as Falstaff, turns it into laughs. As for the storm-tossed nobles, they are mostly a somniferous lot.

One final touch of magic in the Royston production is the music by William Catanzaro, an Argentine-born composer whose original score moodily works its end upon the senses.

1992 Jl 22, C17:1

The Stark Oratory Of a Wild Karen Finley

By STEPHEN HOLDEN

Karen Finley made a sensational stage entrance on Tuesday evening at Alice Tully Hall, where she performed her new 80-minute monologue, "A Certain Level of Denial," as part of the Serious Fun festival. Wearing only shoes and a hat, the performer, her silhouette starkly projected on celluloid screens, delivered an anguished rant that described in harrowing detail the bodily deterioration and appalling medical treatment of an artist friend with AIDS.

The monologue went on to contrast the situation of her friend, whom she described as "a leper," with the fuss over George Bush's brief collapse and stomach upset during his recent trip to Japan. Exploding with rage at the President, Ms. Finley screamed:

"I want to see him suffer! I want to see him hurt! I say just leave him there!"

Her furious cry from the heart was so intense that it reduced the audience to a stunned silence, and it demonstrated that Ms. Finley has grown into a performer of spellbinding charisma. Her rants, with their repeated key phrases and incantatory rhythms echoing the more stentorian verses of Allen Ginsberg, are a powerful fusion of political rhetoric, poetry and shamanic outpouring. Even those who hate her ideas are likely to be shaken by the conviction of her performance.

•

The voice she adopts is an evangelical-style, country-and-western-flavored shout. The words tumble out of her mouth in rolling long-lined cadences that rise to quivering, almost tearful peaks. The oratory is stylized so that it doesn't seem to come from Ms. Finley alone but rather from a presence that speaks through her.

For those familiar with Ms. Finley's work, her vision of America as a death-dealing patriarchy hasn't changed significantly in her new piece.

"To put down a man is to call him a woman and to put down a woman is to call her an animal," she asserted after listing many of the animal metaphors by which women are derisively known, from "cow" to "cold fish" to much worse. Other sections of the monologue argued forcefully for abortion rights and the right to sui-

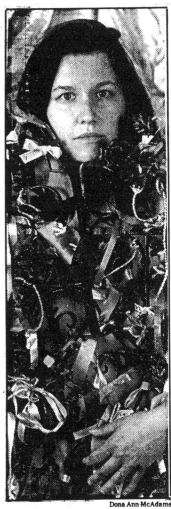

Dona Ann McAdams

Karen Finley

365

cide. With each section of the monologue, Ms. Finley donned another piece of clothing, so that by the end of the evening she was fully dressed.

The declamations were interspersed with fables that Ms. Finley read — in a softer voice — from notes on a music stand. They were illustrated, storybook-style, with slides of original paintings, some of which bore slogans. Typical was a painting of a woman scrawled with the message "The Virgin Mary is pro-choice."

Although some of Ms. Finley's stories turned irate sexual politics into incendiary children's tales, oth-

ers were suffused with a heart-tugging tenderness. The most mysterious and lovely vignette told of a correspondence between two older women living hundreds of miles apart and of a quilt one of them sews in which she memorializes all the griefs of her life and which she sends to the other just before dying. The story's recurrent catch phrase, "small gestures that make the world better," was the necessary and most resonant image of goodness in a show overwhelmingly concerned with exorcising pain and confronting repression.

1992 Jl 23, C17:1

SUNDAY VIEW/David Richards

Picturesque May Be Pleasant, But Is It Drama?

The well-mannered Shaw Festival in Canada soothes more than it challenges.

NIAGARA-ON-THE-LAKE, Ontario

IN THE SHAW SHOP, THE OFFICIAL gift and souvenir boutique of the Shaw Festival, you can purchase the usual assortment of coffee mugs, T-shirts, trinkets and posters. I'm not against this. In these days of penury, a theater troupe needs every source of revenue it can get. You can also buy postcards depicting scenes from past productions. And I guess I shouldn't be against that, either.

But after seeing six of the nine offerings that make up the 31st season, I somehow find the postcards indicative of a worrisome development. The picturesque seems to have gained the upper hand in the three theaters the festival operates in this admittedly picturesque town on the no less picturesque shores of Lake Ontario. Little that's troublesome or unsavory makes its way onto the stages here.

No one says so, of course. The official line of the festival — which runs through Nov. 1 — holds that this is the only company in existence that specializes in plays about "the beginning of the modern world." Shaw himself is the patron saint, and who upset more applecarts and peered under more rocks than he? Yet there's something well bred and tidy about the productions that robs even Shaw's works of their revolutionary zeal. If the playwright insists on raising nettlesome questions about the social and moral order, you can be fairly certain that his characters, at least, will be elegantly costumed and they will inhabit handsome dwellings. The furniture they sit on will be tasteful and the silver tea set will elicit covetous glances from audience members, who, at intermission, will repair to the lobby to take tea themselves.

The liveliest production I saw was probably the most negligible — a 45-minute one act, "Overruled," which Shaw wrote in 1912 and which is presented as lunchtime fare in the Royal George Theater. It's no more than a riff on marriage and adultery, but it is quick and impudent. Mr. and Mrs. Juno, having decided to take separate vacations, are traveling around the world in opposite directions. So are Mr. and Mrs. Lunn. By the time they all meet up by chance in the lounge of a seaside hotel, Mr. Lunn is well along in his seduction of Mrs. Juno, while Mr. Juno is closing in fast on Mrs. Lunn.

A precursor of Noël Coward's "Private Lives" in many ways (there's even a balcony overlooking the ocean), "Overruled" permits Shaw to stand conventional moral principles on their head, and argue mischievously for a little faithlessness in conjugal life. What makes the undertaking hilarious, however, are two explosive performers: Mary Haney, looking, as Mrs. Juno, like a kewpie doll's older, marginally wiser, sister; and Peter Hutt, as Mr. Juno, oozing all the charm of a lesser reptile. "I'm her prospective husband: you're only her actual one. I'm the anticipation: you're the disappointment," Mr. Hutt proclaims at one point to his rival. As he does, delight courses the length of his body, setting everything a-quiver — toenail, mustache, pinkie. Ms. Haney invests equal energy in bold starts of indignation. Even as her eyes are popping open, she is pursing her bee-stung lips, which thereby risk disappearing altogether. Nothing else I caught was half so bold or entertaining.

■

Certainly not Shaw's "Pygmalion," which comes across in the Festival Theater, the company's flagship playhouse, as a perfectly genteel, although scarcely audacious, entertainment. If you think about it, however, Professor Higgins is not far removed from

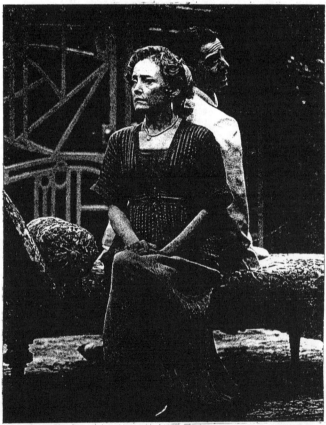

Photographs by David Cooper/Shaw Festival

Mary Haney as Mrs. Juno and David Christoffel as Mr. Lunn in Shaw's "Overruled"—A riff on marriage and adultery.

those mad scientists in old Hollywood films who were always trying to create life in a test tube or graft the head of a man onto the body of a wolf. Higgins's experiment, which happens to involve phonetics and a caterwauling Cockney flower girl, is no less transforming, and he puts Eliza Doolittle through all sorts of hell before she finally reclaims her remade self and walks out the door.

Andrew Gillies is pretty much a standard-issue Higgins — rumpled, self-absorbed, arrogant, but not unlikable. He has nice spells of distraction, and a particularly telling moment at the end of the play, when, after cackling derisively over his pupil's impending marriage to another man, he grows pensive and regretful. You can see by his clouded brow that he's asking himself if the grand experiment was really such a wise idea after all. As Eliza, Seana McKenna is possessed of a certain sharpness, which she never entirely sheds, probably because it extends to her features. I know it's wrong to expect flashes of love between these two characters. (If you want romance, you have to look to "My Fair Lady.") Something warmer than diffidence on his part and animosity on hers would help this production, though.

Its salvation lies in the sets, which the designer Leslie Frankish has constructed with considerable ingenuity out of large wooden letters and words. One of the columns of the church in Covent Garden, for example, is made up of the letters C-O-L-U-M-N, piled on top of one another. The Art Nouveau filigree over the fireplace in Higgins's study is, if you look closely, the word "fire" and the word "place" intricately entwined. Some words — "gossip," "tattle," "banter" — seem to be

Steven Sutcliffe in "Charley's Aunt"— 19th-century Oxford is a magical place.

hanging all by themselves from the rafters, like bats.

Ms. Frankish has two turntables at her disposal, one inside the other, so that when scenes change, language literally comes alive. Verbs are suddenly off and running; nouns are circling one another. You get the unsettling impression that a giant crossword puzzle has gone on maneuvers. It's an imaginative conceit and thoroughly appropriate. After all, hasn't Eliza ventured into a labyrinth of words? Wherever she turns, there's a perverse conjunction or a pesky adjective waiting to trip her up. You could say that "Pygmalion" is the story of how she makes her way out of the diabolical maze to safety.

Even if Eliza and Higgins don't kiss at the end, that story remains a good one. But what are we to make of "Widowers' Houses," the third Shavian offering, which the author described as "a grotesque, realistic exposure of slum landlordism"? Granted, urban housing practices haven't improved much since 1892, when the play was first performed. On the other hand, for all his righteous fury, Shaw isn't exactly in top form here.

He had just begun to write for the theater. The action is haphazardly developed. The ironies are leaden. And only two of the seven characters have much zest — Sartorious (Roger Rowland), self-made man and unrepentent slum landlord, and Mr. Lickcheese (George Dawson), the Dickensian lackey who collects the rents for him. Unfortunately, the plot hinges on a love affair between Sartorious's daughter Blanche and the young doctor she meets on a trip down the Rhine. He's a bit of a dope, and if she is not one of Shaw's least appealing women to begin with, she is by the time Elizabeth Brown gets through playing her.

"Widowers' Houses" has been relegated to the Court House Theater — a thrust stage with the audience seated on three sides. This is "the thinking person's theater," where, the official literature has it, "you can only expect the unexpected." What that really means is that the least commercial endeavors wind up here. I'm less sure what is intended by "thinking person." Probably scholars or academics, who, along with their fine minds, tend to have a higher tolerance of mustiness than the rest of us.

■

In addition to works by Shaw, the festival's mandate allows for plays by his "contemporaries." The term is a loose one, since Shaw lived to the age of 94 and any play written during his lifetime (1856 to 1950) is considered fair game. "Charley's Aunt," Brandon Thomas's farce, which came out the same year as "Widowers' Houses," qualifies for a spot on this year's bill right next to "On the Town," the 1944 Broadway musical by Shaw's great pals, Comden, Green and Bernstein.

So do Noël Coward's "Point Valaine" (1934); Elmer Rice's drama "Counselor-at-Law" (1931); "10 Minute Alibi" (1933), a British murder mystery by the forgotten Anthony Armstrong, and "Drums in the Night" (1922), the first play by Bertolt Brecht to see the boards. If some are clearly less representative of the modern world than others, justification is found for all. "The 30's could almost be defined by the detectives and crooks who linger over a sherry or who lurk around dark corners,"

argues the festival's artistic director, Christopher Newton, in a program note for "10 Minute Alibi." While acknowledging that mystery and detective plays are not great literature, he concludes that "they are great theater."

He may be right. The trouble is, "10 Minute Alibi" has a dandy first act that leaves you wondering why the

More rude gestures and angry words, not fewer, are called for.

play isn't more frequently revived, and a dud of a second act that gives you the answer in no equivocal terms. The first act lets you observe the perfect crime — first, as the villain, a lover spurned (Peter Krantz), pictures it in his mind; then, as he actually goes about committing it. The two versions don't jibe, naturally. The dream is effortless; reality comes with comic hitches. The second act, however, has nothing better to do than sic two detectives on the murderer and see if they can't crack his alibi. All this — which is to say, not much of anything — takes place in a stylish flat in Bloomsbury that could have been designed and furnished by Frank Lloyd Wright. Form may not always triumph over content here, but the sets usually do.

They are easily the smartest aspect of "Charley's Aunt," which is performed with too much visible effort for my taste, but which looks fresh as lime sherbet in the Festival Theater. Still, there's not much point reviving the old war horse these days if you don't have an inspired clown to don the black dress and dour wig of Donna Lucia d'Alvadorez "from Brazil, where the nuts come from." Steven Sutcliffe is only half-inspired. He is fine when it comes to projecting the understandable irritation of a lovesick Oxford student compelled by circumstances to masquerade as an imperious old lady. But he misses the other half, which is to say the giddiness of one who, despite himself, is swept away by a ludicrous disguise.

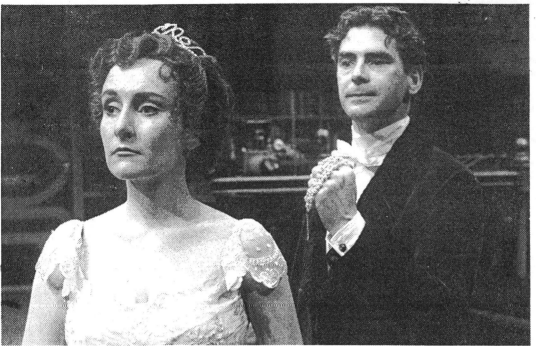

Photographs by David Cooper/Shaw Festival

Seana McKenna as Eliza Doolittle and Andrew Gillies as Henry Higgins in "Pygmalion"—Wordplay.

As Cameron Porteous has designed it, Oxford at the end of the 19th century is a magical place — light and airy rooms giving on to enchanted gardens. The trees, large spirals of green, neatly mirror the confusions of the characters who are spinning dizzily among them. By the last act of the play, Mr. Porteous has crowned each tree with a chandelier. Lovely touch, that.

All the same, it falls to Brecht — clumsy and intractable as he can be — to wrench the festival out of indolence and reverie. Of this season's works, "Drums in the Night" is probably the most representative of the modern world, even if the comparison is hardly comforting. The play is a raw clown show married to an angry nightmare, in which one Andreas Kragler (Peter Millard), a soldier reported missing from the war four years earlier, suddenly shows up on the doorstep of his fiancée. He is little better than a decaying corpse. She is pregnant and about to wed another. Her ignoble parents are obsessed with money and status. Inflation is racing out of control. And revolution has broken out in the streets.

Things do not end happily, although a few characters manage to save their hides. The only colors on stage, apart from a blood-red moon, are black, white and gray — gray being the shade of most of the actors' faces. The prevailing moods are raucous, drunken or confrontational. Given the propriety and politeness elsewhere, it's a little like coming upon a stink bomb at a garden party. But the production, staged in the Court House Theater, is too sloppy and indulgent to do much harm. I'm afraid even thinking people were peeling away in droves at intermission.

■

Yet more rude gestures and angry words, not fewer, are called for, if the Shaw Festival is not to dissolve into so much prettiness. What linked most of the productions I saw was not their

shared roots in some hypothetical 20th-century soil, but their ultimate banality. Audience sensibilities are being soothed more than they're being challenged.

While it takes pride in its reputation as one of Canada's major cultural institutions, the festival is, at the same time, a significant tourist attraction. (More than 68,000 tickets were sold to Americans last season.) The two functions are not necessarily mutually exclusive, but they're not exactly synonymous, either. Art and commerce have their separate demands and pay different rewards.

How the festival might better reconcile them, I don't know. This much

seems apparent, though. Picture-postcard theater, for all its blandishments, is not something to write home about. □

1992 Jl 26, II:5:1

David Shiner
With Bill Irwin and the Red Clay Ramblers

Serious Fun Festival presented by Lincoln Center for the Performing Arts in association with International Production Associates. At Alice Tully Hall.

By STEPHEN HOLDEN

Crucial to the revitalization of the circus arts in what has been called

Peter Millard in "Drums in the Night" at the Shaw Festival.

the New Vaudeville has been a deepening of the relationship between performer and audience. In lowering the traditional fourth wall between actor and spectator, cutting-edge performers have begun to describe their techniques, theorize about their work and barge aggressively into the audience.

David Shiner, who appeared at Alice Tully Hall on Friday and Saturday evenings with his special guests, Bill Irwin and the Red Clay Ramblers, goes further than most in testing the limits of that relationship. His clown personality, which is far closer to Charlie Chaplin's than to Emmett Kelly's, is no icon of wistful sensitivity but a cantankerous practical joker. Audience members he accosts during a performance are commandeered in the theatrical equivalent of a rough-and-tumble silent film.

At the start of Friday's show, Mr. Shiner wreaked mild havoc with an entire row. Making his way across the theater, he tripped over people's feet, plunked himself in their laps, furiously mussed their hair and pantomimed scorn and ridicule for anyone who resisted. The journey took him to a box seat overlooking the orchestra from which he contemptuously rained down popcorn.

●

Returning to the audience later, Mr. Shiner took a man's wallet and began passing around his money and arbitrarily matched audience members into couples and forced them to change seats, sit together and touch.

Because he knows just how far he can go before becoming seriously obnoxious and because his facial and body language are so brilliantly precise, it was all great fun. Near the end of the evening he brought several audience members to the stage to act in a scene from silent-movie melodrama that he directed with an air of impatient grandiosity. The sequence demonstrated how silent clowning, with its universal language of physical movement, is available to just about anyone who is willing to let go and play.

That art's range of expression was underscored by several sketches teaming Mr. Shiner, who is a star of the Canadian troupe Cirque du Soleil, and Mr. Irwin. In contrast to Mr. Shiner's nervous, irritable clown personality, Mr. Irwin's alter ego is a polite, shy Everyman who has to be goaded into vehement self-expression. But once he is stirred up, all hell can break loose. The running theme of their work together was rivalry and theft of each other's ideas.

●

During an ostensibly cheerful vaudeville routine, an accidental blow in the face from Mr. Irwin to Mr. Shiner led to vicious tripping and toe-crushing maneuvers while the two tried to keep smiling and finish the number. In their funniest sketch, which involved a woman from the audience, Mr. Irwin played a pompous waiter wooing Mr. Shiner's date with exaggerated Continental airs and eventually sweeping her to the floor in a hilariously pushy tango.

By the end of the evening, the two clowns had traded signature bits. Mr. Shiner found himself dragged off the stage by one leg that was tugged by mysterious forces from behind the curtain. Mr. Irwin opened an umbrella and found himself nearly lifted off his feet as he was swiftly towed into the wings.

Throughout these shenanigans, the Red Clay Ramblers, a five-member string band from North Carolina, pro-

Laine Wilser for The New York Times

David Shiner, at left, performing with his special guest, Bill Irwin, on Saturday night at Alice Tully Hall in the Serious Fun festival.

vided appropriate background music and sound effects and played peripheral comic roles. Their funniest moment was a propulsive old-timey novelty whose playful catchphrases, "I crept into the crypt and cried/I slipped into the sepulchre and sighed," offered a zany musical corollary to clowns' sublime play.

1992 Jl 27, C15:1

The Penny Arcade Sex and Censorship Show

By Penny Arcade; video and sound by Mitch Markowitz; stage design by Steve Zehentner, Mark Russell, Mr. Markowitz and Ms. Arcade; technical direction and lighting by Jan Bell-Newman; onstage manager and sound operator, Bill Johnson; music by Leta Davis. Presented by Performance Space 122, Mark Russell, director. At P.S. 122, 150 First Avenue, at Ninth Street, East Village.

WITH: Penny Arcade, Leta Davis, Shelly Calcott, Bill Graber, Callie Ryan, Diana Moonmade, Ken Davis, Greta Watson, Taylor Mead, Bina Sharif and Ron Vawter.

By STEPHEN HOLDEN

Toward the end of "The Penny Arcade Sex and Censorship Show," an exuberant two-hour revue with a defiant political agenda, Ms. Arcade and seven scantily clad erotic dancers descend into the audience for some friendly physical contact. To the strains of Steve Winwood's inspirational anthem, "Higher Love," the performers climb through the seats, flirting, dancing and sitting on people's laps. For several minutes, the main auditorium of Performance Space 122, where the show runs through Aug. 23, becomes a low-tech disco and party hangout where the action, were it put on film, might be rated PG-13.

The carefully prepared meeting of the audience and dancers, who ap-

pear to have been chosen for their ethnic and sexual diversity, is the high point of a show that celebrates sex in all its adult consensual varieties. Ms. Arcade, who plays host and ringmaster of the revels, is a veteran East Village bohemian who as a teenager acted in John Vacarro's Playhouse of the Ridiculous troupe and was later featured in Andy Warhol's film "Women in Revolt."

The 42-year-old star is also a character monologuist of modest ability who prefers to impersonate real people rather than invent fictional types. Some of those she plays in the show include the madam of a midtown Manhattan brothel taking calls from would-be customers, a tough-talking advocate for prostitutes, and a bisexual woman who complains that lesbians refuse to accept the fact that she likes men as well as women.

•

Interwoven among these monologues are Ms. Arcade's own stories of growing up in Manhattan, along with her tirades against Senator Jesse Helms and anyone else who would deny Government grants to artists because of their work's sexual content.

Onstage, Ms. Arcade exudes the air of a friendly next-door neighbor fired up in a grass-roots political movement. If she lacks Karen Finley's focused rhetorical power and Eric Bogosian's gift for precise caricature, she is a passionate and likable polemicist for sexual freedom of expression. The most poignant segment of her show is her own confessional monologue about growing up among gay men and observing the changes in New York gay life from the late 60's through the disco era to the age of AIDS. At the end of her reminiscence, she says that the disease has claimed more than 200 of her friends.

The show has no particular structure and flaunts an oldtime bohemian ambiance that is underscored by crude video scenes of Taylor Mead as a prurient priest and Ron Vawter reading a Lenny Bruce monologue.

When the show wanders into deep historical waters, its homemade charms become obscured in a fog of pretension. At one point, Ms. Arcade suggests that the anti-sexual mood in Washington parallels the climate of Nazi Germany, as video monitors offer a few paltry images of Hitler and Goebbels. The argument is dropped long before it is developed into anything more meaningful than a glib analogy.

1992 Jl 28, C13:1

Pie Supper

Written and directed by Le Wilhelm; lighting by Bill Swartz; set by Mr. Wilhelm; fight choreography by James Robert Robinson; costume coordination by Caren Alpert and the Acting Company; stage manager, Loretta Shanahan. Presented by Love Creek Productions. At the Nat Horne Theater, 440 West 42d Street, Clinton.

Eula	Jackie Jenkins
Cleo	Barbara Costigan
Lavinia	Caren Alpert
Lelafaye	Cynthia Brown
June	Kirsten Walsh
Leaetta	Tracy Newirth
Mavis	Nancy McDoniel
Tommy	Dustye Winniford

By WILBORN HAMPTON

There are no actual pies on stage in "Pie Supper," which is a pity because the cast could have raised the level of humor considerably in this silly and boring play by throwing them in one another's faces.

Le Wilhelm has tried to write a nostalgic comedy in which a group of women make preparations for a farewell pie supper in 1959 for 52 residents of a small town in the Missouri Ozarks who, for reasons never explained, are migrating to California.

Absolutely nothing happens. The entire first act is spent snapping beans and shelling peas while this group of backbiting biddies and their bratty daughters gossips.

The only semblance of a plot evolves around Lavinia, a 17-year-old troublemaker and pathological liar who will do anything to join the trek west or cadge a ride to the Dairy Queen, whichever comes first. In the absurd hope that her mother will send her to California out of shame, Lavinia invents a blasphemous tale about being made pregnant by an "angel of the Lord" who visited her room one night and who happened to look just like Tab Hunter.

•

Mr. Wilhelm, who also directed, doesn't seem to like these women very much. Both the play and most of the performances are played for ridicule. It opens with one of the women singing the hymn "Blessed Assurance," a rendition in which she appears to be trying to parody Minnie Pearl with a head cold. The women are by and large a mean-spirited bunch whose favorite pastime is goading the town's retarded handyman to cuss, which sends them all into giggles as though profanity is the funniest thing they've ever heard. And most of the cast speaks in exaggerated hillbilly accents that would make the Joad family sound like elocutionists.

The absence of the menfolk is explained by conveniently having them all gone fishing. By the second act one understands why they've gone and the only question is why they would come back. If there is a play anywhere in all this, it is probably taking place down at the fishing hole.

The cast generally reflects the vacuity of the play with shrill performances. There are a few exceptions. Nancy McDoniel, as Mavis, a woman who has been abandoned by her husband and who has plans of her own for the handyman, and Dustye Winniford, as the backward odd-jobber, are both quite good. And Kirsten Walsh is credible as the prim daughter of one of the women.

1992 Jl 30, C20:1

My Mathematics

Written and performed by Rose English. Music by Ian Hill; lighting by Dan Kotlowitz. Serious Fun festival presented by Lincoln Center for the Performing Arts in association with I.P.A./International Production Associates. Produced in association with Cultural Industry Ltd. and the South Bank Center, London. At Alice Tully Hall.

By LAWRENCE VAN GELDER

Much ado about nothing occupied the stage at Alice Tully Hall on Tuesday night. Not Shakespeare's comedy but a world premiere in Lincoln Center's Serious Fun festival titled "My Mathematics."

In the context of the festival, the occasion was more serious than fun.

Taking pains to disarm her audience, Rose English, the English star of the show, noted early that she was aware that "My Mathematics" was the sort of title that was going to fill some people with dread. Her performance, a convoluted flirtation with cosmic meaning, invoked the relationship between nought and zero and nothing, reminiscences about a circus troupe led by a woman named Rosita, a stallion named Mathematics, an accordionist (Ian Hill), taped songs, wordplay and references to eros. Rather than dread, it seemed to fill the audience with restiveness.

•

Not even a bit of byplay in which Miss English enlisted audience help in trimming an extremely long set of false eyelashes aided matters. Soon afterward, a man asked impatiently when the horse was going to appear. The horse turned up teasingly just before intermission. Some audience members left anyway. Others returned to see what the animal would contribute.

The answer was some deadpan humor. Miss English, who had been clad in a long, silvery gown during the first act, returned in a buttocks-baring version of a circus-horse-trainer's costume for the second, during which Tzigan, the Frisian colt, took part in a promised exploration of obedience and affection.

Part of the humor of the situation was that the obedience and affection were often being displayed not by the animal but by the trainer. An appealing aspect of Miss English's performance was her manifest good humor and the sense that she was perfectly willing to send herself up. The most relaxed and charming moments of the evening arose from her interchange with the audience over the eyelashes and in a bit of deliberately botched magic with pointed hats taken from the accordionist.

•

The tall, blond Miss English links the English vaudeville tradition to the

369

performance arts of a more modern age. But "My Mathematics" seems to be one of those enterprises that speak with more coherence to its creator than to its audience. Mathe-matics may be a universal language, but on this occasion, the numbers onstage simply didn't add up.

1992 Ag 1, 18:4

SUNDAY VIEW/David Richards

A Little Musical Reveals Its Big Heart

At City Opera,
'110 in the Shade'
warms up the
whole theater.

'Say It With Music':
Berlin All by Himself

OVER THE YEARS, I'VE CAUGHT enough lovely little revivals of "110 in the Shade" to confirm my opinion that it is, indeed, a lovely little musical. But it's taken the New York City Opera to convince me that it's also a lovely *big* musical.

By big, I don't mean to suggest that the director has run amok and hired a hundred extras, or that the set designer, seeing that much of the action takes place on a drought-stricken farm in the West, has chosen to give us the whole working spread. Frequently, it turns out that there are only two or three people on the stage of the New York State Theater for entire scenes. And the director, who happens to be Scott Ellis, doesn't seem in any particular hurry to rush on the townsfolk.

As for the sets that Michael Anania has designed for the occasion, they're two-dimensional cutouts — a farmhouse, a far-off church, a tree sheltering a picnic table — profiled against the wide-open sky. No prodigality here, unless you consider a blazing orange sun or several dozen stars in the velvet night to be excessive. What's distinctive about the sets, in fact, is their whittled-down simplicity.

Granted, the New York City Opera has wrought some changes on the musical, which opened on Broadway in 1963 to generally appreciative notices and then found itself overshadowed by that season's blockbusters, "Hello, Dolly!" and "Funny Girl." The composer Harvey Schmidt and the lyricist Tom Jones have added two new numbers and cut an old one, while the playwright N. Richard Nash has rewritten some of the dialogue and dropped a few incidental characters. The choreographer Susan Stroman has sought to weave more dancing into the proceedings, which she does with the exuberant playfulness that is fast becoming her signature. But none of that has changed the basic nature of "110 in the Shade." It has only brought what was always there into sharper focus.

■

The homely story centers on Lizzie Curry, well down the road to spinsterhood despite the best efforts of her father and her two brothers to play matchmaker. File, the local sheriff, is the logical candidate, but ever since his wife ran off on him, he has retreated behind a facade of manly self-sufficiency. Then, just as the temperatures are peaking, Starbuck, con man and rainmaker, blows into town, promising to produce a downpour in 24

Carol Rosegg/Martha Swope Associates/New York City Opera

Brian Sutherland, center, as the con-man rainmaker in "110 in the Shade," promises to end a long drought—A family drama that takes on the dimensions of a fable, pitting the pragmatists against the romantics.

hours for a fee. (Drizzle, he announces, qualifies as a free sample.) By the time the law has caught up with him, he has managed, among other acts of hocus-pocus, to convince Lizzie that she is a beautiful woman. And aren't those storm clouds gathering on the horizon?

Such a tale is going to appear intimate, I suppose, if the circumstances of its telling are intimate. (It had its first incarnation in 1952, as a television drama called "The Rainmaker.") But if you believe that a lonely heart can sometimes be as big as outdoors, that dreamers need dreaming room and that simple acts of decency and generosity impart stature to human beings, then "110 in the Shade" isn't small in the least. The heartache and the yearning will expand to fill the most cavernous of auditoriums.

That's precisely what occurs at the State Theater, where the musical recently joined the City Opera's repertory. How else can you explain the hush that falls over the audience early in the second act? The stage is bare, except for Starbuck's battered truck, which is clearly going no place in a hurry. A few pinholes in the night indicate the stars have come out, but the twinkling is distant and hardly distracting. All there is to capture our attention is a fast-talking rainmaker, talking quietly for a change. He's telling Lizzie that if she'll start thinking she's pretty, she'll *be* pretty. She need only look in his eyes for proof. Hesitantly, she obeys — afraid that he could be wrong, but afraid that he could be right, too — and the first faint stirrings of conviction take hold of her.

Presumably, scenes don't come much smaller than this. The drama depends on the reflection in a man's eyes, on the sudden suspension of breath in a woman's breast, on the spark leaping between prospective lovers who are very nearly face to face, as it is. You'd have to be in the front row to catch it all, wouldn't you? Not so. Lizzie is played by Karen Ziémba with the kind of unvarnished honesty and desperate forthrightness that obliterate distances. And while Brian Sutherland is a quixotic, not to say flimsy Starbuck elsewhere, this particular encounter concentrates his energy and his persuasive charm. What you don't see, you will feel, and when you feel strongly, the mind's eye generally takes care of any invisible details. Wherever

you are seated, I suspect you will "see" the transformation in Ms. Ziémba.

The score, one of Mr. Jones and Mr. Schmidt's finest, avoids the two traps into which the team sometimes falls: the overly cute (see "The Fantasticks") and the unnecessarily sweet (see "I Do! I Do!"). Their best numbers — like those of Rodgers and Hammerstein, whose tradition they carry on — manage to express the eloquence of ordinary people experiencing elemental emotions. The titles alone are indicative: "Love, Don't Turn Away," "A Man and a Woman," "Everything Beautiful Happens at Night." When Lizzie dreams, she dreams of "Simple Little Things," and her discovery that she is beautiful, however exultant, is still framed modestly in the form of a question, "Is It Really Me?" (Ms. Ziémba sings splendidly, but more significantly, she sings bravely.)

■

"Hungry Men," performed in the original version by a full chorus of swaggering husbands and fluttering wives, has been axed. The new additions, both solos, have been assigned to the men in Lizzie's life. "Why Can't They Leave Me Alone" allows File to assert that his solitary ways suit him just fine. Richard Muenz, a strong silent type, starts out angrily. But by the soaring conclusion, he's really pleading for someone to rescue him from his solitude. Mr. Sutherland gets the second number, in which Starbuck compares himself to a "Shooting Star" — here and gone in a whoosh of magic. The song is pretty enough, though it's probably redundant. If nothing else is obvious about Starbuck from the outset, his wanderlust is.

Although "110 in the Shade" does not entertain a complex view of human nature, neither does it reduce its characters to stereotypes. Feminists may argue that Lizzie is not exactly a woman for the times. Without a husband, she feels woefully incomplete, and merely contemplating the prospect of a life alone, which she does in "Old Maid," the first-act finale, makes her more than a little crazed. However, it can be maintained that File and Starbuck are truncated human beings as well — one, all firefly dreams; the other, all solemn business — and if they are to become whole, they need Lizzie as much as she needs them. Mr. Nash's book is sturdily built and Mr. Ellis, who helped cook up the Off Broadway revue "And the World Goes 'Round," lays out its dynamics artfully. When, in the climax, File and Starbuck both reach out for Lizzie's hand at the same time, your heart is apt to follow hers and leap up with joy.

For much of the evening, Noah (Walter Charles), her older brother, has been telling her bluntly to face facts — which means no white knights now, no white knights ever. Jimmy (David Aaron Baker), her good-natured younger brother, has repeatedly rallied to her defense, usually with his fists, since his wits are none too sharp. Meanwhile, H. C. (Henderson Forsythe), the patriarch of this dusty clan, has switched back and forth — wishing for the best and trying not to fear the worst. Because the three actors are so at home in their roles, you can't help recognizing the validity of each stance. Lizzie's predicament escalates into a family drama that soon takes on the even larger dimensions of a fable, pitting the pragmatists against the romantics.

Of course, the rains do come in the end. At the State Theater it's quite a cloudburst — splashing down on the stage, washing upturned faces and undoing neat coiffures. But then, even when the downpour has been no more than a sprinkle, it has struck me that "110 in the Shade" goes out in a big way. The rain represents blessed deliverance — from heat, suffocation and the naysayers who

Liz Callaway, foreground, Kaye Ballard, Ron Raines, rear, and Jason Graae appear in "Say It With Music: The Irving Berlin Revue."

underestimate the powers of a bass drum, beaten soundly in a parched field.

The noise, after all, just may encourage the thunder to respond, which may attract a gathering of clouds, which could very well conclude that a few showers are long over-due. Logic can say what it will. "A Hundred and Ten in the Shade" argues beguilingly that you never know until you pick up the drumstick and try.

'Say It With Music: The Irving Berlin Revue'

Forty-six songs are touched upon in "Say It With Music: The Irving Berlin Revue" (at Rainbow and Stars), but half that number would easily be twice as effective. Never before, we're told, has the Berlin office authorized a revue fashioned out of the great man's work. That may explain why the producers Gregory Dawson and Steve Paul have crammed so many numbers into their 75-minute show. The excitement of being first appears to have overpowered their sense of selectivity.

Far too few songs are getting sung all the way through; far too many have been reduced to a single chorus. Kaye Ballard barely has time to sink her teeth into "Doin' What Comes Natur'lly," for example, before she is elbowed aside by Liz Callaway, blasting out "The Hostess With the Mostes'." But not for long, because Jason Graae, competing for the title of World's Most Elastic Face, apparently, can't wait to butt in with "Heat Wave." From "Heat Wave," it's only a hop to "When the Midnight Choo-Choo Leaves for Alabam'," then a skip to "White Christmas" and a jump to "The Song Is Ended," which concludes one of several dashes through these musical woods.

When the performers are permitted to assert themselves in more than 60-second segments, "Say It With Music" has some nice things to offer. None is nicer than Ms. Callaway's country-fresh interpretation of "I Got the Sun in the Morning," or her a-cappella rendition of "God Bless America." Ron Raines's booming baritone is right for "My Defenses Are Down." And while Ms. Ballard and Mr. Graae tend to bring out the ham in each other, their comic roughhousing makes "You're Just in Love" one of the show's livelier duets.

Still, Berlin is too good to be batted about like this. Theoretically, there's no reason why you can't construct a daisy chain out of his "dance" songs — "Steppin' Out With My Baby," "Cheek to Cheek," "Let's Face the Music and Dance," "Let Yourself Go," "The Best Things Happen While You're Dancing" and the exquisite "Change Partners." But when all four performers are involved and they're constantly cutting in on one another, as they are here, no song is particularly well served and Berlin's brilliance is invariably dimmed.

It's sort of like having Elizabeth Taylor put on all her jewels at once. ☐

1992 Ag 2, II:5:1

Un-Conventional Wisdom
Campaign '92 Update

By Chicago City Limits; produced and directed by Paul Zuckerman; musical director, Gary Adler; house manager, Elliott Lipsey; stage manager, Steve Rouffy; artwork by Cindy Busch; photography by Carol Rosegg. Presented by the George Todisco Improvisational Theater. At Chicago City Limits, 351 East 74th Street, Upper East Side of Manhattan.

WITH: Gary Adler, Carole Buggé, Wendy Chatman, Carl Kissin, Judith Searcy, Rick Simpson and John Cameron Telfer.

By LAWRENCE VAN GELDER

Want to see a high-wire act over a great white shark?

Try an improvisational comedy show. Comedy is always a high-wire act. Failure is the great white shark. And never do the jaws of doom seem so gaping as when the comedy must be made up on the spot.

Try concocting songs and jokes on the spur of the moment when a member of the audience provides the subject: Froot Loops. Try creating a

Carol Rosegg/Keith Sherman & Associates

Carl Kissin in "Un-Conventional Wisdom: Campaign '92 Update," the latest improvisational comedy show by Chicago City Limits.

classical play to fit the title "I Want Your Sex." Try making up a song about sashimi. Try playing Siamese quadruplet urologists running for President. Try playing the roles in a thriller about a baby sitter when the audience dictates the style of the leading character who changes as the tale progresses: a man in the style of Woody Allen, a woman in the Disney G-rated style, a man from a porn film and a woman from a horror movie.

•

Quick-witted reaction is the sine qua non of this sort of work. And it is the sort of work undertaken by Chicago City Limits in "Un-Conventional Wisdom: Campaign '92 Update," running on Wednesday through Saturday nights.

As the title suggests, politics plays no little part in the proceedings. President Bush, Dan Quayle and Bill Clinton turn up. Even Mario Biaggi. But topical references extend beyond politics to the Olympic basketball team, to Amy Fisher, to the Kennedy family and the Middle East.

Because of the constant risk of failure, there is a special excitement to watching improvisational comedy. There is an impulse to cheer when Froot Loops triggers a reference to cereal killers, when the word "barn" prompts a young man to tell a woman, "I'm looking for a stable relationship," and when a parody of "Jeopardy" offers the answer "lying, cheating, embezzlement," and the question comes flying back: "What made America the country it is today?"

But it is rare that improvisational humor can be sustained at an uproar-

ious level over the length of an evening. So it helps that the Chicago City Limits troupe, under the direction of Paul Zuckerman, is so appealing that the audience seems to be rooting for it even as inspiration on both sides of the lights runs thin.

Gary Adler, at the piano, provided the sprightly tunes. Carl Kissin zeroed in with pungent accuracy on the voices and mannerisms of George Bush and Woody Allen, and on "Jeopardy" had a good time as the rabbi from Synagogue Beth You Is My Woman Now. John Cameron Telfer's expressive face lent an extra dimension of wit to his depictions of the porn star and his fraction of the Siamese quadruplets. And Rick Simpson, Judith Searcy and Wendy Chatman tossed a fair share of humor, energy, good will and courage into the evening of scenes, stories and song that teetered above the waiting shark.

1992 Ag 4, C13:1

Paint Your Wagon

Book and lyrics by Alan Jay Lerner; music by Frederick Loewe; directed by André Ernotte; choreography by Tony Stevens; vocal arrangements and musical direction by Michael O'Flaherty; scenery by James Noone; costumes by John Carver Sullivan; lighting by Phil Monat; orchestrations by Keith Levenson and Andrew Wilder; additional dance arrangements by Andrew Lippa. Produced for the Goodspeed Opera House by Michael P. Price. At East Haddam, Conn.

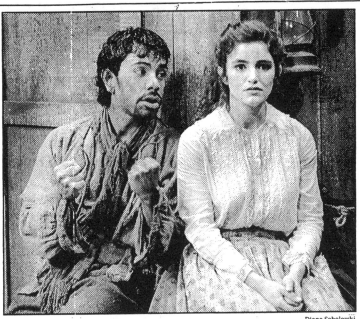

Diane Sobolewki

David Bedella and Marla Schaffel in the revival of "Paint Your Wagon."

Ben Rumson.....................................George Ball
Jennifer Rumson Marla Schaffel
Steve Bullnack....................................Luke Lynch
Jake Whippany............................. Mark C. Reis
Dutchie................................Anthony S. Bernard
Julio Valveras................................David Bedella
Jacob WoodlingStephen Lee Anderson
Elizabeth Woodling Liz McCartney
Sarah WoodlingLeigh-Anne Wencker

By MEL GUSSOW

Special to The New York Times

EAST HADDAM, Conn. — For Alan Jay Lerner and Frederick Loewe, "Paint Your Wagon" was a rare attempt at dealing with Americana, in this case the California Gold Rush. Buoyed by a soaring score, the 1951 musical ran for a season on Broadway, but even after the initial engagement, Mr. Lerner continued to revise it. As author and lyricist, he never stopped tinkering with "Paint Your Wagon." When the show was finally made into a movie 18 years after it opened, Mr. Lerner discarded his original book and wrote a new one, at least partly to accommodate the talents of his stars: Lee Marvin, Clint Eastwood and Jean Seberg.

The revival of the show at the Goodspeed Opera House is the closest one can come to the author's final stage version, and for that reason the production has historical as well as entertainment value. At the same time, if Lerner were alive, he would still undoubtedly be rewriting.

The score is itself a justification for revival, overflowing with lush, romantic airs expressing a poetic longing to be unencumbered by the restraints of civilization. In that sense, among Lerner and Loewe musicals, "Paint Your Wagon" is closest in tone to "Brigadoon." Just repeat the titles of the songs "Wand'rin' Star," "They Call the Wind Maria" and "I Talk to the Trees" and the words take flight into music. And there are other, lesser-known numbers to be rediscovered.

●

But dramatically, "Paint Your Wagon" is lumbering, and André Ernotte's production does little to cosmetize the problems in the narrative. The book changes direction in midstream. The first act deals glumly with a lonely widower, Ben Rumson,

who finds gold, establishes a frontier town and tries to rejuvenate himself through marriage to a younger woman. The brief but cluttered second act shifts to Rumson's daughter and her relationship with a young Mexican miner. The two halves of the story never cohere, and the daughter's suitor, for one, has no character. He is simply here to sing his ballads.

Considering the atmospheric aura, some of which is captured in the songs, the book never conveys the primitiveness of the frontier, as do classic western movies like "Ride the

Goodspeed Opera revives a musical that underwent ceaseless tinkering by its author.

High Country" and "McCabe and Mrs. Miller." The narrative needs wind and rain and fire.

Despite all of Lerner's research into the period, his book leans toward folksiness, as prospectors bluster on and off stage in typical gold-rush musical fashion. In addition, there is a streak of male chauvinism, most irritating in "Can o' Beans," a song that should be stricken from the Lerner-Loewe catalog. The beans refer to the women in the miners' lives. Listening to it, one can almost hear a hum of "Thank Heaven for Little Beans."

Apparently following Lerner's alterations, the musical now ends on more of an up beat. The father offers his blessing to his daughter before leaving on another mining expedition. Neither conclusion is congenial.

●

Although Mr. Ernotte moves the action with a certain swiftness, this is not a musical that takes naturally to the Goodspeed method, which is to reduce a show to essentials and make less speak for more. "Paint Your

Wagon" remains more spectacle than chamber musical. It might benefit from the choreographic expansiveness given "110 in the Shade" at New York City Opera, a show that is far less melodious. For all of its shortcomings, "Paint Your Wagon" would be a challenging choice for revival at the New York State Theater. At Goodspeed, Tony Stevens's cramped choreography is no substitute for the Agnes de Mille dances in the original version. Watching "Paint Your Wagon" on this compact stage, one wishes for a greater pictorial sweep, as in the film.

In common with the show itself, the production has musical strengths but is weak in the dramatic department. In the role of Rumson, George Ball has a perpetual hangdog expression even when he is supposed to be more sanguine. David Bedella makes a weak impression as the daughter's suitor, although his singing voice is sturdy enough to carry "I Talk to the Trees." The supporting actors seem neither rough nor earthy; one could not imagine them enduring the rigors of pioneer life.

On the positive side, there is Marla Schaffel as the daughter. Once she scrubs her face of the tomboy smudges in the opening scene, she is revealed as a convivial actress and singer, at her plaintive best singing "Cariño Mio" with Mr. Bedella. Luke Lynch has only one song, but it is "They Call the Wind Maria," and he delivers it with the necessary passion, personalizing the violence of nature.

It is salutary to hear these songs in context and also to find those that have been overlooked: "Another Autumn" and "In Between," an amusing ode to the father's own romantic insecurity. There is one new Lerner-Loewe number, added for the post-Broadway tour, "Take the Wheels Off the Wagon," a foot-tapping complement to "There's a Coach Comin' In." In common with revivals of much older musicals at the Goodspeed, the book is the price one has to pay to savor the abundant music.

1992 Ag 7, C2:3

The News in Review

By Nancy Holson; directed by Terry Long; musical direction by Stephen A. Sasloe; executive producer, Becky Flora. Presented by ADF Productions. At Del's Down Under, Delsomma's Restaurant, 266 West 47th Street, Manhattan.

WITH: Monique Lareau, Jack Plotnick, Richard Rowan, Linda Strasser and Stan Taffel.

By LAWRENCE VAN GELDER

Who says George Bush and Dan Quayle aren't doing anything about the economy?

Of course they are.

And so are Bill Clinton and Albert Gore, not to overlook Ross Perot and Jerry Brown.

What they're doing is providing plenty of employment for people in show business given to topical humor.

The latest example is "The News in Revue," the new cabaret show by Nancy Holson playing Tuesday through Sunday nights at Del's Down Under, downstairs at Delsomma's Restaurant, at 266 West 47th Street.

The Presidential hopefuls are not alone in these precincts, where a pillar is labeled a Harris pole and the tables come equipped with ballots.

Henry Grossman

Richard Rowan in "The News in Revue" at Del's Down Under.

The five talented singers, who occupy the stage under the direction of Terry Long while Stephen A. Sasloe presides at the piano, provide the audience with plenty of company. The list includes Mario Cuomo, Paul Tsongas, Gennifer Flowers, Mike Tyson, Leona Helmsley, John Gotti, Ted Kennedy, Mikhail Gorbachev, Boris Yeltsin, Clarence Thomas, Anita Hill, Geraldo Rivera, Maria Shriver, Barbara Walters, Larry King, Murphy Brown, Prince Charles, the Reagans, Barbara Bush and Sister Souljah.

If the names are familiar, so, too, is the show's approach. By now, it's no surprise to see Dan Quayle depicted as an intellectual vacuum. So when Jack Plotnick sings to the tune of "If I Only Had a Brain" from "The Wizard of Oz," the material may be apt, but the territory has long ago been thoroughly explored by satirical spelunkers.

And so the show goes. New lyrics applied to old tunes provide the format. Interviewed by Barbara Walters, a Ronald Reagan bereft of recall needs prompting from Nancy, and they sing, "I remember it well." For Ross Perot, "Million Dollar Baby" becomes "Billion Dollar Baby." Clarence Thomas protests his innocence to the tune of "Ain't Misbehavin.' " Too often the material meets expectations without surpassing them.

But now and again song and singer come together to delight: Stan Taffel as the ousted Mr. Gorbachev, cigarette, shot glass and mike in hand, performing as a white-jacketed lounge act, delivering a wistful "The Party's Over," whose lyrics have him yearning for Hollywood; Mr. Plotnick as Jerry Brown, an animated relic of the 60's with shoulder-length tresses, hair band and dashiki, transmitting his message by way of "Aquarius."

Besides Mr. Taffel, who plays characters like Mr. Perot and Mr. Tsongas; and Mr. Plotnick, whose array includes Mr. Bush, Mr. Clinton and Mr. Quayle, the cast includes the tall, big-voiced Richard Rowan, whose impersonations include Prince Charles and Boris Yeltsin; the blond Monique Lareau, whose assignments range from Ms. Flowers to Mrs. Reagan; and Linda Strasser, who sometimes resembles a cross between Carol Burnett and Liza Minnelli and whose roles take her from Ms. Hill to Mrs. Bush.

They're hard-working campaigners. But they're campaigning on a platform that needs more surprises.

1992 Ag 8, 16:1

Roleplay

Book Doug Haverty; music by Adryan Russ; lyrics by Mr. Haverty and Ms. Russ; directed by Henry Fonte; musical director, Mark York; choreography by Karen Luschar; lights by David Edwardson; costumes by Brenda D. Renfroe; set by Mr. Fonte; production stage manager, Lisa Jean Lewis. Presented by the Village Theater Company. At 133 West 22d Street, Manhattan.

Dena.................................Kimberly Schultheiss
Grace...Alyson Reim
Sage..Kate Bushmann
Chlo...Marj Feenan
Molly...Elizabeth Silon
Liz..Anita Lento

By D. J. R. BRUCKNER

Six women who end up in group therapy in "Roleplay," a musical by Doug Haverty and Adryan Russ, are all so interesting they make one conclude there is a lot to be said for social and mental imbalance. These women are desperate, smart, sassy, affectionate, aware and determined. They are comfortable, but they keep one alert.

Ms. Russ's songs, some because they deliberately allude to numbers everyone knows, are memorable and instantly hummable, and in the production by the Village Theater Company most of them are given strong, even gutsy, voice to the accompaniment of piano and bass.

In outline, the story is commonplace. A singer in her 20's, with one big recording hit followed by several years of free fall into oblivion, joins a therapy group. The four others in the group, and their therapist, concentrate on helping her face up to her fears and despair, but it soon turns out that all of them, including the therapist, have problems at least as great as hers. They convince her to try a comeback, in a solo nightclub act, and on the way to stage-managing her triumph they all find solutions to their own troubles.

•

Mr. Haverty's strength is not in plotting; some of the excuses he provides people for singing are purely mechanical, perhaps inevitably, since he and Ms. Russ apparently decided

everyone in the cast must have at least one big number. But he creates characters with strong personalities and some depth, and this cast under Henry Fonte's direction makes them people one would like to know.

Kimberly Schultheiss as Dena, the failed singer, has the least complicated dramatic role but the biggest vocal one. Her Dena is so transparent and vulnerable that even she does not believe her own evasions; she only has to convince herself no one else does to regain her confidence. Ms. Schultheiss has a rare gift of perfect diction and a warm soprano that becomes a little harsh only in her big nightclub song, when she seems not to recognize the difference between a large voice and a loud one.

Anita Lento has the toughest acting assignment, as a successful business executive who is so hard she doesn't even consent to flinch when one of the group members asks her "how long it's been since you had sex when someone else was in the room." By the end of the play, Ms. Lento has revealed some tenderness and hurt in this iron woman, but without asking for understanding or smudging her armor of perfect makeup.

•

Kate Bushmann, as a social mouse who takes ages to give the boot to her selfish (and married) boyfriend, and Elizabeth Silon, as a romantic housewife who only reluctantly acknowledges that her husband is a stupid philanderer, make the audience root for them when they get feisty, especially when Ms. Silon leads a kind of hot gospel number in praise of divorce.

Marj Feenan, as a much misunderstood single lesbian mother of a rebellious teen-age son, and Alyson Reim, as the therapist who can cheerfully shed three unwanted if handsome husbands but cannot shake the constant presence of her demanding patients, are such outgoing homebodies they make the whole audience feel like part of the group.

In fact, that is the secret of this entire merry musical.

1992 Ag 8, 16:4

A Trilogy for Clytemnestra, the Feminist

At the Guthrie in Minneapolis, ancient Greek tragedies tell a modern tale of women facing the messy consequences of male ego.

MINNEAPOLIS

WHILE CLYTEMNESTRA turns up in a handful of Greek tragedies, no trilogy was ever devoted to her ill fortunes. None that we know of, at any

rate — ancient Greek drama having come down to us in a terribly fragmented state. Picking among the splendid ruins of what has survived, however, the director Garland Wright has pieced together a forceful version of her saga for the Guthrie Theater.

He's repaired to Euripides' "Iphigenia in Aulis" for the first part of his two-part endeavor, which is being performed through Aug. 30. The second part is made up of Aeschylus' "Agamemnon," followed by Sophocles' "Electra." All three have been drastically pruned. ("Agamemnon," the shortest, now runs a scant 57 minutes; "Iphigenia" is the longest at 90 minutes.) Mr. Wright wants no distractions, no digressions. This is to be primarily a story of women — Clytemnestra (Isabell Monk) and the three daughters, Iphigenia, Electra and Chrysothemis, who figure in her destruction.

■

You can easily accuse the venturesome director of taking liberties. He is, after all, using three sets of blueprints to build one edifice. What makes Sophocles different from Euripides, and Euripides unlike Aeschylus, is being conveniently downplayed. Even more, there is a strong ideological bent to the productions that says as much about late-20th-century civilization as it does about values in fifth-century B.C. Greece. Still, the edifice is a grand one, and its lean and elegant spaces house some stunning displays of fury.

The gods do not come off well, but that's to be expected. They've always taken particular delight in maneuvering helpless mortals into impossible situations and then watching them wriggle. The revelation of what you could call the Clytemnestra trilogy, although Mr. Wright doesn't, is how badly the men fare. They're patronizing, arrogant, cowardly, headstrong and, for all their ringing appeals to might and right, amazingly ineffectual.

What's more, they're definitely the supporting players. Their recklessness may help determine the course of the drama, but *within* the drama, the positions of theatrical prominence are occupied by women, who must deal with the messy consequences of male barbarism and ego. The feminist overtones are unavoidable. Clytemnestra may be a queen, a mother, a lover and a murderer. At the Guthrie, she is, above all, a woman who refuses to be victimized.

The choral interludes are kept to a minimum, and when the members of the chorus speak, they tend to do so as individuals, straggling voices in the crowd. The enormity of the drama eludes them. For the most part, they watch from the sidelines with the dazed brow and fretful eye of the "humbly born." Susan Hilferty's masks give them that hollow, dumbfounded look you often find on the pedestrians scurrying across German Expressionist canvases.

Singing and dancing, although integral parts of Greek tragedy, are similarly limited. Instead, it falls to the composer Michael Sommers, who is tucked away in the gridwork high above the stage, to punctuate the action with music of his own devising. He's concocted an eerie assortment of noises — twangs, thumps, rumbles and microphone squawks — none of which augur well for the characters. The pleasantest sound, I suppose, is the light shimmer of wind chimes, but even that has an ironic edge, since wind — or the lack of it — is at the root of Clytemnestra's agonies.

When we first meet her in Euripides' play, she is a proud, doting mother, summoned by her husband, Agamemnon, to the seacoast town of Aulis. Presumably, their daughter Iphigenia (Kristin Flanders) is to marry Achilles before the Greeks set sail for Troy

Michal Daniel/Guthrie Theater

Isabell Monk as Clytemnestra and chorus members in "Iphigenia in Aulis" at the Guthrie Theater—The gods do not come off well, but that's to be expected.

and the 10-year siege. Agamemnon has a secret agenda, though. He plans to sacrifice Iphigenia to the goddess Artemis, who has decreed that if he does not, she will hold the winds in check and prevent the army from embarking. While Agamemnon experiences some second thoughts — even he senses the war is being waged over nothing more than a coquette, Helen — his pride as a warrior and his vanity as a leader of men win out over any paternal affections.

Accepting the inevitable, Iphigenia persuades herself that by dying she will contribute to the eventual defeat of Troy, Greece will remain free and "my name will be blessed." Ms. Flanders undergoes impressive transformations in the role — from the giggling bride-to-be, filled with flirtatious delight; to the wan rag doll, stunned by destiny; to the exalted sacrificial victim, flush with religious ecstasy and trembling with new-found purpose.

Ms. Monk, an imposing actress with a grave, almost subterranean voice, is no less mutable. But Clytemnestra's transformation is essentially a regression to a more primitive self — the noble queen, supplanted by the pleading mother, who gives way to the raging beast defending her offspring. Her futile efforts leave her spent and prostrate. Then, as the winds begin to stir, indicating that Artemis has been appeased, Ms. Monk lets loose with a protracted "Noooooo" that rises from her bowels and rips savagely through the air. She is not only protesting a daughter's death but a universe that seems without a moral center.

Indeed, even as Iphigenia is discovering a faith, Clytemnestra is losing hers. The woman who appears 10 years later in "Agamemnon" and eight years after that in "Electra" will no longer believe in the gods. You can already see it at the end of "Iphigenia." Agamemnon has just announced a miracle: as the knife was about to strike Iphigenia, the body vanished from the altar. In its place appeared a bleeding deer. "Your daughter has been taken to heaven," he reports joyously. But the look on Ms. Monk's face, a look of dull, implacable anger, suggests otherwise. What a strange story, it says. What possible consolation can I take from it?

In "Agamemnon," Clytemnestra has acquired a lover, Aegisthus, and her rage has long since congealed into a cold, unquestioning resolve:

they will murder Agamemnon on his return from Troy. To the herald, announcing that the triumphant warrior's chariot approaches, she exults,

"For 10 years I have waited . . .," then pauses ambiguously. You fully expect her to conclude "for this moment" or "for my revenge." But she lowers her eyes and adds "faithfully," instead — a loyal wife, if only for duplicity's sake.

It's not certain that Agamemnon (Stephen Pelinski) would notice her deceit anyway. His command to the chorus, "Rejoice, old men, you are ruled by a king again," pretty much defines him and his suffocating amour-propre. In a rare moment of luxuriousness in the mostly spare and sober staging, Mr. Wright has a covey of handmaidens lay down a path of blood-red silk squares to the palace door. They flutter to the ground, making a carpet of deceptive delicacy, considering the brutality that waits at the other end. Agamemnon has no qualms about crushing it under foot. Overhead, drums and cymbals erupt in mad tumult.

It's a chilling moment, partly because the king goes so dumbly to his death. But just as chilling, in its fashion, is Clytemnestra's subsequent reference to the killing as a "harvest," as if murder were in the natural order of things. Once she was numb with grief. Now she is merely numb.

■

In "Electra," she has also grown old and stiff of joint and come to resemble an aging witch who has mislaid her magic and can no longer stave off mortality. Accordingly, the focus shifts to her children — the dutiful Chrysothemis (Ms. Flanders again, making a surprisingly strong case for a basically passive character); the wild Electra (Jacqueline Kim), who lives only to see her mother slaughtered; and the wily Orestes (Paul Eckstein), who will return secretly from exile and eventually do the horrible deed.

Ms. Kim, a slight actress whose size belies her powers, gives the gal-

Michal Daniel/Guthrie Theater

Jacqueline Kim, as Electra, with the chorus—Hypnotic delivery.

vanizing performance here. It looks like Method madness, at first. The wracking sobs and the convulsive rage, seemingly anchored in a deeply personal sense of injury, threaten to go over the top. The more you watch, however, the more hypnotic her delivery. Psychological realism turns into something close to mystical possession. At one point, Electra is tricked into thinking that Orestes is dead and that his remains lie in the urn at her feet. Reaching into it, Ms. Kim scoops up a handful of ashes, then smears them greedily over her tear-stained face. Her lamentations are close to tribal keening. She could be putting on a gray funeral mask.

Such ferocity is in direct contrast to Douglas Stein's set design, which has the cool formality of a Japanese garden. A cyclorama of pale blue curtains marks the back of the Guthrie's thrust stage, which has been divided by a large black ring into an outer and inner circle. Small stones — talismans, perhaps — have been placed with ritualistic care around the ring. This could be holy ground. Or was. It is obviously an arena for incantations and supplications.

At the same time, there is an emptiness to the set, suggesting that the divinities have long since fled and left mankind to its foolish devices. Cassandra, captured in the Trojan War and brought back in shackles to Greece, takes one look about and concludes sorrowfully, "God hates this place."

I was reminded of the absurdist "King Lear" that the English direc-

The men, arrogant and cowardly, are the supporting players.

tor Peter Brook staged several decades ago in a blasted Beckettian landscape, and wondered at times if Mr. Wright wasn't propounding an absurdist Greek tragedy. Men and women are not the playthings of the gods here; they're one another's playthings. They evoke the gods simply to justify the havoc of their lives.

■

That's why the productions seem so representative of our own times. Our leaders, too, refer endlessly to a national mythology, which is supposed to inform our collective destiny. In its name, ideals are advanced and sacrifices exacted. And yet that mythology may be no more than a smokescreen masking arrantly self-interested deeds.

Is something in the air? Next month, the French director Ariane Mnouchkine brings her widely acclaimed production of "Les Atrides" ("The House of Atreus") to the Park Slope Armory in Brooklyn. Going the Guthrie one better, it is a four-play cycle: Euripides' "Iphigenia in Aulis" followed by Aeschylus' complete "Oresteia" ("Agamemnon," "The Libation Bearers" and "The Eumeni-

des"). We'll have to wait and see exactly where that arc lands us, although Miss Mnouchkine has a similar skepticism toward the proud and her own disenchantment with the powerful.

In the interim, the final word belongs to Clytemnestra, speaking at the Guthrie from beyond the grave. The blood feud has played through another round. Ms. Monk's shrouded body has been laid out in the inner ring for all to behold. Then her rustling voice comes up, like a dry wind, urging women everywhere to awake, for they serve no good asleep.

"Arise, you furies, you women," the voice implores, "and kill my shame — kill my shame — shame."

This time, the cry for vengeance sounds suspiciously like a call to sisterhood. □

1992 Ag 9, II:5:1

Correction

Because of a booking change, a review on page 5 of the Arts and Leisure section today, about three Greek plays at the Guthrie Theater in Minneapolis, includes an outdated schedule for "Les Atrides" in Brooklyn. The Théâtre du Soleil cycle of Greek plays being presented by the Brooklyn Academy of Music opens Oct. 1 at the Park Slope Armory.

1992 Ag 9, 2:5

Life During Wartime

By Wesley Brown; directed by Rome Neal; set by Chris Cumberbatch; costumes by Charles Thomas; lighting by Marshall Williams; sound by Willie Correa; stage manager, Lanette Ware. Presented by Nuyorican Poets Cafe, 236 East Third Street, East Village, Manhattan.

Rhapsody.........................Larry Gilliard Jr.
Eleanor Cummings....................Betty Vaughn
Avery Cummings..............Damon Chandler
Cassandra Cummings..........Magaly Colimon
Bernice Hightower ... Sheryl Greene Leverett
Wanda Waples.....................Carla Marie Sorey
1st Woman......................................Johnnie Mae
2d Woman......................................Arlana Blue
Policeman...............................George Raboni

By STEPHEN HOLDEN

Wesley Brown's drama "Life During Wartime" dives into the heart of one of the most explosive issues a contemporary play could hope to confront — police brutality and race — and handles it with an impressive subtlety and evenhandedness. The play, at the Nuyorican Poets Cafe, is loosely based on the notorious Michael Stewart case, in which a young New York graffiti writer lapsed into a coma and died following his arrest in 1983. After a furious public outcry, six police officers were tried on criminal charges and acquitted.

A quasi docudrama that interweaves the testimony of family members, a police officer, witnesses, a television newswoman and a lawyer, with scenes of domestic conflict, "Life During Wartime" examines the fictional case of a graffiti writer named Daryl Cummings who dies in circumstances similar to Stewart's. Although the play expresses little

doubt that Daryl was beaten to death, it isn't as concerned with proclaiming criminal guilt as with exploring the social and familial tensions that turn Daryl into a larger-than-life symbol. By the end of the play, as one character puts it, he has become everything from a subway Picasso to a common criminal, depending on the observer.

At the center of the play stands the embattled Cummings family. Daryl's parents, Eleanor and Avery (Betty Vaughn and Damon Chandler), are a reticent middle-class couple who very reluctantly allow a crusading lawyer, Bernice Hightower (Sheryl Greene Leverett) who witnessed her own brother's lethal beating by the police, to turn the case into a media circus. Daryl's younger sister, Cassandra (Magaly Colimon), who idolized her brother, complicates matters by refusing to join the campaign.

●

Going directly to the public, argues Bernice, is the only hope of forcing the justice system to act. Her main connection to the media is Wanda Waples (Carla Maria Sorey), an old friend from law school who is now a newscaster. In one of the play's best scenes, the two joke about their professions with an unbridled cynicism.

"Life During Wartime" has many of the same strengths as Mr. Brown's historical drama "Boogie Woogie and Booker T.," which opened at the New Federal Theater five years ago. In that play Mr. Brown created a sophisticated group portrait of America's black leadership at the turn of the century and used it to suggest how little the fundamental issues of racial politics in America have changed in 90 years.

The new play brings the same broadly analytical perspective to contemporary events. Once again Mr. Brown steps back far enough from the principals to let them all have their say. That includes the white arresting officer who talks bitterly about the stresses of his job, loyalty to his fellow officers, the public antipathy toward the police and the malign view of humanity his job encourages.

The play's most dramatically ambitious scenes attempt to show how racism outside the home can still erode the most solid of family edifices. Eleanor and Avery blame each other and themselves for not adequately preparing their son to navigate in the outside world. Their lack of contact with the realities of street life is shown by their difficulty in communicating with their volatile daughter whom they have emotionally neglected.

The dialogue in the family scenes is often clunking, and the playwright gives Eleanor and Avery's troubled marriage an unconvincing lift at the end. Yet "Life During Wartime," has the energy and intelligence of a crackling debate in which many superimposed voices create a larger, more complex picture of strained social fabric.

The performances, though very uneven, have enough energy and conviction to convey the characters' raw emotions and to suggest an urban environment that is so embattled that people have to shout to be heard.

Although the Nuyorican Poets Cafe, a coffeehouse theater on the Lower East Side, is hardly the ideal setting for a play with such sweeping ambitions, the director Rome Neal has skillfully used the theater's tiny stage and various nooks and crannies around the room to suggest settings that range from subway station to a living room to a well-kept bar.

1992 Ag 11, C11:1

2 Hotel Oubliette

Two plays presented by the Williamstown Theater Festival, Peter Hunt, artistic director. At Williamstown, Mass.

2, by Romulus Linney; directed by Tom Bullard; sets by E. David Cosier; costumes, Teresa Snider-Stein; lights, Jeffrey Koger; sound, Darron L. West; stage manager, Scott LaFeber. Presented by special arrangement with Roger L. Stevens.

Hermann Goering...........William Duff-Griffin
Counsel..................................Bernie McInerney
Commandant............................. John Woodson
SergeantDaryl Edwards
Captain...Scott Sowers
Psychiatrist.............................David Chandler
Goering's Wife.......................Laurie Kennedy
Goering's Daughter Jennah Quinn
Justice Robert Jackson Herbert Wolff
President/Tribunal Jason Dittmer
British Prosecutor.......................Jeffrey Shore

HOTEL OUBLIETTE, by Jane Anderson; directed by Jenny Sullivan; sets by Emily J. Beck; costumes; Kimberly Schnormeier; lights, Betsy Finston; sound, Martin Desjardins; stage manager, Tammy Taylor.

Meryl...Steven Keats
Shaw ..Hal Holbrook
Gloria ...Marcia Hyde
Head Guard Phillip Wofford
Guards Tom Caruso, Anthony Fiorillo, Andrew Overton, David Stevens, David Walley

By MEL GUSSOW

Special to The New York Times

WILLIAMSTOWN, Mass., Aug. 7 — The conflict between political expediency and moral responsibility is investigated with chilling intensity in Romulus Linney's "2" at the Williamstown Theater Festival. In this play about Hermann Goering and the Nuremberg war crimes trials, Mr. Linney is unblinking in his confrontation of Nazism, which he regards not as a faceless horror but as the result of individual men swept away by their power and by their craze for greater power.

While "2" is running on the Williamstown main stage, Jane Anderson's "Hotel Oubliette," a study of hostages under siege, is at the company's Other Stage. As a pair, the plays offer summer theatergoers a double dose of theatricalized terrorism.

The Linney play, first staged by Tom Bullard in 1990 at the Actors Theater of Louisville, is most disturbing in its richly textured portrait of Goering, No. 2 in the Nazi hierarchy (hence the odd title of the work) and the only man who could have said no to No. 1. As written by Mr. Linney and as portrayed by William Duff-Griffin, who created the role in Louisville, Goering is arrogant and unrelenting in his devotion to Hitler (even after Hitler deserted him). Conversely, he is erudite, especially about art, and is a shrewd observer of human nature.

●

Watching the play, one repeatedly wonders how a man of such acumen could have been so heinous. This is a question that never seems to cross Goering's mind. Faced with his complicity in crimes against humanity, he can only respond, "Men will do what men will do." Before a theatergoer can silently interpose a qualifying "some men," Goering declares that hate will always exist.

This is not a "Judgment at Nuremberg," in which witnesses step forward to condemn the accused. At the same time, the playwright does not close his eyes, or ours, to the enormity of the crimes that were committed. A film of the concentration camps is screened in the courtroom. But the interest is primarily in Goering's reaction, or rather nonreaction.

Step by step, Mr. Linney leads us into Goering's mind and past, from

Richard Feldman

William Duff-Griffin as Hermann Goering in Romulus Linney's "2," at Williamstown Theater Festival.

the heroic World War I pilot who was adored by his people to the swaggering tyrant who followed Hitler's directives and signed monstrous orders of his own. A theatergoer comes out of this play with a clearer understanding of Goering and his peculiar rationale for his actions: he accepts responsibility but not blame.

Recently, excerpts from Goebbels's diaries were published in England, extracts that turned out to be unrevealing except for occasional personal notes, as in Goebbels's comment after seeing the film "Grand Hotel": "Garbo great." Mr. Linney's play is filled with such small observations by and about Goering. With vast knowledge of his subject, he expresses his appreciation of art, which led him to plunder museums, and he can quote Shakespeare to his purpose. The suggestion is made that if he had been an actor, like his second wife, he might have been satisfied to parade his fantasies on the stage.

●

Mr. Duff-Griffin is uncompromising in his performance, underlining the invidiousness while imbuing Goering with an almost courtly panache. Wily and acerbic in his comments, he manipulates his opposition to his purpose. He could charm his hangman.

Assuming a silky Germanic accent and an attitude of invulnerability, Mr. Duff-Griffin is completely persuasive in character. Unfortunately, that cannot be said about all his fellow actors. As Goering's German counsel, Bernie McInerney is a continent removed in accent and manner, and the offstage voices of members of the tribunal are lacking in authority. The most effective members of the supporting cast are David Chandler as a psychiatrist and Laurie Kennedy in the small role of Goering's wife.

The play itself still has problems, as in the depiction of Goering's guards, a redneck Southerner who admires the prisoner beyond believable bounds and a black sergeant who has an interest in art. Both of these are straw men, as is the American commandant, though that is partly a result of a superficial performance by John Woodson. The commandant should be a steely advocate of military rules and discipline.

What is strongest about the play, in addition to the character of Goering, is Mr. Linney's perspective on history and its lessons. As is true in several of

his other plays (like "The Sorrows of Frederick"), he has done substantial research and then with an artist's eye analyzed the reality behind the myth. In "2," he raises a warning signal against Nazism in all its overt and cryptic forms.

●

In Ms. Anderson's play, the evil is generic. Two Americans, a journalist (Steven Keats) and a university employee (Hal Holbrook) are caged in a dungeon (or oubliette) in an unnamed country. As one might expect, in the course of the play the disparate hostages come to understand each other and the effects of their imprisonment.

"Hotel Oubliette" is far too long and digressive, beginning with a monologue from the garrulous Mr. Keats that vitiates tension. When Mr. Holbrook joins Mr. Keats in his cell, the newcomer expresses his disdain for his fellow prisoner before there is any justification for such a reaction. Furthermore, a fantasy figure is more a dramatic convenience than a necessity. Coincidentally, a play on the same subject, Frank McGuinness's "Someone Who'll Watch Over Me," is currently running in London, dealing imaginatively and insightfully with the rigors (and rituals) of shared confinement.

Ms. Anderson has often undertaken timely themes (in "Food and Shelter" and "The Baby Dance"). "Hotel Oubliette" is her most serious and straightforward effort to date and, under Jenny Sullivan's direction, Mr. Keats and Mr. Holbrook deliver incisive performances.

As a change of pace from the demands of "2" and "Hotel Oubliette," visitors to the theater festival can relax at a cabaret show called "Oops," a collage of popular songs from musicals that failed. The show on Thursday night was enlivened by the guest appearance of Betty Buckley, a member of the Williamstown Equity company, who offered a touching rendition of the meadowlark song from "The Baker's Wife." Other festival regulars often join the apprentice actors in these informal entertainments.

1992 Ag 12, C14:1

Ali

Conceived by Geoffrey C. Ewing; written by Mr. Ewing and Graydon Royce; Performed by Mr. Ewing; directed by Stephen Henderson; boxing choreography by Ron Lipton; set by Sirocco D. Wilson; costumes by Ann Ru-

bin; lighting by Robert Bessoir; sound by Tom Gould; production stage manager, Patricia Flynn. Presented by Eric Krebs Theatrical Management. At the John Houseman Studio Theater, 450 West 42d Street, Clinton.

By MEL GUSSOW

The life of Muhammad Ali has extraordinary highs and lows, from the surprise victory over Sonny Liston in 1964, which made him the heavyweight champion of the world, to his continuing battle against Parkinson's syndrome. There is more than enough material here for a novel or a Spike Lee film. In the new play "Ali," Geoffrey C. Ewing and Graydon Royce brush in the highlights and succeed in jogging one's memory about this admirable athlete, a man of principle as well as punch even as he became a self-made egotist. He was, as he proclaimed, the Greatest, and he had the record to prove it, a record that was interrupted during his prime years when he was stripped of his title because he protested against being drafted for service in the Vietnam War.

As it turns out, there is more heat in Mr. Ewing's performance in the title role than in the monodrama he and his collaborator have constructed around Ali's life. As directed by Stephen Henderson, Mr. Ewing is an artful imitator of his character, assuming the muffled voice of Ali today as well as the boisterous braggadocio of the young champion. But the play is an episodic collage, pasted together from public statements and interviews, testimony from others and guesswork on the part of the authors.

Although Mr. Ewing is the only person onstage at the John Houseman Studio Theater, the play continually alters its point of view. It begins as a lecture, Ali on the road talking about his career, then shifts back to his Olympic days as Cassius Clay. Periodically, the character stops talking and relives bouts (one man pummeling the air in a ring onstage) while the audience hears a blow-by-blow description.

During all this there are dramatic inconsistencies. At various moments, Mr. Ewing addresses the audience as itself, as a group of reporters and as the equivalent of his own reflective conscience. Frequently, he steps out of character to play someone else, including Howard Cosell (whom he mimics effectively). There are also reconstructed scenes with friends and opponents, some of whom, like Liston and Joe Frazier, could command their own time onstage in a more populated play.

"Ali" should have, but does not have, the drama and the trajectory of the fighter's meteoric career as three-time heavyweight champion. What it does have is an actor with empathy for his subject and an ability to communicate that identification on stage. Mr. Ewing conveys both the athleticism of the man in the ring and the theatricality of a competitor who decided to pretend to be a villain, adapting this role from the wrestler Gorgeous George.

Despite that image, Ali retained his ingenuousness. There was always a teasing comic side to his insults as he tried to put his foes off balance. Mr. Ewing demonstrates that beneath the bravado was an insecurity, a need to bolster his confidence before every encounter.

Ali also has his heroic dimensions, both in his dedication to his religious beliefs at the expense of his career and in his activities as an unofficial ambassador of goodwill. In contrast to Mike Tyson, among others, he became a role model. To its credit, the play avoids sanctimony, even as Ali recalls his worldwide celebrity.

●

In the program, Mr. Ewing enumerates the many occupations he has pursued in addition to acting. These do not include boxing. But with the help of Ron Lipton, an Ali sparring partner acting as fight choreographer, he simulates the sinew and suppleness of the fighter who could "float like a butterfly, sting like a bee." Even in retirement, Ali still floats, still stings. At the age of 50, the play's Ali measures the field of heavyweight contenders and jokingly suggests that it may be time to stage another comeback, perhaps against George Foreman.

1992 Ag 13, C17:1

The Real Inspector Hound
The 15-Minute Hamlet

Two plays by Tom Stoppard; directed by Gloria Muzio; sets by John Lee Beatty; costumes, Jess Goldstein; lighting, Pat Collins; sound, Douglas J. Cuomo; production stage manager, Kathy J. Faul. Presented by the Roundabout Theater Company, Todd Haimes, producing director. At the Criterion, 1530 Broadway, at 45th Street, Manhattan.

THE REAL INSPECTOR HOUND

Moon	Simon Jones
Birdfoot	David Healy
Mrs. Drudge	Patricia Conolly
Simon	Anthony Fusco

William Gibson/Martha Swope Associates

Geoffrey C. Ewing in the title role of the new play "Ali," which he co-wrote with Graydon Royce.

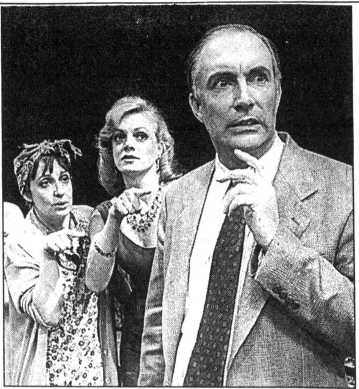

Martha Swope

Patricia Conolly, left, Jane Summerhays, center, and Simon Jones in the Roundabout Theater production of "The Real Inspector Hound."

Felicity	J. Smith-Cameron
Cynthia	Jane Summerhays
Magnus	Jeff Weiss
Inspector Hound	Rod McLachlan
Radio Announcer's Voice	Jeff Weiss
The Body	Gene Silvers

THE 15-MINUTE HAMLET

Shakespeare/Claudius/Polonius	Jeff Weiss
Francisco/Horatio/Laertes	Rod McLachlan
Marcellus/Bernardo/Ghost/Gravedigger/	
Osric/Fortinbras	David Healy
Ophelia	J. Smith-Cameron
Gertrude	Patricia Conolly
Hamlet	Simon Jones

By MEL GUSSOW

Before Tom Stoppard became a playwright, he did a stint as a theater critic. In "The Real Inspector Hound," he gets even with his former colleagues and with the hazards of the profession. With this devious theatrical comedy, nimbly revived by the Roundabout Theater Company, he kills two critical birds, or in Stoppard parlance, one Birdboot and one Moon. For a playwright, this is a case of character assassination. Clearly Mr. Stoppard had fun writing the play, a pleasure that is shared by his audience. In its time, 1971 Off Broadway, it seemed an amusing trifle. It has ripened into an amusing truffle.

At its root, it is a play on criticism. Moon is a second-string drama critic, an eternal stand-in, always a backup and never a lead singer, a role that he describes in an irate stream of resentment that identifies with all the understudies in life. Whenever Moon goes to the theater, he is affronted by the question, "Where's Higgs?" The absent Higgs is his newspaper's first-stringer, and the object of Moon's wrath. Birdboot, in contrast, represents critical complacency. A smug sybarite, he is a blurbster, reveling in the fact that one of his reviews has been reproduced in its entirety in neon at the Theater Royal. For him, no favoritism is strong enough to be labeled a conflict of interest.

As we watch Moon and Birdboot at work at play, they watch the unfolding of a creaky Agatha Christie-like whodunit in which there is a madman loose on the moors. Or is he already inside Lady Cynthia Muldoon's manor house? In rude critical fashion, Moon and Birdboot begin to compose their reviews before they see the show, each finding within the text what he chooses to find.

For Moon, who can spot high art in a flyspeck, the potboiler is "sort of a thriller," but with undercurrents: "The play, if we can call it that, and I think on balance we can, aligns itself uncompromisingly on the side of life." Birdboot is more interested in the acting, or rather, in the actresses. As a freelance philanderer, he has already had a fling with the actress playing the ingénue Felicity and now has his eye on Lady Cynthia.

During a lull in the mystery, the telephone rings on stage, and when it keeps ringing, Moon rises from his seat in the theater and answers it, thereby shattering the fourth wall. To Moon's amazement, the call is for Birdboot. Soon both critics are onstage and enmeshed in the mystery. Bodies fall, the plot spirals and three characters vie for the role of the real inspector, who is a hound but not much of a sleuth. The play wins laughs every which way and disarms all criticism. Repeatedly Mr. Stoppard writes his own review. It is Hound who observes that the show "lacks pace," that it is a "complete ragbag."

•

As a point of fact, "The Real Inspector Hound" is an exceedingly clever lampoon, sharply in focus and at least double-barreled in its own critical assault. But Gloria Muzio's production at the Roundabout could use more pace. The non-mysterious part moves too slowly, and not all of the actors have mastered the art of Stoppardian spontaneity.

Simon Jones, who can be a devilish comic actor, is a shade too dour as Moon; more linguistic enthusiasm would spark even more humor. David Healy has greater vim as the smarmy Birdboot. J. Smith-Cameron and Anthony Fusco are stylish poseurs as the juveniles, and Jeff Weiss dives diabolically into his role as the "wheelchair-ridden half-brother" of her ladyship's husband, "who 10 years ago went out for a walk on the cliffs and was never seen again," at least not until the last scene of the comedy. John Lee Beatty's set, which puts the audience backstage looking at the actors and the critical contingent, has its own drollness.

Along the way to the cliffhanging conclusion, Mr. Stoppard takes time to twit the twaddle critics encounter on stage and to mock the ennui of the English gentry as well as the game of bridge, which is confused with chess and bingo. Critics are the primary target. They are, in the author's words, pillified and viloried.

•

Real critics, of course, are impervious to criticism and always maintain their objectivity, except when they are being subjective. They are not a whit like the fictive Birdboot and Moon. This review, if we can call it that, and I think on balance we can, aligns itself uncompromisingly on the side of "The Real Inspector Hound."

To expand the audience's amusement and also the length of the evening, the play is preceded by Mr. Stoppard's "15-Minute Hamlet," an extract from his play "Dogg's Hamlet." In this curtain-raiser, a ragbag troupe does a fast forward through the high points of "Hamlet." Shakespeare (Mr. Weiss) offers a pauseless prologue that segues from "Something is rotten in the state of Denmark" to "To be or not to be" and Hamlet's own "To be" rushes into "Get thee to a nunnery."

Excising Rosencrantz and Guildenstern (amply provided for in another Stoppard opus), the sketch scampers from battlements to bedchamber, inventing new and tricky transitions. Mr. Jones is a dizzy Hamlet, and Mr. Weiss switches so suddenly from Claudius to Polonius that he almost collides with himself behind the arras. "The 15-Minute Hamlet" is followed by a two-minute tongue-tripping abridgement. It is just long enough to catch the conscience of the king and the short attention span of critics like Birdboot and Moon.

1992 Ag 14, C2:3

In Plain View, Series B

Four one-act plays. Presented by the Turnip Festival Company, executive director, Patricia Golden; artistic director, Joseph Massa; managing director, Gloria Falzer. At the Judith Anderson Theater, 422 West 42d Street, Manhattan.

HOPSCOTCH, by Joseph Massa; directed by Wendy Davidson; music by JoJo Gonzalez.

WITH: Elyse Knight and Howard Pinhasik.

WHEN THEY TAKE ME . . . IN MY DREAMS, by Richard Holland; director, Kathleen Bishop.

WITH: Alexandria Sage and Paul Stober.

DEL MUENZ AT THE BISHOFF GALLERY, by Peter Morris; directed by Charles Catanese.

WITH: Joseph Massa, J. D. Lyons, Gregory Henderson and Janett Pabon.

WHO COULD THAT BE?, by Alan Minieri; directed by Alejandra Lopez.

WITH: Erin Kelly and Richard Henning.

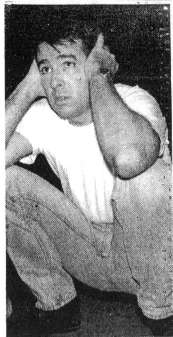

Richard Holland/Turnip Festival Company

Richard Henning in Alan Minieri's "Who Could That Be?" from Series B of "In Plain View," a group of one-act plays.

By D. J. R. BRUCKNER

In Alan Minieri's "Who Could That Be?" — the sharpest and funniest of four pieces in Series B of "In Plain View," the Turnip Festival Company's third annual collection of one-acts — a man and woman discover just how small a self-sufficient world of love and possession can be.

At least one is certain the woman (Erin Kelly) has learned her lesson; the man (Richard Henning) may need a little more time before he realizes how important distraction is for the preservation of high passion. Mr. Minieri pays close attention to his lean words and, under the direction of Alejandra Lopez, so do Ms. Kelly and Mr. Henning.

Telephones, door buzzers and a cannonade of knocking may signal loudly that the outside world wants in, but it is the hiss and snap of the lovers' conversation that one hears, and remembers, as they enter ever more deeply into one another's souls. Though they are appalled at what they are discovering, the only vocabulary they share is a kind of cooing. Mr. Minieri leaves one with the satisfying feeling that he ended this play at exactly the right moment; one minute more and the tension between words and reality would blow the actors off the stage.

•

Peter Morris's "Del Muenz at the Bishoff Gallery" is much less polished, but the director, Charles Catanese, focuses attention on the ridiculous situation, not the words, as a couple of ingenues shatter the fragile sophistication of the art world.

Janett Pabon plays a passionate groupie whose honest enthusiasm strips the lacquer right off a glittery art dealer (J. D. Lyons) and an empty-headed painter (Joseph Massa) she hopes to pawn off on the public. But the best laughs are drawn by Gregory Henderson as a man who creates an uproar when he eats part of an exhibit handed to him by Ms. Pabon. He has an extraordinary abili-

ty to make discomfort — emotional and physical — utterly transform his face, his attitude, his slightest gesture, and his wordless jokes are much more hilarious than the predictable ones in the script.

•

In "Hopscotch," written by Mr. Massa, a husband and wife (Howard Pinhasik and Elyse Knight) are both tripped up as they hop through a pattern of separation created by the demands of professional and domestic life. At one moment he is a businessman and she a housewife teetering on rebellion against boredom; at the next she is the executive and he the housekeeper.

Mr. Pinhasik and Ms. Knight hold one's interest by acting as though their characters were wind-up talking dolls occasionally knocked off balance by a real thought. But once the characters' life roles change, every hop, skip and jump are anticipated.

Richard Holland's "When They Take Me . . . In My Dreams" is far too elaborate. A young woman and a man who wants to marry her (Alexandria Sage and Paul Stober) wander among hills until, when she decides to lay out a picnic for them, they discover they are on opposite sides of a chasm, neither can jump over.

The situation gives the actors some fine opportunities to illustrate the dramatic shock of the recognition of otherness in people we love. But Mr. Holland weighs his characters down with a dialogue so heavy with fragments of memory and allusions to all kinds of historical tragedies and current terrors that one loses interest in their separation and is left wondering only how they managed to struggle to the chasm carrying all that baggage. The exhaustion one feels at the end is probably not what he intended.

1992 Ag 15, 12:3

Twelfth Night

By William Shakespeare; directed by Bram Lewis; set and lighting, James Tilton; music, Michael Ward; costumes, Jan Finnell; sound, Aural Fixation; choreography and fights, Andrew Asnes; production stage manager, Mark Dobrow. Presented by the Phoenix Theater Company, Mr. Lewis, artistic director. At the Performance Arts Center, State University College at Purchase, N.Y., through Aug. 23.

Viola/Cesario	Sharon Polcyn
Sea Captain	Joseph Whelan
Orsino, Duke of Illyria	Paul Carlin
Curio	Cliff Spencer
Valentine	Lloyd Frazier
Sir Toby Belch	David Teschendorf
Maria	Marta Vidal
Sir Andrew Aguecheek	Donald Berman
Feste	Petie Trigg Seale
Olivia	Lea Floden
Malvolio	Ken Kliban
Antonio	Christopher Dansby Fisher
Sebastian	Earl Whitted

By STEPHEN HOLDEN

Special to The New York Times

PURCHASE, N.Y., Aug. 9 — Productions of Shakespeare's "Twelfth Night" tend to tilt in one of two directions. Some directors use this fable of androgyny and headstrong passions to explore the mysteries of erotic enchantment. Others treat the story of the shipwrecked Viola, who disguises herself as a boy, then falls secretly in love with her titled boss, Orsino, as a dry comic farce.

Bram Lewis, who directed the Phoenix Theater's new production of the play, at the Performing Arts Center of the State University College

here through Aug. 23, takes the unromantic view. In his disenchanted interpretation, the characters in the play's central triangle behave like petulant junior high school students passing notes and trying to sort out who gets to go steady with whom. Everyone is a buffoon.

Orsino's obsessive passion for Olivia and her vehement rejection of his advances are portrayed as little more than maneuvers in a childish ego battle. Paul Carlin's Orsino flounces about the stage like a spoiled, moonstruck ninny. Lea Floden's Olivia suggests a shrill, superannuated adolescent on the verge of a tantrum. Their relentless peevishness undercuts any sensuality.

Sharon Polcyn's Viola is by far the most appealing of the three. Disguised as Cesario, Orsino's youthful valet, she wears an Indian headband and has her hair pulled into a pigtail.

•

The Indian imagery makes a certain amount of sense, since this version of the play puts the mythical island Illyria off the coast of Brazil in the 1840's. James Tilton's set suggests a tropical rain forest as it might have been imagined by Henri Rousseau.

The production's most satisfying performance is Ken Kliban's Malvolio. With the lovers reduced to farcical push-me-pull-you shenanigans,

Shakespeare's Illyria is an island off Brazil.

the persecution of Olivia's prudish servant becomes the play's most meaningful event. The actor, his mouth screwed into a scowling half-moon, his eyes glinting with a mean-spirited certainty of his own superiority, is the personification of a petty bureaucrat puffed-up with a ludicrous sense of self-importance.

Malvolio's tormentors — Sir Toby Belch (David Teschendorf), Maria (Marta Vidal) and Sir Andrew Aguecheek (Donald Berman) — are played as rough-and-tumble figures of farce without much personality. If the performances are far too cartoonish, at least they fit the spirit of a production that reduces all the characters to a bunch of noisy brats dashing hysterically around a school playground.

1992 Ag 15, 12:3

The Ups and Downs of 'Paint Your Wagon'

This musical, with its manic-depressive edge, seems to yearn after several things at once.

EAST HADDAM, Conn.

"**P**AINT YOUR WAGON" IS A musical about heartache and greed. About wanting to wrap your arms around somebody and yearning to lay your hands on a fortune. About having stars in your eyes some of the time and dollar signs the rest of the time.

Perhaps these are not mutually exclusive concerns. But they don't go together particularly well in this 1951 musical by Alan Jay Lerner and Frederick Loewe about the rough and tumble and, yes, *tender* days of the California gold rush. The heartache makes for a tone of autumnal wistfulness and the greed is behind the periodic explosions of raucousness. When the grizzled prospectors of Rumson Creek are not threatening to demolish the town dance hall, they are off pining in the woods. Life is not merely uncertain in these here parts. It borders on the manic-depressive.

■

I have to admit that the Goodspeed Opera House, which is in the business of tending to our musical theater heritage, has revived "Paint Your Wagon" with a goodly amount of swagger and certainly no less inward conviction. But I can't pretend that the director Andre Ernotte has been able to reconcile the show's divergent impulses. There just isn't a whole lot of transitional ground here, even though one of the lesser numbers is actually entitled "In Between."

A comic ditty, it is sung by Rumson Creek's founder and mayor, Ben Rumson, who presents himself as "younger than a crank who's pushing 80 . . . and older than a punk of 17," "poorer than a man who's got a million and . . . richer than a bum without a bean." While he can drink more whisky than half the men he knows, the other half can still drink *him* under the table. You see where all this is leading. He's "in between." The song isn't, though. In its little way, it is doing precisely what the show itself is doing in a big way — seesawing.

Lerner and Loewe had "Brigadoon" behind them and were yet to embark on their masterpiece, "My Fair Lady," when they hatched the idea of a "musical play" about the inhabitants of Rumson Creek — all men and, until the dance hall girls arrive at the tag end of Act I, a single woman, Ben Rumson's gawky daughter, Jennifer (Marla Schaffel). The town sits upon what may — or may not — be another Comstock Lode, and the men are feverish with the belief that the next swing of the pickax will be the lucky one. Being without wife or girlfriend, they also

find Jennifer's freshness especially unsettling. Fights break out for nothing. Rumson deems it advisable to pack his daughter back East to finishing school, but not before she falls in love with Julio (David Bedella), a Mexican prospector on the outskirts of town, and exacts a pledge of faithfulness from him.

The presence of the dance hall girls saves the men from tearing one another apart, but the gold gives out at about the same time, and the exodus begins. The big questions for Act II are these: Will Julio be there, when Jennifer returns, prettified and polished, to Rumson Creek? Will Rumson Creek be there? Lerner's script doesn't wring a whole lot of excitement out of either issue. It has trouble enough just keeping track of the various miners and their "yellow dreams." And the ending — the defunct boom town will be reborn as a prosperous agriculture center — is thrilling strictly from a horticultural viewpoint.

Apart from its historical value, the musical's worth these days lies almost entirely in its score, which can be divided neatly into two categories. On one hand, there are the stout and lusty songs, usually for the full chorus ("On My Way," "There's a Coach Comin' In," "Whoop-ti-ay," "Can o' Beans"). They are responsible for the show's manic vigor and allow characters who might otherwise go stir-crazy the opportunity to bust out and emit a few yelps of abandon. The choreographer Tony Stevens has a small but indefatigable crew of dancers at his disposal and in "Can o' Beans" — a cancan that degenerates into a rout — he has them leaping fearlessly off barroom tables and kicking some perilously high kicks.

Then there are the plaintive numbers, solos usually, that explore moodier, more private concerns ("I Talk to the Trees," "Wand'rin' Star," "Another Autumn"). Among the most haunting songs Lerner and Loewe ever wrote, they account for the show's introspective nature and what is, at times, a strange feeling of alienation bordering on the misanthropic. (Lerner's lyrics for "Wand'rin' Star" put it bluntly enough: "Do I know where hell is?/ Hell is in hello./ Heaven is 'Goodbye forever,/ It's time for me to go.' ") The love of gold would seem to be rooted in the restless need to pull up roots, sever ties and move on.

■

Under the musical direction of Michael O'Flaherty, the ensemble fills up the tiny Goodspeed auditorium with some stirring sounds. Mr. Bedella commits himself fully to the romantic sweep of "I Talk to the Trees" and the sweet-bitterness of "Another Autumn." Luke Lynch makes "They Call the Wind Maria" a strapping confession of loneliness. (Here's the nagging despair in Lerner's lyrics again: "But then one day, I left my girl,/ I left her far behind me./ And now I'm lost, so goldurn lost,/ Not even God can find me.") Ms. Schaffel, a perky, strong-willed heroine, is not one to be intimidated by a miner's erratic behavior, although she can't help scratching her head and asking, "What's Goin' On"?

Even if she didn't, you'd be bound to notice sooner or later that spirits at Rumson Creek are up, then down, then up again with near clinical regularity. The one character who could impart some cohesiveness to "Paint Your Wagon" is Rumson. Granted, he's no

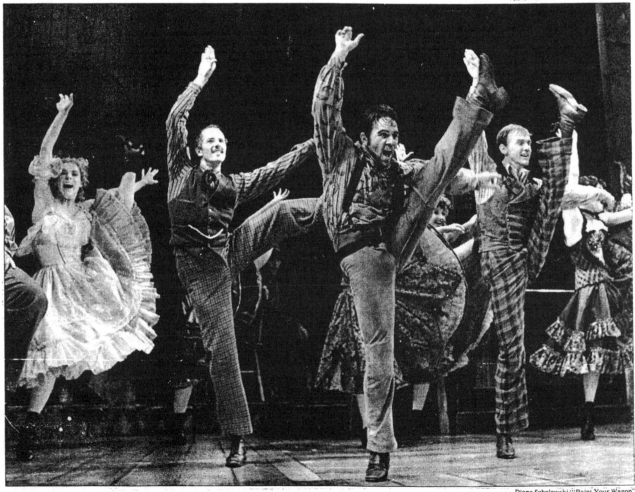

Diane Sobolewski/"Paint Your Wagon"

The kicks in "Paint Your Wagon," at the Goodspeed Opera House, are on the outside. Inside, there is a dark impulse to this curious Lerner and Loewe musical.

less conflicted than anyone else in town. A widower, he's itching to get himself a new wife and settle down, which he does for a while. Not long after, he's eager to sell that wife off to the first bidder and head for the hill beyond the hill. But at least his story runs the entire length of the show, and he doesn't drop out for scenes on end, as some of the other characters do.

He's supposed to be something of an endearing old codger, high in color and expansive of manner. George Ball, who plays him, is hardly charismatic, though, and his performance has no size. He comes across as just another split personality in a town that seems to attract them. As a result, nobody dominates this production. A psychosis does.

When "Paint Your Wagon" was in its early tryout stages — and Lerner, for one, was envisioning it as a realistic, even "gutsy" depiction of the rise and fall of a mining town — Rumson was allowed to die in the end. Philadelphia audiences objected so strenuously that the present conclusion was eventually devised. Rumson shoulders his knapsack, bids his daughter goodbye and takes after his wand'rin' star — which means he disappears into the wild, instead of the wild blue yonder. But a deep sense of melancholia remains.

■

There is, in fact, a dark impulse inside this curiously highfalutin musical. A whisper of craziness, maybe. Or a murmur from beyond. You can't always hear it for the moaning of the wind or the stomp of lumbering feet on wooden floorboards. And the Goodspeed doesn't seem to be paying it much attention. But when the wind lets up and the celebrating dies down, it's there, nonetheless, urging characters who need little urging to drop everything and strike out for a mirage that lies just this side of madness. □

1992 Ag 16, II:5:1

The Comedy of Errors

By William Shakespeare; directed by Cacá Rosset; scenery and costumes by José de Anchieta Costa; lighting by Peter Kaczorowski; original music by Mark Bennett; movement, fight and acrobatics director, David Leong; special participation by Antigravity Inc.; dramaturg, Jim Lewis; production stage manager, Pat Sosnow. Presented by the New York Shakespeare Festival, Joseph Papp, founder; JoAnne Akalaitis, artistic director; Jason Steven Cohen, producing director; Rosemarie Tichler, associate artistic rector. At the Delacorte Theater, Central Park, Manhattan.

Aegeon ... Frank Raiter
Duke Solinus of Ephesus
 Helmar Augustus Cooper
First and Second Merchants. Joseph Palmas
Antipholus of Syracuse Boyd Gaines
Dromio of Syracuse Peter Jacobson
Dromio of Ephesus Howard Samuelsohn
Adriana .. Marisa Tomei
Luciana Kathleen McNenny
Antipholus of Ephesus John Michael Higgins
Angelo .. Larry Block
Nell ... Karla Burns
Officer ... Simon Billig
Courtesan ... Kati Kuroda
Pinch .. Stephen Hanan
The Abbess Elizabeth Franz

By MEL GUSSOW

As a brief farce of mistaken identities, "The Comedy of Errors" has been widely transplanted in place and time, musicalized as "The Boys From Syracuse" and turned into a funny forum for the unbridled theatrics of the Flying Karamazov Brothers. Most recently at the Royal

Shakespeare Company, a portly clownish actor played both of the twin masters (and one actor played both servants) in a quick-witted cartoon version.

Confronted with infinite possibilities for interpretation, Cacá Rosset has settled for interpolation, with a knockabout, or rather a throwaway, production. Broadness is the mode as the actors are led to overreact and innuendo is underscored with a thick crayon. No production of "The Comedy of Errors" can be humorless, but in the case of Mr. Rosset's staging at the Delacorte Theater in Central Park, the laughs are marginal.

The director, whose "Midsummer Night's Dream" in Portuguese last year was an adornment for the New York Shakespeare Festival, takes his cue from the playwright's assertion that Ephesus is a town filled with jugglers, sorcerers and mountebanks. The cast is expanded to include visitors from Antigravity Inc., a troupe of tumblers and dancers, but they are not integrated into the action. Instead, they periodically caper onstage, doing cartwheels and back flips, offering acrobatic interludes. This is in contrast to Robert Woodruff's production at Lincoln Center in which the Karamazovs played leading roles, juggling the plot as well as tenpins and pizzas.

In Mr. Rosset's random production, the actors are left to variable comic devices, most of which would be more

useful in a Punch-and-Judy show as slapstick and pratfalls are carried to excess. This leaves scant room for acting and leads Marisa Tomei, as the wife of Antipholus, to be overly shrewish. She is one of many onstage who hand-flag gestures as if signaling to low-flying aircraft.

•

These gestures are accompanied by sound effects: a chorus of pennywhistles, game-show buzzers and New Year's Eve noisemakers that threaten to drown out the small band of musicians. The sounds are activated by a man at a console, who is so occupied operating auditory equipment that it seems as if the play were being performed for a radio audience.

The maidservant, renamed Nell for no reason, is a representative example of the blunt comedic approach. Shakespeare endowed the character with ample proportions by suggesting that she was "spherical like a globe." The director has cast the role with Karla Burns, a rotund actress with a strong singing voice. (She sings one red-hot blues number.) Then he has encased her in a cushioned costume so that she looks like an inflated toy. The production has a number of such sight gags at the expense of the actors. (One Dromio has to drop his drawers.) Mr. Rosset is irresistibly drawn to sexual overtones, an approach that proves to be self-repeating.

In the circumstances, the relative restraint of Boyd Gaines and John Michael Higgins as the two Antipholuses could be considered an asset. Peter Jacobson is the more amusing of the Dromios, Kathleen McNenny is an attractive Luciana (although late in the play even she is led into mugging) and Elizabeth Franz takes advantage of her cameo role as the abbess to deliver a variation on her Sister Mary Ignatius. In those rare moments when the production tries to be more serious, as in the opening scene of Aegeon's imprisonment, exposition moves at a crawl, and the emotion of the recognition scene is vitiated by the search for still another sight gag.

José de Anchieta Costa's set is as colorful as a street in Disney World, but for production purposes the scenery is more background than play-

ground. Its towers and turrets are unused architecture; most of the action is cramped in and around Antipholus's house. That house has a balcony so that the maid can look up at it and ask, "Dromio, Dromio, wherefore art thou, Dromio?," a question that could be extended to include most of the leading characters in the play. "The Comedy of Errors" should be the breeziest of Shakespearean comedies. Mr. Rosset's production simply makes it the busiest.

1992 Ag 17, C11:3

The Melville Boys

By Norm Foster; directed by Susann Brinkley; set and lighting by Big Deal Productions; costumes, Elizabeth Elkins; production stage manager, David Smith. Presented by Alice's Fourth Floor; Ms. Brinkley, artistic director, and Angels W/O Wings Productions, Lyle J. Jones and Daniel J. Adkins, executive producers. At Alice's Fourth Floor, 432 West 42d Street, Manhattan.

Owen Melville Richard Joseph Paul
Lee Melville Mark Tymchyshyn
Mary ... Katherine Leask
Loretta ... Kellie Overbey

By MEL GUSSOW

In "The Melville Boys" by Norm Foster there is a distinct dichotomy between the play and the production. The play is stitched together from familiar strands, some of them frayed from frequent use in situation comedies. The actors, under the assured direction of Susann Brinkley, are fresh and personable. They hold one's interest even as the characters tread predictable paths.

This Canadian play, in its New York premiere at Alice's Fourth Floor, is a tale of sibling rivalry enacted in a lonely cabin on a lake in northern Michigan. In a very different time, the cabin could have been the setting for a Hemingway short story.

Lee and Owen Melville are blue-collar brothers who have come there for a weekend of fishing and for a renewal of their friendship. As we

Suzanne DeChillo/The New York Times

Marisa Tomei and Stephen Hanan in a scene from "The Comedy of Errors," at the Delacorte Theater.

Martha Swope Associates/William Gibson

Mark Tymchyshyn, left, and Richard Joseph Paul as brothers at odds in "The Melville Boys," at Alice's Fourth Floor.

soon learn, this is in the nature of a last weekend: Lee is terminally ill. The difference between the brothers is immediately set. Owen is irrepressibly outgoing; he seems not to have felt any of life's discouragement. His older brother is quiet and introspective, though much of his withdrawal comes from contemplation of his sickness.

•

Enter two attractive sisters, local residents, one for each man. They, too, are opposites, the older one steady and self-sacrificial, the younger sister a free-living flirt who is made to order for Owen. The pairing is convenient, the plot unsurprising. In his plays dealing with related middle-American subject matter, another playwright, Larry Ketron, is artful in evoking environment and developing character. In contrast, the emphasis in Mr. Foster's case is on banter. Too many moments are played for laughs, beginning with a discussion of death.

"The Melville Boys" borrows from a diversity of sources, including a first-act card game and the curtain line from the movie "The Apartment." There is a second-act confrontation between brothers that reminds one, completely to this play's disadvantage, of Jamie Tyrone's confession in "Long Day's Journey Into Night." It is only at this late point that the play begins to take itself seriously, as Mr. Foster momentarily investigates the themes of failed dreams and false aspirations. A scene in which the older brother and the older sister speak intimately late at night is mentioned the following morning but omitted from the text. That scene could have been the heart of the play.

•

The actors go a long way in persuading theatergoers they are seeing a real situation rather than one manipulated by the playwright. As the

older brother, Mark Tymchyshyn shields his character from self-pity, making him a resilient figure. His criticism of his brother's immaturity remains matter-of-fact rather than censorious. As Owen, Richard Joseph Paul is all elbows and ebullience; he rushes about the cabin as if no building could contain him. Instead of allowing the character to seem callow, the actor imbues him with the impetuousness of youth.

Katherine Leask and Kellie Overbey make the sisters likable. Ms. Leask touches on the older sister's loneliness by remaining self-controlled, even as her character expresses sympathetic concern for her new friend. As the younger sister, a woman who is starry-eyed about acting in commercials, Ms. Overbey exudes an aura of casual sensuality and humor.

As couples and as a quartet, the actors work closely together; they seem like siblings. The cast enhances the author's more effective lines glides over the insubstantial ones and adds spontaneity when needed. For the audience, it is encouraging to catch these young actors at the outset of what should be rewarding careers.

1992 Ag 21, C2:3

Lypsinka! Now It Can Be Lip-Synched

Created and performed by John Epperson; directed by Kevin Malony; gowns designed by Anthony Wong; sets designed by Russ Clower; lighting by Randolph F. Wilson; sound by Mark Bennett. Presented by the Ballroom, 253 West 28th Street, Manhattan.

By STEPHEN HOLDEN

Sylvia DeSayles, Kay Stevens, Fay McKay, Carol Jarvis, Dorothy Squires and Libby Morris are hardly names that, when dropped, produce a universal nod of recognition. But in

the performance artist John Epperson's newest show, "Lypsinka! Now It Can Be Lip-Synched," these nearly-forgotten singers are placed in a vocal pantheon side by side with Ethel Merman, Connie Francis and June Christy.

"Lypsinka! Now It Can Be Lip-Synched," which plays at the Ballroom through Sept. 6, is the newest one-man show starring Mr. Epperson as his drag alter-ego, Lypsinka. The hourlong performance offers further proof, as if any were needed, that yesterday's pop culture never really dies. And if it happens to involve a sequined pop diva with a taste for loud costumes and brassy music, it will probably sooner or later find its way into Mr. Epperson's museum of pop trash.

For those not already acquainted with the performer, his increasingly famous character is a willowy red-headed showgirl with popping clown eyes, penciled brows raised in continual astonishment and a ferociously cheery smile. A composite of Delores Gray, Carol Channing, Shirley Bassey and dozens of other famous and forgotten divas of stage, screen, television and nightclubs, the character never speaks.

Instead Lypsinka mouths the words to these women's usually obscure recordings from the 1940's, 50's and 60's while dramatizing the lyrics in a meticulously choreographed body language of shimmying arms and legs, swiveling hips and clawing fingers. His physical vocabulary is as brilliantly precise a distillation of traditional female stage mannerisms as the movements of a Japanese Kabuki performer.

Interwoven with the songs are snatches of movie dialogue that offer the spoken equivalent of the music. As a ringing telephone punctuates each bit, Lypsinka changes character every few seconds, eventually becoming a hysterical, multi-phrenic personality. The new show's more familiar excerpts include a fragment of a Gloria Swanson monologue from "Sunset Boulevard" and a scene from "Valley of the Dolls."

Mr. Epperson's lip-synching is not the only thing that sets him apart from more conventional drag performers. "Now It Can Be Lip-Synched," like his previous shows, holds together as a high-tension comic psychodrama that offers a scathingly funny critique of modern show business iconography and the role of women.

Behind Lypsinka's desperate grin is a woman on the verge of a nervous breakdown. Periodically the lights around her suddenly flicker and turn greenish, and she clutches at her face in a parody of Joan Crawford in her 1960's ax-murder epic, "Berserk." All the show's emotions, whether sung or acted, have a grotesque larger-than-life quality. That's partly because of Mr. Epperson's shrewd selection of material that emphasizes extremes of self-pity (June Christy's "Lonely Woman") and cheery, look-at-me grandiosity ("I'm the Greatest Star," sung by Mimi Hines, "I've Gotta Be Me," by Miss Squires and "I've Got Everything I Want" by Karen Morrow).

If "Now It Can Be Lip-Synched" celebrates a glitzy kind of stardom as an ultimate form of American glory, it portrays its attainment as an empty desperate "Valley of the Dolls" sort of existence in which women, to succeed, have to be a little monstrous.

Mr. Epperson serves up this vision as pure unfettered comedy executed with dazzling juxtapositions of songs and dialogue and virtuosic high-drag clowning. The new show's funniest moment is Lypsinka's increasingly slurred performance of "The 12 Days of Christmas" (sung by Fay McKay), in which the true-love's gifts have been changed from turtle-doves and French hens into various alcoholic beverages. As the performer becomes completely sloshed, she forges on gamely, even through a fit of vomiting, to finish the song in a daze. After all, the show must go on.

Although "Now It Can Be Lip-Synched" adheres to the format of Mr. Epperson's earlier shows, the concept retains its freshness. One reason is that Mr. Epperson has a

Albert Watson/"Lypsinka"

John Epperson in his "Lypsinka! Now It Can Be Lip-Synched."

seemingly inexhaustible supply of first-class junk from which to draw.

Sooner or later, however, he will have to expand his format. What could be next? A full-length musical that mixes "found" production numbers with live ones? It would be tricky to pull off, but it could be done.

1992 Ag 22, 11:1

SUNDAY VIEW/David Richards

'The Comedy of Errors' and the 'Boing' Factor

Much of the staging by Cacá Rosset is wild and ingenious in this extravagant celebration at the Delacorte of misplaced identities.

BARRING LAST-MINUTE CARNIvals, and assuming some fly-by-night circus doesn't decide to set up its patchwork tent in the Sheep Meadow, "The Comedy of Errors" is as festive as any sight you'll encounter in Central Park this summer.

It has been put together by the Brazilian director Cacá Rosset, who clearly believes in giving an audience lots to look at. To a play that already has a tendency to behave like a fleet of bumper cars, he has added airborne acrobats, undulating harem girls, hyperactive doctors in black robes and pointy hats, nuns less pious than their folded hands would indicate, a crippled fishmonger, bawds galore and the medieval equivalent of the Keystone Kops. He has also cast Karla Burns as Nell, the cook.

Since the acrobats have been dressed by the designer José de Anchieta Costa in candy-striped body stockings, you get the startling impression, when they go into their front and back flips, that colored lightning has just struck the stage of the Delacorte Theater. On the other hand, when Ms. Burns, who is as close to spherical as a living creature can be, chases her man about the premises, the image that springs to mind is that of a large snowball roaring down a mountain and growing larger every second.

The rest of the cast members, while not so physically arresting, are nonetheless kept busy 1) slapping someone else in the face, 2) kicking someone else in the rump, 3) tripping over themselves and 4) toppling ingloriously to the ground. These happenings are underlined by the percussionist in the on-stage band, who makes freely with the "boings" and the "kabooms."

The set, also the work of Mr. Anchieta Costa, depicts the Greek seaport of Ephesus, but it looks like Disneyland on a bender. The plump fairy-tale towers seem to be having a little trouble holding themselves upright, while the turrets could all be wearing silly party hats. There are odd catwalks and crannies you'd love to go exploring and doors everywhere for popping out of, disappearing into and running smack up against. The stage floor also comes with trapdoors, which periodically belch clouds of smoke and some surprising apparitions of their own.

There is so much to look at, in fact, that I feel ungrateful pointing out that the production, the 21st in the New York Shakespeare Festival's marathon, isn't much to listen to. While it's sometimes funny, I'm not sure it would be any less funny if it were being acted in Esperanto or Turkish. The actors are the usual dismaying mixture that the festival manages to round up each time it stages Shakespeare. Some are comfortable with Elizabethan English; some aren't but are making a game effort; still others are brazening the night out. In the past, the occasional director has been able to minimize the discrepancies and impose a semblance of stylistic unity on the throng. But while Mr. Rosset, who is working with an English-speaking cast for the first time, has a colorful vision of the play, he has very little sense of its sound, so the linguistic differences prevail. This is plainly a case of what you see being exactly what you get.

Admittedly, "The Comedy of Errors" is the least reflective of Shakespeare's plays. It contains no memorable speeches and little inward reflection beyond a certain head-scratching on the part of characters who, understandably, are confounded by the goings-on. The play wants only to show what happens when Antipholus (Boyd Gaines) and his servant Dromio (Peter Jacobson), who hail from Syracuse, arrive innocently enough in Ephesus. It turns out that Antipholus's long-lost twin (John Michael Higgins) dwells here, attended by Dromio's long-lost twin (Howard Samuelsohn). Since they all go to the same costumer, confusion rapidly sets in.

Antipholus of Syracuse can't fathom why everyone greets him so warmly, or why the comely Adriana (Marisa Tomei) treats him like an errant husband and drags him off to bed, or why, for that matter, an obliging jeweler (Larry Block) insists on pressing a costly gold chain upon him. For his part, the hometown boy, Antipholus of Ephesus, wonders why all of a sudden he has been locked out of his own house, what has become of the chain he ordered, and why his servant is act-

Karla Burns as Nell, the cook—Visual music of the sphere?

ing so idiotically. The two Dromios are merely carrying out instructions, but they keep repairing to the wrong master for follow-up orders and, consequently, get chastised for their industry. The plot is a bit like the tar baby: whoever comes in contact with it gets stuck.

A few gifted farceurs would help speed this production along. But mostly it's populated by hard-working farceurs, which is not quite the same thing. Mr. Gaines (who appears to be standing pigeon-toed even when he isn't) and Mr. Higgins (who seems to be gritting his teeth, although he may well be smiling) are of the hard-working variety. You appreciate the effort but wish it didn't show quite so much. Mr. Jacobson and Mr. Samuelsohn throw themselves about with reckless abandon, when they're not being thrown. (They're sort of the evening's beanbags.) But neither Dromio is what you'd call light on his feet. Ms. Tomei, as the befuddled wife, seems to be revving up for the part of Kate in "The Taming of the Shrew."

■

The actors on the periphery come over better. Mr. Block's jeweler is a grand blend of subservience and greed, and his gold skullcap sets off a wonderfully doughy face that just could be waiting for a cartoonist to sketch in the features. Stephen Hanan makes a spectacular second-act entry as Dr. Pinch, the schoolmaster summoned to put order into chaos. He then proceeds to *sing* his role with the kind of operatic gusto that huffs, puffs and threatens to blow the whole set down. Even later, Elizabeth Franz careers on in the starched wimple and clinging habit of an abbess with an 11th-hour revelation to spring on the puzzled company. "Be quiet, people," she growls furiously at the audience, before adopting the sweet and slightly patronizing smile that bullies reserve for the bullied. It's Sister Mary Ignatius all over again, and I, for one, was delighted to see her.

Potentially, a knockout "Comedy of Errors" lurks inside this production. I suppose that can be said about lots of shows that don't rise to the mark they've set for themselves. Yet nothing about Mr. Rosset's staging strikes me as wrongheaded, and a good deal of it is wild and ingenious.

He has taken his cue from the visiting Antipholus, who has heard tell that Ephesus is an enchanted place, overrun with "nimble jugglers that deceive the eye, dark-working sorcerers that change the mind, soul-killing witches that deform the body, disguised cheaters, prating mountebanks." Most directors would be happy just to let the misunderstandings pile up. Mr. Rosset envisions the play as an extravagant celebration of people who have momentarily lost track of who they are. To that intoxicated end, he has drawn upon the commedia dell'arte, Molière, Tom and Jerry cartoons, Mardi Gras, High Mass and — I'm hazarding a guess here — the Technicolor dreams in fancy rum drinks.

The execution may be wanting. But the blueprints are deliriously sound.☐

1992 Ag 23, II:5:1

Anna Karenina

Adapted from the novel by Leo Tolstoy; book and lyrics by Peter Kellogg; music by Daniel Levine; directed by Theodore Mann; musical sequences staged by Patricia Birch; orchestrations by Pater Matz; musical direction and dance music arrangements by Nicholas Archer; music coordinator, Seymour Red Press; scenic design by James Morgan; costume design by Carrie Robbins; lighting design by Mary Jo Dondlinger; sound design by Fox and Perla. Presented by Circle in the Square Theater, Theodore Mann, artistic director; Robert A. Buckley, managing director; Paul Libln, consulting producer. At 1633 Broadway, at 50th Street, Manhattan.

Count Alexis Vronsky............Scott Wentworth
Anna KareninaAnn Crumb
Constantine Levin..............Gregg Edelman
Prince Stephen Oblonsky.........Jerry Lanning
Princess Kitty Shcherbatsky.Melissa Errico
Seryozha Karenin.............Erik Houston Saari
Nicolai Karenin....................John Cunningham

By MEL GUSSOW

Every unhappy musical is unhappy in its own way, but no musical is more unfortunate than "Anna Karenina," the travesty of Tolstoy's novel that opened last night at Circle in the Square Theater. This show, the handiwork of Peter Kellogg and Daniel Levine, represents a series of misperceptions and errors in judgment, all of which are compounded in Theodore Mann's production.

The novel is, of course, one of the greatest of tragic love stories and also the most lucid presentation of Tolstoy's ideas on morality and the future of his society. The least to be expected from an adaptation would be for it to capture the passion of Anna, who abandons her marriage and her code of ethics for the sake of her romance with Count Vronsky. The musical "Anna Karenina" reduces the story to the proportions of a historical romance: Barbara Cartland meets Leo Tolstoy, and the band plays on.

In his production, Mr. Mann has undercut the show through a flagrant stroke of miscasting. Ann Crumb, who played the fickle actress in "Aspects of Love," is a continent away from Anna in temperament, bearing and appearance. As Vladimir Nabo-

Martha Swope/"Anna Karenina"
Ann Crumb in "Anna Karenina."

kov said, Anna "is a woman with a full, compact, important moral nature: everything about her character is significant and important." Anna is stunning; when she enters a room, all eyes are upon her. With Ms. Crumb in the musical, Anna is no longer the center of attention. There is a residual coarseness in her performance, beginning with her stridency and her forced laughter. The M-G-M movie version was unsuccessful in capturing the novel but it had Greta Garbo, who was an electrifying presence in the title role.

The failure of the musical is deeper than the actress or the characterization. It is a question of tone, which is much closer to Broadway show business than to Czarist Russia. The adaptation skims the surface of the story and ignores the texture, dropping in songs sometimes at inappropriate moments. The creators of "Annie" had far greater respect for their comic strip orphan than Mr. Kellogg and Mr. Levine have for Anna.

In his reshaping of the novel, Mr. Kellogg freely juggles events, placing Vronsky on the train with Anna from St. Petersburg and on the platform at the end of the play when she meets her doom. This approach invents drama when none is needed. The adaptation is most damaging in the rewriting of two major characters. Levin, one of the noblest of Tolstoy's creations and a close approximation of the author himself, is turned into a musical comedy second lead, a good-natured bumbler. Kitty, his eternal love, becomes the ingénue, a pert and silly flirt who can't say yes so she says no. When they finally confess their love for each other, one of the most powerful scenes in the book is reduced to a joke.

The most that can be said for Mr. Levine's score is that it has several pretty tunes, but in harness with Mr. Kellogg's lyrics they often seem like numbers from a "Forbidden Sondheim," as in the opening song, "On a Train," which enumerates the travails of train travel ("struggling with the luggage, rattling the teacups"). As the show wanders among musicals past, it strives to emulate "A Little Night Music," whose bittersweet air is the opposite of the heartbreaking intensity of "Anna Karenina." There is a four-part harmony that sounds as if the characters are about to embark on a weekend in the country.

●

It is not until the end of the long first act that Anna and Vronsky flee from Russia. This leaves so much plot for the second act that the musical is forced to resort to a version of the movie montage effect. It awkwardly crosscuts between Anna's lonely son in St. Petersburg and the runaway couple in Italy.

Russian atmosphere is left to the costumes and to occasional mazurkas choreographed by Patricia Birch. The mannerisms are decidedly American, especially so in the case of Ms. Crumb. Behind his thick whiskers, John Cunningham is a glum Karenin, for good reason. Almost every time he walks into a room, he catches his wife and her lover in a compromising situation. With more help from the script, Scott Wentworth might be a dashing Vronsky, but Gregg Edelman and Melissa Errico (as Levin and Kitty) seem to have wandered in from a different musical. Alone among the principals, Jerry Lanning (as Anna's well-meaning brother) approaches the complexity of his character.

The Circle in the Square's open stage is not a conducive environment for musicals, a fact that is underscored by this unwieldy show and its constantly shifting landscape. In James Morgan's setting, the floor is lacquered in imitation of a patterned carpet. In modern musical fashion, the designer is overly reliant on chairs for scenery. As in "Grand Hotel," people come, people go, people move chairs — and in this case they also move trains.

Although "Anna Karenina" is certainly an unlikely choice for musicalization, "Les Misérables" demonstrated that musical theater is not necessarily antithetical to great literature. Erwin Piscator's dramatization of "War and Peace" proved that even a Tolstoy epic could be distilled on stage. But "Anna Karenina" is far beyond the grasp of the team at Circle in the Square. Remember the novel, remember Garbo, forget the musical.

1992 Ag 27, C17:2

The Elephant's Tricycle

Written and directed by Elizabeth Cashour; choreography by Peter Pucci; sets and costumes by Steven Saden; lighting by Don Ehman. Presented by Tricycle Productions. At the Atlantic Theater, 336 West 20th Street, Chelsea.

WITH: Catherine Brophy, Douglas Gibson, Brennan Murphy and Lillo Way.

By D. J. R. BRUCKNER

The big question in "The Elephant's Tricycle," a new play by Elizabeth Cashour, is: Will Kate hang onto P. H. after a 10-year affair with him, or lose him to his new boyfriend, Angel, who is in the button business on Seventh Avenue when he is not pursuing P. H.?

If that were the whole plot, the play might well be a post-modern romp of the kind the National Endowment for the Arts would probably not want to underwrite. But Ms. Cashour is in a whimsical, experimental mood; her title comes from a murky Sanskrit tale told by Kate (a puppeteer when she's not pursuing P. H.) as she dons an elephant mask that makes her look like the Hindu god Ganesh in the Peter Brook "Mahabharata" and rides a tricycle around her room. That little visual joke is apt; "The Elephant's Tricycle" is almost as disorderly as the vast Sanskrit epic, if not quite as episodic.

For the production she directs at the Atlantic Theater, Ms. Cashour has brought together an attractive cast that holds one's interest even when the story seems to have spun entirely beyond comprehension or memory.

The actors have no easy task, since the principal characters are often not very decent to one another. Kate (Catherine Brophy), who is often hung over and more often angry, is rude and selfish around Abby (Lillo Way), a woman with whom she has a vague sort of affair at a vague time in the past. And with P. H. (Douglas Gibson), she veers from adoring to nagging and bullying.

P. H. is a problem. Not long into the play one starts wondering why Kate or Angel would want him. He spends most of his energy keeping them at a distance and nowhere in the dialogue is there a hint of what his magnetism might be. When Angel (Brennan Murphy) asks him to make up his mind

and choose to lie in only one of the two beds he's made for himself, he replies: "I need someone *not* to ask me to choose."

In the end the two most appealing characters are Abby and Angel, both rejected when Kate stops nagging and P. H. falls into a choice of sorts. Ms. Way and Mr. Murphy are free to concentrate on giving these two people sharp, clear outlines, and they are memorable. Ms. Brophy and Mr. Gibson succeed admirably in holding one's interest, through a long play, in Kate and P. H., who are mostly mystifying and often downright annoying.

Ms. Cashour, who is the acting executive director of the Joyce Theater when she is not writing and directing, throws a little music and a few dance steps into the play here and there, but the intention is never clear.

1992 Ag 27, C22:3

On the Razzle

By Tom Stoppard; directed by Patrick Sayers; stage manager, Lee Eypper; sets, Bob Carpenter; costumes, Lauren Pytel; lighting, Martin Fahrer; executive producer, Lou Kylis. Presented by Lightning Strikes Theater Company, Jim Williams, artistic director; Paul Tomayko, managing director. At Synchronicity Space, 55 Mercer Street, SoHo.

WITH: Jeff Buckner, Lyle Coffield, Wendy Coates, Derek Conte, Bernice DeLeo, Lee Eypper, Martin Everall, Holly Greif, Fred Harlow, Christina Kelly, Marinell Madden, D. Candis Paule-Riggs, Jed Sexton, Linda Taylor, Paul Tomayko and Michael Wire.

By MEL GUSSOW

When Thornton Wilder adapted Johann Nestroy's 19th-century Viennese farce, "Einen Jux Will Er Sich Machen (loosely, "He's Out for a Fling,") he transposed the action to America, created the character of Dolly Gallagher Levi and called the play "The Matchmaker." By the time Jerry Herman had made the comedy into a musical, Dolly had practically swept all the other characters off the stage. Tom Stoppard's version, "On the Razzle," returns the story to Vienna and holds to Nestroy's basic plot. Two clerks leave their employer's country grocery and have a wild

night on the town — and no one needs a meddling matchmaker to foster romance. But by Mr. Stoppard's own admission, his adaptation is a free-handed departure from the original.

In typical Stoppard fashion, "On the Razzle" is layered with puns and word plays. Wit vies for center stage with burlesque jokes and running gags. Sometimes the linguistic trickery seems at cross purposes with the demands of farce, but the play is funny, as was clear from the 1981 production at the National Theater in London. In the New York premiere at the Lightning Strikes Theater Company, the razzle fizzles.

•

The young and inexperienced cast works energetically, to very little effect. The actors blur the cleverest lines and blunt Mr. Stoppard's comic invention. Timing is off, and for that and other reasons, the direction, or rather the nondirection, of Patrick Sayers bears responsibility. Mr. Sayers has seemingly allowed the actors to follow their own instincts, which carries them into varying degrees of mugging.

There is overacting in small and large roles, with one servant stooped to a right angle to simulate old age and others making excessive use of their arms and eyes to flag the audience that humor is approaching. Derek Conte as the shop's proprietor at least catches his character's pomposity, and Jeff Buckner, as the chief clerk, earns a few smiles with his fumbling inefficiency.

When the entangled couples finally arrive at the Imperial Gardens cafe (Harmonia Gardens in "Hello, Dolly!"), the pace should be breakneck as the waiters rush across the stage and narrowly avoid collision. In this version, even the waiters misfire.

As an adaptation, the play is not on a level with "Undiscovered Country," Mr. Stoppard's masterly rendition of Schnitzler, still not performed in New York. (Hands off, Lightning Strikes.) But "On the Razzle" is much more entertaining than evidenced in the current production. For authentic Stoppard, one should turn to the Roundabout Theater Company's revival of "The Real Inspector Hound" on Broadway.

1992 Ag 28, C2:3

Wendy Coates, left, Derek Conte and Jeff Buckner in a scene from Tom Stoppard's "On the Razzle," staged by Lightning Strikes Theater.

'Distant Fires,' Pushing the Limits of the World of Work

"Distant Fires," first presented in New York by the Atlantic Theater Company, reopened last night at Circle in the Square Downtown, 159 Bleecker Street, Greenwich Village, in a production presented by the Herrick Theater Foundation. Following are excerpts from Mel Gussow's review, which appeared in The New York Times on Oct. 17, 1991.

Tempers are flaring on a construction site in Kevin Heelan's "Distant Fires," as five laborers pour cement and react diversely to the limits of their lives. This perceptive group portrait of men at work is the combined contribution of the playwright, his director, Clark Gregg, and an ensemble cast.

In the David Mamet tradition, the dialogue is pithy and profane. The play moves effortlessly from amusing working-class conversation to an atmosphere that is highly charged with conflicting points of view. While taking part in the specifics of the shared activity, the characters exchange comments on their hard-hat

Learning that the rewards don't always go to the deserving.

world and reveal their emotional bruises, some of them self-inflicted. Three of the men are black, with their opportunities rigidly circumscribed by insidious acts of discrimination in the building industry.

•

The one laborer (Ray Anthony Thomas) who has the capability and ambition to move up in the ranks and become a member of the local bricklayers' union clearly will be thwarted by his own willingness to compromise. The narrative of the play follows Mr. Thomas's growing realization of the causes of his frustration, culminating in a silent scene in which the actor movingly expresses his pent-up resentment. The story line is thin, but sufficient to contain the indirect drama.

Quietly, "Distant Fires" raises sobering questions about racism in the work place and about the roots of urban violence. The play neither overstates its case nor overstays its welcome. The playwright's avoidance of melodrama testifies to his confident command of background and character.

Mr. Thomas, hopeful of progress, is the only member of the crew who has respect for the work ethic. Around him are slackers and talkers. The latter position is appealingly typified by David Wolos-Fonteno as an affable hedonist who works only to be able to play after hours. Idling alongside him is Giancarlo Esposito as a man simmering with rage and unfocused energy. He is easily drawn into the riots that are engulfing a nearby neighborhood (the "distant fires" of the title).

The outsiders on the crew — insiders in life — are a handsome Maryland equivalent of a hillbilly (Jordan Lage), who, because he is white, will advance in the job despite his occupational deficiencies, and a guileless teen-ager (Todd Weeks) who may be the author's spokesman. On the periphery is the man in charge of the project (Jack Wallace), a figure with power but absolutely no conviction.

•

Though some of these characters may seem familiar, each one is highly individualized in the writing and in performance. Under the skillful guidance of Mr. Gregg, functioning as unseen foreman of the work crew as well as director, the actors achieve a veracity within the play and beyond the stage space they occupy. One could imagine them finishing their day's work and dropping in at a local bar for beer and banter, and then returning the following morning to the construction site.

1992 Ag 28, C2:3

Back to Bacharach

A musical tribute to Burt Bacharach and Hal David. Direction and musical arrangements by Steve Gunderson. Presented by Kathy Najimy and Good Dog Productions. At Steve McGraw's, 158 West 72d Street, Upper West Side, Manhattan.

WITH: Steve Gunderson, Melinda Gilb, Sue Mosher and Carla Renata Williams.

By STEPHEN HOLDEN

In one of the wittiest moments of "Back to Bacharach," an irresistibly ebullient new revue of the songs of Burt Bacharach and Hal David, the show's four singers don sunglasses, begin snapping their fingers and slink about the stage of Steve McGraw's singing a super-cool harmonization of "(They Long to Be) Close to You."

At once musically impeccable and slyly satiric, the performance distills the spirit of the show, which was conceived and arranged by Steve Gunderson, one of its four performers, and produced and directed by the comic actress Kathy Najimy. The revue, which plays at the club on Thursday and Friday evenings, manages the difficult feat of simultaneously honoring one of the most durable songwriting catalogues in American pop history and sending up a 1960's Las Vegas concept of hipness as it might have influenced a group of suburban teen-agers.

Although the cast isn't outfitted in Nehru jackets and mini-skirts, their boots, peace symbols and oversize baubles suggest a 60's fashion consciousness realized on a very limited budget.

As classic as Mr. Bacharach and Mr. David's work has proven to be, it was never on the cutting edge of the 60's pop counterculture. Bubbly romantic ballads for young sophisticates, after all, were not the right sounds for manning barricades and exhorting revolution. The team's pas-

Greg Weinel

Steve Gunderson, left, Carla Renata Williams, Melinda Gilb and Sue Mosher in the revue "Back to Bacharach."

sionate, clangy arias for the young Dionne Warwick may have had one foot on the street, but the other remained firmly in the corner of traditional show-business glamour. While Mr. David's lyrics suggested an affluent young-adult echo of Motown transported to suburban New York, Mr. Bacharach's rangy melodies, with their post-Wagnerian harmonies, tricky time signatures and staccato diction, aspired to outdo Cole Porter in dreamy sophistication.

Besides Mr. Gunderson, the show features Melinda Gilb, Sue Mosher and Carla Renata Williams. All four have strong voices that are disciplined enough to deliver without undue strain the demanding semi-operatic flourishes of Mr. Bacharach's ornate melodies. But the performers also have enough feel for rock and gospel to avoid sounding stiff and formal. Just as in Ms. Warwick's memorable recordings, the songs seem to tumble out of them. John Boswell, the pianist who leads a very capable backup combo, keeps the tempos as brisk as the original arrangements on Ms. Warwick's records. That's why even the most passionate, lovelorn ballads like "Anyone Who Had a Heart" and "Walk On By" leap forward with an eager, optimistic energy.

The show's stroke of brilliance is the way Ms. Najimy has directed the performers to ham it up. Songs like "Message to Michael," "I Just Don't Know What to Do With Myself," "Are You There (With Another Girl)," "Always Something There to Remind Me" and "Don't Make Me Over" are fraught with the overwrought teen-age angst of a Sandra Dee movie. Instead of trying to play them straight, the performers dramatize them in informal comic tableaux, injecting discreetly exaggerated squeaks and sobs into key phrases and underscoring the Sturm und Drang with melodramatic body language. The cartoonishness is carried just far enough to give the performances an edge of comic hysteria without completely laying waste to the sentiments being expressed.

If the tone of the show leans toward comedy, the revue is not without its moments of misty romanticism. One is Ms. Gilb and Mr. Gunderson's gracefully entwined renditions of "A House Is Not a Home" and "One Less Bell to Answer," a medley that Barbra Streisand sang in her 1971 album, "Barbra Joan Streisand." The most touching is Ms. Gilb's heart-rending performance of "Whoever You Are, I Love You," a largely overlooked ballad from the 1968 Bacharach-David musical "Promises, Promises."

"Back to Bacharach" is scheduled to play at Steve McGraw's through Sept. 11. It is too good a show not to have many other lives.

1992 S 4, C2:3

Under Milk Wood

By Dylan Thomas; directed by Robert Hupp; set and lighting by Giles Hogya; costumes by Andrea Gibbs; songs and musical direction by Ellen Mandel; production manager, Patrick Heydenburg. Presented by Jean Cocteau Repertory, Robert Hupp, artistic director; Scott Shattuck, managing director; David Fishelson, associate artistic director; Jerry Kolber, general manager. At the Bouwerie Lane Theater, 330 Bowery, Lower East Side.

WITH: Harris Berlinsky, Steve Chizmadia, John Lenartz, Joseph Menino, Elise Stone, Angela Vitale, Mark Waterman and Adrienne D. Williams.

By D. J. R. BRUCKNER

All the unruly, mischievous, lying, lusting and bemused denizens of Dylan Thomas's Welsh fishing village of Llaruggub are back in the Jean Cocteau Repertory Company's production of "Under Milk Wood" at the Bouwerie Lane Theater. And 39 years after they first appeared with Thomas himself in the cast at the 92d Street Y, they remain as lively and diverting a bunch of rascals as one can find onstage.

Eight members of the Cocteau company, directed by Robert Hupp, take on the 55 voices in the play. In devising scenes to illustrate what Thomas called a "play for voices," Mr. Hupp occasionally produces distraction, especially in the children's episodes. (Since there are no real children in this company, it would be far better for the children in the play to be heard and not seen.)

•

But for most of the two hours, the actors stimulate the imagination as the poet's lush and earthy language thunders, lilts and whispers through the auditorium. A few seem breathless at times, but no one garbles any of these vocally acrobatic lines. After a good performance of this play, it is difficult to believe one has not really been in that town on a day when the first warmth of spring coaxed out the buds, and all the merriment of these odd people.

As the Rev. Eli Jenkins, Joseph Menino delivers a fine rendition of the minister's poem greeting the morning, verse Thomas himself made famous as a recorded comic cameo. Mr. Menino is also very funny as the town butcher teasing his wife about a breakfast made of parts of most of the pets in the village. As Lord Cut-Glass he is a bit upstaged, properly, by the rest of the cast members when they become the backwater nobleman's 66 clocks in a set piece audiences always love.

Angela Vitale and John Lenartz are a deliciously grim couple as the Pughs, she prim and nagging, and he slyly obsequious as he revels in dreams of poisoning her. Singing with Captain Cat (Harris Berlinsky), Elise Stone as Rosie Probert has a surprisingly deep, vibrant contralto voice that makes her lines a good deal more memorable than they usually are.

Mark Waterman, as the musical maniac Organ Morgan, could almost make one detest Bach, and his No-good Boyo is a village idiot nonpareil. Steve Chizmadia manages some hilarious contortions and falls as Sinbad the drunkard, but he is even funnier as Willy Nilly, the postman who reads everything before he delivers it.

Adrienne D. Williams, as Mrs. Willy Nilly, is a wonderful ally in his snoopery, with tea kettles steaming all day to unglue the envelopes. She plays other knock-'em-dead roles as well: the buxom and tempting young teacher, the gypsy second wife of the overmarried Mr. Dai Bread, and Polly Garter, the all-too-easy lover of love. Her version of the song about Tom, Dick and Harry and Little Willie Wee is as sharp and sweet as can be.

The actors take on many other characters, of course, and different viewers will choose different favorites. That is what is so satisfying about this play in a good performance: an audience has a rich feast to choose from.

1992 S 4, C2:3

Pastiche of Columbus, Politics and Puppets, Tinged With Pathos

By STEPHEN HOLDEN

Peter Schumann's Bread and Puppet Theater has never shrunk from taking on issues whose scope more than matches the dimensions of the giant puppet masks and figures that the company commonly uses in its productions. And in "Columbus: The New World Order," the two-and-a-half-hour play that inaugurated the Public Theater's international festival of puppetry on Monday afternoon, the topic is nothing less than Christopher Columbus's voyage to the New World in 1492 and its consequences. With Mr. Schumann being devoutly pacifist and left-wing, the fable that unfolds is a brutal tale of conquest, destruction and oppression that ends with an ambiguous warning.

The work, which incorporates text by Mark Twain, Jayce Salloum and Max Schumann, is divided into indoor and outdoor sections. Monday afternoon saw the only New York performance with the outdoor part included. The final performance of the first part, which is far and away the better half, will be at 8 tonight at the Public Theater.

•

The considerable power of the Bread and Puppet Theater's work lies in its skill at creating expressionist, and often giant-size, puppet masks that have the impact of strong political cartoons then using them in ritualistic scenarios whose most resonant moments transcend agitprop.

In the first section of the work, each of the play's seven scenes is introduced by an actor in a skeleton's costume turning a scroll on an easel as a red light flashes and a beep sounds. At the end of each scene, a precise description of the deadly capabilities of weaponry used in the Persian Gulf War is recited. In crude, mythically weighted strokes, the scenes evoke Columbus's birth, his dealings with the Spanish court, his journey and arrival and the conquest and oppression of the New World's native peoples.

Among the play's more insistent themes is the invocation of Christianity to justify all the conquest and bloodshed. In a ceremony early in the play, a blessing of wine is drawn from the arms of a statue of the crucified Jesus.

Clare Dolan

A scene from Peter Schumann's Bread and Puppet Theater production of "Columbus: The New World Order."

Another recurrent motif is the image of everyday people turned into grotesque automatons. In the first part, they are sailors dressed in identical prison-stripe uniforms who hold up placards that give the percentages from bogus public-opinion polls. Later they reappear as literally faceless bureaucrats in baggy suits and eyeless, lipless shoe-shape masks, spouting clichés like "have a nice day" while marching around in formation.

In the most gripping scene, the cutout figures of babies in their mothers' arms are wrenched from their grasp by the conquerers wielding hooks and cables as the eggheaded figure of Columbus, looking a bit like George Washington, watches impassively. The United States is represented by a figure draped in red whose head is a collection of pink-skinned papier-mâché faces around a miniature American flag. The section ends with the establishment of "the New World order" and the waving of that flag.

•

After the indoor section on Monday, the actors, augmented by at least a score of volunteers, moved the play outside, where the audience, led by a brass band, marched under the mast of the Santa María into the heart of Washington Square Park. The image of Columbus changed into a character named Uncle Fatso, who oversees the conversion of Quebec's northern wilderness into a sprawling hydro-electric project. The most striking scenes portray the destruction of trees and animals whose deaths are staged as a series of ritual executions on a kind of scaffold.

Although the lengthy outdoor section included too many songs and lectures, which were nearly inaudible, and too much marching around, it concluded with an image so striking that it was almost worth the wait. Eight actors appeared bearing a giant representation of Mother Nature, a severe, enigmatic figure with ancient wizened features. Clumsily waving her giant hands, she drew the cast to her bosom, then manipulated the huddled actors this way and that, ultimately forcing them to bow to her capricious and possibly angry will.

1992 S 9, C15:1

Joyicity

By Ulick O'Connor; directed by Caroline Fitz-Gerald; original music by Noel Eccles; set design by David Raphel; lighting by Gregory Cohen; production stage manager, Chris Kelly. Presented by the Irish Repertory Theater, Charlotte Moore and Ciaran O'Reilly, artistic directors, and One World Foundation. At Actors' Playhouse, 100 Seventh Avenue South, at Christopher Street, Greenwich Village.

WITH: Vincent O'Neill.

By WILBORN HAMPTON

Whether jigging a jiggily jig down the Liffey or juggling a jangly jingle jiffily, there's joyance and jollity in "Joyicity." Ah, that Jimmy Joyce, he knew a bit of the lingo, by jingo.

All alliterative allusion aside, "Joyicity," an Abbey Theater production being presented by the Irish Repertory Theater, is an inspired hour based on the life and work of James Joyce, a celebration of language through the pen of perhaps our century's greatest master. The material has been judiciously selected and expertly woven together by Ulick O'Connor and is given an enlightened performance by Vincent O'Neill.

Fergus Burke

Vincent O'Neill

The show is basically a succinct yet insightful biography of Joyce told through recitation and enactment of passages from his works as well as anecdotal matter from Richard Ellmann's brilliant "James Joyce."

No prerequisite reading or homework is necessary. "Joyicity" can be a primer for anyone daunted by Joyce's reputation as an Olympian writer of incomprehensible gobbledygook, yet at the same time delight and entertain genuine Joyceans.

What emerges is a miniature portrait of the artist as a young, middle-aged and older man, all too human, searching for the same things we all want to know — Who are we? Where did we come from? Where are we going? — and finding the traditional answers unsatisfying.

•

Appropriately, "Joyicity" begins on the banks of the river Liffey in the English-ruled, Catholic-confessed Dublin where Joyce was bred-and-buttered. There are his alcoholic father and long-suffering mother, who bore 15 children, and his brother Stanislaus, his lifelong critic and friend. And there is his walk down Nassau Street in June 1904, when he first saw Nora Barnacle, the woman who became his wife and muse and would stick with him through thick and thin ("Barnacle by name, barnacle by nature").

Although Joyce soon turns his back on both King and Pope and flees to Paris, Trieste, Zurich and points in between, he can leave neither family nor Dublin nor the Liffey completely behind. As Ellmann pointed out, if Joyce sought to fly past the net of his family, his life's works were all entangled in it.

Mr. O'Connor whisks us along on Joyce's Odyssean exile, pointing out the literary landmarks on the way, while the artist metamorphoses from the witty darling of Dublin's musical evenings into a monkish expatriate, an international literatus, sneaking off from Nora to cadge a bottle of wine from the men's room attendant at his regular Paris bistro.

In weaving this delicate tapestry, Mr. O'Connor has interlaced some of Joyce's early love poetry with lines from "Pomes Penyeach" and even the odd limerick. Scenes from "Ulysses" and "Finnegans Wake" have been deftly edited and seamlessly stitched together and reflect a broader appreciation of the canon than more predictable selections like Molly Bloom's reverie or the final paragraph of "The Dead." Through it all, Mr. O'Connor has kept the conjunctive matter at a minimum and left most of the talking to Joyce.

The adroitness of the text is matched by a masterly reading from Mr. O'Neill. To confront the words alone must be terrifying. One dropped syllable and the whole poetic cadence is lost. Not only does Mr.

O'Neill bring them trippingly off the tongue; he also captures the affectionate irreverence with which they were first sent forth.

In the scene in Barney Kiernan's pub, from the Cyclops section of "Ulysses," Mr. O'Neill delivers a small tour de force. Playing the entire congregation — Bloom, citizen, Joe, Little Alf, John Wyse, Terry, Lenehen, J. J. — Mr. O'Neill switches voices, intonations and attitudes with such dexterity one can imagine a dozen actors on stage and even a real dog growling the part of Garryowen.

One could quibble about technique here and there. One might wish, for example, that Mr. O'Neill would take a bit more time with the final page from "Finnegans Wake" at the end or curtail his occasional tendencies to excessive gesturing.

But portraying a cast, both real and imagined, as rich as any in modern literature — from Gerty McDowell, who leans back to watch the fireworks and watch herself being watched, to the Ondt and Gracehopper fable in "Finnegans Wake" — Mr. O'Neill displays a keen understanding of his characters and material and carries his audience along with him.

1992 S 11, C2:3

Roman Paska
'The End of the World'

Written, directed and performed by Roman Paska; created with the collaboration of Donna Zakowska; puppets and scenic design by Mr. Paska; lighting by Stephen Strawbridge; music by Richard Termini; costumes by Ms. Zakowska with John Schneeman; production assistants, Basil Twist and Jed Weissberg. At the Joseph Papp Public Theater, the New York Shakespeare Festival, Joseph Papp, founder; JoAnne Akalaitis, artistic director; Jason Steven Cohen, producing director; Rosemarie Tichler, associate artistic director; a Jim Henson Foundation presentation of Puppetry at the Public, the International Festival of Puppet Theater, Cheryl Henson, executive producer; Leslee Asch, producing director; Bill Yates and Anne Dennin, associate producers. At the Public, 425 Lafayette Street, Greenwich Village.

By LAWRENCE VAN GELDER

From time to time on the stage of the Susan Stein Shiva Theater at the Joseph Papp Public Theater, tiny bells tinkle.

Send not to know for whom; they tinkle for thee.

Through the medium of puppetry, in a world premiere performance ti-

tled "The End of the World," part of the International Festival of Puppet Theater, Roman Paska is exploring matters that have gripped the imagination of dramatists of all sorts for millenniums: life and death, identity, love, sex, posterity, the afterlife.

•

In this presentation, the third section of a series he calls "Theater for the Birds," the bowler-hatted Mr. Paska deftly manipulates his three characters on and beneath a narrow platform that suggests the precariousness of a balance beam. Behind his left shoulder as he faces the audience floats a balloon imprinted with a map of Earth. Mr. Paska works in a world of his own devising.

At first, this world — a neo-Rube Goldbergian assemblage flanked on one side by a telescope, on the other by a slim ladder — is inhabited by but two characters: a male figure whose partly spangled costume and nearly conical hat suggest both clown and prelate, and a female one with whom he has a less-than-idyllic relationship. Into their life, with the aid of a fly swatter that downs a jumbo jet, are flung objects including a severed leg in a net stocking, a hat, a bundle and finally, forming the drama's triangle, the body of a survivor.

In time, this man will sunder the woman's previous relationship. He will have sex with the woman, recostumed as a nursing nun. On a couch, intoning "The mind is good; the body is evil," he will seek his identity under the influence of the priestly clown figure. In time, the woman will bear his child. Bloody death and continuing existence will round out what Mr. Paska has called his "first clown tragedy with a happy ending."

•

Although Mr. Paska's drama can be elliptical to the point of opacity, there is no question of his gifts as a puppeteer. Their expressions are unchanging, but Mr. Paska invests his characters with vivid life, sometimes in silence, sometimes accompanied by a groan, a sound effect or dialogue. Hands flutter in agony and convey anguish by stroking a face. Postures transmit physical pain, passion, inner turmoil. Richard Termini's music and Stephen Strawbridge's lighting deepen the atmosphere of Mr. Paska's world in the performance, to be repeated tonight and tomorrow at 10 P.M.

Amid the mystery, there is mastery.

1992 S 11, C2:3

Theater in Review

Some are trash, some are disobedient, some are spicy, some are weird and twisted, and they're all in the festival called Puppetry at the Public.

Paul Zaloom
Sick but True

Through tomorrow

Researched, designed and performed by Paul Zaloom; written by Mr. Zaloom, Donny Osman and Jed Weissberg; directed by Mr. Osman; co-director and production manager,

Jim Moore/International Festival of Puppet Theater
Paul Zaloom in "Sick but True" at the Public Theater.

Mr. Weissberg; lighting by William Shipley Schaffner; slide projection by Jan Hartley; slide photography by Elizabeth Ennis and Steve Zitelli. The Jim Henson Foundation presentation of "Puppetry at the Public: The International Festival of Puppet Theater," executive producer, Cheryl Henson; producing director, Leslee Asch; associate producers, Bill Yates and Anne Dennin. At the Joseph Papp Public Theater, 425 Lafayette Street, Manhattan.

"At times I feel like an ant in a sophisticated ant colony," jokes Paul Zaloom in the opening moments of "My Civilization," the introductory monologue in his sardonic one-person show, "Sick but True," at the Public Theater. Musing on how civilization came to be the way it is, Mr. Zaloom stands over a table spread with miscellaneous junk. Manipulating the debris, he builds an iconography of trash that, magnified on an illuminated screen, becomes a mirror of a world congested with filth and poison.

Mr. Zaloom's story begins with the creation of the universe itself. Once it was only the size of a head of a pin, he says, displaying a magnified pinhead. The Big Bang is a messy liquid explosion on a glass slide. Moments later, Christopher Columbus (a drawing of a coin with his likeness) has already set sail for America. Soon skyscrapers (grade school rulers of varying lengths) have been built and cable television (a jumble of wires) has been installed.

Using junky toys, cutout pictures and colored fluids, Mr. Zaloom offers a Mr.-Wizard-at-the-dump science exhibit of how our own garbage comes back to destroy us. A toy boat loaded with garbage lurches into the ocean where it deposits its load and taints some fish. The cycle is complete when a piece of seafood produces diarrhea.

"Sick but True" continues with a two-part theatrical survey of the modern world as imagined through trash. The first part is a demonstration of products and advertisements for products that range from the ludicrous to the lethal. They include hideous men's wear constructed so the crotch bulges, cheery tourist litera-

ture for scientists visiting the site of the nuclear accident in Chernobyl, and health insurance for pets. The creepiest is a lemony masking fragrance that covers up most smells but whose directions state it is dangerous to inhale.

"Sick but True" culminates with devastating comic essays on American education, agriculture, energy and religion in which ordinary household objects stand in for people and architecture. They reveal Mr. Zaloom's uncanny eye for objects that visually evoke people and architecture. A nuclear power plant is represented by a humidifier and three blenders filled with red- white-and-blue liquid. A grade school teacher is a bottle of dishwashing liquid, the principal a dented coffee pot, and the students are a mass of shoes.

The show's tour de force is a savage satire of an interfaith conference where the host is a plastic Santa Claus and the representatives include an archbishop (a plumed fountain pen), a rabbi (a black hat) and a Muslim leader (burnoose). Jovially and without debate they vote no for women, family planning, homosexuality and an enthusiastic yes for bingo. When the question is asked, "Who is God?" Mr. Zaloom mounts a pedestal and unfurls a full-length poster of Elvis Presley.

Much of the power of Mr. Zaloom's work lies in the deceptively casual, almost slapdash comic tone of his little lectures. He appeals to audiences with the humor of a mischievous child who has just returned from the landfill covered with dirt, his hands full of goodies for a game of show and tell. What he shows is a picture of ourselves as the biggest slobs on the planet. A lot messier than ants, he suggests, we are suffocating in our own waste.

STEPHEN HOLDEN

Theater Drak

'Pinokio'

Through tomorrow

Performed by Jan Pilar, Vaclav Poul, Jan Bilek, Ladislav Perina, Jeri

Krestan, Jaroslav Hudossek and Petr Macl; written by M. Klima, Josef Krofta, Petr Matasek and Vladimir Zajic; directed by Mr. Krofta; assistant director, Michaela Domeova; lighting by Milan Steklik; set, costumes and puppets by Mr. Matasek; music by Jiri Vysohlid; choreography by Antonin Klepac; sound by Jiri Tulach. "Puppetry at the Public."

Abandon expectations, all ye who enter the Estelle N. Newman Theater. No Disney wooden head awaits inside, where Theater Drak of Czechoslovakia is presenting "Pinokio." Look for no Cleo, no Figaro, least of all for a Jiminy Cricket.

The unpainted wooden creature who awaits inside — eyeless face, jiggling limbs and long nose, for which his creator, the woodcarver Gepetto apologizes — is not into cute.

"I don't want to be like you," Pinokio promptly announces when an effort is made to mask him like the other performers in the troupe whose impresario (Jan Pilar) has commissioned his construction.

"Pinokio is a paragon of disobedience," says the impresario.

Whatever others might think, Pinokio knows what he is. "I am a wooden puppet with a long nose," he says.

And in the course of his adventures, inspired by the Carlo Collodi classic written in 1880, Pinokio will run off, be jailed, set himself afire while playing with matches, escape by diving into water, be devoured by a skeletal sea monster with blazing red eyes, perform circus acts of lethal danger, pass into the world beyond and do a deed that enables him at last to say, "I am a good boy."

Lively and ingenious best describe the Theater Drak production, directed by Josef Krofta, with a cast that includes Vaclav Poul (reminiscent at times of Harpo Marx) as the long-suffering Gepetto, and Jan Bilek and Ladislav Parina as the impresario's henchmen, Carlo and Luigi, as well as the Fox and the Tomcat, among others.

The principal prop in the proceedings is a two-wheeled cart resembling a tumbrel. Tilted this way and that, it becomes a stage, a set of doors, a prison, a means by which performers enter and exit. A few cloths serve as backdrops where shadow figures suggest an eager audience outside a circus tent or hidden hands manipulate Pinokio's limbs. Hooks and ropes, cleverly applied, add to the illusion of the wooden Pinokio as an independent being. The dramatic lighting by Milan Steklik focuses the action. The music by Jiri Vysohlid underscores the antic, manic mood; and Mr. Poul, aided by a few bubbles blown and figures shrouded in nets, artfully mimes the slow motion and distorted speech of a human on an underwater search.

"Pinokio" will be repeated today at 2 and 8 P.M. and tomorrow at 2 and 5 P.M. This version of the classic is low on sugar, high on spice.

LAWRENCE VAN GELDER

Stuffed Puppet Theater

'Manipulator' and 'Underdog'
Through next Saturday

Written and performed by Neville Tranter; lighting and set design by Ad Leijtens; costumes and puppets by Mr. Tranter; organization and management, Guido Pouw. "Puppetry at the Public."

In the psychologically brutal world of Neville Tranter, an Australian puppeteer based in Amsterdam, the stage is an arena in which the puppe-

teer and his creations are continually competing to determine who gets to abuse whom.

Both "Manipulator" and "Underdog," the thematically related pieces he is performing, are dark comic plays in which the figures Mr. Tranter interacts with try to intimidate and control a master who in one play is a sadist and in the other a psychic victim.

In "Manipulator," the first and lighter of the two pieces, Mr. Tranter portrays a seedy over-the-hill vaudevillian named Nero who wears a curling pencil-line mustache and tells jokes without punch lines. From behind a curtain he produces a procession of puppet figures, most of whom become the objects of his cruel comic pranks.

Dubbing one of his puppets Goliath, Nero plays a taunting David who plucks off its legs and nose and tosses the remains into the audience. Another puppet is made to perform the humiliating trick of spitting a rubber ball through a hoop.

Where Nero's male puppets are victims, his females are aggressors. A long stringy puppet dressed as a Parisian showgirl becomes a pushy dancing partner who towers over him and mashes her face against his. Nero is ultimately undone by a seductive frog-woman whom he warns, "I am the puppeteer and you are nothing more than an object to be used." But it is too late. She turns him into a croaking frog.

In "Underdog," Mr. Tranter portrays the mute, hunched-over, grown-up son of an itinerant variety-show performer named Lazarillo. The bullying old father is a puppet whom Mr. Tranter cradles in his arms as he spews contempt for his son, warning him that he has one last chance to prove that he can carry on the family profession.

Sweating with terror and shame, the son, who can speak only through puppets, performs a psychodrama called the "Theater of Fear, Cruelty and Pain" in which he ritually uncovers figures from his past who are puppets mounted on pedestals in a museum of the mind. They include a half-brother, his mentally ill mother, a transvestite doctor who offers protection in exchange for sex, and finally a voraciously romantic skeleton.

"Manipulator" and "Underdog" are the first works Mr. Tranter created in which he performed in his now characteristic mode, as an actor without a mask working with puppets. This style of interaction, which is a sophisticated theatrical extension of a ventriloquist and his dummy, has similar metaphoric resonances in that the puppets seem inescapably to be alter egos and figures from the unconscious.

Mr. Tranter's puppets range in appearance from floppy toylike figures to soaring beanpole-skinny characters with craggy, leering faces. As charged as they are with dark Freudian implications having to do with parental child abuse and rage, the pieces are not very compelling. "Manipulator" is an episodic sick joke with a tepid punch line. "Underdog" is a more ambitious Freudian allegory, but its dramatic potential is diminished by the sketchiness of its characters.

STEPHEN HOLDEN

1992 S 12, 15:1

Theater in Review
Mel Gussow

Two plays with puppets: one from the 1920's that doesn't show its age and a new one that that takes a hard look beneath the surface.

The Adding Machine

Joseph Papp Public Theater
425 Lafayette Street
Greenwich Village
Today

Written by Elmer Rice; directed by Michael Schwabe; original music composition by Evan Chen; technical direction and stage management by James Rossow; design and construction by Mr. Basgall, Kevin Byrne, Pam Clouse, Richard Goodman, John Gegenhuber, Pat O'Hara, Cynthia Orthal, Timm Reinhard, Mr. Rossow, Mr. Schwabe and Jayson Stahl. A Jim Henson Foundation presentation of Puppetry at the Public: The International Festival of Puppet Theater, executive producer, Cheryl Henson; producing director, Leslee Asch; associate producers, Bill Yates and Anne Dennin.
WITH: Tracey Gilbert, Dave Herzog, Mr. Basgall and Mr. Schwabe.

When "The Adding Machine" was first produced in 1923, it was considered a classic of expressionist theater. Anyone expecting this Elmer Rice play to show its age is due for a jolt. In the expert hands of the Hystopolis Puppet Theater, "The Adding Machine" is a bold and timely reflection on the perils of an industrialized society.

This Chicago-based company has the directness of the Steppenwolf Theater, rushing into Rice as if the play had been newly conceived. At the same time, there is no attempt to update the author's observations. Hewing to the text, Michael Schwabe (as director) and his collaborative team pit the play's hero, Mr. Zero, against the adding machine and not against a computer. But the troupe's scenic and sound effects are strikingly modern, with the puppets themselves influenced by artists like Picasso and Henry Moore. Draped in black, the puppeteers (who include Mr. Schwabe) manipulate the figures Bunraku-style while also dubbing their voices. As actors, the puppeteers consistently enliven the action.

In the opening scene, Mr. Zero is seen in bed, trying to rest after a hard day of bookkeeping, as his shrewish, thickly corseted wife delivers a nonstop monologue verging on a tirade. Her mouth becomes disembodied and flies across the room, enlarging and then multiplying until the husband is besieged by a chorus of viragos. Mr. Zero, whose head looks like a boxing glove in repose, exudes helplessness, deepened in the subsequent scene with his employer. After 25 years of dutiful service, Mr. Zero is made redundant. Rising in outrage, he slays his boss, spinning the play on its tragic trajectory.

When the protagonist goes on trial, society joins him in the dock, as the author explores the reasons for Mr. Zero's rebellion. Approaching this story with full satiric intention, Hystopolis treats it as a mordant cartoon, more "Maus" than "Roger Rabbit."

Later, as Mr. Zero rises from his grave and enters an afterlife, "The Adding Machine" shifts into fantasy,

with an ethereal dance between the hero and his office mate, Daisy, the opposite of his battle-ax wife. These and other puppets are artfully conceived and operated, especially so in the case of Shrdlu, the companion on Mr. Zero's death journey to the Elysian Fields. This flying broomstick of a creature, with spindly parsnip fingers, is a droll devil. Along the way there are incidental amusements, including a heaven-based boss who could be a scolding cousin to Jonathan Winters.

In the second act, there is a brief slackening of tension, more the fault of Mr. Rice than Hystopolis. But it does not seriously detract from a creative partnership between a socially conscious playwright of the past and an innovative contemporary ensemble.

Underground

Joseph Papp Public Theater
425 Lafayette Street
Greenwich Village
Through Sunday

Conceived, designed and directed by Theodora Skipitares; score composed by Robert Previte; scenes written by Andrea Balis, Julie Mars, Garry Rich, Ms. Skipitares and Sebastian Stuart, with excerpts from Ralph Ellison's "Invisible Man"; dramaturge, Ms. Balis; lighting by Liz Lee; technical director, Michael Draper; puppets by Ms. Skipitares, Holly Laws and Daniel Carello; musician, Jerome Harris; voices on tape by Mr. Stuart, Ms. Wittmer, Anna Trainer and Kevin O'Connor; photographer, Valerie Osterwalder. A Jim Henson Foundation presentation of Puppetry at the Public: The International Festival of Puppet Theater, executive producer, Cheryl Henson; producing director, Leslee Asch; associate producers, Bill Yates and Anne Dennin.
WITH: Preston Foerder, Cora Hook, Sara Provost and Ms. Skipitares and Tom Costello and Mary Lou Wittmer as narrators.

Last season in "The Radiant City," Theodora Skipitares explored the expansive world of highways, parks and skyscrapers established under the aegis of Robert Moses. With her new puppet play, "Underground," she turns her sights downward, looking into subterranean spaces, both actual and metaphorical. The results are dark and unrevealing. Collating 10 vignettes from various sources, Ms. Skipitares has created a small, hermetic chamber piece. In most of the scenes, the puppetry seems peripheral and adds very little to the storytelling.

In the director's characteristic fashion, two actors (Tom Costello and Mary Lou Wittmer) narrate the stories and dub the voices of characters. The scenes range through history from the myth of Persephone in Hades to the contemporary story of Jessica McClure, the little Texas girl who was trapped in an abandoned well. In the McClure episode, a large wire sculpture is manipulated by puppeteers and stands in awkwardly for the well. At other times, wall-size environments are animated, often

Valerie Osterwalder/International Festival of Puppet Theater

A scene from Theodora Skipitares's puppet play "Underground."

with minimal effect. In contrast to the scenic elements, the texts are evocative, especially when conjuring historical moments with social and political weight: a cholera epidemic, unionism in coal mines and racial discrimination (in a selection from Ralph Ellison's "Invisible Man").

In one amusing section, "Fallout Shelter," written by Sebastian Stuart, a provocative idea is merged with puppet art. A family of four is ensconced in a shelter, bonding during an unnamed emergency. Although Ms. Skipitares has craftily filled the shelter with brand names of civilization, the room is incompletely equipped in certain crucial areas, raising the question of how ready people are for life underground. Like characters out of "The Brady Bunch," the parents and children privately soliloquize about their true feelings toward one another and their confinement. In a moment of crisis, individualism takes precedence over family values. Except for this scene, the anthology remains a work in progress.

1992 S 16, C16:3

The Roads to Home

Written and directed by Horton Foote; set by Peter Harrison; lighting by Kenneth Posner; costumes by Gweneth West, additional costumes by D. Polly Kendrick; production stage manager, Lori M. Doyle. Presented by the Lamb's Theater Company, Carolyn Rossi Copeland, producing artistic director, in association with Picture Entertainment Corporation, Lee Caplin and Mortimer Caplin, producers. Associate artistic director, Clark Cameron; general manager/special projects, Nancy Nagel Gibbs. At 130 West 44th Street, midtown.

Mabel Votaugh	Jean Stapleton
Vonnie Hayhurst	Rochelle Oliver
Annie Gayle Long	Hallie Foote
Mr. Long	Michael Hadge
Jack Votaugh	Emmett O'Sullivan-Moore
Eddie Hayhurst	William Alderson
Dave Dushon	Devon Abner
Cecil Henry	Frank Girardeau
Greene Hamilton	Dan Mason

By FRANK RICH

Any list of America's living literary wonders must include Horton Foote, whose "Roads to Home" opened the Lamb's Theater Company season last night. Mr. Foote's prolific playwriting career stretches back to the halcyon Broadway of half a century ago. His parallel service to Hollywood has earned him a couple of Oscars ("To Kill a Mockingbird," "Tender Mercies") as well as a latter-day sideline in hard-scrabble independent film making ("1918," "On Valentine's Day").

And here Mr. Foote is now, in a small playhouse in the shadows of the Broadway behemoths, directing his own script, meticulously tending to a vision that has deepened but not wavered throughout his long career. "The Roads to Home," a trilogy of related one-act plays first seen briefly off Off Broadway a decade ago, is modest Foote but echt Foote. The setting is Texas. The time is long ago (the 1920's). The lives on display are unexceptional, undramatic. And just when the audience is set to relax into an elegiac reverie that might resemble nostalgia, the playwright finds a way to make his characters' inner turmoil so ferociously vivid it leaps beyond their specific time and place to become our own.

•

Like Carrie Watts, the displaced Foote heroine played by Geraldine Page in the film "The Trip to Bountiful," the women who dominate "The Roads to Home" live uneasily in the big city of Houston and hunger to return somehow to the cozier venues of their youth. The chattery Mabel Votaugh (Jean Stapleton), in whose parlor the evening's first two acts take place, never tires of gossip and memories of her beloved Harrison, the mythical Texas town that is a fixture on the Foote canon's map. Since Mabel is married to a railroad worker, she notes repeatedly that she is entitled to passes that can be used for a trip back home. But she never gets on the train.

Instead, she plays sympathetic host to neighbors whose own yearnings for home have been shaken. In Act I, titled "A Nightingale," Annie Gayle Long (Hallie Foote), a pretty, younger woman also in thrall to her native Harrison, drops in every day on Mabel rather than look after her two children. The disconnected Annie tends to break into geographically askew homesick song ("My Old Kentucky Home") without provocation even as she compulsively relives the violent murder of her father that shattered her Harrison childhood. In Act II ("The Dearest of Friends"), Mabel's best friend, a transplanted Louisianian named Vonnie (Rochelle Oliver), seeks refuge after her own household is rocked by her husband's infidelity.

A few baldly stated sorrows aside, Mr. Foote buries the heartbreak of these vignettes in humorous talk informed by dense period and character detail. Vonnie's melodramatic chronicle of marital woe must take time out for a description of a splendid meal taken at a prized hotel restaurant; Mabel's prurient and meticulous recounting of distant church scandals invariably upstages the crises at hand. When the women's spouses make their belated appearances, "The Roads to Home" skirts farce. The men exist in a remote orbit of their own, and even the one nominally contented husband, Mabel's frequently somnolent railroad man, addresses his wife only when he needs her to read the living room clock.

Ms. Stapleton is more comfortable with Mabel's sassier outpourings of domestic malice than with her pathos, which her facial muscles oversell. Emmett O'Sullivan-Moore is a dyspeptic delight as her husband, the most sharply realized of the menfolk, and Ms. Oliver is affecting as a desperate wife who turns almost manically to prayer after love, rage and tears have all failed her. But the central and transporting performance in "The Roads to Home" is that of Ms. Foote, the author's daughter, who plays the only character to return in the third act.

That act, titled "Spring Dance," is set four years later in "a garden outside an auditorium" in Austin. "Let Me Call You Sweetheart" wafts in from the unseen dance floor. The smell of roses permeates the April air. Men and women in evening clothes exchange stiff pleasantries and sit even more stiffly. Were it not for the first act's exposition about Ms. Foote's character of Annie, one might not immediately guess that the setting was a state asylum for the insane.

Annie is still an elegant woman and a font of fond, articulate memories of Harrison. As played with eccentric, unsettling dignity by Ms. Foote, a luminous beauty who preserves her regal posture even as she breaks down, she is understandably the Zelda Fitzgeraldesque belle of the ball. A cracked ball it is, however. Though Annie's would-be suitors are highly refined — especially in the delicate performances of Frank Girardeau and Dan Mason — none of them know what day it is, let alone what roads might ever take them home.

The author finds bleak absurdist humor in this party's fugue of utter psychological disorientation, and it carries his usual, disturbing kick. The Austin asylum does not seem much different from the Houston households of the preceding acts. For each of the sad, trapped married women in this ostensibly nostalgic play, not for just the incarcerated and abandoned Annie, life is eked out in a madhouse. In "The Roads to Home," home survives only as an illusion, cruelly out of reach, that allows them to go on.

1992 S 18, C2:3

Frankly Brendan

Adapted by Chris O'Neill, from the works of Frank O'Connor and Brendan Behan; lighting by Gregory Cohen. Presented by the Irish Repertory Theater Company Inc., Charlotte Moore and Ciaran O'Reilly, artistic directors, and One World Arts Foundation. At Actors' Playhouse, 100 Seventh Avenue South, at Christopher Street, Greenwich Village.

With: Chris O'Neill.

By WILBORN HAMPTON

Celt and Saxon have been at war off and on for more than 1,500 years now, but never have the sporadic outbreaks of bloodshed so riven the peoples of Ireland and Britain as the two of this century: the one that began with the Easter Rebellion of 1916 and led to the creation of the Irish Free State, and the one that is still going on today in Ulster, London and points in between.

In a riveting account of one young man's turn at the patriot games, Chris O'Neill ends his one-man show "Frankly Brendan" by transforming a reading of Frank O'Connor's short story "Guests of the Nation" into a fully realized one-act play that is at once powerful and poignant.

"Frankly Brendan," which Mr. O'Neill put together from the writings of O'Connor and Brendan Behan, is the second of two one-man shows being offered through Oct. 4 by the Irish Repertory Theater. The other,

"Joyicity," is an exciting excursion through James Joyce's Dublin, written by Ulick O'Connor from Joyce's works and knowingly performed by Mr. O'Neill's brother, Vincent.

●

The first three-quarters of "Frankly Brendan" is an entertaining portrait of a boy navigating the vicissitudes of a youth circumscribed by those joint pillars of Irish society, the Roman Catholic church and the corner pub.

In "First Confession," another O'Connor story, 7-year-old Jackie must contend simultaneously with the arrival of his newly widowed grandmother to live with the family and the approach of his first confession. It does not help Jackie's peace of mind that among the sins he will have to bare in that first confession is his secret desire to murder his old granny.

Such rites of Irish Catholic passage are further recalled in "Confirmation Suit," a Behan story about a 9-year-old boy's attempts to avoid being seen in public wearing his confirmation suit, tailored by a neighbor whose real vocation was making funeral shrouds. And in "The Drunkard," another O'Connor story, Jackie, now 9 years old, relates how he saved his alcoholic father from falling off the wagon, thereby helping to keep food on the table for a few more weeks and preserving the kitchen clock from the pawnshop.

●

These stories are charming and amusing, and the curly-haired Mr. O'Neill, a veteran of the Abbey and Gate Theaters in Dublin who aptly describes himself as a "cross between Marty Feldman and Harpo Marx," relates them with the skill of a natural storyteller. If the show at this point seems more an evening of literary readings than actual theater, it is not to detract from an enjoyable hour or so passed in the relatively harmless realm of childhood remembrances.

But then, in "Guests of the Nation," Mr. O'Neill takes his audience gently by the ear and pulls it into a very

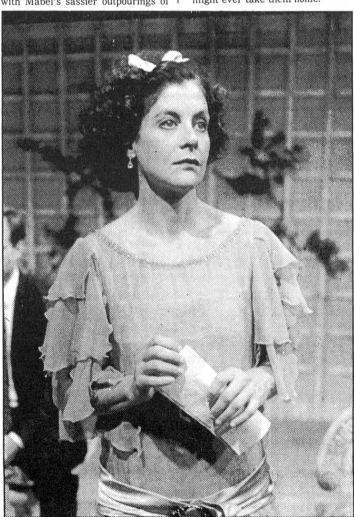

Michael Bailey

Hallie Foote in "The Roads to Home," at Lamb's Theater Company.

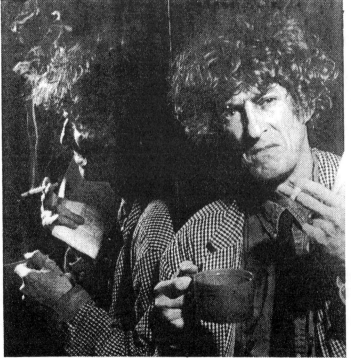

Irene Haupt/"Frankly Brendan"

Chris O'Neill in "Frankly Brendan," at the Actors' Playhouse.

different world, a devious and fearsome place that conducts its business at night at the edge of a bog, and where the price of manhood demands a more exacting coin.

It is 1922, and O'Connor's Jackie is now 19, a soldier in the Irish Republican Army, the forebear in name only of the terrorist group so much alive in today's headlines. He and a comrade have been given the task of guarding two English prisoners in the home of an Irish widow. It is soon clear that the Englishmen are hostages whose fate depends on what happens to four Irish boys being held by the Black and Tans.

Nimbly shifting tone and accent, Mr. O'Neill creates seven separate characters — Jackie and his partner, the two prisoners, two I.R.A. officers and the old widow — and establishes their evolving relationships.

As the gripping tale unfolds, Mr. O'Neill has his entire audience on the edge of their seats, almost afraid to breathe. It is a superb and compelling performance of one of the most moving stories you'll ever hear.

1992 S 19, 12:1

An Old Actress in the Role of Dostoyevsky's Wife

By Edvard Radzinsky; translated by Alma H. Law from the Russian; directed by Eve Adamson; sets and lighting by Giles Hogya; costumes by Susan Soetaert. Presented by Jean Cocteau Repertory, Robert Hupp, artistic director; Scott Shattuck, managing director. At the Bouwerie Lane Theater, 330 Bowery, Lower East Side.

Old Actress................................Jere Jacob
FedyaCraig Smith

By WILBORN HAMPTON

Dostoyevsky, bridling against being called a psychological writer, responded in one of his notebooks: "They call me a psychologist. This is not true. I am merely a realist in the higher sense of the word." The problem, of course, as Dostoyevsky and Edvard Radzinsky would point out, is agreeing on what is real.

Take, for example, Mr. Radzinsky's intriguing play "An Old Actress in the Role of Dostoyevsky's Wife," which is being given its English-language premiere at the Jean Cocteau Repertory. Is the old woman in the institution really a famous actress? Or is she just the actress's makeup woman? Is the man she encounters a lunatic, a film director or Dostoyevsky reincarnate? Is the institution itself an asylum, an old folks' home or a sound stage?

Since all possibilities can be imagined, all must to some degree be real. "Imagination is more real than reality," the man states at one point. At another, he asserts, "There must be limits to madness!" Well, not really.

Mr. Radzinsky, a Russian playwright and historian whose biographical account of the death of the Russian royal family at the hands of the Bolsheviks in 1918, "The Last Tsar," is riding high on best-seller lists, delves into the minds of his two characters in "An Old Actress" without any fixed point of departure or reference.

On the surface, an old woman wanders into the room of a fellow inmate of some sort of institution. She banters with a disembodied voice that

comes from underneath a sofa and, after quarreling, hurls a book at it, or at least at the sofa from which it emanates. The book happens to be a copy of Dostoyevsky's "Gambler" that has an inscription by Stanislavsky.

The voice turns out to belong to a man claiming to be Dostoyevsky himself, or at least he's a red-haired man named Fedya who likes to gamble and just happens to be an epileptic as well. Fedya has a play about the two main women in the Russian master's life: Appolinaria Suslova, Dostoyevsky's onetime mistress, and Anna Gregoriyevna Snitkina, the young stenographer he hired to help him finish "The Gambler" and then married. He wants the old woman to play one of the parts; she agrees to do Anna.

What follows is not so much a search for what is real in our lives as a metaphysical discourse on the nature of reality itself and whether it even exists apart from one's memories and dreams.

The old woman, who seems to be modeled on an aged actress Mr. Radzinsky describes in "The Last Tsar" (whose husband once drank tea at the Métropole with the Romanovs' executioners), can't remember herself as a young girl but can remember all the roles she ever played. She doesn't recall which of her several husbands she loved the best ("They're all forgotten, like old phone numbers") but remembers they all complained because there were no curtains in the apartment. She played in so many cities that she "can't imagine a room without an open suitcase," and she remembers the night her admirers unharnessed the horses from her carriage and pulled her home themselves.

●

In all of this Mr. Radzinsky has crafted an engaging play that has flashes of humor and some piercing observations. But unlike others who have explored this territory before, like Pirandello or Beckett, there is little enlightenment. It is not that one expects answers but rather hopes to come away a little better informed on how to rephrase the questions.

Mr. Radzinsky has a strong advocate in Eve Adamson, the director of the Cocteau production. These philosophical stage games are Ms. Adamson's strong suit, and she is a master at leading from theatrical strengths while deftly finessing the weaknesses. Craig Smith delivers a strong performance as Fedya, finely balancing the character's duality of madness and manipulation. Jere Jacob is mostly convincing in the role of the old woman, although she is more focused in some scenes than in others, almost as though she were still uncertain who the old woman really is.

1992 S 19, 14:1

Cut the Ribbons

Lyrics by Mae Richard; music by Cheryl Hardwick and Mildred Kayden; additional music by Nancy Ford; directed by Sue Lawless; choreographed by Sam Viverito; musical direction by Sande Campbell; arrangements and orchestration by Ms. Campbell, Patti Wyss and Ron Zito; scenery and lighting by Michael Hotopp; costumes by Terence O'Neill; sound by Tom Sorce; production stage manager, Allison Sommers. Presented by George Elmer/Phase Three Productions. At Westside Theater (Downstairs), 407 West 43d Street, Manhattan.

WITH: Georgia Engel, Barbara Feldon and Donna McKechnie.

By MEL GUSSOW

When more and more women are assuming positions of authority in public life, there is something retrograde about a musical concerned with the traditional domestic relationship between mothers and daughters. This might lead a political analyst to suggest that "Cut the Ribbons," the new show at the Westside Theater, is more in tune with Barbara Bush than with Hillary Clinton, that this is a musical in the family values mode. But it would be churlish, not to say sexist, to deny the continuing relevance of the subjects under scrutiny, especially to those people being scrutinized.

"Cut the Ribbons" raises issues but does not raise its voice. It is a mild-mannered revue, starring three di-

The subjects under scrutiny are relevant to those being scrutinized.

verse actresses, Donna McKechnie, Georgia Engel and Barbara Feldon. Only a few of the nearly 30 songs (lyrics by Mae Richard, music by three composers) are tinged with satire. Ms. Richard prefers a soft brush to a stiff bristle.

Anita F. Hill is mentioned in passing, and there are two nimble songs, one (with music by Nancy Ford) about missed opportunities, the other (with music by Cheryl Hardwick) in which the actresses sing tellingly about balancing contradictory aspects of their lives. On the other hand, in a forced attempt at topicality, Ms. Richard and Mildred Kayden have written a number about spermatozoa and an ovum in a Petri dish. Most of the songs are about such rituals as bringing up baby, dressing for a date

Martha Swope/"Cut the Ribbons"

Hi, Mom
Donna McKechnie, left, Barbara Feldon and Georgia Engel star in "Cut the Ribbons," a musical about mother-daughter relationships.

and flying from the nest. The tone is not so far removed from those situation comedies in which Mother knows best and a daughter can always depend on her father to break a tie to her advantage.

●

While courting blandness, the show maintains its amiability. There is nothing here to excite or to agitate an audience. This is certainly not a musical on the cutting edge. The show's appeal derives from its modesty and from its actresses.

Ms. McKechnie is, as always, a striking dancer, although she is less secure vocally. Batting her wide eyes, Ms. Engel seems to have sprung full blown from the head of Carol Channing. She flirts perilously with cuteness, especially when pretending to be a child, but generally maintains her clownish disposition. In one of her roles, she has an amusing running joke about a mother's dutiful dependency on Dr. Spock. Each time the character returns to the stage, her copy of the doctor's baby book is more dog-eared. Ms. Feldon is the most adept musically and dramatically, as demonstrated in her rueful delivery of the song "That Woman in the Mirror" (music by Ms. Hardwick).

Under the direction of Sue Lawless, all three actresses work hard, switching back and forth between generations. Theatergoers are asked to suspend disbelief in matters of age. In an early number, Ms. McKechnie plays an expectant mother. Later she is a 90-year-old woman with a terminal disease.

By covering too much ground, "Cut the Ribbons" loses its focus, in contrast to "Baby" and "I'm Getting My Act Together and Taking It on the Road." In this anthology of uneven songs, the numbers with music by Ms. Hardwick and Ms. Ford are stronger than those with music by Ms. Kayden. The songs are spliced with quotations from sources as disparate as Bette Davis, Harry S. Truman and Socrates. Some of these epigrammatic remarks would be more suitable printed on T-shirts.

One keeps waiting for the musical to take flight, for the actresses to break loose from the restraints of the cabaret-style staging. This does not happen until late in the second act when each woman sings "I Dare You Not to Dance" and does a different dance. This challenge match and several subsequent numbers invigorate the show. With "Cut the Ribbons," the end is livelier than the beginning.

1992 S 21, C14:1

Brother Truckers

By Georg Osterman; directed by Everett Quinton; scenery by Mark Beard; costumes by Elizabeth Fried; lighting by Terry Alan Smith; sound by Mark Bennett; hair by Zsamira Ronquillo; props by Deborah Scott and Jamie Leo; production stage manager, Karen Ott. Presented by the Ridiculous Theatrical Company, Everett Quinton, artistic director; Steve Asher, managing director. At Charles Ludlam Theater, 1 Sheridan Square, at West Fourth Street, Greenwich Village.

Lech Fabrinski..............................Grant Neale
Billie Wilson...........................Georg Osterman
Harry Balskin.......................................Eureka
Lyla Balskin.........................Everett Quinton
Flem Fabrinski.....................Maureen Angelos
Bina FabrinskiLisa Herbold
Frenchy DuVey............................Stephen Pell
Trixie FabuNoelle Kalom
ProsecutorAdam Weitz

Anita and Steve Shevett/"Brother Truckers"

Everett Quinton, left, and Georg Osterman in the Ridiculous Theatrical Company's "Brother Truckers."

By FRANK RICH

No doubt every visitor to "Brother Truckers," the new Ridiculous Theatrical Company extravaganza at the Charles Ludlam Theater, will have his own favorite Everett Quinton costume.

I'm partial to the black-and-yellow-check outfit that Mr. Quinton, in the starring role of the East Hampton hostess and garbage-removal queen bee Lyla Balskin, wears while shopping in Manhattan. The dress not only matches the geometric design scheme of the greasy spoon in which Lyla makes a pit stop between Gucci and Bergdorf's, but it also comes with matching purse, gloves, stockings and, best of all, a couple of gargantuan neck flaps that recall the more lighthearted ecclesiastical fashion trends of the early Middle Ages.

But others may prefer Mr. Quinton in an ensemble that mixes silver vinyl pants, a gold quilted vest and a leopard-skin hat. Or in a skin-tight number that prompts him to repeat Mercedes Ruehl's Tony Awards complaint about the House of Chanel.

What is unlikely to prompt debate is the quality of Mr. Quinton's star turn. Lyla Balskin, a heroine who might be described as rapacious or ruthless or perhaps with a rougher adjective that does not begin with R, may be his funniest comic achievement in a career full of them. Though "Brother Truckers" tends to melt from the memory even as one watches it — which to some extent is the point — Mr. Quinton is indelible as a steely femme fatale who will stop at nothing, least of all fatalities, to get her man. Davis, Crawford, Stanwyck and Lupino are each accounted for in his grand and vindictive Lyla, but the addled combination is pure Ridiculousness, not routine female impersonation. The passionate divas seem to have taken possession of the slight, unglamorous Mr. Quinton rather than the other way around.

"Brother Truckers" is the handiwork of Georg Osterman, another longtime Ridiculous hand. Billed as a "comedy noir," the play is a light genre satire in the manner of a Ludlam piece like "The Artificial Jungle." The florid orchestral soundtrack music (throbbing horns for night, oppressively chirpy strings for the morning after) has been culled from bygone Hollywood melodramas; so have the lethal love triangle of the plot and the staccato dialogue in which big lugs and palookas are capable of philosophical maxims like "The highway of life is a cul-de-sac." Yet the setting is present-day New York, and at times "Brother Truckers" takes its garbage-removal milieu so seriously and prosaically that the scenario suggests a bizarre hybrid of "They Drive by Night" and a Department of Sanitation interoffice memo.

Since Mr. Osterman also has an onstage role — Lyla's raven-tressed, hash-slinging romantic rival, a Runyonesque Rhonda Fleming on steroids — it was most generous of him to give Mr. Quinton the best lines. The best of the best are generally viperish insults hurled at Lyla's alcoholic "insignificant other," her husband, Harry (Eureka), a cigar-chomping garbage-hauling magnate who has nothing "in common with class" except "the last three letters of the word." Invited to bed by Harry, Lyla responds, "I'd rather go to hell in a paper dress, wearing hand-grenade earrings!" Alas, that outfit stays in the closet.

•

How Lyla tries to ditch Harry in favor of her former and now unavailable paramour, the lowly garbage-truck driver Lech Fabrinski (Grant Neale, first seen in Calvin Klein briefs), is a tale that encompasses a Georgica Pond anniversary party, a meticulously staged highway accident, an inopportune childbirth and the Grand Guignol machinations of a wayward mulch-making machine. Along the way, Mr. Quinton gives his tongue an aerobic workout each time he says the name Lech, strikes every pose that has ever inspired a Warner's or Republic close-up and finally goes for his own Oscar nomination in a conscience-inflamed mad scene that might cap a B-movie's nightmarish trial sequence.

When Lyla storms offstage, the comic energy of "Brother Truckers" sometimes exits with her, and at about two and a half hours, the evening is about a half-hour too long. As director, Mr. Quinton has allowed the women in the cast (whatever sex they are playing) to get away with their own unscripted crimes in the form of repetitive, amateurish shtick that is a drag on the men in drag. The physical production sometimes compensates with visual gags, not just those sewn into Elizabeth Fried's priceless costumes but also Mark Beard's many anachronistic, mock-50's settings (replete with pole lamps) and some props (by Deborah Scott and Jamie Leo) that take on a rather ejaculatory life of their own.

One of the funnier scenic jokes is an illustrated roadside billboard promoting "traditional family values," but that election-year aside notwithstanding, the evening is without redeeming social value of any sort. The closest "Brother Truckers" comes to a coherent message can be found in its garbage fraternity's oft-repeated aphorism that "One man's trash is another man's treasure." In which case Mr. Quinton's trash is the mother lode.

1992 S 22, C13:3

Theater in Review

■ An O'Neill expression of unfulfilled longings
■ An early psychoanalytic mystery ■ A comedy about depression of the mental kind.

A Moon for the Misbegotten

Pearl Theater Company
125 West 22d Street
Chelsea
Through Oct. 24

By Eugene O'Neill; directed by Allan Carlsen; set design, Robert Joel Schwartz; stage manager, Todd Gajdusek; costumes, Lyn Carroll; lighting, A. C. Hickox; sound, Donna Riley; fight director, Rick Sordelet. Presented by the Pearl Theater Company, Shepard Sobel, artistic director; Parris Relkin, general manager.

WITH: Arnie Burton, Joanne Camp, Frank Lowe, Paul O'Brien and Hank Wagner.

"A Moon for the Misbegotten," Eugene O'Neill's sentimental plea for atonement for his profligate brother, has struggled for an audience for half a century.

Opening its ninth season, the Pearl Repertory Company has mounted a revival that the play's admirers will find worthy, but that is not likely to win any converts from its detractors. The original 1947 production of the play closed in an out-of-town tryout. Of four major revivals since, only a 1973 staging by José Quintero with Jason Robards and Colleen Dewhurst found success.

The biggest problem with "A Moon for the Misbegotten" is O'Neill's insistence at viewing some disagreeable, if not downright despicable, characters through the prism of a rather rosy memory. Phil Hogan (Frank Lowe) is a bully of an alcoholic whose sons will all run away from home and whose one virtue, as he boasts to his daughter, Josie (Joanne Camp), is "I never struck a woman, not when I was sober." Then there's Josie herself, a rough-tongued farmer's daughter who is so ashamed of her virginity that she invents a list of men who have passed through her bed. And finally, there's James Tyrone (Paul O'Brien), the actor-cum-landlord who quotes Latin and nurtures his reputation as a boozer and womanizer. For O'Neill they are unlikely heroes, harmless leprechauns with hearts of gold buried beneath their pixilated exteriors. It takes the suspension of a lot of disbelief.

Allan Carlson, director of the Pearl revival, manages to bridge some of it. He moves the play briskly through the expository opening scenes. And in the final act, as Tyrone comes to confess his sins to Josie by the light of a harvest moon, Mr. O'Brien and Ms. Camp achieve a credible and touching rapport that expiates much of O'Neill's rather trying romanticism. Mr. O'Brien delivers a fine reading of Tyrone, bringing some blood to a very talky play. In his hands one can almost forget that Tyrone is just a run-of-the-mill drunk. He is chillingly believable going in and out of what O'Neill called the "heebie-jeebies." If Ms. Camp is somewhat tentative in the opening scenes, her performance takes on depth after Tyrone enters "like a dead man walking slow behind his own coffin." Mr. Lowe is a cantankerous curmudgeon as Hogan, who gets most of the humor out of the role.
 WILBORN HAMPTON

The Mystery of Anna O

John Houseman Studio Theater
450 West 42d Street
Clinton
Through Oct. 4

By Jerome Coopersmith and Lucy Freeman; directed by Yanna Kroyt Brandt; associate director/dramaturg, Margot Breier; set by John Farrell; costumes by Tay Cheek; lighting by Heather Rogan; choreographed by Amy Coopersmith; production stage manager, Uriel Menson; stage manager, Susan Hinkson; music by Anthony Brandt. Presented by Playmarket, Inc., and Annette Moskowitz and Alexander E. Racolin on behalf of Play Producers, Inc.

WITH: Bernard Barrow, Ariane Brandt, Barbara Hilson, C. C. Loveheart, David Mazzeo, Bobbi Randall, Peter Tate and Marilee Warner.

In Vienna in the early 1880's, Josef Breuer, a doctor in his late 30's, used a treatment called the talking cure on a young woman known to his colleagues by the pseudonym Anna O.

He achieved a measure of success with his patient, as well as no little renown in the medical community and among the public, but at a certain point, the doctor, a married man in his late 30's, abandoned his treatment and his patient.

Breuer died in 1925, a forerunner of Sigmund Freud and a footnote to the history of psychoanalysis. But what, precisely, happened between doctor and patient and what became of Anna O?

Did she die in a sanitarium, insane and an addict of the morphine commonly prescribed in those days for women diagnosed as hysterics? Or did she recover and emerge in later life as the remarkable Bertha Pappenheim, who labored to save German Jewish women from the white slave trade in Turkey, who founded a settlement house for young women in Germany and who confronted the Gestapo to protect her charges?

The fate of Anna O is the dramatized historical question that lies at the heart of "The Mystery of Anna O," a drama playing Off Broadway at the John Houseman Studio Theater.

As written by Jerome Coopersmith, whose credits include "Baker Street," and Lucy Freeman, an authority on psychology and psychoanalysis, the play also explores the perils of pioneering medicine, multiple aspects of medical ethics and the impact of the case on the doctor's relations with his wife.

Under the direction of Yanna Kroyt Brandt, the "The Mystery of Anna O" shifts back and forth in time. A convincing cast — most of its members playing multiple roles — unfolds the play through scenes that range from Anna's bedroom to a Turkish brothel to a Gestapo headquarters to Breuer's home and office in Vienna and to Chicago in the 1950's. It is in Chicago that the question of Anna's fate is raised in confrontations between Stephanie Gardner, a Chicago reporter and Pappenheim admirer, and Dr. Ernest Jones, the author of a three-volume life of Freud and a defender of Breuer who has come to Chicago in 1956 to make a speech on the centennial of Freud's birth.

C. C. Lovelace, as Stephanie Gardner and Pappenheim, and Peter Tate, as Josef Breuer and Ernest Jones, as well as Bernard Barrow and David Mazzeo in lesser roles, are standouts in a cast that seems thoroughly at home with the characters.

Although many scenes are crisp and electric, "The Mystery of Anna O," taken as a whole, falls short of stirring drama. But it is never less than intelligent in its concerns and fascinating as history.

LAWRENCE VAN GELDER

The Depression Show

One Dream Theater
232 West Broadway
TriBeCa
Through Oct. 10

By Thomas Keith and Jane Young; directed by George Hewitt; music by Marc Steinberg; lyrics by Mr. Keith and Ms. Young; choreography by James Adlesic, Ms. Young and Mr. Keith; production designed by Ronald Gottschalk; musical direction by Michael Shenker; production stage manager, David Alan Comstock. Presented by Young Dog Ensemble.

WITH: James Adlesic, William Flatley, Brian Keane, Thomas Keith, Randy Lilly, Christine Malik, Pamela Newkirk, Marc Reeves, Michael Shenker, Gwen Torry-Owens and Jane Young.

It is no surprise that not all the jokes in "The Depression Show" by Thomas Keith and Jane Young are funny. It is surprising that none are downright offensive, since the depression in this play with music is the psychological kind.

Of course disturbed people are not the targets of this satire; television shows, psychologists and a shamelessly indifferent public are. Still, it glides on thin ice.

Four depressed people fall into the clutches of a television talk-show host and hostess who grin their way through bubbly pieties as they prod their guests into revealing their illnesses on camera. Rescue arrives in the form of an analyst who seizes control not only of the guests but of the hosts, cautioning that all will be well with them only if they avoid being nipped by "the fangs of fairness."

With that kind of story, the humor in the production by the Young Dog Ensemble at the One Dream Theater depends entirely on the performance under the direction of George Hewitt. It is best in several song-and-dance numbers that give the whole cast, a chance to send up the choreography, music and witless lyrics of many a Broadway, Hollywood and television extravaganza.

The actors playing the depressed on prime-time display are occasionally quite funny, with little help from generally weak lines in the script. James Adlesic is truly manic as a man whose childhood with a demanding mother has made him so fragile he doesn't feel welcome at home even though he lives alone. Pamela Newkirk as a suburban housewife who can't stand looking at herself in mirrors is most amusingly transformed by a fantasy that she has become Madonna. William Flatley is explosively comic as Edgar, a universally rejected man whose every effort to express himself is interrupted by the voices he hears (the audience hears them too).

The funniest of all is Brian Keane as Cliff, whose doctors have drugged him so far out of touch that he's convinced he is just fine, a belief he displays in a wonderfully loose-limbed "dance of denial." His woozy complacence makes one wish he had brought his doctors to the play: To an audience in his condition "The Depression Show" might seem a big laugh with no long yawns.

D. J. R. BRUCKNER

1992 S 23, C16:3

The 1992 Young Playwrights Festival

Four plays by writers under age 19. Sets by Loy Arcenas; costumes by Elsa Ward; lighting by Pat Dignan; sound by Janet Kalas; production manager, David A. Milligan; production stage managers, Jana Llynn and Paul J. Smith. Presented by Young Playwrights Inc., Nancy Quinn, artistic director; Sheri M. Goldhirsch, managing director, in association with Playwrights Horizons. At Playwrights Horizons, 416 West 42d Street.

THE P.C. LAUNDROMAT, by Aurorae Khoo; directed by Richard Caliban.

TAKING CONTROL, by Terrance Jenkins; directed by Clinton Turner Davis.

MOTHERS HAVE NINE LIVES, by Joanna Norland; directed by Gloria Muzio.

MRS. NEUBERGER'S DEAD, by Robert Levy; directed by Michael Mayer.

WITH: Danielle Ferland, Peter Jay Fernandez, Seth Gilliam, Elain Graham, Erika Honda, Neal Huff, Afi McClendon, Olga Merediz, Christina Moore, Jennie Moreau, Novella Nelson, Bahni Turpin, Margaret Welsh, Felicia Wilson and Kim Yancey.

By MEL GUSSOW

Each of the four new playwrights in the 1992 Young Playwrights Festival is clearsighted about troublesome social concerns and unafraid to challenge accepted standards and practices. Even when plays waver, the playwrights express a mature point of view that belies their youth. As is customary in this annual festival, the one-acts were written when the authors were under the age of 19, and they are treated to highly polished productions at Playwrights Horizons.

The evening begins on an iconoclastic note with "The P.C. Laundromat," a brief, spin-dry comedy by Aurorae Khoo. Peter Jay Fernandez and Christina Moore play two hospitable attendants in the Laundry of Brotherly Love. Together, they deliver a nonstop vaudeville spiel about ethnicity and assimilation, which pays stylistic homage to Vachel Lindsay's drumbeating poem "The Congo" while rapping in a manner that would also be recognized by a contemporary playwright like Suzan-Lori Parks.

The attendants welcome an Asian-American customer (Erika Honda), whose multi-ethnic laundry includes such items as a dashiki-kimono-kilt. Clothes and racial differences all tumble through stereotype-shattering cycles, until a smiling Ms. Honda dances right out the door. The laundromat, in other words, is a melting pot. In Richard Caliban's jaunty staging, the windows of the washing machines become video screens, providing a double image of live action and animation (a special credit here for the set designer Loy Arcenas). Quick, funny and infectious, the play creates its own rhythmic beat.

Terrance Jenkins's "Taking Control" tackles a more familiar target, a dysfunctional urban family, with authenticity and candor. Abandoned by their parents and ignored by their alcoholic grandmother, the matriarch of record, three sisters form a sibling bond against the world. The middle sister (Bahni Turpin) takes charge. As things become dire, she tries every recourse — and still keeps trying. Periodically, the playwright interposes fantasy sequences in which this hapless family is captured in moments of domestic harmony.

"Taking Control" runs a bit too long (true of all the plays except "The P.C. Laundromat") and it rings in unnecessary symbolism. But the writing is pungent, and the play has the confidential touch of an insider who has privileged information about this particular family. Confronted by the protagonist's determination, one feels that these sisters might yet come through.

In "Mothers Have Nine Lives," a Canadian playwright, Joanna Norland, studies the mother-daughter connection with far more insight than is demonstrated in related circumstances in the new Off Broadway musical, "Cut the Ribbons."

As two actresses play-act children's games, three others step forward with a range of evocative tales about specific problems of motherhood. A woman on welfare is desperately seeking a double stroller for her two babies, but is blocked by bureaucracy because the children are not twins. Resuming full-time work, another mother gradually turns over her daughter to a grandmother's care while deluding herself that she is still offering quality time. Harassed by her children, a third woman makes large and small compromises (yes, the children can mix orange juice with orange soda for breakfast) in order to retain her equilibrium.

The play's kinetic drive and humor reach an apogee in Kim Yancey's personification of a woman with ambitions for her supposedly gifted (but severely maladjusted) child. The mother is so busy speeding the daughter on a fast track, she obliterates the girl's individuality.

Of all the four plays, Robert Levy's "Mrs. Neuberger's Dead" is the strangest. A self-defeating young couple (Neal Huff and Margaret Welsh) are dropouts with no fallback positions. Steadily they deconstruct their lives with drugs and alcohol abuse. Veering between inertia and sudden spells of intensity, the two cohabit in a most rarefied never-never land.

The author manages to instill idiosyncratic humor in what is certainly a no-win situation. The play overreaches for a heavenly metaphor, but the writing and the acting maintain a disarming sense of absurdity. Strange things occur in the middle of the night. A stove disappears, a Bible salesman arrives unannounced and the tap water makes a drinking glass look opaque — all this in a derelict apartment decorated with detritus from a thousand tag sales. The author studied with Nancy Fales Garrett, whose playwriting class at St. Ann's school in Brooklyn Heights has been the most consistent enlivener of this valuable festival during its 11 seasons.

1992 S 24, C18:4

I'm Sorry . . . Was That Your World?

Five one-act plays. Production stage manager, Renee Mesard; stage manager, Renee La Tulippe; lighting by Matthew E. Adelson; sets and costumes by Bernard Jay Ohlstein; sound by Donald P. Johnson. Presented by New Georges, Susan Bernfield, artistic director; managing director, Beryl Jolly; literary manager, Colleen McQuade. At the Samuel Beckett Theater, 412 West 42d Street, midtown.

BIG MISTAKE, by Theresa Rebeck; directed by Maggie da Silva.

PLUMB NUTS, by Bhargavi C. Mandava; directed by Shanna Riss.

RAPID EYE MOVEMENT, by Susan Kim; directed by Jamie Richards.

DOG AND FRUIT, by Lisa A. Reardon; directed by Colleen McQuade and Ms. Riss.

EASY JOURNEY TO OTHER PLANETS, by Neena Beber; directed by Bonnie Mark.

WITH: Carolyn Baeumler, Peter Basch, Christopher Berger, Susan Bernfield, Jessica Hecht, Kathryn Langwell, Deborah Laufer, Eric Lutes, Ellen Mareneck, Ms. McQuade, Eric Nolan, Kevin O'Keefe, Elaine Tse and Adrienne Wilde.

By MEL GUSSOW

Two young men (Eric Lutes and Eric Nolan) are drinking at a neighborhood bar and commiserating with each other about the good old days when men were manly and women didn't spend so much time working out in gyms. This smug lamentation is interrupted by the arrival of two women, one of whom (Deborah Laufer) happens to have had a long, disastrous affair with Mr. Lutes. What follows this accidental encounter in Theresa Rebeck's "Big Mistake" is an abrasive and humorous look at a sexist battleground.

The dialogue in this one-act play (by the author of "Spike Heels") has the rudeness of David Mamet but with a decidedly feminist sound. Ms. Rebeck's comedy, the first of five short plays written by women in an anthology entitled "I'm Sorry . . . Was That Your World?," is rough on the

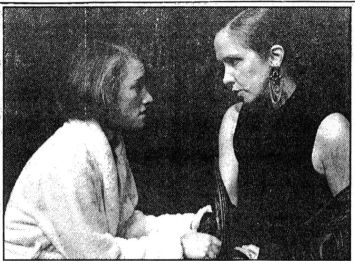

Doug Bost

Susan Bernfield, left, and Ellen Mareneck in "Rapid Eye Movement."

male characters while not forgetting that the women also bear responsibility. Ms. Laufer's character seems to have a serious case of masochism, and her friend (Kathryn Langwell) is burdened with a heavy career chip on her shoulder. One comes out of this play feeling a certain sympathy for the quietly efficient bartender (Jessica Hecht) who has to put up with conversations like this every night.

With one exception, Susan Kim's "Rapid Eye Movement," the other plays at the Samuel Beckett Theater are a moon shot away from Ms. Rebeck's level of awareness. But the evening itself has a purpose, as a showcase for the principles of New Georges, a feminist theater that takes its name from George Sand and George Eliot. Each play deals with women forcibly asserting themselves in what was once designated a man's world.

•

Ms. Kim's play, first seen in 1991 in the Ensemble Studio's one-act marathon, is a delusionary comedy about a wife (in this production, Susan Bernfield) who imagines herself besieged by mad dogs. One is barking outside the door of her apartment and in a fantasy she dreams that her husband has been transformed into a snarling beast. The suggested solution to her fear: "Be careful who you let in, and take lots of pills." The dreams continue in this toxic domestic environment.

In Bhargavi C. Mandava's "Plumb Nuts," a runaway (Colleen

Where the men mourn the days before women spent so much time at the gym.

McQuade), who may or may not have killed her baby and set fire to her uncle's house, is stranded on a highway after her traveling companion (Kevin O'Keefe) has totaled their car. The two argue loudly while the narrative remains stalled.

The second half of the anthology is wasted on two fruitless abstractions. Lisa A. Reardon's "Dog and Fruit" is an incomprehensible still life about a woman (Ms. McQuade), a stuffed dog and a nun who is up a tree (along with the play). Neena Beber's "Easy Journey to Other Planets" is an uneasy amalgam of fact and fiction, mixing the wives of "The Right Stuff" astronauts with references to the Raquel Welch movie "Fantastic Voyage."

In March, New Georges presented Caryl Churchill's "Vinegar Tom," about witch hunting in 17th-century England, a far more provocative platform for the company's ideas.

1992 S 25, C2:3

Nomura Kyogen Theater
Classic Comedies of Japan

Three plays under the artistic direction of Mansaku Nomura: "Momi No Dan," "Tsurigitsune" and "Utsubozaru." Lighting designer, Alan Blancher. Presented by the Japan Society. At the Lila Acheson Wallace Auditorium, Japan Society, 333 East 47th Street, East Side.

WITH: Tanro Ishida, Yukio Ishida, Mannosuke Nomura, Ryosaku Nomura, Takeshi Nomura, Shichisaku Ogawa and Haruo Tsukizaki.

MUSICIANS: Yukimasa Isso, Shinichiro Miyama, Shonosuke Okura, Izuru Sato and Yotaro Uzawa.

By MEL GUSSOW

Kyogen plays, a tradition in Japan since the 14th century, are small-scale folk comedies that are often presented as interludes during evenings of Noh drama. In them, acting and mime take precedence, although the plays can express an aura of grandness within a framework of intimacy.

This is very much the case with "Utsubozaru," or "The Monkey-Skin Quiver," the second of two plays performed on Wednesday by the Nomura Kyogen Theater during a three-day engagement at the Japan Society.

The story is as simple as the emotions it evokes. A lord out on a hunt demands that a monkey trainer kill his pet in order to provide a skin for a quiver of arrows. The trainer refuses, then reluctantly agrees. But when its master lifts his stick, the monkey

interprets the gesture as a cue and begins to dance and perform his tricks. This act so moves the lord that he cries; he gives the animal his fan, his sword and finally his ceremonial robe.

The gestures in this performance are precise and meaningful. Everything is highly stylized, but there is no question about the trainer's loyalty or his fright when threatened, and the lord exudes pomposity in every look and movement.

•

It is primarily the monkey that makes the play such an enjoyable experience. As played in a monkey costume by Tanro Ishida, who is 5 years old, the character seems to have the most natural performance instincts, unlike the lumbering lord, who in a final tribute tries to ape the monkey. When the child's mask is removed at the curtain call, the effect is startling. Can anyone so young be so communicative onstage?

Kyogen is very much a family tradition. The child's father, Yukio Ishida, plays one of the two roles in the evening's first play, "Tsurigitsune" or "The Fox and the Trapper." He is a trapper suddenly confronted by a fox trying to persuade him to give up hunting, a mission that is momentarily thwarted by the fox's insatiable curiosity about a trap and its bait.

The performance is intentionally slow and the events might be confusing were it not for the English translation of the play printed in the program. But, as with the monkey comedy, there is more than enough happening in terms of acting artistry. When the fox walks across the stage pretending to be an elderly man, he bends forward at the waist, exactly duplicating the angle of the tree in the beautiful painted backdrop that dominates the scenic design.

1992 S 25, C2:4

Theater in Review
Mel Gussow

■ A woman fondly tells of her new sensual awareness ■ The death of a sculptor and a look at AIDS, war and avant-garde art.

The American Living Room Reupholstered

Ohio Theater
66 Wooster Street
SoHo
Through Oct. 11

Two one-act plays. Curators, Tim Maner and Kristin Marting; lighting, Cindy Breakfield; production manager, Rachelle Anthes. Presented by Tiny Mythic Theater Company, Mr. Maner and Ms. Marting, artistic directors; Michael Hurst, managing director.

SOAP OPERA, by Ralph Pape; directed by Elizabeth Franzen; stage managed by Tina Trimble.
WITH: Julienne Greer, Shannon Malone and Gerard J. Schneider.

DIALOGUE WITH A PROSTITUTE, written and directed by Howard Ross Patlis; based on Dacia Maraini's "Dialogue Between a Prostitute and One of Her Clients"; translated by Gillian Hanna; stage managed by Tina Magnuson; assistant stage manager, Susan Nanes.
WITH: Susan Huffaker, Anthony Marshall and Howard Ross Patlis.

In "Soap Opera," Ralph Pape's one-act play, the actress Julienne Greer looks directly at the audience and says with total conviction, "I could have just about any man I want these days," and adds, "It's great." Formerly ignored by her office mates, the character has forcibly changed her image. She is proof that self-confidence is the first step to altering the attitude of others. Ms. Greer exudes sensual awareness as she tells the story of her new life of carnality.

That story is the first of three interwoven narratives in Mr. Pape's play. The others in this so-called triologue are delivered by her lover and another woman. As the three take turns addressing the audience — and never make contact with one another onstage — a romance unfolds. At first, the play seems straightforward. Gradually it becomes devious and finally it veers toward melodrama. In a play in which every earlier step is carefully plotted and orchestrated, the end is too wide a leap. But until that point, Mr. Pape (author of the play "Say Good Night, Gracie") is, like his heroine, in sure command of himself, leading theatergoers deeper into his playwright's snare.

The cast and the director, Elizabeth Franzen, are his knowing accomplices in this tale of desire gone awry, with Shannon Malone as an artist attracted to both sexes; Gerard J. Schneider as a mechanic who finds himself the center of womanly attention, and, particularly, Ms. Greer. She creates a corrosive portrait of a wallflower turned black widow spider, playing upon male self-doubts and luxuriating in her own vanity. In this "Soap Opera," all appearances are deceptive.

The play is the first of two one-acts presented by the Tiny Mythic Theater Company in a two-evening repertory of plays culled from the troupe's summer festival. The second, "Dialogue with a Prostitute," is based on a play by Dacia Maraini. Howard Ross Patlis is the adapter, director and leading actor, which is at least two roles too many. The collaboration with himself leads to excesses of self-indulgence in a dead-end drama about role-changing and self-arousal. He has little help from the other actors, Anthony Marshall and Susan Huffaker.

What minimal interest exists comes from the Tiny Mythic approach to its audience. The two plays are grouped as "The American Living Room Reupholstered," and the title is meant to be taken literally. Theatergoers sit on comfortable couches. They can relax and drink beer as if they are at a party and the

Shannon Malone in "Soap Opera" at the Ohio Theater.

Gerry Goodstein

Rocco Sisto, left, and Rob Campbell in Caryl Churchill's "Mad Forest."

actors are offering after-dinner entertainment. Both plays are staged with a minimum of artifice. The first play engages one's attention, the second would encourage one to leave the party early.

Blue Heaven

Theater for the New City
155 First Avenue (at Ninth Street)
Lower East Side
Through Oct. 11

Written and directed by Karen Malpede; production design by Leonardo Shapiro; music by Gretchen Langheld; choreography by Lee Nagrin; video by Maria Venuto; costumes by Karen Young; lighting by Brian Aldus; production stage manager, Sue Jane Stoker; technical director, Rick Murray; cinematography by Nile Southern. Presented by Theater for the New City, George Bartenieff, executive director; Crystal Field, executive artistic director, in collaboration with the Shaliko Company.
WITH: George Bartenieff, Lailah Hanit Bragin, Christen Clifford, Sheila Dabney, Joseph Kellough, Lee Nagrin, Nicki Paraiso, Rosalie Triana and Beverly Wideman.
MUSICIANS: Gretchen Langheld, Nicki Paraiso and James Rohler.

The headline-making story of the sculptor Carl Andre and his wife, the sculptor Ana Mendieta, who died in falling from a window of their Greenwich Village apartment in 1985, is the intriguing inspiration for Karen Malpede's "Blue Heaven." Unfortunately, the play has pretensions equal to its aspirations. Instead of focusing intensely on the artist's death and its repercussions, Ms. Malpede paints on a broad and diffuse canvas, moving all the way from a consideration of avant-garde art in the 1960's to AIDS to the war in the Persian Gulf.

The play itself is like an artifact of another theatrical time. The characters are congregated in the Heaven Cafe on the Lower East Side of Manhattan, reproduced in situ at Theater for the New City. As theatergoers sit at tables, conversations and events occur all around them. The approach is reminiscent of Jim Cartwright's "Road," as well as works that preceded it, beginning with Lanford Wilson's "Balm in Gilead," all to the disadvantage of "Blue Heaven."

Where Mr. Wilson's cafe crackled with life and language, Ms. Malpede's cafe is languorous. Monologues, especially those delivered by Lee Nagrin as the proprietor and introducer of the action, seem to last an eternity. Almost every scene is attenuated, as in Sheila Dabney's portrait of a body painter who daubs herself with paint and then throws herself against a canvas. At the same time, George Bartenieff as the cafe's cook has to work overtime trying to be funny, mimicking Groucho, Harpo and Dracula. Neither of these characters is at the center of the narrative, which ostensibly deals with the mixed alle-

giances of a sculptor (Rosalie Triana) involved with an artist whose life parallels that of Mr. Andre. With insufficient explanation, Ms. Triana is eventually on her way to Iraq as a documentary film maker.

As author and director, Ms. Malpede gathers ideas and images from diverse sources, using film and video (clips of President Bush) while gratuitously referring to Robert Wilson, Richard Foreman and others more adept than she is at theatrical experimentation. It all adds up to a long evening of artistic borrowing.

The cafe setting adds a certain informality. At the performance I attended, the woman at the next table was accompanied by her dog, which promptly fell asleep. On only one level does the play express a novel perspective and that is in the jazz score by Gretchen Langheld, as played by a combo featuring the composer on the saxophone and Nicki Paraiso on the piano. Ms. Langheld makes her instrument sound like everything from a police siren crying through the streets to a shofar announcing the Jewish New Year.

1992 S 30, C16:3

Transition In Romania: An Instant History

"Mad Forest," first produced by the New York Theater Workshop, has reopened at the Manhattan Theater Club, City Center, 131 West 55th Street. Following are excerpts from Frank Rich's review, which appeared in The New York Times on Dec. 5, 1991.

Three months after the 1989 fall of the Ceausescus, the British playwright Caryl Churchill, a director named Mark Wing-Davey and 10 of Mr. Wing-Davey's acting students went to Romania on what promised to be a preposterous mission. Their aim was to become instant experts on a nation in postrevolutionary turmoil and to make a play about what they saw. Their visit was scarcely longer than a week.

Can you picture the results already? The acting students, being by definition romantics, would create a let-a-thousand-flowers-bloom pageant. Miss Churchill, being an archetypal Royal Court Theater ideologue of her day, would insist on equating Elena Ceausescu with Margaret Thatcher.

Or so one might reasonably imagine. But real artists are unpredictable. There is nothing knee-jerk about "Mad Forest," as Miss Churchill named her play, and it turns out to be just as surprising, inventive and disturbing as the author's "Top Girls" and "Fen." The piece has not dated the way newspaper accounts of the same history already have. If anything, this "play from Romania," as it is subtitled, seems to seep beyond its specific events and setting to illu-

minate a broader nightmare of social collapse, especially in the insinuating production Mr. Wing-Davey has fashioned with a crack American cast.

•

"Mad Forest" can penetrate beneath the surface of its well-chronicled story precisely because it is not journalism. Only in the second (and least successful) of the three acts, a Living Newspaper in which the company temporarily simulates Romanian accents to recite an anecdotal oral history of the tumultuous week after the massacre of demonstrators at Timisoara, does the play purport to traffic in documentary reality. The rest of "Mad Forest" forgets about the facts, which remain murky any-

Caryl Churchill's 'Mad Forest,' a vision of frightening times.

way in Romania, and exerts a theatrical imagination to capture the truth about people who remain in place no matter what regimes come and go.

Miss Churchill devotes her first and third acts to an examination of two Bucharest families, one of laborers and one of intellectuals, before and after the revolution. The author's technique is elliptical and atmospheric, often in the manner of Eastern European fiction of the Kundera and Havel era.

In Act I, the double lives of people trapped in a totalitarian state are dramatized by gesture and image rather than by the dialogue, which is oblique or insincere, lest the dread secret police, the Securitate, be eavesdropping. In Act III, the liberated Romanians do little but talk, but they often talk over one another, screaming and arguing in paroxysms of xenophobia and paranoia that sometimes seem even more frightening than the sullen episodes of repression that precede them.

As is the playwright's style, some vignettes are meanly funny. But such

conventional political satire is eventually overwhelmed by a more surreal form of theater. Mythological figures enter the action, among them an archangel and an elegant Transylvanian vampire drawn by the smell of blood. As the phantasmagoric sequences grow more grotesque, Miss Churchill gives poetic voice to the new crisis of a society in which the old totalitarian order has splintered into a no less malignant disorder. Abruptly the new democrats look suspiciously like the old Fascists and a hunt for class and racial enemies becomes the pathological preoccupation of people who remain hungry and enraged.

•

By using a small cast to populate this large canvas, Miss Churchill once again provides exceptional opportunities for actors to play multiple roles. What Mr. Wing-Davey achieves with his familiar but often unsung New York ensemble evokes memories of Tommy Tune's achievement with the American cast of Miss Churchill's "Cloud 9" a decade ago.

As designed by Marina Draghici (sets) and Christopher Akerlind (lighting), the physical production conjures up shadowy tableaux as evocative as the play's title, which refers to the dense forest that once stood where Bucharest is now and was, as a program note says, "impenetrable for the foreigner who did not know the paths." Miss Churchill does not pretend to know those paths, either — each scene is pointedly introduced by a banal sentence read from a tourist's Romanian phrasebook — but she does see the forest, not the trees. Nowhere is this clearer than in the play's wedding finale, where every element of the production whirls together in an explosively choreographed panorama of drunken revelry and sadistic, retributive violence.

Few lines can be heard over the ensuing pandemonium — "This country needs a strong man" is one — and the chaos that engulfs the theater is terrifying. Surely I was not the only American in the audience who found the climax of "Mad Forest," with its vision of an economically and racially inflamed populace on a rampage for scapegoats, a little too close to home.

1992 O 2, C5:1

SUNDAY VIEW/David Richards

The Secret Aches of Broken Families

'The Roads to Home' travels into the heart of loneliness.

'Remembrance' tries to even the odds.

HALLIE FOOTE HAS A LONG delicate nose, frightened blue eyes and a complexion the color of eggshells. Every time she makes an appearance in "The Roads to Home" — the affecting drama by her father, Horton Foote, at the Lamb's Little Theater Off Broadway — you are half afraid that she will shatter.

Everyone connected with the production seems to feel this way, too. There are no loud noises in the play. No sudden movements. I'm pretty sure Ms. Foote would run and hide if there were. As it is, the other actors are mindful not to raise their voices when they're addressing her. They nod solicitously and pretend nothing's amiss, even when the actress, for no apparent reason, is singing "My Old Kentucky Home" in a faintly wavering schoolgirl soprano, or making her finger into a miniature pistol and going "pow, pow, pow," as if she were shooting the feathery tops off dandelion stems.

Ms. Foote, you see, is playing Annie Gayle Long, a young housewife and mother of two in Houston in the 1920's, who seems to have gone crazy after the birth of her second child and now asks only a little "tenderness and mercy" of the world. To that end, she has taken to dressing in her summer pastels, riding the streetcars and turning up with no notice at the screen door of one Mabel Votaugh, who hails from the same hometown. Mabel (Jean Stapleton) doesn't know what to make of the odd visits, much less the zigzagging thoughts in her visitor's head. But she puts out the tea each time, pulls in her double chins and cluck-cluck-clucks whenever compassion seems called for or she simply doesn't know what else to do.

■

One such visit constitutes the first act of "The Roads to Home," which proceeds in the second act to paint the plight of Mabel's next-door neighbor, before concentrating again in the third (and best) act on Annie Gayle Long. By this time, the poor woman has been incarcerated for several years in a state mental asylum and is having severe trouble keeping track of the details of her former existence. The asylum's annual spring dance is taking place, and Annie could easily be the belle of the ball. Somewhere in her muddled mind, though, she seems to remember she is a married woman — or was once — and she believes that her husband — or is it her ex-husband? — would be understandably upset if she danced with anyone but him. So she politely declines the invitations of suitors as unhinged as she and, like a frailer, shyer

Blanche DuBois, takes refuge in her memories of chinaberry blossoms and better times gone by.

The character is beautifully written, and Ms. Foote plays her with exquisite delicacy. Annie may be insane, but she never forgets her manners and almost always talks in ladylike tones befitting a minister's parlor. Every now and then, however, she seems to go out of focus. By that I don't mean her thoughts lose their shape. Her *face* actually seems to blur. The eyes, which have been discreetly darting about the premises just to make sure no danger lies hidden in the floorboards or under the lace tablecloth, open wide and she's seeing encounters that happened years ago and miles away.

The corners of her mouth, unable to decide whether to go up or down, twitch ever so slightly, while a kind of sad hesitancy passes across her wide forehead. For a moment, all the hard lines of her face are erased, and she is soft and heartbreakingly vulnerable. Madness, as Ms. Foote plays it, is not a furious confrontation with reality. She merely absents herself from the world, as if she were excusing herself from a dinner party and hoping to make as little fuss as possible.

If you come right down to it, "The Roads to Home," which is directed by the author, is equally reluctant to indulge in bold gestures and dramatic outbursts. The work is not so much a three-act play as it is three one-act plays with a few shared characters and a similar outlook of bittersweet futility. Women dominate the landscape, although they are all leading marginal lives, ignored by their mates, who either abandon them, cheat on them or settle into overstuffed armchairs and doze off, night after night. In this musty small-town society, someone dropping by for a visit is very likely to be the day's highlight.

Still, as a playwright ("The Widow Claire," "Valentine's Day") and screenwriter ("The Trip to Bountiful" and the current "Of Mice and Men"), Mr. Foote knows his territory and the idiosyncrasies of the people who inhabit it. Honesty is probably his greatest virtue as a writer. Homeliness the second greatest. If you do not object to stories glancingly told, "The Roads to Home" is a lovely,

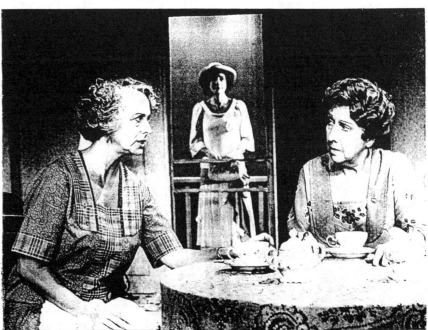

Carol Rosegg/Martha Swope Associates/"The Roads to Home"

Rochelle Oliver, left, Hallie Foote, center, and Jean Stapleton in "The Roads to Home"—A gallant evocation of three forsaken souls trying to carry on.

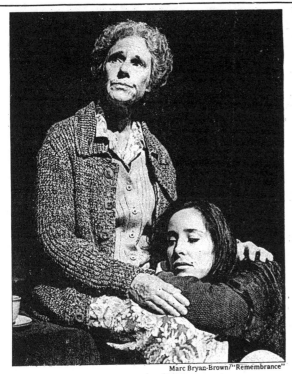
Marc Bryan-Brown/"Remembrance"

Frances Sternhagen, left, and Caroleen Feeney in "Remembrance."

sometimes gallant evocation of three forsaken souls trying to carry on.

Ms. Foote's struggle is the most arresting because her character's sanity is at stake. But you gather it wouldn't take all that much to drive the other two women in the play over the edge. Ms. Stapleton's hair is wound into tight little curls, her cheeks are rouged up, as if for a carnival, and she's got a breathless bounce in her step that suggests she's raring to go somewhere, were there only somewhere to go. But her husband pays her no mind ("He never talks," she observes wryly. "We have Quaker meetings") and her living room is so tidy that any further efforts at housecleaning would wear out the furniture. Gossip is not her vice. It's all she's found to do with the empty hours. Ms. Stapleton, a broad comic, is not without pathos in the role.

ROCHELLE OLIVER PLAYS THE third member of Mr. Foote's trio, Vonnie Hayhurst, who learns in the second act that her husband is having an affair and immediately runs next door to Mabel's for advice and consolation. Vonnie would like to be outraged by the infidelity; mostly, she's just humiliated. She thinks about phoning the other woman, confronting her husband, taking a stand. Deep down, however, she realizes nothing much is to be done.

"God usually answers my prayers," she concludes, with more conviction than she really feels. "So I'm just going to keep on praying, and I know he won't let me down this time." Ms. Oliver creates a touching portrait of fallen gentility. The dark roots of her blond hair attest to her failed stabs at glamour, and the dark circles under her eyes speak of the troubled nights. Even more telling is the actress's melodic voice, fighting to remain ᵒᵃˢˢᵘ˙ᵘᵣ̣ᵉd and gracious when she really ᵤants to scream.

■

Our loud and violent times are not particularly hospitable to retiring creatures like these. We like crackups on the stage, car crashes on the screen and brash characters who will at least go down swinging. Mr. Foote's gentleness will be viewed by some as torpor. Admittedly, his roads to home are little byways — not even paved, I suspect, and doubtless no wider than a Model T. But they lead someplace humane and caring, where heartbreak doesn't have to be desperate and noisy to merit our concern.

Ms. Foote knows her father's ways. Wrapping herself in a courteous madness, she does him proud.

'Remembrance'

Apparently, a fair number of spectators thought Graham Reid's "Remembrance" a touching affair when it was staged two years ago at the Irish Arts Center. I was exasperated by it, although willing to believe that the acting (mediocre) and the production (cramped) had something to do with my reaction. Well, the play has now been recast with such well-regarded performers as Milo O'Shea and Frances Sternhagen, and it's being accorded a much larger production Off Broadway at the John Houseman Theater. But I'm afraid the new incarnation struck me as no less exasperating than the old.

Mr. Reid has written a senior citizens version of "Romeo and Juliet," set in present-day Belfast, Northern Ireland. Bert Andrews (Mr. O'Shea), a pleasant 68-year-old Protestant widower, is lonely. Theresa Donaghy (Ms. Sternhagen), a pleasant 63-year-old Roman Catholic widow, is also lonely. They meet accidentally in a cemetery, where their respective sons, each a victim of the "troubles," are buried, and it's affection at first sight. While they feel a little foolish about it, they soon find themselves sharing tea and sandwiches and holding hands.

Their grown-up children, who are leading uniformly miserable lives, will have none of the prospective match, however. They raise all manner of political and religious objections and even fling their parents' "great" ages in their faces. Jealousy also seems to be part of it. As Theresa's daughter Deirdre (Terry Donnelly) puts it, "Why should you have what I can't have?"

Deirdre's husband, a member of the I.R.A., has been imprisoned for murder. She's saddled with three young kids, no future and a growing appetite for sex that's not likely to be soon appeased. So I guess she has her reasons for acting as disagreeably as she does. Bert's son, Victor (John Finn), a bigoted policeman who yearns to immigrate to South Africa where he believes his kind is better appreciated, is her equal for bile and vituperation. The parents eventually bow to the pressure and break off the romance, although the play's trailing-off ending has them exchanging correspondence and vowing to get together at a later date.

Rather like a Ping-Pong game, the action bounces back and forth between the Andrews house (stage left) and the Donaghy house (stage right), with the occasional timeout at the cemetery (center stage). I presume Mr. Reid wants to illustrate the ghastly toll that two decades of violence have taken on the residents of Northern Ireland. But it is all too easy to view "Remembrance" as the chronicle of some spiteful, self-pitying children who enjoy pushing around their elders. If there's a redemptive subtext here, neither Ms. Donnelly nor Mr. Finn is bringing it to the fore. And despite honorable performances by Ms. Sternhagen and Mr. O'Shea, the parents continue to come across as spineless creatures, entirely too ready to apologize for their crumb of happiness.

Granted, each family can lay claim to one understanding member — in Theresa's case, a second daughter (Caroleen Feeney); in

Bert's case, a daughter-in-law (Mia Dillon). But that's just the author trying to even up the sides, the way a baseball coach balances the neighborhood teams to prevent the game from turning into a rout. An unfortunate sort of fair play seems to prevail. The confrontation in one house has its echo in the other. What Bert suffers, Theresa, too, is bound to endure. It's tit for tat all down the line in Mr. Reid's dramatic universe.

For the record, "Remembrance" is refereed by the director Terence Lamude, who clearly has more patience with these people than I do. □

1992 O 4, II:5:1

Remembrance

By Graham Reid; directed by Terence Lamude; scenery by Bill Stabile; costumes by Barbara Forbes; lighting by John McLain; sound by Tom Gould; dialect coach, Lilene Mansell; production stage manager, Susan Whelan. Presented by David G. Richenthal and Georganne Aldrich Heller. At the John Houseman Theater, 450 West 42d Street, Manhattan.

Bert Andrews....................Milo O'Shea
Victor Andrews....................John Finn
Theresa Donaghy..........Frances Sternhagen
Joan Donaghy..................Caroleen Feeney
Deirdre Donaghy..................Terry Donnelly
Jenny Andrews....................Mia Dillon

By MEL GUSSOW

Beneath the sudden clashes of temperament, Graham Reid's "Remembrance" has an elegiac gentleness in telling the story of two disparate families in Northern Ireland. One, headed by Milo O'Shea, as a retired British soldier, is Protestant; the other, headed by Frances Sternhagen, is Roman Catholic. To a background of violent political conflict, the two, widower and widow, are brought together by their loneliness and their decency. Each is too old to be inimical to anyone. Their adult offspring are an entirely different matter.

"Remembrance" (at the John Houseman Theater, after a 1990 production at the Irish Arts Center) is rueful rather than explosive, although the past carnage haunts the present. Things are momentarily

peaceful in Belfast, but each family has lost a son in the turmoil and each regards its own as an innocent victim. The play's political aspects are more complex than they seem, as is the relationship between Mr. O'Shea and Ms. Sternhagen.

The parents happen to meet in the cemetery where their sons are buried. When friendship begins to ripen into romance, the surviving children are filled with resentment. Mr. O'Shea's son (John Finn) is a policeman who has assumed brutish airs, and Ms. Sternhagen's daughters (Caroleen Feeney and Terry Donnelly) are opposites allied in their sourness about their thwarted lives. Each in turn reveals a cruel streak, assailing a parent for self-interest, then having second thoughts.

•

The play does not have the lyricism of the finest Irish dramas (by playwrights like Brian Friel and Thomas Murphy), and it has its contrivances as well as moments of sentimentality. Scenes are prolonged, especially in the denouement. But Mr. Reid, an Irishman living in London, has compassion for all his characters, and he writes with a leavening humor, as in the father's reaction to his son's repeated vow of abstinence: he always says he is going to stop drinking, but he has to be drunk to say it. Some of the most amusing lines are given to people who believe they are humor-

less: Mr. Finn's stern policeman and Ms. Donnelly, who has a flighty disregard for anyone other than herself.

Two people torn apart by a sorrow that unites them.

As the mother, Ms. Sternhagen is thoughtful and dignified, but the character has few other distinguishing traits beyond her resolve to get on with her life. She will overcome her son's death, her daughters' disappointments and her own widowhood. Although the actress does not seem especially Irish, she captures the woman's indomitability and her urge to rejuvenate herself.

Mr. O'Shea is the heart of the play, delivering a strong and understated performance as a man who has learned to banish despair but has yet to understand all of his own motivations and those of his relatives. In "Remembrance" his education continues as he begins to see what has turned his son against him, and as he begins to deal with the disunion that has poisoned his adopted country.

There is a deft performance by Mia Dillon in a supporting role as the policeman's estranged wife. This is the one character able to see the others in their full strengths and weaknesses. A promised scene between her and Ms. Sternhagen never takes place. It might have added dramatic dimension to a play that has one too many scenes of family argument.

Moving back and forth between households, with stops for dialogue in the cemetery, the play maintains a split-vision view of the two families. With the help of Bill Stabile's utilitarian set, the director, Terence Lamude, keeps the action flowing smoothly. Through the actors, the audience receives a feeling of the divisiveness within the community, which is economic and social as well as religious: the solid middle-class respectability of the dapper Mr. O'Shea in contrast to the subsistence level of Ms. Sternhagen. She is embarrassed by her circumstances and by her outdoor toilet, but her younger daughter keeps the kitchen floor so shiny that "Torvill and Dean could skate on it."

"Remembrance," a play with a quiet but staunch sense of purpose, offers a revealing look at the humanity of people surrounded by strife.

1992 O 5, C13:4

Les Atrides

A four-play cycle directed by Ariane Mnouchkine. Music by Jean-Jacques Lemêtre; sets by Guy-Claude François; masks by Erhard Stiefel; costumes by Nathalie Thomas and Marie-Hélène Bouvet; director's assistant, Sophie Moscoso; musicians, Mr. Lemêtre, Maria Serrão and Marc Barnaud; philologists, Jean Bollack and Pierre Judet de la Combe; makeup design, Catherine Schaub; property and costume design, Ms. Schaub and Simon Abkarian; dances directed by Mr. Abkarian, Mr. Schaub and Nirupama Nityanandan; coach, Myriam Azencot; lighting by Jean-Michel Bauer, Carlos Obregon and Cécile Allogeodt; English translation by William M. Hoffman. Théâtre du Soleil presented by the Brooklyn Academy of Music, Harvey Lichtenstein, president and executive producer. At the Park Slope Armory, 15th Street and Eighth Avenue, Brooklyn.

IPHIGENIA IN AULIS, by Euripides; translation by Jean and Mayotte Bollack.

WITH: Simon Abkarian, Duccio Bellugi, Juliana Carneiro da Cunha, Daniel Domingo, Brontis Jodorowsky, Nirupama Nityanandan and Catherine Schaub.

AGAMEMNON, by Aeschylus; translation by Ms. Mnouchkine.

WITH: Simon Abkarian, Juliana Carneiro da Cunha, Brontis Jodorowsky, Nirupama Nityanandan and Catherine Schaub.

THE LIBATION BEARERS, by Aeschylus; translation by Ms. Mnouchkine.

WITH: Simon Abkarian, Duccio Bellugi, Juliana Carneiro da Cunha, Brontis Jodorowsky, Nirupama Nityanandan and Catherine Schaub.

THE EUMENIDES, by Aeschylus; translation by Hélène Cixous.

WITH: Simon Abkarian, Myriam Azencot, Juliana Carneiro da Cunha, Shahrokh Meshkin Ghalam, Nirupama Nityanandan and Catherine Schaub.

By FRANK RICH

Ariane Mnouchkine, the Parisian director, may or may not be one of the world's greatest theater artists, but who can doubt that even by France's high standards in the field she is a champion control freak?

Those attending "Les Atrides," the 4-play, 10-hour cycle of Greek tragedy with which Ms. Mnouchkine and her company, Théâtre du Soleil, are making their New York debut, will quickly learn that there are strict rules to be obeyed.

Late-comers are not admitted to the Park Slope Armory, where "Les Atrides" is being presented to audiences on punishing bleacher seats under the auspices of the Brooklyn Academy of Music. There are no intermissions. There are no reserved seats, a form of democracy that prompts some ticket-holders to line up hours before curtain time and that leads to picturesque shoving matches, some of them involving celebrities, once everyone gets indoors. During the on-site meal breaks that separate the matinee and evening plays during a weekend marathon, those who finish eating early find attendants blocking the passageway from the picnic tables (dimly lighted, also per Ms. Mnouchkine's orders) to the performance space.

"Didn't you hear? You're all part of the human sacrifice," said an usher to complaining patrons eager to escape captivity for a post-lunch, pre-"Eumenides" stroll. Not so many people laughed as you might think.

•

Given this militaristic atmosphere — which even extends to the director's choices of venue, whether an armory in Brooklyn or a former munitions factory outside Paris — it is easy to imagine the chilling authenticity she will bring to one of her pet projects for the future, a piece on Vichy France. But Ms. Mnouchkine's relentlessly tight leash on her theatrical realm, which in "Les Atrides" sometimes creates an onstage airlessness to match that in the auditorium, can also produce remarkable results.

This is certainly the case with "The Libation Bearers," the middle play in Aeschylus' trilogy about the House of Atreus but the third play of Ms. Mnouchkine's quartet, in which Euripides' "Iphigenia in Aulis" is a prelude. For contemporary sensibilities, "The Libation Bearers" may be the most action-packed drama of the lot: As Orestes returns from exile to avenge the murder of his father, Agamemnon, he is propelled into a reunion with his sister, a grueling act of

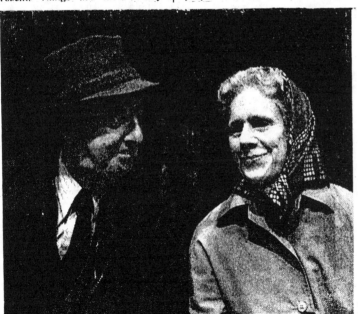

Marc Bryan-Brown/"Remembrance"

Milo O'Shea and Frances Sternhagen in "Remembrance."

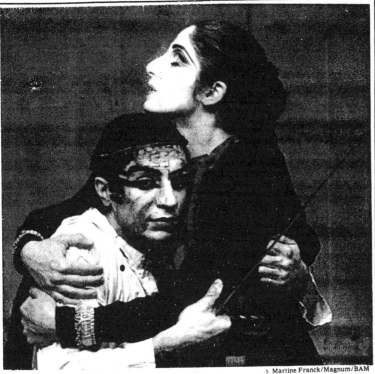

Martine Franck/Magnum/BAM

Simon Abkarian and Juliana Carneiro da Cunha in "The Libation Bearers," one of the plays in the "Atrides" series being presented by Ariane Mnouchkine and Théâtre du Soleil at the Park Slope Armory in Brooklyn.

des play in which Clytemnestra must sacrifice her daughter Iphigenia (a touching Nirupama Nityanandan) to the dubiously greater good of her husband's war machine, Ms. Mnouchkine makes her principal heroine a far more sympathetic (and dominant) figure in the Aeschylus trilogy to come. The director further stacks the deck by imprisoning most of the male characters behind masklike makeup while giving the women more literal and figurative freedom of expression. By the time "The Eumenides" arrives, this slant is more sentimental than provocative: Athena is presented as a syrupy guru (embodied by Miss da Cunha, the previously mesmerizing Clytemnestra), and the three Brechtian bag ladies who lead the Furies are transformed into beaming automatons of saintly matriarchy.

Ms. Mnouchkine's artistic ideology shapes "Les Atrides" far more than her politics does, however. And the extraordinary payoff of her perfectionism, her lengthy rehearsal period and her cultural crossbreeding can be found in all four plays. The dancing of the androgynous chorus, led and co-choreographed by the amazing Catherine Schaub (who also co-designed the costumes), has a fervor, precision and ethereal lightness that cannot be matched by many dance companies, let alone theatrical troupes. Fierce dramatic images, often achieved with means as simple as the rushing forward of a platform or the tearing of a curtain, abound. The five principal

actors, each playing multiple roles, may engage in old-fashioned histrionics, but they do so with a commitment and brilliant intensity that flirts with greatness in the case of Mr. Abkarian's portraits of Agamemnon, Achilles and a finally feral Orestes.

•

What the director's controlling esthetic forbids, by definition, is unruliness, emotional or otherwise, that does not fit the precise meter of her neo-classicism. While early arrivals to "Les Atrides" are encouraged to watch the actors put on their makeup in an open but roped-off dressing-room area behind the bleachers, the spectators soon discover that even this ostensible backstage space is rigorously designed. The rugs underfoot are color-coordinated with the costume accessories hanging above, and every object is as neatly displayed as the goods in a department store window.

Are these impeccably sober, silent actors freely warming up in their own domain, or are they merely executing another one of Ms. Mnouchkine's meticulous illusions within the confines of a public cage? Either way, it is a beautiful, strangely antiseptic and poignant sight that, like much of "Les Atrides," creates an elegant, hermetically sealed world of pure theater that is securely and safely cordoned off from the spontaneity of life.

1992 O 6, C11:3

matricide and finally a mad escape from the Furies. Yet in the Théâtre du Soleil rendition, the storytelling is neither modern nor archaic in the presumed manner of the fifth century B.C. but timeless. Ms. Mnouchkine fulfills her idea of a cosmopolitan, ritualistic theater that is beyond language, plot or any kind of realism and that instead digs deep into the primordial passions, many of them ugly, that seem the eternal, inescapable legacy of the human race.

The director accomplishes this feat with the multi-cultural devices that typify the entire cycle. The playing area is a vast wooden corral, a neutral space reminiscent of the sandboxes used by that other Parisian theatrical visionary, Peter Brook. The performers appear in opulent ceremonial costumes of vaguely Asian provenance. The stagehands are Kabuki-ish while the chorus's choreography emulates the Kathakali dance dramas of Southern India. The musical accompaniment, composed by Jean-Jacques Lemêtre and generally played by him in a rustic bandstand containing more than 140 exotic instruments, careers from eclectic Eastern folk improvisations to Kabuki percussion to recorded Indian music to what might be a hyperventilating Bernard Herrmann film score for Alfred Hitchcock. The acting, fiery and grand and never inward, is classical French (even if the actors themselves are not).

From the moment Orestes (Simon Abkarian) arrives at Agamemnon's tomb, "The Libation Bearers" exerts a subterranean, not easily articulated pull on a viewer's psyche. Some of this is a matter of ominous mood, whether created by the buzzing of Mr. Lemêtre's strings or the cold blue lighting that shrouds Orestes' return. There are also arresting tableaux, including the tall, windblown altar that reveals the sleeping Clytemnestra (Juliana Carneiro da Cunha) on what will be her death bed. And there is the high-throttle confrontation be-

tween mother and son, as Clytemnestra runs but cannot hide from Orestes, whose monomaniacal pursuit of his prey turns the wooden arena into a bullring.

•

But the most extraordinary coup de théâtre in "The Libation Bearers" — and, for that matter, in "Les Atrides" — arrives after the blood is spilled: as the lights dim to black and the barking of approaching dogs rises to a terrifying pitch, individual attempts to remove the bloodied mattress bearing the mutilated corpses of Clytemnestra and her lover, Aegisthus, come to nothing. Finally the entire chorus must advance to do the macabre deed, and the apocalyptic spectacle leaves the anxious audience in dread of an unchanging world in which blood inexorably begets blood and evil forces are never tamed.

So upsetting is "The Libation Bearers" that the cycle's concluding play, "The Eumenides," has a tough time evoking a persuasive vision of justice, peace and reconciliation in its savage wake. Though Ms. Mnouchkine makes the most of her leaping chorus of Furies — snarling, mutated hellhounds, part canine, part simian, and reminiscent of the furious apes in Stanley Kubrick's "2001" — her staging becomes flat once the theater's first courtroom drama begins. When handed lengthy passages of discourse, the director tends to settle for static recitations of the text. Whether heard in French or through earphones in William M. Hoffman's able English rendering, the talk is numbing, not just in the debates of "The Eumenides" but also in the expository first hour of "Agamemnon."

•

The text throughout is somewhat idiosyncratic, seemingly to further the feminist viewpoint that is the undisguised and at times fascinating ideological agenda of "Les Atrides." By opening her cycle with the Euripi-

Theater in Review

■ Timely political satire from two Henry Adams novels via Romulus Linney ■ Prancing at lunacy in a comedy about aspiring criminals.

Democracy and Esther

Church of the Holy Trinity
316 East 88th Street
Upper East Side
Through Oct. 26

By Romulus Linney; directed by Elisabeth Lewis Corley; costumes by Amanda J. Klein; lighting by Nancy Collings; set by Bob Phillips; stage manager, Cathy Diane Tomlin. Presented by Triangle Theater Company, Michael Ramach, producing director.

WITH: Frank Anderson, Fred Burrell, Kathleen Dennehy, Kathryn Eames, Mary Beth Peil, Priscilla Shanks, Maureen Silliman, Paul Urcioli and John Woodson.

Although Henry Adams is best known for his autobiography and his philosophical essays, he also wrote two novels, "Democracy" and "Esther." The first was published anonymously, the second under a pseudonym; because each was a roman à clef, the author was worried about repercussions. "Democracy," an unjustly neglected comic novel, is a malicious satire on Washington politics in the late 1800's.

Since both books deal with the same period and related aspects of society ("Esther" focuses on religion) and have as their heroines remarkably independent women, Romulus Linney had the idea of combining them into a single play entitled "De-

mocracy and Esther." In the play, characters from both novels interact. What is interesting in theory proves to be unwieldy in practice. The two-hour condensation shortchanges both novels, but the play stimulates one's appetite for a full Linney adaptation of Henry Adams, perhaps of "Democracy" by itself, or for a Merchant-Ivory film version of that same book.

The playwright has excised many of the principal characters, including a politician named Nathan Gore who represents cultivated taste. On the other hand, he has expanded the role of the President (undesignated in "Democracy"), giving him his rightful name, Ulysses S. Grant. Mr. Linney's adaptation is part roman, part clef, and the two parts do not mix easily.

The core of the play (and of "Democracy") is Madeleine Lee, a rich young New York widow who descends on Washington, in Adams's words, "bent upon getting to the heart of the great American mystery of democracy and government." In Madeleine's time, Washington is a whirl of parties, in both the social and political sense.

Scandal affects a wide diversity of public officials, including Silas P. Ratcliffe (Ratcliffe in the original), the most powerful man in the United States Senate and a possible future President. Adams is deliberately

"Democracy and Esther"

Priscilla Shanks in a scene from "Democracy and Esther."

slow in unmasking the Senator as a scoundrel, taking time to cultivate a romance between him and Madeleine until a Jamesian friend of Madeleine's family reveals Raitcliffe in his true colors. Mr. Linney has removed that catalytical figure and others in order to give almost equal time to Esther Dudley and her involvement with an Episcopal minister.

The play is most effective when it holds to "Democracy," as in a foreign diplomat's caustic comments on American hypocrisy and in other scenes when people take a longer historical view of the mess in Washington. In Elisabeth Lewis Corley's production, Priscilla Shanks and John Woodson convey some of the magnetism of the widow and the senator and Mary Beth Peil has a few amusing moments as a fashionable hostess, but others in the cast are less persuasive. This amalgam of two novels, written in 1968 and now receiving its delayed New York premiere, lacks the assurance of Mr. Linney's subsequent work. But Adams, with his instinctive feminism and his view of chicanery in high places, proved to be prescient. More than a century later, American politics and politicians remain unchanged. *MEL GUSSOW*

Criminals in Love

TriBeCa Lab
79 Leonard Street
TriBeCa
Through Oct. 18

Written by George F. Walker; directed by Lee Milinazzo; set by Marion Kolsby; lighting by Eric T. Haugen; costume coordinator, Carol Brys; stage manager, Joe Kubala. Presented by Rattlestick Productions Inc., Tribeca Lab and Milinazzo Productions.

WITH: Elizabeth Browning, Grace Campbell, Elizabeth Chapman, John McKie, Ernie Shaheen and Garland Whitt.

In a new production at the TriBeCa Lab an enthusiastic cast and the direction of Lee Milinazzo galvanize George F. Walker's "Criminals in Love" into more comic life than one might suppose this disjointed skeleton of a comic play first seen in 1984 could ever have.

In fact the story, about four innocents inveigled into crime by a demented revolutionary and an imprisoned aspirant to big-time crime, is

not very funny, even at the odd moments when it is outlined clearly enough to be comprehended.

Ms. Milinazzo and the actors wisely concentrate on making the characters, not the story, coherent. Thus William, a homeless alcoholic with a gift for brilliant insights into the world's madness, is simply dropped into the play for laughs in several guises. Ernie Shaheen gives him an underlying compassion and tenderness that make him wise, vulnerable and very funny all at once.

John McKie turns Henry, doing hard time and betraying his son to underworld figures on the outside, into a hilarious victim of his own mad conviction that the world is run by a criminal conspiracy he can join if only he can find out who the big conspirators are. Elizabeth Browning greatly heightens the humor of Wineva, a 1960's-style revolutionary, by toning down the character's lunacy at the outset and letting it only gradually, totally submerge her.

Those in the roles of the three youngest characters have it somewhat easier. Garland Whitt as Henry's son, Junior, and Elizabeth Chapman as his girlfriend, Gail, are supposed to be tender foils to their demented elders, and they make these characters very winning. And Grace Campbell as Sandy, their teen-age friend who is open to any experience — prostitution, robbery, terrorism — that will help her start a career, is so quiet and apparently reasonable that her utter indifference to logic and morality continually surprise one into a smile.

This production is a slightly unnerving experience. One laughs from time to time and afterward has a hard time figuring out what brought it on. *D. J. R. BRUCKNER*

1992 O 7, C16:3

The Holy Terror

Written and directed by Simon Gray; scenery by David Jenkins; costumes by David Murin; lighting by Beverly Emmons; production stage manager, George Darveris. Presented by John A. McQuiggan and Donald L. Taffner, in association with Diana Bliss and W. Scott and Nancy McLucas. At the Promenade Theater, 2162 Broadway, at 76th Street, Upper West Side.

Mark Melon	Daniel Gerroll
Edward Ewart Gladstone	Michael McGuire
Samantha Eggerley	Lily Knight
Michael/Jacob/Rupert/Graeme	
	Anthony Fusco
Josh Melon	Noël Derecki
Gladys Powers	Kristine Nielsen
Kate Melon	Kristin Griffith

By FRANK RICH

Female menopause may make for best-selling books in the United States, but in that smoke-filled men's club known as the English theater, male menopause still hogs center stage. "The Holy Terror," Simon Gray's play at the Promenade Theater, is an uncompromisingly whiny example of a genre that has in the past produced such distinguished dramas as "The Real Thing" and "Betrayal." Mr. Gray doles out his protagonist's self-lacerating confessions, professional crises and petty adulteries as mechanically as a bartender might assemble the ingredients for an astringent martini (with no twist).

Heaven knows this two-hour evening, much of it a monologue, is

dry. You feel nothing for Mark Melon (Daniel Gerroll), a ruthless, philandering London publisher who is patronizing to everyone, from the elderly literary aristocrat (Michael McGuire) whose firm he usurps to a gay psychiatrist friend (Anthony Fusco) to his indolent teen-age son (Noël Derecki) and his long-suffering wife (Kristin Griffith). Though Melon's publishing house harks back to the age of Pound and Eliot, the people who come and go in the psychic wasteland of "The Holy Terror" are more inclined to talk of "office pokes" than Michelangelo.

Mr. Gray can be a very fine writer, but in this effort, the traits of his better works are regurgitated in etiolated form. Melon resembles the erudite, self-flagellating heroes of "Butley" and "Otherwise Engaged," much as the sad-sack characters around him are of a piece with the disappointed intellectuals and academics of "Quartermaine's Terms" and "The Common Pursuit." But

From England, with confessions, crises and adulteries.

Melon, in contrast to his antecedents, lacks wit and depth, and the victims of his abuse are stick figures, little realized in either the writing or performance. Even so seemingly fool-

proof a comic type as the matronly author (Kristine Nielsen) of oversexed pulp novels proves more a bore than a boor in this airing.

•

Perhaps the playwright has simply fussed over "The Holy Terror" for so long that he's overcooked it. The work was first seen under the title "Melon" in the West End five years ago in a clumsy production that was at least intermittently salvaged by Alan Bates's aching performance in the title role. In its current incarnation, now under the direction of Mr. Gray himself, the dramatic format has changed and the text seems briefer and streamlined, but even the edgy passions that sporadically emerged from "Melon" are gone.

The most conspicuous aspect of the revision is Mr. Gray's new framing device: Melon now tells the audience his life story under the guise of giving a lecture ("My Life and Times as a Publisher") to a group of ladies who lunch at the Cheltenham Women's Institute. All "The Holy Terror" gains from this device are a few more juvenile, misogynic asides and a monochromatic set (by David Jenkins) all too naturalistically representing the stage of an institutional auditorium. Now as before, the play remains a dramatically rambling soliloquy of free associations and flashbacks as told by a man who is trying to regain his footing after a nervous breakdown.

At times Melon's footing must literally be regained. Mr. Gerroll is periodically asked to fall to the ground in red-faced paroxysms of paranoia,

Joan Marcus

Anthony Fusco, left, Daniel Gerroll, center, and Michael McGuire in Simon Gray's play "The Holy Terror" at the Promenade Theater.

rage and sobs that typify the play's literalistic presentation of mental illness. The actor handles these sticky passages well enough and, as always, conveys brusque intelligence. Yet if there are notes of vulnerability, not to mention humanity, that might make Melon worthy of an audience's sympathy or constant attention, Mr. Gerroll has not been able to find them. He also looks too young to have reached so advanced a state of male menopause, even in a country where the relatively youthful Prince Charles sets the standard for midlife crises among married men.

1992 O 9, C3:1

The Dolphin Position

By Percy Granger; directed by Casey Childs; set by Ray Recht; costumes by Bruce Goodrich; lighting by Deborah Constantine; sound by One Dream; assistant director, Andrew Leynse; production stage manager, Tony Luna. Presented by Primary Stages Company Inc., Mr. Childs, artistic director; Janet Reed, associate artistic director. At 354 West 45th Street, Manhattan.

Jerry Tremendous	Larry Pine
Cheryl	Charlotte d'Amboise
Paul	Richmond Hoxie
Woman	Anna Holbrook
Tilly, Bohan and Cal	Randell Haynes
Mike, Bernie and Simon	Andrew Weems
J. J.	Ilene Kristen
Ronnie and B. J.	Justin Zaremby

By MEL GUSSOW

In his plays, Percy Granger has revealed a sharp-edged comic perspective on competition in the work place, whether that arena happens to be academia, as in "Eminent Domain," or television, as in "Scheherazade," a witty sendup of the world of soap operas that was presented last season at the Ensemble Studio Theater. Some years ago at the Ensemble Studio, Mr. Granger gleefully savaged unaccountable executives in advertising in a one-act work titled "The Dolphin Position." A full-length version of that play is now running at the Primary Stages Company.

The protagonist is Jerry Tremendous, a partner in Tremendous-Pill, an advertising agency with vast international resources and a callow antiwoman streak. One day, Jerry

Martha Swope Associates/William Gibson
Charlotte d'Amboise and Larry Pine in "The Dolphin Position."

wakes up and discovers a strange, stylish woman and a precocious 8-year-old boy in his home and wonders what they are doing there. They are, of course, his wife and son, and the husband has come down with an attack of amnesia.

From there on, the playwright sends the character through a whirlwind of forgetfulness. The joke is that no one notices.

•

The new two-hour version seems to have forgotten the play's roots in comedy. Instead of the befuddled hero of the earlier play, there is a glum adman played by Larry Pine without his usual antic humor. In trying to be more serious, the play only becomes more captious.

In place of screwball comedy, there is surrealism as Jerry has elaborate dreams and delusions about rectifying the mistakes of his selfish life. In common with the hero of the film "Regarding Henry," a heel turns and tries to reform himself. One can trace this plot all the way back to "A Christmas Carol."

One added problem with the narrative in "The Dolphin Position" is that Jerry seems to suffer from selective amnesia, remembering certain details while obliterating others. My memory of the original is that his earlier life was a blank slate.

•

Casey Childs's direction is stolid, and part of that can be attributed to Ray Recht's scenic design, a modular maze that seems to entrap the actors. Even such an amusing performer as Richmond Hoxie (playing the other half of the Tremendous-Pill agency) is lost in the shadows of the play, although Charlotte d'Amboise as the wife and Anna Holbrook as the secretary have a few funny moments.

In the short "Dolphin Position," every step had a twist. The elongated version proves, once again, the perils of trying to expand a one-act idea. In this case, there was more in less.

1992 O 9, C3:1

Six Wives

Book and lyrics by Joe Masteroff; music by Edward Thomas; directed and choreographed by Maggie L. Harrer; scenic design, James E. Morgan; costume design, Barbara Beccio; lighting design, Fred Hancock; orchestrations, Bob Goldstone; technical director, John Miller; production stage manager, John Kennelly. Presented by the York Theater Company, Janet Hayes Walker, producing director; Molly Pickering Grose, managing director, in association with One World Arts Foundation. At 2 East 90th Street.

Henry	Steve Barton
Katharine of Aragon/Anne of Cleves/Catherine Parr	Tovah Feldshuh
Anne Boleyn/Kathryn Howard/Jane Seymour	Kim Crosby
Minister	Rex D. Hays
Messenger and others	Buddy Crutchfield

By MEL GUSSOW

With countless books, movies and plays based on his life, Henry VIII is the most overexposed of English royals, including those living in the 20th century. Henrys have come in all sizes, from fat (Charles Laughton) to lean (Nicol Williamson in Broadway's "Rex"). But until now, he has never resembled Sir Launcelot. This is the case with the new musical "Six Wives," in which Steve Barton, last seen in the romantic lead in "Phan-

Blanche Mackey/Martha Swope Associates
Steve Barton and Tovah Feldshuh in the musical "Six Wives."

tom of the Opera," plays Henry — at least the young Henry — as a handsome hero. By the time he gets to Queen No. 6, he has been slightly padded, but at no point does he simulate the Rabelaisian robustness of life and cinema.

The Edward Thomas-Joe Masteroff chamber musical (at the York Theater Company) begins with Henry addressing the audience confidentially. He mentions the familiarity of the king's life and wonders why there is need for still another version of his story. Good question, Henry. Then he says what will occur onstage is "all truthful, all historical, all chronological." I would have preferred all singing. The book is ploddingly predictable, except for one out-of-sequence appearance by a later wife who is impatient for her turn. While Mr. Barton holds himself to the role of Henry, Tovah Feldshuh and Kim Crosby play all the queens (three Kates, two Annes, one Jane).

•

Despite ample discouragement, Henry never seems to lose his appetite for romance. As he says at the outset, "I am in love, deeply in love, and so I am a puppy." Even during his brief marriage to the officious Anne of Cleves, he keeps that puppy disposition. The image received is of a king coaxed by a jealous chief minister into becoming an avenger. Henry would have preferred the wives to continue living. But Rex D. Hays as the sinister minister (call me Cranmer or Cromwell) steps on stage and accuses several of them of adultery.

Henry maintains his aplomb even as his penultimate bride announces, with her queenly way with words, that looking at her husband "makes me want to puke." Thankfully, that line is not set to music. Although these royal marriages can end at the gallows, it is never clear if "Six Wives" is supposed to be tragical or satirical.

In the circumstances, Ms. Feldshuh as the foreign wives is able to provide some fairly consistent comic relief. Her Katherine of Aragon has an accent as thick as Chita-Rita in

"Forbidden Broadway," and her Anne of Cleve sounds like a double Dutch vaudeville comedian. Cleverly she keeps those accents when she sings.

•

The oddity is that for all the prolonged (and justified) apologia, "Six Wives" has some melodic show tunes (music by Mr. Thomas, lyrics by Mr. Masteroff). In another context or in a cast album, they might seem better than they do in Maggie L. Harrer's intractable production. There is a full-bodied quality to ballads like "Do Not Deny My Love" and a springiness in the lyrics that make it evident the team is capable of much more. Mr. Masteroff has, of course, already done much more, having written the books for "Cabaret" and "She Loves Me."

Each of the three stars is an experienced and talented musical performer. The greatest vocal demands are put on Ms. Feldshuh, whose dialect comedy is interspersed with songs that would challenge a soprano. Mr. Hays and Buddy Crutchfield, playing the minister and an equally ubiquitous messenger, easily hold their own in this musical company.

"For five centuries I slept," says Henry in a post-death soliloquy. Then he asks the audience if he can go back to sleep, adding, Tinker Bell style, "It's up to you." "Six Wives" is insufficient cause for a wake-up call.

1992 O 10, 16:1

SUNDAY VIEW/David Richards

You Saw It on Film, Now See It on Stage

'The Wizard of Oz' and 'Captains Courageous': the sweetness of familiarity versus the risk of trying to create a new vision.

I'M CONFUSED.

I'd like to come up with a truth of some sort, a dramatic theorem, or at least a generalization that will make sense of my week's play-going. But the conclusions I reached in one theater — fairly confidently, I thought — are directly contradicted by those I formulated — no less confidently — upon leaving the second theater.

If I'd sat down to write immediately after seeing "Captains Courageous," a musical version of the 1937 movie currently at Ford's Theater in Washington, I probably would have said something to the effect that movies are movies and you just can't go and put them on the stage like that. They have to be reimagined, restructured, for the circumstances. Not to oversimplify matters, the theater uses the word as its basic building block; the cinema relies on the image. They necessarily tell their stories differently.

Furthermore, when the climax of the movie has to do, as "Captains Courageous" does, with two fishing boats racing back to the port of Gloucester, you have an especially daunting theatrical challenge on your hands. Spectacle has made a big comeback on our musical stages over the last decade or so. But the Atlantic Ocean in full turbulence? Two majestic ships bearing down upon each other,

Jerry Dalia/"The Wizard of Oz"

Retracing the yellow brick road, above, are Mark Chmiel (Scarecrow), Michael O'Gorman (Tin Man), Eddie Bracken (Wizard), Kelli Rabke (Dorothy) and Evan Bell (Cowardly Lion) in L. Frank Baum's "Wizard of Oz" at the Paper Mill Playhouse in New Jersey. At left, Kel O'Neill and John Dossett form a bucket brigade of sorts on deck in a musical version of "Captains Courageous" at Ford's Theater in Washington.

their sails billowing like great cumulus clouds? Not likely, I would have said. The theater is going to have to find another way, its own way, out of this particular adventure yarn. Then I saw "The Wizard of Oz" at the Paper Mill Playhouse in Millburn, N.J., and I'm no longer so sure.

■

Numerous companies have given us stage versions of L. Frank Baum's classic, and a hip, all-black take on the tale, "The Wiz," had considerable success on Broadway in the mid-1970's. The Paper Mill Playhouse, however, is not going that route. It is putting on the 1939 M-G-M movie. Yes, you read me right.

The songs ("Somewhere Over the Rainbow," "We're Off to See the Wizard," "If I Only Had a Brain," "Ding! Dong! The Witch Is Dead") are those that Harold Arlen and E. Y. Harburg wrote for the movie, plus one ("The Jitterbug") that was dropped from the finished product. The score is supplemented with the original "background music" by Herbert Stothart. The dialogue has been lifted from the screenplay almost verbatim by John Kane, who is credited with the "adaptation," although so little appears to have been changed that "transferal" would seem a more accurate word.

Reasonable facsimiles have been found for Judy Garland, Ray Bolger, Jack Haley, Bert Lahr, Margaret Hamilton, the Munchkins, the flying monkeys and Toto, among others, even if, in some cases, it's makeup and costuming that are doing most of the convincing. Still, everything that you remember happening on the screen happens on stage, including the cyclone that picks up Dorothy's house and sends it twirling through the sky.

The Paper Mill technicians prefer to stir up their storm in the auditorium itself, then set the farmhouse spinning over the spectators' heads. But the building lands, kerplop, where it's supposed to — on the Wicked Witch of the East, squashing all but her ruby shoes. At this juncture, the production, which has

Joan Marcus/"Captains Courageous"

been unfolding in black and white, suddenly breaks out in delirious Technicolor. Just like the . . . well, you've got the idea.

If I'd hazarded a few thoughts beforehand, I would have perhaps suggested that a flesh-and-blood "Wizard" can only be a sad knock-off of the real thing, which enjoys the status of a classified public monument these days. The theater isn't meant to copy Hollywood's ways, anyway. It has feet of its own to stand on.

Here's where matters get muddled. There is considerable pleasure to be had at the Paper Mill's "Wizard," slavishly imitative as it may be. "Captains Courageous" takes the higher creative road by trying to find a new form for a beloved movie. But it isn't working very well. And in many respects it errs because it is not being faithful *enough* to the movie.

The creators — the composer Frederick Freyer, the writer Patrick Cook and the director-choreographer Graciela Daniele — are still developing their show, so this is best considered an interim report. In keeping with the film, the musical wants to chronicle the reformation of a rich little brat, Harvey Ellesworth Cheyne, who tumbles off his father's ocean liner into the Atlantic, is fished out by an affable Portuguese sailor named Manuel, and then spends the next three months learning to chop bait, swab decks and, above all, conduct himself like a man.

The musical, however, rings two significant changes on the screenplay — neither particularly felicitous. First, it amputates the movie's early scenes between Harvey and his father, a tycoon so preoccupied with business that he barely has time for his offspring. By starting out with Harvey's rescue from the drink, the stage version gets right to the action, perhaps. But it deprives us of an explanation for the boy's insufferable ways, and his ultimate reconciliation with his father now counts for nothing.

Second, the musical invents a villain, Captain Troop, who wants to sell his interest in the good ship We're Here (the show's principal set). Diesel-powered trawlers have recently come on the scene, rendering the schooner obsolete. To hasten the process, Troop (Don Chastain) searches out depleted fishing grounds. If the ship limps back to Gloucester half empty, he reasons, his partner will agree to the sale.

"I'll tell ya," grouses one of the crew, contemplating another paltry catch, "there's somethin' funny about this trip." The captain's machinations, which extend to sabotaging the vessel, seem contrived though. They complicate the tale, but they don't enhance it. There must be easier ways to unload a boat.

The cast of characters numbers 16 (15 men, 1 lad), not all of whom are that well differentiated. While Mr. Freyer's score possesses a certain yo-ho-ho lustiness, variety is not its long suit either. Since the action rarely wanders from the We're Here or the waters immediately surrounding it, a real threat of cabin fever sets in. Ms. Daniele combats it with a staging that is undeniably busy. The sailors are forever unfurling sails, uncoiling ropes or weaving giant spider webs out of the rigging. At one point, they engage in a display of precision-rowing on the high seas (oars only, no dories). But the intrigue underneath so much colorful activity remains to be clarified.

∎

John Dossett is a likable Manuel, rugged on the outside, tender on the inside and far more shrewd than his simple demeanor indicates. Kel O'Neill, an obstreperous Harvey initially, wises up nicely enough. In the musical's best number, "Regular Fellas," they indulge in an antic soft-shoe of sorts — clomp-

ing goofily about the deck, their feet in wooden buckets. Although the pairing isn't as magical as that of Spencer Tracy and Freddie Bartholomew in the film, the bond between Mr. Dossett and Master O'Neill is plainly the musical's greatest strength.

Had I not seen the wizardry accomplished by the technicians at the Paper Mill Playhouse, I might still regard the cataclysmic climax of "Captains Courageous" as blatant overreaching. Now, I don't see why the mast of the We're Here can't snap in two and crash into the foaming waters, taking Manuel with it. (Ms. Daniele's slow-motion catastrophe isn't especially convincing, that's all.) In fact, a few more Saturday afternoon movie thrills wouldn't hurt the show.

Certainly, one of the reasons audiences at the Paper Mill are reacting so warmly to "The Wizard of Oz" is because it conforms precisely to their memories of the film. They clap when Toto makes his escape from the picnic hamper on the back of Almira Gulch's bicycle. And they clap when the bicycle takes flight and the austere Miss Gulch (Elizabeth Franz) turns into the Wicked Witch of the West. The first shimmering sight of the Emerald City merits a big hand. So does the Wizard (Eddie Bracken), as he takes off for Kansas in his hot-air balloon, even though Dorothy (Kelli Rabke) isn't aboard. But they really applaud when the Wicked Witch lets out one last cackle and melts into the floorboards, leaving only her pointy hat and an echo behind.

The film has built up such a reservoir of good will over the years that to trigger a loving response, stage actors need only allude to the original performances. *Must* allude to them, actually. Few of us are going to tolerate radical innovations from the Cowardly Lion, the Tin Man or the Scarecrow, although Mark Chmiel, who plays the man of straw at the Paper Mill, does an artful job of asserting his own personality *and* respecting the established boundaries.

The designers have been equally careful not to violate the look of the film, which, fortunately, is heavily stylized to begin with. Statistically, the production boasts 19 sets, 175 costumes, 755 lights (240 targeted for special effects) and, it sometimes seems, half the collective enrollment of New Jersey's performing arts schools. Lavish puts it conservatively. It's as if the Folies-Bergère had decided to branch out into children's shows. Robert Johanson and James Rocco are the directors (I want to say field marshals) of the enterprise and they have pulled off an eye-boggling imitation.

But that's just it — the show is an imitation in the end. They are doing what's already been done, modifying someone else's blueprints, following in the larger footsteps of those who've gone before. Strictly speaking, the problems they have solved so spectacularly are technical, not creative. And we envision loftier challenges for our theater, don't we?

JUDGING FROM THE EARLY WORD, the forthcoming season doesn't appear to have many defining characteristics. But glancing ahead the other day, I did notice this. Four musicals on the horizon — "My Favorite Year," "The Goodbye Girl," "The Kiss of the Spider Woman" and "The Night They Raided Minskys" — are all inspired by popular Hollywood films of the same names and, presumably, plots. What, I can't help wondering, are the ramifications of that?

If Hollywood had the answer to Broadway's woes, then I suppose all we'd have to do to get a boom started is put "Casablanca" in the Booth, "The Bandwagon" in the Marquis and "Beauty and the Beast" in the

Gershwin. (A recent issue of Variety reported that Disney executives were in town a while ago, exploring the possibility of turning the animated feature into a full-scale Broadway musical, so the notion is not as far-fetched as you might think.)

On the other hand, when the theater seems to have trouble conceiving projects on its own, as ours currently does, maybe the studio vaults are going to have to be raided after all.

"Well, why not?" pipes up the pragmatist in me.

"Why?," promptly counters the idealist.

Neither side is about to back off this morning. □

1992 O 11, II:5:1

You Could Be Home Now

Written and performed by Ann Magnuson; directed by David Schweizer; original music and songs composed by Tom Judson; choreographer, Jerry Mitchell; set by Bill Clarke; lighting by Heather Carson; costumes by Pilar Limosner; sound by Eric Liljestrand; production supervisor, Bill Barnes. Presented by the New York Shakespeare Festival and Women's Project and Productions. At the Joseph Papp Public Theater/Martinson Hall, 425 Lafayette Street, at Astor Place, Lower East Side.

By MEL GUSSOW

In her one-woman show "You Could Be Home Now," Ann Magnuson reveals herself as an omnivorous collector of names and buzz words that have gained at least temporary currency. Listening to her monologue at the Joseph Papp Public Theater is a bit like browsing through a stack of trendy magazines and reading everything in bold print.

For a performer who seems to pride herself on her timeliness, the references can seem slightly out of sync: for example, she imagines throwing Beluga caviar at Jay McInerney rather than at Donna Tartt. During the 90-minute performance, she impersonates a variety of characters but without the chameleonesque agility of Lily Tomlin and others who have explored related territory.

•

An earlier version of "You Could Be Home Now," in the Serious Fun festival, directly referred to Thornton Wilder's "Our Town," with Ms. Magnuson playing a contemporary variation of Emily Gibbs. A hint of that character remains as the actress returns to her hometown looking for her roots and for signs of permanency amid drastic change. While this approach gives the monologue a framework of sorts, the show is also marked by its randomness, as she rummages in her basement, literal as well as metaphorical, searching for memories and mementos.

Although she can be an appealing actress (as in the movie "Making Mr. Right"), the material in her monologue is a potpourri of whatever passes through her mind, including an obsession with repeating a tasteless joke about a dead dog. Distillation is not Ms. Magnuson's strong point as a writer and in his direction David Schweizer has been unable to offer her the necessary editing guidance, at least to encourage her to eliminate gratuitous remarks about famous personalities (and dead dogs).

In one extended scene, she plays a real estate broker whose vow is "to learn Japanese and start making money off the decline of civilization." While on the subject of decline, she uses "The Cherry Orchard" as a motif. In this town, open land is being subdivided to put up time-share condominiums. Every time she mentions the orchard, on cue a large branch is moved to center stage over her head.

That amusing sight gag is one of the few aspects of Bill Stabile's cluttered scenic design that is used to make a legitimate point. The setting in her so-called surround looks like the aftermath of a tag sale.

Through all this, Ms. Magnuson sings, lip-syncs and dances the "Oliver Stone Ballet of the Fourth Estate." She tosses off one-liners along with her character sketches while also announcing her concern over AIDS and the plight of the homeless. There are moments when she is on target as in her comments about pollution and in her suggestion that a satellite dish should be named as the new state flower. But there are too many casual elements and more than a few examples of silliness.

Near the end of the monologue, Ms. Magnuson puts aside her alias and as herself sings a raplike song by Tom Judson, interspersing it with piquant observations, as in the line, "It's easier to accept Jesus as your personal savior when he looks like Willem Dafoe." Then she segues into a sarcastic analysis of Richard Gere's social consciousness as represented by the movie "Pretty Woman." But before she gets to this cultural criticism, she has wandered through an erratic performance piece in which she is too often content with identifying the label instead of satirizing the contents.

1992 O 12, C11:1

Correction

A theater review on Monday about "You Could Be Home Now," Ann Magnuson's one-woman show at the Joseph Papp Public Theater, misidentified the set designer. He is Bill Clarke, not Bill Stabile.

1992 O 14, A2:6

Theater in Review

■ A skewed version of Hamlet, from Fortinbras's viewpoint ■ Pinter's 'Caretaker,' with menace intact ■ Words vs. music in a study of identity.

Fortinbras

Kampo Cultural Center
31 Bond Street
Lower East Side
Through Nov. 1

By Lee Blessing; directed by Jeanne Blake; set design, David Birn and Judy Gailen; costumes, Teresa Snider-Stein; assistant costumer, Jonathan Green; lighting, Jeffrey S. Koger; production stage manager, Dean Gray. Presented by Signature Theater Company, James Houghton, artistic director.

WITH: William Cain, Kevin Elden, Steven Guevera, Celia Howard, Albert Macklin, Archer Martin, Samantha Mathis, William Metzo, Keith Reddin, Don Reilly, Anthony Michael Ruivivar, Josh Sebers, Kim Walsh and Timothy Wheeler.

Hamlet and Laertes are dead. The stage is littered with bodies. The rest is "Fortinbras," Lee Blessing's demented lampoon in which the Norwegian prince tries to rewrite Shakespeare to suit his self-important purpose. Quicker than one can say "Alas, poor Hamlet," a fool rules at Elsinore.

The play, the first in a Signature Theater Company season devoted to the work of Mr. Blessing, is scarcely more than an extended comedy sketch, lacking the portent and linguistic complexity of Tom Stoppard's "Rosencrantz and Guildenstern Are Dead." "Fortinbras" operates on a far less ambitious plane, but it is a ripping yarn and offers Keith Reddin a role in which he can commit comic mayhem. As Fortinbras, he is a cheerful scoundrel insinuating himself into everyone else's storyline.

On one level, the comedy offers an iconoclastic course in Shakespearean criticism. To Fortinbras, the plot of "Hamlet" is preposterous. Confronting the carnage and told that he is Hamlet's choice as king, the Norwegian is agog. He cannot believe his eyes, ears or good fortune. As Horatio, the last truth teller in the kingdom, recounts the story of "Hamlet," it is apparent that Fortinbras's far-fetched fabrication is no less believable. He suggests that the catalyst for the tragedy was a Polish spy.

Dutifully, the new king tries to set Elsinore in order and to ally it with

Paula Court/"You Could Be Home Now"

Ann Magnuson in her one-woman show "You Could Be Home Now," at the Joseph Papp Public Theater.

his country in a neo-nation named Normark (or perhaps Denway). Soon the dead become restless. The first to rise is Polonius (William Cain), silent after all his garrulous years. We know this is Polonius because he is holding a large piece of fabric, quizzically contemplating a rent in the arras. When Polonius eventually speaks, he is unveiled as a convert to skepticism. As he says to Fortinbras, "You think eternity is forever?"

The most disarming ghost in the castle is Ophelia (Samantha Mathis), whose ardor has been aroused after her demise. Within minutes she is cutting a seductive swath in Fortinbras's bedchamber. As other specters crowd the stage, one wonders where Hamlet is. Suddenly he appears, his image locked within an electronic box unearthed in the castle's basement. In other words, a Dane has secretly invented television. While others are dumbfounded, Ophelia finds the remote-control switch and becomes Hamlet's master as well as mistress.

As Fortinbras blunders in court, his army peacefully conquers Poland, Transylvania and Carpathia. With twist upon twist, the comedy follows a corkscrew path. Mr. Blessing does not try to imitate Shakespeare, just to needle him.

Because the actor who plays Osric was incapacitated, the playwright filled in for him at the performance I attended, reading his lines from a script. His uncertainty as a performer is offset by his ingenuity as a parodist. Under the discreet direction of Jeanne Blake, the other actors express their fealty to Shakespeare as well as to Mr. Blessing. A number of them, including Don Reilly and Timothy Wheeler as Hamlet and Horatio, seem qualified to play their roles in the prequel to "Fortinbras."
MEL GUSSOW

The Caretaker

Jean Cocteau Repertory
Bouwerie Lane Theater
330 Bowery (at Second Street)
Lower East Side
Through Dec. 10

By Harold Pinter; direction and lighting design by Eve Adamson; set design by John Brown; costumes, Ofra Confino; production manager, Patrick Heydenburg; stage manager, Jonathan R. Polgar. Presented by Jean Cocteau Repertory, Scott Shattuck, managing director.

WITH: Harris Berlinsky, Joseph Menino and Craig Smith.

It is always a lesson to return to the leaky, junk-filled room of Harold Pinter's "Caretaker," the troubling play that brought the playwright his first big success and came to define what Irving Wardle called "the comedy of menace." In a fine new revival, the Jean Cocteau Repertory puts a slightly new spin on the problem of figuring out just what the lesson is.

Eve Adamson, the director of the Cocteau production, has moved the action to the attic of Mr. Pinter's foreboding, vacant house in west London and has set the dialogue at a much more naturalistic pace. By curtailing the number of ominous pauses that are often used to underline the threatening character of "The Caretaker" (and which one has grown to expect in routine Pinter revivals), Ms. Adamson has, in fact, restored the sense of danger that pervades the play. Rather than try to cram the surrealism of our ordinary lives onto every page, Ms. Adamson springs it on us unawares, using the abrupt

Susan Johann

Keith Reddin and Samantha Mathis in Lee Blessing's Shakespearean comedy "Fortinbras" at the Kampo Cultural Center.

silences to suddenly twist a conversation 180 degrees and jar our lulled defenses to full alert.

An excellent cast delivers intelligent readings of all three roles. Craig Smith, who first played the part of Davies in a 1977 Cocteau production, is a portrait of egoism down on its luck. Davies, the old man rescued from a punch-up at a cafe and brought home by Aston, has for all his sniveling and cowering seemed possibly the most dangerous of the three men, and Mr. Smith's performance makes a strong case. A natural scavenger, just waiting for a change in the weather to sort out his life, Mr. Smith's Davies is a man whose eye never wavers from the main chance and who stands ready to bend any way the wind blows between the two brothers.

Harris Berlinsky's Aston, the goodhearted and simple-minded brother, is a study in concentration, spending his days repairing a plug while planning to build his shed out back. Mr. Berlinsky's reading of Aston's account of shock therapy is moving. Joseph Menino, as Mick, the leather-jacketed younger brother, is deceptively smooth and polished. It is an easy role to play heavy, and Mr. Menino's resistance makes Mick all the more menacing.

John Brown's set is wonderfully crammed with a "good bit of stuff ... worth a few bob," and Ofra Confino's costumes might have come straight from Oxfam, the King's Road or a rummage sale at that monastery in Luton.

Empty Boxes

Downtown Art Company
64 East Fourth Street
East Village
Through Sunday

By William Badgett; directed by Kent Alexander; music by Harry Mann; lighting, Lenore Doxsee; stage manager, Ben Voorhies. Presented by Downtown Art Company, Ryan Gilliam, artistic director; Cliff Scott, producing director.

WITH: The Talking Band.

With "Empty Boxes" William Badgett has written a nearly perfect dramatization, and a most entertaining one, of pure thought: a subtle and strenuous meditation on personal identity.

In the presentation by the Talking Band, directed by Kent Alexander,

Mr. Badgett takes the role of a young man armed with a mountain of books, a torrent of words and a whirlwind of athletic motion who confronts Harry Mann as a character armed only with a tenor saxophone and a few sharp remarks. At the end of their hour together they are changed men, and anyone who hears their (sometimes unspoken) interchanges will be mightily changed too.

On the surface the story is simple and smooth. Mr. Badgett plays a bookseller who sets up his table in the street and talks about his self-education in black literature to anyone or no one; he is the avatar of absorption. Mr. Mann's musician happens by with more sounds than words and the two fall into a contest: identifying titles and authors from recited sentences, jazz composers from a few bars on the sax or a few phrases hummed out of tune.

Their patter conjures a whole pantheon of cultural icons, from Richard Wright to Billy Strayhorn, W. C. Handy and Curtis Mayfield. But behind all this Mr. Badgett is revealing — with such sleight of hand that it comes as a shock when the viewer suddenly sees it — a universal struggle for self-possession, self-knowledge, identity; for something once called, in a good old word, soul.

That struggle is difficult, moving, exciting, daring and, in the end, unresolved as Mr. Badgett's character, lugging his mountain of books away, sings about the change that has overtaken him: "It's been long time comin'."

The restraint and intelligence of this little play make it powerful. Given his concerns, Mr. Badgett might have made his characters angry, resentful or desperate. Instead they are puzzled, wary, gentle, kind and in very different ways smart, much smarter at the end than in the beginning. "Empty Boxes" makes one smile throughout and sometimes laugh. Then it sends one away warm and hopeful about human beings, but with a head almost bursting with arguments; lines keep coming back in memory and one keeps saying "yes, but ... "
D. J. R. BRUCKNER

1992 O 14, C18:3

Tartuffe

By Molière; English verse translation by Richard Wilbur; director, Mark Lamos; set design, Christine Jones; costumes, Tom Broecker; lighting, Scott Zielinski; sound, David Budries; dramaturg, John Dias; production stage manager, Deborah Vandergrift; assistant stage manager, K.A. Smith. Presented by Hartford Stage, Mr. Lamos, artistic director; David Hawkanson, managing director. At Hartford Stage, Hartford.

Tartuffe	David Patrick Kelly
Orgon	Gerry Bamman
Elmire	Maureen Anderman
Mme. Pernelle	Patricia Kilgarriff
Dorine	Susan Gibney
Flipote	Harriette H. Holmes
Damis	David Rainey
Mariane	Lisa Gay Hamilton
Cléante	Keith Randolph Smith
Valère	Geoffrey Owens
M. Loyal	John McDonough
Police Officer	Frank Raiter

By MEL GUSSOW

Special to The New York Times

HARTFORD, Oct. 14 — As Mark Lamos's production of "Tartuffe" reaffirms, it is Orgon, not Tartuffe, who is the principal character in the Molière comedy. The focus is on the dupe's deception rather than on the hypocrite who deceives him. At Hartford Stage, Gerry Bamman is the woefully self-deluding and mirthful object of Tartuffe's confidence game.

Orgon has welcomed the scoundrel into his home and then encouraged him in his subversion of his family and its values. For Orgon, Tartuffe can do no wrong, and all proof of his misconduct is considered blasphemy, until the husband is faced foursquare with the truth and his own imminent cuckoldry. As Mr. Bamman plays him, Orgon is not simply an old fool but the sincerest of acolytes totally overcome by guru worship.

As he blindly idolizes the fraud, all modern parallels are here for the taking. It is impossible to watch the production without thinking about television preachers as pitchmen for piety (and for public office). At the same time, this is a "Tartuffe" that remains very much in period — the age of Louis XIV — with actors speaking Molière's words in Richard Wilbur's eloquent verse translation.

•

In Christine Jones's amusing set design, Orgon's home has been stripped of its traditional furnishings and aligned with accoutrements of Tartuffe's trade: a prayer bench, scourges, a crown of thorns and a towering cross that dominates the room. When no one is looking, Mr. Bamman tries out the cross for size, spread-eagling himself against it and miming martyrdom.

With his command threatened, he responds heatedly; then, with impeccable timing, retreats to a slow burn. For good measure, he flagellates himself. Anyone who happens to be within flailing distance is accidently struck by his whip. When Orgon is in high dudgeon, his relatives run for

T. Charles Erickson

David Patrick Kelly, left, and Gerry Bamman in "Tartuffe."

cover. This is a wonderfully addled portrait in which Mr. Bamman does not lose sight of the poignance of Orgon's dilemma. He means well, but he is so Tartuffied that his brain seems washed and dried.

The buildup for Tartuffe's entrance is, of course, enormous. But instead of trying to match Mr. Bamman in agitation, David Patrick Kelly's Tartuffe is subdued. His opening line, "Hang up my hair shirt," is said matter-of-factly, as if it were "Where are my slippers?" Bearded and with his face shaded by his cowl, Mr. Kelly looks likes St. Jerôme come to call. The appearance, like everything about Tartuffe, is misleading. Beneath the dourness, he is diabolical, and when he tries to seduce Orgon's wife, he slithers across a table like a serpent.

Although Mr. Bamman and Mr. Kelly are an artful pair of opposites, there are moments in the production when farce seems to step into overly orchestrated frenzy. But Maureen Anderman delivers a gently determined portrait of Orgon's wife, a woman who has cause for a sexual harassment suit against Tartuffe,

and Susan Gibney is a charming Dorine. As this know-it-all maid, Ms. Gibney blithely maintains her equilibrium as the others do everything to defeat themselves.

It is primarily Mr. Bamman who makes this "Tartuffe" such a treat. He is filled with comic inventiveness, as in the scene in which he tries to convince his bigoted mother that Tartuffe has behaved scandalously. "I saw it," he proclaims. "Saw it with my own eyes," and then, as his mother continues to argue, he saws the air with his hand to underscore the point. Rising in indignation, he looks as if he might explode from apoplexy.

Coming after Mr. Bamman's performance in "The School for Wives" and "The Miser," both under Mr. Lamos's direction in Hartford, his Orgon offers further certification of his clownish authority with Molière and of the drollness with which he can personify such unadmirable traits as gullibility, stubbornness and arrogance.

1992 O 16, C15:1

Home Truths on Two Home Fronts

Simon Gray's hero in 'The Holy Terror' could use a rampage.

Ann Magnuson, at the hearth of things.

WOULDN'T "THE HOLY Terror," the Simon Gray drama at the Promenade Theater, be better off as a one-man play?

Granted, it would have to be one terribly agitated man, given to hallucinations and apt to forget, in a flash of fury, where he is and whom he's talking to. But if the jangled soul were haunted enough by the events of his life, you really wouldn't need the other characters who turn up in Mr. Gray's latest work to reach our shores.

Such an evening just might be more compelling than the bilious muddle that the English playwright has concocted and, doing himself no favors whatsoever, directed soporifically.

Mr. Gray has long shown a fondness for articulate rotters at odds with society, their mates and their jobs. Mark Melon, the central figure of "The Holy Terror," is another in the dishonorable line of sour literary figures who populate such earlier works as "Butley," "Otherwise Engaged" and "The Common Pursuit." Melon (Daniel Gerroll) has had considerable success bringing a venerable but faltering London publishing house into the 1980's, even if it has meant stacking the lists with sex guides and soft-porn novels. He possesses a confidence of iron, a teen-

ager's libido and enough cunning charm to bend others to his driven will.

Or he did once.

When we first meet Melon, he is on the far side of a massive breakdown that has left him dazed and hesitant. The kind ladies of the Cheltenham Women's Institute have invited him to address their assembly — as part of their ongoing series, "Why Me?" — although they seem to be looking forward primarily to the tea and sandwiches that follow the talk.

Appearing from behind a drab curtain and tiptoeing to the center of the stage, Melon resembles more an apologetic mole venturing into the bright light of day than the freewheeling publisher of yore. Lest he go blank, he's even got a stack of 3-by-5 cards carefully tucked away in the pocket of his gray suit to remind himself of the points he wants to make.

No sooner has he begun his lecture, however, than his mind wanders and people out of his troubled past stride on stage, distracting him from the afternoon's civilities. We see him seducing his eager young secretary (Lily Knight), bullying various co-workers, mocking his clients and excoriating his son (Noel Derecki), who has committed the grievous error of eating cornflakes in the evening.

Melon's wife (Kristin Griffith) pads on — wearing only a bra and panties under her powder-blue wraparound coat — and he grills her about her lover, although it's not altogether certain she has one. The titillating talk may be a game between them, a way of getting the "itch" going. If so, the game appears to be veering out of control. Just as quickly as these phantoms materialize, they disappear — leaving Melon barking like a mad dog or standing there stupidly, his trousers about his ankles, or fumbling for another 3-by-5 card.

I suppose the interruptions can be described as flashbacks, but they're too fragmented to qualify as scenes, and too unrealistic to represent what really might have happened during the dark, paranoid days of Melon's breakdown. What we're seeing is the inside of his mind, and now and then it may occur to you that he is coming unglued all over again.

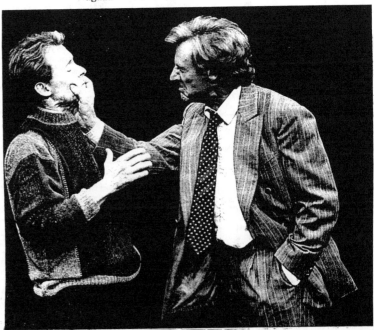

Joan Marcus/"The Holy Terror"

Anthony Fusco, left, and Daniel Gerroll in "The Holy Terror"—An articulate rotter at odds with society.

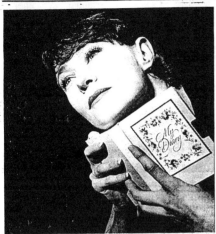

Ann Magnuson in her show, "You Could Be Home Now"— But can you?

Paula Court/"You Could Be Home Now"

"The Holy Terror" made its first appearance in London in 1987 as "Melon." Unhappy with the play, which had the poor man ricocheting from his apartment to the workplace to the psychiatrist's office, Mr. Gray rewrote it completely. In the earlier work, the poisonous suspicion that his wife might be unfaithful fueled the publisher's crackup. (Mr. Gray came to believe that premise too pat, "Othello" notwithstanding.) Now, the publisher seems to be accusing his wife of infidelity *because* he's cracking up. The old motive has become just another symptom of the dark flux overtaking him for no detectable reason.

As he explains to the patient ladies in the audience, he has trouble attaching hard meanings to his experiences. His psychiatrists certainly have no answers — only glib patter that makes them, when they put in their brief appearance on stage, seem like end men in a minstrel line. Melon is adrift in a sea of existential befuddlement — the holy terror, I presume. If there's a God, He's the Supreme Ironist, mainly out to give Himself a chuckle or two.

The supporting characters don't fare well in any of this. They're not so much people as splintered memories of people, bit players in someone else's narrative. They behave according to the whims of Melon's mind, which at best perceives them as threats, bothers or enigmas. Summoned by free association, dismissed at will, they have no dramatic weight of their own. Consider it revelatory that four of Melon's colleagues are played by the same actor (Anthony Fusco) and, except for a twitch here, an accent there, they are virtually interchangeable.

That's why I suspect Mr. Gray could do away with them entirely. There's little benefit to be gained from seeing them in the flesh. "The Holy Terror" would probably be more gripping, in fact, if we *didn't* see them, only sensed from the troubled glaze in Melon's eyes or the sudden shiver down his spine that the demons were back to plague him.

This would put a huge load on the actor playing Melon, agreed, and I'm not sure Mr. Gerroll is the person to shoulder it. He's not inconsequential in the role, but he's not exactly a heavyweight, either. With his shock of sandy hair, trim physique and smartly tailored suit, he comes across as one of those slick Madison Avenue types who make a career out of shallow ingratiation. A certain petulance clings to his torment, trivializing it. He's more spoiled sport than madman.

Still, the next time around, the right actor could go on an impressive rampage in "The Holy Terror." (This production is scheduled to close tonight.) What Mr. Gray has to do first is clear the decks of any hangers-on. The people Melon needs to confront are already lodged in his head. Nobody else is required to show up. All through "The Holy Terror," he's wrestling with himself.

So why not let him?

'You Could Be Home Now'

In the course of "You Could Be Home Now" (in Martinson Hall at the Joseph Papp Public Theater), Ann Magnuson does a quick sendup of Emily Webb, the gushing heroine of "Our Town," who learns too late how wonderful life really is. Ms. Magnuson, a favorite of the downtown performance art scene, isn't about to be caught in such a shameless display of sentiment. There have been too many late nights for that, too many artificial stimulants, too many playmates from the 1980's dying before their time. Nonetheless, she's trying to do precisely what Thornton Wilder's heroine wanted to do — go home again.

And, like Emily, she's failing.

Failure is the pre-ordained conclusion here, as countless playwrights and novelists have already suggested. More interesting, is the place she's trying to get back to — the environs of Charleston, W. Va., where the backwoods accents are still thick and the poisonous clouds from the chemical factories are even thicker. Subdivisions have carved up the landscape, the mayor's been convicted of cocaine use ("We're all looking forward to his 11,000 hours of community service," Ms. Magnuson chirps), while the interstate appears to have carted away the family home. Somehow, the satellite dish is well on its way to becoming "the new state flower."

Apparently, Ms. Magnuson really did return to the region to participate in a ritual she calls the "Famous Persons Day Celebration," although she takes a wry view of her fame and, in the songs and dances that are part of the evening, tends to reduce show business to its cheesier dimensions. I don't want to make this sound too rational, though. "You Could Be Home Now" is chiefly an exercise in ironic surrealism, which allows Ms. Magnuson, the sole performer, to impersonate some of the area's benighted citizens, parody stupid television programs, wreak havoc on "The Cherry Orchard," pay a terpsichorean tribute to Tom Brokaw, and generally wonder where the good times went. The 1990's sit wearily upon her frail shoulders. "At this point, I'd rather see 'Brigadoon' than just about anything with Michael Douglas in it," she sighs.

Under the right lights, the performer looks like a young Shirley MacLaine. (Under other lights, she looks like a prettier Lypsinka.) As a singer-dancer, however, she hasn't advanced much beyond the ballet, tap and baton lessons that she received during her West Virginia childhood. Her skills as an actress are better developed, and she has that startling ability to plunge instantly into a characterization. One minute, she's a redneck cocktail waitress, lamenting her job at the Thirsty Pilgrim in the basement of the Daniel Boone Hotel. The next, she's no less convincing as a dowager, forced by the crumbling economy to auction off the family possessions on the Home Liquidation Club, a cable TV attraction. (In between, she's likely to explore half a dozen not necessarily related issues.)

Assuming audience reaction the other night is indicative, her fans find her uproarious. Frankly, I didn't. Too often, she settles for easy pokes at sitting ducks. I did find her unexpectedly touching, however. A deep sense of loss runs through this crazy, chaotic show. In her heart, Ms. Magnuson knows the party is over and that she really ought to be

heading home, if only she could figure out where home is these days.

When she wasn't looking, someone seems to have uprooted all the signposts. □

1992 O 18, II:5:1

The Destiny of Me

By Larry Kramer; directed by Marshall W. Mason; sets by John Lee Beatty; costumes by Melina Root; lighting by Dennis Parichy; original music by Peter Kater; sound by Chuck London and Stewart Werner; fight director, Nels Hennum; production stage manager, Fred Reinglas; production manager, Jody Boese. Presented by Circle Repertory Company, Tanya Berezin, artistic director; Abigail Evans, managing director. At the Lucille Lortel Theater, 121 Christopher Street, Greenwich Village.

Ned Weeks Jonathan Hadary
Nurse Hanniman Oni Faida Lampley
Dr. Anthony Della Vida Bruce McCarty
Alexander Weeks John Cameron Mitchell
Richard Weeks David Spielberg
Rena Weeks Piper Laurie
Benjamin Weeks Peter Frechette

By FRANK RICH

"What do you do when you're dying from a disease you need not be dying from?" cries out Ned Weeks, the autobiographical hero of Larry Kramer's new play, "The Destiny of Me." If you are Larry Kramer, a founder of the Gay Men's Health Crisis and Act Up as well as the author of "The Normal Heart," you keep crying out: in the streets, on "Nightline" or, at this moment, from the stage of the Lucille Lortel Theater, where the Circle Repertory Company is giving his blistering confessional drama its premiere. As the AIDS epidemic courses into its second decade, Mr. Kramer, weakened by the effects of H.I.V. but still slugging, won't stop shouting at those in authority who he feels impede the search for a cure.

And where has it got him — or us? "When I started yelling there were 41 cases of a mysterious disease," says Ned (Jonathan Hadary) as he checks into the National Institutes of Health for an experimental treatment. "Now they're talking about 150 million. And it's still mysterious. And the mystery isn't why they don't know anything, it's why they don't *want* to know anything."

•

No one can accuse Mr. Kramer of being a boy who cried wolf. History may judge this impossible, reflexively contentious man a patriot. But what makes "The Destiny of Me" so fascinating, and at times overwhelmingly powerful, is not so much its expected single-mindedness about AIDS as its unexpectedly relentless pursuit of the crusader at center stage. Mr. Kramer cannot solve the medical mystery of the virus or the psychological mystery of the world's tardy response to the peril. What he can try to crack is his own mystery: Why was he of all people destined to scream bloody murder with the aim of altering the destiny of the human race?

The writing in "The Destiny of Me" can fall short of Mr. Kramer's ambitions, but it is never less than scaldingly honest. There is nothing defensive or self-aggrandizing or self-martyring about the playwright's presentation of Ned Weeks: This character is every bit as difficult and loudmouthed as the Larry Kramer who has often angered his allies as much as his adversaries. And he is much

more melancholy than an outsider might guess. Throughout the evening, Ned is haunted by "Make Believe" and "This Nearly Was Mine," a pair of songs from beloved Broadway musicals of his childhood, both with lyrics by Oscar Hammerstein 2d. They are songs about love imagined but not attained, blue anthems for a man whose loneliness long predates the isolation imposed by illness.

•

Though "The Destiny of Me" is set in a gleaming, if embattled, government hospital administered by a doctor named Anthony Della Vida (Bruce McCarty) who transparently evokes Anthony Fauci of the National Institutes, the present is usually little more than a backdrop for Mr. Kramer's investigative sifting of his past. Flashbacks to the 1940's and 50's abound and sepia-tinged John Lee Beatty sets roll forward as Ned recalls a Jewish childhood lived in the shadows of the Depression, the Holocaust and McCarthyism in the new suburban subdivisions of a rootless postwar Washington.

Ned, as it happens, is a name Mr. Kramer's hero took in later life (from the glittering Phillip Barry comedy "Holiday"). As a child, Ned was Alexander, a spindly, fluttery, incessantly chattering boy who is rendingly acted in "The Destiny of Me" by John Cameron Mitchell, a young actor who dominates the show with a performance at once ethereal and magnetic. In scenes that are almost too harrowing to watch, Mr. Hadary's affecting Ned, feisty yet frail, looks on from his hospital bed as Mr. Mitchell's Alexander is reviled and beaten by his father, Richard (David Spielberg), for being "different." A Federal bureaucrat who never achieved the aspirations instilled by a Yale education, Richard not only attacks his son as a "sissy" but also coarsely wishes aloud that his wife, Rena (Piper Laurie), had aborted the pregnancy that spawned him. While Rena, a would-be radio actress and congenital community do-gooder, is far more sympathetic to the boy, she never protects or rescues him.

As Ned's rage and creativity alike are a product of these parents, so the 57-year-old Mr. Kramer, as a playwright, is very much a product of the theater of his formative years. Young Alexander, a habitué of the second balcony in Washington's National Theater and prone to mimicking Mary Martin and Cornelia Otis Skinner, decorates his room with contemporaneous Broadway posters of "Mister Roberts" and "A Streetcar Named Desire." Not by happenstance is "The Destiny of Me" a juicy, three-act memory play in the mode of that Arthur Miller-Tennessee Williams era, with occasional flashes of humor reminiscent of latter-day variations on the form by Neil Simon and Herb Gardner. Indeed, Mr. Kramer, like Mr. Simon and Mr. Miller, brackets his autobiographical stand-in with a pointedly contrasting brother: the resolutely straight Benjamin Weeks (Peter Frechette), a golden boy who grows up to become a star lawyer.

Given the conventionality of Mr. Kramer's dramatic format, one sometimes wishes the dialogue fleshing it out were finer. He has a good ear, but it is the ear of a journalist, not a poet. The passages in which Richard, Rena and Ben are in repose, engaged in reminiscence or introspection rather than confrontation, do not always elevate them memorably above type. The performances of Ms. Laurie, whose robust maternal warmth is tempered by a withholding brusqueness, and Mr. Frechette, whose brother is warm and secure despite all his limitations, do a lot to help add nuances of character missing in the language. The same cannot be said, unfortunately, of Mr. Spielberg, who is the only serious shortcoming in the director Marshall W. Mason's otherwise fluent production. While it is to the actor's credit that he never sentimentalizes or caricatures the father's brutality, his acting nonetheless lacks the size and heft that might give this putative Willy Loman a tragic dimension.

Mr. Kramer's journalistic view of his family, though not esthetically transporting, does have its uses, for the reportage is remarkably objective. The play's archetypal familial constellation is enlivened by the fact that Alexander and Ben are allowed widely different but equally credible views of the same two parents; the author is always scrupulous in portraying the differences (not just sexual) in the psychological destinies of men raised in the same household. While the playwright does have an ideological agenda in telling Alexander's coming-out story — he settles

the score with Freudian psychotherapists who commonly viewed homosexuality as a disease to be cured — he never leans on that message as a catch-all rationalization for the angst of the adult Ned.

•

So evenhanded is Mr. Kramer here that in the play's present-day sequences, he stops short of vilifying the American medical establishment represented by Dr. Della Vida and by Ned's nurse (Oni Faida Lampley), who happens to be married to Della Vida. In this instance, the author may be fair-minded to a fault, for the interplay between Ned and the Della Vidas, sketchy and often unconvincing to begin with, ultimately produces the work's only contrived plot twist, an abrupt political conversion that belongs to a lesser breed of agitprop theater.

To be sure, "The Destiny of Me" is polemical when it wants to be, its rage about AIDS ultimately sending forth a seismic jolt of visceral theatricality that tops the similarly electric scene in which an inflamed Ned smashes a milk carton before his dying lover in "The Normal Heart." But standing before the larger canvas of the epidemic — in the intimate twin image of the weary Mr. Hadary and the still-hopeful Mr. Mitchell — is a solitary man as tormented by the meaning of his unhappy life as he is by the meaninglessness of millions of unnecessary deaths. It was Mr. Kramer's destiny, it turns out, to be blessed and cursed by a far larger than normal heart.

1992 O 21, C15:1

Theater in Review

■ Stranded dreamers in erratic times ■ A 25th-anniversary production of 'Jacques Brel' ■ Men who love women who are groupies.

The Madame MacAdam Traveling Theater

Actors' Playhouse
100 Seventh Avenue South (at Grove Street)
Greenwich Village

By Thomas Kilroy; directed by Charlotte Moore; set design, David Raphel; lighting design, Kenneth Posner; costume design, David Toser; sound design, James M. Bay; production stage manager, Pamela Edington; piano music performed by Rusty Magee. Presented by the Irish Repertory Theater Company, Charlotte Moore and Ciaran O'Reilly and One World Arts Foundation, W. Scott McLucas, executive director.

WITH: Ellen Adamson, W. B. Brydon, Denise duMaurier, Rosemary Fine, Michael Judd, Fiona McCormac, Brian F. O'Byrne, Denis O'Neill, Ciaran O'Reilly and Michael O'Sullivan.

For Thomas Kilroy, "The Madame MacAdam Traveling Theater" is an uncharacteristic work, lacking the provocative line of earlier politically-inspired plays like "Talbot's Box" and "Double Cross." This playwright is often linked with his kinsmen Brian Friel and Tom Murphy as investigators of the darker side of Irish life. But with his new play, he takes a

nostalgic view of an impecunious English acting troupe stranded in a small Irish town during World War II.

Although the play has a certain congeniality, it is also marked by its mildness and by a cluttered plot that involves a kidnapping and a scam at a dog-racing track. All this distracts from what appears to be the central issue: theatrical dreamers who try to survive in a world threatening to collapse. The unfulfilled potential of the play is in Madame MacAdam's question: How can actors perform before a nation of performers?

The title character is a middle-aged Englishwoman who has made compromises but retains her indomitability and is able to encourage the spirit of adventure in those who are younger than she is. Her husband, who shares center stage, is a more familiar histrionic sort, a ham actor holding on to the tatters of his frayed career while promising to perform one-man versions of Shakespeare.

Despite Denise duMaurier's stalwart performance as Madame MacAdam, Charlotte Moore's production ambles inconclusively among the various elements of the play. The theatricality of the story would seem to demand a more expansive staging than this cramped production, which

offers little atmospheric sense of community. Everything happens around the acting company's stalled caravan. This means that characters are obliged to enter and exit through thick artificial foliage, whether the scene takes place indoors or outside. The play is lost somewhere in this bushy Birnam Wood.

W. B. Brydon captures the old actor's bluster and there is also evocative work from Rosemary Fine and Fiona McCormac as a pair of impressionable teen-agers. Ms. Fine's love-struck character is amusingly addicted to using large words like apocalypse and euphoria, both of which she is desperately trying to achieve. On the other hand, Ciaran O'Reilly lacks the magnetism to make his character, an anguished young actor, become the catalyst for the events that upset the town. Others in the cast give rudimentary performances. Even in a more accomplished production, the play would probably still seem an undemanding amalgam of sentimentality and histrionics.

MEL GUSSOW

Jacques Brel Is Alive and Well and Living in Paris

Village Gate
160 Bleecker Street
Greenwich Village

By Eric Blau. Production conception, English lyrics and additional material by Mr. Blau and Mort Shuman; based on Brel's lyrics and commentary; music by Jacques Brel, François Rauber, Gérard Jouannest and Jean Corti. Directed by Elly Stone; musical direction by Annie LeBeaux; additional movement by Gabriel Barre; scenery by Don Jensen; lighting by Graeme F. McDonnell; costumes by Mary Brecht; production supervised by Harry A. Kraus, Blue Curl Productions. Presented by Blue Curl Productions, in association with Phyllis Raskind, Harold L. Strauss and Stuart Zimberg.

WITH: Gabriel Barre, Andrea Green, Joseph Neal and Karen Saunders.

When the phenomenally successful revue "Jacques Brel Is Alive and Well and Living in Paris" opened at the Village Gate in January 1968, American audiences took Brel as a sort of European theatrical answer to Bob Dylan. With their antiwar sentiments and sexual directness, the Belgian songwriter's lyrics, translated into English by Mort Shuman, glancingly caught the spirit of the youthful rock counterculture. At the same time, Brel's declamatory melodies, which had little to do with rock, appealed to older audiences. Like the musical "Hair," which opened Off Broadway three months earlier, the show managed the neat trick of working both sides of the generation gap.

The years have been somewhat kinder to Brel's music than to the score of "Hair," with its Aquarian pretensions. Five songs from "Jacques Brel" — "My Death," "Marieke," "No Love, You're Not Alone," "Carousel" and "If We Only Have Love" — have become perennials. And in the revue's 25th-anniversary production at the Village Gate, they are given robust, if uneven performances by a cast of four that includes Gabriel Barre, Andrea Green, Joseph Neal and Karen Saunders.

Today it is obvious just how little in common Brel's songs have with 1960's folk-rock. They really belong to a European music-hall tradition of circusy flourishes and high-flown sentiments that never took deep root in the United States. To work on the stage, they require a kind of stylized physical dramatization that is not in-

grained in the theatrical vocabulary of most American singers.

Elly Stone, who directed the revival at the Village Gate, was a member of the original cast. And she has done a fairly good job of finding ways to link songs that are self-enclosed vignettes, connected only by their authorship, and of moving the performers fluently around the stage. Of the four, Mr. Barre is easily the most theatrically compelling. He mugs, dances and leaps through his numbers with the boldness and agility of a silent-movie clown. His performance of "Next," a howl of rage at life's regimentary rituals, takes the song to a ferocious paranoiac edge.

Two of Brel's most famous ballads — "My Death" and "No Love, You're Not Alone" are respectively taken by Ms. Saunders and Ms. Green, singers whose ample voices are not matched by any special dramatic flair. Ms. Green's performance of "Marieke," Brel's soaring ode to his native Flanders, is marred by a shrill nasality of tone. The show's most touching vocal performance is a rich, tender rendition of "Fanette," by Mr. Neal, an accomplished baritone whose singing is far more secure than his stage presence.

What shines through everything is Brel's intense vitality. If Brel, who died in 1978 at age 49, could be awkward and flagrantly self-pitying, running through every number is a driven, almost desperate energy that still compels. *STEPHEN HOLDEN*

The Men Are Afraid of the Women

Ohio Theater
66 Wooster Street
SoHo
Through Nov. 1

By John Kaplan; directed by Dennis Delaney; scenic designer, Bennet Averyt; lighting designer, Adrienne Shulman; costume designer, Deborah Edelman; sound and technology director, Greg Rajczewski; stage manager, Colleen Davis; artistic director, Robert Lyons. Presented by Project III, in association with Waterfront Ensemble.

WITH: Kevin Agnew, Tim Barrett, Dina Dillon, Funda Duyal, Joseph McKenna, Mary McLain and Jeff Morris.

MUSIC: Jim Cooper, Ernie Muhlback and Mike Soga.

Max is a shallow, superficial and self-indulgent poet who at forty-something is still living off the celebrity he gained for a book of verse he wrote when he was twentysomething. "The Men Are Afraid of the Women" is a shallow, superficial and self-indulgent play by John Kaplan that chronicles Max as he manipulates his way out of his second marriage and into the beds of an increasingly youthful series of girls he picks up at poetry readings.

In fact, "The Men Are Afraid of the Women" is not so much a play as a male-menopause fantasy. It postulates that there is an army of young women hanging out in downtown coffeehouses who yearn to be nothing more than groupies to middle-aged poets. Then it tries to make melodrama out of the seduction by wrapping it in corny dialogue. "I think you have soul," Max intently tells a woman with green toenails. "We were all young once," he somberly observes at another. "I like basketball, sunsets, Dostoyevsky . . .," he woos.

The closest thing to a saving grace in this lengthy exercise is a street person, unhappily named Satan (sophomoric symbolism is sprinkled throughout), who lives in a wheelless BMW set on blocks (actually, the symbolism is laid on with a trowel in places) and who becomes Max's cicerone. In a fine performance by Joseph McKenna, wearing a sort of punk Howdy Doody haircut, Satan steals the show, especially in a funny scene in which he goes to watch his wife in a porn film in Times Square.

The publicity material says "The Men Are Afraid of the Women" was developed in a series of readings and workshops. What has evolved is a three-hour, seven-character play out of material that might be turned into a two-handed one-act. Everything is about three times too much, including most of the acting. Apart from Mr. McKenna's good work, Mary McLain is credible as Max's wife. The others,

including Tim Barrett's Max, are terribly earnest.

Some between-scenes lite-metal music from the trio of Jim Cooper, Ernie Muhlback and Mike Soga is a welcome respite.

Denise Delaney directed.
WILBORN HAMPTON

1992 O 21, C16:3

Under Control

By Paul Walker; directed by Jonathan Silver; set design, Anna Louizos; costume design, Jeffrey Wallach; lighting design, David Smart; sound design, Stuart J. Allyn; graphic design, Victor Stabin; production stage manager, Eileen M. Rooney; assistant stage manager, Linda Loren. Presented by the 29th Street Repertory Theater, Tim. J. Corcoran, artistic director, Annette Moskowitz/Alexander E. Racolin in behalf of Play Producers and Scarborough Productions. At 212 West 29th Street, Chelsea.

WITH: Alison Lani Broda, Chris Burmester, Milton Carney, Linda June Larson, Danna Lyons, Diane Martella, David Mogentale, Anita Pratt Morris and Amy Pierce.

By D. J. R. BRUCKNER

Inspired by recent news articles about the custody battle between the parents of a young woman left comatose by an accident and the woman's lover, Paul Walker's "Under Control" is a rambling and often self-indulgent play that is given a generally compelling performance by a well-chosen cast under the crisp direction of Jonathan Silver.

Where Mr. Walker has modeled scenes on television series like "L. A. Law," Mr. Silver delivers what is in the text, but they often seem like clumsy gags interrupting the complex battle for understanding and compassion engaging the principal characters: Holly, a woman left mute and motionless after a car wreck (Danna Lyons); her parents (Milton Carney and Diana Martella); her younger sister, Loretta (Amy Pierce), and her lover, Diane (Anita Pratt Morris).

The playwright has Holly walking about, talking directly to the audience and commenting constantly on what other characters do even as her inert body is supposed to sit in a wheelchair as the others fight over her. Ms. Lyons brings so much alert attention and tough good humor to the role that one soon forgets the conceptual absurdities and pays close attention to the story.

•

While some lines given to the parents — small-town people with strict and literal religious views — could easily make them ridiculous, Mr. Carney and Ms. Martella, in their movements, looks and voices, quietly transform them into puzzled, hurt and frightened people of great appeal. In the end one feels that the bright, rebellious Holly and her sister, who is her ally in rebellion, could have been bred and reared only by such troubled and thoughtful people.

Ms. Morris's Diane is as hurt as Holly's parents, and much more complex, filled with doubts about herself, her love for Holly, her own intentions in the custody battle. Ms. Morris knows how to speak anguish in silence and how to let her eyes and hands reveal huge passions her voice is trying to hide.

So even though this two-and-a-half-hour play is an hour too long and its upbeat ending is downright annoying, the performance leaves one with the

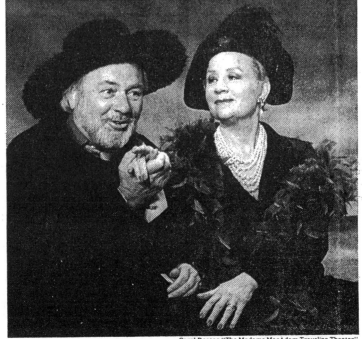

Carol Rosegg "The Madame MacAdam Traveling Theater"

W. B. Brydon and Denise duMaurier in a scene from Thomas Kilroy's "Madame MacAdam Traveling Theater," at the Actors' Playhouse.

satisfying feeling that the company has risen above the words on the page and the thin plot. What we have seen is not merely a glimpse of moral conflict, family division, shifting loyalties and love under fire; the vision is of ourselves, and of the strangeness, mystery and the durability of human beings.

1992 O 22, C25:4

Goodnight Desdemona (Good Morning Juliet)

By Ann-Marie MacDonald; directed by David Esbjornson; scenic design, Donald Eastman; costume design, C. L. Hundley; lighting design, Brian MacDevitt; sound design, John Kilgore; fight director, Byron Jennings; production stage manager, Crystal Huntington; assistant director, Michael Petshaft. Presented by Classic Stage Company, Mr. Esbjornson, artistic director; managing director, Patricia Taylor. At 136 East 13th Street, East Village.

Chorus/Iago/Romeo/Ghost Liev Schreiber
Constance Ledbelly...................... Cherry Jones
Student/Soldier of Cyprus/Juliet. Hope Davis
Othello/Professor Claude Night/Tybalt/Juliet's Nurse .. Robert Joy
Ramona/Mercutio/Desdemona/Servant
Saundra McClain

By MEL GUSSOW

In the inverted world of "Goodnight Desdemona (Good Morning Juliet)," Juliet is standing on the ground delivering the balcony speech, not to Romeo but to a timid, time-traveling Canadian academic. The academic (Cherry Jones) is embarked on a literary mission to prove her theory that "Romeo and Juliet" and "Othello" were originally written as comedies, not tragedies, and magically she has found herself within the plays.

This extended comedy sketch by Ann-Marie MacDonald (at the CSC Theater) has its satirically redeeming features, but it also seems like a collegiate prank. It is arch when it should be airy and it has moments of unnecessary vulgarity. Before the heroine arrives in Verona, she has dawdled too long in Cyprus trying to

Laugh Lines Cherry Jones stars in "Goodnight Desdemona (Good Morning Juliet)," a comedy about Shakespeare by Ann-Marie MacDonald.

T. Charles Erickson/"Goodnight Desdemona"

rectify "Othello." As a rewriter of Shakespeare, Ms. MacDonald cannot compete with Lee Blessing (in "Fortinbras"), to say nothing of Tom Stoppard. Watching "Goodnight Desdemona," one inevitably thinks of Robertson Davies, another Canadian writer with an interest in academia, and how cleverly he would have handled this idea.

For a start, Ms. MacDonald might have swept out the disorder in her plot, especially in the pre-Shakespearean prelude at a Canadian university. The principal comic point is that, acting as Shakespeare's reviser, Ms. Jones's character unintentionally becomes a mischief maker. After she takes the handkerchief from Iago and gives it to Othello, Othello makes up with his wife and puts Iago on cleanup detail — and the heroine realizes that she has wrecked a masterpiece. But for the handkerchief, the play would be lost. It is a rare occasion when the supposed reality might be an improvement over the fiction, as when she encounters the warrior-like Desdemona and says, "Shakespeare really watered her down."

Ms. Jones's performance, however, consistently enlivens the show. As she has demonstrated in "Our Country's Good" and "The Baltimore Waltz," she is a virtuosic actress. In Ms. MacDonald's spoof, she expresses a full range of emotions, from shyness to violent outrage. Behind her mousy appearance, she is a lion, eager to right all wrongs, except when they deal with her own problems. For years, she has been a ghostwriting slave to her opportunistic department head, pursuing an early path to spinsterhood.

Discovering her identity between the lines of Shakespeare, she comes alive. Dueling and debating, the actress is a swashbuckler, though her knees sometimes buckle. It is the playwright's notion that everyone falls in love with her, whether she is posing as a man or being her womanly self (Ms. Jones would be a natural to play Rosalind in "As You Like It"). Both Romeo and Juliet are smitten and are soon battling for her hand.

Unfortunately, the other actors in David Esbjornson's hectic production indulge in histrionics at the expense of humor, except for Hope Davis as a determined (definitely not a dewy) Juliet. It is up to Ms. Jones to carry the comedy uphill.

1992 O 22, C26:5

The Sisters Rosensweig

By Wendy Wasserstein; directed by Daniel Sullivan; sets, John Lee Beatty; costumes, Jane Greenwood; lighting, Pat Collins; sound, Guy Sherman/Aural Fixation; general manager, Steven C. Callahan; production manager, Jeff Hamlin. Presented by Lincoln Center Theater, André Bishop, artistic director; Bernard Gersten, executive producer. At the Mitzi E. Newhouse Theater, Lincoln Center, 150 West 65th Street.

Tess Goode Julie Dretzin
Pfeni Rosensweig Frances McDormand
Sara Goode Jane Alexander
Geoffrey Duncan............................ John Vickery
Mervyn Kant.................................... Robert Klein
Gorgeous Teitelbaum Madeline Kahn
Tom Valiunus...................... Patrick Fitzgerald
Nicholas Pym Rex Robbins

By MEL GUSSOW

"The Sisters Rosensweig" is Wendy Wasserstein's captivating look at three uncommon women and their

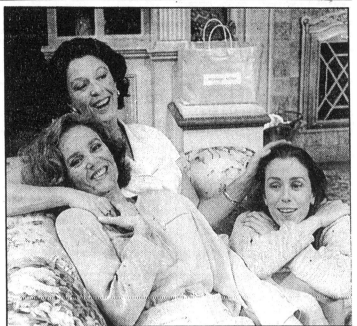

Martha Swope

Jane Alexander, top left, Madeline Kahn, center, and Frances McDormand in "The Sisters Rosensweig," by Wendy Wasserstein.

quest for love, self-definition and fulfillment. Unified by their sisterhood, they are as different as only sisters (or brothers) can be, as each tries to live up to an image imposed by her family. At the same time, each performs her own act of rebellion — or is it penitence? Because of their disparities, they are heroines to one another.

Ms. Wasserstein's generous group portrait (at the Mitzi E. Newhouse Theater) is a not only a comedy but also a play of character and shared reflection as the author confronts the question of why the sisters behave as they do. The immediate answer is that they are Rosensweigs and are only doing what is expected of them. The play offers sharp truths about what can divide relatives and what can draw them together.

The oldest sister is Sara (Jane Alexander), an overachiever, the only woman ever to head an international Hong Kong bank. She is an expatriate in England who is, we are told, "assimilated beyond her wildest dreams." Second is Gorgeous (Madeline Kahn), a triple threat as "housewife, mother and radio personality" in Newton, Mass. The youngest is Pfeni, née Penny (Frances McDormand), a globe-trotting journalist who lives her life as if she were on "an extended junior year abroad."

The three come together in London for Sara's 54th birthday. One of the show's surprises is that in a play essentially about women, the sisters are subtly upstaged by two of the men in their lives, characters enhanced in performance by Robert Klein and John Vickery.

The play is steeped in Jewish culture and humor, but the emotional subtext is broader. None of the sisters can find happiness; they have all been nurtured in a family in which heartbreak has been confused with heartburn. With effort, the women arrive at a new understanding. Bonding as siblings, they can anticipate a more promising future.

With Sara, additional hope comes from a most unlikely source: a wealthy New York furrier (Mr. Klein) who in politically correct parlance manufactures "synthetic animal protective covering." In dealing with social and cultural paradoxes, Ms. Wasserstein is, as always, the most astute of commentators. Along the way, she shatters the myth that Jewish men don't drink ("a myth made up by our mothers to persuade innocent women that Jewish men make superior husbands") as well as national patterns of speech (when an Englishman praises a stew as "brilliant," Mr. Klein adds, "the chicken was very bright, too"). But underlying the comedy is an empathetic concern for the characters and for the prospects of women today.

At the same time, the play has its imperfections. There are gratuitous remarks and irrelevancies. Both Ms. Wasserstein and her director, Daniel Sullivan, should have been more judicious in their editing, especially in dealing with the author's penchant for labeling characters and offering information in the guise of conversation. There is no need, for example, to keep saying that Sara is so intelligent; the character and the actress should speak for themselves. In addition, two stock characters represent the polarities of English society: an upper-class snob and a young radical with incredible gaps in his knowledge (and too many easy jokes made at his expense).

These flaws do not substantially detract from a play with wit as well as acumen. "The Sisters Rosensweig" grows naturally out of the author's previous work. With its Jewish themes and reference to a mother's strong influence on her adult daughters, it looks back to "Isn't It Romantic?" In contrast to the title character in "The Heidi Chronicles," each sister is focused on her life to an obsessive degree. But as with Heidi, each has difficulty with men. Those they meet seldom seem worthy of the Rosensweigs. It is in this area that the play is at its funniest and most observant, with Mr. Klein's faux furrier and Mr. Vickery as a flamboyant theater director. Both roles could lead actors into excess, but the pitfalls are assiduously avoided.

Acting as armchair counselor, the furrier sees through Sara's protec-

tive screen. As written, and as played by Mr. Klein, he is an unpretentious wise man who forces Sara to see herself as he sees her. Shrewdly, the actor plays the role straight, eradicating all thought of his background as a stand-up comic. Mr. Vickery's character is Pfeni's man of many moments, who is unable to commit himself either in love or in art. Evidently a serious man of the theater, he has made his reputation by staging an Andrew Lloyd Webber-like musical of "The Scarlet Pimpernel," from which we hear exuberant excerpts. Mr. Vickery is both dashing and self-mocking, winning laughs with looks and pauses as well as with Ms. Wasserstein's lines.

The women also rise above stereotype. As the expatriate, Ms. Alexander assumes an artful Englishness. Despite her admission of being humorless, she wryly observes her post-marital situation: because her second husband has been married so many times, his wives, past and present, could form a club with "branches in Chicago, New York, London and Tokyo." In the course of the play, Ms. Alexander reveals a vulnerability beneath the ladylike veneer.

For Ms. Kahn, Dr. Gorgeous (who advises everyone including her sisters) is the choicest of roles. Restlessly changing her costumes and interrupting conversations, she is a delirious combination of extravagant plumage and native intuition.

•

Of the three, Pfeni is the most problematic, and the problem is in the character as well as the performance. Given Pfeni's eccentric life style, one would have imagined a more vivid, Auntie Mame-ish personality instead of someone overshadowed by her sisters and by her suitor.

Although Rex Robbins is miscast as the English snob, Patrick Fitzgerald manages to invest the young radical with a certain zeal; and Julie Dretzin, in her professional stage debut (as Ms. Alexander's daughter), easily holds her own with her more experienced colleagues. On John Lee Beatty's tasteful town-house set, Mr. Sullivan leads the actors to play scenes for their reality rather than for their comic effect. As he did with his production of Herb Gardner's "Conversations With My Father," the director reveals his expertise in dealing with a Jewish milieu.

Overlooking the play is the symbolic figure of Anton Chekhov, smiling. Although the characters do not directly parallel those in "The Three Sisters," the comparison is intentional. The Rosensweigs have their own dreams of reclamation by romance, of escaping to a metaphorical Moscow. Ms. Wasserstein does not overstate the connection but uses it like background music while diverting her attention to other cultural matters, as in Mr. Vickery's statement that he would like to make a film entitled, "Three Days That Shook the Rosensweigs." For the two acts, the Rosensweigs (and friends) are entertaining company.

As the characters in Ms. Wasserstein's plays have become older, moving on from college to New York careers to the international setting of the current work, the author has remained keenly aware of the changes in her society and of the new roles that women play. In her writing, she continues to be reflexively in touch with her times. Drawing upon his strength as a nurturer of plays and playwrights, André Bishop has made an auspicious debut as artistic director of Lincoln Center Theater.

1992 O 23, C3:1

Power Pipes

Directed by Muriel Miguel; set design, Nancy Bardawil and Matthew Owens; lighting by Zdenek Kriz; production stage manager, Deborah Ratelle. Spiderwoman Theater presented by Brooklyn Academy of Music, Harvey Lichtenstein, president and executive producer. At the Brooklyn Academy of Music, Lepercq Space, 30 Lafayette Avenue, at Ashland Place, Fort Greene, Brooklyn.

Itzacihuatl/Obsidian Woman Elvira Colorado
She Who Opens HeartsHortensia Colorado
Owl Messenger Lisa Mayo
Mesi Tuli Omen............................ Gloria Miguel
Naomi Fast Tracks.................... Muriel Miguel
Windhorse the Spirit Warrior .Murielle Borst

By LAWRENCE VAN GELDER

Past, present and future, seen through the prism of American Indian culture and feminism, mingle on the stage of Lepercq Space at the Brooklyn Academy of Music, where Spiderwoman Theater is performing the New York premiere of "Power Pipes" through tomorrow in the Next Wave Festival.

Spiderwoman, which takes its name from the Hopi goddess of creation, was founded by three American Indian women, including Muriel Miguel, who directed "Power Pipes" and is a member of the cast. "Power Pipes" roams from ancient culture to current crimes in an evening of drama, comedy, music and sisterhood presented by an engaging cast that is as likely to achieve moments of rollicking humor as it is to slog through a shaggy-dog story.

Episodic in form, broken and accented by dance and song, "Power Pipes" draws with earnestness and good nature upon Indian storytelling tradition, assigning its performers roles like that of the Owl Messenger (Lisa Mayo) as well as those of characters in mini-dramas and skits that deal with everything from sibling rivalry and subway rape to racism and a quest for lesbian love.

The Indian costumes, by Phyllis Maille and Soni, and the pipe and drum music performed by the cast bring to the proceedings both a novel exoticism and a powerful link to history. Rape in the subway is as likely to illuminate the heartlessness of current society as it is the outrages of the past. And it is typical of the humor of the troupe to end the episode with a chorus of "Don't Sleep in the Subways."

In its quest for the universal, "Power Pipes" sometimes stops at the obvious. No ambiance of drumbeats or smoke or chants can rescue lines like, "What's important is love and companionship," or elevate a spat between sisters from the familiar to the profound.

1992 O 24, 18:1

SUNDAY VIEW/David Richards

An Author in Search of 2 Characters: Himself

Larry Kramer's 'Destiny of Me' talks of reconciliation.

'Goodnight Desdemona' dozes.

IN "THE NORMAL HEART," LARRY Kramer's 1985 drama about the early days of the AIDS crisis, one of the characters charges the playwright and activist, or at least his on-stage surrogate, with having "a big mouth."

You might as well cite a leopard for its spots.

Outrage, indignation and blistering scorn have been a part of Mr. Kramer's public persona for so long that we expect nothing less of him. He hasn't merely rocked boats, he's been out to capsize them. Contentiousness is a calling with him and he is the first to admit that his confrontational tactics and his abrasive personality have never made him very lovable.

So the tenderness in "The Destiny of Me," Mr. Kramer's newest play (a production of the Circle Repertory Company at the Lucille Lortel Theater), is apt to catch you by surprise. No one singles him out this time for having "a big heart," but probably could. Blame is no longer foremost on the playwright's mind. Forgiveness and understanding are. "It's funny how everyone's afraid of me. And my mouth. And my temper," says his alter ego, Ned Weeks (Jonathan Hadary), at the start of the evening. "They should only know I can't get angry now to save my soul."

■

Nearly a decade has passed since "The Normal Heart," in which Ned tried to carry the word about AIDS to a complacent gay society, an indifferent medical establishment and a hostile government. Now he is H.I.V. positive himself and has just checked into the National Institutes of Health for an experimental procedure that may or may not repair the deterioration of his immune system. ("National Institutes of Quacks," he can't help cracking, but that's the old automatic reflex at work.)

Part of "The Destiny of Me" chronicles his stay in the hospital and his run-ins with the head doctor (Bruce McCarty), whom he views both as an apologist for the establishment and, until the medical charts say otherwise, as a possible savior. The other part, told in flashbacks, shows him growing up, neither easily nor happily, as the younger son of an abusive father and a philanthropically minded mother who sometimes tended to put the problems of the world before those of her family.

In the hospital, technicians are trying to cleanse his blood of a deadly virus. And I suppose you could say that by looking back with some compassion Mr. Kramer is also trying to rid his bloodline of old poisons. But matters don't work out quite so patly in practice,

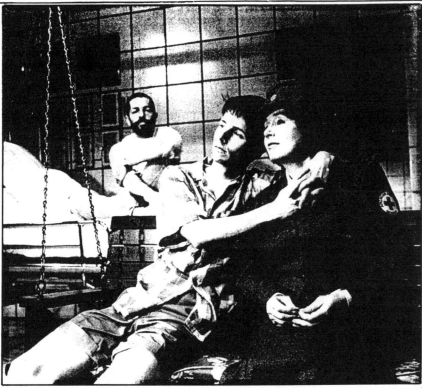

William Gibson/Martha Swope Associates/"The Destiny of Me"

*Jonathan Hadary, at rear left, John Cameron Mitchell and Piper Laurie in
"The Destiny of Me"—Blame is no longer foremost on the playwright's mind.*

even though John Lee Beatty's set, a greenish-tiled hospital room, converts at the flip of a door or a window into the necessary way stations of the past.

Jumping to and fro in time and place as it does, "The Destiny of Me" can seem like two works at once — a gauzy, memory play alongside an outspoken social drama, the one jostling the other for space and attention. The whole is easily a half hour too long for its own dramatic good. And not all of Mr. Kramer's characters can claim a cliché-free existence.

The tenderness does a lot to remedy the evening's flaws or, failing that, distract from them. Mr. Kramer has made no secret of being H.I.V. positive himself, and you sense in "The Destiny of Me" that he is putting his house in order, beginning with the homely family dwelling in a suburb of Washington that he ironically dubs Eden Heights. While the playwright has no apologies for turning out as he did, he does have an abiding regret. After 11 shrinks and countless years of analysis, he's still wondering why a meaningful relationship eluded him for so long. "I wanted it so much," he says. "A love of my own."

And yet, "The Destiny of Me," as Marshall W. Mason has insightfully directed it, *is* a love story. It just happens to involve Ned and his younger self — a goofy-looking adolescent, prone to changing his name, which, for most of the play, is Alexander. Given to histrionics, confused by his longing for men, he flops about the house, worshiping his older brother, hating his father and worrying about where he fits in. From his hospital room, Ned watches him with affection, winces at the old hurts, applauds the headlong pluck and even proffers words of counsel and encouragement.

It is Mr. Kramer's particular inspiration, however, to have this conceit operate both ways. Alexander (John Cameron Mitchell) gets to talk back. If Ned is going to be granted the advantage of hindsight, then Alexander will be permitted the gift of foresight, although he's not sure exactly what to make of it. When, for example, Ned confesses to his

crisp nurse that he was "in love for five minutes with someone who was dying," Alexander rushes on in a panic, his ears atingle, and objects breathlessly, "Did I hear you correctly? You were only in love for five minutes? That's terrible! What did you mean, That's all you get. . . . What's wrong with me?"

MR. MITCHELL IS VERY much the odd duck he's supposed to be. At the same time, the actor is so appealingly alert and so innocently disturbed that he seems fully justified in pointing out sadly to Ned at the end of the play, "I gave you great stuff to work with." I suspect that Mr. Hadary will also have grown on you by then. He's especially adept at rooting Ned's righteous fury in fear and helplessness and letting you know that the withering sarcasm pouring from his lips is supplication in disguise.

Piper Laurie gives the other performance in "The Destiny of Me" likely to command your attention and then, partially because the actress doesn't bother to ask for it, your sympathy. She plays Resa, the mother, who married for security rather than passion and got a life she didn't really want. But there's nothing to be done about that. The character is neither so demented as Amanda Wingfield (in "The Glass Menagerie"), nor so embittered as Kate Jerome (in "Broadway Bound"), but if the three came together, they'd have plenty to talk about. The splendid Ms. Laurie starts out as a rosy, expansive do-gooder and then withdraws, over the years, behind a hard, ironic shell, before disappearing into a rest home. She has no patience for what might have been; self-pity is simply not one of her responses to life.

Mr. Kramer is clearly of many minds about Resa, who enchants, baffles and maddens him, by turns. The ambivalence has resulted in a rich stage character, not as easily pigeonholed as the overachieving older brother or the spiteful father, frustrated by his job as a governmental paper-pusher. Important as those two are in shaping Ned's destiny, they are nonetheless conventional figures playing predictable roles.

In his career as an activist, Mr. Kramer has often found it expedient to simplify the motivations of his adversaries. (You can hear Ned doing it, as well, when he accuses his doctor and nurse of being self-aggrandizing or duplicitous.) But that is not a fruitful tactic for a playwright. "The Destiny of Me" is invariably a better play, a fuller play, when Mr. Kramer resists the urge to score political points off his characters.

He's certainly pushing hard for some kind of truth about himself and the meaning of his existence, and that's what gives the drama its recurring jolts of power. "I wanted to be Moses, but I only could be Cassandra," notes Ned, with seeming offhandedness. The worst of it is that nobody loves a doomsayer. And now the doomsayer knows he's going to die.

Just when despair overtakes him, however, and he is lying, spent, on the blood-spattered hospital floor, who should pad on but Alexander, curious as ever. Tenderly, the youth reaches down and cradles his older self in his bony arms. Then, with wavering voice, they sing "This Nearly Was Mine," the tumultuous lament for lost love from "South Pacific." While the moment could be completely absurd, it isn't. "The Destiny of Me" ends on a transcendent image of self-acceptance. The hope and the reality have been reconciled. Past and present are one.

A man, who has been uncomfortable in his skin all his life, is finally able to embrace himself.

T. Charles Erickson/"Goodnight Desdemona"

Cherry Jones in "Goodnight Desdemona (Good Morning Juliet)."

'Goodnight Desdemona (Good Morning Juliet)'

It's my guess that the Canadian playwright Ann-Marie MacDonald is out to make sport of pedagogues and the cockamamie arguments they're always cooking up to prove that Louis XIV wrote "Tartuffe" or that Emily Dickinson had a secret lover stashed in the armoire.

The mousy academic who is the heroine of her comedy, "Goodnight Desdemona (Good Morning Juliet ') — Off Broadway at the Classic Stage Company — believes that "Romeo and Juliet" and "Othello" were comedies in their original state. Shakespeare then got his hands on them and made them over into tragedies. Still, telltale traces remain. What are a dropped hanky and a delayed wedding announcement if not age-old comic devices?

■

Sucked into a literary warp of some sort, the academic wakes up inside the very plays in question, and promptly sets about gathering evidence to prove her theory. Her mere presence, of course, throws a monkey wrench into the pre-ordained action. One of her first acts is to restore Desdemona's handkerchief to Othello, before Iago can make mischief with it. And by announcing that Romeo and Juliet are secretly married, she prevents Mercutio's death and promotes harmony between the Capulets and the Montagues.

Her influence on the characters themselves is equally disruptive. In short order, Desdemona is seething with a jealousy greater than Othello's, Juliet has changed into a voracious little vixen, while Romeo, appropriating Juliet's ball gown, reveals himself to be "an Hellenic deviant." The academic, acted sportingly by Cherry Jones, struggles to make sense of it all, as do we in the audience. Four other actors, the most entertaining of whom is probably Robert Joy, play the multiple Shakespearean characters. However, the script, much of which is written in iambic pentameter, is a convoluted mixture of grad-uate school erudition and grade school buffoonery.

Under its new artistic director, David Esbjornson, the Classic Stage Company is aiming to venture beyond the established classics and perform new works with classical ties. It's hard to tell with "Goodnight Desdemona (Good Morning Juliet)" whether he's committing to the high road or the low. The play seems to want to have a good time, but like a college dean in a silly party hat, it's entirely too self-conscious to let itself go. □

1992 O 25, II:5:1

Oleanna

Written and directed by David Mamet; scenery by Michael Merritt; costumes by Harriet Voyt; lighting by Kevin Rigdon; production stage manager, Carol Avery. The Back Bay Theater Company production presented by Frederick Zollo, Mitchell Maxwell, Alan J. Schuster, Peggy Hill Rosenkranz, Ron Kastner, Thomas Viertel, Steven Baruch, Frank and Woji Gero, in association with Patricia Wolff. At the Orpheum Theater, 126 Second Avenue, at Eighth Street, East Village.

John .. William H. Macy
Carol .. Rebecca Pidgeon

By FRANK RICH

A year later, a mere newspaper photograph of Anita F. Hill can revive those feelings of rage, confusion, shame and revulsion that were the country's daily diet during the Senate hearings on Clarence Thomas. Sexual harassment remains such a hot button that even at the height of a raucous Presidential and senatorial election campaign a new case involving a relatively obscure mayoral appointee threatens to sweep all other news and issues from center stage in New York City. What are the piddling disputes of Democrats and Republicans, after all, next to the blood feuds between men who supposedly "don't get it" and women who doubt they ever will?

Enter David Mamet, who with impeccable timing has marched right into the crossfire. "Oleanna," the playwright's new drama at the Orpheum Theater, is an impassioned response to the Thomas hearings. As if ripped right from the typewriter, it could not be more direct in its technique or more incendiary in its ambitions. In Act I, Mr. Mamet locks one man and one woman in an office where, depending on one's point of view, an act of sexual harassment does or does not occur. In Act II, the antagonists, a middle-aged university professor (William H. Macy) and an undergraduate student (Rebecca Pidgeon), return to the scene of the alleged crime to try to settle their case without benefit of counsel, surrogates or, at times, common sense.

The result? During the pause for breath that separates the two scenes of Mr. Mamet's no-holds-barred second act, the audience seemed to be squirming and hyperventilating en masse, so nervous was the laughter and the low rumble of chatter that wafted through the house. The ensuing denouement, which raised the drama's stakes still higher, does nothing to alter the impression that "Oleanna" is likely to provoke more arguments than any play this year.

●

Those arguments are more likely to involve the play's content than its esthetics. "Oleanna" can be seriously faulted as a piece of dramatic writing only for its first act, which, despite

Brigitte Lacombe

Rebecca Pidgeon and William H. Macy in David Mamet's new play, "Oleanna," at the Orpheum Theater.

some funny asides about a "Glengarry Glen Ross"-like real-estate deal, is too baldly an expository setup for the real action to come. The evening's second half, however, is wholly absorbing — a typically virtuoso display of Mr. Mamet's gift for locking the audience inside the violent drama of his characters.

This playwright does not write sermonizing problem plays. John, the professor, and Carol, the student, do not talk around the issues that divide them or engage in pious philosophical debates that might eventually bring the audience to some logical, soothing resolution of the conflict. Instead, John and Carol go to it with hand-to-hand combat that amounts to a primal struggle for power. As usual with Mr. Mamet, the vehicle for that combat is crackling, highly distilled dialogue unencumbered by literary frills or phony theatrical ones. (The production, directed by the author, makes do with a few sticks of standard-issue office furniture for a set.) Imagine eavesdropping on a hypothetical, private Anita Hill-Clarence Thomas confrontation in an empty room, and you can get a sense of what the playwright is aiming for and sometimes achieves.

If it is hard to argue with Mr. Mamet's talent, it is also hard to escape his tendency to stack the play's ideological deck. To his credit, the incident of alleged sexual harassment that gives the play its premise is ambiguous: Both Carol and John win scattered points as they argue, Rashomon-style, that a particular physical gesture or a few lines of suggestive conversation in their first office encounter may have been either menacing or innocuous. But once Carol inflates her accusations for rhetorical purposes before a faculty committee, Mr. Mamet's sympathies often seem to reside with the defendant.

John, an intelligent if harried and pedantic man, is given an offstage life that he may lose if found guilty. He is up for tenure, has just made a deposit on a new house and has an apparently loving wife and son. By contrast, Carol is presented alternately as a dunce and a zealot. Though she does not understand the meaning of some garden-variety 25-cent words, she all too easily wields such malevolent jargon as "classist," "paternal prerogative" and "protected hierarchy" once her cause is taken up by an unnamed campus "group." She is given no offstage loved ones that might appeal to the audience's sympathy and is costumed in asexual outfits that come close to identifying her brand of rigid political correctness with the cultural police of totalitarian China.

Like any other playwright, Mr. Mamet has no obligation to be objective. To demand that he come out squarely and unequivocally on the side of women is to ask that he write a pandering (and no doubt tedious) play that would challenge no one and would subscribe to the exact intellectual conformity that "Oleanna" rightly condemns. Nor can one glibly reject his argument against fanatics like Carol who would warp the crusade against sexism, or any other worthy cause, into a reckless new McCarthyism that abridges freedom of speech and silences dissent. Yet "Oleanna" might be a meatier work if its female antagonist had more dimensions, even unpleasant ones, and if she were not so much of an interchangeable piece with the manipulative, monochromatic Mamet heroines of, say, "House of Games" and "Speed-the-Plow."

Even so, it would be overstating the case — and surely it will be overstated by some — to suggest that "Oleanna" is sexist. By evening's end, Mr. Mamet has at least entertained the possibility that there is less to John and more to Carol than the audience has previously supposed. And the playwright is well supported by his able actors in this regard, for Mr. Macy's ostensibly benign professor and Ms. Pidgeon's humorless, vengeful student pass through, a shocking final catharsis that throws any pat conclusions about either character into chaos.

The play's title, taken from a folk song, refers to a 19th-century escapist vision of utopia. "Oleanna" itself evokes, however crudely, what one might wish to escape from: a sexual battleground where trust and even rational human discourse between men and women are in grave jeopardy. No wonder "Oleanna" leaves us feeling much the way the Thomas hearings did: soiled and furious. If some of that fury is inevitably aimed at the author, no one can accuse him of failing to provoke an audience about a subject that matters. The wounds of a year ago have hardly healed. Mr. Mamet, true to his role of artist, rips open what may be his society's most virulent scab.

1992 O 26, C11:4

Nothing Sacred

By George F. Walker; directed by Max Mayer; set design, David Gallo; lighting, Donald Holder; costumes, Harry Nadal; production stage manager, Matt Silver; stage manager, Chris DeCamillis; fight choreographer, Rick Sordelet; music, Glen Roven. Presented by Atlantic Theater Company, Neil Pepe, artistic director; Jeffrey Solis, managing director. At 336 West 20th Street, Chelsea.

Nikolai Petrovich Kirsanov..Daniel De Raey
ArkadyMatt McGrath
BazarovClark Gregg
Pavel Petrovich Kirsanov ..Larry Bryggman
FenichkaMary McCann
AnnaHeidi Kling
GregorRobert Bella
BailiffDamian Young
PyotrDavid Pittu
SitnikovSteven Goldstein
SergeiNick Phelps

By LAWRENCE VAN GELDER

In an era when talk is a product designed to capture ratings and what passes for humor is created by committees of gag writers, there is something to be said for lively conversation and deft wit. Both are in ample supply at the Atlantic Theater in Chelsea, where George F. Walker's "Nothing Sacred" is receiving its New York premiere.

Adapted from the Turgenev novel "Fathers and Sons" and set in Russia in 1859, "Nothing Sacred" is peopled with vivid characters who have a lot to say — and say stylishly — about politics, government, freedom, power, revolution, religion, tradition, class distinctions and love.

•

Change is roiling the halcyon air around the declining estate — more like a farm — of the widower Nikolai Petrovich Kirsanov when his innocent son, Arkady, fresh from the university, comes home with his charismatic nihilist friend, the red-shirted Bazarov. The emancipated serfs are acting up; the bailiff, at the end of his slim wits, is deep into the joy of beatings. The fetching young servant Fenichka has a new baby, father not immediately identified. The dandyish

Carol Rosegg/Martha Swope

Larry Bryggman in George F. Walker's "Nothing Sacred."

Uncle Pavel, former army officer and crack shot, is yearning to put Slavic ways behind him for a while and savor the civilized life of London and Paris.

There are peasants to provide broad comedy to the play and an explosive undercurrent to history. Waiting in the wings is Anna, the alluring young widow, who, it develops, is many things to many men. And if change is in the air, Bazarov is eager to accelerate it.

•

There are some delightful lines in "Nothing Sacred." Arkady on Bazarov: "Only God knows more than you, and just barely." Bazarov on Arkady: "He's a primal force in training." It is hard not to care about the fate of the characters who take shape during the fast-paced first act that Max Mayer has staged.

But even though the scope of physical action expands in the second act, with a nighttime search in a forest and a pistol duel both comic and tragic, the play slows during its resolution. And it becomes increasingly apparent that in the attractive and mostly youthful cast, there are some who are saying the lines and some who are inhabiting their roles. Blessed with a part so flamboyant and meaty that perhaps it should be put up for bidding rather than cast is Larry Bryggman (Pavel). As the mustachioed romantic, he has an opportunity to revel in foppish clothes, sport a monocle and extol the virtues of the old ways in comic speeches that do not mask the profound sadness of the man or the upheaval that will someday devour the world of "Nothing Sacred."

1992 O 27, C17:1

Spic-o-Rama

Written and performed by John Leguizamo; developed and directed by Peter Askin; scenic designer, Loy Arcenas; lighting by Natasha Katz; sound by Dan Moses Schreier; video by Dennis Diamond; musical supervisor, Jellybean Benitez; production stage manager, Michael Robin. Presented by the Westside Theater, Marshall B. Purdy and Michael S. Bregman, producers. At 407 West 43d Street, Clinton.

By FRANK RICH

John Leguizamo arrives on stage in "Spic-o-Rama" like a hip-hop star,

leaping and bouncing in the flash of strobe lights to thunderous music and the cheers of fans. Which makes it all the more amazing when the music fades, and the performer metamorphoses into the first of six characters in his new one-man show: 9-year-old Miggy, a bespectacled, geeky boy with a high-pitched voice, a serious overbite and floppy hands. Mr. Leguizamo is a star, no question — he doesn't need a strobe to burn bright — but he also announces himself from that moment as an actor of phenomenal range. And there's 100 minutes of his tour de force still to come.

"Spic-o-Rama," which is at the Westside Theater, picks up where his previous survey of Hispanic New Yorkers, "Mambo Mouth," left off. This time Mr. Leguizamo's writing is more ambitious. The evening is not a series of sketches but a play of sorts, complete with a Loy Arcenas set that impressionistically evokes an entire neighborhood. All six characters in "Spic-o-Rama" belong to a Jackson Heights family that is preparing for the wedding of its oldest son. As each relative takes a turn at center stage, the audience pieces together the full psychological portrait of a household that may give new meaning to the Spanish word for dysfunctional.

•

Much of "Spic-o-Rama" is hilarious, with comic targets as various as Arnold Schwarzenegger, Telemundo and "The Partridge Family." The most compulsive wisecracker is Crazy Willie, the bridegroom and a veteran of the Persian Gulf war, during which he shot at "people who looked just like us but with towels on their heads." Stalled in life, Willie hangs out by his immobilized car, whose motor has been stolen, and shoots off both his gun and his mouth to kill time. Even before the fact, his marriage to Yvonne, a teeny-bopper with overheated Andy Garcia fantasies, seems doomed. Though Willie has a low regard for monogamy, he has magnanimously told Yvonne that "as a bonus" to their nuptials, "I'm going to let you have my babies."

His brother Raffi is just as funny but far sadder. Wearing a silk bathrobe, platform shoes, briefs over-stuffed with Kleenex and a thick mane of Clorox-bleached hair, Raffi imagines himself to be not only an actor but also the albino illegitimate son of Laurence Olivier. "It's hard to be Elizabethan in Jackson Heights," he says, but Mr. Leguizamo shows Raffi struggling to leap over that cultural divide by affecting a B-movie British accent and preening before the mirror to perfect his pose as an "occasional heterosexual." As he explains: "I don't know why people insist on knowing themselves. It's hard enough to know what to wear."

•

The biggest triumphs of "Spic-o-Rama," both in the writing and in performance, are appropriately saved for last: the parents who pro-

In a sequel to 'Mambo Mouth,' an actor plays 6 family members.

duced these children. Mr. Leguizamo's portrayal of the mother, Gladyz,

is, to be sure, an impressive, even sexy feat of sassy female impersonation, outfitted with cascading hair ("not a hair weave, a hair fusion") and a pink slash of a mouth to match a provocative wardrobe. Gladyz is also a survivor, a lifelong slave to child-rearing who dreams of something more. As she tends the baby who is the youngest of her five children and exchanges gossip and wisecracks with a friend in the Laundromat, she rebels impotently against her status as an "ornament." Gladyz has learned the hard way that when "you go for something you really want, then you're a bitch."

Gladyz's grievances, like those of her sons, are brought into sharpest relief when we meet her estranged, philandering husband, Felix, as he toasts the newlyweds at the wedding. Felix is a cad who feels that lies, half-truths and "critical omissions" are "the key to all relationships." When he isn't belittling his children as misfits or disappointments, he is tipsily singing the theme from "The Godfather" into a hand mike or graphically describing the credo of male sexuality that has imprisoned him and his sons in eternal childhood and his wife, at home. Yet Mr. Leguizamo has sympathy for Felix, as he does for Gladyz. There is pathos in this ridiculous but intelligent, even witty Colombian immigrant who does not have a clue about how to be better than he is.

Perhaps some will see the irresponsible, irrepressibly macho Felix as a stereotype. When Mr. Leguizamo had his first success with "Mambo

Mouth," he was attacked by some Hispanic critics for trading in ethnic clichés. To disarm the thought police this time, "Spic-o-Rama" carries an announced disclaimer: "This Latin family is not representative of all Latin families. It is a unique and individual case. If your family is like this one, please seek professional help." And one would have to be humorless indeed to read Felix or any of the precisely observed characters of "Spic-o-Rama" as noxious generalizations.

Still, there are places where the writing falls short. Another brother, wheelchair-bound, is sentimentally drawn (though well acted); his lines tug at the heartstrings too mechanically to engender real sympathy. Other segments also could lose passages in which the characters announce directly what the audience is supposed to think or feel, and nearly every soliloquy could be shortened. "Spic-o-Rama" lacks a real ending, too, settling for a jokey rather than a cathartic denouement.

Perhaps Peter Askin, the director, might have helped solve these problems, but he has otherwise kept the production fleet. To vamp during the costume changes, there are antic video clips featuring the offstage characters, like Yvonne, described in the monologues. But it's the star, not the videos, that make good on the evening's title. In "Spic-o-Rama," Mr. Leguizamo's huge presence and talent fill the theater so totally you feel he's everywhere at once.

1992 O 28, C13:3

Theater in Review

■ Columbus as a guy with deals to make ■ Disorder in the court ■ Celebrating a Turkish mystical poet across three-quarters of a millennium.

C. Colombo Inc.
Export/Import, Genoa

New York Theater Workshop
79 East Fourth Street
East Village
Through Nov. 8

Written by Leo Bassi; directed by Christopher Grabowski; set, costumes and lighting by Anita Stewart; sound by Mark Bennett; production stage manager, Liz Small; production manager, George Xenos. Presented by New York Theater Workshop, James C. Nicola, artistic director; Nancy Kassak Diekmann, managing director.

WITH: Leo Bassi, Steve Elm and Edwin Newman.

Leo Bassi is a performer provocateur, a one-man Blue Man. Everything he says or does in his show, "C. Colombo Inc.: Export/Import, Genoa," is intended to move his audience to laughter, anger and other visceral responses, like ducking.

First of all, he wants to topple traditional doctrine about Christopher Columbus. To him, Columbus was less an explorer than the first Italian-American businessman. In contrast to Richard Nelson's epic play on the subject, "Christopher Columbus and the Discovery of Japan" (at the Royal Shakespeare Company)

or Philip Glass's science-fiction opera "The Voyage," Mr. Bassi's show is a brief, quirky act of iconoclasm.

The show has its ups and downs. Mr. Bassi has a tendency to be tendentious, as when he delivers a history of Columbus's adventures. But this dissertation eventually leads to a blistering debate with a combative guest (Steve Elm) who represents the American Indian position and wonders why equal time is not given to Gutenberg or Magellan.

During the argument, Mr. Bassi does not neglect his roots in comedy. Looking and acting like an Italianate Don Rickles, he affronts his audience with clownish techniques that would not get him invited back as an overnight house guest. There is something vagabond in the approach. Although the play is scripted (by Mr. Bassi) and directed (by Christopher Grabowski), it seems to be improvised and is evidently dependent on the audience's nightly mood. With a passive crowd, he might be moved to be even more aggressive than he was at the performance I attended.

The stage looks like an overloaded warehouse, stocked to the roof with packing boxes containing "pizza puzzles" he is sending off to Japan. There are several oversize objects including

Martha Swope

Leo Bassi in his show "C. Colombo Inc.: Export/Import, Genoa."

a giant plaster foot. That foot, he tells us, is the beginning (correction: the ending) of a 185-foot statue he hopes to build of Columbus.

That unseen Gulliverian figure dominates the show as Mr. Bassi tumbles and pratfalls across the stage while continuing a nonstop stream of digression. For variety, he juggles with his feet. He is as expert in this vaudeville art as those bears in the Big Apple Circus. Lying on his back, he uses his feet to spin a huge slablike briefcase, which looks suspiciously like a monolith from "2001." Just as that thought enters one's mind, there is a burst of "Zarathustra"-like music in the background.

At the beginning, Mr. Bassi has warned that everything that happens onstage is symbolic. As promised, the show is filled with visual puns, including many variations on the theme of pizza. With "C. Colombo," Mr. Bassi twirls a spicy, crusty performance pizza.

 MEL GUSSOW

Women in Black
Men in Gray

Downtown Art Company
64 East Fourth Street
East Village
Through Sunday

Two one-act plays adapted and directed by Brian Jucha; assistant director, Robin Riddell; lighting by Roma Flowers; costumes by Kasia Walicka-Maimone. Via Theater, Anne Bogart and Mr. Jucha, co-artistic directors, presented by Downtown Art Company.

WITH: R. P. Brink, Sheryl Dold, Tamar Kotoske, David Neumann, Barney O'Hanlon, Tina Shepard, Karla Silverman, Megan Spooner and Lisa Welti.

When the program's cast of characters lists a Judge, Defendant, Counsel for the Prosecution and Counsel for the Defense, one generally can expect a trial play. But when the stenographer breaks into song during the Judge's opening remarks and, a short time later, the entire courtroom forms a chorus line singing ribald lyrics to a sort of cha-cha beat, one quickly realizes it is not going to be a

typical episode from "Family Court."

"Men in Gray," a clever and sometimes caustic concoction by Brian Jucha at the Downtown Art Company, does not waste time on legal niceties about the ethics of accusing the victim. A woman is in the dock on charges of falling in love and Mr. Jucha's play proceeds both to prosecute and defend her with testimony taken from some of the more salacious murder and rape cases, not to mention Senate confirmation hearings, of recent front pages.

In an imaginative and amusing mixture of song, dance and cross-examination woven out of excerpts from the Jennifer Levin murder trial and the William K. Smith and Mike Tyson rape trials, Mr. Jucha uses an absurdist approach to illustrate how blurred the truth becomes once the public via the news media gets its hands on it.

Like most sensational sex trials, there is a certain circus quality to "Men in Gray," and Mr. Jucha, who also directed, keeps two or three things going at once. While the two female prosecutors erotically lead their star witness through his testimony in one torrid scene, for example, the judge is busily pawing the assistant defense attorney. There is some good ensemble work in the company, led by the twin prosecutors Tamar Kotoske and Lisa Welti. David Neumann is credibly befuddled as all the witnesses and Barney O'Hanlon is a slick defense attorney with a fine voice, especially singing "It's a Sin to Tell a Lie" as his closing argument. Megan Spooner as the stenographer and Karla Silverman as the assistant defense attorney add some spice.

The curtain raiser to "Men in Gray" is a revival of a less successful creation by Mr. Jucha called "Women in Black." These particular black-clad women are nuns and the exercise is mainly a deconstruction of old films and some self-help books into a murder mystery set in a convent. There is an occasional hint of outrageousness, but it is mostly unfocused and has little sense of direction.

Even outrageousness needs some focus if it is to be anything more than a parlor piece.

WILBORN HAMPTON

Yunus

La Mama E.T.C.
Annex Theater
74A East Fourth Street
East Village
Through Sunday

Text by Yunus Emre; adaption, direction, music and lyrics by Ellen Stewart. Based on translations by Talat Halman, Huseyn Kat and Erol Keskin; arrangements and additional music by Genji Ito and Yukio Tsuji; Turkish music, Ayla Algan and Ali Altunmese; set realization by David Adams, Jun Maeda and Mark Tambella; puppets by Sylvia Yalkin; costumes by Selcuk Gurisik; lighting by Howard Thies; sound by Tim Schellenbaum. Presented by La Mama E.T.C., in association with Ya Da Tiyatro and T.A.L.

WITH: Ayla Algan, Beklan Algan, Mustafa Avkiran, Du Yee Chang, Rose Davis, Abba Elethea, Kaan Erten, Nadi Guler, Levent Guner, Jonathan Hart, Susan Huffaker, Huseyin Katircioglu, Erol Keskin, Asli Ongoren, Andrea Paciotto, Aka Shigeko Suga, Berk Sonmez, Zisan Ugurlu, Ching Valdes-Aran and Devin Yalkin.

"Yunus," based on the life and poetry of the 13th-century Turkish mystical poet Yunus Emre, is described as a folk opera by Ellen Stewart, who constructed its lyrics from translations of the poet's work, wrote most of the music and now directs the performance at La Mama.

What precisely distinguishes this genre from other productions conceived by Ms. Stewart when she is in an epic mood may not be obvious. But that hardly matters. This is vintage Stewart: staged on an enormous platform with grand stairs at either end that occupies much more space than is given to the audience, the play is filled with magnificently costumed characters who sing and declaim their way in several languages through battles, quests and stunning revelations to a sublime vision of life.

In this case the story line is not as clear as it has been when Ms. Stewart has based other plays on well-known myths or classical dramas. And Yunus Emre's mystical texts do not make great narrative or dialogue. Many of them do make wonderful songs, however, especially in the chants two men intone as Yunus approaches spiritual wisdom, in a thrilling plea for love from the poet's wife, in the dirge of a small boy who has seen his whole village killed, and in a visionary chorus at the end.

"Yunus" was developed last year with an actors' workshop in Turkey to commemorate the 750th anniversary of the poet's birth, and in this production the mostly Turkish cast weaves the episodes together with dances performed to an insistent music that can leave one a bit mesmerized. As always in an Ellen Stewart spectacular, all the characters, larger than life, assume mythic proportions: a towering Mongol lord in silver robe and furs surrounded by bloody guards in gold and black, a mountain guru sprouting luxurious horns, a goddess in gold whose dance is virtually orgiastic, masters of mystic thought draped in blinding white, lines of undulating women in rainbow silk that seems to dance around them as they move.

So, folk opera if the dramatist, composer and director insists. But some folk are pretty exalted.

D. J. R. BRUCKNER

1992 O 28, C18:1

Bubbe Meises
Bubbe Stories

Written and performed by Ellen Gould; original songs by Holly Gewandter and Ms. Gould; directed by Gloria Muzio; musical direction and arrangements by Bob Goldstone; scenic design by David Jenkins; lighting by Peter Kaczorowski; costumes by Elsa Ward; sound by Raymond D. Schilke; production stage manager, Stacey Fleischer. Presented by Richard Frankel, Paragon Park Productions and Renee Blau. At Cherry Lane Theater, 38 Commerce Street, Greenwich Village.

By MEL GUSSOW

"Bubbe Meises, Bubbe Stories" is Ellen Gould's loving tribute to her immigrant grandmothers. A highly personalized one-woman musical play, written and performed by Ms. Gould, it is suffused with homely wisdom and movingly honors formative family influences.

Approaching the end of the 20th century, she looks back to the last turn of the century when her grandmothers, or bubbes, crossed a bridge that was emotional as well as geographic and made their homes in America. Onstage at the Cherry Lane Theater, the actress stands before two striking portraits of her grandmothers and parallels and contrasts their biographies while interweaving reflections about her own life.

Her maternal grandmother, Bubbe Gittie, was a righteous radical turned philanthropist, while Bubbe Annie was a more expansive and worldly person who continually encouraged her offspring to seek their own paths. The play becomes Ms. Gould's journey of discovery as well as the journal of her family's history.

Both matriarchal figures had adages and meises (or old wives tales) for all occasions. The stories always end with a moral, "just so the entertainment should not be a total waste." Instructive lessons are offered about living life to the fullest and also about making compromises in the interest of domestic harmony.

•

The family is not without its tsores, even its tragedies, including the untimely death of several young people of Ms. Gould's generation. Survival comes with a price, but it is endemic to these women, seemingly brought with them from Eastern Europe. One of the keys to the remarkable durability of the grandmothers is their humor, a native wit that cuts everything down to size and helps ward off the evil eye. On a folkloric level, many of the more amusing stories are moored in superstition. Strung together through the reminiscences is a story about a gold chain with a missing link, a story that achieves the quality of legend. Although the narrative is brushed with sentiment, it holds to a pragmatic awareness of obstacles to be overcome again and again.

While keeping her confidences conversational, the actress takes advantage of theatrical devices: those twinned portraits and a selection of songs both new and traditional, played on the piano by Bob Goldstone. The new songs, written by Ms. Gould and Holly Gewandter, have a gentle, almost elegiac flavor as they evoke a more innocent and romantic time. The traditional songs are given a new edge, as in an adaptation of a Scott Joplin rag, which becomes a kind of Yiddish vaudeville number in which the old ladies address their differences.

Ms. Gould, who plays all the characters, has a graceful and disarming presence both as an actress and singer, never overstating a case as she moves seamlessly among moods and voices. Aided by David Jenkins's subtly atmospheric set, Gloria Muzio's direction is impeccable. At the end of this heartfelt memory play, Ms. Gould puts on a wide-brimmed hat like that of Bubbe Annie, establishing an intimacy that unites generations.

1992 O 30, C15:1

Juno

Book by Joseph Stein; music and lyrics by Marc Blitzstein; based on the play "Juno and Paycock" by Sean O'Casey; directed by Lonny Price; scenic design, William Barclay; lighting, Phil Monat; costumes, Gail Brassard; musical direction, Grant Sturiale; additional lyrics, Ellen Fitzhugh; choreography, Joey McKneely; production stage manager, Kenneth J. Davis. Presented by Vineyard Theater. At 108 East 15th Street, Manhattan.

Mrs. Madigan	Anne O'Sullivan
Mrs. Brady	Verna Jeanne Pierce
Mrs. Coyne	Jeanette Landis
Charlie Bentham	James Clow
"Captain" Jack Boyle	Dick Latessa
Joxer Daly	Ivar Brogger
Juno Boyle	Anita Gillette

By MEL GUSSOW

The poetry in "Juno and the Paycock" is evident whenever Sean O'Casey's own voice is heard in the Marc Blitzstein musical "Juno." But Mr. Blitzstein's voice is an entirely different matter, only rarely capturing the mood of the original play. "Juno" was a failure in its Broadway incarnation in 1959 (with a cast headed by Shirley Booth and Melvyn Douglas). Despite alterations, the musical has not markedly improved in its newly revised version at the Vineyard Theater.

The show begins promisingly with the song, "We're Alive," in which a hearty anthem about survival is interrupted by a gunshot killing a young Dubliner. The savage ironies of that scene are not evoked in other aspects of the musical, which focuses on the latent sentimentality within the family relationships and the comic interplay among the characters.

On the most immediate level, Mr. Blitzstein's music wavers in its claim to an Irish lilt. The lyrics often resort to banalities and occasionally to doggerel. Repeatedly, the show overlooks the opportunity to take off from the playwright's words. The score is unworthy of both O'Casey and Mr. Blitzstein, the composer of "The Cradle Will Rock" and "Regina," coincidentally revived at New York City Opera.

•

Necessarily, the insertion of songs is reductive to the book, as Joseph Stein's adaptation is forced to surrender texture and language in order to make room for the music. This was also true in "Daarlin' Juno," an earlier revision of the show presented a number of years ago at the Long Wharf Theater. As suggested by the title, there is a shift in emphasis from Jack Boyle (who has lost much of his rapscallion charm) to his wife, Juno. In the musical, Juno could be a candidate for sainthood instead of an indomitable woman desperately fighting poverty and trying to keep her family intact.

As director, Lonny Price has given the show a quasi-environmental staging, with a chorus and a trio of neighborhood busybodies wandering once too often through the audience with their songs. Anita Gillette and Dick Latessa have the resilience to play their roles as Juno and Jack in either the play or the musical, and they also have strong singing voices. But the adopted Irishness of the actors is a variable. Erin O'Brien as the Boyle daughter conveys the wistfulness as well as the urgency of her character and she is neatly matched by Andy Taylor as the neighbor whose love for her remains unrequited. James Clow and Malcolm Gets are less persuasive as the daughter's lover and brother. Ivar Brogger, a tall, thin Joxer Daly, could be more insidious.

In the showdown between husband and wife, Juno tries to force Jack to face the truth of their tragic lives and he remains blinded by his own selfishness. During this scene, the show abstains from music as the characters speak dialogue directly from the play, which Ms. Gillette and Mr. Latessa do with conviction, underscoring the fact that this is not a drama that needed to be musicalized.

1992 O 31, 16:4

SUNDAY VIEW/David Richards

Wendy Wasserstein's School of Life

The sisters Rosensweig? Their hurts belong to Mama.

'C. Colombo Inc.' is a voyage into a sea of words.

FOR A BRIEF PERIOD, WHEN she was still casting about for titles, Wendy Wasserstein thought of calling her new play "Three Days That Shook the Rosensweigs."

I can't tell you why she settled for "The Sisters Rosensweig" instead. But it was probably a wise choice. "Three Days That Shook the Rosensweigs" implies monumental family clashes and comedy of an antic nature. For anyone heading off to the Mitzi E. Newhouse Theater at Lincoln Center, that would have been misleading.

Granted, "The Sisters Rosensweig" has a Chekhovian ring. However, since Ms. Wasserstein is writing about three middle-aged, vaguely maladjusted Jewish sisters trying to sort out their lives and loves during a weekend in London, there's no deception there. Furthermore, the actual title promises nothing particularly dramatic in the way of action. And that's just as well, too.

■

The disappointing reality of "The Sisters Rosensweig," Ms. Wasserstein's first work for the stage since the widely acclaimed "Heidi Chronicles" four years ago, is that it falls somewhere between a 1930's Broadway comedy of manners (high end) and a contemporary television sitcom (low end). The playwright is entirely too quick-witted not to make her characters amusing companions for an evening. The middle sister, one Gorgeous Teitelbaum (Madeline Kahn), is a virtual compendium of laugh-getting quirks — flightiness, myopia and a fondness for the adjective "funsy" — in addition to which she looks, when she trots through the doorway for the first time, rather like a dish of raspberry sherbet wearing gold jewelry. But for a play that supposedly has the sisters asking themselves significant questions about their past and coming to important decisions about their future, it is curiously empty.

They were raised in Brooklyn by a father, about whom little is said, and by a mother, recently deceased, who expected them all to go out into the world and overachieve. Sara, the eldest (Jane Alexander), has risen the highest. She's a big shot at the London office of the Hong Kong/Shanghai Bank Worldwide, lives in an elegant town house in Queen Anne's Gate (where the play takes place), socializes with some of Britain's finest and has even acquired a whisper of an English accent.

Pfeni (Frances McDormand) has roamed the farthest, as a writer of esoteric travel articles, although she keeps getting pulled back to London by her love for a bisexual theater director (John Vickery), who, momentarily at least, fancies himself a "closet heterosexual." For her part, Gorgeous has pretty much stayed put in Newton, Mass., but she's about to launch "The Dr. Gorgeous Show" on suburban cable TV and she considers herself a serious threat to Dr. Ruth. (As she points out, redundantly, "Talking has always come easily to me.") Meanwhile, she is leading the Temple Beth-El Sisterhood of Newton on a tour of the crown jewels and other dazzlements, which is how she happens to find herself in the English capital.

Good thing, too. It's Sara's 54th birthday, and Sara, twice divorced and losing control of her teen-age daughter, is, by her own clipped admission, fast becoming "an old and bitter woman." The birthday celebration brings the sisters together, along with an unexpected guest — a Jewish furrier (Robert Klein) from the States, who, bowing to the antifur lobby, now deals in "synthetic animal protective covering." Confidences are exchanged. Clever remarks are struck. A few disappointments are expressed.

Martha Swope/"The Sisters Rosensweig"

Madeline Kahn, left, Jane Alexander, center, and Frances McDormand in "The Sisters Rosensweig"—The characters' jobs may merely be something to hide behind.

Eventually, each sister has to face up to a basic truth about herself. Sara, having turned her back on her Jewish heritage, is morally and spiritually adrift. Pfeni's penchant for falling in love with the wrong man may be the mechanism by which she avoids the serious writing she should be doing. Gorgeous's unapologetic materialism is a diversion, too. Her husband has been out of work for two years and the cupboards back home are bare.

If you think that makes for a consequential play, think again. It doesn't even make for an especially emotional play. "The Sisters Rosensweig" gives the illusion of substance, with none of substance's bothersome weight. Call it the new Lite Drama. Ms. Wasserstein has always written clever repartee, some of the better one-liners this side of Neil Simon and the sort of crisp aphorisms ("Love is love . . . gender is merely spare parts") that sound profound, as long as you don't think about them too long. She's definitely in glib, crowd-pleasing form here.

■

For all the intellectual credentials the play keeps dropping, sex is never far from anyone's mind. In the first act, the big question seems to be whether Sara will go to bed with the oafish furrier, although she's just met him and he isn't her type and she's almost pathologically addicted to sleeping alone. The big question for Act II: How good was he? Gorgeous, having no shame, will ask outright, thereby bringing down the house. The Mitzi Newhouse is not a big house, mind you. But since there is nothing else remotely resembling a popular commercial comedy on the Broadway horizon these days, "The Sisters Rosensweig" may turn out to be this year's winner by default.

I wouldn't begrudge Ms. Wasserstein her fans for an instant. Nonetheless, in about every respect the play seems to be a watering down of a work that could have been far more intimate and revelatory. You can sense more raw pain, more stubborn anger, more simple sadness in these lives than the playwright is

willing to acknowledge. Being smart, independent and clever hasn't brought them the warm, cuddly happiness they crave. And their careers may merely be something to hide behind. Gorgeous, I suspect, is putting her finger on the play's central issue when she asks, "How did our nice Jewish mother do such a lousy job on us?" No one chooses to answer that one, however. Ms. Wasserstein has long since discovered that the surest guarantee against an invasion of privacy is a quip.

Under the direction of Daniel Sullivan, the cast rarely ventures out on thin ice, but does its pirouettes and its double axels on the edge of the pond, where there's no danger of tumbling into chilly waters. Ms. Alexander — her hair swept back to emphasize the elegant arch of her neck — seems made of pale porcelain. She's meant to be distant, and is. Unfortunately, the play asks her character to reverse a lifetime of behavior and agree to a one-night stand with Mr. Klein, an entertaining fellow, perhaps, but the least credible of romantic figures. The sexual heat between them is almost nonexistent. Curiosity doesn't even enter into it.

Ms. McDormand has a convincing weariness about her that suggests it's time for Pfeni to come in off the road. But she, too, is up against troublesome casting when forced to declare her helpless infatuation for Mr. Vickery. As the bisexual theater director, the actor is mania itself in a party mood. This is the kind of "on" performance that has you automatically fumbling for the off switch.

Ms. Kahn's behavior is more extravagant yet. I leave it to you whether the actress has come up with a hilarious characterization of an outspoken Jewish housewife or is successfully impersonating a visitor from another planet. She has a formidable ability to follow her own nutty train of thought, no matter what is transpiring around her. Operating on a timetable like no one else's, she can make the most innocent of utterances seem like the wildest of non sequiturs. She winds up stealing everybody's thunder in "The Sisters Rosensweig," although any accusations of theft would probably flabbergast her.

■

There is one other twist in all this I should mention. While the adults are trying to decide what to do with the rest of their lives, Sara's rebellious daughter, Tess (Julie Dretzin), has come to a crossroads, too. Does she finish her school summer project, which is researching the early biography of her mother? Or does she run away to Lithuania with her dimwitted boyfriend and catch the revolution there? In short, is she going to embrace her mother or reject her?

That is the very issue Ms. Wasserstein herself seems to be dancing around all evening long. (Consider it significant that Tess makes her decision *off*stage.) If the ending of "The Sisters Rosensweig" seems dismayingly pat, it is because the playwright is really letting herself off the hook, not simply her characters.

I only wish matters were not so facile. Ms. Wasserstein is gifted. She should be taking the hard way out by now.

'C. Colombo Inc., Export/Import, Genoa'

"My innermost desire is to surprise you," says Leo Bassi in an informal prologue to "C. Colombo Inc., Export/Import, Genoa" (at the New York Theater Workshop's new quarters in the East Village). In the 90 intermissionless minutes that follow, he comes up with two, maybe three, good surprises, which is not a whole lot, considering that a five-minute stroll in Times Square is guaranteed

Martha Swope/"C. Colombo Inc."

Leo Bassi in "C. Colombo Inc."—He demonstrates what must be viewed as the quintessential Italian shrug by elevating his shoulders above his ears.

to net you twice as many. The rest of the time, Mr. Bassi, who is Italian, does a great deal of talking about Christopher Columbus from the European point of view.

About midway through the show, he is joined by Steve Elm, a member of the Oneida Tribe of Wisconsin, who contributes his opinions about Columbus as a native American sees him. That makes for more talking, and the talking soon escalates into heated arguments — Mr. Bassi praising Columbus as a harbinger of the Renaissance; Mr. Elm condemning him as an agent of death and de-

Columbus may be his destination, but Leo Bassi — stunt maker — takes the longer route.

struction. None of this is uninteresting, but it's the stuff of a classroom debate, and I don't see that you necessarily need a theater to house the participants.

Mr. Bassi, who has a basset hound's face and the personality of a punch-drunk fighter, is a clown, foot-juggler, maker of stunts and general gadfly. In other words, a performance artist. Although he finds moments in the course of "C. Colombo Inc." to juggle a giant briefcase with his bare feet, lie on a bed of crushed glass and throw himself head first down a mountain of cardboard boxes, most of

the while he functions as pure pedagogue — nattering in heavily accented English, asking the audience occasionally if he's using the correct idiom, and demonstrating what must be viewed as the quintessential Italian shrug by elevating his shoulders above his ears.

Apparently, he is portraying an aggressive Italian businessman who hopes to erect a 185-foot statue of Columbus on Columbus Circle in Manhattan. (So far, he has only raised enough money for a giant shoe, which sits to one side of the stage.) The conceit, however, gets lost early on in the meandering discussions of the explorer and his controversial legacy, and isn't brought up again until the end. The show bears every sign of having been slapped together, indulgently directed and insufficiently rehearsed. The biggest surprise of all is that Mr. Bassi would want to let the public in to see it. □

1992 N 1, II:5:1

Texts for Nothing

By Samuel Beckett; adapted by Joseph Chaikin and Steven Kent; directed by Mr. Chaikin; performed by Bill Irwin; set design by Christine Jones; costume design by Mary Brecht; lighting by Beverly Emmons; sound by Gene Ricciardi. Presented by the New York Shakespeare Festival, Joseph Papp, founder; JoAnne Akalaitis, artistic director; Jason Steven Cohen, producing director; Rosemarie Tichler, associate artistic director. At the Joseph Papp Public Theater/Susan Stein Shiva Theater, 425 Lafayette Street, East Village.

By MEL GUSSOW

Rising from a crouching position, the tramp surveys his surroundings, a mysterious environment of overlapping planks, and wonders where he is. As Samuel Beckett's "Texts for Nothing" unfolds (at the Joseph Papp Public Theater), we can sense that the man is trapped in limbo. Perhaps the last man on earth, he is hanging on for life while waiting for a "desinence," a Beckettian word meaning an end, as in the end of a sentence. He has no idea when it will come. But until it comes, he is "a prisoner, frantic with corporeality." As he says: "I can't stay. I can't go," and adds with curiosity, "Let's see what happens next."

This prose piece, 13 terse chapters of a fiction, followed onstage by a coda extracted from the novel "How It Is," is a distillation of the author's art and philosophy. Therefore it is fitting that the dramatization of "Texts for Nothing" is given an astonishing performance by Bill Irwin, a clown in an intense tragicomic mode.

•

With Mr. Irwin alone with Beckett's words and thoughts, the play is an eloquent 65 minutes, saying more about man's misfortunes than many plays do in double or triple the time. The performance offers an acting lesson in how Beckett's prose can be transformed into theater.

When the piece was first staged in 1981, the actor was Joseph Chaikin. (The adaptation is by Mr. Chaikin and Steven Kent.) The new production is scrupulously directed by Mr. Chaikin. Beckett's primal themes are all in place: his cogitation of the brief abyss between birth and death, his reflections on man's inability to ascertain his place in the cosmos. Mr. Irwin's character seeks to name what

is unnamable, using a blanket of precise words to prove that words are useless.

•

On the page this is a haunting interior monologue. Onstage, it is both internalized and externalized, moving deeply within the meaning of the prose and also contemplating the subtext, including the kinship between the writer and his character. Shifting from perplexity to wonderment to despair, the actor breathes a visceral actuality into the nightmare. Led by Mr. Irwin, the audience enters that nightmare, as he feels his way around the "inextricable place" searching for a foothold and a mind hold.

A word about the setting: Christine Jones has artfully detailed the wooden landscape (like the interior of a hull of a Viking ship) with hidden crevasses in which Mr. Irwin can amusingly lose himself, or his hat. When he finds that hat, he flips it onto his head and smiles with satisfaction, one of the few moments in which he allows himself a clownish gesture.

Along with other Beckett actors like Bert Lahr and Buster Keaton (in the short "Film"), Mr. Irwin is a masterly clown and mime. He punctuates his words with expressive looks and animates his nimble limbs with a dancer's agility. With him, the visual and performance elements assume equal weight with the text.

With wide-ranging resourcefulness, the actor illuminates the complex narrative, whether he is using his hands to measure the length of an hour or a century (arms stretching elastically across the stage) or miming the ages of man, playing a feeble "Old Tot" reaching high into the air to grasp his nanny's arm for support. When the character talks to his body, the actor becomes his own puppeteer, activating his arms and legs. Searching for a resting position on this unyielding landscape, he sits, lies down, discovers the alternative of kneeling and finds no comfort. Called upon to conjure other characters, he achieves a kaleidoscopic diversity: the scene of a father telling his son a ghoulish bedtime story turns into a small two-character comedy.

In his original performance in the role, Mr. Chaikin assumed a childlike air, retaining his boyishness even as he aged. Maintaining a related aura of innocence, Mr. Irwin pitches his voice in the range of Mr. Chaikin's. When he is briefly heard on tape,

acting as his subconscious, the tone is deeper. The seedy figure, wearing vest and spats to denote his once dapper existence, is marked by his world-weariness and his word-weariness. Has not everything been said, he scolds his author. Through his approach, Mr. Irwin brings the character closer to other Beckett tramps, like Mercier and Camier and Didi and Gogo themselves. In his somber introspection about his "old wander years," about what he has lost in his life, there are also aspects of "Krapp's Last Tape."

•

Hugh Kenner has summarized the events in "Texts for Nothing" as "fantasies of nonbeing." Mr. Irwin makes the fantasies corporeal without losing any of their fanciful context. Although he does not have the richly timbred voice of a Jack MacGowran, he is in total command of Beckett's "pell-mell Babel of silence and words." In performance he offers stunning still pictures as well as tragicomedy in motion.

In Mike Nichols's Lincoln Center production of "Waiting for Godot," Mr. Irwin delivered Lucky's monologue with staccato brilliance. With "Texts for Nothing," he spurs a theatergoer's anticipation for more of the actor's explorations into the world of Beckett.

1992 N 2, C13:1

Robert Wilson Tackles the French Revolution

By JOHN ROCKWELL

Special to The New York Times

HOUSTON, Nov. 2 — Ever since Robert Wilson graduated from his devoted New York ensembles of disciples and started, in 1979, to direct theater and opera all over the world, he has created a huge body of work. And "created" is the proper word, for any Wilson production of a text by someone other than himself is still a Wilson work: not only does he direct, design and light the productions, he also reshapes the original text into something that counts as both his and the author's.

At their best, these productions become conversations across time, juxtapositions of his own very individual, very (post-)modern sensibility with another's from the past. At their worst, they cannibalize the original, allowing mannered superficiality, gimmicks and half-thought-out quirks to replace true dramatic insight.

•

Mr. Wilson's staging of Georg Büchner's play "Danton's Death," which opened at the Alley Theater here Saturday night and will continue until Nov. 15, counts as one of the director's finest achievements. It also serves to announce — if such announcement were needed — that the Alley Theater has entered into a newly vibrant period in its 45-year history.

Indeed, the whole production serves similar testimony to the company as a whole. Under the artistic direction of Gregory Boyd, who came to Houston in 1989 from the Williamstown Theater Festival in Massachusetts, the Alley has refound its footing after a rocky period. Mr. Boyd is also a director and an actor (a wry Thomas Paine in this production), and as an administrator he has been clever enough to enlist several notable directors and actors as "associate artists."

Mr. Wilson, who was born in nearby Waco, is one of those artists, committed to staging something at the Alley every other season. It is an arrangement that promises to benefit both parties: to give Mr. Wilson another American base, this time in his home state, and to enrich the already impressive artistic offerings of this important regional theater company.

Büchner was born in Germany in 1813 and died in 1837, and in his short life he managed not only to earn a medical degree but also to write three plays — this one, "Leonce und Lena" and "Woyzeck" — that proved enormously influential. They were discovered only late in the 19th century, and their epigrammatic form, philosophical richness and attention (in "Woyzeck" especially) to underclass agony helped shape modern drama.

•

Following his usual practice, Mr. Wilson (and his translator and adapter, Robert Auletta) have compressed and slightly reordered Büchner's text, but in a way that does no violence to its depth of detail or its inner message. Danton is still the faded firebrand, consumed with sensuality, trapped by a fatalistic acceptance of his imminent death, yet calmly heroic at the end.

Again as usual, the essence of Mr. Wilson's vision is visual: extraordinarily cool, sensuous, elegant stage pictures that he says are inspired by David but look archetypally Wilsonian. What makes this production more potent than some of Mr. Wilson's recent work, however, is how the formalism contains and contrasts with the passion of the play and of the actors, and the especially beautiful impact of the images Mr. Wilson has conjured.

Out of hundreds, one might mention the scene in which Danton's wife, Julie, knowing her husband is about to die on the guillotine, takes poison. The back of the stage opens to reveal a flat rectangular box of light — pale green backdrop (almost white), a slightly darker shade of green for the floor, Julie (Marissa Chibas) in a ravishing darker green silk dress (John Conklin did the spectacular period costumes), reclining on a couch of black lacquered wood. Three vials, dark blue, ruby and black, lie on the floor bathed in a yellow light subtly warmer than its surroundings. The resonances with classical mythology are inescapable; the immediate esthetic impact profound.

•

The overall level of acting is adequate or considerably better than that, and everyone *looks* impeccably attuned to Mr. Wilson's ideas. Chuck Winkler's presumably synthesized

score is more conventionally theatrical than some of Mr. Wilson's stage music, but effective, as is Joe Pino's sound design (less aggressive than Mr. Wilson's recent norm). The physical realization runs like a watch, always crucial in a Wilson production and a testimony to this theater's technical staff.

For his cast, Mr. Wilson auditioned in New York as well as drawing from the Alley Theater's own ensemble. Richard Thomas, still best known as John-Boy Walton on television in the early 1970's despite a varied stage career since, makes a strong, handsome, cynically charming Danton. Some of the other actors have a little trouble articulating the text with the imperious force their director and characters demand (including, oddly, the Broadway veteran Lou Liberatore as Robespierre), and some indulge in shtick closer to "Oliver" or "Les Misérables" than to Büchner-Wilson (especially James Black in a variety of sans-culottes cameos).

1992 N 3, C13:1

Animal Crackers

Book by George S. Kaufman and Morrie Ryskind; music and lyrics by Bert Kalmar and Harry Ruby; directed by Charles Repole; set by John Falabella; costumes by David Toser; lighting by Craig Miller; orchestrations by Russell Warner; assistant music director, Aaron Hagan; production coordinator, Todd Little; stage manager, Donna Cooper Hilton; choreography by Tony Stevens; dance arrangements and musical direction by Albin Konopka; associate producer, Sue Frost. Presented by the Goodspeed Opera House, Michael P. Price, producer. At the Goodspeed Opera House, East Haddam, Conn.

WITH: Robert Michael Baker, Keith Bernardo, Donald Christopher, Rieka R. Cruz, Dottie Earle, Frank Ferrante, Peter Gregus, Les Marsden, Anna McNeely, Jeanine Meyers, Christopher Nilsson, Brenda O'Brien, Michael O'Steen, Rusty Reynolds, Hal Robinson, Craig Rubano, Jeanna Schweppe, Laurie Sheppard, Celia Tackaberry, Deanna Wells and Patrick Wetzel.

By STEPHEN HOLDEN

Special to The New York Times

EAST HADDAM, Conn., Nov. 1 — In a world overrun with Elvis impersonators and Marilyn look-alikes, it is easy to lose sight of the fact that celebrity impressionists can also be essential perpetuators of show business traditions that might otherwise be lost.

Take "Animal Crackers," the Broadway musical of 1928, which the Goodspeed Opera House has revived in a terrific production that runs here through Dec. 20. The Broadway show catapulted the Marx Brothers to Hollywood, where they made the classic movie version (minus most of the Bert Kalmar-Harry Ruby songs) two years later. Any contemporary mounting of this effervescent slapstick, would be unthinkable without actors who could reasonably approximate the looks, personalities and comic timing of the Marx Brothers, for whom the show was custom-made.

And in Frank Ferrante, who starred on Broadway in "Groucho: A Life in Revue," and Les Marsden, who appeared in the same show as Harpo Marx, it has the next best thing short of an actual resurrection of two comic masters in their early prime.

●

Along with Robert Michael Baker as Chico and Craig Rubano as Zeppo,

they infuse "Animal Crackers" with an anarchic zaniness that at its most uproarious seems scarcely to have dated at all. Perpetually flicking one bushy eyebrow, with a cigar in his teeth, and armed with an inexhaustible arsenal of cheerful insults laced with sexual innuendo, Mr. Ferrante is almost a reincarnation of Groucho. All that is missing is a certain slyness of tone. He even knows how to ad-lib out of the corner of his mouth in a Groucho-like manner.

Mr. Ferrante is more than matched in comic charisma by Mr. Marsden, who actually plays a harp solo late in the show. With his head of blond ringlets and a cherubic hellion's smile on his face, he suggests Harpo as filtered through Gene Wilder. Whether dashing around the stage tooting a horn or impulsively flopping his legs onto the laps of the outraged women in the cast, he is an irresistibly inventive font of slapstick mischief.

Social climbing has rarely been spoofed so mercilessly as in "Animal Crackers," which is set on the Long Island estate of the snooty Mrs. Rittenhouse (Celia Tackaberry). The character, who was immortalized by Margaret Dumont in the play and movie, is a hostess who will endure any insult if she believes the deliverer to be a social asset. The show gleefully skewers the competing hostesses, art snobs, phony aristocrats and pushy journalists who constitute the world that thinks of itself as high society.

The show's satiric linchpin is Groucho's character, Captain Spalding, a bogus African explorer who boasts of catching a polar bear in the jungle and of shooting an elephant in his pajamas. "How it got there I'll never know," he adds with a leer.

George S. Kaufman and Morrie Ryskind, who wrote the book, packed their script with outrageous puns (Habeas corpus gets tangled with "Abie's Irish Rose"), a good number of which still score. There is even an amusing parody of Eugene O'Neill's "Strange Interlude."

●

If the Kalmar-Ruby songs lack the book's sharp wit, they exude more than enough froth to keep the show's spirits aloft. The most famous number is the airy ditty "Three Little Words."

Charles Repole, who directed the revival, has found an ideal balance between pure nonsense and musical comedy convention, so that the show flows with a bubbling energy that doesn't get carried away with itself, and the slapstick routines are never overworked.

The production is not without its run-of-the-mill elements. Tony Stevens's ensemble choreography sticks to standard Charleston routines that work well without adding any extra snap. And in the role of Mrs. Rittenhouse, Ms. Tackaberry is too sweetly accommodating of the shenanigans that threaten to tear apart her home.

If "Animal Crackers" is the kind of musical house party that a hostess would be well-advised not to have, no sooner have the guests arrived than the laughter begins. It continues almost nonstop. When you're having so much fun, who cares what happens to the furniture?

1992 N 4, C19:4

Theater in Review

■ Sholem Asch's dark vision of a doomed family ■ Returning to a life in Dublin as dismal as it ever was.

God of Vengeance

Jewish Repertory
Playhouse 91
316 East 91st Street

By Sholem Asch; adaptation by Stephen Fife; directed by Ran Avni; set by Rob Odorisio; costumes by Gail Cooper-Hecht; lighting by Betsy Finston; music and sound by Raphael Crystal; general manager, Steven M. Levy; production stage manager, D. C. Rosenberg. Presented by the Jewish Repertory Theater, Mr. Avni, artistic director; Edward M. Cohen, associate director, in association with the 92d Street Y.M.-Y.W.H.A. and Play Producers, Annette Moskowitz and Alexander E. Racolin.

WITH: Jodi Baker, Robin Leslie Brown, Christine Burke, Marilyn Chris, Roy Cockrum, Maury Cooper, Deborah Laufer, Bernie Passeltiner, Bernadette Quigley, Stephen Singer and Lee Wallace.

To celebrate its move uptown to Playhouse 91, the Jewish Repertory Theater is presenting a new adaptation, in English, of Sholem Asch's dark and memorable Yiddish play, "God of Vengeance," the first work produced by the company when it started in 1974.

For this version of the controversial novelist's 1907 play about a brothel keeper and a former prostitute who try to protect their daughter from corruption by buying the protection of religion, Ran Avni, the company's artistic director, has assembled a generally impressive cast led by two formidable veterans: Lee Wallace as the father who tries to bargain with God and Marilyn Chris as his wife. And Christine Burke, as the daughter, gives her character just the right

combination of naïveté and passion to make her fate seem inevitable and tragic.

When "God of Vengeance" was first performed on Broadway in English, in 1922, the Society for the Suppression of Vice — appalled at lines it heard as blasphemous and outraged at a public display of lesbianism (the daughter falls in love with one of her father's prostitutes) — raised such a ruckus the play was briefly shut down and its star, the great German actor Rudolph Schildkraut, spent a night in jail.

By now this play is not shocking. But most of Asch's scores of novels and plays have aroused the wrath of many people, and this play still has palpable power. Asch had no fear of dreadful questions that have no answers, and he exposed the greed, hypocrisy and self-deception of his characters with a subtle and scornful vocabulary.

Under Mr. Avni's direction this cast makes the brothel master, his family, his prostitutes, the scribe and the slippery deal maker from the synagogue vivid human beings whose hopes and schemes and self-delusions seem chillingly familiar. When at the end the distraught father, hearing only silence in reply to his defiant demands on God to save his daughter, condemns both wife and daughter to descend forever into the brothel, one can feel a chill run up the back of the neck.

D. J. R. BRUCKNER

The Lament for Arthur Cleary

Irish Arts Center
553 West 51st Street
Clinton
Through Nov. 22

By Dermot Bolger; directed by Nye Heron; music composed, arranged and produced by Brian O'Neill Mor and Nicholas Kean; set by David Raphel; costumes by Carla Gant; lighting by Judith M. Daitsman; mask maker, Mylene Santos; production stage manager, Elizabeth English. Presented by the Irish Arts Center, Jim Sheridan, chairman;

Mr. Heron, artistic director; Marianne Delaney, executive director.

WITH: Ron Bottitta, Jennie Conroy, David Herlihy, Chris O'Neill and Mac Orange.

The title character of Dermot Bolger's "Lament for Arthur Cleary"

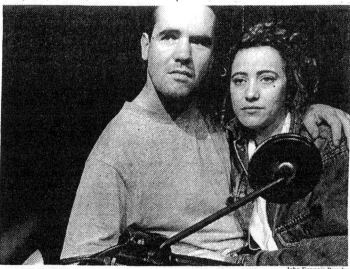

John Francis Bourke

David Herlihy and Jennie Conroy performing in a scene from "The Lament for Arthur Cleary" at the Irish Arts Center.

is an Irish expatriate who returns to the Dublin of his youth after living in on the Continent for 15 years, becomes romantically involved with a teen-age girl and comes to a bad end. It's not much of a story and from Mr. Bolger's slight play one doubts that many, apart from the girlfriend, will even notice Arthur is gone let alone lament his passing. Maybe that's the point.

Arthur is a man of limited imagination and even less ambition. After picking up a girl at a disco for the teeny-bopper set and moving her into the flat of his recently· deceased mother, he is quite content to live on the dole, make nostalgic visits to some childhood haunts and occasionally gaze into the Liffey.

The play is set in the cinder-block and corrugated-tin neighborhood of Dublin's north side, wonderfully captured by David Raphel's set, where crime and drug addiction have been added to the inherent burden of poverty. Much of the play is taken up with Arthur's memories of the city as it was before he left, especially as he bumps into old acquaintances around town. But the only insight to be gleaned from these encounters is that the more things change, the more they stay the same. Even the welfare office has the same flaking paint, and a mean childhood swindler has become a grown-up slum lord.

Mr. Bolger has tried to inject a sense of mystery and drama into the play with the occasional use of voice-overs, masks and one recurring scene of Arthur at a railway border crossing that is meant to carry some rather obvious theological symbolism. But it's all much too heavy for such a frail plot and weak characters.

A fine cast does its best. David Herlihy turns Arthur into an amiable enough lad and tends to make one overlook the fact that the hero is little more than a layabout and daydreamer with no sense of responsibility. Jennie Conroy is thoroughly credible as his girlfriend, conveying the plight of desperate frustration in a young woman who sees nothing but death around her. Chris O'Neill is alternately funny and menacing in a series of cameos that include a bouncer at the disco, a border guard, the rent collector and a police inspector. Mac Orange and Ron Bottitta are also good in multiple roles. Nye Heron directed with a deft hand.

1992 N 4, C22:1

From Far and Wide, Agile Animals and Clowns

By LAWRENCE VAN GELDER

Among the pleasures of autumn in New York are the intimate joys and welcome wows to be found under the big blue-yellow-and-red tent pitched most appropriately by the Big Apple Circus in the cultural cornucopia that is Lincoln Center.

Fifteen years after the founding of the Big Apple by its artistic director, Paul Binder, this year's show seems speedier and more colorful than ever. Zipping along with what seem like only the briefest of pauses for saying, "Amazing!" or "Wasn't that terrific?" or for laughing at the antics of the hard-working clowns, the 1992-93 Big Apple Circus uses its special charm to make a big world appear small.

"Goin' Places" is the title, and not too long into the proceedings, a conveyance that looks like a result of an accident that melded a steam engine with the frame of a galleon and the wheels of a truck sends a couple of clowns and the audience on a journey that embraces talent from Asia, Europe and North and South America and scenes set everywhere from the heavens to the depths of the sea.

•

Along the way, many wonders are to be 'found. There is, for example, Vladimir Tsarkov, from Russia, who is robotic, balletic and acrobatic, a human three-, four-, five-, six-, seven-ring circus who juggles rings while doing flips and contortions.

There are the baker's dozen or so of dogs — lean, fat, sleek, fluffy, tiny, underslung, but all irrepressible — who vault over hurdles, wiggle under one another, turn somersaults and strut about on their hind legs, under the tutelage of Johnny Peers of the United States.

From Mongolia comes the extraordinary Tunga, who seems as if she could have been discovered by Indiana Jones in the Temple of Wonders. In an act titled "The Mysterious Golden Statue," this alumna of the State Circus School of Ulan Bator proves herself a contortionist so supple she can balance her chin on a vase of flowers while arching her legs backward to leave her knees hanging beside her ears.

•

From Russia, too, comes the Yegorov Troupe, in a display called "Shooting Stars and Heavenly Bodies." The Yegorovs look like a trapeze act with one exception: they dispense with the trapeze, swinging from hand to hand across chasms of air from lofty perches while the crowd howls with something between sheer terror and cheers of awed admiration.

And that's all in Act I.

Perhaps the most eye-catching part of the show is "Seascape," which sends humans disguised as luminous fish, octopuses, sea horses, crabs and squid dancing across the darkened arena. For fans of true animal acts, there are the graceful elephants that turn up in the "Carnival in Rio" number and the horses that race about in "Feria Hispánica."

Amid the other acts come the clowns: the red-nosed, red-derbied Jeff Gordon as Gordoon; John Lepiarz as Mr. Fish, who looks as if Mark Twain and Albert Einstein mingled molecules in a time machine on their way to the 1990's, and, from Peru, César Aedo, who mimes a hilarious game of tennis with the assistance of audience members.

There's plenty more in this edition of the Big Apple Circus, sponsored by the Republic National Bank, includ-

ing the invigorating original music by Linda Hudes, the orchestra directed by Rik Albani and the lively scenic designs of James Leonard Joy and the lighting of Jan Kroeze.

"Goin' Places" isn't going anywhere besides Damrosch Park at Lincoln Center until Jan. 10. And that's good news for holiday fun seekers.

1992 N 5, C19:1

The Show-Off

By George Kelly; directed by Brian Murray; set by Ben Edwards; costumes by David Charles; lighting by Peter Kaczorowski; sound by Douglas J. Cuomo; production stage manager, Kathy J. Faul; general manager, Ellen Richard. Presented by the Roundabout Theater Company, Todd Haimes, producing director. At Criterion Center Stage Right, 1530 Broadway, at 45th Street, Manhattan.

Clara	Laura Esterman
Mrs. Fisher	Pat Carroll
Amy	Sophie Hayden
Frank Hyland	Edmund C. Davys
Mr. Fisher	Richard Woods
Joe	Tim DeKay
Aubrey Piper	Boyd Gaines

By MEL GUSSOW

Aubrey Piper, the title character in "The Show-Off," is a braggart buoyed by misplaced self-confidence. But with his blissful unwillingness to accept discouragement, he also has an engaging side. The full dimension of this eternal optimist is captured by Boyd Gaines in the revival of the George Kelly comedy at the Roundabout Theater Company.

The danger in playing the character is to make fun of him instead of simply allowing him to mock himself. Mr. Gaines avoids that possibility as he joins with Pat Carroll to offer a mirthful duel of opposites. Ms. Carroll plays the honest, confrontational Mrs. Fisher, who becomes Aubrey's mother-in-law and chief critic.

•

Over the years, this 1924 play has come to be regarded as a classic of its genre. Actually, it is less a classic than a popular comedy that is close to foolproof as long as actors do not play the characters as fools. The contrivances in the plot and the lengthy exposition are counterbalanced by the clarity of the motivations. Once the personalities of Aubrey and the mother have been established, theatergoers can sit back and enjoy their never-ending family argument.

"The Show-Off" was very much of its period, a time of expanding economic opportunity with ample room for go-getters to get ahead. In telling the story of the brash Aubrey, Kelly also struck a universal theme: the obstreperous outsider breaking into a closed society, in this case a respectable Philadelphia family. Although the author won the Pulitzer Prize the next year for "Craig's Wife," "The Show-Off" became his most produced play.

•

Brian Murray's direction occasionally pushes the comedy into caricature, as in the portrait of an absentminded inventor. But the revival catches the eccentric rhythm of the comedy without obscuring the latent abrasiveness. When Mr. Gaines and Ms. Carroll are going at each other, the amusement accelerates as she withstands all the young man's egocentricities and platitudes. Aubrey maintains his equanimity even when

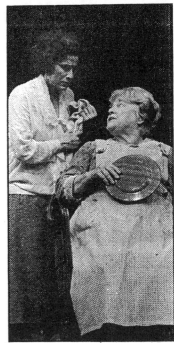

Jack Manning/The New York Times

Sophie Hayden, left, and Pat Carroll in "The Show-Off."

he causes an automobile accident that sends a traffic policeman to the hospital with a broken arm. From his perspective, it was the policeman who ran into the car.

Naturally, one's sympathies are drawn to the mother. Nothing she has done deserves an Aubrey in her life. He demolishes her tranquillity with his back-slapping garrulousness, and his gullible bride remains oblivious to his lies. But underscoring the character's brusqueness, Ms. Carroll keeps her from seeming sweet or lovable. She is, in her own way, as pushy as her son-in-law. Like an Archie Bunker of the 1920's, she peppers her conversation with casual ethnic prejudices.

In contrast, Mr. Gaines has a certain dash in his manner and appearance, with his carnation in his buttonhole (although he is a $32-a-week clerk) and a perpetual smile on his face. Even if he tried, he could not frown; he even has something posi-

George Kelly's 1924 comedy of an obstreperous outsider.

tive to say about death. Through his forthright performance, Mr. Gaines makes it clear that the man means well. For all of his conceit, he truly loves his wife, almost as much as he loves himself.

The others in the cast are catalysts and observers, assorted characters from family comedies of the period. They are all satellites in the orbit of the showoff and the woman who is trying to show him up for the liar that he is. Sophie Hayden and Laura Esterman, neatly contrasted as sisters, stay in the background.

The production fits snugly on the Roundabout stage. The set by Ben

Edwards, filled with period furniture, is especially helpful in preserving authenticity. Watching the play, theatergoers can feel projected back to an earlier, more hopeful time in the theater and in America itself.

The key to the play's revivability can be found in Aubrey. Energized by his ego, he has an Horatio Alger view of success. His favorite slogan is, "Sign on the dotted line." With pluck, luck and a signature on a contract, anyone can get ahead, which is true of salesmen from Willy Loman through the ambitious real estate brokers in David Mamet's "Glengarry Glen Ross."

While offering cautionary advice on self-promotion, Kelly concentrated on writing a comedy of character with two zestful roles for actors. When Mrs. Fisher falls asleep in her rocking chair, it is for her a rare moment of inaction. But then Ms. Carroll's cheeks begin to flutter like a flag blowing in the breeze. Every ripple is a laugh. In the best sense, the actress commands the stage and makes her presence felt even when she is just offstage shouting at her dog to behave itself.

Mr. Gaines is easily her equal. Watch him take an apple from a bowl, bite into it and, with a slow double take, realize that it is a piece of waxed fruit. The look on his face is one of incredulity, but not embarrassment. With calm bordering on panache, he carefully puts the apple back in the bowl and pretends the mistake never happened. He and Ms. Carroll are felicitous in their acting and reacting in this remarkably durable comedy.

1992 N 6, C3:1

Critic's Choice

Gentler 'Juno,' But It Sings

Sean O'Casey's tragicomic masterpiece "Juno and the Paycock" is a drama of such depth and poetic weight that any attempt to turn it into a musical would inevitably soft-

en its devastating portrait of an impoverished Dublin family in the early 1920's. When the composer Marc Blitzstein and the book writer Joseph Stein turned the play into the musical "Juno" in 1959, the show lasted for only 16 performances on Broadway. Since then, however, Blitzstein's score has won many admirers through an original-cast recording. Now the Vineyard Theater is giving "Juno" its first New York production since 1959, with a revised book and some musical additions.

Although the revised "Juno" lacks the play's Shakespearean grandeur, on its own, more modest terms, it is a well-made musical in which the songs and the dialogue are woven together with an impressive fluency. And the performances of Anita Gillette as the matriarch of the embattled Boyle family and Dick Latessa as her lazy, drunken husband have a richness and subtlety too seldom found on the musical stage.

Lonny Price, who directed the successful Off Broadway revival of "The Rothschilds," has given "Juno" a similarly intimate, bare-bones production in a modified environmental setting. If the atmosphere is too homey and the tone at times too sugarcoated to capture the play's profound desperation, the director has masterfully solved the mechanics of staging an intimate production with 14 actors.

Most significantly, the score, for which Blitzstein wrote both music and lyrics and which is performed with only piano accompaniment, retains its freshness and vitality. Opposite in tone from the sophisticated Broadway music of Richard Rodgers or Leonard Bernstein, the songs have a plain, folkish simplicity with muted Irish echoes.

The Vineyard Theater is at 108 East 15th Street. Performances this weekend are tonight and tomorrow night at 8 and Sunday at 3 and 7:30 P.M. Tickets are $25 and $30. Tickets: (212) 353-3874.

STEPHEN HOLDEN

1992 N 6, C6:6

SUNDAY VIEW

A Mamet Encounter and a One-Man Show

By DAVID RICHARDS

"OLEANNA," DAVID MAMET'S CONTRIBUtion to the national debate on sexual harassment, is not going to calm anyone down. It will rankle those who think Anita Hill went too far, just as it will rankle those who think she didn't go far enough. Even those who object to the work on purely theatrical grounds are likely to object strenuously. Everything about Mr. Mamet's play (Off Broadway at the Orpheum Theater) seems guaranteed to induce a state of high anxiety in the viewer.

That goes for the telephone, too.

It sits on the desk of John (William H. Macy), the middle-aged college professor who is one of the evening's two characters (I was going to say opponents). Whenever it rings it does so with a particularly virulent jangle that would fray the sturdiest of nerves, and John's are already seriously frayed. He is engaged in a battle for his life and career — although he doesn't realize it at first — and he's having difficulty marshaling arguments for his defense. Just as he's about to score a point, the phone invariably intrudes, and the point, whatever it was, goes flying out of his head.

A man and a woman battle on stage. Something elemental is being evoked.

Infuriating, that. For him. For us. And it's precisely how the playwright wants it.

If you believe there is anxiety enough in the world, your choice is easy. You had best give "Oleanna" a wide berth. On the other hand, when so many plays these days inspire general indifference, Mr. Mamet's ability to provoke a gut response has to be considered highly welcome. He's always been a rough-and-tumble writer, at his best when chronicling the buddy-buddy rituals and the cutthroat rivalries of men at work and play. Up to now, women have never figured very prominently in the landscape. As if to make up for the oversight, enter Carol (Rebecca Pidgeon), the second character in "Oleanna," looking more like a confused field mouse than the avenging angel she turns out to be.

She has been taking the professor's course for half a semester, dutifully scribbling notes in the accountant's ledger that she carries in her knapsack, and listening with an attentiveness that threatens to put a permanent crease in her brow. But she's hopelessly lost, and so has come by the professor's office for an after-class consultation.

He's about to get tenure and is negotiating the purchase of a new house to mark the impending promotion. Between phone calls from his wife and his lawyer, though, he offers Carol advice and a consoling hand, and just to show he's not some remote authority figure, tells a few mildly self-deprecating tales out of school. A low achiever in his youth, he can sympathize with her plight. The educational system, he sometimes thinks, is nothing more than "prolonged and systematic hazing."

On the surface, that's pretty much it for Act I. All the while, however, you can't help feeling that his casual magnanimity is making an ambiguous situation worse. And the persistence of Carol's frustration is worrisome. "I don't *understand*," she says, with a flagellant's fervor. "I don't *understand*. I don't understand what anything means ... and I walk around. From morning til night: with this one thought in my head. I'm *stupid*."

Then, the bombshells start to explode. In the first scene of Act II, we learn that Carol has registered a complaint with the tenure committee, accusing John of sexism, elitism and pornographic advances. He summons her to the office, this time in an attempt to defuse the situation — "before this escalates," as he puts it, and he loses tenure and has to sacrifice his deposit on the house. She digs in, convinced that his behavior makes a mockery of hard-working students like herself. What are "accusations" in his mind are "facts" in hers. When she refers in passing to "my group," you immediately realize she has rallied others to her cause. The meeting ends badly, with the professor, unable to find the right words, trying to shake some sense into the obdurate young woman.

By the next (and final) scene, John has lost more than tenure and the house, as he feared.

The college has suspended him and he may be facing charges of rape. He is pathetically willing to grovel, when Carol, against the advice of "the court officers," agrees to hear him out a last time. Earlier, she didn't know where to look. Now, he's the one to keep looking away. If John submits to a list of her demands, she suggests, he might be able to salvage his job.

She can't stop herself from reprimanding him, though. While the remark is just a slap on the wrist, really, compared to the upper-cuts the two have been exchanging, it is enough to transform John into the rampaging brute the indictment claims he is. "Oleanna" goes out in the crunch and thud of violence.

What is truly horrifying, however, is that violence is the *only* way out. The play has nowhere else to go, no other solutions to propose. Words have proved useless and reason has failed miserably. Such prior works as "American Buffalo," "Speed-the-Plow" and "Glengarry Glen Ross" have accustomed us

In 'Spic-o-Rama,' John Leguizamo commits himself so totally that you believe with him.

to Mr. Mamet's notion of language as a perverse and truncated thing. ("What you say influences the way you think, the way you act, not the other way around," he once explained.) His characters talk a kind of aural graffiti — scrawling over words they've barely spoken, scratching out sentences before they're finished, recklessly mangling thought and syntax in the process. As a result, just about any declaration is open to interpretation. If beauty is in the eye of the beholder, meaning in a Mamet play is inevitably in the ear of the listener.

In "Oleanna," the gulf between speech and meaning seems deeper and wider than usual. Partly that's because Mr. Mamet is dealing with educated characters for a change — and not with ruffians and salesmen — and we expect a college professor, at least, to be able to say what's on his mind. John is so inarticulate, however, that a spectator seated near me confessed afterward that she had to suppress an urge to scream every time he opened his mouth. I'll take it one step further: the very *sound* of the dialogue — with its jackhammer emphases and splintered rhythms — is intrinsically grating. (And then the phone rings.) You don't have to understand English for "Oleanna" to get on your nerves.

■

Even more distressing is the situation itself, which slips out of control without our really understanding how or why. Of course, Mr. Mamet is not exactly playing fair with us. "Oleanna" (the obscure title refers, ironically, to an idealistic 19th-century commune of folk song fame) is as rigged as a carnival wrestling match. It tells us only so much — so *little,* actually — about the characters. The gaps in our knowledge are what make the play difficult to deal with. If we saw John in the classroom or Carol interacting with other students, if we knew more about their respective pasts, if the members of the tenure committee let us in on their debates, it is likely that we could put the whole unpleasant affair in less troubling perspective. By purposefully withholding information about his

Anthony Neste/"Spic-o-Rama"

John Leguizamo, as Felix, the father of the Gigante family, six of whose members the actor portrays in his show "Spic-o-Rama"—Amazing virtuosity.

characters, Mr. Mamet forces us to chart our own path through the play with only our speculations and prejudices to guide us.

Is Carol intentionally setting up John? Or is she simply the first to sense something destructive about him? Are her accusations legitimate observations? Self-fulfilling prophecies? Mad imaginings? And what accounts for the sudden confidence, not to mention the improved vocabulary, she acquires between Acts I and II? "Oleanna" isn't saying.

Under the direction of the author, Mr. Macy and Ms. Pidgeon are in full possession of their roles — he, plunging from a smug complacency to the wild-eyed panic of one who feels the ground giving way beneath him and is helpless to do anything about it. Meanwhile, she's traveling in the other direction — from bewilderment to the kind of righteous self-assurance that can put the blaze of steel in a crusader's eyes. The anger and indigna-

tion the two performers arouse in an audience transcend the confines of a mere play.

In their head-to-head clashes, something elemental is being evoked — some poisonous sense of disparity that continues to divide the sexes, whatever our current protestations of fair play for all. Mr. Mamet has never had a generous notion of humankind to begin with, but "Oleanna" may be his least charitable drama to date.

Expect to grow hot under the collar. Wear loose clothing.

'Spic-o-Rama'

There are six reasons to catch "Spic-o-Rama" (Off Broadway at the Westside Theater). John Leguizamo is all of them.

His newest one-man show makes good on the intoxicating promise of "Mambo Mouth," his first. Playing half a dozen members of a crazed and crazy Latin family on the day the eldest son is to be married, he confirms himself as an actor of amazing virtuosity. Although his characters often conduct themselves in crass and foolish ways, Mr. Leguizamo never belittles them.

∎

They may go overboard; he never does. They don't always know who they are; he knows exactly. He knows how they walk, talk, style their hair, blow their money, vent their anger, express their love and compensate for the crushing disappointments that seem to be their lot in Jackson Heights, Queens. The quick-change devices of the makeup artist — wigs, mustaches, false teeth — allow him to look like a hyperkinetic 9-year-old boy or a once-flashy middle-aged mother of five, to cite the evening's extremes. Makeup goes only so far, however. The real transformation comes from within. Mr. Leguizamo commits himself so totally to these creatures that you have no option but to believe right along with him.

"Spic-o-Rama" aims significantly higher than "Mambo Mouth," which was a series of unrelated portraits. This time, Mr. Leguizamo is trying to forge some dramatic connections among the family members, which results in a larger, more complex picture. Lily Tomlin's "Search for Signs of Intelligent Life in the Universe" would seem to be the model here. There's a similar mixture of loopy humor, pathos and social commentary. While "Spic-o-Rama" can get gritty on occasion, it is mostly amazed and delighted at the diversity of the human species.

Mr. Leguizamo is certainly outrageous as Rafael, an aspiring actor, who, in a demented attempt to pass for Elizabethan, bleaches his hair with Clorox, affects a breathy British accent, stuffs his polka-dotted undershorts with Kleenex and pretends to be "the love child of Laurence Olivier." But he's no less vivid as Xavier, the paraplegic brother, even though he's virtually frozen to a wheelchair and moves scarcely more than his mouth. If he appreciates the sass in Gladyz, the overburdened mother in pedal pushers, he also recognizes the heartbreak, as she nibbles on a drumstick and makes idle conversation about the lousy state of the world and her marriage.

∎

At the end of the night, we meet Felix, the paterfamilias who left this clan in the lurch long ago but has returned to offer a toast to the newlyweds and pass along some of what he's learned of life. ("The first half is ruined by your parents," he proclaims drunkenly. "The second half is destroyed by your kids.") He's arrogant, irresponsible and crude, and,

in addition, sings off-key. Mr. Leguizamo finds it in him to love this rotter, too.

"Spic-o-Rama" is so refreshingly original that it may be carping to suggest that less would probably be more. Each of the monologues could easily be pruned by five minutes. And while Mr. Leguizamo deserves the set that Loy Arcenas has designed for him — bedroom, vacant lot and laundromat, all rolled into one — he doesn't necessarily need it. What's most exciting about the production takes place inside the actor's head. □

1992 N 8, II:1:1

Solitary Confinement

By Rupert Holmes; Broadway production supervised by Marshall W. Mason; based on original direction by Kenneth Frankel; scenery and art direction, William Barclay; lighting, Donald Holder; costumes, Kathleen Detoro; sound, Jack Allaway; fight director, David Leong; production stage manager, Joe Cappelli; stage manager, Artie Gaffin; music produced by Deborah Grunfeld; production manager, Roy Sears Jr. Presented by Gladys Nederlander, James M. and Charlene Nederlander, and Roger L. Stevens, in association with Normand Kurtz. At the Nederlander Theater, 208 West 41st Street, Manhattan.

Richard Jannings	Stacy Keach
Fillip	Samuel Tate
Conroy	Art Calvin
Girard	Yves Konstantine
Eldridge	Edward Allesandro
Fleischer	Carl Huffman
Miss David	Jane Rollins

By MEL GUSSOW

In "Solitary Confinement," Stacy Keach plays a reclusive and tyrannical billionaire. Isolated in his castle-like office tower, he runs his life and controls the lives of others while sitting at a high-tech computer console. The supporting characters, any one of whom might have murderous intentions against the billionaire, are seen on a large closed-circuit television screen. Despite the elaborate electronic hardware, this is a tepid attempt at a mystery, offering neither chills nor thrills, and substituting contrived special effects for dramatic invention.

The Rupert Holmes play opened last night at the Nederlander Theater on Broadway after playing at the Pasadena Playhouse in California and at the Kennedy Center in Washington. "Solitary Confinement" pushes theater several steps closer to television. A game-show conclusion puts the final seal on the work's limited aspirations. In the theater, the play wastes the audience's time and Mr. Keach's talent. There is no fast-forward button to get us through the slow parts.

With the help of Charles Dickens, Mr. Holmes created the musical "The Mystery of Edwin Drood." Then, on his own, he came up with "Accomplice," a Broadway whodunit in which the author appeared as a character onstage, thereby subjecting himself to double jeopardy. Mr. Holmes does not perform in "Solitary Confinement," but his presence is ubiquitous as he manipulates and mangles his plot, stuffing it with digressions, including an extraneous diatribe against the Dutch. Although there are topical wisecracks as well as quotations from Oscar Wilde and other writers, the dialogue is humorless. Despite the many references to Houdini and his famous escape from a locked trunk, the show is exceedingly slight of hand in the magic department.

The weight of the evening falls on Mr. Keach; for all of his effort, he is unable to lighten the burden. The author has constructed the role from spare dramatic parts, from Howard Hughes to HAL the computer in "2001: A Space Odyssey." With histrionic fortitude, the actor pretends he has something with which to work, trying to knead his villain into a rounded character.

In his varied performance, he demonstrates aspects of his acting prowess, pretending to be both suave and reptilian while dueling and rushing around the scenery. Mr. Keach recycles elements from his past, including his hard-boiled Mike Hammer and his "Richard III," reprising the limp he used in the Washington production. In one case, he offers a homage to Dustin Hoffman in "Tootsie." Mr. Keach is a fine classical actor, equally adept at tragedy and farce. It is good to see him back on the New York stage. (His last role was in "Deathtrap," which is a more viable melodrama.) But one regrets his choice of vehicle in which to return.

●

Necessarily, a critic has to be circumspect about how much of the mystery to reveal, although in this case the central gimmick is telegraphed early in the show. One clue might serve: contradicting the credits in the program, the play has more producers than actors. There are two directors of record: Kenneth Frankel, who is responsible for the "original direction," and Marshall W. Mason, who is the supervisor of the Broadway production. Both directors

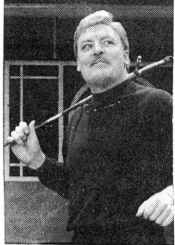

Joan Marcus/"Solitary Confinement"
Stacy Keach in "Solitary Confinement," by Rupert Holmes, at the Nederlander Theater.

are indebted to the set designer, William Barclay, who, after Mr. Keach and Mr. Holmes, is the most active participant in "Solitary Confinement."

•

Mr. Barclay has lined the stage with push-button panels, secret doors and video monitors. There is a pitch-and-putt one-hole golf course, and a dumbwaiter serves up plot devices along with flapjacks for Mr. Keach's breakfast. While waiting for the next twist, theatergoers can watch the scenery. One scans the stage for clues. Will Mr. Keach put on a suit of armor? (Yes.) Will the van Gogh sunflowers play any part in the plot? (No.) And what about the stuffed raven? The bird provokes the character to think of Lewis Carroll as well as Edgar Allan Poe. Repeatedly he poses a question from "Alice in Wonderland": why is a raven like a writing desk? This conundrum is more puzzling than anything in Mr. Holmes's play.

1992 N 9, C11:1

Camp Paradox

By Barbara Graham; directed by Melia Bensussen; setting by Edward T. Gianfrancesco; lighting by Craig Evans; costumes by Mimi Maxmen; sound by Aural Fixation/Guy Sherman; hair by Bobby H. Grayson; production stage manager, John Frederick Sullivan. Presented by the WPA Theater, Kyle Renick, artistic director; Donna Lieberman, managing director. At 519 West 23d Street, Chelsea.

Cory	Meredith Scott Lynn
Edith	Alix Korey
C. J.	Emily Schulman
Renee	Danielle Ferland
Iris	Russell Koplin
Donna	Christina Haag
Carla	Liann Pattison

By MEL GUSSOW

Four teen-age girls gather in their cabin at summer camp, giggling and comparing notes on boyfriends. Cory, who is a heavy reader and would-be author, remains standoffish until she notices that her counselor is staring at her. It takes no leap of the imagination to diagnose the reason for the counselor's interest. In Barbara Graham's "Camp Paradox," the footlockers are crammed with detritus from adolescent fiction. In the course of the play (at the WPA Theater), Cory comes of age in the summer of 1963 and has her first sexual experience while saying things like "I was a trespasser on foreign soil without a map."

The play's one claim to distinction, or at least to difference, is that Cory's initial liaison is not with a boy in a neighboring camp but with that counselor, a 28-year-old lesbian still sulking after an aborted romance with a woman during her college days. Except for the older woman's unhappiness, it is difficult to see what draws her into an affair with the young girl, with whom she apparently has nothing in common.

•

In the narrative approach, Ms. Graham seems to have been overly affected by plays and movies from "The Glass Menagerie" to "Dirty Dancing." Cory tells the story to the audience, interrupting the action for sidelong comments. As the play moves through the camp's daily ac-

tivities, complete with a chorus of "On Top of Old Smoky" and a glimpse of an end-of-season variety show, the atmosphere becomes stifling.

In the background is Cory's mother writing letters to her daughter and talking on the telephone. As played raucously by Alix Korey, she is a cartoon of a Jewish mother. Faced with such a parent, it is easy to see why the 15-year-old daughter would want to go back to summer camp, even at her advanced age. It is less easy to understand why the WPA would have thought this play was worthy of production.

A youngster chronicles a stifling, endless period of change.

Considering the limitations, Melia Bensussen's direction is relatively smooth (except for the scenes with the mother). Meredith Scott Lynn invests the protagonist with a certain sensitivity and Danielle Ferland adds peppiness as her longtime best friend.

In the role of the counselor, Christina Haag manages to play down the awkwardness of scenes that call for her to look soulfully at the young camper and then jump into a narrow cot with her.

•

"Camp Paradox" plods a predictable course to an obligatory flash forward when Cory brings us up to date on what has happened to the characters in the intervening years. As for herself, she confesses, "I didn't become a writer," words that one is not eager to contradict.

1992 N 9, C14:1

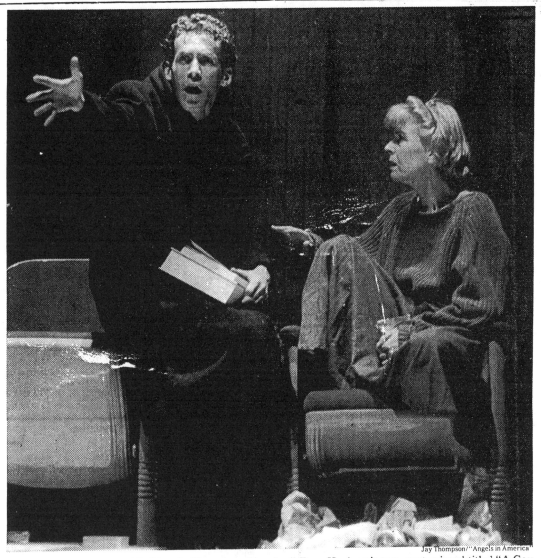

Jay Thompson/"Angels in America"

Stephen Spinella and Cynthia Mace in "Angels in America," Tony Kushner's two- part epic subtitled "A Gay Fantasia on National Themes," which had its United States premiere in Los Angeles on Sunday.

Angels in America
Part 1: Millennium Approaches
Part 2: Perestroika

By Tony Kushner; directed by Oskar Eustis with Tony Taccone; sets by John Conklin; costumes by Gabriel Berry; lighting by Pat Collins; sound by Jon Gottlieb; fight director, Randy Kovitz; original music by Mel Marvin; production stage manager, Mary K. Klinger; stage managers, James T. McDermott and Jill Ragaway; associate producer, Corey Beth Madden. Presented by Center Theater Group/Mark Taper Forum, Gordon Davidson, artistic director and producer; Charles Dillingham, managing director, and Robert Egan, associate artistic director, in association with the New York Shakespeare Festival, JoAnne Akalaitis, artistic director; Jason Steven Cohen, producing director. At the Mark Taper Forum, Los Angeles.

Hannah Pitt	Kathleen Chalfant
Belize	K. Todd Freeman
Joe Pitt	Jeffrey King
Roy Cohn	Ron Leibman
Harper Pitt	Cynthia Mace
Louis Ironson	Joe Mantello
The Angel	Ellen McLaughlin
Prior Walter	Stephen Spinella
Heavenly Attendants	
	Pauline Lepor and Eve Sigall

By FRANK RICH

Special to The New York Times

LOS ANGELES, Nov. 9 — Some visionary playwrights want to change the world. Some want to revolutionize the theater. Tony Kushner, the remarkably gifted 36-year-old author of "Angels in America," is that rarity of rarities: a writer who has the promise to do both.

As a political statement, "Angels in America," a two-part, seven-hour epic subtitled "A Gay Fantasia on National Themes," is nothing less than a fierce call for gay Americans to seize the strings of power in the war for tolerance and against AIDS. But this play, by turns searing and comic and elegiac, is no earthbound ideological harangue. Though set largely in New York and Washington during the Reagan-Bush 80's, "Angels in America" sweeps through lo-

cales as varied as Salt Lake City and the Kremlin, and through high-flying styles ranging from piquant camp humor to religious hallucination to the ornate poetic rage of classic drama.

When was the last time a play embraced intellectual poles as seemingly antithetical as Judy Garland and Walter Benjamin, Joseph Smith and Mikhail Gorbachev, Emma Goldman and Nancy Reagan? Almost anything can happen as history cracks open in "Angels in America." A Valium-addicted Washington housewife, accompanied by an imaginary travel agent resembling a jazz musician, visits a hole in the ozone layer above Antarctica. An angel crashes with an apocalyptic roar through the ceiling of a Manhattan apartment to embrace a dwindling, Christ-like man spotted with Kaposi's sarcoma. A museum diorama illustrating the frontier history of the Mormons comes to contentious life. Ethel Rosenberg returns from the dead to say kaddish for her executioner, Roy Cohn.

No wonder the audience is somewhat staggered as it leaves the Mark Taper Forum, where the complete "Angels in America" had its premiere in a day-and-night marathon on Sunday. (It is scheduled to travel to the New York Shakespeare Festival in February.) The show is not merely mind-bending; at times it is mind-exploding, eventually piling on more dense imagery and baroque spiritual, political and historical metaphor than even an entranced, receptive audience can absorb in two consecutive sittings.

Part 1 of "Angels in America," titled "Millennium Approaches" and a sensation at the Royal National Theater in London this year, remains a dazzling, self-contained piece. While the new, at times stodgy Taper production, directed by Oskar Eustis with Tony Taccone, does not yet reach the imaginative heights of Declan Donnellan's London staging, the work's alternate chords of deep grief and dreamy wonderment still produce exhilaration for the heart, mind and eyes. Part 2, titled "Perestroika" and never before seen in a full production, seems a somewhat embryonic, occasionally overstuffed mixture of striking passages, Talmudic digressions and glorious epiphanies. Mr. Kushner is by no means exhausted, but he may have to harness his energies more firmly to keep his audience from feeling so by the final curtain.

Huge as the playwright's canvas is, both parts of "Angels" focus intimately on two couples, one gay and one nominally heterosexual, in which one partner abandons the other. Louis Ironson (Joe Mantello), a Jewish leftist and legal cleric, runs out on his AIDS-stricken lover, a WASP esthete named Prior Walter (Stephen Spinella), once the disease's ravages leave blood on the floor. Joe Pitt (Jeffrey King), an ambitious Republican lawyer clerking in Federal court, deserts his loyal but long-suffering wife, Harper (Cynthia Mace), once his homosexual longings overpower his rectitudinous Mormon credo. Whether intact or fractured, the couples intersect throughout the play, brought together by chance events, by interlocking fantasies (erotic and mystical) and, indirectly, by the machinations of Roy Cohn.

•

As written by Mr. Kushner with a witty, demonic grandeur worthy of a Shakespearean villain, and played with maniacal relish by the braying

Jay Thompson

Ron Leibman

Ron Leibman in high, red-faced dudgeon, Cohn is the Antichrist of "Angels in America": the witchhunting accomplice of Joe McCarthy is seen in his final guise as an unofficial Mr. Fixit in the Ed Meese Justice Department and New York City's most famous closeted gay AIDS patient. In one brilliant passage, Cohn argues that he is a heterosexual who has sex with men rather than a homosexual because gay men, unlike him, are "men who know nobody and who nobody knows, men who have zero clout." It is Mr. Kushner's sly point that gay people could learn something from the despicable Cohn about the amassing of political power, and it is one of the play's most provocative strokes that this cutthroat often has the funniest and smartest lines. For Mr. Leibman, the vindictive, cadaverous Cohn may be the role of his career, and his performance need only shed some Don Rickles shtick to realize it.

His theatrical power is matched by Mr. Spinella's Prior, another kind of AIDS patient entirely. It is the abandoned, delusional Prior who is visited by an Angel at the end of Part 1 and becomes a heaven-sent prophet of survival for his people in Part 2. Mr. Spinella, a bone-thin young man with a boy's open face and an extravagant spirit, is triumphant in this mammoth part, creating an ethereal but tough-spined sprite who fills the theater with his transcendent will to live even as his body is gutted by "inhuman horror." He is the ideal heroic vessel for Mr. Kushner's unifying historical analogy, in which the modern march of gay people out of the closet is likened to the courageous migrations of turn-of-the-century Jews to America and of 19th-century Mormons across the plains.

None of the other performances are in this league, although Mr. Mantello's cowardly Louis shows a lot of promise and K. Todd Freeman sizzles in the comic role of a one-time drag queen who ends up as Cohn's private nurse. Among the rest, the only one that does damage comes from Ms. Mace, whose lost wife exudes brash sitcom brio rather than the disorientation and vulnerability that might make the play's one major female character touching.

•

In their staging of Part 1, Mr. Eustis and Mr. Taccone have not departed radically from the London choreography of the overlapping scenes and celestial revelations. But the execution can be plodding, and the fabulousness of Mr. Kushner's writing, so verdant with what one line calls "unspeakable beauty," is sometimes dimmed. While the appropriately

chosen set designer is John Conklin, the artist who brought so many levitating dreams to the Metropolitan Opera's "Ghosts of Versailles," his central set here, a stylized Federal building emblematizing a decaying body politic, confronts the audience with a visually heavy blank wall and, like the direction, sometimes lumbers when it might spin or shatter.

When the going gets truly heavy in Part 2, Mr. Kushner must share responsibility. The writing retreats to conventionality as he sorts out the domestic conflicts of his major characters. Long debates about the Reagan ethos and the hypocrisies of gay Republicans seem unexceptional after this year's Presidential campaign. But just when "Angels in America" seems to bog down in the naturalism and polemics Mr. Kushner otherwise avoids, it gathers itself up for a stirring cosmic denouement in which Mr. Spinella's Prior, having passed through a spiritual heaven and five years of physical hell, addresses the audience directly from the Bethesda Fountain in Central Park. Envisioning a new age of universal perestroika in which "the world only spins forward," Prior foretells a future in which "this disease will be the end of many of us, but not nearly all," in which "we will not die secret deaths anymore," in which love and "more life" will be the destiny of "each and every one."

Above him hovers the statue of the angel Bethesda. Angels, as Prior explains, "commemorate death" but hold out the hope of "a world without dying." It is that angelic mission of mercy that seems to inform the entire universe of this vast, miraculous play.

1992 N 10, C15:3

Dog Logic

By Thomas Strelich; directed by Darrell Larson, with Joe Clancy; scenic and costume design, Kert Lundell; lighting by Jan Kroeze; composers, Paul Lacques and Richard Lawrence; sound by Tristan Wilson; production stage manager, Anne Marie Paolucci. Presented by the American Place Theater, Wynn Handman, director; Dara Hershman, general manager. At 111 West 46th Street, Manhattan.

Hertel	Darrell Larson
Dale	Joe Clancy
Kaye	Karen Young
Anita	Lois Smith

By MEL GUSSOW

Thomas Strelich's shaggy sense of humor is the motivating force behind his new play, "Dog Logic," at the American Place Theater. This meandering comedy has its canny moments as a man named Hertel, the caretaker of a seedy pet cemetery in the desert, tries to avoid coming to terms with progress. Taking over Pet Heaven cemetery after the death of his father, he finds that it has become valuable property for real estate development. But before a shopping mall is built over the graveyard, Hertel (Darrell Larson) will fight to retain his 40-acre heritage.

The play languishes, drifting through monologues as the caretaker goes about his daily nonduties. Although "Dog Logic" has a wistful respect for more humane times, it is less of a play than it might have been. This is in contrast to Mr. Strelich's previous desert comedy, "Neon Psalms," presented several seasons ago at the American Place. For one thing, the earlier play had a more fully realized central character. Too often, the caretaker in "Dog Logic" chatters away, offering philosophy and anthropology in lieu of narrative.

One thing Mr. Strelich's plays have in common is an empathy for animals. In "Neon Psalms," the protagonist rescued turtles. In "Dog Logic," Hertel is a friend of all household pets, beginning with old Yappy, a dog that died and that now lies buried in Pet Heaven.

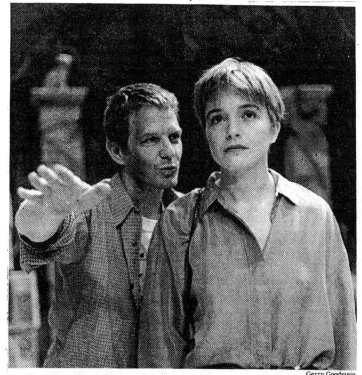

Gerry Goodstein

Darrell Larson and Karen Young in Thomas Strelich's "Dog Logic."

Hertel seems to care more about Yappy than he does about his mother (Lois Smith), and for good reason. Yappy was faithful to him and his father, while his mother abandoned them and pursued a career in evangelism. After drifting away from Jesus and into real estate, she returns to retrieve her share of her husband's will, divided among her, her son and the son's former wife. In eccentric Strelich fashion, the former wife (Karen Young) is a pert and efficient desert police officer.

Although both women are aggressively inclined when it comes to Hertel's lack of gumption, they are also respectful of the morality of his claim. The optimism that pervades the play even alights on the one outsider (Joe Clancy), a bumbling would-be entrepreneur who tries to climb on the real estate bandwagon.

Under Mr. Larson's direction, the actors are rooted in the sandy environment, a kind of pet fairyland in Kert Lundell's design. Ms. Smith plays the mother with a gentle wryness that connotes a woman who has lived in several disparate worlds, and Ms. Young is appealing as an officer torn by indecision. She is fond of Hertel, but when she is with him she feels suffocated by his inertia.

In an excessively wordy role, Mr. Larson maintains his nonchalance and his authenticity as a desert rat who idles away his days and nights, dreaming and watching the weather. For a change of pace, he also looks at animal movies like "Godzilla" on a battery of a dozen television sets. As played by Mr. Larson, Hertel is a sweet-tempered loser who manages to survive.

One wishes the play were more stringent and conclusive. But then it would not be the open-ended work that Mr. Strelich apparently intended. Untidiness is an asset as well as a weakness, as "Dog Logic" circles lazily around itself before settling down in the afternoon sun.

1992 N 10, C22:1

Theater in Review

■ The lighter side of Sean O'Casey in three one-acters ■ A Yiddish family comedy, in Yiddish ■ The essence of sisterhood in a one-woman show.

Three Shouts From a Hill
The End of the Beginning
A Pound on Demand
Bedtime Story

Symphony Space
Broadway at 95th Street
Through Saturday

Three one-act plays by Sean O'Casey; directed by Shivaun O'Casey; set design by Brien Vahey; set decoration by Josie MacAvin; costumes, Nigel Boyd; lighting, Rory Dempster; sound design by Colum and Tommy Sands; production manager, John Ashton; company stage manager, Kate Hyland; production stage manager, Sarah Marshall; company stage manager, John Lyons. Presented by the O'Casey Theater Company of Newry, County Down, Northern Ireland.

WITH: Risteard Cooper, Patrick Fitzsymons, Pauline Flanagan, Gerard McSorley; Madeleine Potter and Shauna Rooney.

Contrary to appearances, the one-act comedy is one of the most difficult of all literary forms to master. The offspring of farce and music hall (and the forerunner of the half-hour sitcom), it is also perhaps the hardest form to bring off successfully. A decidedly mixed evening of three one-acts by Sean O'Casey, billed as "Three Shouts From a Hill" and presented by the O'Casey Theater Company, shows why.

As any farceur can attest, it is a deadly serious game, which is to say if the actor doesn't take it seriously he is dead on stage. Whatever shenanigans take place, the laughs are directly proportional to the credibility of the characters.

The best of these three offerings is "Bedtime Story," a tale of moral caution about a young man caught in post-coital panic after a late-night tryst in his rooms with a lass of loose morals. As he frantically tries to get the woman to leave before a fellow lodger returns home or his landlady awakes, each delay in her departure increases the comic tension. Ably and humorously played by Risteard Cooper and Madeleine Potter, it is funny because the audience believes them.

In "A Pound on Demand," in which an inebriated layabout and his thirsty mate try to withdraw a pound from a Post Office savings account, Gerard McSorley works so hard indicating his drunkenness that he never really connects with anyone else on stage, which is a pity because Pauline Flanagan is an excellent foil as the incensed woman trying to get her letter off to Burma.

In "The End of the Beginning," Mr. McSorley and Mr. Cooper undertake the housecleaning while the wife (Ms. Potter) mows the meadow. Naturally, they break the crockery, spill the oil, smash a window and tether the cow to a chair with a rope dropped down the chimney with predictable results. Yet they set about it with such exaggerated mugging that the catastrophe becomes flat and dull. When Laurel and Hardy, or even Ralph Kramden and Ed Norton, created such disaster they never raised an eyebrow. Even slapstick needs discipline. WILBORN HAMPTON

At the Crossroads

Folksbiene Playhouse
123 East 55th Street

By Harry Kalmanowitz; adapted by Miriam Kressyn; directed by Bryna Turetsky; music director, Renee Solomon; set design, Harry Line; costumes, Guy Geoly; lighting, Alan Baron; production manager, Larry Zolotor; translator, Simcha Kruger; stage manager, Judith Scher. Presented by the Folksbiene Playhouse of the Workmen's Circle, Ben Schechter, artistic director; Morris Adler, president. In Yiddish, with simultaneous English translation.

WITH: Richard Carlow, Mark Ethan, Shira Flam, Celina Gray, Norman Kruger, David Rogow, Amir Shani, Mary Soreanu, Zypora Spaisman and Debra Turetsky.

What's a widowed mother to do?
That nice Benjamin Glick (Yiddish for good fortune) is coming to propose marriage to her, bringing a ring — gold, emeralds and "a diamond for a diamond" — to prove his love.
To marry or not to marry?
Brother Simkha would be all for marriage. After all, this easygoing fellow is madly in love with the ditsy Tzippi. Uncle Nathan, a committed bachelor who writes romances, is another cup of tea. He's against men marrying. "But," he allows, "women may marry as often as they like." Miriam's mother, Esther (Bobsy to her grandchildren), herself a widow, has some advice based on experience: Don't sacrifice your life for the sake of the children.

And what do the children have to say? Flora, who will grow up to study voice at Juilliard, is in favor of the marriage. But Josh, who will become a doctor, is very much against it. He threatens suicide.
So what's a widowed mother to do? And once she has done it, will it prove to have been a wise decision?

The answers in "At the Crossroads" take two acts, three scenes and 13 years to arrive. The play is offered with simultaneous live translation as the opening attraction of the 77th season of Folksbiene, the Yiddish-language theater, at the Central Synagogue, 123 East 55th Street.

"At the Crossroads," written by Harry Kalmanowitz (1886-1966) and adapted by Miriam Kressyn, is the sort of play that lies far closer to soap opera than to high drama. There are lines like "I have a right to live my own life." There are some sweetly melancholy songs. There are mild chuckles, usually provided at the expense of Tzippi (Celina Gray); and Tzippi pushes the evening to its most rousing moment with an uninhibited rendition of "Yidishe Meydl" late in the second act.

Under the direction of Bryna Turetsky, the cast — including such popular veterans of Yiddish theater as Mary Soreanu as the long-suffering Miriam, David Rogow as the mischievous Uncle Nathan, Zypora Spaisman as Esther and such relative newcomers as Ms. Gray and Richard Carlow as Simkha — goes through its paces with the greatest of ease.
But "At the Crossroads" poses no great demands on cast or audience, except perhaps an occasional struggle to hear the translation. Welcome though it may be as an example of the endangered species that is Yiddish theater, "At the Crossroads" is more relic than refreshment.

LAWRENCE VAN GELDER

Sister! Sister!

The American Place Theater
111 West 46th Street

Vinie Burrows's one-woman show; arranged and adapted by Miss Burrows; production stage manager, Ken Starrett; costume designer, Dada's Works. Presented by Ananse Productions.

Vinie Burrows's solo performance piece "Sister! Sister!" sets itself the daunting task of evoking the very essence of womanhood by interweaving the voices of 19 women of diverse

Neil Libbert/O'Casey Theater Company
Madeleine Potter in "Bedtime Story," a one-act play by Sean O'Casey at Symphony Space.

race and culture. The authors of the selections that Ms. Burrows has spliced into a theatrical collage range from the Irish playwright Sean O'Casey to the American poet Muriel Rukeyser to the Ugandan author Okot p'Bitek.

"Sister! Sister!" is subtitled "A Celebration of the Triumphs and Trials of Women the World Over." But unless the strength to endure suffering and sexual discrimination could be called a triumph, the work is primarily concerned with telling the stories of women who are oppressed, neglected and abused. There are no memoirs of pampered princesses, movie stars or yuppie businesswomen, and few of the pieces have happy endings.

The majority of the voices belong to the lower strata of society. Many are women of color. The most famous personage represented is Winnie Mandela. Her stirring speech, "Detention," taken from a United Nations address, offers a devastating description of what political detention in South Africa really means and bluntly calls for black liberation from the oppressive white majority.

Although many of the show's fragments are closer to recitations than to full-blown dramatic turns, "Sister! Sister!" has its powerful theatrical moments. In the funniest and longest selection, from Mr. p'Bitek's "Song of Lawino," Ms. Burrows impersonates an African village woman with no education whose primitive view of Western cultural mores, in particular the custom of telling time, offers a lesson in cultural relativism.

In the show's most anguished moment, the actress becomes an innocent 13-year-old cotton picker who is brutally raped by a drunken neighbor and intimidated into keeping silent. It reveals Ms. Burrows, a veteran of

many Broadway and Off Broadway shows, to be an actress of range and commanding passion.

STEPHEN HOLDEN

1992 N 11, C18:3

Leaving the Homeland for a New Life in America

By MEL GUSSOW

Special to The New York Times

PRINCETON, N.J., Nov. 8 — The dislocation of exiles in America is given a melancholic treatment in "Between East and West," a brief two-character mood piece by Richard Nelson at the McCarter Theater. In a series of precise and subtle vignettes, a Czechoslovak director and his actress wife are seen going through a difficult period of adjustment.

After fleeing their native country for political reasons, the two find themselves without cultural baggage. Having left behind language as well as theatrical credentials, they have to start their careers and their lives from scratch. One of the artful ways that Mr. Nelson pictures their displacement is to show them experiencing the kind of problems any American tourists or émigrés might feel in a foreign country.

The husband (Jeffrey Jones) wants to visit Harlem but finds himself standing on a subway platform unsure about which train to take. Embarrassed by her limited English, the wife (Maria Tucci) is afraid to go shopping unless she can buy something from a machine. When the director travels to Hartford to stage a play, his wife packs food for his trip and also rolls of toilet paper. He assures her that Hartford is not Siberia.

The time is 1983, before perestroika, and in the background there are television reports on the continuing cold war. Remembering the distant Prague Spring, they are unable to believe any promise of change in Czechoslovakia. It was to be six years before the election of Vaclav Havel as the president. Within this political context, the playwright focuses tightly on the highly personal dilemma.

It is interesting to see this 1985 play after such recent large-scale Nelson works as "Two Shakespearean Actors" and "Christopher Columbus and the Conquest of Japan." Just as Mr. Nelson is challenged by the expansiveness of epic theater, he is stimulated by the demands of creating character through the sparsest of words and the most low-key of dramatic situations.

Although the husband seems to undergo a smoother transition, he never completely loses his naïveté about American opportunity. His wife simply gives up before she tries. Both actors deliver touching performances, with Mr. Jones locating the insecurity behind the director's optimism and Ms. Tucci conveying the actress's self-imposed invulnerability. Fearful of failure, she will not let America touch her.

Each remains a displaced person, finding a brief union only in their memories of Prague, especially memories of their life in the theater. With a certain stoicism, the director keeps trying, in the firm belief that in

the United States a Czechoslovak can be a poet rather than a Czechoslovak poet. As a dreamer, he seems eager to lose his identity, or at least to assimilate into a new identity. Gradually we realize the disparities that divide them, symbolized by a scene in which the author replays the couple's reaction on first moving into their new home. The scene is run twice, once from each point of view. It is the husband, as always, who puts a gloss on the actual event.

Mr. Nelson characterizes the continuing language barrier by having the actors use unaccented English when they are supposed to be speaking Czech, but an accent when they speak English. In the most poignant scene, they read from "The Three Sisters," shifting between languages and discovering points in common between themselves and Chekhov's characters. In the wife's case, it is the line "I long to go home" that resonates.

As directed by Jack Hofsiss, the play swims in the vastness of the McCarter stage. The couple's low-rent apartment looks like a large SoHo loft before renovation. The play would, I think, be even more evocative in a confined space. In spite of that fact, the actors achieve an intimacy. Acting as sympathetic witnesses to their homelessness, we watch them disconnect with their new country and with their future.

1992 N 12, C20:1

Cambodia Agonistes

Text and lyrics by Ernest Abuba; music by Louis Stewart; directed and staged by Tisa Chang; sound, Jim van Bergen; lighting, Deborah Constantine; set, Robert Klingelhoefer; costume, Juliet Ouyoung; Cambodian choreography, Sam-Oeun Tes; Chinese choreography, H. T. Chen; orchestration, Jack Jarrett, Kevin Kashka and Mr. Stewart; production stage manager, Robert Mark Kalfin. Presented by the Pan Asian Repertory Theater, Ms. Chang, artistic and producing director. At Playhouse 46, St. Clement's, 423 West 46th Street, Clinton.

WITH: June Angela, Ron Nakahara, John Baray, Richard Ebihara, Lou Ann Lucas, Virginia Wing, Sam-Oeun Tes and Hai Wah Yung.

By MEL GUSSOW

The horrors of Cambodia's killing fields are evoked with deep conviction in the musical "Cambodia Agonistes." With music by Louis Stewart and book and lyrics by Ernest Abuba, this is a collaborative undertaking of the Pan Asian Repertory Theater.

The polarities of the musical drama are set by two words that appear in a glossary in the program: angkor, the golden age of Cambodian civilization, and angka, the ruling organization of the Khmer Rouge. From one to

Kim Garnick for The New York Times

John Baray of the Pan Asian Repertory in "Cambodia Agonistes," at St. Clement's Playhouse 46.

the other is a leap from classical beauty to a reign of terror, both of which are tellingly captured on stage.

At the center of the narrative is a Cambodian dancer (June Angela), a refugee in America suffering from psychosomatic blindness. She has experienced so much in her homeland, including having her child taken from her, that she is forced to block "misery from her memory." As skillfully directed by Tisa Chang, the play swirls in and out of the dancer's consciousness and through recent Cambodian history. The approach is more symbolic than sequential as the indictment against the dictatorship mounts.

With a rueful awareness of the apparent contradictions, the creators of "Cambodia Agonistes" tell the story using classical Cambodian dance, costumes, masks and rituals. Repeatedly, the old and the new are juxtaposed, and the old is undermined in the name of revolution.

When we first encounter the dancer, she is working in a New York sweatshop. With her as guide, we are led back to Cambodia. In a sequence of vivid scenes and songs, a stand-in for Pol Pot embarks on his corruptive climb to omnipotence.

In stylized form, we see the torture and murder of citizens as treachery becomes an everyday occurrence. The Brechtian titles of songs identify the madness: "Song of the Happy

Killer," "Wisdom Is a Sin Against the State." The score is a sinuous blend of classic and modern, Eastern and Western sounds. Mr. Stewart's music has its own insistent beat, with an occasional flavor of an Orientalized Kurt Weill. The songs move effectively from recitative to rap while interposing lilting numbers for Ms. Angela.

The show is, if anything, too ambitious. Not all of the complex elements can be clearly communicated in the relatively brief time and in the economical staging. Despite the long developmental process, it retains its rough edges and narrative confusions. Mr. Abuba's book has a billboard of atrocities, the accumulation of which tends to lessen the impact. But the show is relentless in its approach and burrows its way into the audience's conscience. The strengths are in the subject matter, the score and Ms. Angela's performance.

The actress has a graceful delicacy in both her voice and her movement. She joins with Sam-Oeun Tes, a danc-

A musical finds a dual tragedy in the killing fields.

er and choreographer, in affirming the harmonies of Cambodian court dance, in which hands are as important as feet. With her towering headdress, Miss Tes looks like a dancing temple.

Although Ron Nakahara does not have the musicality to carry the dictator's few attempts at singing, he plays his role with a glowering conceit as a tyrant who relishes his own villainy. In one crucial scene between the dictator and the dancer that encapsulates the barbarism of the regime, he taunts her to serve his sinister purposes and she momentarily considers going along with him for her own vengeful reasons.

While seeking her missing son, the dancer pursues a course of revenge against her oppressors. Eventually she is forced to accept the solitary quality of her journey, realizing that "there are no shadows that can be trusted." The musical leaves the audience with a sense of loss, trying to comprehend how a nation can sacrifice its people as well as its defining traditions.

1992 N 13, C3:1

SUNDAY VIEW/David Richards

Stacy Keach Plays Pac-Man In a Gadget Play

'Confinement' stars the scenery.

Bill Irwin seizes the heroism in Beckett.

'The Show-Off' shouldn't have.

"**S**OLITARY CONFINEMENT" IS one of those theatrical thrillers about which little can be said without divulging the surprises that are its only reason for being. But I guess I'm not spilling any beans by noting that the work (at the Nederlander Theater) is a piece of state-of-the-art junk.

The set, which represents the aerie of the reclusive billionaire Richard Jannings in Albuquerque, N.M., comes equipped with the latest in video technology, computer-run security systems, electronically activated wall safes and paper shredders and I can't begin to tell you what else. If the Sharper Image is your favorite store, you will take instantly to William Barclay's scenery, which performs as industriously as any actor in the cast, including Stacy Keach, its hard-working star.

At the touch of a remote control, a large television screen lights up center stage or a well-stocked bar glides on or impregnable steel panels drop into place, sealing off doors and windows. A wall swings open, a desk automatically opens up, while a dumbwaiter proves not so dumb after all. Even a matched set of armor, although harking back to less sophisticated days of self-protection, manages to figure significantly in the proceedings.

Despite a script by Rupert Holmes, author of such convolutions as "The Mystery of Edwin Drood" and "Accomplice," "Solitary Confinement" turns out to be mostly about gadgetry. It's like a big video game, with this advantage — you can play it seated in a theater, not standing in an arcade.

From the evidence on the stage of the Nederlander, here's what I deduce about Mr. Holmes: he devises impossibly clever treasure hunts and hides the prize where no one ever finds it. His riddles are the puzzle and

Martha Swope/"Texts for Nothing"
Bill Irwin in "Texts for Nothing"—A perpetual state of high alert.

the admiration of the neighborhood. ("Did you hear that nice Mr. Holmes's latest brain-teaser, honey?") When he throws a costume party, he fools everyone by showing up as the caterer. Then, the hoodwinked guests laugh and laugh about it for weeks.

"Solitary Confinement" is deviously and intricately developed, no question of that. The hitch is, the play isn't very solidly grounded to begin with. To have an about-face, you initially need a face. And you can't sabotage a foot race unless you lay out the official course beforehand. With Mr. Holmes, however, you get the idea that the devilish tricks and the frantic flip-flops occur to him first, after which he assembles a plot around them as best he can. The preposterousness of the enterprise doesn't bother him, as long as no one beats him to the finish line. He's one of those playwrights who insist on having the last coup de théâtre.

This much I can tell you. Richard Jannings (Mr. Keach) — who is either mildly eccentric or certifiably insane — lives in splendid isolation on the 51st floor of a high-rise complex, the international headquarters, apparently, of his vast financial and industrial empire. He entertains no one. Whenever he needs to communicate with the outside world, he relies on a closed-circuit television network that allows him to talk with and observe the members of his staff. They, of course, can't see him.

Trouble is brewing in this paradise, though. Someone has sent Jannings a straitjacket. Then he calls up the night watchman on the video screen just as the poor creature is being strangled with a piano wire. (I say piano wire because the notion pleases me. I couldn't tell for sure. Maybe it was yarn.) Jannings's mind is elsewhere and he doesn't spot the crime. But the next time he checks in on the watchman, a killer in a gorilla mask is manning the post and threatening to invade the billionaire's inner sanctum.

The cat-and-mouse game that ensues borrows its elements from such honorable television shows as "Let's Make a Deal," "Name That Tune" and "Beat the Clock"; from such enduring games as chess, Clue and blindman's buff; and from such age-old male rituals as jousting, dueling and pushing your adversary into a trunk. The directors Kenneth Frankel, who staged the play originally in California, and Marshall W. Mason, who has polished it up for Broadway, have coordinated not only seven different performances but enough special effects for a dozen plays. The logistics are mind-boggling, even if the suspense isn't.

Mr. Keach ends up carrying the lion's share of the evening. He can appear smooth and debonair one moment, vulgar and scruffy the next, although even when he's in a tuxedo and minding his manners, he can't entirely divest himself of a faintly sinister aura. Over a long career, he has ascended the classical heights, just as he has descended to the pop-culture lows, which is what he's doing here. "Solitary Confinement" brings out the scenery-chewing side of him, but I will say this: there's plenty of set for him to munch on.

'Texts for Nothing'

Descartes, as it is well known, functioned on the assumption that "I think, therefore I am."

The characters of Samuel Beckett, every bit as philosophical, subscribe to the proposition that "I talk, so maybe I am. On the other hand, maybe I'm not. In the meantime, I'd better keep talking."

Wherever they find themselves — in no man's land, an ash heap, a funeral urn or the pitch-blackness just before the world's end — they natter on, trying to put sense into their

Joan Marcus/"Solitary Confinement"

Stacy Keach in "Solitary Confinement"—There are enough special effects for a dozen plays in this whatdunit.

lives, but mostly just wanting to stave off the roaring silence. The tramp played by the spectacularly talented Bill Irwin in "Texts for Nothing" (at the Joseph Papp Public Theater) is like all the others whose metaphysical reach exceeds their grasp. He falls over his words. He falls over himself. He falls down. Then, to hell with the cosmos. What matters most is "getting standing, staying standing, stirring about."

The 65-minute evening is an adaptation of Beckett's 1955 work of fiction "Texts for Nothing," to which the adapters Joseph Chaikin and Steven Kant have appended a brief coda from Beckett's 1961 novel, "How It Is." In places, the script is dense with anguish and fragmented imagery, and you lose your bearings. In other places, it is so spare and lucid that the Beckettian landscape stands out with terrifying clarity. But that's probably as it should be. To the extent that you both do and don't understand, you are in the quintessential Beckettian fix.

"What variety and at the same time what monotony," observes Mr. Irwin, as he contemplates "this inextricable place" to which he has been drawn — a wooden promenade of sorts, designed by Christine Jones, that rises into a steep wall behind the performer and seems to slope away toward an unseen precipice in front of him. He's come in search of the view, a new perspective, "a way out." A way out, however, suggests that there is a way *in*, and that by passing from one to the other, a person might cover some distance, do something, experience change. Mr. Irwin is not so sure. "What elsewhere can there be to this infinite here?" he asks himself dispiritedly.

Stuck for the time being, which is to say for all time, he engages in the same activities that distract the baggy-pants clowns, the homeless derelicts, the talking heads and the disembodied voices who complain and joke from one end of Beckett's oeuvre to the other. He speculates about life's purpose (to no avail). He recalls the past (hazily). He considers ending his woes (but lacks the courage). He wonders if companionship would make the interminable present more bearable (probably not). He resolves to leave (and goes nowhere).

Mr. Irwin's antic behavior made him a very companionable guy in

such entertainments as "Largely New York" and "The Regard of Flight." He and David Shiner, clowning around together, were the runaway hit of last summer's Serious Fun Festival at Lincoln Center in an untitled romp that's coming to Broadway in February as "Fool Moon." But the physical dexterity takes on an added dimension in "Texts for Nothing," where the deteriorating body and the wandering mind rarely operate in concert.

"I say to the body, Up with you now, and I can feel it struggling, struggling no more, struggling again, till it gives up," muses Mr. Irwin, early in the

George Kelly wrote a leisurely play that's more interested in character than in incident.

evening. "I say to the head, Leave it alone, stay quiet, it stops breathing, then pants on worse than ever. I should turn away from it all, away from the body, away from the head, let them work it out between them, let them cease, I can't."

We've got a battle royal going on here. And who better than Mr. Irwin to think right and stride left at the same time, to yearn with the heart and despair with the shoulders, to puff up on the outside, while collapsing on the inside. The performer, in fact, very often seems caught *between* mind and body — the mind doing its pitiful thing, the body suffering indignities of its own. That leaves Mr. Irwin's choirboy countenance to express bewilderment, spite, rage, or a foolish fleeting joy for the sake of some old time largely forgotten. At the end, the onrush of panic drains the actor's face of any color, save for the innocent, baby-bootee blue of his eyes, while a chilly white light closes in on his head. Like Winnie in "Happy Days," he is up to his neck, going down. Chattering on. The last magpie.

Mr. Irwin brings heroism and gallantry to the ordeal, as do the best interpreters of Beckett's plays. Granted, it's the sort of heroism that holds its ground because there's no place to flee, and the sort of gallantry that can't be content with a low bow but has to push on to a pratfall. Still, a sense of the grand gesture is what separates the men from the beasts.

In his capacity as director, Mr. Chaikin keeps Mr. Irwin in a perpetual state of high alert, priming him for big events and invariably obliging him to settle for twitches of rheumatism. What happens in "Texts for Nothing" is really no different from what happens in any center ring. Both involve elevated hopes, a lot of running around, thwarted expectations and a blackout.

'The Show-Off'

The Roundabout Theater Company could be pointing to a charming re-

vival of "The Show-Off" right about now if only it *had* a showoff. Everyone else in George Kelly's 1924 comedy (at the Criterion Center on Broadway) is present and accounted for. As Boyd Gaines portrays him, however, Aubrey Piper, the $32.50-a-week railway clerk with a $1 million opinion of himself, isn't half the blowhard he could be. And if the role is less than dazzlingly played, the production as a whole is in for some bumpy sledding.

All the other characters, you see, spend the play either loving or hating him. Mostly hating. As soon as Piper enters a room, he takes over — slapping any available back, spouting his latest schemes and generally offering himself to the world as a titan of industry and a paragon of wisdom. Despite a cheap wig that looks rather like an oil slick oozing down his forehead, he fancies himself a dandy. And notwithstanding the outrageous lies he tells, he sees himself as a defender of the truth. It's just that truth needs a little doctoring now and again.

In three acts, Kelly's play shows how Aubrey descends upon the respectable Fisher family of Philadelphia, marries one of the daughters, moves into the house and wreaks havoc on the clan's ordered existence. No one takes this too well, especially Mrs. Fisher, the mother (Pat Carroll), who's something of a sourpuss to begin with and doesn't need an obnoxious son-in-law getting on her nerves. The more he brags, the more she fumes, which only exacerbates his thirst for attention and guarantees a more outlandish story the next time he opens his mouth.

A death in the Fisher family, a $1,000 insurance policy and a crazy automobile accident complicate the plot in ways that probably won't take you by surprise. Kelly wrote a leisurely play that's more interested in character than in incident, and then primarily in a resolutely middle-class kind of character not without a whiff of bigotry. Still, he was a shrewd observer. Although he would win a Pulitzer for "Craig's Wife" the following year, "The Show-Off" is the better work and just feisty enough to qualify as a minor classic of Americana.

■

In a revival mounted by the A.P.A./Phoenix in 1967, Helen Hayes, then beginning to resemble a crusty apple-doll, and a preening Clayton Corzatte faced off memorably over the Fishers' Victorian furniture. (Among her other achievements, Miss Hayes had the astonishing ability to suggest in moments of anger that jets of steam were shooting from her ears.) The Roundabout, less blessed, can only claim half of that equation.

Ms. Carroll is holding up her end of the deal. The indignant huffing and puffing, the dark looks-that-could-kill and the starts of exasperation that ripple her multitudinous chins make their point, but they don't overwhelm the actress's fundamental good nature. While she lays down the law regularly, she doesn't really have the heart to enforce it. Ms. Carroll, who played Falstaff not too long ago, gives what are usually termed big, fearless performances, and does so here.

The trouble is that Mr. Gaines gives a tiny one — neither funny nor

inventive enough to cause much of a commotion. He's a minor squirt, not a major braggart, and it doesn't seem quite right that the sound of his footsteps in the hallway of Ben Edwards's triumphantly dowdy set is enough to send everyone into a deep tizzy. I think the actor misses on one other count, as well. At no time does he ever let the bravado fall and show us the insecurity underneath. He's pure cock-a-doodle-doo — inside and out.

As Aubrey's fiancée and later his wife, Sophie Hayden clasps her hands to her bosom and gazes at him with stars in her eyes. (It is her good fortune to see something that no one else does, although it would help this production considerably if we saw a bit of it, too.) Laura Esterman is the older Fisher sister, over whose eyes wool is not so easily pulled, while Tim DeKay is the inventor brother who will hit the jackpot — $100,000 and a trip to Trenton — with his formula for an anti-rust solution. The three are swell. In fact, the director, Brian Murray, has cast congenial performers pretty much down the line.

In the end, however, it's Piper who calls the tune. "The Show-Off" can only be as entertaining as he is annoying, as fresh as he is eccentric, as heartwarming as he is secretly vulnerable. Mr. Gaines anchors the Roundabout production firmly in mediocrity. ☐

1992 N 15, II:5:1

Joined at the Head

By Catherine Butterfield; directed by Pamela Berlin; scenery by James Noone; costumes by Alvin B. Perry; lighting by Natasha Katz; sound by John Kilgore; production stage manager, Karen Moore. Presented by the Manhattan Theater Club, Lynne Meadow, artistic director; Barry Grove, managing director. At City Center Stage II, 131 West 55th Street, Manhattan.

Maggie Mulroney.........................Ellen Parker
Jim BurroughsKevin O'Rourke
Maggy Burroughs..........Catherine Butterfield
With: Neal Huff, Becca Lish, Elizabeth Perry, John C. Vennema, Sharon Washington and Michael Wells.

By MEL GUSSOW

As "Joined at the Head" begins, Maggie Mulroney is in Boston on a book tour for her new best-selling novel when she gets a telephone call from her old high school boyfriend. But what happens next in Catherine Butterfield's play is not the standard "Peggy Sue" look back at the 1960's. "Joined at the Head," which opened yesterday at the Manhattan Theater Club, is a jaunt into the writer's mind, a vibrant reflection on life, art and friendship.

In this, her first full-length play to be presented in New York, Ms. Butterfield is revealed as a playwright with a refreshing talent for probing the reality of relationships. The play is filled with inner voices and second thoughts. In a manner related to that of Tom Stoppard and John Guare, the work deals enticingly with truth and fiction. Whenever things threaten to become too literary, the playwright quickly edits herself.

Although the play is episodic, it is free flowing, ducking in and out of the protective theatrical framework. The playwright nimbly shifts her course

Gerry Goodstein/"Joined at the Head"
Kevin O'Rourke and Catherine Butterfield in "Joined at the Head."

until no artificial wall is left unbroken. For the audience, there is a pleasurable sense of engagement in the creative act and in the author's unmasking of her characters.

When the novelist visits her old boyfriend and his wife (who not so coincidentally is also named Maggy), she interrupts the apparent domestic harmony to offer shrewd comments directly to the audience. Maggie the novelist (Ellen Parker) always has something smart to say, sometimes to her own disadvantage. But there comes a point when she begins to sound like A Writer, and it is exactly at that juncture that the other Maggy steps forward to lighten things up by telling us her divergent side of the story.

•

As Donald Margulies did in "Sight Unseen" last season on this same stage, an artist looks at the present through the prism of the past. In Ms. Butterfield's play, Maggie prepares to write the novel that is the play we are seeing. She keeps insisting she is only the narrator and the backdrop, that it is the other Maggy who is the protagonist. Actually the play is about the two Maggies. Although they were absolute opposites in high school, they prove to have a symbiosis, which has to do with more than the man both of them have loved.

The play achieves an extra spark because the married Maggy is played by Ms. Butterfield. A charming actress, she tosses off her lines as if she had written them herself (and of course she has). Both she and Ms. Parker offer lovely performances in roles that deal tellingly with questions of identity and mortality. Despite the fact that she has a serious illness, Ms. Butterfield's Maggy remains pragmatic, with a constantly replenishing personality. Ms. Parker's Maggie is edgier and relentlessly self-analytical.

As the three former schoolmates reminisce about not so happy old times, memories collide with facts, and the dialogue retains its pithiness. We hear about Gina Laszlo, the golden girl who peaked in her senior year.

Gina was last seen in a parade on a float advertising her husband's Pontiac dealership, providing the trio — and the audience — with a lingering laugh about false values of high school days.

The play's problem area is the husband (Kevin O'Rourke), who is more an observer than an active participant, although eventually he confesses his feelings in a Socratic dialogue with himself. A watchful Maggie

Truth and fiction blurred by inner voices and second thoughts.

might have made him into a more expressive character, and she might also have reduced an extended sequence in which a landlady serves sentimentally as a substitute mother. There is still room for self-editing.

•

The central story line is enhanced with amusing overheard conversations that could act as journal notes for future books by the novelist. In a series of sardonic set pieces, the playwright also mocks pushy television interviewers and heartless hospital attendants, among others. That television interview is a slap at armchair academics, as the fusty host overanalyzes and misreads Maggie's novel (same title as the play we are seeing). He concludes that it is "a searing indictment of the father-daughter relationship." The novelist intended it as a funny book and prefers one of her earlier more serious works.

"Joined at the Head" wins both ways, as a comedy and as a play about the process of art and the discovery of kinship. It asks how such seemingly disparate women could have so much in common. In a short span of time, they become more than

friends; they are the incarnation of the title of the play.

Pamela Berlin has directed the work as an adagio movement, with James Noone's scenery gliding on wheels and a troupe of agile supporting actors (the true backdrop of this story) playing a panoply of characters. At the curtain call after a recent performance, a theatergoer called out, "Author, author." "Joined at the Head" is a striking accomplishment for Ms. Butterfield as author, actress.

1992 N 16, C16:1

Rockettes And Elves: Christmas Is Near

By LAWRENCE VAN GELDER

One deer a-sleighing, two skaters skating, three lumpy camels, two mighty organs and one Santa Claus. Not to mention 60 years' tradition, 72 legs a-kicking, 100 cast members and a horde of happy fans. Yes, "The Christmas Spectacular" is back, off on a 179-performance run that is expected to pull a million people into Radio City Music Hall before it ends on Jan. 6.

Driven by energy and verve, the 90-minute "Spectacular" is a mad dash through the season, tossing together everything from a Reader's Digest enactment of Dickens's "Christmas Carol" to an abbreviated version of Tchaikovsky's "Nutcracker" performed by humans costumed as various species of bears, to the hardworking, always welcome Rockettes giving new meaning to the word precision with a show-stopping march through "The Parade of the Wooden Soldiers."

•

Not to be overlooked either are romantic evocations of New York City, from the Art Deco tip of the Chrysler Building to Prometheus and the Christmas tree at Rockefeller Center to the skating ponds of Central Park and the scores of carols and hymns and pealing bells. Of course, there are the Rockettes, dancing and playing xylophones attached to the backs of one another's costumes; the huge orchestra delivering the essence of the season as its pit glides up, down and behind the stage; a new number, "Santa's Toy Factory," which features assorted elves, Santa and the Rockettes, disguised as orange-haired rag dolls, which may best be savored by the extremely young, and, of course, the Nativity scene that brings the show, sponsored by Chemical Bank, to its reverent climax amid sheep, camels, donkeys, Wise Men, dramatic lighting and gleaming stars over the Holy Land of long ago.

There's really nothing like "The Christmas Spectacular." Sixty years old. Forever young.

Kitschy coup!

1992 N 17, C16:3

3 From Brooklyn

Conceived and directed by Sal Richards; musical director, Steve Michaels; music and lyrics by Sandi Merle and Mr. Michaels; set design by Charles E. McCarry; lighting by Phil Monat; sound by Raymond D. Schilke; production stage manager, Laura Kravets. Presented by Michael Frazier, Larry Spellman and Don Ravella. At the Helen Hayes Theater, 240 West 44th Street, Manhattan.

WITH: Sal Richards, Raymond Serra, Roslyn Kind, Bobby Alto, Buddy Mantia, Adrianne Tolsch and the B.Q.E. Dancers.

By MEL GUSSOW

Jackie Mason begat "Catskills on Broadway," which begat "3 From Brooklyn," and in the third generation of comedy shows, there is a definite thinning of the line. This revue, which opened last night at the Helen Hayes Theater, is a random series of lounge acts and second bananas who pass time until the headliner appears. But in this case, there is no headliner, only Sal Richards, a comedian who conceived and directed the show. His first words ring with accuracy. Addressing the audience, he says, "I know you people have no idea who the hell I am."

"3 From Brooklyn" takes place on a mock street lined with front stoops. A four-piece combo is crowded into a corner marked garage. The opening act on the bill is a trio called the B.Q.E. Dancers; they are the three in the title. Guy Richards, whose father is Sal Richards, and his two partners do an athletic street dance that is no better or worse than that given by the average outdoor performers in Times Square.

From there on, the show segues into a semblance of a storyline, in which Raymond Serra, playing a Brooklyn cab driver, leads the cast in expounding on the ethnicities, favorite sons and foods of the borough (from bagels to cannoli), each of which is intended to draw applause of recognition. He also offers words of sugary sentimentality. In Brooklyn, we are told, there are "different people but with one goal: happiness," which might come as a surprise to some who live in Crown Heights.

The performers include Roslyn Kind, Barbra Streisand's sister, who tries to establish her individuality by opening her act with "People" and following it with other songs identified with her sibling. Later, she sings while sitting on the apron of the stage and thereby calls our attention to another celebrated singer. Bobby Alto and Buddy Mantia are two men in ties and tails who look as if they have just come from a funeral, carrying their jokes with them. Their cen-

Adrianne Tolsch in "3 From Brooklyn" at the Helen Hayes.

terpiece is a feeble Italian version of "The Wizard of Oz."

As this shopworn revue ambles along, there is one momentary bright spot: Adrianne Tolsch, a standup comic who tells stories about her raucous aunts and their grating voices and her own days growing up in Brooklyn. At least there is an edge to Ms. Tolsch's comedy. But in common with her colleagues, she seems excessively pleased to be on Broadway, albeit at the price of being in "3 from Brooklyn."

More than an hour into the show, Sal Richards makes his appearance, bringing with him a barrage of Italian jokes (and some Jewish and Polish ones). He works hard to little effect; he is all warmup. Then he arrives at his specialty: impressions. He asks the audience for suggestions.

At Wednesday's matinee, theatergoers shouted out the names of Perry Como, Frank Sinatra and Danny Kaye, and he ignored all of them — his one amusing touch — to do Dean Martin, followed by Johnny Cash singing "I'll Walk the Line" in Italian. The impersonations are not precise. The comedian says Sammy Davis Jr. told him that in his imitation of him, Mr. Richards captured his look but not his voice. Then he proves that Mr. Davis was wrong on the first count.

Mr. Richards ends the show short of two hours, informing theatergoers that he is saving them an extra $20 on their parking fees. Call it a public service.

1992 N 20, C3:1

SUNDAY VIEW/David Richards

A New Haunting Musical Triumphs

In Chicago, 'Wings' is an unlikely triumph. Based on

Arthur Kopit's drama of a stroke victim, it is passionately alive.

CHICAGO

FOR A WHILE, WHEN TELEVIsion stations didn't operate round the clock, they would sign off with brief film clips meant to be inspirational. The imagery was usually majestic — golden sunsets, the ocean's mighty surf, or Old Glory, waving over waving amber fields.

One — supplied, as I recall, by the United States Air Force — showed a glistening jet soaring into the pale blue yonder, while a grave voice, the pilot's, described the sensation of slipping off earth's moorings and brushing up against "the face of God."

This little bit of sentimental uplift came back to me the other day as I was leaving "Wings," a musical adaptation of Arthur Kopit's 1978 drama that is playing at the Goodman Studio Theater here. Without the mawkish words or panoramic images, "Wings" does precisely what that sign-off claimed to do: it elevates an audience to a rarefied realm, where the weight of existence melts away and grace actually seems within touching distance.

Playing Emily Stilson — an older woman who suffers a stroke and is plunged into the world of scrambled words and short-circuited thoughts that is aphasia — Linda Stephens gives a sublime performance, equal to any on a New York stage right now. But if "Wings" is very much her triumph, it also signals the bountiful promise of its youthful creators, the composer Jeffrey Lunden and the librettist Arthur Perlman.

While Mr. Kopit himself has written books for musicals — "Nine" and "Phantom," a version of "The Phantom of the Opera" — the idea of musicalizing "Wings" is not one that springs automatically to mind. ("Indians," the playwright's 1969 Wild West show and phantasmagoria, would be a far more likely candidate.)

Mr. Lunden and Mr. Perlman not only had a vision of what could be, but they have held to it with passionate integrity. There was always an odd, fumbling poetry about Emily's gallant struggle back to coherent speech. Having her *sing* the nonsensical words and the broken phrases bobbing around in her head, however, merely reinforces the notion that she is not communicating normally. As she recovers her ability to talk, Mr. Lunden lets his music expand and grow ever more melodious. And that swelling heightens Emily's achievement — bearing the hard-fought words upward, buoying her damaged spirit and lifting ours along with it. The score has only a few self-contained numbers. Mostly, it is a lovely kaleidoscopic coming together of sound and sense, thought and feeling, discord and harmony.

In her adventurous youth, Emily was an aviatrix who walked fearlessly on the wings of the family biplane and turned exhilarating loop-the-loops in clouds thick enough to blank out the earth. So the images of flight that run throughout the 90-minute piece are natural metaphors for her condition. Just as she once plummeted dizzyingly through space, she is now falling through inner space. Lost in the darkness of the night sky, lost in the darkness of a mind — it's the same thing. "What a strange adventure I'm having," she sings to herself, bewildered but curious to press on and discover where she will land.

"Wings" begins with a jaunty jazz-age ditty about "the new daredevils of the sky," playing on an old Victrola. A smile of recogni-

tion crosses Emily's face. Then, the music starts to slur and growl, as if the Victrola were breaking down. Emily is having a stroke. From that point on, the musical takes us inside her head. We perceive her hospital surroundings as she does — as bright shards of reality in endless layers of gauze. And we hear what she hears: echoes of outside life, sentences that approach meaning only to skitter off into incomprehensibility, and the awful blips and wails that evoke an emergency or an emergency ward.

Little by little, the murkiness is transformed into a maze of doors and corridors. A dialogue — most of which is sung — detaches itself from the cacophonous swirl. Emily's doctor (William Brown) and her nurse (Ora Jones) come into focus. The patient is making progress, although at first she needs superhuman concentration and a certain blind luck to identify a toothbrush. ("A toooov . . . brum?" she ventures tentatively.) With breathtaking simplicity, "Wings" goes on to chart her hesitant recovery; her budding friendship with a therapist (Hollis Resnik) who could be her daughter, and the group therapy sessions that are like kindergarten for adults starting over.

∎

Pointing to her head, she asks a fellow patient, "Does it . . . you know, here, does it ever all of it come back?"

Then, when it looks as if it does, and Emily seems to be regaining the vocabulary to accompany her reawakened emotions, a relapse hurls her back into the void. The signposts of the external world go dark, and she is alone in a pool of light, dying. In the musical's exultant view of death, however, she has merely taken flight one more time. The curiosity and bravery that prompted her girlish exploits in the sky have seized her anew.

Ms. Stephens, her face aglow with wonder, her delicate hands reaching for what's ahead, is transcendent in the final (untitled) number. "I'm going out now/ Where I land — well, we'll see," she sings, the soprano voice sure and brave. "I shut my eyes, I feel the wind/ And I am soaring on wings." The actress's performance is so uncompromising that it permits what, under other circumstances, would be the most maudlin of reflections: the wings that are transporting her this time may be those of an angel.

But then "Wings" has a rare ability to raise profound questions, all the while it is telling a story that is almost defiantly simple. Where do words come from? How much — or how little — of our experience do they explain? Is there meaning exclusive of them?

At one point, Emily senses "something wet from both my eyes" and, after a long, agonizing search, recognizes the wetness as "tears."

"And do you know what that means?" the therapist asks gently.

After another heartbreaking search, Emily sings, "It means that I am . . . sad."

Later, in one of the evening's most resonant scenes, Emily rediscovers snow while walking in the park. As soon as she reaches out and picks up the white substance, all cold and crisp, she knows what it is and can recall a long ago time when she fashioned it into a sort of ball, a *snowball*. When she lets the flakes fall through her fingers, however, the word falls away, too, and the memory with it.

But isn't that true of life? Grasped, it has meaning and value. Otherwise, it slips away, forgotten, into nothingness. Like Mr. Kopit's play, this miraculous little musical evokes the glory and mystery of consciousness itself.

The director, Michael Maggio, exercises a masterful control over the production. There isn't a moment

that he hasn't shaved down to its essentials, an emotion that he hasn't distilled of its impurities. But he brings something greater than dramatic rigor to "Wings." Until he underwent a successful double-lung transplant last year, his own life was

in jeopardy. He understands Emily intuitively, having journeyed over similar landscapes and conquered many of the same paralyzing fears. This accounts, I think, for the scrupulous honesty of the evening. Nothing is sentimentalized or overstated. Mr. Maggio wants to present "Wings" as cleanly, as soberly, as possible, knowing that if he does, it cannot fail to move us.

The designers — Linda Buchanan (sets), Robert Christen (lights) and Richard Woodbury (sound) — have made simplicity their goal, too, and their work is no less revelatory. The overlapping of filmy panels alludes to the fractured world of Cubist paint-

'Wings' has a rare ability to raise profound questions.

ing, at the same time that it suggests the various levels of awareness through which Emily is moving. A sudden shaft of brightness striking a face or a prop is akin to an idea popping into her mind, while the wires that stretch across the stage, like lines in a Feininger canvas, are the perfect expression of flight and Emily's intrepid younger days.

∎

Ms. Stephens's performance is the soul of the production. She is impeccably supported, however, by a handful of Chicago's best actors, mostly in smallish parts, although their collective care and conviction bear out the old saw that there are no small parts, just small players. Ms. Resnik's warmth as the therapist, Ms. Jones's good cheer as the nurse, Mr. Brown's efficiency as the doctor, are all critical qualities to the proper functioning of "Wings." And Ross Lehman, as a young man who likes to bake cheesecake and cookies for his fellow therapy patients, is sweet confusion itself. Theirs is more than just good ensemble acting; it is an exemplary display of trust among gifted artists.

Something about the Goodman Studio Theater itself must be right, too. It's an unpretentious facility with next to no backstage space. The auditorium seats a scant 135 spectators. But on its tiny stage were forged the first productions of such unflinching works as David Rabe's "Hurlyburly," David Mamet's "Edmond," Scott McPherson's "Marvin's Room" and, most recently, John Leguizamo's "Spic-o-Rama."

Mr. Lunden and Mr. Perlman's musical is set to close on Dec. 6 — which is the only downside to all this. That "Wings" deserves a larger audience is blindingly obvious. The reverse is no less evident, though. A larger audience deserves "Wings." So much of what we see in the theater today counts for little. Here is a musical that matters deeply. □

1992 N 22, II:5:1

The Sheik of Avenue B

Written and conceived by Isaiah Sheffer; music by Irving Berlin, Lew Brown, Harry Von Tilzer, Bert Kalmar and Harry Ruby and others; direction and musical staging by Dan Siretta; musical direction and arrangements by Lanny Meyers; set by Bruce Goodrich; lighting by Robert Bessoir; costumes by Deirdre Burke; production stage manager, Don Christy. Presented by Mazel Musicals, Lawrence Topall, Alan and Kathi Glist. At Town Hall, 123 West 43d Street, Manhattan.

Don Gonfalon	Paul Harman
Becky Barrett	Judy Premus
Kevin Bailey	Jack Plotnick
Gretta Genug (Diana Darling)	Amanda Green
Sally Small	Michele Ragusa
Pinky Pickles	Mark Nadler
Fanny Farina	Virginia Sandifur
Willie Wills	Larry Raiken

By LAWRENCE VAN GELDER

In the Playbill being distributed at Town Hall these days is a tongue-in-cheek glossary of Yiddish words and phrases like oy, vey and hoo-hah.

What's missing is mishmash, meaning hodgepodge, which might be the best way to describe "The Sheik of Avenue B," which opened last night.

At work in this energetic musical is a 1990's sensibility applied to a recreation of a 1930's radio program yearning to milk nostalgia from songs about the Jewish immigrant experience that were written from 1899 to 1932 by composers better known for other tunes.

Pulled into this extended time warp through the songs and some skits, an audience is off on a hit-and-run excursion through cultural history. There are recollections of Ipana tooth powder and the problems of intermarriage that made a long-running hit of "Abie's Irish Rose." The days before World War I are evoked through "Rose Rosenblatt, Stop the Turkey Trot" and the 1920's through "Yiddisha Charleston."

•

There are references to the Bintel Brief column in The Jewish Daily Forward, where immigrants turned for advice before they became assimilated and moved from the Lower East Side, perhaps to what one song refers to as the Bron-ix. There is a satirical sendup of Jewish avarice (a 1915 Irving Berlin song titled "Cohen Owes Me $97") and a caustic reminder of Henry Ford's reputation for anti-Semitism ("Since Henry Ford Apologized to Me," written by Billy Rose in 1922). Occasionally, an anachronism creeps in, as in a reference to the New York Yankees of 1913 that mentions an edifice called Yankel Stadium, which was not to open its portals until 1923.

Under the direction of Dan Siretta, the show, conceived and written by Isaiah Sheffer and billed as "the ragtime and jazz era comedy revue," moves for the most part at a brisk pace. Unfortunately, "The Sheik of Avenue B" approaches its wealth of material with no particular point of view. More than 25 songs hang from the fragile reed of the radio program, whose cast of eight has only the broadest of types to play.

As a romp through history, bringing all but forgotten songs to life, "The Sheik of Avenue B" may have its value. What it doesn't have is a soul.

1992 N 23, C14:1

A . . . My Name is Alice

Conceived and directed by Joan Micklin Silver and Julianne Boyd; choreographer, Hope Clarke; musical director and arranger, Ian Herman; orchestrations, Brian Besterman; set by Andrew Jackness; lighting by David F. Segal; costumes by David C. Woolard; hair design, Antonio Soddu; production stage manager, Renee Lutz; stage manager, Lisa Iacucci; associate producer, Carol Fishman. Presented by the Second Stage Theater, Carole Rothman, artistic director; Suzanne Schwartz Davidson, producing director. At 2162 Broadway, at 76th Street.

WITH: Roo Brown, Laura Dean, Cleo King, K. T. Sullivan and Nancy Ticotin.

By MEL GUSSOW

Almost a decade after "A . . . My Name Is Alice" was first presented, the sequel to this raised-consciousness revue takes its theme from the lyrics of the opening song, "Two steps forward, one step back." The new show, "A . . . My Name Is Still Alice" shrewdly keeps its optimism in check, especially when women are surrounded by supposedly "Sensitive New-Age Guys," as in the title of one of the revue's most pointed songs.

In that rallying cry by Christine Lavin and John Gorka, the show's all-male band acts as a chorus of approval for almost all the suggestions made by Nancy Ticotin. But there are limits in the sensitivity department. Ms. Ticotin, who is the most vivacious member of an excellent and well-balanced five-woman cast, hits her stride in this number and in a sobering ballad by Michael John LaChiusa, in which a woman tries to excuse an evening of passion without protection.

There are obvious moments in this collage of two dozen songs and sketches at Second Stage, particularly in the first act, as well as a few awkward attempts at timeliness, as in a scene that takes place in the Clarence Thomas Home for Unwed Mothers. But these are outweighed by the esprit of the cast and the authors and composers, some of whom also contributed to the original "Alice." Among those returning is Doug Katsaros, with Francesca Blumenthal as his new collaborator. Together they wrote "Hard-Hat Woman," in which Ms. Ticotin, Laura Dean and Cleo King take their rightful place and prove their toughness on the construction line. With a little encourage-

ment they would be standin' on the corner watching all the guys go by.

•

The other subjects include the rivalry between mothers at the playground and between men and women in the office. In that latter instance, women behind desks are humorously equated with women behind bars. They are trapped in middle management. Two steps forward, one step back.

Interestingly, many of the more assertive numbers are written by men. In "Painted Ladies," by Douglas Bernstein and Denis Markell, women in famous paintings come to life. Mona Lisa explains her smile and the model in Manet's "Déjeuner sur l'Herbe" wonders why she is naked while the men sitting with her are fully clothed. The sketch surrounding the song is weak, but the lyrics are sharply in focus.

Roo Brown, who was in the first "Alice," specializes in authority figures, like mothers and teachers, and also has a pair of wicked blackouts in which she pretends to be Madonna and the Pope, in each case disguised, for personal reasons, as a housewife from Larchmont, N.Y. Ms. King swaggers onstage to announce that after attitude comes posture. Her posture is as amusing as it is militant, as she discovers a way to win respect and a seat on the bus or subway.

Things are tough, especially with the help of sensitive, new-age men.

Laura Dean, remembered from the musical "Doonesbury," sings two wistful songs by Amanda McBroom, which speak poignantly about the entrapment of women. While cutting up with her colleagues, K. T. Sullivan also has her own touching moment in the spotlight, delivering a monologue by Steve Tesich, in which she plays an ordinary woman who dreams about selling her life story to the movies or

television. As she remembers her happiness in childhood, she succeeds in revealing her disappointments as an adult.

The show has been ingeniously directed by Joan Micklin Silver and Julianne Boyd, finding free play within the small stage. The band sits on a ledge above the performers, giving the production an intimate bandbox effect. The closing number is a reprise of the opening song (by Stephen Schwartz and Mary Bracken Phillips). Could one assume that in the next installment of this irreverent revue the theme will be three steps forward, no steps back?

1992 N 23, C14:4

Cross-Dressing in the Depression

Directed by Marcus Stern; written by Erin Cressida Wilson; set by James Schuette; lighting by Scott Zielinski; costumes by Allison Koturbash; sound by John Huntington; production stage manager, Kristen Harris. Presented by SoHo Rep, Marlene Swartz and Julian Webber, artistic directors. At the SoHo Repertory Theater, 46 Walker Street, SoHo. Through Sunday.

WITH: Jan Leslie Harding, Mark Margolis and Erin Cressida Wilson.

By WILBORN HAMPTON

"Cross-Dressing in the Depression," a new play by Erin Cressida Wilson, has little to do with either transvestism or the Depression, except the male lead is played by a female and the characters seem to be poor and hungry. It mostly has to do with a pubescent boy living in the attic of a brothel.

Constructed as a memory play, the story is told through monologues from the point of view of an old man recalling his childhood. This narration is interspersed with scenes of him as a boy with his parents, before and after they send him to live in the bordello, and with a young prostitute on whom he fixes his fledgling passions.

Ms. Wilson has a fine ear, especially when it is tuned to the more visceral and lustful aspects of puberty. And there is a lyrical, almost poetic, quality to some of the writing, although the

imagery is often ordinary and obvious. To indicate poverty, for example, the family eats cornflakes and burns the furniture to keep warm, and among the boy's gifts to the prostitute is a caterpillar, which naturally changes into a butterfly.

•

The main problem with the play is that while some isolated scenes, like the boy's visit to a department store Santa Claus (to ask for a wife) or his flirtations with the young prostitute, have a certain charm, too little of the action is engaging or even credible. No one survives long on a diet of wallpaper and recycled chewing gum, even libidinous 13-year-olds.

A major reason any of this succeeds is due to a fine performance by Jan Leslie Harding as the boy. Employing a savvy innocence that fans of Macaulay Culkin would find endearing, Ms. Harding scavenges for every scrap of humor in the role and creates a sympathy for the character that would elude many. Whatever work Ms. Wilson faces as a playwright, she is an able actress and delivers a strong reading as all the women. Mark Margolis plays the father and recites the monologues of the boy as an old man well enough, but the exposition material itself is more disruptive than elucidating. Marcus Stern directed with a sense of continuity, but even at an hour the play seems long.

1992 N 23, C15:3

Someone Who'll Watch Over Me

Written by Frank McGuinness; directed by Robin Lefèvre; designed by Robin Don; lighting by Natasha Katz; sound by T. Richard Fitzgerald; production supervisor, Jeremiah J. Harris. Presented by Noel Pearson and the Shubert Organization, in association with Joseph Harris. At the Booth Theater, 222 West 45th Street, Manhattan.

Edward	Stephen Rea
Adam	James McDaniel
Michael	Alec McCowen

By FRANK RICH

Although Ella Fitzgerald's lush rendition of "Someone to Watch Over Me" is piped in after every scene, the new West End import at the Booth is not an adjunct to "Crazy for You" at the Shubert next door. "Someone Who'll Watch Over Me," as the Irish writer Frank McGuinness titles his play, is set in a filthy Beirut basement serving as a windowless cell for three hostages. And it features one choreographic gimmick that not even its resourceful musical neighbor came up with: Mr. McGuinness's characters each have a leg shackled to the wall.

I don't mean to sound flip about the evening's subject, but "Someone Who'll Watch Over Me" brings its own light touch to grim matters. Mr. McGuinness's view of the hostages' plight is more Beckett than Costa-Gavras. His unpretentious play offers no bombastic speeches about man's inhumanity to man, no onstage violence and no debates about Middle Eastern politics. Instead of exploiting a real-life tragedy to bring a spurious journalistic reality to the stage, Mr. McGuinness uses his premise as a springboard for imagining the fantasies, jokes and spiritual credos with which ordinary men might somehow survive barbaric incarceration.

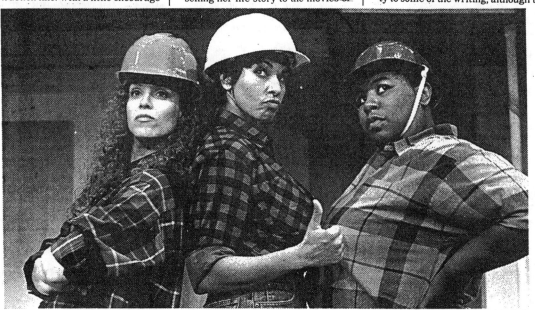

Susan Cook

Laura Dean, left, Nancy Ticotin and Cleo King, right, in a scene from "A . . . My Name Is Still Alice."

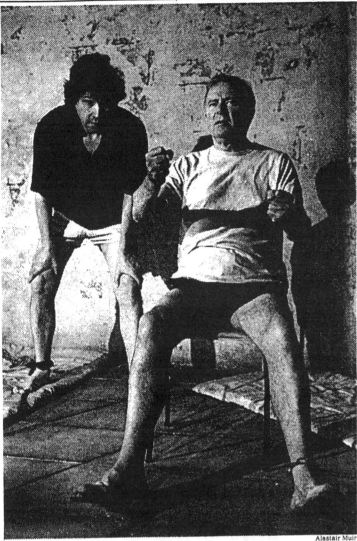

Alastair Muir

Stephen Rea, left, and Alec McCowen in a scene from Frank McGuinness's "Someone Who'll Watch Over Me" at the Booth Theater.

The goal is worthy but difficult. Not even Beckett always succeeded in keeping plays about boredom from being boring. And Mr. McGuinness, if a charming writer in spurts, is no Beckett. Too much of "Someone Who'll Watch Over Me" has the artificial tone of an acting class exercise, as if its cast were doing contrived improvisations designed to show off their skills rather than to reveal characters of real depth. Since those characters are schematically and sometimes stereotypically drawn — each has a pointedly different nationality, marital status, profession, etc. — the play is sporadically amusing without being riveting, moving or particularly credible.

The actors are first rate. If an evening of theater games it is to be, who better to play them than Stephen Rea and Alec McCowen? (James McDaniel, as the American among the hostages, has the briefest and least persuasive part.) Mr. Rea, who may be best known to New York audiences for his appearances in films by Mike Leigh ("Life is Sweet") and Neil Jordan ("The Crying Game"), is a wiry, vinegary presence as a sardonic young Irish journalist. Mr. McCowen contributes his specialty, prim mellifluous grace, in the role of a prissy British professor of Middle English. Together the long-faced Mr. Rea, all nerve ends, and the old-maidish Mr. McCowen, a pudding of repression, refight both the cultural and political conflicts of Ireland and England to a respectful standoff. As they do so, they form a comedy team that now and then suggests Laurel and Hardy or Oscar and Felix, if not Didi and Gogo.

•

Though some of the humor is black absurdism, as befits an existential predicament that even the hostages sometimes see as ridiculous, the playwright also concocts extended vaudeville turns. To keep despair and insanity at bay, the men imagine and enact wild movies they might make, lethal cocktails they might drink to excess, provocative letters they might write. They fly away, mentally at least, by singing "Chitty Chitty Bang Bang," and, in the standout sequence, re-enact Virginia Wade's 1977 victory at Wimbledon, complete with the irrepressible Mr. Rea impersonating Queen Elizabeth.

No one could confuse the parts these actors have here with their greatest roles, but by the final curtain, Mr. McGuinness does let them at least remind the audience of those finer achievements. When Mr. McCowen, fighting off fear, takes valiantly to reciting poetry and when Mr. Rea clings eloquently to his faith in God and family, "Someone Who'll Watch Over Me" fleetingly achieves the universality to which it aspires. In the waning moments, Mr. McCowen even achieves a chilling theatrical image — the production's only one — to go with the many facile verbal riffs.

The excellent director is Robin Lefèvre, last represented in New York by Brian Friel's "Aristocrats." It is neither his nor the talented Mr. McDaniel's fault that the play's third character is an Irish writer's laughably clichéd notion of a contemporary black American: a saintly, musclebound doctor who, amazingly enough, bursts into an angelic rendition of "Amazing Grace" while the white folks look on in dumbstruck awe.

At that moment (which is the Act I curtain) and a few others, Mr. Lefèvre, usually in league with the lighting designer, Natasha Katz, works almost too hard to give "Someone Who'll Watch Over Me" a poetic quality. By the fourth or fifth time that Ella sings the evening's signature song to the accompaniment of Nelson Riddle's celestial strings and a matching lighting effect, you may find yourself wishing that someone had followed Ira Gershwin's admonition to "put on some speed."

1992 N 24, C13:4

Theater in Review

■ How the Depression is like modern times ■ A computer with a mind of its own ■ Sinners and saints in Spain ■ A Greek tragedy by way of India.

On the Bum, or the Next Train Through

Playwrights Horizons
416 West 42d Street
Clinton
Through Dec. 13

Written by Neal Bell; directed by Don Scardino; set by Allen Moyer; costumes by Sharon Lynch; lighting by Kenneth Posner; sound by John Gromada; production stage manager, Dianne Trulock. Presented by Playwrights Horizons, Mr. Scardino, artistic director; Paul S. Daniels, executive director.

WITH: Bill Buell, William Duell, Jim Fyfe, Kevin Geer, John Benjamin Hickey, Robert Hogan, Cynthia Nixon, James Rebhorn, Joyce Reehling, Ross Salinger, Campbell Scott, Maureen Shay and J. Smith-Cameron.

Eleanor Ames (Cynthia Nixon), the protagonist of Neal Bell's comedy "On the Bum, or the Next Train Through" is an unemployed actress in Depression-era New York City who hops a freight train to the Middle Western town of Bumfork to work in a production sponsored by the Federal Theater Project. The play turns out to be a ludicrous verse drama by a local matron named Jessie Mae Burst (Joyce Reehling). "And then again she may not," goes the running joke after each mention of her name. Jessie Mae's play memorializes an actual flood that devastated the town many years earlier when a dam collapsed.

Some of the funniest scenes in "On the Bum" are the poor actors' sing-song recitations of Jessie Mae's "Pyramus and Thisbe"-style verses, with rhymes like "struggle" and "gluggle."

But beneath its raucous humor, "On the Bum" reaches for deeper connections between the depressed cultural climate of 1938 and present-day America, and especially the wary relationship between the Federal Government and the theater. The plot assumes undertones of a thriller when Eleanor begins to suspect that the flood was no act of God but involved skulduggery and a cover-up by people in high places. But because the play's political implications aren't developed until late in the second act and are treated so cursorily, the savage edge of Mr. Bell's humor fails to register.

What the play shows in abundance, however, is the playwright's ear for the poetry of idiomatic American speech. The language of the play is a torrent of colliding styles elevated to a comic poetic rhetoric that is as energized as it is self-conscious. The vernacular game-playing begins in the opening scene where Eleanor, supervised by a pretentious pseudo-English director (Campbell Scott), is rehearsing a rustic comedy whose characters speak in a cartoonishly twangy "L'il Abner" dialect.

"On the Bum" is the inaugural production of Playwrights Horizons under its new artistic director, Don Scardino. In his ingenious and economical production, designed by Allen Moyer, 13 actors assume 35 roles. Ms. Nixon makes an appealingly feisty Candide-like figure. Mr. Scott is commanding in dual roles as the pompous director and as Eleanor's married sweetheart in Bumfork.

The play's staging as a sort of thinking person's vaudeville show echoes the language's riotous ring, as the actors are rolled on and off on giant platforms draped with Edward Hopper-like paintings of rural America. Wonderfully acted with oratorical flourishes that recall the glory days of network radio, and spiced with a soundtrack of vintage swing music, "On the Bum" boldly reimagines an era when people, stimulated by magic voices on the airwaves, really cared about how they spoke.

STEPHEN HOLDEN

Program for Murder

Variety Arts Theater
110 Third Avenue,
at 14th Street
East Village

Written by George W. George and Jeff Travers; directed by Allen Schoer; set by Edward T. Gianfrancesco; costumes by Deborah Shaw; lighting by Natasha Katz; special effects by Gregory Meeh; sound by Guy Sherman/Aural Fixation; production stage manager, Brian Meister. Presented by Dick Feldman and Ralph Roseman, in association with Frederick M. and Patricia Supper.

WITH: Mary Kay Adams, Don Howard, Jon Krupp, Jill Susan Margolis, Colleen Quinn and Stephen Van Benschoten.

The numbers of villainous computers are growing. First, of course, there was HAL in "2001: A Space Odyssey." Then last year there was Lingo, a devious PC that runs for President in Jim Menick's entertaining novel of the same name. And now

there is Alexis, another thinking computer, who writes his own programs for disposing of troublemakers. Or does he?

In "Program for Murder," a new comedy-mystery by George W. George and Jeff Travers, a computer whiz named Jeremy, who gained fame with a game called Mega-Monsters, is besieged by a lot of people with demands on him and his bank account. There is a greedy wife who is about to take him to the cleaners in a divorce, a grasping young mistress who hears wedding bells and a colleague whose idea for a talking computer encyclopedia is about to make Jeremy very rich. Quite by accident, Jeremy's computer, Alexis, gains thought-processing ability and comes up with a plan for murder, or as Alexis puts it, "to eliminate unwanted variables."

Along with some Playwriting 101 plot devices, the authors ask the audience to suspend quite a lot of disbelief. One has to accept that simply by crossing a couple of wires, a hacker stumbles onto artificial intelligence, and that two attractive, intelligent lovers would turn to homicide with less hesitation than they would use to select a movie to rent at a video store. And that's all in the first 15 minutes.

But verisimilitude is not a prerequisite for murder mysteries, and the playwrights have programmed more twists and surprises into their plot than a Super Mario obstacle course. Under Allen Schoer's direction, "Program for Murder" manages to keep the audience guessing (and mostly keeps it from noticing the fact that the dialogue and humor that are somewhat less than scintillating).

Some performances are better than others. Anthony Cummings as Jeremy credibly confirms one's worst suspicions about computer hackers. Colleen Quinn as the mistress and Mary Kay Adams as the wife ably set the pace of the action although it's clear that Ms. Adams has never played a video game. Edward T. Gianfrancesco's delightful set packs a stately Victorian house in Cambridge, Mass., with enough electronic hardware to fill Mission Control in Houston.

WILBORN HAMPTON

Words Divine
A Miracle Play

Intar
420 West 42d Street
Clinton
Through Dec. 13

Translated and adapted by Lorenzo Mans, based on "Divinas Palabras" by Ramon del Valle Inclan; directed by Max Ferra; production design, Rimer Cardillo; music by William Harper; lighting by Mark McCullough; sound by Fox and Perla; movement directors, Janet Watson and B.H. Barry. Presented by Intar Hispanic American Arts Center, Mr. Ferra, artistic director; Eva Brune, managing director, in association with the Mexican Cultural Institute of New York.

WITH: Philip Arroyo, Susan Batson, Luz Castaños, Josie Chavez, Monique Cintron, Christopher Coucill, Shelton Dane, Ron Faber, Peter McCabe, Ofelia Medina, Alec Murphy and Irma St. Paule.

To find satirical comedy as scathing, and as funny, as "Words Divine: a Miracle Play" by the Spanish playwright Ramon del Valle Inclan one would have to go back to Molière or Ben Jonson. The delicious profanity of this 1913 work — the words are not profane, but every action, thought and underlying assumption is — is natural and endemic in countries where the culture is steeped in Ro-

man Catholicism. But the message is universal: People will get away with everything they can and not much of it is good.

Intar Theater's production of a free translation and adaptation of the play by Lorenzo Mans is a wonderful invitation to laughter. Under the direction of Max Ferra, and on a beautiful puzzle box of a set by the Uruguayan sculptor Rimer Cardillo, the cast absolutely revels in the rascality of Spanish villagers captivated by a rogue named Nine Lives (who often seems to have the appearance, and the power, of a devil). These irresistible thieves, liars, hypocrites, cowards and adulterers would inevitably do one another in, except that they are redeemed, in a fashion, by the child Jesus, whom they treat with casual familiarity until he pulls off a small and amusing miracle.

There is no lazy or indifferent acting here, but a few cast members stand out. Christopher Coucill exudes seductive power and feline cunning as the diabolical rogue. Ofelia Medina as the wife of a church sexton lusting for the devil is sexy, funny and vulnerable all at once. Alec Murphy as the Deputy, the personification of law and order, is a fine stammering idiot.

The 7-year-old Shelton Dane as the boy Jesus has the serene confidence that belongs to his character. And Irma St. Paule, an intrepid veteran with three roles, dies deliriously as the drunken mother of a sideshow freak, glows with phony puritanical superiority as a crone whose pigs have no respect for corpses and simply dazzles as the mini-skirted antique hostess of a disreputable bar.

D. J. R. BRUCKNER

Hippolytos

La Mama
74A East Fourth Street
East Village
Through Saturday

By Euripides; a Kannada version in verse by Raghunandana, based on the English translation by Robert Bagg; directed by Vasilios Calitsis; co-produced by Evangelos Tsurdinis; set by George Ziakas; costumes by Prema Karanth; lighting by Howard Thies; sound by Tim Schellenbaum; music by B. V. Karanth and Philip Kovvantis. The State Theater of South India, Nataka Karnataka Rangayana presented by La Mama Etc., in association with the Consulate General of Greece, the Alexander Onassis Center for Hellenic Studies, Cult Productions and Christopher G. Kikis.

ITH: Prameela Bengre, M. S. Geetha, Saroja Hegde, Hulugappa Kattimani, Alexandra Lazaridis, Jagadeesh Manevarthe, N. Mangala, K. R. Nandini, K. C. Raghunath, Mandya Ramesh, S. Ramu and Anju Singh.

One can argue about the direction given by Vasilios Calitsis to Euripides' "Hippolytos" performed by the State Theater of South India at La Mama. But the performance is spectacular and brings some real excitement to this most troubling and dramatically difficult of all the ancient Greek plays.

Instead of exploring the psychological labyrinth in the text, which tempts most directors, Mr. Calitsis goes for the grand theatrical effect, and he achieves it. In fact, for all but the rarest viewer, exploration of the text will be impossible; this is a verse version in the Kannada language of South India mixed with some lines of the Greek original. For those who have forgotten the story, occasional projected supertitles remind one of what is going on.

A formidable array of electronic and costume-making technology

makes gods and choruses glow or flame up out of voids. A score by the Indian composer B. V. Karanth and Philip Kovvantis, based on both Greek and Indian dance music and played on traditional Indian instruments, gives the rhythmic speeches of the play an operatic quality. And the choreographed movements of the actors as well as of the chorus have the odd effect of heightening one's apprehension as the sense of doom in the play becomes almost palpable.

Occasionally the special effects are distracting and the sound amplification annoying, and a couple of scenes are so stretched out they lose essential tension. But on the whole this is a powerful presentation of a mind-twisting drama about divine injustice, the incestuous desire of a woman for her stepson and her posthumous revenge on him for his chastity, and the suffering of a husband and father deranged by his wife's lies and the hidden purposes of angry gods.

The members of this company — especially N. Mangala as Phaedra; K. R. Nandini as the nurse who, in trying to help Phaedra conquer her lust by confessing it, betrays her, and K. C. Raghunath as Hippolytos — make the characters and chorus grow larger than life as the gods involve them in dark Olympian struggles. Their characters are alien enough and elevated enough to be believable in such a situation, and yet close enough to us to be pitiable.

D. J. R. BRUCKNER

1992 N 25, C19:1

SUNDAY VIEW/David Richards

How to Tickle Male Chauvinist Pigs to Death

'A . . . My Name Is Still Alice' is satire without the cleaver.

'On the Bum' wants to be Kaufman and Hart with ideas.

"A...MY NAME IS ALICE" WAS hardly the sharpest-toothed revue on the block when it opened eight years ago in the bowels of the American Place Theater. But it proved a bright and personable collection of songs and sketches with a firm, feminist slant and a cast you would have described as "a honey," if that weren't courting obvious trouble.

The same can be happily said of "A . . . My Name Is Still Alice," the sequel that turned up recently at the Second Stage Theater, where it should do quite nicely for itself, and thank you for asking.

Those who believe satire is not satire unless it burns, maims and generally incapacitates its subject may find the revue, like the abstract set that houses it, on the pastel side. As a general rule, the two dozen or so writers, composers and lyricists responsible for the evening's material forgo the meat cleaver for the ostrich plume and clearly would rather tickle a male chauvinist pig to death than hack him to pieces.

Just because a revue *chooses* to be nice, though, doesn't necessarily mean that it's a pushover. A sketch about the Clarence Thomas Home — where unwed mothers say "the 'a' word" or "birth control" only on pain of having their hair cut by Sinead O'Connor — has plenty of bite. And in Michael John LaChiusa's "Once and Only Thing," Nancy Ticotin sings about her one-night stand with "a real, real Italian" from Queens. It was, she assures her unseen confidante, "a once and only thing for fun, that's all." He was

healthy; she ran no danger. By the end of the driving number, however, she can't shake the morning-after feeling that he may have left her with more than "his real Armani shades"; the dreaded rhyme goes unspoken, however. Disturbing, that.

Nor should you discount the expression that sometimes crosses the face of Cleo King. Of the five performers in "Alice 2," as I shall call it, Ms. King is the one who most resembles Mount Rushmore. In the first act, she gets to explain how she has replaced "attitude" with "posture" as a coping mechanism. When, by way of illustration, she plants her feet firmly on the floor, cocks her head, throws open her eyes and wags a chubby finger at the world, the world plainly has no option but to back off.

On other fronts, the tone is far more accommodating. The topics up for investigation can be serious — the favoritism shown little boys in the classroom at the expense of little girls, say, or the tendency of some mothers to visit their competitive instincts on their offspring. But the treatment is invariably light-handed. Even when the numbers aren't so deft, the performers usually rescue them with some or all of the following:

1) sheer talent,
2) sheer personality,
3) sheer comic flair,
4) great legs (I'll risk it).

Roo Brown, a veteran of the original "Alice," can be counted on to provide a good laugh each time she shows up looking like a Larchmont housewife, all pink and tidy, and holding a bottle of Cover Up, makeup with amazing properties. And her lecture to the students of the First Woman's Medical School on how to deal with naked male patients lends a whole new dimension to gynecology. Dan Berkowitz has provided the outrageous lines here, but one of Ms. Brown's sure-fire tactics, you'll notice, is to domesticate them, so that they seem warm and forthright and crinkly. Like pie.

Or consider the aforementioned Ms. Ticotin. She's pretty much an all-round threat as a singer, dancer and actress, although never quite so appealing as when she just stands there and twinkles. She twinkles a great deal as Juanita Craiga, "a gringa diet goddess," promoting a miraculous new weight-loss program heavy on tortillas washed down with eight ounces of 100 percent imported Mexican tap water. "No aerobics or nothing," she promises, and you know those luminous eyes wouldn't lie. "All you got to do is what we do in Mexico — work." The monologue is by Lisa Loomer and it's hilarious.

Laura Dean has her chance to shine with "Wheels," an entrancing song by Amanda McBroom that charts the life of a woman as she graduates from the baby stroller to the bicycle to the convertible car. "When you have wheels, you know how it feels to be free" goes the wind-whipped refrain. With time, however, the young woman grows old and destitute, and her wheels become those of a laundry cart, filled with tin cans salvaged from alleyways. Ms. Dean, lean and intense, sings the number as passionately as she acts it.

Now and then, you will even see flashes of K. T. Sullivan operating in top form. Unfortunately, Ms. Sullivan seems to have been on the short end of the stick when the best solo numbers were passed out. She's been saddled with "A Lovely Little Life," a diffuse monologue by Steve Tesich, and "So Much Rain," an overly arty song by Craig Carnelia about an older woman and a younger man, and there's not much to be done with

either of them. In her cabaret show, the performer combines some of the better qualities of Judy Holliday and Barbara Cook, but you wouldn't know it in "Alice 2."

She doesn't even get to be a painting, merely a museum guide uttering fatuous remarks about Leonardo's "Mona Lisa," Manet's "Déjeuner sur l'Herbe" and Picasso's Cubist portrait of Marie-Thérèse in the cleverest number of the evening, "Painted Ladies." Once she has exited, the women in the canvases come alive to reveal that it's no clambake being locked in a masterpiece.

Ms. King, in fact, manages to make the Mona Lisa smile a perfect expression of the distaste she feels for Leonardo, who, among other oversights, ignored her reputation as the "best mimic in Florence." (Apparently, her Pope Leo X was a scream.) Ms. Ticotin would like to know why Manet painted her nude, while the men picnicking beside her get clothes. "Alle-

Joan Marcus/"On the Bum"

Cynthia Nixon in "On the Bum"—Out on the street.

gory?!" she sniffs. "That's *his* story." As for Ms. Dean, she lets it be known that Picasso did her no favors by rearranging all her body parts.

The point made by the writers Douglas Bernstein and Denis Markell — that men have robbed the women of their true identities — crops up in one form or another all through "Alice 2." Not that the men in the audience are going to squirm or the women emit whoops of triumph. The show, like its predecessor, has been conceived and directed by Joan Micklin Silver and Julianne Boyd in an expansive spirit of good nature. A ... my name is agreeable, above all else.

'On the Bum, or The Next Train Through'

The writer Neal Bell couldn't have hoped for a better production of "On the Bum" than the one that the director Don Scardino has given him at Playwrights Horizons. Mr. Scardino, however, could have hoped for a better play from Mr. Bell.

This picaresque comedy about the travels and travails of an actress during the Great Depression — it's subtitled "The Next Train Through" — seems to want to be Kaufman and Hart with ideas. But the wisecracking, slang-bang vernacular spoken by the characters sounds awfully phony, and the ideas, once raised, are never really explored.

You don't need a huge intelligence to realize that when Mr. Bell is talking about the theater in troubled economic times and what governmental largesse does or doesn't do for the art form, he just might be referring to our times, as well. But he adds little to the discussion, besides observing that the theater is in a perilous state, that subsidy often comes with strings attached and that a play that tells the truth is probably better than one that doesn't. This much, I suggest, we may know already.

Still, "On the Bum" wouldn't have to dazzle on the intellectual front if it lived up to the antic premise of the plot. All its heroine, Eleanor Ames (Cynthia Nixon), ever wanted out of life was to be an actress in New York

— an ambition that is about to be realized when we first spot her in the midst of rehearsals for a bucolic comedy. Then the Depression strikes, the producer of Fly-by-Night Band-Box Revues goes broke and the show closes before it opens. Eleanor is out on the street and it's not even Broadway.

She rides the rails west and lands a job with the Federal Theater Project in Bumfork, "a jerkwater town in a cornfield." There, the local unit — three performers and a director — is scheduled to put on "The Flood," a historical epic in verse by a certain Jessie May Burst (yes!), about the day the town dam broke, 50 years earlier. But this endeavor also experiences a slew of troubles. The play stinks. The director drinks. Most of Bumfork is indifferent, and one dispossessed farmer (Campbell Scott) is actively hostile to the play, although more than friendly toward Eleanor.

The group substitutes a harder-hitting work by the town radio announcer (John Benjamin Hickey), which reveals that a saboteur from the working class actually blew up the dam. Well, this proves too much for the government inspector out of D.C., who smells sedition in the cornfields and closes down the unit. Once again, Eleanor is out on the street and it's not even paved.

For décor, the set designer Allen Moyer has reproduced some appropriate Edward Hopper canvases on sheets and then hung them from movable scaffolding. The costumer Sharon Lynch has dressed everybody in thrift-shop and/or barnyard finery, while the lighting designer Kenneth Posner not only gets the Midwestern moonlight right, he gets it glinting off the waters of a lake.

Mr. Bell's characters are mostly stock types — smart-alecky actress with gum in cheek, peremptory lady author with pigeon breast, local yokel with straw between teeth — although he gives an odd twist to a few of them. (The radio announcer, for example, claims a war wound as the cause of a limp that really dates from the age of 5, when he was thrown off the back of "an unhappy pig named Zeus.")

The acting of the cast members, some playing two or three parts apiece, is decidedly more spirited than the lines they're called on to deliver. Ms. Nixon makes, as always, a plucky heroine. As fellow performers in the sticks, the wry J. Smith-Cameron and the affable Kevin Geer are troupers in more ways than one. Ms. Smith-Cameron's unflappability constitutes a little sideshow in itself. And the occasional squeals from the audience the other night would indicate that putting Mr. Scott in overalls does nothing to dampen his sex appeal.

Mr. Scardino may not have staged a manic Depression, but matters are about as lively as can be expected, considering that something basic is wrong with "On the Bum." Either Mr. Bell's whimsy is falling short or he is not allowing his sense of the absurd full enough rein. Your guess is as good as mine. ☐

1992 N 29, II:5:1

The Seagull

By Anton Chekhov; translated by David French; directed by Marshall W. Mason; sets by Marjorie Bradley Kellogg; costumes by Laura Crow; lighting by Richard Nelson; sound by Stewart Werner and Chuck London; original music by Peter Kater; production supervisor, Bonnie Panson; technical adviser, Christopher C. Smith; production stage manager, James Harker. Presented by the National Actors Theater, Tony Randall, founder and artistic director; Michael Langham, artistic adviser. At the Lyceum Theater, 149 West 45th Street, Manhattan.

Medvedenko	Zane Lasky
Masha	Maryann Plunkett
Sorin	John Franklyn-Robbins
Konstantin	Ethan Hawke
Yakov	Danny Burstein
Nina	Laura Linney
Polina	Joan MacIntosh
Dr. Dorn	Tony Roberts
Shamrayev	Russel Lunday
Madame Arkadina	Tyne Daly
Trigorin	Jon Voight
The Cook	John Beal
Servants	Kam Metcalf, Kevin Shinick and David Watson

By FRANK RICH

The classics may be the mountains of the theater, but you don't climb them just because they're there.

This is the lesson that seems sadly lost on the well-meaning but floundering National Actors Theater, which officially opened its second season over the weekend with a production of "The Seagull" at the Lyceum Theater. Who would not be in favor of a new company that wants nothing more than to put on great plays with top American actors at affordable prices on Broadway? Lofty as that ideal sounds in principle, however, it becomes meaningless when the productions lack any artistic passion or even coherent points of view. When classics are staged for no compelling reason other than their cultural status, the results are lifeless. The plays stiffen up, much like leather-bound editions of classic novels that remain out of reach, never to be cracked open and read.

The National Actors Theater's predicament is brought into even sharper relief by "The Seagull" because much about the company has improved since last season. The caliber of actors and directors is dramatically higher, and the founding artistic director, Tony Randall, has brought in a far more experienced theatrical hand, Michael Langham, as artistic adviser. Yet the results achieved in this Chekhov production, as directed by Marshall W. Mason, are superior to last season's only in the sense that mediocrity is superior to catastrophe. Given the larger number of good actors onstage, the waste of resources and talent is, if anything, more conspicuous.

•

Take, for instance, the case of Jon Voight, who has chosen to make a welcome return to the stage in the role of Trigorin, the successful, if second-rank, writer who toys destructively with the women at the play's heart. It's an ideal part for Mr. Voight, a romantic presence with a worn spirit and a poetic countenance; his desperation is touching when he cranks up the old magic to woo the adoring young actress, Nina, at the end of the third of Chekhov's four acts. But until that moment at center stage, Mr. Voight's performance, through little fault of his own, has hardly registered. Neither he nor anyone else has been integrated into a mutually supportive acting ensemble that might convey the subtle dramatic undercurrents that animate Chekhov's intensely neurotic provincial household.

Mr. Voight might as well be appearing in a different play entirely from Tyne Daly, who plays Trigorin's present lover, the aging actress Arkadina. Although Arkadina is a selfish mother (to her son, Konstantin, a fledgling playwright) and a determined woman of the theater, traits she nominally shares with Mama Rose of "Gypsy," Ms. Daly is completely miscast in the role. The fading grandeur and vulnerability of this vain 19th-century Russian woman are replaced by a vulgar, 20th-century American brassiness. (Her matching costumes give new meaning to Arkadina's line "My wardrobe alone is enough to ruin me.") The connection, however frayed, between her and Mr. Voight is farcical rather than emotional or erotic, and the same is true of her Oedipal tie to her terminally sensitive son, who is acted by the promising Ethan Hawke with an arm-waving display of unfocused nervous energy.

And so the whole production goes. Unable to sustain the play's weave of interlocking love triangles or its thematic preoccupation with art and artists, Mr. Mason provides a progression of individual front-and-center domestic scenes that have little cumulative effect and allow the actors only brief, transitory victories. Along with Mr. Voight, the more victorious include Joan MacIntosh, who burns to the quick as Polina, the bitter wife of the boorish steward, and John Franklyn-Robbins, whose self-contained turn as the steadily declining estate owner, Sorin, is a concise comic essay on the absurdity of mortality. Laura Linney, the highly gifted young actress cast as Nina, may be the most commanding actor of the lot, but her bracing, unmodulated vitality, so appropriate to the mature Nina of the final act, seems out of sync before then. In smaller roles, Maryann Plunkett (Masha) and Tony Roberts (Dr. Dorn) offer sardonic poses whose potential for depth is left unexplored.

There is no reason why Mr. Mason, who has shown Chekhovian spirit in his fine stagings of Lanford Wilson plays like "Talley's Folly" and "Fifth of July," could not create a moving "Seagull." It is a mystery why he has replicated the same musty style the National Actors Theater established last season, from the standard-issue naturalistic sets (almost indistinguishable from those used for "The Master Builder") to the languid pacing to the melodramatic application of incidental music.

Actually, style is too strong a word for so superficial an approach to a classic text; this "Seagull" recalls laissez-faire stock productions of the naïve American theater of 30 or more years ago. The ambitions, now as then, are virtuous. But it is the night, not Chekhov's view of disappointed lives, that grows long.

1992 N 30, C11:1

Theater in Review

■ A son's anger toward his sexually abusive father ■ 1950's sitcoms, minus the stars ■ A father brutalizes his special son.

Lake Street Extension

Kampo Cultural Center
31 Bond Street
Lower East Side
Through Dec. 20

By Lee Blessing; directed by Jeanne Blake; sets by E. David Cosier; costumes by Teresa Snider-Stein; assistant costume designer, Jonathan Green; lighting by Jeffrey S. Koger; production stage manager, Dean Gray. Presented by the Signature Theater Company, James Houghton, artistic director; Thomas C. Proehl, managing director.

WITH: Keith A. Brush, Joe Sharkey and Rick Telles.

In Lee Blessing's "Lake Street Extension," a young political refugee from El Salvador is given sanctuary in a basement room previously occupied by his protector's prodigal son. When the son returns home, he aims his animosity and his bigotry against the stranger. This is only the start of the heavy turbulence that surrounds Mr. Blessing's brief play. Soon it is clear that the son is both victim and victimizer, having suffered at the hands of an incestuous father.

There are too many crosscurrents of deceit and revenge and too few glimpses into the psychology of the characters. The play is crushed under the weight of the plot, most of which happens offstage. Additional damage is inflicted by the character of the father (in a dour performance by Joe Sharkey), who is presented as an altruist trying to forget, but not to atone for, the sins of his past.

The horrific events might find a parallel in life, but taken in such cursory form they become unreal. At crucial points, the dialogue is unintentionally laughable, as in the father's crass response to his son's story of being raped as a child by the father's employer: "I could never let that happen to him by a stranger."

What little tension accrues derives less from the writing than from the performance of Keith A. Brush as the son. With a reptilian insidiousness, he toys with the other characters. Eventually the refugee (Rich Telles) unveils his own past, adding to the evening's excess of guilty secrets.

This is the second play in a Signature Theater Company season entirely devoted to the work of the versatile Mr. Blessing, author of "A Walk in the Woods" and last represented here by the limber Shakespearean spoof, "Fortinbras." "Lake Street Extension" is not one of his successful efforts. MEL GUSSOW

Visions of Flight Jon Voight and Tyne Daly star in "The Seagull." The production marks the opening of the second season for the National Actors Theater. The Chekhov play, with a cast that also features Ethan Hawke, Laura Linney, Joan MacIntosh, Maryann Plunkett and Tony Roberts, is directed by Marshall W. Mason.

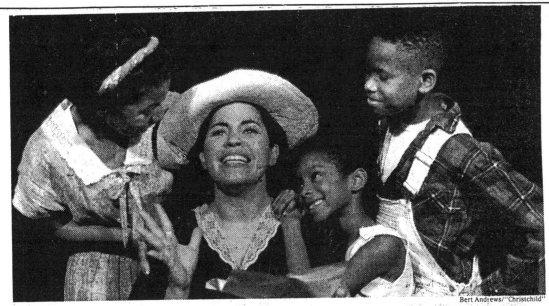

Bert Andrews/"Christchild"

"Christchild," a play by J. E. Franklin at the Henry Street Settlement on the Lower East Side, features, from left, Terri Towns, Michele Shay, Minelva Nanton and Vincent La Mar Campbell.

CBS Live

Minetta Lane Theater
18 Minetta Lane
Greenwich Village

New material written by Bob Bejan, Ben Garant, Michael Schwartz and S. Sydney Weiss; scenic and mixed-media imagery by Cubic B's; costumes, hair and makeup by Thomas Augustine; lighting by Peggy Eisenhauer; video montages by Ira H. Gallen; production stage manager, Allison Sommers; production supervisor, Robert C. Socha. A Controlled Entropy Entertainment Production, presented by Polygram Diversified Theatrical Entertainment.

WITH: Bob Ari, Jonathan Bustle, Kim Cea, Suzanne Dawson, Patricia Masters, Marcus Neville, Hardy Rawls, Sue Rihr and Dana Vance.

Certain sitcoms of the 1950's, namely "The Honeymooners" and "I Love Lucy," have become cultural icons. This is not simply a matter of revisiting memories of past laughter, but something that reaches deeply into what could be regarded as our national caricature. Because Jackie Gleason and Lucille Ball in particular are so identified with their roles as Ralph Kramden and Lucy Ricardo, it would seem unimaginable that anyone else would ever attempt to play them. As it turns out, the unimaginable has occurred.

As America reinvents its past, there has recently been a trend to revivify sitcoms by having new actors perform old scripts in a theatrical setting. What began with "The Brady Bunch" now extends to "The Honeymooners" and "Lucy," in a show entitled "CBS Live." Is Archie Bunker waiting in the wings?

"The Honeymooners" and "Lucy" are vintage sitcoms, if one can overlook — and it is extremely difficult — the pervasive male chauvinism. They are extended vaudeville sketches, with, as "CBS Live" suggests, a resolution every 30 minutes. In the next installment, there they go again: blustering Ralph with his big schemes punctured by skeptical Alice; dizzy Lucy and her exasperated husband.

The actors in "CBS Live" necessarily resort to mimicry. They are reasonable facsimiles, with the closest being Dana Vance's Alice Kramden. She could be a stand-in for Audrey Meadows. Bob Ari has the arrogance but not the humor of Gleason while Jonathan Bustle approximates the side-of-the-mouth nuttiness of Art Carney's Norton. Suzanne Dawson and Marcus Neville conjure some of the spirit of Lucy and Ricky.

All this adds up to a simulation, superimposed with production values, including a flashy sound-and-light show. The show is trapped in its concept. One wonders why people are sitting in a theater rather than watching the real thing in reruns. At the end of the evening, there is an attempt to make it more of a theatrical experience. The programs are scrambled, and suddenly Lucy and Ricky find themselves in the Kramden household. The one amusing suggestion is that each couple regularly watches the other pair on television. But the idea is not developed.

The only time the show makes a legitimate point is in its use of commercials. Between the episodes, there are televised reminders of the naïveté of yesterday, beginning with cigarette slogans ("as cool and as clear as a breath of fresh air"), featuring stars of the period, with the notable exception of Ronald Reagan. Of course the commercials could just as easily be served in the context of a television special, and so could the sitcoms. The question remains: why is "CBS Live" live?

MEL GUSSOW

Christchild

Henry Street Settlement
466 Grand Street
Lower East Side
Through Dec. 20

By J. E. Franklin; directed by Irving Vincent; set designer, Felix Cochren; sound by Bill Toles; costumes by Judy Dearing; makeup by Thelma L. Pollard; lighting by Jeff Guzlik; assistant director, Robert Siverls; production stage manager, Fred Seagraves. Presented by New Federal Theater Inc., Woodie King Jr., producer.

WITH: Patti Bown, Vincent La Mar Campbell, Lee Roy Giles, Minelva Nanton, Michele Shay, Terri Towns and Charles Malik Whitfield.

It is difficult to imagine a more unsparingly bleak portrait of black family life than the one offered by J. E. Franklin's allegorical drama, "Christchild." Set in Houston during the Depression, Ms. Franklin's play portrays the day-to-day struggles of a working-class family of six who are so poor that a new pair of shoes, when affordable, has to be shared among the children.

Benjamin (Lee Roy Giles), the paterfamilias, is a hard-drinking laborer who abuses his wife, Katherine (Michele Shay), and dotes much too fondly on his youngest daughter, Addie (Minelva Nanton). Benjamin harbors a special rancor toward his rebellious adolescent son, Tom (Charles Malik Whitfield), whom he subjects to brutal beatings for imaginary signs of disrespect.

Tom, the play's title character, was born on Christmas Day. And when Gertie (Patti Bown), the witchlike neighbor who was the midwife at his birth, has a mystical vision of a special destiny for him, he also sees the Holy Spirit, is baptized, and tries to control his volatile temper. Tom's belief that he has a special calling ultimately leads him to try to be the family's savior by entering a contest in which he has to fight a bear.

But "Christchild" is less notable for the Christian allegorical structure than for its devastating scenes of family strife. Katherine's ferocious religious faith can sustain her only so far before she comes apart in hysteria. Benjamin deliberately and methodically wreaks revenge on a world that treats him like dirt by tyrannizing his wife and children. The director, Irving Vincent, shows a special skill in organizing the scenes of the four squabbling children, who are superbly played by Mr. Whitfield, Miss Nanton, Terri Towns and Vincent La Mar Campbell.

The play, for all its power, has many flaws. Important details of the story are not spelled out clearly enough, the crucial final scenes seem so hastily written that they barely register and the ending is too abrupt. But if "Christchild" finally lacks the polished eloquence of August Wilson's black history plays, it packs the same kind of emotional wallop.

STEPHEN HOLDEN

1992 D 2, C18:3

Pill Hill

By Samuel Kelley; directed by Marion McClinton; set by James D. Sandefur; costumes by Paul Tazewell; lighting by Allen Lee Hughes; sound by David Budries; dramaturge, Rob Bundy; production stage manager, Barbara Reo. Presented by Hartford Stage, Mark Lamos, artistic director; David Hawkanson, managing director. At Hartford Stage, Hartford, Conn.

Joe	Jerome Preston Bates
Ed	A. Benard Cummings
Charlie	Willis Burks 2d
Al	Eric A. Payne
Scott	Keith Glover
Tony	Rafeal Clements

By MEL GUSSOW

Special to The New York Times

HARTFORD, Dec. 1 — "Pill Hill," by Samuel Kelley, is a penetrating study of the aspirations and defeats of a group of young working-class black men in Chicago. In this play (at Hartford Stage), we meet people who never have a chance for advancement and others who progress but are besieged by questions of guilt and responsibility. Those who succeed in "Pill Hill" pay a severe price, although some steadfastly refuse to acknowledge the consequences.

Mr. Kelley (a recent graduate of the Yale School of Drama) also deals intelligently with the legal system, selling real-estate, and conflict between management and labor. The play is acted with an earthy authenticity by a cast that is finely tuned to the changes in the characters.

The title refers to an upper-class black section of Chicago, the home of doctors and lawyers. We never see this neighborhood and do not learn much about it, but the image as a goal dominates the evening. The opposite of Pill Hill is the steel mill where the characters work. Repeatedly Mr. Kelley asks where his characters are headed and if they can arrive without being blinded by self-interest. In confronting problems of rising black professionals, "Pill Hill" raises issues similar to those in Richard Wesley's "Talented Tenth," among other plays.

•

The only character who achieves a measure of dignity is the oldest by one generation. Beaten down by his work in the mill, he finds a certain relief by returning to the South. The others, in a variety of ways, become shellshocked, even those who are able to mimic the values and acquire the possessions of white society.

Although the play leaves the friends in a state of bewilderment, Mr. Kelley arrives at this point through the use of humor and an agile delineation of character. Events occur over the decade from 1973 to 1983. When we meet this close-knit band, they all believe that the mill is simply a way station. The author knows, of course, that it is a trap.

Joe (Jerome Preston Bates), the pivotal character, says he is going to work there just until he gets his next "two or three paychecks." Then he is going to fill out a college application. The last time he reiterates that statement, he is so defeated by his circumstances he can barely finish the sentence. Conversely, his best friend (A. Benard Cummings) has flown the entire distance. He is the first black lawyer in a high-powered firm and is on the fast track to becoming a partner. He has even learned to play golf but is still excluded from the country club.

As directed by Marion McClinton, the first act of this naturalistic play moves almost too swiftly. As the

characters banter, it is difficult to differentiate individual traits and even to catch all the dialogue. This leads to initial confusion. At the same time, it accentuates the boisterous spirit, the feeling among these friends that all things are possible. Then the older character (Willis Burks 2d) recalls a terrifying encounter with racism, and in a shocking moment all optimism is undermined.

The play proceeds from here with an ironic awareness of life's roadblocks, some of them self-imposed, and the roles they are forced to assume. As the characters grow apart, they become increasingly self-conscious about their youthful friendships. Wisely, Mr. Kelley does not let anyone off the hook, including Mr. Bates's character, whose dreams are like his unread collection of great books. He covers them in plastic to keep them dust free.

In this three-act drama, there are moments that seem attenuated, and the lawyer's self-doubt as he faces a moral crisis comes too suddenly. That character, crucial to the narrative, needs further clarification. But this is a play of substance with a great deal to say about the plight of even the most enterprising men. "Pill Hill" has the aura of a shared life experience, truly told.

1992 D 3, C18:5

SUNDAY VIEW/David Richards

When Games Become Acts Of Heroism

For the hostages in 'Someone Who'll Watch Over Me,' fantasy is refuge.

Theodora Skipitares goes 'Underground.'

THE IRISH PLAYWRIGHT FRANK McGuinness has definitely made things hard for himself in "Someone Who'll Watch Over Me," although his play is so splendidly acted at the Booth Theater that you may not realize how hard at first.

After all, any drama that features Alec McCowen in the cast has already taken a major step toward minimizing its potential trouble spots. As we've known for some time now, Mr. McCowen is a superlative character actor. What is amazing here is how little maneuvering room he requires to do the job. A few square feet is all, illuminated by a single hanging light bulb.

Mr. McGuinness's play, you see, is set in a dank basement cell in Beirut, where his three characters — a black American doctor, an Irish journalist and a prissy English schoolteacher (that's Mr. McCowen) — are being held hostage. There are no windows, no chinks in the cinder-block walls, and the heavy metal door isn't about to give way soon. Furthermore, each prisoner has been shackled to a wall by a chain that runs to his ankle, allowing him freedom enough to do push-ups or (in Mr. McCowen's case) a sprightly toe dance in lieu of calisthenics, but not much else.

Since Mr. McGuinness is taking an essentially realistic view of the rigors of confinement, you can imagine the obvious restraint he is operating under. Two of his characters are in place at the beginning of the play, and the third shows up shortly thereafter. Barring any outside change in their political fortunes, they will remain in those places until the end. Let the American (James McDaniel) lunge for the Irishman (Stephen Rea) in a flash of anger; the chain will draw him up short. If there's to be any action on the stage of the Booth, it is going to have to transpire in the hostages' heads.

Which brings up the second, considerably more significant, limitation that Mr. McGuinness has put upon himself. As a survival tactic, his characters have vowed to ignore the past as much as possible. Memories are forbidden, unless they are sardonic, mocking, and thereby hold the idea of happier days at bay. To feel is to risk feeling sorry for yourself, and once that threshold has been crossed, there's no doubling back.

"They want you to weep," the American warns the Englishman, early on. "Don't ever do that in here. . . . That's what they want. So don't cry. Laugh. Do you hear me? Laugh." Mr. McGuinness's hostages laugh in spite of themselves, laugh even when the noises rumbling up out their throats seem more like strangulated wails. And when they can't manage that any longer, they turn their faces to the wall, keeping the pain out of sight.

Fantasy is the only escape hatch. For the play to break free of its constricting boundaries, the real has to be continually replaced by the imaginary, the sordid by the capricious, the self-pitying by the ironic. Purposefully hoarding any autobiographical data, the characters disclose themselves to us almost exclusively by how they pretend under duress.

They "shoot" epic movies in their minds and "rerun" favorite sporting events. They throw parties at which they drink invisible vodka martinis to the point of inebriation. They compose long (unsentimental) letters home, tell jokes, invent the etymology of words and recite poetry, although poetry is tricky because it can awaken those unwanted emotions.

Stripped of its political underpinnings, "Someone Who'll Watch Over Me" calls instantly to mind the work of another Irish playwright, Samuel Beckett, equally preoccupied with waiting rituals in bleak places. The situation is absurd, a Middle East variation of "Endgame." For no reasons they can fathom, three people have been incarcerated, possibly forever, by unseen captors who may be vengeful madmen or irrational children, but, in either instance, exercise power quixotically. As the Irishman notes, two words sum up their plight: "Ridiculous, ridiculous."

In fact, the five scenes that make up the first (and less satisfying) act are apt to strike you as just so many variations on the theme of filling a void. The Englishman is newly imprisoned, so he has to come to term with the volatility of the Irishman and what Mr. McGuinness, courting stereotype, perceives as the sleek exoticism of a black American. Once he does, the game-playing resumes in earnest. After an hour, you may conclude that the mechanism has been more than sufficiently explored.

■

You'd be wrong to write the play off at intermission, however. Mr. McGuinness has a simple dramatic progression in store, and it makes all the difference. At the start of the second act, the American has disappeared. The cell is down to two inhabitants, and before the evening is over that number will be halved. The removal of the American, who has probably been killed, alters the climate radically. That's no reflection on Mr. McDaniel. The actor, to his credit, manages to sidestep most of the clichés in a role that requires him to be strong and saintly and sing spiritu-

als in a crisis. A note of real danger, however, has been sounded. Time no longer stretches quite so aimlessly into the future. The very games that served to while away the weeks, an act earlier, assume a new urgency and even a measure of heroism.

In the play's most dazzling flight of fancy, Mr. McCowen — jaw firmly set, eyes emitting laser beams of determination — decides to replay the 1977 Wimbledon Ladies' Final and casts himself as Virginia Wade. "Virginia always tossed her head at a tense moment," he explains, a stickler for details, as he shakes the tresses off the nape of his neck and promptly serves an ace. Mr. Rea, obliged by the charade to be Ms. Wade's sizable Dutch opponent, "wee Betty Stove," goes down swinging. Then, rallying from defeat, he assumes the full, bored majesty of the Queen herself and presents the winner's trophy to a triumphant Mr. McCowen. The silliness is sublime because it is pure defiance as well — two men cavorting in the maw of death.

The acting in the second act is also richer, less fettered, as if a certain exhilaration, not caution, were the better part of valor. Mr. McCowen endows the Englishman with a petulant effeminacy at the outset — he was in the midst of preparing a pear flan when he was kidnapped, and a large part of his early dismay seems to stem from the fact that his dessert was ruined. Later on, gripping the "steerymajig," he's positively giddy at the prospect of learning to drive an imaginary car. When, under Mr. Rea's promptings, the vehicle takes to the air, as it did in the movie "Chitty Chitty Bang Bang," Mr. McCowen is beside himself with fear and delight.

In the end, this middle-aged mother's boy proves to be the strongest of the trio. Yet all the actor does is replace petulance, bit by bit, with fussy pride. Physically soft as he is, he stands unapologetically by his flan, his mother and his fluttering idiosyncrasies — which is to say, by himself. The stance is oddly endearing.

Mr. Rea has a long, drawn-out face, a cascade of dark curly hair and a temperament that is part leprechaun, part anarchist. If prison can in any fashion be viewed as a party, he qualifies as the life of it. The antic performance derives its edge, though, from the underlying suggestion that at any minute the bravado could crumble, the fire in the eyes sputter and go dead. Indicatively, this jesting prisoner is always jesting a little too much.

The play's title, as you've probably guessed, is drawn from the Gershwin ballad "Someone to Watch Over Me," which is played between scenes (Ella Fitzgerald does the singing), while a tumble of stars lights up the inky darkness. The effect is lovely the first couple of times, but the director Robin Lefèvre overuses it — his only miscalculation in an otherwise commendably sober staging. I wonder, moreover, if he shouldn't have saved the music and starlight for the very end, when it becomes evident how much these hostages really do care for each other.

Up to then, they have guarded against mushy sentiments, ducked behind laughter and taken refuge in outbursts of zaniness, as the self-imposed rules require. Under the desperate fun and games, love appears to have been building anyway. When the moment arrives for leave-taking, it floods the cell, even if Mr. McCowen and Mr. Rea can only mumble awkward platitudes and shift on their feet.

Slowly, Mr. Rea removes a comb from his pocket and sets about combing the hair of Mr. McCowen. With no less solemnity, Mr. McCowen returns the favor. Spartan warriors performed a similar rite before ventur-

Valerie Osterwalder/"Underground"

A tableau, from "Underground," of a 1961 American family in its fallout shelter.

ing into battle, apparently, and the historical echo lends overtones of nobility to the scene. But the homeliness of the gesture is even more telling.

"I am my brother's keeper," it says, louder than any words could. "I am my brother's reflection."

'Underground'

Theodora Skipitares, who not too long ago investigated the history of urban development and the legacy of Robert Moses in "The Radiant City," has gone underground with her latest piece, Off Off Broadway at La Mama.

Appropriately enough it is titled "Underground," and in slightly more than an hour it examines a wide variety of subterranean creatures — coal miners in their mine, Count Dracula in his coffin, Persephone in Hades, an all-American family in its fallout shelter, a religious fanatic in her buried chapel, and baby Jessica McClure, who tumbled down a well in Texas awhile back and then kept the nation riveted to the TV set until she was fished back up.

As is her custom, Ms. Skipitares constructs miniature environments — the fallout shelter, for example, or the mine shaft — and then populates them with doll-like puppets that deliver strange monologues or act out brief, off-center dramas. The puppeteers manipulating these figures hover over the sets like dark gods, curious about what is happening below perhaps, but also curiously detached from it. Ms. Skipitares is a social critic, and she designs each world and its denizens with a scrupulous attention to detail. At the same time, she is something of a metaphysician, and a disquieting sense of dread and dislocation attends her endeavors.

An Egyptian sarcophagus opens to reveal the mummy inside. Then, the mummy's chest opens and a heart, still pulsating, floats up out of the cavity. The customers in a 19th-century New York ale house lean out the windows to complain about the bitter city water, only to slump over abruptly, victims of cholera. (The disease can be transported underground in polluted water.) A lonely woman, nattering listlessly on a stool in the corner of a tuna-processing plant, turns out to be a former Weatherman who went underground in another way altogether during the Vietnam War and now doesn't know how to surface. As for the genteel prophet deep in her "sacred underground heaven," she gets progressively caught up in a preaching fren-

zy, losing everything about her that's lady-like, until she's a mass of shrill, quivering ecstasy.

Watching these crazed and pathetic souls — mired either physically or spiritually in the dirt — can make you feel a lot like a giant Peeping Tom in a toy village. I suspect that's the effect Ms. Skipitares is after. She wants you to look hard and close into dark nooks and spooky crannies. You'll discover all sorts of mini-revelations and Lilliputian enchantments, if you do. Not to mention astonishments by the thimbleful. □

1992 D 6, II:5:1

Once Removed

By Eduardo Machado; directed by John Tillinger; sets by John Lee Beatty; costumes by Jane Greenwood; lighting by Pat Collins; sound by Donna Riley; production stage manager, William H. Lang. Presented by the Long Wharf Theater, Arvin Brown, artistic director; M. Edgar Rosenblum, executive director. At the Long Wharf Theater, New Haven.

Olga	Karmín Murcelo
Barbara	Karina Arroyave
Rolando	Rafael Baez
Fernando	Carlos Gomez
Rosita	Saundra Santiago

By FRANK RICH

Special to The New York Times

NEW HAVEN, Dec. 3 — For the bourgeois Cuban-Americans in Eduardo Machado's plays, the old adage that you can't go home again is not a sentimental cliché but the overriding fact of life. Exiled to a vulgar country where Spam can pass for food, "Father Knows Best" for culture and Bermuda shorts for fashion, they dream of a return to a Havana that, more than three decades after Fidel Castro's revolution, still remains a mesmerizing 90 miles out of reach.

Mr. Machado, himself a childhood refugee from Cuba, has made a vibrant playwriting career out of dramatizing the displacement of Cubans in the United States, with alternating forays into the Cuban history that propelled his characters out of their homeland in the first place. "Once Removed," his new and typically rueful comedy at the Long Wharf Thea-

ter here, is set in 1960 in Hialeah ("a dirty little town next to Miami, known for its dog races," as one Cuban dismisses it) and then in Dallas a few months later, as a newly relocated young couple, Olga and Fernando, and their extended family balance new American dreams against the fantasy of a liberated Cuba that is not to be.

"Once Removed" ends, pointedly, with the entombment of that fantasy in the failed Bay of Pigs invasion. What makes Mr. Machado a diverting writer, if at times a facile one, is the humor with which he leavens the gravity of his characters' predicament. Ludicrous hypocrisy is as much a part of his plays' human fabric as melancholy and loss. Olga (Karmín Murcelo) did, after all, raise money for Fidel with canasta parties back in the days when she thought he might be a happier alternative to the totalitarian Batista regime. Her sister, Rosita (Saundra Santiago), a devotee of designer clothes who did not grasp the revolution's severity until she lost her hairdresser, had also favored Castro, if only because he was better-looking than Batista.

Tossed into the United States with no possessions other than what jewelry they could sneak out, Mr. Machado's Cubans cope with exotic institutions like Halloween and the Presbyterian Church and suffer through menial jobs where they work beside Mexicans they look down upon as wetbacks. John Lee Beatty, the designer, gives the refugees a pair of homes that are tacky enshrinements

of the low-rent suburbia of the early 60's, the transient antithesis of the aristocratic Havana the Cubans had to abandon. Not that the playwright allows the characters' roseate memories of home to go unchallenged. The inequities of old Cuba still vaguely haunt Olga's conscience — "Under Batista, Cuba was just a big fat whore," she recalls — and stand in pointed contrast to the classless democracy of the United States, cheesy and imperfect as it may be.

•

Full of funny passages, including a wonderful riff about how history might be different if the young Castro had had a more promising baseball career, "Once Removed" is technically the most polished play I've yet encountered by Mr. Machado, whose other works include "The Modern Ladies of Guanabacoa" and "Broken Eggs." Fittingly, John Tillinger directs it with the same authority he brings to the comedies of Terrence McNally. But if "Once Removed" executes its tasks with wit and assurance, it can also be a little too slick.

Except for a final scene, in which the Bay of Pigs disaster is affectingly intertwined with a marital crisis and an unexpected natural "miracle" (a

shower of snow), this linear, realistic play can itself seem Americanized to a fault. One hungers for a deeper dimension, either in the people or in the dramaturgy, that might percolate beneath the brittle surface. Too often the characters tidily stand either for or against assimilation; both the play's dramatic events and its more portentous lines ("Our heritage is not for sale!") become predictable once the evening's thematic direction is clear.

The cast, which includes Carlos Gomez and Rafael Baez as the family's increasingly Yankee-minded men and Karina Arroyave as its petulant teen-age girl, is a good one. Ms. Santiago is particularly funny as the most ridiculous yet the most indomitable of the exiles. As Olga, the most homesick character and easily the most complex, Ms. Murcelo is an arresting figure of both elegance and fortitude, convincing as both the Old World socialite she once was and as the rebellious New World assembly-line worker she is on her way to becoming. By the end of Mr. Machado's play, her triumphant liberation from macho domination, unlike that of her beloved lost Cuba, is most tantalizingly at hand.

1992 D 7, C11:1

Conjuring Up Worlds Out of Silence

By JACK ANDERSON

Marcel Marceau remains a master of silence. The French mime, who first toured America during the 1955-56 season, appeared on Saturday night at Lehman Center for the Performing Arts at Lehman College in the Bronx and was as gently comic and technically spectacular as ever.

As he has done in the past, Mr. Marceau devoted the first half of his program to a variety of themes and the second half to sketches about a clown named Bip. The title of each work was announced on a placard held by Mr. Marceau's assistants, Blanca del Barrio and Bogdan Nowak.

By means of deft gestures, Mr. Marceau can make the empty air seem filled with objects. At his weakest, this ability becomes an excuse for theatrical gimmickry. A few sketches have little point other than that of creating the illusion that Mr. Marceau is touching, holding or reacting to things that aren't really there. For instance, "The Bird Keeper at the Clothiers" abounded with avian flutterings, and in "The Painter" Mr. Marceau fussed with an invisible easel, palette and brush.

Although it was easy to believe that those painter's tools existed, Mr. Marceau never invested them with compelling dramatic significance. Virtuosity was not a means to an expressive end, but something reveled in for its own sake, much in the way that certain technique-obsessed ballerinas are known to relish incessant twirling.

But when Mr. Marceau combines gestural dexterity with thoughts and feelings, the results are often witty and poignant. Giving an old story a new twist, he made "Pygmalion" end

with a statue rebelling against its creator. He peopled an entire courtroom in "The Trial." In "The Hands," his hands mysteriously took on lives of their own. And in the even more enigmatic "Mask Maker," he portrayed someone who found that after trying on several comic and tragic masks, he was unable to remove one of the comic ones. Because he was doomed to wear a laughing face forever, his grin suddenly had the effect of a monstrous grimace.

The Bip sketches varied in quality. "Great Star of a Traveling Circus" found Bip having to serve as a tightrope walker, a tamer of wild animals and a contortionist. Like "The Painter," it was primarily a series of technical exercises. In contrast, in "Bip as a Soldier," which grew increasingly grim as it proceeded, Mr. Marceau made his clown fall in battle. The piece was a heartfelt attack upon militarism. Unfortunately, it was also long-winded.

That military sketch was something of an anomaly, for in most of his adventures Bip manages to squeak through and survive. In "Bip Commits Suicide," Mr. Marceau mimed a shooting, a hanging, the drinking of poison and the sniffing of gas. Yet Bip stayed alive.

"Bip Plays David and Goliath," one of Mr. Marceau's most famous creations, has not lost its power to amaze. By means of changes in facial expression and bodily carriage, Mr. Marceau gives the impression that he is both the gentle David and the blustering Goliath. His actual height even appears to alter at times. And when the sketch is over and Goliath has been toppled, no one can doubt that the meek will one day inherit the earth.

1992 D 7, C12:1

T. Charles Erickson/Long Wharf Theater
Karmín Murcelo in Eduardo Machado's play "Once Removed."

Woyzeck

By Georg Büchner; translated by Henry J. Schmidt; directed by JoAnne Akalaitis; set by Marina Draghici; costumes by Gabriel Berry; lighting by Mimi Jordan Sherin; sound by John Gromada; original music by Philip Glass; lyrics by Paul Schmidt; fight direction by David Leong; production stage manager, Mireya Hepner. Presented by the New York Shakespeare Festival, Joseph Papp, founder; Ms. Akalaitis, artistic director; Jason Steven Cohen, producing director, Rosemarie Ticher, associate artistic director. At the Joseph Papp Public Theater/Newman Theater, 425 Lafayette Street, Greenwich Village.

Franz Woyzeck	Jesse Borrego
Marie	Sheila Tousey
The Captain	Zach Grenier
The Doctor	Denis O'Hare
The Drum Major	Lou Milione
The Seargeant	Michael Early
Andres	Bruce Beatty
Margret	Anita Hollander
The Carnival Barker and the Second Apprentice	Michael Stuhlbarg
The Carnival Showman	Richard Spore
Christian	David E. Cantler
The First Apprentice	Robert Cicchini
Karl	Richard Spore
The Grandmother	Ruth Maleczech

WITH: LaTonya Borsay, Robert Cicchini, Lynn Hawley, Ashley Mac Isaac, Camryn Manheim, Pauline E. Meyer, Imani Parks and Louis Tucci.

By MEL GUSSOW

The title character in "Woyzeck" is, we are told, "running around like an open razor blade." The image, in common with the play itself, is as precise as it is terrifying. Woyzeck, a military barber and the most ordinary of common men, is overcome by dementia. He hears strange sounds, sees visions and is driven to a desperate act of murder. Along with "Danton's Death," the play certified Georg Büchner's reputation as the first modern playwright. Written in the 1830's and discovered as fragments after the author's death, the work foreshadowed explorations by Kafka, Brecht and Beckett. The modernism of Büchner is basic to JoAnne Akalaitis's compelling production at the Joseph Papp Public Theater.

Because of the nonlinear style and the focus on an irrational antihero, the play is open to free-handed interpretation. In search of "Woyzeck," Ms. Akalaitis uses alternate scenes and extracts from early drafts of the play, filtering Henry J. Schmidt's translation through her fervid theatrical imagination. The difficulty this director has had in dealing with Shakespeare is not in evidence in her treatment of Büchner.

In the reordering of scenes the play gains in momentum, accruing intensity and psychological awareness as Woyzeck moves through the last stages of his calamitous life. The director has given greater centricity to the role of Marie, Woyzeck's common-law wife and the object of his homicidal impulse. But of course this is still Woyzeck's tragedy, as he is crushed by people and events beyond his control.

Ms. Akalaitis has accentuated the folk elements within the play, crucial to Büchner, for whom this was a balladlike dramatization of an actual occurrence. Philip Glass's sizzling music is often paired with folk-style lyrics by Paul Schmidt, and martial clog dancing adds to the ritualistic background.

•

In contrast to the stark simplicity of Richard Foreman's version of the play several seasons ago at Hartford Stage, Ms. Akalaitis's approach has a visual richness. The productions are equally valid but they are so dissimi-

lar in concept that they could be staged together in repertory. Naturally they share the same themes, characters and impact.

Ms. Akalaitis takes a cue from her own early work as a director and playwright with Mabou Mines, in terms of using imagery to enhance a text, as she did in "Dressed Like an Egg," her lush collage of the life of Colette. With "Woyzeck," she seems to be influenced by German Expressionist art. In scene after scene there are striking stage pictures of people caught in a frenzy or in a moment of aggrieved anticipation.

The military barracks that is the central environment of the play would need no conversion to become a concentration camp. As designed by Marina Draghici, who did the impressive settings for Caryl Churchill's "Mad Forest," the scenery simulates all the coldness and malevolence of a life in confinement. The bare plastered walls and streaked windows, evocatively lighted by Mimi Jordan Sherin, are like conjurations of the paintings of Anselm Kiefer.

•

Woyzeck (Jesse Borrego) tears across the stage in a fever. In his rag uniform and with a haunted look in his deep-set eyes, Mr. Borrego resembles a prisoner of Dachau suddenly released and brought into a blinding light. Repeatedly he is transfixed like an apparition in a nightmare.

Shaving his captain (Zach Grenier), Woyzeck strops his razor for so long that it seems as if he is sharpening his blade for slaughter. The autocratic officer flinches as the barber approaches his chair; still he never stops badgering his subordinate. Wherever Woyzeck turns, he is besieged, even, as it turns out, in his home, up to then his single sanctuary. In response, he tries to outrun his demons.

In those moments when things stand still, velocity is replaced by what could be called frieze frames. Townspeople sit in a line as in a pew and a grandmother tells the bleakest and most Büchnerian of fairy tales: "Once upon a time there was a poor child with no father and no mother; everything was dead, and no one was left in the whole world."

Ms. Akalaitis uses her painterly eye to illuminate motifs, but along the way there are a few questionable directorial choices. The production begins awkwardly with a film clip of Mr. Borrego climbing rocks. This is apparently a scene from Ms. Akalaitis's adaptation of other Büchner works, which she entitled "Leon and Lena (Lenz)," and presented at the Guthrie Theater. The film has no direct bearing on the play we are seeing. The carnival sequence is surprisingly mundane and a scene of soldiers showering detracts from a later, symbolic moment when Woyzeck tries to wash away his bloody deed.

•

Furthermore, some of the acting lacks resilience, even allowing for the fact that those characters who have no names, like the drum major, are intended to be emblematic. But the production is anchored by the actors in the three most important roles: the commandingly imperious Mr. Grenier as the captain, Sheila Tousey as Marie and Mr. Borrego, who grasps the tortured essence of Woyzeck.

When he turns against Marie, who has been his only source of stability, he attacks her as if she were the incarnation of everything that had

been bedeviling him. The scene is staged with ferocity: the victim is helpless, the murderer uncontrollable. Around the time he was creating "Woyzeck," Büchner wrote a letter to his parents in which he commented on German militarism and what he considered to be the brute force of the law. He asked, "Aren't we in an eternal state of violence?" That question and its accompanying cry for help are searingly captured by the playwright and by Ms. Akalaitis as his contemporary interpreter.

1992 D 7, C14:1

Hello Muddah, Hello Fadduh

Conceived and written by Douglas Bernstein and Rob Krausz; directed and choreographed by Michael Leeds; setting by Michael E. Downs; lighting by Howard Werner; costumes by Susan Branch; sound by Tom Morse; musical direction and vocal arrangements by David Evans; orchestrations by David Lawrence; production stage manager, R. Wade Jackson. Presented by Diane F. Krausz, Jennifer R. Manocherian and David A. Blumberg. At Circle in the Square Downtown, 159 Bleecker Street, Greenwich Village.

WITH: Stephen Berger, Tovah Feldshuh, Jason Graae, Paul Kreppel and Mary Testa

By STEPHEN HOLDEN

Those who were older than 3 in 1963 must surely remember "Hello Muddah, Hello Fadduh," Allan Sherman's epistolary novelty hit about a homesick boy who pleads to his parents for rescue from the evils of Camp Granada. Its crowning comic twist was Sherman's setting of a rhymed list of the summer camp's imaginary horrors to the tune of Ponchielli's "Dance of the Hours," from "La Gioconda." The absurdity of the juxtaposition was underscored by the sound of Sherman's voice bellowing a catalogue of complaints in a dialect that suggested Alan King doing the

Dead End Kids. Ponchielli's ethereal aria has never quite recovered from the assault.

Appropriately enough, "Hello Muddah, Hello Fadduh" is the title of a jolly new revue at Circle in the

A revue that satirizes 1960's suburban Jewish life, gently.

Square Downtown, which features more than two dozen musical parodies by Sherman, who died in 1973. The songs, which gently satirize suburban Jewish life in the 1960's, follow the adventures of a middle-class everyman named Barry Bockman (Jason Graae) from birth to old age in a Florida retirement community.

The show, conceived and written by Douglas Bernstein and Rob Krausz and directed by Michael Leeds, is a triumph of casting and staging over material that often feels quite musty. Three decades after most of them were written, Sherman's social observations seem mild-mannered compared with the spikiness of much contemporary comedy writing. Today, the Jewish ethnic references in his songs, which a glossary in the program wittily defines (Grossinger's: a big resort in the Catskills; disgusting sopranos, altos and tenors), are more sentimental than barbed, with the milder lyrics extracting a gentle humor from such subjects as crab grass, women who eat too much and Mexican vacations.

•

The songs that hold up the best are more concerned with verbal games than with exposing humanity's foibles. The best is "One Hippopotami," which hilariously imagines nonsensical plurals.

The show's title song, which is performed by Mr. Graae, isn't the only

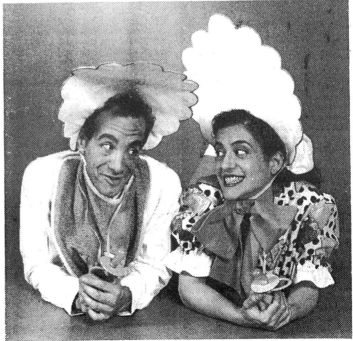

Carol Rosegg

Jason Graae and Mary Testa in "Hello Muddah, Hello Faddah."

number to find bizarre fun in setting a comic lyric to a familiar melody. Its boldest musical joke, "The Ballad of Harry Lewis," eulogizes a fabric seller whose "cloth goes shining on," to the tune of "The Battle Hymn of the Republic."

More than its material, what animates "Hello Muddah, Hello Fadduh" is its breathlessly paced, cartoonishly satirical portrait of Sherman's characters and their world. Dressed in garish, clashing polyesters, Barry Bockman, his family and friends exude a live-wire comic exuberance that crackles across the stage and makes their bad taste seem almost like a proclamation of cultural liberation.

●

Mr. Graae, an original cast member of "Forever Plaid," is irresistibly merry. First seen mugging shamelessly beneath the canopy of his blue bassinet, he clowns his way through marriage and middle age, ending in a caricature of elderly dilapidation that is too delightfully goofy to be unsettling.

Mary Testa, who plays Barry's wife, Sarah, is a perfect partner whose mischievous fire, like Mr. Graae's, seems to emanate from deep within. Stephen Berger takes the show's funniest solo turn as an unwelcome wedding guest who crashes the reception and insists on entertaining the guests. Paul Kreppel and Tovah Feldshuh impersonate assorted Bockman family members, relatives and associates of varying ages in sharply-edged, campy caricatures.

Mr. Leeds has choreographed the show so tightly that the energy rarely flags. When the characters aren't yammering excitedly, they come together in silly group dances that spoof social rituals from courtship to weddings. The pace of the show is so vivacious that there is little time to consider the fact that the songs themselves don't tell much of a story. Many of them seem like asides in a campy allegorical pageant satirizing the shallowness of suburban American life.

Existence, according to "Hello Muddah, Hello Fadduh," is one short, noisy dash from cradle to grave. And when it's finally time to go, a heavenly voice will boom, "Party of five, your table is waiting."

1992 D 9, C22:1

Needles and Opium

A solo piece written, performed and designed by Robert Lepage; music and keyboard, Robert Caux; stage assistant, Claude Lemay; stage manager, Robert Beauregard; drawings, Zilon; multi-image, Jacques Collin, assisted by Pierre Desjardins. Presented by the Brooklyn Academy of Music, Harvey Lichtenstein, president and executive producer. At the Carey Playhouse, 30 Lafayette Avenue, at Ashland Place, Fort Greene, Brooklyn.

By MEL GUSSOW

Robert Lepage's magical "Needles and Opium" begins in a Left Bank hotel in a room formerly occupied by celebrated French artists. Playing himself as a visitor to Paris, Mr. Lepage is facing a long sleepless night when his thoughts are invaded by the spirits of Jean Cocteau and Miles Davis. From here the play embarks on a journey that is filled with indelible imagery and observations about Surrealism, existentialism and jazz.

The show, which opened on Tuesday as part of the Next Wave Festival at the Brooklyn Academy of Music, is a tour de force for Mr. Lepage as playwright, director, designer and solo performer. It is the opposite of his recent, aberrant version of "A Midsummer Night's Dream," staged in a sea of mud at Britain's National Theater. In contrast to that sprawling Shakespearean oddity, "Needles and Opium" is a chamber work marked by its absolute precision.

In some sense, it could be regarded as a movie onstage, artfully merging cinematic and theatrical techniques. Although this is an exceedingly complex production, filled with intricate mechanical devices, it shifts from one form to another without a glitch. In contrast to lesser performance artists, Mr. Lepage veers clear of pretension, lightening the trip with wry humor. As a performer, he moves with an acrobatic agility on a revolving platform that acts as stage, movie screen and trampoline. He disappears and then appears in a new guise, all in the quickest of crosscuts.

At the root of the narrative is the fact that in 1949 Cocteau and Davis, each a major artist in his field, reversed paths. Cocteau, the archetypal French Surrealist, was in New York, and Davis, a maestro of modern jazz, was discovering Paris. He was also discovering Juliette Greco, herself an icon of French existentialists.

The playwright weaves together the stories of the two men, including the bouts each had with drugs. Simultaneously he creates an impressionistic collage of their art and their cities. Filtered through the play are Cocteau's poetic words about his love affair with New York and also Davis's music, the coolest and most limpid of underscorings. The music is one of the show's most essential elements.

Cocteau, portrayed by Mr. Lepage, is headed home. Onstage, he is strapped into a harness that suddenly flies free of his plane. He becomes his own flying machine circling New York. In one of a number of transporting sequences, Cocteau seems to plunge down the caverns between skyscrapers. While Cocteau soars, Davis travels by sea; on a screen we see his trumpet merrily bobbing beneath the waves

Repeatedly Mr. Lepage alters and expands the audience's perspective, swinging back and forth among live performance, film and shadow puppetry. When Davis and Miss Greco meet in a cafe and drink wine, we view the scene from above. On the screen are objects, cleverly manipulated to give a picture of a relationship that will prove to be far more than a flirtation.

Mr. Lepage's own character is the autobiographical conduit between Cocteau and Davis; the play is his search as well as theirs. Often we return to that Paris hotel room for incidents ostensibly from life. In the middle of the night, the telephone rings and the caller demands to speak to Jean-Paul Sartre. Mr. Lepage explains that he has been dead for many years. But the caller persists. Finally, Mr. Lepage sheepishly confesses, "I took the message."

In the course of his performance piece, the playwright uses the word supervision and, I think, the pun is intentional. "Needles and Opium" is a super-visionary work. In common with the character of Cocteau, it flies.

1992 D 10, C16:4

My Favorite Year

A musical based on the motion picture, courtesy of Turner Entertainment Company (screenplay by Norman Steinberg and Dennis Palumbo; story by Mr. Palumbo); book by Joseph Dougherty; music by Stephen Flaherty; lyrics by Lynn Ahrens; directed by Ron Lagomarsino; musical staging by Thommie Walsh; sets by Thomas Lynch; costumes by Patricia Zipprodt; lighting by Jules Fisher; sound by Scott Lehrer; musical director, Ted Sperling; orchestrations by Michael Starobin; dance music arrangements by Wally Harper; fight director, B. H. Barry; director of musical theater, Ira Weitzman; poster art by Paul Rogers; hair by Angela Gari. Presented by Lincoln Center Theater under the direction of André Bishop and Bernard Gersten, in association with A.T.&T.: On Stage. At the Vivian Beaumont Theater, Lincoln Center.

Benjy Stone	Evan Pappas
King Kaiser	Tom Mardirosian
Sy Benson	Josh Mostel
K. C. Downing	Lannyl Stephens
Alice Miller	Andrea Martin
Herb Lee	Ethan Phillips
Belle Steinberg Carroca	Lainie Kazan
Leo Silver	Paul Stolarsky
Alan Swann	Tim Curry
Rookie Carroca	Thomas Ikeda
Tess	Katie Finneran
Uncle Morty	David Lipman
Aunt Sadie	Mary Stout

WITH: Leslie Bell, Maria Calabrese, Kevin Chamberlin, Colleen Dunn, Katie Finneran, James Gerth, Michael Gruber, David Lipman, Roxie Lucas, Nora Mae Lyng, Michael McGrath, Alan Muraoka, Jay Poindexter, Russell Ricard, Mary Stout, Thomas Titone, Bruce Winant and Christina Youngman.

By FRANK RICH

WHO wouldn't want to go back to the New York City of 1954, the year celebrated in the new musical "My Favorite Year"? As Benjy Stone (Evan Pappas), the show's young hero, reminds the audience, 1954 was the time of beefy Buicks and a hit parade dominated by Kitty Kallen. A time when Fifth Avenue was a two-way street and "everything had chlorophyll in it." Most of all, as far as "My Favorite Year" is concerned, it was the Golden Age of live television, as exemplified by "The King Kaiser Comedy Cavalcade," a weekly 90-minute NBC variety show that resembles Sid Caesar's "Your Show of Shows" and for which Benjy is the bright-eyed freshman gag writer.

"My Favorite Year," which opened last night at the Vivian Beaumont Theater, not only wants to re-create that halcyon time, from its Breck girls to its Formica décor, but it also wants to do so in the wonderfully retro Broadway musical-comedy style of the same period. Nineteen-fifty-four was also the year of "The Pajama Game," whose Bob Fosse choreography this show passingly mocks. From its opening number, a sort of "Comedy Tonight" set in

Joan Marcus

Andrea Martin

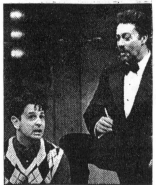

Joan Marcus

Different generations: Evan Pappas, left, and Tim Curry.

a television studio, "My Favorite Year" offers the happy promise of a new musical in the hilarious manner of "Pajama Game," successors like "Bye Bye Birdie" and "Little Me" written by "Show of Shows" alumni.

So why does "My Favorite Year" fail to sustain that lighthearted spirit, or even to replicate the modest farcical charms of the nostalgic 1982 Hollywood movie that is its source? These are questions that can be answered only by its gifted creators: the writer Joseph Dougherty (of Off Broadway's "Digby" and television's "Thirtysomething"), the songwriters Stephen Flaherty and Lynn Ahrens (of "Once on This Island") and the director Ron Lagomarsino (of "Driving Miss Daisy"). Whatever the cause, "My Favorite Year" proves a missed opportunity, a bustling but too frequently flat musical that suffers from another vogue of the 1950's, an identity crisis.

The evening's assets, which include a superior supporting cast led by Andrea Martin and Lainie Kazan, a few good jokes and a zippy physical production, are outweighed by such major failings as the questionable casting of the starring roles and a disappointing score. But this musical's overriding problem, from which all the others spring, is its wayward tone.

For a few scenes, "My Favorite Year" follows its screen progenitor, telling the dizzy backstage yarn of how the green Benjy must baby-sit his television show's guest star, a drunken and reckless Errol Flynn-like movie legend named Allan Swann (Tim Curry), during a frantic week of marathon rehearsals. But by the end of Act I, the musical has radically altered its focus and mood (and dismantled its plot) to concentrate on Swann's tortured relationship with his neglected, nearly adult daughter (Katie Finneran) and on Benjy's courtship of a humorless production assistant (Lannyl Stephens) far drippier than the equivalent heroine of the film.

Certainly Mr. Dougherty and company have no obligation to be faithful to their source, but they never give the audience a reason to care about the new direction they take. The two women who captivate the male leads for most of Act II are bland, underwritten nonentities whose interchangeability extends to their Barbie-blond hair. Concurrently, the relationship between Swann and Benjy turns dour, to the extent that it is dramatized at all. Swann's comical drunkenness all but evaporates, and

Benjy becomes psychologically fixated on replacing the father who abandoned him in childhood.

As Sid Caesar, King Kaiser or Molly Goldberg might say, oy!

•

It is impossible to tell whether the casting of "My Favorite Year" or its libretto is responsible for the transformation of Swann and Benjy from clowns to sentimental straight men. While Mr. Curry and Mr. Pappas are both first-rate musical performers, each seems out of sync here, at least as directed with a heavy hand by Mr. Lagomarsino.

In the Peter O'Toole role, the fit and young Mr. Curry seems neither dissipated by drink nor remotely old enough to have starred in the 58 swashbuckling movies Swann is said to have made. His huge comic talents are hardly called upon after his initial entrance, and he eventually is capsized by repetitive back-to-back songs (before and after intermission) that require him to engage in melancholy introspection. The hyperenergetic Mr. Pappas, whose intense antihero dominated last year's Off Broadway revival of "I Can Get It for You Wholesale," plays Benjy (Mark Linn-Baker on screen) as a moody literary cub, more of a cloying, aspiring novelist than a Hollywood or Broadway-bound purveyor of punch lines.

You know a musical is in trouble when the minor characters consistently upstage the leads. It's no secret that Ms. Martin, of SCTV reknown, is a terrific comedian, but in "My Favorite Year," she brings to the role of a wisecracking comedy writer not just dry timing and nutty voices, but also razor-sharp skills as a burlesque dancer, pratfall artist and satirical chanteuse in the Imogene Coca tradition. It's one of the authors' more conspicuous lapses that the big number they give to the deserving Ms. Martin, "Professional Showbizness Comedy," fails to live up to its title.

•

As for Ms. Kazan, who repeats and expands upon her film role as Benjy's meddling Jewish mother, her uncompromising excess is hard to resist. She steams through "My Favorite Year" like a top-heavy ocean liner that has lost its compass, and she has been costumed accordingly by Patricia Zipprodt, the wittiest artist in the production's design team. Ms. Kazan also retains a belter's singing voice and, fittingly, has been handed the only two melodies in Mr. Flaherty's score with immediate staying power. But one of them, "Rookie in the Ring," is a digression that brings the show to a deadening halt, and the other, "Welcome to Brooklyn," is robbed of its potential theatrical bravura by the woefully stock musical staging of Thommie Walsh.

Tom Mardirosian (whose King Kaiser recalls Carl Reiner's Sid Caesar impersonation on "The Dick Van Dyke Show"), Josh Mostel (as a dyspeptic head writer), and David Lipman and Mary Stout (as the embarrassing relatives of any Jewish boy's nightmares) also have their scattered amusing moments. Usually these occur when Mr. Dougherty reproduces shtick from the film, most notably in the sequence in which Benjy takes Swann to his mother's home (or, as Ms. Kazan famously calls it, her "humble chapeau"). For the leads, Mr. Dougherty has written some talky emotional scenes whose prosaic quality is too often matched by Ms. Ahrens' earnest lyrical essays on the differences between pastel-hued celluloid fantasies and the harsh realities of life.

In "Once on This Island," Ms. Ahrens and Mr. Flaherty also wrote in an anachronistic style; their nominally Caribbean songs had a Rodgers and Hammerstein lilt. Here they are just as consciously evoking the brassy, competing sound of the same Broadway era, even to the point of writing a Manhattan night-life production number, complete with dancing cops and sailors and loose women, of the sort that seemed de rigueur in every musical with a New York setting from "On the Town" to "Mame" to "Annie." But this time the echoes are pale and the gaiety forced. "My Favorite Year" uncorks the intoxicating vintage of 1954 only to send its audience crashing right back into the morning-after sobriety of that less-than-favorite year, 1992.

1992 D 11, C1:1

My Queer Body

A performance work written and performed by Tim Miller; technical direction and lighting realization, Jan Bell-Newman. Presented by Performance Space 122, 150 First Avenue, at Ninth Street, East Village.

By MEL GUSSOW

During one section of his new, uninhibited monologue, "My Queer Body," Tim Miller is naked to the world, or rather to the 93 people who by his count fill the seats at Performance Space 122. Unabashed if a bit self-conscious, he is determined to talk to the audience as freely and openly as possible. After all, his life is on the line. In this and other shows, Mr. Miller specializes in self-exposure, and the approach is emotional as well as physical.

For all his candor and his outrage about homophobia and AIDS, he has a nonthreatening presence. With some accuracy he has characterized himself as "the all-American queer Jimmy Stewart." If he had his way, his would be a more wonderful life.

Mr. Miller, who was a dancer before he was a performance artist, became known to a wider public after Senator Jesse Helms, the North Carolina Republican, took on the National Endowment for the Arts. Two years ago Mr. Miller was denied a grant from the endowment and was aligned with Karen Finley and others as "the N.E.A. four," all of whom used sexually explicit material in their work. Despite his political commitment, he does not have the polemical power of Ms. Finley. He is single-minded, a fact that leads to a solipsistic performance.

•

In his current show, he entreats his audience to join him on a "psychosexual scavenger hunt," which becomes an autobiographical account of what it means to be gay in America. He begins on a fanciful note as a sperm cell swimming upstream and already aware of his homosexuality. From there it is a relatively short hop to high school and his first date with another boy.

About halfway through the monologue, he disrobes, not as a striptease but as a strip-ease. He keeps his equilibrium even as he sits in the lap of a theatergoer. On opening night he discreetly chose a friendly lap, that of the actress Annie Sprinkle. Throughout the show the principal subject is sexual, the context confessional. For those who share his orientation, the message could be emboldening, as he preaches fearlessness in the face of hostility.

One could ask for more art and less exposure. But then Mr. Miller might not be as true to himself or to his partisans. He is who he is, and he is apparently performing exactly as he wants to, which in itself gives him a claim to integrity. At the same time, it must be acknowledged that this is not a show for all audiences.

At the end of his monologue, he reaches for an epiphany, projecting himself into the year 2000 when he greets the election of "the first black lesbian President of the United States." Then, with a look of satisfaction, he adds, "She has appointed me performance art laureate of the nation." If she were, she would.

1992 D 11, C14:6

A Dream World Where Passion Rules

By STEPHEN HOLDEN

"I want to take you swimming in the dark," David Cale intones seductively, with a hint of menace. "It's something you would never do. It's something you would like to do."

Mr. Cale's invitation sets the tone of "Deep in a Dream of You," his wonderful 80-minute show of poetic monologues with music that concludes a three-night engagement at the Knitting Factory this evening.

The work, which was originally produced at the Goodman Theater in Chicago, consists of 12 short monologues by assorted characters in the thrall of erotic obsession. In "The Dolphins," Mr. Cale portrays a proper Englishwoman who is sunning herself by the sea one afternoon when she has a surreal sexual encounter with a stranger who emerges from the water with a blue dolphin on his shoulder. When he returns over succeeding days, their encounters become dreamlike journeys into the middle of the ocean.

•

In "The Warden Hills," Mr. Cale is an Englishman remembering an adolescent sexual encounter with an American sailor who committed suicide the night after molesting him. The narrator of "The Forty Winks Motel" describes with roaring satisfaction an encounter with a prostitute that involves a jar of maple syrup. The longest piece, "Remember," describes a woman's passionate affair with a construction worker about whom she knows next to nothing.

"Deep in a Dream of You" is really an extension of "Smooch Music," a more lighthearted show of monologues on the subject of romance that Mr. Cale performed at the Kitchen five years ago. Like "Smooch Music," the new work has an atmospheric, jazzy score by Roy Nathanson. The music is adeptly performed by a five-member ensemble that includes bass, percussion, two cellos and the composer on saxophone.

•

The show is a significant breakthrough for Mr. Cale, both as a writer and a performer. The best monologues have the poetic resonance of popular song lyrics that have been purged of cliches and deepened with surreal imagery that evokes the connection between passion and dreams with a brilliant clarity. At the same time, his characters' insights about themselves suggest a strong confessional thread running through the writing. Each vignette is elegantly shaped. Never mawkish and at moments pungently witty, Mr. Nathanson's score helps connect the pieces and gives the sequence an arc.

Although Mr. Cale doesn't actually impersonate his characters, he has developed a range of voices and a vigorous, stylized body language that gives his narrators sharply differentiated personalities.

"Deep in a Dream of You" is certainly Mr. Cale's most accomplished work to date. It deserves to be published as well as produced in a larger setting for a longer New York engagement.

1992 D 12, 15:4

SUNDAY VIEW/David Richards

'Woyzeck' Ricochets Through a Mad World

JoAnne Akalaitis

stages a searing

vision of despair

at the Public.

One 'Seagull' that doesn't fly.

"**W**OYZECK," AS JOANNE Akalaitis has directed it at the Joseph Papp Public Theater, is ravishingly grim.

The grimmer matters become, the more ravishing it is, so that the climax of this sordid drama — the stabbing of a cheap prostitute by the soldier who's been living with her for years — is very likely to take your breath away.

Don't misunderstand me. The crime is heinous. But even as you are wincing at the brutality, Ms. Akalaitis blankets the combatants in a powdery white light, silences their voices and throws their flailings into slow motion. The gaping mouths screech their agony in pantomime, the bodies writhe and contort as if in a bad dream. All you hear in the deafening stillness is the persistent drip-drip-drip of water somewhere.

Then the awful realization dawns on you: what sounds like water is really blood pouring off the victim, soaking through her clothes and splattering to the floor.

Compared to the blood bath that Ms. Akalaitis unleashed at the end of " 'Tis Pity She's a Whore" in the very same theater last season, I suppose this is penny-dreadful stuff — the sort of crime passionnel that ends up buried in the police blotter. However, until the light resumes its gray pallor and the bodies revert to the ugly spasms and twitches of the gutter, the murder possesses the magnificent grandeur of a Greek frieze. It is all happening there, right before your horrified eyes, and yet it also seems to have been plucked out of time and place — damnation without end. The double perspective is a stunning directorial effect.

But then "Woyzeck" is, above all, a director's play, crying out for shape. It contains no memorable characters, no great scenes. Peo-

ple, in its view, are madmen or puppets, and the plot is like so much broken crockery. The German playwright Georg Büchner was far from completing the work when he died of typhus in 1837 at the age of 23. What he left behind was a sheaf of bizarre unordered scenes, some containing no more than a few lines of jagged dialogue.

They chronicle the frantic destiny of Woyzeck (Jesse Borrego), who scrapes together a pitiful living as barber and bootblack at an army garrison. To augment his income, he serves as a guinea pig for a mad doctor who feeds him a diet of peas, regulates his urinary habits and bullies him with nonsensical medical jargon. Although Woyzeck has fathered a child by Marie, the local prostitute, they have no relationship beyond the proximity dictated by their poverty, and she is increasingly attracted to the strutting Drum Major, whose spanking red uniform is the only gash of color in the land.

Unable to comprehend the meaning of toadstools or decipher the empty echoes beneath the earth's crust, Woyzeck reels through his paltry life, always late and out of breath. "You're running around like an open razor blade — you might cut someone," observes the Captain, a man who would rather waddle. Then one day, for reasons that have as much to do with the squalor of his lot as they do with any pangs of jealousy in his shriveled breast, Woyzeck kills his mistress and drowns himself.

"A beautiful murder — as good a murder as you'd ever want to see," beams the Doctor, as if propounding a great moral, when there is rarely a worthy moral to be drawn from human wretchedness.

Woyzeck is one of the first examples of a species that would flourish in the 20th-century theater, the alienated man, while Büchner's notion of a senseless universe, indifferent to the gyrations of mankind, would be elaborated with a vengeance by the absurdists more than a century later.

"Such a beautiful hard gray sky," observes Woyzeck. "You'd almost feel like pounding a block of wood into it and hanging yourself." A grandmother, recounting a story to the urchins at her feet, sees similarly stark visions. The moon, she allows with the flatness of one accustomed to despair, is "a piece of rotten wood." The stars, "golden flies stuck up there like the shrike sticks 'em on the blackthorn." The earth itself, "an overturned pot."

The truncated script is not quite a Rorschach test, but obviously a director can forge a lot or a little, a hallucination or a clown show, out of its odd shapes and blank spaces. Ms. Akalaitis, gravitating toward nightmare, has produced her most evocative staging since taking over as head of the Public Theater. The action unfolds in what could be an empty barracks or a derelict warehouse in an industrial slum. A shower room, emitting sulfurous geysers of steam, opens onto the desolate space (Ms. Akalaitis uses it as a stand-in for the pond that Büchner's script calls for). Through the sooty windows in Marina Draghici's concrete set, the outside world is a milky apparition.

Daylight, as the lighting designer Mimi Jordan Sherin recreates it, comes in dingy shades of gray. Most of the characters — conscripts, camp followers and a village idiot — are dressed so drably by Gabriel Berry that when a carnival pulls into town, the plume on the head of a talking horse qualifies as a wild extravagance.

Given the muted palette, Ms. Akalaitis "paints" her production with swirls and rushes of movement instead. Clouds of smoke hover over the

Martha Swope/"Woyzeck"

Jesse Borrego and Sheila Tousey in "Woyzeck"—Mr. Borrego is sensational as the title character, his voice seemingly trapped between a whimper and a howl.

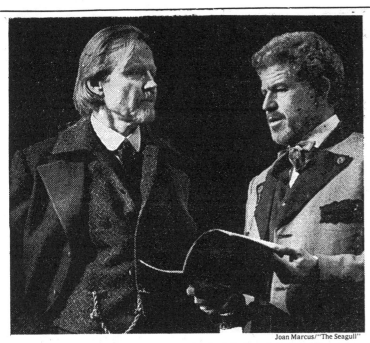

Joan Marcus/"The Seagull"

Jon Voight, left, and Tony Roberts in the National Actors Theater production of "The Seagull"—Right truth uttered at the wrong time.

stage, so that the production seems to be alternately advancing and retreating in the mist, not unlike a mountaintop in the grip of bad weather.

A perverse sense of folklore underscores the proceedings, and it's not just the clog dancing that periodically has the townsfolk beating the floor in unison with their feet, while their upper bodies remain motionless and their flour-white faces almost ghoulishly impassive. The stern hymns of suffering and deprivation they intone loudly elicit no visible reaction either. A stony duty is being observed, that's all. Even a fiddler's antic fiddling can't pierce the leaden sky.

■

Ms. Akalaitis's production of " 'Tis Pity" was equally dour, and she certainly forged stage pictures of arresting beauty in her productions of "Henry IV, Parts I and II." The difference here, I think, is that she has chosen her actors with far more care than in the past, and then kept a hawklike eye on their movements.

Of course, "Woyzeck" doesn't pose insurmountable challenges in that regard. The majority of the characters belong to the walking dead — only the most primal emotions crack the Novocained facades. Or else they are buffoons of science and warfare, conveniently blind to everything but their own sense of self-importance.

Still, the cast members look born to their fallen states, and while I can't swear to it, it's my suspicion that Zach Grenier (the Captain), Denis O'Hare (the Doctor) and Lou Milione (the Drum Major) are inflated with helium just before the show. Sheila Tousey is the only letdown, as Marie; there's more fatigue than vulnerability in her desperation. But Mr. Borrego is sensational as Woyzeck.

He has a close-shaven head, hollow cheeks and sunken eyes that smolder in their sockets. Trapped between a whimper and a howl, his voice suggests the raw edge of winter. You can almost hear the blood coursing

through his restless body, eternally pitched forward for flight or fight.

God may have created him. It seems more likely that Daumier drew him.

'The Seagull'

If Ms. Akalaitis appears firmly on track at last, I fear we'll have to continue to settle for performances in lieu of productions from the National Actors Theater.

Tony Randall's well-intentioned company, which aims to bring the classics to Broadway, has just moved into the Lyceum Theater. Lovely theater, the Lyceum, but that's about it for sweeping changes. The first presentation of the troupe's second season, "The Seagull," is no different from last season's offerings. Here and there you'll spot an actor who's doing good work, and maybe a couple more who look to be on the right track. But there aren't enough of them to form what you would call an ensemble.

Unfortunately, most of the plays that Mr. Randall has chosen so far (Feydeau's "Little Hotel on the Side," Miller's "Crucible") are not the sort that can be rescued by a few good performances. If everybody doesn't function like clockwork in a Feydeau farce, nobody does, and let's not forget that "The Crucible" is an examination of *mass* hysteria. The shortcoming is even more grave when it comes to "The Seagull."

■

Like the rest of Chekhov's dramas, it's as much about the fabric of provincial Russian life at the turn of the century as it is about the sorry souls who can't wrest themselves free of the pervasive ennui or their paralyzing infatuation with the wrong person. The play, in fact, depicts a virtual daisy chain of unrequited love, starting with Madame Arkadina, the vain and aging actress who has attached a world-weary writer, Trigorin, to her entourage. He is quickly attracted to

Nina, an idealistic young woman and aspiring actress who has a crush on Konstantin, Madame Arkadina's brooding son, although not for long. So it goes, around and around, which is to say nowhere. The poignancy comes from the inevitable frittering away of time, hope, youth and dreams.

The director Marshall W. Mason orchestrates a properly Chekhovian atmosphere — the silences that suddenly descend upon animated conversations, paralyzing the participants; the chirping of birds and crickets that mocks so much human misery; the

The poignancy comes from the inevitable frittering away of time, hope, youth and dreams.

muffled offstage noises that attest to more consequential goings-on elsewhere. Atmosphere is only part of it, though; the onstage events *are* the stuff of the play. They've got to be kept interesting, at the same time that they must be made to appear marginal, beside the fact. (Chekhovian drama is the drama of inattention, botched opportunities and the right truth uttered at the wrong time.)

All this presupposes a betterschooled cast than the current one. Tyne Daly's Arkadina is, regrettably, Mama Rose in "Gypsy" minus the songs. There's no insinuating charm here, no capriciousness, no wily femininity. The actress is like a sequined tank, flattening everyone before her. Mind you, it doesn't take a whole lot to flatten Ethan Hawke, who is simply out of his league and gives a dull and artless rendering of Konstantin, or Laura Linney, whose silvery beauty would seem to be her single claim on the role of Nina.

Two performances alone rise above the general mediocrity. Jon Voight, looking far more at home onstage than most movie stars, sees Trigorin for the true weakling he is. What the actor allows him, however, is a strong sense of self-loathing. The moments when he turns on himself for sacrificing so many years to his charming little talent as a writer are among the production's best. The other standout is John Franklyn-Robbins, Madame Arkadina's brother, who has arrived at the end of his long life, whiskers flying, memory collapsing, health broken. All that's left him are crotchety bluster and a lap robe. Whenever one of those actors gets to vent his remorse, the lethargic evening picks up.

Otherwise, on the lofty pretext of performing "The Seagull," the National Actors Theater is giving us a stageful of sitting ducks. □

1992 D 13, II:5:1

Theater in Review

■ Reconcocting Noël Coward and Gertrude Lawrence ■ A musical 30 years in the making and still fiction ■ And a musical with Huck Finn.

'Noël and Gertie'

York Theater Company at Theater at St. Peter's Church
Lexington Avenue at 54th Street
Through Sunday

Devised by Sheridan Morley; directed by Brian Murray; musical director, Michael Kosarin; choreography by Janet Watson; set by James Morgan; costumes by Barbara Beccio; lighting by Mary Jo Dondlinger; technical director, John Miller; production stage manager, John Kennelly. Presented by the York Theater Company, Janet Hayes Walker, producing director; Molly Pickering Grose, managing director, and One World Arts Foundation, W. Scott McLucas, executive director.

WITH: Jane Summerhays and Michael Zaslow.

Anyone familiar with the recordings that Noël Coward made with Gertrude Lawrence in the 1930's is bound to be struck by the tone of mischievous intimacy that the playwright shared with the actress who was his sometime muse. Perched at the pinnacle of cafe society, these charming and talented entertainers seemed the quintessential voices of a philosophy whose cardinal rule was

that nothing in life be taken too seriously.

Although echoes of those high spirits can be felt in "Noël and Gertie," a two-actor celebration of their friendship at the Theater at St. Peter's Church, the show has a decidedly more formal tone than the recordings. Created by the English drama critic Sheridan Morley, who has written biographies of both Coward and Lawrence, "Noël and Gertie" is a carefully woven montage of Coward songs and scenes from his plays in which they appeared together.

The formal tone of the show, which is directed by Brian Murray, has a lot to do with the performers. Michael Zaslow's Coward is a prim, elegant figure who delivers his bon mots with a slight oratorical flourish. As playful as he tries to be, an undertone of tension in his voice and body language lends his Coward an air of gravity that one does not associate with the author of "Blithe Spirit." Jane Summerhays brings a correspondingly aristocratic tone to Lawrence. While there is laughter in her portrayal, there is little giddiness.

Mr. Morley's celebration opens with a scene from "Private Lives." Then the two actors take turns interweaving biographical tidbits with more songs and dramatic excerpts. Among the plays represented are two from the "Tonight at 8:30" cycle and "Blithe Spirit." The songs include "You Were There," "Sail Away," "If Love Were All" and "I'll See You Again," all sung competently but rather stiffly.

Had the musical emphasis tilted more toward Coward's dazzling party songs and less toward his sentimental warhorses, "Noël and Gertie" might have felt more like a marvelous party and less like an engaging and well-organized seminar.

STEPHEN HOLDEN

'A Backers' Audition'

American Jewish Theater
307 West 26th Street
Chelsea

Book, music and lyrics by Douglas Bernstein and Denis Markell; based on an idea by Martin Charnin, Mr. Bernstein and Mr. Markell; directed by Leonard Foglia; musical direction by Michael Sansonia; set by James Noone; costumes by Deborah Shaw; lighting by Russell Champa; artistic consultant, Jack Temchin; production stage manager, Joseph Millett. Presented by the American Jewish Theater, Stanley Brechner, artistic director; Lonny Price, associate artistic director.

WITH: Tom Riis Farrell, Stan Free, Charles Goff, Gretchen Kingsley, Tom Ligon, Sheila Smith, Alice Spivak and Ray Wills.

Lore has it that before Broadway musicals became multi-million-dollar corporate investments, producers held what were known as "backers' auditions." Friends would gather in a Park Avenue apartment, slosh back a few drinks, listen to some songs from the new show and write a check. It was the theater set's equivalent of a Tupperware party.

"A Backers' Audition," a new musical by Douglas Bernstein and Denis Markell at the American Jewish Theater, tries to recapture the romance of that bygone day. You can leave your checkbook at home.

The show seems like a cross between "Tony 'n' Tina's Wedding" and "Catskills on Broadway." As the audience enters the intimate three-quarter round theater, several people are milling about with drinks in their hands, greeting people and chatting amiably. A baby grand is open on stage. The bar is nowhere in sight.

The audience, of course, stands in for the prospective backers of a show called "Raggedy Romeo," and Esther Kanner has taken over from her late husband, Herman, in trying to raise the remaining $953,000 to capitalize it. The show, we are told, has been in workshop for 30 years. That probably explains all the gags with references to Goldwater, Checkers, Florence Henderson, the Rosenbergs, Zabar's and Madame Nhu.

The music ranges from faux Sondheim to faux Loewe and the lyrics make the rhymes of Ogden Nash seem like the cantos of Ezra Pound. In one song Esther prays for guidance from her dead husband: "Should we use Ethel Waters/ or Ethel Merman,/ Herman;/ Should we get Harold Prince/ or Harold Clurman,/ Herman?" Well, you get the idea. If there is any faintly bright spot in any of this, it's "I Want to Work With Someone Dead," a mildly amusing duet in which the composer and lyricist for "Raggedy Romeo" sing of their secret yet understandable desire to be rid of each other's collaboration.

Most of the performances are nothing more than caricatures, and not very good ones at that. One exception is Tom Riis Farrell as Haji, a temperamental third-world set designer with a somewhat imprecise command of the language. Gretchen Kingsley has a fine voice. Leonard Foglia directed.

WILBORN HAMPTON

'Lightin' Out'

Judith Anderson Theater
422 West 42d Street
Clinton

Book and lyrics by Walt Stepp; music by Mr. Stepp and John Tucker; directed by Kevin Cochran; set by Campbell Baird; costumes by Thom J. Peterson; lighting by Paul Bartlett; sound by Jim van Bergen; additional music by Gregory Tucker; additional musical staging by Catherine Ulissey; production stage manager, Marjorie Goodsell Clark; music direction and arrangements by Robert Meffe. Presented by the Dauphin Company.

WITH: Beth Blatt, Tony Fair, Karen Looze, Robert Roznowski, Gordon Stanley and Robert Tate.

If a few hummable tunes, a small but aggressive instrumental ensemble, a stunning set and enthusiastic actors could add up to a fine musical, "Lightin' Out" would be terrific.

But Walt Stepp's book for this play about Mark Twain and what did happen or might have happened to Huck Finn and his slave friend Jim is disorderly, tentative, self-conscious and often confusing. It is a very rare musical that gives an audience time to sit back and puzzle out what is happening onstage; in this one, which packs 22 songs into little more than two hours, the fuzzy plot is fatal.

In the play the writer, at the end of his life and suffering crises of conscience and confidence, reflects on the notoriously manipulative ending of "The Adventures of Huckleberry Finn." As he ruminates and dreams, Huck and Jim appear to relive some of their adventures and then to rewrite the last pages of the novel radically. Why Twain is conscience-stricken and why the Huck-Jim version of the novel turns out the way it does are never made clear; what is clear is that the revision is not an improvement.

The performance, directed by Kevin Cochran, is always lively, and the music by Mr. Stepp and John Tucker, although it derives from many sources, is pleasant enough. Mr. Stepp's lyrics are bland and prosey.

Gordon Stanley plays Twain a bit too much as the great if troubled man to get much sympathy from the audience, and occasionally in his singing he strains for effect. Robert Tate as Huck and Tony Fair as Jim are well matched in their roles and in their voices; their several duets are by far the best-sounding pieces in the play. And when Mr. Tate teams up with Beth Blatt in a song about the Twain novel's tin-eared young female poet who specializes in memorial verses for the dead, their number is genuinely comic, and noisily appreciated by the audience.

But most of the characters in "Lightin' Out" are not realized fully enough in the script to give the actors much chance to make them passionately interesting or amusing. It is telling that the action really only springs to life when Huck and Jim on their raft are out battling the world: they come from the hand of the real Twain, and in them one can feel some of his vitality.

D. J. R. BRUCKNER

1992 D 14, C14:1

Orpheus in Love

A new opera with words by Craig Lucas; music by Gerald Busby; directed by Kirsten Sanderson; musical director, Charles Prince; set by Derek McLane; costumes by Walker Hicklin; lighting by Debra J. Kletter; sound effects by Stewart Werner; production stage manager, M. A. Howard; production manager, Jody Boese. Presented by Circle Repertory Company, Tanya Berezin, artistic director; Abigail Evans, managing director. At 99 Seventh Avenue South, at West Fourth Street, Greenwich Village.

Bass	Bradley Garvin
Bassoonist	Stephen Wisner
Bassoonist	Daniel Shelly
Mezzo-soprano	Belinda Pigeon
Soprano	Diane Ketchie
Violinist	Christina Sunnerstam
Violist	Scott Slapin
Cellist	Nancy Ives
Double Bass Player	Michel Taddei
Tenor	Steven Goldstein
Pianist	Eleanor Sandresky
Musical Director	Charles Prince

By BERNARD HOLLAND

When words and music can't resolve their differences — and in opera they rarely do — what better mediator than Orpheus? He is the musical charmer who seduces Death into taking a holiday, if only a short one. In a way, music has been created in his image: inventing its own clock, persuading time to rearrange itself a little. Dismembered finally by the Bachantes, Orpheus and his lyre continue to sound even past death. Music will last, the song tells us, even in a fractured world of events.

Myths like this live partly because they are malleable. So when Craig Lucas (words) and Gerald Busby (music) deposit the Orpheus myth in the midst of music students at an American community college, minor adjustments make it fit. Tinkering with the ending of this story is an old operatic tradition anyway. The one for "Orpheus in Love," which opened last night at the Circle Repertory Company, falls between happy and unhappy. Lost to an automobile accident, Eurydice prevails over death by becoming a kind of music of her own.

Opera can be a self-defeating operation: first it creates a set of separations, then struggles to put them back together. Musicians are in the pit, singers onstage; music takes its own slower pace, verbal interchange itches to go faster.

•

"Orpheus in Love," at least in its first act, takes some interesting steps toward reconciliation. Orpheus, a slumbering violist, awakes to two bassoonists playing at his bedside. He dreams a quartet of string players; they gather around his bed, play Mr. Busby's music and evoke our protagonist's past and present. Orpheus' music teacher appears. She is Diane Ketchie who, in a stunning bit of multi-media virtuosity, whizzes through difficult piano music, sings lustily and employs deftly funny body English, all at the same time.

There is a lightness and good humor to these rapprochements. Music acts and actors make music; both parties seem delighted. Mr. Lucas strings non and quasi sequiturs into a wandering trickle-of-consciousness style, the bad jokes neutralized by the brighter ones. Mr. Busby's music in Act I is neat and clean. It dabbles in bitonality and stretches traditional harmony to the brink of dissonance and often beyond. Steven Goldstein, as the addled lecturer and the father of Orpheus, adds to the good humor. He is both subtle and genuine.

Act II, which re-enacts Orpheus' trip into Hades, is altogether darker, more spiritually ambitious and less convincing. Musicians withdraw from the stage and gather to the side. A conductor with baton and tails (Charles Prince) ministers to them. Orpheus' parents are encountered in the land of the dead (described as an eighth-grade gymnasium) and past resentments are reconciled. Eurydice is found and lost, but at the end, as Orpheus sits on his bed, the dead live

Worlds of conflict: living and dead, drama and opera, words and music.

on in him and in his music. Remembering an earlier line ("The sound of the viola says 'I love you,'"), one listens to a final paean sung by the ensemble. It announces the interchangeability of love and music.

"Orpheus in Love" thickens and congeals the closer it gets to tragedy, though to its credit, the lugubrious and the sentimental are determinedly fought off. Yet given the insouciance and ease with which its authors manipulate burdensome problems of style earlier in the evening, one feels let down by what follows. The two acts operate as separate operas. The first rearranges opera's furniture with an easy flair; the second seems to change its mind and put things back where they were.

As Orpheus and Eurydice, Bradley Garvin and Belinda Pigeon are handsome looking and sing with trained, accomplished voices. Kirsten Sanderson's direction maneuvers them efficiently around this small space, at one point extending the rear of the stage out onto the sidewalk of Seventh Avenue South. Derek McLane's set offers a bed, a huge picture frame and in the Hades scene, a gilded brick wall. The musicians were young and first rate.

If Mr. Lucas and Mr. Busby want to keep "Orpheus in Love" in circulation, I suggest they sign Ms. Ketchie to a lifetime contract. I can think of no one in the popular, Broadway or classical world who could do all the things she does and do them simultaneously and so well.

1992 D 16, C17:5

Revival of 'Carousel' In London Is a Revelation

By FRANK RICH

Special to The New York Times

LONDON, Dec. 16 — Even in the age of Andrew Lloyd Webber, the British remain in awe of the Broadway musical. Only the most obviously disreputable of American imports and revivals fail to earn critical raves here, and on occasion local versions of New York shows are proclaimed superior to the originals. During the 1980's, this was most famously the case with Richard Eyre's staging of "Guys and Dolls" and Cameron Mackintosh's upbeat revision of Stephen Sondheim's "Follies," though American visitors could see that both productions were far from fluent in Broadwayese. In "Guys and Dolls," Damon Runyon's mugs sometimes spoke with Southern accents and tapped like Bojangles.

So it was with skepticism that I approached the new production of the 1945 Rodgers and Hammerstein "Carousel," which opened last weekend to ecstatic reviews and turnaway crowds at the Royal National Theater, the site of the Eyre "Guys and Dolls." But for once the wild enthusiasm may be an understatement. This is without question the most revelatory, not to mention the most moving, revival I've seen of any Rodgers and Hammerstein musical. The National has recently found startling new ways of looking at the dramas of Tennessee Williams and Arthur Miller under both Peter Hall's and Mr. Eyre's leadership, and now it proves just as imaginative in sweeping away decades of clichés from an American musical classic of the same period.

"Carousel" was Richard Rodgers's own favorite show among his collaborations with Oscar Hammerstein 2d, but it is infrequently revived, in part because its vocally demanding lead role, the carousel barker, Billy Bigelow, is hard to cast, in part because its dark book (adapted from Ferenc Molnar's "Liliom") asks audiences to stomach Billy's wife-beating and suicide. The last major New York production, a good one at Lincoln Center in which John Raitt recreated his original Billy, was nearly 30 years ago. Though almost everyone is familiar with "Carousel," what most audiences have actually seen is the distorted, candied Hollywood film adaptation of 1956.

The National Theater production is a collaboration by Nicholas Hytner, a director whose eclectic reach has extended from opera to "Miss Saigon" to Alan Bennett's "Madness of King George III," and Kenneth MacMillan, the principal choreographer of the Royal Ballet, who died while "Carousel" was still in rehearsal but not before he had finished what a program note says was 85 percent of the dancing. From the very first bars of "The Carousel Waltz," they and the brilliant designer, Bob Crowley, aspire to an adult emotional purity that is devastating in its cumulative effect.

Surely this is the first staging of the piece in which the curtain does not rise to reveal a carousel. Instead the sinister opening bars of Rodgers's waltz are set in the grim late-19th-century New England mill where the heroine, Julie Jordan, works absentmindedly at her loom. The stage is at first dominated by a large Victorian clock that ticks off the minutes until the closing time of 6, at which point the clock flies away, the abruptly liberated mill laborers twirl out of the forbidding factory gates in mad abandon and a full moon sweeps one and all to the fairground. There the drab colors of industrial servitude briefly give way to bright lights and raucous carnival sideshows while the carousel is slowly erected by roustabouts before the audience's eyes. Familiar as the music may be, it has never sounded so urgent or so troubling as it does when illustrated by this bittersweet cinematic panorama of oppression and release.

Without making a British fetish of class conflict, the National's "Carousel" is always conscious of the lowly economic status of its major characters. When Julie (Joanna Riding) and Billy (Michael Hayden) get together in "If I Loved You," the song's indirect expression of feeling comes across not as coy musical-comedy flirtation but as inarticulate, self-protective wariness. These incipient young lovers, aged by drudgery and snubbed by respectable society, are old and achingly lonely before their time, a mere "couple of specks" in the scheme of things, as Billy sadly puts it. The duet's sexual crescendo, so titillatingly elongated and then consummated in the tidal music, becomes Billy and Julie's thrilling defiance of both their own sense of defeat and their community's Puritan propriety. As designed by Mr. Crowley, the scene is set on an Andrew Wyeth hill that is painted in the vivid folk-art colors of Grandma Moses but is suffused with the solitude of Edward Hopper.

●

In this "Carousel," the whalers' tavern is as dark as a saloon out of O'Neill, and the waterfront setting for Billy's attempt at armed robbery could be Steinbeck's Cannery Row. Yet the production is airy, fluid and poetic, not heavy or realistic. Mr. Crowley, whose work has been seen in New York in "Les Liaisons Dangereuses" and the Ian McKellen "Richard III," avoids the busy mechanics of contemporary English musicals, restricting himself to the drops and turntables of the Rodgers and Hammerstein era. His New England fishing village is in a cobalt blue box that doubles as heaven when Billy ascends there in the second act. The visual harmony is matched aurally: amplification in the National's proscenium house, the Lyttelton, is slight, and the original Don Walker orchestrations are sumptuously served by a large pit orchestra.

What is remarkable about Mr. Hytner's direction, aside from its unorthodox faith in the virtues of simplicity and stillness, is its ability to make a 1992 audience believe in Hammerstein's vision of redemption, which has it that a dead sinner can return to Earth to do godly good. Mr. Hytner's principal accomplice in this feat is Mr. Hayden, a previously unknown American actor not long out of Juilliard who brings to Billy a Warren Beatty-like mixture of masculine belligerence, bewilderment and tenderness and sings his marathon "Soliloquy" like an angel well before the character becomes one. Almost as important to the production is Patricia Routledge's Nettie, whose direct and understated delivery of "You'll Never Walk Alone" to the just-widowed Julie shakes the cobwebs from a song long synonymous with sentimental overkill.

The National "Carousel" is not without its sporadic, typically British lapses. Some of the singing is so-so (a flaw in Miss Riding's otherwise fine Julie) and some of the casting is stock (the black Mr. Snow, Clive Rowe, happily excepted). The MacMillan choreography of the Act I ensemble numbers "June Is Busting Out All Over" and "Blow High, Blow Low!," while intended to salute the Agnes de Mille originals, looks like the West End's perennially warmed-

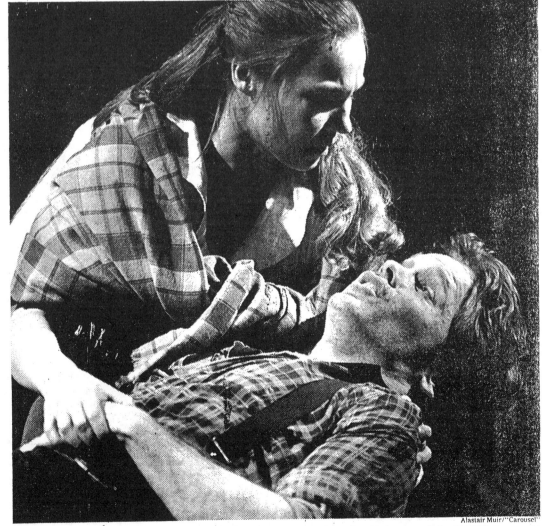

Alastair Muir/"Carousel"

Joanna Riding as Julie Jordan and Michael Hayden as Billy Bigelow in a production of the 1945 Rodgers and Hammerstein musical "Carousel," which opened over the weekend at the Royal National Theater in London.

over idea of Michael Kidd. But in the affectingly performed Act II pas de deux, in which Billy's unhappy teen-age daughter (Bonnie Moore) search-es for her dead father's love by taking up with a fairground boy (Stanislav Tchassov), MacMillan joins the hero in seeming to speak to a spellbound audience from beyond the grave.

'Assassins'

It was Stephen Sondheim, Hammerstein's protégé, who famously saluted the advances of this musical by noting that while its predecessor, "Oklahoma!," was about a picnic, "Carousel!" was about life and death. Mr. Sondheim's own musicals are often about anger and death, especially so in the case of his last work, "Assassins," which has also received a highly acclaimed new production here.

As staged by Sam Mendes, London's hot young director of the moment, at the refurbished, 250-seat Donmar Warehouse Theater, "Assassins" is far more unified and lucid than it was in Jerry Zaks's fussy original production at Playwrights Horizons in New York last year. (It is not so well performed, though Henry Goodman's antic chief Charles Guiteau is a bright spot.) The show also benefits from a fuller band and from a haunting new song, "Something Just Broke," in which ordinary citizens describe a momentous historical event from their vantage point. In theme the number is reminiscent of "Someone in a Tree" from "Pacific Overtures," but this time the chilling event seen from afar is the Kennedy assassination.

The improvements do not alter my impression that, its score notwithstanding, "Assassins" is theatrically and intellectually static. But seeing this Sondheim musical in contrast with "Carousel" is as fascinating as bracketing the anti-colonial "Pacific Overtures" with "The King and I." Both "Assassins" and "Carousel" open in the outlaw world of the fairground. Mr. Sondheim's characterization of assassins like Leon Czolgosz and Giuseppe Zangara as have-nots driven to crime by a corrupt economic system recalls not just his own Sweeney Todd but also his mentor's conception of Billy Bigelow.

Yet the difference in sensibility between Hammerstein and his creative heir is as vast as that separating the innocent pre-Kennedy-assassination America from the cynical country that came after. In "Assassins," the killers are freaks, grotesque specimens to be catalogued and studied from a clinical distance. At "Carousel," at least in the National's magical rendition, the audience is transported back to a time when America believed that even its bad guys could be redeemed in a tearful and forgiving embrace.

1992 D 17, C11:3

The Night Before Christmas
A Musical Fantasy

Original book, music and lyrics by Gary D. Hines; additional creative contributions by Bill Smith/Company; based on the poem by Clement Clarke Moore; director, Brian Grandison; choreographer, Marvette Knight; sets by Vee Corporation and Seitu Jones; costumes by Pam Pryor, Deidre Whitlock, Otis Montgomery and Beverly Mahto; lighting by

James (Slick) Slater; musical director, Mr. Hines; sound by Greg Longtin; production stage manager, Robert Ellis. The Sounds of Blackness, presented by Mr. Hines, producer; K. Leon Saunders, executive producer; Paula Casey, assistant executive producer. At the Apollo Theater, 253 West 125th Street, Harlem.

WITH: Jimmy Wright, Ann Bennett-Nesby, Bill Smith, Shirley Marie Graham, Michael Bowens, David Young, Jamecia Bennett, Russell Knighton, Core Cotton, Terrence Frierson, Jayn Bell, Dorothy Brown, Kimberly Brown, Dorothy Townes, Melody Doyle, Robert Edwards, Carrie Harrington, Valarie Johnson, Geoffrey Jones, Dr. Robert Jones, Patricia Lacy, Beverly Mahto, Trudy Monette, Alecia Russell, Elizabeth Turner and Jennifer Whitlock.

By LAWRENCE VAN GELDER

Dancing mice on a New York stage are nothing new at Christmastime. But what about dancing chitlins? Dancing Christmas stockings? Eight fine reindeer with glittering antlers?

They are all to be found through Sunday at the Apollo Theater (253 West 125th Street, Harlem), where a lively show titled "The Night Before Christmas: A Musical Fantasy" is staking a claim to vie with Balanchine's "Nutcracker" and the Radio City Christmas Spectacular as a holiday perennial.

Created for the Sounds of Blackness, a 40-member Grammy Award-winning ensemble based in Minneapolis, by the group's musical director, Gary D. Hines, the show is a retelling of Clement Clarke Moore's "Visit From St. Nicholas." It takes off from a rollicking Christmas Eve party in the home of a family consisting of mother, father, teen-age son and daughter.

Among the guests, there is scarcely a one, from the grandma and grandpa to the quartet of hefty gospel singers, who can't belt out a song, shake a leg or tell a joke. So, in styles from the spiritual to the swinging, the audience is treated to seasonal favorites like "Santa Claus Is Coming to Town" and "O Come, All Ye Faithful."

When the guests have gone and the family settles down to a long winter's nap, Moore's poem starts to come alive. "Not a creature was stirring, not even a mouse" ushers in dancing, singing mice. The stockings "hung by the chimney with care" come to life. And when Moore's line about visions of sugarplums is transformed, out come the dancing chitlins.

Act II is largely given over to a strike called by the reindeer against the sexism of Santa ("Santa ain't nothing but a big fat jerk, 'cause he gets all the credit but we do the work"). The female uprising is settled with the help of Mrs. Santa and Rudolph, and a plea from the young girl to remember the true spirit of Christmas. "There really is a Santa Claus, and he's a brother, too," says Dad.

The show is at its best when its unidentified performers (a program would be helpful) are singing and dancing. But its drawn-out talking scenes rely heavily on broad acting and obvious humor while hinting at a potential for topical bite with infrequent references to Mike Tyson, Clarence A. Thomas and the Bush Administration's cuts in social programs.

The show is to play the Lyric Opera House in Baltimore from Tuesday through Dec. 27 and the Fox Theater in Atlanta from Dec. 29 to Jan. 3.

There's some lively fun in "The Night Before Christmas: A Musical Fantasy," but a trip to the workshop for revisions wouldn't hurt.

1992 D 17, C18:5

The Mysteries and What's So Funny?

Music by Philip Glass; visual design by Red Grooms; written and directed by David Gordon; music director, Alan Johnson; lighting designer, Dan Kotlowitz; sound designer, David Meschter. Presented by the Pick Up Performance Company Inc., June Poster, managing director, in association with the Joyce Theater Foundation. At the Joyce Theater, 175 Eighth Avenue, at 19th Street, Chelsea.

Young Sam	Scott Cohen
Anger I	Scott Cunningham
Detective, Only Oldest Child	Norma Fire
Young Rose	Karen Graham
Fanny	Jane Hoffman
Pianist	Alan Johnson
Mr. Him	Bill Kux
Old Sam	Jerry Matz
Young Artist	Dean Moss
Old Rose	Lola Pashalinski
Actor, Grandfather, Father, etc.	Alice Playten
Anger II	Adina Porter
Mrs. Him	Tisha Roth
Marcel Duchamp	Valda Setterfield
Assistant Director	Chuck Finlon

By MEL GUSSOW

When one artist is inspired by the work of another artist, the result can be a true homage. This is the case in "The Mysteries and What's So Funny?" in which Red Grooms creates a fanciful visual design to pay tribute to Marcel Duchamp. Unfortunately, the play itself, written and directed by David Gordon, does not have Mr. Grooms's euphoric humor. It is an excessively wordy and arch excursion into art theory and domestic drama.

Should a theatergoer become restless with Mr. Gordon's attempted shenanigans, there is the scenery to brighten the journey. Mr. Grooms's contribution begins with the drop curtain, a flamboyant rebus-like interpretation of the title of the show.

After the curtain rises, the stage at the Joyce Theater becomes an environment for playful tricks. A mustached "Mona Lisa" is flanked by gigantic chessboards, and actors rush by carrying or pushing other

Duchamp signs and symbols. There are cardboard impressions of readymades and a tiny three-step staircase (Duchamp, not nude, descends). When a picture frame is held in front of a person, the person becomes a portrait.

In this and other ways, the show examines the notion that if an artist identifies something as art that certifies its artistry. While this clearly applies in the case of Duchamp, it does not necessarily apply in the case of Mr. Gordon's rambling collage.

●

Duchamp himself is portrayed by Valda Setterfield, who in the show's characteristic anarchic fashion does not look or sound anything like her role model. She offers extracts of Duchamp's philosophy and autobiography, including his pronouncement that his art is his life and vice versa.

Some of these musings are amusing, although that is more a result of Duchamp's wit than Mr. Gordon's ability to construct a play. His limitations as a playwright are even more evident in the second half of the evening: the tale of a longlasting marriage, carried from courtship through old age. The roles of husband and wife, at different ages, are played by two widely disparate pairs of actors. These characters are named Rose, as in Duchamp's alter ego, Rose Sélavy; and Sam, which may be intended as a reference to Samuel Beckett. Their story is maudlin and the connective tissue between it and Duchamp's life and art is tenuous.

In keeping with Mr. Gordon's background as a choreographer, the play is at least partly an exercise in movement, with performers manipulating one another into positions as if preparing to dance a series of pas de deux. This repeated posturing adds to the ennui. Although the performance lasts only 90 minutes, it seems much longer.

The demands of the show call for the actors to play a variety of roles,

Tom Brazil

Alice Playten, left, and Valda Setterfield in the production of "The Mysteries and What's So Funny?" at the Joyce Theater.

with the most adept changes coming from Alice Playten, who stands in for more than 20 characters, from a baby to a grandfather. Philip Glass has provided a minimal background score, played on the piano by Alan Johnson. There are occasional lyrics, sung by the less musically talented members of the company, rather than by, for example, Ms. Playten.

Considering the enthusiasm that greeted this play when it was presented last year in the Serious Fun festival at Lincoln Center, its arrival for a more extended run Off Broadway proves a disappointment. But the show is enlivened by Mr. Grooms. His work has a natural theatricality and is the principal reason for seeing "The Mysteries and What's So Funny?" At least for the duration of the performance, he proves that his art belongs to Dada.

1992 D 18, C3:1

Patrick Stewart's Dickens

Patrick Stewart's one-man version of "A Christmas Carol" was originally presented on Broadway last season. The show has reopened at the Broadhurst Theater, 235 West 44th Street, Manhattan. Following are excerpts from Mel Gussow's review, which appeared in The New York Times on Dec. 20, 1991.

"A Christmas Carol" has been so musicalized and cinematized that it may be difficult to remember the beautiful simplicity of the original Dickens story, an ode to Christmas past, present and future and a moral fable of heartwarming intensity. Patrick Stewart's one-man dramatic version is restorative, revealing the work's full narrative splendor.

Because of Mr. Stewart's virtuosity, the show could be considered a coda to the Royal Shakespeare Company's "Life and Adventures of Nicholas Nickleby." The actor offers his solo equivalent of that expansive ensemble act of the imagination, making an audience believe it has entered a magical world dense with character, atmosphere and action.

His supple look and voice enable him to portray the widest range of Dickens characters without altering his costume or makeup. Classically trained, he has the verbal dexterity of Ian McKellen. All this is combined with his own delectation in performance. In this show, that performance is both Dickensian and Shakespearean, savoring each role as well as the lush descriptive language and, whenever possible, re-creating dramatic encounters.

•

All of the essentials are in place, with the accent on the juxtaposition of despair and joyfulness. At the center, of course, is that "squeezing, wrenching, grasping, scraping, clutching, covetous old sinner," Ebenezer Scrooge. Mr. Stewart allows for no softening around the edges, in either

the character or the story, yet he does not make Scrooge into a caricatured villain.

As Scrooge is returned to his past and then recalled to life, Mr. Stewart plays all the roles as well as imitating sounds like chiming clocks and bells. He mimes the props and the scenic effects, simulating the wind on the streets and the echoes in Scrooge's solitary chamber. As called for, he is cheerful, sepulchral, childlike and feminine, as well as stouthearted when it comes to Bob Cratchit.

The Cratchit Christmas dinner, in which the actor portrays the entire family, Scrooge and the Ghost of Christmas Present, and is also on the verge of impersonating the goose on the table and the Christmas pudding with holly stuck into the top, is a tour de force. It reminds us not only of what an inventive actor he is, but also of Dickens's own great theatricality.

Seeing the actor in this show is the closest we can come to Dickens in his public performance, in which he also dominated a bare stage with his talent and with zest for his subject. At the end of Mr. Stewart's eloquent "Christmas Carol," one wishes he would move on to "The Cricket on the Heart" and other Dickensian treasures.

1992 D 18, C29:1

Quintland

Created and performed by Dan Hurlin; composer and musical director, Dan Moses Schreier; set by Donna Dennis; puppets by Janie Geiser; lighting and stage management by David Bergstein; directorial assistance by Ryan Gilliam; produced by Downtown Art Company. Presented by the Dance Theater Workshop at the Bessie Schönberg Theater, 219 West 19th Street, Chelsea.

By MEL GUSSOW

It takes sheer audacity to create a musical about the Dionne quintuplets and then play all the roles. But that is exactly what Dan Hurlin has done in "Quintland (The Musical)." Fortunately, he has talent as a writer and actor to go with his nerve. He has also done ample research, so that in the course of the performance (at Dance Theater Workshop) he can elucidate the facts, paradoxes and longer-ranging effects of a phenomenal event.

In 1934 an otherwise ordinary mother in a small Canadian town gave birth to five identical daughters. This was of course without the help of fertility drugs. The Quints completely transformed their parents' lives and the life of their doctor, Allan Roy Dafoe, who became the hero of the day as well as of the Hollywood movie "The Country Doctor."

The Quints were an antidote to the Depression, coming between two wars and invigorating the world with a real-life fairy tale. In his show Mr. Hurlin looks beneath the sweet nostalgia, though some of that is there, to talk about the oddities of the story, beginning with the primitiveness of the medical facilities in the town where the Dionnes were born.

•

In this fast-paced collage Mr. Hurlin handles five telephones, playing doctor, reporter, father and other characters as word of the births spreads across the continent. Repeatedly we hear the dazzled father ask if it costs more to have a birth announcement for five babies. It would have been shrewder of him to wonder what the emotional cost would be to him and his family.

Tom Brazil

Dan Hurlin performing in "Quintland (The Musical)" at the Bessie Schönberg Theater at 219 West 19th Street, Chelsea.

It is the country doctor who takes charge and becomes the principal celebrity. As played by Mr. Hurlin, he is wily when wiliness is needed, as offers come in for the Quints to be in commercials for products from soaps to cereals and to appear as a sideshow at Chicago's Century of Progress exposition. Meanwhile, the town itself is transformed into Quintland as people line up daily to stare at the infants and to test the doctor's original observation that at birth they looked like five rats. A local service station owner comes out to say that now he has five pumps in his station, each named after one of the Quints.

Mr. Hurlin does not have the extravagant imagination of John Kelly, the performance artist who has appeared on this same stage, but he has an easygoing presence and there is enough variety in his role-playing to make clear-cut differences between characters. He moves around Donna Dennis's white-tile set with a dancer's agility. Periodically he stops to sing, usually a song of the time: "Quintuplets' Lullaby" and other nursery tunes and jingles that help one understand the extent of the children's popularity. As a tourist attraction in Canada, the Dionnes were rivaled only by Niagara Falls.

Cleverly breaking his time frame, Mr. Hurlin projects himself forward to let us know what happened to the adult Quints (two died, three live in privacy in Montreal) and to describe exterior occurrences, including the Hollywood experience. Because of the brevity of the piece, points are slighted. There is barely time, for example, to allude to the fact that the first journalists on the scene all helped themselves to part of the profits, as screenwriter, official photographer and business manager. Although the Quints received financial support (as did the local priest), the girls proved to be the primary sufferers.

In a climactic scene, Mr. Hurlin places himself inside a small mock-up of the Dionne house. Looking through a metal fence at the audience as interlopers, he plays all the Quints. Each of course looks exactly the same; only the lighting changes. The theme here, as in the rest of this quirky but engaging show, is that the Quints were all mixed up, in several senses. "Quintland" studies them with affection while never overlooking the abrasive realities of their victimization through exploitation.

The show is being repeated on Sunday at 3 P.M. and on Monday at 8 P.M.

1992 D 19, 17:1

SUNDAY VIEW/David Richards

Did 'My Favorite Year' Get Lost in the 1950's?

If the musical has a sense of humor, it isn't showing.

In 'Make Someone Happy!' more is not necessarily more.

WHAT, I'D LIKE TO KNOW first of all, happened to the jokes? Did someone make away with them during rehearsals or did they never get written to begin with?

I realize that "My Favorite Year" is described in the playbills and on subway posters as "a new musical" — no mention of comedy. But if ever a musical had an excuse, no, a duty, to be funny, this is the one.

The year is 1954 and much of the action takes place behind the scenes of "King Kaiser's Comedy Cavalcade," the live 90-minute television show that is convulsing 20 million viewers across the country weekly. Off-camera, Kaiser may be a tyrant and a bully, but he's got a whole team of zanies laboring frantically to produce the lines and sketches that will assure his reign as "America's caliph of comedy."

Until the red light in the studio flashes on and the three long-legged beauties, dressed as coffee cups, dance on to inform the home audience that Maxford House is the evening's proud sponsor, the pressure to come up with the goods is intense. For those of us not under King Kaiser's dictatorial thumb, that pressure ought to be pretty funny, too. So why aren't we laughing heartily at the Vivian Beaumont Theater, where "My Favorite Year," looking like a million bucks, but playing more like $29.95, recently took up residence?

I defer to Andrea Martin, who portrays one of the beleaguered writers faced with the Monday morning task of putting together yet another show. Reading over a page of prospective material, she snaps, "These jokes are old enough to vote." Fortunately, Ms. Martin is amusing with or without words. She has the biggest, widest eyes since Carol Channing and she is not afraid to roll them extravagantly. She doesn't make normal entrances; she seems to pop up on the stage, like the fold-out illustrations in a children's book about elves or comets. She certainly has the properly disenchanted fix on the evening's comedy, though. It is very, very tired.

"My Favorite Year" takes its plot from the 1982 movie of the same name, in which Peter O'Toole starred as Alan Swann, a swashbuckling English actor scheduled to make an appearance on King Kaiser's program, if only he can stay sober long enough. To help keep him more or less vertical during the week's rehearsal period, he is entrusted to the care of Benjy Stone, an ambitious young gofer and aspiring comedy writer who also has an overbearing Jewish mother in Brooklyn to contend with. What was charming on the screen, however — partly because Mr. O'Toole appeared to be having a grand time winking at his own reputation as a romantic wastrel — is lackluster in the flesh.

With plodding industry but little inspiration I could detect, and no joy whatsoever, Joseph Dougherty has adapted the tale for the stage. His work clearly harks back to a time when book musicals were permitted their contrivances and the proper psychological climate didn't have to be cultivated for a song to be sung. As long as something entertaining was going on somewhere, the rules were flexible. I won't say "My Favorite Year" is hopelessly old-fashioned, but it would probably stand a much greater chance of a run if we were gearing up right now to celebrate the arrival of 1957.

The alternative is to treat the musical as a pretext for nostalgia. There are many among us, after all, who still remember the first time a television console entered the living room, bringing with it the hilarity and brilliance of Sid Caesar's "Your Show of Shows," which is, of course, the model for "King Kaiser's Comedy Cavalcade." The musical's appreciation for the 1950's, however, doesn't extend much beyond Patricia Zipprodt's costumes, Thomas Lynch's glamorous sets and the general feeling that New York was somehow a safer, more picturesque place back then.

Central Park definitely looks lush and romantic in deep purple, while Swann's two-story suite at the Waldorf — a gilded staircase corkscrewing up to the bedroom — puts Hollywood to shame. When Benjy (Evan Pappas) and his dewy-eyed girlfriend find themselves alone in the opulent quarters, they instinctively experience the urge to sing and dance, just like Fred and Ginger.

"Shut Up and Dance," though, the number that the composer Stephen Flaherty and the lyricist Lynn Ahrens have given them, is a poor substitute for such classic face-offs as "Cheek to Cheek" or "Dancing in the Dark" and raises the second big question of the evening: What happened to the songs? In "Once on This Island," Mr. Flaherty and Ms. Ahrens managed to evoke the cinnamon flavors and tropical rhythms of the Caribbean. "My Favorite Year" has a more conventional, not to say generic, Broadway score. From the bustling backstage opening number for the full company to Swann's rueful lament, "If the World Were Like the Movies," that ends the first act, the songs come and go, leaving little trace of their passage.

EVEN MS. MARTIN, WHOM I would have thought indestructible, is nearly done in by "Professional Showbizness Comedy," a dull second-act production number that expects her to carry on hilariously as a baggy-pants hobo, but succeeds only in marrying the show's musical shortcomings to its prevailing witlessness. (When the laughs are not forthcoming, Ms. Martin peers out front, eyes big as stoplights this time, and asks, "Is this an audience or an oil painting?")

Still, she's trying. So is the boyish Mr. Pappas, who maintains a chipper attitude and a bright demeanor under circumstances that would send a less resilient juvenile around the bend. "My Favorite Year" seems to want to test his good nature at every turn. His blond girlfriend (Lannyl Stephens) is a humorless drip whose inability to remember a punch line is meant to be endearing but merely makes her seem insufferably stupid. His mother (Lainie Kazan, grossly over-inflating the role she played in the film) is a monster of maternal solicitude wrapped in grotesque fashions that serve to emphasize her kinship with a Rose Bowl float. The musical's biggest error, however, is its failure to deliver Swann in all his splendid, alcoholic glory.

It is entirely possible that our attitudes toward drink have so changed in the last few decades that the dipsomaniac weaving through society has ceased to be an acceptable comic figure. Maybe we no longer subscribe to the notion that a man can be blissfully intoxicated. Imbibing, these days, seems to be viewed as a sign of inner torment. This much is certain. The Alan Swann who spent much of the movie in a blurry-eyed haze and thought nothing of leaping off tall buildings, as long as a fire hose was knotted around his waist, is not the Alan Swann who picks his way prudently through the musical as if he feared a warrant had been sworn out for his relapse.

This reformed Swann is played by Tim Curry, whose tidy goatee, trim suits and quiet air of civility suggest the character has

spent a lifetime laboring in the import-export trade, not romping athletically across movie screens. There are few indications of the tousle-haired matinee idol that Benjy worshiped as a child. Since the story is largely about how Benjy rehabilitates his fallen hero, just as Swann helps his devoted fan outgrow his youthful illusions, "My Favorite Year" has serious troubles dead center — always the worst place to have them.

I'm reluctant to blame Mr. Curry, who proved an incorrigible cutup in the national company of "Me and My Girl," and I'm sure could fall down that corkscrew staircase head first if anyone asked him to. No one's asking, though. As Ron Lagomarsino has directed it, which is blandly, "My Favorite Year" has no rambunctiousness, no abandon, no sense of excess. When the choreographer Thommie Walsh takes the company out for a celebratory night on the town in "Manhattan," the dancers move about the stage in tight packs, as if they were wolves — or tourists from Topeka, fearful of getting separated from the bus. It is curious that a musical about the uncontrollable madcaps of early television, making up the rules (and certainly the sketches) as they go along, should prove so timorous in the end. But there you have it.

"My Favorite Year" even has a sanctimonious moral to pass along: stardom may look great from the outside, but real happiness is knowing who you are, keeping illusions in their place, being yourself. This may be true. But why, I'd like to know in the third place, are we always being told so by people whose livelihood depends on painting their faces and pretending the velvet curtain is a prince's cape?

'Make Someone Happy! The Jule Styne Revue'

Steve Paul and Gregory Dawson, who produce the musical salutes to the legendary Broadway composers at Rainbow and Stars, are up to number five with "Make Someone Happy! The Jule Styne Revue." But they still haven't hit upon much of a format for these glittery little entertainments, unless you consider the grab bag to be an organizational tool.

What we get this time is essentially what we've been getting in the past: a handful of attractive performers, handsomely dressed, singing bits and pieces of about three dozen winning songs in a room that has one of the city's spectacular views. I took a composer friend with me, thinking he might perceive a deeper scheme afoot. But as the singers segued from one Styne classic to another, his single recurring observation was, "Holy mackerel, I didn't realize he wrote that one, too."

Obviously, nobody wants to be inundated with show-business trivia at an affair like this or, worse, the kind of sentimental commentary that views every haunting melody as a cry from the composer's heart. But merely taking a roll call of a composer's work doesn't seem to be the answer either, even if some of those numbers may have temporarily slipped from our memories.

I can't say I didn't enjoy myself at "Make Someone Happy!" The performers — Kay McClelland, Gregg Edelman, Ann Hampton Callaway and David Garrison — are relaxed and personable, and get a kick out of what they're doing. And there's no quibbling over such songs as "People," "Just in Time," "It's Magic," "Don't Rain on My Parade" or "I'll Walk Alone." But given the raw material, I kept thinking I should have been having a better time.

Something is missing. A strong point of view? A revelatory framework? Perhaps a

magnifying glass is called for or more directorial invention. There's really no reason that "Make Someone Happy!" shouldn't be a constant delight instead of the intermittent one it turns out to be. □

1992 D 20, II:5:1

Theater in Review

■ Three rarely performed plays by Thornton Wilder ■ The terrors and turmoil of 'The Idiot.'

'Wilder, Wilder, Wilder'
'Three by Thornton'

Harold Clurman Theater
412 West 42d Street
Clinton
Through next Monday

Three short plays by Thornton Wilder: "The Long Christmas Dinner," "The Happy Journey to Trenton and Camden" and "Pullman Car Hiawatha." Directed by Edward Berkeley; set by Miguel Lopez-Castillo; costumes by Fiona Davis and Dede Pochos; lighting by Steven Rust. Presented by the Willow Cabin Theater Company, Mr. Berkeley, artistic director; Adam Oliensis and Maria Radman, managing directors.

WITH: Cynthia Besteman, Sarah Braun, Sabrina Boudot, Fiona Davis, David Folwell, Ken Forman, Laurence Gleason, Joel Goldes, David Goldman, Deborah Greene, Bjarne Hecht, Patrick Huey, Jon Kellam, Peter Killy, Rebecca Killy, Tasha Lawrence, Charmaine Lord, Tim McNamara, Jerry Mettner, Stephen Mora, Angela Nevard, Adam Oliensis, Dede Pochos, Linda Powell, Maria Radman, Michael Rispoli, Jayson Veduccio and Craig Zakarian.

Arriving like a surprise holiday gift from a favorite aunt you had almost forgotten is a package of three of Thornton Wilder's early one-act plays presented in an ambitious and commendable production by Willow Cabin Theater Company.

Regarded for too long as the author of the High School Senior Play, Wilder was perhaps the American theater's greatest innovative genius. Often with breathtaking effect, Wilder explored the arrangement of time and space not as cosmic forces but as basic elements that define our everyday lives. Willow Cabin's polished staging of these seldom performed plays not only offers a rare chance to glimpse the origins of Wilder's great works to come but also allows them to shine as small gems on their own.

In "The Long Christmas Dinner," Wilder chronicles four generations of the Bayard family eating turkey in an annual ritual in which nothing changes except the people at the table. A succession of baby Bayards enter through a red door on stage right, grow up, leave home, go to war, marry, take their turn with the carving knife and finally exit at their appointed time through a black portal on stage left, silently joining one another in a row of chairs above the stage, not unlike the residents of the Grover's Corners cemetery in "Our Town."

In "The Happy Journey to Trenton and Camden," what seems at first to be a pleasant automobile trip taking the Kirby family to visit an older married daughter turns out to be a grief-stricken cortege disguised by the minutiae of daily conversation.

In both "Happy Journey" and "Pullman Car Hiawatha," Wilder began experimenting with the character of a Stage Manager. In "Pullman Car," the Stage Manager controls not only the passengers on a New York-to-Chicago train, but also the convergence of planets, the time, the weather and the precise place in Ohio the train is passing at the moment of death for one woman on board. It was a device Wilder had employed to devastating effect in "The Bridge of San Luis Rey" and one he would use again in later works.

Edward Berkeley has directed a cast of 28 young actors in an intelligent yet affectionate reading of all three plays. Inevitably in so large a cast some performances are more focused than others, but most are thoughtful and all are credible. Michael Rispoli's Stage Manager in "Pullman Car Hiawatha" is decisive without being tyrannical and Cynthia Besteman deftly ages Cousin Ermengarde into a touching portrait in "Christmas Dinner." Among the other noteworthy roles are Linda Powell as Lucia in "Dinner," Maria Radman as the mother in "Happy Journey" and Tasha Lawrence's Insane Woman, Patrick Huey's Porter, Ken Forman's Tramp, Angela Nevard's Harriet and Sabrina Boudot's delightful Ten O'Clock in "Pullman Car." *WILBORN HAMPTON*

'The Idiot'

Bouwerie Lane
330 Bowery, at Second Avenue
Lower East Side
Through Feb. 12

By Fyodor Dostoyevsky; adaptation by David Fishelson; directed by Mr. Fishelson; set by Robert Joel Schwartz; costumes by Susan Soetaert; lighting by Brian Aldous; sound and music by Ellen Mandel; production manager, Patrick Heydenburg; scenic artist, John Brown. Presented by Jean Cocteau Repertory, Robert Hupp, artistic director; Mr. Fishelson, associate artistic director; Scott Shattuck, managing director.

WITH: Harris Berlinsky, Christopher Black, Steve Chizmadia, Pat Kier Edwards, Robert English, John Lenartz, Joseph Menino, Moses Robinson, Craig Smith, Elise Stone, Angela Vitale, Monique Vukovic, Mark Waterman, Adrienne Williams and Kathleen Wilson.

The amusing, baffling and ultimately terrifying world of 19th-century St. Petersburg that Fyodor Dostoyevsky created in "The Idiot" comes boisterously to life in David Fishelson's adaptation of the novel being presented by the Jean Cocteau Repertory. The program lists 15 actors in 34 roles, but at times they give the impression of multitudes sweeping

through the theater. And while the play lasts three hours, the impression that remains is how swiftly it moves through Dostoyevsky's intricate plot.

While the suffering inflicted on the principal characters is as poignant on the stage as in the book, the emotional force of the staged work is very different. The sense of universal ruin that hangs over the novel is missing. There is no way even a very clever director — in this case Mr. Fishelson — can convey Dostoyevsky's insidious suggestion that a whole society has fallen victim to a lunacy that is not a treatable disease but a divine curse. This performance leaves one shaken, but it does not haunt one the way the book does.

In the leading roles, Craig Smith, an old hand in this company, is a fine Rogozhin — high-spirited, passionate, volatile and menacing by turns — and John Lenartz, a relative newcomer to the ensemble, is a convincing Prince Myshkin, the holy fool of the title whose innocence and virtue protect him from the evil around him but also set him up for destruction. As the story comes to its end and the two of

them watch in the dark over the body of the murdered Nastasya Filipovna, they arouse the kind of horror Dostoyevsky intended.

Elise Stone makes Nastasya as mad, wild and nearly incomprehensible as the scarlet woman of the novel, if not as profound or visionary. And Adrienne Wilson's Aglaya Yepanchin is very much the voluble, bright and confused young woman Dostoyevsky created, but perhaps without the turbulent youthfulness the novelist gives her.

Among the subordinate characters, Joseph Menino as the sly, greedy Lebedev is wonderfully loathesome and engaging, and Angela Vitale is a perfect Mrs. Yepanchin, a scatter-brained stranger to reality who eventually understands better than anyone else what has been going on.

In the long run the novel provides a more fulfilling experience, but this dramatized "Idiot" is an arousing and troubling evening of theater.

D. J. R. BRUCKNER

1992 D 21, C13:1

3 New British Plays With Serious Messages

By FRANK RICH

Special to The New York Times

LONDON, Dec. 20 — It's no secret that the outstanding British farce of the moment is being written every day by the royal family. But who is going to write the great tragedy this reeling former empire demands?

Battered by recession and terrorism, uncertain of its relationship with either the new Europe or the new Washington, Britain would seem, if little else, a fertile subject for its serious native playwrights. But the most celebrated drama in London this year has been "Angels in America," by Tony Kushner, a New Yorker, and the most acclaimed contemporary works on the fringe right now are "The Wexford Trilogy," in which the playwright Billy Roche examines small-town life in his native Ireland, and the expatriate American Timberlake Wertenbaker's satire on the art market, "Three Birds Alighting on a Field." The Wertenbaker play is in a return engagement at the Royal Court, which has already produced John Guare's "Six Degrees of Separation" this year and will soon present Anna Deavere Smith's "Fires in the Mirror" and David Mamet's "Oleanna."

In the West End, where revivals, long-running musicals, thrillers and sex comedies perennially hold sway, new British plays are as scarce as new American plays are on Broadway. But there is one bracing exception: "The Rise and Fall of Little Voice," an acrid comedy by Jim Cartwright that originated at the Royal National Theater before transferring to the Aldwych Theater for its commercial run. Mr. Cartwright, a young Lancashire writer whose "Road" was staged by Lincoln Center Theater in 1988, is not bashful about filling the stage with the muck of present-day England. Set in a squalid lower-middle-class home where the fuses

constantly blow and even the cornflakes have turned rancidly green, "Little Voice" finds some of its funnier gags in onstage bouts of alcoholic vomiting and mechanical sexual grinding. When the house burns down in Act 2, the conflagration seems less a disaster for the frequently stupefied, at most semi-literate characters than a sort of liberating deliverance.

It is not the author's view of his society's collapse that makes "Little Voice" special, however, so much as the extraordinary title role he has written for a one-of-a-kind young actress named Jane Horrocks. Miss Horrocks, whom American audiences have seen as the alienated, bulimic daughter in Mike Leigh's film "Life Is Sweet," is a bone-thin, childlike woman with flat blond hair and a catatonic air. In Mr. Cartwright's play, she is the lonely, shy, agoraphobic daughter of a boozy, barking widow (Alison Steadman, who also played Miss Horrocks's mother in "Life Is Sweet") and is known as Little Voice because she rarely speaks.

What she can do is sing. In the upstairs bedroom where she retreats from her mother, Little Voice spends her time obsessively listening to her dead father's old records of female vocalists. When she chooses to express herself, she does so by impersonating the singers (her "tongues," she calls them), often incoherently intermingling fragments of the patter from Judy Garland's Carnegie Hall concert with snatches of Garland's version of "Chicago" or Marilyn Monroe's "Happy Birthday, Mr. President" or Edith Piaf's "Milord" or Shirley Bassey's "Goldfinger."

The spectacle of these clarion, uncannily accurate voices abruptly taking possession of Miss Horrocks's previously inert face and rag-doll frame is one of the most bizarre sights I've ever seen in the theater. And Mr. Cartwright capitalizes on its

Alastair Muir

Jane Horrocks performing in Jim Cartwright's comedy "The Rise and Fall of Little Voice," at the Aldwych Theater in London.

otherworldly sadness by making "Little Voice" the story of how the heroine's mother and the mother's latest lover, a grotesque small-time agent named Ray Say (Pete Postlethwaite), try to exploit that weird spectacle by selling the terrified girl as a "class act" to the tatty local club.

●

As a play, "Little Voice" is not without its own mimickry — of "A Taste of Honey," "Joe Egg" and "The Glass Menagerie," among others. But Mr. Cartwright's incendiary dialogue and bleak comic vision are his own. They are powerfully augmented by Sam Mendes's wired production, only to be undercut by a fairy-tale denouement and the unintelligibility (to American ears, anyway) of too many lines in Miss Steadman's otherwise bravura portrait of the mother from hell. Yet all else pales before Miss Horrocks, whose Little Voice can be as haunting as the Little Sparrow she sometimes imitates. In one incredible scene, she responds to Ray Say's repeated slaps by skipping violently among her various voices as if a needle were leaping tracks on an LP. For a cathartic finale, she at last sings in her own completely unmusical voice, a harrowing, zombielike wail in which the lyrics of "Just in Time" are used to express the same loneliness, suffering and yearning Miss Horrocks had earlier poured into a mock-Garland "Over the Rainbow."

That finale is set on a glittery variety stage that recalls the shabby domain of Archie Rice in "The Entertainer," by John Osborne. It says much about what has happened to that revolutionary 1950's generation of British dramatists, without whom "The Rise and Fall of Little Voice" could not exist, that Mr. Osborne this month put the original handwritten manuscript of "Look Back in Anger" on the auction block. (His sequel to "Anger" had failed in the West End earlier this year.) Mr. Osborne's most influential theatrical contemporary, Harold Pinter, also remains an infrequent playwright. He is currently acting in a revival of his own "No Man's Land" before directing "Oleanna."

But two other writers of similar longevity, David Storey and Peter Shaffer, are represented on London stages by brand-new work. Both of their plays are running in the small studio spaces of the major theatrical companies, both lament the decline of culture in the 20th century, and both are inward, stock-taking dramas about artists facing the waning of their powers and the prospect of mortality.

●

Mr. Storey's elegiac 75-minute "Stages," at the National, is a monologue with interruptions in which a celebrated painter, paralyzed by depression, tries to untangle the strands of his art, his failed marriage and his impoverished childhood. Mr. Storey, the author of "This Sporting Life" and "Home," wrote a similar and

more effective valedictory play called "Early Days" for Ralph Richardson in 1980. This time the actor is Alan Bates, who happily looks to be a long, long way from retirement and who does his best to mine the poetic riffs and turgid emotions of an almost perversely undramatic exercise. The director is Mr. Storey's career-long collaborator Lindsay Anderson, who, like the entire supporting cast and much of the audience, seems to be fighting off sleep.

"The Gift of the Gorgon," as Mr. Shaffer's new play at the Royal Shakespeare Company's Pit at the Barbican Center is titled, proves a far more ambitious effort. A young Midwestern academic (Jeremy Northam) travels to Greece to research a biography of the father he never knew, a provocative playwright (Michael Pennington) who has just died under mysterious circumstances. To get the story, the illegitimate son must win the confidence of his father's protective widow (Judi Dench).

The conflict is the same as in all Mr. Shaffer's plays, that of ecstatic creative passion vs. deadening reason. The audience learns through flashbacks that the dead playwright, a spiritual equivalent to Mozart in "Amadeus" and the horse-blinding Alan Strang in "Equus," was in favor of violent revenge in both his life and in his epic theatrical works, while his wife exerted the restraining hand of gentility and censorship.

But this time Mr. Shaffer seems more ambivalent than ever about his own position (to the point of confusion in his drama's resolution), and the result is a much more stimulating evening than either of its immediate predecessors in his canon, "Yonadab" (not produced in New York) and "Lettice and Lovage." As directed by Peter Hall and fiercely acted, "The Gift of the Gorgon" is compelling

The writers are taking stock of themselves and their society.

when it champions the power of epic theater against the onslaught of cineplex literalism, or when it deals with its moral themes in the domestic arena. When epic theater is actually attempted — Greek myths acted out in a style reminiscent of Mr. Hall's Lincoln Center production of John Guare's "Four Baboons Adoring the Sun" — ponderousness ensues.

Mr. Shaffer is a compulsive rewriter of even his most successful works, and one hopes that this intriguing but unsettled piece will be no exception. First, he must recover from the heart surgery that was performed as "The Gift of the Gorgon" opened last week, in a London that his play fittingly characterizes as all "drizzle, emotional and physical."

1992 D 23, C9:3

Them . . . Within Us

By Todd David Ross; directed by Allan Carlsen; set by Ray Recht; lighting by F. Mitchell Dana; costumes by Chelsea Harriman; sound by Bob Lazaroff and Mr. Ross; production stage manager, Lisa Ledwich. Presented by the M & J Entertainment Corporation, Samuel Cohen and Joseph Cohen, producers. At the Theater Row Theater, 424 West 42d Street, Chelsea.

Susan	Bonnie Black
Roger	Patrick Barnes
Tommy	Steven Sennett
Sarah	Marceline Hugot

By MEL GUSSOW

"Them . . . Within Us," a situation comedy masquerading as a science-fiction comedy, asks the audience to care about a 30-something couple on the brink of either a breakup or a marriage. The play, by Todd Davis Ross, is at Theater Row Theater (formerly South Street). While visiting the woman's younger brother and his fiancée in their Vermont cabin, the two principal characters find themselves confronted by unseen extraterrestrials who take over their bodies. We know that the characters have been inhabited by E.T.'s when they suddenly speak pompously and stand up straight as if they have boards on their backs. When not possessed, they slump and exchange coy dialogue.

This means that the actors playing the leads, Bonnie Black and Patrick Barnes, each have two voices. In contrast, Steven Sennett and Marceline Hugot, as the other couple, are limited to one-dimensional roles. Were this a fairy tale, they might be called Chirpy and Loony. The play is dopey.

The woman played by Ms. Hugot may have the key to the work's ineptitude. She is presented as a crystal reader who has had out-of-body experiences. If this were at least a semi-comedy, she would have been called upon to exorcise those unearthly demons. Instead, she is shunted aside and turned into a cartoon new-age believer.

Nothing even makes amusing nonsense, least of all Mr. Ross's unadventurous use of science fiction, which is reduced to a few references and one quotation from "Forbidden Planet." Ms. Black and Mr. Barnes are sufficient in their roles, and Allan Carlsen tries to enliven his staging with laser-like bleeps. But the play is hopelessly old-age and galaxies away from "Mork and Mindy."

1992 D 26, 15:1

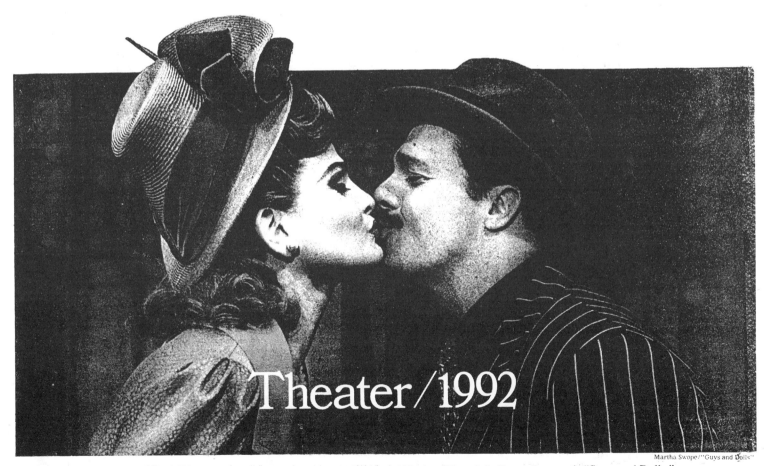

Theater/1992

Martha Swope/"Guys and Dolls"

Faith Prince and Nathan Lane as the sometime lovers Miss Adelaide and Nathan Detroit in Frank Loesser's "Guys and Dolls,"
which won four Tony Awards, including best revival of the Broadway season.

FRANK RICH

'Guys and Dolls' (Thumbs Up), 'Guys Named Moe' (Thumbs Down) And Noël Coward on the Wagon

The Whole World in Their Hands Anna Deavere Smith, in "Fires in the Mirror," and John Leguizamo, in "Spic-o-Rama," brought sizzling, panoramic views of urban America to the theater by acting all the roles in plays of their own creation.

Forever Frank Fresh revivals of Frank Loesser's masterpiece, "Guys and Dolls" (1950), and of his most romantic outpouring of pure song, "The Most Happy Fella" (1956), reminded audiences of what they've been missing in Broadway musicals.

Not the Last Jam William Finn, the composer-lyricist of "Falsettos," George C. Wolfe, the director and author of "Jelly's Last Jam," and Susan Stroman, the choreographer of "Crazy for You," offered true hope that the history of the American musical is not over yet.

Odd Couples Tony Randall and Georges Feydeau. Tony Randall and Henrik Ibsen. Tony Randall and Anton Chekhov.

The Play's Not the Thing Terrific performances in unexceptional plays were delivered by Brian Bedford in "Two Shakespearean Actors," Everett Quinton in "Brother Truckers" and Alec McCowen and Stephen Rea in "Someone Who'll Watch Over Me."

Aging Divas Joan Collins turned Noël Coward's intoxicating comedy "Private Lives" into a sobering experience; an even more facially immobile Glenn Close turned Ariel Dorfman's drama of police-state torture, "Death and the Maiden," into a bus-and-truck "Private Lives."

Better Than Safe Sex Paula Vogel's "Baltimore Waltz," Larry Kramer's "Destiny of Me," Tony Kushner's "Angels in America."

William Gibson/Swope Associates/"Fires in the Mirror"

Anna Deavere Smith played all the characters in her "Fires in the Mirror," a drama about racial tensions.

Talent Sighted In a year packed with notable plays by David Mamet, John Guare, Jon Robin Baitz, August Wilson, Wendy Wasserstein, Horton Foote and Herb Gardner, a lesser-sung young writer, Donald Margulies, proved himself their peer with "Sight Unseen."

Slow Boat to Catharsis The most overhyped theatrical event of the year, the Parisian director Ariane Mnouchkine's 10-hour Greek tragedy marathon, "Les Atrides," didn't race the audience's pulse until the third of its four parts.

Last Call "Five Guys Named Moe" brought the English theme-park musical to its lowest ebb by using a colonial interpretation of African-American jazz as an inducement to get the audience to join a conga line leading into an adjacent cash bar.

DAVID RICHARDS

From an Earthquake to Family Values And a Very Funny Bathtub Murder Besides

Two on the Curb, Please The year's worst idea, turning the Longacre Theater into a courthouse to prosecute petty criminals in the Times Square area, was abandoned when the cost of the renovations proved too high.

The French Revolution Will Be Enacted Tonight by Mr. Pacino Bettering John Leguizamo (who plays six characters in "Spic-o-Rama") and Stacy Keach (who played seven in "Solitary Confinement"), Anna Deavere Smith portrayed 27 real-life people in her searing "Fires in the Mirror: Crown Heights, Brooklyn and Other Identities."

More Myopia The Tony Award nominating committee, always good for an oversight, failed to cite Spiro Malas as best actor in a musical, despite his heart-rending performance in "The Most Happy Fella."

Sex and the Broadway Stage Tonya Pinkins and Gregory Hines, romping in a four-poster in "Jelly's Last Jam," had the year's steamiest love scenes, while Alec Baldwin and Jessica Lange, the couple everyone thought would combust spontaneously, didn't in "A Streetcar Named Desire."

Murder Most Funny In Alan Ayckbourn's hilarious "Small Family Business," the loudest laughs came when a scurrilous private detective went to his maker in a bathtub.

Better Than the Virginia Slims To while away the time in a Beirut cell where they are being held hostage, Stephen Rea and Alec McCowen dazzlingly replay the 1977 Wimbledon Ladies Final in "Someone Who'll Watch Over Me."

You Are There For its stunning production of Caryl Churchill's "Mad Forest," the New York Theater Workshop installed rickety seats in the auditorium, failed to replace burned-out light bulbs and downgraded the premises so theatergoers could experience life in Romania today.

Fooling With Mother Nature A fearless design team at Lincoln Center, headed by Tony Walton, engineered a spectacular on-stage earthquake in "Four Baboons Adoring the Sun," John Guare's play about the less compelling rifts between parents and children.

Ballot Box Family values, a nonissue in the Presidential election, triumphed in "Falsettos," the most moving musical of the season.

And for the Curtain Call, a Backward Somersault Joan Collins earned gasps by doing splits in a revival of "Private Lives." Not to be outdone, Marla Maples performs cartwheels in "The Will Rogers Follies."

M E L G U S S O W

The Power of Words in Jail, the Joy of New Talent

Acting Feat of the Year Chained by their ankles to a prison wall, Alec McCowen and Stephen Rea gave superb performances in Frank McGuinness's "Someone Who'll Watch Over Me."

The Trend That Has to End Re-enacting old sitcoms on stage, as in "CBS Live."

Ain't Got No Respect for a Masterpiece Award To "Anna Karenina," the musical.

Applause, Applause for Author, Actress Catherine Butterfield, most promising new talent, for "Joined at the Head."

Gold Into Dross The National Actors Theater's "Seagull," the Roundabout Theater Company's "Hamlet," Keir Dullea's one-man version of the life of F. Scott Fitzgerald.

The Audience Talks Back David Mamet's "Oleanna," the most provocative politically incorrect play in a politically correct season.

Most Memorable Line "I want my ham," spoken by a man who knows he has been cheated, in August Wilson's "Two Trains Running."

If a Bomb Had Been Dropped Here, Half the Cultural Elite Would Have Been Eliminated The line waiting to enter the Brooklyn armory to see Ariane Mnouchkine's 10-hour marathon, "Les Atrides."

Now It Can Be Told Despite all reports, Stacy Keach did not actually appear on stage, in "Solitary Confinement." He was a hologram.

Acting Between the Lines Bill Irwin's virtuosic performance in Samuel Beckett's "Texts for Nothing."

1992 D 27, II:5:1

Joan Collins did the splits in a revival of "Private Lives" by Noël Coward that arrived in New York after touring the country.

T. Charles Erickson/"Private Lives".

Tommy Tune Tonite!
A Song and Dance Act

Directed by Jeff Calhoun; set by Tony Walton; lighting by Jules Fisher and Peggy Eisenhauer; costumes by Willa Kim; sound by David Dansky. Presented by Pierre Cossette, James M. Nederlander and William E. Simon, producers. At the Gershwin Theater, 222 West 51st Street, Manhattan.

WITH: Tommy Tune, Robert Fowler and Frantz Hall

By STEPHEN HOLDEN

If Tommy Tune could wave a magic scepter, Broadway would be transformed from its currently bedraggled state into an immaculate thoroughfare of diamond-studded glamour and endless high spirits. The years would melt away, and names like George Gershwin, Cole Porter, Fred Astaire and Ray Bolger would blaze on every marquee. To step into a theater would be to enter a Busby Berkeley dream world of top hats, tap shoes and gushing Broadway melodies.

That is the dream that the performer, director and choreographer captures only fleetingly in "Tommy Tune Tonite!," the handsomely mounted song and dance show he has brought to the Gershwin Theater for a limited engagement through Sunday. It is a world in which it is possible to "Tap Your Troubles Away," as the show's opening Jerry Herman song suggests. Or where "Everything Old Is New Again," as proclaims the Peter Allen-Carole Bayer Sager number that serves as one of the program's thematic threads.

The show, a self-described "song and dance act," in which Mr. Tune performs with a 26-piece orchestra and two sidekicks, Robert Fowler and Frantz Hall, is essentially a deluxe cabaret turn proportioned for Broadway. As directed by Jeff Calhoun, it meanders pleasantly along for 90 intermissionless minutes without going anywhere in particular and without building a big charge of energy. Together the designer, Tony Walton, and the lighting designers, Jules Fisher and Peggy Eisenhauer, have given Mr. Tune a spacious, tastefully glitzy environment fronting the bandstand in which to cavort.

Between the song and dance numbers, Mr. Tune tells his own story of growing up in Houston and of planning to be a ballet dancer until his unusual height (he is 6 feet 6 inches or "5-18," as he puts it) made a ballet career improbable.

The show's emotional core is Mr. Tune's reminiscence of coming to New York in the 1960's and auditioning at Variety Arts Theater, a rehearsal studio in the heart of the theater district. On any given day, he recalls, you might find the choreographers Michael Bennett, Bob Fosse and Gower Champion each working on a different project on a different floor of the building. Here is where he had his first New York audition, singing eight bars from the "Damn Yankees" hit "Heart." And here is where he also first met Mr. Bennett, who became a close friend and mentor

and who later cast him in "Seesaw," the 1973 show that won him the first of nine Tony Awards.

For Mr. Tune, the demise of Variety Arts, which burned down in the 1970's, is synonymous with the sad decline of Broadway. His nostalgia for the theater leads to the show's most touching moment, in which he delivers a formal roll call of his Broadway colleagues who have died, many from AIDS.

This elegy is the only somber moment in a program that is otherwise devoted to recapturing the old-time show business spirit that brought Mr. Tune to New York. There are affectionate tributes to both Bolger and Astaire, including an audience singalong of "Once in Love With Amy."

As much as Mr. Tune admires Astaire, his style of movement is not much like his idol's. Swooping about the stage, he looks less like a debonair man-about-town than a willowy cowboy whose elbows and shoulders are at faintly comic odds with his gliding legs. His finest dancing moment is an exquisite "Taking a Chance on Love," in which his tapping feet — and not his voice — sing the melody, with subtle embellishment.

Mr. Tune has always regarded his own gangling physique with whimsical amusement. That playfulness informs two of his best numbers with Mr. Fowler and Mr. Hall. One involves a microphone stand that becomes a ballet barre. In the other, Mr. Tune becomes even taller than he is, as he appears behind a curtain under which impossibly long legs assume anatomically impossible positions. In another vaudevillian turn, his sidekicks become student showoffs who get carried away trying to outshine their teacher.

If the show's dancing offers an engaging overview of Mr. Tune's terpsichorean bag of tricks, musically "Tommy Tune Tonite!" never takes off. Mr. Tune is a passable theatrical singer who continually aspires to the lightness and polish of Astaire but continually falls short. His voice isn't especially mellifluous, and when he pushes it out the tone becomes metallic; nor does the rhythmic acuity that informs his dancing extend to his singing. Underscoring his vocal shortcomings is the failure of his voice to match the punch and vivacity of the band's brass-heavy arrangements.

But even though the star will never be Astaire, Bolger and Carol Channing (whom he briefly impersonates) rolled into one show-stopping package, "Tommy Tune Tonite!" breathes an air of fresh-faced sweetness and enthusiasm that feels genuine. Watching Mr. Tune live out his Broadway dream, some of the wild exhilaration of a young Texan who has conquered the Emerald City comes through. As he taps his way across the stage of the Gershwin in diamond-studded shoes, the notion that you can tap your troubles away seems briefly to be more than just a quaint show-business conceit. Here is someone doing just that, right here and now.

1992 D 29, C11:1

Theater Awards and Prizes 1991–1992

Included in this section are Times
articles covering the following awards
and prizes.

Pulitzer Prizes
for original American plays

New York Drama Critics Circle Awards

Antoinette Perry (Tony) Awards

Drama Desk Awards

Outer Critics Circle Awards

1991

PULITZER PRIZE

Pulitzer Prizes in Letters Go to Updike and Simon

By DENNIS HEVESI

"Rabbit at Rest," John Updike's conclusion to a quartet of novels that portrayed the psychic ups and downs of America through the life of a small-town car salesman, and "Lost in Yonkers," Neil Simon's play about the relationship of two teen-agers and their iron-willed grandmother, won 1991 Pulitzer Prizes yesterday.

Mr. Simon, reached by telephone in Hawaii, said: "I'm overwhelmed. I've been in the business a long time, and you get to be blasé about certain things, but this is not one of them."

"Lost in Yonkers," which opened in February at the Richard Rodgers Theater on Broadway, where it is still running, is set in the summer of 1942 in a two-bedroom apartment over a candy store in Yonkers. The play tells of teen-age brothers who have been forced for economic reasons to move in with their grandmother, a stern, distant and iron-willed German-Jewish refugee whose overpowering personality has stunted the adulthood of her own children.

But Mr. Simon, who has written 26 plays for Broadway, many of them widely acclaimed, had never won a Pulitzer. "I'm really glad I won for 'Lost in Yonkers,' " Mr. Simon said yesterday. "I've had a great deal of success in the business, and I don't feel that I've gone unrewarded, but I'm thrilled with this."

Drama

Neil Simon
"Lost in Yonkers"

Neil Simon, who is 63 years old, won for his play set in the summer of 1942 in a two-bedroom apartment over a candy store in Yonkers. Starring Irene Worth, Mercedes Ruehl and Kevin Spacey and directed by Gene Saks, it tells of two teen-age brothers who have been forced for economic reasons to move in with their grandmother, a stern, distant and iron-willed German-Jewish refugee whose overpowering personality has stunted the adulthood of her own children. "I'm really glad I won for 'Lost in Yonkers,' " Mr. Simon said yesterday on the telephone from Hawaii. "The play came out of instinctive feelings I had and probably awakened in me things I didn't know about." Mr. Simon was born in the Bronx. He was a television writer for Sid Caesar's "Your Show of Shows" and Phil Silvers's Sergeant Bilko show in the 1950's. In the last 30 years, he has written 26 Broadway plays.

1991 Ap 10, A20:2

NEW YORK DRAMA CRITICS CIRCLE AWARDS

'Six Degrees' and 'Rogers' Honored by Critics Circle

By MEL GUSSOW

John Guare's "Six Degrees of Separation" was named best new play of the 1990-1991 season by the New York Drama Critics Circle at the critics annual awards meeting yesterday at the Coffee House. "The Will Rogers Follies" was selected as best new musical and Timberlake Wertenbaker's "Our Country's Good" as best new foreign play. The critics also voted a special citation to Eileen Atkins for her portrayal of Virginia Woolf in "A Room of One's Own."

The winners are to be honored on Monday at the Coffee House, with Mr. Guare receiving a check for $1,000, an annual gift from the producer Lucille Lortel.

"Six Degrees" was an easy winner on the first ballot, with 13 votes from 19 voting members. There were five votes for Neil Simon's "Lost in Yon-

kers" and one for "La Bête" by David Hirson. This is the third Drama Critics Circle prize for Mr. Guare, who has won awards for "The House of Blue Leaves" and the musical version of "Two Gentlemen of Verona." "Six Degrees," starring Stockard Channing, is at the Vivian Beaumont Theater as a production of Lincoln Center Theater.

On the first ballot, "The Will Rogers Follies" received only 6 of a possible 16 votes, but, in a closely fought contest, won on a second, weighted ballot. It received 26 points, followed by "The Secret Garden" with 21, "Assassins" with 18, "Miss Saigon" with 17 and "Falsettoland" with eight points. "Will Rogers" is at the Palace Theater.

"Our Country's Good" also won on a weighted ballot (with 35 points), followed by "A Room of One's Own" (Patrick Garland's adaptation of the Virginia Woolf lectures), Alan Ayckbourn's "Absent Friends," William Nicholson's "Shadowlands" and "The Sum of Us" by David Stevens. "Our Country's Good" is at the Nederlander Theater.

There was considerable discussion to determine the eligibility of "Our Country's Good" as a foreign play because the author is a citizen of the United States. For many years, she has been a resident of England and pays taxes in that country. "Our Country's Good" was first produced at the Royal Court Theater in London.

In a rare moment of harmony, the critics unanimously voted to give a citation to Ms. Atkins for "A Room of One's Own."

1991 My 14, C14:5

TONY AWARDS

Tony Award Winners

Following are the winners of the 1990-91 Tony Awards, presented Sunday night at the Minskoff Theater:

Best Play: Neil Simon, "Lost in Yonkers"

Best Musical: "The Will Rogers Follies"

Best Revival: "Fiddler on the Roof"

Leading Actor in a Play: Nigel Hawthorne, "Shadowlands"

Leading Actress in a Play: Mercedes Ruehl, "Lost in Yonkers"

Leading Actor in a Musical: Jonathan Pryce, "Miss Saigon"

Leading Actress in a Musical: Lea Salonga, "Miss Saigon"

Featured Actor in a Play: Kevin Spacey, "Lost in Yonkers"

Featured Actress in a Play: Irene Worth, "Lost in Yonkers"

Featured Actor in a Musical: Hinton Battle, "Miss Saigon"

Featured Actress in a Musical: Daisy Eagan, "The Secret Garden"

Direction of a Play: Jerry Zaks, "Six Degrees of Separation"

Direction of a Musical: Tommy Tune, "The Will Rogers Follies"

Book of a Musical: Marsha Norman, "The Secret Garden"

Original Musical Score: Cy Coleman, Betty Comden and Adolph Green, "The Will Rogers Follies"

Scenic Design: Heidi Landesman, "The Secret Garden"

Costumes: Willa Kim, "The Will Rogers Follies"

Lighting: Jules Fisher, "The Will Rogers Follies"

Choreography: Tommy Tune, "The Will Rogers Follies"

Regional Theater: Yale Repertory Theater

1991 Je 4, C16:5

DRAMA DESK AWARDS

'Will Rogers' and 'Yonkers' Win Drama Desk Awards

"The Will Rogers Follies" was named best musical and Neil Simon's "Lost in Yonkers" was chosen as best play in the 1991 Drama Desk awards, which were announced yesterday.

"Lost in Yonkers" also won for best actress in a play (Mercedes Ruehl) and best featured actor and actress (Kevin Spacey and Irene Worth). Ron Rifkin of "The Substance of Fire" was named best actor in a play.

Jonathan Pryce and Lea Salonga took the best musical actor and actress awards for "Miss Saigon," which also won for lighting design (David Hersey) and orchestration (William Brohn, who was also cited

for his work on "The Secret Garden").

Jerry Zaks was named best director of a play for "Six Degrees of Separation" and Scott Ellis was chosen best musical director for "And the World Goes 'Round" and "A Little Night Music." "And the World Goes 'Round" was chosen best musical revue and also won for best featured musical actress (Karen Ziemba). "A Little Night Music" was picked as best revival.

Tommy Tune was selected best choreographer for "The Will Rogers Follies," whose composer, Cy Coleman, shared the best music award

461

with William Finn of "Falsettoland."
Mr. Finn also won for best lyrics.

Marsha Norman won the award for best book of a musical, for "The Secret Garden," which was also named for best set design (Heidi Landesman). Best featured musical actor was Bruce Adler of "Those Were the Days."

Other awards went to Patricia Zipprodt of "Shogun: The Musical" for best costumes, Eileen Atkins of "A Room of One's Own" for best solo performance, Aural Fixation for best sound design or music in a play ("Red Scare on Sunset") and the Cirque du Soleil for unique theatrical experience.

Special awards were given to the Brooklyn Academy of Music; to James McMullan for artwork for theatrical productions; to New Dramatists, and to Harold Rome, for his contributions to musical theater.. The Drama Desk, formed in 1949, is an association of New York drama critics, editors and reporters.

1991 My 13, C12:5

Derwent Award Winners

Jane Adams of "I Hate Hamlet," Danny Gerard of "Lost in Yonkers", and "Falsettoland" and James McDaniel of the original cast of "Six Degrees of Separation" were chosen on Monday as winners of this year's Clarence Derwent Awards. A $1,000 prize and an engraved crystal trophy go to "the most promising female and male actors on the metropolitan scene." The awards were established in 1944 by Clarence Derwent, a former president of Actors' Equity Association, and are overseen by the Actors' Equity Foundation.

1991 My 16, C18:3

NEW YORK DRAMA CRITICS CIRCLE AWARDS
Critics Honor 'Lughnasa'

Brian Friel's "Dancing at Lughnasa" has been named the best new play of the 1991-92 season by the New York Drama Critics Circle. The Critics Circle also selected August Wilson's "Two Trains Running" as the best new American play. At the annual awards meeting yesterday in the Time & Life Building, the critics decided not to give an award for best new musical.

The winners will be honored on Monday evening at the Coffee House club, with Mr. Friel receiving a check for $1,000, a prize given annually by Lucille Lortel.

"Dancing at Lughnasa," a memory play about five unmarried sisters living together in Ireland in the 1930's, was an easy winner on the first ballot. It was first produced at the Abbey Theater in Dublin and subsequently

at the Royal National Theater in London, and it is now at the Plymouth Theater. Mr. Friel won a Critics Circle prize in 1989 for "Aristocrats" as best foreign play.

The vote not to give an award to a musical followed considerable discussion as to the eligibility of the shows. "Falsettos" had been eligible in previous seasons for each of its two acts as "March of the Falsettos" and "Falsettoland"; "Crazy for You" is a reworking of the Gershwin musical "Girl Crazy," and "Jelly's Last Jam" uses previously published music by Jelly Roll Morton. The critics' decision to forgo the award was a response to the fact that none of the serious candidates was completely new.

1992 My 12, C17:1

1992

PULITZER PRIZE

'Thousand Acres' Wins Fiction As 21 Pulitzer Prizes Are Given

The drama award went to "The Kentucky Cycle," a six-hour historical epic by Robert Schenkkan, which was never performed on Broadway.

As the announcement of the 21 prizes ricocheted from newsrooms to living rooms, winners laughed, wept and tied up their telephones. Mr. Schenkkan said that when he learned he had won, "I hugged my wife and my child and had a good cry."

Mr. Schenkkan's triumph surprised many theater owners and critics in New York, many of whom had not seen his play. Mr. Schenkkan said he hoped the prize would help spur interest in his two-part, six-hour play.

The California-based playwright had not quite absorbed the fact that he had won a great honor and a cash prize of $3,000. "You mean there is money, too?" he said in surprise.

DRAMA
Robert Schenkkan
"The Kentucky Cycle"

Robert Schenkkan, 39 years old, won for his two-part, 6-hour 40-minute dramatic work that has been described as miniseries theater. An epic 200-year history of Kentucky's Cumberland Plateau performed by 20 actors, it traces seven generations in the lives of three interrelated families. At times intermarrying, they battle for domination of eastern Kentucky from 1775 to 1975. Mr. Schenkkan received a B.A. from the University of Texas at Austin, and a master's degree in theater arts from Cornell. He has worked as an actor and writer on Broadway, Off-Broadway and in regional theaters.

1992 Ap 8, B6:1

TONY AWARDS

The 1992 Tony Winners

Play: Brian Friel, "Dancing at Lughnasa"
Musical: "Crazy for You"
Revival: "Guys and Dolls"
Leading actor in a play: Judd Hirsch, "Conversations With My Father"
Leading actress in a play: Glenn Close, "Death and the Maiden"
Leading actor in a musical: Gregory Hines, "Jelly's Last Jam"
Leading actress in a musical: Faith Prince, "Guys and Dolls"
Featured actor in a play: Larry Fishburne, "Two Trains Running"
Featured actress in a play: Brid Brennan, "Dancing at Lughnasa"
Featured actor in a musical: Scott Waara, "The Most Happy Fella"

Featured actress in a musical: Tonya Pinkins, "Jelly's Last Jam"
Direction of a play: Patrick Mason, "Dancing at Lughnasa"
Direction of a musical: Jerry Zaks, "Guys and Dolls"
Book of a musical: William Finn and James Lapine, "Falsettos"
Original musical score: William Finn, "Falsettos"
Scenic design: Tony Walton, "Guys and Dolls"
Costume design: William Ivey Long, "Crazy for You"
Lighting design: Jules Fisher, "Jelly's Last Jam"
Choreography: Susan Stroman, "Crazy for You"

1992 Je 2, C15:2

OUTER CRITICS CIRCLE AWARD

'Dancing at Lughnasa' Wins Outer Critics Circle Award

"Dancing at Lughnasa," Brian Friel's play about five unmarried sisters in the Ireland of 1936, won the Outer Critics Circle award yesterday for best Broadway play of the 1991-92 season. "Crazy for You," with music and lyrics by George and Ira Gershwin and book by Ken Ludwig, was named outstanding Broadway musical.

Scott McPherson, the author of "Marvin's Room," was given the John Gassner Award for an American playwright; his play also won the award for best Off Broadway play. "Song of Singapore" was chosen best Off Broadway musical and also won awards for its book, music and lyrics.

The award for best actor in a play went to Judd Hirsch for "Conversations With My Father." Best actress was Laura Esterman of "Marvin's Room."

Both awards for best performance in a musical went to cast members of "Guys and Dolls": to Nathan Lane, who plays Nathan Detroit, and to Faith Prince, who is Miss Adelaide.

Ms. Prince was also cited for her work in the musical "Nick and Nora."

Awards for outstanding acting debuts went to two members of the cast of "Two Trains Running": Larry Fishburne and Cynthia Martells. The outstanding comedy was "Catskills on Broadway."

"The Visit" won for outstanding revival of a play, and "Guys and Dolls" for best revival of a musical. The award for choreography went to Susan Stroman of "Crazy for You." Best design awards were won by "Crazy for You": for scenic design by Robin Wagner, for costumes by William Ivey Long and for lighting by Paul Gallo.

The Outer Critics Circle comprises 68 journalists who cover theater in New York City for out-of-town publications.

1992 Ap 28, C15:5

Index

This index covers all the reviews included in this volume. It is divided into three sections: Titles, Personal Names, and Corporate Names.

Citations in this index are by year, month, day, section of newspaper (if applicable), page, and column; for example, 1989 Ja 11,II:12:1. Since the reviews appear in chronological order, the date is the key locator. The citations also serve to locate the reviews in bound volumes and microfilm editions of The Times.

In the citations, months are abbreviated as follows:

Ja - January	F - February	Mr - March
Ap - April	My - May	Je - June
Jl - July	Ag - August	S - September
O - October	N - November	D - December

TITLE INDEX

All plays reviewed are listed alphabetically. Articles that begin titles are inverted. Titles that begin with a number are alphabetized as though the number was spelled out. Whenever possible, foreign plays are entered under both the English and foreign-language titles. Plays reviewed more than once and plays with identical titles are given separate listings.

PERSONAL NAMES INDEX

All persons included in the credits are listed alphabetically, last name first. Their function in the play is listed in parentheses: Playwright, Director, Producer, Choreographer, Composer, Lyricist, Scenic Designer, Lighting Director, Costume Designer, Original Author, Translator. Other functions (such as Sound Designer, Stage Manager, etc.) are listed as Miscellaneous. Where no such qualifier appears, the person was a performer (actor, actress, singer, dancer, musician). A person with multiple functions will have multiple entries.

Names beginning with Mc are alphabetized as if spelled Mac.

Names beginning with St. are alphabetized as if spelled Saint.

Entries under each name are by title of play, in chronological order.

CORPORATE NAME INDEX

All corporate bodies and performance groups mentioned in reviews as involved in the production of the play or in some other function connected with it are listed here alphabetically. Names that begin with a personal name are inverted (e.g., Kennedy, John F., Center for the Performing Arts). The function of the organization is given in parentheses as either Prod. (for Producer) or Misc. (for Miscellaneous). A company that has more than one function is listed twice.

Entries under each name are by title of play, in chronological order.

Y

Z

A

Jake's Women 1992,Ap 5,II:5:1
Alderson, William
Roads to Home, The 1992,S 18,C2:3
Aldous, Brian (Lighting Director)
Mermaid Wakes, The 1991,F 25,C14:3
Leonce and Lena 1991,Mr 24,63:5
Woyzeck 1991,Mr 24,63:5
Amerikamachine 1991,My 29,C14:3
Geneva 1991,O 23,C19:1
Tubes 1991,N 20,C23:1
Mary Stuart 1992,F 26,C19:1
Homo Sapien Shuffle 1992,Mr 10,C12:5
Murder of Crows, A 1992,My 1,C18:1
Vanquished by Voodoo 1992,Je 17,C17:1
Blue Heaven 1992,S 30,C16:3
Idiot, The 1992,D 21,C13:1
Aldredge, Theoni V. (Costume Designer)
Secret Garden, The 1991,Ap 26,C1:1
Nick and Nora 1991,D 9,C11:3
Nick and Nora 1991,D 15,II:1:1
High Rollers Social and Pleasure Club, The 1992,Ap 23,C15:2
Aldredge, Tom
Two Shakespearean Actors 1992,Ja 17,C1:1
Two Shakespearean Actors 1992,Ja 26,II:5:1
Alessandrini, Gerard (Director)
Forbidden Broadway 1991 1/2 1991,Je 21,C3:1
Forbidden Broadway 1991 1/2 1991,Jl 14,II:5:1
Forbidden Broadway/Forbidden Christmas 1991,D 13,C3:4
Best of Forbidden Broadway, The: 10th-Anniversary Edition 1992,Ap 9,C19:3
Alessandrini, Gerard (Lyricist)
Forbidden Broadway 1991 1/2 1991,Jl 14,II:5:1
Best of Forbidden Broadway, The: 10th-Anniversary Edition 1992,Ap 9,C19:3
Alessandrini, Gerard (Miscellaneous)
Forbidden Broadway 1991 1/2 1991,Je 21,C3:1
Forbidden Broadway/Forbidden Christmas 1991,D 13,C3:4
Alessandrini, Gerard (Playwright)
Forbidden Broadway 1991 1/2 1991,Je 21,C3:1
Forbidden Broadway 1991 1/2 1991,Jl 14,II:5:1
Forbidden Broadway/Forbidden Christmas 1991,D 13,C3:4
Best of Forbidden Broadway, The: 10th-Anniversary Edition 1992,Ap 9,C19:3
Alexander, Bill (Director)
Romeo and Juliet 1991,Ja 31,C21:1
Romeo and Juliet 1991,F 10,II:5:1
Alexander, Erika
Casanova 1991,My 29,C11:5
Alexander, Jace
Assassins 1991,Ja 28,C19:3
Assassins 1991,F 3,II:1:2
Alexander, Jane
Visit, The 1992,Ja 24,C1:2
Visit, The 1992,F 2,II:5:1
Sisters Rosensweig, The 1992,O 23,C3:1
Sisters Rosensweig, The 1992,N 1,II:5:1
Alexander, Kent (Director)
Empty Boxes 1992,O 14,C18:3
Alexander, Lorraine (Translator)
Nowhere 1992,Je 3,C15:4
Alexander, Robert
Raft of the Medusa 1991,D 23,C15:1
Alexander, Roslyn
Beau Jest 1991,O 11,C16:6
Beau Jest 1991,O 20,II:5:1
Alexanian, Christina
Iphigenia in Tauris 1992,My 13,C14:3
Alfano, Jorge
Winter Man 1991,F 21,C20:1
Alfaro, Francisco
Tempestad, La (Tempest, The) 1991,Ag 30,C3:3
Alford, David
Hidden Laughter 1992,Mr 8,II:5:1
Algan, Ayla
Yunus 1992,O 28,C18:1
Algan, Ayla (Composer)
Yunus 1992,O 28,C18:1
Algan, Beklan
Yunus 1992,O 28,C18:1
Allan, Laurena (Miscellaneous)
Jersey Girls, The 1991,S 4,C16:1
Allaway, Jack (Miscellaneous)
Solitary Confinement 1992,N 9,C11:1

Allen, Brooke (Playwright)
Big Love, The 1991,Mr 4,C11:1
Big Love, The 1991,Mr 10,II:5:1
Allen, Fred (Lighting Director)
Christmas Carol, A 1991,D 20,C3:1
Allen, Greg (Miscellaneous)
Women in Beckett 1991,N 22,C17:1
Allen, Jay Presson (Director)
Big Love, The 1991,Mr 4,C11:1
Allen, Jay Presson (Playwright)
Big Love, The 1991,Mr 4,C11:1
Big Love, The 1991,Mr 10,II:5:1
Allen, Joan
Earthly Possessions 1991,S 4,C13:2
Allen, Karen
Country Girl, The 1991,Ja 12,16:3
Country Girl, The 1991,Ja 13,II:5:1
Aller, John
Most Happy Fella, The 1992,F 14,C1:4
Allgood, Anne
Most Happy Fella, The 1992,F 14,C1:4
Allinson, Michael
Arthur: The Musical 1991,Ag 18,II:5:1
Allison, Mary Ellen (Miscellaneous)
Funny Thing Happened on the Way to the Forum, A 1991,Mr 28,C16:4
Misanthrope, The 1991,O 9,C18:3
Allogeodt, Cecile (Lighting Director)
Atrides, Les 1992,O 6,C11:3
Allyn, Stuart J. (Miscellaneous)
Song of Singapore 1991,My 24,C26:2
Under Control 1992,O 22,C25:4
Almeida, Gilda (Miscellaneous)
Basement 1991,D 8,83:5
Alper, Steve (Musical Director)
Short Shots 1991,Ag 1,C14:4
Alpert, Caren
Pie Supper 1992,Jl 30,C20:1
Alpert, Caren (Costume Designer)
Pie Supper 1992,Jl 30,C20:1
Alpert, Herb (Producer)
Jelly's Last Jam 1992,Ap 27,C11:1
Alpert, Michael (Miscellaneous)
Invitations to Heaven (Questions of a Jewish Child) 1991,O 2,C18:3
Altieri, Marcia (Scenic Designer)
Eagle in the Bubble 1991,Jl 16,C15:1
Alto, Bobby
3 from Brooklyn 1992,N 20,C3:1
Altunmese, Ali (Composer)
Yunus 1992,O 28,C18:1
Alvarado, Alice
Family Portrait 1992,Ap 22,C17:3
Alvarez, Anthony
Candida Erendira, La 1992,F 9,65:1
Alvarez, Maria Jose
Mayor of Zalamea, The (Alcalde de Zalamea, El) 1991,Ap 14,52:1
Alves, Alza Helena
Maturando 1991,O 17,C19:1
Amaral, Fernanda
Maturando 1991,O 17,C19:1
Amaral, Fernanda (Miscellaneous)
Maturando 1991,O 17,C19:1
Amber
Rules of Civility and Decent Behavior in Company and Conversation 1991,Mr 25,C15:1
Ambrose, Garrick
Amerikamachine 1991,My 29,C14:3
Ambrose, Lauren
Shallow End, The (Marathon '92, Series A) 1992,My 5,C15:1
Ambroziak, Monika
Metro 1992,Ap 17,C1:3
Ameen, Mark
Seven Pillars of Wicca-Dick: A Triumph 1991,N 27,C17:1
Ameen, Mark (Playwright)
Seven Pillars of Wicca-Dick: A Triumph 1991,N 27,C17:1
Anania, Michael (Scenic Designer)
To Kill a Mockingbird 1991,Mr 4,C13:4
110 in the Shade 1992,Ag 2,II:5:1
Anderman, Maureen
Betrayal 1991,F 3,55:4
Booth Is Back 1991,O 31,C18:1
Tartuffe 1992,O 16,C15:1

Anderson, Frank
Democracy and Esther 1992,O 7,C16:3
Anderson, Gerry (Miscellaneous)
Return to the Forbidden Planet 1991,O 14,C13:1
Anderson, Gillian
Absent Friends 1991,F 13,C13:3
Absent Friends 1991,F 24,II:5:1
Philanthropist, The 1992,Ja 16,C17:1
Anderson, Jane (Playwright)
Baby Dance, The 1991,Ap 1,C14:1
Food and Shelter 1991,Je 2,65:1
Baby Dance, The 1991,O 18,C5:1
Baby Dance, The 1991,O 27,II:5:1
Hotel Oubliette 1992,Ag 12,C14:1
Anderson, Joel
Empty Hearts 1992,My 6,C18:3
Anderson, Judith
When the Wind Blows 1992,My 13,C14:3
News Update 1992,My 13,C14:3
Anderson, June (Miscellaneous)
Explosions 1992,Ja 15,C17:1
Anderson, Keith (Costume Designer)
Walt Disney's World on Ice: Mickey Mouse Diamond Jubilee 1991,F 5,C18:1
Anderson, Keith (Scenic Designer)
Ringling Brothers and Barnum & Bailey Circus 1991,Mr 24,63:1
Disney's World on Ice Starring Peter Pan 1992,F 12,C17:1
Anderson, Kevin
Earthly Possessions 1991,S 4,C13:2
Anderson, Lindsay (Director)
Stages 1992,D 23,C9:3
Anderson, Mitchell
Flaubert's Latest 1992,Je 22,C15:3
Flaubert's Latest 1992,Je 28,II:5:1
Anderson, Sherry
Marathon 1991: New One-Act Plays, Series A 1991,My 26,57:5
Anderson, Stephen Lee
Groundhog 1992,My 4,C14:1
Paint Your Wagon 1992,Ag 7,C2:3
Andersson, Benny (Composer)
Chess 1992,F 5,C19:3
Andersson, Bibi
Long Day's Journey into Night 1991,Je 17,C11:3
Andino, Eddie
Oxcart, The (Carreta, La) 1992,Ap 22,C17:3
Andonyadis, Nephelie (Costume Designer)
Almond Seller, The 1991,Mr 2,15:1
Job: A Circus 1992,Ja 15,C17:1
Andonyadis, Nephelie (Scenic Designer)
Job: A Circus 1992,Ja 15,C17:1
Andres, Barbara
Woman Without a Name, A 1992,F 2,54:5
First Is Supper 1992,Mr 18,C17:1
Angel, Tony (Lighting Director)
Humanity (Menschen, Die) 1991,Je 5,C22:3
Angel, Tony (Miscellaneous)
Waste (A Street Spectacle) 1991,Ag 7,C13:1
Angela, June
Cambodia Agonistes 1992,N 13,C3:1
Angelos, Maureen
Brother Truckers 1992,S 22,C13:3
Aniulyte, Jurate
Uncle Vanya 1991,Je 17,C11:3
Annis, Eric (Miscellaneous)
Rivers and Ravines, The 1991,N 14,C28:6
Anthes, Rachelle (Miscellaneous)
American Living Room Reupholstered, The 1992,S 30,C16:3
Anthony, Johnson
Rules of Civility and Decent Behavior in Company and Conversation 1991,Mr 25,C15:1
Antoni, Carmen-Maja
Love and Revolution: A Brecht Cabaret 1991,O 23,C17:4
Antoon, A. J. (Director)
Song of Singapore 1991,My 24,C26:2
Song of Singapore 1991,Je 2,II:7:1
Appel, Irwin
Romeo and Juliet 1991,Ja 31,C21:1
Appel, Marion (Miscellaneous)
Law of Remains, The 1992,F 26,C19:1
Appel, Peter
Good Times Are Killing Me, The 1991,Ap 19,C3:1
Appel, Susan
All's Well That Ends Well 1991,N 25,C14:3

Marathon 1991: New One-Act Plays, Series C 1991,Je 19,C12:3
Oleanna 1992,O 26,C11:4

Averyt, Bennet (Scenic Designer)
Men Are Afraid of the Women, The 1992,O 21,C16:3

Avian, Bob (Choreographer)
Miss Saigon 1991,Ap 12,C1:2

Avidon, Nelson
Festival of One-Act Comedies, Evening B 1991,Mr 5,C16:3

Avila, Alina (Miscellaneous)
Any Place But Here 1992,Je 9,C13:1

Avkiran, Mustafa
Yunus 1992,O 28,C18:1

Avni, Ran (Director)
Encore 1991,Je 19,C12:3
God of Vengeance 1992,N 4,C22:1

Avni, Ran (Miscellaneous)
Taking Stock 1991,Ja 17,C21:1
Fierce Attachment, A 1991,Mr 14,C18:1
Modigliani 1991,My 1,C15:1
Encore 1991,Je 19,C12:3
Life in the Theater, A 1992,F 29,18:1
Sunset Gang, The 1992,My 16,14:3
Last Laugh, The 1992,Jl 2,C16:1
God of Vengeance 1992,N 4,C22:1

Axtell, Barry (Scenic Designer)
Balancing Act 1992,Je 17,C17:1

Ayanoglu, Byron (Playwright)
Eagle in the Bubble 1991,Jl 16,C15:1

Ayckbourn, Alan (Playwright)
Absent Friends 1991,F 13,C13:3
Taking Steps 1991,F 21,C13:1
Absent Friends 1991,F 24,II:5:1
Small Family Business, A 1992,Ap 28,C13:3
Small Family Business, A 1992,My 10,II:1:2

Ayers, Terry (Scenic Designer)
Real Live Game Show, The 1991,O 2,C18:3

Aylward, Tony
Funny Thing Happened on the Way to the Forum, A 1991,Mr 28,C16:4

Ayvazian, Leslie
Marathon 1991: New One-Act Plays, Series B 1991,Je 9,60:5
Jenny Keeps Talking (Marathon '92, Series C) 1992,Je 2,C15:1

Ayvazian, Leslie (Playwright)
Practice (Marathon 1991: New One-Act Plays, Series B) 1991,Je 9,60:5

Azenberg, Emanuel (Producer)
Lost in Yonkers 1991,F 22,C1:4
Jake's Women 1992,Mr 25,C17:3

Azenberg, Karen (Choreographer)
Love in Two Countries 1991,Ap 10,C15:1
Prom Queens Unchained 1991,Jl 5,C3:2

Azenberg, Karen (Director)
Prom Queens Unchained 1991,Jl 5,C3:2

Azencot, Myriam
Atrides, Les 1992,O 6,C11:3

Azencot, Myriam (Miscellaneous)
Atrides, Les 1992,O 6,C11:3

B

Babcock, John
Secret Garden, The 1991,Ap 26,C1:1
Secret Garden, The 1991,My 5,II:5:1

Babich, Yuli
Moscow Circus—Cirk Valentin 1991,N 8,C3:1

Babilla, Assurbanipal
True Story of a Woman Born in Iran and Raised to Heaven in Manhattan, The 1991,My 15,C12:3

Babilla, Assurbanipal (Director)
True Story of a Woman Born in Iran and Raised to Heaven in Manhattan, The 1991,My 15,C12:3

Babilla, Assurbanipal (Playwright)
True Story of a Woman Born in Iran and Raised to Heaven in Manhattan, The 1991,My 15,C12:3

Bach, Johann Sebastian (Composer)
Maybe It's Cold Outside 1991,F 19,C14:3

Bacharach, Burt (Composer)
Back to Bacharach 1992,S 4,C2:3

Backes, Roy W. (Miscellaneous)
Country Girl, The 1991,Ja 12,16:3

Matchmaker, The 1991,Ag 28,C12:4

Backo, Stephen J. (Lighting Director)
Candida 1991,F 25,C13:1
Fridays 1991,My 22,C15:1
Macbeth 1991,S 27,C15:1
Iron Bars 1991,N 20,C23:1

Bacon, Kevin
Spike Heels 1992,Je 5,C3:1

Badgett, William
Fata Morgana 1991,My 3,C20:4
Radiant City, The 1991,O 7,C15:4
Radiant City, The 1991,O 13,II:5:1
Empty Boxes 1992,O 14,C18:3

Badgett, William (Playwright)
Empty Boxes 1992,O 14,C18:3

Badham, John (Director)
Speed-the-Plow 1991,Ag 15,C16:4

Badolato, Bill
Most Happy Fella, The 1991,My 30,C13:1
Most Happy Fella, The 1992,F 14,C1:4

Badrak, Jim (Composer)
Bluebeard 1991,N 15,C3:1

Badrak, Jim (Miscellaneous)
Bluebeard 1991,N 15,C3:1

Badurek, Jacek
Metro 1992,Ap 17,C1:3

Baeumler, Carolyn
Vinegar Tom 1992,Mr 21,14:5
I'm Sorry . . . Was That Your World? 1992,S 25,C2:3

Baez, Rafael
Tempest, A 1991,O 16,C18:3
Once Removed 1992,D 7,C11:1

Bagden, Ron
Dead Mother: or Shirley Not All in Vain 1991,F 1,C3:1
Home Show Pieces, The 1992,Ja 29,C17:1

Bagdonas, Vladas
Uncle Vanya 1991,Je 17,C11:3

Bagg, Robert (Translator)
Hippolytos 1992,N 25,C19:1

Baggott, Kate (Director)
Korea 1992,F 19,C16:3
Fasting (Marathon '92, Series A) 1992,My 5,C15:1

Baggott, Kate (Miscellaneous)
Marathon 1991: New One-Act Plays, Series A 1991,My 26,57:5
Marathon 1991: New One-Act Plays, Series B 1991,Je 9,60:5
Marathon 1991: New One-Act Plays, Series C 1991,Je 19,C12:3
Novelist, The 1991,O 23,C19:1
Appointment with a High-Wire Lady 1992,F 12,C17:1

Bailey, Adrian
Jelly's Last Jam 1992,Ap 27,C11:1

Bailey, Victoria (Miscellaneous)
Life During Wartime 1991,Mr 6,C13:1
Black Eagles 1991,Ap 22,C13:1
Lips Together, Teeth Apart 1991,Je 26,C11:1
Beggars in the House of Plenty 1991,O 24,C17:4
Piece of My Heart, A 1991,N 4,C15:1
Sight Unseen 1992,Ja 21,C13:3
Boesman and Lena 1992,Ja 30,C15:1
Small Family Business, A 1992,Ap 28,C13:3
Groundhog 1992,My 4,C14:1

Bain, Conrad
On Borrowed Time 1991,O 10,C19:1
On Borrowed Time 1991,O 20,II:5:1

Baird, Campbell (Scenic Designer)
Hour of the Lynx 1992,Ap 1,C16:3
Lightin' Out 1992,D 14,C14:1

Baitz, Jon Robin (Playwright)
Substance of Fire, The 1991,Mr 18,C11:1
Substance of Fire, The 1991,Mr 24,II:5:1
Substance of Fire, The 1992,F 28,C3:1
End of the Day, The 1992,Ap 8,C17:3

Baker, David Aaron
110 in the Shade 1992,Ag 2,II:5:1

Baker, Dylan
Bete, La 1991,F 11,C11:3
Bete, La 1991,F 17,II:5:1
Dearly Departed 1991,D 24,C11:1

Baker, Edward Allan (Playwright)
Face Divided (Marathon 1991: New One-Act Plays, Series B) 1991,Je 9,60:5

Baker, Jodi
God of Vengeance 1992,N 4,C22:1

Baker, Robert Michael
Guys and Dolls 1992,Ap 15,C15:3
Animal Crackers 1992,N 4,C19:4

Bakos, John
Moe Green Gets It in the Eye 1991,My 8,C12:3
Futz 1991,O 23,C19:1

Balaban, Nell
Crucible, The 1991,D 11,C17:1
Little Hotel on the Side, A 1992,Ja 27,C17:1

Balassanian, Sonia (Scenic Designer)
True Story of a Woman Born in Iran and Raised to Heaven in Manhattan, The 1991,My 15,C12:3
Law of Remains, The 1992,F 26,C19:1

Baldassari, Michael J. (Lighting Director)
Babylon Gardens 1991,O 9,C17:1

Baldomero, Brian R.
Miss Saigon 1991,Ap 12,C1:2

Baldoni, Gail (Costume Designer)
I Can Get It for You Wholesale 1991,Mr 11,C14:3
Rags 1991,D 4,C22:3
Cinderella 1991,D 23,C16:4

Baldwin, Alec
Streetcar Named Desire, A 1992,Ap 13,C11:3
Streetcar Named Desire, A 1992,Ap 19,II:5:1

Baldwin, Phillip (Scenic Designer)
Raft of the Medusa 1991,D 23,C15:1

Baldwin, Sean
Time of Your Life, The 1991,O 2,C17:1
Time of Your Life, The 1991,O 6,II:5:1

Balfour, Penny
Hidden Laughter 1992,Mr 8,II:5:1

Balint, Eszter
Full-Moon Killer 1991,Ja 13,43:5

Balint, Stephan (Director)
Full-Moon Killer 1991,Ja 13,43:5

Balint, Stephan (Playwright)
Full-Moon Killer 1991,Ja 13,43:5

Balis, Andrea (Lyricist)
Radiant City, The 1991,O 7,C15:4

Balis, Andrea (Miscellaneous)
Underground 1992,S 16,C16:3

Balis, Andrea (Playwright)
Underground 1992,S 16,C16:3

Ball, George
Paint Your Wagon 1992,Ag 7,C2:3
Paint Your Wagon 1992,Ag 16,II:5:1

Ballantine, Sheila
Sarrasine 1991,S 9,C16:4

Ballard, Kaye
Say It with Music: The Irving Berlin Revue 1992,Ag 2,II:5:1

Ballentine, Marjorie (Director)
Vinegar Tom 1992,Mr 21,14:5

Balletta, Dominick (Miscellaneous)
Marathon 1991: New One-Act Plays, Series A 1991,My 26,57:5
Marathon 1991: New One-Act Plays, Series B 1991,Je 9,60:5
Marathon 1991: New One-Act Plays, Series C 1991,Je 19,C12:3
George Washington Dances 1992,F 11,C16:1
Korea 1992,F 19,C16:3
Marathon '92, Series A 1992,My 5,C15:1
Marathon '92, Series B 1992,My 19,C18:3
Marathon '92, Series C 1992,Je 2,C15:1

Balmaceda, Martin
Mayor of Zalamea, The (Alcalde de Zalamea, El) 1991,Ap 14,52:1
Candida Erendira, La 1992,F 9,65:1

Balsam, Talia
Jake's Women 1992,Mr 25,C17:3
Jake's Women 1992,Ap 5,II:5:1

Bamman, Gerry
Tartuffe 1992,O 16,C15:1

Bannister, Mark
As You Like It 1991,Jl 26,C18:4

Baran, Edward
Night Sky 1991,My 23,C24:5

Baranski, Christine
Lips Together, Teeth Apart 1991,Je 26,C11:1
Lips Together, Teeth Apart 1991,Jl 14,II:5:1
Nick and Nora 1991,D 9,C11:3
Nick and Nora 1991,D 15,II:1:1

Baray, John
Cambodia Agonistes 1992,N 13,C3:1

Barbarash, Ernie (Lighting Director)
Any Place But Here 1992,Je 9,C13:1

Barber, Joan Susswein
Man of La Mancha 1992,Ap 25,13:4
Barber, Ricardo
Mayor of Zalamea, The (Alcalde de Zalamea, El) 1991,Ap 14,52:1
Esperando la Carroza (Waiting for the Hearse) 1991,S 18,C15:1
Candida Erendira, La 1992,F 9,65:1
Barcelo, Randy (Costume Designer)
Botanica 1991,Mr 5,C16:1
Barcelo, Randy (Scenic Designer)
Botanica 1991,Mr 5,C16:1
Barclay, William (Miscellaneous)
Solitary Confinement 1992,N 9,C11:1
Barclay, William (Scenic Designer)
Earth and Sky 1991,F 5,C13:1
Grand Finale 1991,Ap 21,60:1
Don Juan and the Non Don Juan, The 1991,D 23,C16:1
Juno 1992,O 31,16:4
Solitary Confinement 1992,N 9,C11:1
Bard, Isaiah
Saint Joan 1992,F 23,51:5
Bardawil, Nancy (Scenic Designer)
Belle Reprieve 1991,Mr 11,C14:5
Power Pipes 1992,O 24,18:1
Bareikis, Arija
Our Lady of Perpetual Danger 1991,O 16,C18:3
Bargonetti, Steve
Jelly's Last Jam 1992,Ap 27,C11:1
Barlow, Roxane
Will Rogers Follies, The: A Life in Revue 1991,My 2,C17:1
Barnaud, Marc
Atrides, Les 1992,O 6,C11:3
Barnes, Bill (Miscellaneous)
You Could Be Home Now 1992,O 12,C11:1
Barnes, Gregg (Costume Designer)
To Kill a Mockingbird 1991,Mr 4,C13:4
Pageant 1991,My 8,C12:3
Big Noise of '92: Diversions from the New Depression 1991,D 18,C25:1
Barnes, Patrick
Them . . . Within Us 1992,D 26,15:1
Barnes, William Joseph (Miscellaneous)
Flaubert's Latest 1992,Je 22,C15:3
Barnett, Bob (Scenic Designer)
Candida 1991,F 25,C13:1
Fridays 1991,My 22,C15:1
Macbeth 1991,S 27,C15:1
Iron Bars 1991,N 20,C23:1
Barnett, Laura (Producer)
She Who Once Was the Helmet-Maker's Beautiful Wife 1992,Je 18,C15:1
Barnhart, Doug
Walt Disney's World on Ice: Mickey Mouse Diamond Jubilee 1991,F 5,C18:1
Barnhill, Jay
Deposing the White House 1991,D 4,C22:3
Awoke One (Marathon '92, Series B) 1992,My 19,C18:3
Baron, Alan (Lighting Director)
Marriage Contract, The 1991,N 6,C21:1
At the Crossroads 1992,N 11,C18:3
Baron, Art
Song of Singapore 1991,My 24,C26:2
Baron, Art (Musical Director)
Song of Singapore 1991,My 24,C26:2
Barone, Sal
Walk on Lake Erie, A 1991,Mr 25,C15:1
Barre, Gabriel
Return to the Forbidden Planet 1991,O 14,C13:1
It's a Bird, It's a Plane, It's Superman 1992,Je 20,16:4
Jacques Brel Is Alive and Well and Living in Paris 1992,O 21,C16:3
Barre, Gabriel (Miscellaneous)
Job: A Circus 1992,Ja 15,C17:1
Jacques Brel Is Alive and Well and Living in Paris 1992,O 21,C16:3
Barreca, Christopher (Scenic Designer)
Heliotrope Bouquet by Scott Joplin and Louis Chauvin, The 1991,Mr 17,II:5:1
Our Country's Good 1991,Ap 30,C13:4
Search and Destroy 1992,F 27,C18:5
Search and Destroy 1992,Mr 8,II:5:1
Hidden Laughter 1992,Mr 8,II:5:1
Hamlet 1992,Ap 3,C3:1

Nebraska 1992,Je 3,C15:4
Barrett, Michael (Musical Director)
Four Baboons Adoring the Sun 1992,Mr 19,C15:3
Barrett, Tim
Men Are Afraid of the Women, The 1992,O 21,C16:3
Barrish, Seth
God's Country 1992,Je 3,C15:4
Barrish, Seth (Director)
Greetings 1991,D 11,C23:1
Barrit, Desmond
Wind in the Willows, The 1992,Mr 3,C13:3
Barrow, Bernard
Mystery of Anna O, The 1992,S 23,C16:3
Barrows, Fred
Charge It, Please 1991,My 29,C14:3
Barry, B. H. (Miscellaneous)
I Hate Hamlet 1991,Ap 9,C13:3
Crazy for You 1992,F 20,C15:3
Words Divine: A Miracle Play 1992,N 25,C19:1
My Favorite Year 1992,D 11,C1:1
Barry, Ellen
This One Thing I Do 1992,Ap 19,45:5
Barry, Lynda (Original Author)
Good Times Are Killing Me, The 1991,Ap 28,II:5:1
Barry, Lynda (Playwright)
Good Times Are Killing Me, The 1991,Ap 19,C3:1
Good Times Are Killing Me, The 1991,Ap 28,II:5:1
Good Times Are Killing Me, The 1991,Ag 9,C3:5
Barry, P. J. (Director)
After the Dancing in Jericho 1992,F 12,C17:1
Barry, P. J. (Playwright)
After the Dancing in Jericho 1992,F 12,C17:1
Barry, Paul
Twelfth Night or What You Will 1991,Je 19,C12:3
Bart, Roger
Henry IV, Parts 1 and 2 1991,F 28,C15:1
March of the Falsettos and Falsettoland 1991,O 15,C13:1
Bartel, Paul (Playwright)
Eating Raoul 1992,My 16,14:3
Bartenieff, George
Fata Morgana 1991,My 3,C20:4
Kafka: Father and Son 1992,Ja 29,C17:1
Blue Heaven 1992,S 30,C16:3
Bartenieff, George (Miscellaneous)
Fata Morgana 1991,My 3,C20:4
Accident: A Day's News 1991,S 23,C14:3
Anna, the Gypsy Swede 1992,Je 11,C16:3
Blue Heaven 1992,S 30,C16:3
Barteve, Reine (Playwright)
Nowhere 1992,Je 3,C15:4
Barthel, Sven (Translator)
Long Day's Journey into Night 1991,Je 17,C11:3
Bartlett, Alison
Family Portrait 1992,Ap 22,C17:3
Bartlett, Lisbeth
Iron Bars 1991,N 20,C23:1
Bartlett, Neil (Costume Designer)
Sarrasine 1991,S 9,C16:4
Bartlett, Neil (Lighting Director)
Sarrasine 1991,S 9,C16:4
Bartlett, Neil (Playwright)
Sarrasine 1991,S 9,C16:4
Bartlett, Neil (Scenic Designer)
Sarrasine 1991,S 9,C16:4
Bartlett, Paul (Lighting Director)
Hour of the Lynx 1992,Ap 1,C16:3
Lightin' Out 1992,D 14,C14:1
Bartlett, Peter
Learned Ladies, The (Femmes Savantes, Les) 1991,Mr 10,58:1
Barton, Alexander
To Kill a Mockingbird 1991,Mr 4,C13:4
Barton, Bruce Edward
Iron Bars 1991,N 20,C23:1
Barton, Steve
Six Wives 1992,O 10,16:1
Barty, Billy
Andre Heller's Wonderhouse 1991,O 21,C15:1
Andre Heller's Wonderhouse 1991,O 27,II:5:1
Baruch, Steven (Producer)
Penn and Teller: The Refrigerator Tour 1991,Ap 4,C15:5
Song of Singapore 1991,My 24,C26:2
Oleanna 1992,O 26,C11:4

Basch, Peter
Festival of One-Act Comedies, Evening B 1991,Mr 5,C16:3
Awoke One (Marathon '92, Series B) 1992,My 19,C18:3
I'm Sorry . . . Was That Your World? 1992,S 25,C2:3
Basgall, Larry
Adding Machine, The 1992,S 16,C16:3
Basgall, Larry (Miscellaneous)
Adding Machine, The 1992,S 16,C16:3
Bash, Phyllis
Blood Wedding 1992,My 15,C3:3
Bass, Eric
Invitations to Heaven (Questions of a Jewish Child) 1991,O 2,C18:3
Bass, Eric (Miscellaneous)
Invitations to Heaven (Questions of a Jewish Child) 1991,O 2,C18:3
Bass, Eric (Playwright)
Invitations to Heaven (Questions of a Jewish Child) 1991,O 2,C18:3
Bass, Eric (Scenic Designer)
Invitations to Heaven (Questions of a Jewish Child) 1991,O 2,C18:3
Bass, George
Jibaros Progresistas, Los 1991,Ag 29,C18:3
Bass, George Houston (Miscellaneous)
Mule Bone 1991,F 15,C1:4
Mule Bone 1991,F 24,II:5:1
Bass, Ines Zeller (Miscellaneous)
Invitations to Heaven (Questions of a Jewish Child) 1991,O 2,C18:3
Bassett, Steve
Babylon Gardens 1991,O 9,C17:1
Bassi, Leo
C. Colombo Inc.: Export/Import, Genoa 1992,O 28,C18:1
C. Colombo Inc.: Export/Import, Genoa 1992,N 1,II:5:1
Bassi, Leo (Playwright)
C. Colombo Inc.: Export/Import, Genoa 1992,O 28,C18:1
C. Colombo Inc.: Export/Import, Genoa 1992,N 1,II:5:1
Bassman, George (Miscellaneous)
Guys and Dolls 1992,Ap 15,C15:3
Bastine, Cadet
It's a Bird, It's a Plane, It's Superman 1992,Je 20,16:4
Bate, Dana
Encanto File, The, and Other Short Plays 1991,Ap 2,C14:5
Bateman, Justine
Speed-the-Plow 1991,Ag 15,C16:4
Bates, Alan
Stages 1992,D 23,C9:3
Bates, Jerome Preston
Pill Hill 1992,D 3,C18:5
Bates, Paul
1991 Young Playwrights Festival, The 1991,O 3,C20:3
Bates, Terry John (Choreographer)
Dancing at Lughnasa 1991,O 25,C1:4
Batson, Susan
Words Divine: A Miracle Play 1992,N 25,C19:1
Battis, Emery
Coriolanus 1991,O 6,II:5:1
Battle, Hinton
Miss Saigon 1991,Ap 12,C1:2
Miss Saigon 1991,Ap 21,II:5:1
Bauer, Beaver (Costume Designer)
Learned Ladies, The (Femmes Savantes, Les) 1991,Mr 10,58:1
Bauer, Jason
When Lithuania Ruled the World, Part 3 1992,Ja 23,C14:4
Bauer, Jean-Michel (Lighting Director)
Atrides, Les 1992,O 6,C11:3
Bauer, Richard
Time of Your Life, The 1991,O 2,C17:1
Time of Your Life, The 1991,O 6,II:5:1
Wonderful Life, A 1991,D 8,II:5:1
Baum, Joanne
March of the Falsettos and Falsettoland 1991,O 15,C13:1
Ruthless! 1992,My 13,C14:3
Baum, L. Frank (Original Author)
Wizard of Oz, The 1992,O 11,II:5:1

Besterman, Douglas (Miscellaneous)
Weird Romance 1992,Je 23,C14:5
Beverley, Trazana
Before It Hits Home 1991,F 17,II:5:1
Marathon 1991: New One-Act Plays, Series B
1991,Je 9,60:5
Bezic, Sandra (Choreographer)
Skating II 1991,Mr 4,C12:3
Chrysler Skating '92 1992,Mr 9,C11:1
Bezic, Sandra (Director)
Chrysler Skating '92 1992,Mr 9,C11:1
Bhasker
Tragedy of Macbeth, The 1991,Je 18,C13:4
Bianchi, James R.
Twelfth Night or What You Will 1991,Je 19,C12:3
Saint Joan 1992,F 23,51:5
Tempest, The 1992,Jl 22,C17:1
Bickford, Stephen (Lighting Director)
Moscow Circus—Cirk Valentin 1991,N 8,C3:1
Bickford, Stephen (Scenic Designer)
Moscow Circus—Cirk Valentin 1991,N 8,C3:1
Biegler, Gloria
Hidden Laughter 1992,Mr 8,II:5:1
Bielski, Marc J. (Playwright)
My Son the Doctor 1991,Ag 10,12:6
Bietak, Willy (Director)
Ice Capades: On Top of the World 1991,Ja 22,C16:4
Tom Scallen's Ice Capades 1992,Ja 22,C17:1
Bietak, Willy (Producer)
Ice Capades: On Top of the World 1991,Ja 22,C16:4
Tom Scallen's Ice Capades 1992,Ja 22,C17:1
Biggs, Casey
Time of Your Life, The 1991,O 2,C17:1
Time of Your Life, The 1991,O 6,II:5:1
Wonderful Life, A 1991,D 8,II:5:1
Biggs, Jason
Conversations with My Father 1992,Mr 30,C11:3
Conversations with My Father 1992,Ap 12,II:5:1
Bigot, Georges
Oresteia 1991,Mr 27,C13:3
Bilek, Jan
Pinokio 1992,S 12,15:1
Bilik, Jerry (Director)
Walt Disney's World on Ice: Mickey Mouse
Diamond Jubilee 1991,F 5,C18:1
Disney's World on Ice Starring Peter Pan 1992,F
12,C17:1
Bilik, Jerry (Musical Director)
Walt Disney's World on Ice: Mickey Mouse
Diamond Jubilee 1991,F 5,C18:1
Disney's World on Ice Starring Peter Pan 1992,F
12,C17:1
Bilik, Jerry (Playwright)
Walt Disney's World on Ice: Mickey Mouse
Diamond Jubilee 1991,F 5,C18:1
Disney's World on Ice Starring Peter Pan 1992,F
12,C17:1
Billeci, John
Canal Zone 1992,My 6,C18:3
Macbeth 1992,My 20,C18:1
Billig, Robert (Musical Director)
Miss Saigon 1991,Ap 12,C1:2
Billig, Simon
Comedy of Errors, The 1992,Ag 17,C11:3
Billings, Jef (Costume Designer)
Ice Capades: On Top of the World 1991,Ja 22,C16:4
Tom Scallen's Ice Capades 1992,Ja 22,C17:1
Billington, Ken (Lighting Director)
Absent Friends 1991,F 13,C13:3
Big Love, The 1991,Mr 4,C11:1
Easter Show 1991,Mr 25,C18:4
Breaking Legs 1991,My 20,C11:1
Lips Together, Teeth Apart 1991,Je 26,C11:1
Radio City Easter Show, The 1992,Ap 15,C19:1
Metro 1992,Ap 17,C1:3
Billman, Larry (Miscellaneous)
Disney's World on Ice Starring Peter Pan 1992,F
12,C17:1
Billone, Joseph (Director)
Arthur: The Musical 1991,Ag 18,II:5:1
Binder, Paul (Director)
Greetings from Coney Island 1991,N 1,C19:1
Binder, Paul (Miscellaneous)
Greetings from Coney Island 1991,N 1,C19:1
Big Apple Circus 1992,N 5,C19:1
Binham, Philip (Translator)
Five Women in a Chapel 1991,Je 5,C22:3

Binkley, Howell (Lighting Director)
Akin 1992,F 25,C14:5
Birch, Patricia (Choreographer)
Anna Karenina 1992,Ag 27,C17:2
Birch, Patricia (Director)
What About Luv? 1991,D 30,C14:1
What About Luv? 1992,Ja 5,II:1:1
Birkenhead, Susan (Lyricist)
What About Luv? 1991,D 30,C14:1
What About Luv? 1992,Ja 5,II:1:1
Jelly's Last Jam 1992,Ap 27,C11:1
Jelly's Last Jam 1992,My 3,II:5:1
Birn, David (Scenic Designer)
Fortinbras 1992,O 14,C18:3
Birney, Reed
7 Blowjobs [reviewed as: SoHo Rep Presents]
1992,Ap 15,C19:1
Murder of Crows, A 1992,My 1,C18:1
Bishoff, Joel (Director)
Our Lady of Perpetual Danger 1991,O 16,C18:3
Bishop, Andre (Miscellaneous)
Assassins 1991,Ja 28,C19:3
Substance of Fire, The 1991,Mr 18,C11:1
Old Boy, The 1991,My 6,C11:4
Marvin's Room 1991,D 6,C1:5
Four Baboons Adoring the Sun 1992,Mr 19,C15:3
Sisters Rosensweig, The 1992,O 23,C3:1
My Favorite Year 1992,D 11,C1:1
Bishop, John (Director)
Empty Hearts 1992,My 6,C18:3
Empty Hearts 1992,My 17,II:5:1
Bishop, John (Playwright)
Empty Hearts 1992,My 6,C18:3
Empty Hearts 1992,My 17,II:5:1
Bishop, Kathleen (Director)
When They Take Me . . . In My Dreams (In Plain
View, Series B) 1992,Ag 15,12:3
Bishop, Thom (Composer)
Book of the Night 1991,Jl 28,II:5:1
Bishop, Thom (Lyricist)
Book of the Night 1991,Jl 28,II:5:1
Bittner, Jack
To Kill a Mockingbird 1991,Mr 4,C13:4
Bixby, Jonathan (Costume Designer)
When We Dead Awaken 1991,Mr 10,59:1
Leonce and Lena 1991,Mr 24,63:5
Woyzeck 1991,Mr 24,63:5
Advice from a Caterpillar 1991,Ap 10,C15:1
Skin of Our Teeth, The 1991,S 7,14:3
Geneva 1991,O 23,C19:1
Galileo 1991,D 11,C23:1
Endgame 1992,My 6,C18:3
Black, Arnold (Composer)
Leonce and Lena 1991,Mr 24,63:5
Woyzeck 1991,Mr 24,63:5
Black, Bonnie
Them . . . Within Us 1992,D 26,15:1
Black, Christopher
Idiot, The 1992,D 21,C13:1
Black, David Horton (Miscellaneous)
First Is Supper 1992,Mr 18,C17:1
Black, Jack
Bert Sees the Light 1992,Mr 11,C15:1
Black, James
Danton's Death 1992,N 3,C13:1
Black, Rachel
Rags 1991,D 4,C22:3
Black-Eyed Susan
Tone Clusters 1992,My 20,C18:1
Blaisdell, Nesbitt
Yokohama Duty 1991,My 22,C15:1
Grandchild of Kings 1992,F 17,C13:1
Blake, Jeanne (Director)
Fortinbras 1992,O 14,C18:3
Lake Street Extension 1992,D 2,C18:3
Blakemore, Michael (Director)
City of Angels 1991,Ja 25,C1:1
Blakeslee, Susanne
Forbidden Broadway 1991 1/2 1991,Je 21,C3:1
Forbidden Broadway 1991 1/2 1991,Jl 14,II:5:1
Forbidden Broadway/Forbidden Christmas 1991,D
13,C3:4
Blanchard, Mary (Miscellaneous)
Grown Ups 1991,Ja 24,C18:5
Blancher, Alan (Lighting Director)
Nomura Kyogen Theater: Classic Comedies of Japan
1992,S 25,C2:4

Blanco, Carol
Richard Foreman Trilogy, The 1992,My 27,C15:1
Blanco, Michael (Miscellaneous)
Uncle Vanya 1991,Je 17,C11:3
Square, The 1991,Je 21,C3:5
Flash and Crash Days, The 1992,Jl 16,C15:1
Blankenship, Paul
Colette Collage 1991,My 15,C12:3
Blaser, Cathy B. (Miscellaneous)
Penn and Teller: The Refrigerator Tour 1991,Ap
4,C15:5
Blatt, Beth
Lightin' Out 1992,D 14,C14:1
Blau, Eric (Miscellaneous)
Jacques Brel Is Alive and Well and Living in Paris
1992,O 21,C16:3
Blau, Eric (Playwright)
Jacques Brel Is Alive and Well and Living in Paris
1992,O 21,C16:3
Blau, Renee (Producer)
Bubbe Meises, Bubbe Stories 1992,O 30,C15:1
Blechingberg, Bill (Director)
Short Shots 1991,Ag 1,C14:4
Bleha, Julie (Miscellaneous)
Skin of Our Teeth, The 1991,S 7,14:3
Endgame 1992,My 6,C18:3
Blei, Dina
Hamlet 1992,Ja 24,C3:1
Blessing, Lee (Playwright)
Fortinbras 1992,O 14,C18:3
Lake Street Extension 1992,D 2,C18:3
Blethyn, Brenda
Absent Friends 1991,F 13,C13:3
Absent Friends 1991,F 24,II:5:1
Bliss, Diana (Producer)
Our Country's Good 1991,Ap 30,C13:4
Holy Terror, The 1992,O 9,C3:1
Blitzstein, Marc (Composer)
Juno 1992,O 31,16:4
Juno 1992,N 6,C6:6
Blitzstein, Marc (Lyricist)
Juno 1992,O 31,16:4
Juno 1992,N 6,C6:6
Bloch, Andrew
Selling Off 1991,Je 17,C13:4
Bloch, Joseph (Miscellaneous)
Novelist, The 1991,O 23,C19:1
Bloch, Scotty
Walking the Dead 1991,My 13,C12:1
Gulf War (Marathon '92, Series B) 1992,My
19,C18:3
Block, Larry
Selling Off 1991,Je 17,C13:4
Pericles, Prince of Tyre 1991,N 25,C13:1
Pericles 1991,D 1,II:5:1
One of the All-Time Greats 1992,Ap 17,C3:1
In the Cemetery (Last Laugh, The) 1992,Jl 2,C16:1
Cure, The (Last Laugh, The) 1992,Jl 2,C16:1
Comedy of Errors, The 1992,Ag 17,C11:3
Comedy of Errors, The 1992,Ag 23,II:5:1
Bloom, Jane Ira
Appointment with a High-Wire Lady 1992,F
12,C17:1
Bloom, Jane Ira (Composer)
Appointment with a High-Wire Lady 1992,F
12,C17:1
Bloom, Michael (Director)
Sight Unseen 1992,Ja 21,C13:3
Sight Unseen 1992,Ja 26,II:5:1
Bloom, Tom (Director)
Countess Mitzi 1991,Mr 13,C12:4
Bloomfield, Nicolas (Composer)
Sarrasine 1991,S 9,C16:4
Blu (Lighting Director)
Kafka: Father and Son 1992,Ja 29,C17:1
Blue, Arlana
Life During Wartime 1992,Ag 11,C11:1
Blue, Pete (Miscellaneous)
Forbidden Broadway 1991 1/2 1991,Je 21,C3:1
Forbidden Broadway/Forbidden Christmas 1991,D
13,C3:4
Blum, Benjamin
Bernie's Bar Mitzvah 1992,Mr 18,C17:1
Blum, Doug (Miscellaneous)
Wedding Portrait, The 1992,Mr 25,C19:3
Blum, Joel
And the World Goes 'Round 1991,S 6,C3:1
Radio City Easter Show, The 1992,Ap 15,C19:1

Blum, Mark
 Lost in Yonkers 1991,F 22,C1:4
 Lost in Yonkers 1991,Mr 3,II:1:1
Blumberg, David A. (Producer)
 Hello Muddah, Hello Fadduh 1992,D 9,C22:1
Blumberg, Judy
 Skating II 1991,Mr 4,C12:3
 Chrysler Skating '92 1992,Mr 9,C11:1
Blumenthal, Francesca (Miscellaneous)
 A . . . My Name Is Still Alice 1992,N 23,C14:4
Blumenthal, Hilarie (Lighting Director)
 Antigone 1992,F 16,70:5
Blunt, Joseph (Composer)
 Julius Caesar 1991,My 15,C12:3
Board, Kjersti (Translator)
 Hour of the Lynx 1992,Ap 1,C16:3
Boardman, Constance
 Love Suicide at Schofield Barracks, The 1991,My
 20,C13:5
 Dressing Room, The (Gakuya) 1991,N 6,C21:1
Boateng, Kwasi
 Law of Remains, The 1992,F 26,C19:1
Bobbie, Walter
 Getting Married 1991,Je 27,C14:3
 Getting Married 1991,Jl 21,II:5:1
 Guys and Dolls 1992,Ap 15,C15:3
 Guys and Dolls 1992,Ap 26,II:5:1
Bobby, Anne
 Groundhog 1992,My 4,C14:1
Boccia, Arthur (Costume Designer)
 Ringling Brothers and Barnum & Bailey Circus
 1991,Mr 24,63:1
 Disney's World on Ice Starring Peter Pan 1992,F
 12,C17:1
Bochinsky, Alan (Lighting Director)
 Rosencrantz and Guildenstern Are Dead 1992,Ja
 31,C15:1
Bockhorn, Craig
 As You Like It 1992,Ja 1,23:1
Bocksch, Wolfgang (Producer)
 Ruthless! 1992,My 13,C14:3
Boddy, Claudia (Costume Designer)
 Marvin's Room 1991,D 6,C1:5
 Hauptmann 1992,My 29,C3:3
Bode, Ben
 Dead Mother: or Shirley Not All in Vain 1991,F
 1,C3:1
 Mysteries and What's So Funny?, The 1991,Jl
 13,11:1
 Two Shakespearean Actors 1992,Ja 17,C1:1
Bodeen, Michael (Composer)
 From the Mississippi Delta 1991,N 12,C13:1
Bodeen, Michael (Miscellaneous)
 From the Mississippi Delta 1991,N 12,C13:1
Boesche, John (Miscellaneous)
 Henry IV, Parts 1 and 2 1991,F 28,C15:1
 Book of the Night 1991,Jl 28,II:5:1
 Earthly Possessions 1991,S 4,C13:2
Boese, Jody (Miscellaneous)
 Road to Nirvana 1991,Mr 8,C1:1
 Walking the Dead 1991,My 13,C12:1
 Babylon Gardens 1991,O 9,C17:1
 Empty Hearts 1992,My 6,C18:3
 Destiny of Me, The 1992,O 21,C15:1
 Orpheus in Love 1992,D 16,C17:5
Bogarde, Lynn (Miscellaneous)
 Ghosts 1992,F 19,C16:3
Bogardus, Janet (Choreographer)
 New Living Newspaper 1992,Mr 4,C19:1
Bogardus, Stephen
 Falsettos 1992,Ap 30,C17:3
 Falsettos 1992,My 10,II:1:2
Bogart, Anne (Director)
 In the Eye of the Hurricane 1991,Ap 10,C13:3
 Another Person Is a Foreign Country 1991,S
 10,C11:1
 In the Jungle of Cities 1991,N 6,C19:2
 Baltimore Waltz, The 1992,F 12,C15:3
Bogart, Anne (Miscellaneous)
 Bitter Tears of Petra von Kant, The 1992,Je 18,C15:1
 Women in Black/Men in Gray 1992,O 28,C18:1
Bogin, Gloria
 Marathon 1991: New One-Act Plays, Series B
 1991,Je 9,60:5
Boglino, James (Miscellaneous)
 Five Women in a Chapel 1991,Je 5,C22:3
 Hour of the Lynx 1992,Ap 1,C16:3

Bogolyubov, Vladimir
 Tom Scallen's Ice Capades 1992,Ja 22,C17:1
Bogolyubov, Yelena
 Tom Scallen's Ice Capades 1992,Ja 22,C17:1
Bogosian, Eric
 P.S. 122 Benefit 1991,F 9,13:1
 Dog Show 1992,Jl 20,C13:1
Bogosian, Eric (Playwright)
 Dog Show 1992,Jl 20,C13:1
Bohmler, Craig (Composer)
 Gunmetal Blues 1992,Ap 8,C21:1
Bohmler, Craig (Lyricist)
 Gunmetal Blues 1992,Ap 8,C21:1
Bohmler, Craig (Miscellaneous)
 Gunmetal Blues 1992,Ap 8,C21:1
Bohmler, Craig (Musical Director)
 Gunmetal Blues 1992,Ap 8,C21:1
Boike, Daniel (Costume Designer)
 When Lightning Strikes Twice 1991,Ja 25,C6:3
Boitano, Brian
 Skating II 1991,Mr 4,C12:3
 Chrysler Skating '92 1992,Mr 9,C11:1
Boitsov, Igor
 Moscow Circus—Cirk Valentin 1991,N 8,C3:1
Boldt, David
 Body and Soul 1991,Jl 10,C18:3
Boles, Steve
 Juba 1991,F 24,60:1
Bolger, Dermot (Playwright)
 Lament for Arthur Cleary, The 1992,N 4,C22:1
Bolger, John
 Macbeth 1992,My 20,C18:1
Bolivar, Eduardo (Miscellaneous)
 Tempestad, La (Tempest, The) 1991,Ag 30,C3:3
Boll, Sidonie
 Hamlet 1991,Je 30,II:5:1
Bollack, Jean (Miscellaneous)
 Atrides, Les 1992,O 6,C11:3
Bollack, Jean (Translator)
 Iphigenia in Aulis (Atrides, Les) 1992,O 6,C11:3
Bollack, Mayotte (Translator)
 Iphigenia in Aulis (Atrides, Les) 1992,O 6,C11:3
Bolton, Guy (Miscellaneous)
 Crazy for You 1992,F 20,C15:3
Bolton, John Keene
 Cinderella 1991,D 23,C16:4
Bonal, Denise (Playwright)
 Family Portrait 1992,Ap 22,C17:3
Bonds, Ian
 Bernie's Bar Mitzvah 1992,Mr 18,C17:1
Bonney, Jo (Director)
 Dog Show 1992,Jl 20,C13:1
Bonnifait, Jean-Claude
 Bay of Naples, The (Baie de Naples) 1991,Je
 12,C14:3
Booker, Margaret (Director)
 Lost Electra 1991,Je 8,11:1
Booker, Tom
 Real Live Brady Bunch, The 1991,O 2,C18:3
Bookman, Kirk (Lighting Director)
 Baby Dance, The 1991,Ap 1,C14:1
 Baby Dance, The 1991,O 18,C5:1
 Invention for Fathers and Sons 1992,Ja 22,C17:1
 It's a Bird, It's a Plane, It's Superman 1992,Je
 20,16:4
Boomsma, Victoria
 Another Person Is a Foreign Country 1991,S
 10,C11:1
Boone, Sherry D.
 Jelly's Last Jam 1992,Ap 27,C11:1
Booth, Penny
 Disney's World on Ice Starring Peter Pan 1992,F
 12,C17:1
Booth, Phil (Miscellaneous)
 Belle Reprieve 1991,Mr 11,C14:5
Boothby, Victoria
 Adventures in the Skin Trade 1991,D 8,II:5:1
Boothe, Power (Scenic Designer)
 Comedy of Errors, The 1992,F 9,65:2
Borba, Andrew
 Misanthrope, The 1991,O 9,C18:3
Borczon, Becky
 Love Lemmings 1991,My 1,C15:1
Borden, Mikel
 Iron Bars 1991,N 20,C23:1
Borges, Jorge (Miscellaneous)
 Tempestad, La (Tempest, The) 1991,Ag 30,C3:3

Borgeson, Jess
 Complete Works of William Shakespeare
 (Abridged), The 1991,Je 15,17:1
Borgeson, Jess (Playwright)
 Complete Works of William Shakespeare
 (Abridged), The 1991,Je 15,17:1
Borkowska, Alicja
 Metro 1992,Ap 17,C1:3
Borod, Bob (Miscellaneous)
 Bete, La 1991,F 11,C11:3
Borovsky, Aleksandr (Scenic Designer)
 Teacher of Russian, A 1991,Mr 7,C16:6
Borow, Rena Berkowicz (Translator)
 Rendezvous with God, A 1991,Jl 25,C14:5
Borowitz, Katherine
 Resistible Rise of Arturo Ui, The 1991,My 9,C15:1
Borrego, Jesse
 Woyzeck 1992,D 7,C14:1
 Woyzeck 1992,D 13,II:5:1
Borsay, LaTonya
 Woyzeck 1992,D 7,C14:1
Borski, Russ (Scenic Designer)
 Winter Man 1991,F 21,C20:1
Borst, Murielle
 Power Pipes 1992,O 24,18:1
Borzykin, Yuri
 Moscow Circus—Cirk Valentin 1991,N 8,C3:1
Bosco, Philip
 Breaking Legs 1991,My 20,C11:1
 Breaking Legs 1991,My 26,II:5:1
Bosse, Claudia (Miscellaneous)
 Dr. Faustus Lights the Lights 1992,Jl 9,C15:3
Boston, Matthew
 My Son the Doctor 1991,Ag 10,12:6
Bostrom, Ingrid
 Miss Julie 1991,Je 12,C13:1
Bostwick, Barry
 Nick and Nora 1991,D 9,C11:3
 Nick and Nora 1991,D 15,II:1:1
Botchis, Paul (Miscellaneous)
 Balancing Act 1992,Je 17,C17:1
Bottari, Michael (Costume Designer)
 Opal 1992,Mr 18,C17:1
 Little Me 1992,Ap 1,C16:3
Botting, Ron (Miscellaneous)
 As a Dream That Vanishes (A Meditation on the
 Harvest of a Lifetime) 1991,N 13,C21:1
Bottitta, Ron
 Lament for Arthur Cleary, The 1992,N 4,C22:1
Bottrell, David (Playwright)
 Dearly Departed 1991,D 24,C11:1
Boublil, Alain (Lyricist)
 Miss Saigon 1991,Ap 12,C1:2
 Miss Saigon 1991,Ap 21,II:5:1
Bouchard, Bruce (Miscellaneous)
 Peacetime 1992,Mr 12,C21:1
Boudot, Sabrina
 Wilder, Wilder, Wilder: Three by Thornton 1992,D
 21,C13:1
Boudreau, Rick
 Tom Scallen's Ice Capades 1992,Ja 22,C17:1
Boudreau, Robin
 Custody 1991,Ap 24,C10:5
Bougere, Teagle F.
 Time of Your Life, The 1991,O 2,C17:1
Boughton, Andrew W. (Scenic Designer)
 Underground 1991,Mr 3,64:1
Bourg, Richard
 Countess Mitzi 1991,Mr 13,C12:4
Bourke, Siobhan (Miscellaneous)
 I Can't Get Started 1991,Jl 13,12:5
Bourne, Bette
 Belle Reprieve 1991,Mr 11,C14:5
 Sarrasine 1991,S 9,C16:4
Bourne, Bette (Playwright)
 Belle Reprieve 1991,Mr 11,C14:5
Boutsikaris, Dennis
 Sight Unseen 1992,Ja 21,C13:3
 Sight Unseen 1992,Ja 26,II:5:1
Boutte, Duane
 Midsummer Night's Dream, A 1992,Ap 8,C21:1
Bouvet, Marie-Helene (Costume Designer)
 Atrides, Les 1992,O 6,C11:3
Bova, Joseph
 Matchmaker, The 1991,Ag 28,C12:4
Bowden, Jonny (Musical Director)
 I Can Get It for You Wholesale 1991,Mr 11,C14:3

Groundhog 1992,My 4,C14:1
On the Bum, or the Next Train Through 1992,N 25,C19:1
Buffaloe, Katharine
Juba 1991,F 24,60:1
Buford, Don (Producer)
Lyndon 1991,Ja 19,19:4
Bugge, Carole
Un-Conventional Wisdom: Campaign '92 Update 1992,Ag 4,C13:1
Buggy, Niall
Shadow of a Gunman, The 1991,N 27,C17:1
Bull, Paul (Miscellaneous)
Shadow of a Gunman, The 1991,N 27,C17:1
Bullard, Thomas Allan (Director)
Woman Without a Name, A 1992,F 2,54:5
2 1992,Ag 12,C14:1
Bullins, Ed (Playwright)
Salaam, Huey Newton, Salaam (Marathon 1991: New One-Act Plays, Series C) 1991,Je 19,C12:3
Bundschuh, Matthias
Dr. Faustus Lights the Lights 1992,Jl 9,C15:3
Bundy, Laura
Ruthless! 1992,My 13,C14:3
Ruthless! 1992,My 17,II:5:1
Bundy, Rob (Miscellaneous)
Pill Hill 1992,D 3,C18:5
Buravsky, Aleksandr (Playwright)
Teacher of Russian, A 1991,Mr 7,C16:6
Burbridge, Edward (Scenic Designer)
Mule Bone 1991,F 15,C1:4
Burck, Wade
Ringling Brothers and Barnum & Bailey Circus 1992,Ap 4,13:1
Burckhardt, Jacob (Miscellaneous)
In the Jungle of Cities 1991,N 6,C19:2
Burdick, Betty
Leonce and Lena 1991,Mr 24,63:5
Woyzeck 1991,Mr 24,63:5
Skin of Our Teeth, The 1991,S 7,14:3
Burke, Christine
God of Vengeance 1992,N 4,C22:1
Burke, Deirdre (Costume Designer)
Sheik of Avenue B, The 1992,N 23,C14:1
Burke, Marylouise
Casanova 1991,My 29,C11:5
Burke-Green, Barrington Antonio
Mermaid Wakes, The 1991,F 25,C14:3
Burke-Green, Barrington Antonio (Choreographer)
Mermaid Wakes, The 1991,F 25,C14:3
Burke-Green, Barrington Antonio (Composer)
Mermaid Wakes, The 1991,F 25,C14:3
Burks, Willis, 2d
Pill Hill 1992,D 3,C18:5
Burmester, Chris
Under Control 1992,O 22,C25:4
Burmester, Leo
Dearly Departed 1991,D 24,C11:1
Burnett, Frances Hodgson (Original Author)
Secret Garden, The 1991,Ap 26,C1:1
Secret Garden, The 1991,My 5,II:5:1
Burnett, Sheila (Miscellaneous)
Sarrasine 1991,S 9,C16:4
Burns, Karla
Comedy of Errors, The 1992,Ag 17,C11:3
Comedy of Errors, The 1992,Ag 23,II:5:1
Burrell, Fred
Unchanging Love 1991,F 10,64:1
Love Suicide at Schofield Barracks, The 1991,My 20,C13:5
Sorrows of Frederick, The 1991,O 17,C22:1
Woman Without a Name, A 1992,F 2,54:5
More Fun Than Bowling 1992,Ap 19,45:2
Democracy and Esther 1992,O 7,C16:3
Burrell, Pamela
After the Dancing in Jericho 1992,F 12,C17:1
Burrell, Terry
And the World Goes 'Round 1991,S 6,C3:1
Burrell-Cleveland, Deborah
High Rollers Social and Pleasure Club, The 1992,Ap 23,C15:2
Burris, Eve (Miscellaneous)
Folks Remembers a Missing Page (The Rise and Fall of Harlem) 1991,O 2,C18:3
Burrows, Abe (Playwright)
Guys and Dolls 1992,Ap 15,C15:3
Guys and Dolls 1992,Ap 26,II:5:1

Burrows, Allyn
This One Thing I Do 1992,Ap 19,45:5
Awoke One (Marathon '92, Series B) 1992,My 19,C18:3
Burrows, Vinie
Sister! Sister! 1992,N 11,C18:3
Burrows, Vinie (Playwright)
Sister! Sister! 1992,N 11,C18:3
Burstein, Danny
Little Hotel on the Side, A 1992,Ja 27,C17:1
Weird Romance 1992,Je 23,C14:5
Seagull, The 1992,N 30,C11:1
Burstyn, Ellen
Shimada 1992,Ap 24,C1:1
Burton, Arnie
Farewell Supper, The 1991,Mr 13,C12:4
Countess Mitzi 1991,Mr 13,C12:4
Tartuffe 1991,S 16,C14:4
Tartuffe 1991,S 29,II:5:1
Trojan Women, The 1991,N 13,C21:1
As You Like It 1992,Ja 1,23:1
Ghosts 1992,F 19,C16:3
Moon for the Misbegotten, A 1992,S 23,C16:3
Burton, Irving
Sunset Gang, The 1992,My 16,14:3
Burton, Kate
Jake's Women 1992,Mr 25,C17:3
Jake's Women 1992,Ap 5,II:5:1
Busachino, Barbara (Miscellaneous)
Walk on Lake Erie, A 1991,Mr 25,C15:1
Busby, Gerald (Composer)
Orpheus in Love 1992,D 16,C17:5
Busch, Charles
Red Scare on Sunset 1991,Ap 24,C10:5
Busch, Charles (Playwright)
Red Scare on Sunset 1991,Ap 24,C10:5
Busch, Cindy (Miscellaneous)
Un-Conventional Wisdom: Campaign '92 Update 1992,Ag 4,C13:1
Bush, Holly
When Lithuania Ruled the World, Part 3 1992,Ja 23,C14:4
Bush, Michael (Miscellaneous)
Life During Wartime 1991,Mr 6,C13:1
Black Eagles 1991,Ap 22,C13:1
Lips Together, Teeth Apart 1991,Je 26,C11:1
Beggars in the House of Plenty 1991,O 24,C17:4
Piece of My Heart, A 1991,N 4,C15:1
Sight Unseen 1992,Ja 21,C13:3
Boesman and Lena 1992,Ja 30,C15:1
Small Family Business, A 1992,Ap 28,C13:3
Groundhog 1992,My 4,C14:1
Bushmann, Kate
Roleplay 1992,Ag 8,16:4
Busia, Akosua
Mule Bone 1991,F 15,C1:4
Mule Bone 1991,F 24,II:5:1
Bussert, Victoria (Director)
Winter Man 1991,F 21,C20:1
Bustle, Jonathan
CBS Live 1992,D 2,C18:3
Butler, Michael
Two Shakespearean Actors 1992,Ja 17,C1:1
Butler, Paul
Pericles, Prince of Tyre 1991,N 25,C13:1
Butler, Rick (Lighting Director)
Sabina and Lucrecia 1991,Ap 14,52:1
Bobby Sands, M.P. 1992,Je 18,C15:1
Butler, Rick (Scenic Designer)
Charge It, Please 1991,My 29,C14:3
Bobby Sands, M.P. 1992,Je 18,C15:1
Butler, Ron
Five Very Live 1992,Ja 8,C17:1
Butler, Soraya
Tempest, The 1992,Jl 22,C17:1
Butleroff, Helen (Choreographer)
Encore 1991,Je 19,C12:3
Butterfield, Catherine
Joined at the Head 1992,N 16,C16:1
Butterfield, Catherine (Playwright)
Joined at the Head 1992,N 16,C16:1
Buxbaum, Lisa (Miscellaneous)
Akin 1992,F 25,C14:5
Buzas, Jason McConnell (Director)
Variations on the Death of Trotsky (Festival of One-Act Comedies, Evening A) 1991,F 12,C14:3
Foreplay, or, The Art of the Fugue (Festival of One-Act Comedies, Evening B) 1991,Mr 5,C16:3

World at Absolute Zero, The (Marathon 1991: New One-Act Plays, Series C) 1991,Je 19,C12:3
Byers, Billy (Miscellaneous)
City of Angels 1991,Ja 25,C1:1
Will Rogers Follies, The: A Life in Revue 1991,My 2,C17:1
Bynum, Betty K.
Ascension Day 1992,Mr 4,C19:1
Bynum, Tom (Scenic Designer)
Humanity (Menschen, Die) 1991,Je 5,C22:3
Byrd, Donald (Choreographer)
Ascension Day 1992,Mr 4,C19:1
Blood Wedding 1992,My 15,C3:3
Byrne, Anne
I Can't Get Started 1991,Jl 13,12:5
Byrne, Catherine
Dancing at Lughnasa 1991,O 25,C1:4
Dancing at Lughnasa 1991,N 3,II:5:1
Byrne, Kevin (Miscellaneous)
Adding Machine, The 1992,S 16,C16:3
Byrne, Michael
Death and the Maiden 1991,Jl 31,C11:4
New World Order, The 1991,Jl 31,C11:4
Byrne, Tom
Tempest, The 1992,Jl 22,C17:1
Byron-Kirk, Keith
Book of the Night 1991,Jl 28,II:5:1

C

Caballero, Luis (Miscellaneous)
Oxcart, The (Carreta, La) 1992,Ap 22,C17:3
Caddick, David (Musical Director)
Miss Saigon 1991,Ap 12,C1:2
Caesar, Burt
Tragedy of Macbeth, The 1991,Je 18,C13:4
Cain, William
Streetcar Named Desire, A 1992,Ap 13,C11:3
Fortinbras 1992,O 14,C18:3
Calabrese, Maria
Will Rogers Follies, The: A Life in Revue 1991,My 2,C17:1
My Favorite Year 1992,D 11,C1:1
Calandra, Denis (Translator)
Bitter Tears of Petra von Kant, The 1992,Je 18,C15:1
Calcott, Shelly
Penny Arcade Sex and Censorship Show, The 1992,Jl 28,C13:1
Calderon de la Barca, Pedro (Playwright)
Mayor of Zalamea, The (Alcalde de Zalamea, El) 1991,Ap 14,52:1
Caldwell, Ezra (Miscellaneous)
Invitations to Heaven (Questions of a Jewish Child) 1991,O 2,C18:3
Caldwell, Matthew
Rivers and Ravines, The 1991,N 14,C28:6
Caldwell, Zoe (Director)
Park Your Car in Harvard Yard 1991,N 8,C1:4
Cale, David
Deep in a Dream of You 1992,D 12,15:4
Cale, David (Playwright)
Deep in a Dream of You 1992,D 12,15:4
Calhoun, Jeff (Director)
Tommy Tune Tonite! A Song and Dance Act 1992,D 29,C11:1
Calhoun, Karl
Lotto: Experience the Dream 1991,D 26,C13:1
Lotto: Experience the Dream 1992,Jl 2,C16:1
Calhoun, Wil (Playwright)
Balcony Scene, The 1991,Jl 21,II:5:1
Caliban, Richard (Director)
Homo Sapien Shuffle 1992,Mr 10,C12:5
P.C. Laundromat, The (1992 Young Playwrights Festival, The) 1992,S 24,C18:4
Caliban, Richard (Miscellaneous)
Two Gentlemen of Verona 1991,D 12,C21:3
Caliban, Richard (Playwright)
Homo Sapien Shuffle 1992,Mr 10,C12:5
Caliste, Canute (Original Author)
Mermaid Wakes, The 1991,F 25,C14:3
Calitsis, Vasilios (Director)
Hippolytos 1992,N 25,C19:1
Callaghan, David (Miscellaneous)
Rules of Civility and Decent Behavior in Company and Conversation 1991,Mr 25,C15:1

Durst, Douglas (Producer)
Murder of Crows, A 1992,My 1,C18:1
DuVal, Herbert
Three Sisters 1991,Ap 18,C14:3
Duyal, Funda
Men Are Afraid of the Women, The 1992,O 21,C16:3
Dworkin, Richard
States of Shock 1991,My 17,C1:3
Dwyer, Terrence (Miscellaneous)
Road to Nirvana 1991,Mr 8,C1:1
Walking the Dead 1991,My 13,C12:1
Babylon Gardens 1991,O 9,C17:1
Rose Quartet, The 1991,D 18,C23:1
Baltimore Waltz, The 1992,F 12,C15:3
Empty Hearts 1992,My 6,C18:3
Dyar, Preston
Ancient Boys 1991,F 24,59:5
Dyer, Michael
49 Songs for a Jealous Vampire 1992,Jl 21,C11:2
Dyson, Erika (Costume Designer)
Forbidden Broadway 1991 1/2 1991,Je 21,C3:1
Forbidden Broadway/Forbidden Christmas 1991,D 13,C3:4
Best of Forbidden Broadway, The: 10th-Anniversary Edition 1992,Ap 9,C19:3

E

Eagan, Daisy
Secret Garden, The 1991,Ap 26,C1:1
Secret Garden, The 1991,My 5,II:5:1
Eames, Kathryn
Democracy and Esther 1992,O 7,C16:3
Earle, Dottie
Animal Crackers 1992,N 4,C19:4
Earls, Paul (Composer)
F.M. 1991,My 20,C13:5
Love Suicide at Schofield Barracks, The 1991,My 20,C13:5
Early, Michael
Woyzeck 1992,D 7,C14:1
Easley, Bill
Jelly's Last Jam 1992,Ap 27,C11:1
Eastman, Donald (Scenic Designer)
Have-Little, The 1991,Je 12,C14:3
Bon Appetit! 1991,S 26,C18:3
Cabaret Verboten 1991,O 29,C16:1
In the Jungle of Cities 1991,N 6,C19:2
Creditors 1992,F 7,C3:1
Canal Zone 1992,My 6,C18:3
Goodnight Desdemona (Good Morning Juliet) 1992,O 22,C26:5
Eastman, Peter (Scenic Designer)
Marathon '92, Series B 1992,My 19,C18:3
Easton, Sheena
Man of La Mancha 1992,Ap 25,13:4
Ebb, Fred (Lyricist)
And the World Goes 'Round: The Songs of Kander and Ebb 1991,Mr 19,C11:2
And the World Goes 'Round 1991,Mr 24,II:5:1
And the World Goes 'Round 1991,S 6,C3:1
Ebersole, Drew
Romeo and Juliet 1991,Ja 31,C21:1
Ebert, Christian
Dr. Faustus Lights the Lights 1992,Jl 9,C15:3
Ebert, Joyce
Booth Is Back 1991,O 31,C18:1
Ebihara, Richard
Cambodia Agonistes 1992,N 13,C3:1
Ebony Jo-Ann
Mule Bone 1991,F 15,C1:4
Ebtehadj, Leyla
True Story of a Woman Born in Iran and Raised to Heaven in Manhattan, The 1991,My 15,C12:3
Eccles, Noel (Composer)
Joyicity 1992,S 11,C2:3
Echeverria, Sol
Streetcar Named Desire, A 1992,Ap 13,C11:3
Eckerle, James (Miscellaneous)
When Lightning Strikes Twice 1991,Ja 25,C6:3
Eckhardt, Sarah
Five Very Live 1992,Ja 8,C17:1
Eckhardt, Sarah (Director)
Virgin Molly, The 1992,Mr 27,C3:3

Eckstein, Paul S.
Mule Bone 1991,F 15,C1:4
Electra 1992,Ag 9,II:5:1
Edelman, Deborah (Costume Designer)
Men Are Afraid of the Women, The 1992,O 21,C16:3
Edelman, Gregg
Arthur: The Musical 1991,Ag 18,II:5:1
Anna Karenina 1992,Ag 27,C17:2
Make Someone Happy! The Jule Styne Revue 1992,D 20,II:5:1
Edelman, Richard (Director)
Invitations to Heaven (Questions of a Jewish Child) 1991,O 2,C18:3
Edelman, Richard (Miscellaneous)
Invitations to Heaven (Questions of a Jewish Child) 1991,O 2,C18:3
Edelstein, Gordon (Director)
Evening of Short Plays by Joyce Carol Oates, An 1991,Ap 27,14:5
Last Yankee, The (Marathon 1991: New One-Act Plays, Series C) 1991,Je 19,C12:3
Homecoming, The 1991,O 28,C13:1
Philanthropist, The 1992,Ja 16,C17:1
Edelstein, Ylfa
Tempest, The 1992,Jl 22,C17:1
Eden, Sean
Richard Foreman Trilogy, The 1992,My 27,C15:1
Edgar, Kate (Musical Director)
Return to the Forbidden Planet 1991,O 14,C13:1
Edgerton, Earle
Tartuffe 1991,S 16,C14:4
Edgerton, Earle (Translator)
Swan Song (Chekhov Very Funny) 1992,Ap 8,C21:1
Edghill, Vinnie
Moe Green Gets It in the Eye 1991,My 8,C12:3
Edington, Pamela (Miscellaneous)
Ruthless! 1992,My 13,C14:3
Madame MacAdam Traveling Theater, The 1992,O 21,C16:3
Edkins, Sarah (Scenic Designer)
Bitter Tears of Petra von Kant, The 1992,Je 18,C15:1
Edmonds, Mitchell
Two Shakespearean Actors 1992,Ja 17,C1:1
Edwards, Ben (Scenic Designer)
Park Your Car in Harvard Yard 1991,N 8,C1:4
Streetcar Named Desire, A 1992,Ap 13,C11:3
Streetcar Named Desire, A 1992,Ap 19,II:5:1
Show-Off, The 1992,N 6,C3:1
Show-Off, The 1992,N 15,II:5:1
Edwards, Daryl
2 1992,Ag 12,C14:1
Edwards, David
Zion 1991,D 5,C22:4
Edwards, Pat Kier
Women in Beckett 1991,N 22,C17:1
Idiot, The 1992,D 21,C13:1
Edwards, Presley
Onliest One Who Can't Go Nowhere, The (Marathon '92, Series C) 1992,Je 2,C15:1
Edwards, Robert
Night Before Christmas, The: A Musical Fantasy 1992,D 17,C18:5
Edwards, Sarah (Costume Designer)
Distant Fires 1991,O 17,C22:1
Big Al 1992,My 18,C15:1
Angel of Death 1992,My 18,C15:1
Edwards, Stephen (Composer)
Four Baboons Adoring the Sun 1992,Mr 19,C15:3
Edwardson, David (Lighting Director)
Roleplay 1992,Ag 8,16:4
Effrey, Bill M. (Scenic Designer)
My Son the Doctor 1991,Ag 10,12:6
Egan, Donal (Miscellaneous)
True Story of a Woman Born in Iran and Raised to Heaven in Manhattan, The 1991,My 15,C12:3
Egan, Robert (Miscellaneous)
Angels in America 1992,N 10,C15:3
Egbert, Susan
Lovers 1992,Mr 25,C19:3
Eggleton, Jaimee
Disney's World on Ice Starring Peter Pan 1992,F 12,C17:1
Ehlers, Heather
Who's Afraid of Virginia Woolf? 1992,Ja 23,C19:4
Hour of the Lynx 1992,Ap 1,C16:3
Ehlinger, Mary
Return to the Forbidden Planet 1991,O 14,C13:1

Ehman, Don (Lighting Director)
Opal 1992,Mr 18,C17:1
Elephant's Tricycle, The 1992,Ag 27,C22:3
Eich, Stephen (Miscellaneous)
Earthly Possessions 1991,S 4,C13:2
Eichhorn, Lisa
Speed of Darkness, The 1991,Mr 1,C1:1
Speed of Darkness, The 1991,Mr 10,II:5:1
Eigenberg, David
Ready for the River 1991,O 16,C18:3
My Side of the Story (Marathon '92, Series B) 1992,My 19,C18:3
Eigenberg, Helen
Ripples in the Pond (Marathon '92, Series B) 1992,My 19,C18:3
Einhorn, Susan (Director)
Making Book 1992,F 12,C17:1
Eisenhauer, Peggy (Lighting Director)
Catskills on Broadway 1991,D 6,C28:4
Eating Raoul 1992,My 16,14:3
CBS Live 1992,D 2,C18:3
Tommy Tune Tonite! A Song and Dance Act 1992,D 29,C11:1
Eisler, Hanns (Composer)
Galileo 1991,D 11,C23:1
Eisler, Hanns (Miscellaneous)
Cabaret Verboten 1991,O 29,C16:1
Eklund, Jakob
Miss Julie 1991,Je 12,C13:1
Eldard, Ron
Servy-n-Bernice 4Ever 1991,O 23,C19:1
Elden, Kevin
Fortinbras 1992,O 14,C18:3
Elder, David
Guys and Dolls 1992,Ap 15,C15:3
Elder, Lauren (Scenic Designer)
Esplendor, El 1991,Je 23,43:1
Elderkin, Annette (Lighting Director)
Painted Tooth 1991,Mr 13,C14:3
Elethea, Abba
Yunus 1992,O 28,C18:1
Elgar, Edward (Composer)
Maybe It's Cold Outside 1991,F 19,C14:3
Elias, Shaul
Rosencrantz and Guildenstern Are Dead 1992,Ja 31,C15:1
Eligator, Eric (Miscellaneous)
Grown Ups 1991,Ja 24,C18:5
Elizondo, Hector
Price, The 1992,Je 11,C13:1
Price, The 1992,Je 28,II:5:1
Elkins, Elizabeth (Costume Designer)
Melville Boys, The 1992,Ag 21,C2:3
Ellens, Rebecca
Eddie Goes to Poetry City: Part 2 1991,Ap 10,C15:1
Elliman, Michele
Atomic Opera 1991,O 30,C14:1
Elliman, Michele (Choreographer)
Atomic Opera 1991,O 30,C14:1
Elliman, Michele (Director)
Atomic Opera 1991,O 30,C14:1
Elliman, Michele (Miscellaneous)
Atomic Opera 1991,O 30,C14:1
Elliman, Michele (Playwright)
Atomic Opera 1991,O 30,C14:1
Ellington, Duke (Composer)
Timon of Athens 1991,Je 30,II:5:1
Ellington, Mercedes (Choreographer)
Juba 1991,F 24,60:1
Elliott, Kenneth (Director)
Red Scare on Sunset 1991,Ap 24,C10:5
Julie Halston's Lifetime of Comedy 1992,F 5,C19:3
Elliott, Milton
Black Eagles 1991,Ap 22,C13:1
Ellis, Brad
Forbidden Broadway 1991 1/2 1991,Je 21,C3:1
Forbidden Broadway/Forbidden Christmas 1991,D 13,C3:4
Best of Forbidden Broadway, The: 10th-Anniversary Edition 1992,Ap 9,C19:3
Ellis, Brad (Musical Director)
Forbidden Broadway 1991 1/2 1991,Je 21,C3:1
Forbidden Broadway/Forbidden Christmas 1991,D 13,C3:4
Best of Forbidden Broadway, The: 10th-Anniversary Edition 1992,Ap 9,C19:3

Evans, Donna (Miscellaneous)
Accident: A Day's News 1991,S 23,C14:3
Evans, Falkner
Five Women in a Chapel 1991,Je 5,C22:3
Evans, Hollis Jenkins (Costume Designer)
Momentary Lapses 1991,My 29,C14:3
Evans, Nicholas (Producer)
High Rollers Social and Pleasure Club, The 1992,Ap 23,C15:2
Evans, Tori
Job: A Circus 1992,Ja 15,C17:1
Evans, Tori (Miscellaneous)
Job: A Circus 1992,Ja 15,C17:1
Evans-Kandel, Karen
Mysteries and What's So Funny?, The 1991,Jl 13,11:1
In the Jungle of Cities 1991,N 6,C19:2
Group, A Therapeutic Moment (Manhattan Class One-Acts) 1992,Mr 11,C15:1
Everall, Martin
On the Razzle 1992,Ag 28,C2:3
Everett, Gintare Sileika (Producer)
Hauptmann 1992,My 29,C3:3
Everett, Pamela
Crazy for You 1992,Mr 1,II:1:1
Ewing, Geoffrey C.
Ali 1992,Ag 13,C17:1
Ewing, Geoffrey C. (Miscellaneous)
Ali 1992,Ag 13,C17:1
Ewing, Geoffrey C. (Playwright)
Ali 1992,Ag 13,C17:1
Eypper, Lee
On the Razzle 1992,Ag 28,C2:3
Eypper, Lee (Miscellaneous)
On the Razzle 1992,Ag 28,C2:3
Eyre, Richard (Director)
Richard III 1992,Je 12,C1:1

F

Faber, Ron
Resistible Rise of Arturo Ui, The 1991,My 9,C15:1
Heartbreak House 1992,Ap 16,C16:1
In the Cemetery (Last Laugh, The) 1992,Jl 2,C16:1
Cure, The (Last Laugh, The) 1992,Jl 2,C16:1
Words Divine: A Miracle Play 1992,N 25,C19:1
Fadeyev, Aleksandr
Skating II 1991,Mr 4,C12:3
Fahrer, Martin (Lighting Director)
On the Razzle 1992,Ag 28,C2:3
Faillace, Alejandro
Tempestad, La (Tempest, The) 1991,Ag 30,C3:3
Fair, Tony
Lightin' Out 1992,D 14,C14:1
Fairley, Michelle
Shadow of a Gunman, The 1991,N 27,C17:1
Faison, Frankie R.
Before It Hits Home 1992,Mr 11,C17:2
Faison, George (Choreographer)
Betsey Brown 1991,Ap 13,14:5
Faithfull, Marianne
Threepenny Opera 1991,Ag 20,C11:1
Falabella, John (Scenic Designer)
Grown Ups 1991,Ja 24,C18:5
Animal Crackers 1992,N 4,C19:4
Faljean, Lawrence
Room 1203 (Short Shots) 1991,Ag 1,C14:4
Joinin' of the Colors, A (Short Shots) 1991,Ag 1,C14:4
Falk, Louis
Walk on Lake Erie, A 1991,Mr 25,C15:1
1991 Young Playwrights Festival, The 1991,O 3,C20:3
First Is Supper 1992,Mr 18,C17:1
Falk, Willy
Miss Saigon 1991,Ap 12,C1:2
Miss Saigon 1991,Ap 21,II:5:1
Fall, James Apaumut
Winter Man 1991,F 21,C20:1
Fallon, Sharon (Miscellaneous)
Currents Turned Awry 1991,Je 26,C12:3
Fallon, Siobhan
As You Like It 1992,Jl 10,C3:1
As You Like It 1992,Jl 19,II:5:1

Falls, Robert (Director)
Speed of Darkness, The 1991,Mr 1,C1:1
Speed of Darkness, The 1991,Mr 10,II:5:1
Book of the Night 1991,Jl 28,II:5:1
Falzer, Gloria (Miscellaneous)
In Plain View, Series B 1992,Ag 15,12:3
Fancy, Richard
Dance of Death 1991,Ja 31,C21:3
Fanning, Tony (Scenic Designer)
Two Trains Running 1992,Ap 14,C13:4
Two Trains Running 1992,My 3,II:5:1
Farer, Ronnie
Festival of One-Act Comedies, Evening A 1991,F 12,C14:3
Farlow, Lesley (Miscellaneous)
Candide 1992,Ap 24,C4:5
Farrell, John (Scenic Designer)
Mystery of Anna O, The 1992,S 23,C16:3
Farrell, Matthew (Miscellaneous)
Free Speech in America 1991,N 18,C11:1
Farrell, Tom Riis
Greetings 1991,D 11,C23:1
God's Country 1992,Je 3,C15:4
Backers' Audition, A 1992,D 14,C14:1
Farwell, Susan
Sublime Lives 1991,S 16,C14:4
Rivers and Ravines, The 1991,N 14,C28:6
Anima Mundi 1992,F 5,C19:3
Fasman, Glen (Lighting Director)
Underground 1991,Mr 3,64:1
Fassbinder, Rainer Werner (Playwright)
Bitter Tears of Petra von Kant, The 1992,Je 18,C15:1
Fast, Howard (Playwright)
Novelist, The 1991,O 23,C19:1
Faugno, Rick
Will Rogers Follies, The: A Life in Revue 1991,My 2,C17:1
Faul, Kathy J. (Miscellaneous)
Pygmalion 1991,Mr 25,C15:4
Subject Was Roses, The 1991,Je 6,C13:2
Homecoming, The 1991,O 28,C13:1
Hamlet 1992,Ap 3,C3:1
Real Inspector Hound, The 1992,Ag 14,C2:3
15-Minute Hamlet, The 1992,Ag 14,C2:3
Show-Off, The 1992,N 6,C3:1
Faulk, Bruce
Hamlet 1992,Ap 3,C3:1
Favier, Louise
Grandchild of Kings 1992,F 17,C13:1
Fay, Elisabeth
Anatomy Lesson, The (Evening of Short Plays by Joyce Carol Oates, An) 1991,Ap 27,14:5
How Do You Like Your Meat? (Evening of Short Plays by Joyce Carol Oates, An) 1991,Ap 27,14:5
Fay, Tom (Composer)
Adventures in the Skin Trade 1991,D 8,II:5:1
Faye, Denise
Guys and Dolls 1992,Ap 15,C15:3
Faye-Williams, Pascale
Guys and Dolls 1992,Ap 15,C15:3
Fazel, Leila
Flaubert's Latest 1992,Je 22,C15:3
Flaubert's Latest 1992,Je 28,II:5:1
Feagan, Leslie
Guys and Dolls 1992,Ap 15,C15:3
Federico, Robert Weber (Costume Designer)
Esperando la Carroza (Waiting for the Hearse) 1991,S 18,C15:1
Federico, Robert Weber (Lighting Director)
Botanica 1991,Mr 5,C16:1
Esperando la Carroza (Waiting for the Hearse) 1991,S 18,C15:1
Candida Erendira, La 1992,F 9,65:1
Federico, Robert Weber (Scenic Designer)
Mayor of Zalamea, The (Alcalde de Zalamea, El) 1991,Ap 14,52:1
Esperando la Carroza (Waiting for the Hearse) 1991,S 18,C15:1
Federing, Karen (Miscellaneous)
Rendezvous with God, A 1991,Jl 25,C14:5
Fedotova, Yelena
Moscow Circus—Cirk Valentin 1991,N 8,C3:1
Feenan, Marjorie
Rivers and Ravines, The 1991,N 14,C28:6
Anima Mundi 1992,F 5,C19:3
This One Thing I Do 1992,Ap 19,45:5
Roleplay 1992,Ag 8,16:4

Feeney, Caroleen
Remembrance 1992,O 4,II:5:1
Remembrance 1992,O 5,C13:4
Feiffer, Jules (Playwright)
Grown Ups 1991,Ja 24,C18:5
Feiner, Harry (Scenic Designer)
Cinderella 1991,D 23,C16:4
Feiner, Mimi
Women in Beckett 1991,N 22,C17:1
Feingold, Michael (Translator)
Grand Finale 1991,Ap 21,60:1
Feist, Gene (Director)
Selling Off 1991,Je 17,C13:4
Feist, Gene (Miscellaneous)
Country Girl, The 1991,Ja 12,16:3
Pygmalion 1991,Mr 25,C15:4
Subject Was Roses, The 1991,Je 6,C13:2
Matchmaker, The 1991,Ag 28,C12:4
Homecoming, The 1991,O 28,C13:1
Visit, The 1992,Ja 24,C1:2
Hamlet 1992,Ap 3,C3:1
Price, The 1992,Je 11,C13:1
Feld, Kenneth (Producer)
Walt Disney's World on Ice: Mickey Mouse Diamond Jubilee 1991,F 5,C18:1
Ringling Brothers and Barnum & Bailey Circus 1991,Mr 24,63:1
Disney's World on Ice Starring Peter Pan 1992,F 12,C17:1
Feldman, Dave (Lighting Director)
Bert Sees the Light 1992,Mr 11,C15:1
Feldman, Dave (Producer)
Bert Sees the Light 1992,Mr 11,C15:1
Feldman, Dick (Producer)
Program for Murder 1992,N 25,C19:1
Feldon, Barbara
Cut the Ribbons 1992,S 21,C14:1
Feldshuh, Tovah
Fierce Attachment, A 1991,Mr 14,C18:1
Six Wives 1992,O 10,16:1
Hello Muddah, Hello Fadduh 1992,D 9,C22:1
Felton, Holly
Bete, La 1991,F 11,C11:3
Good Times Are Killing Me, The 1991,Ap 19,C3:1
Femi (Miscellaneous)
Little Tommy Parker Celebrated Colored Minstrel Show, The 1991,Mr 18,C16:4
Fenhagen, James (Scenic Designer)
Piece of My Heart, A 1991,N 4,C15:1
Fennan, Marjorie (Costume Designer)
Rivers and Ravines, The 1991,N 14,C28:6
Anima Mundi 1992,F 5,C19:3
Feore, Colm
Hamlet 1991,Je 30,II:5:1
Much Ado About Nothing 1991,Je 30,II:5:1
Ferencz, George (Director)
Any Place But Here 1992,Je 9,C13:1
Ferguson, Lou
How Do You Like Your Meat? (Evening of Short Plays by Joyce Carol Oates, An) 1991,Ap 27,14:5
Ferguson, Lynnda
Romeo and Juliet 1991,Ja 31,C21:1
Ferland, Danielle
Crucible, The 1991,D 11,C17:1
Little Hotel on the Side, A 1992,Ja 27,C17:1
1992 Young Playwrights Festival, The 1992,S 24,C18:4
Camp Paradox 1992,N 9,C14:1
Fernandez, Peter Jay
As You Like It 1992,Jl 10,C3:1
1992 Young Playwrights Festival, The 1992,S 24,C18:4
Ferra, Max (Director)
Words Divine: A Miracle Play 1992,N 25,C19:1
Ferra, Max (Miscellaneous)
Blue Heat 1991,Mr 3,64:1
Have-Little, The 1991,Je 12,C14:3
Any Place But Here 1992,Je 9,C13:1
Words Divine: A Miracle Play 1992,N 25,C19:1
Ferrante, Frank
Animal Crackers 1992,N 4,C19:4
Ferraro, John (Director)
Crazy He Calls Me 1992,Ja 28,C11:1
Ferrer, Jose Luis
Mayor of Zalamea, The (Alcalde de Zalamea, El) 1991,Ap 14,52:1
Ferrera, Darryl
Man of La Mancha 1992,Ap 25,13:4

Frazer, Susanna
Yokohama Duty 1991,My 22,C15:1
Frazier, Lloyd
Twelfth Night 1992,Ag 15,12:3
Frazier, Michael (Producer)
Unidentified Human Remains and the True Nature of Love 1991,S 20,C26:4
3 from Brooklyn 1992,N 20,C3:1
Frazier, Randy
Let Me Live 1991,Ja 17,C21:1
Frechette, Peter
Absent Friends 1991,F 13,C13:3
Absent Friends 1991,F 24,II:5:1
Our Country's Good 1991,Ap 30,C13:4
Our Country's Good 1991,My 19,II:5:1
Destiny of Me, The 1992,O 21,C15:1
Free, Stan
Backers' Audition, A 1992,D 14,C14:1
Freedman, Harris W. (Playwright)
Selling Off 1991,Je 17,C13:4
Freeman, John Joseph
Salome 1992,Je 26,C3:1
Freeman, K. Todd
Angels in America 1992,N 10,C15:3
Freeman, Lucy (Playwright)
Mystery of Anna O, The 1992,S 23,C16:3
Freezer, Harlene (Producer)
From the Mississippi Delta 1991,N 12,C13:1
Freidrichs, Hans
Sublime Lives 1991,S 16,C14:4
French, Arthur
Mule Bone 1991,F 15,C1:4
Boxing Day Parade, The 1991,O 9,C18:3
Tempest, A 1991,O 16,C18:3
Ascension Day 1992,Mr 4,C19:1
Onliest One Who Can't Go Nowhere, The (Marathon '92, Series C) 1992,Je 2,C15:1
French, David (Translator)
Seagull, The 1992,N 30,C11:1
Freschi, Bob
Most Happy Fella, The 1991,My 30,C13:1
Most Happy Fella, The 1992,F 14,C1:4
Frey, Matthew (Lighting Director)
Our Lady of Perpetual Danger 1991,O 16,C18:3
Marathon '92, Series C 1992,Je 2,C15:1
Freydberg, James B. (Producer)
I Hate Hamlet 1991,Ap 9,C13:3
Freyer, Frederick (Composer)
Captains Courageous 1992,O 11,II:5:1
Friday, Betsy
Secret Garden, The 1991,Ap 26,C1:1
Fried, Elizabeth (Costume Designer)
Brother Truckers 1992,S 22,C13:3
Friedman, Barry Craig
Grown Ups 1991,Ja 24,C18:5
Friedman, Bernard (Producer)
From the Mississippi Delta 1991,N 12,C13:1
Friedman, Janet (Miscellaneous)
Betrayal 1991,F 3,55:4
Friedman, Jonathan
Best of Schools, The 1992,Mr 11,C15:1
Friedman, Leah Kornfeld (Playwright)
Club Soda 1991,Je 26,C12:3
Friedrich, Marie Juliane (Costume Designer)
Dr. Faustus Lights the Lights 1992,Jl 9,C15:3
Friel, Brian (Playwright)
Making History 1991,Ap 11,C24:1
Dancing at Lughnasa 1991,O 25,C1:4
Dancing at Lughnasa 1991,N 3,II:5:1
Frierson, Andrea
March of the Falsettos and Falsettoland 1991,O 15,C13:1
Frierson, Terrence
Night Before Christmas, The: A Musical Fantasy 1992,D 17,C18:5
Frilles, Anky (Costume Designer)
Best of Schools, The 1992,Mr 11,C15:1
Frisch, Bob
Chess 1992,F 5,C19:3
Frish, Aleksandr "Sasha"
Moscow Circus—Cirk Valentin 1991,N 8,C3:1
Fritz, Joanie
Humanity (Menschen, Die) 1991,Je 5,C22:3
We Should . . . (A Lie) 1992,Ja 29,C17:1
Froeyland, Oeyvind (Director)
Five Women in a Chapel 1991,Je 5,C22:3
Hour of the Lynx 1992,Ap 1,C16:3

Frommer, Laurence
Rules of Civility and Decent Behavior in Company and Conversation 1991,Mr 25,C15:1
Frost, Sue (Miscellaneous)
It's a Bird, It's a Plane, It's Superman 1992,Je 20,16:4
Animal Crackers 1992,N 4,C19:4
Fuchs, Andreas (Lighting Director)
Dr. Faustus Lights the Lights 1992,Jl 9,C15:3
Fudel, Tom (Miscellaneous)
Absolutely Rude 1991,N 13,C21:1
Fueda, Uichiro
Dionysus 1991,Je 23,43:1
Fuertes, Amparo (Costume Designer)
Jibaros Progresistas, Los 1991,Ag 29,C18:3
Fugard, Athol (Director)
Boesman and Lena 1992,Ja 30,C15:1
Boesman and Lena 1992,F 9,II:5:1
Fugard, Athol (Playwright)
Boesman and Lena 1992,Ja 30,C15:1
Boesman and Lena 1992,F 9,II:5:1
Blood Knot 1992,Ap 12,65:3
Fugelstad, Carol (Miscellaneous)
Invitations to Heaven (Questions of a Jewish Child) 1991,O 2,C18:3
Fujii, Satomi
Dionysus 1991,Je 23,43:1
Fulginiti-Shakar, George (Composer)
Midsummer Night's Dream, A 1992,Ap 8,C21:1
Fuller, Susie (Director)
Other Side of Paradise, The 1992,Mr 6,C3:5
Fuqua, Joseph
Two Gentlemen of Verona 1991,D 12,C21:3
Fusco, Anthony
Life in the Theater, A 1992,F 29,18:1
Real Inspector Hound, The 1992,Ag 14,C2:3
Holy Terror, The 1992,O 9,C3:1
Holy Terror, The 1992,O 18,II:5:1
Fusco, Coco
1991 (A Performance Chronicle of the Rediscovery of America by the Warrior for Gringostroika) 1991,O 18,C14:5
Futterman, Dan
Club Soda 1991,Je 26,C12:3
Raft of the Medusa 1991,D 23,C15:1
Raft of the Medusa 1992,Ja 5,II:1:1
Fyfe, Jim
Matchmaker, The 1991,Ag 28,C12:4
On the Bum, or the Next Train Through 1992,N 25,C19:1

<div style="text-align:center">

G

</div>

Gabay, Roy (Producer)
Our Lady of Perpetual Danger 1991,O 16,C18:3
Gabis, Stephen
Shadow of a Gunman, The 1991,N 27,C17:1
Gabor, Nancy (Director)
War in Heaven, The 1991,Mr 26,C15:1
Struck Dumb 1991,Mr 26,C15:1
Gaffin, Artie (Miscellaneous)
Solitary Confinement 1992,N 9,C11:1
Gaffney, Lauren
Grown Ups 1991,Ja 24,C18:5
Good Times Are Killing Me, The 1991,Ap 19,C3:1
Good Times Are Killing Me, The 1991,Ag 9,C3:5
Gailen, Judy (Scenic Designer)
Fortinbras 1992,O 14,C18:3
Gaines, Boyd
Extra Man, The 1992,My 20,C15:4
Comedy of Errors, The 1992,Ag 17,C11:3
Comedy of Errors, The 1992,Ag 23,II:5:1
Show-Off, The 1992,N 6,C3:1
Show-Off, The 1992,N 15,II:5:1
Gaines, J. E. (Playwright)
Folks Remembers a Missing Page (The Rise and Fall of Harlem) 1991,O 2,C18:3
Gaines, Sonny Jim
Mule Bone 1991,F 15,C1:4
Folks Remembers a Missing Page (The Rise and Fall of Harlem) 1991,O 2,C18:3
Gaipa, Amy (Miscellaneous)
Murder of Crows, A 1992,My 1,C18:1
Gajdusek, Todd (Miscellaneous)
Moon for the Misbegotten, A 1992,S 23,C16:3

Galardi, Michael
Hamlet 1992,Ap 3,C3:1
Galas, Diamanda
P.S. 122 Benefit 1991,F 9,13:1
Galati, Frank (Director)
Earthly Possessions 1991,S 4,C13:2
Galati, Frank (Playwright)
Earthly Possessions 1991,S 4,C13:2
Galbraith, Philip (Director)
Currents Turned Awry 1991,Je 26,C12:3
Gale, Gregory (Costume Designer)
Mary Stuart 1992,F 26,C19:1
Galgano, Richard (Miscellaneous)
What Is This Everything? (Marathon '92, Series A) 1992,My 5,C15:1
Galica, Katarzyna
Metro 1992,Ap 17,C1:3
Galindo, Eileen
In Miami as It Is in Heaven 1991,Ja 27,44:4
Galindo, Ramon
Most Happy Fella, The 1992,F 14,C1:4
Gallagher, Fiona
Best of Schools, The 1992,Mr 11,C15:1
Gallagher, Peter
Guys and Dolls 1992,Ap 15,C15:3
Guys and Dolls 1992,Ap 26,II:5:1
Gallen, Ira H. (Miscellaneous)
CBS Live 1992,D 2,C18:3
Gallin, Susan Quint (Producer)
From the Mississippi Delta 1991,N 12,C13:1
Gallo, David K. (Scenic Designer)
Marathon 1991: New One-Act Plays, Series B 1991,Je 9,60:5
Nothing Sacred 1992,O 27,C17:1
Gallo, Paul (Lighting Director)
Assassins 1991,Ja 28,C19:3
I Hate Hamlet 1991,Ap 9,C13:3
Crazy for You 1992,F 20,C15:3
Guys and Dolls 1992,Ap 15,C15:3
Galloway-O'Connor, Cyndi B.
Lotto: Experience the Dream 1991,D 26,C13:1
Galluccio, Laurie
Iphigenia in Tauris 1992,My 13,C14:3
Galman, Peter
Wedding Portrait, The 1992,Mr 25,C19:3
Gamburg, Yevgeny
Rosencrantz and Guildenstern Are Dead 1992,Ja 31,C15:1
Gandolfini, James
Streetcar Named Desire, A 1992,Ap 13,C11:3
Gandy-Doud, Angelique
Tom Scallen's Ice Capades 1992,Ja 22,C17:1
Ganly, Killian (Miscellaneous)
New Living Newspaper 1992,Mr 4,C19:1
Gant, Carla (Costume Designer)
Down the Flats 1992,Ja 17,C5:1
Bobby Sands, M.P. 1992,Je 18,C15:1
Lament for Arthur Cleary, The 1992,N 4,C22:1
Gantt, Leland
Let Me Live 1991,Ja 17,C21:1
Ganun, John
Will Rogers Follies, The: A Life in Revue 1991,My 2,C17:1
Ganzer, Lee James
Zion 1991,D 5,C22:4
Garant, Ben (Playwright)
CBS Live 1992,D 2,C18:3
Garber, Victor
Assassins 1991,Ja 28,C19:3
Assassins 1991,F 3,II:1:2
Two Shakespearean Actors 1992,Ja 17,C1:1
Two Shakespearean Actors 1992,Ja 26,II:5:1
Garcia, Elaine
Sonho de Uma Noite de Verao (Midsummer Night's Dream, A) 1991,Ag 2,C3:1
Garcia, Risa Bramon (Director)
Face Divided (Marathon 1991: New One-Act Plays, Series B) 1991,Je 9,60:5
Jenny Keeps Talking (Marathon '92, Series C) 1992,Je 2,C15:1
Garcia Lorca, Federico (Playwright)
Blood Wedding 1992,My 15,C3:3
Garcia Marquez, Gabriel (Original Author)
Candida Erendira, La 1992,F 9,65:1
Gardali, Glen (Miscellaneous)
Little Hotel on the Side, A 1992,Ja 27,C17:1
Gardenia, Vincent
Breaking Legs 1991,My 20,C11:1

Grant, William H., 3d (Lighting Director)
Little Tommy Parker Celebrated Colored Minstrel Show, The 1991,Mr 18,C16:4
Lotto: Experience the Dream 1991,D 26,C13:1
Grappone, Ray
Weird Romance 1992,Je 23,C14:5
Graver, Steven F. (Costume Designer)
Candida 1991,F 25,C13:1
Fridays 1991,My 22,C15:1
Graves, Kia
Little Hotel on the Side, A 1992,Ja 27,C17:1
Shallow End, The (Marathon '92, Series A) 1992,My 5,C15:1
Gray, Celina
At the Crossroads 1992,N 11,C18:3
Gray, Colin
My Son the Doctor 1991,Ag 10,12:6
Gray, Dean (Miscellaneous)
Woman Without a Name, A 1992,F 2,54:5
Fortinbras 1992,O 14,C18:3
Lake Street Extension 1992,D 2,C18:3
Gray, Ken
Eagle in the Bubble 1991,Jl 16,C15:1
Gray, Paula (Miscellaneous)
Cinderella 1991,D 23,C16:4
Gray, Sam
Resistible Rise of Arturo Ui, The 1991,My 9,C15:1
Deposing the White House 1991,D 4,C22:3
Gray, Simon (Director)
Holy Terror, The 1992,O 9,C3:1
Holy Terror, The 1992,O 18,II:5:1
Gray, Simon (Playwright)
Hidden Laughter 1992,Mr 8,II:5:1
Holy Terror, The 1992,O 9,C3:1
Holy Terror, The 1992,O 18,II:5:1
Grayson, Bobby H. (Miscellaneous)
Walking the Dead 1991,My 13,C12:1
Camp Paradox 1992,N 9,C14:1
Grayson, Jerry
Search and Destroy 1992,F 27,C18:5
Graziadei, Renate
Atomic Opera 1991,O 30,C14:1
Grealy, Freda (Miscellaneous)
Down the Flats 1992,Ja 17,C5:1
Green, Adolph (Lyricist)
Will Rogers Follies, The: A Life in Revue 1991,My 2,C17:1
Will Rogers Follies, The 1991,My 12,II:1:2
Green, Amanda
Sheik of Avenue B, The 1992,N 23,C14:1
Green, Andrea
Jacques Brel Is Alive and Well and Living in Paris 1992,O 21,C16:3
Green, Benita (Lyricist)
Out of Focus (Short Shots) 1991,Ag 1,C14:4
Green, Benita (Playwright)
Out of Focus (Short Shots) 1991,Ag 1,C14:4
Green, David
What About Luv? 1991,D 30,C14:1
What About Luv? 1992,Ja 5,II:1:1
Green, Dor
Vanquished by Voodoo 1992,Je 17,C17:1
Green, Fanni
Mule Bone 1991,F 15,C1:4
In the Jungle of Cities 1991,N 6,C19:2
Blood Wedding 1992,My 15,C3:3
Green, John-Martin
New Living Newspaper 1992,Mr 4,C19:1
Green, Jonathan (Miscellaneous)
Woman Without a Name, A 1992,F 2,54:5
Ambrosio 1992,Ap 28,C15:1
Fortinbras 1992,O 14,C18:3
Lake Street Extension 1992,D 2,C18:3
Green, Larry
Black Eagles 1991,Ap 22,C13:1
God's Country 1992,Je 3,C15:4
Green, Michael (Scenic Designer)
Little Tommy Parker Celebrated Colored Minstrel Show, The 1991,Mr 18,C16:4
Green, Richard Kent (Lighting Director)
Currents Turned Awry 1991,Je 26,C12:3
Greenberg, Edward
Radiant City, The 1991,O 7,C15:4
Greenberg, Gordon
Peacetime 1992,Mr 12,C21:1
Greenberg, Helen
Love Lemmings 1991,My 1,C15:1
One of the All-Time Greats 1992,Ap 17,C3:1

Greenberg, Mitchell
Death and Life of Sherlock Holmes, The 1991,N 27,C17:1
Greenberg, Richard (Playwright)
American Plan, The 1991,Ja 6,II:1:2
Extra Man, The 1992,My 20,C15:4
Jenny Keeps Talking (Marathon '92, Series C) 1992,Je 2,C15:1
Greenblatt, Kenneth D. (Producer)
Catskills on Broadway 1991,D 6,C28:4
Greenblatt, Sandra (Producer)
Catskills on Broadway 1991,D 6,C28:4
Greene, Deborah
Wilder, Wilder, Wilder: Three by Thornton 1992,D 21,C13:1
Greene, Ellen
Weird Romance 1992,Je 23,C14:5
Greene, Erika
Another Person Is a Foreign Country 1991,S 10,C11:1
Greene, Fred (Director)
Varieties 1992,Ja 8,C17:1
Greene, James
Bete, La 1991,F 11,C11:3
Greene, Keith (Musical Director)
Ringling Brothers and Barnum & Bailey Circus 1991,Mr 24,63:1
Greene, Lyn
Assassins 1991,Ja 28,C19:3
Greenfield, Haze
Julius Caesar 1991,My 15,C12:3
Greenfield, T. (Scenic Designer)
Bluebeard 1991,N 15,C3:1
Greenhill, Susan
Better Days 1991,Ja 24,C20:1
Greenquist, Brad
White Rose, The 1991,O 30,C15:1
Awoke One (Marathon '92, Series B) 1992,My 19,C18:3
Greenspan, David
Dead Mother: or Shirley Not All in Vain 1991,F 1,C3:1
Home Show Pieces, The 1992,Ja 29,C17:1
Greenspan, David (Director)
Dead Mother: or Shirley Not All in Vain 1991,F 1,C3:1
Way of the World, The 1991,My 22,C11:1
Home Show Pieces, The 1992,Ja 29,C17:1
Greenspan, David (Playwright)
Dead Mother: or Shirley Not All in Vain 1991,F 1,C3:1
Home Show Pieces, The 1992,Ja 29,C17:1
Greenwood, Bruce (Miscellaneous)
Juba 1991,F 24,60:1
Greenwood, Jane (Costume Designer)
Betrayal 1991,F 3,55:4
Absent Friends 1991,F 13,C13:3
Big Love, The 1991,Mr 4,C11:1
I Hate Hamlet 1991,Ap 9,C13:3
Old Boy, The 1991,My 6,C11:4
Mr. Gogol and Mr. Preen 1991,Je 10,C13:1
Lips Together, Teeth Apart 1991,Je 26,C11:1
Othello 1991,Je 28,C1:1
Othello 1991,Jl 7,II:1:1
Park Your Car in Harvard Yard 1991,N 8,C1:4
Adventures in the Skin Trade 1991,D 8,II:5:1
Two Shakespearean Actors 1992,Ja 17,C1:1
Two Shakespearean Actors 1992,Ja 26,II:5:1
Streetcar Named Desire, A 1992,Ap 13,C11:3
Price, The 1992,Je 11,C13:1
Flaubert's Latest 1992,Je 22,C15:3
Sisters Rosensweig, The 1992,O 23,C3:1
Once Removed 1992,D 7,C11:1
Greenwood, Judith (Lighting Director)
As You Like It 1991,Jl 26,C18:4
Greer, Julienne
Soap Opera (American Living Room Reupholstered, The) 1992,S 30,C16:3
Greer, Michael Barry
Black Eagles 1991,Ap 22,C13:1
Gregg, Clark
Old Boy, The 1991,My 6,C11:4
Old Boy, The 1991,My 19,II:5:1
Unidentified Human Remains and the True Nature of Love 1991,S 20,C26:4
Unidentified Human Remains and the True Nature of Love 1991,S 29,II:5:1
Nothing Sacred 1992,O 27,C17:1

Gregg, Clark (Director)
Distant Fires 1991,O 17,C22:1
Distant Fires 1992,Ag 28,C2:3
Gregson, Mary-Susan (Miscellaneous)
Five Women in a Chapel 1991,Je 5,C22:3
Trojan Women, The 1991,N 13,C21:1
Chekhov Very Funny 1992,Ap 8,C21:1
Gregus, Luba
Will Rogers Follies, The: A Life in Revue 1991,My 2,C17:1
Gregus, Peter
Animal Crackers 1992,N 4,C19:4
Greif, Holly
On the Razzle 1992,Ag 28,C2:3
Greif, Michael (Director)
Bright Room Called Day, A 1991,Ja 8,C11:1
Bright Room Called Day, A 1991,Ja 13,II:5:1
Casanova 1991,My 29,C11:5
Casanova 1991,Je 9,II:5:1
Pericles, Prince of Tyre 1991,N 25,C13:1
Pericles 1991,D 1,II:5:1
Spike Heels 1992,Je 5,C3:1
Greiss, Terry
Antigone 1992,F 16,70:5
Grenier, Zach
Resistible Rise of Arturo Ui, The 1991,My 9,C15:1
Creditors 1992,F 7,C3:1
Korea 1992,F 19,C16:3
Woyzeck 1992,D 7,C14:1
Woyzeck 1992,D 13,II:5:1
Grey, Larry (Miscellaneous)
To Kill a Mockingbird 1991,Mr 4,C13:4
Grice, Brian
Jelly's Last Jam 1992,Ap 27,C11:1
Grieg, Edvard (Composer)
When We Dead Awaken 1991,Mr 10,59:1
Grifasi, Joe
Bella, Belle of Byelorussia 1992,Ja 20,C18:1
Griffin, Carmen (Miscellaneous)
Zion 1991,D 5,C22:4
Griffin, Donald
Mule Bone 1991,F 15,C1:4
Griffin, Scott (Lighting Director)
Lovers 1992,Mr 25,C19:3
Griffin, Zaria
Camp Logan 1991,F 7,C23:1
Griffith, Kristin
Scheherazade (Marathon '92, Series B) 1992,My 19,C18:3
Holy Terror, The 1992,O 9,C3:1
Holy Terror, The 1992,O 18,II:5:1
Griffiths, Michael
Nebraska 1992,Je 3,C15:4
Griggs, Michael (Playwright)
This One Thing I Do 1992,Ap 19,45:5
Grigorescu, Simone
Ice Capades: On Top of the World 1991,Ja 22,C16:4
Grimaldi, Dennis (Producer)
High Rollers Social and Pleasure Club, The 1992,Ap 23,C15:2
Grizzard, George
To Kill a Mockingbird 1991,Mr 4,C13:4
Groblewska, Lidia
Metro 1992,Ap 17,C1:3
Grodin, Charles (Playwright)
One of the All-Time Greats 1992,Ap 17,C3:1
One of the All-Time Greats 1992,My 17,II:5:1
Grody, Donald
Saint Joan 1992,F 23,51:5
Groener, Harry
Crazy for You 1992,F 20,C15:3
Crazy for You 1992,Mr 1,II:1:1
Grollman, Elaine
Invention for Fathers and Sons 1992,Ja 22,C17:1
Gromada, John (Composer)
Bright Room Called Day, A 1991,Ja 8,C11:1
Evening of Short Plays by Joyce Carol Oates, An 1991,Ap 27,14:5
Casanova 1991,My 29,C11:5
Baltimore Waltz, The 1992,F 12,C15:3
Flaubert's Latest 1992,Je 22,C15:3
Gromada, John (Miscellaneous)
Henry IV, Parts 1 and 2 1991,F 28,C15:1
Evening of Short Plays by Joyce Carol Oates, An 1991,Ap 27,14:5
Casanova 1991,My 29,C11:5
Park Your Car in Harvard Yard 1991,N 8,C1:4
Baltimore Waltz, The 1992,F 12,C15:3

H

Hartinian, Linda (Costume Designer)
When Lithuania Ruled the World, Part 3 1992,Ja 23,C14:4
Hartley, Jan (Miscellaneous)
Bright Room Called Day, A 1991,Ja 8,C11:1
Sick But True 1992,S 12,15:1
Hartwell, Peter (Costume Designer)
Unidentified Human Remains and the True Nature of Love 1991,S 20,C26:4
Hartwell, Peter (Scenic Designer)
Unidentified Human Remains and the True Nature of Love 1991,S 20,C26:4
Hasenclever, Walter (Playwright)
Humanity (Menschen, Die) 1991,Je 5,C22:3
Hastings, John (Lighting Director)
Chess 1992,F 5,C19:3
Haugen, Eric T. (Lighting Director)
Criminals in Love 1992,O 7,C16:3
Hauser, Francis A. (Miscellaneous)
Jelly's Last Jam 1992,Ap 27,C11:1
Haverty, Doug (Lyricist)
Roleplay 1992,Ag 8,16:4
Haverty, Doug (Playwright)
Roleplay 1992,Ag 8,16:4
Hawkanson, David (Miscellaneous)
March of the Falsettos and Falsettoland 1991,O 15,C13:1
All's Well That Ends Well 1991,N 25,C14:3
Who's Afraid of Virginia Woolf? 1992,Ja 23,C19:4
Heartbreak House 1992,Ap 16,C16:1
Tartuffe 1992,O 16,C15:1
Pill Hill 1992,D 3,C18:5
Hawke, Ethan
Casanova 1991,My 29,C11:5
Casanova 1991,Je 9,II:5:1
Seagull, The 1992,N 30,C11:1
Seagull, The 1992,D 13,II:5:1
Hawkins, Yvette
Before It Hits Home 1992,Mr 11,C17:2
Hawley, Lynn
Woyzeck 1992,D 7,C14:1
Hawthorne, Nigel
Madness of George III, The 1992,Mr 3,C13:3
Hayden, Michael
Matchmaker, The 1991,Ag 28,C12:4
Nebraska 1992,Je 3,C15:4
Carousel 1992,D 17,C11:3
Hayden, Sophie
Most Happy Fella, The 1991,My 30,C13:1
Most Happy Fella, The 1991,Je 2,II:7:1
Most Happy Fella, The 1992,F 14,C1:4
Most Happy Fella, The 1992,F 16,II:5:1
Show-Off, The 1992,N 6,C3:1
Show-Off, The 1992,N 15,II:5:1
Hayes, Rod C., 3d
Wedding Portrait, The 1992,Mr 25,C19:3
Hayes, Sarah Graham
Iphigenia in Tauris 1992,My 13,C14:3
Haynes, Jayne
Beggars in the House of Plenty 1991,O 24,C17:4
Haynes, Randell
Dolphin Position, The 1992,O 9,C3:1
Haynsworth, Brian (Lighting Director)
Oxcart, The (Carreta, La) 1992,Ap 22,C17:3
Richard Foreman Trilogy, The 1992,My 27,C15:1
Hays, Rex D.
Six Wives 1992,O 10,16:1
Heald, Anthony
Pygmalion 1991,Mr 25,C15:4
Lips Together, Teeth Apart 1991,Je 26,C11:1
Lips Together, Teeth Apart 1991,Jl 14,II:5:1
Lips Together, Teeth Apart 1992,Ja 12,II:5:1
Small Family Business, A 1992,Ap 28,C13:3
Small Family Business, A 1992,My 10,II:1:2
Healy, Anne
Joinin' of the Colors, A (Short Shots) 1991,Ag 1,C14:4
Healy, David
Real Inspector Hound, The 1992,Ag 14,C2:3
15-Minute Hamlet, The 1992,Ag 14,C2:3
Healy, Michael A.
Terrible Beauty, A 1992,Ap 10,C18:1
Healy-Louie, Miriam
Romeo and Juliet 1991,Ja 31,C21:1
Romeo and Juliet 1991,F 10,II:5:1
Othello 1991,Je 28,C1:1

Heard, John
Marathon 1991: New One-Act Plays, Series C 1991,Je 19,C12:3
Heath, Bruce (Miscellaneous)
High Rollers Social and Pleasure Club, The 1992,Ap 23,C15:2
Heath, Kia (Costume Designer)
Five Very Live 1992,Ja 8,C17:1
Hecht, Bjarne
Wilder, Wilder, Wilder: Three by Thornton 1992,D 21,C13:1
Hecht, Deborah (Miscellaneous)
Mad Forest 1991,D 5,C15:3
Hecht, Jessica
Explosions 1992,Ja 15,C17:1
Any Place But Here 1992,Je 9,C13:1
I'm Sorry . . . Was That Your World? 1992,S 25,C2:3
Hedges, Peter (Playwright)
Age of Pie, The (Five Very Live) 1992,Ja 8,C17:1
Hedwall, Deborah
Marathon 1991: New One-Act Plays, Series A 1991,My 26,57:5
Sight Unseen 1992,Ja 21,C13:3
Sight Unseen 1992,Ja 26,II:5:1
Hedwig, Ula
Groundhog 1992,My 4,C14:1
Heelan, Kevin (Playwright)
Distant Fires 1991,O 17,C22:1
Distant Fires 1992,Ag 28,C2:3
Heenan, Milo
Joinin' of the Colors, A (Short Shots) 1991,Ag 1,C14:4
Heenan, Reena (Playwright)
Joinin' of the Colors, A (Short Shots) 1991,Ag 1,C14:4
Hegde, Saroja
Hippolytos 1992,N 25,C19:1
Heidenreich, V. Craig
Tales from the Vienna Woods 1991,O 23,C17:4
Heilovsky, Rolland
Rosencrantz and Guildenstern Are Dead 1992,Ja 31,C15:1
Heinemann, Larry
Tubes 1991,N 20,C23:1
Helde, Annette
Piece of My Heart, A 1991,N 4,C15:1
Helin, Yvette (Costume Designer)
Homo Sapien Shuffle 1992,Mr 10,C12:5
Helin, Yvette (Miscellaneous)
Homo Sapien Shuffle 1992,Mr 10,C12:5
Heller, Adam
Encore 1991,Je 19,C12:3
March of the Falsettos and Falsettoland 1991,O 15,C13:1
In the Cemetery (Last Laugh, The) 1992,Jl 2,C16:1
Cure, The (Last Laugh, The) 1992,Jl 2,C16:1
Heller, Andre (Director)
Andre Heller's Wonderhouse 1991,O 21,C15:1
Andre Heller's Wonderhouse 1991,O 27,II:5:1
Heller, Andre (Miscellaneous)
Andre Heller's Wonderhouse 1991,O 21,C15:1
Heller, Andre (Scenic Designer)
Andre Heller's Wonderhouse 1991,O 21,C15:1
Heller, Georganne Aldrich (Producer)
Remembrance 1992,O 5,C13:4
Heller, Katrin
Dr. Faustus Lights the Lights 1992,Jl 9,C15:3
Heller, Laura (Miscellaneous)
Room of One's Own, A 1991,Mr 5,C11:2
Caged 1991,My 31,C3:1
Heller, Nina (Miscellaneous)
Taking Stock 1991,Ja 17,C21:1
Shmulnik's Waltz 1991,N 6,C21:1
Life in the Theater, A 1992,F 29,18:1
Sunset Gang, The 1992,My 16,14:3
Last Laugh, The 1992,Jl 2,C16:1
Hellerman, Fred (Composer)
Other Side of Paradise, The 1992,Mr 6,C3:5
Hellerman, Fred (Miscellaneous)
Other Side of Paradise, The 1992,Mr 6,C3:5
Hellyer, Paul (Director)
East: An Elegy for the East End 1991,My 22,C15:1
Helm, Tom (Musical Director)
What About Luv? 1991,D 30,C14:1
Helsinger, Jim
Death and Life of Sherlock Holmes, The 1991,N 27,C17:1

Hemstead, Gillian
Misanthrope, The 1991,O 9,C18:3
Henders, Richard
As You Like It 1991,Jl 26,C18:4
Henderson, Gregory
Del Muenz at the Bishoff Gallery (In Plain View, Series B) 1992,Ag 15,12:3
Henderson, Luther (Composer)
Jelly's Last Jam 1992,Ap 27,C11:1
Jelly's Last Jam 1992,My 3,II:5:1
Henderson, Luther (Miscellaneous)
Jelly's Last Jam 1992,Ap 27,C11:1
Henderson, Stephen (Director)
Ali 1992,Ag 13,C17:1
Henderson-Holmes, Safiya (Playwright)
Testimony 1992,My 20,C18:1
Hendra, Jessica
Moonstone, The 1991,Ag 15,C16:4
Henning, Richard
Who Could That Be? (In Plain View, Series B) 1992,Ag 15,12:3
Hennum, Nels (Miscellaneous)
Destiny of Me, The 1992,O 21,C15:1
Henritze, Bette
On Borrowed Time 1991,O 10,C19:1
On Borrowed Time 1991,O 20,II:5:1
Henry, Francis
Leonce and Lena 1991,Mr 24,63:5
Woyzeck 1991,Mr 24,63:5
Henry, Ida
Crazy for You 1992,Mr 1,II:1:1
Henry, Markas (Scenic Designer)
Greetings 1991,D 11,C23:1
Hensley, Todd (Lighting Director)
Hauptmann 1992,My 29,C3:3
Henson, Cheryl (Miscellaneous)
End of the World, The 1992,S 11,C2:3
Sick But True 1992,S 12,15:1
Adding Machine, The 1992,S 16,C16:3
Underground 1992,S 16,C16:3
Hepner, Mireya (Miscellaneous)
Woyzeck 1992,D 7,C14:1
Herbold, Lisa
Bluebeard 1991,N 15,C3:1
Brother Truckers 1992,S 22,C13:3
Herbst, Jeffrey
Funny Thing Happened on the Way to the Forum, A 1991,Mr 28,C16:4
Herlihy, David
Lament for Arthur Cleary, The 1992,N 4,C22:1
Herman, Ian (Miscellaneous)
A . . . My Name Is Still Alice 1992,N 23,C14:4
Herman, Ian (Musical Director)
A . . . My Name Is Still Alice 1992,N 23,C14:4
Hernandez, Felipe
Rules of Civility and Decent Behavior in Company and Conversation 1991,Mr 25,C15:1
Hernandez, Nilda Reillo (Miscellaneous)
Esplendor, El 1991,Je 23,43:1
Heron, Nye (Director)
Down the Flats 1992,Ja 17,C5:1
Bobby Sands, M.P. 1992,Je 18,C15:1
Lament for Arthur Cleary, The 1992,N 4,C22:1
Heron, Nye (Miscellaneous)
Bobby Sands, M.P. 1992,Je 18,C15:1
Lament for Arthur Cleary, The 1992,N 4,C22:1
Herrera, Ariel
Law of Remains, The 1992,F 26,C19:1
Herrera, John
Book of the Night 1991,Jl 28,II:5:1
Herrera, Manuel (Miscellaneous)
Botanica 1991,Mr 5,C16:1
Mayor of Zalamea, The (Alcalde de Zalamea, El) 1991,Ap 14,52:1
Herrero, Chela
Esperando la Carroza (Waiting for the Hearse) 1991,S 18,C15:1
Herrero, Mercedes
Before It Hits Home 1991,F 17,II:5:1
Herring, Britton
When Lithuania Ruled the World, Part 3 1992,Ja 23,C14:4
Herring, Raquel
Betsey Brown 1991,Ap 13,14:5
Herrmann, Edward
Three Sisters 1992,Ja 19,II:5:1
Herrmann, Keith (Composer)
Prom Queens Unchained 1991,Jl 5,C3:2

Ivanek, Zeljko
Two Shakespearean Actors 1992,Ja 17,C1:1
Two Shakespearean Actors 1992,Ja 26,II:5:1
Ivanir, Mark
Rosencrantz and Guildenstern Are Dead 1992,Ja 31,C15:1
Ivanov, Aleksei
Moscow Circus—Cirk Valentin 1991,N 8,C3:1
Ives, David (Playwright)
Variations on the Death of Trotsky (Festival of One-Act Comedies, Evening A) 1991,F 12,C14:3
Foreplay, or, The Art of the Fugue (Festival of One-Act Comedies, Evening B) 1991,Mr 5,C16:3
Sure Thing (Five Very Live) 1992,Ja 8,C17:1
Ives, Nancy
Orpheus in Love 1992,D 16,C17:5
Ivey, Dana
Subject Was Roses, The 1991,Je 6,C13:2
Subject Was Roses, The 1991,Je 9,II:5:1
Beggars in the House of Plenty 1991,O 24,C17:4
Ivey, Judith
Park Your Car in Harvard Yard 1991,N 8,C1:4
Park Your Car in Harvard Yard 1991,N 17,II:5:1
Iwamatsu, Sala
Miss Saigon 1991,Ap 12,C1:2

J

Jablonski, Carl (Choreographer)
Ringling Brothers and Barnum & Bailey Circus 1991,Mr 24,63:1
Jackel, Paul
Secret Garden, The 1991,Ap 26,C1:1
Jackness, Andrew (Scenic Designer)
Road to Nirvana 1991,Mr 8,C1:1
A . . . My Name Is Still Alice 1992,N 23,C14:4
Jackson, Anne
Sparky and the Fitz 1991,Mr 10,59:1
Jackson, David (Composer)
One Neck 1992,My 22,C3:1
Jackson, David (Miscellaneous)
One Neck 1992,My 22,C3:1
Jackson, Dean
Rules of Civility and Decent Behavior in Company and Conversation 1991,Mr 25,C15:1
Jackson, Gary
It's a Bird, It's a Plane, It's Superman 1992,Je 20,16:4
Jackson, Kirk
Almond Seller, The 1991,Mr 2,15:1
Amerikamachine 1991,My 29,C14:3
Jackson, Leonard
Mule Bone 1991,F 15,C1:4
Jackson, Oliver, Jr.
Song of Singapore 1991,My 24,C26:2
Song of Singapore 1991,Je 2,II:7:1
Jackson, R. Wade (Miscellaneous)
Hello Muddah, Hello Fadduh 1992,D 9,C22:1
Jacob, Jere
Old Actress in the Role of Dostoyevsky's Wife, An 1992,S 19,14:1
Jacob, Lou (Director)
Last Laugh, The 1992,Jl 2,C16:1
Jacobs, Craig (Miscellaneous)
Falsettos 1992,Ap 30,C17:3
Jacobs, Jack (Lighting Director)
Women in Beckett 1991,N 22,C17:1
Jacobs, Jason
Hour of the Lynx 1992,Ap 1,C16:3
Jacobs, Max
Romeo and Juliet 1991,Ja 31,C21:1
Jacobs, Peter
Law of Remains, The 1992,F 26,C19:1
Jacobson, Peter
Comedy of Errors, The 1992,Ag 17,C11:3
Comedy of Errors, The 1992,Ag 23,II:5:1
Jacovskis, Adomas (Costume Designer)
Square, The 1991,Je 21,C3:5
Jacovskis, Adomas (Scenic Designer)
Square, The 1991,Je 21,C3:5
Jaffe, Bernard
Betrayal 1991,F 3,55:4
Jaffe, Jill (Composer)
Pericles, Prince of Tyre 1991,N 25,C13:1

Jaffe, Jill (Musical Director)
Casanova 1991,My 29,C11:5
Pericles, Prince of Tyre 1991,N 25,C13:1
Jaffe, Joan
Charge It, Please 1991,My 29,C14:3
Jaffe, Ruth
Underground 1991,Mr 3,64:1
Jaffrey, Saeed
White Chameleon 1991,Jl 31,C11:4
Jagla, Joanna
Metro 1992,Ap 17,C1:3
James, Bob (Composer)
Two Shakespearean Actors 1992,Ja 17,C1:1
James, Daniel
Modigliani 1991,My 1,C15:1
James, Jerry (Miscellaneous)
Forbidden Broadway 1991 1/2 1991,Je 21,C3:1
Forbidden Broadway/Forbidden Christmas 1991,D 13,C3:4
Best of Forbidden Broadway, The: 10th-Anniversary Edition 1992,Ap 9,C19:3
James, Lawrence
Let Me Live 1991,Ja 17,C21:1
Black Eagles 1991,Ap 22,C13:1
Tempest, A 1991,O 16,C18:3
James, Peter Francis
Learned Ladies, The (Femmes Savantes, Les) 1991,Mr 10,58:1
1991 Young Playwrights Festival, The 1991,O 3,C20:3
James, Toni-Leslie (Costume Designer)
Walking the Dead 1991,My 13,C12:1
Babylon Gardens 1991,O 9,C17:1
Jelly's Last Jam 1992,Ap 27,C11:1
James, Wheaton
49 Songs for a Jealous Vampire 1992,Jl 21,C11:2
Jampolis, Neil Peter (Scenic Designer)
It's a Bird, It's a Plane, It's Superman 1992,Je 20,16:4
Jamrog, Joseph
On Borrowed Time 1991,O 10,C19:1
Jando, Dominique (Miscellaneous)
Greetings from Coney Island 1991,N 1,C19:1
Jandova, Elena (Director)
Humanity (Menschen, Die) 1991,Je 5,C22:3
Janicka, Ewa
Dead Class, The 1991,Je 14,C15:1
Janicki, Leslaw
Dead Class, The 1991,Je 14,C15:1
Today Is My Birthday 1991,Je 20,C16:1
Janicki, Waclaw
Dead Class, The 1991,Je 14,C15:1
Today Is My Birthday 1991,Je 20,C16:1
Janikowski, Jaroslaw
Metro 1992,Ap 17,C1:3
Janney, Allison
Making Book 1992,F 12,C17:1
One Neck 1992,My 22,C3:1
Janowski, Robert
Metro 1992,Ap 17,C1:3
Metro 1992,Ap 26,II:5:1
Jarman, Joseph (Composer)
Fires in the Mirror: Crown Heights, Brooklyn and Other Identities 1992,My 15,C1:1
Jarrett, Bella
Trojan Women, The 1991,N 13,C21:1
Jarrett, Jack (Miscellaneous)
Cambodia Agonistes 1992,N 13,C3:1
Jaruseviciene, Birute-Ona (Miscellaneous)
Uncle Vanya 1991,Je 17,C11:3
Jasien, Deborah (Scenic Designer)
Sparky and the Fitz 1991,Mr 10,59:1
Jason, John
Visit, The 1992,Ja 24,C1:2
Jason, Robert
Let Me Live 1991,Ja 17,C21:1
Jatho, Jim (Miscellaneous)
Real Live Brady Bunch, The 1991,O 2,C18:3
Jatho, Jim (Scenic Designer)
Real Live Brady Bunch, The 1991,O 2,C18:3
Jay, Isla (Lighting Director)
Basement 1991,D 8,83:5
Jayce, Michael
Before It Hits Home 1991,F 17,II:5:1
Jeffery, Gayle (Miscellaneous)
Joy Solution 1991,D 16,C14:5
Jelavich, Peter (Miscellaneous)
Cabaret Verboten 1991,O 29,C16:1

Jellison, John
Assassins 1991,Ja 28,C19:3
Nick and Nora 1991,D 9,C11:3
Jemmott, Angel
Betsey Brown 1991,Ap 13,14:5
Jenkin, Len (Playwright)
Candide 1992,Ap 24,C4:5
Jenkins, Daniel
Adventures in the Skin Trade 1991,D 8,II:5:1
Jenkins, David (Scenic Designer)
Subject Was Roses, The 1991,Je 6,C13:2
Subject Was Roses, The 1991,Je 9,II:5:1
Approximating Mother 1991,N 7,C21:1
Crucible, The 1991,D 11,C17:1
Crucible, The 1991,D 22,II:5:1
Two Shakespearean Actors 1992,Ja 17,C1:1
Two Shakespearean Actors 1992,Ja 26,II:5:1
Little Hotel on the Side, A 1992,Ja 27,C17:1
Little Hotel on the Side, A 1992,F 9,II:5:1
Master Builder, The 1992,Mr 20,C3:1
Master Builder, The 1992,Mr 29,II:5:1
Holy Terror, The 1992,O 9,C3:1
Bubbe Meises, Bubbe Stories 1992,O 30,C15:1
Jenkins, Ian
Ice Capades: On Top of the World 1991,Ja 22,C16:4
Jenkins, Jackie
Pie Supper 1992,Jl 30,C20:1
Jenkins, Lillian
Walk on Lake Erie, A 1991,Mr 25,C15:1
Jenkins, Ron (Miscellaneous)
Underground 1991,Mr 3,64:1
Jenkins, Ron (Translator)
Eve's Diary 1991,Ap 24,C10:5
Story of the Tiger, The 1991,Ap 24,C10:5
Jenkins, Terrance (Playwright)
Taking Control (1992 Young Playwrights Festival, The) 1992,S 24,C18:4
Jenkins, Trish
Midsummer Night's Dream, A 1992,Ap 8,C21:1
Jenner, Cynthia (Miscellaneous)
Radiant City, The 1991,O 7,C15:4
Jennings, Byron
Pericles, Prince of Tyre 1991,N 25,C13:1
Pericles 1991,D 1,II:5:1
Jennings, Byron (Miscellaneous)
Goodnight Desdemona (Good Morning Juliet) 1992,O 22,C26:5
Jensen, David (Scenic Designer)
Body and Soul 1991,Jl 10,C18:3
Jensen, Don (Scenic Designer)
Sublime Lives 1991,S 16,C14:4
Jacques Brel Is Alive and Well and Living in Paris 1992,O 21,C16:3
Jesurun, John (Director)
Blue Heat 1991,Mr 3,64:5
Iron Lung 1992,Ja 22,C17:1
Jesurun, John (Playwright)
Blue Heat 1991,Mr 3,64:5
Iron Lung 1992,Ja 22,C17:1
Jesurun, John (Scenic Designer)
Blue Heat 1991,Mr 3,64:5
Iron Lung 1992,Ja 22,C17:1
Jiang, David (Miscellaneous)
Letters to a Student Revolutionary 1991,My 16,C18:1
Jillette, Penn
Penn and Teller: The Refrigerator Tour 1991,Ap 4,C15:5
Penn and Teller: The Refrigerator Tour 1991,Ap 7,II:5:1
Jillette, Penn (Playwright)
Penn and Teller: The Refrigerator Tour 1991,Ap 4,C15:5
Jimenez, Robert
Babylon Gardens 1991,O 9,C17:1
Raft of the Medusa 1991,D 23,C15:1
Jodorowsky, Brontis
Atrides, Les 1992,O 6,C11:3
Joffe, Charles (Producer)
Only the Truth Is Funny 1991,Ap 17,C15:1
Johanson, Don
Jelly's Last Jam 1992,Ap 27,C11:1
Johanson, Robert (Director)
To Kill a Mockingbird 1991,Mr 4,C13:4
Wizard of Oz, The 1992,O 11,II:5:1
Johanson, Robert (Miscellaneous)
To Kill a Mockingbird 1991,Mr 4,C13:4

Keating, Charles
Pygmalion 1991,Mr 25,C15:4
Keats, Steven
Raft of the Medusa 1991,D 23,C15:1
Raft of the Medusa 1992,Ja 5,II:1:1
Hotel Oubliette 1992,Ag 12,C14:1
Keefe, Anne (Miscellaneous)
Booth Is Back 1991,O 31,C18:1
Death and the Maiden 1992,Mr 18,C15:4
Keeler, William
Candide 1992,Ap 24,C4:5
Keene, Daniel (Director)
Estrella!: Who Can You Trust in a City of Lies?
1991,Ag 2,C24:4
Keene, Daniel (Playwright)
Estrella!: Who Can You Trust in a City of Lies?
1991,Ag 2,C24:4
Kehaiova, Dessi
Ringling Brothers and Barnum & Bailey Circus
1991,Ap 7,II:5:1
Kehaiova, Gery
Ringling Brothers and Barnum & Bailey Circus
1991,Ap 7,II:5:1
Keith, Larry
Rose Quartet, The 1991,D 18,C23:1
Keith, Ron
Sublime Lives 1991,S 16,C14:4
Keith, Thomas
Futz 1991,O 23,C19:1
Depression Show, The 1992,S 23,C16:3
Keith, Thomas (Choreographer)
Depression Show, The 1992,S 23,C16:3
Keith, Thomas (Lyricist)
Depression Show, The 1992,S 23,C16:3
Keith, Thomas (Playwright)
Depression Show, The 1992,S 23,C16:3
Kekhaial, Vladimir
Cirque du Soleil 1991,Ap 17,C15:1
Kellam, Jon
Wilder, Wilder, Wilder: Three by Thornton 1992,D
21,C13:1
Keller, Gary
High Rollers Social and Pleasure Club, The 1992,Ap
23,C15:2
Keller, Gregory (Director)
Ancient Boys 1991,F 24,59:5
Keller, Neel (Director)
Moonstone, The 1991,Ag 15,C16:4
Keller, Thomas L. (Costume Designer)
Rose Quartet, The 1991,D 18,C23:1
Kellett, David
Bitter Tears of Petra von Kant, The 1992,Je 18,C15:1
Kelley, Samuel (Playwright)
Pill Hill 1992,D 3,C18:5
Kellogg, Marjorie Bradley (Scenic Designer)
Master Builder, The 1991,Ja 20,II:5:1
Baby Dance, The 1991,Ap 1,C14:1
Lucifer's Child 1991,Ap 5,C1:1
Mesmerist, The 1991,Je 8,11:1
On Borrowed Time 1991,O 10,C19:1
On Borrowed Time 1991,O 20,II:5:1
Seagull, The 1992,N 30,C11:1
Kellogg, Peter (Lyricist)
Anna Karenina 1992,Ag 27,C17:2
Kellogg, Peter (Playwright)
Anna Karenina 1992,Ag 27,C17:2
Kellough, Jim (Lighting Director)
Moe Green Gets It in the Eye 1991,My 8,C12:3
Kellough, Joseph
Blue Heaven 1992,S 30,C16:3
Kelly, Bridget (Costume Designer)
Empty Hearts 1992,My 6,C18:3
Kelly, Chris
Grandchild of Kings 1992,F 17,C13:1
Kelly, Chris (Miscellaneous)
Joyicity 1992,S 11,C2:3
Kelly, Christina
On the Razzle 1992,Ag 28,C2:3
Kelly, David Patrick
Resistible Rise of Arturo Ui, The 1991,My 9,C15:1
Mind King, The 1992,Ja 11,9:1
Tartuffe 1992,O 16,C15:1
Kelly, Dona Lee (Choreographer)
Romeo and Juliet 1991,Ja 31,C21:1
Kelly, Donald (Miscellaneous)
Bobby Sands, M.P. 1992,Je 18,C15:1

Kelly, Erin
Who Could That Be? (In Plain View, Series B)
1992,Ag 15,12:3
Kelly, Frank (Lyricist)
Pageant 1991,My 8,C12:3
Kelly, Frank (Playwright)
Pageant 1991,My 8,C12:3
Pageant 1991,Je 23,II:5:1
Kelly, George (Playwright)
Show-Off, The 1992,N 6,C3:1
Show-Off, The 1992,N 15,II:5:1
Kelly, John
P.S. 122 Benefit 1991,F 9,13:1
Maybe It's Cold Outside 1991,F 19,C14:3
Akin 1992,F 25,C14:5
Kelly, John (Choreographer)
Maybe It's Cold Outside 1991,F 19,C14:3
Akin 1992,F 25,C14:5
Kelly, John (Director)
Maybe It's Cold Outside 1991,F 19,C14:3
Akin 1992,F 25,C14:5
Kelly, John (Playwright)
Maybe It's Cold Outside 1991,F 19,C14:3
Akin 1992,F 25,C14:5
Kelly, Kevin James
Time of Your Life, The 1991,O 2,C17:1
Time of Your Life, The 1991,O 6,II:5:1
Kelly, Kitty
Tom Scallen's Ice Capades 1992,Ja 22,C17:1
Kelly, Randy
Rivers and Ravines, The 1991,N 14,C28:6
Anima Mundi 1992,F 5,C19:3
This One Thing I Do 1992,Ap 19,45:5
Kelly, Reade
God's Country 1992,Je 3,C15:4
Kelly, Thomas A. (Miscellaneous)
Crucible, The 1991,D 11,C17:1
Kelso, Bridget
Lotto: Experience the Dream 1991,D 26,C13:1
Kemp, Shawana
Approximating Mother 1991,N 7,C21:1
Kendall, Atli W.
Wedding Portrait, The 1992,Mr 25,C19:3
Kendall, Corinne Julie
Galileo 1991,D 11,C23:1
Kendrick, D. Polly (Costume Designer)
Roads to Home, The 1992,S 18,C2:3
Kendrick, Richard A. (Lighting Director)
Tartuffe 1991,S 16,C14:4
Kendrick, Richard A. (Miscellaneous)
Farewell Supper, The 1991,Mr 13,C12:4
Countess Mitzi 1991,Mr 13,C12:4
Ghosts 1992,F 19,C16:3
Keneally, Thomas (Original Author)
Our Country's Good 1991,Ap 30,C13:4
Kenin, Rohana (Producer)
Women in Beckett 1991,N 22,C17:1
Kennard, Michael
Caged 1991,My 31,C3:1
Kennard, Michael (Miscellaneous)
Caged 1991,My 31,C3:1
Kennard, Michael (Playwright)
Caged 1991,My 31,C3:1
Kennedy, Allen (Miscellaneous)
Creditors 1992,F 7,C3:1
Kennedy, Beau (Miscellaneous)
Mermaid Wakes, The 1991,F 25,C14:3
Kennedy, Beau (Scenic Designer)
Mermaid Wakes, The 1991,F 25,C14:3
Kennedy, Craig (Lighting Director)
We Should . . . (A Lie) 1992,Ja 29,C17:1
Kennedy, Dev
Hauptmann 1992,My 29,C3:3
Kennedy, Laurie
Candida 1991,F 25,C13:1
2 1992,Ag 12,C14:1
Kennelly, John (Miscellaneous)
Six Wives 1992,O 10,16:1
Noel and Gertie 1992,D 14,C14:1
Kennon, William (Scenic Designer)
Dead Mother: or Shirley Not All in Vain 1991,F
1,C3:1
Way of the World, The 1991,My 22,C11:1
Home Show Pieces, The 1992,Ja 29,C17:1
Kenny, Sue
More Fun Than Bowling 1992,Ap 19,45:2

Kensei, Ken
When Lithuania Ruled the World, Part 3 1992,Ja
23,C14:4
Kent, Steven (Playwright)
Texts for Nothing 1992,N 2,C13:1
Kenton, Lance (Costume Designer)
Ascension Day 1992,Mr 4,C19:1
Kenwright, Bill (Producer)
Dancing at Lughnasa 1991,O 25,C1:4
Keogh, Doreen
Shadow of a Gunman, The 1991,N 27,C17:1
Keogh, Garrett
Hedda Gabler 1991,Ag 20,C11:1
Kerbeck, Robert
How Do You Like Your Meat? (Evening of Short
Plays by Joyce Carol Oates, An) 1991,Ap 27,14:5
Friday Night (Evening of Short Plays by Joyce Carol
Oates, An) 1991,Ap 27,14:5
Family Portrait 1992,Ap 22,C17:3
Kerner, Norberto
Oxcart, The (Carreta, La) 1992,Ap 22,C17:3
Kernz, Bruno (Translator)
Nowhere 1992,Je 3,C15:4
Kerr, Patrick
Romeo and Juliet 1991,Ja 31,C21:1
Midsummer Night's Dream, A 1992,Ap 8,C21:1
Kerr, Philip
End of the Day, The 1992,Ap 8,C17:3
Kerr, Tony (Miscellaneous)
Guise, The 1991,N 20,C23:1
Keskin, Erol
Yunus 1992,O 28,C18:1
Keskin, Erol (Translator)
Yunus 1992,O 28,C18:1
Kessler, Hal (Corky) (Producer)
Hauptmann 1992,My 29,C3:3
Ketchie, Diane
Orpheus in Love 1992,D 16,C17:5
Khaja, Jameel (Director)
Really Bizarre Rituals (Momentary Lapses) 1991,My
29,C14:3
Khalsa, Sardar Singh
Law of Remains, The 1992,F 26,C19:1
Khan, Ricardo (Director)
Black Eagles 1991,Ap 22,C13:1
Khan, Ricardo (Miscellaneous)
Black Eagles 1991,Ap 22,C13:1
Khoo, Aurorae (Playwright)
P.C. Laundromat, The (1992 Young Playwrights
Festival, The) 1992,S 24,C18:4
Kiah, Frederick, Jr.
Lotto: Experience the Dream 1991,D 26,C13:1
Kielar, Paul
Underground 1991,Mr 3,64:1
Wedding Portrait, The 1992,Mr 25,C19:3
Kieltyka, Connie (Miscellaneous)
Full-Moon Killer 1991,Ja 13,43:5
Kikis, Christopher G. (Miscellaneous)
Hippolytos 1992,N 25,C19:1
Kilgarriff, Patricia
Bete, La 1991,F 11,C11:3
Small Family Business, A 1992,Ap 28,C13:3
Tartuffe 1992,O 16,C15:1
Kilgore, John (Composer)
Life During Wartime 1991,Mr 6,C13:1
Kilgore, John (Miscellaneous)
Life During Wartime 1991,Mr 6,C13:1
Stick Wife, The 1991,My 10,C4:3
Piece of My Heart, A 1991,N 4,C15:1
Candide 1992,Ap 24,C4:5
Goodnight Desdemona (Good Morning Juliet)
1992,O 22,C26:5
Joined at the Head 1992,N 16,C16:1
Killy, Peter
Wilder, Wilder, Wilder: Three by Thornton 1992,D
21,C13:1
Killy, Rebecca
Wilder, Wilder, Wilder: Three by Thornton 1992,D
21,C13:1
Kilmer, Val
'Tis Pity She's a Whore 1992,Ap 6,C11:2
'Tis Pity She's a Whore 1992,Ap 12,II:5:1
Kilroy, Thomas (Playwright)
Madame MacAdam Traveling Theater, The 1992,O
21,C16:3
Kim, Daniel Dae
Romeo and Juliet 1991,Ja 31,C21:1

Korey, Alix
I Can Get It for You Wholesale 1991,Mr 11,C14:3
Best of Forbidden Broadway, The: 10th-Anniversary Edition 1992,Ap 9,C19:3
Camp Paradox 1992,N 9,C14:1
Korf, Gene R. (Producer)
And the World Goes 'Round: The Songs of Kander and Ebb 1991,Mr 19,C11:2
Korf, Geoff (Lighting Director)
Two Trains Running 1992,Ap 14,C13:4
Kormanos, George
Iphigenia in Tauris 1992,My 13,C14:3
Kornbluth, Josh
Red Diaper Baby 1992,Ap 5,53:5
Red Diaper Baby 1992,Jl 12,II:5:1
Kornbluth, Josh (Playwright)
Red Diaper Baby 1992,Ap 5,53:5
Red Diaper Baby 1992,Jl 12,II:5:1
Kosarin, Michael (Musical Director)
Secret Garden, The 1991,Ap 26,C1:1
Noel and Gertie 1992,D 14,C14:1
Kosis, Tom
Big Noise of '92: Diversions from the New Depression 1991,D 18,C25:1
Koskey, Monica
Another Person Is a Foreign Country 1991,S 10,C11:1
Iphigenia in Tauris 1992,My 13,C14:3
Koslow, Pamela (Producer)
Jelly's Last Jam 1992,Ap 27,C11:1
Kotelnikova, Larisa (Miscellaneous)
Moscow Circus—Cirk Valentin 1991,N 8,C3:1
Kotin, Vladimir
Skating II 1991,Mr 4,C12:3
Kotite, Toni (Director)
Eating Raoul 1992,My 16,14:3
Kotlowitz, Dan (Lighting Director)
Reno Once Removed 1991,D 30,C14:1
My Mathematics 1992,Ag 1,18:4
Mysteries and What's So Funny?, The 1992,D 18,C3:1
Kotoske, Tamar
Bitter Tears of Petra von Kant, The 1992,Je 18,C15:1
Women in Black/Men in Gray 1992,O 28,C18:1
Koturbash, Allison (Costume Designer)
Cross-Dressing in the Depression 1992,N 23,C15:3
Kourilsky, Francoise (Director)
Nowhere 1992,Je 3,C15:4
Kourilsky, Francoise (Miscellaneous)
Grand Finale 1991,Ap 21,60:1
Tempest, A 1991,O 16,C18:3
Best of Schools, The 1992,Mr 11,C15:1
White Bear, The 1992,Ap 1,C16:3
Nowhere 1992,Je 3,C15:4
Koutoukas, H. M.
Bluebeard 1991,N 15,C3:1
Koutoukas, H. M. (Playwright)
When Lightning Strikes Twice 1991,Ja 25,C6:3
Kouyate, Anna (Miscellaneous)
Bay of Naples, The (Baie de Naples) 1991,Je 12,C14:3
Kovitz, Randy (Miscellaneous)
Angels in America 1992,N 10,C15:3
Kovvantis, Philip (Composer)
Hippolytos 1992,N 25,C19:1
Kowalczyk, Grzegorz
Metro 1992,Ap 17,C1:3
Kozeluh, John
After the Dancing in Jericho 1992,F 12,C17:1
Kozlowski, Matt
Momentary Lapses 1991,My 29,C14:3
Kraar, Adam (Playwright)
Our Lady of Perpetual Danger 1991,O 16,C18:3
Krakower, Bob (Playwright)
Mixed Emotions (Momentary Lapses) 1991,My 29,C14:3
Kramer, David (Lighting Director)
Twelfth Night or What You Will 1991,Je 19,C12:3
Tempest, The 1992,Jl 22,C17:1
Kramer, Larry (Playwright)
Destiny of Me, The 1992,O 21,C15:1
Destiny of Me, The 1992,O 25,II:5:1
Kramer, Nancy (Miscellaneous)
Greetings 1991,D 11,C23:1
God's Country 1992,Je 3,C15:4
Kramer, Rob
How Do You Like Your Meat? (Evening of Short Plays by Joyce Carol Oates, An) 1991,Ap 27,14:5

Friday Night (Evening of Short Plays by Joyce Carol Oates, An) 1991,Ap 27,14:5
Matchmaker, The 1991,Ag 28,C12:4
Kramer, Sherry (Playwright)
World at Absolute Zero, The (Marathon 1991: New One-Act Plays, Series C) 1991,Je 19,C12:3
Kramer, Terry Allen (Producer)
Nick and Nora 1991,D 9,C11:3
Krane, David (Miscellaneous)
And the World Goes 'Round: The Songs of Kander and Ebb 1991,Mr 19,C11:2
Krantz, Peter
10 Minute Alibi 1992,Jl 26,II:5:1
Krasicaka, Maria
Dead Class, The 1991,Je 14,C15:1
Krasker, Tommy (Miscellaneous)
Crazy for You 1992,F 20,C15:3
Krass, Michael (Costume Designer)
Light Shining in Buckinghamshire 1991,F 17,71:1
Subject Was Roses, The 1991,Je 6,C13:2
White Rose, The 1991,O 30,C15:1
Weird Romance 1992,Je 23,C14:5
Kraus, Harry A. (Miscellaneous)
Jacques Brel Is Alive and Well and Living in Paris 1992,O 21,C16:3
Krauss, Marvin (Miscellaneous)
Moscow Circus—Cirk Valentin 1991,N 8,C3:1
Krausz, Diane F. (Producer)
Hello Muddah, Hello Fadduh 1992,D 9,C22:1
Krausz, Rob (Miscellaneous)
Hello Muddah, Hello Fadduh 1992,D 9,C22:1
Krausz, Rob (Playwright)
Hello Muddah, Hello Fadduh 1992,D 9,C22:1
Kravets, Laura (Miscellaneous)
3 from Brooklyn 1992,N 20,C3:1
Krebs, Emmanuelle (Miscellaneous)
Fires in the Mirror: Crown Heights, Brooklyn and Other Identities 1992,My 15,C1:1
Krebs, Eric (Producer)
Lyndon 1991,Ja 19,19:4
Rendezvous with God, A 1991,Jl 25,C14:5
Finkel's Follies 1991,D 18,C25:1
Kreinen, Rebecca (Director)
Wedding Portrait, The 1992,Mr 25,C19:3
Krenz, Frank (Costume Designer)
Song of Singapore 1991,My 24,C26:2
Visit, The 1992,Ja 24,C1:2
Visit, The 1992,F 2,II:5:1
Kreppel, Paul
Hello Muddah, Hello Fadduh 1992,D 9,C22:1
Kreshka, Ruth (Miscellaneous)
Night Sky 1991,My 23,C24:5
Kressyn, Miriam (Miscellaneous)
At the Crossroads 1992,N 11,C18:3
Krestan, Jeri
Pinokio 1992,S 12,15:1
Krieger, Barbara Zinn (Miscellaneous)
Food and Shelter 1991,Je 2,65:1
Don Juan and the Non Don Juan, The 1991,D 23,C16:1
Lady Bracknell's Confinement 1992,F 19,C16:3
Party, The 1992,F 19,C16:3
One of the All-Time Greats 1992,Ap 17,C3:1
Kriessler, Tiffany
To Kill a Mockingbird 1991,Mr 4,C13:4
Krimov, D. (Scenic Designer)
Rosencrantz and Guildenstern Are Dead 1992,Ja 31,C15:1
Kristen, Ilene
Marathon 1991: New One-Act Plays, Series A 1991,My 26,57:5
Dolphin Position, The 1992,O 9,C3:1
Kriz, Zdenek (Lighting Director)
Blues in Rags 1991,Ap 10,C15:1
Eagle in the Bubble 1991,Jl 16,C15:1
Power Pipes 1992,O 24,18:1
Krochmal, Walter (Translator)
Charge It, Please 1991,My 29,C14:3
Kroeze, Jan (Lighting Director)
Greetings from Coney Island 1991,N 1,C19:1
Big Apple Circus 1992,N 5,C19:1
Dog Logic 1992,N 10,C22:1
Krofta, Josef (Director)
Pinokio 1992,S 12,15:1
Krofta, Josef (Playwright)
Pinokio 1992,S 12,15:1

Kronin, Michelle
Unidentified Human Remains and the True Nature of Love 1991,S 20,C26:4
Kruger, Norman
At the Crossroads 1992,N 11,C18:3
Kruger, Simcha (Translator)
Marriage Contract, The 1991,N 6,C21:1
At the Crossroads 1992,N 11,C18:3
Krumholtz, David
Conversations with My Father 1992,Mr 30,C11:3
Krumme, Peter (Miscellaneous)
Dr. Faustus Lights the Lights 1992,Jl 9,C15:3
Krupa, Olek
Bright Room Called Day, A 1991,Ja 8,C11:1
Bright Room Called Day, A 1991,Ja 13,II:5:1
Resistible Rise of Arturo Ui, The 1991,My 9,C15:1
Krupp, Jon
Program for Murder 1992,N 25,C19:1
Kruskal, Jody
Winter Man 1991,F 21,C20:1
Ksiazek, Jan
Dead Class, The 1991,Je 14,C15:1
Kubala, Joe (Miscellaneous)
Criminals in Love 1992,O 7,C16:3
Kubiak, Wiktor (Producer)
Metro 1992,Ap 17,C1:3
Kubicki, Andrzej
Metro 1992,Ap 17,C1:3
Kubota, Glen
Ripples in the Pond (Marathon '92, Series B) 1992,My 19,C18:3
Kuhn, Hans Peter (Composer)
Dr. Faustus Lights the Lights 1992,Jl 9,C15:3
Kuhn, Hans Peter (Miscellaneous)
When We Dead Awaken 1991,F 16,17:1
Kuhn, Judy
Glass Menagerie, The 1991,Ja 21,C11:1
Glass Menagerie, The 1991,Ja 27,II:5:1
Two Shakespearean Actors 1992,Ja 17,C1:1
Kulle, Gerthi
Miss Julie 1991,Je 12,C13:1
Miss Julie 1991,Je 23,II:5:1
Kulle, Jarl
Long Day's Journey into Night 1991,Je 17,C11:3
Kume, Makiko (Lighting Director)
Dionysus 1991,Je 23,43:1
Kung, Azan (Costume Designer)
Underground 1991,Mr 3,64:1
Kupferman, Judy (Lighting Director)
Hamlet 1992,Ja 24,C3:1
Kuroda, Kati
Midsummer Night's Dream, A 1992,Ap 8,C21:1
Comedy of Errors, The 1992,Ag 17,C11:3
Kuroda, Kati (Director)
Dressing Room, The (Gakuya) 1991,N 6,C21:1
Kurowski, Ron
Prom Queens Unchained 1991,Jl 5,C3:2
Kurshals, Raymond (Miscellaneous)
Radiant City, The 1991,O 7,C15:4
Kurtz, Marcia Jean (Director)
My Side of the Story (Marathon '92, Series B) 1992,My 19,C18:3
Kurtz, Normand (Producer)
Solitary Confinement 1992,N 9,C11:1
Kurtz, Swoosie
Lips Together, Teeth Apart 1991,Je 26,C11:1
Lips Together, Teeth Apart 1991,Jl 14,II:5:1
Kuschner, Jason (Miscellaneous)
Resistible Rise of Arturo Ui, The 1991,My 9,C15:1
Kushner, Tony (Playwright)
Bright Room Called Day, A 1991,Ja 8,C11:1
Bright Room Called Day, A 1991,Ja 13,II:5:1
Angels in America, Part I: Millennium Approaches 1992,Mr 5,C15:5
Angels in America 1992,N 10,C15:3
Kux, Bill
Mysteries and What's So Funny?, The 1992,D 18,C3:1
Kuznetsov, Sergei
Moscow Circus—Cirk Valentin 1991,N 8,C3:1
Kylis, Lou (Miscellaneous)
On the Razzle 1992,Ag 28,C2:3

Leijtens, Ad (Scenic Designer)
Manipulator 1992,S 12,15:1
Underdog 1992,S 12,15:1
Leishman, Gina (Composer)
Learned Ladies, The (Femmes Savantes, Les)
1991,Mr 10,58:1
Leite, Jose Wilson (Miscellaneous)
Sonho de Uma Noite de Verao (Midsummer Night's
Dream, A) 1991,Ag 2,C3:1
Lemac, Linda (Miscellaneous)
Easter Show 1991,Mr 25,C18:4
Lemay, Claude (Miscellaneous)
Needles and Opium 1992,D 10,C16:4
Lemenager, Nancy
Guys and Dolls 1992,Ap 15,C15:3
Lemetre, Jean-Jacques
Atrides, Les 1992,O 6,C11:3
Lemetre, Jean-Jacques (Composer)
Atrides, Les 1992,O 6,C11:3
Lemieux, Dominique (Costume Designer)
Cirque du Soleil 1991,Ap 17,C15:1
Lemieux, Robert (Miscellaneous)
Finkel's Follies 1991,D 18,C25:1
Lemme, Christine (Miscellaneous)
God's Country 1992,Je 3,C15:4
Lenartz, John
Under Milk Wood 1992,S 4,C2:3
Idiot, The 1992,D 21,C13:1
Lengson, Jose (Costume Designer)
Easter Show 1991,Mr 25,C18:4
Radio City Easter Show, The 1992,Ap 15,C19:1
Lenny, Jim (Producer)
Ruthless! 1992,My 13,C14:3
Lenny, Kim Lang (Producer)
Ruthless! 1992,My 13,C14:3
LeNoire, Rosetta (Miscellaneous)
Juba 1991,F 24,60:1
Gunmetal Blues 1992,Ap 8,C21:1
Lento, Anita
Roleplay 1992,Ag 8,16:4
Lenzcewski, Amy (Costume Designer)
Our Lady of Perpetual Danger 1991,O 16,C18:3
Leo, Jamie (Miscellaneous)
Brother Truckers 1992,S 22,C13:3
Leo, Melissa
White Rose, The 1991,O 30,C15:1
Leonard, Robert Sean
Speed of Darkness, The 1991,Mr 1,C1:1
Speed of Darkness, The 1991,Mr 10,II:5:1
Leone, Vivien (Lighting Director)
Red Scare on Sunset 1991,Ap 24,C10:5
Julie Halston's Lifetime of Comedy 1992,F 5,C19:3
Anna, the Gypsy Swede 1992,Je 11,C16:3
Leone, Vivien (Scenic Designer)
Anna, the Gypsy Swede 1992,Je 11,C16:3
Leong, David (Miscellaneous)
Let Me Live 1991,Ja 17,C21:1
Romeo and Juliet 1991,Ja 31,C21:1
Henry IV, Parts 1 and 2 1991,F 28,C15:1
Mad Forest 1991,D 5,C15:3
Mad Forest 1991,D 22,II:5:1
Ascension Day 1992,Mr 4,C19:1
Hamlet 1992,Ap 3,C3:1
'Tis Pity She's a Whore 1992,Ap 6,C11:2
Comedy of Errors, The 1992,Ag 17,C11:3
Solitary Confinement 1992,N 9,C11:1
Woyzeck 1992,D 7,C14:1
Lepage, Anne
Cirque du Soleil 1991,Ap 17,C15:1
Lepage, Robert
Needles and Opium 1992,D 10,C16:4
Lepage, Robert (Director)
Needles and Opium 1992,D 10,C16:4
Lepage, Robert (Playwright)
Needles and Opium 1992,D 10,C16:4
Lepage, Robert (Scenic Designer)
Needles and Opium 1992,D 10,C16:4
Lepiarz, John
Greetings from Coney Island 1991,N 1,C19:1
Big Apple Circus 1992,N 5,C19:1
Lepor, Pauline
Angels in America 1992,N 10,C15:3
Lerch, Stuart
Farewell Supper, The 1991,Mr 13,C12:4
Countess Mitzi 1991,Mr 13,C12:4
Trojan Women, The 1991,N 13,C21:1
As You Like It 1992,Ja 1,23:1

Lerer, Shifra
Sunset Gang, The 1992,My 16,14:3
Lerner, Alan Jay (Lyricist)
Paint Your Wagon 1992,Ag 7,C2:3
Paint Your Wagon 1992,Ag 16,II:5:1
Lerner, Alan Jay (Playwright)
Paint Your Wagon 1992,Ag 7,C2:3
Paint Your Wagon 1992,Ag 16,II:5:1
Leroy, A. (Miscellaneous)
News Update 1992,My 13,C14:3
Leskov, Nikolai (Original Author)
Question of Faith, A (Love in Two Countries)
1991,Ap 10,C15:1
Leslee, Ray (Composer)
New Living Newspaper 1992,Mr 4,C19:1
Leslee, Ray (Lyricist)
New Living Newspaper 1992,Mr 4,C19:1
Lesser, Sally J. (Costume Designer)
Return to the Forbidden Planet 1991,O 14,C13:1
Dream of a Common Language 1992,My 26,C12:5
Any Place But Here 1992,Je 9,C13:1
Lester, Adrian
As You Like It 1991,Jl 26,C18:4
Lester, Paul (Choreographer)
Flaubert's Latest 1992,Je 22,C15:3
Letchworth, Eileen
Matchmaker, The 1991,Ag 28,C12:4
Levenson, Jeanine (Miscellaneous)
Secret Garden, The 1991,Ap 26,C1:1
Levenson, Keith (Miscellaneous)
It's a Bird, It's a Plane, It's Superman 1992,Je
20,16:4
Paint Your Wagon 1992,Ag 7,C2:3
Leverett, Sheryl Greene
Life During Wartime 1992,Ag 11,C11:1
Leverett, T. Doyle
Most Happy Fella, The 1992,F 14,C1:4
Levesque, Pascal (Miscellaneous)
Bay of Naples, The (Baie de Naples) 1991,Je
12,C14:3
Levin, Kathy (Producer)
Park Your Car in Harvard Yard 1991,N 8,C1:4
Levin, Michael
Ghosts 1992,F 19,C16:3
Levine, Bunny
My Son the Doctor 1991,Ag 10,12:6
Levine, Daniel (Composer)
Anna Karenina 1992,Ag 27,C17:2
Levine, Ilana
Shmulnik's Waltz 1991,N 6,C21:1
Levine, Richard
I Can Get It for You Wholesale 1991,Mr 11,C14:3
Visit, The 1992,Ja 24,C1:2
Levine, Roberta
When Lithuania Ruled the World, Part 3 1992,Ja
23,C14:4
Levine, Susan
Prom Queens Unchained 1991,Jl 5,C3:2
Levitt, Barry (Miscellaneous)
Marriage Contract, The 1991,N 6,C21:1
Levitt, Barry (Musical Director)
Catskills on Broadway 1991,D 6,C28:4
Levitt, Sandy
Marriage Contract, The 1991,N 6,C21:1
Levy, Dan (Composer)
Cinderella 1991,D 23,C16:4
Levy, Dan (Lyricist)
Cinderella 1991,D 23,C16:4
Levy, Dan (Miscellaneous)
Cinderella 1991,D 23,C16:4
Levy, Louis
Bernie's Bar Mitzvah 1992,Mr 18,C17:1
Levy, Robert (Playwright)
Mrs. Neuberger's Dead 1992,S 24,C18:4
Levy, Simon (Director)
Unfinished Song, An 1991,F 19,C14:5
Levy, Steven M. (Miscellaneous)
God of Vengeance 1992,N 4,C22:1
Levy, Ted L.
Betsey Brown 1991,Ap 13,14:5
Jelly's Last Jam 1992,Ap 27,C11:1
Levy, Ted L. (Choreographer)
Jelly's Last Jam 1992,Ap 27,C11:1
Lewandowska, Katarzyna
Metro 1992,Ap 17,C1:3
Lewis, Bobo
Babylon Gardens 1991,O 9,C17:1
Babylon Gardens 1991,O 13,II:5:1

Pericles, Prince of Tyre 1991,N 25,C13:1
Pericles 1991,D 1,II:5:1
Lewis, Bram (Director)
Twelfth Night 1992,Ag 15,12:3
Lewis, Bram (Miscellaneous)
Twelfth Night 1992,Ag 15,12:3
Lewis, Edwina
Mule Bone 1991,F 15,C1:4
Streetcar Named Desire, A 1992,Ap 13,C11:3
Lewis, Ira (Playwright)
Chinese Coffee 1992,Je 26,C3:1
Chinese Coffee 1992,Jl 5,II:5:1
Lewis, Jim (Miscellaneous)
Comedy of Errors, The 1992,Ag 17,C11:3
Lewis, Lisa Jean (Miscellaneous)
Anima Mundi 1992,F 5,C19:3
This One Thing I Do 1992,Ap 19,45:5
Roleplay 1992,Ag 8,16:4
Lewis, Mark Kevin
Salome 1992,Je 26,C3:1
Lewis, Matthew
Group, A Therapeutic Moment (Manhattan Class
One-Acts) 1992,Mr 11,C15:1
Lewis, Vicki
I Can Get It for You Wholesale 1991,Mr 11,C14:3
I Can Get It for You Wholesale 1991,Mr 24,II:5:1
Book of the Night 1991,Jl 28,II:5:1
Don Juan and the Non Don Juan, The 1991,D
23,C16:1
Lewis-Evans, Kecia
Betsey Brown 1991,Ap 13,14:5
Lewitin, Margot (Miscellaneous)
Estrella!: Who Can You Trust in a City of Lies?
1991,Ag 2,C24:4
Lewittes, Deborah (Director)
Richard Foreman Trilogy, The 1992,My 27,C15:1
Lewittes, Deborah (Scenic Designer)
Richard Foreman Trilogy, The 1992,My 27,C15:1
Leydenfrost, Alex
Tartuffe 1991,S 16,C14:4
Trojan Women, The 1991,N 13,C21:1
As You Like It 1992,Ja 1,23:1
Leynse, Andrew (Miscellaneous)
Dolphin Position, The 1992,O 9,C3:1
Liadakis, Dot (Costume Designer)
Bernie's Bar Mitzvah 1992,Mr 18,C17:1
Liberatore, Lou
One of the All-Time Greats 1992,Ap 17,C3:1
Danton's Death 1992,N 3,C13:1
Libertini, Richard
As You Like It 1992,Jl 10,C3:1
As You Like It 1992,Jl 19,II:5:1
Libin, Paul (Miscellaneous)
Taking Steps 1991,F 21,C13:1
Getting Married 1991,Je 27,C14:3
On Borrowed Time 1991,O 10,C19:1
Search and Destroy 1992,F 27,C18:5
Salome 1992,Je 26,C3:1
Chinese Coffee 1992,Je 26,C3:1
Anna Karenina 1992,Ag 27,C17:2
Lichtefeld, Michael (Choreographer)
Secret Garden, The 1991,Ap 26,C1:1
Lichtenstein, Harvey (Miscellaneous)
Miss Julie 1991,Je 12,C13:1
Long Day's Journey into Night 1991,Je 17,C11:3
Doll's House, A 1991,Je 20,C13:3
Maturando 1991,O 17,C19:1
1991 (A Performance Chronicle of the Rediscovery
of America by the Warrior for Gringostroika)
1991,O 18,C14:5
Hamlet 1992,Ja 24,C3:1
Atrides, Les 1992,O 6,C11:3
Power Pipes 1992,O 24,18:1
Needles and Opium 1992,D 10,C16:4
Lida, Marc (Miscellaneous)
Charge It, Please 1991,My 29,C14:3
Lidstone, Gerry (Scenic Designer)
Tragedy of Macbeth, The 1991,Je 18,C13:4
Lieb, Dick (Miscellaneous)
Easter Show 1991,Mr 25,C18:4
Lieberman, Donna (Miscellaneous)
Red Scare on Sunset 1991,Ap 24,C10:5
White Rose, The 1991,O 30,C15:1
Bella, Belle of Byelorussia 1992,Ja 20,C18:1
Peacetime 1992,Mr 12,C21:1
Weird Romance 1992,Je 23,C14:5
Camp Paradox 1992,N 9,C14:1

Lopez, Alejandra (Director)
Who Could That Be? (In Plain View, Series B)
1992,Ag 15,12:3
Lopez, Carlos
Guys and Dolls 1992,Ap 15,C15:3
Lopez, Daniel
Tempestad, La (Tempest, The) 1991,Ag 30,C3:3
Lopez, William (Miscellaneous)
Tempestad, La (Tempest, The) 1991,Ag 30,C3:3
Lopez-Castillo, Miguel (Costume Designer)
Like to Live 1992,My 6,C18:3
Tissue 1992,My 6,C18:3
Macbeth 1992,My 20,C18:1
Lopez-Castillo, Miguel (Scenic Designer)
Like to Live 1992,My 6,C18:3
Tissue 1992,My 6,C18:3
Macbeth 1992,My 20,C18:1
Wilder, Wilder, Wilder: Three by Thornton 1992,D
21,C13:1
Lopez Martinez, Eduardo
Esplendor, El 1991,Je 23,43:1
Loquasto, Santo (Scenic Designer)
Lost in Yonkers 1991,F 22,C1:4
Lost in Yonkers 1991,Mr 3,II:1:1
Beggars in the House of Plenty 1991,O 24,C17:4
Jake's Women 1992,Mr 25,C17:3
Jake's Women 1992,Ap 5,II:5:1
Loquasto, Santo (Costume Designer)
Lost in Yonkers 1991,F 22,C1:4
Jake's Women 1992,Mr 25,C17:3
Lor, Denise
Ruthless! 1992,My 13,C14:3
Ruthless! 1992,My 17,II:5:1
Lord, Charmaine
Wilder, Wilder, Wilder: Three by Thornton 1992,D
21,C13:1
Loren, Jacie
Romeo and Juliet 1991,Ja 31,C21:1
Loren, Linda (Miscellaneous)
Under Control 1992,O 22,C25:4
Lorenzen, Mark (Miscellaneous)
Food and Shelter 1991,Je 2,65:1
Lortel, Lucille (Miscellaneous)
Advice from a Caterpillar 1991,Ap 10,C15:1
Lortel, Lucille (Producer)
Baby Dance, The 1991,O 18,C5:1
Lortev, Marlene
Rules of Civility and Decent Behavior in Company
and Conversation 1991,Mr 25,C15:1
Loskutov, Sergei, Sr.
Moscow Circus—Cirk Valentin 1991,N 8,C3:1
Loskutov, Serogya, Jr.
Moscow Circus—Cirk Valentin 1991,N 8,C3:1
Lotito, Mark
Most Happy Fella, The 1991,My 30,C13:1
Most Happy Fella, The 1991,Je 2,II:7:1
Most Happy Fella, The 1992,F 14,C1:4
Most Happy Fella, The 1992,F 16,II:5:1
Lott, David (Miscellaneous)
Ready for the River 1991,O 16,C18:3
Loud, David (Miscellaneous)
Crucible, The 1991,D 11,C17:1
Loud, David (Musical Director)
And the World Goes 'Round: The Songs of Kander
and Ebb 1991,Mr 19,C11:2
Over Texas (Marathon 1991: New One-Act Plays,
Series B) 1991,Je 9,60:5
Louden, David
Raft of the Medusa 1991,D 23,C15:1
Louden, Michael
White Rose, The 1991,O 30,C15:1
Group, A Therapeutic Moment (Manhattan Class
One-Acts) 1992,Mr 11,C15:1
Loudon, Dorothy
Matchmaker, The 1991,Ag 28,C12:4
Louizos, Anna (Scenic Designer)
Under Control 1992,O 22,C25:4
Love, Billy (Miscellaneous)
Fata Morgana 1991,My 3,C20:4
Love, Pee Wee
Mule Bone 1991,F 15,C1:4
Love, Wil
Heliotrope Bouquet by Scott Joplin and Louis
Chauvin, The 1991,Mr 17,II:5:1
Loveheart, C. C.
Mystery of Anna O, The 1992,S 23,C16:3
Loveless, David (Costume Designer)
Shmulnik's Waltz 1991,N 6,C21:1

Lowe, Donald
Festival of One-Act Comedies, Evening B 1991,Mr
5,C16:3
Lowe, Frank
As You Like It 1992,Ja 1,23:1
Moon for the Misbegotten, A 1992,S 23,C16:3
Lowe, Rob
Little Hotel on the Side, A 1992,Ja 27,C17:1
Little Hotel on the Side, A 1992,F 9,II:5:1
Lowery, Kristan
Tom Scallen's Ice Capades 1992,Ja 22,C17:1
Lowery, Marcella
Before It Hits Home 1992,Mr 11,C17:2
Lowey, Marilyn (Lighting Director)
Walt Disney's World on Ice: Mickey Mouse
Diamond Jubilee 1991,F 5,C18:1
Disney's World on Ice Starring Peter Pan 1992,F
12,C17:1
Lowinger, Rosa (Playwright)
Encanto File, The (Encanto File, The, and Other
Short Plays) 1991,Ap 2,C14:5
Lozano, Florencia
Candida Erendira, La 1992,F 9,65:1
Lozano, Rosario (Costume Designer)
Candida Erendira, La 1992,F 9,65:1
Lubin, Barry
Greetings from Coney Island 1991,N 1,C19:1
Lubovitch, Lar (Choreographer)
Salome 1992,Je 26,C3:1
Lucas, Craig (Lyricist)
Orpheus in Love 1992,D 16,C17:5
Lucas, Craig (Playwright)
Throwing Your Voice (Marathon '92, Series A)
1992,My 5,C15:1
Orpheus in Love 1992,D 16,C17:5
Lucas, Lou Ann
Cambodia Agonistes 1992,N 13,C3:1
Lucas, Roxie
My Favorite Year 1992,D 11,C1:1
Lucas, Roxie (Choreographer)
Best of Forbidden Broadway, The: 10th-Anniversary
Edition 1992,Ap 9,C19:3
Luce, William (Playwright)
Lucifer's Child 1991,Ap 5,C1:1
Lucifer's Child 1991,Ap 14,II:1:2
Luckinbill, Laurence
Lyndon 1991,Ja 19,19:4
Ludlum, Charles (Playwright)
Bluebeard 1991,N 15,C3:1
Ludwig, Ken (Miscellaneous)
Crazy for You 1992,F 20,C15:3
Ludwig, Ken (Playwright)
Crazy for You 1992,F 20,C15:3
Crazy for You 1992,Mr 1,II:1:1
Lueker, Wendy
Hauptmann 1992,My 29,C3:3
Luftig, Hal (Miscellaneous)
Jelly's Last Jam 1992,Ap 27,C11:1
Luftig, Hal (Producer)
Death and the Maiden 1992,Mr 18,C15:4
Luker, Rebecca
Secret Garden, The 1991,Ap 26,C1:1
Secret Garden, The 1991,My 5,II:5:1
Lum, Mary
Letters to a Student Revolutionary 1991,My
16,C18:1
Luna, Tony (Miscellaneous)
Dolphin Position, The 1992,O 9,C3:1
Lunday, Russel
Seagull, The 1992,N 30,C11:1
Lundell, Kert (Costume Designer)
Dog Logic 1992,N 10,C22:1
Lundell, Kert (Scenic Designer)
And 1992,Mr 9,C12:5
Dog Logic 1992,N 10,C22:1
Lunden, Jeffrey (Composer)
Wings 1992,N 22,II:5:1
Lunin, Slava
Moscow Circus—Cirk Valentin 1991,N 8,C3:1
LuPone, Robert (Miscellaneous)
Manhattan Class One-Acts 1992,Mr 11,C15:1
Lupton, Heather
Marathon 1991: New One-Act Plays, Series B
1991,Je 9,60:5
Lurie, Evan (Composer)
Estrella!: Who Can You Trust in a City of Lies?
1991,Ag 2,C24:4

Lurie, Joan (Composer)
Estrella!: Who Can You Trust in a City of Lies?
1991,Ag 2,C24:4
Luschar, Karen (Choreographer)
Roleplay 1992,Ag 8,16:4
Lutes, Eric
I'm Sorry . . . Was That Your World? 1992,S
25,C2:3
Luthringer, Roy (Miscellaneous)
Disney's World on Ice Starring Peter Pan 1992,F
12,C17:1
Lutkin, Chris
Festival of One-Act Comedies, Evening A 1991,F
12,C14:3
Lutz, Renee (Miscellaneous)
Beggars in the House of Plenty 1991,O 24,C17:4
Don Juan and the Non Don Juan, The 1991,D
23,C16:1
A . . . My Name Is Still Alice 1992,N 23,C14:4
Lyall, Susan (Costume Designer)
Red Diaper Baby 1992,Ap 5,53:5
Lyles, Leslie
Life During Wartime 1991,Mr 6,C13:1
Angel of Death 1992,My 18,C15:1
Lyman, Will
Novelist, The 1991,O 23,C19:1
Lynch, Jane
Real Live Brady Bunch, The 1991,O 2,C18:3
Lynch, Luke
Paint Your Wagon 1992,Ag 7,C2:3
Lynch, Sharon (Costume Designer)
Festival of One-Act Comedies, Evening A 1991,F
12,C14:3
Fresh of Breath Air, A 1992,Je 11,C16:3
On the Bum, or the Next Train Through 1992,N
25,C19:1
On the Bum, or the Next Train Through 1992,N
29,II:5:1
Lynch, Thomas (Scenic Designer)
Speed of Darkness, The 1991,Mr 1,C1:1
Wonderful Life, A 1991,D 8,II:5:1
Visit, The 1992,Ja 24,C1:2
Visit, The 1992,F 2,II:5:1
My Favorite Year 1992,D 11,C1:1
My Favorite Year 1992,D 20,II:5:1
Lyng, Nora Mae
Festival of One-Act Comedies, Evening A 1991,F
12,C14:3
My Favorite Year 1992,D 11,C1:1
Lynn, Jess (Miscellaneous)
Spike Heels 1992,Je 5,C3:1
Lynn, Meredith Scott
Camp Paradox 1992,N 9,C14:1
Lynn, Tonia
Will Rogers Follies, The: A Life in Revue 1991,My
2,C17:1
Lyons, Danna
Under Control 1992,O 22,C25:4
Lyons, J. D.
Del Muenz at the Bishoff Gallery (In Plain View,
Series B) 1992,Ag 15,12:3
Lyons, Jeff
Forbidden Broadway 1991 1/2 1991,Je 21,C3:1
Forbidden Broadway 1991 1/2 1991,Jl 14,II:5:1
Lyons, John (Miscellaneous)
Three Shouts from a Hill 1992,N 11,C18:3
Lyons, Robert (Miscellaneous)
Men Are Afraid of the Women, The 1992,O
21,C16:3

M

Ma, Jason
Miss Saigon 1991,Ap 12,C1:2
McAllen, Kathleen Rowe
Chess 1992,F 5,C19:3
Macao
Andre Heller's Wonderhouse 1991,O 21,C15:1
Andre Heller's Wonderhouse 1991,O 27,II:5:1
McArthur, Neil (Miscellaneous)
Five Guys Named Moe 1992,Ap 9,C17:2
McAteer, Kathryn
Philemon 1991,Ja 20,46:3
MacAvin, Josie (Miscellaneous)
Shadow of a Gunman, The 1991,N 27,C17:1

Three Shouts from a Hill 1992,N 11,C18:3
McBride, Mary
Another Person Is a Foreign Country 1991,S 10,C11:1
McBroom, Amanda (Miscellaneous)
A . . . My Name Is Still Alice 1992,N 23,C14:4
A . . . My Name Is Still Alice 1992,N 29,II:5:1
McCabe, Peter
Any Place But Here 1992,Je 9,C13:1
Words Divine: A Miracle Play 1992,N 25,C19:1
McCabe, Terry (Director)
Hauptmann 1992,My 29,C3:3
McCallany, Holt
Terrible Beauty, A 1992,Ap 10,C18:1
McCamy, Kate (Miscellaneous)
Ancient Boys 1991,F 24,59:5
McCann, Christopher
In the Eye of the Hurricane 1991,Ap 10,C13:3
Mad Forest 1991,D 5,C15:3
Mad Forest 1992,Ja 25,13:3
McCann, Elizabeth Ireland (Producer)
Nick and Nora 1991,D 9,C11:3
McCann, Mary
Three Sisters 1991,Ap 18,C14:3
Five Very Live 1992,Ja 8,C17:1
Nothing Sacred 1992,O 27,C17:1
McCarry, Charles E. (Scenic Designer)
3 from Brooklyn 1992,N 20,C3:1
McCarthy, Patrick
Vinegar Tom 1992,Mr 21,14:5
McCarthy, Sean
Shadow of a Gunman, The 1991,N 27,C17:1
McCarthy, Theresa
Almond Seller, The 1991,Mr 2,15:1
McCartney, Ellen (Costume Designer)
Good Times Are Killing Me, The 1991,Ap 19,C3:1
Dearly Departed 1991,D 24,C11:1
Roy Cohn/Jack Smith 1992,My 15,C1:1
Innocents' Crusade, The 1992,Je 24,C16:5
McCartney, Liz
Paint Your Wagon 1992,Ag 7,C2:3
McCarty, Bruce
Babylon Gardens 1991,O 9,C17:1
Raft of the Medusa 1991,D 23,C15:1
Raft of the Medusa 1992,Ja 5,II:1:1
Destiny of Me, The 1992,O 21,C15:1
Destiny of Me, The 1992,O 25,II:5:1
McCauley, Robbie (Director)
Tempest, A 1991,O 16,C18:3
McClain, Saundra
Pericles, Prince of Tyre 1991,N 25,C13:1
Pericles 1991,D 1,II:5:1
Goodnight Desdemona (Good Morning Juliet) 1992,O 22,C26:5
McClarin, Curtis
1991 Young Playwrights Festival, The 1991,O 3,C20:3
St. Stanislaus Outside the House (Manhattan Class One-Acts) 1992,Mr 11,C15:1
McClarnon, Kevin
Better Days 1991,Ja 24,C20:1
McCleery, Gary
How Do You Like Your Meat? (Evening of Short Plays by Joyce Carol Oates, An) 1991,Ap 27,14:5
Friday Night (Evening of Short Plays by Joyce Carol Oates, An) 1991,Ap 27,14:5
Darling I'm Telling You (Evening of Short Plays by Joyce Carol Oates, An) 1991,Ap 27,14:5
McClelland, Kay
It's a Bird, It's a Plane, It's Superman 1992,Je 20,16:4
Make Someone Happy! The Jule Styne Revue 1992,D 20,II:5:1
McClendon, Afi
1992 Young Playwrights Festival, The 1992,S 24,C18:4
McClennahan, Charles (Scenic Designer)
Black Eagles 1991,Ap 22,C13:1
McClinton, Marion (Director)
Pill Hill 1992,D 3,C18:5
McClure, Kit
Big Noise of '92: Diversions from the New Depression 1991,D 18,C25:1
McClure, Spike
Taking Steps 1991,F 21,C13:1
McConnell, David
Rivers and Ravines, The 1991,N 14,C28:6
Anima Mundi 1992,F 5,C19:3

This One Thing I Do 1992,Ap 19,45:5
McConnell, John
Kingfish, The 1991,Mr 31,39:1
McCormac, Fiona
Bobby Sands, M.P. 1992,Je 18,C15:1
Madame MacAdam Traveling Theater, The 1992,O 21,C16:3
McCormack, Chaz
Camp Logan 1991,F 7,C23:1
McCormick, Michael
Bete, La 1991,F 11,C11:3
Resistible Rise of Arturo Ui, The 1991,My 9,C15:1
McCormick, Robert
Return to the Forbidden Planet 1991,O 14,C13:1
McCowen, Alec
Someone Who'll Watch Over Me 1992,N 24,C13:4
Someone Who'll Watch Over Me 1992,D 6,II:5:1
McCoy, Michael
It's a Bird, It's a Plane, It's Superman 1992,Je 20,16:4
McCrane, Paul
Country Girl, The 1991,Ja 12,16:3
Country Girl, The 1991,Ja 13,II:5:1
Three Sisters 1992,Ja 19,II:5:1
McCullough, Mark (Lighting Director)
Lypsinka! A Day in the Life 1992,Ap 1,C16:3
Words Divine: A Miracle Play 1992,N 25,C19:1
McCutchen, Heather (Playwright)
Walk on Lake Erie, A 1991,Mr 25,C15:1
McDaniel, James
Before It Hits Home 1992,Mr 11,C17:2
Someone Who'll Watch Over Me 1992,N 24,C13:4
Someone Who'll Watch Over Me 1992,D 6,II:5:1
McDermott, Dylan
Glass Menagerie, The 1991,Ja 21,C11:1
Glass Menagerie, The 1991,Ja 27,II:5:1
McDermott, James T. (Miscellaneous)
Angels in America 1992,N 10,C15:3
McDermott, Keith
Grand Finale 1991,Ap 21,60:1
McDermott, Sean
Miss Saigon 1991,Ap 12,C1:2
McDermott, Tom
Unchanging Love 1991,F 10,64:1
MacDevitt, Brian (Lighting Director)
Light Shining in Buckinghamshire 1991,F 17,71:1
And 1992,Mr 9,C12:5
Candide 1992,Ap 24,C4:5
Goodnight Desdemona (Good Morning Juliet) 1992,O 22,C26:5
McDonagh, Seamus
Bobby Sands, M.P. 1992,Je 18,C15:1
MacDonald, Ann-Marie (Playwright)
Goodnight Desdemona (Good Morning Juliet) 1992,O 22,C26:5
Goodnight Desdemona (Good Morning Juliet) 1992,O 25,II:5:1
Macdonald, David Andrew
Two Shakespearean Actors 1992,Ja 17,C1:1
MacDonald, Gordon
Invention for Fathers and Sons 1992,Ja 22,C17:1
McDonald, Heather (Playwright)
Rivers and Ravines, The 1991,N 14,C28:6
Dream of a Common Language 1992,My 26,C12:5
McDonald, Ian (Composer)
Shimada 1992,Ap 24,C1:1
Macdonald, James G.
1991 Young Playwrights Festival, The 1991,O 3,C20:3
Big Frame Shakin' 1991,D 4,C22:3
Gulf War (Marathon '92, Series B) 1992,My 19,C18:3
Macdonald, James G. (Playwright)
Big Frame Shakin' 1991,D 4,C22:3
McDonald, Larry
Balm Yard, The 1991,Mr 25,C15:1
MacDonald, Pirie
Deposing the White House 1991,D 4,C22:3
Gulf War (Marathon '92, Series B) 1992,My 19,C18:3
MacDonald, Robert David (Translator)
Mary Stuart 1992,F 26,C19:1
McDonald, Tanny
Man of La Mancha 1992,Ap 25,13:4
MacDonald, Tim
Two Shakespearean Actors 1992,Ja 17,C1:1
McDoniel, Nancy
Pie Supper 1992,Jl 30,C20:1

McDonnell, Graeme F. (Lighting Director)
Jacques Brel Is Alive and Well and Living in Paris 1992,O 21,C16:3
McDonough, Ann
Anatomy Lesson, The (Evening of Short Plays by Joyce Carol Oates, An) 1991,Ap 27,14:5
How Do You Like Your Meat? (Evening of Short Plays by Joyce Carol Oates, An) 1991,Ap 27,14:5
McDonough, Edwin J.
Pygmalion 1991,Mr 25,C15:4
McDonough, John
All's Well That Ends Well 1991,N 25,C14:3
Tartuffe 1992,O 16,C15:1
McDormand, Frances
Three Sisters 1992,Ja 19,II:5:1
Sisters Rosensweig, The 1992,O 23,C3:1
Sisters Rosensweig, The 1992,N 1,II:5:1
MacDougall, Delia
East: An Elegy for the East End 1991,My 22,C15:1
Mace, Cynthia
Angels in America 1992,N 10,C15:3
McElduff, Ellen
'Tis Pity She's a Whore 1992,Ap 6,C11:2
McElroy, Michael
High Rollers Social and Pleasure Club, The 1992,Ap 23,C15:2
McEvoy, Barry
Bobby Sands, M.P. 1992,Je 18,C15:1
MacFadyen, Christie
Amerikamachine 1991,My 29,C14:3
McGann, Michaeljohn
Hamlet 1992,Ap 3,C3:1
McGarty, Michael (Scenic Designer)
God's Country 1992,Je 3,C15:4
McGee, Gwen
Mixed Babies (Manhattan Class One-Acts) 1992,Mr 11,C15:1
McGhee, Elena
Creditors 1992,F 7,C3:1
McGillis, Kelly
Measure for Measure 1992,My 24,II:5:1
McGovern, Elizabeth
Three Sisters 1991,Ap 18,C14:3
Hamlet 1992,Ap 3,C3:1
As You Like It 1992,Jl 10,C3:1
As You Like It 1992,Jl 19,II:5:1
McGowan, John (Miscellaneous)
Crazy for You 1992,F 20,C15:3
McGowan, Tom
Bete, La 1991,F 11,C11:3
Bete, La 1991,F 17,II:5:1
One of the All-Time Greats 1992,Ap 17,C3:1
McGrath, David
Atomic Opera 1991,O 30,C14:1
McGrath, George
Canal Zone 1992,My 6,C18:3
McGrath, Matt
Life During Wartime 1991,Mr 6,C13:1
Old Boy, The 1991,My 6,C11:4
Old Boy, The 1991,My 19,II:5:1
Streetcar Named Desire, A 1992,Ap 13,C11:3
Nothing Sacred 1992,O 27,C17:1
McGrath, Michael
Forbidden Broadway/Forbidden Christmas 1991,D 13,C3:4
Best of Forbidden Broadway, The: 10th-Anniversary Edition 1992,Ap 9,C19:3
My Favorite Year 1992,D 11,C1:1
McGrath, Michael (Choreographer)
Best of Forbidden Broadway, The: 10th-Anniversary Edition 1992,Ap 9,C19:3
McGruder, Jasper
Let Me Live 1991,Ja 17,C21:1
Tempest, A 1991,O 16,C18:3
McGruder, Sharon
Tempest, A 1991,O 16,C18:3
McGuinness, Frank (Miscellaneous)
Threepenny Opera 1991,Ag 20,C11:1
McGuinness, Frank (Playwright)
Someone Who'll Watch Over Me 1992,N 24,C13:4
Someone Who'll Watch Over Me 1992,D 6,II:5:1
McGuire, Joe (Miscellaneous)
Haunted Host, The 1991,Mr 12,C15:1
Joy Solution 1991,D 16,C14:5
McGuire, Michael
Holy Terror, The 1992,O 9,C3:1

Magnuson, Ann
You Could Be Home Now 1992,O 12,C11:1
You Could Be Home Now 1992,O 18,II:5:1
Magnuson, Ann (Playwright)
You Could Be Home Now 1992,O 12,C11:1
You Could Be Home Now 1992,O 18,II:5:1
Magnuson, Tina (Miscellaneous)
Dialogue with a Prostitute (American Living Room
Reupholstered, The) 1992,S 30,C16:3
Mahal, Taj (Composer)
Mule Bone 1991,F 15,C1:4
Mule Bone 1991,F 24,II:5:1
Mahal, Taj (Musical Director)
Mule Bone 1991,F 15,C1:4
Maher, Denise (Playwright)
Secrets to Square Dancing (1991 Young Playwrights
Festival, The) 1991,O 3,C20:3
Maher, William Michael (Miscellaneous)
Easter Show 1991,Mr 25,C18:4
Gunmetal Blues 1992,Ap 8,C21:1
Radio City Easter Show, The 1992,Ap 15,C19:1
Mahoney, John
Subject Was Roses, The 1991,Je 6,C13:2
Subject Was Roses, The 1991,Je 9,II:5:1
Mahto, Beverly
Night Before Christmas, The: A Musical Fantasy
1992,D 17,C18:5
Mahto, Beverly (Costume Designer)
Night Before Christmas, The: A Musical Fantasy
1992,D 17,C18:5
Mailer, Stephen
Peacetime 1992,Mr 12,C21:1
Innocents' Crusade, The 1992,Je 24,C16:5
Maille, Phyllis (Costume Designer)
Power Pipes 1992,O 24,18:1
Maio, Frankie
Absolutely Rude 1991,N 13,C21:1
Makkena, Wendy
American Plan, The 1991,Ja 6,II:1:2
Mako
Shimada 1992,Ap 24,C1:1
Malas, Spiro
Most Happy Fella, The 1991,My 30,C13:1
Most Happy Fella, The 1991,Je 2,II:7:1
Most Happy Fella, The 1992,F 14,C1:4
Most Happy Fella, The 1992,F 16,II:5:1
Malatesta, Gail Eve (Miscellaneous)
Invention for Fathers and Sons 1992,Ja 22,C17:1
Maleczech, Ruth
Henry IV, Parts 1 and 2 1991,F 28,C15:1
Henry IV, Parts I and II 1991,Mr 10,II:5:1
Way of the World, The 1991,My 22,C11:1
In the Jungle of Cities 1991,N 6,C19:2
Woyzeck 1992,D 7,C14:1
Maletsky, Sophie
Hunchback of Notre Dame, The 1991,My 17,C3:1
Malik, Christine
Depression Show, The 1992,S 23,C16:3
Malina, Joel
Philemon 1991,Ja 20,46:3
Malina, Judith (Director)
Waste (A Street Spectacle) 1991,Ag 7,C13:1
Malina, Judith (Miscellaneous)
Humanity (Menschen, Die) 1991,Je 5,C22:3
Malina, Judith (Producer)
Rules of Civility and Decent Behavior in Company
and Conversation 1991,Mr 25,C15:1
We Should . . . (A Lie) 1992,Ja 29,C17:1
Malka, Moshe
Hamlet 1992,Ja 24,C3:1
Malkovich, John
States of Shock 1991,My 17,C1:3
States of Shock 1991,My 26,II:5:1
Mallen, Tara
Death and Life of Sherlock Holmes, The 1991,N
27,C17:1
Mallon, Brian
Bobby Sands, M.P. 1992,Je 18,C15:1
Malloy, Andrea
Rules of Civility and Decent Behavior in Company
and Conversation 1991,Mr 25,C15:1
Malloy, Judy
Opal 1992,Mr 18,C17:1
Malone, Shannon
Soap Opera (American Living Room Reupholstered,
The) 1992,S 30,C16:3
Maloney, D. J. (Director)
Troubadour 1991,Je 5,C22:3

Maloney, Patty
Andre Heller's Wonderhouse 1991,O 21,C15:1
Andre Heller's Wonderhouse 1991,O 27,II:5:1
Maloney, Peter
Awoke One (Marathon '92, Series B) 1992,My
19,C18:3
Maloney, Peter (Director)
Big Al (Marathon 1991: New One-Act Plays, Series
C) 1991,Je 19,C12:3
Big Al 1992,My 18,C15:1
Malony, Kevin (Director)
Atomic Opera 1991,O 30,C14:1
Lypsinka! Now It Can Be Lip-Synched 1992,Ag
22,11:1
Malony, Kevin (Miscellaneous)
Atomic Opera 1991,O 30,C14:1
Malony, Kevin (Playwright)
Atomic Opera 1991,O 30,C14:1
Malpede, Karen (Director)
Blue Heaven 1992,S 30,C16:3
Malpede, Karen (Playwright)
Blue Heaven 1992,S 30,C16:3
Maltby, Richard, Jr. (Lyricist)
Miss Saigon 1991,Ap 12,C1:2
Miss Saigon 1991,Ap 21,II:5:1
Nick and Nora 1991,D 9,C11:3
Nick and Nora 1991,D 15,II:1:1
Malvern, Larry Grant
Akin 1992,F 25,C14:5
'Tis Pity She's a Whore 1992,Ap 6,C11:2
Mamet, David (Director)
Oleanna 1992,O 26,C11:4
Oleanna 1992,N 8,II:1:1
Mamet, David (Miscellaneous)
Three Sisters 1991,Ap 18,C14:3
Mamet, David (Playwright)
Where Were You When It Went Down? (Marathon
1991: New One-Act Plays, Series A) 1991,My
26,57:5
Speed-the-Plow 1991,Ag 15,C16:4
Life in the Theater, A 1992,F 29,18:1
Oleanna 1992,O 26,C11:4
Oleanna 1992,N 8,II:1:1
Manassee, Jackie (Lighting Director)
Approximating Mother 1991,N 7,C21:1
Mancinelli, Margaret (Director)
Rapid Eye Movement (Marathon 1991: New One-
Act Plays, Series B) 1991,Je 9,60:5
Mancinelli, Margaret (Miscellaneous)
Marathon 1991: New One-Act Plays, Series A
1991,My 26,57:5
Marathon 1991: New One-Act Plays, Series B
1991,Je 9,60:5
Marathon 1991: New One-Act Plays, Series C
1991,Je 19,C12:3
Mandava, Bhargavi C. (Playwright)
Plumb Nuts (I'm Sorry . . . Was That Your World?)
1992,S 25,C2:3
Mandel, Ellen (Composer)
Candida 1991,F 25,C13:1
Skin of Our Teeth, The 1991,S 7,14:3
Macbeth 1991,S 27,C15:1
Geneva 1991,O 23,C19:1
Under Milk Wood 1992,S 4,C2:3
Idiot, The 1992,D 21,C13:1
Mandel, Ellen (Miscellaneous)
Skin of Our Teeth, The 1991,S 7,14:3
Idiot, The 1992,D 21,C13:1
Geneva 1991,O 23,C19:1
Mandel, Ellen (Musical Director)
Leonce and Lena 1991,Mr 24,63:5
Woyzeck 1991,Mr 24,63:5
Under Milk Wood 1992,S 4,C2:3
Mandel, Lenny
Custody 1991,Ap 24,C10:5
Mandel, Thilo
Dr. Faustus Lights the Lights 1992,Jl 9,C15:3
Mandell, Michael
Blood Wedding 1992,My 15,C3:3
Maner, Tim (Miscellaneous)
American Living Room Reupholstered, The 1992,S
30,C16:3
Manetti, Guy (Miscellaneous)
Greetings from Coney Island 1991,N 1,C19:1
Manevarthe, Jagadeesh
Hippolytos 1992,N 25,C19:1
Mangala, N.
Hippolytos 1992,N 25,C19:1

Mangano, Nick (Miscellaneous)
Cabaret Verboten 1991,O 29,C16:1
Creditors 1992,F 7,C3:1
Manheim, Camryn
Woyzeck 1992,D 7,C14:1
Manheim, Ralph (Translator)
Resistible Rise of Arturo Ui, The 1991,My 9,C15:1
Manis, David
Henry IV, Parts 1 and 2 1991,F 28,C15:1
Mankin, Nina
Almond Seller, The 1991,Mr 2,15:1
Mann, David
Fata Morgana 1991,My 3,C20:4
Mann, Emily (Director)
Glass Menagerie, The 1991,Ja 21,C11:1
Glass Menagerie, The 1991,Ja 27,II:5:1
Betsey Brown 1991,Ap 13,14:5
Three Sisters 1992,Ja 19,II:5:1
Mann, Emily (Lyricist)
Betsey Brown 1991,Ap 13,14:5
Mann, Emily (Playwright)
Betsey Brown 1991,Ap 13,14:5
Mann, Harry
Fata Morgana 1991,My 3,C20:4
Empty Boxes 1992,O 14,C18:3
Mann, Harry (Composer)
Fata Morgana 1991,My 3,C20:4
Empty Boxes 1992,O 14,C18:3
Mann, Paula
Nebraska 1992,Je 3,C15:4
Mann, Terrence
Assassins 1991,Ja 28,C19:3
Assassins 1991,F 3,II:1:2
Mann, Theodore (Director)
Anna Karenina 1992,Ag 27,C17:2
Mann, Theodore (Miscellaneous)
Taking Steps 1991,F 21,C13:1
Getting Married 1991,Je 27,C14:3
On Borrowed Time 1991,O 10,C19:1
Search and Destroy 1992,F 27,C18:5
Salome 1992,Je 26,C3:1
Chinese Coffee 1992,Je 26,C3:1
Anna Karenina 1992,Ag 27,C17:2
Manning, Dathan (Miscellaneous)
Big Frame Shakin' 1991,D 4,C22:3
Marathon '92, Series A 1992,My 5,C15:1
Marathon '92, Series B 1992,My 19,C18:3
Manno, Donna
Balm Yard, The 1991,Mr 25,C15:1
Manocherian, Jennifer R. (Producer)
Hello Muddah, Hello Fadduh 1992,D 9,C22:1
Manogue, Larry (Playwright)
Jersey Girls, The 1991,S 4,C16:1
Mans, Lorenzo (Miscellaneous)
Words Divine: A Miracle Play 1992,N 25,C19:1
Mans, Lorenzo (Translator)
Words Divine: A Miracle Play 1992,N 25,C19:1
Mansell, Lilene (Miscellaneous)
Remembrance 1992,O 5,C13:4
Mansur, Susan
Ruthless! 1992,My 13,C14:3
Ruthless! 1992,My 17,II:5:1
Mansy, Deborah
Native Speech 1991,Ap 17,C15:1
Mantel, Ann
Bella, Belle of Byelorussia 1992,Ja 20,C18:1
Mantell, Michael (Director)
Appointment with a High-Wire Lady 1992,F
12,C17:1
Mantell, Paul
New Living Newspaper 1992,Mr 4,C19:1
Mantell, Paul (Lyricist)
New Living Newspaper 1992,Mr 4,C19:1
Mantell, Paul (Playwright)
New Living Newspaper 1992,Mr 4,C19:1
Mantello, Joe
Walking the Dead 1991,My 13,C12:1
Baltimore Waltz, The 1992,F 12,C15:3
Baltimore Waltz, The 1992,F 16,II:5:1
Angels in America 1992,N 10,C15:3
Mantello, Joe (Director)
Babylon Gardens 1991,O 9,C17:1
Babylon Gardens 1991,O 13,II:5:1
Manteuffel, Laura (Miscellaneous)
First Is Supper 1992,Mr 18,C17:1
Mantia, Buddy
3 from Brooklyn 1992,N 20,C3:1

Mintern, Terence
Another Person Is a Foreign Country 1991,S 10,C11:1
Mintz, Alan
Job: A Circus 1992,Ja 15,C17:1
Mintz, Alan (Miscellaneous)
Job: A Circus 1992,Ja 15,C17:1
Mintz, Jonathon (Director)
Mailman (Festival of One-Act Comedies, Evening B) 1991,Mr 5,C16:3
Mintz, Jonathon (Miscellaneous)
Festival of One-Act Comedies, Evening A 1991,F 12,C14:3
Festival of One-Act Comedies, Evening B 1991,Mr 5,C16:3
Miranda, Bobby
It's a Bird, It's a Plane, It's Superman 1992,Je 20,16:4
Mironchik, Jim (Musical Director)
Custody 1991,Ap 24,C10:5
Mironova, Irina
Moscow Circus—Cirk Valentin 1991,N 8,C3:1
Mironova, Mariya
Teacher of Russian, A 1991,Mr 7,C16:6
Mironova, Yelena
Moscow Circus—Cirk Valentin 1991,N 8,C3:1
Mitchell, Adrian (Translator)
Mayor of Zalamea, The (Alcalde de Zalamea, El) 1991,Ap 14,52:1
Mitchell, Aleta
Night Sky 1991,My 23,C24:5
Mitchell, David (Miscellaneous)
Big Love, The 1991,Mr 4,C11:1
Mitchell, David (Scenic Designer)
Big Love, The 1991,Mr 4,C11:1
Betsey Brown 1991,Ap 13,14:5
High Rollers Social and Pleasure Club, The 1992,Ap 23,C15:2
Mitchell, Freja
Amerikamachine 1991,My 29,C14:3
Mitchell, Gregory
Man of La Mancha 1992,Ap 25,13:4
Mitchell, Jerry
Will Rogers Follies, The: A Life in Revue 1991,My 2,C17:1
Mitchell, Jerry (Choreographer)
You Could Be Home Now 1992,O 12,C11:1
Mitchell, Jerry (Miscellaneous)
Lips Together, Teeth Apart 1991,Je 26,C11:1
Mitchell, John Cameron
Secret Garden, The 1991,Ap 26,C1:1
Secret Garden, The 1991,My 5,II:5:1
Destiny of Me, The 1992,O 21,C15:1
Destiny of Me, The 1992,O 25,II:5:1
Mitchell, Lizan
Onliest One Who Can't Go Nowhere, The (Marathon '92, Series C) 1992,Je 2,C15:1
Mitchell, William Charles
Leonce and Lena 1991,Mr 24,63:5
Woyzeck 1991,Mr 24,63:5
Skin of Our Teeth, The 1991,S 7,14:3
Geneva 1991,O 23,C19:1
Galileo 1991,D 11,C23:1
Mitchelson, Bill (Director)
Let Me Live 1991,Ja 17,C21:1
Abandoned in Queens (Working One-Acts '91) 1991,Je 26,C12:3
Mitchelson, Bill (Miscellaneous)
Let Me Live 1991,Ja 17,C21:1
Working One-Acts '91 1991,Je 26,C12:3
Ascension Day 1992,Mr 4,C19:1
Mixon, Christopher
Candida 1991,F 25,C13:1
Iron Bars 1991,N 20,C23:1
Miyagawa, Chiori (Miscellaneous)
Dressing Room, The (Gakuya) 1991,N 6,C21:1
Miyama, Shinichiro
Nomura Kyogen Theater: Classic Comedies of Japan 1992,S 25,C2:4
Miyori, Kim
Piece of My Heart, A 1991,N 4,C15:1
Mnouchkine, Ariane (Director)
Oresteia 1991,Mr 27,C13:3
Iphigenia in Aulis 1991,Mr 27,C13:3
Atrides, Les 1992,O 6,C11:3
Mnouchkine, Ariane (Translator)
Agamemnon (Atrides, Les) 1992,O 6,C11:3
Libation Bearers, The (Atrides, Les) 1992,O 6,C11:3

Modereger, Jeff (Scenic Designer)
Rags 1991,D 4,C22:3
Moffat, Donald
As You Like It 1992,Jl 10,C3:1
As You Like It 1992,Jl 19,II:5:1
Moffett, D. W.
American Plan, The 1991,Ja 6,II:1:2
Mogentale, David
Under Control 1992,O 22,C25:4
Mokone, Tsepo
Boesman and Lena 1992,Ja 30,C15:1
Boesman and Lena 1992,F 9,II:5:1
Molaskey, Jessica
Book of the Night 1991,Jl 28,II:5:1
Weird Romance 1992,Je 23,C14:5
Moliere (Playwright)
Learned Ladies, The (Femmes Savantes, Les) 1991,Mr 10,58:1
Tartuffe 1991,S 16,C14:4
Tartuffe 1991,S 29,II:5:1
Misanthrope, The 1991,O 9,C18:3
Tartuffe 1992,O 16,C15:1
Molina, Arnold
Henry IV, Parts 1 and 2 1991,F 28,C15:1
Pericles, Prince of Tyre 1991,N 25,C13:1
Pericles 1991,D 1,II:5:1
Search and Destroy 1992,F 27,C18:5
Molloy, Dearbhla
Dancing at Lughnasa 1991,O 25,C1:4
Dancing at Lughnasa 1991,N 3,II:5:1
Molnar, Ferenc (Original Author)
Carousel 1992,D 17,C11:3
Monaco, John (Miscellaneous)
Falsettos 1992,Ap 30,C17:3
Monagas, Ismael
Tempestad, La (Tempest, The) 1991,Ag 30,C3:3
Monat, Phil (Lighting Director)
Earth and Sky 1991,F 5,C13:1
And the World Goes 'Round: The Songs of Kander and Ebb 1991,Mr 19,C11:2
Grand Finale 1991,Ap 21,60:1
Lady Bracknell's Confinement 1992,F 19,C16:3
Party, The 1992,F 19,C16:3
One of the All-Time Greats 1992,Ap 17,C3:1
Paint Your Wagon 1992,Ag 7,C2:3
Juno 1992,O 31,16:4
3 from Brooklyn 1992,N 20,C3:1
Monette, Richard (Director)
Much Ado About Nothing 1991,Je 30,II:5:1
Monette, Trudy
Night Before Christmas, The: A Musical Fantasy 1992,D 17,C18:5
Moninger, Shawn (Lighting Director)
Varieties 1992,Ja 8,C17:1
Moninger, Shawn (Miscellaneous)
Varieties 1992,Ja 8,C17:1
Monk, Debra
Assassins 1991,Ja 28,C19:3
Assassins 1991,F 3,II:1:2
Nick and Nora 1991,D 9,C11:3
Nick and Nora 1991,D 15,II:1:1
Innocents' Crusade, The 1992,Je 24,C16:5
Monk, Isabell
Electra 1992,Ag 9,II:5:1
Iphigenia in Aulis 1992,Ag 9,II:5:1
Agamemnon 1992,Ag 9,II:5:1
Monsion, Tim
Marvin's Room 1991,D 6,C1:5
Mont, Ira (Miscellaneous)
Colette Collage 1991,My 15,C12:3
Montague, Helen
I Can't Get Started 1991,Jl 13,12:5
Monteiro, Samantha
Nova Velha Estoria (New Old Story) 1991,Je 12,C14:3
Montel, Michael (Director)
Love in Two Countries 1991,Ap 10,C15:1
Montenegro, Fernanda
Flash and Crash Days, The 1992,Jl 16,C15:1
Montgomery, Chuck
Walk on Lake Erie, A 1991,Mr 25,C15:1
Montgomery, Chuck (Miscellaneous)
Walk on Lake Erie, A 1991,Mr 25,C15:1
Montgomery, Otis (Costume Designer)
Night Before Christmas, The: A Musical Fantasy 1992,D 17,C18:5
Montgomery, Reggie
Mule Bone 1991,F 15,C1:4

Black Eagles 1991,Ap 22,C13:1
Raft of the Medusa 1991,D 23,C15:1
Moody, Michael Francis (Lighting Director)
Appointment with a High-Wire Lady 1992,F 12,C17:1
Moody, Michael Francis (Scenic Designer)
Appointment with a High-Wire Lady 1992,F 12,C17:1
Moody, Michael R. (Lighting Director)
Life During Wartime 1991,Mr 6,C13:1
Innocents' Crusade, The 1992,Je 24,C16:5
Moon, Bert (Composer)
Dressing Room, The (Gakuya) 1991,N 6,C21:1
Moon, Marjorie (Miscellaneous)
Camp Logan 1991,F 7,C23:1
Lotto: Experience the Dream 1991,D 26,C13:1
Mooney, Debra
Price, The 1992,Je 11,C13:1
Price, The 1992,Je 28,II:5:1
Mooney, Robert
Cinderella 1991,D 23,C16:4
Moonmade, Diana
Penny Arcade Sex and Censorship Show, The 1992,Jl 28,C13:1
Moor, Bill
Two Shakespearean Actors 1992,Ja 17,C1:1
Moore, Bonnie
Carousel 1992,D 17,C11:3
Moore, Carman (Composer)
When the Bough Breaks 1991,My 8,C12:3
Moore, Charlotte (Director)
Making History 1991,Ap 11,C24:1
Madame MacAdam Traveling Theater, The 1992,O 21,C16:3
Moore, Charlotte (Miscellaneous)
Making History 1991,Ap 11,C24:1
Grandchild of Kings 1992,F 17,C13:1
Joycity 1992,S 11,C2:3
Frankly Brendan 1992,S 19,12:1
Madame MacAdam Traveling Theater, The 1992,O 21,C16:3
Moore, Christina
1992 Young Playwrights Festival, The 1992,S 24,C18:4
Moore, Clement Clarke (Original Author)
Night Before Christmas, The: A Musical Fantasy 1992,D 17,C18:5
Moore, Crista
Rags 1991,D 4,C22:3
Moore, Dana
Will Rogers Follies, The: A Life in Revue 1991,My 2,C17:1
Moore, Jesse
Mermaid Wakes, The 1991,F 25,C14:3
Moore, Jody
Accident: A Day's News 1991,S 23,C14:3
Moore, Karen (Miscellaneous)
Unfinished Song, An 1991,F 19,C14:5
Bella, Belle of Byelorussia 1992,Ja 20,C18:1
Peacetime 1992,Mr 12,C21:1
Fires in the Mirror: Crown Heights, Brooklyn and Other Identities 1992,My 15,C1:1
Joined at the Head 1992,N 16,C16:1
Moore, Rebecca
Iron Lung 1992,Ja 22,C17:1
Moore, Terry J. (Miscellaneous)
Bernie's Bar Mitzvah 1992,Mr 18,C17:1
Moore, Tom (Director)
Little Hotel on the Side, A 1992,Ja 27,C17:1
Little Hotel on the Side, A 1992,F 9,II:5:1
Moore, Tom (Miscellaneous)
Bluebeard 1991,N 15,C3:1
Moore, Tom (Scenic Designer)
When Lightning Strikes Twice 1991,Ja 25,C6:3
Hunchback of Notre Dame, The 1991,My 17,C3:1
Mor, Brian O'Neill (Composer)
Bobby Sands, M.P. 1992,Je 18,C15:1
Lament for Arthur Cleary, The 1992,N 4,C22:1
Mor, Brian O'Neill (Miscellaneous)
Bobby Sands, M.P. 1992,Je 18,C15:1
Mora, Stephen
Wilder, Wilder, Wilder: Three by Thornton 1992,D 21,C13:1
Morales, Carole (Miscellaneous)
Balancing Act 1992,Je 17,C17:1
Morales, Esai
Salome 1992,Je 26,C3:1

O

Ortiz, Steve
Winter Man 1991,F 21,C20:1
Osakabe, Keiji (Miscellaneous)
Dionysus 1991,Je 23,43:1
Osborn, Paul (Playwright)
On Borrowed Time 1991,O 10,C19:1
On Borrowed Time 1991,O 20,II:5:1
On Borrowed Time 1991,N 17,II:5:1
Osborne, Tracey
Wedding Portrait, The 1992,Mr 25,C19:3
Osgood, Steven
Antigone 1992,F 16,70:5
Osgood, Steven (Musical Director)
Antigone 1992,F 16,70:5
O'Shea, Milo
Remembrance 1992,O 4,II:5:1
Remembrance 1992,O 5,C13:4
Oshima, Atsushi
Walt Disney's World on Ice: Mickey Mouse
Diamond Jubilee 1991,F 5,C18:1
O'Slynne, Timothy (Choreographer)
'Tis Pity She's a Whore 1992,Ap 6,C11:2
Osman, Donny (Director)
My Civilization 1991,Ja 10,C21:1
Sick But True 1992,S 12,15:1
Osman, Donny (Miscellaneous)
My Civilization 1991,Ja 10,C21:1
Osman, Donny (Playwright)
Sick But True 1992,S 12,15:1
Osorio, Carlos
Mayor of Zalamea, The (Alcalde de Zalamea, El)
1991,Ap 14,52:1
Esperando la Carroza (Waiting for the Hearse)
1991,S 18,C15:1
Candida Erendira, La 1992,F 9,65:1
Osser, Glenn (Miscellaneous)
Easter Show 1991,Mr 25,C18:4
Ossorguine, Serge (Miscellaneous)
Let Me Live 1991,Ja 17,C21:1
Mule Bone 1991,F 15,C1:4
Mr. Gogol and Mr. Preen 1991,Je 10,C13:1
Big Noise of '92: Diversions from the New
Depression 1991,D 18,C25:1
O'Steen, Michael
Animal Crackers 1992,N 4,C19:4
O'Steen, Michelle
After the Dancing in Jericho 1992,F 12,C17:1
Ostergren, Klas (Translator)
Doll's House, A 1991,Je 20,C13:3
Ostergren, Pernilla
Doll's House, A 1991,Je 20,C13:3
Osterman, Georg
Brother Truckers 1992,S 22,C13:3
Osterman, Georg (Playwright)
Brother Truckers 1992,S 22,C13:3
Ostermann, Curt (Lighting Director)
Troubadour 1991,Je 5,C22:3
Osterwalder, Valerie (Miscellaneous)
Underground 1992,S 16,C16:3
Ostrow, Carol (Producer)
Beau Jest 1991,O 11,C16:6
Ostrow, Stuart (Producer)
Bete, La 1991,F 11,C11:3
O'Sullivan, Anne
Festival of One-Act Comedies, Evening B 1991,Mr
5,C16:3
Marathon 1991: New One-Act Plays, Series B
1991,Je 9,60:5
Murder of Crows, A 1992,My 1,C18:1
Juno 1992,O 31,16:4
O'Sullivan, Michael
Madame MacAdam Traveling Theater, The 1992,O
21,C16:3
O'Sullivan-Moore, Emmett
Roads to Home, The 1992,S 18,C2:3
Ott, Karen (Miscellaneous)
Hunchback of Notre Dame, The 1991,My 17,C3:1
Bluebeard 1991,N 15,C3:1
Bells, The 1992,F 21,C20:1
Brother Truckers 1992,S 22,C13:3
Otto, Don
Ice Capades: On Top of the World 1991,Ja 22,C16:4
Outzen, Martin
Body and Soul 1991,Jl 10,C18:3
Ouyoung, Juliet (Costume Designer)
Fairy Bones 1992,My 11,C11:1
Cambodia Agonistes 1992,N 13,C3:1

Ove, Indra
Tragedy of Macbeth, The 1991,Je 18,C13:4
Overaite, Dalia
Uncle Vanya 1991,Je 17,C11:3
Square, The 1991,Je 21,C3:5
Overbey, Kellie
Marathon 1991: New One-Act Plays, Series B
1991,Je 9,60:5
Melville Boys, The 1992,Ag 21,C2:3
Overmyer, Eric (Playwright)
Heliotrope Bouquet by Scott Joplin and Louis
Chauvin, The 1991,Mr 17,II:5:1
Native Speech 1991,Ap 17,C15:1
Overton, Andrew
Hotel Oubliette 1992,Ag 12,C14:1
Owen, Meg Wynn
Like to Live 1992,My 6,C18:3
Tissue 1992,My 6,C18:3
Owens, Elizabeth
To Kill a Mockingbird 1991,Mr 4,C13:4
Owens, Geoffrey
Tartuffe 1992,O 16,C15:1
Owens, Gordon
Miss Saigon 1991,Ap 12,C1:2
Owens, Matthew (Scenic Designer)
Belle Reprieve 1991,Mr 11,C14:5
Power Pipes 1992,O 24,18:1
Owens, Rochelle (Playwright)
Futz 1991,O 23,C19:1
Oyamo (Playwright)
Let Me Live 1991,Ja 17,C21:1
Angels in the Men's Lounge (Marathon '92, Series
C) 1992,Je 2,C15:1
Oziernych, Polina
Metro 1992,Ap 17,C1:3

P

Pabon, Janett
Del Muenz at the Bishoff Gallery (In Plain View,
Series B) 1992,Ag 15,12:3
Pace, Roberto (Composer)
We Should . . . (A Lie) 1992,Ja 29,C17:1
Pace, Roberto (Musical Director)
Akin 1992,F 25,C14:5
Bitter Tears of Petra von Kant, The 1992,Je 18,C15:1
Pacino, Al
Salome 1992,Je 26,C3:1
Chinese Coffee 1992,Je 26,C3:1
Salome 1992,Jl 5,II:5:1
Chinese Coffee 1992,Jl 5,II:5:1
Paciotto, Andrea
Yunus 1992,O 28,C18:1
Page, Louise (Playwright)
Like to Live 1992,My 6,C18:3
Tissue 1992,My 6,C18:3
Page, Robert (Miscellaneous)
Most Happy Fella, The 1991,My 30,C13:1
Most Happy Fella, The 1992,F 14,C1:4
Page, Stan
Guys and Dolls 1992,Ap 15,C15:3
Pai, Ian
Tubes 1991,N 20,C23:1
Pai, Liana
Casanova 1991,My 29,C11:5
Painter, Walter (Director)
Ringling Brothers and Barnum & Bailey Circus
1991,Mr 24,63:1
Ringling Brothers and Barnum & Bailey Circus
1992,Ap 4,13:1
Painter, Walter (Miscellaneous)
City of Angels 1991,Ja 25,C1:1
Pakledinaz, Martin (Costume Designer)
Pygmalion 1991,Mr 25,C15:4
Hamlet 1992,Ap 3,C3:1
Palazzo, Paul (Lighting Director)
Five Women in a Chapel 1991,Je 5,C22:3
Bundy 1992,Je 11,C16:3
Paley, Joel (Director)
Ruthless! 1992,My 13,C14:3
Ruthless! 1992,My 17,II:5:1
Paley, Joel (Lyricist)
Ruthless! 1992,My 13,C14:3
Ruthless! 1992,My 17,II:5:1

Paley, Joel (Playwright)
Ruthless! 1992,My 13,C14:3
Ruthless! 1992,My 17,II:5:1
Palmas, Joseph
Working One-Acts '91 1991,Je 26,C12:3
Comedy of Errors, The 1992,Ag 17,C11:3
Palmer, Hugh
Two Gentlemen of Verona 1991,D 12,C21:3
Palmer, Tim (Miscellaneous)
Vanquished by Voodoo 1992,Je 17,C17:1
Palmstierna-Weiss, Gunilla (Costume Designer)
Miss Julie 1991,Je 12,C13:1
Long Day's Journey into Night 1991,Je 17,C11:3
Doll's House, A 1991,Je 20,C13:3
Palmstierna-Weiss, Gunilla (Scenic Designer)
Miss Julie 1991,Je 12,C13:1
Long Day's Journey into Night 1991,Je 17,C11:3
Doll's House, A 1991,Je 20,C13:3
Palucki, Marek
Metro 1992,Ap 17,C1:3
Palumbo, Dennis (Original Author)
My Favorite Year 1992,D 11,C1:1
Panes, Michael (Playwright)
Staged Reading, The (Festival of One-Act Comedies,
Evening B) 1991,Mr 5,C16:3
Pankow, John
Scheherazade (Marathon '92, Series B) 1992,My
19,C18:3
Pannell, Lynn K. (Miscellaneous)
Testimony 1992,My 20,C18:1
Panova, Yelena
Greetings from Coney Island 1991,N 1,C19:1
Panson, Bonnie (Miscellaneous)
Seagull, The 1992,N 30,C11:1
Paolucci, Anne Marie (Miscellaneous)
Dog Logic 1992,N 10,C22:1
Pape, Ralph (Playwright)
Soap Opera (American Living Room Reupholstered,
The) 1992,S 30,C16:3
Papp, Joseph (Miscellaneous)
Home Show Pieces, The 1992,Ja 29,C17:1
'Tis Pity She's a Whore 1992,Ap 6,C11:2
Blood Wedding 1992,My 15,C3:3
As You Like It 1992,Jl 10,C3:1
Comedy of Errors, The 1992,Ag 17,C11:3
End of the World, The 1992,S 11,C2:3
Texts for Nothing 1992,N 2,C13:1
Woyzeck 1992,D 7,C14:1
Papp, Joseph (Producer)
Bright Room Called Day, A 1991,Ja 8,C11:1
Dead Mother: or Shirley Not All in Vain 1991,F
1,C3:1
Henry IV, Parts 1 and 2 1991,F 28,C15:1
Way of the World, The 1991,My 22,C11:1
Casanova 1991,My 29,C11:5
Othello 1991,Jl 7,II:1:1
Sonho de Uma Noite de Verao (Midsummer Night's
Dream, A) 1991,Ag 2,C3:1
Tempestad, La (Tempest, The) 1991,Ag 30,C3:3
Pappas, Evan
I Can Get It for You Wholesale 1991,Mr 11,C14:3
I Can Get It for You Wholesale 1991,Mr 24,II:5:1
March of the Falsettos and Falsettoland 1991,O
15,C13:1
My Favorite Year 1992,D 11,C1:1
My Favorite Year 1992,D 20,II:5:1
Paraiso, Nicky
When Lithuania Ruled the World, Part 3 1992,Ja
23,C14:4
Blue Heaven 1992,S 30,C16:3
Pardo, Amihai
Hamlet 1992,Ja 24,C3:1
Parichy, Dennis (Lighting Director)
Penn and Teller: The Refrigerator Tour 1991,Ap
4,C15:5
Babylon Gardens 1991,O 9,C17:1
Booth Is Back 1991,O 31,C18:1
Rose Quartet, The 1991,D 18,C23:1
Raft of the Medusa 1991,D 23,C15:1
Crazy He Calls Me 1992,Ja 28,C11:1
Boesman and Lena 1992,Ja 30,C15:1
Boesman and Lena 1992,F 9,II:5:1
Baltimore Waltz, The 1992,F 12,C15:3
Empty Hearts 1992,My 6,C18:3
Price, The 1992,Je 11,C13:1
Destiny of Me, The 1992,O 21,C15:1
Parise, Tony (Choreographer)
Pageant 1991,My 8,C12:3

Pitzu, Percy (Composer)
Mermaid Wakes, The 1991,F 25,C14:3
Plakias, Nick
Cure, The (Last Laugh, The) 1992,Jl 2,C16:1
Plakson, Suzie
Bete, La 1991,F 11,C11:3
Plass, Sally (Miscellaneous)
Appointment with a High-Wire Lady 1992,F
12,C17:1
Plass, Sara Gormley (Miscellaneous)
Novelist, The 1991,O 23,C19:1
Plate, Jennifer (Miscellaneous)
Encanto File, The, and Other Short Plays 1991,Ap
2,C14:5
Platt, Howard (Producer)
Speed of Darkness, The 1991,Mr 1,C1:1
Platt, Victoria Gabrielle
Jelly's Last Jam 1992,Ap 27,C11:1
Playten, Alice
Mysteries and What's So Funny?, The 1991,Jl
13,11:1
Mysteries and What's So Funny?, The 1992,D
18,C3:1
Plesent, Mark (Miscellaneous)
Let Me Live 1991,Ja 17,C21:1
Working One-Acts '91 1991,Je 26,C12:3
Plimpton, Martha
Pericles, Prince of Tyre 1991,N 25,C13:1
Pericles 1991,D 1,II:5:1
Plotnick, Jack
News in Review, The 1992,Ag 8,16:1
Sheik of Avenue B, The 1992,N 23,C14:1
Plowright, Joan
Time and the Conways 1991,Ja 6,II:5:1
Pluesch (Lighting Director)
Andre Heller's Wonderhouse 1991,O 21,C15:1
Plunkett, Maryann
Crucible, The 1991,D 11,C17:1
Crucible, The 1991,D 22,II:5:1
Little Hotel on the Side, A 1992,Ja 27,C17:1
Little Hotel on the Side, A 1992,F 9,II:5:1
Master Builder, The 1992,Mr 20,C3:1
Seagull, The 1992,N 30,C11:1
Plunkett, Paul
When Lithuania Ruled the World, Part 3 1992,Ja
23,C14:4
Pochos, Dede
Macbeth 1992,My 20,C18:1
Wilder, Wilder, Wilder: Three by Thornton 1992,D
21,C13:1
Pochos, Dede (Costume Designer)
Wilder, Wilder, Wilder: Three by Thornton 1992,D
21,C13:1
Pocius, Juozas
Uncle Vanya 1991,Je 17,C11:3
Poe, Marjorie
Cabaret Verboten 1991,O 29,C16:1
Poe, Marjorie (Miscellaneous)
Cabaret Verboten 1991,O 29,C16:1
Poe, Marjorie (Musical Director)
Cabaret Verboten 1991,O 29,C16:1
Poe, Richard
Our Country's Good 1991,Ap 30,C13:4
Approximating Mother 1991,N 7,C21:1
Poindexter, Jay
My Favorite Year 1992,D 11,C1:1
Poirier, Cynthia
Rules of Civility and Decent Behavior in Company
and Conversation 1991,Mr 25,C15:1
Polanco, Iraida
Charge It, Please 1991,My 29,C14:3
Oxcart, The (Carreta, La) 1992,Ap 22,C17:3
Polcsa, Juliet (Costume Designer)
Metro 1992,Ap 17,C1:3
Polcyn, Sharon
Twelfth Night 1992,Ag 15,12:3
Polgar, Jonathan R. (Miscellaneous)
Caretaker, The 1992,O 14,C18:3
Polis, Joel
Baby Dance, The 1991,Ap 1,C14:1
Baby Dance, The 1991,O 18,C5:1
Baby Dance, The 1991,O 27,II:5:1
Polito, Jon
Road to Nirvana 1991,Mr 8,C1:1
Road to Nirvana 1991,Mr 17,II:5:1
Pollan, Tracy
Jake's Women 1992,Mr 25,C17:3
Jake's Women 1992,Ap 5,II:5:1

Pollard, J. Courtney (Miscellaneous)
Earth and Sky 1991,F 5,C13:1
Pollard, Thelma L. (Miscellaneous)
Christchild 1992,D 2,C18:3
Pollitt, Barbara (Miscellaneous)
Jelly's Last Jam 1992,Ap 27,C11:1
Polseno, Robin
Man of La Mancha 1992,Ap 25,13:4
Pompeo, Augusto
Sonho de Uma Noite de Verao (Midsummer Night's
Dream, A) 1991,Ag 2,C3:1
Ponazecki, Joe
Fasting (Marathon '92, Series A) 1992,My 5,C15:1
Ponce, Sylvia
Walt Disney's World on Ice: Mickey Mouse
Diamond Jubilee 1991,F 5,C18:1
Ponce, Victor
Walt Disney's World on Ice: Mickey Mouse
Diamond Jubilee 1991,F 5,C18:1
Pont-Verges, Marcelo (Costume Designer)
Tempestad, La (Tempest, The) 1991,Ag 30,C3:3
Pont-Verges, Marcelo (Scenic Designer)
Tempestad, La (Tempest, The) 1991,Ag 30,C3:3
Pope, Peggy
Romeo and Juliet 1991,Ja 31,C21:1
Romeo and Juliet 1991,F 10,II:5:1
Pope, Stephanie
Jelly's Last Jam 1992,Ap 27,C11:1
Popovich, Gregory
Ringling Brothers and Barnum & Bailey Circus
1991,Mr 24,63:1
Porac, Matthew
On Borrowed Time 1991,O 10,C19:1
On Borrowed Time 1991,O 20,II:5:1
Porazzi, Arturo E. (Miscellaneous)
Jelly's Last Jam 1992,Ap 27,C11:1
Portas, Lynn (Composer)
Short Shots 1991,Ag 1,C14:4
Norman (Short Shots) 1991,Ag 1,C14:4
Poopsie (Short Shots) 1991,Ag 1,C14:4
Room 1203 (Short Shots) 1991,Ag 1,C14:4
Portas, Lynn (Lyricist)
Short Shots 1991,Ag 1,C14:4
Portas, Lynn (Miscellaneous)
Short Shots 1991,Ag 1,C14:4
Porteous, Cameron (Scenic Designer)
Charley's Aunt 1992,Jl 26,II:5:1
Porter, Adina
Mysteries and What's So Funny?, The 1992,D
18,C3:1
Porter, Cathy (Miscellaneous)
Job: A Circus 1992,Ja 15,C17:1
Porter, Dawn
Disney's World on Ice Starring Peter Pan 1992,F
12,C17:1
Porter, Maria
Almond Seller, The 1991,Mr 2,15:1
Porter, Mary Ed
Romeo and Juliet 1991,Ja 31,C21:1
Porter, Stephen (Director)
Getting Married 1991,Je 27,C14:3
Getting Married 1991,Jl 21,II:5:1
Porter, W. Ellis
Miss Saigon 1991,Ap 12,C1:2
Posner, Kenneth (Lighting Director)
Walking the Dead 1991,My 13,C12:1
Have-Little, The 1991,Je 12,C14:3
Servy-n-Bernice 4Ever 1991,O 23,C19:1
Canal Zone 1992,My 6,C18:3
Ruthless! 1992,My 13,C14:3
Spike Heels 1992,Je 5,C3:1
Flaubert's Latest 1992,Je 22,C15:3
Roads to Home, The 1992,S 18,C2:3
Madame MacAdam Traveling Theater, The 1992,O
21,C16:3
On the Bum, or the Next Train Through 1992,N
25,C19:1
On the Bum, or the Next Train Through 1992,N
29,II:5:1
Posner, Lindsay (Director)
Death and the Maiden 1991,Jl 31,C11:4
Post, Douglas (Playwright)
Earth and Sky 1991,F 5,C13:1
Earth and Sky 1991,F 10,II:5:1
Postel, Suzan
Groundhog 1992,My 4,C14:1

Poster, June (Miscellaneous)
Mysteries and What's So Funny?, The 1992,D
18,C3:1
Postlethwaite, Pete
Rise and Fall of Little Voice, The 1992,D 23,C9:3
Poston, Tom
Moonstone, The 1991,Ag 15,C16:4
Poteat, Brian
Lovers 1992,Mr 25,C19:3
Potencier, Martine (Miscellaneous)
Bay of Naples, The (Baie de Naples) 1991,Je
12,C14:3
Potter, Madeleine
Pygmalion 1991,Mr 25,C15:4
Getting Married 1991,Je 27,C14:3
Getting Married 1991,Jl 21,II:5:1
Crucible, The 1991,D 11,C17:1
Crucible, The 1991,D 22,II:5:1
Little Hotel on the Side, A 1992,Ja 27,C17:1
Little Hotel on the Side, A 1992,F 9,II:5:1
Master Builder, The 1992,Mr 20,C3:1
Master Builder, The 1992,Mr 29,II:5:1
Three Shouts from a Hill 1992,N 11,C18:3
Potter, Miles
Timon of Athens 1991,Je 30,II:5:1
Poul, Vaclav
Pinokio 1992,S 12,15:1
Pouw, Guido (Miscellaneous)
Manipulator 1992,S 12,15:1
Underdog 1992,S 12,15:1
Powell, Andrew (Miscellaneous)
Andre Heller's Wonderhouse 1991,O 21,C15:1
Powell, Linda
Macbeth 1992,My 20,C18:1
Wilder, Wilder, Wilder: Three by Thornton 1992,D
21,C13:1
Powell-Parker, Marianne (Costume Designer)
Death and Life of Sherlock Holmes, The 1991,N
27,C17:1
Powers, Amy (Lyricist)
Cinderella 1991,D 23,C16:4
Powers, Donna
Hauptmann 1992,My 29,C3:3
Powlett, Shareen
Mule Bone 1991,F 15,C1:4
Joy Solution 1991,D 16,C14:5
Pratt, Noni
As a Dream That Vanishes (A Meditation on the
Harvest of a Lifetime) 1991,N 13,C21:1
Pratt, Noni (Miscellaneous)
As a Dream That Vanishes (A Meditation on the
Harvest of a Lifetime) 1991,N 13,C21:1
Pratt, Wendee
God's Country 1992,Je 3,C15:4
Precious Pearl
Belle Reprieve 1991,Mr 11,C14:5
Precious Pearl (Playwright)
Belle Reprieve 1991,Mr 11,C14:5
Precious Pearl. *See also* **Shaw, Paul**
Premus, Judy
Sheik of Avenue B, The 1992,N 23,C14:1
Prentice, Amelia
Little Me 1992,Ap 1,C16:3
Press, Robert (Director)
We Should . . . (A Lie) 1992,Ja 29,C17:1
Press, Seymour Red (Miscellaneous)
Anna Karenina 1992,Ag 27,C17:2
Pressley, Brenda
And the World Goes 'Round: The Songs of Kander
and Ebb 1991,Mr 19,C11:2
And the World Goes 'Round 1991,Mr 24,II:5:1
Pressner, Stan (Lighting Director)
Maybe It's Cold Outside 1991,F 19,C14:3
Pressner, Stan (Miscellaneous)
Tubes 1991,N 20,C23:1
Preston, Corliss
Piece of My Heart, A 1991,N 4,C15:1
Preston, Michael
Radiant City, The 1991,O 7,C15:4
Kafka: Father and Son 1992,Ja 29,C17:1
Previte, Robert (Composer)
Moscow Circus—Cirk Valentin 1991,N 8,C3:1
Underground 1992,S 16,C16:3
Price, Dylan
Ready for the River 1991,O 16,C18:3
Price, Faye M.
Encanto File, The, and Other Short Plays 1991,Ap
2,C14:5

Q

R

Ramos, Richard Russell
Henry IV, Parts 1 and 2 1991,F 28,C15:1
Ramsay, Remak
Nick and Nora 1991,D 9,C11:3
Nick and Nora 1991,D 15,II:1:1
Ramsey, Galen G. (Miscellaneous)
Hauptmann 1992,My 29,C3:3
Ramsey, Kevin
Juba 1991,F 24,60:1
Five Guys Named Moe 1992,Ap 9,C17:2
Five Guys Named Moe 1992,Ap 19,II:5:1
Ramu, S.
Hippolytos 1992,N 25,C19:1
Rand, Randolph Curtis
Iphigenia in Tauris 1992,My 13,C14:3
Rand, Shuli
Hamlet 1992,Ja 24,C3:1
Randall, Bobbi
Mystery of Anna O, The 1992,S 23,C16:3
Randall, Tony
Little Hotel on the Side, A 1992,Ja 27,C17:1
Little Hotel on the Side, A 1992,F 9,II:5:1
Randall, Tony (Director)
Master Builder, The 1992,Mr 20,C3:1
Master Builder, The 1992,Mr 29,II:5:1
Randall, Tony (Miscellaneous)
Crucible, The 1991,D 22,II:5:1
Little Hotel on the Side, A 1992,Ja 27,C17:1
Master Builder, The 1992,Mr 20,C3:1
Master Builder, The 1992,Mr 29,II:5:1
Seagull, The 1992,N 30,C11:1
Seagull, The 1992,D 13,II:5:1
Randell, Patricia
Rivers and Ravines, The 1991,N 14,C28:6
Randolph, Beverley (Miscellaneous)
Metro 1992,Ap 17,C1:3
Randolph-Wright, Charles (Director)
Cabaret Verboten 1991,O 29,C16:1
Rang, Robert W. (Scenic Designer)
Ice Capades: On Top of the World 1991,Ja 22,C16:4
Tom Scallen's Ice Capades 1992,Ja 22,C17:1
Rankin, Steve (Miscellaneous)
Two Shakespearean Actors 1992,Ja 17,C1:1
Rao, Prasanna
Andre Heller's Wonderhouse 1991,O 21,C15:1
Andre Heller's Wonderhouse 1991,O 27,II:5:1
Raphael, Jay E. (Director)
Invention for Fathers and Sons 1992,Ja 22,C17:1
Raphel, David (Scenic Designer)
Making History 1991,Ap 11,C24:1
Down the Flats 1992,Ja 17,C5:1
Joyicity 1992,S 11,C2:3
Madame MacAdam Traveling Theater, The 1992,O 21,C16:3
Lament for Arthur Cleary, The 1992,N 4,C22:1
Rapoport, Julie
Tempest, The 1992,Jl 22,C17:1
Raposo, Joe (Composer)
Wonderful Life, A 1991,D 8,II:5:1
Rasche, David
Country Girl, The 1991,Ja 12,16:3
Country Girl, The 1991,Ja 13,II:5:1
Marathon 1991: New One-Act Plays, Series A 1991,My 26,57:5
Rashovich, Gordana
Misanthrope, The 1991,O 9,C18:3
Conversations with My Father 1992,Mr 30,C11:3
Conversations with My Father 1992,Ap 12,II:5:1
Raskind, Phyllis (Producer)
Jacques Brel Is Alive and Well and Living in Paris 1992,O 21,C16:3
Ratcliffe, Albert
As a Dream That Vanishes (A Meditation on the Harvest of a Lifetime) 1991,N 13,C21:1
Ratelle, Deborah (Miscellaneous)
Power Pipes 1992,O 24,18:1
Rathgeb, Laura
Trojan Women, The 1991,N 13,C21:1
As You Like It 1992,Ja 1,23:1
Rauber, Francois (Composer)
Jacques Brel Is Alive and Well and Living in Paris 1992,O 21,C16:3
Ravella, Don (Producer)
3 from Brooklyn 1992,N 20,C3:1
Ravitch, Barry (Miscellaneous)
Troubadour 1991,Je 5,C22:3
Rawlins, Adrian
Three Sisters, The 1991,Ja 6,II:5:1

Rawls, Hardy
CBS Live 1992,D 2,C18:3
Ray, Gary
When Lithuania Ruled the World, Part 3 1992,Ja 23,C14:4
Raye, Ina (Costume Designer)
Body and Soul 1991,Jl 10,C18:3
Raymond, Duncan
When Lithuania Ruled the World, Part 3 1992,Ja 23,C14:4
Rayne, Stephen (Director)
Tragedy of Macbeth, The 1991,Je 18,C13:4
Rayner, Martin
Underground 1991,Mr 3,64:1
Raynor, Michael
Festival of One-Act Comedies, Evening A 1991,F 12,C14:3
Raynor, Paul
Threepenny Opera 1991,Ag 20,C11:1
Raywood, Maggie (Costume Designer)
Letters to a Student Revolutionary 1991,My 16,C18:1
Rea, Stephen
Someone Who'll Watch Over Me 1992,N 24,C13:4
Someone Who'll Watch Over Me 1992,D 6,II:5:1
Reardon, Lisa A. (Playwright)
Dog and Fruit (I'm Sorry . . . Was That Your World?) 1992,S 25,C2:3
Reaves-Phillips, Sandra
Before It Hits Home 1991,F 17,II:5:1
Rebeck, Theresa (Playwright)
Spike Heels 1992,Je 5,C3:1
Big Mistake (I'm Sorry . . . Was That Your World?) 1992,S 25,C2:3
Rebelo, Jeffrey (Miscellaneous)
Hunchback of Notre Dame, The 1991,My 17,C3:1
Rebhorn, James
Life During Wartime 1991,Mr 6,C13:1
Innocents' Crusade, The 1992,Je 24,C16:5
On the Bum, or the Next Train Through 1992,N 25,C19:1
Recht, Ray (Scenic Designer)
Taking Stock 1991,Ja 17,C21:1
Fierce Attachment, A 1991,Mr 14,C18:1
Shmulnik's Waltz 1991,N 6,C21:1
Sunset Gang, The 1992,My 16,14:3
Dolphin Position, The 1992,O 9,C3:1
Them . . . Within Us 1992,D 26,15:1
Reckhaus, Martin (Director)
Humanity (Menschen, Die) 1991,Je 5,C22:3
Reddin, Keith
Angel of Death 1992,My 18,C15:1
Fortinbras 1992,O 14,C18:3
Reddin, Keith (Playwright)
Life During Wartime 1991,Mr 6,C13:1
Nebraska 1992,Je 3,C15:4
Innocents' Crusade, The 1992,Je 24,C16:5
Reddy, Brian
Crucible, The 1991,D 11,C17:1
Little Hotel on the Side, A 1992,Ja 27,C17:1
Redgrave, Jemma
Three Sisters, The 1991,Ja 6,II:5:1
Redgrave, Lynn
Three Sisters, The 1991,Ja 6,II:5:1
Little Hotel on the Side, A 1992,Ja 27,C17:1
Little Hotel on the Side, A 1992,F 9,II:5:1
Master Builder, The 1992,Mr 20,C3:1
Master Builder, The 1992,Mr 29,II:5:1
Redgrave, Vanessa
Three Sisters, The 1991,Ja 6,II:5:1
Reed, Bobby
Hunchback of Notre Dame, The 1991,My 17,C3:1
Reed, Janet (Miscellaneous)
Better Days 1991,Ja 24,C20:1
Joy Solution 1991,D 16,C14:5
Murder of Crows, A 1992,My 1,C18:1
Dolphin Position, The 1992,O 9,C3:1
Reed, Janet (Playwright)
Making Book 1992,F 12,C17:1
Reed, Jonathan Beck
Little Me 1992,Ap 1,C16:3
Reed, Rondi
Earthly Possessions 1991,S 4,C13:2
Reed, Vivian
High Rollers Social and Pleasure Club, The 1992,Ap 23,C15:2

Reehling, Joyce
On the Bum, or the Next Train Through 1992,N 25,C19:1
Rees, Adrian (Costume Designer)
Return to the Forbidden Planet 1991,O 14,C13:1
Rees, Roger
End of the Day, The 1992,Ap 8,C17:3
Reeves, Cheryl
Hunchback of Notre Dame, The 1991,My 17,C3:1
Reeves, Marc
Depression Show, The 1992,S 23,C16:3
Regan, Molly
Earthly Possessions 1991,S 4,C13:2
Crucible, The 1991,D 11,C17:1
Regulski, Jaroslaw (Miscellaneous)
Metro 1992,Ap 17,C1:3
Reid, Catherine (Musical Director)
Resistible Rise of Arturo Ui, The 1991,My 9,C15:1
Reid, Dennis
Candide 1992,Ap 24,C4:5
Reid, Graham (Playwright)
Remembrance 1992,O 4,II:5:1
Remembrance 1992,O 5,C13:4
Reid, Kate
All's Well That Ends Well 1991,N 25,C14:3
Reid, M. W.
Eating Raoul 1992,My 16,14:3
Reifsnyder, Daniel
To Kill a Mockingbird 1991,Mr 4,C13:4
Reilly, Don
Candida 1991,F 25,C13:1
Macbeth 1991,S 27,C15:1
All's Well That Ends Well 1991,N 25,C14:3
Virgin Molly, The 1992,Mr 27,C3:3
Fortinbras 1992,O 14,C18:3
Reilly, Michael
Learned Ladies, The (Femmes Savantes, Les) 1991,Mr 10,58:1
Resistible Rise of Arturo Ui, The 1991,My 9,C15:1
Reilly, T. L.
Deposing the White House 1991,D 4,C22:3
Reim, Alyson
Roleplay 1992,Ag 8,16:4
Reinecke, Hans-Peter
Love and Revolution: A Brecht Cabaret 1991,O 23,C17:4
Reinglas, Fred (Miscellaneous)
Road to Nirvana 1991,Mr 8,C1:1
Destiny of Me, The 1992,O 21,C15:1
Reingold, Jacquelyn
Group, A Therapeutic Moment (Manhattan Class One-Acts) 1992,Mr 11,C15:1
Reingold, Jacquelyn (Playwright)
A.M.L. (Manhattan Class One-Acts) 1992,Mr 11,C15:1
Reinhard, Timm (Miscellaneous)
Adding Machine, The 1992,S 16,C16:3
Reinheimer, Cathy
Nebraska 1992,Je 3,C15:4
Reis, Mark C.
Paint Your Wagon 1992,Ag 7,C2:3
Reisman, Jane (Lighting Director)
Like to Live 1992,My 6,C18:3
Tissue 1992,My 6,C18:3
Reisman, Shosh (Musical Director)
Hamlet 1992,Ja 24,C3:1
Relkin, Parris (Miscellaneous)
Moon for the Misbegotten, A 1992,S 23,C16:3
Remme, John
Funny Thing Happened on the Way to the Forum, A 1991,Mr 28,C16:4
Remsen, Michele
Twelfth Night or What You Will 1991,Je 19,C12:3
Renczynski, Bogdan
Dead Class, The 1991,Je 14,C15:1
Renderer, Scott
Unidentified Human Remains and the True Nature of Love 1991,S 20,C26:4
Unidentified Human Remains and the True Nature of Love 1991,S 29,II:5:1
Rene, Nikki
High Rollers Social and Pleasure Club, The 1992,Ap 23,C15:2
Renfield, Elinor (Director)
Practice (Marathon 1991: New One-Act Plays, Series B) 1991,Je 9,60:5
Renfroe, Brenda D. (Costume Designer)
Roleplay 1992,Ag 8,16:4

536

S

Saari, Erik Houston
Anna Karenina 1992,Ag 27,C17:2
Sabella, Ernie
Guys and Dolls 1992,Ap 15,C15:3
Sabella, Joseph
States of Shock 1991,My 17,C1:3
Sabellico, Richard (Choreographer)
I Can Get It for You Wholesale 1991,Mr 11,C14:3
I Can Get It for You Wholesale 1991,Mr 24,II:5:1
Rags 1991,D 4,C22:3
Sabellico, Richard (Director)
I Can Get It for You Wholesale 1991,Mr 11,C14:3
I Can Get It for You Wholesale 1991,Mr 24,II:5:1
Rags 1991,D 4,C22:3
Sabellico, Richard (Miscellaneous)
Invention for Fathers and Sons 1992,Ja 22,C17:1
Sablow, Jane (Scenic Designer)
Mermaid Wakes, The 1991,F 25,C14:3
Tempest, A 1991,O 16,C18:3
Sacharow, Lawrence (Director)
When the Bough Breaks 1991,My 8,C12:3
Sacharow, Lawrence (Miscellaneous)
When the Bough Breaks 1991,My 8,C12:3
Sachter, Robert L. (Producer)
Speed of Darkness, The 1991,Mr 1,C1:1
Sadan, Shlomo
Hamlet 1992,Ja 24,C3:1
Saden, Steven (Costume Designer)
Elephant's Tricycle, The 1992,Ag 27,C22:3
Saden, Steven (Scenic Designer)
Elephant's Tricycle, The 1992,Ag 27,C22:3
Sage, Alexandria
When They Take Me . . . In My Dreams (In Plain View, Series B) 1992,Ag 15,12:3
Saint, David (Director)
Flaubert's Latest 1992,Je 22,C15:3
Flaubert's Latest 1992,Je 28,II:5:1
St. Clair, Michael
We Should . . . (A Lie) 1992,Ja 29,C17:1
Ste. Croix, Gilles (Misc.)
Cirque du Soleil 1991,Ap 17,C15:1
St. John, Gregory
Saint Joan 1992,F 23,51:5
Tempest, The 1992,Jl 22,C17:1
St. John, Michelle
Winter Man 1991,F 21,C20:1
St. Paule, Irma
Words Divine: A Miracle Play 1992,N 25,C19:1
Saito, Dawn
Explosions 1992,Ja 15,C17:1
Saito, James
Ripples in the Pond (Marathon '92, Series B) 1992,My 19,C18:3
Sakato, Toshihiro
Dionysus 1991,Je 23,43:1
Saks, Gene (Director)
Lost in Yonkers 1991,F 22,C1:4
Lost in Yonkers 1991,Mr 3,II:1:1
Jake's Women 1992,Mr 25,C17:3
Jake's Women 1992,Ap 5,II:5:1
Saland, Ellen (Miscellaneous)
Private Lives 1992,F 21,C1:1
Salem, Kario
Native Speech 1991,Ap 17,C15:1
Salesky, Brian (Musical Director)
Man of La Mancha 1992,Ap 25,13:4
Salinger, Marilyn
First Is Supper 1992,Mr 18,C17:1
Salinger, Ross
On the Bum, or the Next Train Through 1992,N 25,C19:1
Salloum, Jayce (Original Author)
Columbus: The New World Order 1992,S 9,C15:1
Sallows, Tracy
Shimada 1992,Ap 24,C1:1
Salmon, Scott (Choreographer)
Easter Show 1991,Mr 25,C18:4
Radio City Easter Show, The 1992,Ap 15,C19:1
Salmon, Scott (Director)
Easter Show 1991,Mr 25,C18:4
Radio City Easter Show, The 1992,Ap 15,C19:1
Salonga, Lea
Miss Saigon 1991,Ap 12,C1:2

Miss Saigon 1991,Ap 21,II:5:1
Saltzman, Shelley (Costume Designer)
Dance of Death 1991,Ja 31,C21:3
Salvatore, John
Pageant 1991,My 8,C12:3
Sams, Jeffrey D.
Five Guys Named Moe 1992,Ap 9,C17:2
Five Guys Named Moe 1992,Ap 19,II:5:1
Samuel, Peter
Secret Garden, The 1991,Ap 26,C1:1
Samuelsohn, Howard
Comedy of Errors, The 1992,Ag 17,C11:3
Comedy of Errors, The 1992,Ag 23,II:5:1
Sananes, Adriana
Mayor of Zalamea, The (Alcalde de Zalamea, El) 1991,Ap 14,52:1
Esperando la Carroza (Waiting for the Hearse) 1991,S 18,C15:1
Sanchez, Betty (Miscellaneous)
Bay of Naples, The (Baie de Naples) 1991,Je 12,C14:3
Sanchez, Jaime
Deposing the White House 1991,D 4,C22:3
Sanchez, Rene
Mayor of Zalamea, The (Alcalde de Zalamea, El) 1991,Ap 14,52:1
Esperando la Carroza (Waiting for the Hearse) 1991,S 18,C15:1
Candida Erendira, La 1992,F 9,65:1
Sandberg, Steven (Composer)
Night Larry Kramer Kissed Me, The 1992,Je 25,C18:5
Sandberg, Steven (Musical Director)
Good Times Are Killing Me, The 1991,Ap 19,C3:1
Sandburg, Carl (Lyricist)
New Living Newspaper 1992,Mr 4,C19:1
Sandefur, James D. (Scenic Designer)
Pill Hill 1992,D 3,C18:5
Sanders, Abigael
Raft of the Medusa 1991,D 23,C15:1
Sanders, Scott (Producer)
Only the Truth Is Funny 1991,Ap 17,C15:1
Sanders, Ty (Miscellaneous)
Letters to a Student Revolutionary 1991,My 16,C18:1
Dressing Room, The (Gakuya) 1991,N 6,C21:1
Sanderson, Kirsten (Director)
Over Texas (Marathon 1991: New One-Act Plays, Series B) 1991,Je 9,60:5
Throwing Your Voice (Marathon '92, Series A) 1992,My 5,C15:1
Orpheus in Love 1992,D 16,C17:5
Sandifur, Virginia
Sheik of Avenue B, The 1992,N 23,C14:1
Sandkamp, Anthony
Marathon 1991: New One-Act Plays, Series B 1991,Je 9,60:5
Sandresky, Eleanor
Orpheus in Love 1992,D 16,C17:5
Sands, Colum (Miscellaneous)
Three Shouts from a Hill 1992,N 11,C18:3
Sands, Tara
Custody 1991,Ap 24,C10:5
Sands, Tommy (Composer)
Shadow of a Gunman, The 1991,N 27,C17:1
Sands, Tommy (Miscellaneous)
Three Shouts from a Hill 1992,N 11,C18:3
San Giacomo, Laura
Three Sisters 1992,Ja 19,II:5:1
Sansanowicz, Lenny
When Lithuania Ruled the World, Part 3 1992,Ja 23,C14:4
Sansonia, Michael (Musical Director)
Backers' Audition, A 1992,D 14,C14:1
Santana, Norman
Tempestad, La (Tempest, The) 1991,Ag 30,C3:3
Santha, Agnes
She Who Once Was the Helmet-Maker's Beautiful Wife 1992,Je 18,C15:1
Santiago, Glen M.
Amerikamachine 1991,My 29,C14:3
Homo Sapien Shuffle 1992,Mr 10,C12:5
Santiago, Saundra
Road to Nirvana 1991,Mr 8,C1:1
Road to Nirvana 1991,Mr 17,II:5:1
Spike Heels 1992,Je 5,C3:1
Once Removed 1992,D 7,C11:1

Santiago-Hudson, Ruben
Jelly's Last Jam 1992,Ap 27,C11:1
Santora, Bill
Man of La Mancha 1992,Ap 25,13:4
Santoro, Mark
It's a Bird, It's a Plane, It's Superman 1992,Je 20,16:4
Santos, Mylene (Miscellaneous)
Lament for Arthur Cleary, The 1992,N 4,C22:1
Santos, Ray
Miss Saigon 1991,Ap 12,C1:2
Sarandon, Chris
Nick and Nora 1991,D 9,C11:3
Nick and Nora 1991,D 15,II:1:1
Sargent, Michael (Miscellaneous)
George Washington Dances 1992,F 11,C16:1
Korea 1992,F 19,C16:3
Sarnataro, Patricia (Costume Designer)
Native Speech 1991,Ap 17,C15:1
Yokohama Duty 1991,My 22,C15:1
Marathon 1991: New One-Act Plays, Series C 1991,Je 19,C12:3
Saroyan, William (Playwright)
Time of Your Life, The 1991,O 2,C17:1
Time of Your Life, The 1991,O 6,II:5:1
Sartain, Darian
Moe Green Gets It in the Eye 1991,My 8,C12:3
Sasloe, Stephen A. (Musical Director)
News in Review, The 1992,Ag 8,16:1
Sato, Izuru
Nomura Kyogen Theater: Classic Comedies of Japan 1992,S 25,C2:4
Satta, Steven
Macbeth 1991,S 27,C15:1
Saucedo, Jose Guadalupe (Director)
Esplendor, El 1991,Je 23,43:1
Saunders, K. Leon (Miscellaneous)
Night Before Christmas, The: A Musical Fantasy 1992,D 17,C18:5
Saunders, Karen
Jacques Brel Is Alive and Well and Living in Paris 1992,O 21,C16:3
Saunders, Lyle (Producer)
One Neck 1992,My 22,C3:1
Savage, Melodee
Betsey Brown 1991,Ap 13,14:5
Savranskaya, Alla (Miscellaneous)
Moscow Circus—Cirk Valentin 1991,N 8,C3:1
Sawaryn, David (Costume Designer)
Marathon 1991: New One-Act Plays, Series B 1991,Je 9,60:5
George Washington Dances 1992,F 11,C16:1
Appointment with a High-Wire Lady 1992,F 12,C17:1
Korea 1992,F 19,C16:3
Sawney, Sheila
My Son the Doctor 1991,Ag 10,12:6
Sawyer, Wendy (Miscellaneous)
Invitations to Heaven (Questions of a Jewish Child) 1991,O 2,C18:3
Saxenmeyer, James
Joinin' of the Colors, A (Short Shots) 1991,Ag 1,C14:4
Sayers, Patrick (Director)
On the Razzle 1992,Ag 28,C2:3
Sayles, John (Playwright)
New Hope for the Dead (Working One-Acts '91) 1991,Je 26,C12:3
Sbarge, Raphael
Booth Is Back 1991,O 31,C18:1
Scallen, Tom (Director)
Ice Capades: On Top of the World 1991,Ja 22,C16:4
Tom Scallen's Ice Capades 1992,Ja 22,C17:1
Scallen, Tom (Producer)
Ice Capades: On Top of the World 1991,Ja 22,C16:4
Tom Scallen's Ice Capades 1992,Ja 22,C17:1
Scanlan, Dick
Pageant 1991,My 8,C12:3
Scanlan, John
As You Like It 1992,Jl 10,C3:1
Scanlon, Carol
I Can't Get Started 1991,Jl 13,12:5
Scanlon, Patricia
What Is This Everything? (Marathon '92, Series A) 1992,My 5,C15:1
Scanlon, Patricia (Playwright)
What Is This Everything? (Marathon '92, Series A) 1992,My 5,C15:1

Sullivan, Jo (Miscellaneous)
Most Happy Fella, The 1991,My 30,C13:1
Most Happy Fella, The 1992,F 14,C1:4
Sullivan, John Carver (Costume Designer)
Paint Your Wagon 1992,Ag 7,C2:3
Sullivan, John Frederick (Miscellaneous)
Camp Paradox 1992,N 9,C14:1
Sullivan, K. T.
A . . . My Name Is Still Alice 1992,N 23,C14:4
A . . . My Name Is Still Alice 1992,N 29,II:5:1
Sullivan, Kevin (Scenic Designer)
Carousel 1991,My 1,C15:1
Sullivan, Kim
Tempest, A 1991,O 16,C18:3
Sumac, Yma (Composer)
Penn and Teller: The Refrigerator Tour 1991,Ap
4,C15:5
Summerhays, Jane
Taking Steps 1991,F 21,C13:1
Real Inspector Hound, The 1992,Ag 14,C2:3
Noel and Gertie 1992,D 14,C14:1
Summers, Alison (Director)
Punch Me in the Stomach 1992,Je 4,C12:1
Summers, Alison (Playwright)
Punch Me in the Stomach 1992,Je 4,C12:1
Summers, LeVerne
Camp Logan 1991,F 7,C23:1
Sumner, David (Scenic Designer)
I Can Get It for You Wholesale 1991,Mr 11,C14:3
Sunnerstam, Christina
Orpheus in Love 1992,D 16,C17:5
Supper, Frederick M. (Producer)
Program for Murder 1992,N 25,C19:1
Supper, Patricia (Producer)
Program for Murder 1992,N 25,C19:1
Sur, Gorsha
Skating II 1991,Mr 4,C12:3
Chrysler Skating '92 1992,Mr 9,C11:1
Surovy, Nicolas
Breaking Legs 1991,My 20,C11:1
Surratt, Sonita
Testimony 1992,My 20,C18:1
Sussman, Mark
When the Wind Blows 1992,My 13,C14:3
Sussman, Mark (Lighting Director)
Accident: A Day's News 1991,S 23,C14:3
Sutcliffe, Steven
Charley's Aunt 1992,Jl 26,II:5:1
Sutherland, Brian
110 in the Shade 1992,Ag 2,II:5:1
Sutton, Pat (Scenic Designer)
Custody 1991,Ap 24,C10:5
Sutton, Robert Lindley
Meet Doyle MacIntyre (Currents Turned Awry)
1991,Je 26,C12:3
Sutton, Sheryl
When We Dead Awaken 1991,F 16,17:1
Suzuki, Tadashi (Director)
Dionysus 1991,Je 23,43:1
Suzuki, Tadashi (Scenic Designer)
Dionysus 1991,Je 23,43:1
Svich, Caridad (Playwright)
But There Are Fires (Encanto File, The, and Other
Short Plays) 1991,Ap 2,C14:5
Any Place But Here 1992,Je 9,C13:1
Swados, Elizabeth (Composer)
Mermaid Wakes, The 1991,F 25,C14:3
Job: A Circus 1992,Ja 15,C17:1
Job: A Circus 1992,Ja 19,II:5:1
Groundhog 1992,My 4,C14:1
Swados, Elizabeth (Director)
Mermaid Wakes, The 1991,F 25,C14:3
Job: A Circus 1992,Ja 15,C17:1
Job: A Circus 1992,Ja 19,II:5:1
Groundhog 1992,My 4,C14:1
Swados, Elizabeth (Miscellaneous)
Mermaid Wakes, The 1991,F 25,C14:3
Job: A Circus 1992,Ja 15,C17:1
Swados, Elizabeth (Playwright)
Groundhog 1992,My 4,C14:1
Swanson, Eric
Bete, La 1991,F 11,C11:3
Swartz, Bill (Lighting Director)
Pie Supper 1992,Jl 30,C20:1
Swartz, Marlene (Director)
Tubes 1991,N 20,C23:1
Swartz, Marlene (Miscellaneous)
Yokohama Duty 1991,My 22,C15:1

7 Blowjobs [reviewed as: SoHo Rep Presents]
1992,Ap 15,C19:1
Tone Clusters 1992,My 20,C18:1
Cross-Dressing in the Depression 1992,N 23,C15:3
Sweeney, Denis
Creditors 1992,F 7,C3:1
Sweet, Jeffrey (Playwright)
What About Luv? 1991,D 30,C14:1
What About Luv? 1992,Ja 5,II:1:1
Swenning, Richard
Ice Capades: On Top of the World 1991,Ja 22,C16:4
Swerling, Jo (Playwright)
Guys and Dolls 1992,Ap 15,C15:3
Guys and Dolls 1992,Ap 26,II:5:1
Swindler, Billy
Leonce and Lena 1991,Mr 24,63:5
Woyzeck 1991,Mr 24,63:5
Sychev, Valery
Moscow Circus—Cirk Valentin 1991,N 8,C3:1
Sydow, Karl (Producer)
Our Country's Good 1991,Ap 30,C13:4
Szarabajka, Keith
Search and Destroy 1992,F 27,C18:5
Search and Destroy 1992,Mr 8,II:5:1
Szawlowska, Ewa
Metro 1992,Ap 17,C1:3

T

Taborda, Diego
Mayor of Zalamea, The (Alcalde de Zalamea, El)
1991,Ap 14,52:1
Taccone, Tony (Director)
Angels in America 1992,N 10,C15:3
Tackaberry, Celia
Animal Crackers 1992,N 4,C19:4
Taddei, Michel
Orpheus in Love 1992,D 16,C17:5
Taffe, Kelly
Another Person Is a Foreign Country 1991,S
10,C11:1
Taffel, Stan
News in Review, The 1992,Ag 8,16:1
Taffner, Don (Producer)
Return to the Forbidden Planet 1991,O 14,C13:1
Holy Terror, The 1992,O 9,C3:1
Tafler, Jean
Philemon 1991,Ja 20,46:3
Tahmin, Mary
Our Lady of Perpetual Danger 1991,O 16,C18:3
Takayama, Haruo
Dionysus 1991,Je 23,43:1
Takemori, Yoichi
Dionysus 1991,Je 23,43:1
Talbert, Joel
49 Songs for a Jealous Vampire 1992,Jl 21,C11:2
Talbert, Joel (Miscellaneous)
49 Songs for a Jealous Vampire 1992,Jl 21,C11:2
Taleporos, Zoe
Four Baboons Adoring the Sun 1992,Mr 19,C15:3
Talman, Ann
Better Days 1991,Ja 24,C20:1
Tambella, Mark (Miscellaneous)
Yunus 1992,O 28,C18:1
Tammi, Tom
Visit, The 1992,Ja 24,C1:2
Tamosiunaite, Irena
Uncle Vanya 1991,Je 17,C11:3
Tanji, Lydia (Costume Designer)
Tubes 1991,N 20,C23:1
Tarantina, Brian
What Is This Everything? (Marathon '92, Series A)
1992,My 5,C15:1
Tarrant, Kevin
Winter Man 1991,F 21,C20:1
Tasahashi, Hiroko
Dionysus 1991,Je 23,43:1
Tasker, Jill
Private Lives 1992,F 21,C1:1
Private Lives 1992,Mr 1,II:1:1
Tate, Peter
Mystery of Anna O, The 1992,S 23,C16:3
Tate, Robert
Rags 1991,D 4,C22:3
Lightin' Out 1992,D 14,C14:1

Taukinaitis, Vytautas
Uncle Vanya 1991,Je 17,C11:3
Taylor, Andy
Juno 1992,O 31,16:4
Taylor, Brooke (Miscellaneous)
Awoke One (Marathon '92, Series B) 1992,My
19,C18:3
Taylor, David (Director)
Chess 1992,F 5,C19:3
Taylor, Dayton (Miscellaneous)
Blue Heat 1991,Mr 3,64:5
Taylor, Drew
Secret Garden, The 1991,Ap 26,C1:1
Taylor, Jeffrey (Miscellaneous)
Amerikamachine 1991,My 29,C14:3
Servy-n-Bernice 4Ever 1991,O 23,C19:1
Nebraska 1992,Je 3,C15:4
Taylor, Linda
On the Razzle 1992,Ag 28,C2:3
Taylor, Mike (Lighting Director)
As a Dream That Vanishes (A Meditation on the
Harvest of a Lifetime) 1991,N 13,C21:1
Taylor, Mike (Miscellaneous)
Law of Remains, The 1992,F 26,C19:1
Taylor, Myra
Mule Bone 1991,F 15,C1:4
Walking the Dead 1991,My 13,C12:1
Taylor, Noel (Costume Designer)
Lucifer's Child 1991,Ap 5,C1:1
Taylor, Patricia (Miscellaneous)
Learned Ladies, The (Femmes Savantes, Les)
1991,Mr 10,58:1
Resistible Rise of Arturo Ui, The 1991,My 9,C15:1
Bon Appetit! 1991,S 26,C18:3
Cabaret Verboten 1991,O 29,C16:1
Creditors 1992,F 7,C3:1
Candide 1992,Ap 24,C4:5
Goodnight Desdemona (Good Morning Juliet)
1992,O 22,C26:5
Taylor, Renee
One of the All-Time Greats 1992,Ap 17,C3:1
One of the All-Time Greats 1992,My 17,II:5:1
Taylor, Robyn Karen (Miscellaneous)
Earthly Possessions 1991,S 4,C13:2
Taylor, Steve
Ice Capades: On Top of the World 1991,Ja 22,C16:4
Taylor, Tammy (Miscellaneous)
Baby Dance, The 1991,Ap 1,C14:1
Baby Dance, The 1991,O 18,C5:1
Hotel Oubliette 1992,Ag 12,C14:1
Taylor-Corbett, Lynne (Choreographer)
Eating Raoul 1992,My 16,14:3
Tazewell, Paul (Costume Designer)
Before It Hits Home 1992,Mr 11,C17:2
Blood Knot 1992,Ap 12,65:3
Pill Hill 1992,D 3,C18:5
Tchassov, Stanislav
Carousel 1992,D 17,C11:3
Teagarden, Geraldine (Miscellaneous)
Fierce Attachment, A 1991,Mr 14,C18:1
Sunset Gang, The 1992,My 16,14:3
Tedlie, Daniel
Pygmalion 1991,Mr 25,C15:4
Teele, Mike (Miscellaneous)
Colette Collage 1991,My 15,C12:3
Teirstein, Alice (Choreographer)
Dance of Death 1991,Ja 31,C21:3
Teirstein, Andy (Composer)
Winter Man 1991,F 21,C20:1
Teirstein, Andy (Playwright)
Winter Man 1991,F 21,C20:1
Teixeira, Raul (Miscellaneous)
Nova Velha Estoria (New Old Story) 1991,Je
12,C14:3
Tejera, Jose
Tempestad, La (Tempest, The) 1991,Ag 30,C3:3
Telfer, John Cameron
Un-Conventional Wisdom: Campaign '92 Update
1992,Ag 4,C13:1
Teller
Penn and Teller: The Refrigerator Tour 1991,Ap
4,C15:5
Penn and Teller: The Refrigerator Tour 1991,Ap
7,II:5:1
Teller (Playwright)
Penn and Teller: The Refrigerator Tour 1991,Ap
4,C15:5

U

V

van Itallie, Jean-Claude (Playwright)
Ancient Boys 1991,F 24,59:5
Struck Dumb 1991,Mr 26,C15:1
Van Matre, David (Playwright)
Five Very Live (Five Very Live) 1992,Ja 8,C17:1
Van Patten, Joyce
Jake's Women 1992,Mr 25,C17:3
Jake's Women 1992,Ap 5,II:5:1
Van Tassel, Craig (Miscellaneous)
Penn and Teller: The Refrigerator Tour 1991,Ap 4,C15:5
Van Tieghem, David
Murder of Crows, A 1992,My 1,C18:1
Van Tieghem, David (Composer)
Murder of Crows, A 1992,My 1,C18:1
Van Tieghem, David (Miscellaneous)
Murder of Crows, A 1992,My 1,C18:1
Varela, Domingos (Miscellaneous)
Flash and Crash Days, The 1992,Jl 16,C15:1
Varnik, Reet Roos
Bitter Tears of Petra von Kant, The 1992,Je 18,C15:1
Varrone, Gene
Sunset Gang, The 1992,My 16,14:3
Vassiliev, Oleg
Skating II 1991,Mr 4,C12:3
Chrysler Skating '92 1992,Mr 9,C11:1
Vasut, Marek
Eagle in the Bubble 1991,Jl 16,C15:1
Vaughan, Melanie
Most Happy Fella, The 1992,F 14,C1:4
Vaughn, Betty
Life During Wartime 1992,Ag 11,C11:1
Vawter, Ron
Roy Cohn/Jack Smith 1992,My 15,C1:1
Penny Arcade Sex and Censorship Show, The 1992,Jl 28,C13:1
Vawter, Ron (Miscellaneous)
Roy Cohn/Jack Smith 1992,My 15,C1:1
Vayssiere, Marie
Today Is My Birthday 1991,Je 20,C16:1
Vazquez, Alden (Miscellaneous)
Earthly Possessions 1991,S 4,C13:2
Vazquez, Andres (Miscellaneous)
Tempestad, La (Tempest, The) 1991,Ag 30,C3:3
Vazquez, Miguel
Greetings from Coney Island 1991,N 1,C19:1
Veduccio, Jayson
Wilder, Wilder, Wilder: Three by Thornton 1992,D 21,C13:1
Vega, Bersaida
Jibaros Progresistas, Los 1991,Ag 29,C18:3
Candida Erendira, La 1992,F 9,65:1
Vega, Cecilia (Miscellaneous)
Sonho de Uma Noite de Verao (Midsummer Night's Dream, A) 1991,Ag 2,C3:1
Tempestad, La (Tempest, The) 1991,Ag 30,C3:3
Vega, Eileen
Blue Heat 1991,Mr 3,64:5
Vega, Lizandra
Candida Erendira, La 1992,F 9,65:1
Veiga, Lilia
Esperando la Carroza (Waiting for the Hearse) 1991,S 18,C15:1
Velez, Kimberly
When Lithuania Ruled the World, Part 3 1992,Ja 23,C14:4
Venito, Lenny
Club Soda 1991,Je 26,C12:3
Vennema, John C.
Selling Off 1991,Je 17,C13:4
Joined at the Head 1992,N 16,C16:1
Venton, Harley
Advice from a Caterpillar 1991,Ap 10,C15:1
Venture, Richard
Sum of Us, The 1991,Ja 6,II:1:2
Venuto, Maria (Miscellaneous)
Blue Heaven 1992,S 30,C16:3
Verderber, William
Sublime Lives 1991,S 16,C14:4
Invention for Fathers and Sons 1992,Ja 22,C17:1
Vergueiro, Maria Alice (Miscellaneous)
Sonho de Uma Noite de Verao (Midsummer Night's Dream, A) 1991,Ag 2,C3:1
Verheyen, Mariann (Costume Designer)
Philemon 1991,Ja 20,46:3
Vermont-Davis, Jennifer (Director)
Boxing Day Parade, The 1991,O 9,C18:3

Vernace, Kim (Miscellaneous)
Rags 1991,D 4,C22:3
Vetere, Richard (Playwright)
Gangster Apparel (Festival of One-Act Comedies, Evening A) 1991,F 12,C14:3
Vetrano, Stephen (Miscellaneous)
Cinderella 1991,D 23,C16:4
Vickery, John
Sisters Rosensweig, The 1992,O 23,C3:1
Sisters Rosensweig, The 1992,N 1,II:5:1
Victor, Craig
Atomic Opera 1991,O 30,C14:1
Vidal, Marta
Twelfth Night 1992,Ag 15,12:3
Viertel, Thomas (Producer)
Penn and Teller: The Refrigerator Tour 1991,Ap 4,C15:5
Song of Singapore 1991,My 24,C26:2
Oleanna 1992,O 26,C11:4
Vig, Joel
Ruthless! 1992,My 13,C14:3
Ruthless! 1992,My 17,II:5:1
Vig, Tommy (Composer)
Iron Bars 1991,N 20,C23:1
Vig, Tommy (Miscellaneous)
Iron Bars 1991,N 20,C23:1
Vilkaitis, Remigijus
Square, The 1991,Je 21,C3:5
Villafranca, Rodolfo
Tempestad, La (Tempest, The) 1991,Ag 30,C3:3
Villamor, Christen
Fairy Bones 1992,My 11,C11:1
Letters to a Student Revolutionary 1991,My 16,C18:1
Villar, Braulio
Mayor of Zalamea, The (Alcalde de Zalamea, El) 1991,Ap 14,52:1
Candida Erendira, La 1992,F 9,65:1
Villar, Braulio (Director)
Esperando la Carroza (Waiting for the Hearse) 1991,S 18,C15:1
Villarreal, Juan
Botanica 1991,Mr 5,C16:1
Mayor of Zalamea, The (Alcalde de Zalamea, El) 1991,Ap 14,52:1
Villegas, Liliana (Scenic Designer)
Candida Erendira, La 1992,F 9,65:1
Vincent, Irving (Director)
Christchild 1992,D 2,C18:3
Viola, Tom (Producer)
Night Larry Kramer Kissed Me, The 1992,Je 25,C18:5
Vitale, Angela
When We Dead Awaken 1991,Ja 20,II:5:1
When We Dead Awaken 1991,Mr 10,59:1
Leonce and Lena 1991,Mr 24,63:5
Woyzeck 1991,Mr 24,63:5
Julius Caesar 1991,My 15,C12:3
Skin of Our Teeth, The 1991,S 7,14:3
Geneva 1991,O 23,C19:1
Galileo 1991,D 11,C23:1
Mary Stuart 1992,F 26,C19:1
Endgame 1992,My 6,C18:3
Under Milk Wood 1992,S 4,C2:3
Idiot, The 1992,D 21,C13:1
Viverito, Sam (Choreographer)
Cut the Ribbons 1992,S 21,C14:1
Viviano, Sal
Weird Romance 1992,Je 23,C14:5
Vlachos, George
Walk on Lake Erie, A 1991,Mr 25,C15:1
Voda, Andy (Miscellaneous)
Invitations to Heaven (Questions of a Jewish Child) 1991,O 2,C18:3
Vogel, George
Shadow of a Gunman, The 1991,N 27,C17:1
Vogel, Martin
Dr. Faustus Lights the Lights 1992,Jl 9,C15:3
Vogel, Paula (Playwright)
Baltimore Waltz, The 1992,F 12,C15:3
Baltimore Waltz, The 1992,F 16,II:5:1
Vogel, Stephen J. (Translator)
White Bear, The 1992,Ap 1,C16:3
Voight, Jon
Seagull, The 1992,N 30,C11:1
Seagull, The 1992,D 13,II:5:1
Volk, Craig (Playwright)
Sparky and the Fitz 1991,Mr 10,59:1

Volkov, Aleksei (Miscellaneous)
Moscow Circus—Cirk Valentin 1991,N 8,C3:1
Volsch, Gabriele
Dr. Faustus Lights the Lights 1992,Jl 9,C15:3
Voltaire (Original Author)
Candide 1992,Ap 24,C4:5
von Bargen, Daniel
Beggars in the House of Plenty 1991,O 24,C17:4
Angel of Death 1992,My 18,C15:1
von Horvath, Odon (Playwright)
Tales from the Vienna Woods 1991,O 23,C17:4
von Mayrhauser, Jennifer (Costume Designer)
Glass Menagerie, The 1991,Ja 21,C11:1
Betsey Brown 1991,Ap 13,14:5
Three Sisters 1992,Ja 19,II:5:1
Crazy He Calls Me 1992,Ja 28,C11:1
von Mayrhauser, Peter (Miscellaneous)
Will Rogers Follies, The: A Life in Revue 1991,My 2,C17:1
von Nessen, Doug
Futz 1991,O 23,C19:1
Von Tilzer, Harry (Composer)
Sheik of Avenue B, The 1992,N 23,C14:1
von Waldenburg, Raina (Director)
Testimony 1992,My 20,C18:1
Voorhies, Ben (Miscellaneous)
Empty Boxes 1992,O 14,C18:3
Vos, Richard (Miscellaneous)
Catskills on Broadway 1991,D 6,C28:4
Vosloo, Arnold
Salome 1992,Je 26,C3:1
Voyt, Harriet (Costume Designer)
Oleanna 1992,O 26,C11:4
Voytulevitch, Igor
Rosencrantz and Guildenstern Are Dead 1992,Ja 31,C15:1
Voytulevitch, Natalya
Rosencrantz and Guildenstern Are Dead 1992,Ja 31,C15:1
Vukovic, Monique
Idiot, The 1992,D 21,C13:1
Vuoso, Teresa (Miscellaneous)
Forbidden Broadway 1991 1/2 1991,Je 21,C3:1
Forbidden Broadway 1991 1/2 1991,Jl 14,II:5:1
Forbidden Broadway/Forbidden Christmas 1991,D 13,C3:4
Best of Forbidden Broadway, The: 10th-Anniversary Edition 1992,Ap 9,C19:3
Vysohlid, Jiri (Composer)
Pinokio 1992,S 12,15:1

W

Waara, Scott
Most Happy Fella, The 1992,F 14,C1:4
Most Happy Fella, The 1992,F 16,II:5:1
Waddell, Eric W. (Producer)
Real Live Brady Bunch, The 1991,O 2,C18:3
Waddell, Wayne
Real Live Game Show, The 1991,O 2,C18:3
Wadsworth, Oliver
When Lithuania Ruled the World, Part 3 1992,Ja 23,C14:4
Wagemann, Kurt (Miscellaneous)
Damien 1991,O 9,C18:3
Bobby Sands, M.P. 1992,Je 18,C15:1
Wagenhoffer, Robert
Chrysler Skating '92 1992,Mr 9,C11:1
Wager, Douglas C. (Director)
Wonderful Life, A 1991,D 8,II:5:1
Wager, Douglas C. (Miscellaneous)
Time of Your Life, The 1991,O 2,C17:1
Waggett, David (Miscellaneous)
Tartuffe 1991,S 16,C14:4
Best of Schools, The 1992,Mr 11,C15:1
White Bear, The 1992,Ap 1,C16:3
Family Portrait 1992,Ap 22,C17:3
Wagner, Daniel MacLean (Lighting Director)
Fresh of Breath Air, A 1992,Je 11,C16:3
Wagner, Hank
Farewell Supper, The 1991,Mr 13,C12:4
Countess Mitzi 1991,Mr 13,C12:4
Tartuffe 1991,S 16,C14:4
Trojan Women, The 1991,N 13,C21:1
As You Like It 1992,Ja 1,23:1

Way, Lillo
Elephant's Tricycle, The 1992,Ag 27,C22:3
Weale, Andrew
Guise, The 1991,N 20,C23:1
Weatherford, Jeff
Glass Menagerie, The 1991,Ja 21,C11:1
Glass Menagerie, The 1991,Ja 27,II:5:1
Weatherly, Ellis (Producer)
Shimada 1992,Ap 24,C1:1
Weatherly, Mike (Producer)
Shimada 1992,Ap 24,C1:1
Weaver, Fritz
Crucible, The 1991,D 11,C17:1
Crucible, The 1991,D 22,II:5:1
Weaver, Lois
Belle Reprieve 1991,Mr 11,C14:5
Weaver, Lois (Director)
Belle Reprieve 1991,Mr 11,C14:5
Weaver, Lois (Playwright)
Belle Reprieve 1991,Mr 11,C14:5
Webb, Alexander
More Fun Than Bowling 1992,Ap 19,45:2
Webb, Helena (Miscellaneous)
Throwing Your Voice (Marathon '92, Series A) 1992,My 5,C15:1
Webber, Julian (Director)
Yokohama Duty 1991,My 22,C15:1
Tone Clusters 1992,My 20,C18:1
Webber, Julian (Miscellaneous)
Yokohama Duty 1991,My 22,C15:1
7 Blowjobs [reviewed as: SoHo Rep Presents] 1992,Ap 15,C19:1
Tone Clusters 1992,My 20,C18:1
Cross-Dressing in the Depression 1992,N 23,C15:3
Weber, Jake
Othello 1991,Je 28,C1:1
Mad Forest 1991,D 5,C15:3
Mad Forest 1991,D 22,II:5:1
Small Family Business, A 1992,Ap 28,C13:3
Small Family Business, A 1992,My 10,II:1:2
As You Like It 1992,Jl 10,C3:1
As You Like It 1992,Jl 19,II:5:1
Weeden, Jamie (Costume Designer)
Carousel 1991,My 1,C15:1
Weeks, Alan (Choreographer)
High Rollers Social and Pleasure Club, The 1992,Ap 23,C15:2
Weeks, Alan (Director)
High Rollers Social and Pleasure Club, The 1992,Ap 23,C15:2
Weeks, Todd
Three Sisters 1991,Ap 18,C14:3
Distant Fires 1991,O 17,C22:1
Virgin Molly, The 1992,Mr 27,C3:3
Distant Fires 1992,Ag 28,C2:3
Weems, Andrew
Fata Morgana 1991,My 3,C20:4
Midsummer Night's Dream, A 1992,Ap 8,C21:1
Dolphin Position, The 1992,O 9,C3:1
Weems, Marianne (Miscellaneous)
Roy Cohn/Jack Smith 1992,My 15,C1:1
Wegmann, Paul
Bella, Belle of Byelorussia 1992,Ja 20,C18:1
Weidman, Jerome (Original Author)
I Can Get It for You Wholesale 1991,Mr 11,C14:3
I Can Get It for You Wholesale 1991,Mr 24,II:5:1
Weidman, Jerome (Playwright)
I Can Get It for You Wholesale 1991,Mr 11,C14:3
I Can Get It for You Wholesale 1991,Mr 24,II:5:1
Weidman, John (Playwright)
Assassins 1991,Ja 28,C19:3
Assassins 1991,F 3,II:1:2
Weidner, Paul (Director)
Pygmalion 1991,Mr 25,C15:4
Who's Afraid of Virginia Woolf? 1992,Ja 23,C19:4
Hamlet 1992,Ap 3,C3:1
Weill, Jean D. (Producer)
Andre Heller's Wonderhouse 1991,O 21,C15:1
Weill, Kurt (Composer)
Threepenny Opera 1991,Ag 20,C11:1
Weinstein, Anita
When the Bough Breaks 1991,My 8,C12:3
Weis, Mari
Real Live Brady Bunch, The 1991,O 2,C18:3
Weiss, Gordon Joseph
Visit, The 1992,Ja 24,C1:2
Jelly's Last Jam 1992,Ap 27,C11:1

Weiss, Jeff
Casanova 1991,My 29,C11:5
Casanova 1991,Je 9,II:5:1
Real Inspector Hound, The 1992,Ag 14,C2:3
15-Minute Hamlet, The 1992,Ag 14,C2:3
Weiss, Jon
Ringling Brothers and Barnum & Bailey Circus 1991,Mr 24,63:1
Weiss, Norman (Miscellaneous)
Philemon 1991,Ja 20,46:3
Weiss, Norman (Musical Director)
Colette Collage 1991,My 15,C12:3
Weiss, S. Sydney (Playwright)
CBS Live 1992,D 2,C18:3
Weissberg, Jed (Miscellaneous)
End of the World, The 1992,S 11,C2:3
Sick But True 1992,S 12,15:1
Weissberg, Jed (Playwright)
Sick But True 1992,S 12,15:1
Weissler, Barry (Producer)
Falsettos 1992,Ap 30,C17:3
Weissler, Fran (Producer)
Falsettos 1992,Ap 30,C17:3
Weissman, Beth (Producer)
Small Family Business, A 1992,Ap 28,C13:3
Weissman, Cliff
Encanto File, The, and Other Short Plays 1991,Ap 2,C14:5
Raft of the Medusa 1991,D 23,C15:1
Raft of the Medusa 1992,Ja 5,II:1:1
Weissman, Walt K. (Producer)
Small Family Business, A 1992,Ap 28,C13:3
Weitz, Adam
Brother Truckers 1992,S 22,C13:3
Weitzenhoffer, Max (Producer)
Will Rogers Follies, The: A Life in Revue 1991,My 2,C17:1
Eating Raoul 1992,My 16,14:3
Weitzman, Ira (Miscellaneous)
Assassins 1991,Ja 28,C19:3
My Favorite Year 1992,D 11,C1:1
Welby, Donnah
Trojan Women, The 1991,N 13,C21:1
As You Like It 1992,Ja 1,23:1
Weldon, Charles
Little Tommy Parker Celebrated Colored Minstrel Show, The 1991,Mr 18,C16:4
Wellman, Mac (Playwright)
7 Blowjobs [reviewed as: SoHo Rep Presents] 1992,Ap 15,C19:1
Murder of Crows, A 1992,My 1,C18:1
Wells, Craig
Colette Collage 1991,My 15,C12:3
Balancing Act 1992,Je 17,C17:1
Wells, Deanna
Animal Crackers 1992,N 4,C19:4
Wells, Fred
Varieties 1992,Ja 8,C17:1
Wells, Mary Jane
Love Suicide at Schofield Barracks, The 1991,My 20,C13:5
Wells, Michael
Marathon 1991: New One-Act Plays, Series B 1991,Je 9,60:5
Fasting (Marathon '92, Series A) 1992,My 5,C15:1
Joined at the Head 1992,N 16,C16:1
Welminska, Teresa
Dead Class, The 1991,Je 14,C15:1
Welminski, Andrzej
Dead Class, The 1991,Je 14,C15:1
Today Is My Birthday 1991,Je 20,C16:1
Welsh, Margaret
1992 Young Playwrights Festival, The 1992,S 24,C18:4
Welti, Lisa
Bitter Tears of Petra von Kant, The 1992,Je 18,C15:1
Women in Black/Men in Gray 1992,O 28,C18:1
Welton, Charles
Marathon 1991: New One-Act Plays, Series C 1991,Je 19,C12:3
Welzer, Irving (Producer)
High Rollers Social and Pleasure Club, The 1992,Ap 23,C15:2
Wencker, Leigh-Anne
Paint Your Wagon 1992,Ag 7,C2:3
Wentworth, Scott
Getting Married 1991,Je 27,C14:3
Getting Married 1991,Jl 21,II:5:1

Gunmetal Blues 1992,Ap 8,C21:1
Anna Karenina 1992,Ag 27,C17:2
Wentworth, Scott (Playwright)
Gunmetal Blues 1992,Ap 8,C21:1
Weppner, Christina (Scenic Designer)
Estrella!: Who Can You Trust in a City of Lies? 1991,Ag 2,C24:4
Werner, Howard (Lighting Director)
Three Sisters 1991,Ap 18,C14:3
Distant Fires 1991,O 17,C22:1
Five Very Live 1992,Ja 8,C17:1
First Is Supper 1992,Mr 18,C17:1
Virgin Molly, The 1992,Mr 27,C3:3
Big Al 1992,My 18,C15:1
Angel of Death 1992,My 18,C15:1
Hello Muddah, Hello Fadduh 1992,D 9,C22:1
Werner, Stewart (Miscellaneous)
Road to Nirvana 1991,Mr 8,C1:1
Lips Together, Teeth Apart 1991,Je 26,C11:1
Rose Quartet, The 1991,D 18,C23:1
Empty Hearts 1992,My 6,C18:3
Destiny of Me, The 1992,O 21,C15:1
Seagull, The 1992,N 30,C11:1
Orpheus in Love 1992,D 16,C17:5
Wertenbaker, Timberlake (Playwright)
Our Country's Good 1991,Ap 30,C13:4
Our Country's Good 1991,My 19,II:5:1
Werthmann, Colleen
Mind King, The 1992,Ja 11,9:1
Wesson, Howard
Moe Green Gets It in the Eye 1991,My 8,C12:3
West, Cheryl L. (Playwright)
Before It Hits Home 1991,F 17,II:5:1
Before It Hits Home 1992,Mr 11,C17:2
West, Darron L. (Miscellaneous)
2 1992,Ag 12,C14:1
West, Gweneth (Costume Designer)
Roads to Home, The 1992,S 18,C2:3
West, Major
Midsummer Night's Dream, A 1992,Ap 8,C21:1
West, Peter (Lighting Director)
Almond Seller, The 1991,Mr 2,15:1
Westenberg, Robert
Secret Garden, The 1991,Ap 26,C1:1
Secret Garden, The 1991,My 5,II:5:1
Weston, Jon (Miscellaneous)
Man of La Mancha 1992,Ap 25,13:4
Weston, Karin (Miscellaneous)
Comedy of Errors, The 1992,F 9,65:2
Wetzel, Patrick
Animal Crackers 1992,N 4,C19:4
Wexler, Jerry (Miscellaneous)
High Rollers Social and Pleasure Club, The 1992,Ap 23,C15:2
Wexler, Susan (Producer)
From the Mississippi Delta 1991,N 12,C13:1
Wheeler, Ed
Little Tommy Parker Celebrated Colored Minstrel Show, The 1991,Mr 18,C16:4
Wheeler, Steve
Tom Scallen's Ice Capades 1992,Ja 22,C17:1
Wheeler, Timothy
Fortinbras 1992,O 14,C18:3
Whelan, Denise
Out of Focus (Short Shots) 1991,Ag 1,C14:4
Whelan, Joseph
Twelfth Night 1992,Ag 15,12:3
Whelan, Susan (Miscellaneous)
Remembrance 1992,O 5,C13:4
White, Al
Two Trains Running 1992,Ap 14,C13:4
Two Trains Running 1992,My 3,II:5:1
White, Alice
Candida 1991,F 25,C13:1
Fridays 1991,My 22,C15:1
Iron Bars 1991,N 20,C23:1
White, Alton F.
Miss Saigon 1991,Ap 12,C1:2
White, Amelia
Crazy for You 1992,F 20,C15:3
White, Conleth (Lighting Director)
I Can't Get Started 1991,Jl 13,12:5
White, Daisy
Festival of One-Act Comedies, Evening B 1991,Mr 5,C16:3
White, Diane (Miscellaneous)
Law of Remains, The 1992,F 26,C19:1

White, Gerald (Producer)
My Son the Doctor 1991,Ag 10,12:6
White, Jane
Coriolanus 1991,O 6,II:5:1
White, Jonathan
I Can't Get Started 1991,Jl 13,12:5
White, Julie
Stick Wife, The 1991,My 10,C4:3
Marathon 1991: New One-Act Plays, Series B
1991,Je 9,60:5
Spike Heels 1992,Je 5,C3:1
White, Karen Malina
Chain 1992,Mr 4,C19:1
White, Matt
On Borrowed Time 1991,O 10,C19:1
White, Melanie (Miscellaneous)
Murder of Crows, A 1992,My 1,C18:1
White, Michael
To Kill a Mockingbird 1991,Mr 4,C13:4
White, Otis (Miscellaneous)
Sublime Lives 1991,S 16,C14:4
White, Patrick
Anima Mundi 1992,F 5,C19:3
White, R. A. (Director)
Bert Sees the Light 1992,Mr 11,C15:1
White, R. A. (Playwright)
Bert Sees the Light 1992,Mr 11,C15:1
White, R. A. (Scenic Designer)
Bert Sees the Light 1992,Mr 11,C15:1
White, Susan (Lighting Director)
Juba 1991,F 24,60:1
White, Susan R. (Miscellaneous)
Time of Your Life, The 1991,O 2,C17:1
Before It Hits Home 1992,Mr 11,C17:2
Blood Knot 1992,Ap 12,65:3
White, Terri
Juba 1991,F 24,60:1
White, Welker
Life During Wartime 1991,Mr 6,C13:1
Search and Destroy 1992,F 27,C18:5
Innocents' Crusade, The 1992,Je 24,C16:5
White, William
Jersey Girls, The 1991,S 4,C16:1
Whitehead, Paxton
Little Hotel on the Side, A 1992,Ja 27,C17:1
Little Hotel on the Side, A 1992,F 9,II:5:1
Whitehead, Robert (Producer)
Speed of Darkness, The 1991,Mr 1,C1:1
Park Your Car in Harvard Yard 1991,N 8,C1:4
Whitehill, B. T. (Scenic Designer)
Red Scare on Sunset 1991,Ap 24,C10:5
Julie Halston's Lifetime of Comedy 1992,F 5,C19:3
Whitehurst, Scott
Black Eagles 1991,Ap 22,C13:1
Whiteley, Opal (Original Author)
Opal 1992,Mr 18,C17:1
Whitfield, Charles Malik
Christchild 1992,D 2,C18:3
Whitford, Bradley
Coriolanus 1991,O 6,II:5:1
Whitlock, Deidre (Costume Designer)
Night Before Christmas, The: A Musical Fantasy
1992,D 17,C18:5
Whitlock, Isiah, Jr.
Food and Shelter 1991,Je 2,65:1
Whitlock, Jennifer
Night Before Christmas, The: A Musical Fantasy
1992,D 17,C18:5
Whitsett, Jeffrey (Lighting Director)
Saint Joan 1992,F 23,51:5
Whitt, Garland
Criminals in Love 1992,O 7,C16:3
Whitted, Earl
Ascension Day 1992,Mr 4,C19:1
Twelfth Night 1992,Ag 15,12:3
Widdoes, Kathleen
Hamlet 1992,Ap 3,C3:1
Wideman, Beverly
Blue Heaven 1992,S 30,C16:3
Widmann, Thom (Miscellaneous)
Mad Forest 1991,D 5,C15:3
Punch Me in the Stomach 1992,Je 4,C12:1
Widulski, E. G. (Costume Designer)
Fata Morgana 1991,My 3,C20:4
Canal Zone 1992,My 6,C18:3
Widulski, Liz (Costume Designer)
Kafka: Father and Son 1992,Ja 29,C17:1
Law of Remains, The 1992,F 26,C19:1

Wierzel, Robert (Lighting Director)
Glass Menagerie, The 1991,Ja 21,C11:1
Glass Menagerie, The 1991,Ja 27,II:5:1
Unfinished Song, An 1991,F 19,C14:5
Wiggall, David (Miscellaneous)
Peacetime 1992,Mr 12,C21:1
Wiggins, James H., Jr.
Return to the Forbidden Planet 1991,O 14,C13:1
Wilbur, Richard (Translator)
Misanthrope, The 1991,O 9,C18:3
We Should . . . (A Lie) 1992,Ja 29,C17:1
Tartuffe 1992,O 16,C15:1
Wilcynski, Gregg (Producer)
Big Noise of '92: Diversions from the New
Depression 1991,D 18,C25:1
Wilde, Adrienne
I'm Sorry . . . Was That Your World? 1992,S
25,C2:3
Wilde, Oscar (Playwright)
Salome 1992,Je 26,C3:1
Salome 1992,Jl 5,II:5:1
Wilder, Alan
Earthly Possessions 1991,S 4,C13:2
Wilder, Andrew (Miscellaneous)
Paint Your Wagon 1992,Ag 7,C2:3
Wilder, Thornton (Playwright)
Matchmaker, The 1991,Ag 28,C12:4
Skin of Our Teeth, The 1991,S 7,14:3
Wilder, Wilder, Wilder: Three by Thornton 1992,D
21,C13:1
Wilding, Sloan
Funny Thing Happened on the Way to the Forum, A
1991,Mr 28,C16:4
Wildpret, Erich
Tempestad, La (Tempest, The) 1991,Ag 30,C3:3
Wilhelm, Le (Director)
Pie Supper 1992,Jl 30,C20:1
Wilhelm, Le (Playwright)
Pie Supper 1992,Jl 30,C20:1
Wilhelm, Le (Scenic Designer)
Pie Supper 1992,Jl 30,C20:1
Wilkins, David
When Lithuania Ruled the World, Part 3 1992,Ja
23,C14:4
Wilkof, Lee
Assassins 1991,Ja 28,C19:3
Assassins 1991,F 3,II:1:2
Willett, John (Translator)
Cabaret Verboten 1991,O 29,C16:1
William, David (Director)
Hamlet 1991,Je 30,II:5:1
Williams, Adrienne
Under Milk Wood 1992,S 4,C2:3
Idiot, The 1992,D 21,C13:1
Williams, Allen
On Borrowed Time 1991,O 10,C19:1
Williams, Allison M.
Jelly's Last Jam 1992,Ap 27,C11:1
Williams, Amir Jamal
Betsey Brown 1991,Ap 13,14:5
Williams, Carla Renata
Balm Yard, The 1991,Mr 25,C15:1
It's a Bird, It's a Plane, It's Superman 1992,Je
20,16:4
Back to Bacharach 1992,S 4,C2:3
Williams, Elizabeth (Producer)
Secret Garden, The 1991,Ap 26,C1:1
Crazy for You 1992,F 20,C15:3
Williams, Gareth
Family Portrait 1992,Ap 22,C17:3
Williams, Garry D.
Visit, The 1992,Ja 24,C1:2
Williams, Jacqueline
From the Mississippi Delta 1991,N 12,C13:1
From the Mississippi Delta 1991,N 24,II:5:1
Williams, Jim (Miscellaneous)
On the Razzle 1992,Ag 28,C2:3
Williams, Julius (Musical Director)
Balm Yard, The 1991,Mr 25,C15:1
Williams, Marshall (Lighting Director)
Life During Wartime 1992,Ag 11,C11:1
Williams, Ralph
Mysteries and What's So Funny?, The 1991,Jl
13,11:1
Booth Is Back 1991,O 31,C18:1
Williams, Rhys (Scenic Designer)
Saint Joan 1992,F 23,51:5

Williams, Robert Neff (Miscellaneous)
Romeo and Juliet 1991,Ja 31,C21:1
Williams, Sandra Lea (Miscellaneous)
Boesman and Lena 1992,Ja 30,C15:1
Williams, Tennessee (Original Author)
Belle Reprieve 1991,Mr 11,C14:5
Williams, Tennessee (Playwright)
Glass Menagerie, The 1991,Ja 21,C11:1
Glass Menagerie, The 1991,Ja 27,II:5:1
You Touched Me! 1991,Mr 31,II:5:1
Streetcar Named Desire, A 1992,Ap 13,C11:3
Streetcar Named Desire, A 1992,Ap 19,II:5:1
Williams, Treat
Speed-the-Plow 1991,Ag 15,C16:4
Williams, Vanessa
Mule Bone 1991,F 15,C1:4
Williamson, Nicol
I Hate Hamlet 1991,Ap 9,C13:3
I Hate Hamlet 1991,Ap 28,II:5:1
Williamson, Ruth
Good Times Are Killing Me, The 1991,Ap 19,C3:1
Guys and Dolls 1992,Ap 15,C15:3
Willis, Jack
Underground 1991,Mr 3,64:1
Wills, Ray
Little Me 1992,Ap 1,C16:3
Backers' Audition, A 1992,D 14,C14:1
Wilson, Atiba J. D.
Ascension Day 1992,Mr 4,C19:1
Wilson, August (Playwright)
Two Trains Running 1992,Ap 14,C13:4
Two Trains Running 1992,My 3,II:5:1
Wilson, Chandra
Good Times Are Killing Me, The 1991,Ap 19,C3:1
Good Times Are Killing Me, The 1991,Ag 9,C3:5
Wilson, Christopher C. (Translator)
Iron Bars 1991,N 20,C23:1
Wilson, Erin Cressida
A.M.L. (Manhattan Class One-Acts) 1992,Mr
11,C15:1
Cross-Dressing in the Depression 1992,N 23,C15:3
Wilson, Erin Cressida (Playwright)
Cross-Dressing in the Depression 1992,N 23,C15:3
Wilson, Felicia
Mermaid Wakes, The 1991,F 25,C14:3
1992 Young Playwrights Festival, The 1992,S
24,C18:4
Wilson, Jonathan (Director)
From the Mississippi Delta 1991,N 12,C13:1
Wilson, Katharina M. (Translator)
Iron Bars 1991,N 20,C23:1
Wilson, Kathleen
Idiot, The 1992,D 21,C13:1
Wilson, Kristen
Nick and Nora 1991,D 9,C11:3
Wilson, Lanford (Translator)
Three Sisters 1992,Ja 19,II:5:1
Wilson, Mark
Salome 1992,Je 26,C3:1
Wilson, Mary Louise
Flaubert's Latest 1992,Je 22,C15:3
Flaubert's Latest 1992,Je 28,II:5:1
Wilson, Michael R.
Learned Ladies, The (Femmes Savantes, Les)
1991,Mr 10,58:1
Resistible Rise of Arturo Ui, The 1991,My 9,C15:1
Wilson, Rainn
Midsummer Night's Dream, A 1992,Ap 8,C21:1
Wilson, Randolph F. (Lighting Director)
Lypsinka! Now It Can Be Lip-Synched 1992,Ag
22,11:1
Wilson, Rhonda
Estrella!: Who Can You Trust in a City of Lies?
1991,Ag 2,C24:4
Wilson, Robert (Director)
When We Dead Awaken 1991,F 16,17:1
Dr. Faustus Lights the Lights 1992,Jl 9,C15:3
Danton's Death 1992,N 3,C13:1
Wilson, Robert (Lighting Director)
When We Dead Awaken 1991,F 16,17:1
Danton's Death 1992,N 3,C13:1
Wilson, Robert (Miscellaneous)
When We Dead Awaken 1991,F 16,17:1
Dr. Faustus Lights the Lights 1992,Jl 9,C15:3
Wilson, Robert (Scenic Designer)
When We Dead Awaken 1991,F 16,17:1
Dr. Faustus Lights the Lights 1992,Jl 9,C15:3
Danton's Death 1992,N 3,C13:1

X

Baby Dance, The 1991,O 18,C5:1
Baby Dance, The 1991,O 27,II:5:1
Zimberg, Stuart (Producer)
Jacques Brel Is Alive and Well and Living in Paris 1992,O 21,C16:3
Zimet, Paul
Almond Seller, The 1991,Mr 2,15:1
Night Sky 1991,My 23,C24:5
Zimet, Paul (Director)
Fata Morgana 1991,My 3,C20:4
Zimet, Paul (Playwright)
Fata Morgana 1991,My 3,C20:4
Zimmerman, Carlota (Playwright)
Man at His Best (1991 Young Playwrights Festival, The) 1991,O 3,C20:3
Zimmerman, Leigh
Will Rogers Follies, The: A Life in Revue 1991,My 2,C17:1
Zimmerman, Mark
First Is Supper 1992,Mr 18,C17:1
Zimmerman, Zoey
Underground 1991,Mr 3,64:1
Zindel, Lizabeth
Night Sky 1991,My 23,C24:5
Shallow End, The (Marathon '92, Series A) 1992,My 5,C15:1
Zinger, Pablo (Composer)
Mayor of Zalamea, The (Alcalde de Zalamea, El) 1991,Ap 14,52:1

Zinn, David (Costume Designer)
Women in Beckett 1991,N 22,C17:1
Zippi, Daniel (Original Author)
When the Wind Blows 1992,My 13,C14:3
Zipprodt, Patricia (Costume Designer)
Crucible, The 1991,D 11,C17:1
Little Hotel on the Side, A 1992,Ja 27,C17:1
Little Hotel on the Side, A 1992,F 9,II:5:1
Master Builder, The 1992,Mr 20,C3:1
My Favorite Year 1992,D 11,C1:1
My Favorite Year 1992,D 20,II:5:1
Ziskie, Kurt
Awoke One (Marathon '92, Series B) 1992,My 19,C18:3
Zitelli, Steve (Miscellaneous)
Sick But True 1992,S 12,15:1
Zito, Ron (Miscellaneous)
Cut the Ribbons 1992,S 21,C14:1
Zmed, Adrian
Eating Raoul 1992,My 16,14:3
Zolkin, Vladislav
Moscow Circus 1991,Ja 18,C5:3
Zolli, Robert
Winter Man 1991,F 21,C20:1
Zollo, Frederick (Producer)
Our Country's Good 1991,Ap 30,C13:4
Death and the Maiden 1992,Mr 18,C15:4
Oleanna 1992,O 26,C11:4

Zolotor, Larry (Miscellaneous)
At the Crossroads 1992,N 11,C18:3
Zook, Benjamin
Real Live Brady Bunch, The 1991,O 2,C18:3
Zorich, Louis
Henry IV, Parts 1 and 2 1991,F 28,C15:1
Henry IV, Parts I and II 1991,Mr 10,II:5:1
Zorn, Danny
Club Soda 1991,Je 26,C12:3
Best of Schools, The 1992,Mr 11,C15:1
Zoueva, Marina (Choreographer)
Chrysler Skating '92 1992,Mr 9,C11:1
Zuber, Catherine (Costume Designer)
Heliotrope Bouquet by Scott Joplin and Louis Chauvin, The 1991,Mr 17,II:5:1
All's Well That Ends Well 1991,N 25,C14:3
Midsummer Night's Dream, A 1992,Ap 8,C21:1
Zuckerman, Lora
Another Person Is a Foreign Country 1991,S 10,C11:1
Zuckerman, Paul (Director)
Un-Conventional Wisdom: Campaign '92 Update 1992,Ag 4,C13:1
Zuckerman, Paul (Producer)
Un-Conventional Wisdom: Campaign '92 Update 1992,Ag 4,C13:1

Manhattan Rhythm Kings (Misc.)
Crazy for You 1992,F 20,C15:3
Manhattan Theater Club (Prod.)
American Plan, The 1991,Ja 6,II:1:2
Absent Friends 1991,F 13,C13:3
Absent Friends 1991,F 24,II:5:1
Life During Wartime 1991,Mr 6,C13:1
Black Eagles 1991,Ap 22,C13:1
Stick Wife, The 1991,My 10,C4:3
Lips Together, Teeth Apart 1991,Je 26,C11:1
Lips Together, Teeth Apart 1991,Jl 14,II:5:1
Beggars in the House of Plenty 1991,O 24,C17:4
Piece of My Heart, A 1991,N 4,C15:1
Lips Together, Teeth Apart 1992,Ja 12,II:5:1
Sight Unseen 1992,Ja 21,C13:3
Sight Unseen 1992,Ja 26,II:5:1
Boesman and Lena 1992,Ja 30,C15:1
Boesman and Lena 1992,F 9,II:5:1
Groundhog 1992,My 4,C14:1
Extra Man, The 1992,My 20,C15:4
Innocents' Crusade, The 1992,Je 24,C16:5
Mad Forest 1992,O 2,C5:1
Joined at the Head 1992,N 16,C16:1
Mazel Musicals (Prod.)
Sheik of Avenue B, The 1992,N 23,C14:1
Merry Enterprises Theater Inc. (Prod.)
Sublime Lives 1991,S 16,C14:4
Metraform's Annoyance Theater (Misc.)
Real Live Brady Bunch, The 1991,O 2,C18:3
Mexican Cultural Institute of New York (Misc.)
Words Divine: A Miracle Play 1992,N 25,C19:1
Milinazzo Productions (Prod.)
Criminals in Love 1992,O 7,C16:3
Miranda Theater Company (Prod.)
Lovers 1992,Mr 25,C19:3
MMM Inc. (Prod.)
Bundy 1992,Je 11,C16:3
Mountaintop Productions (Prod.)
Camp Logan 1991,F 7,C23:1
MTC Productions Inc. (Prod.)
Small Family Business, A 1992,Ap 28,C13:3
Music-Theater Group (Prod.)
Akin 1992,F 25,C14:5
Musical Theater Works (Misc.)
Ruthless! 1992,My 13,C14:3
Musical Theater Works (Prod.)
Love in Two Countries 1991,Ap 10,C15:1
Colette Collage 1991,My 15,C12:3

N

National Actors Theater (Prod.)
Crucible, The 1991,D 11,C17:1
Crucible, The 1991,D 22,II:5:1
Little Hotel on the Side, A 1992,Ja 27,C17:1
Little Hotel on the Side, A 1992,F 9,II:5:1
Master Builder, The 1992,Mr 20,C3:1
Master Builder, The 1992,Mr 29,II:5:1
Seagull, The 1992,N 30,C11:1
Seagull, The 1992,D 13,II:5:1
National Performance Network (Prod.)
Esplendor, El 1991,Je 23,43:1
Negro Ensemble Company (Prod.)
Little Tommy Parker Celebrated Colored Minstrel
Show, The 1991,Mr 18,C16:4
Neo Labos Dancetheater (Prod.)
Atomic Opera 1991,O 30,C14:1
New Faces/New Voices/New Visions (Misc.)
Stitsha 1991,Je 12,C14:3
New Federal Theater (Prod.)
Balm Yard, The 1991,Mr 25,C15:1
Zion 1991,D 5,C22:4
Chain 1992,Mr 4,C19:1
Late Bus to Mecca 1992,Mr 4,C19:1
Testimony 1992,My 20,C18:1
Christchild 1992,D 2,C18:3
New Georges (Prod.)
Vinegar Tom 1992,Mr 21,14:5
I'm Sorry . . . Was That Your World? 1992,S
25,C2:3
New York City Opera (Prod.)
110 in the Shade 1992,Ag 2,II:5:1
New York International Festival of the Arts (Misc.)
Miss Julie 1991,Je 12,C13:1

Nova Velha Estoria (New Old Story) 1991,Je
12,C14:3
Stitsha 1991,Je 12,C14:3
Dead Class, The 1991,Je 14,C15:1
Complete Works of William Shakespeare
(Abridged), The 1991,Je 15,17:1
Long Day's Journey into Night 1991,Je 17,C11:3
Uncle Vanya 1991,Je 17,C11:3
Tragedy of Macbeth, The 1991,Je 18,C13:4
Doll's House, A 1991,Je 20,C13:3
Today Is My Birthday 1991,Je 20,C16:1
Square, The 1991,Je 21,C3:5
Dionysus 1991,Je 23,43:1
Esplendor, El 1991,Je 23,43:1
Miss Julie 1991,Je 23,II:5:1
New York Repertory Theater Company (Prod.)
Nebraska 1992,Je 3,C15:4
New York Shakespeare Festival (Prod.)
Bright Room Called Day, A 1991,Ja 8,C11:1
Dead Mother: or Shirley Not All in Vain 1991,F
1,C3:1
Henry IV, Parts 1 and 2 1991,F 28,C15:1
Way of the World, The 1991,My 22,C11:1
Casanova 1991,My 29,C11:5
Othello 1991,Je 28,C1:1
Othello 1991,Jl 7,II:1:1
Sonho de Uma Noite de Verao (A Midsummer
Night's Dream) 1991,Ag 2,C3:1
Tempestad, La (The Tempest) 1991,Ag 30,C3:3
In the Jungle of Cities 1991,N 6,C19:2
Pericles, Prince of Tyre 1991,N 25,C13:1
Pericles 1991,D 1,II:5:1
Reno Once Removed 1991,D 30,C14:1
Reno Once Removed 1992,Ja 5,II:1:1
Home Show Pieces, The 1992,Ja 29,C17:1
Homo Sapien Shuffle 1992,Mr 10,C12:5
Before It Hits Home 1992,Mr 11,C17:2
'Tis Pity She's a Whore 1992,Ap 6,C11:2
Blood Wedding 1992,My 15,C3:3
Fires in the Mirror: Crown Heights, Brooklyn and
Other Identities 1992,My 15,C1:1
As You Like It 1992,Jl 10,C3:1
As You Like It 1992,Jl 19,II:5:1
Comedy of Errors, The 1992,Ag 17,C11:3
Comedy of Errors, The 1992,Ag 23,II:5:1
You Could Be Home Now 1992,O 12,C11:1
Texts for Nothing 1992,N 2,C13:1
Angels in America 1992,N 10,C15:3
Woyzeck 1992,D 7,C14:1
New York Street Theater Caravan (Prod.)
Blues in Rags 1991,Ap 10,C15:1
New York Telephone (Misc.)
Sonho de Uma Noite de Verao (A Midsummer
Night's Dream) 1991,Ag 2,C3:1
Tempestad, La (The Tempest) 1991,Ag 30,C3:3
New York Theater Workshop (Misc.)
Mad Forest 1992,O 2,C5:1
New York Theater Workshop (Prod.)
Light Shining in Buckinghamshire 1991,F 17,71:1
Jeffrey Essmann's Artificial Reality 1991,Ap
8,C11:1
Eve's Diary 1991,Ap 24,C10:5
Story of the Tiger, The 1991,Ap 24,C10:5
Mad Forest 1991,D 5,C15:3
Mad Forest 1991,D 22,II:5:1
Mad Forest 1992,Ja 25,13:3
Time Flies When You're Alive 1992,F 29,18:5
Lypsinka! A Day in the Life 1992,Ap 1,C16:3
Lypsinka! A Day in the Life 1992,Ap 12,II:5:1
Punch Me in the Stomach 1992,Je 4,C12:1
C. Colombo Inc.: Export/Import, Genoa 1992,O
28,C18:1
C. Colombo Inc.: Export/Import, Genoa 1992,N
1,II:5:1
Next Wave Festival (Misc.)
Invitations to Heaven (Questions of a Jewish Child)
1991,O 2,C18:3
Maturando 1991,O 17,C19:1
1991 (A Performance Chronicle of the Rediscovery
of America by the Warrior for Gringostroika)
1991,O 18,C14:5
Nimble Nijinas (Misc.)
Ringling Brothers and Barnum & Bailey Circus
1992,Ap 4,13:1
92d Street Y.M.-Y.W.H.A. (Prod.)
God of Vengeance 1992,N 4,C22:1
Ninth Street Theater (Misc.)
Accident: A Day's News 1991,S 23,C14:3

NMotion (Misc.)
Ringling Brothers and Barnum & Bailey Circus
1992,Ap 4,13:1
N.N.N. Company (Prod.)
Balancing Act 1992,Je 17,C17:1
Nomura Kyogen Theater (Misc.)
Nomura Kyogen Theater: Classic Comedies of Japan
1992,S 25,C2:4
Northern Lights Theater, Inc. (Prod.)
Five Women in a Chapel 1991,Je 5,C22:3
Hour of the Lynx 1992,Ap 1,C16:3
Nuyorican Poets Cafe (Prod.)
Life During Wartime 1992,Ag 11,C11:1

O

O Solo Mio Festival (Misc.)
Eve's Diary 1991,Ap 24,C10:5
Story of the Tiger, The 1991,Ap 24,C10:5
Time Flies When You're Alive 1992,F 29,18:5
Lypsinka! A Day in the Life 1992,Ap 1,C16:3
O'Casey Theater Company (Prod.)
Shadow of a Gunman, The 1991,N 27,C17:1
Three Shouts from a Hill 1992,N 11,C18:3
**Onassis, Alexander, Center for Hellenic Studies
(Misc.)**
Hippolytos 1992,N 25,C19:1
One Dream (Misc.)
Marathon 1991: New One-Act Plays, Series A
1991,My 26,57:5
Marathon 1991: New One-Act Plays, Series B
1991,Je 9,60:5
Marathon 1991: New One-Act Plays, Series C
1991,Je 19,C12:3
Making Book 1992,F 12,C17:1
God's Country 1992,Je 3,C15:4
Dolphin Position, The 1992,O 9,C3:1
One Dream Theater (Prod.)
True Story of a Woman Born in Iran and Raised to
Heaven in Manhattan, The 1991,My 15,C12:3
Dropper, The 1991,N 6,C21:1
126 Second Avenue Corporation (Prod.)
I Hate Hamlet 1991,Ap 9,C13:3
Jelly's Last Jam 1992,Ap 27,C11:1
One World Arts Foundation (Misc.)
Funny Thing Happened on the Way to the Forum, A
1991,Mr 28,C16:4
What About Luv? 1991,D 30,C14:1
After the Dancing in Jericho 1992,F 12,C17:1
Little Me 1992,Ap 1,C16:3
One World Arts Foundation (Prod.)
Making History 1991,Ap 11,C24:1
Grandchild of Kings 1992,F 17,C13:1
Joyicity 1992,S 11,C2:3
Frankly Brendan 1992,S 19,12:1
Six Wives 1992,O 10,16:1
Madame MacAdam Traveling Theater, The 1992,O
21,C16:3
Noel and Gertie 1992,D 14,C14:1
Ontological-Hysteric Theater (Misc.)
Eddie Goes to Poetry City: Part 2 1991,Ap 10,C15:1
Ontological-Hysteric Theater (Prod.)
Mind King, The 1992,Ja 11,9:1
Open Eye, The: New Stagings (Prod.)
Death and Life of Sherlock Holmes, The 1991,N
27,C17:1

P

Pan Asian Repertory Theater (Prod.)
Letters to a Student Revolutionary 1991,My
16,C18:1
Dressing Room, The (Gakuya) 1991,N 6,C21:1
Fairy Bones 1992,My 11,C11:1
Cambodia Agonistes 1992,N 13,C3:1
Paper Mill Playhouse (Prod.)
To Kill a Mockingbird 1991,Mr 4,C13:4
Wizard of Oz, The 1992,O 11,II:5:1
Paragon Park Productions (Prod.)
Bubbe Meises, Bubbe Stories 1992,O 30,C15:1

Q

R

S

T

U

V

W

Women's Project and Productions (Prod.)
Encanto File, The, and Other Short Plays 1991,Ap 2,C14:5
Night Sky 1991,My 23,C24:5
Approximating Mother 1991,N 7,C21:1
Chain 1992,Mr 4,C19:1
Late Bus to Mecca 1992,Mr 4,C19:1
Dream of a Common Language 1992,My 26,C12:5
You Could Be Home Now 1992,O 12,C11:1
Woolly Mammoth Theater Company (Prod.)
Fat Men in Skirts 1991,Ag 11,II:5:1
Wooster Group (Misc.)
Roy Cohn/Jack Smith 1992,My 15,C1:1
Working Theater (Prod.)
Let Me Live 1991,Ja 17,C21:1
Working One-Acts '91 1991,Je 26,C12:3
Ascension Day 1992,Mr 4,C19:1
Workmen's Circle (Misc.)
Marriage Contract, The 1991,N 6,C21:1
At the Crossroads 1992,N 11,C18:3
WPA Theater (Prod.)
Red Scare on Sunset 1991,Ap 24,C10:5
Club Soda 1991,Je 26,C12:3

White Rose, The 1991,O 30,C15:1
Bella, Belle of Byelorussia 1992,Ja 20,C18:1
Peacetime 1992,Mr 12,C21:1
Weird Romance 1992,Je 23,C14:5
Camp Paradox 1992,N 9,C14:1

Y

Ya Da Tiyatro (Prod.)
Yunus 1992,O 28,C18:1
Yale Repertory Theater (Prod.)
Underground 1991,Mr 3,64:1
Two Trains Running 1992,Ap 14,C13:4
Yara Arts Group (Prod.)
Explosions 1992,Ja 15,C17:1
Yegorov Troupe (Misc.)
Big Apple Circus 1992,N 5,C19:1
York Theater Company (Prod.)
Philemon 1991,Ja 20,46:3

Funny Thing Happened on the Way to the Forum, A 1991,Mr 28,C16:4
Misanthrope, The 1991,O 9,C18:3
What About Luv? 1991,D 30,C14:1
What About Luv? 1992,Ja 5,II:1:1
After the Dancing in Jericho 1992,F 12,C17:1
Little Me 1992,Ap 1,C16:3
Six Wives 1992,O 10,16:1
Noel and Gertie 1992,D 14,C14:1
Young Dog Ensemble (Prod.)
Depression Show, The 1992,S 23,C16:3
Young Playwrights, Inc. (Prod.)
1992 Young Playwrights Festival, The 1992,S 24,C18:4

Z

Zena Group Theater (Prod.)
Momentary Lapses 1991,My 29,C14:3